D0124685

# ENCYCLOPEDIA OF WORLD ART

## Vol. IV
## COSSA – ESCHATOLOGY

# ENCICLOPEDIA
# UNIVERSALE
# DELL'ARTE

*Sotto gli auspici della Fondazione Giorgio Cini*

ISTITUTO PER LA COLLABORAZIONE CULTURALE
VENEZIA–ROMA

# ENCYCLOPEDIA
# OF
# WORLD ART

McGRAW-HILL BOOK COMPANY, INC.

NEW YORK, TORONTO, LONDON

ENCYCLOPEDIA OF WORLD ART: VOLUME IV

Copyright © 1961 in England by McGraw-Hill Publishing Company Limited, London. All
rights reserved. Italian language edition, including all texts and plates, copyrighted © 1958
by the Istituto per la Collaborazione Culturale, Rome, under the Universal Copyright Conven-
tion. All plates herein are the property of the Istituto per la Collaborazione Culturale. Except
for brief quotations in reviews no part of this book may be reproduced without permission
in writing from the publishers.

Paper for plates and text supplied by Cartiere Burgo, Turin — Engraving by Zincotipia Altimani,
Milan — Black-and-white and color plates printed by Tipocolor, Florence — Text printed
by "L'Impronta," Florence — Binding by Stabilimento Stianti, San Casciano Val di Pesa,
Florence — Book cloth supplied by Kohorn Ltd., Egerton, near Bolton, England.

*Printed in Italy*

Library of Congress Catalog Card Number 59-13433
19458

11-29-63
Publisher
3500

# INTERNATIONAL COUNCIL OF SCHOLARS

Mario SALMI, University of Rome, President

Marcel AUBERT, Membre de l'Institut; Dean of Curators, Musées Nationaux, Paris, Vice President
Ernst KÜHNEL, Director, Islamic Section, Berlin Museum, Berlin-Dahlem, Vice President
Amedeo MAIURI, University of Naples; Sovrintendente alle Antichità della Campania, Vice President
Gisela M. A. RICHTER, Honorary Curator, Metropolitan Museum, New York, Vice President
Giuseppe TUCCI, University of Rome; President, Istituto Italiano per il Medio ed Estremo Oriente, Vice President

Alvar AALTO, Architect, Helsinki, Finland
Jean ALAZARD, University of Algiers
Andrew ALFÖLDI, University of Basel; Institute for Advanced Study, Princeton, N.J.
Carlo ANTI, University of Padua
Gilbert ARCHEY, Director, Auckland Institute and Museum, Auckland, New Zealand
A. S. ARDOJO, Jakarta, Indonesia
Bernard ASHMOLE, Oxford University
Jeannine AUBOYER, Curator, Musée Guimet, Paris
Ludwig BALDASS, formerly Director, Kunsthistorisches Museum, Vienna
Sir John D. BEAZLEY, formerly, Oxford University
† Bernhard BERENSON
W. BLAWATSKY, University of Moscow
† Albert BOECKLER, late Staatsbibliothekar, Munich
Axel BOËTHIUS, formerly, University of Göteborg; Director, Swedish Institute, Rome
Helmut T. BOSSERT, University of Istanbul
Cesare BRANDI, Director, Istituto Centrale del Restauro, Rome
Henri BREUIL, Membre de l'Institut; Collège de France, Paris
Peter H. BRIEGER, University of Toronto
Joseph BURKE, University of Melbourne
A. W. BYVANCK, University of Leiden
Guido CALOGERO, University of Rome
Alfonso CASO, Escuela Nacional de Arqueología y Historia, Mexico City
† Carlo CECCHELLI, University of Rome
Enrico CERULLI, Accademico dei Lincei, Rome
Jean CHARBONNEAUX, Curator in Chief, Musée du Louvre, Paris
Gino CHIERICI, formerly Superintendent of Monuments, Pavia
Fernando CHUECA Y GOITIA, Architect, Madrid
Sir Kenneth CLARK, Chairman, Arts Council of Great Britain, London
Giuseppe COCCHIARA, University of Palermo
George CŒDÈS, Honorary Director, Ecole Française d'Extrême-Orient, Paris
Paul COLLART, University of Geneva
W. G. CONSTABLE, formerly, Boston Museum of Fine Arts
Paolo D'ANCONA, University of Milan
Sir Percival DAVID, London
Guglielmo DE ANGELIS D'OSSAT, University of Rome
Otto DEMUS, President, Bundesdenkmalamt, Vienna
Paul DESCHAMPS, Director, Musée des Monuments Français, Paris
R. DE VAUX, Director, Ecole Française, Jerusalem
Prince DHANINIVAT, President, Siam Society, Bangkok
Adrian DIGBY, Keeper of the Department of Ethnography, British Museum, London
Einar DYGGVE, Director, Ny Carlsberg Foundation, Copenhagen
Gustav ECKE, Curator of Chinese Art, Honolulu Academy of Arts; University of Hawaii
Vadime ELISSÉEFF, Curator, Musée Cernuschi, Paris
A. P. ELKIN, University of Sydney
Richard ETTINGHAUSEN, Freer Gallery of Art, Washington, D.C.
Bishr FARÈS, Institut d'Egypte, Cairo
† Paul FIERENS, late Curator in Chief, Musées Royaux des Beaux-Arts de Belgique, Brussels
Giuseppe FIOCCO, University of Padua; Director, Istituto di Storia dell'Arte, Venice
Pierre FRANCASTEL, Director, Ecole des Hautes Etudes, Paris
Giuseppe FURLANI, University of Rome
Albert GABRIEL, Director, Institut Français d'Archéologie, Istanbul
O. C. GANGOLY, Calcutta
Antonio GARCÍA Y BELLIDO, University of Madrid
Alberto GIUGANINO, Vice President, Istituto Italiano per il Medio ed Estremo Oriente, Rome
L. Carrington GOODRICH, Universities of Buenos Aires and Montevideo; Columbia University, New York

R
703
E5Le
v.4

53189

Lloyd Goodrich, Director, Whitney Museum of American Art, New York
André Grabar, Collège de France, Paris
Basil Gray, Keeper of the Department of Oriental Antiquities, British Museum, London
Paolo Graziosi, University of Florence
Albert Grenier, Membre de l'Institut; Collège de France, Paris
Will Grohmann, Berlin
Walter Gropius, Architect, Harvard University, Cambridge, Mass.
José Gudiol, University of Barcelona; Director, Instituto Amatller de Arte Hispánico
Robert H. van Gulik, Minister for the Netherlands, Kuala Lumpur, Malaya
Hans Hahnloser, Bern
Charles Hentze, Trautheim, Darmstadt, Germany
Reinhard Herbig, University of Heidelberg; Director, German Archaeological Institute, Rome
Melville J. Herskovits, Northwestern University, Evanston, Ill.
L. H. Heydenreich, University of Munich; Director, Zentralinstitut für Kunstgeschichte, Munich
Henry-Russell Hitchcock, Smith College, Northampton, Mass.
Jean Hubert, Director, Ecole Nationale des Chartes, Paris
René Huyghe, Collège de France, Paris
José Imbelloni, University of Buenos Aires
† Guido von Kaschnitz-Weinberg, University of Frankfort on the Main
Ahmed Ali Khozad Khan, formerly Director, Archaeological Museum of Kabul
Carl Kjersmeier, Copenhagen
Elie Lambert, Membre de l'Institut; University of Paris
Ernst Langlotz, University of Bonn
Raymond Lantier, Membre de l'Institut; Curator in Chief, Musée des Antiquités Nationales, Saint-Germain-en-Laye
Oliver W. Larkin, Smith College, Northampton, Mass.
Sherman E. Lee, Director, The Cleveland Museum of Art
Paul Lemerle, Directeur d'Etudes, Ecole des Hautes Etudes, Paris
Doro Levi, Director, Scuola Archeologica Italiana, Athens
Roberto Longhi, University of Florence
Hans Peter L'Orange, University of Oslo
Stanislaw Lorentz, Director, National Museum, Warsaw
Otto Maenchen-Helfen, Department of Art, University of California, Berkeley
Arif Müfid Mansel, University of Istanbul
Millard Meiss, Institute for Advanced Study, Princeton, N.J.
Osvaldo F. A. Menghin, National University of La Plata, Argentina; Director, Anthropological Museum of the University
Alfred Merlin, Membre de l'Institut, Paris
Théodore Monod, Director, Institut Français d'Afrique Noire, Dakar
Bernard S. Myers, formerly, Department of Art, The City College, New York
Pier Luigi Nervi, Architect, Rome
† Frans M. Olbrechts, University of Ghent; late Director, Musée Royal du Congo Belge, Tervueren, Belgium
Rodolfo Pallucchini, University of Padua
Erwin Panofsky, Institute for Advanced Study, Princeton, N.J.
Senarat Paranavitana, University of Ceylon, Paradeniya, Ceylon
Luciano Petech, University of Rome
Helmut Petri, University of Cologne
Carlo Alberto Petrucci, formerly President, Accademia di San Luca; Director, Calcografia Nazionale, Rome
Sir Herbert Read, President, Institute of Contemporary Art, London
Alberto Rex Gonzales, Director, Museo de la Plata, Argentina
D. C. Röell, Director, Rijksmuseum, Amsterdam
Jorge Romero Brest, Universities of Buenos Aires and Montevideo
Andreas Rumpf, University of Cologne
Edouard Salin, Membre de l'Institut; Director, Musée Historique Lorrain, Nancy
† Alfred Salmony, Institute of Fine Arts, New York University
Meyer Schapiro, Columbia University, New York
Daniel Schlumberger, University of Strasbourg; Director, Délégation Archéologique Française en Afghanistan
Antonio Serrano, University of Córdoba, Argentina
Osvald Sirén, formerly Curator, National Museum, Stockholm
Calambur Śivaramamurti, Director, National Museum of India, New Delhi
Werner Speiser, University of Cologne; Director, Museum für Ostasiatische Kunst
Ugo Spirito, University of Rome
Alfred Steinmann, Director, Sammlung für Völkerkunde der Universität, Zurich
Philippe Stern, Curator in Chief, Musée Guimet, Paris
† William Suida, Samuel H. Kress Foundation, New York
Charles de Tolnay, Columbia University, New York
Paolo Toschi, University of Rome
A. D. Trendall, Australian National University, Canberra
Naoteru Ueno, President, Bijutsu Daigaku, Tokyo
Luís E. Valcárcel, Director, Museo Nacional de Historia, Lima, Peru
Lionello Venturi, University of Rome
Ernst Waldschmidt, University of Göttingen
Kurt Weitzmann, Princeton University, Princeton, N.J.
Sir Mortimer Wheeler, University of London
Paul S. Wingert, Columbia University, New York
Rudolf Wittkower, Columbia University, New York
Yukio Yashiro, Deputy Chairman, National Commission for Protection of Cultural Properties, Tokyo
Paola Zancani Montuoro, Accademica dei Lincei, Rome

## ITALIAN EDITORIAL BOARD

Editor in Chief, Massimo PALLOTTINO, University of Rome. Section Directors: *Modern Art*, Giulio Carlo ARGAN, University of Rome; *Oriental Art*, Mario BUSSAGLI, University of Rome; *Ancient Art*, Michelangelo CAGIANO DE AZEVEDO, Università Cattolica del S. Cuore, Milan; *Medieval Art*, Géza DE' FRANCOVICH, University of Rome; *Primitive Art*, Vinigi L. GROTTANELLI, Pontificium Athenaeum Urbanianum de Propaganda Fide, Rome. Consulting Director, Sabatino MOSCATI, University of Rome. Coordinating Committee: Mario SALMI, President of the International Council of Scholars; Giuseppe TUCCI, Vice President of the International Council of Scholars; Massimo PALLOTTINO; Giulio Carlo ARGAN.

## AMERICAN EDITORIAL ADVISORY COMMITTEE

W. G. CONSTABLE, formerly, Boston Museum of Fine Arts; Lloyd GOODRICH, Director, Whitney Museum of American Art; Henry-Russell HITCHCOCK, Smith College; Oliver W. LARKIN, Smith College; Bernard S. MYERS, formerly, The City College, New York; Gisela M. A. RICHTER, Honorary Curator, Metropolitan Museum of Art; Paul S. WINGERT, Columbia University.

## EDITORIAL STAFF FOR THE ISTITUTO

*Secretary General*: Prof. Alberto Mario CIRESE. *Section Editors*: Dr. Catia CAPRINO; Dr. Ernesta CERULLI; Dr. Paolo DAFFINÀ; Dr. Fernanda DE' MAFFEI; Dr. Luciana FERRARA; Dr. Luigi SALERNO. *Consulting Editor*: Prof. Eugenio BATTISTI. *Editorial Assistants*: Dr. Margherita ABBRUZZESE; Dr. Margherita ALOSI CATELLI; Dr. Tea COCO; Dr. Franco MICHELINI TOCCI; Dr. Italo SIGNORINI; Dr. Anna Maria TAMASSIA.

*Illustrations. Editor*: Prof. Alessandro MARABOTTINI MARABOTTI. *Consultants*: Maria CALANDRA, Architect; Dr. Enzo CREA. *Assistants*: Dr. Assunta ALBANESI; Dr. Gemma CORTESE DI DOMENICO; Dr. Raniero GNOLI; Bianca Maria MARABOTTINI MARABOTTI; Dr. Romolo STACCIOLI.

*Copy Editing and Index. Editor*: Dr. Nicola TERRANOVA. *Assistants*: Dr. Maria BORSELLINO DE LORENZO; Dr. Emilia BOSCHERINI GIANCOTTI; Adriana CARINI; Dr. Carlo DE SIMONE; Dr. Lia FORMIGARI; Dr. Elsa FUBINI; Prof. Gabriele GIANNANTONI; Dr. Alberto GIANQUINTO; Elena GRILLO; Dr. Mario MIEGGE; Dr. Elena OTTOLENGHI; Dr. Franco VOLTAGGIO. *Secretary*: Dr. Bianca Laura DE VITA FASANI.

## STAFF FOR THE McGRAW-HILL EDITION

*Managing Editor*: Robert W. CRANDALL. *Technical Editor*: Theresa C. BRAKELEY. *Associate Technical Editors*: Lawrence WEISBURG; Iris Roven BLUMENTHAL. *Assistant Technical Editors*: John KREMITSKE; Heidi THANES.
*Translation Editor*: Wayne DYNES.
*Consulting Editor*: Bernard S. MYERS.

## TECHNICAL STAFF

*Technical Director*: Dr. Matilde GIACHETTI, Casa Editrice G. C. Sansoni. *Technical Assistants*: Dr. Gianna BUTI; Dr. Catervo BLASI FOGLIETTI; Giulio GIUFFRIDA RUGGERI. *Photographic Archives, Director*: Dr. Enzo CREA. *Maps*: Dr. Mario RICCARDI. *Drawings*: Bruno BARINCI, Architect. *Assistant Draftsmen*: Ezio LIMITI; Salvatore MARINO.

Production and Technical Direction, English and Italian Editions

## CASA EDITRICE G. C. SANSONI
Florence

# ABBREVIATIONS

*Museums, Galleries, Libraries, and Other Institutions*

| | |
|---|---|
| Antikensamml. | — Antikensammlungen |
| Antiq. | — Antiquarium |
| Bib. Nat. | — Bibliothèque Nationale |
| Bib. Naz. | — Biblioteca Nazionale |
| Brera | — Pinacoteca di Brera |
| Br. Mus. | — British Museum |
| Cab. Méd. | — Cabinet des Médailles (Paris, Bibliothèque Nationale) |
| Cleve. Mus. | — Cleveland Museum |
| Coll. | — Collection, Collezione, etc. |
| Conserv. | — Palazzo dei Conservatori |
| Gal. | — Galerie |
| Gall. | — Gallery, Galleria |
| Gall. Arte Mod. | — Galleria di Arte Moderna |
| IsMEO | — Istituto Italiano per il Medio ed Estremo Oriente |
| Kunstgewerbemus. | — Kunstgewerbemuseum |
| Kunsthist. Mus. | — Kunsthistorisches Museum |
| Louvre | — Musée du Louvre |
| Medagl. | — Medagliere |
| Met. Mus. | — Metropolitan Museum |
| Mus. | — Museum, Museo, Musée, Museen, etc. |
| Mus. Ant. | — Museo di Antichità |
| Mus. Arch. | — Museo Archeologico |
| Mus. B. A. | — Musée des Beaux-Arts |
| Mus. Cap. | — Musei Capitolini |
| Mus. Civ. | — Museo Civico |
| Mus. Com. | — Museo Comunale |
| Mus. Etn. | — Museo Etnologico |
| Mus. Naz. | — Museo Nazionale |
| Mus. Vat. | — Musei Vaticani |
| Nat. Gall. | — National Gallery |
| Öst. Gal. | — Österreichische Galerie |
| Pin. | — Pinacoteca |
| Pin. Naz. | — Pinacoteca Nazionale |
| Pin. Vat. | — Pinacoteca Vaticana |
| Prado | — Museo del Prado |
| Rijksmus. | — Rijksmuseum |
| Samml. | — Sammlung |
| Staat. Mus. | — Staatliche Museen |
| Staatsbib. | — Staatsbibliothek |
| Städt. Mus. | — Städtisches Museum |
| Tate Gall. | — Tate Gallery |
| Uffizi | — Uffizi Gallery |
| Vict. and Alb. | — Victoria and Albert Museum |
| Villa Giulia | — Museo di Villa Giulia |

*Reviews and Miscellanies*

| | |
|---|---|
| AAE | — Archivio per la Antropologia e la Etnologia, Florence |
| AAnz | — Archäologischer Anzeiger, Berlin |
| AAs | — Artibus Asiae, Ascona, Italy |
| AB | — Art Bulletin, New York |
| AbhAkMünchen | — Abhandlungen der Bayerischen Akademie der Wissenschaften, Munich |
| AbhBerlAk | — Abhandlungen der Berliner Akademie der Wissenschaften, Berlin |
| AbhPreussAk | — Abhandlungen der preussischen Akademie der Wissenschaften, Berlin |

| | |
|---|---|
| ABIA | — Annual Bibliography of Indian Archaeology, Leiden |
| AC | — Archeologia Classica, Rome |
| ActaA | — Acta Archaeologica, Copenhagen |
| ActaO | — Acta Orientalia, Leiden, The Hague |
| AD | — Antike Denkmäler, Deutsches Archäologisches Institut, Berlin, Leipzig |
| AEA | — Archivio Español de Arqueología, Madrid |
| AEArte | — Archivio Español de Arte, Madrid |
| AErt | — Archaeologiai Értesitö, Budapest |
| AfA | — Archiv für Anthropologie, Brunswick |
| AfO | — Archiv für Orientforschung, Berlin |
| AfrIt | — Africa Italiana, Bergamo |
| AJA | — American Journal of Archaeology, Baltimore |
| AM | — Mitteilungen des deutschen archäologischen Instituts, Athenische Abteilung, Athens, Stuttgart |
| AmA | — American Anthropologist, Menasha, Wis. |
| AmAnt | — American Antiquity, Menasha, Wis. |
| AN | — Art News, New York |
| AnnInst | — Annali dell'Instituto di Corrispondenza Archeologica, Rome |
| AnnSAntEg | — Annales du Service des Antiquités de l'Egypte, Cairo |
| AntC | — L'Antiquité Classique, Louvain |
| AntJ | — The Antiquaries Journal, London |
| AnzAlt | — Anzeiger für die Altertumswissenschaft, Innsbruck, Vienna |
| AnzÖAk | — Anzeiger der Österreichischen Akademie der Wissenschaften, Vienna |
| APAmM | — Anthropological Papers of the American Museum of Natural History, New York |
| AQ | — Art Quarterly, Detroit |
| ArndtBr | — P. Arndt, F. Bruckmann, Griechische und römische Porträts, Munich, 1891 ff. |
| ARSI | — Annual Report of the Smithsonian Institution, Bureau of Ethnology, Washington, D.C. |
| ArtiFig | — Arti Figurative, Rome |
| ASAtene | — Annuario della Scuola Archeologica Italiana di Atene, Bergamo |
| ASI | — Archivio Storico Italiano, Florence |
| ASWI | — Archaeological Survey of Western India, Hyderabad |
| AttiPontAcc | — Atti della Pontificia Accademia Romana di Archeologia, Rome |
| AZ | — Archäologische Zeitung, Berlin |
| BA | — Baessler Archiv, Leipzig, Berlin |
| BABsch | — Bulletin van de Vereeninging tot bevordering der kennis van de antieke Beschaving, The Hague |
| BAC | — Bulletin du Comité des Travaux Historiques et Scientifiques, Section d'Archéologie, Paris |
| BAcBelg | — Bulletin de l'Académie Royale de Belgique, Cl. des Lettres, Brussels |
| BACr | — Bollettino di Archeologia Cristiana, Rome |
| BAFr | — Bulletin de la Société Nationale des Antiquaires de France, Paris |
| BAmSOR | — Bulletin of the American Schools of Oriental Research, South Hadley, Mass. |
| BArte | — Bollettino d'Arte del Ministero della Pubblica Istruzione, Rome |
| BByzI | — The Bulletin of the Byzantine Institute, Paris |

| | | |
|---|---|---|
| BCH | — | Bulletin de Correspondance Hellénique, Paris |
| BCom | — | Bollettino della Commissione Archeologica Comunale, Rome |
| Beazley, ABV | — | J. D. Beazley, Attic Black-figure Vase-painters, Oxford, 1956 |
| Beazley, ARV | — | J. D. Beazley, Attic Red-figure Vase-painters, Oxford, 1942 |
| Beazley, EVP | — | J. D. Beazley, Etruscan Vase-painting, Oxford, 1947 |
| Beazley, VA | — | J. D. Beazley, Attic Red-figured Vases in American Museums, Cambridge, 1918 |
| Beazley, VRS | — | J. D. Beazley, Attische Vasenmaler des rotfigurigen Stils, Tübingen, 1925 |
| BEFEO | — | Bulletin de l'Ecole Française d'Extrême-Orient, Hanoi, Saigon, Paris |
| BerlNZ | — | Berliner Numismatische Zeitschrift, Berlin |
| Bernoulli, GI | — | J. J. Bernoulli, Griechische Ikonographie, Munich, 1901 |
| Bernoulli, RI | — | J. J. Bernoulli, Römische Ikonographie, I, Stuttgart, 1882; II, 1, Berlin, Stuttgart, 1886; II, 2, Stuttgart, Berlin, Leipzig, 1891; II, 3, Stuttgart, Berlin, Leipzig, 1894 |
| BHAcRoum | — | Bulletin Historique, Académie Roumaine, Bucharest |
| BICR | — | Bollettino dell'Istituto Centrale del Restauro, Rome |
| BIE | — | Bulletin de l'Institut de l'Egypte, Cairo |
| BIFAN | — | Bulletin de l'Institut Français d'Afrique Noire, Dakar |
| BIFAO | — | Bulletin de l'Institut Français d'Archéologie Orientale, Cairo |
| BInst | — | Bollettino dell'Instituto di Corrispondenza Archeologica, Rome |
| BJ | — | Bonner Jahrbücher, Bonn, Darmstadt |
| BM | — | Burlington Magazine, London |
| BMBeyrouth | — | Bulletin du Musée de Beyrouth, Beirut |
| BMC | — | British Museum, Catalogue of Greek Coins, London |
| BMCEmp | — | H. Mattingly, Coins of the Roman Empire in the British Museum, London |
| BMFA | — | Museum of Fine Arts, Bulletin, Boston |
| BMFEA | — | Museum of Far-Eastern Antiquities, Bulletin, Stockholm |
| BMImp | — | Bollettino del Museo dell'Impero, Rome |
| BMMA | — | Bulletin of the Metropolitan Museum of Art, New York |
| BMQ | — | The British Museum Quarterly, London |
| BPI | — | Bollettino di Paletnologia Italiana, Rome |
| BrBr | — | H. Brunn, F. Bruckmann, Denkmäler griechischer und römischer Skulptur, Munich |
| Brunn, GGK | — | H. Brunn, Geschichte der griechischen Künstler, 2d ed., Stuttgart, 1889 |
| Brunn, GK | — | H. Brunn, Griechische Kunstgeschichte, Munich, I, 1893; II, 1897 |
| BSA | — | Annual of the British School at Athens, London |
| BSEI | — | Bulletin de la Société des Etudes Indochinoises, Saigon |
| BSOAS | — | Bulletin of the School of Oriental and African Studies, London |
| BSPF | — | Bulletin de la Société Préhistorique Française, Paris |
| BSR | — | Papers of the British School at Rome, London |
| Cabrol-Leclercq | — | F. Cabrol, H. Leclercq, Dictionnaire d'archéologie chrétienne et de liturgie, Paris, 1907 |
| CAF | — | Congrès Archéologique de France, Paris, 1841–1935 |
| CahA | — | Cahiers Archéologiques, Fin de l'Antiquité et Moyen-Age, Paris |
| CahArt | — | Cahiers d'art, Paris |
| CAJ | — | Central Asiatic Journal, Wiesbaden |
| CEFEO | — | Cahiers de l'Ecole Française d'Extrême-Orient, Paris |
| CIE | — | Corpus Inscriptionum Etruscarum, Lipsiae |
| CIG | — | Corpus Inscriptionum Graecarum, Berolini |
| CIL | — | Corpus Inscriptionum Latinarum, Berolini |
| CIS | — | Corpus Inscriptionum Semiticarum, Parisiis |
| Coh | — | H. Cohen, Description historique des Monnaies frappées sous l'Empire Romain, Paris |
| Collignon, SG | — | M. Collignon, Histoire de la sculpture grecque, Paris, I, 1892; II, 1897 |
| Comm | — | Commentari, Florence, Rome |
| Cr | — | La Critica, Bari |
| CRAI | — | Comptes Rendus de l'Académie des Inscriptions et Belles-Lettres, Paris |
| CrArte | — | La Critica d'Arte, Florence |
| CVA | — | Corpus Vasorum Antiquorum |
| DA | — | N. Daremberg, N. Saglio, Dictionnaire des antiquités grecques et romaines, Paris, 1877–1912 |
| Dehio, I–V | — | G. Dehio, Handbuch der deutschen Kunstdenkmäler, Berlin, I, Mitteldeutschland, 1927; II, Nordostdeutschland, 1926; III, Süddeutschland, 1933; IV, Südwestdeutschland, 1933; V, Nordwestdeutschland, 1928 |
| Dehio, DtK | — | G. Dehio, Geschichte der deutschen Kunst, 4 vols., Berlin, 1930–34 |
| Dehio-Von Bezold | — | G. Dehio, G. von Bezold, Die kirchliche Baukunst des Abendlandes, Stuttgart, 1892–1901 |
| DissPontAcc | — | Dissertazioni della Pontificia Accademia Romana di Archeologia, Rome |
| EA | — | Photographische Einzelaufnahmen, Munich, 1893 ff. |
| EAA | — | Enciclopedia dell'Arte Antica, Rome, I, 1958; II, 1959 |
| EArt | — | Eastern Art, London |
| EB | — | Encyclopaedia Britannica |
| EI | — | Enciclopedia Italiana, Rome, 1929 ff. |
| EphDR | — | Ephemeris Dacoromana, Rome |
| ESA | — | Eurasia Septentrionalis Antiqua, Helsinki |
| Espér | — | E. Espérandieu, R. Lantier, Recueil général des Bas-Reliefs de la Gaule Romaine, Paris |
| FA | — | Fasti Archaeologici, Florence |
| FD | — | Fouilles de Delphes, Paris |
| Friedländer | — | Max Friedländer, Altniederländische Malerei, Berlin, 1924–37 |
| Furtwängler, AG | — | A. Furtwängler, Antiken Gemmen, Leipzig, Berlin, 1900 |
| Furtwängler, BG | — | A. Furtwängler, Beschreibung der Glyptothek König Ludwig I zu München, Munich, 1900 |
| Furtwängler, KlSchr | — | A. Furtwängler, Kleine Schriften, Munich, 1912 |
| Furtwängler, MP | — | A. Furtwängler, Masterpieces of Greek Sculpture, London, 1895 |
| Furtwängler, MW | — | A. Furtwängler, Meisterwerke der griechischen Plastik, Leipzig, Berlin, 1893 |
| Furtwängler-Reichhold | — | A. Furtwängler, K. Reichhold, Griechische Vasenmalerei, Munich |
| GBA | — | Gazette des Beaux-Arts, Paris |
| GJ | — | The Geographical Journal, London |
| HA | — | Handbuch der Archäologie in Rahmen des Handbuchs der Altertumswissenschaft .... herausgegeben von Walter Otto, Munich, 1939–53 |
| HBr | — | P. Herrmann, F. Bruckmann, Denkmäler der Malerei des Altertums, Munich, 1907 |
| Helbig-Amelung | — | W. Helbig, W. Amelung, E. Reisch, F. Weege, Führer durch die öffentlichen Sammlungen klassischer Altertümer in Rom, Leipzig, 1912–13 |
| HJAS | — | Harvard Journal of Asiatic Studies, Cambridge, Mass. |
| Hoppin, Bf | — | J. C. Hoppin, A Handbook of Greek Black-figured Vases with a Chapter on the Red-figured Southern Italian Vases, Paris, 1924 |
| Hoppin, Rf | — | J. C. Hoppin, A Handbook of Attic Red-figured Vases Signed by or Attributed to the Various Masters of the Sixth and Fifth Centuries B.C., Cambridge, 1919 |
| HSAI | — | J. H. Steward, ed., Handbook of South American Indians, 6 vols., Bureau of American Ethnology, Bull. 143, Washington, D.C., 1946–50 |
| IAE | — | Internationales Archiv für Ethnographie, Leiden |
| IBAI | — | Bulletin de l'Institut Archéologique Bulgare, Sofia |
| IG | — | Inscriptiones Graecae, Berolini |
| ILN | — | Illustrated London News, London |
| IPEK | — | Ipek, Jahrbuch für prähistorische und ethnographische Kunst, Berlin |
| JA | — | Journal Asiatique, Paris |

| | | | |
|---|---|---|---|
| JAF | — Journal of American Folklore, Lancaster, Pa. | MnbKw | — Monatsberichte über Kunstwissenschaft |
| JAOS | — Journal of the American Oriental Society, Baltimore | MPA | — Monumenti della pittura antica scoperti in Italia, Rome |
| JAS | — Journal of the African Society, London | MPiot | — Fondation Eugène Piot, Monuments et Mémoires, Paris |
| JBORS | — Journal of the Bihar and Orissa Research Society, Patna, India | MPontAcc | — Memorie della Pontificia Accademia Romana di Archeologia, Rome |
| JdI | — Jahrbuch des deutschen archäologischen Instituts, Berlin | NBACr | — Nuovo Bollettino di Archeologia Cristiana, Rome |
| JEA | — Journal of Egyptian Archaeology, London | NChr | — Numismatic Chronicle and Journal of the Royal Numismatic Society, London |
| JhbKhSammlWien | — Jahrbuch der kunsthistorischen Sammlungen in Wien, Vienna | NIFAN | — Notes de l'Institut Français d'Afrique Noire, Dakar |
| JhbPreussKSamml | — Jahrbuch der preussischen Kunstsammlungen, Berlin | NR | — Numismatic Review, New York |
| JHS | — Journal of Hellenic Studies, London | NSc | — Notizie degli Scavi di Antichità, Rome |
| JIAI | — Journal of Indian Art and Industry, London | NZ | — Numismatische Zeitschrift, Vienna |
| JIAN | — Journal International d'Archéologie Numismatique, Athens | OAZ | — Ostasiatische Zeitschrift, Vienna |
| JISOA | — Journal of the India Society of Oriental Art, Calcutta | ÖJh | — Jahreshefte des Österreichischen archäologischen Institut, Vienna |
| JNES | — Journal of Near Eastern Studies, Chicago | ÖKT | — Österreichische Kunsttopographie, Vienna |
| JPS | — Journal of the Polynesian Society, Wellington, New Zealand | OMLeiden | — Oudheidkundige Mededeelingen van het Rijksmuseum van Oudheten te Leiden, Leiden |
| JRAI | — Journal of the Royal Anthropological Institute of Great Britain and Ireland, London | OpA | — Opuscola Archaeologica, Lund |
| JRAS | — Journal of the Royal Asiatic Society, London | Overbeck, SQ | — J. Overbeck, Die antiken Schriftquellen zur Geschichte der bildenden Künste bei den Griechen, Leipzig, 1869 |
| JRS | — Journal of Roman Studies, London | | |
| JS | — Journal des Savants, Paris | PEQ | — Palestine Exploration Quarterly, London |
| JSA | — Journal de la Société des Africanistes, Paris | Perrot-Chipiez | — G. Perrot, C. Chipiez, Histoire de l'art dans l'Antiquité, Paris, I, 1882; II, 1884; III, 1885; IV, 1887; V, 1890; VI, 1894; VII, 1898; VIII, 1903; IX, 1911 |
| JSAH | — Journal of the Society of Architectural Historians, Charlottesville, Va. | | |
| JSAm | — Journal de la Société des Americanistes, Paris | Pfuhl | — E. Pfuhl, Malerei und Zeichnung der Griechen, Munich, 1923 |
| JSO | — Journal de la Société des Océanistes, Paris | PG | — J. P. Migne, Patrologiae cursus completus, Series Graeca, 162 vols., with Latin trans., Paris, 1857–66 |
| Klein, GrK | — W. Klein, Geschichte der griechischen Kunst, Leipzig, 1904–07 | | |
| KS | — Communications on the Reports and Field Research of the Institute of Material Culture, Moscow, Leningrad | Picard | — C. Picard, Manuel d'Archéologie, La Sculpture, Paris, I, 1935; II, 1939; III, 1948; IV, 1, 1954 |
| Lippold, GP | — G. Lippold, Die griechische Plastik (W. Otto, Handbuch der Archäologie, III, 1), Munich, 1950 | PL | — J. P. Migne, Patrologiae cursus completus, Series Latina, 221 vols., Paris, 1844–64 |
| Löwy, IGB | — E. Löwy, Inschriften griechischer Bildhauer, Leipzig, 1885 | PM | — B. Porter and R. L. B. Moss, Topographical Bibliography of Ancient Egyptian Hieroglyphic Texts, Reliefs and Paintings, 7 vols., Oxford, 1927–51, 2d ed., 1960 ff. |
| MAAccIt | — Monumenti Antichi dell'Accademia d'Italia, Milan, | | |
| MAARome | — Memoirs of the American Academy in Rome, Rome, New York | Porter | — A. Kingsley Porter, Romanesque Sculpture of the Pilgrimage Roads, Boston, 1923 |
| MAF | — Mémoires de la Société Nationale des Antiquaires de France, Paris | Post | — Charles Post, A History of Spanish Painting, 10 vols., Cambridge, Mass., 1930 ff. |
| MAGWien | — Mitteilungen der anthropologischen Gesellschaft in Wien, Vienna | ProcPrSoc | — Proceedings of the Prehistoric Society, Cambridge |
| Mâle, I | — E. Mâle, L'art religieux du XIIe siècle en France, Paris, 1928 | PSI | — Pubblicazioni della Società Italiana per la ricerca dei papiri greci e latini in Egitto, Florence, 1912 ff. |
| Mâle, II | — E. Mâle, L'art religieux du XIIIe siècle en France, Paris, 1925 | | |
| Mâle, III | — E. Mâle, L'art religieux de la fin du moyenâge en France, Paris, 1925 | QCr | — Quaderni della Critica, Bari |
| | | RA | — Revue Archéologique, Paris |
| Mâle, IV | — E. Mâle, L'art religieux après le Concile de Trente, Paris, 1932 | RAA | — Revue des Arts Asiatiques, Paris |
| MALinc | — Monumenti Antichi dell'Accademia dei Lincei, Milan, Rome | RACr | — Rivista di Archeologia Cristiana, Rome |
| | | RArte | — Rivista d'Arte, Florence |
| Mattingly-Sydenham | — H. Mattingly, E. Sydenham, C. H. V. Sutherland, The Roman Imperial Coinage, London | RArts | — Revue des arts, Paris |
| | | RBib | — Revue Biblique, Paris |
| MdI | — Mitteilungen des deutschen archäologischen Instituts, Munich | RDK | — Reallexicon zur deutschen Kunstgeschichte, Stuttgart, 1937 ff. |
| MdIK | — Mitteilungen des deutschen Instituts für ägyptische Altertumskunde in Kairo, Wiesbaden | RE | — A. Pauly, G. Wissowa, Real-Enzyklopädie der klassischen Altertumswissenschaft, Stuttgart, 1894 ff. |
| Mél | — Mélanges d'Archéologie et d'Histoire (Ecole Française de Rome), Paris | REA | — Revue des Etudes Anciennes, Bordeaux |
| MemLinc | — Memorie dell'Accademia dei Lincei, Rome | REByz | — Revue des Etudes Byzantines, Paris |
| MGH | — Monumenta Germaniae Historica, Berlin | REG | — Revue des Etudes Grecques, Paris |
| MIA | — Material and Research in Archaeology of the U.S.S.R., Moscow, Leningrad | Reinach, RP | — S. Reinach, Répertoire des Peintures Grecques et Romaines, Paris, 1922 |
| Michel | — A. Michel, Histoire de l'art depuis les premiers temps chrétiens jusqu'à nos jours, Paris, 1905–29 | Reinach, RR | — S. Reinach, Répertoire des Reliefs Grecs et Romains, Paris, I, 1909; II and III, 1912 |
| | | Reinach, RS | — S. Reinach, Répertoire de la Statuaire Grecque et Romaine, Paris, I, 1897; II, 1, 1897; II, 2, 1898; III, 1904; IV, 1910 |
| MInst | — Monumenti dell'Instituto di Corrispondenza Archeologica, Rome | | |
| MJhb | — Münchner Jahrbuch der bildenden Kunst, Munich | Reinach, RV | — S. Reinach, Répertoire des Vases peints, grecs et étrusques, Paris, I, 1899; II, 1900 |
| | | REL | — Revue des Etudes Latines, Paris |
| MLJ | — Modern Language Journal, St. Louis, Mo. | RendAccIt | — Rendiconti della R. Accademia d'Italia, Rome |
| | | RendLinc | — Rendiconti dell'Accademia dei Lincei, Rome |
| | | RendNapoli | — Rendiconti dell'Accademia di Archeologia di Napoli, Naples |

RendPontAcc — Rendiconti della Pontificia Accademia Romana di Archeologia, Rome
RepfKw — Repertorium für Kunstwissenschaft, Berlin, Stuttgart
REthn — Revue d'Ethnographie, Paris
RhMus — Rheinisches Museum für Philologie, Frankfort on the Main
RIASA — Rivista dell'Istituto d'Archeologia e Storia dell'Arte, Rome
RIN — Rivista Italiana di Numismatica, Rome
RlDKg — Reallexicon zur deutschen Kunstgeschichte, Stuttgart, 1937
RLV — M. Ebert, Real-Lexikon der Vorgeschichte, Berlin, 1924–32
RM — Mitteilungen des deutschen archäologischen Instituts, Römische Abteilung, Berlin
RN — Revue Numismatique, Paris
Robert, SR — C. Robert, Die antiken Sarkophag-Reliefs, Berlin, 1890 ff.
Roscher — W. H. Roscher, Ausführliches Lexikon der griechischen und römischen Mythologie, Leipzig, 1884–86; 1924–37
RQ — Römische Quartalschrift, Freiburg
RScPr — Rivista di Scienze Preistoriche, Florence
RSLig — Rivista di Studi Liguri, Bordighera, Italy
RSO — Rivista degli Studi Orientali, Rome
Rumpf, MZ — A. Rumpf, Malerei und Zeichnung (W. Otto, Handbuch der Archäologie, IV, 1), Munich, 1953
SA — Soviet Archaeology, Moscow, Leningrad
SbBerlin — Sitzungsberichte der preussischen Akademie der Wissenschaften, Berlin
SbHeidelberg — Sitzungsberichte der Akademie der Wissenschaften zu Heidelberg, Heidelberg
SbMünchen — Sitzungsberichte der bayerischen Akademie der Wissenschaften zu München, Munich
SbWien — Sitzungsberichte der Akademie der Wissenschaften in Wien, Vienna
Schlosser — J. Schlosser, La letteratura artistica, Florence, 1956
SEtr — Studi Etruschi, Florence
SNR — Sudan Notes and Records, Khartoum
SPA — A Survey of Persian Art, ed. A. U. Pope and P. Ackerman, Oxford, 1938
SymbOsl — Symbolae Osloenses, Oslo
ThB — U. Thieme, F. Becker, Künstler Lexikon, Leipzig, 1907–50
TitAM — Tituli Asiae Minoris, Vindobonae, 1901–44
TNR — Tanganyika Notes and Records, Dar-es-Salaam
Toesca, Md — P. Toesca, Il Medioevo, 2 vols., Turin, 1927
Toesca, Tr — P. Toesca, Il Trecento, Turin, 1951
TP — T'oung Pao, Leiden
USMB — United States National Museum, Bulletin, Washington, D.C.
Van Marle — R. van Marle, The Development of the Italian Schools of Painting, The Hague, 1923–38
Vasari — G. Vasari, Vite, ed. Milanesi, Florence, 1878 ff. (Am. ed., trans. E. H. and E. W. Blashfield and A. A. Hopkins, 4 vols., New York, 1913)
Venturi — A. Venturi, Storia dell'Arte Italiana, Milan, 1901 ff.
VFPA — Viking Fund Publications in Anthropology, New York
Vollmer — H. Vollmer, Allgemeines Lexikon der bildenden Künstler des XX. Jahrhunderts, Leipzig, 1953
Warburg — Journal of the Warburg and Courtauld Institutes, London
Wpr — Winckelmannsprogramm, Berlin
WürzbJ — Würzburger Jahrbücher für die Altertumswissenschaft, Würzburg
ZäS — Zeitschrift für ägyptische Sprache und Altertumskunde, Berlin, Leipzig
ZfAssyr — Zeitschrift für Assyriologie, Strasbourg
ZfBk — Zeitschrift für bildende Kunst, Leipzig
ZfE — Zeitschrift für Ethnologie, Berlin
ZfKg — Zeitschrift für Kunstgeschichte, Munich
ZfKw — Zeitschrift für Kunstwissenschaft, Munich
ZfN — Zeitschrift für Numismatik, Berlin
ZfSAKg — Zeitschrift für schweizerische Archäologie und Kunstgeschichte, Basel
ZMG — Zeitschrift der morgenländischen Gesellschaft, Leipzig

*Languages and Ethnological Descriptions*

Alb. — Albanian
Am. — American
Ang. — Anglice, Anglicized
Ar. — Arabic
Arm. — Armenian
Bab. — Babylonian
Br. — British
Bulg. — Bulgarian
Chin. — Chinese
D. — Dutch
Dan. — Danish
Eg. — Egyptian
Eng. — English
Finn. — Finnish
Fr. — French
Ger. — German
Gr. — Greek
Heb. — Hebrew
Hung. — Hungarian
It. — Italian
Jap. — Japanese
Jav. — Javanese
Lat. — Latin
Mod. Gr. — Modern Greek
Nor. — Norwegian
Per. — Persian
Pol. — Polish
Port. — Portuguese
Rum. — Rumanian
Rus. — Russian
Skr. — Sanskrit
Sp. — Spanish
Swed. — Swedish
Yugo. — Yugoslav

*Other Abbreviations (Standard abbreviations in common usage are omitted.)*

Abh. — Abhandlungen
Acad. — Academy, Académie
Acc. — Accademia
Adm. — Administration
Ak. — Akademie
Allg. — Allgemein
Alm. — Almanacco
Am. — America, American, etc.
Amm. — Amministrazione
Ann. — Annals, Annali, Annuario, Annual, etc.
Ant. — Antiquity, Antico, Antiquaire, etc.
Anthr. — Anthropology, etc.
Antr. — Antropologia, etc.
Anz. — Anzeiger
Arch. — Architecture, Architettura, Architettonico, etc.; Archives
Archaeol. — Archaeology, etc.
attrib. — attributed
Aufl. — Auflage
Aufn. — Aufnahme
B. — Bulletin, Bollettino, etc.
b. — born
Belg. — Belgian, Belga, etc.
Berl. — Berlin, Berliner
Bern. — Berner
Bib. — Bible, Biblical, Bibliothèque, etc.
Bibliog. — Bibliography, etc.
Br. — British
Bur. — Bureau
Byz. — Byzantine
C. — Corpus
ca. — circa
Cah. — Cahiers
Cal. — Calendar
Cap. — Capital, Capitolium
Cat. — Catalogue, Catalogo, etc.
Chr. — Chronicle, Chronik
Civ. — Cività, Civilization, etc.
cod. — codex
col., cols. — column, columns
Coll. — Collection, Collana, Collationes, Collectanea, Collezione, etc.

| | |
|---|---|
| Comm. | — Commentaries, Commentari, Communications, etc. |
| Cong. | — Congress, Congresso, etc. |
| Cr. | — Critica |
| Cron. | — Cronaca |
| Cuad. | — Cuadernos |
| Cult. | — Culture, Cultura, etc. |
| D. | — Deutsch |
| d. | — died |
| Diss. | — Dissertation, Dissertazione |
| Doc. | — Documents, etc. |
| E. | — Encyclopedia, etc. |
| Eccl. | — Ecclesiastic, Ecclesia, etc. |
| Eng. | — English, England |
| Ep. | — Epigraphy |
| Esp. | — España, Español |
| Est. | — Estudios |
| Et. | — Etudes |
| Ethn. | — Ethnology, Ethnography, Ethnographie, etc. |
| Etn. | — Etnico, Etnografia, etc. |
| Etnol. | — Etnologia |
| Eur. | — Europe, Europa, etc. |
| ext. | — extract |
| f. | — für |
| fasc. | — fascicle |
| Fil. | — Filologia |
| Filos. | — Filosofia, Filosofico |
| fol. | — folio |
| Forsch. | — Forschung, Forschungen |
| Fr. | — French, Francia, Français, etc. |
| Gal. | — Galerie |
| Gall. | — Gallery, Galleria |
| Geog. | — Geography, Geografia, Geographical, etc. |
| Ger. | — German, Germania, etc. |
| Giorn. | — Giornale |
| H. | — History, Histoire, etc. |
| hl. | — heilig, heilige |
| Holl. | — Hollandisch, etc. |
| Hum. | — Humanity, Humana, etc. |
| I. | — Istituto |
| Ill. | — Illustration, Illustrato, Illustrazione, etc. |
| Ind. | — Index, Indice, Indicatore, etc. |
| Inf. | — Information, Informazione, etc. |
| Inst. | — Institute, Institut, etc. |
| Int. | — International, etc. |
| Ist. | — Istituto |
| It. | — Italian, Italy, etc. |
| J. | — Journal |
| Jb. | — Jaarboek |
| Jhb. | — Jahrbuch |
| Jhrh. | — Jahreshefte |
| K. | — Kunst |
| Kat. | — Katalog |
| Kchr. | — Kunstchronik |
| Kg. | — Kunstgeschichte |
| Kunsthist. | — Kunsthistorische |
| Kw. | — Kunstwissenschaft |
| Lat. | — Latin |
| Lett. | — Letteratura, Lettere |
| Lib. | — Library |
| ling. | — linguistica, lingua, etc. |
| Lit. | — Literary, Literarische, Littéraire, etc. |
| Mag. | — Magazine |
| Med. | — Medieval, Medievale, etc. |
| Meded. | — Mededeelingen |
| Mél. | — Mélanges |
| Mém. | — Mémoire |
| Mem. | — Memorie, Memoirs |
| Min. | — Minerva |
| Misc. | — Miscellanea, etc. |
| Mit. | — Mitteilungen |
| Mnb. | — Monatsberichte |
| Mnbl. | — Monatsblaetter |
| Mnh. | — Monatshefte |
| Mod. | — Modern, Moderno, etc. |

| | |
|---|---|
| Mon. | — Monuments, Monumento |
| Münch. | — München, Münchner |
| Mus. | — Museum, Museo, etc. |
| N. | — New, Notizia, etc. |
| Nachr. | — Nachrichten |
| Nat. | — National, etc. |
| Naz. | — Nazionale |
| Notit. dign. | — Notitia Dignitatum |
| N. S. | — new series |
| O. | — Oriental, Orient, etc. |
| Ö. | — Österreichische |
| obv. | — obverse |
| öffentl. | — öffentlich |
| Op. | — Opuscolo |
| Pap. | — Papers |
| per. | — period |
| Per. | — Periodical, Periodico |
| Pin. | — Pinacoteca |
| Pr. | — Prehistory, Preistoria, Preystori, Préhistoire |
| Proc. | — Proceedings |
| Pub. | — Publication, Publicación |
| Pubbl. | — Pubblicazione |
| Q. | — Quarterly, Quaderno |
| Quel. | — Quellen |
| R. | — Rivista |
| r | — recto |
| Racc. | — Raccolta |
| Rass. | — Rassegna |
| Rec. | — Recueil |
| Recens. | — Recensione |
| Rech. | — Recherches |
| Rel. | — Relazione |
| Rend. | — Rendiconti |
| Rép. | — Répertoire |
| Rep. | — Report, Repertorio, Repertorium |
| Rev. | — Review, Revue, etc. |
| Rl. | — Reallexicon |
| Rom. | — Roman, Romano, Romanico, etc. |
| Rus. | — Russia, Russian, Russie, Russo, etc. |
| rv. | — reverse |
| S. | — San, Santo, Santa (saint) |
| S. | — Studi, Studies, etc. |
| Samml. | — Sammlung, Sammlungen |
| Sc. | — Science, Scienza, Scientific, etc. |
| Schr. | — Schriften |
| Schw. | — Schweitzer |
| Script. | — Scriptorium |
| Sitzb. | — Sitzungsberichte |
| s.l. | — in its place |
| Soc. | — Social, Society, Società, Sociale, etc. |
| Spec. | — Speculum |
| SS. | — Saints, Sante, Santi, Santissima |
| St. | — Saint |
| Sta | — Santa (holy) |
| Ste | — Sainte |
| Sto | — Santo (holy) |
| Sup. | — Supplement, Supplemento |
| s.v. | — under the word |
| Tech. | — Technical, Technology, etc. |
| Tecn. | — Tecnica, Tecnico |
| Tr. | — Transactions |
| trans. | — translator, translated, etc. |
| Trav. | — Travaux |
| u. | — und |
| Um. | — Umanesimo |
| Univ. | — University, Università, Université, etc. |
| Urb. | — Urban, Urbanistica |
| v | — verso |
| VAT | — Vorderasiatische Tafeln |
| Verh. | — Verhandlungen, Verhandelingen |
| Verz. | — Verzeichnis |
| Vf. | — Verfasser |
| Wien. | — Wiener |
| Yb. | — Yearbook |
| Z. | — Zeitschrift, Zeitung, etc. |

# CONTRIBUTORS TO VOLUME IV

Margherita ABBRUZZESE, Rome
Jean ALAZARD, Director, Musée National, Algiers
Bianca Maria ALFIERI, Istituto di Studi Orientali, University of Rome
Francisco AMIGHETTI, San José, Costa Rica
Marialuisa ANGIOLILLO, Rome
Giulio Carlo ARGAN, University of Rome
Rosario ASSUNTO, University of Urbino
Jeannine AUBOYER, Curator, Musée Guimet, Paris
Eleanor BARTON, Sweet Briar College, Sweet Briar, Va.
Luisa BECHERUCCI, Director, Galleria degli Uffizi, Florence
Luciano BERTI, Superintendent of the Galleries, Florence
Jan BIALOSTOCKI, Curator, National Museum, Warsaw
Vera BIANCO, Rome
Margarete BIEBER, Columbia University, New York
Sergio BOSTICCO, Museo Archeologico, Florence
Jan BOUZEK, Prague
Wolfgang BRAUNFELS, Technical University of Aachen
Johannes BRØNDSTED, Director, Nationalmuseet, Copenhagen
Giulia BRUNETTI, Florence
Mario BUSSAGLI, University of Rome
Antonino BUTTITTA, University of Palermo
Michelangelo CAGIANO DE AZEVEDO, Università Cattolica del S. Cuore, Milan
Schuyler Van Rensselaer CAMMANN, University of Pennsylvania, Philadelphia, Pa.
Enrico CERULLI, Accademico dei Lincei, Rome
Tage E. CHRISTIANSEN, Nationalmuseet, Copenhagen
Georges CŒDÈS, Honorary Director, Ecole Française d'Extrême-Orient, Paris
Piero CORRADINI, Rome
Enrico CRISPOLTI, Rome
Doris CROISSANT, Berlin
Elisabeth DELLA SANTA, Curator, Musées Royaux d'Art et d'Histoire, Brussels
Fernanda DE' MAFFEI, Rome
Franz DE RUYT, University of Louvain
Porphyrios DIKAIOS, Director, The Cyprus Museum
Lorenz EITNER, University of Minnesota, Minneapolis
Mircea ELIADE, University of Chicago
Carolus C. VAN ESSEN, Vice Director, Netherlands Historical Institute, Rome
Emilio ESTRADA, Guayaquil
Silvio FERRI, University of Pisa
Friedrich W. FUNKE, University of Cologne
Francesco GABRIELI, University of Rome
Giovanni GARBINI, University of Rome
Bruno GENTILI, University of Urbino
John A. GERE, British Museum, London
Raniero GNOLI, University of Rome
Hermann GOETZ, Maharaja Fatesingh Trust Museum, Baroda
Lloyd GOODRICH, Director, Whitney Museum of Art, New York
Luigi GRASSI, University of Rome
Pierre GRIMAL, University of Paris
Alexander B. GRISWOLD, Breezewood Foundation, Monkton, Md.
Vinigi L. GROTTANELLI, Pontificium Athenaeum Urbanianum de Propaganda Fide, Rome
Robert H. VAN GULIK, Minister for the Netherlands, Kuala Lumpur, Malaya
Bo GYLLENSVÄRD, Museum of Far Eastern Antiquities, Stockholm
Madeleine HALLADE, Musée Guimet, Paris

Louis HAMBIS, Institut des Hautes Etudes Chinoises, University of Paris
Jørgen B. HARTMANN, Danish Academy, Rome
Louis HAUTECŒUR, Secretary, l'Institut de France and Académie des Beaux-Arts, Paris
Francis W. HAWCROFT, Castle Museum, Norwich, England
Françoise HENRY, National University of Ireland, Dublin
Robert L. HERBERT, Yale University, New Haven, Conn.
James HOLDERBAUM, Princeton University, Princeton, N.J.
Henry R. HOPE, Indiana University, Bloomington, Ind.
Michael JAFFE, King's College, Cambridge
Clarence KENNEDY, Smith College, Northampton, Mass.
Hedwig KENNER, University of Vienna
Willibald KIRFEL, University of Bonn
Ernst KÜHNEL, Director, Islamic Section, Staatliche Museen Berlin
Lionello LANCIOTTI, Istituto Italiano per il Medio ed Estremo Oriente, Rome
Vittorio LANTERNARI, University of Bari
Helge LARSEN, Nationalmuseet, Etnografiska Samling, Copenhagen
Michael LEVEY, National Gallery, London
Jean LEYMARIE, Geneva
Bates LOWRY, Pomona College, Claremont, Calif.
Luigi MALLÈ, Museo Civico, Turin
Corrado MALTESE, University of Cagliari
Arthur McCOMB, Boston, Mass.
John W. McCOUBREY, Yale University, New Haven, Conn.
Arthur H. S. MEGAW, Director, Department of Antiquities, Nicosia, Cyprus
Salvatore MERGÉ, Istituto Italiano per il Medio ed Estremo Oriente, Rome
A. MERHAUTOVÁ-LIVOROVÁ, Prague
Maja MILETIĆ, Rome
Hans Wolfgang MÜLLER, Director, Ägyptische Staatssammlung, Munich
Bernard M. MYERS, formerly, The City College, New York
Giusta NICCO FASOLA, University of Genoa
Gisela NOEHLES, Biblioteca Hertziana, Rome
Karl NOEHLES, Biblioteca Hertziana, Rome
Otto NORN, Nationalmuseet, Copenhagen
Giovanni PACCAGNINI, Superintendent of the Galleries for the Provinces of Mantua, Verona, and Cremona
Enrico PARIBENI, Soprintendenza, Palatino e Foro Romano, Rome
Agostino PERTUSI, Università Cattolica del S. Cuore, Milan
Carlo Alberto PETRUCCI, formerly President, Accademia di San Luca; Director, Calcografia Nazionale, Rome
Nicolas PLATON, Director, Archaeological Museum, Heraklion, Crete
Armando PLEBE, University of Perugia
Edith PORADA, Columbia University, New York
Paolo PORTOGHESI, Rome
Mario PRAZ, University of Rome
Antonio PRIORI, Rome
Mario PRODAN, Rome
† Louis RÉAU, Membre de L'Institut de France, Paris
John REWALD, New York
Jorge ROMERO BREST, Universities of Buenos Aires and Montevideo
Robert ROSENBLUM, Princeton University, Princeton, N.J.
Annabella ROSSI, Rome
Andreas RUMPF, University of Cologne

Dario Sabbatucci, University of Rome
Luigi Salerno, Rome
Margaretta M. Salinger, Metropolitan Museum of Art, New York
Mario Salmi, University of Rome
Roberto Salvini, University of Trieste
Giuseppe Scavizzi, Rome
Curtis Shell, Wellesley College, Wellesley, Mass.
Calambur Śivaramamurti, Director, National Museum of India, New Delhi
Erik Sjöqvist, Princeton University, Princeton, N.J.
Wilhelm Staude, Houilles, Seine-et-Oise, France
Erich Steingräber, Bayerisches Nationalmuseum, Munich
Engelbert Stiglmayr, University of Vienna

Doris Stone, Museo Nacional, San José, Costa Rica
Zoltán Takáts, Academia Scientiarum Hungarica, Budapest
David Talbot Rice, Edinburgh University
Adolfo Tamburello, Istituto Italiano per il Medio ed Estremo Oriente, Rome
Shin-ichi Tani, Bridgestone Art Gallery, Tokyo
Giuseppe Tucci, University of Rome; President, Istituto per il Medio ed Estremo Oriente, Rome
Laszlò Vajda, University of Munich
Giorgio Vigni, Ministero della Pubblica Istruzione, Rome
Hans Weigert, University of Stuttgart
Allen S. Weller, University of Illinois, Urbana, Ill.
Ralph L. Wickiser, Pratt Institute, Brooklyn N.Y.
Geo Widengren, University of Uppsala, Sweden

# ACKNOWLEDGMENTS

The Institute for Cultural Collaborations and the publishers express their thanks to the collectors and to the directors of the museums and galleries listed below for permission to reproduce works in their collections and for photographs supplied.

ABIDJAN, Ivory Coast, Museum
ALEXANDRIA, Greco-Roman Museum
AMSTERDAM, Allard Pierson Museum
ANKARA, Archaeological Museum
ATHENS, Acropolis, Museum
ATHENS, Benaki Museum
ATHENS, Byzantine Museum
ATHENS, Coll. S. Haracopos
ATHENS, National Museum
ATHENS, Theodore Macridy Coll.
AUCKLAND, New Zealand, Auckland Museum
AUGSBURG, Germany, Diocesan Museum
AUGSBURG, Germany, Städtisches Maximilianmuseum

BAGHDAD, Iraq Museum
BALTIMORE, Walters Art Gallery
BAMBERG, Germany, Staatliche Bibliothek
BANGKOK, National Museum
BARODA, India, Museum
BASEL, Kunstmuseum, Kupferstichkabinett
BASEL, Museum für Völkerkunde
BASEL, Öffentliche Kunstsammlung
BASSANO DEL GRAPPA, Italy, Museo Civico
BAYONNE, France, Musée Bonnat
BEIRUT, Lebanon, National Museum
BELÉM, Brazil, Museu Paraense Emilio Goeldi
BELGRADE, Museum of Art and Archaeology
BERLIN, Kupferstichkabinett
BERLIN, Museum für Völkerkunde
BERLIN, Staatliche Graphische Sammlung
BERLIN, Staatliche Museen
BERN, Kunstmuseum
BOLOGNA, Museo Civico
BOLOGNA, Pinacoteca Nazionale
BOMBAY, Prince of Wales Museum
BOSTON, Museum of Fine Arts
BRUSSELS, Musées Royaux des Beaux-Arts
BRUSSELS, Musées Royaux d'Art et d'Histoire
BUCHAREST, National Museum
BUDAPEST, National Museum

CAGLIARI, Sardinia, Museo Archaeologico
CAIRO, Egyptian Museum
CAMBRAI, France, Bibliothèque Municipale
CAMBRIDGE, England, Fitzwilliam Museum
CAMBRIDGE, Mass., Fogg Art Museum
CAMBRIDGE, Mass., Peabody Museum of Archaeology and Ethnology
CAPUA, Italy, Museo Provinciale Campano

CARDIFF, National Museum of Wales
CHANTILLY, France, Musée Condé
CHICAGO, Art Institute
CHICAGO, University, Oriental Institute
CHIPPING SODBURY, England, Eric B. Porter Coll.
COLCHESTER, England, Museum
COLMAR, France, Musée Unterlinden
COPENHAGEN, Nationalmuseet

DAMASCUS, National Museum
DARMSTADT, Germany, Landesmuseum
DESSAU, Germany, Staatliche Galerie
DEUTSCH ALTENBURG, Austria, Museum Carnuntinum
DRESDEN, Gemäldegalerie
DUBLIN, National Museum of Ireland

EISENSTADT, Austria, Burgenländisches Landesmuseum
ENNS, Austria, Museum
ESSEN, Folkwang Museum

FERRARA, Italy, Museo dell'Opera del Duomo
FERRARA, Italy, Palazzo Schifanoia
FLORENCE, Biblioteca Laurenziana
FLORENCE, Coll. Corsini
FLORENCE, Galleria Buonarroti
FLORENCE, Museo Archeologico
FLORENCE, Museo Bardini
FLORENCE, Galleria dell'Accademia
FLORENCE, Museo Nazionale
FLORENCE, Museo dell'Opera del Duomo
FLORENCE, Pitti
FLORENCE, Serristori Coll.
FLORENCE, Uffizi
FRANKFORT ON THE MAIN, Städtisches Völkermuseum

GÖTTINGEN, Germany, Sammlung der Universität, Institut für Völkerkunde
GREENWICH, England, National Maritime Museum

HAMBURG, Museum für Völkerkunde
HEIDELBERG, Universitätsbibliothek
HERAKLION, Crete, Archaeological Museum
HOLLYWOOD, Stendahl Art Galleries

INDIANAPOLIS, John Herron Art Museum
INNSBRUCK, Tiroler Landesmuseum Ferdinindeum
ISTANBUL, Archaeological Museum

JAIPUR, India, Royal Library

JERUSALEM, Jordan, Palestine Archaeological Museum

KABUL, Afganistan, Museum
KARLSRUHE, Germany, Landesmuseum
KLAGENFURT, Austria, Landesmuseum

LAHORE, Pakistan, Central Museum
LA SPEZIA, Italy, Museo Archeologico Lunense
LEIDEN, Rijksmuseum
LEIPZIG, Museum der bildenden Künste
LE MANS, France, Musée des Beaux-Arts
LENINGRAD, The Hermitage
LILLE, Musée des Beaux-Arts
LIMA, Museo Nacional de Antropologia y Arqueología
LONDON, British Museum
LONDON, Buckingham Palace, Royal Colls.
LONDON, Courtauld Institute
LONDON, National Gallery
LONDON, University, Museum of Egyptology
LONDON, Victoria and Albert Museum
LONDON, Wallace Coll.
LUCCA, Italy, Coll. Garzoni
LYONS, Musée des Beaux-Arts
LYONS, Musée Historique des Tissus

MADRID, Museo Lázaro
MADRID, Prado
MANCHESTER, England, J. Rylands Library
MEXICO CITY, Museo Nacional de Antropología
MILAN, Coll. G. Mattioli
MILAN, Museo Poldi Pezzoli
MILAN, Pinacoteca Ambrosiana
MILAN, Pinacoteca di Brera
MONTPELLIER, France, Musée Fabre
MONTREAL, Museum of Fine Arts
MOSCOW, Tretyakov Gallery
MUCH HADHAM, England, I. Moore Coll.
MUNICH, Ägyptische Staatssammlung
MUNICH, Alte Pinakothek
MUNICH, Bayerisches Nationalmuseum
MUNICH, Staatliche Antikensammlungen
MUNICH, Staatliche Graphische Sammlung
MUTTRA, India, Museum of Archaeology

NAPLES, Biblioteca Nazionale
NAPLES, Museo Nazionale
NAPLES, Museo Nazionale di San Martino
NEW DELHI, Museum of Central Asian Antiquities
NEW DELHI, National Museum of India
NEW YORK, Brooklyn Museum
NEW YORK, Frick Coll.
NEW YORK, Metropolitan Museum
NEW YORK, Museum of Modern Art
NICOSIA, Cyprus, Cyprus Museum
NÜRNBERG, Germanisches National-Museum

ORVIETO, Italy, Museo Faina
OSLO, Universitetets Oldsaksamling
OSTIA ANTICA, Italy, Museo Ostiense
OXFORD, All Souls College
OXFORD, B. Ashmole Coll.
OXFORD, Ashmolean Museum

PALERMO, Galleria Nazionale della Sicilia
PALERMO, Museo Nazionale
PARIS, Bibliothèque de l'Arsenal
PARIS, Bibliothèque Nationale
PARIS, Coll. C. M. de Hauke
PARIS, Ecole des Beaux-Arts
PARIS, Louvre
PARIS, Musée d'Art Moderne
PARIS, Musée de Cluny
PARIS, Musée Guimet
PARIS, Musée de l'Homme

PARIS, Musée du Petit-Palais
PARIS, Musée Rodin
PARMA, Italy, Galleria Nazionale
PATNA, India, Museum
PAU, France, Musée des Beaux-Arts
PERUGIA, Italy, Collegio del Cambio
PHILADELPHIA, Museum of Art
PISA, Camposanto
PISA, Museo Civico
PRAGUE, National Gallery
PRATO, Italy, Museo Comunale

REGGIO CALABRIA, Italy, Museo Nazionale
REIMS, Musée des Beaux-Arts
REIMS, Musée Historique et Lapidaire
ROME, Archivio di Stato
ROME, Biblioteca dell'Istituto di Archeologia e Storia dell'Arte
ROME, Capitoline Museum
ROME, Gabinetto Nazionale delle Stampe
ROME, Galleria Borghese
ROME, Galleria Doria Pamphili
ROME, Lateran Museum
ROME, Museo Africano
ROME, Museo d'Arte Orientale
ROME, Museo della Civiltà Romana
ROME, Museo Nazionale delle Arti e delle Tradizioni Popolari
ROME, Museo Nazionale di Roma
ROME, Museo Nazionale di Villa Giulia
ROME, Museo Nuovo dei Conservatori
ROME, Museo del Palazzo dei Conservatori
ROME, Museo Petriano
ROME, Museo Pigorini
ROME, Museo di Villa Albani
ROME, Palazzo Rospigliosi
ROME, St. Peter's, Treasury
ROME, Vatican Library
ROME, Vatican Museums
ROTTERDAM, Museum Boymans-Van Beuningen

SEATTLE, Washington State Museum
SENS, France, Cathedral Treasury
SIENA, Museo dell'Opera del Duomo
SIENA, Pinacoteca
SINGEN, Germany, Hegau-Museum
STOCKHOLM, Academy of Art
STOCKHOLM, Historiska Museet
STOCKHOLM, Medelhausmuseet
STOCKHOLM, Statens Etnografiska Museum
STUTTGART, Graphische Sammlung der Staatsgalerie
STUTTGART, Linden Museum

TANJORE, India, Art Gallery
TEHERAN, Beghian Coll.
TERVUEREN, Belgium, Musée Royal du Congo Belge
TOKYO, National Commission for the Protection of Cultural Properties
TOKYO, National Museum
TURIN, Biblioteca Reale
TURIN, Galleria Sabauda
TURIN, Museo Egizio

UDAIPUR, India, Coll. of the Maharana
UTRECHT, University Library

VALENCIA, Museo Prehistórico
VALENCIENNES, France, Musée des Beaux-Arts
VENICE, Accademia
VENICE, Biblioteca Marciana
VENICE, Museo Correr
VIENNA, Akademie der Bildenden Künste
VIENNA, Albertina
VIENNA, Kunsthistorisches Museum
VIENNA, Museum für Völkerkunde
VIENNA, Schatzkammer der Wiener Hofburg

WASHINGTON, D.C., National Gallery
WASHINGTON, D.C., Phillips Coll.
WIESBADEN, Sammlung Nassauischer Altertümer
WINDSOR, England, Royal Collections

WINDSOR, England, Royal Library
WINTERTHUR, Switzerland, Oskar Reinhart Coll.
WÜRZBURG, Germany, Universitätsbibliothek

# PHOTOGRAPHIC CREDITS

The numbers refer to the plates. Those within parentheses indicate the sequence of subjects in composite plate pages. Italic numbers refer to photographs owned by the Institute for Cultural Collaboration.

A.C.L., Brussels: 123 (1); 253 (3)
L'ADRIATICA, Rimini: 402 (1)
ALINARI, Florence: 10 (3); 14 (4); 15 (1); 18 (1–5); 26 (3, 4); 27 (4); 29 (2); 106 (1, 2); 111 (2); 147; 148; 149 (2); 150 (2, 3); 151; 153 (4); 157 (1, 2); 158; 159; 160; 161 (1–3); 162 (1–2); 167 (2); 177; 179 (1); 187 (1); 190 (2); 191 (2, 3); 201 (4); 208 (1); 209 (3); 210 (1, 3); 211 (3, 4); 212 (1–3); 215 (4); 217 (2, 4); 219 (4); 220 (1); 228 (2); 229 (2, 3); 230 (2, 4, 5); 231 (2, 4); 232 (4); 243; 245; 249 (2); 270 (1); 277 (4); 285 (1); 287; 315 (2); 342; 393 (6); 394 (1); 397 (1); 398 (4); 400 (2); 401 (3, 4, 5); 407 (5); 412 (1); 450 (6); 451 (5); 454 (1–4); 455 (1, 4); 459 (1); 460 (1); 463; 465 (3)
AMATO: Washington, D.C.: 78 (3)
ANDERSON, Rome: 27 (3); 28 (2); 149 (1); 152; 153 (1–3); 179 (2, 3); 191 (3); 193 (1); 200 (2); 219 (3); 232 (3); 241; 244; 249 (1); 251 (1); 264 (3); 268 (2, 3); 271 (1); 295; 312; 314 (1, 2); 398 (2); 400 (3); 401 (2); 455 (3); 456 (3); 458 (1); 465 (1); 468 (1, 2, 4)
ANDREWS, Wayne: 198 (5)
ANTIKVARISK TOPOGRAFISKA ARKIVET, Stockholm: 176 (3); 207 (1)
ARCHAEOLOGICAL SURVEY OF INDIA, Madras: 254 (1, 2); 255 (1, 2); 256; 257 (1, 2); 258 (1–3); 259 (1, 2); 260
ARCHIV ORIENTÁLUÉ, Prague: 311 (1)
ARTE E COLORE, Milan: 5; 6; 168 (3); 209 (1); 405
AUBOYER, Paris: 204 (3)

BARTESAGO, Avignon: 317 (3)
BAYERISCHE STAATSGEMÄLDESAMMLUNGEN, Munich: 286
BAYERISCHES NATIONALMUSEUM, Munich: 13 (1, 3, 5, 6, 7, 8); 29 (1)
BILDARCHIV FOTO MARBURG, Marburg, Germany: 68 (1); 74 (3); 178 (2, 4); 321 (1, 2); 323 (1); 325 (2); 332 (2); 334 (2); 336; 340 (1); 341 (1–3); 346 (3); 347 (1); 354 (1); 359 (1); 360 (2); 364 (1, 2); 365; 368 (1, 2); 369 (1); 370 (1); 376 (2); 378 (1); 385 (2); 449 (4)
BRITISH MUSEUM, London: 326 (1); 445 (2)
BROGI, Florence: 187 (1, 2); 242 (1, 2); 246
BURGER: 362 (2); 382

CACCO, Venice: 403 (3)
CAISSE NATIONALE MONUMENTS HISTORIQUES, Paris: 16 (1); 96 (1–4); 98; 100 (2, 4); 101 (2, 3); 220 (3); 378 (3); 450 (4); 468 (3)
CAMPONOGARA, Lyons: 414 (1)
CAMPUS STUDIOS, Washington, D.C.: 393 (3)
CHAUFFOURIER, Pietro, Rome: 438 (1)
CREA, Rome: 120 (1)
CURRIE: 227 (4)
CUSSAC, Brussels: 11 (1)

DE ANTONIS, Rome: 12; 31 (1, 2); 53 (2); 54 (1–3); 55; 56; 58; 59 (1, 2); 61; 62; 63; 64 (1–2); 66 (1–5); 67 (1–3); 103; 104; 156; 170; 235; 236; 238; 252; 283; 289; 290; 415 (1); 416; 449 (6); 461 (1)
DELCROIX, Cambrai: 232 (2)
DELTA, Athens: 53 (1)
DEPARTMENT OF ANTIQUITIES, Jerusalem, Israel: 452 (4)
DEPARTMENT OF ARCHAEOLOGY, GOVERNMENT OF INDIA, New Delhi: 19 (2, 4); 127 (1); 128 (1, 2); 129 (1, 2); 131 (1, 2); 132 (1, 2); 133; 211 (1); 217 (1); 221 (2, 4); 222 (1, 2); 457 (2); 259 (3)
DE PRETORE, Rome: 428 (3)
DEUTSCHE FOTOTHEK, Dresden: 4 (1–2); 27 (1); 36 (2)
DEUTSCHES ARCHÄOLOGISCHES INSTITUT, Athens: 70 (1); 166 (5); 208 (2); 262 (1); 461 (2)
DEUTSCHES ARCHÄOLOGISCHES INSTITUT, Rome: 73 (2); 74 (1); 92 (4); 456 (4)

DOBRICK, Darmstadt: 43
DREYER, Zurich: 227 (2, 3)

EDITIONS DE LA SOCIETÉ ARCHÉOLOGIQUE, Athens: 47 (1)
EMIL, Athens: 59 (3); 73 (1, 3)

FELBERMAYER, J., Munich: 377; 387; 390
FELLMANN: 180 (2)
FIORENTINI, Venice: 49; 248
FLEMING, London: 307 (3)
FOGG ART MUSEUM, Cambridge, Mass.: 443 (2); 444 (1)
FOTOLITO C.T.N., Turin: 304
FRANTZ, Alison, Athens: 17 (1); 53 (3); 69; 70 (2); 264 (1)
FREQUIN, The Hague: 271 (2); 272 (1)
FROBENIUS INSTITUT, Frankfort on the Main: 85 (2)

GABINETTO FOTOGRAFICO NAZIONALE, Rome: 28 (3, 4); 154; 180 (1); 189 (2); 193 (3); 199 (1–3); 203 (4); 213 (3); 219 (1, 2); 221 (1); 285 (2); 315 (1); 426 (2); 429 (3); 431 (2); 438 (2); 440 (2); 441 (2); 442 (1–3); 467 (3, 4)
GIRAUDON, Paris: 21; 22; 25; 26 (2); 30 (1); 34 (1–3); 35 (1); 36 (1); 37; 38; 45 (1); 77; 79 (2); 82 (1); 83; 94; 118; 119; 121; 122; 123 (2, 3); 124; 125 (1, 2); 126; 134 (1, 2); 135; 136; 137 (1, 2); 138 (1); 139; 140; 142; 143; 144 (1, 2, 3); 145; 146; 164 (1, 2); 165 (1, 2, 3); 168 (1); 172 (2); 203 (1); 204 (2); 206 (3); 216 (3); 217 (3); 224 (3); 253 (1); 269 (1); 272 (4); 273; 274; 276 (3); 279 (4); 280 (2); 310; 316 (4); 317 (1, 2); 398 (3); 402 (3); 406; 408 (2); 414 (3); 415 (2); 417 (1); 420; 432 (2); 433 (2, 3); 434 (2); 435 (1, 2); 451 (6); 455 (2); 461 (3); 464 (2)
GUILLEN, Lima: 20 (3)

HASSIEL: 335 (3)
HEIDER, Dessau: 39 (1–3)
HIRMER, Munich: 16 (4); 17 (4); 59 (4); 71; 72; 166 (4); 167 (4); 218 (1, 3); 263 (1); 323 (2, 3); 329 (1); 330 (1–3); 331; 332 (1); 333; 334 (1); 335 (4); 338; 344 (1); 355 (1–3); 356 (2, 3); 357 (1); 358 (1, 2); 360 (1); 362 (1); 370 (2); 371 (2); 376 (1); 380 (1); 381 (1, 2); 396 (1); 450 (5); 453 (2); 457 (2, 3); 458 (2); 467 (1, 2)

INDIA OFFICE: 205 (1)
ISMEO, Rome: 445 (3, 4)
ISTITUTO CENTRALE DEL RESTAURO, Rome: 288; 291
ISTITUTO DI ETRUSCOLOGIA, University of Rome: 17 (2)
ISTITUTO DI PATOLOGIA DEL LIBRO, Rome: 265 (1, 2)

JETTER, Hadamar, Germany: 178 (1)
JUTTA GLAHOW, Berlin: 168 (2)

KATZEV: 111 (3)
KEMPTER, Munich: 299; 300; 303
KERSTING, London: 397 (2)
KING, H. M.: 307 (2)
KNOLL, Leipzig: 40 (3)
KUNSTHISTORISCHES MUSEUM, Vienna: 394 (4); 395 (1–3)
KUNSTVERLAG WOLFRUM, Vienna: 27 (2)

LARSEN, Copenhagen: 410
LICHTBEELDEN-INSTITUT, Amsterdam: 166 (3)

McCLEAN, Brussels: 409
MAS, Barcelona: 178 (5); 181; 210 (4); 213 (2); 232 (1); 262 (3); 292; 298 (1, 2); 399 (3); 400 (1)
MEKHITARIAN: 363 (1); 366 (2); 372
MEYER, Vienna: 42; 293
MOLITOR, Joseph W., Ossining, N.Y.: 186 (3)
MÜLLER, H. W., Munich: 215 (5); 319 (1, 4); 326 (2, 4); 328

XX

(1, 2); 334 (3); 335 (2); 337; 343 (1, 2); 344 (2); 345 (1, 2); 346 (1, 2); 348 (1, 2); 349 (2); 352; 353; 354 (2–4); 356 (1); 357 (1); 360 (3); 361 (1–3); 367 (2, 3); 371 (1); 373; 374 (1); 375 (1); 376 (3–4); 378 (2, 4); 379 (1, 2); 380 (2, 3); 383 (2, 3); 386 (1, 2, 3); 388 (1, 2)
MUSEI CIVICI, Venice: 279 (3)

NATIONALMUSEUM, Stockholm: 445 (1)
NATIONAL MUSEUM, Tokyo: 446 (2)

OBERÖSTERREICHISCHES LANDESMUSEUM, Linz: 109
ORIENTAL INSTITUTE, University of Chicago: 457 (1)

PAPAHADJIDAKIS, Athens: 230 (3)
PASQUINO, Paris: 8 (3)
PHOTO STUDIOS LIMITED, London: 307 (1)
PORTOGHESI, Paolo, Rome: 318 (1, 2)
POZZI E BELLINI, Rome: 68 (2); 396 (4); 401 (1)

RAMPAZZI, Turin : 327 (1, 2)
REAL-PHOTO, Paris: 402 (2, 4)
REISNER EXPEDITION: 343 (3)
RICHTER, Rome: 452 (1, 5)
ROSNER, Kitzbühel: 108 (3); 110 (1)

SAVIO, Oscar, Rome: 30 (2, 3, 5, 7); 32 (1–3); 33 (1, 6–9); 44; 45 (2–4); 84; 85 (1, 3–4); 86 (1–3); 87 (1, 2); 88; 89; 90 (1–4); 112 (1, 2); 113 (1, 2); 114 (1, 2); 115 (1, 2); 169 (1); 172 (1); 173 (1, 2); 174; 175 (4); 197 (1); 214; 220 (2); 223 (2); 224 (1); 227 (1); 267 (1, 4); 268 (1, 4, 5); 269 (3); 277 (1); 282 (1); 284; 313 (1, 2); 423 (1–4); 426 (1); 427 (1, 2, 4); 429 (1, 2); 430 (2, 3); 431 (1); 432 (1); 433 (1); 434 (1,

3); 436 (1, 3); 437; 439; 440 (1, 3); 443 (1, 3); 444 (2); 451 (4); 465 (1)
SCALA, Florence: 155; 247
SCUOLA ARCHEOLOGICA ITALIANA, Athens: 57 (1–4)
SNEDDON, James, Seattle: 8 (2)
SOPRINTENDENZA ALLE ANTICHITÀ, Reggio Calabria: 218 (2)
SOPRINTENDENZA ALLE ANTICHITÀ, Rome: 92 (1)
SOPRINTENDENZA ALLE ANTICHITÀ DELL'ETRURIA MERIDIONALE, Rome: 263 (2)
SOPRINTENDENZA ALLA GALLERIA NAZIONALE D'ARTE MODERNA, Rome: 202 (2, 4)
SOPRINTENDENZA ALLE GALLERIE, Florence: 105 (2); 107; 187 (3); 188 (3); 189 (1); 191 (2); 192 (1); 194 (1, 2); 201 (1–3); 233; 239 (2); 251 (2); 266 (3); 267 (2, 3, 5); 286 (1); 424 (1, 2); 425 (1, 2); 427 (3); 428 (2); 429 (4); 430 (1)
SOPRINTENDENZA ALLE GALLERIE, Pisa: 150 (1); 266 (2)
SPARROW, Auckland: 451 (2)
STEINKOPF, Berlin: 40 (2); 234 (2); 297 (1, 2); 301 (2, 3); 302
SUNAMI, Soichi, New York: 75; 76 (1); 78 (1, 2); 81 (1, 2); 82 (2, 3); 183 (1–5); 184 (1–3); 185 (1–4); 202 (1, 3)

TOMBAZI, Athens: 167 (1)

UNIVERSITY COLLEGE, London: 374 (2)

VATICAN MUSEUMS, Rome: 228 (6)
VICTORIA AND ALBERT MUSEUM, London: 30 (4)
VILLANI, Bologna: 1; 2 (1, 2); 3; 7 (3); 314 (3, 4); 441 (1)

WEHRHEIM, Munich: 462 (2)
WULLSCHLEGER, Winterthur, Switzerland: 116 (3); 117

# CONTENTS - VOLUME IV

| | Col. | Pls. | | Col. | Pls. |
|---|---|---|---|---|---|
| Cossa, Francesco del | 1 | 1–7 | Demonology | 306 | 166–182 |
| Costa Rica | 8 | | Demuth, Charles | 335 | |
| Costume | 12 | 8–33 | Denmark | 336 | |
| Courbet, Gustave | 54 | 34–38 | Derain, André | 354 | |
| Coypel | 62 | | Desiderio da Settignano | 355 | |
| Coysevox, Antoine | 63 | | Design | 356 | 183–186 |
| Cranach, Lucas the Elder | 64 | 39–46 | Designing | 358 | 187–202 |
| Credi, Lorenzo di | 71 | | Devotional Objects and Images, | | |
| Cretan-Byzantine School | 71 | 47–52 | Popular | 364 | 203–214 |
| Cretan-Mycenaean Art | 75 | 53–74 | Divinities | 382 | 215–232 |
| Criticism | 114 | | Domenichino | 420 | |
| Crivelli, Carlo | 148 | | Domenico Veneziano | 421 | 233–239 |
| Crome, John | 149 | | Donatello | 427 | 240–251 |
| Cruikshank, George | 149 | | Dossi, Dosso | 441 | |
| Cubism and Futurism | 150 | 75–84 | Douris | 441 | 252–253 |
| Cushite Cultures | 163 | 85–90 | Dravidian Art | 443 | 254–260 |
| Cuyp, Albert | 169 | | Drawing | 459 | 261–282 |
| Cypriote Art, Ancient | 170 | 91–102 | Duccio di Buoninsegna | 503 | 283–291 |
| Cyprus | 183 | | Ducerceau | 509 | |
| Czechoslovakia | 197 | | Duchamp Broters | 510 | |
| Daddi, Bernardo | 223 | 103–107 | Dufy, Raoul | 511 | |
| Dali, Salvador | 225 | | Dürer, Albrecht | 512 | 292–302 |
| Danubian-Roman Art | 226 | 108–111 | Dyck, Anton van | 531 | 303–310 |
| Daswanth | 234 | 112–115 | Eakins, Thomas | 536 | |
| Daubigny, Charles-François | 235 | | Eclecticism | 538 | 311–318 |
| Daumier, Honoré | 236 | 116–121 | Ecuador | 550 | |
| David, Gerard | 242 | | Education and Art Teaching | 557 | |
| David, Jacques Louis | 242 | 122–126 | Egypt | 572 | |
| Davis, Stuart | 248 | | Egyptian Art | 618 | 319–392 |
| Dealing and Dealers | 248 | | Emblems and Insignia | 710 | 393–404 |
| Deccan Art | 262 | 127–133 | Enamels | 734 | 405–420 |
| Degas, Hilaire Germain Edgar | 273 | 134–140 | Engravings and Other Print | | |
| Delacroix, Eugène | 279 | 141–146 | Media | 748 | 421–448 |
| Delaunay, Robert | 286 | | Ensor, James | 785 | |
| Della Quercia, Jacopo | 286 | 147–154 | Epstein, Jacob | 786 | |
| Della Robbia, Luca | 295 | 155–162 | Ernst, Max | 787 | |
| Delorme, Philibert | 302 | 163–165 | Eschatology | 788 | 449–468 |

**COSSA**, Francesco del. Painter, born about 1436 in Ferrara; son of Cristoforo, a member of a family of masons, and Fiordelisia Mastria; Cossa probably died of the plague at Bologna in 1478. Payment is recorded on Sept. 11, 1456, for a *Deposition* with three figures and for some imitation marble paneling around the high altar in the Cathedral of Ferrara — a commission entrusted to him by his father, who granted him his independence as late as Nov. 29, 1460. It is assumed that the work was executed in fresco and that it was lost in 1727, when the altar was destroyed. The records mention that Cossa served as godfather at a baptism in Bologna on Dec. 17, 1462. On Mar. 25, 1470, once more in Ferrara, he sent a letter to Borso d'Este to complain of the low recompense agreed upon by the consultants for some frescoes on a wall "near the anteroom" (i.e., the wall on the east side) of the main hall in the Palazzo Schifanoia.

Disappointed, Cossa went back to Bologna. Here, in 1472, he received 100 ducats for restoring and completing a *Madonna*, said to be in the manner of Lippo Dalmasio, in the Church of the Confraternità del Baraccano; this work he dated and signed, to the extent of declaring his Ferrarese origin. On Sept. 27, 1473, he was paid 2 lire and 16 soldi for a cartoon showing St. Petronius, which was to be used for an intarsia in the choir of the church of that saint. The inlay was executed by Agostino de' Marchi of Crema and his sons. In 1474 Cossa completed the huge tempera on canvas (Bologna, Pin. Naz.) that had been commissioned two years earlier for the Foro dei Mercanti. Still in Bologna, he once again served as a godfather (Feb. 11, 1476). A document of the same year (Nov. 19) mentions him as a citizen of Ferrara, having a permanent address in the Polirone di Sant'Antonio quarter, but living in Bologna; the latter residence was a stipulation of a five-year contract made with his nephews Niccolò and Filippo for the purpose of pursuing the trade of skin and cloth merchants. In 1477 he decorated the vault of the Garganelli Chapel in the Church of S. Pietro with frescoes of "about" twenty figures; these have been destroyed.

Cossa's early education as an artist remains problematic; by 1469 his personal style was fully formed. In that year and the one following, he painted representations of March and April and part of the May panel in the great hall of the Palazzo Schifanoia in Ferrara. These form the point of departure in our analysis of the work of Cossa.

Within an architectural framework the representations of the months are developed in three tiers; the subject is inspired in part by a continuing astrological tradition, modified by the new Humanist interest in classical literature (M. Manilius). The ideological program was formerly ascribed to the astronomer Pietro Buono Avogario, but nowadays informed scholarly opinion attributes it to the historian-astrologer of the Este court, Pellegrino Prisciani; the artistic plan was probably the work of the court painter and leader of the Ferrarese school, Cosimo (Cosmè) Tura (q.v.). Girolamo Baruffaldi (ed. 1844–46) had attributed the frescoes to Tura in the 18th century. The upper register is composed of the triumphs of the gods of antiquity who since classical times had been thought to preside over the lives and actions of men, month by month. Below these comes a narrower band containing the signs of the zodiac and the

decans, astrological personifications believed to preside over the 10-day divisions of each month. In the lowest tier we see the rural labors typifying the months, in combination with scenes of courtly life under Borso d'Este. Unfortunately the decorations are not complete: only the months from March to September remain. However, among the various hands that worked on the frescoes, Cossa stands out because of the construction of his figures, his spatial penetration, and a new chromatic harmony — results of the Renaissance order which came to Ferrara through contact with Padua, as well as by virtue of the art of Leon Battista Alberti and Piero della Francesca (qq.v.). Moreover, a personal note of serene enjoyment of every aspect of the visual world pervades his work.

The Triumph of Minerva from *The Month of March* (PLS. 1, 3, 5) depicts the presiding goddess seated in a chariot decorated with putti and drawn by white unicorns as mettlesome as anything painted by Cosimo Tura. Flanking the goddess are the Wise Virgins, busy at their weaving or sewing or embroidery (PL. 1), and a group of teachers and pupils from Ferrara's university, each one clearly characterized by his costume. These sinewy, self-contained figures recall Tura's style; and the fantastic rocky landscape, with its grottoes, caverns, dolomitic peaks, castles, and strange vistas of almost Asiatic flavor, also echoes those of Tura and Mantegna.

The Triumph of Venus from *The Month of April* (PL. 2) shows Mars in the guise of a knight-errant kneeling before the sovereign goddess, enthroned on a barge drawn by two swans. On the banks of the river amorous couples wander among flowering groves, under the protection of the three Graces.

May is represented by a crowned Apollo, holding the bow and the disk of the Sun and standing upon an even more sumptuous cart drawn by two pairs of horses and guided by Aurora. Flora and fauna are depicted in crisp relief and with technical assurance. Nevertheless, the late Gothic taste for precise rendition of reality, introduced in Ferrara by Pisanello and renewed during the Renaissance, is elsewhere so little in evidence — not so much in the group of poets at the left, as in that of the nine Muses near the fountain Castalia and in the crowd of putti — that the latter areas are certainly due to the hand of a collaborator.

In the three representations of the months examined thus far the nine decans are silhouetted against an azure background, in company with the appropriate signs of the zodiac. The figures are all monumental in conception and powerfully constructed, reminding us of Piero della Francesca's vision of reality; without relinquishing his own personal style, Cossa's articulate draftsmanship has clearly profited from contact with the Florentine school and Mantegna. His stylistic range is well exemplified in the March segment, where the giant in his tattered garments contrasts with the elegant, fine-featured pageboy, who with his arrow and ring is the perfect exponent of courtly vanity. Another aspect of Cossa's versatility is illustrated in the April segment by a young lady as solid and imposing as the Herculean youth at whom she gazes.

Cossa's best effort, however, went into the third tier of the May segment — now, unfortunately, in fragments. Here Borso's long, heavy-featured profile appears frequently, topped by his ducal beret; the courtiers who surround him are characterized with a precision reminiscent of the medalist's incisive art. The

classicizing architecture of the setting (the Este court) and the landscape combine in the March fresco with the splendid costumes of the merry cavalcades going to or from the hunt, accompanied by their falconers and hunting dogs (PL. 3). The penetrating likenesses of the courtiers and the foreshortening of the horses recall the work of Pisanello, but the tone is different; for Cossa could not have painted a metallic figure such as the falconer and the exaggerated pleats of his cloak had he not seen the St. George group of the organ frontal in Ferrara Cathedral, painted by Cosimo Tura in 1469. In front of a harsh landscape bounded by reddish buildings and crossed by hounds chasing their prey, the peasants are pruning the vines of an arbor, shown in perspective (PL. 5). Similar scenes already existed: one by Paolo Uccello in the Chiostro Verde of S. Maria Novella in Florence; another by Mantegna in the Ovetari Chapel of the Eremitani in Padua.

In the April section, above the "Return from the Hunt," we see a city scene, exalting the new Renaissance Ferrara under Duke Borso's aegis: among impressive arches and noble buildings under construction he and his train of courtiers and judges wend their way, as elegant damsels lean over tapestry-draped balconies to enjoy the foot races and the race of asses and horses below (PL. 2). The contestants, done in striking relief that brings to mind archaic friezes, have been attributed to Ercole de' Roberti (q.v.), whose work began with some sections of the September panel. In the May section, where the decans and the Twins accompanying the Sun are executed with a certain heavyhandedness, a part of the third tier was destroyed when a doorway was cut into the wall. Reminiscent of the same subject in books of hours, the haycutting scene is rendered with sculptural solidity and vivacious movement, even though the execution is on a somewhat lower level. (See also II, PL. 25.)

In addition to the Pisanello-like foundation of Ferrarese late Gothic, Cossa experienced the impact of Tura, who may have guided him in his artistic career. He was also affected by Piero della Francesca's monumentality and luminous colors — probably through contact with the Master of the *Autumn* (Berlin, Staat. Mus.), an able follower of Piero living in Ferrara and possibly identifiable with Galasso di Matteo Piva. However, Cossa also exhibits a compositional texture and a kind of emphasized figure articulation which are Florentine and Mantegnesque in origin. In the Schifanoia frescoes Cossa enlivens an abstract theme with original, imaginative narrative and uses an authentic Renaissance vocabulary to effect this transformation. His careful portraits (even though Borso, not satisfied with them, had some of them retouched by Baldassare d'Este), the sumptuousness of the costumes, the splendor of the architecture, and his obvious love of animal and plant life mark Cossa as the foremost narrative painter of the new style in the Po region.

By this time Cossa had made something of a reputation, especially in Bologna, where he is first encountered in 1462. His activity before the Schifanoia period remains problematic, for three works formerly attributed to him have since been decisively rejected by Ortolani as Cossa's. One of these is the cartoon for a stained-glass window, the *Virgin and Child* in the Kunstgewerbemuseum, Berlin; it is rather weak in execution and is the product of a follower working in the shop of the Cabrini, famous Bolognese glaziers. The other two are a *St. Justine* accompanied by a praying figure, in the Kress Collection, New York; and a *Deposition* with the Virgin and St. Francis praying, in the Musée Jacquemart-André, Paris, in a different style. The *Charity*, in the Museo Poldi Pezzoli, Milan, may be attributed to a contemporary of Tura rather than to a follower; hence it is a genuine precursor of Cossa's work. It has been pointed out elsewhere that the geometric pedestal of the throne resembles Cossa's work, and it may be added here that the three putti are very like the putti which decorate Minerva's chariot in the Schifanoia frescoes.

Numerous other works may be grouped around the Schifanoia cycle: for instance, a stained-glass window in the Musée Jacquemart-André (A. Venturi, 1930), a *Virgin and Child* within a tondo. This Virgin has Tura-like features, and the Child shows traces of Florentine formalism. Another window,

the *Virgin Enthroned with Four Angels* at S. Giovanni in Monte, Bologna, is considered to be the one described by Oretti late in the 18th century; a fragment (Ferrara, Pin. Civ. d'Arte) showing the chalice between the heads of two cherubs probably belonged to this window, as did another fragment with an eagle and the coat of arms of the Gozzadini and some ornamental motifs. The latter has been set into a window of the Villa Costanza at Longare (near Vicenza) and still bears the names of Jacopo and Domenico Cabrini and the date 1467. The date (accepted by S. Ortolani, 1941) is disconcerting because the Bolognese part of this work — whose cartoon had previously been attributed to Cossa, although dated about 1474 — shows a more pronounced compositional web, which could only derive from a later phase of Cossa's work.

The Kress *Madonna* (Washington, Nat. Gall.) by Cossa lies close to the Schifanoia works in time, but the modeling is less compact. Flanked by white angels and placed against a perspective receding into a fantastic landscape, the erect and impassive Madonna recalls Piero della Francesca, while her pose, adoring the sleeping Child, points to a Venetian origin. This panel has been cut down somewhat, as can be seen from the truncated halos.

After this panel, Cossa must have worked in Bologna on the *Annunciation* for the Church of the Osservanza (PL. 4), a work in which a marblelike polychromy is combined with ornate decorations. Some elements, such as the division with the double arch, come from Tura, while the clever perspective rendering of the building derives from Piero della Francesca. But the setting is described in Cossa's own manner: a warm, quiet light with discrete shadows spreads over the painting, wherein the angel, seen in profile, faces the monumental Virgin — grave as Piero's, but humble, too — in her mantle of copious, free-falling folds, possibly reflecting a renewal of the Mantegna influence. Two small female saints in the Von Thyssen Collection (Lugano), which are considered to be the end panels of the *Annunciation* predella, show the artist's versatility: one of them, *St. Clare*, is related to the Virgin of the *Annunciation* by her imposing volume; the other, *St. Catherine of Alexandria*, is of the same general plan and type as the *Madonna* in the Kress Collection.

The altarpiece of S. Lazzaro in Ferrara (1470–75; formerly in the Staat. Mus., Berlin, and destroyed in 1945) has been reattributed by Longhi (1934) to Ercole de' Roberti's early period. Longhi suggests that Cossa left the altarpiece unfinished and that the commission passed to his young pupil Roberti. The conception may have been that of Cossa, displaying a monumentality which never appears in his own later works; but the work also bears the stamp of Ercole de' Roberti's powerful personality.

Of the restorations that Cossa undertook at the Church of the Madonna del Baraccano, a *St. Lucy* and a *St. Catherine* (both now lost) are cited by Lamo (1560) as being his. In the vicinity of the profile of Bente or Giovanni I Bentivoglio (by a different hand, and retouched), there still remain a candle-bearing angel on the left-hand side and a corresponding figure on the right, both with abundant, crinkly drapery painted in light tones. Beyond the arcade, in perspective, we glimpse two of those landscape passages so typical of Cossa: antediluvian and at the same time civilized, with rocks seemingly arranged by magic, populated by human figures, and culminating in Renaissance buildings. Again Piero della Francesca and Andrea del Castagno (qq.v.) are suggested as the sources of certain structures. The attribution of these sections to Cossa is confirmed by the triptych (already dismantled in 1776) of the Grifoni Chapel in S. Petronio, which can be dated before 1473, because the records show that Agostino de' Marchi, master in woodwork and intarsia, claimed payment for the frame on July 19 of that year. This triptych in honor of St. Vincent Ferrer, whose cult developed as a consequence of his canonization (1458), shows the saint (London, Nat. Gall.) from a strictly frontal view almost like that of an icon. The perspective is executed with a degree of precision worthy of an intarsia designer. Standing on a complicated hexagonal base covered with a red cloth, the saint is outlined against a pilaster

that seems to echo the figure in its proportions. Above the saint is seen Christ as Judge among angels with the symbols of the Passion, delineated with a miniaturist's precision. In the background we find once again the characteristic harsh landscape with its lakes, jagged rocks, and deep ravines, and this continues into the lateral panels (Milan, Brera) devoted to figures of St. Peter and St. John the Baptist (PL. 6), as massive as the classicizing polychrome pilasters against which they stand. The triptych, which was schematically reconstructed on paper by Crowe and Cavalcaselle (1871), has been correlated (Longhi, 1934) to a gable containing a *Crucifixion* in a tondo, formerly in the Lehman Collection and now in the National Gallery, Washington. (Despite its unmistakably Emilian expressionism, this work had previously been attributed to Andrea del Castagno.) Moreover, and notwithstanding Bargellesi's opinion to the contrary, two arched panels have been identified (Longhi, 1934) as belonging above the two saints on the wings (PL. 7). One of them represents St. Lucy; the other, St. Florian (or St. Liberale?). Against the golden background (the only element that argues against their assignment to the triptych, which lacks this feature) the saints, seen in sharp perspective from below, emerge — especially the St. Florian — with startling physical impact. This use of perspective again calls to mind Andrea del Castagno and Piero della Francesca. Finally there are two small tondi, presumably lateral finials, that are related to the triptych; they depict a graceful *Annunciation* and are both in the Cagnola Collection in Gazzada (Varese).

Although the triptych is of the highest quality, it nevertheless falls short of that organic unity attained by Cosimo Tura in his contemporaneous Roverella altarpiece. The predella (Rome, Pin. Vat.) shows six scenes from the life of St. Vincent Ferrer merged into a single band. Within a reduced height due to the exigencies of the composition, he paints the familiar stony landscape and noble Renaissance buildings — some of them still under construction, probably an allusion to the building fervor of Ferrara at the time of Duke Ercole I, as well as a nostalgic memory of his family trade. Here, Cossa uses the subject matter purely as an excuse to create imposing images in daring foreshortening, which can be compared to Mantegna and Antonio Pollaiuolo (q.v.). The predella, however, contains crudities of form not usual in Cossa's work. Even if the composition is his, he must have had a collaborator for the work: the young Ercole de' Roberti to whom Lamo had already attributed it. [Vasari, in his life of Cossa, speaks of only one pupil, whom he identifies elsewhere as Roberti; the same designation was made by Masini (1666).] Modern critics are divided between those who see the predella as largely the work of Cossa (Frizzoni, Venturi, Berenson), though with the collaboration of Roberti (Gamba); and those who insist that the predella is by Roberti (Longhi, Bargellesi, Ortolani). While it is substantially by Cossa, the hand of his pupil seems evident in the pervasive warmth of color, peculiar to Roberti. Next there is a series of small saints in simple niches, which are believed (Longhi, 1934) to have adorned the small pilasters of the Grifoni triptych. Although these are for the most part in Cossa's style, they are executed with a metallic dryness characteristic of Roberti. Represented are *St. Michael* and *St. Apollonia* (Louvre), *St. Anthony Abbot* (Rotterdam, Mus. Boymans-Van Beuningen), *St. Petronius* (Ferrara, Coll. Vendeghini), *St. George, St. Jerome,* and *St. Catherine of Alexandria* (Venice, Cini Coll.). Cossa's style is seen in the halflength figure of *St. Petronius*, executed in intarsia for the choir of the Bolognese church dedicated to the saint. The same is true of the *St. Ambrose* there, which was ascribed to Cossa by Ricci (1951). In both panels the frontality of the figures and the perspective atmosphere given to the setting reveal Cossa's solid, secure style, even in the attenuated interpretation of De' Marchi.

The large tempera on canvas of the *Virgin and Child with SS. Petronius and John the Evangelist and Donor* (Alberto de' Cattani; PL. 7), done for the altar of the Foro dei Mercanti, obtains powerful plastic values exclusively through the modeling of the figures; the big arch in the background is purely decorative, with its sober ornament and its images of Gabriel and the Virgin Annunciate. In the picture, commissioned by a judge, Alberto de' Cattani, and a notary, Domenico degli Amorini (whose names appear along with the date 1474), a monumental Virgin is seated on a throne with lunettes. Erect and strong — a woman of the people — she holds the robust Child, who is distantly related to those painted by Andrea del Castagno and Bono da Ferrara. The same new monumentality characterizes the bony St. John, facing us in a well-articulated three-quarter pose and holding an open Gospel, and the St. Petronius, who appears as a severe, querulous old man. The artist penetrates beyond the somewhat vulgar physical traits to a level of moral characterization that expresses the conviction of the apostle (St. John) and the gravity of the bishop (St. Petronius). There is hardly room in the altarpiece for the rather faint profile of the fair-haired Alberto de' Cattani, a worthy bourgeois far removed from the aristocratic courtiers of Schifanoia.

The Merchants' altarpiece (Foro dei Mercanti altar) represents a pinnacle in Cossa's development. Left behind, now, is his former stylization in the manner of Cosimo Tura; it has been supplanted by a magnificent firmness of modeling, which was present in embryonic form in the Schifanoia decans. We say that this altarpiece is a pinnacle, for his supreme masterpiece, the decorations of the Garganelli Chapel in S. Pietro, Bologna, was destroyed in 1605. His work here included the four Evangelists and the Doctors of the Church in a vault, half-busts of the Prophets on the soffit of the entrance arch, and an *Annunciation* on the front. The cycle was interrupted by Cossa's death and later continued by Ercole de' Roberti. The frescoes cannot be reconstructed, but a Gospel in the Vatican Library (Cod. urb. lat. 10) contains an echo of them in its Evangelist figures (Salmi, 1958), which are monumental in character. The landscape, where it exists, also contains Cossa-like overtones. At least it confirms a continuity of idiom in the works that followed the Merchants' altarpiece; Cossa carried on the tradition of severely formal illusionism established by the great Tuscan masters of the preceding generation. A reflection of this massive quality may be seen in the *St. John on Patmos*, a round window in S. Giovanni in Monte, Bologna. At one time considered to be the interpretation of a cartoon by Cossa, the work, according to others, was not executed until 1482 by the Cabrini in accordance with the earlier will of Annibale Gozzadini, following the design of Roberti rather than that of Cossa. Still others (Volpe, 1958) date it about 1490 and think it is a work of Lorenzo Costa, while a final faction (Neppi, 1958) insists that the composition and color scheme come from Cossa, from whom it does derive in a certain measure. A male portrait in the Von Pannwitz Collection in Bennebroock, near Haarlem (Longhi, 1934), can be accepted as authentic. Typical of Cossa's style in its wide landscape, it has a well-knit and arresting composition consistent with the master's last period.

Among the works variously attributed to Cossa, we have already mentioned the *Autumn* in the Staatliche Museen, Berlin, although it probably exemplifies the style of Galasso. The *Peppergrinder* in the Musei Comunali, Forlì, traditionally ascribed to Melozzo da Forlì, was attributed to Cossa by Longhi in 1956, but as a matter of fact it is closer to Ercole de' Roberti (Neppi, 1958). The *St. Jerome* in the Pinacoteca Civica of Ferrara is also closer to Roberti (Venturi). The diptych of *Alessandro Gozzadini and His Wife* in the Lehman Collection, New York, also suggesting Roberti (Venturi), was probably executed by Costa (Longhi, 1934). The *Madonna among Cherubim*, formerly in the Contini Bonacossi Collection, Florence, is a later and lesser work that is now thought to be more akin to the work of Panetti (Neppi, 1958). A *Birth of St. John the Baptist* in the Von Thyssen Collection, which was ascribed with some doubts to Cossa (Ortolani, 1941), must be attributed to the Neapolitan school, not to Andrea de Litio (Bargellesi). Finally, the *Portrait of a Youth*, first thought to be Florentine and later to be by Cossa (Meiss, 1951; Neppi, 1958), seems more likely the work of some painter of the Marches.

None of the drawings attributed to Cossa appear to be his. Whether he designed the portal of the Palazzo Schifanoia, as

Venturi has suggested, is disputable. Although its mixture of styles suggests Michelozzo and his Lombard followers, the ornament is so indigenously Ferrarese that others have been reminded of Biagio Rossetti. Nor does it seem probable that Cossa carved (Filippini, 1913; Venturi) the tombstone of Domenico Garganelli (d. 1478) now in the Museo Civico, Bologna.

We have indicated the sources that contributed to Cossa's style. If in his early years he came under the influence of Tura, from whom he derived his desolate, stony landscapes, he soon disassociated himself by his penchant for palpable reality. He fixed this reality very clearly and naturalistically in a tactile style that derives from the Florentines, especially Andrea del Castagno, as well as from Mantegna, and combines this quality with a tonality that originates in Piero della Francesca. Cossa's native gifts are always apparent; whether he is gaily painting a chivalrous theme, immersed in sacred legends, or presenting monumental figures, he always expresses himself with a spontaneity and candor that are somehow rustic, which culture never succeeds in eclipsing and which link him with the great Emilian sculptors of the Romanesque period.

BIOGRAPHICAL AND CRITICAL LITERATURE. After the plaint of A. M. Salimbeni at the moment of Cossa's death in 1478 (Frati, 1900) and after a heartfelt epitaph by L. Bolognini, quoted by Venturi, Vasari in the first edition (1550) of his life of Ercole of Ferrara calls him "Lorenzo Cossa," identifying him with Costa and confusing his pictorial activity with that of Roberti; in the life of Michelangelo, referring to a negative judgment which the great Florentine passed upon Francia and Cossa, Vasari again seems to have confused the latter with Costa. In the second edition (1568) the biographer, still confounding the two, seems to refer to Cossa when, in the life of Costa, he affirms that during a trip to Florence the artist had contact with "Fra Filippo, Benozzo, and others" — thus recognizing the Florentine formalism in Cossa's art. Among diverse works that Vasari ascribes to Costa, only the Grifoni altarpiece belongs to Cossa. Although Cossa's name appears in Lamo (1560), Masini (1666), and other early works, because of his work in Bologna, Lanzi (1795–96) justly avers that the artist was subsequently neglected from the moment that Baruffaldi (1844) perpetuated the confusion with Costa by repeating Vasari. R. Borghini (Il riposo, Florence, 1584, p. 54), Malvasia (1678), and Baldinucci (1728) had made the error before him, and Barotti (1770) continued to do so. Lanzi's evaluation citing the Merchants' altarpiece of 1474 is impartial; Rosini's (1839) cold. C. Laderchi (Descrizione della quadreria costabili, I, Ferrara, pp. 28–30), the first to reevaluate Cossa (who, however, had not yet been disentangled from Costa), credited him with the frescoes on the east wall of the Palazzo Schifanoia (previously ascribed to Tura) and called their author "distinguished." Boschini, in a note to Baruffaldi (1844), points out the Vasarian confusion. Among later scholars only Jakob Burckhardt (Der Cicerone, Basel, 1855) had an appreciation of Cossa's work in Bologna; this recognition was renewed a good deal later by Giovanni Morelli (pseud. Ivan Lermolieff: Kunstkritischen Studien über italienische Malerei, 3 vols., Leipzig, 1890–93; Eng. ed., Italian Painters: Critical Studies of their Works, trans. C. J. Ffoulkes, London, 1892–93), who declared him to be "ingenuous and energetic." But A. Venturi, the true discoverer of Ferrarese painting, defined the distinctive values of Cossa, who was still misappraised, on various occasions (1914 and 1931) and insisted on his Paduan-Mantegnesque derivation. Among other scholars, both Italian and foreign, Berenson (1907) was too insistent upon the Piero della Francesca influence. Renewed interest in Ferrarese painting was stimulated by the 1894 London exhibition of the Ferrarese and Bolognese schools and intensified by the one held in Ferrara (1933). These stimulated new critical reviews and attributions, such as those of R. Longhi (1934). In addition, along with Tura and Ercole de' Roberti, Cossa has his own monographs in the volume of S. Ortolani (1941), albeit the observations and the chronology are not always acceptable. Other studies have followed, such as P. Ancona's (1954) on the Schifanoia "Months"; M. Salmi's on the frescoes of the Garganelli Chapel (1958); and A. Neppi's accomplished, and in some ways perspicacious, monograph (1958).

BIBLIOG. For a bibliography up to 1912, see M. H. Bernath, ThB, VII, 1912; Vasari, ed. Ricci, II, Florence, 1550, p. 153 ff.; P. Lamo, Graticola di Bologna, 1560 (ed. Bologna, 1844), pp. 12, 31, 39; Vasari, III, Florence, 1568, pp. 131 ff., 136, 141 ff.; A. di Paolo Masini, Bologna perlustrata, Bologna, 1666; G. Giovannantonio, Historia della miracolosa immagine di Maria Vergine detta del Baraccano, Bologna, 1674, p. 10 ff.; C. C. Malvasia, Felsina pittrice, 2 vols., Bologna, 1678; C. C. Malvasia, Le pitture di Bologna, Bologna, 1682, pp. 4 ff., 240; F. Baldinucci, Notizie de' professori del disegno da Cimabue in quà . . . , III, Florence, 1728; C. Barotti, Pitture e sculture di Ferrara, Ferrara, 1770, p. 167; M. Oretti, Le pitture nelle chiese della città di Bologna, ms. 30, cc. 265 and 314, Bologna, Bibl. Comunale (noted by G. Zucchini, Le vetrate di S. Giovanni in Monte, BArte, XI, 1917, p. 86); L. Lanzi, Storia pittorica, III, Bassano, 1795–96, p. 122; G. Giordani, Notizie intorno al Foro de' Mercanti, Bologna, 1837, p. 4; G. Rosini, Storia della pittura italiana, 1st ed., Pisa, 1839, 2d ed.; 1848–52; G. Baruffaldi, Vite de' pittore e scultori ferraresi, I, Ferrara, 1844, pp. 102–25, 132–48; L. N. Cittadella, Notizie relative a Ferrara, I, Ferrara, 1864–68, pp. 52 ff., 118, II, p. 337 ff.; J. A. Crowe and G. B. Cavalcaselle, History of Painting in North Italy, I, London, 1871, p. 518 ff.; A. Venturi, Arte ferrarese . . . nel periodo di Borso d'Este, Rivista storica italiana, 1885, p. 722 ff.; G. Frizzoni, Zur Wiederherstellung eines altferrar. Altarwerkes, ZfBk, 1888, pp. 299–302; A. Venturi, Les Arts à la cour de Ferrara: Francesco del Cossa, L'Art, I, 1888, pp. 73–80, 96–101; Exhibition of Pictures, Drawings and Photos of Works of School of Ferrara-Bologna, 1440–1540, London, 1894 (preface by A. Venturi, introduction by R. H. Benson); G. Gruyer, L'art ferrarais à l'époque des princes d'Este, II, Paris, 1897, pp. 101–21; L. Frati, La morte di Francesco del Cossa, L'Arte, 1900, p. 300 ff.; A. Venturi, Due quadri di Francesco del Cossa nella raccolta Spiridon di Parigi, L'Arte, 1906, p. 139 ff.; B. Berenson, The North Italian Painters, London, 1907; F. Filippini, Cossa scultore, BArte, VII, 1913, p. 315 ff.; A. Gatti, L'ultima parola sul concetto di San Petronio, Bologna, 1914, p. 70; J. Mason Perkins, La Crocifissione di Francesco del Cossa, L'Arte, 1914, p. 222 ff.; A. Venturi, Storia dell'arte italiana, VII, part 3, Milan, 1914, pp. 570 ff., 586–650, 656 ff.; C. Gamba, Ercole da Ferrara, Rassegna d'Arte, 1915, p. 191 ff.; C. Ricci, Tarsie disegnate dal Cossa, BArte, IX, 1915, p. 263; F. Filippini, Ercole da Ferrara, BArte, XI, 1917, p. 54; G. Fiocco, L'arte di A. Mantegna, Bologna, 1917; G. Zucchini, Le vetrate di S. Giovanni in Monte di Bologna, BArte, XI, 1917, p. 82 ff.; G. Zucchini, La distruzione degli affreschi della cappella Garganelli, L'Arte, 1920, p. 272 ff.; A. Warburg, Italienische Kunst und internationale Astrologie in Palazzo Schifanoia, Rome, 1922; L. Dussler, Italienische Bilder der Sammlung Spiridon, Pantheon, III, 1929; A. L. Mayer, Ausstellung der Sammlung Schloss Rohoncz in München, Pantheon, V, 1930, p. 316; A. L. Mayer, Two Unknown Panels by Cossa, BM, LVII, 1930; A. Venturi, Eine Madonna des Francesco del Cossa, Pantheon, V, 1930; G. Padovani, Biagio Rossetti, Ferrara, 1931, p. 11; A. Venturi, EI, XII, 1931, pp. 517–18 (with bibliog.); A. Venturi, Pittura del '400 in Emilia, Bologna, 1931; B. Berenson, Italian Pictures of the Renaissance, Oxford, 1932, p. 154; N. Barbantini, Catalogo della esposizione della pittura ferrarese del Rinascimento, Ferrara, 1933, pp. 36, 68, 80, 191; O. H. Giglioli, Disegni inediti di Francesco del Cossa e di Amico Aspertini, BArte, XXVII, 1933–34, p. 455 ff.; G. Bargellesi, Ercole da Ferrara, Rivista di Ferrara, IX, 1934, pp. 11, 18 ff.; R. Longhi, Officina ferrarese, Rome, 1934; G. Zucchini, La chiesa della Madonna di Galliera a Bologna, XI, XII, Bologna, 1935; M. Salmi, Paolo Uccello, Andrea del Castagno, Domenico Veneziano, Rome, 1935, pp. 57–58; R. Longhi, Ampliamenti dell'Officina ferrarese, Florence, 1940, pp. 5, 6, 8, 9; H. Bodmer, Francesco Cossa, Pantheon, XXVIII, 1941, pp. 230–36; S. Ortolani, Cosmè Tura, Francesco del Cossa, Ercole de' Roberti, Milan, 1941, pp. 23–25, 83–143, 173 ff.; G. Righini, L'enigma di Schifanoia, Atti e Memorie della Deputazione provinciale ferrarese di storia patria, II, N.S. 1944, pp. 69–82; G. Bargellesi, Palazzo Schifanoia, Bergamo, 1945; H. Tietze, European Master Drawings in the United States, New York, 1947, p. 28; A. E. Popham and P. Pouncey, Italian Drawings in the British Museum, London, 1950, no. 42; M. Davies, National Gallery Catalogues: The Earlier Italian Schools, London, 1950, pp. 115–18; M. Meiss, Five Ferrarese Panels, BM, XCIII, 1951, pp. 69–70; B. Nicolson, The Painters of Ferrara, London, 1951, pp. 10, 12–14, 19, 20; P. D'Ancona, I mesi di Schifanoia a Ferrara con una notizia critica sul recente restauro di C. Gnudi, Milan, 1954 (Eng. lang. ed., The Schifanoia Months at Ferrara, with a Critical Notice on the Recent Restoration by Cesare Gnudi, trans. L. Krasnik, Milan, 1954); C. Padovani, La critica d'arte e la pittura ferrarese, Rovigo, 1954; G. Bargellesi, Notizie di opere di arte ferrarese, Rovigo, 1955, p. 25; L. Chiappini, Appunti sul pittore Francesco del Cossa e la sua famiglia, Atti e Memorie della Deputazione provinciale ferrarese di storia patria, XIV, N.S. 1955, pp. 107–20; R. Longhi, Officina ferrarese, con "Nuovi ampliamenti," Florence, 1956, pp. 163–64; M. Salmi, Cosmè Tura, Milan, 1957, p. 18; A. Neppi, Francesco del Cossa, Milan, 1958; M. Salmi, Echi della pittura nella miniatura ferrarese del Rinascimento, Comm, 1958, pp. 94–98; C. Volpe, Tre vetrate ferraresi e il Rinascimento a Bologna, Arte antica e moderna, no. 1, 1958, pp. 23–37; E. Ruhmer, Francesco del Cossa, Munich, 1959.

Mario SALMI

Illustrations: PLS. 1–7.

**COSTA RICA.** The republic of Costa Rica, independent since 1821, is bordered on the north by Nicaragua, on the east by the Caribbean, on the south by Panama, on the west by the Pacific Ocean, and is important as a link between North and South America. Evidences of indigenous artistic activity discovered there belong to the pre-Columbian period; there is no contemporary Indian art of any importance. The archaeological finds are located in three regions: the Diquís River basin, the Atlantic watershed and plateau, and the Nicoya Peninsula. Each has its own characteristics. None of the three archaeological areas is completely isolated, but the Diquís basin shows a more pronounced regional development, though this is in part linked with that of the Panamanian province of Chiriquí. Remains of buildings or constructions are lacking; the creativity of the Indians is seen primarily in the fields of stone sculpture, goldwork, and ceramics.

SUMMARY. Pre-Columbian period (col. 9) : *Diquís River basin*; *Atlantic watershed and plateau region*; *Nicoya Peninsula*. Colonial and modern periods (col. 11).

PRE-COLUMBIAN PERIOD. *Diquís River basin*. Monumental stone sculpture in Costa Rica is found only in this zone and in Nicoya. Colossal stone spheres with a diameter of about 42 in. have been discovered, the larger ones coming from the Diquís delta. Their purpose remains problematical, but it appears that some at least were used to mark off the boundaries of cemeteries. Small stone sculptures of male figurines and stylized animals have also been discovered in the Diquís area. The human figure predominates; it is elongated and flattened, with a wedge-shaped base and often with free-standing arms. The animal figures are executed in the round, with the limbs and features of the head carved in high relief. These little statues are to be found in tombs and in dwelling places, where they probably served as votive images.

Pottery, notwithstanding the absence of the wheel, exists in a variety of forms and dimensions all over Costa Rica. In the Diquís area two different general styles appear: one has a sculptural and esthetic character, the other is abstract and stylized. The first appears in a series of unpainted and finely polished vases in which form is the principal esthetic element. They came to this area from Chiriquí in Panama (see CERAMICS). Amphoras and bulb-footed bowl forms predominate. The ornamentation is limited to the minute and realistic representation of animals and geometric motifs on the handles and necks. The tendency to abstraction and stylization appears in vases and also in figurines, ocarinas, and rattles. These too seem to come from Chiriquí. Colors are limited to red and black on a cream-colored background, and the only decoration consists of stylized caymans. The figurines depict genre subjects or seated women with triangular faces and legs spread apart.

Admirable metalwork is found in all parts of Costa Rica except the Nicoya Peninsula. Jewelry in particular had such importance that even the Aztecs sent warrior-merchants to Talamanca to learn the technique, which was thus introduced into Mexico before the arrival of the Spaniards. Gold appears generally alloyed with copper. In the Diquís area the gold content is higher, and a larger number of hammered objects is to be found there, too. Among the many metal-working techniques used, the most common was that of casting, with *mise en couleur* gilding. In this gilding process, the object was cast of a gold and copper alloy and the surface then treated with acid, which dissolved the copper. The pure gold surface that resulted could be burnished.

The pendants represent animals (birds and reptiles) and anthropomorphic figures which, according to the Indians of today, are totem symbols of different clans or representations of myths. Typical of the Diquís area are human figures placed in a frame and birds of prey holding small animals in their beaks. Gold tools and utensils — fish hooks, pincers, and needles — are also found. Perhaps the primitive goldsmith believed that he could utilize the power of the "beautiful" to produce a magic charm helpful in achieving a goal.

*Atlantic watershed and plateau region*. In this zone sculpture is represented by figurines varying from miniature figures to statuettes nearly 4 ft. in height. These are in general anthropomorphic figures in the round, showing realistic characteristics in spite of their stylized attitudes: men seated with arms folded, blowing flutes, or bearing in one hand a trophy head and in the other a battle ax; women holding their breasts with both hands; human heads without bodies that call to mind the widespread practice of human sacrifice by decapitation. The expressions on the faces, the details of the headdresses, and personal ornaments would appear to reflect a tendency toward individual characterization. At times the heads are turned to one side and the glance is slanting.

In the period of the Spanish conquest, a large part of the Atlantic watershed was an active trading area, and its ceramic production presents a mixture of influences and elements. Noteworthy are the portrait vases and the miniature monochrome vases in red or brown. These last serve to suggest the existence of a relationship with the Tairona culture of Colombia (q.v.). The statuettes holding trophy heads and the heads modeled in clay again recall sacrificial decapitation. For both these types a southern origin is likely. The pottery of this area is adorned with appliquéd sculptural elements, and the basic types are either unpainted or painted in a single color; the modeled or applied ornament consists of human forms, animals, or birds. This type of decoration is widespread in Central America.

At Línea Vieja, on the other hand, polychrome pottery predominates, strongly influenced by the styles of Nicaragua and Nicoya and by southern elements recalling the Tairona culture and the portrait vases of Peru (see ANDEAN PROTOHISTORY). Absent in the Diquís zone, but typical of this area and especially of Nicoya, are the grind-

ing stones, which, though first made for practical purposes, were subsequently used in rituals and assumed a more refined artistic character. Most stones have raised rims to facilitate the grinding of the roots and fruit of the palm *Guilielma gasipaes Bailey*, a plant imported by the Indians from the Orinoco Valley, Venezuela. This food was prepared with a short pestle in the form of a stirrup and required the use of water, hence the raised edge on the grinding stone. In this area in particular the stones seem to have had two distinct purposes: utilitarian, for the preparation of the food for daily life; and ceremonial, for offerings to the gods. The decoration of many stones consists of stylized or realistic sculptured heads, probably originating in the custom of human sacrifice. The use of stones as ceremonial objects perhaps gave rise to the circular altar; the form of the grinding surface suggests that these stones could have been used as salvers for the offerings of human heads.

In the Línea Vieja and Reventazón River areas, as well as in Nicoya, are found jadeite objects worked with the absolute simplicity of line demanded by the material. Here the perfection of the polish takes the

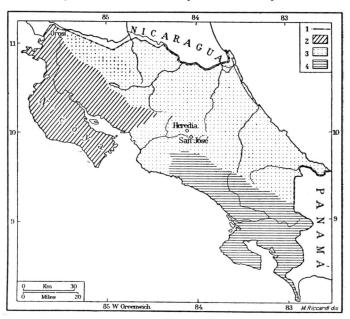

Costa Rica: principal centers and distribution of pre-Columbian cultures. *Key*: (1) Political boundaries; (2) Nicoya Peninsula; (3) Atlantic watershed and plateau region; (4) Diquís River basin.

place of decoration. Pendants with winged motifs and with representations of woodpeckers suggest an origin in northwestern South America, while the anthropomorphic figures with serpents issuing from their mouths or with bifurcated tongues suggest the Colombian style of San Agustín (see ANDEAN PROTOHISTORY); the calendar plaques and the coiled serpents seem to derive from Mexico (see MIDDLE AMERICAN PROTOHISTORY). The jadeites of Línea Vieja generally represent objects related to ceremonial life: miniature tripods, animals, and humorous figures incongruously articulated. The jadeite figures and the combination of jadeite with gold are peculiar to Línea Vieja.

*Nicoya Peninsula*. In this zone, as in the Diquís River area, megalithic sculptures are found. Stone sculpture spread into the Nicoya Peninsula from southwestern Nicaragua. In northwestern Nicoya, anthropomorphic figures representing "alter-ego" motifs are cut in the round or half-round right into the solid rock — realistic male figures, seated or standing, bearing on their backs protector animals (alter egos). The hardness of the stone accentuates the primitive tendency to frontality and emphasizes the monumentality of these sculptures. For the most part the pottery of this area seems to be a stylistic continuation of the unpainted or monochrome vase style. However, the area is also famous for polychrome styles connected with the north. The region in which this pottery is found extends from Managua or the island of Ometepe in Nicaragua up to Nicoya and Línea Vieja. In the northernmost area it was worked by peoples who arrived in relatively late times. Typical of this pottery is the combination of modeled and painted ornament, which indicates the fusion of different cultures: Mexican cultures during the period between A.D. 1000 and 1400, represented in vase-painting themes and figures of a religious character, such as the plumed serpent, the earth monster, and forms related to hieroglyphics. Its polychrome pottery has given

Nicoya the reputation of having achieved a high artistic level, which really stems from the combination of modeled and painted vase ornament. At Nicoya and in southwest Nicaragua, censers with figures of alligators represent a development peculiar to those areas, perhaps originating in the style with modeled or applied ornament; while the big portrait figures, also represented on incense vessels, recall the northern styles and perhaps reveal still more remote influences.

In Nicoya, during the long period of migrations from the north, a rimless stone, slightly concave and having a pestle of an elongated form, is the most commonly found grinding stone. This type is connected with the preparation of maize and is used also at Línea Vieja, although it rarely appears in other areas of Costa Rica. Here too, as in the Atlantic area, may be noted the high technical and artistic level reached in stone carving. Apes, alligators, jaguars, and birds constitute the principal decorative motifs. The stone is often worked with a lightness of touch which suggests the Gothic; the dignity of the conceptions and the superior sculptural ability produce an impression of grace and beauty and show a great mastery of design. Projecting heads often turn to one side, and tails sculptured like handles or interlaced into graceful motifs break the frontality so frequent in primitive art.

The jadeites generally represent gods. The gold objects of Nicoya seem not to have been worked locally but to have come there via trade routes.

As a whole, the pre-Columbian art of Costa Rica had its source in both the north (Mexico) and the south (Panama). Certain objects, notably in the field of metalwork, with its advanced casting and gilding techniques, suggest the possibility of contacts with Asia and especially with Indonesia; these parallels, however, can only be evaluated in a larger cultural context (see MIDDLE AMERICAN PROTOHISTORY). Although pre-Columbian objects from Costa Rica are to be found in various European museums, the principal collections are in the Museo Nacional in San José, Costa Rica.

BIBLIOG. C. V. Hartmann, Archaeological Researches in Costa Rica, Royal Ethn. Mus., Stockholm, 1901; C. V. Hartmann, Archaeological Researches on the Pacific Coast of Costa Rica, Carnegie Mus. Mem., III, I, 1907; S. K. Lothrop, Pottery of Costa Rica and Nicaragua, 2 vols., New York, 1926; D. Stone, A Preliminary Investigation of the Flood Plain of the Río Grande de Térraba, Costa Rica, AmAnt, IX, 1943; J. A. Mason, Costa Rican Stonework, Minor C. Keith Coll., APAmM, XII, 3, 1945; D. Stone, Orfebrería precolombina, Mus. Nacional, San José, Costa Rica, 1951; C. A. Balser, El jade precolombino de Costa Rica, Mus. Nacional, San José, Costa Rica, 1953; P. Keleman, Medieval American Art, 2d ed., New York, 1956; S. K. Lothrop, Archaeology of the Diquís Delta, Pap. of the Peabody Mus., 1958; D. Stone, Introduction to the Archaeology of Costa Rica, Mus. Nacional, San José, Costa Rica, 1958; D. Stone and C. A. Balser, The Aboriginal Metallurgy of Central America, Mus. Nacional, San José, Costa Rica, 1958.

Doris STONE

COLONIAL AND MODERN PERIODS. Costa Rica had no local artistic centers in colonial times, and therefore her production was prevalently the popular work of artisans. It consisted of textiles in the south (at Boruca), pottery in the north, and painted ox carts in the central plateau. In the cotton tapestries of Boruca, typical because the weft designs are visible only on one side (a technique still in use only among the Indians of Ecuador and found in the most primitive tombs of the pre-Columbian era in Peru), the colors are black, light blue, light brown, yellow, a purple extracted from a shellfish, and the white of undyed cotton. Even today the women of three little communities of the Nicoya Peninsula produce pottery not turned on the wheel and painted in red, black, and white. Unusual in the Americas — in fact, found only in Costa Rica — are the painted ox carts. The rustic painter transfers his designs by pouncing (tracing a design on a surface by dusting a fine powder, pounce, on a perforated pattern). He does this on the solid wooden wheel, on the yoke, and on the body, in lively colors. The decorative themes may derive from religious art.

The architecture of the colonial period in Costa Rica was not developed to the same level as that of other Latin American countries. This was the result of economic factors as well as the frequent earthquakes which destroyed Cartago, the capital until 1823. However, interesting buildings are preserved in several places: the church of Nicoya; the church which forms part of the Franciscan monastery of Orosi (1766), with its lovely bell tower and rich polychrome interior; the monumental parish church of Heredia (ca. 1797), built of stone, rectangular in plan, with a semicircular apse and two massive pointed bell towers on the façade; and the church of Ujarrás, which exists now only in ruins. The National Theater, finished in 1897, in marble, imitates the Paris Opéra.

Before independence, sculptures and paintings were imported from Quito, Guatemala, and Mexico. In the second half of the 19th century two local sculptors appeared: Fadrique Gutiérrez, author of monumental stone sculptures, and the realist Juan Mora Gon-

zález, who did vigorous polychrome wood statues and a series of portraits. In the 20th century the sculptor Francisco Zúñiga drew his inspiration from the native tradition; he is responsible for the *Monument to Mother* (1935) in San José and the frieze of the Communications and Public Works Building in Mexico City, where he has lived for some time.

Francisco AMIGHETTI

The School of Fine Arts of Costa Rica was founded in 1897 and directed for 49 years by the Spaniard Tomás Povedano, an academic painter.

The first Costa Rican painter to be trained in Europe was Enrique Echandi, who returned to his native country in 1891. Max Jiménez (1900–47), painter, sculptor, and writer, exercised a great influence in Central America, particularly in Costa Rica and Cuba. Trained in Paris and inspired by Picasso, he is noted chiefly for his scenes of Negro life. Also strongly influenced by European styles is Francisco Amighetti (b. 1907), muralist and printmaker, particularly known for his woodcuts. After exhibiting in South America and teaching in the United States, he returned to teach at the School of Fine Arts in Costa Rica. Others of this same period are the painters Manuel de la Cruz González, Margarita Berthau, Flora Luján, Teodorico Quirós, Manuel Salazar, and the sculptor Juan Portugués.

This group has been succeeded by a generation whose work reflects — to an even stronger degree — social realism, surrealism, and various forms of abstraction: Emilio Willie, César Valverde, Harold Fonseca, Luís Dael, Guillermo Jiménez, Lola Fernández, and Oscar Bakit.

\* \*

BIBLIOG. C. A. Balser, El escultor Juan Mora González, un gran artista desconocido, San José, Costa Rica, 1940; D. Stone, The Boruca of Costa Rica, Pap. of the Peabody Mus., XXVI, 2, 1949; E. A. Verona, Orosi, San José, Costa Rica, 1949; D. Stone, Notes on Present-day Pottery Making and Its Economy in the Ancient Chorotega Area, Middle Am. Research Records, I, 16, 1951, pp. 269–80; P. Keleman, Baroque and Rococo in Latin America, New York, 1951; M. Nelken, Escultura mexicana contemporánea, Enciclopedia Mexicana del Arte, XI, Mexico City, 1951; L. Dobles, Fadrique Gutiérrez, San José, Costa Rica, 1954; F. Amighetti, El arte religioso en Costa Rica, Catálogo de arte religioso, Mus. Nacional de Costa Rica, 1955.

Francisco AMIGHETTI

Illustrations: 1 fig. in text.

COSTUME. Generally speaking, costume is a very practical expression of the relationships between the individual and his natural and social environment. Utensils, furnishings, even architecture are reflections of the same relationships, but costume comprises those elements, such as attire, hair styles, and make-up, which cover or adorn the body. Based on the body's primary need for material protection, dress differs according to external conditions, the nature of the country, its climate, and seasons. Ideas of modesty or, on the contrary, sexual attraction (see SEXUAL AND EROTIC ELEMENTS) also influence the development of dress. Its complication and diversification of forms arose very early. As the intellectual and social structures of man's civilizations evolved, his dress was seen to be the result of the function of the individual in the activity of the group to which he belonged, of its magical, religious, or ritual requirements, and of the desire to manifest personal power, dignity, and wealth externally. This brings us to a consideration of costume as an expression of collective and individual taste. Costume may be said to be equivalent to the conscious image that man creates of his own appearance (see HUMAN FIGURE), but of an appearance that is in a certain sense more perfect and, by means of an integration of nature and "art," socially truer. While the nude, which plays such an important part in the artistic repertory, reflects the ideal human body, costume reflects the image of the individual in his culture and his society. It becomes in itself not only a continual, albeit ephemeral, field of creation, but also a particularly favored theme for the iconography of the great art of all times.

SUMMARY. Costume as art (col. 13). Historical development of costume (col. 20). *The ancient world: a. The Near East; b. The Aegean and Greece; c. Italy and Rome; d. Barbarian Europe; e. Late antiquity and Byzantium; f. Iran. Islam. East Asia: a. India; b. Tibet; c. Mongolia; d. China; e. Korea; f. Japan; g. Southeast Asia. Prim-*

*itive peoples. Medieval and modern West: a. Middle Ages; b. Renaissance; c. 17th and 18th centuries; d. 19th and 20th centuries*. Special classes of costume (col. 42): *Royal costume; Special civil costume; Military costume; Ecclesiastical costume; European folk costume*. Fashion and fashion publications (col. 52).

COSTUME AS ART. As the realization of an image, costume enters into the order of esthetic phenomena, even if only its highest forms achieve artistic value. The esthetic value of dress is found in three aspects: the quality of the materials (see TEXTILES, EMBROIDERY, AND LACE; TAPA), the ornamental accessories (which may have an autonomous esthetic value), and the styles. The work of specialists in the creation and execution of the garment, the level of skill of the artisan or of industrial production, and the direct and indirect influence of representational art may all contribute to the esthetic value. But equally influential on the result are individual taste, the collective taste of a given society, and the great or little emphasis placed on the prestige of each individual and of the persons invested with special functions.

The esthetic character of costume cannot be separated from its function, which, in its broadest meaning, is not only ritual, ceremonial, and representative but also expressive of the social position of certain persons or classes. Almost always the esthetic form of the costume depends on the accentuation or outright translation into symbolic motifs of some of the functional elements. It may frequently happen that certain elements of costume live on after the original function has vanished, to become part of the new fashions either in a stylized form or reduced to a simple sign or reminder. As in architecture, the decoration of the garment may serve as a symbolic allusion to an obsolete function.

Of a highly functional genesis, that is, with given conditions of use predetermining its style, is armor (see ARMS AND ARMOR), which constitutes a class in itself because of its materials and technique and its purpose. While here, too, the esthetic value is largely determined by a formal accentuation of the physical function, there are also psychological and illustrative aspects of armor that demand a visual effect projecting an ideal or heroic image of the warrior. An analogous accentuation of functional elements is seen in sacred vestments (see LITURGICAL OBJECTS) and in ceremonial garments in general. These are designed not only to stress the moral dignity of the religious or civil functionary but also to substitute an ideal personality for the real. On the esthetic level, the costume by which this substitution is made has a value not unlike that of the commemorative statue in relation to its model. Apparel fills this almost imagelike function not only through the austerity and solemnity of the fashion but also through use of traditional symbolic or emblematic elements. A typical example is the mantle, almost everywhere a symbol of royal investiture, or the crown, symbol of divine majesty or of the privileged relationship of a human being with the divine. To the symbolic function of certain styles and elements of dress can be added that of certain materials, for example, ermine; of color, purple; of various accessories, the scepter, the pastoral staff, etc.; and of certain precious stones.

Symbolism also enters into civil dress, determining some of its esthetics. Color symbolism, for example, is present in almost all the historical phases of costume to the present day; in the Western world, white garments for the bride are a sign of purity, and black for ceremony or funerals denotes austerity or mourning. Various customs also depend indirectly on that symbolism, such as the use of light colors for the clothing of the young, dark colors for that of the aged, or, on another level, the more frequent use of light and luminous hues in summer and of dark shades in winter. However, the representative and symbolic function, an essential determinant of the esthetic character of special costumes, is certainly less important in civil dress, which comprises the major part of the vast phenomenology of costume. The characteristics here are, rather, social and often specifically professional, designating occupation and rank. The costume preserves a descriptive function that becomes gradually more specific as one passes

from the liberal to the manual professions. In civil dress the economic factor grows more important, as an indication either of the buying potential of the consumer or of production and market conditions. Profound differences thus arise between the social classes and their fashions. Not only does the dress of each class throughout the centuries remain structurally different from that of the others, but substantial differences are also to be noted between the dress of city and country dwellers. Other less profound divergences are seen within the same social class between persons of different income levels. In general, women's civil dress, having fewer professional requirements, is esthetically more distinguished than men's.

In the development of the social history of costume the following aspects may be noted: (1) a progressive increase in the number of styles and the variations of the types contemporaneously in fashion; (2) a progressive standardization of the basic elements of dress with correspondingly widening variety in the details; (3) the gradual extension of the esthetic interest in dress from the richer to the less well-to-do classes; (4) a progressive attenuation of class differences in dress by means of a reciprocal exchange of types. In the course of this development the esthetic factor of civil dress is the result of improved quality in the production of clothing materials, of advancement in esthetic education and its extension to all social ranks, with a consequent emphasis on individual initiative in improving personal taste, and of the development of professional activity aimed at the esthetics of the person and of dress.

It is opportune to examine these last three points. A fabric can, in itself, be a work of art (PLS. 9, 10, 12, 18). Since its esthetic value, however, depends mainly on the use of costly materials and on the care and time employed in their manufacture, the use of such materials is limited. Progress in production has consisted mainly of quantitative development of an average production and in the setting up of certain standards which, on a wide scale, disseminate esthetic values. The modern product itself certainly preserves some artistic qualities (in color, design, weave, softness, reflections, etc.), but these are rather potentials which assume esthetic value only in the appearance of the finished garment. There is thus a gradual process of integration of the esthetic value of the material with that of the fashion. Ornament and accessories demonstrate a parallel, although less accentuated, process.

The progressive extension of esthetic interest in dress from the wealthy to the other social classes and the consequent emphasis on individual initiative is a complex phenomenon. Contributing to this development is the tendency, increasingly marked through history, to produce the various articles of clothing separately so as to permit various combinations. Domestic craftsmanship, which for a long time has been responsible for a large part of women's dress production, has undoubtedly contributed to the development of individual taste and the multiplication of the variants on basic types. Almost entirely entrusted to personal taste are the choice and harmony of the colors, though certain empirical standards prevail, as to the suitability of specific colors to specific hair and skin tones, or to a given age or condition, or to the harmony or dissonance of certain combinations of shades. The ornamental detail of women's dress often constitutes its most specific intentionally esthetic element and formerly depended largely on domestic craftsmanship (embroidery, laces). This contribution of individual initiative, even if conditioned by the imitation of superior types or by the spread of current models or customs, constitutes one of the most interesting aspects of costume as a collective esthetic creation, characterizing it in its two apparently contradictory but in fact complementary aspects. These are the tendencies toward basic uniformity and at the same time toward innovation or variation in details. It is as if by his dress the individual wanted to affirm his conformity and at the same time to preserve his individuality.

The development of professional activities connected with dress and the gradual specialization of trades (tailor, shoemaker, hatter, furrier, embroiderer, etc.) are important factors in the history of costume. First of all, these activities take place on different levels, ranging from the equivalent of domestic crafts-

manship to that of artistic creation. Through them the manufacturers of clothing materials exert pressure on the consumer to follow frequent changes in fashion, thereby reducing the life of clothing through obsolescence and insuring a continuing high level of consumption. Conscious use is thus made of the esthetic character of dress as the most powerful agent in bringing about the decline of certain fashions and the adoption of others.

The organization of professional work also influences the esthetic quality of dress. At the lowest working level this quality involves simply good workmanship, fine cut, careful finishing, etc. The purchaser's individual initiative is active in choosing the material, the model, and the ornament, and in the details of the execution. The dress is, in this case, the product of an important collaboration, by which the esthetic wishes of the consumer influence the fashion types. Above this level is the qualified artisan capable of planning and executing examples of a superior quality and of inventing new styles or variations on current styles. Then there are the creators and designers of types (fashion designers), working with definite esthetic aims or at least making use of the esthetic factor to cause a more rapid turnover of fashion. These specialists, whose activity has continuously spread and become more specialized since the 18th century, do not aim at esthetics per se, but rather attempt to recognize, interpret, refine, and guide the esthetic desires of the society and to foresee changes. Their task then is to isolate from innumerable confused indications the image of the social type in which a given society loves to recognize itself, and to express in a model the sum of the erotic-sexual, moral, social, and psychological elements that go into the making of that image.

Under the esthetics of dress it is necessary to consider two interacting but distinct sets of factors: esthetic quality of the costume itself as it develops in relation to the contemporary methods of production, and the esthetic value that the costume derives from its relation to art. The second is obviously a consequence of the first, for without a clear recognition of the intrinsic artistry of costume, borrowing from other arts would not have taken place.

The intrinsic esthetic quality of costume is demonstrated by a whole series of phenomena that have little or no connection with professional and manufacturing activities. For instance, all operations executed on the body itself — from the painting and tattooing of the primitive peoples to the most recent cosmetic fashions (make-up), from voluntary deformation and mutilation by certain savage tribes to modern esthetic surgery — have as their scope the adaptation of the particular figure to an ideal image. That is to say, the intention is an extension of the personality and an increase in social prestige. The substitution of artificial elements for natural ones, mostly for ritual or ceremonial purposes, provides proof of this close connection of social and esthetic interest. Examples are the false beards of the rulers and dignitaries of ancient Egypt (PL. 16) and, in the modern world, the wigs of the English judges. In these cases a natural element that is considered to be an indication of wisdom or authority is replaced by an artificial counterpart that has assumed a ritual significance. Nevertheless, while the individual tends by his dress to substitute his own idealized portrait for his real self in social relationships, this does not extend to the suppression of his own individuality. Proof of self-expression is the fact that the esthetic ambition is not limited to the visible parts, but extends to the intimate elements of the costume, whose refinements and ornament are not always dictated only by erotic interests, but often by a sort of cult or regard of the individual for his own body.

From the point of view of form, the history of costume reveals that one of the major factors in fashion is the desire to define, and even to enlarge, the place of the individual in his social sphere. Almost all types of costume aim at increasing physical stature, either by means of the soles or heels of the shoes or high hairdress or, illusionistically, by emphasizing the slenderness of the figure through the cut of the dress or the design and color of the material. Sometimes the volume of the body is also increased through fullness of sleeves, trousers, and skirts (PLS. 14, 17, 23, 24, 28, 31). Moreover, since the domination of space depends in great part on movement and the force displayed by the body therein, the accented volumes are put into contrast with an emphasized slenderness of other parts, such as, for example, the narrow waist or the clean articulation of the joints. The structural difference between the dress of men and women has often been that of space and movement. The style of masculine dress generally permits a freedom of movement that feminine dress limits or restrains, tends to be more precisely modeled to body forms, and makes use of more sober and distinct colors, giving the figure a clearer outline. The feminine costume frequently appears in thin and transparent materials and lighter colors that define a relationship more sensitive and richer in emotional shadings between the figure and its surrounding space or between the person and nature (PLS. 22, 26, 27). Materials and colors, by their transparency or light reflection, relate to the environment, so that the choice of material sometimes depends on the time and place in which the costume is to be worn. A typical example is women's evening dress, to which artificial light gives brilliant effects. The social conventions as to the use of such costumes also have an esthetic aspect, in that they aim at guaranteeing the quality of the over-all visual or spectacular effects, making it truly the image of a social function (e.g., Hogarth's *The Dance*). Furthermore, there is a close relationship between the materials as determinants of light and color effects and the fashions as providing the forms best adapted to these effects. The classic dress of antiquity, with its straight lines, is suitable to soft fabrics and subdued colors (PLS. 17, 18). It is difficult to imagine the 16th-century costume, with its puffs and fullness, in a fabric lacking velvet's sensitivity to light, while the later accentuation of such elements in the 18th century required lighter fabrics with livelier reflections such as silk (PLS. 27-30).

The style of dress, then, implies both a conception of society and a conception of nature in relation to the human being. The esthetic coefficient is obviously higher in the dress of the richest, most cultured classes; the dress of the well to do is aimed at esthetic distinction through imitation of the styles of the privileged classes, who combat this vulgarization by a change of fashions, sometimes in imitation of foreign styles. In some periods, although to a lesser measure, there is a reverse process. The highest social classes imitate certain features of the popular costume, for their picturesqueness, line, and ornament, although refining them in material.

The relationship with art constitutes a particular aspect of the esthetics of costume. In some cases the artist participates directly in the production of elements of costume; in others there occurs a transfer to fashion of the interpretation of clothing in the work of contemporary artists. A less direct relationship lies in the analogies between the formal and color schemes found in art and those of costume. These analogies, demonstrating the taste or style of a period, are also found in furniture, household goods, etc.

The participation of the artist in the elaboration of the costume is a relatively recent activity. The first signs of it are undoubtedly to be found, beginning with the Renaissance, in the employment of artists for preparing theatrical representations, ceremonies, and banquets and designing the costumes (see SCENOGRAPHY). Only in the 18th century, however, did the artist become the arbiter of fashion and begin to supply models. Still later, artists began specializing in the creation of clothing styles. The participation of the artist in the production of fabric designs and accessories or ornaments has always been much more frequent; jewelry and the miniature, often works of art in themselves, form an integral part of the costume.

The study of the exchange of formal elements between art and fashion is difficult, because the history of costume must be largely reconstructed from sculptural and pictorial representations, since few objects of costume have been preserved and there is little literary evidence. At the same time, only when art springs from social interests and aims does it

concern itself specifically with costume; and in the interpretation of costume certain elements are accented, so that the resulting image is not perfectly faithful, although important for its influence on changes in fashion. The artist representing events and personages of his own time in their costume must, however, use his customary expressive means of line, chiaroscuro, mass, color, etc. Since costume itself is the product of a historical or cultural situation, and since its value depends in great part on the visual effect, it is easy to understand that the same principles of form whereby the artist documents the costume are in turn employed to see and define the esthetic value of the costume. Only rarely is this value attributed to the costliness of the fabric. Almost universally it is defined in the same terms as art itself, such as the beauty of the line and the harmony of the colors. Thus, even when representational art is not specifically concerned with costume, it provides the formal terms for definition of the esthetic values of fashion.

There are, however, periods in history in which the artist is positively interested in the social life, either in its collective aspects or in the position of the individual in society. Dress then becomes a prominent object of artistic vision. The first signs of this interest are to be sought in the commemorative representations of this or that historical figure whose status or dignity had to be clearly revealed and emphasized by his attire, as, for example, in imperial Roman iconography, particularly in its later forms. In Byzantine art, which cloaks the historical personality in the superhistorical dignity of the office, the costume assumes a preponderant, final character. In the Ravenna mosaics the ceremonial and ritual robes are full of symbolical meaning in their various parts and in their design and colors (PLS. 18; II, 440, 489). The fabrics that have come down to us, of which the best examples were evidently destined for a particular person and a given ceremonial function, are related to the contemporary art not only by the usual correspondence of taste or style but by an identical search for significance or formal values (II, PL. 490).

Interest in costume as the visible sign of a dignitary, which was prevalent throughout the Middle Ages and is found in related ways in Far Eastern art, was gradually replaced by interest in a caste or social class thought to be spiritually exalted. In the 13th century, especially in France and in Italy and later in the widespread late Gothic culture, society placed the beautiful, which the philosophy of Scholasticism defined within a rigid heirarchy of values, among the ideals to be realized. It is easily seen how the same esthetic canons that governed the representation of divine images and of sovereigns (who considered themselves closely related to divinity) were eventually applied to the higher forms of civil costume. Because of this religious motive it was in this very period that dress acquired its modern character as the visible expression, not so much of what the individual is, but of what the individual aspires to become (PL. 25). And it is also from that time on that the tendency became pronounced toward the continual revision of dress that is fashion, a tendency manifested in the development of the esthetic ideal of the society and the ever-changing myth of the self. The artistic record of the courtly Gothic shows that, on the one hand, the artists tended to exaggerate the formal characteristics of each costume, emphasizing various details of line and color, and, on the other, preferred group representations in which the individuals formed a varied but homogeneous picture (PLS. 22, 26). In the artists' conception of the social scene (and it is from this date that society sees itself as an interesting and often curious spectacle), the individual affirmed his own personality as he moved in a human environment of which he accepted the basic rules, while reserving his right to certain variations.

The artist's task of cultural direction in the field of visual form became more complex in the Renaissance. The artist was truly the expert on that antiquity which was valued as a historical example. While the study of the antique directly influences the style of modern dress only periodically, it is nevertheless certain that the search for a greater simplicity and constructive solidity in art forms caused a simplification and a clearer structural definition in costume. For instance, in the paintings of Fra Angelico, Andrea del Castagno, and Piero della Francesca the dress is often structurally modern but reduced to an antique simplicity and severity of form and color. The idea that the esthetic value or the elegance of dress is not necessarily related to its richness — a view destined to come down to us — probably derived from this very conception. The development of this attitude naturally is also related to the economic progress of the middle classes and their growing capacity to compete successfully, on an economic level, with the aristocrats. The latter therefore attempted to distinguish themselves by qualitative values — fruits of a tradition and an education that the new rich lacked.

In the 16th and 17th centuries, with the marked economic rise of the middle class, there was everywhere, although particularly in Italy and France, a progressive affirmation of elegance as an esthetic value of dress. It is easily noted how the representational ideas of mannerism (q.v.), aimed at perfection of the style rather than the beauty of the art object, contributed to the definition of that value. The fact that the aristocratic classes considered themselves more intelligent and better able to understand artistic values helped to bring about this new concurrence of art and costume on the value of elegance. "Elegance" is a term that entered into common use in the 14th century, but significantly was already in use in France in the 12th century to indicate a value that is born from a choice or selection. In certain 16th-century portraits, for example by Bronzino, Parmigianino, and Lotto, the dress serves to indicate simultaneously the high social level and the discriminatory taste of the subject. In fact, it was in this period that the artist began to influence costume positively, not only in the sense of rendering the styles more elegant, but also in conditioning choice and unusual combinations of color. Furthermore, since the value of elegance is difficult to translate into canons or norms, it became instead the result of a way of doing, the product of the choice of the material and colors and of the accuracy of the cut and manufacture.

In the 17th century the value concept common to art and costume was no longer elegance, but decorum. Instead of tending to isolate the individual, it indicated his place and authority in his social environment. Elegance is essentially the hallmark of the elite, while decorum is a value that could be called "bourgeois" and is often linked with the prestige attributed to the various professional categories. This is why that concept favored the formation of certain types which, although not formally prescribed, remained almost constant, such as the special dress of doctors, lawyers, and magistrates. The feminine dress of the time also adapted itself to simpler and severer schemes in both color and cut. Also in the same period frequent representations of the common people, of peasants and beggars, appeared in art (see BAMBOCCIANTI). Almost as if in contrast to the sober reserve of middle-class costume and the baroque magnificence of ceremonial or court dress, the colorful rags of the poor began to seem picturesque. The poor classes were also part of the show of society. It was the first step in the transmission and gradual equalization of the dress types of the different social classes.

At no other time has the taste or style of a period had such definite and recognizable characteristics as in the 18th century. The first industrial organizations for large-scale production of fabrics, furniture, and porcelain came into being. Handicraft branched into many specializations. The middle classes were by then important consumers of quality products and tended to assert their own taste. Art, departing from the traditional religious and official ends, took on distinctly social interests and objectives. Hogarth (q.v.), an attentive observer of social life, discovered that a single formal principle, that of the wavy line, is found in natural forms and in the artificial ones of furniture, accessories, and feminine dress. The ostentatious costumes based on French and Italian baroque models, rather than merely being the choice of the declining aristocracy, seemed to be the basis of that decline, while the simpler taste of the middle class seemed to express the virtues of frankness, moral health, and good social education. Gainsborough (q.v.), painting in Bath, a popular resort, was the artist who influenced

costume most directly. Gainsborough saw in costume, especially the feminine dress, the tie between the human being, or rather society, and nature — that is to say, a revelation of the frank naturalness which the human being realizes through the education of his sentiments. The vibrant colors, the shimmering tones, the light fabrics, and the veils of the English feminine costume of the 18th century owe much to Gainsborough's portraiture, which made fashionable the dress in the style of the "country maid," bringing to costume the artificially rustic note of the Arcadian poets.

Near the end of the century dress assumed ever simpler lines and forms. The ostentatious court and ceremonial costumes preserved an official and, in a certain sense, commemorative character, while elegance was defined as naturalness and spontaneity or even apparent carelessness, though still displaying the innate sense of quality. As in dress, this tendency came to the fore in hair styles that often imitated the disorder brought about by a sudden gust of wind.

Fashion was thenceforth not only the main phenomenon but the guide of social dress. The European, and soon the world, center was Paris. There all the factors that make up the phenomenon of fashion converged — a fashion that became ever more complex, full of psychological, moral, social, and economic interactions. The painters dearest to the bourgeois taste — Watteau (PL. 29), Fragonard, Greuze, and also Chardin — had a decisive influence, spreading the taste for a loose costume free of conventions but refined in quality of fabric, grace of ornament, choice of colors, and slender and youthful lines. Equally important, however, was the influence of leading personalities of the time, such as Madame Pompadour, who dictated fashion laws, and that of the salons, which constituted centers of elegance outside the court, favoring an ever wider diffusion of fashion. Soon only a few details destined to disappear rapidly distinguished the nobility from the middle classes (for example, the right to carry a sword), while the progressive simplification of styles and the growing diffusion of ready-made clothes allowed even the poorer classes to aspire to a certain elegance or, at least, to dress with taste. For the rest, the diffusion of "fashionable" styles began to be organized by means of printed pattern books or models which served the tailor. Favoring the international circulation of information, they ended by totally eliminating every national or traditional distinction in costume (PL. 30).

The French Revolution had not only radically transformed the structure of masculine and feminine dress but had imposed on changes in fashion a more rapid rhythm and an immediate and virtually unlimited diffusion. The most important factor in the esthetic transformation of costume was, this time, ideological and political. In the name of democracy the styles of the nobility were abolished and the dress of the masses taken as models. Since the esthetic quality was no longer sought in luxury or wealth of ornament, the popular dress became refined in its design, achieving effects of elegance through simplicity of line. This simplicity promoted the spread of forms taken from the antique, Pompeii, etc. (PLS. 15, 33); this classic ideal reestablished a direct relationship between the style of the clothing and the shape of the human body. Undoubtedly this relationship also resulted from a relaxing of moral censure, but it was due as well to the need for dress appropriate to the new way of social life, to the gradual emancipation of woman, and to the more frequent occasions and greater ease of travel.

The relationship between art and costume has not lessened from the past century to the present, but has shifted almost completely to the level of industrial production. The creation of styles and the changes in fashion are normally entrusted to specialists who, although they, too, have an artistic training and make use of design and color, are distinct from the artist, being related rather to the industrial designer. Their activity, based on a vast series of economic and psychological factors, is of interest to the extent that it orients in a general way the esthetic character of the costume, its design or line, and its materials and principal color ranges. The present organization of production has brought about a significant change, namely that fashion, which once represented only the high point of dress, at present covers all, or almost all, its aspects. The influence of art, no longer important in the determination of styles, is instead very important in the production of fabrics, in which the principles, experiences, and methods of industrial design (q.v.) have found widespread application, not only in the patterns but also in the quality of the weave, the texture, etc. The greatest artists of recent times — Matisse, Léger, and others — have themselves occasionally directly furnished designs for woven or printed cloth. Design motifs have also been taken, with few adaptations, from works of art. In any case, the pattern of the fabric reflects more or less directly the graphic and color modes of contemporary art.

Giulio Carlo ARGAN

HISTORICAL DEVELOPMENT OF COSTUME. *The ancient world. a. The Near East.* In Egypt the garments were usually rectangular linen pieces of white or some solid color. Decorative patterns in many colors, however, came into wide use during the New Kingdom, particularly for ceremonial robes. During the same period there was a marked tendency toward elaborately ostentatious fashions.

The fundamental garment used by men was a phallus sheath, consisting of a simple enveloping covering held up by a narrow sash. Widely used in the prehistoric and protohistoric periods, it was later somewhat changed, being incorporated in a short skirt. This skirt, covering the loins, consisted of a rectangular piece of material, held in place by a belt tied in front (PL. 341); it might be smooth or either partially or wholly pleated. Sometimes it was neat in appearance and short, above the knees; in other cases it hung loosely to the ankles and might include a stiffly tailored part in front, a kind of apronlike triangle (with the vertex on top) or else a trapezoid. From the Middle Kingdom on, it was customary to wear two skirts: a short inner skirt and a long, transparent one outside. During the New Kingdom this fashion of two skirts developed rapidly, resulting in complex ostentatiously splendid styles.

Over the skirt a tunic was worn. Representations from the Old Kingdom provide evidence of the existence of an ample garment knotted over one shoulder; this became common, however, only in the New Kingdom, when it was a sort of short, full shirt with or without medium-length sleeves.

Clothes worn by women were long, usually neatly contoured, and dropped straight down to the ankles from the breasts, sometimes covering them, sometimes leaving them uncovered, and were held up by one or two straps (PL. 347).

From the Middle Kingdom onward, there is evidence for a magnificent mantle implying high social position. At that time it was made from a large rectangular piece of material enveloping the whole body and closed in front. During the New Kingdom it was of very fine pleated woven fabric covering one or both shoulders and knotted over the breast (PL. 377). The loose jacket worn over the tunic was reserved to the Pharaoh and was woven in vivid colors. A stole which crossed the chest and back diagonally and dropped from one shoulder was worn by the Pharaoh for public duties and by certain classes of priests. The leopard's skin, which had been widely used during the archaic period, became the distinguishing mark of certain priestly orders and was worn over the shoulders.

As for styles in headdress, people belonging to the upper classes usually shaved off their hair, replacing it with a wig made of human hair or sometimes augmented by vegetable fiber. During the earliest period, a person's head might even look as if were being squeezed into a close-fitting cap of cloth or leather. On some occasions the Pharaoh wore a large, striped wig covering which had two pieces hanging to his chest and a folded portion on his back (PL. 390). For grand ceremonies he wore the double crown of Upper Egypt (the white tiara) and of Lower Egypt (the red cap with a curl in front and a high, thin extension behind). The women used large wigs during the earlier period, letting their thick locks of hair fall down over their breasts. The queens wore an ornament over their wigs which was supposed to be the carcass of a wide-winged vulture, and above this they could also place a low, round

crown topped off with two high feathers (PL. 382). Sandals of leather and vegetable fiber were worn. The only evidence we have for the use of gloves was found in Tutankhamen's tomb. (For Egyptian dress, see also PLS. 321–91).

In Mesopotamia the earliest materials used for clothing were animal skins, obtained first by hunting and later from tame animals such as sheep and goats. Here, unlike Egypt and Greece, clothes were made for the purpose of keeping the body warm and completely covered, without concern for the anatomical proportions of the person wearing the garments (PL. 16). Mesopotamian and Asia Minor artists were never interested in a naturalistic rendering of clothes but handled them instead with a clear-cut formalistic style suggesting rather than actually spelling out their details. During the Sumerian and Akkadian periods (3d millennium B.C.) the most widely used dress was a skirt decorated with fringes or with woolen tassels, having the form of a truncated cone when draped on the figure. Its fringes or flaps or strands of wool were either arrayed in a number of rows or were long enough to cover the whole garment in a single row. The cloak was a kind of sheath enveloping the body and might be decorated with a single flounced border or be entirely covered with flounces. Sometimes, as on the statues from the reign of Gudea, ruler of Lagash, the cloak was so full that it could be draped twice around the person (I, PL. 511). Such clothing, skirts and cloaks, the Greeks called *kaunakes*. The soldiers wore a woolen cloak covering the entire body and fastened by a brooch. Hair styles for men entailed long hair and a beard, except for the priests, who had to be entirely shaven. The headdresses consisted of a kind of turban or round fur cap, but helmets as well as ostentatious headdresses also have been brought to light, for example, the headdress of Mes-kalam-dug of Ur, with a gold imitation of hair wound around his head and knotted at the nape of his neck (I, PL. 508 shows a similar arrangement). Women's hair styles were more varied, consisting of braids and buns of hair wound around the head and gathered at the base of the neck, either tied with ribbons or gathered in a small net like the krobylos the Greeks used. The women also sometimes braided their hair with ribbons and bands, then gathered it into a turban shape held firm with large pins such as were used, for instance, by Queen Shub-ad of Ur. During the first half of the 2d millennium B.C., draped skins and furs were no longer in everyday use in Babylonia; they survived as special garments for gods and monarchs, ultimately becoming more splendid and elaborate, as shown on the stele of Hammurabi. The Kassites, who ruled southern Mesopotamia before they were conquered by the Assyrians, apparently had a style of dress similar to Asia Minor styles. On a boundary stone in the British Museum King Marduk-nadinakhe wears a remarkable round headdress decorated with two small spearshafts or vertical rays. The Assyrians copied Babylonian dress styles, embellishing them, however, with sumptuous, sophisticated ornaments, as seen in the statue of Ashurnasirpal II and in the reliefs from his palace at Nimrud (both, Br. Mus.). The principal garment was a long chiton, over which was worn a large cloak or a small collar very like a shawl. Similar garments appeared on representations of gods and evil spirits, just as both mortal men and evil spirits wore the ancient type of fur skirt (the reliefs from Khorsabad and Nimrud, I, PLS. 515, 516). On their heads they wore tiaras and round crowns, and on their feet, sandals. Babylonian embroidery and then Assyrian embroidery became famous, as did the gold decorations sewn on their clothes (cf. Ashurbanipal's relief from Nineveh; PL. 16).

During the last half of the 2d millennium B.C. traces of the Hittite civilization began to appear in Anatolia. Various reliefs, such as those on the door at Bogazköy, show us that the king wore a uniform consisting of a close-fitting tunic made stronger by horizontal bands and with a fringe border; it was firmly held at the waist by metal buttons. On his head was a decorated cone-shaped helmet. The uniform worn by his soldiers was like this but simpler (I, PL. 518), as can be seen in the Zinçirli warrior (Berlin, Staat. Mus.). For civilian dress the monarch wore a tunic with short sleeves and a cloak. His shoes had long, raised, pointed toes (I, PL. 521). He held a staff with a curved handle as the symbol of his authority. His headdress was a conical hat with a long ribbon falling down from it over his shoulders.

In Syria and Palestine variations in dress reflect the successive settlements there. Ivories from Ugarit (mod. Ras Shamra) and Megiddo, seals, sarcophagi from Byblos, and other artistic remains show us Cretan, Egyptian, Hittite, Assyrian, and Philistine modes of dress. Small bronzes and seals from the 2d millennium B.C. as well as reliefs from 1st-millennium Assyrian and Hittite cities show that inhabitants of the northern part of this area, the Aramaic peoples, usually wore long tunics with medium-length sleeves and high collars (or lapels of the tunics?) distinctive for their borders or large fringes. However, we also find cases of short skirts fastened at the waist by high belts, worn with vests and short sleeves. The clothes worn by people living in the southern parts, the Phoenicians and the Israelites, were quite similar. Here, however, short skirts were seldom used (vests were not worn), and instead tunics in a vast range of colors, with or without fringes, predominated. Women's clothes were basically like the men's (sometimes the lower part of the tunic was pleated). Their most remarkable garment was a long veil which covered their heads and reached the ground (as seen on a relief of Sennacherib in the British Museum, showing the victory of Lachish). The priests' garb of the Israelites had certain distinctive features as we know from the rules laid down in Exodus. A long, white tunic and a high, conical hat, also entirely white, were the identifying garments of a priest. Over their tunics they might wear a cape (*me'il*) over which the high priest placed the ephod, a full flowing rectangular garment embroidered and worn like a mantle. This habit later was adopted by the rabbis also and by the heads of the Jewish communities.

*b. The Aegean and Greece.* Up to the middle of the 2d millennium B.C., Cretan men wore a simple belt or a loincloth, later enriched with colors and embroidery, and sometimes also a sleeveless vest, as may be seen in the Harvester Vase from Hagia Triada and the wall paintings with the Keftiu, that is, the Cretans, in the tombs of Rekhmira and Menkheperraseneb at Thebes, Egypt. Some male figures also wear high leather boots. The dress of the Cretan women was more complicated. In the 3d millennium it consisted of a very wide skirt held by a thick belt wound twice around the waist with the ends hanging down to the ground, a small jacket which left the breasts completely uncovered, and a high peaked cap. The faïence statuettes from Knossos and the frescoes and miniature paintings from Knossos and Hagia Triada in the Middle Minoan period show a skirt made up of several multicolored and embroidered horizontal flounces and a kind of apron (PL. 17).

The kings from the Greek mainland, notwithstanding the Cretan influence, preferred their own dress, the traditional knee-length tunic with borders and a belt. In Homeric Greece the main dress of the men was the linen chiton covered by the woolen *chlaina*, a heavy mantle that could be dyed crimson or purple, and fastened with a clasp. A more elegant garment was the pharos, a mantle of fine linen, mentioned in the Odyssey as a princely prerogative, but more frequently a dress for women. Up to the Olympic games of 720 B.C., warriors and athletes wore only a loincloth. The main dress of the women was the peplos, a large, woolen square, wrapped around the body and fastened at the waist by a belt that emphasized the breasts. The cloth of the upper part could be drawn out to fall over the belt, forming a kind of pouch (*kolpos*). At the shoulders the peplos was held by pins or brooches, of which we have many original examples. It was colored, and sources tell us of the crocus peplos of Eos (reddish-yellow), the blue-black one of Demeter in mourning, that of Hera with woven ornaments, and the purple peplos in which the casket containing the ashes of Hector was wrapped. Over their heads women wore a veil of white linen (blue-black for mourning), fillets, and metal diadems. The jewelry, consisting of gold and amber necklaces, bracelets, and earrings, was very elaborate. From the archaic period on, the main dress of the men remained the linen and wool chiton, short and usually belted for the

youths, long and unbelted for the old men, and long for the charioteers, with colored borders and allover woven patterns. The mantle, the himation, falling symmetrically over both shoulders, is like the Homeric *chlaina* in its form and draping. The woolen peplos, often enriched by an overfold called *apoptygma*, reaching to about the waist, remained the preferred dress of the women. Later its place was taken by the Ionic chiton, consisting of two pieces of cloth sewed together at the sides or in the center of the front and back. On the shoulders and along the upper arm it could be sewed together or fixed with small pins or buttons. Over the chiton the women wore as an upper dress a kind of collar on the shoulders or the himation variously draped (PL. 17). From about 560 B.C. an elegant kind of Ionic dress went out of fashion, in the early 5th century, this Ionic dress went out of fashion, the artists still represented it, fantastically complicating its drapery. Hairdresses were rich and varied. Narrow and broad fillets, diadems, etc., decorated the long hair, which sometimes appears at the back lifted up by ribbons, metal rings, or kerchiefs and made into a knot. (For Greek archaic costume, see also I, PLS. 361, 373.)

At the beginning of the classical period dress had no particular form of its own, consisting only of simple rectangles of wool, linen, or a mixture of both, woven to measure. Colored borders gradually lost their decoration. The wardrobe of the men included the chiton, the chlamys, and the himation; that of the women, the peplos, the *kredemnon*, and the himation. These garments, although made of identical pieces of cloth, were distinguished by the variety of draping. Men and women dressed much alike, and the Doric came very close to the Ionic style. The chiton, of wool as well as linen, remained the most popular men's garment. Artisans, slaves, and warriors wore it to the knee and draped so as to leave one arm free (III, PL. 363). Slaves and foreigners attached long sleeves to the uppermost part of the side edges. It was worn without a belt by children and under the corselet by warriors. The long Ionic chiton was discarded at the beginning of the classical period. It was still worn only by wealthy old men, priests, and charioteers. Long sleeves were used only for the costumes of actors and musicians appearing in sacred performances.

In the early classical period old men wore their hair as a krobylos, a knot of hair fastened by golden clasps or spirals, or had their long hair rolled over a metal ring (*strophion*). Later men wore two braids laid around the head, sometimes covered by the hair falling onto the forehead (III, PL. 358). After the Persian War the young men cut their hair short and sometimes bound it with a ribbon or metal ring (III, PL. 346). A broad fillet indicated either a victory in sport or a religious function. Head coverings were rarely used. Footgear was of great variety. Sandals with leather straps held by a ring were most common (in the 4th century an elegant leaf-shaped piece of leather was added). High boots, called *endromides*, for travelers and hunters, and the Thracian fur-lined boot (*embas*) were used. Only the mode of draping varied in the himation, which had continued in use, sometimes serving to cover the head in religious ceremonies or as a sign of mourning. The *chlaina* and the *diplax*, still shown in representations of the gods, especially Apollo, disappeared from general use. Philosophers seem to have worn a simpler dress, probably of coarse wool, called *tribon*.

The peplos, which in the Peloponnesus had never gone out of style and was therefore called the Dorian dress, came back into fashion for women in the classical period. Of varying dimensions with the passage of time, it is narrow in the sculptures from Olympia, wider in those from the Parthenon and in the Eirene of Kephisodotos. A finer dress in the form of a linen peplos seems to be worn by the Nike of Paionios (III, PL. 367) and the Nereids from the Nereid monument of Xanthos (Br. Mus.). The usual chiton of the women in the classical period was longer and wider than that of the men, and the finer ones, such as those annually dedicated to Artemis in her sanctuary on the Acropolis, were of linen, sometimes transparent, imported from Amorgos. The sleeves were sewed or had a series of buttons along the upper part of the arm. One or two belts, out of which was drawn the pouch or *kolpos*, organized the mass of fine folds to create a rich drapery. Athletes and dancers wore a short chiton. A mantle fastened on one shoulder only, like the *chlaina*, was given to goddesses. A mantle pinned on both shoulders, however, was frequently worn. The *kredemnon* (head veil) is again seen in the Hestia Giustiniani and elsewhere. Among the few kinds of women's hats were a wide-brimmed Thessalian hat and a round hat with a high crown in the center, seen on Tanagra figurines, called *tholia* from the round buildings named tholos (PL. 17). The hair was worn long, except by young slaves and mourners, and dressed in diverse ways, bound by fillets, ribbons, kerchiefs. The most common footgear of the women was sandals, but they also wore soft, closed shoes. In the early classical period the women, like the men, wore the *kothornos*, but this was discarded when it became the shoe of the tragic actors. Clothing and accessories of the classical period were colorful. The peplos generally was red or blue, sometimes with woven borders in different colors. The white linen chiton had ornamental borders.

In the Hellenistic age the frequent contacts with Oriental peoples brought about a great transformation in dress. The use of byssus, a yellowish flax from India and Egypt, was introduced, and together with silk it was used for the finest transparent dresses. The chlamys was rounded off by cutting the lower ends hanging down to the legs (Macedonian chlamys). The himation was decorated with the fringes so dear to the Orientals. A new kind of dress for women was the *peronatris* worn over the chiton and taking the place of the peplos. The chiton, often of wool, was sometimes gathered with many little folds into a band at the neck, thus not allowing for sleeves. The slender silhouette was emphasized by putting the belt directly below the breasts. The himation was, on the contrary, frequently of a lighter material. The Hellenistic dress in respect to the classical, besides being fuller and hiding the body more, was also more brightly colored. Purple became a royal prerogative, but reds and violet hues were much used. The hairdress of the women remained substantially the same.

*c. Italy and Rome.* In Etruria dress followed the changes in the Greek world, with a wealth of color, as seen especially in the painted tombs. Typical in the archaic period were shoes of the Ionic type, with a raised point (*calcei repandi*). Characteristic headdress was the high conical cap or bonnet worn by men as well as by women, later adopted by the flaminica (priestess of Juno), the wife of the flamen (priest of Jupiter), under the name of "tutulus." The *laena*, a woolen mantle that was later worn by the Roman priests, came from Etruria, but it appears to have been originally worn by professional actors. The loincloth, at one time probably the common dress, later became the professional badge of dancers. Another Etruscan garment, worn by the augurs, the Salian priests, the Roman aristocratic knights (the equites), and later by the consuls, was the trabea. It was striped, in a bright color, probably purple, and perhaps was the forerunner of the *tunica angustis clavis* with narrow stripes and the *tunica lato clavo* with wide stripes, a garment said to have been worn by the kings of Rome, which continued as a sacred obligatory dress for the priests. The *trabea* is also called a mantle and in this form would be the forerunner of the *toga praetexta*, decorated with purple bands. The short rounded cloak for men of the Hellenistic age (*tebenna*) became the Roman toga. The garment Vel Saties wears in the painting in the François Tomb at Vulcii (V, PL. 52) is perhaps the *toga picta* which Macrobius (*Saturnalia*, I, 6, 7) attributes to the magistrates. In the late Etruscan period the ornaments of the clothing and the jewelry became heavier and more ostentatious.

Roman dress, in contrast to that of the Greek democracy, reflected the class society, the professions, and the trades. The most common material was wool. Linen, worn by the Samnites, soon also reached Rome. Cotton from Egypt was introduced at the beginning of the 2d century B.C., silk at the end of the Republican period. The most usual dress was the woolen tunic, supplemented by a mantle for the upper classes. It consisted of two rectangles sewed together at the sides and at the shoulders, or a single piece sewed at the side, with

openings for the head and arms. In the later period sleeves were sometimes woven in one piece with the main part. The men's everyday tunic generally reached to the knee. For religious ceremonies it was ankle length like that of the women (PL. 18). The scantier tunic of the slaves and workers often left one shoulder bare. For children it was wide and long, belted at the waist. Usually white, the tunic was decorated with purple stripes of varying widths according to the social class. Old men and working men wore it dark and undecorated. The *latus clavus* was reserved for the emperor and the senators. The stripes went over both shoulders and reached to the front and back hems. The knights had two narrow stripes (*angustus clavus*). After the first century the stripes were worn by every patrician. The *tunica recta* (that later given to Christ) may have been without a belt and seems to have been of Etruscan derivation. The *tunica palmata*, worn by victorious generals at their military triumphs, was probably not decorated with palms but purple (the Greek *phoinike*, of Phoenician purple, wrongly translated as *phoinix*, palm). In the late Roman period the tunic was more richly decorated, as is seen in original tunics preserved in Egypt, with ornaments in tapestry weave or embroidery and a greater number of borders. The chiton with large sleeves (*dalmatica*, perhaps from the name of the province) was taken over by the Christian Church as an ecclesiastical vestment. The official garment of the upper classes was the toga (PL. 18). The privilege of wearing it and its color and decoration were strictly regulated by law. The all-white toga was worn by office seekers (*toga candida*), the purple by high officials, the dark toga (*pulla* or *atra*) for mourning. Youths wore the *toga praetexta* with purple borders, also the sign of those who filled high governmental or religious posts. At the age of sixteen the youth assumed the white *toga pura* or *virilis*. Scanty (*toga exigua*) in the Republican period, it became larger in the late Republican period, reached its maximum size in the Flavian age, became narrow once again in Severan times and then very wide and stiff with complex drapery in the late Imperial period. The pallium, a simple, rectangular mantle that could be draped in the most diverse ways, is nothing but the Roman adaptation of the Greek himation; it was worn by the Greek characters in Latin comedy. The women's cloak was the palla, variously draped.

Prescriptions for dress were particularly rigid for religious ceremonies. The vestal virgins wore the white stola, a long, sleeveless tunic held over the shoulders by ribbons or cords, with a girdle tied into a special knot, their hair arranged in six coils bound with fillets (*infulae*) and covered with a square veil (*suffibulum*). The priest, emperor, and other high officials and also women in most sacrificial rites had to cover their heads with the edge of the toga, for this occasion secured at the waist by a belt (*cinctus Gabinus*). The attendants to the priests, who accompanied and slaughtered the sacrificial animals, were stripped to the waist. The flaminica wore the tutulus on her head and, at the sacrifices, a crown of pomegranate branches. The military dress varied according to the rank. The paludamentum, a large white or purple cloak like the Hellenistic chlamys, was worn by the emperors and generals. The rank and file wore the *sagum*, a cloak that was probably gray or brown. The occupation troops in the north in a late period adopted knee trousers. Other types of mantles, especially adapted as a protection against the inclemencies of the weather, were the *lacerna* and the heavy *paenula* to which was attached a hood (*cucullus*), and the *birrus* or *burrus* of a very coarse material. The lictors, city prefects, and philosophers wore the abolla, a larger and lighter mantle. Footgear also varied according to class. The *calceus*, a closed shoe, was worn by women and by men in toga, but was forbidden to slaves. The *calceus senatorius* had a high tongue and four straps which were wound around the leg up to the middle of the calf. Citizens wore a low shoe (*soccus*), soldiers a military boot (*caliga*). Up to 300 B.C. men wore long hair and beards; then hair was cut short and the beard shaved. Hadrian reintroduced the beard, but it disappeared in the 4th century. Women's hair fashions changed very often. In the Republican period hair was parted, combed back, and made into a small knot behind the head. Complicated hairdresses appeared in the Imperial age and especially in the Trajanic period, when the hair was dressed high and elaborate on the forehead.

Margarete BIEBER

*d. Barbarian Europe.* Information about the barbarian peoples is very scarce, limited to an occasional coin, several bas-reliefs, and a few literary sources. According to Julius Caesar, the Gauls wore animal skins. After contact with Rome they wore belted tunics, long trousers, and small, semicircular capes (*sagum* or *sagulum*), usually with a hood (*bardocucullus*) of rough cloth or skins. Barefoot, or in crude leather sandals, they had untrimmed hair and moustaches.

Similar to that of the Gauls, the costume of the Germans consisted of an overdress of varying lengths, with or without sleeves, closed at the front by a brooch. With this they wore trousers. On the shoulders there was a small mantle with or without hood, on their feet crude sandals. Hairdress varied according to the area. Long hair was gathered in a knot on the right temple and dressed with resin or pomade or let fall long and loose as a symbol of liberty. Mustache and beard were the rule. There are very few sources for women's dress. The wide, sleeveless tunic fastened on both shoulders by a brooch, leaving the arms uncovered, and gathered at the waist by a belt, was of Celtic origin. Near the middle of the 2d century an overdress with short sleeves was often worn over the long-sleeved tunic. The mantle was square and fastened at the shoulder with a brooch. Beginning with pre-Carolingian times women wrapped the head and body in a mantle. Hair was parted in the middle or tied with a ribbon. Married women wore it pinned up with combs and pins, a fashion dear to the entire Middle Ages. Legs were wrapped like the men's, and footwear, too, was similar.

*e. Late antiquity and Byzantium.* With the decadence of the Roman empire, external pomp increased. While Christianity imposed a simple and sober taste, banning ostentatious jewelry, intensified trade with the Orient imported into the heart of the empire itself the Asian taste for lively color and ornamentation. The technique of printing fabrics in several colors was also perfected and took the place of embroidery (III, PL. 100).

When the cultural center was transferred from Rome to Byzantium, love of luxury became even more evident. Although the cut of the garments remained essentially the same as in the late Roman period, the fabrics had a new magnificence. Silk or brocade, stiffened with gold thread, they were woven or embroidered with arabesques, leaves, flowers, animal profiles, and human figures, in sinuously interlaced lines. The cut of the dress tended to hide the form of the body under long, stiff lines that fell without folds or drapery (PLS. 18; II, 446, 448, 489). The dress of the common people was a tunic of medium length, with sleeves and belt, under which were revealed long and usually tight trousers, up to then worn only by Orientals and barbarians. Nobles wore another knee-length tunic over these two garments. With wide sleeves, it was often white and decorated with applied or embroidered bands or disks of many colors. The costume of the upper classes was completed by a kind of embroidered and decorated stole (*loron*) about 10 to 12 inches wide, that perhaps took the place of the ancient clavus. Over the tunic was worn a semicircular mantle, of costly fabric, fastened on the right shoulder by a rich clasp. For footgear the Roman *calceus* remained in fashion, black for the middle classes, red or yellow for the upper classes, and made from a very soft kind of leather, something like morocco, called "leather of Persia."

Women's dress differed from men's only in the absence of trousers. The woman's tunic (*byzantina*), reaching to the feet, was close-fitting at the neck and had tight, wrist-length sleeves. Over this was worn the *loron* and the mantle. Just as the dress of the two sexes was quite similar, so the emperor's was not very different from that of the high dignitaries. The color purple, however, was reserved for his use. After the 4th century a large, square patch in a contrasting color was applied to the front part of the cape. Often richly decorated, it was called

"clavus," perhaps recalling the purple stripes that decorated the tunics of the Roman senators and knights. The men wore their hair long and loose; the women dressed theirs in thick braids, often intertwined with strings of pearls. In comparison to the court pomp which can still be seen in the mosaics of Ravenna, the dress of the people became ever simpler, having in the end a purely protective function.

*f. Iran.* Elamite costume at the beginning of the 3d millennium B.C. consisted of a knee-length tunic or a long narrow gown reaching to the ground. The *kulah*, a high cylindrical or conical felt hat, worn as early as 2000 B.C., has continued in use to recent times. Early Median tribal chiefs in the 1st millennium B.C. wore the tight-fitting, ankle-length coat also used in Elam and the *kyrbasia* (mod., bashlyk), characteristic of the Achaemenid costume, a soft cap with the crestlike top falling forward and three flaps, two of which met under the chin and the third covered the nape of the neck.

The clothing of Luristan was similar to that of the Hittites, consisting only of a kilt or a snug, tightly belted tunic. The king and attendants wore the long gown, also tightly belted and cut round at the neck, closing diagonally from the left shoulder to the right hip, with kimonolike half sleeves that came to a close cuff at the elbow. The men were fully bearded and mustached, the closely curled beard either rounded off or long and cut square. The hair was also long and curled, bound around the brow with a narrow fillet or surmounted by a ribbed tiara (*kindaris*). Women dressed similarly.

After the fall of Nineveh (612 B.C.) Assyrian court fashions became current among the Achaemenids. The gown fell in soft folds to the ankles with very wide sleeves or a kind of cape draped around the shoulders (PL. 21). For fighting, riding, or hunting, these rich garments were caught up between the legs with a girdle.

Under Darius, Median court dress was adopted, but the Persians themselves wore a tight-sleeved coat, reaching to the knees or below, held by a narrow girdle with sword belt and a short sword, close-fitting trousers, and over them felt boots that came up to the knee. An ankle-length cloak with long sleeves, the *kandys*, was thrown over the shoulders, the sleeves apparently used only on ceremonial occasions. The hair was long, and the kulah or the *kyrbasia* was worn. Women's dress was substantially the same, with a long gown, wide sleeves for court ladies and narrow for the commoners, closely fitting trousers, and a veil that fell almost to the ground. The difference between the classes was shown by the materials and accessories such as gloves and shoes. The sovereign's clothes were purple, crimson, and saffron. Only the Magi wore white.

Under the Seleucid ascendancy new styles appeared with the predominance of Syria and Asia Minor. Leggings were worn over the trousers and caught under the foot with a strap (reliefs at Palmyra). Over all was a knee-length tunic or a short coat with narrow sleeves. Princes also wore a heavy mantle coming down to the ankles and held together with a jeweled clasp. The Median bandeau was assimilated to the Syrian circular diadem, prototype of the Sassanian crown. Among the peoples of the interior, however — Scythians, Bactrians, and Parthians — the older Persian costume continued.

In the Sassanian period there was an Iranian cultural renaissance after the philhellenic Parthian rule. Persian costume, maintained almost unchanged in certain districts, swept back into fashion with a narrow, long-sleeved coat almost to the knees, girdled at the waist. As in the Achaemenid period, court costumes were differentiated from those of the people primarily by the fabrics used. Women's clothes showed little change except that the veil was smaller. Their hair was worn in long ringlets held by a bandeau with a large knot in back.

Princely rank in the early Sassanian period was indicated by a floating cloak loosely knotted on the chest. Chief distinction was the elaborate diadem, a true crown, with a mystic meaning attributed to every detail (see EMBLEMS AND INSIGNIA).

* *

*Islam.* The traditional garment of all Islamic peoples of both sexes is the long-sleeved shirt (*qamīs*), worn over knee-length breeches and usually almost completely covered by the other clothing. There is an extraordinary variety of overgarments, tunics, mantles, and jackets worn one over the other as tangible signs of social rank and wealth. They are often embroidered and decorated with beads (*khil'at*, ceremonial robe; *khil'at al-mulk*, royal ceremonial robe), making them suitable as gifts or rewards.

Over the shirt was worn a long-sleeved robe fastened in front or at the side. The long sleeves were ornamented with a strip of cloth (*tirāz*) of varying colors, bearing an inscription which was occasionally religious. The *tirāz*, found as early as a relief from Persepolis representing Darius, lasted in Iran until the beginning of the 15th century. Over the robe women wore a short-sleeved tunic (*sallārī*) of the most varied fabrics, embroidered and sometimes decorated with pearls and precious stones. The embroideries are almost always reproduced with great precision by the miniaturists, possibly indicating that one of their tasks was to furnish embroidery designs. The costume was completed by a mantle, the most usual being the woolen burnoose with a hood, extremely decorative and frequently reproduced in 13th-century Mesopotamian miniatures. It could also be of costly fabric to signify the class or caste of the wearer.

Turkey was also inspired by Iranian fashion. The sultan's mantle was encrusted with pearls and precious stones and had a wide fur collar over the back and shoulders. As footwear the Moslems wore sandals and slippers or boots for horseback riding. Feminine dress differed only in the use of the veil that covered the face, a very full mantle, and the lack of a turban, which women were forbidden to wear.

In every age the most characteristic accessory of the Moslems was the turban, consisting of a strip of cloth wrapped around a skullcap. It underwent considerable change, both in the form of the skullcap and in the varying length of the strip and the tightness with which it was bound. The turban was not only a national and religious symbol but also an indication of social class. For the student of Islamic painting, the form of the turban constitutes a valuable index, particularly for dating the Iranian miniatures of the 15th, 16th, and 17th centuries (I, PLS. 15–17; II, PLS. 297–300). Of course, the changes took place most frequently in the noble classes. The clergy, the men of law, and the wise men were more traditional and conservative. In the 12th century the turban usually had a hemispherical form with one end of the cloth, '*adhaba*, falling down the left side. In the first half of the 14th century the volume diminished, the form of the skullcap was more apparent, and the '*adhaba* was shorter. During the 15th century in Iran the headdress became higher and more imposing. Early in the 16th century it assumed the form of a long-necked bottle decorated with aigrettes, feathers, and strings of pearls; near the end of the century it become softer and fuller. Many courtiers, originally from Turkistan, also wore berets, hats with upturned or wide brims, leather, felt, or cloth bonnets with the skullcap covered with paper, all brightly colored, embroidered or trimmed with fur, making a very picturesque effect. The turbans of the sultans reached impressive dimensions. The uniforms of the Turkish guards consisted of a mantle with frogs and loops and a very high cylindrical headdress.

Wilhelm STAUDE

*East Asia. a. India.* The richness of Indian dress in early times is proved by the Vedic texts, by the reports of the ambassador Megasthenes (sent to India by Seleucus I about 300 B.C.), and by Strabo, who noted garments "worked in gold and ornamented with precious stones." Beginning with the 2d century B.C. there are representations of dress in sculpture, frescoes, miniatures, and coins (I, PL. 48). Although as far back as the Vedic age (ca. 1500–800 B.C.) India knew how to cut and sew cloth, it has always remained true to the traditional draped costume. In the earliest period the men's costume (dhoti) consisted of a wide piece of cloth wrapped around the lower part of the body, leaving the torso bare, and held up

below the waist by a belt. The excess material was pleated at the center or the sides, and sometimes the end was passed between the legs and fastened in back, giving it the appearance of baggy trousers. From the representations it appears that in early times the women also had a similar garment. Later they adopted the sari, a long piece of cloth that, after being wrapped around the hips and legs, was thrown over the shoulders, covering the breast, back, and sometimes the head. Besides the sari there were, however, simpler garments. The costume was usually completed by a kind of scarf (*dupaṭṭa*) wrapped diagonally around the torso and thrown over the left shoulder, and the turban, wrapped spirally around the head. The dress, accessories, and the richness of the fabric indicated the social position of the wearer. The many-colored textiles were varied and prized; for them India became famous all over the world. Soldiers, servants, and the poor wore only a narrow loincloth. From the 2d century B.C. to the 5th century men and women almost always wore the dhoti, draped with many folds and reaching to the calf. The turban, also worn by women, in time lost its fullness and varied with the fashions.

In the 1st century the Indian costume fell under the influence of the northern and western regions. On the coins and statues discovered in Mathura, the Kushan kings wear the heavy costume typical of the Scythians and Parthians, characterized by trousers, boots, a knee-length tunic, and a wide, flaring mantle. The dress of the Buddhist monks (PL. 19), which later became typical of representations of the Buddha, consisted of two garments (the loincloth and a kind of dhoti) worn together and a full mantle (*saṅghāṭi*).

Western influences were still very strong in the Gupta period. The kings of this dynasty as shown on the coins continued to wear the tunic, trousers, and boots, although later the local dhoti, together with the tunic, came back into fashion. The caps and numerous cut-and-stitched garments were of Western origin. In the frescoes of Ajanta and Bagh, people of every rank (king, servants, soldiers, male and female figures) wear short girdles and tunics of varying lengths and styles. The draped garments, however, always remained the most widely used. From the 10th century the dhoti began to be draped diversely in the various regions. From Hsüan-tsang we know that jackets, more suited to the cold climates, were worn in the northwest. With the Gupta period the voluminous type of turban disappeared. Many women dressed their hair with cloth, pearls, jewels, and flowers. Kings and queens sometimes wore high, conical tiaras. Beginning with the 10th century, the fashion of the sari, full enough to cover the head at times, became general for women. And this, with regional variations, became the characteristic feminine Indian dress. After the 16th century, Moslem domination brought skirts and scarfs and especially a large, long-sleeved mantle with a high belt (PL. 24) into use. The dhoti was, however, never completely replaced, and in the south it became the dress of royalty.

Madeleine HALLADE

*b. Tibet.* With diverse tribal groups living in isolated areas, Tibetan costume is very varied. It is, however, possible to find some common elements, such as the heavy overcoat, called *c'u-pa*, knee-length for the men and ankle-length for the women, with narrow sleeves extending below the hands. It is frequently the only garment for the poor, although a shirt and trousers and perhaps thinner robes may be worn beneath it. The *c'u-pa* seldom has buttons and is fastened by a twisted girdle of colored cloth, into which are thrust swords and purses, or appended knife sets, tinder cases, and charm boxes (*gau*). Men and women wear high boots (*lham*) of cloth and leather. Tibetan women, especially of the upper classes, wear one or more blouses, several petticoats and skirts, and an apron. Nobles and officials of Lhasa wear their hair gathered up in a knot at the top of the head with a small charm box fastened to it. Their dress hats are very spectacular. Many Tibetan men go bareheaded, with the long queue which encircles the head passed through silver or ivory rings. In northeastern Tibet women braid their hair into 108 small strands covered by a cloth on which is worn a

tall, conical hat with a brim. The ladies of Lhasa wear across the top of the head a horizontal bar covered with cloth and decorated with coral and jewels on pendant chains. In Shigatse a wooden arch serves as a support for stretching strings of beads. The dress of the Buddhist monks, usually a deep red, consists of a long-sleeved shirt, a sleeveless vest, a wide, wrap-around skirt, a togalike outer cloak, and a narrow shawl. In cold weather or for riding they wear heavy trousers with red boots and an overcoat of the *c'u-pa* type. The sleeveless vests of the high lamas (*bla-ma*) and the abbots are very elegant, of silver or gold brocade. Their hats too are exceedingly elaborate. Special headdresses are used for ceremonial dances and exorcism rites (see MAGIC; MASKS).

*c. Mongolia.* When the Mongols first appeared on the stage of history in the 13th century, as Great Khans and rulers of China, their costume consisted of a long outer robe with short sleeves, worn over a long-sleeved inner robe, tightly belted at the waist, with personal belongings hanging from each side of the belt. They had light summer hats with wide brims and winter hats faced or trimmed with fur, both kinds topped by small feathers and jewels, which may have differed according to rank. High boots, often with upturned toes, completed the men's costume. The women's dress was similar but lacked the belt. They wore an extremely tall, black silk headdress trimmed with beads and precious stones and small feathers.

The costume of the later Mongols differed widely according to locality, but the common garment was the caftan, a long robe with sleeves that came down over the hands or could be folded back to disclose a contrasting lining. In winter the robes of the upper classes were of heavy serge lined with fur, while the lower classes wore jackets and trousers of sheepskin with the fleece inside. Both sexes wore high, decorated, heavy-soled boots of cloth or leather, sometimes with turned-up toes.

The earlier Mongols shaved their heads, leaving a forelock and two braided queues, usually looped up at the sides of the head. Later they adopted the Manchu style of a single, heavy queue worn down the back. The women wore two braids, threading them through rings and other jewelry. In Outer Mongolia both sexes wore a small hat with a very high, narrow crown on which was displayed the jewel of rank.

*d. China.* The Chinese costume tradition, which has strongly influenced the neighboring nations, has not been so strictly conservative as many Occidental writers have imagined. Though the dress changed notably from dynasty to dynasty, one constant element has been the emphasis placed by the Chinese court on distinguishing the rank or social position of the wearer. Paintings on Han tomb tiles (206 B.C.–A.D. 221; III, PL. 232) and some contemporary reliefs are the earliest documentation of Chinese costume. In general it consisted of a long, full robe with full sleeves, overlapping across the front to fasten almost always on the right, first secured by cloth tapes, later, under the Ming dynasty, with buttons. The fullness of the gown and sleeves varied according to the class. The ordinary folk wore close-fitting gowns with narrow sleeves. There was no particular difference between the dress of the men and women, the men adding only a belt or girdle. About 300 B.C. trousers and boots were introduced for convenience in horseback riding. The peasants of both sexes ended by adopting trousers, together with a short jacket, as their working dress.

Aside from their marriage costume (red for the bride), the common people were allowed to wear only blue or black clothing. By contrast, the robes of the nobles and officials were colorful, with special hues prescribed for different ranks or special occasions. The color for mourning was white for all. The old Chinese court and official costume was traditionally divided into three categories — sacrificial dress (*chi-fu* or *li-fu*), court dress (*ch'ao-fu*), and informal or ordinary (*pien-fu* or *ch'ang-fu*). At least after the later Han dynasty (A.D. 25–221), and traditionally for centuries before, the emperor's sacrificial costume consisted of a full, black jacket with broad sleeves and a black, pleated apron wrapped around the waist to form a skirt. Together these were decorated with 12 symbols which represented the

universe in microcosm, indicating the emperor as universal sovereign. With this he wore a hat (*mien*) consisting of a skullcap topped by a rectangular board from which hung 12 strings of jewel beads. The court dress consisted of a long, full-cut robe with very broad sleeves, differing in color (purple, red, green) according to rank. From the back of the belt hung a narrow apron (*shou*) with separate woven or embroidered emblems. Nobles and officials at court were required to carry a flat, curved baton of ivory or fine wood. Of the many hats which accompanied the court dresses, the most formal was the *liang-kuan* with vertical ridges extending down the front to indicate the rank. The informal robes of the courtiers differed from their court robes mainly in color and in the style of the belt. Beginning in the T'ang dynasty (618–906), the black gauze cap (*wu-hsia-mao*) was ordinarily used. Of stiffened black silk gauze tied over a light frame, it jutted upward at the back with two loose ends standing out like wings.

The Ming dynasty (1368–1644), which won China back from the Mongols (1260–1368), although reviving the old T'ang and Sung costumes, made several changes. By the costume laws of 1391 it was decreed that informal dress for nobles and officials was to consist of a full-sleeved, red robe with patterns on the chest and back that differed according to rank. Eventually these patterns were confined to large, square plaques called *p'u-fang* or *p'u-tzu*, known to collectors as "mandarin squares."

Before the Ming dynasty women of noble rank had had elaborate hairdresses with ornamental jeweled pins. Massive crowns in gold filigree with pearls were worn only by the empress, imperial concubines, and the highest princesses. But under the Ming, crowns consisting of a light frame faced with irridescent feathers, on which were set jeweled birds to indicate rank, were commonly worn for formal occasions.

The Manchus of the Ch'ing dynasty (1644–1912) imposed their own costume on the Chinese by their laws of 1652 in order to avoid distinction between the two peoples. Manchu-style robes were much more tight-fitting, with very narrow sleeves ending in "horseshoe cuffs" (*ma-ti-hsiu*). For important ceremonies a short jacket with a wide-spreading collar was worn over a full, pleated skirt. At first winter jackets were completely lined with sable skins (later used more sparingly) and ornamented with dragons. Ch'ing nobles and officials appearing in public were required to wear a dark jacket (*p'u-fu*) which carried the mandarin squares on chest and back. The robes worn under the *p'u-fu* were tightly belted with narrow silk belts with metal buckles. To side rings were attached knife sets, fan cases, purses, and kerchiefs. The Manchu shaved the front of their heads and braided the remaining hair in a single queue down the back. During the cold season Ch'ing officials wore small, round hats with sharply upturned brims faced with dark silk or fur (PL. 23), and in summer a flattened cone of light straw faced with white silk. On both kinds was a long scarlet fringe hanging down from the top of the crown. The Manchu empress and the highest noblewomen of the Ch'ing aristocracy wore gowns and hats similar to those of their husbands, but they decorated themselves with diadems, jeweled torques, and a long scarf hanging down the front of the robe. The Chinese wives of the Ch'ing officials bound their feet and fitted them into tiny slippers, while the Manchu women, who despised the "lily feet" of the Chinese, wore large, embroidered slippers sometimes raised on central platforms. For informal wear they had long, straight gowns and traditionally wore their hair pulled up and back over a wide frame against which they fastened ornaments.

*e. Korea.* The earliest traditional Korean dress consisted of a short jacket (*chogori*), a pair of wide trousers (*paji*) bound by tapes at the knees or ankles (or both), and a kind of high-waisted overcoat (*tsurumagi*) that was tied with ribbons or tapes on the right side.

During the Kōryō period (A.D. 936–1392) the Korean court adopted the fashion of Sung China, changed to Mongol costume in the late Kōryō period when the Mongols overran Korea, and in 1369, when the Ming dynasty expelled the Mongols, took over the Ming costume but modified it in regard to the decorative bird and animal motifs and hat styles. A distinctly Korean form of hat that is still used today is a tall cylinder covered with black silk gauze or woven horsehair, with a very narrow brim. The women wore full trousers under very full skirts and extremely short jackets that sometimes did not even cover the breasts. Usually the women of low degree, like their husbands, wore white. Korean noblewomen arranged large and intricate hairpins into a kind of crown.

*f. Japan.* The elements of Japanese dress, like many other aspects of Japanese culture, are drawn largely from Korea, and by way of Korea, from China. During the long feudal period the costume of the court nobles was characterized by an outer coat recalling the Korean *tsurumagi* (see above). Courtiers and court ladies wore trousers (*hakama*) of Korean model, sometimes so long that they trailed behind like a train. Headgear was varied. Most of the styles seem to have been ultimately derived from the black gauze hats of the T'ang and Sung courts, fantastically elaborated. The basic garment for both men and women is the kimono (literally, "wearing thing"), a gown with broad sleeves, without buttons or ties, overlapping across the chest to close on the right side, secured by a cloth band, or obi. Unlike the men's obi, a simple, narrow girdle of folded cloth knotted in front or back, the women's obi is very long and a foot or more wide. Generally of rich and expensive brocade, it is usually the focal point of the dress. On formal occasions men and women wear over the kimono a jacket (haori) bearing the family crest (PL. 9). Formerly men of the samurai, or warrior, class wore two swords thrust through the obi. In place of the sword men of the lower classes could carry only small medicine boxes (inro) fastened by a netsuke (see IVORY AND BONE CARVING). Netsuke and inro, constituting the only decoration of the clothing, were often extremely fine objects (VIII, PL. 248), the signed work of accomplished artists. Both inro and netsuke derive from Chinese and Korean prototypes. The Japanese Buddhist priests wore the *kesa*, a kind of shawl or oblong cape. To emphasize the poverty of the clergy, it was made of small patches, which paradoxically were often of gold brocade.

Men shaved the front of the head and drew the remaining hair up into a tightly wrapped, short queue which curved forward on top. Noblewomen wore their hair hanging loose down the back. During the Tokugawa (Edo) period (1615–1867) the hairdress of Japanese women, especially professional entertainers, became extremely complex.

Peasants protected their legs with a kind of tight legging called *momohiki*. Traditional shoes are the flat sandals of fine straw often covered with silk (*zōri*) and the wooden clogs (geta), both attached to the foot by cords or straps passing between the great toe and the second toe.

Schuyler Van Rensselaer CAMMANN

*g. Southeast Asia.* The Vietnamese costume covering the whole body may have originated in the Chinese dress of the T'ang period. Earlier, men and women in the north wore a long robe, in the south a loincloth and a jacket buttoned in front. But from the mid-18th century clothing has consisted of trousers for both sexes, a jacket for the men, a kind of halter for the women, and a long tunic. In the zone of Indian influence, the dress of the men consisted of a kind of kilt (Burma, Malay, Indonesia) like the Indian dhoti, with folds (Cambodia, Thailand). For cold weather European influence has brought about the adoption of the Chinese coat or the European jacket. The women wear a long, brightly colored sarong made of a wide piece of cloth with the excess material gathered in folds in front. Once they left the upper part of the body bare, but in modern usage it is covered by a scarf or a blouse. Headgear commonly consisted of a light turban. The bas-reliefs at Angkor show wide, jeweled collars, girdles, bracelets, and anklets and high-spired crowns for ladies of rank.

*Primitive peoples.* The use and development of dress among primitive peoples is conditioned not only by the climatic environ-

ment but also by political-social rank, sex, ceremonial requirements, and to a lesser extent by fashion. The evolution of dress in the Marquesas Islands from the beginning of the 19th century to the present day may serve as an example. The native represented in 1804 by Langsdorff was naked, even if his tattooing "clothed" him with considerable elegance. A few years later the islander shown by Von den Steinen had a feather headdress and was covered by a little cape and a kilt that left the tattooing only partly exposed. By 1896 he resembled a European soldier, with a visor cap, wide-belted jacket, and a pack on his back. The tattooing was visible only on his bare legs. Finally, at mid-20th century, the Marquesan wears a shirt, white trousers, and a dark jacket, has bare feet, a fiber cape, and a hat of leaves. The tattooing is completely hidden. Examples of this kind could be endlessly multiplied.

Among the Indians of North America clothing underwent a radical change following the coming of the white man. But even earlier, partial or total changes had taken place through acculturation among the various indigenous tribes. The Sioux war dress, for example, spread to the Indians of the southeastern United States. In other cases the transformation of the costume coincided with important changes in the economy, as happened with the Plains Indians who, after the introduction of the horse to the continent, became nomad hunters, tied to the migration of the bison, which furnished them not only with food but also with their basic clothing materials.

Innovations in dress have often been the result of European importation, either taken up spontaneously by the natives or imposed by the Europeans. This happened with the so-called "Mother Hubbard" dress introduced by the missionaries to develop a sense of modesty among the Polynesians. Unpopular at first, the garment was later transformed and adapted to the temperament and needs of the islanders, who replaced the monochrome cottons with bright flowered fabrics, shortening the sleeves and adding ruffles and pleated panels. Today that dress, called "moomoo" in the Hawaiian Islands, is the Polynesian national costume. Tourists often carry a "moomoo" home as a souvenir and consider it an element typical of the folklore of the island, while actually it was imported from Connecticut. This is an example of reciprocity in fashion between the primitive peoples and advanced cultures.

One cannot say that there are no lasting fashion elements among the natives. Certain typical elements have been observed to became attenuated only with the disintegration and dispersion of the social structure. It is perhaps right to state that all important changes in fashion coincide with the transformation of existing social norms.

The assertion of many sociologists that costume originates with its protective function is belied by a simple examination of the situation among primitive peoples. Even in the case of the Eskimos, with their weatherproof outfits, the styles and types of ornaments (PL. 8) are so varied that one cannot speak of purely functional dress. The Eskimo does not hesitate to expose the newborn baby to the most rigid climate, naked as it is in the fur bag hanging from its mother's back. Moreover, inside their houses — where the temperature never goes above freezing — the Eskimo goes about almost naked.

Some tribes use clothing so reduced and localized that its purpose is not certain, such as the penis sheaths of the Carajá and Tapirape in the Mato Grosso, which may serve as protection against insect bites. In other cases, the function would seem to be magical protection. The Balinese women, for instance, cover their breasts only when they are nursing.

Some scholars have attributed the origin of dress to the sense of modesty. Actually this exists among some tribes which use no clothing whatsoever, whereas it may not be present among others who cover themselves completely. Nor are the parts covered always the same, even if they generally coincide with the genital region. On the contrary, certain special articles of clothing would suggest a transfer of the original sense of modesty: the facial veil of the Moslem women, the aprons worn in back, the umbilical belts used in Samoa, etc. Costumes of this kind have been in use since prehistoric times, as is shown by some surviving figurines.

Total nudity, where it still exists, appears at times less immodest than certain localized garments, such as penis wrappers of large proportions, which, besides protecting, seem to call attention to the sexual organs. Other customs that stress sexual differences can be linked to this, such as the use of false breasts of painted coconut by New Hebrides young men in the *na leng* dance, in which they imitate the movements of women. Transvestitism is also noted among the Babongo of the Cameroons, the Bajokwe of the Lunda, etc. Almost everywhere, even when dress is reduced to a mere indication, a difference exists between that of the men and that of the women. In certain cases some materials are almost completely reserved for one or the other sex; among the central Eskimos the blue fox is the exclusive property of young girls, while in Greenland the skin of the bear is reserved for seal hunters, and so on.

In addition to differentiation according to sex, there are variations according to circumstances. Even in daily dress there is a difference between the clothing of the rich and that of the poor, which is then emphasized in ceremonial costume. Special dress is worn by young initiates, and costumes that are often extremely elegant are the property of chiefs and nobles. The notables of the Mt. Hagen region in central New Guinea had a special hut in which they accumulated their treasures, among them bird-of-paradise feathers used for the dance.

In the Marquesas Islands the tapa obtained from the *Broussonetia papyrifera*, if pure white, was used only for the nobility. In general, chiefs, priests, witch doctors, shamans, and medicine men wear permanent costumes that may be readily identified, such as the typical fur clothes decorated with fringes and small, iron amulets worn by the Yakut shamans and other Siberian peoples. Other special costumes have instead a periodic or temporary nature, such as dress for war, the dance, weddings, mourning, initiation, etc. Among the Bagobo of Davao Gulf (Mindanao, Philippines) a man who has killed two men has the right to wear a brown costume with white designs; if he has killed four, a pair of red trousers; if six, a completely red dress; if 25, a shiny black garment and red flowers in his hair.

Special dress is less subject to changes in fashion and is esthetically the most developed. In the cultures of ancient Mexico and the Andes, costume reached an esthetic level unmatched in other primitive societies, with a wealth of gold ornament, precious stones, multicolored featherwork, and cloth woven in intricate patterns. The ancient Maya authorities, especially the *halach uinic*, wore a particularly rich costume consisting of an apron decorated with feathers, shells, and strings of jade, ending in front in a long, floating panel, and a long mantle decorated with embroidery or feather mosaics, or the skin of a jaguar thrown over the shoulders. They wore the emerald-green tail feathers of the quetzal on their heads and had very elaborate sandals.

Equally elaborate were the costumes of the great personages of ancient Peru (PL. 20; I, PLS. 181–184, 216, 217); the mummies found in the excavations of Paracas, for example, had enormous turbans, gold jewelry, and splendidly embroidered garments.

Distinction must be made between initiation, wedding, and mourning costumes on the one hand, and those for the dance, feasts, and the theater on the other. Among the costumes of surgeons in initiation rites, that of the Aranda (Australia) is exceptional. Even though worn only a few minutes, it is of great value; it is made of the white down of the sea eagle (*Haliaetus leucogaster*), acquired in long and tiring hunts, and is glued directly to the skin by means of human blood and red ocher. The dress of the initiates varies according to the totem to which each boy belongs. Among the wedding costumes of particular note are the tunic and trousers of embroidered silk for the men and the gold lamé sarong for the women used in the Padang and Lampong districts of Sumatra. They are without doubt of Chinese or Indian derivation. Mourning dress and ornament have been even more elaborated. The Jee-Anim widows of southwestern New Guinea wear an extremely finely braided hood, decorated with coarse, yellow squares and other motifs, long fiber skirts, and a wide, woven band that passes under the armpits and has fringes reaching to the navel. In the 18th

century the director of the funeral ceremony for a Tahitian chief wore an unusual costume composed of large mother-of-pearl shells mounted on a half moon decorated with feathers (PL. 8). In the second half of the 19th century this costume completely disappeared.

Costumes for feasts, dances, and theater are often accompanied by facial painting and complicated masks (II, PL. 97). Sometimes they represent ancestors, as in the Do costume of the Bobo of the Upper Volta, composed of purple-painted fiber and masks decorated with geometric motifs in blue, brown, and white. Even more remarkable are the feast costumes of New Guinea. In the Mt. Hagen district splendid headdresses of feather mosaics, body painting, and the *ken* — large shell disks (*Meleagrina margaritifera*) mounted on pierced pandanus leaves smeared with red ocher — are the prerogative of the well-to-do classes, that is, the owners of pigs. In the Chimbu district ornaments of net and bunches of red bird-of-paradise feathers create brilliant headdresses. Among the Bateke of the middle Congo and the Oklahoma Indians some of the costumes seem to transform man into a bird, with elaborate headdresses, back ornaments, wheels of multicolored feathers tied to the elbows, and bells at the ankles.

Since historical events are also mimed in dance, costume may be termed theatrical. In this sense the *dema* costumes of southwest Dutch New Guinea, in which the variously combined feathers create a stupendous and fantastic over-all picture, are especially noteworthy.

The costumes are usually completed by headdresses, necklaces, belts, girdles, and appendages of every kind (PL. 11; II, PLS. 103, 110). These accessories often have magical or protective functions; the combs of the Semang in Malaya, for instance, are used in healing, and the feathers of the rhea are considered in the Gran Chaco a protection from snake bite.

Accessories and ornament are also used as signs of rank; yellow feathers indicate nobility among the Mbaya-Caduveo, beads among the Ashluslay, Pilagá, and Macá, and the *ken* of Mt. Hagen, in New Guinea. Other ornaments have a symbolical character; the motifs used in North American Indian medallions and beaded belts are tribal insignia and at the same time highly stylized symbols for wind, rainbow, mountain, or sacred animals.

Tattooing, as a substitute for clothing, has a place of its own. Among the Maori, facial tattooing, known as "moko," has a ceremonial character, in connection with an ancient legend. Among the Mbaya-Caduveo a tattooed design is equivalent to a coat of arms, while in the Marquesas Islands the tattooing of the chiefs and warriors has a political-social significance. Among the western Baluba tattooing has varied according to the fashion and the period.

In conclusion, daily clothing in the primitive world rarely takes on esthetic characteristics. Only on ceremonial occasions or for particular social classes is a costume created to connote majesty, luxury, and beauty at the expense of comfort and practicability. Then the functional aspect can be completely overlooked, if it is felt necessary to make living persons participants in the power and mystery of the spiritual world.

Elisabeth DELLA SANTA

*Medieval and modern West. a. Middle Ages.* During the Middle Ages in western Europe dress was reduced to one or more tunics (or gowns) of varying lengths, worn one over the other and tied at the waist by a cord (PL. 10); under these the men tucked their trousers. In the early Middle Ages the colors, as often in periods of crisis, became bleak and dark. Feet were for the most part bare or protected by crude sandals. The face was clean-shaven, and the men wore their hair long, the women theirs in long braids. The Frankish nobles wore an ankle-length tunic ("chainse") with sleeves reaching to the wrist, open at the sides and held at the waist by a belt. Of linen or silk, it was often decorated with orphreys or the clavus, a reminder of Roman-Byzantine days. Over the chainse was worn a mantle fastened under the chin by a brooch. The feet were protected by soled socks or socks and sandals. The women's

tunic had full sleeves; a scarf-mantle (palla or "mavort") covered the shoulders and the head.

The economic rebirth of the late Middle Ages renewed taste for brightly colored clothing, with a juxtaposition of even overly strong contrasts (near the mid-10th century particolored hose came into fashion). Craftsmanship was reborn, and the garments began to be adapted to the lines of the body and to vary according to circumstance and season. Men's dress was formed of three distinct articles of clothing — trousers, undergarment, and overgarment. The undergarment consisted of a rather long tunic, with very tight, buttoned sleeves, close-fitting neckline, and a collar an inch or so high. The overgarment was a second "dress," open in front, with wide sleeves reaching to the elbow. At the waist was a belt to which the purse, dagger, corporation symbols, etc. were fastened. The stockings functioned as trousers and were often furnished with a sole and fastened to the undergarment by pins or straps. In the coldest season a hooded mantle or a fur jacket was worn. Hats varied according to the region. The almuce, a kind of hood, covered head and shoulders. Another type of headgear (*cappuccio a foggia*) was made up of the ornamented Florentine cap, worn as a true hat, and the *foggia*, a fold that fell from it. Hair was cut in a rather long bob, the face clean-shaven. Women's dress remained more uniform with the passing of the years. A shorter tunic with wide sleeves revealed the underlying one with long, tight sleeves.

In the 11th century all women's dresses of any importance were provided with a train, which gave a particular majesty to the figure. Used less in the 12th century, it returned in the 13th, giving rise to sumptuary laws fixing its length. The train could be borne by pages or maids of honor, hooked to the waist, or let trail on the ground. The low neckline, usually of bateau shape, and the hems of the dresses were bordered with embroidery or strips of cloth in a contrasting color.

With the 13th century, interest in costume had a great revival in Italy. A decline in Oriental textile imports led to an increase of production on the peninsula and the creation of perfect textiles in magnificent designs. In Italy usually only the inner tunic (or shirt) was worn. It was rather full, at first made of bright-colored cloth, and from the 14th century on also white. Over the shirt came the doublet, a kind of vest padded with cotton on the shoulders and torso, and over this important persons also wore the jerkin (PL. 10), similar to the doublet.

When the Duke of Athens governed Florence, a new kind of clothing came into fashion among the young people. It consisted of a short, tight kilt, fastened at the waist by a leather belt with a buckle, and a short cape with a long, narrow pointed hood. During the winter months people of the upper social classes wore an overgarment that took different names according to the dialect and the model. Famous among these is the Florentine *zimarra*, a cassock of scarlet or purple velvet or of brocade, without sleeves; the same garment with sleeves was called a *robone*. Also well known was the Florentine *lucco*, of serge, in use until the 15th century. Originally a dress of the nobility, it was later adopted by all Florentines over eighteen years of age.

In the Burgundian court there was a preference for the surcoat, a jacket covering the hips and closed in front by a row of buttons. At the chest it was padded so as to present a voluminous protuberance. In France and in Germany an overdress, common to both sexes, was worn over the surcoat, falling in ample folds over the chest and with wide armholes. As the garments gradually grew fuller and more flowing, the belt became almost indispensable. Made of gold or silver scales, or enameled and decorated with pearls, or more simply of cloth or leather, it was buckled somewhat low and had hung from it purse and knife, or pen and inkpot, etc. The mantle, also with hood, was in general use in all seasons. It was closed in front or on the right shoulder and was often worn inside the belt. The "trousers" were attached to the jerkin or doublet. They were nothing more than stockings fastened to the waist. North of the Alps and in France particolored hose were preferred, sometimes one striped and the other a solid color, matching and

contrasting with the jerkin, which was also made of differently colored pieces. Although even until the 16th century the custom of sewing leather soles to the stockings persisted, the shoemaker's art continually improved. Shoes were leather or cloth slippers. At the end of the 12th century crakows, shoes with a long point, made their appearance in the Burgundian court and spread throughout Europe, remaining in use until near the end of the 15th century.

In addition to a pointed felt cap with the brim turned down in front and up in back that had already come into use some centuries before, there was in France a slightly convex hat with the crown in the form of a cross that became the prototype of the hats of princes. In the second half of the 13th century it acquired an upturned brim of cloth or leather. Gentlemen decorated their hats with bunches of fine feathers.

In the course of the 14th century dress became ever more ostentatious (PL. 26). While the Burgundian dress, bound to medieval taste, was the rule in France and Germany, in Italy those characteristics of pomp and richness typical of the early Renaissance were already appearing. The men wore tight-fitting stockings with a short kilt, jackets with padded shoulders, tight-fitting sleeves reaching to the middle of the hand, and cloaks; all were in bright colors and enriched with embroidery and jewels. The nobles wore overgarments with high, rufflike collars, trains, and wide, long sleeves.

*b. Renaissance.* With the 15th-century development of craftsmanship in clothing, many artists (the most outstanding is Pisanello; PL. 30) loved to design models for the court. Near the end of the century the heavy cassocks and robes almost disappeared, and short jackets, open in front, sometimes with a small circular cape, were worn.

From France a kind of turban with an ornate crest, partly wound around the neck, was imported into northern Italy. But the typical Italian hat was the toque, a small cap in the form of a truncated cone.

For footgear, soles attached to the stockings remained in use. After the second half of the century "duck's-bill" shoes with very wide points appeared. Gloves were of silk, hemp, and leather.

In this period among women it became the fashion to increase the height by wearing shoes with a very high sole. In Venice the most extravagant were 20 inches high at the heel. The custom of going bareheaded created sober and at the same time extremely elegant hairdos with very high, depilated foreheads. The feminine line still followed Gothic taste in France, but in Italy the dresses, for the most part buttoned in front, were full and weighted with extravagant sleeves. The waist was tight and high, and the garment was enriched with linings and borders of fine furs.

After the war with Charles VIII (1495) Italian dress was also introduced into France. In the first half of the 16th century the shapes swelled. The torso was often padded, and the full sleeves added width to the shoulders. By contrast, the legs under the short jacket seemed even slenderer.

The French women accepted the new showy Italian taste more slowly. In the late 15th and early 16th centuries the two tendencies still existed side by side. Some paintings of the period show clothing of a more modern Italian taste next to the severe medieval dress.

Near the mid-16th century two historical events decisively influenced European fashion. The peace of Cateau-Cambrésis gave a definite political supremacy to Spain, and Spanish costume began to replace Italian fashions. Also, the Counter Reformation demanded severity in dress, as can be seen in the dark-colored clothing covering all the body except the face and hands. In its turn Elizabethan England accentuated the stylization of form, and the human figure assumed a completely artificial appearance. In men's dress, especially outside Italy, a short, semicircular cape fashioned so as to project from the body became common. The stiff, tight-fitting doublet, buttoned in front, descended in a pointed flap below the waist (PL. 31). In France, late in the century, this lower part of the doublet was padded and lengthened so as to alter the proportions of the body. The sleeves were smooth and fitted, decorated with laces, ribbons, and slashings, or wide and completely open, attached only at the shoulder. At the collar and wrists the lace-trimmed shirt was visible. The trousers were at first very short and balloon-shaped, later reaching to the knee and sometimes padded, with the slashing transformed into wide bands gathered on the hip so as to show the puffed lining of a contrasting color. Shortly before the end of the century the breeches became less full. They rose to above the knee, becoming flat and decorated only by a band of trimming at the side. "Duck's-bill" footgear was replaced by "bear's-foot" shoes, with puffs of light-colored lining at the toes, or by simple heelless slippers of the same cloth as the suit. Near the end of the century the first leather shoes (PL. 14) appeared, and in France the first wooden heels were applied to small, satin shoes. Hats were of felt with a narrow brim and high, straight, hemispherical or steeple crown. Typical of this period is the slashing in the clothing to show the contrasting lining. The sleeves, the bodice, the trousers, the shoes, and even gloves were picturesquely "cut" in this manner. At the same time large, wheel-shaped collars, white and stiffly starched, appeared. At first of medium proportions, they became ever larger and with more layers until the ruff reached the width of the shoulders. Woman's dress also became stylized. The skirt, rigidly supported with iron stays (farthingale), took the form of a truncated cone, with a triangular opening in front. To this was attached the stiff "duck's-breast" bodice (PL. 27). In Italy the women preferred a small, white collar coming out of a triangular neckline, rather than the large ruff, and in France a white frill decorated the high-necked dress. In Germany a wide, square neckline revealed a high-necked, embroidered, and ruffled shirt. At the end of the century the neckline became lower and was decorated by large upstanding collars, often of lace, called "Mary Stuart collars." The mantles, similar to those of the men, were sometimes replaced by full, stiff overcoats very like our present coats. For headgear the men's toque, set lightly at an angle on a high hairdo, came into wide usage. A small bonnet coming to a point over the forehead and arching over the temples ("Mary Stuart cap") was used chiefly in France, England, and Holland. The tendency to lengthen forms so as to give height was notable especially in the coiffures enlarged by false additions. In France and in the Low Countries the hair was often parted and puffed out at the sides. France under the reign of Henri III (1572–89) displayed a sometimes excessive taste for luxury and cosmetics, in contrast to the severe and stiff Spanish style. Characteristic were the small "sugar-loaf" cap and even more the hat with a curved brim decorated in front with feathers and jewels, placed on hair drawn back and carefully fastened with hairpins. In Flanders the somber dress with a large ruff collar remained in use among the women until about 1640 (II, PL. 206).

At the beginning of the 17th century, with the weakening of Spanish power, a reaction to the stiff dress set in. Light colors were preferred, the stiff, heavy padding definitely disappeared, and the dress began to be more softly molded to the body (PL. 31). Paris began to impose its taste. In men's clothing the doublet or jerkin, elongated and cut in gores, began to resemble the present-day jacket. Open in front, it was buttoned only partly to show the shirt. The sleeves, even fuller, were decorated with large lace cuffs. Trousers also lost their padding and were tied at the knee with rosettes and bows. The mantle, full and collared, became an integral part of the costume. High boots of soft leather or leather shoes with a heel were worn. The dress was completed by a soft hat with a flat crown (used chiefly in northern Europe) or a steeple crown and narrow brim in the Spanish fashion. The hair was worn long on the shoulders; mustaches and beards were pointed (PL. 310).

*c. 17th and 18th centuries.* In women's dress of the early 17th century, the skirt, no longer stiffened by boning, fell in natural folds. The bodice, free from any metallic framework, was laced in front; the waist was barely accented. The lace collar, no longer starched, was very wide and fell on the shoulders and wide, puffed sleeves. The blouse had a lively note in the décolletage, which was at times very low. Shoes were like

those of the men, but higher. Women's hats, too, were very similar to the men's; they were small, soft, and decorated with feathers. Hair was long and loose or gathered at the nape by a net. The fur muff made its appearance and was soon after adopted by men. Under Louis XIV French dress was of an exceptional luxury and splendor, and France became the absolute arbiter of fashion in Europe, excepting perhaps Spain. Mme de Montespan imposed her brilliant taste for gold passementerie, ribbons, laces, and finery. An outstanding feature of Louis XIV dress was the wide hat completely decorated with feathers and set on a wig of curls. Men's dress was characterized by the "rhingrave," a kind of petticoat breeches tucked up at the knee by a thong, and a bolerolike jerkin with very short sleeves exposing the shirt. The collar was very large, with long ribbons. Bows decorated the upper edges of the boots and the dancing shoes with their long, pointed toes and high, red heels. In women's dress, along with brocade and silk damask, painted or embroidered veils appeared. The soft, full skirt was set on a bodice lengthened to a point in front and closed by hooks. In the most elegant dresses there were often two skirts, the upper one revealing a petticoat of pleated flounces. Sleeves were elbow length, and the bateau neckline extended to the shoulders and was often bordered by a larger linen or lace collar. Hats were seldom used. Hairdress was very complicated and varied (PL. 28).

At the end of Louis XIV's reign dress became more moderate. The fundamental elements of present-day men's dress — the jacket, vest, and trousers — made their appearance. The long, semifitted jacket reached below the knee and was completely open and collarless. The pockets had flaps, and the sleeves were very long with cuffs. While the rhingrave continued to be used almost exclusively in France, the coat was quickly adopted all over Europe. The vest was of the same model, differing in its round neckline and in that it was completely buttoned. Trousers were flat and ended below the knee. Stockings remained the same, while the shoes were closed with handsome metal buckles instead of large bows. In women's dress the bodice was tight-fitting at the waist and decorated with passementerie. Light-toned fabrics with small flower designs or narrow stripes were in fashion. Characteristic and commonly used in France were the monumental wigs. At first made with thick curls falling onto the shoulder, they were dressed higher and higher near the end of Louis XIV's reign and varied in color from blond to chestnut to black, and in the 1700s, white.

French *régence* dress was very refined. Fabrics were light silks woven with small, brightly colored flowers on delicate backgrounds. Flounces, laces, and ribbons disappeared. In men's dress the coat was less full and sleeves were wider and always turned back with extremely large cuffs. Shoes had high heels and small buckles of precious metal. For women the Watteau dress with a wide and deep décolletage fell free around the body in soft folds. The heavy hairdresses disappeared. About 1750 the peplum of the man's coat was stiffened and shortened, folds were avoided, and sleeves were longer and less full. The vest, also very wide and stiff in the lower part, was buttoned to the waist, collarless, and decorated by the white lace of the jabot. At the end of Louis XV's reign it shortened to just below the waist. The breeches were held below the knee by a garter. In England the "riding coat" reaching to the knee, with a belt and two overlying collars, was worn. About 1725 this kind of dress was introduced into France, together with the frock coat without pockets or buttons and with a small, turned-over collar. The enormous horsehair wigs were replaced by more graceful and less cumbersome ones (I, PL. 98).

The *robe à la française* dear to the *régence* remained fashionable in Paris till near the end of Louis XV's reign, but during the second decade of the 18th century skirts were being widened by a rush framework (PL. 14). Thus were born the panniers which reached noteworthy proportions near the middle of the century. The bodice was very tight-fitting, in contrast to the skirt, and very décolleté. The sleeves, narrow to the elbow, fell in laces, ruffled flounces, and bows. On the hair, dressed in small curls lying close to the head, the men's tricorne was

sometimes placed. Louis XVI's reign at first accentuated the frivolous character typical of the court of his predecessor. The cloth, no longer woven in an unbroken woof but figured, assumed greater importance in the dress. While for the men there were changes only in the cloth used and in an accentuation of the ornament, in women's dress the panniers became even larger (up to a circumference of 5 yd.) and the coiffures often assumed extravagant forms, imitating monuments or sailing vessels, with constructions of curls, feathers, and papier-maché (PL. 30; III, PL. 426). Footwear was elegant with thin, high heels. After 1780 hairdress became simpler; there appeared a straw hat decorated with ribbons and flowers, a beaver hat with a narrow brim and a crown of medium height, and the "chapeau-bonnet," a compromise between hat and bonnet. With the advent of the French Revolution decorative excesses were abolished. Dress became more moderate also under the influence of the more rational English fashion. Cotton was preferred to silk. The huge panniers disappeared, and, inspired by masculine fashions, the women adopted the redingote, necktie, stiff hat, and walking stick. Men's dress decisively changed its appearance, beginning to acquire modern characteristics. Serge dominated, and figured silks were used only in the waistcoat, the final transformation of the vest which was now raised to the waistline. Trousers were lengthened to cover the knee entirely (PL. 15). In Italy and Spain a mantle with two little capes was worn over the frock coat in winter; in France and Germany, a full overcoat inspired by the English redingote, with three overlying collars. In Venice it was the *tabarro*, the classic mantle, usually accompanied by the domino, the surplice, and the characteristic black-and-white mask. Shoes with small heels and silver buckles were replaced by knee-high boots, the tricorne (PL. 29) by a round hat with a high crown and upturned brim (PL. 125).

After the French Revolution those particular attributes of dress which were a class prerogative definitely died out in Europe. Only taste and financial means were now the decisive elements in the choice of apparel. Especially in women's fashions, clothing which constrained the body disappeared. Simplification, already present in England, was favored by a return to classicizing forms, as in the art of the time. In men's dress in the late 18th and the early 19th centuries, long pantaloons replaced the knee breeches. The vest, which had disappeared in the early years of the revolution, reappeared in the "Robespierre" type with large lapels. The English frock coat had buttons on both sides, a flat lapeled collar, and long, narrow skirts. The English boxcoat or coachman's cape, with its overlying collars, had more the aspect of a mantle. Along with medium-high boots with stiff uppers appeared a low shoe that heralded the modern shoe. Headgear consisted of a high, black felt hat, forerunner of the top hat, and a cocked hat. In women's fashions the change was even more accentuated. The cut of the garment freely conformed to the body. The loose dress or chemise, gathered in folds at the waist with a high belt and wide decolletage, was in simple, light-colored fabrics (PL. 15). Over it was worn a simple, colored garment, open in front (tunic), of three-quarter length, and decorated with fur. Given the lightness of the sometimes transparent dress, lined coats of a warmer cloth (*enveloppe*, *douillete*, redingote), also with a high belt and reaching to the hem of the dress, were used. On the head were worn muslin bonnets or, at the height of the revolution, caps decorated with a cockade. In France about 1800 there was a reaction to the negligence of revolutionary dress. The fops, eccentric dandies, wore showy dress coats with striped pantaloons, yellow-edged boots decorated with bows, and low tricornes with tricolor cockades.

*d. 19th and 20th centuries.* Toward the turn of the century classicism came to the fore in fashion as well as in art, and David made a bold attempt to establish a popular dress similar to a tunic. Under the Directory a return to luxury was added to these tendencies. It was the age of the *Merveilleuses* and the *Incroyables*, of women dressed in transparent muslin tunics, with their hair short or tied in the Greek fashion (PL. 122), of men dressed in very tight-fitting frock coats, with short hair.

The tunic dress also appeared in other nations, where up until the end of the 18th century the crinoline had enjoyed a great reputation. The corset was definitely banished, the fabrics were extremely light, the décolletage very low, with high, lace collars created by the tailor Leroy under the inspiration of Mary Stuart models. The skirt often had a train and the sleeves were mostly puffed. Hats either had a high crown and flaps that covered the cheeks or were in the form of a turban, which had become fashionable after the Egyptian campaign, together with Oriental shawls. In men's dress decorated fabrics and silks were used only in the vest and for evening wear. The hat was a cylinder, the high crown in the form of a truncated cone, or the *feluca* worn for important occasions.

In the early decades of the 19th century masculine dress took on the aspect that it still preserves today with few variations. Somber colors, black and gray, prevailed, and all individuality was abolished. Overcoat, frock coat, and cutaway were always worn with long trousers — always of a light and contrasting color — which about 1818 and for a decade thereafter were fitted to the knee and flared out toward the bottom. But they soon became tight-fitting once more and were kept stretched by means of a strap under the shoes. The frock coat was replaced by the redingote, flaring and with wide upper sleeves. At the neck was a monumental cravat. In 1805 London brought out the silk hat, and in 1812 Paris launched the gibus, an opera hat with a retractable crown. In women's fashions the restoration of the Bourbons marked a return to the 18th century. Fabrics were heavier, and skirts, short enough to show the ankles, widened into a bell shape in the lower part and were covered with beads and lace and, about 1820, with fur flounces.

In the time of Louis Philippe shoulders were slanting but very wide, accentuated by the slenderness of the natural waistline (PL. 33). For men checked fabrics and, in Paris, flashy colors were used. The top hat was standard. Women's skirts in a soft fabric were lengthened to the ankle, taking inspiration from the 18th century in the ruffles and trimming. The décolletage, very low in the evening dress, bared the shoulders, which were then veiled by shawls, mantillas, long fur stoles, and, toward the '40s, fur coats. The hair, leaving the neck and nape free, was worn smooth and bound at the top of the head in a chignon, and about 1840 a few strands were brought down on the sides of the face. Near the end of Louis Philippe's reign the hat, a bonnet with a wide brim that covered the sides of the face, was often replaced by a shawl. In 1830 the parasol came into fashion, first square, then round.

The Second Empire witnessed a burst of luxury in Paris and all of Europe. Skirts, held up by a padding of petticoats and hoops of horsehair and whalebone, reached a circumference of 5 ½ yards. Covered with trimming, ruffled tulle, and festoons, they revealed the ankles encased in white stockings. The bodice and the sleeves were very tight-fitting. About 1850 pagoda sleeves were launched, narrow at the shoulders and widening from the elbow down. Ten years later Paris enthusiastically accepted the tendency to masculinize feminine dress, and full skirts definitely went out of fashion. After 1866 men's dress was more somber. Fabrics were in dark colors, striped or in checks of varying sizes, and for formal dress, black. Along with the frock coat, a hip-length jacket with fitted waist, the final version of the popular carmagnole, appeared in 1850. The trousers, of a contrasting color in stripes or checks, no longer had the strap under the shoe and fell in soft lines. From London spread the first raincoats, called "waterproofs," with cape and cap. After 1870 the somber dress of men contrasted strongly with that of women. The former were dressed in dark tones, jacket and trousers matching. Overcoats included the redingote, the raglan, the circular or semicircular cape, and later the Scotch plaid, while in the last quarter of the century the first sports costumes appeared. Women's dress underwent greater transformations. The skirt narrowed over the hips, becoming full in back with a bustle.

In the last decade of the 19th century and the first of the 20th, costume turned toward a greater practicality. The men's jacket was closed and single-breasted; trousers had an ironed crease; the vest descended below the waist, with the lower part open in a triangle. Styles in overcoats were the double-breasted ulster with a removable cape, the Don Carlos, similar to a single- or double-breasted redingote, and the single-breasted prefect's coat with side pleats. For evening wear the "bat" with open sleeves and cape was preferred. More modest was the sleeveless "loden" with a cape and hood. Near the end of the century the derby, the soft hat, and the straw hat made their appearance. In women's dress the skirts flared out in a bell shape, and the bodice was fitted and finished off with a small, upright, boned collar (PL. 33). At the end of the 19th century the first overcoats of a masculine line were adopted for women; and in the first decade of the 20th, the first women's suit and skirt-blouse combination made its appearance. In 1910 there was a return of the Empire line with a straight skirt and high waistline. The parasol was customary. Hats became larger and had low crowns and very wide brims covered with feathers, ribbons, flowers, and laces; in 1909 they were completed by a veil drawn over the face. At the end of the first decade boots reaching almost to the knee appeared.

After World War I the corset vanished, the chest was flat, hair was very short and shingled at the nape. The skirts of 1928 barely covered the knee. Shoes had a high, thin heel and were cut very low in front. This unassuming dress was common to all classes. The only note of richness was supplied by long necklaces. In 1923 the first raincoats for women appeared in bright colors. Men dressed in a fitted, single- or double-breasted jacket with narrow, rounded shoulders shaped by padding. The single-breasted vest came to below the waistline and was without lapels. Trousers, vest, and jacket were all of a matching fabric. The line of the overcoat was the sack. Soft hats were commonly used. For women the decade of the thirties marked a return to femininity. By 1928 the hair covered the ears, and later it fell over the shoulders. Skirts tended to lengthen, and evening dresses of the 1931 collections once again reached the ground. The waistline returned to its natural point, although the straight line left it unmarked. In the years just before World War II skirts crept higher and shoulders were built up with padding like those of the men.

SPECIAL CLASSES OF COSTUME. So far we have been tracing the evolution of style in dress for society seen as a whole, a process very often linked with changes in pictorial and sculptural taste. In sharp contrast was the deliberately traditional and unchanging character of some features of costume used to distinguish certain classes or castes of people. This is an extremely complex phenomenon present in almost all civilizations (and we have already alluded to it in earlier sections). How far these special costumes are distinguished from everyday dress, of course, varies with the degree of class differentiation in the society. Thus in present-day civilization, where specialized clothing is usually worn either for practical reasons connected with work or as a means of winning public recognition, they are much rarer than in past centuries. In the Roman world distinctive kinds of clothes indicated the rank of the equestrian order, the senators, etc. But in the Greek world such differences were virtually nonexistent, apart from a few exceptions such as the "royal" costume (derived from Persia and made familiar through the theater), which consisted of a long chiton, a girdle crossed over the breast, and sometimes a Phrygian cap. Even the separation between priestly and secular dress, although a universal phenomenon, becomes highly attenuated in certain epochs or cultures. (As late as A.D. 428, Pope Celestine censured the bishops of Gaul for wearing garments different from those the laymen wore.) It is often only when the sacred rites are being performed that special garments are assumed. (See also LITURGICAL OBJECTS.) However, when the ecclesiastical hierarchy wants to accentuate its own exclusiveness and independence, distinctions in dress grow sharper.

In general the initial impetus for establishing a special style of dress emanates from the conservative drives of certain classes which refuse to accept continually changing fashions. At times the decisive factor may lie in regulations of dress for certain groups of workers, such as a requirement to wear aprons or overalls. Undoubtedly, however, specialized clothing, par-

ticularly in the higher ranks of society, is mainly used for symbolic or figurative purposes. (See ARMS AND ARMOR; EMBLEMS AND INSIGNIA.) The costume often stands for power and rank, and it is not by chance that the term "investiture" has survived to designate the assumption of high political and religious office. Medieval chronicles, as well as fables from all over the world, underline the psychological effectiveness of royal or religious costume; and it is exactly in such cases that dress manifests itself most explicitly as an expression and enlargement of the personality (see A. E. Crawley, s.v., Dress, *Encyclopaedia of Religion and Ethics*, V, New York, 1955). Used thus, costume may also acquire a sacred or magical value, not only for religious rites and initiation or marriage ceremonies, but also for social and political life. The large number of metaphors derived from dress in the Bible and throughout literature reflects this fact. In many cases the wearing of such special costumes has been circumscribed by rigid rules, as for example, those governing the color of such garments as the cloak, the military cape, and the toga. Thus purple was reserved for monarchs, a blue mantle distinguishes representations of the Virgin Mary, and particular colors are adopted for various occasions in the Christian liturgical cycle.

The special garments used for all these purposes were given a rigidly fixed form. Sometimes the costumes preserved in tombs, wardrobes, or royal treasuries constitute our only direct evidence for past costumes, in that we can assume that they are accurately preserved.

*Royal costume.* The monarch, in dress as in other spheres, stands at the apex of the social scale. In every culture he is set apart by a more elaborate dress, even when it is not exceptionally different: he wears more valuable materials and special colors and is vested with various emblems of government and power, some of them of world-wide diffusion — e.g., the diadem, the crown, and the staff or scepter. Sometimes he has a different costume for military and for civil occasions, or for civil and religious ones. The physical image of the monarch is crystallized not only by means of clothes but also by his headdress and various insignia.

How far the royal costume is set apart from others naturally depends on the degree of sovereign power. The costume tends to absorb the emblems of power increasingly into a single unified mode of dress. The court functionaries emulate as closely as they can the level of pomp and solemnity displayed by the monarch.

The most typical example of this is the Roman imperial court of late antiquity, where we can trace the development and crystallization of dress through successive stages. The toga for example became increasingly ornate and colorful, eventually being entirely covered with embroidery and gilded ornaments to the point of making it stiff and heavy. In the dress of the western court we can easily follow the great historical vicissitudes of the empire, with its persistent return to classical modes.

A deliberate, if indefinite, revival of Roman and Byzantine models occurred under Charlemagne, although the prevalent tone of the court remained military and religious, and court costumes preserved their severe, standardized appearance, with short tunics, held in by broad belts with large buckles, and the chlamys. For ceremonial occasions the emperor wore a linen tunic and sandals (talaria), and his chlamys was fastened with a precious fibula on his right shoulder. The women's dress was closed at the throat and had tight sleeves; with it was worn an open overdress with full, elbow-length sleeves, a mantle with a train, a belt, and a veil.

The Ottonian emperors revived the Roman ceremonial, wearing their tunics ankle length, full, and white, bordered in gold like the Roman curial toga, as well as a colored outer vestment (dalmatic) held in place by a stole symbolic of the emperor's political and religious power. The members of their court, however, dressed in the German style (III, PL. 64).

In Venice, where throughout the centuries ceremonial pomp was to remain unmatched in splendor, a special form of the toga developed. Radically altered by Eastern influences, this toga, with its full, open sleeves, was made of silk, damask, or velvet in colors varying according to the office or rank of dignity: red for magistrates, violet for *savii grandi* (grand councilors), scarlet for doges. The doge was garbed on almost all occasions in a solemn ceremonial fashion in an ankle-length cassock with full sleeves, over which was a mantle of silk or scarlet brocade fastened in front, covered by an amice (a piece of cloth worn about the neck and shoulders) of ermine. On his head was the *camauro* (doge's cap), sometimes adorned with precious stones (II, PL. 265).

Court costume enjoyed another great efflorescence in France during the last half of the 17th century, contrasting sharply with the somber elegance of the earlier era when Italian styles had been followed as well as the austere dress of the English and Spanish courts. This contrast appears especially strikingly in Charles Lebrun's great tapestry (Versailles Museum) depicting the meeting between Louis XIV and Philip V of Spain in 1660. The sober, old-fashioned garments of the Spanish king and his retainers, with their unrelieved dark colors, are completely overshadowed by the brilliance and luxury of the French royal costumes. Louis XIV is here portrayed in a dark gold-striped coat, with rose stockings, a white shirt, cascades of red ribbons, yellow shoes with large pompons, and a dark hat with red plumes. Louis Philippe of Orléans is wearing a gold cloak, a yellow morning suit with red ribbons, pink stockings, and yellow-and-white shoes. Other persons are wearing capes of gold cloth. Their wigs are large and extremely elegant. Later came a greater restraint, coupled with greater fastidiousness and refinement, continuing down to the Napoleonic era, which is famous for its magnificent costumes and tremendously rich materials and embroideries (PL. 126).

For the various styles of royal costumes and court dress in Eastern civilizations see PLS. 23, 24.

*Special civil costume.* In civilian life special costumes are worn by small groups because of caste, hereditary position, or religious or craft affiliation. Here again we find conservative drives competing with trends toward ostentation or functionalism. Dress for special occasions must be distinguished from everyday dress. Some of the costumes displaying the highest artistic excellence are those designed for special ceremonies such as great civic and religious festivals. In the feasts and pageants of the Renaissance and of the baroque era, costume played a vitally important role, as it did in certain political situations, for example, at ambassadorial gatherings. The 15th-century chronicler Vespasiano da Bisticci describes how six ambassadors sent from Florence for the election of Pope Nicholas V (1447–55) were "all clothed identically, with six vermilion gowns of the richest quality from head to foot, with open sleeves lined with squirrel fur." But this was an exceptional case; generally ambassadors cannot be said to have a group costume, although later on ambassadors did adopt the Venetian toga in various shades of red and so on, thereby aiming at a standardized dress.

Of greater import is the established and almost obligatory dress for certain professions. Unfortunately, no comparative history of this subject exists. Very early, clowns all over Europe began to use stockings of different colors and striped coats; such symbols as the phallus suggest a continuity in dress going back to late antiquity. Lawyers, magistrates, and notaries preserved the traditional Roman dress: the toga, albeit with some clearly perceivable changes. During the last half of the 15th century in Germany, magistrates, notaries, lawyers, and court judges wore the long, red toga with full sleeves, with either a collar or a wide band of fur encircling the neck, and with a hat of the same color, generally shaped like a cylinder or a truncated cone. We may study these in the miniatures and engravings in the *Speculum vitae humanae* (*Mirror of Human Life*) by R. Zamorensis, published in Augsburg in 1471. During the 17th century the round neck fluted in the Spanish fashion or the white lace cravat and large wigs were introduced into the lawyers' apparel. The red toga was supplanted by the black one.

As early as Guido da Vigevano's *Libro di Anatomia* (1316, *Book of Anatomy*) there is recorded a standard apparel for

doctors. They all wore a light, ankle-length tunic with medium sleeves, a hood, tight undersleeves, black shoes with long points, and blue skullcaps with a red tassel. By the end of the century the long Florentine gown, closed at the throat and made of serge or fine wool, was widely used. By the end of the Middle Ages even the universities and academies had taken over the toga in various patterns and colors, the most usual form being one with a cape and full sleeves, open in front. The rectors of the Universities of Padua and Bologna (among the most ancient of the universities) wore the crimson toga trimmed with ermine in the royal manner. University hats or caps identified the various classes of students and teachers. The ermine head covering was the exclusive privilege of the "Rector Magnificus." Red caps were worn by distinguished professors and prelates and dark ones by teachers and prelates of lower rank.

Dress was also exceedingly complex in English universities, where social as well as scholastic distinctions existed. At 17th-century Oxford aristocratic students were set apart from the

has become emblematic and symbolic, although of course much less elaborate. One kind of special dress which has enjoyed a certain vogue in the public imagination, having suddenly penetrated films and science fiction, is the pressureproof and heatproof outfit made from rubber or synthetic fibers or asbestos and used in scientific or space experiments. This may point to an esthetic ideal of man no longer determined by culture and social life solely, but influenced by the new potentialities for attainment held out by modern science.

*Military costume.* Military uniforms are of fairly recent origin. They grew out of the necessity, apart from functional requirements, of distinguishing between national armies and different corps.

Generally speaking, in earlier times the style of military dress depended mainly on its defensive or offensive character (see ARMS AND ARMOR), although standardization did actually exist, as well as distinguishing marks for the various corps

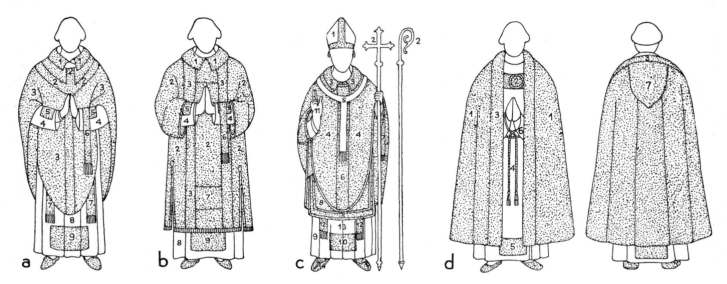

Garments of the medieval Catholic clergy. *a.* Priest robed for Mass: (1) amice; (2) ribbon or embroidery of the chasuble; (3) the chasuble itself; (4) cuffs of the alb; (5) decoration of the cuffs; (6) maniple; (7) bottom of the stole; (8) alb; (9) decoration or embroidery of the alb. *b.* Deacon robed for High Mass: (1) amice; (2) dalmatic or short tunic; (3) embroidery of the dalmatic; (4) cuff of the alb; (5) decoration of the cuff; (6) maniple; (7) decoration of the dalmatic; (8) alb; (9) decoration. *c.* Bishop celebrating Mass: (1) miter; (2) bishop's crosier or cross-shaped staff used by abbots; (3) amice; (4) chasuble; (5) pallium; (6) embroidery of the chasuble; (7) maniple; (8) dalmatic; (9) tunic; (10) decoration of the alb; (11) gloves; (12) fringe of the stole; (13) alb; (14) sandals. *d.* Priest garbed in a cope or pluvial; (1) cope; (2) clasp or brooch; (3) decorative ribbon; (4) alb; (5) lace border; (6) girdle; (7) hood.

commoners by their gold and silver buttons, a velvet cloak, and gold lace on their caps, while wide sleeves, with or without cuffs, differentiated the various categories of teachers. The chancellor wore a black silk toga fastened with a gold cord. The doctors were entitled to wear the mortarboard. For doctors of medicine the toga was black; for doctors of law, red; and for doctors of divinity, scarlet. An infinite number of other details separated the staff members employed and the academic offices. Strict laws forbade the sale or arbitrary abandonment of academic apparel, even when in mourning.

The division of labor characteristic of our own civilization and our concern for functional and suitable dress for special conditions have given rise to an infinite variety of special costumes. Some of these are symbolic as, for example, the outfit of people employed in public services. Some are styled with particular elegance in order to impress the public, as in the case of doormen of great stores. Others are purely functional and utilitarian, such as overalls, smocks, etc., which are worn only during the working day and therefore do not isolate the wearer as a member of a special caste. Nevertheless, the subject of overalls viewed as a trademark of manual, mechanical, or mine labor has stimulated an impressive literature which goes so far as to attribute symbolic meaning to such apparel. More superficially, the same thing has also happened with sportswear, which, like apparel worn for tournaments of old,

and their functions. During the 17th century, when firearms were introduced and armor fell into disuse, the first uniforms appeared on the scene. In that period, for example, the musketeers serving the king of France dressed in a red patience (an outer garment open at the sides), which had a gilded cross, changed by Louis XIV to silver. Frederick the Great of Prussia systematically organized military uniforms classifying the corps with different colors and details. Frogs began to appear on military coats to distinguish them from civilian clothes. During the second half of the 18th century the coat began to be decorated with lapels faced in a different color, capped by a small, lined collar. The tricorne began to be replaced by the modern military cap. Stockings went out of fashion, and high gaiters were worn by ordinary soldiers. At the end of the 18th century, with the widespread appearance of national guards, the difference between civilian and military costume became more marked.

With Napoleon, whose gendarmes had a striking uniform consisting of a blue frock coat without lapels, buttoned tight at the throat, and white waistcoats, there appeared a new development in a utilitarian direction.

*Ecclesiastical costume.* We find in almost every culture an essential separation between laymen and priests, sometimes rather indefinite, but usually persistent and emphasized by the development of sacred rites. Only rarely (as among the

chaplains and worker priests of our own time) does this difference become minimal in order to underline solidarity between priests and ordinary people.

Aside from primitive cultures, where the priest often wears elaborate, fanciful clothes designed to enhance his powers of suggestion and magic, there is a deliberate conservatism in religious dress, more marked than in that of other kinds of special costume. In ancient Rome the Masters of the Arvales and the Camilli were set apart by their ricinium (a cloak of traditional pattern). A similar traditionalism can be observed in the garments associated with anthropomorphic gods: a costume set apart from common dress only by its archaic quality, except where definite rules concerning color come into play (or as in the case of Christianity, rules deriving from interpretations of visions, passages in the Bible, etc.).

The most distinctive example of this conservative tendency is the dress of the Catholic priests. This was crystallized between the 4th and the 9th centuries and preserved the styles of dress worn in ancient Greece and Rome. Among the undergarments those of Roman origin are the amice (a rectangular linen cloth wrapped around the neck and shoulders) and alb (a tunic with tight sleeves, fastened in front with a belt, and almost always made of white linen). Among the outer garments the chasuble, or planeta (derived from the Roman paenula), which resembles a cape; the dalmatic, which little by little became shorter until it was like a tunic; the tunic itself, also called the subtile; the miter (originating in the Roman camelaucum); the gloves; the pontifical shoes; the maniple (an ornamental band of cloth hung over the middle of the left forearm); the pallium (a circular band of white wool worn by archbishops); and the rational (a short vestment worn over the shoulders by bishops in the Middle Ages) (PLS. 10, 13; FIG. 45). However anachronistic they may seem today, even the garments indicating monastic orders (particularly the older ones) were originally no different from the clothes worn by laymen, except for their poorer, more sober quality. The most typical elements are the cowl (the hood worn by both sexes in the earlier Middle Ages) and the scapular, derived from the work apron of the monks in the Order of St. Benedict. In the various orders the type, material, and color of the dress are rigidly prescribed on the basis of paraliturgical symbolism (generally penitential, therefore dark). The Bendictines wear a black woolen cloak, hooded and sleeveless, over a sleeved habit accompanied by the scapular, shoes, and stockings. The dress of the Cluniac monks is analogous. The Carthusian monks have a coarser habit, at present white, and a penitential shirt. The Cistercians wore first a brown habit to distinguish themselves from the monks of Cluny, then a gray or white habit with a brown, and later black, scapular. According to the original rigid dispositions, they could have only two tunics with a hood, and no mantle. The dress of the Augustinians differs with the various orders; it may be black or white or a combination of both. The Trinitarians wear a red and blue cross. The Franciscans originally wore a gray habit, now brown. The Capuchins are bearded and barefoot. The Dominicans wear white woolen tunics with a black cloak and hood, and after 1220 the surplice replaced the scapular. The Carmelites at present wear a white cloak over a brown habit, but initially they had a tunic, scapular, and cowl, all black, brown, or gray, with the cloak made of three black and four white stripes. With the Counter Reformation the monastic orders allied themselves with the clergy in their preaching and missions. The Theatines, the Barnabites, the Jesuits, the Somaschians, the Camilliani, the Canons Regular, and the Scolopi thenceforth had habits similar to those of the priests in their country of origin.

Particularly sumptuous, on the other hand, was the dress of the military orders, soon transformed into aristocratic circles, such as the Knights Templar, the Knights of Malta, the Teutonic Knights, etc., the costume within each order differing according to rank.

*European folk costume.* The traditional costume of many regions is not only one of the most obvious aspects of folklore, but also one of the most difficult to interpret. The articles of clothing which compose these costumes are: skirt, blouse or shirt, bodice, shawl or jacket, bonnet or kerchief for the women; trousers, sometimes with a kilt, shirt, vest, jacket, and hat for the men. Some of these, such as the bodice and the vest, are almost surely recent additions. Others, such as the shirt, skirt, and kilt, go far back in time. For instance, the shepherd's dress, with similar characteristics throughout Europe, consisting of trousers and jacket of untanned skins, undoubtedly harks back to extremely primitive forms of dress. One of the difficulties in tracing the time and place of origin of the elements and types in folk dress is their complicated and composite form, often representing a progressive vulgarization of earlier garments and styles from the world of high fashion. During their travels they were from time to time mingled with local archaic forms, being frequently fashioned by the wearer in his home. Some details derive from sumptuary laws enacted by citizens of large cities against the display of luxury by small landowners. Other changes, such as the lengthening of the skirt, at times quite considerable, were due to religious prescriptions. The continued use of the costume, and therefore its conservation, is a matter of cultural lag and at the same time an affirmation of pride in local values. It can, therefore, give rise to important independent developments. The best costumes are undoubtedly the product of this feeling on the part of the entire community. Notwithstanding the elementary nature of the articles of clothing and the poverty of the raw materials, the inventiveness of the inhabitants of even the most isolated regions has succeeded, through a thousand variations in cut and color, in creating types that are at once unmistakable and highly diverse. They have gradually been refined, in a collective sense, finally becoming objects of superior craftsmanship, calling particularly for the creative aptitudes of the women.

Among the Italian folk costumes, in addition to the justly famed Sardinian variety, those of the Albanian and Greek colonies of southern Italy are particularly noteworthy. The wedding and festival gown of the women of the Piana dei Greci in Sicily (PL. 32) is made up of the following pieces: a *zilona*, a silk dress embroidered in gold; two *mënghëttë*, sleeves of the same fabric with similar embroidery; a *craxëtë*, a matching silk bodice; a *lignë*, an embroidered linen blouse with lace; twelve *scocatë* of *mbëdiet*, varicolored silk ribbons; a *scocctëte jisst*, a large ribbon in the shape of a rose to pin on the breast; a *plexaturi*, a ribbon to braid in the hair; a *schepi*, a silk veil; a *checza*, a bonnet with gold embroidery; and finally a *brezo* or *bresi*, a belt with a large, worked silver buckle.

One of the most noteworthy variants of women's dress in central Italy is the costume of the women of Loreto in the Marches. It consists of a long, red skirt, tied at the hips by a violet sash in the form of a ribbon with long ends hanging below the knee. The very tight-fitting bodice, the low neckline of which allows the lace-trimmed blouse to be seen, has two other long ribbons striped in yellow, red, and black at the outer edges of the shoulders. These are partly covered by a narrow, lace shawl, which is fastened at the center of the waist. The *cartonella* hat, typical of feminine dress in all central Italy, completes this unique costume.

The folk dress of the men in the various regions of Italy is more uniform. The Sicilian costume is formed of the following pieces: *ciliccuni*, blue velvet jacket reaching to the belt with very tight sleeves ending in wide cuffs at the wrists; *cileccu*, vest of the same material; *càusacurta*, trousers, also of velvet, ending at the knee where they are fastened by a silver buckle; long white stockings; *cincedda russa*, a sash of more than 2 yards used to support the trousers, almost always red but with blue, white, yellow, or green stripes; a white, two-pointed hat; and finally two *muccaturi*, pocket handkerchiefs whose many-colored ends hang from the jacket pockets. Different and older characteristics are present in the Sardinian costume. Typical garments include: the *collettu*, a kind of leather jerkin that reaches to the knee like a double apron; the *mastrucca*, a large jacket of untanned skin worn in winter with the fur inside, in summer with the fur outside; the *corittu*, a red serge jacket with the sleeves open in front so as to show the shirt; the *ragas*, kiltlike shorts of *orbàce*, a goat-hair material, very wide at the bottom,

tied at the waist with a belt called a *chintorza* and worn over the trousers; the *carzonis*, trousers of white linen or black *orbàce*, wide and short, open and loose to the knee but ending in the *burzighinos*, gaiters of *orbàce*; the *berritta*, a kind of Phrygian bonnet 16 to 20 in. long, of black wool.

The Iberian costume presents a rich, regional variety. In Spain alone nine basic types are found; the Cantabrian, Basque, Aragonian, Catalonian, that of the west, Serranian, Valencian, Castilian, and Andalusian. These in turn have local variations. As an example of Spanish men's costume, the Catalonian consists of the *armilla*, a vest usually with crossed sashes; the *jec*, a loose jacket often slung over the left shoulder; the *faixa*, purple or red belt; the *calces*, knee-length trousers; the *polaines*, leather gaiters; the *berrettina*, a hat differing from the common Spanish hat but very like the Phrygian bonnet and typical of all of Mediterranean Europe. Among the most typical of Spanish costumes is the *charro*, a variation of the western type. For women it is composed of the following pieces: a very wide skirt turned back over red underskirts (on top it is plain or embroidered; at the bottom it is faced with velvet, finished with a wide, decorated, and embroidered hem); an embroidered jacket; a horseshoe mantilla; a multicolored apron; multicolored ribbons for the hair; a kerchief. The mantilla, its form and length varying according to the region, is typical of feminine Spanish dress. In Galicia, for example, it is semicircular and may either barely cover the shoulders or reach to the belt.

French folk costume, which has undergone few modifications since the 18th century, is as follows: a serge jacket, always colored, with or without a peplum and large metal buttons; vest, usually light-colored, with embroidered or printed flowers, but sometimes dark and dotted with embroidery, checked, or decorated with geometric designs and beadwork, and in winter of untanned skins with fur; heavy silk trousers reaching to the knee; and finally long and short gaiters tied around white woolen stockings, sometimes with multicolored garters. Characteristic of the Frenchman's costume is the blouse, a work garment in blue linen, sometimes almost purple or black, gathered at the neck and reaching to the feet (Rethélais, Morvan) or a little below the knee (Île-de-France, Berry), sometimes richly decorated with stylized floral embroidery (Burgundy). The typical felt cap of the French can be three-pointed (Auvergne, Alsace), with a wide brim (Brittany, Berry), high or low in shape (Normandy). Elsewhere its place is taken by a silk or serge cap (Beauce, Île-de-France) or a pointed cap of white cotton (Normandy), or blue or black, often embroidered all over, the tasseled point falling on the left shoulder (Rethélais, Brie).

The dress of the Frenchwoman, not unlike that of the Italian, consists of a skirt called a *cotte*, with full folds, held stiff and puffed by a starched petticoat; a more or less low-necked, tight-fitted bodice of silk or fine serge; a wide kerchief for the shoulders decorated with bright-colored flowers; an apron tied at the waist, with a bib covering the whole chest. One complex note in this simple dress lends value and differentiates it from the other folk costumes of Europe. It is the bonnet, which has innumerable regional and local variations. Especially noteworthy are: the Angevin bonnet of Pont-de-Cé, very like the Renaissance hairdresses; the *grande volante* of Coutances (Normandy), high and blown up almost as if by a puff of wind; the small, black ribbon bonnet of the Arlesiennes; that worn in Vienne (Isère), like a miter; and the *brelau* of Macon (Saône-et-Loire) and of Bresse (Ain).

The best-known example of the folk costumes of the British Isles is the typical dress of the Scottish Highlanders. Certain other garments, however, have a peculiar character of their own, such as the long white shirt which English peasants wear outside the belt, almost touching the long leather gaiters worn tight on the legs, and the high hat shaped like a truncated cone with a wide, stiff brim which the Welsh women wear. The Irish women protect body and head in a hooded mantle with ruffles framing the face. The Scottish women use for the same purpose a long woolen shawl that falls from the head to the feet.

Among the folk costumes of the Scandinavian peninsula, aside from the pointed Phrygian bonnet of Swedish men, only the Finnish has peculiar characteristics. The dress of the men consists of full, tubular trousers reaching to the ankle; sleeveless pullover of heavy cloth, loose to the hips and tied by a belt at the waist; small bonnetlike hat. The women wear a sleeveless dress covered by a shirt of heavy cloth with loose sleeves. The women's dress of Denmark and the Netherlands is quite similar, except for the well-known caps and the shape of the wooden shoes which are peculiar to the Dutch. The men's dress of the two nations varies more. That of Marken, Netherlands, is particularly remarkable. It includes a double-breasted jacket with three large buttons on each side and a pair of short trousers tight at the waist but very full at the knee. On the contrary, the Danish men wear very tight-fitting trousers, narrow at the knee, and a pair of white stockings with blue stripes, a blue vest with white polka dots, and an embroidered sleeveless cassock open in front.

The folk costumes of Germany and a good part of Austria and Switzerland have many similarities. The Bavarian and Tyrolean men's dress, for example, consists of short woolen or leather pants, usually gray and richly decorated with embroidery or appliqué, which leave the knee and a good part of the leg bare, and white stockings. A jacket of wool reaching just below the fitted waist has tabs and facings of the same color as the vest at the sleeves and collar. The vest, often green, reveals the shirt and the decorated straps of the suspenders across the chest. A low-crowned felt hat with feathers or a badger's brush completes this very typical dress. The women's costume of the same areas consists of a full-skirted dress with puffed sleeves, a high laced bodice, a shawl or kerchief crossed in front, and a very full apron almost like a second skirt. The hat is nearly identical to that of the men.

Hungarian folk costume is full of Turkish-Bulgarian elements. The most common men's dress has knee-high boots; very tight-fitting trousers; a shirt closed in front, the lower part tied at the waist but continuing for several inches outside the trousers, with sleeves full at the wrists; a low, round hat with wide or narrow brim. The women's costume consists of a long, low-necked, full-skirted dress without sleeves; a dark apron; a second, smaller white apron edged in crochet; blouse with sleeves closed at the wrist; bonnet or hat similar to a fez. The most characteristic garment of both sexes is the *suba*, a coat, usually sleeveless, which is ankle-length for men, hip-length for women. The richly embroidered *suba* is always of leather (*ködmen*) or felt (*szür*) and is extraordinarily decorative.

Czechoslovakia presents a rich variety of forms. Particularly interesting are those of the men of Hronov and Litomysil (Bohemia); they include trousers fitted at the knee and knee socks (Hronov) or boots (Litomysil), with openings in front; a belt with a very large buckle of embroidered leather; a full-sleeved shirt and bolero with a high collar (Hronov), or with tight sleeves and a little jacket with lapels and long rows of buttons, open in front (Litomysil); a large kerchief at the neck; a hat like a wide sombrero. The Moravian women's dress, despite its innumerable variations, is well represented by that of Rohatec, most commonly consisting of a short, pleated, red skirt; a white blouse embroidered in black, with puffed sleeves and narrow shoulders; a white, crocheted apron; a black bodice with floral embroidery; a white bonnet decorated with several showily embroidered ribbons that fall to the hem of the skirt. The Slovakian folk costumes retain a definite character of their own, despite strong Hungarian, Turkish-Bulgarian, and generally Oriental influences. The dress of the men of Zvolen (central Slovakia) is to be noted for its archaic character. They wear short, white trousers, loose at the calves, very like a trouser-skirt; a very wide belt; a shirt, often so short as to leave the lower part of the torso uncovered, with full sleeves left loose at the wrist; a short bolero; and a very low, round hat with narrow brim. The trousers resemble those of Sardinia and show that the origin of this garment is to be sought in the kilt pinned up or tucked under the crotch.

The Polish folk costume, notably uniform, consists of the following pieces for the men: light-colored and not very tight-

fitting, or almost puffed (Łowicz), trousers, tight at the knee: black boots; a very wide leather belt; a white shirt with bow tie; a jacket reaching to the knees or to the waist, when it is worn with a vest. There is more variety in the woman's dress, which in its simplest form consists of a full skirt with a multicolored, horizontally striped apron; a richly embroidered bolero; and shirt with puffed sleeves narrow at the wrists. The women's dress of Galicia has a long, strikingly decorated sleeveless jacket reminiscent of the Hungarian *suba*.

In Latvia the folk costume is varied, but there are some articles of clothing common to all the regions. For the woman's dress these are: the blouse, the *sagsa*, the brooch, and the crown. The *sagsa*, which is the most important and characteristic piece of Latvian dress, is like the Greek chlamys or the Latin sagum. It consists of a square piece of wool held by a brooch (*sakta*) and is worn over one shoulder, or on the chest, or carried on the arm. Its types are manifold. The most interesting is that in the vicinity of the Dvina, decorated with alternating green, red, yellow, and blue stripes. The one characteristic feature of men's dress is a kind of sandal with thongs circling the calves up to just below the knee.

The costume of western Russia, despite its evident connection with Asian styles, enters into the European framework. Naturally the dress of each of the peoples has its own characteristics, but in White Russia it is possible to isolate common traits. The women's dress, harmonious and simple, is made up of a long, full skirt with elaborate floral decorations on the lower part; a dark bodice with colored binding; a white blouse with puffed sleeves, but fitted at the wrists and shoulders; a tall, half-moon bonnet, richly decorated. The men's dress consists of full trousers held tightly to the legs by laced thongs or worn inside high boots; a hip-length colored shirt with full sleeves closed at the wrist, worn outside the trousers; a sleeveless doublet a bit shorter than the shirt and held at the waist by a medium-size belt; and a wide-brimmed hat. Among the typical Russian costumes that of the southern Ukrainian woman should be included. It consists of a long skirt with decorated bands on the lower part, protected by an apron; a very tight-fitting, low-necked bodice, continued below the waist by a second skirt reaching to the knees; and a collarless blouse with pleated bosom and puffed sleeves closed at the wrists and embroidered on the upper part.

The Romanian folk costume, although there is little uniformity, is rich in elements that reveal a common tradition. The garments usually worn by the Romanian women are the skirt; the apron, almost always embroidered in colored wool; the blouse, more or less long, in embroidered white linen; two belts of colored wool, one wide and the other narrow; the bodice (but only in some sections); a kerchief or embroidered bonnet; the *obiele*, strips of cloth wound around the feet; the *opinci*, a kind of sandal in various forms; and in winter, a cloak of coarse gray cloth. The men's dress is composed of a linen shirt worn outside the trousers; tight-fitting linen trousers or wide ones of coarse gray cloth, depending on the region; a loose jacket; a wide belt of leather or wool; a fur cap or a felt or straw hat; and finally a mantle of coarse gray cloth for the winter months. A particularly interesting article of the women's dress of Oltenia, Muntenia, and Moldavia is the *marama*, a veil worked on the loom in cotton, silk, and silver threads. Another characteristic garment of Muntenia and the mountainous zones of Romania is the *fota*, a rectangular piece of cloth that is wrapped around the hips, with the ends crossed in front.

Bulgarian dress is similar to that of Romania, showing some Oriental features but in the main following traditional European forms.

The Turkish influence prevails in the costumes of Yugoslavia, Albania, and, in minor measure, in those of Greece. The ethnic and religious diversity of the Yugoslavian peoples is reflected in the varied and multiple clothing fashions. In some areas of Serbia the women wear a full skirt with embroidered bands on the lower part; a little apron also embroidered; another much shorter skirt open in front, the ends caught up and hooked on the hips; a fitted bodice with a large heart-shaped neckline; a blouse with a small necktie and regular

sleeves closed at the wrist with full lace cuffs; and a disklike hat with thin brim and chains at one side. Among the garments peculiar to Dalmatia the *gerdan* should be included. It is made of a long rectangular piece of cloth hanging from the neck and forming a sort of pectoral on which the girls sew silver coins in parallel rows. Another garment typical of this region is the dalmatic, a kind of sleeveless mantle, open in front, that falls to the middle of the upper leg.

Albanian men's dress differs little from that of the other Balkan regions, but that of the women is very diverse, with decidedly Turkish characteristics. In general it is composed of two basic pieces: the flaring jacket that reaches slightly below the hips, is tied at the waist by a sash, and has embroidered sleeves; and very full trousers, embroidered at the lower ends or closed at the ankles. Another costume has, instead of trousers, three superimposed skirts of different lengths; a blouse with puffed sleeves closed at the elbows; and a small bolero with the lower ends hooked on the breast. The Tosks of Albania wear a white, pleated kilt, called *fustan*, over their knee-length trousers.

This garment is also the most typical element of Greek folk dress for men, which is completed by a white shirt with full sleeves; a dark doublet open in front; long, white stockings; and the *opanche* (shoes) with upturned point and pompon. The Greek women's dress, not very different from that worn in all the European Mediterranean, consists of a long skirt with an apron; a white blouse and bodice; a long, sleeveless jacket; a kerchief for the head, of which one end, passing around the throat, falls on the back; and sometimes a pectoral similar to the Dalmatian *gerdan*. In comparison with the elaborate richness of the embroidery in all of the Danubian-Balkan area, the Greek folk costumes have little decoration, in contrast to the extremely rich dress of Crete, which is, however, outside the area of diffusion of European folk dress.

Antonino BUTTITTA

FASHION AND FASHION PUBLICATIONS. As a deliberate accentuation of the esthetic character of costume, fashion is closely related to representational art. Not uncommonly the current dress fashion is taken as the subject or as a division of the representational arts and interpreted as part of an ideal of beauty. Conversely, fashion is frequently inspired by these arts and employs the artists in determining its styles. The fashion phenomenon is also dependent on the economic conditions of the apparel industry and allied activities, and thus upon production and the market, as well as on the qualitative standards of art.

The length of the fashion cycle tends progressively to shorten, with a parallel diminution in the use of costly materials and in the complexity of manufacture. The great speed with which current fashion changes is directly related to the growth of the textile industry as a result of new industrial processes. With the economic need for a parallel, artificial acceleration of consumption, the productive agents of every stage turn to the artist for fabric design, new styles, colors, etc. About 1750, with the development of the first industrial production centers, the fashion designer appeared. Though artistically he is a peripheral and secondary figure, in his contact with the higher forms of art from which he draws inspiration and motifs he contributes to the spread of the esthetic experience.

While fashion periodicals began only in the 18th century, as early as the middle of the 16th century the Italian engraver E. Vico undertook to represent all the costumes of the world in 98 plates. This idea was imitated for his own country by the Fleming Abram Bruger, and for Italian and French dress by the Frenchman Boissard. The histories of costume by Cesare Vecellio (1590; PL. 30) and Bertelli are also of this period. There is also a volume in manuscript form (Venice, Galleria Querini Stampalia) in which the rules for cutting appear next to the models.

Paris in the meantime imposed its taste on Europe, sending mannikin dolls dressed according to the latest fashions to the principal cities. The first fashion periodical, without fashion plates, seems to have been the *Mercure galant*, later the *Mercure*

*de France*, published in Paris in 1670. A century later numerous fashion periodicals made their appearance. Among the most famous in France were the *Courier de la mode* (1768) and the *Galerie des modes* (1770); but most important, because of the designers who collaborated, were the *Monument du costume* (1777–83), a true collection of costumes, with engravings by J. M. Moreau le Jeune and S. Freudenberger; and the *Galerie des modes et costumes français* (1778–87), illustrated by Claude-Louis Desrois, Pierre-Thomas Leclerc, François Watteau de Lille, and Augustin de Saint-Aubin. The last period of Louis XV's reign also marked the beginning of tailoring activity similar to that of today. At that time Paris counted 1,884 tailors and 1,700 dressmakers. Until then, although united in corporations since the 13th century, they had never been of much importance in the creation of dress; they followed the orders of the client and were often advised by great artists. It must not be forgotten that Pisanello, Leonardo, Holbein, to cite only the greatest, created fashion design (PL. 30). The first dressmaker to impose her personality and bring the name of the fashion designer into the lime light was Rose Bertin, Marie Antoinette's dressmaker. With the French Revolution all fashion periodicals in Paris had to close down. The last to suspend publication, in January, 1793, was the *Journal de la mode et du goût* of Lebrun.

In the meantime several had come out in Italy; in Venice, in 1767, *Il giornale per le donne*, probably the oldest fashion magazine; in Florence, in 1770, *La toeletta*; in 1781, the *Giornale delle donne*; in 1788, the *Giornale delle mode dedicato al bel sesso*; in Milan, 1786, the *Giornale delle nuove mode di Francia e d'Inghilterra*. (For satires of fashion, see III, PLS. 426, 427.)

After the French Revolution the sale of ready-made garments was begun. In Paris in 1791 there was a store for men directed by M. Quérier, and one for women under Mme Teilland. In 1799 a similar store was opened in Hamburg by the firm of Korn and Hosstrup. At the beginning of the 19th century men's fashion models, inspired by the personal style of Beau Brummel and then the Count d'Orsay, spread from London. Top place in the field of men's fashions was held by London up to the beginning of the 20th century, when the models of the London firm of Minister ruled. In Paris, during the Empire, the first creator of fashion as it is understood today came forward in the person of the tailor Leroy. He imposed his styles on the Napoleonic court, launching the shawls and large lace collars which he had copied from those of the Mary Stuart period. But it was only with Worth, an English silk merchant, that the history of the French *haute couture* began. The tailor of the Second Empire, he opened the way for others. After the Franco-Prussian war there were about a dozen *couturiers* in Paris. In the years preceding World War I they had risen to 2,000. In the late 19th century and the early years of the 20th the most famous were Lucile, Molyneux, Doucet, and Paul Poiret, who designed the first women's suits for the house of Worth, and again Poiret, Doucet and Paquin, Patou, Redfern, Drecoll, and Bechoff-David, who in 1913 tried to bring the trouser-skirt into fashion. After World War I Chanel truly revolutionized fashion lines, doing away with white fox, furs, and Paul Poiret's exotic gowns and presenting in their place dresses similar to the Western Union messenger uniforms. The innovations of Chanel in the dress field remained important. Shortly after 1930 Elsa Schiaparelli began her activity, launching dresses of synthetic materials.

With the invention of the first sewing machine by Isaac Singer in 1850, the mass manufacture of dresses became possible. After World War II a minor artisan activity of the so-called "boutiques," which produced original models in series, sprang up next to the great fashion houses. As in the large ateliers, the boutiques also sold accessories, from jewelry to hats. Although there were great fashion designers such as Christian Dior in the postwar years, the "little dressmaker" of Paris disappeared, replaced by the American kind of industrialization that changed this field as it had many others.

BIBLIOG. The whole bibliography on costume and fashion prior to 1939 has been collected in Katalog der Freiherrlich von Lipperheideschen Kostümbibliothek, Berlin, 1896–1905; R. Colas, Bibliographie générale du costume et de la mode, Paris, 1933; I. S. Munro and D. E. Cook, Costume Index, 1937, sup. 1957; H. M. Hiler, Bibliography of Costume, A Dictionary Catalog of about Eight Thousand Books and Periodicals, New York, 1939. In addition to these are: A. Cittadini, Il costume nella storia dei popoli, Bagnacavallo, 1938; A. Alföldi, Insignien und Tracht der Römischen Kaiser, RM, 1939, pp. 1–158; M. G. Houston, Medieval Costume in England and France, London, 1939; I. Brooke, Western European Costume, London, 1939–40; L. Ozzola, Il vestiario italiano dal 1500 al 1550, Rome, 1940; A. Blum, Le costume en France, Paris, 1944; I. Brin, Usi e costume, Rome, 1944; M. Tilke, Kostümschnitte und Gewandformen, Tübingen, 1945; A. Sandre, Il costume nei tempi, Turin, n.d.; M. G. Houston, Ancient Greek, Roman and Byzantine Costume and Decoration, 2d ed., London, 1947; M. L. Morales and M. de Lozoya, La moda, el traje y las costumbres en la primera mitad del siglo XX, Barcelona, 1947; N. Truman, Historic Costuming, 2d ed., London, 1947; L. M. Wilson, Fashion, Scranton, Pa., 1947; I. Brooke and J. Laver, English Costume, London, 1948; H. Norris, Church Vestments, London, 1949; M. Boehn and M. L. Morales, Accessorios de la moda, 2d ed., Barcelona, 1950; D. C. Calthrop, English Costume 1066–1830, London, 1950; R. Klein, Lexikon der Mode, Baden-Baden, 1950; M. Leloir, Dictionnaire du costume et de ses accessoires, des armes et des étoffes dès origines à nos jours, Paris, 1950; H. Norris, Costume and Fashion, London, 1950; Arti e costume, Rass. semestrale del Centro internazionale delle arti e del costume, Venice, 1951; M. Boehn and M. de Lozoya, La moda, historia del traje en Europa desde los orígines del cristianismo hasta nuestros días, 3d ed., Barcelona, 1951; S. Grieg, A Detail of Dress History, ActA, XXII, 1951; C. Ferrari, Catalogo della mostra del costume nel tempo, ed. by the Centro internazionale delle arti e del costume, Venice, 1951; J. Laver, Early Tudor, 1485–1558, I, London, ca. 1951; Mostra della moda in cinque secoli di pittura, catalogue, Turin, 1951; S. Piantanida, Mostra dei libri d'arte sul costume, Venice, 1951; C. W. Cunningham, English Women's Clothing in the Present Century, London, 1952; J. Evans, Dress in Mediaeval France, Oxford, 1952; D. W. Gorsline, What People Wore, New York, 1952; L. Mondini Lugaresi, Moda e costume, manuale di storia del costume, Milan, 1952; M. Vocino, Storia del costume: Venti secoli di vita italiana, Rome, 1952; C. Beaton, The Glass of Fashion, New York, 1954; A. Bradshaw, World Costumes, London, 1954; M. G. Houston, Ancient Egyptian, Mesopotamian and Persian Costume and Decoration, 2d ed., London, 1954; L. Morpurgo, Tunica recta, RendLinc, IX, 3–4, 1954; W. Bruhn and M. Tilke, A Pictorial History of Costume, New York, 1955; J. Wilhelm, Histoire de la mode, Paris, 1955; A. Renan, Le costume en France, Paris, n.d.; H. Parmelin, Cinq peintres et le théâtre décors et costumes de Léger-Coutaud-Gischia-Labisse-Pignon, Paris, 1956; Deux siècles du costume, Arts-Spectacles, 595, Nov., 1956, p. 10 ff.; M. Picken, Fashion Dictionary, New York, 1957; M. Davenport, The Book of Costume, 5th ed., New York, 1958; D. Yarwood, English Costume from the Second Century B.C. to 1952, 2d ed., London, 1958.

Illustrations: PLS. 8–33; 1 fig. in text.

Marialuisa ANGIOLILLO, Sergio BOSTICCO, George CŒDÈS, and Giovanni GARBINI have contributed to individual sections of this article.

**COURBET**, GUSTAVE. French painter (b. Ornans, a town in the Franche-Comté, June 10, 1819; d. La Tour de Peilz, near Vevey, Switzerland, Dec. 31, 1877). Jean Désiré Gustave was the oldest child of Eléonor Régis Courbet, a well-to-do rural landowner, and Sylvie Oudot. He first attended the Ornans seminary, where he studied with the abbés Oudot and Lemontey. In 1837, at the age of eighteen, Courbet was sent to the Collège Royal at Besançon, where he studied with little enthusiasm and was in constant protest against the official teaching methods. Having gained the reluctant consent of his father to study as a day pupil at the Collège, Courbet simultaneously attended the Ecole des Beaux-Arts, directed by Charles Antoine Flajoulot, a mediocre pupil of J. L. David. Here the artist made the acquaintance of Max Bouchon — a friendship that endured all his life — and illustrated Bouchon's *Essais poètiques* with lithographs. During the years at the Ecole, Courbet painted some rather academic landscapes of the valley of the Loue. In 1840, after the death of Flajoulot, he went to Paris, ostensibly to begin the study of law, as his father had always intended. In reality, however, he studied painting along with his new friend François Bonvin in the studio of a certain Desprez, called "le père Latin," and assiduously visited the Louvre, where he admired the works of the old masters — the Venetians, the Florentines, the Spaniards, and above all the Dutch. His numerous free adaptations of Rembrandt, Frans Hals, Van Dyck, and Velázquez he called "pastiches."

His first masterpiece, *Courbet with a Black Dog* (Paris, Mus. du Petit-Palais), painted in 1842, was also the first picture he sent to the Salon (1844). Thereafter he sent pictures to various Salons until 1870. In 1846, according to his own words, "after having discussed the errors of the romanticists and the

53189

classicists, I raised along with my friend Max Bouchon a banner which it is convenient to call realistic art." In 1847 he painted the self-portrait *Man with a Pipe* (Montpellier, Mus. Fabre), which was refused by the Salon along with two other works of his. During the same year, Courbet went to Holland as guest of the wealthy Dutch picture dealer Van Wisselingh, who admired him and who had approached him after seeing the *Portrait of Monsieur X* (Besançon, Mus. B.A.) accepted by the Salon of 1846.

Courbet took part in the revolution of 1848 but declared that he did not believe in war "fought with guns and cannons." In a republican France tinged with liberal ideas, the Salon jury ceased to be composed of academicians and was selected by artists. Courbet profited by this fact and exhibited many works: *The Morning, The Midday, The Evening,* and *The Violoncellist* — none of which could be considered narrative — as well as landscapes of the Ornans countryside and self-portraits. *The Violoncellist,* refused by several preceding Salons, exists in at least two versions (Stockholm, Nat. Mus.; Portland, Ore., Mus. of Art), and there is doubt as to which is the original.

Courbet, who had already attracted the attention of critics and public, made a name for himself in the Salon of 1849, which was installed not in the Louvre as before but in the galleries of the Tuileries. Thanks to the more liberal jury, he was able to present his self-portrait entitled *The Man with the Leather Belt* (PL. 37), *Portrait of Marc Trapadoux* (formerly Berlin, Coll. O. Gerstenberg), *Grape Harvest at Ornans* (Winterthur, Switzerland, O. Reinhart Coll.), *Valley of the Loue,* and most important of all, the large composition *After Dinner at Ornans* (Lille, Mus. B.A.). The widely read art critic Champfleury, whose sound judgment and encouragement were unfailingly helpful to Courbet, prophesied that soon the "realist" Courbet "will be one of our greatest artists." From 1848 on, his studio was frequented by Champfleury and other writers and recognized critics, among them Théodore de Banville, Murger, Baudelaire, and the socialist philosopher Proudhon, who was later to make the personality of Courbet pivotal in his important book *Du principe de l'art et de sa destination sociale,* published posthumously in 1865.

The storm that was to rage around the name of Courbet began at the Salon which opened Dec. 30, 1850, where he exhibited several paintings: some landscapes; *Hector Berlioz* (PL. 34), painted in 1848 and refused by the musician; the portrait of the journalist and art critic Francis Wey, with whom he had enjoyed a cordial friendship for some years; *The Peasants of Flagey Returning from the Fair* (Besançon, Mus. B.A.); *The Stone Breakers* (PL. 36); and *The Funeral at Ornans* (Louvre). These last two paintings were notable for their serious purpose and large dimensions (*The Funeral* measures 10 ft., 3½ in. × 21 ft., 9½ in.); they scandalized the public and aroused the critics to violent discussions. In 1851 Courbet was invited to participate in an exhibition in Brussels, where he was received enthusiastically and where *The Violoncellist* and *The Stone Breakers* were acclaimed. Controversies over his work again broke out at the Salon of 1852, where he exhibited *The Village Maidens* (New York, Met. Mus.), which was acquired by Count de Morny before the opening of the Salon.

In the meantime the political atmosphere of France had changed. On Dec. 2, 1861, the *coup d'état* of Louis Napoleon confirmed the beginning of the Second Empire, which in effect had already existed for a year. Its advent was a grave blow for Courbet and his republican friends. Newspapers were suppressed, there were mass arrests, and people were exiled. Even his friend Max Bouchon was forced to seek refuge in Switzerland. Courbet left Paris and went for a time to Ornans.

Three of Courbet's works were exhibited in the Salon of 1853: *The Wrestlers; The Sleeping Spinner* (PL. 34), a portrait of his sister Zélie asleep with a distaff in her hand; and *The Bathers* (Montpellier, Mus. Fabre), which aroused the wrath of Napoleon III, who considered it indecent. Despite the imperial strictures, a young hotel owner of Montpellier, J. L. Alfred Bruyas, enthusiastically acquired *The Sleeping Spinner* and *The Bathers* and invited Courbet to Montpellier, where he remained until the autumn of 1854 in an atmosphere of warm

and respectful friendship. During these peaceful months Courbet painted two portraits of Bruyas, as well as the *Courbet with a Striped Collar, The Meeting* (or *Bonjour, Monsieur Courbet !*), and seascapes of the beach at Palavas painted in a luminous and clear range of colors. (All are in the Musée Fabre, Montpellier.)

After a brief visit in Switzerland with his friend Max Bouchon, Courbet returned to Ornans late in 1854 and started the huge painting (11 ft., 9 ³/₈ in. × 19 ft., 6 ⁵/₈ in.) he intended for the Paris World Exposition of 1855: *The Artist's Studio* (PL. 38), which to him was "a true allegory of seven years of my artistic life" and symbolized his life from 1848 on. Shortly before the opening of the exposition Count Nieuwerkerke, director of the imperial museums, promised Courbet an official commission for the exposition, provided he were willing to present a sketch for the Count's approval. Courbet refused to make this gesture of submission and gave wide publicity to the episode. As a consequence his three entries, *The Artist's Studio, The Funeral at Ornans,* and *The Bathers,* were not accepted by the jury. With the help of his friend and patron Bruyas, Courbet had a pavillion constructed and installed a large exhibition of his canvases. In his preface to the catalogue, Courbet set forth his manifesto on realism.

After a tour of the valley of the Rhine, Courbet returned to Ornans in 1856 and painted, among other pictures, the *Young Ladies by the Seine* (PL. 35). In the same year he made the acquaintance of the critic Castagnary, who had previously attacked him but who from this time on became one of his most persuasive defenders. When he returned to Montpellier, there were enthusiastic receptions for him and other artists who had accepted the realist credo. During his stay there, he embarked upon another series of seascapes. Soon afterward he painted the *Blond Woman Asleep* (Nice, Matisse Coll.) and *Mère Grégoire* (Chicago, Art Inst.). At this point, Courbet seemed to indulge the public's preference for his sea pieces and landscapes and rarely painted figures drawn from daily life, perhaps because they had received little acclaim in the past. During the six months he spent in Frankfort, where he took part in spectacular hunts, Courbet painted a series of hunting scenes and landscapes, of which the most famous are *Fighting Stags* (PL. 36), painted in 1860, *The Dying Stag* (Lons-le-Saunier, Mus. Municipal), and *The Stag Drinking* (Marseilles, Mus. B.A.). The latter was sent with other works to the Besançon World Exposition, where Courbet was awarded a medal "for his pictures which faithfully reproduce places and scenes of the Department of the Doubs." Official recognition was beginning.

Courbet was in Ornans during 1859, and in 1860 he went to Honfleur with Boudin. In the Salon of 1861 he exhibited *The Stag Drinking, Fighting Stags,* and other paintings, which received only modest recognition; but the criticism was favorable, and at the exposition at Antwerp he and Millet had great success. In the meantine, encouraged and aided by Castagnary, he opened his studio to a group of young men who were dissatisfied with the teaching of the Ecole des Beaux-Arts. The first model chosen by Courbet for his students was an ox.

The refusal by the Salon of 1863 of the notorious *Return from the Conference,* because it was so aggressively anticlerical, caused a great scandal. The picture, turned away also by the Salon des Refusés, was acquired by a Catholic who destroyed it. "Out of regard for the morals of Paris," the *Awakening,* or *Venus and Psyche* (formerly Berlin, Coll. O. Gerstenberg), of 1864 was also refused, but it was accepted and exhibited in Brussels. This was the first of a series of nudes painted during these years, of which one of the best known is *The Woman with a Parrot* of 1866 (PL. 35). During 1865 he painted a series of landscapes of the Ornans countryside: *The Puits Noir* (New York, private coll.), *The Stream of the Puits Noir* (Louvre), *The Canal of the Puits Noir* (Besançon, Mus. B.A.). *The Return of the Roebucks* (Louvre) and *In the Forest* (London, Tate Gall.) were painted during 1866. At the Salon of 1865 he exhibited *Proudhon and His Family* (Paris, Mus. du Petit-Palais), which was given a lukewarm reception.

From 1865 to 1869 Courbet often stayed on the coast of Normandy at Etretat and Trouville and, by invitation of the Count de Choiseul, at Deauville, the fashionable beach of the Second Empire. Here he painted portraits of the ladies of the Parisian aristocracy, which earned considerable social success for him. During these years he also painted a series of seascapes, including *The Rock* (New York, Brooklyn Mus.), *Departure for Fishing* (Paris, H. Leroux Coll.), *Calm Sea* (New York, Met. Mus.) and *Stormy Sea* (Louvre) of 1869, several versions of *Cliffs at Etretat* (Ottawa, Nat. Gall.; Louvre), and another hunting scene, *The Kill* (Besançon, Mus. B.A.). At the Paris World Exposition of 1865, Courbet exhibited more than a hundred paintings in a pavilion at the Rond Point du Pont de l'Alma, but he had little success with the public. However, in 1869 another exhibition of his work was notably successful in Munich, where Courbet spent a brief time and painted *The Lady of Munich*.

In June, 1870, Courbet, as a republican who opposed the Empire and a follower of the social theories of his friend Proudhon, refused the Cross of the Legion of Honor, as had Daumier. After the disaster of Sedan, the Empire of Napoleon III fell on Sept 2, 1870, the Republic was proclaimed, and a national defense government was established. On Apr. 12, 1871, the Commune of Paris ordered the demolition of the column in the Place Vendóme. In September of the preceding year, a commission presided over by Courbet had merely proposed, it would seem, to dismantle and transfer the column to the Invalides. Courbet, involved in the blame for provoking the destruction of the monument, was arrested on June 7, 1871, and condemned to six months in prison. His mother had died during this time. Freed from prison, he was affronted by the refusal of Jean Louis Ernest Meissonnier to allow his participation in the Salon of 1872. In 1873 the government of Mac-Mahon, then president of the Republic, debated the reconstruction of the Vendóme column, reopened the trial, and subsequently charged Courbet with the expense: 323,091 francs, 68 centimes. Courbet was forced to flee and took refuge in Switzerland, where at La Tour de Peilz near Vevey, together with some students, he lived the last melancholy years of this life. He was loved by the people of the region, who called him affectionately "le père Courbet." In 1877, just when he could have returned to France — following the forced sale of his property and paintings in Paris — he died.

During his last years he painted a series of still lifes of fruit and flowers; many of these were done in the prison of Sainte-Pélagie in Paris, where his sister brought him the models. Various portraits, numerous land- and seascapes, and several views of the Castle of Chillon on Lake Geneva date from this period. He also did some sculpture, among which are a relief in plaster, *The Lady of the Seagull*; a statue for the fountain at Ornans, *The Chabot Fisherman* (Morteau, France, Coll. P. Chopard); and *Helvetia* for the fountain of La Tour de Peilz.

An analysis of the development of the art of Courbet must take into account what the artist wrote about himself. "From the age of ten I have fought the battle of the spirit," he wrote his parents in 1848. He struck at the very heart of artistic and educational theory in France when, in 1837, at the age of eighteen, he organized his schoolmates at Besançon in opposition to the authorities with the following program: "1. Do not go to confession. 2. Put obstacles in the way of study. 3. Compose music; write verses, novels, and love letters to the girls of the Sacré-Coeur. 4. Try to find food. 5. Organize gymnastics and nocturnal fights. 6. Play tricks on the monitors." (From a note written in 1871.) "I would have willingly studied French and foreign languages," continued Courbet, "history, geography, the liberal arts, and mechanics; but no! One must learn Greek, Latin, and mathematics in order to become a soldier, a profession which horrifies me."

From this and similar statements, it is easy to imagine a Courbet rebellious and romantic, hostile to the classicism of Ingres that dominated the artistic life of France and Europe. However, in his youth Courbet also shied away from the romanticism of Delacroix. Courbet wrote of himself in 1866 that he forgot the ideas and the training he had acquired

in his adolescence in order to follow the socialists of all factions in 1840. When he arrived in Paris, he was a follower of Fourier; then he joined with the students of Cabet and Pierre Leroux but continued at the same time to paint and to study philosophy. He studied French and German philosophers and was for ten years, along with the editors of the *Réforme* and the *National* an active participant in the revolution until 1848. This interest in social and philosophic problems casts a special light on the so-called "romanticism" of Courbet and renders it somewhat less problematic. When he wrote in a letter of 1849 to M. and Mme Wey, describing *The Stone Breakers*, "Art should be put on a lower level: my contemporaries for far too long have produced idealized art, drawn from casts or prints," his attitude henceforth became wholly conscious and foreign to the traditional romantic positions.

Although it was not until 1855 that Courbet completely and explicitly enunciated his principles in the catalogue of his one-man show in the Pavillon du Réalisme, in the letters to the Weys his arguments against art by rote had already exalted the observation of the "true" and had therefore defined the bases of realism. When his *After Dinner at Ornans* was shown at the Salon of 1849, the remarks of Delacroix and Ingres, then the two most important artists of France, served to define Courbet's position. Standing before the picture, Delacroix exclaimed that here was a strong and unusual personality who borrowed nothing from anyone, "an innovator and a revolutionary who has suddenly burst forth." Only the new element in Courbet's "individualism" (romanticism) escaped Delacroix — the attempt to invest his personal genius with a more popular character and purpose. Ingres, more rigid and precise, acknowledged the surprising natural talent and the firm modeling evident in Courbet's work but declared that "art absolutely escapes him" and that "this young man is only an eye"; but the ideas behind the "eye" escaped Ingres. This was precisely what Cézanne was to say of Monet; nevertheless, despite its derogatory intent, this opinion does not contradict what Courbet stated in 1855 about what he was and wished to be.

In a letter of Courbet to Francis Wey in 1850 one reads: "In our overcivilized society, I must lead the life of a savage; I must even keep myself free from governments. My sympathy is with the people; I must turn to them directly, learn from them and derive my life from them. It is for this that I embarked upon the grand independent life of the bohemian." The reasons for Courbet's bohemianism were therefore quite different from those of the traditional romantic bohemian, and if they escaped the romantic Delacroix, they were bound to be rejected by Ingres and all those who shared his classicist point of view (Charles Perrier, Jules and Edmond de Goncourt). Some years later, apropos of *The Bathers* of 1853, the same Delacroix used words similar to those of Ingres to inveigh against the "miserable realist" who attempts to present him with "the crude reality of objects," that is, with exactly the reality he wishes to escape "by taking refuge in the sphere of artistic creation." It is true that for Courbet realism was a "human conclusion which awakened the very forces of man against paganism, Greco-Roman art, the Renaissance, Catholicism, and the gods and demigods, in short, against the conventional ideal" (autobiographical note, 1866). In other words, the realism of Courbet was a sort of realism par excellence, an independent attitude which had indeed some precedents in the past but which now, for the first time, appeared laden with significance and a conscious sense of history in its anticlassical and antiromantic approach. The statements of the artists do not seem to support the thesis that Courbet was essentially a romantic (De Chirico, 1925; L. Venturi, 1947; Hauser, 1951); they support instead the thesis of a revolutionary Courbet whose esthetic positions are explainable only by the reawakening of the proletariat and of its class consciousness (Aragon, 1952); or that of a materialistic and, even if he were unaware of it, a dialectical Courbet (Argan, 1954).

The verbal testimony of the artist must enter into the appraisal of his training as an artist. Contrary to what it seemed to Delacroix, the painting of Courbet did not "suddenly burst forth," nor did it spring, as it seemed to Ingres, only from his

observation of reality. "I continued," said the artist of himself, "the direction of Gros and Géricault," seeking in all the great traditions of Europe "the various ways of painting," in order to produce works "equal to the best pieces in our museums." (The word "museum" implies for Courbet precisely what it was to imply for Cézanne in his statement about impressionism.) Courbet's study of the past explains how it it possible to see in his canvases the reflection of the greatest names in art from Michelangelo to Poussin, from Correggio to Corot, from Titian to Rembrandt; it is precisely his knowledge of old masters that confers an imposing classic accent upon Courbet's so-called "realism." By filtering the present through the sober light of tradition, Courbet reversed the conventional order: the present no longer did homage to the past; it was the past that conferred dignity on the present.

Unable to appreciate the revolutionary nature of this approach, Baudelaire carried on an indirect and covert struggle against Courbet's positions but never dared to attack him personally, as recent studies have made clear (Aragon, 1952). Baudelaire was a guest of Courbet in 1848, as well as the object of his admiration. Courbet painted a portrait of the poet before 1849 and depicted him as the incarnation of Poetry in *The Artist's Studio* of 1855. Nevertheless, in his numerous critical reviews Baudelaire mentioned Courbet only once in 1855 and labeled him as "sectarian" and exclusive in his adoration of "exterior, positive, and immediate nature," as Ingres had appeared to be narrowly sectarian in his adoration "of the Raphaelesque idea of beauty." Surely these words did not altogether displease Courbet, but they missed the target, inasmuch as they did not take into account how much his realism had been affected by the work of other artists — as evidenced by the "pastiches" he had included in his exhibition of 1855.

If in 1849 the position of Courbet was fully defined, in the works that preceded this date the romantic component had been very strong. In some splendid self-portraits, the artist seemed almost to meditate, to analyze himself to the very depths of his soul: *Courbet with a Black Dog* (1842), *The Wounded Man* (1844, Louvre), *Man with a Pipe* (1847). Courbet himself called his portraits "an autobiography told in images," a visual description of his states of mind. The painting of 1842 is the portrait of a man "steeped in the ideal and in the absolute love in the manner of Goethe, George Sand, etc."; that of 1844 is the portrait of a man with the death rattle in his throat; and that of 1847 is the portrait of "a fanatic, an ascetic, a man deluded by the futilities that served as his education." The romantic touch in these sentimental transpositions is more than evident. Although Delacroix may be largely present in the very texture of the paint, however, the density of the color masses, the depth of the shadows, and the compactness of the modeling are descended from the past; in fact, *The Wounded Man* and *Man with a Pipe* hark back to the sensuous painting of the 17th century. *The Man with the Leather Belt* (1849; PL. 37), intense as a Rembrandt, is composed like a Venetian painting of the 16th century. *The Hammock* (1844, Winterthur, Switzerland, O. Reinhart Coll.) is richly lyrical, and yet it displays the firmness, precision, and strength of a Poussin.

In *Grape Harvest at Ornans*, *The Stone Breakers*, *The Funeral at Ornans*, and *After Dinner at Ornans*, Courbet throws off all residue of traditional romanticism. *The Funeral* was conceived like the Dutch 17th-century compositions in which each figure was a portrait from life. Because of its huge size, Courbet could not stand back from the picture to see the overall effect. Although a fierce opponent of *peintures d'histoire*, he made the humblest people of his village the heroes of a true picture of history (De Micheli and Treccani, 1954). In this canvas he gave proof of his full power and wanted to be judged by the same standards that were applied to the old masters in the museums.

*The Stone Breakers* (PL. 36) and *The Funeral* gave rise to heated discussions of Courbet's attitude toward society. According to Champfleury, both pictures could have been painted without his having democratic leanings; Proudhon was of the opposite opinion. Castagnary felt that *The Funeral* had no social significance but that *The Stone Breakers* could not have

been conceived without democratic sympathies. While denying its other implications, Proudhon noted the mythical and religious character of *The Stone Breakers*: "Courbet did not set up contrasts as Victor Hugo would have done. He preferred the great bare road with its monotonous solitude. Some peasants saw the picture by chance, and do you know where they would have wanted to put it? On the main altar of their church. *The Stone Breakers* is a parable of the Gospel; it is a moral gesture." These remarks of Proudhon's imply that he felt that Courbet's "socialism" was limited to a sympathy for the people (Aragon, 1952); they also imply that artistically the picture fell short of Courbet's exalted ideas, because it did not go beyond a pietistic glorification of the physical fatigue of the two workmen.

However, the fact remains that in his letters Courbet wrote of his feelings about social rebellion only apropos of *The Stone Breakers*. But this does not necessarily mean that the antiromantic and anticlassical attitude implicit in *The Funeral* was not motivated by the same ideological and moral stand which tends to consider humble people as the true protagonists of history. The point here is that the figures are not mere instruments of labor; they are living people. While posing for the painter, they address themselves also to the beholder. In Courbet's desire to exalt the humble, there was implicit — more or less consciously — a class discrimination, an anti-aristocratic bias; and his art developed increasingly in this direction. When in his wrath Napoleon III hit *The Bathers* with his riding crop so hard that he might have slashed the canvas, he was giving vent not only to his contempt for the picture as art but also to his class instinct. The Empress Eugénie, on the other hand, confined herself to inquiring whether the nude women were Percherons; and Prosper Mérimée announced that human flesh had never been painted more realistically but that, after all, Parisians were not New Zealand cannibals. These three reactions arose from the notion that *The Bathers* was purely an expression of visual reality or of unseemly carnality, whereas the Michelangelesque poses of the two figures prove Courbet's assimilation of the classical tradition and his epic exaltation of the physical. *The Sleeping Spinner* (PL. 34) and *The Wrestlers* were also exhibited in Courbet's pavilion. While *The Sleeping Spinner* made evident the contrast between the sleep of a peasant woman and the sleep of the Furies or the hermaphrodites in the myths of classical art, *The Wrestlers* was a modern version of the classical ideal of physical vigor. Such works, however, only increased the feeling against Courbet and gave fuel to the hatred which was to explode in 1871 on the question of the Vendôme column and which was apparent in the insults and invective of Alexandre Dumas fils and Barbey d'Aurevilly.

The *Women Sifting Grain* (1854, Nantes, Mus. B.A.) is the culmination of Courbet's poetry of the peasant. The dreamy abandon of the woman who takes chaff from the pan in her lap, the ancient and almost ritual gesture of the woman who sieves, and the warm, soft atmosphere were never again to appear in the art of Courbet. In the same year the painting *The Meeting (Bonjour, Monsieur Courbet!)* proves that Courbet was definitely aware of his place as an artist. From this time on, he never again portrayed himself as thoughtful or sad, in despair or in love; he now saw himself as secure and free. In this encounter with his patron Bruyas he is a man face to face with another man, and their cordial expressions are indicative of their mutual respect. Courbet painted himself (and wrote of himself) as "a man confirmed in his principles." The picture was immediately judged "pretentious"; and it has been observed that in it the palette is lighter than in all previous paintings and is somewhat off key in its harmonies (L. Venturi, 1947). Nevertheless, it is the manifesto not so much of Courbet's narcissism as of his pride and the consciousness of finding himself finally at the center of the artistic life of France.

*The Artist's Studio* (PL. 38) of 1855 is the apotheosis of his ideas, his life, and his world. At the left of this enormous canvas he portrayed a group of figures intended mostly to represent the class that lives on the margin of society, and on the right is a group of figures intended to represent Love, Philosophy,

and Literature, among whom appear Bouchon, Champfleury, Proudhon, Bruyas, Promayet, and Baudelaire. At the center is the painter at work on a landscape while a nude model (Truth) looks on. As soon as Delacroix saw this painting, he pronounced it a masterpiece and praised its composition and feeling of atmosphere. He found only one fault — that the sky of the landscape on the easel looked like a real sky. "They [the jury of the Exposition] have refused," he concluded, "one of the most remarkable works of our times." For L. Venturi the painting derives its high quality from its virtuoso execution and from a certain air of detachment from immediate reality (the portraits were executed from memory and the nude from a photograph). In this same year (1855), Courbet declared his determination to "represent the manners, the ideas, the character of my time as I perceive them; to be not only a painter, but a man — in a word, to create a living art." It is at this moment that "realism" came into the open as the art of the avant-garde.

Nevertheless, soon after defining his aims, Courbet seemed in a certain sense to abandon them. After 1855, in fact, the art of Courbet changed radically; but the difference did not lie in his approach or technique. In constructing his pictures, he always started more or less directly from reality and, above all, clung to the values of light and shadow. The paint texture is thick and tight and emanates from a broad, assured play of the brush and the palette knife. The real change lay in the subject matter, because Courbet henceforth addressed his attention to new and different facets of the surrounding world. Materialism evolved into naturalism in his sensuous exaltation of the female nude and his rendering of the untamed aspects of nature. The energy and vitality of his touch (L. Venturi, 1947) were put at the service of the myth of energy: the struggle of the stag, the dashing of torrents, the hunt in the forest, the roaring wave of the sea, the powerful reefs and cliffs that rise on the horizon. The physical tangibility of bodies became sensuality in *The Awakening* (1864) and *The Woman with a Parrot* (1866; PL. 35) — exaggerated in its eroticism and, according to Venturi, "one of the most frightful absurdities Courbet ever committed." The public was no longer so hostile as it had been, and Courbet appeared passé and reactionary compared with the new rising stars. (Manet, for instance, opened a one-man show in 1867 near the great exhibition of Courbet at the Rond Point du Pont de l'Alma.) Zola declared that Courbet had "gone over to the enemy," and Champfleury spoke of "decadence." It is in this last phase that it is more appropriate to speak of Courbet's "naturalism" (L. Venturi, 1947; Hauser, 1951) rather than of his realism. By this time the tenets of realism could be considered with a certain detachment, and Champfleury could write: "Realism is as old as the world . . . but the critics by perpetually using the word obliged us to use it. . . . Unfortunately, I have too much sincerity and good faith to remain attached to a word. Courbet instead, I believe, was at the same time more shrewd and more ingenuous when he talked of it."

After 1855 Courbet continued to expand upon his artistic position. In 1861 he opened his famous school of painting; its avowed program and his own temperament were only apparently contradictory, because Courbet actually felt that each student should teach himself and that he should have absolute freedom. By this gesture Courbet aimed at demolishing all schools because he had always opposed "authoritarian direction," the academies, and official art. Always antiacademic and revolutionary, he wrote in 1868 to Castagnary: "Without the revolution of February [1848], perhaps my painting would never have been seen." Such a statement, as well as his participation in the Paris Commune, confirms his unswerving belief in revolutionary principles. While his uncompromising artistic individualism, antiofficial and antiacademic, might seem romantic, it formed the link between Courbet and the new generation of artists in France and elsewhere. The embattled principles of Courbet's school of 1861 were not particularly useful to Alfonse Legros, Armand Gautier, and Carolus Duran, who were already mistakenly considered the followers of Courbet (Mantz, 1878); but they were invaluable for Manet, Degas, and Monet, because they were spared the necessity of repeating

these same pronouncements. The ideal of absolute liberty in the arts became the beacon of their individual activity and that of the impressionist group. Courbet also had a wide influence on progressive artists outside France. Although their production now appears insignificant, Courbet had an effect on the Italian *veristi*, who also read Proudhon's *Du principe de l'art*. More directly, he influenced the German Wilhelm Leibl and the Hungarian Mihaly Munkacsy, patriot and conspirator as well as realist painter. Notwithstanding the change of subjects and the seeming contradiction between his new theme and his old revolutionary ideas, Courbet's painting remained grand and powerful to the end. While *The Woman with a Parrot* seems in bad taste, the sensuousness of *The Sleepers* (1866; Paris, Mus. du Petit-Palais) goes beyond transient pleasure and appears rather as a force of nature, not unlike the waves in the *Stormy Sea* of 1869 and the later views of the Castle of Chillon. Courbet's deliberate manner of building compositions in terms of volumes that exalt "thickness" rather than refinement, "density" rather than lightness (Lemonnier, 1878) — while maintaining at the same time an absolute visual, luminous, and chromatic distinctness of forms — prepared the way for Monet (Roger-Marx, 1947) and was never to undergo any extensive modification. Courbet's way of constructing images expressed his sense of exaltation before the spectacle of the human body and the forces of nature, omnipresent and arresting in their material consistency, weight, movement, and agitation. Whether his *œuvre* be interpreted as proof of an aversion to every established myth — that is, of a faith in the concrete so absolute as to set aside every preconception (Argan, 1954) — or whether it be accepted merely as the rendering of well-defined and clear mental images (Castelfranco, 1954), it is certain that Courbet, in spite of momentary vacillations, never repudiated his faith in the palpable existence of material things and in the possibility of grasping their meaning and worth.

BIBLIOG. C. Perrier, Du réalisme, L'Artiste, Paris, Oct., 1855; T. Silvestre, Les Artistes français: Etudes d'après nature, 2 vols., Paris, 1856; Champfleury [J. Husson], Le Réalisme, Paris, 1857; Champfleury [J. Husson], Grandes figures d'hier et d'aujourd'hui, Paris, 1861; M. Guichard, Les Doctrines de M. Courbet, maître peintre, Paris, 1862; J.-A. Castagnary, Les Libres-Propos, Paris, 1864; P. J. Proudhon, Du principe de l'art et de sa destination sociale, Paris, 1865; E. Zola, Mes haines, Proudhon et Courbet, Paris, 1866; T. Duret, Les Peintres français en 1867, Paris, 1867; Thoré [W. Bürger], Salons de 1861 à 1868, Paris, 1870; M. Sulberger, Le Réalisme en France et en Belgique: Courbet et De Groux, Revue de Belgique, Brussels, 1874; H. d'Ideville, Gustave Courbet: Notes et documents sur sa vie et son œuvre, Paris, 1878; C. Lemonnier, Gustave Courbet et son œuvre, Paris, 1878; P. Mantz, Gustave Courbet, GBA, 1878, I, pp. 514–27, II, pp. 17–30, 371–84; G. Castagnary, Exposition des œuvres de Courbet à l'Ecole des Beaux-Arts, catalogue, Paris, 1882; G. Castagnary, Gustave Courbet et la colonne Vendôme, Paris, 1883; G. Castagnary, Salons 1857–70, I, Paris, 1892; G. Geffroy, L'Atelier de Courbet, La Vie Artistique, VI, 1900; J. Troubat, Une Amitié à la d'Arthez, Paris, 1900; G. Riat, Gustave Courbet peintre, Paris, 1906; G. Geffroy, Gustave Courbet, L'Art et les Artistes, IV, Oct., 1906–07, pp. 257–62; J.-A. Castagnary, Fragments d'un livre sur Courbet, GBA, pér. IV, vol. V, 1911, pp. 5–20, pér. IV, vol. VI, 1911, pp. 488–97, pér. IV, vol. VII, 1912, pp. 19–30; B. Lazare, Courbet et son influence à l'étranger, Paris, 1911; T. Duret, Courbet, Paris, 1917; A. Fontainas, Courbet, Paris, 1921; J. Meier-Graefe, Courbet, Munich, 1921; C. Baudelaire, L'Esposizione Universale del 1855, L'arte romantica, Curiosità estetiche, Opere postume, Milan, 1923; G. de Chirico, Courbet, Rome, 1925; P. Courthion, Courbet, Paris, 1934; C. Roger-Marx, Avant la destruction d'un monde (de Delacroix à Picasso), Paris, 1947; L. Venturi, Modern Painters, New York, 1947 (with bibliog.); Les Amis de Gustave Courbet, Bulletin, Mus. d'Ornans, Besançon; C. Leger, Courbet et son temps, Paris, 1948; Courbet raconté par lui-même et par ses amis, 2 vols., Geneva, 1948–50; M. Zahar, Gustave Courbet, Paris, 1950; A. Hauser, Social History of Art, 2 vols., New York, 1951; G. Mack, Gustave Courbet, New York, London, 1951; P. MacOrlan, Courbet, Paris, 1951 (with bibliog.); L. Aragon, L'Exemple de Courbet, Paris, 1952; G. C. Argan, Il realismo di Courbet, Comunità, XXVII, 1954; G. Castelfranco, La XXVII Biennale, BArte, 4, 1954, p. 347 ff.; M. de Micheli and E. Treccani, ed., Il realismo: Lettere e scritti di Gustave Courbet, Milan, 1954; A. Chamson, Gustave Courbet, Paris, 1955; Gustave Courbet, exhibition cat., Philadelphia, Mus. of Art, Dec. 17, 1959–Feb. 14, 1960, Boston, Mus. of Fine Arts, Feb. 26, 1960–Apr. 14, 1960.

Corrado MALTESE

Illustrations: PLS. 34–38.

**COYPEL.** Antoine Coypel (b. Paris, Mar. 11, 1661; d. Paris, Jan. 7, 1722) was the most important member of a French family of painters which included his father, Noël (1628–1707);

his son, Charles Antoine (1694–1762); and his half-brother, Noël Nicolas (1690–1734). Noël Coypel, who was Director of the French Academy at Rome and later Director of the Royal Academy, is best known for his large decorative compositions, notably the ceiling of the Salle des Gardes de la Reine (1679–81) at Versailles and his fresco, the *Assumption* (1705), Dôme des Invalides, Paris. Antoine, trained by his father in Rome and already known through some important religious paintings, entered the Academy at the age of twenty. Supported by the royal family, in rapid succession he became Director of the Royal Collections (1710), Director of the Royal Academy (1714), First Painter (1715), and a member of the nobility (1717). Unlike his father, who was influenced by Poussin, Antoine favored the style of Rubens and the doctrines of his friend De Piles. His indebtedness to Rubens is evident. in paintings done for the Duc d'Orléans in the Palais Royal (1702–04), *Death of Dido* and *Aeneas and Anchises* (Montpellier, Mus. Fabre); but in his *Cupid and Psyche* (Fontainebleau), from a series executed for the Dauphin at Meudon about 1700, an early rococo lightness appears. Antoine's most important decorative work is the ceiling of the chapel of Versailles (1708), for which he turned to Italian baroque models. With Jouvenet and Lafosse he was a leading practitioner of the baroque style which triumphed in France at the end of the 17th century.

Charles was less significant as a painter than his father or grandfather. Although he also became Director of the Academy and later First Painter to the King, he was most influential as an administrator, teacher, and critic. Nicolas, least successful of the family, painted mythological and allegorical scenes somewhat in the manner of Boucher, but was little favored by official patronage. (See FRENCH ART and V, PL. 414).

WRITINGS. C. A. Coypel, Discours sur la peinture, Paris, 1752.

BIBLIOG. P. Marcel, La peinture française au début du dix-huitième siècle, 1690–1721, Paris, 1906; L. Dimier, Les peintres français du XVIIIe siècle, 2 vols., Paris, 1928–30.

John W. McCOUBREY

**COYSEVOX,** ANTOINE. Prolific French sculptor (b. Lyon, Sept. 29, 1640; d. Paris, Oct. 10, 1720) whose works demonstrate the interplay of strains of classicism, baroque, and rococo that characterized French art of about 1665–1715. Coysevox came to Paris in 1657; he trained at the Academy and under Lerambert, but never in Italy. A *Madonna* in Lyon (1676, St. Nizier) exemplifies his genial and moderate baroque style. By 1679 he was active at Versailles, where Colbert's closely supervised corps of sculptors was manufacturing a vast array of garden statuary in strict conformity with the authoritarian classicism of the painter Lebrun. Often Coysevox was required to imitate antique models (*Nymph with Shell*, 1683; *Kneeling Venus*, 1686; both Louvre) or to copy Lebrun's designs, as in the pompous and pedestrian *France Triumphant* (1683, Versailles). After Colbert's death (1683), these classicist restraints were gradually relaxed, and the taste of Louis XIV inclined slowly toward the more florid baroque that the Academy had held in check. Nevertheless, Coysevox' splendid *Tomb of Mazarin* (1689–93, Louvre) — although its scheme is consciously nationalist and the cardinal's intense gesture and mobile draperies are baroque — retains classic allegiances, especially in the superb group of bronze Virtues, which look like figures from a drama by Racine. Working in the lavish new Versailles interiors of the architect Jules Hardouin Mansart liberated the latent talents of Coysevox, and the monumental *Glory of Louis XIV* (1683–85; V, PL. 408), conceived as an integral part of Mansart's Salon de la Guerre, is an early manifestation of his spirited mature style. With draperies flying, the lively image of the ruler is executed in an ingenious, unconventional diagonal alignment to the picture plane and seems about to leap forth from its confines. The famous portrait busts of Coysevox present a characteristically enterprising reconciliation of academic classicism and Berninian baroque, with its lively movement and vivid naturalism, its pictorial textures

and contours, and its deep shadows (II, PL. 178). Earlier busts portraying Lebrun (1676) and Colbert (1677) are conservative; later ones of Louis XIV (1680s) and Condé (1688) are less restrained. With the approach of the 18th century, his portraits often become more intimate and informal (*Matthew Prior*, 1700, Westminster Abbey; *Self-portrait*, ca. 1702, Louvre). In monumental sculpture he also took increasing liberties with academic doctrine, as in the gayer and more naturalistic garden marbles, *Fame* and *Mercury* on winged horses (1700–02, Place de la Concorde), with their open, buoyant masses and finely scaled detail elaborately undercut and often apparently fluttering. These rococo symptoms are further enhanced in the smiling *Duchesse de Bourgogne* (1710, Louvre), a playful travesty of the *Diana* of Versailles, who trips along lightly with rippling drapery, loosened tresses, and billowing scarf. Other major works among some two hundred: *Dordogne, Caronne* (bronze, 1685, Versailles); tombs — *Colbert* (1685, Paris, St. Eustache), *Harcourt* (1711, Asnière-sur-Oise); *Louis XIV* (bronze, 1689, Paris, Mus. Carnavalet); *Virtues* (1691, Hôtel des Invalides); *Equestrian Louis XIV* (1687, Rennes; destroyed). His tradition was developed by his nephews, the Coustous; but truly rococo sculpture, although conceived about 1718 in the paintings of Watteau, was not realized until the late 1730s, by Bouchardon and Pigalle.

BIBLIOG. G. Keller-Dorian, A. Coysevox, Paris, 1920; L. Benoist, Coysevox, Paris, 1930; A. Blunt, Art and Architecture in France, 1500 to 1700, Harmondsworth, 1953.

James HOLDERBAUM

**CRAFTS.** See HANDICRAFTS.

**CRANACH,** LUCAS THE ELDER. Painter and engraver, born at Kronach in northern Franconia in 1472 (document of M. Gunderam, 1556, published in a German version by Schuchardt, I, 1851–71, pp. 17, 185 ff.; Latin original, Müller, 1912, p. 27 ff.). His name is said to derive from that of his native town; the family names Sunder and Müller, which occur in art-historical literature, have not been conclusively verified (Friedländer and Rosenberg, 1932). Cranach learned the engraver's art in the shop of his father Hans, where he seems to have worked, with some interruptions, until 1498 (Strack, 1925, p. 234 ff.). His stay in Vienna, roughly from 1500 until 1503, is documented by several commissions that he executed for Johannes Cuspinian and Stephan Reuss of the University of Vienna. Christoph Scheurl's panegyric ode of 1509 (Schuchardt, I, 1851–71, p. 29) also indicates that he was in Austria before Frederick II (Frederick the Wise), Elector of Saxony, had appointed him his court painter at Wittenberg (1505). In 1508 Frederick the Wise granted him a coat of arms, which could be passed on to his descendants; it showed a winged serpent, crowned and bearing a ring in its mouth. Cranach had previously used this as his mark on his woodcuts (the text of the letters patent was published by Warnecke, 1879; the coat of arms is reproduced in Giesecke, 1955). In 1509 Cranach was sent by the Elector to the Netherlands, where he attended the solemnities in honor of Emperor Maximilian and painted a portrait (now lost) of the heir to the throne, the future Charles V, then eight years old (Gunderam, 1556).

Until 1550 Cranach lived almost uninterruptedly at Wittenberg, where every other year he held the office of councilor (Heller, 1821) from 1519–20 on, and that of burgomaster from about 1537–38 to 1543–44, at which date he declined further service as burgomaster (Schuchardt, I, 1851–71, p. 19). It is likely that he accompanied the Elector to the Third Imperial Diet at Nuremberg (Rosenberg, 1932) and perhaps also sought refuge there during the plague of 1539 (Hampe, Nürnberger Ratserlässe, I, 2443, 2507). In 1547 the elector John Frederick I, defeated and taken prisoner by the emperor Charles V at the battle of Mühlberg, summoned his court painter to join him at Augsburg (Heerwagen, 1903); however, Cranach did not go there until 1550 (Scheidig, 1953, Doc. 66).

At Augsburg, despite his advanced age, Cranach worked a great deal, and probably without assistants. In 1552 he followed John Frederick I to Weimar, where he died in 1553 (Müller, 1912). His various activities at the court of Saxony are documented almost year by year; moreover, he executed works commissioned by other princes, such as Duke Albrecht of Prussia, Cardinal Albert of Brandenburg, and Charles V.

At Wittenberg, as he had previously been in Vienna, Cranach was in contact with the academic world. He became a particularly close friend of Martin Luther, who in 1508 had been appointed court preacher at Wittenberg and who in 1512 was given the chair of theology at the local university. Luther's letters to Cranach, which disclose that the reformer took a lively interest in the painter's family life, are of great interest (see the Weimar edition of Luther's works, 1948, Tischreden, 4, 4787, and Briefe, II, 395). So far, however, it is not clear to what extent Luther's doctrine influenced Cranach's iconography (see particularly Heydenreich, 1939). The only known instance of direct participation on the part of a Reformation leader in any of Cranach's artistic activity is found in a letter Melanchthon wrote to Stigel in 1544, from which we learn that Melanchthon had sent Cranach models ("praeformatas imagines") for his illustrations of the Bible (Schuchardt, I, 1851–71, p. 81). Actually, numerous illustrations for the works of Reformation writers were executed in Cranach's workshop from 1521 on (see Barsch, VII, 1803–21, pp. 37–48; Schuchardt, II, 1851–71, nos. 103–06, 135–48). Luther himself, however, disapproved of the coarseness of these illustrations, as can be seen from one of his letters in which he denounced those that were used for one of his pamphlets against the papacy (1545).

Cranach contributed to the propagation of Protestantism by means other than his artistic work; having been granted, with Christian Döring, a printer's patent by the elector John Frederick I, he also contributed to the Protestant cause by publishing and selling Luther's writings and his translation of the New Testament (Schuchardt, III, 1851–71, p. 71). Tax assessments of 1528 (Scheidig, 1953, Doc. 45) indicate that Cranach was regarded as one of the wealthiest inhabitants of Wittenberg. His wife, Barbara Brenghier of Gotha, bore him three daughters and two sons, Hans and Lucas, both of whom became painters. It is not known when Hans was born; he died in Bologna in 1537 during a study tour he had undertaken on his father's advice. In an elegy by J. Stigel (Schuchardt, I, 1851–71, p. 96 ff.), Hans is praised as a highly gifted painter; however, his works are indistinguishable from the numerous products of his father's workshop. We can safely attribute to him a book of drawings (Hanover, Kestner-Mus.) and two paintings bearing his signature — a portrait of an unknown man of 1534 (formerly Burg Flechtingen near Magdeburg) and *Hercules and Omphale* (Lugano, Von Thyssen Coll.).

The elder Cranach's true successor, and not merely in the office of court painter, was his younger son Lucas, later called Lucas Cranach the Younger, who was born at Wittenberg in 1515 and died there in 1586. He is at his best in his portraits. We may mention especially his portrait of the elector Joachim II of Brandenburg, of 1571 (Berlin, Staat. Mus.); a study for it is in Dresden (Gemäldegalerie). There is also an important group of portrait studies in the Musée des Beaux-Arts, Reims, some of which are still attributed to Cranach the Elder. Lucas the Younger seems inferior in his religious paintings, among which we may mention the altarpieces in the Stadtkirche at Wittenberg, in the Wolfgangskirche at Schneeberg, and particularly those in the Schlosskirche at Dessau.

As yet, nothing has been learned about the works Cranach did in his youth or about those of his father Hans, who gave him his first lessons in art. The earliest works that can be attributed to Cranach all seem to have been executed in Vienna, or at least in Austrian territory, between 1500 and 1504. His travels prior to 1500 are only a matter of conjecture, but it seems natural to suppose that on his way from Kronach to Vienna he stopped at the artistic centers of Nürnberg, Regensburg, and Passau. This is supported by some stylistic echoes of Dürer, Jan Polack, Michael Pacher, and Marx Reichlich

present in the works of his so-called "Vienna group." In 1503 Cranach was beyond a doubt in Vienna, where he was close to the university scholars, as is attested by the portraits he painted in that period. A panel showing the Crucifixion that dates from about 1500 (Vienna, Schottenstift) was probably executed in Vienna. This small painting is remarkable for its dramatic composition and intense, expressive figures. The realistic portrayal of the group crowding around Mary and the ferocious Oriental horsemen is reminiscent of Jan Polack, and the thick brush strokes and the vivid colors recall Marx Reichlich; but there is no evidence of a direct influence from these two painters. In this early work Cranach is already an independent artist of strongly individual character. In the magnificent landscape included in this Crucifixion scene, Cranach anticipates Altdorfer and the other masters of the so-called "Danube school" and asserts himself as a distinctive and most remarkable personality. Two charcoal drawings showing the two thieves on their crosses (Berlin, Staat. Mus., Kupferstichkabinett) were probably preliminary studies for this Crucifixion. The outlines are forcefully delineated, and the tint of the paper and the white highlights produce an effect of space and plasticity. Related in manner is a pen drawing of a Foolish Virgin (Nürnberg, Ger. Nat.-Mus.), a dark gray wash with white highlights. The gnarled, knobby forms recalling roots and other plant imagery are characteristic of Cranach's style in this period; here they are notably evident in the cloak. Closely related to the foregoing works are the drawings of the Vienna *Filocalus* (Vienna, Österreichische Nationalbibliothek, Cod. 3416) attributed to Cranach by Winkler, with some reservations (*Jhb-PreussKSamml*, LVII, 1936). It is certain that Johannes Fuchsmagen, who commissioned this work, belonged to the group of Vienna scholars with whom Cranach was in close contact. A drawing of a pair of lovers in a wooded landscape (Berlin, Staat. Mus., Kupferstichkabinett) is also attributed to Cranach on account of its stylistic affinity to the Vienna works.

Cranach's earliest woodcuts date from the same period. These include two Crucifixions, one of which is dated 1502. Some of the motifs are derived from Dürer's great Passion series; however, it is impossible to conceive of a greater contrast than that between the agitation of Cranach and the compositional clarity of Dürer. Whereas Dürer brings together the individual details in a clearly organized whole, Cranach seems to fashion his work in a more fluid mass that he articulates into dynamic groups which collide and press upon each other. Two other woodcuts, *Christ on the Mount of Olives* and a *St. Stephen*, disclose the same features.

Two small panels, *St. Valentine* and *St. Francis Receiving the Stigmata* (Vienna, Gemäldegalerie der Ak. der bildenden Künste) also probably date from about 1502. In the Vienna painting, the landscape forms the background against which the figures loom rugged and bulky, while in *St. Jerome Penitent*, a small painting dating from 1502 (PL. 42), the wooded landscape is the dominant element. The technique is somewhat more fluid here than in the previous works. The colors of the landscape are orchestrated in warm tones of green and brown; the flesh tones of the saint and the Redeemer on the Cross, as well as the reds of the cardinal's hat and cloak, are strongly set off against the background and form a diagonal in depth. The *St. Jerome* was probably commissioned by the Vienna historiographer Johannes Cuspinian, as Baldass (1922) inferred from the fact that the owl and the parrot in the tree at the left of this painting also appear as astrological symbols in the portraits of Cuspinian and his wife, Anna Putsch (PL. 46). In this diptych, there appears for the first time in German portraiture a landscape background common to the two panels, which determines the mood of both. The pairs of lovers and the nude bathers who animate the landscape are evidence of the open-mindedness of both the sitter, the Humanist Cuspinian, and the young artist. The portraits of Stephan Reuss, the rector of the University of Vienna, and his wife (Nürnberg, Ger. Nat.-Mus.; Berlin, Staat. Mus.) are painted in the same style. This type of portrait later found many followers in the Danube school.

In 1503 Cranach painted another Crucifixion (Munich, Alte

Pin.), which breaks with the iconographic tradition more resolutely than all his previous works. The Cross of Christ has been moved from the center to the right and placed slanting into depth; the crosses of the thieves are at the extreme left. At the center there is the monumental group of Mary and John. The harsh gestures of the earlier works have given way to more introspective, more spiritual expression. The vast landscape at the right, with its very low horizon line, emphasizes the monumentality of the figures, whose foreshortening is certainly derived from Mantegna, via Michael Pacher. There is no doubt that this Munich *Crucifixion* is Cranach's most grandiose creation. This heroic work was followed, in 1504, by the gracefully idyllic *Rest on the Flight into Egypt* (PL. 41). The Holy Family is seen resting in a delightful landscape; the mood is one of deep, typically German meditativeness. The romantic, fairylike character of the picture is underlined by the lively movements of the angel musicians, and the colors are brilliant and luminous.

Another work dating from 1504, *The Martyrdom of St. Catherine* (Budapest, Szépmüvészeti Múzeum; on loan), is strongly dramatic. This painting, which has only recently been identified as a Cranach (Fenyö, 1955), is of great importance in documenting the change in his style after his appointment at Wittenberg, for in 1506 he treated the same subject in a significantly different manner. At the center of the Budapest painting, the kneeling St. Catherine is profoundly absorbed in prayer; behind her the executioner, in a fantastic costume, is brandishing his sword, while supernatural flashes of lightning rend the clouds and put the spectators to flight. This painting derives from a Dürer woodcut, but Dürer's composition is more static and lacks the elemental expressive force of Cranach's painting. Motifs from Dürer's woodcuts, particularly those treating apocalyptic scenes, are frequently found in Cranach's works.

Cranach's first important work executed at Wittenberg after he was appointed court painter by Frederick the Wise is a new version of *The Martyrdom of St. Catherine*; it is dated 1506 (Dresden, Gemäldegalerie). Most likely, Cranach was asked to portray St. Catherine as the patron of the Wittenberg scholars. The figures attending the decapitation are portraits from life, some of whom can even be identified (Friedländer and Rosenberg, 1932, nos. 12–14); in the background we see the fortress of Coburg (Veste Coburg). In comparing the Dresden painting with the Budapest one, in addition to the fact that the scene has been "modernized," one is struck by the absence of unity in the later work. The composition is rigid and adapted to the requirements of courtly taste, as can be seen from the fashionably costumed young page entering from the left and the affected posture of the executioner behind the saint. The charm of the picture lies in the details, the refined colors, and the realistic treatment of the portraits, costumes, and vegetation. Also new is the artificial light, which emanates from the burning wheel and plays on the faces. Wittenberg's courtly atmosphere seems to have curtailed Cranach's artistic freedom; though less obtrusively, its influence is also felt in the wings of the St. Catherine altarpiece (Dresden, Gemäldegalerie; formerly Lützschena, Coll. Speck von Sternburg). Here again the figures of the female saints are portraits of Wittenberg ladies in relaxed poses before a landscape that once again shows the fortress of Coburg.

This change in the artist's development was less abrupt than the comparison between the Budapest and Dresden versions might suggest. Actually, his search for a new formula can be followed in his prints. As early as 1505 we note in his woodcuts a perceptible relaxation of the forms, as well as a greater firmness of composition, for instance, in the *Adoration of the Sacred Heart of Jesus* (Lippmann, 1895). In subjects requiring more animated forms, a tendency toward clearer arrangement of planes manifests itself, as in a woodcut showing the archangel Michael weighing souls and in the *Temptation of St. Anthony*, both dating from 1506. Similar in composition are *St. Christopher* and *Venus and Cupid*, which are usually described as dating from about 1509, although they bear the date 1506. The authenticity of the latter date has been questioned because both woodcuts show the emblem with the serpent, granted

the artist as his coat of arms in 1508. However, Cranach must have been using this emblem earlier, as stated above. Nor is the latter date corroborated by the fact that the *St. Christopher* exists also in prints produced by the chiaroscuro wood-engraving process (Jahn, 1955). Although chiaroscuro prints (which, like gold prints, are probably inventions of Cranach) do not occur before 1509, the plates may well have been executed later from an older woodcut. It is certainly no accident that a copy of *St. Christopher* has come down to us with the date cut out (*B. of the Cleve. Mus.*, XVI, 1929): this was obviously done in order not to present an old date in the new technique.

The argument that the woodcut *Venus and Cupid*, dated 1506, could not have preceded the painting *Venus and Cupid* of 1509 (Leningrad, Hermitage; Jahn, 1955) is equally unconvincing. The clearly articulated modeling of the nude belongs to an earlier period, as do details such as the animated and unfolded drapery and the landscape, which indicate that the woodcut was executed contemporaneously with the *St. George* of 1506; the latter derives from Dürer's *St. Eustace* of the Paumgartner altarpiece (Munich, Alte Pinakothek).

The female nude, which Cranach ventured at first to portray only in the small format of the woodcut, reappears in life size in the Hermitage Venus. In this work the subject only, not the style, reveals the influence of the classicizing art of the time. The pose is unstable, the limbs lack anatomical correctness, and the entire figure stands out against the dark background as a quivering outline.

The woodcuts of 1509, especially a series of the Passion, often betray the influence of Dürer. Cranach's most important copper engraving, *The Penance of St. John Chrysostom* (PL. 45), is a free transposition of a Dürer, with an emphasis on the landscape element.

The number and nature of the commissions given by the Elector to his court painter are detailed in the previously mentioned panegyric composed by Christoph Scheurl in 1509. In addition to a number of altarpieces, the artist executed a large number of secular paintings, including decorations for the Elector's hunting lodges at Coburg, Lochau, and Torgau. He frequently accompanied his princely patrons on their hunts and sketched indefatigably from nature. In the Kupferstichkabinett at Dresden there is a group of animal studies of boars, crows, and magpies executed with great care and accuracy.

Because of the large number of commissions his workshop also received from other princely houses, Cranach was compelled to hire many assistants; we know, for instance, that as early as 1513 he employed ten journeymen for seven weeks for the decoration of the castle of Torgau (Scheidig, 1953, Docs. 18, 19). His trip to the Netherlands, where he was sent by Frederick the Wise in 1508, seems to have had no profound effect on him; however, some influence of the Dutch Romanists is noticeable in the altarpiece known as the "Sippenaltar," of 1509 (Frankfort on the Main, Städelsches Kunstinstitut). The faces, the ladies' Dutch bonnets, and the clearly separated figures arrayed in front of Renaissance buildings are new in Cranach's work; previously he had only introduced interior architecture as a structural element of his compositions. This new, firmer structure marks the end of a period of uncertainty which is best exemplified in his St. Catherine altarpiece in Dresden. The painting with the 14 patron saints, executed two years earlier (Torgau, Marienkirche), still suggests no compositional structure of that kind: the 14 saints form a crowded mass, a restless ensemble of strongly characterized faces.

The so-called "Fürstenaltar" (PL. 39), which must be dated about 1510, is distinguished by a particularly rigorous symmetry. The simple triangular composition of the central panel and the stone parapet in the foreground bring to mind Giovanni Bellini, whose work Cranach may have known from engravings.

Cranach also used the motif of the parapet in his first painting of the Madonna (Breslau, Cathedral). Although some features derive from Dürer's Dresden Madonna (formerly Wittenberg, Schlosskirche), the graceful, intimate atmosphere and, above all, the idyllic landscape are Cranach's personal inventions. For many decades the type of the Breslau Madonna was reproduced with variations by Cranach and his workshop.

In addition to the Madonna, other subjects came out of the workshop in many variations on the prototype created by the artist. Certain themes, reflecting the freedom-loving open spirit of the Renaissance, were most popular; among the Christian themes, too, those which provided an occasion for portraying nudes were preferred. For example, there are many versions of *Adam and Eve* on a black ground (Munich, Alte Pinakothek; Florence, Uffizi), on a background with foliage (formerly Lützschena, Coll. Speck von Sternburg; Berlin, Staat. Mus.), or surrounded by the animals of paradise (Richmond, Surrey, Cook Coll.). Even more frequent is the individual female nude portrayed as Venus (PL. 44), Diana, or a nymph. These figures are set off in delicate outlines against the background, which is for the most part uniformly dark. Because of their cool colors, their sensuality is unobtrusive; yet these small masterpieces are undeniably erotic in the realistic features, in the veils that conceal nothing, and in the splendid jewels shimmering against a background of luminous flesh. Not infrequently the figures portray Wittenberg ladies; even subjects such as *Bathsheba at the Bath* (the finest example is in Berlin; PL. 40) served as occasions for portraying a court lady in a sumptuous costume bedecked with jewels. Other popular themes were taken from mythology, such as the Judgment of Paris, Hercules and Antaeus, Diana and Actaeon, and Apollo and Diana (PL. 40); but only rarely do these show traces of classical style. In some cases Cranach seems to have been inspired by Italian models, as in the *Reclining Nymph* of 1518 (PL. 40), which brings to mind Giorgione's *Venus*. Most numerous are the workshop copies of subjects most in demand; however, these are executed with many variations, so that a certain originality can be claimed for each. Because the quality of the copies is not as a rule appreciably inferior to that of the original, the work of the master can only rarely be distinguished from that of his assistants, especially since all the products of the workshop bear the emblem with the serpent.

Production on this scale, which might almost be called an industry, although conducted with the surviving methods of medieval craftsmanship, could not fail to leave its mark on Cranach. The master's pictorial inventions had to be characterized by simple, comprehensible linear contours; a more elaborate idiom of space and mass could not have been easily interpreted by the journeymen. For this reason Cranach's earlier creations, intensely subjective and notably individual, gradually gave way to simple, objective formulas. It would, however, be erroneous to see in this workshop arrangement the sole cause of the stylistic change in Cranach's development, for a return to the "formula" — that is, to a linear and ornamental manner — together with a tendency to refinement and intellectual coolness, is perceptible throughout European art with the development of mannerism (q.v.) in the second quarter of the 16th century.

Wittenberg had no significant artistic tradition of its own, so that aside from occasional stimulus from Nürnberg — particularly through Dürer's graphic works — Cranach found himself in an *ambiance* free of outside influences. The town's intellectual atmosphere was largely determined by the Humanists of its recently established university, and the *genius loci* certainly played its part in Cranach's artistic development.

Although Cranach had close ties of friendship with Luther, through whom he gained a firsthand insight into the ideas of the Reformation, it is impossible to establish with certainty to what extent Luther influenced Cranach's choice of themes. But works such as *Original Sin* and *Redemption* (Friedländer and Rosenberg, 1932, no. 183) and *Christ Blessing the Little Children* (*ibid.*, no. 291) were certainly inspired by Luther's ideas. (Most of the dogmatic altarpieces, however, were executed by Cranach's son Lucas the Younger, who, together with his brother Hans, had been employed in his father's workshop from early youth.) Cranach's affinity with Protestantism did not prevent him from working for non-Protestant patrons. Thus, from 1520 onward he executed a large number of paintings commissioned by Cardinal Albert of Brandenburg. The most important of these works shows the Cardinal in prayer before the Crucifix (Munich, Alte Pinakothek); another, taking up a motif treated by Dürer on a copper engraving, portrays the Cardinal as St. Jerome in his study (PL. 43).

In addition, Cranach painted a large number of portraits. His early portraits in Vienna were followed by important portraits of members of the Saxon court, foreign princes, scholars, and noble ladies. The landscape background favored in Vienna gave way to a monochrome ground, as in the portrait of Dr. Scheurl (Nürnberg, Coll. Scheurl). Only occasionally are the sitters shown full length, as in the portraits of Duke Heinrich the Pious and his wife Katharina (1514) in richly brocaded costumes (Dresden, Gemäldegalerie). The portrait of Luther's parents, 1529 (Wartburg, near Eisenach), and that of Dr. Scheuring, 1529 (Brussels, Mus. B.A.), are among the best examples of contemporary portraiture.

The growing demand for portraits of Luther and of the Protestant princes was met with a large, almost wholesale, production by Cranach's workshop. For instance, in 1533 he received payment for "sixty pairs of portraits of the two deceased electors" (Schuchardt, I, 1851–71, p. 88). These portraits are usually small panels in pairs showing the two electors mentioned above, or else Luther and his wife, or Luther and Melanchthon. They emphasize the typical features of each, outlined in a summary and rather stylized form.

SOURCES. C. Schuchardt, Lucas Cranach des Aeltern Leben und Werke, 2 vols., Leipzig, 1851–71; N. Müller, Die Funde in den Turmknäufen der Stadtkirche zu Wittenberg, Magdeburg, 1912; H. Ladendorf, Cranach der Ältere und Cranach der Jüngere-Schrifttum, Lukas Cranach der Ältere, Der Künstler in seiner Zeit, Berlin, 1953.

BIBLIOG. A. Bartsch, Le peintre graveur, Vienna, 1803–21 (new ed., Würzburg, 1920); J. Heller, Versuch über das Leben und die Werke Lukas Cranachs, Bamberg, 1821; F. Warnecke, Lukas Cranach der Ältere, Görlitz, 1879; F. Lippmann, Lukas Cranach, Sammlung von Nachbildungen seiner vorzüglichsten Holzschnitte und seiner Stiche, Berlin, 1895; K. Woermann, Deutsche Kunstausstellung Dresden 1899, Abteilung Cranach-Ausstellung, wissenschaftliches Verzeichnis der ausgestellten Werke, Dresden, 1899; C. Dodgson, Lukas Cranach, Paris, 1900 (with bibliog.); E. Flechsig, Tafelbilder Lukas Cranach des Älteren und seiner Werkstatt, Leipzig, 1900; H. Heerwagen, Zu Lukas Cranach, RepfKw, 1903, p. 425; H. Voss, Der Ursprung des Donaustils, Leipzig, 1907; W. Worringer, Lukas Cranach, Munich, 1908; K. Glaser, Lukas Cranach, Leipzig, 1921, 2d ed., 1923; K. Glaser, Die Zeichnungen des Lukas Cranach, Munich, 1922; L. Baldass, Die Bildnisse der Donauschule, Städeljahrbuch, II, 1922, pp. 73–86; P. Strack, Lukas Cranachs Herkunft, Familiengesch. Blätter, Monatschrift für die gesamte deutsche wissenschaftliche Genealogie, Heft 8, 23, Jahrgang, 1925, p. 234 ff.; M. Geisberg, Der deutsche Einblattholzschnitt in der ersten Hälfte des 16. Jahrhunderts, Munich, 1925–29; M. Friedländer and J. Rosenberg, Die Gemälde von Lukas Cranach, Berlin, 1932; J. Rosenberg, Dürer hat Cranach gezeichnet, JhbPreussKSamml, LIII, 1932, p. 204 ff.; T. L. Girshausen, Die Handzeichnungen Lukas Cranachs des Ältern, Frankfort, 1937; H. and A. Hermann, Lucas Cranach der Ältere und Lucas Cranach der Jüngere, Gemälde, Zeichnungen, Graphik, Berlin, Staatliche Museen, 1937; L. H. Heydenreich, Der Apokalypsen-Zyklus im Athosgebiet und seine Beziehungen zur deutschen Bibelillustration der Reformation, ZfKg, VIII, 1939, pp. 1–40; H. Lilienfein, Lukas Cranach und seine Zeit, Bielfeld, Leipzig, 1942; H. Posse, Lukas Cranach der Ältere, Vienna, 1942; H. Lüdecke, Lukas Cranach der Ältere: Der Künstler und seine Zeit, Berlin, 1953; H. Ladendorf, Cranach der Ältere und Cranach der Jüngere-Schrifttum, Lukas Cranach der Ältere, Der Künstler in seiner Zeit, Berlin, 1953 (with bibliog. to 1953); K. Degen, Die Kreuzigungstafel von Poterstein, ein wiederaufgefundenes Werk von Lukas Cranach dem Älteren, ZfKg, XVI, 1953, pp. 193–202; H. Zimmermann, Beiträge zum Werk Lukas Cranach des Jüngeren, das Epitaph und das Bildnis des Caspar Muinec, ZfKw, VII, 1953, pp. 209–15; W. Scheidig, Katalog der Lukas Cranach-Ausstellung Weimar und Wittenberg, mit einem Vorwort von J. Jahn und Einleitung und biographischer Übersicht von H. Lüdecke, Erfurt, 1953; I. Fenyö, Lucas Cranach emlékkiallestás, Országos Szépmüvészeti Múzeum, Budapest, 1953; J. Rosenberg, A Drawing by Lukas Cranach the Elder, AQ, XVII, 1954, pp. 281–85; Lukas Cranach the Elder, St. Eustace: Drawing in Pen, Ink and Wash, BMFA, LII, 1954, p. 95; I. Fenyö, Un dessin et quelques tableaux de Cranach au Musée des Beaux Arts, B. du Musée Hongrois des Beaux Arts, V, 1954, pp. 44–53; I. Fenyö, An Unknown Early Cranach, BM, XCVII, 1955, p. 68 ff.; J. Rosenberg, The Problem of Authenticity in Cranach's Late Period, AQ, XVIII, 1955, pp. 165–68; A. Giesecke, Wappen, Siegel und Signet Lukas Cranachs und seiner Söhne und ihre Bedeutung für die Cranachforschung, ZfKw, IX, 1955, pp. 181–92; J. Jahn, Lukas Cranach als Graphiker, Leipzig, 1955; C. Ozaraowka Kibish, Lukas Cranach's Christ Blessing the Children, a Problem of Lutheran Iconography, AB, XXXVII, 1955, pp. 196–202; N. Grass, Der Thürnfelder Altar und seine Cranach-Bilder, ein verborgenes Kunstwerk zu Hall in Tirol, Festschrift Weingartner, 1955, p. 25 ff.; O. Thulin, Cranach-Altäre der Reformation, Berlin, 1955; J. Rosenberg, Die Zeichnungen Lukas Cranachs, Berlin, 1960.

Gisela and Karl NOEHLES

Illustrations: PLS. 39–46.

**CREDI,** Lorenzo di. Italian painter (b. ca. 1456–60; d. 1537). The son of a goldsmith, Credi is first mentioned as an apprentice to the Florentine goldsmith and painter Andrea del Verrocchio (q.v.), together with the somewhat older Leonardo da Vinci (q.v.). Credi's father died in Venice in 1469, the year when Verrocchio began the tomb of Piero de' Medici (S. Lorenzo, Florence), which is so like a jeweler's casket. Also in 1469 Piero Pollaiuolo was selected to paint the *Virtues* for the Tribunale di Mercanzia (Florence, Uffizi). These works are typical of the art that formed Lorenzo's style. Verrocchio appreciated Credi because he was neat and patient; Credi responded by helping him in his shop and the school for artists established in the Medici dower house, especially after Verrocchio went to Venice to finish the bronze equestrian monument of Colleoni. When Verrocchio died before finishing the casting, Credi became the executor of his will and brought his master's body back to Florence.

While in Venice, Credi had hoped to finish the Colleoni monument and to execute the tomb of a doge for which Verrocchio had left a drawing. Credi was, however, apparently trusted only as a painter. His technique was skillful and meticulous; his colors were carefully ground and laid on with care, but with little range and invention. There is scant variety in his treatment of subject matter. Usually he depicts a seated Madonna, with her head slightly tipped, gazing at the Child or the young St. John — with or without saints standing or kneeling at either side — and silhouetted against a window opening onto a verdant landscape reminiscent of Verrocchio's Pistoia *Madonna* (e.g., *Madonna and Child*, Turin, Gall. Sabauda). Another version of the Madonna seated in a similar pose is set in an open landscape, and young trees may take the place of the back of the throne (e.g., *Madonna and Child and the Young St. John*, Kansas City, Mo., William Rockhill Nelson Gall. of Art). Another composition also used repeatedly shows the kneeling Madonna adoring the Child, with or without the young St. John (e.g., *Madonna Adoring Child*, London, Nat. Gall.) and sometimes accompanied by two angels who are oversweetened versions of those in Verrocchio's *Baptism* (Florence, Uffizi). Credi's version of the *Baptism* (Fiesole, S. Domenico) seems a parody of its model.

Fortunately, Credi also left many portraits which have more interest, especially the sensitive silverpoint studies of youths or old men. A splendid black chalk drawing of an old man (Louvre) and a delicate silverpoint drawing of a youth (Boston, Mus. of Fine Arts) provide an excellent contrast in techniques. A fine self-portrait painted by the artist at thirty-three is in the National Gallery in Washington. Works such as these make us regret that Credi burned many of his drawings and secular works in Savonarola's "burning of the vanities" (1497–98). Credi's later work, so monotonously repetitious, betrays his failure to develop creatively.

Bibliog. Vasari, Vite, ed. Milanesi, IV, pp. 563–71 (Am. ed., trans. E. H. and E. W. Blashfield and A. A. Hopkins, 4 vols., New York, 1913); B. Degenhart, RArte, 1932, pp. 263–300, 403–44; K. T. Parker, Old Master Drawings, vol. 4, no. 3, 1930, p. 3, pl. 8.

Clarence Kennedy

**CRETAN-BYZANTINE SCHOOL.** This school (actually a complex of schools) comprises a group of artists active from the 15th to the 18th century and concerned chiefly with the production of icons to satisfy devotional needs. The most important centers of production were the Greek islands of the western Aegean, the Ionian Islands, and Crete; work of the same type was also done on the Adriatic coast, in the Balkans, and on the mainland of Greece. The distinguishing element in this production is its derivation from Byzantine art (q.v.).

Summary. Sources of style (col. 71). The Cretan-Byzantine school and its regional development (col. 73).

Sources of style. In order to understand the origins of the Cretan-Byzantine school and to differentiate the various subschools, it is necessary to examine the last phase of Byzantine art, which flourished under the Palaeologian emperors — a phase that has not yet been fully clarified.

The old thesis that later Byzantine painting was no more than a decadent survival of an earlier age of magnificence has been universally discarded, and it is now generally recognized that there was an artistic revival of great importance in the 13th and 14th centuries. Gabriel Millet was the first to perceive the outlines of this "Byzantine renaissance," whose momentum persisted after the fall of Constantinople in 1453, and the results of his pioneer work have been accepted and developed by numerous scholars, especially in Greece and the Balkan countries. But there is still some difference of opinion as to how this renaissance came about. Bettini (1940) and certain others in the West, following suggestions put forward many years ago by Kondakov, hold that the initiative came from Italy by way of Crete and the Venetian colonies in Greece. Others hold that the renaissance was indigenous to the Byzantine area, and that the new humanistic, less hieratic type of art which characterizes it developed independently of Italy.

The key to the problem lies in the dates at which the earliest works in the new humanistic manner were produced in the Byzantine area. The icon *Our Lady of Vladimir*, notably humanistic in its deep tenderness, was probably painted about 1130 (II, PL. 451); the wall paintings of Nerezi in Yugoslavia, similar in feeling, were done in 1164; a number of other markedly humanistic works elsewhere date from before 1200; later on, in the 13th century, monuments in the new style were produced with comparative frequency. In Italy, on the other hand, painting was of a far more hieratic character until the arrival on the scene, in the second half of the 13th century, of Cavallini, Duccio, Cimabue, and Giotto (qq.v.). There can thus hardly be any reasonable doubt that the Byzantine renaissance was indigenous.

The center in which the new ideas were first developed was undoubtedly Constantinople, for the change is already hinted at in works that are certainly to be assigned to the capital and to the artistic efflorescence of the 9th–11th century, for example, an ivory of the "court" workshop representing John the Baptist, which is now in the Public Museums in Liverpool. Once the new outlook had been accepted, the style spread rapidly; its dissemination was no doubt facilitated by the Latin conquest of Constantinople in 1204, which drove artists and patrons away from the capital.

Developments took place in different ways in different places, and by the beginning of the 14th century, which seems to have been a period of exceptional vitality, a separation into distinct schools can be discerned. All of these were basically Byzantine, but each was tinted by a particular outlook. As time goes on and knowledge becomes more precise, a considerable number of local groups will no doubt emerge; at present three main schools stand out.

First is the school, best represented by the mosaics and wall paintings of Kariye Camii (Church of the Chora; II, PL. 464), associated with Constantinople; it is characterized by great elegance, a very refined approach, subtle, delicate coloring, and full decorative backgrounds. The second school, centered in Salonika in Macedonia, is characterized by a more dramatic manner; the figures are spirited and vivid, there is a much more emotional approach, the colors are heavier and deeper, and the tendency is toward expression rather than decoration (II, PL. 463). The third school is exemplified by such paintings as those of Mileševa and Sopočani in Serbia (Yugoslavia): the compositions are full, often even overcrowded; many new themes are illustrated and new ideas introduced; the coloring shows a new elaboration; the style is in general more monumental than in the Macedonian school, less decorative and subtle than in the Constantinopolitan (II, PL. 462).

The history of the Serbian school need not concern us here, for its influence was essentially local. Work in the manner of the Macedonian school was done in the south of Greece in the 14th and following centuries, notably at Mistra in the Peloponnesos and even in Crete, and many of the panels loosely called "Italo-Greek" actually have a Macedonian basis upon which

Italianate elements have been imposed. As an outgrowth of the Constantinopolitan style, there developed, beginning in the 14th century, a new and very important school, termed by Millet "Cretan," whose influence permeated the mainland of Greece, Mount Athos, Crete, and, especially, the western islands. Such wall paintings as those of the Peribleptos at Mistra (1340–60), which constitute the first monument that Millet assigned to his Cretan school, derive directly from Constantinople, and Cretan wall paintings on Mount Athos, such as those in the refectory at the Lavra (1512) and the cathol-icon at the Lavra (1535), and the old catholicon at Xenophontos (1544 and 1563) represent 16th-century developments of the same basic style. Sixteenth-century wall paintings in the more expressive and dramatic Macedonian style are preserved, along-side the Cretan ones, in other churches on the mainland and in the monasteries of Mount Athos. By the 16th century, however, numerous other elements than those peculiar to Mac-edonia and to Constantinople, stemming from the old mo-nastic styles of Greece and Asia Minor as well as from the West, had become mingled with the basic idioms.

THE CRETAN-BYZANTINE SCHOOL AND ITS REGIONAL DEVELOP-MENT. The 15th- and 16th-century icon painters were nurtured in both these traditions: their work was sometimes more Cretan, that is, brilliant, polished, decorative, and tending toward abstraction, and sometimes more Macedonian, that is, more vivid, deeper in coloring, and tending more toward expressive narration. This is true regardless of whether the painters came from Crete; there are just as many so-called "Macedonian" paintings in Crete as there are "Cretan" ones on the mainland. Because of the wide geographical diffusion of the style, these names are inadequate, and what we have been calling the "Macedonian" and "Cretan" styles might better be termed, respectively, "Revival Style I" and "Revival Style II."

These two main styles influenced each other, and painters of both schools found their way to Venice, so that Italian elements mingled with those proper to the two basic styles. It is the works in this mingled manner that are assigned to what has been described as the "Italo-Greek," or "Italo-Cretan," school.

Icons of these schools are not easy to attribute with certainty; the styles frequently overlap, and there are a number of subtle subdivisions, dependent on the region in which work was done and on the character of the individual artist. The dis-tinctions cannot as yet be made with any degree of exactness; all that the present state of our knowledge permits is to point out the various subdivisions of the main schools and touch on their salient characteristics.

Early work in Revival Style I is best represented in Salonika by the mosaics of the Church of the Holy Apostles (1312); the dramatic pose of the shepherds in the *Nativity* is characteristic. In Macedonia the early-14th-century work of the painters Michael (Mihailo) and Eutychios (Eutihije) in the Church of St. Clement at Ohrid and elsewhere is typical. In Athens a 16th-century icon of *The Transfiguration* in the Benaki Museum (no. 11; see PL. 48) may be cited, with special reference to the angular, expressive attitudes of the prophets and the marked emotion of the apostles below.

Revival Style II, so well represented in wall paintings such as those of the Peribleptos at Mistra and in numerous monas-teries on Mont Athos, is even more amply exemplified by icons. A *Crucifixion* of the 14th century in the Byzantine Museum in Athens (no. 169; see PL. 47) shows the style in its earliest phase, when it was still closely linked to Constantino-politan work of the Palaeologian period. The tall, elongated figures, the marked restraint, and the rhythmical composition are typical; the picturesque background below and the large expanse of open gold background above are also noteworthy. Light, rather gay coloring, in which bright reds, blues, pinks, and greens play an important part, is characteristic of the school, in contrast to the heavier, deeper, more somber colors to be found in work in Revival Style I. In later icons in Revival Style II, details came to be treated with great precision, the highlights were more markedly stressed, and the compositions tended to become more and more rhythmical; all these features

are clearly apparent in a 16th-century icon of the *Assembly of Angels* in a private collection in Athens (PL. 47). Sometimes the highlights appear as large masses of light-colored over-paint, as on this icon and in the mid-16th-century wall paint-ings signed by Anthony in the Monastery of Xenophontos on Mount Athos; sometimes they appear as thin parallel lines, as in a 17th-century icon of the *Saviour* in the Benaki Museum (no. 44). The work of Michael Damaskenos may be taken as typical; an icon of the *Trinity* in the Benaki Museum (no. 6) and one of *St. Anthony* in the Byzantine Museum (no. 211; see PL. 51) may be cited. These works and many others are Byzantine and show practically no intrusion of Western elements; a *Presentation* in the Byzantine Museum (no. 328) signed by Philotheos Scouphos and dated 1669 is characteristic.

The icons, from the 16th century on, that do show Western influence — which have been roughly grouped together under the designation "Italo-Greek" — reveal varying degrees of Westernization and various regional influences. Sometimes the picture is still essentially an icon but ornamental details that are Western in character have been added. This is the case with a series of 16th-century icons of the feasts of the Church now scattered among various collections: one, with the *Ascension*, is in the Benaki Museum (no. 22); another, with the *Annun-ciation*, is in a private collection in Britain. The carved frames of the whole series were clearly done under Western influence; a vase of flowers reminiscent of such a painter as Crivelli rep-resents another intrusion. In such icons as these the Greek element is clearly to the fore. Many of the works of the painters of the later 16th and 17th centuries whose names we know, Manuel Zanfurnari, for example, are to be assigned to this subdivision of the Italo-Greek school.

Others of these artists, though trained as icon painters, assimilated Western elements to a far greater degree; an icon in the Byzantine Museum, signed by Elias Moschos and dated 1687 (no. 278; see PL. 52), and one in Berlin by Tsane (PL. 50) may serve as examples of this style: the emotional approach, the naturalism of the figures, the baroque quality, the fleecy clouds, are all essentially Western. In the case of the Moschos panel, the iconography is Western as well, though the formal rocks in the background and the treatment of the detail are true to the icon painting tradition. Here we are in the presence of a work of baroque character which is really more Italian than Greek, though the artists are generally of Greek origin; such Italianate paintings may be grouped in a second sub-division of the Italo-Greek school.

A third subdivision is made up of paintings done in the 15th and 16th centuries, in which primitive Italian elements dominate, Greek elements taking a secondary place. Such paintings were probably often the work of Italians, who no doubt worked on the eastern as well as the western shore of the Adriatic. A *Pietà* in the Benaki Museum (no. 79) and a painting in a private collection showing the *Virgin and Child with SS. Jerome, John the Baptist, Andrew, and Augustine* (PL. 52) may serve as examples. The latter is signed by Giu-seppe Allori, priest of Parma; there is a closely similar but less fine painting, apparently a copy of it, in the Museo Nazionale, Ravenna (Bettini, 1940; fig. 15, p. 57). The approach, the iconography of the favored scenes, and the saints depicted were Western; but the debt of these artists to the Byzantine world is obvious: the technique, the open gold backgrounds, and the rendering of the faces of the saints, with their rigid manner and thin highlights, may be cited in this connection. There are many paintings in this style, frequently depicting the Virgin and Child or the Pietà, in Venice and Adriatic cities.

One further subdivision of the Italo-Greek school may be distinguished, primarily on technical grounds. Paintings of this group usually depict the Madonna, and the halos and sometimes the costumes as well are adorned with engraving or with a profusion of detailed patterns in gold. The patterns, which are characteristically in a rather ornate baroque style, begin to appear in fairly early works, such as the Allori *Virgin and Child*, but are more fully developed in later works; a *Virgin and Child* dated 1740, at one time in the collection of Theodore Macridy of Athens, may be cited (PL. 52). A finer example,

in Berlin, is illustrated by Wulff and Alpatov (1925; pl. 96); here the whole rendering is Western, though there are still hints of a Byzantine heritage. Such paintings were probably done in Venice and in the western islands of Greece under Italian inspiration. The small size of many of them suggests that they were intended for homes rather than churches.

In time a greater elaboration and exactness of classification will certainly be possible, for examples of Cretan-Byzantine art are numerous; the artists known to have worked in the style number almost 250, and other names may well await discovery. Although in general these artists were all conservative, in that they adhered to the basic style, there were numerous subtle variations upon that style. By the 15th century, the personality of the artist had no small part to play. Perhaps none of these painters achieved greatness, but there were many minor masters among them and their work deserves closer consideration than it has generally received.

BIBLIOG. O. Wulff and M. Alpatov, Denkmäler der Ikonenmalerei, Hellerau bei Dresden, 1925; N. P. Kondakov, The Russian Icon, Oxford, 1927 (Eng. trans. by E. H. Minns); G. Millet, Monuments de l'Athos: I, Les peintures, Paris, 1927; D. Sisilianos, Greek Icon Painters after the Conquest, Athens, 1935; A. Xyngopoulos, Catalogue of Icons in the Benaki Museum, Athens, 1936 (in Greek); D. Talbot Rice, The Icons of Cyprus, London, 1937; S. Bettini, Pitture cretesi-veneziane, slave e italiane del Museo Nazionale di Ravenna, Ravenna, 1940; ThB, XXXVI, 1947, s.v. Zane, pp. 402–03; M. Hadjidakis, Rapports entre la peinture de la Macédonie et de la Crète au XIVe siècle, Actes du IXe Congrès international des études byzantines à Salonique, 1953, I, Athens, 1955, pp. 136–48; G. Sotiriou, Guide du Musée Byzantin d'Athènes, Athens, 1955 (Eng. trans., P. Drossogianni, Athens, 1960); W. Felicetti-Liebenfels, Geschichte der byzantinischen Ikonenmalerei, Olten, 1956; O. Demus, Die Entstehung des Paläologenstils in der Malerei, Berichte zum XI, Internationalen Byzantinisten-Kongress, Munich, 1958.

David TALBOT RICE

Illustrations: PLS. 47–52.

## CRETAN-MYCENAEAN ART.

The art of the civilization which flourished on the Aegean Islands and continental Greece during the Bronze Age (especially in the 2d millennium B.C.) underwent a relatively unified development. It was an art of striking originality, the most remarkable and stylistically the best product of the protohistoric Mediterranean world (see MEDITERRANEAN PROTOHISTORY), developing in a zone of intense contacts with the civilization of the Near East (see ASIA, WEST: ANCIENT ART; EGYPTIAN ART). Cretan-Mycenaean art constitutes, in a certain sense, an introductory and preparatory chapter to the artistic experience of the Greeks (see ARCHAIC ART; GEOMETRIC STYLE; GREEK ART), not only because of the continuity of sites, religious traditions, and artistic and architectural motifs, but also because an important part of Cretan-Mycenaean artistic development — particularly Mycenaean — is due to a Greek-speaking people. Following the famous discoveries made in 1876 at Mycenae (7 miles north of mod. Argos) by Heinrich Schliemann, who sought to resurrect the world of the Homeric heroes, the early-20th-century excavations of Sir Arthur Evans at Knossos, in Crete, showed Crete to be the center and origin of this civilization. Evans adopted the term "Minoan" from the name of the mythical King Minos to describe the culture of Crete (Evans, 1921–36); but this term cannot be extended to cultures that have been discovered beyond the shores of the island. For the mainland the term "Helladic" was chosen; however, "Mycenaean" is still preferred in speaking of the most developed and outstanding phase on the mainland during the middle and late Bronze Age. "Aegean civilization" is the expression adopted by some to underline the unified character of the Cretan-Mycenaean koine and its geographic extension. On the other hand, the term "pre-Hellenic civilization" (only applicable to the activities of certainly non-Greek peoples) now seems inappropriate. These points of terminology are valid in discussing art as well as culture stages.

SUMMARY. Chronology (col. 76). Cretan art (col. 76): *Prepalatial period (2500–2000 B.C.): a. Relations to neolithic civilization; b. Architecture; c. Pottery; d. Sculpture; e. Seals; f. Minor arts;* *Period of the first palaces (2000–1700 B.C.): a. Architecture; b. Painting and pottery; c. Seals; e. Minor arts; Period of the second palaces (1700–1400 B.C.): a. Architecture and city planning; b. Painting; c. Pottery; d. Sculpture; e. Seals; f. Minor arts; g. Summary; Postpalatial period (1400–1100 B.C.): a. Architecture; b. Painting and Pottery; c. Sculpture; d. Minor arts; e. Evaluation. Mycenaean art (col. 100): Old Mycenaean (1600–1500 B.C.): a. Architecture; b. Painting and pottery; c. Minor arts; Middle Mycenaean (1500–1400 B.C.): a. Architecture; b. Sculpture; c. Painting; d. Pottery; e. Minor arts; Late Mycenaean (1400–1100 B.C.): a. Architecture; b. Sculpture; c. Painting; d. Pottery; e. Minor arts; Evaluation.*

CHRONOLOGY. The classification of Cretan chronology into three periods — Early Minoan (EM), Middle Minoan (MM), and Late Minoan (LM), with further subdivisions in each — was established by Evans on the basis of the development of ceramic forms (Evans, 1921–36). It has formed the foundation of the chronology of cultural development for Crete as well as the Cretan-Mycenaean civilization as a whole. The dates assigned to these periods, with Pendlebury's revisions (1933; 2d ed., 1956) are as follows: EM I, 3500–2800 B.C.; EM II, 2800–2400 B.C.; EM III, 2400–2200 B.C.; MM I (Ia, Ib), 2200–2000 B.C.; MM II (IIa, IIb), 2000–1800 B.C.; MM III (IIIa, IIIb), 1800–1580 B.C.; LM I (Ia, Ib), 1580–1450 B.C.; LM II, 1450–1400 B.C.; LM III (IIIa, IIIb, IIIc), 1400–1100 B.C.

Today, however, this scheme is less adequate, and a different chronology, based on the history of construction of the great Cretan palaces, is preferred (note that the beginnings of Minoan civilization have been moved forward considerably): (1) Prepalatial period (EM I, II, III; MM Ia), 2500–2000 B.C.; (2) period of the first palaces (MM Ib; MM IIa,b), 2000–1700 B.C.; (3) period of the second palaces (MM III; LM Ia,b, II), 1700–1400 B.C.; (4) postpalatial period (LM IIIa,b,c) 1400–1100 B.C.

Period 1 succeeds the Cretan Neolithic age (see MEDITERRANEAN PROTOHISTORY) and retains subneolithic characteristics. Some scholars (N. Åberg, D. Levi) have denied that it is an independent period transitional to Minoan civilization, and prolong the Neolithic age up to the beginning of the construction of the first palaces. This, however, appears to be contrary to the evidence we have regarding the over-all Aegean cultural development. The dating of period 2, and particularly, period 3, which marks the apogee of Cretan civilization, is precisely fixed by points of contact with the chronologies of Egypt and the Near East. Period 4 begins after the total destruction of the palaces and the gradual immigration of the Achaians to Crete. It is the era of the decline and fall of Minoan civilization.

Mycenaean civilization, which first flourished in the area of several city-states on the Peloponnesos, as a result of the great migration and colonization toward the end of the first phase of period 3, is in turn subdivided into three phases: (A) Old Mycenaean (LM Ia of Crete), 1600–1500 B.C.; (B) Middle Mycenaean (LM Ib, II), 1500–1400 B.C.; (C) Late Mycenaean (LM IIIa,b,c) 1400–1100 B.C.

In phase A, which is known to us mainly from the royal tombs of Mycenae, the Minoan is still imperfectly blended with the indigenous element; many explain the foreign influence as a consequence of the Achaian (Mycenae) invasion of Crete. In phase B the fusion between the Minoan and Mycenaean is completed, with a predominance of the former. In phase C the Achaians prevail through their organization and expansion; this phase, however, includes the era of Mycenaean decline (sometimes called "sub-Mycenaean"), historically related to the Dorian invasion of the 12th century B.C., which helped to overthrow Mycenaean civilization.

CRETAN ART. *Prepalatial period (2500–2000 B.C.). a. Relations to neolithic civilization.* In the light of historical and archaeological investigation, the thesis that the basic elements of Minoan civilization are found in germ in the Cretan neolithic is no longer tenable. However, certain subneolithic elements did survive into the prepalatial period (period 1), and are recognizable in the architecture, sculpture, and especially the pottery.

Crete in the Neolithic period, preceding the prepalatial, had considerable skill in the technique of construction. Houses of

several rooms were built, with stone foundations and walls of sun-dried brick. Hard stone was used only for simple tools, chipped from flint or obsidian; but already in this period softer stones and terra cotta were used for the well-known steatopygous statuettes. Their simple, full forms are precious documents of the taste and religious conceptions of the period. Neolithic Cretan pottery is particularly noteworthy: the vases, which were worked by hand, fired without kilns, and carefully polished, often have a geometric incised design that is sometimes filled with white or red. The uneven firing causes accidental color effects. The subneolithic pottery of Pyrgos, Hagios Onouphrios, and Vasiliki is its direct descendant. But, as we shall see shortly, even in these ceramic productions, which are so closely tied to their neolithic origin, there is a progressive penetration of new elements, probably due to the advent of new peoples and cul-

the development of this form of roofing, one must turn to later and better-preserved monuments. Another type of tomb common in the prepalatial period in eastern Crete was that with two or three adjoining rectangular rooms.

*c. Pottery.* The evolution of pottery was profoundly influenced by the developments in metallurgy; shapes and decorative motifs reflect those used in metal vases. The pottery of Pyrgos shows angular shapes with black, polished finish. The pottery from Vasiliki, after a period of using the ornamental effects of firing (mottled ware), returned to a smooth black ground with contrasting whitish undulating and spiral ornamentation. This style is closely related to one of polychrome designs on a black ground; it may, in fact, be an early provincial example of the influence of the polychrome Kamares style that

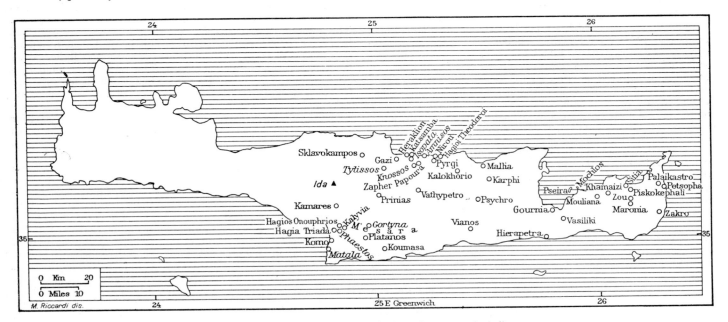

Archaeological sites of Minoan Crete. Ancient place names in italic type.

tural trends. These changes are even more apparent in pottery related to that of the Cyclades Islands.

*b. Architecture.* The houses of the first phase of the prepalatial period (period 1) were still constructed with walls of unfired brick on stone foundations and are indistinguishable from late neolithic constructions. But changes occurred quickly: the walls were made thicker, the openings were placed at regular intervals, and plaster painted in bright colors was used quite frequently. The evolution was complete in the final phase, when walls were made completely of stone, rooms (previously without organic distribution, as in the houses of Vasiliki) became larger and were rationally grouped, and the pavement was frequently given polychrome embellishment; the presence of steps justifies the hypothesis of more than one story to a building. The existence of these significant elements in minor architecture makes the scarcity of documentation for larger buildings lamentable, particularly since in this phase of Cretan civilization the dome appeared for the first time in Europe. The huge domed area, which Evans discovered under the south porch of the palace of Knossos and which was part of the original construction, was filled in after excavation; thus we must depend on Evans' description to visualize it. The purpose of the dome is unknown. Apparently one entered from above, passing along a flight of stairs which descended in a spiral around the wall, with openings on the interior of the room. There is an undeniable analogy to the funerary constructions, sometimes of monumental size, found on the great plain of the Mesara (the largest, at Platanos, has a 43-ft. diam.). These tombs in the Mesara apply the principle of the dome for the first time. To study

prevailed in central Crete. The pottery of Hagios Onouphrios underwent a parallel transformation, although here the ground was light and the decoration black (the so-called "dark-on-light" ware). Bright color was used, however, and there was a preference for shapes derived from metal vases and elegant ornament. Among the favored motifs was the doubleheaded ax formed with paired triangles.

The most significant and prolific stylistic development in prepalatial Cretan pottery was that of Kamares ware (PLS. 56, 57), which displayed one of the most effective modes of ceramic decoration in the whole of the ancient world. The oldest vases in this style were found in the houses beneath the first palaces, and must date from at least a century before the palaces were constructed. The technique of these first examples was already far superior to that of the developed Vasiliki ware. Although the forms were not so bold, they were more varied; among the most common shapes were pitchers with high beaklike spouts, conical cups without handles but sometimes with a foot, hemispherical cups with a raised handle, and bell-shaped vases topped by a pair of horns. White, with red or orange accents, was used for the painted decoration in rectilinear or curving forms. In some cases there are hints of relief decoration in imitation of a shell surface (*à la barbotine*), which was also used in the following period.

*d. Sculpture.* Here too there are echoes in Crete of the neolithic tradition. In this period Cretan sculpture clearly derives from the proto-Libyan and proto-Cycladic models of small and schematic human figures, with flattened bodies and the faces barely sketched out. To the proto-Libyan trend belong

the figures with angular rendering and pointed faces, made of marble, calcite, or ivory. At a later point the large numbers of imported Cycladic idols (all Parian marble except for one of twin figures carved in steatite) were imitated by the local artists. These monotonous, rigid figures of female nudes with hands placed on the breasts (certainly with religious significance) lost much of their stereotyped immobility when rendered by Cretan carvers, who tended to place more emphasis on the rendering of the body. Terra cottas, though more varied in shapes and themes, were bound to conventional, religiously significant themes (PL. 54). For example, there are the well-known libational rhytons in the shape of the mother goddess (or snake goddess), with nude breasts, sometimes in the shape of various animals such as the bull, which appears now for the first time in Cretan art. The tauromachy, or bullfight, also finds its first representation now, with acrobats placed between the horns of the bull.

The stone vases, which are particularly characteristic of the prepalatial period, have certain similarities to analogous predynastic and protodynastic Egyptian forms. The most important series of these stone vases was found on the small island of Mochlos, which was an important commercial center at that period. Many vases were also used as furnishings in the tholos tombs of the Mesara; however, those from Mochlos reveal a more eager search for new and elegant effects of form and a variety of steatites, granites, stalactites, and alabasters, as well as colored, white, and polychrome marbles. Great care was taken to harmonize the veins and mottles with the forms of the vase. A white or a dark vein may ornament the mouth, encircle the base, or accentuate the body of a vase; or it may spiral inside a bowl from the bottom out to the rim. The famous steatite pyxis lid with a dog (Heraklion, Archaeol. Mus.) belongs to this group from Mochlos. The stone vases from the Mesara, most frequently of bird's-nest or saltcellar shape, are somewhat different; there is less variety, although here too incised and even intarsia decoration is used. Evidently custom or cult restrained the inventive fancy of the makers of the Mesara vases.

*e. Seals.* The first seals of steatite or ivory and the appearance of the cylindrical ivory type seem to belong to the second phase of the prepalatial period, according to recent discoveries. Ivory seals have also been found shaped as cones, disks, and polyhedrons. Cylindrical seals found in the tholos tombs of the Mesara belong mainly to the third phase. During the prepalatial period, the new decorative motifs of spiral and braid appeared, heralding the patterns of the Kamares vases. The subjects depicted on the seals, however, maintained the older tradition of groups or series of animals and men. Zoomorphic subjects on ivory seals included animal protomas, reclining or leaping quadrupeds, crouching monkeys, and doves (including one with nestlings tucked under her wings). In spite of a certain conventionalizing, the execution has a distinct grace. Although the artistic level of the steatite seals was inferior, they had a greater variety of design. On those of prismatic shape, hieroglyphics were introduced; their forms adapt well to seal inscription.

*f. Minor arts.* The technique of metal working developed rapidly in the course of the prepalatial period. Tin, the first bronze alloys, and silver were introduced. The production of weapons underwent intensive development; daggers of much larger size were made, their bone and wood handles acquiring a deliberate elegance in shapes and variety. Bronze was used for many other small objects found in the tholos tombs, especially in the later burials. These utensils testify to a relatively high level of material culture. Certain forms such as the double ax acquired a symbolic significance.

The manufacture of jewelry was highly developed. In the later phase of this period, the most diverse techniques were used in goldwork: gold was beaten, worked in foil, and welded by means of pressure or fusion; there are also fine examples of meshwork, repoussé, and the most refined granular work. The jewelry itself presents a great variety of fashions: diadems decorated with rosettes, quadrupeds, etc.; hairpins terminating in a leaf of gold; astonishingly fine chains; necklaces made of repoussé or beaten parts; precious stones such as amethyst, onyx, sardonyx, or rock crystal mounted in gold. Many of these splendid objects were found in the tombs of Mochlos and the plain of the Mesara, in Crete.

Outside of its frequent use in seals, ivory was little exploited. Glassmaking was unknown. This would also seem to be true for glazed ceramics, with the exception of a cylindrical vase of the highest quality found at Maronia (Heraklion Archaeol. Mus.).

*Period of the first palaces* (2000–1700 B.C.). The construction of the great palaces, which followed the concentration of political power in the hands of various local rulers, conditioned the final development of Cretan civilization.

*a. Architecture.* At Phaestos (Crete), stratigraphic excavation has revealed three building periods within the first palace. The building arose on the crest of a hill, so that from the beginning it was planned with several levels joined by stairs. In the first phase it had at least two floors, as is indicated by the remains of interior staircases. The upper floor contained living quarters and the lower floor had small rooms intended for storage. Some of the rooms were embellished with plastered walls and floors of alabaster or mortar; the outside walls were adorned with massive orthostats (stone slabs lining the exterior walls) of either selenite or gypsum. A paved court in the north section was united to the building by a fine flight of stairs. There was probably another central court at a higher level, at the top of the hill. The second phase of construction is not so clearly identified. In fact, the stratum which overlies the remains just described might actually be an upper floor of the first phase rather than evidence of the second. In the third and final phase, the first palace of Phaestos underwent a radical transformation, becoming more monumental in character through the complexity of the plan and the richness of the decoration. It was reconstructed on a new level; the underlying ruins appear to have been leveled with a bed of lime mixed with sand. However, the arrangement of the rooms retains some similarity to the preceding plan, and the ground floor is still reserved for storage. Large pithoi and much other material were excavated in these magazines. The various quarters of the building take advantage of the irregularities of the hilly terrain, but the differences of level are greatly reduced over those of the older phases of construction. The façade, moved back from its earlier position, is essentially of the same design although made more imposing by the addition of a large paved court fronting it, with a sturdy sustaining wall at the west end. Farther to the north was another paved court, surrounded by a small colonnade. The paved corridors and stairs were greatly extended. One broad flight of stairs was initially used for the spectators of rituals which took place in the court and which presumably were related to an adjoining chapel.

The first palace of Knossos must have been of equal importance to the first palace of Phaestos, though there is much less extant evidence. Recent excavations in depth at Knossos, which have brought to light paved floors and rooms evidently used for storage (pithoi and polychrome vases similar to those from Phaestos were found here), indicate that here, too, the building was disposed on several levels leading to the top of the hill, where the central courtyard was. This eliminates Evans' theory that the original plan consisted of several isolated units with open passageways around a central court. The excavations also indicate that the principal elements of the façade as well as the more important apartments of the west section cannot be attributed to the first palace at Knossos. There are traces of three successive phases of construction in this palace, but it is difficult to attribute the remaining structures distinctly to one or the other, except the paved west court, which surely belongs to the third phase.

Even less is known of the palace at Mallia, about 25 miles to the east of Knossos, built on a plain not far from the coast. Only a small and damaged part, discovered below the northwest section of the latest palace, can be dated in this period.

Our knowledge of minor architectural forms in the first

palatial period is quite inadequate. The houses built around the palaces (of which few remains have been found) and the poor villages that have been excavated in other areas, generally show a rather rudimentary type of house without organic plan. Only house A at Vasiliki, on the isthmus of Hierapetra, has a more complex articulation of the numerous rooms, with two wings and stairs. The elliptical building on the high acropolis of Souvloto Mouri near Khamaizi (FIG. 81), cannot be considered simply a house; the trapezoidal rooms, arranged around a central area with a cistern, suggest either a fortification controlling a road or a sanctuary (there are terra-cotta statuettes within).

No innovations of great significance are seen in funerary architecture. The tholos-type tomb persists, continuing without important structural changes until the end of the first palatial period. Tombs with rectangular plan and internal divisions also continue. Sometimes rectangular cult rooms are added externally to tholoi. The recently discovered tholos-type tomb

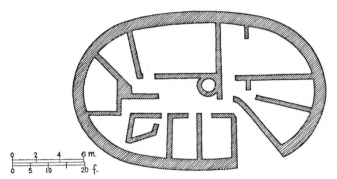

Souvloto Mouri (Khamaizi), plan of building (*from Ephemeris Archaiologike, 1906, p. 126*).

at Kamilari (near Phaestos) provides an element of transition between the prepalatial tombs, those of the second palaces, and the oldest of the Mycenaean tholoi. Most commonly, burials in the first palatial period were in simple cavities carved out of the rock, where the dead were placed in pithoi or small terra-cotta sarcophagi. At times coastal locations were preferred, in which case the dead were placed in inverted pithoi within an enclosure.

On the whole, the architecture of this period was decidedly original. The palaces must have been very rich in color; wall revetments were constructed of selenite slabs, pavements were carefully executed, plaster and supporting elements were colored, wood was used effectively (e.g., trusses and frames), and elaborate cornices were built.

*b. Painting and pottery.* Ornamental painting appears as early as the period of the first palaces. There is a pavement at Phaestos decorated with a curvilinear motif; wall paintings occur at Knossos (small sponges) and at Mallia (garlands). Figure motifs do not seem to have been used.

The Kamares style (so-called from the pottery found in the cave at Kamares on the slope of Mt. Ida) reached its highest splendor (PL. 56) at this time. The polychromy of various tones of one or two colors (at the most two) replaced the monochromatic or purely white decoration that appeared at the end of the prepalatial period. Astonishing effects of color were achieved. Often light colors on a dark ground appear on the opposite side of a vase showing dark colors on a light ground; or the two techniques appear on the same side in contiguous vertical bands. The virtuosity of the Kamares-style potters is also seen in the constant striving for harmony between the decoration and the shape of the vase. The surface of both interior and exterior is frequently filled with curving motifs, undulating lines, spirals, bands, rosettes, and uninterrupted braid patterns. Figures were shunned in the purely ornamental taste of these ceramics. Even when vegetal forms or marine fauna provided the source of inspiration, they were reduced to pure decoration; we find headless octopuses with tentacles winding

around rosettes, or a large fish in a net suggesting a wheel in movement. Nature was also the inspiration for those vases which imitated the spots and veins of certain stones by clever distribution of color, as well as those decorated *à la barbotine*; some vases in the latter technique showed marine forms represented with such skill that they have been taken at first sight as fossil incrustations on the surface.

Another class of ceramics imitated the effect of metal vases, particularly gold and silver. The walls, especially of the cups, became so thin as to merit the name eggshell ware. The forms become capricious, the handles unfurl boldly above the mouth, the relief decoration repeats that of the gold cups, and the shining glaze imitates the iridescence of metal. It is possible that some of these splendid vases belonged to royal table services, for example the large fruit stands, the crater from Phaestos decorated with flowers in full relief (PL. 57), and some extremely delicate cups and bowls. More numerous are the vases for ritual use, the rhytons for libations, and the large vases with various subdivisions for offerings (kernoi), etc.

*c. Sculpture.* The development of ceramics reduced the manufacture of stone vases to a secondary position during the period of the first palaces. The production of the bird's-nest or saltcellar shapes of the preceding period continued, using monochrome materials such as steatite, with small incised or intarsia decoration. The first kylix shapes and the small stirrup cups appeared at this time. More significant was the production of small stone idols, which, although few in number, showed considerable technical progress and a more direct representation of nature. The great majority of the statuettes found in the sanctuaries, particularly those in the mountains, are of terra cotta and are the products of simple craftsmen, sometimes the dedicators themselves. They reflect a well-defined taste, and it is interesting to see how the refined polychrome technique of Kamares ware influenced even those modest figures. The male idols are generally characterized by a narrow belt and dagger at the waist, the females by pleated or bell-shaped garments. There are also representations of single members of the body, evidently symbolic offerings for cures requested. The largest of these finds have been made in the sanctuaries of Palaikastro on Mt. Petsopha and of Kalokhorio on Pedhaidha. At the house sanctuary of Khamaizi were found three fairly large statuettes; a fourth, still larger but headless, evidently a cult image, was found at Hagia Triada.

Very interesting and quite unusual is the small terra-cotta model of a sanctuary which was found in Knossos. It represents an altar adorned with double horns, the enclosure of a sanctuary with a sacred tree, a temple with three columns topped by sacred doves, and a litter with the priestess or possibly the image of the deity.

*d. Seals.* The variety of the stones used, the subtlety of technique, the multiplication of forms, and the rich subject matter (influenced by Egyptian and Near Eastern art) gave a decisive impulse to the development of Cretan art and led to its splendid efflorescence in the first palatial period. The technique is well known to us from the seal-cutter's shop at Mallia; here were found tools, raw materials, and steatite seals (mainly prismatic) in various stages of manufacture. Also used for seals at this time were hard stones such as rock crystal, sardonyx, onyx, amethyst, chalcedony, hematite, and various types of jasper and granular stones. The older techniques proper to softer stones were abandoned, and new modes, using very precise, calligraphic engraving, were adopted. Along with this new decorative taste, which was certainly influenced by goldwork and the pottery of Kamares, went a greater refinement of shapes: hemicylinders and "flattened" cylinders became rarer; the prism was by far the most common shape. Later extremely elegant disk-shaped seals occurred, with the disk gradually taking the shape of a "flattened" cylinder and finally becoming an ellipsoid. In the later phases of the development of seal art in this period, the use of still harder stones determined a further refinement of shapes and technique. The repertory of subjects became very rich, as we know not only from the seals but also from the

many clay impressions. Most of the subjects were the same as those found on the Kamares vases, though the scale was smaller. However, in the adoption of natural themes the seals were precursors to the vase and wall painting of the following period. There were extraordinarily lively representations: a dog barks at a deer, who, from the security of a high rock, seems to mock him; a wild goat flees, nervously turning his head as if pursued; a boy sits in a sheepfold underneath a ram; a fish attacks a cuttlefish; octopuses spy on their prey. Typical were the seals in which an ideogram, probably giving the name and title of the owner of the seal, was added to the representation of the owner working at his trade. Examples of these are a potter, a vendor of tools, a sailor, a king, and a prince. Egyptian and Near Eastern influence (also testified by the importation and local production of scarabs and cylindrical seals) is seen in seals representing demons of the type of Ta-urt, the winged gorgon, heraldic lions etc.

*e. Minor arts.* Unfortunately we are not in a position to appreciate fully the advances made in metalwork during the first palatial period, because the practice of depositing utensils, arms, and metal tools in the tombs declined, and the palaces have been sacked. The only finds that unquestionably belong to this period — because they came from the Mesara tombs and the house sanctuary of Khamaizi — are a few daggers and domestic utensils. Nonetheless, the level of technical perfection and artistic quality of these products can be inferred from the contemporary Kamares pottery based on metalwork models.

There is similar lack of documentation in goldsmith work. Here, however, finds made outside Crete (e.g., Byblos) of objects based on Minoan models are helpful. In Crete itself an important group of goldwork pieces was found in the funerary enclosure of Chrysolakkos at Mallia, including a pendant from a necklace representing two hornets drinking a drop of honey (PL. 66). Recently it has been maintained, with good reason, that the famous Aegina treasure in the British Museum comes from Chrysolakkos and dates from this period (Higgins, 1957). Objects of silver are even rarer, their loss attributable in part to oxidation. As in the preceding period, jewelry was made of various precious and semiprecious materials. Faïence, a technique learned from the Egyptians, began to appear frequently in beautiful vases with shaded, fused colors. For other media, such as work in ivory, wood, and cloth, direct information is practically nil. Only the rare representations of objects of this kind, plus our knowledge of successive developments, attest to what must have been splendid accomplishments in these fields.

*Period of the second palaces* (1700–1400 B.C.). The catastrophe (probably seismic) which destroyed the first palaces of Knossos and Phaestos created a caesura in the history of Minoan civilization. However, reconstruction was almost immediate and occasioned a basic renewal and highest development of all forms of Cretan art.

*a. Architecture and city planning.* Plans of the reconstructed palaces departed decisively from the layout of the earlier structures, whose ruins were not utilized; these were either completely demolished or covered with a layer of lime and clay. Only rarely, however, was a different site chosen for the rebuilding. The new plans appear to be the fruit of long experience and careful study of the terrain, coupled with bold intuition. The palaces were conceived as organic and unified constructions and were built on a prepared foundation with elaborate terracing and extensive use of fill. The significance of these vast architectural projects can be understood through their function in the Minoan world as the seat of the king who was at once the political and religious head; the palace therefore became a sanctuary as well. There were no other sacred buildings, aside from chapels carved out of caves or open pavilions placed atop hills and adorned with modest colonnades.

In the second palace of Knossos there was a distinct rapport with the surrounding landscape: parts of the building projected into it, while hanging gardens placed on different levels brought greenery inside the palace. There was an analogous relationship between the arrangement of rooms and the sources of light and air: windows, porticoes, small courts, and terraces created alternating zones of light and shade and of open and closed areas, the whole accentuated by the unequal heights of the various quarters. The exterior aspect of this palace, as well as others, must have been equally animated, with loggias, gilded entablatures, wooden framing elements, windows with two or three lights, and asymmetrical protruding parts augmenting the play of light and shadow.

The remains of the second palace (FIG. 85; PL. 53), with domestic quarters, large rooms for public audiences, service quarters, workshops, corridors turning in different directions, and sacred areas, seem at first to lack an organic plan. Certainly absent is the coherence and harmony of Greek monuments, or even the symmetry of some Egyptian architectural complexes. The dominating principle is rather a free and picturesque articulation, with a kind of spontaneous growth similar to that suggested by natural forms. The term *Knospenagglomerat* (agglomeration by budding) has been adopted to describe it, although it is inappropriate to apply this word to consciously planned creations.

One has the impression that the architects deliberately avoided axial or symmetrical arrangements unless they were functionally necessary (as was the case in propylaia, throne rooms, areas for ritual processions, etc.). This explains why there was no central monumental entrance and no broad staircase to ascend to the royal apartments — only narrow passages. Otherwise the distribution of the rooms was perfectly rational and dictated by the needs of a refined society (e.g., selection of the best climatic and panoramic orientation for the royal quarters). The most typical room in the living quarters was the so-called "megaron polythyron" (a megaron with many doors or windows), usually consisting of two rooms intercommunicating by means of a series of doors which could be opened to make one large area. One of the two rooms was adjacent to an open space divided from the polythyron by means of two columns; the other room was lighted by high windows and the portico, which ran along one or two sides, furnishing a sheltered area for walking or resting. The size of these large rooms on the ground floor and the even larger dimensions of those above (each frequently the size of two or three below) proves that, contrary to some expressed opinions, the apartments of the Minoan palaces were anything but small and uncomfortable; particular care was even taken to adapt them to Crete's semitropical climate. The bright light was filtered through the little cloisters, and the heat was tempered by the currents of air from opposing porticoes. And if in summer the inhabitants were able to pass pleasant hours in these airy surroundings, they were as well equipped to protect themselves from the rigors of the cold by closing the megaron and heating it with braziers placed on easily movable tripods.

Another type of room, quite large in size and used for court gatherings, was lighted with large double windows and adorned with two or more rows of columns or piers. Throne rooms and audience halls were found in all of the palaces. They generally had a broad and monumental entrance, with stairs from the central or western court. At Phaestos, for example, the well-preserved "Throne Room" (so called) had an open antechamber (of the type of the Mycenaean megaron) and an interior room with four columns which possibly supported the roof and were raised at the center for lighting. One entered through two high doors with sturdy wooden antae. Of the Throne Room at Mallia only the ample staircase is preserved. Other rooms of small dimensions, furnished at times with benches or a lustral basin or, as at Knossos, with dividing columns, were certainly intended for religious ceremonies.

Easily recognizable, and usually grouped as an independent unit, are the rooms which served as the sanctuary. Their identification as such is suggested by the sacred implements or the images found therein and confirmed by the wall paintings. The sanctuaries usually comprise numerous rooms such as cult rooms, sunken crypts with piers bearing representations of the double-headed ax (labrys), treasure rooms, throne rooms for the high priest, and rooms of unusual form (sunken, divided in the middle by a column, and placed near the entrance;

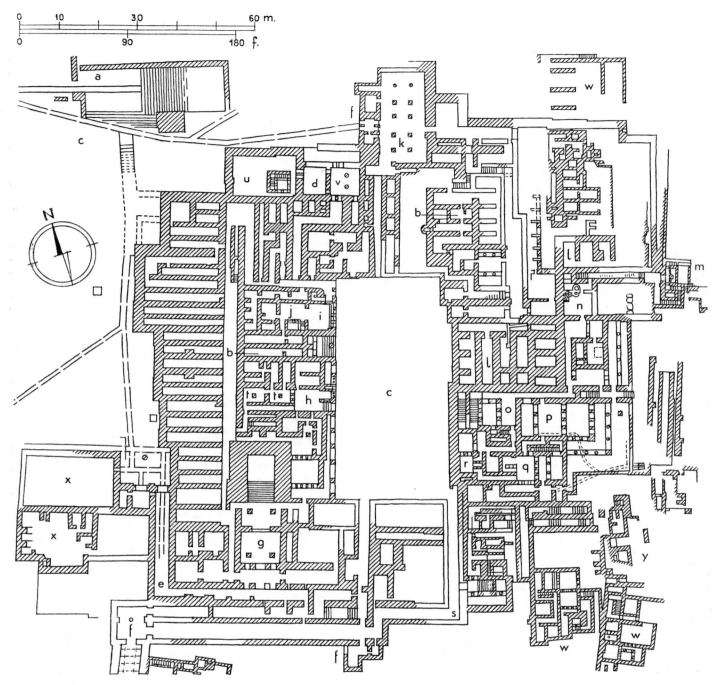

Knossos, plan of palace. (a) Stepped theater area; (b) magazines; (c) courts; (d) porch; (e) Corridor of the Processions; (f) entrances and atriums; (g) south propylaion; (h) initiation-rite area; (i) vestibule; (j) throne room; (k) pillar hall; (l) magazines of the pithoi; (m) bastions; (n) court of the stone spout; (o) hall of the colonnade; (p) hall of the double axes; (q) "Queen's Megaron"; (r) bath; (s) ramps; (t) pillar crypt; (u) lustration room; (v) portico; (w) Minoan houses; (x) palace area with indications of later house construction; (y) buildings earlier than palace (from J. D. S. Pendlebury, A Handbook to the Palace of Minos at Knossos, 2d ed., London, 1956).

perhaps intended for lustration). A small painting (in the Cretan "miniature" style) shows that the sanctuary at Knossos had a façade on the central court consisting of three sections of unequal height. Excavations attest to the presence of a shrine above the crypt; another painting in "miniature" style was found at Knossos which aids us in imagining its appearance.

Access to a palace of this period was through various entrances on different sides, approached by paved streets slightly raised above the surrounding ground. The gates varied in shape and size according to their importance. The main gate was usually preceded by an antechamber with a huge column and an adjoining guardroom. At Knossos the columned room,

which was placed between the two doors of the north entrance, could have served as an antechamber. The main entrance at Knossos, however, was on the west side, from which one passed through the Corridor of the Processions to the equally richly decorated propylaion, so called from the obvious analogies to the Greek propylaia. Another important forerunner to Greek architecture is seen in a few rare quadrangular porticoes, which call to mind the peristyle form.

The pictorial effect of these grandiose architectural complexes must have been greatly enhanced by the addition of exterior and interior decoration. We would have no idea of the former without the aid of the *Town Mosaic*, a series of small

faïence plaques representing house façades (FIG. 87). These convey to us the important ornamental role played by wooden beams, polychrome cornices, double windows, the frequent use of ashlar masonry with a thick layer of plaster accentuating joints, and the picturesque dormers projecting above the flat roofs. The interior decoration is better known: Slabs of gypsum

Schematic representations of façades of Minoan houses, after terra cottas in the Archaeological Museum, Heraklion (*from Lawrence, 1957*).

were frequently used for the floors, laid with red plaster and decorated along the border or in the center with slabs of green schist or black stone. Small polychrome slabs were also used, arranged in irregular patterns. Friezes, mainly of ornamental motifs, decorated the lintels and frames of the doors; only the larger doors had jambs of carved stone. Dadoes were reveted with gypsum, which has a more brilliant appearance than true alabaster. The remainder of the wall was covered with brightly colored plaster — red, blue, or yellow — varying from room to room. Frequently however, frescoes with figured scenes covered the entire upper wall. Friezes decorating the walls and ceilings of the important rooms were in relief. Frescoes were extensively used at Knossos and Hagia Triada but to a lesser degree at Phaestos and Mallia. Although gardens must have played a large role in the decoration of the palaces, of which they were an integral part, our knowledge is so inadequate on this point that we must rely entirely on inference.

The so-called "theater" (annexed to the palaces) was a new architectural form which came to assume great historical importance. The existence of two essentially similar structures of this kind at Knossos and Phaestos (with minor differences) confirms that they were intended for performances. Both theaters had stairs from which the spectators viewed the performance, a central paved space for performances, and seats reserved for court dignitaries. At Knossos the flight of steps was divided into two wings which met in a right angle exactly where the elevated royal seating area was placed; at Phaestos a single wide flight had adjoining stairs, and a passage, certainly intended for processions, crossed the steps and led to what was probably the royal seating area.

The absence of true fortification of the palace hills is amply justified by the local monarch's political dominance over the islands; the fleet, furthermore, was an excellent defense against possible invasion. The palaces were surrounded only by a simple enclosure (or sometimes several) with access via narrow passages, controlled by small towers and guard posts.

The villas, the megara, and even sometimes simple houses repeat in small scale the principal structural elements of the palaces. The so-called "small palace" and the royal villa of Knossos, the villa at Hagia Triada, the megara at Tylissos, Vathypetro, Nirou, and Amnisos, and the two country houses in the region of Sitia (eastern Crete) all present the polythyron type of room, rooms for servants, sanctuaries, storerooms, workshops, and stairs (with separate service stairs). The private houses are much less complex but just as elegant and picturesque. The so-called "caravansery" at Knossos, near the road to the south of the palace, is an unusual case: probably it was an inn, as is indicated by the large rooms and many small rooms for the guests. The facilities included rooms with basins and hot-water systems for baths and foot washing. There was also an annex with a fountain, a small sanctuary, and a watering trough for animals.

Artisans' workshops include the kilns for ceramics and metalwork at Knossos, Phaestos, Vathypetro, and Zou at Sitia;

the wine press in the megaron at Vathypetro; and the small oil press for olives at Palaikastro.

All of our knowledge of the architecture of the second palatial period, even though very detailed in some cases, is insufficient to form a complete picture of the plan of a Minoan town. In fact, most of the towns have not yet been excavated. From what has been uncovered, however, it appears that the houses were grouped in a large, compact, sometimes irregular nucleus, divided by main arteries and relatively narrow intersecting streets. The appearance of towns varied. Commercial centers like Palaikastro, or the town on the island of Pseira, which flourished on the trade with the East and Egypt, reflected prosperity in the buildings and layout. At Palaikastro the roads were paved and carefully aligned and the large houses well constructed (FIG. 88). At Pseira the town was located on the side of a hill and had narrow and winding streets; its luxurious buildings and frescoes were, however, similar to those of the palace of Knossos. The town that offers the most complete document of a Minoan city plan is Gournia (FIG. 91), on the southern coast of Crete on the isthmus of Hierapetra, in a position dominating both the Mediterranean and Aegean Seas. It was an agricultural, commercial, and manufacturing center, but it had a poorer appearance than Palaikastro or Pseira, with rather small houses grouped in large blocks and small paved lanes radiating from the center; two large elliptical arteries carried the main flow of traffic. The megaron of the prince dominated the town at its highest point. Although poorly preserved, certain elements suggesting a small palace — vestibule with entrance through propylaia at one corner, interior portico, magazines, residential quarters — are still recognizable.

In the period of the second palaces, especially in central Crete, large public works were undertaken, such as bridges and guard posts placed at strategic points, a remarkable network of paved roads, and terracing works. A large viaduct on huge piers connected the highway with the palace of Knossos. No less care was taken with harbor installations; of these, however, only traces remain at the two ports of Knossos (Amnisos and Katsamba) and at the two ports of Phaestos (Komo and Matala). At Hagioi Theodoroi and Mochlos, deep cuts in the rock attest to the presence of yards for the construction of small boats.

Funerary architecture is poorly documented. In general, however, one can say that a first phase within the second palatial period, in which the old forms of burial persisted without important change, was followed by a conspicuous preference for chamber tombs cut into the rock, with access through a

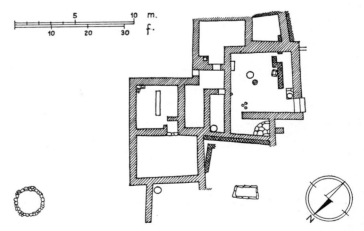

Palaikastro, plan of house A (*from B.S.A., VIII, 1901-02, p. 307, fig. 21*).

long dromos. At this time the tholos tomb with underlying hypogeum first appeared in Crete; this tomb was to have an important development in Crete itself as well as on continental Greece. In the area of Knossos there have been found two interesting tombs preceded by vestibule and dromos and with fully hemispherical domes built with carefully placed freestone

in isodomic rows. These tombs must have been built about 1600 B.C. Probably somewhat later the majestic tomb at Isopata (in the same area) was built; it is likely that the Isopata tomb belonged to members of the royal family, since it is not inferior in monumentality to the royal tombs at Mycenae, Orchomenos, etc. Here a large rectangular room was approached from a long dromos and a vestibule with niches whose function was religious. A blind door at the end symbolized the communication of the dead with the underworld. The form of another tomb south of the palace of Knossos is very different; it is situated in a natural cleft in the rock, which was easily adaptable for the purpose, and communicates with a sanctuary for the cult of the dead king. In this tomb we find some of the elements most typical of the palatial architecture: the entrance with a small portico, a miniature court with the door protected by two small towers, a vestibule connected with the sanctuary on the upper floor by means of stairs, the ritual crypt with quadrangular piers, and the funerary room itself, completely dug into the rock, with a ceiling of large crossed beams supported by a square pier. The revetment and decoration of the walls is also similar to that of the palace. Two other tombs, of rectangular plan, have been found near Knossos; the so-called "tomb of the double-headed ax" is the better known of these.

*b. Painting.* Wall painting reached its full maturity in the second palatial period and was found throughout the palaces as well as the richer houses. The nature of the technique is still not entirely clear: the background color was applied to the wet plaster, which was first built up in several increasingly thin layers; then the other colors were added in an unknown manner. At times the superimposition of layers of color on the plaster created a sort of relief painting. The motifs were for the most part purely decorative, in keeping with tradition, and arranged in zones consisting of spirals, braids, schematizations of octopuses or lotus flowers, rosettes of various types, etc. But quite soon figured scenes also appeared, usually inspired from nature; they were rendered with great vivacity and freshness. As in the pottery, subject matter was drawn mainly from the marine world and from the island's rich vegetation. Entire walls were covered with dolphins, octopuses, sponges, and corals. Gardens were represented, their rocks populated with exotic animals, monkeys in comic poses, and rare birds of splendid color. At times more animated vignettes enliven the natural surroundings: a cat moves silently among the plants watching a pheasant who is unaware of his danger; a pair of partridges dip into a brook and hide among the rocks, beating their wings. These scenes, vivid though they are, are completely generalized and do not describe a particular landscape; the play of colors is unreal, the plants twist in an unnatural way, voids are filled with decorative plant motifs, and the background is painted in various tones.

The frescoes with human figures usually represent religious festivals, and the royal court is shown in a gay setting. At times the ceremonies take place in the palace, at times in the sacred wood; in the former case, the three different parts of the sanctuary, with balconies and loggias, are never omitted. In one of these compositions the main sanctuary of Knossos is apparently depicted, with the three columns and the symbolic double-headed axes. The most striking element is the vivacity of the persons represented, particularly in the paintings in "miniature" style: the women, shown with different skin color from that of the men, are seen at times with complex hair styles, embroidered dresses, and weighted with jewels. Often, as in the scene in the olive grove, they are depicted seated under the trees in natural poses, gesticulating and intent in their conversations; in another scene they dance on the grass. Other frescoes show single twirling dancers, painted on a larger scale; they wear a kind of bolero. Athletic games are represented in "miniature" style frescoes from Tylissos. Scenes with pairs of priestesses, their dresses adorned with the sacred knot, alternate with scenes placed against contrasting backgrounds in which young priests seated next to one another, in female garb, solemnly perform rites. The well-known "La Parisienne" is one of these female figures (PL. 61). An analogous arrangement with alternating sections is seen in a painting of the tauromachy, the bullfight, represented with rare virtuosity: three acrobats — two female and one male — fight a huge bull, in the best-preserved panel. Various other tauromachies were painted on the walls of the palace of Knossos, but only isolated fragments remain. The single relatively well-preserved tauromachy is a relief painting in a loggia at the north entrance of the palace, showing the capture of the bull. Toward the end of the period of the second palaces, ritual processions were frequently painted: at Knossos more than 350 figures covered the walls of the Corridor of the Processions and the propylaia, where they were arranged in two superimposed rows. There was a stupendous fresco at the entrance, with rows of musicians, bearers of gifts, priests, and richly dressed court ladies, who with rhythmic step approached the divinity, recognizable by his garments; unfortunately only the lower part of this fresco is preserved, showing the well-known figure of the cupbearer (rhytophoros).

The famous painted sarcophagus from Hagia Triada, which may have been made for a royal personage, belongs to the same period. The scenes show the ritual of the sacrifice of the bull, an offering of fruit, a libation accompanied by the music of a double flute, a crowned woman (probably the wife of the deceased) offering a libation, followed by a lyre player (PL. 62), the apparition of the dead, and the offering of funerary gifts including a boat. Two chariots are present, one drawn by winged griffins and certainly for a divinity, the other by horses and for the royal family. Because of its excellent state of preservation, as well as the subject treated (which is so important for our knowledge of Cretan religion) and the method of narration in successive episodes, this sarcophagus is a unique monument in the history of art and of Minoan civilization.

The paintings of the second palaces are distinguished by an extraordinary originality, even though they are undeniably influenced by other artistic traditions. Mesopotamian and, above all, Egyptian influence is seen in some compositional schemes (e.g., the procession at Knossos) and in the richness of the colors, which, however, the Minoans treat with a more vital and gay sensibility. This same immediacy of expression is seen in the drawing of the figures, whose movement creates dynamic effects, as well as in the selection of subjects. In Minoan painting of the second palatial period, subject matter takes more direct inspiration and pleasure from nature than it does in the courtly and ceremonial scenes of the monumental painting in Near Eastern and Egyptian civilizations.

*c. Pottery.* As early as the beginning of the second palatial period, various innovations departed from the Kamares style: Figured themes began to assert themselves, and there was a progressive abandonment of polychromy in favor of a two-color scheme (dark figures on a light ground). At first, plant motifs prevailed, later marine forms; the various traditional decorative themes such as undulating lines, interlaces, and the spiral passed into secondary importance and were always accompanied by plant forms. Human figures, so frequent in monumental painting, were absent. The rhythm of the compositions was remarkable, as in the reiteration of certain marine elements, the use of netlike stylizations for water, and the whirling movement of plants or octopuses. A pitcher from Phaestos shows a dense growth of slender stalks rising above short grasses, swayed by a light breath of wind. Religious symbols, such as horns, the double-headed ax, or the sacred knot, frequently appear together with marine or vegetable decoration. At the apogee of this naturalistic phase the decoration was no longer confined to zones but freely distributed on the surface; it is impossible to trace any determining design beyond the necessity to adapt the motif to the form of the vase.

The so-called "palace style," typical of the region of Knossos, followed a more regular and symmetrical type of decoration, while in other areas of Crete the naturalistic manner persisted. In the palace style the ornamentation is distributed in horizontal and vertical zones; the forms become schematized and more decorative, even achieving a monumental aspect at times. Garlands frequently ornament the base of the neck of the vase; architectural motifs, such as friezes with half rosettes and

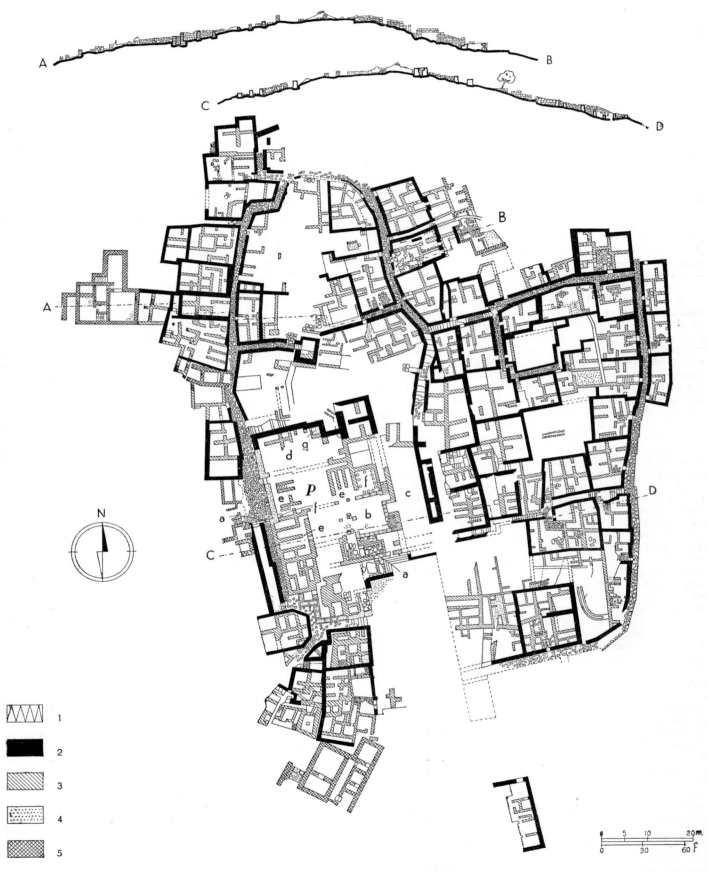

Gournia. *Above*: Transverse sections A–B, C–D. *Below*: Plan. *Key*: (A–B, C–D) Location of corresponding sections above; (1) Middle Minoan walls; (2) Late Minoan I (second palatial) exterior walls; (3) Late Minoan I partition walls; (4) Late Minoan I cement walls; (5) Late Minoan II (second palatial) walls. Palace (*P*): (*a*) entrance and corridors; (*b*) central hall; (*c*) women's apartments [?]; (*d*) men's apartments [?]; (*e*) magazines; (*f*) magazines with pithoi; (*g*) bath (*from H. B. Hawes, Gournia, Philadelphia, 1908, p. 26*).

triglyphs, appear. The most important examples of this style are two pithoi, one adorned with double-headed axes (PL. 65), and the other with papyri in relief. New tendencies coming from the Mycenaean world probably contributed to the formation of the palace style, though the ground was already prepared by the previous tradition of Cretan pottery. The evolution of the vase shapes paralleled that of the decorative motifs. There was a tendency to elongation, with the greatest convexity at the highest point and accentuated narrowing at the base. The handles were attached higher up or were purely ornamental. The most common shapes were pitchers, stirrup vases, alabastra, rhytons, small conical or ovoid pithoi, and the so-called "Ephyraean" cups.

*d. Sculpture.* As large-scale sculpture was a form foreign to Minoan civilization, cult statues of considerable size have been found only rarely. Despite the difficulties of stone as a material, there are some examples of this type of sculpture, such as the *Snake Goddess* in the Fitzwilliam Museum (Cambridge, Eng.). The authenticity of this work has been frequently questioned, however.

The modeling of small figures continued to flourish in the second palatial period, particularly in the rich production of clay ex-votos. The statuettes were far superior in quality to those of the first palatial period, although many elements, particularly the treatment of the face, were carried over to the later era. The most interesting series of statuettes is that from Piskokephali, in eastern Crete; among the figurines of orants, the female examples are noteworthy for the great variety of costumes and headdresses, while the male figures wear the usual perizoma, or loincloth. Many other statuettes of quite varied types (note, for instance, the bold figurine on a seesaw), found in different areas of central and eastern Crete, show that clay modeling was following new directions as well as conservative tendencies.

In this period a widely used technique is faïence; it was especially suitable for luxurious toilet articles, the extremely fine vases intended for the sanctuaries, ornamental relief slabs such as the *Town Mosaic* from Knossos (dated from this period rather than the preceding), or the plaques found in the sanctuary of the palace, which treat the theme of maternity with great sensitivity — for example, a cow nursing her calf, and a wild goat with two kids. Among the statuettes of faïence, two outstanding examples are the two well-known snake goddesses (PL. 55). They wear a rich dress that clings to the body, leaving the breasts nude. On one statuette serpents spiral around the body from below the waist to the top of the crown, and on the other they are held in the hands; the serpents are evidence of the chthonian character of the goddesses.

A genre in which ceramics rival stone carving is the plastic vases in zoomorphic shapes. Libation rhytons in the form of the foreparts or the whole figure of a bull have been found in various areas of Crete, particularly the east. The main features of the animals are vigorously represented, though not without a certain conventionalism and the usual taste for decoration (e.g., the bull caught in a net, from Pseira).

The sculptured vases made of stone (which at this time returned to use for every kind of household item) are of very high quality. They are, for the most part, luxury items, made of valuable stones worked with great mastery and refinement in techniques that are at times quite complex. These characteristics are evident not only in the beautiful examples that have been found intact but also in the tools, unfinished pieces, and leftover materials. Sometimes very hard and resistent stones, such as basalt or obsidian, were used. The greatest care was usually taken in the selection of the colors, whiteness, or transparency of such stones as porphyry, green serpentine, granites, veined marbles, spotted basalts, various types of alabaster and calcite, and rock crystal. The chromatic effects were enriched by intarsias of various materials, especially mother-of-pearl, and by the skill in making a vase of separately prepared parts. Piecemeal preparation permitted a greater boldness in the shapes (which were, in fact, always quite elegant) as well as more varied treatment of the surfaces, which were adorned with striations, interlacing vine patterns, series of leaves, spirals, rosettes, etc. There were many kinds of conical or oval rhytons, large bowls certainly for ritual use (such as those of alabaster, with handles in the shape of the figure-eight type of shield and the cover decorated with rosettes), basins with an ivy leaf for a spout, amphoras with trilobed mouths decorated with spirals, pithoi with relief elements, etc. Other utensils of carved stone that are of particular interest are lamps and tables for offerings and libations. The lamps frequently have a tall foot in the form of a bundle of papyrus stalks terminating in an open flower with two, three, or four little channels for the lights. There are also low lamps, without feet, with the different channels fed by separate little basins. The offering tables have as many different shapes and frequently bear sacred inscriptions.

The use of softer stones such as steatite gave rise to another series of products — vases with relief decoration, some of which are to be counted among the best of all Minoan art. It is probable that some of the steatite vases were sheathed in gold foil. (Occasionally traces of foil can be seen.) The three best preserved, and most famous, examples (all in Heraklion, Archaeol. Mus.) come from Hagia Triada: the "Chieftain's Vase," with booty of the hunt (perhaps an elephant's skin) offered to a king or prince, the conical rhyton (PL. 59), with four superimposed registers of gymnastics and athletics (jumping, wrestling, boxing, and bull racing), and the "Harvester Vase" (PL. 63), which has a ritual procession of thanksgiving for a good harvest on an upper, separately worked part. The almost Dionysiac spirit which animates this scene, accented by the comic episode of the drunk who falls, is perfectly in character with the joyful and rich atmosphere of Minoan art at its height.

The repertory of relief decoration on the other stone vases, often remarkable for the grace and vigor of the representations, includes sanctuaries, rites, religious symbols, demons, pursued animals, athletes, octopuses, etc. Related to this class of products is a weight of porphyry from Knossos, decorated with two octopuses. It is in the shape of a truncated cone and has a hole for suspension.

The vases of hard stone have many similarities to the steatite relief vases, and they are also related to the ceramic rhytons of sculptural shapes, both in their use for libations and in the shapes themselves, which often represent the heads of sacred animals, the bull and the lion (PLS. 59, 64). Well known is the rhyton of steatite in the shape of a bull protoma from Knossos (PL. 64). Here the vigor of the features is accentuated by the contrasting material of the eye (mother-of-pearl, red jasper, and rock crystal). Even the wings of the nostrils are outlined with mother-of-pearl. Of equally high artistic quality is the head of a lioness, also from Knossos; unfortunately the inlaid pupils are lost. Of more modest quality are the figures of a seated sphinx (perhaps under Hittite influence), a small pregnant monkey, and marine tritons of rhyolite and of alabaster.

Even in the use of precious materials such as ivory and gold, the Minoan artists were not only perfect masters of technique but were also capable of infusing life into their superb creations. An admirable ivory figurine from Knossos (PL. 64) represents an acrobat executing a bold leap over the head of the bull, who is unfortunately lost. The Boston Museum of Fine Arts possesses a chryselephantine goddess (whose authenticity is no longer in doubt) that is an exact copy of the faïence goddess from Knossos, though the serpents, the nipples of her breasts, and the borders of the many folds of her dress, are of gold. Other fragments of ivory sculptures, of larger dimensions and even finer technique, have been found in various houses in the regions of Knossos and Palaikastro.

In addition to gold, electrum, and silver (which were widely used in the production of small sculpture), copper and bronze were also employed. The tauromachy was a further source of inspiration for artists working in these materials (as in the running bull carrying an acrobat, in an English private collection); but figures of worshipers were more frequent, quite small in size, and usually executed in copper. The men were represented with the upper part of the body thrown back and one or both hands raised to the face, or, more rarely, on the

chest, in a gesture of adoration. The women, which many consider to be dancers, have their hands raised toward the head and lean over slightly. Often the faithful are accompanied by animals, especially bulls, consecrated to the divinity. Despite the monotony of the subjects, there is a certain variety among the individual pieces. The best statuettes have been found in the sanctuaries. Those from Tylissos, of larger size, are in the Archaeological Museum at Heraklion, where there is also an outstanding statuette from Hagia Triada. Another three are in the museums of Leiden (PL. 60), Athens (Nat. Archaeol. Mus.), and Berlin (Staat. Mus.). Unique in subject is the copper statuette of a worshiper carrying a sacrificial ram on his shoulders, in the Giamalakis Collection at Heraklion.

*e. Seals.* Seal art reached its highest point in the second palatial period. The most important collections of seals are in the museums at Heraklion (Archaeol. Mus.), Oxford (Ashmolean Mus.), London (Br. Mus.), New York (Met. Mus.), Paris Cab. Méd.), and the Giamalakis Collection at Heraklion. There were also numerous clay impressions of seals found at Knossos, Hagia Triada, Zakro, and Sklavokampos. The evolution of the shapes continued with some innovations: the prism with incurving sides and the "flattened" cylinder were slowly supplanted by the almond shape and the disk, which became increasingly lenticular in shape. Elements of writing were no longer used in seals because, with the evolution toward a linear script, the decorative character of the calligraphy was lost; furthermore, the slightly convex shapes that came to be preferred were more adaptable to figured scenes. The figured scenes differed from the "miniature" style wall paintings only in dimensions. There still appeared the animal and vegetable world of both land and sea in their most characteristic forms. All aspects of human life, such as wrestling games, pastimes, and religious rites, were represented; also depicted were the gods with their appropriate attributes and ceremonies, as well as the rich and fantastic world of the demons, who in some cases were placed in symmetrical, heraldic schemes revealing the persistence of Oriental traditions. Among the demonic creatures, the appearance of the man-bull is significant to us in connection with Cretan mythology, while the representations of horses testify to their introduction to the island.

*f. Minor arts.* With the perfection of metal alloys and the various techniques of metalwork (melting, hammering, soldering, lamination, relief, and the use of incised designs, metal inlays, and molds) the craft found much wider use; it was particularly developed in the production of arms of every type. Some exceptionally long swords (the longest known in the ancient world) were made during the second palatial period. They were splendidly hammered and even today retain their resilience; the handles were made of valuable materials such as alabaster, ivory, agate, gold, and silver, with incised, repoussé, or relief decoration of high artistic quality. Some swords, found in the necropolis of Knossos, were laminated with gold and decorated with twining plant tendrils and lions pursuing other beasts; others from Mallia have ivory handles sheathed with gold (on one of these an acrobat is represented with bent body, executing a leap; cf. PL. 64). The production of soldered daggers, decorated with inlays like those on the Mycenaean daggers, must have originated in Crete; some daggers with gold and silver rivets have been found elsewhere, but they can be considered Cretan in origin because of their similarity to Minoan examples. Other arms were produced in great numbers: lance heads, javelins, arrows, and double-edged knives, all of excellent manufacture and elegant shape. There is also a rich typology of defensive arms, helmets, and shields. Two helmets from Knossos are particularly interesting — one with cheek pieces and cone for the insertion of the crest, the other decorated with boars' teeth. The shields in the form of a figure eight are typical, though we know them only through miniature reproductions; probably they were made of perishable materials — for example, leather built up in layers.

The cult objects found in great abundance in the sacred caves, together with the arms placed there as ex-votos, are also frequently of metal, executed with various decorations and techniques (for example, soldered or with hammered laminae). There are even miniature reproductions of these in gold and silver, decorated and sometimes inscribed. Particularly large in size are the four double-headed axes from the megaron at Nirou, which certainly were part of the furnishings of a sanctuary.

The greatest advance in metalwork is seen in the enormous production of utensils of all kinds that have been found as tomb furnishings or in the ruins of houses. Some are decorated with incised or relief motifs, usually spirals, foliage, marine shells, or rosettes. There are cauldrons (lebetes) of various types with concave or tripod bases, pitchers with swinging handles, washing basins, small pans, porringers, amphoras, pitchers, cups, bowls, lamps, etc.; in addition, there is a large assortment of toilet articles such as razors, hair tweezers, small pyxides, and mirrors with elaborate handles sometimes of ivory. Doubtless all of these objects had counterparts in precious metals; those few that have been found show analogies to the examples from the royal tombs of Mycenae. Mention should be made of the finely worked silver pieces from the so-called "house of the high priest" to the south of Knossos, and the gold cup, also from the Knossos area, decorated with spirals, semicircles, and dots.

There was an enormous variety of work tools used in every craft and trade, for example, double-headed axes, simple axes, hammers, chisels, hoes, saws for stone and wood, wheels, scales, fish hooks, levers of various kinds, instruments probably for dental use, and small tools for working precious metals, seals, and ivory.

In the field of goldsmith's work, a certain change in taste occurred: there was an increase in the production of tiny jewels, rings with figured bezels (PL. 66), and bracelets of less precious materials. The preferred techniques included laminae worked in relief and foil worked on a copper core; special effects were achieved with metal wire and granulation. Jewelry of solid gold was rare. There were earrings in the shape of stylized bulls' heads with granulated work, as well as heart- and leaf-shaped pendants attached to chains of the greatest delicacy. One of these heart-shaped pendants is decorated with a poisonous spider, a scorpion, a starfish, and an open hand — all apotropaic symbols. The artistry of the gold rings is more praiseworthy than that of the other objects; the bezel was usually elliptical and decorated with religious scenes incised for use as seals (PL. 66). The most significant of these was one called "the ring of Minos," which has unfortunately been destroyed; it showed the transport by boat of the god and his altar from one sanctuary to another. A similar theme is treated in a small ring from Mochlos. The cult of the mother goddess is represented on small rings found in the necropolis of Kalyvia at Phaestos and on one large one which is now in the Archaeological Museum at Heraklion. The royal ring from Isopata, a true masterpiece of Minoan goldwork, represents a divinity with a group of dancers in ecstasy.

Handles of mirrors, combs, knobs of scepters, jewel chests, and so on, were made of ivory and embellished with intarsia, rock crystal, faïence, or lapis lazuli and frequently worked into figured patterns such as interlaced dragons. The *Town Mosaic*, and likewise a large rosette of crystal, must certainly have decorated wooden caskets now completely disintegrated. There are remains of dice and gaming pieces (e.g., the well-known chess pieces from Knossos) made entirely of precious materials.

We have no direct evidence of the textiles, knitwork, embroidery, furniture, and other craft products of the period, but from the painting and sculpture we may deduce the existence of extremely delicate and transparent textiles with exquisite embroidery in decorative and even figured patterns. In furniture the great refinement that had been attained is indicated by an alabaster copy of a throne as well as the throne from Knossos with a baldachin supported on columns.

*g. Summary.* We can perceive three successive phases in the lines of development of Minoan art in the period of the second palaces. Though still in the wake of preceding traditions, the first phase saw the birth of a bold search for new

creative directions; in the second, a lively and original interest in the surrounding world led the taste for naturalism to its highest point; in the third phase, a rigidity set into the previously developed forms, though the stylizations, and at times conventionalizations, did achieve a certain monumentality. The ground was thus prepared for the later dominance of common craft forms, with a continually increasing tendency toward industrialization in some types of production. The total destruction of the palaces about 1400 B.C. must certainly have contributed to the acceleration of this phenomenon.

*Postpalatial period* (1400–1100 B.C.). The dramatic destruction of the second palaces signals a clear interruption in the development of Minoan civilization. The fall of the palaces was accompanied by a decline in indigenous traditions in Crete and a general lowering of the level of culture, despite the continuation of life in numerous centers, the gradual repopulation of others, and the development of new communities. It is doubtful that the fall of the palaces and the concomitant cultural changes were due to a single catastrophic event such as the conquest of the island by the Achaians (Mycenaeans), who, at this time, were beginning to assert themselves. Evans (1921–36) had supposed a continuous development without the intrusion of new ethnic elements in the period of the second palaces. If, however, there were confirmation of the deciphering of the inscriptions in Minoan Linear B (dating from the last phase of the second palatial period, ca. 1450 B.C.), one might hypothesize a penetration of Achaian elements *during* that phase, since the inscriptions seem to reveal a very archaic Achaian dialect.

Following this hypothesis, the change in taste seen in the palace style of pottery could be explained. In any case, shortly after the fall of the palaces there occurred complete merging of the Minoan and Mycenaean worlds.

*a. Architecture.* The destruction was so thorough as to render immediate rebuilding impossible. There were provisory agglomerations of houses at first, in or near the previous centers; their existence is documented mainly by the necropolises — Zapher Papoura at Knossos and Kalyvia at Phaestos, where the tombs date for the most part from the period immediately following the destruction. These new agglomerations quickly took on a truly architectural character, and there was a certain independence from traditional forms. The polythyron (megaron with many windows and doors) disappeared; the characteristic small porticoes were replaced by interior courts; whether or not there were second stories in houses is undocumented, but the arrangement of the rooms is fairly complex. The most typical urban center in this period, recently found at Khondros near Vianos, presents houses brought together in large architectural complexes.

With the return of normality, the inhabitants turned first to the reconstruction of the old sacred buildings. At Knossos all three of the sanctuaries existing at the time of the palaces were restored: the sanctuary of the double axes in the palace received a bench for the cult statues and a podium for offerings; in the small palace a new baetylic sanctuary was constructed behind an old lustral tank; the spring chamber, which existed next to the so-called "caravansery" on the road to the south of the palace, was provided with statues placed in a niche at the rear. The typical benches for the images are also found in two newly constructed sanctuaries, one at Gournia and one near the megaron at Hagia Triada. This megaron is of particular interest as it represents the point of transition from the old polythyron type to the Mycenaean *in antis* type, from which the Greek temple evolved. The pavement was still painted in the Minoan manner, and inside the building were found cylindrical containers where perhaps the sacred snakes were kept.

The opinion that the postpalatial architecture remained quite modest throughout the period is belied not only by truly princely residences but also by well-constructed and -arranged houses at Tylissos (FIG. 98), Hagia Triada, Mallia, Gournia, Palaikastro, and Zakro. They were distinguished by greater size, costly construction, and — most important — the typical Mycenaean megaron. Thus at Tylissos (only partially preserved)

the megaron was preceded by a vestibule with two large columns and is surrounded by a series of secondary rooms and larger areas, among which is a polythyron. The megaron area at Hagia Triada consisted of an open vestibule, an antechamber, the megaron itself, and a rear room. Large paved courts with porticoes and passageways surrounded the buildings at both sites. Under the floors there was a system of pipes for carrying water, and at Tylissos a large round cistern was found.

The appearance of the first stoa, with two floors and shops, in the second phase of the postpalatial period is of great importance. The stoa is clearly of Mycenaean origin and later became a fundamental element of the Greek agora. On Crete, however, the columns on the ground floor alternated with rectangular piers, thus differing from the Mycenean stoa.

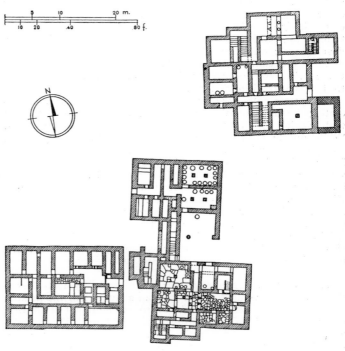

Tylissos, house plans (*from Lawrence, 1957*).

In funerary architecture both chamber tombs and tholoi continued in the postpalatial period. The rooms were of various shapes (round, quadrangular, elliptical, etc.) and generally small in size. It is impossible to discern the Minoan inheritance of the tholoi of this period because of the overwhelming Achaian penetration. The most remarkable examples of this type of tomb, and those in the best state of preservation, are found mainly in the eastern part of Crete. In western Crete there are extant tombs with a central corridor and several large adjoining rooms.

*b. Painting and pottery.* There is scarcely any evidence of wall painting in the first phase of the postpalatial period, and later there is none. Only sporadically does one find some element of clear Mycenaean derivation, such as the wall painting with gazelles at Hagia Triada. However, there are also at Hagia Triada scenes that return to the traditions of Minoan taste; a scene of offering, and a pavement decorated with fish, dolphins, and octopuses; another scene, with a procession of bearers of offerings, recalls the sarcophagus from Hagia Triada.

After a transitional period, in which the palace style continued, pottery moved in new directions which were to give rise to the proto-Geometric style quite a bit later. The continuity of the palace style is seen in the technique of glossy glaze, the good surface finish, and the persistence, or continued development, of existing shapes (cups with a high base and low or raised handles, stirrup amphoras, pyxides, braziers, plates with a

pouring lip, vases with spool-shaped handles, and censers with perforated lids). However, instead of the naturalistic motifs of decoration such as leaves, drops, or papyrus, increasingly simplified and schematized elements were used (the octopus, for example, was transformed into one or two rhythmical lines undulating from a schematized body). Angular and semicircular elements were frequently repeated in a series — a scheme easily adapted to the shapes of vases. However, figured designs, usually in a frame were preferred for the ample surface of craters.

The tendency to schematization became successively more pronounced, accompanied by a reduced variety of shapes; this was partly a result of mass production, partly a reaction to increasingly frequent contacts with the Mycenaean world. Two styles prevailed: one limited to the basic decorative motifs from which the designs of proto-Geometric pottery derived and the other containing an overabundance of decoration, the clarity of the design lost in a pattern of lines. At a still later period, termed "sub-Minoan," these two styles underwent their final development: on the vases from the tombs at Mouliana, the pictures are completely schematized and abstract, and proto-Geometric elements appear; the vases from Karphi are closer to Minoan traditional taste.

The terra-cotta sarcophagi were variously shaped and decorated; the most usual shapes were the tub (PL. 67) and chest with a pitched lid. The decoration recalls that of pottery. While purely ornamental motifs prevailed (such as papyrus, lotus, marine animals, birds, and particularly the spiral), the funerary function of the sarcophagi suggested particular themes such as monsters or persons performing rituals. The two most important examples of sarcophagi are from Palaikastro and Hierapetra. The sarcophagus from Palaikastro is decorated with symbols and griffins; the one from Hierapetra, with figured scenes such as the departure for the hunt in a chariot and religious ceremonies in which the bull plays a prime role. In some sarcophagi, as well as some ritual vases, there was a return to polychromy, but with delicate and subtle colors.

*c. Sculpture.* Terra-cotta sculpture gradually lost all the elegance and movement of the Minoan statuettes of the palatial periods, and the general tendency to conventional stylization was accompanied by a certain grossness of form. There was a repetition of the scheme of the hands raised in adoration and a reduction of the lower part of the body to a simple cylinder; the symbols that the figures carried on their heads were usually rather large. Maternity was emphasized in the female figures. The most important groups of figurines were found at Gournia, Gortyna, Gazi (PL. 67), Prinias, and Karphi. Faïence, or even glass paste, is frequently used in this genre of sculpture; some very interesting molds for these statuettes are also preserved. Figurines of the Mycenaean type are very rare in Crete.

The same tendencies can be seen in figures of animals; some pieces from Phaestos and Hagia Triada may be taken as representative — for example, a large bull and an ass loaded with jugs. Some rhytons were also executed in sculptural shapes.

The copper statuettes of men and animals found in caves and palaces were more closely related to past traditions, though even these reflected the new taste dominating sculpture. Stone statuettes are rare. The commonest material, frequently monochrome, was used for stone vases, with monotonous results.

*d. Minor arts.* There was no perceptible decline in the technique of metallurgy in the postpalatial period. The earlier stylistic traditions persisted, although there was less variety of shape and a simplification of decoration owing to increasing industrialization. This is evident in tools, vases (now of more angular profile), toilet articles (mirrors and rectangular razors), and weapons. The hilts of swords and daggers became more elongated; a new type of sword with lengthened grip and rounded shoulder seems to have been introduced by immigrants. The most important find of bronzes of this period occurred in the tomb with the tripod brazier at Knossos.

Jewels and necklaces underwent the same sequence of initial persistence of tradition, decreased variety due to mass production (although beautiful pieces, especially necklaces, were made),

and finally, in the last phase, complete decline. More economical materials, such as glass, were frequently used for necklaces.

Seals (usually of flattened shape) had a similar evolution in the material, technique, and subject matter. The themes were at first closely related to the repertory of palace productions but then became impoverished, and even showed a certain incomprehension of the subject matter (lions, bulls, gods, sacred rites, etc.), which became almost undecipherable in the latest pieces. The same is true of ivory objects.

*e. Evaluation.* Minoan art found its inspiration primarily in the world of nature and life, which was observed attentively and joyfully, with a more descriptive than narrative interest; thus the grand and solemn themes of history as well as death were absent from the subject matter. Hieratic rigidity in religious scenes and the divinization of nature, while characteristic of the art of other civilizations, were missing in Crete.

The characteristic taste of the naturalistic phase of Minoan art can be defined essentially as dynamic and illusionistic. The tectonic construction of the figure was overlooked; interest was concentrated on the image and the effects of color and movement. Perhaps no other art, except Chinese and Japanese, made such effective use of a miniature style. The search for picturesque effects utilized many devices: in painting, the colors were profuse and juxtaposed almost playfully in polychrome compositions, and the effects of light were used with sometimes abrupt alternation of light and shade to increase the chromatic values; in other arts, picturesque effects were achieved by the choice and combination of materials according to their color values — tone, brightness, delicacy, transparency, and veining.

Movement interested the Minoan artist both in purely decorative art as well as in the representation of nature as a means of suggesting animation. One finds extraordinary effects of tension, of elastic springiness, and vertiginous movement.

MYCENAEAN ART. Parallel to the development and flourishing of the Minoan civilization in Crete was the origin and evolution of other, less advanced, cultures in continental Greece and in the Cyclades Islands, namely, the older and middle phases of the Helladic and the Cycladic cultures (see MEDITERRANEAN PROTOHISTORY). Very little in these cultures presages the richness of the Mycenaean civilization, which is more directly related to the Cretan. The origin of the Mycenaean culture is thus a complex question: some scholars see it as a result of an intense current of Minoan influence on the continent (Evans hypothesized an actual Cretan colonization of the Aegean); others attribute the Mycenaean cultural flowering to the economic and cultural advances of the mainland Greek populations who invaded Crete about 1600 B.C. and destroyed its palaces. This problem is still far from its final solution.

*Old Mycenaean (1600–1500 B.C.). a. Architecture.* The evidence for construction in this period is very fragmentary: it is a question of a few ruins that have come to light underneath the more recent palaces (part of a stairway, a crypt with rectangular piers, a pier under the royal megaron at Mycenae) and a few sporadic traces of villages placed on heights and without systems of fortification. In these few remains, however, there is enough evidence to ascertain that in this early Mycenaean period architecture was related to the Minoan. The megaron was not yet developed, and the palace of Kadmos at Thebes, dating back to the beginning of the Middle Mycenaean period (ca. 1500 B.C.), had similarities to Minoan models, with its winding corridors, small porticoes, and more than one story.

Funerary architecture in Mycenae is better known. Pit graves prevailed, covered with slabs and often marked by a stele. Even the royal tombs, whose rich deposits are the principal source of knowledge of the various phases of this period, are pit graves, though larger and of better construction than the others. This method of burial was not unknown to the Minoans, who frequently cut rectangular pits within the tholoi.

*b. Painting and pottery.* While the existence of Old Mycenaean wall painting is suggested by the remains dating from

this era, vase painting is amply documented by the finds in the royal tombs of Mycenae. The dating of these tombs depends in large measure on the vases, which ranged throughout the 16th century B.C. and perhaps extended into the first third of the 15th century B.C. Imported Minoan ceramics have been found along with the indigenous products in the tombs. The latter are clearly contrasted with the imported vases; Mycenaean vases, principally vermilion (the so-called "Minyan" ware) and brown, show Cretan influence transmitted through the Cycladic cultures. Dark, two-colored vases are very similar to those found at Phylakopi on Melos (Cyclades); red is used for linear emphasis of the decorative themes on the vermilion vases with opaque surfaces. In a later period there was (in that class of vases which Evans compares with Late Minoan I*c*) a greater independence from the Cretan models: the flora and marine fauna themes were still more or less the same, with the typical Minoan symbols of the double-headed ax and sacred knot; but the background, or the outline, of the designs is covered with a pattern of minute dots.

*c. Minor arts.* The preference for precious metal explains why stone vases were uncommon in the Old Mycenaean period. Those vases found in the royal tombs were mostly imports from Crete; there were, however, faithful local imitations. The most frequently used materials were alabaster and calcite; typical are the shallow alabaster vases decorated with interlaced leaves. Other noteworthy pieces are a small crater with high spiral handles, a spoon for ritual use in the form of two hands clasped to catch the libation, conical ritual vases with high bases, and a rock-crystal toilet vase in the form of a duck. The working of steatite was not different from the Cretan way; some fragments of rhytons in the form of bull protomas are so similar to Minoan vases as to leave no doubt of their Cretan origin.

The objects of precious metals found in Mycenaean tombs (PL. 73) frequently give a better documentation of the development of Cretan metalwork than do the few examples that have been found in Crete itself. The Minoan originals are of such a high artistic level that they are easily distinguished not only from the local inferior copies but also from relatively faithful representations. The majority of the metal vases are of copper or gold; those of electrum or silver are rather rare. There was the usual large variety of decoration, techniques, and shapes: conical bowls with ribbon- or spool-shaped handles, shallow cups, bowls with two handles of various types, bowls on high bases, etc. Minoan influence is evident in the decoration, even in the oldest phases of Mycenaean art: semicircular motifs in double or single rows, crowns of leaves, closed calyxes, or rosettes in relief recall the Kamares vases; the simple, double, or interlaced spirals, on the other hand, were inspired by the pottery of the second palaces in Crete; and finally, figured themes (dolphins, octopuses, long rows of lions, bulls) reflect particular aspects of the Minoan taste in subject matter. Cretan influence was also reflected in the techniques of workmanship — for instance, in the frequent use of different materials for one vase. As in Crete, the shallow silver cups have gold plating on the lip and the handles; golden rosettes were applied to the walls of silver vases; a beaker of electrum is decorated with a singular flowering altar, executed with inlays.

The vases with figured scenes are particularly interesting; two outstanding examples are the gold cups found in a tholos tomb at Vaphio (in Laconia), which are certainly both by the same artist (PL. 73). They are truncated cones in shape, with spool-shaped handles; the decoration is repoussé on the outer layer of metal, while the interior is smooth. Both cups have scenes of the capture of bulls, on one cup by means of nets and on the other by a cow as a lure. In two further examples (Athens, Nat. Mus.), these from the royal tombs of Mycenae, Minoan influence is evident, although the subjects are not representative of Cretan taste. Two scenes of war are represented. The first vase is a crater with a battle scene, the other a conical rhyton with a scene of siege. Both are plated with gilded silver. Cretan derivation is also evident in metal rhytons of sculptural form, even though the Minoan models are of other materials (steatite or marble). The beautiful gold head

of a bull, with gilded ears, nostrils, and horns, a gold rosette on the forehead, and intarsia eyes, is almost identical with the bull protoma of steatite from Knossos. The theory has been advanced that some golden rhytons in the shape of lions' heads — unusual for the angular treatment of the surface, the expressive force, and the pleasing balance of naturalism and decorative stylization — are products extraneous to Minoan taste; other scholars, however, have cited the lioness rhyton from Knossos (PL. 59) as comparable. Another rhyton, in the rather heavy shape of a stag, has been considered Anatolian in influence, but here, too, excellent parallels can be found in Crete.

With exception of the cups, rhytons, and washbasins (as common in Mycenae as in Crete), utensils of precious metal are rare. Some very small utensils have been found, evidently toilet articles such as pyxides and graceful miniature jugs. The most beautiful examples of all of these types are undoubtedly the work of Minoan artists; the imitations and copies made in local workshops are at times so inferior that it must be concluded that superior metalworking remained a Cretan monopoly.

The products of Mycenaean metalworking in the oldest phase were mainly weapons. All the royal tombs were full of arms, which suggests that the Mycenaean kings, in contrast to the peaceful Cretan sovereigns, were warriors. Some of the weapons, however, were purely symbolic — evidently marks of rank (*insignia dignitatis*). The long Cretan type of sword (type A) has been found; it is formed of a narrow blade with a sharp point at one end and at the other a tongue-shaped tang attached to the hilt, which has a small decorated pommel and a cylindrical or polygonal grip. The swords of type B are broader and shorter, with a curved or flat back; the hilt is rather long and elaborately worked, with conical pommel and a grip composed of two halves attached to the two faces of the tongue-shaped tang. Many characteristics of the swords are found in the daggers, though with a greater variety of shapes which go back to Cretan types of a much older period. Only the style known as the halberd (*Dolchstab*) seems to be inspired by central European models. The decoration of these weapons is so deeply permeated with Minoan style that there is no doubt of their origin in Crete or in workshops closely related to the Minoan traditions. The dearth of comparable examples in Crete can be easily explained by the despoiling of the royal tombs; an example found at Psychro (Crete), however, incised with a hunting scene, may be considered a prototype of the group. The inlay decoration of these daggers, found at Mycenae and also in the area of Pylos (Peloponnesos), in Laconia and Achaia, was frequently extended to the blade (PL. 71), and showed the usual Minoan subjects: spirals, running lions, galloping wild horses, marine scenes, hunting scenes, lilies and other botanical motifs. The inlay technique frequently achieved the effects of a true niello, with such materials as gold and electrum on a ground of black sulfurous alloy. Copper weapons, such as lances and arrowheads, are probably also of Minoan origin.

The absence of preserved examples indicates that the armor (e.g., breastplates, shin guards, kneepieces) was made of perishable material such as leather or felt; however, it must be remembered that the large shields that covered the whole body may have made the use of other armor superfluous. Fragments found in the royal tombs of Mycenae have permitted the reconstruction of a helmet reinforced with boars' teeth and equipped with cheekpieces — a type that, together with the crested helmet, existed also in Crete. Of the two types of shields frequently represented in Mycenaean painting, the bilobed, or fiddle-shaped, type was certainly of Cretan origin; the other, curved to a hemicylindrical shell and extending to nearly the length of the body, had no precedent on the island. Copper utensils differed little from the Minoan ones.

Mycenaean goldwork is richly documented by the finds in the royal tombs. The general impression is of almost barbaric taste: while there are good imitations of Cretan work, together with a few actual Cretan jewels of highest quality, the great mass of the finds are inferior local products. The principal decorative motifs are rosettes of gold foil, wavy borders, and geometric forms. There are diadems with ornaments in the form of calyxes or rosettes, and half-diadems of radiating forms,

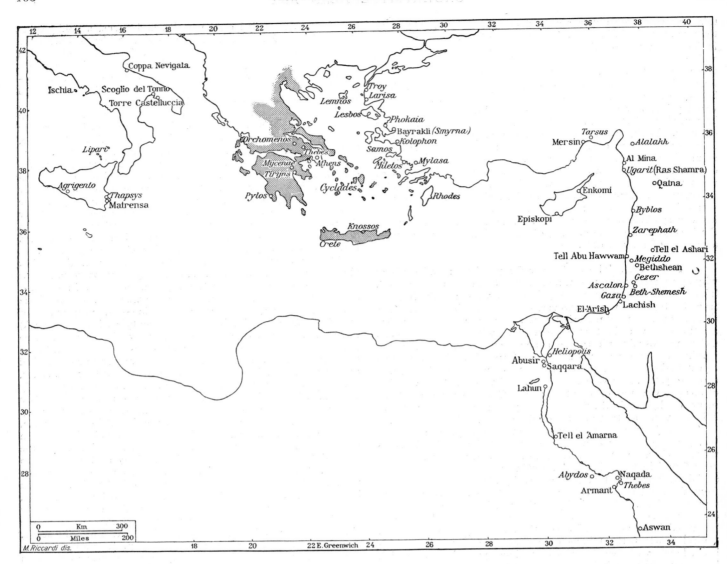

Area of Mycenaean civilization (indicated by hatching) and sites of finds of Mycenaean pottery. Ancient place names in italic type.

executed in the same technique and spirit of decoration as the buttons and other elements which adorned belts, and the hilts of type B swords. The many appliqués of gold foil that have been found — flowers, disks, leaves, and more complex forms such as butterflies, octopuses, sacred animals, griffins, sphinxes, marine animals, sacred symbols, divinities, and plants — were probably attached to the funeral shrouds or to wooden sarcophagi. The same designs are found on necklaces. One of the royal personages had a golden chain with eagles as the symbol of sovereignty; another had a heavy armlet with star-shaped flowers excellently made of various precious metals — certainly a Minoan product. Hairpins, earrings, necklaces, and rings were part of the Mycenaean grave furnishings of the queens and princesses. The hairpins, which are frequently heavy, suggest that the hair was worn in high coiffures in the manner of Cretan women. Magnificently executed gold rings repeat the typically Minoan subjects of battles and hunts; the rings, like all of these jewels, are made with such imagination and virtuosity that there is no doubt of their origin in Crete. Some of the goldsmiths' products were exclusively for funerary use: among these the famous gold masks represent the dead kings (PLS. 73, 449), at times with interesting realistic touches and at times with rigid conventionalization. Even the jewelry made of other materials than metal (rather rare in the royal tombs) is inspired by Minoan models, although the Mycenaean pieces are of inferior quality. For instance, a crystal painted with a gleaming pattern

of veins recalls the technique of the crystal from Knossos with the bull-fighting scene. A few stone seals, of mediocre workmanship, were found in the royal tombs.

We have only a sketchy idea about the working of wool, embroidery, ivory, bone, wood, and faïence; but the same conclusion is indicated — the faithful continuation of Minoan traditions. The Cretan type of inlay work is indicated by numerous fragments. Mirrors with ivory handles and figured decoration, as well as spoons, are among the most typical of the royal-tomb equipment.

Without doubt, the influence of Minoan civilization was completely dominant in the Old Mycenaean period, with only a few types of pottery indicating a thread of indigenous continuity.

*Middle Mycenaean* (1500–1400 B.C.). In this phase there occurred a synthesis of elements of Helladic tradition and those acquired through Minoan influence. Mycenaean civilization developed a unified and homogeneous character — so slowly, however, that a clear distinction between Old and Middle Mycenaean is difficult; nor are there indications of historical events that might have marked some interruption in this continuity. We find, therefore, that royal burials in the grave circles of Mycenae had not stopped by the beginning of the middle period; a dynastic change is therefore excluded as a cause of the Helladic-Minoan synthesis.

*a. Architecture.* Our information about Mycenaean architecture is also very fragmentary in the 15th century B.C. Only the palace of Kadmos at Thebes (built at the beginning of this period) now remains to show the continuation of traditional Minoan forms. At Mycenae a painted wall frieze has been found; it undoubtedly belonged to a megaron, thus documenting the appearance in the Middle Mycenaean period of this form which is so important in Hellenic architecture. Even the megaron seems to have been introduced through Cretan influence. Villages and single houses of this period are practi-

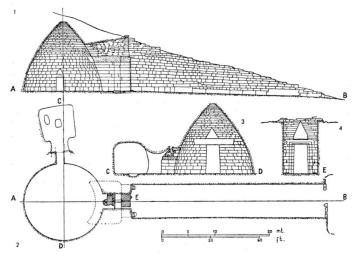

Mycenae, so-called "Treasury of Atreus": (1) Longitudinal section, A–B; (2) plan, with A–B, C–D, and E corresponding to sections in (1), (3), and (4); (3) transverse section; (4) elevation of entrance (*from Robertson, 1943*).

cally unknown in Mycenae, and fortification works did not appear until the end of the 15th century B.C. or perhaps at the beginning of the 14th century.

The evolution of funerary architecture is clearer and better documented than other Middle Mycenaean architectural structures. The monumental tholos tomb began to take on its definitive form, with the long dromos bounded by handsome masonry and an imposing entrance. There is no doubt that the tholos derived from Crete, where one can follow the various phases of development; such a highly perfected architectural form would be incomprehensible except as the fruit of a gradual evolution. The Mycenaean tombs vary in size, system of construction, length of the dromos, the presence or absence of decorative stonework and lateral rooms added to the rotunda, and in the relieving triangle above the entrance door. It is very probable that the most monumental tholoi were built in the course of the 15th century B.C., such as the so-called "Treasury of Atreus" (PL. 68; FIG. 105), the "tomb of Clytemnestra" at Mycenae, the "Treasury of Minyas" at Orchomenos, and two or three tombs in the region of Pylos. The "Treasury of Atreus" is the most imposing, distinguished by its size (ht., ca. 44½ in. max.; diam., ca. 47 ft.), by the perfect placing of its huge square blocks of stone, by its extremely long dromos reveted with courses of stone, by the enormous monolith (120 tons) used as an architrave over the door, by the splendid decoration of the façade with carved half columns and entablature and the large reliefs of bulls, and by the massive rotunda surmounted by a dome decorated with metal rosettes and flanked by a smaller rectangular room. The "Treasury of Minyas" is almost a copy of the Atreus treasury. The lateral room has a monolithic ceiling ornamented with reliefs of intertwined spirals and papyrus, motifs clearly derived from Crete. The "Tomb of Clytemnestra" is not much smaller; here too the façade is decorated with half columns and reliefs. Similar tombs, though of less monumental size, exist also in the Argolid (Argolis), Laconia, Messenia, Attica, and Thessaly. The tholos at Thorikos is unusual for its elliptical room. In the Mycenaean domain there were also numerous tombs carved out of the rock, with dromos and chamber; they are contemporary with the

oldest tholoi but have a greater variety in the plans and the dimensions and at times have painted doors in the Cretan manner.

*b. Sculpture.* Architectural sculpture in the Middle Mycenaean period is known mainly through the tomb decorations (FIG. 107) and reflects Cretan forms; the half columns decorating the façades recall the entrances of Minoan palaces, for example, that of the royal apartment from the central court in the second palace of Phaestos (PL. 53). The ceilings decorated with reliefs (PL. 70) — for example, the ceiling of the "Treasury of Minyas" — have analogies to the ceilings stuccoed and painted with interlocking spirals in the palace of Knossos. The reliefs from the façade of the "Treasury of Atreus," now in the British Museum, are related to those of the north entrance to the palace of Knossos. Because of the almost total destruction of the Mycenaean palaces, the friezes and cornices which must have adorned their façades (as on the Cretan examples) have been lost.

The oldest steles (of limestone) marking the royal tombs of Mycenae (PL. 70), with representations of battles and hunts, were in many cases replaced by later ones. They were doubtless the work of Cretan craftsmen.

*c. Painting.* Wall painting has been rarely found from the Middle Mycenaean period, though the fragments preserved from the palace of Mycenae and the palace of Kadmos at Thebes are sufficiently representative. From the former, a small part of a frieze which decorated the megaron remains. As in Minoan painting, the figures are pictured on various levels, above a border of undulating bands; however, the choice of subject is completely different, representing a scene of war. Hundreds of figures animate the various scenes with extraordinary vivacity and variety of pose: the camp, the preparation of the war chariots, the arming of the warriors, the two armies marching against each other, the battle on the acropolis which is dominated by a palace from which the women watch the combat. There is an unavoidable comparison of these details with those on the silver rhyton from Mycenae. The sleeved jackets of the warriors are characteristic.

The wall decoration of the palace of Kadmos at Thebes must be, at least in part, contemporary with that of the palace of Mycenae. A long ritual procession, again in the Minoan manner, is represented at Thebes; the figures mainly are bearers of offerings, sumptuously dressed, with high coiffures in the Cretan style. The painting recalls the procession at Knossos (Corridor of the Processions).

*d. Pottery.* It is the vase painting which gives us the best idea of monumental painting in the Middle Mycenaean period. The style is parallel to the palace style of Crete, but from those roots it reaches its greatest maturity on the mainland. The vases made in continental Greece can be differentiated from the Cretan products in some details of the technique and decoration, especially in the second half of the 15th century B.C. The majestic three-handled amphoras testify to an impressive evolution, with gradual stylization, of the decorative motifs of plant and marine life. The so-called "Ephyraean," cups which originated in Crete, became characterized at this time by a bilateral decoration using a stylized motif. There was a great prevalence of pitchers with truncated beaklike spouts.

*e. Minor arts.* Workmanship in ivory was noteworthy during this period. In addition to actual sculptures (an outstanding piece is the group of two women with a child, recalling similar ivory figures from Palaikastro, Crete), there were covers of pyxides, mirror handles, and combs decorated with reliefs of Minoan inspiration. Terra-cotta sculptures, such as statuettes, little figures of animals, and rhytons are rare.

Rings (Athens, Nat. Mus.) and pieces of gold necklaces belonging to this period have also been found. They are splendidly worked and often decorated with sacred subjects. One of the most beautiful of the rings, from Mycenae, represents the adoration of the goddess of fertility, who is seated beneath a tree, receiving an offering of flowers. On the well-known

Two decorative elements from so-called "Treasury of Atreus" at Mycenae (*from B. Fletcher, A History of Architecture, New York, 1950*).

"ring of Nestor" (of questioned authenticity) the scene is divided into four sections by the trunk and the branches of the tree of life — apparently a young couple's descent into Hades.

The variety and preciousness of the finds from the royal or princely tombs of Midea, Vaphio, Pylos, and Kakovatos provide ample documentation of all fields of the minor arts. From Vaphio, in addition to the two magnificent cups and the daggers of beaten gold, came utensils of silver and copper, arms and armor, fragments of necklaces, seals, and rings with ritual scenes. At Midea the rich funeral furnishings included silver cups with scenes of a deer hunt and bull racing, a golden cup with octopuses in relief, a rhyton made of a decorated ostrich egg, and rich weapons for ritual use. From the tholoi of Pylos came the most interesting series of three-handled amphoras decorated in the palace style, with plant and marine motifs, as well as various types of vases similar to Minoan ones, daggers of beaten gold laminae, copper utensils, exquisite jewels and other objects, among which the seals and miniature ivories are excellent. The furnishings of the royal tomb at Staphylos, on the island of Skopelos, are representative of the fusion occurring between the Cretan and Mycenaean civilizations; here have been found copper utensils, alabastra, jewels, double-headed axes, a sword, two-handled "Ephyraean" cups on high bases, a terracotta statuette representing a woman carrying a jug, and an ovoid rhyton decorated with lilies in the Minoan manner. That the level of commerce and industry was improving is evidenced at Thebes by the workshops for seals, the kiln found in the palace, and the numerous amphoras with inscriptions.

*Late Mycenaean* (1400–1100 B.C.). With the destruction of the Minoan palaces at the end of the 15th century B.C., the political and economic control of the Aegean world passed to the Mycenaean kingdoms, which also became the cultural center of the area. Once the Cretan influence had ceased, the Helladic substratum on the continent had the opportunity to assert itself and realize its particular needs in new artistic forms, though without renouncing the Minoan heritage.

*a. Architecture.* In this last Mycenaean period, architectural forms appeared that seemed to reflect the new dynasties' changed conception of palace life. First of all, the palaces were surrounded by strong systems of defense. At Tiryns the first walls included only the upper part of the acropolis, but subsequently they were enlarged; a stone gate, inspired by that at Mycenae, replaced the old wooden gate approached by a ramp. Toward the end of the 13th century B.C., the powerful defenses were complete and included almost the whole hill, offering secure refuge to the inhabitants of the city in case of emergency. The walls had a thickness of up to 36 ft., and within them huge galleries (with corbel vaults formed by superimposed courses of massive projecting blocks) led to a series of casemates and storage rooms. At Mycenae (FIG. 108) the fortification walls were built according to an over-all plan and enclosed even the old royal-tomb circle, which was leveled with fill and circled by slabs forming a low wall with a separate entrance; the circle thus took on the character of a religious precinct. It was at this time that newer steles were substituted for the older ones.

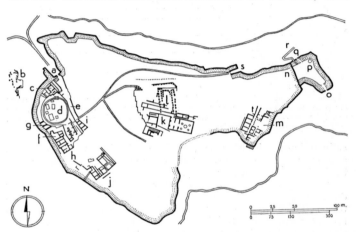

Mycenae, plan of citadel; (*a*) Lion Gate; (*b*) prehistoric burial; (*c*) magazines; (*d*) royal tombs; (*e*) ramp; (*f*) house of the "Warrior Vase"; (*g*) house of the ramp; (*h*) south house; (*i*) Hellenistic structures; (*j*) Tsountas' house; (*k*) palace; (*l*) foundation of temple: (*m*) house of the columns; (*n*) northeast wall; (*o*) gate; (*p*) moat; (*q*) Hellenistic cistern; (*r*) hidden cistern; (*s*) passage within bastions; (*t*) terracing wall (*from Wace, 1949*).

The walls of Mycenae are of Cyclopean construction; in some stretches they are 19½ ft. thick, with a filling of rock and earth between the inner and outer walls. Most imposing is the Lion Gate (PL. 69) at the entrance to the acropolis, approached by a road controlled by a sturdy bastion. The gate has monolithic piers and an enormous architrave surmounted by a triangular slab showing two lions flanking a column; the lions were a symbol of divine protection and the power of the royal dynasty. A second, smaller, gate served as a secret exit and assured the supply of water — a spring that was reached through a long subterranean gallery with 104 steps.

Similarly the large acropolis of Arne on Lake Kopais was encircled by a massive defense wall with many fortified gates, built by the Minyan dynasty of Orchomenos in Boeotia. At Athens, too, the old walls were reinforced and extended, and the new wall (later known to the Greeks as the Pelasgian wall) was given nine gates. Here too the access to the source of water was well protected by a path cut in the rock.

Palace architecture is known to us through the ruins of Mycenae, Tiryns, Pylos, Arne, and Iolkos. The megaron in its most developed form was present in all of these palaces. There seems to be a new spirit, profoundly different from the Minoan, in the axial arrangement of space — as if the intention was to enhance the royal magnificence by the impact of

Types of columns; (*a*) From rhyton of Hagia Triada; (*b*) from Lion Gate at Mycenae; (*c, d*) from a fresco of sanctuary of palace of Knossos; (*e*) from façade of "Treasury of Atreus" at Mycenae (half columns).

the visual perspective. On the acropolis of Mycenae a broad stepped road leads from the royal-tomb precinct to the upper terrace, from which the highest part of the palace can be reached by means of a double staircase of the Cretan type. The royal megaron was entered from a court whose surrounding walls were decorated with timber work, two-lighted windows, and a triglyph frieze. The megaron area was composed of a vestibule with a portico of two columns, an anteroom, and the megaron proper, which served as throne room. It had a large circular fireplace in the center, four columns supporting a kind of open clerestory to admit light and allow smoke to escape. The throne was situated to the right of the fireplace. The walls and floor were richly decorated. There are only slight vestiges of the other quarters of the palace.

Much more revealing are the remains of the palace at Tiryns. The first propylaion, of Cretan form, is reached by a series of gates. A large court surrounded by a small portico follows, and then another propylaion leading to the central columned court. The megaron opens on the axis of this court and is a rich development of the Mycenaean type. The vestibule leads to the anteroom through three doors, and is decorated with a triglyph frieze composed of alabaster and lapis lazuli incrustations. Even the floor of the throne room was richly decorated with painted squares with pairs of octopuses alternating with pairs of dolphins. In addition to the main megaron, there was a smaller one, which one reached through twisting corridors that recall the Minoan palace. Also reminiscent of the Cretan constructions were the bathroom, with a gently inclined monolithic pavement, and the service rooms. The roofs must have been flat and of different heights.

Many of these same characteristics are found in the palace at Pylos: courts, propylaia, one megaron for the men and one for the women, bath, workshops, and storerooms. The fireplace of the megaron was extremely large and was covered with several layers of decorated plaster. Hundreds of inscribed clay tablets were found in a small room which served to store the archives. The palace at Arne was simpler and more modest; it had two wings with corridors, along which were the rooms. The Mycenaean megaron found near the Erechtheion on the Athenian Acropolis also provides an interesting example of Late Mycenaean architecture.

Large public works were also undertaken in this period. In Boeotia the Minyan dynasty drained the area of Lake Kopais, constructing a system of underground canals. In the Argolid the kings of Mycenae and Tiryns laid out a remarkable network of well-cared-for roads furnished with guard posts; they also redirected the course of a river to avoid the danger of floods. Although Late Mycenaean towns were numerous, they have not yet been sufficiently studied. There are many indications of a great variety of building forms. A remarkable piece of religious architecture is the sanctuary which has been excavated under the Telesterion at Eleusis, which seems to present the oldest form of the Hellenic temple. The small temple at Asine, on the other hand, still tied to the Minoan type, has lateral benches.

Funerary architecture continued with monumental tombs, no less imposing than those of the preceding period, although there was a certain technical decline. Necropolises with chambers carved out of the rock became considerably more numerous; in the last phase these tombs became small and irregular, showing narrow dromoi with walls inclined toward the top to facilitate roofing.

*b. Sculpture.* Late Mycenaean monumental sculpture remained strictly dependent on architecture. The large relief of the Lion Gate at Mycenae (PL. 69) is the most significant of the finds. The theme of two heraldically opposed lions was known in Crete, and the technique of the execution is clearly inspired by Cretan sculpture. The anatomical details are only superficially indicated, although the movement of the two beasts, erect beside the column, is forceful. The heads, which are unfortunately lost, must certainly have considerably increased the expressive vigor. Minoan tradition is also evident in the steles over the royal tombs, although new elements occur here and there. Mycenaean reliefs tend to flatness, and the accen-

tuated geometric schematization of the usual battle themes disguises the imperfection of the execution. The traditional Minoan style remained intact only in the interlacing spirals. An interesting stucco head of a woman from Mycenae shows a new concern with rendering the basic forms of the face, though at the same time the surface is decoratively painted white, with rosettes accentuating the cheeks and chin (PL. 72).

Terra-cotta sculpture, on the other hand, was less imaginative. Idols with wings or disk-shaped bodies were repeated again and again; there were, however, occasional kourotrophos figures (mother nursing a child), twin figures, divinities on horseback, sphinxes, or enthroned gods. Large terra cottas are rare, though there is extant an interesting figure of a woman from Asine.

*c. Painting.* The palaces of Mycenae, Tiryns, Orchomenos, Thebes, and Pylos were all decorated with wall painting. All the themes dear to Cretan art are repeated fairly faithfully: bullfights, sanctuaries, processions, demons, griffins, and hunting and fighting scenes. From Tiryns comes a boar hunt with dogs attacking the wounded beast, pavement decorations with octopuses and dolphins, and a scene of two women in a wagon very similar to a group on the sarcophagus from Hagia Triada. There is a frieze of deer and gazelles which is also similar to paintings from Hagia Triada, but this is probably a case of Mycenaean influence on Crete. Mycenaean painting style is profoundly different from Cretan in its tendency to a more abstract and cerebral decorative character; this is illustrated by the clear outlines, the disciplined compositions, and the rich (though not intense) color scale — all elements which forecast the balance and harmony of Greek art.

*d. Pottery.* In the Mycenaean world, as in Crete, wall painting profoundly influenced pottery, which, however, treated the themes of monumental painting symbolically rather than realistically (PL. 74). There are pottery depictions of hunters and warriors in their chariots, but the ceramicists' preference for symmetrically arranged compositions led them to represent not the hunt or battle itself but rather the departure or the return. There was an increasing tendency to geometrical schematization; the bodies of horses became simple cylinders, and rows of figures were identical, all depicted in the same pose (e.g., a row of warriors whose feet are all in the same position and who carry their weapons in exactly the same way). The vases which lent themselves best to this type of decoration were, because of their shape, craters. They can be divided into two groups: the western group, with Mycenae as the center of production, and the eastern one, located at Rhodes.

On later vases the human figure was only rarely found. Ornamental themes predominated; these, and even the surviving figured motifs, evolved in the direction of schematization and abstraction. This process was more rapid and complete than it had been in Crete. The Argolid can now be isolated as a main center of production, with a great abundance of mass-produced pottery originating there (vases for the table, kitchen, and market). The decoration became more and more mechanical and schematized until finally the original motifs were no longer recognizable. This does not deny, however, that the best workshops still produced vases of the highest quality. The large production of vases in the Argolid contributed to the rapid exportation and diffusion of Mycenaean ceramics throughout the Mediterranean basin, which in turn gave rise to other workshops. The production of all of these partook of the Mycenaean common style, and it is frequently difficult to recognize the work of local centers. In general, the pottery of continental Greece was more conservative than that of the east, whose main centers were Rhodes and Cyprus. In Cyprus particularly, local taste modified somewhat the typical Mycenaean characteristics, creating quite original vases, with the surface frequently divided into metope-like fields and an axial arrangement of the decoration (see CYPRIOTE ART, ANCIENT). Toward the end of the Mycenaean period the two tendencies that had appeared in Crete by the close of the postpalatial period (i.e., a limitation of decoration to basic motifs, with an emphasis on schematization; and an abundance of decoration and pattern, closer to

traditional Minoan taste) become more and more accentuated. There was the so-called "granary" style, of simple linear or curvilinear ornaments; and the so-called "close" style, in which every void was filled with lines and accessory elements that almost suffocate the surviving traditional motifs.

*e. Minor arts.* Few innovations appeared in any branch of the minor arts during the Late Mycenaean period. The old forms were repeated and adapted to the new taste for less elaboration and more practicality: In stonework — the steatite and

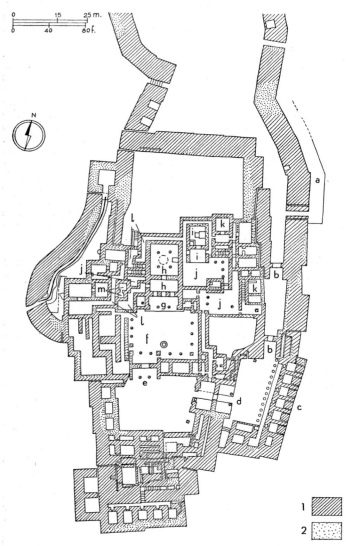

Tiryns, plan of palace and south part of citadel: (1) Existing walls; (2) restored walls; (a) ramp; (b) gates; (c) magazines; (d) outer propylon; (e) little propylon; (f) court with round altar; (g) large propylon; (h) vestibule and large megaron; (i) vestibule and small megaron; (j) courts; (k) megaronlike rooms; (l) corridors; (m) vestibule and bath (*from Lawrence, 1957, pp. 69–73*).

alabaster vases and lamps, for example — the decoration was particularly impoverished. In copper utensils the shapes became more rigid and linear; however, the lebetes (cauldrons) on a tripod base, with small plastic ornaments, made their first appearance in the last phase of the Late Mycenaean, or sub-Mycenaean, period. Implements such as razors with rectangular blades, mirrors, and works of ivory, and, in part, goldwork all became less elaborate. However, the technique of cloisonné enamel appeared at this time, and glass paste jewelry became highly developed and varied. Beads of necklaces frequently took on the shape of small placques decorated in relief with occasional figured motifs. Coral charms were introduced, and amber was frequently used.

More significant innovations were made in weapons, especially swords and daggers. Here too the older traditions dominated at first, but toward the end of the period, the characteristic central European sword appeared. It contained a tang with raised edges and a curved blade; the daggers are of similar form. Contemporaneously, or perhaps a little later, new customs and cultural elements appeared in the Mycenaean world, also of northern origin — for example, the practice of cremation and new styles of clothing that supplanted the traditional sewn garments; the latter is indicated by the fibulas and pins. Iron was increasingly used; in fact, the great numbers of weapons, especially lances and swords, indicate a general state of crisis. It was precisely during the sub-Mycenaean phase that vase painting began to apply a new concept to the organization of its repertory of ornamental motifs: the proto-Geometric style was born.

At this point an unforeseen event gave the death blow to Cretan-Mycenaean civilization: the destruction of the principal Mycenaean cities by the sword and fire, followed by the construction of modest villages on the sites where Greek cities later grew. This change has been attributed to the Dorian invasion.

*Evaluation.* It is undeniable that the Mycenaean civilization was born from the Minoan. Probably as a result of Cretan colonization of Mycenae a sudden leap forward was made in regions on the Peloponnesos that until then had known only the modest culture of the Middle Helladic period.

It is not justifiable to speak of originality in Mycenaean art, except in the latest period. The Achaians of the Old Mycenaean period surrounded themselves with weapons, even in death, and were prolific in representations of bellicose subjects. There were similar tendencies in Minoan society (though in smaller measure), as the large royal swords and the interest in hunting scenes indicate; it is easy to imagine that such tendencies gave rise to a period of colonization. However, once the first period of adjustment to Cretan dominance was over, religious subjects and peaceful themes from daily life took precedence in Mycenaean art. The tie between Mycenaean and Minoan art was tenacious. This is seen in the manner in which Old Mycenaean royal-tomb furnishings combined imported Minoan objects with products made by immigrant Cretan artisans; it is also apparent in the local products that imitated Minoan models (or in any case belonged to the same artistic trend) and in the ceramics of indigenous Mycenaean style with, none the less, some foreign influence.

It is precisely the tie with Crete that determined the development of Mycenaean art. In the Old Mycenaean period the indigenous traditions retained a certain autonomy, although Cretan influence was dominant. This was followed by a period of synthesis, in which a uniform culture, mainly of Minoan tone, was developed. However, the local substratum — only in appearance dormant — retained its vitality intact and was reawakened in the phase immediately following; Middle Mycenaean created new styles and a new form of civilization. This reaction seems to have had a strongly political character. Indeed, the use of the Achaian language in the royal court at Knossos, as has been hypothesized on the basis of translations of Minoan tablets in Linear B script, suggests a precocious penetration of the Achaians into Crete (second palatial period). Shortly afterward, about 1400 B.C., the Cretan palaces and their communities were destroyed; the radical transformation indicates the advent of new dynasties in Crete.

These changes also had a profound spiritual significance for both Cretan and Mycenaean cultures: The fortified acropolis, symbol of the power of the lord, became the center of social life. The general diffusion of the megaron gave a new character to domestic life. All this meant a change from the Minoan theocratic concept of life to one which centered on the figure of the sovereign as a man. It was also reflected in the formal religion and art. The Minoan cult of nature divinities was retained, but the divinities became part of an anthropomorphic pantheon in which they assumed a more precise individual character. Man became the main subject of art. The deeds of the sovereigns were no longer anonymous, and a world of musicians, poets, and artists immortalized them; thus was born

the concept of the hero. In this setting the antecedents of the Homeric epic matured. In painting and sculpture there was a preference for subjects taken from royal life, with man as the protagonist, as is seen on funerary steles and wall paintings. The change in artistic style was profound. It is true that some elements fundamental to Minoan art persisted, which proves the great fascination that they commanded; and this fascination controlled and limited the Late Mycenaean tendency to abstract and geometric organization of forms. A greater autonomy was achieved only in pottery, where the geometric tendencies were more decisively manifest in easier technical procedures. But even these tendencies were fully explicit only at the end of the Mycenaean cycle.

NOTE: The great majority of Minoan artifacts discussed in the article may be viewed at the Archaeological Museum, Heraklion; those of Mycenaean origin at the National Museum in Athens.

BIBLIOG. a. General: R. Dussaud, Les civilisations préhélléniques, 2d ed., Paris, 1914; C. Praschniker, Kretische Kunst, Leipzig, 1921; A. Evans, The Palace of Minos at Knossos, 4 vols., London, 1921–36 (with index); D. Fimmen, Die kretisch-mykenische Kultur, 2d ed., Leipzig, Berlin, 1924; V. Müller, Kretisch-mykenische Studien, JdI, XL, 1925, p. 85 ff.; B. Schweitzer, Altkretische Kunst, Die Antike, II, 1926, p. 291 ff.; V. Müller, Studien zur kretisch-mykenischen Kunst, JdI, XLII, 1927, p. 1 ff.; G. Rodenwaldt, Die Kunst der Antike, Hellas und Rom, Berlin, 1927; H. R. Hall, The Civilization of Greece in the Bronze Age, London, 1928; O. Montelius, La Grèce préclassique, 2d ed., 2 vols., Stockholm, 1928; J. Charbonneaux, L'art égéen, Paris, Brussels, 1929; J. Forsdyke, Minoan Art, Proc. Br. Acad., XV, 1929; V. G. Childe, The Bronze Age, Cambridge, New York, 1930; G. Karo, Die Schachtgräber von Mykenai, 2 vols., Munich, 1930–33; N. Åberg, Bronzezeitliche und früheisenzeitliche Chronologie, 6 vols., Stockholm, 1930–36; S. Marinatos, Les origines de l'art minoen, CahArt, VI, 1931, pp. 133–43; S. Snijder, Kretische Kunst, Berlin, 1936; H. T. Bossert, Altkreta, 3d ed., Berlin, 1937; P. Démargne, La Crète dédalique, Paris, 1947; R. W. Hutchinson, Notes on Minoan Chronology, Antiquity, XXII, 1948, p. 61 ff.; G. D. Thomson, The Prehistoric Aegean (Studies in Ancient Greek Society, I), London, 1949; H. Gallet de Santerre, Délos, la Crète et le continent mycénien au second millénaire, in Mél. Picard, I, Paris, 1949, p. 387 ff.; F. Matz, Die Ägäis, HA, II, 1, 1950; F. Matz, Zur ägäischen Chronologie der frühen Bronzezeit, Historia, I, 1950, p. 173 ff.; H. L. Lorimer, Homer and the Monuments, London, 1950; V. G. Childe, The Dawn of European Civilization, 5th ed., London, 1950; G. Glotz, La civilization égéenne, 3d ed., Paris, 1952; R. W. Hutchinson, Minoan Chronology Reviewed, Ant., XXVIII, 1954, pp. 155–64; J. D. S. Pendlebury, The Archaeology of Crete, 2d ed., London, 1955; F. Schachermeyr, Die ältesten Kulturen Griechenlands, Stuttgart, 1955; D. Levi, Gli scavi italiani a Creta, Nuova Antologia, XCI, 1956, pp. 221–40; F. Matz, Kreta, Mykene, Troja, die minoische und die homerische Welt, Stuttgart, 1956; C. Zervos, L'art de la Crète néolithique et minoenne, Paris, 1956; D. Levi, Gli scavi del 1954 sull'Acropoli di Gortina, ASAtene, XXXIII–XXXIV, 1957, p. 207 ff.; R. Matton, La Crète au cours des siècles, Athens, 1957; B. E. Moon, Mycenaean Civilization Publications since 1935 (bibliog.), London, 1957; G. Mylonas, Ancient Mycenae: The Capital City of Agamemnon, Princeton, 1957; H. Pars, Göttlich aber war Kreta, Olten, Freiburg im Breisgau, 1957; C. Zervos, L'art des Cyclades, Paris, 1957; D. Levi, Gli scavi a Festos nel 1956–57, ASAtene, XXXV–XXXVI, 1958, p. 193 ff. (with bibliog.); G. Karo, Greifen am Thron: Erinnerungen an Knossos, Baden-Baden, 1959; S. Marinatos, Crete and Mycenae, New York, 1960; G. Karo, RE, Sup. VI, 1935, s.v. Mykenische Kultur. b. Architecture: W. Dörpfeld, Die kretischen, mykenischen und homerischen Paläste, AM, XXX, 1905, p. 257 ff.; W. Dörpfeld, Die kretischen Paläste, AM, XXXII, 1907, p. 576 ff.; J. Durm, Über vormykenischen und mykenischen Architekturformen, ÖJh, X, 1907, p. 41 ff.; A. Boëthius, Mycenaean Megara and Nordic Houses, BSA, XXIV, 1919–21, pp. 161–84; Ecole française d'Athènes, Etudes crétoises, 6 vols., Paris, 1928–42; L. Pernier and L. Banti, Il palazzo minoico di Festos, 3 vols., Rome, 1935–51; C. W. Blegen, Preclassical Greece, in Studies in the Arts and Architecture, Philadelphia, 1941; E. B. Smith, The Megaron and Its Roof, AJA, XLVI, 1942, pp. 99–118; D. S. Robertson, A Handbook of Greek and Roman Architecture, 2d ed., Cambridge, Eng., 1943; V. Müller, Development of the "Megaron" in Prehistoric Greece, AJA, XLVIII, 1944, pp. 342–48; C. W. Blegen, The Roof of the Mycenaean Megaron, AJA, XLIX, 1945, pp. 36–44; C. Weickert, Antike Architektur, Berlin, 1947; W. B. Dinsmoor, The Architecture of Ancient Greece, 3d ed., London, New York, 1950; R. W. Hutchinson, Prehistoric Town Planning in Crete, Town-planning Rev., XXI, 1950, pp. 199–220; A. W. Lawrence, The Ancestry of the Minoan Palace, BSA, XLVI, 1951, pp. 81–85; B. Schweitzer, Megaron und Hofhaus in der Ägäis des 3.–2. Jahrtausends v. Chr., BSA, XLVI, 1951, p. 160 ff.; R. W. Hutchinson, Prehistoric Town-Planning in and around the Aegean, Town-planning Rev., XXIII, 1952–53, pp. 261–79; N. M. Kondoleon, Mégaron, in Mél. Merlier, I, Athens, 1956, pp. 293–316; J. W. Graham, The Central Court in the Minoan Bull-ring, AJA, LXI, 1957, pp. 255–62; A. W. Lawrence, Greek Architecture, Harmondsworth, 1957; H. Rau, Kretische Paläste, Mykenische Burgen, Stuttgart, 1957; J. W. Graham, The Residential Quarter of the Minoan Palace, AJA, LXIII, 1959, p. 48 ff. c. Pottery: A. Furtwängler and G. Loeschcke, Mykenische Vasen, Berlin, 1886; E. Reisinger, Kretische Vasenmalerei vom Kamares bis zum Palast-Stil, Leipzig, Berlin, 1912; H. Frankfort, Studies in Early Pottery of the Near East, 2 vols., London, 1924–27; C. Dugas, La céramique des Cyclades,

Paris, 1925; P. Démargne, Classification des céramiques antiques; Céramique de la Crète préhellénique, Paris, 1931; A. Furumark, The Mycenaean Pottery, Analysis and Classification, Stockholm, 1941; A. Furumark, The Chronology of Mycenaean Pottery, Stockholm, 1941; A. Furumark, The Mycenaean III Pottery and Its Relation to Cypriote Fabrics, OpA, III, 1949, p. 194 ff.; F. Stubbings, Mycenaean Pottery from the Levant, Cambridge, Eng., 1951; A. Furness, The Neolithic Pottery of Knossos, BSA, XLVIII, 1953, pp. 94–134; F. Schachermeyr, Dimini und die Bandkeramik, Vienna, 1954; W. Taylour, Mycenaean Pottery in Italy and Adjacent Areas, Cambridge, Eng., 1958. d. Sculpture: W. Reichel, Die mykenischen Grabstelen, in Eranos Vindobonensis, Vienna, 1893, p. 24 ff.; K. Müller, Frühmykenische Reliefs aus Kreta und von griechischen Festland, JdI, XXX, 1915, p. 242 ff.; V. Müller, Frühe Plastik in Griechenland und Vorderasien, Augsburg, 1929; K. A. Neugebauer, Die minoischen und archaisch griechischen Bronzen (Katalog der statuarischen Bronzen im Antiquarium, I), Berlin, 1931; E. Homann-Wedeking, Die Anfänge der griechischen Grossplastik, Berlin, 1950. e. Painting: G. Rodenwaldt, Die Fresken des Palastes Tiryns II, Athens, 1912; G. Rodenwaldt, Der Fries des Megarons von Mykenai, Halle an der Saale, 1921; O. Walter, Studie über ein Blumenmotiv als Beitrag zur Frage der kretisch-mykenischen Perspektive, ÖJh, XXXVIII, 1950, p. 17 ff.; H. Reusch, Die zeichnerische Rekonstruktion des Frauen Frieses im böotischen Theben, Berlin, 1956. f. Seals and gems: Furtwängler, AG, III; S. Xanthoudides, Προϊστορικαὶ σφραγῖδες τοῦ Μουσείου Ἡρακλείου, Ephemeris Archaiologike, 1907, p. 142 ff.; S. Xanthoudides, Σφραγῖδες χρηστικαι, Ephemeris Archaiologike, 1913, p. 98 ff.; F. Matz, Die frühkretischen Siegel: Eine Untersuchung über das Werden des minoischen Stiles, Berlin, 1928; H. Biesantz, Kretisch-mykenische Siegelbilder, Marburg, 1954; D. Levi, L'archivio di cretule a Festos, ASAtene, XXXV–XXXVI, 1956–57, p. 7 ff.; A. Xenaki-Sakellariou, Les cachets minoens de la collection Giamalakis, Etudes Crétoises, X, Paris, 1958; V. E. G. Kenna, Cretan Seals: With a Catalogue of the Minoan Gems in the Ashmolean Museum, Oxford, 1960; Corpus der kretisch-mykenischen Siegel, Ak., Mainz (in preparation). g. Metalwork: A. Evans, The Ring of Nestor, JHS, XLV, 1925, p. 1 ff.; A. Reigl, Zur historischen Stellung der Becher von Vaphio, in Gesammelte Aufsätze, Augsburg, Vienna, 1929, pp. 71–90; H. Thomas, The Acropolis Treasure from Mycenae, BSA, XXXIX, 1938–39, p. 65 ff.; R. A. Higgins, The Aegina Treasure Reconsidered, BSA, LII, 1957, p. 42 ff. h. Iconography and decoration: E. Hall, The Decorative Art of Crete in the Bronze Age, Philadelphia, 1907; A. Gotsmich, Entwicklungsgang der kretischen Ornamentik, Vienna, 1923; M. Oulié, Décoration égéenne, Paris, 1923; M. Möbius, Pflanzenbilder der minoischen Kunst in botanischer Betrachtung, JdI, XLVIII, 1933, p. 1 ff.; F. Matz, Torsion, Abh. Ak der Wissenschaften und der Literatur, Mainz, 12, 1951; A. Dessene, Le griffon créto-mycénien, BCH, LXXXI, 1957, pp. 203–15. A. Dessene, Le sphinx, étude iconographique, Paris, 1957. i. Guides and catalogues: L. Pernier and L. Banti, Guida degli scavi italiani in Creta, Rome, 1947; A. J. B. Wace, Mycenae: An Archaeological History and Guide, Princeton, 1949; J. D. S. Pendlebury, A Handbook to the Palace of Minos at Knossos, 2d ed., London, 1956; N. Platon, A Guide to the Archaeological Museum of Heraclion, 3d ed., Heraklion, 1959.

Nicolas PLATON

Illustrations: PLS. 53–74; 13 figs. in text.

**CRITICISM.** Art criticism is the process leading to a qualitative judgment on works of art and the product of that process. Commonly the term is applied to judgment of man-made objects from the esthetic point of view. Art criticism may be regarded as a branch of esthetics. Like literary, musical, and other kinds of criticism, art criticism is distinct from esthetics (q.v.) as such in that its purpose is to judge single works or groups of works, while esthetics is directed toward the evaluation of art in general, dwelling on individual works and on the artist's personality only in so far as they represent appropriate applications of the theory esthetics tries to formulate as a whole. Furthermore, criticism is distinct not only from esthetics but also from the philosophy of art, in that the latter aims at interpreting works, not assessing their quality, and discovering the nature, significance, and symbology of art in general. This distinction, however, does not imply any incompatibility or conflict. Every esthetic theory presupposes a body of criticism, and is expected to be applied practically in criticism, just as every criticism puts an esthetic theory into practice, and, in doing so, reinvigorates and modifies it. Criticism is always a practical manifestation of esthetics, even as esthetics is the theory of criticism. There is a similar reciprocity, though of a different type, in the relation between art criticism and the philosophy of art; generally, every interpretation implies a qualitative judgment already formulated by criticism and paves the way to other such judgments, while every evaluation of the quality of a work of art is always an implicit or explicit interpretation of the meaning and value of such a work. Art criticism, on the one side, and esthetics and the philosophy of art,

on the other, form a unified body, and it is, therefore, very difficult to find a criticism, an esthetics, or a philosophy of art in isolation. An investigation of art criticism will require constant reference to the allied fields of esthetics and the philosophy of art, in so far as they complete the framework of art criticism and illuminate judgment.

SUMMARY: Introduction (col. 115). Art criticism in the Western world (col. 118): *Antiquity*; *The Middle Ages*; *From the Renaissance to modern times*; *The rise of modern art criticism*. Art criticism in Eastern countries (col. 142): *Islam*; *India*; *Far East*.

INTRODUCTION. The qualitative judgment of which art criticism consists can take form either in words or as behavior, in the sense of individual or collective, private or public action with regard to one, some, or all of the works of an artist or a related group of artists or the artistic heritage of a given historical period. We can see criticism as behavior in public and private collecting, in the patronage of artists, in art dealing, and in the preservation and restoration of works of art. Criticism as behavior may be shown, at its extremes, by an idolatrous cult of certain works of art and the voluntary or careless destruction of others. These are the practical applications of a criticism, not always expressed as such, deriving from the theoretical, religious, philosophic, or political points of view which have inspired that behavior.

The procedures of verbal criticism are varied, but they may conveniently be divided into the two great branches of rational criticism and emotional and imaginative criticism. The former is the kind of criticism based on purely logical arguments and setting forth its judgments with rigor; the latter is the kind of criticism that rises from the reaction of esthetic pleasure or displeasure to the formal qualities of the work and manifests such feelings through literary media, such as essays, poetic or narrative writings, books of travel, and journalism. With these the writer strives to make the quality of the work more evident to the beholder or even attempts to suggest it to a reader who has never seen it, by means of a literary equivalent capable of arousing a feeling that is as near as possible to the emotion roused by the work in question.

The two types of criticism (rational and emotional-imaginative) cannot always be separated so clearly as to allow the classification of a critical piece of writing as unequivocally one or the other. The expression of criticism often mingles both approaches, and such a fusion takes place in varying manners. Very often formulations that are outwardly impeccably and even aridly rational, when carefully analyzed, reveal a pattern of approval or disapproval founded entirely on emotion or imagination. Sometimes a judgment rooted in a strictly rational process is manifested by means of images and allusive verbal suggestions. More frequently the two procedures are integrated, producing a continual and, sometimes, imperceptible passage from the rational plane to that of emotion and imagination and vice versa.

Such a variety of formulation in the expression of criticism — scholarly work on the one hand and poetry or imaginative writing on the other — greatly increases the sources to which one must refer in the study of art criticism. Their number increases with the addition of the texts necessary for the understanding of criticism in action, or, as we have called it, criticism as behavior.

We must actually discover anew the documents and the reasons underlying each critical action, ranging from the inventories of public and private collections to the documents in the archives tracing the successive ownership of a work of art; from the legal regulations concerning the preservation, or the damage and destruction, of one or more works of art to the political directives, religious prescriptions, and philosophic treatises from which those provisions and actions drew their ideological justifications. A brief examination of the sources constitutes, therefore, part of the preliminaries to any knowledge of art criticism.

The sources for the study of art criticism as expressed in words may be found not only in specialized works but also in philosophical treatises or in purely creative writings. It is not rare that letters and travel diaries are true collections of critical essays, in which the rational and emotional-imaginative processes alternate or are blended together indissolubly. At times the epistolary form is only a mask which the critic uses to allow himself a greater freedom of procedure and expression. The growth of written art criticism is, therefore, such that "art literature," rather than forming a section by itself easily classified in the literature of a country or an epoch, represents an inner aspect of the whole literary output.

The sources for the study of criticism in action consist not only of the documents of its activity and the theoretical enunciations by which it is inspired, but of the very works of art for what they are in themselves and for the state in which they have reached us. Every work of art reflects not only the esthetic ideals of its author, but also his cultural milieu, which would condition him according to the requirements of clients, the preferences of patrons, and the demands of the market. The present condition of any work of art of the past may represent a collection of critical judgments, revealed in such ways as the intentional damage, the restoration, or the overpainting to which that work has been subjected. Where works of architecture are concerned, not only their alterations, but also the willful transformations of their settings are to be considered as critical judgments. Each of those transformations is the "practical application" of an esthetic theory. Moreover, the appearance of cities is the result of successive critical judgments in action; the surveyor's maps, the plans, the views, the descriptions are documents for the history of such criticism, just as the documents relating to the fortunes and vicissitudes of a painting or of a statue are documents for the history of criticism in action.

When, besides verbally expressed criticism in all its variations, one also views the many and different aspects of criticism in action, the act of identifying and choosing the sources for the study of art criticism means no less than considering the connections between art criticism and the other fields of human activity: connections with philosophical and religious thought, with political ideologies and institutions, with literature, with the means of production, and with the social order. The reciprocity of these connections makes it possible to discover art criticism in other activities and to identify its features. Whether it appears independently or is implicit in other activities, art criticism is identified by a qualitative judgment. Even when emotional and imaginative criticism takes the form of purely literary creation, it is still criticism in that it formulates judgments on art. Verbal paraphrases, lyrical effusions, and imaginative passages are criticism only in the degree in which they effectively contribute to the recognition and the appreciation of the work under examination. The same must be said with regard to philosophy: the philosophical interpretation of a work is criticism if it helps to understand the work itself and appreciate its quality, but the philosophy, psychology, and sociology of art exist in themselves and are recognizable by their own specific characteristics. They are of interest from the point of view of criticism in the measure with which they imply a qualitative evaluation or contribute to such an evaluation.

Critical action — criticism as behavior — is always related to other human activities, exactly as verbally expressed criticism is. There is no social structure, no political upheaval, no religious movement that does not translate itself into a certain attitude toward works of art: preference for some and contempt (sometimes enacted in vandalism) for others. There is no policy of the arts, no public or private patronage, no buying or selling of works of art that is not the esthetic manifestation of a direction which also reveals itself in other aspects of life. The connection between such manifestations is a matter of cohesion and not of dependence; of reciprocally active influence and not mechanical causality.

In these connections also art criticism is the qualitative evaluation of the works which determines a mode of behavior with regard to them. Such critical action can promote the creation of works of art having certain features rather than

others. It can also, through deliberate destruction or neglect, provoke the disappearance of works of the past, selectively; and, by dint of restorations, alterations, and overpainting, it can tamper with works of the past to make them conform with new esthetic ideals.

In whatever way it proceeds and whatever means it has chosen in order to declare itself, art criticism is contemporary and coextensive with art itself and covers all art fields. Where there is art there is always a reaction to art, a choice and a judgment. There is an art criticism even when the literary output of a given period and place lacks writings classifiable as "art literature"; the absence of such writings does not necessarily indicate a gap in the critical consciousness. The absence or scarcity of verbally expressed criticism may, at a given moment and in a given place, point to a concentration of what we have called criticism as behavior, or criticism in action. The reasons may vary, but they are always related to the civilization of that period and place, to the character of the culture in which the civilization becomes conscious of itself. At other times it may happen that within the same historical framework there is an inferior and erroneous criticism in action at the same time as a verbally expressed criticism of a very high level, and that, vice versa, there may be critical actions more mature and better directed than the contemporary critical writings, which can be the slaves of prejudice, obtuseness, and the residues of a forgotten culture. In such cases we face particular manifestations, within art criticism, of the perpetual conflict between "cultivated" and "mass" consciousness (personified in turn in criticism as speech and criticism as behavior), which both struggle to dominate the "common" consciousness. Art itself cannot escape the repercussions of such a conflict, carried into the very heart of art criticism, with regard to both the treatment to which the works are subjected and the reception given to contemporary production.

Parallel alternatives are to be found in the character of verbally expressed criticism at various epochs and places. In certain situations one can notice a prevalence of rational criticism, while in certain other situations imaginative and emotional criticism prevails or is better orientated. The diversity and the inner complexity of criticism in action are no less important; private individuals, sometimes public institutions, whether civic or religious, or the great economic organizations hold in turn the initiative of such criticism. Naturally there follow clashes between direction and choice, parallel to those which we find between criticism as action and verbal criticism, or between the various aspects of the latter.

In every concrete historical situation art criticism takes on, therefore, a particular physiognomy, both with regard to the manner of critical action (speech or behavior and their interplay, imaginative and emotional writings, rational and critical action by individuals or by institutions, whether they concur or contradict each other, etc.) and with regard to the direction of taste, the criteria of choice, brought to bear on art of the past and new art. With regard to the art of the past, criticism chooses "touchstones" for its own tastes, leaving all the rest in darkness. Criticism is then guided by the standards thus epitomized in encouraging some aspects of contemporary art and opposing others. Beneath these changing and unpredictable choices there is a constant web of "forms" in which the inexhaustible novelty of experience creates an order.

We can say that the manifold and varied aspects of artistic experience are given order by art criticism, by means of the constant forms in which it takes shape. The measure of a work of art is given by its capacity to survive antithetical or opposing criticisms, each of which throws light on some aspect, unnoticed and unperceived in other critical attitudes. The validity of a certain type of criticism must always be assessed by its capacity to embrace, without any surrender of its own point of view and its own premises, as much art as is possible, thus adding something to the discoveries made by other types of criticism, based on other premises and considering that same art from a different point of view. The only task of criticism that can be categorically defined is to deliver, through words and actions, a qualitative judgment on works of art, and the only ultimate criterion according to which one may pass judgment on criticism can be found in its harmony with the esthetic requirements of the concrete situations in which the criticism is practiced. Outside of concrete situations, it is not possible to set up a scale of merit betwen the two methods of criticism and among alternative orientations of taste. In changing from one situation to another, procedures and critical tendencies which were foremost become obsolete and retarding. The task of clarifying the new values, simultaneously rediscovering the art of the past in a new light, requires other procedures, other points of views, other types of criticism, which in the former situation had not assisted or had even hindered the process.

An exhaustive definition of art criticism can present itself only as a description of its manifestations in the historical process; the assessment of what art criticism should be and how it should act is possible only in its reference to each of the individual and unique stages of this process.

Rosario ASSUNTO

ART CRITICISM IN THE WESTERN WORLD. *Antiquity.* Classical antiquity did not produce art criticism as an independent activity. It produced manuals of precepts concerning the techniques of sculpture, painting, and architecture and informative descriptions of works of art which rarely attained the level of historical and critical definition. This is partly due to the widespread opinion that, where art is concerned, critical judgment could only take note of the technical precision of the execution, contrary to the judgments pronounced on literature. As example, note *On the Sublime* (36, 3), by the Pseudo-Longinus: "In statues one looks only for the exact resemblance to the man, while in literature [one looks for] what transcends the human level."

Even in texts which are not concerned with criticism, but, rather, with problems of philosophic esthetics and historiography and in poetical and literary texts in general (J. Overbeck, H. Jucker, G. Becatti), one can find critical observations — not always lacking a love and understanding of art. An example of this is the description, in *Thyrsis*, by Theocritus (29 ff.), of a cup adorned with figures, which reveals the poet's ability to appreciate the expressive values in individual parts of a work of art. The same perception is to be found in Leonidas of Tarentum with regard to a statue of Anacreon (*Greek Anthology*, 304, 3); and in the lively account of the *Equus Maximus Domitiani* in the *Silvae* by Statius (I, 1, 46), describing vividly the agility and lively movement of the work. There is both intensity and good taste in Lucian's description of the beauty of the limbs of the Aphrodite of Knidos (*Amores*, 13).

The philosophers concerned with esthetics show a definite critical aim, but their remarks regarding art criticism are nearly always contained in discussions of philosophical esthetics on the model of the literary criticism which flourished in 5th-century Greece, particularly that of the Sophists. Already in Gorgias (*Encomium of Helen*, 18) we find the idea that painting and sculpture produce a "sweet malady," because they lift us into a world beyond reality, in which one believes in the existence of things that do not actually exist. Condemned by Plato, this deception of art was a source of admiration for Gorgias, who, however, did not develop his position critically; he was probably influenced by Pythagorean thinkers.

One must come to Plato to find a certain orientation of art criticism, though he also is given more to esthetic-philosophical considerations than to critical attitudes. More than once he attempts to identify the criterion of what is "suitable" (πρέπον) as essential for passing judgment on works of sculpture and painting. Socrates is asked by an imaginary questioner why Phidias made Athena's eyes in ivory, with centers of stone, and not of gold, which is a much more precious material. Socrates answers (*Hippias Major*, 290, a–e) that Phidias was right in using such a material, because it was "suitable" to that statue: in art beauty is to be found in what is "suitable" and ugliness in what is "not suitable." The idea of πρέπον seems to find definition in a strict realism and does not admit the possibility of an idealization of the model on the part of the representational

arts, as recognized, on the contrary, by Aristotle: "You must not believe," says Plato's Socrates, "that we must paint eyes of such beauty that they no longer seem eyes" (*Republic*, LV, 420, c–d).

According to Plato, the criterion of the "suitable" with regard to painting and sculpture becomes in the field of architecture the criterion of "precision." Because of it architecture, "which employs countless measures and instruments," is called the "most technical" of the arts (*Philebus*, 56, b) and, as such, is contrasted with music and literature. From this originated the belief in a continuous progress of the visual arts through the centuries. While, with regard to music, he believed in a decadence which was proper to his own time, when he came to sculpture he maintained that if Daedalus could have come back to life, he would have seemed ridiculous, owing to the progress made by sculpture in the 5th century B.C. (*Hippias Major*, 282, a).

Plato did not develop these critical remarks, particularly as his main interest was not in art. He, in any case, admitted that he admired literature more than the representational arts: "For those who are capable of following, any figure can be expressed by means of speech far better than by means of drawing or of any other work of the hand" (*Politics*, 277, c). Moreover, the greater part of his reflections on art derive from his convictions regarding poetry: Plato appropriates the saying of Simonides of Keos according to which painting is speechless poetry and poetry a speaking picture. Thus the whole of Plato's attitude with regard to a political and social appraisal of art — which is the subject of the well-known Books III and X of the *Republic* — is founded on notes of literary criticism, and only incidentally on observations pertaining to art criticism. The very opposite happens for the theory of art as deception of the senses, which is founded on reflections concerning pictorial art which aim to show that the painter imitates the imitation of the imitation and that he has no experience of the objects he imitates (*Republic*, X, 598, b–c; 602, c–d); this theory is then extended, by way of analogy, from painting to poetry. These, however, are reflections which concern esthetics rather than criticism.

In Plato's dialogues, apart from these philosophical reflections, which are closely bound to the system of Platonic metaphysics, one meets here and there critical remarks which, however, are only sporadic empirical observations. In the *Statesman* (277, a–b), for example, Plato criticizes the habit of certain painters who add "ornaments more numerous and larger than necessary"; in *Laws* (VI, 769, a–b) he seems, instead, to appreciate the pictorial technique consisting in "shading" the colors and making them "fade" (χραίνειν and ἀποχραίνειν). In any case, he generally interprets the visual images by analogy to literary images. This prevents him from developing a critical appraisal of the work of art.

In Aristotle we have a more adequate appreciation of art, particularly with respect to painting and sculpture. He differs from Plato in that he thinks that the artist can idealize his model and, while copying it, transform it into an image of a superior nature. For Aristotle such was the case of Zeuxis: "It is probably impossible to be one such as Zeuxis painted, but he painted better things [than us]; one has, in fact, to transcend the model" (*Poetics*, 1461, b). From this quotation one might say that Aristotle thought that art must always idealize the model; elsewhere, however (*Poetics*, 1448), he distinguishes three types of art without setting up any order of precedence: the art that idealizes and paints things better than reality, the art that makes a caricature and deforms reality, and, lastly, the art that reproduces reality faithfully. Aristotle cites Polygnotos as representing the first type, Pauson the second, and Dionysius of Colophon the third. However, he shows no preference for any of the three different types of art in this passage. In *Politics* (IX, 1340, a) he considers Polygnotos superior to Pauson for moral reasons. Elsewhere Aristotle draws a distinction between the painters who tried to represent not only the human figure but also character, and those who, on the contrary, did not trouble to be ἠθόγραφοι: he places Polygnotos among the former and Zeuxis among the latter, but does not

show a marked preference for either type of art (*Poetics*, 1450, a). With regard to the question as to whether drawing or color is more important in painting, he decides for drawing, in conformity with ancient tradition, and upholds the preeminence of the artist who draws only a white image (λευχογράφον) over the one who, instead, puts colors together without any design (*Poetics*, 1450, a–b).

But the essential value of painting and sculpture as seen by Aristotle — in conformity with his esthetic doctrine — is the perfection with which imitation of the models is achieved. According to Aristotle, the greatest pleasure to be got from a picture consists in being able to detect straight away "what each image is, or that this is such a thing" (*Poetics*, 1448, b). Aristotle himself raises an objection which alleviates the strictness of this absolute theory of mimesis: if the contemplator has never seen the model portrayed and has never seen anything like it, in what will his esthetic pleasure consist? In this instance he admits that it may reside in the "exactness of execution" (ἀπεργασία), or in the color, or in "some other cause of this nature" (*Poetics*, 1, c). There are also other passages in which Aristotle dwells on the value of color, especially of green (*Problems*, XXXI, 19, 959, a). However, the theory of mimesis allows him to justify "artistic ugliness" also in a well-known passage of *Poetics* (1448, b): "We enjoy seeing the representation of things we actually see with revulsion: for example, the images of the vilest animals and of the dead."

Aristotle does not appear to have applied his concept of catharsis to the representational arts: he developed that concept, according to the Pythagorean tradition, only in the field of music and literature. In the *Nicomachean Ethics* (11, 5, 1106, b), however, he stresses the need for even good artists to follow the right middle path; this brings us back to the esthetic ideal of συμμετρία, which in Aristotle is closely connected with the concept of esthetic catharsis. In any case, as far as art criticism is concerned, Aristotle has the advantage over Plato in having conceived the possibility of a mimesis which is at the same time an idealization of the model. He is, therefore, attempting through a process of abstraction to rise from single experiences to universal values. As with Plato, the esthetic valuation is always made with ethical and social values in mind; this is an attitude common to all antiquity.

The compendiums of precepts, known to us through Roman sources, were a determining factor for the orientation and the currents of criticism proper, which started in Greece during the 3d century B.C. As early as the 5th century B.C. (Galen, *De placitis Hippocratis et Platonis*, V, 425, 14) the sculptor Polykleitos had laid down the principles inspiring his art in the *Canon*: his norm of *symmetrica quadratio* was the culmination of the systematic study of problems of rhythm with which all the works of the Greek severe style were concerned. During the 4th century B.C. the school of Sikyon and the Attic, or Theban-Attic, school made decisive contributions to the perfecting of artistic technique, particularly in painting. The major exponents of the school of Sikyon were the painters and essayists Eupompos, Apelles, Melanthius, and Pausias, who propounded theories on the problems of color and chiaroscuro. To the Theban-Attic school, less academic and freer from tradition, belonged the artists and theoreticians Euphranor, Leonidas, and Nikias, who thoroughly investigated those problems of symmetry, light, and tonal and plastic effects which were to mark the passage from colored drawing to the so-called "impressionist" painting of the Hellenistic age and of Pompeii.

In the post-classical period the problems of art were considered from a new angle: chiaroscuro and perspective transcended the theory of mimesis formulated by Plato and Aristotle; the influence of the intuitive art of Lysippos left the artist's sensibility free to play with the illusion of perspective, which renders man's dimensions, not as they actually are, but as they appear. Thus a proper criticism came into being in the early 3d century B.C.: its founder was the Athenian Xenokrates, a sculptor trained in the school of Lysikrates, who followed the tradition of Lysippos. He was the first who — independently from any esthetic attitude — put the problem of art criticism on a concrete basis. According to Xenokrates any

judgment of value is based on the four elements which are the essence of foreshortening and perspective: symmetry, proportion, accurate technical imitation of nature, and incisive quality of individual forms. These are the four postulates which, as a criterion of analysis, ensure the historical validity of critical judgment and make it possible to trace the evolution of the problems of form. A follower of Xenokrates was Antigonos of Karystos (3d cent. B.C.), artist and author of a work on painting and sculpture. He stands out for the critical diligence with which he faced problems relating to the authenticity and the interpretation of works of art, examined the influence of schools among the various artists, and extended his search to the biographical and antiquarian fields. He showed the first signs of that tendency toward erudite criticism and encyclopedism of a Peripatetic and Stoic type which was to predominate in the late period of Greek culture.

The character of anecdotal and topographic literature is different. The history of art by Douris of Samos (3d cent. B.C.), a follower of Theophrastos, was not a proper critical history of the works of art, but a history of the lives of the artists, in which love for the anecdote and erudite information were associated with the taste for βίος (life) of Peripatetic tradition. No different was the tone of descriptive literature which came to the fore with the Athenian Heliodoros in the 2d century B.C. and, later, with Pausanias in the 2d century of our era. Pausanias' *Itinerary of Greece*, one of the few sources dealing specifically with ancient works of art, does not make any important contribution to criticism; the interest shown in the description of monuments and works of art is essentially topographic and documentary. His occasional judgments, influenced by the rhetorical emphasis of late Greek culture, are, substantially, the judgments of value expressed by classical criticism of Greek art. Though the artistic form of his work is rooted in the Ionic historiography of Hecataeus and Herodotos, in substance it belongs to the neoclassical critical trend whose major exponent was Apollodoros of Athens (second half of 2d cent. B.C.).

Art criticism, which seems to have progressed so much with Xenophon and Antigonos, declined in quality with Apollodoros' *Chronica*, becoming chronographical and classicistic. According to this vision, which was no longer dynamic, but retrospective (and, as R. Bianchi Bandinelli has pointed out, drew life from the political condition of the Greek states, by this time Roman subjects), Greek art had reached its apex with Phidias and Polykleitos, had decayed with the experiences of the artistic schools of the 3d century B.C., and had risen once again about 150 B.C. with the classicizing and academic movement of the Athenian school.

Such was the conception of art which Rome absorbed and took over on coming into contact with Greek culture. This classicizing conception found a fertile soil in the provincial and utilitarian culture of the Romans. The critical concepts which the Roman cultured class inherited from the classicizing theories of the later Hellenistic age were the abstract concepts of beauty, grandeur, worthiness, grace, truth, and genius (*pulchritudo, maiestas, dignitas, decor, veritas*, and *ingenium*). As Ferri has pointed out, they translated the corresponding concepts of Greek rhetoric, namely, κάλλος, μέγεθος, πρέπον, αὔξις, ἀλήθεια, and φαντασία. These theories assumed an ethical and educational aim in art taken as a faithful reproduction of nature and, therefore, were eminently suitable for the Roman mentality, with its practical disposition. Hence came the criteria of the useful and the pleasing, which were the basis for qualitative judgments, as well as the illustrative and decorative criteria of choice that inspired the collectors' taste (a full analysis of the critical tendencies and attitudes of Roman writers has been made by G. Becatti, 1951). Such criteria and taste characterized the personal evaluations of Pasiteles, an artist from Campania (first half of 1st cent. B.C.), who was the author of a large work in five volumes, the *Mirabilia*, which disseminated the history of art and the critical theories of the Greeks to the Romans. The same neoclassical trend was followed also by Vitruvius, *On Architecture*. This is a work of broad scope on Greco-Roman architecture, in which esthetic and rhetorical doctrines of the Peripatetic and Stoic schools are brought together and remolded into a rigid system, in harmony with the professional and poetical aims of the work. *Ordinatio, eurythmia, symmetria, decor*, and *distributio* are the esthetic canons on which the Vitruvian system rests. For instance, Vitruvius follows the criterion of *decor* in evaluating (*On Architecture*, 1, 2, 5) the architectural styles of buildings of a religious character (the Doric style is suitable for the gods of war, the Corinthian for the divinities of love, the Ionic for those of an intermediate character), but he turns to the criterion of *symmetria*, inspired by the Polyclitan canon of the symmetry of the human body, when he evaluates the proportion between the constituent parts of the same work and the degree of correspondence of each part with the shape of the general plan. But if Vitruvius almost reached art criticism when he commented on esthetic principles, though his personal contribution was limited to practical and utilitarian precepts, Pliny the Elder did not come near to art criticism. His review of artists and works of art in Volumes XXXIV, XXXV, and XXXVI of his *Natural History* has an amateurish character and the quality of a catalogue. Its value is of a documentary nature, in that it affords the most complete source for the knowledge of ancient art and the history of art criticism. Pliny mingles sources of very different character, such as Xenokrates, Antigonos, Douris, Apollodoros, rhetoricians, epigrammatists, Pasiteles, and Varro. The only ideas of value which constitute art criticism are those, taken from Xenokrates, with regard to the achievements of sculptors and painters, but in the rare instances in which he expresses personal ideas one can clearly see a neoclassical attitude in his interpretation of art history which is not historical, but static and of a mythical character. The criterion of mimesis as an exact reproduction of external reality is still dominant.

A new starting point can be found in Plotinus, who defended the representational arts against Plato's idea that they are mere imitations. According to Plotinus they are not confined to an imitation of what the artist sees, but are also an attempt to reach the concept from which reality itself springs. Moreover, the artist, who has an inner idea of beauty, adds thereto images which do not exist in external reality: thus the Zeus of Phidias was not the portrayal of an external model, since no such individual could be found in nature (*Enneads*, V, 8, 1). In any case, art never imitates the external aspect of things, but probes their soul; for this reason the pictorial representation of a living being always appears superior to that of a still life, for it really reproduces a soul (*Enneads*, VI, 7, 22). Plotinus must necessarily ask himself how one can represent with means belonging to the world of the senses an image that transcends the senses. He, however, maintains that the suprasensible can shine through the sensible; to give an example, the real aspect of a house consists in its intrinsic form, underlying the mass of stones and other materials (*Enneads*, I, 6, 3). These principles, however, constitute the mere embryo of a possible art criticism which he never developed. Fundamentally, Plotinus ended by always adhering to the old Aristotelian concept of symmetry: σύμμετρον καὶ ἀνάλογον καὶ τεταγμένον (symmetry, proportion, and regularity; *Enneads*, II, 9, 16). Nevertheless his theoretical reflections may be considered as the inspired forerunners of ideas which were to be fruitful for art criticism in later times.

Bruno GENTILI and Armando PLEBE

*The Middle Ages.* Between the Middle Ages and the ancient world stands St. Augustine. Although he tried to give philosophical reasons for his attitude, St. Augustine belonged to the late-antique period in mental formation and taste and expressed the preferences of that time. Elements of his esthetics reappeared in later centuries, producing, however, far freer orientations of criticism than those to which he was tied. The same attachment to the principles of taste of the ancient world can be found in the 6th-century writers Cassiodorus and Boethius.

As an art critic Boethius was still a man of antiquity, but the recognizable principles of his thought were to be taken up again in the following centuries. If we pass from Boethius

to Cassiodorus, the treatise *On the Soul* reveals an interest in the art of portraiture as a representation of psychological types, while from the letters that Cassiodorus wrote for Theodoric we can see the directing principles of the artistic policy of that monarch and, therefore, of his criticism in action. These consisted in an acceptance of the artistic heritage of the past as a treasure to be cherished and brought back to its original splendor and in the continuity of contemporary artistic production, which was to be encouraged, so that it might equal that of the past and even surpass it. A similar situation can be observed in the field of Byzantine culture. In this the formal interest of the work of art, stressed by Schlosser as a characteristic trait differentiating it from the West, has to be related to the unbroken continuity of Byzantine culture as compared with the violent changes occurring in the east Greek culture of late antiquity. Procopius, Paulus Silentiarius, and the Patriarch Photius have handed down the more significant documents of this formal interest, which also involved an appreciation of the artist's ability.

In western Europe during the "dark" centuries there was a complete break with the ancient world. This showed itself in an appreciation of the quality of the material with which the work of art is made rather than in an appreciation of the ability of the craftsman. This appreciation of material rested mainly on its capacity to receive and reflect light; the artistic form was praised according to the degree with which it revealed the capacity of the materials to capture, preserve, and multiply the luminosity of the universe, the materials themselves being valued in proportion to their splendor. In several tituli (notices) compiled by Venantius Fortunatus the stress is placed on the luminosity, the solidity of buildings, the splendor of material; the proficiency with which artists portray nature is praised only occasionally — "artificemque puto hic animasse feras" ("the craftsman seems to have made the animals come alive") — and on these occasions one notices a taste for realistic representation, a conception of art as an imitative ability for purposes of decoration. In a few tituli of the *Tabula insigniorum mansionum Monasterii Sancti Galli* ("The Guestbook of the Monastery of St. Gall") we notice, however, a certain admiration for allegorical pictures, which, from the formal angle, allow a far greater liberty of imagination. It is possible that both naturalism and intellectualism with its predilection for allegory contributed to form the taste of pre-Carolingian Europe and that, although at variance with one another, the two principles were reconciled in the imaginative and colorful compositions adorning sacred buildings.

We can recognize in these critical tendencies the practical application of a theory formulated by Isidore of Seville, who placed *venustas* (beauty) next to the other two fundamental elements of architecture — *dispositio* and *constructio* — and defined *venustas* as "quidquid ornamenti et decoris causa aedificiis additur, ut tectorum aurea distincta laquearia, et pretiosi marmoris crustae et colorum picturae" ("that which is added to a structure for ornament and decoration, viz., the gilt paneling of roofs, precious marble inlay, and painting in color"). As to painting, Isidore says that it is a fiction destined to help memory which must keep faithful to the reality of the things it portrays.

A century later came the work of the Venerable Bede, who proceeded along lines similar to those of Isidore. Like him, Bede seems to have a great love of color, which in those days was common to both the supporters of realism and the partisans of deformation and fantastic abstraction. The only exception, in the ecclesiastical field, consisted of a few rigorists such as St. Donatus the Bishop (7th cent.). But these manifestations of rigorism, in the 7th and the 8th centuries, were the first skirmishes of the theological and esthetic controversy concerning images. The controversy was to last more than a century, from 717 to 842, and did not affect only the Byzantine-Oriental area but spread to western Europe, giving birth to new artistic evaluations, more or less explicitly stated in the theological-metaphysical context in which they were inserted (see IMAGES AND ICONOCLASM).

The fight against the cult of images which the emperor Leo the Isaurian started was urged not only by a stern religious conscience, which was angered by idolatry, but also by an esthetic orientation, whose origins are to be traced back to Greek antiquity (Plato) and to eastern patristic literature, that is, to the notion that Godhead cannot be represented by images. This eventually brought about the replacement of sacred images with other symbols, possibly implying a different formal and stylistic orientation. Problems of this kind, however, were not unknown to Western culture; even in the 7th century St. Gregory the Great had perceived the necessity of using images as signs similar to writing, that is, for the instruction of the illiterate. Their quality was to be judged with reference to the finished work and not to the initial outline or sketch, thus proclaiming the supremacy of color over design.

Going back to the opinions expressed by Gregory the Great, Gregory II insisted on the emotions stirred through contemplation of the images. We may detect in him a critical judgment of the paintings which is based on psychology and literary content. A similar attitude was taken by Adrian I, who replaced the love for beautiful material and colorful decoration, typical of the preceding generations, with an interest in the power of suggestion of the painted images, in so far as they are the means which allow one to go "per visibilem in invisibilem" ("through visible to invisible things").

Charlemagne did not keep out of the controversy about images. He made a clear distinction between the image and the idol, which differ in the same way in which the representation of things and the embellishment of a place differ from things which neither represent nor adorn but are the object of worship in themselves, in all their primitive materiality. Also, an image is different from an idol because its workmanship may vary qualitatively, according to the ability of the craftsman, whereas no esthetic judgment can be brought to bear on idols. Moreover, the judgment on the quality of images must be related to their function, which is that of decorating, while evoking real things. For Charlemagne and his court, beauty and truthfulness are a single thing: all that excites fantasy beyond the limits of reality is untrue and, therefore, cannot embellish. Authors such as Theodulph of Orléans and Sedulius Scotus have left us examples of description and evaluation of works of art attuned to the taste for realism and for classicism which was typical of Carolingian culture.

The appreciation of the freedom of imagination in artistic production was to receive fresh impulse from the introduction in the West of the writings of the Pseudo-Dionysius and the philosophy of Johannes Scotus Erigena, who translated the former, developing further his "visionary theology," centered on the symbolic-allegorical interpretation of natural forms and on the imaginative creation of new forms, whenever the patterns of nature did not seem adequate to express allegorically the truths of human thought. As a result of these principles, in his *On the Division of Nature*, Erigena shows an implicit understanding of art criticism when he writes that beautiful things must be admired without desire, as their beauty is an act of praise of the Creator.

The severance from the barbaric taste, which valued material more than anything else, increased in the 10th and 11th centuries. From the *Chronicon Thietmari Merseburgensis* ("Chronicle of Thietmar of Merseburg") we learn that Conrad II offered to the church of Kaufungen a wooden cross "parvam quidem in materia, sed maximam in virtutem" ("modest in material, but great in virtue"), while in the *Versus super Romam* ("Verses on Rome") by Hildebert of Levardin, we read that the images of the ancient gods were worthy of veneration not because of their false divinity but because of the artistry of their creators. During the 10th and 11th centuries criticism in action acquired special relevance, as it was practiced by religious orders, and particularly by the Benedictines of Cluny, to which belonged the chronicler Raoul Glaber. The *Historia sui temporis* ("History of His Times") by this writer has left to posterity one of the oldest testimonials regarding the artistic renewal of the 11th century. Almost contemporary with this celebration of the splendors of the Cluniacs is that of the Benedictines of Monte Cassino, contained in the *Chronica Monasteri Cassiniensis* ("Chronicle of the Monastery of Monte

Cassino"). Here the idea that the beauties of Rome should be a standard for all artistic renewal is accompanied by the conception of Constantinople as the inheritor of Roman culture. The same concepts emerge from the *Carmen in laude Desiderii abbatis Cassiniensis* ("Song in Praise of Desiderius, Abbot of Monte Cassino").

Very soon there arose rivalries between the various religious orders, which influenced their respective artistic preferences. One of the most notable examples of such rivalries was the conflict between the Benedictines of Cluny and the Cistercians, of which Bernard of Clairvaux was an authoritative exponent. In the twelfth chapter of the *Apologia ad Gulielmum sancti Theodorici abbatem* ("Apologia to William, Abbot of Saint-Thierry") Bernard opposes fiercely the esthetic tendency advocated by the monks of Cluny and the town bishops. This writing is one of the most lively documents of critical controversy of the Middle Ages. It contains a perspicacious and detailed description of Romanesque sculpture, which Bernard does not consider worthy of monks. To this art Bernard opposes another ideal of beauty, theoretically defined in the *Sermones super Cantica canticorum* ("Sermons on the Song of Songs"): the ideal of a *spiritualis effigies* ("spiritual likeness"), which was to be attained through the simplicity and the purity of shape of the Cistercian oratories.

The critical ideal of Abbot Suger, who built the basilica of Saint-Denis, was totally opposed to that of Bernard, notwithstanding their friendly personal relations. In opposition to Bernard, Suger placed the richness of the decorations, of the sculptures, of the gilding, before pure spatial composition. He upheld the necessary continuity of the pictorial decorations and of stained-glass windows. He cited as an example the beauty of Hagia Sophia, which pilgrims had repeatedly described, revealing his intention to build a basilica which was to be for the French monarchy, on the verge of asserting its own power, what Hagia Sophia was for the Byzantines.

With the Abbot Suger and his work a new center of artistic activity asserted itself. It was parallel to and sometimes clashed with the papacy, the Holy Roman Empire, the religious orders: it was the French monarchy, whose tastes were to find their theoretical premises not only in the writings of Suger, but also in the thought of the Canons Regular of St. Victor and of the masters of the episcopal school of Chartres.

Hugh and Richard of St. Victor took up and developed Erigena's conception, exalting the allegorical and symbolic significance of all the beauties of the world. Their esthetic ideal, which was to be appropriated by the supporters of Gothic art, turned on the concept of beauty "compacta ex multis concurrentibus in unum" ("formed through the commingling of the many in the one"), of beauty which "secundum spatia locorum explicatur, per figuras ex multis coaptatas videtur" ("unfolds in space, in appropriate figures deriving from many elements"), of beauty not "simplex et uniformis" ("simple and uniform"), but "multiplex et varia proportione conducta" ("complex and various in proportion"), allowing the concomitance of unlike things.

Another aspect of Gothic art — fidelity to natural forms — was to be appreciated, in the second half of the 12th and in the first half of the 13th centuries, by the culture promoted by the Chartres philosophers Thierry of Chartres and William of Conches, who theorized on the autonomy of nature as such, which deserves to be studied and observed for and by itself. Hugh of St. Victor started the theoretical preference for lively and brilliant colors which was to mark the 13th century's predilection for miniatures and stained-glass windows. The optical studies of the Pole Erazm Ciolek (Vitello or Witelo), who continued the work of the Arabs and of the Englishmen Robert Grosseteste and Roger Bacon, gave further support to this preference.

According to Ciolek, light and color are the visible *par excellence*, while sight alone is not sufficient to distinguish the light from the dark. Visual pleasure is enjoyment of light and color, and only of light and color. Other elements contribute to beauty besides color, which must be even, pure, and without halftones; they are the sound distribution and placement of objects of various colors, the conformity of shapes to their geometrical requisites, and appropriate dimensions.

The pictorial ideal of a taste culturally based on Ciolek's optics found expression in stained-glass windows and in miniatures, the latter, by their abundant use of gold, aimed at achieving by their particular means the same effects of intense luminosity that are produced by light in stained-glass windows.

Grosseteste acknowledged the utmost beauty in light as such. According to him, light propagates in a straight line. This notion was congenial to English taste, which shaped a transformation of Gothic architecture in which the rectilinear propagation of light plays a decisive role, together with that unity of multiplicity theorized by Grosseteste as beauty of the "multiplicatio et variatio universorum" ("multiplication and variation of the whole").

The oldest critical document of English Gothic architecture is the description by Gervase of Canterbury in his *Chronicle* of the fire which destroyed the first Canterbury cathedral and of its reconstruction, in which French craftsmen were employed. In the course of this description Gervase dwells at length on the manner in which the new church differs from the old one and on its greater wealth and variety of ornaments.

A contemporary of Gervase of Canterbury was the monk Helinand, who left a description of the Church of St. Gereon at Cologne, in which he praises its columns, its varied ornamentation, and its glittering gold decorations. All these elements, side by side with architectural complexity, are given a place in the *Mitrale Seu de officiis ecclesiasticis summa* ("Summa of the Ecclesiastical Offices") by Sicardo, bishop of Cremona. A few decades later the chronicler Burckhardt of Halle expressed a feeling of novelty no different from that found in the chronicle of Gervase of Canterbury. Burckhardt spoke of the astonishment and admiration with which the Germans considered the Gothic architecture imported from France, with all its variety and magnificence, in contrast to the austerity of the Romanesque style which the Salic and Swabian emperors had preferred even at a time when Gothic architecture was flourishing in France. An appreciation of Gothic art and of its daring architectural forms can be found in the various references to the art of building scattered in the philosophical works of Albertus Magnus.

Some other indications of the taste of Albertus Magnus and of his influence on the artistic culture of the Rhineland are to be found in the ideal of feminine beauty which he upholds and describes in *De Laudibus Beatae Mariae Virginis* ("In Praise of the Blessed Virgin Mary") and in the *Mariale, Sive quaestiones super Evangelium* ("Questions Concerning the Gospel"): a beautiful forehead, high and white, cheeks like pomegranate segments, a small nose, ruby lips, a neck like a column, straight or sweetly inclined, according to the posture, and small, white hands.

Master Eckhart also considered Gothic architecture and sculpture. For him the tendency to verticality in Gothic architecture was an image of the never-ending presence of God and of his incommensurable distance from the world of creatures, who endeavor to reach him by rising as sparks, in the same way that the figures carved on the façade of the Cathedral of Strasbourg seem to climb up. Eckhart was acquainted with the cathedral both as a plan and as a building in course of construction. He said that works of art are the speech of the artist, the word through which he expresses and reveals himself and all that belongs to him in so far as he is an artist. According to Eckhart, the quality of the work of art does not consist in its relation to an external model, but rather in its capacity to express the image that the artist has in his mind, whether or not he has a model before his eyes. The intellectualism of Albertus Magnus and the mysticism of Eckhart are two ways of reacting critically to the Germanic-Rhenish version of Gothic architecture, sculpture, and painting, even as Grosseteste's and Roger Bacon's philosophy of light and number allow us to detect a critical orientation reflecting the character of Gothic art in its English version.

In all these cases we meet examples of the organic structure which characterizes medieval culture. Medieval philosophical

thought aspired to the compilation of encyclopedias, in which all human knowledge could be organized according to the same principles in any field, and to a reciprocal interplay which rendered any autonomy unthinkable. In the same way, in the medieval way of thinking the arts were techniques of which human thought availed itself in order to express conceptions and to give actual form to the same attitudes that found verbal expression in philosophic treatises, sermons, and poems, in a rational or emotional and imaginative manner. For this reason the arts as such were usually counted among the manual, or mechanical, activities. The artist was the craftsman, the technician to whom the thinkers would resort, giving him suitable instructions, so that he might give actual form to their conceptions. The choice of one craftsman, or one group of craftsmen, rather than another, was itself an act of criticism, a valuation of an artistic personality. The choice depended on whether the proficiency and the tendency, or theory, of this or that organization of builders made them appear to be the most suitable to give material form to the conceptions the creators had in mind. Thus, William of Sens was called to work on Canterbury Cathedral, and the commission to build the Collegiate Church at Wimpfen, Germany, was given to a stonemason well versed in architecture, "qui tum noviter de villa Parisiensi e partibus venerat Francie" ("who has recently come from the city of Paris in France"). This was a manifestation of criticism as the choice of a taste, of an idea, and of the most suitable person.

Villard de Honnecourt's *Sketch-Book* is a technical manual which includes ideals of taste and precise judgments of quality. With their theories and their writings Villard de Honnecourt and Vincent de Beauvais express the taste of the French monarchy and of the ecclesiastical and secular milieus which were bound to it. The Angevins brought this taste to the south of Italy as the artistic aspect of their attempt to set up a monarchy modeled on that in France. Nevertheless they gathered, in this attempt, the heritage of the Normans and Swabians, whose artistic policy had not been dissimilar to that of the French sovereigns, inspired by the ideas of Suger.

The Cathedral of Cefalù, Sicily, begun in 1131, bears the name of King Roger, the sovereign who ordered its construction. But in the *Chronica civitatis Januensis* ("Chronicle of the City of Genoa") by Jacopo da Voragine, written in the late 13th century, we read, in connection with the construction of S. Lorenzo in Genoa: ". . . credimus autem quod opus tam somptuosum et nobile . . . fecit comune Janue et non persona aliqua specialis . . ." ("for we think that a work of such sumptuousness and nobility was made by the commune of Genoa and not by any one person"). Some years before, the monk Salimbene of Parma had expressed himself in similar terms with regard to the works of art of his own city. He attributed the initiative to the people of Parma and not to this or that single person. In Italian towns the commission of a work of art was given by a council; the signature, which in the inscriptions and minutes of the abbeys had been that of the abbot — St. Odilon at Cluny, William of Volpiano at Dijon, Suger at Saint-Denis — and in the documents of the monarchies had been those of sovereigns, was gradually replaced by that of the craftsman, whose name, inscribed on the façade of a church, could not entail any danger to the delicate balance of power on which rested the constitution of the communes. Artistic activity proper began to shed its anonymity. Creative conception and execution tended to be identified with the activity of a single person. Henceforward criticism began to be a distinction between the personalities of artists, and not a mere description of objects. It was, therefore, in the Italian cities that a new conception of art ripened, centered on the personality of the individual as inventor and executant of the work. Criticism now became a judgment of the work taken as an individual creation. The concept ripened slowly in the late Middle Ages, but once it had become completely defined and had reached explicit consciousness, thanks to Humanistic culture, it found a conclusion in the conception of art as *disegno* — a mental operation of the artist, who devises his work and then realizes it materially — and in the notion of art as independent from the manual, or mechanical, arts, among which it

had been placed by the culture of the Middle Ages proper by virtue of the distinction between the creative thought of one person and the material execution entrusted to the craftsman.

In Italy the personality of Dante dominated the 14th century. In his works are summarized all the concepts and the critical predilections of medieval culture. With regard to that culture, considered as a whole in spite of its variety, and not restricting it to its Thomistic-Aristotelian phase, Dante appears as the inheritor who recapitulates its aspects and themes, fusing them in a cultural synthesis in which each has its individual place and contributes to the physiognomy of the whole.

Specific art criticism is seen in the judgments made by Dante in the eleventh canto of the *Purgatorio*. From them emerges a valuation of art as an individual creation, characterized by the personality of the maker and by his ambition to achieve prominence. This shows that Dante had an awareness of art as a personal activity, as the expression of the quality and value of the individual.

In the *Convivio* Dante expounds his ideas about art, which cling to the traditional concept of the "mechanical arts" as operations which "our reason considers and carries out in matter which is external to it." What is more revealing is the fact that Dante attributes "virtue" and, therefore, "nobility" to the practice of the mechanical arts as well, notwithstanding the difficulties imposed on them by the material and the hand called to work on such a material. The artist, even as a practitioner of a mechanical art, is not, in Dante's conception, a mere instrument of the creative ideas of others or the more or less anonymous collaborator in a group production. He is himself the creator of the forms which his hand imposes on the external material in spite of its resistance.

Besides such judgments and conceptions, one finds in Dante a critical penetration into the spirit of art, of which he had direct experience. The *Divine Comedy* itself is a historical retracing of medieval theories of art.

The concept of art as a personal activity constituted the theoretical acquisition of the Florentine 14th century. It was the beginning of criticism as a definition of personality and not only as a description of objects. Boccaccio's judgment on Giotto compares an art which "pleases the eyes of the ignorant" with another, such as Giotto's, which "satisfies the intellect of the wise." The former is alluring to the senses and, as such, is barbaric, while the latter, based on a creation of the mind, and not on the materiality of colors, points to a civilized maturity. This implies the assumption of *disegno*, or conceptual form, as the foundation of art; in the course of the preceding centuries such ideas had appeared sporadically, but in 14th-century Florence it became common property.

The development of the theory of *disegno* as the central principle of art proceeded side by side with the recognition of art as a personal activity. The concept of the artist as simple technician, whose task was to realize ideas formulated by others in a given material, was rejected. The absence of individuality which was characteristic of medieval culture came to an end in 14th-century Florence. Art was now recognized as a specific activity, having a life and a history of its own. When this awareness was reached, the history of criticism began to be established as a separate subject, although at first it was not completely distinct from anecdotal and encomiastic literature. The history of criticism, moreover, can be understood through specific critical sources and need not be reconstructed from fragmentary or incidental remarks. Encomiastic literature takes as its subject the personality of the artist as such, whereas prior to this time, even when praising a work of art, it was centered on the personality of the patron, and the craftsmen were barely mentioned or not mentioned at all. The last, chronologically, of the medieval technical manuals, *Il Libro dell'Arte* (*The Craftsman's Handbook*) by Cennini, is different from its distant predecessors, Heraclius and Theophilus, precisely in the degree to which it forms part of this culture. At the very start Cennini gives a brief historical outline of art, in which he shows his awareness of the esthetic ideal which inspired the technical precepts contained in his treatise: "Il quale Giotto rimutò l'arte del dipignere di greco in latino e ridusse al mo-

derno; ed ebbe l'arte più compiuta che avesse mai nessuno."
("The said Giotto changed the art of painting from the Greek
to the Latin idiom, making it modern, and possessed the most
complete craftsmanship anybody ever had").

In conclusion, in the criticism of the Florentine 14th cen-
tury the following factors stand out: the artist's personality
as a subject of critical judgment; the conception of art as "li-
beralis," and no longer as "mechanica," together with the
acknowledgment that those who practiced it had that "in-
genium" and that "traditio" which the second Council of
Nicaea (787) had reserved for the patrons; finally, the first
appearance of a criticism which, rather than describing things,
set itself the task of defining personalities.

*From the Renaissance to modern times.* Together with a
study of the literature of the 15th century containing com-
mentaries on works of art and artists, principles, standards
of taste, and esthetics in general, which assumes an importance
and a relevance unknown in the Middle Ages, we must con-
sider another kind of criticism, brought about by the increasing
interest in collecting works of art (see MUSEUMS AND COLLEC-
TIONS). The principles and concepts inspiring and guiding this
second type of criticism are to be found not only in the works
of art chosen by collectors, but also in inventories, in collections
of letters, in memoirs of persons directly or indirectly con-
cerned in collecting activities, and in the reminiscences of
travelers.

The presence, or absence, of a widely spread literature con-
sciously dealing with art criticism constitutes one of the features
which differentiate the Renaissance from the "waning of the
Middle Ages," as defined by Johan Huizinga (1924). The
Renaissance had its center in Italy, and from Italy its principles
of taste and its esthetic concepts spread throughout Europe;
the waning of the Middle Ages had its center in the Franco-
Burgundian area.

The existence of a literature dealing exclusively with art,
the very concept of which had been unknown to the preceding
centuries, is an indication of the growing appreciation of art
and gives us a clue to the nature of the esthetic ideals of the
Italian Renaissance. The new way of looking at art sprang from
two sources: from the growth of individuality of style and
from the fact that art was rising above the level of mechanical
skills and crafts. The artist in his study of mathematics and
science began to take on the attributes of the philosopher. Two
concepts can be identified as playing an essential role in critical
thought and as leading to this development: the concept of
nature (see MIMESIS) and the concept of geometry (see PRO-
PORTION). The most important principle from which both
these concepts emanate is that of art as *disegno*, a rational,
intellectual process.

The reinstatement of Roman antiquity as the supreme
esthetic ideal was another fundamental idea of the Italian Ren-
aissance. This turning toward antiquity and Rome differed
from the allusions to the classical world which had been fre-
quent during the Middle Ages in that, in the Renaissance, we
have a conscious break with the past, a decline and a collapse
of values which had never occurred in the Middle Ages, since
medieval culture considered itself as a direct continuation of
Roman culture, whose tradition was immediately recovered after
suffering temporary periods of eclipse. In the 15th century
the revival of the esthetic standards of the ancient world took
on the aspect of a crusade against the more recent past whose
culture was considered valueless, true culture (see TRADITION)
belonging only to antiquity.

In connection with the concept of art as an individual
occupation, a concept which had already made its appearance
in 14th-century Florentine criticism, we have the first appear-
ance of art history. The artist was no longer judged from a
moralistic standpoint, but through a critical study of his works.
An example of this is to be found in Lorenzo Ghiberti's *Com-
mentarii.* Ghiberti, in stressing the importance of the rediscovery
of antiquity and in his hostility toward medieval culture,
illustrates in this work two important elements in Italian 15th-
century criticism. The life of Brunelleschi attributed to Antonio

Manetti is another example of a critical biography, written
from a point of view completely foreign to the spirit of the
Middle Ages.

The concept of *disegno* finds theoretical expression in Leon
Battista Alberti's *Trattato della Pittura* (*On Painting,* ca. 1435).
The introductory letter in which the author dedicates this
treatise to Filippo Brunelleschi contains his critical views on
the works of contemporary artists, the first among whom is
Brunelleschi himself. Alberti states his belief that geometry
is the very basis of the art of painting; this concept was found-
ed, to some extent, on optical theories following the principle
of the rectilinear propagation of light elaborated by Robert
Grosseteste. *Disegno,* conceived in almost Platonic terms, is
declared by Alberti to be the principle by which one may
distinguish good paintings from bad ones. In another treatise,
*De re aedificatoria* (*On Building,* VI, 2), Alberti gives his idea
of architectural beauty: "I shall define beauty to be a harmony
of all the parts . . . fitted together with such proportion and
connection that nothing could be added, diminished, or al-
tered but for the worse." This is in direct contrast with the
medieval principle *multiplicatio et variatio universorum* (the in-
finite multiplicity and variety of all things). The identification
of geometry with the very essence of art was to find another and
more complete affirmation in *De prospettiva pingendi* (*Of the
Perspective of Painting*), in which Piero della Francesca declares
that art and science are one and the same, an ideal which domi-
nated the Italian Renaissance.

Outside Italy, the prevailing critical attitude toward paint-
ing and architecture remained unchanged; in the former, color
and not *disegno* continued to be considered the most important
attribute, and in the latter the *mutiplicatio et variatio universo-
rum* was the guiding principle. Corresponding to the diffe-
rence between these esthetic ideals, there was also a difference,
in 15th-century Italy, in another aspect of criticism in action,
the beginning of a new point of view toward collecting works
of art (see DEALING AND DEALERS; MUSEUMS AND COLLECTIONS;
PATRONAGE).

This interest in collecting, at the close of the Middle Ages,
marks the beginning of an appreciation of art for its own sake:
a work of art is valued for its intrinsic worth. The Medicis,
beginning with Cosimo the Elder, may be considered among
the first great collectors, since their choice was guided by the
quality of the works of art themselves, and not by how well
they fitted into the palace hall or chapel for which they had
been commissioned. With the example of the Medicis, it became
fashionable to own a collection, and the ability to appreciate
works of art and to judge them according to their true worth,
that is to say, the ability to exercise critical judgment, became
necessary qualifications for anyone who aspired to that social
distinction conferred by wealth, of which art had become an
attribute. The concept of art and of its social and cultural
importance as it was understood in Florence at the time of the
Medicis spread rapidly, spurred on by the spirit of competition
existing between the Italian city-states, bestowing its imprint
on a whole civilization. Collecting and patronage diffused
through all the cities of Italy a new kind of critical literature
dealing with art, which together with the criticism in action
previously described, acted as mediator between the collector
and the artist.

The principles guiding the collector's choice were similar
throughout Italy. Canons of taste, however, varied, just as
the social importance and the contacts with the outside world,
its customs and esthetic ideals, varied between city-state and
city-state. A preoccupation with theory was not an essential
part of patronage in northern Italy as it was in Florence. The
taste of the northern patron was still bent toward heraldry,
exuberant and full of color, typical of the nearby Burgundian
region and of northern Europe in general. Filarete (q.v.)
in his treatise on architecture criticizes this taste, comparing
antiquity with what, to him, living as he did in Milan, was the
decadence of the "modern" or Gothic style. In this same work,
Filarete gives his opinion of contemporary artists, culminating
in a eulogy of the Florentine artists of his own generation.
Once they are dead, he exclaims, it will be difficult to find

others capable of taking their places. Next to the Florentines, but in a lower category, Filarete places a few northern Italian artists, Squarcione and Cosimo Tura; Flemish artists, Jan van Eyck and Rogier van der Weyden; and a French artist, Gracchetto (perhaps Jean Fouquet). There is another reference to Flemish artists (again specifically to Jan van Eyck and Rogier van der Weyden) in Giovanni Santi's apology in verse to Federigo da Montefeltro. The only interest this work holds for us is in its description of the life at the court of Urbino and of Federigo as a patron of the arts. Toward the end of the century the *Hypnerotomachia Poliphili* by Francesco Colonna was published in Venice. This provides the basic documentation on art criticism in 15th-century Venice. Here the approach to criticism is emotional and imaginative rather than rational, and the feeling for antiquity, considered "sancta e veneranda" ("sacred and to be revered") in that it has been tested by time, has a lyrical quality. Nature, too, is treated lyrically, as being at the same time both a mother and a stepmother. This poetic tendency was characteristic of Venetian taste in art, a sharp contrast to the Florentine taste, which was based on a scientific and intellectual approach.

Leonardo also considered art a science: the fact that it springs from the senses and ends in a manual operation was, for Leonardo, a proof of the scientific nature of painting, intellectual and experimental at the same time. To him painting was based on the relationship between light and shadow, on the "chiaro e scuro," while both drawing and color were of secondary importance. Leonardo's influence on the critical attitude of both artists and public is proved by the transformation which took place in the Lombard taste through his efforts. Of similar significance is the transformation which Michelangelo's critical thought was to bring to the taste and culture of central Italy.

The origin of art, according to Michelangelo, can be compared to Eros (Love), who falls in love with earthly beauties because they are the reflection of absolute beauty. From Eros comes the urge toward art, which tries to catch this elusive flash of absolute beauty and to fix it forever in material form so that it may conquer the mortality of the flesh, whose "life is but a lame one," running as it does, inevitably, toward death. Painting and sculpture are bent on the same task: to reveal the beauty of the human form. By giving this common ideal to both painting and sculpture, Michelangelo, in a letter to Benedetto Varchi, explains his stand in the argument over the supremacy of the arts, a point frequently discussed at that time. These concepts, voiced by Michelangelo and his admirers and followers, mark the beginning of a critical trend which bases its judgment on a tragic and uncompromising ideal; an ideal which is characterized both by the artist's knowledge of the difficulty of realizing in plastic form a beauty whose essence can be caught by the mind alone and by his rejection of the embellishments which can please the eye.

While Michelangelo was formulating these concepts, the expression of an uncompromising esthetic ideal, Castiglione was expounding theories more lenient toward the tendencies of the times. His book, *The Courtier*, is interesting for the art critic because it reports the criteria by which literary men and gentlemen of the same social position as the author judged art and artists: "Behold in painting Leonardo da Vinci, Mantegna, Raphael, Michelangelo, Giorgio da Castelfranco (Giorgione): they are all most excellent doers, yet are they in working unlike, but in any of them a man would not judge that there wanted aught in his kind of trade; for every one is known to be of the most perfection after his manner."

The opinions held by the people taking part in Castiglione's imaginary conversations at the court of Urbino, one of the most active centers of art collecting and patronage of Renaissance Italy, reflect above all the general tastes of the gentleman-collectors and of the experts who formed part of their entourages. For this reason the tone is relaxed and there are no impassioned diatribes such as are found in works of criticism written by artists themselves.

The anecdote of the painter Zeuxis who selected five virgins from the city of Croton as models for his famous image of Helen of Troy is often quoted in works of 15th-century criticism. There are references to it in both Raphael and Castiglione, and a full account is also given by Paolo Pino in his *Dialogo della Pittura* (*On Painting*), published in Venice in 1548. Pino sets down the canons of taste then dominant in Venice, which Pietro Aretino had already commented upon in his letters, and which, a few years later, were taken up by Lodovico Dolce. Dolce, speaking of the painters of central Italy, distinguishes Michelangelo for his "terribilità" and Raphael for his "grazia."

The chief aim of painting is, according to Pino, "to make figures in imitation of nature," and in this imitation of nature, which includes the human figure, landscape, and architecture, the "god of painting" would be he who combines the draftsmanship of Michelangelo with the color of Titian. Through their use of color, which Pino would like to see fused in a kind of synthesis with drawing as conceived by the Florentines, the Venetians expressed a critical taste reflecting a culture quite different from the humanistic culture of Florence. Saturated with Platonism, the latter, with its emphasis on drawing, stressed the intellectual, not the sensual side of painting; in Venice, the marked taste for color was expressive of a less intellectualistic culture which sought in art the vital appearance of nature and not the reflection of an intellectual truth.

In contrast to its significance in medieval painting, color, in the critical thought of Renaissance Venice, stood for faithfulness to nature as it is felt through the senses. As the Florentine emphasis on drawing expressed in terms of art criticism the rational aspect of Renaissance culture, so the Venetian emphasis on color expressed its sensual side. Against both these aspects, and against the art which reflects them, the religious and cultural movement of Protestantism rebelled.

In the years which marked the beginning of the Reformation the Fuggers, the most prominent family of the German Catholic financial world, were beginning to spread the esthetic ideals of the Italian Renaissance. Jakob Fugger deserves a place in the history of criticism because the chapel to St. Anne in Augsburg, commissioned by him, reveals a deliberate esthetic choice, a rejection of the Gothic tradition still alive in Germany. With him began the diffusion of Renaissance forms which his nephew Hans was to continue both through his own efforts and through the friendship of the Duke of Bavaria, William V of Wittelsbach, whose descendants also harbored a predilection for the style developed in Renaissance and post-Renaissance Italy. The diffusion of Italian taste in Munich took place between the building of the Gothic Frauenkirche (1468–88) and the Renaissance Church of St. Michael (1583–97).

Charles V, heir to the Flemish collection of his aunt, Margaret of Austria, and to the Spanish collection of his grandparents, Ferdinand and Isabella, completed the diffusion of the esthetic ideals of the Italian Renaissance throughout Europe. His preference for Titian indicates an explicit individual choice, a preference for Venice and Venetian taste. Albrecht Dürer belongs to the generation immediately preceding Charles V, and through him the Italian conception that art and science are one and the same was acquired by the German world.

If we pass from Germany to France, we find that the spreading of the esthetic concepts of the Renaissance was closely tied to the invasions of Charles VIII and Louis XII, which brought soldiers and intellectuals still steeped in the memory of quite a different cultural climate, that of the waning of the Middle Ages, into contact with the culture of the Renaissance. With Francis I and Henry II the assimilation of Italian culture was complete, to the point that in the 16th and 17th centuries France may be considered the true heir of the Italian Renaissance. While the rest of Europe was beginning to assimilate these esthetic concepts, in Italy Vasari (q.v.) was molding them into a formal code.

Vasari's critical method has two salient characteristics: the work of art is considered as an expression of the artist's personality and as a reflection of the evolution of art, according to a scheme of rise and fall which Vasari applied to antiquity as well as to contemporary art. Vasari considered that perfection of technique was the basis of progress in art. This concept became generally accepted and gave origin to the prejudice against and

the devaluation of medieval art, a condition which lasted until the discovery of the Middle Ages by romanticism.

Vasari, educated in Florence, considered drawing the very essence of art: progress in art coincided with progress in drawing, which reached its climax in the work of Michelangelo. Next to Michelangelo, Vasari placed Raphael. In the second edition of the *Lives* Vasari recognized Raphael's originality and discussed the fundamental differences between him and Michelangelo. In a synthesis of the special qualities of these two artists, Vasari visualized an ideal of absolute artistic perfection. In spite of this rigid classification, the feeling that Vasari had for individuality in art allowed him to recognize, within limitations, the worth of artists who did not fit into his scheme, such as Giorgione and Titian. In the second edition of the *Lives* Vasari revised some of his opinions and gave evidence of having assimilated, to some extent, the spirit of the Counter Reformation, then already challenging the esthetic ideals of the Renaissance; to a certain degree, though with a different end in view, the Reformation's attitude of revolt against Renaissance ideals was adopted by the Counter Reformation.

The religious crisis which preceded the Reformation and the Counter Reformation had already brought to the fore the urgent need for a new justification of art. The problem of giving art a place within the limits of a philosophical system had already arisen during the Middle Ages. Artists and theorists resolved upon the pursuit of liberty of the imagination: liberty of "inner design" (*designo interno*) as conceived by the mind of the artist, quite different from the 15th-century conception of drawing as a means of attaining scientific knowledge (see MANNERISM). In support of these propensities, which led away from classicism and which, as in the Middle Ages and for analogous reasons, had a predilection for deformations, extravagances, and monsters, came the theory of allegory (see SYMBOLISM AND ALLEGORY). Art as metaphor was brought back by the Counter Reformation. The theory of "inner design," the esthetics of allegory, and the liking expressed by Lomazzo for the "serpentine figure," for the "frenzy of the figure," are significant in that they show the effort made by the followers of this new school to justify their revolt against all that is classical in art through creating a new set of principles. These principles give us an insight into the relationship between the new taste in art and the Counter Reformation.

Contemporaneous with these developments in the field of painting was the rise of the classicistic school in architecture, headed by Serlio, Vignola, and Palladio (see TREATISES).

Classicism, realism, and baroque are the three contrasting trends which dominated 17th-century Europe. The baroque had its roots in a restlessness, in a yearning toward the absolute which led its followers either into the most supine conventionality or into the most radical eccentricity. Heinrich Wölfflin has pointed out both in St. Ignatius of Loyola and in Giordano Bruno passages which are fundamental in reconstructing the esthetic ideal of the baroque. And, in truth, as the very basis of this ideal we find a searching for the absolute " in art" (and no longer the absolute "of art"), for infinity, and for a dynamic quality and restlessness of form which may express this pursuit. The concept which dominated the esthetic ideals of the admirers of baroque art was the concept of the sublime. A feeling for the sublime also inspired the classical school during the 17th century, although the latter emphasized a different aspect of this concept from that embraced by the followers of the baroque.

The *Vite de' pittori, scultori et architetti moderni* by Giovanni Pietro Bellori was published in Rome in 1672, two years before Boileau's translation of the treatise of Longinus. Bellori had already exposed the main principles behind his critical theory in a lecture, entitled *The Idea of the Painter, Sculptor and Architect*, given before the Academy of St. Luke in Rome in May, 1664. Fundamental to Bellori's critical approach, which, some years later, was taken up by Reynolds, is the classical idea of the sublime: the ideal of a figure more beautiful than can be found in nature, rendered in an elevated style, or the esthetic equivalent of what is referred to as greatness of soul in ethics. Bellori's criticism is based on the following theory: the ideal in painting is to depict beauty not as our eyes see it, but as we see it in our minds; Bellori remonstrates with "those who glory in the name of naturalists and [who] do not carry in mind any *idea*; they copy the defects of bodies and accustom themselves to ugliness and errors . . . ." The complete decadence of painting, for Bellori, occurs when it is torn between two extremes, "the one completely subjected to nature, the other to the imagination; as can be seen in Michelangelo da Caravaggio and Giuseppe di Arpino: the former copied bodies just as they appear to the eye, without making any selection, the latter ignored the model and followed the freedom of his imagination." For the same reasons Bellori condemns baroque architecture, whose followers "madly deform buildings and even towns and monuments with angles, breaks and distortions of lines; they tear apart bases, capitals and columns by the introduction of bric-a-brac of stucco, scraps and disproportions," while on the other hand, "the good architects preserve the most excellent forms of the orders. The painters and the sculptors, selecting the most elegant natural beauties, perfect the *idea*, and their works go forward and become superior to nature; this, as we have proved, is the ultimate excellence of these arts." A similar point of view inspired Monsignor G. B. Agucchi, who, first with Annibale Carracci and later with Domenichino, wrote a treatise which is quoted by Bellori. Agucchi's critical theory is based on an uncompromising set of esthetic principles against which all works of art are measured, and just as it gives full recognition to works of art which follow these principles, so it refuses to see the qualities of works which refute this ideal, only because they are the material expression of another and different ideal.

In 17th-century Italy the living antithesis of Bellori was personified by the Venetian Marco Boschini, author of the *Carta del navegar pitoresco*, 1660, of the *Funeral fato della pittura venetiana*, 1663, and of the *Minere della pittura*, 1664. While Bellori bases his criticism on philosophic concepts and couches it in logical terms, Boschini bases his on visual experience and expresses himself in imaginative and emotional terms. His judgments are poetical paraphrases of a work of art, approached through emotion and imagination. Color is considered the supreme expression of beauty in nature, and Venetian painting its happiest exponent. In this criticism, which can be ranked among the first examples of subjective criticism, as opposed to criticism based on a philosophical scheme, we find a continuation of the sensual tradition of Venetian culture, which had already found expression during the Renaissance in the works of Pino and Dolce; in Bellori, on the other hand, we have the continuation of the intellectual tradition of the Florentine Renaissance and of the later Roman Renaissance. In his feeling for nature and for color as the highest expression of nature, Boschini naturally excludes the concept of the sublime, as it was understood both by the baroque and by the classical schools. The fact that he shared baroque tastes, another aspect of his disagreement with Bellori, does not mean that Boschini believed in an ideal beauty superior to reality, or in searching for the absolute in art and for infinity in art, but is an assertion in favor of freedom of imagination, freedom from the rules dictated by the intellect. This belief in freedom is reflected in the boldness of some of his metaphors.

A survey of art criticism in 17th-century Europe would be incomplete if no mention were made of the esthetic ideas then current in Holland and in England. The establishment of Calvinism in Holland led to the almost complete abandonment of religious painting. In time this meant the end of the belief in the ideal of the sublime, which was so closely tied to the religious experience of the Counter Reformation. The belief in the sublime is indicative of a desire to go beyond reality; the religious experience of Calvinism led to a recognition of reality as the field of the human mission and vocation. A Calvinistic society must prefer an art which accepts reality and strives to comprehend it, an art which, based on an analytical study of facts, can give these facts a lyrical, dramatic, and psychological interpretation.

In 17th-century England, active criticism may be studied from an account of collecting activities and in the interest of art patrons and collectors in the works of the Italian

Renaissance. In 1694 Dryden compared Raphael to Homer, Titian to Vergil. A year later, he translated Bellori and Du Fresnoy, prefacing his translation with a comparison between poetry and painting inspired by classical principles.

The most noteworthy development in English esthetic thought during the 17th century occurred in the field of architecture, with the change from the Gothic, still common as late as 1674, to the classical school. This change did not take place without arousing considerable opposition, especially where religious architecture was concerned; as Christopher Wren's son reports, his father's plans for St. Paul's Cathedral were neither understood nor appreciated by many of his contemporaries, who found them too different from the Gothic style to which they were accustomed in all provincial church architecture.

Most unusual and destined to have wide repercussions in the field of criticism in 17th-century England was the voice of Sir Francis Bacon, who in 1625 began his essay *Of Building* with the following words: "Houses are built to live in, and not to look on." In another essay Bacon discusses gardens, and says that a garden must also include a kind of heath which must "be framed as much as may be, to a natural wilderness."

Toward the end of the century Sir William Temple published his essay on gardening, in which he recommends, for the beauty of a garden, the inclusion of a "wilderness." In a description of a garden by Evelyn, which dates back to 1679, there appears a word which, more than a century later, was to be widely used — "romantic." While the classical ideal was being given its most complete expression in the *Discourses* of Sir Joshua Reynolds, another concept was changing the course of esthetic thought during the 18th and the beginning of the 19th centuries: the pursuit of a fluid beauty in art, of a beauty capable of renewing itself constantly, an extraordinary beauty, unexpected and unpredictable. In other words, an artistic beauty which should reflect as closely as possible the beauty of nature and the complexity of life itself. Toward the end of the century, Reynolds wrote (*13th Discourse*, 1786) that the object and purpose of all art "is to supply the natural imperfection of things" and to praise the "symmetry and proportion by which the eye is delighted, as the ear is with music." Earlier Edmund A. Burke had expressed a consciousness of a new aspiration, that of the sublime, which often carries with it a certain sense of horror, and the dissociation of beauty from proportion and perfection (*Philosophical Enquiry into the Origin of Our Ideas of the Sublime and the Beautiful*, 1756).

The sublime, in the theory developed by Burke, is the expression of that ideal which demands that art take an intimate part in the variety and novelty of nature, refuting the classical ideal. At the same time, however, a new esthetic ideal, that of an art identified with the life of a society, was being developed by Hogarth (q.v.) in his *Analysis of Beauty*. Here, variety is opposed to uniformity, and great emphasis is laid on the importance of "intricacy in form" or "that peculiarity in the lines which compose it that leads the eye a wanton kind of chase." Hogarth sees the origin of beauty and grace in "waving" and "serpentine" lines.

While this conflict of esthetic ideals was running through artistic and cultural circles in England, in France during the last quarter of the 17th century Roger de Piles had dealt a severe blow to the classical tradition by maintaining that beauty dwells as much in color as in drawing. For De Piles, Titian was the great master all painters should follow. Poussin was criticized for his servile attitude toward classical antiquity: the great masterpieces of the ancient world were to be admired, then *interpreted*, not copied, by the artist.

The most important event in the development of French criticism during the 18th century was the opening of the Parisian Salons in 1737. With the Salons the cultural and social position of art in the modern world was officially defined. The social and cultural position of art in the modern world differs as much from the position it held during the baroque and Renaissance periods as it does from its position during the Middle Ages. The fact that expositions of art are held at regular intervals and have become a social institution shows that art is finally recognized, by the general public as well as by elite cultural circles, as being an end in itself and an independent activity. The appearance of art criticism as a specialized occupation whose task it is to give an account of the new works of art on view for the public and to follow the day-by-day development of art, reacting constantly to any innovations, is closely tied to the establishment of the Salons. The most authoritative figure among the critics of this period was Denis Diderot, and if we wish to reconstruct his esthetic principles, we need only read his reviews of the Salons: "Le couleur est dans un tableau ce que le style est dans un morceau de littérature" ("Color is to painting what style is to literature").

In 1781, the last year of Diderot's Salons, Francesco Milizia's *Arte di vedere nelle belle arti del disegno* was published in Venice. Clarity of reasoning and classical perfection are the ideals upon which Milizia based his critical opinions. The historical sketch at the beginning of his *Principi di Architettura civile* (Finale, 1781; see ARCHITECTURE) dwells lovingly on Greek architecture. Extremely hostile toward romanesque architecture, which he refers to as "ancient Gothic" and which he sees only as Greco-Roman architecture despoiled of all its noble elegance and reduced to a massive, dark, and heavy style, Milizia shows a certain comprehension of Gothic architecture itself, full of daring, lightness, and elegance. Following an idea first put forward in the early 16th century, Milizia attributes the origin of Gothic architecture to an imitation of a northern forest. And, while he admits that it must seem "most insufferably absurd" to those "accustomed to the apparent and real solidity of Greek architecture," he praises it as being "completely original, drawn from nature . . . studied as a whole, in its vividly beautiful and majestic entity," and he recognizes that it "does great honor to the human intelligence." Milizia's neoclassicism (see NEOCLASSIC STYLES), inspired by reason and not by a set of hard and fast rules, tends to admire both the technical and the intellectual daring of Gothic architecture, and the close relationship between form and function. "When one considers that that astounding lightness was necessary to give the feeling of a rural place of worship, one cannot admire enough such a sublime invention." Milizia's hostility toward anything which eludes a rational explanation and which, therefore, is not functional and appears to him to be simply the personal caprice of the artist is implacable. In his demand that beauty be founded on necessity, Milizia comes close to Fra Carlo Lodoli, to whom he refers, and for whom architecture, according to Memmo's report, is "an intellectual and practical science whose purpose it is to establish by reasoning the best use and proportions of the various elements, and through experience, to learn the nature of the materials which compose them." Lodoli, like Milizia, was opposed to personal caprice and taste and, therefore, to his own pupil, Algarotti.

In the thought of A. R. Mengs the esthetic ideal of antiquity appears as a kind of paradise lost. This idea, which in neoclassicism is a foreshadowing of romanticism (q.v.), he shares with Winckelmann, his immediate heir. In his *Gedanken über die Nachahmung der griechischen Werke in der Malerei und Bildhauerkunst* (*Thoughts on the Imitation of Greek Art in Painting and Sculpture*, Dresden, 1755), Winckelmann states that "to take the ancients for models is the only way to become great, yes, unsurpassable." The fundamental quality of beauty is tranquillity (*Stille*), "a noble simplicity and a silent greatness, in pose as in expression. As the depths of the sea remain always at rest however the surface may be agitated, so the expression of the figures of the Greeks reveals in the midst of passion a great and steadfast soul." These are the qualities which make up Raphael's greatness, a greatness unknown to those who look for the little beauties in the works of Raphael, which, on the other hand, form the virtue of Dutch painting. As an example of "noble simplicity" and "silent greatness," Winckelmann refers us to the Laocoön in the Vatican, who expresses the agony of his body without opening his mouth to cry out. In the same page, Winckelmann draws a comparison between the silence of the marble Laocoön and the terrible cry of Vergil's Laocoön. Lessing saw in this passage a depreciatory allusion to Vergil and felt it incumbent on him to justify in critical terms both the silence of the statue and the

cry in Vergil's narrative. He felt he must prove the inevitability of both solutions and found his answer in the different media used by sculpture, painting, and poetry.

What is ugly within the limits of one art form may be beautiful if expressed through another form. Lessing's reaction against the onesidedness of Winckelmann's theory led him to differentiate between the arts of time and the arts of space, that is, between the narrative and the representational arts, and to recognize that each art form has its own way of expressing beauty. The problem which faced Lessing, product that he was of the culture of his age, was a problem in criticism: must sculpture be considered the supreme art, the art which all other forms of art look upon as their model? In other words, has not each art its own peculiar form of beauty, derived from its own most intimate nature and not to be discovered through a comparison with the other arts?

The neoclassic school held firmly to the supremacy of sculpture, which embodied for them the ideal of noble simplicity and silent greatness. Lessing affirmed that there is a beauty of movement as well as a beauty of stillness, a beauty of dramatic action as well as a beauty of tranquillity, a beauty of what is complex, torn by inner dissensions, as well as a beauty of simplicity — even if they do not and cannot all belong to sculpture. This is the meaning of Lessing's division of the arts. For Lessing accepted the neoclassic theory, and at the same time went a step beyond it, in his attempt to discover the particular beauty of each art through rational research.

The term "representational arts" (bildende Künste), with which Lessing replaced the traditional term "arts of drawing," answers the same need. The medium used by painting is, according to Lessing, essentially different from that used by poetry, in that the latter expresses itself through sounds uttered in time, while the former uses shapes and colors in space; sculpture is an imitation of the solid figure.

Herder took up Winckelmann's apology of Greek sculpture and of nakedness as one of its essential features, but to it added another kind of beauty, the "clothed" beauty of painting: sculpture is body, nakedness; painting is color, decoration. In this Herder reacted against the neoclassic ideal which claimed that beauty in painting is based on the same requisites as beauty in sculpture.

For the history of art criticism the interest of these theories lies in their breaking away from neoclassicism. They indicate the recognition of other artistic values which lie beyond the scope of the neoclassic ideal, and form a premise for the re-valuation of medieval art: for that very revaluation which the young Goethe undertook in his essay on German architecture, Von deutscher Baukunst: D. M. Erwini a Steinbach, published by Herder in Hamburg, 1773, in a pamphlet entitled Von Deutscher Art und Kunst. Goethe's essay is an attack against the Abbé Marc Antoine Laugier, who had popularized the theories of rationalistic classicism. It is a plea for, or better, an apology of, Gothic architecture. His enthusiasm for his subject was awakened when, as a student in Strasbourg, after growing up in a milieu which despised Gothic architecture, he first caught sight of the cathedral of that city. This vindication of Gothic architecture, confirmed two years later in Dritte Wallfahrt nach Erwins Grab in Juni, 1775, was destined, particularly because of its aggressive tone, to become a model for all later German romantic criticism: in Heine, Tieck, Clemens Brentano, and Friedrich Schlegel, the apology of the Strasbourg Cathedral and with it of all Gothic art, considered German national folk art, became an article of faith — even for writers who, like Tieck, had never seen the building in question. While the romantics were concentrating their enthusiasm on medieval art, the French Jacobins, inspired by the same motives which had influenced St. Bernard of Clairvaux and the iconoclasts, contemplated the destruction of "toutes les statues de pierre qui sont autour du temple de la Raison" ("all the statues which surround the Temple of Reason"; 1793); and in Strasbourg, a municipal councilor proposed that the tower, which was "offensive to the spirit of equality," should be torn down. His proposal was not carried out. These resolutions, and the discussion which preceded them, are rude and violent expressions of a kind of esthetic criticism based on that very subordination of the imagination to reason which the romantics were fighting in their rebellion against the Enlightenment and neoclassicism.

After his enthusiasm for Gothic architecture (which, however, he judges equitably in Dichtung und Wahrheit, congratulating himself on the fact that he had given the first stimulus to the Boisserées and to Bertram), Goethe passed through another phase: the phase reflected in the pages of Italienische Reise and in an essay written in 1789 entitled Simple Imitation of Nature, Manner, Style, a sort of compendium of theories. The simple imitation of nature, Goethe writes, cannot lead in itself to a high degree of perfection; "manner" seizes a resemblance with light and capable spirit; "style," on the other hand, is based on the soundest and most profound principles of knowledge. In 1805 Goethe wrote an essay on Winckelmann which shows his detachment from the romantics who, at the time, under the leadership of Schlegel, were vindicating medieval painting.

Friedrich Schlegel's ideas on criticism are to be found mainly in Ideen und Ansichten über christlichen Kunst, 1801, in Grundzüge der gotischen Baukunst, a diary of his travels through Holland, the Rhineland, Switzerland, and France in 1804–05, and in Aufforderung an die Maler der jetzigen Zeit, 1804. In Ideen und Ansichten, Schlegel bases his judgment of medieval painting on the theory that color is the fundamental element of painting and that it is through color that the conflict brought by Christianity to the human conscience finds its expression. The world of classical antiquity, on the other hand, is a serene world, untroubled by internal conflict, and so finds in sculpture its best medium for expression. The difference between painting and sculpture for Schlegel, as for Herder and to a certain extent for Lessing, consists in a difference in what each art is capable of expressing, which in turn reflects a difference of esthetic ideals, each of which is in itself an expression of one phase of the history of the human spirit. This concept allows Schlegel to bring back medieval painting to a place of honor by developing theories taken from the mysticism of his friend W. H. Wackenroder and translating them on a formal plane. All these concepts were to be developed in Hegel's Lectures on Esthetics, delivered in 1818–28.

The third section of Hegel's Lectures explicitly proposes to be a "system of the various arts." Hegel gives his system an ascending order; in architecture there is only "an outward reflection of the spirit"; sculpture, "determined by its content, is the real vitality of the spirit which has given shape to the divine in all its tranquillity and silent grandeur, untouched by the discord and limitations of action." With painting begin "the arts which are called upon to give shape to the conflict of the inner soul."

With these fundamental concepts as his basis, Hegel develops a history of the various arts through a dialectic approach. In treating the history of sculpture, Hegel takes many examples given by Winckelmann and Visconti. He points out the intrinsic relationship between sculpture and architecture in the Middle Ages, and explains it as deriving from the fact that medieval sculpture (which he calls Christian or romantic) was not self-sufficient from an esthetic point of view, in that it tried to express what cannot be expressed through sculpture: "subjective spiritual personality." When he discusses painting, Hegel asserts, once more adopting the romantic conception, that "color is what makes a painter a painter."

The importance of Hegel for the history of criticism lies in the fact that his dialectic system opened for him a wider point of view than was held by his predecessors of the romantic school, from whom, however, he got his initial inspiration. The limitation of romantic criticism consists in having replaced the classical prejudice with another prejudice based on the same premises. The romantics, like the neoclassicists, were convinced that each form of art reaches the summit of perfection during a given historical period, and that subsequently, in order to retain this perfection, it must closely follow the original model. The romantic critics, therefore, confirmed the neoclassical idolization of ancient sculpture, almost ignoring medieval sculpture, whose dependence on architecture was deplored by Schlegel as a proof of its inadequacy as a separate form of

art. On the other hand, they regarded medieval painting as having attained the highest degree of perfection attainable by painting, and thus considered it the permanent model for all later painting which aspires to greatness.

For this reason Schlegel, the most authoritative and most significant exponent of German romantic criticism, considered the *Dombild* of Cologne the most beautiful painting in existence; in it he saw, fully realized, all the characteristics which make up medieval painting, and thus of painting *tout court*. Such was the enthusiasm of the romantic critics for this picture (which Goethe praised in 1816) that they could speak of it only in poetical terms. This conviction of the absolute perfection of medieval painting, like all convictions of the same nature, became a prejudice, and turned Schlegel into a supporter of the painter Johann Friedrich Overbeck (whose theories on art were approximately those of Wackenroder) and of the Nazarene movement (see PRE-RAPHAELITISM AND RELATED MOVEMENTS) headed by him.

The involution of English romantic criticism, which was to support both the Pre-Raphaelite school in painting and the Gothic revival (see NEO-GOTHIC STYLES) in architecture, did not differ from the German. The ideal which Ruskin saw embodied in the medieval Gothic, and which he believed could only be attained by retrogression of culture and modern methods of production until they reached the medieval level, was the ideal of a society vivified by individual inventiveness and freed from the stultifying effects of mass production in which art is an exception, and in which imagination and emotion are placed before knowledge intellectually conceived. This program of Ruskin's implies a condemnation of that form of intellectualism which he considered scientific pride, and whose influence he saw in the art of the Renaissance, which considered itself a science. On the social plane it condemns industrialism. A return to the Middle Ages signified for Ruskin a return to an appreciation of craftsmanship and a spreading of esthetic interest to include not only art, but also "the smallest things."

The rehabilitation of the Middle Ages and of Gothic art by the French romantics led principally to a reawakening of a historical conscience in France, for the Enlightenment and Jacobinism had ignored certain aspects of the past, their misconceptions of medieval art and its true worth amounting practically to vandalism. The recognition of the value of medieval art, instead of becoming, as in England, a kind of sociological creed, in France manifested itself in a recognition of the necessity of preserving and restoring works of art which a previous generation had actively scorned. The most vital critical current in 19th-century France, which found in Baudelaire one of its chief spokesmen, was not influenced by the theories which held an exalted opinion of the art of the past, considering it an example of absolute perfection, but followed closely and with no preconceived ideas the development of contemporary art.

As opposed to the development of criticism in France, in Germany the most discerning critical trend throughout the 19th century and the first decades of the 20th continued to base itself on philosophy. Its most important currents derived from the esthetic principle of empathy (*Einfühlung*) and of "pure visibility." The most authoritative representative of this current was Konrad Fiedler, who gave his theory its first complete expression in 1876, in an essay which discusses the judgment of works of representational art. He says, "The judgment of a work of art solely by its subject matter can only lead to erroneous results"; likewise, to consider artistic activity an imitative activity leads the critic into new errors. "First one can imitate an object only by making another which resembles it": but the work of art is not like the real object which it is supposed to imitate, because art "has nothing to do with forms that are found ready-made prior to its activity and independent of it. Rather, the beginning and the end of artistic activity reside in the creation of forms which only thereby attain existence. What art creates is no second world alongside the other world which has an existence without art; what art creates is the world, made by and for the artistic consciousness .... A work of art is not an expression of something which can exist just as well without this expression. It is not an imitation of that figure as it lives within the artistic consciousness, since then the

creation of the work of art would not be necessary for the artist; it is much more the artistic consciousness itself as it reaches its highest possible development in the single instance of one individual." Fiedler considers the conflict between realism and idealism in art an "idle" (*müssiger*) one, because art "if it deserves the name, cannot be either idealistic or realistic; it can only be always and everywhere one and the same thing, whatever name may be given it. The so-called realists are not, therefore, to be blamed because in their works they put the main stress upon sensuous appearance, but on account of the fact that commonly ... they imitate a nature which may be called commonplace and ordinary because that is the nature which their own common and ordinary minds reflect .... The idealists, however, by neither feeling satisfied with nature as they observe it, nor being able to develop their perceptions of nature to ever higher levels, try to remedy the artistic insufficiency of their own creations by giving them a non-artistic content .... Art is always realistic, because it tries to create for men that which is foremost their reality. Art is always idealistic, because all reality that art creates is a product of the mind."

The most authoritative recognition of the importance of pure visibility and of the critical work of the Fiedler-Marées-Hildebrand group was given by Benedetto Croce in his essay of 1911, the *Teoria dell'arte come pura visibilità*. In this essay, Croce gives Fiedler the credit for having replaced art on its rightful basis in the structure of a theory of knowledge, and for having recognized the intimate tie between image and expression. The praise of Croce, even though it is expressed in cautious terms, opens the possibility of basing art criticism on the concept of art as language: this concept constitutes the basis not only of Croce's esthetics but of much other art criticism in the 20th century; criticism which, notwithstanding the variety of taste and orientation, is all inspired by the theoretic premises of Croce.

Rosario Assunto

*The rise of modern art criticism.* Although it is only in the 20th century that the art critic's power seems to have been fully realized as a tastemaker for the public and even as a molding force on the creative effort itself, this modern role was foreshadowed as early as the 18th century. Then, however, most critics tended to generalize in Olympian fashion on the esthetic aspects of art, so that by present standards they could hardly be regarded as critics. Such writers as Roger de Piles and Johann J. Winckelmann were concerned with their own broad convictions, such as Winckelmann's belief, for instance, that the standards of the classical world should govern the creations of the art of his own time. And Denis Diderot set forth standards that reflected the 18th-century rationalism and sentimentality of the middle class in his belief that only art which expressed a moral point of view was worthy of respect. This was not merely an esthetic generalization but his measure for specific artists, e.g., Greuze, whom he therefore valued highly.

By and large, most 18th-century criticism was more concerned with esthetic and moral generalizations than with specific artists and their problems or with the problems of art as they are recognized today. Consideration of such problems emerged only as the critic became more intimately associated with the artists themselves. The development of the modern art critic as we know him was furthered by new periodicals with their demand for art writing with the same kind of professional approach that was given to literature and music. This writing moved to a high literary plane when it commanded the service of such writers as Baudelaire and Zola, who produced significant art criticism. Even more important, from the artist's point of view, is the emergence of the modern critic who, through his identification with the artist, became his champion and interpreter. By the 60s and 70s of the 19th century such figures began to appear as Théodore Duret and Edmond Duranty, friends and defenders of the impressionist movement, which they tried to "explain" to the public. Duret did so in *Les peintres impressionistes* (Paris, 1878), and Duranty in the preface which he helped Degas to prepare for the impres-

sionists' exhibition of 1876. In the decades to follow, the post-impressionists also had their defenders and "explainers," professional critics (if one may use the term) who wrote regularly for the daily, weekly, and monthly press to clarify what was going on in art at that time. One of these was Félix Fénéon. From this point on down to the present there have been the art critics of reviews, such as Duranty and Fénéon, the more analytical critics such as Duret, as well as the "explainers" who address themselves to contemporary movements. Thus, formalist critics such as the Englishmen Clive Bell and Roger Fry attempted to convey to their somewhat reluctant audience what the modern movement, beginning with postimpressionism, was attempting to accomplish. At the same time, Sir Herbert Read, who had begun primarily as a literary figure, took up the cudgels for specific movements as well as for individual painters of his own time and country.

Between the two world wars an increasing number of critics in both the United States and Europe began to preach the gospel of modern art. Although the rate of acceptance of modern art varied from country to country, the professional critic played a major role in such acceptance in all countries. Among early defenders in the United States were Willard Huntington Wright and Sadakichi Hartmann. By the mid-20th century, because of the enormous increase of popular interest in art, the number of art critics for newspapers and periodicals had become greater than ever. Among American critics of painting and sculpture may be mentioned Thomas B. Hess, Clement Greenberg, and Harold Rosenberg, authors of books of criticism as well as reviews in the journals.

Another form of criticism that has assumed increasing significance in the 20th century is expressed through the establishment of exhibitions and the selection of the material to be presented in these and in the printed catalogues describing and explaining what the exhibition is designed to accomplish. Thus, from the beginning of the 20th century, European museum directors have exercised a vital critical role in selecting for purchase and exhibition mainly younger and more promising artists of their time. In some instances, and this has become increasingly true in the years about mid-century, the introductions in their catalogues have become significant critical appraisals of the artists exhibited. In Europe, such a figure as Jean Cassou, director of the Musée d'Art Moderne in Paris, and in the United States, museum directors Alfred H. Barr, Jr., of the Museum of Modern Art, and James Johnson Sweeney, formerly of the Solomon R. Guggenheim Museum, New York, have played major roles in devoloping a public for contemporary art and artists. The many catalogues edited by Barr for his institution have made modern art significant to a generation of students and general readers. Both he and Sweeney, as well as others, have also involved themselves in the problems of the avant-garde.

From Diderot to modern times we have had the literary artist as champion and critic of the visual arts. During the same period the artist has also emerged as critic, especially in the United States, where many reviewers, especially those writing regularly for the art journals, are themselves practicing artists.

At no time in the history of criticism has there been such widespread interest in critical evaluation of what is being done, both by those who are defending or attacking and by the general public to which many of these statements are addressed. Although critics sympathetic to the development of progressive movements in art have been mentioned, there have been, throughout the 19th and 20th centuries, perhaps as many opponents as champions of such movements among the critics. In an age harassed by totalitarianism from the left and the right, it is inevitable that art criticism should not escape untouched. Thus, critical views developed by the Union of Soviet Artists on the one hand and the Nazi Reichskulturkammer on the other have imposed standards of evaluation for the artists of their respective times and milieus which are based on political considerations that have very little, if anything, to do with what are commonly recognized as critical standards in a culturally free society.

Bernard S. MYERS

ART CRITICISM IN EASTERN COUNTRIES. In the following sections, devoted to art criticism in the sphere of Islamic, Indian, and Chinese civilizations, only verbal criticism is discussed. At the present stage of our knowledge the critical aspects cannot be clearly separated from phenomena such as art collecting, art patronage, and art dealing, which are examined elsewhere in a specific way (see DEALING AND DEALERS; MUSEUMS AND COLLECTIONS; PATRONAGE). The status of mere craft given by the Chinese not to sculpture only, but also to architecture, which is the form of art most bound to social life; the utterly practical and instrumental character which Indians attribute to sacred images and buildings; and the characteristic rarity of representational images in Islamic art all correspond to spiritual attitudes which have worked in various ways to prevent the conflict of different esthetic conceptions — if such conflicts ever did exist — from acting in social life, or from translating themselves into as many actions for or against artistic monuments. In any case, separate treatment is given to the reactions of the social environment to the various artistic expressions and experiences, according to the civilization examined (see SOCIOLOGY OF ART). Similarly the reaction of individual artists and schools are dealt with separately (see PHILOSOPHIES OF ART). We have, finally, to remember that during recent years, side by side with the awakening of political consciousness on the part of several Asiatic and African peoples, there has been a "rediscovery" of the artistic traditions of the past, followed by that particular form of criticism in action which consists in the restoration and preservation of monuments.

**⁂**

*Islam.* For the theoretical and historical reasons which are treated in detail elsewhere (see ESTHETICS), the representational arts have not aroused in Islamic civilization an interest and a critical study comparable to that aroused by literature. In northwestern Arabia, where Islam was born, there was an almost total absence of a traditional representational art (see ISLAM). Furthermore, the well-known aversion on the part of the Jews for representations of living creatures (such aversion is incorrectly attributed to all Semitic peoples), which was accepted and shared by Mohammed, brought about that hostile attitude toward art which is reflected in a great part of the *hadīth* (sayings attributed to the Prophet). This attitude curbed the free growth of art of this type in the subsequent development of Islamic civilization. For the earlier Islam the problem of representational art was, therefore, of a purely religious and juridical nature, regarding the principle and the limits within which it was permissible. For that more ancient stage a criticism based on esthetic criteria does not exist. Some literary echoes of the artistic act have reached us only in the form of isolated comments on single objects and manufactured goods and occasionally in real descriptions of monuments and works of art, in verse and in prose, which became more frequent in the Abbasside period (dating from the mid-8th century) but only very seldom indicate value judgments and stylistic peculiarities. One can obtain other information regarding the building activities of individual monarchs and governors from the writings of chroniclers, geographers, and travelers, or from the descriptions of monuments specifically connected with the religion (mosques and oratories), with a prevalence, however, of purely technical information (proportions, iconography, materials employed, etc.), as all esthetic judgments, when given, consist merely of praise of a general nature and of rhetorical comparisons. In earlier Islam almost the whole artistic activity is anonymous, and the modest social status of the artists (generally slaves or freed slaves, and half-castes of foreign origin) curtailed further the possibility of an incipient art criticism.

Only at a later stage of Islamic civilization did a development along such lines take place. This happened more definitely among the Persians and the Turks than among the Arabs and was contemporary to the European Renaissance, with analogies which should be further studied. Particularly under the Timurids of Persia (see TIMURID ART), the Moghuls of India (see MOGHUL SCHOOL), and the Osmanlis (see OTTOMAN

SCHOOLS) the taste for and appreciation of representational art (even on the social plane) and of its creators spread from the court circles to every section of the population; the personalities of individual artists emerged, biographical data on architects, painters, and calligraphers were collected, and the first valuations and stylistic classifications appeared, together with the first attributions and the definition of artistic personalities (e.g., the famous judgments regarding the style of the painter Bihzād, q.v., in Bābur's memoirs). The character of the artist began to appear more and more often in narrative and anecdotal literature, sometimes with a hint of criticism, difficult, however, to translate into coherent and precise terms. Even in an age in which art had such popularity and refinement, this tentative criticism lacked an adequate theoretical basis.

Only when Western thought came into contact with Islamic culture and revealed to it, in this field, its own methods of philosophical and historical treatment of representational art — hence, only in our own time — did art history and criticism start in the Moslem world, and there are now several specialists, among whom the Lebanese-Egyptian Bishr Fares and the Egyptian Zakī Ḥasan are particularly worthy of mention. They are working on their artistic inheritance with European ideas and methods. Up to now Islamic art has been studied mainly by European and American scholars.

<div align="right">Francesco GABRIELI</div>

*India.* The esthetics of India are as rich in theoretical formulations as they are poor in their practical application. This is specially true for the representational arts. Occasional and general judgments with regard to this or that painting, this or that image, exist. But, since these judgments are vague, they do not explain the taste and the esthetic feeling of ancient India. When a poet such as Kālidāsa or Bhavabhūti writes that a certain figure was so lifelike that flies did not dare to light on it, the observation is of so general a nature that it could equally be a product of India or of any other country. A comparatively scarce literary documentation records the artistic taste of Indian society and its evolution through the centuries.

In Indian thought, if the onlooker loses himself in the object he is considering, at a certain point his contemplation comes to an end and the state of esthetic consciousness is replaced by the ordinary state of consciousness. Criticism takes place when the onlooker begins to consider his past experience and tries to investigate its nature and causes. These two phases are vastly different. Whereas in the first there is an absence of the logical categories of knowledge, and even of the abstract awareness itself of the object contemplated as an esthetic object, the very opposite happens in the second. The basis of this separation into two different moments is not esthetics but theology and metaphysics. According to a fundamental principle, which pervades Buddhist philosophy and logic, intuitive, or immediate, knowledge and discursive knowledge are, in effect, different in quality. Consciousness of these two separate moments comes only when the philosopher or the critic (*tattva-cintaka, vyākhātṛ*) replaces the practical man (*vyavahartṛ*). The philosopher and rhetorician Abhinavagupta (10th–11th century), quoting a passage of the Buddhist philosopher Dharmakīrti (7th century), speaks of a judge who discriminates, or criticizes the nature of things (*vastuvṛttavivecaka*) as opposed to the one who is rapt in esthetic experience or enjoyment, in a sort of suspension of all activities in which man is silent and full of awe (*camatkṛ*).

Works of art are viewed in two different ways, according to whether they have a definite religious function (images of gods, statues, paintings, sacred buildings, etc.) or have merely decorative and hedonistic aims. In the former case the idea of the practical purpose of the works of art clearly prevails over an unbiased valuation of their artistic merit. Many ancient representations of gods served definite purposes (as an aid to meditation, rites, adoration, etc.) and were taken as instruments for these purposes. Pragmatism in religious art was so overt that the Indian philosopher Abhinavagupta, speaking of the theater, points to the fact that an actor — in so far as he is

an actor — is only an instrument that sets in motion the esthetic experience, which is aroused by him and perceived and enjoyed by the public. He offers the following example in support of his thesis: "The actor, in this connection, is similar to an object of meditation. What our thought must rest on is certainly not this image of Vasudeva, as it actually is . . . . This [image] is in reality only an instrument, through which the god will finally appear to our imagination with absolute clearness. It is the god, and not the statue, who will provide the meditator with the fruits he craves. The same thing is true of the actor, through whose activity a particular form of knowledge will reveal itself, unaffected by time and space . . . ." (*Abhinavabhāratī*, 2d ed., I, 287).

These purely pragmatic criteria of evaluation do not exclude, however, esthetic beauty in all its forms. Such beauty remains, but is subordinate to those criteria. Beauty — all that is pleasing to the sight — disposes the mind to a state of serenity and makes it more fit and inclined to meditation. We find the germ of these notions, ostensibly accepted and developed by certain Indian philosophic schools, in the observations contained in works on iconography composed for painters and craftsmen. They are naïve and empirical and, therefore, much more significant. "The coming of the god," we read in the *Hayaśīrṣa Pañcarātra*, "is caused by the beauty of his images." "An image that is beautiful to the sight and that is made in all its parts according to the canons," we are told by another text, the *Śukranītisāra* (IV, 1523), "is the source of spiritual merits. An image presenting contrary features, however, deprives us of life and wealth and perennially increases our sorrow."

Apart from these typical examples of arts subservient to religion, the quality most appreciated in painting was realism. To paint in such a manner that images really seem to move, laugh, etc., constitutes the acme of the artist's ability. This idea is reflected in an infinite number of texts. Whereas poetry was never considered an art of imitation, except by a single thinker, Śaṇkuka (10th century), painting was always held to be a copy (*anukāra, pratikṛti*) of reality. This imitation is all the more pleasing the better it reproduces external things. One of the more appreciated qualities of a painter is the capacity for rendering perspective. The philosophers speak of such spatial effects, through which a flat surface appears to advance and to recede (*nimnonnata*), seeing in these effects a kind of similitude to reality. Another interesting observation is to be found in Bhartṛhari (7th cent.). He says that painting shows the same phenomenon as language, in which at first the words are unconnected and then, in the mind of the speaker, they are unified by intuition, which is unique and out of time, and finally they are expressed. In the same way, when an artist paints the image of a man, he starts with the various component parts, understood in a naturalistic way and distinct from one another; in a second stage the image as a whole takes form in the artist's mind; and finally, in the third stage, he gives expression to these various parts on a canvas or on a wall. In short, this unique intuition cannot find expression otherwise than by stages (*Vākyapadīya*, I, 53, and commentary). This philosophical conception is reflected by the Buddhists, who maintain that pictorial unity is nothing but an illusion of our mind, and that, in reality, it consists of so many distinct forms, colors, etc. (*Pramāṇavārttika*, 2, 200 ff.).

Sculpture was judged differently, as it was far more bound to traditional and religious patterns, with their complicated canons of an iconological or a decorative order, which prevented the formulation of an esthetic judgment with regard to this art. At the most sculpture has been the object of only very general evaluation. A particular example is offered by the painted clay models (*citrapusta, citraputraka*, etc.), which have always been considered the most pedestrian imitation of reality. Judgments on works of architecture are rare, though generally appreciative.

*Far East.* In Chinese culture painting in its highest forms is not rated as the activity of a craftsman — nor are the painters themselves considered craftsmen — but is an art strictly connected with poetry and reserved to the man of letters, or the

official. This attitude toward painting is due to the special character of ideographic writing, which, when not monumental or clearly decorative, has ceased to be the domain of a craftsman and has come to form a special part of the education of the literary official, or of the well-born man. In reality the difference between ideographic characters and painting is not one of quality, but one of degree. Each character is, so to say, a concentrated piece of painting, a sort of summary. A poem is not only written, but also painted. At the same time painting has been, in its turn, profoundly influenced by writing, in which monks and artists have often seen a kind of ideal standard of painting (e.g., the Ch'an, or Zen, school), in which every sign is essential and any embellishment avoided. One should not wonder, therefore, if this art, which was practiced not so much by craftsmen but (from the T'ang dynasty onward) chiefly by poets and literary men, furnished the Chinese with a rich theme for reflection. Even though the Chinese rarely attain the level of an articulate and conscious system of ideas (see ESTHETICS), these reflections, nevertheless, bear witness to the current taste and to the spirit with which art was considered.

However, apart from literary painting, there is also painting that describes and exalts people and events of the past, the value of which has never been denied, although it was bound to craftsmanship. "The exercise of painting," says Lu Chi (A.D. 261–303), "may be compared to the reciting of songs and ballads extolling the beauty of great deeds. In order to praise things nothing is better than words and in order to recall forms nothing is better than painting." From this point of view painting serves to fix the past and to preserve a part of it. The feelings and the state of consciousness we experience before a painting are identical to whose which we would experience before the subject which it represents in its effective reality. (See the quotation of the philosopher Ts'ao Chih, III, col. 377).

The painting of noble subjects and, in a broader sense, every painting which succeeds in capturing the soul of the thing represented are means of spiritual elevation. The essence of painting lies in transmission of the essence of the thing, which lives beneath the veil of the forms which the painter concentrates into a calligraphy reduced to essentials. If these and other conceptions of the same kind found great support in the Ch'an school of Buddhism, imported into China, according to traditional belief, about the 6th century (see BUDDHISM), the acknowledgment of such a spiritual function of painting goes, however, much farther back. "The sages," says the landscape painter Tsung Ming (375–443), "love Tao and are in harmony with things; virtuous men conceive in their minds the beauty of forms. As to landscape paintings, they have, in truth, a material side, but they also have a spiritual influence .... Only in this way is it possible to depict in a painting the beauty of the Sung and Hua mountains with their mysterious spirit. Such pictures satisfy the eyes and the mind because of their good quality. If they have been painted with considerable ability, they are in harmony with the eye, move the heart deeply, and excite the soul, which is satisfied, perceiving their adequacy. Therefore, what need is there to go back to dark and dangerous pitfalls? The divine soul has no limits: it lives within the shapes and stimulates everything." "When I see a painting by Chang," says Fu Tsai, poet and official, "I do not feel that I stand in front of a picture, but in the presence of Tao. Every time he goes to work he shakes off every artistic artifice; his thoughts are wholly bound up with the mysterious [transformations]. Things exist in his spirit and not in his eyes. His hands give execution to what his mind conceives. Solitude is represented by the tree, which is really majestic. His spirit mingles with the limitless and draws near to the divine."

Landscapes, from the end of the T'ang dynasty and during the whole Sung dynasty, were the favorite theme of the painter-poet-official characteristic of the epoch, together with flowers, birds, and bamboos, which gave birth to a special artistic point of view (see PHILOSOPHIES OF ART). Portrait painting, which is more bound to a practical interest, to a more objective reality, more removed from calligraphy, was deliberately left to professional craftsmen.

A special place in esthetic judgment was given to the sacri-

ficial utensils, particularly vases and caldrons, whose shape excited the admiration even of the most orthodox Confucians (see CONFUCIANISM). Other objects, such as religious statues, whether Taoist or Buddhist, have always been judged by practical demands. While reality is beyond every image and every sign, it cannot be apprehended and reached in the absence of such images and signs. From this point of view statues and paintings have a purely instrumental value and derive their *raison d'être* and their validity itself from this instrumentality. "The deeper principles," we read in an inscription dated 517, from the Ku-yang cave at Lung-mên, "are void and remote and their sphere is distant from the boundaries of this corrupt [world]. The divine ordinances have a sublime vacuity and their principles are inaccessible in this realm of impurity. If one did not use the visible resources of art so as to capture a radiant resemblance, or did not base oneself on oral teaching so as to propagate the marvelous rules of faith, how could we turn, in anxiety of spirit, toward the most perfect of symbols, or imitate the divine achievements?"

Under the artistic influence of China, Japanese criticism follows, in the main, the path charted by the Chinese. Japan greatly appreciated the works of the Ch'an, or Zen, school of Buddhism; a wealth of such works was imported by monks and collectors. They attracted more study and admiration than in China itself, where, with the passage of time, they evoked an ever-decreasing interest.

Raniero GNOLI

BIBLIOG. *Antiquity.* Overbeck, SQ, Leipzig, 1869; J. Walter, Geschichte der Ästhetik im Altertum, Leipzig, 1893; H. Stuart Jones, Select Passages from Ancient Writers Illustrative of the History of Greek Sculpture, London, 1895; E. Sellers, The Elder Pliny's Chapters in the History of Art, London, 1896; G. Pasquali, Die schriftstellarische Form des Pausanias, Hermes, 1913, p. 161 ff.; A. Dresdner, Die Entwicklung der Kunstkritik, Munich, 1915; B. Schweitzer, Xenokrates von Athen, Halle, 1932; P. M. Schuhl, Platon critique d'art, B. de l'Institut d'Art et d'Archéologie, 1937, p. 39 ff.; P. Friedländer, Spätantiker gemäldezyklus in Gaza, Vatican City, 1939; S. Ferri, Plinio il Vecchio: Storia delle arti antiche, Rome, 1946; R. Bianchi Bandinelli, Storicità dell'arte classica, Florence, 1950; G. Becatti, Arte e gusto negli scrittori latini, Florence, 1951; Galen, De placitis Hippocratis et Platonis, V, in H. Diels, Die Fragmente der Vorsokratiker, ed. W. Kranz, I, Berlin, 1951, p. 391; H. Jucker, Vom Verhältnis der Römer zur bildenden Kunst der Griechen, Frankfurt, 1952; P. M. Schuhl, Platon et l'art de son temps: arts plastiques, 2d rev. ed., Paris, 1952; R. Bianchi Bandinelli, Il Problema della pittura antica, Florence, 1953; B. Schweitzer, Platon und die bildende Kunst der Griechen, Tübingen, 1953; H. Koller, Die Mimesis in der Antike; Nachahmung, Darstellung, Ausdruck, Berne, 1954; E. de Keyser, La signification de l'art dans les Ennéades de Plotin, Louvain, 1955; A. Plebe, Die Begriffe der Schönen und Kunst bei Platon und in den Quellen von Platon, Wiener Z. für Philosophie, Psychologie, Pädagogik, 1957, p. 126 ff.; Plotinus, Enneads, Eng. trans. by S. MacKenna and B. Page, 2d rev. ed., New York, 1957.

*The Middle Ages.* H. Janitschek, Dantes Kunstlehre und Giottos Kunst. Leipzig, 1892; Paulus Silentiarius, Descriptio Ecclesiae Sanctae Sophiae, in W. Lethaby and H. Swaison, The Church of Sancta Sophia, London, New York, 1894, p. 33 ff.; J. Schlosser, Quellenbuch zur Kunstgeschichte des abendländischen Mittelalters, Vienna, 1896; J. Schlosser, Schriftquellen zur Geschichte der Karolingischen Kunst, Vienna, 1896; Hugonis Falcandi, Epistola ad Petrum Panormitanae Ecclesiae tesauriarum, ed. G. Siragusa, Rome, 1897; Isidore of Seville, Etymologies, ed. W. Lindsay, XIX, De navibus, aedificiis et vestibus, Oxford, 1911; V. Mortet, Recueil de textes relatifs à l'histoire de l'architecture et à la condition des architectes en France au moyen âge, 2 vols., Paris, 1911–29; P. Friedländer, Johannes von Gaza und Paulus Silentiarius: Kunstbeschreibungen justinianischer Zeit, Berlin, Leipzig, 1912; V. Mortet, Mélanges d'archéologie, 2 vols., Paris, 1914–15; A. Pellizzari, I trattati attorno le arte figurative in Italia e nella penisola iberica dall'antichità classica al secolo XVIII, I, Naples, 1915; Witelo, Perspectiva, ed. Bäumker-Hertling, Beiträge zur Geschichte der Philosophie des Mittelalters, III, 2, Münster, 1918; L. Venturi, La critica d'arte di F. Petrarca, L'Arte, XXV, 1922, p. 238 ff.; J. Callahan, A Theory of Esthetic According to the Principles of Saint Thomas Aquinas, Washington, 1927; C. Cennini, Il libro dell'arte, ed. and Eng. trans. D. V. Thompson, 2 vols., New Haven, London, 1932–33; Theophilus, De diversarum artium schedula, ed. W. Theobald, Berlin, 1933; V. Grecu, Byzantinische Handbücher der Krichenmalerei, Byzantion, IX, 1934, p. 675 ff.; Villard de Honnecourt, Livre de portraiture, ed. H. Hahnloser, Vienna, 1935; O. Lehmann-Brockhaus, Schriftquellen zur Kunstgeschichte des 11. und 12. Jahrhunderts für Deutschland, Lothringen und Italien, 2 vols., Berlin, 1938; M. Menéndez y Pelayo, Historia de las ideas estéticas en España, 2d ed., II, Madrid, 1940; Suger, Liber de rebus in administratione sua gestis, cr. ed. E. Panofsky, Abbot Suger on the Abbey Church of St. Denis, Princeton, 1946; E. de Bruyne, Etudes d'esthétique médiévale, 3 vols., Bruges, 1946; L. Venturi Gli studi di storia dell'arte medievale e moderna, Scritti in onore di Benedetto Croce, II, Naples, 1950, p. 175 ff.; A. J. Visser, Nikephoros und der Bilderstreit, The Hague, 1952; E. Spargo, The Category of the Aesthetic in the Philosophy of Saint Bonaventure, Franciscan Inst. Pub., Philosophy

Ser., XI, 1953; L. Grassi, Costruzione della critica d'arte, Rome, 1955; O. Lehmann-Brockhaus, Lateinische Schriftquellen zur Kunst in England, Wales und Schottland vom Jahre 901 bis zum Jahre 1307, 5 vols., Munich, 1955–58; Photius Patriarch, Homily X: Inauguration of a Church, in Homilies, cr. ed. and Eng. trans. C. Mango, Cambridge, Mass., 1958; P. Frankl, The Gothic: Literary Sources and Interpretations through Eight Centuries, Princeton, 1960. Other medieval texts may be consulted in J. P. Migne, Patrologiae cursus completus, Ser. Latina, 221 vols., Paris, 1844–64, and J. P. Migne, Patrologie cursus completus, Ser. Graeca, 162 vols., with Latin trans., Paris, 1857–66.

*Renaissance to modern times.* M. Boschini, Le minere della pittura, 2d ed., Venice, 1672; A. Félibien des Avaux, Des Principes de l'architecture, de la sculpture, de la peinture et des autres arts, Paris, 1676; R. De Piles, Cours de peinture par principes, Paris, 1708; L. Dolce, Dialogo della Pittura (1557), 2d ed., Florence, 1735; R. de Piles, The Principles of Painting, 2d Eng. ed., London, 1743; J. Blondel, Architecture française, 3 vols., Paris, 1752–56; A. Mengs, Gedanken über die Schönheit und den Geschmack in der Mahlerey, Zürich, 1762; H. Walpole, Anecdotes of Painting in England, 5 vols., Strawberry Hill, 1762–71 (mod. sup. by F. Hilles and P. Daghlian, New Haven, 1937); F. Algarotti, An Essay on Painting, London, 1764; J. Winckelmann, Reflections on the Painting and Sculpture of the Greeks, trans. H. Fuseli, London, 1765; F. Milizia, Dell'Arte di vedere nelle belle arti, Venice, 1781; C. Du Fresnoy, The Art of Painting (1668), 4th Eng. ed., London, 1783; A. Memmo, Elementi d'architettura Lodoliana, Rome, 1786 (2d ed. in 2 vols., Zara, Milan, 1834); B. Varchi, Due lezioni... (corresp. with Michelangelo; 1549), new ed., Milan, 1834; B. de Dominici, Vite de' pittori, scultori, ed architetti napoletani, 2d ed., 4 vols., Naples, 1840–46; G. Lomazzo, Trattato dell'Arte della Pittura (1584), 3 vols., Rome, 1844; F. Baldinucci, Notizie de' professori del disegno (1681–1728), 5 vols., Florence, 1845–47; J. Ruskin, Modern Painters, 2 vols., London, 1846; L. de Laborde, Les ducs de Bourgogne, II, 3 vols., Paris, 1849–52; J. Ruskin, The Seven Lamps of Architecture, London, 1849; G. E. Lessing, Laocoön: An essay on the limits of painting and poetry, trans. E. Beasley, London, 1853; J. Ruskin, The Stones of Venice, 3 vols., 2d ed., London, 1858–67; J. le Viateur (Viator), De artificiali perspectiva (2d ed. 1509), repr. Paris, 1860; J. A. Ducerceau, Les plus excellents bastiments de France (1576–79), 2 vols., Paris, 1868–70; C. Baudelaire, Curiosités esthétiques (Œuvres complètes, II), Paris, 1868; A. Averlino (Filarete), Traktat über die Baukunst (1451–64), trans. W. von Oettingen, Vienna, 1890; F. Colonna, Hypnerotomachia Poliphili (1499), Eng. trans. A. Lang, London, 1890; B. Cellini, Due trattati (1568), Eng. trans. C. Ashbee, The Treatises of Benvenuto Cellini on Goldsmithing and Sculpture, London, 1898; K. Vossler, P. Aretinos Künstlerisches Bekenntnis, N. Heidelberger Jhb., X, 1900, p. 38 ff.; M. A. Michiel, Notizie d'opere di disegno (1521), cr. ed. G. Frizzoni, Bologna, 1844, Eng. ed. G. C. Williamson, The Anonimo: Notes on Pictures and Works of Art in Italy, London, 1903; E. Panofsky, Dürers Kunsttheorie, Berlin, 1915; G. Hegel, The Philosophy of Fine Art, trans. F. Osmaston, 4 vols., London, 1920; V. Blake, Relation in Art, Oxford, 1925; Francisco de Hollanda, De pintura antigua (1548), Eng. trans. A. Bell, Four Dialogues on Painting, Oxford, 1928; C. van Mander, Het schilder-boeck (1604), Eng. trans. C. Van de Wall, Dutch and Flemish Paintings, New York, 1936; L. Venturi, History of Art Criticism, New York, 1936; Leonardo da Vinci, Literary Works, ed. J. P. Richter, 2 vols., 2d ed., London, 1939; L. Venturi, Les archives de l'impressionisme, 2 vols., Paris, New York, 1939; T. M. Greene, The Arts and the Art of Criticism, 2d ed., Princeton, 1940; L. Venturi, Art Criticism Now, Baltimore, 1941; G. Bellori, Le vite de' pittori, scultori, ed architetti moderni, (1672), cr. ed. Rome, 1942; Piero della Francesca, De prospectiva pingendi (14—), Florence, 1942; A. Houbraken, De groote schouburgh der Nederlantsche konstschilders en schilderessen (1718–21), new ed., Maastricht, 1943–53; S. C. Pepper, The Basis of Criticism in the Arts, Cambridge, Mass., 1945; P. Pino, Dialogo di Pittura (1548), cr. ed.. Venice, 1946; L. Ghiberti, Commentarii (1439), ed. O. Morisani, Naples, 1947; R. Goldwater and M. Treves, Artists on Art, New York, 1947; D. Mahon, Studies in Seicento Art and Theory, London, 1947; A. Palomino de Castro y Velasco, El museo pictórico y escala óptica (1715–24), 2 vols., new ed., Madrid, 1947; F. Castiglione, The Courtier (1528), ed. W. Rouse and D. Henderson, London, 1948; K. Fiedler, On Judging Works of Visual Art, trans. H. Schaefer-Simmern and F. Mood, Berkeley, 1949; H. Koch, Vom Nachleben des Vitruv, Baden-Baden, 1951; H. Read, The Meaning of Art, 2d ed., New York, 1951; B. Croce, Aesthetic, trans. D. Ainslie, 2d rev. ed., New York, 1953; G. H. Hamilton, Manet and His Critics, New Haven, 1954; L. B. Alberti, De re aedificatoria (1485), trans. J. Leoni, ed. J. Rykwert, On Architecture, London, 1955; C. Baudelaire, The Mirror of Art, trans. J. Mayne, London, 1955; J. G. von Herder, Plastik (1778), ed. S. Begenau, Dresden, 1955; W. Hogarth, The Analysis of Beauty (1753), Oxford, 1955; H. Read, Icon and Idea, Cambridge, Mass., 1955; P. Rubens, Letters, ed. R. Magurn, Cambridge, Mass., 1955; L. B. Alberti, De pictura... (1540), On Painting, trans. J. R. Spencer, New Haven, London, 1956; F. Cossio del Pomar, Crítica de arte de Baudelaire a Malraux, Mexico City, 1956; H. James, The Painter's Eye, ed. J. L. Sweeney, Cambridge, Mass., 1956; Leonardo da Vinci, Trattato della pittura (1651), cr. ed. and trans. A. McMahon, 2 vols., Princeton, 1956; G. Mancini, Considerazioni sulla pittura (1614–21), new ed., Rome, 1956–57; Raphael Sanzio, Tutti gli scritti, Milan, 1956; J. Schlosser, La letteratura artistica, 2d ed., Florence, Vienna, 1956; D. Diderot, Salons, ed. J. Seznec and J. Adhémar, Oxford, 1957 ff.; P. Menzer, Goethes Ästhetik, Cologne, 1957; E. G. Holt, A Documentary History of Art, 2 vols., New York, 1957–58; S. K. Langer, ed., Reflections on Art, A Source Book of Writings by Artists, Critics and Philosophers, Baltimore, 1958; P. Grate, Deux critiques d'art de l'époque romantique: Gustave Planche et Théophile Thoré, Stockholm, 1959; J. Reynolds, Discourses on Art, cr. ed. R. Wark, Oxford, 1959; F. von Schlegel, Ansichten und Ideen von der christlichen Kunst (1801), ed. H. Heichner, Munich, 1959; J. J. Jarves, The Art Idea, ed. B. Rowland, Cambridge, Mass., 1960. See also, in general, Quellenschriften für Kunstgeschichte und Kunsttechnik des Mittelalters und der Neuzeit, Vienna, 1871–1908.

*The East*: W. Winternitz, Geschichte der indischen Litteratur, 3 vols., Leipzig, 1907–23; A. K. Coomaraswamy, Rajput Painting, 2 vols., London, New York, 1916; S. K. De, Studies in the History of Sanskrit Poetics, London, 1923–25; T. W. Arnold, Painting in Islam, Oxford, 1928; V. Sankaran, The Theories of Rasa and Dhvani, Madras, 1929; C. Śivaramamurti, Painting and Allied Arts as Revealed in Bāṇa's Works, J. O. Research, VI, 1932, p. 395 ff., VII, 1933, p. 60 ff.; C. Śivaramamurti, Kalidāsā and Painting, J. O. Research, VII, 1933, p. 158 ff.; Srī Harṣa's Observations on Painting with Special Reference to the Naiṣadhīyacarita, J. O. Research, VII, 1933, p. 331 ff.; O. Sirén, The Chinese on the Art of Painting, Translations and Comments, Peiping, 1937; G. Rowley, Principles of Chinese Painting, Princeton, 1947; K. Pandey, Indian Aesthetics, Benares, 1950; H. P. Bowie, On the Laws of Japanese Painting, New York, 1951; A. C. Soper, Kou Jo-hsü's Experiences in Painting, Washington, 1951; C. Lancaster, Keys to the Understanding of Indian and Chinese Painting: The "Six Limbs" of Yasodhara and the "Six Principles" of Hsieh Ho, J. of Aesthetics and Art Criticism, XI, no. 2, Dec., 1952; W. Acker, Some T'ang and Pre-T'ang Texts on Chinese Painting, Leiden, 1954; R. Gnoli, The Aesthetic Experience according to Abhinavagupta, Rome, 1956; Kai Wang, The Tao of Painting... with a translation of the Chieh tzŭ yüan hua chuan... by Mai-mai Sze, 2 vols., New York, 1956; H. Zimmer, Philosophies of India, ed. J. Campbell, New York, 1956. For further references see the bibliographies of ESTHETICS and HISTORIOGRAPHY.

**CRIVELLI, CARLO.** Venetian painter who worked mostly in the Marches. Born in Venice between 1430 and 1435; died about 1495. In 1457 Crivelli seems to have left Venice forever; thereafter, beginning in 1468, his activity may be followed almost uninterruptedly in Fermo, Macerata, Fabriano, Ascoli, and other towns of the Marches.

Crivelli's artistic origin remains somewhat obscure and controversial. Earlier critics (Ridolfi, Zanetti, Ricci, Lanzi) believe Jacobello del Fiore to have been Crivelli's teacher; Crowe and Cavalcaselle suggest instead Giambono and the school of Murano, but also consider Squarcione's influence of decisive importance in the formation of Crivelli's style. This position is supported by several other critics (Rushforth, Berenson, Testi, A. Venturi, Geiger, Drey). The marked characteristics of the Squarcione school are definitely evident in Crivelli's art. The taut severity of form and silhouette is as typical of the school of Padua as are the angular folds of the metallic drapery or the abundance of decorative and classical motifs — flower-and-fruit garlands, antique columns, capitals, volutes, egg-and-dart moldings, etc. The affinity with Squarcione, Mantegna, Marco Zoppo, and the Vivarinis is apparent in Crivelli's earlier works, such as the *Madonna della Passione* (Verona, Mus. di Castelvecchio) and the polyptych (1468; Massa Fermana, Ascoli, Municipio).

In the Marches, isolated from the more progressive art centers of Italy, features of Crivelli's early style became confirmed characteristics. The elaborate late Gothic shape of the altarpieces, in which figures are allotted separate panels, remains traditional. The polyptych (1473; Ascoli, Cathedral of S. Emidio) and the reassembled Demidoff Altarpiece (1476; London, Nat. Gall.; PL. 170) are typical works of that period. In the 1480s a new intensity of expression, increased stylization of the gnarled, ascetic figures, and greater compositional concentration characterize the mature style of Crivelli. In the *Pietà Panciatichi* (1485; Boston, Mus. of Fine Arts) a remarkable note of pathos is achieved. In the *Annunciation* (1486; London, Nat. Gall.) the harmonious integration of naturalistic detail and decorative motifs with a unique spatial arrangement comprises one of Crivelli's most original conceptions.

In the later works, the *Madonna and Child with St. Peter* (ca. 1488; Berlin, Staat. Mus.), the *Madonna della Candeletta*, and the *Coronation of the Virgin* (both 1493; Milan, Brera), the decorative accessories become ostentatious and even threaten to overpower the figures. The forms become attenuated, brittle, and arid, and the former pathos of expression is weakened by overaccentuation and superficiality. Nevertheless, the prolific career of Crivelli manifests the essence of north Italian Quattrocento art: the awareness of central Italian artistic problems, the reawakened interest in classical forms, the traditional emphasis on the decorative beauty of the picture surface, and the

rendering of an emotional scale ranging from the lyrical to the intensity typical of the late Gothic period.

BIBLIOG. J. A. Crowe and G. B. Cavalcaselle, The History of Painting in North Italy, I, London, 1871, p. 82 ff.; G. Rushforth, Crivelli, 2d ed., London, 1910; B. Geiger, ThB, VIII, pp. 128–33; F. Drey, Carlo Crivelli und seine Schule, Munich, 1927; P. Zampetti, Carlo Crivelli nelle Marche, Urbino, 1952.

Curtis SHELL

**CROME, JOHN** (called "Old Crome" to distinguish him from his sons). British painter of the Norwich school (b. Norwich, Dec. 22, 1768; d. Norwich, Apr. 22, 1821). Crome was the son of a journeyman weaver. In 1783 he commenced seven years of apprenticeship to Francis Whisler, a Norwich house and sign painter, from whom he acquired a knowledge of painting technique in its crudest sense. During this period Crome and his friend Robert Ladbrooke decided to study painting more seriously. About 1790 he met Thomas Harvey of Catton, near Norwich, a collector and amateur artist who helped him considerably and introduced him to the successful London portrait painter William Beechey. While at Catton, Crome copied a Hobbema landscape and Gainsborough's *Cottage Door* (San Marino, Calif., Huntington Gall.).

After marrying Phoebe Berney in 1792, Crome set himself up as a drawing master at Norwich in order to support his family. He taught the daughters of John Gurney of Earlham, whom he accompanied to the Lake District in 1802. Sometime before 1805 Crome had been to the Wye Valley, and he visited London quite frequently throughout his life. By 1803 Crome was a leading figure in Norwich art circles, and in that year, with the help of Ladbrooke and others, he founded the Norwich Society of Artists. The society held its first exhibition in 1805, and Crome became its President in 1808. He contributed regularly to these local exhibitions and also displayed his work at the Royal Academy between 1806 and 1818.

Crome's only journey to the Continent was made in 1814, when he went to France to see Napoleon's art collection in Paris. Sketches done on this journey were used as subjects for later paintings. Just before his death, Crome started a large regatta scene, undoubtedly *Yarmouth Water Frolic* (London, Kenwood), which was finished by his son, John Berney Crome. Another son, W. H. Crome, also became a landscape painter.

Crome was influenced most by the works of Wilson, Gainsborough, and certain Dutch landscape painters. He had great affection for the scenery of Norfolk and concentrated on the more intimate and peaceful aspects of nature. Though lacking the genius of his two renowned contemporaries Constable and Turner, Crome nevertheless rendered landscape with considerable feeling and pleasing simplicity.

WORKS. *Blacksmith's Shop, Hingham,* ca. 1808, Philadelphia, Mus. of Art. - *The Beaters,* 1810, Viscount Mackintosh of Halifax. - *Back of New Mills,* Norwich, Castle Mus. - *Boulevard des Italiens,* 1814–15, Quintin Gurney. - *Bruges River, Ostend in Distance,* ca. 1816, Norwich, Castle Mus. - *Mousehold Heath,* London, Tate Gall. - *Poringland Oak,* London, Nat. Gall.

BIBLIOG. W. F. Dickes, Norwich School of Painting, London, 1905; C. H. Collins Baker, Crome, London, 1921.

Francis W. HAWCROFT

**CRUIKSHANK, GEORGE.** English illustrator, caricaturist, and occasional painter (b. London, 1792; d. London, 1878). Cruikshank, whose father was also a well-known caricaturist, received no formal art education. In 1811, the son began the series of caricatures that made him, in succession to James Gillray, the leading caricaturist of the period. One of his most famous works of this period was the *Bank Restriction Note* (1811); Cruikshank called this "the great event of his artistic life" and claimed, with characteristic exaggeration, that it was responsible for the abolition of the death penalty for passing forged bank notes.

Although his activity as a caricaturist continued until about 1825, by 1820 he was beginning to do book illustrations, either etched or engraved on wood. Cruikshank was extremely prolific, and Cohn (1924) lists 863 books illustrated by him. Some of the best-known are Pierce Egan's *Life in London* (1821), Chamisso's *Peter Schlemihl* (1823), and Grimm's *Popular Stories* (1824–26); but he is above all celebrated for his associations with Harrison Ainsworth and Charles Dickens. Among the books he illustrated for the former were *Rookwood* (1836), *Jack Sheppard* (1839), *The Tower of London* (1840), and *Old St. Paul's* (1841); and for the latter, *Sketches by Boz* (1836–37), *Oliver Twist* (1838), and the *Memoirs of Grimaldi* (1838). Cruikshank's grotesque, often sinister, fantasy made him an ideal interpreter of Dickens. Many of his designs appeared in books and periodicals published by himself; among these are *George Cruikshank's Comic Almanack* (1835–54), *Omnibus* (1841–42), and *Table Book* (1845). In the late 1840s he became an ardent propagandist of temperance reform by means of two series of etchings, *The Bottle* (1847) and *The Drunkard's Children* (1848), which pointed their moral in a manner derived from Hogarth. Cruikshank's gigantic painting (7 ft., 8 in. × 13 ft., 3 in.) *The Worship of Bacchus* (1862; London, Tate Gall.) consists of a series of small tableaux illustrating the ill effects of alcohol.

Cruikshank was essentially an etcher and draftsman in black and white — at his best when working on a small scale — and though he painted in oils at intervals throughout his career, his paintings (such as *Grimaldi Shaved by a Girl* or *The Runaway Knock*) are not significant additions to his œuvre. (See ENGRAVINGS AND OTHER PRINT MEDIA.)

BIBLIOG. B. Jerrold, The Life of George Cruikshank, London, 1897; G. W. Reig, Descriptive Catalogue of the Works of George Cruikshank, London, 1871; A. M. Cohn, George Cruikshank: A Catalogue Raisonné of the Work Executed 1806–77, London, 1924; M. D. George, Catalogue of Political and Personal Satires Preserved in the Department of Prints and Drawings in the British Museum, IX, X, London, 1949.

John A. GERE

**CUBA.** See ANTILLES.

**CUBISM and FUTURISM.** In any study of the various movements that have been most significant in forming contemporary taste (see EUROPEAN MODERN MOVEMENTS), it is appropriate that cubism and futurism be considered together. They are linked by their common effort to solve similar or identical problems, by close reciprocal connections (in spite of emphatic differences regarding theoretical assumptions), by their common characteristics as avant-garde movements, by their revolutionary aims, which have a vaguely social background, and by their close chronological parallelism.

SUMMARY. Cubism (col. 150): *The antecedents; Braque and Picasso; Gris; Delaunay and Orphism; Diffusion of cubism.* Futurism (col. 156).

CUBISM. *The antecedents.* At the end of the first decade of the 20th century, when the innovations of the Fauves (q.v.) were already showing signs of exhaustion, there appeared in the work of several painters living in Paris the tendency to resolve the representation of landscape, figure, and still life by referring them to geometric forms such as cubes, prisms, and pyramids. At the outset, this approach was evident particularly in the work of Braque and Picasso (qq.v.). A phrase of Henri Matisse, recorded by Louis Vauxcelles (*Gil Blas,* Nov. 14, 1908; Apr. 25, 1909), seems to be the origin of the name which was soon to distinguish the cubists. Pierre Francastel has described cubism as a specifically pictorial mode of expression attained by artists in an epoch in which the total of human attitudes was oriented by new conditions of life, which in turn were determined directly by technology and

indirectly by all the scientific, esthetic, philosophic, and literary thought of the preceding generations.

The adherents of impressionism (q.v.), postimpressionism, and symbolism, particularly artists such as Manet, Monet, Degas, Van Gogh, Toulouse-Lautrec, Gauguin, Cézanne, and Seurat (qq.v.), had initiated or contributed to experiments tending toward affirmation of the expressive possibilities of pictorial or sculptural values independent of the naturalistic appearance of the subjects chosen. Then in the work of the Fauves — above all, of Matisse and Raoul Dufy (qq.v.) — the images tended to be realized on one plane as color areas, even when the spatial structure was still respected. In 1906 the Salon d'Automne exhibited Gauguin, and in 1907 a commemorative exhibition of Cézanne was held, on which occasion the famous letter of April, 1904, from the painter to Emile Bernard was published, where Cézanne says, among other things, "traiter la nature par le cylindre, la sphère et le cône . . . " (Golding, 1959, p. 64).

The creators of cubism had had experience of other significant art movements: Georges Braque had been a Fauve; Pablo Picasso had behind him the important experience of his Blue and Rose periods and contact with Negro sculpture (1906–07), represented by *Les Demoiselles d'Avignon* (PL. 75).

*Braque and Picasso.* An initial cubistic phase (1908–09) evidencing the influence of Cézanne was followed in 1910 by a phase of more explicit innovation. Emphasis upon analysis of the volumetric components of an image led to their reduction within a single plane. The analytic method (whence the term "analytic cubism," applied to the first phase) does not wholly dispense with the object, but reconstitutes it in accordance with a rhythm determined by the artist himself and not derived from the object. This new esthetic no longer concerned itself with creating fully realized forms for the sake of either ontological significance or realistic modeling; instead it created structures composed of smaller elements, the planes, which in their juxtaposition, superimposition, or mingling produce a complex and pervasive rhythm. This approach results in the suppression of the traditional antinomy between figure and ground. The oscillation of planes suggests, but does not represent, a space that transcends the three-dimensional; in other words, the forms appear to be space-time symbols. The link between the new painting and concurrent scientific developments was emphasized by the mathematician Maurice Princet.

In their canvases of 1911 (when they worked at Céret), of 1912 (at Sorgues), and of 1913 (when they were with Gris and Max Jacob at Céret), as well as in those painted at Avignon with André Derain in the summer of 1914, Braque and Picasso are so close that many of their paintings of this period appear to be done by the same hand. These apparently indistinguishable works supply early affirmation of the concept of the impersonal touch, which has had considerable importance for the painting of our time. In both Braque and Picasso, as well as in the other cubists, the symptoms of a return to a spirit of tranquil objectivity became increasingly evident, that is, a reversion to the expression of a calm and reflective feeling by means of quiet, clearly defined forms (PLS. 76, 78).

Thus there was actually a return, at least conceptually, both to a three-dimensional space and to the contradistinction of image and background ("synthetic cubism"). This led some cubists to use the plane as an element in the construction of representational images, rather than as an autonomous expressive element. Furthermore, the use of *papier collé*, introduced by Braque and Picasso in some of the canvases done during the summer of 1912 at Sorgues, was adopted by almost all the cubist painters (see MEDIA, COMPOSITE).

*Gris.* If on the surface Braque is a romantic and Picasso essentially a baroque spirit, both tend toward the use of a dynamic system of forms; by contrast, the Spaniard Juan Gris (q.v.), who went to Paris in 1906, brought to cubism a definite predisposition toward classicism. The first stages of the cubist evolution are absent from Gris's *œuvre*, and from 1912 onward his works were already, practically speaking, in the synthetic phase. He structures the painting with planes that only lose a part of their descriptive value: "I begin by organizing my picture; then I characterize the objects . . . . I want to endow the elements I use with a new quality . . . ." Gris's method of working — from the initial organization of the canvas as a solid, rigorously geometric architecture, to the individualization of the objects "in order that the spectator shall not do so for himself, and in order to prevent the combination of colored forms from suggesting to him a reality which I have not intended" — reveals the traditional character of his work. This method accounts for both the charm of the still-life subjects that he painted between 1914 and 1919 (PLS. 78, 80) and the lack of energy that is typical of his figures. Until 1916, he maintained in his figure studies the chiaroscuro contrasts that Braque and Picasso had rejected; in those done after 1922, he returned to the arabesque and took leave of cubism.

*Delaunay and Orphism.* Guillaume Apollinaire (1913) called the painting of Robert Delaunay (q.v.; PL. 77) "Orphic" cubism and extended the term to refer also to Picasso, Fernand Léger (q.v.), Francis Picabia, and Marcel Duchamp in a manner which today seems very imprecise; he defined his term as "the art of painting new structures out of elements which have not been borrowed from visual reality, but are suggested to the artist by instinct and intuition." Apollinaire alludes here to an intention that is purer than that of the other cubists, and for this reason "Orphic." However, the work of Delaunay and of his wife Sonia Terk Delaunay can be identified only partially with the aims of the cubists. Even when they employed the analytic method of fragmentation, as in Delaunay's *Eiffel Tower* (shown at the Salon des Indépendants of 1911; now New York, Solomon R. Guggenheim Mus.), they stressed chromatic effects that are almost independent of the forms and thereby identified themselves with a strain of objective impressionist lyricism rather than with the subjective lyrical forms of the cubists. This tendency became much clearer in 1913, when the Delaunays began creating the intensely chromatic "simultaneous disks" (see NONOBJECTIVE ART). Delaunay's chromatic innovations had a significant influence in Germany, in connection with the experiments of the Blaue Reiter group (see EXPRESSIONISM). The Americans MacDonald Wright, Morgan Russell, and Patrick Henry Bruce, who were influenced by the Delaunays during their activity in Paris between 1912 and about 1915–16 (the first two founded the synchromist movement in Paris in 1913), continued their work in the United States (see AMERICAS: ART SINCE COLUMBUS).

*Diffusion of cubism.* In 1909 Braque and Picasso, who had been introduced in 1907 by Apollinaire, began their prolific collaboration. The year before, after several of his canvases had been rejected by the Salon d'Automne, Braque had given a one-man show at the Galerie Kahnweiler in Paris. In 1910 Delaunay and Léger exhibited at the Indépendants. In 1911 these painters were shown in a separate room at the Indépendants, along with Albert Gleizes, Henri le Fauconnier, and Jean Metzinger. At the Salon d'Automne of the same year all these artists, as well as Marcel Duchamp and Jacques Villon, were seen. In 1912 Gleizes, Metzinger, Delaunay, Gris, Roger de La Fresnaye (q.v.), and others exhibited in the Section d'Or at the Galerie de la Boétie, Paris, along with the brothers Jacques Villon (pseudonym for Gaston Duchamp), Marcel Duchamp, and Raymond Duchamp-Villon (see DUCHAMP BROTHERS). In the same year Delaunay exhibited at the Indépendants the *Simultaneous Windows* (*Fenêtres simultanées*; Paris, Coll. J. Cassou) that led Apollinaire to coin the term "Orphism"; Léger had a showing at Kahnweiler's; and Gleizes and Metzinger published *Du "Cubisme."* In 1913 *Les peintres cubistes* of Apollinaire appeared; in the same year Michael Larionov published the rayonist manifesto (dated 1912) in Moscow. In 1914 Marc Chagall (q.v.) exhibited at the Galerie der Sturm in Berlin, and Wyndham Lewis published *Blast*, the vorticist review, in London. In that year Jean (Hans) Arp (q.v.) met Apollinaire, Arthur Cravan, Delaunay, Max Jacob, and Picasso. In the following year Amédée Ozenfant founded *L'Elan* in Paris.

In 1916 Villon exhibited in Oslo. In 1917 Francis Picabia published the first number of *391* in Barcelona; in New York, Duchamp founded the reviews *Rongwrong* and *The Blind Man*; in Paris, Pierre Reverdy founded *Nord-Sud*; and in Zurich, Tristan Tzara published *Dada*. In the same year Picasso was in Rome with Serge Diaghilev's Ballets Russes. In 1918, which was also the year of Apollinaire's death, Ozenfant and Charles-Edouard Jeanneret (later, Le Corbusier, q.v.) published *Après le cubisme*. In 1919 both Braque and Gris exhibited at l'Effort Moderne in Paris. Publication of the Ozenfant and C.-E. Jeanneret review *L'Esprit Nouveau* began in 1920 (it survived until 1925). During that year *Le néo-plasticisme* of Piet Mondrian (q.v.) appeared in Paris, and in 1921 Gino Severini's *Du cubisme au classicisme* was published there (see EUROPEAN MODERN MOVEMENTS).

In contrast to the cooperative spirit manifested in the phases discussed thus far (sometimes known collectively as the "heroic years"), in the period after 1920 the leading artists tended to individualize their formal structures. Thus, the group lost its cohesion at the very moment when some of the cubist innovations were becoming established among artists and were gaining acceptance with the educated public. The crisis which occurred in these years, though shaped by the cubist leaders, was brought about by the influence of other painters who did not belong to the school of Paris. As a result some artists adhered to the principles of "abstract art," while others developed what they called "concrete art" (see NONOBJECTIVE ART). Despite the falseness of the artistic theory it sustained, the Ozenfant and C.-E. Jeanneret *La peinture moderne* (1925) clearly indicated the future possibilities of cubism: "It achieved liberation from literal imitation, an obstacle to lyricism which the greatest masters have always desperately fought. Cubism led to the conception of the picture as an object independent of nature, and subject only to the laws of sensibility and the spirit. This general conception characterizes the painting of the future." Braque and Picasso, although directly responsible for the revolutionary phase of cubism, did not draw upon its most fruitful and original consequences but returned to some extent to traditional forms. Their paths, however, were different.

Léger is termed by Sir Herbert Read (1933) a "tough-minded" cubist: "All organic sensibility is suppressed. We are in a world of inorganic, of mechanic sensibility." Gris, on the other hand, is grouped by Read among the "tender-minded" cubists, who "seem to carry their abstraction toward a decorative end" and "to carry with them some suggestion of the organic world, an undertone." While Gris achieves an over-all tone that is solid, austere, and reflective and enlivens forms with color without dissociating one form clearly from another, Léger undertakes to construct complicated dynamic structures that seem to be inspired by machines. However, a note of pragmatic impersonality is common to both artists. For Léger, who had become a friend of Delaunay in 1909 and met Picasso and Braque the following year and who had exhibited *Nudes in the Forest* (Otterlo, Rijksmus. Kröller-Müller) at the Indépendants of 1910, the cubist adventure was over in 1914, and his subsequent career was that of a distinctly representational painter. Moreover, even his mechanistic cubist images are substantially representational.

André Derain (q.v.) figures in the early history of cubism; he is cited as a precursor of the movement by Apollinaire in *Les peintres cubistes* (1913) and by Gleizes and Metzinger in *Du "Cubisme"* (1912). He has also been reevaluated by Daniel Henry Kahnweiler in his monograph on Gris — and rightly, if one recalls the tough, rationalistic spirit of Derain, who after his Fauvist period dedicated himself to the austere task of intellectual purification. However, his greatest enthusiasm was for the so-called "primitive" painters, and this interest led him to a method of expression that was completely representational, in addition to being inspired by intentions wholly opposed to those reflected in the contemporaneous paintings of Braque and Picasso, with whom he worked in 1910 at Cadaqués in Catalonia.

Albert Gleizes (PL. 79) and Jean Metzinger (PL. 83) are different cases. Gleizes was primarily a theoretician and, dedicating himself to the figure by preference, showed less boldness in his painting than in his writing. Both painters use planes in a stiff, austere manner, even though these are ordered dynamically, so that a connection with the Italian futurists is suggested. The relation of the futurists to cubism, however, became important in the later phase of the movement, early in the postwar period, when there was a preoccupation with geometric organization.

Marie Laurencin's connection with cubism was marginal, mainly a matter of sentiment and friendship. Henri le Fauconnier and Auguste Herbin were also somewhat exceptional participants in the movement. The former remained essentially an expressionist; the latter was propelled by a spirit more rigorous than that of the cubists themselves, so much so that his work later became the basis of the Abstraction-Création group (1932), which promoted nonobjective "concrete" art in France. Marcel Duchamp and Francis Picabia (PL. 79), like many others, can be regarded as painters who found in cubism a point of departure for their personal development, rather than as authentic cubists. They were intimate friends, and their work is characterized by a sense of actuality oscillating between a fantastic dynamism and the spirit of Dada. The only important subject of Duchamp executed in the cubist style, represented by the famous *Nude Descending a Staircase* (No. 2, 1912), which he called a "chromotography," inclines us to connect him with futurism rather than with cubism. (A later version of this theme is reproduced in PL. 79.)

Perhaps the most outstanding among the minor cubist masters is the Pole Louis Marcoussis, who, even when working in the apparently straightforward terms of planes, manages to imbue his compositions with an essentially romantic spirit that sometimes reveals traces of sentimentality. A brief period of cubist experiment occurs in the work of Marc Chagall, who arrived in Paris in 1910; this is evident in paintings such as *I and My Village* (New York, Mus. of Mod. Art) and *Dedicated to My Fiancée* (Bern, Kunstmus.), both of 1911.

Various followers of cubism have proceeded from its germinal principle — that planar forms have independent expressive possibilities — with the aim of rejuvenating, modifying, or even casting aside the original premises of the movement. The least ambitious of these offshoots was concerned solely with cubistic analysis and compositional solutions and employed them for the presentation of images that remain bound to empirical reality, in accordance with traditional conventions. Such personalities as Roger de La Fresnaye (PL. 78) and André Lhote exemplify this approach. The former, not a true cubist, was a follower of Cézanne until 1914; in certain large still-life paintings he was influenced by Degas, and eventually he turned to an anachronistic revival of clearly representational elements from 14th-century Italian painting. He is, however, related to cubism in one group of canvases, including *Conquest of the Air* (1913; New York, Mus. of Mod. Art). Lhote, an eminent writer about art and a master of refined analysis and caustic judgment, was undoubtedly a strong personality; but he was incapable of achieving pictorial creation beyond an indifferent and mechanical application of cubist principles in paintings that are otherwise closely bound to a traditional vision.

The second of these modifying tendencies is represented by the Purism of Ozenfant and C.-E. Jeanneret, which attempts to carry to the extreme the impersonality of cubist expression and which is therefore more closely related to Gris and Léger than to Braque and Picasso. Such striving for impersonality would seem a legitimate attempt at liberating cubism from its residual romanticism. However, instead of achieving a definite abstraction of the planes and a truly geometric structuring of the picture, independent of any empirical experience, Purism resolved itself into a geometric stylization of visible reality that dealt mainly with the humble objects of which still life is composed. The above-cited book by Ozenfant and C.-E. Jeanneret (1925) and Ozenfant's *Art* (1928) are still extraordinary, both for their lucid analysis and contagious enthusiasm.

Still a third tendency is represented by the work of artists who, using planes which unite and interpenetrate in a manner more or less related to visible reality, succeed in endowing cubist forms with a new dynamism and insinuate into them a somewhat romantic spirit; this group includes the Frenchman

Jacques Villon, the American Lyonel Feininger (q.v.), and the Englishman Wyndham Lewis. Villon became a cubist in 1911; however, his interest in nature and man continued and formed the point of departure for the creation of his own images, which are organized in a play of planes that are incorporeal and clear as crystal and painted with a light and luminous palette. Villon's art is related to that of Feininger, certainly another artist indebted to cubism. Feininger, however, only partially assimilated the cubist esthetic, perhaps because he was rooted in a romantic expressionism that was evident in his structures of delicate, almost laminated, planes. Lewis, the creator of English vorticism, was a more dynamic artist, in spite of a preponderance of verticals and horizontals in his canvases. He was influenced by futurism, as well as by cubism.

One line of development that led from the premises of cubism and in the direction of constructivism was followed by Piet Mondrian, who derived neoplasticism from an elaboration of synthetic cubism by means of an increased dissociation or abstraction of rhythm as an entity independent of the image originally analyzed. Mondrian arrived in Paris in 1910 and worked in the cubist ambient from 1911 to 1916.

Similarly, for Kazimir Malevich the cubist experience, at first a dynamic "analytic" schematization particularly close to the work of Léger (ca. 1911–12, the so-called "cubofuturism") and later "synthetic" (ca. 1912–14), was the formal antecedent of his suprematism. Around Malevich, who visited Paris briefly during these years, the Russian cubist movement grouped itself, represented by Antoine Pevsner, Nikolai Puni, Alexandra Alexandrovna Exter, Lyubov Popova, and Udalzova. The numerous cubist works in Moscow private collections, such as those of Serge Stchoukine (Shchukin) and Ivan Morosov, contributed greatly to the orientation of this group, which also felt the influence of futurist dynamism. Cubist elements also appear with futurist ones in the rayonist experiments of Michael Larionov and Nathalia Gontcharova, which were exhibited in Paris in 1914 at the gallery of Paul Guillaume, with a catalogue for which Apollinaire wrote the preface.

The various degrees of orthodoxy that existed within the scope of cubism and the spread of its influence were clearly apparent in the Section d'Or exhibition held in Paris in 1912. The participants were, among others, Gleizes, Metzinger, Villon, Kupka, Picabia, Marcoussis, and Lhote. Periods of rapport with the cubist experimentation are to be found in France in the work of Dunoyer de Segonzac (1908), Luc Albert Moreau (1909), Jean-Louis Boussingault (1911–14), Yves Alix (1913), Jean Marchand (1911), and André Mare and in the engravings of Jean Emile Laboureur and Démétrius Galanis. Carlo Carrà felt the influence of cubism from 1912 onward; and Gino Severini (q.v.), who worked in Paris and admittedly took an intermediate position between cubism and futurism, took up synthetic cubism in 1916. After World War I an interlude of cubist influence is apparent in Charles Dufresne, Paul Elie Gernez, M. Blanchard, Marcel Gromaire, and Henri Hayden; subsequently Jean Souverbie, Léopold Survage, Jean Lurçat, René Auberjonois, and Alfred Reth also felt its influence. Later the Australian G. Growley was affected by the work of Lhote and Gleizes. A cubist component is present in the syncretism of Dada. Among the Dadaists, Hans Richter and Kurt Schwitters in particular were interested in cubism. Other American artists who had encounters with cubism during their sojourns in Paris included Marsden Hartley (1912–13), Max Weber (before 1915), Stuart Davis (1928–29), and A. E. Gallatin (1921–38).

The cubist movement also had consequences for sculpture. It was Picasso himself who announced the possibilities, above all in the celebrated *Head of a Woman* of 1909 (casts in New York, Mus. of Mod. Art, and Basel, Kunsthaus; V, PL. 128). In this work the planes fragment but do not destroy the volumetric entity, in a manner that oscillates between pseudogeometric reconstruction and baroque effusion of the volume, which is made dynamic by its component planes. The *Head of a Woman* corresponds chronologically to analytic cubism and can in fact be compared to landscapes of that period by both Picasso and Braque.

In sculpture the most complex problem was the transition from analytic to synthetic cubism through the rendering of planes independent of volume. The sculptors could not attain the kind of lyrical expression that had been the aim of the painters, because their medium seemed to prevent them from creating masses composed of sharply outlined planes while working freely in a three-dimensional space. The cubists did not succeed in overcoming this limitation, which was to be the task of the Spanish sculptor Julio González.

This seemingly unsolvable challenge explains the strange phenomenon that is noticeable in the works of the first cubist sculptors, Henri Laurens, Jacques Lipchitz (q.v.), and Aleksandr Archipenko, who returned to the monumental tradition and took inspiration especially from the Egyptians. In their canvases of 1911 and 1912, the painters had attained a lyrical harmony by diffracting their images into freely organized planes, with which they suggested a space of infinite dimensions and established the basis for an impersonal vocabulary of forms. Hardly a year later, ostensibly applying the same principles, the sculptors achieved quite the opposite result in works of stone, wood, and bronze that remained dense masses of material occupying a well-defined place in space.

On the other hand, the relief was by its nature more closely related to the problems of painting, aside from the varied materials involved. The three early cubist sculptors mentioned above created their best works in relief; in fact, these are the only pieces that can really be considered cubist sculpture. Thus the cubist adventure had to be more short-lived for the sculptors than for the painters. By diverse roads, all the major cubist sculptors traveled toward an art that, whether representational or nonobjective, was essentially based on mass. Another direction, clearly distinguishable from cubism by its eroticism, was taken by Constantin Brancusi (q.v.). After an ephemeral contact with cubism, he began to create unique and personal work that has placed him among the greatest sculptors of the century.

Because he was a member of the cubist group, the sculpture of Duchamp-Villon assumes a special importance. More dynamic than Laurens, Lipchitz, and even Archipenko, Duchamp-Villon, perhaps because he was an architect, had a deeper understanding of the problem presented by applying the principles of cubism to sculpture. At least in the case of the famous *Horse* (PL. 82), he succeeded in investing a still largely representational form with a structure of force lines that replaced the traditional volumetric entity: "When sculpture departs from nature it becomes architecture" (Apollinaire, 1913).

The importance of an art movement should be judged, aside from the intrinsic worth of the works produced by its leaders, by the extent of its influence. In this respect cubism, "this revolution, which has no equal in the history of art since the Renaissance, has exercised its influence on the whole sphere of artistic activity, from poetry to music, and from architecture to theatre" (Argan, 1950).

The relation between the development of contemporary functional architecture and cubism is not discernible as a direct formal influence of the latter upon the former, because the points of contact between architecture and painting are marginal. Even if indirect, however, such a connection is present in the basic influence of the formal direction that cubism affirmed for the first time at the beginning of the second decade of this century. Bruno Zevi (1950), in connection with Le Corbusier (C.-E. Jeanneret) and Walter Gropius (q.v.), has said: "A new spatial intelligence impels architects to conceive systematically in terms of pure surfaces and volumes, that is of spaces defined by planes. In this sense cubism and, in architecture, the International Style represent a focal point of development in modern art."

Jorge ROMERO BREST

FUTURISM. The manifesto by Filippo Tommaso Marinetti that signaled the birth of futurism, published in *Le Figaro* of Feb. 20, 1909, proposed a radical renovation of all artistic activity in keeping with the dynamism of modern mechanized life. Marinetti, who had edited *Poesia* with Sem Benelli since 1905 (where the manifesto was reprinted, in numbers 1–2 of

1909), was and always remained essentially a man of letters. In February, 1909, he met Umberto Boccioni (q.v.), Carlo Carrà, and Luigi Russolo, who in the following year were the signers, with Giacomo Balla (q.v.) and Gino Severini, of the *Manifesto dei pittori futuristi* (Feb. 11) and, with Aroldo Bonzagi and Romolo Romani, of the technical manifesto *La pittura futurista* (Apr. 11). Marinetti's political activity was on the side of interventionism, anticlericalism, and nationalism. In July, 1910, in the preface to the catalogue of Boccioni's one-man show in the Ca' Pesaro, Venice, Marinetti spoke of Boccioni and of Balla, Carrà, Russolo, and Severini as "futurist" painters who adhered to a movement that paralleled one in poetry. Actually none of these artists strayed far from a representational style based on the techniques of divisionist painting. The *Manifesto dei pittori futuristi* merely declared a vague, general approval "of the tangible miracles of contemporary life," while the subsequent technical manifesto spoke more precisely of a dynamic sensation eternalized as such: "Things in motion are so multiplied and so distorted that they succeed each other like vibrations in the space through which they move."

The exhibition held in Venice in 1910 by Boccioni — who, with Severini, had frequented the studio of Balla in Rome from 1900 to about 1904 — revealed a development toward a divisionist technique, evolving between the poles of a socially motivated realism (*Suburb*, 1909; Milan, Banca Commerciale) and a symbolism (for example, the drawing *Blessed Solitude, Only Solitude*, Birmingham, Mich., Winston Coll.) that was certainly connected with analogous phases of Central European postimpressionism. Balla's orientation was realist, with social overtones (*The Sewer*, 1902; Rome, Acc. di S. Luca); although also based on the divisionist perception of form, his work contained expressionist elements (*The Mad Woman*, 1905; Rome, Coll. Balla). Subsequently his interests led him to inquire particularly into symbolist correspondences (*The Lamp*, 1909; New York, Mus. of Mod. Art). Carrà was also identified with divisionism, but symbolist and expressionist elements were prevalent in his work as well (PL. 81). From origins among the post-*macchiaioli* (see MACCHIAIOLI), Severini reached divisionism through the influence of Balla and was confirmed in this style (*Boulevard*, Paris, private coll.) when he moved to Paris in 1906 and became acquainted with the work of Seurat.

The crisis in Boccioni's representational divisionism occurred between 1910 and 1911 and resulted in a dynamic accentuation that engages both the image and its milieu in a single complex visual and dynamic rhythm based on a system of directive or "force" lines. The chromatic quality is expressionistic (*The City Rises*, 1910-11, New York, Mus. of Mod. Art, V, PL. 131; *Dynamism of a Cyclist*, PL. 84). Balla, whose *Iridescent Interpenetrations* date back to 1912, turned toward nonobjective art. In 1911-12 he was working on analyses of dynamism in terms analogous to those cited in the technical manifesto (*The Violinist's Hands*, 1912; London, Esterick Coll.). These experiments, however, were soon concluded, and by 1912 (*Abstract Speed*, Rome, Coll. Balla; *Speeding Automobile*, PL. 81) he had turned to a dynamic construction of chromatic forms on a ground of pure colors, almost always lying uniformly on the plane, that was to remain characteristic of Balla until after 1920. In Carlo Carrà's canvases of the year 1911 (*Carriage Jolts*, formerly Munich, Coll. H. Walden) the fragmentation is accentuated, but the dynamism is checked by a tonal chromaticism even more intense than that of the French cubists, whom the artist was watching with increasing attention. The influence of cubism on Carrà was preponderant between 1912 (*The Gallery of Milan*, Milan, Coll. Mattioli) and about 1914. At the end of 1915 he began a series of paintings with "concrete forms (men, women, bottles, glasses, horses, etc.) placed in space," as he wrote to Ardengo Soffici. This trend marks the beginning of his "metaphysical" interests (see CHIRICO).

It was Severini, however, who had the closest connections with cubism. He favored a kind of faceting of small planes in minute color patches of postimpressionist origin (*Ballerina + Light + Bunch of Flowers*, Venice, P. Guggenheim Coll.). In 1916 he adopted synthetic cubism and created compositions in which the objects are drawn in profile on rudimentary and circumscribed chromatic planes. In the 1920s he renewed his interest in the figure, while after World War II his work became nonobjective. Carrà's premetaphysical activities of 1915-16, Severini's adherence to synthetic cubism, and particularly the frankly representational investigations that were carried on by Boccioni under the influence of Cézanne in 1915-16 (*The Drinker*, 1914-15, Milan, Gall. d'Arte Mod.; *Portrait of Ferruccio Busoni*, 1916, Rome, Gall. Naz. d'Arte Mod.) signaled a crisis in the futurist movement. The events of the war, including the deaths of Boccioni and the architect Antonio Sant'Elia, delayed its resolution. Consequently, there ensued until about 1920 a phase of transition involving both futurist work that was prevailingly dynamic and expressionist, even nonobjective, and work of a "metaphysical" kind originating from a new way of conceiving images. (It was in the latter sector that relations with Dada were particularly active.)

The statements of Boccioni, Carrà, Russolo, Balla, and Severini on the occasion of the first Paris exhibition of the group (Feb., 1912) affirm, among other things, that "simultaneity of states of mind means simultaneity of surroundings and, consequently, dislocation and fragmentation of objects." In the manifesto *La scultura futurista* by Boccioni (Apr. 11, 1912) this intention is defined as "the translation into plaster, bronze, glass, wood, or any other material, of the atmospheric planes that connect and intersect things." Only for Boccioni was dynamic fragmentation based on "line-force," a substantial element in the creative process. The elements of pure chromaticism and dynamic linearism affirmed in the manifesto *La pittura dei suoni, rumori e odori* (Aug. 11, 1913) are especially relevant to his expressionist works (1908-11). The idea of "plastic analogy," mentioned in the same manifesto by Carrà, was developed especially by Severini (*Manifesto delle analogie plastiche del dinamismo*, Sept.-Oct., 1913). Balla, on the other hand, tended toward an abstract dynamism or a largely decorative chromaticism.

Another signer of the 1910 manifestos was Russolo, who lived in Milan and was interested primarily in music; his work as a painter was very limited. After a short period of divisionism, in which he was close to Boccioni (*Lights*, Rome, Gall. Naz. d'Arte Mod.), there were evident in his paintings, especially those of 1911, symbolic schematizations derived from Art Nouveau (*Revolt*, The Hague, Dienst voor Schone Kunsten der Gemeente). In Florence during 1912 Ardengo Soffici, who had been hostile to futurism at first, began to participate in the movement. His futurist paintings date from the years 1912-13 (*Synthesis of an Autumn Landscape*, Rome, Gall. Naz. d'Arte Mod.); these have a dynamic character based on the use of line-force. On the other hand, his collages, done between 1913 and 1915, demonstrate the reappearance of strongly representational elements, juxtaposed with printed words. These works are related to cubist collages. An article entitled "Futurismo e Marinettismo," which appeared in *Lacerba* (Feb. 14, 1915) and which was also signed by Giovanni Papini and Aldo Palazzeschi (Giurlani), marked Soffici's break with futurism, and his subsequent development led to a naturalistic style related to 19th-century Italian work. The founding by Papini and Soffici (Jan., 1913) of *Lacerba*, a review under the auspices of the group previously responsible for *La Voce*, contributed to the formation of the Florentine futurist group influenced in part by Soffici himself: Ottone Rosai; Primo Conti, a futurist between 1915 and 1919; Italo Griselli, later a representational sculptor; and others. In Paris in 1913 Ugo Giannattasio was in touch with the futurists. The brief futurist phase of Arturo Martini also belongs to that year (*Portrait of O. Soppelsa*, 1913, Venice, Gall. Internaz. d'Arte Mod.). Futurist influence is evident in works of Giorgio Morandi of about 1914, mixed with elements taken from Cézanne and from cubism (*Still Life*, Milan, Coll. Scheiwiller) and forming a prelude to his "metaphysical" work. Futurist tendencies followed a phase of tonal representational work in Osvaldo Licini, who was an abstract painter from 1931 on. Giannattasio, Martini, Morandi, and Licini, along with Gino Rossi (of whom, however, no futurist works are known), Mario Sironi, and Enrico Prampolini, participated in the international Esposizione Libera Futurista (1914)

held at the Galleria Sprovieri in Rome. Sironi, who had been in contact with Boccioni and Balla before the formation of the futurist movement, entered the group in March of 1915 with canvases that are characterized by a strong expressionist accent. In 1919 he took part in the futurist exhibition at the Palazzo Cova, Milan, in which Achille Funi also participated.

Sant'Elia wrote the preface to the catalogue of the first art exhibition of the group Nuove Tendenze, which took place in 1914 at the Famiglia Artistica, Milan (May 20–June 14). In it he affirmed that "the new architecture is an architecture of cold calculation, of foolish audacity, and of the simplicity of reinforced concrete, iron, glass, pasteboard, fiber textiles, and all those substitutes for wood, stone, and brick that permit us to attain the maximum of elasticity and lightness." In the *Lacerba* of Aug. 10, 1914, Sant'Elia published a manifesto, *Dell'architettura futurista*, in which these affirmations took their place among the announced aims of the futurist group. Sant'Elia's death (1916) prevented the realization of his projects, which have survived in some 250 drawings (1906–16) dealing with the theme of the "new city": buildings with external elevators, covered passages, various street levels, stations, and so forth. A pupil of Sant'Elia, Mario Chiattone, used the same motifs in a series of drawings done before 1920. The activity of Virgilio Marchi can be dated about 1920 and that of Vinicio Paladini in the following years; the latter formed the link, especially because of his activity as a publicist (which preceded that of Fillia), with the Italian form of the international style in the decade between 1925 and 1935. The problem of a futurist architecture also interested Enrico Prampolini, who dedicated to it a manifesto, *L'"atmosfera-struttura" futurista, basi per un'architettura* (1914–15). The modernization of domestic furnishings and fittings (see FURNITURE) was the particular aim of Balla (1917), Fortunato Depero, and later Nikolai Diulgherov, who decorated several establishments, both public and private. The manifesto *Il mobilio futurista* was published in *Roma Futurista* (Feb. 22, 1920) by Francesco Cangiullo. Exaltation of the unadorned beauty of the modern machine recurs in all the futurist writings.

The futurists turned their interest to other artistic activities, especially to stage design (see SCENOGRAPHY). Prampolini's manifesto *Scenografia futurista* (*Der Futurismus*, Aug., 1922) dates from April–May, 1915. It was he more than anyone else who considered the problem from a theoretical point of view: "We must create an abstract entity that will be identified with the scenic action" (see also the *Manifesto del teatro futurista sintetico* by Bruno Corra, F. T. Marinetti, and E. Settimelli). In 1917 Depero and Balla created stage designs for Diaghilev's ballets in Rome; in 1918 Depero and Gilbert Clavel created the "balletti plastici," with music by Lord Berners, at the Teatro dei Piccoli, Rome. Prampolini's activity resulted in some one hundred works. The following were centers of scenographic activity: the Casa d'Arte of Anton Giulio Bragaglia in Rome (1917–21), Bragaglia's own Teatro degli Indipendenti (where he used his own designs), and the Teatro della Pantomima Futurista (Paris, Turin, Milan, 1927–28).

Bragaglia was actively interested in photography ("fotodinamismo") and made many photographs of images in motion (cf. *Fotodinamismo futurista*, Rome, 1911); he produced the only futurist film, *Perfido incanto* (1916), which was full of pre-Dadaist and presurrealist elements (see CINEMATOGRAPHY). In 1916 Marinetti — who in 1914, with Valentine de Saint-Point, had started making a futurist film, which was then interrupted by the war — Corra, E. Settimelli, Arnaldo Ginna, Balla, and Remo Chiti published *La cinematografia futurista*.

That a renovation of the esthetics of typography (see GRAPHIC ARTS) was a continuing aim of the futurists is proved in particular by the title pages of their periodicals. The *tavole parolibere* have a place by themselves, directly connected with the poetry of *parole in libertà* ("words in liberty"). The great futurist painters, from Boccioni to Carrà, as well as Marinetti and Francesco Cangiullo, created many *tavole* in *Lacerba* (1913–15). *Guerrapittura* by Carrà (Milan, 1915; 2d ed., 1920) is a whole volume of *tavole parolibere*. To the same genre belong *Bif § ZF + 18*, *Simultaneità*, and *Chimismi lirici* (Florence,

1915; 2d ed., 1919) by Soffici, who dedicated to the problem several pages of his *Primi principi di un estetica futurista* (Florence, 1920, but written between 1914 and 1917). In the second futurist generation Tullio d'Albisola tried similar experiments with his *litolatte*. Marinetti established the principles of the *tavole parolibere* in "Immaginazione senza fili e le parole in libertà" (*Lacerba*, June 15, 1913). This new, free approach to typographical problems, which was taken up and elaborated by the Dadaists, has remained fundamental to the development of the esthetics of modern typography and influenced advertising as well (see PUBLICITY AND ADVERTISING); nor was advertising neglected by the futurists, among whom especially Depero and Diulgherov of the second generation were active.

From the earliest years, the many traveling exhibitions and the publicizing activities of the futurist group in the big cities of Europe spread knowledge of their aims, promoted their influence, and gave rise to imitations and repetitions. In April, 1911, the Japanese review *The Contemporary Western Painting*, directed by Sohachi Kimura, published the first futurist manifesto and dedicated numerous articles to the movement during that year and the next. This attention produced a certain local adherence to futurist aims in the following years. In Poland "formism," which arose after 1917 and flourished until about 1922, was closely bound both in its ideas and its technique to Italian futurism (Tytus Czyzewski, Leon Chwistek, Stanislaw Igacy Witkiewicz, etc.). A strong futurist component is to be found in the development of the rayonism of Larionov and Gontcharova (their manifesto dated June, 1912, was published in 1913), who exhibited in Rome in 1917 (when the brochure *Radiantismo* appeared in Italian), as well as in the "cubofuturism" of Malevich (ca. 1911–12), V. E. Tatlin, Yury Annenkov, and P. Mansurov, along with the cubist component (especially of Léger). In Germany futurist elements are present in the work of Franz Marc (q.v.). In Portugal a futurist movement in painting arose around Luiz de Macedo. Spanish "ultraism" is linked to futurism (F. G. Marcadal, J. M. de Aizpurna, etc.). A significant futurist component occurs in the vorticism of Wyndham Lewis in England. Futurism also influenced many painters working in Dada circles, e.g., Viking Eggeling, Christian Schad, George Grosz, and Hans Richter. Futurist ideas were carried to the United States by Joseph Stella, who had been active in Italy before 1920. In about 1920 a group of Belgian painters, and particularly Prosper de Troyer, was closely connected with Italian futurism; and during this and the succeeding years, Victor Servranckx was close to the initial investigations of the second futurist generation. This second generation tried to keep alive and multiply the ties established by the first generation, but it was not always successful. It is significant, however, that Marinetti, in the manifesto *Il futurismo mondiale* of 1924 (*Noi*, ser. II, nos. 6, 7, 8, 9), brought together the names of the foremost members of the European avant-garde.

Enrico CRISPOLTI

SOURCES. *a. Cubism.* G. Apollinaire, Les jeunes: Picasso, peintre, La Plume, XVII, 1905, pp. 478–83; G. Apollinaire, Preface to the Catalogue of the Braque Exhibition at the Galerie Kahnweiler, Paris, Nov. 9–28, 1908 (repr. CahArt, VII, i–ii, 1932, p. 104); J. Metzinger, Picasso et le cubisme, Pan, Oct.–Nov., 1910 (repr. CahArt, VII, iii–v, 1932, p. 104); A. Salmon, La jeune peinture française, Paris, 1912; A. Gleizes and J. Metzinger, Du "Cubisme," Paris, 1912 (Eng. ed., Cubism, London, 1913); M. Denis, Théories, Paris, 1912; G. Apollinaire, Les peintres cubistes, Paris, 1913 (Am. ed., The Cubist Painters: Aesthetic Meditations, New York, 1944); G. Apollinaire, Peinture et les papiers collés, Montjoie, Mar. 14, 1913, p. 6; G. Braque, Pensées et réflexions sur la peinture, Nord-Sud, X, Dec., 1917, pp. 3–5; G. Apollinaire, L'esprit nouveau et les poètes, Mercure de France, CXXX, Dec. 1, 1918, p. 385 ff.; A. Ozenfant and C.-E. Jeanneret, Après le cubisme, Paris, 1918; M. Raynal, Quelques intentions du cubisme, Paris, 1919; R. Allard, L'avenir de la peinture, Nouveau Spectateur, no. 1, Paris, May 1919; L. Rosenberg, Cubisme et empiricisme, Paris, 1921; G. Severini, Du cubisme au classicisme, Paris, 1921; E. Bernard, Souvenirs sur Paul Cézanne et lettres, Paris, 1921; M. Denis, Nouvelles théories, Paris, 1922; A. Gleizes, Tradition et cubisme, Vers une conscience plastique; articles et conférences, 1912–24, Paris, 1927; M. Jacob, Souvenirs sur Picasso, CahArt, II, 1927, pp. 199–202; P. Sérusier, L'ABC de la peinture, Paris, 1942; L. Faure-Favier, Souvenirs sur Guillaume Apollinaire, Paris, 1945; R. Delaunay, Du cubisme à l'art abstrait: Documents inédits publiés par P. Francastel et suivis d'un catalogue de l'œuvre de R. Delaunay par G. Habasque, Paris, 1957. *b. Futurism.* M. Drudi Gambillo and T. Fiori, Archivi del Futurismo

(repub. of the most important manifestos — general, political, and on various subjects — including all those related to the representational arts, with prefaces, articles, and lectures of special interest until ca. 1920; also many letters, a detailed chronological table, illustrated catalogue raisonné of works, and bibliog. Also repub. complete: A. Soffici, Primi principi di un'estetica futuristica, Florence, 1920; U. Boccioni, Opera omnia, Foligno, 1927, Rome, 1958–60. Further sources are F. T. Marinetti, Le futurisme, théories et mouvement, Paris, 1911; L. Vauxcelles, Les futuristes, Gil Blas, Feb. 6, 1912; A. G. Bragaglia, Fotodinamismo futurista, Rome, 1913; R. Longhi, Pittori futuristi, La Voce, Florence, Apr. 10, 1913; Poetry and Drama, 3, 1913 (special number dedicated to futurism); G. Apollinaire, Futurisme, Mercure de France, Oct. 16, 1913, pp. 869–70 (repr. in Anecdotique, Paris, 1955); U. Giannattasio, A la recherche de l'absolu, L'Action d'Art, Paris, Dec. 25, 1913; G. Apollinaire, Nos amis les futuristes, Les Soirées de Paris, XIV, 21, Paris, 1914; Manifesto del futurismo, Florence, 1914; R. Longhi, Scultura futurista: Boccioni, Florence, 1914; G. Papini and A. Soffici, Il futurismo e Lacerba, Lacerba, Dec. 1, 1914; C. Carrà, Guerrapittura: Futurismo politico, dinamismo plastico . . . , Milan, 1915; G. Apollinaire, La nouvelle religion de la vélocité, Mercure de France, Oct. 16, 1916, pp. 755–59 (repr. in Anecdotique, Paris, 1955); H. Walden, Umberto Boccioni, Der Sturm, Sept., 1916; Fillia [E. Colombo], Pittura futurista: Realizzazioni, affermazioni, polemiche, Turin, 1920; V. Paladini, Arte d'avanguardia e futurismo, Rome, 1923; V. Marchi, Architettura futurista, Foligno, 1924; T. Grandi, Futurismo tipografico, Turin, 1926; Fillia [E. Colombo], Il futurismo, Milan, 1928; F. T. Marinetti, Marinetti e il futurismo, Rome, Milan, 1929; F. T. Marinetti, Futurismo e novecentismo, Milan, 1930; F. Cangiullo, Le serate futuriste, Naples, 1930; A. Soffici, Ricordi di vita artistica e letteraria, Florence, 1931 (2d enlarged ed., Florence, 1942); Fillia [E. Colombo], La nuova architettura, Turin, 1931; F. T. Marinetti, Il paesaggio e l'estetica futurista della macchina, Florence, 1931; Fillia [E. Colombo], Il futurismo: Ideologie, realizzazioni e polemiche del movimento futurista italiano, Milan, 1932; Fillia [E. Colombo], Architettura futurista e rinnovamento dei materiali nella costruzione, Futurismo, Dec. 18, 1932; F. T. Marinetti, Manifesti del futurismo, 1st ed., Milan, 1932, 2d ed., 1945; C. Carrà, La mia vita, Turin, 1935; 2d ed., Milan, 1945; Fillia [E. Colombo], Gli ambienti della nuova architettura, Turin, 1935; Fillia [E. Colombo], Il futurismo e l'estetica della macchina, Stile Futurista, II, 8–9, 1935, pp. 6–7; G. Severini, Ragionamenti sulle arti figurative, Milan, 1936; T. d'Albisola, La ceramica futurista, Savona, 1939; E. Prampolini, Arte polimaterica, Rome, 1940, 1944; F. Depero, So I think, so I paint: Ideologies of an Italian Self-made Painter, Rovereto, 1947; E. Prampolini, La plastique futuriste (Du dynamisme plastique à l'architecture spirituelle), Les Cahiers Jaunes, Paris, n.d.

BIBLIOG. a. General. F. Léger, Les origines de la peinture et sa valeur représentative, Montjoie, I, 9–10, June 14–29, 1913, pp. 9–10; Der Sturm, IV, 172–73, Aug., 1913, pp. 76–78; U. Boccioni, I Futuristi plagiati in Francia, Lacerba, Apr. 1, 1913; C. Carrà, Da Cézanne a noi futuristi, Lacerba, May 15, 1913; M. Deri, Die neue Malerei: Impressionismus, Pointillismus, Futuristen, die grossen Übergangsmeister, Kubisten, Expressionismus, absolute Malerei, Munich, 1913, 2d ed., Munich, 1914; J. N. Laurvic, Is It Art? Post-impressionism, Cubism and Futurism, New York, 1913; W. H. Wright, Impressionism to Synchronism, Forum, L, 1913; A. Soffici, Cubismo e oltre, 1st ed., Florence, 1913, 2d ed., Cubismo e futurismo, Florence, 1914; G. Coquiot, Cubistes, futuristes, passéistes, Paris, 1914; A. J. Eddy, Cubism and Post-impressionism, Chicago, 1914, 2d ed., 1919; W. Hausenstein, Die bildende Kunst der Gegenwart, Stuttgart, 1914, 1923; F. T. Marinetti, Gli sfruttatori del futurismo, Lacerba, Apr. 1, 1914; S. Kimura, The Arts of Futurism and Cubism, n.p., 1915; W. H. Wright, Modern Painting, Its Tendencies and Meaning, New York, 1915; T. Däubler, Der neue Standpunkt, Dresden, 1916, 2d ed., Leipzig, 1919; G. Severini, La peinture d'avant-garde, Mercure de France, June 1, 1917 (repr. Noi, II, 1–2, Feb., 1918, III, 1, Jan., 1919); T. van Doesburg, De nieuwe Beweging in de Schilderkunst, Delft, 1917; A. Pit, Cubisme, Expressionisme en Futurisme, Tijdschrift voor Wijsbegeerte, Haarlem, 1917; H. Walden, Einblick in Kunst: Expressionismus, Futurismus, Kubismus, 1st ed., Berlin, 1917, 2d ed., 1920, 3d ed., 1924; H. Walden, Expressionismus: Die Kunstwende, Berlin, 1918; G. Severini, Eenige Denkbeelden over Futurisme en Cubisme, De Stijl, Jan., 1919, p. 25; T. Däubler, Im Kampf um die moderne Kunst, Berlin, 1919; F. De Pisis, Pittura moderna, Ferrara, 1919; T. van Doesburg, Drie Voordrachten over de nieuwe beeldende Kunst, Amsterdam, 1919; O. Grautoff, Formzertrümmerung und Formaufbau in der bildenden Kunst, Berlin, 1919; A. Soffici, Scoperte e massacri, Florence, 1919, 1929; C. Mariotti, Modern Movements in Painting, London, 1920; A. Sakheim, Expressionismus, Futurismus, Aktivismus, Hamburg, 1920; E. Salmon, L'art vivant, Paris, 1920; V. Petrković, Ekspresionizam, futurizam, kubizam, Novji Život, II, 8, 12, 1921, pp. 378–82, II, 9, 1, pp. 25–36; I. Hevesy, A Futurizmus Expressionizmus és Kubizmus Müvészete (Futurism, Expressionism, and Cubism in Art), Gyoma, 1922; L. Kassak and L. Moholy-Nagy, Buch neuer Künstler, Vienna, 1922; P. F. Schmidt, Die Kunst der Gegenwart, Berlin, 1922; K. S. Dreier, Western Art and the New Era, New York, 1923; S. Cheney, A Primer of Modern Art, New York, 1924 (rev. ed., The Story of Modern Art, New York, 1948); T. van Doesburg, Grundbegriffe der neuen Gestaltenden, Munich, 1924; W. Pach, The Masters of Modern Art, New York, 1924; H. Kroller-Müller, Die Entwicklung der modernen Malerei, Leipzig, 1925; C. Pavolini, Cubismo, Futurismo, Espressionismo, Bologna, 1926; F. Rutter, Evolution in Modern Art, London, 1926; C. Einstein, Die Kunst des 20. Jahrhunderts, Berlin, 1926; K. Malevitč, Die gegenstandlose Welt, Munich, 1927; E. Prampolini, P. Dermée, and M. Seuphor, Documents internationaux de l'esprit nouveau, Paris, 1927; R. Wilensky, The Modern Movement in Art, London, 1927, 1945; H. Focillon, La peinture: XIXe et XXe siècles, Paris, 1928; A. Salmon, Art russe moderne, Paris, 1928; A. Ozenfant, Art, Paris, 1928 (Am. ed., Foundations of Modern Art, New York, 1952); J. Hélion, Evolution of Abstract Art, New York, 1933; H. Read, Art Now: An Introduction to the Theory of Modern Painting and Sculpture, London, 1933, 1936, 1948; E. Prampolini, Futurismo e cubismo: La città nuova, Turin, 1934; H. Read, The Modern Movement in English Architecture, Painting and Sculpture, London, 1934; J. Sweeney, Plastic Redirections in 20th Century Painting, Chicago, 1934; C. Belli, KN, Milan, 1935; A. H. Barr, Jr., Cubism and Abstract Art, New York, 1936; C. Giedion-Welcker, Moderne Plastik, Zurich, 1937; S. Giedion, Space, Time and Architecture, Cambridge, Mass., 1941, 1942, 1943, 1944, 1949, 1954 (enlarged) (It. trans., Milan, 1954); M. Guggenheim, Art of This Century, New York, 1942; R. Gómez de la Serna, Ismos, 1943; G. C. Argan, L'architecture moderne, GBA, XIV, 47, 1945; L. Moholy-Nagy, Space-Time Problems in Art, New York, 1946; L. Moholy-Nagy, The New Vision, New York, 1947; L. Moholy-Nagy, Vision in Motion, Chicago, 1947; G. C. Argan, Difficoltà della scultura, Arte e Letteratura, 1949 (repr. Studi e Note, Rome, 1955); C. Maltese, Introduzione alla scultura moderna, Ulisse, II, 1950, p. 683 ff.; B. S. Myers, Modern Art in the Making, New York, 1950; A. Soffici, Trenta artisti moderni italiani e stranieri, Florence, 1950; R. Motherwell, The Dada Painters and Poets: An Anthology, New York, 1951; C. L. Ragghianti, Pittura italiana e pittura europea, Sele Arte, 3, Nov.–Dec., 1952, p. 26 ff.; M. Raynal, Modern Painting, Geneva, 1953; K. Schoor, Stilkunde der Malerei: Vom Impressionismus zum Surrealismus, Linz, 1953; N. Walden and L. Schreyer, Der Sturm, Baden-Baden, 1954; W. Haftmann, Malerei im 20. Jahrhundert, Munich, 1954, 1955; Dictionary of Modern Painting, New York, 1955; C. Giedion-Welcker, Contemporary Sculpture, New York, 1955; M. Seuphor [F. L. Berckelaers], Dictionary of Abstract Painting, New York, 1957; B. S. Myers, The German Expressionists, New York, 1957; W. Verkauf, Dada: Monographie einer Bewegung, Teufen, 1957 (Eng. trans., Dada: Monograph of a Movement, Teufen, 1957); cf. also the bibliogs. of AMERICAS: ART SINCE COLUMBUS; EUROPEAN MODERN MOVEMENTS; NONOBJECTIVE ART. b. Cubism. A. J. Eddy, Cubists and Post-impressionism, Chicago, 1914, 2d ed., 1919; P. E. Küppers, Der Kubismus, Leipzig, 1920; D. Henry [Kahnweiler], Der Weg zum Kubismus, Munich, 1920; S. Coquiot, Les indépendants (1884–1920), Paris, 1920; E. Wiese, Aleksandr Archipenko, Leipzig, 1923; G. Coquiot, Les peintres maudits, Paris, 1924; A. Gleizes, Du cubisme et des moyens de le comprendre, Paris, 1925; A. Ozenfant and C.-E. Jeanneret, La peinture moderne, Paris, 1925; P. Courthion, André Lhote, Paris, 1926; A. Basler, La peinture . . . religion nouvelle, Paris, 1926; F. Carco, De Montmartre au quartier latin, Paris, 1927; E. Tériade, Fernand Léger, Paris, 1928; A. Basler, Le cafard après la fête, Paris, 1929; G. Janneau, L'art cubiste, Paris, 1929; J. Cassou, Marcoussis, Paris, 1930; G. Olivier, La naissance du cubisme, Mercure de France, CXXVIII, June 15, 1931, pp. 558–88; F. Olivier, Neuf ans chez Picasso: Picasso et ses amis, Mercure de France, CXXVII, May 1, 1931, pp. 549–61; A. Salmon, Picasso et le cubisme, CahArt, VII, iii–v, 1932, p. 104; C. Zervos, Georges Braque et le développement du cubisme, CahArt, VII, i–ii, 1932, pp. 13–28; A. Lhote, Les créateurs du cubisme, La Nouvelle Revue Française, May 1, 1935, pp. 785–89; Les étapes de l'art contemporain: Les créateurs du cubisme (preface by M. Raynal; catalogue by R. Cogniat, Paris, Mar.–Apr., 1935); E. Nebelthan, Roger de la Fresnaye, Paris, 1935; A. H. Barr, Jr., Cubism and Abstract Art, New York, 1936; V. Crastre, Naissance du cubisme (Céret, 1910), Geneva [1940]; G. Lemaître, From Cubism to Surrealism in French Literature, Cambridge, Mass., 1941, 1947 (revised); B. Dorival, Les étapes de la peinture française contemporaine, Paris, 1943–44; F. Carco, L'ami des peintres, Geneva, 1944; E. Bonfante and J. Ravenna, Arte cubista, Venice, 1945; Le cubisme, 1911–1918, Paris, Galerie de France, May 25–June 30, 1945; E. de Rouvre, ed., La peinture et la littérature libres, Mantes, 1945; D. H. Kahnweiler, Juan Gris, sa vie, son œuvre, ses écrits, 5th ed., Paris, 1946 (Eng. ed., trans. D. Cooper, London, 1947); S. Finkelstein, Art and Society, New York, 1947; The Cubist Spirit in Its Time, London, Tate Gallery, 1947 (texts by R. Melville and E. L, T. Mesenz); W. O. Judkins, Toward a Reinterpretation of Cubism, AB, XXXIV, 1948, pp. 270–78; A. Lhote, Traité du paysage, Paris, 1948 (Eng. ed., trans. W. J. Strachan, Treatise on Landscape Painting, London, [1950]); C. E. Gauss, Aesthetic Theories of French Artists, Baltimore, 1949; P. M. Laporte, Cubism and Science, J. of Aesthetics and Art Criticism, 1949; J. Lassaigne, Jacques Villon, Paris, 1950; A. Lhote, Traité de la figure, Paris, 1950 (Am. ed., trans. W. J. Strachan, Theory of Figure Painting, New York, [1954]); L. Koenig, Peintures de l'école de Paris: La période cubiste ou quarante ans après, Liège, Apr. 29–May 25, 1950; G. C. Argan, Il cubismo alla XXV Biennale, Ulisse, II, 1950, p. 667 ff. (repr. in Studi e Note, Rome, 1955); D. H. Kahnweiler, Les années héroïques du cubisme, Paris, 1950; J. Lassaigne, Painters of the Twentieth Century: Cubism and Fantastic Art, Geneva, 1952; C. Gray, Cubist Aesthetic Theories, Baltimore, 1953; [G. Vienne and B. Dorival], Le cubisme (1907–1914), Musée National d'Art Moderne, Paris, Jan. 30–Apr. 9, 1953 (preface by J. Cassou); G. Wagner, Wyndham Lewis and Vorticist Aesthetics, J. of Aesthetics and Art Criticism, XIII, 1954, p. 1 ff.; J. Lassaigne, Dufy, Geneva, 1954; A. Verdet, Fernand Léger, Geneva, 1955; F. Fosca, Bilan du cubisme, Paris, 1956; P. Descargues, Le Cubisme, Paris, 1956; History of Modern Painting (texts by M. Raynal, J. Lassaigne, W. Schmalenbach, A. Rudlinger, and H. Bollinger), III, Geneva, 1956; F. Elgar, Picasso, époque cubiste, Paris, 1957; J. Golding, Cubism, New York, 1959; G. Habasque, Cubism: Biographical and Critical Study, trans. S. Gilbert, Geneva, New York, 1959; R. Lebel, Sur Marcel Duchamp, Paris, 1959; J. Leymarie, André Derain, Paris, n.d.; J. Toorop, Le Fauconnier, Amsterdam, n.d.; cf. also the bibliogs. of BRAQUE, GEORGES; PICASSO, PABLO. c. Futurism. H. Walden, U. Boccioni, Berlin, 1918; F. Flora, Dal romanticismo al futurismo, Piacenza, 1921, 2d ed., 1925; P. Mondrian, De "bruiteurs futuristes italiens" en "Het" Nieuwe in de Musik, De Stijl, Aug. 8, 1921, pp. 114–18, Sept. 9, 1921, pp. 130–36; Die Futuristen: Umberto Boccioni, Carlo D. Carrà, Luigi Russolo, Gino Severini, Berlin, 1922; N. E. Radlov, O futurisme (On Futurism), Petrograd, 1923; J. Rodker, The Future of Futurism, London, 1926; B. Croce, Storia d'Italia dal 1870 al 1915, Bari, 1928; G. C. Argan, Il pensiero critico di Antonio Sant'Elia, L'Arte, Sept., 1930, pp. 491–98; P. Courthion, Gino Severini, Milan, 1930; Fillia, Glorificare Sant'Elia,

La provincia di Como, May 13, 1930; F. T. Marinetti, EI, s.v. Boccioni, Umberto, J. Maritain, Severini, Paris, 1930; G. Scheiwiller, Cento artisti italiani: Futuristi, novecentisti e indipendenti, Paris, 1930; G. Scheiwiller, Mario Sironi, Milan, 1930; N. Tarchiani, EI, s.v. Balla, Giacomo; F. T. Marinetti, EI, s.v. Sant'Elia, Antonio; W. Grohmann, ThB, s.v. Prampolini, Enrico; Dopo Sant'Elia (writings of G. C. Argan, C. Levi, M. Marangoni, A. Pecchioni, G. Pagano, A. Pasquali, A. Pica, L. Venturi), Milan, 1935; C. Belli, KN, Milan, 1935; Achille Lega pittore, Terzo anniversario della morte, Faenza, 1937; A. Moretti, Futurismo, Turin, 1939; F. Depero, Fortunato Depero nella vita e nelle opere, Trento, 1940; E. Pfeister, Enrico Prampolini, Milan, 1940; E. Prampolini, Scenotecnica, Milan, 1940; A. Parronchi, O. Rosai, Milan, 1941, 2d ed., Florence, 1947; R. T. Clough, Looking Back at Futurism, New York, 1942; G. Pacchioni, Carlo Carrà, Milan, 1945; A. Sartoris, Mario Sironi, Milan, 1946; G. Dorfles, Le tappe di Boccioni, La Fiera Letteraria, Feb. 27, 1948; A. H. Barr, Jr., and J. T. Soby, Twentieth Century Italian Art, New York, 1949; U. Apollonio, Pittura italiana contemporanea, Venice, 1950; R. Carrieri, Pittura e scultura d'avanguardia in Italia, 1890–1950, Milan, 1950; G. Ballo, Poetiche e sviluppi della scenografia da Wagner alla scenodinamica, Varese, 1950; F. A. [Arcangeli], I futuristi al museo, Paragone, I, 7, July, 1950, pp. 61–63; Cinquante ans d'art italien, CahArt, XXV, 1950; G. Marchiori, Pittura moderna italiana, Venice, 1950; M. Valsecchi, Umberto Boccioni, Venice, 1950; B. Zevi, Storia dell'architettura moderna, Turin, 1950, 2d ed., 1953; Fratelli Ghiringhelli, Storia del futurismo, Milan, 1951; G. Severini, Quarant'anni d'arte astratta in Italia, Spazio, II, 4, Jan.–Feb., 1951, p. 45 ff.; L. Venturi, Italian Paintings from Caravaggio to Modigliani, trans. S. Gilbert, Geneva, 1952; A. Parronchi, Preistoria di Rosai, 1911–19, Paragone, Jan. 25, 1952, pp. 31–40; G. C. Argan, Umberto Boccioni, Rome, 1953 (with a selection of writings edited by M. Calvesi); G. Marchiori, Scultura italiana moderna, Venice, 1953; R. Maroni, Fortunato Depero pittore, Trento, 1953; F. Arcangeli, Notes on Contemporary Italian Painting, BM, XCVII, June, 1955, p. 174 ff.; G. Bernasconi, L'espressionismo nei disegni di Mario Chiattone, Rivista Tecnica della Svizzera Italiana, XLII, 471, Sept., 1955, pp. 218–26; C. L. Ragghianti and O. Rosai, Cinquant'anni di disegno, Florence, 1956; M. Seuphor [F. L. Berckelaers], Le futurisme hier, L'Œil, Feb., 1956; B. Zevi, Poetica di Sant'Elia e ideologia futurista, L'Architettura, II, 13, 1956, pp. 476–77; G. Ballo, Pittori italiani dal futurismo ad oggi, Milan, 1956; R. V. Gindertael, Œuvres futuristes et cubistes de Severini, XXᵉ Siècle, June, 1956; G. Marchiori, Scultura italiana tra due tempi, Quadrum, 3, 1957, pp. 99–101; A. Parronchi, Un futurista in incognito, Mario Nannini (1895–1918), Paragone, VIII, 85, Jan., 1957, pp. 87–99; P. Courthion, Prampolini, Rome, 1957; P. C. Santini, O. Rosai, Ivrea, 1957; E. Crispolti, Appunti sul problema del secondo futurismo nella cultura italiana fra le due guerre, Notizie, 5, Apr., 1958, pp. 34–51; A. Galvano, Futuristi torinesi, Notizie, 5, Apr., 1958, pp. 28–33; G. Perocco, I primi espositori di Ca' Pesaro, Venice, Sept.–Oct., 1958; E. Crispolti, I primi espositori di Ca' Pesaro, Il Verri, Milan, 1958; M. Calvesi, Il futurismo di U. Boccioni: Formazione e tempi, Arte Antica e Moderna, 2, 1958, pp. 149–69; M. Drudi Gambillo, Boccioni prefuturista, La Fiera Letteraria, Sept. 14, 1958; U. Apollonio, Antonio Sant'Elia, Milan, 1958 (with bibliog); M. Porebski, Il formismo polacco, La Biennale di Venezia, VIII, 32, July–Sept., 1958; C. L. Ragghianti, Fotodinamica futurista: Una postilla a fotografia e arte, Sele Arte, 39, Jan.–Feb., 1959, pp. 2–10; G. Marchiori and E. Crispolti, Scultura di Mino Rosso, Turin, 1959; A. Jorn and E. Baj, Farfa futurista, Milan, 1959; E. Crispolti, Appunti per una storia del non-figurativo in Italia, Ulisse, XII, VI, 33, 1959, pp. 29–45; M. Calvesi, Il futurista Sant'Elia, La Casa, 6, May, 1959; E. Falqui, Bibliografia e iconografia del futurismo, Florence, 1959.

Jorge ROMERO BREST and Enrico CRISPOLTI

Illustrations: PLS. 75–84.

## CUSHITE CULTURES.

Within the framework of African arts (see AFRICAN CULTURES) the works of the Cushite peoples occupy a unique place, since they cannot be included in the corpus of art objects that have their origins among Negro peoples or with those of Asiatic derivation (see AZANIAN ART; ETHIOPIAN ART). The artistic production of the Cushite peoples comprises both archaeological and contemporary examples; it is unpretentious in its forms and is limited to sculpture in wood and stone, applied arts, and weaving.

SUMMARY. Geographic distribution and culture of the Cushites (col. 163). Architecture: dwellings, tumuli, dolmens (col. 164). Sculpture and funerary monuments of southern Ethiopia (col. 165). Gold- and silverwork (col. 168). Minor arts (col. 168).

GEOGRAPHIC DISTRIBUTION AND CULTURE OF THE CUSHITES. In present-day ethnologic and linguistic studies the term "Cushite" (an extension of an older ethnic term derived from the Biblical Cush, the land of the Hamites) is assigned to a group of East African peoples who dwell across the Ethiopian Plateau from the middle valley of the Nile eastward to the Indian Ocean. These interrelated peoples are distinct from their neighbors, who speak either Semitic languages (such as Arabic and the Semitic languages of Ethiopia) introduced through migrations from Asia or African languages of the Nilotic, Sudanese, and Bantu groups.

The Cushite peoples inhabit two principal geographical areas: (1) the low plain extending inward from the eastern coast and stretching to the northwest as far as the Nile, and (2) the Ethiopian Plateau. In the area of the low plain are the Beja in Sudan and Eritrea, the Saho in Eritrea, the Afar (Danakil) along the Red Sea, and the Somali from the Gulf of Tadjoura (French Somaliland) to the mouth of the Tana River (Kenya). On the Ethiopian Plateau live the Agau, who are scattered in various areas from the region north of Lake Tana (where they are called Kemant) to Eritrea (Bogo group); and the Sidamo, who still occupy a sizable area of southern Ethiopia from the high valley of the Juba River through the basin of Lake Abaya (Wallamo), to the upper valleys of the Omo River (Kafa), and as far as the Blue Nile, where the small group of the Shinasha (Bworo) resides. A special position is occupied by the Galla, who emigrated en masse to the Ethiopian Plateau from their first home in present-day Somalia and in the valleys of the Webbi Shibeli and the Juba Rivers. The Galla now occupy vast regions; in some areas they supplanted and, in large part, assimilated the Sidamo peoples who preceded them.

Some scholars have advanced the theory of a special linguistic and cultural connection between the Cushites and the people of Meroë, who inhabited the valley of the Upper Nile in antiquity. The linguistic connection still has not been proved, but it is a working hypothesis worthy of consideration — probably not in the sense of a direct link between Meroitic and the Cushite languages spoken today in the immediately adjacent area, but rather as a general family relationship between Meroitic and the various Cushite linguistic groups.

Within these geographic and ethnic limits, a precise definition of Cushite cultures (and of their art forms) is difficult because of the variations in ethnic substrata in the regions where the Cushites have established themselves. The substratum is Bantu in the Somaliland area, Nilotic in the southwest, from Lake Rudolf to the valley of the Omo River, and Sudanese along the eastern ridge of the plateau. In various areas other ethnic groups have, through successive migrations, subdued and at least partially assimilated the Cushite peoples. Arabs from Yemen, Hadhramaut, and the Arab countries of the Persian Gulf immigrated for several centuries, both before and after the spread of Islam. Along the coast, even the Persians were established in the Middle Ages (see AZANIAN ART). A historical reconstruction of the culture and art of the Cushites still presents a complex problem, even with the material made available by recent investigations. This difficulty has undoubtedly been increased by the fact that in East Africa the Cushite peoples have often been forced to move from one area to another. In western Ethiopia, for example, the Sidamo (Cushites) supplanted the Nilotics and were in turn supplanted by the Amhara (speaking a Semitic language); in Somaliland, the Bantu (Negroes), the Galla (Cushites), the Somali (Cushites), and minor Arab and Persian immigrations followed one after the other and left traces in the ethnic structure and cultural complex.

ARCHITECTURE: DWELLINGS, TUMULI, DOLMENS. The typical portable dwelling of the nomads is the round beehive hut, with a dome formed by an armature of branches covered with mats. Neither these tent-huts nor the various types of permanent dwellings constructed of vegetable materials and wattle and daub, whatever their variations in type, are of architectural or esthetic interest. However, in the territories now inhabited by Cushite populations, their stone structures of dry-masonry construction are worthy of consideration. This building technique has had extensive development in a wide area of southern Ethiopia that reaches as far as northern Somalia.

It is desirable to distinguish between the crude enclosing walls of some ancient tombs and the more finished building techniques found at the holy city of Shekh Hussen (in Bale), a place of pilgrimage for the Moslem Galla and the Somali. In this locale extensive enclosures and tomb structures of dry

masonry have been preserved. The masonry is usually ashlar, and contemporary architectural models of other more developed Moslem countries are reproduced in this ancient technique.

The dry-masonry enclosures of some ancient tombs in Mijertins (northeastern Somalia) are much cruder structures. In these the direction for prayer is sometimes indicated simply by means of small slabs of stone superposed at the corners, an elemental form of the niche (mihrab) found in mosques that shows the faithful the direction of Mecca. Similar enclosures are found in Danakil. An analogous type of construction, perhaps even more archaic in character, is represented by the tumuli scattered over a wide area of southern Ethiopia and eastern Somalia, from the region of Harar as far as Heis, in Mijertins, and south from there as far as the area of the Rahawein and beyond the Juba. These tumuli, piles of rough stone that are often of considerable size, are interpreted by local tradition as the tombs of warriors fallen in battle or of famous members of the tribe.

Some other structures composed of slabs of stone and found in the region of Harar, in what is Galla territory today, have been characterized as dolmens. Other authorities have ascribed them to the culture of Semitic Ethiopia, as imitations or rough copies of the so-called "chairs" of the kings or judges of ancient Aksum (see ETHIOPIAN ART). Both theories await confirmation.

SCULPTURE AND FUNERARY MONUMENTS OF SOUTHERN ETHIOPIA. Funerary monuments are the most numerous and interesting of the art forms of the Cushites. Although no analogous form has yet been discovered among the peoples living farther north than the Galla of the Ethiopian Plateau, similar customs exist to the south of Ethiopia among the Negro peoples who have been in contact with the Galla at least since the 16th century and who inspired their peculiar social ranking by age grades (gada). Funerary figures therefore represent a Negro cultural element assimilated by the southernmost Cushites.

The geographic distribution of these funerary forms, as far as has been determined, is as follows: Wooden figures appear among the Konso in the Galana Sagan Basin north of Lake Stefanie; among the Galla of the Goro region, formerly called Gabba Ilun, in western Ethiopia along the Baro; and among the Galla Lieqa of Wollega, in the Bako region, immediately to the north of Gabba. They are of stone among the Galla Arusi in the upper basin of the Webbi Shibeli, as well as in the territory now occupied by the Gurage Selti and Aymallal south of the Hawash River. Stone figures are found in the territory of the Sidamo along the divide between the Webbi Shibeli and Juba Rivers and Lake Abaya.

The area of diffusion is characteristic, and analysis of it confirms what has been said about the probable origin of this art. Differences of technique correspond to the groupings into various regions. Konso figures represent the human form as noticeably elongated, for no other reason than to adapt the squared-off cross section of the log to the curves of the body (PLS. 88, 89). The head is elongated; the eyes and mouth are incised and often deeply undercut, while similar cuts outline the ear lobes. Another deep cut marks the hairline. Among the Cushites, various coiffures indicate different social positions. The body is formed from a single piece of wood; the arms are, with rare exceptions, lacking or are summarily indicated in very low relief, as are the legs. This type, at least as seen today among the Konso, does not lend itself on the whole to distinctive, individual artistic representation. The figures, which give a general impression of almost alarming severity, are assembled in groups and are often indistinguishable from one another. The only recurrent distinction is the greater height of the statue of the warrior being honored, which stands out from the figures grouped around him that represent enemies he has killed. The warrior is adorned with a trophy necklace that is sometimes carved in the wood of the statue and sometimes added as an actual necklace. In some cases small representations of the wild beasts brought down by the hero are included in the group of figures of slain enemies. On the whole, it is an art that can scarcely be distinguished from handicraft work for ritual purposes, at least in the monuments discovered thus far.

A different technique is found in the representation of the human form in the wood figures of the Galla Gabba and Galla Lieqa. In the two kinds of monument that have been studied — Ari and Bako — there is an attempt at realism, however crude. The soldier Wayessa and the magician Abba Gersho, both in their poses and in their surroundings, are represented as they must have been in life. The two figures are dressed in suits and headgear of fabric. The warrior is followed, according to Ethiopian custom, by the servant who carries his arms; and the servant is of small size, demonstrating, as in the Konso monuments, the relation between the height of the figure and social rank. The magician, to whose body has been nailed a wooden phallus

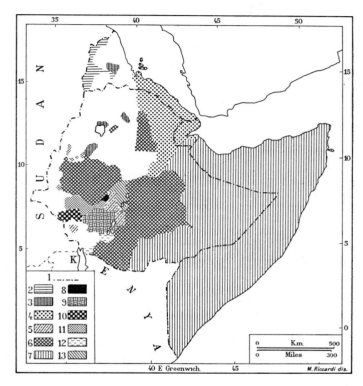

Distribution of Cushite cultures in Ethiopia and the Somali territory. *Key:* (1) Political boundaries; (2) Beja; (3) Agau; (4) Saho-Afar; (5) Sidamo; (6) Galla; (7) Somali; (8) Janjero; (9) Ometo; (10) Gimira; (11) Kafa (and Shinasha); (12) Konso-Geleba; (13) Gurage.

in ithyphallic position, has his arms extended in the ritual position of invocation; above him is an umbrella, a symbol of honor, and he is surrounded by bunches of wild asparagus, a sacred plant used for divinations. This type of object, more fully developed than those of the Konso, reveals an artistic attempt to rise above stylization to a monumental rendering of everyday reality. That these works are considered more than mere representations of those portrayed is proved by the deep-rooted belief that any damage or alteration to the object is a direct injury to the hero glorified.

Another stylistic tendency may be seen in the funerary stones of the Galla Arusi, carved on one side only. Instead of representations of the human figure geometric designs are found, sometimes rather complex, formed of circles and intersecting lines. Although the outward aspect of these patterns recalls astral symbols, comparison with the groups of monuments previously described leaves no doubt that they are geometric stylizations of the figure and of the warrior's customary arms, shield, and spear. Sometimes the funerary monument comprises a group of several stones representing the hero and the enemies conquered by him, as observed in the Konso monuments. At other times the stylization is so marked, either because of the lack of skill of the artisan or perhaps because of the quality of the material itself, that ornamentation is reduced to a few lines and dots.

Of still another character are the funerary stones of the Sidamo, also sculptured on one side only. These depict an elongated human form, with the head enclosed by a double oval that is incised and whitewashed; the mouth is strongly marked, the eyes sometimes protrude, and the eyebrows are indicated. The breasts are protuberant, perhaps to distinguish the warriors of this group from those of other ethnic groups, such as the Janjero of the Gibbe Valley, among whom it was the custom to cut off one of the nipples as an indication of their warlike nature. The rest of the body is held in by double intersecting lines that have been interpreted as lianas, for such vines are still used by the neighboring peoples to bind the corpse into a compact position for ritual burial.

The most highly developed funerary monuments are the Gurage ones, often called the "stones of Grañ," from the epithet of the Moslem conqueror of Ethiopia in the 16th century; he

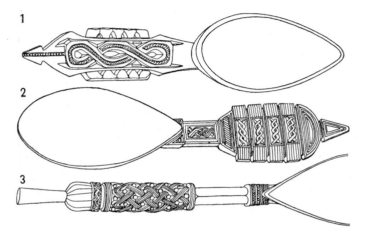

Somali decorative art, carved spoons: (1) Rome, Mus. Africano; (2, 3) Rome, Mus. Pigorini.

represents in present-day Gurage folklore everything that is opposed to Christianity and therefore symbolizes paganism. The stones of Grañ evidence a rather elaborate artistic development. Entire scenes of the warrior's victories over enemies and wild beasts are represented. Wars are usually depicted in the upper part and hunts below. Evident also is a certain stylization of the animals, as in a stone at Silte. In other versions the hero may appear in relief in the upper half, while below are representations of *ensete* (banana) plants, the characteristic vegetation of the region, flanked by human figures and animals that may represent the people of conquered villages, as in another type of stone found at Silte (described as a "menhir" by Azaïs and Jensen). These latter stones are accompanied, within the same funerary group, by a representation of the dead warrior, sometimes carved on a rock in a geometric manner and sometimes simply incised on a slab. In both types of monument emphasis is placed on the warrior's arms (generally lacking in Konso and Sidamo sculpture); they may be raised in prayer or invocation (PL. 87), and the armpits may be indicated by large cavities in the stone.

In the Gurage region is found still another style of funerary stone, in which the warrior's victories are usually represented by swords and daggers incised in the stone in such a way as to form a decorative motif that has some esthetic value. The coexistence of these varied types of sculpture in southern Ethiopia consequently poses the question of the historical development of such an art. The stones of Grañ, the most fully developed representations, constitute the height of artistic achievement in the area; however, some of the cruder examples of these may evidence a return to barbarism, a possibility that should be carefully examined. The purpose of the various monuments is the same: the glorification of a dead warrior or magician through the recording of his exploits. The monuments described are found in regions that produced others of no artistic interest,

in which the more detailed statues and gravestones are replaced by crudely carved sticks or stones; these are the "tombs of the poor" that, for reasons perhaps not entirely economic, are limited to an elementary set of symbols. Similar "tombs of the poor" are found outside Ethiopia, among such Bantu tribes as the Wagiryama. This form seems to be the elemental type that gave rise to the various tendencies in sculpture. Only two types of funerary monument are still produced in these regions: the wood figures of the Konso and those of the Galla Gabba and Galla Lieqa. Finally, and perhaps outside the strict limits of art history, it should be added that these funerary monuments are historically related to the tombs with herringbone decoration discovered in northern Somalia, in a region where the Somali have supplanted the Galla.

Rather numerous sculptured stone phallic pillars have been found in the Wallamo region north of Lake Abaya. These have been linked to a fertility cult whose traces remain in the present culture of the Cushites.

GOLD- AND SILVERWORK. Among the Cushites the working of gold is usually connected with the monarchy. The insignia of the sovereign in many Sidamo and Galla regions of western Ethiopia was the golden bracelet, called the "king's gold," which was inherited by his successor. Even today in the small Galla state of Jimma, only the king may have gold worked by the goldsmiths (in recent times foreigners, generally Arabs), who reside within the royal compound. A similar royal monopoly of goldwork was in force in the Kafa region, where the king (dethroned in 1897) had among his ceremonial insignia a golden helmet adorned in front with a triple phallus. In imitation of the Shoa, the Galla and Sidamo high chiefs also had gold trappings for their war horses, as well as parade shields of gold. Such ornaments were clearly influenced by the art of the Arab goldsmiths (especially Yemenites).

Among the Somali the working of silver, which must be imported, is even more closely related to Arab metalwork. Among the nomadic shepherds of Somaliland, women's bracelets and armbands of silver are considered a form of savings, since they are often fashioned by melting down coins and therefore represent available capital in case of need. In contrast to the thick but narrow and sparsely ornamented bracelets in use among the Somali of the south are the wide, ornate armbands with fastening pins found among the northern Somali.

MINOR ARTS. The working of ivory is limited, but the ivory and silver handles of the Somali daggers should be noted. The blade form of these daggers, with triangular point and double cutting edge, is also diffused among other Cushite peoples and has been compared with similar Egyptian weapons.

Little need be said concerning Cushite pottery, which is sometimes pleasing and original in form. Containers of wood or gourd with geometric decoration burned into them (PL. 85) are also among the minor arts of the Cushites.

Wood is used for the log seats of the great chiefs of the Galla; these seats are generally carved from a single log and decorated with geometric ornamentation. River boats are also constructed of wood. Among the Galla, boats are rather long and are carved from a single piece of wood; Somali boats are mainly for the ferrying of rivers and are rectangular and made of nailed planks. On the lakes of southern Ethiopia are found canoes made of rushes or papyrus as at Lake Tana. Among the Somali, especially the Hawiya and the Rahawein of southern Somaliland, incised decorative motifs of some esthetic merit are sometimes found on small wooden objects (PL. 85). It is doubtful that this modest art of incised wood, well represented in Italian and other European museums, is derived from indigenous Cushite traditions. In certain cases the very nature of the objects precludes it: inkwells, boxes, and reading desks, even if fashioned by Somali artisans, are certainly derived from the urban Islamic culture of the coast and are not to be found among the nomads of the interior who have retained the more rudimentary forms of the traditional culture. The same is true of the production of the disks, elaborately incised with ornamental motifs, that surmount the central support of the

roof in some coastal buildings (PL. 86; see also COSMOLOGY AND CARTOGRAPHY); the type of conical-roofed hut on which they are found is not of Somali origin. Of African, but not necessarily Cushite, origin are the small wooden combs (FIG. 169) used for hairdressing by both men and women and sometimes worn by the men; the large carved combs found in simpler forms among more northerly Cushite peoples, such as the Beni Amer and the Bogo; the spoons with richly carved handles (FIG. 167); and the two distinct types of neck rests — the men's supported on a rather slender column that is sometimes carved and pierced, the women's supported on a thick base or on several pillars (PL. 86). The neck rest, in evidence among the Galla, is entirely lacking in Mijertins and in part of east-central Somalia, but it is in general use in southern Somalia.

Cushite incised decoration makes use of a notable variety of geometric motifs, intricately combined even in small objects;

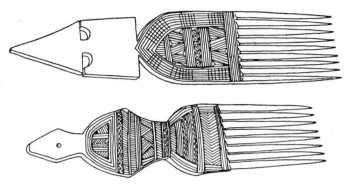

Somali decorative art, women's small combs. Rome, Mus. Africano.

opposite sides are incised with straight and oblique strokes, herringbone motifs, plaiting, lozenges, reticulations, and wavy ribbons. The centers of this craft have not been located with certainty, but the fact that the technique is generally concentrated in the northern regions nearer the coast and in the low basins of the Webbi Shibeli and the Juba Rivers leads to the supposition that such carving may be attributed to the presence of Bantu farmers (who, however, do not at present have any art forms worth mentioning), and to the stimulation and refining influences of the Orientalizing coastal culture (see AZANIAN ART).

Although the weaving of cotton (PL. 90) is the work of low castes, the so-called "fute Benadir" — a cotton cloth dyed with very bright natural colors that was prepared in the Arabo-Somali city of Mogadishu (Mogadiscio) — was famous in the markets along the maritime route of the monsoons as far as the Laccadive Islands and the East Indies. Such vegetable colors are still used in the dyeing of Jimma carpets, which are no longer so widely diffused in the markets of the world.

BIBLIOG. A. Cecchi, Da Zeila alle frontiere del Caffa, 3 vols., Rome, 1886; P. Paulitschke, Ethnographie Nord-Ost-Afrikas, 2 vols., Berlin, 1893–96; E. Cerulli, I risultati scientifici del viaggio Chiomio-Ciravegna nel sud etiopico, Africa italiana, II, June, 1929, pp. 201–05; E. Cerulli, Etiopia occidentale, 2 vols., Rome 1930–33; B. Azaïs and R. Chambard, Cinq années de recherches archéologiques en Ethiopie, Paris, 1931; L. A. di Savoia, La esplorazione del Uabi-Uebi Scebeli, Milan, 1932; N. Puccioni, Antropologia e etnografia delle genti della Somalia, Etnografia e paletnologia, III, 1936; A. E. Jensen, Im Lande des Gada, Stuttgart, 1936; V. L. Grottanelli, Missione etnografica nel Uollega occidentale (I, I Mao), Rome, 1940; E. Cerulli, Somalia, 2 vols., Rome, 1957–58.

                                                        Enrico CERULLI

Illustrations: PLS. 85–90; 3 figs. in text.

**CUYP, ALBERT (AELBERT).** Dutch painter of landscapes, animals, portraits, and still lifes (b. Dordrecht, Oct., 1620; d. Dordrecht, Nov., 1691). He was the son of Jacob Gerritsz. Cuyp, the first gifted and independent portraitist of the city of Dordrecht. Albert studied with his father and spent his entire life in his native city. He married a well-to-do woman and occasionally held public office. His work shows the influence of Dutch artists from other cities, especially that of Salomon van Ruysdael. The landscape style of Jan van Goyen is reflected in some of the gray-toned early canvases of Albert Cuyp. These paintings, like those of Van Goyen, exhibit a remarkably convincing rendering of the Dutch countryside. He made countless small landscape studies, rendering simple motifs in a light blond tone. His great gift lay in depicting the peculiar light that bathes the low-lying plains and the waters of Holland with a serene golden sunshine that transfigures the scene and the figures and animals depicted in it (VI, PL. 72). In an age when Dutch painters tended to specialize in one particular kind of subject, Albert Cuyp was many-sided, painting not only portraits and landscapes, but also still-life, religious, and mythological subjects and even the then-popular church interiors. Sometimes, especially toward the end of his life, he combined two kinds of subject, placing his portrait figures within landscapes.

Cuyp's art exerted little influence outside of Dordrecht, but it impressed the brothers Calraet there, and Cornelis Saftleven and Ludolf de Jongh also submitted to his influence. At the end of the 18th century the brothers Abraham and Jacob van Stry painted careful imitations of his work. Many of Albert Cuyp's masterpieces are preserved in English collections. His versatile talent showed a mastery of each of its phases; his figures and animals are well understood and beautifully constructed; his landscapes are not only vivid and impressive renderings of the scene, but are also fine in balance, composition, and total effect. In certain paintings such as the *River Landscape* (Rotterdam, Mus. Boymans-Van Beuningen) there is so clear a reflection of the painting of Claude Lorrain that one supposes Cuyp may have had an indirect introduction to his work, perhaps through the mediation of Jan Both, who had studied in Italy with the great French artist. Cuyp has indeed been called the Dutch Claude Lorrain, and his finest works, in their breadth and sweep, are to be counted among the great productions of Dutch art of the 17th century. See FLEMISH AND DUTCH ART.

BIBLIOG. G. H. Veth, Aelbert Cuyp, Jacob Gerritsz. Cuyp en Benjamin Cuyp, in Oud Holland, II, Amsterdam 1884, pp. 233–90; W. Bode, Great Masters of Dutch and Flemish Painting, London, 1909, pp. 187–200; W. Martin, De Holandsche Schilderkunst in de Zeventiende Eeuw, II, Rembrandt en zijn Tijd, Amsterdam, 1936, pp. 340–50.

                                        Margaretta M. SALINGER

**CYPRIOTE ART, ANCIENT.** In the context of eastern Mediterranean culture, the development of the island of Cyprus has an individual character. Although the local culture of Cyprus emerged from common prehistoric Mediterranean traditions (see MEDITERRANEAN PROTOHISTORY), the island was never completely absorbed into the orbit of any of the great civilizations that flourished nearby — in Asia Minor, Syria, Palestine, Egypt, and the Aegean. Yet throughout Cyprus, life was influenced in various ways by these other cultures, the effects being sometimes immediate, sometimes felt only later (see ARCHAIC ART; ASIA, WEST: ANCIENT ART; CLASSIC ART; CRETAN-MYCENAEAN ART; EGYPTIAN ART; SYRO-PALESTINIAN ART). Cypriote art, strongly conservative, maintained its independence down to the beginning of the Hellenistic age (see HELLENISTIC ART).

SUMMARY. The Neolithic period (col. 170). The Bronze Age (col. 171). The Iron Age (col. 173). The archaic period (col. 174). The subarchaic period (col. 178). The early classical period (col. 179). The late classical period (col. 181).

THE NEOLITHIC PERIOD. As early as the first half of the 4th millennium B.C. there existed in Cyprus a neolithic culture of exceptional originality, named "Khirokitian" from the territory at the foot of the Troodos range (not far from Limassol), where it was first identified and studied. Here was a prehistoric settlement with an almost urban organization. It was made up of a dense cluster of round, vaulted stone dwellings (tholoi), and its streets were paved. The stone products are of high

quality: especially worthy of note are the large stone bowls, some with incised decorations; also interesting are the fiddle-shaped idols. Pottery appeared at Khirokitia only in the latest phase of its development, but the examples from this site are the earliest in a really splendid series of Cypriote neolithic artifacts. This includes a ware known as "combed," from the designs scratched on with a comblike tool, and a ware with geometric designs painted in red on a white ground.

Other sites that give evidence of the long and interesting growth of the high culture that the Cypriots had developed during the Neolithic period are at Sotira and Erimi, near the southern coast of the island, and Ambeliku, near the northern coast; the magnificent painted vases of Erimi represent the culminating point of this development. During the last three hundred years of the period (2700–2400 B.C.) the creative spirit dwindled, and pottery became a monochrome red, as at Ambeliku. No convincing parallels with the artifacts of this first great phase of Cypriote art are found outside the island; the cultural picture indicates an energetic native development whose products compare favorably with those of contemporaneous Asia Minor, Syria, and the Aegean.

THE BRONZE AGE. At the beginning of the Bronze Age (ca. 2400 B.C.) there was a strong cultural influx from Asia Minor, especially from its western coast, bringing to Cyprus types of pottery similar to the products of Troy II and III (see MEDITERRANEAN PROTOHISTORY). There is evidence of this in the tombs of Philia, 18 miles west of Nicosia, the most ancient yet discovered of those classified as "Early Cypriote." (The period is subdivided into Early Cypriote I, II, and III.) The culture of the Bronze Age developed rapidly, spurred by the discovery of abundant deposits of copper; its chief centers were along the northern coast, the richest sites being at Lapithos and Vunus. Pottery tends increasingly toward the monochrome; toward the end of the 3d millennium the well-known "red polished" ware dominated the ceramic repertory (PL. 91). Although the original impetus for the development of this ware probably issued from Asia Minor, the fine large globular vases, excellently wrought and decorated in relief or incised and painted with white pigment, came to be exclusively characteristic of Cyprus. In the history of Cypriote art the period around 2000 B.C. can be considered the second vigorously creative period.

The following period, known as "Middle Cypriote" (1800–1550 B.C.), was a period of transition, generally marked by a lessening of quality. Vase decoration passed from monochrome to polychrome, and ornament frequently consisted of curvilinear motifs contained within straight lines. Composition and craftsmanship were less refined and careful. Vases tended to assume irregular, oblong shapes.

During this period the island emerged from its relative isolation. Its products have been found in great numbers in Syria and Palestine, indicating considerable trade with these countries. The eastern part of the island, in which the exchange of wares was liveliest, began to differ in its work from the western part; the difference is especially evident at the end of the period. The tombs of Paleoskutella, of Agios Iakovos, and of Milea house a ware very unlike that found farther west, as at Lapithos. The dichotomy reflects the migrations and struggles of peoples in this age, which saw the invasion of Egypt by the Hyksos. It may be in fact that the eastern half of Cyprus was for a time dominated by an invading Syrian tribe.

In the last phase of the Bronze Age, the vast region of the eastern Mediterranean experienced a fortunate period of cultural and political unity attributable in a measure to the role played by Cyprus as intermediary between the Near East and the Aegean. In the period known as "Late Cypriote" (ca. 1550–1100 B.C.) the island's relations with the east and with Egypt were maintained, if not intensified, but at the same time Cyprus was strongly influenced by the Aegean to the west. Located as it was on the great trade route from the east to the west, the island itself enjoyed a prosperity never again achieved (with the possible exception of the era of the Crusades), and this led to a profound cultural change, the development of a

koine, or common culture, that temporarily effaced the differences between the eastern and western provinces of the island.

The important archaeological sites that give a clear picture of this period are on the southern coast of the island: Kurion (mod. Episkopi), to the west, and Salamis (mod. Enkomi), to the east. The latter, referred to in the diplomatic correspondence of Tell el 'Amarna by the name of Alasia, is the more famous. Its tombs, which maintain the indigenous form of irregular chambers, contain for the most part the types of Cypriote vases known as "base-ring" and "white slip." Together with these, there appear a number of characteristic Mycenaean vases of the type known as "Levanto-Mycenaean," or "Mycenaean-Orientalizing" (PL. 92). It is not impossible that some of the examples of this pottery found in Cyprus and in the Near East were imported from the Aegean world, especially from Argolis and Crete, but the shape and décor indicate that the bulk of it was of local manufacture. The over-all cultural picture as seen in Salamis is in many ways similar to that displayed by the powerful city of Ugarit (mod. Ras Shamra) on the Syrian coast; the contacts between these two centers must have been very close. However, the western orientation of Cyprus shows itself in the syllabic alphabet in regular use during this period, which is a derivative of Minoan Linear A (not of the cuneiform writing then universal in western Asia).

The historical significance of the archaeological evidence seems clear. The island maintained its separate character, which was closely linked not only to its native cultural heritage but to that of the Near East. At the same time it entered into the political and cultural sphere of influence of the Mycenaean world. Also, it became host to an immigration of Achaeans, who (without in any sense colonizing the whole island) organized themselves into small enclaves within the great cities and brought with them the culture of their homeland.

Thus about 1400 B.C. there began a third great productive period in the art of Cyprus: Cypriote and Levanto-Mycenaean pottery, metalwork, and goldwork of the time are outstanding. Among the ceramic products are to be noted the large craters, or mixing bowls, with figures painted on them (PL. 92). This pictorial style, perhaps originating in Minoan metalwork and initially elaborated in Argolis, developed in Cyprus into a great vase-painting art. Various "masters" can be differentiated; their products found a ready market even in Greece. The vases of glass paste — especially the rhytons, or drinking cups in the shape of animal heads — combined Egyptian and Minoan stylistic elements. In sculpture, a figure such as the bronze statuette of the so-called "Apollo Alasiotas" from Salamis (PL. 92), itself probably of local manufacture, seems from its style to have been produced in the Syro-Mycenaean tradition at the end of the 13th century B.C. The architecture of the fortified city of Salamis (13th–12th cent. B.C.) is monumental, and the rectangular network of streets and buildings of ashlar masonry indicate city planning of a high order. Sacred architecture may be studied in the earliest level of Agia Irini (FIG. 174).

The economic prosperity and artistic flowering of the late Bronze Age in Cyprus came to an end rapidly in the closing years of the 12th century B.C., probably as a direct consequence of the incursions of the Peoples of the Sea documented in the Egyptian historical records of Merneptah and Ramses III. The trans-Mediterranean routes, of vital importance to the cultural unity of the eastern Mediterranean, were disrupted. At the same time came the dissolution of the political structure of Mycenaean Greece. However, recent finds of late Mycenaean pottery of type IIIc in the interior of the island — at Kurion, at Salamis, and at Sinda — show that the contacts with the waning Mycenaean world were still alive. Legend tells how Teucer and other Greek heroes among the nostoi (those who returned from Troy) and among the emigrants from Greece founded many cities on the island: Teucer became the founder of Salamis, Agapenor of Paphos, Acamas of Soloi, etc. In this case mythology reflects historical fact which has been confirmed by archaeological evidence. The particulars of legend cannot be corroborated by actual data of history, but there is no doubt of the basic fact that toward the middle of the 12th century B.C.

the foundation for real Greek colonization was laid. We have tangible evidence of this from the second quarter of the 11th century, the period that marks the beginning of the Iron Age on the island.

THE IRON AGE. In Cyprus production in the Geometric style proper (commonly classified as "Cypro-Geometric") falls in the period 1050–700 B.C.; preceding this there was a brief "proto-Geometric" period lasting about a quarter of a century (see GEOMETRIC STYLE).

Proto-Geometric pottery and that of Cypro-Geometric I (1050–950 B.C.) can be studied in the tombs of Kaloriziki near Kurion and in the necropolis of Kastros in Lapithos. The general artistic picture is profoundly different from that of the previous period. The tombs of the first generation of the Greek immigrants and of their sons are rich and show a renewed creative vigor; the development of the pottery heralds new stylistic principles and produces notable innovations. The repertory of shapes is extensive. Among the most characteristic are the round dish, the low kylix, or drinking cup, the one-handled cup, the oinochoe, or wine pitcher, the large crater-amphora, and the amphora.

In the proto-Geometric tombs the stirrup vase and the kylix on a high foot have survived from the late Mycenaean repertory. In the vases of Cypro-Geometric I the design as a whole and its details — including wavy bands, hatched triangles, and panels and friezes — often resemble proto-Geometric vase painting as it is known from the necropolis of Kerameikos in Athens. This parallel convincingly documents the close contact between the colonists and their homeland. However, the differences between the two artistic traditions, in technique and design, must not be overlooked. In Greece the ornaments are painted in clear varnish, while in Cyprus they are laid on in mat paint. Even more important is the fact that in the Cypriote production there appear vase types without parallel in the Greek repertory. Vases with two-color painting (red and black on white) and others with black-painted flutings in relief copied from metal prototypes are purely Cypriote. As to form, the globular pitchers, the cylindrical bottles, the askoid, or zoomorphic, vases, the kernoi, or vessels made up of several small cups joined on a pottery ring, the tripods, are all types that seem either to be indigenous or to show Near Eastern influence. Thus the typical Cypriote individuality is manifested even during a period when the Greek influence must have been very great.

The pottery classified as Cypro-Geometric II (950–850 B.C.) and Cypro-Geometric III (850–700 B.C.) shows the differences between the two parts of Cyprus becoming more marked but the island as a whole continuing on its ever more independent path. Such great mainland styles as the late Geometric style of the Dipylon in Attica and of Argolis have no parallels in the pottery of the island. Even in the architecture of the tombs this pattern of originality emerges. Some of the most ancient tombs, those of the proto-Geometric period and of the beginning of Cypro-Geometric I, show, alongside of typical native forms, clear reflections of the Greco-Mycenaean style (in the long dromos, or narrow passage, and the fairly regular chamber); later, as at Stylli, near Enkomi, at Marion, on the northwest coast, and at Idalion, in the interior of the island, native forms become ever more dominant and the Mycenaean prototypes are modified or forgotten.

From the cultural and commercial points of view, in the latter part of the Cypro-Geometric period Cyprus entered gradually but steadily into the sphere of Syria and Anatolia. It seems likely that toward the middle of the 9th century B.C. the island received groups of immigrants from these regions. To these immigrants perhaps can be attributed the birth of a new ceramic style, characterized by black concentric rings on a red ground (PL. 93), that for a long time dominated the entire vase production of Cyprus. Like the other styles that were imported, and hence in the last analysis should be credited to non-Cypriote sources, this too was transmuted and became typically Cypriote. Simultaneously there appeared new decorative elements on vases in the shape of stylized plant, animal,

and human forms, originating probably among the new contacts with Syria. If the Syro-Anatolian immigration of the mid-9th century B.C. is as yet hypothetical, the historical evidence — as seen at Kition (mod. Larnaca), midway on the southern coast, and in the surrounding territory — clearly indicates that about the year 800 a part of the island was conquered and colonized by Phoenicians from Tyre.

The cultural and artistic effects of the arrival of the Phoenicians are not easily traced, except in the field of metalwork. The famous gold, silver, and bronze plates and cups found on Cyprus appear immediately after 800 B.C., and their stylistic development can be followed uninterruptedly until the end of the 7th century B.C. (see ORIENTALIZING STYLE). Thought by some scholars to be Phoenician imports, these are in fact

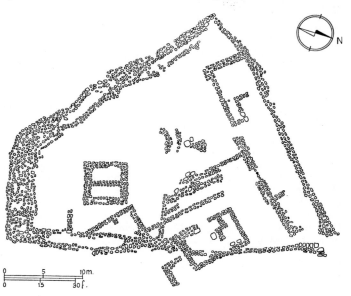

Agia Irini, ground plan of the sanctuary, late 2d millennium B.C. (from The Swedish Cyprus Expedition, II).

products of the local Cypro-Phoenician art (PL. 94). In their style Syrian, Egyptian, Cypriote, and Greek elements are fused in such a way as to make their local origin virtually certain.

Cypriote sculpture of the Geometric period is limited to small primitive clay figures of idols and animals made for religiomagical purposes and of little or no artistic value.

THE ARCHAIC PERIOD. In judging the artistic development of Cyprus during its archaic period, which can be said to have begun about 700 B.C., it is important to keep historical factors in mind, remembering that political domination is not necessarily equivalent to cultural domination. It is possible for indigenous forces and artistic traditions to remain fully active even in a period of complete political passivity. The initial phase of the archaic period (Cypro-archaic I, 700–600 B.C.) begins coincidentally with the conquest of the island by Sargon II of Assyria (709 B.C.). However, after the beginning of the reign of Ashurbanipal (669 B.C.) Cyprus regained its liberty, and a great period of Cypriote independence (perhaps the "thalassocracy," or sea hegemony, mentioned by Eusebius) was ushered in. This golden era came to an end with the conquest of the island by Egypt just after 570 B.C. But Egyptian rule was brief. The Cypriote kings were quick to exchange Egyptian rule for that of the Persians, once the dynamic policies of the new Achaemenid empire had registered their first success, the conquest of Lydia (546 B.C.). The act of submission of 545 B.C. guaranteed a certain autonomy to the island dynasties, but under Darius I (521–486 B.C.) Cyprus became a part of a regular satrapy and until the end of the archaic period (ca. 475 B.C.) remained firmly in Persian hands.

As always, pottery constitutes a sure guide to stylistic trends. There is not the slightest doubt that in this area the

indigenous mode developed during the preceding period continued without interruption. Greece seems still more remote; the few imports of Greek pottery that can be designated as Cypro-archaic I remain isolated cases having no creative repercussions. It is significant that only four proto-Corinthian vases have been discovered on the island, only one of which (found at Amathus, on the south coast) is certainly from Greece. An Attic crater, unique of its type, was found at the same place. This would seem to indicate that Greek commerce with Cyprus had declined and that, not surprisingly, Greek traders followed the sea route south of the island straight to the Phoenician coast. Much more numerous are the Syrian imports, and the influence of these can be felt in the form and the decoration of the native pottery, whereas western influence seems absent. As in the earlier periods Cypro-Geometric II and III, Cyprus remained firmly linked to the Syro-Phoenician east. In this sphere the native style progressed toward ever greater decorative richness, reaching a degree of perfection that places it far above the achievements of neighboring countries.

A rich assortment of vases has been brought to light by the tomb excavations at the well-known sites of Amathus, Marion, Idalion, and Stylli. In their decoration there recur as characteristic elements the concentric rings known from the preceding period. Especially during Cypro-archaic I this type of design is almost everywhere paramount. Around the big vases the circles form chains and horizontal or vertical rings; on the smaller ones they are intertwined and intersected in every direction. The so-called "black-on-red" vases — a bright ware already present in Cypro-Geometric III — are very frequently found in the western part of the island; in the eastern part of the island the type with two-color decoration, often large and monumental, is more common. The design of the latter type is less abstract; as in the preceding period, motifs are derived from plants, animals, and, rarely, the human figure. Among these can be distinguished some of clearly Near Eastern inspiration; the arbor vitae (or tree of life) flanked in heraldic fashion by animals, the single lotus blossom and lotus chains, the open palmetto, are common. Among the animal motifs the most popular is the bird, vigorously stylized and drawn with great mastery. An oinochoe with a single bird on the side of the body opposite the handle is a local form typical of this period (PL. 93).

Metalwork and goldwork had achieved a high level of quality by the beginning of the archaic period. Here, as in pottery, the over-all stylistic picture shows an energetic native creative force, fed by contact with the east. (In the case of products of the bronze industry, especially the embossed round shields, parallels can be found in the Greek world as well, and the most common fibula of the period seems to derive from the Greek types.)

Cypro-archaic I style attests, as has been noted, to a more lively cultural contact with the east than with the west. Cyprus owed its growing wealth to its traditional function as intermediary between the Aegean and the eastern Mediterranean, in a world which even in Greece was known as "Orientalizing," hence interpretation of the evidence of reciprocal contacts between Cyprus and Greece is difficult. Relations were probably closer than archaeological findings would indicate. It can be assumed that the dominant tongue was a local Greek dialect, whose affinities with that of Arcadia are traceable to the time of Greek colonization. Besides Greek, Phoenician was spoken, at Kition and in its environs, while in the more remote regions and near Amathus the indigenous Eteo-Cypriote language was still in use.

The period known as "Cypro-archaic II" (600–475 B.C.) opened in an atmosphere of political freedom (which continued until the Egyptian conquest of Cyprus, in 570), and ended, as has been stated, with the island under Persian dominion. Political vicissitudes did not always leave their mark on artistic development in the manner that might be expected. In the second half of the 7th century B.C., monumental sculpture had appeared in Cyprus for the first time. It was in the period preceding 600 B.C. that Egypt opened its doors to the Greeks, who founded the city of Naucratis in the Nile Delta as a com-

mercial center. The presence in Naucratis of archaic Cypriote pottery indicates that the Cypriots had direct relations with Egypt. These relations, amply documented not only in the arts but also in ancient literary sources, were naturally intensified during the period of Egyptian political domination. It is generally recognized that the contacts of Greece with Egypt at the end of the 7th century B.C. gave a decisive impetus to the creation of archaic Greek monumental sculpture; it does not seem unlikely that Egyptian art had a similar influence on the sculpture of Cyprus. If this hypothesis is accepted, it must be remembered that the effects of the contact with Egypt were entirely different in the two countries. In Greece the marble kouros, though unmistakably bearing from the outset a Greek stamp, reveals in its iconography the direct influence of Egyptian prototypes. In the first large Cypriote sculptures, the style is not Egyptian nor can the iconography be traced directly to Egyptian sources. The style and the iconography in which Cypriote artists expressed themselves were from the beginning fundamentally non-Egyptian. If Cypriote art does owe a debt to Egypt, the debt is limited to the concept of monumental sculpture as a medium of expression.

If we look to Assyria, the great power that dominated the Cypriote political scene during most of the first half of the 7th century B.C., to find the source of inspiration of the earliest Cypriote sculptors, the results are negative. Assyria herself and her monumental art — as in Khorsabad and Nimrud — seem not to have had the slightest influence on the plastic art of Cyprus. In sculpture, even more than in other branches of art, the Cypriote style is typically insular. Doubtless a contributing factor to this independence of the art of nearby countries was the absence in Cyprus of marble or other hard stone. The media available to Cypriote sculptors were clay and a local calcareous stone. The latter is creamy white and very soft when quarried; its surface hardens upon exposure to air. The natural limitations inherent in these materials to a great extent determined the development of Cypriote sculptural style. The modeler used the soft, tractable clay to express what seemed to him to be essential in form, and the carver, working with a knife more often than with chisel or hammer, created a linear style that remained for centuries uniquely Cypriote.

What has been said applies particularly to the earlier phase of archaic sculpture, known as "proto-Cypriote" sculpture (ca. 630–540 B.C.). Two sites are of particular importance: Agia Irini, on the northwest coast, and Arsos, in the interior of the island. At Agia Irini is a great quantity of archaic terracotta sculpture, well documented and easily identified from its relation to pottery, gem carving, and other crafts. The site presents us with an unbroken series of works of art of great interest, comprising the backbone of Cypriote sculptural chronology. Arsos, on the other hand, furnishes us with the first sculptures in stone of monumental size and scope.

Among the more than two thousand statues, statuettes, figurines, idols, etc., almost all representing males, found at Agia Irini, a considerable number are fine works (PL. 95). A few are life size, indicating that the technical difficulties inherent in modeling and firing large terra-cotta statues had been mastered virtually at the outset of the period. The most striking characteristic of the proto-Cypriote style is the concentration of the sculptor on the rendering of the face and his indifference to bodily form. The heads, nearly triangular in shape, are dominated by expressive eyes; the eyebrows are rendered plastically; the noses are large and aquiline; the lips are full and firmly closed. Pointed beards and conical helmets emphasize the geometrical structure of the heads. The intensity of expression obtained by simple means is often very affecting, and the contrast between head and body only augments the impression. In many cases the amorphous body, without formal detail, resembles a flattened cylinder. This part of the statue was often shaped on a potter's wheel, in two parts. Frequently there is no indication of feet; sometimes these emerge from the base of the cylindrical trunk. Arms, made separately and inserted under the shoulder, hang stiffly vertical. This stylization is sometimes attenuated, especially in the medium-sized statues, without, however, any modification of the absolute frontality

of the figure. Sometimes the drapery of the long ceremonial dress worn by many of the statues is indicated by symmetrical and conventionalized folds. It is obvious that this initial style of Cypriote sculpture has not been directly influenced by Ionia, Assyria, or Egypt.

At Arsos the greater number of monumental sculptures are of limestone and represent females (PL. 99). Despite the inherent differences in material and subject, these sculptures are in many respects similar to the terra cottas of Agia Irini. The vigorous modeling of the face, in which the large eyes dominate, the frontal symmetry of composition, the flattened, abstract form are all present in the sculpture of Arsos. The figures of female worshipers are adorned with splendid jewels, which for them obviously assumed an importance equal to that of the armor of the warriors of Agia Irini. Similar sculpture has also been found in Trikomo, Athienu, Idalion, and Lefkoniko, all in the interior of the island (PL. 98).

Small terra-cotta statuary is abundant and varied. The amorphous "idol" is common, as are the "naked deity" and the richly ornamented "priestess" — all types in the same style. Figures of horsemen appear in great numbers in the temenos of Apollo at Kurion. Quadriga groups, modeled with a certain liveliness, are particularly numerous at Agia Irini, where they have been found in the same primitive strata of the sanctuary as animal figures and hybrid creatures such as the minotaur. The sculpture of this genre, especially the "naked deity," demonstrates, more clearly than the monumental sculpture, the artistic rapport with Syria and Asia Minor. The link between Syria's Astarte and the Cypriote form of the goddess is clear. Also, there are stylistic resemblances between certain minor Cypriote sculptures of this period and archaic Etruscan sculpture, as has been pointed out by E. Gjerstad (1933).

During the course of the first part of the 6th century B.C., the proto-Cypriote style developed organically in its insular setting. The force of expression gradually lost its vigor. The figures gained in naturalism but tended to lose their sculptural quality. In rare cases, however, the quality remained high, and some of the works produced can be considered masterpieces. The figure became more plastic and in its entirety more balanced and harmonious. There is a hint, especially in the limestone sculpture of Arsos, of the archaic Ionian smile. Later the inspiration of eastern Greece began to be felt, but before this influence could give a new direction to Cypriote sculpture, Egypt conquered the island. With the conquest was born a new style in which Egyptian elements were dominant. Examples of this style, known as "Cypro-Egyptian," are relatively rare; the most important ones are to be found, naturally, in the stone sculptures. The style is characterized by a more or less successful imitation of Egyptian prototypes and the suppression of provincial characteristics. A large limestone female head from Arsos (PL. 97) is the finest example of this interlude in the development of Cypriote art. Iconography and style are clearly Egyptian. Local character, very much to the fore in lesser works, is in this head imperceptible.

When, in 545 B.C., Cyprus passed from Egyptian to Persian dominion, the event, far from "Orientalizing" Cypriote art, turned it back decidedly toward the Greco-Ionic modes. Under Persian rule Cyprus became an integral part of the culturally Greek world made up of the western provinces of the Achaemenid empire. For the first time since the Greek colonization of the 12th century B.C. the links with Greece were strongly felt. Cypriote sculpture was affected not by the political reality but by new philhellenic sentiments. This did not extend to the minor arts, which, especially pottery, continued in their independent direction.

For about two decades certain proto-Cypriote stylistic tendencies lingered on in the sculpture of the new period, which is designated as "Greco-Cypriote" work (PL. 100). In some centers of the indigenous style, as in Agia Irini, the new ideals were accepted only very reluctantly; the archaic smile and the soft forms of Ionic art were incompatible with the rigid severity and the volumetric principles of the sculptors working in the native tradition, and the new period seems to mark the end of the sculptural tradition of this important school.

At Arsos, however, and in the other centers in the interior mentioned above, there is continuity in the stylistic development. A characteristic Cypriote quality permeates the sculpture during the greater part of the new period: still evident are the more or less marked lack of interest of the artist in bodily form and his concentration on the head and the facial expression. At Arsos the female statuettes of limestone are strangely elongated and geometric. Drapery reveals little of the anatomy; the heads are still very plastic and often of exquisite workmanship. At Kition a large number of votive statues display the same characteristics. The form is exaggeratedly flattened, almost as though it had been carved on a wooden board, and often the back is only summarily worked. The eyes are obliquely set and larger than in the Ionic prototypes, and the dress remains for the most part the traditional garb of Cyprus, namely a long cloak covering the figure down to the feet. During the last decade of the 6th century B.C. the Ionic style of dress employing the chiton (tunic) and himation (outer garment) made inroads even in Cyprus, and the style of drapery begins to take forms parallel to that of the korai of the Athenian Acropolis. In the male figure a seminudity appears for the first time, as in the so-called "Apollo" from Mersinaki (PL. 99). A mantle covers only the shoulders and thighs of the figure, and the bodily forms are rendered in the style of the Attic kouroi of the last quarter of the 6th century B.C.

While sculpture in local limestone absorbed to a great extent the influence of archaic Greece and adapted itself to the new Ionic ideals, terra-cotta sculpture tenaciously retained certain indelible Cypriote hallmarks. The large terra cottas from the last decade of the 6th century B.C. found at Mersinaki show the same stylization of anatomy — the large flattened cylinders, the absence of balanced articulation of the limbs or drapery — as marks the proto-Cypriote sculpture of Agia Irini. The little statuettes of the same region are completely cylindrical, having been in fact thrown on the wheel, and sometimes they have a little "window" at the base affording a glimpse of feet. Any stylistic changes found are characteristically in the heads. These are no longer rendered in definite, hard, almost geometrical forms but are softer and more curvilinear in outline. Often the heads are cast in molds. The archaic smile, betraying Ionic Greek influence, is omnipresent. The figures, however, retain much of their Cypriote flavor; the male figures have full beards and the typical conical helmets, while the figures of women are richly adorned with necklaces and diadems. Color was of great importance: eyes, lips, beard, and whiskers, often only barely modeled, acquired prominence from the use of bright hues — blue, red, and brown — traces of which remain.

THE SUBARCHAIC PERIOD. The great events of the first quarter of the 5th century B.C., which in Greece gave impetus to the rapid transition from the archaic to the early classic style, did not produce in Cyprus the same phenomenon of reinvigoration and almost explosive creative activity. The miraculous victory over the Persians that saved Greece had entirely different consequences in Cyprus. After the unsuccessful revolt of the Ionian Greeks in Asia, the Cypriots were so completely in the hands of the Great King that 150 Cypriote ships fought at the Persians' side in the battle of Salamis. The Persian war was thus a double humiliation to the Greeks of Cyprus, whose sympathies must certainly have been with their homeland. This, together with the diminution of direct communication with Greece in the new political climate, helped to bring about that stagnant period in the development of the art of the island which is manifested by the tightening of archaic forms already superseded in Greece itself. The tendency is particularly evident in the period after the repeated vain attempts of the Athenians to conquer the island, which were finally quelled in the peace of Callias in 448 B.C.

During the decades before and after the battle of Salamis, Cypriote art continued in the Greco-Cypriote phase of the archaic style. To this period belong some real masterpieces; the best example is the statue of a kore found at Vuni (PL. 99) in a semenos together with many other votive statues and

statuettes. Among these are several in terra cotta of the type described above as coming from Mersinaki. The palace of Vuni (FIG. 181) was built at the time of the Ionic revolt as a philo-Persian fortress, yet the art of Cyprus that it has yielded is intimately allied with that of Greece. This apparent paradox can be explained by the nostalgic atmosphere of a Hellenic Cyprus dominated by the Persians. The more adverse the political conditions, the more openly Hellenic the art. It is also typical that the Greek prototypes of this art are at least a quarter of a century older than the Cypriote works. In its most representative examples the archaic Greco-Cypriote style is not in fact archaizing; it is purely archaic in a period when Greece was abandoning the artistic ideals of the 6th century B.C. There is nothing Persian in Cypriote sculpture of this period, just as nothing of the Assyrian mode had affected the proto-Cypriote. Not everything, however, in the works in the "style of Vuni" is Greek, even in the finest examples. The female heads are often crowned with high diadems richly decorated in Oriental fashion (PL. 100), which contrast with the Greek elements and the thin archaic smile. Even in the magnificent votive statuette (PL. 99) — sometimes mistakenly called "Zeus Keraunios" — found at Kition, the Phoenician center on the island, in a temenos dedicated to Herakles-Melqarth (or Melkarth), the Hellenic spirit and style are in sharp contrast to the typically Cypriote dress. The Greek stylistic elements are not so evident in the lesser sculptures and in the votive figurines of minor importance. The Ionic smile is not enough to obscure the fundamentally Cypriote character of such works. The flattened, stylized body with its linear drapery and the absolute rigidity of modeling are convincing testimony of the supremacy of local tradition.

THE EARLY CLASSICAL PERIOD. Of the great efflorescence of the Periclean age in Athens no repercussions can be traced in Cyprus. In the early part of what is known as the "Cypro-classical" period (Cypro-classical I, 475–400 B.C.) the artistic climate of the island became increasingly unproductive. Throughout the 5th century the sculpture of Cyprus re-elaborated the themes, already overworked and impoverished, of the Ionic art of the 6th century. As the interval between Greek prototype and Cypriote product increased, the similarity between them became less apparent. The Cypro-archaic style lingered on in subarchaic forms revealing a drying up of the creative springs. Cypriote sculpture of the time fell back into a monotonous and mechanical repetition of a formula which had lost its vitality. The indigenous Cypriote forms, now strangely anachronistic, returned, and the general level of sculptural quality declined.

In the otherwise undifferentiated mass, a few exceptions to this dismal rule can be found. From Vuni, where toward the middle of the 5th century B.C. the philo-Persian dynasty was overthrown by Stasioikos, whose sympathies lay with the Greeks, comes a small head of Athena (PL. 101) that, despite its archaizing character, has surprising vitality. Two hand-

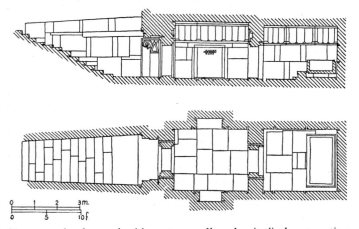

Tamassos, chamber tomb, 6th cent. B.C. *Above*: longitudinal cross section; *below*: ground plan (*from The Swedish Cyprus Expedition, IV, 2*).

some bronze groups from the same place, showing two lions devouring a bull, can be ascribed to the same period (PL. 102). Their composition is heraldic and archaic, but the forms are lively and the modeling is convincing. We can trace at Vuni, in these three works, a certain revitalizing influence from contemporary Attic art as it is known in the work of Myron. An exquisite bronze statuette of a heifer (PL. 102), also from Vuni, is perhaps a direct import from Athens. Attic red-figured vases appear in limited numbers at the same site.

Cypriote pottery of the 6th century B.C., as has been said, developed within the confines of local tradition. But artistic inventiveness waned with the passing of time, and artists fell into the repetition of favorite themes. The production of undecorated pottery increased, coming to dominate the general scene in the 5th century. During the 7th century, and occasionally in the first part of the 6th century, some reflections of Rhodes and Crete could be traced in the ornamental repertory: the use of the rosette, the lotus, the meander, etc., recall the style of Rhodes. But from the end of the 6th century and throughout the 5th century this influence diminished until it consisted of no more than a few vague impressions received from Attic pottery. Greek influence in this field is much less important from an artistic point of view than in the major arts. Attic vases were frequently imported; they are found in the tombs of Kurion, Amathus, Idalion, Vuni, Kition, Marion, Salamis, Tamassos, and other places. The vases are mostly undecorated, but there are a certain number of black-figured and red-figured examples.

The rich silver coinage of the 5th century is artistically interesting. This is the only area in the artistic life of Cyprus into which the Greek classic influence penetrated fully and dominated. The laureate head of Apollo on the staters from Marion is clearly classic (PL. 102), and the Herakles with a bow on the coins of Kition may be regarded as an example of the great numismatic art of Greece despite the inscriptions — which in the first case are in Cypriote characters and in the second in the Phoenician alphabet. The Athena on the staters from Lapithos with Phoenician inscriptions on the reverse is in a fine Attic style without provincial traits (PL. 102). Certain morphological characteristics, such as the preference for incuse squares on the reverse side, seem to indicate that the engravers were Cypriots. The ornamented silver cups of the archaic period, the goldwork from Arsos, and the treasure of Vuni with its silver vases and bracelets are clear proof of the metalworking skill of Cypriote artists in the 6th and 5th centuries. This tradition, applied to the making of coins, could explain the very high quality of Cypriote 5th-century coins. The stylistic purity of this production remains a problem, however, and it is possible that Greek die cutters were imported by the Cypriote kings.

Archaic and classical architecture is known from tombs (FIG. 179) and sanctuaries and from the palace of Vuni (FIG. 181). The native form of sacred architecture was the open temenos, known at Agia Irini as early as Cypro-Geometric II and amplified and modified during the archaic period (FIG. 174). Roughly trapeziform, with a simple enclosure, a baetylic altar, and an interior enclosure around the sacred grove, it shows in its ground plan a lack of architectural logic. The votive gifts were placed out in the open about the altar. The same type appears in Achna and Tamassos. At Kition and Vuni two little shrines were added and at Idalion a simple portico. At Vuni (Temple of Athena and principal temenos of the palace) and at Idalion (temenos of Aphrodite), the shrine is at the foot of the courtyard temenos and in almost axial relation to it; as a result it dominates the sacred complex in a new way and the ground plan represents a major architectural articulation. The cella of the Temple of Athena at Vuni is tripartite, as was the most famous temple on the island, the Temple of Aphrodite at Paphos, known to us only by way of ancient literature and representations on Roman coins.

The palace of Vuni, constructed shortly after 500 B.C. and destroyed about 380 B.C., is a grandiose complex that is unique in Greek and Cypriote art (FIG. 181). In its initial phase, which can be attributed to the philo-Persian dynast Doxander, the plan reveals a conspicuous Persian-Oriental influence. The

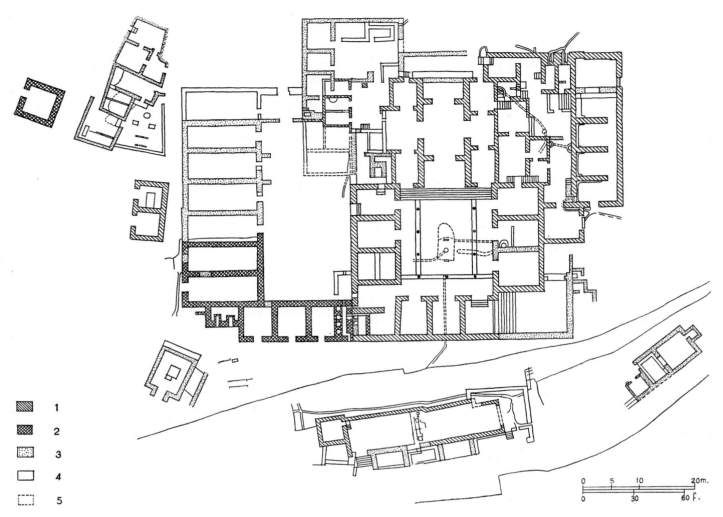

Vuni, palace, ground plan showing successive phases of construction. (1) First period; (2) second period; (3) third period; (4) fourth period; (5) water conduits and cisterns beneath the pavement (*from The Swedish Cyprus Expedition, III*).

entry takes the form of a *prothyron* (vestibule), through which one passes into two large rooms that probably housed the palace guard, and thence to the central pillared courtyard. This gives upon the reception rooms and living quarters, the largest of which, with open front, is on the left as one enters, on the lateral axis of the palace. Later divided into two separate rooms, it was probably the audience hall; the room at the end of the longitudinal axis is of normal size. Around the living quarters are the service quarters: baths, storerooms, kitchens, etc. The general plan resembles that of the Persian governor's residence at Lachish in Israel, while the monumental entrance with its *prothyron* finds its counterparts in Hittite architecture. Two capitals, related in their iconography to the Egyptian Hathor capital, are in the archaic Greco-Cypriote style and go back to the second building phase of the palace, about 450 B.C.; they were probably executed under the philhellenic Stasioikos. The Persian and Oriental elements of the plan were in this period ingeniously obliterated by appropriate remodeling. It was at this time that the audience hall was divided, the great entrance way was closed and transformed into a kind of megaron, or main hall, a new entrance was added to the north side, and a second courtyard with additional storerooms and service quarters was created. The palace of Vuni is the most monumental example of secular architecture of the 5th century B.C. not only in Cyprus but in the whole Hellenic world.

THE LATE CLASSICAL PERIOD. The 4th century B.C. began with the meteoric triumphs of Evagoras, king of Salamis (410?-374 B.C.), who, in close alliance with Athens, was able, through a combination of able diplomacy and fortunate military engagements, to unite most of the island under his rule. The court at Salamis, made famous by the orations of Isocrates, was an intellectual center of considerable importance in this period. Evagoras and his successors had a program for the Hellenization of the island's intellectual, cultural, and political life. In this sense Evagoras was a founder of true Hellenism comparable to the dynast Mausolus in Caria, the Greek princes on the Bosporus, and Dionysius I of Syracuse. Greece became in all cultural matters the model to be imitated. The Greek alphabet was officially adopted. Handicrafts, goldwork, coinage, and dress copied contemporary Greek products. Cypriote art as an independent phenomenon can be said to have come to an end at the close of this period (ca. 400–300 B.C.), termed "Cypro-classical II."

In the field of sculpture, imitations, sometimes of good quality, were produced — as witness the large female heads in the style of Leochares found at Arsos (PL. 101) — but more often provincial in character and of little interest. The old *kyprios charakter* continued to live, almost in caricature, down to the end of the century in archaizing and decadent folk sculpture. This was a period of great material prosperity and of close contacts with Greece, but also, perhaps for that very reason, of deteriorating artistic production.

With the advent of Alexander the Great this falling off became accentuated. In 312 B.C. the old governmental system of the island, with its 10 "kingdoms," was abolished and Cyprus became a province of Ptolemaic Egypt. Cypriote art and culture were merged in the Hellenistic koine and remained through-

out antiquity an integral part of the Greco-Roman world. The original, creative Cypriote spirit died with the amalgamation of the island into the unifying cultures of the great Hellenistic and Roman empires, and the development of Cypriote art became a provincial chapter in the larger story of the Mediterranean art of the period.

CYPRIOTE ARTISTS. Akesas and his son Helikon, rug weavers, of Salamis in Cyprus, active perhaps in the archaic period. Legend attributes to them the first peplos of the Athena Parthenos in Athens (Sauer, ThB, s.v. Akesas; E. Pernice, ThB, s.v. Helikon). – Sikon of Cyprus, sculptor, lived in the second half of the 6th century or between the 6th and the first two decades of the 5th: lower half of a signed statuette from Naucratis; votive statue dedicated to Herakles (Lippold, RE, Sup. VIII, s.v.; Lippold, GP, p. 67). – Styppax of Cyprus, sculptor active in Athens in the second half of the 5th century: *Splanchnoptes* (slave roasting entrails), bronze, on the Acropolis in Athens (Lippold, GP, p. 176). – Anaxiles, engraver or perhaps owner of a gold ring discovered in a tomb, second half of the 5th century (E. Pernice, ThB, s.v.; A. Stazio, EAA, s.v.).

BIBLIOG. a. General. L. Palma di Cesnola, A Descriptive Atlas of the Cesnola Collection of Cypriote Antiquities in the Metropolitan Museum of Art, 3 vols., New York, 1885–1903; M. Ohnefalsch-Richter, Kypros, die Bibel und Homer, Berlin, 1893; J. L. Myres, ed., Handbook of the Cesnola Collection of Antiquities from Cyprus, New York, 1914; The Swedish Cyprus Expedition, 4 vols., Stockholm, 1934–56; G. F. Hill, A History of Cyprus, I, Cambridge, Eng., 1940; P. Dikaios, A Guide to the Cyprus Museum, Nicosia, 1947, 2d ed., 1953. b. Protohistory. E. Gjerstad, Studies on Prehistoric Cyprus, Uppsala, 1926; P. Dikaios, Excavations at Erimi, 1933–1935, Report of the Department of Antiquities, I, Cyprus, 1936; E. Sjöqvist, Problems of the Late Cypriote Bronze Age, Stockholm, 1940; E. and J. Stewart, Vounous 1937–1938, Field Report on the Excavations, Acta Instituti Romani Regni Sueciae, XIV, 1950; F. H. Stubbings, Mycenaean Pottery from the Levant, Cambridge, Eng., 1951; C. F. A. Schaeffer, Enkomi-Alasia, Paris, 1952; P. Dikaios, Khirokitia, Oxford, 1953; P. Åström, The Middle Cypriote Bronze Age, Lund, 1957. c. Sculpture. F. N. Pryce, Catalogue of Sculpture in the Department of Greek and Roman Antiquities of the British Museum, I, 1–2, London, 1928–31; E. Gjerstad, Cyprisk och etruskisk skulptur, Konsthistorisk Tidskrift, II, 1933, pp. 51–64; A. Westholm, The Temples of Soli, Studies in Cypriote Art during the Hellenistic and Roman Periods, Stockholm, 1936; M. Borda, Kyprios Charaktér, Rend-PontAcc, XXII, 1946–47, pp. 1–68; E. Gjerstad, The Swedish Cyprus Expedition, IV, 2, Stockholm, 1948, pp. 92–129, 207–11, 318–72; J. H. and S. H. Young, Terracotta Figurines from Kourion in Cyprus, Philadelphia, 1955. d. Ceramics. H. B. Walters, Catalogue of the Greek and Etruscan Vases in the British Museum, I, 2, London, 1912.

Erik SJÖQVIST

Illustrations: PLS. 91–102; 3 figs. in text.

**CYPRUS.** Situated in the northeast corner of the eastern Mediterranean, Cyprus (Κύπρος), with an area of 3,584 square miles, is its third largest island. Cyprus has a population of over half a million.

From prehistoric times to the present, geographical position has played a decisive role in the cultural, ethnic, and political development of the island. Asia Minor, the nearest of the neighboring lands, lies to the north, Syria and Lebanon to the east, Egypt to the south, and the Greek islands to the west. The cultures of the ancient Near East, the classical world, and the Byzantine Empire, of the Islamic world and the European west, have left many evidences of their influence. On the other hand, Cyprus has always been marked by a certain insular and traditional individuality. Diverse peoples made their contribution against a background in which the older strains were superimposed, one upon another, and mingled. At about the end of the Bronze Age (mid-11th cent. B.C.) the Greek element began to predominate. For many centuries Cyprus was subject to foreign rule; the island gained its independence in 1960.

Apart from the monuments that stand above ground or have been excavated, Cyprus comprises many archaeological sites which, although known, have not been explored, and further exploration may revolutionize our knowledge of the architectural and other remains on the island. This applies not only to the settlements of the Neolithic period and the Bronze Age but also to the city-states that flourished in the Iron Age. The few architectural remains laid bare — at Salamis, Kition, Amathus, Palaipaphos, Kurion, and other towns, which have hardly been touched — give only a glimpse of the magnitude of the Iron Age culture.

SUMMARY. Periods (col. 184): *Antiquity; Middle Ages and modern period.* Principal towns and sites (col. 186).

PERIODS. *Antiquity.* Even if the archaeological record were complete, no definitive dating of the subdivisions of protohistory in Cyprus could yet be offered. The scheme followed here, though widely accepted, is used with full awareness of the continual additions that are being made to the body of scientific evidence and of the differences of opinion among authorities on the interpretation of the evidence.

During the Neolithic period (from about the beginning through the middle of the 4th millennium B.C.) there were settlements, at Khirokitia, at Tenta, and at Petra tu Limniti, characterized by the tholos, which served as both dwelling and tomb. Buildings of this type had a stone foundation, on which the superstructure of mud bricks, or merely mud, rested. During the later stages of settlement large houses with strong walls were erected; these were sometimes divided into three parts, a main room and two subsidiary ones (workshop and kitchen) and had a courtyard in front. Graves, dug in the floor of the dwellings, were prevailingly pit-shaped. By the second half of the 4th millennium the tombs were no longer in the dwellings and there were square and rectangular as well as circular houses, sometimes joined in groups of two or three. At Kalavasos is found a round dwelling of a different type, the lower part sunk in soft rock and the upper part, either thatched or built of wattle and daub, sometimes supported by posts. From the late Neolithic, or Aëneolithic, period are settlements at Erimi, Lapithos, Kythrea, and Ambeliku; the houses are circular and have foundations of stone and superstructures of brushwood or reed bound up with mud and held up by posts. Graves are mostly pit-shaped; they are situated near the dwelling or under the floor of an outlying part of it.

The Bronze Age is here divided into early (2400–2000 B.C.), middle (2000–1600), and late (1600–1050) periods; the subdivisions of the Bronze Age are also termed "Early Cypriote," "Middle Cypriote," and "Late Cypriote" (see CYPRIOTE ART, ANCIENT). The earliest Bronze Age tombs are of the chamber type, dug out of the rock, with dromos; this remains the prevailing type in all the successive periods until Early Christian times. Such tombs have been found, for example, at Agia Paraskevi, at Philia, at Vasilia, and (with decorated façades) at Vunus and Lapatsa-Karmi. Sometimes, as at Paleoskutella, the chamber tombs are surrounded by earthen mounds. At Alambra there has come to light an L-shaped house of two rooms with two courtyards. The walls were built of rubble, with mud bricks presumably used in the upper part; the roof was probably flat. At Ambeliku a complex consisting of several rooms has been found. Excavation of a house near Kalopsida belonging to the Middle Cypriote period revealed that it had 11 rooms surrounding an inner courtyard and an additional, external courtyard; the construction is like that of the house at Alambra.

There are interesting examples of military architecture of the Late Cypriote period in the fortifications at Nitovikla, Nikolides, and Enkomi; these were complicated structures, consisting essentially of reinforced walls, courtyards, and towers, and were often of two stories. They were abandoned about 1400 B.C., in a time when growing Egyptian power secured the peace in the eastern Mediterranean and made them unnecessary. Civil architecture of this time is known chiefly through the excavations at Enkomi, where houses built round three sides of a courtyard and with chamber tombs dug out of rock in the courtyard have been found. In the rebuilding of Enkomi, after its destruction toward the middle of the 13th century B.C., the houses were constructed of ashlar masonry on a tripartite plan, with a large central hall and smaller side wings. From this period there are numerous examples of religious architecture, among them the sanctuaries of Agios Iakovos, Mirtu, Enkomi, Idalion, Agia Irini.

Our knowledge of military and civil architecture in the Cypro-Geometric period (1050–700 B.C.) is slight. Tombs are for the most part trapezoid, rectangular, or irregular, with long and narrow dromoi. At the beginning of the Cypro-archaic period (700–475 B.C.) there were a number of city-states on the island; these belonged at first to the kings of Phoenicia and later to those of Assyria. At the beginning of the 6th century, they were subject to Egypt, then in 525 B.C. they yielded to the Persians, from whom they were not able to free themselves, in spite of the attempt of Evagoras during the Ionic revolt, until the time of Alexander the Great. Culturally speaking, the island was Greek both in archaic and in classical times. Civil architecture is best illustrated by the palace of Vuni (see CYPRIOTE ART, ANCIENT, FIG. 181).

Of religious architecture we have wider knowledge. There were

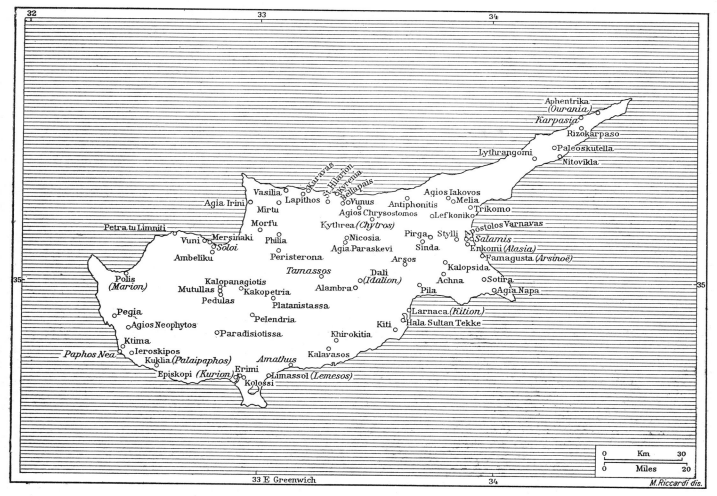

Cyprus, principal centers of archaeological and artistic interest.

various types of sanctuaries: the temenos with open court and peribolos, with the altar in the center; the shrine separated from or forming part of the temenos; the temenos with one or two adjoining courts with a niche or sacred cella at the back of the inner court; and, finally, the temple of Greek type. In tomb architecture, as has been said, there were no innovations. Tombs are of the chamber type; they are preceded by a dromos carved in the rock or, especially after Assyrian domination came to an end (669 B.C.), they were faced with blocks of stone. Following the struggles which broke out upon the death of Alexander the Great, Cyprus fell to the Ptolemies; it remained a part of their dominions until 58 B.C., when it became a Roman colony. At the time of the reforms of Diocletian, Cyprus became part of the Diocese of the East and on the division of the Empire passed to Byzantium. The architecture of the Hellenistic and Roman period is illustrated by houses and villas with mosaic works and by the temples of Soloi, Paphos (Kuklia), Salamis (Enkomi), and Kurion (Episkopi), as well as by restoration work done on archaic sanctuaries. There are also on the island theaters, agoras, aqueducts, and a gymnasium. For the art of Cyprus from the Neolithic period to Hellenistic times see CYPRIOTE ART, ANCIENT.

Porphyrios DIKAIOS

*Middle Ages and modern period.* In the Byzantine period there was a good deal of church building but this was cut short by the Arab conquest and subsequent rule (A.D. 649–965), which led to an impoverishment of the whole island. A revival occurred during the period when the island was again part of the Byzantine Empire (965–1191): once more, castles, churches, and monasteries were built. The Lusignans (1191–1489) established a strong connection with western Europe, and during this period Cyprus became a bridge between East and West. This was the period, too, when a characteristic Gothic architecture, the best to be found in the Levant, made its appearance. The Greek Church, however, followed the Cypro-Byzantine tradition up to the time of the Turkish conquest. Venetian domination (1489–1571) brought with it much activity

in the way of modernization of fortifications. During the Turkish dominion (1571–1878) churches and monasteries continued to be built, but Latin churches were turned into mosques.

Arthur H. S. MEGAW

A period of decadence was ended with the British occupation in 1878. Roads and ports (Famagusta, Larnaca, Limassol, Pato, Kyrenia) were improved, and hospitals were built (in Larnaca, 1900, in Nicosia and Pato, 1909, etc.). There is almost no development in town planning, but some modern schools have sprung up, such as the one in Ktima (1956) and the one (by A. MacDonald) in Limassol. The new churches of Varosha and Larnaca are very modest structures.

\* \*

BIBLIOG. E. Oberhummer, RE, s.v. Kypros; L. Pama di Cesnola, Cyprus: Its Ancient Cities, Tombs and Temples, London, 1877; C. Enlart, L'art gothique et la renaissance en Chypre, 2 vols., Paris, 1899; G. Jeffery, A Description of the Historic Monuments of Cyprus, Nicosia, 1918; E. Gjerstad, Studies on Prehistoric Cyprus, Uppsala, 1926; G. A. Sotiriou, Τὰ παλαιοχριστιανικὰ καὶ βυζαντινὰ μνημεῖα τῆς Κύπρου (Early Christian and Byzantine Monuments in Cyprus), Πρακτικὰ τῆς Ἀκαδεμίας Ἀθηνῶν (Acts of the Acad. of Athens), VI, 1931, pp. 477–90; Report of the Department of Antiquities, Cyprus, 1934; The Swedish Cyprus Expedition, E. Gjerstad et al., 4 vols., Stockholm, Lund, 1934 ff.; G. A. Sotiriou, Τὰ βυζαντινὰ μνημεια τῆς Κύπρου (Byzantine Monuments in Cyprus), I, Athens, 1935; S. Casson, Ancient Cyprus, London, 1937; D. Talbot Rice, The Icons of Cyprus, London, 1937; E. Sjöqvist, Problems of the Late Cypriote Bronze Age, Stockholm, 1940; G. F. Hill, A History of Cyprus, 4 vols., Cambridge, Eng., 1940–52; P. Dikaios, A Guide to the Cyprus Museum, Nicosia, 1947, 1953; P. Aström, The Middle Cypriote Bronze Age, Lund, 1957.

Porphyrios DIKAIOS and Arthur H. S. MEGAW

PRINCIPAL TOWNS AND SITES. Agia Irini ('Αγία Εἰρήνη). The earliest buildings of the sanctuary (see CYPRIOTE ART, ANCIENT, FIG. 174)

are of the Late Cypriote period; they are arranged around three sides of an open court. In the Cypro-Geometric period the sanctuary was rebuilt as an oval temenos. Toward 775 B.C. there were further changes, and again in 650, when the sanctuary was enlarged, taking on an almost triangular form; it was destroyed ca. 510–500 B.C. About two thousand votive statuettes were found on the site. In the vicinity there are tombs of the Cypro-Geometric period and a Hellenistic dwelling.

BIBLIOG. E. Sjöqvist, Die Kultgeschichte eines kyprischen Temenos, Archiv für Religionswissenschaft, XXX, 1932, pp. 308–59; The Swedish Cyprus Expedition, ed. E. Gjerstadt et al., Stockholm, II, 1935, pp. 642–824, IV, 2, 1948, pp. 1, 3 ff.

Agios Chrysostomos (Μονὴ τοῦ Ἁγίον Χρυσοστόμου). The Byzantine domed chapel and frescoes of the monastery are noteworthy. In the principal church, which is modern, Byzantine marble architraves and wooden doors have been used.

BIBLIOG. G. Jeffery, Byzantine Churches of Cyprus, Proc. of the Soc. of Antiquaries, XXVIII, 1915–16, p. 115.

Agios Iakovos (Ἅγιος Ἰάκωβος). In the vicinity is to be found a Late Cypriote temenos, almost circular in form, with two altars and a rectangular shrine of the Cypro-Geometric period; the last was divided into two parts in the Cypro-archaic period. About half a mile to the east, at Melia (Μέλια), there is a necropolis with Middle and Late Cypriote chamber tombs.

BIBLIOG. a. for Agios Iakovos. The Swedish Cyprus Expedition, ed. E. Gjerstad et al., Stockholm, II, 1935, pp. 356–70, IV, 2, 1948, pp. 2–3; E. Sjöqvist, Problems of the Late Cypriote Bronze Age, Stockholm, 1940, pp. 2–4. b. for Melia. The Swedish Cyprus Expedition, ed. E. Gjerstad et al., I, Stockholm, 1934, pp. 302–55.

Agios Neophytos (Μονὴ τοῦ Ἁγίου Νεοψύτου). In the country hermitage here there is a tomb of ca. 1160 containing frescoes of the period and later. The 15th-century church is a vaulted basilica, with dome; there are remains of contemporaneous frescoes.

BIBLIOG. A. C. Indianos and G. H. Thomson, Wall-Paintings at St. Neophytos Monastery in Cyprus, Κυπριακαὶ Σπουδαι (Cypriote Studies), III, 1940, pp. 155–224.

Amathus (Ἀμαθοῦς, Amathus Cypri). The ancient city, which was perhaps of Phoenician origin, remained faithful to Darius during the revolt of the Cypriotes against the Persians and later put up a long resistance against Evagoras; in the Ptolemaic period it followed the fortunes of the rest of the island. On the slopes of the acropolis there have been found a necropolis of the Cypro-Geometric period having tombs of the chamber type with dromos, a necropolis of archaic and classic times, and Hellenistic and Roman tombs; no trace has yet been found of the temple of Aphrodite for which Amathus was famous in classical times.

BIBLIOG. The Swedish Cyprus Expedition, ed E. Gjerstad et al., II, Stockholm, 1935, p. 1 ff.; G. Bendinelli, EAA, s. v. Amatunte.

Antiphonitis (Ἀντιφωνητής). The large-domed monastic church is of the 12th century; it contains frescoes of the period, as well as some of later date.

Aphentrika (Ἀφέντρικα, anc. Οὐρανία, Urania?). There are chamber tombs ranging in date from the 5th to the 2d century B.C. The vaulted church dedicated to the Panagia (ca. 1550) was erected in the nave of an Early Christian basilica; it was rebuilt during the Arab wars with piers and barrel vaults (now fallen). Also in ruins is the basilica of Asomatos, similarly rebuilt; the vaulting over the south aisle remains. The ruins of the Chapel of Agios Georgios, with twin apses opening from a domed bay, indicate that the chapel probably dates from the period of the Arab wars.

BIBLIOG. D. G. Hogarth, Devia Cypria, London, 1889, p. 85; G. F. Hill, A History of Cyprus, I, Cambridge, Eng., 1940, p. 166; The Swedish Cyprus Expedition, ed. E. Gjerstad et al., IV, 3, Lund, 1956, p. 30; A. H. S. Megaw, Three Vaulted Basilicas in Cyprus, JHS, LXVI, 1948, pp. 48–56; E. Dray and J. du Plat Taylor, Tsambres and Aphendrika, Two Classical and Hellenistic Cemeteries, Report of the Department of Antiquities, Cyprus 1937–39, 1951, pp. 57–99.

Apostolos Varnavas (Μονὴ τοῦ Ἀποστόλου Βαρνάβα). The church is a large Byzantine structure with two domes, each on four piers. Following the discovery of relics of the apostle Barnabas nearby, a basilica was erected, ca. 485, as a martyrium; the capitals of its west part (the east end has since fallen) were incorporated into the church, which was built ca. 900.

Bibliog. G. A. Sotiriou, Ὁ Ναὸς καὶ τάφος τοῦ Ἀποστόλου Βαρνάβα (Temple and Tomb of the Apostle Barnabas), Κυπριακαὶ Σπουδαί (Cypriote Studies), I, 1937, pp. 175–87.

Asinou (Ἀσίνου). The Byzantine church has vaults covered with wood and painted; the east and west parts are the earliest (1106). The narthex with the Last Judgment was repainted in 1333; the central section of the church was repainted ca. 1500.

BIBLIOG. V. Seymer and W. H. Buckler, The Church of Asinou, Cyprus and Its Frescoes, Archaeologia, LXXXIII, 1934, pp. 327–50.

Bellapais (Μονὴ τοῦ Πελλαπαΐς, Belapais Manastiri). The abbey was founded by the Lusignans for Augustinian (later Norbertine) canons. The church, pure early Gothic in style, has transepts, narrow aisles, a rectangular sanctuary, and terrace roofs over ribbed vaulting, probably completed by Hugh III (1267–84). The cloister and large vaulted refectory with crypt below were added by Hugh IV (1324–58); there are substantial remains of a contemporaneous vaulted chapter house and imposing dormitory.

BIBLIOG. F. Sesselberg, Das Praemonstratenser-Kloster Belapais, auf der Insul Cypern vom Kirchen- und Kunstgeschichtlichen Standpunkte, Heidelberg, Berlin, 1901; A. H. S. Megaw, A Brief History and Description of Bellapais Abbey, Nicosia, 1955.

Dali (Δάλι, anc. Ἰθάλιον, Idalium). Idalion is mentioned in Assyrian tablets of the 7th century B.C. as one of the ten cities of Cyprus governed by kings. In the 5th century B.C. it fell under the rule of the Phoenician kingdom of Kition and in the 4th under that of the Ptolemies. On the acropolis is a settlement of the Late Cypriote period; excavations have shown that at first it was composed of modest houses placed haphazardly within the walls, but later it underwent a typical urban development, in the course of which houses were separated by lanes and squares, and walls were provided with towers, bastions, etc. At the summit of the acropolis is a sanctuary consisting of a house with two trapezoid rooms; a third room and a small atrium are later additions. Also on the acropolis is a sanctuary of Athena, which goes back to the Cypro-Geometric period; it is dated 890 B.C. It underwent modifications in the Cypro-archaic period; the fortified wall served as peribolos of the temenos, which enclosed an altar and a chapel. The so-called "temenos of Aphrodite" had an open court with doorways along the south and west sides and a shrine. The sanctuary of Apollo had two courtyards, one of which enclosed the shrine.

BIBLIOG. G. F. Hill, A History of Cyprus, I, Cambridge, Eng., 1940, pp. 99, 113, 125, passim; The Swedish Cyprus Expedition, ed. E. Gjerstad et al., Stockholm, II, 1935, pp. 460–641, IV, 2, 1948, pp. 5–8.

Enkomi, Engomi (Ἔγκωμι, anc. Alasia, Alašia?). Situated near the classic Salamis, the city of Enkomi goes back to the 2d millennium B.C. The oldest city dates from the period 1900–1600 B.C.; on it was built the Mycenaean city, which flourished 1600–1200 and disappeared ca. 1050. From the Late Cypriote period date some clusters of houses built on three sides of a courtyard; chamber tombs were cut in the rock of the courtyards. Also Late Cypriote is a building of a military nature, abandoned ca. 1400 B.C., on the site of which a fortress was constructed. Destroyed in the 13th century B.C., Enkomi was rebuilt and surrounded with a bastioned wall. The houses are of ashlar masonry and tripartite in type. In a sacred building, also tripartite, a bronze statue of a horned god was found.

BIBLIOG. The Swedish Cyprus Expedition, ed. E. Gjerstad et al., I, Stockholm, 1934, p. 467 ff.; P. Dikaios, The Oldest Known Representation of Apollo, ILN, Aug. 27, 1949, pp. 316–17; New Light on Ancient Cyprus, ILN, Sept. 5, 1953; C. F. A. Schaeffer, Enkomi-Alasia, Paris, 1952; P. Dikaios, Recent Excavations at Enkomi by the Department of Antiquities of Cyprus, AJA, CVII, 1953, p. 106 ff.; C. Picard, El Kinyras, ou quelque guerrier chypriote?, RA, XLV, 1955, pp. 48–49; FA, VIII, 1956, no. 1737, IX, 1956, no. 2219, X, 1957, no. 2009; P. Dikaios, Enkomi II (in preparation).

Episkopi (Ἐπισκοπή, anc. Κούριον, Kurion, Curium). On the plain to the southwest of the latest city, the oldest remains of which go back no farther than the end of the 8th century B.C., there has been found an uninterrupted sequence of tombs starting in the Bronze Age and extending into the Roman period; these attest to a continuing life on the site. The name Kouri appears in the late Bronze Age settlement, on the hillside of Pambula near Kurion; the exact situation of the settlement at the beginning of the Iron Age is not known. Kurion was one of the oldest kingdoms of Cyprus; it is mentioned in Assyrian tablets at the end of the 8th century B.C. During the Persian period Kurion was one of the ten cities of the island governed by kings. In 332 B.C. it supported Alexander in the expedition against Tyre. The Pambula settlement has a fortified wall, of which the lower part is built of rubble and the upper of mud bricks; there are traces of streets and of four- and five-room houses of irregular shape. Some of the houses date from Cypro-Geometric I.

Outside the latest city is a sanctuary of Apollo Hylates, which

has yielded a large number of terra-cotta figurines of dates ranging from 750 B.C. to A.D. 100. The sanctuary has had a long life, having been several times rebuilt; the existing remains are part of a reconstruction carried out after the earthquake of 76–77 and go back to ca. A.D. 100. It was again destroyed by an earthquake in the 4th century of our era (at this time it also included a gymnasium). Near the sanctuary are baths of the 2d century of our era, and between the sanctuary and the city is the stadium, which was also built in the 2d century and remained in use until ca. A.D. 400. On the acropolis are other baths and a building (perhaps a mint) of the 5th century B.C. A public building of the 4th century of our era has mosaic pavements with representations of Achilles in Skyros and of the Rape of Ganymede. There were at one time remains of an aqueduct of the Roman period. In the Early Christian period a bishopric was established in Episkopi.

BIBLIOG. *a. for Pambula.* J. F. Daniel, Excavations at Kourion, AJA, XLII, 1938, p. 261 ff.; E. Sjöqvist, Problems of the Late Cypriote Bronze Age, Stockholm, 1940, p. 132 ff.; FA, III, 1950, no. 1338, X, 1957, no. 1856. *b. for Kurion.* J. F. Daniel, Two Late Cypriote III Tombs from Kourion, AJA, XLI, 1937, pp. 55–85; G. H. McFadden, A Tomb of the Necropolis of Ayios Ermoyenios at Kourion, AJA, L, 1946, pp. 449–89; G. H. McFadden, Kourion, the Apollo Baths, Univ. [Pa.] Mus. B., XIV, June, 1950, pp. 14–26; D. C. Fales, Kourion, the Amusement Area, Univ. [Pa.] Mus. B., XIV, June, 1950, pp. 27–37; FA, III, 1950, no. 2356; G. H. McFadden, A Late Cypriote III Tomb from Kourion-Kaloriziki no. 40, AJA, LVIII, 1954, pp. 131–42; J. H. Young and S. H. Young, Terracotta Figurines from Kourion in Cyprus, Philadelphia, 1955; A Brief History and Description of Curium, Nicosia, 1956; FA, VIII, 1956, no. 2701; The Swedish Cyprus Expedition, ed. E. Gjerstad et al., IV, 2, Stockholm, 1948, pp. 12, 23, 29 ff., 185, passim, IV, 3, Lund, 1956, pp. 9, 11, 21, 24, passim.

Erimi ('Ερήμη). The prehistoric settlement here represents the neolithic and aëneolithic phases of the culture of Cyprus. The earlier houses are circular and semisubterranean; those of the later period are of the tholos type.

BIBLIOG. P. Dikaios, Excavations at Erimi, 133–35, Final Report, Report of the Department of Antiquities, Cyprus, 1936, 1st part, Nicosia, 1938.

Famagusta ('Αμμόχωστος, Magusa, anc. 'Αρσινόη, 'Αμμόχωστος, Arsinoë). Ptolemy II (Philadelphus), who founded the ancient city, named it Arsinoë after his wife. In the environs, at Sinda, a site of the Late Cypriote period has been partially excavated, and chamber tombs of a still earlier period have been found. During the Crusades Famagusta became a place of great importance; after the fall of Acre (1291) the Lusignans, kings of Cyprus and Jerusalem, chose it as their capital. It became Genoese in 1373, Venetian in 1489; by the Turkish period Famagusta had lost its importance entirely. The citadel, dating from the Lusignan period, has a 13th-century courtyard, a keep with outer wall, and later additions, including the remains of a large 14th-century hall above an undercroft with ribbed vaulting. The fortifications include a town wall (ca. 1300), a curtain with slits at ground level, towers (now mostly obscured by Venetian additions), and a rock-cut moat.

Lala Mustafa Mosque (formerly the Cathedral of St. Nicholas) is a large early-14th-century building in French Gothic style; the ornate west front (towers unfinished), terrace roofs over aisles ending in lateral apses, and lofty clerestory (partially rebuilt after an earthquake in 1735) are noteworthy. Other examples of church architecture include: St. George of the Latins, shell of a small church in pure late-13th-century style; Sinan Pasha Mosque (formerly Church of SS. Peter and Paul), a well-preserved three-aisled building, 14th-century Gothic in style, incorporating a fine 13th-century doorway (north); St. George of the Greeks, shell of a large three-aisled Orthodox cathedral, 14th-century Gothic in style, formerly domed and retaining in the apses some paintings showing Western influence; remains of earlier chapels of Agios Georgios Exorinos, a small 14th-century Nestorian church, three-aisled, retaining traces of paintings with Syriac inscriptions; St. Anne, a small 14th-century Gothic church in which are preserved paintings with Latin inscriptions. There also survive the shells of substantial 14th-century Gothic churches of the Franciscan and Carmelite orders, the latter with traces of paintings, as well as five other small churches that are intact and several others (two of them domed) in ruins.

From the Venetian period date the early artillery towers and encasing wall of the citadel, the work of Nicolo Foscarini, 1492. Dated 1496 and later are the sea gate, the interior of which is domed, the remodeling of the Lusignan town wall and towers with artillery emplacements, and the widening of the moat — the work of Nicolo Priuli. The original land gate (it was restored by the Turks) dates from 1544; the protecting ravelin is undated. The Martinengo bastion was designed by Gian Girolamo Sanmicheli and is dated 1558–62; heart-shaped, it has deeply recessed emplacements linked by a curving vaulted passage. In the center of the city rises the palace;

the façade, designed by Sanmicheli, and the shell of the armory are additions, dated 1552–54, to the original structure. From the Turkish period date the restoration of the land gate and the bridge, the conversion of the ravelin into a bastion, and the rebuilding of the landgate tower, arsenal tower, and other parts of the fortifications damaged in 1571.

BIBLIOG. C. Enlart, L'art gothique et la renaissance en Chypre, Paris. 1899, I, pp. 392–93, II, pp. 633–37; J. L. Myres, Excavations in Cyprus, 1913, BSA, XLI, 1940–45, p. 68 ff.; L. A. Maggioretti, Architetti e architetture militari, I, Rome, 1933, pp. 433–68; R. Gunnis, Famagusta, A Short Guide, Nicosia, 1934; E. Langenskjöld, Michele Sanmicheli, Uppsala, 1938, pp. 169–70; R. Gunnis, Historic Cyprus, London, 1936, pp. 90, 177–78, 215–17; G. F. Hill, A History of Cyprus, III, Cambridge, Eng., 1948, p. 1127, no. 1; FA, II, 1949, no. 1312.

Galata (Γαλάτα). The wood-roofed Church of Panagia Podithou was erected in 1502; the wall paintings are of the period and show Italian influence. In the adjoining Chapel of the Archangel (formerly

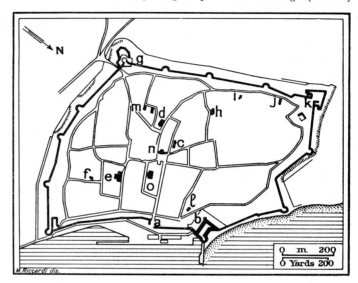

Famagusta, plan of the city showing 15th- and 16th-cent. walls. Monuments: (a) Sea gate; (b) citadel; (c) Franciscan church; (d) Sinan Pasha Mosque (formerly Church of SS. Peter and Paul); (e) Church of St. George of the Greeks; (f) Lala Mustafa Mosque (formerly Cathedral of St. Nicholas); (g) land gate; (h) Nestorian church; (i) Church of St. Anne; (j) Carmelite church; (k) Martinengo bastion; (l) Church of St. George of the Latins; (m) ruined churches.

Theotokos) is a well-preserved Cypro-Byzantine cycle by Symeon Auxentis, dated 1511. The Church of Agios Sozomenos contains another cycle, dated 1513, by the same painter.

BIBLIOG. W. H. Buckler, Frescoes at Galata, Cyprus, JHS, LIII, 1933, pp. 105–10; A. and J. Stylianou, Ήμονὴ Ποδύθου (The Monastery of Podithou), Κυπριακαὶ Σπουδαί (Cypriote Studies), XVIII, 1955, pp. 49–72.

Ieroskipos ('Ιεροσκίπου). The Byzantine Church of Agia Paraskevi is noteworthy. The nave has three domes, and there are two domes at the center points of the vaulted side aisles. Western influence is evident in what remains of the paintings, which date from the 15th century.

Kakopetria (Κακοπετρεία). The Byzantine Church of Agios Nikolaos (ca. 1000) has a dome resting on four piers. Some of the paintings in the so-called "monastic" style are of the period; others are later in date.

BIBLIOG. A. and J. Stylianou, Ὁ ναὸς τοῦ Ἁγίου Νικολάου τῆς Στένης (The Church of St. Nicholas of Steni), Κυπριακαὶ Σπουδαί (Cypriote Studies), X, 1948, pp. 95–106.

Kalavasos (Καλαβασός). The prehistoric remains here show three succeeding phases: (1) a settlement of the early Neolithic and the beginning of the late Neolithic period, with stone houses of the tholos type and paved streets; (2) a settlement of the late Neolithic period with semisubterranean circular houses, the upper parts built of perishable materials; (3) a settlement of the beginning of the Bronze Age, with houses similar to but more developed than those of the second phase. In the region of Kalavasos there are Bronze Age tombs, some Early Cypriote and others Late Cypriote.

BIBLIOG. FA, II, 1949, no. 1229, IV, 1951, no. 1743, V, 1952, n. 1692.

Kalopanagiotis (Καλοπαναγιώτης, Kalopanayotis). The 11th-century chapel attached to the shrine of Agios Ioannis Lampadistis contains both paintings of the period (unfortunately spoiled by overpainting) and later ones; a unique painted wood iconostasis dates from ca. 1400. The vaulted Latin chapel to the north has Byzantine doors and contains paintings in Italianate style of ca. 1500. On the frame of the icon of the patron saint are scenes from his life, which date from ca. 1400.

BIBLIOG. A. and J. Stylianou, Byzantine Cyprus as Reflected in Art, Nicosia, 1948, pp. 13-17.

Karavas (Καραβάς, Acheiropiitos, Κανανα). In the Byzantine church of the Acheiropiitos monastery is incorporated the apse of the metropolitan basilica of Christian Lapithos. Some parts of the original marble chancel have been reused in an iconostasis. The portico, which displays some Gothic elements, was added toward 1550. In the domed Church of Agios Evlalios, built ca. 1590 but still revealing Gothic tendencies, Early Christian columns have been reused.

Khirokitia (Χοιροκοιτία). Representing mostly the early Neolithic period, this settlement has a main street flanked by houses of the tholos type with three rooms and a courtyard in front; the characteristic pit graves of the period were dug in the floor of the dwellings.

BIBLIOG. FA, I, 1948, no. 813, III, 1950, no. 1419; P. Dikaios, Khirokitia, Oxford, 1953.

Kiti (Κίτι). The Byzantine Church of Panagia Angeloktistos, with dome on four piers, incorporates an apse from an Early Christian basilica. Inside is a mosaic of the 7th century depicting the Virgin and Child flanked by Michael and Gabriel; the mosaic is enclosed by a decorative border. A Latin chapel adjoining, to the south, has Gothic vaulting. At Cape Kiti, nearby, there is a machicolated watchtower of the Venetian period.

BIBLIOG. J. J. Smirnov, Kristianskiye Mozaiki Kipra (Christian Mosaics of Cyprus, Vizantiskii Vremennik (Byz. Ann.), IV, 1897, pp. 1-93; T. Schmit, Παναγια Ἀγγελόκτιστος (Panagia Angeloktistos), Izvestija Russkogo Arkheologicheskogo Instituta Konstantinopolya (B. Rus. Archaeol. Inst. of Constantinople), XV, 1911, pp. 206-39; G. Galassi, I musaici della Panagia Angeloktistos, Felix Ravenna, LXVI, 1954, pp. 18-22.

Kolossi (Κολόσσι). The castle, erected in 1454 as the headquarters of the Cyprus commandery of the Knights of Rhodes, comprises a massive keep of three stories. The building next to it, a sugar factory, has a vaulted roof; it was repaired by Murad Pasha in 1591.

BIBLIOG. G. Jeffery, Kolossi and Kyrenia Castles, Cyprus Monuments, N. Ill. S., no. 5, Nicosia, 1933, pp. 1-23; A. H. S. M[egaw], A Brief History and Description of Kolossi Castle, Nicosia, 1954.

Ktima (Κτῆμα, near anc. Πάφος Νέα, Paphos Nea). According to tradition, Paphos Nea was founded by the Arcadian Agapenor on his return from Troy, but there are no remains in the area earlier than the classical era. In later times Ktima came under the rule of the Ptolemies. It was, from the second half of the 2d century B.C. until the Roman era, the military and maritime capital of Cyprus, superseding Salamis. Rebuilt by Augustus after the destruction wrought by the earthquake of 15 B.C., it was named Augusta. In the 4th century of our era it yielded first place to Salamis once more. Paphos Nea ("New Paphos") and Palaipaphos ("Old Paphos"; see Kuklia) are 10 miles apart; the distinction between these two ancient cities goes back to the beginnings of the Empire. Between Ktima and Paphos Nea there have been found peristyle tombs, perhaps of Alexandrian derivation. A stadium and also a theater remain, the latter situated within the limits of the modern town of Kato Paphos. In the environs has been found a necropolis including tombs of the Cypro-Geometric and Cypro-archaic periods and of the 4th century B.C. From the medieval period are: the so-called "Castle of the Forty Columns" near the harbor (probably built for defense against the Arabs in the 7th century); Agia Solomoni, a chapel with a sacred well and remains of early Byzantine paintings in a catacomb dug out of the rock; the Chrysopolitissa, a Greek church with nave and aisles, transept, and dome of the 15th century (pointed vaults and arches); the fort, a Turkish construction of 1592 incorporating a Lusignan tower.

BIBLIOG. C. Enlart, L'art gothique et la renaissance en Chypre, II, Paris, 1899, pp. 478-79; H. Tiersch, Zwei antike Grabenlagen bei Alexandria, Berlin, 1904, p. 14, fig. 9; H. C. Lukach and D. J. Jardine, The Handbook of Cyprus, London, 1913, p. 64; R. Gunnis, Historic Cyprus, London, 1936, pp. 144, 147, 165, 372, 438; L. Philippou, Paphos Guide, Paphos, 1936; FA, VI, 1953, no. 3366; J. Bérard, Recherches archéologiques dans la région de Paphos: La nécropole d'Iskender près de Ktima, CRAI, 1953, pp. 429-32; J. Bérard, Recherches archéologiques à Chypre dans la région

de Paphos: La nécropole d'Iskender, RA, XLIII, 1954, pp. 1-16; J. Bérard and J. Deshayes, La seconde campagne de fouilles à la nécropole d'Iskender en Chypre, CRAI, 1955, pp. 137-38.

Kuklia (Κούκλια, anc. Παλαίπαφος, Palaipaphos). In old Paphos, or Palaipaphos, was the site of the cult of Aphrodite, who according to myth arose here from the foam of the sea. The priest-kings who governed the two cities (see Ktima) were attached to this cult. The remains of a building with portico can perhaps be identified with the celebrated Temple of Aphrodite, the appearance of which is known from Roman coins; in the vicinity of this building is a settlement with remains, dates ranging from Late Cypriote to Roman times (house with pavements in mosaic and peristyle). Late Cypriote fortifications (trench, wall with portal flanked by two towers, 12th-11th cent. B.C.), probably marking the circumference of Palaipaphos, have been found 400 yd. to the north of Kuklia; a later refacing of the outside of the foot of the mound seems to go back to the 5th century B.C. In the environs of Kuklia are two large stone columns, graves of the Aëneolithic period, and an important necropolis with Late Cypriote chamber tombs; there are also groups of Late Cypriote and earliest Cypro-Geometric tombs.

BIBLIOG. T. B. Mitford and J. H. Iliffe, Excavations at Kouklia (Old Paphos), Cyprus, 1950 AntJ, XXXI, 1951, pp. 51-66; J. H. Iliffe, Excavations at Aphrodite's Sanctuary of Paphos, Liverpool Libraries, Museums and Arts Com. B., I, 1951, pp. 25-36; J. H. Iliffe, Excavations at Aphrodite's Sanctuary of Paphos (1951), Liverpool Libraries, Museums and Arts Com. B., II, 1952, pp. 28-66; FA, IV, 1951, no. 1802, V, 1952, no. 1756, VI, 1953, no. 1979, VII, 1954, nos. 1556-57, 1559, VIII, 1956, nos. 1712, 2180.

Kyrenia (Κυρήνεια, Κερύνια). The castle includes the remains of an early square fortress with hollow circular towers at the angles; ca. 600 the castle was reinforced on the south side by means of a massive rampart with solid pentagonal towers. There are later reconstructions and additions from the Lusignan period. An old crypt on the west side and galleries and embrasures on the north and east are of the 14th century. From the Venetian period are the two cylindrical angle towers and the outside walls at the west (finished in 1544) and the rectangular bastion at the southwest (1560).

BIBLIOG. G. Jeffery, A Summary of the Architectural Monuments of Cyprus, Prefatory Notes, Nicosia, 1907, p. 27; G. Jeffery, Kolossi and Kyrenia Castles, Cyprus Monuments, N. Ill. S., no. 5, Nicosia, 1933, pp. 25-34; G. Jeffery, Kyrenia Castle and Its Sieges, Cyprus Monuments, N. Ill. S., no. 4, Nicosia, 1932, pp. 7-29; R. Gunnis, Historic Cyprus, London, 1936, pp. 126, 198, 215.

Lagudera (Λαγουδερά). In the domed Byzantine Church of Panagia Araku there are frescoes in the finest Byzantine court style, dated 1193, in a good state of preservation.

BIBLIOG. G. A. Sotiriou, Θεοτόκος ἡ Ἀρα ἰώτισσα (The Madonna of Araku), Τόμος εἰς μνήμην Τ. Π. Οἰκονόμου (Volume in memory of T. P. Iconomos), Athens, 1954, pp. 81-91; A. Stylianou, Αἱ τοιχογραφίαι τοῦ ναοῦ τῆς Παναγίας τοῦ Ἀράκου (Frescoes of the Church of the Most Holy Virgin of Araku), Πεπραγαένα τοῦ Θ' διεθνοῦς βυζαντινολικιχοῦ Συνεθρίου (Acts of the IX International Congress of Byzantine Studies at Salonika), I, Athens, 1954, pp. 454-67.

Lapithos (Λάπηθος, anc. Λάπαθος, Λάπηθος, Λάπιθος, Lapathus, Lapethus, Laphito). Founded, according to tradition, by Laconian stock, the city was dominated by its Greek inhabitants until the period of Phoenician expansion (middle of the 5th cent. B.C.). In the late 4th century B.C. Lapithos again had a Greek king, eventually deposed by Ptolemy I. In the Roman period, it was the capital of one of the four districts into which Cyprus was divided. Among the remains of the Roman city, which include a gymnasium, there has come to light a necropolis of the Early and Middle Cypriote periods; of the same time is the sepulcher of Vrisi tu Barba. Groups of smaller tombs belong to the Middle and Late Cypriote periods. Nearby, at Platies, there has come to light a settlement of the Aëneolithic period which is in part overlain by a necropolis of the Cypro-Geometric period. The necropolis of Kastros is of the same period.

BIBLIOG. The Cyprus Expedition, ed. E. Gjerstad et al., Stockholm, I, 1934, p. 13 ff., IV, 2, 1948, p. 29 ff.; FA, IX, 1956, no. 2114.

Larnaca (Λάρναξ, Λάρνακα, anc. Κίτιον, Kition, Citium). Remains dating from the Mycenaean era indicate that the region was settled as early as the 2d millennium B.C. Evidence so far uncovered seems to indicate that at the end of the Late Cypriote period the inhabitants resettled on the nearby hill of Pambula (Bambula), which from then on was their acropolis. Kition, which is mentioned in Phoenician inscriptions, was one of the most important kingdoms of the island; it played a significant part in the struggle between the Greeks and the Persians and retained its independence until the

ascendancy of the Ptolemies. There is a Late Cypriote settlement with burial ground to the west of Hala Sultan Tekke (see below), and there are tombs of the Cypro-Geometric and Cypro-archaic periods at Turabi Tekke. On the hill of Pambula there are remains from the early Iron Age and the Cypro-archaic period, when the city expanded and was circumvallated; in Hellenistic and Roman times the city continued to expand outside the walled fortifications. There is also a temenos dedicated to the city god, Herakles-Melkarth; this was built 650–600 B.C. and rebuilt 600–570 with an open courtyard and a chapel for the cult statue of the god. About 475 B.C. the temenos was covered over and another temenos was built consisting of an outer court and an inner temenos, the latter with two altars. This was destroyed ca. 400 B.C.; its place was taken by a similar temenos that was used until ca. 325 B.C.

During the excavations of the temenos of Melkarth at Kition a house dating from the Hellenistic period was found. From the Roman period is a tomb of the ashlar type (one of two known examples), the so-called "Tomb of Cobham"; it has a dromos with steps and three rooms on the same axis. The Church of Agios Lazaros, originally with three domes, each on four piers, was built ca. 900 on the site of an Early Christian basilica, whose capitals it incorporates; under the altar is the plain sarcophagus from which the relics of Lazarus were removed by the emperor Leo the Wise in 901. The small fort, erected by the Turks in 1625, incorporates remains of a Lusignan tower. Hala Sultan Tekke contains the tomb of a relative of the prophet Mohammed who came to Cyprus in Muawiyah's expedition of 649 and died there; the shrine in its present form is a much later construction, ca. 1760.

BIBLIOG. C. O. Cobham, ed. and trans., The Story of Umm Harám, Royal Asiatic Soc. J., 1897, p. 81 ff.; C. Enlart, L'art gothique et la renaissance en Chypre, II, Paris, 1899, p. 418; G. Jeffery, Rock-cutting and Tomb-architecture in Cyprus during the Graeco-Roman Occupation, Archaeologia, LXVI, 1915, p. 171 ff.; R. Gunnis, Historic Cyprus, London, 1936, pp. 118, 248–49, 263–68, 407–09; The Swedish Cyprus Expedition, ed. E. Gjerstad et al., Stockholm, III, 1937, p. 1 ff., IV, 2, 1948, pp. 10–13; G. F. Hill, A History of Cyprus, I, Cambridge, Eng., 1940, pp. 12, 21, 99, 104, 107, passim; J. L. Myres, Excavations in Cyprus, 1913, BSA, XLI, 1940–45, p. 85 ff.; FA, III, 1950, no. 1302, VIII, 1956, no. 1621.

Limassol (Limasol, anc. Λεμεσός, Νέα Πόλις). Antiquity is represented here by Greco-Phoenician tombs of the 7th century B.C. and a temple with Cypro-archaic sculptures. There are tombs of the Roman era. A small Lusignan keep constructed by James I, ca. 1390, in the shell of a 13th-century Gothic chapel, is the sole relic of a Templar castle which passed to the crown in 1308. Damaged in 1373, it was restored as an artillery fort by the Turks in the late 16th century.

BIBLIOG. G. F. Hill, A History of Cyprus, I, Cambridge, Eng., 1940, p. 108, n. 1; C. Enlart, L'art gothique et la renaissance en Chypre, II, Paris, 1899, pp. 450–52, 685; R. Gunnis, Historic Cyprus, London, 1936, p. 135; FA, VIII, 1956, no. 1674.

Lythrangomi (Λυθράγκωμη, Litrangomi). The Church of the Panagia Kanakaria, in its original form an Early Christian basilica, was rebuilt during the Arab wars with barrel vaults on piers, to which a Byzantine dome was later added. Of the original building there remains an apse with fragments of a 6th-century mosaic (Virgin enthroned flanked by angels).

BIBLIOG. J. J. Smirnov, Khristianskiye Mozaiki Kipra (Christian Mosaics of Cyprus), Vizantiiskii Vremennik (Byz. Ann.), IV, 1897, pp. 1–93; A. H. S. Megaw, The Mosaics in the Church of Panayia Kanakaria, Atti del VIII Congresso di Studi Bizantini (Palermo, 1951), II, Rome, 1953, pp. 199–200; G. Galassi, I musaici della Kanakaria, Felix Ravenna, LXVI, 1954, pp. 5–9.

Mutullas (Μουτουλλᾶς, Mutula). In the wood-roofed Chapel of Panagia is part of a cycle of Cypro-Byzantine paintings dated 1280.

Nicosia (Λευκωσία, Lefkosia, Leucosia). The name Lefkosia (from which the Latinized form Nicosia is derived) goes back to the period of the Crusades. In 1192 Nicosia became the capital of the Lusignan kingdom. Except for a brief period (1373) when it was under the rule of the Genoese, it remained in the hands of the Lusignans until its cession to Venice in 1489. In 1570 it was captured by the Ottoman Turks. The plan of the city remains today as it was in Venetian times.

There are a number of monuments of the Lusignan period. The east end of Selimiye Mosque (formerly the Gothic Cathedral of St. Sophia), with ambulatory and transept chapels, was completed 1217–51; the remainder, with portico (marble figure over central door) and tower added, was completed 1319–26. The Armenian church (possibly Notre Dame de Tyr), a small building in pure Gothic style, is dated ca. 1300. Omerieh Mosque, a large Augustinian church, which has lost its vaulting, is of ca. 1330. Haidar Pasha Mosque,

a small but intact Gothic church (possibly St. Catherine) with semi-hexagonal buttresses, is dated ca. 1360. The now partly roofless Bedestan, which became the Orthodox Cathedral in the Venetian period, and later a market, comprises work of various dates superimposed on remains of an Early Christian basilica, the dome having been added ca. 1500; the north façade, rebuilt ca. 1550, incorporates three Gothic doorways, originally in another building. The Church of Agios Kassianos has a panel painting of the Virgin and Child surrounded by small scenes with Latin inscriptions, ca. 1340, possibly from St. Sophia, and a fine icon of the Ascension in Cypro-Byzantine

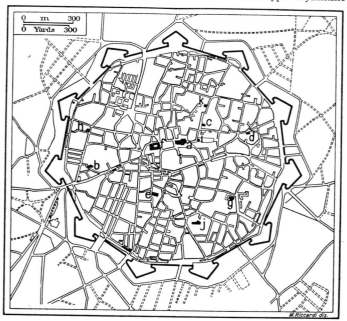

Nicosia, plan of the city showing fortified walls of the 16th cent. Monuments: (a) Selimiye Mosque (formerly Cathedral of St. Sophia); (b) Armenian church; (c) Haidar Pasha Mosque (possibly Church of St. Catherine); (d) Church of Agios Kassianos; (e) Phaneromene church; (f) Beuyuk Khan; (g) Agios Ioannis Cathedral; (h) Ahmed Mosque; (i) Lapidary Museum; (j) Omerieh Mosque; (k) Yeni Mosque.

style of ca. 1350. A collection of icons housed temporarily in the Phaneromene church contains good examples from churches in Nicosia and elsewhere.

The Venetian period is represented by artillery fortifications designed by Giulio Savorgnano in 1567; these form a circle and have 11 pointed bastions and 3 gates.

Work of the Turkish period is variously exemplified. Beuyuk Khan, a large caravansery around a cloister with two stories of pointed vaulting, dates from ca. 1590. Agios Ioannis Cathedral, a simple vaulted building, dated 1665, has a full cycle of paintings of ca. 1731. Sultan Mahmud's small library, which contains illuminated Korans, etc., and the Arab Ahmet Mosque are of Turkish domical style.

The Cyprus Museum is rich in Cypriote antiquities; the collection of Phoenician ceramics and the Byzantine treasure of Lambusa are particularly important.

BIBLIOG. T. J. Chamberlayne, Lacrimae Nicossienses, Paris, 1894; C. Enlart, L'art gothique et la renaissance en Chypre, Paris, 1899, I, pp. 90–104, 164–67, 178–79, II, pp. 525, 538–40; O. M. Dalton, A Second Silver Treasure from Cyprus, Archaeologia, LX, 1906, pp. 1–24; M. Rosenberg, Der Goldschmiede Merkzeichen, IV, Frankfurt am Main, 1928; L. A. Magiorotti, Architetti e architetture militari, I, Rome, 1933, pp. 427–33; G. Jeffery, Cyprus Monuments, N. Ill. S., no. 7, The Mosques of Nicosia, Nicosia, 1935; R. Gunnis, Historic Cyprus, London, 1936, pp. 45–47, 55–56, 71–74, 162–63, 172, 222, 320, 344, 347, 380, 436, 453; FA, II, 1949, nos. 1268, 2068, III, 1950, no. 1454, IV, 1953, no. 1955.

Nikolides (Νικολίδης). Here, in the neighborhood of Idalion, there is a settlement of the early Bronze Age with houses built without mortar. There are also fortifications of Late Cypriote I. Destroyed about 1450 B.C., these were shortly rebuilt on the same plan; they were abandoned ca. 1400 B.C. The necropolis spans the entire period of the Bronze Age.

BIBLIOG. E. Gjerstad, Studies on Prehistoric Cyprus, Uppsala, 1926, pp. 5 ff., 37 ff.

Pegia (Πέγια, Peya). On the coast at Agios Georgios are ruins, partly excavated, of an Early Christian town: a large basilica with

atrium, baptistery, and annexes, and remains of 6th-century mosaic pavements.

Platanistassa (Πλατανιστάσα). The Church of Stavros is decorated with a cycle of Cypro-Byzantine paintings of 1477 in an excellent state of preservation.

BIBLIOG. A. and J. Stylianou, Byzantine Cyprus as Reflected in Art, Nicosia, 1948, pp. 9–13.

Rizokarpaso (Ριζοκάρπασος, anc. Καρπασία, Karpasia). Karpasia is mentioned in sources from classical times on. The town was taken by Demetrius Poliorcetes in 306 B.C. In Early Christian times it was the seat of a bishop. When the town was destroyed, perhaps by Saracens, the population moved to the site of the present Rizokarpaso. There has been found here a chamber tomb of the Cypro-Geometric period. The Byzantine Church of Agios Philon, on the site of Karpasia, was constructed, probably in the 10th century, on the remains of an Early Christian basilica with large baptistery annex; the dome, now fallen, rested on four piers.

BIBLIOG. E. Oberhummer, RE, s.v. Karpasia; Report of the Department of Antiquities, Cyprus 1935, 1936, pp. 14–16; J. du Plat Taylor, An Early Iron Age Group from Rhizokarpaso, Report of the Department of Antiquities, Cyprus 1937–39, 1951, pp. 14–21; G. F. Hill, A History of Cyprus, I, Cambridge, Eng., 1940, pp. 166, 231, 268.

Saint Hilarion (Φρούριον τοῦ Ἁγίου Ἱλαρίου). The castle at the top of the hill, now in ruins, was built ca. 1100 around a Byzantine monastery, of which ruins of a large-domed church remain.

BIBLIOG. C. Enlart, L'art gothique et la renaissance en Chypre, II, Paris, 1899, pp. 578–96; A. H. S. M[egaw], A Brief History and Description of St. Hilarion Castle, Nicosia, 1957.

Salamis (Σαλαμίς, Constantia). It is possible that the Silua mentioned on Assyrian tablets can be identified with Salamis. From the 6th century B.C. to 310 B.C., when the city came under Egyptian dominion and became the capital of Cyprus, it was governed by kings, a great majority of whom were of Greek extraction. After Paphos Nea became the capital, Salamis nevertheless retained its importance. It was destroyed during the Jewish revolt of A.D. 116–17 and again in the earthquakes of 332 and 342. Rebuilt by the emperor Constantius II, the city was named Constantia in his honor, and until it was destroyed by the Arabs in 648, it was the seat of the Bishop of Cyprus. The agora is rectangular, with colonnades going back perhaps to the time of Augustus. The Temple of Olympian Zeus, at the south end of the agora, rises on a high stylobate and has a square cella. The originally Hellenistic gymnasium (known to us only through inscriptions) was rebuilt in the time of Augustus and again after the destruction of 76–77. Destroyed again at the beginning of the 4th century, it was then rebuilt, by Justinian, as baths.

The aqueduct and the well at the north side of the agora are from the time of Septimius Severus, or perhaps later; the so-called "Prison of St. Catherine" dates from Hellenistic or Roman times and is of megalithic construction. The large basilica of St. Epiphanios, originally with nave and six aisles, was replaced ca. 700 by a much smaller church with a wooden roof on piers (which gave place ca. 900 to three domes); this small church is now in ruins.

BIBLIOG. M. Ohnefalsch-Richter, Mittheilungen aus Cypern, AM, VIII, 1883, pp. 133–40; J. A. R. Munro and H. A. Tubbs, Excavations in Cyprus, 1890, JHS, XII, 1891, p. 59 ff.; M. Ohnefalsch-Richter, Kypros, the Bible and Homer, London, 1893, p. 113 ff.; G. Jeffery, The Basilica of Constantia, AntJ, VIII, 1928, pp. 344–49; A. Westholm, Built Tombs in Cyprus, OpA, II, 1939, p. 29 ff.; M. Bardswell and G. Soteriou, The Byzantine Paintings in the Water Cistern, Salamis, AntJ, XIX, 1939, pp. 443–45; A Brief History and Description of Salamis, Nicosia, 1956; The Swedish Cyprus Expedition, ed. E. Gjerstad et al., IV, 3, Lund 1956, p. 17 ff.; FA, VIII, 1956, no. 258, IX, 1956, no. 2745, X, 1957, no. 3181; A. H. S. Megaw, Archaeology in Cyprus, 1952, JHS, LXXIII, 1953, pp. 136–37.

Soloi (Σόλοι, Σολία, Σῶλοι, Soli). According to tradition, Soloi was founded by Attic colonists; it is mentioned in Assyrian tablets of the 7th century B.C. The town took part in the revolt against the Persians in 498 B.C. and, until its ultimate defeat, heroically resisted a long siege. Under Persian dominion it was the capital of one of the ten kingdoms of the island. In 321 Soloi allied itself with Ptolemy I against Perdiccas, and it held a privileged and independent position under the Ptolemies until the beginning of the 3d century B.C. In the Roman period, too, Soloi preserved its autonomy and was ranked among the principal cities. On the acropolis are the remains of a large rectangular building (probably the royal palace), constructed of large blocks of stone, and a Greek temple in antis, with pronaos, cella, and opisthodome. A series of six temples has thrown much light on the architecture of the period: Temple A, of Aphrodite-Cybele, dating from the middle of the 3d century B.C., with two courtyards and cella in the back; Temple B, of Aphrodite, after 50 B.C., with a plan

similar to that of temple A; Temple C, of Isis, after 50 B.C., with square court, porticoes, and cella; Temple D, similar in style to A, B, and C but with the portal flanked by two towers; Temple E, of Serapis, similar to D but with numerous alterations dating from the middle of the 3d century of our era; Temple F, probably Mithraic, of later date, in a style suggesting the Antonine period.

BIBLIOG. A. Westholm, The Temples of Soli, Stockholm, 1936; G. F. Hill, A History of Cyprus, I, Cambridge, Eng., 1940, pp. 38, 113, passim; The Swedish Cyprus Expedition, ed. E. Gjerstad et al., III, Stockholm, 1937, p. 412 ff.

Sotira (Σωτήρα). In the late neolithic settlement found at this site there are both houses of the tholos type and rectangular houses with rounded corners; streets are stone-paved. On the slope, great wall substructures have been found. There are graves in some of the tholoi. In an open area have been found a small group of burials of bodies in a constricted position. There is a necropolis of the Aëneolithic period.

BIBLIOG. P. Dikaios, Trial Excavations at Sotira, Site Teppés, Phila. Mus. of Art B., XIII, 1948, pp. 16–23; P. Dikaios, Excavations at Sotira 1951, Phila. Mus. of Art B., XVII, 1952, pp. 48–58; FA, II, 1949, no. 1315, III, 1950, nos. 1915, 2028, VII, 1954, nos. 1595, 1596, IX, 1956, no. 2239.

Statos (Στάτος). Statos Agia Moni is an abandoned dependency of the Kykko monastery; the church with vaulting was rebuilt in 1638, incorporating the apse of an Early Christian church, decorated with an acanthus stringcourse.

Tamassos (Ταμασσός, Tamassus). This very ancient place was a kingdom in its own right until 340 B.C., when it came under the rule of the king of Kition, who in turn, under pressure from Alexander the Great, ceded it in 332 B.C. to the king of Salamis. After the fall of the Cypriote kingdoms the destiny of Tamassos was the same as that of the other cities of the island. In Christian times it regained a certain importance and was the seat of a religious community. A sanctuary in Cypro-archaic style was still in use in Hellenistic times. Chamber tombs of the Cypro-archaic period, with columns surmounted by proto-Ionic capitals, have been excavated here, and a furnace for glassmaking has been dug out of the rock.

BIBLIOG. M. Ohnefalsch-Richter, Kypros, the Bible and Homer, London, 1893, pp. 7 ff., 352 ff.; The Swedish Cyprus Expedition, ed. E. Gjerstad et al., IV, 2, Stockholm, 1948, pp. 33, 39, 42, 337, IV, 3, Lund, 1956, p. 216 ff.

Vuni (Βουνί). The palace, several times rebuilt in the years 500–380 B.C. (see CYPRIOTE ART, ANCIENT: FIG. 181), in its first state consisted of a number of rooms grouped about a central courtyard. To this, access from the entrance was afforded by a flight of steps; on the other three sides there was a colonnaded peristyle. One of the recovered capitals is a Cypriote version of the Hathor capital with a relief of a female head surrounded by the uraeus. The courtyard contains a cistern; in the northeast corner there are baths. The second palace, dating from about the middle of the 5th century B.C., is a larger version of the first, with an additional court, a second story, and another entrance in place of the original one; the palace had a number of chapels, the lower parts built of stone and the upper of clay bricks. The sanctuary of Athena to the south of the palace is of the same period as the second palace; it has a cella facing a long courtyard, an irregular open space, and a smaller courtyard whose southeast corner contains a group of three adjoining rooms. A semicircular altar stood at the north of the entrance of the inner court. The sanctuary of Apollo, which comprises a temenos and a chapel with altar, is of the Cypro-archaic period. There are chamber tombs of the Cypro-classical period.

BIBLIOG. The Swedish Cyprus Expedition, ed. E. Gjerstad et al., III, Stockholm, 1937, pp. 76 ff., 298 ff.; M. Obnefalsch-Richter, Catalogue of the Cyprus Museum, Oxford, 1899, pp. 3 ff., 352 ff.; E. Gjerstad, Four Kings, OpA, IV, 1946, pp. 21–24; W. Schwabacher, The Coins of the Vouni Treasure Reconsidered, Nordisk Numismatisk Årsskrift, Stockholm, 1949.

Vunus (Βούνους). At this site, near Bellapais, there are two burial grounds, one dating from Early Cypriote II and III. The chamber tombs are of the type with dromos; some have a façade decorated with architectural reliefs.

BIBLIOG. P. Dikaios, Vounous-Bellapais , Archaeologia, LXXXVIII, 1940, p. 1 ff.; E. and J. Stewart, Vounous 1937–1938, Acta Instituti Romani Regni Sueciae, XIV, 1950.

NOTE: In the above treatment of the several sites on the island, in each case the part dealing with antiquity is the work of Porphyrios Dikaios and Vera Bianco and the medieval part is the work of A. H. S. Megaw.

Illustrations: 3 figs. in text.

**CZECHOSLOVAKIA.** Czechoslovakia, now a People's Republic (Lidová Republika Československá), became a political entity after the fall of the Austro-Hungarian Empire. The new state was the result of a nationalistic movement, as much cultural as political, based upon affinities of race and history among the peoples of Bohemia and Moravia (Českomoravsko), and Slovakia (Slovensko). Artistically, Czechoslovakia is one of the richest lands of central eastern Europe, having kept intact its great heritage of monuments from antiquity as well as from the Gothic and baroque periods. Political reasons have been responsible for the varying strength of Czechoslovakia's artistic ties to southern Germany and Austria; relationships with these areas, however, have been almost continuous.

SUMMARY. Cultural and artistic epochs (col. 197): *Antiquity and the early Middle Ages*; *Pre-Romanesque and Romanesque*; *Gothic*; *Renaissance*; *Baroque and rococo*; *The 19th and 20th centuries*. Chief art centers (col. 209): *Bohemia and Moravia* (*Českomoravsko*); *Slovakia* (*Slovensko*).

CULTURAL AND ARTISTIC EPOCHS. *Antiquity and the early Middle Ages.* The earliest prehistoric manifestations of artistic interest date from the Upper Paleolithic period, to which era several famous sites belong: Předmostí, near Přerov, in central Moravia, where, together with skeletons of about 1,000 mammoths, were found rudimentary female figures, representations of mammoths, and figures incised in bone, including a female figure similar in style to others of the same period found farther east; Dolní Věstonice in southern Moravia, where three-dimensional figurines of women and animals in clay and crushed bone were found, and also the kiln in which they were baked; the Pekárna cave, near Brno (Brünn), which contained a depiction of three bison fighting, incised on a horse rib; the site of Ostrava-Petřkovice, where a hearth containing half-burned anthracite was found and also a female statuette in hematite. The style of this paleolithic art, as a whole, lies between that of the western paleolithic, which is rather naturalistic in character, and that of the eastern, which inclines more toward a geometric, schematic style (see PREHISTORY). The principal mesolithic site is Ražice (southern Bohemia), which has a nucleus of tent dwellings.

The Neolithic period in Czechoslovakia marks, as it does in all of Europe, a profound cultural change: the *Bandkeramik* (ribbon-decorated ware) appears, in conjunction with a particular type of house structure, rectangular, narrow, and sometimes several tens of yards long, divided into five parts by parallel rows of posts, three of which support the roof and two the walls, which are made of interlaced branches covered with clay. This culture is thought to have been introduced from the southeast, a hypothesis confirmed by the pottery decorated with spirals of its earliest phase and by the two-bladed axes incised on two cups, as well as by several steatopygous female figures.

In the Aëneolithic period the people began to develop animal husbandry and to trade in amber and the raw materials for stone tools; the plough also made its appearance. The long houses were replaced by structures of smaller dimensions, often grouped together to form fortified villages on hills, as in Jevišovice in southern Moravia, and in Homolka in central Bohemia. The plastic arts were more rudimentary, and infrequent stone sculptures recall the products of the Balkans to the south, and of the Aegean basin. Even before the Bronze Age, invasions had introduced two characteristic types of ceramics: corded pottery and the type illustrated by the bell-shaped vases; and as early as the Aëneolithic period, the people had copper tools, examples of which were found in the cemeteries of Tibava, in the eastern section of Slovakia.

The use of metal became widespread only in the Bronze Age, which probably began earlier in Slovakia and Moravia than in Bohemia; in the two latter regions the Unětice culture also developed. There were tin mines in the Ore Mountains (Erz Gebirge) in northeastern Bohemia and copper mines in central Slovakia. Fortified communities on hills appeared toward the end of the first Bronze Age at Maďarovce in Slovakia and Věteřov in Moravia, from which come bone buttons decorated with incised spirals in a style comparable to that of objects from the shaft graves of Mycenae in Greece. We know of a few rare specimens of earthen pieces modeled in the shape of animals and some faïence beads imported from Egypt or Syria, mostly scattered in Moravia. The mound culture, which is characteristic of tribes of shepherds, was followed by the late Bronze Age, i.e., the Lusatian culture, which developed in Silesia and northern Moravia, together with minor episodes of artistic development, such as the cultures of Knovíz, Velatice, and Milaveč. To this same period belong numerous deposits of objects made of bronze and, occasionally, of gold: they consist of merchants' wares or votive offerings. Toward

the end of the period, in the 9th to the 8th century B.C., a network of fortified castles, probably tribal centers, was established. At this point, structures of solid wood replaced those of interlaced branches.

In the 8th and 7th centuries B.C., the manufacture of iron weapons was begun. Most of the Czechoslovakian territory was part of the Hallstatt culture complex, centered in the Salzkammergut in Austria; the Scythians also penetrated into Slovakia. The most highly developed class of the Hallstatt peoples buried their dead in large tombs, which had a central room made of wood; the poorer classes used simple urns. The painted pottery was decorated chiefly with triangles and lozenges; less frequently, triskelions, rosettes, and crosses are found. At the end of the Hallstatt period appeared princely tombs containing carts. One of the richest was that of Býčí Skála, near Brno, which contained also a bronze statuette of a bull identical in workmanship with that of the Italian situlae (buckets dating from Roman antiquity, provided with handles, for purposes of ritual sprinkling). There were also many statuettes of horses at Podilí Obřany in central Moravia and at Nynice in southwest Bohemia. This socially elevated class reached its peak of culture in the first La Tène epoch, as is revealed by the rich mounds of Hradiště near Písek in southern Bohemia; from these mounds, beaked pitchers and jewelry imported from Etruria were uncovered, as well as the local products of characteristic workmanship, such as the fibulas in the shape of masks. Most of the tombs of this period are poor, however, being intended only to receive the urns of ashes, and are without mounds. To this same period, i.e., the 5th century B.C., belong the first few vases turned on the wheel that have been found. (For a general survey of these art activities and works, see EUROPEAN PROTOHISTORY.)

In the 3d century B.C., with the spread of burial tombs in northern and central Bohemia, and in Moravia and Slovakia, there is evidence of invasion by the Celts. The high point of the La Tène civilization is marked by the fortified cities of Strakonice and Závist in central Bohemia, and of Staré Hradisko in central Moravia, similar to the Gallic *oppida* of the 1st century B.C. Besides the iron mines, there are also mines of sapropelite (the raw material for bracelets) at Nové Strašecí in central Bohemia, and of graphite at Třísov, in southern Bohemia, where gold also is found. This society was familiar with a system of weights and measures. Minted gold coins (patterned upon Greek models) were found in Bohemia and Moravia, and in the territory of Bratislava (Pressburg) in Slovakia, silver coins of the Roman type appeared, often inscribed with the names of chiefs, among which the name of Biatec frequently recurs. In addition to the small sculptures of human and animal figures, particularly of wild boars, there is an example of monumental sculpture found at Mšecké Žehrovice, in central Bohemia, the only piece of the sort found east of the Rhine, dating from about 50 B.C. (see CELTIC ART; III, PL. 112).

As early as the 2d century B.C., the Germans, who by the 1st century were pushing southward, appeared in northern Bohemia (as is evidenced by the cemeteries of Podmokly and Kobyly), probably impeding the completion of several great fortified cities, such as Závist. By the beginning of the Christian era, the Germans ruled the entire territory of Czechoslovakia. During the next two centuries, the territory of Bohemia and western Moravia was to be dominated by the Marcomanni, the rest of Moravia and western Slovakia by the Quadi; in the latter regions there were still groups of Celts and other tribes. Next the Sarmatian Jazyges appeared in southern Slovakia. Toward the beginning of the Christian era, the Germans were reunited by the intrepidity of Marbod, who resisted the Romans for a long while, finally yielding, between A.D. 18 and 19, to Catualda. Cemeteries of the 1st and 2d centuries have been explored, particularly in Bohemia, at Dobřichov Pičhora and Třebušice. The explorations show that some Quadi kings were under Roman protection: thus, there was a *regnum Vannianum* in the 1st century, and another in the time of Antoninus Pius. However, the direct Roman penetration of Slovakia and Moravia took place only at the time of the wars of Marcus Aurelius, who completed his philosophic essays near the Hron River. An inscription on rock at Trenčín-Laugaritio attests the existence of the winter camp of a detachment of the *Legio II Adjutrix* in A.D. 189–90. (Recently, at Zama, in North Africa, an inscription was found bearing the *cursus honorum* of its commander, Marcus Aurelius Maximianus.) After Emperor Marcus Aurelius's death the Romans abandoned efforts to establish a province beyond the Danubian frontier. Nevertheless, some castles and outposts located in Czechoslovakia are known to us: Mušov, in southern Moravia, in which were found bricks of the *Legio X Gemina* (second half of the 2d cent.), and Stupava, in southwestern Czechoslovakia (early 2d cent.). Both ceased to exist around A.D. 180. However, Kelementia Leányvar, near Iža, bridgehead of Brigetio, and Děvín, near Bratislava, persisted until the 4th century. A minor settlement at Milanovice, in southern Slovakia, dates from the 4th century. Roman bricks are also found at Bratislava and Staré Město in southern Moravia.

Many objects were imported from the Roman Empire: in central Bohemia are found many bronze vases brought from Italy early in the 1st century; the *terra sigillata* of the 2d century is frequent in Moravia and Slovakia, though rare in Bohemia. Even today, in Moravia and Slovakia, numerous remains of pottery imported from Pannonia are constantly coming to light, as well as Roman coins and bronze fibulas from Noricum and Pannonia. The early 4th century marks the appearance in Slovakia (at Stráže, Ostroviany, and Čejkov) of princely tombs, sumptuously furnished with imported objects — bronze vases, tripods, silver services, golden cups, gold and silver fibulas, glassware, etc. At Kostelec, in central Moravia, a great cemetery of this period has been explored.

During the period of the great invasions, the territory of Czechoslovakia was traversed by the Lombards (as is shown by the cemeteries

In the 12th century, building activity was in full swing throughout Bohemia. Within the castle at Prague (first fortified nucleus of the city, with buildings of various types, surrounded by a fortified wall), was built the palace, of ashlar, with a great vaulted hall on the ground floor. This architectural style spread to the houses in the suburbs, which, with the castle and the great arched bridge (1166–69), constitute even today a complex unique in central Europe.

From the 10th to the 12th century, sculpture remained on a craft level or functioned as architectural ornament. Its evolution can be most clearly followed in the Bohemian coins, which are among the most important relics in central Europe. Only toward the mid-12th century did specimens of sculptured ornament of high quality appear, revealing various influences (e.g., the gates of Záboř and Tišnov and the Church of St. George of Třebíč). The most important

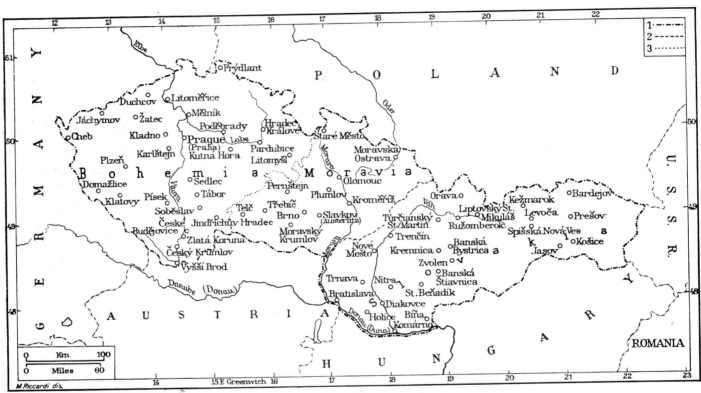

Czechoslovakia, principal art centers: (1) Modern national boundaries; (2) boundaries of modern provinces; (3) former boundaries between Bohemia and Moravia.

of Šaratice in southern Moravia), who in 488 were striking out for the territory of the Rugii, and in 406 by other Germans, Quadi, and Vandals, en route to Spain and Africa. In the 6th century, Bohemia came within the orbit of the Thuringian kingdom, and the Goths and Huns penetrated Slovakia. It is difficult to attribute the archaeological discoveries to specific tribes. Many tombs, originally very rich, were despoiled in antiquity (e.g., in Blučina, near Brno). One of the later evidences of the tradition of the Roman workshops is the store of silver objects at Zemianský Vrbovok, in Slovakia, dated as of 670–71 through the Byzantine coins found there. In the late 4th century, Slavic tribes probably appeared in Czechoslovakia. In 566–67 came the invasion of Pannonia by the Avars, who seized part of southeastern Czechoslovakia. After 620, the Slavs rebelled, and under Samo formed the first independent Slavic state in central Europe.

Jan Bouzek

*Pre-Romanesque and Romanesque.* In 865, with the conversion of the prince of Bohemia to Christianity, Czechoslovakia became oriented toward the Latin culture of southern and western Europe. As early as the 9th century appeared the first stone religious buildings, which reveal Carolingian influences in their structure (e.g., the basilican Church and ancient Rotunda of St. Wenceslas in the castle of Prague). In the 11th century, infiltrations of Ottonian type are apparent in the basilicas with facing choirs. (Those in the Churches of St. Vitus and St. George still exist in Prague.) The longitudinal type of basilica without transept appears about the middle of the 11th century (cf. the Church of St. Wenceslas at Stará Boleslav, with a crypt under the eastern choir).

work is the relief on the tower of the Mostecká Věž Bridge, from about 1150.

The first works in the field of painting consist of the very remarkable miniatures of the codices, whose beginning can be fixed with the *Legend of St. Wenceslas* by Gumpoldo in 1006. Toward the middle of the 11th century, probably in the scriptorium of Břevnov, a group of miniatures was executed in which the influence of Regensburg is apparent (the Vyšehrad Codex). In the 12th century, though miniature painting was influenced more by Salzburg, many Byzantinesque elements were derived from Aquileia, in Italy, as is evident in the Franciscan Bible and in the Antiphonary of Sedlec. Few examples of wall painting date from this period. The remaining works — including fragments of the figures of sovereigns, at present in the Municipal Museum in Prague, and the vaults of the church of Třebíč — are stylistically linked to the Danubian regions.

*Gothic.* Toward the late 13th century, the monastic orders introduced the Gothic style (as in the monastery at Osek, 1235), and the economic prosperity of the land led to a vast increase in building. The importance of Czechoslovak centers then equaled that of other cities in Europe. Cistercian Gothic architecture appeared not only in the churches but also in the secular architecture (e.g., the castle of Zvíkov, 1240–60). Burgundian elements modified the interiors of the buildings (as in Tišnov), while pure Gothic appeared in the Prague Synagogue. Late German Gothic, characterized by the accentuation of linear values, is exemplified in the convent of Zlatá Koruna (1275–1310). The process of assimilating the new style was completed, about 1330, with the adoption of the Hallenkirche type of building, in which the nave and side aisles are of equal height,

as in the Church of St. Bartholomew in Plzeň (Pilsen). This type was to be of great importance in later times.

Throughout the 13th century, sculpture, much more than architecture, remained faithful to the Romanesque tradition, fulfilling a chiefly decorative function (as in the church at Police nad Metují). Only rarely do figures in the round appear (Prague, Church of St. Francis in the Clarician Convent of St. Agnes). The *Madonna of SS. Peter and Paul*, in Brno, the sole monumental work of the time, is probably attributable to French influence, transmitted via Germany. About 1300, Gothic linearism began to be established (cf. the Madonnas of private collections in Prague and the *Madonna of Strakonice*). The rhythmic elements and stylization were accentuated (cf. the Madonnas of Rouchovan and of the Museum of Znojmo). The second half of the 13th century reveals greater refinement in the use of drapery and in the effort to achieve a typically gentle expression of the face. Along with these French characteristics appear many distinctive German traits (as in the Crucifix in the Dominican Church of Jihlava).

Only in the 14th century did painting attempt to adapt its style to the taste of western Europe. The quality of the works is very uneven; elements which reveal Byzantine influence, perhaps derived from Italy, merge with typically Gothic traits (as in the *Miniatures of Queen Rejčka*, 1315–23). An exceptional work is the Passional of the Abbess Kunhuta (Queen Cunegonda; ca. 1321). To these may be added the Velislav Bible, the *Liber depictus*, and, in the early 14th century, the Missals of Chotěšov and Dražice. The transition from the Byzantine-influenced forms to the Gothic is much more evident in wall painting (as is seen in the frescoes in the churches of Písek and Janovice nad Úhlavě), and Gothic linearism reached its peak at Strakonice.

During the reigns of Charles IV and Wenceslas VI, there was an apparent effort to attain, within the Gothic style, a typically Bohemian stylistic solution, especially evident in the architecture, in a renunciation of excessive verticality. On the exterior of religious structures, the two façade towers were no longer employed, and the flying buttresses gradually disappeared; within, the outer walls acquired a more massive aspect, and the vaults rested on simple corbels. The clustered piers disappeared, and churches with only two aisles were built (as at Třeboň, 1367–80).

The most important architect was Peter Parler (Petr Parléř), who harmonized the regional taste with that of his native Swabia. His masterpiece is the choir of the Church of St. Vitus in Prague, which had been built as high as the triforium under the direction of Mathieu d'Arras (d. 1352). The stellate vault of the choir, which rises from the ground with no break of continuity, became typical of Czech architecture; it was widely used, particularly throughout southern Bohemia. The influence of the Parler style spread to secular structures as well. Through the initiative of Charles IV, the University of Prague (Carolinum) and an entire new part of the city were built. Typical is the burgher residence with a spacious hall (*Mazhaus*) on the ground floor and rooms on the second floor.

For defensive reasons, city walls were built, including towers and bastions, and numerous castles, enclosing residential complexes. The most notable is the castle of Karlštejn.

In the early 15th century, building activity came to a halt because of the religious and political wars arising from the movement of Wycliffe and Huss, but as it was resumed in the latter part of the century, it either followed the style of Parler or accepted innovations from the surrounding regions, but with a marked rejection of plastic feeling. The walls of the halls offer examples of exuberant ornamentation (of a foliate type, as is seen in the oratories of the Church of St. Vitus in Prague and in the works by Matěj Rejsek in the castle of Křivoklát). The ribs of the vaults were replaced by a grooved structure, in which the play of light and shade produces a markedly picturesque effect. One of the most significant monuments is Vladislav Hall in the castle of Prague, executed by Benedikt Rejt, which marks the end of the varied career of the Gothic style in Bohemia. On the exterior of the hall, in fact, Renaissance elements were already present.

Under Charles IV, sculpture reached quite a high level: the line became softer, the material was modeled pictorially, and the rhythmic movement of the figures was perfectly integrated. Even when an effort toward realism was evident, as in the busts in the triforium of the Church of St. Vitus, a sense of gentleness and sweetness persists. This tendency spread from Prague into the Bohemian countryside, where a certain preference for accentuating the volume was apparent. But in the last decade of the century there was a return to linear and two-dimensional treatment of drapery, and the faces of the figures were idealized in a uniform fashion. This trend, the so-called "beautiful style," reached its zenith in 1400 (e.g., in the *Madonna of Český Krumlov*), without, however, supplanting the taste for dramatic realism, which continued to be manifest in representations of the Pietà and Ecce Homo.

In the post-Huss period, various foreign influences were evident. The stylistic refinement abated and the figures became more thickset and stiff (as in the *Sorrowing Christ* of Znojmo and the *Madonna of Březno*). Toward the end of the 14th century, Dutch influences reawakened a sense of movement and of the values of surrounding space, but the minuteness of detail (in the *Agony in the Garden*, in Jihlava) is detrimental to the compositional unity, and hinders the clear exposition of the subject (as is evident in the *Annunciation* of Jindřichův Hradec).

In the transition from the 15th to the 16th century, two tendencies are apparent: one, descriptive-realistic, the other, more stylized. The first is particularly exemplified by A. Pilgram, whose style was in harmony with the Italian Renaissance, the direct influence of which was already felt in 1495 in the reliefs of the castle of Moravská Třebová.

In painting, during the reign of Charles IV and Wenceslas VI, linearism and the taste for landscape survived, but in the facial types, in the vigorous modeling of the figures, and in the emphasis on spatial composition, Italian influences are apparent. An exceptional personality was the Master of the Vyšší Brod Altar. In later times, the court painter Theodorik, who was responsible for the fresco of the *Heavenly Host*, in the castle of Karlštejn, modeled his figures coloristically and skillfully accentuated the character of his personages, but his art had no successors. The local tradition is continued by the Master of the Třeboň Altar (cf. also the *Madonna of Jindřichův Hradec*). The year of 1400 marked the beginning of the "beautiful style," characterized by the same elements already encountered in the plastic arts, with the addition of very felicitous use of color.

Outstanding among the numerous manuscripts produced under the sponsorship of ecclesiastics, lords, and rich burghers, is the Evangelistary of Jan z Opavy (John of Opava), preserved in Vienna. The "beautiful style" reached its peak in the group of miniatures collected about the Bible of Wenceslas. An authentic masterpiece is the Hasenburg Missal, executed by Vavřinec z Klatov in 1409, which also possesses drawings of outstanding quality.

The development of murals during this period is less coherent. Of considerable importance is the group of works which represent the taste of the court, for example, the paintings of the Emmaus Monastery in Prague, of the castle of Karlštejn, and of the Church of St. Vitus. Outside this circle, we may note a tendency to depart from the "beautiful style" (as in Holubice and Roudnice) and a progressive reaffirmation of plastic and volumetric values (as in Hradec Králové and Lučice). This situation persisted, with a progressive deterioration in content and form, until the Hussite wars — a period in which the iconoclastic struggle against the excessive decoration of churches was initiated.

Art had meanwhile penetrated all social strata. Genre scenes, caricatures, etc., of popular flavor, were sometimes introduced into religious paintings (as on the altar of Rajhrad and the Ark of Reininghausen). The high point of the Hussite style, although belated, is the Vienna Codex. In the regions in which, in opposition to Hussitism, the "beautiful style" was preserved, stale and vapid forms were thereafter encountered (e.g., the Schwarzenberger *Visitations*).

In the late 1400s — in panel painting, as in sculpture — there are Flemish influences (cf. the *St. George Altar* in the Nat. Gall. of Prague), and interest is centered upon the characterization of the figures, even to the extent of deformation. The colors are intense and glowing (cf. the altar of the Grand Master Puchner, 1482).

It was probably panel painting which liberated painting from the stale tradition of the "beautiful style" (as may be seen in the decoration of the Tower Hall of the castle of Blatná). Only about 1500 did fresco painting acquire typically local accents. With the prevalence of realistic interests, meanwhile, the representation of secular subjects became more frequent, first in the princely palaces and then in the homes of the burghers. Of exceptional merit is the decoration of the Chapel of the Smíšeks in the Cathedral of St. Barbara of Kutná Hora.

The panorama of miniature painting is very heterogeneous: realistic tendencies are evident only after the end of the century (cf. the Psalter of the Smíšek Chapel and the Gradual of Kutná Hora), concurrently with the penetration of Renaissance-influenced ornamental motifs (Antiphonary of Louka). Toward the end of the century appeared the first printed books, decorated with woodcuts.

*Renaissance.* The Hapsburgs, after taking possession of the throne in 1526, established a strong, centralized monarchy, which continued to favor the accretion of power by the aristocracy. Bohemian life was, however, characterized by the activity of the urban middle class and was sharply distinguished, particularly in the latter half of the century, from the tone of the Viennese court. In Bohemia, Germans and other foreigners popularized south European tastes and customs. The Renaissance influence, widespread especially through

the work of Benedikt Rejt, still remained predominantly decorative, without modifying the structure of the churches and private homes, which, despite the addition of pediments and other classically influenced elements, remained basically Gothic. The cities founded in this period near the castles (Pardubice, Telč) follow a regular plan.

With the influx of Italian artists (Mattia Borgorelli and others), particularly strong toward the middle of the century, Renaissance taste was also evident in the construction of castles, villas, and palaces scattered throughout the Bohemian region (cf. the Belvedere in Prague, the small Kratochvíle Palace, the castles at Jindřichův Hradec and Bučovice), particularly in conformity with north Italian practice. Ecclesiastical architecture remained Gothic.

The principal influence on Slovakian architecture up to the fifth decade was Buda in Hungary (as is illustrated in the Town Hall of Prešov), but certain northern tendencies may be singled out (e.g., in the Chapel of St. Michael at Košice) as well as certain Danubian trends, transmitted via Vienna (as at Nové Zámky and Banská Bystrica), in both the palaces of the nobility and in public edifices. Although the over-all picture appears very complex, the architectural style is quite homogeneous in the territory of Spiš, whose churches have typically Italianate belfries.

Sculpture in the early 16th century was generally the work of foreigners: in Bohemia, and in general in Moravia and Slovakia, of Italians (Paolo della Stella); in the north, of Saxons (Karl Walter). In the second half of the century, the number of foreigners increased, but no one tendency was predominant. The important stucco decorations, for instance, in the chapel of the castle of Telč, and in the Imperial Hall in the castle of Bučovice, are by Italians. The end of the 15th century and the beginning of the 16th saw a remarkable development in sculpture, particularly in late Gothic works of a realistic nature (cf. the *Coronation of the Virgin*, in the Chapter House of Spiš, about 1499, and the group of the *Vir dolorum* at Bardejov, about 1500). Productivity in the plastic arts was particularly rich in Slovakia (e.g., *St. John the Baptist* of Slatvin, about 1500 and *St. Nicholas of Mira*, in Tarnov, near Bardejov, early 16th cent.). The Master "MS," the creator of the old high altar from Banská Štiavnica (1506), was active in central Slovakia in the late 15th century. The most distinguished representative of Slovak Renaissance sculpture was Paul of Levoča (Pavel z Levoče), who created the high altar of the Church of St. James of Levoča (about 1508–17) and to whom many other works are attributed; he had a very long succession of followers in Slovakia and elsewhere. Master Alexander resembled him rather closely.

Anonymous are the *Via crucis*, at Spišská Nová Ves (first quarter of the 16th cent.), the statues of the high altar in Sásová and the *St. Andrew* of Strážky (ca. 1520). Deserving of mention is Vincenz Strašryba, creator of the marble fountain in the Old City in Prague.

In painting, the realistic tendency of the 15th-century late Gothic, allied to the Danubian school, dominated the early 16th century (e.g., the altars of St. Nicholas, 1507, and of St. John, 1520, at Levoča) and was resolved along Renaissance lines. Of particular importance is the previously mentioned Master "MS" (cf. the paintings of the high altar in Banská Štiavnica, 1506), who is intensely dramatic, and whose influence is felt in various works (e.g., in the *Crucifixion and Deposition*, 1508). The Master of the Litoměřice Altar is the greatest representative of the Renaissance; later, with the decline of his workshop, no further examples of plastic works in relief were to be found. New techniques, such as sgraffito, were introduced in this period for the exterior decoration of the urban mansions. Miniature painting reveals a more unified style; however, it suffered a definite decline with the end of the 16th century.

The group of painters, sculptors, and goldsmiths, mostly Netherlanders, Germans, and Italians (including B. Spranger, Hans von Aachen, and Adriaen de Vries), who were active at the court of Rudolph II and were representative of a refined mannerism, remained completely aloof from the Czech taste.

In the realm of minor arts (in which there were strong German, Netherlandish, and, in particular, Italian influences) only metalworking revealed special excellence as in the work of T. Jaroš, and Brykcius of Zinnberg (Brikcí z Cimperka). Toward the end of the century, the art of glassmaking received a strong impetus from the artists of the court of Rudolph II — an awakening of interest which gave rise to an important local school.

A. MERHAUTOVÁ-LIVOROVÁ

*Baroque and rococo.* After the death of Rudolph II (1612), the court was transferred to Vienna. Most of the intellectuals left Czechoslovakia, and cultural and artistic life grew weak to the point of extinction; there was, however, a certain cultural revival with the Counter Reformation, particularly through the agency of foreigners. Italians were responsible for the introduction of baroque architecture, following either the Roman example (as in the Church of St. Mary Major at Prague) or the Lombard (particularly in the works of Carlo Lurago; for example, the Clementinum — the Jesuit University — in Prague). That the local climate was ready to receive the new baroque treatment of spatial relationships was demonstrated by the relative rapidity with which the Roman style was diffused in Bohemia and Moravia after the latter part of the 17th century.

The first definite affirmation of a taste adjusted to coloristic experiments occurred in a series of palaces, such as the Nostic Palace in Prague (begun ca. 1660), whose single order of moldings and tripartite division of the façade relate it to Bernini's Palazzo Odescalchi in Rome; the Černín (Czernin) Palace (begun 1669; see II, PL. 159), which has a rough and animated picturesqueness; and the castles of Roudnice (1666) and Plumlov (begun 1680). The latter castle was designed with the superposition of three orders of free-standing columns, evoking, perhaps intentionally, a Roman-theater setting.

In this group of works it is not easy to distinguish the directly Italian influences from the French and Austrian. The two latter indubitably had a decisive influence. J. B. Fischer von Erlach (q.v.) built the castle of Vranov in Moravia (1688) and designed the Clam-Gallas Palace in Prague (1700–08); Johann Lukas von Hildebrandt (q.v.) built the Church of St. Lawrence at Německé Jablonné (1699) and the Premonstratensian Abbey at Louka (1748).

The contribution of the Italians was important, perhaps more because of the artisans who were active for long periods throughout the 18th century than for the architects. Outstanding among the latter were Ottaviano Broggio, Anselmo Lurago, and Marcantonio Canevale. Their activity became part of the native tradition.

The original development of Czechoslovakian baroque is attributable chiefly to architects of very divergent cultural origins and training: Jean-Baptiste Mathey, Giovanni Santini Aichel, and Christoph and Kilian Ignaz Dientzenhofer. Mathey, born in France, was trained in Rome in the circle of Carlo Fontana and attempted a compromise between the demands for a new handling of space and the desire to participate in a vast European debate which would also take into account the reservations of French academic culture with regard to baroque art. His major works, the Church of St. Francis of the Knights of the Cross, the Toscan Palace, and the Troja Palace in Prague, show commendable consistency and an unwavering restraint in ornament.

The resurgence of Catholicism following the conclusion of the Thirty Years' War was responsible for an unprecedented revival of building activity. The propagandistic and social function of architecture, which had been elaborated in Rome in the early 17th century, suggested a vast experiment of a political nature in Czechoslovakia. The Gothic forms, associated with the heyday of the kingdom of Bohemia, constituted an invaluable frame of reference and were destined to appeal to the baroque inclinations of the architects and the religious sentiments of the men who commissioned their work.

Giovanni Santini Aichel, despite his distant Italian origin, represented the most original voice. One of his first works, the chapel in the forest of Lomec (1692–1702), gives the measure of his cultural maturity. A baldachin, clearly inspired by Bernini, which is placed within the curved boundaries of the church, taking up much of its space, is pleasing to the eye because of its transparent structure. The plan reveals the influence of Borromini's lantern of S. Ivo in Rome, but the plastic treatment of the order and the grandiose external crown, executed in wood, suggest Slavic models. In the Church of the Benedictine Monastery of Kladruby and in the church at Sedlec, the Neo-Gothic style, in contrast to that of the Chapel of St. John of Nepomuk in Zdář, remains a somewhat academic reference point, almost archaeological in its exhaustive technical exhibitionism. In his works unaffected by the Neo-Gothic experiment, Santini Aichel never again reached the intensity of the first examples just cited, but conducted an organic spatial experiment of his own, akin to that of his architectural contemporaries in Austria and Bavaria, as well as in Bohemia and Moravia. The church of Křtiny (1712) and the monastery church of Rajhrad developed themes remotely derived from Guarini, filtered through the experiments of Lukas von Hildebrandt. The effect of spatial amplification was obtained through the use of large frescoed surfaces that were to be the rule in German rococo.

Santini Aichel was most successful in his efforts to arrive at a regional characterization within the baroque style; the two Dientzenhofers, especially Kilian Ignaz, simply consolidated the advances they had made by creating models and initiating procedures later to be universally adopted. In Christoph's work, the taste, derived from Guarini, for juxtaposed spatial nuclei (as in the Church of St. Nicholas in Malá Strana, Prague, and in the Church of St. Margaret in Břevnov, Prague) is evident. Kilian Ignaz shows a tendency toward a more animated and complex decoration and a sensitivity tinged with sophistication, which led him to envision complex arrangements of planes, tending toward theatrical effects — effects reinforced by the dramatic accents created by the sometimes convulsive succession of broken lines and by the systematic counterplay of

concave and convex curves and straight lines. Although the Cathedral of St. Mary Magdalene in Karlovy Vary (Karlsbad), the Church of St. John of Nepomuk-on-the-Rock in Prague, and the Church of St. Thomas, in the same city, lose somewhat in purity and intensity, they acquire greater richness and animation of tone. The fact that they demonstrate a conscious search for the quality of an indigenous style indicates at once the maturity and the decline of a style.

Paolo PORTOGHESI

In sculpture, after a long stretch of the doldrums, Bohemian production was revived about the middle of the 17th century, generally through the initiative of masters who were either trained abroad or were foreigners (e.g., I. Bendl), and soon reached the level of contemporary European sculpture (as may be seen in the decoration of the Troja Palace in Prague by the Heermann brothers). Direct and indirect Italian influences were responsible for a particularly rapid development after 1700. Characteristic of this movement was a somewhat exaggerated pathos expressed in completely pictorial forms (e.g., M. W. Jäckel). Pictorialism attained full expression in the Bernini-like work of M. B. Braun. Further aided by the nature of the local material, sandstone, he achieved an especially suave quality in his modeling. His works are in Prague (cf. the statue of St. Luitgard, on the Charles Bridge), and many other places in Bohemia (e.g., Kuks, and Betlém, near Kuks). Another dominant personality of the early 18th century, who may well be considered Bohemian, was F. M. Brokoff. Following in the footsteps of his father Johann, he, unlike Braun, showed a remarkable vigor (cf. the group of statues on the Charles Bridge and the atlantes on the façade of the Morzin Palace, Prague).

In the works of Braun and Brokoff, in the last quarter of the century, appeared rococo elements that, combined with classic elements, were to characterize the subsequent development of the 18th-century plastic arts, just as they had affected architecture. The rococo style, established with the art of J. M. Hiernle, J. A. Quitteiner, and F. Weiss, triumphed after the mid-century in both the decorative arts and sculpture. Of decisive influence in this direction was the workshop of I. Platzer (cf. the decoration of the Church of St Nicholas, Prague), whose tastes were continued in the work of successive members of his family and pupils.

In Moravia, 18th-century sculpture was strictly subordinate to the influences from Vienna, whence came such German and Italian masters as F. Bendl (cf. the Mercury Fountain, in Brno, 1693–99) and A. T. Kracker (cf. the Parnassus Fountain, Brno, 1690–97). These ties did not weaken during the 18th century. However, the sculptors working in Moravia began to come to the fore (e.g., V. A. Zahner, J. Schauberger). J. I. Winterhalter developed a style, classical in tendency, that is related to that of G. R. Donner and was to culminate in the style of J. A. Fritsch (cf. the decoration of the cemetery at Strilky, 1743) and of O. Schweigl.

The history of 17th-century Bohemian painting has not been adequately clarified; only at the start of the 18th century was a clearly defined trend apparent. One of the major personalities was Karel Škréta, who was Italianate in his tastes. From his stay in Italy he brought back both Venetian (cf. the *St. Wenceslas* cycle, 1641–43, in the Lobkovic Palace, Mělník) and Caravaggian influences (e.g., *St. Charles Borromeo Visiting the Victims of the Plague*, 1647), which were particularly evident in his portraiture (*D. Miseroni and Family*, dating perhaps from 1653). Between 1660 and 1670 Škréta seemed to incline toward the idealization of forms (*Annunciation*, Prague, Nat. Gall.), which was subsequently to be resolved in terms of pathos (cycle of *The Passions*, about 1670). At the same time, Škréta continued to paint realistic pictures, akin to Flemish and Dutch painting (cf. the *Portrait of Ignace Vitanovsky of Vičkovice*, dating, perhaps, from 1669).

Among the noteworthy artists influenced by Škréta was J. G. Heintsch, who developed along realistic lines (cf. the *Lives of the Jesuit Saints*, in the Church of St. Prokop, at Jinonice, 1680–90).

Wall painting of the early 17th century was predominantly decorative and showed traces of the taste of Andrea Pozzo (cf. J. Hiebel); later in the century, large-scale painting of allegoric or mythological subjects was established. In the transition from the 17th to the 18th century, the realistic tendency was weakened or transformed into illusionism. Working along these lines were M. L. Willmann (*St. Jerome*, ca. 1664, Prague, Nat. Gall.; *The Martyrdom of SS. Philip and James*, ca. 1750, at Sedlec) and J. K. Liška; M. W. Halbax remained faithful to realism (*St. Ludwig Distributing Alms*, after 1700, at Bechyně).

Peter Brandl, who departed from these contrasting tendencies, retained, even in his baroque and luministic compositions, a definite realism, giving to certain scenes even a genre tone (as in his *Birth of the Virgin Mary*, at Doksany, 1703). In his later works, the chiaroscuro contrasts were replaced by brighter, warmer tones (cf.

the *Adoration of the Magi*, at Smiřice, 1727, and the paintings in the church at Sedlec, 1728–29, and in the Church of St. Mary Major in Prague). Realism remains more evident in the portraits (as in the *Portrait of Count Sporck*, Prague, Nat. Gall., 1729).

Václav V. Reiner tended toward predominantly illusionistic effects (as in the *Combat of the Giants*, in the Černín Palace, in Prague, 1718; the *Last Judgment*, in the dome of the Church of St. Francis of the Knights of the Cross, 1723, in Prague; and the decorations in the Chapel of St. William at Roudnice, 1729). A definitive composure in composition was attained only by Reiner's successors, who were influenced by Venetian painting, for example, F. X. Palko (whose work appears in the dome of the Church of St. Nicholas in Prague) and J. L. Kracker (who decorated the vault of the nave of the above-mentioned church, 1726).

After Brandl's death (1739), several painters emigrated, as did Jan Kupecký; most of them devoted themselves to landscape painting, chiefly Arcadian in taste. Toward the middle of the century, N. Grund combined Venetian coloring with Flemish and Dutch minuteness in realistic reproduction of costume (Prague, Nat. Gall.). But from then on, Bohemian painting was of only local interest.

In Moravia, painting was dominated by the Viennese. In fresco, outstanding figures were J. G. Etgens (cf. the vault of Minorite Church, in Brno, 1732) and J. I. Winterhalter. The few surviving portraits of F. A. Maulpertsch show how preference was given to foreigners. This happened even more often in Slovakia: the southwest was subordinated to Vienna, and other places were influenced by Italians or Germans. Painters from Bohemia also came to Slovakia, seeking to flee from the Counter Reformation.

Of particular note in the arts and crafts between the late 17th century and early 18th century is the high development of the art of glassmaking (see GLASS). Cabinet work and intaglio reached a quite high level, not only in Bohemia, but also in Slovakia. Pottery factories, founded in Holice in 1743, were also active in Slovakia.

A. MERHAUTOVÁ-LIVORAVÁ

*The 19th and 20th centuries.* Architecture, soon after the middle of the 19th century, after a neoclassic phase, experienced the effects of the penchant for historical styles: first it leaned toward the Neo-Gothic, then, at the end of the century, toward the Neo-Renaissance; and finally it adopted a foreign-influenced eclecticism. Among architects deserving mention are J. Kranner, K. Hilbert, and J. Mocker (cf. the Church of St. Vitus in Prague). Working in the Neo-Renaissance style were A. Barvitius, V. Ulmann, A. Wiehl, and J. Zítek, creator of the National Theater in Prague.

J. Kotěra, a pupil of Otto Wagner in Vienna, inaugurated a profound revival associated with the development of the International Style in central Europe. Kotěra oriented toward modern tastes the new generation of architects, B. Hübschmann and A. Engel in particular. A later revitalization occurred with P. Janák, who was also a theoretician, and J. Gočar, O. Novotný, and others. Especially notable is Dušan Jurkovič, who revived the use of motifs derived from Slovakian folklore.

Toward 1925, in Czechoslovakia, as in other countries, the International Style became established. Its chief representatives were J. A. Fragner, builder of industrial structures, J. Havlíček and K. Honzik (General Pensions Institute in Prague), and B. Fuchs, who is the designer of numerous structures at Brno. Important in the field of city planning is the systematization of the industrial center of Zlín, and of Hradec Králové, the latter through the agency of J. Gočar. The problems of city planning have been tackled with special acumen in the postwar reconstruction after 1945, following the principle of decentralization of industry and of civic buildings.

Neoclassic painting and sculpture were of local importance only. The German Nazarenes found disciples in the painter F. Tkadlík and the sculptor V. Levý. Toward the middle of the 19th century, the painter Josef Mánes stimulated the romantic taste through his representation of the customs of the people. The greatest of his disciples was M. Aleš. Connected with the school of Munich were V. Brožík and L. Marold. Linked with the developments of French naturalism in landscape were A. Chittussi, already close to impressionism, J. Čermak, K. Purkyně, H. S. Pinkas, and V. Hynais. Impressionism became popular, particularly in the last decade of the century, with the work of such artists as A. Slavíček, J. Preisler, and, later, V. Radimský. Emil Orlik, a student of Japanese art, worked in a postimpressionist and symbolist style.

At the end of the first decade of the 20th century appeared expressionist and, later, cubist works (E. Filla). There was also a return to late 19th-century realism (V. Špála, V. Rabas). Modern art became well established about 1930. In general, a moderating and traditionalist tendency was discernible in Slovak painting (C. Majerník, M. A. Bazovský, and L. Guderna), whereas Czech painting was international in character. Stemming from the "Group of

Eight" (E. Filla, B. Kubišta, A. Procházka, and V. Beneš) were the two principal movements in Czech painting: the Umělecká Beseda ("artistic circle"), seeking to portray modern urban life (B. Kubišta, J. Čapek, Jan Zrzavý, and, successively, F. Hudeček, K. Lhoták, and others), and the Mánes (with E. Filla, V. Tikal, and others), aiming more toward formal experimentation. Filla, the major personality of contemporary Czech painting, was turned toward expressionism by postcubism and Picasso.

Nineteenth-century naturalism still continues to have a considerable following, as in other east European countries (V. Beneš, M. Švabinský, J. Slavíček, V. Sedláček, Jan Bauch, and M. Holý). Related to this tendency is realism, which was first revived in a patently expressionistic manner. Later, in the socialist postwar period, realism was inspired by the war and the resistance under the German occupation — which also decimated the ranks of Czechoslovak painters. The efforts of the latest generation of painters in this postwar period developed on the basis of international taste (F. Gross, F. Jiroudek, V. Černý). And although officially realism continues to prevail, especially in relation to the problem of the dissemination of art among the masses, and to the cult of folklore (A. Pelc, B. Dvorský, K. Sonck, V. Tittelbach, A. Fisarek, W. Novák, K. Sokol, and L. Guderna), Czechoslovakia does not lack masters who are familiar with nonobjective art (J. Kotík, J. Šíma).

The course of Czech sculpture is not dissimilar to that of painting, although of less interest. Noteworthy among the artists of the second half of the 19th century are V. Levý and J. V. Myslbek, both of whom show naturalistic tendencies, particularly Myslbek, on whom its influence was decisive; naturalism continues despite the penetration of impressionism and postimpressionist tastes, represented particularly by J. Štursa. Also worthy of mention are the sculptors B. Kafka, O. Gutfreund, O. Španiel, J. Mařatka, and F. Bílek. Among the naturalists are Stefan, A. Sopr, J. Wagner, J. Jiřikovský, J. Kostka, V. Vingler, and others. J. Wielgus proposes a popular synthesism reminiscent of the tradition of the German Ernst Barlach.

Book illustration retains particular importance. Among its practitioners in the late 19th century were Josef Mánes and M. Aleš, illustrators of folk songs. Contemporary production bears the impress of their tradition, whether it is humorous and expressed in vignettes (J. Lauda, J. Hašek), folkloristic (Vlastimil Rata, Slovinský), inspired by children's art (V. Trnka, also a creator of animated cartoons, A. Zábranský, V. Karel, A. Strnadý, L. Fulla), or illustrative (A. Pelc, V. Tittelbach, J. Liesler, V. Sivko, and many others).

Last, mention must be made of artists who emigrated while young and received their training in other European countries, as did Alfred Kubin in Austria, and František (Frank) Kupka, one of the pioneers of nonobjective painting, in Paris, from 1895 on; and among the masters of the latest generation, I. Serpan.

Czechoslovak folk art still finds expression today in the handicraft products intended for daily use; these include textiles, in particular, employed in the characteristic national costumes, silk and bead embroidery, and lace, particularly among the Slovaks. Among the Slovaks, also, there is a thriving industry in majolica ware (produced today, however, mainly on an industrial scale), and in furniture and wood intaglio. The latter craft, highly developed in the 17th and 18th centuries, particularly in the Bohemian forests, was widely used, as in all Alpine countries, to decorate rural buildings constructed of beams which were subsequently replaced by masonry structures.

\* \*

BIBLIOG. *Antiquity. a. General*: A. Stocký, La Bohême à l'âge de la pierre, Prague, 1924; J. Schránil, Vorgeschichte Böhmens und Mährens, Prague, 1928; A. Stocký, La Bohême à l'age du bronze, Prague, 1928; A. Stocký, La Bohême à l'age du fer, Prague, 1933; V. Budinský-Krička and others, Slovenské dějiny (History of Slovakia), I, Bratislava, 1947; J. Filip, Pravěké Československo (La Tchécoslovaquie préhistorique), Prague, 1948; H. Preidel, Die vor- und frühgeschichtlichen Siedlungsräume in Böhmen und Mähren, Munich, 1953; J. Neustupny, ed., Chronologie préhistorique de la Tchécoslovaquie, session scientifique: Résumés des comptes rendus et des discussions, Prague, 1956. *b. Paleolithic*: H. Breuil, Notes de voyage paléolithique en Europe centrale, L'Anthropologie, XXXIV–XXXV, 1924–25; J. Skutil, Přehled českého paleolithika e mesolithika (Survey of the Paleolithic and Mesolithic Periods of Bohemia), Prague, 1952; J. Neustupný, Le paléolithique et son art en Bohême, Artibus Asiae, XI, 1944, pp. 214–38; K. Žebera, Československo ve starší době kamenné (Die Tschechoslowakei in der älteren Steinzeit), Prague, 1958; *c. Neolithic, Bronze Age, and the Hallstatt epoch*: A. Stocký, La Bohême préhistorique, I: Le néolithique, Prague, 1926; J. Filip, Popelnicová pole a počátky železné doby v Čechách (Die Urnenfelder und die Anfänge der Eisenzeit in Böhmen), Prague, 1936–37; J. Böhm, Základy hallstattské periody v Čechách (Die Grundlagen der Hallstattperiode in Böhmen), Prague, 1937; J. Neustpný, Studies on the Eneolithic Plastic Arts, Prague, 1954; B. Novotný, Die Slowakei in der jüngeren Steinzeit, Bratislava, 1958 (Ger. trans., L. Kramerová); *d. La Tène civilization*: J. L. Píč. Le hradischt de Stradonitz en Bohême, Leipzig, 1906 (Fr. trans.), J. Dechelette. *trans.*); J. Břeň, Černé (svartnové) náramky v českém latténu (Fabrication de bracelets en sapropé-

lite soi-disant lignite en Bohême), Prague, 1955; J. Filip, Keltové ve střední Evropě (Die Kelten in Mitteleuropa), Prague, 1956; B. Benadík, E. Veček, and C. Ambros, Keltische Gräberfelder in der Südwestslowakei, Bratislava, 1957. *e. Roman period*: J. L. Píč, Die Urnengräber Böhmens, Leipzig, 1907; A. Gnirs, Zprávy čs. státního archeologického ústavu, II–III, 1930–31, pp. 9–28; E. Benninger and H. Freising, Die germanische Bodenfunde in Mähren, Liberec, 1933; E. Benninger, Die germanische Bodenfunde in der Slowakei, Liberec, 1937; J. Dobiáš, Le strade romane nel territorio Cecoslovacco, in Quaderni dell'impero: Le grandi strade del mondo romano (Istituto di Studi Romani: Gli studi romani nel mondo), IV, 5, Rome, 1938; J. Dobiáš, Il limes romano nelle terre della repubblica Cecoslovacca, in Quaderni dell'impero: Il limes romano (Istituti di Studi Romani: Gli studi romani nel mondo), VI, 8, Rome, 1938; J. Eisner, Historica Slovaca, I–II, 1940–41, pp. 108–38; T. Kolník, Archeol. rozhledy, IX, 1957, pp. 816–27, 833–36; V. Ondrouch, Bohaté hroby z doby rímskej na Slovensku (Reiche römerzeitliche Gräber in der Slowakei), Bratislava, 1957; V. Ondrouch, Historica Slovaca, III–IV, 1945–46, pp. 62–118; B. Svoboda, Čechy a římské imperium (Bohemia and the Roman Empire), Prague, 1948. *Middle Ages to the present. a. General*: J. Braniš, Dějiny středověkého umění v Čechách (History of Medieval Art in Bohemia), I, II, Prague, 1892–93; Topographie der Kunstdenkmale im Königreich Böhmen von der Urzeit bis zum Anfang des 19 Jahrhunderts, Prague, 1948 ff.; A. P. Schmitt, Bericht über einige Kunstdenkmale Böhmens, Mittheilungen der K. K. Central-Commission, Erhaltung der Baudenkmale, III, 1863, pp. 320–24; F. Benesch, Steinmetzzeichen und Marken an alten Baudenkmalen Böhmens gesammelt, Mittheilungen der K. K. Central-Commission, 1864, pp. XLI–IV; B. Grüber, Die Kunst des Mittelalters in Böhmen, Vienna, XVI, 1871, XVII, 1872, XIX, 1874; M. Pangerl, ed., Das Buch der Malerzeche in Prag (Quellenschriften für Kunstgeschichte und Kunsttechnik des Mittelalters und der Renaissance, 33 vols.), XIII, Vienna, 1878; A. Horčička, Beiträge zur Kunstgeschichte Böhmens im XII und XIV Jahrhundert, RepfKw, IV, 1881, p. 183; E. Wernicke, Urkundliche Beiträge zur Prager Künstlergeschichte, Mittheilungen der K. K. Central-Commission, N.S., XII, 1886, pp. VIII–X; K. Chytil, Über einige Madonnen-Bilder Böhmens aus dem 14 und 15 Jahrhundert, Mittheilungen der K. K. Central-Commission, N.S., XIII, 1887, pp. XIX–XXV; J. Brausewetter, Aus dem nordöstlichen Böhmen, Mittheilungen der K. K. Central-Commission, N.S., XIV, 1888, pp. 26–30, 71–76; J. Neuwirth, Geschichte der bildenden Kunst in Böhmen vom Tode Wenzels III bis zu den Hussiten-Kriegen, Prague, 1893; Gesellschaft zur Förderung deutscher Wissenschaft, Kunst und Literatur in Böhmen, Prague, 1896; Soupis památek historických a uměleckých v kralovství českém (Catalogue of the Historic and Artistic Monuments of Bohemia from 1897); F. J. Lehner, Dějiny umění českého (History of Czech Art), Prague, 1903–07; A. Prokop, Die Markgrafschaft Mähren in Kunstgeschichte, Beziehung I–IV, Vienna, 1904; J. Truhlář, Catalogus codicum manuscriptorum bibliothecae universitatis, I, Prague, 1905; F. H. Harlas, České umění (Czech Art), I, II, Prague, 1908–11; Umělecké poklady Čech. Sbírka význačných čl výtvarného umění (The Artistic Treasure of Bohemia: Selection of Characteristic Art Works), Prague, 1915; A. Matějček and Z. Wirth, L'art tchèque contemporain, Prague, 1920; Z. Wirth (comp.; with V. Birnbaum, A. Matějček, and J. Schránil), Die čechoslovakische Kunst von der Urzeit bis zur Gegenwart, Prague, 1926 (Eng. ed., Czechoslovak Art from Ancient Times until the Present Day, Prague, 1926); F. M. Bartoš, Soupis rukopisů narodniho musea v Praze (Catalogue of Manuscripts in the Prague National Museum), 1926, II, 1927; Jihočeský Sborník Historický (Historical Review of Southern Bohemia), I–VIII, Tábor, 1928–35; Dějepis výtvarného umění v Čechách (The History of Representational Art in Bohemia), Prague, 1931; H. Lapaire and J. Chopin, Prague et la Tchécoslovaquie, Grenoble, 1932; V. V. Štech, Czechoslovak Pavilion, Catalogue of the XIX Biennale, Venice, 1934, pp. 272–73; V. V. Štech, Czechoslovak Pavilion, Catalogue of the XX Biennale, Venice, 1936, pp. 238–40; V. M. Nebeský, L'art moderne tchécoslovaque, Paris, 1937; České baroko: Katalog výstavy (Czech Baroque: Catalogue of the Exhibition), Prague, 1938; O. Schürer and W. Erich, Deutsche Kunst in der Zips, Brno, 1938; K. M. Swóboda, ed., Beiträge zur Geschichte der Kunst im Sudeten- und Karpathenraum, Brno, Leipzig, 1938–43, I: K. M. Swoboda, Zum deutschen Anteil an der Kunst der Sudetenländer, 1938, II: K. M. Swoboda and E. Bachmann, Studien zu Peter Parler, 1939, III: E. Bachmann, Eine spätstaufische Baugruppe im mittelböhmischen Raum, 1940, IV: E. Bachmann, Sudetenländische Kunsträume im 13. Jahrhundert, 1941; Die Kunst in der Slovakei: Eine Sammlung von Dokumenten, Prague, 1939; O. Schürer, Alte Städte in Böhmen und Mähren, Moderne Bauformen, 1939, p. 5; V. Wagner, Czech Baroque, Prague, 1940; K. M. Swoboda, Peter Parler, Der Baukünstler und Bildhauer, Vienna, 1940, 2d ed., 1942; O. Kokoschka, An Approach to the Baroque Art of Czechoslovakia, BM, 1942, pp. 263–68; H. W. Hegemann, Die deutsche Barokkunst Böhmens, Munich, 1943; J. Kropáček, Malířství doby husitské (Painting of the Hussite Period), Prague, 1946; O. J. Blažíček, Rokoko a konec baroku v Čechách (Rococo and Late Baroque in Bohemia), Prague, 1948; J. Kotalík, Czechoslovakia, Catalogue of the XXIV Biennale, Venice, 1948, pp. 237–39; A. Kutal, D. Líbal and K. Matějček, České umění gotické (Czech Gothic Art), Prague 1949; E. Giorgio Alberti, O. Stefan, and P. J. M. Preiss, Arte italiana in Cecoslovacchia, Istituto di cultura Italiana (photographic exhibition), Prague, 1950; A. Matějček and J. Pešina, Czech Gothic Painting, 1350–1450, Prague, 1950 (trans. J. C. Houra); J. Pešina, Česká malba pozdní gotiky a renesance (Czech Painting of the Late Gothic and Renaissance), Prague, 1950; J. Neumann, Malířství 17 století v Čechách (Seventeenth-century Painting in Bohemia), Prague, 1951; V. Denkstein and F. Matouš, Jihočeská gotika (Gothic Art in Southern Bohemia), Prague, 1953; M. Mičko, Czechoslovakia, Catalogue of the XXVII Biennale, Venice, 1954, pp. 234–36; V. Denkstein and F. Matouš, Südböhmische Gotik, Prague, 1955; A. Friedl, Magister Theodoricus, Prague, 1956; M. Mičko, Czechoslovakia, Catalogue of the XXVIII Biennale, Venice, 1956, pp. 345–48; J. Gállego, El arte antiguo en Checoslovaquia (exhibit at the Mus. des Arts Décoratifs, Paris, 1957), Goya, 21, 1957, pp. 192–98; L'art ancien à Prague et en Tchécoslo-

vaquie au Musée des Arts Décoratifs, Paris, 1957 (catalogue by J. Urbani, preface by V. Novotný); V. Jindra, Il Rinascimento in Cecoslovacchia, Palladio, 7, 1957, pp. 26–29; J. Kotalík, Czechoslovakia, Catalogue of the XXIX Biennale, Venice, 1958, pp. 223–25. b. Architecture: B. Grüber, Charakteristik der Baudenkmale Böhmens, Mittheilungen der K. K. Central-Commission, 2, Erhaltung der Baudenkmale, I, 1856, pp. 189–200, 213, 222, 241, 248; U. Belli, Influenze dell'architettura italiana . . ., Il Meridiano di Roma, no. 30, 1939; D. Líbal, Gotická architektura v Čechách a na Moravě (Gothic Architecture in Bohemia and Moravia), Prague, 1948; V. Mencl, Česká architektura doby lucemburské (Czech Architecture of the Luxembourg Period), Prague, 1949; V. Mench, Onze cents années d'architecture en Tchécoslovaquie, Prague, 1957. c. Sculpture: V. Birnbaum, J. Pečírka, A. Matějček, and J. Cibulka, Dějepis výtvarného umění v Čechách (History of the Plastic Arts in Bohemia), Prague, 1926; J. Opitz, Die Plastik in Böhmen zur Zeit der Luxemburger, Prague, 1936; Československá vlastivěda (Czech National History), Prague, 1937; A. Kutal, Česká gotická plastika (Czech Plastic Arts in the Gothic Period), Prague, 1938; K. Ottinger, Altdeutsche Bildschnitzer der Ostmark (preface by K. H. Waggerl), Vienna, 1939; H. Bachmann, Schlesien und die böhmische Plastik des 14 Jahrh., Festschrift für Dagobert Frey, Vienna, 1953, pp. 518–29; E. Poche, La scultura del Barocco ceco, Arte, 57, 1958, pp. 35–37. d. Painting: A. Michiels, Origines de la peinture allemande, école de Bohême, GBA, VI, 1872, p. 498, VII, 1873, p. 146; A. Woltman, Zur Geschichte der böhmischen Miniaturenmalerei, RepfKw, II, 1879, p. 1; R. Ernst, Beiträge zur Kenntnis der Tafelmalerei Böhmens im XIV und am Anfang des XV Jahrhunderts, Prague, 1912; F. Burger, Die deutsche Malerei der Renaissance, I, Berlin, 1913, pp. 121 ff.; A. Matějček, Die böhmische Malerei des XIV Jahrhunderts, Leipzig, 1921; A. Matějček, ed., Gotische Malerei in Böhmen, Tafelmalerei 1350–1450, Kunsthistorisches Institut der Karls-Universität, Prague, 1939; V. Wagner, Gotické tabulové maliarstvo na Slovensku (Die gotische Tafelmalerei in der Slowakei), Knižnica výtvarného umenia, 3, Matica Slovenská, 1942; P. Descargues, Trente ans de peinture tchécoslovaque à l'Orangerie, Arts, Dec. 6, 1946; J. M. Tomes, La peinture tchécoslovaque moderne, Arts, Oct. 31, 1947; J. Loriš, Czech Baroque Drawing, Prague, 1948; M. Seton, Czechoslovak Painting, Magazine of Art, XLI, 1948, pp. 146–48; A. Matějček and J. Pešina, Czech Gothic Painting, 1350–1450, Prague, 1950 (trans. J. C. Hovra); J. Mašín, Románská nástěnná malba v Čechách a na Moravě (Romanesque Wall Painting in Bohemia and Moravia), Prague, 1954 (also Eng. trans.); Z. Drobná, Gotische Zeichnung, Prague, 1957; O. Strettiová, Das Barockporträt in Böhmen, Prague, 1957.

Jan Bouzek and Margherita Abbruzzese

CHIEF ART CENTERS. Bohemia and Moravia (Českomoravsko).

Brno (Brünn). Chief city of Moravia. Built on the site of a Roman settlement, it grew up during the 11th and 12th centuries around a castle of the same name, and the enlarged community was subsequently surrounded by walls. It received its own charter in 1243. After the Thirty Years' War, it was transformed into a fortress with a new set of walls. From the early 19th century on, Brno developed as an industrial center, and in the 20th century, its new buildings gave it, more and more, the aspect of a modern city. It suffered grave damage during World War II.

The Gothic Cathedral of SS. Peter and Paul has a nave and two side aisles; it was built on the ruins of a Romanesque church, recorded on the coins of the Emperor Conrad (1092); again rebuilt after 1645, it has recently received the addition of two towers of Gothic-influenced style. The parish Church of St. James, of the early 14th century, was remodeled in the baroque period and in the 19th century; the Jesuit Church is from the end of the 16th and early 17th century. The Gothic Church of St. Thomas has a nave with two side aisles, and is of the 14th century, with baroque alterations. The Capuchin Church and Monastery are of the 17th century. The Palace of the Moravian Provincial Administration (formerly the Augustinian Monastery), of the 13th century, restored in the 18th, is an important baroque monument, although badly damaged. The Town Hall, begun in the early 14th century, has a Gothic portal and a Renaissance courtyard; the New Town Hall has late Renaissance and baroque decoration. Noteworthy among the individual monuments are the splendid fountain by Fischer von Erlach, in Zelný Trh, and the Plague Column, from the 18th century. The Moravian Provincial Museum; the Institute of Archaeology of the Czechoslovak Academy of Sciences; the National Archives (codices); the Municipal Archives; the Library of St. James, from the 14th century, rich in incunabula and woodcuts; the Museum of Decorative Arts — all these are important institutions.

BIBLIOG. M. Bretholz, Eine Bevölkerungsziffer der Stadt Brünn aus dem Jahr 1466, Weimar, 1896; F. Šujan, Dějepis Brna (History of Brno), Brno, 1902, 2d. ed., 1928; J. Leisching, Das Erzherzog Rainermuseum in Brünn, Vienna, 1913; B. Bretholz, Brünn, Geschichte und Kultur, Brno, 1938; Z. des mährischen Landesmuseum, N.S., 1941; K. Hucke, Wie das mährische Landesmuseum entstand, Z. des mährischen Landesmuseum, N.S., III, 1943; V. Kratinová, Gotické nástěnnémalby v Brněuské Muzejní kaplí (The Gothic Wall Paintings in the Chapel of the Museum of Brno), Časopis Moravského zemského musea v Brně, 2, XXXV, 1950; A. Kusáková, Čtyri kresby Václaca Mánesa v grafické sbírce moravského Musea (The Four Designs by Václav Mánes in the Graphic Collection of the

Moravian Museum), Časopis moravského Musea v Brně, 2, XXXVI, 1951, pp. 242–54; H. Böhmova Hájková, Restaurace obrazu Nálezu Sv. Křiže od J. v. Sandrart (The Restoration of the Picture "The Discovery of the Cross" by J. Sandrart), Časopis moravského Musea v Brně, XLII, 1957, pp. 201–05.

České Budějovice (Budweis). Major center of southern Bohemia, it was founded by Ottokar II Premysl, in the 13th century; recently it has become industrialized. The Convent and Church of the Holy Virgin were founded in 1265 by Ottokar II; the Dominican Monastery has a beautiful 13th-century cloister; the Cathedral of St. Nicholas, from 1294, which has a tower, the Černa Věž, from 1540–77; the Piarist College, built in 1771; the ruins of the castle, dating from the 15th century; the square, with Gothic houses and the so-called "Samson Fountain," from 1727; the Town Hall, in baroque style, built 1727–30 — all combine to give the center an antique and monumental aspect. The Municipal Museum has prehistoric collections, manuscripts from the 13th and 14th centuries and sculptures in wood. Among the impressive industrial structures is the Hardmuth pencil factory, founded in 1790.

Český Krumlov. On the Vltava River, in southern Bohemia, Český Krumlov is a city of medieval character, rich in Gothic and Renaissance architecture. The Minorite Monastery and Church, from about 1357, were rebuilt in the 17th century; the Church of St. Vitus, with a cloister, dates from the 14th century and the Clarician Convent from the same period; the Gothic Church of Corpus Christi was built in the 15th century; the Jesuit College was rebuilt by the Lombard Balthasar Majo de Vonio in the 16th century. The castle of Krumlov, on a narrow island in the Vltava, dates from the early 13th century; rebuilt several times, it is today the result of reconstructions in Renaissance style executed about the middle of the 16th century by Balthasar Majo de Vonio. It contains a rich collection of tapestries and paintings and an 18th-century theater. Noteworthy among the other structures in the city are the Renaissance Town Hall and the Růže House, the Regional Museum.

Hradec Králové. This city is the center of northeast Bohemia. Originally the castle of the Slavnik princes and later (after 996), of the Premyslides, it became an administrative district in the 11th and 12th centuries and was elevated from commune to city in the third decade of the 13th century. After 1363, Hradec Králové became a dower city of the queens of Bohemia. The Gothic Cathedral, from 1306, is of brick, with a Gothic tabernacle by Matěj Rejsek and a St. Anthony by P. Brandl. The baroque Jesuit Church of the Holy Virgin (1666) has conserved paintings by P. Brandl. The Jesuit College dates from 1671; the Bishopric (1710) is in rococo style. Also noteworthy are the White Tower (Bílá Věž), from 1574, and the Column of the Virgin, from 1737. The Regional Museum, founded in 1878, now in an edifice built by J. Kotěra in 1909, has archaeological and historical collections, as well as collections of the decorative arts, manuscripts, ancient books, etc. Particularly notable among the modern buildings are those by J. Kotěra and J. Gočar.

BIBLIOG. J. J. Solař, Dějepis Hradec Králové nad Labem a biskupství hradeckého (The History of Hradec Králové on the Elbe and of the Bishopric of Hradec), Prague, 1870; M. Jähns, Die Schlacht von Königgrätz, Leipzig, 1876; V. V. Tomek, Místopisné paměti města Hradec Králové (The Topographical Remains of the City of Hradec Králové), Prague, 1885; B. V. Spiess, Příspěvky k starému místopisu a dějinám Hradec Králové (Contributions to the Old Topography and History of Hradec Králové), Hradec Králové, 1895; A. Cechner, Soupis památek historických a uměleckých v politickém okresu Královéhradeckém (The Historic and Artistic Monuments in the Political District of Hradec Králové), XXI, Prague, 1904; L. Domečka and F. L. Sál, Královéhradecko (The Region of Hradec Králové), I, Hradec Králové, 1928.

Jindřichův Hradec. This city is the center of southeast Bohemia. It developed from the nucleus of a castle founded about the end of the 12th century, and became a city in the late 14th century. The Church of St. George contains frescoes from 1320; the Church of the Assumption dates from 1480. The castle is a splendid structure, with Romanesque vestiges (cf. the round so-called "Hunger Tower" and the high residential building), but it was completely remodeled in the 16th century, under the direction of the Italians Antonio Cometa, Giovanni Mario Faconi, Antonio Melana, Balthasar Majo de Vonio, Andrea Austalis de Sala, and Giovanni Pietro Martinelli, who added to it a spacious courtyard surrounded by loggias, an arcaded gallery, and a magnificent rotunda in the garden. Within, the Chapel of St. George contains important 14th-century frescoes, a collection of utensils, an icon of the Virgin (13th-century panel), paintings by Rosa, Škréta, and P. Brandl, and rich stucco decoration from the late 16th century.

BIBLIOG. J. S. Claudius, Geschichte der Stadt Neuhaus, Jindřichův Hradec, 1850; F. Rull, Monografie města Jindřichova Hradce (Monograph on the City of Jindřichův Hradec), Jindřichův Hradec, 1876; E. Teplý,

Dějiny města Jindřichova Hradce (The History of the City of Jindřichův Hradec), 1926–31; J. Muk, Historická bibliografia města Jindřichův Hradec (The Historical Bibliography of the City of Jindřichův Hradec), Jindřichův, Hradec, 1928; Z. Wirth and J. Benda, Státní hrady a zámky (The State Fortresses and Castles), Prague, 1955.

Karlštejn (Karlův Týn). The castle of Karlštejn was founded in 1348 by Charles IV to house the crown jewels, the royal archives, and relics. Built in ogival Gothic style by Mathieu d'Arras and Peter Parler, it was later modified and largely rebuilt in 1888. It is a complex of edifices of various periods, including the Church of Our Lady, with notable frescoes from the late 14th century and a very fine wooden ceiling; and the Chapel of St. Catherine, which has remarkable marbles and paintings and a beautiful stained-glass window representing the Crucifixion, from the last quarter of the 14th century. The Chapel of the Holy Cross is sheathed in marble and contains 127 portraits of saints and prophets, by Master Theodorik, active from 1357 to 1367. The castle houses a museum of sacred art (14th- and 15th-century objects).

BIBLIOG. A. Sedláček, Hrady, zámky a tvrze království Českého (The Fortresses, Castles, and Cities of the Kingdom of Bohemia), Prague, 1889; Z. Wirth and J. Benda, Státní hrady a zámky (The State Fortresses and Castles), Prague, 1955.

Kroměříž. The city has preserved the beautiful Church of St. Maurice, dating from 1260. In the city are also the Abbey of the Virgin, in rococo style, from 1724; the Piarist Cathedral of St. John the Baptist, from 1837, with fine frescoes; the 16th-century Town Hall, the Archiepiscopal Palace, from 1680–1711, which houses a picture gallery rich in the works of Italian and Flemish masters; the palace is built above the 15th-century castle, of which only the Round Tower, richly decorated with paintings and sculpture, still stands.

Kutná Hora. Kutná Hora was a famous center of the Middle Ages, whose fortunes were linked with the rich deposits of silver discovered by the Cistercians in the 12th century. It reached its zenith from the 13th to the 14th century; here were coined the famed "Groschen" of Prague, one of the most renowned coins in Europe. From 1700 on, the city declined. In 1952 it was declared a national monument, and many buildings were restored or changed back to their original condition. The Cathedral of St. Barbara, begun in 1380, continued into the 16th century by B. Rejt and M. Rejsek, and later restored, is an impressive structure with a nave and four side aisles, which contains 15th-century frescoes and distinguished paintings by I. J. Raab and P. Brandl. The Cathedral of St. James, of the 14th century, has paintings by Škréta and Brandl; and in the Church of Our Lady, from the 16th century, are the Chapel of the Trinity (1417) and the tomb of P. Brandl. The Jesuit College is an imposing structure designed by Carlo Lurago (1626–67); the Ursuline Convent was built by K. I. Dientzenhofer in the 18th century. The Town Hall is a complex of Gothic-style structures, including the royal residence and the mint, built in 1278 and restored under Vladislav II Jagellon (1471); it was called the "Italian Court" because of the presence of Florentine coiners. In it are conserved 16th-century paintings and sculptures. Among the notable works in the city is the stone fountain, dating from 1495, attributed to Matěj Rejsek. The Stone House (Kamenný dům) is an interesting 15th-century structure ornamented with many sculptures; in it is the Municipal Museum, containing rich collections of decorative art, coins, and the so-called "Bible of Kutná Hora," dating from 1489.

Olomouc (Olmütz). Olomouc is the principal center of northern Moravia. Once the seat of the Moravian seigneurs from the 11th century on, it is at present an industrial center. The Cathedral of St. Wenceslas was built about 1107 above an old castle, whose fine Romanesque windows still remain; it was rebuilt in the 13th century, and again in Neo-Gothic style in the 19th century. It contains 15th-century tomb slabs, a Gothic cloister with frescoes from the early 16th century, and sculptures. The Church of St. Maurice, begun in the 13th century, was also remodeled in the 17th century. The baroque Church of St. Michael (1676–1701) is the work of A. D. Saterer. The Church of Our Lady of the Snows dates from 1720. The Town Hall, from the 13th century, has a splendid 15th-century musical clock and a Renaissance loggia (1564). The Archiepiscopal Palace is by A. D. Saterer. Also noteworthy are the monumental group of the *Holy Trinity* (1716–55) and the Fountains of Hercules (1690) and of Caesar (1720). The university library is extemely rich in manuscripts. In the vicinity of Olomouc stands the Military Hospital, formerly the convent of Hradisko, founded in 1078 and rebuilt by B. Fontana in 1686 in imitation of the Escorial.

BIBLIOG. J. V. Fischer, Geschichte der Königl. Hauptstadt und Grenzfestung Olmütz, Olomouc, 1802; A. V. Šembera, Paměti a znameni osti města Olomouce (The Landmarks and Monuments of the City of Olomouc),

Vienna, 1861; W. Müller, Geschichte der königl. Hauptstadt Olmütz, Vienna, 1882; G. d'Elvert, Zur Geschichte des Erzbisthums Olmütz, Brno, 1895; H. Doležil, Politické a kulturní dějiny král. hlav. města Olomouce (The Political and Cultural History of the Royal Capital of Olomouc), Olomouc, 1903–05; H. Kux and M. Kres, Das Rathaus zu Olmütz, Olomouc, 1904; B. Navrátil, Jesuité olomoučtí za protireformace (The Jesuits of Olomouc at the Time of the Counter Reformation), I, Prague, 1916; V. Nešpor, Olomouc, Olomouc, 1927.

Pardubice. Pardubice is the center of northeastern Bohemia. Built around a castle, it is not only an important example of medieval city planning, but the only Bohemian city to have a predominantly Renaissance character. The Decanal Church (1226) was reconstructed in 1538; on the high altar is a *St. Bartholomew* by P. Brandl. There are noteworthy remains of fortifications, such as the Zelená brána ("green gate"), from 1537, with a copper roof. The castle (15th–16th cent.), with halls in various styles, mostly Renaissance, contains a historical and ethnographic museum.

BIBLIOG. Z. Wirth and J. Benda, Státní hrady a zámky (The State Fortresses and Castles), Prague, 1955.

Pernštejn. The castle of Perštejn, founded in the 13th century, was rebuilt several times between 1458 and 1522, and later in 1530, finally acquiring its present form in 1604; it is one of the most beautiful in central Europe. Despite the reconstructions, it retains the austere aspect of a medieval fortress, with its large courtyard, five towers, five portals, and three circles of walls. Within is a great hall from the early 16th century, with a vaulted, unribbed Gothic ceiling, a 17th-century chapel, a library, and a picture gallery.

BIBLIOG. A. Sedláček, Hrady, zámky a tvrze království Českého (The Fortresses, Castles, and Cities of the Kingdom of Bohemia), Prague, 1882; Z. Wirth and J. Benda, Státní hrady a zámky (The State Fortresses and Castles), Prague, 1955.

Plzeň (Pilsen). Plzeň is the capital of western Bohemia. Situated in a valley traversed by various streams, it still keeps the appearance of the medieval fortified city. It was founded in 1290 by Wenceslas II, and its fortunes fluctuated during the 15th and 17th centuries. In the 19th century a considerable growth in population followed the industrialization of the city. The Church of St. Bartholomew is a beautiful structure from the early 14th century, with a very high belfry; it has preserved a valuable 14th-century Madonna; within the church is the Sternberg Chapel, dating from 1510–29. The baroque Church of St. Anne is from 1711. The Franciscan Church and Monastery were rebuilt in the 18th century but conserve frescoes from the 15th century. The Town Hall, from 1556, is the largest Renaissance structure in Bohemia; it houses the Municipal Gallery, which contains works by Czech painters. The city has outstanding 17th-century palaces, including the imperial residence, from the latter half of the century. Among the noteworthy industrial structures is the municipal brewery, founded in 1842. Other important buildings are the theater (1899–1902); the Regional Museum; the Ethnographic Museum; and the Regional Gallery.

BIBLIOG. J. V. Sedláček, Paměti Plzeňské (The Monuments of Plzeň), Plzeň, 1821; M. Hruška and J. Koráb, Kniha pamětní král. Krajského města Plzně od roku 775 až 1870 (The Book of Monuments of the Royal Province of Plzeň from 775 to 1870), Plzeň, 1883; Prameny a přispěvky k dějinám města Plzně (Sources and Contributions to the History of the City of Plzeň), from 1883; Sborník městského historického musea v Plzni (Misc. of the Civic Historic Mus. of Plzeň), from 1909; K. Kern, Pilsen in Mittelalter, Prague, 1930; F. Macháček, Dvě studie k dějinám Plzně a Plzeňska (Two Contributions to the History of Plzeň and Its Region), Plzeň, 1931.

Poděbrady. Although the site of Poděbrady was already inhabited in prehistoric times, it was only in the 12th century that a castle was erected there which later became the center of a great domain; from 1268 on, it was the property of the king of Bohemia. It experienced a remarkable growth as a spa in the 20th century. Among its outstanding landmarks are the 13th-century church, which contains the Chapel of Our Lady (16th cent.); the castle (12th–13th cent.), rebuilt in Renaissance style by the Italian architect G. Austalis de Sala (1548–60); the rococo Column of the Virgin, from 1765; and the Regional Museum.

BIBLIOG. A. Sedláček, Hrady, zámky a tvrze království Českého (The Fortresses, Castles, and Cities of the Kingdom of Bohemia), XII, Prague, 1900; Lázne Poděbrady (Poděbrady Hot Springs), Prague, 1922.

* *

Prague (Praha). Prague, the capital of Czechoslovakia, had its beginning in the castles of Vyšehrad and Hradčany, built on two heights, close to a ford in the Vltava River. The first, according to historic sources and archaeological reports, was the first seat of the

dukes of Bohemia (9th cent.); the second, from the 10th century, became the residence of the rulers and also the political, cultural, economic, and religious center (from 973 on, an episcopal see). The castle was later enlarged, and on the other bank of the river the market was built, the nucleus of the suburb. Prague became a free city under Wenceslas I (1230–53). Thirty-one Romanesque churches of basilical or central plan and a number of religious houses were built between the 11th and 12th centuries. The two centers and the suburb were joined together by a stone bridge, constructed by order of Judith, the wife of Vladislav I (1169–71). In the following century, on the slopes of Hradčany, the new quarter of Malá Strana ("small town") was built, which in 1257 obtained the privileges of a free city. A hundred years later, Charles IV founded the quarter of the New City (1348), inhabited chiefly by Czechs. Under the auspices of this sovereign Prague quickly became the equal of other European cities; he had the new palace built, founded the university, modeled upon that of Paris, and encircled the quarters of the city with fortifications and towers. The architecture of the Cathedral and numerous churches, all built on the initiative of Charles IV, gave Prague an exclusively Gothic appearance. After the Hussite domination, which brought about a period of stagnation in the life of Prague, the Jesuits and the aristocracy assumed leadership in the city. Italian and Bavarian masters covered the slopes of Hradčany and Malá Strana with palaces and gardens, and the painters were given the task of portraying in mythological guise the victors in the Thirty Years' War. The architectural styles that followed one another — baroque, neoclassic, Neo-Gothic, Neo-Renaissance — were of only local importance. However, certain modern buildings are distinctive.

*a. Churches.* The first religious structures built in the territory of Prague had centralized ground plans, influenced by Italy and south Germany. Only the foundations remain, and some rare examples from the 12th century: the Church of the Holy Cross in the Old City, and the Chapel of St. Longinus, beside the Church of St. Stephen. The Basilica of St. George in Hradčany, built over the remains of the rotunda of 915, rebuilt in 973, and joined to the convent of the Benedictine nuns by Werner of Saxony, was transformed into a basilica in 1145–51 and restored, without change of ground plan, in 1888–1905. In it is an important Romanesque bas-relief representing the Madonna and Child and two women founders of the convent. The vestiges of the wall painting in the apse of the church (*Christ in Glory* and the *Coronation of the Virgin*) are the sole examples of Romanesque painting preserved *in situ* in Prague. The Basilica of SS. Peter and Paul at Vyšehrad (1070), with nave and two side aisles, and with two towers, was rebuilt in Gothic style and preserved intact up to the 20th century. The Basilica of St. Lawrence in Malá Strana, dates from the Romanesque period also, but later constructions have altered its original appearance. The Church of St. Francis in the Clarician Convent of St. Agnes (1233–53), which, together with the Church of St. Barbara and other structures, forms an important architectural complex, is the first example of Gothic architecture on Bohemian soil.

The Church of St. Vitus, beside the castle, was constructed over the ruins of the first shrine, built by St. Wenceslas; here the kings of Bohemia and the emperors of the Holy Roman Empire were crowned. On the site of the Romanesque basilica (1060–96) which replaced the rotunda, a magnificent structure was built (1344) on the initiative of Charles IV, first by Mathieu d'Arras, who worked on it until 1356, and then by Peter Parler, from 1356 until 1399–1406. The construction (chancel, apse, and transept) was interrupted during the Hussite domination, resumed later in the 16th–17th century, and finally completed by J. Kranner, J. Mocker, and K. Hilbert (1859–1929). Among the important works within are: twenty-one portraits in the triforium from the time of the Luxembourg dynasty; the Chapel of St. Wenceslas; the oratory of King Vladislav II Jagellon; the silver sepulcher of St. John of Nepomuk; the presbytery of the choir; the mausoleum of Emperor Rudolph II by A. Colin (1589); the royal tomb in the crypt; four Chapels of the Premyslides and Vlasim with tombs (the work of P. Parler and M. d'Arras); the Chapel of the Holy Face, decorated by Tommaso da Modena (1368); the Renaissance pulpit (by B. Wohlmut, 1557–61); and a rich treasure from the 10th to the 20th century. The sculptures (1374–86) are of the school of P. Parler, who created the beautiful statue of *St. Wenceslas.*

Gothic churches are the Church of All Saints in the castle (1263, rebuilt by P. Parler in 1372–87); the Church of St. Henry (1348–51); the "Na Slupi" Church; the Church of Our Lady of the Snows (1370–97, restored in 1611); the Church of St. Apollinaris (1362, rebuilt in baroque style in 1757, and later in Neo-Gothic, by J. Mocker, in the 19th century, although conserving the 14th-century frescoes). Many churches combine Gothic work with other styles. The Church of St. James, with the Minorite Monastery, in the Old City has Gothic elements and a baroque superstructure from 1689

(decorated by Fischer von Erlach and V. V. Reiner; the tomb monument for Václav Vratislav of Mitrovice is the work of F. M. Brokoff). The Church of Our Lady of Týn (1370–1510), a parish church of the Old City, shows successive phases of the Gothic style. It has a magnificent tympanum over the lateral portal, with three scenes of the *Passion* in the style of P. Parler. Within, there are works by K. Škréta (1649). In 1679, the church was partially remodeled in baroque style. The Church of St. Mary of Karlov, with the Augustinian Monastery (1350–57), was built by P. Parler on an octagonal plan, on the model of the Palatine Chapel of Aachen, and modified in the baroque period. The Monastery and Church of Emmaus, called "Na Slovanech," retains Giottesque frescoes from the 14th century. The Old-New Synagogue (1230–46) is Gothic in style; it stands beside the Jewish Town Hall. The Church of St. Bartholomew, originally Gothic, was completely rebuilt by the Jesuits and is the first building in Renaissance style. (This style is found also in the south portal (1520) of the very ancient Basilica of St. George.)

The Church of Our Lady of Victory (or St. Salvator) in Malá Strana (1611–13), despite the persistence of Renaissance elements, marks the entrance of Roman baroque into Prague; within, there are altars with paintings by P. Brandl and the statuette of the *Infant Jesus.* The Church of St. Salvator, beside the Clementinum, was built by Italian architects (C. Lurago and others, 1576–1602); its façade was altered in 1654, with the addition of statues by J. Pendl; the octagonal dome dates from 1649. The Italian Chapel, added to the Clementinum, surmounted by a dome, copies Italian 17th-century models. The Capuchin Monastery Church, dedicated to Our Lady of Loreto (1626–1736), became one of the gems of the new baroque taste through the work of Orsi, Domenico Canevale, and K. I. Dientzenhofer. The Gothic tower, famous for its carillon, has survived. The Holy House, in the courtyard of the church, was decorated with bas-reliefs by J. Agosto. Before the Holy House is J. M. Biederle's beautiful sculpture of the *Assumption.* The Church of St. Ignatius, built beside the Jesuit University by the architects Orsi and I. Bayer (1665–92), has a sumptuous interior with gilded, stuccoed vault and paintings. The Church of St. Francis of the Knights of the Cross, by J. B. Mathey (1678–87), shows a compromise in its façade between the Palladian and the Roman baroque styles; the green dome is in Borrominian style. Within is the masterpiece in fresco by V. V. Reiner, the *Last Judgment.* The Church of St. Joseph is also by J. B. Mathey (façade from 1686–92; within, works by P. Brandl). The Church of St. Mary of Břevnov (the work of C. Dientzenhofer, 1709–22), together with the Benedictine Monastery, has vault and altars painted by P. Brandl. The Church of St. John of Nepomuk, in Hradčany, baroque, articulated in vertical lines, is the work of K. I. Dientzenhofer (1720–28), and contains paintings by V. V. Reiner. The Church of St. John of Nepomuk-on-the-Rock, in Vyšehrad, is the masterpiece of K. I. Dientzenhofer; on the altar is the statue of the saint by J. Brokoff. The Gothic Augustinian Church of St. Thomas (1379), in Malá Strana, was magnificently restored by K. I. Dientzenhofer and contains frescoes by V. V. Reiner and K. Škréta. Rubens's paintings, which formerly adorned the high altar, are now in the Gallery of the Society of the Patriotic Friends of Art. The Church of St. Nicholas (1704–45), in Malá Strana, is the most impressive of the churches of Prague. The highest expression of the local baroque style, it reveals Guarinian influence. It was begun by C. Dientzenhofer and brought to completion by his son, Kilian Ignaz (the choir and dome). The parts executed by the son are more composed, in contrast to the exuberance of Dientzenhofer. Within, sumptuous stucco decorations accompany paintings by J. L. Kracker, H. Kohl, K. Škréta, I. J. Raab, and Solimena. Other churches rebuilt by K. I. Dientzenhofer were: the Church of St. Nicholas in the Old City, often compared to S. Agnese of Borromini; the Church of St. Charles Borromeo, with its massive piers; the Church of St. Catherine, which retains the two Gothic towers from 1355, and has a nave decorated with frescoes by V. V. Reiner. The Premonstratensian Church at Strahov, rebuilt in 1746 by M. Canevale, contains sculptures by I. Platzer, paintings by J. Kramolín, I. J. Raab, and J. V. Neuherz. The façade of the famous Monastery Library, by G. Palliardi (1782), is the first example of the Louis XVI style in Prague. In Strahov, the Church of St. Roch, despite the Renaissance and baroque additions, retains its Gothic appearance. The Church of the Trinity (1713) is classically influenced. The Church of the Holy Cross is in neoclassic style (1816). The Church of St. Ludmila is Neo-Gothic. The Church of St. Wenceslas, originally Romanesque, was rebuilt in Neo-Gothic.

*b. Civil structures.* The castle of Prague was for a millennium the official residence of the dukes and kings of Bohemia. Vestiges of the 10th-century fortifications have been found in the third courtyard. The Romanesque tower is incorporated into one of the castle wings, between the second and third courtyards. Repeatedly restored and enlarged, it was completely rebuilt by Ottokar II; in the

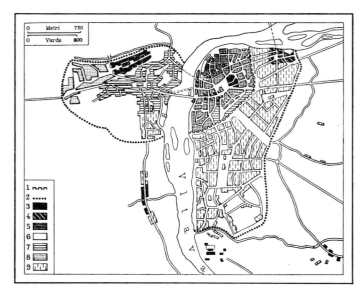

Prague, plan of the medieval city: (1) 13th-century wall; (2) 14th-century walls; (3) castles and fortified centers of the 10th century; (4) settlements of German artisans in the 12th century; (5) Jewish quarter; (6) Old City in the early 13th century; (7) urban expansion in the late 13th century; (8) expansion of the fortified center in the 14th century; (9) subsequent urban expansion in the 14th century.

new walls were incorporated the 25 towers of the old fortification. In 1333, Charles IV enlarged the building. About 1500, the Vladislav wing was added, with the famous vaulted Vladislav Hall, by B. Rejt (1484–1502), the greatest masterpiece of Bohemian Gothic. In Renaissance style are the windows of the great hall (restored by B. Wohlmut, 1493), of the German Hall (1579), and of the Spanish Hall (1598). The monumental castle portal is by Vincenzo Scamozzi (1614). At the instance of Maria Theresa, under the direction of A. Lurago (1758–75), the architectural complex was unified in style. On the stairway are sculptures by F. M. Brokoff, and in the entry, by I. Platzer (1700–80).

The Charles Bridge, built in 1357 in Gothic style by P. Parler, with two towers and sixteen arches, is the oldest of 13 bridges over the Vltava; it united Hradčany with the Old City. It is decorated with 30 baroque sculptural groups by J. Hillinger, J. and F. M. Brokoff, M. B. Braun, and others. The Powder Tower, the only remaining one of the eight which surrounded the Old City, has rich decoration in flamboyant Gothic. The Town Hall of the Old City (1338) retains Romanesque vestiges: tower and chapel from 1383; the famous Prague clock by Master Hanuš, of 1490 (destroyed 1945); and Renaissance additions. It was rebuilt in Neo-Gothic style. The Town Hall of the New City was begun in 1348 and continued in 1419 and 1483, with Renaissance restorations. The Carolinum, the university founded by Charles IV in 1348 on the model of the University of Paris, originally had four buildings around an inner court, to which a Gothic chapel was later added.

The Belvedere is one of the most beautiful Renaissance palaces north of the Alps. It was built, together with its marvelous garden, by the Italians Giovanni da Spatio, Paolo della Stella, and Pietro Ferrabosco di Laino, and has a ground floor with loggias and an upper floor by J. Tirol and B. Wohlmut. In the royal garden the Mičovna ("games court"), also by Wohlmut — is the bronze fountain (1564–69), by T. Jaroš, perhaps after the designs of an Italian master. The Schwarzenberg Palace (1545–63), the work of Agostino Italiano, with lateral pediments reminiscent of the Gothic, is the first Renaissance palace. The Hvězda Hunting Lodge with stucco decoration (1555), is interesting for its star-shaped plan. The Pernštejn Palace was later restored by C. Lurago. The Rožmberk Palace was built by the Italian Austalis de Sala (modified in 1755 by A. Lurago). The "U Minuty" (1610) is profusely decorated. The new Archiepiscopal Palace in Hradčany, built by Austalis de Sala, was modified in rococo style by J. Wirch (1764–68). The Wallenstein Palace (1623–30), in pure baroque style (built by A. Spezza, G. B. Marini, and G. Pieroni), has a beautiful garden reminiscent of Roman gardens, and a marvelous loggia by Baccio (Bartolommeo) del Bianco. The interior is gorgeously decorated. Various statues by Adriaen de Vries were carried off by the Swedes in 1648; they have been replaced by copies. The Michna Palace (today the Tyrš House) by F. Caratti imitates models from northern

Italy. The Nostic Palace (1666), by F. Caratti, with a posterior portal by A. Haffenecker (1770), is classically influenced. The Clementinum — the Jesuit citadel of the Counter Reformation — and the College of St. Ignatius (1665–99), by P. I. Bayer, are examples of baroque architecture. The Černín Palace (1669–1750; II, PL. 159), built by various architects (F. Caratti, A. Lurago, F. M. Kaňka), has an immense façade of great majesty, recalling the Florentine palaces and Palladio. The Troja Palace (1679–97) has a monumental double-ramp staircase, with ten baroque statues by J. G. Heermann. The Toscan Palace (1689–91) was by P. A. Fontana. The Thun-Hohenstein Palace dates from 1650–1750. The Buquoy Palace (ca. 1715) is attributed to J. B. Mathey. The Clam-Gallas Palace (ca. 1713), designed by J. B. Fischer von Erlach, contains frescoes by J. Hiebel and atlantes by M. B. Braun. The Lobkovic Palace (1702–07), by G. Alliprandi, has a magnificent garden by J. J. Ka-Paul. The Schönborn Palace, begun in the early 17th century, was reduced to its present form probably by G. Santini Aichel (1715). The Thun Palace (II, PL. 159; 1721–26) has a portal adorned with eagles by M. B. Braun. The Morzin Palace was rebuilt in 1713–14 by G. Santini Aichel, with sculptures by F. M. Brokoff. The Piccolomini Palace (now the Sylva-Tarouca Palace) was built in 1749 by K. I. Dientzenhofer and A. Lurago. The Fürstenberg Palace (1749–60) with terraced garden; the "U Montágů," by J. Jäger, with towers; the Sternberk Palace (18th cent.); and the Kinský Palace, by A. Lurago and J. Koch, from the second half of the 18th century, are all notable. The Villa America (1715–20) marks the contact with French classicism; it is the work of K. I. Dientzenhofer, with sculptures by M. B. Braun. The classical tendency is even more accentuated in the architecture of the Kounic Palace (1773–74), by J. Schmidt; in the House of the Invalids, by K. I. Dientzenhofer (1729–35); and in the Prichovský Palace. The Klárov Palace, by V. Kulhánek, the Platýz Palace, by J. Hausknecht (1813–22), and the Rohan Palace (1838), by V. Kulhánek, are all in neoclassic style. The National Theater (Národní divadlo; 1868–84) and the Parliament building are both by J. Zítek. The Rudolfinum ("artists' house"; 1884) is by J. Zítek and J. Schulz. The Palacký Bridge (1876–78) is one of the most beautiful in Prague, with sculptures by J. V.

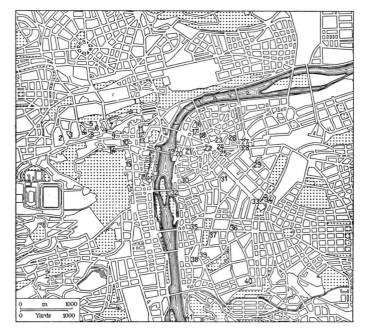

Prague, city plan showing art monuments. *Hradčany*: (1) Belvedere; (2) Černín Palace; (3) Our Lady of Loreto; (4) Toscan Palace; (5) Sternberk Palace; (6) Archiepiscopal Palace; (7) Castle, St. Vitus, St. George; (8) St. Benedict; (9) Morzin Palace; (10) St. Nicholas; (11) Wallenstein Palace; (12) St. Thomas and Fürstenberg Palace; (13) St. Joseph. *Malá Strana*: (14) Lobkovic Palace; (15) Our Lady of Victory. *Old City*: (16) Old-New Synagogue; (17) Old Jewish Cemetery; Jewish Town Hall; (19) Charles Bridge; (20) St. Francis of the Knights of the Cross; (21) Clementinum, St. Salvator, and Clam-Gallas Palace; (22) Old-City Town Hall; (23) Kinský Palace; (24) Our Lady of Týn and St. Nicholas in Old City; (25) Carolinum; (26) St. James; (27) Town Hall; (28) Powder Tower; (29) St. Henry; (30) Holy Cross and St. Bartholomew. *Nové Mesto*: (31) Our Lady of the Snows; (32) National Theater; (33) National Museum; (34) Theater 5th-of-May; (35) St. Charles Borromeo; (36) St. Longinus; (37) St. Ignatius; (38) Emmaus Monastery; (39) St. John of Nepomuk; (40) St. Mary of Karlov and Augustinian Monastery; (41) SS. Peter and Paul.

Myslbek. The National Museum is by J. Schulz (1884–91). The Wilson Station (1901–09), is by J. Fanta. The architect A. Wiehl, creator of various modern buildings, drew his inspiration from local folklore.

*c. Museums.* Among the numerous museums in the city, the following are worthy of mention: the Museum of Industrial Arts, with one of the most important collections of glass and porcelain in the world; the Gallery of the Society of the Patriotic Friends of Art, dedicated to Czech and foreign painting, which contains works by Rembrandt, Rubens, Lucas Cranach, Tiepolo, school of Caravaggio, etc.; the Ethnographic Museum, with costumes, furniture, various objects, etc.; the National Museum, with archaeological and prehistoric sections, archives, library, etc.; the Municipal Museum and the Gallery of Modern Art, with paintings by Delacroix, Cézanne, Renoir, Gauguin, etc.

BIBLIOG. W. W. Tomek and J. Mocker, Das Agnes-Kloster in Prag, Vienna, 1891; B. Matějka, Přestavba a výzdoba chrámu sv. Tomáše (The Restoration and Decoration of the Church of St. Thomas), Prague, 1896; A. Matějček and Z. Wirth, Modern and Contemporary Czech Art, London, 1924; E. Dostal and J. Sima, L'architecture baroque de Prague, Paris, New York, London, Berlin, 1926; J. Guenne, Prague, ville d'art, Paris, 1930; O. Schürer, Prag, Vienna, Leipzig, 1930; Masarykův slovník naučny (Masaryk Encyclopedia), V, 1931, s.v. Prague, pp. 944–49; O. Pedrazzi, Praga, Prague, 1932; V. Vojtíšek and D. Líbal, Le Carolinum, Prague, 1948; A. M. Matteucci, L'arte in Boemia dal gotico al barocco alla Galleria Nazionale di Praga, Emporium, LXII, 10, 1956, pp. 169–75.

Maja MILETIĆ

Sedlec. Sedlec is a center east of Prague. The Church of Our Lady, founded in the 12th century, was rebuilt in the 14th century, and is one of the most beautiful in Bohemia; it conserves paintings by P. Brandl. The Gothic cemetery of the 13th century is in the vicinity of the castle of Kačina, which is built in Empire style, with a great park in the English manner (1802–22).

BIBLIOG. F. Benesch and J. Zettl, Die Kirche zu Sedletz in Böhmen, Mittheilungen der K. K. Central-Commission, II, Erhaltung der Baudenkmale, I, 1856, pp. 25–26.

Tábor. Tábor, originally a castle of the Vitbrovice family (13th cent.) and a Hussite camp in the 15th century, subsequently developed into a notable center. Among the religious monuments, the following are noteworthy: the late-Gothic Church of the Transfiguration, the work of Master Staněk, of 1512; the late-Gothic Decanal Church; the Augustinian Church of 1662. The Round Tower, 13th century, is the last vestige of the former castle. Still numerous are the Gothic and Renaissance houses. The Bechyně gate dates from 1420. The Town Hall, built in 1516–21, in late-Gothic style, by Master Staněk, contains a historical museum. The Jewish cemetery of 1634 is notable.

BIBLIOG. K. Thir, Hradiště hory Tábor jako pevnost v minulosti (Hradiště of the Mountain of Tábor as a Fortress in the Past), Tábor, 1895; A. Sedláček, Sbírka listovních pamětí města Tábora (Collection of Documentary Records of the City of Tábor), Tábor, 1897; K. Thir, Staré domy a rodiny táborské (The Old Houses and Families of Tábor), Tábor, 1920; Sborník historických prací prof. Martina Koláře o dějinách Tábora (Miscellany of the Historical Writings of M. Kolár about the History of Tábor), Tábor, 1924.

Telč. Telč, formerly a medieval fortress, is an interesting city. The Church of St. James, two-aisled, dates from the 14th century. The remains of Gothic fortifications include the clock tower. The ancient square with arched porticoes remains intact, and there are many Renaissance and baroque houses. The Town Hall is from the 16th century. The castle, perfectly preserved within and without, was begun in 1399 and renovated in the 16th century by the architect Balthasar Majo de Vonio, who gave it a Renaissance sheathing, with covered galleries and decorations in grotesque style.

Vyšší Brod. The city is situated on the Vltava. The Cistercian Abbey, founded in 1259 by John II, archbishop of Prague, includes: the church, which, although damaged several times by fires and wars, retains its former Gothic character, and the monastery. In the monastery is a chapter hall from the early 13th century, with a very rich library of manuscripts, incunabula, and prints. The picture gallery includes paintings by Raphael, Titian, Rembrandt, Škréta, Brandl, and south Bohemian artists of the 14th century; the old Ark of the high altar, with a painted panel of the 14th century; and the famous 13th-century Byzantine *Cross of Záviš*, inlaid with precious stones.

BIBLIOG. K. Chytil et al., Kříž svany Závišův . . . (The Cross of Záviš), Prague, 1930; Dějepis výtv umění v Čechách (History of the Arts in Bohemia), 1931; A. Friedl, Obrazarna klastera vyššebrodského (The Picture Gallery of the Convent of Vyšší Brod), Prague, 1934.

\* \*

*Slovakia (Slovensko).* Politically linked to Hungary from 1030 to 1918, the country was naturally attuned to Magyar culture, though its relationships with Bohemia and Moravia were always maintained, particularly between the 16th and 17th centuries. The infiltration of German influences was also apparent.

Banská Bystrica. The city was founded after the Tartar invasion of 1242. The Gothic Church of the Assumption of the Virgin dates from this period. In the court are interesting medieval pictures and, within, a fragment of a sculptured *Annunciation* from the 14th-15th century, the Madgalen altar (1473), and a notable Chapel of St. Barbara (1477). Baroque additions were made in the form of paintings by J. L. Kracker (1774) and A. Schmidt (1770). The bronze baptismal font (1475) is by Master Jodok.

BIBLIOG. F. Drahotuszky, Neusohler Taufbecken, Mittheilungen der K. K. Central-Commission zur Erforschung und Erhaltung der Baudenkmale, II, 1867, p. 111; V. Wagner, Vrcholne gotická drevená plastika na Slovensku (High Gothic Sculpture in Wood in Slovakia), Turčiansky St. Martin, 1936; Die Kunst in der Slowakei, Prague, 1939; V. Wagner, Gotické tabuľové maliarstvo na Slovensku (Gothic Panel Painting in Slovakia), Turčiansky St. Martin, 1942; M. Jurkovič. ed., Slovenské múzeá (The Slovak Museums), Turčiansky St. Martin, 1945; V. Wagner, Vývin výtvarného umenia na Slovensku (The Development of Representational Art in Slovakia), Bratislava, 1948; K. Plicka, Die Slowakei, Prague, 1955; E. Lorad, Umeleckó-historické pamätné kostoly na Slovensku (The Churches of Historic and Artistic Importance in Slovakia), Trnava, 1957.

Banská Štiavnica. This city was one of the most important medieval centers in Slovakia. It has preserved a circular charnel house, dating from the early 13th century, with Romanesque elements. The Dominican Church is Gothic; the Church of the Madonna is late Gothic (15th cent.); the Church of St. Catherine dates from 1488–91 and the Church of Our Lady of the Snows is from 1512–14. At the time of the Turkish invasion, the parish church was transformed into a fortress (1546–50). The old castle (13th and 16th cents.) and the new (1564) are well preserved. In the city are the Mestské Múzeum and the Státné Banské Múzeum Dionyza Štíra. The city was one of the principal centers of the Danubian school of painting during the 16th century.

BIBLIOG. S. Klíma, Slovenské zámky (The Slovak Castles), Prague, 1921; V. Wagner, Gotické tabuľové maliarstvo na Slovensku (Gothic Panel Painting in Slovakia), Turčiansky St. Martin, 1942; M. Jurkovič, ed., Slovenské múzeá (The Slovak Museums), Turčiansky St. Martin, 1945; V. Wagner, Vývin výtvarného umenia na Slovensku (The Development of Representational Art in Slovakia), Bratislava, 1948; K. Plicka, Die Slowakei, Prague, 1955; E. Lorad, Umelecko-historické pamätné kostoly na Slovensku (The Churches of Historic and Artistic Importance in Slovakia), Trnava, 1957.

Bardejov. The most noteworthy building in Bardejov is the medieval Church of St. Egidius, begun by Master Nicholas (15th cent.), who is responsible for the presbytery, and continued (1482–85) by Masters Stefan Lapicide and Urbanus, who drew their inspiration from the Cathedral of St. Elizabeth of Košice. In 1486 F. Stemasey of Ansbach was active in further building. A hundred years later, the south chapels and the vault of the central nave were rebuilt in Renaissance style. Of the twelve Gothic altars of the 15th century, with sculptures and paintings, several are of the school of Veit Stoss. The *Veil of Veronica*, painted in oil on the altar of the Holy Cross, was inspired by the style of Albrecht Dürer. The Gothic Town Hall (Master Alexander, 1508), with Renaissance portal, windows, and chapel (Master Alexius, 1508–09) is a very clear example of influence by late Gothic and Renaissance elements. The Státné Sarišské Múzeum is important.

BIBLIOG. V. Wagner, Vrcholne gotická drevená plastika na Slovensku, (Gothic Sculpture in Wood in Slovakia), Turčiansky St. Martin, 1936; Die Kunst in der Slowakei, Prague, 1939; V. Wagner, Gotické tabuľové maliarstvo na Slovensku (Gothic Panel Painting in Slovakia), Turčiansky St. Martin, 1942; M. Jurkovič, ed., Slovenské múzeá (The Slovak Museums), Turčiansky St. Martin, 1945; V. Wagner, Vývin výtvarného umenia na Slovensku (The Development of Representational Art in Slovakia), Bratislava, 1948; K. Plicka, Die Slowakei, Prague, 1955; E. Lorad, Umelecko-historické pamätné kostoly na Slovensku (The Churches of Historic and Artistic Importance in Slovakia), Trnava, 1957.

Bíňa. Bíňa is remarkable for the Romanesque Premonstratensian Church of St. Mary, remodeled in the baroque period, with three polygonal apses, a transept, and two towers (13th cent.), with an atrium in Burgundian style, ribbed vaults of German type (cf. the Church of St. George of Bamberg), and Lombard capitals; an interesting detail is a relief depicting a hunting scene. A few yards away from the basilica is the ancient Rotunda of the Holy Apostles.

BIBLIOG. V. Wagner, Vývin výtvarného umenia na Slovensku (The Development of Representational Art in Slovakia), Bratislava, 1948; E. Lorad, Umelecko-historické pamätné kostoly na Slovensku (The Churches of Historic and Artistic Importance in Slovakia), Trnava, 1957.

Bratislava (Pressburg). Chief city of the Slovak region, Bratislava stands near the site of the Roman colony of Carnuntum. In the 19th century there was a castle here, which was the residence of the Slovak dukes. In 1291, the suburb of the castle became a free city. The ancient castle was rebuilt in the 13th–15th century; in 1552–63 it was improved by the addition of an arcaded courtyard; subsequent restorations were made in the baroque (17th cent.) and neoclassic periods (F. Hildebrandt, 1768). From 1536 to 1683, Bratislava became the capital of the Hungarian kingdom and the seat of the state diet, following the fall of Budapest to the Turks. Today, as capital of Slovakia, it has had considerable urban development.

*a. Churches.* The Cathedral of St. Martin, with vestiges of the 1221 structure, has a nave with side aisles and a transept in Gothic style (14th–15th cent.). The adjoining shrine is late Gothic (1476–87), erected by order of Matthias Corvinus. The slender belfry, completed in 1577, was rebuilt in Neo-Gothic style. The plastic decorations on the exterior of the Cathedral are of the 14th and 15th centuries. The structure of the interior vaults is credited to H. Buchsbaum (late 15th cent.). In the central nave is the equestrian statue of *St. Martin*, in lead, by G. R. Donner, formerly a part of the high altar (1734), which was surmounted by a baldachin in imitation of that of Bernini. The Chapel of St. Anne has a bas-relief of the *Holy Trinity*, from the mid-15th century. The Chapel of St. John the Almoner is decorated with baroque sculptures by Donner (1732); the baptismal font is from 1404. Except for the round, two-storied, Romanesque charnel house, which dates from 1221, the Franciscan Church is the oldest structure in the city. Of an adjoining monastery (1297) the only remains are the walls and the heavy buttresses, the ribs, decorated with ornamental foliate motifs, the pointed arches of the vaults, and the windows, of primitive Gothic style, with Romanesque vestiges. The Gothic belfry, with a square base, terminates in a hexagonal form; it is one of the most beautiful in central Europe. With its reconstruction in 1616, the church acquired a baroque vault. The Chapel of St. John (1361) shows foreign influences. The late-Gothic Clarician Church has an adjoining convent, rebuilt in 1637–40 with a spacious, loggiaed courtyard. The little 15th-century Church of St. Michael was rebuilt toward the end of the 17th century. Also noteworthy are the churches of St. Salvator (1636) and St. Nicholas (1661), the Ursuline Church (1640), the Church of the Brethren of Charity (1692–99), and the Capuchin Church (1708–1718). The Church of the Holy Trinity (1717–25), built on the model of the Church of St. Peter in Vienna by the architects C. Canevale, F. Hildebrandt, and Fischer von Erlach, contains painted decoration, with simulated architecture, by A. Galli Bibiena (1736–40). The Church of St. Elizabeth, with a façade by A. Pilgram (1739–42), is the first Slovak example of the use of painted perspective; in the interior are frescoes by P. Troger (1742). The Church of the Holy Cross (19th cent.) is in neoclassic style.

*b. Civil structures.* The Town Hall, rebuilt in the 13th century and subsequently enlarged, has a vestibule with Gothic vaults and windows of the 15th century, an arcaded Renaissance courtyard (1558), and an eastern loggia (1581); within are stucco decorations by Corati Orsati, and Italianate frescoes by J. Drentwett (1695). Now the Municipal Museum, it houses collections of antiquities, ceramics, sculpture, and ancient and modern paintings. In front of the palace is the Fountain of Roland (1572). Other important secular structures are the National Gallery, the Slovak Museum, and the Military Museum. The New Town Hall (late 18th cent.) has, on the ground floor, a frescoed chapel, and on the first floor above, a famous mirrored hall. It contains invaluable English tapestries depicting mythological scenes (17th cent.). In the Archiepiscopal Palace, rebuilt in 1781, is a chapel decorated with late baroque frescoes by J. Drentwett. Also notable are the Jessenius Palace (1730), the Royal Chamber (by G. P. Martinelli, 1753–56), the Grasalkovič Palace (1760), the Esterházy Palace (1762), the Czáky Palace (1768–70), and the Aspremont Palace (1770).

BIBLIOG. J. Kiraly, Geschichte des Donau- Mauth- und Urfahrrechts der Freistadt Pressburg, Bratislava, 1890; T. Ortay, Geschichte der Stadt Pressburg, Bratislava, 1892; A. R. Franz, Wiener Baukünstler in Pressburg im Theresianischen Zeitalter, Jhb. des Kunsthistorischen Instituts, XIII, 1919, pp. 5–62; S. Klíma, Slovenské zámky (The Slovak Castles), Prague, 1921; K. Chaloupecký, K. nejstarším dějinám Bratislavy (Concerning the Earliest History of Bratislava), Bratislava, Turčiansky St. Martin, 1922; G. Weyde, Pressburger Barockfresken, Belvedere, VII, 1925, pp. 135–44; O. Beusch, Zwei niederländische Altarflügel in der pressburger "Tiefenwegkapelle," Pantheon, I, 1928, pp. 68–70; M. Horniak, Bratislava, l'antica Carnuntum, nella storia e nell'arte, Illustrazione Vaticana, IX, 1938, pp. 457–61; Die Kunst in der Slowakei, Prague, 1939; V. Wagner, Gotické tabuľové maliarstvo na Slovensku (Gothic Panel Painting in Slovakia), Turčiansky St. Martin, 1942; M. Jurkovič, ed., Slovenské múzeá (The Slovak Museums), Turčiansky St. Martin, 1945; V. Wagner, Vývin výtvarného umenia na Slovensku (The Development of Representational Art in Slovakia), Bra-

tislava, 1948; K. Plicka, Die Slowakei, Prague, 1955; E. Lorad, Umelecko-historické pamätné kostoly na Slovensku (The Churches of Historic and Artistic Importance in Slovakia), Trnava, 1957.

Diakovce. The town has a Romanesque basilica with nave and two side aisles, and two towers (1228), on the type of the Basilica of S. Lorenzo in Verona; adjoining it is a small 11th-century church. There is a noteworthy fresco of Christ in a mandorla (after 1228), in the fashion of medieval German paintings.

BIBLIOG. V. Wagner, Vývin výtvarného umenia na Slovensku (The Development of Representational Art in Slovakia), Bratislava, 1948; E. Lorad, Umelecko-historické pamätné kostoly na Slovensku (The Churches of Historic and Artistic Importance in Slovakia), Trnava, 1957.

Holice. In this town is the Church of SS. Peter and Paul, one of the first Slovak Gothic structures (late 13th cent.).

BIBLIOG. E. Lorad, Umelecko-historické pamätné kostoly na Slovensku (The Churches of Historic and Artistic Importance in Slovakia), Trnava, 1957.

Jasov. Jasov contains the Premonstratensian Church, with baroque frescoes by J. L. Kracker (1762–65), and sculptures in wood by A. Grassi (1765–70).

BIBLIOG. V. Wagner, Vývin výtvarného umenia na Slovensku (The Development of Representational Art in Slovakia), Bratislava, 1948; E. Lorad, Umelecko-historické pamätné kostoly na Slovensku (The Churches of Historic and Artistic Importance in Slovakia), Trnava, 1957.

Kežmarok. In Kežmarok is a parish Church of the Holy Cross, Gothic, with nave and two side aisles, with a very beautiful stellate vault (1444–98), and a high altar from the late 15th century; the church has a Renaissance belfry (1586). The Renaissance castle of Tokoly contains a baroque chapel (1658). The Town Hall has a Renaissance doorway, with reliefs executed by Master Kunz (1541), remodeled in the baroque period. There is a museum.

BIBLIOG. Die Kunst in der Slowakei, Prague, 1939; M. Jurkovič, ed., Slovenské múzeá (The Slovak Museums), Turčiansky St. Martin, 1945; V. Wagner, Vývin výtvarného umenia na Slovensku (The Development of Representational Art in Slovakia), Bratislava, 1948; K. Plicka, Die Slowakei, Prague, 1955; E. Lorad, Umelecko-historické pamätné kostoly na Slovensku (The Churches of Historic and Artistic Importance in Slovakia), Trnava, 1957.

Komárno. The fortified city of the 13th century had a castle, which was rebuilt in Renaissance style in 1543–50. The Church of St. Andrew (1756) has frescoes by F. A. Maulpertsch. There is a museum of Roman antiquities.

BIBLIOG. V. Wagner, Vývin výtvarného umenia na Slovensku (The Development of Representational Art in Slovakia), Bratislava, 1948; E. Lorad, Umelecko-historické pamätné kostoly na Slovensku (The Churches of Historic and Artistic Importance in Slovakia), Trnava, 1957.

Košice. The Cathedral of St. Elizabeth was built by several architects, who directed its construction successively (1382–1417; 1474–99; 1775). It reflects the Gothic style of the Rhineland. The first design, with nave and two side aisles, transept and choir, and radial chapels, was provided by Villard de Honnecourt. Next, the local architect Stefan added two other aisles. After 1494, Crompholz of Nissa and Wenceslas of Prague were active in further construction. Both within and without, the building is of definitely Gothic structure. One of the towers is from the time of Matthias Corvinus, and is in Renaissance style. The building contains many sculptures, as well as paintings by the school of Friedrich Herlin of Nördlingen. The predella is in Renaissance style (1477). Beside the Cathedral is the rich Gothic Chapel of St. Michael, of the 14th century. The Dominican Church (1305), restored in 1755, and the Franciscan Church are interesting. The Town Hall (1756) is in baroque style, with a staircase by J. Kraus (1780) and neoclassic paintings by E. Schrott (1792). In the town is the Museum of Eastern Slovakia.

BIBLIOG. L. Kémeny, A réformácio Kassán (The Reformation in Košice), Košice, 1893; L. Kémeny, Száz èv Kassa legrègibb történetèbol 1329–47 (One Hundred Years of the Earliest History of Košice), Košice, 1893; F. Krones, Beiträge zur Städte- und Rechtsgeschichte Oberungarns, Vienna, 1894; C. Divald, Der Kaschauer Dom und seine Meister, Szepmüveszeti Müzeum Evkönyvei, V, 1927–28, pp. 220–22; M. Horniak, Le opere della fede e dell'arte: il Duomo di Košice nella Slovacchia, Illustrazione Vaticana, IX, 1938, pp. 111–16; Die Kunst in der Slowakei, Prague, 1939; V. Wagner, Gotické tabuľové maliarstvo na Slovensku (Gothic Panel Painting in Slovakia), Turčiansky St. Martin, 1942; M. Jurkovič, ed., Slovenské múzeá (The Slovak Museums), Turčiansky St. Martin, 1945; V. Wagner, Vývin výtvarného umenia na Slovensku (The Development of Representational Art in Slovakia), Bratislava, 1948; K. Plicka, Die Slowakei, Prague, 1955; E. Lorad, Umelecko-historické pamätné kostoly na Slovensku (The Churches of Historic and Artistic Importance in Slovakia), Trnava, 1957.

Kremnica. Important buildings are the Romanesque circular charnel house; the remains of fortifications from the 14th century and 1539; the ancient castle with the adjoining Church of St. Catherine (1485); the Gothic Church of St. Elizabeth (14th cent.); the baroque Franciscan Church (1653); the local museum.

BIBLIOG. V. Wagner, Gotické tabuľové maliarstvo na Slovensku (Gothic Panel Painting in Slovakia), Turčiansky St. Martin, 1942; K. Plicka, Die Slowakei, Prague, 1955; E. Lorad, Umelecko-historické pamätné kostoly na Slovensku (The Churches of Historic and Artistic Importance in Slovakia), Trnava, 1957.

Levoča. Levoča is famous for the medieval Church of St. James (16th cent.), with seven beautiful altars which are masterpieces of Slovak Gothic. The high altar (1508–15), by Paul of Levoča, disciple of Nicholas of Leiden and Veit Stoss, anticipates the Renaissance style, particularly in the predella. The St. Elizabeth altar is by Nicholas of Levoča (15th cent.); that of St. Catherine is from 1460, and that of St. Anne from the 16th century; the St. John altar is from 1520. In the latter, Renaissance elements are accentuated (cf. the panel painting by T. Stanzel). The sculptures, such as the *Vir dolorum* (1476–80), are characterized by strong realism. The *Calvary*, sculptured on the south triforium, is of the school of Stoss. In the north aisle, Gothic frescoes, from about 1420, of the *Life of St. Dorothy*, were executed under the influence of the Bohemian school; the same may be said of the decoration of the south portal (1380). The bronze baptismal font is of the 14th century, and the Renaissance-baroque pulpit is by K. Kolmitz (17th cent.). The Minorite Church, with Bohemian-inspired Gothic frescoes, was reconstructed in baroque style (1748). The Franciscan Church has a rococo interior. The Renaissance Town Hall (1552) has a loggia of later date (1599). The Regional Museum is notable. There are many beautiful residences in the city.

BIBLIOG. V. Wagner, Vrcholne gotická drevená plastika na Slovensku (High Gothic Sculpture in Wood in Slovakia), Turčiansky St. Martin, 1936; Die Kunst in der Slowakei, Prague, 1939; V. Wagner, Gotické tabuľové maliarstvo na Slovensku (Gothic Panel Painting in Slovakia), Turčiansky St. Martin, 1942; M. Jurkovič, ed., Slovenské múzeá (The Slovak Museums), Turčiansky St. Martin, 1945; V. Wagner, Vývin výtvarného umenia na Slovensku (The Development of Representational Art in Slovakia), Bratislava, 1948; K. Plicka, Die Slowakei, Prague, 1955; E. Lorad, Umelecko-historické pamätné kostoly na Slovensku (The Churches of Historic and Artistic Importance in Slovakia), Trnava, 1957.

Liptovský St. Mikuláš. The Gothic Church of St. Nicholas, with Romanesque-Gothic belfry, was fortified in the 13th century. There are three precious Gothic altars, that of the Virgin Mary (1470–80) by an artist from Silesia. The parish church is in neoclassic style (1790). The Múzeum Slovenského Krasu is notable.

BIBLIOG. V. Wagner, Gotické tabuľové maliarstvo na Slovensku (Gothic Panel Painting in Slovakia), Turčiansky St. Martin, 1942; M. Jurkovič, ed., Slovenské múzeá (The Slovak Museums), Turčiansky St. Martin, 1945; V. Wagner, Vývin výtvarného umenia na Slovensku (The Development of Representational Art in Slovakia), Bratislava, 1948; E. Lorad, Umelecko-historické pamätné kostoly na Slovensku (The Churches of Historic and Artistic Importance in Slovakia), Trnava, 1957.

Nitra. Nitra is the earliest seat of the dukes of Slovakia (9th cent.) and the earliest Slovak Christian center. It was built on the site of an ancient fortress of the time of the Marcomanni and Quadi. Outstanding is the Rotunda of St. Emeramus, from the 12th century, built over the vestiges of the oldest Slovak church (833). In 1200 it was transformed into a late-Romanesque basilica, with two towers, but it retains, incorporated into the apse, the remains of the church of 833. Beside this building was erected the new Gothic Cathedral of 1333. The two edifices were incorporated into the fortifications of the castle, restored in the Renaissance (1580) and transformed in 1673–74 for defense against the Turks. The Gothic Cathedral, when rebuilt in 1622–42 acquired a baroque appearance; within are frescoes by G. A. Galliardi (1720–40); a *Crucifixion* in high relief by J. Pernegger (1662); and the baptismal font, of 1643. The Church of SS. Peter and Paul dates from 1630; of the same period is the reconstruction of the Episcopal Palace. The Piarist Church, formerly in neoclassic style, is from 1750–70. In the city is the State Museum.

BIBLIOG. A. Stránsky, Dejiny biskupstva nitranského (The History of the Bishopric of Nitra from the Earliest Times to the End of the Middle Ages), Trnava, 1933; V. Wagner, Vývin výtvarného umenia na Slovensku (The Development of Representational Art in Slovakia), Bratislava, 1948; K. Plicka, Die Slowakei, Prague, 1955; E. Lorad, Umelecko-historické pamätné kostoly na Slovensku (The Churches of Historic and Artistic Importance in Slovakia), Trnava, 1957.

Nové Město nad Váhom. In this city is the baroque shrine of the Birth of the Virgin, one of the most picturesque in Slovakia.

BIBLIOG. E. Lorad, Umelecko-historické pamätné kostoly na Slovensku (The Churches of Historic and Artistic Importance in Slovakia), Trnava, 1957.

Orava. The monumental castle situated on a high crag near Námestovo, was rebuilt several times from the 13th to the 18th century.

BIBLIOG. S. Klíma, Slovenské zámky (The Slovak Castles), Prague, 1921; Die Kunst in der Slowakei, Prague, 1939; K. Plicka, Die Slowakei, Prague, 1955.

Prešov. In Prešov is the beautiful late-Gothic structure of the Church of St. Nicholas (1520), in which the ribs of the vault rest directly on piers. It was remodeled within, during the baroque period, by J. Brengiszeyn (1709). The oratory portal (1511) and the baptismal font are in Renaissance style.

BIBLIOG. V. Wagner, Vrcholne gotická drevená plastika na Slovensku (High Gothic Sculpture in Wood in Slovakia), Turčiansky St. Martin, 1936; Die Kunst in der Slowakei, Prague, 1939; Š. Sabol, Prešov v minulosti a dnes (Prešov in the Past and Today), Bratislava, 1943; M. Jurkovič, ed., Slovenské múzeá (The Slovak Museums), Turčiansky St. Martin, 1945; V. Wagner, Vývin výtvarného umenia na Slovensku (The Development of Representational Art in Slovakia), Bratislava, 1948; K. Plicka, Die Slowakei, Prague, 1955; E. Lorad, Umelecko-historické pamätné kostoly na Slovensku (The Churches of Historic and Artistic Importance in Slovakia), Trnava, 1957.

Ružomberok. The oldest church in this city is that of St. Sofia (14th cent.), fortified during the Middle Ages. The Church of St. Andrew is from 1585, and the Piarist Church, from 1727. Liptovské Múzeum.

BIBLIOG. M. Jurkovič, ed., Slovenské múzeá (The Slovak Museums), Turčiansky St. Martin, 1945; V. Wagner, Vývin výtvarného umenia na Slovensku (The Development of Representational Art in Slovakia), Bratislava, 1948.

Spišská Kapitula. The Church of St. Martin was built on the site of an ancient church destroyed by the Tartars; it has a nave with two aisles, with Gothic vaults (1245–75), and is the work of Lombard masters. The reconstruction in 1472–78 gave the building a Gothic structure, except for the towers and several characteristically Renaissance additions. Conserved in it is the oldest Gothic fresco in Slovakia (1317), representing King Charles Robert of Anjou with his entourage; the fresco reveals the influence of Simone Martini. Of great merit are the four altars of the 15th century. Beside this church is the Gothic Chapel of the Zápoľský family (1488–93). There is a diocesan museum.

BIBLIOG. V. Wagner, Vrcholne gotická drevená plastika na Slovensku (High Gothic Sculpture in Wood in Slovakia), Turčiansky St. Martin, 1936; Die Kunst in der Slowakei, Prague, 1939; V. Wagner, Gotické tabuľové maliarstvo na Slovensku (Gothic Panel Painting in Slovakia), Turčiansky St. Martin, 1942; V. Wagner, Vývin výtvarného umenia na Slovensku (The Development of Representational Art in Slovakia), Bratislava, 1948; K. Plicka, Die Slowakei, Prague, 1955; E. Lorad, Umelecko-historické pamätné kostoly na Slovensku (The Churches of Historic and Artistic Importance in Slovakia), Trnava, 1957.

Spišská Nová Ves. The Gothic church with nave and two aisles was built after the Tartar invasion (1271); despite the reconstruction in 1441, it retains its original appearance. The church has a very fine Neo-Gothic tower (1894). The influence of P. Parler is evident in the rich portal; the *Calvary*, on the other hand, is akin to the style of Paul of Levoča. A Flemish painting of the *Madonna and Child* dates from 1545. The bronze baptismal font is from 1549.

BIBLIOG. V. Wagner, Vývin výtvarného umenia na Slovensku (The Development of Representational Art in Slovakia), Bratislava, 1948; E. Lorad, Umelecko-historické pamätné kostoly na Slovensku (The Churches of Historic and Artistic Importance in Slovakia), Trnava, 1957.

St. Beňadik nad Hronom. The Gothic Basilica of St. Benedict (1370–75), rebuilt after the Hussite wars (1483), has a very fine portal with late Gothic decoration (1532). The rococo altars are from 1766. There are medieval frescoes of the story of St. George.

BIBLIOG. V. Wagner, Gotické tabuľové maliarstvo na Slovensku (Gothic Panel Painting in Slovakia), Turčiansky St. Martin, 1942; V. Wagner, Vývin výtvarného umenia na Slovensku (The Development of Representational Art in Slovakia), Bratislava, 1948; E. Lorad, Umelecko-historické pamätné kostoly na Slovensku (The Churches of Historic and Artistic Importance in Slovakia), Trnava, 1957.

Trenčín. The baroque Church of St. Francis Xavier (1653) has illusionistic frescoes after designs of Andrea Pozzo (1709); a high altar by C. Tausch, replacing the original (1607); and a fine funerary monument of the Illéshazy family (1649). The castle, of the 13th century, was rebuilt in 1551. There is a Jesuit College, of 1653, and a museum.

BIBLIOG. S. Klíma, Slovenské zámky (The Slovak Castles), Prague, 1921; V. Wagner, Gotické tabul'ové maliarstvo na Slovensku (Gothic Panel Painting in Slovakia), Turčiansky St. Martin, 1942; M. Jurkovič, ed., Slovenské múzeá (The Slovak Museums), Turčiansky St. Martin, 1945; V. Wagner, Vývin výtvarného umenia na Slovensku (The Development of Representational Art in Slovakia), Bratislava, 1948; K. Plicka, Die Slowakei, Prague, 1955.

Trnava. The Gothic parish Church of St. Nicholas, with a nave and two side aisles, two towers, and apse (1380), underwent considerable alteration in 1619. The polygonal Chapel of the Virgin, with dome without drum, is by G. R. Donner (1745), who also erected the illusionistic frescoes in the dome. The baroque Church of St. John the Baptist (architect Pietro Spezzo, 1637-1700) has stucco decoration by L. da Colombo. The monumental high altar in wood with 27 figures of saints arrayed in three rows, is the work of B. Knilling, L. Knoth, and V. Stader (1640). Also notable are the Franciscan Church, 14th century, the neoclassic Town Hall, and the museum.

BIBLIOG. Die Kunst in der Slowakei, Prague, 1939; M. Jurkovič, ed., Slovenské múzeá (The Slovak Museums), Turčiansky St. Martin, 1945; V. Wagner, Vývin výtvarného umenia na Slovensku (The Development of Representational Art in Slovakia), Bratislava, 1948; K. Plicka, Die Slowakei, Prague, 1955; E. Lorad, Umelecko-historické pamätné kostoly na Slovensku (The Churches of Historic and Artistic Importance in Slovakia), Trnava, 1957.

Turčiansky St. Martin. Center of the Slovak national independence movement, this city had a vast urban development after 1918. The National Museum contains an important collection of folklore material. The Slovenská Matica is a center of Slovak studies.

BIBLIOG. V. Wagner, Gotické tabul'ové maliarstvo na Slovensku (Gothic Panel Painting in Slovakia), Turčiansky St. Martin, 1942; M. Jurkovič, ed., Slovenské múzeá (The Slovak Museums), Turčiansky St. Martin, 1945.

Zvolen. The castle of Louis the Great (1361) has preserved a Gothic atmosphere; it has groined vaults and a Renaissance covered gallery (1548-58). The parish church (14th century), has frescoes of the *Passion*, of the Danubian school of the 15th century. The museum is notable.

BIBLIOG. S. Klíma, Slovenské zámky (The Slovak Castles), Prague, 1921; Die Kunst in der Slowakei, Prague, 1939; M. Jurkovič, ed., Slovenské múzeá (The Slovak Museums), Turčiansky St. Martin, 1945; V. Wagner, Vývin výtvarného umenia na Slovensku (The Development of Representational Art in Slovakia), Bratislava, 1948; K. Plicka, Die Slowakei, Prague, 1955; E. Lorad, Umelecko-historické pamätné kostoly na Slovensku (The Churches of Historic and Artistic Importance in Slovakia), Trnava, 1957.

Maja MILETIĆ

Illustrations: 3 figs. in text.

**DADA.** See EUROPEAN MODERN MOVEMENTS.

**DADDI, BERNARDO.** Florentine painter. The date of his birth is unknown, but probably it was toward the end of the 13th century, since in two books of records, dated from 1312–20 and 1320–53, he is mentioned as a member of the guild of doctors and apothecaries (Arte dei Medici e Speziali). His triptych for the Church of Ognissanti (PL. 106) is dated 1328; the small altarpiece in the Loggia del Bigallo, 1333; and the *Madonna dell'Accademia*, 1334 (although the date is no longer visible). In 1335 he painted a panel, now lost, for the altar of S. Bernardo in the Palazzo della Signoria, Florence. (Daddi also bought a house in Via Larga in this year.) In 1338 he executed an altarpiece representing three Dominican saints, formerly in the Church of S. Maria Novella, Florence, now also lost. In 1339 his name is listed among the councilors of the Compagnia di S. Luca and also appears as a witness to a death. In 1340 Daddi painted a panel for the choir of S. Maria a Quarto, a country church about four miles north of Florence, and in 1341 he did another panel for the high altar of the same church. Both are now lost. His polyptych with Madonna and saints for an altar in the Chiostro Verde of S. Maria Novella was executed in 1344. In 1347 he was paid for a *Virgin and Child* (PL. 107) for Orsanmichele. The next year, 1348, in which his death is reported, Daddi painted a polyptych, formerly at the Church of S. Giorgio a Ruballa, near Florence, at present in the Gambier-Parry Collection, Highnam Court, Gloucester, England.

Daddi is mentioned by early historians only in rare and casual references. In modern times the researches of Passerini (1886) and Milanesi (1901) have resulted in identifying the Bernardo di Daddo of the records with Bernardus de Florentia, whose signature appears on a number of 14th-century paintings. The first historical outline of Daddi's activities, however, was the study devoted to him by Vitzthum (1903). The admiration which modern taste has accorded Daddi has unduly swollen the list of works attributed to him. Offner, in his exhaustive study (1930 and 1934) of Bernardo Daddi and his followers, rightly reacted against the indiscriminate attribution of paintings to Daddi and shortened, perhaps too drastically, the list of those works considered genuine. The excess of pictures attributed to Daddi is due particularly to inadequate knowledge of the artists who worked around him in the Florentine environment of Giotto (q.v.) and his immediate followers. Even an understanding of Daddi as an artistic personality suffers from the uncertainty of his historical framework. To some, in fact, he appears to be a painter of indecision, vacillating between the styles of Florence and Siena, according to the scope and size of his works. Others see him as a kind of rebel, full of contradictions, who seems suddenly to have freed himself from his early education in the school of Giotto and to have turned toward the new Gothic style favored by the Sienese painters of his day. However, Daddi's first works, generally considered different from his later and more valued paintings, point in the direction of his later development. The lively interest he was to develop in the Sienese painters, in particular Ambrogio Lorenzetti, did not arise from any desire to free himself from his Giottesque training. On the contrary, it grew naturally from a wholehearted adherence to the fullness, serenity, and intense color of the compositions of Giotto's last period. It may well be that Daddi perceived the letter rather than the spirit of Giotto's great paintings. It is undeniable, however, that the triptych of Ognissanti, showing the Virgin and Child with saints (PL. 106), which Daddi painted in 1328, derives from such works of Giotto as the polyptych with a Madonna in the central panel (once attributed to Daddi), now in the National Gallery, Washington, and the polyptych of the *Madonna and Four Saints* in Sta Croce in Florence. Daddi's frescoes of the *Martyrdom of St. Lawrence* (PL. 106) and *Martyrdom of St. Stephen* in the Pulci-Berardi Chapel of Sta Croce are strongly influenced by Giotto's paintings in the Peruzzi and Bardi chapels in the same church. It is precisely in these large-scale works, rather grandiose in character, that one realizes the limitations of Daddi's art. As far as present knowledge of him allows one to judge, his talent does not appear to be suited to compositions of ample spread. When Daddi uses the same spatial relationships of the large works in smaller compositions, such as the beautiful panels of the story of St. Cecilia, now in Pisa (Mus. Civ.; PL. 105), his true poetic qualities are revealed in the delicate simplicity of the interrelation of colored surfaces.

The small altarpiece of the loggia of the Bigallo, which depicts an enthroned Madonna in the center panel (1333), is usually cited as the sudden turning point in the development of Daddi's style. In fact, it does not depart far from the canons then current among Giotto's followers, as can be seen in a similar composition of the triptych by Taddeo Gaddi in Berlin (Staat. Mus.). Little portable triptychs similar to these with a particular type of Madonna — the loving mother playing with her child — were popular in Florence and a frequent product of Daddi's studio.

One of the most characteristic examples of the art of Daddi in full maturity is the polyptych of S. Pancrazio (PLS. 103, 104), which is imposing in construction and virtually complete in every element. In this work reflections of Ambrogio and Pietro Lorenzetti and Simone Martini, as well as ideas drawn from the sculpture of Andrea Pisano, are fused together into a harmonious composition the style of which combines gravity with esthetic beauty. The predella takes the form of a fresh, spontaneous, though far from simple, narrative. Other works by Daddi of a similar character include the predella depicting the legend of the Virgin's Girdle (PL. 105); the panels

of the story of St. Stephen in Rome (Vat. Mus.); and the panels of the story of St. Dominic in Paris (Mus. des Arts Décoratifs), New Haven, (Yale Univ., Jarves Coll.), and Poznán (Nat. Mus.). Among Daddi's best works are the enchanting Madonna formerly owned by Bernard Berenson and a representation of the archangel Michael (Crespina, near Pisa, S. Michele), with poignant intensity of expression. The latter should be placed in Daddi's mature period rather than in his youth (Offner, 1930 and 1934), if, as appears to be the case, it was influenced by the similar composition of Ambrogio Lorenzetti at the Badia a Rofeno, near Asciano.

Despite his contacts with Sienese painting, Daddi was never to forget his training in the school of Giotto, and its influence was to remain effective in his work to the end. There is evidence of this in the polyptych of the Church of S. Giorgio a Ruballa, near Florence, and in the *Virgin and Child* in Orsanmichele (PL. 107), in which the severe style of Andrea di Cione, called Orcagna, and his brother Nardo is foreshadowed. The highest note of lyric beauty in Daddi's later period is perhaps sounded in the three very beautiful panels of the story of St. Barbara (or St. Catherine, according to some authorities) now in the Metropolitan Museum, New York, and the Wauters Collection, Brussels.

A list of works attributed to Daddi is to be found in the appropriate volume of Offner's *Corpus*. There are, however, several more recent attributions to be added, such as the *St. Benedict* (Coletti, 1936) in the Bardini Collection, Florence; the *Enthroned Madonna with Child, Angels, and Saints* (Offner, 1930 and 1934) in the Beckland Collection, Hove, Sussex, England; the polyptych with *Madonna, Child, and Four Saints* (Bacci, 1939), once in the Church of S. Pietro alle Stinche, discovered in the presbytery of the Church of S. Martino at Monterinaldi, near Radda, Tuscany; and the two fragments of an altar frontal with the story of St. Ursula (Longhi, 1950, and Berenson, 1932) in the Stoclet Collection, Brussels, and the Landesmuseum, Zurich.

BIBLIOG. L. Passerini, Curiosità storico-artistiche fiorentine, Florence, 1886; G. Milanesi, Nuovi documenti, Florence, 1901; G. Vitzthum, Bernardo Daddi, Leipzig, 1903; G. Vitzthum, ThB, s.v.; R. Offner, The Works of Bernardo Daddi, New York, 1930; R. Offner, A Critical and Historical Corpus of Florentine Painting, sec. 3, vol. III (Bernardo Daddi), New York, 1930, and sec. 3, vol. IV (close and distant followers of Daddi), New York, 1934; B. Berenson, Italian Pictures of the Renaissance, Oxford, 1932; P. Bacci, Dipinti inediti e sconosciuti di Pietro Lorenzetti, Bernardo Daddi..., Siena, 1939; G. Sinibaldi and C. G. Brunetti, Pittura italiana del Duecento e Trecento, Catalogo della mostra giottesca del 1937, Florence, 1943; L. Coletti, I primitivi, II, I senesi e i giotteschi, Novara, 1946; R. Longhi, Un esercizio sul Daddi, Paragone, III, 1950, pp. 16–19; P. Toesca, Il Trecento, Turin, 1951, pp. 622–24; M. Cohn, Due tondi sconosciuti della pala di S. Pancrazio di Bernardo Daddi, BArte, Ser. 4, XLII, 1957, pp. 176–78.

Giovanni PACCAGNINI

Illustrations: PLS. 103–107.

**DALI,** SALVADOR. Spanish painter (b. Figueras, Spain, May 11, 1904). In 1921 he entered the Escuela de San Fernando, Madrid, but after a stormy student career was finally expelled in 1926. In 1925–26, he exhibited in Madrid and Barcelona; and in 1928, while visiting Paris, he met the surrealists. He moved to Paris in 1929 and exhibited there in that year. In 1934 Dali made his first trip to the United States, where he settled in 1940 after visiting Italy between 1937 and 1939. In 1939 he designed the pavilion *Dali's Dream of Venus* for the New York World's Fair. After World War II he revisited Europe, and in 1956 delivered a lecture at the Sorbonne. Characteristic paintings are *The Persistence of Memory* (1931; New York, Mus. of Modern Art), *Soft Construction with Boiled Beans; Premonition of Civil War* (1936; Philadelphia, Mus. of Art), and *The Last Supper* (1955; Washington, Nat. Gall.). His activities, however, extend to many other media, including jewelry. He has collaborated with Luís Buñuel on such films as *Un Chien andalou* (1929) and *L'Age d'or* (1931) and has also designed many ballet sets and costumes, among which are *Bacchanale* (1934), *Labyrinth* (1941), and *The Mad Tristan* (1944). Dali's work also comprises many book illus-

trations, such as those for Lautréamont's *Les Chants de Maldoror* (1934) and *Don Quixote* (1946) and his own writings.

The most famous of the surrealists, Dali began to formulate his characteristic style and attitude in the early 1920s under the influence of De Chirico and Carrà. His pursuit of the irrational, however, reached a more extravagant extreme after his contact with such Paris surrealists as Ernst, Yves Tanguy, and Breton in 1929, when he dedicated himself to the transcription of dreams and paranoiac visions. In part inspired by the realistic styles of such masters as Vermeer and Meissonier, Dali achieved these "dream photographs" with a meticulous technique that paradoxically recorded as objective fact the most subjective fantasies. His description of the subconscious world includes such enigmatic phenomena as the juxtaposition of unrelated objects, the malleability of solid forms, hallucinatory double images, and immeasurable perspectives. See EUROPEAN MODERN MOVEMENTS; V, PL. 133.

WRITINGS. La Femme visible, Paris, 1930; The Secret Life of Salvador Dali, New York, 1942; Dali on Modern Art, New York, 1957.

BIBLIOG. J. T. Soby, Salvador Dali, 2d ed., New York, 1946; A. Oriol Anguera, Mentira y verdad de Salvador Dalí, Barcelona, 1948; J. A. Gay, Nuño, Salvador Dalí, Barcelona, 1950; R. Santos Torroella, Salvador Dalí, Madrid, 1952; A. Reynolds Morse, Dali, a Study of His Life and Work, Greenwich, Conn., 1958.

Robert ROSENBLUM

**DANUBIAN-ROMAN ART.** This category encompasses the art of the Roman period in the valley of the Danube from its upper course to its mouth. The area includes the Roman provinces of Raetia, Noricum, Upper and Lower Pannonia (superior and inferior), Upper and Lower Moesia (superior and inferior), and Dacia. While the process of Romanization in Upper Moesia goes back as far as the second half of the 1st century B.C., it did not begin in Dacia until the time of Trajan (A.D. 107). In the other Danubian regions Roman cultural elements were already plainly visible early in the 1st century. The golden age came in the 2d century. In the 3d century, local trends reappeared, though at first still within the limits of Roman culture. With the abandonment of Dacia in A.D. 271, under Aurelian, the Romanization of the province came to an end; the disorder created by migrations in the 5th century led to the dissolution of Roman culture in other Danubian lands. Isolated pockets of Roman culture survived till the 6th century in southern Noricum.

The characteristics of artistic production in the whole of the Danubian territory are essentially Roman provincial, but the influences apparent in it are not homogeneous. Along the upper course of the river, about as far as the area of Passau (anc. Castra Batava) and Salzburg (anc. Juvavum), types deriving from the Gallo-Roman regions (see GALLO-ROMAN ART) — especially Upper Germany (the Rhineland) — prevail in relief sculpture and architecture. Architectural forms originating there penetrated as far as Pannonia. On the other hand, the influence of official Roman art from the south was rarely felt; it reached the Danube only indirectly through the work of the northern Italian sculptors or the workshops of southern Noricum, particularly those at Virunum. As might be expected, along the lower course of the river (Lower Moesia), Greco-Hellenistic stylistic tendencies prevailed over Italo-Roman ones.

In any consideration of the art of the Danubian regions in Roman times, local characteristics rather than the Roman elements should be examined more closely. Therefore, artistic importations from the south or east will not be dealt with here, nor will buildings and urban centers of an evidently Roman character. That art which seems to be more explicitly indigenous will be emphasized.

SUMMARY. Architecture (col. 226): *Sacred buildings; Funeral monuments; Houses; Villas; Baths.* Wall painting (col. 229). Mosaics (col. 230). Sculpture (col. 230). Minor arts (col. 232).

ARCHITECTURE. *Sacred buildings.* The Celtic-Roman temple with an external ambulatory, a square cella, and a wooden porch,

common in France and western Germany, appears even more frequently in Noricum (FIG. 229; see CELTIC ART). Another Celtic type may be seen in the round temple at Budapest (anc. Aquincum). Locating the entrance on the long side, as found in three sacred buildings in Linz (anc. Lentia), Austria — a large temple (perhaps that of the Capitoline triad), a temple with a bipartite cella, and a Mithraeum — may also be traced to an indigenous tradition. Certainly of local origin are the sacred enclosures containing various small shrines. A unique indigenous form is the double temple at Zollfeld (anc. Virunum) near Klagenfurt, Austria.

*Funeral monuments.* Because of their poor state of preservation only a few types of funeral monuments can be recognized. The so-called "Belgian-Germanic pillar tombs," re-

Hungary; and Istrus, north of Constanța, in Romania. The only known example of a megaron house is a rustic villa at Wimsbach, Austria, from the 1st century. A more frequent type of structure is a house that in its simplest form consists of a single room with hearth. Smaller secondary rooms sometimes lead off from one or both sides of the entrance, and an atrium may be placed in front of the house. The principal room may have its dimensions greatly reduced, or it may be elaborated in various ways and may take on quite different forms: rectangular, L-shaped, or T-shaped (FIG. 229). The function of this principal chamber also varies, from a main living room that can be heated to simply a connecting hall or even a narrow open courtyard. The earliest examples of this wooden building technique, found at Kempten in Bavaria, go back to the 1st century; the most recent examples of the stone

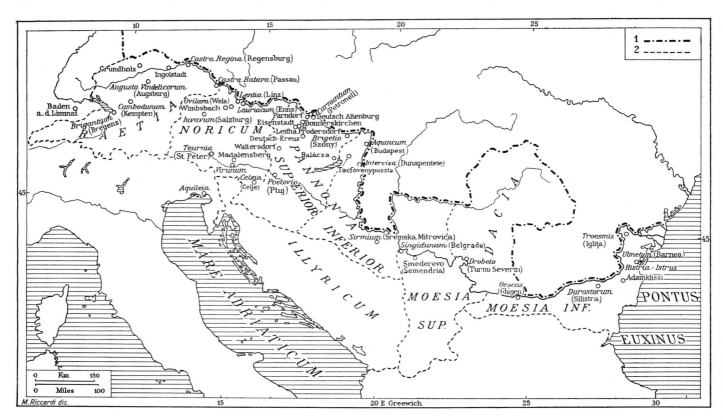

Roman centers in the Danube basin: (1) Boundary of the Roman Empire in the 2d cent. of our era; (2) boundaries of Roman provinces.

sembling towers with pyramidal roofs, occur in a few places in the upper valley of the Danube. Along the Danube from Enns (anc. Lauriacum) in Austria to the Black Sea, there is found a type of tall funeral chapel having two recumbent lions on its roof and walls adorned with sculpture. The richly decorated funerary buildings of southern Noricum often have roofs like baldachins and contain statues of the deceased. A singular form is the so-called "pillory" at Ptuj (anc. Poetovio), Yugoslavia, a stone stele about 15 ft. high and 6 ft. wide that is decorated with numerous reliefs. A funeral building having a pyramidal roof supported by four columns and containing a statue of the deceased in the center was discovered at Aquincum.

*Houses.* There are two principal building techniques: one in masonry, utilizing stone alternated with rows of brick; the other — more frequently used — in stone and wood, i.e., wooden beams resting on a stone foundation, with the intervening spaces filled with clay or stone.

The peristyle house imported from the south, with a court-yard and portico in the center of the structure, is more rare; there are examples at Augsburg (anc. Augusta Vindelicorum) and Kempten (anc. Cambodunum) in Bavaria; Budapest in

and wood construction, at Petronell (anc. Carnuntum) in Austria, may be placed in about the second half of the 3d century.

*Villas.* The construction of the country house is usually very simple. The building faces an ordinarily irregular quadrangle, as at Burgweinting near Regensburg (anc. Castra Regina), Bavaria (1st cent. to the middle of the 3d cent.), and Donnerskirchen, Austria. In this basic type, the bath is generally a separate building. Occurring with even greater frequency is a more pretentious type, the so-called "porticus villa," in which the façade consists of a porch having a colonnade set between two projecting wings that are usually formed by apsidal rooms. In this more elaborate layout, the bath is usually in one of the wings. Villas of this kind are especially numerous in the Rhineland, where they probably represent the enlargement of the residence of a Celtic lord according to Roman architectural plans. There is often an apsidal room at the back, and the center may be occupied by a court containing secondary structures. The evolution of this sort of country house extends from the 1st to the 3d century. Examples of the style are seen in a villa at Grundholz near Mauren, northwest of Donauwörth, Bavaria; at Parndorf near Eisenstadt, Austria (FIG. 231); the

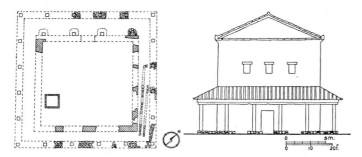

Celtic-Roman temple with external ambulatory at Linz (anc. Lentia), Austria (*hypothetical reconstruction of plan and elevation after P. Karnitsch, Jhb. der Stadt Linz, 1954*).

Gölbesäcker villa, northwest of Eisenstadt; a town hall at Bregenz (anc. Brigantium); the governor's place in Budapest; and a villa at Balácza, Hungary.

Unlike the porticus villa, the peristyle villa (central court with portico) seems to derive from a purely southern tradition. Usually, it also has an apsidal room at the back of the interior court. Examples of the peristyle villa are found in country houses in the following locales: at Westerhofen near Ingolstadt, Bavaria; at Tacfövenypuszta, Hungary; and at Barnea (anc. Ulmetum), Romania. The chronological limits for this style are also from the 1st to the 3d century.

*Baths.* These structures are mentioned merely to stress that the type with rooms placed next to one another (calidarium, tepidarium, frigidarium) is prevalent in the area under discussion in this article. This preference may originate in the fact that the existing indigenous installations had a similar layout. The characteristic Roman centralized plan is found only once — at Augsburg in Bavaria.

WALL PAINTING. A richer style of painting, similar to that known as the Pompeian Style III, appeared only in Virunum. In the other Danubian regions, stylistic differences are most apparent between the painting done along the upper Danube and that found along the middle and lower Danube. The style of the first area is similar to the wall decoration of the Gallo-Germanic territories, that is, Romanized Western Europe. The second style, on the other hand, shows a prevalent Hellenistic-Oriental influence. In both areas the basis of the style is a simple division of the composition into fields. This characteristic simplicity of composition increases gradually as one proceeds downward along the Danube; the farther south one goes, the rarer the use of figures in the paintings. In some of these southerly areas, simulations of inlay are a prevalent artistic form. Walls are faced with slabs of colored stone, and these otherwise undecorated fields are separated by framing bands. A stucco frieze set about a third of the way down the wall usually completes the decorative scheme. The so-called "floral style" (floral motifs scattered over the wall surface) appeared in the first half of the 3d century, while the "carpet style" (a motif repeated as a regularized all-over pattern on a rectangular field) developed toward the end of the century. With

the 4th century came further simplification. Tomb paintings of the 3d and 4th centuries are characterized by figures with strong outlines and squat proportions (PL. 111).

MOSAICS. Mosaic pavements of good quality that are extant in Danubian regions are surely the work of foreign artists and therefore show no local characteristics. The beautiful mosaic in a villa at Westerhofen near Ingolstadt recalls other examples from the Rhineland dating from the beginning of the 3d century. The Dionysus mosaic found in the public bath of Virunum belongs to a later phase of the same group — about the second half of the 3d century. The sizable mosaic pavement at Balácza, Hungary, may be compared with Italian mosaics. The mosaic in Ghigen (anc. Oescus), Bulgaria, depicting a scene from an unknown comedy by Menander, displays Greek influence, both in its inscriptions and in its technique. While the discoveries at Petronell, Austria, have little importance for the study of mosaics, the villa at Parndorf near Eisenstadt has provided 380 sq. yd. of mosaic from this period, the most notable find north of the Alps. The motifs are for the most part ornamental, and a central panel appears in only two instances. The first such panel portrays Bellerophon fighting the Chimera; the second is a medallion showing the bust of a goddess. In the pavements at Parndorf, which date from the second half of the 3d century, the ornamental plait motif is absent. Some of the figure panels at Aquincum (e.g., Hercules wrestling Antaeus, the punishmant of Dirce), attributable to the 2d and 3d centuries, are purely linear and betray a provincial heaviness. In a large hall in the governor's palace at Aquincum is a mosaic representation of a stylized marine landscape rendered in the Greek taste of the Eastern Empire; this work dates from the first half of the 3d century. The most recently discovered antique mosaics from Noricum are those of Felicitas in Salzburg, which date from the first half of the 5th century and consist of purely ornamental reticulated motifs; and the carpet-like Early Christian mosaic in the cemetery church of Sankt Peter im Holz (anc. Teurnia), Austria, which dates from the beginning of the 6th century.

SCULPTURE. At most, an attempt can be made here to supply an over-all picture of the most important stylistic trends in the sculpture of the Danubian regions in so far as it differed from that which was manifestly Roman. A classification of the abundant available material according to content must necessarily be omitted; it can merely be pointed out that funerary art furnishes the greater part of Danubian sculpture.

Three indigenous stylistic trends can be distinguished in Danubian sculpture. The first style is close to Roman sculpture but is characterized by a provincial simplification. A typical example of this trend is the funerary relief of a husband and wife from the Göggingen bridge at Augsburg (PL. 108). The figures are still perceived in a completely tactile manner; they move with relative freedom in their space and, despite a certain degree of stiffness, elicit the classical quality of ponderosity. The clothing takes the contours of the body into consideration, and the folds fall according to the laws of gravity, with the Greco-Roman drapery scheme essentially unchanged. The provincial characteristics are revealed in the degree and kind of simplification. In the execution of the folds, smooth areas

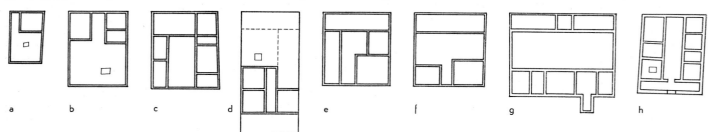

a          b          c          d          e          f          g          h

Indigenous house plans of the Roman period: (*a*), (*b*), (*c*), and (*d*) from Kempten (anc. Cambodunum), Austria (*from L. Ohlenroth, Allgäuer Geschichtsfreund, LIII, 1952*; (*e*) and (*f*) from Budapest (anc. Aquincum), Hungary (*from T. Nagy, Antiquitas Hungarica, II, 1948*; (*g*) from Deutsch Kreuz Austria (*from A. Barb, Wissenschaftliche Arbeiten aus dem Burgenland, IV, 1954*); (*h*) from Petronell (anc. Carnuntum), Austria (*from E. Swoboda, Carnuntum, 2d ed., Vienna, 1953*). The plans are not drawn on the same scale.

predominate, and the folds themselves are not always rounded but are often simply indicated by a groove. While this manner of modeling is particularly frequent in the territories along the Rhine, there are also many examples of it in the Danube Valley, for the most part limited to its upper course, especially around Augsburg and Regensburg. The works of the Master of Virunum, from the first half of the 2d century, demonstrate how this style of provincial simplification is realized in sculpture in the round. When not making actual copies, he reworks classic types and in his versions confers on them an accentuated frontality and a more deliberate rigidity, such as in his *Mars* (PL. 108). As one goes downstream along the Danube, only isolated examples of this style are encountered, such as the figure in a toga from Oescus, now in Sofia (Ferri, 1933, figs. 532–33).

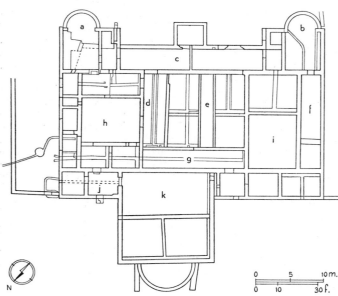

Plan of the Parndorf villa near Eisenstadt, Austria: (*a*) Small apsidal hall; (*b*) small apsidal hall (probably a bath); (*c*) porticus; (*d*), (*e*), (*f*), (*g*) corridors; (*h*) large heated room; (*i*) court (?); (*j*) vestibule with four entrances; (*k*) apsidal hall (*from B. Saria, Burgenländishe Heimatblätter, XIII, 1951*).

The dates for these works coincide with the flowering of the Roman provinces, that is, the period between the second half of the 1st century B.C. and the beginning of the 3d century of our era. Around the lower reaches of the Danube this provincial simplification assumes a different aspect, for here the underlying influences are Greco-Hellenistic. Consequently, even in the crudeness of the provincial work, one is aware of both the pathos and the more elaborate drapery that are characteristics of the Hellenistic style (Ferri, 1933, figs. 488–89).

The second stylistic direction is distinguished by what may be called an archaic manner and is divided into two types. One of these is characterized by a massive, blocklike appearance [A. Hekler's so-called "military style" (*Soldatenstil*)]; the other exhibits a taste for grooved work. The family gravestone from Leitha-Prodersdorf, Austria, exemplifies the qualities of the former type (PL. 108). The figures are very simply expressed in this blocklike fashion, and absolute frontality prevails. The lack of interest in working out spatial problems is obvious and even accentuated here (for instance, the boy placed above and between the two women). Works in this style, generally funerary reliefs, are seldom uncovered in the upper valley of the Danube (Ferrari, 1933, figs. 16, 20, 21); but at Carnuntum and farther downstream they appear more frequently. The chronological limits for the style are difficult to establish.

The type within the second style that is characterized by grooving, like the block type, also originated in a naïve and archaic attitude toward sculptural form but is executed on a higher and more complex level. In the drapery — at first still massive in its proportions — grooved parallel folds are often inserted and arranged in a decorative manner. The re-

liefs from Trajan's monument at Adamklissi in the province of Dobruja, Romania, are executed in a grooved block technique (PL. 111). This approach was also used sometimes by local masters who had good classical training; and the combination of this style and Greco-Roman figure types takes on particular charm, as in the funeral clipeus of a husband and wife in Wels (anc. Ovilava; PL. 108). The grooved style, of which examples dating as far back as the first half of the 1st century of our era are extant, has a timeless quality that makes it difficult to date pieces not accompanied by external evidence. Along the upper Danube and in southern Noricum the style is rare; but the farther one goes downstream, the more frequently it is met with and the more easily identifiable are its products. This local preference for an archaic quality in their art is not so much a sign of primitivism as of a special taste among the Danubian peoples. This is true to the extent that even in imported pieces the preference is for works in the archaic style. In the local sculpture and reliefs archaic curls, folds stylized in the archaic manner, strongly emphasized musculature of a protoclassic type, and lack of feeling for space in the placing of the figures (e.g., the bas-relief of Orpheus from Intercisa; PL. 110) are noted. The block style and the grooved style were both evident in all the Roman provinces. The simplified provincial style and the work in the archaic manner were essential forerunners of late-antique sculpture.

The third style, characterized by knotwork and curves, is for the most part influenced by the artistic production of the Celts in the Danubian area. A small Celtic coin of the first half of the 1st century, of the type known as Karlstein, that bears the image of a horseman typifies its characteristics (cf. III, PL. 116). The figures of rider and horse are barely recognizable; the rider is defined by four knots, the horse by many rounded spots that tend visually to separate from one another. The tail has become a separate raised curve. This tendency to accentuate sculptural values through isolated involutions and thus to break the closed context of the figure can often be observed in the sculpture of the Noric-Pannonian areas. One example of such work, a small bronze plate from Mühlendorf near Eisenstadt, dating from the 1st century of our era, is so full of knotwork and curves in relief that at first the mask and two reclining figures can hardly be apprehended. A second example of this manner is an impression from a cake mold from Carnuntum, belonging to the second half of the 3d century (PL. 110). In a bust of Jupiter, the beard and hair, the eye, the nose, the lips, the leaves of the wreath, the scepter, and the rosettes are all reduced to so many isolated knots. A third example, a relief of Orpheus from Enns, Austria, serves as an illustration of the adaptation of knotwork and self-contained curves to classic models (PL. 109). The figure of Orpheus, the lyre, the tree, and the birds are achieved largely in terms of rounded forms set apart from one another. All provincial Noric-Pannonian works of art that are sometimes described as "baroque" belong to this knotwork-curve manner. The highest expression of this style in the field of sculptural decoration is the so-called "Noric" cyma, which certainly represents a survival of the so-called "La Tène" ornament of the ancient Celts. This type of sculptural expression may be seen in the detail of a sarcophagus from Sremska Mitrovica (anc. Sirmium), Yugoslavia (PL. 110), and in a relief with *sella curulis* from Waltersdorf, Austria (PL. 110). The knotwork-curve manner — whose golden age was in the 3d century — begins along the upper Danube, is prevalent between Lauriacum and Aquincum, and disappears along the lower Danube. It is also linked with the block and the grooved styles; this connection is clear from a comparison of the two reliefs of Orpheus.

MINOR ARTS. A characteristic kind of work called *ajouré* ornament may be considered the major form under this heading. It is a technique that appears in pins, belt buckles, and horse trappings. Two types can be distinguished. The first style uses curvilinear motifs, especially the pelta (shield) and the trumpet, and is undoubtedly a survival of the La Tène ornament. Here the positive and negative sculptural areas have almost equal significance and effect and are complemen-

tary. Examples of this tendency exist in the upper Danube, but the richest area for finds of this type extends from Lauriacum to Aquincum. These works are dated between the turn of the 2d and the first half of the 3d century. In the second type of *ajouré* ornament, the pierced design is composed of a network of geometric motifs and is applied to the body of the so-called Noric-Pannonian "wing brooches," belt buckles, and sword sheaths. Often, letters are inserted within the pattern. These decorations, already found in the 1st century, were used until the 3d century. A workshop producing examples of this technique certainly existed at Baden an der Limmat in Switzerland, and works of this kind may also have been made in the valley of the Danube. Brooches and pendants with varicolored enamel inlay work are of Gallic origin, despite the fact that examples are frequently found along the Danube.

ARTISTS. *a. Architects.* Apollodoros ('Απολλόδωρος) of Damascus, reign of Trajan: bridge over the Danube, near Turnu Severin (anc. Drobeta), Romania, A.D. 104–05; monument at Adamklissi (attributed; see APOLLODOROS). – Sempronius Valens, military architect active at Troesmis (Igliṭa), Romania; named in a list of veterans of A.D. 134 (CIL, III, 6187, 1, 5; I. Calabi Limentani, EAA, s.v. Architetto. – Athenaios ('Αθήναιος) and Kleodamos (Κλεόδαμος) of Byzantium, reign of Gallienus: restored and fortified the cities damaged by the Scythians in the Danubian area (ThB, s.v. Athenaios; I. Calabi Limentani, EAA, s.v. Architetto). – Aurelius Maximus, military architect of uncertain period; mentioned in an inscription of Turda (anc. Potaissa), Romania (Ephemeris Epigraphica, IV, 1881, no. 138, II, 12; I. Calabi Limentani, EAA, s.v. Architetto). *b. Sculptors.* Master of Virunum, to whom is attributed a group of statues found in the baths of Virunum and who worked from ca. A.D. 120 to ca. mid-2d cent.: two Dioscuri, Ares, Apollo, Hermes, Dionysus, Hermaphrodite, Sleeping Girl, an Aphrodite of the so-called "Fréjus" type, Isis-Noreia, Amazon (C. Praschniker, Der Meister von Virunum, Carinthia, I, 140, 1950, p. 3 ff.). – Romulianus, probably a sculptor of Pannonia, 2d–3d cent.; signature on base of the temple of Jupiter Dolichenus in Brigetio (Lippold, RE, Sup. VIII, s.v.). *c. Silversmiths.* C. Refidius Eutichus, 1st–2d cent.; named in a funerary inscription from Smederevo (Upper Moesia, CIL, III, 1652; I. Calabi Limentani, EAA, s.v. Argentarius).

BIBLIOG. *Architecture. a. Sacred buildings*: M. von Groller, Limes-station und Tempelanlage auf dem Pfaffenberg bei Deutsche-Altenburg, Der römische Limes in Österreich, I, 1900, col. 65 ff.; R. Egger, Ein heiliger Bezirk im Gebiete von Teurnia, ÖJh, XXV, 1929, col. 149 ff.; R. Egger, Aus dem römischen Kärnten, Carinthia, I, 128, 1938, p. 3 ff.; H. Dolenz, Ausgrabungen in Baldersdorf, Carinthia, I, 132, 1942, p. 28 ff.; Budapest Története (History of Budapest), I, 1942, Budapest az Okorban (Budapest in Antiquity), p. 353 ff.; H. Vetters, Der heilige Bezirk von Wabelsdorf, Carinthia, I, 136–138, 1948, p. 280 ff.; P. Karnitsch, Ein gallo-römischer Umgangstempel in der Linzer Altstadt, Jhb. der Stadt Linz, 1954, p. 503 ff.; J. Szilágyi, Aquincum, Budapest, 1956, p. 88; P. Karnitsch, Der heilige Bezirk von Lentia, Jhb. der Stadt Linz, 1956, p. 189 ff.; H. Vetters, Der Georgenberg bei Micheldorf, Oberösterreich, ÖJh, XLIII, 1956–58, Beiblatt, col. 123 ff. *b. Funeral monuments*: A. Conze, Römische Bildwerke einheimischen Fundortes in Österreich, Heft 2, 1875; F. Drexel, Die Belgisch-germanischen Pfeilergrabmäler, RM, XXXV, 1920, p. 27 ff.; S. Ferri, L'arte romana sul Danubio, Milan, 1933, p. 448; Budapest Története, I, 1942, Budapest az Okorban, p. 473 ff.; J. Klemenc, Das römische Gräberfeld in St. Peter in Sanntale, Archaeologia Jugoslavica, II, 1956, p. 57 ff.; H. Vetters, Zu den Spolien aus den Steinkistengräbern des Ziegelfeldes, Forschungen in Lauriacum, IV–V, 1957, p. 195 ff. *c. Houses*: F. Oelmann, Gallo-römische Strassensiedlungen und Kleinhausbauten, Bonner Jhb., 128, 1923, p. 77 ff.; Germania romana, II, 2d ed., Bamberg, 1924, pls. 4, 11; T. Nagy, Az Albertfalvai Romai telep (The Roman Station of Albertfalva), Antiquitas Hungarica, I, 1948, p. 92 ff., III, 1949, p. 135 ff.; J. Szilágyi, Az Aquincum (Egyszerü) lahóház-tipusok (The Simple House Types of Aquincum), Archaeologiai Ertesitö, LXXVII, 1950, p. 84 ff.; H. Vetters, Die Villa rustica von Wimsbach, Jhb. des oberösterreichischen Musealvereines, XCVII, 1952, p. 87 ff.; L. Ohlenroth, Cambodunum, 19, Grab-ungsbericht, Allgaüer Geschichtsfreund, LIII, 1952; Casa din epoca romană Tărzie (The Late Roman House), Histria, I, 1953, p. 324 ff., pl. 33; Sectorul din sud-vest al ceṭătii (The South-west Section of the Citadel), Histria, I, 1953, p. 293 ff., pl. 32; E. Swoboda, Carnuntum, 2d ed., Vienna, 1953, p. 158 ff.; Geschichte der Altertumsforschung im Burgenland bis 1938, Wissenschaftliche Arbeiten aus dem Burgenland, Heft 4, 1954; L. Ohlen-roth, Zum Stadtplan der Augusta Vindelicorum, Germania, XXXII, 1954, p. 76 ff.; J. Szilágyi, Aquincum, Budapest, 1956, p. 91. *d. Villas*: S. Jenny, Bauliche Überreste von Brigantium, Mitt. der Central Commission für Denkmalpflege, XII, 1886, p. 72 ff.; D. Laczkó and G. Rhé, Balácza, ed. K. Hornig, Veszprém, 1912; Germania romana, II, 2d ed., Bamberg, 1924, pls. 26, 2, 28, 2; W. Kubitschek, Römerfunde von Eisenstadt, Vienna, 1926, pp. 18 ff., 48 ff.; F. Wagner, Römer in Bayern, 4th ed., Munich, 1928, p. 57; W. Schmid, Archäologische Forschungen in Steiermark, ÖJh, XXV, 1929, Beiblatt, col. 97 ff.; L. Nagy, Die römische Villa auf dem Csúcshegy in Obuda (Altofen), Budapest Régiségei, XII, 1937, p. 27 ff.; J. Barnea, Nouvelles considerations sur les basiliques chrétiennes de Dobrudja, Dacia,

X–XII, 1945–47, p. 228, fig. 16 (peristyle villa, not basilica); B. Saria, Der Mosaikenfund von Parndorf zwischen Parndorf und Bruckneudorf, Burgen-ländische Heimatblätter, XIII, 1951, p. 49 ff.; E. Thomas, Die römerzeit-liche Villa von Tacfövenypuszta, Acta archaeologica Academiae scientiarum Hungaricae, VI, 1955, p. 79 ff.; J. Szilágyi, Aquincum, Budapest, 1956, Beilage II, p. 29 ff. *e. Baths*: E. Nowotny, Ein römisches Bad zu Mühldorf im Möllthale, Carinthia, I, 90, 1900, p. 125 ff.; M. von Groller, Grabungen in der Zivilstadt, Der römische Limes in Österrich, IX, Vienna, 1908, col. 43 ff.; R. Egger, Ausgrabungen in Noricum 1912–13, ÖJh, XVII, 1914, Beiblatt, col. 17 ff.; D. Krencker and E. Krüger, Trierer Kaiserthermen, Augsburg, 1929, p. 239, fig. 336; H. Vetters, Ein doppelapsidaler Bau aus der Zivilstadt Lauriacum und des Legionsbad von Lauriacum, Forschungen in Lauriacum, I, 1953, pp. 42, 49 ff.; L. Ohlenroth, Zum Stadtplan der Augusta Vindelicorum, Germania, XXXII, 1954, p. 76 ff., fig. 62; J. Szi-lágyi, Aquincum, Budapest, 1956, p. 39 ff.

*Wall painting*: L. Nagy, Die römischpannonische dekorative Malerei, RM, XLI, 1926, p. 79 ff.; A. Frova, Pittura romana in Bulgaria, Rome, 1943; H. Kenner, Antike römische Wandmalerei in Kärnten, Carinthia, I, 140, 1950, p. 150 ff.; K. Parlasca, Römische Wandmalerei aus Augsburg, Mate-rialhefte zur bayerischen Vorgeschichte, VII, 1956. *Mosaics*: R. Egger, Frühchristliche Kirchenbauten im südlichen Noricum, Vienna, 1916, p. 48 ff.; O. Klose and M. Silber, Juvavum, Vienna, 1929, p. 30 ff.; J. Wol-lanka, Ein römisches Mosaik aus Balácza, ÖJh, XXV, 1929, p. 1 ff.; Buda-pest Története, I, 1942; Budapest az Okorban, p. 598 ff.; C. Praschniker and H. Kenner, Der Bäderbezirk von Virunum, Vienna, 1947, p. 50 ff.; B. Saria, Der Mosaikenfund von Parndorf zwischen Parndorf und Bruck-neudorf, Burgenländische Heimatblätter, XIII, 1951, p. 48 ff.; T. Ivanov, Une mosaïque romaine de Ulpia Oescus, Sofia, 1954; J. Szilágyi, Aquincum, Budapest, 1956, p. 99 ff.; M. Kaba, Die Mosaikfussböden des Statthalter-palastes von Aquincum, Budapest Régiségei, XVIII, 1958, p. 79 ff.; R. Par-lasca, Die römischen Mosaiken in Deutschland, 1959, p. 101 ff. *Sculpture*: A. Hekler, Forschungen in Intercisa, ÖJh, XV, 1912, p. 174 ff.; A. Hekler, Kunst und Kultur Pannoniens in ihrer Hauptströmungen, Strena Buliciana, Zagreb, 1924, p. 107 ff.; B. Filow, L'art antique en Bulgarie, Sofia, 1925; F. Wagner, Die Römer in Bayern, 4th ed., Munich, 1928; S. Ferri, L'arte romana sul Danubio, Milan, 1933; G. G. King, Some Reliefs at Budapest, AJA, XXXVII, series 2, 1933, p. 64 ff.; A. Alföldi, Tonmodel und Relief-medaillons aus den Donauländern, Laureae Aquincenses, Festschrift für V. Kuzinszky, I, Budapest, 1938, p. 312 ff.; C. D. Daicoviciu, Siebenbürgen im Altertum, Bucharest, 1943; A. Frova, Lo scavo della Missione archeolo-gica italiana in Bulgaria, Rome, 1943; C. D. Daicoviciu, La Transylvanie dans l'antiquité, Bucharest, 1945; E. Diez, Die sella curulis auf provinzial-römischen Reliefsteinen der Steiermark, ÖJh, XXXVI, 1946, p. 97 ff.; C. Praschniker and H. Kenner, Der Bäderbezirk von Virunum, Vienna, 1947, p. 56 ff.; R. Noll, Kunst der Römerzeit in Österreich, Salzburg, 1949; C. Praschniker, Der Meister von Virunum, Carinthia, I, 140, 1950, p. 3 ff.; L. Ohlenroth, Grabmäler römischer Ehepaare aus Augsburg, Germania, XXXI, 1953, p. 32 ff.; A. Schober, Die Römerzeit in Österreich, 2d ed., Vienna, 1956; H. Kenner, Die Götterwelt der Austria Romana, ÖJh, XLIII, 1956–58, p. 99 ff.; H. Vetters, Zu den Spolien aus den Steinkistengräbern des Ziegelfeldes, Forschungen in Lauriacum, IV–V, 1957, p. 202 ff. *Minor arts*: M. Abramic, Zwei Bronzebeschläge vom norisch-pannonischen Limes, ÖJh, XII, 1909, Beiblatt, col. 113 ff.; W. Jenny, Keltische Metallarbeiten, Berlin, 1935, p. 15; W. Jenny, Zur Herkunft des Trompeterornamentes, Jhb. für prähistorische Kunst, X, 1935, p. 31 ff.; J. Sellye, Les bronzes émaillés de la Pannon e, Dissertationes Pannonicae, series 2, VIII, 1939.

Hedwig KENNER

The list of artists was prepared by Giovanna Quattrocchi and Anna Maria Tamassia.

Illustrations: PLS. 108–111; 4 figs. in text.

## DANUBIAN SCHOOL. See ALTDORFER; CRANACH.

## DASWANTH.
Indian painter of the Moghul school (q.v.), 16th century. Abū'l Fadl 'Allāmī, historian of Akbar's reign (1542–1605), says in his work *Ā'īn-i Akbarī* that Daswanth soon surpassed all the other painters of the court and became the first painter of his day. Although the same author admits that there were those who would have given preference to Basāwan (q.v.), Daswanth remains one of the most important figures of the Moghul school and in some respects unique.

Abū'l Fadl 'Allāmī further notes that Daswanth was of humble origin. His name seems to be connected with the Sanskrit *dāsa* ("slave"), which suggests that he was a Hindu. It is said that, as a boy, he was so taken with the love of drawing that he even drew on walls. These youthful attempts must certainly have been more than amateurish scrawls, since re-portedly the Emperor himself, when he saw them, considered Daswanth worthy of studying under Ḫvāğa 'Abdu'ṣ-Ṣamad (see 'ABDU'Ṣ-ṢAMAD), director of the imperial art school. It is likely that Daswanth was soon chosen to work with the artists charged with the illustration of the famous *Dastān-i Amīr*

*Ḥamza.* Unfortunately, none of these lovely miniatures bears its author's name, and it would be hazardous to attribute to Daswanth any specific one among them.

It is again Abū'l Fadl 'Allāmī who tells us that the life of this great artist ended tragically — that he killed himself during a fit of madness. We are further told that Daswanth left many works, but this seems unlikely since very few of the works which have come down to us bear his name. The fact that we do, however, know of many paintings signed by contemporaries who must have enjoyed less favor than he at the court and among connoisseurs has not been explained. Daswanth's name is to be found under only one illustration of a copy of the *Tīmur-nāma* in the library of Bankipore (Bihar Province, India), dated shortly after 1577, and on a large number of the miniatures illustrating the *Rasm-nāma* (the Persian translation of the *Mahābhārata*) in the library at Jaipur (cf. Hendley, 1883). A painting in the National Museum of India at Delhi is signed with the name of Daswanth; but this is undoubtedly a forgery by a mediocre painter who hoped to increase the value of his own work by signing it with the name of a very famous artist.

The *Rasm-nāma* of Jaipur is therefore the only source that allows us to judge of Daswanth's talents. The copy in question was probably destined for the Emperor himself and was perhaps done shortly after 1584, the year in which the translation of the *Mahābhārata* seems to have been concluded. Each miniature was the work of two artists chosen from among the best of the day; one of them worked out the design and the other applied the colors. According to notes placed below the illustrations by court functionaries, at least 21 compositions appear to be the work of Daswanth, with Maskīna, Kēsū, Sārwan, and others as his highly talented collaborators. Of the 169 miniatures in the Jaipur library manuscript, 147 have been published by T. H. Hendley, enabling us to reconstruct by comparative study some of the characteristics of Daswanth's art. His great familiarity with the gods and heroes of the Hindu pantheon is remarkable, and these figures are prominent in this manuscript. Daswanth represented aptly monsters such as the revolting vampire that springs from the body of Sikhaṇḍin and drinks the blood of the dead from a cup; but his talents were most happily applied in illustrations of mythological scenes in which elements of the daily life of his time, both Hindu and Moslem, are deftly mingled.

A degree of perspective is suggested by the larger size of the foreground figures, and balance in the compositions is achieved by emphasis of the vertical axes and the central elements of the design. The artist was undoubtedly inspired by Western models, since these must certainly have existed at Akbar's court; but with his highly personal talent and his knowledge of the ancient, purely Hindu traditions, Daswanth creates an individual art distinct from any external influences.

SOURCES. Abū'l Fadl 'Allāmī, The Ā'īn-i Akbarī, trans. H. Blochmann, 2d ed., rev. D. C. Phillot, Calcutta, 1939, p. 114.

BIBLIOG. T. H. Hendley, The Rasm-nāma Manuscript, Memorials of the Jeypore Exhibition 1883, IV, London, 1883, figs. 6, 9, 12, 15, 24, 32, 43, 47, 48, 54, 62, 63, 67–71, 74, 88, 100; Delhi Museum of Archaeology, Loan Exhibition of Antiquities, Coronation Durbar, Delhi, 1911, pl. 35; K. de B. Codrington, J. Irwin, and B. Gray, The Art of India and Pakistan, A Commemorative Catalogue of the Exhibition Held at the Royal Academy of Arts, London, 1947–48, ed. L. Ashton, New York, [1950?], p. 94; W. Staude, Les artistes de la cour d'Akbar et les illustrations du Dastān i-Amīr Hamzah, Arts Asiatiques, II, 1955, pp. 49, 83 ff., fig. 12.

Wilhelm STAUDE

Illustrations: PLS. 112–115.

**DAUBIGNY,** CHARLES-FRANÇOIS. French painter (b. Paris, Feb. 15, 1817; d. Auvers-sur-Oise, Feb. 21, 1878); member of a family of landscape painters. Daubigny had decided early in life to visit Italy; and after financial difficulties, he finally managed the trip in 1835 in the company of another young painter, Mignan, and spent four months in Subiaco. Returning to Paris in 1836, Daubigny began to work for François-Marius Granet on the restoration of paintings at the Louvre and joined a small community of artists. In 1838 he entered the studio of Paul (Hippolyte) Delaroche. Daubigny exhibited at the Salon of 1838 for the first time; from 1840 on, he exhibited his works at almost every Salon and sent etchings as well as paintings to the Salons of 1841 and 1845. In 1857, after the success of *Le Printemps* (Louvre), he was made Chevalier de la Légion d'Honneur; and in 1859–60 he worked on the commissioned decorations for the chambers of the Ministère d'Etat at the Louvre. Between 1870 and 1872 Daubigny traveled in England and Holland, where he befriended Monet. A list of Daubigny's characteristic paintings would include: *Le Printemps* (1857), *Les Bords de l'Oise* (1872; Louvre), and *Mills of Dordrecht* (1872; Detroit, Inst. of Arts). Among his many collections of etchings are: *Chants et chansons populaires de la France* (1843), *Cahiers d'eaux-fortes* (1851), and *Voyage en bateau* (1862).

Daubigny's art, consisting almost exclusively of landscape, belongs to the milieu of the Barbizon school. Like such masters as Théodore Rousseau (q.v.), Jules Dupré, Diaz de la Peña, and Jean François Millet (q.v.), he perpetuated romantic attitudes toward nature by creating quiet, contemplative idyls of the countryside. His attempt to reproduce faithfully natural phenomena such as light reflected in water led him to paint out of doors from a houseboat that he had constructed in 1857. Known as "Le Botin," this floating studio enabled him to sketch from nature while sailing on the river Oise, a working method later subscribed to by several of the impressionists. In this preoccupation he foreshadowed the increasingly objective approach of the impressionists, whose art he encouraged in the 1870s. Daubigny's son, Karl-Pierre, was a close imitator of his father's style.

BIBLIOG. F. Henriet, C. Daubigny et son œuvre gravé, Paris, 1875; J. Laran, Daubigny, Paris, 1913; L. Delteil, Charles-François Daubigny (Le peintre-graveur illustré, XIII), Paris, 1921; E. Moreau-Nélaton, Daubigny raconté par lui-même, Paris, 1925.

Robert ROSENBLUM

**DAUMIER,** HONORÉ. French lithographer, painter, and sculptor. Born in Marseilles on Feb. 26, 1808, son of Cécile Catherine Philip and Jean Baptiste Louis Daumier. His father was a worker in glass, who went to Paris in 1814 to try his fortune as a writer of poems and plays. His poverty there obliged him to have his young son employed as the messenger of a bailiff in the law courts. Honoré Daumier thus came to know the world of law, which later was to be the object of his implacable satire. At an early age he showed an aptitude for drawing, sketching things that he saw in the street, and in his free time he haunted the Louvre. He was employed as a clerk in a bookstore until his parents placed him under the painter and archaeologist Alexandre Lenoir. The copying of casts and exercises in academic drawing did not stop him from observing and sketching on his own the life he saw around him, nor did it hinder his study of 4th- and 3d-century B.C. Greek art, and Venetian, Spanish, Dutch, and Flemish painting, especially the work of Rubens. Having learned the recently discovered lithographic technique, Daumier employed it in illustrating a few pictorial alphabets and small journals. In 1828 he was enrolled in the Academy, a pupil of an artist named Boudin (not to be confused with the later Eugène Boudin). He made friends with the sculptor Antoine Auguste Préault and with the painters Philippe Auguste Jeanron, Narcisse Virgile Diaz, Paul Huet, and Nicolas Louis Cabat. Daumier during this time made drawings for the publishers Béliard and Hautecoeur-Martinet. In 1829 a series of fantasies (now almost all lost) in the manner of Nicolas Toussaint Charlet was published by Achille Ricourt. His mature activity began only in 1830, the year of the July revolution. In that year Daumier plunged into the political ferment in France, expressing his violently antimonarchist and liberal sentiments through his lithographs. At first he worked for *Silhouette* (the first French satirical illustrated weekly, founded by Ratier and Ricourt in 1829) and then, in 1831, joined the staff of *Caricature*, launched in 1830 by the ardent republican artist-publisher Charles Philipon. Al-

ready collaborating on the journal were Charlet, Gustave Doré, J. I. I. Gérard (known as Grandville), and Gabriel Alexandre Decamps. While there he met Auguste Raffet, Eugène Lami, Auguste Bouquet, Franz Desperret, Jacques Arago, Achille Devéria, and Honoré Balzac.

At first Daumier used the name Rogelin, then his initials or signature. He achieved great success between 1831 and 1833 with the well-known series *Masks*, a set of lithographs and a parallel group of busts (perhaps 45 in all) of polychrome terra cotta. The 36 that have survived were reproduced in bronze in 1925 and are now in the Le Garrec Collection. The series portrayed prominent political men: Alexandre Lameth, François Guizot, Louis Thiers, Nicolas Soult, Antoine d'Argout, and even the king, Louis Philippe himself.

The satire against Louis Philippe culminated with a famous print, *Gargantua*, sold in separate sheets, which cost Daumier a 300-franc fine and six months in prison, a sentence which he served only after executing a new caricature directed against the prefect of police, Gisquet. In prison (from Aug. 30, 1832) Daumier continued to make lithographs and drawings, published by Ramelet. When his term ended, he resumed even more bitterly his attack on the political figures in power and on the inertia of the moderate opposition. His scorching satire against the *Constitutionnel*, the most important French moderate-liberal journal of the time, is from this period.

As a result of the insurrection of April, 1834, Daumier published four large lithographs, which rank among his most important in the political genre: *Le Ventre législatif* (*The Legislative Body*); *Ne vous y frottez pas* (*Don't Meddle with It*, also called *Liberty of the Press*); *Enfoncé Lafayette ... attrappe mon vieux* (*Lafayette Is Buried ... You've Had It, Old Man*); and *Rue Transnonain, 15 Avril 1834*. After the suppression of *Caricature* in 1835 Daumier joined the staff of *Charivari*, founded by Philipon in 1832, and turned to social satire. One of his most important series of prints during this period features the personage of Robert Macaire (PL. 120).

From this time Daumier's sphere of cultural interests gradually shifted; Paul Gavarni and Baudelaire were added to his circle of friends. Daumier began to study the great masters more assiduously and tried some paintings himself. In 1846 he married Alexandrine Dassy.

After the revolution of 1848 Daumier was able to return to political caricature; he executed new lithographs and a famous statue, *Ratapoil* (cast in bronze only in 1888), in an attack against Neo-Bonapartism. Also among the sculptures of this period is the bas-relief, the *Emigrants*. Louis Bonaparte's *coup d'état* and the proclamation of the Empire (1852) obliged Daumier to fall back on the satire of manners. In this period Daumier's graphic work breathes a profound dejection and a sense of ill-concealed impatience, caused not only by the lack of political liberty but also by a crisis in his relations with *Charivari*. He was disturbed, too, because he disliked being considered only a draftsman; this led him to cease all activity as a caricaturist between 1860 and 1863.

In the meantime, Daumier's circle of acquaintances was again modified. In 1855 he left Paris for Valmondois and there associated with the painters of the Barbizon school — Jean François Millet, Théodore Rousseau, Charles-François Daubigny, and Jean Baptiste Corot. In the same year the journal *Le Réalisme* opened a new outlet for his polemical work.

Daumier, who since 1848 had dedicated himself with growing passion to painting, ended by giving it the best of his talent. The first known painting, on the theme of the Republic (Louvre), was entered in a national competition won by Jean Léon Gérôme. In the Salon of 1849 Daumier exhibited *The Miller, His Son, and the Ass* (Glasgow Art Gall.), based on a fable by La Fontaine; in 1851, *Nymphs Pursued by Satyrs* (PL. 116) and *Don Quixote and Sancho Going to the Wedding of Camacho*; in 1861, a *Washerwoman* (perhaps the one now in the Louvre); in 1869, *The Print Collector* (PL. 121) and two water colors, *Judges of the Assizes* and *The Physicians*. The public, however, showed no signs of being aware of his work. Only in 1878, a year before Daumier's death, did the first great exhibition, comprising 94 paintings and many water colors and drawings, shown at the art gallery of Durand-Ruel in Paris, give critics the opportunity to recognize his greatness.

Toward 1870 Daumier was stricken with progressive blindness that eventually forced him to abandon work. He died at Valmondois on Feb. 11, 1879.

The first book on Daumier, written in 1888 by Arsène Alexandre at the suggestion of Théodule Ribot, made use of verbal accounts and some documents. In 1904 A. Hazard and L. Delteil brought out a catalogue of lithographs that led to a 10-volume corpus, the most complete history of the artist's graphic interests, published between 1925 and 1930. A book by R. Escholier, published in 1913, was enlarged 10 years later; the work of E. Fuchs is dated between 1927 and 1930; and the study of Daumier by J. Adhémar culminated in the volume of 1954. In the meantime minor contributions, exhibitions, and catalogues have multiplied.

In discussing the sources of Daumier's style, a significant fact has generally been overlooked by the critics, with the exception of Adhémar (1954). In Daumier's studio there were casts of Trajan's Column; their presence certainly testifies to the classical education that the artist received under Alexandre Lenoir (one of the few artists of his time capable of appreciating color as well as drawing, and of praising Rubens and Titian). To Daumier's eye, however, the classicism in these reliefs must have had a popular and not an academic character. If one remembers this viewpoint of Daumier, his first lithographs in the style of Charlet seem less germinal. It is possible, in fact, to trace throughout the artist's career popular tendencies, which emerged between 1846 and 1849 in the relief, *The Emigrants*, and in his copy of Rubens' *Kermesse* in the Louvre. None of the suggested influences on Daumier's development — Goya, Rembrandt, Decamps, Delacroix (whose *Shipwreck of Don Juan* in the Louvre is similar to some works of Daumier), and Géricault (whose art was as Michelangelesque as Daumier's) — were as early or as lasting as the 16th-century Venetians and the 17th-century Flemish. The Venetian and Flemish styles, with their synthesis of form and color and their popular content, were capable of appealing most profoundly to the young artist. The development of photography (q.v.) must also be taken into account in discussing the influences on Daumier's style. Daumier was an acquaintance of the photographer Nadar (Félix Tournachon), and his interest in the refinement of chiaroscuro effects was certainly inspired by the photographic technique. At once classic and romantic in personality, Daumier cannot be identified with either of these two stylistic trends.

Perceptive critical evaluation of Daumier's work appeared from the time his first lithographs were published. Balzac, an editor of *Caricature*, said of Daumier's sculptural style, "In this youth there is something of Michelangelo." The theme was taken up later by Théodore Banville, by Edmond About, and finally by Daubigny, who, when visiting the Sistine Chapel, exclaimed, "C'est du Daumier!" The publisher Ricourt declared to the artist very early in his career, "You catch the movement to the life" ("Vous avez le geste, vous"). It is not so much the plasticity or the able use of chiaroscuro that characterizes Daumier's work as it is his ability to catch the expression on a face, the significance of an attitude, the personality of a man. Daumier does not merely select the essential or characteristic traits in a head or a pose; he observes them in their movement and their relationship with reality. He portrays forms not just in their existence pure and simple but in their implications of meaning, their interplay, and their communicative value. Herein lies the explanation for Daumier's graphic technique of abbreviation in the representation of men and objects; the artist eliminates everything superfluous and extraneous to the action. This is also the explanation for the mingled realism and fantasy that characterize Daumier's drawings, based on observations drawn from life but executed from memory. It must also be in part the source of Daumier's taste for the world of the theater, especially strong in his later years. Finally, it is the basis of the process through which the artist transformed his "types" (for example, Robert Macaire, Ratapoil, and Monsieur Proudhomme) into personalities. Each is not merely the transient vehicle for a joke or a portrait sketch but a personage

who develops in time, acting out a well-articulated and structured life cycle. Each character represents or constitutes, together with others of his ilk, an entire world. Many of Daumier's characters originated in the theater: Robert Macaire was created in 1823 by the actor and playwright Frédéric Lemaítre, who brought him on stage again in 1834; Monsieur Proudhomme was created by the artist, actor, and playwright Henri Monnier in 1830. Daumier was a friend of the artist-actor Etienne Marin Mélingue as well as of Monnier himself. The artist's relations with the theater have been thoroughly discussed by J. Adhémar (1954). From this point of view, the history of Daumier's art may be seen as the story of his characters.

Among the earliest of the lithograph characters is Saute Ruisseau, a messenger boy for a judiciary bailiff. A poverty-stricken daredevil, he is reminiscent of the very young Daumier. Louis Philippe was the inspiration for Daumier's first popular and consistent character. In effect, his caricature presented the king as a hypocrite, induced by circumstances to countenance evil but at the same time capable of pretending very ably, even to himself, that he is sorry — indeed, truly distressed by it. Daumier indicated that the origin of the evil lies in the monarch's complicity with the men surrounding him. That the satire was neither abstract nor impersonal is evident enough in the previously mentioned lithograph of *Gargantua* (1832), which represents Louis Philippe as a giant planted in an armchair. A file of pygmies weighed down by baskets heavy with gold pieces climbs up a plank rising from the ground to Gargantua's mouth and pours the money down his throat. Little by little as he is stuffed, Gargantua has digested and emitted "from the lower orifice of his person" an avalanche of patents, decorations, marshals' batons, and portfolios, avidly scrambled for by the carriers of the baskets (Escholier, 1923). At the right are massed the exploited whose sacrifices fill the coffers: poor men, war casualties, workers, and proletarian women. Another splendid lithograph, of 1834, depicts the monarch at the bedside of a dying man, evidently a political prisoner. "This one may be granted his liberty," says the king to a judge standing nearby.

In his battle with the opposition press, Daumier transformed even a newspaper into a personality. Criticizing the political inertia of the *Constitutionnel*, Daumier personified it by giving it the features of its editor in chief, Charles Guillaume Etienne, depicting him as slow-witted, fat, and asthmatic, his eyes shaded by a visor or even blindfolded.

To confront this figure and the entire official political world, Daumier set up an adversary — the man of the people. It is the only one of Daumier's characters that is not thoroughly developed as an individual. The man of the people has no definite history, no organic evolution. He is an ideal type, a symbol, a formula, rather than a real man. The worker in the lithograph of the *Liberty of the Press* stands proudly, putting to flight the little men who have tried to gag him. In some ways he resembles the fine, robust figure that appears mortally wounded in *Rue Transnonain*, but in the *Liberty of the Press* Daumier's desire to depict the symbol of the people in a positive and appealing form led him, though imperceptibly, into the sphere of the rhetorical image. Within this context, L. Venturi's (1947–50) definition of the political aspect of Daumier's caricature as polemical and nonpoetic is completely valid. It might be noted, furthermore, that Daumier is the first to attempt idealization of the people without falling into any classical mannerism.

According to Baudelaire, when *Caricature* was suppressed in 1835, caricature took a new direction and was no longer specifically political. It became a general satire of modern life; it entered the sphere of the novel. The most important character created by Daumier in this new orientation was Robert Macaire (PL. 120). In a series running from 1836 to 1838 and several times resumed, though less successfully, until 1841, Daumier represented Robert Macaire, accompanied by his toady Bertrand, as the personification of knavery in yellow gloves, speculator on the stock market, false industrialist, crooked salesman, exploiter of women, usurer, unscrupulous doctor or lawyer, or journalist without honor. He is a kind of Bel Ami, the character

created by Guy de Maupassant, anticipated by some forty-five years, but less frivolous and base than Bel Ami and animated by an aristocratic grandeur that gives him the quality of a rascally hero.

Robert Macaire was followed by many other characters: the Bathers (1839–42, 1864); Bluestockings (1844); Professors and Pupils (1845–46); the Papas (1846–49); the Good Bourgeois (intermittently from 1846 to 1865); and Divorcées (1848). In the last, Daumier captured admirably female "intellectual" pretensions and fanatical feminism. French Types (1835) and Bachelors (1839) caricatured the well-to-do little egoist. Others of the characters were national guardsmen, miserable and shivering, betrayed by their wives during night service, and the shopkeeper, generally shown decked out in Sunday best with his wife and children. Whether on an outing in the country or at home, he was everywhere prey to ridiculous apprehensions; Daumier portrayed him as obtuse and limited in his naïve desires, in his pleasures, in his habits, even in his eccentricities. From 1841 come the Tragico-Classic Physiognomies, from 1841–43 the Stories from Antiquity, and from 1851 the Tragic Physiognomies. In these series Daumier joined the battle between classicism and romanticism, ridiculing the Greeks and Romans dear to the ruling classes (III, PL. 430).

Also among Daumier's creations are the Parisian Types (1839–42), the Bohemians of Paris (1841–42), and the Men of Justice (*Les Gens de Justice*, PL. 120; 1845–49). The last is a vivid, perpetually moving panorama, dominated by a formidable central character, the lawyer, many-faced but always recognizable. At his feet swarms a crowd of poor unfortunates: litigating wives and husbands, widows, orphans, thieves, and tricksters. The captions were often composed for the finished drawings by the editors of *Caricature*, but Daumier himself wrote a large number.

In political caricature after 1848, Daumier's discovery was Ratapoil, "the imperialist agent, sly and insolent, who wears his hat shoved back over a ravaged face, twists his greasy mustache, and twirls a heavy cane reminiscent of Robert Macaire's walking stick" (Escholier, 1923). Ratapoil's distinction is that he personified a well-defined social stratum, the anti-Republican social outcasts, while at the same time resembling the future emperor, Louis Bonaparte. Thus social satire became interwoven with political satire.

In the satire of manners after 1852 — series with themes of the hunt, the baths, trips to the country, the battle between the classicists and the romanticists, the salons, late trains, mishaps of railway travel, the excitement over the comet of 1857, and the campaign for the consumption of horsemeat — Daumier found and created material for his genius. He also launched occasional furtive but ferocious thrusts at the Empire, such as the *Madame Gargantua* of 1866. The principal character in this period is Monsieur Proudhomme, a potbellied, bespectacled bourgeois, brimming with dignity and moralistic pronouncements, accompanied by a wife and son whom he guides with a protective air through the perils of Parisian life.

The polemical content of Daumier's art has been valued positively or negatively according to the critic's political and moral interests or esthetic viewpoint. If by polemics one means an overt expression of the social conscience, it is a fundamental element in his caricature, more basic than the comic, grotesque, or sublime (see COMIC ART AND CARICATURE).

Lionello Venturi has distinguished the more polemic works, of the phase before 1848, from the more poetic ones of the following phase. In the latter, the comic is sublimated to a loftier sentiment, a purer artistic creation. The distinction is justified in the sense that in the later works, especially in the paintings, Daumier's message becomes refined, veiling itself in a kind of cosmic pessimism, and the conflict of forces and passions becomes tragic. In fact, Daumier's caricatures were never purely comic. He never liked the witticism for the sake of the witticism; and the contrast between what ought to be and what is was often shot with irony, sarcasm, ridicule, and, finally, with the tragic. Daumier's art was executed in the name of a higher conception of society, although never becoming fixed in a predetermined scheme. But the polemic element

was always present. Toward 1870 Daumier neglected no opportunity to raise his voice in the political struggle against rearmament and war. After the surrender of Napoleon III to the Germans at Sedan, however, there was nothing left for him to do but to title a summary yet powerful drawing of ruined houses and corpses with the tragically ironic epitaph: "L'Empire, c'est la paix" ("The Empire is peace"). The phrase was Napoleon Bonaparte's. In another composition he symbolically nailed the plucked imperial bird to the Book of History, fulfilling Victor Hugo's prophecy in *Les Châtiments*.

In Daumier's paintings this new attitude is clear. He both contributed to and borrowed from artists such as Jean François Millet, and he influenced the works of Doré, Adolf von Menzel, Pissarro, Van Gogh, Toulouse-Lautrec, and Rouault, as well as such writers as Flaubert, Joris Karl Huysmans, and Daudet. All the same, the true character of Daumier's painting has perhaps escaped understanding. J. Adhémar suggests that Daumier underwent a Caravaggesque phase between 1834 and 1839, as did such artists as Jules Claude Ziegler and Adolphe Brune. However, the attention that Daumier gave to the classics of 17th-century art, not only in painting but also in literature, indicates a general interest in the period. He was very fond of La Fontaine and Molière, and his predilection for Cervantes is not inconsistent with this propensity. Even certain works which show a fleeting influence of the style — or perhaps themes — of Fragonard are characterized not so much by vaporous and abbreviated forms as by a meditative introspection. Such a work as *Pierrot Strumming the Guitar* (1868; PL. 117), in spite of superficial similarities, is more reminiscent of Frans Hals. In discussing the influence of the 17th century, the presence of certain tragic or cruel themes must not be neglected. Such paintings as *Christ and the Disciples*, the *Kneeling Magdalen* (1848), and *The Butcher* are inspired by 17th-century themes, expressed in a style that became progressively more rhetorical. The kneeling Magdalen cries out, asking pardon for her guilt. The three women in *The Miller, His Son, and the Ass* (ca. 1849; Glasgow Art Gall.) call derisively and gesture broadly in the style of Rubens. The *Nymphs Pursued by Satyrs* (ca. 1849–50; PL. 116) express their alarm violently, their movements recalling Rubens' *Rape of the Daughters of Leucippus* (II, PL. 195); and a sweeping Rubens-like movement agitates the painting of the *Thieves and the Ass* (1865–68; Louvre).

The figures in *Saved* (1860–62; formerly Camentrol Coll.), a woman and a man holding a half-drowned child in his arms, are silhouetted, as though by the half-lights of a theater, against a light backdrop. Their positions and gestures carry the weight of meaning. Other figures by Daumier are silhouetted in the same way, as, for example, the groom leading a horse to water in *The Watering Place* (1860–62; formerly London, Colnaghi Coll.), the person in the *Man Climbing the Rope* (ca. 1860–62; Boston, Mus. of Fine Arts), and Sancho Panza on his ass watching Don Quixote in armor moving away into the distance in *Sancho and Don Quixote* (Glasgow Art Gall.). The *Man Climbing the Rope* may represent a gallant adventurer, the flight of a political prisoner, or a thief.

Daumier's late paintings and drawings return insistently to such subjects as strolling actors, ballad singers, wandering minstrels, wrestlers about to enter the ring, and actors reciting. There is a profound and tragic autobiographical motif in these themes. Daumier evidently identified himself with these characters, having, like them, amused the crowd without being understood; he mirrored himself in those for whom life consists in the feigning of life.

Daumier took up the 17th-century idea of the continuity and basic identity between reality and dream, the idea of life as the pursuit of a shadow, as *vanitas vanitatum*. The searching honesty that characterizes the art of Daumier comes from the affirmation of this repressed and disturbing truth.

BIBLIOG. For sources and bibliography see J. Adhémar, H. Daumier, Paris, 1954. *General*: C. Baudelaire, Salon de 1845, ed. Crépet, Paris, 1923, ed. Ferran, Paris, 1933; C. Baudelaire, Curiosités esthétiques, Paris, 1868; J. F. H. Champfleury, Histoire de la caricature moderne, Paris, 1878; A. Alexandre, Honoré Daumier: L'homme et l'œuvre, Paris, 1888; Catalogue of the Centennial Exposition, Paris, 1900, nos. 173–90, 841–61; A. Hazard

and L. Delteil, Catalogue raisonné de l'œuvre lithographié de Daumier, Paris, 1904; H. Marcel, H. Daumier: Biographie critique, Paris, 1907; ThB, VIII, pp. 434–37; R. Escholier, Honoré Daumier, 2d ed., Paris 1923; L. Delteil, Le peintre-graveur illustré: XIXᵉ et XXᵉ siècles, XX–XXIX, Paris, 1925–30; E. Fuchs, Der Maler Daumier, Munich, 1927; E. Fuchs and H. Krämer, Die Karikatur, Berlin, 1927; E. Fuchs, Daumier, Lithographien, Holzschnitte, Munich, n.d.; C. Sterling, Catalogue de l'exposition Daumier a l'Orangerie, introd. C. Roger-Marx, pref. A. de Monzie, Paris, 1934; J. Lassaigne, Daumier, trans. E. B. Shaw, New York, 1938; L. Venturi, Modern Painters, 2 vols., New York, 1947–50; M. Fischer, Daumier, pittore, Milan, 1950; M. Govin, Daumier, sculpteur, Geneva, 1953 (with cat.); J. Adhémar, Daumier: Drawings and Watercolors, introd. J. Adhémar, pref. C. Roger-Marx, trans. E. Winkworth, New York, 1954; K. E. Maison, Daumier Drawings, New York, London, 1960.

Corrado MALTESE

Illustrations: PLS. 116–121.

**DAVID, GERARD.** Flemish painter (b. Oudewater, near Gouda, Netherlands, ca. 1460; d. Bruges, Aug. 13, 1523). The earliest recorded date in the life of Gerard David is 1484, when he, a stranger who had not been born or trained in that city, was admitted to the painters' guild in Bruges. His style shows such strong similarities to that of Geertgen tot Sint Jans that it has been supposed that he, like Geertgen, had received his early training in Haarlem in the studio of Albert van Ouwater. Soon after his admission to the guild, in which he held a respected place, David was given commissions by the government of the city of Bruges. He married the daughter of the head of the guild of goldsmiths soon after 1496. In 1515 David was listed as a member of the painters' guild in Antwerp, possibly as a requirement for fulfilling a commission from an Antwerp patron. Documents indicate that as early as 1487 he was painting pictures for the Hôtel de Ville at Bruges, including a *Last Judgment* which has completely disappeared.

Although Gerard David is credited with a large body of work, most of it is ascribed to him on the basis of style, and his documented paintings are limited to three: a pair of pictures made for the Judgment Hall of the Hôtel de Ville (Bruges, Mus. Com.) and the large painting of the Virgin and Child attended by angels and female saints (Rouen, Mus. B.A.). The pictures from the Judgment Hall, following a convention that called for subjects that would set the magistrates an example for the administration of justice, show the accusation and the punishment by flaying of the unjust judge Sisamnes. The accusation section bears the date 1498. The Rouen *Virgin* was painted in 1509 and presented to the Carmelite cloister of Sion by the artist, who included in it portraits of himself and his wife. Other important works by Gerard David are the triptych with the Baptism of Christ that shows on the wings the donor with his first and second wives, their children, and patron saints (Bruges, Mus. Com.); the *Marriage at Cana* (Louvre); the *Nativity with Donors and Patron Saints* and the pair of panels showing *The Annunciation* (New York, Met. Mus.); and the dramatically impressive *Crucifixion* (Genoa, Gall. di Palazzo Bianco).

With its homely types and forthrightly simple settings, David's early style gives evidence of his origins in the northern Netherlands. In Flanders he soon succeeded to the position of importance previously held by Memling, who died a decade after David settled in Bruges. Acquaintance with works of earlier 15th-century painters, especially Jan van Eyck and Rogier van der Weyden, rapidly trasformed David into a painter of emotional power and depth and of great technical finish. His mature style is characterized by an air of tenderness and sobriety, exquisite refinement, and dignified emotion. See FLEMISH AND DUTCH ART and V, PL. 286.

BIBLIOG. E. von Bodenhausen, Gerard David und seine Schule, Munich, 1905; M. J. Friedländer, Altniederländische Malerei: Memling und Gerard David, VI, Berlin, 1928; M. Davies, The Early Netherlandish School of Painting, 2d ed., London, 1955.

Margaretta M. SALINGER

**DAVID, JACQUES LOUIS.** French painter, born in Paris in 1748 — when Fragonard (q.v.) was sixteen years old and Boucher (q.v.) approaching old age — died on Dec. 29, 1825. On

the advice of Boucher he entered the studio of Joseph Marie Vien in 1766, and in the same year was admitted to the Academy as a student, where he was immediately attracted to the antique revival (q.v.).

Despite David's subject matter — allegory, history, and mythology, which later became the requisites of Academy art — his painting retains a certain amount of 18th-century elegance and grace. The influence of Boucher is still evident in the *Combat of Mars and Minerva* (1771; Louvre) and in *Apollo and Diana Piercing the Children of Niobe with Arrows* (1772; private coll.). In *The Death of Seneca* (1773; Paris, Mus. du Petit-Palais), however, there are already signs of a Diderot-like sensibility; and touches of Fragonard enter into the decorations of the Hôtel Guimard, which Fragonard himself had begun but which were completed by David in 1773. David won the much-coveted Prix de Rome (for which he had been rejected no fewer than four times) with his *Antiochus and Stratonice* (in full, *Antiochus, Son of Seleucus, King of Syria, Languishing in His Infatuation for Stratonice, His Stepmother; The Doctor Eristratus Discovers the Nature of His Illness;* 1774; Paris, Ecole B.A.). In these paintings David exhibited a resolute spirit different from that of his contemporaries, an inherent seriousness that motivated him to depict historical subjects in a way that would elicit an emotional response.

His stay in Rome, where he went in October, 1775, at the age of twenty-seven, opened a new world to him in the revelation of the Bolognese painters (the Carraccis, Domenichino, Reni) and Raphael. But the determining factor in the evolution of his style was unquestionably the wealth of ancient sculpture he encountered. These discoveries influenced David in his quest for a firm, clean line, then considered indispensable to the attainment of ideal beauty, the foundation of the imminent neoclassic style (q.v.).

Alexandre Lenoir relates that, as a young student, David set himself to drawing eyes, ears, mouths, feet, and hands for an entire year and limited himself to working from the most beautiful statues. In this disciplined reaction to the chromatic exuberance of the rococo, David gratified his own desire for perfection. In the pursuit of the antique he discerned the possibility of combining a more naturalistic style (as opposed to the artificialities of the rococo) with a spirit of austerity and grandeur that avoided all fantasy and mystery — a synthesis of naturalism and rationalism.

The *Triumph of Paulus Aemilius, Burial of Patroclus,* and *Hector* — the first canvases he sent from Rome to Paris (now lost) — were still timid, and academicians deplored the lack of transparency in their dark shadows, which made it seem as if the scenes were taking place at night.

*St. Jerome* (1779) and *St. Roch Interceding for the Plaguestricken* (1780; Marseilles, Santé) still showed Bolognese influence. But *Belisarius Asking Alms* (Montauban, Mus. Ingres), exhibited in Paris in 1781, revealed a growing classicism and was generally recognized as a departure from his previous work.

David's success at the Salon of 1784 established his reputation and gave him a definite following. His *Andromache by the Body of Hector* (1783; PL. 123) secured his admission to the Academy — the same Academy he was later to forsake. In 1784 he painted the *Oath of the Horatii* (I, PL. 307), which immediately became the model for all grandiose and noble art of a commemorative character. The theme, with its Corneillian overtones — the Horatii swore on their swords, in the presence of their father, "to win or die for liberty" — was soul-stirring and explicit in its praise of rebellion: the French Revolution lay only five years away.

*The Death of Ugolino* (1786; Valence, Mus.), *The Death of Socrates* (1787; Met. Mus.), and above all *Brutus and His Dead Son* (1789; Louvre), placed on exhibition when the States-General was assembled and the assault on the Bastille had begun, are dramatic scenes in which the new rhetoric of David found expression: historical with libertarian connotations, as indicated by the titles themselves; revolutionary in theme, not in style. They are works of unquestionable quality, but cold and systematic, well thought out and composed in accordance with the rationalism of the times. Although inspired by genuine

sentiments, they lack spiritual depth. In *Paris and Helen* (1788; Louvre, PL. 124), painted with a richer palette and a more expert hand, David expressed his deepest feelings, if only episodically. The influence of the works of Rubens and Van Dyck and even of Greuze diverted him from his main objectives for a while; but a little after the outbreak of the Revolution, without exactly returning to his previous manner, he continued to paint in the style of a "Roman" academician. Thus terminated the first period of David's life.

"His work is like a weapon, like the *Encyclopedia, The Spirit of the Laws,* or *The Marriage of Figaro,*" commented Agnès Humbert (1937). David's pronounced hatred of the Academy (which perhaps in turn was the cause of his hatred of the *ancien régime*) was probably also his reason for belonging to the third estate. In the following years he took part in the Revolution as a citizen, supported Robespierre and the Jacobins, and at one time presided over the Convention, of which he was for a short while a member. He chose to concern himself with the Academy and eventually (Aug. 8, 1793) brought about its dissolution. He then created a new body of 300 members, known as the Commune of the Arts, which was replaced on Oct. 30, 1793, by the Popular and Republican Society of the Arts. He put forward projects for commemorative monuments, organized popular celebrations, and interested himself in the preservation of old works of art. Old and new ideas mingled in his mind, as we can see in the curtain for the Opéra on which he was working at this time and which represented the triumph of liberty and the people, with a crowd of some 30 figures representing classical and contemporary personages.

Nevertheless, David felt the urge to deal directly with revolutionary rather than historical subjects, that is, with actual events of the day. In the fervor of revolt, he was chosen to immortalize the scene of the Tennis Court Oath (*Serment du Jeu de Paume,* 1791; Louvre), for which, however, he finished only the sketch. Then followed the paintings of the martyrs of the Revolution: *Death of Lepeletier de Saint-Fargeau* (1793; private coll.); *Death of Marat* (1793; PL. 123), his first truly great work; and *Death of Joseph Bara* (1794; Avignon, Mus. Calvet). In these, David forgot his Roman storytelling, his stringent pictorial rules, and his severity of color; he resolved to depict reality mercilessly. The cold and rhetorical theatricalism of his earlier paintings became ardent and alive, though still controlled.

After the 9th Thermidor (July 27, 1794), David fell from favor. He was imprisoned first in Fresnes prison, then in the Luxembourg, and his political passion cooled. From the moment of his release he was finished with the life of political action. His grandiose revolutionary gestures were obliterated by his subsequent conduct. He repudiated Robespierre — the friend with whom he had offered to drink from the same cup of hemlock. He tried to minimize the importance of his revolutionary actions and began to pose as a theoretician in love with history. He was now seized with a new passion — this time for Napoleon — that tended to divert him from his preoccupation with Roman allegory. He remained the portraitist, however, and it was in this capacity that he distinguished himself in the Napoleonic period.

David had painted portraits from the beginning of his career and, although he did not think too highly of them himself, these constitute his finest work. Some portraits of this period are the early, freely painted portrait of his uncle and aunt, *Jacques Buron and His Wife* (1769), and the equestrian portrait *Count Potocki* (1781; Warsaw, Nat. Mus.). There are also those portraits which are contemporary with the Roman allegories, revealing the contrasting sides of his character: the architect *Desmaisons* (1782; Buffalo, Albright Gall.); *Alphonse Leroy* (1783; Montpellier, Mus. Fabre); *Monsieur and Madame Pécoul* (1784; Louvre); *Mademoiselle Joly* (1784); and, justly famous, *Lavoisier and His Wife* (1788; New York, Rockefeller Inst. for Medical Research).

During the Revolution David painted many portraits besides those already mentioned; among them are the *Marquise d'Orvilliers* (1790; Louvre), the flutist *Devienne* (1792; Brussels, Mus. Royaux B.A.), *Madame Chalgrin* (1792; Louvre), *Michel Gérard*

and His Family (Le Mans, Mus. B.A.), the wonderful self-portraits of 1790 and 1794 (Louvre), the cruel likeness, La Maraichère (1795; Lyons, Mus. B.A.), and — one of his masterpieces — Madame Sériziat and Her Daughter (1795; PL. 125). In 1797 he painted his first portrait of Napoleon — according to Michel, "the most characteristic portrait of the hero" — a sketch in which a great expressive power is only glimpsed. When later he once more took up an imposing theme of contemporary history — Bonaparte Crossing the St. Bernard Pass (1800; Versailles) — a certain academic dogmatism reappeared and the revolutionary impetus seemed spent. Of the same date as this scenographic portrait of Bonaparte is the portrait of Madame Récamier (1800; PL. 122), of which the sober palette and exquisite distillation of spirituality and sentiment pleased the young Ingres, then David's assistant.

Napoleon held David in high esteem and showered him with honors. Nevertheless, the Emperor prevented him from recovering the artistic scepter; to David's cold perfection, Napoleon preferred Gros's unequivocal rhetoric, Gérard's gravity, or Prud'hon's slightly bombastic sensuality. Commissioned by the Emperor, David painted several great compositions of contemporary events, such as the Coronation of Napoleon and Josephine (1805–07; PL. 126), the Distribution of the Eagles (1810; Versailles), and the sketch of the Entry of Napoleon into the Hôtel de Ville (1805). In these paintings he sought to emulate the expansiveness and chromatic brilliance of Rubens but was unable to achieve his epic grandeur; yet there is also evident a serious effort at naturalness in rendering human expression. The figures of Josephine, Napoleon and his brothers, and Pius VII, precise and formal, are invested with a grandeur that derives less from their political position than from their vitality and assurance.

Forsaking the Napoleonic myth, David now seemed to have found himself again, as evidenced by several successive portraits: those of his children, Pauline Jeannin and Emilie Meunier (1812; Paris, Coll. M. Cailleux) and that of Madame David (1813; private coll.), in which he attains an extraordinary freedom, completely without academic prejudice. He is more respectful of his model in the portrait of Pope Pius VII (1805; Louvre) and another portrait in which the same Pope is shown with Cardinal Caprara (1805). In the 20 years between the fall of Robespierre and that of Bonaparte, during which David was in effect head of the official school, the fundamental contradictions of his nature as a painter seemed to grow. In the View of the Luxembourg Gardens (1794; Louvre) as seen from his prison window, he painted a landscape which can be regarded as one of the first romantic works; and at the same time he produced what may be called a manifesto of neoclassicism — The Sabine Women Ending the Battle between the Romans and the Sabines (commonly called The Rape of the Sabines; 1794–99; PL. 123). In the details of both nude and clothed figures, David strove for a kind of contained energy combining Greek idealized synthesis with Roman descriptive realism. He developed a new type of composition that emphasized the diagonal axis and the contrapuntal massing of figures, as well as an atmospheric background in sharp contrast to a clearly defined foreground. If we compare The Sabines with The Horatii we see that, although 10 years and revolutionary events separated the two paintings, the same ideal governed David. He himself considered The Sabines his masterpiece. No doubt he was right from the point of view of his general theory; but the truth is that these figures are reasoned, not felt: they have no interior life of their own; and the vital element in them, their movement, is frozen into statuesque immobility. Nevertheless, when David painted The Sabines, he still felt something of the revolutionary zest, even though it was expressed indirectly and allegorically. In the succeeding works, this zest diminished — only the rules of neoclassicism remained, and even these were growing stiff with age. Sappho and Phaon (1809: Leningrad, The Hermitage) shows how little David was able to express the sensual; Leonidas at Thermophylae (1814; Louvre) is merely a studio production, showing little sign of creative imagination. In exile at Brussels, where he took refuge at the time of the Bourbon restoration, he painted Cupid and Psyche (1817; Paris, Coll. Princesse Joachim

Murat), Telemachus and the Nymph Eucharis (1818; private coll.), the Wrath of Achilles (1819; private coll.), and Mars and Venus (1824; Brussels, Mus. Royaux B.A.). These later paintings are of historical rather than artistic value and are very far from the ideal beauty that Ingres, with his unconsciously romantic temperament, was to produce. David believed that in these late works, especially the Leonidas, he had attained the Greek ideal, but the spirit of the ancient world, barely hinted at in these themes, is held in check by a Flemish preoccupation with detail and texture.

Toward the end of his life David gave some final proofs of his artistic vitality. There is the rather reserved portrait of a member of the Greindl family (1816), the magnificent portrait Madame Morel de Tangry and Her Two Daughters (ca. 1818), and above all that of the actor Wolf, called Bernard (1820; Louvre). These are poignant expressions of that new universality which we associate with the greatest romantic, Eugène Delacroix, who was then still a young man.

In passing judgment on David it should be realized that, though he was undoubtedly responsible for the propagation of an essentially artificial manner, he nevertheless foreshadowed the development of a mode of expression later known as the "romantic style," which reflected the true spirit of the times.

David's urge to be "classical" must be borne in mind for an understanding of the artist. It reveals a fundamental contradiction between his nature and his attitude toward his own time, which was not without consequences in the representational arts for almost the next half century. If he had listened more to his inner voice, he might have turned out to be, not the creator of the neoclassic style, but perhaps the greatest of the romantics. But, moved as he was by political passion and by a fatal belief in "ideas," he preferred to make himself the interpreter of passing ideologies. Thus, in a sense, he ended by inhibiting his own genius. He was "a genius who arouses our admiration" — wrote Jacques-Emile Blanche (1919) — "but not our love, without doubt because of the false note of classicism insistently resounding in his canvases, which mitigates against the realization of harmony." However, we should not attribute all these shortcomings to David himself, for the emotional climate of the times had long been favorable to the love of antiquity. In the years at the end of Louis XV's reign and at the beginning of that of Louis XVI, this mood was encouraged by Madame de Pompadour and the archaeological activities of Count Caylus. The rediscovery of the sublime in Greece and the heroic in Rome kindled enthusiasm for the epic and engendered the belief that these qualities could be recaptured in the contemporary world.

With the uncompromising study of the past by Quatremère de Quincy, who was a more profound and effective exponent of the antique than Count Caylus, the outlines of the neoclassic style were definitely traced. All that was lacking was a man to put into effect the program of the theorists, which had been approved by the philosophers and the archaeologists and encouraged by the leaders of the third estate, who had been the vanguard of the Revolution. That man was David.

The theories of David were actually less rigid than they appeared to his contemporaries, for they rested on ideas which were difficult to reconcile. On the one hand, there was a search for truth as found in nature, corresponding to either a philosophical or a political order; and on the other, there was the quest for an ideal beauty founded on the study of the antique. David, though temperamentally drawn to the former view, sought to define beauty on an absolute level, in opposition to observed reality. As his inmost feelings were essentially anticlassical, David cannot be said to have succeeded in this quest.

There was still another reason for his lack of success as a classical artist. In his neoclassical compositions, the forms are rigid and inexpressive; having borrowed them from sculpture, he was forced to reduce the three-dimensional vision of that medium to the two dimensions of painting. If his color is inexpressive and limited in range, it is because he used color to create the illusion of space rather than as an element of pictorial enrichment. Nevertheless, a few of his figures, such as that of Brutus or the central one in The Sabines, show that

he did not always comply strictly with the Greco-Roman tradition. Here David's genuine originality may be seen; he followed in the path of Poussin, which was not classical but implicitly romantic. Thus in many of the portraits and the one landscape which David painted color is used in a more genuinely pictorial manner. In the presence of living models he became more spontaneous and his work inclined toward the sentimental, as it might always have done had he not imposed upon himself the neoclassical style.

Sentiment was precisely what the triumphant third estate — which became the bourgeoisie of the 19th century — was beginning to demand. That is, sentiment and natural truth in the sense of a love of life as it is found and the negation of idealism. David's romanticism was not individualistic and despairing; he assumed, on the contrary, the heroic tone — though along with this went that glorification of liberty which again strikes a romantic note.

There is another interpretation of David's work that is given by those who dwell on the formal perfection of his figures. Compared to other neoclassicists, David painted with extraordinary force, in an abstract manner which allows of comparison with contemporary art. André Lhote wrote: "We consider David a prototype of modern painting, and as the creator of that revolution which is continued in us, and which we ourselves carry on."

<div align="right">Jorge ROMERO BREST</div>

SOURCES. *a. Writings*: Discours prononcé dans la séance du 17 brumaire, l'an deuxième de la République, Paris, 1792; Convention Nationale, discours sur la nécessité de supprimer les Académies, séance du 8 août 1793, Paris, 1793; Discours prononcé à la Convention Nationale, le 29 mars 1793 en offrant un tableau de sa composition, représentant Michel Lepeletier au lit de mort, Paris, 1793; Rapport fait au nom du Comité d'instruction publique pour l'explication de la médaille frappée en commémoration de la réunion civique du 10 août 1793, Paris, 1793; Second rapport sur la nécessité de la suppression de la Commission des Muséums fait au nom des comités d'instruction publique et des finances dans la séance du 27 nivôse, l'an 2, Paris, 1793; Rapport fait à la Convention Nationale, Paris, n.d.; Rapport fait au nom du Comité d'instruction publique sur la nomination des cinquante membres du jury qui doit juger le concours des prix de peinture, sculpture et architecture, Paris, n.d.; Rapport sur la suppression de la Commission des Muséums, Paris, n.d. *b. Contemporary criticism*: Explication de la Section du Muséum, rapport et arrêts relatifs à David, citoyen de cette Section et représentant du peuple, Paris, 1794; Le Tableau des Sabines, exposé publiquement au Palais national des sciences et des arts, salle de la ci-devant Académie d'Architecture, Paris, 1799; P. J. B. Chaussard, Sur le tableau des Sabines par David, Paris, 1800; Description du tableau au Musée Napoléon représentant le Couronnement de Leurs Majestés Impériales et Royales, peint par M. David, peintre de leurs Majestés, Paris, 1808; A. Peyranne, Les Ages de la peinture: Ode à David premier peintre de Sa Majesté l'Empereur et Roi, Paris, 1810; Concours pour les prix décennaux, peinture, examen du tableau des Sabines et de l'école de M. David, par un amateur des arts, Paris, 1810; L'Injustice: Ode à David par M. L. de Lamothe H., Paris, 1810; Lettres à David sur le Salon de 1819, par quelques élèves de son école, Paris, 1819.

BIBLIOG. Notice sur la vie et les ouvrages de M. J. L. David, Paris, 1824; A. Thibaudeau, Vie de David, Paris, 1826; A. Thomé, Vie de David, Paris, Brussels, 1826; A. Rabbe, Notice sur J. L. David par l'auteur de la notice sur Canning; Biographie universelle et portative des contemporains, Paris, 1827; P. A. Coupin, Essais sur J. L. David, peintre d'histoire, Revue Encyclopédique, Apr., 1827; D. Cles, Les Deux fous, boutade classique, Paris, 1831; Séance publique de la Société libre des Beaux-Arts, tenue à l'Hôtel de Ville le 30 décembre, 1832, Paris, 1833; A. Perou, Examen du tableau du Serment des Horaces peint par David, suivi d'une notice historique du tableau lue à la Société libre des Beaux-Arts, Paris, 1839; C. Blanc, Histoire des peintres français du XIXᵉ siècle, I, Paris, 1845; J. Michelet, David, peintre et député à la Convention, Paris, 1850; Pièces diverses sur David: Collection historique de M. C. Renard, Caen, 1854; E. J. Delecluze, Louis David, son école et son temps: Souvenirs, Paris, 1855; E. Chesneau, Le mouvement moderne en peinture: Louis David, Revue Européenne, 1861; Notice sur le Marat de Louis David, suivie de la liste des tableaux dressée par lui même, Paris, 1867; J. L. Jules David, Le peintre Louis David, 1748-1825: Souvenirs et documents, Paris, 1880-82; Quelques observations sur les 19 toiles attribuées à Louis David à l'exposition des portraits du siècle (1783-1883), Paris, 1883; E. Chesneau, La Peinture française au XIXᵉ siècle, Paris, 1883; J.-L.-T. Géricault, Souvenirs du Collège de France (1846), Revue des Deux Mondes, CXXXVIII, 1896; J. Guiffrey, David et le théâtre pendant son séjour à Bruxelles, GBA, 1903; C. Saunier, Louis David, Paris, 1903; L. Hautecoeur, Rome et la renaissance de l'antiquité à la fin du XVIIIᵉ siècle, Paris, 1912; Exposition de David et ses élèves, Apr. 7–June 9, 1913, catalogue, Paris, 1913, preface by H. Lapauze; J. E. Blanche, Propos de peintre: De David à Degas, Iᵉʳᵉ ser., Paris, 1919; W. R. Valentiner, Jacques Louis David and the French Revolution, New York, 1929; R. Cantinelli, Jacques-Louis David, 1748-1825, Paris, 1930; Ecole nationale supérieure des Beaux-Arts, David, Ingres, Géricault et leur temps, exposition de peintures, dessins, lithographies et sculptures faisant partie des collections de l'Ecole, Paris, 1934; A. Humbert, Louis David,

peintre et conventionnel, Paris, 1937, 2d ed., 1947; P. Courthion, David, Ingres, Gros, Géricault, Geneva, 1942; J. Maret, David, Monaco, 1943; P. Melon, Deux lettres à S. M. le Roi de Hollande, Institut Napoléon, recueil de travaux et documents, Paris, 1945; L. Venturi, Modern Painters, New York, 1947; D. L. Dowd, Pageant Master of the Republic, J. L. David and the French Revolution, Lincoln, Nebraska, 1948; A. Maurois, J. L. David, Paris, 1948; M. Florisoone, Orangerie des Tuileries, David, exposition en l'honneur du deuxième centenaire de sa naissance, catalogue, preface by R. Huyghe, Paris, 1948; David, 1748-1825, Catalogue of Exhibitions of Paintings and Drawings, The Arts Council of Great Britain, London, 1948; D. L. Dowd, J. L. David, Artist Member of the Committee of General Security, American Historical Review, LVII, 4, 1952, pp. 871-92; W. Friedlaender, David to Delacroix, Cambridge, Mass., 1952, pp. 12-35; D. L. Dowd, Jacobinism and the Fine Arts: The Revolutionary Careers of Bouquier, Sergent and David, AQ, XVI, 1953, pp. 195-214; J. Adhémar, David, naissance du génie d'un peintre, [Monte Carlo?], 1953; L. Hautecoeur, Louis David, Paris, 1954; R. Zeitler, Klassizismus und Utopia, Stockholm, 1954; A. Boschot, Portraits de peintres, Paris, 1954; L. Rosenthal, Louis David, Paris, n.d.; P. Chaussard, Notice historique sur Louis David, n.p.,n.d.

Illustrations: PLS. 122–126.

## DAVIS, Stuart.

**DAVIS**, STUART. American painter born in Philadelphia, Dec. 7, 1894, the son of a newspaper art director and cartoonist. In 1910 he entered the art school that had recently been opened in New York by Robert Henri. The Armory Show of 1913, in which five of the young artist's water colors on social themes were included, was a decisive event for him because it afforded an initial contact with the work of Cézanne, Van Gogh, Gauguin, and Matisse.

Davis subsequently published drawings in the liberal magazines *The New Masses* and *Harper's Weekly*. He lived at various times in Provincetown and Gloucester and went to New Mexico with John Sloan in 1923. Influences from cubism and futurism, plus the mechanistic elements of Léger, combined in an important series of experimental works (1928–30) in which an austere grouping of an electric fan, a rubber glove, and an eggbeater on a tabletop was designed and redesigned with increasing comprehension of all its space, color, and form implications, as in *Eggbeater No.5* (1930; New York, Mus. of Mod. Art).

During 1928–29, a stay in Paris sharpened his urban visual sense, which was further developed on his return to New York (see *House and Street*, 1931; New York, Whitney Mus.). From 1932 to 1939 he was involved with WPA art projects, the Artists Congress, and teaching. A large mural, *The History of Communication* (now destroyed), was painted for the New York World's Fair of 1939.

Davis's work is essentially realistic (though not illustrational) in its use of specific and identifiable shapes, colors, and details. Every element in his paintings is sharply rendered and given equal significance; he frequently incorporates letters, signs, symbols, straight edges, and pointed accents in his works and paints with unmodulated color, as in *The Mellow Pad* (1941–51; New York, Edith and Milton Lowenthal Coll.). Often the over-all composition is divided into interlocking rectangular areas, with space skillfully realized through color relationships. A characteristic device is his studied use of a sprawling calligraphic signature translated into an arresting decorative form. His works are full of verve and often of humor, which sometimes overflows into the punning, alliterative titles, such as *Owh! In San Pão* (1951; New York, Whitney Mus.; I, PL. 126) and *Rapt at Rappaport's* (1952; Great Neck, N.Y., Mr. and Mrs. Stanley Wolf Coll.). His style has been compared to certain types of jazz, which Davis admires and enjoys. It suggests not only characteristic American material but also a distinctively American way of seeing.

BIBLIOG. Stuart Davis, American Artists Group Monograph No. 6, New York, 1945; J. J. Sweeney, Stuart Davis, Mus. of Mod. Art, New York, 1945; D. G. Seckler, Stuart Davis Paints a Picture, AN, 52, 4, 1953, pp. 30-33, 73-74; Stuart Davis, Walker Art Center, Minneapolis, 1957.

<div align="right">Allen S. WELLER</div>

**DEALING AND DEALERS.** An interesting aspect of the social function of the representational arts is the trade in objects of art. These objects may attain a material value which often,

although not always, corresponds to the ideal value attributed to them by criticism (q.v.). The market makes its valuations in a less theoretical manner than does criticism, such valuations paralleling current taste (see also SOCIOLOGY OF ART).

SUMMARY. The art market (col. 249). Art dealing in the ancient world and in the East (col. 249). The modern and contemporary art market (col. 252).

THE ART MARKET. In the most advanced art markets, in places where collecting flourishes, the commercial value of a work of art is determined principally by two factors: its intrinsic merit or uniqueness and the demand for it. The first factor concerns the object: the ability with which it has been executed, the quality of the material of which it is made, its state of preservation, and its authenticity (the value falls drastically if it is shown to be a copy or a forgery; see FALSIFICATION AND FORGERY). The second factor depends on the attraction which the object has for amateurs and art lovers generally.

The desire to possess works of art is variously motivated, but three fundamental attitudes may be distinguished. It can be a question of simple esthetic attraction, and in this case the act of acquisition and the price itself constitute an implicit critical judgment. Again, the appreciation of a work can — and does more often than not — arise from extraesthetic considerations such as those of utility, fashion, luxury or prestige value, documentary or historical interest, piety, curiosity value, or the desire to make a good financial investment. In periods of inflation especially, works of art may attract the investor because of their relative independence of fluctuations in the value of currency. Furthermore, the collecting spirit per se may affect the final price of a work, since serious collectors often attach great value to an object that will complete a series or to qualities such as patina and other effects of time (considerations which rarely if ever enter into a purely esthetic evaluation).

ART DEALING IN THE ANCIENT WORLD AND IN THE EAST. It is difficult to limit the types of articles to be treated in a discussion of commerce in art objects, because no precise distinction can be made between utilitarian products and works of an artistic character. Even in prehistoric times, people well supplied with raw materials of various sorts no doubt had occasion to make reciprocal trading arrangements involving manufactured articles. These exchanges became systematized with the appearance of metals, which were always much in demand in those countries that had no mines of their own. Trade was facilitated where communication by sea was possible. Good examples of participants in such exchanges in the ancient Mediterranean world were Cyprus and Tartessus (mod. Andalusia).

It is impossible to establish exactly when commerce in art, as distinguished from commerce in general, began in the ancient world. Neither can we say at what point a perfectly made functional object may, because of this very perfection, have acquired the value and esteem generally attached to an object of art. That bone harpoon which is most functional and that bronze hatchet which cuts best are preferred, and this preference may develop into the artistic judgment that the object which is best adapted to its purpose is beautiful. With increasing civilization, the taste for luxury on the part of individuals and classes becomes more common and an independent esthetic interest develops. This interest leads to the collection of art objects, and with it the art market is born.

In the two millenniums B.C., in the eastern Mediterranean, there were active exchanges of metals, leather, textiles, and the like. The trade was principally from east to west. In the more richly furnished Etruscan tombs have been found bronze objects from Asia Minor, silver plates decorated with Egyptian and Mesopotamian scenes, scarabs, and vases of Phoenician glass (see ORIENTALIZING STYLE). Mycenaean and Geometric vases and large red- and black-figured vases came into Italy in a continuous stream for use as tomb furnishings. This was true commerce in the arts, since these objects were produced in the eastern Mediterranean solely for the export trade. The Panathenaic amphoras are the proof of this; they are frequently found in Italy in the tombs of persons who had never won a Panathenaic contest. These amphoras were made of terra cotta, whereas the true Athenian examples are generally bronze.

The commerce which is most important in the history of art was that between Greece and Rome after the fall of Corinth (146 B.C.) and also, in a certain sense, that which occurred somewhat earlier, between the fall of Syracuse (212 B.C.) and the battle of Pydna (168 B.C.). Economic and psychological factors operated to produce in the Roman world — especially among the richer classes of the capital — a strong wish to adorn their villas with the kind of statuary that Mummius, the Roman general, had brought back from Corinth. Even copies of such objects were popular. This pressing commercial demand brought about a flourishing copying industry in all the centers of Hellenism. Families of artists worked feverishly in Athens, producing reelaborations of works of the two preceding centuries and pushing Greek art toward a kind of neoclassicism. Romantic pathos and Asiatic baroque influence also made their appearance in these productions, which opened the way to the severe eclecticism of Pasiteles, to archaizing taste, to the refined as well as to the hazy and ambiguous. A new emphasis on surface at the expense of structure made its appearance, and a superficial technical virtuosity triumphed over spiritual content (see ATTIC AND BOEOTIAN ART; CLASSIC ART). It would be a mistake to assume that these characteristics of late Hellenistic art were brought about by spontaneous artistic enthusiasm. They were, on the contrary, the natural outcome of an insistent but superficial Roman commercial demand.

The Romans — like the Etruscans — could not understand the work of Phidias, but they understood very well the severe style of Kalamis and the archaistic-calligraphic outline art. They appreciated and sought out the subtle and voluptuous, the Venuses and the hermaphrodites; and they liked genre statuettes. Greece produced works within this range and Rome bought them. Experts, middlemen, propagandists, and exporters appeared, and little by little a kind of stock market was created which established a "list" of prices. These were based naturally on demand as determined by fashion — not on intrinsic value.

The letters of Cicero provide an accurate picture of this curious commercial situation between Greece (Athens, Delos, Rhodes, Sicyon, Ephesus) and Rome. In *Ad familiares* vii. 23, of 62 B.C., Cicero explains that his friend Fabius Gallus bought for him some Bacchantes and a Mars which did not please him. Though Cicero did not wish to displease his friend by refusing them, he feared that Damasippus, a noted dealer, would change his mind and not be willing to repurchase them (cf. *Ad familiares* i. 4, 8, 10, etc.).

If one thinks of the many villas — Cicero furnished three — libraries, picture galleries, portrait galleries, baths, porticoes, forums, and temples (e.g., Concord) built by the Romans at this time, one realizes that enormous numbers of art works were required to furnish such buildings.

Among the principal Roman collections may be mentioned those of Sulla, Lucullus, Crassus, Pompey, Caesar, Brutus, and Anthony. Caesar paid 80 talents for two originals by Timomachos of Byzantium, and Sicyon settled its debts in 56 B.C. by giving up its picture gallery. Horace, Martial, and Juvenal tell us that the negotiators — i.e., antique dealers (among whom members of the gens Cossutia stood first) — had their business headquarters in the Saepta and along the Via Sacra. Restorers and copyists — among them Arkesilas, the friend of Caesar — were at the head of the markets. A marginal note by Horace (Epistulae ii. 2, 180) indicates that Etruscan statuettes were frequently to be found in Roman collections.

There are records of various shipwrecks involving vessels carrying works of art. Among the most noted were those of the ships of Sulla and Verres. To incidents of this kind we owe the chance recovery of statues, vases, etc., which the sea has given up. Such rescued works include the *Apollo of Piombino*, the Sabouroff *Ephebus* from Eleusis, and the *Poseidon* of Artemision. On two occasions the entire cargo of a ship was recovered, once near the island of Antikythera, and again at Mahdia off the Tunisian coast. Petronius, Juvenal, and Martial tell us that the fashion of spending large sums on

works of art continued unchanged during the early period of the empire, and that the emperors themselves were subject to it and had sometimes to sell in order to replenish their treasuries. Thus Marcus Aurelius sold at auction gems, precious vases, rare silks, gowns belonging to the Empress, taken from "the most sacred deposits of the Emperor Hadrian" (Julius Capitolinus, *Marcus Antoninus Philosophus* xvii. 4), in order to pay the expenses of the war against the Marcomanni.

Silvio FERRI

The natural aversion of Christians to the statues of the ancient world led to the destruction or burial of many of them. Those objects which could somehow be reconsecrated were saved. Evidence of this practice is given by the *Benedictio super vasa reperta in locis antiquis*, a benediction used on vases found in ancient places, preserved in an Anglo-Saxon ritual text of Durham. Collecting continued in Byzantium in the imperial palace and in the houses of rich patricians, and the market in works of art — though it was no doubt reduced in scale — must have continued as well. During the Middle Ages and thereafter in the West, art objects were sought as luxuries (e.g., precious Eastern silks and Byzantine silverware); as talismans, sacred furnishings, and symbols of power (e.g., antique ornaments set with jewels, reliquaries, etc.); and as accessories for buildings and tombs. From Early Christian times, pagan sarcophagi were frequently reused for Christian burials. The Venerable Bede (in his *History of the Church* iv. 19) tells, for example, of the monks of Ely who searched among the ruins of a Roman city (near modern Cambridge) for a stone sarcophagus for the Abbess Ethelreda.

In the 13th century the idea of collecting or trading in antique sculpture astonished the chronicler of Frederick II, who could not imagine why the Emperor wished to transport two fountain figures from Grottaferrata to Lucera or the portrait of a man to Lucca (Riccardi de S. Germano, *Notarii chronica*; A.D. 1242). At the end of the 12th century, with the secularization of culture and the consolidation of cities as commercial centers (and the corresponding development of the *bourgeoisie*), interest in works of art as such, which reached its full development in the Renaissance, began to revive.

Marco Polo, himself a merchant, confirmed that commercial traffic in genuine works of art was rather small in volume (at least as far as his own time was concerned). Although this was a period of intense commercial activity between East and West, Marco Polo's account makes no mention of Chinese works of art. This omission is significant in view of the brilliance of that period of Chinese culture.

In the East, commercial exchanges involving painting, sculpture, and literature coincided with the great waves of religious proselytizing. In the course of spreading Buddhism from India into China, Ceylon, Malaya, Burma, Siam, and Tibet, missionaries used the art of their native countries as an expedient to gain converts. The exhaustive work of these missionaries eventually led to the development of trade in art objects. The brief contact that Christianity had with the Orient brought opposite results, as the strong influence of Oriental art objects (which were imported by the Christian missionaries) influenced the development of the rococo style.

In the West, the relaxation of religious constraints made possible the appreciation of objects that originated in different spiritual environments. Trade in such objects had an appreciable influence on the work of 18th-century craftsmen. The trading of art objects became common between the Oriental countries themselves.

The Chinese manufacturers decided on the color, decoration, and style of the objects that they exported, although they were influenced to some degree by the recommendations of importers familiar with Western taste. The well-known trade in porcelain with the Moslem world in exchange for cobalt was less important commercially than the trade in certain house furnishings. (Chinese lacquer, for example, was much prized for its fine practical qualities as well as for its beauty.) Although Chinese styles are known to have influenced those

of the countries that imported these objects indirectly through the Moslem world, such influence through direct contact seems to have been less than has been supposed. We know that in Roman times large quantities of Chinese silks were imported, yet there is no evidence of Han influence in the decorative motifs of Roman imperial art.

There is little question that much trade in works of art originated in the ambassadorial custom of exchanging gifts. Delicately glazed Persian earthenware was imported into China in this manner — soon influencing the local ceramics industry — as was finely decorated Persian silverwork. The demand for such silver that developed in China assured a good reception to the Sassanian silversmiths who eventually went there. Ambassadorial gifts also led to the introduction of such Indian works as sculptured ivory, finely incised gold, and decorated tortoise shell into China.

The gift considered most suitable for these exchanges was undoubtedly silk. In antiquity, therefore, silk was much in vogue as an object of trade, and the silk market subsequently had a great influence on the historical development of Europe and Asia. Silk first appeared in Rome during the 1st century B.C. It arrived by way of Parthia before enterprising merchants began to import it from India by sea and across Egypt. Meanwhile Chinese caravans, sent out under the urging of the Han rulers, reached the Roman provinces by way of Khotan, Balkh (Bactra), and Damascus (the famous silk route).

Porcelain first arrived in Europe through the Moslem countries. As early as the T'ang dynasty (A.D. 618–906), China exported porcelain to Mesopotamia, Egypt, and Iran. Although the traders were generally Arabs — particularly along the southern route — we have evidence indicating that Chinese ships were also engaged in the export of porcelain.

The trade in Chinese ceramics (porcelain and porcelanous stoneware known by the Chinese as *tz'ŭ*) soon began to rival the silk trade and extended as far as east Africa, Iran, and Baghdad. Some importers attributed magical qualities to this Chinese ware.

Information about the trade in lacquer is less plentiful. Lacquer ware was very useful because of its lightness, its impermeability to water, and its extraordinary hardness. Moreover, in its early forms at least, it was decorated with great delicacy. Lacquer ware was already widely exported before it appeared in the West. The products of Szechwan were sent into northern Mongolia and northern Korea, and as early as the 8th century of our era, Buddhist images made of "dry lacquer" — and thus light enough to be conveniently carried in processions — were imported into Japan together with Buddhism itself. Chinese lacquers seem not to have reached Europe until the 16th century, or 800 years after they had reached Japan. In the 18th century, after the East India Company (of London) had brought large quantities of these unusual products into Europe, lacquer ware became extremely popular in the West. The East India Company — which, half military, half commercial, was the successor of the great Venetian, Genoese, Portuguese, and Dutch merchants — must be given the credit for having promoted the taste for Oriental art in Europe.

While the importation of porcelain, lacquer, patterned silks, ivory, and precious furniture — almost all of contemporary manufacture — continued in the tradition of the East India Company into the second half of the 19th century, in the present century interest has instead been concentrated on older art objects. Such objects — unearthed in the course of excavations connected with industrial development or taken from ancient tombs — passed through the hands of merchants in Peking and Shanghai to the markets of London, New York, and Berlin and eventually into the great museums of the West.

Mario PRODAN

THE MODERN AND CONTEMPORARY ART MARKET. As late as the 16th century, artists' fees were determined by such considerations as the size of the work in question, the number of assistants who worked on it, and the cost of the materials that were used. For example, the amount of precious color (i.e., gold

leaf or aquamarine) employed in a work affected its price. Figures, which required greater skill for their execution, were paid for at a higher rate than other subjects. Although patrons spent very large sums by the standards of those days, artists, like artisans, were compensated according to the amount of work they produced. Only the well-known masters could occasionally command somewhat higher fees because of their skill. Payment was generally made in the form of a periodic stipend, or the artist's services might be contracted by the payment of an advance fee.

The great masters were the most sought after, with the result that, as their fame grew, they tended to become heads of workshops, merely supervising the works that ultimately bore their signatures. As a result of the Humanist movement and the concomitant revival of interest in antiquity, ancient books and works of art were highly valued for sentimental, historical, and esthetic reasons. Because these classical works became objects of value in the market, forgeries were occasionally produced. Vasari, for example, tells us that when Michelangelo showed Lorenzo de' Medici a cupid which he had done, Lorenzo said to him, "If you put that in the ground, I'm sure it would pass for an ancient work. If you then sent it to Rome, you could get much more money for it than you would by selling it here." Thus we learn that the best market for antique works was in Rome. This very cupid was, in fact, finally sold as an antique by Baldassarre del Milanese to Cardinal Riario; but the cardinal, as soon as he became aware of the deception, returned it. The popes themselves were collectors and sought to prevent the export from Rome of works of art. This pressure naturally influenced prices. A letter of Isabella d'Este, written in 1499 to her agent in Rome, illustrates this point. She asked him to send her "una bella tabula di pietra" (a handsome stone relief) and added that it would be necessary to exercise some skill ("usar arte") with respect to the *conservatori* (curators) to get things out of Rome (Lanciani, *Storia degli scavi*, I, p. 126).

Closely connected with the esteem in which antiquity was now held was the transformation — especially marked in Italy — of artisans into artists in the modern sense. In the course of this transition, their profession became less and less associated with simple craftsmanship (see HANDICRAFTS). The rich patron also made his appearance at this time (see PATRONAGE). Buyers began to compete for the works of the artists with the foremost reputations. In the Cinquecento, sales began to be made through agents or middlemen, though the system of direct commissions continued. Bernardino De Rossi, for example, paid Perugino 100 florins for a painting of St. Sebastian, which he resold to Francis I for 400 ducats (Vasari, III, p. 577). Dealers began to appear on the scene: Giovanni Battista della Palla, for example (who in 1529 sent a *Hercules* by Michelangelo to Francis I), or Jacopo Strada and Niccolò Stoppi ("antiquaries" to the emperor), and many others (see MUSEUMS AND COLLECTIONS). It is significant that the Italian words *antiquario* and *antiquariato* have continued to mean "art dealer" and "art market," while in England an "antiquarian" is an amateur (who is often also a collector) interested in the art of the past.

The crash of the Antwerp stock market in 1557 and the inflation following the importation of large quantities of gold from the New World significantly encouraged the trade in art objects. The commercial value of works of art soon became more precisely determined. Prices were influenced by the age of the object and were first set on the works of those more famous early Cinquecento artists who had been considered by critics to be the equals of the ancients, and then on the works (which had necessarily become rare) of any good master not living. Vasari, who was instrumental in popularizing the new method of evaluation in Italy, was guided by historical and critical, as well as esthetic, considerations. A painting by Raphael, the master par excellence, became a capital investment. The art market in Italy catered in this period only to the courts and the high aristocracy. It was dominated by the artists themselves, in whose correspondence may be found evidence of early *expertise* in the modern sense. At the end of the Cinquecento, the official judgment and evaluation of works of art was still the province of the master artists.

Private trading continued to increase in the more advanced bourgeois states (such as Venice or Flanders) and led to the foundation of firms corresponding to those of modern dealers. Sales, according to ancient custom, were made *in piazza* (in the market place or square). Such an open exhibition, organized by the artists' guilds, is known to have been held in Antwerp in 1540. The Friday markets, where works intended for the *bourgeoisie* were sold, were regulated by the Guild of St. Luke, to which the artists belonged. The courtyard of the Bourse became the locus of art dealers' shops. With time the trade became more selective and international in character, and the value given to works of art increasingly followed the law of supply and demand.

Italy, too, had art merchants as early as the 16th century. Exhibitions were regularly held at S. Marco and S. Rocco in Venice. In 17th-century Rome, exhibitions were held in the Pantheon, in the headquarters of the Accademia dei Virtuosi, at S. Maria di Costantinopoli, in the courtyard of S. Giovanni Decollato, and at the headquarters of the Pio Sodalizio dei Piceni. In 17th-century England auctions were frequently held, and the first printed catalogues appeared in connection with them. In France, under Louis XIV, the first Salons were held.

In brief, the market acquired a "modern" character in the 17th century. Giulio Mancini's *Considerazioni sulla pittura* (ca. 1620) tells how to distinguish copies from originals and discusses restoration, conservation, and questions relating to exhibition and appraisal.

The account books of Guercino (*Notizie della vita e delle opera del cavaliere G. F. Barbieri detto Guercino da Cento*, Bologna, 1808, p. 58 ff.), in which Paolo Antonio and Giovanni Francesco recorded their receipts and expenses, give a good idea of the relation between the cost of living and the artist's income. In comparison with modern works, the old masters brought fabulous prices. In the 16th century, for example, Mary of Hungary offered a barber surgeon an income of 100 florins per annum for life in return for J. van Eyck's portrait of Giovanni Arnolfini and his wife (V, PL. 223); and in 1604, the Gonzagas gave a fief worth 50,000 scudi (the price of a princely palace) for the *Madonna della Perla*, which was thought to be by Raphael.

In the Gonzaga inventory of 1627 no old painting in the collection was valued at more than 100 to 200 scudi of Mantua (1 scudo equals 6 lire of Mantua). But Daniel Nys offered — on behalf of Charles I of England — 20,000 ducats (1 ducat equals 10 lire of Mantua) for a group of paintings from this collection. In all, Charles I spent 80,000 pounds for the Gonzaga collections. When, after the death of the King in 1649, the Commonwealth sold the royal collection at very low prices, the total receipts reportedly amounted to the unheard-of figure of 118,080 pounds.

In the second half of the 17th century, prices in Italy seem to have been comparatively low. The inventories and documents of the Chigi archives (V. Golzio, *Documenti artistici nell'archivio Chigi*, Rome, 1939) indicate that ancient sculptures were bought at prices ranging from 10 to 100 scudi each. The payments made for pictures by living artists varied from 10 to 150 scudi.

Because collecting became popular with the *bourgeoisie* in the 17th century, sales increased everywhere. Italy and Holland produced the most paintings and had the largest sales and lowest prices, while much higher figures were reached in London and Paris. Entire Italian collections were sold en bloc in the latter markets. Tourists in general, and English tourists in particular, eagerly purchased thousands of paintings of landscapes in Italy. These found their way into English country houses, where they remained until postwar economic crises forced their more recent owners to sell them. Auctions were frequent, particularly in France and England. The first house with fixed prices was that of Edward Millington in Charles Street, London. The first auction held by the famous James Christie the Elder (1730–1803) took place on Dec. 5, 1766, in the rooms in Pall Mall that had previously been occupied by the paint shop of Richard Dalton. Christie's catalogues and those of the equally famous Sotheby are an index of English and international taste during two centuries. In 18th-century France, auctions were

held in the monastery of the Grands-Augustins, in the Hôtel Aligre in the Rue St. Honoré, in the Hôtel des Américains, and in the Salle Lebrun. In the 19th century, first the Hôtel Bullion, then (until 1883) the Hôtel des Fermes, and finally (from 1854 on) the Hôtel Drouot were well known to art lovers.

In the 17th century the amateur had the upper hand over the artist in the market. In the following century the more erudite connoisseur established his position, and the catalogues, frequently put together by the dealers or middlemen, became more numerous, precise, and methodical.

The activities of forgers increased proportionately to the development of the market, and as early as the 17th century numerous copies and forgeries circulated (see FALSIFICATION AND FORGERY). Toward the middle of the 18th century, after the discovery of the ancient city of Herculaneum, forgeries of ancient classical works increased in number. As neoclassicism became increasingly fashionable, the prices of genuine ancient works rose.

Sales catalogues (of the Mireur, Graves, and Redfort collections, etc.) allow us to follow the variations of the market from the end of the 17th century to contemporary times. The catalogues indicate that the works of Caravaggio's school were neglected during the rococo and neoclassic periods, as were the paintings of the Italian primitives. In addition to works of antiquity, those of the great masters of the Cinquecento and of Reni, Albani, Claude, Poussin, the Carraccis, etc., were very much in favor. The low price of primitive paintings probably helped, along with a general change in taste, to bring about their revaluation. The prices of works of the Carracci school began to go down after the middle of the 19th century, while those of Botticelli, Filippo Lippi, Antonello, Angelico, etc., increased in value, as did the works of the Venetian *vedute* painters (painters of views and panoramas) and the impressionists.

The art market expanded tremendously in the 19th century. Dealers' galleries multiplied rapidly throughout Europe and in America. In addition to the growing number of auctions, the galleries of Georges Petit, Wildenstein, Colnaghi, Seligmann, Agnew, Knoedler and others became famous. Many of these galleries are still active today.

To be sure, unscrupulous organizations such as the Venice Art Company were not lacking, but the art dealer, in selecting works of art, restoring them, presenting them attractively, and authenticating them, made a direct contribution to criticism. Dealers were thus influential in guiding and developing the taste of the collecting public.

The establishment of public museums and the increasing frequency of exhibitions resulted in the diffusion of knowledge about art and had enormous consequences for the art market. These developments were, of course, related to the rise of the *bourgeoisie* and the development of industry. The aristocratic patron was replaced by the modern capitalist or businessman, who bought for investment and speculation. Although collectors continued to purchase works of art, patronage began to disappear.

The artist, deprived of the support of his patron, now had to struggle against middle-class taste, mass production and advertising, officially sponsored academic art, and the caprice of fashion. In this situation the art dealer replaced the cultivated patron of earlier times.

Luigi SALERNO

"A genuine picture dealer," Durand-Ruel wrote in his memoirs, "should be at the same time an enlightened patron, ready if necessary to sacrifice his immediate interest to his artistic conviction and preferring a fight against speculators to an association with them." These high principles had guided him since, in 1855, he succeeded his father and became the dealer of such still-unknown or little-appreciated masters as Corot, Millet, Courbet, and Boudin. In dealing with them, he also became their personal friend and helped to establish their reputations. He remained faithful to these principles when, after 1871, he began buying the works of the impressionists, stoically enduring scorn and contempt from the very clients who at last had come to appreciate the Barbizon school but were now unwilling to follow the dealer in his new venture. Born in 1831, Durand-Ruel was of the same age as Manet; his intimate acquaintance with the works of the preceding generation obviously enabled him to see in the impressionists the logical successors of Corot, Courbet, and Boudin. Yet the cleavage between artists and public during the second half of the 19th century was such that for many years Durand-Ruel was practically alone in recognizing the merits of the impressionists.

This situation was acknowledged by the influential critic Théophile Gautier when he wrote in 1868: "Confronted with the startling examples [of new artistic tendencies], those with some integrity ask themselves whether, in art, one can understand anything but the works of the generation with which one is contemporaneous, that which was twenty when you were the same age." Indeed, his venturesome spirit notwithstanding, Durand-Ruel did not go beyond the impressionists; he failed to take interest in such younger men as Seurat, Van Gogh, Gauguin, or Toulouse-Lautrec, not to speak of the Nabis and the Fauves, all of whom appeared on the scene during the long span of his life (he died in 1922, having seen the impressionists acclaimed all over the world).

The gap between the artist and the public meant two things: the dealer concerned with living art had to search for the true values, as yet unrecognized, and to stake his own fate on them; and newcomers among the artists had to find dealers who were ready to wage a hazardous battle for their reputations. Not many dealers were interested in taking such chances, accumulating unsalable merchandise and trusting that the future would vindicate their judgment. (Not many dealers had much judgment in the first place.) On the other hand, to be the sole representative of a new style, as Durand-Ruel was for many years, established a monopoly that was not always healthy. Although Durand-Ruel was in a position to dictate his prices, this privilege meant little so long as there was no demand for his ever-growing stock; he found himself accused of "pushing" the impressionists merely because he had invested so heavily in them. The situation began to improve only after Durand-Ruel's greatest rival, Georges Petit, began to acquire impressionist works in the 1890s and other dealers started bidding on them when they appeared at public auctions. Previously, Durand-Ruel had often been forced to bid on works at public sales to prevent his already low prices from being further reduced by even lower auction results. In other words, the confidence of the public became firmer once several dealers were handling the impressionists, allowing prices to be determined in open competition. While buyers had to pay more, they did so more willingly, and Durand-Ruel's devotion found its reward when latecomers tried to "cash in" on the rising market.

Owing to his comparative wealth and his willingness to stake everything on his convictions (an attitude which more than once brought him near bankruptcy), Durand-Ruel's name, fate, and ultimate fortune became inseparably linked to the impressionists, though he was not the only one to take an interest in them. On a much more limited scale, the picturesque color grinder Père Tanguy handled works by Monet, Renoir, Pissarro, and particularly Cézanne (whom Durand-Ruel had passed by), as well as Van Gogh, Gauguin, Seurat, Emile Bernard, etc. While Tanguy could not contribute so significantly as Durand-Ruel to the success of his artists, his small shop attracted many young painters who there acquainted themselves with the revolutionary works of their neglected contemporaries. For many years Cézanne's canvases could be seen only at Tanguy's, and it was the influence these paintings then exerted on younger painters that eventually paved the way for Cézanne's recognition.

In the late 1880s, Theo Van Gogh (the brother of Vincent Van Gogh), an employee of the important gallery of Boussod & Valadon, which specialized in high-priced Salon "masters," did his best to interest his superiors and clients in Gauguin, Lautrec, Bernard, and such older but still struggling artists as Redon, Jongkind, and Pissarro. (Durand-Ruel, who had been showing Pissarro's work until the latter's conversion to neoimpressionism, thereafter lost sympathy with him.) Theo Van Gogh's natural discretion and his knowledge that he could

supply his brother's needs prevented him from actively trying to create a market for Vincent's work, a task Tanguy assumed in a modest way.

The death of Père Tanguy in 1893 coincided with the appearance of a new figure in the Paris art world, Ambroise Vollard, who was ultimately to become an important dealer but who, in the beginning, met with the same difficulties Durand-Ruel had faced. Less idealistic than the latter, though probably shrewder, Vollard — finding that the work of most of the impressionists was contracted to other dealers and was already commanding respectable prices — became the sole representative of Cézanne and Gauguin, as Pissarro and Degas had advised him to do. (Vollard organized Cézanne's first one-man show in 1895; Gauguin sent him pictures in 1899 and signed a contract with him the following year.) Since there was no competitive demand for their work, Cézanne and Gauguin had no choice but to accept Vollard's rather low offers. Subsequently Vollard also handled works by Renoir and Degas. In 1899 he held an exhibition of paintings by Van Gogh, and in 1901 he gave Picasso his first one-man show and invested in the latter's Blue period. In 1904 Vollard held an exhibition for Matisse, and shortly thereafter he purchased the Fauve output of Vlaminck and Derain. He did not hold on to the works of any of the younger artists with the exception of those of Rouault (whose exclusive representative he became in 1907) and Maillol (whose small sculptures, of which he made numerous casts, he handled for many years). Vollard took no interest in cubism or the new movements following it, leaving the next generation to find dealers among men of its own age. Vollard also sponsored a number of painters whose names have been completely forgotten, so that his fame rests on the few "winners" he was lucky enough to pick and whose works, incidentally, he stocked without trying very hard to find buyers. The masterpieces that accumulated in Vollard's cellar became the source of his wealth, since he began to sell at comparatively high prices only when collectors and dealers sought him out, begging to be shown his treasures and ready to purchase whatever he consented to part with at whatever price he asked.

The next generation of dealers was much more active, possibly because some of the artists were more aggressive and also because the complacency of the buying public, somewhat shaken by its proven incapacity to grasp significant trends and personalities of the recent past, dictated a more assertive attitude. Some large establishments came into being after the turn of the century, such as the Bernheim-Jeune galleries (which, with the assistance of Félix Fénéon, handled many of the Nabis, neoimpressionists, and Fauves including Matisse and Van Dongen, but also traded impressionists) and the Galerie Druet, with its huge show place for important exhibitions. Most of the important new artists were, however, represented by a number of small dealers: Berthe Weil, Clovis Sagot, Libaude (who sold Utrillo's early paintings), Daniel-Henry Kahnweiler (mostly cubists), Léonce Rosenberg, Zborowski (Modigliani and Soutine), and several others. What these dealers lacked in financial strength they made up for through fervor and devotion, often serving the artists in whom they believed with selfless energy. The years before World War I, however, were relatively lean ones, since collectors in Europe and America — just discovering the impressionists — flocked to Durand-Ruel and Vollard, frequently ignoring the little galleries that were drowning in their supplies of fresh paintings by Matisse and Picasso (both of whom had admirers in Russia), Braque, Dufy, Utrillo, etc.

After the war, the most active new figure to appear on the market was Paul Guillaume, who quickly rose to fame and fortune, partly through supplying Dr. Albert C. Barnes of Merion, Pennsylvania, with works nobody else seemed to want. Barnes made his most rewarding purchases during the depression of the 1930s, when masterpieces went begging. As the general situation slowly improved, a new attitude, which became increasingly common after World War II, was adopted by the collectors — they no longer avoided the new and the unconventional. The increasing popularity of impressionist paintings and the unheard-of prices they began to command led many to the conclusion that by choosing the work of young or unknown contemporaries they might find themselves owning the masterpieces of the future. The only fallacy in this logic was that the previous discoverers of new talents had not been speculators but people genuinely interested in art who — guided by instinct, love, deep understanding, and selflessness — possessed true discernment.

During the postwar period, the search for new talent was intensified. Interest in art, both in Europe and in the United States, increased steadily, and a new wave of collectors appeared. Particularly the younger and less wealthy among these began to give their exclusive attention to contemporary artists of all nationalities (whose works were more likely to be within their means). Partly as a result of this development and partly because tax laws in the United States encourage collectors to leave their treasures to public institutions (permanently removing them from the market), the paintings of the impressionists and other expensive artists are beginning to lose their leading role in the international art market. Thus, American museums, which in recent years have already inherited important works from such benefactors as the Cone sisters, Maurice Wertheim, Samuel Lewisohn, Walter Arensberg, G. G. de Sylva, Leonard C. Hanna, William C. Osborn, John T. Spaulding, Philip Goodwin, Adele M. Levy, and countless others, can look forward to further magnificent harvests. Because the number of first-rate works available for purchase is thus constantly decreasing, the prices of these are being driven up. As a result, the handling of such important paintings is increasingly confined to a few international establishments such as the Wildenstein and Knoedler galleries, while there has been a marked tendency to "rediscover" secondary artists in order to fill the ensuing gap. Although some neglected artists have thus been rescued from undeserved obscurity, the public has been confused by the number of also-rans with which it has suddenly been confronted. These secondary works are often touted as masterpieces ready to be snatched up at bargain rates and are "guaranteed" to increase enormously in value. Simultaneously, many secondary works by first-rate artists are being offered to eager buyers as works of outstanding quality (and they are priced accordingly).

While most art dealers are prospering, a remarkable trend toward public auctions has also appeared. In England, following special new currency regulations, this type of sale took an undisputed lead. Prices obtained at auctions — for both old and modern masters — are often exceedingly high, possibly as a result of the fact that only at public sales can prospective and rich buyers be prompted to bid against one another until the most determined or most affluent among them obtains the coveted object. In the recent past, even during minor business recessions, auction prices have continued their steady climb, proving that buyers now have greater faith in the value of art works than in that of most other commodities.

The rapidly increasing interest in art has completely changed the character of art dealing. Dealers fervently devoted to a cause in which they believe are being replaced by others attracted by the fortunes that can be and are being made fairly rapidly in this field. People from all walks of life and all professions have flocked to the art market and, in many instances, have been extremely successful. This invasion of the art market by profiteering dealers and manipulators — who, even if they are not unscrupulous, are ignorant and trade in art as if it were simply another commodity — is crowding out the few remaining connoisseurs. One of the sad results of such speculation is the hoarding of works by a given artist (a practice introduced by Vollard) who, by contract, is forced to create for the vaults of his "benefactor" and therefore has little opportunity to participate in the contemporary art world. His works generally reappear only when their owner finds the time ripe — possibly after the artist's death. On the other hand, artists are often encouraged or even forced to hold frequent exhibitions, to show works which are hardly dry and which they themselves cannot judge properly for want of the distance that only time affords.

Another consequence is the frightening frequency with which spurious works are sold quite openly. Forgers are now brazen enough to counterfeit even works of living artists. These

forgeries are being peddled not only by fraudulent dealers but also by many honest merchants who do not know better. It is one of the peculiar facts of the art trade that experience benefits only a very few. Indeed, those who have no intimate relation to the works they handle seem also immune to visual experience and therefore incapable of gaining insight and knowledge. Even after long years of dealing with art, many merchants are unable to distinguish between good and bad, genuine and false. These people — whose sole endeavor is to satisfy a rising demand and who do not pretend to guide the public's taste (as their predecessors had done at the risk of being ruined) — can afford to display their ignorance only because their clients are often equally ignorant and even more gullible.

To "protect" themselves, many buyers insist on certificates of authenticity, thus indirectly admitting that they are paying primarily for the picture as an investment. They are blissfully unaware that anyone can set himself up as an authority, and that even the genuine expert is not financially responsible for the mistakes he may make. Moreover, unscrupulous dealers will always provide "satisfactory" documents with their wares, since it is obviously even easier to forge certificates than paintings.

Most of the scholarly catalogues and reference books on 19th-century artists have been issued by dealers, who either assembled them themselves or commissioned others to edit them. Thus, Georges Wildenstein has published catalogues of the *œuvres* of Manet and Seurat, while announcing those of Morisot, Gauguin, and Monet; Paul Rosenberg has published those of Cézanne and Pissarro; C. de Hauke and P. Brame have issued a Degas catalogue; Durand-Ruel has published a Sisley catalogue; Bernheim-Jeune has undertaken a catalogue of Bonnard's paintings; the dealers of Braque and Utrillo have begun publication of catalogues for these two artists; and Daniel-Henry Kahnweiler, the dean of Paris art dealers, has written a definitive book on his friend Juan Gris, to be followed by a catalogue of the artist's *œuvre*.

<div style="text-align: right">John REWALD</div>

One of the most remarkable developments of contemporary art dealing has been the proliferation of commercial galleries throughout the world. The number of these in New York City alone has been estimated at three hundred, and about the same number exist in Paris. To some extent this burgeoning parallels the great development of interest in art among the general public. It also reflects the tremendous pressure from the constantly increasing number of artists and would-be artists who require exhibition and sales space. The need for such space is satisfied only to a limited degree by museums, universities, and other public agencies; the chief burden still falls on commercial galleries. Although these galleries in France, Britain, and the United States have traditionally been established by dealers ready to take financial risks on the basis of a belief in the future of a particular artist (see above), the pressures of recent times have tended to make the probability of immediate economic success the dominating consideration. Relatively few dealers are now willing to support an artist until his work achieves wide acceptance.

Several factors help to account for this change. First among these is the immense number of artists of varying degrees of competence turned out by an ever-increasing number of art schools, academies, and (particularly in the United States) college art departments. Since artists tend to gravitate toward the art centers (there is usually only one important exhibiting center in each country), fantastic congestion results. New galleries spring up in answer to this need.

Moreover, the increasing popularity of painting among amateurs produces another crop of would-be artists, with little if any professional training, who put further pressure on the commercial galleries. Since some amateurs are able to pay for exhibitions, they automatically preempt space which would ordinarily be available to professional artists. Some galleries devote themselves solely to renting space to aspiring artists for a short period. Indeed, advertisements soliciting potential exihibitors appear in United States newspapers. The amateur artist adversely influences the sales potential of the trained artist in other ways: by flooding the market with additional work and, since he does not rely upon painting for a living, by giving away or selling cheaply a great deal of his work.

In spite of the increase, in the 1950s, of the number of galleries, there still does not seem to be enough exhibiting and sales space. One way in which some artists, particularly those of the avant-garde, have met this difficulty has been through so-called "artists' cooperatives," which are run by the members themselves and provide exhibiting and sales space as well as a meeting place. The commercial success of such agencies has been relatively negligible.

One of the novel features of mid-20th-century art dealing is the widespread concentration on contemporary, particularly avant-garde, art. By contrast, in the markets of late-19th-century Paris and Munich, for example, the avant-garde, however important culturally, received a far smaller share of attention. The contemporary equivalent of the artist who struggled for recognition during the impressionist and postimpressionist periods is today sought out all over the world, as much by museums, universities, and publications as by the commercial galleries. Thus, a Jackson Pollock is reported to have been sold in 1957 for about $30,000; paintings by Nicholas de Staël, during the same period, were valued up to $22,000.

The increased general interest in art is paralleled by a greatly increased number of potential buyers, not only of the works of recognized masters among the impressionists and postimpressionists, but also of paintings of subsequent schools down to World War II. A shortage of distinguished works of these schools has led to the astronomical inflation of prices, which, judging by recent sales in London and New York, have apparently not yet reached their final ceiling. In 1958, Cézanne's *Boy in a Red Vest* was sold for $616,000, the highest price ever bid on any single painting at an auction (higher prices have often been paid in privately negotiated sales). The shortage of important works by accepted modern masters has also led to the sale of works ranging from minor sketches down to studio sweepings. In certain circles the possession of a work by a "name" painter has almost become a social necessity.

The shortage has also led to a demand for paintings of schools other than the French moderns, notably those of the German expressionists, whose work could not be sold extensively before World War II. Since that time, however, and especially since the impressive 1957 exhibition at the Museum of Modern Art in New York, these works have had a new vogue; a single painting by Kirchner, for example, which had been valued at about $1,500 in 1949, had risen in price by 1958 to $25,000. Moreover, a good Klee or Kandinsky could bring as much as $45,000 in the same year. Commercial galleries have also tried to develop interest in contemporary Italian and Spanish painting.

As for the old masters, dealing in these continues unabated, although with a changed emphasis. During the first decade of this century, the Barbizon painters were extremely popular. A painting by Tryon, for example, was sold in 1907 for $65,000; by 1937, however, the same painting brought no more than $3,500. Other more or less academic and anecdotal paintings also brought extremely high prices until World War I, but their vogue has distinctly passed. In the period after World War I, English 18th-century paintings were immensely popular, partly as a result of the machinations of art dealers. The prices of such works reached an astonishingly high level at that time, a level from which they have receded drastically. Gainsborough's *Blue Boy* was sold in 1921 for $875,000; it is doubtful that it could command such a price today. Certain types of old masters have maintained a continuing and undiminished popularity among world art buyers, the works of Raphael being the most notable examples. The sale of his *Alba Madonna* in 1933 for $1,100,000 could probably be repeated.

Among the most interesting undercurrents of 20th-century picture dealing is the way in which modern movements in art may influence the demand for old masters. Thus the "rediscovery" of El Greco, for example, during the first decade of this century, was related to the development of the new expressionist school in Germany and Austria. As early as 1905, an

El Greco *Adoration* was sold for $37,500. Similarly, interest in other schools of Spanish painting, especially those related to impressionism (e.g., Velázquez and Goya), had been mounting since the latter part of the 19th century. In 1911 a portrait of Philip IV by Velázquez was sold for $475,000; and as late as 1934, a Goya portrait brought $275,000. On the other hand, the works of "nonmodern" Spanish masters (Murillo, for example) have been in eclipse for a long time, commanding only modest prices. It may be possible to relate the growing interest in the 15th-century Flemish school to the increased enthusiasm for the dreamlike reality promoted by surrealism. (The relative scarcity of good paintings of this school also adds to their price.) One such work, Robert Campin's *Mérode Altarpiece*, was sold for $850,000 in 1957.

Another contemporary trend in art dealing that distinctly reflects movements in modern art is the vogue for so-called "primitive" art. This trend shows itself in a variety of ways, depending upon the particular school of modern art to which it is related. Thus, in 1905, the German expressionists in Dresden and the Fauves in Paris, through their contact with African and Oceanian art, incorporated into their work some of the vigor and freshness of these cultures. Although the artifacts of Africa, the South Pacific, and similar areas had until then been regarded primarily as curios, they began from then on to achieve a new status, becoming objects of interest to the art market within a relatively short time. In New York, for example, a number of galleries specialize in African and Pacific art. The Blaue Reiter movement, which began in 1911, presented in its famous *Almanac* a wide variety of primitive forms as sources from which modern art could derive stimulation. These forms included not only those of the art of Africa and of the Pacific but also those of pre-Columbian periods, of folk art, and, indeed, of every kind of expression that is considered "unsophisticated." The interest artists expressed in pre-Columbian art was, in subsequent decades, taken up by collectors and, ultimately, by dealers. A number of galleries are now exclusively dedicated to pre-Columbian art. As in the case of old masters and modern paintings, the market for African, Oceanian, and pre-Columbian art is governed partly by vogue and partly by scarcity. In general, and particularly in the case of pre-Columbian art, export restrictions imposed by the countries of origin tend to augment scarcity and raise prices.

In addition, each major Western country has developed an interest in and a market for what is called "folk art." Thus, in Germany, since the beginning of the 20th century, interest in 19th-century glass paintings has revived. In other European countries, carved wooden sculptures — many of them religious in character — have begun to interest collectors, while in the United States a wide range of art forms — the paintings of the limners, wood carvings of various kinds, tombstones, and many other varieties of folk art — have entered the market.

What differentiates the art market in the mid-20th century from that of a half century earlier is its tremendous variety, a variety matched only by the diversity of interests of an increasingly educated public. What is perhaps most striking, however, is the great attention given to contemporary artists in all parts of the world. The work of contemporary painters, sculptors, and graphic artists is being sold as it has never been sold before.

Bernard S. MYERS

BIBLIOG. *Ancient*: E. Bonaffé, Les collectionneurs de l'ancienne Rome: Notes d'un amateur, Paris, 1867; A. Riegl, Über antike und moderne Kunstfreunde, Kunstgeschichtlichen Jhb. der kaiserlichen und königlichen Zentralkommission, I, Beiblatt, 1907, p. 1 ff. (reprinted in A. Riegl, Gesammelte Aufsätze, Augsburg, Vienna, 1929, pp. 194–206); R. Cagnat, Naufrages d'objets d'art dans l'antiquité, Ann. du Musée Guimet, XXXVI, 1912, p. 69 ff.; G. Ricci, Relazioni artistico-commerciali tra Roma e la Grecia, Antichità, II, 1950, p. 33 ff. *Medieval*: G. Marangoni, Delle cose gentilesche e profane trasportate al uso ed ad ornamento delle chiese, Rome, 1764; T. Wright, On Antiquarian Excavations and Researches in the Middle Ages, Archaeologia, XXX, 1844, pp. 438–54; F. de Mély, Du rôle des pierres gravées au moyen âge: Les lapidaires de l'antiquité et du moyen âge, Paris, 1896–1902; C. Enlart, Jewels of the Middle Ages and the Renaissance, Oxford, 1922; J. Evans, Magical Jewels of the Middle Ages and the Renaissance, Oxford, 1922; C. Enlart, Manuel d'archéologie française depuis les temps mérovingiens jusqu'à la renaissance, Paris, 1927; G. A. S. Snijder, Antique and Medieval Gems on Bookcovers at Utrecht,

AB, XIV, 1932, pp. 5, 52; W. S. Heckscher, Relics of Pagan Antiquity in Medieval Settings, Warburg, II, 1938, pp. 204–20; W. von Heyd, Histoire du commerce du Levant au moyen-âge, 2 vols., Amsterdam, 1959. *Modern*. *a. Coinage*: E. Martinori, La moneta, Rome, 1915. *b. Sales catalogues*: M. P. Defer, Catalogue général des ventes d'art, Paris, Marseilles, 1901–12; A. Graves, Art Sales from Early in the XVIII Century to Early in the XX Century, 3 vols., London 1918–21; F. Lugt, Marques de collections de dessins et d'estampes, Amsterdam, 1921; F. Lugt, Répertoire des catalogues de ventes publiques, I, The Hague, 1938. *c. Modern and contemporary sales*: (See various dealers' catalogues, World Collectors Annual, Art Prices Current, and Art Prices Annual; for fluctuations of the international art market see The Connoisseur, Art News, Art et spectacles, L'Oeil, Connaissance des arts, The London Times, The Observer, The New York Times, and Espresso.) H. Floerke, Studien zur niederländischen Kunst und Kulturgeschichte: Die Formen des Kunsthandels, das Atelier und die Sammler in den Niederländen vom 15–18 Jahrhundert, Munich, 1905; J. Schlosser, Die Kunst und Wunderkammern der Spätrenaissance: Ein Beitrag zur Geschichte des Sammelwesens, Leipzig, 1908; A. Luzio, La galleria dei Gonzaga, Milan, 1913; L. Brieger, Das Kunstsammeln, Munich, 1918; H. Lerner-Lehmkuhl, Zur Struktur und Geschichte des florentinischen Kunstmartes im 15 Jahrhundert, Wattenscheid, 1936; J. Rewald, The History of Impressionism, New York, 1946; S. N. Behrman, Duveen, New York, 1951; F. H. Taylor, The Taste of Angels: A History of Collecting from Rameses to Napoleon, Boston, 1955; J. Rewald, Post-Impressionism from Van Gogh to Gauguin, New York, 1956; A. L. Saarinen, The Proud Possessors, New York, 1959. *The East*: E. Zimmermann, Altchinesische Porzellane im alten Serai, Berlin, Leipzig, 1910; E. H. Warmington, The Commerce between the Roman Empire and India, Cambridge, Eng., 1928; G. F. Hudson, Europe and China, London, 1931; T'ien-tse Chang, Sino-Portuguese Trade, Leiden, 1934; W. B. Honey, The Ceramic Art of China and Other Countries of the Far East, London, 1945.

Vera BIANCO, Mario PRODAN, and Luigi SALERNO

**DECCAN ART.** The highlands of the Indian peninsula, since ancient times called the Deccan (Dakhin, from Skr., *dakṣiṇapātha*, "south land"), are linked with northern India by the passes of the Vindhya range and the tableland of Malwa as well as by the valleys of the Narbada and Tapti and the plains of Gujarat; with the coast of the Arabian Sea by the difficult but short passes of the steep Western Ghats; and with the Gulf of Bengal by the valleys of the Godavari, Kistna, and Penner. The Deccan forms the natural link between Aryan northern India and the Dravidian lowlands of the south and is a natural base for overseas trade to southwestern Asia and the Mediterranean and for shipping to Indonesia and the Far East. It has, therefore, been the focus of all cultural influences coming from the north and west or flowing back from the south. It has, however, also been sufficiently isolated to develop a characteristic civilization of its own. The carriers of this civilization were successively the Andhras of the Godavari delta, the Kanarese of the southwestern highlands, the Telugu of the eastern plateau, and finally the Marāṭhas of the western hills, all of them peoples of pure or predominantly Dravidian origin. In the northwest only was there considerable immigration, via Malwa and Gujarat: Aryans, Scythians, and Abhiras, Indians from the Maurya and Gupta empires, Gurjars, and finally Mohammedans, from the north or from overseas. Thus Marāṭhi became an Aryan language, though on a Dravidian substratum. In the Deccan are found the religious centers marking the progress of early Hindu civilization and religion down to the south; and here also the influence of north-Indian art — Buddhist, Jain, Hindu, and Moslem — became most evident.

SUMMARY. Earliest civilization (col. 262). Sātavāhana art (col. 263). Transitional period (col. 264). Pallava art (col. 264). Early Chalukya art (col. 265). Rāṣṭrakūṭa art (col. 268). The late medieval art of the Deccan (col. 269). Vijayanagar art (col. 270). Islamic art in the Deccan (col. 270). Marāṭha art (col. 271).

EARLIEST CIVILIZATION. The beginnings of Deccan history and civilization are still shrouded in considerable obscurity. Though Brahman (priestly caste) and Kshatriya (warrior caste) colonies from northern India seem to have settled there from the 6th century B.C., the indigenous population continued to use polished, pointed-butt stone axes, various wooden instruments sharpened with small chips of jasper, flint, agate, or crystal, and pottery shaped without a wheel. Copper was known but was very rare and costly. When in northern India mighty empires developed, the Nanda dynasty (4th cent. B.C.)

seems to have extended its conquests as far as Nander in the northern Deccan; and the Mauryas (ca. 320–184/83 B.C.) conquered the whole Deccan down to Mysore. Edicts of the great emperor Aśoka (ca. 268–ca. 233 B.C.) have been discovered on rocks at Sopara near Bombay; Gavi Math and Palkigundi, near Kopbal, and Maski, in former Hyderabad State; Yerragudi in the Kurnool District (Kistna Valley); and Brahmagiri and Jatinga-Ramesvara in the Chitaldroog District, Mysore State. But when after Aśoka's death the empire disintegrated, the southern Deccan was overrun by a still unidentified people who used iron implements and constructed elaborate megalithic tombs of a type known along the shores of the Red Sea and the Mediterranean and even in western Europe and the British Isles.

SĀTAVĀHANA ART. In the north the Sātavāhanas of Andhra (q.v.) founded a great empire which lasted until the early 3d century. In the first two centuries of our era this empire comprised practically the whole peninsula except the Tamil country, Mysore (Maisur), and Malabar. Intensive trade with the Roman empire, centered mainly in the harbor of Kalyan (Roman Kalliena, at the foot of the Western Ghats) and at the mouths of the Godavari and Kistna, and also with Malaya and Indonesia, brought great wealth. North Indian and Roman art found their way into the country from the beginning of our era, and as early as the 1st century a distinctive Andhra style of civilization and a refined art had developed.

The table mountains of the Ghats and their vicinity, with their steep cliffs, narrow gorges, and grandiose views, are an ideal region for ashrams (hermitages) and viharas (monasteries). The merchants who carried the Roman trade over the passes (the Bhor-Ghat, Nana-Ghat, and Thal-Ghat) from Kalyan to the Deccan founded numerous monasteries along their route, at Bhaja, Bedsa, Karli, Kondane, and Nasik, at Kanheri and later Kondivte on Salsette Island (near Kalyan), at Junnar beyond the Nana-Ghat, on the mountainsides not far from the Sātavāhana capital Pratishthana (Paithan, south of Aurangabad), at Pitalkhora, Ajanta, Aurangabad, Ambivale, Garodi, Nadsur, Nenavali, Kuda, and other sites. These monasteries consisted of simple cells with a stone bench, built around a quadrangular hall, often reached by a colonnade in front, and a *caityaśālā*, where the monks assembled for common prayers in front of a relic shrine (chaitya, stupa). The chaityas were churchlike halls consisting of a vaulted central nave ending in an apse where the stupa stood and two narrow lateral aisles meeting behind the apse. The hall received light through a gigantic window above a gallery on top of a screen wall with three doors giving access to the nave and aisles.

The style of this architecture imitated that of contemporaneous wooden buildings with their wagon roofs, domes, and trelliswork walls. During the three centuries of Sātavāhana rule it developed from rather simple to rich forms. The plain walls were decorated with reliefs depicting railings, balconies, and windows, sometimes with a perspective view of the hall ceilings inside. The ceilings began to have ribs. The cell doors received semicircular pent roofs. The colonnades were enriched by railings, the entrances by steps. The columns, at first pilasters of quadrangular or octagonal ground plan, were provided with pot-shaped bases and bell or cushion (i.e., inverted pot) capitals; on this bell were piled another cushion, an abacus of more and more corbeling slabs, and, on top of all, groups of animals couchant without (and later with) riders. Figural sculptures were added: elephants, lions, donors, minor deities, and occasionally scenes from various legends. This sculpture at first lagged behind that of northern India by about a century but subsequently developed rapidly. At Bhaja and Bedsa, for example, it is still very awkward, but at Karli there is an amazing sureness of technique, vitality, and expressiveness. At Ajanta (Caves IX and X) remnants of murals still survive, in poor condition but revealing a naturalism closely related to the Sanchi reliefs (see BUDDHIST PRIMITIVE SCHOOLS) and very different from the work of Gupta (q.v.) and Chalukya times.

When the Sātavāhana power was at its zenith, the sculptures on the railings and gateways (toranas) round the stupas of Sanchi (near Bhilsa in Malwa, constructed over earlier Maurya sanctuaries under the Śuṅga kings) were completed; these must be reckoned among the finest monuments of Indian art (see II, PLS. 402–406). Other stupas and monasteries were erected along the eastern coast, at Sankaram, Gudivada, Ghantasala, Bhattiprolu, Guntupalle, Jaggayyapeta, Ramatirtham, and especially at Amaravati and Nagarjunakonda. But most of them belong to the 2d or even 3d century, when the Sātavāhanas had been forced to retreat to the east before new hordes of barbarian invaders. The monuments of Nagarjunakonda, erected under a short-lived local successor dynasty, the Ikṣvākus, reveal the Sātavāhana style in full degeneration.

In its golden days the influence of Sātavāhana art was far-reaching. It had a decisive influence on the formation of ancient Ceylonese art (q.v.); and all over Greater India, from Burma and Malaya to Borneo, Funan (Cochin China), and Champa (Annam; see CHAM, SCHOOL OF; VIETNAM) Buddha statues of the Amaravati type have been found. The greatest treasure of Indian secular art, the exquisitely carved ivory chest of a princess, was excavated at Begram in Afghanistan; an ivory statuette of the goddess Lakṣmī (identified with Aphrodite, patroness of mariners) was discovered some years ago at Pompeii. And in the Deccan the Sātavāhana tradition remained the root of all later art developments. This, in fact, differentiates them from northern Indian art, which was based on the new style that originated under the barbarian Kushan emperors (1st–2d cent.) at Mathura in reaction against the provincial Roman art of Gandhara (Afghanistan) and was to flower in the classic art of the Gupta empire (4th–6th cent.).

TRANSITIONAL PERIOD. After the downfall of the Sātavāhana dynasty there followed three centuries of warfare and political instability. Eventually the Pallavas from the eastern Deccan and the Chalukyas from the west emerged as the main contenders for supremacy over the entire Deccan. But the influence of the Gupta empire to the north was powerful; it penetrated far to the south because of the prestige of its highly refined culture, the emigration of Jains from western India, and the emigration of innumerable refugees after the collapse of the Gupta empire in the 6th century under the attacks of the White Huns and other Central Asian nomads. Gupta artists created masterpieces at Ajanta and Aurangabad, in some of the earliest caves of Ellora, in the Buddhist Do Thal monastery with its chapel reminiscent of the Tun-huang caves in China, in the coastal region at Kondivte, Kanheri, Karli, and Bhaja, and at Elephanta. Farther south, Gupta influence is evident in the art of the Deccan and the eastern coast, though it could never supersede the indigenous tradition going back to Sātavāhana times. Its last wave came as late as the early 7th century, in the reign of the great Pulakeśin II Chalukya (609/10–42).

PALLAVA ART. Toward the end of the 6th century a cultural recovery set in, inspired by an enthusiastic revival of the cult of Śiva, sweeping away Jainism as well as Buddhism. The centers of the revival were the Chola and Pallava countries of the Tamil south, where under the Pallava kings Mahendravarman I (ca. 600–30), Narasimhavarman Māmalla (ca. 630–68), and Narasimhavarman II Rājasimha (ca. 680–720) a new art developed, starting from the Andhra tradition but finding its own solution for a new task and a new vision.

Its architecture evolved from the simple huts and halls depicted on the reliefs of Bharhut and Sanchi and from the Buddhist chaitya halls and monasteries once so common in the Sātavāhana empire. Eventually the walls were organized by pillars, colonnades, and niches for the images of various gods; the assembly rooms became cult halls, and the cells became shrines; the upper stories were reduced to a mere sham architecture, with several terraces of miniature huts interconnected by railings (*panchārām*) ending in a crowning dome (*śṛnga*) or (seldom) a wagon roof. In the early caves (reign of Mahendravarman) this architecture was still very modest; at Undavalli there were already caves of four aisles and three stories; and at Bhairavakonda the evolution of the classic Pal-

lava type is almost complete. The full Pallava style is represented by the caves and rathas of Mamallapuram (see DRAVIDIAN ART, also PL. 254): one copies a simple hut, two are chaitya halls (only one with an apse), and two others are Buddhist viharas several stories high. The walls are decorated with slim columns with reduced cushion capitals but exaggeratedly broad abacuses. The rocks have been carved into figures of lions and elephants, and in one place a charming group of monkeys. Somewhat farther to the north there is a gigantic relief cut into the cliff at both sides of a waterfall, variously known as *Arjuna's Penance* and *The Descent of the Ganges* (PL. 256). The last stage of the Pallava style (under Rājasiṃha and his successors) was reached in the Shore Temple at Mamallapuram; the Kailāsanātha (PL. 255), the Vaikuntha Perumal, the Muktesvara, and the Matangesvara at Kanchi; and other temples at Pana-malai, Oragadum, Tiruttani, and Gudimallam. The vimana (tower) had now become a pyramid of small cupolas and wagon roofs; the sanctuary is surrounded by a circumambulation passage (*pradakṣiṇāpatha*); a vast cult hall (mandapa) is placed in front of it, and sometimes an enclosure of small shrines sur-rounds it. The forms have become involved and heavy, full of conflicting rhythms and contrasts of light.

Sculpture developed in a similar manner. The figures, at first rather clumsy and often with big bull horns on the helmets, under Māmalla became slim and elegant with high, cylindrical miters, reminiscent of the Amaravati reliefs, and under Rāja-siṃha, heavy and restless. This art depicts in lively scenes full of innovations the great Hindu gods Śiva, Durgā, Viṣṇu, and Lakṣmī and their myths. In painting, a few beautiful remains have survived in the Kailāsanātha and at Sittanavasal (Pudukkottai, south of Tiruchirapalli).

EARLY CHALUKYA ART. By the first half of the 7th century the Chalukyas had become the leading power of the Deccan. Moreover, Pulakeśin II had in 624 conquered Andhra, the former home of the Sātavāhanas, and installed there his brother Viṣṇuvardhana. These eastern Chalukyas, independent after the fall of Pulakeśin II, became rulers of the great Chola empire, and their kingdom was absorbed into it. At the begin-ning of the 8th century the Chalukyas were the masters of the whole Deccan including Gujarat and parts of Malwa. But their bitter struggle with the Pallavas forced them to leave the defense of their northern frontier to their feudatories, the Rāṣṭrakūṭas, who eventually became independent and over-threw the Chalukyas between 753 and 755.

The rise of the Chalukyas is connected with Aihole in the Malprabha Valley, the only town of Gupta times still more or less intact. About a score of temples stand within the town, and two cave temples are cut into the flanks of the ridge. All are small, but they must have provided a numerous priest-hood with an income and the ambitious princes with devoted propagandists. In these temples can be seen the genesis of a new art in the Deccan. The oldest temples are of three types. Those of the Kontgudi group seem to have been inspired by Buddhist monasteries (viharas). They consist of a rectangular hall surrounded by a gallery of heavy pillars with very simple brackets supporting a sloping roof of heavy slabs, a few steps before the center of the front gallery, and a chapel at the back of the central hall. At the Lād Khān Temple another chapel is erected on the roof. Another approach was tried in the Durgā Temple (I, PL. 220), the ground plan of which is that of a Budd-hist chaitya hall. At Ter there were already small temples of this type, the Uttareśvara and Kāleśvara. The Durgā Temple represents a further step: it is raised on a high platform of Gupta type; the central pillared hall has been transformed into a massive shrine; the aisles enclosing it have become a gallery opening to the outside; a projecting penthouse roof has been added to the sloping stone slabs on top of the gallery; and the roof chapel on top of the sanctuary has been replaced by a north-Indian shikhara (a conic spire of square ground plan) with double projections on each side, rising in many diminutive "roofs" (*bhūmikā*) with rudimentary "windows" (*gavāksha*) periodically interspersed with coping stones (*āmala*). A third group has only one to three roof stories of miniature arcades

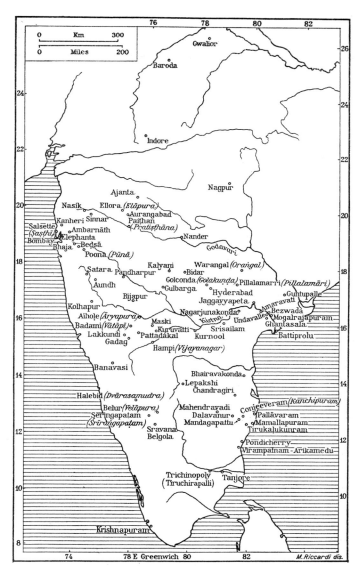

Principal centers of archaeological and art interest in the Deccan.

and balustrades, the topmost reminiscent of the *harmikā*, or pavilion, on top of Buddhist stupas. (A cave temple of similar type is the Pātālesvar at Bhamburda near Poona.) These build-ings, and especially their pillars, are decorated with sculptures (half to three-quarter life size) of gods and goddesses in a clumsy provincial style which probably stems from the Sātavāhana tradition but has absorbed much of contemporaneous Gupta typology. The gandharva and yaksha couples of the Lād Khān Temple especially have a certain charm.

Pulakeśin I transferred the capital from Aihole to Vatapi (the present Badami), at that time an almost impregnable fortress. In the cliffs to the south he and his immediate successors ex-cavated cave temples overlooking a great artificial lake. Their dimensions are vast, and their sculptures reveal the increasing influence of late Gupta art. The figures are slimmer and richly decorated; their modeling still belongs to the indigenous tra-dition and their movements are awkward, but they reveal a tremendous energy unknown in earlier sculpture, though characteristic of the medieval Deccan.

Under Pulakeśin II the Gupta style finally dominated the Chalukya empire, but the Chalukyan variety of Gupta art in the early 7th century is strong, healthy, and athletic, in contrast to the boneless softness of contemporaneous art in the north. Under Pulakeśin the small but beautiful Malegitti Śivālaya (ca. 625) and a ruined Viṣṇu (Kṛṣṇa?) temple were erected on

the northern cliff; on the ridge above Aihole the Meguti Temple was built; in Aihole itself the Durgā Temple was decorated with perhaps the finest sculptures of the time; outside Aihole several temples rose, notably the Hucchimalligudi and Gyotirlinga; at Ajanta the Buddhist monasteries Nos. I, II, XXIII, and XXIV and chaitya No. 26 were excavated; and at Ellora (Elura) were erected the first stages of the Rāmeśvara Temple, perhaps the most beautiful of the caves there. The most northern representatives of Chalukya art are the temple of Lakrodā in Gujarat and probably also the temple-tower of Gop in Saurashtra (mod. Soruth) in Kathiawar.

Most of the later Aihole temples, as well as the Nāgeśvar at Nagral, consist of a plain tripartite hall (vimana), the higher central aisle of which is covered by horizontal, and the lower lateral aisles by sloping, stone slabs; in front there is a pillared porch, and behind it the sanctuary, topped either by a stepped pyramid of five to seven "roofs" or by a shikhara. However, the Meguti Temple and the Malegitti Śivālaya represent a more developed type, on a sculptured Gupta plinth, the walls divided into receding sections (with windows) and projecting sections (with image niches), separated by slim columns; the Meguti, moreover, has a broad circumambulation passage. Characteristic of the Chalukya-Gupta style are the long friezes of droll dwarfs, for example, along plinths and cornices in Ajanta caves.

The second half of the 7th and the beginning of the 8th century witnessed a synthesis of all the Pallava and Chalukya elements in an art known to us mainly from the Buddhist and the Brahmanic cave temples of Ellora and Elephanta (Gharapuri). The caves of Ellora are excavated in a cliff slope of the same range in which Ajanta is located; they form a vast arch, the southern end of which houses the Buddhist temples and the northern, the Jain temples; in the center the Saiva caves flank a sacred waterfall. The Buddhist caves belong to the later Mahayana sect, with its numerous pantheon of savior-deities. Not all of them are monasteries; one (Viśvakarmā) is a chaitya hall, another one (Mahanvāda or Dhervāda) is a refectory or assembly hall, and the rest are temples or have at least an image shrine flanked by huge statues of dvārapālas (guardians of the door). Some (e.g., the Do Thal and Tīn Thal) have several stories, one serving as a cult room (the prototype of the chapels and image halls in Chinese and Japanese temples), the others as abodes for the monks. The Buddha is always represented in the company of several bodhisattvas and disciples; in his stead there appear also Padmapāṇi, Avalokiteśvara, Tārā, and occasionally even terrible tantric deities (PL. 171). Probably the Tīn Thal caves were added in the late 7th century to the older ones (Viśvakarmā and Do Thal). The Saiva caves are of the same general type. To what extent they were excavated in Chalukya or in Rāṣṭrakūṭa times is often uncertain.

At Elephanta the caves — all Saiva — are cut into the flanks of a hill, the biggest one being lighted by two lateral exits on courts excavated in the rock. In the center is a shrine for the linga (phallic symbol representing Śiva), guarded by huge dvārapālas; and filling the back wall is a gigantic bust of the god with three heads, one gracious, one displaying feminine sweetness, and one of horrible ferocity (generally known as Trimūrti, more correctly Sadāśiva).

The last phase of Chalukya art, under Vikramāditya II (733/34–44/45), is of a very different character. Its principal monuments are the temples of Pattadakal (south of Badami), the Virūpākṣa (erected by Vikramāditya's queen after 740; see PLS. 128, 129), the Mallikārjuna, the Pāpanātha, and the Samgameśvar. Vikramāditya had in 740 stormed the Pallava capital Kanchipuram, and in all probability the Virūpākṣa, which is a copy of the Kailāsanātha at Kanchi (PL. 255), was built by masons deported from there. The walls of the cult hall are broken up into sections flanked by slim columns which enclose either an image niche crowned by an elaborate foliage arch that emanates from the mouth of two makaras (fantastic marine animals) or a window closed by perforated stone slabs worked into complicated designs. This hall opens into three porches, the heavy pilasters of which are decorated with lifesize dvārapālas, heavenly nymphs and musicians, and mythological scenes; the roof and the śṛṅga tower are also decked with sculptures. In contrast, the interiori s rather plain, though the square pilasters are covered with delicate reliefs. The Mallikārjuna is a less successful imitation of the Virūpākṣa, as is the Pāpanātha, a Saiva expansion of an original Viṣṇu temple.

The Kedsiddheśvar and Galagnātha are pure north-Indian temples of the final Gupta style; though nothing is known of their history, they probably belong to the short period of Kashmir supremacy (736–48) which initiated the collapse of the Chalukya empire.

Chalukya art was the source of two later styles: the art of the Chola empire (9th–13th cent.) in the south, to which it imparted, mainly through the mediation of the eastern Chalukyas, the Gupta influence from the north; and that of the Rāṣṭrakūṭa empire, its direct heir.

RĀṢṬRAKŪṬA ART. The Rāṣṭrakūṭas had been a powerful family in the northern Chalukya kingdom since at least the late 7th century, in Berar, Gujarat, and Nasik. Krishnarājā (755/57–75) united all the Rāṣṭrakūṭa dominions and defeated the Chalukyas; his successors defeated the Pallavas and other regional dynasties. In the 9th and 10th centuries the Rāṣṭrakūṭa empire was at its zenith and comprised the whole of India except a fringe in the northwest, Bengal, and the southeastern coast, where the eastern Chalukyas and Pallavas offered obstinate resistance.

The extensive though ruined remnants of the Rāṣṭrakūṭa capital, Manyakheta (Malkhed, Malkair), have not yet been explored. No Rāṣṭrakūṭa temples have yet been identified. Thus the only monuments which can at present be attributed with certainty to this period are the later cave temples of Ellora and the last sculptures of Elephanta; and even at Ellora the attribution of some of the finest caves is doubtful.

To the Rāṣṭrakūṭa period belongs one of the most famous monuments of India, the Kailāsanātha at Ellora. The excavation had been started by Dantidurgā (742–55/57). Krishnarājā I completed the original temple, a one-storied imitation of the Virūpākṣa at Pattadakal (and thus of the earlier Kailāsanātha at Kanchi), probably reached by a flight of steps. Before the end of his reign the front court was deepened by one story and a new entrance excavated; the back court was completed only in the reigns of Krishna III (939–68) and Bhoja Paramāra (1010–65). Dhruva (780–93/94) constructed the beautiful chapel of the river goddesses; Govinda III (793/94–814), that of the mother goddesses; Amoghavarsha (814–80), the Lankeśvara cave; Krishna III, the famous relief showing the demon Rāvaṇa shaking the mountain Kailasa (PL. 171); and Bhoja, the lion frieze round the plinth. The galleries around the back court may be as late as the 12th or 13th century. In its later development the temple is reached through an entrance gopura (gate tower) and the ground floor of the Nandi mandapa (cult room of Śiva's bull); two staircases lead to the Nandi mandapa proper, the great pillared cult hall with its balconies and the sanctuary surrounded by a circumambulation passage giving access to five subsidiary chapels. The style of the sculptures varies considerably. The earliest examples, of Dantidurgā's time, reveal a barbarian taste and a provincial craft tradition going back to the early Badami caves (late 6th cent.). Under Krishna I the Pallava-Chalukya style of Pattadakal dominated; later the influence of the late Gupta tradition was felt. Added to these were new Pallava and eastern Chalukya features under Dhruva. Under Govinda III a grandiose imperial Rāṣṭrakūṭa style developed, to some degree leaning on the local Chalukya tradition of the late 7th and early 8th century. Under Amoghavarsha the style became restless and baroque; under Krishna III, light and elegant, to some degree under the influence of the late Pratīhāra sculpture of northern India. The Paramāra and the still later (south-Indian) work tended again to become dull. The interior of the temple was once painted, but most of the work is hidden by an 18th-century restoration. What is still visible shows a progressive transition from the naturalistic, though mannered, Gupta style to a medieval concept of decoratively composed, flat, colored drawings.

The Kailāsanātha provides a basis for dating some of the other caves. The Daśāvatāra, with its powerful reliefs, though

begun as a Buddhist monastery in the middle of the 7th century, was completed by Dantidurgā as a Hindu temple. The beautiful Rāvaṇaka-Khai, the Indra Sabhā, and the Jagannātha Sabhā resemble the interior of the cult hall of the Kailāsanātha. The Rāmeśvara, though begun in the 6th or early 7th century, received its glorious Saiva reliefs probably under Govinda III; and at approximately the same time the adjoining Brahmanic caves may have been completed (the Dhumar Lenā, or Sītā Nahānī, which resembles the great cave temple of Elephanta, may have been laid out in the late 7th century). At the Jain caves, with their good but dull sculptures, work went on until the late 10th century, perhaps even later.

THE LATE MEDIEVAL ART OF THE DECCAN. With the fall of the Rāṣṭrakūṭas the golden age of Deccan art came to an end. Such creative urges as still existed found their outlet in the rising world empire of the Cholas, who had superseded the Pallavas and eastern Chalukyas in the Dravidian lowlands of the southeast coast. Here Saivism experienced a last renaissance; here a new style sprang from the synthesis of Pallava, Chalukya, and indigenous traditions; here the types evolved under the earlier dynasties were brought to their artistic perfection (see DRAVIDIAN ART).

The art of the Deccan, however, represented a renaissance. The western Chalukyas of Kalyani (973–ca. 1200) resumed the art tradition of their earlier namesakes, taking as their model the temples of Pattadakal. The imitation, though clever, rich, and exuberant, lacked the original vision. No new architectural or sculptural types were developed, though the traditional ones were more and more elaborated; the sculptures, though elegant, increasingly lost contact with nature. Instead there developed a most elaborate and often technically accomplished decoration. Temples of this period are found at many places in the Kanara country; most famous are the Kāśiviśveśvara Temple at Lakkundi (1087), the Mahādeva at Ittagi (1112), the Mallikarjuna at Kuruvatti, the Trikūteśvara and Sarasvatī at Gadag, the Mahālakṣmī at Kolhapur, and probably also the great temple at Aundh.

The ultimate stage of this art was reached under the Hoyśalas (ca. 1022–ca. 1350) in Mysore (Maisur), where the reform of the Viṣṇu cult by Rāmānuja provided a new creative stimulus. The sanctuaries of the late temples have a star-shaped ground plan; their cult rooms are polygonal halls with thick columns; their walls are closed with perforated stone screens; their spires represent a cross between the old Deccan *śṛṅga* pyramid and the north-Indian shikhara. Everything is covered with a filigree of sculptures, many bearing the signature of the artist. Some represent queens — especially Śāntale, the first wife of Viṣṇuvardhana — as temple dancers. More than 75 Hoyśala temples are known. The most famous are the Chennakeśava at Belur (Beluhur, Velapura, the second capital) erected by Viṣṇuvardhana (1100–52), the enthusiastic royal disciple of Rāmānuja, in 1117; the Hoyśaleśvara at Halebid (PL. 131), erected by his successor Narasimha I in 1141; and the small triple Keśava Temple at Somnathpur, built in 1269 by Soma, a high official of Narasimha III (1254–92). Another famous monument of Mysore, the Gommateśvara colossi at Sravana Belgola, had already been erected before the rise of the Hoyśalas, by the Ganga king Cāmuṇḍa in 981.

Farther north, art degenerated quickly. The Śilāhāras took over the north-Indian temple architecture of their allies, the Parāmaras. These temples, with their massive shikhara towers, are found mainly in and near the Western Ghats, from Khandesh in the north to Kolhapur in the south; best known are those of Ambarnath (1060) and Sinnar. The art of the Yādavas (1189–1321) of Deogiri (Daulatabad) and of the Kākatīyas (1000–1326) of Warangal also was increasingly influenced by that of northern India, perhaps owing to the immigration of refugees from the Moslem conquests in the north. Iconographic types became fewer, the figures became mummylike dolls, even the ornament was reduced to a minimum. Occasionally, as at Palampet, these sculptures have a quaint archaic charm, but generally they are utterly dull. More interesting is the military architecture of the Yādavas, especially of the capital Deogiri, a volcanic cone defended by a moat cut about 170 ft. into the rock, with an entrance through an underground passage which could be exposed to the gases of a furnace.

VIJAYANAGAR ART. After the victorious advance of the Moslems through the Deccan and southern India in 1305–10, there followed an internal crisis of the Delhi empire which ended in the secession of the Deccan, Bengal, Gujarat, and Malwa between 1334 and 1392. In consequence the Hindus were able to rally their forces and, under the four Vijayanagar dynasties (1336–1675), reconquered the whole country south of the Kistna, at one time even up to the Godavari. Even after their power had been broken in the battle of Talikota (1565), the disintegrating empire lingered on as a federation for another century. With this political recovery went a cultural and art renaissance carried on the crest of a strong religious revival. One of the aims of this movement was the restoration, repair, and embellishment of the Hindu temples destroyed or desecrated by the Moslems. When the empire stood at the zenith of its glory, innumerable new temples and palaces were erected, richly decorated with sculptures and paintings; bronze images were dedicated; and a gorgeous luxury characterized the daily life of the court and aristocracy. But the old art was dead, and its revival was artificial.

Moreover, the Deccan and the south were now welded together in one empire. The Deccan (Vesara) and the southern (Dravida) style, therefore, mixed in a new, very rich, but somewhat lifeless art. The high temple gateways (gopura) that had developed in the Tamil areas since the end of the Chola period were adopted; vast open halls (mandapas) in front of the cult rooms came into fashion; pillars were replaced by complicated pilasters with attached slim columns, horsemen, and lion and elephant groups. But the trend toward a simple folk art, evident in the northern Deccan even in the 12th and 13th centuries, slowly got the upper hand. For secular purposes a simple architecture of wooden or stone beams decorated with paintings and rich cloth or with metal knobs, plates, or rings developed, into which Islamic forms soon infiltrated. Naïve but very lively reliefs decorated first the funeral steles, then public buildings such as the substructure of the throne hall of the emperors, and at last even the walls of temples (Hazāra Rāma at Vijayanagar, Mallikarjuna at Srisailam). The same tendency appeared in pictorial art: while the religious murals were a last echo of the seminaturalistic Gupta tradition (Lepakshi, Pillamarri, Anagundi, Vijayanagar), the folk style became the rule for erotic and other manuscripts and at last even invaded the temples (Tiruparuttikunram).

Vijayanagar (mod. Hampi) covered an area of over 10 sq. miles and was once one of the largest metropolises of the world, with its many temples (among them the Viṭṭhala, the Pampāpati, the Kṛṣṇa, the Hazāra Rāma, and the Pattabhi Rāma), the citadel with its royal palace, Zenāna, the prime ministers' palace, and other monuments. The later royal residence, Chandragiri, also has some fine palaces.

ISLAMIC ART IN THE DECCAN. The Moslems had come as conquerors, and their art was foreign, inspired by that of Russia and Turkestan. In the long run, of course, the influence of the Indian milieu made itself felt, beginning in the north in the 14th century and becoming strong in the 15th. New developments in the Deccan, however, were initiated by overseas relations with other Moslem countries — Persia, Arabia, Egypt, and Ottoman Turkey. For the architecture of Gulbarga, the first capital of the Bahmani sultans, Mongol Persia supplied the model (see ILKHAN ART); for the second capital, Bidar, the art of the Timurids of Persia and Turkestan (see TIMURID ART). Yet Indian art infiltrated through the Hindu women (wives, concubines, musicians, and dancing girls) in the Moslem harems, first in the costume to which many of them remained faithful, then through luxury goods of many sorts — textiles, jewelry, furniture, and musical instruments. Hence certain Hindu motifs were taken over into secular architecture. This development started under the learned and tolerant Firuz Shah (1397–1422). It is apparent in the throne hall (Takht Mahal, 1428–32) of

the Bidar palace and is most pronounced in the Rangīn Mahal (a combination of Hindu wood architecture and Persian wall decoration of encaustic tiles), which belongs to the last Bahmani period (1482–1518). Then the great victory of Talikota in 1565 caused a complete reversal of the Moslem attitude. The Hindus ceased to be a danger; the successive sultanates of the Bahmani kingdom pushed their conquests farther and farther southward. The sack of Vijayanagar had brought many Hindu artisans, prisoners of war as well as refugees, into the Deccan sultanates, and the sultans and their grandees became either tolerant on principle (Ibrāhīm Qutbshāh, 1550–80; Ibrāhīm 'Ādilshāh, 1580–1626) or subject to the influence of Hindu favorites (Muhammad, 'Abdullah, and Abū'l-Hasan Qutbshāh, 1580–1687; Ibrāhīm II and Muhammad 'Ādilshāh, 1580–1656; Chand Bībī, 1557–1600; the last Nizāmshāhs). Soon after the sack of Vijayanagar, miniature paintings (mainly illustrating Hindu love lyrics and treatises on music or astrology) came into fashion at Bijapur (the 'Ādilshāhī capital), Golconda (capital of the Qutbshāhs), and Ahmadnagar (Nizāmshāhs). Hindu temples in the Vijayanagar style were built in the territories of Hindu fief holders of the sultans (e.g., at Mahabalesvara). In the 16th century this Hindu element was integrated. Hindu architectural elements such as brackets, balconies, and columns became common, and stools, metal rings, plates, and knobs and other studs were transferred from Hindu furniture and wood architecture to the decoration of Islamic buildings. Even the Deccan Hindu coat of arms, a lion holding one or several elephants in his claws, was taken over as a royal emblem instead of the Persian lion. These features can be traced in many buildings, alongside Persian, Arabian, Egyptian, and Turkish motifs; the best examples are the mausoleum of Ibrāhīm 'Ādilshāh, the Mihtarī Mahal and the entrance building of the mausoleum of Muhammad 'Ādilshāh at Bijapur, and the Bhagmatī, Tolī, and other mosques at Golconda.

This trend continued even after the Moghul emperors of Delhi had conquered the Deccan in 1686–87. Though Moghul architecture penetrated, many features of the later style of the Deccan sultanates were taken over; they even became the fashion in northern India and determined the character of late Moghul architecture. This tendency is felt even more strongly in the architecture of Mysore under the sultans Haidar 'Alī (1759/60–82) and Tipu Sahib (1782–99); for example, in the Daryā Daulat Bāgh (summer palace, the principal palace having been destroyed in 1799) and the sultan tombs in the Lāl Bāgh at Seringapatam. The Hindu element is still more evident in the Moghul miniatures of the school of Hyderabad. They are often reminiscent of Rajput paintings, and a number of Hindu art motifs such as the *salābhañjikā* (tree goddess) recur, though in a purely secular interpretation.

MARĀṬHA ART. Originally feudatories of the Bahmani, Nizāmshāhī, and 'Ādilshāhī sultans, the Marāṭhas of the Western Ghats had in the last half of the 17th century become the most dangerous adversaries of the Moghuls. In the 18th century they became, under the leadership of the Peshwās of Poona (1714–1818), the sole great power of India, for some time extending their control from Calcutta to the passes of Afghanistan. They were a rather rude race of peasants, fervently orthodox Hindus but without a deep cultural heritage. As rulers, however, they acquired some refinement, built palaces and rich mansions, and restored or founded innumerable temples, bathing ghats, pilgrim houses, and the like all over India. Their art was eclectic and did not grow into a national style until the second half of the 18th century. Their temples were copies of the medieval monuments of the Deccan, western Chalukya as well as Śilāhāra, but with an admixture first of 'Ādilshāhī forms, later of Moghul domes, scalloped arches, and even columns. From the middle of the 18th century on, the Moghul influence became predominant, and a very curious temple-tower evolved, consisting of a pyramid of miniature Moghul pavilions crowned by a Deccan lotus dome, arranged exactly like the *śṛṅga* and *upaśṛṅga* of a medieval sikhara. In the 19th century the temples often resembled royal audience halls, the throne being replaced by a chapel. Marāṭha secular

architecture evolved from the wooden framework, filled in with bricks and placed on a stone platform, of the indigenous peasant houses; but it was richly decorated, especially on the brackets and arches, with wood carvings, first of Gujarat, later of Chinese, type. In the Konkan the roofs of some temples were even decked with Chinese figural tiles. In northern India palace architecture was more dependent on Moghul models. In their temples and palace chapels the Marāṭhas cultivated a folk sculpture faithfully representing living people, grandees, officials, and dancing girls; the funeral shrines even have doll-figure portraits of the deceased. Marāṭha painting was dependent mainly on Rajput (late Jaipur school; see RAJPUT SCHOOL) or Deccan-Moslem art but took over painting under glass from the Chinese via Bombay. Even in its best creations Marāṭha art is rustic, heavy, and rather crude, though not without a certain homely charm. The best Marāṭha monuments are found in their home country, especially at Chandor, Nasik, Poona, Satara, Pandharpur, and Kolhapur, but there are some also in the former Marāṭha states, at Nagpur, Baroda, Indore, and Gwalior, and in the great orthodox center, Benares. The most important temple builder was the saintly queen Ahilyā Bāi of Indore. A curious mixed Marāṭha–south-Indian art developed at Tanjore, also a Marāṭha conquest. Tanjore paintings and metalwork have become rather well known, but their fat, dull figures and overelaborate ornament are one of the sources of European prejudice against Indian art. Whether a specifically Deccan art will develop in modern India cannot yet be foretold; the art of modern India is still in the melting pot.

BIBLIOG. J. Burgess, Memorandum on the Buddhist Caves at Junnār, Bombay, 1874; J. Burgess, Report on the Antiquities in the Bīdar and Aurangābād Districts, London, 1878; J. Burgess, Report on the Buddhist Cave Temples and Their Inscriptions, London, 1883; J. Burgess, Report on the Elora Cave Temples, London, 1883; J. Burgess, The Buddhist Stūpas of Amarāvatī and Jaggayyapa, London, 1887; A. Rea, South Indian Buddhist Antiquities, Madras, 1894; A. Rea, Chālukyan Architecture, Madras, 1896; J. Burgess, The Ancient Monuments, Temples and Sculptures of India, London, 1897; A. Rea, Pallava Architecture, Madras, 1909; J. Ferguson, History of Indian and Eastern Architecture, London, 1910; G. Jouveau-Dubreuil, Archéologie du Sud de l'Inde, Paris, 1914; H. Cousens, Bijāpur and Its Architectural Remains, Bombay, 1916; G. Jouveau-Dubreuil, Pallava Antiquities, London, 1916, 1918; R. Narasimhachar, The Keśava Temple at Somnāthpur, Bangalore, 1917; R. Narasimhachar, The Keśava Temple at Belūr, Bangalore, 1919; R. Narasimhachar, The Lakshmīdevī Temple at Dodda Goddavalli, Bangalore, 1919; G. Jouveau-Dubreuil, Pallava Painting, Pondicherry, 1920; A. Rodin, A. Coomaraswamy, and V. Goloubew, Sculptures Çivaites de l'Inde, Brussels, 1921; P. V. Jagadisa Ayyar, South Indian Shrines, Madras, 1922; G. Yazdani, The Temples of Palampet, Calcutta, 1922; R. Narasimhachar, Inscriptions of Śravana Belgola, Mysore, 1923; A. H. Longhurst, Pallava Architecture, Calcutta, 1924–30; H. Cousens, The Architectural Antiquities of Western India, London, 1926; H. Cousens, Chālukyan Architecture, Calcutta, 1926; H. Krishna Sastri, Two Statues of Pallava Kings and Five Pallava Inscriptions in a Rock Temple at Mahābalipuram, Calcutta, 1926; H. Heras, The Aravīdu Dynasty of Vijayanagara, Madras, 1927; S. A. Asgar Bilgrami, Landmarks of the Deccan: A Guide to the Archaeological Remains of Hyderabad, Hyderabad, 1928; T. N. Ramachandran, Buddhist Sculptures from a Stūpa near Goli, Madras, 1929; T. G. Aravamuthan, Portrait Sculpture in South India, London, 1931; H. Cousens, Mediaeval Temples of the Dekhan, Calcutta, 1931; K. R. Subramanian, Buddhist Remains in Āndhra and the History of Āndhra between 225 and 610, Madras, 1932; A. H. Longhurst, Hampi Ruins, Delhi, 1933; T. N. Ramachandran, Tiruparuttikanram and Its Temples, Madras, 1934; T. W. Arnold and J. V. S. Wilkinson, The Library of Chester Beatty: A Catalogue of the Indian Miniatures, London, 1936; G. Jouveau-Dubreuil, Iconography of Southern India, Paris, 1937; S. Kramrisch, A Survey of Painting in the Deccan, Hyderabad, 1937; A. H. Longhurst, The Buddhist Antiquities of Nāgārjunikonda, Delhi, 1938; A. Maiuri, Una Statuetta Eburnea di Arte Indiana a Pompei, Le Arti, I, 1938/9, p. 111 ff. (repr., J. Uttar Pradesh H. Soc., XIX, 1948, p. 1 ff.); J. Hackin and J. R. Hackin, Recherches Archéologiques à Bégram, Paris, 1939; H. Goetz, The Fall of Vijayanagar and the Nationalisation of Muslim Art in the Dekhan, J. Indian H., XIX, 1940, p. 249 ff.; C. Minakshi, The Historical Sculptures of the Vaikuntha Perumal Temple, Kānchī, Calcutta, Delhi, 1941; C. Sivaramamurti, Amarāvatī Sculptures in the Madras Government Museum, Madras, 1942; Hirananda Sastri, A Guide to Elephanta, Delhi, 1943; G. Yazdani, Bīdar, London, 1947; H. Goetz, Art and Architecture of Bikaner State, London, 1950; R. Narasimhachar, Guide to Talkad, Mysore, 1950; Stuart Piggott, Prehistoric India, Harmondsworth, 1950; H. Goetz, The Kailāsa of Ellora and the Chronology of Rāshtrakūta Art, Artibus Asiae, XV, 1952, p. 84 ff.; H. D. Sankalia and M. G. Dikshit, Excavations at Brahmapuri (Kolhāpur) 1945–46, Poona, 1952; G. Yazdani, A History of the Deccan: Fine Arts, London, Bombay, 1952; T. N. Ramachandran, Nāgārjunikonda, Calcutta, Delhi, 1953; Douglas Barrett, Sculptures from Amaravati in the British Museum, London, 1954; J. Hackin, J. R. Hackin, J. Carl, and P. Hamelin, Nouvelles Recherches Archéologiques à Bégram, Paris, 1954.

Illustrations: PLS. 127–133; 1 fig. in text.

Hermann GOETZ

**DEGAS**, HILAIRE GERMAIN EDGAR. French painter (b. Paris, July 19, 1834; d. Paris, Sept. 27, 1917). Degas was the eldest son of a banker, whose family had Italian as well as French antecedents. His mother, whose family had emigrated to America, was born in New Orleans; she died in 1847. Degas went to the Lycée Louis-le-Grand and there made friends with Henri Rouart. His father, a cultivated man, a lover of music and art who surrounded himself with men of taste, took his son to the Louvre at an early age and, before the boy was twenty, had introduced him to the most eminent collectors in Paris: Lacase, Marcille, Soutzo (who taught him etching), and Valpinçon, an Ingres enthusiast and the owner of Ingres's *Odalisque with the Turban*, generally known as the *Baigneuse de Valpinçon* (Louvre). Degas's artistic bent clearly was not only given free rein but even highly favored by circumstances. In 1852 he transformed a room in the Rue Mondovi house into a studio looking down on the Concorde and the Tuileries. The following year he began to work under Félix-Joseph Barrias and studied the prints of Dürer, Mantegna, Goya, and Rembrandt in the Cabinet des Estampes, which was then under the curatorship of Achille Devéria. In 1854 he was admitted to the studio of Louis Lamothe, a disciple of Ingres who transmitted to him the cult of the master. Soon after, Degas met Ingres through Valpinçon. In 1855 Lamothe saw his pupil enrolled in the Ecole des Beaux-Arts; but Degas was impatient with the academic program there, did not participate in the competition for the Prix de Rome, and preferred to find his way alone to the classical sources of art. From 1854 to 1859 he spent long and regular periods of study in Italy, where he stayed with his relatives in Naples and Florence and frequented the circle of the Villa Medici, seat of the French Academy in Rome. His travel notes, so revealing of his character and tastes, end with this resolve: "I am now going back to the life of Paris. Who knows what will happen? But I shall always be an honest man."

In April, 1859, he moved to the Rue Madame in Paris and concentrated at first on portraiture and the painting of historical subjects. The discovery of Japanese prints and in 1862 the crucial meetings with Manet and, about the same time, Edmond Duranty, the "realist" writer and theoretician who was to be Degas's closest confidant, turned him gradually toward the study and depiction of contemporary life. He became an active participant in the famous soirées at the Café Guerbois, where the new impressionist (see IMPRESSIONISM) generation gathered around Manet. Duranty, in a novel intended as an objective description of contemporary Parisian artistic circles, introduced Degas by name as "an artist of rare intelligence, much concerned with ideas, which seems strange to most of his fellow artists." His cultivated mind, his spirit, his biting wit and brusque frankness, his absolute objectivity, and his deep-rooted and unbending honesty soon made him a formidable and legendary figure.

Enrolled in the artillery during the Franco-Prussian War of 1870–71, Degas reencountered as captain of his battery his former schoolmate Henri Rouart, a brilliant engineer and a passionate lover of art; their renewed friendship was to prove close and lasting. After he had experienced a serious chill during the war, Degas's sight began to trouble him. In October, 1872, to escape the disruption following upon defeat and to relax with a change of scene, he sailed to Louisiana, where his uncle and two brothers were in the cotton business in New Orleans. On his return in April of 1873, he lived in the Rue Blanche in the section of Montmartre that would remain his and committed himself definitely to the modern vision and to *peinture claire* — the new painting in a high-keyed palette. In December he left for Turin to see his ailing father, who died in February of 1874, leaving a complicated will that was to cause Degas much mental and material suffering.

Although also differing from the impressionists in both character and doctrine, Degas, unlike Manet (q.v.), displayed a generous solidarity with them in their struggle. Together with Pissarro, whose moral rectitude he admired, he was in fact the most active organizer and most faithful supporter of the group's exhibitions over the period 1874–86. In 1877 he installed himself in the Rue Frochot and frequented the Café de la Nouvelle Athènes, successor to the Guerbois as a meeting place. In 1886 he ceased to exhibit, and the progressive failure of his eyesight accentuated his isolation. He gave up oil for pastel, with which he obtained very striking effects; he also practiced engraving and sculpture and, using a few basic themes (bathers and dancers), continued his endless investigation of form and technique. Now and then he tore himself away from his heroic labor for brief trips to Spain and Switzerland and for excursions into Burgundy and the south of France. In 1896 he visited the Musée Ingres at Montauban with his friend, the sculptor Albert Bartholomé. During the winters he dined weekly with his few intimates, the Rouarts or the Halévys, and in the summers he often joined them on their vacations in the country.

Degas's last years were saddened by an almost total blindness that made it impossible for him to devote himself to his one passion. In 1912, already cruelly tried by the death of his friend Henri Rouart, he was evicted from the Rue Victor Massé, where he had been living for 20 years. He took refuge in the nearby Boulevard de Clichy in an apartment found for him by his former model Suzanne Valadon, who was by then a painter, but he never really settled there. The outbreak of World War I added to his distress and loneliness. Tormented by the forms which excited his imagination but which he could not fix on paper, he wandered aimlessly through the streets of Paris, in constant danger of accident; it has been said that he was like an aged Homer of painting, or a King Lear dispossessed of his secret kingdom.

Degas's genius and personality compelled the fear and respect of his contemporaries. "Respect, here, absolute respect," Odilon Redon declared without reservation. Gauguin, hardly the moralist as a rule, nor prodigal with praise, bowed to his colleague: "With the man as with the painter, everything is an example." And Pissarro, the discerning and generous prophet, did not hesitate to call him in a letter to his son Lucian (May 9, 1883) "certainly the greatest artist of our epoch."

Assuredly, Degas was most complex in his aims and their results. The richness of his work has in fact been definable only in oxymorons (Leymarie, 1947): "realistic fiction" (R. Huyghe); "lyrical cruelty" (E. Faure); "visionary analysis" (H. Focillon). Degas himself, in a letter to De Valernes (Oct. 26, 1890), wrote of "bewitching the truth."

The years 1854–59 constitute the educational and formative period for his art. Degas was not gifted with Manet's instinctive, dazzling virtuosity. Like Cézanne and, later, Matisse, he arrived at his personal mode of expression only with difficulty and by degrees. "No art," he admitted, "is as little spontaneous as mine. What I do is the result of reflection and the study of the great masters." A brief period at the Ecole des Beaux-Arts showed him the failure of the academic program to transmit the true artistic tradition, which he then decided could be found only through personal experience and direct study of the best masters of the past. He executed many copies in the Louvre and the Italian museums and chose the most diverse works for models — according to his own formula, "seeking the spirit and love of Mantegna with the verve and coloring of Veronese." Among the moderns, his early passion for the paintings of Ingres (q.v.) was soon matched by an equal admiration for those of Delacroix (q.v.). To give up none of the basic principles of art and at the same time reconcile technically the demand for synthesis of classical culture and his own sharp sense of reality was for him the dilemma to be resolved. He expressed it in a phrase from a notebook of his youth: "Ah! Giotto, let me see Paris; and thou, Paris, let me see Giotto."

He put this youthful credo to the test in his large group portrait *The Bellelli Family* (PL. 134), majestic in spite of a certain formalism, and five history paintings done in 1860–65: *Young Spartan Girls Challenging Spartan Boys* (London, Nat. Gall.), *Alexander and Bucephalus* (Basel, Coll. Hänggi), *Semiramis Building a City* (Louvre), *Jephthah's Daughter* (Northampton, Mass., Smith College Mus. of Art), *Misfortunes of the City of Orléans* (Louvre). These paintings may fail in their rigidity and lack of coherence, but they are nonetheless interesting and revealing in their failure. The figures, taken from admi-

rable preparatory sketchbooks and handsome individually, are not successfully related to one another and betray a preoccupation with immediate reality at odds with the idealist conventions governing the compositions.

In 1865 Degas definitely renounced this anachronistic manner to which admiration for Ingres had led him and gave himself unreservedly to the concerns of his day. The years 1865–72 mark the creation of his personal style, formed in the midst of the revolutionary movement inaugurated by Manet and based on methodical exploration of what Baudelaire poetically called *modernité*. Even earlier than Manet, Degas began to depict racetrack scenes; this subject delighted both artists, not solely for the beauty of the horse, as had been the case with Géricault (q.v.), but as an elegant and worldly spectacle, the last surviving ritual of the aristocracy and a diversion much in vogue during the Second Empire (PL. 137). The two artists evoke the whirl of speed and light differently: Manet, by a spontaneous shower of strokes forming alternate light and dark patches; Degas, by the multiplication of cleverly harmonized lines and planes.

The race course and some beach scenes done in 1869 represent Degas's only attempts at outdoor painting. As unmoved by the picturesque qualities of the street as by the attractions of natural landscape — "the air that one sees in the paintings of the masters," he declared, "is never air that one can breathe" — he was preoccupied with the human being, whom he wished to represent in a manner more objective and truthful than had any of his predecessors. He proved himself a moralist and psychologist in the best French tradition in the many portraits done during this period (about fifty from 1865 to 1870, some on commission); his subjects are depicted in their everyday surroundings and with an air of privacy. "Do portraits of people in their familiar and typical attitudes; and, above all, give their faces the same kind of expression as that given to their bodies." Consequently, his character studies also become interior scenes, where new light effects add to the magic of the atmosphere. "Work a great deal with the effects of evening, lamps, candles, etc. It is provocative, rather than invariably to show the source of the light, to indicate the effects of the light. This aspect of art can become immense today — is it possible not to realize it?" Among the most successful of his portraits are the *Woman with the Chrysanthemums* (1865; New York, Met. Mus.); *Rose Degas* (1867; Louvre); and *Madame Camus at the Piano* (1869; Zurich, Coll. E. Bührle).

Degas's friendship with Désiré Dilhau, bassoonist at the Opéra, led him to discover the world of dance and theater and inspired him to work on a "series on the instruments and their players — their forms: for example, the twisting of the hand, arm, and neck of the violinist; the swelling and hollowing of the bassoonist's or oboist's cheeks." The performers are seen in mutual activity, differentiated but working together, in the *Orchestra at the Opéra* (ca. 1869; Louvre), which for the first time boldly confronts the two opposed worlds: the realistic orchestra pit with the musicians seen in half-shadow, and the rose and blue fairy tale of the dancers lighted by the footlights.

In April of 1873, the crucial year for impressionism, Degas returned from a six-months' stay in New Orleans. With *The Cotton Exchange at New Orleans* (PL. 134), his last composition in a realistic style that was still traditional and linear, the initial phase in his development came to a close. He had been enchanted by the charm of New Orleans and its inhabitants: "Everything attracts me here," he confided to his friend the painter Lorens Frölich. "I look at everything.... Nothing pleases me so much as the Negresses of all shades carrying in their arms little white babies, so white...." But no trace of exoticism appeared in his work. "One should not indifferently create," he explained, "an art of Paris and another of Louisiana." It was to the art of Paris, outside the Salon and academic conventions, that he now meant to devote himself. His studies of dancers, practicing or resting, seen from different angles and under different lights, executed after his return from New Orleans, show his change of manner and his conversion to the new *peinture claire*. For so dedicated a draftsman, line undoubtedly remained an essential consideration, but it was no longer absolute, and its importance yielded increasingly to the demands of color, light, and movement.

The years 1873–80 saw the flowering of his art, served by an astonishing mastery and variety of technical means. During this period he participated actively in most of the impressionist exhibitions but preserved his fundamental position as an "independent." Hostile to the plein-air school, the vogue for which was spreading, and — except for a single youthful attempt — quite indifferent to the revival of the still life, he was distinguished from his impressionist comrades by his choice of subject as well as by the spirit of his work. Whereas they cultivated a bucolic, sensual, and optimistic kind of painting, Degas's art, exclusively urban and centered about the human being, showed uncompromising and almost cruel objectivity. He was not, like Monet (q.v.) or Renoir (q.v.), the affectionate landscapist of Paris, of her decorative and picturesque exterior. It was the inner life of a great city then in full process of metamorphosis — all those closed, artificial places hidden behind her brilliant façade — that attracted his sharp eye even before Toulouse-Lautrec. When Edmond de Goncourt visited Degas in February of 1874, he congratulated himself that he saw the artist following his literary example in attempting to represent the most characteristic contemporary scenes and types. This kinship is reflected in the following note from De Goncourt's journal: "In the depiction of modern life, up to now he is the man whom I have seen catch the soul of that life best."

Degas's psychological curiosity is as extraordinary as his acute powers of visual analysis. Frequently an innovator in the search for subjects, he was motivated by a taste for realism and a love of movement. As he said one day to his friend Rouart, "If the leaves on the trees did not move, how sad the trees would be, and we too." Gifted to an extreme with that *sensibilité mimique* (mimetic sensibility) which Valéry attributes in part to his Neapolitan antecedents, Degas did not hesitate to attempt the depiction of any milieu, however strange. There was no new gesture that he did not wish to catch in order to transfix both its spontaneous and meaningful qualities. His sketchbooks abound in the most unexpected series of studies and disclose the prodigious effort that went into his preparatory work. He was particularly interested in individuals of a specialized skill at their work: musicians, ironers (PL. 139), washerwomen, milliners, acrobats, singers. He captured their attitudes and habitual movements, and the sentiments implicit in their gestures.

The dance, aristocratic and popular, unreal and precise, modern and traditional, became his favorite theme (PLS. 136, 137, 140). Inexhaustible repertory of contortions and graces, paradoxes and contrasts, "a world of exact forces and studied illusions" (Valéry) where the miracle springs from constant discipline — did it not present the very image of his own art, a compound of the surest instinct and the strictest calculation? "One must redo a thing ten times," wrote Degas, "a hundred times, the same subject. Nothing in art must resemble an accident, not even movement!" Under the theater lights, seen from the side or from above, the spangled dancers endlessly unfolded those harmonies of arabesques and that scintillation of forms and colors which enchanted him and suited the complexity of his intentions. "A painting," he declared, "is an original combination of lines and tones that becomes a valid whole." ("Un tableau est une combinaison originale de lignes et de tons qui se font valoire.") Movement is highly diversified in the ballet scenes, and although space and dancers are rendered with over-all exactitude, they are subjected to subtle systematic distortions that are intensified by the play of light or the reflections of mirrors. In his notebooks may be read: "After having made portraits while looking down on the subject, I shall make some looking up. Seated very near a woman and looking at her from below, I shall see her head in the chandelier, surrounded by crystals, etc."; and also, "Study from all its views a face or an object or anything. One can use a mirror for that...." The circus, the theater, the café, the concert, with their accidental effects of perspective and artificial lighting, offered him unlimited opportunity for experiments in these areas. A masterpiece of minute format and of so personal a

technique as the pastel on monotype *Women on the Terrace of a Café* (1877; Louvre) or the famous *Aux Ambassadeurs* (1876–77; Lyons, Mus. B.A.) can evoke for us better than any naturalistic description the atmosphere of Paris at the time; such a work can portray one whole facet of her nocturnal picturesqueness and at the same time suggest another, fantastic universe.

In the transformation of style and visual approach, Degas and his contemporaries benefited from the discovery of Japanese prints and the progress of photography (q.v.). After the reopening of trade with Japan in 1854, the first prints made their way into Europe as wrapping papers. Degas was a friend of the engraver Félix Braquemond, who in 1856 discovered the work of Hokusai (q.v.), and was one of the first to frequent the famous shop that Madame Soye opened under the arcades of the Rue de Rivoli in 1862. Encouraged by copious literature and by the success of the Oriental pavilions at the Universal Expositions of 1867 and 1878, *japonaiserie* quickly became a general fad. Artists decorated their studios with fans and posed their models in kimonos. This superficial and rather artificial vogue, the most precious example of which was to be found in Whistler, was a continuation of romantic exoticism (see EXOTICISM). The more serious painters, however — each according to his own needs — sought deeper significance in Japanese art. Monet found a new clarity; Manet, the tension of light and dark surfaces in opposition; Degas, the asymmetry and foreshortening and a noncentralized composition, as well as nonaxial figures cut by the borders and brought close to the spectator in a direct and intimate view. Like all valid influences, Japanese art was less an actual source of inspiration than a catalyst for implicit tendencies. The same relationship held for photography, which Degas practiced as an amateur and from which he adopted a number of ideas: fresh and unusual sight angles, steeply sloped ground, subtly inconsistent space and perspective, effects of natural and suffused lighting. Many of the photographs from which he derived inspiration for his portraits or his compositions have been found; for instance, it is known that in order to understand the mechanism of a horse's gallop he studied Major Muybridge's photographs of animals in movement, published in 1881. Instead of leading him to rely on stock illusionary devices, the opposite of reality, the camera freed him of such conventional solutions and fortified his own stylistic bent, an approach to the universe that was simultaneously analytic and visionary.

From 1880 to 1893 Degas was at the height of his powers. More and more frequently he employed pastel in preference to oil, for it was more supple and susceptible to reworking, and hence more suitable to his nervous, perfectionist temperament. Using ingenious personal techniques and a special fixative, he brought new life to the pastel medium, enriching to the highest degree its resonance and expressive potential. He combined pastel with gouache, tempera, or some kind of volatile spirit; he applied it to heighten his famous monotypes, a technique of his own invention. Sometimes he used it dry and powdery as was traditional, and sometimes he wet it with a spray in a unique manner. "He thus made the color powder into a paste," notes Denis Rouart in his invaluable essay on the artist's techniques (1945), "and worked this paste with a more or less hard brush; or with water sprayed on thin pastel, he obtained instead of a paste a wash that he spread with a brush." He deftly varied texture and brushwork on a single surface according to differences in *décor* and lighting or in the character of the elements to be rendered — a dancer's flesh or her costume, for example (PL. 140).

Two new themes appear during this period: the milliners, a brilliant *divertissement* that occupied him mainly in 1882–83; and the women at their toilet (PL. 138), a subject he continued to develop in the following years. The milliners and their clients are observed, without their knowledge, trying on hats before the mirror. A subject such as this allowed the artist dazzling variations of color and arrangement, of facial types and gestures. In 1886, at the eighth and last impressionist exhibition (whose star was really Seurat), Degas showed a "suite" of female nudes bathing, washing themselves, drying themselves, combing their hair or having it combed. This celebrated series aroused disgust at the vulgarity of the subjects and wonder at the splendor of the technique and the uncommon quality of the lighting. Together with Rodin, Degas is the true inventor of the modern nude: a nude freed from studio conventions and mythological idealizations, frankly shown in commonplace attitudes without erotic or picturesque overtones and impassively observed with extraordinary insight. "It is," Degas himself said to George Moore, "the human beast occupied with herself, a cat licking herself. Until now the nude has always been represented in poses that presuppose an audience. But my women are simple, honest people, who have no other thought than their physical activity." Now that Huysmans' (ca. 1908) ferocious pages on Degas's misogyny seem so outdated, the classical authority of these superlative works recalls the words of Baudelaire in *La Fanfarlo*: "He loved the human body as a material harmony, as fine architecture, with movement added." In the fullness and density of their forms, the women at their toilet, despite their realistic contortions rendered with a modern sensibility, hark back to the rhythms of the antique. Renoir was not deceived: "there remains in my eye," he said, "a nude by Degas, a charcoal drawing. There seemed nothing but that in the room. It was like a fragment of the Parthenon."

From 1893, the year in which Degas exhibited for the last time, at the Galerie Durand-Ruel (a curious group of simplified landscapes), to 1908, when blindness forced inactivity upon him, the final period was a moving struggle against approaching night, from which he snatched intense flashes of vision. Degas tended toward an art of synthesis. "Art does not aggrandize," he declared; "it sums up." He concentrated almost exclusively on two basic motifs, nudes and dancers, which sufficed for all formal and coloristic combinations. He shared with Monet the taste for "series," a taste perhaps originating in the romantic "variation" and corresponding to the experimental attitude of the time. The format of his pastels became larger, and one or two figures often occupy the entire space. His forms are no longer treated as a passing spectacle or a decorative motif but are given more profound and lasting significance. Presented from a close view, the figures appear monumental against abstract backgrounds. Degas no longer sought external disorientation of space but achieved great depth and intimacy by means of what appear to be luminous vibrations radiating from the objects in the picture. His anguish is revealed in the dramatic contours of his figures; his creative joy, in the glow of the colors. He devised methods of superimposing layers of pastel, fixing each one as it was laid on, to obtain a consistency rich and transparent as the Venetian glazes. The movements, slowed as if in suspension, are no longer suggested by contours and linear planes but by the rotation of sculptural masses in a palpable and multifaceted space quivering with color. It seems as if the artist's eyes were dazzled by an interior vision in the measure that they were outwardly dimmed. "It is fine," he confided to Jeanniot at this time, " to copy what one sees; it is much better to draw what one sees no longer except in memory. You reproduce only what has struck you, that is, the essential. There your recollection and your imagination are freed from nature's tyranny. That is why paintings made in this way by a man with a cultivated memory, well acquainted with both the masters and his craft, are almost always remarkable works. Look at Delacroix." Departing from an earnest search for reality and the faithful representation of daily life and contemporary sights, the art of Degas, like that of Cézanne and Renoir, ended in a fantastic and lyric vision of glowing, timeless forms. In his last years, Degas was occupied with making the many statuettes of horses and dancers that take a major place among the very original sculpture done by painters, which is a characteristic of our time (VII, PL. 434).

Although Degas was apparently cold and detached in his concern with ultimate values, his work radiates a warm and vital humanity. Quite unintentionally, his influence on the finest contemporary artists — from Manet to Gauguin, from Bonnard to Picasso — was noteworthy. The prophetic declaration with which Duranty presented him in 1876 now appears fully justified: "The series of new ideas was formed above all in the brain of a draftsman . . . a man of the rarest talent and eve

rarer spirit. Enough people have profited by his conceptions and his artistic disinterestedness for justice to be rendered him; the source drawn upon by so many painters should be known."

The hope that Degas confided to Alexis Rouart, "I want to be famous and unknown," has been literally fulfilled. The most celebrated and certainly, except for Cézanne, the greatest artist of his generation is also the one whose biography is the most elusive. "A painter," he said, "has no private life"; and Degas sacrificed his to his art. "There is love; there is work. And we have but a single heart." As it was impossible for him to divide his, he chose solitude and work within the four walls of his studio and concealed his vulnerability and his endless sufferings behind a mask of hauteur and bitterness. Beneath its extreme modesty, the poignant and oft-quoted letter of Oct. 26, 1890, to his old friend De Valernes betrays his private drama and his tightly reined sensibility: "I was, or I seemed, hard toward all the world, because of a kind of attraction toward brutality that came from my doubt and bad temper. I felt myself so badly made, so ill-equipped, and so weak, while it seemed to me that my reasonings in the matter of art were so right. I sulked against all the world and against myself. I ask your pardon if, under the pretext of this damned art, I have hurt your very noble and very intelligent spirit; perhaps even your heart."

BIBLIOG. G. Geffroy, Degas, L'Art dans les Deux Mondes, Dec. 20, 1890, pp. 46–48; J. K. Huysmans, Certains, Paris, ca. 1908; G. Grappe, Degas, L'Art et le Beau, 1911, special number; P. A. Lemoisne, Degas, Paris, 1912; W. Sickert, Degas, BM, XXXI, 1917, pp. 183–91; A. Alexandre, Essai sur Monsieur Degas, Les Arts, XIV, 166, 1918; P. Lafond, Degas, 2 vols., Paris, 1918–19; L. Delteil, Le Peintre-graveur illustré, IX: Edgar Degas, Paris, 1919; A. Michel, Degas et son modèle, Mercure de France, Feb. 1 and 16, 1919; H. Hertz, Degas, Paris, 1920; J. Meier-Graefe, Degas, Munich, 1920 (Eng. trans., I. Holroyd-Reed, New York, London, 1923); F. Fosca, Degas, Paris, 1921; P. A. Lemoisne, Les Carnets de Degas au Cabinet des Estampes, GBA, LXIII, 1921, pp. 219–31; A. Vollard, Degas, Paris, 1924 (Am. ed., trans. R. T. Weaver, New York, 1927, 1937); P. Jamot, Degas, Paris, 1924; Lettres de Degas. recueillies et annotées par Marcel Guérin, Paris, 1931, 1945 (Eng. trans., M. Kay, New York, London, 1948); L'Amour de l'Art, 1931, special number; G. Jeanniot, Souvenirs sur Degas, la Revue Universelle, LV, Oct. 15, 1933; A. Alexandre, Degas, nouveaux aperçus, L'Art et les Artistes, N.S., XXIX, Feb., 1935, pp. 145–73; G. Rivière, M. Degas, bourgeois de Paris, Paris, 1935; P. Valéry, Degas, danse, dessin, Paris, 1938 (Am. ed., trans. H. Burlin, New York, 1948); J. Rewald, Degas' Works in Sculpture, New York, 1944; D. Rouart, Degas à la recherche de sa technique, Paris, 1945; E. Degas, Huit sonnets d'Edgar Degas, Paris, New York, [1946] (preface by J. Nepveu-Degas); J. Rewald, Degas and His Family in New Orleans, GBA, XXX, ser. 16, 1946, pp. 105–26; J. Rewald, The History of Impressionism, New York, 1946; R. H. Wilenski, Degas, 1834–1917, London, 1946; P. A. Lemoisne, Degas et son œuvre, 4 vols., Paris, 1946–49; J. Leymarie, Les Degas du Louvre, Paris, 1947; D. Rouart, ed., Monotypes [of Degas], Paris, New York, [1948]; J. Fèvre, Mon oncle Degas, Geneva, 1949; D. Rouart, Dessins de Degas, Paris, London, 1949; L. Browse, Degas' Dancers, New York, 1949; D. C. Rich, Degas, New York, 1951; D. Cooper, Pastels [of Edgar Degas], Basle, London, [1952]; F. Fosca, Degas, Geneva, 1954; P. A. Lemoisne, Degas et son œuvre, Paris, 1954; J. S. Boggs, Edgar Degas and the Bellellis, AB, XXXVII, 1955, pp. 127–36; P. Cabanne, Edgar Degas, Paris, 1957 (Am. ed., trans. M. L. Landa, New York, 1958); J. Rewald, Degas' Sculpture, New York, 1957; Los Angeles County Museum, An Exhibition of Works by Edgar Hilaire Germain Degas, Los Angeles, 1958.

Jean LEYMARIE

Illustrations: PLS. 134–140.

## DELACROIX, EUGÈNE.

DELACROIX, EUGÈNE. French painter, born at Charenton-Saint-Maurice (Seine) on Apr. 25, 1798. (Charenton and Saint-Maurice are today two contiguous suburbs of Paris.) He died in Paris on Aug. 13, 1863. Delacroix is one of the best-known 19th-century French artists, in part owing to his letters and his journal (the latter published in full by A. Joubin, 1932), in which he is revealed as a keenly intelligent and highly cultured man.

The son of a diplomat, Delacroix early showed his bent toward drawing, and entered the studio of Pierre Narcisse Guérin, a painter of somewhat academic inclination. Among Guérin's students was Jean Louis Géricault (q.v.), with whom Delacroix formed a close bond and whom he came to consider almost as his master. In his early years Delacroix was possessed by a yearning for Italy, a country he was never to see.

At the age of twenty-four, in 1822, he exhibited a painting representing an episode from Dante's Inferno, that of Vergil and Dante crossing the lake that washes the dark walls of Dis, their boat weighed down by the clutches of the drowning damned (PL. 144). The work, long in preparation, in color resembles Géricault's Raft of the Medusa (Louvre; VI, PL. 118), the bodies of the dead being painted in somber hues. It met with great success, Baron Gros commenting that here was a "chastened Rubens." Other disciples of David proved more severe, however. One of the most favorable reactions was that of the journalist Louis Adolphe Thiers, who praised the painting in the Constitutionnel, alluding to the forcefulness of Michelangelo and the exuberance of Rubens, and discovering in Delacroix's work the promise of a great new artist. Thiers as a journalist always supported Delacroix, and in later years, when he became a political power, he was to obtain important official commissions for the artist. "Monsieur Thiers," wrote Delacroix, "is the only man in an influential position who has held out a hand to me in the course of my career."

Strongly influenced by Géricault, Delacroix began an earnest study of the anatomy of horses: "I must absolutely begin to do horses, to go to a stable every morning." He also copied old masters: Veronese, Rubens, and in particular Velázquez. The latter's work, which he saw in a private collection, enchanted him.

Of Delacroix's painting The Massacre at Chios (PL. 142), criticisms were varied. Thiers wrote about it favorably; Anne Louis Girodet, though noting the fallen young mother as a fine bit of painting, said, "When I come close to the picture, I no longer see the drawing of the eye." To this Delacroix retorted, "If you must draw near in order to perceive the defects, allow me to beg you to remain at a distance." Théophile Gautier, however, was enthusiastic over the feverish, convulsive drawing and the violent coloring of the work.

In May, 1825, Delacroix took a trip to England. At first he disliked the country, but there he saw works of Turner, Constable, and others of the English school. He met Richard Bonington (q.v.) and in his company sketched the armor in the Mayrick Collection. At this time he became interested in northern literature, and he read Shakespeare. Bonington followed Delacroix back to France, where they became fast friends. Delacroix's interest in the water-color medium, which dates from this time, was no doubt in large measure due to his friendship with the English artist, whose work attracted him by its vivacity and spontaneity.

Delacroix began to receive official commissions. Asked to take part in the decoration of the Palais du Conseil d'Etat, he proposed a Justinian Presiding over the Compilation of the Pandects. He labored over this work, but only sketches and preparatory drawings remain, the painting itself having been destroyed when the Commune, the insurrectionary government which ruled briefly in 1871, set fire to the building.

From Byron, whom he admired greatly, Delacroix took the theme for his Execution of the Doge Marino Faliero (London, Wallace Coll.), depicting the moment just after the guilty magistrate's decapitation on the staircase of the Doges' Palace. The rich, vibrant coloring of the painting recalls Venetian art.

The Greek war of independence, which had already inspired The Massacre at Chios, aroused Delacroix's interest in Eastern cultures. From 1827–28 come many drawings, sketches, and paintings representing not only scenes from the Greek war, but combats between giaours and pashas, a head of a young Indian girl, and highly interesting studies of Persian miniatures. In these years of the late 1820s he exhibited, with many other things, The Death of Sardanapalus (PL. 143). This theme, also taken from Byron, shows the King of Nineveh at the moment when he awaits death. Having set fire to his closely besieged palace, he is surrounded by his women and his treasures, all destined to perish with him. The work was preceded by a number of preparatory drawings (PL. 144). It is a fine painting, especially in details. Two light splotches formed by the bodies of the women have a Venetian splendor. Despite the magnificence of its colors, the painting met with critical reactions ranging from indifference to outrage. After the exhibition of The Death

*of Sardanapalus* occurred the famous exchange between Delacroix and Viscount Josthène de la Rochefoucauld, who, as a kind of superintendent of fine arts, had charge of assigning commissions on behalf of the state. The Viscount, polite but sharp, insisted that if Delacroix wished to receive state commissions he must "change his manner." The painter replied that he would adhere to his own way "though the earth and the stars were on the other side."

Governmental ostracism pushed Delacroix in the direction of Victor Hugo and the romantics, though his education and temperament were firmly classical. He took part, although indirectly, in the philhellenic campaign launched by Hugo's *Les Orientales*. He painted *Greece Dying on the Ruins of Missolonghi* (Bordeaux, Mus. B.A.), a somewhat rhetorical but technically accomplished work.

It was not a happy epoch in Delacroix's life. He worked hard and exhibited his paintings; but he was not appreciated, and found himself in economic difficulties. He was, in fact, poverty-stricken. At the beginning of 1830 he wrote to a friend, "There is no worse situation than not knowing how one will be able to eat in a week, and that is mine."

Under the influence of Hugo and Bonington, Delacroix devoted himself to history painting. Attracted principally by medieval themes, he studied in libraries, reading works that evoked the past he wanted to paint. In *The Battle of Nancy* (1831; Nancy, Mus. B.A.) and *The Battle of Poitiers* (1830; Louvre) he sought to combine historical accuracy and beauty of coloring and expressive intensity of movement. Of all Delacroix's work this series of history paintings is the most romantic. Similar to them is *The Assassination of the Bishop of Liège* (Lyons, Mus. B.A.), inspired by Sir Walter Scott's *Quentin Durward*. The scene is very animated; the group of the bishop and his executioners is powerfully conceived. The setting, of which the form of the vault was taken from sketches that the artist had made in the Palais de Justice at Rouen, gives grandeur to the whole.

Delacroix's economic situation began to mend. He lived a worldly life, frequenting the salon of the Baron Gérard, where he met Stendhal and Mérimée and where he renewed his acquaintance with Thiers. Furthermore, the revolution of 1830 had brought to power the Duke of Orléans, who patronized Delacroix. This revolution appealed to the imagination of the liberal-minded artist, who celebrated it with a picture exhibited in the Salon of 1831: *Liberty Guiding the People* (Louvre). The salons had originated in the 17th century with exhibitions of works by members of the French Royal Academy, and were held annually in Delacroix's time. There was no other public exhibition of any standing. The composition of Delacroix's entry is excellent but the color rather wan. The concepts of *The Massacre at Chios* were applied to a contemporary scene and combined with the artist's memories of what he had seen with his own eyes in the streets of Paris.

Delacroix was called upon to form part of a diplomatic mission sent by Louis Philippe to the Sultan of Morocco. The letters from this Moroccan journey are very interesting, for Delacroix was excited by the new sights that everywhere met his eyes. He would have liked to paint and draw unceasingly, but was able to accomplish little other than sketches. (He made many studies from memory after he had returned to France.) "I have passed most of my time here," he wrote, "in a state of boredom, because it has been impossible for me to draw from nature so much as a hut. To climb onto a terrace exposes one to stoning or even gunfire." However, despite difficulties in the course of this trip, Delacroix made many sketches, and his travel notebooks (Paris, Louvre, Coll. Moreau-Nélaton; Chantilly, Mus. Condé) are extraordinarily interesting. He arrived at Tangier on Jan. 24, 1832. Shortly thereafter he made an excursion into Andalusia and to Seville, returned to Tangier, and then went to Oran. He stayed three days in Algiers before returning to France. He was in Toulon on July 5.

Delacroix was the first great painter to have actually seen the sights of the Islamic countries of North Africa; and from this Moroccan voyage he retained very exact memories of color and light. In the Salon of 1834 he exhibited two works inspired by his experiences: the *Rue de Meknès* and the *Algerian Women in Their Apartment* (*Women of Algiers*; Louvre; V, PL. 201). The latter is one of the most famous works of the 19th century. In Algiers Delacroix had succeeded in being admitted into a harem, and he was enchanted with the "charm of the figures and the luxury of the clothing." Delacroix repeated the theme again in a canvas now in Montpellier, France (Mus. Fabre). Never before had the exotic Islamic culture given to an artist the opportunity of expressing himself so freely, in hues so vivid as to suggest the great Venetians.

Thiers became a minister in the French government and began confiding to Delacroix important state commissions. As a result Delacroix became a painter of monumental compositions. His activity was prodigious. From Thiers he received a commission to decorate the Chambre des Députés (otherwise known as the Palais-Bourbon), where in 1838 he completed the decoration for the Salon du Roi; hardly had he finished that when he received an even more important commission for the same Bourbon palace. This was the decoration of the library, perhaps Delacroix's greatest work, and one to which he gave his utmost effort. At the same time he was charged with decorating the dome of the library of the Luxembourg Palace. For a decade Delacroix was absorbed almost completely in these major works, preparing study after study. During this period Veronese's *Wedding at Cana* (Louvre) and the works of Rubens exercised a decisive influence on him.

On the ceiling of the Salon du Roi of the Chambre des Députés, Delacroix depicted what he called the living forces of the state: Justice, Agriculture, Industry, and War. On the pilasters were allegorical figures representing the principal rivers of France and also the Atlantic Ocean and the Mediterranean Sea, the natural boundaries of the artist's country. The last two are particularly powerful in construction. The Salon du Roi revealed a new conception of life and humanity in which Delacroix showed himself in his handling of monumental compositions a worthy heir to the Venetian tradition. He had by this time shaken off his close tie with romanticism and in the classical tradition was painting allegorical subjects, though in rich colors. He was attracted to two kinds of painting simultaneously, to a calm, serene art based on classical tendencies and to an art of mass and movement, full of color.

While he was working on the decoration of the Salon du Roi of the Chambre des Députés, Delacroix painted *The Battle of Taillebourg* (1837; Versailles, Mus. Nat.), *The Convulsionists of Tangier* (1838; St. Paul, Minn., Louis Hill Coll.), and *Medea Enraged* (1838; Lille, Mus. B.A.). From the same period comes his *Hamlet and the Gravediggers* (1839; Louvre). Inspired by highly diverse sources, such as the Middle Ages, classical antiquity, Shakespearean drama, and the Orient, Delacroix created paintings on subjects from them all. The most epic work of his career, also from this time (1841), is *The Entrance of the Crusaders into Constantinople* (PL. 145). The composition is powerful; the crusaders are magnificent in presence; and the tragic groups of suppliants — particularly the women in the foreground — are admirable.

Inspired by Delacroix's travels in North Africa was *Jewish Wedding in Morocco* (Louvre), with its musicians and dancers, brilliant colors, and effective lighting. This painting was exhibited in the Salon of 1841, as was *The Entrance of the Crusaders into Constantinople*. From a theme in Byron came *The Shipwreck of Don Juan* (Louvre) of the same time. The boat of Don Juan and his companions is tossed by towering waves in a drama recalling the early *Dante and Vergil* (PL. 144). The artist also turned once more to antiquity, interpreting it in a dramatic and violent manner, as in his *Justice of Trajan* (Rouen, Mus. B.A.), in which a widow asks Trajan to avenge her son. Though the theme is developed with a rather theatrical romanticism, the pomp of the Roman empire is evoked with considerable success.

In the decoration of the library of the Chambre des Députés, which occupied him for a great length of time and for which he engaged numerous assistants, Delacroix borrowed many subjects from antiquity: *Pliny the Elder during the Erup-*

*tion That Destroyed Pompeii; Archimedes, in the Midst of His Meditations, Killed by a Soldier; Seneca Causing His Veins to Be Opened; Socrates and His Daemon;* and *Cicero Accusing Verres before the Roman People.* To these were added scenes from the Old and New Testaments, such as *The Expulsion of Adam and Eve* and *The Death of St. John the Baptist.*

The subjects that he chose for the library of the Luxembourg Palace are likewise borrowed from antiquity. It may have been his friend Frédéric Villot who gave him the idea of painting a scene from Canto IV of the *Inferno,* in which Dante tells of going down to Limbo, where he found the unbaptized great men of ancient times. Before him appeared Homer, Horace, Ovid, Lucian, and others. Delacroix represented on one side the famous Greeks, on the other, the Romans.

Delacroix thus became, through Thiers's protection, one of the great official painters of Louis Philippe's reign. He was fortunate in receiving commissions which allowed him to demonstrate the true measure of his genius. Théophile Gautier then called him chief of the romantics. Besides the official works, he painted during this period of the 1840s many others, in which his confidence and power are evident. The commissions did not cease. In 1844 he decorated a chapel of the Church of St. Denis-du-Saint-Sacrement in Paris with a *Pietà,* very dramatic and full of movement. This work at the time provoked angry comment, but it remains one of Delacroix's most striking creations. In 1849, after the revolution which ended Louis Philippe's rule, he was charged by Charles Blanc, who had become director of fine arts for the new government, with painting the central panel of the Galerie d'Apollon in the Louvre. Charles Lebrun (q.v.) had planned a *Triumph of the Sun* for the panel; Delacroix remained faithful to the program of the painter of Louis XIV, but his work of 1851 was nothing like the allegorical representation that Lebrun would have designed. Delacroix painted the contest between the God of Day and the serpent Python, the battle of life against chaos.

In 1854 Delacroix started his decorations for the Salon de la Paix at the Hôtel de Ville, or town hall (destroyed in 1871). The Salon of 1855 was the occasion of a triumph for Delacroix. In this exhibition his work was shown in conjunction with that of Ingres, who was the other artist with whom he shared the cultured public's favor. Ironically, Delacroix could not abide Ingres's work, upon which he pronounced the most severe judgments. Two years later, in 1857, Delacroix became a member of the Institut de France, acceptance in which signified official recognition and to which he had presented himself many times in vain.

Delacroix's energy did not flag in the following years. When Théophile Silvestre, compiling his history of living artists, asked him for information on his projects, the painter replied, "You may put in that in the matter of compositions, I have enough for two human lifetimes; and as for projects of all kinds, I have enough for four hundred years." He exhibited nine paintings in the Salon of 1859.

The last years of Delacroix's life were largely devoted to the decoration of the Chapel of the Saints-Anges in the Church of St. Sulpice. The decoration of the chapel includes two important panels, representing *The Expulsion of Heliodorus* and *Jacob Wrestling with the Angel.* On the ceiling is a painting of *St. Michael Trampling the Devil.* Particularly vivid in coloring, these works also recall the Venetians. In the *Jacob Wrestling with the Angel* there are reflections of Delacroix's Moroccan journey. It appears that his impressions from that trip to North Africa had been so profound that they reemerged almost every year as a source of inspiration. In 1858, for example, he painted *Fording a Stream in Morocco* (Louvre); in 1859, *The Wounded Arab;* and in 1860, *Arab Horses Coming out of the Sea* (Washington, D.C., Phillips Coll.). During the year 1859 Delacroix attacked subjects of widely diverse origin; from Shakespeare he took the theme of *Hamlet and Horatio in the Graveyard* (Louvre), and from the New Testament, *The Ascent to Calvary* (Metz, Mus. Central), to which he gave dramatic movement and color. He painted animals, no doubt under the influence of Antoine Louis Barye (q.v.), and drew lions and tigers. His activity and curiosity were boundless, and

though exhausted, he wanted to work to the last moment of his life.

Delacroix's art developed under the influence of several masters. Primary among them was Rubens, whose work he studied in the Louvre. Others were Géricault and Gros, and also Constable and Bonington, the painters of light and air. The case of *The Massacre at Chios* is significant: "My painting," he said, "takes on an energetic movement that must absolutely be completed. It needs a fine black, that felicitous muddiness!" Then Delacroix saw in the Louvre Constable's landscapes with their transparent atmosphere. He repainted *The Massacre at Chios,* giving it a sunlit landscape and a gilded horizon. His journey to Morocco with "the strong blues of its sky and its soft half-tints" was also important in turning his palette toward clear tones that, reminding one of Veronese and Rubens, give his paintings their coloristic splendor. It seems now almost incredible that words used to criticize him were "fanaticism for the ugly," "barbarous execution," and "the composition of a sick man in delirium." It was the brilliance of his colors that must have most amazed his contemporaries. Delacroix himself said, "Painters who are not colorists are illuminators, and not painters." For him color was as basic to the art of painting as chiaroscuro, proportion, and perspective. "Proportion applies to sculpture as to painting; perspective determines contour; chiaroscuro gives relief, by the placing of shadows and lights relative to the background. Color gives the appearance of life." Others of his maxims were: "The enemy of all painting is gray," and "Banish all earth colors." In using pure, unmixed hues, Delacroix was the forerunner of the impressionists: "It is well if the brush strokes are not actually fused. They fuse naturally at a certain distance by the law of sympathy that has associated them. The color thus gains in energy and freshness."

At heart Delacroix was a solitary, a man for whom worldly obligations existed — indeed, he sacrificed much to them — but whose interior life remained untouched. He wrote in 1824, "The torment of my soul is its solitude." His life was one of mental suffering, with periods of great enthusiasm alternating with deep disillusionment. Always conscious of the force of his genius, he was embittered by the battles that he had to fight against mediocrity. "Almost all great men," he wrote, "lead a life more thwarted, more miserable than that of other men." What he found to reproach in others was their feet of clay, their lack of imagination: "The ignorant and the vulgar are happy; for them all is neatly arranged in nature. They explain that which exists by the reason that it does exist." The solitude which was a source of great suffering to Delacroix was, at least in part, self-imposed, for he could not bear to be on friendly terms with other artists. He said, "Vulgarity is in every moment of their conversation." He also seemed removed from much human passion, because "what is most real in me are the illusions that I create with my painting; the rest is shifting sand." For only a few friends, such as Raymond Soulier and Jean Baptiste Pierret, had he a true and lasting affection. Delacroix's picture of existence was not sunny, and his notion of life as a whole was pessimistic. That man must submit to the laws of an implacable destiny plunged him into boundless melancholy: "Oh, sad fate. To desire ceaselessly the expansion of myself, of the spirit that is myself, lodged in a vile clay vessel."

Passionately fond of music, Delacroix adored Mozart and Gluck. Oddly enough, he misunderstood Berlioz, and as for the romantic writers, he ridiculed them. It is noteworthy that, though Delacroix has rightly been considered a romantic, his first love was for the classic writers such as Racine: "I know the ancients, and I have learned to place them above all others; this is the best result of a good education, and I am glad of it — the more so since the moderns, in love with themselves, neglect those august examples of ability and intelligence." Delacroix's personality is quite different from that of Victor Hugo, with whom he is often compared. The only contemporary writer who offers any close parallel to Delacroix is the poet Alfred de Vigny, a similarly melancholic and aristocratic mind, always battling against the mediocrity of the mass and its prejudices.

Delacroix's *Journal* has a companion piece in the writer's *Journal d'un Poète*.

Delacroix's place in the history of painting is considerable. He himself seemed to describe it in defining what he understood by romanticism: "If by romanticism is meant the free display of my personal impressions, and my repugnance for the types invariably admired in the schools and for academic formulas, I must confess that not only am I a romantic, but that I was so even at fifteen: I already preferred Prud'hon and Gros to Guérin and Girodet."

SOURCES. a. *Writings*: T. Silvestre, Eugène Delacroix, documents nouveaux, Paris, 1864; E. A. Piron, Eugène Delacroix, sa vie, ses œuvres (literary works), Paris, 1865; P. Burty, ed., Lettres de Eugène Delacroix, new ed., Paris, 1878; Journal de Eugène Delacroix, Paris, 1893–95 (introduction by P. Flat, notes and comments by P. Flat and R. Piot); Journal de Eugène Delacroix, Paris, 1932 (new ed. from the original ms., introduction and notes by A. Joubin); A. Joubin, ed., Correspondence générale de E. Delacroix, 5 vols., Paris, 1935 ff.; Écrits d'Eugène Delacroix, extraits du journal, des lettres et des œuvres littéraires, Paris, 1942; E. Delacroix, Journal et correspondence, ed. P. Courthion, Freibourg im Breisgau, 1944 (introduction by P. Courthion); The Journal of Eugène Delacroix, trans. W. Pach, 2d ed., New York, 1948; H. Wellington, ed., The Journal of Eugène Delacroix, trans. L. Norton, London, 1951 (introduction by H. Wellington).
b. *Contemporary criticism*: A. de Montaiglon, articles published Dec. 13, 1846–Jan. 31, 1847, Moniteur des Arts, Paris, 1847; G. Planche, Etudes sur les arts, Paris, 1855; E. de Mirecourt, Eugène Delacroix. Paris, 1856; A. Cantaloube, Eugène Delacroix, l'homme et l'artiste, ses amis et ses critiques, Paris, 1864; J.-A. Castagnary, Les Libres propos, Paris, 1864; C. and L. Duval, Eugène Delacroix et Hippolyte Flandrin: Parallèle: Le salon de 1864, Meaux, 1864; C. Clément, Etudes sur les beaux-arts en France, Paris, 1865; A. Moreau, E. Delacroix et son œuvre, Paris, 1873; T. Silvestre, Les Artistes français: Etudes d'après nature, Paris, 1878; M. Tourneux, Eugène Delacroix devant ses contemporains, ses écrits, ses biographes, ses critiques, Paris, 1886; L. de Planet, Souvenirs de travaux de peinture avec M. Eugène Delacroix, Paris, 1929 (introduction and notes by A. Joubin); T. Silvestre, Histoire des artistes vivants français, études d'après nature, Paris, n. d. c. *Catalogues*: Exposition des œuvres d'Eugène Delacroix, Paris, 1864; Exposition Eugène Delacroix au profit de la souscription destinée à élever à Paris un monument à sa mémoire, Paris, 1885; L'œuvre complète d'Eugène Delacroix, peintures, dessins, gravures, lithographies, Paris, 1885 (catalogues and reproductions by A. Robaut, notes by E. Chesneau); L. Delteil, Ingres et Delacroix, Le peintre-graveur illustré (XIXᵉ et XXᵉ siècles), III, Ingres & Delacroix, Paris, 1908; Exposition E. Delacroix, Louvre, Paris, 1930; Eugène Delacroix (1798–1863), Kunsthaus Zurich, Zurich, 1939.

BIBLIOG. E. Delacroix, Fac-similé de dessins et croquis originaux, ed. A. Robaut, Paris, 1864–65; H. du Cleuziou, L'œuvre de Delacroix, Paris, 1865; A. Robaut, Peintures décoratives par Eugène Delacroix, le Salon du Roi au palais législatif, Paris, 1880; E. Chesneau, La Peinture française au XIXᵉ siècle, Paris, 1883; G. Dampt, Eugène Delacroix, à propos de la dernière exposition de ses œuvres, Paris, 1885; P. Lira, Eujenio Delacroix: Estudios de Eujenio Veron sobre el gran maestro publicados en "El Arte" y comentados por Pedro Lira, Santiago, Chile, 1885; E. Veron, Delacroix, Paris, London, 1887; A. Michel, Notes sur l'art moderne, Paris, 1896; M. Tourneux, Eugène Delacroix, Paris, 1902; J. La Farge, The Higher Life in Art, London, 1908; J. Guiffrey, Le voyage d'Eugène Delacroix au Maroc: Fac-similé de l'album du château de Chantilly, 2 vols., Paris, 1909; P. G. Konody, Delacroix, London, New York, 1910; M. Robin, Eugène Delacroix (Portraits d'hier, I, 21), Paris, Jan. 15, 1910; P. Signac, D'Eugène Delacroix au néo-impressionisme, Paris, 1911; J. Meier-Graefe, Eugène Delacroix, Beiträge zu einer Analyse, Munich, 1913; E. Moreau-Nélaton, Delacroix raconté par lui-même, Paris, 1916; G. Janneau, Le dessin de Delacroix, Paris, 1921; P. Ratouis de Limay, Les Artistes écrivains, Paris, 1921; R. Escholier, Delacroix, peintre, graveur, écrivain, Paris, 1926–29; L. Languier, En compagnie des vieux peintres, Paris, 1927; E. Delacroix, trente et un dessins et aquarelles du Maroc, Paris, 1928; H. Gillot, E. Delacroix, l'homme, ses idées, son œuvre, Paris, 1928; P. Fortlumy, Entretiens avec une ombre: Devant la mort de Sardanapale et l'entrée des croisés à Constantinople, Paris, 1928; F. Gysin, Eugène Delacroix, Studien zu seiner künstlerischen Entwicklung, Strasbourg, 1929; R. Escholier, Delacroix voyageur, Rev. de l'Art Ancien et Mod., LVII, 1930, pp. 13–18; L. Hourticq, Delacroix, Paris, 1930; A. Jubin, Eugène Delacroix, voyage au Maroc, 1832: Lettres, aquarelles et dessins, Paris, 1930; F. Vallon, Au Louvre avec Delacroix, Grenoble, 1930; J. d'Elbée, Le Sourd et le muet, notes parallèles sur Goya et Delacroix, Paris, 1931; R. Piot, Les Palettes de Delacroix, Paris, 1931; R. Regamay, Eugène Delacroix, époque de la Chapelle Saints Anges (1847–63), Paris, 1931; R. Escholier, Delacroix et sa "consolatrice," Paris, 1932; H. Gillot, Figures romantiques, Paris, 1933; C. Becker, L'œuvre d'art selon Eugène Delacroix, Rev. d'H. de la Philosophie et d'H. Générale de la Civilisation, N.S., V, 1934; A. Joubin, L'Amitié de George Sand et d'Eugène Delacroix, Rev. des Deux Mondes, 1934, pp. 832–865; E. Lambert, Delacroix et les femmes d'Alger, Paris, 1937; P. Courthion, Delacroix, Paris, 1939; L. Rudrauf, Eugène Delacroix et le problème du romantisme artistique, Paris, 1942; J. Cassou, Delacroix, Paris, 1947; F. Fosca, Delacroix, Bern, 1947; P. H. Michel, Les massacres de Scio, [de] Delacroix, Paris, 1947; L. Venturi, Modern Painters, New York, 1947; E. Goldschmidt, Frankrigs malerkunst, dens farve, dens historie, VII, Eugène Delacroix, VIII, Delacroix og impressionismen, Copenhagen, 1950; J. Lassaigne, Eugène Delacroix, Paris, 1950; U. Christoffel, Eugène Delacroix, Munich, 1951; M. Sérullaz, Delacroix, aquarelles du Maroc, Paris, 1951; W. Friedlaender, David to Delacroix, Cambridge, Mass., 1952; A. Fontaine, Delacroix poète, Paris, 1953; A. Boschot, Portraits de peintres, Paris, 1954; U. Apollonio, Delacroix, Milan, 1956; G. Bideau, Eugène Delacroix, Lyons, 1957; Delacroix (Les Peintres illustres), Paris, n.d.; C. Mauclair, Eugène Delacroix, Paris, n.d.; M. Sérullaz, ed., Eugène Delacroix: Dessins, aquarelles et lavis (1817–1827), Paris, n.d.

Jean ALAZARD

Illustrations: PLS. 141–146.

**DELAUNAY**, ROBERT. French painter (b. Paris, Apr. 12, 1885; d. Montpellier, Oct. 25, 1941). In 1902 Delaunay was apprenticed to a stage designer, Ronsin, and in 1904 began to paint during his vacations in Brittany. In 1910 he married the Russian artist Sonia Terk. From 1909 to 1914 he was closely affiliated with Apollinaire and the cubists, exhibiting at the Salon des Indépendants, and in 1912 with the Blaue Reiter group in Berlin and Cologne. Delaunay traveled to Berlin with Guillaume Apollinaire in 1913 and exhibited with Der Sturm. Between 1915 and 1917 he lived in Spain and Portugal and befriended Diaghilev, for whose ballet *Cleopatra* (1918) the artist and his wife designed sets and costumes. In 1921 he returned to Paris and in the following year had a retrospective exhibition at the Galerie Paul Guillaume. Delaunay was commissioned to do decorative murals for both the Paris Exposition Internationale des Arts Décoratifs of 1925 and the Paris Exposition Universelle of 1937; and in 1938 he and his wife did decorations for the sculpture hall at the Salon des Tuileries. In 1939 he helped to found Réalités Nouvelles. Characteristic paintings include *The Eiffel Tower* (1910; Basel, Kunstmus.; V, PL. 127), *The City of Paris* (1912; Paris, Mus. d'Art Mod.; PL. 77), and *Sun Disks* (1913; New York, Mus. of Mod. Art).

After being influenced by various late-19th-century styles, Delaunay began to adhere to cubism as well as to investigate the light and color theories of Chevreul and the neoimpressionists. To the monochromes of the early cubist palette he introduced pure and brilliant hues as a means of creating space and light. By 1912 he had even abandoned the cubist dependence on reality in favor of an art constructed solely of colored planes and simple geometric forms, thus becoming one of the pioneers of pure abstraction, together with Kandinsky and Kupka. His new abstract use of color, which Apollinaire designated as "Orphism," was especially influential upon such artists as Marc, Macke, and Klee (who visited Delaunay in Paris in 1912), and upon the American synchromists, Morgan Russell and Stanton MacDonald-Wright.

WRITINGS. P. Francastel, ed., Robert Delaunay: du cubisme à l'art abstrait, Paris, 1957.

BIBLIOG. F. Gilles de la Tourette, Robert Delaunay, Paris, 1950; Robert Delaunay, 1885–1941, Paris, Mus. Nat. d'Art Mod., 1957; Robert Delaunay, Arts Council of Great Br., 1958; H. Chipp, Orphism and Color Theory, AB, XL (Mar., 1958), pp. 55–64.

Robert ROSENBLUM

**DELLA QUERCIA**, JACOPO. Italian sculptor of the late 14th and early 15th century. Called Della Guercia or Ghercia or Ghuercia in contemporary documents, he was later nicknamed Jacopo della Fonte. It is not known for certain how he came to be called Della Quercia; some think it was because he was a native of Quercia Grossa, near Siena. Jacopo was the son of Pietro di Guarnieri, painter, sculptor, and goldsmith, and brother of the painter Priamo. We have no conclusive evidence concerning the date of Jacopo's birth, but most critics, relying on remarks made by Vasari, have supposed that it was about 1374. Since the artist's name is mentioned in connection with a payment in 1386 (Bacci, 1929), an earlier birth date is possible, though not before 1371, in view of his father's marriage in April of 1370. Vasari, in the first edition of the *Lives*, wrote that Jacopo was in Florence from 1396 to 1401. In the second edition, when mentioning Jacopo's participation in the competition for the second pair of doors for the Florence Baptistery, Vasari states that he came from Lucca; and it is almost certain that Jacopo passed his youth there with his father,

who was working for Paolo Guinigi. Recent research (Brunetti, 1952), however, has reintroduced the theory that the artist might have visited Florence and worked in the Cathedral before 1395. In 1401 he took part in the Baptistery competition; in 1406 he was probably in Lucca (this is the most likely date for the tomb of Ilaria del Carretto); in 1408 he was in Ferrara, where his hand may be recognized in the *Virgin and Child* now in the Museo dell'Opera del Duomo of that city (PL. 147). At the end of the year we find him in Siena, where he received his first commission for a fountain (Fonte Gaia) in the Piazza del Campo; this commission was renewed the following year. On Dec. 31, 1408, Jacopo, a member of the more progressive political party, was elected to the Consiglio del Popolo for the ward of San Martino. In 1412 he received the first advance payments for the Siena fountain, for which his friend and frequent collaborator Francesco di Valdambrino stood guarantor. But by 1413 he was in Lucca, where he received a commission to execute sculptures of the twelve apostles. (He completed only one.) His departure so annoyed the commissioners of works in Siena that they threatened him with legal action. In the same year, he was charged with adultery and sodomy and had to flee from Lucca to Siena. Jacopo spent the following years in both Siena and Lucca; in the latter city he carved tomb slabs for Lorenzo Trenta and his wife, and was commissioned to decorate their family chapel in S. Frediano, finishing the altar in 1422. To the great annoyance of the Sienese, he delayed his work on the Fonte Gaia and did not complete it until September, 1419. In 1421 he received payment for the wooden statues of the *Annunciatory Angel* and the *Virgin Annunciate* for the parish church of San Gimignano; during these years, according to documents discovered by Bacci, he was also active as a military engineer and may have taken a hand in the transformation of the Sienese defenses. In May, 1424, he married Agnese di Nanni Fei. At the same time he began work on the central portal of S. Petronio in Bologna (PL. 152). The hardships of the many arduous journeys he made at the beginning of this period (to Verona, Venice, Milan, and Ferrara) in search of Istrian limestone, as well as the conflicting demands of his important commissions in Bologna and Siena, the badgerings of commission agents, and the threats of lawsuits and heavy fines, embittered him. In 1427 he agreed to collaborate on the baptismal font at Siena; but here too he failed to complete his commitment. On Feb. 9, 1433, he was commissioned to transport six pieces of marble to Siena and to make two or three statues for the Loggia di S. Paolo, a commission which he never executed. In 1435 he was appointed *capomaestro* for the Cathedral, and according to documents found by Bacci, his misappropriation of funds in this capacity led to a posthumous lawsuit.

In 1436, frightened by the threats of the Bolognese and irritated by the constant interruptions of his work, Jacopo took temporary refuge in Parma. The papal legate in Bologna, Cardinal A. Casini, commissioned him to decorate a chapel in Siena Cathedral, and to this, together with the Bologna doorway, he devoted the last years of his life; a considerable part of a lunette from this chapel has been discovered (Supino, 1910; Bacci, 1929). Exhausted and unable to attend to his work in peace, Jacopo fell ill while on a journey to Bologna in 1437; he returned to Siena and died there on Oct. 20, 1438, eighteen days after making his will.

As the work of Jacopo della Quercia consists of a number of important, authenticated pieces which are fairly easy to date, the critic's main problem has been to understand their intrinsic significance and their connection with contemporary Florentine art, especially that of Donatello. This has not been easy, in view of Jacopo's very personal idiom and the widespread use of the conventions of Renaissance art and culture in his time. In the present century, certain attributions have been suggested, mainly in order to fill in the undocumented years of the artist's youth. This is a rather obscure period, since Jacopo's first authenticated work is the tomb in Lucca Cathedral. Vasari (*Lives*) records that the artist made this monument for Ilaria, the young wife of Paolo Guinigi, who died in December, 1405, when Jacopo was over thirty (PL. 148). Vasari's statement that

he had already worked in Siena Cathedral is not improbable since the Cathedral was a workshop which was always open and which gave the young sculptor a chance to study the work of Giovanni Pisano at close range. It is probable that Jacopo first worked alongside his father, a craftsman in several fields. Mario Salmi (1930) thinks we may find examples of these early exercises in three fragments which appear to form part of the base of a marble polyptych, the *Pietà and Saints* (Lucca, S. Martino); but these show no signs of individuality, only an uncertain reflection of the late influence of Nino Pisano on a sculptor working in the last years of the 14th century.

The late Gothic style of Pisa and Siena influenced Jacopo, for there was much for him to learn from that great genius Giovanni Pisano. The tomb in Lucca shows a sculptor who is already mature, with a more advanced artistic background than the Sienese and with a novel classical bent; by 1401 Jacopo must indeed have developed a considerable personality if he ventured to compete for the bronze doors against the greatest of the Florentines. Since there is convincing evidence that he collaborated with Giovanni d'Ambrogio on the Porta della Mandorla of Florence Cathedral, Vasari's suggestion that he paid a visit to Florence in his youth seems worthy of consideration (Brunetti, 1951-52). In the portal jamb three busts of angels in relief set in a hexagon stand out because of their characteristic features; two are of crude workmanship, but one has a Sienese sense of breadth and emotion. Also similar in style are two little nude figures of Orpheus and of Hercules framed by curly acanthus leaves. Of special note are figures of the *Annunciatory Angel* and the *Virgin Annunciate*, once on the lunette of the same doors and now in the Museo dell'Opera del Duomo, Florence. These have been attributed to various sculptors, most recently Nanni di Banco (O. Wulff, *JhbPreussKSamml*, 1913, pp. 99-164; L. Planiscig, *Nanni di Banco*, Florence, 1946; Galassi, 1949), but they may be Jacopo's work of about 1397, as they are related to some features of his later sculpture. The ample cadence of the monumental, clear-cut composition and the placing of the two figures in attitudes expressive of lively participation are typically Gothic; but Jacopo also aspired to that classic regularity which he felt to be dignified and scholarly, and he managed to harmonize this with the inner vitality of Giovanni Pisano's Gothic style.

Another possible attribution from the period about 1397 is a statuette, the *Madonna and Child*, now on the Piccolomini Altar in Siena Cathedral (Carli, 1949), which has formal affinities with Jacopo's work. These are possibly due only to a common artistic heritage (cf. Nicola Pisano's *Madonna* on the pulpit of the same cathedral); in any case, the modeling seems less assured than that of Jacopo's work in Florence Cathedral.

Jacopo's links with Florence may clarify the origins of the tomb of Ilaria del Carretto (PL. 148). Damaged by the Sienese because of their hatred for Paolo Guinigi, the tomb was reassembled in 1913 by Bacci, utilizing one side of the sarcophagus, which was found in the Uffizi, and the intarsia headpiece with the arms of Guinigi and Ilaria, rediscovered in the Ducal Palace. It was almost certainly conceived as a freestanding sarcophagus and not as part of a group, either architectural or religious in concept. There was no lack of examples of this type of tomb. With the Gothic conception of the *gisant*, or recumbent figure, Jacopo combined the Roman use of funereal genii, though in this case they have no symbolic meaning; here he depicted a rhythmic dance of cupids holding garlands of fruit and flowers. Early critics (even Burkhardt) found difficulty in relating these diverse motifs and interpreted them as a compromise between Gothic and Renaissance. The truth is that Jacopo, already sure of his technique, had welcomed whatever might help him to express himself.

Atop the sarcophagus the delicate figure of the dead Ilaria seems to have the calm of suspended animation; it reclines between a pillow under the head and a dog at the feet, both simple masses clearly defined in polished marble. The bust and the hands are almost luminous; the folds of the drapery flow as if still animated by some secret vitality and in no way restrained by the narrow confining space. The chubby cupids with their blunted wings are of a different substance and seem

weighted down by the garlands. They are set in flat relief and in an anticlassical composition which continues around three sides of the sarcophagus. Their continuous sense of movement is in sharp contrast to the modeling of the upper half of the tomb. A less fluid quality on the left-hand side has been taken as an indication of Valdambrino's collaboration (Bacci, 1936); but if Valdambrino did aid Jacopo, it was only in the actual execution.

The statue of the *Virgin and Child* (PL. 147), now in the Museo dell'Opera del Duomo at Ferrara, was first attributed to Jacopo by Perkins (1864), rejected by Cornelius (1896), then reattributed by Reymond (1898); the attribution has been accepted by the majority of critics, at least in regard to Jacopo's hand in its conception, if not its execution. We are told in a document of June 18, 1408, published by L. N. Cittadella (*Notizie relative a Ferrara*, Ferrara, 1864), that the statue was made for the Silvestri Chapel. The inscription on the base, "Giacomo da Siena 1408," is apocryphal. This statue, although of modest dimensions, is impressive in its monumental structure. While Jacopo seems here for the first time to follow the tradition of Arnolfo di Cambio and Andrea Pisano, he retains his conception of a unifying sense of constant motion, which gives this group its vitality. Though the sculpture is unusually severe and almost archaic and though the handling of the marble is somewhat harsh, we may see in the springiness of the leg (a detail which was to be taken up again and developed throughout two centuries), in the effect of movement given by the folds of the drapery, and above all in the treatment of the Child as part of the Madonna's body, Jacopo's unceasing determination to preserve the influence of Giovanni Pisano in his figures, and yet to compose them in a more monumentally classical fashion. To this period may be attributed another sculpture, a *Madonna of Humility* (Seymour and Swarzenski, 1946), now in the Kress Collection of the National Gallery, Washington. Its undeniable quality comes out in the delicate modeling and the inventiveness displayed, especially in the way in which the body and drapery are gathered together at the base of the statue. Because of a considerable negligence in the treatment of the hands and faces and a certain preciosity, which is foreign to Jacopo, critics are not agreed in recognizing this as the master's work.

The only apostle (probably St. John) which Jacopo managed to complete of the twelve ordered for Lucca Cathedral dates from some years later, about 1413. Venturi (*Storia dell'arte italiana*, VIII, Milan, 1923), however, attributes to Jacopo a *Head of a Youth*, also in the interior of the Cathedral. The complicated folds of the apostle's drapery do not obscure the clearly defined lines of the youthful body, to which the arms cling in such a way as to give the effect of a spiral movement of liberation; the diagonal of the tensed leg and the lively undulation of the drapery across the chest provide a perfect balanced setting for the proud, inspired head, and the whole is expressive of dynamic readiness. A holy-water stoup adorned with thick Gothic foliage and small heads, also in the Cathedral, was attributed to Jacopo by Burckhardt (1855) and E. Ridolfi (*L'arte in Lucca*, Lucca, 1882), but is a work by followers.

In the tombstone of Lorenzo Trenta in S. Frediano, Lucca, there is an unusual vitality in the linear fluidity of the drapery, which still suggests the solid structure of the body beneath. The workmanship of the tomb of Trenta's wife is more detailed and, especially in the lower part, the design more confused; Bacci (1936) attributes this to the collaboration of Giovanni da Imola, who worked with Jacopo in S. Frediano. The tombstone of Antonio da Budrio (d. 1408), discovered in 1949 at the Monastery of S. Michele in Bosco, Bologna, seems to be closely related to these works.

In 1408 the Sienese commissioners of works entrusted Jacopo with the construction of the new fountain (Fonte Gaia) in the Piazza del Campo in front of the Palazzo Pubblico. The following year the contract, "in accordance with the design presented," was confirmed at 200 gold florins. Lányi (1927) supposes that this design was the one now in the Victoria and Albert Museum, London, but Bacci thinks that the London drawing is rather the remains of the cover of some administrative register; certainly it does not seem to be by Jacopo. A fragment representing the left-hand part of the fountain, by the same hand, has been acquired by the Metropolitan Museum, New York (Krautheimer, 1952).

Jacopo was slow to begin work on the fountain, and in 1415 the commissioners decided, perhaps at the suggestion of the sculptor, to improve the plan by enlarging the basin, sloping the front, broadening the sides, and facing the back with marble. Such a low, horizontal structure in the Sienese tradition, with its basin below ground level and animated by an organic grouping of sculpture, is admirably adapted to the curve of the Campo. This large piazza opens toward the Palazzo Pubblico and is cleverly linked to its surrounding space by sloping sides. In a reconstruction of the fountain made in the 19th century, lifeless copies were substituted for the original sculptures, which because of deterioration were dismantled and are now displayed in a loggia of the Palazzo Pubblico. The whole fountain was also moved nearer the center of the piazza. Its ethical and religious conception was medieval, for it had in the middle a *Virgin and Child* flanked by two angels (PL. 150), and on each side four figures of Virtues. (For reasons of symmetry, another figure was added to the seven cardinal and theological virtues.)

*The Creation of Adam* and *The Expulsion from Paradise* (PL. 149) from the now-dismantled fountain express the two presuppositions of the whole of Christian eschatology. On the two end pilasters, as a grandiose and animated conclusion to the whole, were two female figures, each with two babies; these have been variously interpreted as Rhea Silvia and Acca Larentia — references to the Roman origins of Siena; Bacci (1936) has seen them as figures of Charity or the Earth Mother (PL. 150). Perhaps the best interpretation is that provided by a Sienese diary of the 18th century, which refers to them as representing Public Charity; Charity as one of the virtues is already depicted at the back of the basin. The municipal council also commissioned another subject with a historicomythical allusion — recumbent figures of wolves, each spouting water and with cupids sitting astride them — but this has disappeared.

Jacopo intended the continuous horizontal theme to give a rhythmic unity of movement, which is manifest in the three-quarter view of the Madonna and in the inspired variety shown in the composition of the allegorical figures. Whether it is due to the ovals, unrestricted by strong architectural moldings, in which the figures are framed, or to their freedom of movement, the figures certainly have a suggestion of depth into which they recede, only to emerge again more effectively. The placing of the heads toward the top of the available space creates an impression of liberation rather than of the weight of mass. The ample drapery, treated in pictorial rather than linear terms, gives the figures an effect of movement and spontaneity. High relief has thus become a fully exploited technique.

The poor state of repair of the Biblical scenes does not obscure their great dramatic force. In *The Expulsion from Paradise* (PL. 149) the arch, which is only sketched in lightly, suggests a nonexistent spatial breadth that is completely filled by the movement of the three figures; Jacopo's modeling of the nude also retains its dynamic or, as in this case, dramatic power. His forms are never isolated, for the distortions of the limbs, the sweeping planes where anatomy is subordinated to expression, all combine to produce a new and complex kind of unity, which provides a grandiose, almost heroic environment for the nude figures.

In the statues themselves Jacopo preserved the integrity of the composition of the body so that limbs and drapery form a whole that maintains a vitality of both outline and invention. The left-hand group shows particular originality, especially in the unexpected rotundity of the Child and in the use of a bold and swift play of light. In the modeling of the shoulders and the gently pensive face, the sculptor employed smooth-flowing surfaces, capturing the movement of the figure, the restless flutter of hair and veil. The right-hand group seems a little more statically composed, possibly owing to repairs necessary when the statue fell; because of this, Bacci attributes it to Valdambrino, to whom the *Cronaca Senese* from the end of the 15th century assigns one of the figures on the fountain. Here,

however, it can be a question only of partial authorship, for none of Valdambrino's other statues is so inspired or so original.

Jacopo's reputation as a classicist has been due especially to the fountain. This classicism is seen particularly in his treatment of the nude and the regularity of facial features, as well as in the supposed Roman inspiration of the subject.

Although it was already known from Vasari that Jacopo had also worked in wood, it was only after the discovery of the record of a payment made in 1421 (Bacci, 1929 and 1936) that it became possible to attribute to him with certainty at least the figures of the *Annunciation*, made for the Collegiata at San Gimignano; these were previously assigned to an unknown Sienese or to Jacopo's studio (Schubring, 1907). An inscription on the pedestal of the figure of the *Virgin Annunciate* tells us that it was painted in 1426 by Bartolomeo da Siena; the coloring has been renewed in part. Here the classicism is more obvious, almost didactic, in the figure of the wingless angel in a toga, standing firmly on bare feet, but it is overshadowed by the vivacity of the dialogue between the two figures — direct, lacking in mystery, yet full of implications. A certain harshness, especially in the figure of the angel, has given rise to the theory (Bacci, 1936) that here too Jacopo was assisted by Francesco di Valdambrino.

The altar of the Trenta Chapel is still in S. Frediano, signed "Hoc opus fecit Jacobus magistri Petri de Senis," with the year 1422 (Bacci, 1933; PL. 151). Jacopo must have begun this work some time previously, for Trenta had obtained permission to redo the altar as early as 1416. The general conception is Jacopo's most archaic (perhaps at the wish of his patron), with its high, narrow compartments containing the *Madonna and Four Saints* (Lawrence and Lucy, Jerome and Richard) and high pinnacles in the florid Gothic style. Although Jacopo tried to indicate the figures underneath the swirling of the draperies, the planes were too fragmented to achieve this with complete success. In fact, critics have always found difficulty in placing this altar later than the Sienese fountain, and as early as Burckhardt (1855) it was suggested that at least the upper half was executed before the fountain. The collaboration of Giovanni da Imola might explain the complexity of form shown in the work. Hints of Donatello and a trace of Jacopo's inventiveness are present, but the general effect is labored.

On the other hand, the predella which depicts episodes from the lives of the saints, in the upper part of the altar, shows a remarkably varied inspiration with its truly Renaissance partitions, where subtle differences of plane produce a sense of space and descriptive variety. The work opens the way to an understanding of the possibilities of the bas-relief as a pictorial medium, mingling as it does figures and background in a completely new use of space and breadth; this treatment differs from that of Donatello (q.v.), who for years had been interpreting relief not as the isolation of figures from a background but as a carefully composed spatial unity, though hinting at almost limitless vastness and at the possibility of a synthesis of man and the universe.

The wooden figure, *St. Leonard* (PL. 150), discovered in the Church of the Madonna degli Ulivi at Massa, near Carrara, was correctly attributed (1958), after restoration, to Jacopo. The statue may reasonably be assigned to a date sometime after the Trenta altar; it shows signs of the softening characteristic of Jacopo's later work. But high quality and formal coherence are revealed throughout the piece, in the hair, in the hands, in the expressive drapery, in the patterned diffusion of waves of movement, in the elastic tension in the balance, even in the eloquently parted lips.

Jacopo's collaboration on the baptismal font in Siena provided him with another opportunity to express himself in bas-relief; the conception of this font has also been traditionally attributed to him, though it has been rejected for stylistic (Nicco, 1934) and documentary (Bacci, 1929) reasons. Jacopo produced only one of two scenes assigned to him, *The Appearance of the Angel to Zacharias* (PL. 149), employed on one side of the basin. (He also sculptured five prophets used on the marble tabernacle which was added after 1427.) But Jacopo delivered his panel only in June of 1430, later than Ghiberti and Donatello, whose influence is clearly present; the flat Donatellesque relief of the background, with its receding architectural planes, is contrasted to the vigorous foreground figures which are thereby all the more emphasized. The meeting at the altar is full of power, the formal tension and the animated treatment of the figures giving the relief a dramatic quality intensified by the highlights on the bronze.

The prophets on the tabernacle of the font, like the saints on the Trenta altar, show strong signs of Jacopo's touch in the projection of the figures in their shallow niches, the dramatic agitation of the drapery, and the faces overshadowed by flamboyant hair. The few signs of waning inventiveness are probably due to assistants rather than to Jacopo's own conception of these figures. The *St. John the Baptist* that crowns the tabernacle cannot be attributed to Jacopo.

The work which, though unfinished, best shows the range of Jacopo's genius and the inventive power that brought him to a command of form astounding for his time is his sculpture of 1435–38 for the main portal of S. Petronio in Bologna (PL. 152) — perhaps the least understood of his creations.

In the contract of Mar. 26, 1425, between Jacopo and the papal legate to Bologna, it was stipulated that the work was to correspond to Jacopo's design and that he was to be responsible for the architecture and sculpture; the price fixed was 3,600 papal florins. The approved plan provided for two pilasters, each with seven bas-reliefs, a sculptured architrave, and a statue of the Madonna in the lunette with S. Petronio and Pope Martin V kneeling before her. A Gothic gable ending in a foliation containing a crucifix was to have surmounted the portal; this gable would have been tall and integrated into the Gothic church; 28 busts of prophets were to form an outer frieze (Gatti, 1913). On Jacopo's death only the architrave with five scenes was in position.

The present composition dates from 1510 and imparts a Renaissance aspect to the portal; the other parts which Jacopo had completed, five scenes in relief and nine prophets, were moved to the two sides of the door, and in the lunette the Pope was replaced by St. Ambrose.

The later Renaissance found Bolognese reliefs of scenes from Genesis adequate to its taste, especially in their breadth of form and the emphasis placed on the nude; but these factors of taste seemed to hinder understanding of Jacopo's figures, with their profusion of moving draperies. This misunderstanding persisted and was shared even by Cornelius (1896); and it has remained for more recent criticism to point out the spiritual unity of expression in the fleeting and pictorial quality of the modeling, which not only determines a continuity of forms with its smooth-flowing surfaces but also dramatically breaks up the play of light and shadow.

The statues in the lunette, especially that of the Madonna, show Jacopo's increasingly confident treatment of figures which are not posed but are engaged in an action that embodies the artistic and spiritual significance of the work. It is especially in the bas-relief scenes from the Old and New Testaments (PL. 153) that the artist achieved the fullest expression of his increasingly dramatic view of man. Each episode is gathered to a peak of tension, the figures straining against one another, nullifying the effect of the empty spaces; even architecture and landscape are brought into the orbit of the action. The shifting surfaces of the flaring, elongated figures give an unexpectedly varied effect of light and shade to the relief and permit the sculptor a wide range of expression, rich in implication. Naked limbs and drapery, rocks and foliage, the streaming of hair, and the fluttering of cloth contribute to a spirited and unified composition. Here Jacopo has moments of inspired poetry, as for example in *The Creation of Eve* and *The Labors of Adam and Eve* (PL. 153), which are vibrant with the speed, ardor, and nobility of his touch. In these reliefs the creation of sensual beauty is not the aim. The sculptor, reshaping proportions and forms, retains only the essential features of the action. In fact, modern criticism sees in these bas-reliefs the greatest expression of Jacopo's genius and one of the high points of 15th-century art.

Although Jacopo's lunette for the Casini Chapel in Siena Cathedral does not attain the liveliness and boldness of some of the S. Petronio reliefs, it does belong to this period characterized by works of dramatic intensity. The lunette was recognized by Bacci (1929) in a fragmentary bas-relief in the Ojetti Collection in Florence published by Supino (1921–22). The work represents the Virgin and Child in the middle and on the right Cardinal Casini with St. Anthony Abbot.

The tomb in S. Giacomo in Bologna, made by Jacopo for the jurist Vari but later destined for A. G. Bentivoglio, is more traditional in composition; it is documented by the record of a payment (1433), but the work was unfinished at Jacopo's death. Perhaps at Vari's wish, Jacopo followed the Veneto-Bolognese schema already adapted by Andrea da Fiesole in the tombs he had produced for the professors at the University of Bologna. But in the bas-relief figure of the dead man on the sloping slab, the sculptor returned to the flowing surfaces we have already seen in his earlier tombstones. On the front of the sarcophagus Jacopo employed the medieval theme of the scholars; but he imparted a novel effect of unity to the crowd, in which, however, each person is individualized through the furrows and angles of the face, the attitudes, even the placing of the feet on the ground. In other parts of the sarcophagus, especially in the statues of the Virtues, we can detect the hand of assistants; Supino (1926) assigns only the figures of Fortitude and Temperance to Jacopo.

Several other sculptures have also been attributed to Jacopo della Quercia. Among the most important is a statuette of a bishop in Ferrara Cathedral, which was published by A. Venturi, who dated it after 1408 but linked it with a Madonna in the same cathedral (L'Arte, XI, 1908, pp. 53–54; and Storia dell'arte italiana, VI, Milan, 1908); Supino thought that the statuette was of a later date. The attribution has found little favor because of the poor quality of the work.

In the Church of S. Martino in Siena there is an important group of five statues of gilded and polychromed wood, representing the Virgin and Child with four saints. While the Virgin and Child (PL. 154) have all of Jacopo's inventiveness, the saints are considerably inferior in quality and are partially or totally assigned to the master's studio; Carli (1946–47) attributes the figures of SS. Bartholomew, Andrew, and John the Baptist to Giovanni da Imola, Jacopo's collaborator in Lucca and Siena, dating the group between 1419 and the beginning of 1425. However, he does attribute to Jacopo another group in gilded and painted wood, representing the Annunciation. The group comes from the former Monastery of S. Maria degli Angeli in Siena; after various attributions (to Neroccio di Bartolomeo, Giovanni di Turino, and Goro di Neroccio) it was finally reassigned by Bacci to the circle of Valdambrino. A. Michel (1897) found affinities between the Virgin of S. Martino and a polychrome wooden Madonna and Child in the Louvre; though not recognized by A. Venturi and Supino, the Louvre attribution has found favor with most modern critics because of the severe pathos of its composition and modeling.

A marble triptych in the Museo Civico in Bologna has been grouped with Jacopo's later work, but Supino, who first discussed it in 1926, judged it to be a studio piece; Ragghianti (1938) attributes it to the master and suggests that it may be connected with a fragment in a private collection in Cologne.

Guido Zucchini (1934) relates to Jacopo's Bologna period or at least to one of his disciples discussed by Supino (1910) a relief representing St. Anthony Abbot, now at Maggio near Bologna. On the basis of a wooden model for the figure of an apostle, now in the Detroit Institute of Arts, W. R. Valentiner (1940) has suggested that Jacopo might have paid a visit to Venice when in northern Italy and hence attributes (1953) to him the tomb of Paolo Savelli (d. Oct., 1405) in the Frari church, both because it is difficult to relate the statues on this tomb to contemporary Venetian sculpture and because of their affinities with the Ferrara Madonna and the Lucca Apostle. These attributions, however, are not so convincing as Valentiner maintains. He thinks that the work was probably completed by Jacopo in the years 1406–07 and consequently falls back on the hypothesis that Bacci had already (1936) shown to be groundless, that the Lucca tomb did not date before the middle of the second decade of the 15th century.

The originality of Jacopo's work did not receive the recognition it deserved outside his own homeland. Vasari mentions his "application" and "industry," but is interested only in the precursive implications of his adherence to nature, although Michelangelo had already shown that he appreciated Jacopo's art. Filippo Baldinucci (Notizie de' professori del disegno da Cimabue in quà . . . , 6 vols., Florence, 1681–1728) considered Jacopo primarily in relation to the Sienese artists preceding him, as did Leopoldo Cicognara in his Storia della scultura (Venice, 1813); and although Burckhardt (1855) saw Jacopo as one of the initiators of the Renaissance and especially noted his importance for north Italian sculpture, in 1864 Perkins still judged the abundant drapery of Jacopo's figures to be a formal weakness and encumbrance, in comparison with classic purity of form.

As classical prejudices diminished, Jacopo began to be better understood. Reymond (1898) compared him to Nanni di Banco, and in contrast to Vasari, linked him to the Gothic tradition which he thought still had vitality in 15th-century Florence; Eugène Müntz, too (Histoire de l'art pendant la Renaissance, Paris, 1889–95; Precursori e propugnatori del Rinascimento, Florence, 1902), saw in Jacopo an imaginative revival of the Gothic spirit, though he found the S. Petronio reliefs decadent and jaded. The first critic who really recognized Jacopo's greatness was Carl Cornelius, who was also the first to devote a monograph to him (1896). Although the critical prejudices of the time made it difficult for him to comprehend such aspects of Jacopo's work as the treatment of the garments, he did understand and was the first to maintain that even the forms which seemed exaggerated and strangely distorted were "a triumph over nature" in that Jacopo passed from observation of nature to expression of his own feelings. He also pointed out the difference between the torsions of Jacopo's figures and the formalistic contrapposto of the mannerists, and found an affinity with similar expressions of feeling by Michelangelo.

Adolfo Venturi in his Storia dell'arte italiana (Milan, 1901–39) recognized Jacopo as a genius and saw him not only as a "restorer of Roman and Etruscan majesty to art," but also as continuing from Giovanni Pisano, with an almost 16th-century grandeur of effect. The spiritual relationship with both Giovanni Pisano and Michelangelo is underscored when one recognizes Jacopo's wealth of invention, the driving force of religious and human emotion in his art, and his breakthrough toward the future. Such ideas are to be found in Paul Schubring, Jakob Burckhardt, and Wilhelm von Bode.

With the increasing tendency of art critics in recent decades to appreciate freedom of expression and strength of personality, Jacopo della Quercia has taken a position in the first rank, and the creative strength of his art has finally been understood. What had seemed a sign of impediment or weakness has been recognized as a courageous self-liberation from mere description in order to attain intensity of expression. Several monographs followed one another. After the more generalized works of Gielly (1930) and Supino (1926), who also did important research into the influence of Jacopo's art on 15th-century Bolognese sculpture, there followed other works of more strictly critical content (Nicco, 1934), philological documentation (Biagi, 1946), and detailed information. The documentary research of P. Bacci has been of great importance.

Today the art of Jacopo appears as modern for its own time as that of Donatello and the other great Florentines, though his world is less intellectual and his invention directed less toward outward natural appearance than to the inner feelings and motive forces of humanity. Even his religious expression, like that of the Humanists, lays less stress on the transcendent than on delving into human life with its trials and passions. For him space was never an object of speculation or abstract constructions; it was inseparable from man and the world in which his actions take place. Through the unique way opened to him by his genius, Jacopo also took part in the great adventure of Humanism (q.v.) in its most constructive aspect. And as Jacopo's field of experience was man with his spiritual vicis-

situdes, his art was bound to be congenial, in various ways, to Michelangelo.

BIBLIOG. A. Foratti, ThB, s.v., XVIII, 1933; J. Burckhardt, Der Cicerone, Basel, 1855; C. C. Perkins, Tuscan Sculptors, London, 1864; C. Cornelius, Jacopo della Quercia, Halle, 1896; A. Michel, La Madone et l'Enfant: Statue en bois peint et doré attribuée à Jacopo della Quercia (Louvre), MPiot, III, 1897, pp. 261–69; M. Reymond, La sculpture florentine, première moitié du XVe siècle, Florence, 1898; P. Schubring, Die Plastik Sienas im Quattrocento, Berlin, 1907; A. Venturi, Una statuetta ignota di Jacopo della Quercia, L'arte, XI, 1908, p. 53 ff.; J. B. Supino, La scultura in Bologna nel secolo XV, Bologna, 1910; A. Gatti, La basilica petroniana, Bologna, 1913; J. B. Supino, Un'opera sconosciuta di Jacopo della Quercia, Dedalo, II, 1921–22, pp. 149–53; J. B. Supino, Jacopo della Quercia, Bologna, 1926; J. Lányi, Der Entwurf zur Fonte Gaia in Siena, ZfBK, LXI, 1927, pp. 257–66; P. Bacci, Jacopo della Quercia. Nuovi documenti e commenti, Siena, 1929; M. Salmi, La giovinezza di Jacopo della Quercia, RArte, XII, 1930, pp. 175–91; L. Gielly, Jacopo della Quercia, Paris, 1930; J. Lányi, Quercia Studien, Jhb. für Kw., 1930, pp. 25–63; J. B. Supino, EI, s.v., XII, 1931; P. Bacci, L'altare della famiglia Trenta, B. Storico Lucchese, V, 1933; G. Nicco, Jacopo della Quercia, Florence, 1934; G. Zucchini, Opere d'arte inedite, Il Comune di Bologna, XXI, 2, 1934, pp. 23–46; P. Bacci, Francesco di Valdambrino, Florence, 1936; Catalogo della Mostra di scultura d'arte senese del XV secolo, Siena, 1938; S. Bottari, Jacopo della Quercia, Emporium, XLIV, 1938, pp. 183–94; R. Paribeni, Jacopo della Quercia: Discorso per il V centenario della morte, Rome, 1938; C. L. Ragghianti, Su Francesco di Valdambrino, CrArte, III, 1938, pp. 136–43; E. Lazzareschi, Le opere toscane di Jacopo della Quercia, Illustrazione Toscana, 1939, pp. 25–28; W. R. Valentiner, A Statuette in Wood by Jacopo della Quercia, B. of the Detroit Institute of Arts, XX, 1940, pp. 14–15; E. Carli, Capolavori dell'arte senese, Florence, 1946; C. Seymour, Jr., and H. Swarzensky, A Madonna of Humility and Quercia's Early Style, GBA, LXXXVIII, 1946, pp. 129–52; L. Biagi, Jacopo della Quercia, Florence, 1946; G. Galassi, La scultura fiorentina del '400, Milan, 1949; E. Carli, Jacopo della Quercia, Florence, 1949; E. Carli, Una primizia di Jacopo della Quercia, CrArte, VIII, series 3, 1949, pp. 17–24; E. Carli, Catalogo della Mostra dell'antica scultura lignea senese, Florence, 1949; E. Carli, Sculture lignee senesi, Florence, 1949; G. Zucchini, Un'opera inedita di Jacopo della Quercia, Arte Mediterranea, ser. 3, 1949, p. 14; G. Brunetti, Jacopo della Quercia a Firenze, Belle Arti, 1951, pp. 3–17; G. Brunetti, Jacopo della Quercia and the "Porta della Mandorla," AQ, XV, 1952, pp. 119–31; R. Krautheimer, A Drawing for the Fonte Gaia in Siena, BMMA, X, 1952, pp. 265–74; W. R. Valentiner, The Equestrian Statue of P. Savelli in the Frari, AQ, XVI, 1953, pp. 281–92; "A. BA.," Una Sibilla del duomo di Orvieto, Paragone, 1953, no. 39; J. Pope-Hennessy, Italian Gothic Sculpture, London and New York, 1955; P. Sanpaolesi, Una figura lignea inedita di Jacopo della Quercia, BArte, XLIII, 1958, pp. 112–16.

Giusta NICCO FASOLA

Illustrations: PLS. 147–154.

**DELLA ROBBIA**, LUCA. Luca di Simone di Marco, sculptor, was born in Florence in 1399 or 1400 and died there on Feb. 23, 1482. He was one of the most significant personalities of the Renaissance and founder of a famous enameled-terra-cotta workshop (see CERAMICS). The information concerning his life which has come down to us, beyond that given in the tax records, is mostly concerned with his artistic activities. In September of 1432 he matriculated in the guild of stonemasons and wood carvers, in which he held various offices. In 1471 he was put forward for the consulship of the guild but excused himself on the grounds that he was too old and infirm. (One of his wills survives from this year.) Nevertheless, Luca served in a number of offices in the years up to 1480. He was also a member of the Society of St. Luke (1472), and although our information is uncertain, he seems to have held a number of offices in the guild of physicians and apothecaries. The first document we have pertaining to his work is dated October, 1431, and refers in all probability to the celebrated singing gallery (PL. 157) in the Museo dell'Opera del Duomo in Florence. (Two bronze putti from this work are now in the Musée Jacquemart-André in Paris; some architectural elements have been lost.) Luca was certainly at work on the singing gallery the following April (1432). According to various documentary lists relative to this work, it was finished in 1438. The artist applied himself meanwhile to other commissions for the Cathedral of Florence. In 1434 he was given the contract in competition with Donatello for a head to be used as the keystone in the main dome of the Cathedral. In June of 1436 he received payment for the gilding of the bells of the wardrobe of the New Sacristy. The years from 1437 to 1439 were occupied with five reliefs for the north side of the base of the Campanile

and two reliefs for an altar dedicated to St. Peter (Florence, Mus. Naz.). In March, 1440, he received payment for a terracotta model and a drawing, both now lost, for a funerary monument for Count Hugo of Tuscany, to be executed for the Badia in Florence. During the years 1441–42 he worked on the great tabernacle of marble and enameled terra cotta now in S. Maria at Peretola (originally in S. Maria Nuova in Florence). A number of works completely in glazed terra cotta followed, including the group in the round of the *Visitation* in S. Giovanni Fuorcivitas at Pistoia (known to have been completed prior to Nov., 1445) and lunettes with a *Resurrection* and an *Ascension* in the Cathedral of Florence. The *Resurrection* (1442–45) was placed under his singing gallery on the door of the New Sacristy, while the *Ascension* (1446–51) was designed for the Sacristy of the Canons. By 1448 two candelabra-supporting angels had been executed for the Chapel of the Sacrament; these are now in the Sacristy of the Canons.

Della Robbia also took part in the work on the bronze doors of the New Sacristy, for which he as well as Michelozzo and Maso di Bartolomeo had been commissioned in December, 1445. A more specific contract was drawn up in the following February. The frame of the doors was finished in 1451, but Giovanni di Bartolomeo, brother of Maso, who had died in the meantime, was entrusted with the finishing touches in 1461. From this period comes the decoration of Michelozzo's tabernacle in S. Miniato al Monte (1448) and the relief with the *Madonna and Saints* in the lunette of the portal of S. Domenico at Urbino (1449–50). In 1449 Della Robbia also executed a *spiritello*, which is now lost and which was to have been placed above a door in the Palazzo Vecchio. It is not known exactly what this *spiritello* was. In the years 1454–57 he executed the funeral monument of Bishop Benozzo Federighi for S. Pancrazio (now in Sta Trinita). Meanwhile he had executed the enameled-terra-cotta decoration of the pavement and ceiling of a study for Piero dei Medici in the palace in the Via Larga (known to have been completed prior to 1456). The 12 tondos of this ceiling, which are not in relief, representing the *Occupations of the Months* (II, PL. 27), are now in the Victoria and Albert Museum, London. On Apr. 14, 1461, Della Robbia was commissioned to execute the enameled-terra-cotta decoration of the ceiling of the Chapel of the Cardinal of Portugal in S. Miniato al Monte, which was consecrated in 1466; and on Sept. 28, 1463, to produce a coat of arms of the Tribunale di Mercanzia for the exterior of Orsanmichele. In August, 1464, Della Robbia alone was recommissioned to complete the bronze doors of the New Sacristy in the Cathedral, which were finished in 1469. In November, 1466, through the Cathedral chapter, he received a payment from Filippo di Giovanni, the bursar of the Compagnia di S. Maria dell'Impruneta, and also a payment for a cherub, the arms of this chapter, which was intended for the parish church of Signa.

Around these most noted creations of the artist have been grouped various other works whose attributions, although not documented, are clear from the principal sources and are unanimously accepted by modern critics. The dating of these works is less clear. Uncertainties are connected with the problem of the evolution of Della Robbia's style, and especially with his individual temperament. It is the uniformity of his development — a result of his stylistic purity — that makes analysis difficult.

Vasari's idea that Luca served an apprenticeship with the goldsmith Leonardo di ser Giovanni has been discarded for chronological reasons. Filippo Baldinucci expressed the opinion that the master of Luca was Lorenzo Ghiberti, with whom he was also connected by Piero Cennini (1475), who tells us that Luca collaborated with Ghiberti on the second doors of the Baptistery. This statement, however, is not confirmed by the documents. The idea of an apprenticeship with Ghiberti tends to prevail even today, although the importance of Donatello's influence on Luca's style is also recognized. On the other hand, the hypothesis proposed by 19th-century critics that Della Robbia was connected with Nanni di Banco (see RENAISSANCE), which recently has gained more adherents, has now been advanced so far as to suggest an actual discipleship under Nanni.

In his best works Luca played an important role in the development of early Renaissance sculpture. Profiting from the work of Jacopo della Quercia, Lorenzo Ghiberti (qq.v.), and Nanni di Banco, he exploited the inheritance of the Gothic period with great talent. This Gothic influence was coexistent in his style with the more revolutionary one of Donatello (q.v.). Despite the former, however, it nevertheless seems probable that in his youth Luca was more influenced by Donatello than by anyone else.

The 10 reliefs of the singing gallery (PL. 157) are arranged in two rows within a decorated architectural frame conceived in the style of Brunelleschi (q.v.). Within this setting groups of boys and girls bring to life Psalm 150. The creator of these 10 reliefs can be most appropriately placed in that circle of Florentine sculptor-architects who worked under the regenerating inspiration of Donatello and Brunelleschi, a circle which participated in that passionate investigation of ancient art that furnished models to the most diverse temperaments.

That the singing gallery could not have been Luca's first notable work can be proved by the fact that Alberti in his *Della pittura* (*On Painting*, 1435) speaks of Luca, along with Brunelleschi, Donatello, Ghiberti, and Masaccio, as a person worthy of praise. (Alberti's mention of Luca apparently stems from contacts in Florence in 1428, but they could in any case have met in Rome, since it is very probable that Luca visited that city.) The style of the singing gallery, even if it was executed when the artist was over thirty, does not seem to differ greatly from the hypothetical style of Luca's formative period. Even the works which immediately follow the singing gallery are still far from attaining that extraordinary uniformity which characterizes Luca's mature production. The fundamental qualities of his personality are, however, already abundantly expressed in the singing gallery: his serene conception of life, his open hedonism, his lively interest in human feeling, as well as his profound idealism. Stylistically there is a certain crowding of the figures and heaviness of decoration in the gallery, but there is also an evident desire for clarity, a strong architectonic sense, and a compelling feeling for symmetrical balance.

At times the artist's desire for expressiveness is achieved at the expense of refinement in the features, although subtlety is by no means lacking. In addition to figures with angelic faces — whose aloof reserve makes us think of Piero della Francesca — there are others posed in popular attitudes, such as the sturdy and heartily laughing putti from the gallery, now in the Musée Jacquemart-André in Paris. Similar characteristics can also be observed in the work of the youthful Filippo Lippi (q.v.), who wanted to re-form his style not only on Masaccio's example but also on Donatello's, while yet conserving the decorative possibilities inherent in his original Gothic taste. Mainly because of Donatello's work, a recurring naturalism had become an important artistic trend. Luca was not so deeply influenced by this as Lippi; certainly none of his figures would ever have displayed the nearly irreverent unconventionality of the Trivulzio reredos (Milan, Musei Civici). Nevertheless it is important to keep in mind the realism through which Luca expressed his deep sense of humanity.

This realism does not diminish the justly famous charm of Luca's early work, which, perhaps because it does not achieve the synthesis of the later productions, is characterized by an incomparable freshness. Because of this freshness the beautiful marble relief of a half-length *Madonna and Child* in the cloister of the Church of the SS. Annunziata in Florence can be attributed to the early period of the 1430s. The Virgin's form is muffled and nearly hidden by the thick folds of her garments. Her somewhat coarse mouth is that of a woman of the people, yet the hands with which she tenderly holds the Child in swaddling clothes are delicately formed. This work is too full of affectionate warmth to be by Michelozzo (q.v.), to whom it has generally been attributed, while its style is consistent with that of Luca's singing gallery. The similarity is especially notable in the less developed parts. A gradual diminution of exuberance, perceivable in this piece, can be detected in the course of Luca's early work, as the artist evolved a sobriety and quiet rhythmic flow in his style.

At this time Luca was engaged in executing the last five of the hexagonal plaques for the north side of the Campanile of the Cathedral of Florence (1437–39). A decisive Gothic influence appears in these, finding its fullest expression in the marvelously idyllic scene of Orpheus playing the lute, surrounded by plants and animals (PL. 160). The most significant personalities of the Gothic tendency are suggested by the style of these plaques, particularly in the scene of Orpheus, which reflects the work of Jacopo della Quercia. The plasticity of Nanni di Banco, robust yet inert, is also present, animated by the heroic vitality of the great Sienese sculptor. Also recognizable are traits found in Donatello, particularly the liveliness of certain scenes. The plaque of the *Dialectics* employs the motif of the two disputants, which is certainly related to the reliefs of the Old Sacristy in S. Lorenzo.

In the relief *The Liberation of St. Peter* (Florence, Mus. Naz.), which belongs to the period immediately following, a return to the influence of Jacopo della Quercia is seen in the heavy archaic architecture, while certain subtleties in the treatment echo Donatello's *schiacciato* relief technique. In another relief, representing the martyrdom of the saint, the strong plastic quality seems even more powerful because of the unfinished condition.

For the Chapel of St. Luke in S. Maria Nuova, Luca executed a tabernacle which is now in the Collegiata of Peretola. Against a narrow background draped with damask, two robust figures of angels carry a thick crown of olive leaves. Solemn, courtly in their stability, smiling somewhat vaguely, they are closer to Michelozzo's style than any of Luca's other figures, and the architecture of the tabernacle closely follows that of Michelozzo as well. In a lunette the dead body of Christ is supported by an angel, according to an iconographic scheme favored in northern Italy. These two figures are flanked by the weeping Virgin and St. John. The moderation of the gestures through which the three mourning figures express their controlled grief is remarkable. In the tympanum the figure of God the Father making the gesture of benediction might have come from a composition of Masaccio (q.v.).

This tabernacle is interesting from a technical point of view, since it is the earliest documented work of enameled terra cotta that we have. The blue background of the lunette, the polychrome garlands in relief on the frieze, and the two-dimensional polychrome decoration of the spandrels and the podium are notable. This use of color is linked with the tradition of architecture and sculpture, which employed polychrome generously, using marbles of various colors, vitreous glazes, or paint. One should remember that the wide use of unglazed terra cotta and stucco, sometimes simply painted, continued after Luca's innovation. The new technique, however, met with instant favor, especially for the decoration of pure Florentine architecture.

The cycle of the Pazzi Chapel, adjoining the Church of Sta Croce, contains some highly important works in enameled terra cotta. The Pazzi cycle is an early example of the use of this technique. Several parts of the cycle — cherubim on the frieze of the atrium and also those alternating with lambs on the frieze of the interior — are of unglazed terra cotta, and provide an excellent contrast to Luca's innovation. The style of the reliefs suggests a somewhat early date, while most of the figures of the apostles in the tondos of the interior and above the portal are similar to the lunettes of the Cathedral (1442–51). In their simple white garments against a blue background, majestic and withdrawn but with no trace of haughtiness, the apostles are admirably placed in their architectural setting of *pietra serena* (a gray stone favored by Brunelleschi and other Florentine architects). This decorative scheme emphasizes the integration of Brunelleschi's architecture. We know that Luca understood and admired Brunelleschi, since in an anonymous biography of the architect, Luca is described as expressing regret at the way in which Brunelleschi's plans for the construction of S. Lorenzo had been changed after his death.

The cherubim, because of their heavy forms and grave expressions, belong to a type closer to Jacopo della Quercia's style than to that of Donatello. They are also similar to the

enameled-terra-cotta cherubim of the tabernacle at Peretola, and even closer to those of painted terra cotta of the frieze of the Old Sacristy of S. Lorenzo. The latter certainly are not by Donatello. If Luca did collaborate on the Old Sacristy, however, it would confirm a connection with Donatello during Luca's formative years which would have been closer than that which has been generally conceded, as we know Donatello was active in the Old Sacristy.

The *Resurrection* (1442–45) and the *Ascension* (1446–51) above the portals of the Cathedral of Florence are two sublime works in which the influence of Ghiberti is undeniable. This is consistent with Luca's evolution as it has been described, which up to this time can be clearly demonstrated. The group of the *Visitation* in S. Giovanni Fuorcivitas at Pistoia should be dated at about the time of the *Resurrection*. In this work Luca's particular faculty of rendering the effects of action without diminishing the mood of calm serenity is most happily expressed. No less exalted in feeling are the two candelabra-supporting angels of the Cathedral of Florence, which, like the *Visitation*, are freestanding pieces.

A lunette in S. Domenico at Urbino is dated shortly after the *Ascension* of the Cathedral of Florence. The empty space on both sides of the half-length Madonna and the method of disposing the figures — the Madonna and Child in the center flanked by pairs of Dominican saints — produce a more fully developed Renaissance composition than that of any of the works previously discussed. (In the Dominican saints there is perhaps a hint of the style of Piero della Francesca or of the ideas of Alberti.) A real *sacra conversazione* is taking place in the shadow of the great arch bordered by a thick molding carved in stone. The absorbed, almost withdrawn expression of the figures seems to isolate each from the other, while a spiritual undercurrent — a suggestion of grief and of a shared mystical experience — unites them. This quality of expression is perhaps reminiscent of Fra Angelico. The central group of the Madonna and Child is dominated by a frontality and compactness which anticipate Antonello da Messina (q.v.). This Madonna of 1449 is the only one by Luca which can be dated.

The many Madonnas by Luca which must have preceded this one include the *Madonna* of the Musée Jacquemart-André in Paris, a more developed variant of the marble one in the cloister of the Church of the SS. Annunziata; and the *Virgin and Child* with angels for the lunette of the portal of S. Pierino (now in Florence, Palazzo di Parte Guelfa; PL. 161), which represents a further development of the Paris *Madonna*.

Other important Madonnas in enameled terra cotta by Luca, despite the fact that their dating is uncertain and that they may not be related chronologically to his development at this period (late 1440s), may now be mentioned. All these are characterized by unaffected, graceful poses, in accordance with Alberti's recommendation ("con posari ariosi, pieni di semplicità"). They are: the so-called "Madonna of the Via dell'Agnolo" (PL. 161), the *Madonna in the Rose Garden* (PL. 155), and the *Madonna of the Apple* (PL. 161), all in the Museo Nazionale, Florence; a *Madonna* in the Ospedale degli Innocenti in Florence; the *Altman Madonna* in the Metropolitan Museum, New York; and the *Mugello Madonna* and the *Frescobaldi Madonna* in Berlin (Staat. Mus.). A polychrome tondo on the exterior of Orsanmichele, representing the coat of arms of the guild of physicians and apothecaries, contains a Madonna enthroned beneath an arch flanked by lilies. The background is decorated with geometric and floral motifs, while the heavy folds of her garment fall in swinging Gothic rhythms which are consistent with the style of the plaques on the exterior of the Campanile of the Cathedral of Florence. The interesting relationship between this work and the Madonnas of Domenico Veneziano (q.v.) is not an isolated case, since the beautiful *Occupations of the Months* in London (Vict. and Alb.), also reminiscent of Domenico, can be attributed to Luca. This attribution was made by Filarete as early as 1456.

The tondo with the coat of arms of the guild of stonemasons and wood carvers in Orsanmichele should be mentioned among Luca's polychrome works not in relief because of the freshness of its colors and the fineness of the design. The most original of these flat decorated polychrome pieces, however, is the garland of fruit and flowers of intarsio against a gold background that frames the marble tomb of Bishop Benozzo Federighi (PL. 156). It is interesting to note that this piece has been attributed to Baldovinetti (q.v.) because of the style of its design.

The Pietà of the Federighi tomb is even more serene than that of the artist's tabernacle in Peretola. The arrangement of the three figures, each in its own frame, is to some extent still reminiscent of the 14th century, yet the figures are united to their architectural setting. In the center is the figure of Christ, flanked on the right by St. John, whose face is contorted in grief, and on the left by the Virgin, who stands lost in prayer. Two angels support a crown of olives on the front of the bishop's sarcophagus, a classical motif which had been used before, most recently by Ghiberti and Bernardo Rossellino. The angels resemble the two adoring angels in the S. Pierino lunette, but differ in their greater plasticity, which makes them even more similar to the angels adoring the Sacred Host in the Capella della Croce in the parish church of S. Maria at Impruneta near Florence. Luca's enameled-terra-cotta altar, which covers the entire end wall of this Chapel of the Crucifixion, is one of the artist's most complex works, remarkable not only for the beauty of its proportions, but also for the originality of its ornament. One notes particularly the pilasters framing the tabernacle, as they are decorated by white arabesques in relief against a background of variegated colors. In the center, demonstrating Luca's capacity for a sincere and profound expression of grief, stood originally the scene of the Crucifixion flanked by the mourning figures of St. John the Baptist and a bishop saint. The passionate intensity of Andrea del Castagno (q.v.) was here tempered by Luca's serenity, resulting in a quality which again reminds one of Domenico Veneziano.

The chronological position in Luca's development of work in the Chapel of the Madonna in the same church is difficult to determine. Two enameled-terra-cotta saints, Paul and Luke, at the sides of the marble tabernacle can be attributed to Luca, as can the frieze of the two visible exterior architraves. The decoration of each consists of a polychrome garland flanking a panel containing a half-length figure of the Madonna. These Madonnas, because of the expression of affection between the Mother and Child, are among the most notable of Luca's works. They should be grouped with the Madonnas of the so-called "Genoese" type, named after the example at one time in Genoa, now in Vienna (Kunsthist. Mus.). In composition they are among the finest of this series.

The bronze doors of the New Sacristy (PL. 158) in the Cathedral of Florence, perhaps designed by Michelozzo, are reminiscent of Ghiberti's first doors for the Baptistery and of the Donatello doors of S. Lorenzo, though having neither the grace of the former nor the strength of the latter. They were finished in 1469. The 24 heads of prophets projecting from the frame, a classical motif which follows the plan of Ghiberti's earlier doors of the Baptistery, are characterized by a generalized classicism in which it is difficult to distinguish Luca's hand. Della Robbia's style can, however, be more clearly detected in the 10 panels of the doors. Each panel shows one seated figure flanked by angels. On the 10 panels, the Madonna, St. John the Baptist, the four Evangelists, and four Fathers of the Church are represented. These figures are executed according to Luca's scheme, but not without a certain mechanical quality, an overminuteness (possibly the result of Andrea della Robbia's participation in the work), and an undeniable monotony. This monotony cannot be altogether attributed to the absence of a frieze that has disappeared and which was decorated with damascene ornament.

The Cardinal Virtues (1461–66) from the polychrome ceiling of the Chapel of the Cardinal of Portugal in S. Miniato al Monte, however, display all the freshness of inspiration of which the master, in his sixties, was capable. Winged maidens symbolizing the virtues are clad in garments whose light folds flow in natural rhythms without losing their decorative beauty. The luminous white figures against the blue background of their tondos look as though they are set against an azure sky. The quiet and harmony of the chapel are reflected in their beautiful

faces, which have been often compared to the faces of Raphael, as both have an Attic purity of feature and an expression of sovereign calm somewhat withdrawn yet permeated with human warmth. An ingenuous humility, as in the figure of Justice, is sometimes combined with a quality which reminds us of a classical Victory or the archangel of the Expulsion. In other figures — for example, the one symbolizing Temperance, who is shown decanting liquid into a goblet — the childlike absorption in a simple action fills us with respect and tenderness. The greatness of Luca della Robbia lies in his balance between the heavenly and the terrestrial, between the divine and the human.

Among the artists who worked on the doors of the Baptistery, Luca expressed his gift in terms of a more reserved temperament than that of Ghiberti, in this regard being more closely related to Jacopo della Quercia and Nanni di Banco. Luca, with his marvelous sense of form and decoration, avoided an affected elegance sometimes found in the work of Ghiberti, and was able to endow his work with a profound significance. His figures express the artist's belief in the dignity of the human body; his famous garlands of fruit and flowers (PL. 156) are symbols of his healthy joy in life, which coexisted with his deep spirituality without conflict.

Opinion of Della Robbia's work from 15th-century literature to our own time has been unanimously appreciative. Despite his reputation as the "inventor" of enameled terra cotta, however, he merely perfected the technique and applied it to monumental sculpture (see CERAMICS). From the point of view of scholarly evaluation, his position has remained substantially unchanged from the time when the first attempts to understand his development were made (Baldinucci, 1728; later Reymond, 1897, and Bode, 1928). The highly systematic investigation of the documents by 19th-century scholars has resulted in a more thorough and precise treatment of the problems of his *œuvre* and in an expansion of the list of works attributed to him, especially of terra cotta.

Andrea di Marco di Simone (Florence, 1435–1525), Luca's nephew, partner, and immediate follower, worked under several influences, especially that of Verrocchio. Andrea, who also took the name of Della Robbia, was industrious and gained a great popularity with his enameled terra cottas, even if, because of his superficiality, he did not achieve the excellence of his uncle's production. He has left, however, a number of very fine works, for example, the famous *Infants in Swaddling Clothes* in the 10 tondos of the loggia of the Ospedale degli Innocenti in Florence; the altarpieces of Verna (Tuscany), including the well-known *Annunciation*; the lunette of the *Meeting of St. Francis and St. Dominic* in the loggia of the Ospedale di S. Paolo in Florence; and the *Virgin Adoring the Child* (PL. 162) of the Museo Nazionale in Florence.

Andrea's son Giovanni (1469–1529) collaborated with his father, enlarging the workshop production (PL. 162 and III, PL. 307), which often became cheap and was distributed widely throughout Tuscany and elsewhere. The decoration of the Ospedale del Ceppo in Pistoia, the best parts of which are by Giovanni's followers Benedetto and Santi Buglioni, deserves mention, however. Other sons of Andrea known to have worked in enameled terra cotta were Marco (1468–1534?) and Pierfrancesco (1477–1528), who were monks in S. Marco under the names of Mattia and Ambrogio; Luca (1475–1550); and Girolamo (1488–1566), the youngest, who worked and died in France. Of these, Girolamo seems to have been the most worthy of mention.

SOURCES. L. B. Alberti, Della pittura, ed. L. Mallé, Florence, 1950, p. 53; A. Filarete, Trattato d'architettura, ed. W. von Öttingen, Vienna, 1896, p. 748 (index); P. Cennini, Lettera a Pirrino Amerino, 1475, in A. Mancini, RArte, 1909, p. 221; A. Manetti, Huomini singhulari in Firenze dal MCCCC° innanzi: Vita di Filippo di ser Brunellesco, ed. Milanesi, Florence, 1887, pp. 147–48, 168; F. Albertini, Memoriale di molte statue et picture sono nelle inclyta cipta di Florentia . . . , Florence, 1510, facs. ed. Campa, Florence, 1932; A. Billi, Il libro di Antonio Billi (1481–1530), ed. K. Frey, Berlin, 1892; K. Frey, ed., Il Codice Magliabechiano, Berlin, 1892; G. Vasari, Le vite de' più eccellenti architetti, pittori et sculptori italiani, Florence, 1550, ed. Ricci, Milan, Rome, 1927, I, p. 248 ff., II, p. 167 ff.; F. Baldinucci, Notizie de' professori del disegno da Cimabue in quà . . . , III, Florence, 1728.

BIBLIOG. For bibliog. until 1934, see I. B. Supino, ThB, s.v.; L. Cicognara, Storia della scultura dal suo risorgimento in Italia fino al secolo di Canova, IV, Prato, 1823, p. 233 ff.; K. F. von Rumohr, Italienische Forschungen, ed. Schlosser, Frankfort on the Main, 1920, p. 653 (index); G. Gaye, Carteggio inedito d'artisti, I, Florence, 1839, pp. 182 ff., 559; J. Cavallucci and E. Molinier, Les Della Robbia, Paris, 1884; M. Reymond, Les Della Robbia, Florence, 1897; M. Cruttwell, Luca and Andrea Della Robbia, London, New York, 1902; A. Venturi, Storia dell'arte italiana, Milan, VI, 1908, p. 544 ff., VIII, 1, 1923, p. 331 ff., X, 1, 1935, p. 539 ff.; A. Marquand, Della Robbias in America, Princeton, London, 1912; A. Marquand, Luca Della Robbia, Princeton, London, 1914; A. Marquand, Robbia Heraldry, Princeton, London, 1919; A. Marquand, Giovanni Della Robbia, Princeton, London, 1920; A. Marquand, Benedetto and Santi Buglioni, Princeton, London, 1921; A. Marquand, Andrea Della Robbia and His Atelier, 2 vols., Princeton, London, 1922; A. Marquand, The Brothers of Giovanni Della Robbia: Fra Mattia, Luca, Girolamo, Fra Ambrogio, Princeton, London, 1928 (ed. and extended by F. J. Mather, Jr., and C. F. Morey); W. von Bode, Florentine Sculptors of the Renaissance, 2d ed., New York, 1928; A. M. Ciaranfi, EI, s.v.; M. Salmi, Paolo Uccello, Andrea del Castagno, Domenico Veneziano, Milan, 1938, pp. 97 ff., 183 ff.; R. W. Kennedy, Alesso Baldovinetti, New Haven, 1938, p. 81 ff.; J. Lányi, Kleine Beiträge zur Donatello-Forschung, Mitt. des Kh. Inst. in Florenz, V, 1939, p. 213; U. Middeldorf, Two Florentine Sculptures at Toledo, Art in America, XXVIII, 1940, p. 13 ff.; M. Salmi, L'arte italiana, II, Florence, 1942, p. 221 ff.; L. Planiscig, Nanni di Banco, Florence, 1946, pp. 36, 46 ff.; A. M. Ciaranfi and U. Procacci, Catalogo della Mostra di opere d'arte trasportate a Firenze durante la guerra e di opere d'arte restaurate, Florence, 1947, pp. 6, 16, 19, 21, 23; L. Planiscig, Luca Della Robbia, Florence, 1948 (with bibliog.); G. Galassi, La scultura fiorentina del Quattrocento, Milan, 1949, p. 115 ff.; M. Moriondo et al., Catalogo della Mostra d'arte sacra della diocesi e della provincia, dal secolo XI al XVIII, Arezzo, 1950, p. 109 (index); W. and E. Paatz, Di Kirchen von Florenz, VI (index), Frankfort on the Main, 1954, p. 145 ff.; P. Francastel, ed., Les sculpteurs célèbres, Paris, Geneva, 1954; G. Brunetti, Luca Della Robbia, p. 222 ff.; S. Bottari, Storia dell'arte italiana, II, Milan, Messina, 1956, p. 77 ff.; R. Krautheimer and T. Krautheimer-Hess, Lorenzo Ghiberti, Princeton, London, 1956, p. 453 (index); L. Grassi, L'arte del Quattrocento a Firenze e a Siena, Rome, 1957, pp. 31 ff., 65, 94; J. Pope-Hennessy, Italian Renaissance Sculpture, London, 1958, pp. 26 ff., 291 ff., 362 (index); G. Brunetti, Note su Luca Della Robbia, Studi in onore di M. Salmi, Rome, 1960.

Giulia BRUNETTI

Illustrations: PLS. 155–162.

**DELORME**, PHILIBERT. French architect, whose name, written sometimes de l'Orme, de Lorme, or De L'Orme, comes from the location of the family house built near the elm (*orme*) of Saint-Vincent in Lyons.

Philibert, the son of Jean Delorme, a master mason of Lyons, was born there about 1510 and died in Paris on Jan. 8, 1570. He received his education and passed his examinations in theology at Lyons while, at the same time, supervising his father's construction yards. Philibert was both architect and cleric. In 1533 he went to Rome, where he became deeply interested in architecture and antiquity. There he measured monuments, excavated at his own expense, and was employed by Pope Paul III, who gave him "une belle charge à Saint-Martin dello Bosco, à la Callabre." He was a member of the Vitruvian Academy and knew Cardinal Jean du Bellay (who undertook two royal diplomatic missions to the Vatican in 1534 and in 1535–36). The Cardinal, and his brother Guillaume du Bellay, encouraged Philibert's return to France. Back in Lyons, in 1536, he built the Hôtel de Bullioud for the *général des finances* of Brittany. Without doubt it was Bullioud who appointed Philibert, in March, 1545, Superintendent of Fortifications of this province, which required that he visit the coast and the fortresses of Brittany twice a year.

Philibert began for Cardinal du Bellay the Château de Saint-Maur near Paris about 1541, but built only the main *corps de logis*, which was finished in 1544. In 1545 Philibert was architect to the Dauphin, the future Henry II. When this prince succeeded his father, Francis I, on Mar. 31, 1547, Philibert became architect to the King and to his favorite, Diane de Poitiers. On April 8, 1548, he was named inspector of the royal châteaux, and on March 9, 1556, he was promoted to Master of the Accounts.

In payment Philibert received certain ecclesiastical titles: he was abbott of Géveton in the diocese of Nantes (undoubtedly Géneston at Monbert-Géneston, Loire-Atlantique) and of Saint-Barthélémy of Noyon (Apr. 21, 1548). He later relinquished these abbeys and was given those of Saint-Eloi of Noyon,

Saint-Serge of Angers, and Ivry. He was also often called "Monsieur de Saint-Serge" or "Monsieur d'Ivry." From 1550 he was canon of Notre-Dame in Paris and was given the title of King's Almoner.

On July 12, 1559, immediately after the death of Henry II, Catherine de Médicis named her compatriot Primaticcio to replace Philibert. In disgrace and, with his brother, accused of malpractice and even criminal acts, Philibert defended himself in a statement entitled *Instruction de Monsieur d'Ivry* (Berty, 1860, pp. 49–59).

The works undertaken from 1547 to 1559 are the most important nucleus of the architect's activity; in these works he sometimes had his brother Jean as a collaborator. Noted primarily as a military engineer, Jean was a municipal magistrate of Paris, and worked in Piedmont, in Parma, in Siena, and on Corsica. He succeeded his brother in 1549 in the post of Superintendent of Fortifications of Brittany.

WORKS. *a. Works for Henry II*: Abbey Church of St.-Denis: The designs for the tomb of Francis I date from 1547 (statues and bas-reliefs were executed by F. Carmoy, F. Marchand, and P. Bontemps). The tomb was finished in 1557 or 1558. In February, 1550, Philibert commissioned Bontemps to carve the urn for Francis I's heart. – Paris: Philibert worked on the Arsenal (1547–56); on the Hôtel des Tournelles (fountain, 1548; banquet hall commemorating the King's entrance into Paris, June 16, 1549; stables, 1554–57; project for a monumental entrance, 1559); on the Royal Abbey of Montmartre (the abbess's quarters, 1555; project for the nuns' buildings, 1559); on the Palais de Justice (statue of Francis I, 1556); on the Couvent des Cordeliers, 1550; and on the hospital of the Couvent de St.-Jacques du Haut-Pas, 1555. – Château de Vincennes: Philibert, from 1546 to 1556, continued the chapel begun by Charles V (choir and vaults, 1548; decoration of the vaults, 1549; gallery and doorway by Scibec de Carpi, 1550; stained glass by N. Beaurain, 1551–59; main stair, 1551–55). – Château de Fontainebleau: Gallery of the Chapelle Haute, 1548; remodeling of the ballroom (Gallery of Henry II), ceiling, 1550–54; Queen's room, water supply, 1550; foundations of the Chapelle de la Trinité, 1551; the Four Seasons fireplace (sculptured by P. Bontemps), 1555; the King's rooms in the Pavillon des Poêles, 1556; ceiling of the King's room in the central pavilion of the Cour du Cheval Blanc, 1558; and the marquetry of the King's armory room, 1559. – Other royal châteaux: The architect worked on the two châteaux of the Bois de Boulogne, Madrid (1548–59) and La Muette (1550), and on La Muette of St.-Germain-en-Laye (1548–59), where he was also commissioned to build the Château-Neuf; repaired Villers-Cotterets and the chapel in the park; did paneling for St.-Léger-en-Yvelines (Seine-et-Oise, 1551); and invented a new type of wood framing for the promenade of the Château de Monceaux-en-Brie, Seine-et-Marne.

*b. Works as an engineer*: Philibert states that he was employed by Guillaume du Bellay, Governor of Piedmont from 1537. What he did is unknown, but it is known that his brother Jean worked on fortifications in Piedmont under Paul de Termes, the successor to Guillaume du Bellay, in 1543. Philibert, as Superintendent of Fortifications in Brittany, worked in Brest (1546), Concarneau, Nantes, St.-Malo, and Cancale (R. Grand, 1951, p. 359). He also superintended the construction of ships at Le Hâvre and Boulogne-sur-mer and, according to his own statements, designed fortresses. He worked on the St.-Michel bridge in Paris and on bridges in Poissy and St.-Germain-en-Laye.

*c. Works for Diane de Poitiers*: Château d'Anet (Eure-et-Loire; PLS. 163–65): *Corps de logis* opposite the entrance wing (destroyed in the Revolution; the *avant corps* is reassembled in the courtyard of the Ecole des Beaux-Arts in Paris); reconstructed the cryptoporticus (1547–49); chapel (1549–52; PL. 165; for the chapel and its influence see E. Grashoff, 1940); right wing (1549–51); entrance (1549–55); grand gallery (1549–56); and the King's room (1552). Remaining today are only the entrance, the left wing, and the chapel (concerning attributions of sculpture see P. du Colombier, *Jean Goujon*, Paris, 1949, pp. 129–34). Philibert also did the bridge and, gallery of the Château de Chenonceau (Indre-et-Loire) (1556–59), the enlargement of the Hôtel de Diane at Fontainebleau (1550), and some work on the Château de Limours.

*d. Other works*: House of Philibert Delorme, rue de la Cerisaie, Paris (1554–58), is known from engravings in his *Architecture* (fols. 253–55); house of the financier Patouillet, rue de la Savaterie, Paris (Sauval, *Antiquités de Paris*, Paris, 1733), and, perhaps, work done on the Château de Beauregard, at Cellettes, Loire-et-Cher (F. Gébelin, 1957), belong to this period as well.

*e. Works after 1559*: In disgrace after the death of Henry II, Philibert worked on his *Nouvelles Inventions*, which appeared in 1561, and his *Architecture*, published in 1567. In 1564 Catherine de Médicis decided to demolish the Hôtel des Tournelles, where Henry II was killed, and commissioned Delorme to design the Tuileries palace (see Hautecoeur, 1927). In 1566 he continued work on the stair of the Henry II wing of the Château of Chambord. He executed in 1569 some work at Notre-Dame in Paris, where he was a canon.

*f. Doubtful works*: The chapel of St.-Eloi or of the Orfèvres, rue des Orfèvres, Paris, was attributed to Philibert by G. Brice and J. Piganiol de La Force in their guides to Paris. Philibert signed a contract on Dec. 31, 1550 (Pichon, 1882), but the accounts of the *communauté des orfèvres*, discovered by Mantz (see Lance, 1872), cite as architects only F. de la Flasche and Jean Marchand.

*g. Works wrongly attributed*: Château d'Uzes (Gard); portions of the Château de Valençay (Indre); doorway of the Church of St.-Nizier, Lyons, by Jean Vallet (1578; Kleinclausz, 1928); doorway of St.-Nicolas-des-Champs, Paris (which is derived from an engraving in Philibert's *Architecture* but not executed until 1578–81). Sir Anthony Blunt (1958) attributes the *jubé* of St.-Etienne-du-Mont in Paris to Philibert, but Terrasse (1922) has shown that the arch dates from 1530–35 when Philibert was in Lyons and in Italy. As for the balustrade and the stairways (dated 1545), the existence of interlacings similar to those at Anet is not convincing proof, as such ornament was common in France at the time (Hautecoeur, 1943, p. 456).

Philibert Delorme remains one of the creators of the classic style in France, and he occupies a unique place in that his grounding was both practical and theoretical.

Son of a master mason, he became familiar with construction yards, materials, machinery, tools, and clients' desires starting at the age of fifteen years. He was an heir through his father to the great medieval master builders. He valued, as they did, beautiful Gothic vaults, and was, like them, first a builder. He used the squinch, which allowed use of the corbels so admired in the 15th and 16th centuries (Lyons and Paris), but he also knew how to employ these forms in novel devices, as, for example, the stair for the Tuileries (one of the first encircling a large open stairwell), supported only on squinches. Philibert held that the first duty of an architect is the satisfying of needs. "It is better for the architect," he wrote, "to fail on the ornaments of columns or on the proportions of a façade than to fail concerning those beautiful rules of nature which deal with the comfort and profit of the inhabitants." He recommended respecting the exigencies of the climate: in France, where it is colder and more humid than in Italy, wood paneling is to be preferred to marble facing. Forms were chosen by Philibert according to their function: since, at the Tuileries, there were no monolithic shafts for columns, Philibert used columns made of drums, hiding the joints with bands and ornament such as he had seen in Rome. Lacking large wooden beams, he invented a new type of truss construction, carrying his name, which is made up of small beams pinned together. In his *Architecture* (fol. 303) he gives a design for a vast basilica with a barrel-vaulted roof. He entitled one of his treatises *Nouvelles inventions pour bien bastir et à petits frais*: in the client's interest he wished to unite strength and inexpensiveness. Philibert did not want the architect to be a traditionalist but wanted him to be, like the heroes created by his friend Rabelais, a scholar acquainted with physics, geology, acoustics, geometry, and perspective. He wanted to add theoretical deductions to the fund of knowledge derived from experience. He demonstrated rules of composition using grids and triangles; he designed and drew vaulting schemes; and while he knew no descriptive geometry, he anticipated it and attempted to give stonecutters calculable methods rather than rules of thumb.

In Rome Philibert would have been able to observe the development of Platonist theories by members of the Vitruvian Academy and the significance given to the part played by numbers in Plato's *Timaeus*. He himself sought to determine what relation between these numbers would produce universal harmonies. He often declared that he was inspired by "divine proportions," not those outlined by Luca Pacioli in his *De Divina Proportione*, but those given by God in the human body and those which might be discovered in the descriptions of

sacred buildings found in the Bible. Here the theologian was integrated with the architect. He announced that in another volume of his *Architecture* (which never appeared) he would disclose his proportional system "which, I may say without boasting, I was the first to use." Like other men of his time Philibert urged the study of ancient buildings as a guide to building techniques, to the intellect, and to the rules of beauty. He measured Roman monuments and adapted their forms (at Anet he made chimney stacks in the shape of sarcophagi, designed a mantelpiece "following the Doric order," and designed a cryptoporticus). At the Château-Neuf de St.-Germain his forms recall the many-lobed plans which Italians had seen at Hadrian's Villa and in other antique buildings. He also copied the banded columns he had seen in Rome.

Even so, in spite of his admiration for antiquity, Philibert was not afraid to criticize certain passages in Vitruvius or to demonstrate the illogicality of certain forms seen in Italy. He had — very rare in his time — a sense of historical development: he suspected that there had been moments of uncertainty and of decadence in antiquity and did not want respect for it to override the principles of truth and simplicity. The majesty of architecture lay, for him, in proportion, not decoration.

A classicist, Philibert believed the first requisite of architecture to be clarity; plans should, while being adapted to their function, present a beautiful design pleasing to eye and mind. He liked regular configurations. His project for the Hôtel Dieu was a cross inscribed in a rectangle; the Tuileries was a long parallelogram with the sides linked by perpendicular wings; the court of the Château-Neuf de St.-Germain-en-Laye was a quatrefoil, the chapel of Villers-Cotterets a trefoil, and that of Anet a Greek cross surmounted by a dome.

Philibert Delorme knew of the new designs of his Italian colleagues. He knew the work of Bramante and of the Sangallos. He must have seen Baldassare Peruzzi's drawings which were owned by his friend Sebastiano Serlio, which he praised. Like many of them Philibert was a classicist, but a classicist who lived at a time that already showed signs of a baroque spirit, which can be seen in the curved lines of his plans, the play of his volumes, the relief of his doorways, the undulations of his squinches, the picturesque symbolism of the chimney stacks at Anet, the cosmic dome designed for the Abbey of Montmartre, his use of leather, and many other details which prove his propensity for fantastic invention. Capable minds, he said, know well how to invent. However, being a good French rationalist, Philibert cautioned against an excess of imagination, criticized useless decoration, the piling up "of pilasters, columns, cornices, moldings, friezes, *basses-tailles*, and marble inlays," which only collected dust even though they were pleasing to certain aristocrats. When ordered by Catherine de Médicis to add more ornament to the façade of the Tuileries, he clearly placed the responsibility for such excess upon the Queen.

Philibert Delorme was an accomplished practitioner, an inheritor and follower of the medieval masters, a Humanist in search of truth, and a liberal admirer of the ancients. He wanted architecture to have grandeur and proportion, balance, symmetry, and harmony; and yet, at the same time, he was an artist who asserted the right to creative freedom. In him theory never hindered creativity, but his creativeness was always subject to the requirements of the intellect.

WRITINGS. Nouvelles inventions pour bien bastir et à petits frais, Paris, 1561 (later eds. 1576, 1578); Le premier tome de l'Architecture de Philibert de l'Orme, Paris, 1567 (later eds. 1568, 1576, 1626, 1648, 1895).

BIBLIOG. H. Sauva, Antiquités de Paris, Paris, 1733, II, pp. 53-54, III, pp. 20, 31, 153, 330; A. Berty, Grands architectes français de la Renaissance, Paris, 1860; A. Lance, Dictionnaire des architectes français, II, Paris, 1872, p. 4; A. Bourgeois, Le Château d'Anet, Paris, 1877; N. Rondot, Les ascendants de Philibert de l'Orme, Rev. Lyonnais, 4th series, VIII, 1879, pp. 326-30; A. Roux, Le Château d'Anet, Paris, 1911; E. L. G. Charvet, Ph. de l'Orme, Ann. Soc. académique Lyon, VI, 1880, pp. 87-144 (with bibliog.); J. Pichon, Notes sur la Chapelle des Orfèvres, Mém. Soc. historique Paris, IX, 1882, p. 95; M. Vachon, Philibert de l'Orme, Paris, 1887; E. L. G. Charvet, Lyon artistique, Les architectes, Lyon, 1899, pp. 273-93; H. Clouzot, Saint-Maur, Rev. études rabelaisiennes, VII, 1909, p. 259; H. Clouzot, Philibert de l'Orme, Paris, 1910; A. Lefranc, Philibert de l'Orme, grand architecte du roi Mégiste, Rev. seizième siècle, IV, 1916, p. 142, V, 1917, p. 75; C. Terrasse, Le jubé de Saint-Etienne-du-Mont et sa date, Rev. art ancien et moderne, XLII, 1922, pp. 165-76; L. de la Tourasse, Le Château Neuf de Saint-Germain-en-Laye, GBA, ser. 5, IX, 1924, pp. 70-73; F. Gébelin, Châteaux de la Renaissance en France, Paris, 1927 (material on Philibert de l'Orme, pp. 28-31; his castles of Anet, pp. 41-48, Chenonceau, pp. 81-86, Fontainebleau, pp. 97-105, Les Tuileries, pp. 135-36, Saint-Germain-en-Laye, pp. 161-66, Saint-Maur, pp. 167-69, Villers-Cotterets, pp. 181-84); L. Hautecoeur, Le Louvre et les Tuileries de Louis XIV, Paris, 1927; A. Kleinclausz, Philibert de l'Orme et le portail de l'église Saint-Nizier, Rev. Université de Lyon, III, 1928, pp. 193-208; H. Vollmer, ThB, s.v. L'Orme (with bibliog.); M. Roy, Artistes et monuments de la Renaissance en France, I, Paris, 1929, pp. 157-390; P. S. Wingert, The Funerary Urn of Francis I, AB, XXI, 4, 1939, pp. 383-96; E. Grashoff, Die Schlosskapelle von Anet und die deutsche Barockarchitektur, Z. des deutschen Vereins für Kw., VII, 1940, p. 123; G. Lebel, Les statues de Henri II et François II en la Grande Salle du Palais de Justice de Paris, BAFr, 1941, pp. 142-56; L. Hautecoeur, Histoire de l'architecture classique en France, I, Paris, 1943, pp. 219-33, 344-50, 427-29 (with bibliog.); P. Héliot, Les dates du Château d'Anet, BAFr, 1945-47, p. 58; J. Prévost, Philibert de L'Orme, Paris, 1948; P. Héliot, Documents inédits sur le Château d'Anet, MAF, LXXXII, 1951, pp. 257-69; R. Grand, L'architecture militaire en Bretagne jusqu'à Vauban, B. monumental, CIX, 1951, p. 359; L. Brion-Guerry, Philibert de l'Orme, Milan, 1955; F. Gébelin, Les Châteaux de la Loire, 3d ed., Paris, 1957; A. Blunt, Philibert de l'Orme, London, 1958.

Louis HAUTECOEUR

Illustrations: PLS. 163-165.

**DEMONOLOGY.** Demoniacal spirits play a large part in the religious iconography of most civilizations. They are represented in various forms that frequently show a deliberate transformation from the anthropomorphous to a more fantastic or monstrous type. Because of the close relation between demons and gods (see DIVINITIES), demonic representations presuppose a divine iconography as well. In the more advanced civilizations, demons are generally conceived as being more or less in opposition to the deities, and they have close and manifold connections with the world of myth (see MYTH AND FABLE), above all with the realm of the dead (see ESCHATOLOGY; MASKS). Popular beliefs and sentiments (see MAGIC; FOLK ART) helped to create through the centuries an attitude evidencing both repulsion and attraction toward demonic themes. Even after they had been removed from their original context in religion and myth and transferred to a purely psychological plane, such themes continued to give rise to original and varied representations, particularly in the modern world (see MONSTROUS AND FANTASTIC SUBJECTS).

SUMMARY. Introduction (col. 306). Representations of demons in the ancient world and in non-European civilizations (col. 308): *Prehistory; The ancient Near East and the Aegean world; Greece, Rome, and Etruria; Celtic and Iberian civilizations; Iran; Asiatic East; Primitive cultures.* Representation of demons in the medieval world (col. 320): *Introduction; Islam; Barbarian world; Medieval Christian world; Medieval tradition and the beginnings of the modern world; Popular and folk art.* The demonic since the 17th century (col. 329).

INTRODUCTION. The representation of demoniacal figures must be considered as an integral part of religion, just as the growth of mythology is also an inevitable outcome in another direction. This relationship must be affirmed from the beginning, not as a theory to be proved, but as an essential working principle in our attempt to identify and understand the representations of demons as expressions of the supernatural, as well as artistic expressions.

The extraordinary range of demons evident in the various religious traditions may be summarized in the following general groups: (1) mythical beings; (2) spirits of some cosmic sphere (earth, subterranean world, sky, sea), of a locality (wood, mountain, river, etc.), of a natural realm (animal, vegetable, mineral), or of a particular species of animal, plant, or mineral; (3) maleficent spirits (bearers of death, misfortune, sickness, poverty, etc.) or benign spirits (bearers of good health, prosperity, fertility, wealth, etc.); (4) spirits from the underworld or the next world, specters, and apparitions of particular individuals (see ESCHATOLOGY). However, not all mythical beings, nature spirits, specters, etc., are demons: such classification depends on how they are represented. A summary of the requirements for their portrayal as demons follows. (1) A mythical being (existing at an earlier time and therefore "different") must look different from present-day figures: he cannot be a man, an animal, or a

plant; that is, he cannot be represented under any existing form of life. Hence there is the genesis of the monster and the hybrid, the mixture of human, animal, and vegetable characteristics required to indicate the special status of this being. (2) The spirits of the cosmos or of nature are depicted as being quite different in nature from their particular area of influence (cosmic or terrestrial world, flora, fauna, etc.). Therefore they acquire anthropomorphous personalities, but not human figures, for they represent a natural world that is antithetical to humanity. The outgrowth is the demon who belongs to neither the human nor the natural world but takes certain characteristics from the former (anthropomorphous attitude, human limbs, etc.) and other characteristics (animal or vegetable features, etc.) from the latter. (3) The same distinction occurs for the benign or maleficent spirits. They are portrayed in such a way as to be distinguished from purely impersonal force (e.g., the Polynesian mana) or natural law (destiny), of which good and evil are the manifestations, but are invested with features that allude to the malevolence or good will which they bear. (The evil ones may bear similarities to animals that are supposed to bring death, sickness, misfortune, etc.; the good ones may suggest animals or plants believed to bring prosperity, health, etc.) (4) In relation to life on earth the spirits from the other world, whether spirits of the dead or spirits of the nether regions, are in the same position as the mythical inhabitants of the primeval world. They also must appear in forms different from those of the natural or everyday world; consequently, they become "surrealist," unusual, or monstrous (even the dead are transformed from their prior human state and acquire new features, generally zoomorphic in character).

From this brief account it is clear that the same feature (for example, an animal body) may characterize demons of diverse categories. This repetition is not merely a formal coincidence due to the limited choice of elements for illustrating an abnormal condition (though this may sometimes be the reason); frequently the demoniacal being assumes features which accord with his own nature and sphere of action but which may also be common to several other categories. Thus the depiction of the Devil in the Christian world ranges over nearly all the fields that have been distinguished in our summary analysis: (1) he is in evidence in the epoch of man's origins and before (rebellion of the angels, temptation of Adam); (2) he has his own cosmic sphere (subterranean) and particular localities (woods, caves, etc.) where he is wont to show himself; (3) although usually the giver of evil, he may bestow good things as well, such as wealth and prosperity; (4) he represents par excellence the damned among the dead and may displace the soul in the obsessed and for a certain time possess the individual (just as the genius of Roman religion might possess a man for a whole lifetime).

Most religions seek to personalize the sacred and establish contact with this personification. The paradoxical characteristic of the demonic conception, as distinct from the divine, is inherent in the very act of representation, for particularization and the resulting personal contact are in this case self-canceling. To mold, draw, or represent in some other way a demoniacal being fulfills the need of a cult; demons are not worshiped, just as mythological heroes were not worshiped. To have portrayed a demon is almost equivalent to possessing him, or at least to controlling him. Then if such control brings about a particular kind of religious behaviour, generally of a magical nature, it is caused by factors extraneous to the demonic conception or may be due to incorporation of the demonic conception into the complex civilization around it. Nor should we arbitrarily classify as probable forms of worship certain modes of representation that merely differ from the most widely accepted forms (for example, some dances which describe demonic natures), even if the representational arts are truly the most suitable and customary means. Moreover, in these dances the appearance of the dancer — as if in a *tableau vivant* — or of his mask is demoniacal (see CHOREOGRAPHY; MASKS). As a historical reality, the tendency of demonic conceptions to reduce to unnatural or surrealist forms the strangeness or "otherness" of the supernatural is merely one aspect of the positive religions:

it is often accomplished by compromise and fusion with other religious tendencies. For example, there are gods with animal features that are useful but not necessary adjuncts to asserting their superhuman natures (see DIVINITIES); there are also totemic animals that are the focal points of a whole socio-religious complex which could hardly be conveyed fully in terms of the animality of their conception and representation (see TOTEMISM). In polytheistic religions some cults of demons arose by analogy with cults of the gods. However, with such observations one undertakes a more comprehensive inquiry that seeks to distinguish stratifications, areas and lines of diffusion, stylistic elements, etc., in the immense wealth of divine and demonic representations from Upper Paleolithic times to our own. Such an inquiry would consider both the similarities and variations of these demonic conceptions as evidenced in iconographies that, because of folk preferences, frequently maintained their traditional types throughout epochs, cultures, and varying religious structures. Diffusion of this sort occurred with Eastern demon-monster types prevalent throughout the Aegean world, in Greece and especially in the ancient peripheral civilizations of Etruria and along the western Mediterranean. This folk transmittal is also seen in the recurrence of ancient forms — the Greek satyr or Pan, Etruscan funerary demons, etc. — in medieval devil figures.

Dario SABBATUCCI

REPRESENTATIONS OF DEMONS IN THE ANCIENT WORLD AND IN NON-EUROPEAN CIVILIZATIONS. *Prehistory.* The rock paintings and portable art objects in Franco-Cantabrian art of the Upper Paleolithic era include a certain number of anthropomorphous figures that present, in regard to the heads only, characteristics of a generically monstrous type not proper to any particular animal species. The only one of the representations of this type that might offer some clues for their interpretation is a scene painted in black in the Lascaux cave (Dordogne): a sketchy anthropomorphous figure with a bird's head appears to have been felled by a bison; to the side is a kind of stave — possibly a throwing stick — which terminates in the form of a bird. The bird's head of the fallen figure does not seem to be a mask in these circumstances; it is more likely a totemic symbol that is repeated in the emblem on the stave. Another possibility is that this was the means used to indicate the aspect of a dead man according to an animist conception, which would justify the probability that the demonic is represented among analogous figures elsewhere. In a second group of anthropomorphous figures, all of the Magdalenian period, the animal features are clearly defined and are not restricted to the heads. An engraving on a slab from Lourdes (Hautes-Pyrénées) shows a bearded individual with a bushy horse's tail. His head, which is anthropomorphous and bald, has marks that could be interpreted as the horns of a deer. Some dancing figures, engraved on a pierced stick from Abri Mège at Teyjat (Dordogne) and with the heads and fur of chamois, look as if they were wearing masks. A human figure with a bison's head, engraved on a wall of the cave of Les Trois-Frères (Ariège), also appears to be wearing a mask; but this is probably not true of another figure in the same cave, which has the head and body of a bison and only the legs of a man. In addition, the man with the bison's head is linked with two other hybrid beings that are entirely animal, a reindeer with webbed hind feet and a beast that is half bison and half reindeer. Other similar figures are present in the same cave (a bear with a wolf's head and another with a bison's tail). The conjecture that these are demoniacal images seems even more clearly confirmed by a dancing "wizard" also at Les Trois-Frères, particularly because of his larger size and dominating position with regard to the figures near him. This figure, incised and painted in black, displays the horns and ears of a deer, the eyes and face of an owl, the beard and body of a man, and the tail of a horse.

The possibly demonic representations evident in prehistoric art are related to certain manifestations found in primitive art (see below) that may be repetitions of these concepts.

* *

*The ancient Near East and the Aegean world.* In Egypt some deities have been, however incorrectly, classified as demons because they appear inferior to others in station and are often endowed with evil powers. These are divine beings symbolizing the powers of the underworld and of darkness, and their appearance seems closely related to those animals which were considered expressive of those powers: serpents, crocodiles, and lions. The demon-animal may be portrayed simply as an animal or in the monstrous guise of the anthropomorphous creature with an animal head; in both cases daggers and flames are frequently present as attributes. The best-known and most terrifying demon was the serpent Apophis, the personification of the storm clouds that were believed to obstruct and darken the course of the sun-god. A great company of demons and chthonian monsters appear in the vignettes that illustrate the text called the Book of Amduat (or the Book of That Which Is in the World beyond the Grave): the best of these, in which Apophis sometimes appears as a four-headed monster, are found in the royal tombs of the 19th dynasty (1314–1200 B.C.). Other grotesque figures and fire-breathing serpents are found in a similar composition called the Book of Gates. The Devourer of the Dead (Am-Ut), with a crocodile head, the hind parts of a hipopotamus, and the bust of a lion, is celebrated in literature and in funerary iconography. He is often represented with open jaws, ready to devour all the damned, in the vignettes of the Book of the Dead that show the scene of the judgment of the dead. Even the 42 judges who preside at the judgment may be considered as demons, since many of them appear with animal heads and are armed with daggers. In the magical iconography "good" demons were deliberately made to look as terrifying as "bad" demons. Thus, upon a type of magic stave, fashioned of ivory in the form of a boomerang and frequently found in the Middle Kingdom (ca. 1991–1650 B.C.), are engraved monstrous beings and terrifying beasts: crocodiles; winged serpents; lions and cats tearing serpents to pieces; leopards, lions, and hippopotamuses attacking human beings; hybrids formed with an admixture of lions' and bulls' heads; winged griffins; and other quadrupeds with long necks and leopards' heads. This formidable menagerie was intended to ward off from the living and the dead the danger of harmful beasts and evil spirits. In the Late period similar images were engraved upon so-called "pillars of Horus upon the crocodiles" and upon the "healing" statues.

Sergio BOSTICCO

In Mesopotamia, notwithstanding the special emphasis given to the incorporeal nature of demons in the magical texts, representations of these evil spirits are rather numerous. They are generally found upon amulets, often made of terra cotta, which sometimes contain magic formulas for exorcism; there are also small figurines, probably worn hanging from the neck. Particularly characteristic of these are the animal heads and clawlike feet; often there may be one or two pairs of wings. Among the wicked spirits, seven are given preeminence in the books of magic as being related to specific illnesses. These are Alu, Asakku, Etimmu, Gallu, Ilu limnu, Namtar, and Utukku (this last name — the Sumerian Udug — is also used to indicate demons in general). They are usually represented together in a row on terra-cotta amulets, each with a man's body and the head of an animal (lion, goat, sheep, eagle, etc.); but except for the lion-headed Utukku, it is not known to which animal each of the others corresponded. Besides these seven, one of the most feared and most commonly represented demons in apotropaic statuettes is Pazuzu (PL. 166), the bearer of malaria. He is portrayed as a naked, almost skeletal, man with a monster's face and clawlike feet, has four wings, and sometimes appears ithyphallic. The most important of the female demons are Lamashtu and Lilith. The former personifies fever and is represented with a lion's head and with snakes in her hands. Lilith arouses men's concupiscence without satisfying it and is shown, in a terra-cotta relief (Frankfort, pl. 56) used in cult ritual, as a handsome woman with a tiara and wings; for feet she has the powerful claws of a bird of prey, which rest on the shoulders of two lions. A special sort of demon is Humbaba (Huwawa in the most ancient texts), who is represented, according to the epic tradition, as a man of gigantic size killed by the hero Gilgamesh and his friend Enkidu. He is also connected with divinatory practices: the windings of the entrails are in fact reflected in his face, furrowed with wrinkles (III, PL. 131).

There are also various unidentified demons, such as the one with a lion's head and an eagle's claws frequently found on *kudurru* (boundary stones) and on seals of the first Babylonian dynasty (possibly Utukku, known to be lion-headed) and the one-eyed monster, also killed by a hero, whose face is a radiating sun (Frankfort, pl. 58B) and who appears on a terra cotta dating from the Early Babylonian period. On the other hand, it is uncertain whether we should regard as demonic all the many representations of monstrous animals, fantastic beings, and hybrids (see MONSTROUS AND FANTASTIC SUBJECTS; TERROR IN ART). Among these last we might perhaps consider as entering within the demonic category the "blessing" figures that appear on Assyrian reliefs and seals, as well as the tutelary spirits placed beside the portals of cities or of buildings.

In Syria, Palestine, and Anatolia there are many representations of demons, although these seem to have played a less important role than in Mesopotamia. The artists restrict themselves to reworking of the Mesopotamian motifs and repeat individual motifs such as triple pairs of wings or double heads. It is difficult to class as demons, however, the various types of sphinx found very frequently in these peripheral areas (PL. 166), the confronting winged figures found on Phoenician ivories, the winged cherubim that surmounted the ark of the covenant (cf. A.V. I Kings 6: 23–28), or the tutelary spirits represented on the portals of the Achaemenian cities (in imitation of the Assyrian figures).

Giovanni GARBINI

In the Cretan-Mycenaean world very few of the numerous fantastic creatures that appear on the Cretan seals are truly demoniacal; the great majority are merely fanciful combinations of animal limbs and vegetable elements. There seems to be some religious significance in a type of bestial creature that is shown erect and with a body bristling with spines or mottled as if covered with hair (cf. PL. 166). This figure has sometimes been considered the prototype of the Minotaur. Toward the end of the 3d millennium B.C., through Oriental influence, the sphinx and the griffin were introduced. There is no marked difference between the Cretan and the Mycenaean griffin. The more ancient type, which shows it in pursuit of its prey (Zakro seals, Mycenaean dagger and vases), is followed by the type that shows it attacking its prey (engraved gems from Knossos and Mycenae) and, finally, by that in which it is engaged in bodily combat (Mycenaean ivories). Sometimes the griffins appear as an antithetical pair guarding a tree (ring from Mycenae) or a pillar (stucco from Knossos), or as the companions of the Great Mother, the goddess Demeter. Only at a later period do they assume the role of "angels of death" (sarcophagus of Hagia Triada, Heraklion, Crete, Archaeol. Mus.).

The sphinx appears for the first time upon some seals from Zakro and on the miniature frescoes of Knossos. It seems probable that, like the griffin, it came from Syria. The Cretan sphinx presents some original features: it is frequently depicted frontally, with wings outspread in butterfly fashion. Another local motif is the running sphinx (some seals from Zakro and later, in the Orientalizing period, the shields of Mount Ida). The arrangement of the hair is also different, and the figure is crowned with a diadem. On the mainland the sphinx appears for the first time in the second half of the 16th century B.C. (gold panels from the third tomb of Mycenae); numerous examples are also found on gold rings from Mycenae (similar to the Cretan ring from Zapher Papoura) and on ivories (e.g., from the House of the Sphinx at Mycenae). This composite figure is found as late as the sub-Mycenaean age.

\* \*

*Greece, Rome, and Etruria.* The diffusion of Greek philosophical concepts freed Western man from the threat of demonia-

cal spirits, who were overcome by gods of ideal beauty. Archaic Greek art represented essentially an attitude of reaction against the monsters inherited from Oriental art that were now opposed by the fighting heroes: Bellerophon slays the Chimera; Oedipus, the sphinx; Perseus decapitates the Gorgon Medusa; Herakles kills the Hydra of Lerna and the Nemean lion, fights Geryon and many other monsters. Nevertheless, many demoniacal images survived for a long time afterward. Although at first there were simply derivations from the Oriental repertory, soon centaurs, giants, Amazons, and satyrs were called upon to evoke the demonic aspect of man in imaginative antithesis to the conception of ideal beauty. Later certain grotesque representations, especially those of the Kabeiroi and the Phlyakes, were to be used to ward off the power of wicked spirits by their comic effect.

The first demonic representations in this area are, in fact, Oriental monsters in the shapes of animals or hybrids. Thus the griffin resumes its role as an infernal being, which it is to maintain most notably in Etruscan art. The sphinx is variously and widely used as a symbol of fate (PL. 167). An even more marked funerary significance is attached to the sirens, who have women's busts on birds' bodies and outstretched wings but never have the fishlike bodies elsewhere evident. The sirens are often confused with the Harpies (PL. 167), winged women having the claws of birds of prey (Hesiod, *Theogony*, 265). In the metopic decoration of a proto-Attic vase from Aegina (Berlin, Staat. Mus., Antiquarium, F. 1682), the Harpies are labeled "Arepuia"; they are dressed in short tunics and shown in rapid flight, set in opposition to Perseus and Athena. The characteristics of a chthonian demon seem proper to Typhon — winged, bearded, and serpent-legged — the enemy of Zeus, who appears in his company upon a Chalcidian hydria of the 6th century B.C. (Munich, Antikensamml.). Chimera, the daughter of Typhon, has a similar character; she is conceived as a Lycian monster, who is a composite of a lioness, a she-goat, and a serpent that spews flame. The Chimera, like the siren and the sphinx, is also found on the reliefs of funerary plaques of the 7th century from Praisos and Lato, Crete.

Preeminent among these monsters is the Gorgon, frequently represented in ancient art over a long period. The grinning Gorgon mask displays large eyes projecting from their orbits, a flattened nose, sharp claws, a lolling tongue, and hair of coiled serpents (PL. 167). The Gorgon Medusa, of the petrifying glance, was decapitated by the hero Perseus, and from her severed neck sprang Pegasus and Chrysaor. This legend gave rise to a series of representations. The Gorgoneion, a horrible head symbolizing death and as terrifying as the contemporary Assyrian demon Pazuzu (7th cent. B.C.), seems to have preceded the Gorgon type. As early as Homer (*Iliad*, V, 741; VIII, 439; XI, 36; *Odyssey*, XI, 633), there are references to a menacing mask that adorns the shields; and an outstanding example from the Geometric period has been found in the excavations at Dreros. The origin of this image lies in the mask with curved fangs, open jaws, and lolling tongue that had been used to represent the infernal monster. Examples from about 700 B.C. were found in the Heraion of Tiryns and are at present in the Archaeological Museum at Nauplia.

Numerous lion masks of this type adorn proto-Corinthian vases. That these figures denote attempts to ward off fate is attested by the inscription MOIPA painted under the Gorgoneion adorning the shield of Achilles in the scene where he lies in wait for Troilos near the fountain, as depicted on a Corinthian alabastron painted by Timonidas (Athens, Nat. Mus., second half of 6th cent.). Whatever may be the origin of the Gorgoneion, it is used as an allusion to death, even if by antithesis; this is perhaps the reason why it was so frequently incorporated into the Dionysiac theme of superabundant and licentious life, which lent itself so well to the decoration of cups in the late 6th century B.C. Painted in the center of a medallion on the Nikosthenes cup (Louvre) is the Gorgon, wearing a short tunic, doeskin, and winged red sandals; the rest of the vase surface is decorated with Dionysos and his band of revelers, and the whole forms a sort of *danse macabre* in strongly contrasting colors. A similar bowl was found at Vulci and is now in a museum at Cambridge, England (W. Deonna, AntC, XXVI, 1957, I, p. 59 ff.). There is another, with black figures, in the Scheurleer Collection (Amsterdam, Allard Pierson Mus.). Frequently the Gorgon theme assumed a purely decorative function, which is especially evident toward the end of the 6th century B.C.

Besides these principal monstrous beings, the image of Alastor, "the spirit of vengeance" described by Aeschylus (*The Persians*, 354; *Agamemnon*, 1468–1508), by Sophocles (*Oedipus at Colonus*, 788; *Women of Trachis*, 1902), and by Euripides (*Helen*, 979; *Hecuba*, 948; *Hippolytus*, 818; *Medea*, 1260, etc.) can probably be identified in the guise of a small black hairy creature with a protruding snout, a little beard, and one large white eye. This figure appears in two paintings of the 7th century B.C. that are now in the Berlin Antiquarium. One of these paintings occurs on a bowl from Aegina (A 32), the other on a conical pedestal (A 40). The Keres (Homer, *Iliad*, II, 854, V, 22, 83; *Odyssey*, XXII, 330, XXIV, 127; Hesiod, *Theogony*, 211; *The Shield*, 249) were Furies with bluish flesh, sharp teeth, and curving talons, who fed on corpses; however, they soon disappeared from Greek iconography, including that of the funerary monuments. Even the demon of death Thanatos, whose folklore is set forth by Euripides (following the example of Phrynikos) in *Alcestis*, has no particularly terrifying characteristics in art: he appears in the company of Hypnos (Sleep), who helps him to transport the dead to the other world (PL. 168), and is pictured as a bearded and winged spirit, with rather handsome human limbs, on the graceful white lekythoi, on the Pamphaios cup, and on a kantharos in the British Museum. Occasionally one finds on some lekythoi a more vivid representation which shows him with haggard eyes and unkempt hair, particularly on an example in the Louvre (C.A. 1264) where Thanatos rushes toward the dead man with his fingers curved like hooked claws according to the popular conception described by Hesiod (*Theogony*, 764–66) and Euripides (*Alcestis*, 49, 55, 62 ff.).

Charon, the steersman of the Styx, who also appears on the funerary lekythoi, is portrayed as a servant of Hades — either as a bearded old man or as a beardless youth, but always in a peaceful and benign attitude. In some later inscriptions, by an extension of his function, he is endowed with greater power and likened to Thanatos or to Hades himself; hence the origin of the Byzantine myth of Charos: Death mounted on a horse.

Certain other images in Greek art may be considered as demonic only by virtue of some formal aspects: for instance, the Erinyes and the winged Furies frequently found in representations of the infernal world on Greco-Italic vases, with snakes in their hands or on their heads and sometimes with winged sandals on their feet; also, certain heads of Seilenos, such as the horned head with a markedly demoniacal expression in a scene depicting the torture of a Negro on a black-figured lekythos (Athens, Nat. Mus., no. 1129). The head of Seilenos was sometimes used also to represent the infernal abyss. Such a connotation must be construed from a surprising scene that appears on a black-figured Attic skyphos (Copenhagen, Nationalmus.): Herakles, armed with a club, is dragging behind him at the end of a red rope an enormous head of Seilenos, with a flattened nose and a tongue protruding from a wide-open mouth. In some steles at Bologna gigantic heads of Seilenos receive the dead man, who comes on horseback or in a chariot, while a woman offers flowers. It is evidently an image of the Mouth of Hell, the ancient prototype of a terrifying theme very common in the Middle Ages. Customarily identified as Boreades are winged spirits with a man's body, sometimes bearded, who wear winged sandals and are shown in full flight like the Nike; or else these may be associated with Hermes. Nevertheless, their general aspect has nothing diabolical about it.

The expressionist, and therefore anticlassical, character of the very original funerary art of the Etruscans is clearly shown in their love of violent and abnormal forms. In archaic times the monsters derived from Oriental art betray the influence of Greek Ionian iconography. In Etruria, however, there is a marked accentuation of the most expressive features, even when the purpose of the work is purely ornamental, for example, in

the griffins, sphinxes, and lions of the Orientalizing bronzes and jewels; in some stone carvings of the 6th century; in the Tritons and sirens of the antefixes of Satricum; in the grinning mask of the stylized Gorgon in an antefix from Veii (V, PL. 38); in the powerful Chimera from Arezzo (V, PL. 40); and in the serpent-legged spirits of the steles from Bologna, which are prototypes of a figure on a cup in the Vatican. As is well known, the decoration on the Etruscan funerary monuments from the 7th to the 5th century B.C. is mainly an expression of the joys of life, which it is hoped the dead man will continue to experience in the other world: feasts, banquets, dances, and competitive games.

Nevertheless, there are some isolated examples testifying to the presence of terrifying demons in certain Etruscan religious rites and games of this epoch; in fact, this may be deduced from some passages of Livy (IV, 3, 2; VII, 35) that describe the Etruscan priests masquerading as demons. If the Phersu found in the funeral games illustrated in the Tomb of the Augurs or that of the Olympiads at Tarquinia seems inspired more by a figure of popular folklore (a kind of Pulcinella) than by the god of the infernal regions, from the 6th century onward the Zannoni stone and other Bologna steles present the still primitive type of a psychopompos demon, who intervenes at the moment of death to conduct the soul to the other world. Thanatos, the Greek personification of death, seems at times to reappear in Etruscan art: he may in fact be recognized in the painting on one of the Campana plaques of the 6th century (Louvre) and is also recognizable later in certain small bronzes in Florence (Mus. Archeol.). In both cases he is bearing his victims away in his arms.

The rarity of these identifiable archaic types puts added emphasis on the meaning and importance of the innumerable representations of local demons, varied and original in character, which abound in the funerary art of Etruria from the late 5th century until the end of Etruscan art, particularly in the 4th century. The demons roughly sketched on the Bologna steles were later differentiated into various figure types, the most frequent of which was a personage with a hooked nose, animal ears, unkempt beard and hair, and large pointed teeth in a grinning mouth. Sometimes this figure is winged, wears a tunic, and is of a bluish, corpselike hue; he is usually armed with a hammer or occasionally with a sword (PLS. 168, 169). Undoubtedly, he embodies the death blow to the human being. By confusion with the Greek Charon he is called Charun or Charu; however, the Etruscan motif differs totally from the Greek, both in mythological meaning and in figurate type. Still, the name appears only in iconological contexts rife with imagery transposed from the Greek repertory: the frescoes of the Tomba dell'Orco at Tarquinia and the François Tomb at Vulci; in the decoration of a bowl from Vulci (Paris, Bib. Nat.), showing the sacrifice of the Trojan prisoners; and on an urn from Volterra depicting Orestes' matricide. This demon also appears in more than 150 representations without inscriptions as well as in familiar scenes in which he evokes the moment of violent death. He interrupts the dying man's farewell to his family, guards the tomb, accompanies the dead man on his last journey (on foot, on horseback, or in a chariot) to conduct him to the nether regions, and sometimes, with upraised hammer, symbolizes the death blow itself. He is also shown alone, and masks in his image adorn funerary urns or the walls of tombs. Like the Greek Gorgon, Charun may also be represented antithetically in an attitude of challenge. This is perhaps the reason why he is found even in a figurine on a bronze shaft used for the game of cottabus (Florence, Mus. Archeol.).

With this most typical spirit are associated other demoniacal figures that are equally expressive: above all, the demon with the curved beak of a bird of prey — called Tuchulcha — found on a fresco in the Tomba dell'Orco at Tarquinia, where he is seen in the role of the Fury who threatens Theseus in Hades. Brandishing handfuls of serpents, this demon may also be identified in other images where he appears with a bird's claws, as in a fine bowl from Vulci (Paris, Bib. Nat.) in which the Etruscan demons appear beside Alcestis and Admetus. Young male demons are also represented as followers of Charun and Tuchulcha.

Female demons, sometimes in the guise of Charun or the Erinyes, with or without wings, and with their shoulder bands crossed over their naked breasts (as on certain vases from the Greco-Italic centers), are often found in company with Charun or in the act of carrying out his functions. Some Furies are assigned a name, as is often the case with Vanth, who is generally winged and bears a papyrus scroll whereon is marked the sentence of death in the Book of Destiny (François tomb at Vulci; Chiusi urn). This is the same scroll on which a winged demon is writing in a fresco and on a sarcophagus at Tarquinia.

Under the Roman Empire, art tended to fall under the influence of Greek mythology or Hellenistic iconography. The representations of Seilenos, Pan, and the satyrs were no longer demoniacal figures in the true sense of the word. The realism consonant with the Roman historical narratives and portraits plainly did not favor the revival of folk motifs, which no longer reflected the officially recognized religious beliefs. Nevertheless, the monsters and devouring lions still survived in funerary art, especially on the sarcophagi of the 3d century of our era, as symbolic elements intended to contrast the hope of immortality with the voracity of death. This appears clearly on a sarcophagus (Brussels, Mus. d'Art et d'Histoire) whereon winged spirits seem to be uncovering the effigy of a dead man amid confronting lions and peacocks. This theme preserved its funerary significance also in the art of Roman Gaul, as evidenced by the image of a man-eating wolf at the archeological museum in Arlon, Belgium, and other similar monuments.

Franz DE RUYT

*Celtic and Iberian civilizations.* The decorative art of the Celtic civilization of the La Tène period presents a great number of monster figures of varied types, almost always of remote Oriental origin. Undoubtedly indigenous, and one of the most ancient, is the spirit represented as a horned serpent or, in Roman times, a ram's head. His demonic character is apparently demonstrated by his association with such varied divinities as the stag-god and the wheel-god and by his position in a scene of human sacrifice before a procession of horsemen (cf. the Gundestrup cauldron; III, PL. 118). The serpent-legged monster, depicted lying beneath a horse ridden by a god (the so-called "Dispater") or coiling about its hoofs (column from Windecken, near Hanau; column from Wiesbaden), seems to have had its prototype in ancient Greco-Italic art, where a sphinx was often used to support a mounted personage. A similar creature is a strange serpent-bodied being in a group at Eckelsheim, a veritable Triton with three heads. Three-headed gods and monsters were fairly common in Gaul, especially in classical times, when death was sometimes represented as a three-headed dog, undeniably connected with Cerberus. The conception of all-consuming death, however, was definitely indigenous. It assumed various aspects, sometimes appearing as a monster with a horse's head and lion's claws, sometimes having a man's head covered with wolfskin, etc. Of a particularly monstrous character is the so-called "Tarasque" of Noves (Avignon, Mus. Calvet), a polyform being that rests its paws on two human heads while clenching a forearm in its teeth. This conception is analogous to other representations of man-eating animals, such as lions (from Bavai and Speyer), griffins (from Lillebonne), horses (from Les Baux), sphinxes, etc.; very often they are shown with only the heads of their victims (the so-called "têtes coupées"; III, PL. 111). Also worthy of note is the function of guardian for tombs or funerary urns, attributed to the horse or lion (above-mentioned sarcophagus in Brussels).

Iberian demonology clearly has two principal influences, the Celtic and the Greco-Roman. The lion pouncing upon a warrior (relief from Osuna) and the man-eating wolf (from Baena) are evidently related to the Celtic world; while the sphinxes (from Villacarrillo and from El Salobral), the man-headed bull (from Balazote), the griffins, and various semibestial monsters

(centaurs, typhons) all belong to the Hellenized world (all examples cited are in Madrid, Mus. Arqueológico Nacional). Bulls may also sometimes appear as guardians of the dead.

\* \*

*Iran.* In Iranian religion Ahriman is the great adversary of Ahura Mazda, and descriptions of his power are found in the Mandaean and Manichaean systems, which are both derived from Iranian religion. The hypothetical identification of Ahriman with the winged, lion-headed figure having a serpent coiled about his body, depicted in the Mithraic mysteries, is in fact based on these descriptions. However, the globe upon which he is represented seems to allude to dominion over the whole universe and thereby precludes positive identification. Moreover, several texts of Iranian origin or inspiration assert that Ahriman assumed the form of a frog, but no image of him in this guise is known. There must also have been an anthropomorphous representation of him, for one version persisted in Islam as a survival of Manichaean-Sassanian religious art (cf. Arnold, 1924, pl. 15).

One of the great adversaries of Ahura Mazda and the other good spirits is the dragon Azhi Dahaka (Pahlavi, *Aždahāk*), who was venerated by warrior communities (for example, there is a dragon crest on a helmet from eastern Iran). At a later date, there was evidently an anthropomorphous representation of Azhi Dahaka, somewhat similar to those of ancient Mesopotamian deities such as Ningizzida, where he was shown with two serpent heads on his shoulders (as in the famous seal of Gudea) and with chthonian characteristics. The human figure trampled by the hoofs of Ahura Mazda's mount in the scene of the investiture of Artaxerxes I may be interpreted as the dragon that he slew, according to the book relating his exploits. In fact, this figure has coiled snakes instead of hair. It is possible that he is meant to depict Ahriman himself, and one is tempted to connect this image with the "snake-bearing" god of Hatra, which in turn has been identified either with Ahriman or with the Mesopotamian god Nergal, the lord of the nether regions (PL. 171).

Demons, or daeva (Skr., *dēvān*), were also presumably represented as snakes in Armenia, which was directly influenced by Parthian culture; but of this area very little is known. Some beings of uncertain identity, shown with a hero in pursuit, appear on jewels and seals. This theme can also be traced to the period of the Achaemenid dynasty. Certain reliefs depict a king fighting a griffin or other monster, and on cylinder seals the hero may be in combat with two animals; this motif is derived from the glyptic art of ancient Mesopotamia. Demonic images are also found in some Manichaean miniatures, but these are always under the direct influence of Buddhist themes or conceptions.

Iranian demonology, known from literary sources to have been rich and varied, unfortunately has left few iconographic examples. Many of its most important motifs may, however, be reconstructed through study of the classical and Christian art that perpetuated them.

Geo WIDENGREN

*Asiatic East.* The millennial history of India clearly reveals the evolution from an ingenuous empirical conception of the world to a system of metaphysical speculation, and thence to its descent into the sphere of primitive and folk cults. The polytheistic divinities of the ancient Vedic period seem to have been personifications of natural phenomena. They had nothing demonic in their origin. In the course of this evolution, they gradually lost more and more of their anthropomorphic character and acquired greater ethical substance (see HINDUISM). In India this development led to the formation of a genuine philosophy that first found expression in the Upanishads and in early Buddhism (q.v.). At the same time, however, the primitive religious ideas of the pre-Indo-European epoch were gradually penetrating the cults of the Aryans. Thus the original god of nature, Rudra, the lord of the whirlwind, only later progressively assumed a terrifying character, which was in some re-

spects demonic and led to his transformation into Śiva. The hymns of the *Ṛgveda* (Ang., *Rig-Veda*) still exalted the power and activity of the gods of nature; in that period a pure theism reigned. Later, but only in the most recent of the Vedas, the *Atharva-Veda* (the songs of which were codified from the 7th century B.C. onward), the divine being of primitive times reappeared. At this point there appear the earliest forms of those lesser divinities which in their maleficent aspects may be regarded as demonic. Particularly characteristic of these figures, however, is their anthropomorphic nature and the absence of any terrifying expression. These spirits of nature depicted in male and female form are the yakshas and yakshis, whose chief attribute is fertility. The most ancient figure of the kind, the famous yaksha of Patna (II, PL. 403), has powerful, virile features. The yakshis are always represented in association with a tree. They show in an unequivocal manner the attributes of female fecundity in their exaggeratedly swollen breasts and disproportionately wide pelvis. The yakshi relief figures from Bharhut (II, PL. 408) are typical images of this kind (see BUDDHIST PRIMITIVE SCHOOLS). These forces of nature still maintained their human form even in the more advanced art of Andhra (q.v.). The yakshi of the eastern gate (Skr., *toraṇa*) of the great stupa of Sanchi, who rises from the earth like a graceful and seductive female, is at the same time a fertility spirit.

These early images in Indian art are not distinguished by any terrifying features but rather by the license of their erotic expression. The gods of the pre-Aryan period were obliged to assume human forms and serve the Indian deities. Kubera, the god of wealth, is their king. Only in the late Hindu period did the demoniacal beings assume a terrifying aspect. Today, especially in southern India, representations are used as images of the tutelary spirits of villages, and their terrifying aspect is intended to ward off evil influences from the community.

Thus, the story of Indian art disproves the thesis of a progressive evolution from demonism to theism; in fact, the development here was in the opposite sense. Only at a later stage did the polytheistic deities begin to show essentially demonic features, as is shown in the emergence of the god Śiva. The objects of veneration of the original native population were degraded to the state of anthropomorphic beings but did not become demonic until much later.

The art of Tibet contains an abundance of demonic representations. Tibetan mythology attributes to the most important Lamaist saints the signal capacity of "demon taming." The Tibetan demons were originally local spirits of nature connected with Bon, the primitive religion of Tibet. They were later "tamed" by the heroes of the Buddhist religion. This expression means that the great ascetics of early Lamaism "converted to the true religion" those mysterious powers, who were placated and reduced to the role of guardian spirits of the new religion, the so-called "yi dam" that are now included in the group of "terrifying gods" of Lamaism. Carved figures and large paintings of demons are found in all the Tibetan temples and monasteries. This copious iconographic material has been made accessible only in very recent times, chiefly through the publications of Filchner and Tucci. From this it is evident that the demoniacal gods — in reality authentic demons — bear terrifying attributes, such as human skulls used as goblets for blood. The appearance of these figures is terrifying and horrible, and this explains their significance in the Lamaist religion: they repel those powers which are evil and inimical to religion. The more monstrous their aspect, the more efficacious the protection they offer against maleficent spirits. Among them are found Pe-dkar, the guardian of divine images, and dKor-bdag-rgyal-po, the guardian of monastery property. Other tutelary demons are the *c'os skyoṅ*, protectors of religion (by *c'os* is implied the Buddhist religion); Yamāntaka, ruler of the nether regions; and the horrible Mahākāla, with his pig's snout (see ESCHATOLOGY).

According to the Lamaist conception, legions of demons inhabit the world and represent primeval powers that are still active. By means of a ritual magic they have been subdued and made to serve the Buddhist religion; thus they have become coadjutors of the Buddha. If these demons rebel against

the order imposed upon them, they must once more be tamed with magic formulas. Nevertheless, according to the Lamaist conception, many demons still remain at liberty and may do harm to religion and to men if they are not overcome by magic. Furthermore, according to the Lamaist doctrine, demons occupy an intermediary position between gods and men.

The demoniacal masks used in Tibet for ritual dances are widely known. The heads of the most important demons are carved in wood and then painted in brilliant colors. In certain dances in which there survives a substitution for the ritual human sacrifice, many demoniacal masks are employed. Among these are the "lords of the field of corpses," dancing figures with dead men's skulls, the servants of Mahākāla, the "terrifying deities," and also a certain number of interesting animal masks. These demoniacal figures with the heads of yaks and deer are derived from the very ancient shaman cult of central and northern Asia. In the hunting civilization of northern Asia the deer is considered, even today, as symbolic of peculiar animal powers. For instance, the shaman of the Yenisei believes that binding a strap of deer hide around his brow will protect him against evil powers. The dance masks of Tibet are similarly intended to represent the horrible. The purpose of the demons, tamed and placed at the service of the Buddhist religion, is to drive away malign influences.

In the rituals of Ceylon demonic imagery plays an important part. The Singhalese in particular believe that they must wage continual warfare against the evil spirits, which cause illness and death. To dispel maleficent spirits, they have from ancient times made use of exorcising practices in which are merged primitive animistic customs and religious concepts of Buddhism (q.v.) and Hinduism (q.v.), as well as some knowledge of medicine — the whole forming an occult system.

Of the various manifestations of disease, the greatest number are described in Singhalese with the term *bhūtaviva*, as was revealed in the fundamental research of Paul Wirz. The inhabitants of Ceylon indicate by this inclusive term the pathological phenomena caused by evil spirits and demons. These wicked powers may be the souls of the dead — in which case they are generally easy to dispose of — or the spirits of nature that we have already come across in India, the yaksha and the yakshi; or finally, they may be specifically demons of disease. The Singhalese believe that these beings are everywhere in nature and that they lie in wait for man to take him by surprise, enter his body, and produce illness therein. At one time these demons had unlimited powers over mankind, but since the god Indra and the Buddha dealt with them, they have only had the power to make men ill. This myth confirms the thesis that these beings also are very ancient divinities, degraded from their original rank.

Exorcist healers try to free anyone who is possessed by a demon of disease by means of an ecstatic dance in which they wear the mask of the appropriate demon. With this dance they seek to coax him from the sick man's body. These masks are generally more than life size and are carved from softwood. Hideously protruding eyes are believed to strengthen the magical potency, and painting in bright, variegated colors lends further efficacy to the masks. The *rākṣasa* masks of Ceylon are characteristically adorned with many bodies and heads of serpents. Their ears are formed of the coiled bodies of serpents. On their heads are placed high crowns made of wreathed cobras, while from their nostrils, from the corners of their mouths, and from between their teeth protrude the repulsive heads of other cobras. The demon Mahāsanny, as the supreme head of the spirits of disease, bears on both his cheeks, like ornamental plaques, representations of the sixteen most dangerous diseases to which man is subject, among which are leprosy and syphilis.

In Indonesia images of demons are found at all cultural levels. Among the farmers, artistic activity is restricted to very simple forms. Their woodwork, for the most part, consists of carved poles and engravings, while their weaving and painting never go beyond purely ornamental forms. Three-dimensional representations are found chiefly on the island of Nias, while tribes of the interior of Borneo and Celebes prefer the ornamental forms.

The principal object of artistic activity among the headhunters of the interior of Borneo is the shield (PL. 175). Especially among the Kayan and the Kenya, these arms seldom show any naturalistic representations of demons but are generally highly stylized in their imagery. Some more naturalistic works clearly show the anatomical features, while in others the stylized bodies of the demons are almost dissolved into remarkable and elaborate ornament in compositions dominated by decorative central eyes. To understand these bizarre figures, one must remember that for the headhunters the skull is the seat of the life force. The demon depicted on the shield serves to ward off enemy attacks. As the belief in the guardian demon became more and more abstract, the Kayan warrior ultimately restricted the representation of his supernatural protector merely to that part constituting the effective defense against the foe, namely, the head.

The *tempatungs* carved by the inhabitants of Borneo also deserve mention. These elongated decorations are mounted on poles and incorporate demoniacal faces that function as protectors against disease or surprise attacks by the enemy. The long lolling tongues, often in the form of snakes, and the abnormally long incisors that protrude from the mouth are reminiscent of prototypes in the Indian colonial art of Indonesia.

The more advanced Indonesian cultures, particularly in Java and Bali, are rich in demonic representations. Bali has been called the "island of demons." The people of this island believe that the land, the air, the whole universe, and the world beyond the grave are populated with good and bad demons. Therefore, according to the religious concepts of these people, it is necessary to win the friendship and aid of the good demons in order to render the harmful spirits innocuous. To this end, offerings are directed to these superhuman beings, along with ritual dances and certain other deceptive and ingeniously devised maneuvers, such as those resorted to on the occasion of the cremation of corpses (see ESCHATOLOGY).

The representations of demons in Bali are infinitely varied and are generally on small metal amulets or in relief carvings over the entrances to houses; also, as testimony to the ancient and advanced civilization of Bali in the first millennium of our era, such images occur in the form of gigantic stone sculptures that guard the temple entrances. Even during the earlier advanced civilization of Java, demoniacal heads were set up to guard the entrances of temples and palaces. Several such heads of Banaspati may still be seen among the ruins of Singasari in eastern Java.

In China the representations of demons are found chiefly in the Buddhist zone of influence. Here, as in Tibet, the function of these spirits is to protect the Buddhist doctrine and community from hostile powers. At the portals of Chinese Buddhist temples demon guardians repel the evil spirits with the terrifying power of their aspect and with their weapons. These are carved in wood and painted. Stone carvings larger than life also guard the Buddhist cave sanctuaries of Lung-mên in the province of Honan (see CHINA), which date from the 6th century; in the style of these statues may be recognized the influence of the remote art of Gandhara (q.v.). The demon images on the reliefs of the Huang-ssŭ ("yellow temple") before the gates of Peking are repulsive spirits of the earth. Turned toward the four cardinal points of the compass, they guard representations of scenes from the life of the Buddha (see BUDDHISM).

The dragon and the pearl are important symbols in Chinese art. The demonic forces of life, in continual agitation, find expression in the figure of the dragon, which roams frantically in search of the pearl of perfection. The attitude of this dragon is violent and typically demoniacal.

The masks of the actors who take part in Chinese ritual sacrifices are often expressions of the demoniacal nature. In this way barbarous and inhuman activities are represented. The dark-hued faces are intended to express this inhuman or diabolical character.

Friedrich W. FUNKE

Japanese demonology is derived from two principal sources, the one popular and the other mainly Buddhist. In the Buddhist religion one may not properly speak of absolutely evil powers, because this creed does not recognize a situation or a condition of life that is lasting and eternal. The very demons who preside over the various infernal regions are dogmatically defined as images evoked by an evil act: they do not exist as real creatures but as mental projections upon which the sin itself confers particular characteristics; the inevitable consequences of the evil follow and eventually induce an act of expiation (PL. 173). In fact, certain other demoniacal creatures are simply manifestations of the militant forces of goodness, which assume these particular forms in order to oppose or repel evil and sin or to protect the sanctity of the temple and the sacred places. Fearsome and implacable power is expressed in the vigorous muscles, the cruel sneer, and the agitation of the limbs; from the gaping mouth jut the teeth, sharpened and protruding as if athirst for their prey, the hair on the head rises like flames, and the withering glance is full of menace. Such are the images of the lokapalas (or guardians) in which Japanese art, inspired by Chinese models, achieved superb expressive power and convincing representations. The monstrous character of the images is largely the effect of emphasizing the superhuman power and aggressiveness of these forces. The weak or imperfect spirit is, as it were, overcome by the superhuman will and invincible determination that some artists have succeeded in expressing in their work, as for example in the *Meikira Taishō* of the Shin Yakushiji at Nara or in the *Jigoku-ten* at Nara. In their fearfulness these works, although inspired by T'ang models, perhaps surpass their prototypes in expressive power.

This penchant for the terrific is asserted even more plainly in some statues that may be considered among the boldest productions of the Kamakura period, such as the *Kongōrikishi* of Unkei and Kaikei (qq.v.) and their disciples, preserved in the Tōdaiji at Nara. The massive muscles, the violent thrust of the bodies, and the ferocity that emanates from every movement illustrate perfectly the qualities of the assistance anticipated from these forces which oppose the evil that threatens man from all sides.

Similar in type are the numerous images of Fudō (Acala), often with many arms, who brandishes his weapons to drive away the malign spirits. The classical Japanese No drama has placed upon the stage many of those wicked and malevolent spirits which swarm unseen, seeking to harm mankind, as well as persons so deformed by sinful passions as to have all traces of human feeling effaced and to be transformed gradually into demoniacal beings. Thus, through the masks intended to portray them, dramatic art has fixed the characteristics or the passions of both these classes of creatures. A special type of mask, such as the *Ō-akujō* with the studied monstrosity of its aspect, represents an interior perversion. Still more fearful in form and spirit are the tengu, which are assigned the mask called *Ko-beshimi* in the No theatre. Also considered demoniacal are the spirits of men who have died in the fullness of their wrath or in vengeful passion or who have been destroyed by anguished yearning for unattainable peace. The origins of these spirits or demons are very remote; but legends have subsequently endowed them with vitality, and the vicissitudes of religious experience have given them new and more complex qualities. These more palpable images have since been assimilated by popular tradition, the theater, and local cults. They are thus the expression of a forlorn primordial humanity, vainly searching for that poise and serenity reflected in images of the gods or teachers of the more advanced and cultivated religions.

Giuseppe TUCCI

*Primitive cultures.* In North America the Kwakiutl of the Northwest Coast had multicolored masks of demons that were half human and half birdlike. These masks were closely connected with the secret societies, and in order to be admitted to one of these societies, a man had to be possessed by a demon. The prospective member wore the mask of that demon during a ritual dance.

The generally close association of demonology with agricultural civilizations is evident among the Hopi of Arizona: here, demoniacal masks were worn during dances intended to increase the fertility of the fields or to bring rain, as well as to ward off illness.

The demons found in farming communities of the plains of Brazil are for the most part spirits of the forest in animal form. The eastern Tupi and the Peressí perform dances that are magic in character, which have the function of inducing the demons to promote the fertility of the land and the reproduction of wildlife. T. Koch-Grünberg, after a long sojourn among the Indians of northwestern Brazil, has collected ample documentation of the masks and the masked dances that are intended to represent the activity of the demoniacal powers.

In the ancient Andean civilizations the innumerable vase paintings in the Chimu and Nazca styles illustrate the diverse appearances of demons in the form of masked dancers: serpents and other reptiles, jaguars, birds, and other figures resembling dragons (PL. 175). The spirits of vegetation, such as the demon of maize and the demon of potatoes, seem to have had great importance among these primitive farmers.

The belief in supernatural powers of demonic character seems — at least in our present state of knowledge — to have been absent in Australia and the greater part of the Oceanian archipelagoes; in all these regions, with a few minor exceptions, there is no iconography related to demons.

In Melanesia, the secret Iniet society of the Bismarck Peninsula is dedicated to a demon who, according to some authors, is represented by the carved wooden figure of a sea eagle. A demonic character is also evident in certain masked dances of the people of New Caledonia, during which there are worn heavy masks of black wood with a distinctive trunklike nose. These probably represent a sea demon.

In Africa images of demons appear only in the upper coastal area along the Gulf of Guinea (PL. 175). Here, as elsewhere, intensive cultivation seems to have been the requisite for belief in demoniacal beings. The masks of forest spirits found among the Mende of Sierra Leone are imbued with supernatural powers that must be rejuvenated periodically by means of magical practices. As a consequence, the wearers of these masks become possessed of supernatural powers. The demoniacal masks of the Guro of the Ivory Coast are credited with a peculiar characteristic: when their edges are pierced for the cords that hold them in place, the masks have to be "consoled."

Friedrich W. FUNKE

REPRESENTATION OF DEMONS IN THE MEDIEVAL WORLD. *Introduction.* The Old Testament rarely makes reference to demons. The words of the Psalms (95:5; A.V. 96:5), "All the gods of the Gentiles are devils," were literally repeated by St. Augustine (PL, XXXVI, 1231-32); consequently, Christianity considered the ancient gods as demons who had originated the pagan myths and caused the persecution of the Christians (Justin Martyr, PG, VI, 335, 442). Elsewhere in the Psalms (21:6-9), there is evidence of apotropaic magic in the figure of the brazen serpent. The New Testament recognizes demons as angels who, under the leadership of Lucifer, have rebelled against God (Luke 10:18; Apocalypse 12:7-10). Together with Satan, the Devil, these fallen angels form the kingdom of evil that tries to destroy the kingdom of Christ. The demons may take possession of men and make them mad, blind (Matt. 12:22-24), dumb (Matt. 9:32-33), or infirm (Luke 13:11-13). It was also believed that Christ was capable of exorcising devils from the possessed.

Demons do not occur in Early Christian imagery; there is only the Devil in the form of a serpent, dragon, or lion. Nevertheless, in classical times pagans, Hebrews, and Christians all believed in the power of demons, which were, however, not yet opposed with magic images but merely with words.

\* \*

*Islam.* At the head of the Islamic demons is Satan (al-Shaitan) — better known under the name of Iblis (PL. 172).

By his side we have the jinn (djin) who were both good and bad, as well as other vaguely defined demons. Satan is represented as the being who is absolutely evil and malevolent. In the guise of the haughty Iblis, he disobeys Allah's command to bow before Adam, because he considers himself superior to man. Like all the other demons, he emerged from fire. Iblis was condemned to hell by God, but he obtained the right to torment those men whom Allah himself selects for him. Individuals who are exposed to Satan's attacks include those who do not believe in God, those who do not follow the way laid down by the Koran, and the worshipers of idols.

The Satan of the Koran may therefore be considered in some ways similar to the Satan of the Old Testament, to whom God granted the power to dispose of Job's property but not of his life; however, he is unlike the Satan described by the Evangelists. The jinn were created before Adam from the clear bright flames of the "fiery furnace" (Koran 15:26–27; 55:14). They may live in community with men (op. cit., 41:24; 7:36; 46:17; 6:128); and some of them follow the ways ordered by the Koran (112:1 ff.; 46:28 ff.), while others are unfaithful (112:6; 6:100). The jinn also dwell in the space between the earth and the sky. Some faithless men worship the jinn, and for this they merit punishment (34:40).

The jinn like the rest of creation are subject to the will of Allah; but Allah may delegate his power to those he has chosen. Thus the jinn were placed at the disposal of Solomon (op. cit., 34:11–12) to perform various tasks (38:36–37; 21:829). No better source than the Arabian Nights can be found to give us information about the appearance of the jinn and of the malign and evil spirits of Islam in general. Some Mohammedan theologians have furnished horrifying descriptions: such spirits may present themselves to man in the guise of serpents, black dogs, or scorpions, and they may also melt into the burning desert wind. Ghouls (Ar., ghūl, evil spirit), on the other hand, may often assume the appearance of beautiful women. The good spirits are almost always very beautiful; and some of them, such as the peris, have mated with human beings and borne children. Among the nomadic tribes these descriptions of the world of demons were restricted to verbal expression. However, even when a school of painting was formed in Mesopotamia in the 12th century and a cultivated ruling class began to desire books adorned with illustrations, the artist found means to represent human beings, animals, and plants, but never demoniacal beings. This deficiency cannot be explained solely by the proscription against representing living beings but must have also been due to fear of seeing evil spirits, or perhaps even good spirits, at work through their representations. One must not forget that belief in the evil eye was — and still is — deeply rooted in the Near East and that it was also thought the eye of an evil being could work harm even when it was merely a painted image. Christian Armenian, Ethiopian, and even Italian and Spanish artists tried to avoid this risk by depicting malign spirits only in profile. The Arabs and the painters who worked for them undoubtedly preferred to eliminate completely the representation of beings that might be dangerous to man. It was only after contact with Iranian culture that representation of some demons became accepted, and then only by the shahs, admirers and patrons of the arts, and by the court dignitaries. This change almost certainly came about through the influence of the Far East. Such influence is recognizable not only in the figure types of the diw, evil spirits found chiefly in Iranian painting of the 15th century, but also in the unusual sculptural quality of these images.

The diw are generally depicted in semihuman form and are covered with hair. They may grimace grotesquely or exhibit animal faces, and their eyes are surrounded with more or less stylized flames. In particular, the Shah-nāma of Firdausi (940 ?–1020 ?) offered the occasion for this type of representation. One of the earliest examples of such figures is seen in a goblet of the 13th century (Detroit, Inst. of Arts), the decoration of which shows Zahhāk, king of the demons, with the two serpents that sprang from his shoulders as the result of a kiss from Iblis, his friend and accomplice. The struggle against Zahhāk and his punishment were to be the favorite subjects of the Shah-nāma miniatures. One of the finest examples is found in the Shah-nāma of Gulistan (at Teheran), a manuscript copied by Ja'far Baysunghuri in the year 833 of the hegira (A.D. 1429–30) for the library of Baysunghur, the son of Shah Run; this miniature shows Zahhāk nailed to the mountain Demavend. In the same manuscript, there is another miniature showing Rustam's combat with a white diw, in which the hero holds his long-nosed enemy by the horns. Other diw are blue, red, pink, and yellow.

In the illustrations for the legend of King Solomon and the Queen of Sheba, the painters brought together various diw, along with all sorts of beasts and jinn. Thus we see in a Treatise of Marvels, copied in 1388 (Paris, Bib. Nat., Ms. supp. Pers. 332), a miniature showing the jinn bearing the throne of the Queen of Sheba into the presence of Solomon. Another miniature (formerly Coll. Vignier, 14th–15th cent.) portrays a grotesque diw being chained by two peasants. Nevertheless, even if the Mohammedan painters frequently dared to represent jinn and the diw, they were less tempted to represent Satan himself. A notable exception is a miniature representing Satan in the presence of Adam and the angels (Istanbul, Topkapi Palace, 15th cent.). Exceptional also are the illustrations of a manuscript containing the Mirāj-nāma in the Uigur language, a description of the Prophet's journey to heaven and his descent to the nether regions (Paris, Bib. Nat., Ms. supp. Turk. 190). According to E. Blochet, this copy of a work translated from the Arabic was made at Herat in 1436. In his miniatures the artist represents the tortures of hell, and accordingly a great host of devils with horrible bodies and blue eyes, for blue was the color of evil influences. At the door of hell is Satan himself, wearing a crown and receiving Mohammed. In the same manuscript is also depicted a gathering of peris in a paradisiacal landscape; some of these have large flowers in their hair and give the appearance of fairies. A similar subject is represented in a miniature (formerly Coll. F. Sarre) that E. Kühnel has attributed to an artist of Western Turkistan and ascribed to approximately the year 1500. In this work a diw acts as guardian, and the winged peris are dressed in the style of the late 15th century and are shown banqueting, making libations, and dancing. There are other examples of Islamic representations of demons which are of secondary importance and which do not merit detailed description.

Wilhelm STAUDE

*Barbarian world.* The Germanic tribes had two contrasting forms of magical representations. In the Bronze Age they had known only the benign power of the sun and the efficacy of faith, which incurred the favor of the gods. At the time of the Barbarian migrations there arose instead the magical recognition of demons, and their exorcism was represented in numerous images. Evidence of this representational apotropaic magic can be found in the following:

1. In the laws of the vikings (Land-nāma-bók, 95) it is said that "one must not sail toward the land with open jaws"; that is, the dragon heads must be removed from the prow, "lest the spirits of the land be frightened." The dragon heads of the viking ships, as seen in the ship burial of Queen Asa (ca. 850) from the excavations of Oseberg (PL. 176), perhaps originated in the spiral form of the prow, or they may have been taken over from Mediterranean culture, for the Assyrian, Egyptian, and Cretan ships already bore the heads of animals on their prows (Köster, 1923, pls. 10, 13). This device is seen also in the provincial Roman ship on the funerary monument of Neumagen (Trier, Rhein isches Landesmus.). Among the vikings the prow dragons probably appeared in the 8th century, thereby transforming into a magical element what had been purely ornamental. Such heads also appeared on tents and sledges to ward off evil.

2. In other carved figures on the Oseberg ship and on the furnishings (Osebergfundet, 1917–27) are depicted hybrid figures of dwarfs and fish; ribbons of animals biting each other's tails, which serve as cornices; monkeys with staring eyes; and other bands of animals shown biting each other in a general melee, as if in an infernal struggle of mutually hostile spirits and

demons — forces by which the vikings evidently felt they were surrounded.

3. Other images that certainly represent demons include those on the West Frankish fibulas of the 6th century, upon which occur monsters in the form of weasels, as well as one similar to a hippopotamus. The latter is, it may be conjectured, the Grendel from the Beowulf saga, who every day carried away for his food a Dane from the great hall and who was killed by Beowulf in his dwelling on the moor (G. Hübener, 1930, chap. 3).

4. A similar purpose may be attributed to the "motif of menace," which is frequently found among pagan Germanic remains. The Galsted silver fibula of the 6th century shows a human head that two confronted monsters are preparing to devour (PL. 176). In the same way, two monsters threaten two human heads on a silver ferrule found at Nydam bog (Schleswig, Schleswig-Holsteinisches Mus.; 5th cent.).

At Sutton Hoo, northeast of London, in a ship burial (probably 7th century; I, PL. 286) was found a purse lid on which two men are shown frontally, with each flanked by two monsters who bite his head. In the center are demons beating down birds.

5. The persistence of demons in popular belief also attests their purported magical powers. In Scandinavia they are called "trolls"; in Germany, "Alben." The *Albdruck* is the weight of the demon on the chest of a dreamer (*Handwörterbuch des deutschen Aberglaubens*, 1927, 1932–33, s.v. Alp, Kobold).

*Medieval Christian world.* In the early medieval period Christianity mingled the early Christian belief in demons with that of the Germanic tribes. Belief in demons, which among the first Christians had characterized an inferior expression of the faith, became from the Romanesque period onward a theme as valid as the representation of divine powers. Representations of the demons in the Middle Ages were no longer used, as among the Germanic tribes, to exorcise the demons of nature, but to subdue the sinful instincts of men. Characteristic, in this respect, is the image of a church embroidered on the arras of the church of Skog, Sweden (PL. 176). The figures inside, which are visible as in a cutaway child's drawing, represent the community. Flying from the right-hand side — that is, from the west — toward the bell tower are two gigantic demons, who are held at bay by the church bells and the apotropaic heads of animals placed on the ends of the architrave. In many churches in Europe, St. Michael, the leader of the struggle against the demons, has a similar function, and his altar is at the western end. Facing the west, the direction from which all that is hostile to God proceeds and whence the demons launch their attacks, St. Michael protects the vulnerable back of the community as it prays turned toward the east. The motif of menace reappears throughout Europe in the 12th century on many capitals, usually inspired by pagan imagery or the theme of Daniel in the lion's den.

Several sources contributed to demonic representations in the Romanesque period. Many of these images repeat the fantastic beasts and beings depicted in classical antiquity; these reappear first in the miniatures and, from 1100 onward, also in the sculpture adorning buildings. The lions, bulls, and rams, as well as the fantastic creatures such as griffins, sirens, harpies, and centaurs, were assimilated from the East into the works of classical antiquity, or in some instances were perhaps created for these. They are present in literature from Homer onward: in Aristotle's lost work on rare animals, in the *Natural History* of Pliny the Elder, and in the *Physiologus*, a work probably written at Alexandria in the 2d century of our era and translated into almost all the European languages (C. Cahier and M. Martin, *Mélanges d'archéologie*, ser. I, 1851, p. 85 ff.; III, 1853, p. 203); from these ultimately derived the bestiaries that were to be a major source of inspiration for miniatures and sculpture. St. Augustine also described animals in *The City of God* (Book XVI, chap. 8). Particularly in France, another source was the Oriental fabrics and furnishings which were found in most churches but which were largely destroyed during the Revolution. In most examples the figures of animals were merely decorative, as E. Mâle (Mâle, I) and K. Künstle have pointed out.

In Romanesque art the following demoniacal figures appear:

1. The Devil, the prince of demons called Satan, Beelzebub, or Diabolus. In the early centuries he was represented only symbolically, as a serpent (Gen. 3:1 ff.), sometimes with a human head; or as a sea monster (Isa. 27:1), a dragon (Apocalypse 12:9), or a lion (I, Pet. 5:8). In the Middle Ages he appears in human form in the Descent into Hell, as Lord of the damned in the hell of the Last Judgment, and as the Tempter of Christ, St. Anthony, Job, Cain, and Pilate. In the Byzantine version of the theme Christ descended into hell, chained its lord, strode over him, and stretched out the hand of salvation to Adam. In the West, the 11th-century frescoes of S. Maria Antiqua and S. Clemente in Rome took up the Descent into Hell theme; and it was only in Western art that the Devil offered fierce resistance. Later he was depicted as a dragon or with the gaping jaws of a beast. In the inferno scene in the Camposanto of Pisa (ca. 1350) he presides in the form of a giant composed of iron breastplates. In the Last Judgment there, the Devil seizes the sinners and tries to cheat in the weighing of the souls and to torture the damned. The ancient Kronos and Saturn, devourers of men, are fused with Oriental figures, the Ba'al of Babel and the Milcom (Moloch) of the Ammonites, in a single image of the Devil as devourer of men. As such, he is shown possibly for the first time in the Psalter of Utrecht, which illustrates Psalm 9. The theme culminates in the 13th century with the vault mosaic in the Baptistery of Florence (PL. 177), in which the giant, his throne, and some serpents are all swallowing up human beings. In the hell of the *Hortus deliciarum* of Herrad von Landsberg, the Devil holds on his lap a figure that may perhaps be that of the Antichrist (A. Straub, 1879–99, pl. LXXIII).

The temptation of Christ by the Devil is described by St. Matthew (4:1–11) and St. Luke (4:1–13). In Syria the Tempter is represented as an eidolon, a small winged being; and in Byzantium he is portrayed as a handsome youth (Paris, Bib. Nat., Gr. 510, 9th cent., from an earlier source). This interpretation is followed in the Carolingian Sacramentary of Drogo (Paris, Bib. Nat., Lat. 9428, ca. 842) and in the Gospels of Otto I (Aachen, Cathedral Treasury) and of Otto III (Munich, Bayerische Staatsbib., Clm. 4453, ca. 1000), in the last of which he is depicted as clothed in rags. The process of the Devil's physical degradation is carried further in the Gospels from Echternach (Bremen, Stadtbib., Cod. b. 21, ca. 1040), and he appears similarly degraded in Giotto's *Pact of Judas* in the Arena Chapel in Padua. He has a human figure also in the parable of Lazarus and the worldly rich man (Luke 16:19–31) in the porch at Moissac and in the *Psychomachia* (Brussels, Bib. Royale, Mss. 9968–72). The first temptation of St. Anthony appears on a capital in the narthex at Vézelay (12th cent.).

The depiction of the Devil as a terrifying bestial monster is developed in the 12th century (capitals at Vézelay, Beaulieu, Souillac). Here he has become merged with the satyr of antiquity, who had the pointed ears and beard of a goat (the symbol of lust for the Greeks), a hairy body, and cloven feet, sometimes replaced by a bird's claws. The mouth is set in a wide grin that bares the teeth. Besides the wings on his shoulders, he has now sprouted others (borrowed from Hermes or the Gorgon) on his legs or posterior. He appears thus on the west porch of the Cathedral of Arles and in the Last Judgment at Burgfelden (ca. 1000), as well as in the cathedrals of Chartres, Reims, Paris, Amiens, and Bourges during the 13th century. The Pisan sculptors placed the satyr-devil on the pulpits of the Cathedral of Siena and the Baptistery of Pisa. In the 14th century the Devil was given bat wings, which were derived from the dragons of China by way of the Middle East. These are found in Giotto, as well as in the Triumph of Death in the Camposanto at Pisa. Perhaps through the influence of the mystery plays, the Devil was now ridiculed as the fool who is deceived by Christ, first in the Gospels from Echternach and later in the altarpiece of Master Bertram from Grabow (Hamburg, Kunsthalle, 14th cent.). This comic element is also found in England (*Life of St. Guthlac*, Br. Mus., Harl. Y6); but in France and Italy the Devil is not shown as a comic figure. In the late Middle Ages the Devil and his train of demons assume fantastic forms, some-

times even the forms of insects, as in scenes of the temptation of St. Anthony.

2. The followers of the Devil. When Christ exorcises the Devil in the land of the Gadarenes, the obscene spirit replies to Christ's question: "My name is Legion: for we are many" (Mark 5:9). The Devil is their master (Mark 3:22). The origin of the army of demons is traced to the fall of the angels from heaven after their rebellion against God (Isa. 14:12; Apocalypse 19:20; 20:2). St. Augustine (*City of God*, XI, 9) describes the fall of the angels as having occurred during the first day of Creation, when God divided the light from the darkness. In the Mount Athos treatise on painting the description reads: "Lucifer and all his army fall from heaven. Many when on high still appear very beautiful, lower down they become angels of darkness... still lower down they are half angels and half devils; at the end they have become completely transformed into horrible black demons." This transformation was shown in the destroyed *Hortus deliciarum* (fol. 3b from copies); in the frescoes of St. Quiriace, Provins; and in the Psalter of St. Louis and Blanche of Castile (Paris, Bib. de l'Arsenal, Ms. 1186). In the Utrecht Psalter (Bib. der Rijksuniversiteit, Script eccl. 484, 9th cent.) the demons are winged men who fight against the angels. The Bamberg Apocalypse (Staat. Bib., Bibl. 140, early 11th cent.) represents the demons as frogs (H. Wölfflin, *Die Bamberger Apokalypse*, Munich, 1918, pl. 39).

In exorcism scenes demons are represented as small slender figures, generally with wings. These figures are derived from the eidolon, which in antiquity represented the human soul that descended into Hades after death, and which was often shown on vases and gems. They are placed, for example, on Hector's body as it is dragged behind the chariot or on the body of Achilles supported by Ajax (A. Furtwängler, *Antike Gemmen*, Leipzig, Berlin, 1900, pl. XVI, no. 19). In this guise are also depicted the fleeing devils of Gadara and a devil who is seen being exorcised in the *Hortus deliciarum* (Straub, 1879–99, pl. XXX). In sculpture, there is a representation of an eidolon on an ivory of the 10th century in the Darmstadt Landesmuseum. On the bronze doors of the Cathedral of Gnesen in Poland and of the Church of S. Zeno Maggiore at Verona, the demon exorcised is shown as a small devil in human shape. The devils of discord that Brother Sylvester chases from the city of Arezzo in obedience to the orders of St. Francis (Assisi, S. Francesco, upper church) are anthropomorphous but are also winged. In the Triumph of Death in the Camposanto of Pisa, the demons are doglike monsters. Sometimes the demons are shown in human and animal form in the same miniature (A. Boeckler, *Das Stuttgarter Passionale*, Augsburg, 1923). Various animals have been used as symbols of demons.

3. The lion, who may be a symbol for the Devil. In the first Epistle of St. Peter (5:8) the following description is found: "The Devil goes about like a raging lion, seeking whom he may devour." In Psalm 21, verse 14 (A.V. 22:13), we read also of the raging and devouring lion. Still today every Mass of the dead contains the prayer "Libera eos de ore leonis" ("Free them from the mouth of the lion"), according to Psalm 21, verse 22 (A.V. 22:21). The lion symbolizes the Devil when he has his fangs in a bull (Pescia in Tuscany, pulpit support in the cathedral library) or has a man in his jaws or between his claws (Trent, Cathedral; St. Zeno, near Reichenhall, Austria; Fidenza, Cathedral, west porch; Modena, Cathedral, porch; Königslutter, abbey church). This fight between animals originated in Sumer and was passed down to classical antiquity through the Hittite and Minoan seals. In the Middle Ages the man in peril was used to illustrate Psalm 69: "Deus in adjutorium meum intende" ("Come to my assistance, O Lord"; Freising, Cathedral, crypt column with animals).

4. The dragon, represented as a winged lizard with four claws, as an asp with two claws, or as a basilisk with a cock's head that issues on the seventh day from a cock's egg, always with a tail knotted for the purpose of exorcism. The basilisk appears in the 11th century in a relief now in the museum at Sorrento and in the 12th century on a capital at Vézelay. Its diabolical connotation originates in the following text: "Rex est serpentum basiliscus sicut diabolus rex est daemoniorum."

("The basilisk is the king of serpents, as the devil is the king of demons.") The dragon is conquered by the archangel Michael, the leader of the fight against the demons; by St. George; or by an exorcism beneath the image of Christ (Isen, Bavaria) or on capitals (Como, S. Abbondio; Kilpeck, Hereford, south portal of church; Freising, Germany, Cathedral, crypt pillar; S. Pietro near Cividale, arch painting). From the 14th century onward the dragon, like the Devil, exhibits the bat wings that originated in China. The first representation of this type is in the Psalter of Edmond de Lari (d. 1258) in Belvoir Castle. There is frequently a horseman fighting the dragon (façades of S. Zeno Maggiore, Verona, and S. Michele Maggiore, Pavia), and at times he is rescuing another horseman who is already half swallowed by the dragon (Basel, Cathedral, choir capital; Andlau in Alsace, lunette; Staubing in Bavaria, St. Peter, lunette; R. Wiebel, 1924).

5. The serpent with the apple, also an image of the Devil (Gen. 3:1-6). He is spewed forth by demons in the north portal of the cloister of S. Isidoro in Léon; he is represented for the first time with a human head in 1181 in Nicholas of Verdun's altarpiece at Klosterneuburg, near Vienna. He emanates from the head of the Devil in a capital of the lower church at Quedlinburg.

6. The centaurs, demons (Isa. 34:14, "et occurrent daemonia onocentauris") who are used particularly as symbols of heresy. For St. Jerome they also symbolize the Devil (PL, XXIII, 22). They carry a bow and arrow in imitation of the archer of the Zodiac, who is represented as a centaur (Augsburg, Cathedral, bronze doors; Regensburg, St. Emmeram, cloister).

7. Sirens with the bodies of birds and human heads, which are sometimes bearded. In ancient times these figures represented the demons of death or the spirits of the dead, because the ancients imagined the human soul in the form of a bird. The sirens were essentially similar to the Harpies and the Erinyes. They come from Hades and are able to fascinate men, as they fascinated Ulysses; therefore they are described in the *Hortus deliciarum* (fol. 44) as seductive passions that sometimes ensnare men. Honorius of Autun considers them to represent concupiscence, vanity, and greed (PL, CLXXII, 855). In the Middle Ages the demons that were half woman and half bird were called Harpies (Modena, Cathedral, capitals; Arles, Mus. d'Art Chrétien, capital demon figure with the body of a bull); whereas the sirens appear from about the 6th century onward (cf. ms. *De Monstris*, pub. by Berger de Xivray, 1836, VIII, p. 25) as women similar to the Nereids and have a double fishtail, the ends of which they hold in their hands. They appear in the bestiaries of the 12th and 13th centuries, and in an inscription at Pesaro they are designated "lamiae," from the Greek *lamia* (cf. also Florence, Mus. Naz., decorated pilaster; Pisa, Baptistery, roof corbel; Regensburg, St. Jakob; Königslutter, abbey church, where they have wings and knotted tails).

8. Among the innumerable other hybrid creatures who do not follow the natural order and are therefore demoniacal, there are men with the bodies of snakes (Ancy-le-Duc, Saône-et-Loire) and pairs of birds that share the head of a man (Saint-Aignan-sur-Cher). Many different kinds of hybrids are found in the St. Gallus portal of the Cathedral of Basel.

With the arrival of the Gothic, the demons were relegated to the adornment of waterspouts and became gargoyles. Besides the symbols of the sacred world, the portals now displayed only certain aspects of the secular world: symbols of the months, the activities of the months, and the seven arts. In France after about 1190 the capitals had only foliage decoration. In the Gothic style, dread of the demons melted into humor. They became *drôleries*, or grotesques in the choir stalls (PL. 178) and the borders of illuminated manuscripts; they were largely amusing curiosities. Nevertheless, some contrast between the sacred and the profane was still maintained in the choir stalls and miniatures. The grotesques were not purely amusing, for in some degree they continued to represent the demonic element, exorcised by the holiness of the Scriptures. On the choir stalls and manuscript borders there developed a whole fauna of demons, the monstrous product of exotic fantasy,

inspired chiefly by the influence of the Orient. These marginal creatures of fantasy betokened the more realistic style that was beginning to emerge.

<div align="right">Hans WEIGERT</div>

*Medieval traditions and the beginnings of the modern world.* In the late Gothic world, especially in the north, as if by way of deliberate reaction to the rational temper of the Renaissance, which was evident even in the religious field, there was a widespread revival of demoniacal iconography. This was promoted by intensive study of the relief carvings of the ancient world. This revival was associated with mystical tendencies and arose from the same cultural background that had produced a body of sacred imagery which was dramatic and full of expressive grotesques. In a sense, it might be said that all Nordic religious imagery is imbued with the demonic spirit and often has a demonic significance allusively expressed. Obviously, in this hospitable context, many Italian Renaissance themes such as the grotesques were retraced to magical connotations which they may have originally embodied but which they had later lost. As in the Middle Ages, many demoniacal attributes were derived from imagery on ancient gems; from sculpture with magical and religious representations, sometimes even pre-Roman; and from remote medieval precedents and heretical subject matter. Naturally, the influence of Biblical texts, particularly from the Apocalypse, was very great. There was also the influence of popular hagiography and tales, which in turn had been inspired by very archaic literary prototypes, sometimes transmitted with great accuracy and attention to detail. Nevertheless, the chief literary source was St. Athanasius' *Life of St. Anthony*, which was already famous throughout the Middle Ages and acquired special importance during the Renaissance because of the emphasis given in religious devotion at this time to the theme of temptation, particularly associated with the legend of this saint. In the development of illustrations for this theme, there is a vast array of the artifices of the Devil. Other literary sources, according to Castelli, were the works of St. Augustine, those of Albertus Magnus, the *Ars magna* of Raymond Lully, the numerous editions of St. Gregory's *Magna moralia*, the treatise *De lamiis et pythonicis mulieribus* by Ulrich Molitor, the *Malleus maleficarum* by Jacob Spraenger and Heinrich Institor, the *Visio Tundali*, the *Golden Legend* by Jacopo da Voragine, and others. Almost all these works were widely diffused with the development of the printing press, a fact which probably explains the revival of monstrous and demoniacal iconography from the middle of the 15th century onward. To these sources must be added the geographical treatises, which contained descriptions of monsters that dwelt in unexplored lands. Stylistically, the demonic is related to the macabre and the monstrous and comprises one sector of the exploration of the unnatural. The Devil appears as an admixture of incongruous elements, often derived from magic or alchemy or from the bestiaries but put together with emphasis on a naturalistic expression that gives him an aspect of physical reality (PL. 170). A subspecies is that of the witches, often depicted as naked old women. The precise details generally denote, in the work of the best artists, a careful study of the works of nature, particularly reptiles and insects. The popular theater naturally exerted a strong influence, as did the masks and the folk festivals.

Through such influences the demonic world came to assume, in many regions, a sort of Alpine flavor with numerous appearances of wild woodland folk, etc. Another new feature is the liveliness of the imagery, which is due not only to the artist's preoccupation with expressiveness but also to the deliberate opposition of this dramatic northern conception of the world to the static and contemplative ideal characteristic of the Mediterranean Renaissance. The most important manifestations of Nordic demonology, in fact, coincide with the turning point of the Renaissance (see MANNERISM). Here, one might recall the well-known study made by Michelangelo from one of Schongauer's (q.v.) most terrifying graphic inventions. In northern Europe demonology was divided, as has already been indicated, into two ambits or phases. In the Flemish world, with Bosch

(q.v.), there was what really was more a symbolical system, very complex and sometimes difficult to interpret, through which the demonic was presented as another realm of nature perceived through an almost dreamlike process (PL. 180).

In the German world and among other Flemish artists such as Bouts and Pieter Bruegel the Elder (qq.v.), the subject is the struggle between two opposing powers, often with the tragic sense of the conquest of good by evil. An illustration of this is the scene of the temptation of St. Anthony in the Isenheim altarpiece by Grünewald (PL. 180), or the same subject depicted by Niklaus Manuel (q.v.) in a panel in the Berne Kunstmuseum. The demoniacal apparitions operate in an apocalyptic atmosphere: they split the darkness of night and are at home in terrifying, woody or mountainous landscapes, thus giving rise to an attempt to portray effectively the truly supernatural (see SUBLIME, THE). Most probably these images were officially favored by the Protestant Reformation partly because of their popular appeal; in fact, they mark the revival of a great medieval tradition. In Italy the representation of demons is very rare; of great interest, however, is Bernardo Parentino's panel of the temptation of St. Anthony (PL. 179). Many artists, in particular Signorelli and Michelangelo, display a profound interest in this theme, but their treatment of it is still affected by their interest in the anatomical interpretation of the human body: the Charon of the Last Judgment in the Sistine Chapel seems derived not so much from hagiographical sources as from ancient images of the Laocoön; this is also true of at least some of the fearful figures in Orvieto Cathedral (PL. 179).

The Counter Reformation approached the problem of the demon world in a more abstract manner; however, since it did consider the demons as existing in reality, it was recommended that they should be represented according to the descriptions left by the Church Fathers. Actually, such preoccupation with fidelity to historical truth robbed the demonic imagery of its dramatic, exciting, and fearful aspect, and — in accordance with the thesis that the demons were but fallen angels — the representation once more became anthropomorphous. Nevertheless, the color of their skin remained dark, their eyes were fiery, and vapors suggested their abode in the nether regions. In various examples they continued to allude to the Biblical serpent. Thus they differed from the representations of witches and from other scenes that even by the 17th century, as in Callot and Salvator Rosa (qq.v.), had almost the character of grotesques.

<div align="right">* *</div>

*Popular and folk art.* The Devil is one of the key personages of popular superstitious belief; therefore it is not surprising that his image is found frequently in the folk art of all periods and all countries. The folk artists, like their more cultivated medieval and Renaissance counterparts, depict the Devil as a man with a repulsive face, horns on his heads, and sometimes a shaggy body, bestial limbs, and a long coiling tail. He is often armed with a trident with which he tosses souls into hell, which is represented as the cavernous throat of a monstrous animal.

Some of the earliest popular images of the Devil are contained in the *Vigilie mortuorum*, a small volume printed in the early 16th century at Rouen. In one of these illustrations (fol. LXXXIV) he is portrayed with the horns and face of a goat, a hen's neck, arms ending in great talons, bat wings, and a tail resembling the tentacle of an octopus. In another scene in the same book (fol. LXXXII), which shows a man on his deathbed, two devils of varying aspect are depicted. One, lying on the ground beside the bed, has a very long face, a beard, horns, the limbs of an animal, and a human body covered with scales; he has no wings. The other, who seems to be creeping out from under the bed, has a pig's snout, horns, animal limbs, and a very long tail; the upper part of this body is covered with feathers, and he is also wingless. A devil with more human features is to be found in the illustrations of a popular little volume entitled *Il sogno del Caravia* (1541). In this, although he still has horns, his face and body are those of a man and he is wingless. Also without wings is the devil image in some Swiss prints, preserved in the Zentralbibliothek of Zurich,

and in a very old French popular print contained in a Troyes edition of the *Danse macabre*. In both of these, moreover, the features of the Devil, although monstrous, are still anthropomorphic. Only in comparatively recent times have the popular artists, evidently following the example of the more cultivated, begun to attribute to the Devil a more bestial aspect. Although he is sometimes depicted with a bird's head, a viper's tail, and other very abnormal physical features, his appearance has commonly become conventionalized as that of a man with bat wings, horns, normal arms which sometimes end in great talons, and cloven feet or hooked claws like those of a bird of prey.

The Devil is shown with bat wings, horns, the claws of a bird of prey, and a green and yellow body like that of a salamander in certain cartoons (some of which are preserved in the municipal library at Quimper in France), features similar to those used by the popular storytellers. Some of these were used during the first half of the 17th century by Michel Nobletz to illustrate his evangelical preaching in Brittany. Throughout Europe the horns, cloven feet, and bat wings are characteristic features of the anthropomorphic Devil in the votive tablets that, from the 17th century onward, record the miraculous cures of people possessed of devils. Similar images of the Devil are also found in the 19th-century cartoons of Sicilian storytellers (Palermo, Mus. Pitrè) and the devotional prints of all European countries (PL. 182). No less common and persistent among the popular artists is the representation of the Devil in the guise of a dragon or winged serpent. In one of the cartoons of Michel Nobletz, he has the appearance of a winged serpent and is depicted in flight. Nevertheless, the representation of the Devil in this guise is somewhat of an exception. In fact, he assumes this aspect only in the prints and popular paintings on glass (very common in Eastern Europe) representing the fight between the archangel Michael and Lucifer or St. George slaying the dragon — that is to say, in well-defined and invariable iconographic types.

<div align="right">Antonio BUTTITTA</div>

THE DEMONIC SINCE THE 17TH CENTURY. The representation of demons in the "high" religious art of the 17th century is not frequent in comparison with the medieval contribution to demonic iconography. This earlier body of work had been stimulated by Oriental influence [Baltrusaitis holds that some infernal beings painted by Chao Mêng-fu (q.v.), a painter of the court of Kublai Khan, were seen by French missionaries and in this way may have passed into European art] and by popular traditions rooted in very ancient cultures. Examples from this period will be found not in that "Biblia pauperum" which comprised the decoration of the medieval cathedrals, but in the popular literature of devotional readings that contained the religious "emblems" which were to prove particularly useful to the Jesuits. A Jesuit, Herman Hugo, was the author of the widely circulated volume which may be said to have started this literature: the *Pia desideria emblematis, elegiis et affectibus SS. Patrum illustrata* with illustrations by the great Baroque engraver Boetius of Bolsward, printed at Antwerp in 1624 by Aertssen and reprinted in very many editions. It had many imitators, among others the mystical Madame Guyon at the beginning of the following century.

The ninth emblem of the first book illustrates Psalm 17: "Dolores inferni circumdederunt me, praeoccupaverunt me laquei mortis." ("The pains of hell surrounded me, the snares of death oppressed me.") Anima, the soul, in the guise of a young maiden, falls into the trap prepared by a skeleton lying in wait for her and is about to be devoured by a band of black devils; a demon hunter with the snout of a dog, three feathers on the crown of his head, clawlike feet, a hunting horn about his neck, pendulous breasts, and three snakes brandished in his right hand approaches, followed by two horned, shaggy, and long-eared hounds that are also diabolical. This is the theme of the demon huntsman, which had already appeared in a German caricature at the time of the Reformation in a scene showing a Pope, some monks, and their mistresses pursued by a pack of baying hounds and assailed by demons. It was also the subject of a poem called

*Daimons* by Pierre de Ronsard : "Un soir vers la minuict..../ J'ouy, ce me semblait, une aboyante chasse/De chiens qui me suivaient pas à pas à la trace./Je vis auprès de moy sur un grand cheval noir/Un homme qui n'avait que les os, à le voir,/Me tendant une main pour monter me en croupe.... " ("One evening, toward midnight... I heard, so it seemed, a clamorous hunt. Dogs followed my track step by step. I saw behind me on a great black horse a man whose form consisted only of bones. He held out his hand to lift me to the back of his mount.... ") This motif of the demon huntsman was to enjoy great favor in the romantic period in the various forms it assumed in the works of Bürger, Heine (*Atta Troll*), Victor Hugo, Carducci (*La leggenda di Teodorico*), and even down to Verlaine (*Cauchemar*); among the painters it was taken up by Louis Boulanger, Ary Scheffer, Tony Jahannot, and especially Delacroix, who painted Faust and Mephistopheles mounted on demon chargers with flying manes, about to hurl their riders into the abyss.

Among the emblems of the Jesuits in the *Pia desideria* appear some accessory allegorical figures who personify various aspects of the idea of evil; these figures will recur often in the books of sacred emblems. They include the jester with his cap and bells, a symbol of worldly folly; the richly dressed lady holding a fan and a goblet from which there rise bubbles, symbol of the vanity of this world; and the skeleton armed with a sword, the emblem of death. These accessory figures frequently occur in the vignettes of another delightful little volume published at Antwerp in 1626 with the title *Amoris divini et humani effectus*, and later in 1629 as *Amoris divini et humani antipathia*. It was also published in France and Austria. This work resembles in its general conception the *Antithesis Christi et Antichristi* of the Protestants (Geneva, 1578): the works of the Devil are contrasted with the works of God, and the effects of worldly love with those of divine love. Michael Snyders and Gillis van Schoor designed the emblems for the work.

In the fourth emblem (*Navigium amoris*) the ship of divine love, bearing the symbols of the Passion, is approached by a skiff rowed by a human creature who is threatened from behind by a devil. However, from the divine ship a volley from a harquebus is fired at this devil, who is the usual deformed, paunchy, long-eared being with bat wings that is already familiar from medieval representations.

Similar in form are the diabolical beings who appear among the flames in the fifth emblem of the second book (*Babylon amoris*) and in the flaming interior of the globe in the twenty-second emblem of the same book (*Incuria amoris*). They also guard the prison of Anima in the thirty-first emblem, but here they are dressed in armor and bear halberd and lance (*Auxilium amoris*). In the twenty-third and thirty-ninth emblems of the third book (*Extasis amoris*) the Devil, with bellows, is close to the ear of Anima, who clings to the Cross and is surrounded by the instruments of the Passion. Here he has the body of a satyr, a lion's face, horns of a bull, and bat wings.

Similar images occur in *Typus mundi* (Antwerp, 1627), in which, however, the twenty-seventh emblem contains more bizarre elements — though even these are extremely mild when compared with the fantasies of Bosch. From the crystal globe of the world, like a monstrous chicken from an egg, issues a foul creature, a tiny winged homunculus with an owl's head and armed with a bow and quiver. Thus worldly love is revealed in its true nature as an aspect of evil.

In *Cor Jesu amanti sacrum*, the series of engravings by Anton Wierix used in many emblem books (Etienne Luzvic, *Le cœur dévot trône royal de Jésus pacifique*, Salomon, 1626), the Devil has the face of a bearded man with horns, as well as the body of a satyr with the tail of a lion and bat wings. In another of these emblems Jesus enters the heart bearing a lamp, and the glow sets to flight the toads, serpents, and all the slimy beasts that occupy the cavern. In yet another he sweeps away from the heart a swarm of these filthy creatures, among which are serpents, lizards, a little devil of the usual type, and so on. In fact, we find few variants in the conventional representation of the Devil in these emblems. Sometimes, as in the *Imitatio Crameriana* (Nürnberg, 1647), instead of the human face of the customary faunlike devil, there is the head of a

bird of prey; that is about the most extensive deviation from type.

Not even the highly imaginative 19th-century artist Robert Cruikshank, in the first of his illustrations for *Divine Emblems... after the Fashion of Francis Quarles* for Johann Albricht (London, 1838), could give the Devil any other shape than that of a horned satyr with bat wings. Such is the Satan of Delacroix, shown in flight through a stormy sky over the spires of a city. This same being, horned and armed with a trident and often with a beak, is found in the lithographs by Quinart that illustrate the strange work of A. V. C. Berbiguier de Terre-Neuve du Thym, *Les farfadets, ou tous les démons ne sont pas de l'autre monde* (Paris, 1821).

To find in the 17th century any of the prodigious inventiveness of Hieronymus Bosch in the province of the demonic and grotesque, so rich in sinister absurdities, one must turn to the *Temptations of St. Anthony* of David Teniers and Jacques Callot, which were certainly inspired by the engravings of compositions by Bosch and Pieter Bruegel the Elder then circulating in Italy. Callot, in typically mannerist style, succeeded in combining the extremes of affected elegance and monstrous ugliness in clever representations in which the surrealism of the 20th century was to find one of its sources. This movement was also to acknowledge its debt to the fantastic allegories and anthropomorphous landscapes of the 16th-century artist Giuseppe Arcimboldi, whose *capricci* are imbued with a hallucinatory atmosphere, the voice of chaos.

Nevertheless, it was the 17th century which saw the stereotyped medieval mask of Satan give way, through the influence of the poet G. B. Marino (who had endowed Tasso's devil with a Promethean melancholy), to the heroic figure of Milton's Satan, who maintained the nobility of his angelic origin despite the loss of this original innocence. Thus Milton conferred upon the figure of Satan all the fascination of the indomitable rebel that had previously characterized the Prometheus of Aeschylus and the Capaneus of Dante.

With Milton the Devil finally assumes the air of degenerate beauty and splendor overshadowed by melancholy and death — majestic though in ruin. The figure of the Adversary becomes strangely beautiful, not in the ephemeral way of those sister sorceresses Alcina and Lamia, whose apparent beauty is due to enchantment and is a vain illusion that dissolves into ashes like the apples of Sodom. An accursed beauty is the permanent attribute of Satan; the thunder and the stench of Mongibello (Mt. Etna), relics of the sinister figure of the medieval Devil, are gone. In Milton's own century, however, one would search in vain for any representations of Satan inspired by this new conception. The first artist to express it was William Blake (q.v.) at the beginning of the 19th century in his *Satan Calling His Legions*, illustrating Milton's *Paradise Lost*. Here the heroic figure of Satan is twin to that other invented by Blake to represent *The Spirit of Nelson Guiding Leviathan*. It must be remembered that Blake in his *Marriage of Heaven and Hell* (1790) had stated that, while the good is the passive element which obeys reason, evil is the active element which springs from energy. In the wake of the Encyclopedists and the *Système de la nature*, Blake had arrived at conclusions similar to those of the Marquis de Sade. Evil, in the form of an angry and deformed Michelangelesque conception, is one of the dominant themes of the illustrations with which Blake adorned his *Prophetic Books*.

The Swiss Henry Füssli (or Fuseli, q.v., as he spelled his name in England) was akin to Blake and was to some extent his teacher. Since Fuseli's most impressive picture — famous ever since its appearance in 1782 — is the *Nightmare* (Detroit, Inst. of Arts), and since he said that "one of the least explored regions of art is that of dreams," he has been acclaimed as the painter of dreams and the subconscious. Moreover, since in him Michelangelesque anatomy is combined with the violent and unrestrained gestures of the Shakespearian theatre as represented in London at the time of his visit, the expressionists have hailed him as a forerunner. Such indeed he was, for his heroes were already animated by the Titanism of the superman. The violent action of his stories inspired by Nordic myths or the Ho-

meric poems, or by the supernatural world of Milton, seems to evolve in an amorphous and cataclysmic world, a magical world. His heroes and heroines wear strange improbable robes and towering coiffures, looking like sea anemones or the wing cases of beetles. (Fuseli was a coiffure fetishist). His fury and his pomp seem aimless, as in a dream. For all these reasons surrealists have drawn inspiration from him, and the existentialists have been fascinated by the intensity of the passion that invests his haunting, possessed creatures. This painter of nightmares and satanic women (for example, the drawing *Brunhilde Watches Gunther, Whom She Has Bound to the Ceiling*, Nottingham City Mus.; reproduced in G. Schiff, *Zeichnungen von J. H. Füssli*, Zurich, 1959, p. 47) is a contemporary of the painter of the *Caprichos*; but he is also contemporary with the authors of the "black romances" and with De Sade, with their atmosphere of outlaws, prisons, and tyrannical and fatal deeds. Nevertheless, his work is too theatrical to convey the depths of horror of Goya (q.v.); his men are like galvanized robots. There is always in them a suspicion of pose, of artful drapery, those relics of classicism that Fuseli — as well as Blake— never succeeded in eliminating.

With Fuseli, and still more with Goya, the sense of the demonic becomes more subtle and diffused: they no longer present specific scenes of temptations or witchcraft, as in the bizarre compositions of Salvator Rosa and Magnasco (qq.v.; cf. the three pictures by the former in the collection of A. Busiri Vici, Rome). The theme is still sometimes vaguely cruel and sinister, with something of the nature of nightmare and obsession. The Devil is no longer a clear and well-defined personage: he pervades the whole atmosphere, and the sense of his presence emanates from the total effect of the picture. Probably Goya's deafness contributed to the feeling of bewildered terror that permeates his *Caprichos* and *Disparates*, for it must have made him view the world around him as a series of acts proceeding from stupidity and folly. With him ugliness entered the domain of art, as the bizarre had already entered in the work of Bosch and Bruegel. Goya's subject matter is summarized in a stanza of Baudelaire's *Phares*: "Goya, a nightmare full of unknown things, / Of fetuses roasted amid witches' sabbats, / Of old women admiring themselves in mirrors, and naked girls, / Fixing their stockings to tempt devils the more." From the torpor of Reason swarms a mob of criminal and obscene suggestions: "El sueño de la razón produce monstros" ("Reason's slumber brings forth monsters"), as a famous motto of one of the *Caprichos* declares (VI, PL. 402). The quality of symmetry, which throughout Dante's Inferno constitutes a lasting reminder of the divine order, is absent from the visions of Goya, which surface like flotsam in a slimy whirlpool. The faces are terrifying in their very anonymity, or because they look like the withered trophies of headhunters. Even the evil is not made individual: it is the impersonal creation of the crowd, the mass, the band of witches and sorcerers who adore the Great Goat (*El macho cabro presidiendo una reunión de brujas*, a famous canvas painted by Goya in 1798 for the Osunas; PL. 181). In the *Disparates*, the last series of Goya engravings, everything is counterfeit, topsy-turvy, chaotic: the disintegration of regular forms and the combination of the most antithetical conceptions produce a universal and monstrous disorder which proves that the demon of stupidity has been installed as ruler of the world. This is described at the close of Pope's *Dunciad* in a passage (Book IV, l. 649 ff.) that might serve here as comment: "Nor human spark is left, nor glimpse divine! / Lo! thy dread empire, Chaos! is restor'd, / Light dies before thy uncreating word: / Thy hand, great Anarch! lets the curtain fall, / And universal darkness buries all." It might be postulated that this type of somber inspiration, which uses the chaotic and the incongruous as material for art, is one of the characteristics of the Spanish genius. It is found again in Picasso (q.v.), who, through a kind of corruption of the process of artistic conception described by Michelangelo in a famous sonnet ("Non ha l'ottimo artista alcun concetto..."), seems to have sought in matter all its most improbable and illegitimate latent forms, thereby controverting creation in the same way that the gospel preached by the Antichrist is an inverted

gospel. Thus certain of the works of Picasso might also be included in the category of demoniacal representations (PL. 281); this classification finds some confirmation in his frequent recourse to primitive Iberian and African models for inspiration. The inheritance of Goya passed to Eugenio Lucas, whose whirling brush popularized in vast compositions the world of witches and their sabbats and the tortures of the Inquisition, which Goya had used as themes for art. In another follower of Goya, Leonardo Alenza (1807–45), the demoniacal inspiration becomes sensational and melodramatic: his caricatural *Romantic Suicide* (formerly Coll. Marquis de Cerralbo) exemplifies a genre akin to that of the diabolical pictures of that turbid follower of Rubens, Antoine Wiertz (1806–65), whose range of subjects is that of the chamber of horrors and the Grand Guignol.

What has been said of Picasso might be repeated for other modern painters. Paul Klee wrote: "The world in its present form is not the only possible world." If one of the criteria of demonic representation is the deformation of the existing world according to principles that appear to invert those which governed the creation of our world, then the legion of artists of the demonic must be increased to include not only all the surrealists (particularly Salvador Dali, Yves Tanguy, Max Ernst, René Magritte, etc.) but also artists such as Klee and Miró (qq.v.; see EUROPEAN MODERN MOVEMENTS). In Miró, representations of monsters in the fetal state and of obsessively anthropomorphous blots of color evoke an atmosphere of nightmare and sorcery. The work of Max Ernst, particularly by bringing together the most dissimilar objects, produces a sinister and demoniacal atmosphere, as in *Une semaine de bonté* (1934) and *La femme 100 têtes* (1929) where the obsessive effect is deliberately cultivated by methods of bizarre suggestion. However, in the *Métamorphoses du jour ou les hommes à tête de bête* (1854), Grandville sought effects that were to be only pleasantly caricatural. Certainly the imagery of Odilon Redon (q.v.) has demonic qualities, and in his prints and drawings the black areas themselves arouse fear and anguish. The demonic is also in evidence in the work of Martini, the illustrator of Poe's horrifying tales, and that of Alfred Kubin, obsessed by the frightful anatomical imagery of corpses and victims of torture.

Mario PRAZ

BIBLIOG. *Prehistory*: L. Capitan, H. Breuil, P. Bourrinet and D. Peyrony, Observations sur un bâton de commandement orné de figures animales et de personnages semi-humaines, Rev. de l'Ecole d'Anthropologie, XIX, 1909, pp. 62–76; H. Alcalde del Río, H. Breuil and L. Sierra, Les cavernes de la région cantabrique, Munich, 1911, pl. LV; H. Obermaier, El hombre fósil, Madrid, 1916, p. 369, pl. XXV, 12, 13; L. Capitan, H. Breuil and D. Peyrony, Les Combarelles aux Eyzies (Dordogne), Paris, 1924; H. Breuil, Les peintures rupestres schématiques de la péninsule ibérique, Lagny, 4 vols., 1933–35; H. Bégouën and H. Breuil, De quelques figures hybrides (mi-humaines et mi-animales) de la caverne des Trois-Frères, Rev. Anthropologique, XLIV, 1934, p. 115 ff.; H. Bégouën, Les grottes de Montesquieu-Avantès (Ariège), Tuc d'Audoubert, Enlène, Les Trois Frères, Musée de Pujol, Toulouse, 1926, p. 20; H. Kühn, Menschendarstellungen im Paläolithikum, Z. für Rassenkunde, IV, 3, 1936, p. 225; J. Cabré Aguiló, Figuras antropomorfas de la cueva de los Casares (Guadalajara), AEA, XLI, 1940, pp. 81–96; E. Saccasyn-Della Santa, Les figures humaines du paléolithique supérieur eurasiatique, Antwerp, 1947, p. 124 ff.; F. Windels, Lascaux, Montignac-sur-Vézère, 1948, p. 57; G. Kossack, Studien zum Symbolgut der Urnenfelder und Hallstattzeit Mitteleuropas, Römisch-germanische Forsch., XX, 1954; P. Graziosi, Palaeolithic Art, New York, 1960, pp. 87 ff., 139, 182.

*Ancient Orient. a. Egypt*: H. Bonnet, Reallexikon der ägyptischen Religionsgeschichte, Berlin, 1952, s.v. Dämon. *b. Mesopotamia*: K. Frank, Babylonische Beschwörungsreliefs, Leipziger semitische Studien, III, 3. 1908; F. Thureau-Dangin, Rituel et amulettes contre Labartu, Rev. d'Assyriologie, XVIII, 1921, pp. 161–98; E. Unger, Reallexikon der Assyriologie, II, Berlin, Leipzig, 1938, s.v. Dämonenbilder; H. Frankfort, The Art and Architecture of the Ancient Orient, Harmondsworth, 1954; J. B. Pritchard, Ancient Near Eastern Texts Relating to the Old Testament, Princeton, 1955.

*Cretan-Mycenaean and Greco-Roman civilizations*: H. Schrader, Die Sirenen . . . , Berlin, 1868; A. Rosenberg, Die Erinyen, Berlin, 1874; A. Winkler, Die Darstellung der Unterwelt auf unteritalischen Vasen, Breslau, 1888; C. Robert, Die Nekyia des Polygnot, Halle, 1892; K. Heinemann, Thanatos, Munich, 1913; E. Pottier, Thanatos, MPiot, XXII, 1916, p. 35 ff.; F. De Ruyt, Les Thanatos d'Euripide et le Charun étrusque, AntC, I, 1932, p. 61 ff.; C. Hopkins, Assyrian Elements in the Perseus-Gorgon Story, AJA, XXXVIII, 1934, p. 341 ff.; F. De Ruyt, Charun, démon étrusque de la mort, Brussels, Rome, 1934; F. De Ruyt, Etudes de symbolisme fu-
néraire, B. de l'Institut Historique Belge de Rome, XVII, 1936, p. 143 ff.; F. De Ruyt, Les traditions orientales dans la démonologie étrusque, AntC, V, 1936, p. 139 ff.; H. Besig, Gorgo und Gorgoneion, Berlin, 1937; C. Picard, Néréides et sirènes: Observations sur le folklore hellénique de la mer, Ann. de l'Ecole des Hautes-Etudes de Gand, II, 1938, p. 125 ff.; R. Enking, Lasa, RM, LVII, 1942, p. 1 ff.; R. Enking, Culsu und Vanth, RM, LVIII, 1943, p. 48 ff.; G. Bazin, Formes démoniaques, Satan (Etudes carmélitaines), Paris, 1948, pp. 507–20; R. Herbig, Götter und Dämonen der Etrusker, Berlin, 1948; F. De Ruyt, Reflets étrusques de thèmes du symbolisme funéraire en Méditerranée orientale dans leur évolution iconographique et idéologique, in Atti I Cong. internazionale Preistoria e Protostoria Mediterranea, Florence, 1952, p. 423 ff.; K. Schefold, Das dämonische in der griechischen Kunst, in EPMHNEIA, Festschrift Otto Regenbogen, Heidelberg, 1952, p. 28 ff.; D. Frey, Uomo, demone e Dio, in Filosofia dell'Arte, Rome, 1953, pp. 115–26; H. Seldmayr, Art du démoniaque et démonie de l'art, in Filosofia dell'Arte, Rome, 1953, pp. 99–114; G. van Hoorn, Charon, Charu, Kerberos, Nederlands Kh. Jb., V, 1954, p. 141 ff.; T. P. Howe, The Origin and Function of the Gorgon Head, AJA, LVIII, 1954, p. 209 ff.; J. H. Croon, The Mask of the Underworld Daemon, JHS, LXXV, 1955, p. 9 ff.; A. Dessenne, Le griffon créto-mycénien, BCH, LXXXI, 2, 1957, p. 211 ff.; A. Dessenne, Le sphinx, étude iconographique, Paris, 1957.

*Celtic and Iberian civilizations*: D'Arbois de Jubainville, Les druides et les dieux celtiques à forme d'animaux, Paris, 1906; W. Krause, Religion der Kelten, in Bilderatlas zur Religionsgeschichte, Leipzig, 1933, p. 1 ff.; P. Jacobsthal, Imagery in Early Celtic Art, Oxford, 1941; P. Lambrechts, Contribution à l'étude des divinités celtiques, Bruges, 1942; P. Jacobsthal, Early Celtic Art, Oxford, 1944; F. Benoît, Des chevaux de Mouriès aux chevaux de Roquepertuse, Préhistoire, X, 1948, p. 137 ff.; A. Grenier, Le dieu au maillet gaulois et Charun, SEtr, XXIV, 1955–56, p. 129 ff.; P. M. Duval, Les dieux de la Gaule, Paris, 1957.

*Iran*: T. W. Arnold, Survival of Sassanian and Manichaean Art in Persian Painting, Oxford, 1924; see also DIVINITIES.

*Asiatic East. a. India, Tibet, Indonesia, China*: A. Grünwedel, Singalesische Masken, IAE, VI, 1893; W. Wundt, Mythus und Religion, II, Leipzig 1906; N. Utsirikawa, Demon Design on the Bornean Shield: A Hermeneutic Possibility, AmA, XXIII, 1921, pp. 138–48; C. T. Bertling, "Hampatongs" of "Tempatongs" van Borneo: Aanvulling, Nederlandsch Indië, oud en nieuw, XII, 1927–28, pp. 249–54; W. Filchner, Kumbum Tschamba Ling, Leipzig, 1933; W. Münsterberger, Die Ornamente an Dayak-Tanzschilden und ihre Beziehung zu Religion und Mythologie, Cultureel Indië, I, 1939, pp. 337–43; P. Wirz, Exorzismus und Heilkunde auf Ceylon, Bern, 1941; G. Tucci, Tibetan Painted Scrolls, 3 vols., Rome, 1949; R. de Nebesky-Wojkowitz, Oracles and Demons of Tibet, the Cult and Iconography of Tibetan Protective Deities, The Hague, 1956; B. Rowland, The Art and Architecture of India, Harmondsworth, 1956. *b. Japan*: G. Tucci, The Demoniacal in the Far East, East and West, IV, 1953–54, pp. 3–11.

*Primitive world*: T. Koch-Grünberg, Zwei Jahre bei den Indianern Nordwest-Brasiliens, Stuttgart, 1921; R. Eberl-Elber, West-Afrikas letztes Rätsel, Vienna, 1936; G. Kutscher, Nordperuanische Keramik, Monumenta Americana, I, 1954; H. Himmelheber, Negerkünstler, Stuttgart, 1955; O. Riley, Masks and Magic, London, 1955.

*Islam*: G. Weil, Biblische Legenden der Muselmänner, Frankfurt, 1845; J. F. von Hammer-Purgstall, Die Geisterlehre der Muslimen, Denkschriften der philologisch-historischen Klasse der kaiserlichen Ak. der Wissenschaften, Vienna, 1852; F. Spiegel, Eränische Alterthumskunde, II, Leipzig, 1873, p. 121 ff.; A. Pavet de Couteille, Midrâdj-Nâmeh, publié pour la première fois d'après le manuscrit ouigour de la Bibliothèque Nationale, Paris, 1882; M. Grünbaum, Neue Beiträge zur semitischen Sagenkunde, Leiden, 1893; pp. 60–61; G. Salzberger, Die Salomo-Sage in der semitischen Literatur, Berlin, 1907, p. 99 ff.; O. Rescher, Studien über den Inhalt von 1001 Nacht, Der Islam, VIII, 1918, pp. 21 ff., 26, 27; P. A. Eichler, Dschinn, Teufel und Engel im Qoran, Leipzig, 1928; A. von Le Coq, Von Land und Leuten in Osttürkestan, Leipzig, 1928, pp. 111, 127 ff.; H. A. Winkler, Die Reitenden Geister der Toten, Stuttgart, 1936, p. 36; H. Massé, Croyances et coutumes persanes, suivies de contes et chansons populaires, II, Paris, 1938, pp. 351–68; B. A. Donaldson, The Wilde Rue, London, 1939; A. Christensen, Essai sur la démonologie iranienne, Det kgl. Videnskabernes Selskab., Historisk-filologiske Meddelelser, XXVII, 1, Copenhagen, 1941; E. Zbinden, Die Djinn des Islam und der altorientalischen Geisterglaube, Bern, 1953.

*Christian world*: M. C. Hippeau, Guillaume de Normandie, Le bestiaire divin, in Extrait des Mémoires de la Société des Antiquaires de Normandie, Caen, 1852; E. H. Langlois, Essai sur les danses des morts, Rouen, 1852; Herbordi dialogus de vita Otonis episcopi Babenbergensis, MGH, XX, 1868; A. Straub, ed., Herrade de Landsberg, Hortus deliciarum, 4 vols., Strasbourg, 1879–99; A. Goldschmidt, Der Albanipsalter von Hildesheim, Berlin, 1895; E. P. Evans, Animal Symbolism in Ecclesiastical Architecture, London, 1896; A. de Molin, Etude sur les agrafes de ceinturon burgondes à inscriptions, RA, I, 1902, p. 350; G. Weicker, Der Seelenvogel in der antiken Literatur und Kunst, Leipzig, 1902; D. A. Endres, Honorius Augustodunensis, Kempten, Munich, 1906; L. Maeterlinck, Le genre satirique dans le peinture flamande, 2d ed., Paris, 1907; F. J. Dölger, Der Exorzismus im altchristlichen Taufritual, Paderborn, 1909; L. Maeterlinck, Le genre satirique, fantastique et licencieux dans la sculpture flamande, Paris, 1910; A. H. Collins, Symbolism of Animals and Birds Represented in English Church Architecture, London, 1913; J. Scheftelowitz, Das Schlingen und Netzmotiv im Glauben und Brauch der Völker, Religionsgeschichtliche Versuche und Vorarbeiten, XII, 1913; Osebergfundet, ed. A. W. Brgger, H. Falk, and H. Shetelig, 5 vols., Oslo, 1917–27; A. Köster, Das antike

Seewesen, Berlin, 1923; R. Koechlin, Les ivoires gothiques, Paris, 1924; R. Wiebel, Drachenbilder und Drachenkampfdarstellungen in der romanischen Kunst, Deutsche Gaue, XXV 1924; Mâle, II; E. G. Millar, English Illuminated Manuscripts from the Xth to the XIIIth century, Paris, 1926; K. Löffler, Romanische Zierbuchstaben und ihre Vorläufer, Stuttgart, 1927; G. Boroffka, Kunstgewerbe der Skythen, in Geschichte des Kunstgewerbes aller Zeiten und Völker etc., I, Berlin, 1928, pp. 101–57; M. R. James, The Bestiary, Oxford, 1928; H. Kohlhaussen, Minnekästchen im Mittelalter, Berlin, 1928; K. Künstle, Ikonographie der christlichen Kunst, I, Freiburg im Breisgau. 1928; Mâle, I; W. Krause, Die Kelten, Religionsgeschichtliches Lesebuch, XIII, 1929; A. van Scheltema, Der Osebergfund, Leipzig, 1929; G. Hübener, England und die Gesittungsgrundlagen der europäischen Frühgeschichte, Frankfort on the Main, 1930; J. Baltrusaitis, La stylistique ornamentale dans la sculpture romane, Paris, 1931; R. Bernheimer, Romanische Tierplastik und die Ursprünge ihrer Motive, Munich, 1931; O. Erich, Die Darstellung des Teufels in der christlichen Kunst, Berlin, 1931; W. von Jenny, Sitzungsbericht der archäologischen Gesellschaft, Archäologischer Anz., XLIX, 1934, col. 296; I. Levron, Le diable dans l'art, Paris, 1935; B. Salin, Die altgermanische Thierornamentik, Stockholm, 1935; D. Jalabert, De l'art oriental antique à l'art roman..., II, Les sirènes, B. monumental, XCV, 1936, p. 433 ff.; H. Weigert, Die Bedeutung des germanischen Ornaments, in Festschrift W. Pinder, 1938, p. 81 ff., H. Kühn, Die Danielschnallen der Völkerwanderungszeit, IPEK, XV–XVI, 1941–42; F. J. Tritsch, The Harpy Tomb at Xanthus, JHS, LXII, 1942, p. 51 ff.; W. von Blankenburg, Heilige und dämonische Tiere, Leipzig, 1943; E. Buschor, Die Musen des Jenseitz, Munich, 1944; H. Reiser, Norwegische Stabkirchen, Oslo, 1944; E. Langton, Essentials of Demonology, London, 1949; A. Moortgat, Tammuz, der Unsterblichkeitsglaube in der altorientalischen Bildkunst, Berlin, 1949; A. Minon, La doctrine catholique sur les anges et les démons, Rev. ecclésiastique de Liège, XXXVIII, 1951; R. Bernheimer, Wild Men in the Middle Ages: A Study in Art, Sentiment, and Demonology, Cambridge, Mass., 1952; M. L. Sjoestedt, Gods and Heroes of the Celts, London, 1953; G. Troescher, Ein bayerisches Kirchenportal und sein Bilderkreis, ZfKg, XVII, 1954, p. 1 ff.; J. Baltrusaitis, Le moyen âge fantastique, Paris, 1955; E. von Petersdorff, Dämonologie, 2 vols., Munich, 1956–57; J. Baltrusaitis, Reveils et prodiges, Paris, 1960.

*Popular and folk art*: P. Sébillot, L'enfer et le diable dans l'iconographie, Rev. des traditions populaires, IV, 1889, pp. 129 ff., 509 ff., V, 1890, p. 20 ff., IX, 1894, p. 327; R. Bayon, L'enfer et le diable dans l'iconographie, Rev. des traditions populaires, VI, 1891, p. 99 ff.; A. Segarizzi, Bibliografia delle stampe popolari italiane, Bergamo, 1913; P. L. Duchartre, L'imagerie populaire française, Paris, 1923; M. Summers, The History of Witchcraft and Demonology, London, 1926; A. Bertarelli, L'imagerie populaire italienne, Paris, 1929; J. Turnel, Histoire du diable, Paris, 1931; G. Cocchiara, Le immagini devote del popolo siciliano, Palermo, 1940; G. Cocchiara, Il diavolo nella tradizione popolare italiana, Palermo, 1945; R. Weiss, Volkskunde der Schweiz, Zurich, 1946; K. Sourek, L'art populaire en images, Prague, 1956; R. Kriss and Rettenbeck, Das Votivbild, Munich, 1958.

*The demoniacal since the 17th century*: M. Rudwin, The Devil in Legend and Literature, Chicago, 1931; J. Levron, Le diable dans l'art, Paris, 1934; M. Praz, La carne, la morte e il diavolo nella letteratura romantica, Florence, 1948; E. Castelli, Il demoniaco nell'arte, Milan, 1952; Rome, Palazzo Barberini, Mostra del demoniaco nell'arte, 1952; G. Martin-Méry, Bosch, Goya et le fantastique, Bordeaux, 1957; R. Villeneuve, Le diable dans l'art, Paris, 1957.

Illustrations: PLS. 166–182.

**DEMUTH, CHARLES.** American painter (b. Lancaster, Pa., Nov. 8, 1883; d. Lancaster, Oct. 25, 1935). A member of an old, prosperous Pennsylvania German family, Demuth grew up in Lancaster. His health was delicate; at four an injury lamed him for life. He studied at the Pennsylvania Academy of Fine Arts, 1905–10, except for a year in Paris, 1907–08. He was again in Paris from 1912 to 1914, where, studying at the academies of Colarossi and Julian, he came in contact with the modern movements. His work reached maturity about 1915. Demuth's permanent home remained Lancaster, with summers in Provincetown and Gloucester, but he visited New York frequently and became associated with Alfred Stieglitz's group. A third visit to Paris came in 1921. In 1920 he was found to have diabetes, from which he suffered until his death.

Much of Demuth's work was in water color. In his flower paintings, a lifelong theme, concentration on pure form and color achieved distinguished decorative values. His cosmopolitanism is reflected in his 1915–19 water colors of vaudeville, circus, and café life, which express both relish for such public pleasures and ironical mockery of their banality. Among his most original works, their style was subtle, apparently casual, but extremely sensitive in draftsmanship and handling of the medium. In a similar vein were his water colors (also 1915–19) illustrating favorite authors — Zola, Wedekind, Poe, Henry

James — not done for publication but psychological interpretations pervaded with a sense of horror and the power of evil.

A more impersonal, constructive development commenced in 1918, when Demuth began using American industrial and architectural subjects, adding to his media tempera and, about 1921, oil. A pioneer in this subject matter, he found structural form equally in 18th-century churches (I, PL. 115) and 20th-century factories. While profiting from cubism, he never followed it into abstraction; he continued to represent natural objects, but isolated their formal elements and transformed them into geometric designs. Demuth's later works, combining extreme refinement and precision with an essential energy, a passion for the purely plastic, and a gift for ordered dynamic design, were among the most mature achievements of American modernism. In them Demuth proved himself a classicist — a type rare in American art.

The chief public collections of Demuth's works are in the Metropolitan Museum and the Museum of Modern Art, New York; the Barnes Foundations, Merion, Pennsylvania; and the Columbus Gallery of Fine Arts, Columbus, Ohio.

BIBLIOG. A. E. Gallatin, Char es Demuth, New York, 1927; W. Murrell, Charles Demuth, New York, 1931; A. C. Ritchie, Charles Demuth, New York, 1950.

Lloyd GOODRICH

**DENMARK.** Owing to its peninsular shape, stretching along the North Sea, and its many islands, Denmark is exposed to varied cultural influences from the north, east, or south generally reaching it through maritime contacts and often superimposed upon various local schools. Its relative remoteness from the great European art centers has given its several stylistic directions a development independent of that of central Europe. However, numerous foreign influences have until quite recently shaped the artistic course of Denmark.

SUMMARY. Cultural and artistic epochs (col. 336): *Prehistory and protohistory; The Romanesque period; The Gothic period; The Renaissance and baroque period; The neoclassic period; The 19th and 20th centuries.* Chief art centers (col. 345).

CULTURAL AND ARTISTIC EPOCHS. *Prehistory and protohistory.* The oldest settlements, from the late Paleolithic and Mesolithic periods, are those of Bromme (Zealand or Sjaelland) and Klosterlund (Jutland), which mark the appearance of flint axes. Following them were the mesolithic culture of Maglemose (Zealand), contemporaneous with the so-called "Tardenoisian" culture, and the Ertebølle culture (Jutland), coeval with the French culture of Campigny, in which the first clay pottery appears. These hunting and fishing cultures were replaced by an agricultural one of the type found in the villages of Barkær and Troldebjerg, with their cabins aligned along a street. Characteristic of this culture were burials in chambered tombs — *dysser,* or dolmens, and *jaettestuer,* or "giant rooms" — so called because of their megalithic structure; burial was no longer by inhumation. A people also appeared in Denmark who were called the "Snorekeramikerne," after their characteristic pottery, decorated with motifs imitating cord; they were succeeded by the Dolktid people, so called from their use of a sharpened flint dagger. The Bronze Age (1500–400 B.C.) marked the appearance of inhumation in stone or wooden coffins covered by high mounds of earth, in which woollen garments have been preserved (the barrows of Muldbjerg, Borum Eshøj, Egtved, and Skrydstrup); cremation, which was to predominate later, also appeared. The favorite decorative motif of this period was the spiral. Dating from the 14th century is the famous sun chariot of Trundholm (Zealand; V, PL. 169). The technique of working gold and bronze was highly developed, and metals for these crafts were obtained by exchanging Danish amber for them in the flourishing trade with southern lands. During the period between the 9th and 5th centuries B.C. the Danes produced items of heavy jewelry, goblets of gold and bronze, and large horns (luren), trumpets of thin wrought bronze, generally made in pairs and played in unison. Cultural strains originating in southern Europe and Italy are discernible in the working of bronze and in pottery making. In the first Iron Age, which lasted until the beginning of the Christian era, the Celtic peoples were penetrating all Europe except Denmark, where, however, articles of Celtic style were available, for example, the Gundestrup caldron (V, PL. 184) and the Dejbjerg wagons (Jutland)

(see EUROPEAN PROTOHISTORY). The Romans did not reach Denmark either, but they sent their products there, especially silver vessels such as the Hoby cups. From the 5th century of our era onward, the Roman influence was replaced by a German influence, as seen in the stylistic modification of objects already fairly common such as luren (the golden horns of Gallehus, for example; presumably destroyed) and gold bracteates (coins which at first imitated the late Roman medallions but later took on a purely Nordic character; see EUROPE, BARBARIAN). The coins (see COINS AND MEDALS) were convex on one side and concave on the other, plated with gold. The Viking period (A.D. 800–1100), known to us through excavations and the discovery of objects and inscriptions, was a splendid one in Denmark. The ship tomb discovered near Ladby on the island of Fyn is famous, and even more so is the royal tomb of Jelling in Jutland, with its great wooden chamber inside the barrow. Near this is the runic stone dedicated by King Gorm the Old to his Queen, Thyra Danebod, and the stone dedicated to their memory by their son Harald Blataand (Harold Bluetooth) about A.D. 980. Many silver objects and coins were produced in this period. Also worthy of mention are the Danevirke fortifications (a stone and brick wall built across Schleswig in the early Middle Ages) and the circular military camps of Trelleborg, Aggersborg, Fyrkat, and Nonnebjerget (see SCANDINAVIAN ART).

Johannes BRØNDSTED

*The Romanesque period.* Numerous recent excavations have brought to light important traces of wooden ecclesiastical architecture, which became widely diffused in Denmark after its conversion to Christianity (A.D. 950–1050).

The buildings were constructed of beams set in the ground; the holes into which the beams were fitted are still visible today. Among the outstanding ruins are those of the church of the royal residence of Jelling, dating from before the year 1000.

Early in the 11th century the Danes began to use travertine as a building material, employing building procedures of Roman origin (Church of Our Lady at Roskilde; church at Tamdrup, west of Horsens). Anglo-Saxon influences are discernible in the Benedictine abbey of Venge, near Skanderborg (Jutland), built before 1100.

In the 12th century this soft stone was replaced by cut stone — particularly granite, available in the glacial boulders of east Jutland — as in the Cathedral of Viborg, rebuilt during the 19th century. More interesting, however, are the numerous village churches, a group of which are the work of Horder, a master stonemason who was also known as a sculptor. In the region of Skaane, sandstone largely replaced granite. The most important monument from this period is the Cathedral of Lund (Danish archiepiscopal see from 1104), built by local masters. Four churches on Bornholm Island in the Baltic Sea, dating from the late 12th century and all having centralized ground plans, are veritable fortress-churches; the Church of Østerlars is the most complex of all in plan.

Near the end of the 12th century, Lombard masters popularized the use of brick, an invaluable material in Denmark because of the dearth of rock quarries. Brick was used to build the churches of the Benedictine monastery of Ringsted and those of the Cistercian monasteries of Sorø and Vitskøl, the church of Kalundborg, and the Cathedral of Roskilde. The small churches on the southern islands of Lolland and Falster exhibit all phases of the stylistic transition from the Romanesque to the Gothic and show analogies with north German ones along the Baltic and in Schleswig.

Secular edifices of the Romanesque period are rare, save for the very few traces of the fortifications and homes of the nobility.

Until the end of the 1200s, central Zealand, and the city of Jelling in particular (the seat of the royal family), were the most important centers for sculpture. The golden altars and jewelry made here were remarkable. In various Jutland workshops granite was carved for decorating churches and baptismal fonts.

Paintings were few and unimportant. The earliest, in fresco and of varied styles (none before 1150), are found in southeastern Jutland. About 1200 there was a particularly active school in central Zealand (in Broby, Alsted, Fjenneslev, Hagested, and Skibby). Even Byzantine influence may be seen in work from this period.

*The Gothic period.* After 1200, with the rapid development of the cities of the Hanseatic League, Denmark underwent a period of decline. For about 150 years, the German city of Lübeck exerted a strong influence in the field of art. This is clearly shown by the additions made to earlier structures (cathedrals of Roskilde, Ribe, and Aarhus). In this period the epoch of great cathedrals came to an end, but many convents and monasteries were built; only the one at Helsingør (Elsinore) is well preserved.

At this time too, the most interesting ecclesiastical structures were built in small villages. In general, activity was limited to remodeling or enlarging the old Romanesque churches. Even Gothic

secular buildings are scarce (ruins of the 13th-cent. royal fortresses of Kalø and Vordingborg; fortification walls of the Krogen Citadel incorporated in Kronborg Castle in Helsingør; the Kärnan tower at Helsingborg, Skaane; the ruins of the Hammershus fortress with late Gothic keep, on Bornholm island). Almost intact, and unique as an architectural type, is the stronghold of Gjorlsev (Zealand), with its cruciform plan.

The only medieval gate to survive is the Mølleport at Stege. Old brick houses remain in Kalundborg and Helsingør (Zealand).

The introduction of brick marks the complete disappearance, toward 1200, of architectural sculpture. In the church interiors sculpture in wood continued (crucifixes, figures of Mary and saints in the churches of Skaane, Zealand, and Schleswig, and a large ivory crucifix at Herlufsholm), inspired more or less by the French Gothic

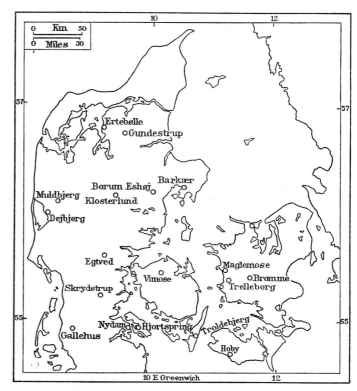

Denmark, prehistoric and protohistoric sites.

style. About the end of the century German influences were felt, first through Lübeck from Westphalia and Cologne, later from Lübeck itself. The polished naturalism so highly developed in the Burgundian court is reflected in the tomb of Queen Margaret, dated 1423 (Roskilde Cathedral), almost certainly the work of Johannes Junge of Lübeck, to whom the *Pietà* of Sønder Alslev (Copenhagen, Nationalmus.) is also attributed.

In the 15th century carved altar fronts of modest artistic worth were imported, generally from Lübeck. The one of the high altar of the Aarhus Cathedral, by Bernt Notke of Lübeck, is exceptional in size and artistic merit. In the decades before the Reformation — which signalized a vast building activity — three great sculptors were active in Denmark: Claus Berg, disciple of Veit Stoss, whose finest work is the altarpiece of the Odense Cathedral; Hans Brüggeman, influenced by Dutch realism, who carved an altarpiece for the Cathedral of Schleswig; and Adam van Düren, from the Lower Rhine, who was active in eastern Denmark.

Reaching Denmark belatedly, and chiefly through Lübeck, the echoes of French Gothic painting began to be felt (early 14th cent.) in the Schleswig region.

Masterpieces of this period are the decorations of the Chapels of the Three Kings in Roskilde Cathedral, from about 1450, and of the church of Fanefjord, on the island of Møn. From the late 15th century until after the Reformation, painting was thriving, particularly in Jutland (Aarhus Cathedral, church of Skibby, and church of the Carmelite monastery of Sæby).

Danish late Gothic painting is quite heterogeneous. Various works (chiefly wooden altars, whose façades are painted in tempera) from the early 16th century are found in western Zealand.

*The Renaissance and baroque period.* The social and economic results of the Reformation were also felt in architecture. Many churches and houses of religious orders were torn down, and the materials were used in defensive works. About 1550 the resumption of building, sponsored by Christian III and the nobility of the Catholic Church, was influenced by the Renaissance. Johan Friis, the king's chancellor, employed Veneto-Dalmatian motifs in the building of the castle of Hesselagergaard, which is still in existence. Other notable princely castles from late in the 16th century are those of Egeskov (Fyn), Borreby, Gisselfeld (Zealand), and Rosenholm (Jutland). Kronborg Castle at Helsingør (completed in 1583), designed by the Flemish architect Anton van Opbergen, is one of the first examples of the Dutch Renaissance style in Denmark. The residences of Lystrup in southern Zealand (1579) and Voergaard in northern

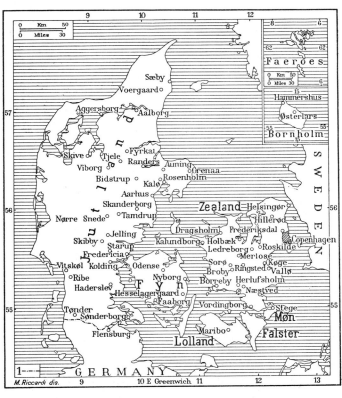

Denmark, principal medieval and modern centers. *Key:* (1) Modern national boundaries.

Jutland (1581–91) are decorative. A castle worthy of note was Uraniborg (destroyed), built by the great Danish scientist Tycho Brahe on the island of Hven, on the Öresund strait. It was central in plan and inspired by the works of Sebastiano Serlio. The writings and designs of Jacques Ducerceau (q.v.) influenced the conception and arrangement of these structures.

The economic prosperity of the late 16th century produced a great urban expansion. King Christian IV (1577–1648) founded many new cities according to modern principles and made of Copenhagen a great modern capital. Famous among the royal architects were the Steenwinkels, of Dutch origin.

After the Reformation (1536) no more religious painting or sculpture was produced, although occasional murals were still being painted (e.g., those of the church of Estruplund). In the residences of the nobility, the costly gobelins were sometimes replaced by frescoes (Hesselagergaard). The nobles were obliged to order abroad, particularly from Antwerp and no longer from Lübeck, those *objets d'art* they wished to surround themselves with. Cornelis Floris de Vriendt executed a series of very fine tomb monuments for the princes and other members of the Danish nobility (Cathedral of Schleswig, Cathedral of Roskilde, and Herlufsholm). Christian III's widow purchased from Frans Floris de Vriendt, Cornelis' brother, a large triptych for Sønderborg Castle's chapel. Famous portrait painters, mostly Dutch, were active. Melchior Lorch, a maker of copper reliefs, was distinguished for his portraits and perspective views. The most skillful painters under Christian IV were Karel van Mander and Abraham Wuchters.

In the early years after the Reformation, the few Danish sculptors for the most part carved tombstones with figures in relief for the nobility. Schools of stonecutters arose in Zealand and Jutland (Gert van Groningen, Aarhus); sculptors, stonecutters, and carvers came mostly from the workshop of Kronborg Castle, closed about 1585, and from other castles. In the late 16th century and early 17th, in almost all the important cities, there were wood carvers' workshops in which altar frontals, pulpits, and epitaphs were produced, imitating work in incised copper (Køge, Holbæk, and Næstved in Zealand; Odense in Fyn; Flensburg, today south of the Danish border, in Jutland; and Aalborg, Randers, Horsens, Sønderborg, and Tønder).

More up-to-date foreign artists frequented the court in Copenhagen: Georg Labenwolf of Nuremberg built the fountain (now lost) of Kronborg Castle; the Dutch sculptor Adriaen de Vries, influenced by Giovanni da Bologna, built the fountain of Frederiksborg Castle. Peter Husum made a free copy of the Capitoline group of the *Combat between a Lion and a Horse* for Christian IV. After the revolution of 1660 and the establishment of the absolute monarchy, artistic activity was more closely linked than ever to the court and the nobility of Copenhagen and northern Zealand. The Swedish artist Nicodemus Tessin the Younger, a pupil of Bernini, prepared a project, never carried out, for a new royal castle in Copenhagen. The villa built at the gates of Copenhagen for Queen Sophie Amalie (Amalienborg, built 1670, burned 1689) was modeled after Dutch and Italian prototypes (Vicenza, Rome, and Frascati); the Palace of Charlottenborg (1672–79) was built for the Governor of Norway, Count Ulrik Gyldenløve. Lambert von Haven, the royal architect, built the Church of Our Saviour (Vor Frelsers Kirke, 1749–50) in the Christianshavn quarter of Copenhagen in sumptuous baroque style, with classic overtones. Early in the 18th century, the results of travels in Italy by Danish architects became evident; thus, in the Opera House in Copenhagen (at present the seat of the Superior Court) and the royal residence of Frederiksberg (1707–09) and Fredensborg (ca. 1720), the Italian influence is apparent. The latter building was built from the designs of Johan Cornelius Krieger, architect to Frederik IV, and was originally a central-plan structure with a dome.

In 1754 the Royal Academy of Fine Arts was founded in Copenhagen. The most important architects of this period were Nikolaj Eigtved (1701–54) and Lauritz L. de Thurah (1706–59). The principal works of the latter were the villa of Hirschholm (destroyed), the Palace of Roskilde (1733), the Eremitagen hunting lodge (1736), and the spire of the Church of Our Saviour (1750; clearly inspired by Borromini's Church of S. Ivo in Rome). De Thurah published a long work in two volumes, *Den danske Vitruvius* (1746–49), containing the dimensions and plans of royal castles and public edifices, as well as the *Hafnia hodierna* (1748; Copenhagen). Eigtved displayed more modern tastes. Abroad, particularly in Saxony, he had approached the baroque; among his surviving works are the marble bridge and the interiors of the royal Castle of Christiansborg (built by E. D. Häusser and burned in 1794) in Copenhagen. Eigtved's masterpiece is Amalienborg Square. The aristocracy commissioned these architects to design such villas and country homes as Ledreborg, Lerchenborg, and Frederiksdal in Zealand, and Margaard on the island of Fyn. In Jutland, on the other hand, a bold architecture in rococo style, executed by local artists, became established. Outstanding examples are the palace of the merchant Gerhard Hansen of Lichtenberg, at Horsens, the two villas of Bidstrup, and the beautiful church of Granslev and Gessinggaard, near Randers.

The portraits of Christian IV and Frederik III (at Rosenborg and in the Citadel of Copenhagen), the work of the Flemish artist François Dieussart, and the equestrian statue of Christian V (on the Kongens Nytorv Square in Copenhagen) by the French artist Abraham César L'Amoureux (1688), introduced the baroque style in sculpture to Denmark. Funerary sculpture was very highly developed: J. C. Sturmberg built, for Christian V and his wife Charlotte Amalie, two magnificent cenotaphs of white marble in Roskilde Cathedral (1716–19); and Thomas Quellinus (1661–1709) of Belgium executed a series of funerary monuments for the aristocracy, in white and black marble, in rather theatrical style. Quellinus' masterpieces are at Herlufsholm in Zealand, in the Cathedral of Odense (Fyn), in the Cathedral of Aarhus, and at Auning (Jutland). Nicodemus Tessin made the model for the altar in the Church of Our Saviour at Christianshavn (Copenhagen, 1707), which shows the influence of Bernini. J. F. Ehbisch (d. 1748) created funerary monuments in the style of Quellinus in the churches of Tjele and Oxholm (Jutland), and acanthus-leaved altars and pulpits for the Copenhagen churches, destroyed by the 1728 fire.

Representing the Dutch tradition in baroque painting were Karel van Mander (d. 1670) and Abraham Wuchters (1610–82). The latter's monumental portraits of Danish princes (Copenhagen, Nat. Mus., Frederiksborg Castle, Rosenborg Castle, and State Mus. of Art) reveal a remarkable gift for color. Jacques d'Agar (1640–1715) was a mediocre painter who popularized the elegant pictorial style

of the French-English court. Hendrik Krock (1671–1738) and Bendix le Coffre (1671–1722), the first a disciple of Carlo Maratti, the second influenced by Poussin, decorated the ceilings of the royal castles of Frederiksborg and Rosenborg with historical paintings. The portraitists J. S. Wahl and Marcus Tuscher followed the southern German manner. Distinguished among the rococo portraitists was the colorist Carl Gustaf Pilo (1711–92), a Swede, whose portraits in the State Museum of Art, Copenhagen, and in many castles and villas of the nobility influenced contemporary artists, one of whom was Johan Hørner (1711–63). The Frenchman Louis Tocqué, during his brief stay in Denmark (1758), did a series of magnificent portraits of members of the court.

*The neoclassic period.* The Royal Academy of Fine Arts in Copenhagen exerted a decisive influence on architecture, both through its technical instruction and through its grants of scholarships for study in Paris and Rome. The first professor was the Frenchman N. H. Jardin, who favored neoclassicism. He designed the dining hall of the Moltke Palace, Amalienborg, the Bernstorff Castle near Copenhagen, Marienlyst near Helsingør, the Frederiks Kirke (1756, inspired by the Pantheon in Rome), and the Sølvgade Barracks (1765–69), the last two in Copenhagen. He also modified the Thott Palace in that city. He was succeeded by the Dane C. F. Harsdorff (1735–99), whose training had been completed in Paris and Rome and who designed palaces in Copenhagen and oversaw the restoration of the Fredensborg Castle, the Chapel of Frederick V in the Cathedral of Roskilde, and the colonnade of Amalienborg.

In the first half of the 19th century the dominant figure, with his school, was the Neo-Palladian C. F. Hansen (1756–1845). Hansen, a pupil of C. P. Harsdorff, was active also in Germany. In Copenhagen he built the Cathedral of Our Lady, the Slots Kirke, the Town Hall, and the Law Courts (1805–15), the latter in the Palladian style. Hansen also rebuilt Christiansborg Palace in Copenhagen. G. F. Hetsch (1788–1864) followed in the footsteps of Hansen with very little originality, and was influenced by the Germans.

The equestrian monument of Frederik V in Amalienborg Square, by J. F. J. Saly (preliminary sketch in 1764, dedicated in 1771), was inspired by French models. Johannes Wiedewelt (1731–1802), a friend of Winckelmann, popularized a decorative neoclassic style. Bertel Thorwaldsen (1770–1844), trained in the Academy of Art in Copenhagen, matured his style in Rome (*Jason with the Golden Fleece*, 1802) in the years 1797–1838 and 1841–42. His masterpieces are in Italy, Germany, England, and Poland; in Denmark his sculptures are in the Church of Our Lady and in the museum dedicated to him. His best Danish pupil and collaborator was H. W. Bissen (1798–1868), who later turned to realism in the *Monument to the Victorious Soldier* (1850–51) at Fredericia.

Late in the 18th century the two principal exponents of painting were N. A. Abildgaard (1743–1809), classically trained, who decisively influenced the young Thorwaldsen, and Jens Juel (1745–1802), an outstanding painter of portraits and landscapes.

*The 19th and 20th centuries.* M. G. Bindesbøll (1800–56) repudiated the academic neoclassicism of C. F. Hansen in the name of romanticism, drawing inspiration from the Middle Ages and the local Renaissance. He started a national style that was alive until 1915–20. The representatives of this style are J. D. Herholdt, who designed the Library of the University in Copenhagen in Neo-Gothic style (1857–61), H. B. Storck (1839–1922), and A. Clemmensen (1852–1928), skillful restorers and students of the Middle Ages. Martin Nyrop (1849–1921), in the Copenhagen Town Hall (1894–1903), drew his inspiration from the Palazzo Pubblico in Siena, Italy. On the whole, the tastes of Danish architects were greatly influenced by their travels in Italy. Interesting in this respect is the Grundtvig Church in Copenhagen (1921–27) by P. V. Jensen Klint (V, PL. 108). Antagonist of Nyrop and supporter of a "European" style, Ferdinand Meldahl (1827–1908), the artist charged with the reconstruction of the Frederiksborg Castle and the completion of the Frederiks Kirke in Copenhagen, exerted a strong influence. Almost the sole representative of Art Nouveau was Anton S. Rosen (1859–1928), an architect of fertile imagination. In about 1915–25 several young architects returned to neoclassicism; they designed public buildings adorned with columns, such as the Faaborg Museum (1912–15) of Carl Petersen and the Copenhagen Police Headquarters (1918–24) by Hack Kampmann and Aage Rafn. Other architects, such as Povl Baumann, Henning Hansen, and Kay Fisker, strove to combine classic taste and functionalism in Copenhagen's enormous housing blocks.

Modern architecture in Denmark dates from the Stockholm Fair of 1930. Outstanding city-planning innovations, involving the design of "satellite" working-class quarters, individual homes, and industrial architecture, have been introduced by Kaare Klint, Kay Fisker, C. F. Møller, Vilhelm Lauritzen, Finn Juhl, Ole Wanscher, and Arne Jacobsen. Design in these areas is highly developed today. A predominating quality is consistency in form and in the choice of materials; examples are the Aarhus University complex in Jutland, by Møller, and the Grundtvig Church in Copenhagen, by Jensen Klint. Deserving mention is the recent development of building in the International Style (particularly in buildings in the downtown section of Copenhagen, in several large decentralized residential complexes, in school construction, and in the separate one-family home). Among those who contributed to this development were Eva and Nils Koppel, V. Wohlert, J. Bo, J. Utzon, and C. Sørensen.

The chief representatives of Danish romantic sculpture were H. E. Freund (1786–1840), a pupil of Thorvaldsen, who treated romantic subjects in an academic manner (the Ragnarok frieze and the statuette of Loki, suggested by Nordic mythology), and J. A. Jerichau (1816–83), who was violently opposed to neoclassicism despite his stay in Rome as a young man. After the dull naturalism of the late 19th century, early in the 20th the influence of French sculpture (of Rodin and Maillol, especially) was apparent in the works of Kai Nielsen (1882–1924), Johannes C. Bjerg (1886–1955), and Einar Utzon-Frank (1888–1955). Remaining faithful to the academic-classicist tradition were Gerhard Henning (b. 1880), Svend Rathsack (1885–1941), Gottfried Eickhoff (b. 1902), and Jørgen Gudmundsen-Holmgreen (b. 1888). In opposing the tradition, Kai Nielsen notably influenced the subsequent development of Danish sculpture. Naturalistic sculptors include A. Keil (b. 1907), H. Starche (b. 1899), and Astrid Noack (1888–1954), inspired by Maillol, Mogens K. Bøggild (b. 1901), and Hugo Liisberg (1896–1958). Representing the nonobjective trend are Henry Heerup (b. 1907), influenced by the European post-Dadaist tradition; Erik Thommesen (b. 1916), the creator of extremely fine wooden constructions; and Robert J. T. Jacobsen (b. 1912), a sculptor in iron working in Paris. An expressive portraitist is Knud Nellemose (b. 1908).

Outstanding in the first decades of the 19th century was C. W. Eckersberg (1783–1853), a mediocre historical painter but an excellent painter of portraits and seascapes. Eckersberg's students were in general inclined toward a sober realism, but romantic accents were not lacking, e.g., Jørgen V. Sonne. The following generation (the painters of the "golden age") concerned themselves with historical subjects, as they were advised to do by the art historian N. L. Høyen. Christen S. Købke (1810–48) was a fine colorist. A group of young painters went to Italy between 1820 and 1840 to find subjects in the life of the people (V. N. Marstrand, A. Küchler, C. Hansen, Ernst Meyer, Martinus C. Rørbye). Vilhelm Marstrand (1810–73) was a figure painter and illustrated Italian scenes or characters from the comedies of Holberg with subtle humor. Among the leading landscapists were Johan T. Lundbye, Peter C. T. Skovgaard, and Vilhelm Kyhn. Toward 1860 German influence became established (Düsseldorf school). Carl Bloch (1834–90) came to the fore with his large figure compositions, generally of historical or religious subjects. Peter S. Krøyer (1851–1909) worked in Paris, where he did luministic experiments. With Michael and Anna Ancher and others, he subsequently settled in Jutland (Skagen), interesting himself in the life of the fishermen. Kristian Zahrtmann (1843–1917), after withdrawing from the Academy of Fine Arts, opened a free school; he later made frequent trips to Italy, finding his subjects in the life of the people of the Abruzzi. Theodor E. Philipsen (1840–1920) painted landscapes and animals in an impressionist style; Gottfried Christensen (1845–1928) interpreted Jutland landscape; Vilhelm Hammershøi (1864–1916) was a painter of delicate interiors. Jens F. Willumsen (1863–1958), also a sculptor, approached French symbolism, and postimpressionist French influences are also discernible in the work of Edvard Weie (1879–1943), Harald Giersing (1881–1927), Sigurd Swane (b. 1879), Olaf Rude (1886–1957), and Karl Isakson (1878–1922). Ejnar A. Nielsen was a macabre symbolist (b. 1872). Among the memorable *avant-garde* groups were Den frie Udstilling (Salon des Refusés, 1891) and Grønningen (1915). The post-cubist tendency immediately after World War I is represented by Vilhelm Lundstrøm (1893–1950) and Christine L. Swane (b. 1876); artists linked to naturalism, particularly in landscapes, were Niels Bjerre (1864–1942), Oluf Høst (b. 1884), and Olivia Holm Møller (b. 1875), already active in the first years of the 20th century. Among the pupils of Kristian Zahrtmann were Niels C. Lergaard-Nielsen (b. 1893), Erik Hoppe (b. 1897), Søren Hjorth Nielsen (b. 1901), Knud Agger (b. 1895), Harald Leth (b. 1899), Jens Sondergaard (1895–1958), Lauritz Harts (b. 1903), Axel W. Johannesen (b. 1908), Jeppe Vontilius (b. 1915), Poul Ekelund (b. 1920), Peter M. Hansen, Fritz Syberg, Paul S. Christiansen, and Johannes Larsen. Zahrtmann founded the so-called "Fyn school," intent upon faithfully reproducing the local landscape. Niels K. and Joakim F. Skovgaard, sons of P. C. Skovgaard, preferred national and religious subjects; the second decorated the Cathedral of Viborg with large Biblical frescoes and had a talented follower in Niels Larsen-Stevns. There have been few painters of large-scale murals in Denmark; however, the work

of Niels W. Scharff is known in this field, as are the mosaics of Vilhelm Lundstrøm. Among the artists whose works are memorable from the period between the two world wars are Immanuel Ibsen, Ole B. Kielberg (b. 1911), Egon Mathiesen, Karl C. Bovin, and Carl Østerby. The magazine *Konkretion* (1935–37), directed by the painters W. Freddie and Vilhelm Bjerke-Petersen, widely propagated in the Scandinavian countries the sources of international surrealism and brought many young Danish and Swedish artists to public attention. Harry F. E. Carlsson was also an exponent of surrealism. In 1938, after a schism within the Scandinavian surrealist group, the Danish abstract-surrealist movement arose. Richard Mortensen (b. 1910; who moved to Paris and became an adherent of neoplasticism), Arvid Jorn, and Eiler Bille were the theoreticians of the movement, and others who participated in it were Egill Jacobsen, C. H. Pedersen, and the painter and sculptor Henry Heerup, mentioned earlier. These were soon joined by the architect R. Dahlmann-Olsen and the poets Ole Sarvig and Jens A. Schade. The movement gathered around the magazines *Helhesten*, *Aarstiderne* (1945–51), *Spiralen*, and *Cobra* (1948–51), becoming known as the "Danish experimental group," which developed within a markedly expressionist post-cubist sphere experiments that are the basis of the present informal trends. The Icelanders Svavar Gudnason and Thorvaldur Skulason, blockaded in Copenhagen by the war, worked there from 1940 to 1945 and markedly influenced such painters as K. Davidson and V. Petyrssen. Among the younger members of the group, who became known through the *Spiralen* exhibition of 1950, are Mogens Balle, Sven Dalsgaard, and J. Lange. Among the nonobjective painters worthy of note are Asger Jørgensen, Knud Jans, and Vestergaard-Jensen.

BIBLIOG. *General.* L. de Thurah, Den danske Vitruvius, 2 vols., Copenhagen, 1746–49; N. L. Høyen, Skrifter, 3 vols., Copenhagen, 1871–76; Tegninger af ældre nordisk architektur, 6 vols., Copenhagen, 1872–1914; J. Lange, Billedkunst, Copenhagen, 1889; J. Helms, Danske tufstenskirker, Copenhagen, 1895; J. Lange, Nutidskunst, Copenhagen, 1895–1914; E. F. S. Lund, Danske malede portrætter, 10 vols., Copenhagen, 1895–1910; J. M. Petersen, Kalkmalerier i danske kirker, Copenhagen, 1895; P. Weilbach, Nyt dansk kunstnerlexikon, 2 vols., Copenhagen, 1896–97, new ed., 3 vols., 1947–52; K. Madsen, ed., Kunstens historie i Danmark, Copenhagen, 1901–07; C. A. Been and E. Hannover, Danmarks malerkunst, 2 vols., Copenhagen, 1902–03; F. Meldahl and P. Johansen, Det kongelige Akademi for de skjønne kunster: 1700–1904, Copenhagen, 1904; P. Johansen, Nordisk oldtid og dansk kunst, Copenhagen, 1907; S. Müller, Nordens billedkunst, Copenhagen, 1907; Kunstmuseets Aarsskrift, 1914 ff.; H. B. Storck and M. Clemmensen, Danske teglstenskirker, Copenhagen, 1918; M. Mackeprang, Vore landsbykirker, Copenhagen, 1920; L. Bobé et al., eds., Danske herregaarde ved 1920, 3 vols., Copenhagen, 1922–23; V. Lorenzen, Københavnske palæer, 2 vols., Copenhagen, 1922–26; H. B. Storck, Jydske granitkirker, Copenhagen, 1922–23; P. Nørlund, Gyldne altre: Jydsk metalkunst fra Valdemarstiden, Copenhagen, 1926; S. Schultz, Dansk genremalerei, Copenhagen, 1928; K. Gottlob, V. Lorenzen, and G. Georgsen, eds., Danske herregaardshaver, Copenhagen, 13 vols., 1930–39; V. Thorlacius-Ussing, C. Elling, and J. Sthyr, eds., Kunst i Danmark, Copenhagen, 1930–39, 1958 ff.; P. B. C. Westergaard, Danske portrætter i kobberstik, litografi og træsnit, 2 vols., Copenhagen, 1930–33; Artes, I–VIII, 1932–40; Danmarks kirker, Copenhagen, 1933 ff. (12 vols. pub. to date); Dansk kunsthistorisk bibliografi, Copenhagen, 1935; L. Bobé, ed., Rom og Denmark, 3 vols., Copenhagen, 1935–42; G. Galster, Danske og norske medailler og jetons ca. 1533–1788, Copenhagen, 1936; H. Bramsen, Dansk kunst fra Rokoko til vore dage, Copenhagen, 1942; C. Elling, Danske herregaarde, Copenhagen, 1942; H. Langberg and H. E. Langkilde, Dansk byggesæt omkring 1792–1942, Copenhagen, 1942; C. Elling, Danske borgerhuse, Copenhagen, 1943; V. Wanscher, Danmarks architektur, Copenhagen, 1943; E. Zahle, Danmarks malerkunst, Copenhagen, 1943; A. G. Hassø, ed., Danske slotte og herregaarde, Copenhagen, 4 vols., 1943–45; J. Sthyr, Dansk grafik, 1500–1910, 2 vols., Copenhagen, 1943–49; J. B. Hartmann, Dansk skulptur, Copenhagen, 1946; J. B. Hartmann, Dansk arkitektur, Copenhagen, 1947; V. Lorenzen, Vore byer: Studier i bybning, 5 vols., Copenhagen, 1947–58; V. Thorlacius-Ussing, ed., Danmarks billedhuggerkunst, Copenhagen, 1950; J. P. Trap, Danmark, 5th ed., 5 vols., Copenhagen, 1953–60; H. Langberg, Danmarks bygningskultur, 2 vols., Copenhagen, 1955; V. Poulsen, Danish Painting and Sculpture, Copenhagen, 1955; V. Poulsen, Illustrated Art Guide to Denmark, trans. E. Hagemann, New York, Copenhagen, 1959; Analecta Romana Instituti Danici, 1960 (1 vol. and sup. pub. to date). *Prehistory and protohistory. a. General:* T. Mathiassen, ed., Danske oldsager, I, Ældre Stenalder, by T. Mathiassen, 1948, II, Yngre Stenalder, by P. V. Glob, 1952, III, Ældre Bronzealder, by H. C. Broholm, 1952, IV, Yngre Bronzealder, by H. C. Broholm, 1953 (the series will be continued with vols. V–VIII); J. Brøndsted, Danmarks oldtid, 3 vols., Copenhagen, 1957–59. *b. Late Paleolithic:* For Bromme: T. Mathiassen and J. Iversen, Aarbøger for nordisk oldkyndighed og historie, 1946, pp. 121–98; for the Maglemose culture; G. Sarauw, Aarbøger, 1903, pp. 148–316; K. Friis Johansen, Aarbøger, 1919, pp. 106–235; H. C. Broholm, Aarbøger, 1924, pp. 1–44; for the Ertebølle culture: A. P. Madsen and S. Müller, Affaldsdynger fra Stenalderen i Danmark, Copenhagen, 1900. *c. Neolithic:* On the beginnings of agriculture and cattle raising: C. J. Becker, Aarbøger, 1947, pp. 5–318; J. Troels-Smith, Aarbøger, Copenhagen, 1953, pp. 5–62; on Barkær: P. V. Glob, Fra Nationalmuseets arbejdsmark, 1949, pp. 5–16; for Troldebjerg: J. Winther, Troldebjerg, Rudkøbing, 2 vols., 1935–38; for individual burials (Snorekeramikerne): P. V. Glob, Aarbøger, Copenhagen, 1944, pp. 1–283. *d. Bronze Age:* For costumes: H. C. Broholm and M. Hald, Costumes of the Bronze Age in Denmark, tr. E. Aagesen, Copenhagen, 1940; for the

Trundholm sun chariot: S. Müller, Nordiske fortidsminder, I, 6, 1903; for the horns; H. C. Broholm, W. P. Larsen, and G. Skjerne, The Lures of the Bronze Age, trans. A. Svart, Copenhagen, 1949. *e. Iron Age:* For the Gundestrup caldron; S. Müller, Nordiske fortidsminder, I, 2, 1891; for the Dejbjerg wagons: H. Petersen, Vognfundene i Dejbjerg Præstegaardsmose, Copenhagen, 1888; for the Hjortspring boat: G. Rosenberg, Nordiske fortidsminder, III, 1, 1937; for the Hoby cups: K. Friis Johansen, Nordiske fortidsminder, II, 3, 1923; for the Nydam boat: C. Engelhardt, Nydam mosefund, Copenhagen, 1865; H. Shetelig, ActaA, I, 1930, pp. 1–30; for the golden horns of Gallehus: J. Brøndsted, Guldhornene, Copenhagen, 1954; for the Ladby ship tomb: K. Thorvildsen, Nordiske fortidsminder, VI, 1, 1957; for the Jelling tombs: J. Kornerup, Kongehøiene i Jellinge, Copenhagen, 1875; E. Dyggve, ActaA, XIII, 1942, pp. 65–99; E. Dyggve, ActaA, XXV, 1954, pp. 221–39; for the defense wall (Danevirke): S. Müller and C. Neergard, Nordiske fortidsminder, I, 5, 1903; V. la Cour, Danevirkestudier, Copenhagen, 1951; H. Jankuhn, Haithabu: Ein Handelsplatz der Wikingerzeit, 3d ed., Neumünster, 1956; for Trelleborg: P. Nørlund, Nordiske fortidsminder, IV, 1, 1948. *Middle Ages.* J. B. Løffler, Udsigt over Danmarks kirkebygninger fra den tidlige Middelalder, Copenhagen, 1883; F. Beckett, Alteravler i Danmark fra den senere Middelalder, Copenhagen, 1895; J. M. Petersen, Kalkmalerier i danske kirker, Copenhagen, 1895; V. Lorenzen, De danske klostres bygningshistorie, 11 vols., Copenhagen, 1912–41; F. Beckett, Danmarks kunst, 2 vols., Copenhagen, 1924–26; P. Nørlund, Gyldne altre, Copenhagen, 1926; M. Mackeprang, Danmarks middelalderlige døbefonte, Copenhagen, 1941; P. Nørlund, Danmarks romanske kalkmalerier, Copenhagen, 1944; R. Broby-Johansen, Den danske billedbibel, Copenhagen, 1947; M. Mackeprang, Jydske granitportaler, Copenhagen, 1948. *Renaissance and baroque period.* F. Meldahl, Denkmäler der Rensaissance in Dänemark, Berlin, 1888; F. Beckett, Renaissancen og kunstens historie i Danmark, Copenhagen, 1897; H. J. Holm and F. Beckett, Danske herreborge fra det 16. aarhundrede, Copenhagen, 1903; T. Oppermann, Kunsten i Danmark under Frederik V og Christian VII, Copenhagen, 1906; C. A. Jensen, Danmarks snedkere og billedsnidere 1536–1660, Copenhagen, 1911; F. Beckett, Frederiksborg, Copenhagen, 1914; V. Lorenzen, Landgaarde og lyststeder i Barok, Rokoko og Empire, 2 vols., Copenhagen, 1916–20; M. Krohn, Frankrigs og Danmarks kunstneriske forbindelse i 18. aarhundrede, 2 vols., Copenhagen, 1922; V. Lorenzen, Studier i dansk herregaards arkitektur i 16. og 17. aarhundrede, Copenhagen, 1922; F. Weilbach, Arkitekten Lauritz Thura, Copenhagen, 1924; V. Thorlacius-Ussing, Billedhuggeren Thomas Quellinus, Copenhagen, 1926; C. Elling, Slotte og herregaarde i Barok og Rokoko, Copenhagen, 1928; V. Lorenzen, Dansk herregaards arkitektur fra Baroktiden, 2 vols., 1928–34; C. Elling, Palær og patricierhuse fra Rokokotiden (Kunst i Danmark, II), Copenhagen, 1930; F. Weilbach, Dansk bygningskunst i det 18. aarhundrede, Copenhagen, 1930; F. Beckett, Renæssancens portrætmaleri (Kunst i Danmark, VI), Copenhagen, 1932; C. Elling, Rokokoens portrætmaleri, Copenhagen, 1935; V. Wanscher, The History of Kronborg Castle, IV (1577–1585), Artes, VII, 1939, pp. 97–190; O. Norn, Christian III's borge, Copenhagen, 1949; C. A. Jensen, Danske adelige gravsten 1470–1600, 2 vols., Copenhagen, 1951–53. *19th and 20th centuries:* M. Misserini, Thorvaldsen, 2 vols., Rome, 1831; J. M. Thiele, Den danske billedhugger Bertel Thorvaldsen og hans værker, 2 vols., Copenhagen, 1831–32 (English ed., 4 vols., New York, 1869); J. M. Thiele, Thorvaldsens biografi, 4 vols., Copenhagen, 1851–56 (German ed., 3 vols., Leipzig, 1852–56); E. Plon, Thorvaldsen, sa vie et son œuvre, Paris, 1867; E. Hannover, Maleren Christen Købke, Copenhagen, 1893; E. Hannover and C. W. Eckersberg, Copenhagen, 1898; E. Hannover, Maleren Constantin Hansen, Copenhagen, 1901; E. Hannover, Dänische Kunst des 19. Jahrhunderts, Leipzig, 1907; Dansk arkitektur gennem 20. aarhundrede: 1892–1912, Copenhagen, 1912; T. Oppermann, Herman Ernst Freund, Copenhagen, 1916; H. Öhmann and J. F. Willumsen, Copenhagen, 1921; T. Oppermann, Thorvaldsen, 3 vols., Copenhagen, 1924–30; K. Fisker, Modern Danish Architecture, Copenhagen, 1925; V. Wanscher, Kai Nielson, Copenhagen, 1926; F. Hendriksen, En dansk kunstnerkreds fra sidste halvdel af 19. aarhundrede, Copenhagen, 1928; K. Madsen, Skagens malere og Skagens museum, Copenhagen, 1928; S. Schultz, Nyere dansk billedhuggerkunst, Copenhagen, 1928; F. Weilbach, Arkitekten C. F. Harsdorff, Copenhagen, 1928; S. Schultz, Nyere dansk billedhuggerkunst, Copenhagen, 1929; L. Swane and J. F. Clemens, Copenhagen, 1929; K. Borschenius, ed., Vor tids kunst, I, Copenhagen, 1930 ff.; C. Elling, Documents inédits concernants les projets de A. J. Gabriel et N. H. Jardin, Copenhagen, 1931; C. V. Petersen, Italien i dansk malerkunst (Kunst i Danmark, IV), Copenhagen, 1932; K. W. Tesdorph, Johannes Wiedewelt, Dänemarks erster klassizistischer Bildhauer, ein Anhänger von Winckelmann, Hamburg, 1933; H. Bramsen, Landskabsmaleriet i Danmark 1750–1875, Copenhagen, 1935; Villa à Copenhague, L'architecture d'aujourd'hui, VI, 1, 1935, pp. 46–47, VI, 2, 1935, p. 48; K. Fisker, Københavnske boligtyper, Copenhagen, 1936; J. Rubow and C. F. Hansens arkitektur, Copenhagen, 1936; Danemark, L'architecture d'aujourd'hui, VIII, 10, 1937, pp. 3–29; L'architecture d'adjourd'hui, XI, 1940; L. E. Wanscher, Danmarks arkitektur, Copenhagen, 1943; K. Fisker, Terrace House, Copenhagen, 1944; L'architecture d'aujourd'hui, XVI, 1945; H. Rostrup, H. W. Bissen 1798–1868, 2 vols., Copenhagen, 1945; Architectural Rev., CIV, Nov., 1948 (whole issue devoted to Denmark); Dänische Architektur, Das Werk, XXXV, 5, 1948, pp. 129–64; Forum, III, 11, 1948 (whole issue devoted to Denmark); J. Zibrandtsen, Moderne dansk maleri, Copenhagen, 1948; L'architecture contemporaine danoise, exposition au Mus. Municipal d'Art Moderne, Paris, Copenhagen, 1949; L'architecture d'aujourd'hui, XX, 24, 1949 (whole issue devoted to Denmark); The Architecture of Denmark, London, 1949; K. Madsen, Johan Thomas Lundbye, Copenhagen, 1949; S. E. Rasmussen, Byer og bygninger, Copenhagen, 1949; K. Millech, Danske arkitektur strømninger 1850–1950, Copenhagen, 1951; J. and J. Ditzel, Danish Chairs, Copenhagen, 1954; J. Pedersen, Arkitekten Arne Jacobsen, Copenhagen, 1954; Rome, Palazzo delle Esposizioni, Arte mosaica contemporanea, April–May, 1955, pp. 1–17, 27–39; K. Fisker, Contemporary Danish Architecture, Copenhagen, 1958; F. Monies and G. Jensen, eds., Træ og arkitektur, Copenhagen,

1958; H. Bramsen, Gottlieb Bindesbøll, Copenhagen, 1959; J. B. Hartmann Thorvaldsen a Roma, Rome, 1959; J. P. Hodin, Scandinavia: L'arte dopo il 1945, la pittura, Milan, 1959, pp. 265–68, pl. 142.

Otto NORN

CHIEF ART CENTERS. Copenhagen (København). The first mention of the inhabited center (the village Havn, or Hafnia) dates from 1043, although the site appears to have been inhabited as early as the Stone Age. The city, still the principal port of Denmark, de-

(1641), built by Christian IV, begun in 1619, restored in 1873: king's portal originally in the Cathedral at Roskilde (1635). – Citadel Church (1704). – Garrison Church (Garnisons Kirke; 1706). – The Marble Church (Frederiks Kirke; 1749), interrupted for economic reasons until the 19th century, completed by F. Meldahl (1894). – Christian's Church (1755–59) by N. Eigtved, with belfry by G. D. Anthon. – Church of Our Saviour (Vor Frelsers Kirke, 1696), baroque, designed by L. von Haven; spiral tower, patterned after the Church of S. Ivo in Rome, by L. de Thurah (1749–52). – Catholic Church of St. Ansgar,

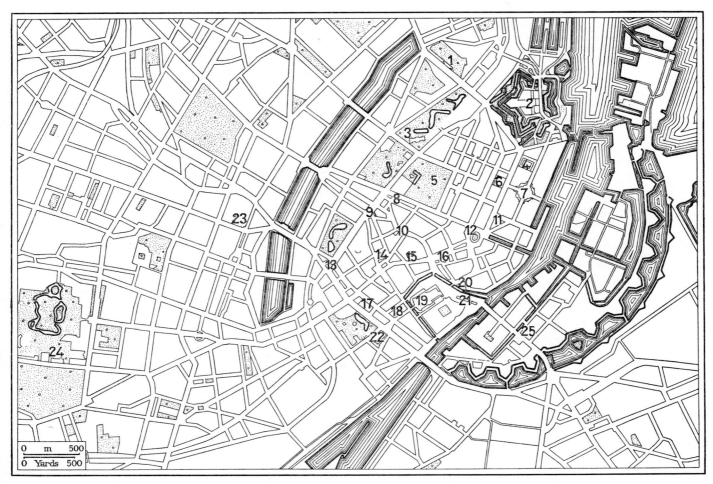

Copenhagen, central area and principal monuments: (1) Garnisons Kirkegaard and Holmens Kirkegaard; (2) Kastellet and St. Albans Kirke; (3) Fine Arts Museum and Hirschsprung Collection in Østre Anlæg; (4) Museum of Decorative Arts, formerly Frederiks Hospital and St. Ansgar Kirke; (5) Rosenborg Castle, royal garden, and Sølvgade Barracks; (6) Frederiks Kirke; (7) Amalienborg and Landsretten; (8) Reformed Church; (9) Regensen College in Kjøbmagergade; (10) Borkss and Elers Colleges, Trinitatis Kirke, and Runde Taarn; (11) Garnisons Kirke; (12) Kongens Nytorv and Charlottenborg; (13) Jarmers Taarn; (14) Petri Kirke and Vor Frue Kirke; (15) Helligaands Kirke; (16) Nikolaj Taarn; (17) Raadhuset; (18) National Museum; (19) Thorvaldsens Museum, Christiansborg, and Theater Museum; (20) Holmens Kirke; (21) Exchange and "Red Building"; (22) Glyptotek; (23) State Radio Building; (24) Frederiksberg; (25) Vor Frelsers Kirke.

veloped when Hafnia was given by King Waldemar the Great to Archbishop Absalon; it was then fortified (1167) and churches were built there (1290). In 1248 and 1362 it was captured and burned by the citizens of Lübeck. The fortifications of the late 13th century remained unaltered until the middle of the 17th century, when (1642) Christian IV replaced them. The community prospered and grew with the presence of the court, especially under Christian I (1448–81) and Frederik I (1483–1533). Christian IV (1577–1648) transformed the city, built entire quarters — such as Christianshavn (Christian's port) and the seamen's quarter (Nyboder) — and planned the expansion of the city toward the north (Urbs Nova). The city's growth and enrichment continued under Frederik III (1648–70), Christian V (1670–99), and Frederik V (1746–66), who built the Frederiksstaden quarter. Copenhagen suffered from fires (particularly serious ones occurred in 1728 and 1795) and was also destroyed in large part by the English bombardment in 1807.

a. Churches. Saint Peter's (Petri Kirke), the German parish church (1574). – Church of the Holy Ghost (Helligaands Kirke) of the 16th century, rebuilt in Renaissance style (1728). – Reformed Church (1689–1731). – Holmens Kirke, or Bremerholm Church

by G. F. Hetsch (1841–42). – The Cathedral of Our Lady (Vor Frue Kirke), built (1811–29) by C. F. Hansen upon the ruins of a medieval cathedral. – Church of St. Paul (ca. 1870–80). – English, or St. Alban's, Church (1885). – Bethlehems Kirke, by K. Jensen Klint (1934–37). – Grundtvigs Kirke by P. V. Jensen Klint (1923–40), inspired by the Gothic country churches.

b. Civil structures. Jarmer Tower, part of the old city fortifications. – Arsenal, built in 1604 (the basin was filled in 1868–70). – The Exchange, by Lourens and Hans van Steenwinkel, was built (1619–24) during the reign of Christian IV. The green copper spire formed of the twisted tails of four dragons was designed by L. Heidtrider (1625). The structure has sculptured ornamentation and sandstone trim. – Regensen College (1623, 1749, 1909). – Round Tower (Runde Taarn), belfry of the Trinity Church, erected under Christian IV, originally an astronomical observatory. – Valkendorff College, 17th century. – The Citadel (Kastellet; 1661), erected at the entrance to the port. – Staldmestergaarden (ca. 1700), now the Ministry of Ecclesiastical Affairs and Board of Education. – Charlottenborg, built (ca. 1675) under Christian IV by Ulrik F. Gyldenløve; seat of the Royal Academy of Fine Arts since 1754; it stands on the

Royal Square (Kongens Nytorv) near the Thott Palace (formerly the Juel Palace; 1683–88); altered by N. H. Jardin in 1764. – Haand-vaerkerforeningen (Artisans' Association; late 17th cent.). – Superior Court Building, formerly the Opera House, by V. F. von Platen (1703). – Palace of the Royal Archives, built by Frederik III as an arsenal (Royal Library and Cabinet of Art and Rarities: Museum Regium). – Markskalsgaarden, now the Central Post Office (1729); Ministerial Building (1723); Vartov Church (1754–55), formerly a hospital, now a center for theological studies of Grundtvig's doctrines; all by Philip de Lange. – Prince's Palace (Prinsens Palais; 1743–44) by Eigtved, now the National Museum. – Royal Palace of Christian VI (Christiansborg Palace), rebuilt in the 18th century by E. D. Häusser in Viennese baroque on the site of the old royal castle, with interior decoration by Eigtved (who designed the Marmorbroen, marble bridge), De Thurah, the French sculptor Le Clerc, and the Italian stuccoers

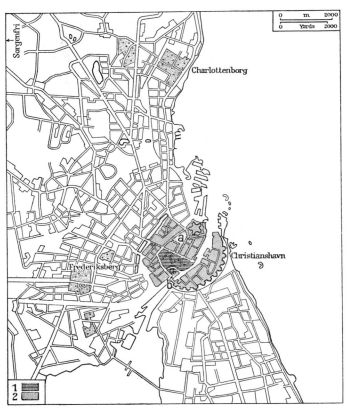

Copenhagen, urban development. *Key*: (1) Original city; (2) expansion of the city from the end of the 16th century to the middle of the 18th century. (a) Nyboder quarter; (b) Christiansborg Palace. Castles at one time outside the city but now incorporated within it are shown.

C. E. Brenno, Fossati, and G. F. Guione. Court theater, "Carrousel," and stables by E. D. Häusser. Burned in 1798 and reconstructed in the first decades of the 19th century by C. F. Hansen; again destroyed by fire in 1884 (only the Royal Chapel and the Supreme Court were spared), and rebuilt in its present baroque style by Thorvald Jørgensen (1907–28). It is divided into two wings, the northern containing the Parliament (with decorations by Bundgaard) and the southern containing the House of Representatives, with paintings by Abildgaard, Thorvaldsen's *Triumph of Alexander*, and other sculptures by Bissen, Jerichau, and Bjerg. – Frederiksberg Palace, built in 1707 by J. C. Ernst, with an Italian garden by H. H. Scheel (1697), patterned after the villas of Frascati and Tivoli, later transformed into an English park with Chinese pavilions by A. J. Kirkerup (1800). – Four palaces of the nobility forming the Amalien-borg (now the royal residence; mid-18th cent.), by Eigtved, surrounding the square of the same name, in the center of the new residential quarter built by Frederik V (Frederiksstaden). – Palace of Christian VII (formerly the Moltke), decorated by Le Clerc, Fossati, and Jardin; little temple in the garden, by Jardin; neoclassic colonnade by C. F. Harsdorff (1795). – Frederiksstaden, in the Bredgade: Dehn Palace; Berckentin Palace (Schimmelman Palace); Lindencrone Palace; Fred-eriks Hospital, by Eigtved and De Thurah (begun 1752, now the Museum of Decorative Art); Surgical Academy by P. Meyn (1785–87). – In the Amaliegade: private houses (*gaarde*), the homes of

Pfeiffer and De Thurah, the Harsdorff house, Kongens Nytorv (1780). – Yellow Palace, by Jardin (1764). – Sølvgade Barracks, by Jardin (1765–69). – Erichsen Palace, by Harsdorff, Neo-Palladian (ca. 1796). – Bank of Agriculture, formerly Peschiersgaard, by C. F. Harsdorff (1799). – Law Courts building, by C. F. Hansen, neoclassic (1805–15), formerly the Town Hall. – The Prison (1815) and the Metropolitan School (1816), by C. F. Hansen, near Vor Frue Kirke. – University, Neo-Gothic in style (1818–35), by P. Malling; deco-rated by Constantin Hansen and G. C. Hilker. – Thorvaldsen Museum (1839–1848), by M. G. Bindesbøll, with frescoes by Jørgen Sonne (restored in 1959 by A. Salto). – University Library (1860), by J. D. Herholdt. – Royal Theater (1874), built upon an 18th-century theater by Eigtved. – Ny Carlsberg Glyptotek, built (1892–97) by Dahlerup, a building added (1903–06) by Kampmann, decorated with sculptures by J. Bjerg, R. F. Larche, A. L. Barye, E. L. Le-quesne, S. A. Sinding, Constantin Meunier, and H. W. Bissen; in the garden, a cast of Rodin's *Thinker*. – Art Museum, in eclectic style, completed in 1896 from plans by V. Dahlerup. – Town Hall by Martin Nyrop, inaugurated in 1905; façade decorated with a gilded statue by Bissen. – New University City buildings. – State Radio Building (1938–45), by V. Lauritzen. – Hospital Københavns Amts Sygehus. – Skolen ved Sundet (1938), by K. Gottlob. – S. A. S. House, Falkonércentret (with theater and hotel). – Europa Hotel.

*c. Museums and collections.* State Museum of Art (Statens Museum for Kunst) with collection of drawings and engravings. – Ny Carlsberg Glyptotek. – Rosenborg Castle, with the Chronological Collections of the Danish Kings, including the crown jewels and a collection of Venetian glass (ca. 1700). – The National Museum (Nationalmuseet). – Thorvaldsens Museum. – The Hirschsprung Collection (19th-cent. Danish painting). – Gallery of Contemporary Art (formerly Johan Hansen Collection). – The Museum of Dec-orative Arts (Det danske Kunstindustrimuseum), with adjoining library and C. L. David Collection. – Town Museum (Københavns Bymuseum). – Arsenal Museum (Tøjhusmuseet). – Mineralogical Museum. – Theater Museum. – Zoological Museum. – Library of the Academy of Fine Arts (Kunstakademiets Bibliotek), founded in 1758, with adjoining photographic gallery (Statens kunsthistoriske Fotografisamling) and a rich collection of architectural plans.

*d. In the vicinity of Copenhagen.* Frederiksberg Town Hall, completed in 1953, by G. H. Nimb and H. Holm. – Kastrup Air-port, by V. Lauritzen. – Municipal school, Gladsaxe, by Eva and Nils Koppel (1956). – Town Hall, Rødovre (Copenhagen), by Arne Jacobsen (1956). – Church of St. Canute the Duke, Lyngby (Co-penhagen), by C. R. Frederiksen (1956). – Dyrehaven Park at Klam-penborg, with the Eremitagen hunting lodge by L. de Thurah (1736). – Sorgenfri, royal château at Lyngby (F. Dieussart, 1705–06; L. de Thurah, 1743–44).

*e. Museums.* Louisiana Museum (contemporary art) by V. Wohl-ert and J. Bo (1958). – Nivaagaard Collection (Italian painting of the Renaissance, Dutch painting of the 17th cent., Danish painting of the 19th cent.). – Ordrupgaard (French painting from Corot to Matisse). – Open-Air Museum (Frilandsmuseet, Lyngby).

BIBLIOG. O. Nielsen, Kjøbenhavns Diplomatarium, Copenhagen, 8 vols., 1870–87; O. Nielsen, Københavns historie og beskrivelse, Copenhagen, 6 vols., 1877–92; C. Bruun, Kjøbenhavn, Copenhagen, 3 vols., 1887–1901, København og omegn (pub. of the Turistforeningen), Copenhagen, 1897 ff.; Historiske meddelelser om København, Copenhagen, 1907 ff.; Forskønnelsen, 1911–28; V. Lorenzen, Christianshavns borgerlige bygningskunst, Copen-hagen, 1914; C. Elling, Palæer og Patricierhuse fra Rokokotiden (Kunst i Danmark, II), Copenhagen, 1930; V. Lorenzen, Problemer i Københavns historie, belyst ved samtidige kort, I, 1600–60, II, 1660–1757, Copenhagen, 1930, 1942; C. Elling, Det klassiske København, Copenhagen, 1944; J. B. Hartmann, København: Interiører og prospekter 1800–1860, Copenhagen, 1948; København fra bispetid til borgertid, Copenhagen, 1949; Danmarks kirker, Københaven, Heft 7, Helligåndskirker, Copenhagen, 1958; J. P. Trap, Danmark, Storkøbenhavn I, II, Copenhagen, 1959.

Jørgen B. HARTMANN

Aalborg. In northern Jutland; a royal residence in the 11th century, but as a city developed only recently. *a. Churches.* Budolfi Kirke (Cathedral), late Gothic, much restored; within, baroque sculptures in wood by Lauridtz Jensen. *b. Civil structures.* Castle (ca. 1540) by Morten Bussert, built after the destruction by the iconoclasts. – Hospital of the Holy Ghost (1431), formerly a mon-astery, largely restored. – Town Hall, 18th century. *c. Notable examples of burghers' homes.* The Jens Bangs Stenhus (1624), baroque, in brick and sandstone. – Jørgen Olufsens Gaard. – Ellen Marsvins Gaard (1616). *d. Monuments.* The Man of Aalborg by S. Wagner (ca. 1912). – The Cimbrian Bull by A. Bundgaard (1937). – The Goose Girl by G. Henning (1937). *e. Museums.* Aalborg Museum, con-

taining collections from the prehistoric era onward (objects from the Lindholm Høje Viking-era excavations) and collection of contemporary Danish painting.

BIBLIOG. V. Lorenzen, Danske helligaandsklostres byningshistorie, Copenhagen, 1912; O. Smith, Aalborg: Vandringer i den gamle Limfjordsby, Copenhagen, 1913; P. C. Knudsen, Aalborg bys historie, 3 vols., Aalborg, 1931–33.

**Aarhus.** Chief city of Jutland; because it was destroyed at various times by fire, it is largely modern. *a. Churches* Church of Our Lady (ex-cathedral), begun ca. 1100, completed in the 15th cent. – The Cathedral, of brick (13th cent., enlarged in the 15th cent.), contains a triptych with sculptures and paintings by Bernt Notke (1479); pulpit by Gert van Groningen (1588); many tombstones and epitaphs; the funerary monument of the Rodsteen-Marselis family, by Thomas Quellinus (1703–04), *b. Civil structures.* Moesgaard villa (1780), neoclassic, by C. J. Zuber; south of the city. – The University, by C. F. Møller, K. Fisker, and P. Stegmann (1933–46). – Theater (1900) by Hack Kampmann. – Town Hall (1938–42), by Arne Jacobsen and Erik Møller. – State Library (Statsbiblioteket) by Hack Kampmann. *c. Monuments. Awakening* (1923–24) by K. Nielsen. – *Girl of Aarhus* (1921), also by Nielsen; near the Stadium. *d. Museums.* Prehistoric Museum. – Aarhus Museum, with contemporary Danish paintings. – Civic Museum (Købstadmuseet "Den gamle By" [The Old Town]), with examples of half-timbered houses from all over Denmark, furnished with native handicrafts.

BIBLIOG. F. Beckett, Aarhus historie og udvikling gennem 1000 Aar. Aarhus, 1903–06; Aarhus Købstadsmuseet aarbog, 1927 ff.; Aarhus gennem tiderne, Aarhus, 4 vols., 1939–41.

**Bornholm.** Noteworthy on this island are the Romanesque churches of Sols, Ny, Nylars, and Østerlars. These are round, fortified structures from the late 12th century, with circular barrel vaults supported by a single pier. The Church of Aakirkeby has a Romanesque baptismal font by Mester Sighraf. Late 17th-century fortifications may be seen at Christiansø.

BIBLIOG. O. Norn, Bornholms byer og fæstninger, Christiansø, 1952; Danmarks kirker, Bornholm amt, Heft 2, Copenhagen, 1954; J. P. Trap, Danmark, IV, 2, Bornholm amt, Copenhagen, 1955.

**Helsingør (Elsinore).** Mentioned as early as 1230 and destroyed in the 14th century by the Hanseatic League, Helsingør rose again early in the 15th century near the Ørekrog fortress, on the remains of which Erik of Pomerania erected Krøgen citadel (ca. 1420). Frederik II had Kronborg Castle built by the Dutch architects Hans van Pashen and Anton van Opbergen in 1575–85; it was restored in the years 1926–29. It has four towers of sandstone, three of them with spires. In the chapel are works dating from 1580 to 1630. The King's Hall has a ceiling painted by G. van Honthorst. On the third floor is the Museum of Commerce and Navigation. Remains of the 17th- and 18th-century fortifications may be seen at this site. *a. Churches.* St. Mary's Church adjoins the Carmelite monastery. It is built of brick (15th cent.), with frescoes and sculptures by Adam van Düren. – The Carmelite monastery (1516) is today the home of the Provincial Central Library. – The Olai Kirke (ca. 1200, continued in the 15th cent. and later restored) contains a wealth of Renaissance and baroque art works, including an altar frontal by Lorentz Jorgensen (ca. 1650). *b. Civil structures.* There are several interesting houses and apothecarys' shops in the Stengade and Strandgade, late Gothic (Johan Oxes Gaard, ca. 1480), Renaissance (David Hansens Gaard, 1579), and 18th century. – The Marienlyst, a summer royal residence, is a Renaissance structure remodeled (1759–63) after plans by N. H. Jardin. Its elegant interiors are in Louis XVI style. – South of Helsingør, at Humlebæk, is the Gardhuse (1958), by J. Utzon.

BIBLIOG. C. A. Jensen and V. Lorenzen, Helsingørs borgerlige byningskunst til c. 1850, Copenhagen, 1910; V. Lorenzen, De danske Karmelitterklostres bygningshistorie, Copenhagen, 1924, pp. 24–65; L. Pedersen, Helsingør i Sundtoldstiden 1426–1857, 2 vols., Copenhagen, 1927–29; V. Wanscher, Kronborgs historie, Copenhagen, 1939; J. P. Trap, Danmark, III, 1, Frederiksborg amt, Copenhagen, 1953; O. Norn, Kronborg (Eng. text), trans. E. Nissen, Copenhagen, 1954.

**Hillerød.** Here is the notable Frederiksborg Slot (Frederik's Castle), built under Christian IV (ca. 1600–20) by Hans and Lourens van Steenwinkel. It was destroyed in 1859 and reconstructed as the National Historical Museum by Meldahl. Left intact were the church and the domed Audience Chamber by Lambert von Haven (ca. 1680), with rich interiors. The Museum has extremely fine historical collections and a portrait gallery. In the vicinity is Fred-

ensborg Slot, with a domed hall (1719–22), by J. C. Krieger; later enlarged (1750– 75) by N. Eigtved and C. F. Harsdorff. The church (ca. 1725) is by Krieger. The interiors are rococo and neoclassic. The Park (1759) by N. H. Jardin is considered the finest in Denmark. Sculptures by J. Wiedewelt, among others, may be seen here.

BIBLIOG. F. Beckett, Frederiksborg, Copenhagen, 1914; Hillerød by, Hillerød, 1925; J. P. Trap, Denmark, III, 1, Frederiksborg amt, Copenhagen, 1953.

**Horsens.** The Church of the Redeemer (Vor Frelsers Kirke), with nave and side aisles, is late Romanesque in style. It is built of brick and has an early 13th century triforium on the third story. The church was restored in 1934 by V. Norn. Its pulpit was carved by Peder Jansen (1650). The Franciscan monastery church (the monastery buildings no longer exist), dating from the 14th century, has rich wood carving, a late Gothic altarpiece and pulpit, baroque epitaphs, and a metal choir balustrade. The baptismal font chapel contains work by local sculptors. The Horsens Museum has historical collections and examples of contemporary Danish art. In the vicinity, at Tamdrup, is a Romanesque church (11th cent.) of stone, with nave and two side aisles. It was remodeled in the late Gothic period. The Romanesque frescoes in the choir arch (early 13th cent.) are similar to those of Ørritsle, north of the city.

BIBLIOG. F. Schiøtt, Gerhardt Hansen de Lichtenberg og hans byggevirksomhed, Architekten, IX, 1906–07, p. 337 ff.; H. Matthiessen, Gamle gaarde i Horsens, Architekten, XVII, 1914–15, p. 137 ff.; O. Norn, Harsdorff og palaiset i Horsens, Historisk samfund for Aarhus stift, Aarbøger, XXXI, 1938, p. 193 ff.; J. P. Trap, Danmark, III, 2, Holbæk amt, III, 3, Sorø amt, Copenhagen, 1954.

**Jelling.** This city was a religious center and royal residence in the Viking epoch and early Middle Ages. Two large mounds, one of which contained a burial chamber, are located in a field bounded by gigantic cuneiform stones. Two runic stones, the largest of which bears a historical inscription and scenes in bas-relief, were commissioned by King Harald Blataand (d. ca. 980), who introduced Christianity into Denmark. A small limestone church, erected on the site of an earlier wooden one, has Romanesque frescoes from the early 11th century (restored). In the choir of the nearby church of Skibby there is a frieze of knights (1150). Romanesque works may be seen in the church of Sindbjaerg also.

BIBLIOG. E. Dyggve, Jellingkongernes mindesmærker, Kolding, 1956.

**Kalundborg.** The Church of Our Lady, the ground plan of which is in the form of a Greek cross (highly unusual in Denmark, perhaps of Byzantine influence), has five towers and was founded about 1170. The Kalundborg og Omegns Museum has collections of historic and cultural interest in a building dating from the mid-18th century. In the vicinity is the Lerchenborg Manor (1743–45), with interiors in the style of Eigtved.

BIBLIOG. C. M. Smidt, Fra det gamle Kallundborg, Fra Holbæk amt, II, 1908, pp. 113–38; M. Clemmensen and V. Lorenzen, Kallundborg kirke, Copenhagen, London, 1922; J. P. Trap, Danmark, III, 2, Holbæk amt, Copenhagen, 1954.

**Maribo.** The Cathedral (1400–70) of the Order of St. Bridget (Birgittinerordenens Kirke) has a nave and two side aisles; the eastern choir has been torn down. Remaining are a painting on canvas of the late 15th century, a large crucifix carved in wood, of about 1450, and a portrait in wood of St. Augustine, of the late 15th century. The diocesan museum has historical and cultural collections, a series of medieval sculptures in wood, and a collection of modern Danish art. The country churches of Lolland and Falster (1200–1500), built of brick, show the influence of North German architecture.

BIBLIOG. V. Lorenzen, De danske klostres byningshistorie, IV, Copenhagen, 1922; C. C. Haugner, Maribos historie, 2 vols., Copenhagen 1937–38; B. Berthelson, Studier i Birgittinerordens byggnadsskirk, Copenhagen, 1947; Danmarks kirker, Maribo amt, 7 nos., Copenhagen, 1948–51; J. P. Trap, Danmark, IV, 3, Maribo amt, Copenhagen, 1956.

**Nyborg.** The Church of Our Lady, with nave and two side aisles, dates from about 1400. The castle, incorporating a Romanesque palace from the early 13th century, was enlarged about 1520 and again in 1550, at which time new fortifications were added to the city. The remains of the fortification towers may still be seen. The open-air museum (Købmandsgaard) dates from 1600. In the neighborhood may be seen the fortified Hesselagergaard Manor, built of brick in 1550 by the chancellor Johan Friis.

BIBLIOG. H. C. Holst, I Svendborg amt, Copenhagen, 1914; T. Løgstrup, Nyborg kirke, Copenhagen, 1923; P. Severinsen, Nyborg kirke,

Svendborg amt, Copenhagen, 1927–28; O. Norn, Danske slotte og herre-gaarde, III, Copenhagen, 1943; O. Norn, Christian III's borge, Copenhagen, 1949; O. Norn, Nyborg slot, Copenhagen, 1950; J. P. Trap, Danmark, V, 2, Svendborg amt, Copenhagen, 1957.

Odense. The chief city of the island of Fyn, Odense exemplifies a medieval city plan, irregular in layout. *a. Churches.* The Gothic Church of St. Knud (ca. 1300), of brick, was completed in 1450, and restored in 1868–74 by J. D. Herholdt. In the choir is a large altarpiece carved in 1521, the masterpiece of Claus Berg. The tomb of King Hans in the crypt is by the same artist. Also worthy of note is a funerary monument in marble by Thomas Quellinus (early 18th cent.). Other churches are the late Gothic St. John's and the Church of Our Lady (12th–15th cent.). *b. Civil structures*: Police station (1951–53), by M. Borch. – Tietgen Schools (1954), by V. O. Kyed. – Hans Christian Andersen Commemorative House, frescoed by Niels Larsen-Stevns (1929–32). *c. Museums.* The Museum of Art (Fyns Stiftsmus.) contains Danish paintings. – The Historic and Cultural Museum is in the old houses of wood and masonry and in the courtyards of the Møntestrædegaard (by Eiler Rønnov, 1547). – Large open-air museum "Den fynske Landsby" (the village of Fyn). – Prehistoric Museum.

BIBLIOG. V. Lorenzen and H. V. Aygner, Planer og kort over Odense købstad og dens jørder, Copenhagen, 1922; H. S. Holbeck, Odense bys historie, Odense, 1926; J. P. Trap, Danmark, V, 1, Odense amt, Copenhagen, 1956.

Randers. St. Mortens Kirke (St. Martin's Church), late Gothic, with nave and two side aisles, extensively restored. – Notable private homes: the Niels Ebbesensgaard, three storied, Renaissance; Withshus in the Brødregade (18th cent.). – Town Hall (1778). – North Jutland Armory (19th cent.), by Anders Kruuse. – Randers Museum, with historic and cultural collections and modern Danish paintings. – The region abounds in Romanesque country churches, of granite and stone, among which the Djursland church reveals the influence of the old Norman-English architecture. The church of Raasted has 13th-century frescoes in the choir.

BIBLIOG. P. Spreckelsen, ed., Randers købstads historie, 2 vols., Randers, 1952.

Ribe. The Romanesque Cathedral (12th cent.) is reminiscent of the Rhine cathedrals, and is in tufa and Bremen sandstone (transported from Bremen itself to Ribe by sea). The high brick belfry is of the Flemish type (14th cent.). The tomb of Bishop Ivar Munk (d. 1539) is by Claus Berg. – The Church and monastery of St. Catherine, late Gothic, is built of brick. – Many half-timbered private homes of the 16th century may be seen here. – In the region between Ribe and Tønder is the church of the Cistercian monastery of Løgum, of brick (13th cent.). It has a reliquary with paintings from 1300.

BIBLIOG. J. Helms and H. C. Amberg, Ribe domkirke, Copenhagen, 1906; H. Matthiessen, O. Smith, and V. Hermansen, Ribe bys historie, 1660–1730, Copenhagen, 1929; V. Lorenzen, Vore gamle domkirker, Copenhagen, 1953.

Ringsted. The Church of St. Benedict (adjoining the monastery), is built of brick (ca. 1160, completed in the 13th cent.). The spacious choir and the transept with its chapels show Lombard influence, due perhaps to the assistance of Italian craftsmen. The frescoes in the choir are of the 14th and 15th centuries; the stalls are from the early 15th century. The sole royal monument conserved here is the Flemish tombstone of Erik Menved, in brass (ca. 1319). The large tombstone with reliefs referring to Oluf Mouridsen Krognos is from the workshop of Morten Bussert (ca. 1550). The marble and alabaster epitaph in honor of Anne Hardenberg (1575) is the work of the Master of the Alabaster of Copenhagen.

BIBLIOG. M. Clemmensen and P. Nørlund, Ringsted kirke, Copenhagen, 1927; V. Lorenzen, De danske klostres bygningshistorie, X, Copenhagen, 1933; Danmarks kirker, Sorø amt, 2 nos., Copenhagen, 1936–38; J. P. Trap, Danmark, III, 3, Sorø amt, Copenhagen, 1954.

Roskilde. Episcopal see since the 10th century, Roskilde was a royal residence in the 12th and 13th centuries. The brick Cathedral, erected about 1170, is late Romanesque. The 14th-century and late Gothic additions are reminiscent of the ecclesiastical architecture of northern France and of Flanders. Outstanding are the portico by Oluf Mortensen and the chapels of Christian IV, of Frederik V (the latter by C. F. Harsdorff), and of the Three Kings. Within may be seen a Flemish altar frontal (1560), Gothic sculptures in wood, choir stalls from the early 15th century, and late Gothic frescoes. This is the burial church of most of the Danish kings. Among the funerary monuments are those of Queen Margaret (1423), Christian III (by Cornelis Floris de Vriendt, 1579), and Frederik II

(by Gert von Egen, 1598), all in marble and alabaster; and the sar-cophagi of Christian V and Queen Charlotte Amalie (by J. C. Sturm-berg), Frederik V (by Johannes Wiedewelt), and Christian VI. Little remains of the Church of Our Lady, of travertine, from the late 11th century, or of the Church of St. Lawrence. The "Palaiset," or Palace (De Thurah, 1732), is interesting. In the vicinity is the splendid château of Ledreborg (J. C. Krieger, 1739), remodeled about 1750 (Eigtved, De Thurah), with rich interiors and art collections. The Riddersal (Knights' Hall) contains portraits of the Holstein-Ledreborgs (Tuscher, Wahl, Als, ca. 1750).

BIBLIOG. J. Lange, Bemærkninger om Roskilde domkirkes alder og stil, in Udvalgte skrifter, I, Copenhagen, 1900, pp. 293–340; V. Lorenzen, Roskilde domkirke, Roskilde, 1924; A. Fang, Roskilde i gamle dage, Roskilde, 1930; C. Elling, Ledreborg, Kunstmuseets aarsskrift, XXI, 1934. pp. 214–76; Danmarks kirker, Københavns amt, 16 nos., Copenhagen, 1944–51.

Sønderborg Slot. Late Gothic circular fortress, converted into a Renaissance castle after 1550, and rebuilt in 1718 by V. F. von Platen. Surviving from 1570 are the church (by Hercules von Ober-berg) with Frans Floris' reredos, the baptismal font by Cornelis Floris, and the marble portal, perhaps by Philipp Brandin. In the fortress there are important historical and military collections. The neighboring church of Ulkebøl contains a late Gothic Flemish triptych (1520).

BIBLIOG. J. Raben, Sønderborg slot, Sønderborg, 1920; O. Norn, Christian III's borge, Copenhagen, 1949.

Sorø. The Cistercian church, of brick, begun about 1170, was completed in 1200. Notable art works are two crucifixes, one carved of wood (ca. 1250), and the other by Claus Berg (ca. 1520). In the choir is the tombstone of Bishop Absalon (d. 1201) by Morten Bussert. The baroque reredos, with carvings by Hendrik Werner, was painted by A. Wuchters. The Academy is composed of two residences (designed by the pupils of Lauritz de Thurah, 1738–43) and the main building, which is classic in style (by P. Malling, 1823–26). In the vicinity are the Romanesque churches of Bjernede and Fjenneslev (ca. 1150), the first being round and two-storied. The Church of Fjenneslev contains fresco portraits of its founders; Romanesque frescoes are found also in the churches of Broby and Alsted. The Fort of Trelleborg (ca. 1000) marks the transition between the Viking era and the Middle Ages. It is a circular fortress which once had four blocks of wooden houses; one house has been rebuilt on the remnants of the foundations. The objects which have been excavated here are in the National Museum of Copenhagen.

BIBLIOG. Danmarks kirker, Sorø amt, 2 nos., Copenhagen, 1936–38; V. Lorenzen, De danske klostres bygninghistorie, XI, Copenhagen, 1941; J. P. Trap, Danmark, III, 3, Sorø amt, Copenhagen, 1954.

Viborg. Located in central Jutland, Viborg was an important trade center in the Middle Ages and an episcopal see after 1065. The Romanesque Cathedral (ca. 1150) was extensively restored and reconstructed in the 19th century. Of the original structure, only the granite crypt now remains. The Cathedral contains frescoes by Joakim Skovgaard (1912–13). In the church of Søndresogn (former Dominican monastery), remodeled in 1726, there is a triptych with paintings and carvings executed in Antwerp in 1520. The old Town Hall (1728), by Claus Stallknecht, now houses a museum. In the environs are Romanesque churches containing granite sculptures. Other noteworthy centers are Faaborg, Haderslev, Kolding, and the island of Møn.

BIBLIOG. N. L. Høyen, Viborg domkirke, Danske mindesmærker, I, 6–7, 9–10, Copenhagen, 1864–68; Viborg købstads historie, 4 vols., 1940–41; Danmarks kirker, Viborg amt, Copenhagen, 1954.

Otto NORN and Jørgen B. HARTMANN

Faeroes (Færøerne). This island group in the North Atlantic belonged to Norway in the Middle Ages but now forms an autonomous region of the kingdom of Denmark. In the Middle Ages it had its own diocese, with an episcopal see at Kirkebø, in the southeastern part of Strømø (the largest island). Bishop Erlend (ca. 1300) was the first to be recognized as of equal status with other European bishops. At this time also, the episcopal palace and the Cathedral were built. Of the former, consisting of two parallel wings enclosing a square, there remain large portions of the ground-floor masonry; the wooden structure on the upper story seems not to be original. The Cathedral is rectangular in shape, with a single aisle. It was never completed. Remaining are its outer walls and a sacristy. On the western façade, which is broken by a lofty, slender arch, may be seen the beginnings of an unfinished tower. The portals and

decorations are rich. Because the basalt of which the Cathedral is built tends to crumble in a cold climate, the fine architectural detail of the windows and the carved supports (intended to support a vault) have disintegrated. It is hard to classify the Cathedral's style; it appears to have been built by artisans who had worked on the big churches in western Norway, particularly in Bergen, and who were familiar with English Gothic. The little stone church which the Cathedral was intended to replace still exists, but it has been spoiled by a 19th-century restoration.

BIBLIOG. Foreningen til norske fortidsminders bevaring, Aaarsberetning, LXII, 1906, pp. 85–246; D. Bruun, Fra de færøske bygder, Copenhagen, 1929.

Tage E. CHRISTIANSEN

Greenland. Until June 5, 1953, Greenland (Grønland) was a Danish colony, as it had been for more than two hundred years; but on that date Greenland became an integral part of Denmark. With an area of 839,800 square miles, Greenland is the largest island in the world. Of this area, 707,900 square miles of the interior are covered by the huge, compact icecap called the "inland ice," which leaves only 131,900 square miles of ice-free shores and islands remaining. Only a fraction of this ice-free area is habitable.

Greenland was first settled by the so-called "Paleo-Eskimos," representing an ancient cultural stratum which precedes the culture of the present-day Eskimo population of Greenland and other parts of the Eskimo territory. The earliest archaeological discoveries, made in the northernmost part of Greenland, date back to about 2000 B.C., but neither these nor other early finds of Paleo-Eskimo culture have yielded any objects of art, most of the objects found being stone implements. The earliest known art in Greenland is that of a later phase of the so-called "Dorset" culture, which also belongs to the Paleo-Eskimo culture complex. Artifacts of this phase of the Dorset culture, which has been estimated to date back to the 10th century of our era, have been found in the Thule district, in the northwestern part of the country. The art is characterized by small zoomorphic and anthropomorphic figures in walrus ivory, antler, and wood; and by a straight-line decoration which undoubtedly is a derivative of a more naturalistic skeleton motif as found in the art of the Ipiutak culture (see ESKIMO CULTURES). Many examples of Dorset art have been found in arctic Canada, from which Greenland received the Dorset culture and all other forms of Eskimo culture. A few examples of Dorset art have been found farther south on the west coast of Greenland, including a very fine wooden carving with many human faces, found in a grave in the Umanak district.

The earliest finds of the Thule culture, which is a Neo-Eskimo culture ancestral to the culture of the Greenlanders, were made in the Thule district. Characteristic of Thule art are small figurines of wood and walrus ivory, most of them human; animal figurines, however, have also been found, as have carvings in walrus ivory and antler which were used as ornaments, combs, etc. The rather sparse surface decoration on these objects consists of dots, spurred lines, and Y-shaped figures. The culture existed in Greenland during the 13th century and possibly earlier.

Remains of the Thule culture may also be found in west Greenland and northeast Greenland, but the culture soon developed into one unique to Greenland which has been named the "Inugsuk culture" after the first known site, an island in the Upernavik district. One of the main differences between the art of the Thule and Inugsuk cultures is the presence in the latter of certain characteristics which indicate that these Eskimos had been in contact with the Norsemen who settled in southwest Greenland in the Middle Ages. This contact with the Norsemen is reflected in wooden figurines carved by Eskimos in Eskimo style but wearing costumes which clearly show that the figurines represent Norsemen.

Otherwise Inugsuk art does not differ from that of the Thule culture; we find the same small human and animal figurines and simple line decoration. The Inugsuk culture may date as far back as the 13th century; it is definitely known to have been in existence during the 14th and 15th centuries.

The Inugsuk culture, which gradually spread over most of Greenland, developed slowly into the culture of the present-day Greenlanders. The most conspicuous break in this gradual development was caused by the arrival in Greenland of European whalers in the 17th century, and later, in 1721, of Danish missionaries and colonizers.

Though the culture of all present-day Greenlanders stems from the same mother culture (Thule), the development has taken a slightly different course in various parts of the country. Until the very recent modernization began its leveling action, three major cultural areas were distinguishable: those of the Thule district, west Greenland, and east Greenland. The art of the Thule district was limited to tiny, primitive bone and ivory figurines of animals and human beings. The art of west Greenland found expression mainly

in carved ivory buttons and buckles for kayak straps and clothing (most of them with zoomorphic motifs), in small human and animal figurines, and in decorations on eyeshades. While the carvings were men's work, the women showed great taste and excellent craftmanship in embroidering skins.

East Greenland, and particularly the Angmagssalik district, occupies an exceptional position as far as Eskimo art is concerned. No part of the Eskimo culture outside Alaska has undergone an artistic development comparable to that which took place in the Angmagssalik district in the 19th century. For some inexplicable reason, this development began at a time when the tribe was on the verge of extinction, a fate averted only by the white man's discovery of the tribe in 1884 and subsequent colonization of the area. The forms of the work produced at that time are manifold. The men carved masks, fantastic figurines, and dolls of wood, as well as small ivory and bone figurines to be nailed as ornaments on weapons, tools, and household utensils. The women did very fine embroidery on skins, and created, among other things, a variety of new forms of skin bags.

The remains of an entirely different culture have also been found in Greenland, that of the old Norsemen who occupied the southern part of the west coast from A.D. 985 or 986 to about 1500. Their farms were concentrated in two settlements, the east settlement in the Julianehaab district and the west settlement in the Godthaab district. Of these the former is said to have had 190 farms, 12 churches (of which the ruin of the Hvalsey church is the best preserved), a monastery, and a convent, while the smaller west settlement presumably had 90 farms and 4 churches. Through excavations of farms, churches, and cemeteries, a considerable number of artifacts have been brought to light, among them carvings of artistic significance in wood, walrus ivory, and soapstone (see SCANDINAVIAN ART).

BIBLIOG. S. Holm, Ethnological Sketch of the Angmagsalik Eskimo, Meddelelser om Grønland, XXXIX–XL, 1914–23; W. Thalbitzer, Ethnographical Collections from East Greenland, Meddelelser om Grønland, XXXIX, 1914; T. Thomsen, Implements and Artifacts of the North-east Greenlanders, Meddelelser om Grønland, XLIV, 1917; K. Birket-Smith, Ethnography of the Egedesminde District, with Aspects of the General Culture of West Greenland, Meddelelser om Grønland, LXVI, 1924; P. Nørlund, Buried Norsemen at Herjolfsnes, Meddelelser om Grønland, LXVII, 1, 1924; M. Vahl et al., eds., Greenland, 3 vols., Copenhagen, 1928–29; T. Mathiassen, Inugsuk, a Medieval Eskimo Settlement in Upernavik District, West Greenland, Meddelelser om Grønland, LXXVII, 1930; T. Mathiassen, Ancient Eskimo Settlement in the Kangâmiut Area, Meddelelser om Grønland, XCI, 1, 1931; P. Nørlund, Norse Ruins at Gardar, Meddelelser om Grønland, LXXVI, 1, 1931; T. Mathiassen, Prehistory of the Angmagssalik Eskimos, Meddelelser om Grønland, XCII, 4, 1933; H. Larsen, Dødemandsbugten, an Eskimo Settlement on Clavering Island, Meddelelser om Grønland, CII, 1, 1934; T. Mathiassen, Contributions to the Archaeology of Disko Bay, Meddelelser om Grønland, XCIII, 2, 1934; P. Nørlund, De gamle Nrodbobygder ved Verdens Ende, Copenhagen, 1934; P. Nørlund and M. Steenberger, Brattahlid, Meddelelser om Grønland, LXXXVIII, I, 1934; P. V. Glob, Eskimo Settlements in Kempe Fjord and King Oscar Fjord, Meddelelser om Grønland, CII, 2, 1935; A. Roussel, Sandnes and the Neighbouring Farms, Meddelelser om Grønland, CVIII, 2, 1936; E. Holtved, Archaeological Investigations in the Thule District, I–II, Meddelelser om Grønland, CXLI, 1–2, 1944; E. Holtved, Eskimo kunst, Copenhagen, 1947; K. Birket-Smith, Grønlandsbogen, Copenhagen, 1950.

Helge LARSEN

Illustrations: 4 figs. in text.

DERAIN, ANDRÉ. French painter (b. Châtou, near Paris, June 10, 1880; d. Garches, near Versailles, Sept. 2, 1954). During 1898–99, while studying at the Académie Carrière, he formed a friendship with Vlaminck, which he was to maintain throughout his life. Matisse also became his friend at this time. As early as 1900 he demonstrated an interest in the style and techniques of the old masters by making copies of such Italian works as Ghirlandajo's *Deposition* (Louvre). In 1904 Derain entered the Académie Julian and in the following year worked with Matisse at Collioure and exhibited with the Fauves (q.v.) at the Salon d'Automne. In the same year he exhibited at Berthe Weill's gallery as well as at the Salon des Indépendants. In 1906 the artist visited London on Vollard's instigation, and in 1907 made a contract with the dealer Kahnweiler. About 1908, Derain's work began to show the influence of cubism; this influence reached a climax in those paintings executed at Cagnes in 1910, the year of his visit to Spain and to Picasso at Cadaqués. After his military service during World War I, his career was spent mainly in southern France

and in Italy. In 1928 he won first prize at the Carnegie International in Pittsburgh. Among his characteristic paintings are *L'Estaque* (1906) and *Window on the Park* (1912), both at the Museum of Modern Art, New York, and *The Two Sisters* (1914; Copenhagen, Royal Mus.). Derain is also known for the books he illustrated, which include those of Guillaume Apollinaire, *L'Enchanteur pourrissant* (1909); Max Jacob, *Les Œuvres burlesques et mystiques de Frère Matorel mort au couvent* (1912); Georges Gabory, *La Cassette de plomb* (1920); Oscar Wilde, *Salome* (1938); and Rabelais, *Pantagruel* (1945). Derain also designed a number of sets for the Ballets Russes, among which are *La Boutique fantasque* (1919), *Jack-in-the-Box* (1924), *La Concurrence* (1932), and *L'Epreuve d'amour* (1936).

Derain's career presents the curious phenomenon of a painter who began as a progressive and ended as a conservative. During the first decade of this century he was influenced by the most advanced contemporary art and allied himself with the radical innovations of color and brushwork characteristic of the Fauves. By the end of the decade he had become interested in the even more revolutionary style of cubism, but he never assimilated it fully. In the 1920s, however, he turned his back on his youth and developed a more conservative style that paid homage to the discipline of the old masters and, particularly, of the French classical tradition. Like De Chirico and Carrà, he has often been criticized for abandoning the modern movement in favor of a less contemporary style dependent on inherited methods of realism and pictorial order. See V, PLS. 123, 257, 262.

WRITINGS. Lettres à Vlaminck, Paris, 1955.

BIBLIOG. C. Carrà, André Derain, Rome, 1921; E. Faure, A. Derain, Paris, 1923; A. Salmon, André Derain, Paris, 1929; M. Vaughan, Derain, New York, 1941; J. Leymarie, André Derain, Geneva, 1948; G. Hilaire, Derain, Geneva, 1959; D. Sutton, Derain, London, 1959.

Robert ROSENBLUM

## DESIDERIO DA SETTIGNANO.

Florentine sculptor (b. Settignano, ca. 1430; d. Florence, 1464) also known as Desiderio Meo. Although Desiderio's short working career, entirely centered in Florence, brought him great and deserved fame during and after his lifetime, curiously few details of those years are recorded with certainty. He was the youngest of three sons of a mason of Settignano, all of whom joined the guild of masters of stone and wood carving and frequently worked together. Desiderio may have been a pupil of Donatello before Donatello's Paduan journey in 1444. When Desiderio matriculated in 1453, he had already established a reputation. He completed the tomb of the Humanist Carlo Marsuppini (Sta Croce) sometime after 1453, the year of Marsuppini's death, and in 1461 finished his second major monument, the Tabernacle of the Sacrament (S. Lorenzo). Desiderio's other works have been grouped by comparison with these monuments. Such reliefs as the frieze of putti heads on the exterior of the Pazzi Chapel (Sta Croce), the *Madonna and Child* (Turin, Gall. Sabauda), and *St. John* (Florence, Mus. Naz.) are considered to precede the Marsuppini tomb. His later works, after 1461, may include the tondo relief of the *Christ Child and Young St. John* (Louvre), the *Portrait of a Lady*, the Martelli *Baptist*, and the Panciatichi *Madonna* (all Florence, Mus. Naz.). According to Vasari, Desiderio's last work was the painted wooden statue *The Magdalen* (Sta Trinita), left unfinished at his death and completed by Benedetto da Maiano.

Whether or not Desiderio was formally a pupil of Donatello, he was unquestionably one of the most gifted members of the circle of younger artists strongly influenced by this forceful artistic personality. Desiderio's great distinction lay in his ability to create and sustain an independent style, stimulated by the example of Donatello but not overwhelmed by it. While Desiderio's work stems from the more lyrical and poignant of Donatello's representations, he should not be valued simply as a minor master limited to developing one aspect of a more complex and many-sided genius's work. To do so would be to ignore the astonishing quality of Desiderio's performance within the very short interval of his working life. In this interval Desiderio interpreted traditional themes — the Madonna and Child, the young St. John, the infant Christ, angels — with such singular grace and felicity that his versions met an instant response and were often copied during and after his lifetime (often translated from his medium of marble into lighter materials). Desiderio's work was never reduced to a formula; there are surprisingly subtle variations of expression, type, and design. A strong feeling for structure lends authority to graceful and sweetly shaped figures; attractive forms are given poise and dignity by his perceptive intelligence. Desiderio's incredible facility and control in carving marble gave him assurance in dealing with the special problems of relief sculpture; delicate gradations suggest strongly felt volumes, while his precise and sensitive lines are drawn with an unerring calligraphic skill. The result is an apparently effortless harmony and balance.

BIBLIOG. C. Kennedy, Studies in the History and Criticism of Sculpture, V, The Tabernacle of the Sacrament by Desiderio, Northampton, Mass., 1929; C. Kennedy, Documenti inediti su Desiderio, RArte, XI, 1930, pp. 243–91; L. Planiscig, Desiderio da Settignano, Vienna, 1942.

Eleanor BARTON

## DESIGN.

Design is a means of ordering visual and emotional experience to give unity and consistency to a work of art and to allow the observer to comprehend its meaning. The attention of the observer must be not only initially attracted but also held long enough to perceive all the parts of the work and to comprehend their significance individually and as aspects of the whole. Design is essentially visual control, and consciously or unconsciously the artist develops methods of ordering that are visually comprehensible. He arranges the visual elements (line, form, tone, color, texture, light, and space) in a manner compatible with his ideas and feelings. Design is therefore integral to artistic expression, communication, and all types of structuring.

Although the execution of a work of art is dictated by a logic that reflects an order seen in other aspects of life and nature, this logic is felt "intuitively" by the artist; harmony, rhythm, and movement are often sensed rather than worked out primarily on a rational level. However, formal knowledge of movement and relationships can be used by the artist as a critical tool. This same knowledge aids the theoretician to understand and explain a work of art (see CRITICISM; PHILOSOPHIES OF ART).

The need for expression and environmental control vary greatly from one age to another, owing to differences in ideology and aspiration; theories of vision (see OPTICAL CONCEPTS) and the human element in design reflect these changes (see PSYCHOLOGY OF ART). Thus the terminology in the art field varies not only from age to age but also from person to person. The concept of "pure design" is often used by art critics, historians, or estheticians when referring abstractly to design principles; in this usage design can be "pure," without art referent.

SUMMARY. *The elements of art; Principles of arrangement.*

*The elements of art.* The visual elements of art (see above) are the building blocks with which the work is structured; along with the principles of arrangement, they form the basis of art criticism and esthetics. Knowledge concerning the elements is vital to understanding and appreciating a work of art. They are closely interrelated, each possessing characteristics of the other elements. A line, for example, has a certain color, texture, and shape; it may function as the edge of a form. Color too has tone, texture, and when applied, a given shape. What distinguishes the elements is the specific characteristic that is emphasized.

The artist uses the visual elements to convey his thoughts and feelings and to arouse emotion. The elements can stimulate sensation, provoke perception, and suggest imagery. Lines,

through variations in direction, movement, and force, may suggest changes in mood or states of being, and may evoke sadness, exhilaration, or pride. Reds and oranges tend to excite, blues and blacks to depress. Every daub of color, scratched line, fragment of metal or wood, or twisted lump of clay can be evocative. The relation of the elements to emotion is even reflected in popular expressions: we "feel blue," or describe someone as a "rough character."

The historical use of signs and symbols draws freely on the elements of art (see EMBLEMS AND INSIGNIA; SIGNS AND CONVENTIONAL SYMBOLS). For centuries white has stood for purity; red and green are used as signs of warning; the cross, the star, and many other shapes have been used at various periods with symbolic significance. The use of larger areas of space, such as space for living, also has symbolic significance. Man constantly searches for new spatial dimensions more compatible with his need for inner harmony.

*Principles of arrangement.* Arrangement, or organization of the elements of art, is often referred to as "composition." In organizing the elements the artist follows certain principles, sometimes rigidly but often rather as guides, as the art impulse dictates. As such, these principles are subjective and open to many interpretations. Many of them seem to be evidenced in nature and human behavior. Since ideas and feelings in a work of art must be fitted into a unity and a plan of action, the basic principle of arrangement is "unity"; without it the elements cannot be understood as part of an over-all harmony. All the parts of the work are coordinated in such a way that the individuality of each element is achieved but the wholeness of the work is not impaired. The final order that makes continuity and ease of perception possible is often referred to as "beauty." If, however, the parts of the work are chaotic in arrangement, the observer is left with feelings of dissatisfaction and incompleteness, and the total effect is considered ugly. There is, however, no absolute beauty or ugliness; perceiving the order in a work depends on understanding and feeling.

The principle of unity affects the element of color in the distribution of tonal areas, hues, and intensities; within the unity a variety is achieved. Unity of form and space are evidenced in the use of proportion in a work of art. Unity of line implies sensitivity to its variation in thickness, direction, and placement. Textures are varied and effects interestingly distributed.

Each artist designs within given limitations of space. To exploit the possibilities of the elements and to avoid dullness, imagination and invention are necessary on the part of the artist. He is like a symphony conductor who must understand and guide many instrumental voices that shift in key and change relationships. By creating a pattern through "repetition" or "alternation," the artist can accomplish a similar task visually. A great deal of simple decoration is created through the use of repetition and alternation; more involved designs using complicated movement are achieved by setting up oppositions and progressions. Through "emphasis" and "sequence," rhythmic "transition" can be developed, leading the eye from one point to another, either forcefully or subtly. "Contrast" can also be effectively utilized. By combining unlike elements, contrast provides the variety that most complex designs employ.

"Development" refers to orderly growth or movement obtained by judicious use of the principles of sequence and transition. It utilizes a series of elements which develop a theme and emphasize certain design qualities. "Dominance" and "subordination" create focal points that control the attention of the observer; line may be subordinated to color, or forms may dominate color and texture. The terms refer to the arrangement of elements related naturally or by juxtaposition.

Colors, forms, and tones have suggested weight; lines, textures, space, and light can create stress. The artist often uses "tension," or imbalance, to establish excitement and agitation. However, just as some means is needed to accelerate the movement of the elements, another is needed to adjust their tempo or decelerate them. "Stability," or balance, is the principle behind various methods to regulate movements and forces. It places equal or unequal elements in a state of equilibrium or poise. "Radiation," a principle used in creating balance, is movement away from a center. The point of radiation may be inside or outside the composition. Good design, either symmetrical or asymmetrical, is not obvious in its means.

"Proportion" is a space concept that concerns the relationship of the elements as to size, scale, quality, purpose, variety, or meaning. Proper application of the principle requires using the "right" amount and distribution, which vary for each work and the particular purpose of the artist. Variety is achieved by a judicious selection of differing sizes, shapes, and character of parts and elements. Commonly referred to as "taste," this selection displays the artist's sensitivity, discrimination, and awareness of proportion relationships.

From the Greeks to contemporary man, artists and theoreticians have sought objectivity in art. This has embraced a search for absolute form and a priori universal principles of composition, development of the golden section, various theories of vision and color, and sets of principles as a key to understanding particular works of art; the nature of the search has varied from age to age. Essentially the development of styles in art is a history of design ideas.

In painting, sculpture, and architecture, various design principles and ideas of order are often rejected today because the artists feel that new concepts and beliefs are emerging which have radically changed the ideas of what art is and have thus rendered the old principles invalid. However, this rejection is accompanied by a new terminology for what seem to be the old principles, as well as a reinterpretation of their meaning.

Plates 183–186 exemplify some stages in the evolution of design ideas in modern sculpture, painting, and architecture. For other practical applications of the theory of design, see DESIGNING; GRAPHIC ARTS; INDUSTRIAL DESIGN; PUBLICITY AND ADVERTISING; etc.

BIBLIOG. D. W. Ross, A Theory of Pure Design, Boston, 1909; E. Faure, The Spirit of the Forms, trans. W. Pach, New York, 1930; W. Abell, Representation and Form, a Study of Aesthetic Values in Representational Art, New York, 1936; R. G. Collingwood, The Principles of Art, London, 1938; L. Moholy-Nagy, The New Vision, trans. D. M. Hoffmann, New York, 1938; H. Focillon, The Life of Forms in Art, trans. B. Hogan and G. Kubler, New Haven, 1942; G. Kepes, Language of Vision, Chicago, 1944; W. Kandinsky, Concerning the Spiritual in Art, New York, 1947; R. L. Wickiser, An Introduction to Art Activities, New York, 1947; A. Pope, The Language of Drawing and Painting, Cambridge, Mass., 1949; H. M. Rasmusen, Art Structure, New York, 1950; M. E. Graves, The Art of Color and Design, New York, 2d ed., 1951; R. G. Scott, Design Fundamentals, New York, 1951; R. L. Wickiser, An Introduction to Art Education, New York, 1957; P. C. Beam, The Language of Art, New York, 1958; B. S. Myers, Understanding the Arts, New York, 1958.

Ralph L. WICKISER

Illustrations: PLS. 183–186.

**DESIGNING.** "Designing," according to one definition, is that part of the creative process in which the artist follows (often unconsciously) specific esthetic principles in arranging and/or inventing elements or details to compose a work of art; these elements may include form, color, line, and volume (see DESIGN; ESTHETICS). However, the definition to which we shall confine ourselves in the present article is more restricted: Designing is any act in the creative process which presupposes a fairly clear idea of the final work of art, which furthers its execution, which is based upon existing means of achieving the objective (e.g., mechanical, as in architecture), and which is brought to a clearly documented conclusion. This documentation (the "design") must be a specific plan or model; it may take the form of drawings and preliminary sketches (PLS. 187, 200–202), a scale structure (PL. 193), or an outline of the main features of the work (e.g., the plan of a building; PL. 188). The materials used in such documentation must be either direct or indirect forerunners of the materials employed in the final creation.

Thus, on the basis of our second definition, activities such as a painter's mixing of colors to obtain the precise shade he wishes to use on the canvas do not fall within the category of designing; color mixing as described does not satisfy an essential criterion of designing: the development of a specific plan or model. Plans showing how to build the vault of a dome or

how to dovetail two constructional elements do fall within the sphere of designing; but instructions on how to make the bricks of a wall adhere do not, unless they pertain to special visual effects. Nearly always a technical solution to a formal problem is involved (see STRUCTURAL TYPES AND METHODS; TECHNIQUES).

SUMMARY. *Designing as an aspect of artistic production; Designing in the history of art; Designing and execution; Social and economic aspects of designing; Designing and ready-made production; Designing and the use of modular elements; Designing and town planning.*

*Designing as an aspect of artistic production.* The process of designing is neither a preliminary nor an auxiliary one but rather an integral stage of the artistic production. This thesis is supported not only by the parallelism or identity of materials used in the design and the final product but also by the fact that the design frequently has an artistic value wholly independent of the final work. A drawing or model may be of considerable esthetic merit even though the project has not been carried out (PL. 194). It may have qualities not evident in the final work, and even be superior to it. As an artistic undertaking the design is carried out through various phases of development and has its own formal character. Often, instead of directly contributing to the execution, a design gives rise to a new design.

The types of designs and the purposes they may serve are numerous. A design may present the formal idea visually — either schematically or in a fairly immediate fashion. It may be of the whole or of details. It may consist of rapid sketches and illustrations of the successive stages of development, or diagrams limited to specific details and explanations of technical processes. Designs may be carefully worked out as finished pieces, such as cartoons for tapestries and other pictorial representations or models for sculpture or architecture. A design may serve only to record what the artist wishes to remember for his records, for the eventual elaboration of his idea, or for the final execution of the work (see PERSPECTIVE: PROPORTION; SCENOGRAPHY). It may be used by workmen carrying out the artist's ideas, or it may be an expression of theories and principles involved (see TREATISES).

It is possible, if we develop the point, to include within the category of designing any process furthering the realization of the final work of art that *precedes* the visual representation, once the formal idea has been conceived in a general way. Among these are the selection of materials for executing the design proper, the painter or sculptor posing a live model, or the architect studying the site on which his building is to be erected. It has been pointed out that in this aspect of "designing" the artist is not acting creatively but rather out of custom and tradition. The objection is invalid, however, because by turning to tradition the artist shows that he presupposes artistic results of a definite nature; the traditions are, in a sense, part of the creative act.

*Designing in the history of art.* The type and extent of designing varies according to the culture, the period, and the kind of artistic work to be produced. Although some designing is necessary in every artistic activity, the process is of particular importance in architecture (q.v.). This is true not only because of the considerable size of architectural structures and the complexity of their erection but also because a building is usually executed by workmen who are not even under the supervision of the artist; this requires a more extensive apparatus of mediation between ideator and executor. Thus in architecture the process of designing has been precisely and methodically codified into definite systems for the transcription and explanation of the structure. Architectural treatises, particularly those of the 16th century, are outstanding examples of the codification of methods of designing; this type of codification, however, does not demand a written text and may utilize drawings instead. In architectural designing the architect is often obliged to make notations not only describing the technical methods of realizing the forms but also, for particularly difficult or original elements, specifying necessary mechanical apparatus such as scaffolding, machines for raising heavy weights, and means of solving problems of ventilation, lighting, or acoustics (q.v.). For these the architect must be aware of the inadequacies of traditional methods and, to achieve new formal effects, must be able to devise new methods of production.

In areas of purely formal design the requirements of the artist are analogous. Working under given cultural conditions and attempting to fit his own work into these conditions, the artist cannot ignore established usage in either concept or execution. Established usage, as we have seen, may include designing methods gradually developed and codified into a fairly rigid system, which not only exercises control over the work but also provides the benefit of accumulated experience with the problem.

Within the broader fields, specific subareas in which there is considerable codification of designing methods are, for the representational arts, iconography (see ICONOGRAPHY AND ICONOLOGY) and, for architecture, typology (q.v.); in both these areas are found schemata without which the artist could not begin his particular work. Thus the artist who accepts a given type of Crucifixion or a round temple needs only to sketch out a first, summary composition of his work and then to make it more precise and determine the formal details. If the original model is not absolutely standardized, the ultimate version may give rise to a transformation of the prototype itself. A certain amount of freedom in designing is often allowed: In the designing of Roman wall paintings, for example, there was an accepted scheme for spatial distribution, but the tradition did not dictate the themes the artist was to design within these limits. Architectural profiles, which may be slavishly followed or freely adapted in plastic and pictorial decoration, also belong to established design, although in a more general way. In contemporary minor arts the typological factor dominates to such an extent that it almost excludes true designing; the process is reduced to copying the model with only slight variations. When this occurs, a basic type replaces design, in large measure, for long periods of time and in entire groups of works such as furniture (q.v.), household objects (q.v.), and textiles (see TEXTILES, EMBROIDERY, AND LACE).

Just as there are periods in which designing is negated because artists are dominated by traditional or acquired models, so there are other periods in which the whole or nearly the whole conceptual process is part of a strict method and a pre-established order of development which is rich in possibilities for true designing (see MODERNISM). Typical of the latter group is the Italian Renaissance; much of the artistic endeavor of this era was concentrated on the development of new ideas, on formal innovation, and on devising principles and rules for such innovation. The change in the position of the arts from that of crafts to liberal arts — and the resulting change in the position of the artist from that of craftsman to man of education — brought about an apparent division between ideation and execution; this division may be considered one between theory and practice (see CRITICISM). The change also resulted in a considerable development in the techniques of innovation and in the methods of accurate transmission of formal ideas to those who were to turn them into finished products. The executors of these ideas were often the assistants and disciples of the artist or, particularly in the case of architecture, the workmen employed in the construction. The fact that classic art became the model, although less in the sense of a formal prototype than as a source of "perfect" knowledge and inspiration, encouraged a study of antique monuments. This study was accomplished with the aid of innumerable illustrations. Most studies of antique monuments were concerned with discovering the underlying structural laws — the basic ideas and designing processes that could result in such admirable buildings. To this end artists examined the proportions, decorations, forms, and unifying elements of a style considered exemplary. This type of analysis may be considered a generalized process of designing which was concerned with developing a common level of work; thus it became the starting point for the design of individual works of art. It produced treatises devoted to studies of a historical nature, as well as practical

manuals supplying the builder with scientific or empirical designs that could replace those phases of designing based on the commonly accepted concepts of contemporary practice.

*Designing and execution.* A complete dichotomy between the ideation and execution is as artificial as that often made between ideation and designing. To so-called "pure" ideation we may relegate only those imaginary or utopian buildings and cities which are not intended for actual construction; and these cannot correspond to any true design, since true design presupposes the possibility of plans being translated into fact. Since designing is always the process of planning an artistic project through existing means of achieving that objective, the means must be flexible enough to permit any development or innovation that the design itself can furnish or encourage. The designer works within a historical and cultural environment in which he intends to place his own work either as a visible fact or as a plan that solves certain technical problems and thereby furthers the progress of later designs (see SOCIOLOGY OF ART); but the design is valid only if it deals with and solves all the technical problems inherent in the execution. The application of the design usually occurs in several stages, supported with detail designs and, at times, modifications of previous designs when difficulties of execution or new technical developments demand them. Certain stages of designing, particularly detailing and ornamentation, sometimes require a comparatively advanced phase of the execution so that the special effects can be worked out in relation to the real structure. A project that has already been developed and partially executed may therefore serve as a basis for the final design; and this final design, though related to the preceding one, is often quite different from it. This situation sometimes occurs with the design and application of architectural ornamentation, as well as other projects that retain a high degree of autonomy — for example, the stained-glass windows of a Gothic cathedral.

The process of designing constitutes the progressive visualization of the formal idea, that is, its gradual translation from a mental image into real space and (often) form. Architectural designs best illustrate this progression, since they usually develop from a simple schematic plan to a three-dimensional representation that may also be in color: In the ground plan the building is considered in its horizontal plane (PL. 188); in the elevations it is considered in its vertical planes (PL. 188); in the isometric projection the two are combined (PL. 192); finally, in the three-dimensional model the whole unit is seen in actual space (PL. 193). Perspective and mathematical scales are of fundamental importance in determining with precision the relations between the dimension of the design and those of the actual building. Written notations of measurements are frequently added to architectural plans. Designs for painting may have notations or samples of the main colors to be used.

A complex relationship exists between the decorations and the space they fill (see SPACE AND TIME). The limitations in size and shape of a given space, such as a frieze or a lunette, oblige the artist to use one of the following devices in planning his decoration: (1) Adapt the character and dimensions of the decoration to the dimensions of the space provided (usually done with a wall or niche). (2) Emphasize the limitations of the given space and develop the decoration along its surface rather than utilize its depth. (3) Use illusionistic effects which suggest greater depth than actually exists; these effects must be coordinated with the structural space by various perspective devices. Whatever expedient is used to correlate the decoration and the dimensions of the space, it results in alterations in the designing stage which are later reflected in the finished work. These alterations include foreshortenings, the veiling of elements that would otherwise be too prominent, and modifications in color relations as well as the toning down of colors that may be too bright.

*Social and economic aspects of designing.* Another purpose of the design is the very practical one of giving those who commissioned the work an idea of what it will look like. Obviously the demands of the patron constitute a preliminary conditionion for design in all fields of art (see PATRONAGE). Frequently the individual patron, a scholar working for him, or a theologian supplied the artist with the scheme for a fresco cycle or even a smaller work such as a painting or statue; thus the artist began with at least a summary design. Other factors beyond the artist's control also influence the design for a building. Such factors may be a previously chosen site or the funds available, which place limits on size, nature of the structure, materials, and operative processes. The importance of the economic factor increases when the work is to be sold on the open market, as occurs in the production of handicrafts (q.v.) and industrial design (q.v.). Economics influences not only the quantity produced but also the general appearance of the object. Economics does not, however, touch upon methods of representation or formal processes.

*Designing and ready-made production.* As we have noted, individual designing is based to a great extent on the type of artistic production favored by the society, or that portion of the society with which the artist is in direct contact. The artistic production reflects an esthetic tradition of various ideas and formal schemata. The process is not unlike the social tendency that Alois Riegl termed the *Kunstwollen* ("artistic volition"). Riegl introduced the term in reference to certain recurring ways of treating decorative motifs, such as the meander or the palmette, that form the heritage of a given craft; to this heritage the artist turns for ornamental additions to his work. Sometimes ornamental elements may be produced by workshops independent of the artist and his assistants, so that the artist procures these additions on the open market. A typical example, taken from antiquity, is the column. A piece of raw marble could be ordered by the architect and then finished according to his specifications; or the column could be acquired from workshops specializing in the production of completed or partially finished pieces of various types and sizes. In both cases, however, the column is a constant factor, the result of a design process of its own and a formal entity within the architect's larger design. And in both cases the architect draws upon certain types and combinations of formal elements that are subsumed under the theory of the orders. The form and dimensions of the column depend not only on tradition but also on a synthetic process that groups the multiplicity of forms into a series of types; this standardization simplifies the accessory activity of ornamentation and provides an available body of accepted solutions.

Some advance production of materials used by the artist appears in practically every artistic operation, whatever the period or society; this process can be regarded as "predesigning." The materials prepared may include squared stones, bricks, canvases or panels suitable for painting, and industrially made colors. However, their characteristics fall outside the scope of the artist's design and belong to another designing process; certain aspects of this process anticipate and in some ways condition the artist's design.

The production of predesigned or prefabricated elements has been of major importance since the industrial revolution, and is of particular significance for those arts associated with the construction industry (PL. 198). Simple ready-made elements such as panels or metal strips in standard sizes, and more complex units such as fixtures, have become so prevalent that they have radically changed methods of designing and construction. To some extent, designing has been reduced to a process of combining and organizing available elements.

*Designing and the use of modular elements.* Achieving a formal unity in a finished design that incorporates separately designed and produced elements requires both a limitation in the forms that can be used and a selection of one or more methods of combining and coordinating these forms. The latter procedure implies a predetermined method of designing. Use of the module, or modular planning, is such a method. Originally the module was a measuring unit selected by the architect; in classical architecture, for example, it usually corresponded to the radius of a column. Fractions and multiples of the module determined the dimensions and proportions of all

members of the building. Closely connected to the theory of proportion (q.v.), the module provides a point of departure and a system of relationships that are developed throughout a structure. Since World War II the module has received considerable attention through Le Corbusier's *modulor* (see LE CORBUSIER), a principle of architectural composition based on the human figure. Modular elements in 20th-century architecture may also be identified in panels of various materials or in metal segments, as in the paneled houses of Gropius (q.v.) and the structures of Konrad Wachsmann. The extreme simplicity of these elements and their combinations opens the way to the client's determination of the layout or his gradual modification of it during the course of construction. Advanced trends in modern architecture support this a posteriori designing by the client. The tendency has the effect of placing design within an even broader social context, since the client as well as the artist is conditioned by economic and social factors. Thus the planning of individual buildings becomes progressively more enmeshed in the over-all process of the development of society, with the role of the individual designer diminished in favor of the collective element.

*Designing and town planning.* Frequently the designing of a building or a group of buildings enters into a larger context which requires the coordination of various designing activities and establishes conditions to which they must conform. In some respects town planning (q.v.) forms a part of designing, as when sites of buildings and their areal and volumetric extension are determined. However, town planning is concerned in only a general way with the highly technical problems involved in the execution of individual buildings or elements. It should be noted that contemporary opinion inclines strongly to recognize artistic quality in series and groupings, and according to this conception, town planning ranks as a true esthetic activity. Furthermore, responding to the needs of the entire community, a town plan places practical and economic problems in an over-all framework, thus greatly enlarging the role of the designer in controlling man's environment.

Giulio Carlo ARGAN

NOTE. Further discussions of designing and design may be found in the following articles: ARCHITECTURE; DESIGN; DRAWING; EDUCATION AND ART TEACHING; INDUSTRIAL DESIGN; MODELS; PAINTING; PERSPECTIVE; PROPORTION; SCULPTURE; TOWN PLANNING.

BIBLIOG. (See also bibliogs. of articles listed above). P. L. Marks, The Principles of Architectural Design, London, 1907; D. W. Ross, On Drawing and Painting..., Boston, New York, 1912; E. A. Batchelder, Design in Theory and Practice, New York, 1925; M. Borissavliévitch, La science de l'harmonie architecturale, Paris, 1925; V. Blake, The Art and Craft of Drawing..., London, 1927; J. F. Harbeson, The Study of Architectural Design, with Special Reference to the Program of the Beaux-Arts Institute of Design, New York, 1927; A. Tucker, Design and the Idea, New York, 1930; A. Fenn, Design and Tradition: A Short Account of the Principles and Historic Development of Architecture and the Applied Arts, London [1932]; E. Pickering, Architectural Design, New York, London, 1933; P. Johnson, Machine Art, New York 1934; Le Corbusier, La Ville Radieuse, Boulogne, 1935; A. Speltz, Styles of Ornament..., trans. from 2d German ed. by David O'Conor, New York [1935]; P. E. Nobbs, Design: A Treatise on the Discovery of Form, London, New York, 1937; A. Bertram, Design, Harmondsworth, 1938; G. Sacchi, L'iconographia: I metodi di studio delle piante degli edifici nella teoria dell'architettura dall'era classica al rinascimento e all'era moderna, Milan [1938]; E. J. Carter and E. Goldfinger, The County of London Plan, Harmondsworth, 1945; A. Dorner, The Way beyond "Art": The Work of Herbert Bayer, New York, 1947; D. A. Fletcher, Introduction to Architectural Design, New York, 1947; C. E. Jeanneret-Gris, The City of Tomorrow and Its Planning..., trans. from 8th French ed. of Urbanisme by F. Etchells, London [1947]; E. H. Hubbard, Materia pictoria [An Encyclopedia of Methods in Painting and the Graphic Arts], 2d ed., London, 1948 ff.; C. E. Jeanneret-Gris, Le modulor: Essai sur une mesure harmonique à l'échelle humaine applicable universellement à l'architecture et à la mécanique [Boulogne, 1950]; N. Pevsner, Pioneers of Modern Design, New York, 1950; S. W. Thompson, Basic Layout Design: A Pattern for Understanding the Basic Motifs in Design and How to Apply Them to Graphic Art Problems, New York [1950]; T. Triffet and D. Carlson, An Approach to Architectural Design [Boulder, Colo., 1950]; M. Borissavliévitch, Les theories de l'architecture: Essai critique sur les principales doctrines relatives à l'esthétique de l'architecture, new ed., Paris, 1951; S. Giedion, C.I.A.M.: A Decade of New Architecture, Zurich, 1951; M. Velte, Die Anwendung der Quadratur und Triangulatur bei der Grund- und Aufrissgestaltung der gotischen Kirchen, Basel, 1951; M. C. Ghyka, A Practical Handbook of Geometrical Composition and Design, London, 1952; H. Robertson, Modern Architectural Design, London [1952]; R. Wittkower,

Architectural Principles in the Age of Humanism, 2d ed., London, 1952; F. Gibberd, Town Design, London, 1953; M. Sacripanti, Il disegno puro e il disegno nell'architettura, [Rome], 1953; M. Borissavliévitch, Traité d'esthétique scientifique de l'architecture, Paris, 1954; E. Pittini, Lezioni di architettura tecnica con applicazioni pratiche, 3d ed., Turin, 1954; L. de Simoni, Esempi e tecnica del disegno architettonico, Rome [1954]; E. D. Ehrencrantz, The Modular Number Pattern, Flexibility through Standardization, London, 1956; C. E. Jeanneret-Gris, The Modulor, a Harmonious Measure to the Human Scale, Universally Applicable to Architectures and Mechanics, trans. P. de Francia and A. Bostock, London [1956]; W. Lotz, Das Raumbild in der italienischen Architekturzeichnung der Renaissance, Mitteilungen des kunsthistorischen Institutes in Florenz, VII, 3-4, July, 1956, pp. 193-226; G. Nelson, Problems of Design [New York, 1957]; C. E. Jeanneret-Gris, Modulor 2, 1955 (Let the User Speak Next): Continuation of the Modulor, 1948..., trans. P. de Francia and A. Bostock, London [1958]; G. K. König, Il disegno dell'architetto come mezzo mediato fra la intuizione e la realizzazione dell'opera di architettura: Memoria sulla funzione del disegno..., Florence, 1958; M. Salvadè, Considerazioni sulla progettazione architettonica: Impostazione e sviluppi, Milan, 1958; G. Soergel, Untersuchungen über den Theoretischen Architekturentwurf von 1450-1550 in Italien, [Cologne], 1958.

Illustrations: PLS. 187-202.

## DEVOTIONAL OBJECTS AND IMAGES, POPULAR.

The art of all times and cultures — often in its noblest manifestations — has been inspired to a great extent by religion and official forms of worship. Within this vast field there exists a kind of minor sacred art dealing with the forms of private and individual worship. Although the religions with which they are connected are very different, these art forms often have analogous themes and characteristics. Even in the early religions the belief in the possibility of supernatural intervention was the essential motive for direct dealings between the individual and the divinity. Sacred objects and representations originate out of such aspects of private worship as prayer or the veneration of images, and they are most widespread in the sphere of folk art (q.v.). Especially at the margins and outside the orbits of great religious civilizations, particularly in the primitive world, such objects are often believed to be of supernatural origin (see MAGIC).

SUMMARY. Origins of devotional art (col. 364). Antiquity (col. 365): *Ancient Near East; Iran; Greco-Italian civilizations.* East Asia (col. 369): *India; China; Japan; Southeast Asia.* The primitive world (col. 373). Western Christendom (col. 374): *Cult images and icons; Andachtsbilder; Ex-votos; Souvenirs and miscellaneous devotional objects.*

ORIGINS OF DEVOTIONAL ART. The individual can seek to establish a personal rapport with the sacred, independent of the duties sanctioned by the common religion or the forms of organized worship. This activity involves particularly the free choice of an object of veneration (whether a supernatural force or a sacred place, a deity or a demon, God or a saint), direct revelation by means of dreams and miracles, and a relationship established through prayers and offerings of personal and precious objects. One of the most typical expressions of the devotional impulse in Western civilization is in the offering promised in order to obtain supernatural intervention for a specific individual need (salvation, healing, success, victory, etc.). From the Latin word for such a promise, *votum*, are derived the words "vow" and "votive." When the promise bound the very life of the individual who made the offering (or that of another) to the deity, especially of the underworld, the Romans used the word *devotio*. This term passed into the Christian religious vocabulary to indicate a deep and obligating personal bond of the individual to God, the Virgin, or the saints. In its everyday use the word "devotion" is understood in this sense; it generally defines the individual, active, voluntary aspects of worship as opposed to the collective legalistic position of organized religion, whether ancient or Christian.

In primitive religions there is no clear distinction between personal devotion and communal practice. Primitive sacred art in its utilitarian, ritual products (see LITURGICAL OBJECTS) and images, as far as we know, was also devotional art. Nor can a clear boundary be drawn between religious devotionalism and the practice of magic (q.v.). The latter has given a strong impetus to the production of art objects.

From the earliest times objects of worship (which eventually became divine personalities with specific fields of action and were ultimately anthropomorphized in the great polytheistic religions) seem to have been connected with specific places: trees, stones, caves, springs, and the like. In the Neolithic age, and ever more frequently in the later metal ages, offerings consisting of useful objects such as vases, ornaments, or utensils were placed in caves (Grotta della Pertosa near Salerno, Grotta delle Mosche at S. Canziano near Trieste) or near springs (St. Moritz in Switzerland, Bath in England) or were thrown into swamps (a typically Nordic rite, occasionally including the famous "sun chariots" as at Balkakra, Sweden, or Trundholm, Denmark; PL. 207) or collected in storage places whose religious purpose is in many cases uncertain. Such customs as worshiping springs, especially salutary ones, with offerings (e.g., the rich deposit in the springs of the Senne in Gaul), or decorating sacred trees with small offerings, ribbons, or crowns (often attested to in the art of the classic age and also widely known outside the Mediterranean world) are primitive survivals. They present qualities characteristic of the typically spontaneous individual folk rituals of the great religious civilizations.

Initially these forms of worship were no different from offerings to the deceased made near tombs (see ESCHATOLOGY). With few exceptions, the ancestor cult always remained essentially in the sphere of personal or private religion. Funeral offerings did not differ substantially from votive ones, and it is sometimes even difficult to establish the nature of the deposits. In both, the transfer of objects to a sacred domain and the inutility of such ordinarily useful objects is common. These account for the offering of furnishings or instruments intentionally broken and rendered useless and for the creation of objects so small and fragile and made of such precious materials that they seem to have been intended solely for ritual use. Similarly, extremely rich and fertile thematic material in which the reproduction of the human figure occupies a preeminent place developed from the institution of human sacrifice, either funerary or votive. A typical example is the female idol of Mediterranean prehistory.

Only with the rise of the higher civilizations and the great organized religions can one begin to distinguish devotional themes, as we have defined them, from art inspired either by collective beliefs (divine images, mythological representations, and sacred histories such as lives of the saints) or by official forms of worship (e.g., religious architecture and accouterments) in such iconographic motifs as scenes of presentations, offerings (PL. 204), and prayers, and, above all, in the monuments and votive gifts. Votive gifts were extremely common in the ancient religions and became instruments of Christian religious practice as well, with, at times, startling parallels (PL. 203). These votive gifts were collected in sanctuaries, developing and transmitting the most diverse ideas and points of departure: from the semiarchitectural forms of the altar — the cippus, the stele, and the little chapels — to the "substitute" figures of men and animals (PL. 206); from compositions depicting the favor requested or granted (PL. 209) to reproductions of the parts of the body concerned in the vow (PL. 208). Finally, the individual religious feeling centered on particular images or made use of special instruments for prayer (PL. 211). These products always have, to a greater or lesser degree, the quality of folk art, rigidly traditional yet also at times spontaneously imaginative. It is precisely this folk quality that gives at least a degree of unity to devotional art.

Dario SABBATUCCI

ANTIQUITY. *Ancient Near East.* Among the works of Egyptian antiquity, several specifically devotional types of statuary may be identified. One of these is the block statue of the Middle Kingdom, which represents a person crouched in a position of concentration (PLS. 354, 376). Another type of devotional object, originating in the votive offerings of the temple of Osiris in Abydos, permitted the production of statuary in series and reduced the technical difficulties of making a statue in the round. The New Kingdom produced statues representing a kneeling figure sitting on its heels and bearing a symbol or a sacred edifice, or with hands held to the height of the chest, flanking a stele inscribed with a hymn to the sun god. Votive steles, dedicated to a god or a deified sovereign, also appeared. In these the god is generally represented on the right side of the stele with a donor before him, either kneeling with uplifted arms or presenting an offering or incense. A unique aspect of piety is shown by a series of small votive steles of the New Kingdom, on which appear pairs of ears or eyes, indicating that the god had heard the prayer. During the Late period votive bronzes representing gods and sacred animals were frequently offered in the sanctuaries and assembled in great numbers in the repositories.

Small votive statuary was widespread throughout Mesopotamia from earliest times. An example of a common type is a standing figurine with its hands clasped on its breast (e.g., the archaic female figurine from Khafaje as well as other figurines from the same locality and from Tell Asmar, Lagash, and Mari). The kneeling statuette with hands on chest (figurine from Tell Asmar) or with one hand in front of the mouth (bronze probably representing Hammurabi) was fairly common. Also typical is the seated figurine with hands on chest (statues of Gudea). In a late period statuary depicting the crouching figure, of evident Egyptian derivation (figurine of Ashurbanipal in Prague, Coll. E. Filla) appeared in Mesopotamia. A few figurines of donors carrying small living animals exist. This theme is of the greatest interest, for with it began that iconographic tradition which developed into the Greek Kriophoros and eventually expressed itself in the form of the Christian Good Shepherd. Among other votive objects were small models of sanctuaries (perhaps domestic), perfume burners, figurines of animals, etc.

The so-called "presentation" scenes have a typically devotional character. This characteristically Mesopotamian theme was extensively used by Gudea (who loved to have himself represented before Ningirsu with his personal god, Ningizzida, holding his hand). Later, especially in the Kassite period, it was used on seals. The presentation scene depicts a human personage (generally a ruler) who is being presented to an important divinity, shown seated (PL. 203), sometimes by his tutelary deity (who precedes him and holds his hand) and by another god who follows him; these three figures are shown standing. The motif reappears, intentionally archaized, on the stele of Nabupaliddina (870 B.C.).

Small altars placed along the roads (*Strassenaltäre*), known both from remaining examples and depictions of them on reliefs and seals, may also be mentioned among the devotional objects of this region.

The devotional art of Syria, Palestine, and Anatolia is clearly differentiated from that of Egypt and Mesopotamia. The widespread preference for open-air cult practices, heritage of a populace with nomad and seminomad origins, shows itself in the field of individual devotion by a minor interest in temple offerings and a greater use of monuments in the open outside the sanctuaries.

While the materials found in the temples (the foundation treasures found in Byblos and the statuettes of Ugarit) reveal the existence of ex-votos, Biblical and Ugaritic sources and archaeological finds attest to the widespread use of votive stones (massebahs and baetuli) and steles. The baetulus and massebah, whose origins are not clear, were set up in remembrance of an important religious event (e.g., Gen. 28:18) in the open on a height or inside a sanctuary, as was done at Byblos. Like those of Byblos, votive stones might be roughly conical (phallic?) in shape. Some, like those found in the sanctuary of Hazor (on which an extended arm is shown), were engraved. The use of similar votive stones in Anatolia is also documented. A relief from Bogazköy shows a male figure offering a sacrifice in front of a stone base on which reliefs are carved. On top of the base stand two baetuli. Related to the baetulus and massebah is the wooden column erected near a grove; its use, however, was ritual rather than devotional. The figured steles brought to light in fairly large numbers in Phoenicia and Syria were true votive offerings. Usually they bear representations of divinities (stele of Ba'al with lightning, from

Ugarit, stele of 'Amrit, stele of the "god with the quill," from Ugarit), sometimes in the act of receiving an offering from a male figure (stele of El, from Ugarit). The votive nature of such steles has been demonstrated by the Aramaic inscription on one found near Aleppo, representing Melkarth (stele of Bar-Hadad I). A devotional character is also evident in the small altars (similar to the Mesopotamian ones and clearly Assyrian in origin) found frequently in Phoenicia and Anatolia, especially in a relatively late period. In Palestine many small horned altars (from Megiddo, Beisan, and the Negeb) and offering tablets have been found; these, however, seem to be connected with the domestic cult, as do the frequent votive models of sanctuaries and cult objects.

Sergio BOSTICCO and Giovanni GARBINI

*Iran.* Our limited knowledge of the religious life of the Iranian territories often makes the sure identification of devotional objects very difficult. Moreover, in historic times many of these must have been perishable; for example, the most important of the liturgical instruments, the *barsman*, was made of a bunch of branches or flower and leaf crowns. In other cases the objects in question are not easily identifiable, since they are still in a natural, unmodified condition (e.g., shells).

Prehistoric female figurines representing a divinity of the Magna Mater type are as widespread in Iran as in the Near East. They are either geometric in style, like the alabaster figurine from Tepe Hissar (3d millennium B.C.), or naturalistic, like the numerous images from Susa (2d millennium B.C.) or those of gray pottery from Tureng Tepe (3d–2d millennium B.C.). Sometimes the image holds its breasts with its hands; the significance of this gesture is essentially religious. In other instances the hips of the figure are enormously widened and reduced almost to a flat disk.

Another important group of devotional objects, the so-called "Luristan bronzes," consists of sculptures and various small objects. Although their stylistic differences have not yet been studied, the Luristan bronzes can be divided into two types, which have been found in different areas. The isolated tombs placed high on the sides of the valleys have revealed arms and objects connected with the use of horses (various kinds of bits and bridle ornaments) as well as the so-called "finials." Stylized in a variety of ways, the design of the latter is always heraldic, with facing animals. The representations are often devotional and symbolical, connected with a divinity who assumes the iconographic schema of Gilgamesh but with apparently new values. Roman Ghirshman has suggested that the being conquering the beasts may represent Sraosha. Sraosha, a pre-Zoroastrian Iranian divinity who accompanies Mithras, is connected with the underworld, a fact which might explain his presence in the tombs. Both the frequent appearance of the cock's head, used as a complementary ornamental motif in these objects, and the form of the sustaining base (which is that of a war club, characteristic attribute of Sraosha) correspond to the god's hallmarks. The standard terminals, generally square, in which the image of Sraosha or of a female divinity with long ears and enormous ram's horns is outlined in pierced work, had a different value, perhaps secretly devotional, but above all identifying and apotropaic. Particularly to be noted is the symmetrical head of a large pin with the god flanked by a pair of animals in a plantlike stylization (II, PL. 5).

From a sanctuary built on the hill of Surkh-i Dum in the plain of Koh-i Dasht, with bricks of a type similar to those of the late Assyrian period (883–612 B.C.), came most of the Luristan bronzes belonging to the second typological category. In addition to small amulets in the shape of rams, horses, or birds (II, PLS. 5, 6) a number of other objects (in the form of large discoidal plaques whose long stems turn them into a kind of pin) have been found attached to the sanctuary walls and fixed in the earth nearby. There is therefore no doubt of their being ex-votos. The engraved or repoussé compositions decorating them are of great artistic and religious interest. René Dussaud and Roman Ghirshman have shown that some of them were of pure Iranian inspiration. On one, Ghirshman

has been able to identify the multiple image of Zurvan, the god of time. The female face that often occurs, always in repoussé, is probably that of the Great Goddess. A figure engraved on another example suggests that it was created as a thank offering or a request for a successful delivery. Stylistically more complex, the disk pins are nevertheless related to the objects of the mountain tombs, as is shown by some of the iconographic motifs and by a few whole compositions. These objects were probably produced by a single people during different phases of their development, nomad shepherds having constructed the mountain tombs, while a seminomad or definitely sedentary people built the temple in the valley. A considerable length of time may have separated these phases. Setting aside the problem of dating and that of the identity of this people (Medo-Cimmerians, according to Ghirshman), it can be pointed out that stylistic traits connected with earlier vase painting are revealed in these devotional objects. These traits are extremely characteristic and certainly not free of either Iranian (Elamite) or other foreign (Mesopotamian and Hittite) influences.

Mario BUSSAGLI

*Greco-Italian civilizations.* During the Bronze Age and above all in the Iron Age, the number, variety, and typological categories of votive objects increased in the Mediterranean world. Storage places for utilitarian metal objects (often rendered useless) were generally employed; the collections suggested precoinage treasuries. The Near Eastern influence, however, brought about the spread of sanctuaries — found in early Greece, Cyprus, and Asia Minor, later in Italy, Sardinia, Iberia, etc. — containing mostly statuary representing gods or donors.

Some of these statues came close to being works of art and contributed to the rise of great Greek sculpture, such as the kouroi and the korai (see ARCHAIC ART; I, PLS. 342, 345, 346). Others led instead to a minor production in series of bronzes and terra cottas, the latter especially often reproduced from single matrices by a mechanical procedure. In the 6th century votive paintings, or pinaces, also made their appearance, either with a mythological subject or representing the donor in his professional activity. Characteristically documentary and realistic in style are some of the marginal productions of the Greek world, such as the small votive bronzes from nuraghic Sardinia with warriors, musicians, peddlers and the like (PL. 207), which have the spontaneity and vivacity typical of folk art.

With the development of the culture and improvement of the economy, the number of altar offerings grew, and the votive repositories were filled to overflowing with hundreds and thousands of objects. Special buildings called "thesauroi" were built in the larger Greek sanctuaries. In these the offerings coming from individual cities were collected (e.g., the Siphnian and Athenian treasuries at Delphi and the treasuries of Corcyra, Corinth, and Gelo at Olympia). In other cases (the sanctuary of Artemis Orthia at Sparta) the objects, after having been displayed for a certain length of time, were deposited in pits dug in the earth, particularly if they were of little value.

When Pericles had the Propylea of the Acropolis of Athens renewed, one wing of the new building was reserved for the pinaces (votive paintings offered to Athena, whence the name pinakotheke). From the Acropolis itself comes the pinax with the names of Megakles and Glaukytes, representing a warrior in action whose life the goddess had evidently saved. Even more interesting is the pinax dedicated by Ninnion to Demeter and Kore on the occasion of her initiation into the mysteries of Eleusis (II, PL. 54). These votive traditions continued into the 4th century without any great changes. At this time reliefs with images of the devotees presenting themselves to the god or bearing offerings became increasingly numerous, as did the offerings at the sanctuaries of the health gods, especially at the temples of Asklepios at Epidauros and at Kos. These offerings show the god, often with Hygeia, worshiped by his followers. At times the reliefs reproduce parts of the body that the god cured while the afflicted person was immersed in the ritual sleep.

In Italy as well, and therefore in all the Mediterranean world, the sanctuaries prospered from before the archaic period

into the Hellenistic age and imperial Rome. The conception and form of the offerings tended to take on interesting and often original characteristics. The repository for ex-votos at Bagni di Vicarello on Lake Bracciano, begun during the Neolithic era with knives and other stone objects, continued to be used for collections of *aes rude* (blank coins) and later of *aes signatum* (decorated coins). All the numismatic phases up to the 4th century of our era are represented by coins found there. Other precious objects, such as silver votive cups upon which were engraved drawings of the journey to the sacred spring, were also found in this repository. Coins or other objects of value so deposited could be spent for building, provided that the building itself was linked to the god: "... lacum de stipe fecere" (Diehl, 1911, no. 106). The large repository of Carsoli, recently excavated with great care, has permitted the identification of various strata, all containing small objects. Sometimes vases bearing (in graffiti) the names of the divinities are found. Between the two great Punic wars, a workshop which produced cups with figures and inscriptions painted in white (*Lavernai pocolom* type) existed in Latium. Unfortunately, the connection between the divinity and the representation on the cup is often not clear; the *pocolom* for Juno, for example, has a cupid riding on a dog. Of great interest are monuments dedicated to the *matres* in the sanctuary of the Magna Mater discovered in the Fondo Patturelli near Santa Maria Capua Vetere (PL. 207) and fertility gods such as Fortuna (cf. the formula "nationus cratia ...," expressing gratitude for successful childbirth, on the votive base found in Palestrina; Diehl, 1911, no. 58). The votive epigraph series with the formulas "donum dedit lubens merito ..." ("d. d. l. m. ...."), "de praidad ...," and "ex manubieis ..." also began to appear at this time. Statuettes of gods and of donors, terra-cotta heads with a realistic air (typical are the Italic ones of Carsoli), and bronze figurines and images of animals, disproportionately long, make up by far the largest part of the votive offerings. Above all, the use of terra-cotta or bronze ex-votos representing the parts of the body (eyes, trunks, hands, feet, genitals, etc.) touched by the grace of the gods became ever more common (PL. 208). As has already been noted, these traditions continued through the entire imperial age.

Carolus C. VAN ESSEN

EAST ASIA. *India.* The life of the individual in India is governed by belief in the transmigration of souls, or samsara (see BUDDHISM; HINDUISM). Among the means proposed for liberating the soul from the cycle of life, death, and reincarnation, the most effective are held to be gifts, offerings (PL. 204), and the construction of sacred buildings. Gifts might consist of large holdings of land, cattle and servants included, or of temples and even complete monasteries (maintained by perpetual endowments) to which, generation after generation, true masterpieces of art were added. These works were executed with piety and considered objects of veneration as soon as they were finished. Among them were reliefs and wall paintings representing various gods or the Buddha and illustrating the "golden legend" of Buddhism — stories (Jātakas) of the previous lives of the Buddha, his last earthly life, and his miracles — or the ancient myths of Hinduism (q.v.).

The visitor, honoring the work of art with his reverent admiration and respect, participates in the devotional act begun by the donor and added to by the artist. He usually expresses his veneration by touching with his right hand and unconsciously polishing, but at the same time wearing away, the parts of the object or painting held to be most propitious. Large portions of certain frescoes have been rubbed away in this manner. This traditional gesture, which is still customary today, is in some cases carried further by dipping the hand into red (or sometimes white) pigment and then applying the hand directly to the wall. Bas-reliefs from Bharhut bear witness to this custom as well as to another devotional gesture that is still repeated today, the *añjali.* It consists in raising the hands, joined palm to palm, above the head in cases of extreme veneration, or more commonly to the height of the chest. Magnificent works of art have been inspired by this gesture, perhaps the

most beautiful being those at Amaravati (ca. 2d cent.) and at Karli (see ANDHRA; BUDDHIST PRIMITIVE SCHOOLS).

The statues or images are believed to embody supernatural forces because they have been consecrated and because at the moment of their consecration (which, it is believed, magically gives them life) they are given a double name containing both that of the god and that of the donor. Because of its name, of great importance to the Indians, the image becomes a kind of deified portrait. This portrait is particularly beneficent because the worshiper receives at one and the same time the power of the god and, no less valuable, that of the pious individual who has acquired merit in having it made. It should be added that this influence is valid only if the artist who produced the work has scrupulously followed the prescribed rules (shastra), thereby rendering the object perfect both from the artistic and from the symbolic and spiritual points of view.

The esthetic quality of a sacred image was considered of secondary importance to its ritual significance. This view led to cheaper methods of production whereby four principal kinds of objects were manufactured: souvenir objects, used also in our time; small figurines that were worn or placed on household altars; series of identical images (the beneficial power of which was believed to be increased with each additional painted or engraved replica); and finally, "magic" drawings or diagrams (*yantra*), painted on walls, on various bases, or simply drawn on the ground with colored powders, beads, and the like. The most common objects in the first category are small, molded-clay steles, an inch or so high, painted red and gilded, reproducing a particularly well-known and worshiped statue or temple, or a group of scenes in which the "great miracles" of the Buddha are easily recognized. Bought at the entrance to the sanctuary and during the pilgrimage, they permit the pious visitor to carry away with him a souvenir of the holy place and to continue in his own home the meditation inspired by the pilgrimage, receiving the same beneficial effect therefrom. Of a relatively late period (ca. 7th cent.), they are generally of mediocre quality, although important for the iconography.

The portable figurines are often of poor quality except for some of bronze or tin made in southern India. A little-known relief from the school of Mathura (q.v.) shows a male personage holding such a sacred statuette folded in his arms. Devotion was customarily shown by passing the fingers repeatedly over the object of worship; many examples have their features almost completely smoothed away.

A series of images constitutes the third category of cult objects. The series is almost always a representation of the "thousand Buddhas," innumerable identical images of the Buddha lined up side by side in rows one over another. The execution of these images is almost always hasty, and their very low esthetic level indicates that the principal object of their maker was to express, by repetition, the measure of his devotion toward the divinity represented.

Indian customs of worship express themselves in a more original form in the works belonging to the fourth category, the diagrams, or *yantra.* These abstract drawings, by means of geometric and representational elements, render the phonetic formulas known as "mantras," which are devotional formulas or magical evocations of the deity. They are often used by mystics, but on a more elementary level they belong to the forms of coercive magic. Of ancient origin, they appear in early Buddhist art and on Hindu (chiefly Brahman) monuments. They occupy an important place in Tantrism.

The idea of synthesis and repetition mentioned previously also determined the reproduction in miniature of sacred buildings that rise around a main sanctuary. These structures express not only the desire to create the most numerous and lasting witnesses possible but also hope or gratitude for the fulfillment of a prayer. Therefore they are votive offerings in the true sense of the term. This usage (principally in Buddhist art, in which innumerable reproductions in miniature of stupas exist) became widespread during the Gupta period (5th–6th cent.; see GUPTA, SCHOOL OF) and reached its peak under the Pala (see PALA-SENA SCHOOLS). One way of honoring these miniatures is by painting them, completely or partially, in white,

minium (red lead), or saffron, or by applying gold leaf to them. The same devotional impulse may be expressed by facing a stupa with larger stonework, as is still done today in Thailand. The small votive stupa, like the large one, usually has a foundation deposit which, at the time of its construction, is buried in a cavity in its base. Sometimes the small stupas have no such cavity and therefore have value only as souvenirs. The reliquaries, which may be of various forms, are related to these architectural miniatures. Those of the earliest periods are often clay or stone vases (PL. 211), very elegant in form and well rounded, with a cover terminating in a pointed arrow like the umbrella point of the stupa. Many are made of silver or gold; among these, one of the most famous is that of the Kushan king Kanishka (see KUSHAN ART; GANDHARA). Another, attributed to the 1st–2d century, has recently been excavated in Ceylon. Both of these small golden stupas, with gates (torana) and balustrades (vedika), are real masterpieces of the goldsmith's art.

Devout Buddhists and Hindus often leave perpetual endowments for sanctuary lamps. These lamps, of various and often original forms, are made up of several cups, generally odd in number, decorated with horses and birds in the round and with scrolls of ornamental leaves. Many are decorated with chains, and some have handles. They bear emblems such as the trident (trisūla) of Śiva and the disk (cakra) of Viṣṇu. They are often of high quality and are used in processions. The oldest examples extant are in bronze, going back to about the 10th–11th century; these come from the workshops of southern India. Both the Brahmans and the Buddhist monks also use rosaries and emblems of the god Brahma as a mechanical aid in their prayers or litanies. All cult objects and work tools are sacred, and almost all of them are objects of devotion, as, for example, the ankle bracelets of the dancers. Most important among these objects of devotion is the water jar (pūrṇaghaṭa, kalaśa). Sacred in itself, it is worshiped also because it receives the purifying holy water.

<div style="text-align: right">Jeannine AUBOYER</div>

*China.* A considerable quantity of the ritual pottery and many bronzes of prehistoric and Bronze Age China (Shang and Chou dynasties) must be classified as devotional objects because of the uses to which they are put and the symbolic significance of their ornamentation.

Ancestor tablets were used in every Chinese household to symbolize the communion between the living family and those of its members who had died. The tablets first appeared in China in historical times and were the principal and most common devotional objects. Although such tablets are generally of little artistic value, they were of supreme importance in the regulation of family life; offerings and gestures of devotion were made before them. Wooden tablets were often dedicated by entire communities to divinities such as the earth god. The tablet symbolizing such a divinity was sometimes taken from its place of worship to be carried in battle in a chariot specially made for that purpose.

Much of ancient Chinese art (bronzes, ceramics, jades, zoomorphic and anthropomorphic wooden representations such as those of Ch'ang-sha) can be considerered religious art, and many of the objects produced at that time are devotional in character. After the appearance and affirmation of Taoism (q.v.), devotional objects were produced in great numbers, though almost none are of significant artistic value.

These devotional objects are of five types. (1) Talismans (see MAGIC) were very widely used and were often considered as "edicts of a divinity." They are inscribed with special characters and symbols that only a few people were able to interpret. (2) Popular prints — depicting gods, deified personages, protectors of categories, lucky animals, symbolic plants, propitiatory scenes, and ideograms wishing longevity and wealth — were also very common; they were usually attached to the door of the house or burned. (3) Amulets were worn hung around the neck, most often by children. (4) Good-luck phrases are found on many objects (of embroidery, bronze, porcelain, lacquer, etc.). Finally, there are (5) the parallel inscriptions, consisting of phrases of religious or ethical significance.

Buddhism (q.v.) brought some of the devotional objects and customs of other countries into China, such as the rosary with 108 or more beads, incense burners, the use of incense sticks, the images of the Buddha and the bodhisattvas repeated innumerable times, the use of religious statues in the home (a custom soon imitated by Taoism and thereafter by the modern popular religion), reliquaries, and bells.

In more recent times, above all during the Ch'ing dynasty (1644–1912), the Chinese artisan continually increased his production, almost to the scale of a small industry, of objects of ivory, bone, hard stone, metal, and wood. These objects represented divinities and figures from the popular syncretistic pantheon and were intended for use in the home as devotional objects. The use of popular devotional prints also became more common during this period.

<div style="text-align: right">Lionello LANCIOTTI</div>

*Japan.* The most important devotional manifestation of Shinto, the national Japanese religion, is the temple, a simple, unornamented wooden structure. The foundation of this structure rests on piles, and the temple is entered by way of a flight of wooden steps. In primitive Shintoism the place of worship was in the open and consisted of a sacred compound (himorogi) fenced in by rice-straw rope (shime-nawa) stretched between four poles and hung with the strips of paper that conferred a holy character to the spot. Inside the compound was placed a tree (sakaki, the Cleyera ochnacea, sacred tree of Shintoism), on which the divinity was believed to descend. The Shinto temple has a more concealed part (shinden), on a higher level and accessible by a flight of stairs, in which the symbols of the deity, the shintai, are situated. These consist of a sword, a stone, a mirror, a tree, and a tablet with the name of the deity written on it. They represent the spirit of the god (mitama).

Next in importance to temple worship is worship within the family, which is centered around the kami altar (kamidana), a small reproduction of a Shinto temple. It is set up in a suitable place in the house and faces south, east, or west, but never north or northwest (directions considered unlucky). It consists of a small tabernacle containing the shintai, and before it are stairs flanked by banisters. Offerings are placed at the foot of these stairs. The kamidana is made of wood and may be quite simple and without decoration or very elaborate, with artistic elements derived from those of Buddhist temples (Butsuden). In the square in front of the little temple are set up small tablets (o-fuda) bearing the name of the divinity. These are of no particular interest artistically except in the calligraphic execution of the ideographic characters. Among the offerings placed on the altars are strips of paper attached to a small stick (gohei), symbolizing the primitive offerings of food and drink. The purposes for which these offerings were intended have changed in the course of time, some of these articles having become sanctified or even having attained the status of symbols of the divinity. They are therefore objects of worship and, as such, given by the priest to the devotee to place on his domestic altar.

Finally there are the small portable shrines (mikoshi) that are carried on the back during sacred processions and that enclose the shintai. Usually made of wood and occasionally of worked metal, they have a richly decorated rooflike cover, at the four angles of which are representations of birds with votive strips of paper and cloth attached. Tabernacles are found all over the countryside, on the mountains and in all those places which must be consecrated to the local kami. They are always reproductions in miniature of the Shinto temple.

Only after the development of Ryōbu-Shinto, the result of a Shinto-Buddhist syncretism, were a few images to be found in the temples. They, however, remain rare iconographic expressions, since Shintoism was and has remained a fundamentally aniconic religion (see DIVINITIES; IMAGES AND ICONOCLASM; SHINTOISM).

<div style="text-align: right">Antonio PRIORI</div>

*Southeast Asia.* The distinction between religion and magic is even less clear in southeast Asia than it is in India. The

devotional objects most common in southeast Asia can be roughly divided into the following classes: idols, relics, sacred texts, sacred trees and stones, and magic diagrams.

The belief in the supernatural power of divine images which is common in India becomes even more important in southeast Asia. Theoretically the image of the Buddha should be no more than a remembrance of the Master, who has been absorbed into nirvana and is no longer capable of intervening in human affairs. In practice, however, some images of the Buddha are held to be gifted with specific powers. The same holds true for the small votive tablets, terra-cotta reliefs of a specific design. These were originally no more than souvenirs of pilgrimages to the sacred place in which a particular image was worshiped, but they became objects of worship in themselves and, in a further evolution, good-luck amulets.

The large number of small statuettes of Hindu gods found during excavations indicates that these idols once were of great importance in popular worship. They were probably placed in the domestic sanctuary, as is still done in Buddhist homes.

From the beginnings of Buddhism in India, relics of the Buddha and his disciples have always been objects of great veneration. They are so numerous that the authenticity of most of them is with good reason doubtful. The mortal remains of ancestors are also objects of devotion, particularly during the annual feast of the dead or on anniversaries. The remains, in the form of ashes where cremation is customary, are often placed in stupas and other objects of periodic worship. In ancient times the statues consecrated by apotheosis were probably "animated" by the placement of ashes or bones into receptacles in their bases. These statues represented the deceased under the aspect of a divinity and had a name which also included that of the deceased (see ESCHATOLOGY).

The sacred texts, made up of the body of the Law of Buddha and preserved in Thailand, Cambodia, and Laos in sarcophagus-shaped coffers, are greatly respected. Short fragments of the texts are sometimes incised on metal strips that are rolled up, fixed to a chain or cord, and hung at the neck.

Very widespread in all of southeast Asia is the worship, once common in India, of particular trees thought to be the habitations of sylvan deities. Buddhism has not repudiated this worship (of animistic origins) but has centered it on the tree at the foot of which the Master woke to "Enlightenment," that is, the Bo tree, or *Ficus religiosa*. The trees grown from a cutting of the original tree of Bodhgaya, or a shoot of this cutting planted in Ceylon, are objects of particular devotion. Some stones, natural or worked, and sometimes pieces of old sculptures, are objects of devotion because they are believed to be the abodes of genii or the manifestations of the genii themselves. The *yantra*, or magico-mystical diagram, is used in southeast Asia just as it is in India.

George Cœdès

THE PRIMITIVE WORLD. At least some of the numerous statues (mostly of terra cotta) that have been found in American and African temples are known to have been votive in character. Among these are the figurines found in the sanctuary of Tago (Tchad) by the Lebeuf mission (PL. 206), the Attie ritual ceramics (Ivory Coast), and the terra-cotta figurines from Tlatilco and Michoacán (Mexico). They appear to be images of deified ancestors or figurines connected with particular fertility cults. Another series of representations to which a devotional significance could be attributed consists of the figurines bearing offerings or receptacles for offerings (PL. 206). The donor figurines are much more numerous and are found everywhere, from America to Africa to Oceania. To this category belong two groups of figurines, both from Nigeria. In one of them, collected among the Yoruba, there are three people: two women at the sides holding a child in their arms, and a figure in the center holding a disklike object (a fan?). At their feet are two containers with covers and a plate with offerings. This, like the second group, probably represents a group of the faithful carrying their offerings to the god. The second group of clay figurines was found among the Ibo. A chicken is clearly identifiable among the offerings (PL. 206).

Another important example of a votive offering is a Maya stone stele from Santa Lucia Cozumalhualpa on the Pacific coast of Guatemala. On it is carved a figure in ceremonial dress, probably a pelota player (pelota was the national sport of the ancient Mexicans). He holds an unidentifiable offering in his left hand, which is raised toward the anthropomorphized image of the sun god (PL. 204).

Little is definitely known about the devotional aspects of Oceanic religion. To attribute a devotional character to the numerous figurines with joined hands found on many of these islands would therefore be hazardous. This is also true of the ancestor images — more properly discussed under the heading of eschatology (q.v.) — found in the temples and of the sacred tablets from New Guinea that are covered with feather mosaic (see FEATHERWORK). Nevertheless, these Pacific islands — with their complex rites and dances and their cyclical new year's feasts — have produced some of the most interesting and dramatic manifestations of the relationship between man and god.

\* \*

WESTERN CHRISTENDOM. *Cult images and icons.* In Christianity also there is a natural antithesis between the official cult and popular devotion. It is particularly pronounced among those sacred images which are venerated for the thaumaturgic power that is attributed to them, often because of their historical origins.

The first sporadic information we have concerning the veneration of images on wood or canvas comes from the middle of the 4th century of our era. St. Augustine (A.D. 354–430) was the first to speak of "sepulcrorum et picturarum adoratores," and his contemporary St. Epiphanius, bishop of Salamis (ca. A.D. 315–403), was the first to denounce the adoration of images. In manuscripts from the middle of the 6th century evidence of veneration of images begins to multiply, many communities boasting the possession of miracle-working images of supernatural origin. Images not painted by the hand of man (*acheiropoietoi*), whose magic qualities served an apotropaic purpose, are spoken of. The oldest and most famous of these, cited for the first time about A.D. 560–74, is that of the Christ painted on canvas that was found by a pagan woman at Camulia in Cappadocia and was believed to have reproduced itself spontaneously. It was held responsible for miraculous healings. In A.D. 574 this image was carried to Constantinople, and after having served as a palladium for the Empire in several wars, it disappeared about A.D. 800. Antonius of Piacenza mentioned in about 570 an Egyptian *acheiropoieton* in Memphis, distinguishing it from, among others, the image in the house of Pilate in Jerusalem painted when Christ was still living. A third Roman *acheiropoieton*, which today is generally believed to date from the 5th century of our era, was carried in procession in 752 by Pope Stephen II. In manuscripts of the 8th–9th century of our era, one first reads of miraculous images of Mary, of which that of Lydda is held to be the oldest. In the following centuries images of this kind were known in Constantinople, Hyrtakion, Kosinitza, Salonika, Ettal, Piedigrotta, and Rome (S. Maria in Trastevere). Also venerated was the image of Christ from Edessa, already mentioned in A.D. 544 (see CHRISTIANITY). Lastly, there is the so-called "veil of Veronica," whose legend came into being in the 6th century.

During the 5th and 6th centuries the power of the image always came from its contact with holy relics, the veneration of which, from the 7th century on, was most extensive in the West. About A.D. 790 this practice was fully justified in the *Libri carolini* (III, 16). The veneration of relics became of the first importance, and they were thereafter enclosed in marvelous reliquaries (PL. 211).

Beginning with the 10th century, monumental wooden sculptures, used as reliquaries and usually gilded, became numerous in the West (seated figure of St. Faith at Conques; Virgin of the treasury of the Cathedral of Essen, 973–82). With the end of the iconoclastic war, the Eastern Church's attitude toward veneration of images became clearer. This development was due especially to the work of St. John of Damascus (d. ca.

A.D. 749). The production of icons received a powerful impetus from the orthodox definition of Feb. 19, 843, which stated that images permitted an approach to the original and to the contemplation thereof. The theology of the image called for artistic skills of the highest quality and, at the same time, for conservatism (PL. 210). The painting of the middle and late Byzantine period is pervaded by an ethic that takes this double and contrasting obligation into account, eventually determining the character of Russian art. The iconostasis, a partition having doors and covered with images, functioned as a barrier between the congregation and the altar. Under the Patriarch Nicephorus (806–28), a strong defender of image veneration, the first iconostasis with icons appeared. Images of saints were increasingly replaced by those of Christ, Mary, and the Trinity, while sculptures continued to be prohibited. Soon an icon was in every private home and became the center of family worship.

In the 9th century, Byzantine icons began to arrive in ever-increasing numbers in Italy, Spain, France, and Germany, where they were usually venerated as vehicles of grace. The defeat of Constantinople (A.D. 1204) brought about the triumph of the Byzantine manner in Italian painting. The crucifix and the image of the Madonna were the commonest motifs in the evolution of the art, particularly of the Tuscan workshops. In addition to the altarpieces, single works were produced in great numbers. During the 13th century the size of the panels continually increased, culminating in the large Madonnas and triumphal crosses of Cimabue (q.v.), Giotto (q.v.), and Duccio (q.v.). This monumentality, never striven for in the East, was determined by the West's emphasis on the thaumaturgic importance of images. These images also began to assume a new significance in the political life of the Italian communal cities. The great representations of the Maestà, frequent above all in Siena, thus arose.

*Andachtsbilder.* A particular type of devotional image, known in German as an *Andachtsbild*, came into being, not without Byzantine influences, at the end of the 13th century and in the 14th century, primarily in the monasteries that were centers of the mystical movement. The production of *Andachtsbilder* flourished in the 15th century and continued to survive even during the Counter Reformation and the baroque period. These images (paintings and sculptures) were — unlike the icons — intended to be objects of meditation. Erwin Panofsky has compared the *Andachtsbild* to a lyric poem, distinguishing it from works such as the altarpieces and fresco cycles, which he compares to dramas or epic poems.

One of the arguments of the Second Council of Nicaea in defense of images is based on psychological elements that were consciously stressed in later devotional images. St. Fulbert of Chartres (d. 1028), in clarifying the function of such works, defined the theory of the devotional image. Thus, already in the 10th and 11th centuries, there were representations of Christ on the Cross (PL. 210) that reflected the mysticism of the Passion (Lothair Cross, Aachen Cathedral, ca. 1000, and other German examples). Images for private worship are particularly documented in Italy (Thomas of Celano, *Tractatus de miraculis S. Francisci*, ca. 1250). From the 14th century onward, an image of the Madonna was in almost every home. The activity of the religious brotherhoods led to the development of this new kind of artistic attitude as well. Among the favorite subjects, the Ecce Homo and the Pietà predominated, and the austere mysticism of the Passion is a basic motif of 14th- and 15th-century art. This mysticism also influenced the development of the traditional themes of the Deposition and the Lamentation, and particularly the Crucifixion. A gentler lyric tonality permeates the depictions of Christ and St. John, and Christ bearing the Cross. Another, more joyous mysticism is expressed through such motifs as the Mother and Child, the Madonna of Humility, the Virgin among her heavenly companions, the Madonna of the Rose Bower and the Garden of Paradise, and the so-called "beautiful Madonnas" of the "soft style" (e.g., Angelico, Ghiberti, and Luca della Robbia; qq.v.).

The painters took pains to indicate, by means of the imagery, that the painting was to be understood as a prayer (PL. 203); that the work sprang from an act of devotion; that, even more, it addressed an admonitory and fervent exhortation to the observer. A representative example, among many, is given by Giovanni Bellini in the Brera Pietà (II, PL. 258).

Numerous legends of the lives of the mystics bear witness to the spiritual power of images. Thus, St. Catherine of Siena received the stigmata after having contemplated a crucifix in Pisa. While observing Giotto's *Ship of the Church* (Old St. Peter's, Rome), she reflected that it was to her alone that the task of drawing the heavy ship of the Church fell; this realization produced a contraction of her limbs that lasted all her life.

In the 15th century began a transition from the isolated image to the series of images illustrating a cycle of prayers or theological complexes. One of the first examples of this development is found in Siena in the stalls of the Chapel of the Palazzo Pubblico, where Domenico di Nicolò dei Cori illustrated the articles of the Creed, to which a series of images in the pavement of the Cathedral choir are also dedicated. The theme of the Rosary led to representations of the Madonna around whom the Joyful and Sorrowful Mysteries of the Rosary are placed in tondos (e.g., *Annunciation* by Veit Stoss, 1517, in the Church of St. Lawrence in Nürnberg; *Madonna of the Rosary* by L. Lotto in the Church of S. Domenico in Cingoli).

With the Counter Reformation the devotional image took on a new form. In place of an event from the Gospels, the figure of a saint was depicted, raised from the earth in ecstasy, or in prayer, absorbed in meditation on an object pertaining to salvation. Almost all the important saints of the period are found in these paintings — Charles Borromeo, Philip Neri, John of the Cross, Vincent de Paul — but their iconography has received little study.

*Ex-votos.* An ex-voto, or votive offering, is a work of art that is made by an individual for a public place or shrine. A distinction may be made between votive offerings that are simply the outcome of a donor's personal experience and others — such as churches, altars, retables, or reliquaries — that also serve some ritual purpose. The former, which we shall discuss here, are intended as thank offerings for rescue from a particular danger, or as requests for the fulfillment of some need.

By the end of the 15th century the ex-voto (in the form of painting or sculpture) had become common in the folk arts of Italy, Spain, the Latin-American countries, France, and the Catholic areas of German-speaking countries. Ex-votos do not occur in the arts of England or the Scandinavian countries.

The coming of Christianity did not affect the motives that led to the production of ex-votos, and even the places in which they were collected often remained the same. In many places the worship of Hera Eileithyia, goddess of childbirth, was transferred to that of the Madonna. In Mexico, Christians continued to place votive offerings in the sacred places of the ancient Mexican civilization. In Portuguese Goa a Hindu image resembling the Good Shepherd was newly interpreted by the Christians and its use as an ex-voto in the same place continued. Chthonian cult places of Celtic France contain offerings, similar in character, from both Celtic and Christian times.

Single examples of votive offerings of wax, clay, gesso, lead, and copper from the early and high Middle Ages have been preserved. So far no popular votive paintings prior to the 15th century are known; all older pieces were generally executed on commission and belong rather to the sphere of fine art. The oldest existing ex-votos date from the second half of the 15th century and were found in the Church of S. Maria del Monte in Emilia (1450), the Church of S. Nicola in Tolentino in the Marches (1470), in Cesena (Emilia), Altötting (Bohemia), and Montserrat (near Barcelona). In many places of pilgrimage, the use of ex-votos continues in the 20th century (PL. 209).

Large collections of ex-votos are also found at Aigen am Inn in Austria, at Vierzehnheiligen, at Sankt Erhard in der Breitenau in the valley of the Mur, at the Schachernbauer Kapelle near Braunau, and in the sanctuaries of Maria Weldrast in the Tirol and Rankweil in the Vorarlberg. The most famous Swiss sanctuaries are those of Sachseln, Longerborgne, Belalp,

of the Madonna del Sasso, and of Einsiedeln (in the last, the clay tiles with the Madonna are very beautiful). The custom of thanking the saints — invoked in times of need — with ex-votos is still very widespread in Belgium, as can be seen in the sanctuaries of Hérent, Léau, Ogy, Rebaix, Saint-Souweur, Saint-Arache, Westroosebeke, and Huyssinghem. In France, the principal collections of ex-votos are found at Ste-Anne-d'Auray in Brittany, in Notre-Dame-des-Victoires, Notre-Dame-de-Clery, Notre-Dame-de-la-Garde, Saint-Remy-de-Provence, and at Vasina in Corsica. The Italian churches and sanctuaries containing ex-votos and votive tablets of artistic value are innumerable. A few examples are the Madonna di Bagno, near Deruta; S. Maria del Monte, near Cesena; the Santuario di Montenero, not far from Leghorn; the Carmine and the Madonna dell'Arco, in Naples and vicinity; the Madonna of the Rosary, at Pompeii; the Madonna of Loreto, in the province of Palermo; and Nostra Signora di Bonaria, in Sardinia. A considerable number of votive tablets from the region near the upper Adige River and from Naples have been collected in the Museo delle Arti e delle Tradizioni Popolari in Rome. Two rooms of the Museo Etnografico Giuseppe Pitrè in Palermo are devoted to Sicilian ex-votos.

Though ex-votos differ stylistically from one locality to another, they are all generally characterized by realism and close adherence to the object or event represented. In the narrative paintings, minute details are faithfully executed. Often, however, an afflicted limb or organ is represented in gigantic proportions, or a model of the member is offered as a single sculptured piece (PL. 208).

In Germany and in France, the compilation of a systematic catalogue of all ex-votos has begun. In Switzerland, such a work has been finished and now awaits further study. In Italy, Spain, Portugal, and the Latin-American countries, there have so far been only single studies or summary works. The greatest collection of ex-votos is in the Bayerisches Nationalmuseum of Munich (PL. 209).

*Souvenirs and miscellaneous devotional objects.* Whereas votive images originate in a personal devotional impulse (becoming objects of public veneration after they have been placed in a public shrine), devotional souvenirs are those objects that, generally distributed at places of public worship, are carried home by pilgrims and then become appurtenances to personal devotions. These remembrances of a circumstance or religious event are never individual works; they are usually mass-produced.

Devotional souvenirs may be natural and unworked (e.g., earth from the Holy Land or oil from the lamps of the Holy Sepulcher), or they may be manufactured objects of various kinds to which popular belief attributes a particular virtue (e.g., little shirts of Loreto, a wax Agnus Dei, strips of paper with prayer formulas on them). The latter may have some historical importance, but they have little artistic value. To the category of manufactured objects also belong reproductions or symbols of the shrines or images that the pilgrim has visited. Such reproductions or symbols of ancient sanctuaries often allow the art historian to get some idea of artistic and architectural monuments that have since been destroyed.

Devotional souvenirs point to an important cultural and sociological phenomenon in the 19th and 20th centuries; during this time many such souvenirs, of a run-of-the-mill and meretricious quality, have been produced.

The earliest fairly extensive information concerning natural souvenirs, clay tablets, medals, and ampullae which reproduce (either plastically or in graffito) images or buildings from holy places and sanctuaries stems from the 5th century of our era. There are examples from Asia Minor (tomb of St. John in Ephesus), from Egypt (ampullae and small bottles from Abu Mina), from Palestine, and from Italy (ampullae at Monza and Bobbio). The reliefs and representations on these objects were venerated as relics. Miraculous healings, the power of guarding against the perils of travel, and apotropaic powers were attributed to them. They were always easily reproducible commercial products and were made and sold in great numbers. The ampullae of Monza and Bobbio (ca. A.D. 600) are of particular importance in the reconstruction of mosaics that are believed to have existed in Palestinian churches.

In the later Middle Ages the ampullae were replaced by medals, made of zinc or lead, that reproduced miraculous images and the objects of the great pilgrimages, especially of the Marian sanctuaries. The production of miraculous medals became a widespread industry, but unfortunately much of the fascinating material produced during the 13th and 15th centuries has not yet been studied sufficiently. With the diffusion of the cult of relics, the use of reliquaries became customary. These took the form of statues, busts, chests, or reproductions in miniature (often simplified) of architectural works. They were uncovered for the veneration of the faithful on certain feast days in the churches (PL. 211). Amulets and devotional vials with reproductions of relics and miraculous images recall the pilgrimages of the Renaissance and baroque periods.

With the invention of the woodcut, a vast new field was opened to the manufacturers of devotional images. Between 1410 and 1420, the first woodcuts of miraculous images, printed on broadsheets, were sold at popular prices. A distinction must be made between these early devotional woodcuts, which were substitutes for the more expensive private devotional images, and those which (as picture post cards do) merely reproduced famous objects of pilgrimages such as the Roman churches, the great treasures of the churches, and famous reliquaries. Prints, sometimes colored, were also made of particularly venerated Madonnas (the Madonna of the Ears of Wheat in the Cathedral of Milan, *The Beautiful Mary* attributed to Altdorfer, ca. 1518, in St. Johann, Regensburg). Sometimes the print itself also became a miraculous image (e.g., image at Kevelaer, near Cleve). Up to the end of the 16th century these motifs inspired woodcuts and copper engravings of high quality (Cranach, Dürer, Altdorfer); however, the quality of such works declined in the 17th and 18th centuries to that of a purely popular art.

Wolfgang BRAUNFELS

Among the popular devotional objects, glass paintings must be mentioned. These were also cult objects, and as such never represented everyday events or ordinary people. Although found to some extent everywhere, glass paintings were most common in the eastern European countries, many having been found in Czechoslovakia and in Romania. Until a few years ago, the largest center producing these unique paintings was Nicula in Transylvania. Although the art of painting on glass is believed to have spread from this town to the nearby regions at the beginning of the 18th century, it is more probable that the craft arrived in Nicula from the Slovakian Carpathians, soon becoming the most important one of Nicula. Other Transylvanian centers which competed with Nicula were the cities of Brașov and Făgăraș and the villages around Sebes and Sibiu. An interesting 18th-century print representing a Transylvanian fair shows a man carrying on his shoulder a long pole from which glass paintings are hung.

All glass paintings have similar subjects, not only in Romania and Czechoslovakia, but also in all the countries where they are popular, as in Sicily, for example. They are almost always paintings of saints or of episodes from the Bible, and throughout Europe a great number are dedicated to the Virgin. Commonly represented saints include George, Joseph, Nicholas, Lucy, Constantine, Helen, Francis, Anthony Abbot, Wenceslas, Cosmas and Damian, Isidore, and Theresa. The archangel Michael is also frequently represented. The most common Biblical themes are the Finding of Moses, the Beheading of John the Baptist, the Marriage of the Virgin, the Nativity, the Flight into Egypt, and the Crucifixion. Although a stylistic relationship between the glass paintings and Byzantine art has been hypothesized, there is no evidence of a historical relationship between the two. The techniques of glass painting are "primitive" and spontaneous and unrelated to any particular artistic trend, even from the remotest past.

On religious holidays, artistic genius and popular devotion both express themselves to the full. During these holidays housewives everywhere offer votive cakes and breads to the

saint who is being celebrated. Worked into various forms, these cakes and breads reproduce the saint's effigy or bear simple geometric designs, among which is always the cross. Enormous artistically worked candles are also sometimes offered to the saint. Famous for their beauty are the candles of Sassari, Sardinia, and those of Gubbio, Italy, and of Salé in France. Wooden constructions of singular design are also raised in honor of many saints. For example, obelisks dedicated to St. John the Baptist are erected in the villages of Irpinia, and the very high "machines" of St. Rose have been carried in procession yearly for three centuries in Viterbo (PL. 213). Of these characteristic machines, the most monumental are the sacred chariots, which in all parts of Europe have a shiplike form. As they require many days and sometimes even months of work from whole squads of craftsmen, these are exceptionally notable expressions of popular devotion.

Also carried in the religious processions are the standards of the lay confraternities. They are usually rectangular, edged with strips or fringes, and on them is embroidered or painted the image of the saint to whom the group is dedicated.

In addition to their standards, the confraternities have typical medals, which the members wear at their necks during processions. These medals, which are usually passed down from father to son, are made of silver and represent the patron saint of the brotherhood. In Spain they are of silver filigree, and in their technique and style they clearly reflect Moslem precedents.

Although often simpler and of even older origin, the small devotional medals worn at the neck, sewn on clothing, or attached to rosaries are related to the medals of the confraternities. The Spanish *collares de novia*, to which are attached dozens of devotional medals representing the patrons of the Spanish sanctuaries, are famous. The most valuable of these medals is a type in silver filigree with a tiny crucified Christ at the center. Others represent the Annunciation or the Holy Family.

The rosaries are almost always decorated with devotional medals. They may also have the images of the saints directly carved or incised on the beads. Rosaries of this kind are used in many European countries and especially in Spain. Some pins also have a devotional character; among the most interesting are those used by the Polish peasants.

Some of the confraternities have, instead of standards, crosses of great artistic value, and in some countries the statue of the patron saint is replaced by a large crucifix. These crosses are usually of carved wood, those executed by shepherds (e.g., crosses of Lascari, in Sicily) being of exceptional sculptural interest. Of an even higher artistic quality are the famous calvaries of northern and eastern Europe. They are placed at the crossings of country roads where they seem to become an integral part of the landscape. Particularly notable examples are the calvaries of Brittany (I, PL. 393).

<div align="right">Antonio BUTTITA</div>

BIBLIOG. *Prehistory and protohistory*: A. Mosso, Le origini della civiltà mediterranea, Milan, 1910, p. 77 ff.; S. Müller, La représentation solaire de Trundholm, Nordiske fortisminder, I, 1913, p. 303 ff.; G. Wilke, Die Religion der Indogermanen in archäologischer Betrachtung, Leipzig, 1923, p. 226 ff.; G. Wilke, RLV, II, p. 362 ff., s.v. Depotfund; F. von Duhn, RLV, II, p. 365 ff., s.v. Depotfund; R. Thurnwald, RLV, VIII, p. 145 ff., s.v. Menschenopfer; G. Ekholm, RLV, IX, p. 59 ff., s.v. Nordischer Kreis; G. Wilke, RLV, X, p. 154 ff., s.v. Pia Fraus; G. Wilke, RLV, XIII, p. 415 ff., s.v. Totenopfer; J. Brönsted, Danmarks Oldtid, II, Copenhagen, 1939, pp. 115 ff., 166 ff., 174 ff., 201 ff., 234 ff. *Ancient Near East*: H. Frankfort, Sculpture of the Third Millenium B.C. from Tell Asmar and Khafajeh, O. Inst. Pub., XLIV, 1939, pls. 21–23, 24B, 25A, B; E. Drioton, Un orant de style populaire, Studi in memoria di I. Rosellini, I, Pisa, 1949, pp. 253–59 (bibliog.); H. Frankfort, The Art and Architecture of the Ancient Orient, Harmondsworth, 1954; W. S. Smith, The Art and Architecture of Ancient Egypt, Harmondsworth, 1958. *Iran*: R. Dussaud, Anciens bronzes du Luristan et cultes iraniens, Syria, XXVI, 1949, pp. 169–229; R. Ghirshman, Le dieu Zurvan sur les bronzes du Luristan, Artibus Asiae, XXI, 1958, pp. 37–42; L. van den Berghe, Archéologie de l'Iran ancien, Leiden, 1959. *Greco-Italian civilizations*: Reisch, RE, col. 2069, s.v. Anathema; Lammert, RE, cols. 1361–62, s.v. Manubiae; Hug, RE, cols. 2538–40, s.v. Stips; J. Toutain, DA, pp. 969 ff., s.v. Votum. a. *Greece*. W. H. D. Rouse, Greek Votive Offerings, Cambridge, Eng., 1902; (1) *Sacred trees*: E. Saglio, DA, pp. 356–62, s.v. Arbores sacrae; (2) *Sparta*: R. Traquier, Excavations at Sparta, BSA, XII, 1905–06, p. 277 ff., pls. XI, XII; Ziehen, RE, col. 1466, s.v. Sparta. (3) *Pinaces*: Pfuhl, pp. 212–13; 493–94; J. Boardmann, Painted Votive Plaques..., BSA, XLIX, 1954, pp. 183–201. (4) *Reliefs of nymphs*: R. Feubel, Die attischen Nymphenreliefs und ihre Vorbilder, Heidelberg, 1935.

(5) *Reliefs of Asklepios*: J. N. Svoronos, Das athener Nationalmuseum, Athens, 1908; U. Hausmann, Kunst und Heiltum, Untersuchung zu den greichischen Asklepiosreliefs, Potsdam, 1948. b. *Italy*. (1) *Vicarello*: Hübner, RE, s.v. Aqua(e), no. 13; CIL, XI, 496; R. Lanciani, Ancient Rome, London, 1888, p. 46; R. Lanciani, Wanderings in the Roman Campagna, London, 1909, p. 50. (2) *The stipe of Carsoli*: A. Cederna, NSc, 1951, p. 169 ff. (3) *The pocola*: P. Ducati, Storia della ceramica greca, II, Florence, 1922, pp. 482–83; E. Diehl, Altateinische Inschriften, Bonn, 1911, nos. 1, 2, 56, passim. (4) *Capua*: J. Heurgon, Recherches sur l'histoire, la religion et la civilisation de Capoue préromaine, Paris, 1942, p. 330 ff. *East Asia*. a. *India*: see bibliogs. for BUDDHISM, HINDUISM, INDIAN ART, JAINISM, b. *China*: see bibliogs. for BUDDHISM, CHINESE ART, CONFUCIANISM, TAOISM. c. *Japan*: G. Sansom, Japan, A Short Cultural History, London, 1932, revised ed., 1946; S. Kiyowara, Shintō-shi (History of Shintoism), Tokyo, 1935; M. Muccioli, Shintoismo, Le civiltà dell'Oriente, III, Rome, 1958. d. *Southeast Asia*: see bibliogs. for BUDDHISM, BURMESE ART, SIAMESE ART, VIETNAMESE ART. *Western Christendom*. a. *Cult images and icons*: E. von Dobschütz, Christusbilder, Untersuchungen zur christlichen Legende, Leipzig, 1899; L. Bréhier, La querelle des images, Paris, 1904; N. P. Kondakov, Ikonografija Bogomateri (Iconography of the Virgin), Leningrad, 1914; K. Holl, Die Schriften des Epiphanios gegen die Bilderverehrung, SbBerlin, XXXV, 1916, (republished Gesammelte Aufsätze zur Kirchengeschichte, II, Tübingen, 1928, pp. 351–87); H. Koch, Die altchristliche Bilderfrage nach den literarischen Quellen, Göttingen, 1917; V. Grumel, Culte des images, Dictionnaire de théologie catholique, VII, 1, 1927, pp. 766–843; E. Sandberg-Vavalà, La croce dipinta italiana e l'iconografia della passione, Verona, 1929; L. Bréhier, L'art en France dès invasions barbares à l'époque romane, Paris, 1930; W. Elliger, Die Stellung der alten Christen zu den Bildern in den ersten vier Jahrhunderten, Studien über christliche Denkmäler, N.S., XX, Leipzig, 1930; Art populaire, travaux artistiques et scientifiques du Ier congrès international des arts populaires (Prague, 1928), I, Paris, 1931; M. Durand-Lefebure, Etude sur l'origine des vierges noires, Paris, 1937; L. Koch, Zur Theologie der Christusikone, Benediktinische Monatschrift, XIX, 1937, pp. 375–87, XX, 1938, pp. 32–47, 168–75, 281–88, 437–52; H. Menges, Die Bilderlehre des Heiligen Johannes von Damaskus, Münster in Westfalen, 1938; I. B. Konstantinowicz, Ikonostasis, Lvov, 1939; L. Bréhier, Vierges romanes d'Auvergne, Le Point, Rev. Artistique et Lit., V, 1943, p. 12 ff.; S. Der Nersessian, Une apologie des images du septième siècle, Byzantion, XVII, 1944–45, pp. 58–87; E. Saillens, Nos vierges noires, Paris, 1945; P. Toschi, Segni di fede nell'arte popolare italiana, Saggi sull'arte popolare, 1945, pp. 55 ff.; A. Grabar, Martyrium, recherches sur le culte des reliques et l'art chrétien antique, 2 vols., Paris, 1946; P. Stephanou, La doctrine de Léon de Chalcédoine et de ses adversaires sur les images, Orientalia Christiana Periodica, XII, 1946; E. Gombrich, Icones symbolicae: The Visual Image in Neo-Platonic Thought, Warburg, XI, 1948, p. 163 ff.; R. Longhi, Giudizio sul Duecento, Proporzioni, II, 1948, p. 5 ff.; L. H. Grondijs, Images des saints après la théologie byzantine du VIIIe siècle, Actes du VIe Cong. Int. d'Et. Byz., Paris, 1948–51, pp. 145–70; E. B. Garrison, Italian Romanesque Panel Painting, Florence, 1949; L. Schneider, RACr, I, 1950, pp. 68–71, s.v. Acheiropoetos; H. N. Baynes, The Icons before the Iconoclasm, Harvard Theological Rev., XLIV, 1951, pp. 93–106; H. Keller, Zur Entstehung der sakralen Vollskulptur in ottonischer Zeit, Festschrift H. Jantzen, Berlin, 1951, p. 71 ff.; H. F. von Campenhausen, Die Bilderfrage als theologisches Problem der alten Kirche, Z. für Theologie und Kirche, XLIX, 1952, pp. 33–60; P. J. Alexander, The Iconoclastic Council of St. Sophia (815) and Its Definition (Horos), Dumbarton Oaks Pap., VII, 1953, pp. 35–66; G. B. Ladner, The Concept of the Image in the Greek Fathers and the Byzantine Iconoclastic Controversy, Dumbarton Oaks Pap., VII, 1953, pp. 3–34; R. Mrlian, Art populaire slovaque, 2 vols., Bratislava, 1953; M. V. Anastos, The Ethical Theory of Images Formulated by the Iconoclasts in 754 and 815, Dumbarton Oaks Pap., VIII, 1954, pp. 21–35; E. Kitzinger, The Cult of Images in the Age before Iconoclasm, Dumbarton Oaks Pap., VIII, 1954, pp. 83–150; J. Kollwitz, RACr, XVI, 1954, pp. 318–41, pl. III; J. Kollwitz, Christusbild, RACr, XVII, 1955, pp. 1–24; L'art populaire en Roumanie, Bucharest, 1955; K. Sourek, L'arte populaire en images, Prague, 1956; A. Grabar, L'Iconoclasme byzantine, Paris, 1957; H. Schrade, Vor- und frühromanische Malerei, Cologne, 1958. b. *Devotional images*: A. Peltzer, Deutsche Mystik und deutsche Kunst, Strasbourg, 1899; A. Baumstark, Die syrisch-griechische Marienklage, Gottesminne, IV, 1906, p. 11 ff.; G. Millet, Recherches sur l'iconographie de l'Evangile, Paris, 1916; N. C. Brooks, The Sepulchre of Christ in Art and Liturgy, Univ. of Illinois Studies in Language and Literature, II, 2, 1921; G. Swarzenski, Insinuationes divinae pietatis, Festschrift für Adolf Goldschmidt, Leipzig, 1923 p. 65 ff.; E. Panofsky, Imago pietatis, Ein Beitrag zur Typengeschichte des Schmerzensmannes und der Maria Mediatrix, Festschrift für Max Friedländer, Leipzig, 1927 p. 261 ff.; R. Bauerreis, Pie Jesu: Das Schmerzensmannsbild und sein Einfluss auf die mittelalterliche Frömmigkeit, Munich, 1931; G. G. King, The Virgin of Humility, AB, 1935, p. 474 ff.; G. von der Osten, Der Schmerzensmann, Typengeschichte eines deutschen Andachtsbildwerkes von 1300–1600, Forsch. zur deutschen Kg., herausgegeben von dem deutschen Verein für Kw., VII, Berlin, 1935; H. Swarzenski, Schriftquellen zum deutschen Andachtsbild, ZfKg, IV, 1935, p. 141 ff.; M. Meiss, The Madonna of Humility, AB, 1936, p. 435 ff.; W. Körte, Deutsche Vesperbilder in Italien, Kunstgeschichtliches Jhb. der Bibl. Hertziana, I, 1937, p. 1 ff.; G. de' Francovich, L'origine e la diffusione del Cristo gotico doloroso, Kunstgeschichtliches Jhb. der Bibl. Hertziana, II, 1938, pp. 143–261; R. Berliner, The Freedom of Medieval Art, GBA, 1945, p. 263 ff.; E. Mâle, L'art religieuse de la fin du XVIIe et du XVIIIe siècle, Paris, 1951; M. Meiss, Painting in Florence and Siena after the Black Death, Princeton, 1951; E. Panofsky, Early Netherlandish Painting, Cambridge, Mass. 1954; E. M. Vetter, Maria im Rosenhag, Düsseldorf, 1956. c. *Ex-votos*: R. Andrée, Votive und Weihegaben des katholischen Volkes in Süddeutschland, Braunschweig, 1904; R. Peixoto, Tabulae votivae Portugalia, materies para o estudo do povo portuguez, II, 1906, pp. 187–212; A. Vierling, Votivbilder aus dem Isarwinkel, Z. für Volks-

kunst und Volkskunde, VIII, 1910, pp. 43–45; G. Pitrè, La famiglia, la casa, la vita del popolo siciliano, Palermo, 1913; O. Menghin, Zwei alte Votivbilder in Riffian bei Meran, Werke der Volkskunst, M. Haberlandt, I, 1914, pp. 43–45; J. Blau, Das Urbild der wächsernen Leonhardetafel, Bayerischer Heimatschutz, XXV, 1929, p. 130 ff.; J. Levy, Die Wallfahrt der Mutter Gottes im Elsass, 2d ed., Colmar, 1929; A. Albareda, Historia de Montserrat, Montserrat, 1931; R. Kriss, Votive und Weihegaben des italienischen Volkes, Z. für Volkskunde, VI, 1931, pp. 249–71; Wernert, Figurines humaines en fer forgé et en tôle, L'Art populaire en France, III, 1931; E. Blind, Ex-voto alsaciens en forme de crapauds, L'art populaire en France, IV, Strasbourg, 1932; A. Mitterwieser, Beim Votivbildner, Bayerischer Heimatschutz, 1933, p. 77 ff.; J. E. Guillén, Exvoto marineros, Madrid, 1934; H. Mang, Heimische Pesterinnerungen aus der Zeit vor 300 Jahren, Der Schlern, XV, 1934, pp. 494–96; G. Schreiber, Wallfahrt und Volkstum in Geschichte und Leben, Düsseldorf, 1934; E. Mang, Gli ex-voto dell'Alto Adige, Atti del III Congr. nazionale di arti e tradizioni popolari (Trento, Sept., 1934), Rome, 1936, p. 219; J. M. Ritz, Deutsche religiöse Volkskunst, zu ihren Forschungsaufgaben, Volk und Volkstum, Jhb. für Volkskunde, I, 1936, p. 138 f.; D. Gomes, Costumes e gente do Ilhavo, os "ex-votos" da sua igreja, Arquivo do Distrito de Aveiro, III, 1937, pp. 117–24; G. Karo, Weihegeschenke, Epidaurus, Stuttgart, 1937; G. Cocchiara, La vita e l'arte del popolo siciliano nel Museo Pitrè, Palermo, 1938; N. Curti, Über Votive, Schweizerische Volkskunde, XXVIII, 1938, pp. 58–64; E. Müller-Dolder, Über Votive im Luzernergeviet, Schweizerische Volkskunde, XXVIII, 1938, pp. 464–67; G. Schreiber, Deutsche Mirakelbücher, Düsseldorf, 1938; M. A. König, Weihegaben an U. L. Frau von Altötting: vom Beginn der Wallfahrt bis zum Abschluss der Säkularisation, I, Munich, 1939; E. Baumann, Votivtafelsprüche aus Mariastein, Der Schwarzbueb, 1942; E. Baumann, Die Wallfahrt von Mariastein, Basler Jhb., 1942; E. Bona, Arte religiosa popolare in Italia, Cat. generale della mostra di arte religiosa popolare (July 10–Sept. 20), Venice, 1942; S. Mikuž, Ex-voto: Zaobljubljene podobe po slovenskih romarskih cerkvah, Obisk, III, 1942, pp. 140–41; F. Sidler, Wauim fehlen Votivtafeln im "Heilig Blut" zu Willisau?, Schweizerisches Archiv für Volkskunde, XL, 1942, p. 1 ff.; A. Senti, Votivbilder, vom Jura zum Schwarzwald, 2 vols., 1943; P. Toschi, L'arte popolare negli ex-voto, Saggi sull'arte popolare, 1945, p. 45 ff.; E. Baumann, Die Votivbilder von Mariastein: Ihre Geschichte und Beschreibung, Die Glocken von Mariastein, Laufen, 1946; E. Baumgartner, Maria Sonnenberg: Seelisberg-Uti, Seelisberg, 1948; T. de Flandreysy, Les Saintes-Maries-de-la-Mer: Ex voto avec un poème liminaire de Folco de Baroncelli et quelques vers de Frédéric Mistral, Avignon, 1948; J. S. Galter, El arte popular en España, Barcelona, 1948; B. J. Amich, Mascarones de prosa y ex-votos marineros, Barcelona, Buenos Aires, 1949; T. Gebhard, Votivbilder, Bavaria, II, 1949, pp. 17–19; P. Bianconi and G. Martinola, L'ex-voto nel Ticino, Locarno, 1950; P. Bianconi, Ex-voto del Ticino, Schweiz-Suisse-Svizzera-Switzerland, Nov., 1950; R. Montenegro, Retablos de México: Mexican Votive Paintings, Mexico City, Mexico, 1950; P. Bianconi, Il costume nel ex voto, Locarno, 1951; H. Neugebauer, Tiroler Votive, Tiroler Heimat, XV, 1951, pp. 91–106; J. Staber, Volksfrömmigkeit und Wallfahrtswesen des Spätmittelalters im Bistum, Freising, Höhenkirchen, Munich, 1951; J. Amades, Los exvotos, Barcelona, 1952; E. Boyd, Mexican milagros, Q. of the Los Angeles County Mus., X, 2, 1953, pp. 17–18; Catalogue descriptif illustré des principaux ex-voto marins offerts à Notre Dame de Bon Port du XVIᵉ siècle à nos jours, Antibes, 1953; K. S. Kramer, Votivtafeln als kulturgeschichtliche und volkskundliche Quellen, Schönere Heimat, XLII, 1953, pp. 84 ff.; R. Kriss, Die Volkskunde der Altbayerischen Gnadenstätten, 3 vols., Munich, Pasing, 1953–56; G. Gugitz, Die Wallfahrten Oberösterreichs, Linz, 1954; L. Rettenbeck, Heilige Gestalten im Votivbild, Kultur und Volk, Festschrift für Gustav Gugitz, Vienna, 1954, pp. 333–59; R. Roussel, Les pélerinages à travers les siècles, Paris, 1954, p. 115 ff.; F. Benoit and S. Gagnière, Pour une histoire de l'ex-voto: Ex-voto en métal decoupé, de la région de Saint Rémy-de-Provence, Arts et traditions populaires, Jan.–Mar., 1954, p. 23 ff.; P. Fougerat, Un ex-voto vitrail de Saint Nicolas, dans l'église de Saint-Jacques-le-Majeur, à Cosne-sur-Loire, Arts et traditions populaires, Jan.–Mar., 1955, pp. 35 ff.; R. and H. H. Kriss, Peregrinatio neohellenika, Vienna, 1955; L. Schmidt, Votivbild: Notizien in den Wallfahrten rings um der Kaisergebirge, Festschrift für Matthias Mayer, 1954 p. 163 ff.; O. von Zaborsky, Votivtafeln als Werke der Folkskunst, Beispiele aus Niederbayern, Bayerisches Jhb. für Volkskunde, 1955, pp. 86–92; E. Richter, Einwirkung des Paracelsismus auf die Entwicklung des Votivwesens, Actes du IVᵉ Cong. Int. des Sciences Anthropologiques et Ethn. (Vienna, 1952), III, Vienna, 1956, pp. 91–100; E. Stärk, Schenkenberg und seine Wallfahrtskapelle, Badische Heimat, XXXVI, 1956, pp. 173–82; R. Kriss and L. Rettenbeck, Das Votivbild, Munich, 1958; F. Alziator, Gli ex-voto del santuario di Nostra Signora di Bonaria, Picaro e folklore ed altri saggi di storia delle tradizioni popolari, Florence, 1959, p. 113 ff.; F. Alziator, Un inventario cinquecentesco di ex-voto, Picaro e folklore ed altri saggi di storia delle tradizioni popolari, Florence, 1959, p. 191 ff. d. Devotional objects: P. Sébillot, L'imagerie en haute et basse Bretagne, Paris, 1888; F. S. Kraus, Geschichte der christlichen Kunst, I, Freiburg, 1895, p. 195 ff.; A. von Sallet, Münzen und Medaillen, Berlin, 1898; M. Carlo and L. Palm, L'imagerie scandinave, Ord och Bild, Stockholm, 1899; J. Hoppenot, Le crucifix dans l'histoire, 4th ed., Lille, Paris, 1905; W. Bombe, Gonfaloni umbri, Augusta Perusia, II, 1907, p. 1 ff.; Cabrol-Leclercq, s.v. Amulettes; E. van Heurck and G. J. Boekenoogen, Histoire de l'imagerie populaire flamande et de ses rapports avec les imageries étrangères, Brussels, 1910; C. M. Kaufmann, Ikonographie der Menasampullen, 4, Veröffentlichung der frankfurter Menas-Expedition, V, 1910; V. Gnoli, Il gonfalone della peste, BArte, 1911, p. 63 ff.; Duchartre, L'imagerie populaire francaise, Paris, 1923; C. Cecchelli, Note iconografiche su alcune ampolle bobbinensi, RACr, IV, 1927, pp. 115–39; B. Rubino, Pani e caci festivi in Sicilia, La Lettura, XXVII, Sept. 1927, p. 708 ff.; K. Holl, Der Anteil der Styliten am Aufkommen der Bilderverehrung, Gesammelte Aufsätze, II, 1928, p. 388 ff.; J. Neubner, Die heiligen Handwerker, Mun-

ster, 1928; A. Bertarelli, L'imagerie populaire italienne, Paris, 1929; P. Santyves, L'imagerie religieuse et les images de sainteté, Rev. du folklore français, I, 1930: A. M. Hind, An Introduction to a History of Woodcut, I, London, 1935, p. 93; A. Berterelli and P. Arrigoni, Rappresentazioni popolari di immagini venerate nelle chiese della Lombardia, Milan, 1936; G. Vidossi, Appunti sulle denominazioni dei pani e dolci casarecci in Italia, Archivio glottologico italiano, XXX, 1938, p. 69 ff.; G. Narducci, Pani e dolci festivi della Libia, Ann. del Mus. libico di storia naturale, 1940; G. Cocchiara, Le immagini devote del popolo siciliano, Palermo, 1940; V. Loubignac, La procession des cierges à Salé, Hespéris, XXXIII, 1946; B. Bagatti, Eulogie palestinensi, O. Christiana Per., XV, 1949, pp. 126–66; B. Kötting, Peregrinatio religiosa, Wallfahrten in der Antike und das Pilgerwesen in der alten Kirche, Münster, 1950; E. Richter, Devotionalen, RDK, III, 1954, col. 1354 ff.; R. Corso, Le arti popolari nelle feste pubbliche italiane, Studi di tradizioni popolari, Pozzuoli, 1956, p. 80 ff.; R. Corso, I carri sacri in Italia, Studi di tradizioni popolari, Pozzuoli, 1956, p. 182 ff.; F. Winkler, Vorbilder primitiver Holzschnitte, ZfKw, XII, 1957, pp. 37–50; A. Grabar, Ampoules de Terre Sainte, Paris, 1958.

Illustrations: PLS. 203–214.

# DIVINITIES.

In all periods and among nearly all peoples, images of the gods constitute one of the richest sources and most important aspects of iconography. Because of the transcendental character of the gods themselves, and for reasons set forth more fully in the introductory portion of this article, one cannot speak of genuine unity among the diverse phenomena of divine imagery. However, in the great civilizations of the world, linked by ideological and cultural bonds, there do exist some threads of continuity in the manner of depicting the gods. These links are to be noted especially where an anthropomorphic conception of divinity is present; they are opposed or supplemented in many periods by theriomorphic, fantastic, and symbolic or aniconic forms of divinity. The varied and complex material of this article has been collected because the quest for divinity made visible has been a continuing source of inspiration in the representational arts.

SUMMARY. Art and the divine (col. 382). Divine iconography in the ancient world (col. 387): *Prehistory and protohistory; The ancient Near East; Iran; Greco-Roman civilization: a. Aegean art; b. Archaic Greece; c. From the classical period to the Hellenistic period; d. Italic and Roman divinities.* Divine iconography in Asia (col. 398): *India; China; Japan; Southeastern Asia.* Divine iconography in "primitive" cultures (col. 404). Islam (col. 406). The Christian world and the representation of God (col. 407): *God the Father; The Holy Spirit; The Trinity.*

ART AND THE DIVINE. The fact that originally all art was "sacred" should not be allowed to obscure the distinction that has always existed between activities in which this sacred quality is merely implicit (for instance, the manufacture of utensils according to a model that had been revealed by a divine being in mythical times) and those activities designed specifically to proclaim, meditate upon, and worship a sacred power or being (for instance, the creation of an altar, religious symbols, or the statue of a god). In this latter activity man is directly concerned with a sacred concept and seeks to give it form and definition. Through the mediation of artistic expression the attributes of a religious abstraction are revealed, so to speak, for it is presented in a visible form. Hence, it may be said that sacred art seeks to represent the invisible by means of the visible. This intent is especially true of more highly developed cultures, in which philosophical speculation has evolved a systematic treatment of the nature and attributes of divinity. Thus in India after the period of the Upanishads (Skr., *Upaniṣad*), artists and philosophers were aware of the fact that a work of art gives form (Skr., *rūpa*) to what is in itself beyond form (Skr., *arūpa, para-rūpa*).

Even in archaic and "folk" cultures, lacking any philosophical system and vocabulary, the function of sacred art was the same: it translated religious experience and a metaphysical conception of the world and of human existence into a concrete, representational form. This translation was not considered wholly the work of man: the divinity also participated by revealing himself to man and allowing himself to be perceived in form or figure. Every religious expression in art represents, therefore, an en-

counter between man and the divine. Such encounters may be, on the one hand, a personal religious experience; or on the other, a religious perception of the world, the discovery that the world is a divine work, the creation of the gods.

The first form of encounter or experience presupposes the consent of the deity in letting himself be grasped as a "form" or "figure"; that is, these artistic images of the deity are to be considered the immediate consequences of divine dispensation. In India, for example, Shankara writes: "The Supreme Lord may if he wishes assume a corporeal form consisting of maya (Skr., *māyā*), as a favor to his devout worshipers" (*Brahmasūtra-bhāṣya*, I, 1, 20). The popular worship of idols and cult objects (see DEVOTIONAL OBJECTS AND IMAGES, POPULAR) is interpreted by Vishnuite theologians as proof of the god's compassion in manifesting himself to men, in letting himself be perceived by the senses, even at the risk of being transformed into an idol and of being confused with the material objects that he had sanctified with his presence.

The great paradox common to all religions is that God in showing Himself to mankind is free to take any form whatsoever but that, by this very assertion of His freedom, He "limits Himself" and reduces Himself to a mere fragment of the whole which He represents. In effect, God's freedom to reveal Himself to men brings with it the risk of being interpreted in the opposite sense — especially of being taken as evidence of anthropomorphism, that is, of a dependence upon the human imagination or intelligence (see IMAGES AND ICONOCLASM). All the varieties of idolatry, as well as all the arguments against the existence of God, ultimately derive from the initial paradox that divine revelation is accessible only within the context of human experience. Nevertheless, once this paradox has been accepted, every manifestation of divinity — however humble or contradictory it may be — deserves to be considered for its own sake, not discarded for reasons extrinsic to the religious experience.

The mystery of the Incarnation, which is the ultimate form of God's self-revelation, led William of Ockham to write: "Est articulus fidei quod Deus assumpsit naturam humanam. Pari ratione potest assumere lapidem aut lignum." ("It is an article of the Faith that God took on the nature of a human being. By this same token He can take on that of a stone or of a piece of wood.") Aside from any theological considerations, Ockham's conception of divine freedom provides a context within which the so-called "primitive" religions may be viewed simply as a series of paradoxical, frequently even grotesque, "revelations." In archaic stages of culture it is believed that the divine may be manifested both in natural objects (stones, plants, etc.) and in various sectors of the universe (heavens, stars, bodies of water, etc.); in fact, a large part of the history of archaic religions may be reduced to such cosmic revelations, that is, to the worship of the sacred as directly manifest in the universe. Without pursuing the details of this sacred dialectic, one may remark that the sacred is manifested in a variety of aspects and in the most archaic religions as well as in the more complex; and that in manifesting itself it becomes limited and altered. If one may speak of any continuity in the religious history of mankind, it lies in the simple fact that from the most ancient times the divine has been revealed to the religious man by means of "something other" than itself. This characteristic may be ascribed to the Christian mystery of the Incarnation.

The various formulas that men have used to express this encounter with the divine are by no means homologous; when their structures and characteristics are examined, one becomes aware of the diversity of religious situations that these represent. On the one hand, there are manifestations that disclose the sacred significance of a part of the cosmos (the sky, the earth, etc.) or of a natural object (a tree or stone, etc.); on the other hand, there are manifestations which reveal a divine "form" or "figure" and which are in the strictest sense epiphanies and theophanies. In the former case, the religious man is confronted with the sacred character of the cosmos; that is, he discovers that the world has a sacred significance in its very structure. In the latter experience he discovers something more, for he finds himself before a supernatural being that has a

form and a biography or mythology (see MYTH AND FABLE), a divine history.

To cite only a single instance, the heavens have transcendent and sacred implications. Rising infinitely, they are immutable and overpowering; they intimate that such loftiness is a dimension inaccessible to human beings, and hence an attribute of divinity. This celestial imagery leads man to understand existentially that the sacred is something totally different from himself, that it belongs to a different order of being and is thus, in philosophical terms, transcendent. The student of comparative religions also finds many cosmic deities, even among archaic cultures such as those of the hunters and trappers of Australia, Tierra del Fuego, etc. Although these celestial gods display certain cosmic attributes (they inhabit the heavens, manifest their presence through meteorological phenomena, dispense rain, have the stars as their eyes, etc.), they embody something more: a personality and a history. In this respect such cosmic deities are closer to man than was the purely abstract awareness of celestial sacredness, but they differ from him in being considered the omnipotent and omniscient creators of the universe and of man. If they have not become *dii otiosi*, they are still benevolent and terrifying at the same time, for their actions are essentially unpredictable. They do not resemble man; yet they have a shape and a personality that render them more accessible and intelligible than the abstract magico-sacred forces which men find everywhere in the cosmos. And there clings to them still the memory of a distant time when the gods descended from the skies and met with men on earth. For the most part these supreme beings are not represented by means of images; or if so, the images are created only during the secret initiation rituals, to be shown to the neophytes and then carefully destroyed (as in the case of Daramulun, the supreme being of the Yuin, in Australia).

Artistic endeavor inspired by divine subject matter seeks to demonstrate the nature of the gods and their creations. It is an effort to depict both their "forms" and their "works." The forms of the gods are not necessarily anthropomorphic: they may be inspired by any sort of morphology, concrete or imaginary; but their depiction — or suggestion — is always a question of forms, even when these are reduced to the most elementary geometric shapes. More important for artistic purposes is the desire to show what these gods have created. This impulse was often one of the sources of inspiration for architecture since it was thought that altars and sanctuaries represent an *imago mundi*, a miniature cosmos — and the cosmos is the supreme example of the work of the gods (see COSMOLOGY AND CARTOGRAPHY).

Even certain prehistoric rock carvings seem to show supernatural beings enacting parts of their histories, now obscure to us: a magical gesture, a dance, a ritual, or some act essential for prolonging life (in general, there are more easily comprehensible references to hunting, to the gathering of the harvest, or to sexuality). It is not always possible to decipher the religious connotation of these figures or to determine whether they represent gods, demons, or wizard-priests; but by representing magico-religious ceremonies (see MAGIC), they indicate directly or indirectly what supernatural beings have done as an aid or example to mankind. In fact, the "history" of what the gods have accomplished and of the consequence of their creative act — the world — has furnished the subject matter for a large part of the world's art. The acts of the gods, like those of the heroes, are illustrated in a great variety of motifs, genres, and techniques in the art of the ancient Near East and Mediterranean, as well as in India, Indonesia, and pre-Columbian Central America. Even when a divine history is not being recounted directly, one may assume that forms and iconographic systems which tend to reveal some aspect of the world or of the fundamental interplay between cosmic life and human existence are intimately related to the personality and creative activity of the gods. This relationship is true in ancient China, where the *t'ao-t'ieh* — already found on the ritual bronzes of Shang and Chou — whatever its precise interpretation may be, is illustrative of the sacred aspects of the cosmos (see ASIATIC PHOTOHISTORY). It alludes to the structure of the

world in a less symbolic form than does the sacred diagram *t'ai-chi t'u*, which unites the two opposed principles of *yin* and *yang* that form the very essence of life. Apparently these graphic forms either refer to the sacred character of the cosmos, and therefore indirectly to cosmogonic divinity, or else they constitute an aniconic representation of the divinity. China was, in fact, to create divine images only as a result of Buddhist influence, shortly after the beginning of the Christian era.

At this point there arises the complex problem of the relationships between divinities and their symbols (see SYMBOLISM AND ALLEGORY). It should not be forgotten that, in some parts of the ancient Near East, in India, and elsewhere, symbols precede any actual figures of the gods. For instance, in Mesopotamia one finds a number of vegetable symbols, the lunar crescent, the sun, lightning, or geometrical designs, which are independent of the deities and which precede their appearance on monuments. Many of these symbols were assimilated by those divinities who later dominated the religious life of Mesopotamia. One cannot discount the possibility that a symbol had belonged to a prehistoric deity who disappeared from worship and that it was later assimilated by another deity. Such cosmic symbols have a magico-religious potency sufficient to preserve their autonomy even when they are incorporated into the personality of a god. Furthermore, it is known that some Mesopotamian divinities had no anthropomorphic form: for example the celestial god Anu and the god of the earth Enlil were represented simply by a horned tiara resting on a throne. Hence it is possible that religious symbols at times took the place of the gods themselves. Subsequently, when the divinities were represented in anthropomorphic form, the symbols that had formerly replaced them became their attributes (lightning, the bull, the stag, or the eagle in the case of Teshub, the Hittite weather god; the lotus flower for Ea, a water god).

Symbols never wholly vanish from art and religious iconography, even when anthropomorphism reaches the perfection of classical Greece. Lightning, the winged disk, the ear of corn, and many other symbols indicate that a particular statue is not of a human being but of a divinity. The supernatural character of the image is seen still more clearly when the divinity is presented in theriomorphic, phytomorphic, or fantastic forms (see MONSTROUS AND FANTASTIC SUBJECTS). Formal elements drawn from the animal and vegetable worlds or from the realm of the imagination clearly show that the divinity who exhibits them enjoys a mode of being different from the human and controls magico-religious forces inaccessible to men. The theriomorphic elements of a divine image testify that the divinity shares the secrets and magic of the animal world and partakes of all its fertility and creative potential, manifest and hidden. The same mystery of a paradoxical unity that transcends the various manifestations of the divine is suggested by the formal elements taken from the vegetable world. The phytomorphic and dendromorphic aspects of divinities indicate their polymorphism, their possibility of existing simultaneously on a number of different levels, and their control over the sources of the earth's fertility. The integration of theriomorphic and phytomorphic elements in sculptural representations of divinities expresses something more than the mere manifestation of the cosmic sacredness of the animal or vegetable worlds. Such symbols touch upon secrets that are more abstruse, and sometimes even terrifying, since they allude to incomprehensible bonds between the most important gods and certain animals or plants — as though these gods in a part of their lives unknown to men had led a secret existence, disguised as beasts and plants.

These complex and polymorphic gods appear in the agricultural religions and are especially dominant in the urban civilizations of the ancient Near East, the Mediterranean, and India. They have a richer, more dramatic mythology than do the ancient gods of the heavens, the lords of animals, and the goddesses of earlier civilizations. The artistic creation of antique cultures has been especially stimulated and enriched by these gods. In Egypt, Mesopotamia, and Greece they were responsible for inspiring the artist to translate into concrete forms their cosmogonic power, unlimited force, and combative drive, as well as the characteristics that distinguish them from humans, their majesty and the inexorability of their decisions. Still more striking are the iconographic elements taken from the realm of fantasy and dream: the monstrous, grotesque, and demonic figures (see DEMONOLOGY), or the many-headed divine beings that have multiple arms and bodies covered with eyes. Obviously there is a structural difference between the first group of purely fantastic creations and the second, in which the essential factor is the multiplicity of members (heads, arms, eyes); nevertheless, all these figures not only manifest the irreducible quality of the gods — the fact that they do not belong to the world of humans — but underline their strangeness, their extravagance, and their freedom to assume any form whatsoever. Among primitive peoples the worship of the dead and the presence of masked societies have favored the creation of monstrous figures, representing various personifications of some legendary ancestor who is simultaneously considered the first mortal to have died and the lord of the underworld. The imaginary world from which these terrifying forms derive is at the same time the world of dreams and that of the dead (see ESCHATOLOGY). Sometimes these two worlds are in communication, for the dead return in dreams, and during sleep the soul wanders in the realm of the dead.

In one way or another, all divine, semidivine, or demonic images with a monstrous and terrifying aspect either belong to funerary mythologies or have at least some connection with death. This is not to say that all the deities of death have a fantastic form or a sinister aspect and are intended to cause fear. Throughout the mythology and iconography of Persephone, but above all during the Hellenistic period, the Mediterranean and Roman worlds produced certain images that show death as a deep sleep, a return to the maternal womb, a ritual passage toward a blessed world, or an upward journey through stellar space. In the primitive world, however, in India as well as in Tibet and southeast Asia, the divinities having a terrifying aspect are more or less directly connected with death, even when their principal function is not funerary. Although Śiva and Kālī-Durgā are not funerary divinities, their iconographic representation clearly shows that the continual destruction and re-creation of the universe inexorably implies death, even if this death is sometimes viewed as a spiritual experience: that is, to die in one's profane, unenlightened human condition in order to proceed to a superior level of being, that of liberty or immortality.

The iconographic representation of divine beings with numerous members is clearly different from that of the terrifying divinities. The multiplicity of members expresses by means of an aristic convention the fact that one is dealing not with a human being but with a god. Many-headedness signifies that a god is capable of looking in different directions at the same time, that he is all-seeing and consequently omniscient. The three-headed god is found on seals from Mohenjo-daro (PL. 217), and two-headedness is seen in Mesopotamian and Greek art (Argus, for instance). Three-headed divinities are quite frequently shown on Thracian and Celtic monuments, while polycephalic divinities were illustrated in the statuary of the pagan Slavs. Mut, Horus, and Bes are shown in Egypt as covered with eyes, like Argus. In India, the multiplication of arms is expressive of divine omnipotence, especially in the divinities that control the rhythms of the universe (Śiva, Kālī). Mahayana Buddhism led to the diffusion in Tibet, China, and Japan of iconographic figure types with innumerable arms and with hands sometimes covered with eyes (Tārā, in Tibet; Kwannon, in Japan).

When Greek art reached its formal perfection in the classical period, and the gods — long since anthropomorphic in their forms — came to be represented as types exemplary of human beauty, artistic genius still managed to retain the divine quality in the structure of the image itself. Perfect serenity, a mysterious smile, and wide-open eyes, all serve to indicate that one is dealing with personages who transcend human modes of being. Symbols, which have by now become attributes of the gods, complete these divine images: they are there to remind

one that mysteries, potencies, and absolute autonomy are an integral part of the personality of a god. A similar technique was developed, as a consequence of Greek influences, in Buddhist statuary. The iconography of the Buddha expresses the blessedness and serenity of the individual who has experienced the supreme enlightenment and who has been transported from his human condition.

The creativity of the artist was nowhere so fully tested as in classical Greece, Buddhist Asia, and Christian Europe. Although approached from different points of view, the central problem was the same: how to project a personal concept of divinity by means of an image that as far as possible was to resemble the human figure (see HUMAN FIGURE). The Greeks sought to exalt bodily beauty, without trying to transfigure it. For the Buddhists the problem was less difficult, since Buddha had been and remained human despite his having become superior to the gods. Essentially it was a question of expressing through iconography the fact that the human condition may be radically altered as a consequence of spiritual illumination.

For the Christian artist the problem of representing divinity has been and still is practically insoluble (see CHRISTIANITY; REFORMATION AND COUNTER REFORMATION), for no means has yet been found to demonstrate in convincing pictorial form that Christ is God, other than introducing some symbolic element such as the halo. It is for this reason that the masterpieces of Christian art almost never show Christ preaching his message (although there were in Early Christian times attempts to show Christ as the Logos in the figure of a philosopher, as in the sarcophagus in S. Ambrogio, Milan), but show instead the crucified or resurrected Christ, Christ in Majesty, or Christ as judge and ruler of the Universe, since all these epiphanies of Christ could be expressed in comprehensible form. Such restriction of subject matter reflects the difficulty of expressing by artistic means the mystery of the Incarnation, the simple fact that God concealed Himself in human flesh and thereby made Himself no longer recognizable as God.

Mircea ELIADE

DIVINE ICONOGRAPHY IN THE ANCIENT WORLD. *Prehistory and protohistory.* Divine forms, whether explicit or presumed, belonging to the prehistoric or protohistoric periods may be classified as either genuine idols (anthropomorphic or zoomorphic) or symbolic figures.

The nature of idols has been attributed especially to the paleolithic "Venuses," free-standing figures in which there is a striking emphasis of the secondary sexual characteristics. The interpretation of these as representations of a fertility goddess, though uncertain, is no less valid than, for example, the theory that they are objects of sympathetic (occult) magical practices of a sexual nature or are connected with the attainment of fertility. However, it should not be forgotten that divine figures — not to be confused with those of an animistic or totemistic character (see DEMONOLOGY) — are never included in the cave paintings and portable objects of the Upper Paleolithic epoch. True female idols, on the other hand, are found in statuettes which doubtless represent a goddess of agricultural fertility and which were widely diffused in the Neolithic period from the Near East to the Mediterranean and into the Balkans. Their typology ranges from the more sculptured forms, which in their emphasis of breasts, stomach, and buttocks are connected to some extent with paleolithic statues (Cretan neolithic, Malta, Thessaly, earlier phases of the Vinča, Cucuteni, Tripolje, and other Balkan-Danube cultures), to flat and schematic forms, such as the "violin-shaped" idols with accentuated pelvis (Cretan subneolithic and Minoan, Cyclades, Troy, etc.) or the bitriangular and rectangular forms found in Iberian megalithic cultures. One must not forget, however, that many of these statuettes, although discovered as funerary objects (Cycladic cultures, predynastic Egyptian cultures, etc.), with the passage of time may have assumed the significance of votive objects and replaced human sacrifices (such as wives or slaves of the deceased; see ESCHATOLOGY).

Still more complex is the problem of symbolic representations, which began to appear in the Aëneolithic age and evidence

a progressively greater diffusion in the Bronze and Iron ages. Some of these forms are doubtless linked to male fertility cults, as with the taurine protomas, horns, and phallic images; others, to celestial cults, as with the solar symbols — in particular that of the "solar idols," containing the ship of the sun being drawn by birds, which is found in the urn field culture — so frequent among Nordic cultures. Still other symbolic forms such as battle-axes and double-headed axes are related to warrior-god cults. In all these cases it is extremely difficult to establish whether one is dealing with genuine representations of a divinity or merely with sacral symbols or votive figures.

\*  \*

*The ancient Near East.* In Egypt the first representations of divinities were stylized cult objects that were placed atop processional insignia in the predynastic period. These reproduced trees, boughs, mountains, the solar disk, a scepter, or birds, quadrupeds, and all varieties of fetishes linked to individual territorial districts (*numina locorum*). At the beginning of the historical period (ca. 2850 B.C.) one finds a gradual shift toward the anthropomorphic in these animals and cult objects. The traditionalism of the Egyptian mentality was reluctant to abandon the old cult forms, however, and in many cases a compromise was reached that depicted the divinity with a human body and an animal head or else retained the archaic symbol on his head as an attribute. This transformation, which was favored by the identification of the sovereign-god with the hawk-headed god Horus, was neither rapid nor absolute, since the worship of certain animals that were considered incarnations of divinities continued up to the period of Roman occupation.

The most ancient reproduction of a hybrid anthropomorphic divinity is found on the votive palette of King Narmer in the Egyptian Museum, Cairo (1st dynasty) and is the head of the goddess Hathor, an otherwise human form that has the ears and horns of a cow. This representation, frequently with the horns omitted, was very popular in subsequent periods as a decorative or architectural element. Two other types of divine figures, existent in very early times, had great popularity down to the Late period as architectural decorations: the winged solar disk and the uraeus, or sacred asp, the personification of the goddess Wadjet of Buto, the protectress of sovereignty. The annals of the 1st dynasty record as a significant event the creation of a statue of the god Min. At Qift (anc. Coptos), the center of worship for that deity, three fragmentary limestone statues of the god were discovered which may be dated approximately from the 1st dynasty and which constitute the most ancient representation of an Egyptian deity. The god is wholly anthropomorphic in form, bearded, naked except for a perizoma, and ithyphallic, with legs joined and arms held in along his sides. The right hand is perforated, probably in order to hold a whip. A similarly archaic technique is found in the representations of two other anthropomorphic divinities during the historical period: Ptah, the chief divinity of Memphis, and Osiris, the old god of Busiris, who became the god of the dead and who is found iconographically only from the beginning of the Middle Kingdom (PL. 215). As for the representation of other deities during the Early Kingdom, one may cite only the slate triads in the funerary temple of Mycerinus (4th dynasty; Boston, Mus. of Fine Arts; Cairo, Egyptian Mus.), where the Pharaoh appears with the goddess Hathor and a female figure personifying a nome. The god Set appears for the first time in an anthropomorphic form and with his characteristic animal head in a seal of King Peribsen (2d dynasty). Other divinities appear on reliefs in the funerary complex of Zoser at Saqqara (3d dynasty).

From the Middle Kindom on, the representation of the gods becomes general and extends to various categories of monuments, even private ones. This phenomenon is the result of the gradual diffusion into all levels of society of funeral rites that had formerly been reserved to the Pharaoh and his court. Although the iconography had become established along anthropomorphic lines, certain divinities preserved an archaic tradition that had represented them in wholly theriomorphic forms. It is not possible to attribute the determining factor to this conservative tendency; nor is the typology fixed, for the

same deity — even during the same period — may appear in wholly theriomorphic, in semitheriomorphic (with an animal head), or in clearly anthropomorphic forms. In general the deities hold in one hand the hieroglyphic symbol "ankh" ("life") and in the other a scepter. In the case of the gods the scepter is surmounted by the animal head of the god Set and is forked below, corresponding to the hieroglyph "was" ("well-being"); for goddesses the scepter consists of a stem terminating in a lotus blossom. As an attribute, some female deities hold the sistrum, a musical instrument that also serves to avert evil. The whip is an attribute of Min and Osiris; and the latter also holds a scepter with a curved handle. All the anthropomorphic male deities are given an artificial plaited beard. Almost all the deities have some realistic or symbolic headgear: Anubis has a dog's head; Set, the head of an unspecified animal (PL. 215); Sokaris, the head of a hawk; and Ptah wears a simple tight skullcap. Various elements influenced the formation of this typology, not the least of which was the criterion of eurythmy for group sculpture or relief compositions. Some subjects may present two solutions: a typical case is that of the Pharaoh nursed by the goddess Hathor, who may be shown in the form of either a cow or a human. The representation of Osiris, interpreted during the historical period as necromorphic, that is, resembling a mummified body wrapped in ritual bands, is simply a new interpretation of the original form of an idol in which the arms and legs were shown adhering to the body. The distinct tendency toward concrete form, which is typical of the Egyptian mentality, led to the anthropomorphic representation of deities personifying cosmic or abstract elements. Thus the solar divinities bear a solar disk on their heads, and the lunar ones (Thoth, Khonsu) have the disk and the crescent. Winged heads are typical of the celestial deities (Shu, a divinity of the atmosphere; Onuris, Amen). Hieroglyphic signs decorate the heads of deities such as Justice, Command, or Wisdom. Some indication of teleological elaboration appears in statuary in the person of divine triads formed by a pair of parents with their son (Osiris-Isis-Horus; Ptah-Sekhmet-Nefertem; Amen-Mut-Khonsu). A singular aspect of religious iconography is seen in the symbolism based on ancient cult objects, such as the so-called "column" of Osiris and the "knot" of Isis (PL. 219). Among the most noteworthy symbols is the solar disk, the image of the sun god. During the religious reform of Akhenaten, the only deity recognized and represented was this solar disk (Aten), from which emanated life-giving rays in the form of human arms (PL. 215). No forms of aniconic worship are known.

<div style="text-align:right">Sergio BOSTICCO</div>

In Mesopotamia are found anthropomorphic representations of divinities dating back to the prehistoric eras of the Uruk IV period (ca. 3000 B.C.) and of Jamdet Nasr (ca. 2800 B.C.); therefore it is not easy to determine an order of precedence for divine symbols that recur from prehistoric times onward. At the beginning of the historical period, in the sculpture of the 3d millennium B.C., deities were equal in stature to man (later, they were to be represented as larger than life) and were distinguished solely by the presence of horns, plumage, or vegetable elements in their hair: an attribute that later took the form of a horned tiara. The gods had their hair gathered in a knot behind their heads, while goddesses wore it long on their shoulders. The gods also were shown with beards and wore a long garment with flounces (known by its Greek name, *kaunakes*). Later, from the time of the 3d dynasty of Ur (ca. 2050–1950 B.C.), the *kaunakes* was replaced by a straight garment, and the horned tiara by a turban (for example on the stele of Hammurabi in the Louvre; I, PL. 512). The deities were generally shown either seated or standing, holding the emblems of their authority (a baton and circle, a mace, or a curved weapon called the "harpe," which was perhaps originally a boomerang) or in the act of offering to the faithful a vase, from which water sometimes gushed (PL. 216).

Among the most common scenes are those of sacrifice, sometimes with the participation of musicians (evidenced in a vase fragment in the Louvre), those of an agricultural character, and various incidents of war. On a stele commemorating the victory of Eannatum over the city of Umma, the god Ningirsu, of gigantic proportions, holds a large net in which the conquered enemy is trapped; in the reliefs of Ashurbanipal the god Ashur, represented by a winged disk from which a human bust protrudes, hurls arrows at the enemy. Another theme, which was especially frequent during the 3d dynasty of Ur, is that of the presentation to the deity: for example, the relief (Berlin, Staat. Mus.) that shows King Gudea held by the hand by Ningizzida, the king's "personal god" or patron, and being conducted before Ningirsu, the god of the city.

The iconography of individual divinities shows several recurring motifs: the bearded god seated on a throne, or standing as he receives adoration; the naked goddess with her hands on her breasts, etc. The identification of the gods is made possible by attributes determined both by the sacred texts and by the liturgy, and ultimately by the artistic tradition itself. Anu (god of the sky) and Enlil (god of the earth), the supreme gods, are never represented anthropomorphically: their presence is indicated only by the horned tiara, the symbol of divinity, placed on a throne. Ea (god of the waters and the depths) is represented with a vase in his hand or with water streaming from his shoulders; his symbols are a fish with a goat head and perhaps also the tortoise. Shamash (the sun god) is sometimes shown with rays on his shoulders, or between two mountains; he has a curved weapon in his hand, and his symbols are the solar disk and the lion. Sin (the moon god) has as his symbol the lunar crescent. Marduk, the principal god of the Babylonian pantheon, is accompanied by a dog, a dragon with a serpent's head, or a hoe on a pedestal. Nabu (the god of letters) has for his symbols a dragon, a pen, or a clay writing tablet. Ashur, the supreme god of the Assyrians, is represented anthropomorphically or else by a conventional symbol partly of Anatolian derivation: a winged disk with a tail (of Egyptian origin), from which emerges a bearded male bust that sometimes is immobile and sometimes hurls arrows. Ningirsu and Ninurta (war gods) have a lion-headed eagle as their symbol; the latter also has an S-shaped weapon consisting of serpents. Dumuzi or Tammuz (the god of vegetation) is represented with grain on his shoulders and is symbolized by the goat. Deities with the same attributes of fertility are very numerous, however, for each locality considered its principal god to be one of fertility. Because of the geography of Mesopotamia, these gods were sometimes shown on board or symbolized by a ship. The figure of a nude woman, the prehistoric symbol of the earth's fertility, is transformed into the goddess Innina-Ishtar, who has a warrior's form and sometimes has wings (or possibly Bilulu, the goddess of rain). In this form she was found more often in Syria and among the Hittites than in Mesopotamia.

In Palestine, Syria, and Anatolia anthropomorphism prevails, although the iconographic repertory is somewhat independent of that of Mesopotamia and is not free from Egyptian influences. In the Syrian-Palestinian region the oldest type of divinity is a statuette of a naked goddess expressive of the earth's fertility, with accentuated secondary sexual characteristics (PL. 217). In the historical period the prevalent iconographic type was a striding god who brandished a bolt of lightning or a mace in his upraised right arm. It is difficult to give a name to this figure, and this is true of all the other Syrian-Anatolian figures: probably it is to be identified with Ba'al in Palestine and Phoenicia, with Hadad in northern Syria, and with Teshub in Anatolia. In general this type wears Syrian garments, with a short tunic and a high Hittite or Egyptian headpiece. Its symbol is the bull, upon whose back it often stands. El, the supreme god of the Phoenician pantheon, is usually seated and dressed in copious robes, as seen on a stele at Ugarit (mod. Ras Shamra); in late Phoenician seals he is given wings like an Assyrian genius. In Anatolia the female deity, generally accompanied by a lion, is usually in the form of a solemn seated matron; in Syria and Palestine the nude goddess that had prevailed in prehistoric times continued into the historical period. This goddess is designated by various names: Shala, Kubaba, or Isharra for the veiled Anatolian figure; Astarte, Asherah, Anath, or Qadesh for the nude figure.

<div style="text-align:right">Giovanni GARBINI</div>

*Iran.* According to Herodotus (I, 131), the western Iranian tribes knew nothing of the use of cult images, shrines, or temples. Clement of Alexandria makes a similar observation concerning the Medes and the Persians (*Protreptikos*, V, 65, 1). Among the more northern tribes, located in southern Russia, the nomadic Scythians as late as the time of Herodotus (cf. VI, 61) had no images, altars, or shrines, except for that of the war god (cf. also Ammianus Marcellinus, *Rerum gestarum*, XXXI, 2, 23). In many regions one found great heaps of logs, atop which was set a short sword (*akinakes*) to which cattle, horses, and prisoners were sacrificed annually. Certain popular customs that are still current among the Ossets, the descendants of the ancient northern Iranians, provide confirmation of Herodotus' account. Moreover, it is probable that not only this warrior god but also the other deities associated with the public functions of the state, with sovereignty, and with agriculture and cattle breeding were represented symbolically within the cult by means of objects pertaining to their respective functions.

Cultural contact between Iranians and Greeks quickly led to anthropomorphic representations of the deities in Iran. On a rhyton from Karagodeuashkh the deity, in an investiture scene, is depicted offering the king a rhyton from which to drink. This rendering serves as a model for subsequent representations of royal investitures. Such a representation of the god of monarchy, who corresponds to Mithras, also appears on coins from the kingdom of Pontus in post-Achaemenian and Parthian times.

Of great importance among the Scythians was a goddess who was portrayed in similar scenes of investiture, as on a triangular gold plaque from Karagodeuashkh (VI, PL. 465) and on a rhyton from Merdzhany (VI, PL. 471) both from the 4th or 3d century B.C. In a conspicuously Hellenized form, the image of the goddess continued to appear on coins from the Bosporan kingdom (1st and 2d centuries of our era). The Karagodeuashkh plaque shows a deity seated in a chariot who may be identified as the sun god, presented in an iconographic form that clearly reflects the corresponding Greek representations of Helios. This type quickly found favor in eastern Iran as well.

The aniconic stage of western Iranian religion lasted until the time of Artaxerxes II (404–359 B.C.; cf. Clement of Alexandria, *Protreptikos*, V, 65, 3), whose mention of Anahita and Mithras made him the first of the Achaemenian kings to name in his inscriptions any god other than Ahura Mazda.

Even before Artaxerxes II, the supreme god Ahura Mazda (Per., *Ormazd*) was represented in a half-symbolic, half-anthropomorphic form as a winged solar disk containing the figure of a deity holding a wreath. This symbol, derived from Egypt and passed on to the Assyrians and subsequently to the Medes, was finally inherited by the Persians and survived the downfall of the Achaemenian empire.

Anahita, the ancient pre-Zoroastrian mother goddess and symbol of fertility, enjoyed widespread worship not only in Iran but also beyond its borders in Mesopotamia, Syria, Armenia, and Asia Minor. Her statue was erected in various places, sometimes even in solid gold (Pliny, *Natural History*, XXXIII, 4). The description of her given in the Yasht (5, 126–29) is clearly inspired by an anthropomorphic concept, as is also true of coins from Asia Minor and Pontus. On still other coins, from Hierokaisareia, the goddess is known as "the Persian Artemis" and is shown killing a deer. A female divinity also appears on precious stones dating from Achaemenian or Parthian times.

Mithras, along with Anahita, was one of the most popular Iranian deities and was usually shown in Iranian costume, with a halo and holding a bundle of twigs in his hand. The monuments at Nimrud Dagh from the reign of Antiochos I (69–34 B.C.) provide representations of other deities, such as Ahura Mazda (identified with Zeus; PL. 216) and Vartagn, while Anahita appears in the guise of the "all-nourishing Commagene," protectress of the country where Antiochos ruled (W. Dittenberger, *Orientis graeci inscriptiones selectae*, I, 383, Leipzig, 1903). Vartagn is identified with Herakles, one of many indications of the Hellenistic-Iranian syncretism prevailing in Commagene. Anahita appears to be related to the Hellenistic Tyche.

Other representations of Mithras, belonging to a different culture area, are related to the so-called "Mithraic mysteries." Two Mithras types are predominant: one showing the god on horseback, and the other showing him slaying a bull (PL. 220). The latter may have come from Asia Minor, but its most archaic form is actually found at Dura-Europos in Mesopotamia. A more Hellenized type is found later, but even in this version the clothing of the god preserves typical Iranian, and especially Parthian, characteristics. This iconographic scheme recalls the image of Anahita struggling with the stag. Mithras is also shown as a horseman hunting wild animals in mural paintings at Dura-Europos which were to serve for a thousand years as the model for all hunting scenes in Iranian art.

In the Sassanian period following, we find numerous representations of King Artaxerxes I, the founder of the new dynasty, usually depicted receiving a beribboned crown from the supreme god Ahura Mazda in a scene similar to that on the Scythian rhyton which serves as its prototype. Another type portrays Artaxerxes II (A.D. 379–83) flanked by Mithras and Ahura Mazda. In another typical scene Anahita invests Narsai (A.D. 293–303) with the royal power. In the famous bas-reliefs of Taq-i-Bustan, Ahura Mazda (on the right) and Anahita (on the left) extend the royal emblems to King Khosrau II (A.D. 590–627). The two deities have garments strikingly like those of the high priest in a painting of the Dura-Europos synagogue. This iconographic type also spread to eastern Iran.

Deserving of mention also is the bust of the deity incised on coins from eastern Iran; it represents the supreme god Ahura Mazda atop a flaming altar. In the markedly syncretistic religion of northwestern India, Iranian deities were dominant. Coins are of particular importance in this connection, for they portray those gods which were officially recognized by the various ruling dynasties.

In the tripartite system the following gods appear: Vāth, the deity introducing the gods of the three functions, a running bearded figure with loose hair and flowing garments; Mihr, the sun god, shown with with a halo; Māh, the moon god, who is also seen seated as Mānha Baga; Farr, "the royal glory," with a scepter in his hand; and Ardvaxš, a goddess holding a cornucopia and serving as the Avestan goddess of fortune Aši. In the second class, that of the warrior gods, are found, Šahrēvar, the Avestan Xšathra vairya, with Greek helmet and shield; Ošlagn, the Avestan Varathragna, also shown as an Iranian warrior with the bird Vāragna on his helmet; Vanind, the Avestan Vanaiñiti, a winged goddess holding a garland. The third function, that of agricultural deities, includes Lruvāsp (originally Druvāsp), a bearded god with a horse trotting beside him; Tīr, who corresponds to the Avestan Tištrya star, with bow and arrow in hand; and finally Āthr, from whose shoulders flames rise and who holds fire tongs in his hand. The absence of Ahura Mazda in this scheme is remarkable, since he is known to have existed among the Sacae in the east as the sun god Urmaysde. However, his bust, in a version inspired by a Sassanian model, appears on coins.

The Sun and Moon (Mihr u Māh), the protectors of the town of Kabul, are pictured and clearly labeled on the fine reliquary of King Kanishka, where they grant investiture to the ruler. Among the works found in Afghanistan, there appears an erect solar deity; a fine sculpture shows the deity Sūrya driving his chariot and wearing the ceremonial garments of the local kings (PL. 221). Whereas horses are always associated with the sun in Iranian religion, the moon god has oxen attached to his wagon, as on the famous Klimova plate (III, PL. 490).

Iranian deities were represented in animal as well as human forms, but the identities of these are much more uncertain. The symbolic emblems found everywhere among Iranian tribes should probably be assigned royal rather than divine connotation.

Geo WIDENGREN

*Greco-Roman civilization. a. Aegean art.* The oldest representations of deities found within that geographic area which

is today defined as Hellenic are female statuettes with accentuated sexual characteristics, the so-called "steatopygic idols." These are found almost everywhere in southeastern Europe and the Near East, especially in the Cyclades and in Crete. Already present at the neolithic level, they are of stone or, more frequently, are modeled in clay. They indicate the dominant position that anthropomorphism had already attained, even though one cannot with certainty assert that all the figures of this type are representations of deities; some of them probably served as funerary offerings.

Such anthropomorphic representations were not long in becoming the preeminent forms, both in Crete and elsewhere. The most famous are undoubtedly those of the "snake goddess," exemplified by the famous ceramic statuettes coming from the palace at Knossos (PL. 55). The snakes seem to suggest a chthonic reference, even though it is not easy to support the premise that these and other images which show a human form emerging from such natural objects as a tree, mountain, or pile of rocks, or even from wild beasts, were all intended to represent a single deity, an archetypal figure known as the Great Mother and analogous to the classical Kybele (Cybele). In addition to these tree, snake, and animal goddesses, there were goddesses of the shield, the sword, and the bow, as well as a male divinity, the Master of the Beasts (he is encountered, for example, on a gem from Kydonia), and figures of armed genii. It is impossible to say which of these are deities and which are demons. All that can be said is that the Minoan world left the Hellenes a rich repertory of anthropomorphic representations, not yet free from a naturalistic fetishism destined to have influence throughout the course of antique paganism.

*b. Archaic Greece.* In the epics of Homer, which constitute the oldest document we possess concerning the Greek religion, the gods appear in a distinctly humanized form that seems to have evolved independently of the contribution of the visual arts. The Tyszkiewicz kouros in the Boston Museum of Fine Arts, which dates from about the 7th century B.C., shows clearly that the visual representation of the divinity was still at an elementary stage, while at the time of Homer, a century or two earlier, the divine personalities were already the object of a complex and subtle literary treatment. One may assert, however, that the Hellenic pantheon already had an extensive mythology (see MYTH AND FABLE) before it began to be realized in sculpture in the 7th century B.C. through a variety of influences, not only Mycenaean but also Asiatic and Egyptian. At this point Greek religion began to exist on two planes: on the one hand was a pre-Hellenic substratum that survived in the countryside, and on the other was the Homeric religion. Between these two levels there existed a current of reciprocity; and from this same complexity and interchange the profound originality of classical Greek religion and the rich humanity of ancient paganism were derived. There were many other strains and influences; thus, neither the "popular religion" nor the "aristocratic religion" is to be considered an isolated entity. In the Homeric religion, the anthropomorphic conception of divinity seems to have been an a priori formulation of an ideal of the divine. It has been noted (P. Chantraine, 1952) that to depict the river Scamander (*Iliad*, XXI, 212–13), addressing Achilles "in human form," poses a virtually insoluble representational problem, since "we are dealing with a god who can take human form, but whose complete power lies in the waters of the river that he incarnates." The poet makes an implicit distinction between the river as a natural body of water and the "daemon" that animates it. For the moment a human form is attributed to this spirit; therefore it is merely a temporary manifestation of the divine being. In Homer the gods are represented by means of their actions, words, or sentiments, but their physical appearance is rarely described. This approach parallels a passage from Heliodoros (*Ethiopica*, III, 12), which shows that the ancients had recognized the temporary and fallacious character of the form in which gods appear to man. Examining the nature of the divine epiphanies in Homer, the commentators concluded that they were only a matter of disguises, which the initiate could penetrate by seeking out various

characteristics of the deities, such as their fixed, unblinking eyes and especially their aerial bearing, which was more like gliding than walking.

It is impossible to determine the number of deities that were recognized, for any natural force or abstraction could acquire a distinguishing personality. For example, in the *Iliad* (IX, 502–12) the Prayers ("Litai"), daughters of Zeus, are personified as women "lame, wrinkled, and squinting in both eyes, who run along after Ate" (goddess of infatuation). Here we have less a portrait of deity than a description of the nature of prayer. Frequently divine attributes are simply born of the necessity to materialize a function or a moral characteristic. Nevertheless, certain attributes of the gods remain irreducible to this type of symbolism: for example, the owl of Athena seems to refer to the ancient significance of that bird, which was used on Minoan monuments to indicate the presence of a deity; here one finds the "popular religion" influencing the sculptural conception of one of the most typical deities of the Homeric Olympus. But whatever may be the origin of these inherited attributes, the Homeric gods, when they come to be depicted in art, display a personality so fixed by literary precedent as to admit of their immediate translation into stone or clay. This literary creation of a divine iconography continued long after Homer. Thus when Plato, in the *Symposium*, imagines an Eros who is the son of Poros (Plenty) and Penia (Poverty), he gives him traits quite different from those traditionally belonging to the Eros who was the son of Aphrodite and Ares.

Alongside the Homeric anthropomorphism there existed, as has been remarked, numerous cult practices involving gods that were not anthropomorphic. Weapons were worshiped, as in the myth of Kaineus establishing his lance as an object of adoration; and one also encounters cults of architectural elements such as the column, which seems to have a variant in the figure of Apollo Ἀγυιεύς, the guardian of public places. In the case of Dionysos, even natural elements seem to have been worshiped, as is seen from the Dionysos Kadmos at Thebes, a wooden log bound in metal. The Dioskouroi are frequently represented in the archaic period by two juxtaposed amphorae around which serpents are entwined or by two adjacent columns (the δόκανα). Under the influence of Achaean anthropomorphism, these ancient fetishes were transformed into representations worthy of the name of statues, though even these remain deeply impregnated with fetishism. For a long time the xoana, crudely modeled wooden or stone carvings that barely suggested the human figure, were the objects of ritual. Their use survived for a long time, and they came to be considered the works of a divine hand, fallen from heaven or brought to earth by some hero. Frequently such xoana were colored for purposes of magic: for example, both in Greece and Rome objects designed to counteract the evil eye were painted red. Precious materials, especially ivory and gold, were used for the faces, presumably because they were to be used for ritual purposes. In the evolution of cult statues in the direction of anthropomorphism, a special role must have been played by masks; their use is attested in the Spartan rites of Artemis Orthia and in the Dionysiac cult (see MASKS). It is probable, however, that many of the archaic statuettes found in the sanctuaries were simply ex-voto sculptures meant to manifest the donor to the divinity (see DEVOTIONAL OBJECTS AND IMAGES, POPULAR).

During this same period the types of the major deities were developed; certain sculptures such as that of the Apollo of Delphi, youthful, long-haired, and beardless, prefigure the classical period. Such representations show a marked variation from one sanctuary to the next: the Delphic Apollo contrasts with a bearded and helmeted Apollo from Amyklai. Idiosyncrasies are evident in the iconography of various cities: on the pediment of the Temple of Artemis at Kerkyra (Corfu), Zeus is a beardless youth, while in a bronze at Olympia he has a pointed beard and a long drooping mustache. The female divinities tend to be characterized as mother figures and are frequently seated — for example, the Demeter (?) of Tegea — or as younger figures that can be traced to the kore type. Along with these anthropomorphic representations, there are also found

in archaic sculpture composite figures such as the late 6th-century ram-god in the Archaeological Museum of Sparta, which may represent the Apollo Karneios. Most of these composite deities are winged figures; this is particularly true of the images of Athena, Artemis, and Hera. The oldest example of this genre is undoubtedly the Hera that comes from the very ancient Heraion of Delos, on the western slope of Mount Kynthos. Minor deities are almost always equipped with wings, which they retained even after the major Olympian gods had acquired completely human form. It is possible, but not certain, that some representations of winged genii, such as those on the disks from a cavern of Mount Ida in Crete (VII, PL. I), derive from Assyrian prototypes. The images of Nike (goddess of victory), which are found everywhere, derive from the Aegean Lady of the Beasts (PL. 217); or so it would seem, at least, from the type of Nike that appears on the sarcophagi of Klazomenai at the beginning of the 6th century, where the double-winged goddess stands between two horsemen and has two small animals at her sides, in the customary hieratic disposition. In the 6th century, abstract concepts were frequently presented in the form of winged divinities: thus on the Chest of Kypselos, between figures of Ajax and Hector in combat was depicted a winged Discord (Eris) resembling a Gorgon.

In the archaic period there are many representations of monsters; these do not appear by themselves, however, but are inserted into the context of larger scenes. They were introduced at about the same time as the theme of cosmogonic struggle (see MYTH AND FABLE) but did not themselves become objects of worship. Such grotesquerie on monuments has no ritual character but is rather moralistic in emphasis: for example, on the Chest of Kypselos, the ravisher Boreas, who is elsewhere represented as a winged youth, was shown with serpentlike legs to signify that he is committing an act of violence. From the very beginning, the Greek gods were comely human beings glorified and made immortal; they were never conceived as nightmare creatures. Ugliness was relegated to the damned.

*c. From the classical period to the Hellenistic period.* By the beginning of the 5th century B.C., anthropomorphic iconography was dominant and uncontested, as if the aristocratic religion advanced by Homer had decisively overcome the Mediterranean "popular" tradition. Still, however much the splendor of Attic art may disguise the older popular fetishism, the latter was not dead; and the expansion of the Hellenic world through the conquests of Alexander the Great gave new vitality to iconographic forms that had been latent.

The major Olympian deities benefited most from the flourishing of classic sculpture (PLS. 218, 219). In an Athens stirred by victory over the Persians to a new consciousness of its own power, the seated Athena Polias, the older iconographic type found on the Acropolis in votive statuettes, was abandoned in favor of the image of a standing goddess. Such was the Athena Parthenos of Phidias (q.v.), who was armed and helmeted and had her hand resting on a shield. Artists now depicted Athena wearing the Doric peplos, which, unlike the filmy Ionic tunic that had been favored by the sculptors of the preceding epoch, conceals the contours of the body, as if the warrior goddess wished to hide her femininity. In the classic period Hera was generally portrayed seated on a throne as queen of Olympus; Polykleitos represented her in this manner (Pausanias, *Description of Greece*, II, 17, 4), holding a pomegranate and a scepter surmounted by a cuckoo, the fruit and the bird indicating the goddess's assimilation of appurtenances from divinities of pre-Hellenic folk religion.

Since the Homeric Olympus encompasses two generations, that of the Titans and that of their offspring, sculptors tend to characterize the second generation of deities in two forms: one representing them as fully mature, and the other as in the flower of their youth. This twofold representation was not practiced during the preceding period, when Hermes was consistently bearded, for example. From Polykleitos on, however, the Arcadian shepherd of the Peloponnesian type gives way to the figure of a youth barely emerged from adolescence. On the other hand, Zeus no longer appears in a youthful form, as in the Temple of Artemis at Corfu, but displays the diadem and beard of the ruler of the Olympian court, as in the Zeus of Histiaia (Athens, Nat. Archaeol. Mus.) and on the pediment at Olympia. Phidias in particular represented him in this fashion. Dionysos, as the son of Zeus, is made much younger and is often represented as an infant deity, the god of the double birth (alluding to the peculiar circumstances of his birth). Without doubt, the cult statue in the sanctuary at Athens was still an image of the bearded Dionysos on his throne (Pausanias, *Description of Greece*, I, 20, 2; cf. III, PL. 349); but Praxiteles later established the figure of a youthful Dionysos.

On the Parthenon frieze, Aphrodite wears the transparent Ionic chiton. Besides this type, which Praxiteles adopted for the statue that he executed for Kos, he created the famous nude Aphrodite of Knidos, so often copied (III, PL. 374). We know from legends such as that of Aktaion that the nakedness of the goddesses was accompanied by a supernatural peril and that whoever saw it was cruelly punished. In the case of the goddess of life, however, the power emanating from her body was considered beneficial.

The highly refined — almost secular — divine images from the 4th century B.C. often have sacred connotations that are now difficult to identify: for example, the Apollo Sauroktonos (III, PL. 374) may represent the triumph of Apollo over the maleficent powers represented by the lizard, an animal cursed for having mocked Demeter. In the art of the 4th century very human emotions and impulses begin to be evident in the figures of the gods. No longer are their portraits limited to expressions of remote majesty and omnipotence. It has often been noted that images of deities from the classical period direct their gaze toward a distant horizon, while the statues of Praxiteles look toward the earth. This characteristic does not signify any abandonment of the ideal — for the world had not yet experienced the Christian denunciation of its pleasures — but rather it signifies the contrast between cosmic reflection, the consciousness of the organization and workings of the universe, and an awareness centered on the earth and limited to the affairs of the moment. This is perhaps one of the reasons that induced artists, especially sculptors, to devote increasing attention to the deities of life and propagation. The favorite subjects of Praxiteles were Eros, Aphrodite, and Dionysos; whereas he never sculptured images of Athena, he made innumerable studies of satyrs and the demons of the Bacchic thiasos that were repulsive to Athena. Ultimately, the very perfection of this classical representation of the gods in human terms caused the image itself to become "too human." The inspiration for a statue of Aphrodite is no longer an ideal of the divine but rather the body of a specific woman, as if each artist or each man were evolving the divine from his own human experiences. It is at the North African colony of Cyrene, the Cyrene of Aristippos and of hedonism, that the group of the three naked Graces is honored. Nevertheless, although this extreme humanization of sculptural types contributed increasingly to bringing the deity down from heaven to earth, by an inverted movement the things of the earth also acquired a sort of divine dignity. Thus the Latin elegiac poets, who were disciples of the Alexandrians, called their mistresses Delia or Cynthia. Even the dead were represented with characteristics of a deity into whom it was believed they had been transfigured after death. The earliest of these deified portraits that are known are those of Alexander, traditionally attributed to the sculptor Lysippos (Plutarch, *De proverbiis Alexandrinorum*, II, 2).

As the empire of Alexander extended farther, Greek art assimilated deities that were not Hellenic and gave tangible form to the efforts of thinkers who sought to find analogies with Hellenic worship in foreign cults (PL. 219). This tendency produced, for instance, an Egyptian Hermes and a Dionysos-Serapis, along with an Isis assimilated into the figure of Tyche.

*d. Italic and Roman divinities.* Throughout the historical period, that is, from about the end of the 4th century B.C., the Roman gods were presented in forms established by Greek art, but only at the expense of profound alteration in their natures. Marcus Terentius Varro wrote that the Romans had worshiped

their gods for 170 years without vesting them in any palpable images. He was referring to the period from the founding of the city to the building of the Capitoline sanctuary of Jupiter Optimus Maximus; the results of archaeology have not weakened this assertion. It is true that "fetishes" existed: for example, the stone on the Capitoline symbolizing Terminus or the sacred flame at the hearth of Vesta. Similarly, in the oldest temple of Mars, the regia in the Roman Forum, were preserved sacred shields that may safely be considered symbols of the god. It is also possible that the mysterious figure of Janus was originally simply the deity of the gates and that he did not assume his distinguishing double visage until long after the foundation of Rome, under the influence of Etruscan divine iconography. According to tradition, Aeneas brought sacred statuettes to Rome, the so-called "penates" of the Roman people, which were guarded in the Penus Vestae ("storeroom of Vesta"). It is not known whether these were anthropomorphic images or simple fetishes; but since the Romans asserted that these penates included the Palladium, which Aeneas himself had saved from the burning of Troy, it is possible that there was also among them a very old xoanon which had come from the Hellenic Orient at the time of the first colonization, that is, during migrations supposed to have occurred in Italy during the Mycenaean age. The beginnings of divine art in Rome are customarily dated from about the 6th century B.C., when King Tarquin Priscus commissioned the sculptor Vulca of Veii to decorate the Temple of Jupiter Capitolinus and to create the statue of the god himself. Excavations have confirmed the existence of a sculptural school of notable importance at Veii. Most representations of deities from the Etruscan pantheon derive from Greek anthropomorphism, with provincial variations, and assimilate other forms of different origin by way of this Greek influence. This is the case with the *bifrons* type, or double face, which was not unknown in Greek sculpture of the archaic period, although very rare and apparently derived from Asiatic deities. The *bifrons* was very frequent in Etruria, however, and served as the direct prototype of the Roman Janus.

Although it remained quick to absorb foreign deities, Roman religion always tried to find in them analogies with indigenous deities. Gradually the images of these foreign gods came to be wholly superimposed on the personalities of the traditional gods. Thus Mutunus Tutunus, the phallic deity of Velia, was replaced by Priapus, the god of Lampsacus, who had been introduced in Rome along with other deities surrounding Bacchus. With the influx of Greek works that began in the 3d century B.C., the Hellenic concept of divinity was definitely established in Rome (PL. 219). The works imported belong to all periods and all schools: archaic statues, Attic types derived from Phidias, and Hellenistic deities were all accumulated indiscriminately. In their religious veneration the Romans were confronted by a complex of artistic types that were difficult to interpret, just as on the philosophic plane they were faced with reconciliation of a complex of theological speculations derived from Hellenic schools. Thus an effort was made to discover the true nature of the gods by analyzing their appearances: for example, a Janus whose gesture serves to point out the number 365 (the days of the year) was thought to express his function as the god of time. Some schools of philosophy, such as the Stoic, denied that the gods actually resembled their material images. These speculations are known to us only through such Latin authors as Cicero, Varro, and Macrobius. This evidence leads to the supposition that the earlier Roman tendency to give homage to the gods without resorting to artistic imagery made the Romans particularly susceptible to religious concepts which undoubtedly would have clashed with the firmly anthropomorphic traditions of Greece. For a Roman, images of the gods always remained symbols that were to a certain extent foreign to and incommensurable with the idea of divinity. However paradoxical it may appear, the religious thought of the Romans developed in an area wholly distinct from that of the arts; it evolved on the level of ritual and, for the elite, on the level of pure introspection. When the Romans began to create their gods during the historical period, they conceived of them as celestial beings, still supernatural and incomprehensible in their new identities. Caesar was transformed into a comet, but the *sidus julium* is itself only a "sign" (as *signum* refers to any divine effigy) that accompanies images of the terrestrial appearance of the deified Julius. Going beyond the esthetic realism of Greek representations of the divine, Roman religion adopted a purely spiritual concept of divinity; the Stoicism of Seneca is the highest testimony of this transcendental religious philosophy.

Pierre GRIMAL

DIVINE ICONOGRAPHY IN ASIA. *India.* When the Aryan nomads burst into northwestern India between the middle and the end of the 2d millennium B.C., they worshiped as their supreme deity the Sky Father (*Dyauṣ pitṛ*), as did all the other Indo-European peoples; however, this concept must already have been replaced partly by that linked with the name of Indra, which is still uncertain. In addition, from the pre-Vedic period this single god of the heavens had been split into various divine figures with specific cosmic functions. Thus, side by side with Indra, the lord of thunder and king of the gods, are seen Varuṇa, god of the heavenly ocean and of the moral order of the world; Parjanya, god of rain; Vāta or Vāyu, god of the wind; Sūrya or Saviṭr, god of the sun; Agni, god of the domestic hearth; Rudra and the Maruts, spirits of the tempests in the retinue of Indra; and several other deities. As the Aryans came under the influence of the earlier inhabitants of India, their deities ultimately became simple cosmic symbols and were superseded by other divine figures.

On the other hand, in the old culture of Harappa (see INDUS VALLEY ART) the iconographic type of the divine pair, which in subsequent times was to dominate India, was already definitely in evidence. In the excavations made in the valley of the Indus, there have come to light numerous female statuettes that may be interpreted as images of the "mother goddess" worshiped in archaic times throughout an extensive area ranging from the shores of the Mediterranean to India.

This deity was soon differentiated into numerous local types with a variety of names, each with its own traits and characteristics. In fact, in India each village and city had, and still has, its own deity to be invoked as a protection against evil spirits and epidemics and as the source of prosperity and fertility. These are the so-called "village deities" (Skr., *grāma-devatā*), venerated in sanctuaries that often, but not always, contain a crude image. The mother goddess was worshiped as the creator of the universe and all its inhabitants and was in fact called *Jagad mātṛ* or *Jagad ambā* ("mother of the world") and later, in the historical period, Mahādevī ("great goddess"). From her are derived the highly varied Śakti (female personifications of the creative power of a god) that, in conjunction with a male deity, constitute one of the dominant themes not only of the Hindu pantheon but also — and to a greater extent — of the pantheon of Mahayana Buddhism (see BUDDHISM).

The mother of the world has twin attributes: not only is she the power that gives life and preserves it, but she is also the womb to which all returns; thus she may display either the radiant features of a benign mother or the somber aspect of a goddess of death.

There is some reason for thinking that even in very early times the mother of the world, the archetype of the eternally productive force of nature (Prakṛti), was accompanied by a male figure (Puruṣa), who gradually became more conspicuous and later took on the traits of the god Śiva. This hypothesis makes possible an explanation of the two fundamental principles of the old Sāṃkhya philosophy: the feminine Prakṛti, which is creative and changing (matter), and the immutable Puruṣa (the spirit).

As early as the Vedic hymns there is mention of an obscure divine figure named Rudra, who, like his successor Śiva, was regarded as a maleficent deity and destroying agent and who was already fused with other divinities in the oldest known references to him. In the Indus Valley civilization are encountered symbols which are undoubtedly related to the antithetical function of Śiva, that of the restorer or healer, and which characterize him as a god of fertility; these include the linga,

an image of the male sexual organ, together with the yoni, the female sexual symbol. Śiva also preserves certain characteristics from the prehistoric cult of the bull, which once extended throughout the environs of the Mediterranean and reached India itself. This cult is the source not only of the white bull Nandi (I, PLS. 222, 225), the mount of Śiva, but also of the fact that Śiva himself has sometimes been represented as a bull. Furthermore, in anthropomorphic descriptions and representations of Śiva, one of his emblems is the so-called "lunar crescent" on his head, which actually represents the horns of a bull. Still other symbols clearly demonstrate that many other attributes derived from various periods and stages of culture were connected with this figure. His two antithetical aspects, as fertility god and as a god of destruction, are also reflected in his two sons, who were perhaps originally autonomous figures: Kārttikeya (Skanda), the six-faced god of war; and Gaṇeśa, the genius of success and fertility, whose elephantine head with a single tusk may perhaps suggest some combination of agricultural implements (the plow, two winnowing fans, and a sheaf). The two contrasting aspects of Śiva are also found in his Śakti — Pārvatī, Durgā, Umā, etc. — also called Gaurī ("white") in the benign aspect and Kālī ("black") in the terrifying aspect.

Śiva is also conceived of as a three-eyed yogi (Skr., yogin), with his body covered with ashes, his hair plaited, a necklace of human skulls around his neck, his coloring dark blue, and an apron of elephant skin, standing meditatively in the solitude of the Himalayas. The necklace of skulls, which passes to all the figures derived from him, indicates the part played by the headhunters of Assam and Farther India in defining his attributes. The same environment, or a similar one, is responsible for the appearance of Śiva as a shamanic dancer: in many instances Śiva is shown executing, either alone or in the midst of his followers, the Tāṇḍava, the dance with which he is to end the world. The essential characteristic of Śiva and all the figures derived from him is the third eye in the forehead, of which there are parallels in the literature and arts of Western antiquity as well.

Śiva is frequently shown later with three heads; this form also has many parallels in the West. The three faces of the god correspond to various aspects of Śiva, as creator, preserver, and destroyer of the universe — functions subsequently expressed by the Trimūrti as well. This iconographic scheme seems to appear for the first time in a tricephalic statuette that came to light during the excavation of the Indus Valley. The five heads of the eternal Śiva, on the other hand, are quite clearly related to physical space. These heads, oriented toward the four directions and the center of the universe and decorated with interwoven crowns (Skr., jaṭāmukuṭa), allude to the five incarnations of the god, which are mentioned for the first time in the Taittirīya-Āraṇyaka (X, 43–47). They are associated with a typical color and directional symbolism that also recurs in central and eastern Asia, by which white and the west correspond to Sadojāta; red and the north to Vāmadeva; yellow and the east to Tatpuruṣa; black and the south to Aghora; and crystalline clearness and the center to Īśāna. This symbology, in relation to the ontological principles of Sāṃkhya philosophy, finds surprising correspondences with Mahayana Buddhism, especially in the area of eastern Asia. The final aspect in which Śiva may sometimes be presented, especially in the texts, is the bisexual or androgynous figure of Ardhanārīśvara (half man and half woman). In this form Śiva has male attributes on his right side and female on his left; on the right he has his hair bound as an ascetic and holds the lunar crescent and the trident; on the left he has a caste mark on his forehead, a female breast, and holds a mirror or a lotus.

The second great deity of Hinduism is Viṣṇu (Eng., Vishnu). Since no traces of any prehistoric cult of Viṣṇu have been found in the excavations of the Indus Valley, it may be supposed that the worship of this deity began on Indian soil later than that of Śiva. In spite of repeated attempts at philological interpretation, even the origin of his name remains obscure. However, in three passages of the Ṛgveda (Eng., Rig-Veda) the god plays a very modest role: he is said to have measured the universe and is given the characteristics of a solar god.

In the scheme of the divine genealogies of the Purāṇas, Viṣṇu is one of the twelve Ādityas, or sun gods, whom the patriarchal creator Kāśyapa had begotten by Aditi, one of his eleven wives. In the Hinduism of historical times, on the other hand, he is worshiped as a transcendent deity who, by a process of emanation, has given being to the universe and all its inhabitants, keeps them alive, and at the end of each aeon takes them back into himself, only to resurrect them after an equivalent period of time.

The goddesses Lakṣmī (Śrī) and Satyavāmā, who have been given other names as well, are considered wives of Viṣṇu; but unlike Śiva, no mention is made of his progeny. Viṣṇu is often shown resting on the coils of the cosmic serpent Ananta ("infinity"; PL. 222), sheltered by a canopy arrangement of the seven hoods of the seven-headed snake and with his feet resting on the lap of Lakṣmī; frequently, from his navel there rises a lotus that encloses the universe, over which there hovers the demiurge Brahmā. His symbols are a shell, a disk, a cudgel, a lotus, a high miter (Skr., kirīṭa), and a rustic crown. He rides Garuḍa, a being half man and half bird that is reminiscent of the winged solar disk.

Typical of Viṣṇu is his incarnation (Skr., avatāra) as various animals (fish, tortoise, or boar), semianimals (man-lion), and human beings [as a dwarf, as Paraśurāma; and later as Rāma and Kṛṣṇa (Ang., Krishna), favorite heroes in the popular worship; as Buddha and, at the end of the universe, as Kalki], forms that he has already embodied during the course of the present aeon or will embody in the future for the defense of the good and the destruction of evil.

Of the three great Hindu gods, Brahmā is the most elusive. His name does not figure in the oldest texts, which attribute the creation to Prajāpati ("lord of creatures") or to Hiraṇyagarbha ("golden seed"), gods that are only later identified with Brahmā. He must be considered a personification of the abstract concept of the illimitable Brahman, recognized by the authors of the Brāhmaṇa and the Upanishads (Skr., Upaniṣad) as the supreme principle or essence of the cosmos, that is, as the Absolute itself. This personification must have occurred prior to the rise of Buddhism and Jainism, since the god is often mentioned in the sacred writings of these two religions. According to the lexicons, the name of Brahmā figures for the first time in the Taittirīya-Āraṇyaka. Even though he may at one time have had a wide following, the worship of Brahmā is by now almost extinct; today two temples at Pushkar and Idar are the only remaining ones dedicated to him. In more recent mythology Brahmā is reduced to the rank of a demiurge who, at the beginning of each aeon, creates the world at the command of the other two major deities. He is shown with four heads oriented toward the points of the compass (PL. 222); consequently one should apparently see in him an anthropomorphic representation of space. He rides a swan, and the tokens he holds in his four hands are a text of the Veda, a vessel with water from the Ganges, a staff, and a rosary (or sacrificial spoon), all objects related to the Brahman caste.

The tendency to fuse various divine figures or aspects in a single entity has already been remarked. It is a characteristic that seems to go back to the culture of Harappa, since excavations in this region have brought to light a statue with three faces that is generally believed to represent Śiva in his triple function as creator, preserver, and destroyer. This interpretation is strengthened by the fact that about the 7th century similar tricephalic figures were given the iconographic symbols of the three great gods, that is, the creator, the preserver, and the destroyer of the universe. Furthermore, numerous correspondences — some very old ones — of the tricephalic anthropomorphic image are found not only in the classical literature and that of the subsequent period but also in sculpture of this epoch.

In addition to these major deities, the Indians recognized many divine beings of less elevated rank, among which stand out — in the area of the visual arts as well — the yaksha (Skr., yakṣa) and the yakshi (Skr., yakṣī), the nadīdevatā and the nāga. Like the gnomes and dwarfs of European mythology, the yakshas are guardians of treasure and live in caverns; the yakshis, as

vegetation spirits, are always accompanied by flowers or trees and correspond to the good fairies or the women of the woods in European fables. All are deities of the pre-Aryan period; the oldest evidence of a cult devoted to them is provided by a bas-relief found in the Indus Valley, which shows one of these spirits of vegetation between the branches of a tree.

Like the yakshis, the *nadīdevatā*, comparable to the naiads of classical antiquity, also lost their sacred significance in the course of time. The genii of the Ganges (Skr., *Gangā*) and of the Jamuna (Skr., *Jamnā*), the sacred rivers of India, were very extensively represented; images of them are found in the most diverse areas of northern India.

Serpents (Skr., *nāga*), which were also considered genii of fertility, are portrayed on many stone monuments (Skr., *nāgakal*) erected under fig trees in the vicinity of temples. In these works there recurs a motif — found also in Babylonia — similar to the caduceus, the staff of Aesculapius coiled round with a male and a female serpent. The Indians, however, represent the male serpent with a single head and the female with a varying number of heads.

Buddha and the bodhisattvas are and yet are not deities, since they combine some divine and some human attributes with others that seem to refer to an impersonal cosmic principle. As far as visual representations of Buddhist deities are concerned, therefore, these do not differ much from the Hindu tradition, though they refer to different sets of symbols (for their iconographic origins and the study of their significance, see BUDDHISM).

<div align="right">Willibald KIRFEL</div>

*China.* The earliest representations of deities in China date either from the prehistoric (Neolithic) period or the Bronze Age (which begins with the 2d dynasty, the Shang-Yin); much evidence from the latter period has come to light recently at An-yang, the next to last Shang-Yin capital, as well as other centers that were more or less contemporary (see CHINA; CHINESE ART). Among these early representations the perforated jade disks (*pi*) symbolized, according to some writers, the celestial deity or, according to others, the solar wheel. However, we are dealing with conceptions of divinity that are remote in time (end of Chou period, beginning of the Han), and the existence of a cult of the heavens or the sun during the Neolithic period has not yet been proved. According to Laufer, the hollow jade tubes known as *ts'ung* represented the deity Earth; this hypothesis (accepted by many Western scholars, including Eduard Erkes and others, but rejected by Bernhard Karlgren) is not documented until the *Ritual of the Chou* (Chin., *Chou-li*), a relatively late text (end of Chou period, early Han).

The supreme deity at the time of the Shang dynasty was the Dominator (Ti), who was later assimilated in the deity Sky (T'ien). In the ideograms of the sounds "Ti" and "T'ien," as they appear in the inscriptions on oracular bones of the first period of the Bronze Age (15th to 12th cent. B.C.), the stylization of an anthropomorphic figure may be noted. Furthermore, it is known from somewhat later texts that the supreme deity (Shang-ti) was conceived anthropomorphically. According to Karlgren, the ideogram denoting the god of the soil (Shê) was simply the representation of a stake, which could be assimilated into that of the phallus; this double meaning was also true for the ancestor tablets and the ideogram that denotes both ancestors and tablets (*tsŭ*). The stakes of the god of the soil, according to Chêng Hsüan (2d cent. of our era), were of stone; and in the Museum of Far Eastern Antiquities in Stockholm a phalloform stone is preserved with inscriptions similar to those on the oracular bones, which Karlgren relates to the stakes of the cult of the soil god. In the early Chou period the tablets symbolizing the earth god were at times provided with eyes and ears. The wooden tablets of the ancestors were subsequently derived from these.

Among the decorations on archaic bronzes, the thunder pattern (*lei-wên*) symbolizes both fertility and human fecundity; the recurrent motifs of dragons and the *t'ao-t'ieh* were considered powerful magical and apotropaic symbols. Excavations made a short time before World War I near Ch'ang-sha (Hunan; the most important center of the kingdom of Ch'u, 6th to 3d cent. B.C.) brought to light many anthropomorphic and zoomorphic wooden figures that may represent, as they later did in the Han epoch, the escort that followed the dead into the tombs; alternatively, they may represent supernatural protective beings or refer to figures with magical powers (Salmony, 1954). The most ancient example of silk painting found at Ch'ang-sha in 1949 is a religious scene representing a female figure (perhaps a witch or a shaman) accompanied by a phoenix and a one-legged dragon (*k'uei*); it seems to be a mythological scene and is from about the 5th cent. B.C. A roughly contemporary silk painting also found at Ch'ang-sha, with figures of animals, tricephalic men or deities, and objects not easily identifiable, is probably apotropaic or magical in its purpose. Tricephalic figures are also found in the decoration of one of the so-called "hunting bronzes" (5th to 3d cent. B.C.) of the late Chou period. In the local lacquers (see LACQUER), there are representations of mythical animals which are sometimes naturalistic and sometimes stylized.

In the Han period following (206 B.C. – A.D. 221), scenes or figures with religious connotations gradually increased in number, but examples of pictorial representation were still scarce. We have literary evidence, however; the most valuable of these writings is that of the great poet Wang Yen-shou (2d cent. of our era) which describes the frescoes of a palace in the province of Shantung. The reliefs of the Han funerary slabs, derived if not actually copied from contemporary paintings, provide a large number of divine representations, especially Taoist (see TAOISM). These are often in what was to be their definitive iconographic form. One of the tombs that has preserved the greatest number of reliefs is that of the Wu family in the vicinity of Chia-hsing, with its series of historical, mythological, and religious scenes of Taoist inspiration.

Among the rarest examples of Han painting is a decorated hollow tile (Tokyo, Nezu Art Museum) from Sian, generally dated in the first Han period (3d to 1st cent. B.C.). This work contains the earliest-known pictorial example of winged deities in Chinese art. Sculptured figures are represented on several drum-shaped vases discovered in 1954 during excavations on Shih-chia-shan in the Chin-ning district (Yunnan); these containers have on their covers numerous little sculptures in bronze appliqué that portray scenes of a religious character.

The first representations of deities or divine beings in China are traceable, therefore, to about the beginning of the Christian Era. The hypothesis that this happened under the influence of Buddhism (q.v.), which at this time was introduced into China, should not be excluded. The representation of divine beings in anthropomorphic form or their expression in theriomorphic or mixed forms is even more frequent after the Han period, as a result of the formation of a Taoist religion based on the model of the Buddhist.

This discussion will be limited to tracing the representation of some of the principal deities, particularly those of the popular religion that slowly developed during the 16th century through a gradual combination of Taoist, Buddhist, and Confucian (see CONFUCIANISM) elements.

The supreme deity of the folk pantheon was Yü-huang (the Jade August One), derived from the Taoist divinity of the same name. Supreme ruler and sovereign, he was dressed in ceremonial garb similar to the imperial costume (see COSTUME) and was shown seated on his throne, surrounded by a group of hierarchic deities depicted as a kind of imperial administration. Secondary divinities connected with various atmospheric phenomena, such as Ch'ang-ngo or Heng-ngo (Moon Lady), Sao-ch'ing-niang (Lady Whose Passage Calms the Heavens), Lei-kung (Master of Thunder), and T'ien-mu (Mother of the Lightning), were often represented in popular prints.

Among the more important personages noted among the court of the Jade August One are the Five Controllers (Ti) of the Five Sacred Mountains of China, always portrayed in imperial ceremonial costume. The most important of these was the controller of the eastern peak, whose cult is already documented toward the beginning of our era. This deity covered the entire country, while the protection of specific places or

objects (cities, walls, houses, parts of the house, furniture, etc.) was generally entrusted to the Ch'êng-huang, or deities of the walls and ditches, and to other deities dependent upon them. The Ch'êng-huang were for the most part real personages (mandarins, literati, generals) who were deified after death. Also honored were the god of the hearth, the gods of the doors (Mên-shên), two generals who lived during the T'ang period and who were subsequently deified, and the god of wealth (Ts'ai-shên).

The protectors of the professions, trades, and guilds were also numerous. The literati paid homage to the Great Emperor of Letters (Wen-ch'ang Ti-chün), to K'uei Hsing, to Chu-i, and to Confucius himself, to whom sanctuaries were dedicated throughout the imperial territory during the Han period. Among others, the peasants paid homage to the part-human, part-animal image of the Great General (Pa-cha), the destroyer of insects and locusts. Also important was the anthropomorphic deity of the millet plant. It is difficult to say, however, to what extent the prints and statuettes of these deities had a religious rather than a merely talismanic function.

Interesting divinities of the popular pantheon include Kuan-ti, the deification of the general Kuan Yü, who lived during the 3d century of our era and whose name had a magical, apotropaic value; Shou-shên, the god of longevity; Lu Hsing, the deity of earnings, who protected civil servants; and Fu Hsing, the god of happiness. The popular pantheon, Taoist in its inspiration, also includes the famous figures of the Eight Immortals (Pa-hsien), who never enjoyed true worship, even though their complex legends as protectors of Taoism and their popularity in Chinese folklore made them one of the chief subjects of Chinese popular religious representations.

Lionello LANCIOTTI

*Japan.* Magico-religious ideologies are connected with certain neolithic statuettes, chiefly of clay, with the female characteristics particularly conspicuous and emphasis of the breasts and the stomach, which is sometimes furrowed to represent the vulva. Such representations are connected with fertility rites, as is true also of a series of stone rods that serve as phallic symbols (see JAPANESE ART).

With the appearance of metalworking, there is no evidence that religious ideology availed itself of its possibilities for iconographic representations. Shintoism (q.v.), which was without divine imagery from its beginnings, expressed the generating forces of nature by means of aniconic elements such as batons and pillars and symbolized the presence of deities with sacred attributes such as necklaces, mirrors, swords, and lances (see IMAGES AND ICONOCLASM).

Later, under the influence of Buddhism, one finds the first anthropomorphic representations. With the religious syncretism of the Ryōbu-Shintō (see SHINTOISM), images of divinities and heroes were created, often in relation to the artistic canons of Buddhism (q.v.; PLS. 224, 225).

Adolfo TAMBURELLO

*Southeastern Asia.* From early times the religion, especially the folk religion, of southeastern Asia has been mostly animistic. Ancestors preside over the household, the village, and the district; dragons, demons, spirits, and nymphs live in the streams and caves, in the rocks and the trees, and on the cliffs and hilltops. In the holy places the invisible presence of all these spirits, which can be invoked by magic or placated with offerings, is often marked by a stone or a crude image. In the tradiional worship of ancestors the spirits are provided with stone seats, and sometimes figures of warriors and priests, crudely carved in stone or wood, are erected near the jars where their bones are deposited. For the ancestor-founder of a community there may be a whole pyramid of stones.

Early in our era, when Indian settlers introduced their religions and culture, a new aristocracy with an admixture of Indian blood rose to power. Ancestral spirits were replaced by Indian deities, which assumed local dress. In representations of these, limbs and faces may be multiple, and the right half of one divinity may be combined with the left half of another. A god may be shown riding on his appropriate beast, which serves as his *vāhana* (vehicle). In some avatars Viṣṇu himself is wholly or partly an animal; Gaṇeśa is elephant-headed; Śiva, if not portrayed in human form, may be represented by the linga (phallus). Mahayana Buddhism had many concepts in common with Hinduism; it developed a similar architecture, and the Mahayana bodhisattvas resembled their counterparts in the Hindu pantheon.

This syncretistic tendency is particularly evident in the later, or Tantric, phase. About the 13th century both Buddhism and Hinduism began to lose ground, and by the 16th they had practically disappeared from southeastern Asia, with the exception of Bali. This decline was chiefly due to the influence of Hinayana Buddhism, which had been introduced before the 6th century. Hinayana had made constant progress in Burma and, after the 14th century, in Siam as well as in Cambodia and Laos. Althought tolerant toward other beliefs, this strain of Buddhism ended by discrediting local and Hindu gods in the popular mind.

Alexander B. GRISWOLD

DIVINE ICONOGRAPHY IN "PRIMITIVE" CULTURES. The concept of God as pure spirit, a singular being who is a first principle and wholly self-contained, of infinite fullness and perfection, is found among the so-called "primitive" peoples only in the figure of their supreme being. In most cases this conception does not admit of any sort of representation (see IMAGES AND ICONOCLASM). From this preeminent archetypal deity it is expedient to distinguish all the other divinities, particularly in the polytheistic religions: multiple deities cannot be comprehended in themselves unless — contrary to the nature of spirits — they are clearly invested with strong personal characteristics and exercise unlimited sovereignty over one or more areas in which they are subordinated to no one. Obviously, it is not easy to arrive at precise definitions in this connection. It follows from this evidence that polytheistic systems evolve only in higher civilizations: among primitive peoples they appear for the most part only as a reflection of a more advanced culture. Additional phenomena such as the erection of hypostases and the personification of natural phenomena are involved in classic polytheistic systems, as J. Haeckel (1959) has shown for Mexico.

Examination of iconographic material raises yet another question, namely, how far we are dealing with truly representational forms as opposed to mere symbolic tokens of one deity or another. According to the ideas of primitive peoples, however, since not even their anthropomorphic representations customarily have any significance as portraits, symbolic representations must also be carefully considered. As was mentioned earlier, these more simple cultural levels rarely evidence extensive representations of deities; nevertheless, it would be impossible to treat exhaustively all areas of diffusion within the necessary limitations of an article intended as a cross-cultural survey.

In Polynesia it is customary to distinguish between the major gods (Tangaroa, Tu, Tane, Rongo, etc.) and local or district gods that are worshiped only in certain areas. Various examples lead one to suppose that the latter are simply deified ancestors. Often the leader of the first group of occupants of an island received divine honors, as for example did Tangiia, one of the most famous navigators of Polynesia, who is venerated at Rarotonga. It should also be noted that only a deity for whose cult there existed a divinely sanctioned priest was transported to a new home during a migration. At present it appears that only two probable representations of the great Polynesian deities survive, and even the identity of these is somewhat uncertain. The first example, found on Rururtu in the Austral Islands and preserved in the British Museum, is a wooden figure about 44 in. high that is said to represent Tangaroa, the sea god, creating the other gods and men. In its back, which is hollow and has a cover, are found small sculptured figures; similar figures are carved into the outside of the body and are sometimes arranged to represent body parts, such as the nose, eyes, and ears of the god (PL. 226). A second and

even more valuable sculpture, also in the British Museum, is believed to represent the god Rongo with his three sons: actually there are at least seven statuettes applied to the arms and chest of the god, a multiplicity suggestive of a generative principle similar to that observed in the image of Tangaroa (PL. 226). But in the case of Rongo it appears that the intention of representing a creative act may be discounted, for according to Polynesian myths of creation the gods were not created but begotten; consequently the deities are believed to have issued from the body of the mother of the gods. A more likely alternative is that it is a representation of a demon of disease (*atua*: sickness, demon, etc.), and in this event the smaller statuettes would represent various diseases. Other well-known representations of Polynesian deities include that of Kihe Wahine, the Hawaiian goddess of hobgoblins and lizards (Berlin, Mus. für Völkerkunde), and especially those of the war god Kukailimoku (Göttingen, Inst. für Völkerkunde; London, Br. Mus.; Berlin and Vienna, Mus. für Völkerkunde). The latter deity appears both in the form of a wooden sculpture and also as a plaited fabrication that is limited to a representation of the head alone and covered with a feather mosaic (see FEATHERWORK). Another noteworthy wooden statue, thought to represent the Hawaiian god of war Tu, is of doubtful attribution. Positive identification is also lacking for another wooden sculpture in the British Museum, which has human hair and mother-of-pearl eyes with pupils of black wood and which has been interpreted as a figure of Pele, the goddess of volcanoes. In Polynesia there are also found numerous representations of the so-called "tiki," sculptures of wood or stone (in New Zealand of nephrite) with human or quasi-human features. The tiki is often thought to represent the first man, and it might therefore be considered an ancestor image, like the famous sculptures of Easter Island.

Among the Kolam of India, Dravidian farmers of the Central Provinces and Berar, the tribal god is named Ayak; he is symbolized in various villages in the form of two biangular stakes that terminate in a tuft of peacock feathers. These constructions are not to be regarded as images of Ayak, but merely as receptacles in which the god is purported to be present during feasts. Noteworthy also are the wooden or stone images of Bir Kuar, the god of the flocks of the Ahir tribe, keepers of buffalo in Bihar (PL. 226; see ASIA, SOUTH: TRIBAL STYLES).

Western Africa is well known for its representations of divinities, although in reality these are not so numerous as is commonly believed. For example, there is only one known representation of Mawu or Mau, the supreme being of the Ewe, that in the Abomey Museum, Dahomey. It is a wooden figure painted in red, which has large breasts and holds a half moon in its left hand. Mawu, especially in the area of Abomey, is conceived of as a female being in some areas, while among the coastal Ewe he is male, inasmuch as the latter are unaware of the existence of Lisa, the husband of Mawu. Lisa himself, where he is worshiped, appears in the form of a chameleon with the sun in his mouth, an attribute that leads to even more uncertainty concerning the original character of this deity. Anthropomorphic divine images are rare among the Ewe and the Yoruba; figures of spirits and ancestors are the most prevalent types. Chuku, the supreme being of the Ibo, has neither sanctuaries nor cult symbols; however, the earth spirit Ale is a very important deity, with a sanctuary in every village and a central place of worship in the original village of the larger communities. The Edo believe in a supreme being designated Osanobua or Osa, the creator of all things and all beings. In praying to the god for health or offspring, one makes a little pile of sand into which a stick with a strip of white cloth is inserted. Olokun, the eldest son of Osanobua, is on the other hand represented by life-size clay figures in the centers of his cult (*urhonigbe*). Each family has an altar dedicated to Olokun, where one often finds clay figures that represent him. Ogun, the god of the smiths, is worshiped in sanctuaries in which pieces of metal and various objects are preserved; but no images of him have been found. The Ivbiosakon, a northern subtribe of the Edo group, also venerate Osa, and one finds everywhere representations of him in clay or wood, which have an apotropaic purpose and are set in front of the entrances of the habitations.

Oghene, the supreme being of the Isoko and the Urhobo, is represented by a long stake, atop which there is attached a piece of cloth.

The many incarnations of Nyamye, the supreme being of the Akan, are represented by the most varied symbols and also by figures of animals, especially of antelopes. This deity apparently has both male and female manifestations. As the bestower of the sun, Nyamye is represented as two crocodiles arranged in the form of a cross. Other of his symbols are the "female cross" (*crux decussata*), the symbol of the "creator of the revolving universe"; the triangle, as the ruler of the universe (heaven, earth, and underworld); the spiral, as the genetrix of the world; the moon, as the great mother; and the symbol of water for the distributer of the rain. These symbols play an important role in the life of the Akan and are often executed on everyday objects as well.

In Peru the most powerful servant of the creator god Wiraqocha was the sun god, the divine founder of the dynasty of the Incas. He was conceived of as a man but was normally represented by a golden disk showing a human face surrounded by rays, as is found in the Temple of the Sun at Cuzco.

In the Bolivian lowlands, the Araona of the Tacana group show strong Inca influences. The principal god is Bababuada, a wind god to whom is attributed the dignity of creator. Next to him, and in addition to the spirits, were various lesser deities (of the wind, the sun, and the moon), represented by carved pieces of wood decorated with feather mosaics. The deities of the maize, the yucca, and the banana were symbolized by objects of various sorts, such as lances with wooden points, arrows, hatchets, and vases, as well as little black stones.

Among the Maya of Mexico, the supreme god Hunabku is never represented; in this respect he differs from Itzamná, later the most important god of the pantheon, who took the place of Hunabku when the latter became a "leisure god." One of his distinctive symbols, which recurs in all periods of Mayan art, is a representation of serpents or of two-headed alligators or lizards. There also exist anthropomorphic forms of Itzamná in his role as celestial dragon.

In the ancient higher civilizations of Mexico (Aztecs, Mixtecs, Zapotecs, etc.), there were various polytheistic systems, which had artistic representations of most of the gods recognized by them. Of the supreme divine pair, however, there are no representations. A characteristic aspect of the Mexican gods is the superabundant use of emblems in their representation, emblems that constitute both their attributes and their distinctive symbols, permitting us to distinguish one deity from another. In the area devoted to worship in the pyramid temples, a statue of the principal deity to whom the edifice is dedicated is usually found. Although these gods are for the most part represented in anthropomorphic form (PL. 227), they may occasionally assume animal aspects. Quetzalcoatl, one of the most important figures in the Mexican pantheon, is a god of the wind and of life and a creator god, but at the same time he is also a messenger of the supreme being, a savior, a mythical high priest, the founder of a royal line; and he has astral characteristics as well. Generally Quetzalcoatl is represented in human form, with a beaked mask or as a bearded man. For him, as for the other deities, different functions and characteristics are expressed by means of appropriate symbols. The national deity of the Aztecs, Uitzilopochtli, god of war and of the new sun, also often wears a beaked mask resembling a hummingbird (the symbol of the souls of warriors), which constitutes his mystical disguise. The face of the rain god Tlaloc appears surrounded by blue serpents, an allusion to the connection between serpents and fertility. The majority of these deities are simply personifications of natural phenomena and cosmic forces (Xolotl; PL. 227), a fact often apparent in their images.

Engelbert STIGLMAYR

ISLAM. No representation or symbol of the powers and attributes of God has ever appeared in the art of Islam, which rejected on a priori grounds all representational means for the diffusion of its doctrine. Even when the iconoclastic prohibi-

tion became subject to less severe interpretation, representational subjects were strictly confined to the sphere of secular art to the absolute exclusion of all religious themes. Though Persian painting did, in fact, show Mohammed received and accompanied by angels in his mystical assumption, in this scene there is no allusion to the Omnipotent Presence which the prophet contemplated. Compositions showing paradise and its beatitudes are treated in a markedly realistic manner, with lush landscapes populated by djinns, but no hint of the nearness of God.

The severely theocentric concept of Mohammed, according to which everything with the exception of God Himself is created and re-created through a continuing series of miracles without recourse to natural laws and systematic rules, has not led to a depiction of the creation of the world. The Koran does relate that God breathed his spirit into Adam, but the idea that the latter is created in God's image and likeness is affirmed by tradition only. The ineffable character of the relationship between God and man excludes any translation of it into the terms of representational art. Though Islamic theologians on occasion attributed anthropomorphic features to God, these are nonetheless vague and imprecise. The idea that at the Last Judgment God would appear seated on a throne, supporting the earth with one finger and the heavens with the other and pressing down into Hell with one foot, was transmitted from generation to generation; no painter, however, has ever ventured to depict it.

In mystical literature, especially in that of Iran, divine love was not infrequently expressed in the language of earthly passion. But the form that God assumed in such visions was never set forth. This lack of imaginative stimulation has prevented the artists from being tempted to concern themselves with such subjects.

Islamic art, in contrast to that of Christianity, excludes not only the treatment of religious themes but also the use of symbolic allusions to the articles of faith. Various images to be found from time to time in Islamic lands — the knot, the swastika, eyes, etc. — which have a definite apotropaic or cosmological value in other civilizations, are here only the remnants of an ancient folk legacy. The same may be said of other motifs such as the tree of life, animal combats, the dragon, and the phoenix; these had a deep significance for earlier Iranian art as for that of China, but in Islam they merely provide the elements of a decorative repertory.

Equally removed from symbolic or mystical preoccupation are the cult buildings, whether in their typology or in their individual elements. Cult images and liturgical apparatus are absent in mosques, which are exclusively places of congregation for teaching and prayer (see IMAGES AND ICONOCLASM; ISLAM).

<div align="right">Ernst KÜHNEL</div>

THE CHRISTIAN WORLD AND THE REPRESENTATION OF GOD. The representation of the Deity, like that of almost every other being, was strictly forbidden among the Hebrews (see IMAGES AND ICONOCLASM). This prohibition was categorically formulated from various Biblical passages (Exod. 20:4-5; Deut. 4:16; 27:15). Naturally there were transgressions against such laws; in fact, there is evidence of the existence of sculpture from a quite early period (see JEWISH ART).

<div align="center">* *</div>

*God the Father*. Christianity tended to accept the prohibition against representing the Deity set forth in the Old Testament, but the triune essence of the Christian God placed the problem of divine representation on a wholly new plane. The second of the three persons, embodied historically in Christ's assumption of human nature, obviously points to a justification of at least one type of image, that of Christ as a man (see CHRISTIANITY). Nevertheless, this image met considerable opposition from some of the early Church Fathers (cf. Can. 36, Synod of Elvira, ca. 306; see IMAGES AND ICONOCLASM), who were opposed by a current of compromise that recognized an anagogical and didactic value in images of the incarnate God (see

CHRISTIANITY). Representations of God the Father were consistently proscribed [Facius Judaeus (d. 384), *Expositio fidei catholicae*, chap. v.; *De fide et symbolo*, chap. vii].

Nevertheless, in catacomb paintings, on sarcophagi, probably in illuminated manuscripts, and later in the great basilicas, art was oriented toward Christian themes that required the presence of God — at least in a metaphorical sense — both in Biblical episodes and in symbolic or allegorical compositions. Manifestation of the Deity was always linked with atmospheric phenomena (Exod. 24:10, 17; Matt. 28:3); this is probably why the sky is colored in a wholly unrealistic manner in Early Christian painting (Rome: mosaics, S. Maria Maggiore, ca. 440; apse, S. Pudenziana, 401-17).

A very common way of referring to the Deity in Old Testament texts is as "the arm of God," "the hand of God," or the "strong right hand of God," which comforts, castigates, and sustains the Hebrew people. By the 3d century the Jews of the Diaspora at Dura-Europos had translated this literary metaphor to a representational medium. Their artists employed a disembodied hand with open fingers (PL. 228), derived perhaps from Eastern cults (Ba'al) and from that Hebraic sect of the 2d century B.C. which was influenced by Hellenistic elements in Phrygia and Lydia and which worshiped Yahweh Sabaoth (Lord of Hosts), to whom bronze hands were sacrificed. In Early Christian art, the hand also became the favorite symbol of the Almighty, as demonstrated in some of the mosaics in the nave of S. Maria Maggiore and on numerous sarcophagi (J. Wilpert, *I sarcofagi cristiani antichi*, Rome, 1929-32, pls. 139, 1; 172, 2; 195; 237, 2). Sometimes it is shown with open palm, at other times in benediction, and at still others in the typical hortatory pose of the Roman orator. In scenes representing colloquies of the ancient patriarchs with the Lord, the heavenly hand extends a rotulus (Ravenna, S. Vitale, first half of 6th cent.), a situation that directly corresponds to a Biblical text (Ezek. 2:9). Conversely, one rarely finds the Hand of God in scenes from the New Testament, with the exception of those of the Baptism (Early Christian sarcophagi; gold medallion, Washington, D.C., Dumbarton Oaks Coll., 6th cent.), the Ascension (ivory, Munich, Bayerisches Nationalmus., ca. 400; PL. 228), and the Pentecost ampulla (Monza, S. Giovanni Battista, 6th cent.).

In allegorical compositions this hand is detached from the human events below (Salonika, Hosios David, apse mosaic, late 5th cent.). Located always at the top of the scene, it sometimes holds a crown (Ravenna, S. Apollinare Nuovo, 6th cent.; Poreč, Yugoslavia, Euphrasian Basilica, apse, 6th cent.; Rome, S. Stefano Rotondo, apse, first half of 7th cent.; Rome, S. Agnese, apse, 7th cent.), or it may be shown within a circle, the symbol of eternity.

Abandoned by the Byzantine world during the iconoclastic period, as were all other representational elements of a religious character (see IMAGES AND ICONOCLASM), the right hand of God is nevertheless present in the iconography of Carolingian art, which strenuously defended the use of images in the West (*Libri carolini*, 790); subsequently, the theme was continued in Ottonian art, where the hand is generally accompanied by a nimbus with cross. This device is resorted to particularly by the illustrators of the Psalms (cf. Utrecht Psalter, Bib. der Rijksuniversiteit, Script. eccl. 484, 9th cent.). Sometimes, as in the Stuttgart Psalter (Landesbib., Bib. fol. 23, early 9th cent.), derived in part, perhaps, from Byzantine models, it expresses divine intervention not so much as a historical occurrence but rather as a matter of individual ethics, demonstrated by the crude illustrations (fols. 52v, 67r, 137r.). In the Ascension scenes of the Carolingian period, which follow the iconography of the Munich ivory mentioned above, the hand of God the Father grasps that of the Son, thereby symbolizing the motive power of the miraculous event; however, it is immobile when it appears above Transfiguration scenes (Gospel Book of Otto III, Munich, Bayerische Staatsbib. Clm. 4453, ca. 1000), the Baptism (cover of Gospel Book, Munich, Bayerische Staatsbib., Clm. 4451, 10th cent.) or — holding a crown — the Crucifixion (ivory, Florence, Mus. Naz., 11th cent., Goldschmidt, I, no. 114, 1914-26; ivory, Paris, Mus. de Cluny,

Goldschmidt, II, no. 48; cover of Book of Pericopes of Henry II, Munich, Bayerische Staatsbib., Clm. 4452, ca. 870). The iconography of the last of these examples perhaps originates in the sarcophagi of the Passion or the late-antique apse compositions dictated by St. Paulinus of Nola (353–431).

During the Holy Roman Empire, the Hand of God came to play a particularly significant role in compositions of a political nature, such as the full-page miniatures showing the emperor (London, Br. Mus., Grandval Bible, Add. 10546, ca. 840; Paris, Bib. Nat., Vivian Bible, Lat. 1, 846, Second Bible of Charles the Bald, Lat. 2, 9th cent.), where it hovers above the head of the sovereign as part of an arrangement that is perhaps related to verses 20 and 21 of Psalm 89. This coronation theme is repeated in the renascent Byzantine world; but the divine hand is superseded by the image of Christ, who places the crown on the head of the emperor, an iconography already used in the Ottonian epoch (Sacramentary of Henry II, Munich, Bayerische Staatsbib., Clm. 4456, 1002–04). Apparently unknown in the Irish–Anglo-Saxon world, the Hand of God is found from time to time in pre-Romanesque codices (Gospel Book, Breslau, Univ. Lib., Rehd. 169, fols. 35a, 75b, 8th cent.) and continued in Romanesque representations; it was extended to scenes of the Nativity and the Annunciation (sometimes it appears also on the cross at the center of the paten) but lost the vitality it had evidenced in Carolingian iconography. It appears immobile and sometimes gigantic, as in the bronze doors of Hildesheim Cathedral or the frescoes of the Church of S. Clemente in Tahull (Barcelona, Mus. de Arte Cataluña) or is completely isolated in capital decorations. In Gothic art this symbol progressively gave way to figure representations.

In the oldest representations of the six days of Creation, contained in two illuminated codices datable to the 6th century but probably dependent on more ancient prototypes (see BIBLICAL SUBJECTS), God the Creator appears in two different forms. In the Vienna Genesis (Österreichische Nationalbib., Vindob. theol. gr. 31), probably of Syriac origin, the manifestation is the traditional Hand of God; but in the fragmentary Cotton Bible (London, Br. Mus., Otho. B.vi), apparently produced in Alexandria, there appears the Western image of the beardless Christ (see CHRISTIANITY). In the successive scenes of the latter work, as in that in which the Almighty appears to Moses, there is a return to the motif of the hand surrounded by rays of light. In the miniatures of Genesis, all manuscripts of the successive period adhere to the iconographic scheme of the Cotton Bible, rather than that of the Vienna Genesis.

In 325 the First Council of Nicaea had explicitly condemned the Arian heresy, which saw in Christ not the Logos, existing ab eterno, but the Son created by — and hence inferior to — the Father. All the orthodox religious literature following the First Council of Nicaea is preoccupied with this grave question. Among the writings in defense of the dogma, an excerpt from the De Trinitate of St. Eusebius, Bishop of Vercelli (4th cent.), is of importance: "Memento quia deus, dei filius ad imaginem unitam dei patris fecit hominem" ("Remember that God made man in the image of God the Son and of God the Father."). Facius Judaeus, also of the 4th century, in his Expositio fidei catholicae repeats the same concept in almost the same words; furthermore, this had been rendered as an article of faith according to the Nicene Creed. Thus if the Father has created through the agency of the Son, while Himself remaining creator, the image of the Son becomes a translated image of the Father. An artistic image of the six days of Creation together with the Christ figure enabled the illiterate to grasp the meaning of this subtle theological reasoning; and the impression that this image made upon the minds of the faithful proved effective in combating heresy (cf. St. Augustine, Tractatus CXXIV in Joannis Evangelium, 413–18). Christ the Creator, like the hand of God, is therefore simply a metaphor of the Almighty; nor could the Church interfere with the representation of Christ as a man, which was officially recognized, as affirmed by St. Augustine. A confirmation of the above thesis seems to exist in a mosaic from the apse of S. Michele in Africisco, Ravenna, where the Christ is flanked by two angels and holds a book with the inscription: "Qui vidit me vidit et patrem, ego et pater unum sumus" ("Who sees Me sees also the Father; I and the Father are one;" PL. 228). This saying of Christ (John 8) constituted one of the basic elements in the defense of orthodoxy.

In the Carolingian world, for which "Deus pingi non posset" ("God the Father cannot be depicted"; Libri carolini), the Creator reappears in the aspect of the youthful Christ; while in the earlier Ashburnham Pentateuch (Paris, Bib. Nat., Nouv. acq. lat. 2334, 7th cent.), probably of Spanish origin and hence foreign to the Carolingian world, the Christ follows the iconography of the so-called "Ancient of Days" and also that of the Eastern Christ, with long hair and beard. The latter is a figure found in the Roda Bible (Paris, Bib. Nat., Lat. 6, fol. 6, 10th or 11th cent.), the Monreale mosaics, the Salerno altar frontal (S. Matteo), etc.; in the Barberini Psalter (Vatican Lib., Barb. gr. 372), the frescoes at Ferentillo, and the Genesis mosaics in St. Mark's, Venice, the Christ as Creator is again the above-mentioned youthful type. The use of the two different typologies is not surprising for the works cited belong to different stylistic currents and are much later than the Arian controversy. The aversion of theologians, and of the Church in general, to human representations of the Father is confirmed by the fact that the bust figure which appears in three of the mosaics of S. Maria Maggiore (PL. 228) — perhaps to be interpreted as the Logos (Justinus, Dialogue with Trypho, LV, 4), even though it obviously alludes to the Eternal, and probably derived in its iconography from the figure of Jupiter assisting the warriors found on the Column of Trajan — remains a unique portrayal in the Early Christian world. (It does not seem accurate to speak, as has been done, of a bust figure of the Father in connection with the story of Jonah in the Catacomb of Callixtus in Rome). The attempt to portray the Eternal in human form is next documented much later, in Carolingian times, in the Utrecht Psalter (PL. 231) and the Stuttgart Psalter (early 9th cent.; fol. 127v), which depict two figures with identical features enclosed in a circle — the Father and the Son — one of whom has a simple halo and the other a halo with cross. It may be deduced that representations of this sort existed in an earlier period from the explicit condemnation by the Church Fathers (St. Caesarius, Sermon IX; St. Augustine, Tractatus VIII in Joannis Evangelium; Venerable Bede, Homily I, 187–89), which probably explains why a figure has been erased in the Stuttgart Psalter. But this type of representation, however important it was for the future, also remained without a following for several centuries.

In the Byzantine world, on the other hand, there appears from time to time the figure of the Ancient of Days, as it was seen in the Octateuch of Smyrna (10th–11th cent.; destroyed), in the Vision of Ezekiel of Codex Vaticanus graecus 1162, and in a later period, in the Macedonian churches of Yugoslavia (patriarchal churches of Péc, 13th cent.; Dečani, 14th cent.), an iconography presumably developed during the 6th and 7th centuries.

Beginning with the Romanesque and Gothic periods, only when the fears of idolatry and of the Arian heresy had been overcome, artists were granted much greater liberty with respect to the representation of the Deity. Then the bust figures found in S. Maria Maggiore and the Utrecht Psalter reappeared. At first the figure of the Father was identical to that of the Son (copy of the Hortus deliciarum of Herrad von Landsberg, destroyed in 1870), or else presented only slight divergencies (e.g., red hair in one and brown in the other, as in the De universo of Rabanus Maurus at Montecassino, before 1023); later, the Father becomes clearly distinguished and appears as the Ancient of Days. The theologians emphasize once more the didactic value of images. Thus it is that in scenes of the Creation the iconography of the Cotton Bible is abandoned, and the Creator no longer has the features of Christ but those of the Father instead, for "Patri attribuitur et appropriatur potentia quae maxime manifestatur in creatione; et ideo attribuitur Patri creatorem esse" ("To the Father is attributed and appropriated the great power seen in the Creation; for that reason the Father is regarded as the Creator"; St. Thomas, Summa theologica, I, quaestio xlv, art. 6).

A wholly isolated case, but one which is interesting as a sign of transition from the Middle Ages to the modern world, is that of the Hamilton Bible (Berlin, Staat. Mus., 14th cent.). Executed in Naples with a group of analogous manuscripts, this work contains scenes of the Creation presided over by a hybrid figure with two faces (which recalls those of the antique two-headed Janus), one of a young man and the other of an old man — the Logos and the Ancient of Days — to which there is sometimes added the figure of the dove (Vatican Lib., Vat. lat. 3550a, fol. 49; fresco, S. Croce, near Andria).

From the 15th century on, with the exception of the Byzantine world, which remained faithful to the ancient traditions, every metaphorical or abstract form of the Father was almost exclusively abandoned in favor of a concrete form of the Deity, as for instance in the scenes from Genesis by Paolo Uccello (q.v.) in S. Maria Novella in Florence (now destroyed). In the Renaissance, the renewed love of the antique (see ANTIQUE REVIVAL; CLASSICISM); sometimes gave to the Father the features of the Olympian Jove. God appears in this form in Michelangelo's ceiling of the Sistine Chapel and in Raphael's Vision of Ezekiel in the Loggia frescoes of the Vatican. In decorations of illuminated manuscripts, the Almighty sometimes appears alone, seated on His throne (initials of antiphonals, etc.); while in large fresco compositions or in the finials of altarpieces He is always surrounded by angelic hosts. The tiara or miter often appears on His head, especially in northern iconography prior to the Reformation, and His body is wrapped in an ample cope. Sometimes, when psychological elements are being emphasized, certain artists (especially when presenting the visions of saints) convey the miraculous presence of the Deity by means of the ecstatic posture of the person being depicted (Leonardo, *St. Jerome*, Mus. Vat.; Raphael, *St. Catherine*, London, Nat. Gall.; Bernini, *Ecstasy of St. Theresa*, II, PL. 273). The baroque, however, delights in heavenly spectacles of angels as the signs of the presence of the Almighty.

*The Holy Spirit.* It was much easier to portray the third person of the Trinity, manifested twice according to the New Testament, as a dove in the Baptism of Christ and as tongues of fire at Pentecost. Thus the two means of representing the Paraclete have been available to artists and, except for stylistic modifications, have remained unvaried over the centuries. No objection to these conventional images was raised by the Church, except for the command of Severus, the Monophysite patriarch of Antioch (ca. 465–538), who had doves of gold and silver removed from altars and baptismal fonts.

The first representation of the dove as a sign of the Holy Ghost (for other symbolic meanings, see SYMBOLISM AND ALLEGORY) is in connection with the scene of the Baptism (as in frescoes of the catacombs, where it appears above and to one side of the main scene). In a later period (Ravenna, Baptistery of the Orthodox, ca. 450; Baptistery of the Arians, PL. 229), the dove is located above the head of the Messiah in accordance with an antique pagan iconography. The change may be connected with the comments of the Church Fathers on the relevant passage in the Gospels (St. Gregory Thaumaturgos, *Sancta Theophania sive de Christo baptismo*, 3d cent.; St. Jerome, *Commentary on the Gospel of St. Matthew*, I). The dove is naturally white (Lactantius, *Institutiones divinae*, IV, 15, 3, 304–11), a color recognized even by the ancients as an attribute of divinity (Cicero, *De legibus*, II, 45). In the Middle Ages there were representations in which, by analogy, the dove appears on the heads of the baptized. In relation to the Baptism, one should consider the interesting miniature of the blessing of the baptismal font in the Bari Book of Benedictions of the 11th century and also the representation in the *Benedictio fontis* (Rome, Bib. Casanatense, Ms. 724, 10th cent.). This iconography was followed, though in a wholly independent form, in the sculptured doves that surmount 17th- and 18th-century baptismal fonts.

In the scene of Pentecost the Gospel text does not speak of the dove but of the tongues of fire that flicker above the heads of the Virgin and the apostles. The two oldest representations of Pentecost, however, also include the dove (ampulla, Monza, Cathedral Treasury, 6th cent.; Rabula Gospels, PL. 229). The fusion of these two images arises probably from the constant juxtaposition of the two manifestations of the Paraclete, interpreted by the Church Fathers as closely integrated symbols (St. Augustine, *Tractatus VI in Joannis Evangelium*, 3, 10; St. Gregory the Great, *Moralia*, I, 2). Later, on the other hand, these two representations frequently became separated again; and sometimes the tongues of fire, instead of burning individually over the head of each apostle, are knotted like seven burning ribbons that emanate from the Hand of God (II, PL. 284) or from a single source (altar at Klosterneuburg, near Vienna). With the conclusion of the medieval cycle, manifestations of the transcendent are sought less in symbols than in the expression of human contact with the transcendent; there are representations of the Pentecost such as those of Titian (Venice, S. Maria della Salute) and El Greco (Madrid, Prado) where the hands of the apostles are ecstatically extended on high, as if the flame that burns over their heads were also burning within them. The dove is at this point inconspicuously located at the top of the canvas or else is wholly lacking.

Another scene frequently, but not invariably, linked with the appearance of the Holy Spirit in the form of a dove is that of the Annunciation. This type is found for the first time, in what remained for some time a unique instance, in the mosaics of the triumphal arch of S. Maria Maggiore (PL. 229). The evangelical text speaks of conception by means of the Holy Ghost (Luke 1:35), but not of the appearance of the Spirit. The polemical intent of the presence of the Paraclete in the Annunciation at S. Maria Maggiore is therefore obvious: it represents the public affirmation of the divine impregnation of the Virgin asserted by the First Council of Nicaea (325), where the Holy Ghost was defined as the active principle of the Incarnation. This iconography was next repeated, as far as is known, in a considerably later period in the mosaic of Cavallini at S. Maria in Trastevere (late 13th cent.; III, PL. 110); and it was widely adopted in Flemish painting of the 15th century (Hubert and Jan van Eyck, Ghent Altarpiece, V, PLS. 215, 216; the Eyckian Friedsam *Annunciation*, New York, Met. Mus.; as well as later examples). In the Renaissance, the Holy Spirit is sometimes complemented by the other two persons of the Trinity, with the Christ Child seen on a ray of light directed to the Virgin.

From the early history of the Church onward, there were attempts to reconcile the Gospel texts that speak of the Holy Spirit with passages from the Old Testament in which evident reference is made to the Spirit. Genesis offers the first such reference, in the statement that "the spirit of God moved over the waters." In the previously mentioned mosaics in the atrium cupola of St. Mark's, Venice, the dove does in fact spread its wings above the waters, repeating in all probability — as happens with other scenes — the iconographic motif of the Cotton Genesis. Another passage from Genesis that the Church Fathers deem a prediction of the Paraclete is that of the dove of Noah. The chief emphasis on these parallels comes in the monumental illustrated Bibles of the Romanesque and Gothic periods, such as the *Biblia pauperum* (New York, Pub. Lib., Spencer Coll., copy ca. 1420) and the *Bible moralisée* (II, PL. 288). With the Renaissance, the scene of Noah and the dove gave way to others that offered more freedom to the artist's imagination; in fact, it is omitted entirely in Raphael's Loggia frescoes.

In the list of themes from the Old Testament in which the Paraclete may appear, mention must be made of the Tree of Jesse (Isaiah, 11:1–2; see CHRISTIANITY). However, this motif is not found until the beginning of the Romanesque period and did not survive beyond the Gothic. In most cases, the great tree rising from the bosom of Abraham is topped not only by the Virgin and Christ but also by the white dove (Dijon, Bib. Municipale, Ms. 129, fol. 4v, Ms. 641, fol. 40v; abbey cloister, S. Domingo de Silos, near Burgos). On other occasions, the figure of Christ is surrounded by seven doves (the seven gifts of the Holy Spirit; London, Lambeth Palace, Ms. 3, fol. 198; west window, Chartres Cathedral); sometimes only the seven doves are depicted on the seven branches of the tree

(Prague, Univ. Lib., Ms. XIV. A. 13, fol. 4v; London, Br. Mus., Ms. Harl. 2889, fol. 42).

One of the most widespread representations is that of the dove of the Holy Ghost as a source of divine inspiration. This concept derives from the New Testament description of Pentecost (Acts 2:4). A marble slab found among the ruins of the Mausoleum of St. Helen, Rome (first half of 5th cent.; Cabrol-Leclercq, III, I, col. 69), of which only a drawing remains today, showed an episcopal chair with a dove placed atop the back. The same arrangement is found in a panel of the bronze doors of Hagia Sophia in Istanbul (6th cent.). The dove as inspiration is often seen in connection with the figure of David (Paris, Bib. Nat., Gr. 139, fol. 7, 10th cent.). With the spread of the belief in the appearance of the dove to the holy bishops (anonymous biography of St. Ephraem Syrus, in Migne, PL, LXXIII, 323), there was developed in the Carolingian period a distinctive composition with the dove *in auris suggerentem* resting on the shoulders of the person represented: an iconography linked especially to Gregory the Great (PL. 229), on the basis of the account of Paul the Deacon (*Vita S. Gregorii Magni*, 28), which was repeated in similar form but less frequently throughout the baroque period (anonymous canvas, chapel altar in S. Gregorio Magno on the Caelian, Rome). For these same reasons the dove became the favorite decoration of the canopies of pulpits during the baroque period. Bernini represented it among the cherubs in St. Peter's, Rome.

*The Trinity.* In comparison with other motifs, representations of the Trinity are rare in the early centuries of the Church, perhaps because of the difficulty of the theme. The first triune image of which we have information adorned the apse of St. John Lateran (4th cent.). The three persons were expressed as the metaphorical Hand of God (replaced today by a cherub, owing to the restoration by Torriti, late 13th cent.), a medallion with the bust of Christ, and the dove of the Holy Spirit in a vertical arrangement. The next representation that is known is the Trinity of the apse of S. Felice at Nola (ca. 400; destroyed), inserted in a vast allegorical complex dictated by St. Paulinus of Nola and recounted in a letter written to Sulpicius Severus. For the medallion with Christ found in St. John Lateran, Paulinus substituted the lamb and thereby excluded any human figure, perhaps as a result of influences derived from the East, where iconoclastic tendencies were latent even before the iconoclastic struggle (PL. 230).

The same trinitarian arrangement, but incorporated in a historical context related in the New Testament, is found in the previously mentioned Pentecost scene on the ampulla from Monza and the Baptism on the medallion in the Dumbarton Oaks Collection, which in all probability repeat representations from the monumental apses in Palestine. Abolished throughout the Christian Orient during the iconoclastic period, this scheme is maintained in the West in the ivories and miniatures of the Carolingian and Ottonian periods and appears again in the monumental sculpture of Le Puy (Notre-Dame, 12th cent.) and in the second golden age of Byzantine art (Baptism in the Catholicon at Daphne, Greece, late 11th cent.). It is echoed, though sporadically, in the Renaissance (Raphael, *Disputa*, PL. 230) in a more relaxed and naturalistic form, with the Hand of God replaced by the figure of the Father.

Much more interesting is the representation found in the baptistery at Albenga, Italy (5th or 6th cent.), where three concentric circles of descending tones of blue indicate the three persons of the Deity, proceeding as "lumen de lumine," with an insertion of the monogram of Christ showing the alpha and omega as in the destroyed mosaics of the Church of the Dormition, Nicaea (perhaps 6th cent.). In the latter version the circles were accompanied by the Hetimasia at the center, in which the throne indicated the Eternal, the Cross the Christ, and the dove the Holy Spirit, from which there radiated seven rays symbolizing the seven gifts mentioned by the prophet. In the apse as well, arranged overhead and surrounding the hand of the Eternal, were three blue semicircles above the Cross, which was later replaced by the figure of the Virgin. More rays emanated from the hand, naturally in symbolic multiples

of three. In addition, in the mosaic of the narthex (restored) there appeared a representation, analogous to that of the Albenga baptistery, which in the part that was presumably original again shows three zones of different colors as a background for two crosses with equal arms. This trinitarian scheme, derived perhaps from Constantinople, is continued in the frescoes of Macedonian Greek Orthodox churches in Yugoslavia (Ohrid, St. Clement, 13th cent.; Dečani, 14th cent.) in connection with narrative contexts.

In the West, a similar means of representing the Trinity did not arise until the 12th century in the *Liber figurarum* of Joachim of Floris (ed. L. Tondelli, Turin, 1936, pl. XIII). The same image concludes the final canto of the *Divine Comedy*, Dante's vision of Paradise. The baroque period reverted to the convention of the circle of light around the name of Christ or in representations of the Holy Spirit, but it became an indication of eternity rather than of the Trinity, sometimes with a much more complicated symbolism (J. G. Bergmüller, Trinity in the chapel of the Castle of Haimhausen, 1748).

It is possible that from the earliest times of Christianity the Trinity was represented by geometric symbols, a type of divine representation already in use among the most ancient civilizations (on the other hand, the figures so interpreted by Garrucci are doubtful). This hypothesis appears justified by passages from the Church Fathers, who early in the Christian Era condemned representations of this sort as characteristic of certain heretics (e.g., the Manicheans: St. Augustine, *Contra Faustum Manichaeum*, 397–98), and against these there is a specific anathema in the *De Trinitate* (18, 15) of St. Eusebius of Vercelli. But when the Feast of the Holy Trinity was included among the principal feasts of the Church by Pope John XXII in 1344, there arose a symbolism — though not too frequent a one — linked to the circle and the triangle, which appeared for the first time in the Gospel Book of Uta from Regensburg (Munich, Bayerische Staatsbib., Clm. 13601, 11th cent.), though prototypes may have existed in Anglo-Irish art (Elbeen, 1955). Johannes Beleth (d. 1202), in his *Rationale divinorum officiorum*, gives a clear explanation of this: "Per delta enim circulariter clausum divina figuratur natura, quae nec principium nec finem habuit" ("Divine nature is represented by a triangle enclosed in a circle, which has neither beginning nor end"). But these abstract themes tend always to be clothed in naturalistic elements: in the circle there are three men bound by their hair, as in a keystone from Nagold (Stuttgart, Städt. Kunstsamml., 14th cent.), three hares linked by their ears, etc. The number three, conveyed by repetition of three identical objects, also becomes an allusion to the Trinity at a much later date: the shamrock of St. Patrick, the three windows of the tower of St. Barbara, the three cherries of St. Clare, etc. Most of these representations, found for the most part in illuminated manuscripts and sometimes in sculpture, are perhaps the result of overly subtle speculation along the lines followed by the previously cited Joachim of Floris; it is difficult to find any consequences of this overrefinement in representational art. The triangle was adopted in the Renaissance, however — and in this connection it is interesting to note a painting of the 16th-century Lombard school (Lisbon, Mus. Nacional de Arte Antiga) in which Christ carries a triangle in His left hand — and became especially dominant in the baroque period. For the most part it is not an isolated symbol but is transformed into the characteristic halo of the Father, as it appears in the Bible of Borso d'Este (Modena, Bib. Estense, Lat. 422–23, vol. II, fol. 6), where its angles are marked by the initials of the three persons of the Deity. At other times, even in the Protestant world, the triangle contains the eye of the Deity (Pontormo, *Supper at Emmaus*, PL. 230; J. F. Fromiller, ceiling of church at Ossiach, Austria, 1746–53) or the monogram of Christ.

In the Middle Ages the effort to embody trinitary symbolism in architecture is seen in the cloister of Saint-Riquier, "triangulum factum" ("made in the form of a triangle") by the monk Angilbert. Later evidence of it is found in the plan of Longford Castle, England, (1580); and in the baroque period in the chapel of Stadl Paura, near Lambach, and in

the commemorative columns of the Trinity found in southern Germany (Braunfels, 1954).

A representation of the Trinity frequently used in the early centuries of the Christian Era, with echoes ultimately in the Byzantine world of the middle period and in the areas influenced by it, is that of the Hetimasia (PL. 230). The iconography of the throne as a symbol of divinity is of very ancient date, and its origin as a symbol is to be sought in India. In Christian iconography it stems from Biblical texts, especially the visions of Ezekiel, Daniel, Isaiah, and John, which describe the manifestation of the Eternal preceded by the appearance of His throne. But the Hetimasia is not always explicitly understood as a trinitarian representation: sometimes it indicates divinity more generally (Grottaferrata, S. Maria, 12th cent.); at other times it carries the symbols of the Son (Rome, S. Maria Maggiore; Ravenna, Baptisteries of the Arians and of the Orthodox); and elsewhere it is explicitly linked to the apocalyptic vision (Rome, SS. Cosma e Damiano, 526–30).

An early example of the Hetimasia in a trinitarian sense is provided by the destroyed mosaic of the chapel of St. Priscus in Santa Maria Vetere near Capua (6th cent.); and in the 6th century the motif was found, as mentioned above, in the Church of the Dormition, Nicaea. The same iconography returns in the 12th century at the center of the golden altarpiece in St. Mark's and in one of the small cupolas in the atrium of the same basilica in the scene of the Pentecost (PL. 230). In relation to the Pentecost, it had already been used in the Homilies of St. Gregory Nazianzen (Paris, Bib. Nat., Gr. 510, 880–86) and in the rock churches of Cappadocia.

The above-mentioned abstract representations, arising from theological speculation for the most part — except, of course, for the narrative contexts — remained in a sense limited to a circle of the learned. Thus, from the early centuries an effort was made to return to anthropomorphic trinitarian representations that were more easily comprehended, as is seen from Lateran Sarcophagus 104. But even here the intervention of the Church Fathers was to be decisive (it is enough to read the violent anathema of St. Eusebius in his *De Trinitate*, VI, 15, 7), since an iconography of this sort was not found again for a long time in the history of the Church. Not until about the 11th century was an increasing predilection toward representational forms observed. These began to recur in illuminated manuscripts, which have always been in the vanguard of sacred iconography. A notable example of the first such illustrations is an English work of the 10th century (Paris, Bib. Nat., Lat. 943), in which three almost identical figures are explicitly distinguished as the Father, the Son, and the Holy Spirit. In the previously mentioned *Hortus deliciarum* of Herrad von Landsberg (12th cent.), this form merges with another derived from Carolingian illustrations of Psalm 110, and in the resulting scheme three perfectly equal figures are seated on a throne. The anthropomorphic Trinity, seated or standing, often represents the divine council that presides over the driving of the angels into hell (Bible of Guyart Desmoulins, Brussels, Bib. Royale, cod. 9001, fol. 19, 1410), the mandate to the archangel Gabriel (Shaftesbury Psalter, Br. Mus. Lansd. 383, fol. 12v), the Coronation of the Virgin, or the Creation. In a magnificent Brussels tapestry of about 1510 (Belgium, private coll.), there are three persons with regal mantles and crowns, who bring forth the universe from nothingness, each bearing a scepter in his left hand. The Vasai bas-relief at Baden (PL. 231; executed for the Cathedral of St. Stephen in Vienna and transported to Baden in 1750 in consequence of the breve of Benedict XIV) is also of interest: in it the traditional Maiestas Domini, surrounded by the symbols of the Evangelists, appears as an anthropomorphic triad; the only distinctive symbols are the tiara on the head of the Father, the Son's naked side with its wound, and the flowering wand with the lily in the hand of the Spirit that indicates the Incarnation (PL. 231). This northern iconography, which was perhaps spread by means of prints, is encountered in Italian art as well, though only sporadically and chiefly in Tuscan art of the 15th century. Its very brief duration in this area is due to the manifest opposition of the Church.

In the Byzantine world the Trinity appears only sporadically and derives from the scene of Abraham's meeting with the three angels. The earliest representations are in the basilica at Mamre in Palestine and in S. Maria Maggiore, Rome. The same scene is repeated at S. Vitale, Ravenna (PL. 231), and at Monreale (late 12th cent.). The interpretation of such mosaics as a trinitarian representation is based on the well-known passage from St. Ambrose (*De Spiritu Sancto libri tres*, Migne, PL, XVI, 475): "Tres vidit et unum adoravit" ("He sees three and adores one"). Furthermore, this theme disappears in the West with the coming of the Renaissance; or it assumes a purely narrative character, as in a predella by Antonello da Messina (I, PL. 313) or as in Giovan Battista Tiepolo's fresco in the archiepiscopal palace at Udine, Italy, painted in the 1720s.

Among the anthropomorphic representations of the Trinity, mention should be made of one that is common today in the Alpine regions. This version surely originates in very ancient traditions which not only represented deity with three heads but represented the spirit of evil similarly. (In fact, Dante gives this form to Lucifer.) Although it was disavowed by the Church Fathers as early as the 4th century (St. Eusebius, op. cit.) and although those who displayed the Trinity in such a form were considered heretics (St. Filaster, Bishop of Brescia, *Liber de haeresibus*, CXIII, 1, late 4th cent.), it is prevalent from the Romanesque period through the 16th century. In fact, in Psalter illustrations, the two figures often tend to become fused at Psalm 110, and it is not uncommon for two busts to be developed from a single body or for three heads to be attached to a single bust. From these tripartite figures, there is a fairly rapid progression to a representation of the three heads alone, usually joined so that the eyes of the central head belong to those on the two sides. In Tuscany Luca di Tommè adopted this iconography, which — though declared heretical by Bishop Antoninus (*Opera*, II, chap. IV) — was also used by the Dominican, Fra Bartolommeo (*Trinity*, Florence, Palazzo Vecchio, 1510) and by Andrea del Sarto, Bronzino, and other Tuscans (PL. 231), perhaps under the influence of German prints, which were widely diffused. Similar representations, called *monstra* by Bellarmine, were condemned by Urban VIII in 1628 and publicly burned. The condemnation was confirmed by Benedict XIV (1740–58).

The representation derived from Psalm 110 is, on the other hand, the prevalent one in the period following the Counter Reformation. The theme, known as the Celestial Glory, is dominant in church ceilings and in sculptured form at the peaks of altar decorations. The form is extremely naturalistic, and the Christ frequently bears the Cross. Angels and saints surround Him in the midst of clouds (PL. 232). In the Coronation of the Virgin, another widely diffused theme, one finds the same iconography.

One of the most typical representations of the Trinity, which also had wide diffusion from the Romanesque period through the 16th century, is the so-called "Gnadenstuhl" (Throne of Mercy). The oldest datable representation of this sort is seen in a portable altar from Hildesheim (London, Vict. and Alb. Mus., before 1132); another early example is a French miniature of the first half of the 12th century, now at Cambrai (PL. 232), in which among the symbols of the four Evangelists there appears God the Father, who is inserted in the traditional mandorla and seems to hold in His lap the Cross with Christ, while the dove extends its wings from the mouth of the Father to that of the Son to indicate the procession, not the generation, from the two persons. This iconography derives from various influences, such as the Christ Child in the bosom of the Father (derived in all probability from the enthroned Madonna) that appears to St. Nicolás of Tudela (PL. 232); the portal and window of the Church of St. Elizabeth (Marburg an der Lahn, Universitätsmus.); and perhaps the depiction of the Last Judgment from the Ottonian period, where Christ holds the Cross in His lap. In this connection one should also note that the Throne of Mercy theme became widespread in a period when the veneration of the Cross was assuming a principal role in the liturgy of the Church. From beginnings in illuminated manuscripts the Throne of Mercy later spread to monumental

painting, and not only to that of the north; it was adopted in particular by Tuscan painters, starting with Luca di Tommè and his studio (*Crucifixion and Trinity*, New York, private coll., ca. 1360), who, in accordance with formal tastes of a somewhat hybrid quality, replaced the figure of the Father with three figures of equal importance. One of the most handsome representations in this area is the Trinity by Masaccio in S. Maria Novella, Florence (ca. 1427). In a later period the figure of the Father was reduced to a bust that appears at the top of the Cross. Baroque artists subsequently gave a more human and dramatic character to the scene: the Cross is eliminated and the dead body of the Son is alone in the arms of the Father (Jan Polak, Blutenberg, 1491). The theme was also translated into sculpture and is found among the wooden devotional images of the Alpine valleys (see certain late Gothic examples, Bressanone, Mus. Diocesano). Along with the Gloria Domini, this representation remained one of the most common ones of the baroque and rococo periods and is usually referred to as the Pietà of Our Lord.

The last of the representations of the Trinity to evolve was that in which the figure of the Virgin is added. This appeared for the first time in the destroyed mosaics from the apse of the Church of the Dormition, Nicaea; in these the Virgin held the Son in her arms (a form substituted for the presence of the Cross previously), and the Hand of God and the dove of the Holy Ghost appeared at her head. Centuries later, this iconography was repeated in the so-called "Carnesecchi Tabernacle," by Domenico Veneziano (PL. 239), in which the Hand of God is replaced by a bust of the Eternal, who holds His hands downward in a protective gesture toward the Virgin and the Son. In the frequently cited Utrecht Psalter the Virgin, with the Son in her arms, participates in the Celestial Glory and stands before the throne of the Deity. In all probability, the latter representation led to the unique composition of the Canterbury Psalter (Br. Mus., Harl. 603); here the Virgin, with the dove weighing heavily upon her crowned head, holds the Son on her left arm as she stands upright next to the Father and the Son, who assume poses approximating those of the two analogous figures in the Utrecht Psalter. A chained demon, Judas, and Arius, trampled by the central figure, are banished to hell, symbolized by a monster with gaping jaws. In all probability the artist has here fused the themes of the Redemption and the Trinity. Jean Fouquet, in the Adoration of the Trinity in the Book of Hours of Etienne Chevalier (Chantilly, Mus. Condé, ca. 1450), places the Virgin, over whom the dove flutters, on a throne at the right of one that holds an anthropomorphic Trinity. The Virgin appears again in Titian's *Triumph of the Trinity* (PL. 232); in a miniature illustrating St. Augustine's *City of God* (Paris, Bib. Nat., Fr. 18–19, ca. 1473); and in the Glory fresco by Matthäus Günther (Rott am Inn, Germany, Benedictine abbey church, 1761–63).

Fernanda DE' MAFFEI

BIBLIOG. *Art and the divine*: A. K. Coomaraswamy, Elements of Buddhist Iconography, Cambridge, Mass., 1935; G. Tucci, Indo-Tibetica, III, I templi del Tibet occidentale e il loro simbolismo artistico, Rome, 1938; E. D. van Buren, Symbols of the Gods in Mesopotamian Art, Analecta Orientalia, XXIII, 1945; A. K. Coomaraswamy, Figures of Speech or Figures of Thought, London, 1946; M. Eliade, in Le symbolisme cosmique des monuments religieux, Rome, 1951, pp. 58–82; C. Hentze, Bronzegerät, Kultbauten, Religion in ältesten China der Schang-Zeit, Antwerp, 1951; S. Cammann, Types of Symbols in Chinese Art, in Studies in Chinese Thought, Chicago, 1953, pp. 195–231; F. Boas, Primitive Art, 2d ed., New York, 1955; R. Pettazzoni, L'onniscienza di Dio, Turin, 1955. *Prehistory and protohistory*: A. Mosso, Idoli femminili e figure di animali dell'età neolitica, Mem. della R. Acc. delle Scienze di Torino, ser. II, LVIII, 1908, pp. 375–95; M. Hoernes and O. Menghin, Urgeschichte der bildenden Kunst in Europa, 2d ed., Vienna, 1925; O. Almgren, Nordische Felsenzeichnungen als religiöse Urkunden, Frankfurt on the Main, 1934; O. Menghin, Die ältere Steinzeit (Eiszeit): Europäische Kunst des Miolithikums, HA, I, 1939, pp. 404–23; G. Kaschnitz-Weinberg, Italien mit Sardinien, Sizilien und Malta, HA, II, 1950, p. 311 ff.; O. Menghin, Europa und einige angrenzende Gebiete ausser dem ägäischen und italischen Kreis, HA, II, 1950, p. 5 ff.; G. Kossack, Studien zum Symbolgut der Urnenfeldern und Hallstattzeit Mitteleuropas, Römisch-germanische Forsch., XX, Berlin, 1954; P. Graziosi, Palaeolithic Art, New York, 1960. *The ancient Near East*: C. Contenau, La déesse nue babylonienne, Paris, 1914; C. Contenau, Manuel d'archéologie orientale, Paris, 1927, I, pp. 377–86; L. Legrain, Les dieux de Sumer, Rev. d'assyriologie, XXXII, 1935, pp. 117–24; W. F. Al-

bright, Astarte Plaques and Figurines from Tell Beit Mirsim, Mél. Dussaud, I, 1939, pp. 107–20; L. H. Vincent, La représentation divine orientale archaïque, Mél. Dussaud, I, 1939, pp. 373–90; C. G. von Brandenstein, Hethitische Götter nach Bildbeschreibungen in Keilschrifttexten, Leipzig, 1943; E. D. van Buren, Symbols of the Gods in Mesopotamian Art, Rome, 1945; H. Frankfort, Ancient Egyptian Religion, New York, 1948; H. Bonnet, Reallexikon der ägyptischen Religionsgeschichte, Berlin, 1952 (see entries for the various deities); P. Amiet, Le taureau androcéphale, Sumer, IX, 1953, pp. 233–40; P. Amiet, Problèmes d'iconographie mésopotamienne (I), Rev. d'assyriologie, XLVII, 1953, pp. 181–85, (II), XLVIII, 1954, pp. 32–36; M. T. Barrelet, Taureaux et symbolique solaire, Rev. d'assyriologie, XLVIII, 1954, pp. 16–27; M. T. Barrelet, Les déesses armées et ailées, Syria, XXXII, 1955, pp. 222–60; A. Spycket, La coiffure féminine en Mésopotamie des origines à la I\ère dynastie de Babylone, Rev. d'assyriologie, XLIX, 1955, pp. 118–22, 128; E. D. van Buren, Representations of Fertility Divinities in Glyptic Art, Orientalia, XXIV, 1955, pp. 345–76; P. Amiet, Le symbolisme cosmique du répertoire animalier en Mésopotamie, Rev. d'assyriologie, L, 1956, pp. 113–26. *Iran*: M. A. Stein, Zoroastrian Deities on Indo-Scythian Coins, London, [1887]; F. Sarre and E. Herzfeld, Iranische Felsreliefs, Berlin, 1910; E. Herzfeld, Am Tor von Asien, Berlin, 1920; E. Herzfeld, Der Thron des Khosro, JhbPreussKSamml, XLI, 1920; M. Rostovtzeff, Iranians and Greeks in South Russia, Oxford, 1922; F. Sarre, Die Kunst des alten Persien, Berlin, 1922; M. Rostovtzeff, L'art grécoiranien, RAA, VII, 1931–32, p. 202 ff.; M. Rostovtzeff, The Great Hero of Middle Asia, Artibus Asiae, II, 1932, p. 99 ff.; E. Herzfeld, Archaeological History of Iran, London, 1935; M. Rostovtzeff, Dura and the Problem of Parthian Art, Yale Classical Studies, V, 1935, pp. 157–304; A. Godard, Les monuments du feu, Athâr-é-Irân, III, 1938, pp. 7–80; A. U. Pope and P. Ackerman, eds., Survey of Persian Art from Prehistoric Times to the Present, 6 vols., London, New York, 1938–39; K. Erdmann, Das iranische Feuerheiligtum, Leipzig, 1941; E. Herzfeld, Iran in the Ancient East, London, New York, 1941; C. Hopkins, The Parthian Temple, Berytus, VII, 1942, pp. 1–18; G. Dumézil, Naissance d'archange, Paris, 1945; R. Ghirshman, Begram, Cairo, 1946; L. I. Ringbom, Graltempel und Paradies, Stockholm, 1951; L. I. Ringbom, Paradisus terrestris, Helsinki, 1958. *Greco-Roman civilization*: A. Baudrillart, Les divinités de la victoire en Grèce et en Italie, Paris, 1894; W. H. D. Rouse, Greek Votive Offerings: An Essay in the History of Greek Religion, Cambridge, Eng., 1902; G. Wissowa, Religion und Kultus der Römer, Munich 1902; H. Graillot, Le culte de Cybèle mère des dieux à Rome et dans l'empire romaine, Paris, 1912; E. Küster, Die Schlange in der griechischen Kunst und Religion, Religionsgeschichtliche Versuche und Vorarbeiten, XIII, 2, 1913; D. Le Lasseur, Les déesses armées dans l'art classique grec et leurs origines orientales, Paris, 1919; A. Meillet, Linguistique historique et linguistique générale, Paris, 1921; M. P. Nilsson, The Minoan-Mycenaean Religion, Lund, 1927; R. M. Dawkins, The Sanctuary of Artemis Orthia at Sparta, London, 1929; C. Picard, Les origines du polythéisme hellénique, I, L'art créto-mycénien, Paris, 1930, II, L'ère homérique, Paris, 1932; W. Deonna, Dédale, Paris, 1930–31; U. von Wilamowitz-Möllendorff, Der Glaube der Hellenen, Berlin, 1931; L. Gernet and A. Boulanger, Le génie grec dans la religion, Paris, 1932; P. M. Schuhl, Essai sur la formation de la pensée greque, Paris, 1934; F. Chapouthier, Les Dioscures au service d'une déesse, Paris, 1935; F. Altheim, Roman Religion, London, 1938; E. Ehnmark, Anthropomorphism and Miracle (Uppsala Universitetsårsskrift, XII), Uppsala, 1939; M. P. Nilsson, Geschichte der griechischen Religion, Munich, 1941; P. Grimal, Le dieu Janus et les origines de Rome, Association Guillaume Budé, Lettres d'Humanités, IV, 1945, pp. 15–121; H. P. L'Orange, Apotheosis in Ancient Portraiture, Oslo, 1947; C. Picard, Les religions préhelléniques (Crète et Mycénes), Paris, 1948; W. K. C. Guthrie, The Greeks and Their Gods, London, 1950; H. Jeanmaire, Dionysos, Paris, 1951; P. Chantraine, Le divin et les dieux chez Homère, in Entretiens sur l'antiquité classique, Geneva, 1952, I, pp. 47–94; C. J. Herington, Athena Parthenos and Athena Polias, Manchester, 1955; J. Bayet, La religion romaine, Paris, 1957; J. Bérard, La colonisation grecque de l'Italie méridionale et de la Sicile dans l'antiquité, 2d ed., Paris, 1957; N. Himmelmann-Wildschütz, Zur Eigenart des klassischen Götterbildes, Munich, 1959; K. Schefold, Griechische Kunst als religiöses Phänomen, Hamburg, 1959. *India*: R. Pischel and K. F. Geldner, Vedische Studien, Stuttgart, 1889, I, p. 55 ff.; G. Weicker, Der Seelenvogel in der antiken Literatur und Kunst, Leipzig, 1902; A. K. Coomaraswamy, History of Indian and Indonesian Art, New York, 1927; W. Kirfel, Das Purāṇa Pañcalakṣaṇa, Bonn, 1927, p. 39 ff.; H. Meinhard, Beiträge zur Kenntnis des Śivaismus nach den Purāṇa's, BA, XII, 1928, pp. 2–45; A. K. Coomaraswamy, Yakṣa, 2 vols., Washington, 1928–31; J. H. Marshall, Mohenjo-Daro and the Indus Civilization, London, 1931, p. 37 ff.; W. Kirfel, Die dreiköpfige Gottheit, Bonn, 1948; J. Gonda, Aspects of Early Viṣṇuism, Utrecht, 1954. *China*: B. Schindler, Development of the Chinese Conceptions of Supreme Beings, in Hirth Anniversary Volume, London, 1923, pp. 298–366; H. Maspero, Mythologie de la Chine moderne, Mythologie asiatique illustrée, Paris, 1928, pp. 227–362; B. Karlgren, Some Fecundity Symbols in Ancient China, BMFEA, II, 1930, pp. 1–54; E. Erkes, Some Remarks on Karlgren's "Fecundity Symbols in Ancient China," BMFEA, III, 1931, pp. 63–68; W. Fairbank, The Offering Shrines of Wu Liang Tz'u, HJAS, VI, 1941, pp. 1–36; B. Karlgren, Legends and Cults in Ancient China, BMFEA, XVIII, 1948, pp. 199–365; H. C. Rudolph and Wen Yu, Han Tomb Art of West China, Berkeley, Calif., 1951; A. Bulling, The Meaning of China's Most Ancient Art: An Interpretation of Pottery Patterns from Kansu (Ma Ch'ang and Pan-shan) and Their Development in the Shang, Chou and Han Periods, Leiden, 1952; K. Finsterbusch, Das Verhältnis des Schan-hai-djing zur bildenden Kunst, Berlin, 1952; F. Waterbury, Bird-Deities in China, Ascona, 1952; Ch'u wên-wu chan-lan t'u-lu (Catalogue of the Exhibition of Objects of the Ch'u State), Peking, 1954; A. Salmony, Antler and Tongue: An Essay on Ancient Chinese Symbolism and Its Implications, Ascona, 1954; K'ao-ku hsüeh-pao (Archaeological J.), I, 1956; Mizuno Seiichi, Handai no ega (Pictures of the Han Dynasty), Tokyo, 1957; E. Erkes, Credenze religiose della Cina antica, Rome, 1958.

*Japan*: R. Pettazzoni, La mitologia giapponese, Bologna, 1926; M. Anesaki, History of Japanese Religion, London, 1930; Tokyo National Museum, Pageant of Japanese Art, 6 vols., Tokyo, 1952–54; Y. Kobayashi, Nihon Kōkogaku Kenkyū (Studies in Japanese Archaeology), Tokyo, 1957. *Southeast Asia*: See the bibliogs. of ASIA, SOUTH; BUDDHISM; BURMESE ART; HINDUISM; INDONESIAN CULTURES; SIAMESE ART. *"Primitive" cultures*: E. Best, Maori Religion and Mythology, Wellington Dominion Mus. B., X, 1924, p. 88 ff.; W. Schmidt, Der Ursprung der Gottesidee, 12 vols., Münster in Westfalen, 1926–55; H. Baumann, Lunda: Bei Bauern und Jägern in Inner-Angola, Berlin, 1935, p. 158; C. von Fürer-Haimendorf, Die Hochgottgestalten der Ao und Konyak-Naga von Assam, Mitteilungsblatt der Gesellschaft der Völkerkunde, VIII, 1938, pp. 25–30; W. Koppers, Bhagwān, the Supreme Deity of the Bhils, Anthropos, XXXV–XXXVI, 1940–41, pp. 264–325; J. H. Rowe, Inca Culture at the Time of the Spanish Conquest, HSAI, II, 1946, pp. 183–330; A. Métraux, Tribes of Eastern Bolivia and the Madeira Headwaters, HSAI, III, 1948, pp. 381–454; E. L. R. Meyerowitz, The Sacred State of the Akan, London, 1949; M. Leach, ed., Standard Dictionary of Folklore, Mythology, and Legend, 2 vols., New York, 1949–50; D. Forde and G. I. Jones, The Ibo and Ibibio-speaking Peoples of Southeastern Nigeria, Ethn. Survey of Africa, Western Africa, III, 1950; H. Kühn, Das Problem des Urmonotheismus, Ak. der Wissenschaft und der Literatur, Mainz, Abh. der geistes und sozialwissenschaftlichen Klasse, XXII, 1950, pp. 1637–72; E. W. Smith, African Ideas of God, London, 1950; H. Junker, Christus und die Religionen der Erde, Vienna, 1951, II, p. 584; G. C. Vaillant, The Aztecs of Mexico, Harmondsworth, 1951; W. Koppers, Primitive Man and His World Picture, London, 1952; L. Adam, Primitive Art, Harmondsworth, 1954; M. Eliade, Die Religion und das Heilige, Salzburg, 1954, p. 66; H. Tischner, Kunst der Südsee, Hamburg, n.d. (Am. ed., New York, 1954); J. Maringer, Vorgeschichtliche Religion, Einsiedeln, Cologne, 1956; J. Maringer and F. König, Religionswissenschaftliches Wörterbuch, Vienna, 1956, p. 669; F. Anders, Das Pantheon der Maya, Diss., Vienna, 1957; R. E. Bradbury, The Benin Kingdom and the Edo-speaking Peoples of South-western Nigeria, Ethn. Survey of Africa, Western Africa, XII, 1957; F. Herrmann, Die afrikanische Negerplastik als Forschungsgegenstand, in Beiträge zur afrikanischen Kunst (Veröffentlichungen des Museums für Völkerkunde zu Leipzig, 9), Berlin, 1958, pp. 2–29; W. Schmalenbach, Grundsätzliches zur primitiven Kunst, Acta Tropica, XV, 4, 1958; J. Haeckel, Hochgott und Götter im alten Mexico: Kritische Bemerkungen zum Problem des Polytheismus, Salzburg, 1959. *The Christian world. a. General*: A. N. Didron, Iconographie chrétienne: Histoire de Dieu, Paris, 1843; A. L. Richter and F. Schulte, Canones et decreta concilii Tridentini, Leipzig, 1853; G. Garrucci, Storia dell'arte cristiana nei primi otto secoli della Chiesa, Prato, 1872–81; O. Zöckler, Religiöse Sinnbilder, aus vorchristlicher und christlicher Zeit, 1881; H. Detzakn, Christliche Ikonographie, Freiburg im Breisgau, 1896; Cabrol-Leclercq (relevant entries); H. Koch, Die altchristliche Bilderfrage nach den literarischen Quellen, Göttingen, 1917; W. Molsdorf, Führer durch den symbolischen und typologischen Bilderkreis der christlichen Kunst, Leipzig, 1920; Mâle, I–IV; K. Künstle, Iconographie der christlichen Kunst, 2 vols., Freiburg im Breisgau, 1928; W. Ellinger, Die Stellung der alten Christen zu den Bildern, Leipzig, 1930; J. B. Frey, La question des images chez les Juifs à la lumière de récentes découvertes, Biblica, XV, 1934, pp. 265–300; N. J. A. Visser, Die Entwicklung des Christusbildes in Literatur und in der frühchristlichen und frühbyzantinischen Zeit, Bonn, 1934; K. Baus, Der Kranz in Antike und Christentum, Bonn, 1940; P. U. Rapp, Das Mysterienbild, Münster, Schwarzach, 1952; W. Schöne, J. Kollwitz, and H. von Campenhausen, Das Gottesbild in Abendland, Witten, Berlin, 1954; L. Réau, Iconographie de l'art chrétien, 6 vols., Paris, 1955–59. *b. God the Father*: A. Goldschmidt, Die Elfenbeinskulpturen, 4 vols., Berlin, 1914–26; L. Heilmeier, Die Gottheit in der älteren christlichen Kunst, Munich, 1922; H. Gerstinger, Die Wiener Genesis, Vienna, 1931; A. Krücke, Zwei Beiträge zur Ikonographie des frühen Mittelalters, Marburger Jhb., X, 1937, pp. 1–36; C. Schmidt, Die Darstellungen des Sechstagewerkes von ihren Anfängen bis zum Ende des 15 Jahrhunderts, Diss., Rostock, Hildesheim, 1938; H. Schrade, Der verborgene Gott: Gottesbild und Gottesvorstellung in Israel und im alten Orient, Stuttgart, 1949; A. Grabar, La représentation de l'intelligible dans l'art byzantin du moyen âge, Actes VIᵉ Congrès Int. Et. Byz. Paris 1948, II, Paris, 1951; K. Wessel, Das Mosaik aus der Kirche San Michele in Affricisco zu Ravenna, Berlin, 1955; K. H. Bernhardt, Gott und Bild: Ein Beitrag zur Begründung und Deutung des Bilderverbotes im alten Testament, Berlin, 1956; A. Krücke, Der Protestantismus und die bildliche Darstellung Gottes, ZfKw, XIII, 1959, pp. 59–90. *c. Holy Spirit*: W. Stengel, Formalikonographische Detail-Untersuchungen, I, Das Taubensymbol des heiligen Geistes (Zur Kunstgeschichte des Auslandes, 18), Strasbourg, 1904; H. Küches, Der heilige Geist in der Kunst, Knechtsteden, 1923; F. Sühling, Die Taube als religiöses Symbol im altchristlichen Altertum, RQ, Supplementheft 24, 1930; A. Watson, The Early Iconography of the Tree of Jesse, Oxford, 1934; C. K. Barrett, The Holy Spirit and the Gospel Tradition, London, 1947. *d. Trinity*: P. Gautier, Le dogme de la Trinité, Paris, 1909; J. B. MacHay, Visual Representations of the Trinity, Columbia Univ., diss., New York, 1917; J. Lebreton, Histoire du dogme de la Trinité des origines à St. Augustin, 2 vols., Paris, 1919–28; M. Alpatov, La "Trinité" dans l'art byzantin et l'icone de Roublew, Echo d'Orient, XXVI, 146, 1927, pp. 150–86; A. Hackel, Die Trinität in der Kunst, Berlin, 1931; A. Stoltz, Theologisches zu Dreifaltigkeitsbildern, Benediktin Monatsschrift, XV, 1933, pp. 322–40; A. Heimann, L'iconographie de la Trinité: Une formule byzantine et son développement en occident, Art chrétien, I, 1934, pp. 37–58; T. Pesendorfer, Die heiligste Dreifaltigkeit, Christliches Kunstbull., LXXVI, 1935, pp. 3–9; A. Michel, Trinité, in Dictionnaire de théologie catholique, XV, 1936, col. 17 ff., pp. 53–67; G. Stuhlfauth, Das Dreieck: Die Geschichte eines religiösen Symbols, Stuttgart, 1937; RDK, IV, cols. 403–57 and 502–11 with bibliog.; A. Heimann, Trinitas creator mundi, Warburg, II, 1938–39, pp. 42–52; R. Pettazzoni, The Pagan Origin of the Three-headed Representation of the Christian Trinity, Warburg, IX, 1946, pp. 135–51; E. H. Kantorowicz, The Quinity of Winchester, AB, XXIX, 1947, pp. 73–85; W. Kirfel, Die dreiköpfige Gottheit, Bonn, 1948; W. Braunfels, Die heilige Dreifaltigkeit, Düsseldorf, 1954; H. Elbern, Die Dreifaltigkeitsminiatur im Book of Durrow, Wallraf-Richartz-Jhb., XVII, 1955, pp. 1–53; H. Gerstinger, Über Herkunft und Entwicklung der anthropomorphen byzantinisch-slawischen Trinitäts-Darstellungen des sogenannten Synthronoi- und Paternitas-(otéchestow) Typus, in Festschrift W. Sas-Zaloziecky, Graz, 1956, pp. 79–84.

Illustrations: PLS. 215–232.

**DOLLS.** See GAMES AND TOYS.

**DOMENICHINO.** Italian painter of the Bolognese school (b. Bologna, Oct., 1581; d. Naples, Apr. 6, 1641), whose real name was Domenico Zampieri. He was originally placed by his father in the studio of Calvaert, but he soon entered the academy of the Carraccis, where he is recorded to have won a prize for drawing. By 1602 he was in Rome, where he joined other Bolognese painters at work in the Palazzo Farnese; three of the frescoes there are traditionally ascribed to him. Monsignor G. B. Agucchi, littérateur and theorist in Roman artistic circles, was patronizing him at least by 1604; *St. Peter in Prison* (Rome, Church of S. Pietro in Vincoli) is of that year. Agucchi remained his devoted patron and friend. It was apparently through him that Domenichino obtained (ca. 1607) the important commission for frescoes at the Villa Aldobrandini in Frascati. These frescoes depict ten scenes from the legend of Apollo, of which eight survive (formerly in the Lanckoronski Coll., Vienna). Domenichino was assisted in this work by his friend Viola and by a pupil, Fortuna; the frescoes show evidence of more than one hand. Following their completion, Annibale Carracci admitted the painter into the Galleria Farnese scheme (e.g., *Woman with a Unicorn*, Rome, Gall. Farnese; III, PL. 392). At Annibale's instigation a commission for frescoes of the lives of SS. Nilus and Gregory (completed in 1610) in the Chapel of St. Nilus (at Grottaferrata, near Rome) was given to Domenichino by Cardinal Odoardo Farnese. The famous *Last Communion of St. Jerome* (Mus. Vat.) is dated 1614, and in these years the artist produced both altarpieces and easel pictures. In 1614 Domenichino was commissioned to paint scenes from the life of St. Cecilia in the Church of S. Luigi de' Francesi, Rome. In December, 1617, his *Assumption of the Virgin* on the ceiling of the Church of S. Maria in Trastevere was unveiled. Soon thereafter he probably left Rome for Bologna.

Domenichino's movements and activities during the next four years are uncertain, but, as well as oil paintings, he seems in this period to have executed frescoes at Fano (ruined *Life of the Virgin* series in the Cathedral). On Apr. 1, 1621, he was appointed papal architect by the newly elected Bolognese pope, Gregory XV; a portrait of the Pope and his nephew the cardinal by Domenichino is at Béziers, France. Domenichino's return to Rome was followed by the important commission for frescoes in the tribune of the Church of S. Andrea della Valle (begun in Oct., 1624; finished in Nov., 1628). In June, 1631, he left Rome for Naples to work on frescoes for the Chapel of St. Januarius (S. Gennaro) in the Cathedral; and he was soon commissioned further to paint six altarpieces (five extant) for the same chapel. The favorable reception of his work and the jealousy of Neapolitan painters resulted in his withdrawal to Frascati and then to Rome in 1634. The following summer he returned to continue work in the Chapel of St. Januarius, and at his death one altarpiece remained unfinished. Among his contemporaries, Domenichino's most famous picture was probably *The Hunt of Diana* (Villa Borghese), painted for Cardinal Borghese. Domenichino painted a few portraits and a number of landscapes (some of which were to win high praise from Constable), as well as religious pictures and frescoes. The vast bulk of his drawings belonged to Carlo Maratti; many are now at Windsor Castle. Although the influence of the Carraccis on Domenichino's work was of para-

mount importance, he also felt the direct influences of Raphael and Titian.

Despite his fame, Domenichino seems to have been a lonely figure often at bitter odds with fellow artists. Although his great reputation became somewhat obscured after the 18th century, it has been considerably revived in recent years. He is regarded by many as the most important link in the transmission to the 17th century of Annibale Carracci's classicistic baroque style. See also II, PL. 194.

BIBLIOG. G. Baglione, Le vite de' pittori, scultori, architetti, dal pontificato di Gregorio XIII, del 1572, fino a' tempi di Papa Urbano VIII nel 1642, ed. Valerio Mariana, Rome, 1672, 1935; G. P. Bellori, Le vite de' pittori, scultori, ed architetti moderni, part I, Rome, 1672, Pisa, 1821, Rome, 1931; C. C. Malvasia, Felsina pittrice: Vite de' pittori bolognesi alla maestà christianissima di Luigi XIII, 2 vols., Bologna, 1678; G. B. Passeri, Vite de' pittori, scultori ed architetti che hanno lavorato in Roma, morti dal 1641 fino al 1673, Rome, 1772, (Ger. ed., Römische Forschungen der Biblioteca Hertziana, Bd. XI, Vienna, 1934); L. Serra, Domenico Zampieri detto il Domenichino, Rome, 1909 (the first monograph); J. Pope-Hennessy, The drawings of Domenichino in the collection of His Majesty the King at Windsor Castle, New York, 1948.

Michael LEVEY

**DOMENICO VENEZIANO.** Italian painter born near the beginning of the 15th century; died in 1461. Vasari tells us that he lived to the age of fifty-six. From a letter of Domenico written in 1438 we know that he considered himself the equal of the best masters of his time in Florence. His name appears in documents as Domenico di Bartolomeo da Venezia and also simply as Domenico da Venezia, as he signed himself in the letter of 1438. Domenico also used the Latinized version of this signature on the so-called "Carnesecchi Tabernacle" (PL. 239) and the Magnoli altarpiece (PL. 233). These signatures provide unassailable evidence of his Venetian birth, and we can disregard a hypothesis of Cavalcaselle (1864) that he merely belonged to a family of Venetian origin. The first document known to us is Domenico's letter of April, 1438, written from Perugia. (Vasari mentions a room painted by Domenico in a house belonging to the Baglioni family in Perugia; this house was later destroyed during work on the fortress of the Rocca Paolina.) The letter was addressed to Piero di Cosimo dei Medici, who was then at Ferrara. Having learned that Cosimo dei Medici was thinking of ordering an altarpiece, Domenico asked Piero's help in obtaining the contract, promising to do wonderful things ("chose meravigliose"). The letter seems to show direct knowledge of Florence (for a contrary opinion see Brandi, 1957), since Domenico mentions "una tavola che va in Santo Spirito," which is Fra Filippo Lippi's Barbadori altarpiece, commissioned in 1437, now in the Louvre.

In September, 1439, Domenico was working in the Cappella Maggiore of the Church of S. Egidio at Florence, aided by Piero della Francesca (q.v.). He worked there also in 1441 (with Bicci di Lorenzo as his assistant) and again in 1443 and 1445. He left part of his fresco, *The Betrothal of the Virgin*, in this chapel unfinished. (A part at the side was painted by Andrea del Castagno between 1451 and 1453, and it was completed by Alesso Baldovinetti in 1461.) The cause for this interruption of the work is unknown; it could have been simply a breaking of the contract. Mario Salmi, however, has suggested a trip to the Po Valley and also to Loreto (near Ancona), where Vasari mentions lost frescoes by Domenico, as well as ones by Piero della Francesca. The Domenico frescoes could, however, have been painted before 1438, since in Vasari's text (*Lives*) they are mentioned as predating the artist's arrival in Florence. In 1448 Domenico painted two *cassoni*, or wedding chests, for the marriage of Marco Parenti and Caterina Strozzi, and received a compensation of 50 gold florins. In 1454 Benedetto Bonfigli was entrusted with painting the chapel of the Palazzo Pubblico in Perugia, on the condition that it be judged by Fra Filippo Lippi, Fra Angelico, or Domenico. In 1455 Domenico rented a house in Florence in the quarter of San Paolo. On July 10, 1457, with Fra Filippo Lippi, he estimated how much Francesco Pesellino, who was then at the point of death, had executed of a *Holy Trinity* at Pistoia.

In all probability Domenico was buried on May 15, 1461, in S. Pier Gattolini in Florence. In any case, Antonio Filarete in the dedication of his treatise (*Trattato d'architettura*), not later than 1464, mentions him as having been dead only a short time. Gaetano Milanesi held that the story told by Vasari (*Lives*) that Domenico was murdered by the envious Andrea del Castagno (who actually died in August, 1457) is an alteration of an incident which really occurred, the murder in 1443 of Domenico di Matteo, a Florentine painter. Vasari's portrait of a romantic Domenico Veneziano with a kindly disposition, addicted to nocturnal serenades, remains hypothetical.

Although Domenico was one of the fathers of the Florentine Renaissance, only a few paintings exist which can be attributed to him. His *œuvre* has recently been subjected to a cross fire of theories on the formation of his style and on the chronology of his work. The more important of these are summarized at the end of the article.

The present author's reconstruction of Domenico's activity coincides largely with that of Salmi (1936). The theory postulates for Domenico origins in the so-called "International Style" but also assumes an early contact with Florence (Gentile da Fabriano and Masolino da Panicale) and with Pisanello. (The "International Style" was the last flowering of Gothic mannerism, which dominated much of European art from about 1350). The maturation of Domenico's style about 1435 is considered to have been principally under the influence of Fra Angelico (q.v.). By 1438 his work must have possessed distinctive originality, and he must already have given the Medicis proof of this, unless one is willing to regard his letter of that year to them as a piece of daring presumptuousness.

The fresco from the so-called "Carnesecchi Tabernacle," now in the National Gallery in London (PL. 239), was mentioned by Vasari, perhaps on the basis of tradition, as Domenico's first work. It could have been executed just before or shortly after the letter of 1438, but not so much later as Pudelko (1934) thinks. Comparing it with other Florentine paintings of the period, he has dated it 1454–55. Its forced perspective, however, is in striking contrast to the freedom achieved in the later Magnoli altarpiece, which itself is not so late as that. There is in the Carnesecchi work a formal, "geometrized" construction. The Virgin and Child, seemingly contained within a cylinder, are characterized by a marked symmetrical frontality, notwithstanding a slight turning to the right. The profound depth of the back of the throne and of its predella has been achieved by a perfectly measured perspective, as can be seen by analyzing the structure of the globes of the arms of the throne. The painting achieves an originality of its own in its combination of gentle idealism in the portrayal of the figures, reminiscent of Fra Angelico, and use of perspective, which reminds one of Paolo Uccello (q.v.). The sensitivity of the drawing and handling of the light foreshadows Domenico's later Magnoli altarpiece. In this respect, the "Carnesecchi Tabernacle" may also be compared with other works in the Florentine style, such as Fra Angelico's polyptych of 1437 in Perugia (I, PLS. 267, 269) and Fra Filippo Lippi's previously mentioned Barbadori altarpiece, commissioned in 1437 (Louvre). The Carnesecchi work in its aristocratic style, which achieved a subtle balance between realism and idealism, may even be described as the first Renaissance painting to put into practice the principles enumerated by Leon Battista Alberti in his treatise *De pittura* (*On Painting*; 1435), or thought of as a source for Piero della Francesca in its refined melancholy and certain iconographical details, such as the nude Christ Child who stands and blesses. (Precedents for the latter, however, can be found in paintings of Fra Angelico.) Like another work by Domenico which is perhaps slightly earlier (the Berenson *Madonna*, in the Berenson Foundation at Settignano, near Florence), it maintains contact with the world of the artist's origins. One is reminded of the work of Jacopo Bellini and Antonio Vivarini in the 1440s. This collective evidence confirms a date for the Carnesecchi fresco of about 1437–39.

From 1439 to 1445 Domenico was working on a cycle of paintings in the Cappella Maggiore of the Church of S. Egidio in Florence, certainly a work of great importance, which un-

fortunately is lost and cannot be reconstructed. Vasari, writing of the frescoes in this cycle, mentions *The Meeting of Joachim and Anna*, and in connection with *The Nativity of the Virgin*, describes a decorated chamber and a child who beats on the door of the room with a hammer in a graceful action. In *The Betrothal of the Virgin*, he tells us, there were many portraits from life, among them Bernardetto dei Medici, constable of the Florentines, wearing a red biretta; Bernardo Guadagni, a standard-bearer; Folco Portinari with other members of his family; an animated dwarf breaking a staff; and several women wearing charming gowns, out of fashion in Vasari's day but in style at Domenico's time. A few fragments of the frescoes that have survived the baroque reconstruction of S. Egidio were discovered through Mario Salmi's efforts, and parts of these were detached from the wall in 1955. These fragments represent at least one podium, the slabs of which are polychrome marble arranged in geometric patterns similar to those of the "Carnesecchi Tabernacle." (This technique is reminiscent of work in St. Mark's in Venice.) Fretted moldings on dividing piers and vaults are somewhat Gothic in style. In the left partition there is a small figure in red underdrawing of the Virgin, a nude study with a linear elasticity similar to that of the Madonna in Domenico's *Adoration of the Magi* (PL. 237).

An echo of the S. Egidio frescoes is perhaps perceptible in the Uccello-like frescoes of the Bocchineri Chapel in Prato Cathedral, which have been attributed to Domenico by Schmarsow (1893). Salmi and the present author think that Domenico's S. Egidio frescoes, however much they may have shown an influence of the richly detailed Flemish style, would always have maintained a monumentality. (The Flemish influence had appeared, for example, in 1440 in the frescoes of Domenico di Bartolo and Lorenzo di Pietro, called "Il Vecchietta," at the Pellegrinaggio in the hospital of the Church of S. Maria della Scala in Siena.) This monumentality was later to be recaptured in the work of Piero della Francesca.

On the other hand, in paintings of a different technique and format, such as the tondo of the *Adoration of the Magi* (PL. 237) in Berlin, Domenico was able, while maintaining the monumentality, to strive with greater freedom for that profuse, detailed, and graceful narrative style recommended by Alberti. The Berlin tondo has been dated early by some scholars, while Salmi places it in the 1440s. He thinks that Domenico made a trip to upper Italy at this time and sees influences of this journey in the style of the painting. It would seem, however, that the tondo is contemporary with the work in S. Egidio (1439–45), and that any influences of style from upper Italy came from memories (especially of Pisanello) of an earlier trip. The tondo was also influenced by Masaccio (q.v.). It seems to be a product of the movement that between 1442 and 1445 displayed a taste for the elaborate and the profuse, and which also influences the Kress tondo of Fra Filippo Lippi. The Domenico tondo has been described by R. Longhi as "equal to the Flemings in the almost photographic truthfulness, equal to Masaccio in mastery of space, equal to Fra Angelico in its enchanting color." For its time it is unique.

A little Madonna by Domenico in Bucharest (State Art Mus.), which is generally dated about the time of the Berlin tondo because of its affinities with Masaccio, also resembles the Madonna of the Magnoli altarpiece (PL. 233) in the elliptical structure of the body and form of the face.

There does not appear to be a difference of many years between the Berlin tondo (PL. 237) and the well-known scenes of the predella of the Magnoli altarpiece (PL. 234). Similarities are noted, for example, in the treatment of the rocks and types of the human figure. This altarpiece (PL. 233), executed for the Church of S. Lucia dei Magnoli in Florence and now in the Uffizi, could have been painted by Domenico after he had finished the work in S. Egidio, perhaps between 1445 and 1448, in accordance with evidence proposed by Pudelko (1934) and Salmi (1936). In addition to a gentle morning light which unites the colors in a delicate harmony, the painting displays a complex structure of perspective which clarifies the earlier, still confused experiments of Fra Filippo Lippi and harmonizes the successive planes of figures and architecture. (The altarpiece is similar in style to the Duveen *Madonna* by Domenico in the National Gallery in Washington.) In the five equally extraordinary scenes of the predella — *St. Francis Receiving the Stigmata* and *St. John in the Desert* in the National Gallery, Washington; *The Annunciation* and *The Miracle of St. Zenobius* in the Fitzwilliam Museum, Cambridge, England; and *The Martyrdom of St. Lucy* in the Staatliche Museen, Berlin (PLS. 234, 238) — the calmly contemplative beauty of the altarpiece is replaced by a more vital one with vibrant chromatic accents.

The Magnoli altarpiece was to become an example in Florence for the whole of the second half of the 15th century, who apparently felt its influence in his *Assumption* (probably 1449–50) in Berlin (I, PL. 241). Domenico, in turn, seems to have derived the two figures of St. Francis and St. John the Baptist in Sta Croce in Florence (PL. 239) from Castagno's style of the period of *The Trinity* (1454–55; I, PL. 236) in SS. Annunziata in Florence. Domenico, however, through his effusive sentiment, softened the rather brutal realism of Castagno. In Domenico's painting the two saints stand under a festooned Renaissance arch that is strongly foreshortened. In the background is seen a fragment of a Tuscan hill bathed in a crepuscular light. This fresco painting of John the Baptist and St. Francis concludes our list of works which are unquestionably by Domenico.

Domenico, who was appreciated by his contemporaries, such as Antonio Filarete and G. Rucellai (the latter calls him one of the "best masters we have had for a long time in Italy"), has not enjoyed since Vasari's time the recognition that he deserves. This may be due to his refined temperament and lack of ostentation. This critical belittling has to some extent lasted to our own period. Today, however, most critics see him as participating as an equal — after Masaccio and Fra Angelico — with Fra Filippo Lippi, Paolo Uccello, and Andrea del Castagno in the pursuit of those great aims of Renaissance painting that were triumphantly fulfilled about the middle of the 15th century. Actually, in 1440 in his work in S. Egidio, Domenico was more advanced than any of his contemporaries. In spite of his prodigious assimilation of Florentine ideas, a non-Florentine quality has been observed in Domenico's work, a quality perhaps felt by his contemporaries. None of the many who were affected by his style, including Francesco Pesellino, Alesso Baldovinetti, the Adimari Master, the Master of Pratovecchio, and the various *cassoni* painters, appears to have understood him completely. Nevertheless, his influence lived on in the work of Piero della Francesca, who was one of his pupils. Domenico's style, in fact, adumbrated ideas that were in the future to lead the Renaissance, not merely as a Florentine movement, but as a development that was to spread over the whole of the Italian peninsula.

THEORIES ABOUT DOMENICO VENEZIANO. In presenting a brief survey of the various theories about the formation of Domenico's style and the chronology of his work, it is useful to begin with mention of an often overlooked passage about Domenico in Kennedy's study of Baldovinetti (1938). Mrs. Kennedy offers a plausible hypothesis concerning Domenico's development, although the sequence of events suggested by her as real biographical facts may be regarded more safely as inferences drawn from internal evidence of the painter's work. According to Kennedy, Domenico probably appeared in Florence about 1422–25 with Gentile da Fabriano (q.v.), whom he may have followed to Rome in 1426–27. After Gentile's death, Domenico might well have become Masolino's assistant in the execution of the frescoes in the Church of S. Clemente there (1428–30). Finally, it is suggested that he settled in Florence about 1435, where he could have come into contact with Florentine painters, especially Fra Angelico. His relation with Pisanello, whose influence is seen in Domenico's *Adoration of the Magi* (PL. 237), might have been the result of a trip to Verona about 1430. (According to a suggestion of Salmi, this journey could have been made even later.) It is also possible that the two artists might have met in 1428, when Pisanello went to Rome to finish Gentile's work in the Church of St. John Lateran.

Traces of Gentile's style are visible in Domenico's painting. Aristocratic, somewhat melancholy Madonnas with backgrounds of flowered or sumptuous textile were painted by both, and a certain sensitivity of expression in the faces found in Gentile's work is also visible in that of Domenico, for example, in St. John the Baptist in the Magnoli altarpiece (PL. 233). This altarpiece, especially the figures of the saints, is reminiscent of Gentile's Quaratesi altarpiece (Uffizi), with its enthroned Madonna and four saints. Even Domenico's tondo of the *Adoration of the Magi* (PL. 237) — a very "modern" version of the story in terms of Renaissance use of perspective — is as descriptive of the splendid dress of the time as Gentile's representation of the same subject in the Uffizi.

Masolino da Panicale is also thought by some (Kennedy, 1938, and Brandi, 1957) to have influenced Domenico. From what we know with certainty to be Domenico's, however, we realize that he belonged to the avant-garde of Florentine painting of the Renaissance. It is therefore logical to think that his style was formed as a result of more immediate contacts in Florence itself. Fra Angelico, whose over-all gracefulness, unusual sense of light and color, and lyrical narrative gifts reveal special affinities to Domenico's art, is the master whose example would probably have made an important impression on him (Pope-Hennessy, 1951, and Paccagnini, 1952). (Fra Filippo Lippi, who is also mentioned in the letter of 1438, is less likely to have influenced his work.) Pope-Hennessy advances the theory that Domenico collaborated in about 1438–39 on Fra Angelico's *Coronation of the Virgin* and the predella paintings (Louvre). Paccagnini, who also discusses Gentile's influence on Domenico, suggests a later contact with Fra Angelico and Fra Filippo Lippi, attributing to Domenico the *Cedri Madonna* in the Museo Nazionale in Pisa. This painting he dates about 1430. (Longhi, on the other hand, believes that the *Cedri Madonna* is by a painter, perhaps Spanish, who is very close to the Master of the Chiostro degli Aranci.)

Two other authoritative opinions (Fiocco, 1927, and Salmi, 1938) put Domenico under the influence of Paolo Uccello. Fiocco thinks that Domenico came into contact with Florentine ideas as a result of a visit to Venice by Paolo Uccello about 1425–30, and believes that we can see evidence in Domenico's style that he received instruction from Uccello. We know too little of Uccello's work before 1440, however, to accept this. Nor is Domenico's considerable knowledge of perspective sufficient in itself to prove Uccello's influence on his style. On the contrary, Domenico's gradual development was very different from Uccello's increasing emphasis on deep space. Salmi mentions a *Madonna of Mercy* (Perugia, Gall. Naz. dell'Umbria), which he believes to possess Uccello-like qualities. He thinks this painting reflects Domenico's style at the time of his sojourn in Perugia in 1438, but his reasoning is not altogether convincing.

One does not wish to deny the possibility that Paolo Uccello influenced Domenico; an association can perhaps be seen in the deep perspective of the so-called "Carnesecchi Tabernacle." The similarity, however, would appear to represent a cultural affinity to Uccello's work, not a discipleship. For this reason, attributions by Berenson (1936), based on a presumed discipleship, are not acceptable. These attributions include three scenes from the story of Paris (New York, Kress Coll.; Vienna, Coll. Lanckoronski) and a *Diana and Actaeon* (Frankfort on the Main, Fuld Coll.). Among the more plausible of Berenson's attributions are two portraits of members of the Olivieri family (New York, Rockefeller Coll.; Washington, Nat. Gall., formerly Mellon Coll.). These paintings, however, lack the strength of an authentic Domenico.

Other authorities have assigned to Domenico three portraits of noblewomen, in the Isabella Stewart Gardner Museum, Boston; the Lehman Collection in New York; and the National Gallery, London (No. 585). The first of these can more convincingly be ascribed to the school of Paolo Uccello, and a previous attribution of the third to Baldovinetti in this author's opinion seems feasible.

Equally unacceptable are a number of attributions to Domenico that are based on the hypothesis of an association with Paolo Uccello in or near Venice in the 1430s. These are a *Pietà* in the Museo di Castelvecchio in Verona (Semenzato, 1954), which belongs instead to the school of Jacopo Bellini and Antonio Vivarini in the early 1440s; a saint in the Church of S. Gottardo at Asolo, near Venice, accepted by Salmi (1958); the *Visitation* in the Mascoli Chapel in St. Mark's in Venice, for which a collaboration with Paolo Uccello has been suggested; the *Rape of Helen* from Arezzo (London, Nat. Gall., No. 591), which is by a pupil of Fra Angelico; a tondo, *Solomon and the Queen of Sheba* (New York, Strauss Coll.), which is not even Florentine; and a portrait of a lady in a private collection in Switzerland, which is reminiscent of Pollaiuolo. Affinities to Domenico in the work of Antonio Vivarini in the 1440s (Coletti, 1953) are too vague to be considered, even though the possibility that Vivarini was influenced by Domenico cannot be excluded. It is difficult to see why scenes from the lives of the saints in Bergamo (Gall. dell'Accademia Carrara), Bassano (Mus. Civ.), and Washington (Nat. Gall.) should be ascribed to the workshop of Domenico in the 1430s (Coletti, 1953, and Brandi, 1957), when the more credible attribution is to Vivarini in the 1440s (Longhi, 1952). Finally, the opinion of Michelangelo Muraro, shared by Salmi (1958), that Domenico painted the figure of *St. John the Evangelist* in the apse of the Church of S. Zaccaria in Venice, decorated by Andrea del Castagno in 1442, is rejected for external reasons and also because the figure, both in color and drawing, can be attributed to Castagno himself. Although one must not exclude the possibility that Domenico, after leaving Venice, made one or more visits to his native city, no decisive proof of this has yet been brought forward.

A theory of Longhi (1952) ascribes to Domenico an important role in Florence during the decade 1430–40 and suggests that Domenico was instrumental in initiating the Renaissance in Siena and Umbria. (Longhi dates the Berlin tondo 1430–35.) It does not, however, seem necessary to identify Domenico in this way with a movement that was an inevitable result of the general tendencies in the years after Masaccio's death in 1428. In fact, the trail blazed by Masaccio was followed first by Fra Filippo Lippi in the *Confirmation of the Franciscan Rule* of 1432–33 in the Church of S. Maria del Carmine in Florence and by Fra Angelico in the *Madonna of the Linen Guild* (1433; I, PL. 269) in the Museo di S. Marco, also in Florence. A revival of Renaissance ideas and of the influence of Masaccio came to Florence with improved economic and political conditions that, with the return of Cosimo dei Medici from exile in 1434, succeeded difficult years of costly external wars and internal strife (U. Procacci, Sulla cronologia delle opere di Masaccio e di Masolino tra il 1425 e il 1428, *RArte*, Ser. III, XXVIII, 1954, pp. 3–55).

Domenico, it would seem evident, was in Florence before 1438, and would certainly have participated in the development of this period. If one advances the date of the "Carnesecchi Tabernacle" to this early period, he must disregard the influence of Paolo Uccello. On the other hand, if the Berlin tondo (PL. 237) is dated earlier than 1435, one is forced to the conclusion that the most responsive talents in Florence (Fra Angelico and the Master of the Chiostro degli Aranci) were very primitive in representing landscape at a late date. In the Berlin tondo all landscape problems were solved for the 15th century.

If one studies Domenico's development as revealed in the latest of his known works (*John the Baptist and St. Francis*; PL. 239), the artist appears to be a gifted eclectic, a highly sensitive temperament whose growth was intimately related to the developments around him. He achieved an integration of these influences that was personal, and he also evolved an internal coherence of style. The student then must try to relate Domenico's work to his cultural environment and to consider particularly those transient aspects which appear to reflect contemporary attitudes, for example, the treatment of perspective in the "Carnesecchi Tabernacle." One should also expect to see Domenico's innovations immediately reflected in the works of other painters, especially in view of the lively exchange of artistic ideas characteristic of the age. Strangely, however, this is not the case. For example, the first work in which the in-

fluence of the Berlin tondo is unquestionable is an anonymous tondo, the *Triumph of Fame* (New-York Historical Society), which is dated 1449.

SOURCES. L. Landucci, Diario fiorentino dal 1450 al 1561, Florence, 1883; G. Rucellai, Zibaldone (15th cent.), Florence, 1881; A. Filarete, Trattato d'architettura, ed. W. von Öttingen, Vienna, 1896; G. Santi, Cronaca rimata (1482–94), Stuttgart, 1897; F. Albertini, Memoriale di molte statue et picture sono nelle inclyta cipta di Florentia..., Florence, 1510, facs. ed. Campa, Florence, 1932; A. Billi, Il libro di Antonio Billi (1481–1580), ed. K. Frey, Berlin, 1892; K. Frey, ed., Il Codice Magliabechiano, Berlin, 1892; R. Borghini, Il Riposo, Florence, 1584; F. Bocchi, Bellezze della città di Fiorenza, Florence, 1591.

BIBLIOG. F. Baldinucci, Notizie de' professori del disegno da Cimabue in quà..., III, Florence, 1728; L. Lanzi, Storia pittorica d'Italia, I, Bassano, 1789; K. F. von Rumohr, Italienische Forschungen, II, Berlin, 1827, p. 387 ff.; J. A. Crowe and G. B. Cavalcaselle, History of Painting in Italy, II, London, 1864, (It. ed., V, Florence, 1892); W. Bode, Aus der Berliner Gemäldegalerie: Eine Predellatafel von Domenico Veneziano, JhbPreuss-KSamml, IV, 1883, p. 89 ff.; A. Schmarsow, Die Cappella dell'Assunta im Dom zu Prato, RepfKw, XVI, 1893, pp. 159–97; B. Berenson, Florentine Painters of the Renaissance, New York, London, 1896 (revised ed., Italian Painters of the Renaissance, London, 1952); W. Bode, Domenico Venezianos Profilbildnis eines jungen Mädchens in der Berliner Galerie, JhbPreuss-KSamml, XVIII, 1898, p. 187 ff.; A. Schmarsow, Domenico Veneziano, L'Arte, XV, 1912, pp. 9–20, 81–97; R. Longhi, Un frammento della pala di Domenico Veneziano per S. Lucia de' Magnoli, L'Arte, XXVIII, 1925, pp. 31–35; G. Fiocco, L'arte di A. Mantegna, Bologna, 1927, pp. 42–44; R. Offner, Italian Primitives at Yale University, New Haven, 1927; Van Marle, X, 1928; B. Berenson, Italian Pictures of the Renaissance, Oxford, 1932; G. Gronau, ThB, s.v. (with bibliog.); P. Toesca, EI, s.v. (with bibliog.); G. Pudelko, Studien über Domenico Veneziano, Mitt. des Kh. Inst. in Florenz, IV, 40, 1934, pp. 139–200 (with bibliog.); B. Berenson, Pitture italiane del Rinascimento, Milan, 1936; M. Salmi, Paolo Uccello, Andrea del Castagno, Domenico Veneziano, Rome, 1936, 2d ed., Milan, 1938; R. W. Kennedy, Alesso Baldovinetti, New Haven, 1938, pp. 4–20; M. Salmi, Civiltà fiorentina del primo Rinascimento, Florence, 1943; R. Pallucchini, Catalogo della Mostra di capolavori dei Musei veneti, no. 1095, Venice, 1946; G. Vasari, Le vite, ed. C. L. Ragghianti, IV, Milan, Rome, 1947–49, pp. 352–53; J. Pope-Hennessy, The Early Style of Domenico Veneziano, BM, 580, 1951, p. 216 ff.; R. Longhi, Il Maestro di Pratovecchio, Paragone, 35, 1952, pp. 10–37; G. Paccagnini, Una proposta per Domenico Veneziano, BArte, XXXVII, 4, 1952, p. 115 ff.; C. L. Ragghianti, Sele-Arte, 2, 1952, p. 65; L. Coletti, Pittura veneta del Quattrocento, Novara, 1953; L. Berti, Catalogo della Mostra di Quattro Maestri del primo Rinascimento, Florence, 1954 (with bibliog.); M. Salmi, Fuochi d'artificio o della pseudocritica, Comm, V, 1954, p. 65 ff.; C. Semenzato, Un'opera giovanile di Domenico Veneziano?, RArte, XXIX, 3, 1954, p. 133 ff.; L. Berti, Catalogo della Mostra di affreschi staccati, Florence, 1957, pp. 65–66; C. Brandi, I cinque anni cruciali per la pittura fiorentina del Quattrocento, Studi in onore di M. Marangoni, Pisa, 1957, pp. 167–75; L. Berti, Catalogo della II Mostra degli affreschi staccati, Florence, 1958, pp. 33–34; M. Salmi, Ancora di Andrea del Castagno, BArte, XLIII, 4, 1958, pp. 124–30; H. Wohl, Domenico Veneziano Studies (dissertation, New York University), New York, 1958; M. Muraro, Domenico Veneziano at S. Tarasio, AB, XLI, 1959, pp. 151–58.

Luciano BERTI

Illustrations: PLS. 233–239.

**DONATELLO.** Italian sculptor; born in Florence, probably in 1386, into a declining branch of the Bardi family. His father, Niccolò di Betto di Bardo (d. before 1415), was a wool comber; his mother, one Mona Orsa, was more than eighty in 1427. He had a widowed sister, Tita, who had a son, Giuliano, apparently a paralytic. Although little precise biographical information exists, a wealth of anecdotes, especially those collected by Giorgio Vasari (*Lives*), indicate Donatello to have been a man of the people, living modestly until his death (Dec. 13, 1466), even when his fame had spread far beyond his native city. The paucity of information is due in part to the fact that Donatello's life was turned inward, absorbed by an intense artistic activity. He grappled with the fundamental problems of the art of the Renaissance, profoundly affecting its evolution.

It is recorded that he was trained as a goldsmith. Vasari claims an early collaboration with Dello Delli (who, however, was born in 1404) in the making of stucco, gesso, and paste ornaments in bas-relief for the furniture of a room belonging to Giovanni di Bicci de' Medici. At seventeen he was active in the workshop of Lorenzo Ghiberti (q.v.) in Florence, where he was one of those employed in chasing bronze for the reliefs of the first doors of the Baptistery. In 1407 he left Ghiberti's workshop (an act which has been open to various interpretations) for the workshops of the Cathedral. Here he produced

his first authenticated piece, a marble *David* (1408; III, PL. 389). This was removed first to the Palazzo Vecchio, and then in the 1870s to the Museo Nazionale in Florence. A little figure of a prophet on the Porta della Mandorla of the Cathedral of Florence was once attributed to the young Donatello. After a long controversy, it is now ascribed to Nanni d'Antonio di Banco (d. 1421), since rather imprecise documents suggest Nanni's authorship of a later, corresponding figure.

Donatello's activities until his work on the *David* are not known. This sculpture, like Nanni's *Isaiah*, was intended for the buttresses of the transept of the Cathedral. The removal of the two sculptures from the church in 1409 was associated with the problems inherent in the construction of the dome, which had caused the supervisors of the Cathedral fabric to consult Filippo Brunelleschi (q.v.) in 1404. Their changing ideas about the size of the dome resulted in a commission for Donatello in 1412 to execute a much larger statue, *Joshua* (now lost), to replace the *David*. Brunelleschi may have been preparing a model of the dome in 1415, when Donatello received from him the material for a small figure destined for it. The *Joshua* was still in progress in 1419.

The two artists were associated in a problem which rapidly changed from a merely technical one to one of style; it may have been the great interest this problem held for him that induced Donatello to leave Ghiberti's circle. Brunelleschi's architectural concern for the relationship of the form to the space enclosing it became for Donatello, as for Nanni di Banco, a sculptural as well as a structural matter.

Nanni, son of the head master for the construction of the Porta della Mandorla and an expert in marble cutting, might have taught Donatello, skilled as a goldsmith and in the making of bronze reliefs, in the art of sculpture. The work of Donatello rapidly assumed an individual character. In the *David* the new "realism" introduced a century earlier by Giotto (q.v.) is resolved in a manner which reflects neither Nanni's clear structural form nor Ghiberti's grace and Humanism. The *David* is conceived with a sharp, youthful energy and in its freedom from tradition is in contrast with the Gothic and classical elements in Ghiberti's style. Whereas for Ghiberti light was another aspect of space, for Donatello it was an attribute of form itself, so that the dynamic play of light and shadow seems to burst through the cadenced harmony of the whole figure. The teaching of Ghiberti was modified in the youthful mind of Donatello by new problems; their solution was to be based on the new Brunelleschian techniques.

In 1408 and 1411, Donatello, by that time a confirmed sculptor, received commissions for other large statues. A *St. John the Evangelist* (PL. 240) was one of the four Evangelists destined for the façade of the Cathedral of Florence, and is now in the Museo dell'Opera. A *St. Mark* was executed for the exterior of Orsanmichele. In their conception Donatello utilized his experience of classic art, then the object of Humanist admiration, seen on a trip to Rome. Such a journey by Donatello to Rome with Brunelleschi is attested to by the most reliable early biography of Brunelleschi, that written about 1480 by an artist, perhaps Antonio Manetti (1423–97), who probably had his information at first hand. This trip has sometimes been denied by scholars or assigned to other dates. The biographer, however, speaks explicitly of 1409. Furthermore, there are in Donatello's life before 1412, when work on the two statues became more continuous, intervals sufficient for a sojourn of several months in Rome. Brunelleschi, in his investigations on this journey, which included measuring the remains of antique architecture, was already concerned with problems connected with construction of the dome of the Cathedral of Florence. Donatello must have looked with the eye of a sculptor at the immense repertory of forms in Rome and been aware not so much of their perfect proportions as of another great principle which classic art had elaborated during its thousand-year course: a chiaroscuro suggestive of motion.

Donatello's reaction to classicism therefore was not so much one of direct suggestion as of fresh perception rather different from that of the contemporary Humanism, as may be seen in the two statues. In *St. John the Evangelist* (PL. 240), completed

by 1415, a strong chiaroscuro breaks up the drapery into a vigorous interplay of masses. Both this sculpture and the *St. Mark* display a heightened tension of form which resulted from Donatello's painful effort at self-knowledge.

A famous dispute about the crucifix by Donatello in the Church of Sta Croce in Florence which took place during these years (ca. 1420) indicates Brunelleschi's shock at this daring change of direction. Indeed, Donatello's position in public opinion often hung in the balance as he sought radically new solutions to artistic problems in each successive work.

From the crucifix he moved to his next major contribution to Florentine sculpture — the development of perspective in reliefs. During his lifetime, mathematical exactitude — number regarded as an absolute — was becoming the ideal principle and the new abstraction of form that Humanism sought in classicism. Brunelleschi's theoretical studies on the subject were to culminate in his two celebrated perspective panels, now lost, for the geometric representation of space. Meanwhile, Donatello was intuitively integrating these principles into his sculpture. Even before Brunelleschi's model for the dome (on which Donatello and Nanni had collaborated) in 1419 established the new Brunelleschian concept — the dynamic play of form within a rationally ordered space — Donatello was engaged on two works for Orsanmichele, a marble tabernacle with a gilt-bronze statue of St. Louis and a statue of St. George (PLS. 241, 242). Although the date of 1417 proposed by Milanesi (1887) on the basis of a document now refers only to the purchase of the marble for the works — which were completed in the following years — the time can be said also to mark the beginning of a rapid mastery of the principles later to be fixed scientifically by Brunelleschi. These were in time codified by Leon Battista Alberti (q.v.). In the relief for the base of the *St. George* (PL. 242), spatial depth is achieved by instinct, not by measure. The high relief characteristic of Ghiberti, in which the figures tend to separate from the background, is transformed in this work into pictorial low relief. The background is a source of atmosphere and light, out of which forms emerge. Their relation to space lies not in the rational gradation of proportions (sketchily indicated by the arcade at the right) but rather in what might be termed their existence in it. The sculpture, especially where it emerges in the round, seems to advance beyond its prison of space within the stone.

Donatello's "realism" is thus a revelation of movement, a tendency to which a rational scheme can only be a limitation. It represents a milestone of Humanist research into the nature of form. The statement of form as the dynamic counterpoint to space anticipated a theme which was to become dominant in the art of the High Renaissance.

Donatello's Humanist training led him to seek in the representation of man the potentialities of humanity. The statues of the prophets that he was employed after 1415 to carve for the Campanile of the Cathedral of Florence reveal the progress of an experience which has been methodically reconstructed by such scholars as Poggi and Lányi (1935) from the numerous yet imprecise documents of disbursements for Donatello's work for the Cathedral. Donatello appears to have executed in the course of 20 years four of the eight sculptures; the remainder, though executed by other hands, reveal his presence and inspiration. The two earlier figures for the east façade — the unnamed prophet with chin in hand (1415–18) and the beardless prophet (1415–20) — testify to an interest in the individual. This gave birth to a long-lived critical judgment that Donatello's realism attained no purity of style. His attempt to affirm the fullness of the human drama in its individual manifestations, however, was actually a search after coherent artistic form. The range of facial configurations in his work sums up a universal tragic mask. In the draperies reminiscences of Roman togas and unrealistic Gothic wrappings are united into a nervous chiaroscuro which defies precise definition of form or space. His tragic sense of realism is given such emphasis in the sculpture sometimes called *Joshua* that it is almost a protest against the mathematical certainties of Brunelleschi, just as the relief from the base of the *St. George* had been a kind of defiance of the intellectual Humanism of Ghiberti. The *Joshua*, for-

merly on the façade and now within the Cathedral, was turned over to Donatello in 1418 after having been commissioned to Bernardo Ciuffagni (1381–1457). The *Abraham and Isaac* (1421) — which, despite the documented collaboration of Nanni di Bartolo, called "Il Rosso" (fl. 1419–39), must be considered as conceived and largely executed by Donatello — moves within a space which cannot be reduced to any rational perspective construction. From any point of view, the two figures are related in a spiral, so that their three-dimensional existence appears the free creation of fancy. The 16th century was to see the evolution of this vision into the intellectual gymnastics that created the unreal serpentine forms of mannerism (q.v.).

It is difficult to reconstruct exactly the decade of 1420–30, which saw the end of a period of experimentation and the maturation of Donatello's style. Commissions multiplied and their execution became so intertwined as to obscure the thread of the artist's artistic evolution. Its direction is discernible in the shift from the contrapuntal vigor of the *Marzocco* of 1418–22 (PL. 401) to the rhythmic softness of the heads of a prophet and a sibyl installed in 1422 by Donatello, after the death of Nanni di Banco, to complete the gable of the Porta della Mandorla of the Cathedral. The *Marzocco*, or *Lion of Florence*, is a stone figure of a lion executed for the papal apartments in the Church of S. Maria Novella. About 1812 it was placed outside the Palazzo Vecchio and is now in the Museo Nazionale in Florence. The gentle quality perceptible in the heads was absent in the earlier excitement of innovation.

The very nature of the commissions — monumental tombs and statues within tabernacles — posed the problem of reconciling Donatello's violent interplay of light and dark with the limpid harmony of Brunelleschi's architecture. He found new solutions. An example is the tomb of Onofrio Strozzi in the sacristy of the Church of Sta Trinita, which, although indifferently executed by Piero Lamberti (1393–1435), was probably modeled on a scheme of Donatello. The restraint of Brunelleschi is compromised by weighting the trim around the extrados of the arch. Almost in reaction Donatello had turned for inspiration to a sculptural model of the 14th century, the funerary monument. The tombs of the Humanist Baldassare Coscia (who became the antipope John XXIII; d. 1419) for the Baptistery in Florence (III, PL. 13) and of Cardinal Rinaldo Brancacci (d. 1427) for the Church of S. Angelo a Nilo in Naples (PL. 245) were in progress in 1427 in the workshop that Donatello shared for some time with Michelozzo di Bartolomeo (1396–1472). This can be deduced by their joint declaration in a tax return for that year. Also in progress were gilt-bronze sculptures for the font in the Baptistery in Siena; reliefs for the tomb of Bartolomeo Aragazzi for the Cathedral of Montepulciano (near Perugia), which after its inception was completed by Michelozzo alone; and the final prophet for the Campanile in Florence. Various concepts were simultaneously taking form. The work that most completely exhibits their fruition is the previously mentioned marble tabernacle with its gilt-bronze statue of St. Louis (the statue now in the Church of Sta Croce in Florence), executed 1423–25 for Orsanmichele for the Guelph party.

In the St. Louis tabernacle for the first time a figure by Donatello was harmoniously enclosed in its architectural niche. This work is in accord with but distinct from the Brunelleschian idiom, thus giving rise to an unresolved controversy as to the authorship of the architectural framework. The tendency has been to exclude Donatello as architect and to suggest the collaboration of Michelozzo, on the grounds that it would have been natural for Donatello to entrust the structural organization of his complicated sculptural plan to a collaborator who was an experienced follower of Ghiberti and Brunelleschi. However, the figure of St. Louis, far from being merely placed in the niche, was an integral part of the design of the tabernacle. It is a clear example of Donatello's stylistic evolution. The strained forms of the prophets on the Campanile are echoed but muted in the subtle swing of the drapery and the subdued chiaroscuro of the facial planes. Complaints of awkwardness and heaviness, first formulated by Vasari, who saw the sculpture removed from its intended setting, arise from its mistakenly

frontal placement. This has been perpetuated even in its most recent recomposition in the museum of the Church of Sta Croce, Florence, within a plaster model of the original tabernacle. A slight pivot toward the right, which is suggested by the flow of the individual elements, would give grace and thrust to the whole. The niche itself, derived, like Masaccio's fresco *The Trinity* in the Church of S. Maria Novella (Florence), from the forms in Brunelleschi's Barbadori Chapel in the Church of S. Felicita (Florence), exhibited the same subtle chiaroscuro in the slender spiral flutings of the columns and the low reliefs in the pediment, spandrels, and base. A sense of instability had penetrated even the lucidity of Brunelleschian design. It is this dynamic, yet lyrical, quality imposed by Donatello on the style created by Brunelleschi that places him among the great creators of Renaissance architecture, even though he did not erect a single building (A. Venturi, *Storia dell'arte italiana*, Milan, 1901–39).

Although they remained uncompleted until after 1427, the previously mentioned Coscia and Brancacci monuments illustrate the rudimentary stages of this elaboration of a personal idiom. The still uncertain architectural conception of the Coscia tomb (which appears in the tax declaration of 1427 as three-quarters paid and therefore near completion) presages the full synthesis of the Orsanmichele St. Louis tabernacle. On the other hand, the refinement of form, suggested rather than defined, under the restless rippling of drapery in the Coscia figure suggests an evolution of sculptural mastery beyond that of the St. Louis in the tabernacle.

Michelozzo, as a pupil of Ghiberti, found this treatment of drapery congenial to his rather Gothic taste. He appears for the first time as Donatello's collaborator in his figure of a Virtue on the right of the base of the Coscia monument; but his translation of the nervous rhythms of Donatello's figure above is an insipid flow of folds. The other two Virtues and the Madonna on the lunette reveal the awkward hand of another sculptor, perhaps Pagno di Lapo Portigiani (1406–70).

Michelozzo's translation into a minor key of Donatello's ideas and perhaps even of his designs, apparent in the Virtue, may suggest a solution to the still unresolved question of the authorship of a statue, *St. Peter*, outside Orsanmichele. Critics have recognized in this sculpture a devitalized but inherently Donatellesque concept, which seems therefore to support its attribution to Michelozzo in the years 1425–27. During this time he was following Donatello's lead, without, however, acquiring his vigor of execution.

Modern criticism, emerging from the old prejudice against Donatello's realism as incoherent, is relegating Michelozzo to his proper role and reducing his undeserved prestige as a refined and coherent stylist. Donatello is now seen as turning away, in the decisive decade 1420–30, from an anguished "naturalism" to a more lyrical note. For this reason, it is the author's opinion, in concurrence with Lányi (1932–33) as opposed to Janson (1957), that the last of the Campanile prophets, still in progress in 1427 and fully paid for in 1436, was not *Jeremiah* (PL. 243) but *Habakkuk*, popularly known as *Zuccone* ("baldpate"). In the face of this figure, where form is almost dissolved by the force of the spirit, the immediacy of the large features of *Jeremiah* (executed probably 1423–25) has disappeared. The "movement within the stone" has become emotion rather than action. Henceforth Donatello's concept of man as an ideal expression of natural truth was to give way to his vision of man as a symbol of the universal drama of existence (Lányi). This struggle against the bonds of mortality — one might almost call it a nostalgia for the infinite — which was basic to Renaissance thought is mirrored in work during the 20-year period from a gilt-bronze reliquary figure, the so-called "S. Rossore," commissioned after 1422 and completed by 1427 for the Brothers of Ognissanti (now in Pisa, Mus. Naz. di S. Matteo) to the *Gattamelata* in Padua, which will be discussed later.

Donatello was working with Michelozzo on the Rinaldo Brancacci tomb (Naples, S. Angelo a Nilo) in Pisa from July to December, 1426. The whole structure had been conceived years before and therefore does not achieve the coherence of the St. Louis tabernacle. The caryatids, bearing the figure of the dead man, reveal the presence of Michelozzo and other assistants as executors. The relief of the Assumption (PL. 245), on the sarcophagus itself, strikes a completely different note from that of the St. George relief (PL. 242). The sense of space, independent of perspective, expresses Donatello's new feeling for infinity. Around the quiet figure of the Virgin, in a misty sky of indefinite extent, whirl the figures of angels, contorted and magnified beyond human proportions. Masaccio (q.v.), who was working nearby on the Carmine polyptych and who is mentioned with Donatello in certain documents, must certainly have suggested these exaggerated forms. Donatello's more lyrical treatment may in turn have been responsible for the tragic quality of the Magdalen in Masaccio's *Crucifixion* (Naples, Mus. Capodimonte).

*The Feast of Herod* (PL. 242) is a relief for the baptismal font in Siena, which was initially entrusted to Jacopo della Quercia (q.v.) and given in May, 1423, to Donatello, who completed it in 1427. The relief has been considered a complete demonstration of Donatello's use of scientific perspective. Close scrutiny, however, reveals it rather to be his overthrow of perspective. In spite of the multiplication of planes across interlacing arcades, it cannot be said that their proportional gradation links them in any real sense to the figures placed within them or to the tumultuous forward plane. The plastic forms evolve independently, not according to the laws of perspective. The drama of interpenetrating, constricted masses gives meaning to the drama of horror described. The broken planes and confused drapery are illuminated by fitful flashes of a light that is not homogeneous with space. This same unreal light plays about the two small figures of Faith and Hope, which Donatello carried out for the same font. These lyrical, intermittently lighted forms can be explained by reference not to the nearby reliefs of Ghiberti, as has been attempted, but to the logic of Donatello's evolution as an artist. This development answers the old accusations of incoherent experimentation and realism without style. It is a progress from the breathing inner life of the prophets of the Campanile to the dreamy emotionalism of the figure of St. Louis or the figure of Bishop Pecci on his tomb slab in the pavement of Siena Cathedral (1426).

Modern criticism is now beginning to understand the true measure of the importance of Donatello's development and innovations to the evolution of Renaissance art as a whole. The new lyricism was, incidentally, to influence Jacopo della Quercia's inspired prophets in the niche above the font, which Donatello in 1429 crowned with little angels (two *in situ*, one in Berlin, Staat. Mus.). Documents list payments in 1431 to Giovanni di Turino (ca. 1384–1455) for three companion angels as well.

Donatello made a second trip to Rome, this time with Michelozzo (Martinelli, 1957–58), after both had signed (July 14 and Nov. 27, 1428) a contract, and perhaps made a first model, for a pulpit to display the famous relic, the Girdle of the Virgin, outside Prato Cathedral. Effective work on the pulpit was not begun before 1434, however, the two artists having been diverted by military works undertaken with Brunelleschi during the siege of Lucca in 1430 and by the Roman journey, which seems to have taken place late in 1432. While in Rome, Donatello and Michelozzo collaborated on the tabernacle of the Sacrament (formerly in a chapel in the Vatican, dismantled about 1540, and from the 18th century on in the Sagrestia dei Beneficiati in St. Peter's, Rome). Valentino Martinelli (1957), in contradiction to other scholars, has linked to it the two reliefs, the *Delivery of the Keys to St. Peter* and the *Lamentation* (London, Vict. and Alb.), a reconstruction which is fully justified by the stylistic intent common to these sculptures. It is the same quality that reached its final evolution after the work in Siena on another relief of *The Feast of Herod* (Lille, Mus. B.A.). In this work the interrelation between the restless multiplication of architectural elements and the tense modeling of the figures is complete. Its harmony is achieved not through perspective but through the reconstruction of the whole space by the effects of light and shade in the very shallow relief. This luminous synthesis of space was the sculptural counterpart

of what was to be the principal achievement of Renaissance painting.

The architectural design and the sculpture of the tabernacle of the Sacrament in Rome are so infused with this new perception that the style of Brunelleschi is lost. Pilasters rise out of tight groups of angels, and a looming pediment robs the structure of all sense of quiet. The figures in the low relief above are massed together in *The Deposition*, Donatello's first portrayal of a tragic theme which he was frequently to elaborate thereafter. The structure of the nude is hidden within the tortuous draperies. In *The Delivery of the Keys*, supposed by Martinelli (1957) to have been at the base of the tabernacle, the draperies, reminiscent of the monumental forms of Masaccio, are massed so as to fill the whole space. Even more than in the work of Masaccio, light is the essential element, the creator of space itself. This concept permeates the *Lamentation* (whether or not it belonged to the original altar), detectable even through the too-correct execution of Michelozzo. A *Flagellation*, formerly in Berlin, should also be ascribed to Michelozzo in this period. This work was destroyed during World War II before having found its rightful place as one of Michelozzo's translations of Donatello's concept.

To an artist with a fully matured style based on the discovery of space as motion, classical Rome — arbiter of form for the Humanist — had little to offer. During the second sojourn (Martinelli, 1957) Donatello studied with interest the various artistic perceptions of Christian Rome: early medieval, Byzantine, and Romanesque. The concept of the mosaics and frescoes from these periods was in opposition to the great rational canon of classical times. Henceforth a new tonal range suggested by them was to be added to Donatello's vocabulary — not, however, as some critics have suggested, as a pictorial attempt at the irrational effects realized through the play of light and shade. For Donatello light remained an inherent attribute of form, and its tonal play only a final qualification. This was true even when form was consumed by light in an attempt to reveal the internal energy and dynamic relationship of form to space — and in this sense he was typical of his age.

In Rome Donatello must have met his fellow Florentine, the Humanist Leon Battista Alberti, who a few years earlier had seen that the quest of early Humanism for form was taking a new direction. The first of Alberti's treatises on the three arts, published slightly later (1435), was devoted to painting, because only in this category did tradition permit him to allude to the new artistic perception of motion as the life of form within a space the fullness of which had been revealed by perspective. The term *pittura* became for him at this time the theoretical expression of this free action of form. In this sense, therefore, and not in a quest after exterior effect, the art of Donatello realized to the full Alberti's concept of *pittura*.

The Roman sojourn — to which Martinelli (1957) plausibly assigns the tomb slab of Giovanni Crivelli (Church of S. Maria in Aracoeli) and the head of Pope Martin V on the slab of his tomb in the Church of St. John Lateran, which was executed by Simone Ghini (1407–91) — was to conclude shortly after, when the administrators for Prato Cathedral sent Pagno di Lapo Portigiani on Apr. 1, 1433, to get Donatello and Michelozzo to finish the outdoor pulpit for which they had contracted. Late in May both artists were in Florence to complete their tax declarations. During 1433–34 Michelozzo followed Cosimo de' Medici into temporary exile in Venice. Donatello, remaining in Florence, continued with a new project for the pulpit, for which he had already carved a marble relief (completed by June 19, 1434). The execution of the pulpit became interwoven with the project for a singing gallery (choir loft, or *cantoria*) for the Cathedral of Florence (commissioned July 10, 1433; PLS. 244, 247). In these works the fruits of his Roman experience appear in an increased vocabulary of forms and a new stimulus to his imagination, which enriched the lyrical quality of his mature style.

Critics are uncertain whether to assign a work in the Church of Sta Croce, the Annunciation tabernacle, to the eve of the trip to Rome or to the time just after Donatello's return. Executed in *pietra serena* (gray sandstone), it was perhaps commissioned by Niccolò Cavalcanti. Analogies with the tabernacle of the Sacrament have been pointed out: the switch from the classical vocabulary of Brunelleschi to fanciful forms, such as the masks that make up the capitals and the fish-scale motif of the pilasters, and the weighting of the pediment so as to subvert the rational scheme of the structure. The Annunciation tabernacle appears to reflect the Roman sojourn and probably postdates it, if it is conceded that the return to the fullness of high relief in both it and the singing gallery are the result of classical suggestion. Mary and the angel stand out against their flatly ornamented background. Their lyrical treatment, far from resulting from an excessive collaboration with Michelozzo, reflects another facet of Donatello's perception of the range of human emotions. From the St. Louis tabernacle and the Virtues for the Siena font he had grown steadily in psychological insight. His development is displayed in the two figures, who share a bond that irresistibly unites the anxiously reaching angel and the timidly withdrawing Virgin. The refining of Ghiberti's style in the second doors of the Baptistery can be traced to this new lyricism of Donatello. Even Michelozzo took the cue, perhaps from the master's own designs, in his inspired figures for the Aragazzi monument in Montepulciano.

The present writer would also assign the marble *David* (formerly Martelli Palace, now Washington, Nat. Gall.) to these years and not to an earlier period (Kennedy and Janson, 1957). This figure is reminiscent of the compact structure of the *Zuccone* on the Campanile at Florence but is relieved of that statue's exaggerated play of light on drapery, which emanates from its deliberately (not, as some scholars maintain, unintentionally) "unfinished" surfaces. Its attribution to Bernardo Rossellino (1409–64) by Pope-Hennessy (1959) is stylistically inadmissible.

The singing gallery (PL. 244) which Donatello had undertaken in 1433 and completed, with the help of assistants, in 1439 was installed in 1450. Luca della Robbia (q.v.) was at work after 1431 on a comparable choir loft (PL. 157). The approach to high relief is quite different in the two works. The rhythms of Luca are an ecstatic restatement of the pure harmony of the Greek metope. Donatello's experience of antiquity, on the other hand, was charged with new portents. The extreme foreshortening which abridges the forms of the wildly dancing putti (PL. 247) translates the traditional classical language into Dionysian terms. This is Donatello's final answer to the Humanist quest after antique culture, which he had continually opposed with his own "naturalist" vision.

As work progressed on the singing gallery with its two bronze heads (later removed), the Prato pulpit was nearing completion. Donatello himself was paid for four of the seven friezes of the latter between 1434 and 1436, and he and Michelozzo were paid jointly for the balance in 1438. The complex was finished and installed by Maso di Bartolomeo (1406–ca. 1456) in 1441. In spite of the considerable collaboration involved in executing these works, Donatello's stamp on the singing gallery is unmistakable. The putti, contained within the architectural structure, speed around the balustrade and up into the ring of a large canopy above with dynamically radiating perspective caissons.

This concept of architecture as tension, as a lyrically irrational movement, was in direct contrast to the Brunelleschian achievement of balanced forms. The falling out of the two artists after their long journey on similar paths was inevitable. The year in which Donatello was called to do the sculptures for the Old Sacristy of the Church of S. Lorenzo in Florence, which had been completed by Brunelleschi in 1428, is uncertain. The stylistic evolution which can be read in Donatello's work there is a complete summation of his progress during the decade 1430–40. Certain scholars (Sanpaolesi, 1940–42, and Parronchi, 1959) hold that the stucco tondi of the *Story of St. John the Evangelist* in the vault are executed according to Brunelleschi's spatial concepts, which had opened up a vastness beyond the possibilities of natural vision. The tondi would logically therefore have followed the construction of the Old Sacristy, before a second trip by Donatello to Rome. Even if this were possible, the composition of the tondo of *St. John*

*in Patmos*, for example, argues against it. Here any perspective scheme is dissolved and vanishes in the boundless luminosity of a kind of marine horizon, so that the architectural definition of space is lost in a bottomless depth. The idiom of Brunelleschi is pushed to an extreme which the architect had not intended or foreseen. Below, in the succession of four lunettes of the Evangelists (*St. Mark*, PL. 246) which were executed later, the tension of the forms has been heightened. The draperies are charged with energy, the seats and desks overburdened by an erudite assemblage of classical ornaments. Furthermore, the balanced curve of Brunelleschi's clear white walls of the apse has been shattered by the niches which Donatello cut into the sides for his monumental saints and by the huge pediments below them, which jut above the small bronze doors. Pairs of apostles and prophets face each other on the panels of the doors in a tempestuous colloquy. Their agitated forms, contrasted with the smooth abstract background, echo the vigor of the dance of the singing gallery.

Tradition tells of the indignation of Brunelleschi, who saw in Donatello's work the negation of his own art. He had wished to give a form to space which was founded on the absolutes of mathematical relationships. Donatello denied limitations to the freedom of space and form. Brunelleschi is known to have composed an epigram whose cutting irony railed at the sculptor turned "architect." To Donatello, architecture had become yet another expression of form as motion, that quality which Alberti, as we have noted, called *pittura*. With this discovery Donatello was to dominate the Florentine art of the 1430s. In 1434 he was preferred over Ghiberti for the project of a stained-glass window of the *Coronation of the Virgin* for the dome of the Cathedral of Florence. He was preeminent in the cathedral workshops and with the Medici. He was the favorite of Cosimo the Elder, whose collections of antique art he encouraged. His influence is seen in the painting of Fra Filippo Lippi (1406–69) and Domenico Veneziano (d. 1461). His own lyricism drew from Humanist culture those same romantic and imaginative suggestions that were to nourish the poetry of Poliziano and the painting of Botticelli in succeeding decades.

Of the various dates proposed for the bronze *David* (Florence, Mus. Naz.), executed for the Medici, the most probable is about 1440. A restless luminosity disturbs the classical harmony of form, while the iconographical ambiguity of the youth, shown both as Biblical shepherd and agile Mercury, leads the observer into that rarefied climate where history and myth are confused and burdened by improbable and mysterious allusion. This same ambiguity has made difficult the interpretation of another of his works of this period, a winged putto, *Attis-Eros*, in Florence (Mus. Naz., formerly Doni Palace).

The refined culture of Florence had little further nourishment to offer Donatello at this time; his development had gone far beyond the aims of the early Renaissance. Perhaps this is why he left Florence at the peak of his success. His presence there is attested by a document of 1443, after which he went to Padua, apparently attracted by the possibility for fulfillment in the *Gattamelata* (PL. 249), the monumental equestrian statue for the Venetian *condottiere* Erasmo da Narni, who died Jan. 16, 1443 (Vasari, *Lives*, and Janson, 1957).

In Florence, Michelozzo and not Brunelleschi — who was, however, still active — succeeded to the Medicean commissions. In 1444, shortly after Donatello's departure, work began on a palace for Cosimo the Elder, who had rejected a previous project of Brunelleschi. (This is the present Palazzo Medici-Riccardi in the center of Florence.) It is striking that Michelozzo was engaged in directing along Brunelleschian lines the construction of the Monastery of S. Marco, on which he had been working since 1436, and at the same time was erecting the new palace, with its ornate entablature and graduated chiaroscuro, which everywhere displays the dynamic tension of Donatello's architectural style. A hypothesis presents itself that in the Medicean commission, as well as in a renovation of the Palazzo Vecchio, conducted during Donatello's absence, Michelozzo may have been the executor of projects already defined by the master.

Donatello's spiritual presence (A. Venturi, *Storia dell'arte italiana*, Milan, 1901–39) is seen in the bulk of Florentine architecture and sculpture completed between 1440 and 1450 by the artists he had educated. Many of their commissions are traceable to Medicean initiative, as, for example, the Medici palace and the shrine of the SS. Annunziata. In leaving Florence, Donatello was to place his imprint not only on the final phase of Florentine Quattrocento art but on that of the rest of Italy as well.

Although it was the *Gattamelata* commission that took Donatello to Padua, his first activity there was on the ambitious renovations of the Church of S. Antonio. Adolfo Venturi has seen his undeniable imprint on the choir screen begun in 1443, but there are few documents to help establish at what point and to what degree he participated. While it is improbable that he is to be identified with the sculptor "Donato" who was working there in March and April, he was, early in that year, at work on a large bronze crucifix, also for the choir (Padua, S. Antonio; PL. 249). In this work can be seen the luminosity which had so subtly transfused the silken planes of the *David* now breaking in on the modeling of the suffering body and the anguished face.

In the crucifix Donatello brought to Renaissance "naturalism" the full, terrible revelation of divinity and death as the compelling forces of human destiny. His solitary meditations in Padua were to carry him still further in a search for the final liberation into eternity. This is the theme which has been recognized as his final concern, not as an intellectual struggle with the problems of form and space, but as an inspiration that was to be their ultimate conquest.

The high altar of the Church of S. Antonio is the grandiose expression of this new theme. Initiated Apr. 13, 1446, as a result of a gift of Francesco Tergola, it was conceived by Donatello as a giant sculptured architectural group. The statues of the Virgin (PL. 250) and the saints stood upon a high base adorned with reliefs (PLS 248, 251) and were enclosed in a tabernacle adorned by a vaulted baldachin. Donatello exploited the resources of his medium to the utmost, going from the shallowest bas-relief to the fullness of sculpture in the round. The forms, unlike those in earlier works, are realized in an unreal light arising from the material itself, the brilliance of the bronze and gold and the polychrome of the stone. The whole suggests the solemn splendor of the medieval altarpiece.

Donatello had made wax models for the figures as early as Feb. 11, 1447. He had as apprentices Pisan and Florentine artists, and as an assistant the Paduan sculptor and painter Niccolò Pizzolo (1421–53). Donatello worked on the altar continuously until St. Anthony's Day, June 13, 1448, when the statues and reliefs, already executed but not finished, were provisionally exhibited in a wooden model of the architectural framework. The translation of the structure into marble and stone was completed in June, 1450, and it remained intact until its dismemberment in 1591. It was given its present form by Camillo Boito (1836–1914) in a mistaken effort at recomposition.

Subsequent hypothetical reconstructions, based especially on the 16th-century description of the altar by Marcantonio Michiel (1484–1552), have more closely approximated the original design. Most convincing are those of Kauffmann (1935), Band (1940), and especially Janson (1957). The latter, besides reestablishing the probable locations of the statues on different planes, with the two bishop saints on the ends, places the Virgin in powerful isolation between two columns and flanks the base by the musician angels that are at present badly placed on the antependium of the altar below. The statues, now freestanding, seem meager and constrained by comparison with the space around them. Within the narrow limits of the original structure they must have had a heightened expressive effect. Enclosed and barely moving, beside the absorbed and awe-inspiring immobility of the Virgin, they were sculptured mediators between her remoteness and the human drama furiously enacted on the reliefs (PLS. 248, 251) of the predella below. In the reliefs of *The Miracles of St. Anthony*, the perspectives of improbable buildings, encrusted with accessories and ornaments, are mere suggestions emanating from the luminous forward planes. The forms twist in spasmodic, inextricable invention

reaching the limits of virtuosity. Donatello's expressive mastery, the fruit of long experience, had become innate, permitting the direct impression of his thought on the material. The reliefs represent a new stage in his unceasing exploration of reality in the quest of form.

In the *Gattamelata* (PL. 249), in progress 1447–53, Donatello was to continue the explorations that had begun with his struggle at Brunelleschi's side to achieve the freedom of form within space. It was at Donatello's express desire (Janson, 1957) that the Venetian Senate agreed in 1447 to the transformation of the traditional Venetian funerary portrait statue into the ideal image which Roman antiquity had utilized to commemorate its emperors. Donatello's naturalism is subordinated to the symbolic character of the classical model that he had adopted. To this purpose he concentrated on the face, the intense glance of which is turned inward, as if summoning up that purposefulness needed to sustain an army. The Roman emperor has merged with the Donatellian man, whose certainty is achieved through the tortuous windings of doubt. It is a new being, conqueror and conscience, the Renaissance man.

The art of Donatello was a revelation for all northern Italy. His works were sought after in the principal centers. A controversy with one Ser Petruccio is recorded, involving a wooden model for a chapel intended for a group of Florentines living in Venice (1447), for which Donatello had not received payment. The episode has been linked to the wooden *St. John* that he carved for the Cappella dei Fiorentini in the Church of S. Maria dei Frari (Venice), dated by Milanesi (with no indication as to source) in 1451.

From the years 1450–51 there is an impressive list of works contracted but not executed: a tomb for the body of St. Anselm for Lodovico Gonzaga, marquis of Mantua; a crucifix and a Virgin with SS. John, George, and Maurelius, for which Donatello went to Ferrara in January, 1451, to obtain the commission; and a gilt-bronze statue of Duke Borso d'Este, which he had agreed to do in Modena (Mar. 10, 1451) and for which he received money on account and procured the stone for the base. Although he was unable to fulfill these commissions, the Paduan altar spread his revolutionary message. His influence is apparent in such works as Andrea Mantegna's altarpiece, *The Virgin and Saints* (Verona, S. Zeno).

When Donatello returned to Florence between 1454 and 1456, the artistic climate must have seemed very foreign to his way of thinking. Ghiberti's pictorial reliefs for the second Baptistery doors (completed 1452) were so accomplished that he reconquered the favor of both artists and public, which he had previously lost to Donatello. Young artists such as Desiderio da Settignano (1428/31–1464) and Antonio Rossellino (1427–79) now looked to him. A new movement, varying from pure spirituality to superficial grace, produced a flood of paintings and sculptures designed to satisfy the requirements of an increasingly sophisticated and luxury-loving society. Perhaps for this reason Donatello went to Siena, where the mysticism of the Middle Ages, unaffected by the inroads of the new culture, remained the source of inspiration. He was there during September and October, 1455, working on the bronze *St. John* (now in Siena Cathedral). This statue, like the wooden *St. John* in Venice, carried over to sculpture in the round the breaking up of forms seen in the Padua reliefs. A sense of desolation and inwardness pervades these works of the aging master, now alone in an alien world. *The Magdalen* (Florence, Baptistery; III, PL. 211) is of this period (either before or after the Siena sojourn). The lyrical tone of the figures for the baptismal font in Siena of the 1420s is not immediately apparent in the tragic destruction of form in this work. The new antipoetic concept influenced the young Desiderio da Settignano, to whom should be assigned (in the author's opinion) the marble *St. John* (Florence, Mus. Naz.; formerly Martelli Palace).

In Siena, where he had established himself on Oct. 20, 1458, Donatello was commissioned to do a statue of St. Bernardino (lost or not executed) and a group that was to surmount the main portal of the city's chief monument, the Cathedral. He did prepare wax models of the reliefs for the latter and perhaps several bronze studies. A suggestion by Janson (1957)

that one of these may be *The Deposition* in London's Victoria and Albert Museum is attractive from the point of view of style, although unsupported by precise dates. Donatello, however, soon abandoned Siena; the last record of his presence there is Mar. 6, 1461. His motives are unknown, unless credence can be given to gossip recorded by Vasari (*Lives*). He may have left for the same reason that he gave in Padua — that he needed the criticism of his fellow Florentines to make him happy.

Donatello's unceasing struggles against obstacles were now directed against a culture which was abandoning, for a path of intellectual subtleties, the main route opened by Brunelleschi, Masaccio, and himself. Once again Donatello brought to the fray a new "reality," this time the naked reality of the soul. His last Florentine works — which tradition says were entrusted to him by Cosimo de' Medici, another member of an outdated generation — isolated him, almost in solitary and disdainful protest, from the esthetic creed that was creating such graceful works as the Chapel of the Cardinal of Portugal in the Church of S. Miniato, in Florence. The sense of composition that had unified the figures in the previously mentioned *Sacrifice of Abraham* (1421) for the Cathedral of Florence was shattered in the *Judith and Holofernes* (PL. 250). The rhythms, without harmony, seem to erupt from the bitter dissonances of the cruel event portrayed.

In his last work, the bronze pulpits for the Church of S. Lorenzo (PL. 251), a similar sense of absolute tragedy seems almost to consume the forms. Donatello's collaborators, Bartolomeo Bellano (ca. 1434–96/7) and Bertoldo di Giovanni (ca. 1420–91), followed his intentions with difficulty. *The Passion of Christ* finds an expression different from all previous traditions in reliefs that are drastically compressed in a supreme effort to synthesize the human drama. The little classical putti in the frieze are not Humanist but Dionysian in their revels. Perspective as a source of harmony is a remote or forgotten allusion. Forms are submerged and rhythms lost within the impetuously jutting pilasters that divide the scenes. Form is denied altogether in *The Deposition*, the only relief wholly executed by the master. The lament of the Madonna over the dead Son is merely a deepening of the shadow of the veil. Donatello had arrived at the final stage of his search into the meaning of life. He then saw man's brief and wearisome span as a reaching for a union with the infinite, to be achieved only across the dissolution of death. This theme was to pervade the religious thought of the Renaissance and to be frequently expressed in art.

Donatello's assistants were unable to interpret this ultimate, total perception and foundered over the complexity of forms. This difficulty is apparent even in the fine works before the master's death on Dec. 13, 1466, although Donatello directed their execution. An example is the *Crucifixion* in Florence (Mus. Naz.). Yet the Florentine work of the last generation of the Quattrocento would have been impossible without his presence. His influence was felt by Antonio Pollaiuolo, Andrea del Verrocchio, and Sandro Botticelli (qq.v.), known as "naturalists" and "romantics." These artists approached his work only tangentially, however, reducing to personal nostalgia or revolt that which for Donatello had been the sense of universal life.

The contemporary imitations initiated a critical trend (both literary and historical) which has continued down to the present day. Only Michelangelo was able to renew the drama of form, so that Borghini (1584) was to see in him Donatello's spiritual reincarnation. Indeed, it was Vasari (*Lives*) who recognized the impossibility of classifying Donatello, whom he placed in the second great period of Renaissance art, which was a prelude to the classic fruition of the 16th century. He described the master as "having in himself all the parts which one by one were divided among many" and as going beyond both classical and modern (Renaissance) art because "he reduced his figures to motion." Vasari thus summed up the artistic impetus of the Renaissance.

Vasari's achievement passed almost unnoticed by criticism, which was soon to become codified and academic. Baroque artists were to discover in the world about them sensible values

very different from Donatello's "naturalist" perceptions. Nineteenth-century critics (Rumohr, 1827, and Semper, 1875) in the name of the *beau idéal* leveled against him an accusation of brutal and vulgar naturalism that has never been entirely dissipated. Nor was the 19th-century romantic espousal of his presumed "naturalism," as an aid to its polemic against the current academic concept of the Renaissance, any better informed. Later criticism, while rejecting this mistaken interpretation, further confused the issue by expanding the body of Donatello's work with a flock of inept attributions in which the true figure of the artist lost all coherence. Sculptures such as the bust of Niccolò da Uzzano (Florence, Mus. Naz.) were exalted as the highest expression of Donatello's "realism." This work modern critics ascribe to followers or to modern forgers. Forgers did, indeed, increase the difficulty in their obliging attempts during the 19th century to satisfy the demands of both private and public collectors, for whom Donatello had become the Renaissance standard-bearer in the reaction against academicism. Fortunately, modern efforts at removal of this incrustation on the genuine works of the master have already borne fruit.

A clear understanding of Donatello's art was impossible in the light of the incomplete and polemic evaluation of the Renaissance by romantic and postromantic critics, who saw the expression of that era as a restriction of the free life of the spirit. Modern research has begun to lift the veil, and critics such as Ernst Cassirer (*Individuum und Kosmos in der Philosophie der Renaissance*, Leipzig, Berlin, 1927) have seen in the Renaissance a rediscovery of man's relation to the cosmos as a fluid integration, an action untrammeled by the bonds of mortality. In this light, Lányi (1939) has with justifiable zeal posited Donatello's "naturalism" as not an imitation but a new perception of the actual, which also motivated those other two creators of modern art, Brunelleschi and Masaccio. It is an estimate which has disencumbered Donatello of the myths which surrounded him and made possible the new critical appraisal of his style. A final prejudice still hangs on, the comparison of Donatello's art — which is an unremitting struggle to lay bare the nature of form in all its dynamism — with that highly intellectualized sublimation of form which reached its peak in Piero della Francesca (d. 1492) and represented the opposite pole of Renaissance style. In other words, this criticism of Donatello is the reinvocation of the old concept of naturalism as the negation of style.

The significance of Donatello's work as a new unity and a new intuition which helped to shape the course of cultural history is today apparent. In the light of the new critique, which has been able to expose the nature of his spiritual well-springs, there exists an emerging appreciation of Donatello's position as one of the founders and active protagonists of Renaissance culture.

SOURCES. R. Albizzi, Commissioni per il Comune di Firenze dal 1399 al 1433, III, Florence, 1867–73, p. 448; B. Facio, De viris illustribus (ca. 1457), ed. Mehus, Florence, 1745; A. Manetti (?), Operette istoriche, Uomini singolari in Firenze dal MCCCC innanzi, ed. G. Milanesi, Florence, 1887; A. Manetti (?), Vita del Brunellesco, ed. E. Toesca, Florence, 1927; V. da Bisticci, Vite di uomini illustri del secolo XV, Florence, 1938, Vita di Cosimo de' Medici, p. 280; P. Gaurico, De sculptura, Florence, 1504; F. Albertini, Memoriale di molte statue e pitture di Florentia, Florence, 1510, ed. H. P. Horne, London, 1909; U. Verino, De illustratione urbis Florentiae libri tres (ca. 1512), 2d ed., II, Florence, 1636; L. Landucci, Diario fiorentino dal 1450 al 1516, ed. J. del Badia, Florence, 1883, p. 3; M. Michiel, Notizia d'opere del disegno (ca. 1520), ed. T. Frimmel, Vienna, 1888, p. 2 ff.; A. Billi, Il libro di Antonio Billi, ed. K. Krey, Berlin, 1892; K. Frey, ed., Il codice Magliabechiano, Berlin, 1892; Vasari, II, p. 395 ff.; R. Borghini, Il Riposo, Florence, 1584.

BIBLIOG. F. Bocchi, Le bellezze della città di Fiorenza, Florence, 1591, revised ed., ed. G. Cinelli, Florence, 1677; L. Cicognara, Storia della scultura, IV, Prato, 1823, p. 86 ff.; K. F. von Rumohr, Italienische Forschungen, Berlin, 1827, and J. von Schlosser, Frankfort on the Main, 1920, p. 446 ff.; G. Gaye, Carteggio inedito d'artisti de' secc. XIV–XV–XVI, I, Florence, 1839, p. 120 ff.; M. Gualandi, Memorie originali italiane riguardanti le belle arti, ser. IV, Bologna, 1843; F. Baldinucci, Notizie de' professori del disegno da Cimabue in quà . . . , ed. F. Ranalli, I, Florence, 1845–47, p. 404 ff.; G. Milanesi, Documenti per la storia dell'arte senese, II, Siena, 1854, p. 295 ff.; B. Gonzati, La Basilica di S. Antonio di Padova, Padua, 1854; G. Campori, Gli artisti italiani e stranieri negli stati estensi, Modena, 1855; J. Burckhardt, Der Cicerone, 10th ed., 2 vols., Leipzig, 1910; C. G. Perkins,

Les sculptures italiens, Paris, 1869; H. Semper, Donatello, seine Zeit und Schule, Quellenschriften für Kunstgeschichte, ed R. Eitelberger, Vienna, 1875; W. Bode, Die italienische Skulptur der Renaissance in den königlichen Museen zu Berlin, JhbPreussKSamml, V, 1884, p. 27 ff.; E. Müntz, Donatello, Paris, 1885; O. I. Cavallucci, Vita ed opere di Donatello, Milan, 1886; A. Schmarsow, Donatello, Breslau, 1886; G. Milanesi, Catalogo delle opere di Donatello e bibliografia degli autori che ne hanno scritto, Florence, 1887; H. Semper, Donatellos Leben und Werke, Innsbruck, 1887; H. von Tschudi, Donatello e la critica moderna, R. Storica Italiana, IV, fasc. 2, Turin, 1887; C. Guasti, Il Pergamo di Donatello pel Duomo di Prato, Florence, 1887 (repr. in Opere, IV, Prato, 1897, p. 462 ff.); A. Manetti, Operette istoriche, ed. G. Milanesi, Novella del Grasso legnajuolo, Florence, 1887; D. Gnoli, Le opere di Donatello in Roma, Archivio storico dell'Arte, I, 1888, p. 24 ff.; C. von Fabriczy, Neue Daten über Donatello, RepfKw, XII, 1889, p. 212 ff.; M. Semrau, Donatellos Kanzeln in S. Lorenzo, Breslau, 1891; W. Pastor, Donatello, Giessen, 1892; G. B. Cavalcaselle and J. A. Crowe, Storia della pittura in Italia, V, Florence, 1892, pp. 8–18; C. von Fabriczy, Filippo Brunelleschi, Stuttgart, 1892; W. von Bode, Denkmäler der Renaissance — Sculptur Toscanas . . . , 12 vols., Munich, 1892–1905; H. von Geymüller, Die architektonische Entwicklung Michelozzos und sein Zusammenhang mit Donatello, JhbPreussKSamml, XV, 1894, p. 247 ff.; A. Gloria, Donatello fiorentino e le sue opere mirabili nel Tempio di S. Antonio in Padova, Padua, 1895; C. Boito, L'altare di Donatello e le altre opere nella Basilica Antoniana di Padova, Milan, 1897; M. Reymond, La sculpture florentine, II, Florence, 1898, p. 8; C. von Fabriczy, Donatellos heiliger Ludwig und sein Tabernakel an Or S. Michele, JhbPreussKSamml, XXI, 1900, p. 242 ff.; B. Marrai, Il tabernacolo col gruppo del Verrocchio in Or San Michele, L'arte, IV, 1901, p. 346 ff.; W. Bode, Donatello als Architekt und Dekorator, JhbPreussKSamml, XXII, 1901, p. 3 ff.; A. Venturi, Storia dell'arte italiana, Milan, 1901–39, VI, La scultura del Quattrocento, p. 237 ff., VIII, L'architettura del Quattrocento, part I, p. 235 ff.; C. von Fabriczy, Ancora del tabernacolo col gruppo del Verrocchio in Or San Michele, L'Arte, V, 1902, p. 46 ff.; I. B. Supino and B. Marrai, Ancora del tabernacolo col gruppo del Verrocchio in Or San Michele, L'Arte, V, 1902, p. 185 ff.; M. Reymond, La tomba di Onofrio Strozzi nella Chiesa della Trinità in Firenze, L'arte, VI, 1903, p. 7 ff.; C. von Fabriczy, Pagno di Lapo Portigiani, JhbPreussKSamml, XXIV, 1903, p. 119 ff.; A. G. Meyer, Donatello, Bielefeld, Leipzig, 1903; S. Fechheimer, Donatello und die Reliefskunst, Strasbourg, 1904; F. Schottmüller, Donatello, Munich, 1904; G. Bertoni and E. P. Vicini, Donatello a Modena, Rassegna d'Arte, V, 1905, p. 69 ff.; L. Ciaccio, Copie di un'opera perduta di Donatello in Roma, L'Art, VIII, 1905, p. 375 ff.; V. Lazzarini, Nuovi documenti intorno a Donatello e all'opera del Santo, Nuovo Archivio Veneto, N.S., XII, 1906, p. 161 ff.; F. Burger, Donatello und die Antike, RepfKw, XXX, 1907, p. 1 ff.; P. Schubring, Donatello, Klassiker der Kunst, Stuttgart, Leipzig, 1907; M. Semrau, ThB, s.v.; G. Poggi, Il Duomo di Firenze, Italienische Forschungen, Inst. Florenz, II, Berlin, 1909; D. von Hadeln, Ein Rekonstruktionsversuch des Hochaltars Donatellos im Santo zu Padua, JhbPreussKSamml, XXX, 1909, p. 35 ff.; R. Gorwegh, Donatellos Sängerkanzel im Dom zu Florenz, Berlin, 1909; E. Bertaux, Donatello, Paris, 1910; M. Cruttwell, Donatello, London, 1911; A. Viligiardi, Una meravigliosa opera d'arte mutilata, Rassegna d'Arte Senese, XII, 1919, p. 11 ff.; W. Bode, Die italienische Plastik, 6th ed., Berlin, Leipzig, 1922; M. Dvořák, Geschichte der italienischen Kunst, 2 vols., I, Munich, 1927, pp. 76–88, 97–124; E. Rigoni, Notizie di scultori toscani a Padova nella prima metà del Quattrocento, Archivio Veneto, ser. V, VI, 1929, p. 118 ff.; P. Bacci, Jacopo della Quercia, Siena, 1929; G. de Francovich, Appunti su Donatello e Jacopo della Quercia, BArte, IX, 1929–30, p. 145 ff.; A. Colasanti, EI, s.v.; M. Marangoni, Donatello e la critica, Florence, 1930; A. Colasanti, Donatello, Rome [1930?]; L. Guidaldi, Il Santo, IV, 1932, p. 329 ff.; G. Fiocco, Fragments of a Donatello Altar, BM, LX, 1932, p. 198 ff.; R. Niccoli, Di due disegni . . . per un nuovo altar maggiore nella Basilica del Santo a Padova, RArte, XIV, 1932, p. 114 ff.; R. Oertel, Die Frühwerke des Masaccio, Marburger Jhb. für Kunstwissenschaft, VII, 1933, p. 191 ff.; A. Colasanti, Donatelliana, RArte, XVI, 1934, p. 45 ff.; H. Kauffmann, Donatello: Eine Einführung in sein Bilden und Denken, Berlin, 1935; J. Lányi, Tre rilievi inediti di Donatello, L'Arte, N.S., XXXVIII, 1935, p. 284 ff.; J. Lányi, Le statue quattrocentesche dei Profeti nel Campanile e nell'antica facciata di Santa Maria del Fiore, RArte, XVII, 1935, p. 121 ff.; J. Lányi, Il profeta Isaia di Nanni di Banco, RArte, XVIII, 1936, p. 138 ff.; J. Lányi, Zur Pragmatil der florentiner Quattrocentoplastik (Donatello), Kritische Berichte zur kunstgeschichtlichen Literatur, V, 1932–33, Leipzig, 1936, p. 126 ff.; U. Middeldorf, Review of H. Kauffmann, Donatello, AB, XVIII, 1936, p. 570 ff.; R. G. Mather, Donatello debitore oltre le tombe, RArte, XIX, 1937, p. 181 ff.; R. Band, Donatellos Altar im Santo zu Padua, Mitt. Kunsthist. Inst. Florenz, IV, 1937–40, p. 315 ff.; A. Prosdocimi, Le cantorie del Santo a Padova, RArte, XXI, 1939, p. 156 ff.; J. Lányi, Problemi della critica donatelliana, CrArte, fasc. XIX, Jan.–Mar., 1939, p. 9 ff.; L. Planiscig, Donatello, Vienna, 1939; P. Sanpaolesi, Brunellesco e Donatello nella Sacristia Vecchia di San Lorenzo, Pisa [1940–42?]; W. and E. Paatz, Die Kirchen von Florenz, Frankfurt on the Main, 1940–54; G. C. Argan, Il David di Donatello, Domus, XIX, 2, 1941, p. 32; E. Cecchi, Donatello, Rome, 1942; R. G. Mather, New Documents on Michelozzo, AB, XXIV, 1942, p. 226 ff.; G. Swarzenski, Donatello's "Madonna in the Clouds" and Fra Bartolomeo, B. of the Mus. of Fine Arts, Boston, XL, 1942, p. 64 ff.; R. Buscaroli, L'arte di Donatello, Florence, 1942; L. Planiscig, I profeti sulla porta della Mandorla del Duomo fiorentino, RArte, XXIV, July–Dec., 1942, p. 125 ff.; L. Planiscig, Donatello, Florence, 1947; W. R. Valentiner, Donatello or Nanni di Banco, CrArte, ser. II, VIII, 1949, p. 12 ff.; J. Pope-Hennessy, Donatello's Relief of the Ascension, Vict. and Alb. Monographs, no. 1, London, 1949; G. Galassi, La scultura fiorentina del Quattrocento, Milan, 1949; W. R. Valentiner, Studies of Italian Renaissance Sculpture, New York, 1950; P. Vaccarino, Nanni, Florence, 1950; A. Chastel, Le jeune homme au camée platonicien du Bargello, Proporzioni, III, 1950, pp. 73–74; B. Bearzi, Considerazioni di tecnica sul S. Ludovico e la Giuditta di Dona-

tello, BArte, XXVI, 1951, p. 119 ff.; W. R. Valentiner, Notes on the Early Works of Donatello, AQ, XIV, 1951, p. 307 ff.; G. Marchini, Di Maso di Bartolomeo e d'altri, Comm, III, 1952, p. 108 ff.; O. Morisani, Studi su Donatello, Venice, 1952; C. L. Ragghianti, Donatello giovane, Sele-Arte, July–Aug., 1953; E. Berti Toesca, Il cosiddetto Omero degli Uffizi, BArte, XXXVIII, 1953, p. 307; A. Marabottini, Review of O. Morisani, Studi su Donatello, Comm, V, 1954, p. 256 ff.; G. Marchini, Le vetrate italiane, Milan, 1956; V. Martinelli, Donatello e Michelozzo a Roma, Comm, VIII, 1957, p. 167 ff., IX, 1958, p. 3 ff.; H. W. Janson, The Sculpture of Dona-tello, 2 vols., Princeton, 1957; L. Grassi, Tutta la scultura di Donatello, Milan, 1958; A. Parronchi, Le due tavole prospettiche del Brunelleschi, part 2, Paragone, 109, 1959, p. 3 ff.; J. Pope-Hennessy, The Martelli David, BM, CI, 1959, p. 134 ff.; J. Pope-Hennessy, Some Donatello Problems, Studies in the History of Art Dedicated to W. Suida, London, 1959, p. 47 ff.

Luisa BECHERUCCI

Illustrations: PLS. 240–251.

**DOSSI,** DOSSO. A late Renaissance Italian painter of the school of Ferrara whose real name was Giovanni de Lutero. He was probably born in the vicinity of Mantua (ca. 1479), where his father had a small property, and he died in Ferrara (Aug., 1542). His family, originally from Trent, had moved to Ferrara, where his father had become an estate agent of the duke.

Little is known about Dosso's training as a painter, but he was very much influenced by Giorgione and Raphael. As was natural in a Ferrarese master, his palette was warmer than that of Giorgione, his Venetian exemplar. Giorgione's pastoral quality, however, is successfully carried over into Dosso's personal style, and to it is added a somewhat more magical, romantic, and literary tone, all of which qualities are nicely illustrated in what is probably his best-known painting, the *Circe* of the Borghese Gallery.

Dosso had a younger brother Battista (d. 1548), a painter of secondary rank with whom he sometimes collaborated. Ariosto mentions both brothers in *Orlando furioso*, and both were indebted for themes to this poet, with whom they appear to have had an affinity of mood. Of the two, Battista was the more influenced by Raphael. Since his name disappears from the ducal accounts from 1517 to 1524, it may be assumed that he spent this period in Rome and there became familiar with Raphael's work.

The work of both brothers for the Ferrarese court was of diverse kinds; in addition to the painting which they did in palaces and churches, they made cartoons for tapestries and designs for Ferrarese majolica, and they are also mentioned as sculptors. Battista designed coins, and both artists were from time to time employed in making festival decorations.

The early work of the Dossis consisted of fresco decorations as well as mixed oil and tempera work. Since most of these works are poorly preserved (for example, those in the Castello in Trent and those in the Villa Imperiale at Pesaro, ca. 1533), a true idea of the merits of the Dossis can be obtained only from the oil paintings.

The following is a short list of authenticated and characteristic examples of paintings from the hand of Dosso Dossi, chronologically arranged (although few are actually dated): *Circe* (early, perhaps ten years before the Borghese *Circe* mentioned above), New York, Met. Mus. – *Nymph and Satyr* (highly Giorgionesque but at once more literary and less dreamily poetic), Florence, Pitti Palace. – *John the Baptist* (half length), Florence, Uffizi. – *Madonna and Three Saints*, Modena, Duomo. – *Madonna with Saints* (formerly inscribed 1527), Rome, Gall. Naz. – *Justice*, 1544 (finished by Battista), Dresden, Gemäldegal. – *Coronation of the Virgin with Saints*, Dresden, Gemäldegal. – *Coronation of the Virgin with Four Church Fathers*, Dresden, Gemäldegal. – *St. Sebastian*, Milan, Brera.

BIBLIOG. W. C. Zwanziger, Dosso Dossi, Leipzig, 1911; H. Mendelsohn, Das Werk der Dossi, Munich, 1913.

Arthur McCOMB

**DOURIS.** An Attic vase painter, whose activity is documented for an exceptionally long period, from the late 6th century through at least the 3d decade of the 5th century B.C.

More than thirty of his signed works have survived, and around them it has been possible to group some two hundred others. All these vases are of modest proportions, and most of them are cups. Douris ordinarily signed his work as a painter: Δοῦρις ἔγραψεν (painted by Douris); but in two cases the formula 'ἐποίησεν (made by Douris) appears, as if to exemplify the logical, normal development of the career of a ceramist, from painter to head of an atelier. The two vases in which he testifies to his activity as a potter, the Amazon kantharos in Brussels (PL. 253) and the Athens aryballos (Nat. Mus., no. 15.375), are particularly elaborate in form, leading to the conclusion that Douris himself made them (rather than having merely supervised their manufacture). In other cases he collaborated with the potters Kleophrades, Kalliades, and Pyrhon. Since it is to the last that the type of cup most frequently used by the master has been attributed, a stable artistic collaboration such as that of Brygos and the Brygos Painter, of Hieron and Makron, etc., may be postulated.

Because of the vastness of his output, his fecund inventiveness, and the exceptional artistic quality of many of his works, Douris is one of the central figures in the field of Attic red-figured vases. His great popularity among his contemporaries is indicated by the large number of works signed by him that have survived, the signature being taken in this case as proof of the authenticity of a product of superior quality. Clearer evidence of his prestige is seen in the fact that younger artists imitated him in ways that range from the open admiration of the Cartellino Painter, who inscribed Douris' name emblematically on a scroll, to the more deceitful practice of the Triptolemos Painter, who forged Douris' signature on those of his works which imitated the master's most closely.

Thanks to the large number of his signed works and to the striking individuality of his style, Douris was among the first vase painters to be identified by students of ancient art. Precisely because of the pleasing facility that made him so eminently acceptable to the tame, classicizing taste of the scholars of the last century, the 20th century has turned away from him in favor of a more rugged and exciting primitivism. However, Douris was a sincere and genuine artist. His best quality is the direct sincerity with which he was able to renew his art continuously in the course of a long and industrious life. If, in their supreme moments, Exekias, Euphronios, or the Panaitios Painter give the impression that their manner of painting is free and unconstrained, and for this reason valid in any medium, Douris remains always faithful to the limitations of vase painting. His motifs generally consist of condensed and compact text illustrations or friezes of sustained choral character that appear on the two sides of a cup. Even in his more dramatic themes, Douris' work is not of an aggressive character, as his narrative charm softens the quality of his subject matter. In his painted medallions we do not find the rarefied, crystalline equilibrium of Epiktetos or the energetic, swastikalike gyrations of the Panaitios Painter's figures. The equilibrium that Douris attains, sometimes with consummate felicity, is not related to these almost obsessive preoccupations of other painters. His images — figures isolated or in pairs — are disposed harmoniously in space; and this is done with no apparent effort. Thus the rotating form of Theseus throwing the brigand Skiron into the sea from a high cliff, a motif which the artist treated twice (Berlin, cup, no. 2288: PL. 253; Louvre, cup, G. 126), possesses its own quality of lightness and suspension, contrasting with the explosiveness typical of the masters of action.

Douris' personal accomplishments — his fluid yet solidly structural touch, his compositional balance, and his joyous lyricism — are difficult to appreciate fully because we seem to have accepted them a priori as intrinsic characteristics of Attic vase painting. His lyrical and serene temperament expressed itself most completely in idyls, genre and love scenes, and banquets. But actually his felicity of invention and lack of presumption enabled him to represent almost all the subjects found in ancient vase painting. Because of the variety and persuasive charm of his style, he depicted with equal skill the compact bodies of athletes, the shining breastplates of heroes, and radiant feminine faces. He treated with great success fore-

shortened compositions such as that in which the kneeling Ajax sustains the bow-bent body of Achilles (Paris, Bib. Nat., cup, no. 537), or the motif of the banqueter seen from behind, which he repeated several times (London, Br. Mus., E. 50). The world of heroes had an irresistible attraction for Douris: the splendor of arms, a well-matched duel, pity for the fallen, the Amazon Penthesileia, and the pathetic Memnon in the arms of his mother Eos (PL. 253) appear repeatedly in his work and are always evoked with fresh imagination. In spite of his disarming sincerity and his lyricism, it is Douris who has left us the most complete and consistent image of the world of the epic with its glories and its tragedies. To turn to other examples (see *Bibliog.*), the same freshness is seen in his depiction of Jason emerging from the throat of the enormous dragon, to be thrown at the feet of Athena (Vatican kylix, no. 578), or struggling with a Minotaur that is spotted like a panther (London, Br. Mus., cup, E. 48). On the other hand, the elevated and intense spirituality of some of his interpretations is shown by the trepidation with which the young Neoptolemos confronts his paternal inheritance, the fateful armor of Achilles (Vienna, Kunsthist. Mus., no. 325), and the virginally timid withdrawal of Iphigeneia on the Selinous lekythos, in which her acceptance of the supreme sacrifice is suggested (Palermo, Mus. Naz.).

Three distinct phases have been distinguished in Douris' long and productive life. Of these the last, verging on classicism, corresponds in part with the *œuvre* of the Twig Master (Hartwig, 1893). The work shows no abrupt changes but rather a slow, continuous flow. The artist proceeded in a natural way from forms that look incised or carved to increasingly soft, indeterminate ones. The compositions of the last period are less varied and less solidly articulated, having gray zones of clothed figures disposed in heavy, monotonous rows. It is probable that exigencies of a physical kind, such as the weakened eyesight that comes with old age, account at least in part for this change. However, in contrast with the sloppiness of form or with the real decadence that shames the old age of so many artists, Douris' innate grace and honesty of craft remain all but intact in his last works.

Douris' development seems to have been almost unaffected by external contacts or influences, and it is therefore difficult to define his origins. Although it is possible to show limited contacts with the Panaitios Painter, such collateral contacts with an artist who was substantially a contemporary throw no light upon the sources from which Douris' work emerged.

The frequent occurrence of "love names" (names of young men whose beauty was admired by the painter), in particular that of Chairestratos (see rim of kantharos in PL. 253), serves as an external proof of the continuity of Douris's *œuvre*, as well as an aid in separating the vases into groups corresponding to the various phases mentioned above. The period of Chairestratos corresponds to the first phase and the beginning of the second; Hippodamos and occasionally Polyphrasmon and others appear later. The name of Athenodotos, on the other hand, which appears only twice in Douris' *œuvre*, is important because it is also found among the love names on cups by the Panaitios Painter and Peithinos, thus constituting a kind of bridge between the three artists and establishing their contemporaneity.

BIBLIOG. W. Klein, Die griechischen Vasen mit Meistersignaturen, Vienna, 1887; P. Hartwig, Die griechischen Meisterschalen, Stuttgart, 1893, pp. 200, 582; Furtwängler-Reichholdt, I, p. 246, II, p. 85; E. Buschor, Neue Douris-Gefässe, JdI, XXXI, 1916, p. 74 ff.; Beazley, VA, p. 97; Pfuhl, p. 475; Beazley, VRS, p. 199 ff.; Beazley, ARV, p. 279; M. Robertson, A Lost Cup by Douris with an Unusual Scene, JHS, LXVI, 1946, p. 123 ff.; Beazley, ABV, p. 400; E. Pottier, Douris, Paris, n.d.

Enrico PARIBENI

Illustrations: PLS. 252, 253.

**DRAVIDIAN ART.** The artistic production of the Dravidian peoples of India occupies an important position within the context of the over-all development of Indian art (q.v.); thus a separate treatment is appropriate, permitting a careful evaluation of this contribution and providing a basis for further, more detailed studies. Ethnically and linguistically the Dravid-

ian peoples are distinct from the Aryan groups in India; they continue old patterns of religious thought and adhere to different ways of living. Although the cohesive and integrating power of Indian culture must not be underestimated, the distinctive Dravidian attitudes produce certain differences in taste; these are seen particularly in architecture and in the form and arrangement of images, which, though retaining religious values and iconographic features common to all of India, present independent stylistic formulations and occasional iconographic peculiarities. Leaving aside the problem of the degree of indebtedness of Indian iconography and religious thought to the Dravidian peoples, it is obvious that the southern art trends gain greater clarity when historically considered apart from their interconnections with the other areas of Indian art, following their own continuous lines of development.

SUMMARY. Introduction (col. 444). Architecture (col. 447): *Pallava*; *Pāṇḍya*; *Chola*; *Vijayanagar*; *Kerala*. Sculpture (col. 451): *Pallava*; *Pāṇḍya*; *Chola*; *Vijayanagar*; *Kerala*. Painting (col. 457).

INTRODUCTION. The Dravidians are a group of peoples inhabiting southern India, with particular concentration in the extreme south and in part of the Deccan; today they number some 70 million. Even in the mid-20th century, after thousands of years of trade, cultural contact, and conquest, the south of India is distinct from the northern and central regions. The Aryan wave that descended from the Hindu Kush and rapidly pressed across the Indus had less effect on the areas south of the Vindhya Mountains, which for a time remained underdeveloped, thereby retaining the older traditions.

A Dravidian component seems to have been present in the early Indus Valley civilization (see INDUS VALLEY ART). Even today the Brahui group inhabiting Baluchistan, where the early Zhob and Nal cultures flourished (see CERAMICS), speak a Dravidian language and bear witness, so it would seem, to a very ancient migration of vast proportions that covered almost the entire Indian subcontinent. In the religious images of the Indus Valley sites of Harappa and Mohenjo-daro it is possible to discern analogies with that Hindu thought which has its stronghold in the Dravidian areas.

It is not difficult to identify the iconographic and stylistic trends that radiated from the Dravidian area to meet tendencies of different origin. Thus a bilateral system of exchanges was formed, which, though it did not integrate the individual tendencies of the participating elements into a single whole, was nevertheless fecund for their development. The examination of Dravidian art styles naturally overlaps that of the Andhras (see ANDHRA) as well as the study of the Deccan area (see DECCAN ART). With the Andhras the task is to recognize the characteristics, importance, and diffusion of a particular style chiefly within the orbit of Buddhism. In the Deccan one must study, together with a long historical development, a center of broad Indian influence in foreign countries (e.g., Burma, Indonesia). The study of Dravidian art styles, however, involves assessing, in so far as possible, the manifold contributions of a large group that was undoubtedly responsible for many characteristics of the spiritual attitude of the Indian world.

Though often neglected, the contribution of the south to the Indian subcontinent as a whole — a contribution of new ideas as well as profound reinterpretations — is of particular interest, and its understanding is essential for a true understanding of the history of Indian art. A number of trends that had a long development in Indian art may have originated in the south. One example is architecture carved from the living stone (PL. 255), diffused by Buddhism (q.v.), which penetrated far outside the borders of India, ultimately reaching northern China (q.v.; see also CHINESE ART). Another is the use of stone temples (rathas; PL. 254) imitating the heavy wooden carts employed in processions. Both these inventions manifest a spirit of imitation and an experimental drive expressed in terms of hollowing out or carving that achieves the qualities of masonry construction or reproduces in stone the plastic masses of wooden carts while enormously magnifying the proportions. Analogously, the great crowning pyramids of temples reveal

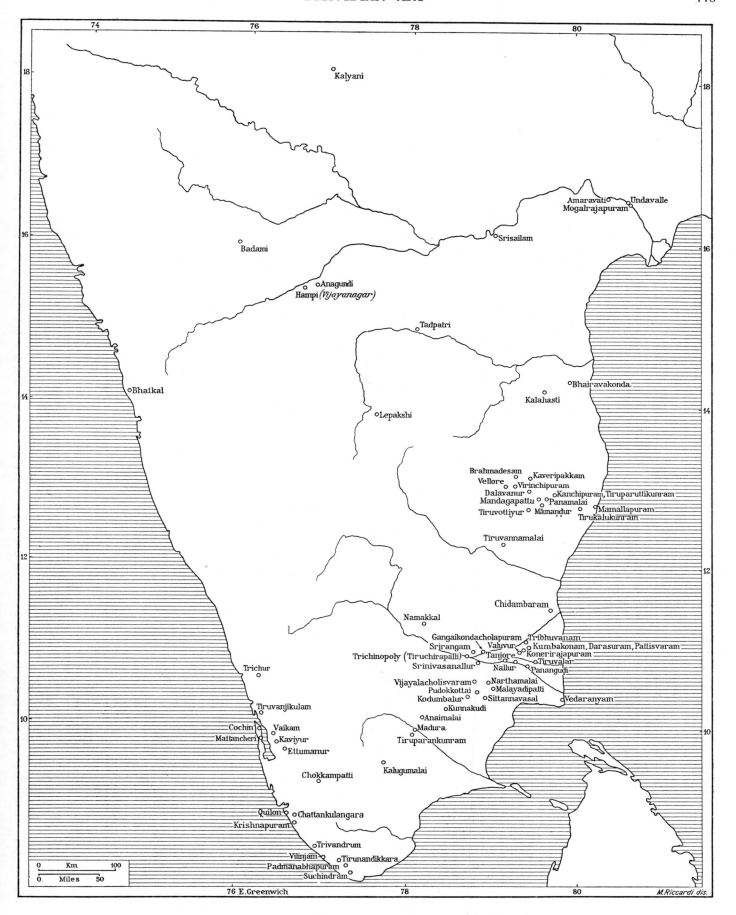

Art centers in Dravidian India and peripheral areas.

their humble origins in the thatch coverings of Dravidian huts, though of course their gigantic masses (called "Dravidian" in the Indian architectural manuals) had to compete with the curvilinear shikaras of the north.

Though the historical evolution of the Dravidian peoples culminated in the seafaring empire of the Cholas (9th–12th cent. of our era; the only such empire in Indian history), the artistic evolution was prolonged through the Hindu medieval period, persisting even when elsewhere the creative *élan* was exhausted. This may be due to that logical and precise mode

Types and development of the *kūḍu*.

of thought which the Dravidians demonstrated in their social organization as in their art, a vehicle of elevated religious feeling rich in experience.

Mario Bussagli

ARCHITECTURE. *Pallava*. The earliest known examples of the art and architecture of the land of the Tamils (Tamiḷanāda or Tamiḷadeśa) or Dravidians (Dramiḷadeśa) are of a comparatively late date, the time of the ruler Mahendravarman I (600–30) of the Pallava dynasty (ca. 4th–9th cent). However, this does not mean that art in some form did not flourish in an earlier period in southern India. Constructions of perishable materials must have existed but are no longer extant; these structures probably were the forerunners of those still preserved in stone or in painted panels in the later monuments of this area.

From an inscription of Mahendravarman I found at Mandagapattu we learn that these earlier constructions were of wood and other impermanent material and that he introduced for the first time in southern India a more durable type of architecture — that carved from rock. In another of Mahendravarman's inscriptions, found at Kanchipuram (mod. Conjeeveram), there is a clear reference to the existence in this period of masonry temples, but only rock-cut ones have been found. Thus discussion of the known history of Dravidian art must begin with the rock-cut monuments, with only a hint of earlier art as seen in the monuments of the Sātavāhana period (3d cent. B.C.–end of 2d cent. of our era) found in the Kistna Valley (see ANDHRA). The Sātavāhanas extended their rule in the Tamil area almost as far as Chidambaram, and their art dominated southern India at the beginning of the Christian era. In the Kistna Valley at Mogalrajapuram and Undavalli, in the territory where his grandfather Vikramahendra of the Viṣṇukuṇḍin dynasty had ruled, Mahendravarman as a youth may have admired the rock-cut architecture that he later introduced during his reign.

The style of the period of Mahendravarman was characterized by massive pillars divided into three parts, the upper and the lower parts square in section and the middle part octagonal; the corbel above the pillars is cut obliquely at a 45° angle or is rounded and often has a wavy ornament on either side of a smooth central band. The *kūḍu* (FIG. 447), originally the window of a Buddhist temple (chaitya; Skr., *caitya*), became a simple horseshoe arch crowned by a shovel-head finial and adorned by the representation of a human head; the divinities guarding the doors (*dvārapāla*s) at either end of the temple or flanking the entrance are sometimes horned.

The pillars of the rock-cut temples of Mahendravarman were clearly inspired by the earlier ones at Mogalrajapuram, but the three facets and the medallions in the form of a lotus that adorn them reveal another source of inspiration, the railings of the balustrade from Amaravati (2d cent. of our era; see I, FIG. 403). In the caves of this time, as at Dalavanur, the *kūḍu*

arch issues from the mouth of a *makara* (fantastic aquatic animal) bearing a rider on its back and is derived from the motif of an undulating garland emerging from the mouth of a *makara* ridden by a *gaṇa* (dwarf) that adorns the balustrade at Amaravati.

The style of Mahendravarman I is followed by the Māmalla style, named after Narasiṃhavarman I Mahāmalla (or Māmalla; 630–68), under whose reign the tradition of temples carved inside a cave still continued. In addition, however, freestanding monolithic temples also carved out of rock began to appear. Famous examples of the work of Pallava sculptor-architects of this period are the monuments built by Narasiṃhavarman to adorn his seaport of Mamallapuram (Mahabalipuram) — a row of monolithic temples having the form of chariots (rathas) used in religious processions: the Draupadī Ratha, the Arjuna Ratha, the Bhīma Ratha, the Dharmarāja Ratha, and the Sahadeva Ratha (PL. 254). In each of these it is possible to find prototypes of architectural forms that developed through southern India. Thus, for example, the roof of the Draupadī Ratha, imitating a thatched roof, is found later in the temples of the Chola period, as at Chidambaram; the wagon roof of the Bhīma Ratha developed into the immense gopura (towered gateway) so famous all over southern India; while the Dharmarāja Ratha and the Sahadeva Ratha are the the the antecedents, respectively, of the vimana (Skr., *vimāna*; a pyramidal tower roofing the central shrine) and of the apsidal temple. The pillars of the temples at Mamallapuram are more slender than those of the Mahendravarman period and slightly more ornamented. They are supported by crouching lions, as in the rock-cut temples at Bhairavakonda built by Siṃhaviṣṇu (575–600). The *kūḍu* is still simple and has a shovel-head finial; the pavilion ornament resembles a thatched hut with a simulated railing below; the torana (Skr., *toraṇa*; originally the gateway of honor that led into the enclosure of the Buddhist stupa; see BUDDHIST PRIMITIVE SCHOOLS), or arch, at the top of the niches has at either end a *makara* with floriated tail and with a rider on its back.

Toward the end of the 7th century, under the successors of Narasiṃhavarman I (Mahendravarman II, 668–70; Parameśvaravarman I, 670–80), the excavation of temples was abandoned and freestanding temples (no longer "carved" from the rock but "constructed") were built instead. In the complex of sacred buildings that make up the Kailāsanātha at Kanchipuram, built under Narasiṃhavarman II (also called Rājasiṃha; 680–720), it is possible to observe the origins of the technique and style of construction of southern India and to find the elements that are employed, though with changing emphases, in all successive architecture: the mandapa (Skr., *maṇḍapa*, porch), the *ardhamaṇḍapa* (pillared porch), the small surrounding cells, the gopura, and the vimana (PL. 255).

The pillars of the Kailāsanātha are slender and are supported by rampant lions, not by crouching ones as in the monuments at Mamallapuram; the shovel-head finial of the *kūḍu* is more richly ornamented; the central vimana, inspired by the Dharmarāja Ratha at Mamallapuram, is given greater emphasis and is large compared with the tiny gopura, which resembles the small *śāla*, or hall, of a Buddhist monastery although it is a little larger than the cellas arranged around the *pradakṣiṇā* (circumbulatory) passage.

There are several Pallava temples of the period of Narasiṃhavarman II at Kanchipuram, Panamalai, and Mamallapuram (the Shore Temple). This last monument, now in ruins, is especially noteworthy. In the temple, which is dedicated to the cult of Śiva, are two shrines dedicated to the cults of Iśvara and of Mukunda, suggesting a tradition of great religious tolerance that was obvious in an earlier period in the triple cellas dedicated to Trimūrti, or the triad (Brahmā, Śiva, and Viṣṇu) at Mandagapattu and Mamallapuram.

These, in turn, are echoed in the triple temple at Prambanam in Java (see INDONESIAN CULTURES), directly influenced by Pallava art.

One of the latest in this series of Pallava temples is the Vaikuṇṭha Perumāl at Kanchipuram. In this very elaborate building, the central chapel of the divinity and its dependencies have larger proportions. The high outer wall of the temple is effectively decorated, on its inner side, with sculptures and

inscriptions relating the history of the Pallavas. The *pradakṣiṇa* path surrounding it, with its arcades, colonnades of lion pillars, and carvings of divinities, makes this temple a veritable treasure house of art.

Examples of Pallava architecture of the 9th century are the Vāḍāmalliśvara at Oragadam and the Mukteśvara at Kanchi. The Viraṭṭāneśvara temple at Tiruttanur, an example of the Aparājita style (named after the last Pallava sovereign, 879–97), has the same apsidal form as the Sahadeva Ratha at Mamallapuram, its prototype, which was itself derived from the earlier apsidal Buddhist chaitya. This apsidal form later became a favorite in structures of the Chola period (9th–11th cent.), especially for the central vimana.

*Pāṇḍya.* The art of the Pallavas was not confined to its place of origin. Farther south, the fame of the fine constructions of Mahendravarman I and his successors stimulated the Pāṇḍya kings (6th–14th cent.) to follow the same path.

The rock-cut temples at Tirumalaipuram, Virasikhamani, Sendamaram, Kunnakudi, Chokkampatti, Tiruparankunram, Anaimalai, Kalugumalai, and other places are eloquent testimony to the prestige enjoyed by Pallava art and to the renewed religious zeal that swept the region ruled by the Pāṇḍyas. The massive pillars divided into three cubical parts, the corbels, the arrangement of the cells, the *dvārapāla*s, and the ornamentation and placement of the figures of the deities are all characteristic of the rock-cut temples of the Pāṇḍya region (e.g., the one at Tirumalaipuram, which is similar to those of the period of Mahendravarman I) and show the powerful and widespread influence of Pallava art in this area.

The cave temple at Tiruparankunram is worthy of mention. It is reached by going through a gopura and mandapa, both added at a later date. Inside the temple are the usual massive pillars flanked by pilasters. Unlike Tirumalaipuram, where there is only a single cella, here there are five cellas of deities: three facing the mandapa, dedicated to Somāskanda, Durgā, and Gaṇeśa, and two side cellas dedicated to Viṣṇu (Eng., Vishnu) and the linga of Śiva (Eng., Shiva). The many lovely carvings that adorn the temple are among the earliest Pāṇḍya sculptures.

The most beautiful building of this period is the temple at Kalugumalai (PL. 254), reminiscent of the Kailāsanātha temple at Ellora (see DECCAN ART); it was carved and worked from the top to the bottom of a small rocky hill. The façade, which faces east, and the entire lower portion are roughly cut and unfinished. The front portico of this temple is nearly devoid of ornamentation except for two very lovely long rows of *gaṇa*s in comic poses, some playing musical instruments. The vimana, of many tiers, is an early Pāṇḍya work. The *kūḍu*s of the octagonal peak of the vimana are decorated alternately with lion-head and shovel-head finials. Four fine figures face the cardinal points of the compass, just under the eaves of the peak of the vimana. The four corners are adorned by exquisitely carved figures of Nandi (the bull, Śiva's mount). Below a frieze of *yāli*s (fantastic monsters) is the next tier, with a row of lion-head *kūḍu*s. The charming faces of young girls peep through the *kūḍu*s, while in the niches at the bottom of the *kūḍu*s are half-length figures of young girls. The whole tier is supported by *gaṇa*s in a variety of poses. In the course below there are miniature pavilions on the four sides interrupted at the center of the south, west, and north sides by *śāla*s with elegantly decorated barrel vaults supported by *gaṇa*s that function as caryatids. In the niches within the three *śāla*s are the figures of Dakṣiṇāmūrti (south), Viṣṇu (west), and Śiva (north). Between the pavilions and the *śāla*s are lion-head *kūḍu*s, with seated figures in the shallow niches under each.

*Chola.* The true heirs and perpetuators of the artistic tradition of the Pallavas were the Cholas (9th–13th cent.). Among the temple-building sovereigns of this dynasty were Aditya I (ca. 871–907), Parāntaka (ca. 907–55), Rājarāja I (ca. 985–1014), Rājendra I (ca. 1014–44), Kulottuṅga II (1133–50), and Kulottuṅga III (1173–1216). The earliest Chola temples, e.g., the Śiva temple at Vijayalayacholisvaram, the Nāgeśvara at Kumbakonam, the Aga-

styeśvara at Panangudi, the Mūvarkovil at Kodumbalur, and the Kuraṅganātha at Srinivasanallur) are characterized by great simplicity and modest proportions. The vimana has a quadrangular roof with Nandi figures facing each corner and is connected to the mandapa by an *antara* (corridor). Beneath the eaves is a frieze representing troops of demons (*bhūta*) depicted by the artist in humorous and fanciful poses. But the decoration even in the early temples is richer and more profuse than that of the Pallava period, especially where the influences of the Rāṣṭrakūṭas (ca. 8th–10th cent.) and the Pāṇḍyas were felt; and gradually the dimensions of the sacred buildings increased, the structures became more complicated and the decorations more elaborate, and the whole aspired to a richness and grandeur that clearly differentiates Chola from Pallava art.

The highest expression of this new style was the Bṛhadiśvara (or Rājarājeśvara) at Tanjore, constructed by Rājarāja I about 1009, which echoes the earlier Tiruvāliśvara at Brahmadesam.

Typical columns from Dravidian monuments.

The Bṛhadiśvara is made up of various structures aligned on the central axis of an enclosed sacred inner courtyard, surrounded by cloisters on all sides. The principal outer entrance of the temple is surmounted by two gopuras a short distance apart, the smaller one decorated with themes from the Śiva Purāṇas (sacred medieval Hindu texts). Two rows of niches, one above the other, with representations of deities, run along the three sides of the shrine on the massive plinth. At the temple's east entrance, a flight of steps leads to a long mandapa of a later date. At either side of the entrance are beautiful figures of *dvārapāla*s and princely warriors. Other flights of steps are found at the north and south sides, and still others lead from the *mukhamaṇḍapa* (outer porch) to the north and south flanks of the principal vimana, which rises from the western end of the enclosure and is the main structure comprising the Bṛhadiśvara; it is about 100 ft. on each side and over 200 ft. high and is surmounted by a large pyramidal spire or shikara (Skr., *śikhara*). According to tradition, the spire was transported on an inclined ramp about 4 miles long. A hill-shaped relief on the east side of the vimana is a symbolic allusion to Mt. Meru, residence of the gods (see COSMOLOGY AND CARTOGRAPHY), which ancient tradition identifies with Mt. Kailasa in the western Himalaya.

The strong masculine force of the rectangular contours of the Tanjore temple of Bṛhadiśvara and the martial figures of men and gods that make up its reliefs contrast with the feminine grace of the rounded contours of the huge Bṛhadiśvara temple erected by Rājendra I about 1030 at Gangaikondacholapuram, then the capital of the Cholas, of which this temple is today the only trace (PL. 257). It is the center of a vast enclosure. The *mukhamaṇḍapa* is about 173×95 ft. and rather low; between the *mukhamaṇḍapa* and the vimana there is a kind of transept, at right angles to the principal axis of the complex,

which leads to the south and north entrances. The vimana, at the western end, measures about 98 ft. on each side and consists of a plinth, a pyramidal body formed by eight steps, and a cupola-like top, the whole rising to a height of about 183 ft. Along the sides of the enclosure are little shrines of minor divinities (*parivāradevatā*).

The temple of Airāvateśvara at Darasuram (PL. 257) is characteristic of later Chola art in its attention to detail and taste for sumptuous and elaborate decoration. The plan of the main building is very similar to the two Bṛhadīśvara temples described above and is distinguished by the numerous secondary buildings grouped around it and by its profuse decoration. The mandapa is characteristic: two of its sides are carved with a huge wheel, and in front of it are two galloping horses, which convert the mandapa into a ratha.

*Vijayanagar.* After a long and complex period of struggle, the Vijayanagar kingdom, so called from the name of its capital city, became, about the middle of the 14th century, the dominant power of southern India. The art and architecture of Vijaganagar (14th–17th cent.) was a continuation of the Chola and Pāṇḍya traditions, to some extent combined in the provinces where Kanarese and Telugu are spoken with the earlier Chalukya (Skr., *Cālukya*) traditions (see ANDHRA). The architecture of the period was distinguished by the emphasis given to the gopura, the mandapa, and the corridors at the expense of the vimana, and to the circumambulatory passage, which was transformed into a hypostyle gallery.

One of the greatest rulers of Vijayanagar was Kṛṣṇadevarāya (1509–29), who was not only a statesman, ruler, and notable warrior but also a scholar, poet, and patron of the arts. Like Aśoka, who according to legend built 8,400 stupas all over India, Kṛṣṇadevarāya built for practically every temple of any importance in southern India one of the gopuras called by his name — Rāyala gopuras, or towers built by Rāya (PL. 260). A magnificent example of Vijayanagar art is the temple of Viṭṭhala at Hampi (anc. Vijayanagar), now in ruins; another is that of Bālakṛṣṇa, also at Hampi. The gopura constructed by Kṛṣṇadevarāya at Chidambaram, with his portrait in a niche, is particularly fine. Among the mandapas of this period are those at Vellore and Srirangam, which have pillars richly decorated with beautiful reliefs.

*Kerala.* At the southwest end of the Indian peninsula is Kerala, a region which took the name of the local dynasty of Kera (ca. 2d–12th cent.). In this area the main currents of Dravidian art met — Pallava, Pāṇḍya, Chola, and Vijayanagar.

The oldest temples in Kerala (e.g., that at Kaviyur, near Tiruvallara, and that at Vilinjam, near Trivandrum; PL. 255) are carved in rock and recall those of the Pallavas in their structure and reliefs (*dvārapāla* figures). In Mamallapuram the temples are reminiscent of the 8th-century ones at Namakkal (in Salem District).

Along with typical Dravidian architecture, another type developed in Kerala is related to the ancient wooden architecture of civil and religious buildings. Temples of this type have circular or rectangular ground plans, consisting of a central building (*śrīkoil*), where the divinity is housed, and the customary adjacent structures. In the lower part the projections depart only slightly from the usual Dravidian type; in the entablature and the roof, however, the structural elements are modified because of the heavy rainfall and high humidity of the region. The rafters supporting the roof are designed to allow rain to run off more easily; the pitched wooden roof is sheathed with tiles and has dormer windows protruding from it for ventilation. There are always two or more stories rising in decreasing size. These picturesque structures in Kerala are comparable to some in Bengal and Nepal (see NEPALESE ART).

SCULPTURE. *Pallava.* As mentioned above, the Pallava ruler Mahendravarman I introduced elements of the art of the Kistna Valley during his reign. The *dvārapālas* in his rock-cut temples are massive but more human in aspect than the later ones. These *dvārapālas* have only a single pair of arms,

resembling those at Mogalrajapuram and Bhairavakonda, executed during the reign of Siṃhaviṣṇu (574–600). Typical examples of ancient Pallava sculpture are seen in the caves at Tiruchirapalli (mod. Trichinopoly), Tirukalukunram, and Kilmavilangai. The famous panel representing Śiva Gaṅgādhara (Śiva receiving the waters of the Ganges) at Tiruchirapalli is one of the noblest achievements of Pallava sculpture. The figures of the worshipers and the great dignity of Śiva as the rushing stream flows among the locks of his hair are outstanding.

True masterpieces of Pallava art in the temples of Narasimhavarman I at Mamallapuram are the rathas carved in rock (described under *Architecture*) and the so-called *Arjuna's Penance* (or *Descent of the Ganges*; PL. 256), with panels depicting Varāha, Gajalakṣmī, Viṣṇu, and Mahīṣamardinī, among others. The panel of Mahīṣamardinī was so admired that a century later it was reproduced in similar form in the caves at Ellora (see DECCAN ART). Among the fine works executed for Narasimhavarman I are the portrait sculptures of his father Mahendravarman I and his grandfather Siṃhaviṣṇu, both accompanied by their queens, in the cave of Varāha. There is a portrait of Narasimhavarman himself on the Dharmarāja Ratha at Mamallapuram.

Unlike earlier Pallava sculpture, which is simpler, heavier, and more primitive, the later Pallava sculpture reveals greater richness of detail, lighter anatomy, and a more developed artistic finish. Fine examples of this period are the sculptures of the Vaikuṇṭha Perumal and of the Airāvateśvara, Mukteśvara, and Mataṅgeśvara at Kanchi. The Viraṭṭāneśvara at Tiruttani is especially rich in sculptures of the last phase of Pallava art, from the period of Aparājita (879–97). Typical sculptures of this period are also found at Satyamangalam. The iconography of this period was highly developed and widespread; among the forms used are Śiva in the *ālīḍhanṛtta* pose, Śiva Ardhanarīśvara on a bull, and Śiva Dakṣiṇāmurti with an *ardhayogapaṭṭa* (robe used by ascetics to assist in assuming and maintaining difficult Yoga positions).

The late Pallava sculpture at Kaveripakkam marks the fusion of Rāṣṭrakūṭa elements in Pallava art. The Rāṣṭrakūṭas invaded Pallava territory in the 9th century, and we know of their influence from inscriptions. Notable examples of the influence of Rāṣṭrakūṭa style on late Pallava art are the images of *dvārapāla*s and the Brahmā at Kaveripakkam.

*Pāṇḍya.* The earliest Pāṇḍya sculpture is similar to early Pallava sculpture. Carved panels closely resembling examples from the early Pallava period can be seen in the cave at Tirumalaipuram in the Tirunelveli District, discovered by Jouveau-Dubreuil. The figures of these reliefs are akin to early Pallava reliefs in anatomic structure (heavy form, well-rounded limbs) and in the ornaments with which they are adorned, as in the figures of Brahmā, of Śiva dancing, and of Viṣṇu. In the formation of the splendid iconographic theme of Śiva dancing (Naṭeśa) characteristic of early Chola sculpture, the Pāṇḍya dancing Śiva of Tirumalaipuram has perhaps contributed as much as the one in the Dharmarāja Ratha at Mamallapuram.

Among the most beautiful sculptures of southern India in the early medieval period are those in the magnificent monolithic temple at Kalugumalai. The *gaṇa*s, Nandis, and figures of Śiva and Pārvatī are excellent specimens of Pāṇḍya sculpture. The physiognomy of Śiva and the particular twist of the *jaṭā* (knot of hair) proclaim the affinity of this school of art with late Pallava sculpture and with that of western Chalukya (10th–13th cent.) in its latest phase. Especially noteworthy in this temple are the studies of animals and the youthful figures that fill the niches below the *kūḍu*s: the maidens are shown preparing themselves for a bath or just after a bath; others are drying their hair before perfuming it; still others are arranging their tresses. These half-length figures are not an innovation; at Mamallapuram, couples of embracing divinities are carved in a similar fashion on the Arjuna Ratha.

One of the most beautiful works of Pāṇḍya sculpture is the scene of Naṭeśa on the side wall of Śiva's cella at Tiruparankunram. This work is composed of two panels: one is entirely covered by the dancing Śiva; the other depicts an

orchestra that keeps time for the dance while Pārvatī, Nandī, and others watch the performance. Various elements of this representation — the long staff surmounted by a bull (nandīdhvaja) in Śiva's hand, the position in which is portrayed the dwarf Apasmāra who supports Śiva — are also found in the Naṭeśa at Pattadakal. This iconographic affinity shows how strong the rapport among various regions of southern India had become in this period, with similar themes and motifs being found among the Chalukyas, Pallavas, Cholas, and Pāṇdyas.

In the adjacent panel the tiara (mukuṭa) of Pārvatī is simple and recalls, in its form, that of Lakṣmī at Mamallapuram. The way in which the legs of the goddess are portrayed and her general pose recall a similar figure of an attendant of Lakṣmī in the cave of Varāha and the Princess at Her Toilet at Ajanta, which has long been a source of inspiration for sculptors.

Excellent Pāṇdya sculptures, very similar to the human and divine figures carved in the Pallava caves of the 7th century, are in the rock-cut temples at Virasikhamani, Sendamaram, Kunnakudi, and Chokkampatti; the dvārapālas represented resemble strikingly those at Tirukalukunram, Dalavanur, Mandagapattu, and other cave temples of Mahendravarman.

*Chola.* The earliest monuments of Chola art (which attained its culmination in the grand style of the rulers Rājarāja I and Rājendra I) are rather small. Early Chola sculpture is distinguished by the sense of volume and the disposition of the figures and by a naturalness and lightness that differentiates it from the more massive figures of the early Pallava period. The figures are slender, the ornamentation more delicate and intricate, though restrained, and the faces, which toward the end of the 10th century assumed the rounder form characteristic of this art, are elongated. The filigreed crown and sacred thread, the necklace, the lion-head clasps fastening the waist, and the folds and decorative patterns of the garment are all traits of the early phase of Chola art that continued even in the great later Chola art of the temples of Nāgeśvara at Kumbakonam, of Śiva at Kiliyur near Tirukkovilur, and of Kuraṅganātha at Srinivasanallur in Trichinopoly District (PL. 258). This early Chola sculpture incorporates a variety of elements. A definite Rāṣṭrakūṭa influence, for example, can be recognized in the fine early sculptures at Kaveripakkam in North Arcot District.

Apart from rock sculpture, bronze (PL. 259) in the early Chola period also achieved extraordinary perfection. Fine bronzes typical of this period are the Naṭarāja from Tiruvarangulam (National Mus. of India, New Delhi; PL. 221), the Kirātamūrti from the temple at Tiruvetkalam near Chidambaram, and the bronzes in the Madras Government Museum: the group of Rāma, Śiva, Lakṣmaṇa, and Hanumān from Vadakkuppanayur; Viṣṇu with Śrīdevī and Bhūdevī from Peruntottam; and Naṭeśa and Somāskanda from Tiruvalangadu. There are excellent bronzes, suggesting a continuation of the grand Pallava tradition, at Tiruvalur, in the temple at Gangaikondacholapuram, and in the Bṛhadīśvara at Tanjore.

The characteristics that distinguish the style of Rājarāja from that of his predecessors are already recognizable in the little temple of Tiruvālīśvara at Brahmadesam in Tirunelveli District, in which the carved figures are rich in iconographic detail; but the first triumph of this new style is represented by the two Bṛhadīśvara temples at Tanjore and at Gangaikondacholapuram, the latter built by Rājendra I.

Most of the figures adorning the niches in the temple at Tanjore are represented also at Gangaikondacholapuram; noteworthy here is an image of Brahmā flanked by the goddesses Sarasvatī and Sāvitrī. Although in southern India Brahmā is normally represented as a slender, beardless youth, the figure at Gangaikondacholapuram shows him with a beard, probably a representation seen by Rājendra during the course of his campaigns in the north and brought back by him to his kingdom. A curious creation of Rājendra is a stone representation of the sun and eight planets (PL. 259), an eloquent testimony to the syncretist tendency of this art (see ASTRONOMY AND ASTROLOGY). Another indication of the breadth of this ruler's artistic appreciation is the iconographic theme of Lakuliśa, taken by Rājendra from Kalinga, which can be seen in the so-

called "Gauliśa sculpture" in the early Chola temple at Tiruvottiyur. The bull garlanded with bells, the Nolamba pillars, the dvārapālas at Kalyani, the Orissan type of Ganeśa at Kalinga — all represent northern influences traceable to Rājendra's military campaigns.

The art of southern India in its most imposing and grandiose form is seen in the Chola art of the 11th century, begun under Rājarāja. The famous and magnificent temple of Rājarājeśvara (or Bṛhadīśvara) built by Rājarāja and that at Gangaikondacholapuram built by Rājendra are reminiscent of the glory of the Egyptian pyramids. These temples and the one at Tribhuvanam have pyramidal towers surmounting the most sacred part, the sanctum sanctorum. The huge dvārapālas on all sides of these structures show the gigantic scale of the conception of early Chola art and, at the same time, the ability of its sculptors. These dvārapālas, the largest in southern India, have the trident (triśūla) on their heads and carry the emblems of Śiva, including an enormous club joined to a sword, on which they rest one leg. One hand is in the position indicating threat (tarjanī), the other in the position of wonder (vismaya) — the latter a hand position characteristic of the dvārapālas of some late Pallava and most early Chola sculpture.

Massive and masculine in feeling, the temple of Bṛhadīśvara at Tanjore finds its counterbalance in the Bṛhadīśvara at Gangaikondacholapuram, which is as elegant and light in its sculpture as in its architecture. Among the fine works in the temple at Gangaikondacholapuram are Ganeśa dancing (Tāṇdavaganeśa) and Naṭarāja in stone, and the panel of Śiva Candeśānugrahamūrti (PL. 258), in which the motifs of late Chola sculpture begin to appear.

Fine specimens of Chola sculpture that, although slightly later in date, are endowed with equal grace and elegance are seen in the niches of the gopura and also around the temple at Chidambaram. Especially important for the history of the dance in India are the sculptures of the gopura of this temple, vividly depicting the dance positions described in the famous Nāṭyaśāstra of Bharata (6th cent.?).

In the Chola period, portrait statues were also notable. Among the more outstanding portraits are that of Gandarāditya, which his pious and noble queen Śembiyammādevī had executed in the temple of Konerirajapuram; the portrait of Rājarāja at the entrance to the Ekāmreśvara shrine at Kanchi; and the portrait bronzes of Śolamādevī and Kulottuṅga at Kalahasti. There are earlier portraits, beautifully executed and marked by careful attention to detail, in the early shrine of the Nāgeśvara temple. Also important, although not strictly contemporary portraits, are the numerous representations of Sundara, Māṇikka Vachakar, and Tirujñānasambandha.

Among the finest examples of the later phase of Chola sculpture are those in the temple at Darasuram, especially the notable figure of Śiva Gajāntaka accompanied by his obviously terrified consort. Śiva dances in the bhujaṅgatrāsita pose on the head of the demon Gajāsura, destroying him. Other outstanding works from this temple are a rare depiction of Śarabha killing Narasimha; the large and lovely group of Kaṅkālamūrti, admired by a host of ṛṣipatnī (wives of sages) and accompanied by troops of demons (bhūta); and the portrait of Rājarāja II and his queen. Unlike the art of the temples of Tanjore and Gangaikondacholapuram, where the accent is above all on the heroic element, here the sculpture is marked by a sense of peace and tranquility, more religious and thoughtful.

Figures of rishis (Sks., ṛṣi; sages), of ascetics, of Brahmans, and of rulers with the insignia of their rank, sacred stories, scenes of dance and music, ponds and rivers full of fish and shells — these are the preferred themes in this art, recalling similar scenes depicted in the earlier temples at Prambanam and Borobudur in Java. Nor should this be surprising: the relationship between India in the Chola period and Indonesia, some of whose islands were for a time under the rule of the Cholas, was such that sculptural parallels were logical. There are other resemblances, too; certain decorative elements — for example, the foliate patterns that form medallions for the dancing figures on the pillars as well as some of the pillar capitals — suggest the influence of the Rāṣṭrakūṭas and Cha-

lukyas, which was inevitable because of the frequent Chola incursions into their kingdoms. At Kaveripakkam, for example, such Rāṣṭrakūṭa influence on late Pallava and early Chola sculpture is obvious: fine sculptures illustrating this are in the Madras Government Museum.

The sculpture from Pattisvaram, of a slightly later period, has all the characteristics of late Chola art. The weapons — in a manner common to Chola sculpture from the middle of the 11th century on — are almost always held in the two upraised fingers of the hand in the so-called kartarīmukhahasta pose; the shell (śaṅkha) and the wheel (cakra) of Viṣṇu and Durgā show flames; the cakra tends to face forward; the yajnopavita (Skr., yajñopavīta; garland), which in early sculpture was broad, sinuous, and ribbon-shaped, is separated here into three strands of nearly equal width, thus becoming more regular and symmetrical; the kirīṭa (a type of tiara) of Viṣṇu, originally cylindrical, has become conical; and in this period the bhṛṅgipāda, a small bell on the right foot of Śiva, first appears. Fine examples of this phase of Chola art are the Bhikṣāṭanamūrti at Valuvur, the Vṛṣavāhana at Vedaranyam, and the Kalyāṇasundara at Tiruvattiyur.

*Vijayanagar.* The rulers of this dynasty, who were illustrious patrons of culture and learning, fostered the Tamil art of the Cholas so that in a short time it became dominant in almost all of southern India and gradually triumphed over local traditions. In the art of this period the Tamil artistic ideal found one of its last and most compatible expressions.

In the early phase of Vijayanagar art, especially that from the Kanara District and Konkan, the characteristic ornamentation and mode of drapery of the Chalukya style persist. A good example of this transitional period is the ruined temple on the river bank at Tadpatri. The gopura sculptures, now scattered over the ground and the river bed, have a grace and finish that, together with other characteristics, reveal the influence of the Chalukya style, as well as certain Tamil stylistic elements.

A further stage in the development of Vijayanagar art is seen in the carvings from the temple of Viṣṇu at Tadpatri. The beautiful monolithic ratha of this temple vies with the similar one in the temple of Viṭṭhala at Hampi. The temple of Virūpākṣa also has fine sculptures from this early period. Another temple worthy of special mention is that of Mallikārjuna at Srisailam, notable for its typical 14th- and 15th-century sculptures. Some of these carvings, particularly the earlier ones such as that representing Bhṛṅgi and a princess with hands joined in worship, assigned to the 14th century, show a fusion of all the characteristics of early Chalukya and contemporaneous Vijayanagar art, as does the sculpture that adorns the temples of Ketapi Nārāyaṇa and Tirumala Nāyak, erected in the Vijayanagar period at Bhatkal in Kanara: the dvārapālas at the entrance, the surulyalis below them, the Gajalakṣmī on the doorway, the carvings and pillars, the nāgabandhas (friezes of nagas), and the panels depicting deities.

The most illustrious ruler of the Vijayanagar dynasty was Kṛṣṇadevarāya (1509–29), who built numerous towers, mandapas, and shrines, all decorated with fine carvings. One of the most famous shrines is that at Hampi representing Kṛṣṇa as a child (Bālakṛṣṇa), which portrays him as a plump little boy, seated, with a butter ball in one hand. The sculpture, now mutilated, is in the Madras Government Museum; its original appearance can be seen on a coin of Bālakṛṣṇa, bearing an exact image of the figure, which was issued by Kṛṣṇadevarāya for distribution on the day the image was consecrated. The most magnificent temple constructed by Kṛṣṇadevarāya at Hampi is that of Viṭṭhala.

An outstanding sculpture executed under Kṛṣṇadevarāya in 1528 is the huge figure of Lakṣmīnarasiṃha at Hampi, which, according to an inscription on a stone slab nearby, was carved out of a single piece of rock. This figure, 22 ft. high and worked with great care, remains one of the gems of the art of this period, even though it is in a mutilated condition. Another monolithic figure of similar dimensions and probably from the same period is that of Gaṇeśa.

Perhaps the best examples of Vijayanagar sculpture are to be seen in the kalyāṇa mandapas and other pillared halls that were built in great numbers during this period in all the temples of southern India. One of the most beautiful halls of this type is the kalyāṇa mandapa at Vellore, rich in sculptures and elegantly carved reliefs. Other admirable carvings adorn the mandapa pillars at Srirangam. Similar to those at Vellore, but of inferior quality, are the carvings of the mandapa at Virinchipuram, executed, according to tradition, by the son of the man who did the sculptures at Vellore. Other mandapas worthy of note are the nāṭya mandapa (hall for dancing) of the temple of Vīrabhadra at Lepakshi, whose pillars are decorated with scenes of musical and choreographic subjects, and the mandapa of the temple of Varadarāja at Kanchi, whose sculptures of monkeys, cats, and doves are animated by a lively naturalistic sense. There are fine sculptures also in the mandapas at Tirukalukunram and Tiruvattipuram in North Arcot; in those of the temples at Kumbakonam; and at Tiruvannamalai, in the "Thousand-pillared Mandapa."

Portrait sculpture, already eminent under the Pallava and Chola monarchs, advanced still further under the Vijayanagars and their feudatories, the Nāyaks. These rulers and chieftains and their queens and ladies, all active builders of temples, can be recognized in attitudes of adoration of the deities to whom the temples were dedicated. Most of these portraits are in relief, but some are freestanding; they may be of stone or of metal. A particularly notable bronze group is that of Kṛṣṇadevarāya with his queens Chinnādevī and Tirumaladevī (I, PL. 226), now in a mandapa at the entrance of the temple of Śrī Veṅkateśvarasvāmi, on the hill at Tirupati. A portrait bronze of Veṅkata I, the son of Tirumala, in the same place, exceeds in its individuality and forcefulness of expression even the Kṛṣṇadevarāya group. A special position among the portraits is occupied by the ivory carvings representing Tirumala Nāyak and his queens, now in the museum of the temple at Srirangam.

*Kerala.* Among the earliest Kerala sculptures are the dvārapālas at Kaviyur, near Tiruvallara, which recall similar figures in Pallava caves. A further stage in Kerala sculpture is seen in the reliefs on either side of the entrance of the cave temple at Vilinjam (PL. 255). The dancing figure of a god and a goddess beside him are typical examples of this 8th-century sculpture and resemble certain late Pallava sculptures of the Arcot region and Chingleput. Another sculpture inspired by the final phase of Pallava art, when it bordered on early Chola art in the 8th century, is a stone image of Viṣṇu at Kurathiyara (Darsanamkoppu). A dvārapāla with a single pair of arms, unearthed at Vilinjam, is also of the same date. The decorative element in this figure and in that of Viṣṇu mentioned above already presages the more elaborate ornamentation characteristic of late Kerala art as seen in wood carvings and paintings. Other excellent examples are a fragmentary Viṣṇu of late Pallava style found at Talakkāt, near Irinjalakkuda in Cochin; the Buddha figures from Bharanikkani and Murudukulangarai; the Jaina figures carved in rock at Chitaral in Travancore and those in the Palace Museum in Padmanabhapuram; and other images of divinities in Tiruvattar, Kulikode, and Sastamangalam. Also worthy of note are the panels with musicians and dancers from Trivikramangalam, and among works in metal, the two early bronzes of Viṣṇu from Ambalappula, now in the museum at Trivandrum, which are very similar to some late Pallava ones.

In the later phase, sculpture in Kerala assumed a decorative and picturesque style, similar to and yet distinct from that of the Hoyśala school. The stone sculpture in this region is strongly reminiscent of its prototypes in the wood-carved decoration of temples. Themes and popular legends found in the Itihāsas (historical narratives) and the Purāṇas (sacred texts of medieval Hinduism) are portrayed in long wooden friezes on the temple cornices and pillars. A series of Rāmāyaṇa scenes from a temple at Quilon (now in the Madras Government Museum), several pieces from the museum at Trivandrum, and the carvings in the temples at Ettumanur, Sathankulangara, Palur, and Padmanabhapuram are eloquent testimony to the ability of the carvers. The ornamentation of the figures recalls the appearance of the dancers of the kathakali, a dance still performed in the nāṭya mandapas of Malabar temples. There are numerous

sculptures and portraits of the Vijayanagar period in the temple at Suchindram. One of the most beautiful pieces from this temple is a wood panel representing Viṣṇu Trivikrama, which can be ranked with the best of the earlier Indian representations of this divinity.

Exquisitely carved wooden rathas are a tradition in southern India. Some of these (e.g., the very large one at Tiruvalur) are practically full-size vimanas on wheels. The custom of carrying these vehicular shrines in religious processions became increasingly popular, and there was scarcely a temple in southern India that did not have a ratha or other form of *vāhana* (vehicle or mount) of carved wood, painted and embellished with gold plate.

PAINTING. In 1918 Jouvreau-Dubreuil called attention to the discovery at Sittannavasal of early paintings similar to those at Ajanta. One of these is a painting on the ceiling of a cave representing a magnificent lake where geese disport themselves and fish dart among flowering lotuses; youths are intent on gathering the flowers. The figures are drawn with great delicacy of feeling. The finest of the figures is that of a king who, adorned with a diadem and protected by a parasol, is shown in the company of his queen. On the cubical parts of the pillars in front of the king are portraits of two dancers of exquisite grace and proportions. These paintings, rather damaged by time and by man, probably date from the period of Mahendravarman I. Except for the wall paintings at Sittannavasal, the only other evidences of the great wealth of murals painted during this period are the traces in other temples (e.g., Mamandur and Mamallapuram). Some idea of the development of this art in successive decades can be drawn from fragments of painting in the structural Pallava temples such as those at Panamalai and Kanchi. Two fine examples of paintings done during the period of Rājasiṃha (680–720) are a crowned goddess protected by a parasol, at Panamalai, and the remains of a gracious princely figure and an image of Somāskanda between the seated figures of Śiva and Pārvatī in the temple of Kailāsanātha at Kanchi. The figures in this panel, though fragmentary, are impressive for their calmness and dignity of line.

In the cave temple at Tirumalai are fragments of paintings executed in the early Pāṇḍya period and closely resembling contemporaneous Pallava ones; for the most part they represent themes inspired by nature. Certain hunting scenes (such as the hunter carrying a wild boar, surrounded by other hunters and their wives) are unusual in Indian art and suggest the possibility of foreign influence — Roman or Hellenistic — perhaps the result of trade in the early centuries of the Christian era between the Pāṇḍyas and Rome. (Pāṇḍya pearls were much sought after by Rome; and Madura had an established colony of foreigners from the Hellenistic-Roman Levant.) To this same period also belongs a face in classical style, the only remaining fragment of the paintings that at one time decorated the cave temple at Tirunandikkarai and practically all that survives of 8th–9th-century Kerala painting.

Although there are fragments of early Chola painting at Narthamalai, Malayadipatti, and other places, the great treasure house of this art is the temple of Bṛhadīśvara at Tanjore, where an entire picture gallery dating from the first period of Chola art was discovered in a dark passage around the main cella by S. K. Govindaswami about 1930. The themes of these paintings are divine personages, and they show penetrating psychological insight and an extraordinary feeling for composition. On the west wall is Śiva Dakṣiṇāmūrti, seated on a tiger skin and contemplating the dance of two apsarases (celestial nymphs) while Viṣṇu and some *gaṇas* beat time on a drum, accompanied by heavenly musicians. Another lovely scene shows Śiva dancing, with priests and devotees on one side and a prince (probably Rājarāja), accompanied by three queens and numerous relatives, in adoration. The entire space of the north wall is occupied by a huge figure of Śiva Tripurāntaka who, mounted on a chariot driven by Brahmā, is in the act of using his powerful bow against a host of asuras (demons).

These Chola paintings admirably illustrate the theory of the *rasa*, or principal sentiments or states of mind of man, which theoreticians of painting transposed from poetry to art (see ESTHETICS). The blood-stained figure of Śiva Tripurāntaka and the dominating accent of the scene express the heroic sentiment (*vīra*), wrath (*raudra*), and terror (*bhayānaka*); the weeping of the ladies who embrace their lords suggests pity (*karuṇā*) and love (*śṛṅgāra*); the sentiment of peace (*śānta*) is mirrored in the figure of Śiva Dakṣiṇāmūrti seated serenely on a tiger skin, and the attitudes of the worshipers depict devotion (*bhakti*); and wonder (*ādbhūta*), aroused by the *vismaya* pose of the celestial dancers, mingles with mirth (*hāsya*) at the comically posed *gaṇas*.

The Vijayanagar monarchs were generous patrons and connoisseurs of painting as well as of the other arts. A lovely series of paintings from this period can be seen in the temple of Virūpākṣa, situated in their capital city of Vijayanagar (mod. Hampi). The paintings, which decorate the ceiling of the large outer mandapa, illustrate the glory of the great spiritual master Vidyāraṇya. Fragments of other paintings of this period can be seen at Anagundi near Hampi, at Tadpatri, Kanchi, Kalahasti, Tirupati, Tiruvannamalai, Chidambaram, Tiruvalur, Kumbakonam, and Srirangam.

One of the most splendid paintings of the Vijayanagar period is the colossal figure of Vīrabhadra painted on the ceiling of a mandapa at Lepakshi. The other scenes depicted here are from the *Mahābhārata*, the *Rāmāyaṇa*, and the Purāṇas and date from the time of Acyutaraya (1529–42); among the recognizable portraits are those of the builders of the temple, Virūpaṇṇa and Vīraṇṇa. Of particular importance among the scenes, many of which are in poor condition, are the coronation of Rāma, Arjuna fighting with Kirāta, Bhikṣāṭana, Kālāri, Gaṅgādhara, and Tripurāntaka; all these paintings reveal a mastery of the brush and of color.

A simple but pleasing example of late Vijayanagar painting is seen in a small mandapa in the temple of Varadarāja at Kanchi. The subject of this representation is taken from the cycle of legends woven around the figure of Māmmaṭa, the god of love. The scenes showing the playful manifestations (Skr., *līlā*) of Śiva on the ceilings of the mandapas at Tiruvalur are picturesque and original, especially the figure of Muchukunda, the mythical monkey-faced king. Other representations of the legends of Śiva and scenes from the *Rāmāyaṇa* and *Mahābhārata* are at Tiruvannamalai, Tiruvottiyur, and elsewhere.

Painting from the later phase of the Vijayanagar period is abundantly represented in many temples. Particularly outstanding among these mural paintings are those at Madura, which are divided into separate panels representing the 64 *līlās* of Śiva, and the inspired ones at Tiruparuttikunram, especially vigorous and original. Many of these pictures have explanatory legends in the Tamil or Telugu language. Vijayanagar painting, always rather conventional, became even more so in its final Nāyak phase. All the characteristics of this period seen in the sculpture, such as the angular contours of the limbs and the type and arrangement of garments, are much more evident in the painting, where they are emphasized by the use of color.

The Kerala painting at Tirunandikkarai progressed toward a distinctive type closely resembling contemporaneous sculpture in stone and wood. The rather robust and squat figures, the rich ornamentation, and the characteristically elongated halo that surrounds the crown in western Chalukya figures clearly reveal the combination of Kanarese and Dravidian elements. At Ettumanur, the many-armed Śiva Naṭarāja holding a *nandidhvaja* in one hand is reminiscent of the figures of Śiva dancing at Badami, Pattadakal, and Nallur and also resembles a similar painting in the Kailāsanātha at Ellora. This huge painting can compete in strength and beauty with the Chola panel of Tripurāntaka at Tanjore and with the contemporaneous Vijayanagar Vīrabhadra at Lepakshi.

Other noteworthy paintings in Kerala are those from Tiruvanjikulam, Pallimanna, and Cochin; those in the Vaḍakkunātha at Trichur; and those in the palace at Mattancheri. In the area of Travancore the paintings from Vaikam, Ettumanur, and Chitaral are outstanding; and the high point is reached with the famous paintings of the palaces of Padmanabhapuram

and Krishnapuram. Characteristic of this school are the rather wide mouth, the eyes with a slanting gaze, the smile, the rather heavy build of the body, and the reproduction in the most minute detail of the costumes and mode of life of the period.

BIBLIOG. O. C. Gangoly, South Indian Bronzes, London, 1915; G. Jouveau-Dubreuil, Pallava Antiquities, 2 vols., London, 1916–18; G. Jouveau-Dubreuil, Dravidian Architecture, Madras, 1917; G. Jouveau-Dubreuil, L'archéologie du sud de l'Inde: L'architecture, Paris, 1926; A. K. Coomaraswamy, History of Indian and Indonesian Art, New York, 1927; F. H. Gravely and T. N. Ramachandran, Catalogue of South Indian Hindu Metal Images in the Madras Museum, Madras, 1932; S. Kramrisch, A Survey of Painting in the Deccan, London, 1937; F. H. Gravely and C. Sivaramamurti, Guide to the Archaeological Galleries, Madras, 1939; S. Kramrisch, The Hindu Temple, Calcutta, 1946, pp. 93–121; H. Zimmer, Myths and Symbols in Indian Art and Civilization, New York, 1946; S. Kramrisch, Dravida and Kerala in the Art of Travancore, Ascona, 1953; B. Rowland, The Art and Architecture of India, Harmondsworth, 1953; C. Sivaramamurti, Royal Conquests and Cultural Migrations in South India and the Deccan, Calcutta, 1955; H. Zimmer, The Art of Indian Asia, 2 vols., New York, 1955; C. Sivaramamurti, Early Eastern Chalukyan Sculpture, Madras, 1957; K. A. Nilakanta Sastri, A History of South India from Prehistoric Times to the Fall of Vijayanagar, Oxford, 1958, pp. 431–81.

Calambur ŚIVARAMAMURTI

Illustrations: PLS. 254–260; 3 figs. in the text.

**DRAWING.** The word "drawing" covers in general all those representations in which an image is obtained by marking, whether simply or elaborately, upon a surface which constitutes the background. In this sense drawing is the basis of every pictorial experience, particularly that of painting (q.v.). In modern times drawing has become associated with a particular tradition and special artistic techniques: its methods comprise simple delineation to which may be added effects of light and shadow (produced by hatching or washes), highlights, and cursory color notations.

SUMMARY. Introduction (col. 459). Drawing in primitive cultures (col. 462): *Prehistory and protohistory*; *Tribal art.* Drawing in antiquity and in the Middle Ages (col. 468): *The ancient Near East*; *Greece and Rome*; *Late antiquity and Byzantium*; *Medieval Europe.* Art and practice of drawing in modern Europe (col. 478): *Drawing theory*; *Drawing from the Renaissance to the 18th century*; *The 19th and 20th centuries*; *a. Linear or contour*; *b. Expressive or dynamic*; *c. Picturesque or lyrical.* Drawing in the Orient (col. 497): *India*; *China*; *Japan.*

INTRODUCTION. Within the framework of artistic expression, the word "drawing" is applied to works that vary widely both in effect and in degree of elaboration. It includes (1) preparatory works which are separate and distinct from the final artistic product and which have, for the most part, an artistic value of their own; (2) preparatory works which are deprived of their independent value because they are materially incorporated into the finished work of art; (3) works executed according to the usual drawing techniques but having the character of independent works. To the first group belong all the drawings which reflect the studies of the artist, whether in relation to a particular work or to his explorations of style (PL. 267). In the second group fall the linear or shaded markings which, on panel, canvas, or wall, serve as the basis and guide for the execution of a work (sinopia, pouncing, etc.; PL. 266). The third group comprises linear or shaded drawings which are in themselves finished works and yet retain the appearance of drawings (PLS. 261–264).

The elemental or schematic image obtained through the medium of drawing (in all cultures and periods of history) has led us to identify it with the initial or inventive moment of the artistic process. Its function within the whole process changes, however, with shifts in the importance and value attributed to other technical factors. For example, the prehistoric rock drawings were executed as an end in themselves without any thought of further elaboration; in the Oriental arts, where there is no break in continuity between invention and execution, the drawing develops, with no separate phase, into the finished work; in the classical tradition of Western

art, which admits the dualism of ideation and execution, the phase of drawing, or ideation, is theoretically distinct, though continuously related to the process of execution.

Although drawing is the first phase of the artistic process, defining it as "spontaneous expression" is not warranted. Even prehistoric and children's drawings presuppose conventional ways of representation or communication (see PSYCHOLOGY OF ART). First and most fundamental among these conventions, and still accepted as the starting point for drawing, is the line, or stroke. In so far as line is conceived of as an interruption of continuity, or as a division of space, it is, basically, the expression of a boundary or limit; it thus limits a surface, because it defines a spatial entity as distinct from the space in which the entity functions.

To draw means to make a subjective image extrinsic, to give it a limit, a position in space, and a form. It is impossible to postulate an origin for the art of drawing that does not lead back to signs or symbols which form a common ground between the experience of the artist and the experience of man in general. It is easy to establish relationships, differing in detail in the various cultures, between principles of drawing and symbolic representations of the cosmos and also between drawing and writing.

But even if the fact that drawing is the first step in the artistic process does not necessarily mean that it is extemporaneous or always spontaneous in character, certain types of finished work which are intended to appear extemporaneous are left in the stage of drawing. Such is the case, for example, with caricatures and illustrations. On the other hand, even in the earliest critical writings we find the theory that drawing is the loftiest phase of artistic creation, and this conception was especially developed during the Italian Renaissance, when drawing came to be associated with the concepts of "idea" and "theory." There is no real contradiction between these points of view, for, as the first step in the artistic process, drawing already has an esthetic value, independent of the values arising from the following steps in the process: in fact, that first act implies an intuitive rather than an analytical approach to reality.

The gradual growth of an artistic idea may be detected even in the most ancient pictorial remains: the artist changes his mind; he progressively adjusts and focuses the image. In periods of high artistic achievement a drawing may contain many lines to define the same contour, thereby suggesting a variety of solutions in the relation of the figure and its environment (PLS. 263, 276, 277). Further evidence of the gradual process of creation and of the interweaving of ideation and execution may be found in the progression of drawn details or of sketches of the total work; of the successive addition of shadings or color notes within the contours; of the frequent recourse during execution to the drawing technique in order to obtain a better definition of certain portions; in the draftsmanlike character that is often preserved in the finished work (especially in Far Eastern art); in the tendency (frequent in modern art, for instance in Cézanne) to keep "drawing" up to the last touch of the brush, so as to preserve the ferment and intensity of ideation throughout the execution.

To identify "line" with what is called "contour" is valid only within certain limits. The word "contour" conveys an intention to reduce the various aspects that an object can assume (according to point of view, incidence of light, etc.) to an ideal image which includes and synthesizes these variables so as to be no longer subject to exterior change. Also the space which the contour defines together with the object assumes an absolute and invariable existence that cannot be altered by light, atmosphere, point of view, etc. However, apart from its association with contour, a line may develop on a single plane with no suggestion of three-dimensional form, simply following a rhythmic flow, as in the case of an arabesque. Or, again, a line may define an object within space, but with the suggestion of sudden movement or the fusion of its masses with the surrounding light and atmosphere, in which case it abandons the continuity of the contour: the line may be either broken abruptly, or warped and softened, or even elided, in order to suggest a modulation of light and shadow, the incidence of intense light,

the depth of shadow, or the different colors of the object itself.

Techniques vary according to the artist's intention: while a drawing with clear contours calls for a sharp line of pen or pencil on a smooth ground (as in the technique of graffito in antiquity), a painterly drawing calls for rough paper, often colored, and yielding or thick media, such as charcoal, soft pencils, chalks, pastels, or even water-color washes that partially or completely dissolve the line to produce nuances and blurs.

Whole categories of drawings are a means to an end and serve as a practical guide in the execution of a work of art (PL. 266). Cartoons for large works, such as tapestries, are elements in the process of execution, for they translate the artist's invention at an advanced stage, and their function in relation to the finished work is similar to that of scaffolding for architecture. The underdrawing of a fresco in sinopia serves as a guide to the execution of the painting. In some cases it represents an active part of the artist's invention; in other cases, it may be only a transitional stage in which the material the artist has already worked out is transferred to the wall. When part of the execution of a work is entrusted to students, helpers, or even to a crew of craftsmen, as in the case of architectural or decorative works, the executants are given expressly prepared drawings which indicate details of structure or successive stages of technical processes.

Exercise or study drawings should also be considered as tools, as a means to an end (PLS. 266, 267). Into this category fall most copies from the antique or from the works of great masters, life drawings of the figure, and portrait sketches. Drawings such as these may be simple exercises of the artist's eye or hand, or they may be used as a basis for more important works. Paintings and sculptures more often than not are worked out through many preparatory drawings that chronicle the development of the artist's idea and the progressive stages of its elaboration. Copies of great works may be literal and pedestrian, but in many instances they give rise to sensitive and penetrating observations, because by selection and interpretation the copyist reveals problems of style that he is exploring through historical analysis.

The formative and preparatory nature of drawing accounts for the insistence upon draftsmanship in art schools, where teaching proceeds gradually through technical and mechanical stages to objective copies and finally to interpretation and the study of styles (see EDUCATION AND ART TEACHING).

Drawing, however, has an independent value as a form of art, and it is susceptible to esthetic judgment. In past centuries artists often gave drawings to kings, rulers, patrons, and important literary personalities. Ever since the Renaissance the collecting of drawings has been considered a mark of refinement and taste. It is important to remark that in both the East and the West certain artists have restricted their activity exclusively to drawing and refined their technique to an extreme degree. From the 15th century on, printmaking (see ENGRAVINGS AND OTHER PRINT MEDIA) afforded a method by which drawings could be duplicated and disseminated, and this served further to establish drawing as a definitive form of art.

While the drawings of painters and sculptors are generally important as independent works of art, the drawings of architects are sometimes less interesting, because the successive phases of construction call for many technical renderings often not by the master himself (see DESIGNING). But when an architectural drawing or even the drawing of a ground plan stands at the very root of the architect's invention, it has as much artistic importance as the drawing of a figure. The fact that architectural drawings are carried out according to conventions of projection and perspective does not detract from their value as works of art, since every drawing, no matter of what kind, must conform to certain more or less conventional systems.

The first thing to be ascertained before making a value judgment is the authenticity of a drawing, that is, whether it is by the hand of the master. Authentic drawings by an original master may be artistically uninteresting inasmuch as they may be copies, memory aids, or sketches of a practical or technical character. The idea of artistic authenticity is often identified

with immediacy of expression and in consequence with a quick and fresh line, but actually a drawing should be considered artistically important when it documents an active moment of ideation quite independently of its formal aspects, which vary according to the shifting idioms of representation. Research in the field of drawings aims to establish the attribution, authenticity, dating, and possible relationship to other works, and it is aided by the analysis of paper, watermarks, and drawing media. Old drawings present special difficulties, because they are often in bad condition, altered or maladroitly retouched, and inscribed at later dates with unreliable notes or signatures.

*  *

DRAWING IN PRIMITIVE CULTURES. *Prehistory and protohistory.* The mazes of lines and zigzags on the walls of caves in the Cantabrian Mountains of Spain and in the south of France, which were produced by the hunters of Upper Paleolithic times, have the character of drawing. Considered by many writers as the earliest monuments of human art, they were not so much abstract symbols as a magical concretization of the idea of the object to which they referred, realized in an arbitrary manner.

Aside from this limited group of works, Upper Paleolithic drawing rapidly became a highly representational art and quite distinct from any form of decorative art (PL. 261). Wall paintings and the decoration of small objects of the early and middle Aurignacian are largely of animals, and the figure, whether engraved or painted, is essentially a drawing and keeps rigidly to contours alone. With the final Aurignacian stage, drawing became more complex and expressive. The figure was usually conceived frontally, its static form delineated in silhouetted outline. But the prevailing linear and tectonic quality was occasionally accompanied by a kind of illusionism in those few cases where there was an attempt at expressive methods. Thus the indication of hair now broke into the outline with a series of brief slanted strokes or gave a certain plasticity of the area enclosed, thereby anticipating in drawing a pictorial effect which later was often to be obtained through the use of color. Thus in some parts of the painted figures, such as horns and legs, the outline was extended to form a filled-in surface.

The sharpening of the drawing in such efforts and its fusion with other means of expression explain the appearance in this phase of evidences of preliminary drawing. There are pebbles engraved with five or six partial or complete animal profiles in a complex of lines which is often so difficult to disentangle that it is clear that they were not intended as an end in themselves. Similar manifestations are to be found from the Solutrean. In the early phases of this culture, drawing retained the qualities of late Aurignacian, a stasis which can, at least partly, be explained by the lesser importance of drawing as compared with high and low relief in Solutrean art. In the later Solutrean phases and even more in early Magdalenian, representational art was focused so much on pictorial methods that drawing gradually lost its original preeminence. In the form of fine engravings, it served merely to emphasize the effect of color. Both outlines of the figure and interior details were delineated with great mastery, these last having acquired major importance. Sometimes merely decorative effects obtained, but more often drawing tended to be resolved as an impressionistic notation: contours and internal delimitations of the figure became negated and dissolved in the varied play of dots, hatchings, and colored surfaces.

Late Magdalenian art witnessed the development in drawing of two opposing tendencies which had already been presaged in the preceding phase: On the one hand, there was a naturalistic effort, through the techniques of drawing, after such illusionistic effects as were achieved in the 2d millennium B.C. in the great flowering of Minoan art; on the other, artists produced a purely decorative art, sometimes expressing themselves in conventionalized forms.

Both tendencies contributed to the restoration to drawing of the predominance which it had lost in the Solutrean and early Magdalenian. In this later phase there were new evidences, generally graffiti on bone and stone, of the frequent use of

preparatory sketches. In this connection a figure of a bison — if it be authentic — engraved on a rock fragment from Albri de la Genière (Ain) is of great interest. It is identical to one of the large painted bisons in the cave of Font-de-Gaume (Dordogne). Cases of replicas of a scene carved on small objects of differing provenance can also be cited.

Also, where there was a return to frontality and stylization, drawing acquired still greater importance. Figures were again stated in terms of contour, although the treatment of the surfaces, such as the fur, remained illusionistic. Even this remnant of illusionism was finally abandoned in the general tendency to omit treatment of interior detail. In order not to interrupt an outline, the artist ended by including in it or juxtaposing to it details such as the curl of fur on the neck of a reindeer or a horse's mane.

This development holds especially true for the paleolithic art of continental Europe generally and of France and the Cantabrian area in particular. Of lesser interest is the development of drawing among other groups, known under the inclusive name of "Mediterranean" (eastern Spain, lower valley of the Rhône River, central and southern Italy and Sicily, North Africa). In the art of these groups (some of it coeval with, some later than, the art just discussed) we meet with the coexistence of a naturalistic mainstream and a tendency to abstraction and geometrization to a far greater degree. The drawing of eastern Spain shows a certain originality, especially in the representation of the human figure, which is intellectually treated, although not without some poetic fluency. Runners are shown with the upper parts of their bodies in filiform, while their legs are quite thick. Animal figures are more naturalistic, but the drawing is here limited to outline while the interior is only filled in.

For a short period which corresponds to the late Aurignacian the artistic influence of the Cantabrian area and southern France furthered a less rigid style of drawing. We find outline figures in which some parts (such as horns) are filled in, while the interior surfaces are covered, at least partially, with spots of color and dashes, which serve to indicate anatomical details or to suggest a certain plasticity. Later phases, however, witnessed a return to the old conventions.

In the Mesolithic age the repertory of Spanish rock paintings continued to be varied. The major interest was concentrated on the human figure, treated now in a conventionalized fashion which was no longer cursive but rigidly geometric and largely symbolic. Similar figures appear on the painted Azilian pebbles. At least in part, the seminaturalistic figures on Scandinavian rocks, until recently (especially because of their location) thought to be linked with paleolithic traditions, are really of mesolithic origin. Here outlines were delineated by shallow engravings and were probably laid over with color. The early figure drawings of the following era were more decidedly conventionalized, although not without some representational qualities. They differ from their predecessors also in the use of a technique in which outlines are traced in dots (Scandinavian group) or even the whole surface within the outlines is filled in (White Sea).

The traditions of paleolithic drawing continued unabated in the rock drawings of the Sahara, where a certain naturalism persisted. Figures were executed in deeply engraved linear outlines. A few interior details were indicated. Here also a seminaturalistic phase with a tendency to stylization succeeded a more decidedly naturalistic phase.

Drawing in neolithic times and in the ages of metal appears, with few exceptions, in the context of decorative art and of ceramics (see CERAMICS; ORNAMENTATION).

Throughout the Neolithic, representational elements are to be found only in the ceramic art of the Danubian-Balkan area, where they occur as geometrized anthropomorphous designs (sometimes an ornamental repetition of the conventionalized figure in a series of superposed triangles) or as representations of animals (toads). Zoomorphic figures appear more frequently only in the culture of Tripolje (Ukraine) with some accent on scenic compositions (series of animals in motion). These are of higher artistry than the Tripolje anthropomorphic rep-

resentations, in which heads and legs are shown in profile and the body frontally.

Later, toward the mid-3d millennium B.C., the prevailingly coloristic and dynamic decorative art of certain parts of the Aegean, for instance Crete (proto-Minoan), underwent Oriental influences and borrowed from that source representations of animals and other figures. The forms and composition are livelier than their models and often show some interaction. Ornamental figures generally are made to submit to abstract decorative schemes, which are in turn transformed into representational motifs that are largely vegetal. Also, in the Cyclades, even though art tended strongly to geometrization, figures appeared in outline (boats, fish).

Thus, for the first time after the Upper Paleolithic phase, figurative drawing played an independent role in Mediterranean and European art. Animal representations of aëneolithic art in the region of Pontus (Russia) and the Caucasus were also noteworthy. They were often enriched by details of landscape.

The ornamental style of the megalithic culture on the island of Malta included some interesting representational elements. Of note are large slabs of rock decorated with spiral ribbon motifs in which ornament and background were painted in two different shades of the same color. These spirals often assumed a vegetal character as in the proto-Minoan art of Crete. The same phenomenon was present on painted pottery. A rock slab from Hal Tarxien (Malta) bears a series of animal representations.

A particular flowering of figure drawing occurred also in western megalithic cultures, where the influence of the Near East and the Aegean is visible alongside local traditions dating back to the Upper Paleolithic. At any rate, a decided tendency to geometric abstraction was dominant here, accentuated by a continuous exchange of representational and decorative elements. On the other hand, stylization rarely reached the point of rendering the object unrecognizable. Anthropomorphic representations were most current (indicated, for example, by two triangles counterposed at their vertices), along with solar motifs, zoomorphic elements (bulls with exaggerated horns), organs of the body (eye motifs), and weapons and other objects (axes, bows, plows, wagons, boats, etc.).

In the megalithic burials of Britain, and also in other areas, exclusively linear figures in outline are common. Notable in certain monuments of megalithic times on the Iberian Peninsula is the use of preparatory sketches engraved on enormous stones which were plastered over before painting. Along with these monuments of funerary art should be mentioned the Spanish rock paintings and the engravings of Monte Bego (north Italy), which were still being made in the early Bronze Age, and the oldest series from Valcamonica (north Italy), where the engraving was usually done with the aid of a hammer. In the representation of the figure there is a change from the linear rendition of members and trunk to a thickening of the body with the outline filled in. Western influence resulted in the introduction of representational elements (eye motif) in the Nordic regions (late phase of the corridor graves).

In central Europe these developments came much later, in the late Bronze Age. Motifs originating in the figure have been found here executed in repoussé on thin bronze sheets in lines of dots: e.g., the widely diffused Danubian motif of the solar boat drawn by birds. The few cases of timid figure drawing which appeared in Iron Age cultures (those of Villanova, Hallstatt), as in western megalithic cultures earlier, did not depart very far from a purely ornamental style. Sometimes, at any rate, representations are varied, as in the figures engraved on the Hallstatt urn from Sopron (Ödenburg) in Hungary (V, PL. 175), despite the monotonous rendering of the body with fat triangles which repeat the decoration of the vase: women with a spindle or at the loom, lyre players, battling warriors, chariots, etc.

Rock pictures offer a richer field, e.g., those of the early Iron Age in Valcamonica and in Scandinavia, where such funerary art as the famous slab from Kivik was produced (V, PL. 180). The human figure recurs frequently, especially in scenes of battle or of riders on horseback, as do ships with their

fittings, weapons, solar images, etc. Figures are depicted entirely in silhouette, more rigidly in the Valcamonica group, more fluently in the Scandinavian group, where curvilinear, if static, outlines prevail, sometimes occurring on different planes by means of superimposed details.

From these small beginnings the civilizations of the western Mediterranean and Europe were to emerge, sometimes with considerable time lags, through contact first with Orientalizing art and then with that of the Greco-Roman world.

* *

*Tribal art.* The presence in our own day of societies recently emerged from very modest stages of culture offers the opportunity to study at first hand the forms of drawing at relatively "primitive" levels, that is, without written tradition. They are subject in part to the same considerations as those discussed above regarding prehistory, and in certain cases — among the aborigines of Australia and the Bushmen of south Africa, to cite classic examples — prehistoric forms have survived to the present without an appreciable break in continuity (see II, PL. 63). The primitive world, however, offers a rather greater scope because of the very broad diffusion of drawing over all the continents apart from Europe and because of the vast range of production in perishable materials, whose parallels in prehistoric civilizations have been entirely lost — if, indeed, they ever existed. Present forms also have the advantage of immediacy, so that in the conjectural reconstruction of a cultural world which gave birth to the truly primitive drawings of prehistoric man we can rely to some extent on a comparative study of these latest developments and the observation of creative activity *in statu nascendi*.

In cultures which lack paper and the ordinary graphic media, drawing must naturally be understood as a conceptual activity inherent in the most varied forms of representation, but especially those in which the idea is represented two-dimensionally and in line, whatever the technique of execution and without regard to the rendition of plastic or chromatic effects. ("Drawing" is, of course, inseparable from any work of art, including sculpture and painting.) The materials on which drawings are made at these levels are prevailingly those offering smooth surfaces, though these may not be flat; rocky walls or ground cleared and polished by nature or smoothed by man; the plastered walls of huts; bone and ivory, sea shells, and tortoise shell; the shell of an ostrich egg, wood and bamboo, tapa and woven fabrics; leather and skins; pottery and objects of metal (when they exist); and even the human skin. On such surfaces drawing is produced by such techniques as engraving and painting, impression by means of stamps, sewing, and embroidery. Sometimes the technique itself serves to create *ex novo* (in whole or in part) the basic surface at the same time that it creates the drawing, as in the case of basketry, weaving, intarsia and mosaic, and painting with colored sand.

In these latter cases, drawing seems to be more closely related to technology than when it is created freehand. In the case of basketry, drawing is the automatic production of the technical process itself. But even if the form a drawing takes is occasionally suggested to the craftsman by the mechanics of production, a deliberate quest for form is rarely absent even at the lowest levels. On the other hand, whatever the origin of specific arrangements and motifs of a drawing, the well-known phenomenon of the transposition of these to other techniques bears witness to an almost universal interest in drawing as such, as an expression of the style of a particular people or of personal taste, if not as the statement of a symbol.

The relative level of "primitiveness" in backward peoples of our own day, even by comparison with prehistoric peoples, has relevance to the search for the origins of drawing or at least for the cultural levels at which it appears to emerge and to become clarified. This search, indeed, suggests itself spontaneously in a comparison between the production of the Upper Paleolithic in Europe, whose high merit is well known, and that of the contemporary hunting and food-gathering peoples whose works afford by contrast so negative a picture. Even

from other standpoints, some scholars have suggested that this represents a more primitive level than that of the Aurignacian or Magdalenian hunters. But rather than postulate the survival among present-day food gatherers of extremely primitive cultural forms, which is the same as hypothesizing a static situation enduring over many millenniums, we can consider the low level as a cultural regression due — in some instances — to the precarious conditions of existence in unfavorable natural habitats and to prolonged ethnic isolation. Similar cases of degeneration exist when a group of people have lost interest, either partly or totally, in the production of art and the attendant technical mastery, e.g., the Bushmen (see PALEO-AFRICAN CULTURES) and some Eskimo groups (see ESKIMO CULTURES), to cite only two familiar examples. In most cases, however, it is impossible to make any serious statement as to the genesis of early drawing on an ethnological basis, as we have no longterm knowledge of the antecedents of any branch of present-day production. It is true that among the primitive peoples (*Urvölker*) existing in modern times there is a relative poverty of creative imagination and a lack of interest and ability in any form of representation. Clearly the level of technical development is not in itself decisive. The Upper Paleolithic hunters of Europe certainly did not possess a knowledge of tools superior to that of the present-day hunters and food gatherers. Nor is geography a decisive factor. The Eskimos, who continue a tradition of drawing which is bimillenary at the very least, live in geoclimatic conditions far more inclement than those of Tasmania or Tierra del Fuego. However, when the first rudimentary attempts at graphic representation make their appearance in these simpler cultures, they often appear to derive from the models of more highly evolved peoples living nearby. Thus the rude decorations of bark cloth among the Bambuti in the region of the Congo are inspired by similar Bantu techniques, and the elementary engravings on bamboo by the Semang and Sakais of the Malay Peninsula are simplified but recognizable representations of Malayan products. These and several similar cases, incidentally, give the lie to the presumption of general precedence of naturalistic representation (or "physioplastic," to use a term of Max Verworn) over abstraction ("ideoplastic"). If we had to assume as illustrative of the earliest art the production of such peoples as the Semang, the Yaghan (Yamana) of the Tierra del Fuego, or the Andaman Islanders (an assumption which would be correct or at least justifiable on a purely ethnological level), we should have to conclude that at these simplest levels of civilization a geometric type of decoration exists unqualified by any knowledge of or interest in representation of natural forms. But the multiple influences to which even the most remote and isolated groups have been subjected — not excluding those considered primitive — make it impossible to identify their work as residual or even as the traces of aboriginal drawing.

Another factor to be considered is that of the stimuli and motivations which originally impelled man to undertake the experiment of drawing with still rudimentary means. Sympathetic and apotropaic magic are often cited as being the impelling factors. They certainly had their influence, but not so much as to exclude esthetic aims in themselves or the attempt at visual expression of an embryonic sense of rhythm, symmetry, or color (which is inseparable from form). The love of adornment is also an element, as is the desire to make a symbol or a mnemonic device. Over the years the mastery of certain simple techniques induces the satisfaction of achieving an almost automatic control over the repetition of pleasing forms, and with it an elementary virtuosity. But such experiences and such esthetic stimuli on the part of early man may be deduced only indirectly. There are attempts at decoration and representation even where mastery is still very far from having been achieved.

The presence of geometric forms in the earliest drawings leaves in doubt the question of the influence of the imitation of nature, where straight planes and perfectly regular curved lines are the exception rather than the rule, although, on the other hand, the technical effort required to make an exact copy demands a marked level of ability. Concentric circles may have been suggested by the rings in a segment of a tree

trunk or by the concentric wavelets induced by a disturbance of smooth water. But without the help of a compass other more complex and less "natural" motifs are hard to reproduce. These at any rate are only indefinitely associated with the former — e.g., on the *churinga* or the rhomboidal motifs (concentric rectangles, meanders, wavy lines, etc.) of Australia. The spiral may have been inspired by that of certain sea shells, although it may also have had its origin in the similar and very ancient form in basketry, while in more sophisticated examples it is the final point in a progress of artificial stylization inspired by the curling of a lizard's tail (on the *kapkap* pendants of the Solomon Islands), or of the "bird's head" motif (among the Massim of Melanesia), or of sheep horns (among the Transbaikalia Buriat in Mongolia), etc. Like other simple motifs, the spiral illustrates well the limitless variety of stylistic expression achieved by various peoples with the same basic point of departure. Spirals, whether single or evolving in parallel forms from a base line in continuous series, counterposed, interlaced, alternating in opposite directions, branching, with narrowed tips or widening in a serif, made up of a single line or two parallel lines, etc., suffice to identify an ethnic style. Regardless of varying graphic techniques or of individual applications on specific concrete objects, in terms of pure abstract design the motif is a signature of the culture which has adopted and developed it, and the Indonesian spiral can never be confused with that of the Maori in New Zealand or of the people of the Amur region in east Siberia. Certain of the most interesting studies of cultural spread, both regional and intercontinental, have been based on various interpretations and elaborations of simple design elements.

Besides the demonstrable diffusion of given motifs, there are also demonstrable cases of "convergence," or the independent origins of a single element in different places. The motif familiar in the Greek or Latin cross is characteristic of American Indian designs; it is often seen, engraved by an indigenous technique, at the center of shell earrings found in Illinois and Tennessee mounds. A Mayan symbol, e.g., in a stone carving of Uxmal (Mexico), corresponds in shape to the star of David. These symbols, as in other cases of more or less simple motifs (the rosette, the swastika, the dot and circle, the wolf's tooth, etc.), must represent the phenomenon of fortuitous parallelism resulting independently from experiments in drawing in different places and periods. To admit the convergence naturally does not exclude even a secondary local (or continental) spread of individual elements. The observation of parallels becomes more singular when we pass from geometric to naturalistic or seminaturalistic design. There is no sure historical connection, for instance, between the filiform anthropomorphic figures of the Tassili (Sahara) and those from Wonalirri and from the valley of the King Edward River (Australia) said by A. Lommel to be in "elegant style": in all these cases, widely separated in time and the work of different peoples, an almost identical type of stylization and reduction of the human figure to pure line was invented (see CALLIGRAPHY AND EPIGRAPHY).

Such cases of stylistic convergence are actually quite rare. The more stylization is developed — and removed from simple design motifs — the more the conventions become unreproduceable and comprehensible only within the range of a given culture. The motifs of the frigate bird, which is widespread in the art of the Solomon Islands and nearby archipelagoes, and of the rattlesnake among the extinct Indians of Tennessee are classic examples of a motif refined to such a degree that it excludes all parallels. What seems at first sight to be an inextricable labyrinth of straight and curved lines, of capriciously placed dots and perforations, under close comparative scrutiny is revealed as preordained in the smallest detail, a symbolic arrangement in which each line has its exact position and meaning; the interpretation is made possible by consecutive comparison of analogous design sequences going from those which still partly preserve the realistic features to the most highly stylized. The progressive stylization of a single motif can in such cases be explained by the ever-increasing virtuosity of artists over the generations. In other cases, however (e.g., the so-called "velvets of the Kasai," II, PL. 116), a range of geom-

etrizing motifs has survived in a crystallized form no longer in contact with the actuality which inspired it, although the surviving names of the motifs (grasshopper, peninsula, birds, smoke, clouds, etc.) indicate their origin.

The manner of stylization leads to the subject of symmetry. It is useful to recall the observation of Franz Boas that symmetry in primitive drawing is more often on a vertical axis (correspondence of right and left) than on a horizontal axis (correspondence of top and bottom), a fact which reflects the symmetry in nature. When a drawing consists of two symmetrically opposed halves, these are mirror images of each other. In the cases of circular or elliptical forms (as in ceramic plates and bowls, certain shields, emblematic motifs, etc.), and also of forms disposed within a square, as in heraldry, a sense of regularity is achieved by the alternation of motifs or by inverting two symmetrical halves with the diameter as axis.

The rhythmic repetition of motifs may follow the free selection of spaces in painted or engraved decoration, and it may result from technique, in which the mechanical repetition of productive gestures (as in basketry or weaving) automatically generates a constant order, projecting temporal rhythm onto a spatial plane. The elaboration of new processes may in such cases introduce new elements of design, almost independently of artistic invention. But as a rule, at the primitive cultural level techniques are perpetuated in the spirit of static traditions and act as conservative restraints on drawing. When the artist works on commission or in a position dependent on the favor of others, further limits are added to these almost automatic limitations on creative fancy: the Bakuba (Congo) women are called upon to apply traditional motifs in their embroidery on raffia mats already woven by the men; the weavers of the famous Chilcat (British Columbia) blankets have to copy on the loom motifs from models expressly carved on wooden slabs by their husbands. The nature of the raw materials, in particular the greater or lesser smoothness of available surfaces, influences the originality and variety of the design as much as the execution: the crudeness of graffiti scratched by Bushmen on ostrich shells is in contrast to their more facile compositions on the surface of bare rock; the outlines of Melanesian pictures on bark cloth are of necessity far less sure and precise than the carvings on wood by the same people. The fact that the greatest precision, refinement, and variety of design is to be observed, probably more than in any other field, in the decoration of pottery is without doubt partly to be explained by the generally smooth working surfaces.

From the ethnological standpoint, it appears that the more highly evolved the culture, the more factors of ecology, technique, and sociology exert their influence. This does not contradict the fact that drawing even at the simplest levels is already a free expression of the artistic spirit within the framework of individual traditional cultures. Drawing is basic to many artistic products, if not to all. Its character is of necessity functional, that is, directed toward (and influenced by) a tremendous range of concrete aims (ritual, magical, totemistic, symbolical, emblematic, etc.). And from the most elementary to the most elaborate forms, it never loses completely its essential function of the creation of visually harmonious effects, both as an end in themselves and as a guide and model for further productions. A connected function (more inclusive and therefore often denied or not recognized by critics) is also generic, namely, the satisfaction of the esthetic impulse of the artist who finds an ultimate pleasure in conceiving, producing, or even in repeating and elaborating the interplay of pure form.

Vinigi L. GROTTANELLI

DRAWING IN ANTIQUITY AND IN THE MIDDLE AGES. *The ancient Near East.* Egyptian potsherds of the New Kingdom prove that preliminary drawings were made in the Near East in preparation for works of art. On them were sketched subjects to be represented on the walls of tombs (PL. 261). In addition to these fragments, we have Egyptian papyri and Mesopotamian clay tablets with plans of buildings and cities

(III, PL. 493), which may also be considered preliminary sketches (see COSMOLOGY AND CARTOGRAPHY; DESIGNING).

Examples of drawing as an art in its own right have also come down to us from ancient Egypt and Mesopotamia. These examples were in the beginning connected with writing; both hieroglyphic and cuneiform writing developed from the intention to represent creatures and objects. The technique, depending on the material on which the drawing was made, was either painting or graffito.

In Egypt, wall paintings are of primary importance, and we can follow their execution step by step. After the surface had been prepared, a preliminary tracing was brushed on in red pigment, often corrected by black brush strokes. During the New Kingdom the subjects to be represented were previously sketched on potsherds, which were used both as models and as studies. The figured potsherds collected in the Theban necropolis are a valuable source for the study of drawing in the phase of free invention. Often the drawing was done freehand. For compositions of greater dimensions, however, with long sequences of objects and figures, vertical guidelines regularly spaced and intersected by horizontal lines were used (see PROPORTION). The figures are in general tied to a rather rigid and static conventional arrangement, but during the New Kingdom we encounter a greater freedom and a growing impressionist tendency.

Beginning with the New Kingdom, many funerary papyri are decorated with illustrations. These are usually in black hatching or in dichrome (red and black); rarely, in polychrome. Caricatures on papyrus dating from the end of the New Kingdom belong to a separate category: they are usually made up of amusing scenes with animals for protagonists. Other papyri show drawings of maps: the most famous example, preserved in Turin (Mus. Egizio), gives us a map of a mining region. Cliff graffiti scattered in various regions of Upper Egypt provide a rich field for the study of extemporaneous drawing.

In Mesopotamia the earliest drawings are found on pottery and juxtapose two techniques, painting and linear graffito, lightly incised. In the earliest examples, from Tell Mattara and Hassuna, the designs are geometric; later, in the phase which derives its name from Samarra, stylized human and animal figures appear along with geometric designs.

Fresh clay, the usual material in Mesopotamia, lends itself only to incision. We can consider as belonging to the same category as drawing both some Sumerian tablets from Nippur, on which outlines are lightly incised, and several maps (III, PL. 493) and building plans. The most important examples of the latter also come from Nippur.

Metal, on the other hand, lends itself better than clay to light incision. Suffice it to mention the exquisite incision of the silver vase of Entemena (I, PL. 504), which defines the outline of the figures while suggesting their volume in delicate gradations of density within the contour.

Sergio BOSTICCO and Giovanni GARBINI

*Greece and Rome.* Practically nothing has come down to us in the way of preparatory drawings and sketches from this period. The lack is most noticeable in the field of architecture. Vitruvius (*On Architecture,* I, 2) writes that architects prepared ground plans (*ichnographia*), drawings (*orthographia*), and elevations (*scaenographia*) of their works and that land surveyors made use of maps to establish the boundaries between pieces of land. We know also that there were geographical drawings, of which both the map of Aristagoras of Miletus mentioned by Herodotus and the map on parchment referred to by Suetonius are known only through literary references, while the greater part of a Roman road map, the so-called "Peutinger Map" (III, PL. 493), still exists in a medieval copy in the Albertina Library, Vienna (see ASTRONOMY AND ASTROLOGY; COSMOLOGY AND CARTOGRAPHY). From the classic period we have only the remnants of the *Forma Urbis,* a city plan of Rome which was cut into marble at the time of the emperor Septimius Severus (Capitoline Mus., Rome), and various fragments of maps engraved on milestones and executed in mosaic. We

can, perhaps, form an idea of the elevations, the *scaenographiae* mentioned by Vitruvius, from the numerous views of villas on the walls of Pompeian houses.

Still less remains of the preliminary drawings made by sculptors, but we have no doubt that such drawings existed, since there are sketches for sculptures on Egyptian papyri which have come down to us. The engraving on a herm from Delos, while perhaps not for a statue, may be from a sculptor's hand. Midway between drawings for sculpture and those for painting are the sketches done for repoussé work in bronze or silver, which literary tradition attributes to painters such as Mys and Parrhasios (q.v.).

Pliny the Elder (*Natural History,* XXXV, 68) tells us that even in later centuries artists learned drawing from sketches done by Parrhasios. The materials on which these *graphidis vestigiae* were done are specified as wooden panels (*tabulae*) and parchment (*membranae*). Rough and spontaneous and akin to caricature are the heads often found painted underneath the bases of vases, the incisions on limestone or ivory from Sparta, and later, in the Roman period, the wall graffiti on stucco in Pompeii and in a graffito found on the Palatine in Rome showing a caricature of the Crucifixion (Mus. Naz. Romano). On the other hand, in a head incised upon a block of limestone, originally from Samos and now in the Louvre, we can detect the hand of a great artist. Beneath the finished surface of vase paintings we can often detect traces of the preliminary sketch: a rough outline composed of a few quick strokes serves to indicate the spacing of the figures and motifs. These drawings are incised with a blunted instrument on the clay before it is baked and hard. In monumental painting, and especially in the Etruscan tombs in Tarquinia (PL. 263), we also find similar rough sketches incised on the walls. The final composition does not always follow closely the preparatory sketch.

In every period, however, besides serving this secondary purpose, drawing has been an end in itself and has produced definitive works of art. It is hard to differentiate between painting and drawing in the ancient world, since, in Latin as well as in Greek, both are designated by the same word. In addition, up to the middle of the 5th century B.C. the qualities which are peculiar to painting, that is, the rendering of light, shadow, and three-dimensional depth, did not exist. There was only monochrome or polychrome drawing.

Even later it is not easy to draw a sharp line between drawing, painting, and sculpture. In a Cretan caldron (8th cent. B.C.) the heads and necks of the griffins emerge from the walls modeled in the round; the breasts of the fabulous creatures are done in relief, while the legs and the wings are drawn in. Similarly, on a situla from Crete and on a pinax from Athens, the face of the goddess is in relief while the rest of her body is painted.

Although from a strictly intellectual point of view the following distinction cannot be considered accurate, and although the same materials were originally used for every form of art, we can distinguish between painting and drawing by arbitrarily listing under painting works which attain a certain size, such as scenes on the walls of burial chambers, terra-cotta metopes in temples or tombs, funerary columns adorned with life-size, or nearly life-size, figures, and, on the other hand, gathering under the heading of drawing only works of smaller dimensions in which the outline and the interior design are traced with a blunted instrument on a soft substance, or cut into metal, stone, or ivory with stylus or chisel, or reproduced on a smooth surface with the stroke of a brush. Having established these premises, we can go on to say that there are "drawings" cut into wood belonging to the 8th century B.C. and found in Samos. Among the discoveries at Pitsa in the northeastern Peloponnesus there are scenes drawn and painted upon wooden tablets which have previously been primed. In both these cases the preservation of the wooden tablets is due to the fact that the region is marshy, as also is true for the delicate incisions on ivory from Pontus found in the Crimea (PL. 264).

The situation with regard to incisions on metal, of which we have some important examples, is much clearer. The most important among these are some superb golden fibulae from

Attica, consisting of small squares on which are incised animals, sailing vessels, or decorations in the style of the Geometric vases. Next, we have a series of bronze fibulae from Boeotia belonging to the late Geometric period. These are less precious than the Attic ones not only because of the material in which they are executed but also because of their style, whose crudeness suggests an earlier period than that to which they actually belong. Their lack of artistic merit, however, is compensated for by the subject matter of the incised scenes, which constitute the earliest illustrations of Greek myths: namely, the adventures of Herakles and the Trojan legend.

It happens that the greater part of the drawings which have come down to us are on terra-cotta vases, a fact which may influence unduly one's estimate of the importance of this type of art. Other factors, however, indicate that the differences between vase painting and painting on other materials at this period are only technical and that many vase paintings of high quality may be the counterparts of works otherwise lost (see CERAMICS). Beginning with the 7th century, incisions were made on the glazed background and used to indicate outlines. At the same time colors able to withstand the heat of the oven were discovered, first white and then cherry red. As the variety of media increased, the strictly geometric structure of the decorations and compositions began to disappear. It is interesting to note that this development corresponds rather closely to the idea of the evolution of drawing current during the classical period, especially since this first art criticism, which made its appearance between the end of the 4th century and the beginning of the 3d century B.C., was inevitably naïve. The Elder Pliny, here as ever our principal source, declares (*Natural History*, XXXV, 15) that the first step in the art of drawing is the reproduction in monochrome of the human silhouette, followed by internal drawing in a single color.

Usually the shape of the vase is closely related to its decoration, whether figured or ornamental, but the actual drawing, although it takes the shape of the vase into account, is not determined by it. This is so also in the square terra-cotta plaques (pinaces) of varying size, which show the same stylistic evolution as the vases, and whose decoration is in very close relationship to the latter. We have pinaces of the Geometric period and of the so-called "Idaic" or Orientalizing period immediately following it. In the "Daedalic" period, which began about the middle of the 7th century, the terra-cotta pinaces and vase painting are supplemented by incisions on metal, mainly on armor: diadems from Crete, breastplates from Olympia, and a Corinthian helmet. Toward the end of the "Daedalic" period the black-figure technique in ceramic painting began. The male figures are covered with black, and the inner design and sometimes the outlines are indicated with incised lines (PL. 263). The female figures are done in white. It is a technique which adopts the colors of ceramics and which ends by becoming stiffly conventional; it was used only in the field of pottery, and not always there.

As a result of the general development in art which occurred during the last third of the 6th century B.C., the black-figure technique lost its importance after nearly a century of predominance. The red-figure technique made its first appearance in Athens during the period when it was the chief center of the pottery trade. The new trends in drawing which endowed the human body — here, as always, the dominant theme in Greek art — with an anatomical structure represent the figures not only standing, but in attitudes of jumping or running, and show a preference for themes dealing with the gymnasium. They thus made necessary the use of a flexible brush rather than the rigid stylus. In order to prevent the lines from becoming too soft and indefinite, a raised contour line was introduced; it was obtained by using a special tool, perhaps a bristle. With this device, drawing was able to reproduce all the innovations attributed by art critics of antiquity to Kimon of Kleonai. Foreshortening in particular was obtainable through this technique. With the turn of the late archaic period we find in a few isolated drawings a suggestion of shading, produced by groups of fine lines. This first shading was limited to shiny metal objects: bronze vases, helmets, shields.

In comparison with the number of vase paintings which have survived from the late archaic period, examples of other techniques discovered in Greece are rare. In fact, we can cite only one incised bronze helmet. However, incision on bronze then made its appearance in Italy with scenes incised on Etruscan mirrors. This kind of metalwork called for a particularly steady hand, since, in order to protect them from scratches, the metal mirrors were made of a very hard alloy (PL. 263). The production increased steadily throughout the 5th century B.C. and the two centuries following. During the last period of their production the Etruscan mirrors do not always have great artistic value, but in no generation are masterpieces of workmanship entirely lacking. By the 4th century Latium also came to the fore in art. The most important site of discoveries is Praeneste (Palestrina), not only for mirrors, but also for the cylindrical and oval toilet boxes called cists. In Greece itself it is only at the end of the 5th century that we find incisions on mirrors, some of which are inlaid with silver. This type of work was in vogue during the age of Phidias.

The development of vase painting can be followed through each successive phase. The archaic manner was abandoned about 480 B.C. The new heavier proportions, the serious faces, no longer conventional masks but expressive of personality, the bold foreshortening, the natural fall of the drapery, can be studied most thoroughly in vase painting. By contrast, some contemporary incisions on bronze disks look provincial.

During the period when classic art reached its climax, in the age of Phidias, we can again follow in the red-figure style of vase painting (PL. 263) an evolution parallel to that of the plastic arts. Notable also is a series of works in silver with incised figures partly inlaid with gold, found in Thrace and in the Crimea, which repeat the same schemes and motifs found in vase paintings. Besides the red-figure ware, of particular interest for the study of drawing are those vases in which the decorations are painted on a white slip. This genre, conventionally used for certain fixed purposes (e.g., funeral lekythoi), enlisted the talents of most of the best red-figure and black-figure painters.

The white-slip technique has its roots in the late archaic period, from which a series of enchanting vases and pinaces survives, but the apex was not reached until the 5th century. The decorations on vases with a white-slip background, while somewhat adapted to the shape of the vase, are designed to produce an effect analogous to that of drawings on white wood or parchment. For the most part they appear on lekythoi, whose principal surface is almost perfectly cylindrical. The composition, therefore, can easily be transposed onto a rectangle. Beginning with the middle of the 5th century, the outlines were often drawn in an opaque color wash rather than with a raised line, a development which brings painting and drawing still closer together. In modern graphic art, under the influence of printing, a black line is generally used on a white background, but in antiquity the outline of the figures was usually red, except, naturally, for red figures, in which case the outline was black. In the 8th century these red outlines were used in the painted metopes of Thermon (National Mus., Athens) and in the Campana tomb, near Veii in Etruria; during the 6th century they continued to appear in the pinaces from Pitsa and in the tomb frescoes at Tarquinia, and during the 5th century in the white lekythoi and in the copy at Herculaneum of the painting of the knuckle-bones players. They continued through the 4th century, as seen on the polychrome relief at Eleusis, the marble slab with scenes from a tragedy, and the Tomba dell'Orco at Tarquinia, and even into the postclassic period, with the marble slab of the Niobids. Since we can follow this practice through the centuries both in Greece and in Etruria, it must have been the rule throughout the ancient world. An additional confirmation is found in Pliny, who reports that the contours of the *monochromata* were executed in red lead.

The white lekythoi faithfully follow the stylistic evolution of the classic period, from the sculptures of Olympia (Pistoxenos Painter, Penthesileia Painter), to the Parthenon (Achilles Painter), to the post-Phidian age. At the end of the 5th century two trends emerge. In one group of large lekythoi, the so-

called "group R," with the abandonment of all inner modeling, the pure outline brilliantly emerges. The unusual beauty of these lekythoi can be appreciated by comparing them with the contemporary ivory incisions from the Tauric Chersonese. The incisions are also of high quality, as becomes evident if they, in turn, are compared with the red-figure ware done by the school of the Meidias Painter of the same period. They lack, however, the boldness of line which distinguishes group R. Another group of large lekythoi of the same period show a completely different tendency (PL. 264). There is shading on the male figures, which are done in color, and on their garments. They were painted with a large brush, so that the term "drawing" is no longer really applicable. This was the first time in the history of art (not only of Greek art) that a breach was opened between painting and drawing. The first half of the 4th century was a period of decadence for Attic red-figure ware. The vase paintings of the same period produced on the Italian mainland are superior, even though they represent a survival of the classic period. In Boeotia the vase paintings from the sanctuary of the Kabeiroi (Cabiri) near Thebes show greater originality in their lively caricatures.

Toward the middle of the 4th century in Attica, drawing again emerged with a definite style. In the Panathenaic amphoras, decorated in the black-figure technique following the old tradition, the modeling of the figures is clear and vigorous. According to literary tradition, the works of Euphranor were done in this same style. Examples of the red-figure ware of this period are the charming work of the so-called Jena Painter as well as the more pretentious vase paintings found particularly in the Crimea. In all these Attic vase paintings shading, commonly used in the monumental painting of the period, is purposely avoided. Only in isolated examples of Etruscan vase painting of this same period do we find faint shadows (Hesione Crater, Perugia, Mus. Archeologico) or shading indicated by hatching. Shading, however, is not foreign to Greek drawing of the 4th century; this is proved by the incised Etruscan mirrors of this period, which include pieces of superior quality in both drawing and technique directly related to Greek prototypes. We can add to these the group of cists from Praeneste, and in particular the largest one, the so-called Cista Ficoroni, signed by Novios Plautios and bearing scenes from the myth of the Argonauts (V, PL. 50), and the mirrors from Praeneste, which are often decorated with free and flowing forms.

In the last quarter of the century drawings on the Attic red-figure ware and on the Panathenaic amphoras were done very sketchily in short, unconnected strokes. These sketches are the latest extant examples of drawings on vases. In later centuries, on the few vases which are not decorated in relief but painted, there are only figures or scrolls, for the most part quite unambitious, done with a wide brush. During these last centuries of antiquity, in spite of the increasing number of monumental frescoes and mosaics, our knowledge of drawing proper is limited to a few isolated examples.

The reason for the dearth of real drawing is that vase painting after the beginning of the 3d century B.C. was no longer a common practice. A solitary example of monumental drawing is the 3d-century stele from Thessaly, erected to the hero Aeneas, who is represented in a manner reminiscent of Asklepios, god of health. This engraving must certainly have served as the basis for a painting, now lost. To this same period belong the gravestones discovered in Chios, of black marble with scenes incised on a rough background, and a cup from Calabria, with lively hunting scenes. Some slates from Delos, bearing decorative scrolls and used in all probability as table surfaces, date from the 2d century B.C.

Very little Roman drawing has survived, with the exception of wall graffiti, the most famous of which are found in Pompeii. For the most part they are nothing more than rough sketches done by a childish or untrained hand. However, they are sometimes remarkable for their spontaneity and liveliness. From the 2d century of our era we have some illustrations on papyrus representing Eros and Psyche. The incisions of the constellations on the bronze planisphere in Salzburg belong to the same period. The lively cartoons of the labors of Herakles on a papyrus from Oxyrynchos, in Egypt, belong to the early 3d century of our era.

Andreas RUMPF

*Late antiquity and Byzantium.* Still rarer are the remnants of illustrations on papyrus in the following centuries, the latest of which belongs to the 6th century. More noteworthy survivals from this late period are the careful incisions on metal, particularly on silver cups, unearthed in what is now the southern part of Russia, and pieces in inlaid bronze. Outstanding among the latter is the situla in the Galleria Doria Pamphili, Rome, with scenes from the Iliad, which can be attributed to the first years of the 7th century. The 7th-century Coptic drawings on parchment and potsherds bring us to the last phase of ancient art.

It is not surprising that drawing plays such a small part in the representational arts of the late-antique period. Drawing becomes superfluous both as an outline and as a means of defining detail. Color defines the appearance of the object and places it in space, which is itself understood as light. Thus, in mosaics the background appears first in blue and then in gold as a contrast to matter which is dark, or better, which is represented by darkness. And from the 3d century on, in paintings such as the fresco of the Praecones (Palatine Mus., Rome) or the Barberini Goddess (Mus. Naz. Romano, Rome), in mosaics such as those at Piazza Armerina in Sicily, and in intarsias such as those in the Basilica of Junius Bassus in Rome, we seem to see the practical application of the theories which Plotinus develops in Book VI of the *Enneads*. Only later and under Byzantine influence was there to be a return to drawing; it did not pretend to give a realistic impression of the volume of an object but transposed the figure, the human figure in particular, to an unreal plane.

Michelangelo CAGIANO DE AZEVEDO

*Medieval Europe.* Confronted with the scarcity and the problematical quality of medieval drawings, critics have reached opposite conclusions. Some (e.g., Oertel) hold that, aside from miniatures accompanying texts, no form of autonomous drawing existed during the Middle Ages and that preliminary drawings existed only on a monumental scale. Such drawings would have been on walls or for architecture and sculpture; charcoal sketches for wooden panels; sinopias (underdrawings on the walls) for mosaics and frescoes; and in the case of miniature painting, pen or pencil sketches to be gone over in color. In painting the preliminary sketch developed into and was covered by the finished product. Other scholars, chief among whom is Degenhart, have tried to prove that drawing for its own sake and preliminary drawing on a small scale existed in the Middle Ages much as it did in the Renaissance. Two things might explain the extreme scarcity of autonomous medieval drawings. First, preliminary drawing had no place in medieval esthetics, which took a craftsman's view of art and, therefore, valued only the finished product; second, parchment was very expensive before paper came to be extensively used.

The function of medieval drawing as "an aid to memory" (Oertel) and as the principal means of transmitting traditional forms from generation to generation is illustrated by the notebooks in which artists collected drawings as "exempla" for their own use, for their workshop, and for their pupils. There are only ten or so of these in existence, besides a number of single sheets which have been casually inserted in collections of other documents. The earliest of these notebooks belonged to a miniature painter, Adémar de Chabbannais d'Angoulême, who about 1030 copied a number of illustrations from a 9th-century Prudentius in order to use them as a guide, particularly for the iconography, for the illustration of a manuscript. Earlier still is a sheet of "exempla" from a 10th-century Rhenish scriptorium inserted into a Carolingian manuscript now in the Vatican Library (Pal. lat. 135). The most important notebook for miniature painters, however, is the Einsiedeln Codex (Stiftsbibliothek, Ms. 112) of the 11th-12th century. It could have been used also for wall painting. Of particular interest too is

the Wolfenbüttel notebook (ca. 1230–40; Landesbibliothek, cod. 3662, 61.2 Aug. oct), which contains a series of copies of Byzantine miniatures that slightly later served as models for the illustration of the *Goslar Gospels* (Saxon mid-13th cent.; in Rathaus, Goslar): it permits us to witness the transformation of a copy into an original work of art, and to observe the flowering of the "expressionistic" Occidental style out of the classical Byzantine tradition. To this same period belongs the famous album of Villard de Honnecourt (PLS. 197, 267; VI, 298), assembled by the Picard architect as a collection of architectural motifs (plans and elevations of the cathedrals of Vaucelles, Reims, Lausanne, etc.), decorative motifs, and figures drawn from works done in widely divergent techniques and destined to serve as models, more or less interchangeably, for sculpture, painting, and the decorative arts. The drawings of figures are taken from works of diverse kinds and periods: from Rhenish sepulchral sculpture, from Early Christian and Gothic miniatures, from mural painting, from Gothic cathedral sculpture, from gold- and silverwork. As is typical of this kind of "portraiture," the artist reduces his subjects to such a uniform style that it is often difficult to distinguish the technique in which they were originally executed. The interest of the draftsman is centered on the iconography, on the illustrative motif, and perhaps on the formal solution rather than on the qualities more intimately connected with style. From this fact we can draw the conclusion that in the Middle Ages the precept that one must remain faithful to the model and to tradition did not prevent the artist from working out his own style. Drawings from living models are included; among these are two sketches of a lion expressly labeled as such. Almost certainly the drawing of a juggler performing for a lady is also taken from life. But they are exceptions, inspired by the unusual subjects. The wild beast, where it is not stylized by a hand used to drawing the stone lions of church portals, is drawn so awkwardly and with such disregard for detail as to show clearly that the study of nature was not a habit with the medieval artist. In drawing the juggler and the lion tamer, Villard sketched the body so that it is seen underneath the clothes, because his attention is attracted by the body mechanics and the rhythmical quality of the movement. Of particular interest for the study of the survival of the classical tradition and the esthetic concepts of the period is the series of figures and groups constructed of or fitted into geometric configurations.

At times the notebooks take on the aspect and function of a well-ordered catalogue of motifs to be consulted by the client: a typical example is the one, now in Vienna, of a Bohemian painter of about 1400, with 56 carefully drawn heads of sacred personages. But through this "interpretive" copying an increasing measure of originality gradually came into drawing. By the end of the 14th century, in the notebook of Giovannino de' Grassi (III, PL. 9, Bergamo, Bib. Civica), we have certainly gone beyond the strictly utilitarian catalogue and are beginning to deal with drawing for its own sake.

Outside the notebooks, too, copying is much in evidence, and we find this reproductive activity infused, in varying degrees, with the characteristics of creative drawing. Most significant for the study of new trends in art are the variances from the original to be found in the famous group of drawings (New York, Met. Mus.; Northamptonshire, Castle Ashby; Chantilly, Musée Condé; Bayonne, Musée Bonnat) based on Giotto's *Navicella* (Rome, St. Peter's). The beginnings of a new approach are visible in the chiaroscuro drawing, after a fresco of the *Presentation in the Temple* by Taddeo Gaddi (PL. 269), which served as a model for the Master of the Rinuccini Chapel in Sta Croce, Florence; and later, in the fragment of a drawing of the Forty Martyrs (Vatican Library, Barb., lat. 144), which interprets a lost Byzantine mural painting, with a pathos reminiscent of Cimabue, we can detect the emergence of a new expressive technique.

<div align="right">Roberto SALVINI</div>

The most important single aspect of drawing in the Middle Ages is represented by line drawings, in one or several colors, executed in monastic centers to accompany manuscripts (see MINIATURES AND ILLUMINATION). Although a certain number of such drawings have come down to us in Merovingian texts of the 7th and 8th centuries, these examples from the formative stage of Western culture seldom rise above the level of schematic vignettes. With the Carolingian revival, however, the cultural situation was radically improved and the Reims school of illumination, which especially favored drawing as a means of embellishing both sacred and secular texts, came into being. The greatest achievement of the Reims school is the Utrecht Psalter, executed in the first half of the 9th century (III, PL. 58). In the superb monochrome illustrations for this work two different stylistic tendencies are successfully fused. On the one hand, a vivid illusionism is evident, which is of Mediterranean derivation and is familiar to us in such ancient works as the Odyssey landscapes in the Vatican Library (VII, PL. 180), with their fluid atmospheric quality. On the other, we find an excited expressionism and depth of emotional characterization that are the contribution of the northern peoples.

Some time before A.D. 1000, the Utrecht Psalter found its way to Anglo-Saxon England, where it exercised a profound and lasting influence on the development of manuscript illumination. A psalter in the British Museum (Harley Ms. 603) includes a series of fine drawings copied from the Utrecht Psalter in the early years of the 11th century. In the fluttering arabesques of this work the expressive and decorative qualities of the Utrecht Psalter were advanced further. Like other English manuscripts of this type, the linear patterns of these miniatures were executed in several colors, though the use of solid or opaque colors was excluded. Another trend in English manuscript illumination of the time is seen in the delicate, elongated figures of the Trinity in a manuscript now in Paris (PL. 265); the style of these miniatures is derived from the Ada school of Carolingian illumination (see CAROLINGIAN PERIOD).

Although England made the greatest contribution to the field of drawing in the pre-Romanesque period, a number of works of great vigor are known from contemporary Ottonian Germany (e.g., the Gospels from Paderborn; Kassel, Landesbibliothek, Cod. theol. fol. 60), while southern Italy, largely under Byzantine influence, produced a series of beautifully stylized manuscript drawings (PL. 265).

With the rise of Romanesque art (q.v.) in western Europe at the beginning of the 12th century, these styles, which may be termed "calligraphic," gave way to a new concept of form which adjusted individual features to a rigidly patterned whole. The mature Romanesque style may be seen in illuminations by the Master of the Apocrypha Drawings in the Winchester Bible (Winchester, Eng., Cathedral Library). Here the artist endows drapery, architecture, and faces alike with a flowing linear structure which subordinates all details to the carefully organized composition.

In the early 13th century the acceptance of the Gothic style of illumination, with its taste for backgrounds in opaque gold and brightly colored squares, put an end to the independent tradition of manuscript drawings (see GOTHIC ART). When these reappear, as in the exquisite miniatures of the *Hours of Jeanne d'Evreux* (New York, The Cloisters; ca. 1325) by Jean Pucelle (q.v.), we find an altogether new type of work. Here the delicate grisaille chiaroscuro of the figures contrasts with the subtle wash tones of surrounding areas and reveals the influence of the monumental painting of the time.

<div align="center">* *</div>

The marginal sketches found on many manuscripts are often complete, if extemporaneous, works of art. These sketches are sometimes the work of an amateur and sometimes the work of the miniature painter himself. In a few cases (Montecassino, Monastery Library, 1174, G, 191, NN) the pen sketch which served as a model is preserved next to the finished miniature. Caricatures belong to still another category and are also sometimes by a dilettante and sometimes by a consummate artist (Decretals of Salzburg, Stift Sankt-Peter, M III 44; Bolognese codex, 13th cent.). It is among these marginal sketches that we must look for "free" drawings, and Degenhart has

done extensive research on this subject. The earliest of these drawings, in a Coptic Bible, represents an imperial family of the 7th century and is important as a completely achieved graphic expression. Next in chronological order, to mention only the most noteworthy examples collected by Degenhart, are two magnificent Carolingian female figures in a Bible in the Vallicelliana Library in Rome (B 6) by an artist accustomed to monumental painting and the marginal sketches of figures within a nimbus by a Mosan miniature painter in an Old Testament in the Vatican Library (Pal. lat., 14). For the 10th-11th century we have studies of motifs for a Last Judgment in a Bede at Verona (Biblioteca Capitolare Ms. XXI). These studies have a spontaneous freshness reminiscent of folk art of the period. For the Romanesque period we have sketches of a brilliant directness in a Bible in the Vallicelliana (A 1) done, perhaps, by a sculptor closely affiliated with the authors of the Porta di San Zeno in Verona; the sketches contained in the three volumes of an Old and New Testament in the Vatican Library (Pal. lat., 3–5), in all likelihood the work of a northern European sculptor of the end of the 13th century; and finally the beautiful series of female heads in another Vatican manuscript (Reg. lat., 2090), the work of a Roman artist of the second half of the 13th century closely related to the author of the icon in S. Maria in Trastevere. A common trait in some of these drawings is the way the artist works out a series of variations of the same motif.

In the second half of the 14th century appear loose sheets of parchment or paper (PL. 269) like the ones commonly used during the Renaissance, with real studies for paintings (e.g., Haarlem, Koenigs Coll., J 190 v., three Crucifixions; Louvre, Inv. R.F. 1870/419v, three Annunciations: the first from Tuscany, the second from northern Italy). The earliest extant compositional drafts for paintings are thought to be two sheets of parchment (Albertina and Koenigs Coll.) by Tommaso da Modena, from about 1352. From the beginning of the 15th century we have the sheet with a story of Alexander II in the Morgan Library (New York), a draft by Spinello Aretino for one of the scenes for the Palazzo Comunale in Siena. This particular scene was later excluded from the series, but the cartoon belongs nonetheless to the category of preparatory drawings (Oertel). Not all sketches of pictorial compositions can be considered preparatory drawings. Some are copies or adaptations for the artist's catalogue, for instance, the two scenes of St. John the Evangelist by Spinello in the Louvre. In this same category probably belong many chiaroscuro drawings, including those by Lorenzo Monaco in Berlin. There is evidence, at least with regard to the beginning of the 15th century, that it was customary for the artist to give a drawing to his client or patron as a guarantee that the finished work would follow a given composition; an example of such "contractual" drawings is the *Death and Coronation of the Virgin* in the Louvre, attributed to Beauneveu. The earliest sheet of multiple drawings from life which has come down to us — and probably one of the first to exist — is a drawing of five heads by Agnolo Gaddi (ca. 1380) in the Castello Sforzesco in Milan. If we compare these heads to the ones most like them in Gaddi's frescoes in Sta Croce, Florence, we see that there is a warm, sensuous quality in the drawings which is partly lost when they are reproduced in the fresco.

Sinopias, of which there are notable examples in the Camposanto, Pisa (PL. 266), have been subjected to very thorough research by Oertel. As we have shown above, however, they cannot be considered the only form of preliminary drawing practiced during the Middle Ages.

To sum up, drawing in the Middle Ages was first of all the means of ensuring the continuity of a tradition through copies. However, since the artist's greatest concern was to copy faithfully iconography rather than style (for it was thought that in the works of previous centuries authentic likenesses of sacred personages and historically accurate portrayals of sacred events were to be found), there was room for the development of original styles in the very act of copying. Even though an understanding of the significance of artistic liberty was lacking, and conditions were not favorable for the development of

drawing in and for itself, and still less for the preservation of autonomous drawings, it is impossible to believe that this activity, so innate in the artist, did not exist. Nor can preparatory drawings have been so rare as the dearth of extant examples might suggest, even if it is true that the greater part must have been on a monumental scale and closely bound in with the execution of the final work of art.

Roberto SALVINI

ART AND PRACTICE OF DRAWING IN MODERN EUROPE. *Drawing theory.* From the 14th century on, the theoretical problems connected with drawing, either as an independent art form or as a subdivision of painting, have been the subject of much critical writing. For the 14th-century writer Cennino Cennini (in his technical treatise, the *Libro dell'Arte*) the position of drawing as the very cornerstone of art was perfectly clear: it was considered to be both the necessary foundation of practice for all and a natural intellectual inclination of the talented. In the opinion of L. B. Alberti (*Della Pittura*, 1436), however, drawing was contour, the subtle outline of forms, which constituted only one component of painting in conjunction with two other equally important factors, composition and effects of light and shade ("circumscriptione, compositione, e receptione di lumi"). Drawing was, therefore, "equivalent" to the structure of a given painting and did not represent in more general theoretical terms the "basis" of either painting or sculpture. Closer to the traditional Florentine theoretical point of view, however, was Lorenzo Ghiberti (*I commentari*, ca. 1455), for whom drawing represented a formal principle, the generative reasoning behind both painting and sculpture, of which it formed the foundation.

For Leonardo (q.v.) drawing was of use primarily as a recording instrument in his investigations of nature; it was a means to analytical precision of description and might be subordinated to the discipline of linear perspective. However, to his mind line was merely an intellectual abstraction, while the true meaning of reality could be culled only from the intuitive apprehension of nature (that is, from the famous "inner discussion," or "discorso mentale," in the course of which the mind of the artist becomes "like a second nature"). Further, the vitality of nature thus intuitively grasped could be concretely rendered only in the synthetic terms of aerial perspective or through the dynamic imprecision of a rough sketch (of the whole image to be represented, not simply a part). Thus, the analytical processes of linear perspective and detailed line drawing became merely tools, of use in the reconstruction of a synthetically perceived and synthetically rendered image of nature.

In Venice, Paolo Pino (*Dialogo della pittura*, 1548), formulating the division of painting into three elements, drawing, invention, and color ("disegno, invenzione, e colorire"), subdivided the first into four components: judgment, outlining, technique, and correct composition ("giudizio, circoscrizione, pratica, e retta composizione"). Judgment consisted of the artist's inner image of the thing subsequently physically realized in terms of outline ("circoscrizione") and perspective composition. Yet "circoscrizione" itself was no longer (as in Alberti) simply linear contour, but was extended to include light and shadow as well; that is, it comprised the first undefined image or rough sketch in all its aspects.

More simply, Ludovico Dolce (*Dialogo della pittura*, Venice, 1557) considered drawing to be a "manipulation of lines" ("giramento di linee") that lent form to figures, in the process producing a compositional invention. At the same time, however, the search for compositional motifs, or "invenzioni," was rendered possible primarily through reference to these same immediate drawings or quick sketches.

The Neoplatonic writings of Anton Francesco Doni, in their tendency to interrelate art and theology, reflect the beginnings of the Counter Reformation spirit. In his *Disegno* (Venice, 1549), Doni anticipated the theories of Federigo Zuccari (as expressed in his *Idea dei Scultori, pittori ed architetti*, Turin, 1607) by identifying drawing with "divine speculation," that is, with God's invention of the universe at a point prior to its physical manifestation in form and color. The artist,

in whose mind arises the inventive faculty of drawing or design, the condition and guide of painting, was thus represented as acting analogously to God.

Giorgio Vasari (whose theoretical notions are chiefly contained in the *Proemio* to his famous *Lives*, first published in Florence in 1550) also saw drawing as originating in the intellect, as the idea or form of things, but this idea arose independently in the artist's own mind and was not transmitted to him through divine power. Furthermore, invention ("invenzione"), which was included and embodied in the idea, was concretely realized through the agency of drawing and thus began its physical existence as a sketch. The views of Raffaelle Borghini (*Il Riposo*, Florence, 1584) and Giovanni Battista Armenini (*Dei veri precetti della pittura*, Ravenna, 1587) were not essentially different from those of Vasari.

The historical position of Gian Paolo Lomazzo in the stylistic world of late mannerism and the spiritual climate of the Counter Reformation is apparent. In his writings (two influential treatises, *Trattato dell'arte della pittura*, Milano, 1584, and *Idea del tempio della Pittura*, Milan, 1590), drawing assumed the character of eurythmy of lines and proportion, and was thought of as the structural framework of painting, upon which was based the "perspective light." Within the rhythmic framework imposed by drawing, painting consisted in exact imitation not so much of physical reality as of the artist's inner image, a requirement that necessitated constant meditation and reference to divine precepts on the part of the artist.

In the writings of Federigo Zuccari, finally, drawing was identified with idea, which descended Neoplatonically from God to the mind of the artist. Thus, drawing became a universal metaphysical principle "which is found in all things created and uncreated, visible and invisible, spiritual and material." From this assumption followed the importance of distinguishing between "disegno interno" (i.e., the "inner design" of the artist, which is a divine category of knowing and the formative source of images) and "disegno esterno" (i.e., the physical actuality of drawing, the linear outline), which in late mannerist theory became ever more complex, being subdivided into "natural," "artificial," and "artificial but fantastic" types. The "artificial but fantastic" manner of drawing was that most congruent with mannerist taste; in effect, it embraced "all the oddities, caprices, inventions, fantasies, and whims of man."

There were no important additions to the theoretical speculations on the nature of drawing during the 17th and 18th centuries. The conclusions of Zuccari, directed at elevating drawing to a universal supernatural principle through his identification of drawing with idea, represented the logical extreme of a long development of artistic theory. Seventeenth-century theory returned to distinguishing between drawing and idea. The concept of idea was related during this period to the notion of beauty in the classical sense (as, for example, in the writings of the academic critics, Agucchi and Giovanni Pietro Bellori), and, in general, interest in the theoretical aspects of drawing was replaced by interest in drawings themselves and in their classification, both qualitative and attributive. The figure of the theoretician was superseded by that of the connoisseur, of the amateur or dilettante, of the collector and the antiquarian. The drawing collections already in existence, such as that of the Grand Duke of Tuscany (rearranged by Filippo Baldinucci at this time), were enriched, and many new ones were formed, such as those of Ridolfi, Malvasia, the Duke of Modena, Bellori, Maratti, Padre Resta, Chantelou, Crozat, Mariette, Reynolds, and others. The only writer to present a theoretical discussion of drawing was Giulio Mancini (*Considerazioni sulla Pittura*, 1624–30), who made a distinction between two opposing modes of vision: the picturesque (i.e., an image which is at once graphic, coloristic, and illusionistic) and the sculptural (i.e., a plastic image, constructed by means of objective measurement). Pure design was, for Mancini, quite different from the ideas of mannerist theoreticians, being an abstraction formed in the mind on the basis of sensory data, rather than arising spontaneously in it.

Eventually the theoretical discussion of drawing became impoverished, rigidified in the controversy over the superiority of the two opposed principles of drawing and color. While in Italy this argument was mainly devoted to the differentiation between various schools of art, in France it was personified in the followers of Poussin, classicist proponents of the priority of draftsmanship, and the followers of Rubens, who asserted the preeminence of color.

In Italy classicists such as Domenichino and Carlo Maratti regarded drawing as a formal principle, which subordinated and determined color, and Passeri (in *Vite de' pittori, scultori . . .*, Rome, 1772), distinguishing between the function of the painter and that of the draftsman, called drawing "the father of painting." Even more important is the fact that Baldinucci (*Notizie de' professori del disegno . . .*, Florence, 1681–1728) was the first to affirm, even though cautiously, that one ought "to include under the name of works of art not only paintings, but also drawings . . . even to first thoughts or sketches." Inherent in the new interest in the classification of drawings was the problem of attribution (that is, the possibility of ascertaining individual manners of drawing), which was at this point resolved by the observation of the analogy between drawing and handwriting as unmistakable personal characteristics. On the basis of this analogy, the Venetian Marco Boschini, who advocated the supremacy of painting over drawing, compared drawing to the scribbled notes used by an author while writing, only to be thrown away later. More interesting is the opinion of the French writer Roger de Piles, who distinguished among three ascending levels of drawing; the highest of these consisted of the expressive line of color, a living pictorial line that imparts truth and vitality to form, which was perceived by de Piles in the "spirited contour" of Rubens.

Particularly deserving of mention among the collectors and antiquarians of the 18th century is Padre Sebastiano Resta, who explained the phenomenon of the sketch in terms of the concept of "enthusiasm." The more intense the enthusiasm of the artist for his subject, the more direct and immediate its translation into the "unique manner" of the artist; otherwise, a number of styles or tendencies might be present in the same sketch. In another direction, the highly developed 18th-century taste for drawings provided an opportunity for the beginnings of scholarly criticism. While studying the Crozat collection, Pierre Jean Mariette produced a first, imperfect yet penetrating attempt at the critical examination of individual graphic styles (in his *Réflexions sur la manière de dessiner des principaux peintres*, Paris, 1741). Even earlier in England Jonathan Richardson the Elder (*An Essay on the Theory of Painting*, London, 1715) had arrived at some acute intuitive perceptions about drawings. Richardson noted in them a liveliness that diminished as soon as the painter added color. In his opinion drawings were the first thoughts, the true originals entirely from the hand of an artist, the very essence of art. Antoine Joseph Dézallier d'Argenville also was to say (*Abrégé de la vie des plus fameux peintres*, Paris, 1745) that drawings embody the first ideas, the inventive resources, the basic style, and the genuine mode of thinking of an artist. (For later concepts, see below.)

*Drawing from the Renaissance to the 18th century.* From the 15th century on, drawings have been executed in a variety of more or less complicated technical media. Depending on his requirements, the artist might employ a simple contour line, or add chiaroscuro shading or highlights in chalk or white lead, or suggest color through the use of pastels, water color, or tempera. Metal point, chalk, pen with ink or water color, and charcoal were all popular drawing tools, and in the second half of the 15th century red chalk and red ocher began to be used.

During the 15th century, highly finished drawings were sometimes bound into albums either to serve as patterns for manuscript illumination or to preserve the inventive heritage of a workshop. The notebooks of Jacopo Bellini, Pisanello (qq.v.), and other Lombard and Venetian masters are particularly famous. More generally, however, from the 15th century on, drawings were done on single sheets of paper, of various grains, either white or colored, sometimes prepared with tempera.

The drawings of the Florentine masters of the 15th century

clearly reveal the fundamental importance of drawing in Florentine art. While certain particular curvilinear rhythmic inflexions and an interest in the play of light over layered surfaces seem to be characteristics peculiar to the drawings (and paintings) of Lorenzo Monaco, his general stylistic predilections were shared by others, such as the Master of the Bambino Vispo and Parri Spinelli. The sheet of studies for a Flagellation in the Albertina in Vienna (no. 24409) may be the work of Lorenzo Ghiberti (q.v.). We have a considerable group of drawings belonging to the school of Fra Angelico, within which it is, however, difficult to attribute surely any drawings to Angelico himself. (The *Crucifixion* in the Albertina is among the more plausible candidates.) On the other hand the group of drawings by Angelico's assistant Zanobi Strozzi, even though close to the master, is easily distinguishable. Benozzo Gozzoli (q.v.) manifests in his drawings a narrative and poetic truth and a force in portraiture (as in the *Portrait of a Man* at Windsor) beyond anything he achieved in painting.

The new directions of Florentine 15th-century art are clearly evident, though seen through a whimsical Ghibertian style, in the drawings of Paolo Uccello (q.v.), in the energetic naturalism of the famous Uffizi profile portrait, in the distorted Donatello manner of the *St. George on Horseback* (Uffizi 14502A), and in the crystalline perspective studies (Uffizi 1757A and 1758A) of a *mazzocchio* (a wooden or wicker headdress common in Florentine male attire of the 15th century, which because of its complex geometric form presented a particularly intriguing compositional problem to the artist) and a chalice (PL. 267). In a male portait in the Uffizi ascribed to Andrea del Castagno (q.v., esp. I, PL. 244), linear incisiveness operates in the service of enhanced plasticity and reflects the naturalistic energy of Donatello's style, here interpreted in a highly individualistic manner. A combination of the stylistic legacy of Donatello with that of Masaccio characterizes the few, but significant, drawings of Filippo Lippi. Although the energetic and expressive linearism of Donatello was isolated and exaggerated in the drawings of Antonio Pollaiuolo (see ENGRAVINGS AND OTHER PRINT MEDIA; PL. 270), Andrea del Verrocchio looked back to Donatello for a renewed equilibrium between pictorial volume and linear energy.

The example of Verrocchio was of fundamental importance, and out of the bustling activity of his workshop emerged both the exquisite graphic production of Lorenzo di Credi (far more convincing than his efforts as a painter) and the nascent genius of the young Leonardo (q.v.). Nor should the basically Verrocchio-like character of the youthful drawings of Perugino, later the chief master of the Umbrian school, be forgotten. The narrative-descriptive tendency in Florentine art is represented in the drawings of Domenico Ghirlandajo (q.v.), an acute, even merciless portraitist (as in the *Portrait of an Old Man with Bottle Nose* in Stockholm) and a very adept inventor of multifigure pen-and-ink compositions. The numerous drawings in the style of Ghirlandajo still constitute a difficult problem of attribution; among these can be distinguished the work of Sebastiano Mainardi, but the attribution (by Berenson) of a number of drawings to Davide Ghirlandajo remains in the realm of hypothesis, and the drawings, which are sometimes close to Raffaellino del Garbo, sometimes to Filippino Lippi, may in fact belong to more than one artist. The uneasy, expressive flow of line of Filippino Lippi's drawings (PL. 270), which also incorporate some features of Leonardo's chiaroscuro, is derived from the work of a still greater graphic genius, Sandro Botticelli (q.v., esp. II, PL. 332). The secret of the musical enchantment and subtle pathos of Botticelli lies in the fundamental value assumed by line in the construction of his pliant and restless images.

The Sienese school of the 15th century is represented primarily by the large group of drawings attributed to Francesco di Giorgio (q.v.), in which the artist's complex, many-leveled background is evident. The subtle yet incisive hatching characteristic of his drawings both defines solid form and lends to it a now fluid, now staccato rhythmic movement. The graphic vision of Martini reveals his quite personal reaction to many influences: Donatello, Verrocchio, Pollaiuolo, even Girolamo da

Cremona. Certain other 15th-century drawings of the Sienese school, such as the series, *Prophets and Sibyls*, in the British Museum, are the work of Girolamo di Benvenuto.

Noteworthy among the drawings of the Umbrian school are those of Niccolò Alunno, which display the same pathetic woodenness of form as do his paintings. The drawings of Perugino, reflecting as they do various stages in the evolution of his style, represent a storehouse of graphic methods and motifs (intricate cross-hatches, gentle linear rhythms, derivations from Verrocchio and Leonardo), later often repeated and variously interpreted by his followers and pupils and by other Umbrian masters, such as Pinturicchio (q.v.), Eusebio da San Giorgio, Lo Spagna, and others. Standing apart from these as a draftsman was Luca Signorelli (q.v.), whose energetic structural line (in both pen and charcoal) embodies his searching and harshly dramatic investigation of human anatomy and gesture, clearly inspired by the work of Pollaiuolo and Piero della Francesca.

The Lombard artists of north Italy produced many drawings (PL. 269), which were often highly finished and intended for the illustration of manuscripts (e.g., the Lancillotto drawings by Bonifacio Bembo, in Florence, Bib. Naz.) or bound in notebooks that were monochrome equivalents of illuminated manuscripts (e.g., the previously cited notebook of Giovannino de' Grassi, in Bergamo, Bib. Civ.). Many Lombard drawings are anonymous, but all display, in conjunction with a general attachment to the international style, the more elaborate pictorial study and the penetrating observation of nature characteristic of the Lombard art of the time. Examples of drawing that exhibit the new Renaissance tendencies present in Lombard art before Bramante are rare; of the few such drawings that have come down to us, some are attributable to Vincenzo Foppa (q.v.) and Bernardino Butinone.

Of great importance as an art center within the sphere of influence of the late Gothic international style was Verona, with its two chief masters, Stefano da Zevio (or da Verona) (PL. 269) and Pisanello (q.v.). Stefano's incisive pen stroke rapidly constructs images of a bold capriciousness that is not always paralleled in his paintings. The graphic activity of Pisanello was prodigious and reveals in its equally acute observation of animals and of subtly stylized courtly figures "from life" not only a corresponding variety of graphic modes, but the very complexity of his idiom, simultaneously late Gothic and naturalistic. This stylistic complexity is apparent in the drawings securely attributed to Pisanello (in the Codex Vallardi in the Louvre, and elsewhere), which contain indisputable evidence of his attachment to the naturalistic tradition of the Padua-Verona region (Altichiero, etc.), as well as direct references to Gentile da Fabriano (q.v.), to the Lombard school of manuscript illumination, and to the Franco-Flemish style.

The two famous volumes of drawings by the Venetian painter, Jacopo Bellini (q.v.; PL. 270), one in the Louvre and one in the British Museum, reveal his closeness to Pisanello, but even more to Gentile da Fabriano and Masolino (qq.v.). In these drawings, Jacopo's imagination often seems to have been stimulated by the requirement of Renaissance (i.e., central Italian) perspective constructions, which in his hands quickly assume a fairy-tale expressive quality, frequently rendered by means of a delicately pictorial system of hatching.

On the Paduan scene, there are few drawings that can be attributed to Francesco Squarcione himself, but his antirealistic and expressionistic translation of the Renaissance legacy of Donatello and the study of the antique into a highly unclassic idiom is reflected in the incisive pen drawings of Marco Zoppo, whose style was also influenced by that of the Ferrarese Cosimo Tura (q.v.). Tura himself likewise reveals the influence of Squarcione in his drawings, which are characterized by an even more extreme expressionism heightened by an insistent exploitation of the effects of light on form. The contribution of Andrea Mantegna (q.v.) and the many anonymous engravers of his school was of fundamental importance for the drawing style of all northeastern Italy. The drawings of Mantegna are generally characterized by the insistent use of hatching to render modeled form and by a rigorous sense of drama, and they reflect the artist's highly personal adaptation of Donatello,

of Piero della Francesca, and of antiquity. The precision of hatching apparent in these drawings reveals Mantegna's experience as an engraver (see ENGRAVINGS AND OTHER PRINT MEDIA), which constitutes a fundamental aspect of his artistic personality. There exist also drawings of a different type: quick sketches, more broadly executed in a loosened system of hatching which lends fluency and emotion to the figure movement. These drawings represent an attribution problem, since it has been assumed that some, if not all, belong to the period of Giovanni Bellini (q.v.), that was under Mantegna's influence. In his later drawings Bellini exhibits the interests that oriented him toward Antonello da Messina (*Study of a Child*, Oxford, Ashmolean Mus.), Piero della Francesca (the attribution of the *Foreshortened Head of Christ* in the British Museum is disputed between Bellini and Melozzo da Forlì), and ultimately the gentle and mysterious pictorial atmosphere of Giorgione.

The drawings of Gentile Bellini, some quick pen sketches, others more highly finished, according to compositional and perspectival requirements, confirm his reputation as the serene and observant recorder of Venetian life and of Oriental personages observed in Constantinople, though no drawing firmly established as his documents his early dependence on Mantegna. More intimate and animated in his illustration of the life and mores of the Veneto was Vittore Carpaccio (q.v.), who left many drawings, most of them studies of figures, in pen and ink heightened with white lead, executed with a vibrant but economical touch, which marvellously renders the poetic overtones of gestures and of life itself.

From the Ferrarese school after Tura, some drawings survive that may be attributed to Francesco del Cossa (q.v.); more striking, however, are the examples of the graphic activity of Ercole de' Roberti (q.v.), which both reiterate the dramatic vision of Roberti's painting and reveal analogies with the work of Pollaiuolo and the Bellinis. In his earliest drawings Lorenzo Costa appears as a follower of Roberti, while his later graphic works proclaim a change of style in the direction of the "modern classical" manner of Perugino and Raphael (qq.v.). The numerous drawings and engravings of Francesco Francia (q.v.) are still more closely involved with this latter trend.

The graphic remains of the earliest Flemish school are few indeed; still, some drawings by Jan van Eyck, Rogier van der Weyden, Hugo van der Goes, and Hans Memling (qq.v.) have survived. All these painters drew chiefly in silverpoint, or, more rarely, in pen and ink heightened with white lead. Despite the wide stylistic diversity among them, the Flemish draftsmen shared a feeling for the detailed analytical examination of nature, which, even when most stylized, does not lose its portraitlike veracity. This is true above all of Jan van Eyck (q.v.; a famous example is the silverpoint portrait of Cardinal Albergati, V, PL. 219), while Van der Weyden's style is more telling in expressive content and broader in drawing technique, and Van der Goes evokes a still more complex psychological world (as, for example, in the pen study of St. Luke, PL. 272).

At the beginning of the 15th century in France the relation between drawing and manuscript illumination remained very close. As in Lombardy, drawings were primarily intended as courtly and decorative illustrations for manuscripts. A notable exception to this rule was Jean Fouquet (q.v.), who was an extraordinarily modern portraitist (as in the black chalk portrait of Guillaume des Ursins in the Kupferstichkabinett, Berlin), even though a great miniature painter.

German drawings of the 15th century are rare and mostly anonymous, though some examples by Hans Multscher and Conrad Witz (q.v.) are known.

Drawing assumed an even greater importance in Italy and indeed, in all of Europe at the beginning of the 16th century. The drawings of Leonardo da Vinci (q.v.), first in Florence, then in Milan, illustrate the habitual searching experimentation of this singular universal genius (PLS. 268, 271, 273; also III, PL. 418). In these drawings, simultaneously the agents of experimental research and of poetic expression, art and science become one. In dealing with the drawings of Leonardo (often characterized by left-handed hatching), it is useful to differentiate roughly between those of the Florentine period and

those of the Lombard period. The latter exercised a profound influence on an entire generation of Lombard draftsmen, including Bernardino Luini and Cesare da Sesto.

Outstanding among the many painter-draftsmen of early 16th-century Florence were: Fra Bartolommeo (q.v.), whose drawing style presupposes the complex graphic idiom of Piero di Cosimo and occasionally reveals singular affinities to that of the Bolognese circle of Aspertini and Costa; his collaborator, Mariotto Albertinelli; Andrea del Sarto, prolific and ever-dependable draftsman (I, PL. 256), who arrived at an extraordinary equilibrium of mannerist stylization, a portraitist's fidelity to his models, and assimilations from Leonardo and Michelangelo. References to Michelangelo and to Andrea del Sarto form the substratum of the graphic language of Pontormo (PL. 274), whose splendid drawings epitomize the restless and anticlassical vision of the early mannerists (see MANNERISM). The graphic idiom of the first generation of mannerists is exemplified also in the drawings of Rosso Fiorentino and Domenico Beccafumi, which, however, differ in structure and rhythm from those of Pontormo. Particularly individual are Beccafumi's drawings, which display the same capriciously artificial exploitation of light effects and the fluidly attenuated images that characterize his woodcuts and paintings.

The uniquely dramatic, essentially sculptural vision of Michelangelo is completely expressed in his drawings, which embody with unsurpassed power his active anticlassicism and his translation of all existence into heroic terms. Michelangelo drew a great deal, employing a variety of drawing media: pen and ink, charcoal, sanguine, and black chalk; and drawings remain to us from all phases of his long career. In many of the pen drawings the form seems to be carved out of the paper by the penstroke just as the sculptural form emerges from stone under the impact of the chisel. Other drawings represent half-defined first thoughts of the working-out of specific compositional motifs, while in still others (such as the late drawings devoted to the theme of the Crucifixion) the "unfinished" quality is a deliberate esthetic and expressive device, achieved through the use of smoky chiaroscuro and intended to intensify the religious significance of the graphic image.

The drawings of the school of Michelangelo are extremely numerous and mostly anonymous; however, among those who based their drawing styles on his graphic methods was Baccio Bandinelli. Bandinelli, more convincing as a draftsman than as a sculptor, characteristically intensified chiaroscuro contrasts for sculptural purposes and frequently exhibited stylistic affinities to Rosso Fiorentino as well as to Michelangelo. Mention must be made of the numerous and skillful Tuscan draftsmen of developed 16th-century mannerism, among them such artists as Giorgio Vasari, Cecco di Salviati (Francesco de' Rossi), Alessandro Allori, Daniele da Volterra, and Santi di Tito. The last-named artist set in motion the first academic reform of painting, which aimed at reestablishing simplicity and severity in figural representation through the discipline of drawing. This reform movement stimulated a whole group of prolific and in some cases notably gifted draftsmen, such as Jacopo da Empoli, Andrea Boscoli, Ludovico Cardi ("Il Cigoli"), Domenico Cresti ("Il Passignano"), and Giacomo Ligozzi.

Raphael (q.v.), using as a basis the Umbrian drawing style of Perugino (q.v.), created his own graphic language, in which the essence of his art — which has been summarized critically as grace, charm, ease, and classicism — finds its simplest and perhaps its most perfect expression. It is extraordinary how the antithetical influences of Michelangelo and Leonardo were spontaneously assimilated in the drawings of Raphael (PLS. 266, 276), while in related paintings (for example, the Borghese *Deposition*) the same disparate impulses were occasionally not completely blended. The graphic manner of Raphael's mature Roman style set the example for the drawings of Giulio Romano (q.v.), of Perino del Vaga, and of Polidoro da Caravaggio, who created the widespread genre of monochrome antiquarian decorations for palace façades.

The style of Raphael was reflected also in the drawings of the Sienese painter Baldassarre Peruzzi (PL. 267; q.v.), whose later work seems also to betray the influence of Beccafumi.

In the drawings of Sodoma (q.v.) a mixture of influences from Raphael and Peruzzi nourished and modified the Lombard-Piedmontese stylistic heritage which always remained the core of this artist's style, and is strongly apparent in such a drawing as the *Swooning St. Catherine* (London, British Mus.). Later on in Siena the drawings of Francisco Vanni and Ventura Salimbeni reveal their attachment to the reformed Florentine tradition of Santi di Tito, as well as to the manner of Federico Barocci (q.v.), whose drawing style was exceedingly influential throughout Tuscany, Umbria, and the Marches during the late 16th and early 17th centuries. Once he had digested the results of his first exposure to the facile drawing style of the Venetian mannerist Battista Franco, Barocci achieved in his drawings a synthesis of the pictorial "sfumato" (smoky shading) of Correggio, the luminous color of Venice, and central Italian mannerism. The drawings of Barocci, always statements of an extraordinary technical and intellectual discipline, are characterized by a soft and pictorial use of the graphic medium and are always complex in technique, because of the extensive use of colored chalk, as in true pastel.

In Lombardy the few drawings ascribed to Bramante (q.v.) are characterized by a robust rhythm of stroke and composition, always related to a specific perspective projection. The explanation for these qualities may be found in the influence of Piero della Francesca, of Mantegna, of Ercole de' Roberti, and of Melozzo da Forlì. To the style of Bramante is linked that of Bramantino (q.v.), a fine draftsman who, emerging from the Mantegnesque background of Ferrara, eventually devoted himself to luministic studies closely related to the early mannerist graphic style which was subsequently developed in Piedmont by Gaudenzio Ferrari and his pupils, such as Bernardino Lanini.

Also flourishing as important art centers were the Lombard cities of Brescia and Cremona, which were more receptive to the Venetian tradition of Giorgione and the Bellinis than to central Italian influences. Venetian, Ferrarese, and even Umbrian elements may be found in the work of the Cremonese Boccaccio Boccaccino, while such draftsmen as Altobello Meloni and Girolamo Romanino adhered more closely to the style of Giorgione, interpreted, however, in a thoroughly anticlassical manner whose origins are clearly northern. Romanino's graphic work also contains specific reminders of Titian, as do the few drawings attributable to the Brescian painter Girolamo Savoldo, who interpreted the elements borrowed from Titian in accord with his more exclusively luminist interests.

The single drawing accepted as the work of Giorgione (q.v.), *The View of Castelfranco with a Shepherd* (Rotterdam, Mus. Boymans-Van Beuningen; PL. 271), a landscape in sanguine, has his characteristic romantic and musical atmosphere. In all probability some of the other drawings that have been attributed to Giorgione are in fact by him, but in any case his example bore fruit in the work of the many Venetian draftsmen and engravers of the early 16th century. His example is clearly apparent in the work of Jacopo de' Barbari, who combined this influence with that of Dürer (see ENGRAVINGS AND OTHER PRINT MEDIA), in some drawings of Lorenzo Lotto (q.v.), in the early drawings of Titian (q.v.), whose later drawings use a more complex linear system to achieve their rich and impassioned evocations of movement and of tone (PL. 276), and in the youthful drawings of Sebastiano del Piombo (q.v.), whose later Roman drawings belong completely within the circle of Michelangelo. However, the two artists who were chiefly responsible for the interpretation and dissemination of the graphic modes of Giorgione and the young Titian were Giulio and Domenico Campagnola (see ENGRAVINGS AND OTHER PRINT MEDIA), who were primarily draftsmen and engravers. While references to Titian predominate in the drawings of Palma Vecchio (q.v.), the extraordinary graphic work of Giovanni Antonio da Pordenone contains elements derived from Raphael and the early mannerists as well. The tradition of Antonello da Messina and the earlier Bellini was continued and variously modified by Bartolommeo Montagna of Vicenza, by Alvise Vivarini (q.v.), and by other conservative or provincial painters of the Veneto.

The Venetian scene in the later 16th century was dominated by Tintoretto and Veronese (qq.v.). The drawings of Jacopo Tintoretto (PL. 277), for the most part figure studies executed in charcoal, adumbrate his fulminating pictorial mannerism in distinctively rhythmic, pulsing outlines. Paolo Veronese, also a rapid and prolific draftsman, worked mostly in pen and ink or charcoal heightened with white lead; his drawing style, very different in its pen work and also in its coloristic orientation, does, however, reveal a certain dependence on that of Parmigianino (q.v.), a dependence even more marked in the drawings of Andrea Meldolla (Lo Schiavone). Similarly indebted to Parmigianino were Jacopo Bassano (q.v.) and Jacopo Palma (il Giovane), both highly accomplished draftsmen.

In Bologna during the first decades of the 16th century the graphic contributions of such painters as Amico Aspertini and Jacopo Ripanda, whose study of antique archaeology bore fruit in a genuine "grotesque style," were of considerable importance. These artists derived from the graphic tradition of Costa and Francia, as did Benvenuto da Garofalo, but Aspertini later inclined toward more openly pictorial modes, deriving from Giorgione and Dosso, as in the *Miracle of the Paralytic* (Venice, Accademia).

Among the Emilian painters in Parma were Correggio (q.v.), who drew in his *maniera sfumata*, wrapping his figures in a delicate haze of indistinct chalk lines and shadings; and Parmigianino (q.v.; PL. 277), who partially through the stimulus of Beccafumi, perfected an elegant drawing style, exquisitely insidious in its mannerist rhythms. Through the agency of Niccolò dell'Abate and Primaticcio, it provided a model for the draftsmen of Fontainebleau. Lelio Orsi da Novellara was also affected by the example of Parmigianino, but the strong element of Nordic antirationalism equally apparent in his tempestuous drawings is completely idiosyncratic.

During the second half of the 16th century a group of draftsmen emerged in Genoa who, basing themselves on the Raphaelesque style of Perino del Vaga and the Sienese manner of Beccafumi, formed the foundations of a school that was to reach its greatest importance in the 17th century. The singular faceted drawings of Luca Cambiaso (PL. 277) and those of Bernardo Castello, even though falling chronologically partly within the 17th century, remain within the stylistic idiom of late mannerism.

The drawings of many Flemish and Dutch painters of the 16th century have survived, and their typically precise and detailed stroke frequently acts as the agent of a penetrating, poignantly expressive vision of reality. Even the diabolical hallucinations of the drawings of Hieronymus Bosch (q.v.) are expressed in terms of a precise outline, which preserves veracity of detail within the surrealistic total image. Bosch's acuteness of vision was transmitted to Pieter Bruegel the Elder (q.v.), first appearing in some drawings simply as a taste for the demoniac, but later serving a broader purpose as the indispensable foundation of Bruegel's representation of the world of peasants and of nature. A more delicately pictorial flavor is apparent in the landscape drawings of Joachim Patinir (q.v.), while Bernaert van Orley's narrative drawings of landscapes with hunting scenes reveal a style permeated with the influences of Roman mannerism (see MANNERISM). Two other important draftsmen are Hendrik Goltzius (q.v.), known for his engravings, and Jan Gossaert (q.v.), who should be included in the group of Netherlandish mannerists.

German draftsmen of the 16th century were often engravers rather than painters, and their graphic activity thus tends to express their peculiarly poetic fantasy with the utmost precision and completeness (see ENGRAVINGS AND OTHER PRINT MEDIA). In this connection one has only to think of the drawings of Altdorfer (q.v.), or, perhaps above all, those of Albrecht Dürer (q.v.; PLS. 272, 302), which, whether rapid sketches or minutely detailed finished drawings, are equally among the most trenchant realizations of form ever achieved in the graphic medium. Other German masters, too, exhibit an original graphic language of high quality: for instance, Grünewald, Schongauer, Burgkmair, Hans Holbein the Younger (PL. 272), and Lucas Cranach (PL. 45; qq.v.); Hans and Barthel Beham, Wolf Huber (PL. 275), and Hans von Kulmbach (PL. 275).

In regard to French drawings of the 16th century, those of the school of Fontainebleau (see MANNERISM), inspired by Primaticcio and Niccolò dell'Abate, deserve mention, as do the subtly executed and psychologically acute fashionable portraits "à trois crayons" (in chalks of three colors) by François Clouet (q.v.), François Quesnel, and the mysterious Lagneau.

During the 16th century Spain, too, was represented by a sizable graphic production, which was thoroughly saturated with the style of Tuscan mannerism, as is demonstrated by the work of Alonso Berruguete (q.v.), Fernandez Navarrete (El Mudo), Eugenio Caxés, and Pablo de Céspedes. The late mannerist drawings of El Greco (q.v.) are, like his paintings, notable for their expressive use of light effects.

Seventeenth-century Italian drawings attest to the complexity of the stylistic tendencies current in the different centers of artistic activity. Although no drawings by Caravaggio remain to us, his influence is frequently in evidence, as in some of the drawings of Bartolomeo Manfredi, Carlo Saraceni, Gerard van Honthorst (q.v.), and Pieter van Laer. It enters into the drawing style of Guercino (q.v.), with its extraordinary linear realization of chiaroscuro effects, which cannot be explained only as the influence of Ludovico Carracci, and the simultaneous operation of influences from Ludovico and from Caravaggio is apparent also in the drawings of Leonello Spada. More or less direct adherence to the idiom of Caravaggio provides a common denominator among Neapolitan drawings by authors otherwise quite different in their training and development, such as Mattia Preti, Luca Giordano, and Salvator Rosa (q.v.). On the other hand, the classicist principles promulgated under the auspices of the Accademia degli Incamminati in Bologna are paramount in the many-sided graphic activity of Ludovico, Agostino (III, PL. 421), and Annibale Carracci (q.v.). Experimenting and teaching by means of drawing in different genres and styles, the Carraccis sought to demonstrate the proper relation between the "natural" (as interpreted by the great masters of the past) and "invention." They studied the graphic modes of Emilia and the Veneto and those of Raphael, Leonardo, and Michelangelo, and then interpreted them in new and various ways, producing nude studies (called *accademie*), portraits full of character, Titianesque landscapes, caricatures, and so on. The teaching of the Carraccis is reflected in the work of other important Bolognese masters, such as Domenichino, Guido Reni (qq.v.), Francesco Albani, and Giacomo Cavedone.

In Florence the tradition of Renaissance and mannerist draftsmanship was not lost but was revivified in the school of Matteo Rosselli and transmitted to a group of audaciously modern painter-draftsmen, chief among whom were Giovanni da San Giovanni and Francesco Furini. Of importance as well was the group of Florentine engravers, outstanding among whom was Stefano Della Bella (see ENGRAVINGS AND OTHER PRINT MEDIA), who, profiting from the examples of Jacques Callot and the Dutch, were true masters of drawing, esteemed throughout Europe. Among the artists active chiefly in Rome, Giovanni Lanfranco developed a complex graphic expression compounded of neo-Venetian, Bolognese, and baroque elements, a mixture of strains which also appears, though differently interpreted, in the drawings of Pierfrancesco Mola and of Pietro Testa (Il Lucchesino). The baroque current enjoyed full expression in the drawings of Pietro da Cortona and of Gian Lorenzo Bernini (q.v.). A classicizing neo-Venetianism pervades the noteworthy drawings of Andrea Sacchi, working in a tradition that included also another important Roman draftsman, Carlo Maratti. Numerous too were the Genoese painter-draftsmen of the 17th century, among them Bernardo Strozzi and Giovanni Benedetto Castiglione (Il Grechetto; see ENGRAVINGS AND OTHER PRINT MEDIA), in whose work the impact of Venetian and Flemish influences was absorbed into a coloristic and extremely fluent graphic idiom.

Few in number are the drawings that can be attributed to the painters of 17th-century France related to the tradition of Caravaggio. For instance, the Caravaggesque period of Simon Vouet (q.v.) is not represented in the notable group of his drawings preserved in the Louvre, although the other elements in his style, Venetian, classicist, and Bolognese, can

readily be deduced from them. The highly evocative drawings of Jacques Bellange, full of slender, pliable, elongated forms, evidently spring from an experience of the Florentine idiom of Il Rosso (G. B. de' Rossi) as transformed in the school of Fontainebleau. References to the mannerist tradition also assisted Jacques Callot (q.v.; III, PL. 421) in the perfection of the supremely chic and provocative graphic language that provided him, as an engraver, with the means for a bitterly ironical description of the life and customs of his time. The portrait drawings of Claude Mellan maintained the high standards and subtle psychological observations of the French portrait tradition. Although the classicist current in French art is supremely exemplified in the works of Nicolas Poussin (q.v.), his drawings, often rich in pictorial values, affirm also his neo-Venetian (more specifically, Titianesque) proclivities (PL. 278). The famous landscape drawings of Claude Lorrain (q.v.), ancestors of the whole genre of picturesque landscape, are permeated with romantic sentiment and a typically neoclassical nostalgia for antiquity, rendered in a style in which color is compellingly evoked by the use of sepia washes (PL. 278). The French classicist tradition was continued throughout the reign of Louis XIV by other painters who were also able draftsmen, chief among whom were Eustache Le Sueur and Charles Lebrun (qq.v.), others being Nicolas and Pierre Mignard, Laurent de la Hyre, and Jacques Stella. In the baroque tradition, Jacques Courtois (Le Bourguignon) was noted for his battle scenes.

An exceptionally interesting graphic contribution within the tradition of Caravaggio is a notebook of pen drawings preserved in the Frankfurt museum, a large part of which were done by Adam Elsheimer. The close attachment of Elsheimer, who lived in Rome, about 1600–10, to the idiom of Caravaggio is evident in his paintings, as well as in the pen drawings, in the quick, broad stroke that conveys the effect of light. It is difficult, in connection with the Frankfurt notebook, to distinguish between the pages executed by Elsheimer himself and those by his Dutch pupil and imitator, Hendrick Goudt. Of far greater importance, however, is the fact that the drawing methods of Elsheimer were passed on to Rembrandt (q.v.; see ENGRAVINGS AND OTHER PRINT MEDIA), who transformed them; his peculiarly complex system of hatching serves not to define plastic form by means of light and shadow but to evoke color and atmosphere. The representation of tavern and peasant life is as effectively rendered in the rapid and spontaneous pen drawings of Adriaen van Ostade (q.v.) as in his paintings; the drawing style of Isaac van Ostade is quite similar. Other important draftsmen were Hendrick Avercamp, Abraham Furnerius (both noted for their landscape drawings), Adriaen Bloemaert, Jan Brueghel the Elder, David Teniers (q.v.), Philips de Koninck, and Jacob Jordaens (q.v.). Of particular importance, partly in view of their direct connections with Italy, were Peter Paul Rubens and Anton van Dyck (qq.v.), who developed all the possibilities of the Italian baroque style, displaying in their expanded forms a profound immersion in the color tradition of Venice.

Of the few Spanish drawings of the 17th century, those of Francisco Herrera the Elder reveal a vestigial Michelangelesque mannerism. The drawings of Francisco de Zurbarán (q.v.) are definitely marked by the lighting effects of Caravaggio, while the few drawings that have been connected with Diego Velázquez (q.v.) are at once pictorial and intensely naturalistic in the heads and in the portraits. Also notable are some portrait studies by Claudio Coello. Finally, the drawings of Bartolomé Esteban Murillo (q.v.), even in their obvious fluent pictorialism, are singularly in accord with the sculptural drawing style of 17-century Florentine mannerism, as revived and practiced by the school of Matteo Rosselli.

The Italian draftsmen of the 18th century developed and intensified, generally through a lightening of hatching and stroke, the free virtuosity of graphic technique already attained by the most advanced exponents of the baroque style. By this time the possibility of reworking the greater drawing styles of the past, frequently in impressionistic terms of exquisite sensibility, was easily accessible to all artists. However, the highly sophisticated exponents of the so-called "grand style"

before the advent of neoclassicism still reveal in their drawings creative energies of the highest order. The drawings of the Venetian Giovanni Battista Piazzetta (q.v.; PL. 279) seem at first to constitute an exception to the prevailing 18th-century style because of the broad handling of the modeling (of Caravaggesque origin) that characterizes them, but the graphic fabric itself (i.e., the actual network of strokes) accentuates the luminous softness of flesh and the pictorial values of surface, thus relating Piazzetta to his rococo contemporaries. Pietro Longhi's studies (q.v.) in sanguine with highlights in chalk represent his characters with familiar but always fresh effectiveness. The architectural vistas of Canaletto (q.v.), in large part views of Venice, are executed with quick and disciplined strokes of the pen, with a perspective that results from the painter's automatic intuitive perception of spatial geometry. Even freer, more volatile, and filled with wash highlights and flickering movement are the pen caprices of Francesco Guardi (q.v.; PL. 279), drawings which, though presupposing a firm grounding in the nervous and impassioned drawing style begun by the Genoese Alessandro Magnasco and carried on by Sebastiano and Marco Ricci, translate their graphic modes into a new and unique stylistic entity. Most effective are the sheets of drawings by Giovanni Battista Piranesi (q.v.), which are characterized by his consuming interest in landscape, architecture, and the picturesque aspects of Roman antiquity. The graphic idiom of the Riccis is again reflected, against a background of reference to the Renaissance style of Veronese, in the virtuoso drawings of Giovan Battista Tiepolo (q.v.; PL. 279), so rich in poetic fantasy and electric in their linear rhythms. Giovanni Domenico Tiepolo imitated his father in his often very attractive drawings, which reveal, however, a more superficial, less organic and functional, graphic handwriting. Among the other important Venetian draftsmen of the 18th century, Gaspare Diziani, Giovanni Battista Pittoni, and the landscapists Francesco Zuccarelli and Giuseppe Zais can be mentioned. Toward the end of the century and even within the climate of neoclassical art, the Venetian tradition survived in the elegant and pictorial temper of the vibrant graphic inventions of Antonio Canova (q.v.), whose activity as a sculptor was thoroughly classicistic in tone.

In the Piedmont Gregorio Guglielmi and Filippo Juvara (q.v.), exponents of a drawing style of great energy within the context of the decorative and theatrical style of the 18th century, were of considerable importance. Among the Genoese, Alessandro Magnasco has already been mentioned, but the principal representatives of the rococo style were Domenico Piola and Gregorio De Ferrari. During the 18th century a sizable body of drawings was produced in Emilia, particularly in Bologna, and many Emilian artists also worked outside the region. The chiaroscuro drawings of Ubaldo Gandolfi, in pen and sepia, though still in the tradition of Guercino, are highly individual in character. Among the artists whose primary subjects were landscape and ruins, Giovanni Paolo Pannini of Piacenza excelled in drawing as well as in painting; and real technical virtuosity was achieved by the Bolognese Bibiena family (among whom Ferdinando and Giuseppe were outstanding) in the areas of decorative architectural drawings and of stage design (see PERSPECTIVISTS). Finally, among the painters of scenes active in Rome, the Fleming Gaspare Vanvitelli (Van Wittel) also produced excellent landscape drawings in pen and ink, while 18th-century Roman life was amiably described in the gallery of pen portraits, which are genuine caricatures, by Pier Leone Ghezzi (see COMIC ART AND CARICATURE, esp. III, PL. 422). Of the graphic production of 18th-century Naples, the drawings of Francesco Solimena both extend the graphic tradition of Luca Giordano and Mattia Preti (in the decorative terms and lighter rhythms of the 18th century) and demonstrate a close relation to the graphic styles of Bologna and of the Riccis. Further, the style of these drawings became widely diffused, partly through the activity of Solimena's followers, Corrado Giaquinto (who worked in Spain), Francesco de Mura and others, thus achieving importance throughout Europe.

It was from this Neapolitan stylistic environment that the great Spanish draftsman of the late 17th and early 18th centuries, Francisco Goya (q.v.), emerged (see ENGRAVINGS AND OTHER PRINT MEDIA). Goya's numerous drawings and sketches combine savage naturalism with caricatural irony in their portrayal of the human condition in the artist's own time and place: in their obsession with universal agony they are related to Spanish Renaissance and baroque thought, while at the same time their influence on the graphic idiom of 19th- and 20th-century romanticism has been powerful and lasting.

A large group of draftsmen were active in pre-Revolutionary France, and their soft, sprightly, and refined drawings (mostly executed in sanguine accented with charcoal or pen and ink) variously express the preoccupation with sensory experience implicit in the *esprit de finesse*, which made inevitable both the intellectual crisis of the Enlightenment and the end of the rococo style. Such is the significance of the drawings of Jean-Antoine Watteau (q.v.; PL. 279), at once more delicate and more searching than those of Jean-Honoré Fragonard (q.v.), in which hints of the neoclassical style are found, while a soft sensuality pervades the drawings of François Boucher (q.v.). The portrait drawings of Maurice Quentin de La Tour are in no way inferior to his pastels, and the drawings of landscapes and ruins by Hubert Robert (q.v.) are as distinguished as his paintings. Sensuous textures and moral instructiveness characterize the bourgeois and peasant life of the times as rendered in the drawings of Jean-Baptiste Greuze (q.v.). A number of other highly competent French draftsmen can only be listed here: Claude Gillot, Gabriel de Saint-Aubin, Pierre-Paul Prud'hon (q.v.), Jean Antoine Houdon (q.v.), Claude Louis Chatelet, Charles Nicolas Cochin, Antoine Coypel (q.v.), Nicolas Bernard Lépicié, Charles Joseph Natoire, Charles Parrocel, Claude Joseph Vernet.

Graphic activity in Holland, Austria, and Germany in the 18th century is largely of local importance. Not so that of England, where the portrait tradition that originated with Van Dyck continued, stimulated and modified by French and Italian influences (Francesco Bartolozzi and G. B. Cipriani both worked in England). Among the English portrait draftsmen, particular mention should be made of Hugh Douglas Hamilton, Henry Edrige, John Hoppner, Richard Cosway, and Thomas Lawrence (q.v.). William Hogarth (q.v.), lively and highly pictorial in his pen work, Thomas Gainsborough (q.v.), and the landscapists Robert Crone and Joseph Farington were all excellent draftsmen, while the field of contemporary political caricature profited by the activity of a great exponent of satiric humor, Thomas Rowlandson (q.v.).

*The 19th and 20th centuries.* During this period the methodological classification of drawings in the form of catalogues, previously begun by Baldinucci, Resta, and Marietta, was highly developed, along with research into the methods of faithful reproduction of drawings, first through lithographs in facsimile and then through photographs. Among the important works of this period are: W. Y. Ottley's volume on Italian drawings (1823), the later Morellian study of the drawings of the Albertina in Vienna (1891–92) by F. Wickhoff, the famous catalogue of Florentine drawings by Berenson (1903; amplified ed., 1938), the volumes of Oskar Fischel on the drawings of Raphael (1913 ff.), the works of Von Hadeln on the drawings of Titian, Tintoretto, G. B. Tiepolo, Canaletto, and the Venetian painters of the 15th and 16th centuries (1922–29), and the valuable catalogue of Albertina drawings produced by A. Stix and L. Fröhlich-Bum. More recent, but not less useful, are the catalogues (still in progress) of the drawings in the Royal Library at Windsor by various authors and the volume by H. Tietze and E. Tietze-Conrat, following the example of Berenson, on the drawings of the Venetian painters of the 15th and 16th centuries (1944).

A new approach to drawings was initiated by Berenson, who supplemented the identification of "handwriting" with an insistence on more broadly conceived characteristic qualities as a means of recognizing drawings by artists whose works in other media were familiar to the critic. In *Aesthetics and History in the Visual Arts* (New York, 1948) Berenson emphasized the importance of functional line, which implies movement.

"Good drawing" is a synonym for movement, and when a drawing has movement, "we can affirm that it also possesses quality and style." As for recent studies on the theory and methodology of drawing and drawings, the attempt of B. Degenhart (1937) to isolate and define regional graphic "constants," recognizable in drawings of different periods from the same region, was fruitful.

Luigi GRASSI

The pioneers of classicism (Joseph-Marie Vien, Raphael Mengs, A. J. Carstens), though stressing drawing in their theory and teaching, were not themselves original draftsmen, nor did they practice a distinctively classicist graphic style. J. L. David's compositional designs are oddly indecisive and fumbling in their lines; his crayon portraits, on the other hand, possess an 18th-century richness of tone, and his occasional caricatures are admirable late-comers in a baroque tradition. Anne-Louis Girodet produced remarkable erotic drawings in a mannerist vein and some vivid portraits, but these no more represent classicism than do the drawings of his more academic contemporaries, Pierre-Narcisse Guérin and François Gérard. By contrast, Pierre-Paul Prud'hon, unjustly assigned to the rearguard of the rococo, was in a truer sense classical. His drawings, with all their subtlety of light, their seeming softness of definition, possess a strength of contour and a solidity of body beside which comparable drawings by David look schematic and thin. In his magnificent studies of the nude, in black and white chalks on blue paper, the figures emerge from the shadows with quiet intensity and achieve a reposeful sensuous presence. Prud'hon was the only French draftsman of his generation to develop an original technique. His light and dark chalk strokes, applied in parallel or crossed hatchings that interweave like threads in a tapestry, define form through line and light at once.

About 1800, younger artists began to react against classicist practices then in vogue. Their discontent expressed itself in two different ways: some strove for a renewal and radicalization of classicism, for a style more abstractly pure, more truly "Greek"; others groped toward greater expressive freedom, for an art based on personal feeling and individual experience. Neoclassic and romantic (qq.v.), the labels by which these two movements are known, describe them poorly and exaggerate their disparity. Both began in protest, both were progressive and "romantic" in spirit. For the study of 19th-century drawing, the terms "romantic" and "neoclassic" are, at any rate, of little use, since they do not describe clear-cut styles — there never was such a thing as a "romantic style." A more truthful grouping is suggested by the terms (a) linear or contour, (b) expressive or dynamic, and (c) picturesque or lyrical.

*a. Linear or contour.* The severe contour style first gained wide currency through illustrations of Homer (1793), Aeschylus (1795), and Dante (1802) by John Flaxman (q.v.), acclaimed throughout Europe and influential far beyond their actual worth. Flaxman's drawings reduce form to its essence, to terse outline without indication of space, light, or color. The appeal of this Spartan simplicity was ethical rather than esthetic; its archaic hardness corresponded to an admired heroic attitude of disdain for sensuous charm. William Blake (q.v.) transformed Flaxman's brittle linearism into an expressive and personal instrument. His drawings are filled with the clichés of classicism, the cameo profiles, the overmuscled bodies, the mannerist attenuations and distortions (I, PL. 309), but he endowed these commonplaces with unsuspected poetry. Instead of formal abstraction, we find in Blake's drawings an emotional calligraphy which — through Fuseli, who influenced him — had its roots in northern line fantasy rather than classical tradition. The emotional flow of contour, the rhythmic gesticulation of the stunted or weirdly elongated figures convey the exaltation of an inward vision with naïve sincerity. In Germany the development of a lyrical arabesque style, partly of classicist, partly of native later Gothic inspiration, can be traced in the work of P. O. Runge (1777–1810), whose cycle of the *Tageszeiten* (1808–10) has affinities of form and content with Blake. The didactic, moralizing tendency of the severe contour style is evident in the case of the Nazarenes (see PRE-RAPHAELITISM AND RELATED MOVEMENTS), young Germans who banded together in Rome, in a quasi-monastic brotherhood (founded 1809), seeking to restore holiness to art through a return to simplicity of form and feeling. With Raphael, Dürer, and Fra Angelico as guides, they strove to reconcile purity of style with pious truth to nature. The graphite pencil, invented in 1790 by N. J. Conté, was their favorite medium; it allowed them to trace the cool, clear contours they desired. Among the older Nazarenes, the mild Johann Friedrich Overbeck (1789–1869) and the more masculine Franz Pforr (1788–1812) stand out. Both relied on archaistic formulas. Overbeck's tame design amounts to a chastening and sweetening of Raphael; his religious compositions are often marred by a rather vacant prettiness. Pforr's drawing is harder and tenser, indebted to early German traditions. Peter von Cornelius (1783–1867) in his early years produced contour drawings of steely hardness, a mixture of Dürer and Flaxman; later he renounced archaistic linearism and drew monumental cartoons in a dramatic, Michelangelesque style. Among the younger German artists in Rome, Julius Schnorr von Carolsfeld (1795–1872) revealed a talent of the first magnitude in his early work. His Italian genres have a freshness and capricious vivacity rare in the Nazarene milieu; his studies of the nude and his pen portraits are masterly in their energetic characterization and vigorously textured detail. Carl Philipp Fohr (1795–1819) progressed from the naïve starkness of his Heidelberg portraits to the profundity and technical brilliance of his pencil drawings of the artists at the Caffè Greco in Rome. In these a willful strangeness of stylization is precariously allied to minute attention to detail; the texture of hair, beard, and skin are convincingly suggested by finely nuanced hatchings which, on closer inspection, turn out to be calligraphic fantasies. A similar ambiguity of realism and stylization also appears in Fohr's landscape studies. In the drawing of Franz Horny (1798–1824), the split between objective observation and eccentric distortion becomes glaringly evident.

In France the demand for severe truth and purity in drawing arose about 1800 among a group of heretical disciples of David, nicknamed "penseurs" or "primitifs." It was in this milieu that J. A. D. Ingres (q.v.), began to form his style, which draws its energies from emotions pent up rather than released and is full of inner tension rather than balance and harmony. In his portrait drawings and studies of the nude Ingres used thin, hard pencils with loving nicety of touch; for all their steady precision, his lines are taut with feeling; they caress the forms which they describe (PL. 280). Compared to the Nazarenes, Ingres was not only technically more fluent; he was at once more intellectual and more sensuous. His erotic fantasy is restrained by the will to remain true to visual fact — Ingres considered himself a strict realist — but it manifests itself in a certain strangeness of the proportions and in distortions which are all the more effective for being stated with sobriety and seeming objectivity. In the portraits his flair for the significant feature, for economy and concentration, enabled him to create likeness with sparing suggestion. His line is expressive or decorative rather than structural.

The ramifications of the movement represented by the Nazarenes, by Blake, and by Ingres extend far into the 19th century. Among the followers of Blake, Samuel Palmer (1805–81) deserves mention for his visionary landscapes. In the wake of the Nazarenes we find Edward Steinle, Josef von Führich, the strange Erwin Speckter, the Biedermeier masters, Adrian Ludwig Richter and Moritz von Schwind, and a host of illustrators. Théodore Chassériau (q.v.) carried on certain features of Ingres's design in a slighter, more nervous vein, tinged with a certain morbidity.

*b. Expressive or dynamic.* This drawing style is the second important trend of the first half of the 19th century. The baroque traits which appear in drawings of this type by Antoine Jean Gros, Géricault, and Delacroix (qq.v.) are symptoms of a revival rather than of continuity; they indicate a reaction against classicism. With Gros, this reaction was a matter of

temperament, not of program. Géricault also does not seem to have been fully conscious of his revolutionary role. His most vigorously expressive drawings date from his middle period (ca. 1812–19) and often treat classical subjects in a contour manner which has its roots in classicism. But these pen drawings, sometimes shaded with washes and heightened with gouache, break the classical form in their stress on muscular conflict, and in their impassioned intensity of statement they differ from the severely reasoned work of the linearists in their expressive, rather than descriptive, use of line (VI, PL. 120). In the drawings of Delacroix this expressive quality is intensified, the conduct of line becomes more nervous, more impulsively abrupt. The dominant suggestions are of energy and movement, not of body. In his early work the handwriting shows constant preference for dynamic shapes: spirals, whorls, turbulences thrown onto the paper in the heat of excitement, often incoherently. His later work is quieter and has greater amplitude and firmness. Daumier (q.v.) drew with equal spontaneity, but with a greater sense of the corporeal and a truly sculptural feeling for weight and mass (PL. 118). Of all the draftsmen of the 19th century, he represents most forcefully a continuing baroque tradition. His contours never appear as hard edges; they intervene between the substance of body and the surrounding space as a zone of blurred, bundled, vibrating strokes, a zone in which body and space fuse dynamically. The individual line does not confine; it expands the forms and gives them motion. Leaping across the paper with reckless speed or streaming with emphasis, sometimes tremulous, sometimes decisive, it is the seismographic tracing of feeling.

*c. Picturesque or lyrical.* This style, based on the study of visual reality, is the third main manifestation of romanticism in drawing. It was of particular importance in landscape drawing, where pure linearism was only of limited use — though the attempt to apply contour style to landscape was actually made (J. A. Koch, C. D. Friedrich, q.v.). The necessity of rendering distance, atmosphere, and light inevitably led landscape painters to concentrate on effects of color and tone. In this the English were pioneers. Thomas Girtin, Turner, and Constable (qq.v.) followed an established tradition when they began to interpret nature in terms of optical sensations, dissolving the forms of their landscapes in contourless transparencies of water color or wash, so loosely brushed as to verge on abstraction. Turner in particular produced drawings in which water, sky, and foliage are fused in one great turbulence. Compared to linearism, this manner seems vague, but it has its own precision, that of tonal nuance, which can evoke reality more vividly than can contour. The Germans (Peter von Hess, August Lucas, Ernst Fries, Karl Rottmann) were more inclined to the near view, the exact recording of details of grass and leaf and of the complex anatomy of mountains. In their treatment of light they were somewhat hesitant, though after 1820 their work tended toward a more differentiated optical realism.

R. P. Bonington (q.v.) and Copley Fielding taught English water-color techniques to their French contemporaries, to Géricault and Delacroix (qq.v.) among others. A French school of water-color drawing arose, best represented by F. M. Granet (1775–1849), whose atmospheric river views deserve to be better known. Another stimulus for tonal drawing came from the new medium of lithography, enormously popular after 1815 and used by most of the younger artists. The subtleties of texture and tone which characterize Géricault's late drawings reflect the influence of lithography, as well as the influence of English water color. Within this general milieu flourished the artists (Paul Huet, Eugène Louis Gabriel Isabey, Louis Boulanger, Eugène Devéria) who formed the vanguard of the brilliant but short-lived romantic impetus of 1830.

Camille Corot (q.v.) began in a French tradition of classical landscape, attempting to reconcile it with scrupulous truth to nature. His early drawings, executed with hard pencil or pen, recall the delicate refinement of line in the work of German romantic landscape painters, some of whom Corot had met during his first Italian stay (1825–27). But his design is more spare, more concerned with the large view. His realism is highly selective; instead of accumulating detail, he accents significant features with gentle insistence. His conduct of line is often tremulous, faltering, imprecise; yet the total impression is one of striking visual truth, resulting from a perfect adjustment of value gradations and an extraordinary luminosity obtained from the white of the paper and the pale tissue of pencil strokes. About 1850 Corot changed to a broader, more generalized manner, using soft chalks or crayons in rough strokes and overlapping transparencies, aiming at effects of filtered light or suspended haze, very much like those found in his later paintings.

"Romantic" drawing is widely found in book illustrations and in newspapers. In France there come to mind the names of Célestin-François Nanteuil, the brothers Johannot, Grandville (J. I. I. Gérard), Bertall (C. A. Arnoux), H. B. Monnier, Gustave Doré, Gavarni (G. S. Chevalier), Constantin Guys.

The so-called "realist" movement, which originated in romanticism and culminated in impressionism, never developed a coherent style of drawing. Gustave Courbet (q.v.) is revealed by his fairly rare drawings as a rather disappointing draftsman who practiced a heavy-handed chiaroscuro technique. Jean François Millet (q.v.) drew his starkly simplified figures in a grand, sculptural style, solidly carving them with bundled crayon or charcoal strokes that sometimes recall the line of Daumier. Both his figure compositions and landscapes reveal a flair for solid construction and dramatic arrangement, rather than for visual objectivity. The German Adolph von Menzel combined penetrating visual objectivity with phenomenal technical skill. Capable of trompe l'oeil realism in rendering the exact tone and texture of matter, he never descended to mere imitation, but interpreted what he saw with a formal and psychological audacity that sometimes causes his studies to resemble those of Degas. Manet (q.v.), less interested in drawing, developed an evocative, abbreviated technique of form and color notation that, in his later work, assumes a wholly impressionist character (PL. 280). The landscape artists of the midcentury, particularly the Barbizon painters, sought for a simple style of drawing, minimizing the element of emotional or intellectual distortion. Their drawing stressed flexible, spontaneous, factual notation, and an unpretentious manner. Théodore Rousseau (q.v.) developed a technique for the precise rendering of the contours of tree and rock, obediently following every detail of shape and texture. Unlike the English water colorists and Corot, he concentrated on tangible forms, rather than the purely optical realities of light and color. Eugène Boudin and Johan Barthold Jongkind the true ancestors of impressionism, devoted themselves, on the contrary, to effects of light and atmosphere, tending to fragment and scatter solid matter, and to spot these scattered accents over the surface of the design.

To the impressionists (Monet, Sisley, Pissarro, qq.v.; see IMPRESSIONISM), drawing was not of primary importance. Pissarro's drawings are, for the most part, in the tradition of Millet and Barbizon. Monet, on the other hand, originated an authentically impressionist graphic manner which expressed the main features of the new styleless naturalism and casual arrangement, and rendered the transitory phenomena of light and atmosphere by means of an extremely flexible, rapid technique. Swirls or scumblings of loose-meshed line texture define objects as isolated spots or vague masses against the luminosity of the paper.

The battle against naturalism was fought by artists who would not accept the role of objective observer that it assigned to them and insisted on the search for a truth beyond surface appearance. In England the Pre-Raphaelite Brotherhood (founded in 1848) practiced an archaic contour style similar in its essential features to that of the Nazarenes (see PRE-RAPHAELITISM AND RELATED MOVEMENTS). Dante Gabriel Rossetti interpreted Quattrocento motifs with morbid intensity; J. E. Millais, a fluent linear mannerist, managed to endow his medievalism with a certain angular elegance; Edward Burne-Jones emphasized pattern and decoration. In France Pierre Puvis de Chavannes, one of the great draftsmen of the century, sought to maintain the tradition of severely stylized, monumental design. His charcoal and crayon studies for wall paintings present ample, grandly simplified figures encompassed by contours of supple

strength and disposed in spacious, balanced groupings. The drawings by the German Hans von Marées have a similar grandeur and dignity of conception, a classical repose tinged with romantic melancholy.

Besides these neoromantic stylists, we find poetic visionaries such as Victor Hugo, who, in his later years, drew crumbling ruins, crepuscular landscapes, and stormy seas in a violent pen-and-wash technique, Rodolphe Bresdin, Gustave Moreau, and Odilon Redon (q.v.), whose somber charcoal drawings have a controlled plainness of line and a rhythmic harmony of composition reminiscent of Puvis de Chavannes.

Within the impressionist group itself, Renoir (q.v.) exemplified the return to a more disciplined, traditional style of drawing. Until about 1883 he had practiced a diffuse, tonal manner, influenced by Manet; then he suddenly shifted to a hard contour style, strongly suggestive of Ingres. Finally, he managed to reconcile his two manners, composing his voluminous, sculptural figures with loosely massed pastel or crayon strokes (PL. 280). Degas (q.v.) began as a linearist in the severe tradition of Ingres and, though influenced by impressionism, never lost sight of the underlying principles of formal composition (PL. 138). A stylist rather than a naturalist, deeply indebted to a variety of traditions ranging from the Renaissance to the Japanese, he attempted to create the appearance of "accidental" nature through subtle artifice.

All the masters of this movement were important as draftsmen, but they differed sharply in their personal styles. Cézanne (q.v.) used drawing as a necessary instrument in realizing his figure and landscape compositions. In his drawings the form does not assume substance through sustained contours or coherent light and dark relief; it is based, rather, on line fragments, on accents of dark scattered across the paper — an eye socket, a nostril, a shaded roofline. From these points of concentration, interlocking areas of hatching or spots of water color are spread across the paper until they join, seeming to model the form in a succession of semitransparent facets. This plastic re-creation of every surface gives Cézanne's drawings their peculiar intensity. The drawings of Seurat (q.v.) pose the problem of translating body and space into surface design in quite a different manner. Seurat built his compositions with contourless areas of graduated grays and blacks, stroked onto the rough paper with Conté crayon (PL. 280). Gauguin (q.v.) drew in heavy outlines without relief. His figures have the rigid solemnity of icons. Van Gogh (q.v.), with a broad reed pen, covered the paper with a dense texture of agitated strokes, "writing" the individual forms as points, dots, or spirals, organizing them in excited streams or vortices. Toulouse-Lautrec (q.v.) adopted the contour style of Degas, but his line is more nervous, more loosely agile; its tremors and rhythmic pulsations give it a vitality quite independent of the subject (PL. 281).

One of the by-products of postimpressionism was a new kind of arabesque, abstract and spaceless, but suggestive of organic life. Such curvilinear patterns, reminiscent of flowing water or weaving stalks, first appeared in designs by Seurat, in Gauguin's and Van Gogh's landscapes, and in the posters of Toulouse-Lautrec. They later played an important part in the fantasies of James Ensor (q.v.) and in the graphic work of Edvard Munch (q.v.). Popularized through posters, cartoons, and illustrations in such periodicals as *La Revue Blanche*, *L'Assiette au Beurre*, *Simplicissimus*, and *Pan*, this expressive arabesque, the so-called *Jugendstil*, or Art Nouveau (q.v.), became the artistic signature of the period (1890–1905). It strongly affected most of the younger artists active about 1900 (e.g., Picasso, Kandinsky, Modigliani). Among the draftsmen formed by it were the Austrians, Gustav Klimt and Egon Schiele, and the cosmopolite, Jules Pascin. Auguste Rodin's (q.v.; PL. 281) later drawings bear a distant relationship to Art Nouveau in their vital fluidity of line.

The group known as the Nabis (Maurice Denis, Ker-Xavier Roussel, Pierre Bonnard, J. E. Vuillard), influenced by Gauguin and the painters of Pont-Aven, tried to revive the art of monumental decoration. Bonnard and Vuillard (qq.v.) combine a subtle calligraphy with much freshness of observation. Their lyrical art is the final manifestation of romantic realism.

The Fauves (q.v., Matisse, Vlaminck, Derain, Dufy, Braque) offered an art of strong emotional impact and expressive spontaneity. They disdained technical refinement, and their drawing is blunt, heavy, and a little crude, most frequently executed in ink with the blunt pen or brush. Its bold formal abbreviations and distortions betray the influence of African sculpture, which the Fauves were among the first to discover. Ultimately, the various members of the group went their separate ways, Derain (q.v.) toward eclectic classicism, Dufy (q.v.) toward agile rococo calligraphy, and Braque (q.v.) toward cubism. Only Rouault (q.v.) persisted in his ponderous brush manner, framing massive figures with enormously broad, rigid contours. Matisse (q.v.) developed from Fauvism to a serenely assured style of outline drawing which sought to reduce the forms of the female body, fruits, and flowers to their beautiful essences, without sacrificing vitality, or even sensuousness. His is the most powerfully evocative line in modern drawing.

The German painters who formed the group Die Brucke (1905–11, see EXPRESSIONISM) shared basic tendencies of the Fauves and were influenced, like them, by postimpressionism and primitive art. Expressive linear drawing was of central importance in their work. Ernst Ludwig Kirchner (q.v.), the group's strongest talent, began with fluent, strongly patterned designs, a little like Matisse's, but by 1910 had developed a harshly dissonant, aggressive, and exalted "Gothic" manner. Erich Heckel's drawings strike a quieter, often lyrical note, while Karl Schmidt-Rottluff's barbaric monumentality reveals a wholly different, robust temperament. Related to these artists, though not a member of Die Brücke, Max Beckmann (q.v.) developed from an early cramped, Gothicizing manner toward ampler, more tectonic design. His drawings are based on emphatic sustained contours which give an intense suggestion of corporeality. Oskar Kokoschka (q.v.), stemming from Viennese Art Nouveau, early formed an original graphic technique which combined heavy, craggy outline with tightly systematic hatchings. From about 1914 onward, he began to draw in a looser highly spontaneous manner, dissolving form in a rapid flow of line. Figural expressionist design enjoyed an influence extending to the present day.

Braque (q.v.) painted landscapes in a Fauve style, Picasso (q.v.) drew in the Gothicizing linear manner of his romantic Blue period, before the impact of Cézanne and of primitive art turned their interest to sculptural form analysis. Beginning in Picasso's Negro period (1906–07), the expressive barbarization of the figures gradually led to formal dissection. The drawings of 1908–09 illustrate the continuation of this process, which led from a sculptural conception of form to an increasingly abstract, two-dimensional translation of anatomical forms into shaded, angular facets which, by their overlapping and interlocking, suggest a relieflike body. About 1910 the facets became more regularly spaced, more abstractly geometric; the effect of body and space lessened; the image became flat. In this second, "synthetic" phase of cubism (see CUBISM AND FUTURISM) drawing lost importance. The line functions only as the neutral edge of colored or textured planes. Braque modified this austerity by introducing calligraphic and textural enrichments into the geometric pattern. Juan Gris (q.v.), on the contrary, strove for an ever purer logic and clarity in his nakedly geometric, flat design. The drawings of Marcel Duchamp and Delaunay (qq.v.) reassert the expressive element in cubism by using cubist form dissection as a device for suggesting motion. In this they closely resemble the work of the Italian futurists (Boccioni, Severini, qq.v., Carlo Carrà, see CUBISM AND FUTURISM), who regarded motion as a prime manifestation of reality and sought to render it visual through form fragmentation or multiplication and through the use of graphic symbols for energy and speed. The drawings of Franz Marc (q.v.) tend in the same direction; beginning with lyrical naturalism, influenced by cubism and futurism, Marc at the end of his life attained dynamically expressive abstraction.

Purely nonobjective drawing first appeared in the work of Wassily Kandinsky (q.v.) about the year 1911. The postimpressionists had already explored the possibility of making abstract line an instrument for emotional expression. Art Nouveau

had further helped to free dynamic line from descriptive function. In Kandinsky's early nonobjective drawings, the criss-crossing lines shoot across the paper, singly or in tangles, like the traces of a sudden energy discharge, signifying motion or tension rather than body. Paul Klee (q.v.) invented a highly personal hieroglyphic style, a free play with suggestive forms. The line, both light and sharp, runs its adventurous course across the paper, an active force, almost a personality, lending its character to the images which it capriciously circumscribes. The experiments of the Dadaists (Jean Arp, q.v.) with automatic gesture drawing and the abstract-expressionist compositions of Joan Miró (q.v.) belong in this same current.

With the rise of formal and expressive abstraction in the second decade of the 20th century, there emerged a conservative countercurrent, reaffirming the traditions of figure drawing, of firm contour, and of constructive, representational design. In Picasso's work, this reaction became manifest about 1915, in his so-called "classical" style, which, for twenty years afterward, ran parallel to his cubist work. Picasso's contour drawings of that time were at first inspired by Ingres; later their lines became more fluent and, in the mythological compositions of the 1930s, achieved an almost baroque mood (PL. 281). The refined linear eclecticism of Modigliani (q.v.) is probably the most beautiful manifestation of this conservative strain in modern drawings (PL. 281), which is being continued, in our time, mainly by such sculptors as Marino Marini (q.v.), Giacomo Manzù, and Emilio Greco.

Lorenz EITNER

DRAWING IN THE ORIENT. *India.* Outline drawing has always been the basis of Indian painting. Only in the 5th–7th centuries, and again in the 17th, has a more picturesque approach prevailed, which gave the same importance to light, shadow, and color patches. Since the 19th century, artists have worked also in a purely impressionistic technique, under Far Eastern and European influence. Generally, however, Indian painting consisted of outlines filled in with simple, clear colors. Shading was used only in the Gupta period (4th–7th cent.) and again under the Moghul emperors (16th–19th cent.). In consequence this outline became very sensitive: lines generally of uniform strength, flowing in harmonious curves and rhythms and enclosing well-balanced color surfaces. The rhythm of these lines has varied in the course of time: rather heavy until the 1st century B.C.; then of a pretty elegance; since the 5th century of our era, of a grand sweeping flow; more and more angular and jerky since the 8th–9th centuries; an alternation of hard angles and simple curves since about the 12th century; and again a sweeping flow since the 16th century, which reached its maximum fluidity in the late 18th century.

However, drawing as a special kind of pictorial art existing side by side with painting did not become known before the end of the 16th century, when it was introduced from Persia, where, in its turn, it had been inspired by Chinese ink painting and Islamic calligraphy. Before that time drawing was merely an auxiliary method of visual annotation or a preparation for painting (see DESIGNING). What we know of earlier drawings is very little, because such as must have existed were perishable sketches. Educated people generally had training in drawing, as is evident from classical Sanskrit drama, in which lovers are described as sketching portraits from memory. That artists must have made extensive use of sketches is proved by the fact that famous temple reliefs are found copied or adapted in distant parts of the country and often many centuries later. The Ajanta murals of the 7th and 8th centuries reveal that in that period of cultural decay even tracings and stencils had been used, not always successfully pieced together, in composing new pictures. These sketches were executed with a brush (*lekhni*) on wooden boards and on cotton cloth. Some small wooden panels of this sort were found by Sir Aurel Stein at Dandan-uilik in Sinkiang. A drawing of the life of Buddha on a piece of cotton cloth is represented on a mural (VIII, PL. 404) in one of the cave temples at Ming-oi near Kucha, and also in Sinkiang (where Buddhist Indian art dominated in the 2d–7th centuries). In India proper only drawings engraved on

rocks (e.g., by the side of Aśoka's Khalsi edicts, in the Sonbandhar Cave at Rajagriha, at Nagarjunakonda, also in many decorative bas reliefs), on metal, such as the backs of idols, brass vessels (e.g., the copper lota from Kundla in the British Museum) or copper-plate charters, or on ivory (e.g., the Begram toilet box, now in the Musée Guimet, Paris, and Kabul Museum) have been preserved. During the Middle Ages palm leaves were used for manuscripts, and texts as well as pictures were scratched into them by means of a steel style and afterwards blackened with carbon; in order not to split the palm leaf it was necessary to avoid long straight lines along the softer fibers, which created a script and a drawing style of innumerable small curves. Such manuscripts come mainly from southern India, Orissa, and Bali and are often of a quaint charm when the technical demands of the material meet the needs of a baroque expression. In northern India, especially in Bengal, Nepal, and Gujarat, miniatures were also painted on palm leaves and book covers, in the latter case on a grounding of polished chalk, afterward varnished.

Since the 14th century the palm leaves have been replaced by paper, introduced by the Moslems, who, in their turn, had learned its preparation from the Chinese. Indian drawings dating from the 16th century on are known to us in considerable numbers. Pictures intentionally left as sketches were generally called "Irānī-qalam," i.e., in the Persian style, because this manner had been introduced in India on the model of the works of Bihzād (q.v.), Āqā Rizā, and Rizā-i-'Abbāsī (q.v.). These were merely sketched in black on white ground, perhaps slightly heightened by a few patches of gold, red, green, or blue (PL. 265).

Such sketches classified as Irānī-qalam were much in favor under the Moghul emperors Jahangir (1605–27) and Shah Jahan (1628–58), but also in the Deccan, especially during the later years of Ibrāhīm II (1581–1626) and under Muhammad 'Ādilshāh (1626–56) of Bijapur. Especially of Āqā Rizā, who went to India probably in 1595 after the surrender of Kandahar and joined the service of Sultan Salīm (later the emperor Jahangir), we have some fine sketches in the later Safawid style. Under the influence of European oil paintings brought to the Moghul court by the Jesuits and the English ambassador Sir Thomas Roe, Nādir-az-Zamān, Mansūr, and others evolved a very delicate and exact technique. In the later 17th century the Irānī-qalam rapidly degenerated into a sort of crude sketchwork sold in the bazaar at cheap rates to travelers, soldiers, and pilgrims.

The really interesting sketches are those of the painters' personal collections, although not of all of them. With the decline of the Moghul empire and of its successor states during the 18th and early 19th centuries, the painters were compelled to industrialize a part of their business by selling a considerable number of copies or merely slightly altered replicas. For this purpose pounced tracings (*khāka*) were prepared on very fine deerskin (*charba*), from which copies could be taken by rubbing some carbon dust over them (PL. 266). However, good artists used to alter these copies freely until they were absorbed in the new composition. Later, however, artists just pieced together a number of such copies into a new composition, with the result that the sizes of the figures and the perspective of the various parts of the scene are in conflict. Thereafter the sketch was covered with a grounding of fine chalk powder (*chunam*) and polished, and on this the actual painting was executed in black ink and finally colored. However perfect such paintings may be, they seldom have the spontaneity and vivacity of the original sketch.

Architectural drawings known to us come mainly from south India, and some of them are found in books on the theory of Indian architecture. Almost all of these are of rather recent date. A few old examples have, however, likewise been preserved, engraved on stone, at Dhar (Malwa), Vijayanagar (Hampi), etc. Similar Indo-Moslem drawings once must have existed but have not yet been discovered. Drawings of the monuments of Delhi, Agra, Lucknow, Allahabad, etc. — precursors of the picture post card — were the fashion in the early 19th century and were also reproduced in lithographs but are inexact and unreliable.

Hermann GOETZ

*China*. The distinction between drawing and painting does not apply to traditional Chinese and Japanese pictorial art; the two methods are considered as one and are designated by one and the same term, namely *hua*. This is explained by the fact that in China and Japan both drawing and painting depend on the selfsame technique, which is dictated by the sole instrument used, the Chinese brush. Nevertheless, certain brush techniques more than others approach our conception of drawing. In the oldest realistic art the brush is used to make outlines of a uniform thickness. The subject is reproduced as a stereotype. There is no shading of any sort, and what cannot be expressed in linear design does not exist for the painter. Water and waves are represented by curved lines, and so are clouds, fire, etc. The only exceptions are vast expanses of water or large masses of clouds, which are represented by sweeping, formless brush strokes in thin ink or washed colors, or simply by leaving a blank space.

The above technique, which in Western terminology might be described as "pure drawing," has remained in use throughout the ages. It is apparent especially in the wood-block prints used for book illustrations, an art which flourished in the 16th and 17th centuries in China and in the 18th and 19th centuries in Japan (see ENGRAVINGS AND OTHER PRINT MEDIA; GRAPHIC ARTS). If no colors are added, this technique is called in China *po-miao* ("outline drawing").

Further removed from our conception of drawing is the "calligraphic" linear technique, which developed in China in the first centuries of our era. The perfecting of the brush allowed a more subtle modulation of the brush stroke; instead of the line of uniform thickness, we find brush strokes greatly varying in strength and thickness, and thereby acquiring an amazing capacity for three-dimensional expression. Thereafter linear and calligraphic techniques were used in combination. In the human figure, for instance, the head, face, and hands were drawn in thin lines of uniform thickness, but the robe in modulated, calligraphic strokes that give a modeled quality to its folds. In Western terms we might call "drawings" those pictures in which the linear brush stroke predominates, and "paintings" those in which the calligraphic stroke prevails. To the first category belong the *chieh-hua* ("ruled paintings"); i.e., realistic pictures of palaces, temples, towers, bridges, etc., carefully executed with all architectural details and drawn with the aid of compass and ruler (see DESIGNING).

Farthest from the Western conception of drawing are the schools of painting which developed in the 9th and 10th centuries, with masses of trees and foliage represented by piled ink blotches, or distant mountains indicated by a kind of *pointillé* technique. Such pictures might be called " painted," except that, along with the portions painted as described, there are also linear designs — called "bones" by the Chinese — which bring them under the heading "drawing."

The only technique which according to Western standards could be classified as "pure painting" is the *mo-ku*, or "boneless," method, which employs color blotches without, or with only very little, linear work. But pictures done in this technique constitute an insignificant minority.

Chinese artists rarely made preliminary sketches in charcoal, and not often with the brush; they started as a rule immediately on the work itself and if it did not come out to their satisfaction began anew. Japanese painters, on the contrary, liked to draw sketches in Chinese linear technique in order to record an impression, or as a preliminary to a painting, or again just as exercise. Such sketches come close to our conception of drawing. Also in such "drawn" designs the imaginative element is stressed at the expense of the descriptive.

It is only Buddhist and Taoist religious pictures that are drawn with painstaking accuracy, both in the execution of details and in the proportion of the component parts. This is to be explained by the fact that a carefully defined ritualistic canon had fixed all those details, and deviation therefrom was considered sacrilegious, while it robbed the representation also of its magic efficacy. Religious artists therefore preferred the precise linear technique to the calligraphic one. It was as a rule only religious pictures meant to be used as decoration in

secular surroundings that were done in calligraphic technique; for instance, calligraphic sketches of Kuan-yin, or of the Taoist devil-queller Chung-k'uei. (See PL. 282; CHINESE ART.)

Hans Robert VAN GULIK

*Japan*. A fundamental characteristic of Japanese drawing is that it is drawn with a *mohitsu*, or brush, in the same way as Chinese pictures. In Japanese painting, what corresponds to drawing in a European picture is an outline picture of an object drawn with a *mohitsu* in black ink, called *sumi*, that is, a picture which is not yet filled in, though its outline is finished.

Japanese drawing may be divided into four types, as follows:

1. The type that corresponds to a sketch. The artist looks at the object from various angles and standpoints, drawing the outline in *sumi* only. He draws animals, plants, men and women, and landscapes in outline, and when a picture is requested, he makes use of these graphic notes of which he has a vast store. When he makes copies of compositions of some old pictures for future reference, he adopts this method of line drawing. The most appropriate examples are found in Buddhist iconographical pictures.

2. The type considered as a preparatory stage to a finished work. In this case it is called a *shita-e* in Japanese, which means "a preparatory picture." The artist draws only the composition in line on a sheet of paper as large as the finished picture. Next he puts a sheet of paper or silk of the same size on the outlined picture and traces the lines of its composition, and then perfects it by adding color.

3. The method called *kakiokoshi*, which means "drawing again." A picture is colored, and the artist goes over the original lines so that they may become more noticeable. The artist often takes great care to avoid obscuring the original lines by his coloring.

4. The mode of drawing called *sumi-e* or *suiboku-ga*, by which is meant a black-and-white picture in which *sumi* or India ink is used as the sole medium. This style was introduced from China during the Kamakura period (13th cent.). The picture is drawn in *sumi* only, and the artist draws thin lines as well as thick ones, sometimes using the *sumi* in various ways to attain effects of chiaroscuro. In a Japanese painting the lines of the drawing are not mere outlines but have a meaning somewhat the same as color, and for this reason Japanese paintings are sometimes spoken of as "line pictures" (PL. 282; also III, PL. 435).

After the Meiji period (late 19th cent.) such drawing materials as pencil, charcoal, and the graphite Conté pencil were introduced into Japan, and a number of Japanese artists used them in making sketches of the first type discussed above. Nevertheless, when drawing a *shita-e* Japanese artists still use a hair pencil and *sumi*. (See JAPANESE ART; VIII, PLS. 287, 298, 305–309.)

Shin-ichi TANI

BIBLIOG. *Primitive cultures*: F. Parkyn, An Introduction to the Study of Prehistoric Art, London, 1915; M. Hörnes and O. Menghin, Urgeschichte der bildenden Kunst in Europa von den Anfängen bis um 500 v. Chr., Vienna, 1925; A. H. Luquet, L'art et la réligion des hommes fossiles, Paris, 1926; H. Obermaier, El hombre fósil, Madrid, 1926; F. A. von Scheltema, Das alteuropäische Kunstgewerbe der jüngeren Stein- Bronze- und vorrömischen Eisenzeit, in H. T. Bossert, Geschichte des Kunstgewerbes, I, Berlin, 1928; H. Kühn, Kunst und Kultur der Vorzeit Europas, I, Das Paläolithikum, Berlin, 1929; R. de Saint-Périer, L'art préhistorique, 1932; H. Breuil, L'évolution de l'art pariétal dans les cavernes et abris ornés de France (Congrès préhistorique de France, XI), Périgueux, 1934, p. 102 ff.; F. A. von Scheltema, Die Kunst unserer Vorzeit, Leipzig, 1936; O. Menghin, Die ältere Steinzeit (Eiszeit): Europäische Kunst des Miolithikums, HA, I, 1939, p. 404 ff.; C. Schuchhardt, Alteuropa, Berlin, 1941; G. von Kaschnitz-Weinberg, Italien mit Sardinien, Sizilien und Malta, HA, II, 1950, p. 311 ff.; F. Matz, Die Ägäis: Jüngere Steinzeit, Kupfer-Bronze-Zeit, HA, II, 1950, p. 181 ff.; O. Menghin, Europa und einige angrenzende Gebiete ausser dem ägäischen und italienischen Kreis: Bildkunst und Ornamentik der jüngeren Steinzeit: Bildkunst und Ornamentik des Bronzezeit, HA, II, 1950, p. 10 ff.; H. Breuil, Quatre cents siècles d'art pariétal, Montignac, 1952; H. Kühn, Die Felsbilder Europas, Stuttgart, 1952 (Eng. ed., London, Fair Lawn, N.J., 1956); P. Graziosi, Palaeolithic Art, New York, 1960.

*The ancient world. a. General*: Pfuhl; M. H. Swindler, Ancient Painting, New Haven, 1929; HA, IV, I, 1953. *b. Near East*: M. Baud, Les dessins

ébauché de la nécropole thébaine, Mém. de l'Inst. français d'archéologie orientale, LXIII, 1935; A. Badawy, Le dessin architectural chez les anciens égyptiens, Cairo, 1948. c. *Greece and Rome.* (1) *Panathenaic amphoras:* S. Dow, Hesperia, V, 1936, p. 50 ff.; N. M. Konteleon, Archaiologike Ephemeris, 1937, p. 576 ff.; S. Papaspyridi-Karouzou, ibid., 1948–49, p. 5 ff.; G. R. Edwards, Hesperia, XXVI, 1957, p. 320. (2) *Stele of Aineas:* P. R. Frank, AAnz, LXXI, 1956, col. 183 ff. (3) *Attic steles:* S. Papaspyridi-Karouzou, AM, LXXI, 1956, p. 124 ff. (4) *Bowl of Calabria:* AAnz, XXIX, 1914, cols. 197–98. (5) *Tablets:* A. Hekler, Die Sammlung antiker Skulpturen in Budapest, Vienna, 1929, no. 86; W. Deonna, Le mobilier délien (Ecole française d'Athènes, Exploration archéologique de Délos, XVIII, 1938), p. 58 ff. (6) *Papyri:* K. Weitzmann, Illustrations in Roll and Codex, Princeton, 1947; C. H. Roberts, The Oxyrynchus Papyri, XXII, London, 1954, pl. 12. (7) *Doria situla:* H. Brunn, Kleine Schriften, I, Leipzig, 1898, p. 127; H. B. Walters, Catalogue of the Bronzes, Greek, Roman and Etruscan in the British Museum, London, 1899, p. 162, fig. 23; AAnz, LVIII, 1943, col. 154. d. *Late antique and Byzantium.* (1) *Silver bowls:* L. Matzulewitsch, Byzantinische Antike, Berlin, Leipzig, 1929. (2) *Coptic drawings:* R. Delbrück, Die Consulardiptychen, Berlin, 1929, p. 271 ff.

*The European West:* S. Resta, Indice del libro intitolato Parnaso de' pittori, Perugia, 1707; S. Resta, Indice del tomo de' disegni . . . intitolato l'Arte in tre stati, Perugia, 1707; M. Tesi, Raccolta di disegni originali, Bologna, 1787; W. Y. Ottley, The Italian School of Design, London, 1823; A. N. Didron, Manuel d'iconographie chrétienne (Book of Mount Athos), Paris, 1843 (Eng. trans., E. J. Millington, London, 1886); E. Santarelli, Catalogo della raccolta dei disegni autografi antichi e moderni donata dal prof. Emilio Santarelli alla Regia Galleria di Firenze, Florence, 1870; F. Lippmann and F. Winckler, Zeichnungen von Albrecht Dürer in Nachbildungen, 7 vols., Berlin, 1883–1929; P. N. Ferri, Catalogo riassuntivo della raccolta dei disegni antichi e moderni posseduti dalla Regia Galleria degli Uffizi, Rome, 1890; F. Wickhoff, Die italienischen Zeichnungen der Albertina, JhbKhSammlWien, XII, 1891, pp. ccv–cccxiv, XIII, 1892, pp. clxxv–cclxxxiii; J. Schönbrunner and J. Meder, Handzeichnungen alter Meister aus der Albertina und anderen Sammlungen, Vienna, 12 vols., 1896–1908; J. von Schlosser, Zur Kunstüberlieferung im Mittelalter, JhbKhSammlWien, XXIII, 1902, p. 279 ff.; S. Colvin, Drawings of the Old Masters in the University Galleries and in the Library of Christ Church Oxford, 3 vols., Oxford, 1903–07; Vasari Society for the Reproduction of Drawings by Old and Modern Masters, Oxford, 1905 ff.; P. Toesca, Disegni di antica scuola lombarda, L'Arte, X, 1907, p. 52; K. Frey, Die Handzeichnungen Michelagniolos Buonarroti, 3 vols., Berlin, 1909–11; R. Soriga, I disegni del Museo civico, Pavia, Collezione Malaspina, Milan, 1912; P. Toesca, Pittura e miniatura nella Lombardia . . ., Milan, 1912; F. M. Clapp, Les dessins de Pontormo, Paris, 1913; G. Fogolari, Venezia: I disegni della Regia Galleria dell'Accademia, Milan, 1913; O. Fischel, Raphaels Zeichnungen, 8 vols., Berlin, 1913–41; M. Marangoni, I disegni della Regia Galleria degli Uffizi: Disegni di pittori bolognesi dei secoli XVI–XVIII, Florence, 1916; O. Fischel, Die Zeichnungen der Umbrer, Berlin, 1917; M. Krascenninikova, Catalogo dei disegni del Pisanello nel Codice Vallardi del Louvre, L'Arte, XXIII, 1920, pp. 5, 125 ff.; A. L. Mayer, Dibjos originales de maestros españoles, 2 vols., New York, Leipzig, 1920; M. J. Friedländer and E. Bock, Handzeichnungen deutscher Meister des 15. und 16. Jahrhunderts, Berlin, 1921; D. von Hadeln, Zeichnungen des Giacomo Tintoretto, Berlin, 1922; C. J. Herringham, trans., The Book of the Art of Cennino Cennini, London, 1922; J. Meder, Die Handzeichnung, ihre Technik und Entwicklung, 2d ed., Vienna, 1923; D. von Hadeln, Venezianische Zeichnungen Hochrenaissance (Quattrocento, Spätrenaissance), 3 vols., Berlin, 1925–26; H. S. Ede, Florentine Drawings of the Quattrocento, London, 1926; A. Stix, ed., Beschreibender Katalog der Handzeichnungen in der graphischen Sammlung Albertina, Vienna, 6 vols., 1926–41; Old Master Drawings, London, 1926–39; D. von Hadeln, Titian's Drawings, London, 1927; D. von Hadeln, The Drawings of Tiepolo, 2 vols., Paris, 1928; H. Voss, Zeichnungen der italienischen Spätrenaissance, Munich, 1928; Reale commissione vinciana, I manoscritti e i disegni di Leonardo da Vinci, Rome, 5 vols., 1928–36; W. George, Le dessin français de David à Cézanne, Paris, 1929; D. von Hadeln, The Drawings of Antonio Canal called Canaletto, London, 1929; F. Rücker and H. R. Hahnloser, Das Meisterbuch von Wolfenbüttel, Die graphischen Künste, 1929, p. 1 ff.; I. Budde, Beschreibender Katalog der Handzeichnungen in der Staatlichen Kunstakademie Düsseldorf, Düsseldorf, 1930; P. Lavallée, Le dessin français du XIIIᵉ au XVIᵉ siècle, Paris, 1930; H. Brauer and R. Wittkower, Die Zeichnungen des G. L. Bernini, 2 vols., Berlin, 1931; C. Dodgson, Modern Drawings, London, 1933; H. Bodmer, Drawings by the Carracci: An Aesthetic Analysis, Old Master Drawings, VIII, March, 1934, p. 51 ff.; H. R. Hahnloser, Villard de Honnecourt, Vienna, 1935; E. Schilling, Deutscher romantiker Zeichnungen, Frankfort on the Main, 1935; B. Degenhart, Zur Graphologie der Handzeichnung, Kunstgeschichtliches Jhb. der Bib. Hertziana, I, 1937, p. 223 ff.; O. Kurz, Giorgio Vasari's Libro de' disegni, Old Master Drawings, XII, June–Dec., 1937, pp. 1, 32; L. Rovere, V. Viale and A. E. Brinckmann, I disegni di Filippo Juvarra, I, Turin, 1937; B. Berenson, The Drawings of the Florentine Painters, 2d ed., 3 vols., Chicago, 1938; A. van Schendel, Le dessin en Lombardie jusqu'à la fin du XVᵉ siècle, Brussels, 1938; R. Benz and A. von Schneider, Die Kunst der deutschen Romantik, Munich, 1939; W. Friedlaender and A. Blunt, The Drawings of Nicolas Poussin, 3 vols., London, 1939–53; R. Oertel, Wandmalerei und Zeichnung in Italien, Mitt. des kunsthist. Inst. in Florenz, V, 1940, pp. 217–314; L. Grassi, Ricerche intorno al padre Resta e il suo codice di disegni all'Ambrosiana, RIASA, 1941, p. 151 ff.; J. Piper, British Romantic Artists, London, 1942; L. Becherucci, Disegni del Pontormo, Bergamo, 1943; B. Degenhart, Europäische Handzeichnungen, Berlin, Zurich, 1943; C. De Tolnay, History and Technique of Old Master Drawings, A Handbook, New York, 1943; B. Dörries, Deutsche Zeichnungen des 18. Jahrhunderts, Munich, 1943; V. Moschini, Disegni di Jacopo Bellini, Bergamo, 1943; L. Grassi, Disegni del Bernini, Bergamo, 1944; A. E. Popham and J. Wilde, Italian Drawings at Windsor Castle, London, 1944; H. Tietze and E. Tietze-Conrat, The Drawings of the Venetian Painters, New York, 1944; M. Wheeler, Modern Drawings, Museum of Modern Art, New York, 1944; A. Blunt, The French Drawings at Windsor Castle, Oxford, London, 1945; A. Mongan and P. Sachs, Drawings in the Fogg Museum of Art, Cambridge, Mass., 1946; G. Reynolds, Twentieth Century Drawings, London, 1946; O. Benesch, Venetian Drawings of the Eighteenth Century in America, New York, 1947; L. Grassi, Storia del disegno, Rome, 1947 (with bibliog.); H. Tietze, European Master Drawings in the United States, New York, 1947; R. Huyghe and P. Jaccottet, Le dessin français au XIXᵉ siècle, Lausanne, 1948; R. Ironside, Pre-Raphaelite Painting, London, 1948; P. Lavallée, Le dessin français, Paris, 1948; K. T. Parker, Canaletto Drawings at Windsor Castle, London, 1948; J. Pope-Hennessy, Domenichino Drawings at Windsor Castle, London, 1948; P. Lavallée, Les techniques du dessin, 2d ed., Paris, 1949; A. Mongan, One Hundred Master Drawings, Cambridge, Mass., 1949; G. Reynolds, Nineteenth Century Drawings, London, 1949; K. Berger, French Master Drawings of the Nineteenth Century, New York, 1950; A. Chastel, Les dessins florentins du XVᵉ au XVIᵉ siècle, Paris, 1950; B. Degenhart, Autonome Zeichnungen bei mittelalterlichen Künstlern, Münchner Jhb. der bildenden K., III, 1, 1950, pp. 93–158; M. Florisoone, Les dessins vénitiens du XVᵉ au XVIIIᵉ siècle, Paris, 1950; J. Gómez Sicre, Les dessins espagnols du XVᵉ au XIXᵉ siècle, Paris, 1950; A. E. Oppé, English Drawings at Windsor Castle, London, 1950; A. E. Popham and P. Pouncey, Italian Drawings in the Department of Prints and Drawings in the British Museum, 2 vols., London, 1950; J. Besançon, Les dessins flamands du XVᵉ au XVIᵉ siècle, Paris, 1951; J. Cassou and P. Jaccottet, Le dessin français au XXᵉ siècle, Lausanne, 1951; O. Fischer, Geschichte der deutschen Zeichnung und Graphik, Munich, 1951; L. Marcucci, Mostra di disegni d'arte decorativa, Florence, 1951; F. Boucher and P. Jaccottet, Les dessins français au XVIIIᵉ siècle, Lausanne, 1952; G. Castelfranco, I grandi maestri del disegno: Leonardo, Milan, 1952; G. A. Dell'Acqua, I grandi maestri del disegno: Pisanello, Milan, 1952; L. Marcucci, Mostra di strumenti musicali in disegni inediti degli Uffizi, Florence, 1952; R. Wittkower, Carracci Drawings at Windsor Castle, London, 1952; F. Wormald, English Drawings of the Tenth and Eleventh Centuries, London, 1952; A. Bertini, I grandi maestri del disegno: Botticelli, Milan, 1953; F. Daulte, Le dessin français de David à Courbet, Lausanne, 1953; G. Delogu, I grandi maestri del disegno: Tintoretto, Milan, 1953; M. Muraro, Mostra di disegni veneziani del sei e settecento, Florence, 1953; J. Vallery-Radot and P. Jaccottet, Le dessin français au XVIIᵉ siècle, Lausanne, 1953; J. Wilde, Michelangelo and His Studio, London, 1953; J. Adhémar and C. Roger-Marx, Honoré Daumier, Zeichnungen und Aquarelle, Basel, 1954; C. R. Dodwell, The Canterbury School of Illumination, Oxford, 1954; F. Fosca, Les dessins de Fragonard, Paris, 1954; P. J. Sachs, Modern Prints and Drawings, New York, 1954; H. Swarzenski, Monuments of Romanesque Art, London, Chicago, 1954; O. Benesch, The Drawings of Rembrandt, 6 vols., London, 1954–57; L. Becherucci, I grandi maestri del disegno: Andrea del Sarto, Milan, 1955; G. Fiocco, Cento antichi disegni veneziani, Venice, 1955; O. Kurz, Bolognese Drawings at Windsor Castle, London, 1955; B. Degenhart, Italienische Zeichner der Gegenwart, Berlin, 1956; L. Magagnato, Disegni del Museo civico di Bassano, Venice, 1956; D. Mahon, Mostra dei Carracci: I disegni, Bologna, 1956; E. Trier, Zeichner des XX. Jahrhunderts, Berlin, 1956; E. Bassi, I grandi maestri del disegno: Canova, Milan, 1957; W. Drost, Adam Elsheimer als Zeichner, Stuttgart, 1957; M. Muraro, Disegni veneti della collezione Janos Scholz, Venice, 1957; K. T. Parker and J. Mathey, Antoine Watteau: Catalogue complet de son œuvre dessiné, 2 vols., Paris, 1957; J. Watrous, The Craft of Old-Master Drawings, Madison, 1957; W. Bernt, Die niederländischen Zeichner des 17. Jahrhunderts, 2 vols., Munich, 1957–58; A. Bertini, I disegni italiani della Biblioteca Reale di Torino, Rome, 1958; F. Daulte, Renoir, aquarelles, pastels et dessins en couleurs, Basel, 1958; A. Forlani, Mostra dei disegni di Jacopo Palma il Giovane, Florence, 1958; M. Mrozinska, ed., Disegni veneti in Polonia, Venice, 1958; K. T. Parker, ed., Disegni veneti di Oxford, Venice, 1958; J. Richardson, Manet: Paintings and Drawings, London, 1958; J. Bialostocki, Disegni fiamminghi e olandesi, Arte figurativa antica e moderna, XII, 1959, p. 56 ff.; L. Dussler, Die Zeichnungen des Michelangelo, Berlin, 1959; J. S. Held, Rubens: Selected Drawings, with an Introduction and a Critical Catalogue, 2 vols., London, 1959; N. Ivanoff, I disegni italiani del Seicento, Venice, 1959; S. Modena, Disegni e maestri dell'Accademia Ambrosiana, Arte Lombarda, IV, 1959, pp. 92–122; M. Mrozinska, Disegni del codice Bonola nel Museo di Varsavia, Venice, 1959; Rome, Galleria nazionale d'arte antica e gabinetto delle stampe, Disegni fiorentini del Museo del Louvre, Rome, 1959 (exhibition cat.); Rome, Palazzo Venezia, Il disegno francese da Fouquet à Toulouse-Lautrec, Rome, 1959 (exhibition cat.); Oude Teekeningen van de Hollandsche an Vlaamsche School in het Rijksprenten Kabinet te Amsterdam, The Hague, n.d.

*The East:* S. S. Jacob, Jeypore: Portfolio of Architectural Details, London, 10 vols., 1890–98; A. Stein, Ancient Khotan, 2 vols., Oxford, 1907; A. K. Coomaraswamy, Indian Drawings, Garden City, 1912; F. R. Martin, Miniature Painting and Painters of Persia, India and Turkey, London, 1912; A. K. Coomaraswamy, Rajput Painting, London, 1916; V. Saunders, Portrait Painting as a Dramatic Device in Sanskrit Plays, JAOS, XXXIX, 1919, p. 299 ff.; P. K. Acharya, Manasara, Oxford, 1921; P. Brown, Indian Painting under the Mughals, Oxford, 1924; E. H. Hankin, The Drawing of Geometrical Patterns in Saracenic Art, Calcutta, 1925; O. C. Gangoly, An Early Indian Copper Lota in the British Museum, Rupam, 27–28, 1926, p. 78 ff.; P. Brown, Indian Painting, Calcutta, London, 1927; Ram Raz, Essay on the Architecture of the Hindus, London, 1934; S. Kramrisch, The Hundred Verses of Amaru Illustrated, JISOA, VIII, 1940, p. 225 ff.; see also bibliographies for CHINESE ART and JAPANESE ART.

Illustrations: PLS. 261–282.

**DUCCIO DI BUONINSEGNA.** Italian painter, master of the Sienese school of the 13th and 14th centuries. He is first mentioned in 1278 in connection with payment for having painted 12 chests designed to hold the official papers of the Sienese commune. Since in this document Duccio is referred to as a painter, we may suppose that he was at least twenty at that time, possibly somewhat older, and therefore born about the year 1255. The individuality of style which he manifested in 1285 further supports this supposition. Works of the same kind as the chests, especially the decoration of wooden tablets serving to bind the communal registers, are mentioned in documents of 1279, 1285, 1286, 1291, 1292, 1294, and 1295. In the document of 1295 Duccio is called a *disegnatore* ("illuminator"), instead of a painter, but this may apply only to a specific role of the artist at the time. In 1295 he was in charge of examining the site for the construction of a fountain in Siena (Fonte d'Ovile), and also shared a commission with Giovanni Pisano, chief architect of the Cathedral of Siena. Duccio also had other less pleasant dealings with the communal authorities. It appears, in fact, that he accumulated a considerable number of fines, a rather heavy one inflicted for unknown reasons in 1280 (100 lire) and others in 1295, 1299, and 1302. This last year seems to have been a particularly difficult one because of debts, difficulties over his refusal to fight in a war in the Maremma, and an alleged accusation against him for witchcraft. It is unfortunate that we know nothing more of Duccio as a person. As it is, we catch only a glimpse of a passionate vigor which contrasts with the noble, detached quality of his art.

Only two documents, both of primary importance, refer to works by Duccio extant today. One, from Florence, dated Apr. 15, 1285, tells of a commission given to "Duccio quondam Boninsegne pictori de Senis" ("Duccio di Buoninsegna, painter of Siena") to do a great painting of the Madonna for the Compagnia dei Laudesi of the Church of S. Maria Novella (*Rucellai Madonna*; PL. 286), now in the Uffizi in Florence. The other, dated Oct. 9, 1308, commissioned Duccio to execute the famous *Maestà* for the main altar of the Cathedral of Siena (PL. 285). Nearly a quarter of a century elapsed between the two works, during which time, according to the documents, Duccio did another relatively important painting, which unfortunately has been lost. This work, a *Maestà* (1302), adorned with a predella, was for the altar of the Capella dei Nove in the Palazzo Pubblico in Siena. There also exist supplementary documents dealing with the *Maestà* of the Cathedral, the last one of June, 1311, referring to a festival given by the commune and the Sienese people to celebrate the moving of the painting from the workshop to the church. Documents from 1318–19 support a tentative conclusion that Duccio was dead at that time. The strongest evidence is supplied by a document concerning the inheritance renounced by the painter's sons, from which we must conclude that Duccio died before Aug. 3, 1319. It appears that Duccio's artistic activity spanned approximately forty-five years, from about 1275 until his death. It is a period which marks the transition from the Middle Ages to a new cultural epoch in Italy, normally exemplified by the names of Dante and Giotto.

The histories of the *Rucellai Madonna* and the Siena *Maestà*, the two works that serve as the only definite basis for a study of Duccio's art, are completely different. There has never been any doubt concerning the authenticity of the *Maestà*. In addition to being recorded in documents, it is signed by the painter in an invocation on the step of the throne: "Mater Sancta Dei sis causa Senis requiei Sis Ducio vita te quia pinxit ita" ("Holy Mother of God, grant peace to Siena and life to Duccio, who painted thee in this wise"). This painting, as it is the only signed work, serves as the model to which other paintings attributed to Duccio are compared.

The *Rucellai Madonna*, on the other hand, was wrongly attributed to Cimabue as early as the 15th century. It is still spoken of with reservation, as several scholars (Toesca, 1927 and 1951; Berenson, 1932; Cecchi, 1948) maintain that it is the work neither of Duccio nor of Cimabue but of an anonymous master. This compromise solution to the long-standing problem of attribution was proposed (Perkins, 1902; Suida, 1905) in order to explain the mixture of Sienese and Florentine characteristics in the work. The question arose because of the conflict between the document supporting the attribution to Duccio, which was published for the first time in 1790 but not taken into consideration until a century later (Wickhoff, 1889), and the traditional attribution to Cimabue, also maintained by Vasari. Since the attribution of the work to Cimabue cannot be maintained, attribution to a third master had a certain plausibility. It served to introduce the idea of a painter who reconciled closely, and in an admirable way, the characteristics of two schools considered to be essentially different from one another. This theory paved the way for the generally recognized view, which no longer questions that the painting is by Duccio.

There is the further problem of how Duccio in 1285 manifested the characteristics of Florentine art and how he, a Sienese, could have been given such an important commission by the city of Florence. Studies along these lines, even though unsupported by concrete historical data, are of the utmost consequence and have raised several serious problems with regard to Italian painting of the last decades of the 13th century, for example, the date of frescoes in the Church of S. Francesco at Assisi and the dating and chronological order of Cimabue's works. In fact, it has been postulated that Duccio was "not merely a pupil, but practically a creation of Cimabue" (Longhi), a conclusion reached from a study of "Ducciesque features in the oldest frescoes of the Upper Church of S. Francesco at Assisi." In opposition to this hypothesis it has been stated that these frescoes were painted after 1285 instead of between 1270 and 1280 (Brandi, 1951), and that the whole chronology of Cimabue is based exclusively on conjectures. At the present time the difference of opinion on this matter can be settled only by the discovery of a factual chronology.

The *Rucellai Madonna*, therefore, remains at the heart of the problem of the artistic training of Duccio and the works which may possibly be attributed to him (and also those which have been attributed to him in the past), and the paintings which because of a stylistic affinity have been assigned to the category of Cimabue-Duccio and their respective workshops. It was to explain the latter works that the hypothesis of a third, anonymous master of the *Rucellai Madonna* was put forward. A *Madonna* in Turin (Gall. Sabauda), formerly in the Gualino Collection, once considered earlier than the *Rucellai Madonna* (Longhi), is an example. It has affinities with a Madonna attributed to Cimabue in the Church of the Servi in Bologna, and also with the *Crevole Madonna*, almost certainly by Duccio (Siena, Mus. dell'Opera del Duomo). Of the works of doubtful attribution the Turin painting seems the most likely to be by Duccio. One is forced, however, to make some reservations as to its quality and to take into account the uncertainty of the dating of the *Madonna* attributed to Cimabue in Bologna. A *Madonna* in the Church of S. Verdiana at Castelfiorentino, near Florence, seems to be excluded from consideration (Longhi), and is connected rather with the Badia a Isola Master (Toesca, 1951). A *Madonna* in the Church of S. Remigio in Florence is likewise rejected (Volpe, 1954).

This inquiry into attribution may be extended to include two crucifixes that would belong to Duccio's early period. These are the Loeser cross (Volpe, 1954) in the Palazzo Vecchio in Florence, donated by the American collector Charles Loeser, and one in the Church of the Carmine in Florence (Marcucci, 1956). A third cross, that of the Orsini Castle at Bracciano, near Rome (Volpe, 1954), is slightly later. All of these are relevant to the inquiry, even though no conclusions with regard to them have been reached.

Another theory, designed to fill in the void of Duccio's youth, identifies Duccio's paintings prior to the *Rucellai Madonna* with the works generally assigned to the Badia a Isola Master, considered a follower of Duccio (Carli, 1946 and 1952). This postulate, however, is rather dubious in view of the air of shyness, formal timidity, and archaic *hauteur* that is peculiar to the Badia a Isola group. It is perhaps better to attribute these to a gentle master of the end of the century.

The only work earlier than the *Rucellai Madonna* that reveals with certainty the hand of Duccio, according to the

most widely accepted critical opinion, is the *Crevole Madonna* of the Museo dell'Opera del Duomo at Siena, named thus because it is from Crevole, near Siena. This work has also been attributed to the so-called "Master of the Rucellai Madonna" and to the Badia a Isola Master. These artists are considered by Toesca (1951) to be one figure.

The thick tangle of problems, which have been only briefly summarized, naturally prevents drawing any definite conclusions, as they would be based on faith rather than on historical fact. It is clear, however, that about 1285 Duccio was in touch with the Florentine school, and therefore with Cimabue, its leader at the time. With regard to the artistic rapport between Siena and Florence, one recalls that a Florentine, Coppo di Marcovaldo, was at Siena in 1261. By opening the Sienese circle to the art of a rival city, he might have had an important effect on Duccio, as well as on other artists. In 1285, however, Duccio already had a completely distinct personality and style that, despite his appreciation of Florentine art, was all his own. The local Sienese painting, dominated by Guido da Siena and his school, does not seem to explain sufficiently this individuality. (A beautiful altar frontal of St. Peter in the Siena Pinacoteca shows signs of having been influenced by Duccio's work, and therefore is not pertinent to this argument.) Neither do non-Sienese works, such as the attractive altarpiece of St. John the Baptist in the same gallery, offer sufficient explanation. One always turns, and justly so, to miniatures and ivories brought from Byzantium and Paris, which enabled Duccio to become familiar with the art of the two most refined schools of the time. The importance of the connections Duccio had with other large Tuscan centers of the second half of the 13th century must also be emphasized. In order to find inspiration, Duccio instinctively turned to those sources of greatest creative significance in the rapidly changing world of his era. Pisa was then the principal center for the diffusion of Greek culture; Vasari in his *Lives* says Duccio "painted many things in Pisa." This city was also the home of the sculptor Nicola Pisano, his pupils, and the Master of S. Martino of Pisa.

Duccio was a painter, not a sculptor, and necessarily bound to the expression provided by the pictorial tradition which dominated his time. He belongs spiritually, however, to the movement initiated by Nicola Pisano (q.v.), because of the influence of classicism that appears in his work and because of his feeling for humanity, which even in the earliest works, in contrast to Byzantine art, is unmistakably revealed. In all probability the art of Arnolfo di Cambio and Giovanni Pisano (qq.v.), with the work of Nicola, had a great influence on Duccio's personality. The Master of S. Martino also seems to have belonged to the movement which originated with Nicola. The connection which exists between this master's *Madonna* in the Museo Civico in Pisa and those of Duccio (*Rucellai Madonna*) and Cimabue (especially the one attributed to Cimabue in the Louvre, originally from Pisa) is unquestionable. It is difficult, however, to define the relative chronological position of these works, with the exception of the *Madonna* at Pisa, which is definitely earlier than the others. The relationship, however, between the Pisa *Madonna* and the *Rucellai Madonna* seems to be a direct one. Duccio and Cimabue both knew the painting at Pisa and were also acquainted with each other's work.

Cimabue's influence on Duccio was to be mitigated in the later course of the latter's artistic development. The inherent differences in their styles lead one to believe that they met after Duccio's own manner had already been formed in the Greco-Byzantine tradition and influenced by Pisan classicism, which was in turn soon affected by Gothic trends. If one looks at certain aspects of Duccio's work, for example, the veil in the *Crevole Madonna*, one is inclined to assume a direct influence of Arnolfo di Cambio. Similarly, in the later *Madonna of the Franciscans* (PL. 283), one cannot help being reminded of Giovanni Pisano. In view of this rich cultural background, it is possible to understand more readily the presence of the Gothic spirit, evident already in the *Rucellai Madonna*, in Duccio's work. This is all the more understandable when one remembers that the most intensive expression of the Italian

Gothic movement developed at Siena in the work of Giovanni Pisano between 1284 and 1296.

It seems best, therefore, to avoid repeating the cliché "Duccio, pupil of Cimabue." (In the past it was "pupil of Guido da Siena.") It must be kept in mind that Duccio was a great man with a complex personality who tried to overcome the dominating Byzantine influence of the time in painting, just as it had already been subdued in sculpture. He found solutions to certain problems inherent in Cimabue's work and evaluated them in the light of his own understanding.

A truly original work, the *Rucellai Madonna* (PL. 286), emerged from this understanding, in spite of the studied preparation which preceded it. It is enough to note that Duccio's modeling suggests very low relief work, reproduced in line and color. The figures are characterized by a contemplative detachment, which nevertheless is intimately lifelike because of the way they are modeled. Duccio lingered over every line in the search for harmony; in the angels he attains passages of truly Hellenic beauty. Cimabue's figures, who seem determined to step into the world, to descend from the heights of their time-honored origins into an immediate reality, differ from these remote figures. In the 23-year interval between the *Rucellai Madonna* (commissioned in 1285) and the *Maestà* at Siena (commissioned in 1308), a stylistic change, sometimes exaggerated by those who deny Duccio's authorship of the former, naturally occurred. The fundamental characteristics of Duccio's work, however, remained the same, even though his style did undergo certain alterations. Duccio's humanity, filtered as it was through the medium of a delicate and courtly sensibility and endowed with an intuitive poetic quality, distinguishes him from Cimabue as well as from Giotto.

One work which unquestionably falls into Duccio's earlier period is the large stained-glass window in the apse of the Cathedral of Siena, executed in 1288, which depicts the Entombment, the Assumption, and the Coronation of the Virgin. These scenes are flanked by the four Evangelists and by the four protective saints of the city. Good evidence exists for attributing the design of this work to Duccio (Carli, 1946).

Characteristics in two other works make one suppose that they were done after the window, with a lapse of time between them. These are two Madonnas, one in the Bern Kunstmuseum, the other in the Siena Pinacoteca. The small Bern painting, *The Virgin Enthroned* (PL. 286), bears two iconographical motifs found in Cimabue: six standing angels at the side of the throne, as in the *Madonna* attributed to Cimabue now in the Louvre, and the standing Child who leans to caress the Mother, as in the previously mentioned *Madonna* in the Church of the Servi in Bologna. The Virgin's mantle with a gold border falls in a less ornamental manner than that in the *Rucellai Madonna*, distinguishing the form in a more direct way. Another difference lies in the soft, muted quality of the colors, the highlights of which seem to rise into a warm, light mist. Compared to the lapidary clarity of design in the *Rucellai Madonna*, this painting represents a striking change in Duccio's style. From the hierarchic placement and the elongation of the angels at the sides of the throne, one might assume that the artist's inspiration was derived from a fresh consideration of Byzantine-influenced works, such as the anonymous altarpiece of St. John the Baptist in the Siena Pinacoteca. In the latter example, however, one cannot find the lifelike quality of the Bern *Madonna*.

The other work, *The Madonna of the Franciscans* (PL. 283), also small in size but monumental in concept, has been unanimously attributed to Duccio. The figures, like those in the Bern *Madonna*, have a modeled quality, as if fashioned of soft wax. There is a feeling of compassion in the conception of the three friars, in the Child's solemn regard toward them, and in the extension of the Madonna's mantle, as if to cover and protect them. It reminds one of effects created by Giovanni Pisano, and might very well be regarded as a pictorial counterpart to his soft transitions and dense shadows.

*The Madonna of the Franciscans* is very similar to the *Madonna* in the Stoclet Collection in Brussels. One may clearly see the change in Duccio's style by comparing the Stoclet

*Madonna* with the *Crevole Madonna*, in which the artist repeats, though in a more intimate way, the Child's gesture of clinging to the Madonna's veil. The tension of the Crevole work is transformed in the Stoclet painting into a pulsating naturalness by the treatment of light, the folding of the veil, and the plasticity of the figures. The latter represents an important and lasting advance in the development of Duccio's style.

A few other works dated before the Siena *Maestà* remain to be mentioned. They are the *Madonna* in Perugia (Gall. Naz. dell'Umbria), which presents with great intensity and delicacy the rapport between the Child and Mother; a triptych in London (Nat. Gall.); and a polyptych in Siena (Pin., no. 28). If the latter were considered to be entirely by Duccio, it would represent an academic standstill, even though the painting is of the highest quality. Because of its greatness it is thought of as a work executed by Duccio with the aid of one of his pupils (possibly Ugolino di Nerio), who was carefully supervised by the master himself.

The *Maestà*, most of which is in the Museo dell'Opera del Duomo in Siena, until 1505 was found on the high altar of the Cathedral of Siena, for which it was originally created. The work was damaged in 1771, when it was cut in order to separate the front from the back. In the main area of the front are depicted the Virgin and Child with angels and saints (PLS. 284, 285). The main area of the back consists of 26 scenes from the Passion (PLS. 285, 288–291). The panels of the predella depict the infancy of Christ on the front and the public life of Christ on the back. Crowning panels, separated by pinnacles decorated with angels, completed the ensemble, with scenes from the life of the Virgin after the death of her Son on the front, and the appearances of Jesus after his death on the back. The two largest panels at the center of the latter series, which probably depicted the Assumption of the Virgin on the front and the Ascension of Christ on the back, as well as some minor pieces from the work, have been lost. Eight scenes from subordinate areas of the altarpiece are scattered, three in London (Nat. Gall.); two in New York, in the Rockefeller and Frick collections; and three in Washington (Nat. Gall.).

In the main area of the front (PL. 285), symmetry is the basic element in the representation of the celestial court which surrounds the Virgin. When the work was intact, the effect of a rhythmic separation into two groups, slightly joined by the curving motion of the angels around the throne, must have focused attention even more effectively than now on the central figures. Even today they are emphasized by the two friezelike areas in the upper corners, which depict the 10 apostles not placed in the main composition. The open space created around the Madonna by the great marble throne is not so much a spatial void as a temporal pause in the succession of halos. On three different levels, with scarcely any indication of intervening depth, are figures in slightly varied poses, in most cases turning to one another. Despite the over-all choral effect, this group of Duccio figures is so silent and compact that at times the figures seem rapt in supreme, yet at the same time very human, contemplation.

Duccio's hand is seen in the individual portrayals of the figures and in the manner in which each is linked to the other and to the group as a whole. He achieved a relationship through a rhythmic rapport without constructing a real space. The modeling, rich and sensitive in itself, contributes to the unique beauty of the personages (PL. 284). The unity of the whole is created by an extraordinarily beautiful harmony of colors and by the light, which seems to enter the picture as if projected from the gold background. Perhaps even more important in unifying the composition are the gestures, attitudes, and movement of the figures, which are all resolved into an elegant linear rhythm. Duccio treats these groups as if they were links in a continuous chain, and yet they are free. A ritual quality of gesture of Byzantine derivation is the basis of the pictorial concept. Thus, the temporal element necessary in understanding the series of details which make up the whole is more important than the space designed to hold the participants. Substantiated by a feeling of humanity that has been enriched by innumerable details gathered by a loving and attentive observation of life, Duccio's

Byzantine training enabled him to realize with ease a narrative continuity in the individual scenes of the great ensemble. The portrayal never assumes the dramatic violence, the temporal unity, nor the immediacy of action set in real space, which qualities we associate with Giotto.

The finest results that Duccio achieved in the condensation of the composition into a shallow space confined between the picture plane and a wall of light of the gold background are seen in such scenes as the *Presentation in the Temple*, the *Flight into Egypt*, the *Three Marys at the Sepulcher* (PL. 291), the *Journey to Emmaus*, and the *Entry into Jerusalem* (PL. 290). The classic dignity and the new sensibility resulting from the fusion of Romanesque and Gothic elements thrive together in these compositions of exceptional beauty. In the scenes with the largest number of people, such as the *Taking of Christ* the *Agony in the Garden* (PL. 289), and the *Crucifixion* (PL. 288), the highest powers of the artist are revealed in the stylization of the narration.

A comparison of the *Maestà* with the work of the major artistic personalities of the time with whom Duccio probably came into contact points up even more clearly his profound individuality. The rigid drama of Cimabue contrasts with Duccio's harmonious pictorial composition, severe and gentle at the same time, drawn from classical antiquity through the intermediary of the Byzantine court tradition. The moving compassion of Giovanni Pisano is transformed into exquisite cadences, a characteristic in Duccio's art derived from his familiarity with the refined French Gothic style. The spatial rendering of Giotto, as has been noted, is ignored in favor of effects of frontal distribution. It is possible, however, that Giotto's influences made themselves felt in the narrative panels.

Unfortunately it is impossible to chart in detail the development of Duccio's style after 1311, when the *Maestà* was completed. It is essential, however, to take into account the remarkable indication of progress discernible in the polyptych in the Siena Pinacoteca (no. 47; PL. 287), even though it is little more than a ruin in its present state. Its austere beauty must be attributed to the personal activity of the master. He, of course, received help from pupils in the figures of the saints on the sides. The austerely composed Madonna, however, seems to indicate an evolution, foreshadowed in certain parts of the *Maestà*, toward a more monumental form.

Among Duccio's immediate followers are Ugolino di Nerio, who possessed the most forceful personality, and Segna di Bonaventura. Of the anonymous artists who followed Duccio, the most noteworthy are the Badia a Isola Master, already mentioned, and the Città di Castello Master, who represents a direct link between the art of Duccio and that of Pietro Lorenzetti. It is also significant that the greatest Sienese painters of the 14th century, especially Simone Martini (q.v.), were influenced by Duccio. While Giotto laid the foundations, powerful in their natural force, of a future development which was to be more popular, Duccio transposed the worn symbols of an ancient tradition into the pictorial language of the courtly art of the future.

BIBLIOG. G. Milanesi, Documenti per la storia dell'arte senese, I, Siena, 1854; F. Wickhoff, Mitteilungen des Instituts für Österreichische Geschichtsforschung, X, 1889, p. 244; A. Lisini, Notizie di Duccio pittore e della sua celebre ancona, B. Senese di Storia Patria, V, 1898, p. 4 ff.; R. Davidsohn, RepfKw, XXIII, 1900, pp. 313–14; F. M. Perkins, Giotto, London, 1902; W. Suida, Einige Maler aus der Übergangszeit vom Ducento ins Trecento, JhbPreussKSamml, XXVI, 1905, pp. 28–39; C. H. Weigelt, Duccio, Leipzig, 1911; G. de Nicola, B. Senese di Storia Patria, XVIII, 1911, pp. 431–33; F. M. Perkins, Appunti sulla mostra Ducciana a Siena, Rass. d'Arte, XIII, 1913, p. 36; R. van Marle, The Development of the Italian Schools of Painting, II, The Hague, 1924; R. Offner, Italian Primitives at Yale University, New Haven, 1927, pp. 4, 14, 37, 38 and fig. 27; P. Toesca, Il Medioevo, I, Turin, 1927; C. H. Weigelt, The Problem of the Rucellai Madonna, Art in America, XVIII, 1929–30, pp. 2–24, 105–20; P. Toesca, L'Arte, XXXIII, 1930, pp. 4–15; C. H. Weigelt, Sienese Painting of the Trecento, Florence, New York, 1930; V. N. Lasareff, Duccio and Thirteenth Century Greek Icons, BM, LIX, 1931, p. 15 ff.; B. Berenson, Italian Pictures of the Renaissance, Oxford, 1932; G. H. Edgell, A History of Sienese Painting, New York, 1932; C. Brandi, Cat. della Pinacoteca di Siena, Rome, 1932; P. Toesca, EI, s.v.; M. Salmi, Emporium, 1937, pp. 353–56; G. Sinibaldi and G. Brunetti, Cat. della Mostra giottesca di Firenze del 1937, Florence, 1943; P. Bacci, Fonti e commenti per la storia dell'arte senese, Siena, 1944; L. Coletti, I primitivi, II, Novara, 1946; E. Carli, Ver-

tata duccesca, Florence, 1946; G. H. Edgell, A Crucifixion by Duccio with Wings by Simone Martini, BM, LXXX, 1946, p. 107 ff.; E. Cecchi, Trecentisti senesi, Milan, 1948; R. Longhi, Giudizio sul Ducento, Proporzioni, II, 1948, pp. 5–54; E. Garrison, Italian Romanesque Panel Painting, Florence, 1949; C. Brandi, Duccio, Florence, 1951; P. Toesca, Il Trecento, Turin, 1951; M. Meiss, A New Early Duccio, AB, 1951, p. 95 ff.; R. Longhi, Prima Cimabue, poi Duccio, Paragone, 23, 1951, pp. 8–13; E. Carli, Duccio, Milan, 1952; R. Örtel, Die Frühzeit der italienischen Malerei, Stuttgart, 1953 (with bibliog.); E. Sandberg-Vavalà, Sienese Studies, Florence, 1953; C. Volpe, Preistoria di Duccio, Paragone, 49, 1954, pp. 4–22; J. H. Stubblebine, The Development of the Throne in Dugento Tuscan Painting, Marsyas, VII, 1954–57, pp. 25–39; E. Carli, La pittura senese, Milan, 1955; E. T. de Wald, Observations on Duccio's Maestà, Late Classical and Mediaeval Studies for A. M. Friend, Princeton, 1955, pp. 362–86; L. Marcucci, Un crocifisso senese del Duecento, Paragone, 77, 1956, pp. 11–24; M. Meiss, The Case of the Frick Flagellation, J. of the Walters Art Gallery, XIX–XX, 1956–57, pp. 42–63; L. Marcucci, I dipinti toscani del secolo XIII (Cat. della Galleria Nazionale di Firenze), Rome, 1958; W. R. Valentiner, Notes on Duccio's Space Conception, AQ, XXI, 1958, pp. 352–81; R. Arb, Reappraisal of the Boston Museum's Duccio, AB, XLI, 1959, pp. 191–98.

Giorgio VIGNI

Illustrations: PLS. 283–291.

## DUCERCEAU (or Du Cerceau).

DUCERCEAU (or Du Cerceau). French Protestant family of architects and engravers active during the 16th and 17th centuries. Its founder was Jacques Androuet Ducerceau (b. ca. 1515; d. ca. 1585), who was principally known for his vast production of ornamental and architectural engravings. His most important publications were two volumes (1576, 1579) illustrating the principal French châteaux (PL. 163) and two volumes (1559, 1572) presenting in systematic fashion designs for different types of domestic dwellings. The latter volumes had considerable influence on the work of contemporary and succeeding architects. Probably Jacques Ducerceau also worked as an architect, principally on the châteaux of Verneuil and Charleval. However, the recorded architectural activity of the family commences only with the work of his two sons: Jean Baptiste (b. ca. 1555; d. 1590) and Jacques II (b. 1556; d. 1614). In 1578 Jean Baptiste was appointed by Henry III to the important post of superintendent of the royal building works, in which capacity he designed the Pont Neuf (1578) and a royal chapel for the Louvre (1580; destroyed). The existing Hôtel de Lamoignon (Paris) has been attributed to him. Jacques II was appointed one of the several official architects of Henry IV, in which capacity he probably helped to design the extensive works undertaken by the King in Paris (Grande Gal. of the Louvre, Place des Vosges, etc.) and at Fontainebleau. This family's succeeding generation consisted of two cousins: Jean (b. ca. 1585; d. 1650), son of Jean Baptiste; and Salomon de Brosse (b. 1571; d. 1624), son of Jean Baptiste's sister. Both were appointed architects of the crown, De Brosse in 1608, Jean in 1617. Jean constructed the famous Escalier du Fer-à-Cheval (1634) at Fontainebleau, and the Hôtel de Bretonvilliers (1634–43; destroyed), a Parisian town house of great architectural influence. It was De Brosse, however, who was the principal architect of the period and the major figure in the family's history. His designs for the châteaux of Coulommiers, Blérancourt (ca. 1613–16; both destroyed), and Luxembourg (built for Marie de Médicis, 1613–24) influenced much later 17th-century architecture, notably the works of François Mansart (q.v.). He also built the façade of the Church of St. Gervais (1623), a work greatly admired in the 17th and 18th centuries. Jacques III (son of Jacques II) and Paul de Brosse (son of Salomon) continued the family's connection with the crown by being appointed royal architects, but their work apparently was minor, as was that of the succeeding members of the family, some of whom were still active as engravers during the 18th century. (See FRENCH ART.)

BIBLIOG. C. Bauchal, Nouveau dictionnaire biographique et critique des architectes français, Paris, 1887; H. A. Geymuller, Les Du Cerceau, Paris, 1887; J. Pannier, Un architecte français du commencement du XVIIIᵉ siècle, Salomon de Brosse, Paris, 1911.

Bates LOWRY

## DUCHAMP BROTHERS.

DUCHAMP BROTHERS. The three Duchamp brothers represent a rare phenomenon in modern times — a family whose members are distinguished artists. The oldest, Gaston, is widely known as a painter and engraver by the pseudonym Jacques Villon (adopted in 1922). He was born at Damville (Eure), Normandy, in 1875. Raymond Duchamp-Villon, a year younger, was the sculptor of the family. He died in battle during World War I, in 1918. Marcel Duchamp, born in 1880, became one of the founders of Dadaism. The Duchamp family belonged to the bourgeoisie of Normandy, the father having been a notary in Rouen.

Gaston, after attending the local art school, went to Paris in 1894. He was soon selling humorous drawings to reviews such as Le Rire and L'Assiette au Beurre, to which Toulouse-Lautrec and Steinlen also contributed at this time. After working for several years as an engraver, he took up painting and in 1912 helped to organize the Section d'Or, a society of painters influenced by Cubism. After World War I Villon worked as a commercial engraver, making prints of paintings by Renoir, Cézanne, and the impressionists. He returned to painting in 1930, gaining international fame late in life with the winning of the first prize at the Carnegie International of 1950 and the grand prize at the Venice Biennale of 1956. In 1956 the French government commissioned Villon to design a series of frescoes for the technical school at Cachan and six stained-glass windows for the Cathedral of Metz. Called a cubist who paints with the colors of an impressionist, Villon has given his latest work gay, atmospheric colors set in prismatic patterns. His sensitivity and craftsmanship are evidenced by the spontaneity and graphic precision of his paintings (see CUBISM AND FUTURISM; V, PL. 138).

Raymond Duchamp-Villon was a medical student and had nearly completed his training when, in about 1900, he decided to abandon medicine in order to devote all his time to sculpture. He had a keenly intelligent and highly disciplined mind as well as a strong urge toward esthetic creativity. Although only a few of his works — those of his last years — have had lasting significance, critics have recognized Duchamp-Villon as one of the pioneers of the modern movement in sculpture. His earliest work (1905–06) bore a general resemblance to that of Rodin, whose influence was enormous in the first years of this century. By 1908 Duchamp-Villon was modeling small nudes (e.g., Song and Young Girl Seated) that have the well-rounded harmonies of Maillol's sculpture. Shortly thereafter he began to experiment with twisted poses (e.g., Torso, 1910), introducing an angular quality to his treatment of anatomy. In his Head of Baudelaire (1911), the influence of Cézanne's emphasis of "cones, cylinders, and spheres" is quite marked. The features of this head are stern in expression and severely simplified; the skull is round and smooth.

Also in 1911 Duchamp-Villon began to make architectural sketches and small models in a purely rectilinear style. Although these architectural designs were conventional for the period — rather like those of Auguste Perret — the prismatic character of the ornamentation around doors and windows showed the influence of cubism. This influence was also revealed in the artist's sculpture (e.g., roundels representing a curled-up dog or cat, schematic treatment of heads). The most ambitious work of this kind is The Lovers (1913), an intaglio relief carved in plaster in an angular, semiabstract style. Duchamp Villon, approaching the peak of his short career, completed his Seated Woman (bronze) in 1914. This small, compact figure has the tentative, uncertain quality of a new style in the making. The body is that of an athlete or dancer with powerful muscles in momentary repose. The modeling is simplified and well rounded; the head — an ovoid — is as abstract as a work by Brancusi. After many preparatory sketches, Duchamp-Villon completed The Horse (bronze, 1914; PL. 82), which is now considered his masterpiece. In this work, possibly influenced by the futurist sculptor Boccioni (q.v.), he attempted to portray not the shape but the spirit of the horse. It is a dynamic, truly three-dimensional composition of sweeping spiral curves and straight shafts projecting at sharp angles to one another in a complex arrangement of solids and voids. Far ahead of its time, it stands out today as a landmark in early modern sculpture.

Marcel Duchamp (see CUBISM AND FUTURISM) began as a painter and will probably be remembered best for his cubist-futurist canvas, *Nude Descending a Staircase, No. 2* (cf. PL. 79), the scandal of the New York Armory Show in 1913. Duchamp's paintings, sculptures, and "inventions" (V, PL. 132) played an important part in the Dada movement both in Europe and the United States. With his wit, irony, and fantasy, he attacked bourgeois and academic concepts of art. Perhaps unintentionally, Duchamps also widened the horizons of contemporary artistic expression with the introduction of his so-called "ready mades." In 1911 he exhibited a metal rack for bottles. In 1917 he sent a urinal marked *Fontaine by R. Mutt* to the Independents show in New York. Although this contribution was rejected, it created a sensation. Among his other works were a weird machine containing a paddle wheel and a bird cage filled with sugar lumps and labeled *Rose Selavy*. His inventions of strikingly juxtaposed objects have helped to liberate sculpture from its traditional subject matter of the human figure.

BIBLIOG. R. Duchamp-Villon, Raymond Duchamp-Villon, Sculpteur (1876–1918), Paris, 1924; G. H. Hamilton, Duchamp, Duchamp-Villon, Villon, B. of the Associates in Fine Arts at Yale Univ., XIII, 2, Mar., 1945, pp. 1–4; J. P. Crespelle, Villon, Paris, 1958; R. Lebel, Marcel Duchamp, New York, 1959.

Henry R. HOPE

**DUFY, RAOUL.** Modern French painter, one of the Fauves (b. Le Havre, June 3, 1887; d. Forcalquier, Mar. 23, 1953). In 1892 Dufy began attending art classes at night in Le Havre; in 1900 he entered the Ecole Nationale des Beaux-Arts in Paris. By 1902, when he met Matisse and the other artists who were later to become known as the Fauves (q.v.), Dufy had acquired a sophisticated late-impressionist manner. He exhibited with the Fauves in the Salon d'Automne of 1906 and rapidly developed an uninhibited richness of color and a brilliant line. He was concerned with the minor arts from the beginning of his career and helped break down the old division between fine and applied arts. The first of the many books he illustrated appeared in 1910 (Apollinaire's *Le Bestiaire*). In 1911, he began designing textiles, later pioneering the revival of the high-warp techniques of tapestry weaving. Dufy started working on ceramics in 1923. Three years later, he designed a ballet set (for De Beaumont's *Palm Beach*). In the late 1930s he executed a number of murals, principally at the Jardin des Plantes and the theater of the Palais de Chaillot. He was on the staff of the Musée de la Guerre from 1917 to 1919 but otherwise worked independently, mainly in Paris and southern France. He visited the United States in 1950–51, and was awarded the grand prize at the Venice Biennale in 1952. In spite of severe arthritis, he continued to paint until his death. Though Dufy was a prolific artist in many fields, he is best known for his oil paintings.

The wit and elegance of Dufy's line — reminiscent of the work of Constantin Guys and the free sketches of Ingres — were combined with a magnificent control of intense color harmonies (V, PL. 255). His decorative impulse expressed itself in the transparent tones of his compositions, merging line and color. The fact that Dufy retained a naturalistic vision in the 20th century gives evidence of his heritage, the French decorative tradition as seen in the joyful public art of Boucher and Fragonard. Their work, like Dufy's, communicates readily while retaining a highly personal esthetic quality.

Among his best-known works are the following: *The Waterfront at Honfleur* (1906, Coll. Dr. A. Roudinesco); *The Park at Hyères* (1913, Paris, private coll.); *The Casino at Nice* (1927, Coll. Georges Moos); *Amphitrite* (1935, Paris, private coll.); *Sunday* (1943, Paris, Coll. Louis Carré); *The Black Freighter* (1952, Paris, private coll.).

BIBLIOG. L. Carré, Dessins et croquis de Raoul Dufy, Paris, 1944; P. Courthion, Raoul Dufy, Geneva, 1951; A. Werner, Dufy, New York, 1953; J. Lassaigne, Dufy, Geneva, 1954.

Robert L. HERBERT

**DÜRER, ALBRECHT.** Dürer was born in Nürnberg on May 21, 1471, the son of Albrecht the Elder, a goldsmith from Hungary, who came to Nürnberg in 1455 and later married Dürer's mother, Barbara Holper, the daughter of Hieronymus Holper, also a goldsmith. Dürer was first apprenticed to his father. On Nov. 30, 1486 he entered the workshop of the Nürnberg painter and woodcut designer Michael Wolgemut, and remained there until April, 1490, when he started on his bachelor journey. His route is unknown, until the time he appeared in Colmar early in 1492. By summer he was in Basel and worked there in woodcut workshops until the fall of 1493, when he went to Strasbourg. In May, 1494, Dürer returned to Nürnberg and on July 7 of that year married Agnes Frey. In the autumn he set off for Italy, visiting Venice and perhaps some towns in the north. He returned to his native city in the spring of 1495 and established his workshop. For many years he did not leave Nürnberg. In 1498 appeared the *Apocalypse* cycle, the most important work in this period. Dürer's father died in 1502. In 1505 (summer or autumn) the artist made his second Italian journey. He stayed in Venice until January, 1507, and before his departure made a trip to Bologna. After returning to Nürnberg he worked on some paintings and on many woodcut cycles. Between 1512 and 1519 Dürer was employed by Emperor Maximilian I and participated in various decorative undertakings. In July, 1520, he left for the Netherlands to meet Charles V and returned to Nürnberg in July, 1521. Dürer died on Apr. 6, 1528 and was buried in the Johannes-Friedhof.

The enormous importance of Albrecht Dürer in the development of German art and, in general, of non-Italian art of the 16th century derives from the fact that he was the only northern European artist who was able to "translate" the basic principles of the Italian Renaissance into an idiom intelligible to northern artists and laymen. He combined great sensitivity to the new currents in Italian art with training in the practices of German and Netherlandish artists of that period, and was able to unite Italian theoretical insight (*Kunst*, in Dürer's terminology) and northern practical skill (*Brauch*).

Though Dürer's painting was undoubtedly very important, it does not compare with his achievement in the field of graphic arts. Before entering the workshop of Wolgemut, Dürer made some drawings, which are interesting records of the skill he had acquired from his father, who "learned with the great masters" in the Netherlands. Significantly, Dürer's *œuvre* began with a self-portrait, done in the very difficult medium of silverpoint (Vienna, Albertina; recent dating, 1484; signed by the artist). A second drawing, undated, representing a young woman with a falcon (London, Br. Mus.), and a third, *Madonna with Musical Angels* (1485, pen; Berlin, Kupferstich-kabinett), reveal Netherlandish influence, especially that of Van der Weyden (q.v.), as well as acquaintance with the Rhenish art of Schongauer.

Before Dürer came into closer contact with Schongauer, however, he felt the influence of Nürnberg artistic tradition as reflected in the expressive and decorative style of his new teacher Michael Wolgemut. In Wolgemut's workshop he may also have been influenced by the perhaps more important, monumental and quiet tradition of Hans Pleydenwurff, a Nürnberg exponent of post-Eyckian Netherlandish painting, represented in the Augustiner Altarpiece (formerly called "Peringsdörffer Altarpiece") executed during the years of Dürer's apprenticeship (1486–89). Dürer's first essays in the field of landscape owe much to this Pleydenwurff tradition. They include water-color studies of the surroundings of Nürnberg (*Wire-drawing Mill*, Berlin, Kupferstichkabinett; *Cemetery of St. John's*, Bremen, Kunsthalle).

The goldsmith's training Dürer had received from his father was useful to him in becoming a designer for woodcuts, an important part of the activity of Wolgemut's workshop. It is possible that Dürer had a part, however small, in designing the woodcuts of H. Schedel's *Nürnberg Chronicle* published by Dürer's godfather Anton Koberger in 1493. Dürer may also have come in contact with another, simpler woodcut style, that represented by artists from Ulm workshops, then employed by Koberger. In the drawings he executed before he

left on his bachelor journey the influences of the Housebook Master are apparent in Dürer's great interest in the picturesque, lively representation of life and in the creation of immediate emotional appeal.

When Dürer left Nürnberg in the spring of 1490, he probably intended to visit the Netherlands, the most important artistic center in northern Europe. We have no record of such a visit but many stylistic similarities to the art of Geertgen tot Sint Jans (spatial concepts) and Dirk Bouts (interior design) lead us to think that Dürer's first venture abroad brought him to the country where his father had received instruction from the great masters. In Colmar, where he went in 1492, Schongauer and the Housebook Master were undoubtedly two attractions for the young artist. As Schongauer had died, Dürer continued his journey to Basel. During his stay, having made many contacts in artistic and literary circles, he developed an important and considerable graphic activity, the precise character and scope of which is still a matter of discussion. There is only one woodcut from this period which can be ascribed to Dürer with a great degree of probability because of the artist's inscription on the original wooden block: *St. Jerome Curing the Lion* (the title page of *Epistolare beati Hieronymi*, Basel, 1492). This woodcut (evidently very successful, as it was copied 12 times for subsequent editions) shows, in the rendering of the interior, of the still life, and of the diversity of textures and materials, Dürer's efforts to learn from the early Netherlandish masters. At the same time his own graphic style, a fusion of Wolgemut's pictorial illusionism and of "Ulmian" simplicity, is expressed. Also evident in the studies drawn from life at this time is his passionate desire to give the most accurate representation possible of the different objects appearing in the pictorial space, with great emphasis on the diversity of their character and texture.

There have been many theories regarding Dürer's execution of woodcuts illustrating books which appeared in Basel at the time he was there. Many art historians could not believe that Dürer, still a very young master on his bachelor journey, would have developed so intense a productivity in the graphic arts. Flechsig, Geisberg, and Röttinger, in different degrees, denied Dürer's authorship of woodcuts in Basel publications and created the rather short-lived myth of an unknown important master. Meder, Musper, Panofsky, and especially F. Winkler now agree on the much sounder theory that Dürer himself was responsible for these graphic works in Basel. He took part in the important, though unfinished, preparation of the Terence edition by Johannes Amerbach. Of the work done for that purpose we know 124 drawings preserved on the uncut, whitened wooden blocks, as well as some cut-out blocks and some prints from lost blocks (Basel, Öffentliche Kunstsammlung). These drawings, owing to their function, are repetitions probably made by the artist himself after his original designs and represent a very lively, free, and almost grotesque style. Very important also is Dürer's considerable share in two other Basel editions: *Ritter vom Turn von den Exempeln der Gotsforcht und Erberkeit* (Michael Furter and Johann Bergmann von Olpe, Basel, 1493), in which four-fifths of the 45 woodcuts can be considered Dürer's or after his designs and the rest show evident marks of Dürer's influence; and second, Sebastian Brandt's *Das Narrenschyff* (Johann Bergmann von Olpe, Basel, 1494), in which about one-third of the 106 woodcuts may be attributed to Dürer. His share in the *Narrenschyff* was not so great owing to his departure from Basel in the autumn of 1493. These woodcuts, as well as two works done in Strasbourg, *Crucifixion with the Virgin Mary and St. John* (from *Opus Speciale Missarum*, published by Grüninger and Prüss in 1493 at Strasbourg) and the title page of *Gerson's Opera* (issued at Strasbourg from 1494 on, by M. Flach the Younger) with Jean Charlier de Gerson as Pilgrim — attributed to Dürer by Musper and Winkler, though Panofsky considers it an attempt by an anonymous artist to modernize the old woodcut following Dürer's style — already contain many motifs of Dürer's later work and show him to be an extremely lively artist with great interest in the portrayal of daily life.

In Dürer's years of travel he executed many drawings, including the *Wise Virgin* (1493, pen; Vienna, Albertina), the two Holy Families (pen; Erlangen, Universitätsbib.; Berlin, Kupferstichkabinett), and the *Young Couple Taking a Walk* (pen; Hamburg, Kunsthalle). In these drawings can be discerned the influence of Schongauer's precise craftsmanship as well as Dürer's desire to follow the Housebook Master's free imagination. Among the drawings made at that time are two self-portraits (pen; Erlangen, Universitätsbib., 1493, and New York, Lehman Coll.). Dürer revealed a sharp and direct observation of himself in his first painted self-portrait (1493), the magnificent picture in the Louvre showing the artist with the eryngium, a plant with traditional amorous significance. The picture may have had reference to Dürer's coming engagement and marriage. The youthful artist is seen in a meditative pose and seems to contemplate with calm seriousness the life before him, confident not only of his own genius but of the favorable verdict of heaven, if we are to judge by the inscription above his head: "My affairs will go as ordained on high" ("*Myn sach dy gat als es oben schtat*").

In 1494, after his return to Nürnberg and his marriage, Dürer again set off for Italy in the autumn. Contact with and reaction to Italian art constitute the main theme in Dürer's thought and creative work. Dürer's interest, not only in Renaissance form, but also in the Humanistic content and subject matter of Italian Quattrocento works, was awakened shortly before his departure for Italy and was probably the most important factor directing him southward. It is difficult to judge whether some of the copies Dürer made of Italian prints were executed before his Italian trip or in Venice. However, all these drawings are of the utmost importance in that they show how Dürer was able to translate the severe and sculptural idiom of Andrea Mantegna into his own lyrical, lively, and free draftsmanship and at the same time to catch the ephemeral "Giorgionesque" mood suggested by Poliziano's *Stanze* in the beautiful *Abduction of Europa* (pen; Vienna, Albertina).

Dürer's Italian visit, lasting until spring, 1495, was limited to Venice and its surroundings (Padua and Mantua), although it has also been argued, probably wrongly, that he went as far as Rome (Rupprich).

Dürer must have been profoundly impressed to find himself in a country where the arts had undergone their "Wiedererwachsung," as he expressed it. We have no record of his thoughts on his first sojourn in Italy, but perhaps it was an even greater experience for him than his second visit in 1505–07 (fully documented in his correspondence). Dürer was susceptible not only to the classical beauty of the human form revealed to him by Italian works of art but also to their expressiveness and emotional values. He copied the works of Pollaiuolo, Mantegna, Credi, and above all, Bellini; and even when confronted with the difficult task of giving form to a myth or allegory known only in inferior works of art he could create scenes imbued with true Renaissance feeling for classical pathos and harmony (e.g., *Death of Orpheus*, 1494, pen; Hamburg, Kunsthalle).

"It is almost a miracle, that an artist educated in the tradition of Wolgemut, the Housebook Master, and Schongauer could capture the spirit of Antiquity. But he did not even have direct access to its material remains. So far as we know he never copied a classical statue or relief, but approached the originals only through the intermediary of Italian prints and drawings." His interpretations, nevertheless, though "two steps removed from the originals," are sometimes "more classical in spirit than were his direct Italian sources" (Panofsky).

In Venice Dürer's interest in art theory was stimulated and flourished especially after his second visit there. His first drawings of the nude show that his interest in the problem of proportion, however, dates from the months of his first Venetian sojourn (the *Nude Woman Seen from the Back*, 1495, brush and pen; Paris, Louvre).

But theoretical pursuits and the strong appeal of classical art, of the works of Venetian painters, and of the followers of Leonardo da Vinci did not dispel Dürer's lifelong interest in nature. Along with Venetian *gentildonne*, strange and picturesque animals, and the splendid heads of St. Mark's lions, his drawings include beautiful landscapes he had seen when he crossed

the Alps. In comparison to his first efforts in portraying scenes near Nürnberg, these Alpine drawings (executed principally on his way home, in the spring of 1495) possess quite a new unity and astonishing directness (e.g., the *Pass in the Alps*, water color; Madrid, Escorial). They range from topographical views, such as *The Castle of Trent* (water color; London, Br. Mus.), to the most impressionistic scenes, such as the famous *Wehlsch Pirg* (water color and gouache; Oxford, Ashmolean Mus.). The same new attitude toward nature reveals itself in the timeless, poetic, and almost incredibly "modern" water colors Dürer made when he returned to Nürnberg. These studies manifest a strong and refined feeling for nature as well as a marked tendency toward the expressive value of color (*Nürnberg from the West*, Bremen, Kunsthalle; *House on an Island in a Pond*, London, Br. Mus.), which was to burst forth in the dramatic visions of the *Apocalypse*.

The *Apocalypse*, a cycle of 15 woodcuts published with a German as well as a Latin text in 1498, is one of the greatest achievements of all German art; it is one of Dürer's masterpieces. Its greatness lies both in its theme, reflecting the social and religious spirit in Germany at the end of the 15th century, and in Dürer's masterly synthesis of German graphic tradition and Italian dramatic formulas. Under Dürer's knife the technique of woodcutting had lost its primitive roughness. He adapted Schongauer's flexible, long lines of engraving to the new needs of the woodcut. This perfect application of technique and artistic form to the requirements of the subject matter enabled Dürer to create the unique work he called *Apocalipsis cum figuris*. The cycle was not destined "for a few collectors and for the shelves of print shops, but for the low rooms of the burghers in German towns, for the workshops of craftsmen and of artists" (Waetzoldt). Dürer wished to impress princes and bishops, to move the imagination of Humanists, to force aristocrats and merchants to meditation. Even the size of the *Apocalypse* woodcuts is unusual: "they are big for speaking as loud as possible."

It was not difficult to find an audience in those dramatic times. In the years of the outbreak of the Reformation religious and social conflicts arose in the towns and villages of Germany, creating an atmosphere of hysteria and an expectation of great, necessary, and violent changes. Dürer's work was a response, as it were, to this state of mind.

One of the first woodcuts of the *Apocalypse*, the *St. John before God and the Elders*, gives us the key of the whole work. In the lower zone a beautiful German landscape of mountains, forests, rivers, and castles is represented; above the peaceful countryside, in a Romanesque tympanum, is a vision of St. John kneeling before God, between the towering clouds. Around the apparition of God surrounded by the Elders flames explode, separating the vision from the quiet and silence of nature below.

Dürer achieved great intensity in the *Apocalypse* by mingling elements of reality and imagination. The visions are shown with unusual force in contrast to the real world existing in pictorial three-dimensional space. "It was thanks to Mantegna or rather to classical models, transmitted through him and his followers, that Dürer was able to 'realize' the visions of St. John without destroying their fantasmagoric quality" (Panofsky). To achieve a strong and unified effect Dürer compressed the long narrative into 14 plates (the fifteenth, in reality the first one, represents the *Martyrdom of St. John*). The *Apocalypse* is revealed in 14 scenic episodes, each of which can stand alone, but together they compose a powerful polyphonic unity. Perhaps Thomas Mann in *Doctor Faustus* showed a feeling for this musical quality of Dürer's work when he had Adrian Leverkühn write an oratorio called *Apocalypsis cum figuris*.

"And there was war in heaven. Michael and his angels fought against the dragon; and the dragon fought and his angels" (Rev. 12: 7). The image of this duel of the forces of good and evil created by Dürer belongs to works of art that cannot be forgotten: "To represent this great moment Dürer discarded all the traditional poses that had been used time and again to represent, with a show of elegance and ease, a hero's fight against a mortal enemy. Dürer's St. Michael does not strike any pose. He is in deadly earnest. He uses both hands in a mighty effort to thrust his huge spear into the dragon's throat, and this powerful gesture dominates the scene. Round him there are the hosts of other warring angels fighting as swordsmen and archers against the fiendish monsters, whose fantastic appearance defies description. Beneath this celestial battlefield there lies a landscape untroubled and serene" (Gombrich). But disasters are coming to the earth with the opening of the fifth and sixth seals, and the cosmic catastrophe is powerfully depicted by the young artist. The most famous woodcut is that of the *Four Horsemen*: three of them gallop trampling upon whomever they meet whether emperor or peasant, bishop or beggar. The fourth horseman, Death with a pitchfork, rides gathering his prey.

St. John's Apocalypse may have been directed against the Roman empire and its corruption; it heralded a new epoch and a triumph of Christianity. Dürer adopted an analogous idea on the eve of the Reformation, creating in his art "a sermon of Luther's depth and eloquence" (PL. 467). One of the woodcuts shows the Babylonian Whore riding on a monstrous seven-headed beast. Max Dvořák interprets the seven heads of the beast as representing the seven hills of Rome; the whore dressed in the low-cut gown of an Italian courtesan represents the papacy. In front of the impure woman, instead of St. John, who is the beholder of visions in the other woodcuts of the cycle, stands a group of men, "deceived and lost mankind shown in the representatives of all the social orders, ecclesiastical and secular" seen by Dürer "as having just stepped out of Nürnberg" (Waetzoldt). Only the monk kneels before the "Roman whore"; other members of the group stand unyieldingly. From the heavens punishment already threatens: angels bring a millstone and fire to burn the sinful Babylon. Far off, seen through the clouds, gallops the rescuing army.

The last scene of the *Apocalypse* represents the day of peace on earth and in heaven (*The Angel with the Key of the Bottomless Pit*): the devil is thrust into the pit, the angel shows the Evangelist not Jerusalem, the "Civitas Dei" (as in the text of Revelation), but an earthly paradise, a beautiful German city, protected by the angel of peace. (Such is the interpretation of Max Dvořák, which, however, is not accepted by all Dürer students.)

Research indicates that Dürer used traditional iconographic patterns for the elements of his *Apocalypse* woodcuts (Neuss, Heydenreich, Schmidt, Panofsky, Marx). But even with these evident borrowings, this grandiose work is utterly original when compared with the achievements in graphic arts before Dürer. To be sure, the vast panoramic landscapes constituting the scenery of that "gigantomachy" can be traced to Netherlandish art; the violent expressive formulas, the tragic masks of despair, and the eloquent gestures of the fighting protagonists find their prototypes in the artistic language of Mantegna and other Italian Quattrocento artists (and their origin in the art of Greek antiquity). But the great talent of a unique artist harmonized these different voices with an ardor that touched the depths of the human conscience.

All the other religious woodcut cycles made by Dürer, *The Large Passion* (begun before 1500, pub. 1511), *The Small Passion* (1509–11), *The Life of the Virgin* (1500–11), and *The Engraved Passion* (copper, 1507–13) fulfilled the same function and served the same ideas: they interpreted the Gospel in a new way and brought it to the people in a human and comprehensible form, according to the principles of Renaissance realism. Many European artists both famous and obscure were profoundly impressed with the "language" of Dürer.

It is no wonder, therefore, that in the *Self-portrait* (Madrid, Prado; PL. 292), painted in 1498, the year of the publication of the *Apocalypse*, Dürer showed himself in the figure of a young conquistador. It was probably the first self-portrait painted without any utilitarian aim. The artist wrote on the panel: "I made this according to my appearance, when I was 26." It is the portrait of an elegant and refined gentleman whose social status has changed immensely in relation to that of his father or of his master Wolgemut. We notice no professional attribute: Dürer did not wish to show the pencil and easel associated with an artist's manual activity. In the struggle

being waged (in Italy, too, e.g., in Leonardo da Vinci's *Paragone*) to win a new social position for artists Dürer played a role. He portrayed himself as a young Humanist, the sure, unyielding glance and the powerful gesture of the joined hands suggesting that the man represented was something more than a dilettante. The social advance of the artist consisted in the profound transformation of his own consciousness. His clothing and his gestures express his new inner attitude and his new *Weltanschauung*. Dürer expressed these ideas when he wrote: "There were many talented youths in our German countries who were taught the art of painting but without fundamentals and with daily practice only. They grew up, therefore, unconscious as a wild uncut tree." They were inferior to the Italians who had "rediscoverd 200 years ago the art revered by the Greeks and Romans and forgotten for a thousand years." These words show clearly that Dürer was conscious of the fundamental differences between the attitudes of the artist in Italy and the artist in the north. But his longing for the new art was still not expressed in his painting, except in the Madrid self-portrait.

He executed some altarpieces with the help of assistants: *Mater Dolorosa* surrounded by the Seven Sorrows of the Virgin (1496-97, Munich, Alte Pin., and Dresden, Gemäldegal.); *The Dresden Altarpiece*, Madonna Adoring the Infant Jesus, with SS. Anthony and Sebastian (center, 1496-97, wings, 1503-4; Dresden, Gemäldegal.); *Lamentation of Christ* (ca. 1500, Munich, Alte Pin.); and some portraits, including *Frederick the Wise* (canvas; ca. 1496, Berlin, Staat. Mus.); *The Father of the Artist*, known from a replica (1497, London, Nat. Gall.); the so-called "Fürlegerin," known from two replicas (1497, Lützschena, Germany, Coll. Speck von Sternburg; Frankfurt, Städel Inst.); three Tucher portraits (1499, Weimar, Schlossmuseum, and Kassel, Staatliche Gemäldegalerie); and *Oswolt Krell* (1499, Munich, Alte Pin.).

While his religious feelings were expressed in woodcuts, his intellectual and Humanist interests found expression in engravings. The specific technical character of the engraving and the subtlety of the cut required a great deal of the artist's personal attention, which was not necessary in producing woodcuts, because a specialist cutter executed the technical part of the process. Engraving therefore became Dürer's particularly personal artistic medium. The most complicated, "never-thought-of" themes, as he puts it, drawn from mythology or literature, symbolic and allegorical compositions containing erudite allusions, sometimes extremely difficult to understand today, were all expressed in Dürer's engravings. Interested in the observation of nature and life, he often portrayed simple genre scenes: peasants, lansquenets, Turks, which he treated with emphasis on characteristic traits. These scenes show Dürer's curiosity regarding people "exotic" to him, in the literal or in the social sense.

In his portraits, drawn or engraved, we meet an entire gallery of his Humanist friends, dominated by the powerful figure of Willibald Pirckheimer. Dürer portrayed his famous contemporaries mostly during his stay in the Netherlands in 1520-21. For them he also engraved learned and beautiful allegorical compositions in which the female nude for the first time in northern art shone with all its sensuous charm.

It took some time for Dürer to find courage to introduce nudes into printed art. One of the most beautiful of his early drawings, the *Abduction of Europa* (of which he never made a print), shows how closely Dürer approached the same idea of antiquity as that of Raphael, Giorgione, and Titian. Dürer's *Europa* is a typical Renaissance (rather than medieval) work, in that a classical theme is shown in classical form. It was not until the period of the Italian Renaissance that the integration of classical themes with classical formal motifs was reestablished and the emotional values of classical art were discovered (Panofsky). The notion of beauty was associated once more with the sensual perfection of the body. The *Europa* is beautiful in this respect.

Between 1495 and 1500 Dürer made a number of engravings in which he used the classical nude, but before about 1505 "classical nudity seemed to require a safe conduct to pass the barriers of medieval prejudices; it seemed acceptable only when made subservient to an idea of nonclassical and preferably moralistic character" (Panofsky). Among the moralistic or allegorical engravings of that time are *The Four Witches* (1497), the magic content of which is not even now clearly understood; and *The Dream of the Doctor* (after 1497), interpreted by Panofsky as the temptation of the idler by a beautiful nude (Venus) instigated by the devil, who is seen in the background. Also moralistic is the content of the print known as *Hercules* (1498), a new interpretation of the allegory of Hercules at the crossroads; in Dürer's work the representatives of the two ways of life not only present their arguments to the hero, but fight a real battle, with Hercules trying to be neutral and to end the fighting. Another engraving with the nude as a central motif is the *Sea Monster* (ca. 1498), whose theme, although akin to the *Abduction of Europa*, is unknown to classical literature and may have some link with adventure narratives.

Not only classical erudition, but the world of fantasy, always so attractive to Dürer, found expression in his subtle and refined copper engravings. Every time he undertook to interpret even a popular theme in an unusual or personal way, Dürer used the technique of engraving. One of Dürer's most popular prints, *The Prodigal Son* (ca. 1496; PL. 297) is an engraving. There were different approaches to this theme in the history of art, and one of the most frequent was the representation of the reconciliation between the father and his son, as in Rembrandt's Leningrad version. Flemish and Dutch painters of the 16th and 17th centuries chose to represent the genre side of the story by showing the prodigal son amid courtesans. Dürer has united in his work the psychological approach characteristic of Rembrandt and genre scenery. The representation of the miserable man kneeling before the swine trough underlines the genre character of the picture and heightens the psychological appeal and tragic pathos of the scene. Dürer has not chosen the moment of luxury and sin or the moment of repentance and reconciliation but the most significant part of the story — when the son in his great humiliation becomes conscious of his sinful life.

From the religious visions of the *Apocalypse* to the genre studies of peasants, and from the complicated allegories suggested by Dürer's Humanist friends to a simple but moving rendition of the Biblical story, Dürer was master of the worlds of fantasy and reality. This justified his pose in the Madrid self-portrait as the young intellectual conqueror of the world. But there was no pride in him. He was always a humble Christian. "The Genius of the artist comes from God," Dürer noted, and the idea of an artist expressing God's will, imitating God, and to some degree, in a mystical way, identifying himself with God gave birth to the strangest self-portrait Dürer ever painted (1500, Münich, Alte Pin.), in which the artist "styled himself into the likeness of the Saviour." This literal interpretation of the idea of *imitatio Christi*, however, was not so rare at that time. It found realization not only in art but in political and religious life; for example, Luther's deeds and destiny were compared to those of Christ (Bainton). More than twenty years later Dürer expressed this idea once more, representing his own body, emaciated after an illness, in the iconographic scheme, with the attributes of the Man of Sorrows (1522, Bremen, Kunsthalle).

The German Humanist and reformer Philipp Melanchthon, one of Dürer's friends, relates that the artist, in his old age said: "When I was young, I craved variety and novelty; now in my old age, I have begun to see the native countenance of nature and come to understand that this simplicity is the ultimate goal of art." Although this was said at the end of Dürer's life, the evolution of his art from the "brain-confusing" fantasmagorias of the *Apocalypse* (to use Goethe's words) to simple and harmonious compositions began even before Dürer reached his 30th year.

About 1500 Dürer's interest in the rational foundations of art awoke. From his first sojourn in Italy he brought home the conviction that theoretical knowledge is indispensable for artistic creation. Now this conviction bore fruit in the form of Dürer's growing interest in the theories of perspective and

of proportion. In these interests Dürer was probably helped by the Venetian artist Jacopo de' Barbari, whom he met in Venice in 1494-95 or in Germany in 1500. He must have seen in about 1503 the theoretical drawings of Leonardo da Vinci, or more probably, studies made after these drawings.

Between 1502 and 1504 he painted an altarpiece, ordered by the Paumgärtner family (München, Alte Pin.). In this work, the central panel of which represents the Nativity (PL. 299) and the wings, St. George and St. Eustace, he confronted the same artistic problems as he did in his engravings of that time — questions of perspective and proportion. *Nemesis* (1501-02) and the *Fall of Man* (1504) are studies of human proportions; *The Nativity* (1504) shows the same perspective construction as the central panel of the Paumgärtner Altarpiece. This picture is linked to the traditional "picturesque" late-Gothic conception of the Adoration of the Infant, developed in German and Netherlandish art of the 15th century; but here the picturesque quality of the ruined stable is rationalized in the precise order of the perspective. The wings of the altarpiece show saints on a neutral, plain background; the warrior saints are conceived as portraits of the Nürnberg patricians, Lucas and Stephan Paumgärtner, who commissioned the work and whose figures reflect Dürer's interest in proportion.

This concern for proportion is exceptional in his painting, as his theoretical interests were generally expressed in the graphic arts, and painting was not so important for Dürer in these years. His feeling for this medium changed on his second Italian journey, which led him to Venice. The city justly claimed to be one of the three artistic capitals of Italy, and its artists concentrated even more on painting than did the artists of Rome and Florence.

The plague, the direct cause of Dürer's departure for Italy, was depicted in one of his finest drawings, *Crowned Death on a Thin Horse* (1505, Br. Mus.; PL. 301), drawn in expressive, soft charcoal lines.

In Venice Dürer forgot this dreadful specter. He lived among nobles, princes, scholars, musicians; he was admired and loved by many men. Only the painters were hostile. As a painter he could not impress the contemporaries of Bellini and Giorgione; his prints were appreciated and imitated, but the paintings were judged to be better in design than in color. Giovanni Bellini was the only painter to speak well of Dürer: "He praised me much in the presence of many gentlemen. He wanted to have something of my work and came himself to me and begged me to make something for him — he said he would pay well," Dürer wrote to his friend Pirckheimer, from Venice. Wishing to perfect his painting in the atmosphere of the city of Giorgione and Titian, Dürer concentrated on the problems of brush and of color.

In Italy he painted his greatest work and, in terms of color, his most perfect picture. Ordered by the German merchant colony in Venice, it represents the *Feast of the Rose Garlands* (1506, Prague, Nat. Gall.; PL. 296) and was painted for St. Bartholomew's, the German church in Venice. The work was finished at the end of August or the beginning of September, 1506. His self-portrait appears in the landscape background with an inscription, "Exegit quinquemestri spatio Albertus Dürer Germanus." It is clear that the five months mentioned in the inscription must refer only to the actual painting; the period of preparation of both the wooden panel and the working drawings was longer. The present state of this work is unfortunately very poor, great damage having been caused by 17th- and 18th-century restorations. But even today "the solemn splendor of the southern town rests upon the picture" (M. J. Friedländler), and even in its present condition it can be considered the most successful of Dürer's paintings of this period. The Venetians were at last compelled to admit that they had seen no more beautiful colors; so, at least, Dürer wrote when relating his successes to Pirckheimer. Here he was, indeed, able to make his colors glow with Venetian fire and to grasp something of Bellini's monumental compositions. But in contrast to the Venetian *sacre conversazioni*, in which contemplation and silence or meditation and angelic music reigned in static, quiet, and solemn compositions, in Dürer's work there

is a fullness of life: the Virgin and the Infant distribute rose garlands to the joyful crowd, while flights of angels fill the air. But the large landscape vista and the background drapery held by the angels balance the movement in the pictorial space. Dürer knew how to join to southern richness and monumentality not only northern dynamism but also northern lyricism. *The Feast of the Rose Garlands* still has something of the German painting of Stephan Lochner (Panofsky); the lively movement is balanced by the solid triangular composition of the main group, whose severity is mellowed by the charming figure of a little angel derived directly from the "musical" pictures of Giovanni Bellini.

Not all the pictures painted in Venice show Dürer's development toward the classical style of the "ripe" Renaissance. This movement, however, manifests itself clearly in his portraits of that period. The Madrid self-portrait, already described, and other portraits of the early period have the sharpness of linear drawing typical of the young Dürer's painting; their modeling is hard and so justifies the opinion of Goethe, who, though he was an admirer of Dürer's work, spoke of his "wood-carved figures." Just after 1500 a greater softness appeared in the charcoal portrait drawings; the forms became less sharply detached from the surrounding atmosphere. The impression began to have greater importance than the form of the precisely drawn objects. In Venice the "sculptural" hardness in the modeling of heads disappeared. The young girl in Lombard costume (PL. 293) with the big, rectangular decolleté is painted with great subtlety in the rendering of light and of chiaroscuro effects (1505, Vienna, Kunsthist. Mus.). Simplicity unites here with a sense of the natural; the painter's eye catches the sculptural form of the head and facial expression, distinguishing the constant elements from those that change with the light, the mood, and the time.

A beautiful portrait painted in Venice shows an unknown man [Burcardus de Burcardis (?), 1506; Hampton Court, Royal Colls.], who appears also among those adoring the Virgin in *The Feast of the Rose Garlands*. "In this picture a solemn calm reigns, a restraint which emphasizes psychological characteristics giving expression to the man's character — a soft modeling, a lack of linear sharpness. The German, inspired, it seems, by the taste of Giovanni Bellini, has modulated his own style in this work, which does not impose itself and is closed in its own world" (M. J. Friedländer).

In his last letter written from Venice to Pirckheimer, Dürer said that, before setting off for Germany, he wished to go to Bologna, where someone had agreed to teach him the principles of the "secret" perspective. The second Venetian sojourn, the contact with Humanistic circles and with the world of learning and archaeology, excited Dürer's interest in theory and confirmed his belief in the rightness of his life's mission.

Theory in general and the problem of proportion in particular had already borne fruit before Dürer's departure to Venice; in his engraving *Adam and Eve* (PL. 301) the results of his studies of Vitruvius and of Italian works of art after famous classical sculptures are condensed and utilized. Adam was given the perfect form of the Apollo Belvedere, Eve appeared in the flesh of the Medici Venus. A subtle, clear modeling separates these figures, white as marble statues, from the darkness of the "Nordic" forest, full of animal and vegetable life. But the hard arrangement of figures, seen partly in front view, partly in profile, as well as the conventional *contrapposto* position, have deprived them of the appearance of reality.

Dürer's sojourn in Venice also brought about greater liberty and naturalness in his drawing of the human figure. The drawings which preceded the execution of the *Adam and Eve* (more correctly, *The Fall of Man*) of 1504 were constructed with the help of straight and curved lines. Now the drawings became more supple and flexible, the line suggesting rather than outlining the living and animated body (e.g., *Nude Woman Seen from the Back*, brush, heightened with white, on blue Venetian paper, 1506; Berlin, Kupferstichkabinett). The new idea of beauty appears also in another painted version of Adam and Eve (1507, Madrid, Prado; PL. 298). The figures are represented in movement, in a transitory moment; their proportions are more

slender than those in earlier works and show Dürer's esthetic liberality, his aversion to any dogma establishing rigid canons of beauty. The lines are fluid and without too great a precision; the gestures are somewhat nervous and shy. In comparison with the heroic and "Apollonic" beauty of the Adam and Eve engraved in 1504, the pictures painted in 1507 are conceived in terms of lyrical and "Dionysiac" beauty; it seems as if the severe, classical tendencies were softened by the influence of the "pictorial" Venetian manner of seeing.

For some years afterward Dürer concentrated on painting, creating among other things two altarpieces. The Heller Altarpiece, the central part of which was burnt in Münich in 1729 and is known only from a copy by Jobst Harrich (Frankfurt, Historisches Mus.), consisted of several panels, ordered in 1507 by Jacob Heller of Frankfurt; it was not finished until 1509. A long correspondence between Dürer and Heller, relating to the execution of this work, survives. The second, *The Adoration of the Trinity* (1511, Vienna, Kunsthist. Mus.), and a picture ordered by Frederick the Wise, *Martyrdom of the Ten Thousand* (1508, Vienna, Kunsthist. Mus.), although not lacking essential values, iconographical as well as artistic, constitute no further important step in Dürer's development as an artist. On the contrary, the dimmer Dürer's Venetian memories became, so the color of his works became less perfect, his manner of painting harder and more metallic. Gradually he returned to his native and thoroughly graphic way of seeing and thinking.

The creative activity of Dürer after his return from the second Italian journey can best be estimated from the development of his engraving. There are three engravings which mark the highest points of his graphic invention. They are the so-called "Master Engravings": *Knight, Death and the Devil* (1513; PL. 297), *St. Jerome in His Study* (1514), and *Melencolia I* (1514; III, PL. 203). In these scenes, larger in size than most of his engravings, Dürer epitomized his outlook on life and art. This triad contains allegories of virtue (according to the medieval classification) in three different spheres of activity. The *Knight* is an allegory of "the life of a Christian in the practical world of decision and action"; the *St. Jerome* shows the "life of the saint in the spiritual world of sacred contemplation"; the *Melencolia I* is an allegory of the intellectual life, "of the secular genius in the rational and imaginative worlds of science and art" (quoted from Panofsky, who refers to Lippmann). The *Knight* recalls two older graphic works of Dürer's: the *Battle of St. Michael* (*St. Michael Fighting the Dragon*) of the *Apocalypse* series and the *Fall of Man* engraving of 1504. The similarity with *St. Michael* is in content, since both prints depict forces of good and evil. The *Apocalypse* woodcut shows these forces in conflict; the *Knight* shows them in a state of tension. In the latter, the rider, resolute and noble, filled with an inner strength, like Verrocchio's *Colleoni*, rides forward in spite of the persistent interference of evil forces. In *The Fall of Man* the figures of Adam and Eve were conceived as models of formal, classical beauty placed in a northern, Gothic setting of wild, undisciplined nature. In the *Knight* these contrasting ideas were conceived as moral qualities: the classical rider, perfect in proportions, represents the value of Christian ethics; the "Gothic," rough, strange, wild world of nature and of materializing specters represents evil forces, opposing the clear forces of humanism and goodness.

The idea of the "Christian Knight," which Erasmus of Rotterdam had expressed some years earlier in his treatise *Enchiridion militis Christiani* (Handbook of the Christian Soldier), Dürer transformed and gave a general human significance. "The *St. Jerome* differs from the *Knight, Death and Devil* in that it opposes the ideal of the *vita contemplativa* to that of the *vita attiva*" (Panofsky). Everything is pleasant in the cell of the learned man. The mathematical perspective, the orderly placing of objects in the room, reflect the order of the mind in concentration and create an atmosphere of peace and intimacy, guarded by the lion at the threshold. The brightness and warmth of the room's physical light symbolizes "the spiritual light of contemplation," in which St. Jerome seems bathed.

The third "master engraving," the *Melencolia*, is the most famous. To the *St. Jerome* it offers a contrast too perfect to be accidental. While St. Jerome is comfortably installed at his writing desk, the winged Melencolia sits in a crouching position on a low slab of stone by an unfinished building. While the saint is secluded in his warm, sunlit study, she is placed in a chilly and lonely spot not far from the sea, dimly illuminated by the light of the moon — inferred from the cast shadow of the hourglass on the wall — and by the lurid gleam of a comet encircled by a lunar rainbow. While he shares his cell with his contented, well-fed animals, she is accompanied by a morose little putto who, perched on a disused grindstone, scribbles something on a slate, and by a half-starved, shivering hound. And while the saint is serenely absorbed in his theological work, she has lapsed into a state of gloomy inaction (Panofsky). The coldness, helplessness, and despair of this evocative image take possession of the mind. The strange gathering of objects under a gloomy sky full of dreadful signs, the helpless being, conscious of her weakness, create a mood which invades the soul of the beholder. *Melencolia I* is a poem in honor of a man in whose breast contradictory forces conflict; it is an image of the genius, who must incessantly choose "to be or not to be." Every action, every endeavor is annihilated in its very origin by the critical analysis of the consciousness. The silvery gray of the metallic surface of the print shines with a dull, faint brightness. In the sky a bat carries a banner with the gloomy word "Melencolia." All this is seen immediately. The first impression is enriched, however, by an analysis of the symbolism of the elements represented in the engraving. Hundreds of pages have been written in an attempt to penetrate the mystery of its meaning.

In this engraving two traditions can be discerned: The first is that of the pictorial representation of Melancholy as one of the so-called "four temperaments," associated in antiquity, in the Middle Ages, and in the Renaissance with the influence of the planets upon human life (see CHARACTERIZATION; ASTRONOMY AND ASTROLOGY; HUMAN FIGURE). The second tradition in which the content of Dürer's *Melencolia* is rooted is that of the representation of Geometry as one of the liberal arts, an art which includes the several human activities founded on mathematics. Dürer "depicted a Geometry gone melancholy or, to put it in another way, a Melancholy gifted with all that is implied in the word geometry, in short, a *Melancholia artificialis* or Artist's Melancholy" (Panofsky). The sad and beautiful genius, therefore, sits inert among scattered geometrical instruments. "The mature and learned Melencolia typifies theoretical Insight which thinks but cannot act. The ignorant infant, making meaningless scrawls on his slate and almost conveying the impression of blindness, typifies Practical Skill which acts but cannot think.... Theory and practice are thus not together, as Dürer demands in his theoretical writings, but thoroughly disunited; and the result is impotence and gloom" (Panofsky).

This beautiful engraving is so profound in its content that it is most probably based on a personal experience of the artist. He made the print in 1514. At this time Dürer passed through a period of skepticism and doubt concerning the existence of objective laws of artistic creation. He aimed at the ideal harmony of classical art, but he knew — and this thought never occurred to the Italians at that time — that the existence of other valid means of artistic expression had enabled him to create the profound and moving visions of the *Apocalypse*. "The lie is in our understanding, and darkness is so firmly entrenched in our minds that even our groping will fail," Dürer wrote at that time. But he fought against skepticism: "Now, since we cannot attain the very best, shall we give up our research altogether? This beastly thought we do not accept. For, men having good and bad before them, it behooves a reasonable human being to concentrate on the better." In Dürer's art theory the notion of genius appeared, of the gift which gives creative activity to the artist. Thus the idea that art can be learned from rules rationally compiled was modified by the acknowledgement of the value of artistic genius.

The execution of complicated works, hardly intelligible to anyone but Humanist erudites, did not prevent Dürer from

recording his more simple and direct experience of the world and of human life. In spite of its almost hieroglyphic richness of detail, Dürer knew how to imbue the *Melencolia* with a mood communicable to the beholder. He was even better able to do this when his art reflected a simple and moving experience, as it did in the dramatic drawing Dürer made of his mother (PL. 302) two months before her death (1514; Berlin, Kupferstichkabinett). The *Melencholia* demonstrates the artist's ability to give to struggling ideas and thoughts a concrete shape imbued with mood; this portrait shows his simplicity and ardent emotion. Soft lines of charcoal mark the shape of the meager face and model the sunken cheeks, but these lines become hard in describing sharply the narrow, long nose, pitiless in rendering the system of bones and tendons under the thin parchment of the skin, in drawing the lined forehead and the eyes gazing emptily into space. Strange, indeed, in this drawing is the union of unyielding realism and a son's tenderness.

The years following the execution of the three engraving masterpieces constitute the most "secular" period in Dürer's work, when he served Maximilian I, whose passion for Humanism and whose Renaissance ambitions were expressed by patronizing numerous artistic enterprises. Dürer, with other German artists, participated in these undertakings (some of which were managed by Pirckheimer), which helped to elaborate his new style, ornamental and flat, wherein late Gothic traditions were united with the elements of the Italian Renaissance. He cooperated in the execution of the gigantic woodcut *The Triumphal Arch of Maximilian I* (1515–17) and of its "dynamic" counterpart, *The Triumphal Procession of Maximilian I*, which was not finished because of the death of Maximilian in 1519. Dürer also made for the Emperor a prayer book, decorated with 45 marginal colored-ink drawings and prepared according to Maximilian's ideas. It was first printed in 1513 in Augsburg. The pen illustrations of the prayer book (1515; Munich, Staatsbib.) were probably intended as models for woodcuts to be printed in color, while the complete prayer book, the text of which was set in deliberately archaic type, may have been intended as an imitation of the Books of Hours of the 14th and 15th centuries. The Emperor's death and the interruption of this work indirectly brought about an important event in the artist's life: his trip to the Netherlands to obtain from the new sovereign, Charles V, confirmation of the yearly salary of 100 florins allotted to him by Maximilian I.

During the period of his work for Maximilian, Dürer developed his tendency to a decorative, flat treatment of forms and objects, apparent in pictures done at that period (e.g., *SS. Philip and James*, 1516; Florence, Uffizi) and in six of his etchings executed in the years 1515–18 (e.g., *The Desperate Man*, ca. 1514–15; *The Sudarium*, 1516). Dürer's ornamental style influenced German graphic arts, handicrafts, and decorations of the 16th century. His influence increased from year to year, spread beyond Germany, and dominated all Europe.

Dürer discovered this himself when, after a journey of less than a month, he entered Antwerp. "On Sunday, on the day of St. Oswald the painters invited me together with my wife and my servant to the room of their guild," Dürer wrote in his journal, where lists of his expenses and sums earned alternated with autobiographical and tourist notes. "Their vessels were all made of silver or were otherwise richly decorated and the food was excellent. All their wives were present too. And as I was led to the table the crowd stood on both sides as though I were a great lord. There were even some distinguished persons, whose names are well known, and they all bowed to me with the greatest respect and said that they would like to do all they could, according to my wishes. And as I sat there with honors, in came the city clerk of Antwerp with two servants and gave me four carafes of wine in the name of the councillors who told me that they wanted to honor me in this way and to show their good will. Afterwards came Master Peter, the City's engineer, and gave me two carafes of wine with his most courteous compliments. We thus made merry together and late at night they saw us home in state with torchlights and told me to be sure of their good will and that they would be glad to help me in anything."

The Netherlands visit of nearly a year was a period of success and satisfaction. Dürer was entertained by princes and saw the most famous works of the "old masters," Jan van Eyck, Rogier van der Weyden, Hugo van der Goes, and Michelangelo "from Rome." It was at a church in Bruges that he saw Michelangelo's beautiful, classical, marble Madonna. He made friends with "a good landscape painter," Joachim Patinir. He grew friendly also with the gifted young Lucas van Leyden; with Conrad Meit, an excellent sculptor; with the painter Provost; and with Dirk Vellert, who painted on glass.

Studies and sketches of people and things seen fill his sketchbook (*The Silverpoint Sketchbook of the Journey to the Netherlands*, 1520–21), from which 27 drawings are preserved in various collections. Among the landscapes and architectural views are the best drawings of the kind that he ever did. In his drawing *The Antwerp Harbor* (1520, pen; Vienna, Albertina) he finally reached a total unity of landscape conception such as he had never before attained. Portraits done in the Netherlands are among the most interesting in his artistic production. He drew merchants, kings, and Humanists, his new Flemish friends, and the greatest men of that time. He made a portrait drawing of Erasmus of Rotterdam (1520, charcoal; Paris, Louvre), whose engraved effigy he later executed (the engraving is dated 1526; PL. 301). Well satisfied with his travels, he returned home. His mind, however, was not serene and quiet. Maximilian's death and the explosion of the Reformation at the end of the second decade of the 16th century meant the end of an epoch. "Dürer is in bad shape," Pirckheimer noted soon after the Emperor's death.

At the end of Dürer's service for Maximilian, a period during which he had been able to concentrate solely on the problems of form, the uncertainty and anxiety that many years before had inspired the *Melencolia* returned. In the Reformation Dürer did not hesitate to take Luther's part against the "Roman Babylon" whose decline he had prophesied with a youthful passion in his woodcuts of the *Apocalypse*.

In his work he concentrated on matters he considered most important: theoretical works (the publication of which he felt to be his duty toward German art and artists); and "Protestant" subjects, treated in a very severe style, in which, profoundly inspired, he attained a monumental grandeur. The violent strength of his religious experience was expressed in the last drawings of the dramatic scenes of the Passion (so-called "Oblong Passion," in 10 drawings, 1520–24; *The Bearing of the Cross*, 1520, pen, Florence, Uffizi; and *The Agony in the Garden*, 1521, pen, Frankfurt, Städel Inst.). The tragic expression is controlled by a severe composition; Dürer was influenced by the classical Andrea Mantegna.

His stay in the Netherlands only partly distracted his thoughts from essential questions. Antwerp was no quieter than the German towns. In Brussels he met Erasmus of Rotterdam, and this learned man became a second Luther to him. He put all his hopes in Erasmus when he received the false news of Luther's murder. The explosion of his feelings in the otherwise quiet tenor of his travel journal shows his immense anxiety. "O, God, never was any people so burdened by the human laws as we, miserable under the Roman throne . . . . O, God, if Luther is dead, who shall henceforth so clearly expound to us the Holy Gospels? . . . . O all ye pious Christians, help me to weep over this God-illuminated man and beg Him to send us another enlightened one. O Erasme Roderodame, where wilt thou take thy stand? . . . Thou art but an old man; I have heard that thou givest thyself no more than two years in which to accomplish something good. Use these well, for the benefit of the Gospels and the true Christian faith and let thy voice be heard and then the Gates of Hell, the Roman See, as Christ has said, will not prevail against thee . . . ."

It was Dürer himself, however, who created an ideal of strength and zeal in the Reformation struggle. In his last big work, the monumental panels of the so-called "Four Apostles" (1526; Munich, Alte Pin.), the immobile dignity of the figures placed in an undefined and shallow space is animated only by the vigor of their expression. The effect of sculptural masses is achieved by the use of color. The hue of St. John's clothes

"is a rather warm red. St. Paul's cold white is still further cooled by a greenish-gray shade" (Wölfflin). Monumental and realistic, like the work of the anonymous Naumburg Master, the figures of the apostles differ in their expression, age, psychological type, and character: the young contemplative St. John, the manly, unyielding Paul, the vehement Mark, the aged, weary Peter. The traditional title of "Four Apostles" is not fully justified; the left panel represents SS. John and Peter (PL. 300), the right one SS. Mark and Paul, who were not apostles. The four saints were probably to constitute the wings of a triptych on which Dürer worked for a long time after his return to Nürnberg. The central panel was intended to be a kind of *sacra conversazione* uniting characteristics of Venetian style with the Netherlandish influence of David or Metsys (e.g., pen drawings, 1521, Chantilly, France, Musée Condé; 1521, Paris, Louvre; and others). This picture was never painted; only the wings were completed. In 1526, two years before his death, Dürer presented the "Four Apostles" to the council of his native town.

It has been thought recently that the panels could have been conceived as wings to be attached to the chancel. Thus the theme of the Divine Word would constitute the iconographic scheme, a procedure allegedly used in Protestant churches (Lankheit). This hypothesis, however, cannot be proved. "The Four Apostles" became Dürer's symbolic testament which he wanted to be interpreted in a specific way. Therefore he placed in the lower part of the composition inscriptions containing quotations from the writings of the saints represented: "But there were false prophets also among the people, even as there shall be false teachers among you, who privily shall bring in damnable heresies..." (II Pet. 2:2). "Because many false prophets are gone out into the world" (I John 4:1). "This know also, that in the last days perilous times shall come. For men shall be lovers of their own selves, covetous, boasters, proud, blasphemers.... Having a form of godliness but denying the power thereof: from such turn away" (II Tim. 3:1–5). "And he said unto them in his doctrine, Beware of the scribes, which love to go in long clothing, and love salutations in the market places, And the chief sits in the synagogues, and the uppermost rooms at feasts..." (Mark 12:38–39). The accusation that the painting proclaims is directed against "false prophets," specifically the Roman Church. But the appeal of this painting lies elsewhere: in 1525 the Nürnberg council had already "dismissed the Pope," and Protestantism was victorious in that town. (Perhaps another reason for dropping the central panel was that the representation of the Virgin was not favored by Luther's followers.) The pictures of the apostles proclaim the unity of the new faith, its subordination to Luther's doctrine against the other reformers, visionaries, and theologians, so numerous in the stormy years of the Reformation.

In the same year occurred the Peasants' War, one of the most tragic events of modern German history. Its program was opposed by both burghers and patricians; Luther disavowed it, and the wiser Humanists feared anarchy and the disaster of Protestantism without unity. Though Dürer sympathized with the peasants and acknowledged the legitimacy of their grievances, he did not agree with the revolt. His attitude to the Peasants' War, however, is not clear. The monument he designed to commemorate victory over the rebellious peasants (and placed as a woodcut in his geometrical treatise *Underweysung der Messung*, 1525) is ironic: on a fantastic pyramid of farming implements and agricultural products is the figure of a peasant, stabbed in the back with a sword and sitting in an attitude reminiscent of the *Christ in Distress* (cf. frontispiece woodcut from *Small Passion*, 1509–11). "This monument constitutes a mockery of the conqueror rather than of the conquered" (Waetzoldt). Dürer never showed open sympathy to any reform movement other than orthodox Lutheranism; he craved unity in strong Protestantism. It would be unreasonable to expect a man who wanted to become a Venetian nobleman to understand the new and "fantastic" revolutionary program of the peasants. But he remained an honest and ardent follower of the new religion of the burghers.

Dürer died on Apr. 6, 1528 without having completed his theoretical work on the science of proportions. It was published, however, in the same year and, with his two other books, was the fulfilment of the task he had chosen for himself.

Dürer worked for a long time on art theory. The period between 1507 and 1513 especially abounded in theoretical sketches and drawings. The results of Dürer's work were published in the last years of his life: (1) *Underweysung der Messung mit Zirckel und Richtscheyt in Linien Ebnen und gantzen Corporen durch Albrecht Dürer zusammen getzogen und zu Nutz allen kunstlieb habenden mit zugehörigen Figuren in Truck gebracht im Jar MDXXV*; (2) *Etliche Underricht zu Befestigung der Stett Schloss und Flecken*, Nürnberg, 1527; (3) *Hierin sind begriffen Vier Bücher von Menschlicher Proportion durch Albrechten Dürer von Nürnberg erfunden und beshriben zu nutz allen denen, so zu diser Kunstlieb tragen MDXXVIII*. These books represent what seemed to Dürer at the end of his life to be most important, although his original intention had been far more ambitious. The work begins with a study of the problems of human proportions, to which Dürer was introduced, at least partly, by Jacopo de' Barbari either in Italy or when Jacopo went to Germany about 1500. To understand the principles of good proportion was for Dürer "like seeing a new kingdom." But Barbari did not explain clearly the principles underlying the drawings he showed him. Then Dürer began to read Vitruvius, who became the fundamental source of his theoretical knowledge.

It was probably in the period of intense work on theoretical problems, after his second return from Italy, that Dürer conceived the idea of writing a complete treatise on painting, modeled after Italian writings such as Leonardo's *Trattato*, about which Dürer may have learned in Bologna. The treatise was to be called *Underricht der Malerei* or *Ein Speis der Malerknaben*. About 1512 Dürer was convinced that he would in a short time be able to finish his writings, since he prepared an introduction to the proposed treatise on painting in which he said that it would give young painters the knowledge he had gathered in his artistic practice. He set forth the main ideas of the treatise in a rather scholastic way; it was to be divided into three parts and each part into three chapters. Part I was to deal with the selection of the student of painting, his general education, and the pleasures and usefulness of the art of painting. Part II, an Exposition of Painting, was to give instruction in gaining manual skill and to treat of the problems of proportion and perspective. Part III would describe the conditions in which the trained painter should work and the praise and pay he should receive. Dürer's introduction is especially valuable since he never wrote the treatise itself. His specialized treatises — books in the fields of geometry or anthropometry, rather than art — were influential in the development of German scientific language.

The "Praise of Painting" intended as one of the chapters of the first part of the general treatise, as well as the entire educative program sketched by Dürer, are a northern European parallel to the famous *Paragone* of Leonardo da Vinci, which was a defense of the dignity and values of painting in relation to the other arts. Dürer's was a new, transalpine endeavor to introduce painting into the family of the liberal arts. Trained only in workshop tradition and practice (*Brauch*), Dürer sought to make theoretical knowledge (*Kunst*) a fundamental of the art of painting. Though manual, practical skill was of course indispensable, he believed it should be enriched and transformed by a knowledge of the general principles of creative artistic activity.

He also worked out a second, restricted program, containing chapters on proportion, perspective, light and shade, color, composition, and finally, painting "out of one's head," as a result of previous observation and of imagination. But Dürer, busy with his work for Maximilian, had no time to develop his theoretical projects until after his return from the Netherlands, when he resumed his studies in this field. He prepared the part dedicated to the study of proportion. The so-called Dresden manuscript of the treatise on proportion was ready in 1523, but then Dürer began to work out the geometrical treatise, *Underweysung der Messung*, which appeared first in 1525.

Dürer's second publication was, unexpectedly enough, a treatise on the fortification of towns, boroughs, and villages, printed in 1527 (*Etliche Underricht zu Befestigung der Stett*). Its appearance at this time was probably connected with the peasant revolt and the Turkish danger.

Dürer's last theoretical work, *The Four Books on Proportions* (*Hierin sind begriffen vier Bücher von menschlicher Proportion*), appeared some months after his death. In trying to create a system of theoretical knowledge for the artist, Dürer developed an astonishing, manifold activity in the fields of science and of art, somewhat approaching the scope of Leonardo.

Before Dürer began to study art theory, he was familiar with the empirical perspective used in the workshops of northern Europe. Later, from reading Euclid, he learned the principles of classical optics. In 1506 he went to Bologna to study "secret" perspective, i.e., *perspectiva artificialis*, and above all, the correct method of constructing the visual pyramid or cone. Dürer in his treatise on measurement presented the *costruzione legittima* as well as the abbreviated perspective construction described by L. B. Alberti. The introductory chapters to the theory of perspective treated of linear and plane geometry, the practical application of geometry to construction, typography, and decoration, and concluded with a section on stereometry.

Dürer's theory of proportion presented laws for the correct representation of the beautiful human body. Two periods can be discerned in his attitude to the problem of proportion: the first, a practical and traditional one, before his Italian journey of 1505–06; and the second, a "scientific" period, after his return from Italy. During the first period, Dürer drew figures after classical models (copied by Italian artists) and the models of Vitruvius; he conceived his figures in terms of schematic patterns, composed of lines, drawn with the compass and the ruler. These patterns placed on the anatomy of the human figure facilitated the artist's work, according to the drawing traditions practiced in northern artists' workshops. Dürer's artistic and creative activity in this period is shown in the engraving *The Nemesis* as well as in *The Fall of Man*. Alberti's and Leonardo's theory of proportion, based on mathematics, had a scientific rather than practical character. In 1507 Dürer followed, in general, the Italian methods, though he differed in more than one point from his Italian masters. He conceived the theory of proportion as descriptive knowledge and studied normal bodies, rather than the ideal. The "realistic" character of his theory is evident in the 26 types of proportions he compiled to show nature's variety in creating many kinds of beauty. Wishing to avoid the stiffness and immobility of figures drawn according to the proportion canons, he tried to create dynamic drawings, showing figures in movement, although their movement is represented only as either parallel or at right angles to the picture plane. He showed how to achieve the foreshortening of figures in movement by dividing them into units inscribed into stereometric bodies, such as cubes, pyramids, etc. This different way of approaching the principles of beauty did not, however, imply the denial of universal principles.

It was about 1512 that Dürer lost faith in the absolute value of beauty and in criteria of its definition. He became convinced that it was impossible for man to have a perfect knowledge of the beautiful — that this was the privilege of a divine being. Such doubts distinguished the more complex thought of the German master from that of Italian art theoreticians. Dürer recommended avoiding ugliness because it is, unlike beauty, an absolute value, and was confident of finding a relative beauty, based on eternal principles of harmony and symmetry (in Dürer's German, *Vergleichlichkeit*), which in the first period of his development were conceived in terms of numerical proportions, and later qualitatively. "But in all these things," he wrote, " I believe the harmonious to be the most beautiful." Qualitative harmony, comparable to the Renaissance concept of decorum, depends on a concordance of age, sex, kind, function. The notion of "harmony," which for Italian theoreticians signified supreme beauty, for Dürer became a principle of relative beauty.

While Italian art theory accentuated above all the objectivity of artistic creation and considered a work beautiful when the reality correctly represented in it was beautiful, Dürer, on the contrary, did not identify with beauty all the values a work of art could possess and he distinguished between the beauty of the work of art and the esthetic value of objects and figures represented. He said that the work of a great artist, done rapidly and simply and representing ugly and deformed figures, may be a better work of art than a picture representing beautiful figures or a picture diligently executed by an artist lacking artistic genius. This artistic genius (*Gewalt*), however, must be combined with technical ability (*Brauch, Usus*) and theoretical knowledge (*Kunst, Ars*). The artist must represent nature not as it should be, but as it is: "For, verily, art [the knowledge of esthetic principles] is embedded in nature; he who can extract it, has it." In studying nature the artist can achieve "outward selection" and "inward synthesis" (Panofsky): "No man can ever make a beautiful image out of his private imagination unless he has replenished his mind by much painting from life . . . . The mind of the artist is full of images . . . ." The artist, in Dürer's conception, is not a passive beholder and copyist of nature but opposes nature in an active way, trying to extract the secret of its laws. By conceiving general experience as the foundation of artistic creation, Dürer somewhat approached the concept of Leonardo da Vinci.

Yet another idea lives in the pages of Dürer's theoretical notes and publications: the idea of the divine character of the artist. A great artistic genius has, so Dürer thought, a creative force to be compared only with God: "A good painter is inwardly full of figures, and if it were possible for him to live on forever he would always have to pour forth something new from the inner ideas of which Plato writes." These words, written in 1512 and based on Italian Neoplatonism assimilated by the Germans through Agrippa of Nettesheim, gave way in a later version of Dürer's esthetic theories to another concept: the power of the artist is given by God, but the art itself does not come "from above." Here Dürer approached his other great Italian contemporary, the "divine" Michelangelo, and the concepts of beauty and genius which developed in the period of mannerism (q.v.).

Even during his lifetime Dürer had gained a fame equaled only by the greatest Italian artists. The renown and influence of his art were widespread partly because of the graphic technique which permitted the reproduction of his work on a large scale. From Spain to Mount Athos, from France to Poland, Dürer was a source of inspiration; in the Netherlands and Germany in the mid-16th century, in the work of most artists might be found Dürer's ideas, motifs, or style. Nor did this influence end immediately following his death. Dürer's art had a strong revival about 1600 in the German countries: in the artistic circle of Rudolph II, in the work, for instance, of Hans Hoffmann, as well as in the collections of German princes such as the elector Maximilian I. The Romantic period saw a second great revival of Dürer, who had become an almost symbolic German painter, as he was for the young Goethe, for Wackenroder, and other romantics. In the second half of the 19th century a scientific study of Dürer's life and works was begun. Moritz Thausing's monograph of 1876 (2d enlarged ed., 1884) was the first serious attempt to present Dürer and his achievements in a methodical way. Fundamental works by Heinrich Wölfflin (1905; 6th ed., 1943), Eduard Flechsig (1928–31), and Erwin Panofsky (1943; 5th ed., 1957) followed, covering more and more completely the multiple and rich picture of Dürer's public and private life and of his place in the artistic evolution of Europe.

Bibliog. *a. General*: H. W. Singer, Versuch einer Dürer Bibliographie, 2d ed., Strasbourg, 1928; H. Bohatta, Versuch einer Bibliographie der kunsttheoretischen Werke Albrecht Dürers, Börsenblatt für den deutschen Buchhandel, XCV, 91, 110, 1928. For a complete bibliography of publications after 1928 see E. Panofsky, Albrecht Dürer, 3d ed., Princeton, 1948.

*b. Monographs*: M. Thausing, Albrecht Dürer, Geschichte seines Lebens und seiner Kunst, Leipzig, 1876, 2d ed., 1884; M. J. Friedländer, Albrecht Dürer, Leipzig, 1921; E. Flechsig, Albrecht Dürer, 2 vols., Berlin, 1928–31;

A. Neumayer, Dürer, Paris, 1930; H. Wölfflin, Die Kunst Albrecht Dürers, 6th ed., Munich, 1943; W. Waetzoldt, Dürer und seine Zeit, 5th ed., Königsberg, 1944 (Eng. ed., 1950); H. T. Musper, Albrecht Dürer, Der gegenwärtige Stand der Forschung, Stuttgart, 1952; E. Panofsky, The Life and Art of Albrecht Dürer, Princeton, 4th ed., 1955; F. Winkler, Albrecht Dürer, Berlin, 1958.

*c. Techniques*: C. Ephrussi, Albrecht Dürer et ses dessins, Paris, 1882; F. Lippmann, Zeichnungen von Albrecht Dürer Nachbildungen, 7 vols., Berlin, 1883–1929; S. R. Koehler, a Chronological Catalogue of the Engravings, Dry-Points and Etchings of Albrecht Dürer as Exhibited at the Grolier Club, New York, 1897; R. Bruck, Das Skizzenbuch von Albrecht Dürer in der Königlichen Oeffentlichen Bibliothek zu Dresden, Strasbourg, 1905; W. M. Conway, The Art of Albrecht Dürer, Liverpool, 1910; F. von Schubert-Soldern, Zur Entwicklung der technischen und künstlerischen Ausdrucksmittel in Dürer's Kupferstichen, Mnh. für Kw., V, 1912, pp. 1–14; C. Dodgson, Albrecht Dürer, London, Boston, 1926; W. Kurth, Albrecht Dürer's Vsämtliche Holzschnitte, Munich, 1927 (Eng. ed., London, 1927); H. Tietze and E. Tietze-Conrat, Kritisches Verzeichnis der Werke Albrecht Dürers, 2 vols., Augsburg, 1928, Basel, 1937, Leipzig, 1938; F. Winkler, Dürer des Meisters Gemälde, Kupferstiche und Holzschnitte (Klassiker der Kunst, IV), 4th ed., Stuttgart, Leipzig, 1928; J. Meder, Dürer-Katalog: Ein Handbuch über Albrecht Dürers Stiche..., Vienna, 1932; F. Winkler, Die Zeichnungen Albrecht Dürers, 4 vols., Berlin, 1936–39; E. Schilling, Dürer, Drawings and Water Colors, New York, 1949; H. Tietze, Dürer als Zeicher und Aquarellist, Vienna, 1951; H. Jantzen, Dürer der Maler, Bern, 1952; E. Buchner, Das deutsche Bildnis der Spätgotik und der frühen Dürerzeit, Berlin, 1953; A. M. Cetto, Watercolours by Albrecht Dürer, New York, Basel, 1954; F. Winkler, Dürerfunde, Kunstgeschichtliche Gesellschaft, Berlin, Sitzungsberichte, N.S., III, 1954–55, p. 8 ff.

*d. Writings of Dürer*: W. M. Conway, Literary Remains of Albrecht Dürer, with Transcripts from the British Museum Manuscripts, Cambridge, 1889; K. Lange and F. Fuhse, Dürers schriftlicher Nachlass, Halle, 1893; R. Fry, ed., Albrecht Dürer, Records of the Journey to Venice and the Low Countries, Boston, 1913; J. Veth and S. Müller, Albrecht Dürers Niederländische Reise, 2 vols., Berlin, Utrecht, 1918; Albrecht Dürer, Journal de voyage dans les Pays-Bas (eds. J. A. Goris and G. Marlier), Brussels, 1937; E. Reicke, Willibald Pirckheimers Briefwechsel, I, Munich, 1940; H. Rupprich, Dürers schriftlicher Nachlass und seine Veröffentlichung, Vom Nachleben Dürers, Anz. des Germanischen National-Museums, 1940–53, Berlin, 1954, pp. 7–17; G. Lang, Albrecht Dürers Underweysung der Messung. Vergleich der deutschen und lateinischen Fassung, Vienna, 1946; H. Rupprich, Dürers schriftlicher Nachlass, I, Berlin, 1956.

*e. General artistic problems*: V. Scherer, Die Ornamentik bei Albrecht Dürer, Strasbourg, 1902; W. Suida, Die Genredarstellungen Albrecht Dürers, Strasbourg, 1903; E. Heidrich, Geschichte des Dürerschen Marienbildes, Leipzig, 1906; E. Heidrich, Dürer die Reformation, Leipzig, 1909; H. L. Kehrer, Dürers Selbstbildnisse und die Dürer bildnisse, Berlin, 1934; P. Wescher, Dürer und die deutschen Kaufleute, JhbPreussKSamml, LXIII, 1942, pp. 43–56; G. Schönberger, The Drawings of Mathis Gothart Nithart called Grünewald, New York, 1948; U. Christoffel, Das Marienbild bei Albrecht Dürer, Aschaffenburg, 1949; A. Weixlgärtner, Dürer und Grünewald, Göteborg, 1949; E. Plüss, Dürers Darstellungen Christi am Olberg, Zurich, 1954; F. Anzelewsky, Albrecht Dürer und Mathis Gothard Nithardt, Festschrift Edwin Redslob, Berlin, 1955, pp. 292–300; C. D. Cuttler, Some Grünewald Sources, AQ, XIX, 1956, pp. 101–24.

*f. Dürer, Italy, and Humanism*: A. Warburg, Dürer und die Italienische Antike, 1905 (repr. in Gesammelte Schriften, Leipzig, Berlin, 1932, II, pp. 443–49); E. Panofsky, Dürers Stellung zur Antike, Wiener Jhb. für Kg., I, 1921–22, pp. 43–92 (Eng. trans. in Meaning in the Visual Arts, Garden City, 1955, pp. 236–94); G. Pauli, Dürer, Italien und die Antike, Vorträge der Bibliothek Warburg, 1921–22, pp. 51–68; G. F. Hartlaub, Dürers "Aberglaube," Z. D. Vereins für Kw., VII, 1940, pp. 167–96; G. Weise, Dürer und die Ideale der Humanisten, Tübingen, 1953; G. de Tervarent, Les Enigmes de l'art, IV, L'Art Savant, Bruges, 1956, p. 12 ff.

*g. Dürer's influence*: J. de Vasconcellos, Albrecht Dürer e a sua Influencia na Peninsula, Renascenza Portuguesa, Oporto, 1877; O. Hagen, Das Dürerische in der Italienischen Malerei, ZfBK, LIII, 1918, pp. 225–42; A. Weixlgärtner, Alberto Duro, in Festschrift für Julius Schlosser, Zurich, Leipzig, Vienna, 1927, pp. 163–86; T. Hetzer, Das Deutsche Element in der Italienischen Malerei des XVI. Jahrh., Berlin, 1929; J. Held, Dürers Wirkung auf die Niederländische Kunst seiner Zeit, The Hague, 1931; F. Baumgart, Biagio Betti und Albrecht Dürer..., ZfKg, III, 1934, pp. 231–49; L. H. Heydenreich, Der Apokalypsen-Zyklus im Athosgebiet und seine Beziehungen zur Deutschen Bibelillustration der Reformation, ZfKg, VIII, 1939, pp. 1–40; W. Wallerand, Altarkunst des Deutschordensstaates Preussen unter Dürers Einfluss, Danzig, 1940; H. Tietze, Among Dürer's Plagiarists, J. Walters Art Gall., 1941, pp. 89–95; C. Gould, A Probable Adaptation by Correggio of Dürer's Iconography, BM, XC, 1948, pp. 286–87; K. Harrison, Designs from Dürer in the Windows of King's College Chapel, Cambridge, BM, XCVI, 1954, pp. 349; E. W. Palm, Dürer's Ganda and a 16th century "Apotheosis of Hercules" at Tunja, GBA, VI, ser. 6, XLIX, 1956, pp. 65–74; F. Abbad Rios, Carpaccio, Durero y el Greco, Goya, XI, 1956, pp. 292–96.

*h. Critical reception*: St. Eucker, Das Dürerbewusstsein in der deutschen Romantik, Berlin, 1939; H. Kauffmann, Dürer in der Kunst und im Kunsturteil um 1600, Anz. des Ger. National-Museums 1940-53, Nürnberg, Berlin, 1954, pp. 18–60; A. Ernstberger, Kurfürst Maximilian I und Albrecht Dürer, Anz. des Ger. National-Museums 1940-53, Nürnberg, Berlin, 1954, pp. 143–96; A. von Einem, Goethe und Dürer; Goethes

Kunstphilosophie, Hamburg, 1947; W. Stechow, Justice Holmes' Notes on Albrecht Dürer, J. Aesthetics and Art Criticism, VIII, 1949, p. 119 ff.; H. Lüdecke and S. Heiland, Dürer und die Nachwelt, Berlin, 1955.

*i. Periods of Dürer's development*: J. Huizinga, Dürer in de Nederlanden, De Gids, LXXXIV, 2, 1920, pp. 470–84; E. Panofsky, Dürers Darstellungen des Apollo und ihr Verghältnis zu Barbari, JhbPreussKSamml, XLI, 1920, pp. 359–77; W. Röttinger, Dürers Doppelgänger, Strasbourg, 1926; E. Römer, Dürers ledige Wanderjahre, JhbPreussKSamml, XLVII, 1926, pp. 118–36; XLVIII, 1927, pp. 77–119, 156–82; E. Holzinger, Der Meister des Nürnberger Horologiums, Mitteilungen der Gesellschaft für vervielfältigende Kunst, Die graphischen Künste, sup. 50, 1927, pp. 9–19; E. Holzinger, Hat Dürer den Basler Hieronymus von 1492 selbst geschnitten? Mitteilungen der Gesellschaft für vervielfältigende Kunst, Die graphischen Künste, sup. 51, 1928, pp. 17–20; E. Rupprich, Willibald Pirckheimer und die Erste Reise Dürers nach Italien, Vienna, 1930; K. Bauch, Dürer's Lehrjahre, Städeljahrbuch, VII–VIII, 1932, pp. 80–115; F. Kriegbaum, Zu den graphischen Prinzipien in Dürer frühem Holzschnittwerk, Festschrift A. Goldschmidt, Berlin, 1935, pp. 100–8; H. Beenken, Zu Dürers Italienreise im Jahre 1505, Z. D. Vereins für Kw., III, 1936, pp. 91–126; O. Schürer, Wohin ging Dürers "ledige Wanderfahrt"? ZfKg, VI, 1937, pp. 171–99; F. Winkler, Der sogenannter Doppelgänger und sein Verhältnis zu Dürer, Münchner Jhb. bildenden Kunst, ser. 3, I, 1950, p. 177 ff.; F. Winkler, Dürer Baseler und Strassburger Holzschnitte: Bemerkungen über den Stand der Forschung, ZfKw, V, 1951, pp. 51–6; F. Winkler, Dürer und die Illustrationen zum Narrenschiff. Die Baseler und Strassburger Arbeiten des Künstlers, Berlin, 1951; J. H. Schmidt, Albrecht Dürers Reise in die Niederlande, Rheinischer Verein für Denkmalpflege und Heimatschutz, Der Niederrhein, 1953, pp. 123–34; K. Oettinger, Zu Dürers Beginn, ZfKw, VIII, 1954, pp. 153–68; L. Grote, "Hier bin ich ein Herr," Dürer in Venedig, Munich, 1956.

*Individual works or groups of works*: F. Schestag, Kaiser Maximilian I Triumph, Jhb.Kunsthist.Samml., 1883, pp. 154–81; E. Chmelarz, Die Ehrenpforte des Kaisers Maximilian I, Jhb. Kunsthist. Samml des allerhöchsten Kaiserhauses, IV, 1886, pp. 289–319; K. Giehlow, Dürers Stich "Melencolia I" und der Maximilianische Humanistenkreis, Mitteilungen der Gesellschaft für vervielfältigende Kunst, Die graphischen K., sup. 26, 1903, pp. 29–41; 27, 1904, pp. 6–18, 57–78; E. Heidrich, Zur Chronologie der Dürerschen Marienlebens, RepfKw, XXIX, 1906, pp. 227–41; K. Giehlow, Kaiser Maximilians I Gebetbuch, Vienna, 1907; K. Giehlow, Die Hieroglyphenkunde des Humanismus in der Allegorie der Renaissance, besonders der Ehrenpforte Kaisers Maximilian I, Jhb.Kunsthist.Samml. des allerhöchsten Kaiserhauses, XXXII, 1915, pp. 1–229; J. Meder, Dürers "Grüne Passion," Munich, 1923; E. Panofsky and F. Saxl, Dürers Kupferstich "Melencolia I," Leipzig and Berlin, 1923; M. Dvořák, Dürers Apokalypse, Kunstgeschichte als Geistesgeschichte, Munich, 1924, pp. 191–202; K. Rathe, Der Richter auf dem Fabeltier, Festschrift J. Schlosser, Zurich, Leipzig, Vienna, 1927, p. 187 ff.; E. Schilling, Albrecht Dürers Niederländisches Reiseskizzenbuch, Frankfurt, 1928; F. J. Stadler, Dürers Apokalypse und ihr Umkreis, Munich, 1929; E. Panofsky, Zwei Dürerprobleme, II, Die "Vier Apostel," Münchner Jhb.bildendenKunst, N.S. VIII, 1931, pp. 18–48; W. Neuss, Die ikonographischen Wurzel von Dürers Apokalypse, Festschrift G. Schreiber, Cologne, 1932; H. Swarzenski, Dürers "Barmherzigkeit," ZfKg, II, 1933, pp. 1–10; A. Rusconi, Per l'identificazione degli acquarelli tridentini di Albrecht Dürer, Die graphischen K., N.S., I, 1936, pp. 121–37; H. Kauffmann, Dürers Dreikönig-Altar, Wallraf-Richartz Jhb., X, 1938, pp. 166–78; E. Wind, "Hercules" and "Orpheus": Two Mock-Heroic Designs, Warburg, II, 1939, pp. 206–18; F. H. A. van der Oudendijk Pieterse, Dürers Rosenkranzfest en de Ikonografie der Duitse Rosenkransgroepen van de XV en het begin der XVI eeuw, Amsterdam, 1939; E. Wind, Dürer's "Männerbad": A Dionysian Mystery, Warburg, II, 1939, pp. 269–71; M. L. Brown, The Subject Matter of Dürer's Jabach Altar, Marsyas, I, 1941, pp. 55–68; F. Winkler, Dürers kleine Holzschnittpassion und Schäufeleins Speculum-Holzschnitte, Z. D. Vereins für Kw., VIII, 1941, pp. 197–208; E. Panofsky, Conrad Celtes, and Kunz von der Rosen, AB, XXIV, 1942, p. 39 ff.; F. Winkler, Dürers Lissaboner Hieronymus, Pantheon, XXXII, 1944, pp. 12–16; R. H. Bainton, Dürer and Luther as the Man of Sorrows, AB, XXIX, 1947, pp. 269–72; H. Rox, On "Knight, Death and Devil," AB, XXX, 1948, pp. 67–70; E. Schilling, A Drapery Study by Albrecht Dürer, BM, XC, 1948, pp. 322–25; E. Tietze-Conrat, A Drawing in Stockholm and Dürer's Engraving B. 73 and B. 1, Nationalmusei Årsbok, N.S., XIX–XX, 1949–50, p. 38 ff.; F. Ehrenfest, Albrecht Dürer's "Crucifixion in Outline," Print Collectors Q., XXX, 1950, p. 48 ff.; E. Panofsky, Dürer's "St. Eustace," Record of the Art Museum, Princeton University, IX, 1, 1950, pp. 1–10; G. de Tervarent, Dürer's "Pupilla Augusta," BM, XCII, 1950, p. 198; H. Kauffmann, Dürers "Nemesis," Tymbos für Ahltmann, Berlin, 1951, p. 135 ff.; P. Rossiter, Maximilian's Triumphal Arch; A Woodcut by Dürer, BMFA, XLIX, 1951, p. 95 ff.; K. Lankheit, Dürers "Vier Apostel," Z. für Theologie und Kirche, XLIX, 1952, p. 238 ff.; R. W. Horst, Dürers "Melencolia I," Ein Beitrag zum Melancholeia-Problem, Wandlungen christlicher Kunst im Mittelalter, II, 1953, p. 411 ff.; F. von Juraschek, Blatt vom Starken Engel und die Zweiteilung im Text der Apokalypse, Wandlungen christlicher Kunst im Mittelalter, II, 1953, pp. 359–409; O. Kurz, "Huius Nympha Loci," A Pseudoclassical Inscription and a Drawing by Dürer, Warburg, XVI, 1953, p. 171 ff.; G. von der Osten, Job and Christ, Warburg, XVI, 1953, pp. 153–58; W. Fränger, Dürers Gedächtnissäule für den Bauernkrieg, Albrecht Dürer, Die künstlerische Entwicklung eines grossen Meisters, Deutsche Akademie der Künste, BM, 1954, pp. 85–98; E. Schilling, Werkzeichnungen zur "Grünen Passion," Berliner Museen, N. S., IV, 1954, p. 14 ff.; F. Winzinger, Albrecht Dürers Münchener Selbstbildnis, ZfKw, VIII, 1954, pp. 43–64; F. Anzelewsky, Albrecht Dürers grosser Kreuzigungsholzschnitt von 1494–95, ZfKw, IX, 1955, pp. 139–50; F. van Juraschek, Das Rätsel in Dürers Gottesschau, Die Holzschnittapokalipse und Nikolaus

von Cues, Salzburg, 1955; E. Marx, Die Herkunft von einigen Bildmotiven in Dürers Apokalypse, Festschrift E. Redslob, Berlin, 1955, pp. 301–10; J. Bialostocki, La "Mélancholie Paysanne" d'Albrecht Dürer, GBA, ser. 6, L, 1957, pp. 195–202; A. Giesecke, Eine Dürer Inschrift und ihre Richtige Lesung (zu Dürers Malancholie Stich), Gutenberg Jahrbuch, 1955, pp. 305–14; D. Caritt, Dürer's "St. Jerome in the Wilderness," BM, XCIX, 1957, pp. 363–66; E. Schilling, Dürers Täfelchen mit dem hl. Hieronymus, ZfKw, XI, 1957, pp. 175–84; A. Stange, Zwei neuentdeckte Kaiserbilder Albrecht Dürers, ZfKg, XX, 1957, pp. 1–24; F. Anzelewsky, A propos de la topographie du parc de Bruxelles et du quai de l'Escaut à Anvers de Dürer, Bull. Mus. Royaux, Brussels, 1957, pp. 87–107; K. Bauch, Zwei Dürer Zeichnungen in Kassel, ZfKg, XXI, 1958, pp. 50–55; S. Sulzberger, Dürer a-t-il vu à Bruxelles les Cartons de Raphaël?, GBA, ser. 6, LIV, 1959, pp. 176–84; J. Bialostocki, "Opus Quinque dierum": Dürer's "Christ among the Doctors" and Its Sources, Warburg, XXII, 1959.

*k. Dürer's Art Theory*: G. Staigmüller, Dürer als Mathematiker, Programm des Königl. Realgymn. in Stuttgart, Stuttgart, 1891; L. Justi, Konstruierte Figuren und Köpfe unter den Werken Albrecht Dürers, Leipzig, 1902; E. Panofsky, Dürers Kunsttheorie vornehmlich in ihrem Verhältnis zu der Italiener, Berlin, 1915; H. Schuritz, Die Perspektive in der Kunst Dürers, Frankfurt, 1919; E. Panofsky, Die Entwicklung der Proportionslehre als Abbild der Stilentwicklung, Mnh.fürKw., XIV, 1921, pp. 188–219, (Eng. trans., Meaning in the Visual Arts, Garden City, 1955, pp. 55–107); W. Stechow, Dürers Bologneser Lehrer, Kunstchronik, N.S., XXXIII, 1922, p. 251 ff.; H. Beenken, Dürers Kunsturteil und die Struktur des Renaissance-Individualismus, in Festschrift Heinrich Wölfflin, Munich, 1924, pp. 183–93; H. Kauffmann, Albrecht Dürers rhythmische Kunst, Leipzig, 1924; J. Kurthen, Zum Problem der Dürerschen Pferdekonstruktion, Rep fKw, XLIV, 1924, pp. 77–106; E. Panofsky, Idea: Ein Beitrag zur Begriffsgeschichte der älteren Kunsttheorie, Leipzig, Berlin, 1924, p. 64 ff. (Ital. ed., Florence, 1952, pp. 92–7); E. Panofsky, Albrecht Dürers rhythmische Kunst, Jhb.fürKw., 1926, pp. 136–92; J. Giesen, Dürers Proportionsstudien im Rahmen der allgemeinen Proportionsentwicklung, Bonn, 1930; E. Crous, Dürer und die Schrift, Berlin, 1933; A.M. Friend, Jr., Dürer and the Hercules Borghese-Piccolomini, AB, XXV, 1943, pp. 40–49; M. Steck, Dürers Gestaltlehre der Mathematik und der bildenden Künste, Halle, 1948; W. Funk, Das rechte Mass bei Albrecht Dürer, Mit. der Vereinigung für Geschichte der Stadt Nürnberg, XLV, 1954, pp. 326–60; J. Bialostocki, Albrecht Dürer jako pisarz i teoretyk sztuki, Warsaw, 1956; G. Eimer, Abstrakte Figuren in der Kunst der Renaissance, Konsthist. Tidskrift, XXV, 1956, pp. 113–45; G. Arnolds, Opus quinque dierum, Festschrift F. Winkler, Berlin, 1959.

Jan BIALOSTOCKI

Illustrations: PLS. 292–302.

**DUTCH ART.** See FLEMISH AND DUTCH ART.

**DYCK,** ANTON (or ANTOON) VAN. Flemish painter (b. Antwerp, Mar. 22, 1599; d. London, Dec. 9, 1641) the son of Frans van Dyck and Maria Cuypers. In 1609 he was entered in the Antwerp Guild of St. Luke, as a pupil of Hendrik van Balen. By 1615–16, he was living at the Dom van Keulen, with his own studio and pupils, among them H. Servaes and J. van Egmont. At this time he was engaged in painting the series of apostles with Christ (documented by a lawsuit of 1660–61), and in 1616 he completed his first dated portrait, that of Jan Vermeulen (Vaduz, Liechtenstein Coll.). Two years later he was enrolled as a Master in the Antwerp Guild of St. Luke. In 1620 he dated a portrait of Gaspard C. von Nieuwenhuys (New York, Knoedler Gall.). On Mar. 29 of the same year he was named as leading assistant, in the contract drawn up between Rubens and R. P. Tirenius, Prefect of the Jesuits, for decorations in the Church of St. Charles Borromée, in Antwerp. A letter dated July 17 to the Earl of Arundel from his secretary, Francesco Vercellini, stated that Van Dyck was still with Rubens, that his work was much esteemed, and that it was difficult to persuade him to leave Antwerp.

He did, however, go to England on Nov. 25, 1620, and was granted a court pension of 100 pounds a year. After having obtained royal leave to travel "for eight months," he left London for Antwerp Feb. 28, 1621, and thence for Italy, arriving Nov. 20.

He stayed in Genoa with the brothers Lucas and Cornelis de Wael, Flemish art dealers and painters, until February, 1622, when he went to Rome. From there he traveled to Florence, Bologna, probably Mantua, and Venice. In this and the following year he spent various periods of time in Rome, painting the portraits of English visitors, Sir Robert Shirley and Lady Shirley (Sussex, England, Lord Leconfield's Coll.); of fellow artists

F. Duquesnoy (Brussels, Mus. des Beaux-Arts) and G. Petel (Munich, Alte Pin.); and of Cardinals G. Bentivoglio (Florence, Pitti), and D. Rivarola (Des Moines, C. Weeks Coll.).

He was in Palermo by July 12, 1624 (the date of his pen portrait of Sofonisba Anguissola, in the Br. Mus. sketchbook), but during the plague which had been raging in Sicily since May of that year, the Viceroy Emanuele Filiberto di Savoia, who had invited Van Dyck to the island, died. His portrait, now in London (Dulwich College Gall.), must have been finished by then. On Sept. 20, since the plague had broken out once more, Van Dyck left Sicily, having finished work on the *Apotheosis of St. Rosalie* (New York, Met. Mus.).

Once more in Genoa (1625), he completed the dated portraits of the children of Marchese G. B. Cattaneo, Filippo and Clelia (Washington, D.C., Nat. Gall.), and in 1626 he executed those of Gian-Vincenzo Imperiale (Washington, D.C., Nat. Gall.; Brussels, Mus. Royaux des Beaux-Arts). In the autumn of the following year he left Italy, having painted the double portrait of L. and C. de Wael (Rome, Capitoline Mus.), and executed a signed and dated portrait of Peter Stevens (The Hague, Mauritshuis) before the year was out.

The next year, 1628, saw the portrait of Peter Stevens' wife, Anna Wake (signed, dated; The Hague, Mauritshuis), and on Apr. 8 he was paid for the *Madonna of the Rosary*, begun in Sicily in 1624 and finished in Genoa, for the Oratorio del Rosario, Palermo. He was also paid 600 gulden for the *Ecstasy of St. Augustine*, commissioned by Marinus Jansenius for the Church of St. Augustine, Antwerp.

During the course of 1629 he signed and dated the portraits of Adriaen Stevens and his wife (Leningrad, The Hermitage), and received from the Confraternity of Recollects the sum of 300 gulden for a *Madonna and Child with Saints* (Vienna, Kunsthist. Mus.). When, during March of that year, a loan was raised for the city of Antwerp, Van Dyck was in a position to contribute no less than 4,800 gulden. On Dec. 5 there was recorded a repayment to one Endymion Porter for the purchase from Van Dyck, on behalf of Charles I of England, of *Rinaldo and Armida* (Baltimore, Mus. of Art).

In 1630, at a salary of 250 gulden per annum and with permission to reside in Antwerp, Van Dyck was made Court Painter at Brussels by the Archduchess Isabella Clara Eugenia. The Antwerp Recollects paid him 150 gulden for the *Blessed Herman Joseph* (Vienna, Kunsthist. Mus.), and the Ghent Confraternity of the Holy Cross paid him 800 gulden for the *Crucifixion*, still to be seen in St. Michael's Church (a grisaille sketch exists in a private collection in Brussels).

In 1631 he painted the portraits, signed and dated, of Philippe le Roy and his wife (London, Wallace Coll.), and between Dec. 6 and 16 of the same year, B. Gerbier bought in Brussels a *Madonna and Child with St. Catherine*, to send to the Earl of Portland as a gift to Charles I. The following year he painted the portrait of Marten Pepyn (Antwerp, Mus. Royal des Beaux-Arts). By Apr. 1, 1632, he was in London, where a Crown indemnity was issued to E. Norgate for the daily entertainment of the artist. On July 5 he was knighted, named Principal Painter, granted a house at Blackfriars, and given a summer residence at Eltham, in Kent. On Aug. 8 he received payment for eight royal portraits and for replacing the *Vitellius* and repairing the *Galba* in the set of Titian Emperors recently purchased in Mantua.

On May 7, 1633, he received payment for nine portraits of Charles I and Henrietta Maria. In his *Self-portrait with a Sunflower* there appears a gold chain, which, with a medal, had been ordered for him on Aug. 30. His pension was now fixed at 200 pounds a year, exclusive of special payments for work done for the Court, and on Oct. 20 he received an advance of 40 pounds from the King, evidence that the portrait of Henrietta Maria for Wentworth was finished.

In the census of foreigners resident in Blackfriars at the time, the following entry appears: "Dutch. Sir Anthony Vandike. Limner. 2 years. 6 servants." But on Mar. 28, 1634, his presence in Antwerp was recorded, when he purchased a country property at Steen, which was afterward sold to Rubens. April saw him in Brussels, where he transferred the conduct

of his Antwerp affairs to his sister, Susanna. This is also the date of *The Lamentation* (Munich, Alte Pin.; PL. 306), if we judge by what appears to be a reliable monogram and the date it bears. The request, on Dec. 16, of the City Secretary of Antwerp to the Brussels Municipality for a copy of the portrait of the Cardinal-Infante Ferdinand shows that this work must have been completed by then. On Feb. 23, 1637, he was in London to receive payment of 1,200 pounds.

The signed and dated portrait of Killigrew and Carew (Windsor, Royal Coll.), is a work of 1638, and at the end of that year, Dec. 14, he received further payment for pictures, and an arrears in his pension was made up. More works were paid for on Feb. 25, 1639. In the following year he was welcomed to the Antwerp Guild of Painters and nominated Dean thereof on St. Luke's Day (Oct. 18). Two months later, on Dec. 1, he was in Paris, asking M. de Chavigny permission to return to London, on account of ill health.

According to P.-J. Mariette, he was still in Paris at the beginning of the following year, although he was in London for the wedding of William of Orange to Mary, daughter of Charles I (May 12). In a letter from the Countess of Roxburgh to Baron von Brederode, Aug. 13, 1641, the painter is mentioned as having been ill for some time, and as intending to return to Antwerp passing through Holland. This plan was never carried out, for on Dec. 9, 1641, a few days after the birth of a daughter to his wife Mary Ruthven, he died at his house in Blackfriars. Two days later he was buried in St. Paul's.

Astonishing precocity is apparent in his self-portrait (Vienna, Akademie), and, from ca. 1615, in the various series of apostles (Althorp, Northampton, Earl of Sunderland's Coll.; formerly, Munich, Böhler Coll.) both by his own hand and with assistants. Practice in these and similar studies, no less lively in their sense of structure and intensity of expression, enabled him to produce the dramatic heads required for the ambitious figure compositions of his first period in Antwerp (1615–20). These reveal some incoherence, soon to be overcome, in composing subjects and a rhythmic distortion of form that was to remain with him until he reached Italy. This is evident especially in faces and in the long angular ripple of muscle on silhouetted limbs, e.g., the *Martyrdom of St. Sebastian* (Paris, Louvre) and the *Crucifixion of St. Peter* (Brussels, Mus. Royaux des Beaux-Arts). In this, his earliest manner, he crowded his foregrounds more for intricacy of pictorial pattern than to gain the effect of bas-relief, e.g., the *Carrying of the Cross* (ca. 1617) for St. Paul, Antwerp; for his formative eye, unlike that of Rubens, was not disciplined by sculpture. He did, nevertheless, allude to the Borghese *Hermaphrodite* in the sleeping hero of his *Samson and Delilah* (London, Dulwich College Gall.) and make a pen and wash copy (Paris, Louvre; Lugt, 1949) of a Niobid relief. The most ordered development of surface interest and the firmest control of compositions, which despite their intricacy tend to sprawl, appeared about 1619 in the *Feeding of the 5,000* (Potsdam, Neues Palais) and its pendant frieze, the *Entry into Jerusalem* (Indianapolis, Ind., The John Herron Art Mus.; PL. 307). There the characteristic contrast between rough dry impasto and rich glazing achieves the maximum of life and luminosity.

The idea of painting sets of apostles and Christs was probably stimulated by Rubens' *Apostelado* (ca. 1611) series commissioned by the Duke of Lerma (Madrid, Prado). Whether or not the allusion to "my best pupil" in a letter of August, 1618 (Rubens to Carleton) refers to Van Dyck, Rubens was surely employing him regularly by this date. He painted for Rubens the kneeling man in the *Madonna with the Penitents* (Kassel, Germany, Staat. Kunstsamml.) and also the *St. Ambrose aud Theodosius* (Vienna, Kunsthist. Mus.) after Rubens' own sketch (London, Nat. Gall.). His actual participation in the ceiling canvases for the Jesuit church in Antwerp cannot now be ascertained; but there are heads painted by Van Dyck in the lower part of the *Miracle of St. Francis Xavier* (Vienna, Kunsthist. Mus.), the high altarpiece which Rubens designed for the same church. Examination of the cartoons for the Decius Mus tapestries belies Bellori's statement that Van Dyck executed these from sketches by Rubens. More reliable is Bellori's information, confirmed by Mariette, that the young Van Dyck was entrusted with the exacting task of preparing drawings from Rubens' paintings, to send to the engravers; and certainly the *Lot Abandoning Sodom* (Paris, Louvre; Lugt 1126) is of high enough quality to have been drawn by him. The two versions of *St. Martin Dividing His Cloak* (Saventhem, Pfarrkirche; Windsor, Royal Coll.; PL. 307) are his independent creations, but in the clarity of composing in depth with figures in strong relief he consciously emulated Rubens' reinterpretation of High Renaissance ideals. Yet the deep divergence of their artistic natures is manifest if we compare the almost contemporary *St. Jerome* of Van Dyck with the one by Rubens (both, Dresden, Gemäldegalerie).

Further proof of Van Dyck's close relation to Rubens well before 1620 exists in the former's unpublished sketchbook filled with copies from Rubens' notebook, both of the master's own drawings and of his copies from Dürer, Andrea del Sarto, and B. Bandinelli, as well as with independent observations, inventions, copies from Serlio (Lib. IV) and from prints by Renaissance masters (P. Bruegel, Holbein, Mantegna, Michelangelo, Rosso, Raphael, Giulio Romano, Titian, and Tintoretto). The whole offers an insight into the artistic education which prepared him for his journey to Italy. He must have longed for this from the time of his apprenticeship to Van Balen and after having received the advice and encouragement of Rubens. At the urging of Lord Arundel, he seemed attracted for a time to the court of James I, but after seven months of intense work in Antwerp, he left for Italy.

Another famous sketchbook (London, Br. Mus.) is the lively record of what Van Dyck saw during his first years in the Italian cities. Generally his interests developed those shown in the first sketchbook, with a marked preference for Venetian art and Titian in particular (e.g., his copy of Titian's *Madonna and Child with St. Dorothy*); but, more aware of his destiny now as a portraitist, he noted everything of seeming relevance to that, listing all the Titian portraits he had seen. In fact, he went against his inclination in painting the *Madonna of the Rosary*, his first and almost only attempt to produce a baroque altarpiece on the heroic scale and in the manner of Rubens.

Genoa was his headquarters, and the Genoese aristocracy, to whom he was introduced through Rubens or his constant hosts the De Waels, were subjects of a marvelous series of portraits of which the most spectacular is that of the Marchesa Elena Grimaldi Cattaneo (Washington, D.C., Nat. Gall.; PL. 309). Carbone and others imitated his practice in these eulogies, which were themselves inspired by the portraits Rubens painted in Genoa fifteen years before. Van Dyck's self-portrait (ca. 1621; New York, Met. Mus.), neurotically intent and consciously elegant, flaunts his fitness to create a vision of aristocracy for itself, and suggests why in Rome he, "il pittore cavaliere," remained unpopularly aloof from other Northern artists.

The portraits done in Italy, as well as his overt tribute to Venetian art, the *Four Ages of Life* (Vicenza, Mus. Civ.), are painted in the Venetian technique of crusts and glazes glowing on the warmth of bole-prepared canvas. Back in Antwerp, Van Dyck cooled his tones and lightened his grounds, but without Rubens' marked preference for gessoed panels to reflect light. The spiritual adventure of Italy purged the second phase of Antwerp portraiture of the attractive casualness of the 1616–18 portraits (Vaduz; London, Seilern Coll.) in arranging the sitter. The Abbé Scaglia portrait (Basingstoke, England, Viscount Camrose's Coll.) is a considered monument both to the personality and to the office of the man. A retrospective comparison may be made of the dignity, stance, and reserve of this figure of 1634, from which no adjunct can be separated; the more sparkling show and radiant vitality of the portrait of Cardinal Bentivoglio (ca. 1623), enthroned amid agitated draperies and richly provided with accessories; and the engagingly impromptu effect of the *Young Man* (Vaduz, Liechtenstein Coll., ca. 1617), standing carelessly before the accepted, but here unexploited, studio properties of pillar and curtain. Matching this progress in presentation, the paint quality grew ever more refined, reaching eventually during his English period that fluency of tense handling which, no less than the

nobility of his conceptions, was to excite the active admiration of Gainsborough.

From the end of his Italian period until his departure for England, his religious pieces, unlike his highly individual portraits, tend to show an uneasy dependence on Rubens or on Venetian and Bolognese masters. His most satisfactory achievements in a genre which he can hardly have been unwilling to abandon in the service of a Protestant king were in comparatively small works: either those very closely dependent on another master, e.g., an oil sketch for an *Assumption* (Vienna, Akademie) inspired by Reni's S. Ambrogio altar, or those evincing a truly personal intensity of feeling, e.g., *The Blessed Herman Joseph*. During the last decade of his life, with the exception of his beautifully individual treatments of the *Lamentation* (Munich; Antwerp), he reverted for the purposes of history painting to his early interest in mythology and romance, as in his imposing introduction to the Caroline court, the *Rinaldo and Armida* (Baltimore, Mus. of Art), and, eight years later, in the idyllic beauty of *Cupid and Psyche* (PL. 307), where he comes closest in an independent masterpiece to the spirit of Titian.

Charles I, mounted, pacing through an archway with M. de St. Anthoine (London, Buckingham Palace), painted to adorn the end wall of the gallery in St. James's Palace, seems about to review the row of Titian Emperors, purchased in 1628 by the king, which Van Dyck himself had restored. This exalted compliment to his most enthusiastic and understanding patron was his only attempt to create a baroque unity in decoration, since his plan to display the "Garter procession" around the Banqueting House did not advance beyond a grisaille sketch in oils (Leicestershire, England, Duke of Rutland's Coll.). The impression of a personality in action, brilliantly captured in the portrait of Lucas van Uffel (ca. 1627; New York, Met. Mus.) and in the equestrian portrait of the Comte d'Arenberg (ca. 1630; Norfolk, England, Earl of Leicester's Coll.) was a baroque feat which he seldom attempted; although the particular pose of Charles on horseback appears also in the Marqués F. de Moncada portrait (Paris, Louvre).

Such occasional economy of poses when the master was in fashionable demand and needed assistants — indeed, there is virtual identity of pose and background in the portraits of Anne Kirke and Isabella de la Warr — has given rise to the false notion that Van Dyck in England gradually tired of invention and even grew feebler in brushwork. This calumny is repudiated by his Killigrew and Carew portrait (Windsor, Royal Coll.) of 1638 and the Hanmer (The Grove, Lord Oxford) portrait probably of the same year. *Charles I on Horseback* (London, Nat. Gall.) and *Strafford with His Dog* may seem unadventurous adaptations of Titian prototypes portraying Charles V. But in the *Charles I of England in Hunting Dress* (Paris, Louvre; PL. 310), where the symbolic meaning is intensified by apparent informality of setting and costume, and in the *Strafford in Armor* (Nottinghamshire, Duke of Portland's Coll.), where unflinching intelligence is revealed by gaze and comportment, he concentrated on these same men an unsurpassed force of imaginative penetration. This mature strength of Van Dyck as a portraitist, even when limited to a head, finds testimony in Bernini's exclamation, "Che volto funebre!" on receiving the *Triple Study of Charles I* (Windsor, Royal Coll.) sent as a guide for sculpture. An undiminished zest for portraiture is attested by his promotion before and after 1634 of the printed *Iconography*, which eventually comprised nearly 200 notables. Not only did he, a skilled etcher, prepare some of the plates, but many more were made after his drawings or grisaille oils.

Rubens' habit of sketching on panel in oils was not otherwise often followed by Van Dyck. Only for the religious compositions of 1627–32 did he regularly essay ideas in colored grisailles. The first known instance was for an *Adoration of the Shepherds* (ca. 1620; formerly Königs Coll.); one of the last was for an *Equestrian Portrait* (ca. 1635; Wilton, Earl of Pembroke Coll.). He appears to have made numerous composition trials in pen and wash, supplemented by chalk studies of special features or figures. His pen work was much affected by Rubens' current

style, but Van Dyck tended to a more mannered calligraphy of elongations, abbreviations, and careless spread of form. For him wash emphasized illumination, not relief. Only the chalk studies executed throughout his career show a plastic sense comparable to that of Rubens. Portraiture apart, the English drawings are landscape, another interest which emerged in the Italian sketchbook. These scenes are in bister penwork (e.g., the Rye series) or colored in a mixed technique, also used by Rubens, of water color and body color on tinted paper. The significance, for the future of English painting, of these scenes and of certain landscape passages in his portraits is still underestimated.

His last illness prevented Van Dyke's succeeding to Rubens' supremacy in Flanders in 1640, and, together with the return of Poussin from Italy, precluded his hoped-for employment in Paris.

SOURCES. Sketchbook, unedited, English private coll.; T. Rombouts and T. van Lerius, De Liggeren en andere Historische Archieven der Antwerpsche St. Lucasgilde, Antwerp, n.d.; C. de Bie, Net gulden cabinet vande edele vry Schilder-Const, Antwerp, 1661; G. P. Bellori, Le vite de' pittori, scultori, ed architetti moderni, Rome, 1672; J. van Sandrart, Academie der Bau-, Bild- und Mahlerey-Künste, Nürnberg, 1675; R. de Piles, Abrégé de la vie des peintres, Paris, 1699, pp. 414–19; A. Houbraken, De Groote Schouburgh der Nederlandsche Konstschilders en Schilderessen, Amsterdam, 1718; H. Walpole, Anecdotes of Painting in England, London, 1762; R. Soprani, Le vite de' pittori, scultori, ed architetti genovesi e de' forestieri che in Genova operarono, Genoa, 1768; Manuscrit inédit sur la vie, les ouvrages et les élèves de Van Dyck, Bibliothèque du Louvre, Paris, n.d.; J. Smith, A Catalogue Raisonné of the Works of the Most Eminent Dutch, Flemish and French Painters, III, London, 1831, IX, London, 1842; W. H. Carpenter, Pictorial Notices Consisting of a Memoir of Sir Anthony van Dyck, with a Descriptive Catalogue of the Etchings, London, 1844.

BIBLIOG. J. Guiffrey, Antoine van Dyck, sa vie et son œuvre, Paris, 1882; W. Bode, Antoon Van Dyck in der Liechtenstein Galerie, Die Graphischen Kunste, XII, 1889, p. 42; L. Cust, Anthony Van Dyck, An Historical Study of His Life and Work, London, 1900; F. M. Haberditzl, ThB, X, 1914, s.v.; R. Oldenbourg, Studien zu Van Dyck, Münchner Jahrbuch der bildenden Kunst, III, 1914–15, p. 224; A. M. Hind, Catalogue of Drawings by Dutch and Flemish Artists Preserved in the Department of Prints and Drawings in the British Museum, II, London, 1923; M. Vass, Le séjour d'Antoine van Dyck en Italie, B. de l'Institut historique belge de Rome, Rome, IV, 1924, VII, 1927; H. Rosenbaum, Der Junge Van Dyck, Munich, 1928; G. Glück, Van Dyck, des Meisters Gemälde, Stuttgart, 1931; J. Denucé, De Antwerpsche Konstkamers, Antwerp, 1932; G. Glück, Rubens, Van Dyck, und ihr Kreis, Vienna, 1933; O. Benesch, Zur Frage der frühen Zeichnungen Van Dijks, Die graphischen Künste, III, Vienna, 1938; G. Adriani, Anton van Dyck, Italienisches Skizzenbuch, Vienna, 1940; A. J. J. Delen, Antoon van Dijck, Antwerp, 1943; F. Lugt, Inventaire général de dessins des Ecoles du Nord, Ecole Flamande, I, II, Paris (Louvre), 1949; L. van Puyvelde, Van Dyck, Brussels, 1950; E. K. Waterhouse, Painting in Britain, 1530–1790, London, 1953; O. Millar, Charles I, Honthorst, and Van Dyck, BM, XCVI, 1954, pp. 36–42; A. Seilern, Flemish Paintings and Drawings at 56, Princes Gate, London, 1955; R. S. Magurn, The Letters of Peter Paul Rubens, Cambridge, 1955; O. Millar, Van Dyck at Genoa, BM, XCVII, 1955, pp. 313–715; M. Jaffé, Rubens' Drawings at Antwerp, BM, 1956, pp. 314–21; H. Vey, De tekeningen van Anthonie van Dyck in het Museum Boymans, B. Museum Boymans, VII, 2, 3, 1956, pp. 45–55, 82–91; M. Mauquoy-Hendrickx, L'Iconographie d'Antoine van Dyck, Catalogue raisonné, I, II, Brussels, 1956; R. R. Wark, A Note on Van Dyck's Self Portrait with a Sunflower, BM, 1956, p. 53; M. Whinney and O. Millar, English Art, 1625–1714, Oxford, 1957; O. Kurz, Van Dyck and Reni (Miscellanea Prof. D. Roggen), Antwerp, 1957, pp. 179–82; H. Vey, Anton van Dycks Ölskizzen, B. Koninklijke Musea voor Schone Kunsten, 1957, pp. 167–208; H. Vey, Einige unveröffentlichte Zeichnungen Van Dycks, B. Koninklijke Musea voor Schone Kunsten, 1957, pp. 175–209; J. S. Held, "Le roi à la ciasse," AB, 1958, pp. 18–26; O. Millar, Van Dyck and Sir Thomas Hamner, BM, C, 1958, p. 249; H. Gerson and E. H. ter Kuile, Art and Architecture in Belgium, 1600 to 1800, Harmondsworth, 1960; R. A. d'Hulst and H. Vey, Antoon van Dyck: Tekeningen en olieverfschetsen (exhibition cat.), Antwerp, 1960.

Michael JAFFÉ

Illustrations: PLS. 303–310.

**EAKINS**, THOMAS. American painter (b. Philadelphia, July 25, 1844; d. Philadelphia, June 25, 1916). Eakins studied art at the Pennsylvania Academy of the Fine Arts and anatomy at Jefferson Medical College. In September, 1866, he went to Paris, working at the Ecole Nationale des Beaux-Arts for three years under Gérôme, and briefly with Bonnat. In 1870 Eakins spent six months in Spain. He went first to Madrid, where he discovered for himself the paintings of Velázques and Ribera (these two and Rembrandt were Eakins' favorites),

and from thence to Seville to paint. In July, 1870, he returned to Philadelphia, where he spent the rest of his life. The artist's first American paintings were scenes of Philadelphia life (genre and outdoor subjects) and portraits of his family and friends. They showed a strong sense of character, utter fidelity to facts, and a deep attachment to his community; they were the creations of an original mind dealing directly with everyday realities. By the middle 1870s he was exhibiting fairly frequently, and he soon became known as a leader of the naturalistic movement in America. Eakins' work, however, had little popular success; by 1880 he had sold only eight paintings for a total of about $2,000. Fortunately he had a small private income and owned the family home. In 1884 he married Susan H. Macdowell, a former pupil. They had no children.

Eakins' unusual combination of artistic and scientific interests included mathematics, perspective, and anatomy. His most important early painting, *The Gross Clinic* (1875; Philadelphia, Jefferson Medical College), depicts a famous surgeon operating — a subject rare in modern art. This painting and the later *Agnew Clinic* (1889; Philadelphia, Univ. of Pa.) shocked critics and the public. The artist's photographic studies (in the 1880s) of human and animal locomotion involved experiments which anticipated the motion picture.

A born teacher, Eakins began instructing at the Pennsylvania Academy in 1876 and became head of the school in 1879. He revolutionized American teaching methods by subordinating the drawing of antique casts to the study of the nude, anatomy, and dissection and by encouraging students to begin painting immediately rather than devote their earliest efforts to drawing. His insistence on the study of the nude brought opposition, and in 1886 he resigned from the school. For about eight years more he taught in his own school and at the Art Students League of Philadelphia, and he lectured on anatomy in other schools. The Academy affair was a serious blow to his career as both teacher and artist; after his resignation he found himself in opposition to the "respectable" forces of his community.

In the middle 1880s, probably because of these difficulties and the public's indifference to his work, Eakins largely abandoned the American scene as a subject and began to concentrate on portraiture. In this more limited field he achieved increasing power. In addition to his mastery of anatomy and his uncompromising, unflattering realism, his portraits reveal profound psychological insight. They have intense vitality and are convincing, whether the subjects are ugly or beautiful.

Eakins had almost no commercial success as a portraitist. He received few commissions; most of his sitters were friends or people who interested him and whom he asked to pose. The official art world neglected him until, in old age, he received a few honors.

Eakins was the strongest figure painter of his period in the United States. Every painting he produced was constructed with an extraordinary apprehension of three-dimensional space and possesses exceptional substance. That he was capable of structural design of a high order is particularly evident in his few paintings based on the nude; but the prudery of his environment, opposed to his own intransigent realism, thwarted his development in this direction. His art unquestionably suffered from lack of recognition and a vital, functional relationship to society. Within the limits of naturalism and portraiture, however, his achievement was monumental.

The Philadelphia Museum owns a large collection of his works. Other important paintings are in the Metropolitan Museum, New York, and in the Addison Gallery of American Art, Andover, Massachusetts. See AMERICAS: ART SINCE COLUMBUS; I, PL. 112.

BIBLIOG. L. Goodrich, *Thomas Eakins: His Life and Work*, New York, 1933; R. McKinney, *Thomas Eakins*, New York, 1942; H. Marceau et al., *Thomas Eakins*, J. of the Pa. Mus. of Art, XXV, 1944, pp. 1–33; M. McHenry, *Thomas Eakins, Who Painted*, Philadelphia, 1946; F. Porter, *Thomas Eakins*, New York, 1959.

Lloyd GOODRICH

**EASTER ISLAND.** See POLYNESIAN CULTURES.

**ECLECTICISM.** In art, as in philosophy and literature, the term "eclecticism" is applied to the practice of selecting and reconciling elements from different schools and systems. The Greek term *eklektikos* means "selective," and this is the key to the eclectic approach in the appraisal of art. In the eclectic work of art the varying styles drawn upon maintain their own recognizable characteristics, and the conjunction produces no new synthesis of form. One example is provided by the Persian architecture of the Achaemenian period at Persepolis. Here a Mesopotamian type of platform is surmounted by an Egyptian hypostyle hall employed in the Mesopotamian *bît-hilani* fashion, while the columns show Greek flutings and volutes, Mesopotamian bulls placed back to back, and Egyptian-inspired bell and floral capital shapes. Though the Persians would not have recognized the term "eclectic," which was introduced by modern art criticism, they did employ the eclectic approach in their selection of elements from differing sources and styles. This was in part the result, we may assume, of artistic interest and in part a consequence of a conscious attempt to assimilate as many facets of their world empire as possible. Thus the Great King even styled himself "King of Babylon and King of Egypt."

Although the term "eclecticism" appears only in modern art criticism, the phenomenon (sometimes described as syncretism) has characterized many different periods and places in the course of civilization when a combining force dominated intellectual life. When, however, only one aspect of a given style or object is adapted rather than a group of elements, the term "eclectic" is not usually applied. If the unfavorable attitude toward eclecticism is due (as in part it must be) to the lack of originality displayed by an adapter who borrows simultaneously from many sources, one might logically extend the stigma to artists who are "guilty" of adapting only one style at a time, or even a number of styles in succession, rather than developing one of their own. The first group would include many Chinese painters of the Ming and Ch'ing periods who, out of reverence for the styles of their ancestors, took over the manner of one or another earlier master to the complete satisfaction of their public. The second would include such painters as Raphael, who successively borrowed from various styles. In Raphael's case, however, the borrowings, recognizable and numerous though they are, resulted in something fresh that is unquestionably marked by the personality of the "borrower"; for this reason one cannot properly use the term "eclectic."

Although "eclecticism," according to its terms of reference, applies to conscious or intellectualized adaptations only, there are a great many cultures in which borrowings and influences of an entirely different kind are clearly evident, as in the ancient Near East or in the Far East (see below). Because these stylistic effects result not from conscious borrowing but rather from a natural diffusion of political, economic, and cultural forces, they are not in the narrow sense characterized as eclectic.

This introduction has already suggested some of the ambiguities connected with the definition of eclecticism and with assigning the word to particular works of art. In addition to those which are eclectic in the narrow sense — that is, which combine in a conscious or intellectualized way styles that retain their recognizable characteristics — this article will also discuss works that have often been called "eclectic" but to which the term "eclecticism" may be applied only if the meaning of the word is enlarged. These include the products of mixed cultures that have attained a stylistic unity (e.g., Cypriote art). There is also some disagreement among critics, implicit in the discussion, as to whether the works of certain artists are eclectic in the narrow or broad sense of the word, for example, those of the Carraccis.

In the course of the discussion it will become clear that the idea of eclecticism has traditionally carried with it a pejorative implication. Since World War II, however, there have been signs that a more balanced point of view is in the process of formation, in which it is recognized that eclectic procedures can, in fact, play a valid role in creative activity.

SUMMARY. Formation and history of the concept of eclecticism (col. 539). Eclecticism in artistic practice (col. 544). Antiquity. (col. 544). From the Middle Ages to modern times (col. 547). The Orient (col. 549).

FORMATION AND HISTORY OF THE CONCEPT OF ECLECTICISM. The concept and the term "eclecticism" itself were introduced into the history of art by Johann J. Winckelmann (1764; see TREATISES), who took it from current philosophical terminology and used it to isolate with a critical definition a tendency of which earlier art history (see HISTORIOGRAPHY) had already been aware.

The notion of eclecticism appeared very early in history, since the problem of the choice and synthesis of various elements, which inevitably enters into the creation of an art work, could hardly have escaped esthetic speculation. It is significant that it always is found in historical sources with a declared attitude, favorable or unfavorable, toward it. In medieval theory, though an explicit thesis of conscious eclecticism is lacking, the condemnation of stylistic mixtures may be noted. Examples are the theoretical writings on poetry of Matthew of Vendôme and Geoffrey of Vinsauf in the 12th century (cf. E. De Bruyne, *Etudes d'esthétique médiévale*, II, Bruges, 1946, pp. 14–49) and the anti-eclectic declarations of Cennino Cennini in the 15th century. Though counseling the study of the works of the masters, Cennini warned the student to "be sure to choose always the best one, and him who has the greatest reputation," for "if you undertake to copy after one master today and after another tomorrow, you will not acquire the style of either the one or the other, and you will, through enthusiasm, necessarily become capricious, because each style will be distracting your mind . . . but if you follow the course of one man, continually practicing, your intellect would have to be dull indeed not to get some nourishment from it" (*Libro dell'arte*, XXVII, Florence, 1943, pp. 33–34; Eng. ed., *The Craftsman's Handbook*, New Haven, 1933).

The Renaissance theory of an ideal imitation of nature (see TREATISES), already clearly formulated by Leon Battista Alberti, implied a principle of selection and synthesis basically anti-eclectic in so far as it was directed toward realizing a single and absolute beauty. None the less, this principle of selection held in it the germ of a positive program of eclecticism, which was in fact formulated in the 16th century, as soon as the source of the ideal choice was transferred from nature to the *maniera* of masters. Giorgio Vasari wrote that Raphael (PL. 314) "studying the works of the old masters and those of the moderns, took the best from each, and, having gathered all together, enriched the art of painting with that entire perfection possessed in antiquity by the figures of Apelles or Zeuxis, or an even greater perfection if one could describe or show their works in comparison to his" (*Lives*). A precedent for Vasari's argument had appeared in Gianfrancesco Pico della Mirandola's reply to Pietro Bembo during a dispute in 1512 over the Ciceronian question in literature (cf. G. Santangelo, *Il Bembo critico e il principio d'imitazione*, Florence, 1954; also studied in relation to the fine arts by E. Battisti, ("Il concetto d'imitazione nel Cinquecento da Raffaello a Michelangelo," *Comm.*, VII, 1956, pp. 86–104). Pico, despite the possibility of an eclectic outcome, supported the principle of imitating more than one model, selected freely either from examples offered by tradition or from nature. Both sources were to be surpassed in the new creation (*Epistolae de imitatione*, ed. Santangelo, Florence, 1954, pp. 27, 30, 31).

About the middle of the 16th century Paolo Pino, a writer of classical inspiration, wrote that "if Titian and Michelangelo were a single body, or if to Michelangelo's drawing were added the coloring of Titian, that artist might be called the god of painting" (*Dialogo di pittura*, Venice, 1948).

Vasari's attitude was substantially favorable to eclecticism; he rebuked artists for imitating Michelangelo alone when, by having imitated Raphael too, "many of our artists . . . would not have labored in vain nor created a hard manner, strained and without grace, without coloring, and poor in invention in those parts of painting wherein they might, by seeking to be universal and to imitate the other parts, have worked to their own profit and that of the world" (*Lives*). Giovanni Paolo Lomazzo gave a further twist to the eclectic theory: "I have never found that anyone who has followed the footsteps or the example of another has been able to equal him, let alone to surpass him." He also added: "But the whole strength of this externalization of what is impressed in the mind consists in exercising great care in knowing oneself and that which one's mind desires, and with facility and grace expressing it in the work, selecting what is beautiful and good from what has been seen in others." And again, he spoke of ". . . Figino, our disciple, who with such prudence and industry composes his pictures partaking of Leonardo's lighted shadows and exactness, of Raphael's harmonious grandeur, of Correggio's lovely coloring, and of Michelangelo's contour drawing; persevering thus, with these various parts, in the attempt to bring into being that which, according to his particular genius, he has conceived in his mind" (*Trattato dell'arte della pittura*, Milan, 1584, pp. 437–38). And elsewhere he wrote: "He who would like two paintings of the highest perfection, such as should be those of an Adam and an Eve, which are the noblest bodies in the world, would have to give the Adam to Michelangelo to draw, to Titian to color, taking the proportions and harmony from Raphael; and the Eve to Raphael to draw and to Antonio da Correggio to color: and these two would be the best paintings that had ever existed in the world" (*L'Idea del Tempio della pittura*, Milan, 1590, chap. xvii).

Denis Mahon has shown that the first of these last two passages appears almost to the letter in a work by Lucio Faberio *Il funerale d'Agostin Carraccio...*, Bologna, 1603, p. 36 ff.). Faberio presented it as the program of Agostino Carracci himself ("The aim of our Carraccis was to assemble the perfections of many and to incorporate them with perfect harmony into one body, in which nothing better could be wished for"). Here lies the origin of the ascription to the Carraccis (see CARRACCI) of a programmatic eclecticism issuing from the 16th-century courtly tradition. Raffaele Borghini wrote that Tintoretto "took as his principal master the work of the divine Michelangelo" and "himself admitted no other masters in the matter of drawing than the Florentine artists; but in coloring said that he had imitated nature and afterwards, in especial, Titian" (*Il riposo*, Florence, 1584, p. 551). G. B. Armenini wrote: "Just as it is necessary to good poets to see many volumes of books treating of different subjects, as an aid in making beautiful and praiseworthy works or compositions; so are they duty bound to do who would strive for excellence in painting, since when they have come to a good understanding of drawing, and have well experimented in coloring in different manners to find the best and truest tints, they are then obliged, if they would pursue the goal of perfection, as one should, to become familiar with and to partake of the different manners of painting used by the most excellent of our moderns, from whom comes the true insight into how to unite the different mixtures and colors so that they result pure, radiant, and pleasing; and likewise take the manner of their [the moderns'] composition and dress, found here and there in their [paintings], in order that in making their own they should be without defect" (*De' veri precetti della pittura*, Ravenna, 1587, pp. 48–49).

In the artistic literature of mannerism the eclectic methodology was thus applied to a free imitation of both nature and the examples offered by tradition. These last, however, came to be ordered in ascending classes according to the values worked out by the art historians of the time. This division paved the way for the definition of schools (see HISTORIOGRAPHY). In mannerist instruction (see MANNERISM), in fact, an exercise in the composition of elements from the various Renaissance styles and local schools, with a correlative choice from nature without regard to natural or rational proportion, became basic to the process of formulation of artistic expression, which was primarily ideological and intellectual (G. Briganti, *Il manierismo e Pellegrino Tibaldi*, Rome, 1945).

The problem of Carraccesque eclecticism (PL. 314) in relation to the preceding tradition may be understood in analogous terms. It is an eclecticism that, if it should not be regarded

as programmatical in the traditional view (D. Mahon, 1950), nevertheless remains, according to others (Venturi with Mahon, 1950), one of fact and inherent in the artistic activity of the Carraccis. This is evidenced both in their manifold links with the recent tradition (C. Gnudi, *I Carracci*, Bologna, 1956) and in certain specific carry-overs from the mannerist circle, as, for example, in prints (M. Calvesi, "Note ai Carracci," *Comm*, VII, 6, 1956, pp. 263–76).

The authors opposed to this free and arbitrary imitation with its implied eclecticism were the same ones opposed to mannerism itself. Giovanni Andrea Gilio, wishing to return to the "former purity" of art, adjudged "far more ingenious that artist who adapts his art to the truth of the subject, than he who warps the purity of the subject to suit the graces of art" (*Due dialoghi*, Camerino, 1564, pp. 86–87). Gregorio Comanini (*Il Figino, ovvero del fine della pittura*, Mantua, 1591) favored the direct and controlled imitation of nature "not as though art played or jousted with nature, but showed and taught." Furthermore, the Counter Reformation view, bent on ideological usefulness and iconographic correctness, naturally excluded eclecticism, whether as syncretism of elements of natural beauty, as opposed to a direct imitation of nature; as formal syncretism; or as iconographic syncretism (St. Charles Borromeo and Federigo Borromeo; cf. E. Battisti, "Il concetto d'imitazione nel Cinquecento dai Veneziani a Caravaggio," *Comm*, VII, 1945, pp. 249–62).

In the 17th century the establishment of the academies and their relative doctrines, already initiated in the second half of the 16th century, led to the assumption of a fully eclectic teaching program. The sonnet that Carlo Malvasia (*Felsina pittrice*, I, Bologna, 1678, p. 159; Eng. trans., E. G. Holt, *A Documentary History of Art*, II, New York, 1958, pp. 73–74) in his life of Niccolo dell'Abate accredited to Agostino Carracci contained the recipe for good style that was to become the accepted one. It found its precedents in the previously quoted passages from Lomazzo. Didactic collections of engravings were widely published and imitated even outside Italy. One such collection was called "The Perfected School for Learning to Draw the Human Body Derived from the Study and Drawings of the Carracci" (Rome, n.d.).

Italian classicism was translated into a rigorous set of precepts and an eclectic methodology in the doctrine of the French Academy of Charles Lebrun and André Félibien des Avaux. Discussions among Academy members "turned on learned and enlightened discourses regarding the principles of drawing as simple imitation; on the manner of enriching and ennobling what is done, from nature, by the beauties of the antique; on the character and merit of the great men of the Roman school and of that of Bologna; in fact, on everything that might relate to this fundamental part of the fine arts" (*Memoires inédites de l'Académie Royale de Peinture et de Sculpture*, Mss. Ecole des Beaux-Arts, Paris; quoted in Fontaine, 1906, p. XVII).

Desportes, among others, maintained that the artist must first of all make a choice among masterpieces offered by tradition; and Philippe de Champaigne in a lecture of 1572 advised against adopting a single model, since one should rather "take what is most beautiful from all the individual manners, and in imitation of the bees, form for oneself a nectar, that is to say, a beauty, which is one's own" (Fontaine, 1906, p. 103). This demanded that criticism (q.v.) should investigate and define the beauties of each constituent part of the art work; the same kind of eclecticism recurred in the classicizing precepts of Félibien, Charles Du Fresnoy, and Rolland de Fréart de Chambray, the last of whom also saw, as did Jacques François Blondel, symmetrical beauty as a concurrence of the single parts. Such sets of ideas inspired didactic manuals with practical examples, such as the *Livre de portraiture tiré de Carache, Villamene, et autres excellans maistres d'Italie* (Paris, n.d.).

None the less, the idea of beauty itself, and hence the eclectic process implied in it, was taking on a new flavor. André Félibien himself wrote: "Beauty is born from the proportion and symmetry with which the bodily and material parts meet. And grace is engendered by the consonance of interior feelings caused by the affections and sentiments of the soul" (*Entre-*

*tiens sur les vies et sur les ouvrages des plus excellens peintres*, I, Paris, 1725, p. 83). Desportes defined taste in drawing as "in general a fine and delicate discernment which draws us toward that which objects possess which is most beautiful, most piquant, and most appropriate to imitate" (Fontaine, 1906, p. 54).

If the Academy favored an inherently eclectic methodology, decidedly opposed to it were the major protagonists of the baroque and of classicism itself. Gian Lorenzo Bernini (q.v.) made fun of the anecdote about Zeuxis and the selection from nature (F. Baldinucci, *Vita di Gian Lorenzo Bernini . . .*, Milan, 1948, pp. 143–44). Poussin (q.v.) deprecated eclecticism as a stylistic pastiche in the name of a historical principle (*Les lettres de Poussin*, ed., P. du Colombier, Paris, 1929, pp. 240–43; cf. P. Alfassa, "La lettre de Poussin sur les modes," *Bull. de la soc. de l'histoire de l'art française*, 1933, pp. 125–43). And Marco Boschini derisively alluded to the practice of "standing before a great painting and constructing copies of it in sifted flour without recourse to nature" (*La carta del navegar pitoresco*, Venice, 1660, p. 339).

The antibaroque critics, however, again proposed an eclectic methodology. Roger de Piles's "Balance of Painters," a table for evaluating the merit of artists, published in his *Cours de peinture par principes* (Paris, 1708), is based on eclectic principles of taste. Eclectic also was the new ideal of "grace," which began to replace classicizing beauty with the rococo (q.v.) point of view. The very elusiveness of "grace," which for De Piles as for B. J. Feijoó was an indefinable quality, opened up to eclectic methodology an entirely new set of possibilities. The academic tradition progressively enriched itself with a whole new range of officially recognized models, the breadth of choice allowing the coexistence of almost antithetical stylistic positions.

The Scottish thinker Francis Hutcheson (*Enquiry into the Original of Our Ideas of Beauty and Virtue*, London, 1723) attributed our sense of the beautiful to an inner faculty that distinguishes unity within variety. In this idea we find a new stress on variety as the result of an eclectic procedure, exercised especially before nature, the imitation of which was once more regarded as fundamental. This feeling for variety was an important characteristic of rococo art. The "universal" imitation of nature, which Ignacio de Luzán (*Poética*, Madrid, 1737) opposed to that which is "particular" (*icástico*), is selective in character. Denis Diderot placed the Carraccis beside Raphael because of the intimate balance they achieved between tradition and nature (*Essai sur la peinture: Salon de 1765*; critical ed. in J. Seznec and J. Adhémar, *Diderot: Salons*, II, Oxford, 1960).

Winckelmann gave the first modern definition of eclecticism, introducing the term into the history of art. He placed the activity of imitators in the next-to-last phase of the evolution of art, comparing their position to that of the eclectic philosophers working in Rome and Greece toward the end of the 2d century B.C., whose thought was characterized by a conscious syncretism of Academic, Peripatetic, and Stoic doctrines. Finally, he compared the attitude of the ancient imitators to that of the Carraccis. As Mahon has shown, this idea of Winckelmann lay at the root of the modern commonplace concerning the programmatic eclecticism of the Carraccis. This idea was formulated on the basis of a tradition crystallized by Winckelmann himself, and goes back to G. B. Agucchi, Giovanni Bellori, and Malvasia. It is one to which Anton Raphael Mengs, at the time, linked himself (*Opere*, II, Bassano, 1783, p. 59). Winckelmann's definition immediately met with success among the various German writers on art, and was taken up by Lanzi, thus remaining tied, in modern art history, to the activity of the Carraccis, which in reality was different in character. Under the influence of James Barry (*A Letter to the Dilettanti Society*, London, 1798, p. 25) and Henry Fuseli (Füssli; *Lectures on Painting Delivered to the Royal Academy*, London, 1801, p. 80 ff.), the formula of Carraccesque eclecticism, summed up in the famous sonnet previously mentioned as published by Malvasia, spread into English art literature. Fuseli and especially Friedrich Schlegel ("Gemäldebeschreibungen aus Paris und den Nieder-

länden in den Jahren 1802–04," *Sämmtliche Werke*, VI, Vienna, 1823, pp. 30–58) gave the concept of eclecticism an essentially pejorative connotation.

Franz Kugler (1837), separating artists into eclectics and naturalists, included among the former the greater number of artists working in Italy at the end of the 16th and during the first half on the 17th century. Among these the Carraccis naturally found their place, accompanied in fact by a citation of the famous sonnet (Kugler, I, p. 331). The Campi of Cremona are there, too, and also G. C. Procaccini of Milan (*ibid.*, pp. 345–46). Lanzi had already so categorized the first, and Malvasia, the second. Pietro da Cortona was included as well (*ibid.*, p. 350). Kugler discovered an eclectic "revival" in Anton Raphael Mengs and Pompeo Batoni (*ibid.*, p. 358 ff.). Through the numerous English editions of Kugler's manual the formula of Carraccesque eclecticism spread anew into English art literature, where it reappeared in John Ruskin and others (Mahon, 1947). As a result, there arose in the 19th century the truly self-contradictory notion of "eclectic schools." As Mahon noted, B. de Koehme's catalogue (St. Petersburg, 1863) of The Hermitage collection, for example, classified the artists of the second era of modern art as naturalists, eclectics (the Carraccis, Domenichino, Reni, Tiarini, Albani, Mola, Sacchi), and those of local schools. (The second epoch of modern art was thought of as following the first, which had an era of formation in the 15th century, a high noon at the end of the 15th and beginning of the 16th century, and a time of decline with Bronzino and Veronese.) It is evident that the term "eclecticism" was taking on a value no longer positive.

Though many romantic artists were, in fact, eclectics in practice, romantic thought favored a rationale for artistic creation based on a process much more personal and homogeneous than the eclectic process of aggregation. Romanticism (q.v.) reacted against formal rules in the name of the artist's freedom to choose, a freedom which was to be exercised both stylistically and thematically. (Delacroix, for example, copied the works of a number of old masters.) Schelling, however, declared that "works originating in a juxtaposition of forms, however beautiful these forms, would none the less be without beauty. Since that which makes the work beautiful is the whole, it cannot then be the form. For above the form is the essence, the semblance and expression of the spirit of nature contained in art" (*Uber das Verhältnis der bildenden Künste zu der Natur*, Munich, 1807).

The critics allied with realism (q.v.) were naturally opposed to eclecticism, which Baudelaire held antithetical to "temperament" (*Curiosités esthétiques*; *Œuvres complètes*, II, Paris, 1868) and which Zola deprecated as a mannerism remote from life (*Mes Haines*, Paris, 1866). Baudelaire considered Ingres' formal archaism eclectic; while Eugène Fromentin preached: "Study method in the masters, the truth in nature; but search only within yourself for the innate image of the beautiful" (cf. M. Pittaluga, *La critica dei Salons*, Florence, 1948, p. 117). The term "eclecticism" was taking on a negative qualification as a synonym for lack of personality. Nineteenth-century architecture however, was marked by a conscious eclectic tendency that still continues (see below).

In the 20th century the concept of eclecticism — while undergoing a process of historical definition and testing (cf. Mahon's repudiation of the idea of a Carraccesque eclecticism and the debate arising from it) — has lost some of the pejorative connotation that has accompanied it since its introduction. The term is coming to be used to indicate syncretistic phases in the history of art, whether in that of the ancient or the Oriental, the medieval or the modern world. At times this term may be appropriately applied to a whole series of phenomena, so that eclecticism is among the characteristics of certain periods. The architecture of the 18th century in France provides an example (Hautecoeur, 1943–57). This extension and the consequent generalization of the term have engendered reactions. These, however, turn more upon points of terminology than on any real denial of the validity of the concept. Giuliano Briganti (*Il manierismo e Pellegrino Tibaldi*, Rome, 1945, pp. 18, 25–33), while denying the mannerists' eclectic use of Renaissance sources, does affirm a syncretistic attitude of the Renaissance toward materials derived from antiquity.

ECLECTICISM IN ARTISTIC PRACTICE. Whatever the genesis of the concept of eclecticism or its present critical meaning, there is no doubt that the term can legitimately be employed to describe phenomena and tendencies often widely different and at times even apparently contradictory. These date from the earliest times in the history of artistic expression to the present. The term appears closely linked to the classical theory of poetry postulating the selection from natural beauty as well as to the later neoplatonic doctrine of selection on the basis of the idea, and hence also to modern forms of classicism (q.v.) and neoclassicism (see NEOCLASSIC STYLES). It characterizes phases in history during which cultural units were dissolved under the impact of the formation of a new koine, or common style. Its history ranges from the age of the intermingling and diffusion of cultural traditions of the ancient Near East (see ORIENTALIZING STYLE) and of Hellenism (see HELLENISTIC ART) to the late Gothic (see GOTHIC ART) and mannerist (see MANNERISM) eras, and to some phases of contemporary art (see AMERICAS: ART SINCE COLUMBUS; EUROPEAN MODERN MOVEMENTS). It appears in eras manifesting the phenomena of cultural assimilation and critical evaluation. Notably anti-eclectic, on the other hand, are avant-garde movements, which are characterized by their single-minded and antihistorical programs. This is especially true of modern ones such as cubism and futurism (q.v.) and De Stijl (see NONOBJECTIVE ART). Eclecticism is connected to romanticism to a certain degree, since the latter sought to incorporate material from points distant in time or space (see ANTIQUE REVIVAL; EXOTICISM). The eclectic method, explicit or not, may be distinguished furthermore in the *de facto* eclecticism inherent in the syncretism found in unsuccessful artistic efforts and in cases of followers' adaptations. Nietzsche defined civilization as the "unity of artistic style in all a people's vital manifestations" and barbarity as the "lack of and chaotic mixture of all styles" (*Unzeitgemasse Betrachtungen*, 1873–76). Henri Focillon later wrote: "Each artist chooses, weighs, and combines in an image of the world certain elements which are his own, and which characterize his creation, his universe" (*Piero della Francesca*, Paris, 1952, p. 133). Connected with an eclectic methodology, though only vaguely, are also such notions as Delacroix's "dictionary of nature," implying an initial free and personal choice from nature herself, which then takes on an altogether new and personal character. Eclecticism thus constitutes an attitude recurring in various forms and differently felt throughout the development of artistic expression. The term is not applied when only single elements of the art work — iconographic (see ICONOGRAPHY AND ICONOLOGY) or technical, for example — are adapted from other styles, but rather when the whole artistic process is involved.

Enrico CRISPOLTI

ANTIQUITY. It is difficult to distinguish clearly the relationship between phases of coherent stylistic unity and phases of cultural syncretism when documents describing the theoretical tendencies of an era are lacking, when insight into a civilization's most profound experiences is not to be obtained, or when the artistic manifestations themselves are known but partially and fragmentarily. Such is the case for many epochs and many areas in the history of art, beginning with prehistory. An investigation concerning such matters extended to the art of the primitives, to the ancient world, and to the non-European civilizations might produce interesting results, but at present conclusions are limited by the sparseness of material available for study. To give a typical and concrete example, we do not yet have sufficient data to determine whether the rock engravings of the Sahara regions in such sites as Mt. Ahaggar and Fezzan (see AFRICA, NORTH; PREHISTORY), which have elements resembling those found in Western prehistoric art and also motifs more or less vaguely Egyptianizing, are to be considered a result of the encounter of different currents and traditions in a receptive world of seminomadic communities, thus counting as an embryonic instance of eclecticism; or whether they represent an

innovating culture paralleling that of predynastic and proto-dynastic Egypt, as is now suspected by some scholars. Only the accumulation of data from continued discoveries can give the answer, or at any rate allow of a clearer definition of the problem, which is obviously one of chronology, that is, one concerning the dating of the works in question and the time span over which they recur.

That the great national art traditions of ancient Egypt and Mesopotamia, the evolutionary cycles of which are relatively self-contained, should offer no important material for a study of iconographic or stylistic syncretism is understandable. There are, however, more or less isolated instances of stylistic adaptations or borrowings. The Syrian goddess Anath appeared in Egypt, her Hathor coiffure and the lilies in her hand not masking the original Asiatic iconography. She was, in fact, represented nude, sometimes standing on an animal. In Mesopotamia also the Anatolian-type deity standing on an animal may be seen, as in the rock-cut processions of gods at Maltai and Bavian, at the sources of Sennacherib's (705-681 B.C.) aqueduct. The fact that these sculptures are cut in the living rock also reveals an influence outside the Mesopotamian tradition. The winged solar disk of Egyptian lineage spread into Hittite and Assyrian art, where it was, however, stylistically and conceptually assimilated. But it is clear that the principal spring of any culture — or even of specific and pronounced aspects of its production — cannot be described as eclectic unless historical conditions, resulting in the breaking down of its autonomous development, have led to an intermingling of cultural streams that are complementary and reciprocally nourishing.

This occurred in the Near East just before the end of the Bronze Age, in those border zones subject to rapid political shifts and frequent trade migrations. This was especially true in Syria and Palestine, which felt the prolonged, overwhelming, and mutually conflicting influences of the Egyptian, Mesopotamian, Anatolian, and Aegean civilizations. But from the beginning of the 1st millennium B.C. a new system of worldwide expansions and local fragmentations, inaugurated by the Assyrians, replaced the earlier balance of stable national powers. All the Near East was invested by the phenomenon — more or less pronounced, more or less progressive — of a religious, institutional, technico-economic, and hence also artistic, syncretism. Within the individual orbits of the ancient national cultures, instances of reciprocal influences multiplied. Egypt, though essentially resistant to the penetration of other cultures, first absorbed Assyrian influences. These are observable in 25th-dynasty reliefs, for example, those of Taharqa at Gebel Barkal with their characteristic emphatic rendering of the muscles. (It is uncertain, however, whether these are the works of Egyptian eclectics or Egyptianizing Syrians.) Egypt next absorbed Persian, Greek, and Roman influences. The architecture, sculpture, and painting of the Ptolemaic and Roman eras (see EGYPTIAN ART) represent a hybrid Greco-Egyptian production that is not devoid of superficially pleasing characteristics (PL. 311). Assyrian and neo-Babylonian art adapted Egyptian, Syrian, and Anatolian motifs. Examples are the statuette of Ashurbanipal, conceived according to the Egyptian "cube" scheme (PL. 311), and the voluted palmettes of Nebuchadnezzar's palace. Foreign craftsmen were always welcome to set up their shops in the cities, as the Syrian ivory carvers did at Nimrud.

Bordering these areas was Urartu, which combined Mesopotamian and Syrian traditions with other, local ones — Mannaean and perhaps South Iranian. The new Hittite cities of northern Syria and of Cilicia (Tell Halaf, Carchemish, and Karatepe) grafted the Anatolian heritage onto the already composite trunk of Syrian culture.

Almost the whole area of hither Asia became absorbed in a common style (see ASIA, WEST: ANCIENT ART). The Syrian and Palestinian centers, and those of nearby Cyprus, assumed the most active role as producers and furnishers of luxury objects made by goldsmiths, metal engravers, and other artisans. The technical virtuosity of their products, dissociated from all traditional religious or dynastic purposes, resolved itself into eclecticism. The mixture of the different ancient Oriental influences in iconography, drawing style, and ornament is especially evident in, for example, silver gilt plates with embossed designs of Cypriote origin (PL. 94). Egyptian themes overlie the primary Asiatic ones, and the disparate formal conceptions are reconciled in a facile decorative manner. Through the Phoenician expansion westward and the intense commerce of the maritime Greeks, this tendency in taste, which we call "Orientalizing," and its products spread out and conquered the markets and the local artisan schools of Greece and of Italy. The style adopted new elements from the new lands, so that it took on a character of internationalism, and gave its stylistic stamp to an entire, important phase in the cultural history of the Mediterranean world between the 8th and the 6th century B.C. (see ORIENTALIZING STYLE).

A very different explanation, not commercial but political and ideological, underlies the other great phenomenon of Oriental eclecticism: that of Achaemenian Persia. Last heirs to the ancient Eastern world, the Achaemenian empire deliberately robed itself in universalism, calling artists from all parts of its immense domain, and selecting the best elements of each individual tradition. Egypt inspired the massiveness of the hypostyle halls and their columns with leaf capitals. Other architectural elements came from Greece. Syrian models, already subject to archaic Greek influences, reformed the relief style. Mesopotamian and Egyptian motifs influenced iconography, sometimes fusing elements together, as evidenced by the four-winged genii wearing Egyptian headgear. The contribution of Scythian, Central Asian, and Medean art appeared in the treatment of animals and in certain kinds of interlace motifs. Also observable in Iranian territory was a process of assimilation of West Asian influences that, already manifesting itself in original forms within the Achaemenian domain, was to prepare the ground for the unity of Parthian and of Sassanian art.

The Greek world's last encounter with the koine of the Near East after the conquest of Alexander the Great might, from the point of view of historical conditions, have represented an ideal matrix for a final and vaster syncretism. On the contrary, Greek art imposed itself in the great cities and the newly created towns (see HELLENISTIC ART), where it coexisted with local traditions. This situation gave rise to only a few authentically eclectic works, such as the sculpture of Syria and Cappadocia and the above-noted Greco-Egyptian examples. Evidently, the mere convergence of heterogeneous traditions does not necessarily result in eclectic art forms, especially when one of the traditions has vitality enough to impose itself on the others. In fact, the "eclectic crisis" in art always results from an exhaustion of expressive force in the various trends making up the cultural complex in which it occurs.

Such trends may originate not only from other civilizations, but from other phases of the same civilization, when older formal elements reflower alongside more recent ones. This may be called a "diachronic" eclecticism, though in reality the diachronism is only apparent, since the concurrent elements, whatever their era of origin, present themselves at the same moment to the consciousness of the time. One cannot speak of true eclecticism when a return to the antique (see ANTIQUE REVIVAL) dominates a style, even though it absorbs from the style technical and formal elements; or when the art of a time tends to innovate by drawing upon ancient art.

These reservations apply especially to another characteristic phase of ancient eclecticism — that appearing at the end of the Hellenistic and the beginning of the Roman imperial era within the great cultural koine created by Rome's conquest of Greece and the Orient. The neo-Attic sculptors (see NEO-ATTIC STYLES) in particular are often referred to as eclectics. In fact, there appeared in many of their productions a conscious juxtaposition of elements from earlier styles (archaic, 5th or 4th century B.C., Hellenistic) or from different tendencies (Attic, Asiatic, and the rococo trend in Hellenistic art). In this case too the lack of conviction — even stylistic indifference — led to a preeminently decorative form of art characterized by a tendency to virtuosity of design and preciosity in execution. The word "eclecticism," however, often used in too sweeping a sense, must be applied with caution to the manners

of individual artists or to the style of single works, especially when these are in the line of development of a well-defined traditionalist trend. Such is the case with the 2d-century B.C. sculpture of a Timarchides, a Damophon, or a Euboulides, in which the elements diverging from Atticism are barely perceptible, or with the copies or paraphrases of older works; it also applies when the various elements from different traditions are resolved in a new creation. Instances of obvious, and to us unpleasing, eclecticism may be noted in certain famous statues representing extreme cases, as in the so-called "Group of S. Ildefonso" (PL. 312). In this sculpture a Praxitelean figure is unabashedly associated with a Polykleitan one. The oddity of this conjunction may be understood perhaps by imagining a painting with one figure in the style of David, the other in that of Delacroix.

The time at which Greek culture encountered the Roman world was one of syncretist attitudes. This may be explained by the convergence on Rome — which lacked a unified and traditional cultural image of her own, though she was the administrative and economic capital of a great empire — of artistic, literary, and religious trends coming not only from Greece but also from Egypt and Asia. This was partially manifested in the form of innumerable art works. Intellectual ideals, love of luxury, dilettantism, and speculation inevitably led to a search for the most prized works from every part of the empire, and hence to a propensity for selection and juxtaposition of the most diverse kinds of objects, motifs, and styles, at times in the most unrestrained manner. This must have been especially evident in the heterogeneous furnishings of the imperial dwellings and villas of wealthy persons, something of which is described in Cicero's *Letters*. The last and most spectacular manifestation of this cultural attitude was Hadrian's enormous villa at Tivoli, near Rome, where the separate groups of buildings in their architecture and ornament were intended to evoke famous places touched on in the imperial travels, all brought together in a fantastic kind of sample fair. The concept of the *variae artes* (Statius, *Silvae*, i, 3, 55); the universally diffused theory of the great ones in art, comprising the names of Myron, Phidias, Praxiteles, Zeuxis, and Apelles; and even, on the lowest level, the blundering mishmash of attributions made by incompetent persons, derided by the poets (Petronius, *Satyricon*, lii; Martial, *Epigrams*, viii, 5) — all these are indications of a conventional, noncritical, and muddled attitude toward the authentic qualities of artistic styles and personalities in the ancient world. This attitude lay behind such unfortunate sculptural pastiches as classicizing torsos blighted by crudely realistic portrait heads (for example, the Roman matron depicted as Venus; PL. 313) and monstrous statuary contrivances such as Polytimus as a mythical hunter in the Capitoline Museum in Rome. Architecture, too, was subject to these tendencies, though in a more restrained way, and with accents more congenial to the Roman feeling for building. In the composite or figured capitals, for example, which have some precedents in Etrusco-Italic architecture, the clash was resolved with precocious and positive ornamental inventions. The joining of a Greek pronaos with a Roman domed rotunda in Hadrian's Pantheon in Rome appears simply a more drastic manifestation of the ancient experiments in adapting a cloak of classical orders to an Italic spatial structure and a curvilinear covering.

FROM THE MIDDLE AGES TO MODERN TIMES. The term "eclecticism" is not commonly used by criticism in reference to the Middle Ages except when, at times, as in 14th-century painting after Giotto's death, Sienese or Riminese elements are met with in Florentine painters or Giottesque elements in the northern painters. It is in fact just this general translation of Giotto's style into the current language of the century, capable of the most varied inflection, that lay behind Cennini's disapproval of the fickle imitators of more than one manner.

During the Quattrocento borrowings from antiquity became more frequent. The first great artist to take from all without being dependent on any was Raphael, whose influences — Perugino, Leonardo, Michelangelo, antiquity, and Venetian colorism — were diverse and mutually opposed. It is not mere chance that Raphael was the model for Vasari's eclectic theory, for Raphael attempted not the mere juxtaposition of forms but a synthesis between Tuscan-Roman drawing and Venetian coloring. Modern critics disallow the use of the term "eclecticism" for Raphael because of the pejorative overtones of the word and its incompatibility with the artist's capacity for assimilating and transforming all into his own very personal style. The influence of Michelangelo and the antique are manifest in many of his works (*The Deposition*; PL. 314), but they represent phases in an absolutely coherent stylistic development.

The eclectic label may perhaps be applied rather to pupils such as Giulio Romano, who did not always succeed in fusing his master's style with the Michelangelesque manner. Sebastiano del Piombo attempted a synthesis between the Giorgionesque colorism in which he was first trained and Michelangelo's linear and plastic force. Tintoretto was pointed out by Renaissance writers as the protagonist of an analogous attempt to reconcile different "manners," but his instinctive style does not fall within the modern concept of eclecticism. Of the Carraccis referred to already, it is in reality Annibale alone who is here concerned (PL. 314). From the Parmesan and Venetian tendencies of his northern schooling, he moved gradually toward an ideal classicism in a development whose logic is now acknowledged. The 17th-century writers thought of Annibale as the artist who, by synthesizing the various "manners," realized a beauty which was superior because it summed up many different beauties. This served to define the painter's historical postion, differentiating it from that of a Caravaggio. And that position remained a valid one for at least two centuries for artists who were the Carraccis' ideal successors. These include Poussin, Rubens, and Reynolds. Poussin (e.g., *Bacchanal*, or *The Childhood of Bacchus*; PL. 315) and Rubens both studied the antique and modern styles (Titian and Raphael), though they arrived at different destinations — Poussin extolling drawing and Rubens color. It was Reynolds who finally, in the 18th century, attempted a conscious synthesis of the Roman, Venetian, Flemish, and Dutch manners, looking simultaneously to Raphael, Rubens, and even Rembrandt, in an attempt to realize an ideal composite style.

Almost all the the artists who shared eclectic theories eventually arrived at personal styles, transforming or even distorting the very models themselves. The eclectic procedure was apparent in the 17th century more in the academic teaching (from the moment when the Academy began to take on that conservative and negative function that its name suggests in our times) than in the artists' creative practices. Those artists of most "classical" bent — Poussin or Anton Raphael Mengs — though their point of departure was an eclectic formula, aimed at a unique and absolute beauty which is the antithesis of eclecticism. Evident exceptions are certain minor painters such as Sébastien Bourdon, who cultivated simultaneously more than one genre and several manners, from the classical to the naïve, in an era of profound and general specialization.

* *

In the 18th and 19th centuries one may speak of a true and proper eclectic movement — true and proper because conscious and in many cases programmatic — especially in regard to architecture (PLS. 316, 317). Important factors were the comparative study of architectural styles, inaugurated by J. B. Fischer von Erlach in his *Entwurff einer historischen Architectur* (Vienna, 1721) and cultivated also by Piranesi; the Gothic revival; and even 18th-century exoticism (see EXOTICISM) with its assumption of defined styles. They led to a conscious architectural eclecticism, welded into formulas — especially in France, where the trend was related, on the theoretical plane, to the philosophical eclecticism of Victor Cousin. Reacting against the hegemony of the Greco-Roman style and conjoined with a trend toward historical reevaluation (as expressed in the works of Gailhabaud, J. N. L. Durand, Cousin, and others), this architectural eclecticism proposed historical models that were medieval (Byzantine, Romanesque, and Gothic), Renaissance, and Oriental. Until 1850 a "Gothic" phase prevailed in French architecture. This was followed by a "Renaissance" phase,

manifested by J. F. Duban, Léon Vaudoyer, Jacques Lacornée, P. B. Lefranc, L. Feuchère (also a designer of many interiors and of ornament), Henri Labrouste, A. N. Diet, H. M. Lefuel, Charles Garnier, G. J. A. Davioud, and H. J. Espérandieu. Alfred de Musset wrote in 1846: "The apartments of the rich are curiosity cabinets: the antique, the Gothic, the Renaissance and Louis XIII; all is jumbled together" (Hautecoeur, VI, 1943, p. 382). The theoreticians of eclecticism carried on an energetic campaign against classicism (*ibid.*, pp. 332–41). Daly thus justified the new architecture: "The eclectic architect is a positive and practical man par excellence; he does not become enthusiastic about any particular epoch of the past but plunges himself into a dream of the architecture to come. His notion of architecture is more often than not altogether material: to build well and to meet to his best ability the requirements of commodiousness and plastic harmony, and first of all, to satisfy the client; that, approximately, is his doctrine" (*Revue générale d'architecture*, XX, 1863, p. 164). In 1865 Charles Ernest Beulé declared in his funeral oration for Meyerbeer: "Eclecticism is the dominant trait of the 19th century."

Eclecticism, which represented in reality a transmutation of the preceding classicism, found itself in opposition to narrowly historical positions such as that of Viollet-le-Duc (q.v.). (It cannot be denied, however, that his aim was to create a means of expression eclectically, even though within a determined historical area.) And within France there were voices raised against eclecticism; Laborde Camp, Gautier, Lassus, Castagnary, Vitet, and others criticized it in the name of rationalist and functionalist principles (Hautecoeur, VII, 1957, pp. 290–99). Eclecticism, all the same, having within its own orbit made a marriage between architecture and engineering, remained a strong force. In the second half of the 19th and for a good part of the first half of the 20th century — until the appearance of the International Style (see AMERICAS: ART SINCE COLUMBUS; EUROPEAN MODERN MOVEMENTS) — it characterized European, North American, and especially South American building. Italy has its examples of modern eclectic architecture (PL. 318), and Spain played an important role in its diffusion in the Latin-American countries (cf. J. de Contreras, *Historia dell'arte hispanico*, V, Barcelona, 1949, chap. ix ).

In European art eclectic procedures reappeared in the orbit of the symbolist movement toward the end of the 19th century, where they were connected with a vague historicism. In the development of contemporary art, instances of eclecticism have coincided with the breaking up and regrouping of the different avant-garde movements and also with phases of critical reflection and elaboration, as in Dada, for example, just before and immediately following World War I (R. Motherwell, *The Dada Painters and Poets: An Anthology*, New York, 1951). They have also been present in postcubist experiments and in the influx of surrealist elements, especially in the United States in the period 1930–60 (S. Janis, *Abstract and Surrealist Art in America*, New York, 1944). Finally, they are found in the present postfunctionalist architecture.

Enrico CRISPOLTI

THE ORIENT. The history of Asia's artistic evolution offers, from the earliest epochs, numerous instances of the overlapping of different cultures of the most widely varied styles and esthetic attitudes. The meeting of Indian and Chinese currents in southeast Asia; the mingling of Western classical, Iranian, Indian, Chinese, and barbarian currents in Central Asia (see ASIA, CENTRAL); the art of Gandhara (q.v.); and to some extent that of the steppes (see STEPPES CULTURES) — to mention only the most salient examples — have for long attracted the attention of scholars. It must be noted, however, that the characteristic attitude of the Asian civilizations and cultures — each in general effecting an official isolationism prompted by its belief in its own superiority to any other — excluded eclectic theorizing. Furthermore, the cultural encounters were almost never sterile and, even though the various components remain fully recognizable, constantly gave birth to new departures that had a quality of their own, independent of their sources and different from anything previously existing in the compounded elements. For these reasons it is preferable to speak of "irradiations" and influences, even though such expressions appear inadequate and merit closer examination from the theoretical point of view. The term "eclecticism," even understood without its negative implications, is ill-adapted to describing the complex character of the new totalities that these encounters engendered and then projected onto the following centuries.

Some notion at least of the extensiveness of these cultural interminglings, irradiations, and influences may be given by stating that almost a third of the modern historiography of Asian art is concerned with such phenomena, either in individual areas or individual schools (Indo-Iranian, Sassano-Gupta, etc.; see INDO-IRANIAN ART). Similar results were obtained from the reworking of personal styles copied, absorbed, and in part adapted by successive artists, as was often the case in Chinese art. The spread of religious forms and the expansion of certain cultural currents over a vast area resulted in iconographical interpenetrations and transformations that may be considered either as instances of eclecticism or as cross-influences.

BIBLIOG. (See the bibliog. of CARRACCI and HISTORIOGRAPHY.) J. J. Winckelmann, Geschichte der Kunst des Altertums, VIII, Dresden, 1764, chap. 3, par. 18; F. Kugler, Handbuch der Geschichte der Malerei, Berlin, 1837; A. Fontaine, Conférences inédites de l'Académie Royale de Peinture et de Sculpture d'après les manuscrits des Archives de l'Ecole des Beaux-Arts, Paris, 1906; L. Hautecoeur, Histoire de l'architecture classique en France, VI, VII, Paris, 1943–57; D. Mahon, Studies in Seicento Art and Theory, London, 1947, pp. 193–229; D. Mahon, L'eclettismo e i Carracci: un post scriptum (with reply by L. Venturi), Comm, I, 1950, pp. 163–71; C. L. V. Meeks, Picturesque Eclecticism, AB, XXXII, 1950, pp. 226–35; D. Mahon, Eclecticism and the Carracci: Further Reflections on the Validity of a Label, Warburg, XI, 1953, pp. 303–41.

* *

Illustrations: PLS. 311–318.

**ECUADOR.** A republic of South America, Ecuador occupies an expanse of the Andean territory and of the Pacific Coast to the north of Peru, with geographic conditions similar to those of Peru. Outstanding archaeological remains of pre-Columbian civilization (see ANDEAN PROTOHISTORY) have been found there; but with the exception of the distinguished works produced by native craftsmen under the influence of Spanish acculturation, almost no genuinely indigenous art is being produced today. Ecuador is divided into three regions with appreciable ethnic and cultural differences: the Pacific coastal region; the highland plateau; and the eastern region, known as the Oriente.

SUMMARY. Pre-Columbian epochs: cultural areas (col. 550): *The coastal region*; *The highland plateau*; *The Oriente region*. Art of colonial derivation (col. 555). Principal art centers (col. 556).

PRE-COLUMBIAN EPOCHS: CULTURAL AREAS. *The coastal region.* The Pacific coastal region, comprising the most fertile and productive areas, has a hot, humid climate, which makes it highly suitable for tropical crops. The region is crossed by many large river systems that irrigate much of its area and is still inhabited by the descendants of ancient peoples now intermixed with European immigrants.

Up to now no relics of preceramic peoples have been found in the coastal lowlands, but a very ancient civilization of simple fishermen has been identified in Valdivia, a site in the central part of the Ecuadorian coast. These were related to the fishermen of Guañape, Ancón, and Supe in Peru, as well as to the peoples of Tlatilco in central Mexico and Playa de los Muertos in Honduras. It is presumed that they arrived in Valdivia almost four thousand years ago. Four sites of this culture have been found on the coast in protected bays. Its major artistic products were numerous and elaborate nude female figurines made of terra cotta, having a variety of sophisticated coiffures.

This culture was followed by that of Machalilla, which produced for the first time red-line painted pottery of high quality and also a type of short stubby vase with stirrup spouts. Machalilla seems to have been occupied briefly by a migratory and possibly seafaring people who left their imprint in only two places on the coast, one of which is in direct contact with the previous Valdivian population.

Later, but still within the Chavinoid horizon of Peru and before the Christian era, the Chorrera culture on the coast came into flower, producing new types of vases characterized by an iridescent, metallic sort of paint, negative painting (a technique whereby color is applied to the negative area surrounding a given silhouette), annular bases, and straight spouts with whistling devices. Crude textiles were also manufactured. The Chorrera culture, defined by C. Evans and B. Meggers, was the first to move inland in Ecuador, leaving traces in the southern section of the highlands, the Cañar Azuay area. Artifacts of this culture have been found as far away as northern Manabí, Los Ríos, and Guayas province. The population increased tremendously, and the Chorrera culture for the first time marked a somewhat independent complex of elements (perhaps forming the ethnological basis of the present country).

The Chorrera culture was followed by the Guangala horizon, discovered by J. H. S. Bushnell, which extended over practically the same territory. This culture introduced the first polychrome painting (in three-color negative); tall cylindrical vases and goblets; copper tools; and a renewal of the figurine cult.

At the time of the Chorrera-Guangala transition, the Bahía period in central Manabí presents the first stone construction on the coast in the Manta region, temple mounds encased by simple walls and stairways. This culture also had the first mold-made figurines found in Ecuador.

North of Bahía de Caráquez, an independent civilization flourished in Jama, Coaque, Cojimíes, and Esmeraldas, appearing contemporaneously with the Guangala horizon. Apparently it extended across the present national boundary into the Tumaco area of Colombia.

Goldwork of the highest quality is found in this area, the greatest manufacturing center appearing to have been La Tolita. Copper, silver, and platinum were also used there. Gilding, casting, forging, and welding appear to have been well-known processes at that time. At La Tolita, Ecuadorian metallurgy reached its climax. Repoussé gold plaques and figurines are probably the best examples of this art. They are akin to the Calima goldwork of Colombia (q.v.).

Pottery, too, was highly developed in coloring, paste, and plastic composition; the elaborate and numerous mold-made pottery figurines of the area north of Bahía de Caráquez are marvels of naturalness. Also striking are the pottery neck rests. Here a fairly direct Mexican contact is felt, apparently Zapotec in origin but also having links with other Mexican areas. Contact was probably by sea at that time. This culture was finally invaded by the Spaniards, who found in Coaque one of the great gold treasures of the Conquest.

South of Bahía de Caráquez, all the way to Puná Island, flourished the so-called "late Manteño culture," the only one to have produced large-scale stone sculpture, including the famous and abundant Manabí stone chairs and a number of simple stone statues carved from square blocks, strikingly similar to the San Agustín statuary of Colombia (see ANDEAN PROTOHISTORY; I, PL. 165). This culture developed ocean-going balsa rafts or floats, which are reported in historical times to have ranged as far north as Panama. Black pottery, plain or burnished in sections, with feline or human decoration on the necks of the vessels, was made for ceremonial use. The extensive shard deposits attest the existence of the first large cities and a further tremendous increase of population. No trace has been left of the type of building construction used — probably wattle and daub, as in earlier times.

In late prehistoric times, inland in the lowlands, bordering the navigable rivers of the Guayas River system and that of the Esmeraldas all the way to the first ramparts of the western Andes, developed the culture of the Colorado Indians (the so-called "Quevedo-Milagro" phases), the funeral-mound builders, who developed a highly specialized type of urn burial involving large urns surmounted by chimneys of several cylinders.

This culture extended as far south as El Oro province, next to the Peruvian border. Several thousand Colorado Indians still live in their aboriginal state near the headwaters of the Esmeraldas River — the last living remnants of a culture that once covered almost half of the coastal lowlands of Ecuador. Witch pots of dark pottery, with sculptural decorations of snakes, frogs, birds, and human figurines, are elaborate and striking demonstrations of a fertility and death cult presided over by Colorado shamans.

*The highland plateau.* The highland plateau, limited by the two parallel Andean mountain chains running north to south, enjoys a particularly good climate, which is probably why it holds the greater part of the total present population. One finds here the descendants of the Quechua-speaking Indians who, having been brought here by the Incas, mingled with the aboriginal highland tribes which in the north were related to Colombian peoples of ancient times. This is the region in which the Spaniards founded most of their cities, and to which immigration is still heaviest.

The cultures of the Ecuadorian highlands have been studied mostly by J. Jijón y Caamaño, although M. Uhle, W. C. Bennett, and D. Collier and J. V. Murra have also done a certain amount of work. It was the first-named author, however, who first set up the basic chronology in the studies he made at San Sebastián, near Guano, in the central highlands.

The oldest culture, stratigraphically, discovered by Jijón was that of Tuncahuán — represented basically by pottery decorated with three-color negative painting which appears in this country to be a horizon style found in practically the whole territory. Three-color negative ware has been found in the lowlands as well, but it seems to have been produced more abundantly in the northern part of the highlands, where the cultures had a great deal in common with those of Colombia.

Jijón proposed that another culture, called the proto-Panzaleo (I and II), be placed below that of Tuncahuán, but this he based only on stylistic grounds. Stratigraphic studies in the lowlands indicate that this culture was late, as had been suspected by Bennett, who saw the same decorative tradition and that of San Sebastián. We must, therefore, begin the north-central highland sequence with the Tuncahuán culture. Bowls, compotes, and tall vessels are the main shapes of this style, which is probably the oldest in the northern highlands near the Colombian border and extending beyond it. This period correlates with the middle cultures of the coastal region — Jama, Coaque, Guangala, and perhaps Tejar. Shaft burials were then common in the northern highlands. Later, burial in ceremonial mounds came into use.

In the upper part of the central highlands, according to Jijón, flourished the Panzaleo culture, which, he claims, began contemporaneously with that of Tuncahuán. It is more likely, however, that it corresponds to the slightly later culture of the highlands. In its upper phases, the Panzaleo culture extended as far east as the Oriente, where statigraphically it has been found mingled with Spanish remnants in more recent levels.

In the central highlands, the San Sebastián culture followed the Tuncahuán. Incised decorations are common in the pottery of this period, and the similarity of incised dishes, compotes, and tripods to those of the lowland cultures of Quevedo-Milagro gives clear proof of close relations between those regions at that time. It is probable that the people of the San Sebastián culture and related groups crossed over the Andes from the Amazon basin and then came down into the lowlands.

The Elen Pata culture came next, developing greater plasticity in its pottery forms as well as a highly decorative type of black negative painting on the bases of its tall vessels. These vessels have flaring necks, and their handles sometimes depict human faces.

The following period, that of Huavalac, seems to have been degenerative; it was the period in which Inca invasion occurred in the Andean plateau. The Inca culture extended over most of the highlands, but aside from a single site on the island of La Plata, 25 miles off the coast, no traces of it have been found on the coast.

Our knowledge of southern-highland cultures is more definite, thanks to the work of Collier and Murra and of Bennett. The three-color negative ware, probably the oldest characteristic ware of the north and central highlands, has also been found in the Cañar Azuay section, where other wares representative of older cultures underlie it. Ceramic wares of the Chorrera coastal period have been found there at the bottom of the deposits, in the cultures which the above authors have called the "Monjashuaico," "Huancarcuchu," and "early Narrío." Tuncahuán artifacts have been found in the late Narrío deposits, as has Elen Pata material. All these cultures were followed later by a culture called the "Cashaloma," remains of which lie just below the strata of the Inca invasions and dominance. The most characteristic ware of the early and late Narrío is a type of red on buff. Several minor wares of the late Narrío period seem to be closely related to coastal pottery types, especially those of the Jama-Coaque cultures, again indicating direct highland and coast contacts at various times.

*The Oriente region.* The Oriente, whose large rivers drain into the Amazon River system, is a flat, tropical country, sparsely inhabited by savage and semicivilized tribes, with poor communication and few agricultural or other natural resources. Ethnographically, its links are with Amazon tribes of Cariban or Arawakan origin.

Recent excavations carried out by C. Evans and B. Meggers in the northern part of the Oriente region have given proof of direct relationship with Marajó cultures. The valley of the Quijos, located in northern Oriente in the foothills of the Andes, was closely related to the late Panzaleo culture. Father Porras has recently found stone buildings and fortifications of this culture. The ceramics and simple stone statues found here appear to be related also to art of the Tierradentro region in Colombia. South of this area, only meager traces in Macas indicate relationship with the southern-highland cultures.

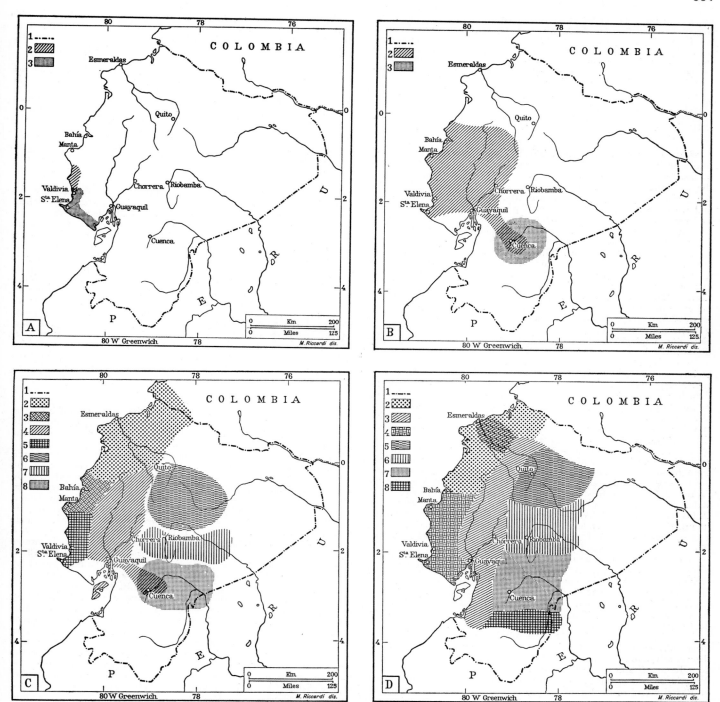

Ecuador: development and distribution of the pre-Columbian cultures (with indication of principal modern centers for reference). (*A*) Archaic formative phases (ca. 2000 B.C.). *Key*: (1) Modern national boundaries; (2) Machalilla culture; (3) Valdivian culture. (*B*) Late formative phase (ca. 1000 B.C.). *Key*: (1) Modern national boundaries: (2) Chorrera culture; (3) Proto-Narrío–Monjashuaico cultures. (*C*) Phase of regional development (1st cent.). *Key*: (1) Modern national boundaries; (2) Jama-Coaque I culture; (3) Bahía culture; (4) Guangala culture; (5) Guangala culture; (6) Panzaleo I culture; (7) Tuncahuán culture; (8) late Narrío culture. (*D*) Phase of integration (A.D. 1000). *Key*: (1) Modern national boundaries; (2) Jama-Coaque II culture; (3) Quevedo-Milagro culture; (4) Manteño culture; (5) culture of Panzaleo I and II; (6) culture of San Sebastián–Elen Pata and Huavalac; (7) Cashaloma culture; (8) Paltas culture (*after Swett*).

Farther out in Tiputini, well into the Oriente lowlands, the polychrome ceramics are also related to those of Marajó. Oriente, except for the northern part, is still unexplored as far as archaeology is concerned.

BIBLIOG. G. A. Dorsey, Archaeological Investigations on the Island of La Plata, Ecuador (Field Columbian Mus., Publication 56, Anthropological Ser., II, 5), Chicago, 1901; M. Saville, The Antiquities of Manabí, Ecuador, 2 vols., New York, 1907–10; R. Verneau and P. Rivet, Ethnographie ancienne de l'Equateur, 2 vols., Paris, 1912–22; O. von Buchwald, Migraciónes sud-americanas, Boletín de la Sociedad ecuadoriana de estudios históricos americanos, I, 3, 1918; M. Uhle, Estudios Esmeraldeños, Anales de la Universidad central, XXXIX, 262, 1927, pp. 219–79; M. Uhle,

Estudio sobre las civilizaciones del Carchi y Imbabura, Anales de la Universidad central, L, 284, 1933, pp. 351–409; M. W. Stirling, Historical and Ethnographical Material on the Jivaro Indians (Smithsonian Institution, Bur. of Am. Ethn., B. 117), Washington, 1938; F. Huerta Rendón, Una civilización precolombiana en Bahía de Caráquez, Revista del Colegio nacional Vicente Rocafuerte, XVII, 51, 1940, pp. 85–96; D. Collier and J. V. Murra, Survey and Excavations in Southern Ecuador (Chicago Natural H. Mus., Publication 528, Fieldiana: Anthropology, XXXV), Chicago, 1943; E. N. Ferdon, Characteristic Figurines from Esmeraldas (Papers of the Schools of Am. Research, N.S. 40), Santa Fe, N.M., 1945; G. H. S. Bushnell, The Archaeology of the Santa Elena Peninsula in South-west Ecuador, Cambridge, Eng., 1951; J. Jijón y Caamaño, Antropología pre-

hispánica del Ecuador, Quito, 1951; J. M. Corbett, Some Unusual Ceramics from Esmeraldas, Ecuador, AmAnt, XIX, 2, 1953; J. C. Cubillos, Tumaco, notas arqueológicas, Bogotá, 1955; E. Estrada, Valdivia: Un sitio arqueológico formativo en la costa de la provincia del Guayas, Ecuador, Publicación del Mus. Víctor Emilio Estrada, I, 1956; E. Estrada, Ultimas civilizaciones pre-históricas de la Cuenca del Río Guayas, Publicación del Mus. Víctor Emilio Estrada, II, 1957; E. Estrada, Los Huancavilcas, Ultimas civilizaciones prehistóricas de la Costa del Guayas, Publicación del Mus. Víctor Emilio Estrada, III, 1957; E. Estrada, Prehistória de Manabí, Publicación del Mus. Víctor Emilio Estrada, IV, 1957; C. Evans and B. Meggers, Formative Period Cultures in the Guayas Basin, Coastal Ecuador, AmAnt, XXII, 1957.

ART OF COLONIAL DERIVATION. The Spanish domination introduced into Ecuador the forms of baroque religious art. These were superimposed upon the traditional local forms, without, however, hindering the continuation of a local decorative style. In the decoration of the numerous churches, the minor arts, particularly stucco work and wood carving, hold a position of primary importance in so far as they determined or conditioned the architectural decoration or continued the local tradition. Gabriel Guillachamín, Francisco Tipán (17th cent.), and Fray Francisco Benítez (18th cent.) were outstanding for their gilded wood carvings. The activities which made Ecuadorian artists famous were wood and stone carving, painting, and figurine modeling. Cultural and tribal differences, as well as the aborigines' own pottery-making or stone-carving techniques and tastes, disappeared. The low level to which the Indians were relegated permitted none of the artistic production of their former free society, with its own pottery figurine cult and religious stone carving.

There are practically no traces of colonial art in the lowlands, since the temples and villages, having been built of wood, frequently disappeared because of fires or Indian wars and feuds.

The larger Spanish cities were founded in the highland area mainly because of its cooler climate. Even the Incas found it impossible, perhaps for the same reason, to conquer the lowlands of Ecuador; unusual stamina was required to endure life in the hot, humid tropical forest. It took centuries to accomplish large-scale clearing of such forest land. The highlands were a much easier travel route and offered better soil for farming. On the other hand, the lowland Indians could not resist Spanish-introduced plagues, which thinned their numbers more than forced labor under the encomiendas. The colonial period, therefore, can be judged only from highland art. At Quito, under the monks and Jesuits, were erected the first colonial buildings, similar to the contemporaneous forms of European baroque in their exuberantly decorative local style. Among those who contributed to this development were Fray Pedro Gosseal, Fray Jodoco Ricke, Antonio Rodríguez of Quito (the S. Francisco Church and monastery, and the churches of S. Clara and S. Domingo), José Jaime Ortiz (Church of La Merced), Marcos Guerra (the Cabildo), and Jean Vives.

Keeping pace with architecture, and closely related to it, were painting and sculpture. As early as the 16th century there were thriving religious and secular schools of painting and sculpture. Noteworthy artists of the period were Diego de Robles, Luís de Ribera, Fray Pedro Bedón (who decorated Dominican convents in Santa Fé, Bogotá, and Tunja), Miguel de Santiago, Nicolas Javier de Gorívar (painting of the prophets in the Church of the Jesuits in Bogotá), Bernabé Lobato, Simón de Valenzuela, Manuel Samaniego (Assumption of the Virgin and Christ at the Column in the Cathedral at Quito), Morales, Vela, Oviedo, Fray Hernando de la Cruz, José Ramírez, and Juan Benavides. After a period of decadence, Antonio Salas was the last representative of colonial art. The work of Rafael Salas marked the development of landscape painting as well as the treatment of religious themes. Later, Luís Cadena, J. Manosalvas, Rafael Troya, Joaquín Pinto, J. Cortés and his sons, Victor Sánchez Barrionuevo, Antonio de Silva, and Francisco Villaroel developed eclectic forms imported from French, Italian, and Spanish sources.

Memorable in the field of sculpture were Diego de Robles (who was very active in Quito, particularly in the Church of S. Francisco), Antonio Fernández, Bernardo de Legarda, M. Chili (called Caspicara), José Olmos (called Pampite, painter of the Christ in Agony in the Church of S. Roque, Quito), Father Carlos, Manuel Salas, José D. Carrillo, Gaspar Zangurima (called "the Deaf" — el Lluqui), and Juan Bautista Menacho. Also characteristic are the small private altars of the great homes of Spanish colonial society. Active in recent times were the skilled wood carvers such as Miguel Angel Tejada, a master of the carved furniture then in demand by the convents and churches of the capital.

Toward the south, in Cuenca, another great religious center flourished where even today excellent gold- and silver-filigree work is produced. These skills were probably a heritage from precolonial days. A wood carver of this region who is worthy of mention was Miguel Vélez, a pupil of Zangurima.

In the northern highlands, the home weaving industry is still flourishing, and the local rugs are well known the world over. The renaissance of Indian craftsmanship has been felt in the highlands, where native pottery and cloth are in demand, mostly for export.

BIBLIOG. F. Gonzáles Suárez, Historia general de la República del Ecuador, Quito, 1890–1903; M. Noel, Contribución a la historia de la arquitectura hispanoamericana, Buenos Aires, 1923; B. Pérez Merchant, Diccionario biográfico del Ecuador, Quito, 1928; J. G. Navarro, La escultura en el Ecuador, Madrid, 1929; J. C. Lozoya, Historia del arte hispánico, Barcelona, 5 vols., 1931–49; M. Noel and J. Torre Revello, Estudios y documentos para la historia del arte colonial, I, Buenos Aires, 1934; J. G. Navarro, Artes plásticas ecuadorianas, Mexico City, 1945; J. G. Navarro, Ecuadorian Sculpture, BMMA, N. S., III, 9, May, 1945, pp. 209–13; G. Kubler and M. Soria, Art and Architecture in Spain and Portugal and Their American Dominions, 1500–1800, Harmondsworth, 1959.

PRINCIPAL ART CENTERS. Quito. The origins of this city are vague and legendary, though the Quitus seem to have been the earliest Ecuadorian inhabitants. Their territory was invaded by the Caran Shyri, who between A.D. 800–1000 had pushed forward from a coastal settlement all the way to the capital of a vast territory dominated by a king named Quito. After the Inca invasion (ca. 1450) and the settlement of the Spanish in Peru in 1533, Sebastián de Benalcázar, one of Pizarro's lieutenants, conquered Quito and burned it, proceeding on Aug. 28, 1534, together with Diego de Almagro, to found a new city of Spanish type. Having grown in importance through the privilege, the title, and the coat of arms granted by Charles V, Quito became the seat of the governmental Real Audiencia (1563). Until the rebellion for independence in the 19th century, it was one of the most peaceful strongholds of the colonial empire.

Quito is located at an altitude of 9,300 ft., and the modern city is an important railroad center. Its development has been slow because of lethargic and limited activity in commerce and industry, but its growth in recent times has been remarkable; it is the seat of the Central University of Ecuador (18th cent.) and of many cultural institutions and libraries.

The character of the city, except for the very modern quarters, has been determined by the many specimens of Spanish colonial architecture in plateresque style, the work of members of religious orders in the 16th and 17th centuries.

There are many outstanding churches of this period. The Church of S. Francisco (1534–1650), with its adjoining monastery, is the work of several architects, including Fray Jodoco Ricke and Antonio Rodríguez. It is baroque colonial in style, and has two heavy lateral towers. It has a nave with two side aisles, decorations in stucco and polychromed wood, and an admirable choir. On the high altar is the Baptism of Christ by Diego de Robles; the statue of St. Francis de Paula is by José D. Carillo. The church has a cloister with two porticoes, a chapel with richly carved and gilded altars, paintings by Manuel Samaniego, and a statue of St. Francis by M. Chili. The Church of La Merced (with adjoining convento and cloister by José Jaime Ortiz) is plateresque in style, and contains works by Samaniego and J. Pinto. The Church of S. Domingo has in its Chapel of the Madonna of the Rosary a statue of the Virgin given by Charles V. It also contains works by Samaniego and by Italian and Spanish artists. The Chapel of the Communion Rail was decorated by Gorívar. It contains works by Luís Cadena, and its cloister was designed by Antonio Rodríguez. The Church of the Company of Jesus is baroque with plateresque decoration, and it contains works by Gorívar. The Church of S. Agustín has works by Miguel de Santiago and Gorívar. The Carmen Antiguo Church, the Chapel of the Sanctuary, and the Cathedral (with works by Samaniego, Antonio Fernández, and Caspicara) are also notable. Outstanding among the civil structures are the Government Palace (1747), the Military School, the Central University of Ecuador, the astronomical observatory, the National School of Fine Arts, and the Sucre Theater.

Guayaquil. The modern port and railroad center of Guayaquil is the commercial capital and largest city of Ecuador. Although the city dates back to the 16th century, there is nothing about it to suggest antiquity. It was twice destroyed by Indians, sacked and burned by buccaneers, leveled by earthquakes, and five times swept by fire. It has survived epidemics of malaria, yellow fever, and bubonic plague. Termites destroyed many of the old wooden structures, and much of the present city is built of concrete.

At the base of St. Anne's Hill near the Plaza Colón are the remains of the ancient fortress, La Planchada, which defended the town against a succession of attacks by privateers. Also nearby is the Church of S. Domingo (1640), the oldest in Guayaquil.

The cultural life of the city is centered in the University of Guayaquil, the National Conservatory of Music, the Ecuadorian Fine Arts Association, the Institute of Historical Research, the Casa de la Cultura, and the several libraries and museums. Of special interest

in the Municipal Museum are collections of carved stone objects and ceramics antedating the Spanish conquest. An important archaeological relic is the carved wooden totem pole called the *palo de brujo* (sorcerer's post), on display in the City Hall.

Cuenca. The picturesque inland city of Cuenca, 8,517 ft. above sea level, is the third largest in Ecuador. Notable examples of the work of local sculptors and wood carvers may be seen in Cuenca's historic churches, particularly those of La Concepción (1599) and Las Carmelitas Descalzas (1682). The Neo-Gothic Cathedral (20th cent.) dominates the city. Spanish colonial buildings of historic interest are the Government House and the old Cathedral. In the Municipal Museum are archaeological collections (chiefly ceramics) from the ancient civilizations of the Cañari Indians, and valuable relics from the Inca ruins of Tomebamba, which may be seen in the southwest section of the city.

Bibliog. J. de Velasco, Historia del reino de Quito, Quito 1841–44; J. G. Navarro, El arte quiteño, in Monografía ilustrada de la provincia de Pichincha, Quito, 1922, pp. 21–27; J. G. Navarro, Contribuciónes a la historia del arte en Ecuador, 2 vols., Quito, 1925, 1939; I. J. Barrera, Quito colonial, Quito, 1927; J. G. Navarro, Curiosa ordinación arquitectónica en el claustro del Convento de San Agustín de la ciudad de Quito, AEArte, IV, 1928, pp. 179–82; J. G. Navarro, Un pintor quiteño: Un cuadro admirable del siglo XVI en el Museo arqueológico nacional, Archivos, 1929; J. G. Navarro, La iglesia de la Compañía en Quito, Madrid, 1930; J. M. Vargas, La cultura de Quito colonial, Quito, 1941; J. Jouanen, Historia de la Compañía de Jesús, en la antigua provincia de Quito, 2 vols., Quito, 1943.

Emilio Estrada

Illustration: one fig. in text.

# EDUCATION AND ART TEACHING.

The teaching of art in a particular area of civilization is influenced by the ideals, theories, philosophies, and methods of art that exist there (see CRITICISM; ESTHETICS; HISTORIOGRAPHY; PHILOSOPHIES OF ART; SOCIOLOGY OF ART; TREATISES). In this article we are concerned mainly with concepts of art instruction, inasmuch as the specific techniques of transmitting knowledge and the types of schools and institutes are discussed in greater detail under INSTITUTES AND ASSOCIATIONS.

SUMMARY. General discussion (col. 557). Ideals and aspects of instruction in the arts (col. 559): *Antiquity*; *The Middle Ages*; *The Renaissance*; *The Western world since the 17th century*; *The Orient*: a. *India*; b. *China and Japan*; c. *Southeast Asia*.

GENERAL DISCUSSION. The aim of instruction in the arts may be either to prepare for a professional career or to contribute to a general cultural background. Practice and theory are involved in both. Practice is essential in learning how to create art and use it as a means of expression; theory in learning how to understand and appreciate works of art. The amount of time devoted to each of these varies according to the esthetic (see ESTHETICS) and educational ideals that prevail at a particular time and place. Two extremes are possible and have been practiced throughout history: technical instruction, exclusive of theory, in which the understanding and appreciation of art is implicit in the experience; and instruction in the understanding and appreciation of works of art solely on the basis of theory, exclusive of practice. To be sure, there are, and have been, many intermediary approaches to art teaching.

Esthetic and cultural ideals, which change with time and place, determine the role assigned to art instruction in various institutes and educational programs. The course of study may be intended as direct preparation for specialization in a given medium, and the number of pupils may be limited. In other instances it may be considered an integral part of a broad, educational program, a fundamental training for future specialization. The educational program that teaches how to understand and appreciate art may be deemed an accessory or extracurricular activity, restricted to an elite of amateurs; in other cases, it may be termed an indispensable factor for a cultural background and become an integral part of the program as a whole. Between these two points of view there are such intermediary solutions as the one adopted by elementary and high schools, which begin with basic instruction in the lower classes, teaching the student how to express himself through art (drawing), and then continue in the later years of high school with specialized courses for a professional career. The history of art is often an integral part of study courses in liberal arts schools but is infrequent in schools of science and technology. The prevailing trend today holds that instruction in art, both in practice and in theory, is basic and fundamental to all programs of study. There are many advocates of the doctrine that views it as the focal point in the educational development of the child and adolescent.

Objections to this idea are due to the concept, inherited from the past, that the creation of art objects is a manual activity and, therefore, not so elevated as the creation of literature. Traces of this concept may be found in the philosophy of Hegel and in all idealistic philosophies and forms of instruction inspired by him. Other objections are raised by the school of thought which defines education as a discipline repressing spontaneity; it thus doubts the value of art instruction, which it considers unsuited for conveying to the student that bit of spontaneity necessary for the creation of a work of art. Other opposition to the teaching of art appreciation, or at least the teaching of it in schools other than those of the humanities, stems from the idea that knowledge of art is superfluous, if not damaging, to technical and scientific studies.

Instruction in the creative arts follows, in the main, two major ideals: formal instruction and instruction the aim of which is to promote the spontaneity of the individual imagination. The former tends to discipline, if not to repress, creative spontaneity through imitating nature and copying works by famous masters. Its predetermined esthetic is the ideal of classicism and realism. Inherent in its premise is the belief that teaching is an authoritative transmission of knowledge. The academies of fine arts founded in the 17th century are the most important of the institutes that practice a normative scheme in artistic training.

The form of instruction that aims at encouraging spontaneity does not profess to have specific ideals of absolute beauty, recognizable only in some works and certain styles and not present in others. In teaching the creative arts, it utilizes cultural knowledge and technical training as instruments that release and promote spontaneous vision and individual expression, rather than as curbs that guide the expressive capacity of the student in a predetermined direction. Individual artistic expression, with its own intrinsic canon of perfection, is the avowed esthetic of this school of thought. Its doctrine is founded on the principle of collaboration between master and student toward a common goal and on the concept of teaching as the evaluation of personal aims. As in every other aspect of art education, the trend in the creative arts that enjoys popularity today is oriented toward spontaneity rather than toward the formal and normative.

A distinction must also be made between private and public instruction in art. Private instruction began in ancient civilizations as a natural training in the artists' workshops. The standards of the professional craftsman's work sometimes gave such training the kind of legal sanction that is reserved today for public instruction. The founding of academies of art in the 16th and 17th centuries led to an extensive public interest in the teaching of the creative arts. In the beginning many of these schools were private ones. The period of romanticism in the 19th century brought doubts about the merit of public instruction, which had come to be identified with the academies and their normative procedure; it praised instead the superiority of teaching by independent artists and even lauded the pleasures of self-education.

Today the problems of instruction in art throughout the world are, however, viewed in a different light. This is because training for an art career that is linked to commercial production can be satisfied neither by the academies, which grew at a time when ties between art and production were lacking, nor by private instruction, which has always had a personal character. Even less adaptable to industry are the improvisations to which self-education leads. The prevalent

tendency in advanced courses in art schools today is to plan the programs and methods of study with a view to training persons to judge the artistic qualities of industrial production. This concept has modernized a practice that medieval workshops employed at a craftsman's level. It was also characteristic of the individual academies and similar institutes founded in the 18th century in connection with manufactured products (for example, porcelain), which were distinctly different from the academies of fine art. Indeed, in some instances schools were founded by industries and attached to factories.

Even the concept of "fine art" as a fundamental principle of art education, which was born with the academies and has been closely tied to their doctrine, as well as to the idea of art as luxury, tends today to be replaced by the concept of industrial design (q.v.). In other words, art tends today to be thought of as a knowledgeable search for esthetic quality in industrial production. Hence, there is in some places a tendency to transform art schools into schools of art design and, consequently, to modify the programs and methods of instruction.

When art education is part of a general cultural program, the age of the student and the scholastic curriculum are important factors. In elementary schools, the problems of teaching art are related to the training of the child (see PSYCHOLOGY OF ART). Here, too, a conflict exists between normative instruction, which provides the child with models to be imitated, and the type of teaching that encourages and stimulates his attitudes, sensibilities, and creative vision. The latter recognizes in the child a capacity for esthetic judgment equal to that of the adult.

The problems of art education at a more advanced level vary according to the program of study. For studies of a technical nature, the teaching of art follows the traditional scheme of emphasizing drawing as preparation for a professional career. Sometimes this is accompanied by introductory courses in the history of architectural styles. This concept is in crisis today, because the union of art and technology, which characterizes modern culture, is substituting the concept of industrial design for that of the fine arts. The problems of art training in the science programs of secondary schools are similar. In these it is a question of presenting on a school level an amalgamation of science and art, a problem which has begun to concern such great scientists as Werner Heisenberg. In high schools where the humanities are emphasized, art education consists mainly in teaching how to understand and appreciate art through art history courses. This study is completed in the university program, where it becomes an academic discipline. In the university, however, the traditional primacy of literature is still dominant in the humanities.

Rosario ASSUNTO

IDEALS AND ASPECTS OF INSTRUCTION IN THE ARTS. *Antiquity.* In Greece and Rome, as well as in the ancient Orient, technical training of artists was almost exclusively provided by masters and competent artists, who upon being paid a reasonable sum of money transmitted their experience and knowledge to apprentices. Prior to his arrival at the workshop, the apprentice studied at a school for youths where a grammarian taught reading, writing, and arithmetic. He would also have studied at schools which taught music and gymnastics, the fundamental disciplines of Greek education. Instruction in art was considered a branch of higher learning, comparable in some ways to the arts of the quadrivium (geometry, astronomy, arithmetic, and music) in medieval times.

This instruction was practiced in private and in a limited way. It was not in general use, because the ancients denied to the representational arts the quality of ethos, which was assigned to poetry and music. Aristotle thought that the visual arts do not contain real images of ethos, but merely indications of it (*Politics,* viii, 5, 1340a). Nor do the representational arts constitute the basis of education in Plato's philosophy (*Republic,* iii, 401b–d), but Plato does say that they help to create a cultural environment. Art was termed *techna* (a profession based on a special skill that involves application and experience) and was, therefore, distinctly practical (see ART).

One can assume that real art training took place only in the studio of a master.

In the first half of the 4th century B.C. Pamphilos, the student of Eupompos and teacher of Apelles, founded a painting school at Sikyon. Preparatory to practice in art, the student was given theoretical instruction, especially in accuracy of drawing, geometry, and artistic sensibility (Pliny, *Natural History,* xxxv, 77). Teachers of drawing and young students in their charge are reported about 240 B.C. (Joannes Stobaeus, a compiler, quoting Teles). Inscriptions testify to the existence a century later of scholastic competitions at Teos and Magnesia (Charles Michel, *Recueil d'inscriptions grecques,* Paris, 1900, no. 913; F. W. Dittenberger, *Sylloge inscriptionum graecarum,* III, Leipzig, 1920, no. 960, p. 58), in which drawing was one of the specific aims of the competition. These are exceptional instances; education in Greece was primarily linked with traditional instruction in literature, music, and gymnastics until Hellenistic times and later. Papyrus documents confirm the fact that in the provinces from the 1st century B.C. to the 2d century of our era novices made contracts of apprenticeship (*didaskalikai*). The master usually received no payment, since he could sell the work of the apprentice, but the contract of a bronzeworker (*chalkotypos*) in A.D. 66 (*Papiri greci e latini,* VIII, Pubbl. della Soc. Italiana, p. 871) indicates that a master could be compensated with goods or with a payment of money.

In Roman times education in the arts assumed some emphasis during the reign of Augustus, but the founding of professorships in such artistic disciplines as architecture was accomplished only under Alexander Severus, who reigned 222–35 (*Scriptores historiae augustae,* xliv, 4). This subject, taught by master builders, remained in the Roman curriculum, as is witnessed in Diocletian's edict of 301 (T. Mommsen and Hugo Blümner, *Der Maximaltarif des Diocletian,* VII, Berlin, 1893, p. 120). In keeping with the extensive construction during his rule, Constantine the Great (reigned 306–37) saw the need to increase instruction in art. In addition to recommending the institution of new schools of architecture for youths of 18 years, to be attended after they had completed an academic program, *litterae liberales* (*Cod. Theodosianus,* XIII, 4, 1, Aug. 27, 334), he offered special privileges to various types of artists, such as architects, workers in stucco, stonecutters, silversmiths, masons, goldsmiths, painters, sculptors of statues and reliefs, and mosaicists, "that they may be more zealous in increasing their skill and in training their children" ("quo magis cupiant et ipsi peritiores fieri et suos filios erudire"). This we learn from documents of Aug. 2, 337, which postdate Constantine's death (*Cod. Theodosianus,* XIII, 4, 2; and *Corpus juris civilis* [*Cod. Justinianus*], X, 66, 1). These privileges were partly confirmed by Constantine II and Constantius II (*Cod. Theodosianus,* XIII, 4, 3, July 6, 344, and *Corpus juris civilis* [*Cod. Justinianus*], X, 66, 2). Privileges were also conceded by Valentinian to painting instructors in Africa in an edict of June 20, 374 (*Cod. Theodosianus,* XIII, 4, 4).

Agostino PERTUSI

*The Middle Ages.* During the medieval period painting and sculpture did not, as a rule, enjoy an independent position but were closely allied with architecture, as evidenced in treatises of Isidore of Seville, *De navibus, aedificiis, et vestibus,* and Rabanus Maurus, *De universo* (PL, LXXXII, CXI), as well as others by Theophilus, St. Vincent of Beauvais, and Villard de Honnecourt. Artists in various techniques — painting, sculpture, stucco, mosaic, and stained glass — were craftsmen who executed their works at the construction site under the supervision of the master builder. The artists, in turn, had assistants, mainly apprentices, who performed minor tasks. Thus, the training for a profession was essentially apprenticeship. The same may be said of other undertakings on a large scale, involving craftsmen but not immediately related to architecture, such as the furnishing of equipment for liturgical purposes, providing the objects of public and domestic life, and transcribing and illuminating of manuscripts.

The purely practical aspect of artistic instruction, bound as it was to the idea that painting and sculpture are mechanical

arts (*artes mechanicae*), explains its exclusion from the trivium (grammar, rhetoric, and logic) and quadrivium. Architecture alone had some rapport with the sciences of the quadrivium, in that it involved a knowledge of mathematics. In the 13th century Albertus Magnus referred to the architect as a scientist (*Metaphysicorum*, I), thus setting him apart from those who practiced the purely mechanical arts. Architecture, in so far as planning and execution were concerned, was a responsibility of the supervisor, usually an ecclesiastic or a nobleman who had had instruction in the trivium and quadrivium. For problems of a technical or practical nature, he had the help of a master builder. The survival of Vitruvius' *De architectura*, a treatise cited in a letter by Einhard (d. 840) and later in the writings of St. Vincent of Beauvais, testifies to the way knowledge of the art of building was diffused among learned persons — noblemen and clergymen — who were called to plan and supervise the construction of buildings. In a sermon delivered at the obsequies of the monk Gerardus, St. Bernard of Clairvaux (1091–1153) mentioned that the monk had helped him in architectural projects (*Sancti Bernardi Opera*, I, Editiones Cistercienses, Rome, 1957).

The apprentice became an artist by acquiring skill in the use of instruments and handling various materials of his craft. The idea that art was the capacity to work materials and that the object was esteemed for its durability and function in addition to its beauty is known through the writings of St. Bonaventure (1221–74). Formulas and collections of rules and examples were merely aids in practice and manual instruction.

The direct participation of the supervisor-designer in the production of works of art meant that he brought to the task at hand both practical experience and knowledge inherent in the creative procedure. He had some comprehension of drawing and competence in questions of color. It is noteworthy that writers frequently made drawings to illustrate their thoughts, as in a text by St. Bonaventure and Dante's reference in the *Vita Nova* to his own practice of drawing. The writings of Ugo da San Vittore (*Eruditionis Didascalicae*, PL, CLXXVI) and Albertus Magnus reveal a lively sensibility for the effects of painting. The study of geometry furnished a theoretical basis for exercises in drawing, while the paramount study, theology, with its metaphysical interpretations of light, was the theoretical basis for the knowledge of color and optics in painting. In later times this knowledge was enhanced through research in the natural sciences, promoted by Aristotelian philosophy and Arabian scientific theories.

Heraldry and its symbolism often figured in the instructions given to artists and must have also contributed to the diffusion of practical knowledge concerning artistic problems. Thus, teaching in the arts was largely a matter of collaboration in artistic activity between the craftsman who executed the work and the supervisor who planned it.

Documents on the relationship between master and student in the Middle Ages are rare, but they become more numerous and significant with the approach of the Renaissance. Notices concerning 14th-century workshops tell us that the eight- or ten-year-old boy began an apprenticeship that could last from two to six years, during which time he learned to grind colors and prepare panels, to execute minor works, and to perform various tasks. In general, students lived together under the supervision of the master, sometimes even in his house, and there are many cases of the student's being adopted by the master as a foster child. Cennino Cennini wrote that Taddeo Gaddi became Giotto's stepson.

After the period of apprenticeship, the young man was free of the workshop and could work independently on a daily basis. Within a few years he obtained a certificate or diploma from the local guild, and this made him completely independent. In his *Treatise on Painting*, Cennino Cennini advised that an apprenticeship of six years, spent in "the working up of colors; and to learn to boil the sizes and grind the gessos; and to get experience in gessoing anconas, and modeling and scraping them; gilding and stamping," should be followed by another period of six years when the student was to gain "experience in painting, embellishing with mordants, making cloths of gold,

getting practice in working on the wall." The young artist ordinarily received his certificate and began his independent career at the age of twenty or thereabouts. Through this period the youth had to comply with the strict rules of the local guild — in Florence, called an *arte*; in Venice, a *matricola*; in Lombardy, a *consolato*. Two guild notices in Siena, dated 1355 and 1561, give the following rules concerning the relationship between student and master: "No one (master) should attempt to lure or take away a worker belonging to another; no worker or apprentice should work at his own house, but only in the workshop; no worker or apprentice may sell works; no one may buy works of art from workers or apprentices; workers may neither sell nor buy anything which pertains to the art; no worker or apprentice may produce work without a license; no work may be commissioned to the apprentice of another master; no worker or apprentice may keep engraving tools; no one may operate a workshop without approval of the guild."

*The Renaissance.* The technical and practical instruction of the Middle Ages — in the various crafts as well as in cultural education — continued in the 15th century. The artists' formative years were spent in the workshop, learning a profession. Various sources mention that Francesco Squarcione adopted many of his numerous students. The youths were apprenticed to the master through contracts, which set forth their stipend and working conditions. Generally the student contracted to stay under the guidance of the master and follow him everywhere in exchange for a modest sum of money, sometimes only for room and board. "For wages and recompense necessary to feed and clothe him" ("Pro eius mercede et salario dare victum et vestitum sibi necessarium"), said a contract of 1468 between Piermaria da Pescia and Matteo da Pistoia. Michelangelo, who was placed in Ghirlandajo's shop in 1488, was paid 24 florins during three years. When students followed a master to another city, they were sometimes given an additional sum. The period of apprenticeship also included time spent in copying works and drawing from nature under the supervision of the master or an advanced pupil. According to the documents about Squarcione, the basis of 15th-century instruction consisted of the study of perspective and proportion and of drawing after the sketches and details of other masters.

Two types of apprentices' contracts are known from documents concerning Squarcione's shop. Some youths received stipends for helping the master in various ways; others paid for instruction in painting. In a contract of 1467 Giovanni di Uguccione agreed to pay the master one-half ducat each month in addition to the "usual gifts." In this period theoreticians of education continued to stress the transmission of practical knowledge inherent in the mechanical arts, but this had no place, or, at most, only a marginal one, in the liberal education. Regarding the art of drawing, Pietro Paolo Vergerio (*De ingenuis moribus et liberalibus studiis adulescentiae*) wrote that while it was accepted by the Greeks among the disciplines to be taught because "it assisted in the purchase of vases, panels, and statues, which were greatly appreciated in Greece," in his time "nevertheless it is not of use to a man of liberal education, except perhaps in so far as it pertains to writing, but for the rest, it belongs to the domain of painting." Maffeo Vegio expressed a similar opinion in *De educatione liberorum clarisque eorum moribus*. Vittorino da Feltre, the Italian educator, placed painters at the disposal of those scholars who wished to learn the art, but Francesco Prendilacqua, who referred to this circumstance in his *Dialogue*, took pains to state that these were masters of the lesser arts (*levioris artis*). He added the names of the painters after a list of Greek and Latin scribes and immediately before the dancers, vocalists, lyre players, and riding masters.

During the 15th century, however, the concept of art as science helped to promote an attitude among artists that was to raise their creations to the dignity of the nonmanual arts. This trend signaled the beginning of a different form of art instruction, one in which the transmission of intellectual knowledge was more important than technical and practical instruction. The theoretical writings of Leon Battista Alberti (q.v.), Francesco di Giorgio, and Piero della Francesca (q.v.) were

more than simple pronouncements on esthetic ideals. They urged the exploration of the scientific validity of painting, sculpture, and architecture, thus bringing them into the realm of the liberal arts. Their aim was didactic, for they demonstrated the amount of knowledge the artist must have at his command in order to be an accomplished one. Treatises (q.v.) took the place of medieval recipe books and emerged as texts for the development of artists. Scientific, rather than merely practical, knowledge became the basis for artistic education. The artists' works began to be viewed as the application of theory, and the essence of art was identified with drawing as a work of the mind, the rules of which are transmitted through science, not through simple practice. While the master was still considered a craftsman, dependent upon commissioned work, in training the apprentice for a career he stressed the science on which technique was based.

As changes occurred in the education of the professional artist, that of cultivated persons followed suit. This was reflected in the formation of collections under the guidance of specialized masters. Vittorino da Feltre retained teachers of painting for his scholars; hence, the study of art must have been widespread in erudite circles. When, in the second decade of the 16th century, Baldassare Castiglione required the courtier "to know how to draw and be knowledgeable about the art of painting," we may suppose that his statement reflected a well-established custom. Castiglione referred, as had Vergerio earlier, to the ancient Greeks "who wanted the children of nobility to learn painting because it is an exalted and necessary experience; and painting was admitted in the first place among the liberal arts." In Castiglione's time, however, there were people who held stubbornly to tradition and, foreseeing their protests, he added, "Do not be surprised by this recommendation (to teach children to paint), which now seems mechanical and of little use to the gentleman."

With connoisseurs lending their support to the artist's claim that painting transcended the mechanical arts and Humanists recommending the ability to paint as a necessary qualification for the gentleman, the visual arts had moved away from the realm of the manual to that of the liberal arts. Because the creation of art was understood as an intellectual process (*disegno*; see DRAWING), acquisition of the practical skill that produces art was not so ignoble as learning a menial trade. Through this experience, comparable to writing, the scholar learned a science. These concepts were developed by Leonardo da Vinci (q.v.) into an epistemology: "All true sciences are the result of experience that has passed through our senses; ... if you say that these true sciences that are founded on observation must be classed as mechanical because they do not accomplish their end without manual work, I reply that all arts that pass through the hands of scribes are in the same position, for they are a kind of drawing which is a branch of painting ... which arises in the mind of the contemplator but cannot be accomplished without manual operation." The claim that painting is an investigation by the mind — a science — makes manual exercise permissible, placing it in a reciprocal relationship with expressiveness. Painting is the science par excellence precisely because of this reciprocity, which is common to all the sciences; and also because the origin, the means, and achievements pass through the senses, and "experience does not feed investigators on dreams."

Leonardo's theory of learning and education was unique for his time; it had no parallel in the educational institutions, except that it shared with contemporary culture the concept of *disegno* (art as an intellectual process or science) as a foundation for artistic instruction and development. Fifty years later, when Vasari discussed the form of training received by the artists whose biographies he wrote, he defined painting, sculpture, and architecture as arts of *disegno* and clearly assigned a didactic function to the manual work. In his discussion of the three arts of *disegno*, prefixed to the 1568 edition of the *Lives*, Vasari established the fundamental concepts which should be the basis for the education of artists: "In the mind is formed that thing which the hand expresses and which is called *disegno* ... for *disegno* the hand must be well-trained through many years of study and exercise ... in order that when the intellect releases pure concepts, the hand which has had many years of experience in *disegno* will reveal the perfection and excellence of the arts as well as the artist's knowledge."

<div style="text-align: right">Rosario ASSUNTO</div>

In the early decades of the 16th century, the apprentice paid a small fee for the training received from a master. Often he received no stipend, but there are instances of young artists receiving considerable recompense. In his autobiography Benvenuto Cellini recalls that when he was hardly fifteen years old and working in various shops, he succeeded in earning well. Speaking of his apprenticeship to a goldsmith in Pisa, he said, "I earned a great deal of money in the year I spent with him; ... I earned enough to help my father and my own family." At the end of the apprenticeship the young artist could either work in the master's shop or select a shop in which to execute works commissioned to him personally, provided he agreed to give a part of his earnings to the shopowner. According to Cellini, the amount paid was one-third of the sum earned ("such is the custom that a two-thirds sum goes to the worker and the other third to the master of the shop"). Other young artists opened their own shops by pooling their resources. Donatello and Michelozzo had already done so in the early 15th century, and a century later Fra Bartolomeo and Mariotto Albertinelli joined forces, as also did Andrea del Sarto and Franciabigio.

During the High Renaissance, when a clear distinction in the modern sense was made between the craftsman and the artist, changes in instruction occurred. The "students" of a master, who were not necessarily the shop assistants, were given a form of instruction that was essentially a study of concepts. Michelangelo scorned assistants, preferring to select his students largely from youths of noble family. Leonardo took on as students Francesco Melzi and Giovanni Boltraffio while at the same time in his shop there were apprentices, such as Salai, who worked on the traditional, medieval basis. Some shops were exceedingly crowded; others were limited in number. Bernardino Scardeone (*De antiquitate urbis Patavi et claris civibus patavinis*, Basel, 1560) noted that Squarcione had had 137 pupils in Padua, but this is difficult to believe. Cellini listed 12 workmen in Lucagnolo's goldsmith shop in Rome. In a mid-16th-century engraving, Baccio Bandinelli is shown in his study surrounded by at least a dozen students.

The first academy of fine arts in the strict meaning of the term, the Accademia del Disegno, was founded in Florence in 1563 by Vasari with Grand Duke Cosimo de' Medici at its head. The last chapter of the second edition of Vasari's *Lives* (1568) is devoted to the academicians of *disegno*. The affirmation of the concept of *disegno* as the intellectual essence of art signaled the passing of technical instruction in the workshop and the emergence of the theoretical instruction of the academies. The founding of the academy in Florence was followed by those of Bologna and Rome, and similar institutes soon emerged in other cities. Among the first theoreticians in academic training were Lodovico Carracci, Giovan Battista Armenini, Vincenzo Danti, Federigo Zuccaro, and Romano Alberti. Instruction, as practiced in the academies, emphasized theory and the concept that technique is intrinsic to theory. The decisive supremacy of the theoreticians culminated in a form of teaching in which the study of models and prototypes was of central importance. This form of instruction assumed an increasingly normative character as it submitted to a ready-made esthetic ideal.

<div style="text-align: center">* *</div>

*The Western world since the 17th century.* The academies at first replaced the workshops largely in the teaching of theory rather than in providing practical experience. Even after the founding of the Accademia del Disegno in Florence, practical training was still available in the shops of qualified masters. In the academy theoretical studies were related to lessons in geometry and anatomy. That the academy was not specifically

devoted to technical instruction is proved by the fact that amateurs and dilettantes were admitted in addition to professional artists. The hybrid character and the inefficiences of the academy in Rome prevented it from replacing the workshop, and by the end of the 16th century it was all but abandoned. In the 17th century instruction was modified again through the emergence of classes in the painters' studios, often called private academies.

The academies in Rome and Florence helped to promote the release of artists in those cities from their local guilds. This was decreed by Pope Paul III in Rome and made a law in Florence in 1571. Artists in these cities no longer had to belong to the *arte* and work for its certificate; as a result, it was no longer strictly necessary to adhere to the workshop routine. In cities without these changes in law, artists had to comply with the traditional requirements. In Genoa the painter Giovanni Battista Paggi was accused by his colleagues in the guild of practicing his art without having attended a workshop for the required seven-year period. That the academies in Rome and Florence were without a real function in artistic education is clearly manifest in the fact that in the next 50 years only one other was founded (in Milan), whereas in the same period private academies founded by artists flourished.

The normative in academic instruction assumed greater emphasis in the academies established in other countries of Europe, culminating in the founding in France of the Académie des Beaux-Arts by Jean Baptiste Colbert in 1648. The name *beaux arts*, or "fine arts," which came into use at this time, is an index of its standard. The beauty to which the original name alludes is that of the classical ideal professed by 17th-century French culture. In its immutable system the absolutism of Louis XIV found its esthetic. As F. H. Taylor (1948) has pointed out, the academic system was an intellectual ideal and, at the same time, a practical basis on which to found a program for the glorification of the French king. The method of teaching at the Académie des Beaux-Arts did not go beyond that of the Italian schools, since the copying of models and drawing of sculpture, followed by studies of nature according to prescribed methods, always remained fundamental to the student's education. As in the Italian academies, studies in theory evolved from geometry, perspective, and anatomy. The idea of the importance of travel as a means of learning had originated in the 15th century, but from this time it was given special emphasis. In terms of organization and regulated courses, however, the academy marked an advance in method, and the German and Dutch academies (Nürnberg founded in 1652; The Hague, in 1656) followed its system.

With the growth of the mercantile system, the second half of the 18th century witnessed the birth of a number of art schools connected with various industries. In many German and English cities the schools were allied with industries manufacturing such products as ceramics, tapestries, and prints. In keeping with this trend many academies (for example, Mainz, Leipzig, and Berlin) returned to a craftsman's concept of art. In these schools emphasis was placed on geometry, drawing of figures, ornament, landscape, and depicting animals and flowers. Drawing was conceived as the copying of given decorative schemes rather than as a study of nature. The method was adopted by the academies at St. Petersburg, Copenhagen, The Hague, Dublin, Vienna, and Sèvres. The Ecole Royale de Dessin at Sèvres had an enrollment of 1,500 students.

Giuseppe SCAVIZZI

The academic ideal, with its training in theory and classicism, spread from France to other countries of Europe. In 1770 the Royal Academy was founded in London under the guidance of Joshua Reynolds (q.v.), whose ideas shaped the principles on which its teaching was based. "When the artist has by diligent attention acquired a clear, distinct ideal of beauty and symmetry; when he has reduced the variety of Nature to the abstract idea, his task will be to become acquainted with the genuine habits of Nature, as distinguished from those of fashion; ... though ... our art, being intrinsically imitative, re-

jects this idea of inspiration more perhaps than any other. ... Genius, at least what generally is so called, is the child of imitation."

Reynolds' concept of genius therefore correlates ability with academic training. The diffusion of another idea of genius in the course of the 18th century, however, inaugurated a philosophical revolution that was to have its effect in the field of artistic education. The latter concept, that of genius as spontaneous creativity, with a related idea of originality that accompanied it, did not agree with the normative education of the academies. According to this new concept, genius — as an activity of nature — recognizes in nature, not in the great masters, its real example and living model. Reynolds' theory of genius, which associated creation with imitation, ultimately came into conflict with the theory of genius as spontaneous inspiration.

The idea of an education that promotes rather than suppresses creative freedom emerged clearly in Eugène Delacroix's (q.v.) *De l'enseignement du dessin*, published in 1850. "Who does not remember those pages filled with noses, ears, and eyes that were inflicted on our adolescence? Those eyes systematically divided into three perfectly equal parts ... that inevitable oval, the point of departure for drawing the head, which, as everyone knows, is neither oval nor round; and finally, all those parts of the human body — infinitely copied and always separated — with which the student finally had to reconstruct the whole figure." Delacroix compared this training, which he said was the "source of errors and confusion," with the artist's instinct, adding that "reason and even sentiment should only come later."

In contrast to Delacroix, Ingres (q.v.) recommended the study of the ancients, while giving expression to the concept of a return to nature: "Do you think I send you to the Louvre in search of what is commonly called the ideal beauty? Nonsense of that sort is responsible for the decadence of art in the worst periods of its history. I send you there to learn from the ancients, because they themselves are nature."

In the mid-19th century there was a growing need for an art education applicable to industry as well as to the fine arts. This idea of education is based on the concept that art is an activity applicable to every field of endeavor. In this connection John Ruskin (1819–1900) was the first to proclaim the need to free the craftsman from industrialization. His central premise was that a fundamental need of modern civilization was the restitution of art training as a part of the creation of works of art. It was William Morris who first devised the practical means on which a program for such instruction could be realized, taking steps which were intended to give new impetus to technical training in art. Teaching was closely linked with production, as it had been during the Middle Ages; Morris, like Ruskin, viewed that period as a sort of golden age.

The firm of Morris, Marshall, and Faulkner, founded in 1816, attempted a reunification of artistic training with production through the Arts and Crafts movement. The aims of the movement were in keeping with the premise that history, as evidenced in 19th-century mechanics and industry, could be halted. Charles R. Ashbee, founder of the Guild and School of Handicraft in 1888, was aware of the limitations of the Arts and Crafts movement. He concluded that modern civilization would remain tied to the machine, and that a system of artistic education and instruction that did not confront the very real problems imposed by this fact would never produce good results.

The movements and institutes that grew in Europe and the United States in the years around World War I were based on this concept. Among the more important ones were the *Werkbund*, founded in Berlin in 1907 through the initiative of Hermann Muthesius; the Design and Industries Association, founded in England in 1915; and, most important of all, the Bauhaus, founded by Walter Gropius (q.v.) in Weimar in 1919 and suppressed in 1933 by the National Socialist government.

Rosario ASSUNTO

The Bauhaus program recognized the need for both self-education and manual work, the latter having developed in the

European schools of applied art. It aimed at establishing a form of training that was free and yet involved the students in a common experience. By working in various laboratories the imaginative individual was at liberty to discover his personal manner of expression. The training program was divided into three stages, and its concern for techniques was modeled on the concepts of William Morris. A first period of six months sounded out the student's potential. A second period, called *Werklehre*, which lasted three years, offered practical instruction in the use and handling of stone, metals, wood, glass, textiles, sculpture, colors, and other materials.

This period guided the student to a special field. He could enter the third period (*Baulehre*) only after an examination. In this, the students, whose interests and skill had led them to various branches of art, participated in a common aim, toward that unity of the arts as a whole which was Gropius' real goal. After these studies the student could go on to schools in specialized fields, such as the *Technische Hochschulen* for architects. A similar program was offered at the school in Berlin directed by Bruno Paul, where all students were first given standard training (*Einheitkunstschule*) and only subsequently went on to specialization (*Kunstfachschule*).

After World War II the schools of applied arts in many countries of Europe and the United States felt the need to raise the artistic level of industrial production. Among these schools is the Neue Bauhaus at Ulm, Germany. Clearly the industrial designer has assumed great importance. In England the London Central School of Arts and Crafts offers courses in decoration, glasswork, furniture, textiles, graphic arts, and bookbinding. In Italy various institutes and schools train students for the applied and industrial arts that are traditional and characteristic of certain regions of the country. A five-year program in various fields (decorative arts, metalwork, woodcraft, ceramics, photography, glasswork, and graphic arts) prepares the student for work in these crafts and in industry. Among the schools founded since World War II is the Istituto d'Arte per l'Arredamento Navale in Trieste. Schools in Florence and Urbino offer courses in advertising and design.

The method of instruction in the academies of today does not differ substantially from that of the 19th century. This is true of those in Italy as well as the Royal Academy in London, where the number of students is very limited. Pupils are admitted to the Italian academies usually after preparation in high schools of art, and the four-year program includes subjects of cultural interest (history of art, literature, mathematics, and science) and courses in the creative arts. The latter vary according to the program selected. Students of painting take courses in anatomy and etching, in addition to figure painting, landscape, and still-life painting. Majors in sculpture study the techniques of stonecutting. Students of the decorative arts learn to execute ornamental sculpture and take courses in interior decoration and the history of costume. The training of stage designers includes courses in stagecraft technique. Architecture was taught in the academies in Italy until 1926, when it was transferred to special schools. In addition to classroom instruction, the architectural student works in the professor's offices, which are situated nearby, in order to share common experiences of the work.

Giuseppe Scavizzi

Art education in the United States is of many different kinds and is conducted in primary and secondary public schools, in independent professional art schools, in college and university art departments, and in art museums, many of which have education programs. The introduction of art into elementary education was probably made by Amos Bronson Alcott in Boston during the years 1834 to 1839. Alcott was perhaps the earliest educator to recognize the expressive possibilities of children's artistic activities and their part in the development of the total human personality. The kindergarten movement from 1860 saw a new emphasis on the creative aspects of elementary education. The specialized training of art teachers for the elementary schools received a strong impetus from the work of Walter Smith, who came to the United States from England in 1872 to become director of art education in Massachusetts. Today art as a medium of self-expression is a recognized part of the total educational program. In many states all elementary school teachers are required to have a certain amount of training in art.

The training of the professional artist in America was originally carried on outside of the traditional academic disciplines, first in the individual master's studio (Benjamin West in London), later in art academies (New York Academy of Fine Arts, 1802; Pennsylvania Academy of Fine Arts, 1807; and National Academy of Design, New York, 1826).

At first these organizations offered little instruction beyond the opportunity of drawing from casts of classical sculpture. They were, however, the ancestors of the independent art schools, usually located in large cities, often closely related to major art museums (Cooper Union, New York, 1859; Massachusetts School of Art, Boston, 1873; Art Students League, New York, 1875; Chicago Art Institute, 1879; Cleveland Institute of Art, 1882; Art Academy of Cincinnati, 1887; and Pratt Institute, New York, 1887).

The university art departments followed a different pattern. Many of them are located away from the great centers of urban population. The study of the history of art and of classical archaeology, as well as training in drawing, entered the curriculum in the 19th century (Princeton, 1831; New York University, 1832; Michigan, 1852; and Yale, 1866). Later a few universities began acquiring works of art, and instruction sometimes developed around such collections. In other cases the study of art took technical approaches, usually in relation to engineering or architecture. The training in universities of art teachers for the public schools laid the foundations for other approaches to the subject. Not until comparatively recent times has there been much emphasis on its study as a liberalizing phase of the total educational process. Strong programs in art history, with much emphasis on research at the graduate level, have developed in a group of eastern universities (Harvard, Princeton, and New York University), while a greater emphasis on professional training in creative work has been characteristic of a group of Middle Western schools (Iowa, Illinois, and Washington University in St. Louis, Missouri).

The professional art school and the university art department are comprehensive in scope. They have by no means confined themselves to the traditional fields of painting and sculpture, but have developed in such areas as advertising and industrial design and have shown a growing interest in graphics. The study of materials and techniques has had profound effects on the ways in which students are introduced to creative work and is a significant field for advanced experimentation and research. (The foundation of the Institute of Design in Chicago in 1937, on the basis of the Bauhaus program, had wide influence in this respect.) Work in ceramics, metals, and all forms of sculpture is often stressed. Specialization in art history continues, while new programs in museum administration and conservation have been introduced. There are many service courses for other areas, such as drawing for architects, crafts for occupational therapists, and basic design. Noncredit courses for persons who are not planning professional careers are frequent, and in some cases extension programs spread such work far beyond the physical confines of the school itself.

The student who majors in art in a department of a college of liberal arts will ordinarily receive a bachelor's degree at the end of a four-year program. If he has worked along professional lines, he will receive the degree of Bachelor of Fine Arts. In recent years there has been a notable increase in graduate work in the fine arts, which usually leads to the degree of Master of Fine Arts. This requires the student to concentrate upon studio work for two or three years, and to produce as his thesis either an individual work of art or a group of works. This is offered in place of the written thesis that embodies the results of original research for an advanced degree in art history or criticism.

An interesting recent movement has been the use of the artist-in-residence. This consists of the appointment of an important creative artist in a capacity comparable to that granted

to a research professor in other fields. The artist-in-residence is not ordinarily assigned a normal teaching schedule, but is available for consultation and as example. Several institutions have given such artists important commissions and have thus made it possible for students and staff to observe the creation on the campus of major accomplishments.

Another important development has been the growth of university art galleries and exhibition programs. An increasing number of institutions have realized the necessity of keeping works of art before the eyes of the students. The university gallery usually attempts to collect representative examples of historic art for study purposes, and it usually exhibits contemporary art, often making most of its acquisitions in this field. Important comprehensive collections, formed for educational purposes, are found at Yale, Princeton, Harvard, Oberlin, Michigan, and Kansas; others have specialized in contemporary American work (Nebraska and Illinois).

Meanwhile, there have been comparable developments in the independent professional art schools. Originally these were modeled on the concept of the traditional European academy, where the student worked closely with an individual instructor without the idea of obtaining a degree. Most of these schools are in large cities, where it has not been necessary for the school itself to initiate many of the activities that have developed within the university framework. Many of these schools, however, are now concerned with the concept of total education, with the realization that technical training is not complete unless the artist is an educated man in other senses. Just as the universities have expanded into professional training with strength and vigor, so the professional schools have stiffened their intellectual requirements. In some cases this has been done in cooperation with neighboring universities; in others the art school has assembled its own staff in humanities, the social sciences, literature, psychology, and other subjects. There has been a marked tendency toward the introduction of an academic degree in such independent schools, in place of the more informal certificate that was once common. Many artists trained in professional schools are now on university faculties.

An unusual element in American art education is found in the educational programs carried on by most major American museums, which do not think of themselves simply as repositories for the art of the past but actively seek to form public taste, to develop art appreciation, and to stimulate contemporary art. This is done by gallery lectures, by formal courses, by sales and rental galleries, and by all kinds of publications. The last include catalogues of exhibitions that in many cases are permanent contributions to the literature.

Allen S. WELLER

*The Orient. a. India.* Despite the fact that art activity flourished in ancient India, little is known today about the method of teaching. Teachers of art (*citravidyopādhyāya*) and those of craft techniques (in the Pali dialect, *sippāyariya*) were greatly admired as early as the 1st century, particularly among the Buddhist and Jain communities. The existence of treatises (*śilpaśāstra*) on esthetics, architecture, sculpture, and painting attests to the great interest in these subjects (see TREATISES). There is reason to believe that apprenticeship with a master lasted for a long time and included both theory and practice. Then, as is the case today among village craftsmen, the apprentice received special instruction in executing individual parts of a statue destined for festivals and the puja (a devotional service of a deity in the presence of his or her icon). The works executed may be likened to workshop pieces, and this accounts for the perpetuation of a given style over a long period of time, as well as for the general anonymity of the work. On the other hand, it would seem that even the specialists were well acquainted with a wide variety of techniques. The *Atthasālinī*, a 5th-century Buddhist commentary, attributes to one artist the knowledge of seven different arts. Many years of experience were necessary to achieve the skill of supreme perfection (*hastoccaya*), as manifested in, for example, the sublime simplification of a masterpiece.

Training in the fine arts was not reserved exclusively for professionals; it was part of the education of the caste of nobles (Kshatriya). State and private schools were established as early as the 4th to 5th century for instruction in painting and music. Instructors of art were respected as much as those who taught grammar or religion. Teachers who were held in high esteem for their doctrine and ability lived in the royal palace and worked for the king. Among their duties were the evaluation of works of art and the teaching of techniques and criticism. Their pupils included princes, courtiers, dignitaries, and nobles of the court.

The role of the workshops and schools of art must have had considerable importance for the development of Indian art, assuring it uninterrupted continuity, uniformity, and a high level of perfection. While treatises were useful guides for artists, they seem not to have thwarted the development of the imagination.

The ancient tradition began to decline in the 15th century. Painters were persecuted under Moslem domination and Islamic iconoclasm and were forced to take refuge in mountain villages or at the courts of princes who had not succumbed to Islam. The destruction of India's tradition in art was largely brought about through European influences and through the diffusion of mediocre and strictly academic models. The last traditional art schools in Kangra were destroyed when the city was demolished by earthquake in 1905. Shortly before 1900 new schools were founded in the major cities, particularly in Calcutta. This was accomplished through the nationalist movement and the influence of Sir Rabindranath Tagore and Subhas Chandra Bose and with the help of teachers from England. Today every university has a department of fine arts, but despite the instructors' efforts, a renaissance of the arts has been extremely slow to develop.

Jeannine AUBOYER

*b. China and Japan.* Any discussion about art education in China must first call attention to the fact that, in contrast to other peoples, the Chinese have always made a distinction between painting (calligraphy being inseparable from it) and the other arts. Except for the execution of Buddhist pictures, painting was always conceived as the noble avocation of the enlightened upper class, the literati, and persons holding high office. Other persons might produce objects of rare artistic beauty in the minor arts and sculpture, but they were considered mere craftsmen.

In the long history of Chinese culture many schools of painting are known, and in the Sung dynasty academies of art were founded. Both the schools and the academies helped to determine the rise and development of certain trends, which in turn characterized the taste of an epoch or of a region. In treatises such as the unique *Li-tai ming-hua-chi* (*Chronicle of Famous Painters of All Ages*) by Chang Yen-yüan (A.D. 847), there are complete genealogies of painters. The texts, however, consist almost entirely of monotonous lists of names and a few brief notes regarding the way a particular student succeeded in surpassing his master. They do not clarify how painting was taught.

The literature on Chinese art is, however, rich in treatises (see TREATISES) on esthetics, in technical manuals, and in volumes that reproduce individual elements of a painting in order to teach how to produce a composition in the manner of a given school. Thus, the literature on theory and practice is plentiful. Among the practical manuals the two most famous are from the 17th century, *Shih-ch'ü-chai shu-hua-p'u*, or *Album of the Ten Bamboo Hall*, and *Chieh-tzŭ-yüan hua-chüan*, or *Mustard Seed Garden Manual of Painting* (Eng. trans., *The Tao of Painting*, New York, 1956).

As for the other arts, it is known that in ancient times metal casters, ceramists, and other craftsmen developed special, secret techniques for their work. These secrets were passed on by the artists to associates, who were sometimes members of their families. This is known largely from legends dating before the Han period, which began in 206 B.C., and from the written testimony of a bronze caster who recorded the secret techniques

learned from his predecessor. The operators of various kilns had special techniques, which were associated with areas in which the kilns were located. The discovery of the same technique in more than one place can be explained only through the transfers of groups of ceramists. A case in point concerns pottery of the Northern Sung dynasty. When the capital was transferred from Kaifeng to Hangchow during the Mongol invasion, a ceramic then manufactured in the south was the same one that had been produced several decades earlier in the north. In recent times craftsmen were united into groups comparable to guilds, but the techniques of manufacture and craft of particular objects remain secret and the monopoly of a few persons. This is especially true of ceramic products.

The educational value of art (painting and calligraphy) as an instrument of individual enlightenment is discussed under CONFUCIANISM and TAOISM.

Lionello LANCIOTTI

In Japan the method of teaching was more or less similar to that of China, except that "schools of art" stemming from leading personalities tended to prevail. In the Buddhist art of Japan there are reflections of foreign influence; in addition to the fact that Buddhism originated in India, the art itself was rooted in the techniques of Chinese and Korean artists who came to Japan and worked there. The organization of Japanese art schools in modern times and the introduction of important innovations have resulted in a fusion of ancient traditions and new international styles.

\* \*

*c. Southeast Asia.* The methods of teaching art in India and China were probably adopted in southeast Asia as well. Artists were joined together in societies, and the craft was transmitted from father to son or from master to apprentice.

Under Western influence the ideas of public schools and of art training outside the traditional group or family were introduced for the first time in the 19th and 20th centuries. Two trends may be noted in this phenomenon during the period of European influence. The first developed an art training that was exclusively European in so far as classes were taught by European masters or by nationals trained in Europe. The most famous school, the Ecole des Beaux-Arts at Hanoi, Vietnam (formerly French Indochina), developed painters, sculptors, and architects whose styles were completely divorced from the ancient, local tradition. The second trend, far more important than the first, revived traditional art by means of a systematic study of ancient forms. This step, which was due, in general, to Western initiative, brought wonderful results in the crafts — the production of silver and enamel objects in Cambodia, the revival of the art of niello (a process of decorating metal with incised designs filled with black alloy) in Thailand, and major improvements in the batik process (a method of dyeing fabric) in Java.

George CŒDÈS

BIBLIOG. *a. General*: R. H. Wilenski, The Study of Art, London, 1934; G. Calogero, La scuola dell'uomo, chap. VIII, Florence, 1939; C. A. Sacheli, Cocetto di didattica, Messina, 1943; H. Read, Education through Art, 2d ed., New York, 1945; G. Gentile, Sommario di pedagogia come scienza filosofica, II, 5th ed., Florence, 1954. *b. Antiquity*: L. Grasberger, Erziehung und Unterricht im Klassischen Altertum, II, Der musische Unterricht oder die Elementarschule bei den Griechen und Römern, Würzburg, 1864–81, pp. 343–50; Overbeck, SQ; K. Jex-Blake and E. Sellers, The Elder Pliny's Chapters on the History of Art, London, 1896; K. J. Freeman, Schools of Hellas, London, 1908; C. Barbagallo, Lo stato e l'istruzione pubblica dell'impero romano, Catania, 1911, pp. 171 ff., 195 ff.; F. Winter, Schulunterricht auf griechischen Vasenbildern, BJ, CXXIII, 1916, pp. 275–85; W. Christ, O. Stähling and W. Schmid, Geschichte der griechischen Litteratur, II, 1, Die nachklassische Periode der griechischen Litteratur, Munich, 1920, pp. 234 ff., 421; B. Schweitzer, Der bildende Künstler und der Begriff des Künstlerischen in der Antike, Heidelberg, 1925; A. Zambon, Didaskalikai, Aegyptus, XV, 1935, pp. 1–66; L. Venturi, History of Art Criticism, trans. C. Marriott, New York, 1936; A. Zambon, Ancora sulle Didaskalikai, Aegyptus, XIX, 1939, pp. 100–02; W. Jäger, Paideia: The Ideals of Greek Culture, trans. G. Highet, New York, 1939–44; V. Paladini, La storia della scuola nell'antichità, Milan, 1952; M. Cagiano de Azevedo, La chrestographia, AC, VIII, 1956, pp. 24–28; P. De Francisci, Le arti nella legislazione del secolo, IV, RendPontAcc, XXVIII, 1956, pp. 63–73; H. I. Marrou, A History of Education in Antiquity, trans. G. Lamb, Lon-

don, [1956]. *c. Middle Ages*: E. Panofsky, Abbot Suger on the Abbey Church of St. Denis and Its Art Treasures, Princeton, 1946; J. Bühler, Die Kultur des Mittelalters, Stuttgart, 1954, pp. 289–302; A. Pellizzari, I trattati attorno alle arti figurative in Italia e nella penisola iberica dall'antichità classica al Rinascimento, Naples, 1955; J. Schlosser, La letteratura artistica, 2d ed., Florence, 1956, pp. 25–34, 91–98; B. Nardi, Il pensiero pedagogico del Medioevo, Florence, 1958. *d. Renaissance to the 20th century*: J. Reynolds, Discourses Delivered at the Royal Academy, London, 1820; Manual of the Guild and School of Handicraft, ed. C. R. Ashbee, London, 1892; C. R. Ashbee, An Endeavor towards the Teaching of John Ruskin and William Morris, London, 1901; C. R. Ashbee, Craftsmanship in Competitive Industry, London, 1908; G. Hartman and A. Shumaker, Creative Expression: The Development of Children in Art, Music, Literature and Dramatics, New York, 1932; P. Hiss and R. Fansler, Research in Fine Arts in the Colleges and Universities of the United States, New York, 1934; H. Bayer, Bauhaus, 1919–1928, New York, 1938; A. Blunt, Artistic Theory in Italy 1450–1600, Oxford, 1940; N. Pevsner, Academies of Art: Past and Present, Cambridge, Eng., 1940; H. Hagstotz, The Educational Theories of John Ruskin, Lincoln, Nebr., 1942; R. J. Goldwater, The Teaching of Art in the Colleges of the United States, College Art J., II, 4, Supp., May, 1943; M. M. Rossi, L'estetica dell'empirismo inglese, Florence, 1944; J. Dewey, A. Barnes, and L. Buermeyer, Art and Education, Merion, Pa., 1947; H. Read, The Grass Roots of Art, New York, 1947; Ingres raconté par lui-même et par ses amis: Pensées et écrits du peintre, Geneva, 1947–48; H. Read, Culture and Education in World Order, New York, 1948; F. H. Taylor, The Taste of Angels, Boston, 1948; E. F. Carritt, A Calendar of British Taste from 1600–1800, London, 1949; G. C. Argan, Walter Gropius e la Bauhaus, Turin, 1951; E. Cassirer, The Philosophy of the Enlightenment, trans. F. C. A. Koelln and J. P. Pettegrove, Princeton, 1951; F. M. Logan, Growth of Art in American Schools, New York, 1955; E. Garin, Il pensiero pedagogico dell'umanesimo, Florence, 1958; Art Education Today, New York (Ann.). *e. Orient*: See bibliogs. of BUDDHISM; CONFUCIANISM; HINDUISM; SHINTOISM; TAOISM; and the various countries.

**EGYPT.** This article is concerned with the Egyptian region of the United Arab Republic, including Egypt proper and Nubia up to the Second Cataract. In chronology it follows the system worked out by A. Scharff on the basis of parallels between the 1st dynasty and the Jemdet Nasr period in Mesopotamia (see ASIA, WEST: ANCIENT ART); the unification of Upper and Lower Egypt, from which dates the beginning of the 1st dynasty, is placed at about 2850 B.C. The differences between this system and the somewhat earlier "short chronology," followed in the article on Egyptian art (q.v.), involve chiefly the historical problems of the earliest dynasties.

SUMMARY. *Phases of cultural and artistic development* (col. 572): *Introduction; Prehistoric and predynastic era; Pharaonic Egypt; Greco-Roman and Byzantine Egypt; Islamic Egypt. Topographical survey* (col. 579): *The Delta: a. Eastern sector of the Delta; b. Central sector of the Delta; c. Western sector of the Delta; d. Apex of the Delta; Memphis area; The Valley: a. Lower Valley; b. The Fayum. c. Central Valley; d. Thebes area; e. Upper Valley; f. First Cataract area; Peripheral regions: a. Nubia; b. The Oases; c. Sinai.*

PHASES OF CULTURAL AND ARTISTIC DEVELOPMENT. *Introduction.* The present Arab name for the area known to us as Egypt is Misr, which is related to the Hebrew Mitsraim. The Greek Αἴγυπτος, from which the various Western forms derive, appears to be linked with the toponym He-ka-Ptah, which in ancient documents indicates the Memphis area but is nowhere found applied to Egypt as a whole. The Egyptians called the arable part of their country Kemet ("the Black Land") in contrast to Doshre ("the Red Land"), the desert areas to the east and to the west. Other common names were Tomery ("the *Mera* Land"), the meaning of which is uncertain, and Towe ("the Two Lands"), the latter an allusion to the geographical and political duality of Valley and Delta. When the Two Lands were mentioned separately the Delta was called To-mehu ("the Land of Swamps") and the Valley was called To-shema'u ("the Land of the *Shema* Plant"), *shema* perhaps meaning "reed."

Egypt has clearly defined natural boundaries; on the north the Mediterranean, on the east the Red Sea, on the west the Libyan Desert, and on the south the First Cataract. With the addition of the province of Nubia, in historical times, the southern boundary was extended up to the Second Cataract. Outlined thus is an irregular rectangle lying within 22° and 31° of north latitude and 25° and 35° of east longitude. The total area is about 386,100 square miles, of which only about 13,670 square miles (7,800 of them in the Delta) are arable. The clear geographic boundaries assigned to Egypt by nature are reflected in the unfolding of its history: its culture, which developed in distinctly autonomous centers, has been called a "civilization of oases."

The fertilizing element of the oases is of course the Nile, which runs through Egypt for about 940 miles. In the north opens out the great fan of the Delta (156 miles from east to west and about 100 miles north to south), an immense, slightly undulant plain cut through by a network of canals. The coast, desert toward the west and swampy in the northeast sector, does not favor the establishment of ports, except in the area of Alexandria. The Delta possesses, from west to east, four great salt lakes: Mareotis, Edku, Burullus, Menzala. To the east are Lake Timsah and the Bitter Lakes, still linked to the Nile, as they apparently were in antiquity, by the Wadi Tummilat. Toward this region, Lower Egypt, political life has gravitated from earliest times. The need for systematic irrigation and working of the soil favored the unification of the long river valley; on the other hand its elongated proportions made effective control difficult, and this accounts for the recurring tendency to divide into districts.

The Valley begins at Cairo. It is a narrow, arable strip of land bounded on either side by an uninterrupted row of limestone cliffs, at varying distances from the river. At no point is the distance between the two deserts beyond the cliffs (the Arabian on the east, the Libyan on the west) more than 12½ miles. A secondary branch of the Nile, the Bahr Yusef, already canalized in the days of the Pharaohs, leaves the main river at Derut, runs parallel to it, and ends in a depression in the Western Desert, the Birket Qarun. The last stretch of Bahr Yusef, also canalized in antiquity, created one of the most fertile districts in Egypt: the Fayum. In the stretch between Nag Hammadi and Luxor the Nile turns eastward and the Valley narrows decidedly; at Gebel Silsileh the desert bluffs drop almost directly down to the river. At Aswan appears the First Cataract, formed by a granite outcrop on which the great dam was built. After this, as the Valley ascends between masses of granite and basalt into the Wadi Halfa, below the Second Cataract, it takes on a wild appearance.

The Libyan Desert rises to a median elevation of between 490 and 650 ft.; its composition appears stony is some areas, sandy in others. Its vast stretches of wasteland are relieved by the great oases of Siwa, Bahrieh, Dakhla, and El Kharga. The Wadi Natrun depression constitutes an important area in the north. The Arabian Desert is rocky and impenetrable, with mountains reaching the height of 5,530 ft. The Wadi Hammamat route between Qift and Quseir constitutes the oldest road of communication between the Nile Valley and the Red Sea. Sinai, though geologically related to the Arabian peninsula, has historically been linked to Egypt by close ties, especially through the working of its copper and turquoise mines, beginning in dynastic times.

In its geological conformation Egypt may be divided into four zones: the massive granite outcrop occupying the region of the First Cataract, the sandstone area reaching from Aswan to Esna, the limestone area comprising the remaining part of the Valley, and the alluvial zone of the Delta. This variation was of great significance for the development of the architecture and sculpture of ancient Egypt. Along with the two excellent granites (red, or syenite, and black) and the soft, fine limestones, Egypt offers a broad selection of stones adaptable for use by artist or artisan: alabasters, basalts, breccias, diorites, obsidians, porphyries, quartzites, schists, serpentines.

The Egyptian climate is dry, with high daytime temperatures and considerable variation from day to night. The soil's fertility depends on the Nile's annual overflow, the result of the spring and summer rains in Ethiopia. Until the end of the 19th century, when a system of dikes and canals was instituted, making possible the storing and rational distribution of water, the fertilizing waters had annually spread over and submerged the fields from mid-July until October.

Egypt's flora shows little variety. Cereal grains have always occupied the main place; the cultivation of cotton is recent. The fauna includes a great variety of aquatic birds, web-footed and stilt-legged. The fine breeds of cattle depicted in ancient reliefs have disappeared; the ass and the camel (which in fact appear rarely in Pharaonic times) are still used. Among the nondomestic animals, gazelles, wolves, and jackals are common. The crocodile and the hippopotamus, once found throughout Egypt, are limited to the upper reaches of the Nile. Reptiles and insects are numerous; of fish, about twenty species are known.

Anthropologists have reconstructed an original proto-Egyptian type, brown-skinned, short of stature, and with a long, narrow skull. By the predynastic era there were present in the Delta types close to the Asiatic races, with short, wide skulls, and an infiltration of Negroid elements in the south is evident. The present population shows an admixture of Arab stock.

The ancient Egyptian tongue appears to have been composed of an African substratum upon which were superimposed Semitic radicals and syntactic elements; the Islamic conquest in the 7th century of our era introduced the Arabic language, which became dominant in the area.

BIBLIOG. H. Hume, Geology of Egypt, 2 vols., Cairo, 1925–35; F. Hommel, Ethnologie und Geographie des alten Orients, 2 vols., Munich, 1926, pp. 741–983; Atlas of the Normal 1/100,000-scale Topographical Series of Egypt (Survey of Egypt), Cairo, 1932; R. Fedden, The Land of Egypt, London, 1939.

*Prehistoric and predynastic era.* The presence of paleolithic hunting man is evident in Egypt several millenniums before the historical

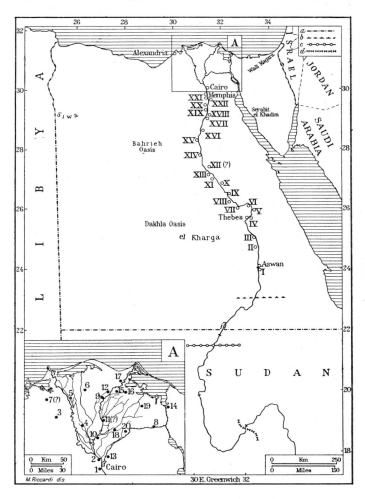

Egypt: general map. *Key: a.* Modern political boundaries. *b.* Limit of southward expansion in the Old Kingdom. *c.* Limit of southward expansion in the Middle Kingdom. *d.* Limit of southward expansion in the New Kingdom. The ancient nomes are indicated by Roman numerals for Upper Egypt, Arabic numerals for Lower Egypt (inset A). *Upper Egypt:* I. 'bw (Elephantine). II. Dbw and Bḥdt (Apollinopolis). III. Nḫb (Eileithyaspolis). IV. Wȝst (Diospolis Magna). V. Gbtyw (Koptos). VI. 'Iwnt, then 'Iwnt-tȝ-ntrt (Tentyris). VII. Ḥwt-sḫm (Diospolis Parva). VIII. ȝbdw (Abydos). IX. Ḫnt-Mn, then 'Ipw (Panopolis). X. Tbw, then Dw-kȝ (Antaeopolis). XI. Šȝs-ḥtp (Hypsele). XII. Pr-'nty (Hierakon). XIII. Sȝwty (Lykonopolis). XIV. Kis (Kussai). XV. Ḥmnw (Hermopolis Magna). XVI. Ḥbnw. XVII. Ḥr-dy (Kynopolis). XVIII. Ḥwt-nsw. XIX. Spr-mrw. XX. Nn-nsw (Heracleopolis). XXI. Šn'-ḥn or Smn-Ḥr. XXII. Tp-iḥw (Aphroditopolis). *Lower Egypt* (in inset A): 1. Mn-nfr (Memphis). 2. Ḥm or Sḥm (Letopolis). 3. 'I(ȝ)mw or Pr-nb-'I(ȝ)mw. 4. Dk'. 5. Sȝw (Sais). 6. Ḥȝsww (Xois). 7. Pr-Ḥȝ-nb-'Imntt. 8. Ṯkw. 9. Pr-Wsir-nb-Ddw (Busiris). 10. Ḥwt-tȝ-ḥry-ib (Athribis). 11. Ḥsb. 12. Tb-ntr (Sebennytos). 13. 'Iwnw (Heliopolis). 14. Msn or Tȝrw (Sele). 15. Pr-Dḥwty-wp-Rḥwy (Hermopolis Parva). 16. Ddt, then Pr-Bȝ-nb-Ddt (Mendes). 17. Bḥdt, then Smȝ-Bḥdt (Diospolis Inferior). 18. Pr-Bst (Bubastis). 19. 'Imt. 20. Pr-Spd.

period, in a time when warm, humid climatic conditions favored a rich vegetation. The transition to the agricultural phase that occurred during the Neolithic era is documented in the Delta centers (Fayum, Merimdeh, El 'Omari). The later chalcolithic period, which in the south appears at Badari, 'Amra, and Naqada and in the north at Gerza, coincides in its last phase with the predynastic age, during which certain cultural influences of Mesopotamian origin may be noted. The neolithic burials were simple elliptical pits; those of the late Aëneolithic era were rectangular, and in some cases had an interior lining of bricks.

*Pharaonic Egypt.* The beginning of Egyptian history — generally divided into dynasties according to the system of the Greco-Egyptian historian Manetho (ca. 280 B.C.), of which we have had direct knowledge since Champollion's decipherment of Egyptian — goes back to the unification of the two predynastic kingdoms by Narmer (Menes), ruler of Hierakonpolis, about 2850 B.C. The geographical and political dualism of the Valley and Delta continued to be a dominant factor in the cultural development of the following periods. The capital moved to Thinis, and the first two dynasties (ca. 2850–2650) are called the Thinite dynasties. However, in this period the city of Memphis, whose foundation has traditionally been ascribed to Menes, assumed great importance. The oldest evidence indicates that royalty was considered of divine origin and the ruler a true god; in a general way this conception remained a basic element of the ancient Egyptian monarchic institution. The Thinite epoch is marked by the rapid and decisive transition from a patriarchal regime to a bureaucratic state; that this had been accomplished as early as the 1st dynasty is proved by the titles of functionaries recurring on cartouches. Not only was the internal administrative organization worked out; the relations with neighboring countries were also developed, as is evidenced by the coniferous woods from Lebanon used in the Abydos tombs and the ceramics of Palestinian provenance in the tombs of Saqqara.

The first great phase of Egyptian history, the Old Kingdom, comprises the 3d–6th dynasties. In general the Old Kingdom, which had its capital at Memphis, is sparse in documentation though rich in funerary monuments. A form typical of Memphis is the mastaba (from the Arabic for "bench"), from which, by way of the step pyramid, the royal pyramid was derived. The greatest figure of the 3d dynasty (ca. 2650–2600) was Zoser, famous especially for his funerary complex at Saqqara, the first elaborately planned group of buildings in stone. The 4th dynasty (ca. 2600–2480) began with Sneferu, of whose campaigns of plunder in Nubia and Libya there are fragmentary records. The fame of his three successors, Cheops (Khufu), Chephren (Khafre), and Mycerinus (Menkure), rests largely on the imposing mass of their respective pyramids, which testify to an efficient organization of collective labor. With the 4th dynasty, the state administration was broadened at the base, the number of officials being multiplied. The advent of the 5th dynasty (ca. 2480–2350) marks a new element in the dynastic successions: the influence of the priestly class. In fact the first three rulers, Weserkaf, Sahura, and Neferkara, were elected by the priests of Heliopolis. The 6th dynasty (ca. 2350–2200), though still enjoying a certain prosperity and scoring successes in Nubia and the Syro-Palestinian area (especially under Pepi I and Pepi II), was unable to stem the encroachment of the central officials or to check the separatist ambitions of the local governors, the nomarchs. The result was violent revolt, which degenerated into a series of civil wars. These led to the collapse of the central authority and the creation of small feudal kingdoms; the accompanying disturbance of the human conscience seems to have evoked an uneasy sense of individual responsibility. This in general is the situation during the First Intermediate Period, which comprises the 7th–10th dynasties. About the 7th and 8th dynasties practically nothing is known; the 9th and 10th dynasties had their capital at Heracleopolis, and for a limited time the 10th dynasty extended its influence to Upper Egypt. In the meantime, concurrent with the 10th, the 11th dynasty had arisen at Thebes; its energetic rulers succeeded, about the year 2050, in overcoming their Heracleopolitan adversaries and in reestablishing national unity, an achievement in which the efforts of Mentuhotep Nebhepetra (Mentuhotep II) were effective.

Thus began the second major phase, the Middle Kingdom, during which the efficacy of the central power was reestablished and the nomarchs were reduced to the level of royal officials. The 12th dynasty (1991–1778) was one of the most flourishing periods of Egyptian civilization in all fields — economic, military, artistic, literary. Its founder, Amenemhet I, transferred the capital to a northern site near the present Lisht and not far from Memphis, and he fortified the frontiers of the eastern Delta. Sesostris III is famous for his conquests: the subjection of Nubia was completed under his reign, and campaigns were undertaken into western Asia. The name of Amenemhet III, on the other hand, is linked with a pacific work of great economic importance: the reclamation of the Fayum area, which he transformed into a fertile oasis. The 13th and 14th dynasties (1778–ca. 1670) saw the beginning of a rapid decay, characterized by the swift succession of kings lacking in personality and of usurpers. This is the Second Intermediate Period, very sparsely documented, during which Asiatic elements made their way into the Delta — the Hyksos of Greek tradition (their name is from the Egyptian for "rulers of foreign lands"), who established the 15th and 16th dynasties (ca. 1670–1570) with a capital at Avaris (Tanis). It was the Hyksos who introduced the war chariot into Egypt. In the meantime, there had arisen at Thebes, about 1610 B.C., the 17th dynasty, which gradually won dominion over Upper Egypt, then led a victorious war of liberation against the Hyksos, with especial success under the last ruler, Kamose.

The third major phase of Egyptian history, the New Kingdom, comprises the Theban dynasties, the 13th to 20th, under which Egypt ran the gamut of imperial power: from a country enjoying great prestige gained through triumphant ventures into western Asia to a country weakened and passively submitting to its adversaries' attacks. The first ruler of the 18th dynasty (ca. 1570–1318) was Ahmose I, who finally expelled the Hyksos for good; he reconquered Nubia, placing a viceroy at the head of the administration for the territory. With Thutmosis I the expansion in Asia reached as far as the Euphrates. During the reign of Queen Hatshepsut there was a period dedicated to peaceful works, among them an expedition into the land of Punt (the Somali coast). Her successor, Thutmosis III, resumed the drive into Asia, personally leading a series of auspicious campaigns through which the Egyptian empire reached its greatest territorial expansion. The conquered countries were allowed to retain the local political forms, but they were placed under imperial control and fortresses were set at strategic points. After the death of Thutmosis III (ca. 1448) it was easy enough for his immediate successors, Amenhotep II and Thutmosis IV, to maintain their privileged position. But the empire cracked under Amenhotep III and Amenhotep IV, who were not interested in foreign policy; in fact, the latter caused a grave internal crisis by pressing a revolt against the Theban priesthood and its god Amen (Amon), to whom he opposed the sun-god Aten, conceived as an only god. Amenhotep IV changed the god's name to Akhenaten and established his new capital at Tell el 'Amarna. With the advent of Tutankhamen the priests regained their supremacy; the capital returned to Thebes and Amarna was destroyed. The dynasty ended with Horemheb. Power now passed to the 19th dynasty (ca. 1318–1200), originating in Tanis. Seti I proved an energetic ruler, leading victorious campaigns against the Hittites and promoting great building works. His son Ramses II continued the work of his father both abroad and at home, concluding with the Hittites a treaty into which the two states entered as equals. The tide of Indo-European Peoples of the Sea was stemmed by the next ruler, Merenptah, who intervened in Palestine as well. In the 20th dynasty (1200–1085) the sole outstanding figure is Ramses III; he successfully resisted renewed invasions by Indo-Europeans and by coalitions of tribes on the Libyan front. The succeeding rulers, the Ramessides IV to XI, saw decadence creeping in and the dissolution of established institutions.

In this inauspicious atmosphere began the Late Period, in which there was a religious capital at Thebes, directed by the high priest, and a political capital in the Delta. Among the rulers of the 21st dynasty (1085–935), some of whom lived at Tanis, may be singled out Psusennes I, Psusennes II, and Paynozem. Over the years bands of Libyan soldiers had installed themselves in various places in the country, and from one of these groups sprang the 22d dynasty (935–719), which had its capital at Bubastis. A noteworthy figure in this dynasty was Sheshonq I, who made a sortie into Palestine and sacked Jerusalem. The 23d dynasty arose at Tanis, running parallel with the 22d, but both were overthrown by the 24th, established by Tef-nekht, prince of Sais. As the 24th dynasty began to stabilize itself in the Delta, the victorious Piankhy, second ruler of the 25th Nubian dynasty, moved in from the south and deposed Tef-nekht, about 725 B.C. The deposed ruler's son Bocchoris (Bakenrenef), who had reconquered the Delta, was overpowered by Shabako, Piankhy's successor; with Bocchoris the 24th dynasty came to an end. The following dynasty, the 25th, had to face invading Assyrian might at two different times: in 670 B.C., when the invaders reached Memphis, and in 666 B.C., when they wiped out Thebes. After this defeat the 25th dynasty withdrew into Nubia, where the kingdom of Meroë had its origin. The last period of Pharaonic history — during which national unity was once more achieved and the country once more enjoyed a sense of stability and prosperity — takes its name from the new capital, Sais, the birthplace of the 26th dynasty (663–525). The founder, Psamtik I, supplementing his forces with Greek mercenaries, took advantage of the internal weakness of the Assyrian empire and shook off its dominion over Egypt. His son Necho (609–594) drove down into Egypt against the new Babylonian empire, but after his first successes he was defeated by Nebuchadnezzar. The policy of interference was taken up by his successor, Apries (594–568), but with no better results. Apries was dethroned by one of his own generals, Amasis (570–526). Egypt was unprepared to face the growing power of the Persian Empire, which easily put an end to the dynasty in 525, after the brief reign of Psamtik III. The Achaemenids, from Cambyses to Darius II, provided Egypt, now reduced to the status of a satrapy, with a 27th dynasty. Between 404 and 341 three indigenous dynasties followed one another, a war of liberation led by Amyrtaios of Sais, the only king of the 28th dynasty, having once more given the country its independence. The four rulers of the 29th dynasty had their capital at Mendes, the three rulers of the

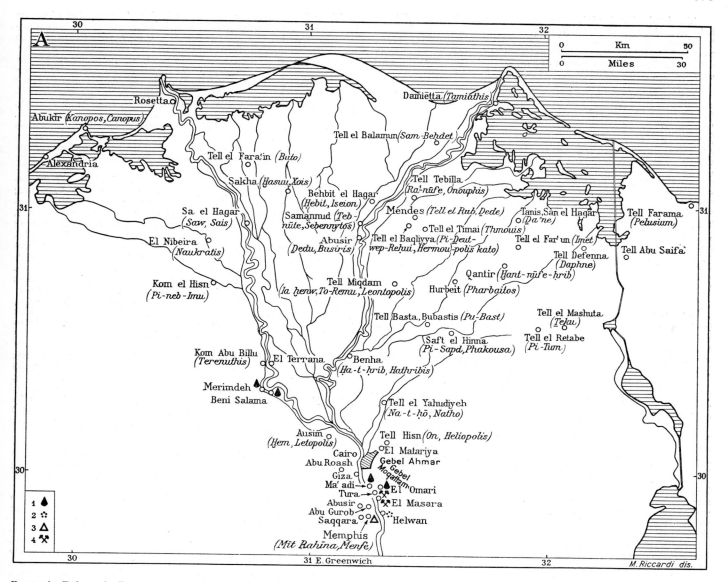

Egypt: the Delta and adjacent areas, showing principal ancient centers (see also inset A, FIG. 581). *Key:* (1) Prehistoric finds; (2) tombs; (3) pyramids; (4) mines and caves.

30th at Sebennytos; of this last indigenous dynasty the names of the two great builders, Nectanebo I and Nectanebo II, may be remembered. After the 30th dynasty came the second Persian domination, and in 332 the conquest by Alexander the Great.

*Greco-Roman and Byzantine Egypt.* With the partition of Alexander's empire, Egypt fell to Ptolemy I, founder of the dynasty that ruled from 323 to 30 B.C. The government was absolutist, with a strictly centralized administration run by a closely organized network of functionaries and tax collectors. Agriculture and commerce were encouraged; these activities, particularly in the Delta, were administered by Greeks. The early Ptolemies fostered letters, the arts, and the sciences, and in their time the city of Alexandria became the center of Greek culture. In the field of foreign policy a long contest for the possession of Coele-Syria was the chief preoccupation of the Diadochi and their successors. In their relations with the natives the Ptolemies posed as heirs of the Pharoahs, showing great deference to the priests and the cult (temples of Philae, Edfu, Kom Ombo, Dendera). A characteristic manifestation of Greco-Egyptian syncretism was the cult of Serapis. The end of the Ptolemaic period was marked by dynastic conflicts and by the decay of the central power, which, in the person of Cleopatra VII, deluded itself that it could block Roman expansion in the East. The battle of Actium put an end to these hopes.

From 30 B.C. Egypt was a Roman province, governed by a prefect. The emperors were regarded as successors to the Pharaohs, and public laws, couched in Greek, were dated with the years of their rule. Alexandria kept its magistrates and retained the privilege of coining money with its own emblems on the reverse. The first Roman prefects had to deal with local revolts and repel an invasion of Ethiopians led by Queen Candace (23 B.C.). From the middle of the 1st century of our era to the beginning of the 2d there were violent conflicts between the Greeks and the Jews. In A.D. 130 Hadrian visited Egypt, interesting himself in public works and founding the city of Antinoë in honor of his favorite. Under Aurelian two invasions were repulsed: one in the Delta, led by Zenobia, queen of Palmyra, and the other, in Upper Egypt, led by the Blemmye nomads. In the course of the reforms of Diocletian, Egypt, divided into three provinces, became a part of the *Diocesis Orientis*, governed from Antioch by a Praetorian Prefect of the East.

Christianity, which had spread in Egypt during the apostolic period, was first granted toleration under Constantine. In 325, the Arian heresy was condemned at Nicaea, and Athanasius, the victor at the Council, was acclaimed at Alexandria by bishops and people. Later he initiated a fundamental reform of Christian life; he had as collaborator Pachomius, who reorganized monastic life. The emperor Theodosius made Alexandria once more the administrative center of Egypt, and he decreed, in 389, that all pagan temples should be closed. This date marks the beginning of the great flowering of Christian art in Egypt. The Alexandrian patriarch Dioscorus, rebelling against Constantinople and condemned by the Council of Chalcedon (451), confirmed the trend in Egypt to Monophysitism; the heresy thus gave rise to the national Coptic Church, firmly opposed both politically and theologically to Byzantium.

The battle that Justinian conducted against this heresy did not help to avoid schism. Internal conflicts between Monophysites and Melchites, subsiding only during the Persian invasions (617–628), troubled the Coptic Church. The Melchites gained the ascendancy during the Byzantine reconquest of 640, but their domination lasted only up to the Arab conquest in 641.

Bibliog. Cabrol-Leclercq, IV, 2, s.v. Egypte; see EI, XIII, pp. 584–86; B. Porter and R. L. B. Moss, Topographical Bibliography of Ancient Egyptian Hieroglyphic Texts, Reliefs and Paintings, I, The Theban Necropolis, Oxford, 1927 (2d rev. ed. forthcoming), II, Theban Temples, Oxford, 1929, III, Memphis, Oxford, 1931, IV, Lower and Middle Egypt, Oxford, 1934, V, Upper Egypt: Sites, Oxford, 1937, VI, Upper Egypt: Chief Temples, Oxford, 1939, VII, Nubia, the Desert, and Outside Egypt, Oxford, 1951 (basic topographical-bibliog. description, which, though principally concerned with hieroglyphic inscriptions, contains many plans of buildings with the identification of elements in situ as well as objects found there; E. Drioton and J. Vandier, L'Egypte, 3d ed., 1952, pp. xxxiv–xxxv (listing basic historical accounts); J. Vandier, Manuel d'archéologie égyptienne, 3 vols., Paris, 1952–58 (still being pub.); W. Helck and E. Otto, Kleines Wörterbuch der Ägyptologie, Wiesbaden, 1956 (a brief, informative manual with bibliog. notes); the following institutes and foundations have pub. and continue to pub. notices concerning explorations, discoveries, and excavations: Egypt, Service des antiquités; France, Inst. fr. d'archéologie orientale du Caire; Germany, Inst. für ägyptische Altertumskunde in Kairo; Great Britain, Br. School of Archaeol. in Egypt, Eg. Exploration Fund, Eg. Exploration Soc.; U.S., Boston, Mus. of Fine Arts, New York, Met. Mus., Chicago, Oriental Inst.).

Sergio Bosticco

*Islamic Egypt.* Egypt, at first a marginal province of the Mohammedan civilization, increased in importance, occupying a position of the first rank from the 10th century on, first rivaling and then entirely supplanting Iraq as the center of the Abbasside empire (see ABBASSIDE ART). The monumental heritage of Islamic Egypt reflects this historical evolution: of the earliest epoch there are in fact very few vestiges and those much altered; of the Tulunid dynasty (9th cent.) only grandiose, isolated elements remain; the Fatimid (see FATIMID ART), Ayubite, and, especially, the Mameluke epochs (see MAMELUKE ART) are represented by an outstanding number of monuments, the most important of which are noted below in the descriptions of their respective localities. The historic topography of the country had an illustrious student in the erudite Maqrīzī (d. A.D. 1442), whose great work *'al-Mawā'iz wā'l-i'tibār fī dikr al-hitat wa'l-ātār (Book of Information and Observations on the History of the Quarters and Monuments...)* is an invaluable document from the historical, archaeological, and antiquarian points of view; unfortunately the modern scientific edition undertaken by G. Wiet, as well as the translation annotated by U. Bouriant and P. Casanova, has remained incomplete, so that this classical description of Islamic Egypt must still often be referred to in the unsatisfactory original edition.

There are relatively few significant Mohammedan monuments in Egypt outside the two metropolises of Cairo and Alexandria. In the case of Alexandria, the scarcity results from the transformation wrought in the city by the modern age; in the provinces the lack reflects the poverty of economic and cultural life, which discouraged the construction of buildings of any importance, sacred or profane. The mosques which are found everywhere, even in such small centers as Rosetta (Rashid), are generally of recent date (from the Turkish or, at the oldest, the Mameluke period). From the earliest period, the Ayubite (or perhaps the Fatimid) — and in ruins — is the mosque of Abū'l Ma'tī, in a surburb to the north of the modern city of Damietta (Dimyat); it has some ancient columns and Kufic inscriptions. The mosque of Qāit Bey at Medinet el Fayum, the principal Mohammedan monument in the area, is Mameluke, and the mosque of Sīdī-al-Badawī at Tanta is, at least in its present form, Turkish. The principal center in Upper Egypt, Asyut, and the localities famous for the archaeological remains of the ancient Egyptian civilization, (Qus, Esna, Luxor, Aswan, El Shallal) have from the Islamic period no sacred buildings of artistic significance. At Aswan part of the ancient city walls, perhaps going back to the time of the first Arab conquests, and the Arabian cemetery, with ancient steles, remain.

After the Arab domination the art of Egypt was influenced by European models, particularly French and English. During the 19th and 20th centuries most of the Egyptian cities witnessed a revival of building, and the construction of whole districts alongside the old Arabian ones has given these cities a new aspect.

Francesco Gabrieli

TOPOGRAPHICAL SURVEY. The establishment of an agricultural economy and the formation of great centers of population brought about from earliest times a subdivision of the country into territorial districts (Eg., *spt*, then *tš*; Gr., νομός), each with its chief town. This division into districts, or nomes, constituted a basic element in the political and social life of Egypt, even during the periods in which national unity was most strongly felt. The number of nomes was subject to variation in the course of the centuries; the most widely used classification assigns 22 nomes to Upper Egypt and 20 to Lower Egypt (FIG. 574). Each nome had an emblem connected with its cult object (fetish, sacred animal, or anthropomorphic divinity) or with a peculiarity of the nome itself. Since familiarity with the nomes is basic to the study of the archaeological topography of ancient Egypt, a list of them is included here; it follows the traditional order of the hieroglyphic sources, that is, from south to north. For each nome the distinguishing emblem and the chief town are given, the latter first in consonantal transcription from the hieroglyphic form and then (if known with certainty) as found in classical sources. In a few cases two contiguous nomes have the same emblem and are distinguished between by their numbers and their capitals.

*Upper Egypt:* (1) The land of the *sty* mineral (Nubia), '_bw (Elephantine); (2) Throne of Horus, Dbw and Bhdt (Apollinopolis); (3) Plumed fortress, Nhb, (Eileithyiaspolis); (4) Scepter, W_3st (Diospolis Magna); (5) The two lords, Gbtyw (Koptos); (6) Crocodile, 'Iwnt, then 'Iwnt-t_3-ntrt (Tentyris); (7) Sistrum, Hwtshm (Diospolis Parva); (8) Feathered wig (later interpreted as reliquary for the head of Osiris), _3bdw (Abydos); (9) Emblem of the god Min, Hnt-Mn, then 'Ipw (Panopolis); (10) Serpent, Tbw, then Dw-k_3 (Antaeopolis); (11) Animal of the god Seth, Š_3s-htp (Hypselis); (12) Mount of the cerastes, Pr-'nty (Hierakonpolis); (13) Upper *ndft* tree, S_3wty (Lykonpolis); (14) Lower *ndft* tree, Kis (Kussai); (15) Hare, Hmnw (Hermopolis Magna); (16) Oryx, Hbnw; (17) Dog, Hr-dy (Kynopolis); (18) Falcon, Hwt-nsw; (19) Two scepters, Spr-mrw; (20) Upper pomegranate tree, Nn-nsw (Herakleopolis); (21) Lower pomegranate tree, Šn'-hn or Smn-Hr; (22) Knife, Tp-ihw (Aphroditopolis).

*Lower Egypt:* (1) White wall, Mn-nfr (Memphis); (2) Ox leg, Hm or Shm (Letopolis); (3) West, 'I(_3)mw or Pr-nb-'I(_3)mw; (4) Emblem of the goddess Neith, Dk'; (5) Emblem of the goddess Neith, S_3w (Sais); (6) Desert bull, H_3sww (Xoïs); (7) Western hook, Pr-H_3nb-'Imntt (8) Eastern hook, Tkw; (9) The god Andjeti, Pr-Wsir-nb-Ddw (Busiris); (10) Black bull, Hwt-t_3hry-ib (Athribis); (11) Hsh bull, Hsb; (12) Calf and cow, Tb-ntr (Sebennytos); (13) Intact scepter, 'Iwnw (Heliopolis); (14) Eastern frontier, Msn or T_3rw (Sele); (15) Ibis, Pr-Dhwty-wp-Rhwy (Hermopolis Parva); (16) Dolphin, Ddt, then Pr-B_3-nb-Ddt (Mendes); (17) Throne, Bhdt, then Sm_3-Bhdt (Diospolis Inferior); (18) Royal boy, Pr-Bst (Bubastis); (19) Royal boy, 'Imt; (20) Plumed falcon, Pr-Spd.

These nomes remained in traditional use up to the Roman era — as is proved by hieroglyphic inscriptions in the temples — but we know from Herodotus that considerable modification had been brought about in the administrative districts by the time of the Persian domination. Some nomes were divided into two; some, incorporated into their neighbors, disappeared; on the other hand, newly formed ones made their appearance. Diodoros, who visited Egypt in 60 B.C., states that the country was subdivided into 36 nomes (10 of them constituting the Delta). Strabo, who came there in 25 B.C., confirms this subdivision: 10 in the Thebaid, 16 in central Egypt, and 10 in the Delta. According to the testimony of Pliny the Elder, the nomes under the emperor Vespasian numbered 47, two of them in the oases. At the time of Ptolemy's compilation, that is, in the middle of the 2d century of our era, the number of nomes had risen to 49. The data supplied by 2d-century coins raise the number of nomes to 52. From the year 202, in accordance with a decree of Septimius Severus, the chief city in each nome was governed by a senate (βουλή; curia). A fundamental modification in the administration was made between 307 and 310, under Maximinus Daza, separating the territory of the nome from that of its chief city and subdividing the territory into pagi, each pagus headed by a *praepositus pagi*. Later, in the 6th century, groups of pagi were combined to form pagarchies, each of these governed by a pagarch named by the emperor. However, the nome kept its place in popular usage up to the Arab conquest. Byzantine records show Egypt divided into five sectors (Egypt proper, Augustamnica, Arcadia, the Thebaid, Libya), each of which was composed of two eparchies, with the exception of Arcadia.

Sergio Bosticco

For fiscal reasons the Arabs at first retained the pagarchy (*kūra*) as an administrative division, with its basic unit the pagus (*qarya*); in the first century of Arab rule there were about thirty pagarchies each in Lower Egypt and Upper Egypt, the total pagi numbering several thousand. Though the two parts of the country formed two separate administrative districts, both were subject to the authority of a governor general and an intendent of finance. This structure was changed toward the end of the Fatimid period (11th cent.), when the pagarchies were replaced by provinces (*a'māl*); there were

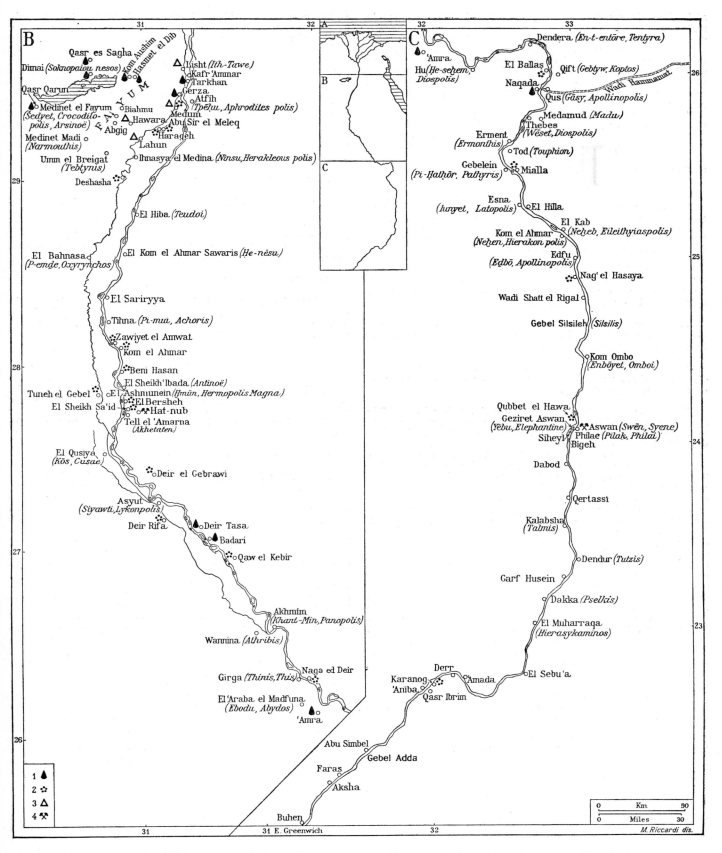

Egypt: the Valley and Lower Nubia, showing principal ancient centers. *Key:* (1) Prehistoric finds; (2) tombs; (3) pyramids; (4) mines and caves.

**26** in the entire country, 10 in Upper and 16 in Lower Egypt. In succeeding centuries, as the country declined economically and demographically, the number of administrative units was reduced and individual provinces increased in size. In the early 14th century there were only 15 provinces, and under Ottoman rule there were fewer still. There were 14 at the beginning of World War I; subsequently, with the addition of the oasis regions, the number was increased. In the 19th century the *a'māl* were called *mudīriyya*, and this term is still used.

The present administrative divisions of Egypt are as follows: the governorates of Alexandria, Cairo, Canal, Damietta, and Suez; the Frontier Provinces and District; and the provinces of Lower and Upper Egypt. The former are Beheira, Daqahliya, Gharbiya, Minufiya, Qalyubiya, and Sharqiya; the latter are Aswan, Asyut, Beni Suef, Fayum, Girga, Giza, Minya, and Qena.

Francesco GABRIELI

BIBLIOG. G. Steindorff, Die ägyptischen Gaue und ihre politische Entwicklung, Abh. der philosophischen Klasse der königlichen sächsischen Gesellschaft der Wissenschaften, XXVII, 25, Leipzig, 1909; H. Gauthier, Les nomes d'Egypte depuis Hérodote jusqu'à la conquête arabe, Mémoires de l'Inst. d'Egypte, XXV, Cairo, 1935.

*The Delta.* The following account proceeds by sectors, from east to west and from the coast to the interior, and includes several localities traditionally considered part of the Delta although actually they are on the east bank of the Nile.

*a. Eastern sector of the Delta.* Port Said. The city is entirely European in appearance. Its residential section, Port Fuad, on the Asian shore, has grown up since 1925.

Damietta (Ταμιαθις). For the ancient era there is nothing here of archaeological interest; the Mosque of al-Mu'eynī is from the second quarter of the 14th century.

Tanis, Ṣān el Ḥagar (Ḏ'nt, Da'ne; Heb., Ṣō'an; Τανις). The most important archaeological site in the eastern Delta, explored by Mariette, Petrie, and Montet, Tanis is probably to be identified with the Hyksos city of Avaris (Ḥwt-w're; Αὔαρις). Tanis was especially important during the 12th dynasty, the Hyksos period, and the 19th dynasty. Under the 22d and 33d dynasties it was the capital. The central area (ca. 32 acres) of the tell is occupied by the impressive ruins of a great temple; it must have had three pylons and a hypostyle hall. There survive ten obelisks (height ranging between ca. 32 and 50 ft.) and remains of four colossal statues and a colonnade with palmiform capitals — all with the cartouche of Ramses II. From this temple comes an important group of statues and sphinxes, usurped during the Hyksos period, which research has restored to the 12th dynasty. The temple possessed a broad, massive brick precinct wall with four doors, the greatest of which, the work of Sheshonq II, had two high towers built of reused material, flanking a colossal granite statue of Ramses II, which must originally have been at least 55 ft. high. Within the wall Montet discovered the royal necropolis, which was found to contain underground tombs (some still intact) of 21st- and 22d-dynasty rulers: Psusennes I, Osorkon II, Sheshonq III. The tomb of the first yielded particularly rich finds. Inside the great precinct wall the ruins of a second temple, called the "eastern temple," have emerged; of this there remain 10 granite columns having palmiform capitals, incised with the cartouche of Ramses II, usurped by Osorkon II. On the ruins of a third temple, dedicated to the goddess Anat — this one outside the great temple precinct — can be seen cartouches of 19th-, 21st-, and 26th-dynasty rulers. There has also been discovered at Tanis a group of private dwellings of the Ptolemaic era.

BIBLIOG. PM, IV, pp. 13–26; P. Montet, Tanis: Douze années de fouilles dans une capitale oubliée, Paris, 1942; P. Montet, Les constructions et la tombe d'Osorkon II à Tanis, Paris, 1946; P. Montet, Les constructions et le tombeau de Psusennès à Tanis, Paris 1947; P. Montet, Les énigmes de Tanis, Paris, 1952.

Hurbeīt (Šdnw; Φάρβαιπος). In the foundations of many of the modern houses here are granite blocks inscribed with the cartouche of Ramses II. Not far from the inhabited city was discovered a cemetery for sacred bulls; some were buried in granite sarcophagi.

BIBLIOG. PM, IV, pp. 26–27.

Bubastis, Tell Basṭa (Bst Bast and Pr-Bst, Pu-Bast; Heb., Pībeset; Βούβαστις). Chief city of the 18th nome of Lower Egypt, center of the cult of the cat-goddess Bubastis or Bastet, whose name means "She of the city of Bast," this center has been the source of many monuments, the greater number of them scattered among various museums. Its history is closely linked with that of Tanis. Bubastis possessed a great temple, which was explored by Naville. At the entry rose two colossal royal statues; there followed a court in which were discovered four granite statues of Ramses II; at the back of the court opened a monumental door, the work of Osorkon II, giving access to the hypostyle hall, which had smooth-shafted columns with palmiform capitals and bundled papyrus columns with Hathorhead capitals. The remains of a smaller temple bear the cartouches of Ramses II and Osorkon I. That the sacred architecture of Bubastis goes back as far as the Old Kingdom has been proved by the discovery of a 6th-dynasty chapel and of numerous architectural elements bearing the cartouches of Cheops, Chephren, and Pepi I. The famous find of a 19th-dynasty treasure comprising cups, paterae, and vessels of gold and silver should also be noted.

BIBLIOG. PM, IV, pp. 27–35.

*b. Central sector of the Delta.* Mendes, Tell el Rub' (Ḏdt, Dede; Μένδης). Chief town of the 16th nome of Lower Egypt, Mendes was the center of a ram-god cult. A great monolithic granite naos in the area of a temple bears the cartouche of Amasis. Nearby is the village of Tell Timai (Θμοῦις), in which there are unexplored ruins.

BIBLIOG. PM, IV, pp. 35–37.

Behbīt el Ḥagar (Ḥbt, Ḥebit; Ἰσεῖον). There remain here the chaotic ruins of a great temple to Isis, built entirely of granite, begun in the 30th dynasty and finished in the Ptolemaic era. Many of its reliefs have been removed and carried off.

BIBLIOG. PM, IV, pp. 40–42; G. Steindorff, Reliefs from the Temple of Sebennytos and Iseion in American Collections, Baltimore, 1945.

*c. Western sector of the Delta.* Rosetta (Rashid). The locality (whose ancient name is unknown) is famous for the discovery of the tablet that, inscribed with a decree in three scripts, provided the key to hieroglyphic writing. The Rosetta stone is now in the British Museum.

BIBLIOG. PM, IV, pp. 1–2, 50, 58.

Alexandria (Ἀλεξάνδρια). The Hellenistic capital, founded by Alexander, according to tradition, in the winter of 332–331 B.C., developed near an earlier village called R'kd (Ῥάκωτις), which became the western quarter of the city. Alexandria appears as an elongated peninsula between the Mediterranean to the north and Lake Mareotis to the south. A long dyke, the Heptastadion, linked the city with the little island of Pharos, dividing the port into two halves: the Great Harbor to the east, and to the west the Eunostos, which in turn included a tiny basin, Kibotos, receiving a canal derived from the Nile. The growth of Alexandria was constant from the time of Ptolemy II to that of Augustus, who founded the eastern suburb of Nikopolis, or Juliopolis. The complex of royal palaces faced the Great Harbor; flanking the promontory of Lochias on which they stood was the Regia (later Bruchium) quarter. Strabo records other landmarks of the quarter: the Poseideion, the Emporium, the Caesareum, and the Navalia, near which was found the famous library. The city was devastated in the reigns of Aurelian and Diocletian, in the course of the conflicts between the Christians and pagans during the religious struggles of the 6th century, and in the sieges of the 7th century. Archaeological remains are relatively rare: there remain elements of the circle of walls; a commemorative column of Diocletian, called Pompey's Pillar, its plinth formed of blocks with inscriptions of the Pharaonic era; traces of the Emporium and of the buildings of the Serapeum, which rose in the Rhakotis quarter. Of this temple, which appears to have had a rectangular ground plan, foundation deposits with the cartouche of Ptolemy III were found. Nothing remains of the celebrated Pharos or of the Caesareum; it was beside the latter that Augustus set the two famous royal obelisks, which have been removed, one to New York, the other to London. The site of the royal necropolis, which must have contained the tomb of Alexander and of his successors, has not been determined; the known underground cemeteries of the Hellenistic era (Mustafa Pasha) and of Roman times (El Wardān, Kom es-Shugafa, Hadra) have several chambers strung along a single axis or grouped about a peristyle court.

Of the Early Christian monuments mentioned by Eusebius, Epiphanius, and others, virtually nothing remains. We know that from the time of the edict of toleration of Galerius (311) up to the Arab domination Alexandria saw the construction of many splendid churches — some, such as St. Mark's, with martyria. About 366 Athanasius built, on the ruins of the ancient Caesareum, which had been destroyed in the course of Arian-Orthodox battles, the great

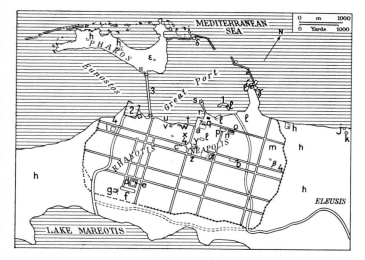

Alexandria. Plan of the ancient city, as reconstructed: (1) Antirrhodos; (2) Kobotos; (3) Heptastadion, with bridge at either end; (4) the Canopic street. Monuments whose locations are known from archaeological remains: (a) Caesareum; (b) Gymnasium; (c) temple of Serapis; (d) the great Serapeum; (e) Pompey's Pillar; (f) stadium or hippodrome known as Lageion; (g) catacombs of Kom es-Shugafa; (h) cemeteries; (i) Church of St. Theonas; (j) tomb of Stratonike; (k) hypogeum of the mercenaries. Monuments whose location is derived from texts: (l) royal palaces; (m) Nemeseion; (n) Palaestra; (o) the so-called "Maiandros"; (p) theater; (q) Emporium; (r) Poseideion; (s) Timonium; (t) Apostases; (u) Navalia; (v) Arsinoeion; (w) Bendideion; (x) Mouseion, with library probably adjacent; (y) Dikasterion; (z) tomb of Alexander (?); (α) Paneion; (β) Heroon of Pompey; (γ) temple of Isis Lochias (?); (δ) Pharos; (ε) temple of Isis Pharia; (ζ) temple of Neptune (adapted from EAA).

church dedicated to St. Michael that was to become the Cathedral of Alexandria. A part of the Serapeum was dedicated in 389 to SS. Cosmas and Damian. In this period there was in the center of the city a great public square with markets; excavations in 1874 uncovered the street that led from the river port to the seaport. The catacombs, in existence before 260 on the city's periphery — those of Karmuz, excavated by Wescher, and of Kom es-Shugafa, originally pagan — perhaps served the first Christians as meeting places. Unfortunately, only copies remain of the interesting frescoes, Hellenistic in style, in the Karmuz catacombs.

Alexandria lagged behind Cairo in the creation of monuments of Islamic art, and buildings of that era are almost totally lacking in the modern city. The circle of Arab walls has disappeared, leaving as remnants only the fort of Qāit Bey, with its ruined mosque, on the site of the ancient Pharos. The other mosques in the city are all, at least in their present form, from the Turkish era: examples are the mosques of Ibrāhīm Ṭerbānā (17th cent.), of 'Abd al-Bāqī al-

Šurbaği, and of Abū 'l-'Abbās el Mursī (18th cent.); an exception is the modern Mosque of Nabī Daniyāl, which stands on what may be the site of the tomb of Alexander the Great.

The modern city is linked to the old Arab quarter by great main avenues running between buildings, squares, and streets of a monumental character; examples of an official Europeanizing architecture in which predominates a kind of "Italian" style. The once royal palace of Rās el Tīn, sumptuous but eclectic in its furnishings, deserves mention, as does the arsenal built at the beginning of the 19th century by the French architect Cérisy and since enlarged. Other important features of the city are the Greco-Roman Museum, the Institute of Hydrobiology, and the museum of fine arts with its cultural center and library of art history.

Bibliog. PM, IV, pp. 2–6; G. Botti, B. de la Soc. archéologique d'Alexandrie, I, 1898, p. 7; Cabrol-Leclercq, I, 1, col. 1098; E. Breccia, Alexandrea ad Aegyptum, Bergamo, 1914; A. Baudrillart, Dictionnaire d'histoire et de géographie écclésiastique, II, Paris, 1913, p. 338; E. Breccia, Le Musée gréco-romain à Alexandrie, 1925–31, Bergamo, 1932; U. Monneret de Villard, Atti del Congresso internazionale di archeologia cristiana, I, 1940, p. 291; L. Antonini, Le chiese cristiane nell'Egitto dal IV al IX secolo secondo i documenti dei papiri greci, Aegyptus, XX, 1940; U. Monneret de Villard, Studi di archeologia cristiana d'Egitto, 1920–40, Orientalia Christiana periodica, VII, 1941, p. 274 ff.; A. Badawy, Kyrilliana, Cairo, 1947, p. 321; A. Adriani, Scavi e scoperte alessandrine (1949–1952), B. de la Soc. royale d'archéologie d'Alexandrie, XLI, 1956, pp. 1–48; E. M. Forster, Alexandria: A History and a Guide, 3d ed., New York, 1961.

Sais, Sa el Hagar (S;w, Saw, Σάις). Chief city of the 5th nome of Lower Egypt, capital under the 26th dynasty, Sais was the center of the cult of the goddess Neith. It has not been subjected to systematic exploration, but its tell has yielded numerous monuments of the Late Period. Part of the great city wall still stands (ca. 1,640 × 2,296 ft.).

Bibliog. PM, IV, pp. 46–49; L. Habachi, Sais and Its Monuments, AnnSAntEg., XLII, 1942, pp. 369–416.

Naukratis, el Nibeira (Nỉwt-Krt, Ναύκρατις). The first Greek settlement in Egypt in this locality, probably conceded to Milesian colonists by Psamtik I; the original name is thought to have been Pi-meryet. Petrie and Gardner discovered here the remains of a major sacred enclosure and four minor ones; further discoveries included pottery of the Greek type and terra-cotta products, as well as monuments from the Pharaonic period.

Bibliog. PM, IV, pp. 50–51.

Merimdeh and Beni Salama. Artifacts found in these localities document the neolithic culture of the western Delta.

Bibliog. H. Junker, Vorläufiger Bericht über die Grabung der Akademi-der Wissenschaften in Wien auf der neolitischen Siedelung von Merimde-Beni Salâme, 6 vols., Vienna, 1929–40.

d. Apex of the Delta. Heliopolis, Mataria, and Tell Hisn ('Iwnw, On; Heb., Ōn; Ἡλίου πόλις, Heliou polis). Heliopolis was the capital of the 13th nome of Lower Egypt and the famous center of the cult

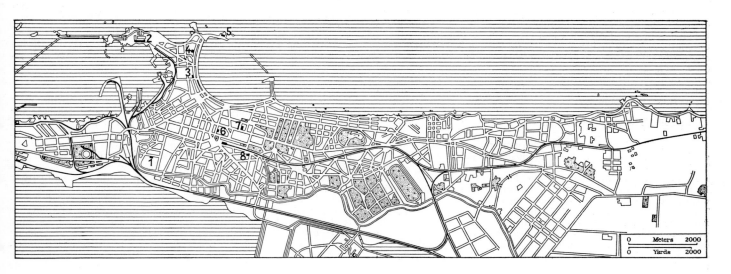

Alexandria. Plan of the modern city: (1) Catacombs of Kom es-Shugafa; (2) palace of Rās el Tīn; (3) Mosque of Ibrāhīm Ṭerbānā; (4) Mosque of Abū 'l-'Abbās el Mursī; (5) fort of Qāit Bey; (6) Mosque of Nabī Daniyāl; (7) Greco-Roman Museum; (8) Museum of Fine Arts.

of the sun. Sole testimony to the existence of the once-famous temple to the sun god is the presence of an obelisk (68 ft. high) erected by Sesostris I and fragments of others. Archaeological exploration has been obstructed in part by the infiltration of underground water and in part by the expansion of the built-up modern area of the city. The necropolis contains tombs of high priests of the 6th dynasty and of functionaries of the Saite era. To the south rise the Gebel Aḥmar and the Gebel Moqattam which furnish the limestone for almost the whole of the Memphis area.

BIBLIOG. PM, IV, pp. 59–65.

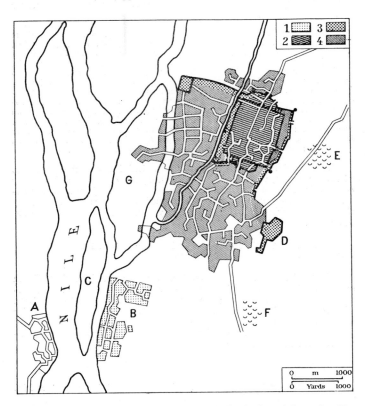

Cairo: development from the 10th cent. to the beginning of the 19th. *Key.* (1) Early limits and Coptic quarter in 640; (2) area of the city from 964 to 1087; (3) expansion under the Saladins, late 12th cent.; (4) growth of the city from the Middle Ages to 1800. Outlying areas and historic sites: (A) Giza; (B) Old Cairo (Fostat); (C) Roda; (D) Citadel; (E) tombs of the caliphs; (F) tombs of the Mamelukes; (G) Bulaq.

Fostat (Maṣr el ʿAtīqa, Miṣr al-qadīma). These place names designate the area of Old Cairo, occupying the site of the Roman Babylon (Βαβυλών); Atar el Nabī, something over a mile farther to the south, seems to be identifiable, on the basis of legends of a sphinx of Amasis and a statuette of Merenptah found *in situ*, with Pi-Ḥaʿpy (Pr-Ḥ py). It should be noted also that there are to be found in some of the buildings of the Citadel of Cairo and in many of its mosques architectural elements from Pharaonic times, many of them from Heliopolis.

BIBLIOG. PM, IV, pp. 69–71, 73.

Cairo, al-Qāhira. In Early Christian times a settlement grew up in the old Roman fortress, founded probably by the emperor Trajan, the remains of which, called by the Arabs Qasr ash-Shema, are still visible to the south of the Egyptian capital, near Fostat. In the interior of this quarter are eight Early Christian churches, restored chiefly after the Arab invasions and in the 12th century. The most important are: St. Michael, since converted into a synagogue; Abu Serga (St. Sergius), according to legend founded on the place where the Holy Family lived during the flight into Egypt; Muallaqa (and near it the little Muallaqa); St. Barbara. Typical of these churches, which are transeptless, is the rectangular presbytery with three incorporated apses.

Cairo, as the center of the social, political, and cultural life of the country during the Moslem era, contains the greatest concentration in Egypt of the Mohammedan heritage. Of the old Mohammedan

structures of Fostat (Old Cairo) all that remains is the Mosque of ʿAmr; its foundation goes back to the earliest days of the conquest, but in its present form, which results from repeated and generous alterations, nothing of the modest original structure has been left untouched. Better preserved, and with something of its original quality recovered by good modern restoration, is perhaps the most ancient example of Islamic art in Egypt: the Mosque of Ibn Ṭūlūn in the suburb of al-Qaṭāʾiʿ (established to the north of Fostat and then incorporated in the Fatimid foundation of Cairo). It introduced into Egypt the use of pilasters and the pointed arch, both elements of the Abbasside architecture of Iraq. Another clear reflection of

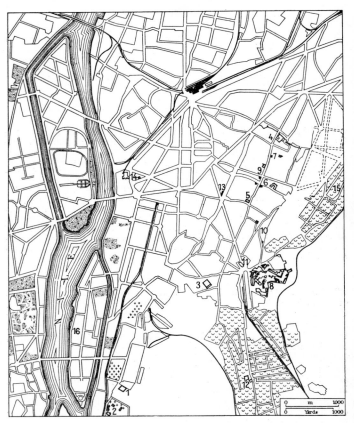

Cairo. Principal monuments: (1) Mosque of ʿAmr; (2) fortress of Qasr ash-Shema, Church of St. Sergius (Abu Serga), Coptic Museum; (3) Mosque of Ibn Ṭūlūn; (4) Bāb al Futūḥ, Bāb an-Naṣr, Mosque of al-Ḥākim; (5) Bāb Zuwayla, Mosque of Ṣāliḥ Ṭalāʾiʿ, Mosque of al-Muʾayyad; (6) Mosque of al-Azhar, Mosque and fountain of al-Ghūrī; (7) Mosque of al-Aqmar, Mosque of al-Ẓāhir Baybars; (8) Citadel, with al-Qalāʾūn complex, Mosque of Mohammed ʿAlī; (9) palace of Dār Bishtāk, Mosque of Barqūq; (10) Darb el-Aḥmar quarter, with Mosque of Aq Sunqur, Mosque of Kijmās el Isḥāqī, Mosque of al-Mardānī; (11) Mosque of al-Ḥasan; (12) tombs of Imām al-Shafʿī and royal tombs; (13) Arabic Museum; (14) Egyptian Museum and Modern Art Museum; (15) Mosque and cemetery of Qāit Bey; (16) island of Roda.

Iraqi art is seen in the minaret of Ibn Ṭūlūn, square in the lower part, round in the upper, and with an external stair recalling the minaret of the Mosque of al-Mutawakkil at Samarra. The art of the Tulunid period is thus clearly dependent on that of Mesopotamia.

Cairo proper was, as is well known, a creation of the Fatimids, built immediately after their conquest of Egypt in the second half of the 10th century. From Fatimid times, even though altered in the same epoch, are the remnants of the city walls, with high curtain walls, square towers, and great gates, three of which are still standing [Bāb al-Futūḥ, Bāb an-Naṣr (V, PL. 247) and Bāb Zuwayla]. Completely vanished are the palaces of the caliphs, whose magnificence is described at length in literary sources. Of sacred architecture of the time there are, however, important remains — foremost among them the Mosque of al-Azhar, seat of Islam's chief theological seminary, whose original Fatimid characteristics may still be discerned in the pointed arches of the court façade and of the sanctuary. The Mosque of al-Ḥākim, modeled on Ibn Ṭūlūn, with two several-storied towers on the façade, and the smaller mosques of al-Aqmar and Ṣāliḥ Ṭalāʾiʿ are also noteworthy.

From the following era, the Ayubite (12th–13th cent.), although it included the reigns of the great building sultans, such as the famous Saladin and Kamil, little remains in Cairo beyond the Citadel — which Saladin began and Kamil continued but which was developed especially under the Mamelukes — and a pair of madrasahs (Kāmiliyya and al-Ṣāliḥ Najm al-dīn).

The majority of Cairo's existing Islamic monuments go back to the period of the Mamelukes, who ruled up to 1517 and who really shaped the artistic physiognomy of the Egyptian metropolis. The three fundamental types of religious construction, mosque, madrasah, and mausoleum — often juxtaposed or mixed in a single complex — are well represented in the art of the Mameluke period. The principal examples, in chronological order, are the Mosque of al-Zāhir Baybars, which reflects the oldest architectural tradition; the marvelous group of Qalā'ūn (mosque, mausoleum, and *mūristan*, or hospital); the Mosque of an-Nāṣr on the Citadel; the Mosque of Aq Sunqur; the monumental Mosque of al-Ḥasan, one of Cairo's major buildings; the mosques of Barqūq and al-Mu'ayyad; and the madrasah and mausoleum of al Ghūrī. To the Mameluke era belong likewise the picturesque sepulchral monuments commonly known as the "tombs of the caliphs," especially important among them those of Barkuk and of Qāit Bey. From the same period are the palaces of the emirs Dār Bištāk and Dār Qāit Bey, as well as caravansaries and storehouses (*wakāla*).

The Turkish period (16th–18th cent.) added little to the monumental patrimony of Cairo. The chief monuments are the Mosque of Sināniyya (16th cent.), and a few *sabīl-kuttāb* (fountains for ablutions, with texts from the Koran). The Mosque of Mohammed ʿAlī on the Citadel, whose characteristic outline distinguishes the profile of the city, was built at the beginning of the 19th century, in the Ottoman style of the mosque of Constantinople.

In the second half of the 19th century, under Ismail Pasha, there was a great enlargement of the city: new quarters, with broad streets laid out on a gridiron plan, sprang up; the Ezbakiyah Gardens were planned by Barillet and Delchevalerie (1867); the opera house, with the equestrian statue of Ibrahim Pasha by Cordier in the square before it, was built (1869).

Its rapid and at times convulsive growth in modern times has greatly affected the appearance of the Islamic metropolis, obscuring some monuments and characteristic sights (among others, the Khalig Canal, derived from the Nile, which once ran through the city), while restoring and preserving others. The Oriental character of the architecture of the Egyptian metropolis has been much attenuated since the mid-19th century; of the inventory of monuments listed in the 15th century by Maqrīzī only a few have come down to us. Cairo's Arabic Museum is the sole museum in Egypt dedicated to Islamic art. Its collections are rich in marble and wood sculpture, tombstones, bronzes, glass, ceramics, and textiles. The provenance of these objects is in large measure Cairo itself, but the provinces are also represented; the minor arts or handicrafts often bear witness more faithfully than the few modest surviving monuments to the artistic life that existed outside the capital.

The Modern Art Museum has contemporary works of Moḥammed el Nağī, Aḥmed Ṣabrī, Georges Ṣabbāğ, Maḥmūd Saʿīd Bey.

Bibliog. A. J. Butler, The Ancient Coptic Churches of Egypt, I, Oxford, 1884, p. 155; J. H. Middleton, On the Coptic Churches of Old Cairo, Archaeologia, XLVIII, 1885, p. 397 ff.; Cabrol-Leclercq, II, 2, col. 1552; U. Monneret de Villard and A. Patricolo, La chiesa di S. Barbara al vecchio Cairo, Florence, 1922; R. L. Devonshire, Quatre-vingts mosquées et autres monuments musulmans du Caire, Cairo, 1925; U. Monneret de Villard, Note storiche sulle chiese di Al-Fusṭāṭ, RendLinc, VI, 5, 1929, p. 285 ff.; E. Drioton, Le musée égyptien, Cairo, 1939; G. Migeon, Le Caire, Paris, n.d.

Tura (R-ȝw, Ro-au, then Trȝw; Τροία, Troia) and El Masara. These localities are noted for their white limestone quarries, which still show inscriptions and graffiti ranging in date from the Middle Kingdom to the Ptolemaic age. In this area are the prehistoric sites of Maʿadi and El ʿOmari and the vast necropolis of Helwan, whose tombs, datable to the 1st and 2d dynasties, reveal structural affinities with the archaic ones at Saqqara. In the most evolved types the walls of the burial chamber are lined with brick or stone and there are two or more storerooms and an entry stair; the ceilings are formed of wood beams or stone slabs.

Bibliog. O. Menghin and M. Amer, The Excavations of the Egyptian University in the Neolithic Site at Maadi, 2 vols., Cairo, 1932–36; F. Debono, El-Omari, Exposé sommaire sur les campagnes de fouilles 1943–44 et 1948, AnnSAntEg., XLVIII, 1948, pp. 561–69; F. Debono, La paléolithique final et le mésolithique à Hélouan, AnnSAntEg., XLVIII, 1948, pp. 629–37.

*Memphis area.* A relatively small area on the left (west) bank of the Nile contains the richest concentration of monuments from the Old Kingdom and may be treated separately. Starting with Memphis, the capital of Egypt in several periods of its history, the following account then proceeds in the direction from north to south.

Memphis, Mit Rahina ('Inb-ḫd, "White Walls," then, from the name of the pyramid of Pepi I, Mn-nfr, Menfe, Heb. Sōf; Μέμφις). Chief town of the 1st nome of Lower Egypt and famous capital of the Old Kingdom, Memphis has been explored repeatedly, by Caviglia, Mariette, Petrie, Grébaut, Daressy, Badawy. The site has yielded many monuments of various epochs, but the topographic documentation of its edifices remains sparse and tentative. Of the grandiose temple of Ptah there survive only parts of a precinct wall. A colossal statue of Ramses II that was found before the southern entry to the temple is *in situ*; a second, smaller one is now in Cairo (Eg. Mus.). There have been discovered also the remains of a palace built by Apries reusing blocks bearing the cartouche of Sesostris I, a chapel of Seti I, and a small temple from the time of Merenptah, at Kom el Qalʿa. Nothing is known of the size of the city.

The Memphis necropolis was one of the largest — certainly the most imposing, studded as it is with royal pyramids and mastabas — of antiquity. The area is divided into five sectors, as listed below.

Bibliog. PM, III, pp. 217–27; R. Anthes, Memphis (Mit Rahineh) in 1956, Univ. [Pa.] Mus. B., XXI, 2, June, 1957, pp. 3–34.

Abu Roash. Here may be seen the ruins of the pyramid and the mortuary temple of Radedef, successor of Cheops; the recovery of fragmentary statues of the Pharaoh made possible the identification of the complex. There survives also a greatly damaged cemetery of 4th-dynasty dignitaries.

Bibliog. PM, III, pp. 1–3.

Giza. The famous burial grounds here are dominated by the great royal pyramids. The most imposing is the Pyramid of Cheops; originally its base measured about 755 ft. on a side and its height (now ca. 450 ft.) was about 480 ft. The interior is furnished with three burial chambers, entered from the north side, that were built in successive enlargements of the pyramid. The middle one (incorrectly called the "queen's chamber") and the lowest one were abandoned. The third one, entered, after two narrow passages, through a great ascending gallery 28 ft. high, 153 ft. long, and $6\frac{1}{2}$ ft. wide, faced with limestone. At the upper end of the gallery a vestibule, originally blocked, leads into the chamber (ca. $50 \times 32 \times 19$ ft.); it is faced with granite slabs, and the sarcophagus which it contains is also of granite. Above this chamber, to lighten the weight of the pyramid on it, were constructed five relieving chambers. The tomb chamber is furnished with two shafts for ventilation. The pyramid temple had a great porticoed court with 48 granite pillars, one side opening into a kind of vestibule with two rows of pillars, one of 8 and the other of 4. Hewn out of rock in the neighborhood of the temple may be seen three large pits meant to receive funeral boats. Two other pits, containing boats in perfect condition, have been discovered on the south side. Three small pyramids, intended for queens and princesses, stand to the southeast of the pyramid temple. Of exceptional interest as revealing the technical perfection of Old Kingdom cabinetwork is the tomb furniture discovered in the secret shaft tomb of the queen Hetepheres, mother of Cheops.

The pyramid of Chephren originally measured something under 700 ft. on a side at the base and about 450 ft. in height; it retains on the apex its facing of limestone slabs. To the north appear two entrances, one in the rock pavement surrounding the pyramid, the other at a height of about 50 ft. The corridor of the lower entrance leads down to an abandoned burial chamber and then climbs up to join the corridor descending from the second entrance. The funeral chamber proper is reached directly by a passage (104 ft. long) leading from the second entrance. The pyramid temple comprises a vestibule, an entrance hall with granite pillars, a pillared peristyle court behind which are five chapels, and subsidiary rooms. The valley temple, also called, "the granite temple," discovered by Mariette in 1852, constitutes architectural documentation of exceptional interest (FIG. 637). Square in plan (each side 147 ft. long), cut partly into the rock, it has square door frames, architraves, and pillars worked entirely of polished granite. Two entrances, symmetrically placed, each originally preceded by a pair of confronted sphinxes, led into a vestibule giving access to two rooms so disposed as to form an inverted T, the first divided into two aisles by a row of 6 pillars, the second divided into three aisles by two rows of 5 pillars; the pillars are 13 ft. high. The whole structure displays a severe massive monumentality conjoined with the most exact technical execution. From a pit in this temple comes the famous diorite statue of Chephren in Cairo (PL. 340), which was discovered together with eight fragmentary ones. Not far from the temple lies the Great

Sphinx (ca. 66 ft. high, frontal width 13 ft.; PL. 333), its colossal lion's body expressing sculpturally the ideal of the mighty sovereign. It is cut directly into the rock that served as quarry for the construction of the pyramids; some of its lower parts have been repaired with limestone blocks. The Sphinx is apparently to be attributed to the reign of Chephren. In front of it were discovered the remains of a 4th-dynasty temple with a vast central courtyard (150×75 ft.) with great pillars. During the New Kingdom the sphinx image was considered the representation of the sun god, as is witnessed by the numerous votive steles found in the vicinity of the Great Sphinx.

The third royal pyramid, that of Mycerinus, is of more modest dimensions than the other two (at the base 356 1/2 ft. on a side; height originally 218 ft.); two burial chambers, and the two corridors leading to the upper one, testify to a modification of the original plan. In the lower chamber, which is entirely faced with granite slabs, was found a basalt sarcophagus (afterwards lost in a shipwreck while being transported to England). Along the south side stand three

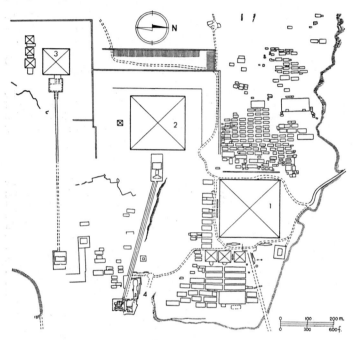

Giza. Pyramid area: (1) Pyramid of Cheops; (2) pyramid of Chephren; (3) pyramid of Mycerinus; (4) Great Sphinx.

small pyramids, one of them still partly faced with granite, the other two stepped. The pyramid temple, the ground plan of which shows some affinities with that of Cheops, was completed in brick by the next king, Shepseskaf, who built his valley temple of the same material; from these two temples have come statues of Mycerinus, some in a perfect state of preservation.

The great field of the Giza mastabas has been explored by various expeditions; Lepsius, Mariette, Schiapparelli, Reisner, Junker, and Hassan have studied the site. The tombs are grouped about the pyramids almost invariably according to a regular gridiron plan. The oldest are those near the pyramid of Cheops; these have outside chapels. Toward the end of Cheops' reign appear mastabas with the offering room — whose essential element remains the false door — recessed into the body of the structure. The entrance and the offering room are decorated with sober reliefs representing the deceased, often partaking of a funeral banquet; sometimes offering scenes appear. In some of the mastabas life-size limestone heads (the so-called "reserve heads") were discovered in the room preceding the burial chamber. These heads, which are clearly characterized portraits, may have been intended as an element of individuation for the use of the wandering souls of the dead. There may also be seen excavated in the quarry faces around the second and third royal pyramids a group of rock-cut tombs with several chambers, many of them belonging to members of Chephren's family. These tombs are noteworthy in that their walls are richly decorated with lovely polychrome scenes and with high reliefs treated almost like sculpture in the round. To the south of Giza, at Zawiyet el Aryan, is to be found a vast leveled area prepared for an unfinished step pyramid.

BIBLIOG. PM, III, pp. 3–69. Principal recent references: H. Junker, Giza ... Baricht über die Grabungen auf dem Friedhof des alten Reiches bei den Pyramiden von Giza, 8 vols., Vienna, Leipzig, 1929–47; S. Hassan, Excavations at Giza, 6 vols., Cairo, 1932–48; G. Jéquier, Douze ans de fouilles dans la nécropole memphite 1924–36, Neuchâtel, 1940; G. A. Reisner, A History of the Giza Necropolis, I–II, Cambridge, Mass., 1942–55; A. M. Abu-Bakr, Excavations at Giza, 1949–50, Cairo, 1953.

Abusir. Near the village is the plateau chosen by some of the 5th-dynasty rulers (Sahura, Neferirkara, Neuserra) for the construction of their mortuary complexes. The ruins were explored and excavated by the Borchardt-Bissing expedition. The main interest of the site lies not in the pyramids, now reduced to shapeless mounds (Neferirkara's, the highest, originally ca. 230 ft., now measures 143 ft.) but in the sumptuousness of the mortuary temples. Notable use was made of materials: basalt for pavements, alabaster for pavements in the shrines, and granite for jambs, architraves, sills, and columns, in addition to limestone in the structure, and fine limestone for wall facings. The best-documented architectural group seems to be that of King Sahura (FIG. 638). His little valley temple, the oldest of the type known, was provided with two porticoes ornamented with palm columns. From it a long covered causeway led to the pyramid temple, comprising an entrance hall, an open court surrounded by palm columns, a hall with five niches devoted to ritual purposes, the sanctuary itself, and a series of rooms for the practice of the cult. South of the temple may still be seen a small subsidiary pyramid. Such fragments as are left of the delicate reliefs that once decorated the walls of the temple complex give an idea of the pictorial cycles that depicted the activities of the ruler; the themes include desert hunts and processions of war booty brought back from military expeditions in Libya and Asia.

In the Abu Gurob area were discovered the remains of a great sun temple built by Neuserra. The unique design of this group had as its principal feature a stubby obelisk constructed of limestone blocks, resting on a base resembling a truncated pyramid (the whole originally rising to ca. 114 ft.). The cult ritual was performed around an altar standing before this obelisk, symbol of the sun, in a vast walled enclosure. In the enclosure may still be seen sections devoted to sacrifices and, along the north side, a series of magazines. The temple was approached through a portico with a covered causeway leading from a large pavilion in the valley. Another covered corridor ran along the east and south sides of the enclosure, turning in toward the base of the obelisk. In the remaining fragments of the reliefs that ornamented these corridors the theme of the seasons is depicted. The fragmentary decoration of a chapel near the south side of the obelisk contains the oldest known representation of the foundation of a temple and the celebration of the Heb-Sed, or jubilee, festival of the Pharaoh. Outside the walled enclosure have been discovered the ruins of a great imitation sun-boat (97 1/2 ft. long) made of brick.

BIBLIOG. PM, III, pp. 71–83.

Saqqara. The vast necropolis on this site, which perpetuates the name of the ancient local funerary god, Socharis, or Sokri, is of exceptional interest; it has been explored by Lepsius, Mariette, Quibell, Firth, Emery, Lauer, Zaki Saad, Goneim, and others. In the northern and oldest sector is preserved a group of great mastabas in which were found jar seals and other objects with the names of the early dynastic rulers Aha, Zer, Zet (Wadji), Wedymu, Az-ib, and Qay-a, of the queens Merneith and Herneith, and of a dignitary named Hemaka. The discovery of these tombs has created a problem, because more modest tombs of the same sovereigns were already known at Abydos; the hypothesis has been advanced that the great tombs were constructed for privileged persons close to the king. Rectangular in plan (the largest 210×129 ft.), these monuments have, typically, a substructure with a burial chamber in the center surrounded by other chambers used for storage; the ceilings were originally of wood planking. The massive superstructure of raw brick (median height 26 ft.) had on the outside a regular sequence of recesses with polychrome panels imitating the monumental gateways of the royal palaces (e.g., see FIG. 627). The mastaba was surrounded by a low wall, originally crowned with rows of life-size clay bull heads with real horns; in some cases this ornamentation has been partially preserved. Outside the wall are sometimes found rows of servants' tombs (the mastaba of Zet has 62). Each of the tombs of the servants (who were probably poisoned at the funeral) has its own funerary furnishings. A mastaba of the time of Az-ib shows on three sides a stepped superstructure (at a later date incorporated into the customary niched wall). The most evolved mastaba, from the structural point of view, is that of Qay-a, last king of the 1st dynasty: on one side it has a group of cult chambers distinct from the body of the tomb but still enclosed within the encircling wall. This group of tombs, though looted in very ancient times, has yielded an important series of ceramics and stone vases, as well as ivories, furniture, and even leather objects. In the storeroom of the mastaba

of Hemaka was found a series of objects (utensils, arms, games) revealing an exquisite decorative sense.

The funeral complex built by the architect Imhotep for King Zoser, founder of the 3d dynasty, is the earliest large-scale architectural work in stone (FIG. 633); it is dominated by a great stepped pyramid around which are grouped buildings with varied ground plans (PLS. 329, 330). The pyramid, constructed with a core of local stone and an outer facing of dressed Tura limestone, developed from a mastaba of square plan. On this was placed a series of stepped elements, at first four, then, while the base was correspondingly broadened, six. In the final stage the north–south side of the base measured about 358 ft., the east–west about 400 ft.; the original height of the pyramid was about 200 ft. The substructure comprises a great shaft, about 23 ft. square, reaching a depth of 92 ft. At the bottom of the shaft was a rectangular tomb chamber, about 13 ft. high, encased in massive granite slabs. The entrance to the cell (which at the moment of discovery still contained some of the king's remains) was blocked after his burial by an enormous cylindrical granite plug weighing about three tons. The underground part of the pyramid is traversed by a maze of corridors, some leading to chambers decorated with turquoise-blue glazed tiles and with reliefs depicting the king. Under the east side of the pyramid have been discovered tombs of queens and princes formed by a series of 11 shafts sunk to an average depth of 98 ft., each one communicating with a horizontal corridor about 98 ft. long. Two of these tunnels have yielded a remarkable collection of thousands of stone vases. The pyramid stands in the middle of a great rectangular walled enclosure (ca. 1,800 × 900 ft.) paved with fine limestone, presenting a sequence of 211 bastions, regularly spaced, with 14 imitation doors, distributed among the four sides, and a single entrance door near the southeast corner. The portal led into a covered entrance hall (ca. 176 ft. long), whose roof was supported by two rows of 20 papyrus bundle columns, tapered toward the top and engaged with short masonry elements projecting from the side walls of the hall. The hall led into a small vestibule with 8 paired, ribbed columns of an unusual type (ca. 16 ft. high; none preserved in its entirety); they have circular bases, abaci in the form of parallelepipeds, and are composed of about twenty superimposed drums. The vestibule gave onto a large court on the south side of the pyramid, in which may be noted two B-shaped marking stones setting the course of the ritual race run by the ruler during the Heb-Sed, or jubilee festival, customarily celebrated during his life-time (PL. 334). An extension of this court to the south consists of a rectangular offering place delimited by a paneled wall crowned by a frieze of raised cobra heads (PL. 330). This paneled wall in turn forms part of a low structure containing a chapel; behind this is a massive dummy tomb, or cenotaph, with a shaft, a granite burial chamber, and passages and chambers decorated with glazed tiles and reliefs. Along the southeast side of the enclosure is a second court, lined east and west by dummy shrines, characterized by a platform designed to receive the double throne of Upper and Lower Egypt. This whole complex, as well as a pavilion on the southwest side, was intended for the celebration of the Heb-Sed festival. To the north of the jubilee buildings can be seen two buildings, or rather dummy buildings, each with a court before it, representing symbolically north and south Egypt. The walls of the first are characterized by a series of engaged columns with papyrus capitals; the façade of the second has four engaged fluted columns (original height 39 ft.) with leaf-shaped capitals and abaci on which rested a curved cornice. The pyramid temple lay against the north side of the pyramid, next to the serdab, in which was found a statue of the king, the earliest life-size one known (PL. 331). The west side of the enclosure contains a series of galleries used for storage.

At a short distance from the enclosure of Zoser, in a northeast direction, are the remains of the mortuary complex of Weserkaf, first king of the 5th dynasty; the pyramid, greatly damaged, has a chapel on the east, and on the south a pyramid temple with its entrance from the side rather than on the axis — all particulars differentiating this complex from that at Giza. The pyramid temple has a court surrounded on three sides by a portico of granite pillars; on the fourth side there must have stood the colossal statue of the Pharaoh of which only the head has been found. The portico walls were decorated with delicate reliefs; from a few fragments it can be established that these depicted the king hunting birds in the papyrus marshes. The court gave onto a pillared hall with two rows of four pillars and to other rooms for cult use. The pyramid temple communicated on the west with a small subsidiary pyramid.

In the neighborhood of the Zoser enclosure, not far from its southwest corner, Unas, last king of the 5th dynasty, prepared his mortuary complex. The modest pyramid (base originally 220 ft. on a side; height 62 ft.) had an entrance on the north side, in the surrounding pavement. The substructure shows a corridor first descending at an incline, then, following a horizontal stretch, originally blocked at three points by granite portcullises, entering a vestibule leading on the west side into the sarcophagus chamber and on the east into a serdab composed of three chambers. On the walls of one section of the corridor, of the antechamber, and of the sarcophagus chamber, appear for the first time (incised and filled with blue pigment) the Pyramid Texts — a collection of spells designed to ensure the ruler's immortality. The pyramid temple, placed on the east side, as was customary, had an antechamber, a court with a peristyle portico, its granite columns having palmiform capitals, a broad transverse corridor leading to five ritual niches and to various service apartments with elaborate ground plans. There is the usual small subsidiary pyramid. The causeway was ornamented with interesting reliefs: cult scenes, scenes of the hunt and of war, and scenes of agricultural, architectural, and artisan work have been preserved.

Still in the north sector of Saqqara are found the remains of the mortuary complex of King Teti (6th dynasty). The ground plan of the pyramid's substructure appears similar to that of the pyramid of Unas, and here too recur the Pyramid Texts. Of the pyramid temple it can be said only that it had the traditional elements (vestibule, peristyle court, room with five ritual niches, storerooms) and that alabaster was used for all the pavements and wall facings.

The private tombs north of Saqqara, which embrace a vast area, are distributed irregularly around the great royal tomb complexes. The 5th- and 6th-dynasty mastabas constitute the most important group; also to be noted are an archaic cemetery and groups of tombs from the New Kingdom and the Saite period. Among the most noteworthy of the brick mastabas attributable to the 3d dynasty is that of Hesira, which is distinguished by having an internal chapel shaped like a long corridor, inset with 11 niches of the palace-façade type with polychrome decorations in imitation of matting. Backing the niches are wood panels carved in relief, some of them well preserved; these are the earliest relief representations in which the human figure is depicted in accordance with the conventions that were to remain unalterably traditional (PL. 334). In the contemporaneous mastaba of Khabawsokar there is also a corridor with niches; these lead, however, to two cruciform chapels, the backs of which were faced with stone slabs decorated with reliefs.

The 5th- and 6th-dynasty mastabas are built of stone, and their walls are decorated with great relief panels; many are furnished with a pillared hall. Some tombs appear to be equipped for two personages (for example, that of Ptahhotep and Akhethotep), and therefore have two distinct chapels. The mastaba of Mereruka (ca. 130 × 78 ft.) appears to have been planned as a family tomb; it is subdivided into three sections, which comprise, respectively, 21 chambers for Mereruka himself, 6 for wives, and 5 for sons. The wall reliefs of this mastaba (PL. 336) and those of the mastaba of Ti are among the most representative, both as to fineness of execution and as to originality of composition. It has already been noted that reliefs with representations of hunting scenes, of activities linked with the cycle of the seasons, and with special events decorated the mortuary complexes of the 5th- and 6th-dynasty Pharaohs. In the private mastabas similar themes were highly developed. In these figured sequences (which are accompanied by inscriptions that have proved invaluable in the study of the language), a whole world flourished. In addition to affording precious documentation, the mastabas have yielded, in situ, some of the most vigorous early sculptured representations — the statues of Ranofer and of Kaaper, the so-called "Sheikh el Beled," in Cairo, and the famous seated scribe in Paris (PLS. 341, 342), to mention only the most famous. In the intact serdab of the mastaba of Mitri were found 11 perfectly preserved wood statues, several life size.

The principal feature of the necropolis of the Late Period is the well-known Serapeum, the vast burial vaults of the sacred Apis bulls, discovered by Mariette. It includes one group comprising isolated tombs ranging in date from Amenhotep III to Ramses II, a second group comprising small vaults, close to one another, representing the period from Ramses II to Psamtik I, and a third group comprising great underground vaults, on a long east–west gallery, ranging from the year 52 of Psamtik I to the last Ptolemies. This succession of tombs, characterized by steles bearing the dates of the rulers' reigns, provided the documentation for the chronology of the Late Period. In the great vaults are 24 massive monolithic sarcophagi of granite, basalt, and limestone (ranging in height from 10 to 13 ft. and in length from 13 to 16 ft.). Along the avenue leading to the Serapeum are Ptolemaic sphinxes, a hemicycle in which were discovered 11 portrait statues of Greek philosophers and men of letters, and a small temple, much damaged, of the 30th dynasty.

In the south sector of Saqqara the oldest royal tomb is that of King Shepseskaf (4th dynasty); it is characterized by a different arrangement of elements. Instead of being pyramidal in form, the Mastabat Fara'un, as this tomb is commonly called, was conceived as an enormous sarcophagus (328 × 246 × 59 ft.), the roof slightly arched longitudinally, finished at either end by parapet extensions of the walls. The substructure has a corridor running, first obliquely

then horizontally, to the antechamber and the sarcophagus chamber. The walls of both chambers are entirely faced with granite slabs; the ceiling of the antechamber consists of two rows of rectilinear slabs placed to form an acute angle at the apex, that of the sarcophagus chamber by slabs placed so as to give the illusion of a barrel vault. The burial apartment also includes five storerooms. The mortuary temple, much of which is destroyed, appears of modest proportions.

Other pyramids in the south sector of Saqqara are those of the 6th-dynasty kings Pepi I and Merenra; these have been explored in summary fashion, chiefly in relation to the study of the Pyramid Texts. Their substructures appear similar to those of the pyramids of Unas and Teti. The pyramid called Haram esh-Shauwaf has been identified with that of King Isesi (5th dynasty).

Better known, since it has been systematically explored, is the funerary complex of Pepi II, the latest of the great Old Kingdom funerary complexes. Its ground plan reveals little variation from those of Unas and Teti. Such reliefs as survive from the mortuary temple show that themes depicted included the public life of the Pharaoh, religious rites, processions celebrating the spoils of war, and, in the chapel, the funeral repast. Despite the fact that the period was one of political and economic decadence, the reliefs are refined and careful in execution. The valley temple, the only example known from the 6th dynasty, was preceded by a series of ramps and terraces leading to a pillared hall and to two other halls communicating with the causeway and the storerooms. Near the causeway uniting the valley temple with the mortuary temple, about halfway up, were discovered the remains of the modest pyramid (base less than 70 ft. on a side) of Ibi, ruler of the First Intermediate Period.

The private tombs of the south sector of Saqqara are much less numerous than those of the north sector; they are for the most part from the 6th dynasty. Finally, in connection with Saqqara must be mentioned the rich tomb, the exact location of which is no longer known, of the general Horemheb (who later assumed the title of Pharaoh, initiating the 19th dynasty), wall reliefs from which are scattered among various museums.

BIBLIOG. PM, III, pp. 83–215. Principal recent works: C. M. Firth and J. E. Quibell, Excavations at Saqqara: The Step Pyramid, 2 vols., Cairo, 1935–36; J. P. Lauer, Fouilles à Saqqarah: La pyramide à degrés, 3 vols., Cairo, 1936–39; G. Jéquier, Le monument funéraire de Pepi II, 3 vols., Cairo, 1936–41; W. B. Emery, The Tomb of Hemaka, Cairo, 1938; P. Montet, Le tombeau de Ti, Cairo, 1939; P. Duell, The Mastaba of Mereruka, 2 vols., Chicago, 1939; W. B. Emery, Excavations at Saqqara: Great Tombs of the First Dynasty, 2 vols., Cairo, 1949–54; M. Z. Goneim, The Buried Pyramid, London, 1956; J. P. Lauer, L'œuvre d'Imhotep à Saqqarah, CRAI, Paris, 1956, pp. 369–78; M. Z. Goneim, Horus Sekhemkhet: The Unfinished Step Pyramid at Saqqara, Cairo, 1957.

Dahshur. In this southernmost sector of the Memphis necropolis particular interest adheres to the two pyramids erected for the Pharaoh Sneferu, founder of the 4th dynasty. The dating and the quarry marks painted on the blocks indicate that both pyramids were built for Sneferu, and the fact that there were two pyramids for him at Dahshur is confirmed by the copy of a decree of Pepi I found among the ruins of the valley temple of the north pyramid, in which there is mention of "the funeral city of the two pyramids of Sneferu." There exists at Medum a third pyramid of Sneferu, constructed with blocks bearing the same marks as those on the blocks for the south pyramid at Dahshur. The order in which the three pyramids were built has not been established; it appears probable that for a time work was proceeding simultaneously on all three. The north pyramid at Dahshur — called the "Red Pyramid" from the color of the blocks of which it is constructed, the original facing of fine limestone slabs having disappeared — constitutes the first example of a true pyramid conceived and carried out as such (base ca. 715 × 725 ft.; height 342 ft.). The substructure has not been adequately explored. Better known is the south pyramid, called, because the angle of inclination of the faces increases sharply about halfway up, the "Bent Pyramid" (base ca. 620 ft. on a side; height ca. 315 ft.). It is of a type intermediate between the step pyramid and the true pyramid. Internally the Bent Pyramid is unique in having two separate entrances leading to two different burial chambers, one excavated in the base rock, the other in the body of the construction, at ground level. The valley temple — preceded by a rectangular court running east–west, at either end of which stood a tall stele with the cartouche of the king — comprises an antechamber, flanked by four rooms (two on each side), leading to a great court at the back of which rose a portico formed by two rows of five pillars each, ornamented with reliefs depicting the ruler associated with deities. Behind the portico were six chapel niches, each containing a statue of the king cut in one with the block forming the back of the niche; three of the statues have been preserved.

Three rulers of the 12th dynasty chose the Dahshur area for the preparation of their burial complexes: Amenemhet II, Sesostris III, and Amenemhet III. The superstructures of the royal tombs of this epoch still follow the pyramid scheme but the building techniques, and in some cases the materials as well, are different. The builders of the pyramid of Amenemhet II, called the "White Pyramid," instead of placing layer upon layer of blocks concentrically, with a graded rise, constructed a series of rough retaining walls radiating from the center, with cross walls between them forming compartments, which were then filled with rubble and sand. The whole was faced with neatly dressed blocks of limestone, which have disappeared in the course of various spoliations. The nuclei of the pyramids of the two later Pharaohs are formed of horizontal layers of brick. The substructure of these 12th-dynasty pyramids reveals an increasing preoccupation with techniques for baffling tomb robbers: great stone plugs blocked the passages at intervals, the funeral chambers were encased in hard stone (Amenemhet II), and a maze of passages branched out in various directions (Amenemhet III). In general these pyramids measure at the base not much over 325 ft. Little of importance remains of the mortuary temples. A short way from the north side the pyramid of Sesostris III, within the vast brick wall, are the tombs of four princesses, intercommunicating by means of a corridor in which was found a cache containing a splendid treasure of jewelry (necklaces and pectorals of gold and precious stones). Inside the encircling wall of the burial complex of Amenemhet III was discovered the tomb of a king with the name Horus, probably a coregent with Amenemhet. In it was found a wooden naos containing a statue, also of wood, depicting this ruler's ka. Near the royal complexes are tombs of contemporary dignitaries.

BIBLIOG. PM, III, pp. 229–40; A. Fakhry, The Bent Pyramid of Dahshur, Cairo, 1954.

*The Valley*. The following account proceeds from north to south; each entry is followed by the letter "l" or "r" indicating whether the locality is on the left or the right bank (facing downstream) of the Nile. The Valley is treated under the headings Lower Valley, The Fayum, Central Valley, Thebes area, Upper Valley, First Cataract area.

*a. Lower Valley*. Lisht (l). The village is situated in the environs of the ancient 12th- and 13th-dynasty capital Ith-Tawe. In the neighborhood are the ruins of two 12th-dynasty pyramids, those of Amenemhet I and Sesostris I, both constructed according to the method used in the "White Pyramid" at Dahshur. The pyramid of Amenemhet I has been reduced to a mound of detritus, and of its mortuary temple only fragments remain. The pyramid of Sesostris I (originally 350 ft. on a side at the base and 200 ft. in height) has two enclosing walls, one incorporating the small supplementary pyramid and the temple sanctuary, the other, in brick, enclosing the forepart of the temple and nine small pyramids belonging to members of the royal family. The substructure, reached through the pavement of a chapel standing against the north side of the pyramid, has not been explored, owing to the infiltration of water, and the burial chamber has not been found. The plan of the pyramid temple matches those of the temples of Unas and Pepi II. From a cache near the northeast corner of the temple came ten statues, very much alike, of the king, evidently hidden in a period of political instability. In a second hiding place, to the south of the vestibule, were found six statues of the king as Osiris, similar to other fragmentary ones discovered in the ascending corridor. Near the burial complex of Sesostris I are the mastabas of contemporary dignitaries, noteworthy among them that of Senwosretankh, whose burial chamber contains versions of the Pyramid Texts.

BIBLIOG. PM, IV, pp. 77–85.

Tarkhan (l). The cemetery here functioned from the beginning of the dynastic era to the end of the Old Kingdom. Tombs of the protodynastic period have yielded jar seals bearing the names of rulers, arms, utensils, and remains of furniture.

BIBLIOG. PM, IV, pp. 85–86.

Gerza (l). In the vast necropolis here the various phases of the middle and late predynastic era in Lower Egypt can be studied. The most ancient tombs are oval, without linings; the more recent are rectangular, with wood or brick facings. Some tombs have supplementary compartments for the funerary furnishings.

BIBLIOG. PM, IV, pp. 86–87, 89.

Medum (l). The village is dominated by the nucleus of a pyramid, which appears as a kind of large tower in two steps, the remaining steps being concealed by a high mound of rubble. This, the third pyramid of Sneferu (the other two being at Dahshur) was originally

conceived as a step pyramid, first of seven, then of eight steps; these were later filled in and the outside was cased with slabs of limestone (base 475 ft. on a side; original height ca. 250 ft.). Opening from the north face is the corridor (190 ft.) that descends to the two antechambers; from the inner one a vertical shaft leads upward to the tomb chamber on the ground level, constructed of limestone blocks. The small mortuary temple on the east side of the pyramid consists of only two chambers, parallel, followed by a small court in which stand two steles without inscriptions. Especial interest attaches to two great mastabas built at the beginning of the 4th dynasty. The mastaba of Nefermaat originally had two niches, separated by stone casing, one for the king himself, the other for his wife Atet. In a later enlargement of the mastaba's core these niches were converted into a cruciform chapel; in a third stage, a final enlargement of the core, a new niche was added, corresponding to but not communicating with the cruciform chapel. In the second mastaba, that of Prince Rahotep, his own cruciform chapel and the chapel niche of his wife Nofret were walled up. The famous painted limestone statues of Rahotep and Nofret found in the chapel, perfectly preserved, are unusual in that they retain most of the original paint (PL. 338). The decoration of the chapel and corridor walls, unfortunately fragmentary and now scattered among various museums, lends further interest to these two mastabas. Here first appear scenes (executed partly in relief, partly in fresco) using thematic material drawn from ordinary activities of daily life. The brilliant decoration of the chapel of Atet, variegated by a wealth of detail, was arranged in two horizontal panels: the hunting of waterfowl with a net, which has been reconstructed — the famous "Medum geese" in Cairo (PL. 328) formed part of it — and a plowing scene. Other themes developed in the decoration of the mastabas are the hunt, fishing, and boatbuilding. The Medum cemeteries came into use again during the Late Period and were used up to the Roman era; these were modest burials, in some cases placed in Old Kingdom mastabas.

Bibliog. PM, IV, pp. 89–96.

*b. The Fayum.* El Fayum (l) (To'-š, To-še, "Land of the Lake"; Λίμνη, Coptic Phion, from P;-ym, "Sea"; Gr. Μοῖρις from Mr-wr, Mi-wer, "Great Canal," name of a city corresponding to the present Kom Medinet Ghurab). The broad district called the Fayum, roughly circular in shape, is rendered fertile by the Bahr Yusef, which flows into a shallow lake, the Birket Qarun, once a vast body of water. The zone, which had as its local god Sobek, depicted as a crocodile, was irrigated and reclaimed by the 12th-dynasty rulers. It offers important documentation for the Neolithic (at Dimai, Kom Aushim, Qasr es Sagha) and Aëneolithic (at Dimai, Qasr Qarun, Hasmet el Dib) ages in Egypt.

Lahun (R-n-ḫnt, Re-n-hōne, "Mouth of the Lake"). North of the village, which is located near the entrance to the Fayum, stand the ruins of the pyramid of Sesostris II (base originally 350 ft. on a side), built of brick by the compartment-wall system, around a rocky spur 40 ft. high. The substructure, entered from the south side, has an elaborate arrangement of shafts, rooms, and corridors going in various directions. The funerary chamber, not centered on the base of the pyramid, is cased with granite slabs and has a barrel-vaulted ceiling; its fine granite sarcophagus has been preserved. Along the north side of the pyramid, within the enclosure, stand eight mastabas and the queen's pyramid; from the south side open three shafts in addition to the one giving access to the pyramid. In the bottom of these shafts were the tombs of the princesses, one of which contained a splendid treasure of jewels (diadems, necklaces, pectorals, bracelets). About the pyramids lie various burial centers of the 12th dynasty, with a few tombs reused in a later epoch.

The greatest interest of the area attaches to the ruins of a town built for those engaged in the work on the pyramid of Sesostris II. The town plan appears delimited by a rectangular enclosure wall about 1,300 ft. on a side; the streets and the great thoroughfares intersect at right angles. A quarter for laborers and one for officials can be distinguished: the houses in the workers' quarter, as a rule of three or four rooms, are arranged in contiguous, united blocks, with a back wall in common; the officials' quarter, separated by a wall from the workers', comprises vast residences, in some cases of more than 50 rooms, among them reception rooms and living and service quarters.

Hawara. At this site, not far from Lahun, there are remains of the second brick pyramid of Amenemhet III; the Pharaoh was buried in this one, not in the one at Dahshur. The inside is characterized by an elaborate system of corridors and plugs, and the burial chamber, at the bottom of a shaft, was cut from a block of quartzite weighing about 110 tons. Despite these precautions the sarcophagus was violated. Above the cell there are two relieving chambers of slab

construction; the ceiling of one of these is flat, that of the other in the form of an inverted V surmounted by a great brick arch. Of the grandiose funerary temple, the famous Labyrinth described by Strabo (Book XVII), only unrelated architectural fragments and a few statues remain, among the latter a figure of Amenemhet III.

Medinet el Fayum (Šdyt, Šedyet; Κροκοδείλων πόλις, then 'Αρσινόη, Crocodilopolis, Arsinoë). The ancient chief town of the district, situated in its center, preserves architectural elements of a temple dedicated to Sobek, from the *kiman* of which have emerged many Greco-Roman papyri. A later monument of interest is the Mosque of Asil Bey, wife of Qāit Bey, dating from the years 903–05 of the Hegira (1497–99).

Abgig. A red granite obelisk of Sesostris I that was erected in this locality is to be seen *in situ*.

Biahmu. There are the remains here of two colossi of Amenemhet III; they once stood before a temple, of which nothing remains.

Dimai (anc. Σοχνοπαίου νῆσος). In this village, one of the settlements that grew up in the north of the district, near the Ptolemaic towns, there may be seen remains of a Ptolemaic temple.

Qasr Qarun. On this site are the remains of a late Ptolemaic temple, in a fairly good state of preservation.

Medinet Madi (Ναρμοῦθις, Narmouthis). Explorations of the ruins on the south edge of the Fayum by the Vogliano expedition have revealed a small 12th-dynasty temple, the only one known from the period. Rectangular in plan (the shorter dimension 32 ft.), it comprises a hypostyle hall whose roof was supported by two papyrus columns, a vestibule, and a sanctuary with three shrines. In the Ptolemaic era another sanctuary was built on.

Umm el Breigat (Τεβτῦνις, Tebtynis). From the ruins of this village have emerged many papyri of the Greco-Roman era.

Bibliog. PM, IV, pp. 96–112.

*c. Central Valley.* Ihnasya el Medina (l) (Nn-nsw, Ninsu; Heb., Ḥānēs; 'Ηρακλέους πόλις, Heracleopolis). Chief city of the 20th nome of Upper Egypt, this was also the capital of the 9th and 10th dynasties. The local god was Harsaphes; his temple, built during the 12th dynasty, rebuilt in the 18th, and altered in the 19th, has yielded architrave fragments, columns, and statues of kings. The necropolis, situated on the Gebel Sidmant, contains both late Old Kingdom and New Kingdom tombs. Three important churches have been uncovered by excavations on this site and noteworthy sculptures with mythological and pagan motifs, Hellenistic in style, combined with elements pointing toward the Coptic style, have been found. Most of the sculptures are in the Coptic Museum in Cairo. In the adjoining desert stood the convent of Deir Amba Samueli, since destroyed, where, in the 7th century, lived Samuel of Kalamon.

Bibliog. PM, IV, pp. 118–21; E. Naville, Ahnas el Medineh, London, 1894; U. Monneret de Villard, La scultura ad Ahnas, Milan, 1923; J. Georg, Neueste Streifzüge durch di Kirchen und Klöster Ägyptens, Berlin, 1931, p. 12.

Deshasha (l). The extensive necropolis of the late Old Kingdom here was explored by Petrie; it comprises about one hundred tombs, some in mastaba form, others excavated in the rock of the plateau. The most noteworthy are the tombs of Iteti and Inti, with their pillared vestibules and their wall reliefs. In the latter tomb, besides the usual subjects, is an interesting scene of the capture of a Syrian fortress.

Bibliog. PM, IV, pp. 121–23.

El Kom el Ahmar Sawaris (r) (Ḥwt-nsw, Ḥe-nēsu). The discovery of inscriptions *in situ* made possible the identification of this as chief town of the 18th nome of Upper Egypt. Its necropolis is notable for the large tomb, decorated with reliefs, of the priest Pepi-'Ankh (6th dynasty). In the neighborhood have been discovered reused blocks with the cartouches of Ptolemy I and Ptolemy II.

Bibliog. PM, IV, pp. 125–26.

El Bahnasa (l) (Pr-mdd, P-emde; 'Οξύρυγχος; Oxyrhynchos). The discovery of Greco-Roman papyri here was the special circumstance that made known this site, which shows remains of a village and of a late cemetery. Almost opposite, on the right shore, near the present El Sheikh Fadl, where there survive shaft tombs containing mummified dogs, must have been the ancient Ḥr-dy (Ḥarday), the Greek Κυνῶν πόλις, chief city of the 17th nome.

Bibliog. PM, IV, pp. 124–26.

Tihna (r) (Pr-mʒiw, Pi-mui; ᾿Αχῶρις, Achoris). On this site are the ruins of two Roman temples (one datable to the reign of Nero), a Greco-Roman rock-cut chapel with reliefs, a group of rock-cut steles, and a cemetery zone of the Late Period. Farther south is a group of 5th-dynasty rock tombs, called, after their discoverer, the "Fraser tombs."

BIBLIOG. PM, IV, pp. 127–33.

Beni Hasan (r). An interesting rock cemetery here contains some thirty tombs of local princes of the 11th and 12th dynasties. The tombs are of three types: those consisting of one or two rooms without columns; those having one great room, at the back of which are two or three rows of bundled columns with lotus capitals; those with an *in antis* vestibule characterized by two fluted polygonal (proto-Doric) columns, leading into a room with two or three rows of similar columns. In all cases the burial chamber lies at the bottom of a shaft. The interest of the cemetery is heightened by the painted biographical texts and reliefs adorning a number of the tombs. The subject matter is rich, including some themes — military life, for example — treated here for the first time. South of the necropolis, in the Istabl ῾Antar locality, is a rock-cut temple called in Greco-Roman times Speos Artemidos. It consists of a vestibule with pillars (originally eight, in two rows), leading to a chapel. The inscriptions state that the complex was dedicated to the lioness-headed goddess Pakht by Queen Hatshepsut and completed by Seti I.

BIBLIOG. PM, IV, pp. 141–65.

El Sheikh ῾Ibada (r) (᾿Αντινόεια, ᾿Αντίνοου, Antinoë or Antinoopolis). That Hadrian founded this city near a preexisting Pharaonic center is known from the remains of a temple of Ramses II, in which materials from a temple of the epoch of Akhenaten, presumably destroyed at the end of the Amarna period, were used. The imperial center is in ruins, and unsystematic excavations have caused some confusion, but a theater, a hippodrome, and monumental buildings of the epoch can be traced. In the 4th century Antinoë already numbered among its buildings many monasteries and was the seat of a bishop, who at first was subordinate to Thebes; it was later elevated to the status of Metropolis of the Thebiad and also became its administrative center.

The necropolis, excavated by Gayet and Schmidt, yielded many textiles dating from the 2d century to the time of the Arab conquest; most of these are now in the museums of Lyons, Paris (Louvre), and Berlin. Besides fabrics of local production there have been found Indian and Sassanian stuffs; other textiles show Persian, Armenian, and Byzantine stylistic influences resulting from the mixture of elements in the local population. To the south of Antinoë are the ruins, still containing important frescoes, of the domed, three-aisled church of Deir Abu Hennis, founded probably in the 5th century by a Christian group that took refuge there during the Arab invasions. The city around the church was destroyed probably in the 13th or 14th century.

BIBLIOG. PM, IV, pp. 175–77; J. Strzygowski, RQ, XII, 1898, p. 1 ff.; Cabrol-Leclercq, I, 2, col. 2326; E. Guimet, Les portraits d'Antinoé au Musée Guimet (Annales du Musée Guimet, V), Paris, 1912; E. Breccia and S. Donadoni, Aegyptus, XVIII, 1938, p. 284; A. Badawy, Kyrilliana, Cairo, 1944, p. 369; S. Donadoni, I lavori della missione fiorentina al tempio di Ramesese II ad Antinoe, Scritti dedicati alla memoria di I. Rosellini, Florence, 1945, pp. 173–90; H. Bonnet, Reallexikon der ägyptischen Religionsgeschichte, Berlin, 1952, s.v. Antinoupolis.

El Ashmunein (l) (Ḫmnw, Ḫmun, "The Eight Primordial Gods"; ῾Ερμοῦπόλις μεγάλη, Hermopolis). Chief town of the 15th nome of Upper Egypt, El Ashmunein was the center of the cult of the god Thoth. In the area of the sacred buildings are preserved three great monumental gates, the first of the 12th dynasty, the second of the 19th dynasty, and the third of the Ptolemaic era. The second gave access to a sanctuary, of which all that remains are two colossal statues of Ramses II. In the north sector survive remnants of a temple dedicated to Thoth by Seti II; a pylon leading to a hypostyle hall with four rows of columns, four in each row. At Hermopolis there have been found, used in Ramesside buildings, many architectural elements attributable to Akhenaten's era; it remains uncertain whether they are from a temple built here or were transported from Amarna. The Hermopolitan cemetery, located about seven miles to the southwest, in the vicinity of Tuneh el Gebel, is known especially for a group of tombs of the Ptolemaic era showing Greco-Egyptian influence, sometimes in the architectural structure and sometimes in the decoration. Exceptional interest attaches to the tomb of the priest Petosiris (ca. 300 B.C.), which consists of a small temple comprising a porch, its roof supported by four columns, and a sanctuary. The intercolumnar walls in the porch, as well as the internal walls of the porch and of the sanctuary, together with the surfaces of the columns, display a cycle of well-preserved painted reliefs; within the framework of traditional themes (offering bearers, field laborers) appear certain Greek elements (treatment of drapery, attempts at perspective rendering).

BIBLIOG. PM, IV, pp. 169–75; S. Gabra, Rapport sur les fouilles d'Hermopolis Ouest (Touna el-Gebel), Cairo, 1941.

El Bersheh (r). The rock tombs of the nomarchs of the 15th nome of Upper Egypt found here, dating from the late Old Kingdom to the 12th dynasty, are in a rather precarious state of preservation. There are about ten tombs, in most cases having a single room with one or two cult niches on the back wall. An exception is tomb 5, which has two rooms, in the first of which two pits intended to receive sarcophagi have been excavated. Among the decorations of tomb 2 is an interesting scene showing the transportation of a colossal statue. Farther south, at El Sheikh Sa῾id, is found the rock-cut necropolis of the Old Kingdom nomarchs of the 15th nome, containing the most ancient tombs of this type known.

BIBLIOG. PM, IV, pp. 177–92.

Tell el ῾Amarna or Amarna (r) (Ȝḫt-'Itn, Akhenaten, "The Horizon of Aten"). The celebrated capital, built from the ground up by the heretic king Akhenaten and destroyed under Horemheb, has been explored by, among others, Petrie, Borchardt, Frankfort, and Pendlebury, and their researches have contributed to its hypothetical reconstruction. Situated in a level area bounded by the Nile and a great semicircle of cliffs of the eastern chain, the city required no walls but had its extensive boundaries marked by 14 rock-cut steles, some of them on the left bank. In the north sector a monumental gate opened upon an unusual palace with the characteristics of a reception building, rather than of a residence. This official palace comprised a great court with altars for the worship of Aten, space for stabling animals, a peristyle garden, royal hypostyle apartments with throne rooms, a great court with a pool, and many rooms whose function remains uncertain. Some cubicles on the court north of the throne room were decorated with delicate paintings representing waterfowl. The center of the city was cut by a great thoroughfare, traversed by a bridge linking the official palace with the royal residence. The latter, rectangular in plan, had a vast garden, storerooms, and apartments; among the apartments can be distinguished the quarters reserved for servants, and the royal quarters, comprising a hypostyle hall, a chapel for private worship, sitting rooms, and an alcoved bedroom. Nearby were found the archives in which the well-known Amarna tablets were discovered.

The royal palace had a private section, including storerooms, harems, etc., in addition to the official section. One of the vast courtyards of the official section had along one side a row of colossal statues of the king and the queen. The throne room was preceded and flanked by great pillared halls, the largest of which had 32 rows of 17 pillars each. Also along the main thoroughfare stood a great temple dedicated to Aten, within a rectangular wall about 2,600 × 900 ft. The complex was designed for worship in the open, hence both the temple and the sanctuary took the form of a series of great courts punctated by a succession of monumental gates and porticoes. Characteristic features were the offering tables and sacrificial altars. The residences of officials were mostly located in the southern part of the city, surrounded by gardens, service quarters, and lodgings for the staff, all enclosed by a brick wall. In the center rose the great residential building, in which can still be distinguished the formal apartments, consisting chiefly of three hypostyle halls (with wooden columns), providing for receptions, dinners, and guest accommodations, and private apartments, comprising alcoved bedrooms, sitting rooms, bathrooms, and closets. Many of the houses had loggias. In the house of the chief sculptor Thutmosis were discovered a series of sculptures of exceptional significance for the light they shed on the esthetic ideals of Amarna's art; among these was the famous head of Nefertiti now in Berlin (Staat. Mus.).

To the southeast was a workmen's village built within a walled square about 230 ft. on a side. The houses, disposed in six blocks of five parallel streets running north–south, include, typically, antechamber, sitting room, bedroom, and kitchen. The rock-cut tombs — some twenty-five, not all of them furnished — prepared for Akhenaten's courtiers are to be found in two groups, one to the north and the other to the south, in the rock spurs that bound the city on the east. These for the most part have two cruciform or T-shaped rooms, with the cult chapel at the back; the first room may have two or four columns. The painted decoration of the tombs is of considerable importance, not only for the religious texts relating to Aten and for the varied depictions of scenes from public and private life but for the representations of the city's buildings. Excavation of the tomb of Akhenaten, located in a rocky valley, the Wadi Abu

Hasah el Bahri, revealed a descending corridor giving access to two groups of secondary chambers intended for members of the family, an antechamber, and the pillared hall that contained the sarcophagus (of which many fragments were found). Of relief decorations some have been dispersed; those that remain are much damaged. Particularly interesting is the scene of the king and queen lamenting over the lifeless body of a princess. From the south section of Amarna a track led southeast to the area of the alabaster mines (called in antiquity Hat-nub), which were worked during the Old and the Middle Kingdoms, according to the evidence of a series of rock inscriptions.

BIBLIOG. PM, IV, pp. 192–239.

Bawit. The important complex forming the Coptic monastery comprising a building for men, to the north, and one for women, to the south, as well as hospices for pilgrims and some fifty chapels, was founded by St. Apollo (d. 395), a pupil of St. Pachomius, who in his time had had a monastery built at nearby Deir el Meharrag. Before the death of its founder the Bawit monastery housed as many

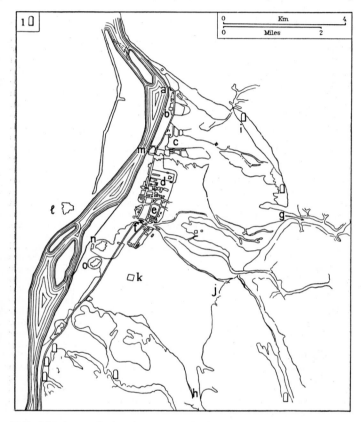

Tell el ʿAmarna. Archaeological plan: (a) Monumental gate; (b) palace; (c) suburb; (d) center of the city; (e, f) residential complex for officials; (g) valley with the tomb of Akhenaten; (h) edge of area of alabaster mines of Hat-nub; (i) north tombs; (j) south tombs; (k) Roman castrum (camp); (l, m, n, o) modern dwellings. Key symbol in upper left-hand corner is used to indicate boundary steles.

as five hundred monks, but its most illustrious phase was reached under Justinian, to whose time belong most of the frescoes and sculptures which Chassinat, Clédat (1901–04), and Maspéro (1913) discovered in the wall-girdled churches of the monastery. The Arab invasions of the 9th century contributed to its destruction; the last buildings fell into ruin in the 12th century. Many fragments of paintings and sculptures from Bawit are in Cairo, Paris (Louvre), and Berlin.

BIBLIOG. W. E. Crum, Z. für Ägyptischen Sprache und Altertumskunde, XL, 1902–03, pp. 60–62; J. Clédat, Le monastère et la nécropole de Baouît, 2 vols., Cairo, 1904, 1916; Cabrol-Leclercq, II, col. 203; J. Maspéro, Mémoires de l'Inst. fr. d'archéologie orientale du Caire, LIX, 1932.

El Qusiya (l) (Ḳis, Ḳōs; Κοῦσσαι, Cusae). Of the chief town of the 14th nome of Upper Egypt, sparse traces remain. Nearby, in the environs of the village of Meir, is the well-known rock-cut necropolis of nomarchs of the late Old Kingdom and the Middle Kingdom. The tombs consist of one or two rooms, with the cult niche at the back. The decoration is markedly provincial in character;

its chief interest is in the vivacity of the scenes and the expressive spontaneity of the figures. Other nomarchs of Ḳōs preferred to have their tombs prepared on the left bank, near the present village of Quseir el ʿAmarna.

BIBLIOG. PM, IV, pp. 247–58; A. M. Blackman, The Rock Tombs of Meir, V, London, 1953.

Deir el Gebrawi (r). The rock necropolis is known to be the burial place of the nomarchs of the chief town of the 12th nome of Upper Egypt, but the town itself has not been located with any certainty. The tombs, datable to the end of the Old Kingdom and numbering about a hundred, have one or two rooms, often asymmetrical; few of the tombs are decorated.

BIBLIOG. PM, IV, pp. 242–46.

Asyut (l) Sꜣwty; Siyawti; Λύκων πόλις, Lykon polis). Of the chief town of the 13th nome of Upper Egypt, center of the cult of the wolf-god Upwaut, there remains only the rock-cut necropolis of the Middle Kingdom nomarchs. Some of the tombs have elaborate ground plans; for example, in the tomb of Hepzefa I, from the back of an antechamber and a chapel there open three passages leading to three rooms, of which the middle one was in turn divided into three chambers. The tomb of Hepzefa III was preceded by a level space with a portico supported by a row of four pillars, followed by a row of four columns; at the back of the cult chapel are three niches.

BIBLIOG. PM, IV, pp. 259–69.

Deir Tasa and Badari (r). These two sites are important in the documentation of the Upper Egyptian Neolithic and Bronze Ages, respectively.

Qaw el Kebir (r). This is the site of the rock-cut burial ground of the Middle Kingdom nomarchs of the 10th nome of Upper Egypt. Three of the mortuary complexes here were, to judge from the remains, among the most elaborate of their era. They comprised a series of terraced elements: a valley portico, a covered causeway leading to a first court (peristyle in the tomb of Wahka III), a transverse portico followed by an axial hypostyle hall, with pillars, connecting with the antechambers, halls, and chapels excavated in the rock. In the surrounding countryside are cemeteries of various epochs.

BIBLIOG. PM, V, pp. 9–16; H. Steckeweh, Die Fürstengräber von Qaw, Leipzig, 1936.

Sohag. In the Libyan Desert in this vicinity are two very important Early Christian monuments: the White Monastery (Deir el Abiad) and the Red Monastery (Deir el Ahmar; III, PL. 447). Of the first almost nothing remains except the church, restored in 1907 and surrounded by a gigantic wall in the ancient Egyptian style. According to an inscription the White Monastery was built between 430 and 440 under the Abbot Shenute (d. 451) and with the help of Count Caesarius of Byzantium. The present church was built on the site of a smaller edifice of the Constantinian epoch. Its apse frescoes, executed in 1137 by an Armenian monk, were part of a 12th-century restoration. Arab ravages destroyed the tomb of Shenute in 1168, but a funeral stele is preserved in Berlin (Staat. Mus.). In the 15th century Maqrīzī wrote that the monastery was already in ruins. The north portal led directly to the great three-aisled basilica, which had a transept and three apses and was preceded by a narthex. The apses, like those of the Red Monastery, were decorated with niches and columns of the same type as those in the basilica of St. Menas near Alexandria. Nothing remains of the 5th-century decoration. The Maiestas Domini of the central apse, flanked by medallions with the four Evangelists, bears an Armenian inscription with the name of the painter Theodore (1124). In the south apse is depicted the Cross in a mandorla, with a veil over its arms.

BIBLIOG. W. de Bock, Matériaux pour servir à l'archéologie de l'Egypte chrétienne, St. Petersburg, 1901, p. 40; W. M. F. Petrie, Athribis, London, 1908, p. 14; S. Clarke, Christian Antiquities in the Nile Valley, Oxford, 1912, p. 145; O. Wulff, Altchristliche und byzantinische Kunst, Neubabelsberg, 1914, p. 223; Cabrol-Leclercq, IV, 1, col. 459; U. Monneret de Villard, Les couvents près de Sohâg, II, Milan, 1925–26; A. L. Schmitz, Das weisse und das rote Kloster, Die Antike, III, 1927, p. 326 ff.

Akhmim (r) (Ḫnt-Mn, Ḫant-Min, then ʾIpw, Ipu; Χέμμις, Πανός πόλις, Panos polis). Of the chief town of the 9th nome of Upper Egypt, center of the Min cult, the necropolis alone survives, as is true of many ancient urban centers. In this case the burial ground is located at El Hawawish; its rock-cut tombs are of little interest. In the El Salamuni locality is an 18th-dynasty rock-cut temple

dedicated to Min, its ground plan similar to that of the Speos Artemidos at Beni Hasan. Like Sohag, Akhmim is the seat of a bishop of the Coptic Church. Of the early Coptic sanctuaries only a few ruins remain, and the once very important city is a mere village. The Early Christian necropolis extending for two miles along a hill near the Nile — in the first centuries of the Church an extension of the city — still shows its myriad tombs. Widely renowned were the great monasteries founded at Akhmim by St. Pachomius (d. 346) and his successors. In 451 Nestorius, Patriarch of Constantinople until his deposition by the Council of Ephesus, died here in exile. The finds made in the area are important, particularly those from the necropolises, the excavation of which yielded, among other things, fine examples of wool, linen, and silk fabrics that make it possible to reconstruct the development of Coptic textiles from the Hellenistic era to the time of the Arab invasion. Most of these textiles are in museums in Berlin, London, Brussels, Trier, Mainz, etc.

BIBLIOG. PM, V, pp. 17–26; R. Forrer, Die Graeber und Textilfunde von Achmîm, Strasbourg, 1891; R. Forrer, Die frühchristlichen Altertümer, von Achmîm, Strasbourg, 1893; Cabrol-Leclercq, I, 1, col. 1042; RE XVIII, 3.

Wannina (l) (Athribis). Found here are the ruins of a temple dedicated to the eponymous goddess Triphis; its construction was begun late in the Ptolemaic era and completed in Roman times.

BIBLIOG. PM, V, pp. 31–34.

Naga ed Deir (r). This site is known for a group of cemeteries whose dates range from the predynastic era to the end of the Old Kingdom. On the opposite bank stands Girga, near which must have been located the ancient Thinis, or This (Tni). About 32 miles from Girga, at the village of Beit Khallaf, was discovered a great brick mastaba whose underground rooms contained vases and jars with seals of King Zoser.

BIBLIOG. PM, V, pp. 26–28.

El ʿAraba el Madfuna (l) (ʾbdw, Ebodu; "Αβυδος, Abydos). Chief town of the 8th nome of Upper Egypt and burial center of the Thinite kings, Abydos grew famous as a result of the increasing popularity of the cult of Osiris; it became the aspiration of all Egyptians to possess a memorial in the holy city where the god of the dead was supposedly buried. The necropolis of the Thinite kings, situated in the sector called Umm el Gaab, was excavated in large part by Petrie. Here, as in the north sector at Saqqara, are tombs or cenotaphs consisting, for the earliest kings, of a vast underground chamber with a wooden roof surmounted by a parallelepiped structure in unbaked brick. The tombs of the succeeding kings show, around the main chamber, a series of minor rooms containing steles honoring members of their families. From this necropolis comes the famous stele of the Serpent King (PL. 325). The celebrated temple of Osiris, also excavated by Petrie, is in the north sector, but study of it is difficult owing to the frequent alterations made in the course of time, as well as to the poor state of preservation of the (largely brick) remains. Painstaking excavation in strata has yielded foundation deposits and architectural fragments from which it can be ascertained that the original nucleus goes back to the 1st dynasty. The temple was enlarged later in the Old Kingdom, and again in the 11th dynasty; it was entirely rebuilt under Sesostris I, then enlarged and altered again during the 18th and 20th dynasties. In the neighborhood were found numerous statues and steles of private persons. Also in the north sector can be made out the remains of two fortified palaces attributable to the 2d dynasty. Extending from the north to the south sector are a succession of burial zones of different epochs, known by the names of their respective explorers: Amélineau, Mariette, Petrie, Peet, Garstang, Randall-MacIver, Frankfort. Generally speaking, the northern necropolises are composed of Middle Kingdom tombs; the center ones of Old Kingdom tombs (including the very famous mastaba of Unas with its important biographical inscriptions); and those to the south of New Kingdom tombs.

Toward the south stand two great temples, built for the funerary cults of Seti I and Ramses II. The first, its ground plan showing notable departures from the traditional schemes, is the Memnonion described by Strabo (ca. 205 ft. across the front). The outermost elements — the first pylon, the first court, and the second pylon — have been almost entirely destroyed. Beyond the second pylon is a second court, from which a ramp leads up to a vestibule with a row of 12 pillars. This communicates with two hypostyle halls, separated by a dividing element, in which are seven openings corresponding to the seven chapels of the temple. The first hypostyle hall has two rows of columns with papyrus-bud capitals, 12 in each row; the second hypostyle hall has two rows of 12 similar columns

and a third row of 12 columns without capitals, standing on a raised platform. Behind the row of 7 chapels is a complicated group of hypostyle rooms and other chapels. The outstanding anomaly consists in the fact that the temple has a great lateral arm at the back of the south side, comprising hypostyle rooms and storerooms. Although marked by a rather cold academicism, the reliefs decorating the walls and pillars are, in the refinement of their drawing, among the finest known; as usual, they illustrate themes of a religious character. Behind the temple is the underground cenotaph of Seti I, decorated with heads and funerary images, and reached through a long corridor (ca. 325 ft.). There follows a large vestibule (65 × 20 ft.) communicating with a pillared hall (ca. 100 × 65 ft.), from which one passes into a sarcophagus room of the same dimensions as the vestibule. The mortuary temple of Ramses II shows a well-balanced distribution of elements, marked by strict symmetry. Of the first pylon only traces survive. The second pylon leads into a peristyle court, with Osiris pillars, communicating, through an atrium having a row of 8 pillars, with two hypostyle halls (two rows of 4 pillars each); the chapels are at the back and along the sides of the hypostyle halls.

BIBLIOG. PM, V, pp. 39–105, VI, pp. 1–41; A. H. Gardiner, ed., The Temple of King Sethos I at Abydos, 4 vols., London, Chicago, 1933–58.

Dendera (l) ('Iwnt, then 'Iwn-tȝ-ntrt, En-t-entōre; Τεντύρα). Chief town of the 6th nome of Upper Egypt, Dendera was the center of the cult of the goddess Hathor; her temple, of late Ptolemaic and Roman times, is, owing to its excellent state of preservation, the monument of major interest. The sacred precinct, almost square (ca. 920 × 950 ft.), is delimited by a great wall having in its north side a monumental gate with the cartouches of Domitian and Trajan. The temple is without pylons but has a surrounding wall with entrances on the sides. The front of the building (138 ft. wide; 59 ft. high), with a door in the center preceded by a vast court, presents two groups of three columns each, with Hathor capitals, surmounted by a cornice; the intercolumnar space is filled by a wall reaching halfway up the shafts. This forepart opens into the first hypostyle hall, whose columns (18 in three rows) are on the same axis and of the same type as those on the front. On the ceiling are remains of an astronomical decoration. The second hypostyle hall, flanked by six rooms used for storage, has 6 columns in two axial rows. There follow two vestibules and the sanctuary, about which are set 11 chapels. The temple is also unusual in having 12 crypts, of which 6 are cut into the underground part and 6 into the body of the wall surrounding the back end. On the roof there still exist two shrines dedicated to Osiris, and a kiosk dedicated to Hathor. The temple walls, both inside and out, as well as those of the crypt, show an uninterrupted series of reliefs with religious themes, a true liturgical corpus. The building also has two Birth Houses, one begun in the 30th dynasty and completed in the Ptolemaic period, the other from the time of Augustus. The latter, decorated in the Hadrianic era, is surrounded on three sides by a portico with intercolumnar walls, the columns having campaniform capitals with abaci depicting the god Bes. West of the temple lies the sacred lake, and along the rear are the remains of a temple dedicated to Isis in the Augustan era. Within the sacred area was discovered an 11th-dynasty chapel; this was reconstructed and is in Cairo (Egyptian Mus.). The Dendera necropolis, explored by Petrie, contains several great Old and Middle Kingdom mastabas.

BIBLIOG. PM, V, pp. 109–16, VI, pp. 41–110.

Qift (r) (Gbtyw, Gebtyw; Κόπτος, Koptos). Chief town of the 5th nome of Upper Egypt, center of the cult of the god Min, Qift was linked by an important caravan route through the Wadi Hammamat with the Red Sea. The remains of three temples have been identified. In the north temple were found, below the Ptolemaic stratum, architectural elements of the 18th, 12th, and 6th dynasties, as well as two archaic statues of exceptional interest depicting the local god. The central temple goes back to Thutmosis III but there are late alterations. The southern temple reveals 30th-dynasty and Roman elements. Northeast of Qift, in the area of El Qalʿa, is a small temple built in the time of Claudius.

BIBLIOG. PM, V, pp. 123–34.

Qus (r) (Gsy, Gāsy; 'Απολλωνος πόλις). Of the late Ptolemaic temple that stood here all that remains is the ruin of the pylon. A mosque with a very fine pulpit dates from the year 550 of the Hegira (1155), and there is a contemporaneous mausoleum.

BIBLIOG. PM, V, pp. 135–36.

Naqada (l). The necropolis on this site represents early and middle predynastic times, a period chiefly important for the develop-

ment achieved in the ceramic industry and the perfection of its products. In the north sector De Morgan discovered a great mastaba (ca. 185×88 ft.) datable to the 1st dynasty. It has the usual regular sequence of niches on the exterior but lacks a substructure; the burial chamber and the other peripheral chambers, which do not intercommunicate, are at ground level.

BIBLIOG. PM, V, pp. 118–19.

Medamud (r) (M'dw, Madu). Excavations by Bisson de la Roque, Robichon, and Varille have made it possible to interpret the confused ground plan of an important temple that underwent many transformations. The original nucleus, datable approximately to the end of the Old Kingdom, consisted of a sacred grove surrounded by a polygonal brick wall, within which were two tumuli, each accessible in the interior through a tunnel leading from a court preceded by a pylon. The titulary deity has not been established with certainty. About this nucleus Sesostris III built a temple dedicated to the god Monthu; foundation deposits of this temple have been discovered, and certain of its architectural elements appear to have been utilized in the foundation of a Ptolemaic temple. The area of the sanctuary of Sesostris III, which is on a north–south axis, was found below the rear part of the Ptolemaic temple, which is oriented west–east. In the central part of the Ptolemaic temple elements of an 18th-dynasty temple were reused; the great forecourt, which has two rows of columns on the sides bearing the cartouche of Antoninus Pius, is preceded by three kiosks and an audience room.

BIBLIOG. PM, V, pp. 137–50; C. Robichon and A. Varille, Description sommaire du temple primitif de Médamoud, Cairo, 1940.

d. *Thebes area*. El Aqsur (Luxor) and Karnak (r) (W'st, Wēset; Heb., Nō; Θῆβαι; Διὸς πόλις, Diospolis). The limits of the ancient urban center of Thebes — chief town of the 4th nome of Upper Egypt, famous capital of the New Kingdom and center of the cult of the god Amen — are not known with any exactness. It encompassed the ruined city on the left bank of the Nile, the site that still carries the name, as well as Karnak and Luxor on the right bank. The only surviving buildings are the temples of Karnak and the temples of Luxor, which originally formed part of a broad avenue flanked by criosphinxes. The central group of the Karnak temples is dominated by the Temple of Amen, originally a Hermopolitan divinity, introduced here in the 11th dynasty, when the city's development began. The most imposing religious complex of all antiquity, this famous temple was enlarged during the New Kingdom around its original modest Middle Kingdom nucleus. Surrounded by a great circle of bricks (perimeter ca. 7,800 ft.), the sanctuary (to whose reconstruction Legrain and Chevrier contributed especially) consists of two distinct sections: a main part, on a north-west–southeast axis, and another, added part with its axis at right angles to this, that is, northeast–southwest. In the main part the first pylon (370×45 ft.), preceded by a landing stage originally linked with a canal intended for the navigation of the sacred barque, is without decoration, resembling in structure a work of the Late Period. There follows the great court (328 ft. wide, 267 ft. long), with a colonnade of undecorated columns on each of the shorter sides. The colonnade on the south side is interrupted by the pylon of a temple of modest dimensions (174×82 ft.) constructed by Ramses III — which is thus partly included in the larger temple.

Also dedicated to Amen, the smaller temple consists of the classical elements, well preserved: a pylon (preceded by two colossi) with a representation of the scene of the king defeating his enemies before the god, a court surrounded on three sides by Osiris pillars, a hypostyle hall (two rows of four columns running transversally), a sanctuary. The south corner of the great court is called the "Bubastid Portal," because of its 22d-dynasty decorations. In the northwest part of the great court is a small sanctuary with three chapels built by Seti II, and in the center are the remains of a great pavilion formed by two axial rows of columns (5 in each) with open papyrus capitals, of which only one (the column of Taharqa; 68 ft. high) is whole. The second pylon is preceded by a structure before which stand two colossi, partially preserved, one of Ramses II, the other of Paynozem. Among the foundation blocks of the colossus of Ramses II was found an important stele relating to the expulsion of the Hyksos. There have been recovered, from among the elements employed in the construction of the second pylon, begun under Horemheb and completed in the early 19th dynasty, about 15,000 decorated blocks from a building constructed under Amenhotep IV. The great hypostyle hall, which runs from the second to the third pylon (338 ft. wide, 170 ft. long), was begun by Seti I and completed by Ramses II. It comprises a central axial colonnade formed by two rows of 6 columns each, with open papyrus capitals (63 ft. high without abacus), flanked by two lateral colonnades, each of seven rows of single papyrus columns with bud capitals (height over

48 ft. without abacus), running axially. The innermost rows of the lateral colonnades comprise 7 columns each, the others 9: thus the great hypostyle hall contains 134 columns in all. The differing heights of the roofs of the central and lateral colonnades were harmonized by interposing a series of pillars alternating with stone grill windows in the clerestory. A ong the side walls of the hypostyle hall, on the inside, are reliefs on religious themes; along the outside is a succession of scenes and inscriptions commemorating the military campaigns of Seti I and Ramses II, including the poem describing the battle of Kadesh and the treaty of peace concluded with the Hittites. The third pylon, constructed under Amenhotep III, was at first a source of puzzlement to archaeologists, since elements of other buildings were discovered in the foundation structures. It has been possible to reconstruct almost in its entirety a small pavilion of Sesostris I, harmonious in line and decorated with delicate relief, and an alabaster shrine of Amenhotep I. There have also been recovered elements of religious buildings belonging to three other rulers. The fourth pylon is the work of Thutmosis I, as are the two obelisks that preceded it, one of which still stands. The fifth pylon too goes back to Thutmosis I, who built, as well, the colonnade before it with two transverse rows of columns. The two obelisks before the fifth pylon were erected by Queen Hatshepsut (the one still standing is ca. 98 ft. high). The sixth pylon, the smallest, and the central vestibule with partly colonnaded court preceding it, belong to Thutmosis III. The two faces of the sixth pylon and the walls of the vestibule that follows it, characterized by two pillars with the heraldic emblems of Upper and Lower Egypt, are inscribed with important texts — annals of Asiatic campaigns.

After an area occupied by a granite sanctuary of Philip Arrhidaeus comes the section having an original 12th-dynasty sanctuary incorporating certain datable elements, whose exploration has not yet been completed. The terminal part of this great temple is occupied by a singular complex, known as the "Festival Hall," built by Thutmosis II. The most important nucleus appears to be a vast hypostyle hall running transversally (143 ft. wide, 55 ft. long); its roof is supported by two central rows of columns imitating wooden tent poles, 10 in each row, and by 34 pillars arranged in a peristyle. The added part of the temple comprises a series of four pylons preceded by courts and linked by lateral walls. The function of these elements was to establish a connection with the temples of Amen and Mut. In the first court, preceding the seventh pylon (scenes of the victory of Thutmosis III), Legrain discovered a vast cache containing more than 700 statues, many of them depicting rulers. On the wall of this same court recur scenes and texts of historical importance (Ramses II, Merenptah). The eighth pylon goes back to the reign of Queen Hatshepsut; the ninth and the tenth to Horemheb. All the gates in these pylons were originally flanked by colossal statues. The great sacred lake (ca. 390×250 ft.) is found to the southeast. Other features of the area of the great Temple of Amen are a small temple dedicated to Ptah by Thutmosis III, preceded by Ptolemaic structures (north side); the remains of a temple of Ramses II, where was found *in situ* the base of the obelisk now in Rome (Lateran Museum) which stood at the center of a preexisting structure; the ruins of a small temple of Tuthmosis III, resting against the great temple (south side); a sanctuary of Taharqa (to the southeast).

The most noteworthy construction is the Temple of Khons on the southwest side. It is preceded by a Ptolemaic propylon, and its essential elements (pylon, colonnaded court, transverse hypostyle hall, vestibule, sanctuary) are well preserved. Begun under Ramses III, it was completed, except for the pylon, by Herihor. Beside it is the Ptolemaic temple dedicated to the goddess Apet. Outside the great enclosure of the Temple of Amen are two minor enclosures: that of the Temple of Monthu to the north; and that of the Temple of Mut to the south. The Temple of Monthu, preceded by a Ptolemaic propylon, goes back to Amenhotep III. It had no pylon, but two obelisks stood before it; then came the colonnaded court, the hypostyle hall (4 columns), and the central sanctuary, flanked by minor chapels. In the sacred zone are temples and chapels of the Late Period. The Temple of Mut, also preceded by a Ptolemaic propylon, is in a poor state of preservation; its pylon goes back to Seti II, the original nucleus to Amenhotep III. In the vicinity of the Temple of Mut there are remains of two other temples: one of the 18th dynasty, the other, contructed by Ramses III, having a ground plan analogous to that of his temple incorporated in the first court of the Temple of Amen and showing battle scenes on the outer walls. Finally it should be noted that hundreds of statues of rulers, divinities, and dignitaries have been found at Karnak.

BIBLIOG. For the Thebes area in general: E. Otto, Topographie des thebanischen Gaues, Berlin, 1952; for the temples of Karnak: PM, II, pp. 3–97. Principal recent works: yearly accounts of the excavations are pub. in the ASAE; University of Chicago Oriental Institute, Reliefs and Inscriptions at Karnak, 2 vols., Chicago, 1936; H. Chevrier, Le temple reposoir de Séti II à Karnak, Cairo, 1940; L. A. Christophe, Karnak-Nord,

Cairo, 1951; P. Barguet and J. Leclant, Karnak-Nord, 2 vols., Cairo, 1954; H. Ricke, Das Kamutef-Heiligtum in Karnak, Cairo, 1954.

Temple of Luxor. This was the sanctuary toward which the procession with the sacred barque containing the image of Amen made its way from the great Karnak temple. In its essentials the

sectors. Along the edge of the plain stand the remains of the mortuary temples of several rulers; the temples of other rulers, and all the tombs both royal and private, are scattered in groups in the rocky escarpment.

Of Luxor's monuments of Islamic architecture, mention should be made of the minaret of Abu'l Haggag.

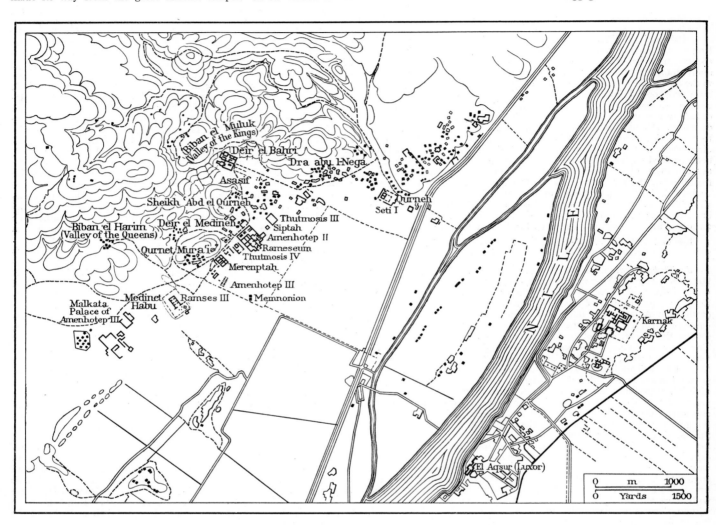

Archaeological plan of the Thebes area.

sanctuary (ca. 850 ft. long), is the work of Amenhotep III (FIG. 673). Explored and restored by Grébaut, Daressy, and Legrain, it is well preserved. The first pylon and the colonnaded court following it were added by Ramses II, but somewhat off the principal axis of the temple, since they were designed to incorporate a three-celled sanctuary of Thutmosis III. Before the first pylon, which is decorated with scenes and texts relating to the battle of Kadesh, stood six colossal statues — three on each side — and two obelisks (one still stands here; the other is in Paris). The colonnaded court, with two rows of columns, has on its south side a series of colossal statues. With the second pylon begins the work of Amenhotep III; it continues with a majestic colonnade of two axial rows each of 7 great columns with open papyrus capitals, by a court (156 × 169 ft.) bordered on three sides by a double row of papyrus bundle columns with bud capitals. The court gives upon a transverse, hypostyle hall, with 32 columns (four rows of 8). This leads to the inner part of the temple, which comprises four hypostyle antechambers (the first and last of these at right angles to the axis), flanked by minor rooms — including one with reliefs recounting the divine birth of Amenhotep III — and, at the back, the innermost sanctuary, comprising three rooms.

BIBLIOG. PM, II, pp. 99–110.

On the left bank, facing the ancient city, where the Libyan cliffs present a semicircle of great buttresses sloping toward the plain, stretches the famous Theban necropolis area, divided into several

Qurneh. Of the Temple of Seti I, completed by Ramses II, there remains the front part of a colonnaded court (163 ft. wide) with a single row of columns, leading into a sanctuary showing a clear tripartite division in the axial direction. The central sector has a hypostyle hall (6 columns in two rows), surrounded by lateral chambers (three on each side), followed by a vestibule and the sanctuary for the barque of Amen. The two flanking sectors are completely different in ground plan. The right-hand sector has a great colonnaded court intended for the sun cult; that on the left has a vestibule and a sanctuary dedicated to Ramses I.

BIBLIOG. PM, II, pp. 141–46.

Rameseum. The great mortuary temple of Ramses II, celebrated by Diodoros, is enclosed, together with a number of brick storehouses, by a precinct wall. The temple and the surrounding wall are not on the same axis, since a part of the wall, on the north side of the temple, is superimposed on the wall of an earlier small temple of Seti I, probably abandoned when that Pharaoh built his other temple at Qurneh. The first, massive pylon (over 220 ft. wide) has, on its inner façade, reliefs recalling the battle of Kadesh and the king's victories in Syria. The first court, much damaged, had on the north side a portico with a single row of pillars; on the south a portico with two rows of columns gave access to a palace comprising a great hypostyle audience hall with 16 columns (four rows of 4) and a throne room with 4 columns (in two rows), as well as a considerable number of minor rooms. In the first court stood a colossus of

Ramses II of exceptional size (over 55 ft. high), whose impressive trunk remains. The second court, preceded by a second pylon (partially collapsed), whose reliefs deal with religious themes and, again, recall the battle of Kadesh, had two rows of columns on either side and a row of Osiris pillars against the entrance wall; opposite these, on the far side, on a slightly higher level, is a row of similar pillars matched by one of columns. The hypostyle hall (130 × 98 ft.) comprises a central nave formed by two axial rows of columns with open papyrus capitals, 6 in each row, and two side sections each containing three rows of 6 papyrus columns with bud capitals — a total of 48 columns, not all of which remain. As in the great temple of Karnak, the difference in ceiling height between the central aisle and the side sections was harmonized through the interposition of pillars and windows. Beyond the great hypostyle hall lie other, smaller hypostyle rooms, the first of which is called the "Astronomical Room" because of its ceiling decoration. The terminal part of the temple has suffered much destruction. In the neighborhood of the Rameseum were discovered mortuary temples of other Pharaohs, identified by sporadic findings; to the north, temples of Thutmosis III, Siptah (Merenptah), and Amenhotep II; to the south, of Thutmosis IV and Merenptah.

BIBLIOG. PM, II, pp. 149-57.

Colossi of Memnon. The sole remains, above ground, of the funerary temple of Amenhotep III (PL. 356) are the two colossal statues (ca. 65 ft. high including base) depicting the Pharaoh seated on a cubical throne. Famous since classical antiquity, they were thought by the Greeks to represent the hero Memnon, son of Tithonos and Eos. The statue to the north is the one reported by ancient writers to have emitted at sunrise a musical sound ("the voice of Memnon") — a phenomenon that has been explained as due to the expansion in sunlight of stone chilled by the cool Egyptian night.

BIBLIOG. PM, II, pp. 160-61.

Medinet Habu. Preserved here is the grandiose mortuary complex built for Ramses III (FIG. 676); in the area was found a small 18th-dynasty temple (not a mortuary temple) comprising a peripteral vestibule followed by a hypostyle vestibule (four columns) and by six decorated chapels. The temple, subjected to radical alterations in the Late Period, was later incorporated into the great outer precinct wall built by Ramses III. This wall, 34 ft. thick, had two massive fortified gates, one (almost entirely destroyed) to the west and the other (well preserved) to the east (PL. 359). Preceded by a landing stage leading down to a canal communicating with the Nile, the gate (original height, 72 ft.) is formed by two massive towers, solid at the base, and has apartments in the two upper stories, which joined at the back above the first story, leaving a passage below, originally closed by a big door. Particularly interesting are the reliefs adorning the inside walls of the upper rooms, among them the famous scenes showing the king in the intimacy of the harem. The doorway leads into a court in which were discovered traces of minor buildings intended to serve as staff and service quarters. The temple, similar in plan to the Rameseum, stands 260 ft. from the main gate and is surrounded by a wall. The first pylon (206 ft. wide), adorned on both sides by reliefs of war and hunting scenes, leads into the first court (137 ft. wide, 112 ft. long), which has on the northeast side a portico with a row of Osiris pillars and on the southwest a portico with a row of columns having campaniform capitals. As in the Rameseum, the remaining side of the court gave access to a palace having a columned audience hall with 12 columns (four rows of 3) and a throne room with 4 columns (two rows of 2), surrounded by subsidiary apartments. The second court, preceded by a second pylon, had a row of columns at either side and a row of Osiris pillars on the entry wall; on the far wall the row of Osiris pillars is again backed by a row of columns.

The ground plan of the following rooms, though these are damaged, is clear. In the central portion rose three hypostyle halls. The first, as in the Rameseum, had a central nave (two axial rows of 4 columns) and two lateral sections (two rows of 4 columns). The other two hypostyle halls had 8 columns each (two transverse rows of 4), while the sanctuary was supported by 4 pillars (two rows of 2). Around the hypostyle halls and the sanctuary are numerous decorated chapels; the walls of the temple too were adorned with reliefs, some of historical importance; among them may be noted the naval battle with the Peoples of the Sea. Numerous storerooms and magazines existed in the space within the walls of the temple and the inner wall. About 220 yards to the southwest stand the ruins of a Ptolemaic temple, called Qasr el 'Aguz, dedicated to Thoth.

BIBLIOG. PM, II, pp. 161-97; University of Chicago Oriental Institute Medinet Habu, 5 vols., Chicago, 1930-57; U. Hoelscher, The Mortuary Temple of Ramses III, 2 vols., Chicago, 1941-51.

Malkata. This site, in the environs of the Birket Habu, does not relate to the great mortuary temples but contains the remains of a vast residence built by Amenhotep III in which four palaces have been distinguished. The Birket Habu itself is a remainder of the ancient artificial lake made by the Pharaohs.

In the following account the necropolises are listed according to their topographical distribution, but a basic distinction must be made between the tombs of the rulers and those of private persons. The latter numbering 371, almost all of the New Kingdom, present documentation of the highest order, not so much in their structure (little court, vestibule, chapel with niche, and burial shaft), as in their decoration, painted in tempera, rarely in relief, which offers a complete picture of the private life from social activities to funeral ceremonies.

BIBLIOG. See for an introduction: G. Steindorff and W. Wolf, Die thebanische Gräberwelt, Leipziger ägyptologische Studien, 4, 1936. For the private tombs: PM, I, pp. 51-194. Many tombs have been published in the Theban Tombs Ser., London, Eg. Exploration Soc.

Dra abu'l-Nega. This is the oldest part of the Theban necropolis, as is indicated by the remains of burials of 11th-dynasty rulers (3 tombs) and dignitaries (ca. 100 tombs). Also located here is a necropolis of private tombs from the New Kingdom (ca. 60). Notable among these for the quality of the decoration are: tomb 261 (18th dynasty, scenes of grape harvest and wine pressing); tomb 19 (18th dynasty, religious and funerary scenes); and tomb 16 (19th dynasty, religious themes and lively agricultural scenes).

Asasif. In this hollow is a group of tombs, prevalently Saite, some of vast dimensions; especially interesting for their reliefs, which document the "Saite revival," are nos. 34 and 279.

Khoka. In the necropolis, which contains some forty tombs, the most famous is no. 181, prepared for two sculptors of the transition period between the 18th and the 19th dynasties. Particularly deft are the depictions of goldsmiths, cabinetmakers, carpenters, sculptors, and painters at work.

Deir el Bahri. A great natural semicircular embrasure in the cliffs here was selected by Mentuhotep II (Nebhepetra), of the 11th dynasty, for the preparation of his great mortuary complex, a terraced structure climaxed by a pyramid. First came a vast walled courtyard; at the far (west) end of this was a portico with two rows of pillars (11 to the south and 13 to the north) divided by a great ramp leading to a terrace articulated externally on three sides by a colonnaded portico with 124 square pillars in a double row. Within the upper portico (as within the lower one) was a peristyle ambulatory; the roof of this was supported by 140 octagonal columns, and in its rear wall were six tombs of princesses. The complex penetrates into the cliffs with a colonnaded court moving into a deep columned hall in the rock; deep within the rock was the burial chamber (another burial chamber, Bab el Hosan, was discovered under the pyramid).

The Mentuhotep complex, surrounded by tombs of contemporary dignitaries, is flanked on the north by the famous 18th-dynasty mortuary temple (the actual tomb was elsewhere) of Queen Hatshepsut (PL. 356; FIG. 671), arranged in terraces, probably on the inspiration of the 11th-dynasty structure. From a great walled courtyard, the far side of which is marked by a portico divided into two sections (each comprising a double row of 11 pillars), a ramp ascends to a terrace. This too is backed by a bipartite portico with two rows of 11 pillars on either side of a ramp. On the wall under the second portico are the famous reliefs depicting the queen's birth and her expedition to the land of Punt; beside the portico were, on the left (south), a rock-cut chapel dedicated to Hathor, preceded by a hypostyle room (with proto-Doric columns and Hathor columns), and, on the right, a rock-cut chapel dedicated to Anubis, preceded by a rock-cut hypostyle room. Finally, along the north side of the terrace was a portico with 15 proto-Doric columns. The second ramp leads to a portico giving access to a peristyle court enclosed by a double row of columns; the portico and the court are much damaged. At the far end of the court lies the rock-cut sanctuary, flanked on the right by a room for the cult of the sun and on the left by one for the royal cult. In both structure and ornament Hatshepsut's temple shows admirable clarity and refinement of line and proportion.

In the neighborhood are the underground tomb of the architect of the temple, Senmut, decorated with fine reliefs, and a quarry into which had been thrown a group of statues of the queen, doubtless by order of Thutmosis III. Deir el Bahri is also known for the famous find of royal New Kingdom mummies, discovered by clandestine excavators in a cache where they had been hidden against the depredations of tomb robbers, and later identified by Maspéro.

BIBLIOG. PM, II, pp. 113-28; H. E. Winlock, Excavations at Deir el Baḥri 1911-1931, New York, 1942.

Biban el Muluk. This very famous necropolis, "the Valley of the Kings," contains rock-cut tombs of the rulers of the 19th-20th dynasties; it is divided into two parts, the east valley (54 tombs) and the west valley (4 tombs). Basically the tombs are planned with an entry, a descending corridor divided by a succession of narrowings and widenings into three or four sections, and a sarcophagus chamber with a roof supported by pillars; minor rooms may branch off from the descending corridor, or the burial chamber may communicate with other rooms. The length of the descending corridor is almost always more than 325 ft. The decoration of the rooms, which may be painted or sculptured in relief, consists of an uninterrupted sequence of images dominated by symbolism relative to the other-worldly life of the Pharaoh ("The Book of What Is in the Underworld"; "The Book of the Caverns"; "The Book of Gates"; "The Book of the Day and the Night"). The most complex tomb is that of Seti I, discovered by Belzoni. It is rich in delicate ornament and has the added interest that in some places the technique by which the surfaces to be decorated were prepared can be observed. Universally known for its furnishings, intact when found by Carter, is the tomb of Tutankhamen. Its four small chambers were crammed with spectacular funerary furniture sufficient to document fully the artistic taste of this transitional epoch. In the antechambers were massed beds, chariots, stools, chairs, thrones (PL. 391), alabaster vases, caskets containing precious objects, and clothing. Two statues of gilt wood flanked the entrance to the burial chamber ($20 \times 13$ ft.); here four great shrines of gilt wood contained the stone sarcophagus, in which were enclosed three nested anthropoid cases, the two outer ones of gilt wood, the inmost of solid gold; the mummy was still covered with its mask of gold, worked in gem stones and enamel, and was adorned with necklaces, pectorals, rings, and earrings.

BIBL. PM, I, pp. 1-32.

Sheikh 'Abd el Qurneh. This site contains the most representative group of tombs (ca. 70) of 18th- and 19th-dynasty dignitaries and one (tomb 60) belonging to the Middle Kingdom (reign of Sesostris I). The decoration documents fully the severe style characteristic of the early 18th dynasty; outstanding are tomb 22 (banquet scenes), tomb 82 (offering bearers, concert), tomb 86 (foreign princes bearing tribute, artisan workshops). Especially noteworthy is the great tomb of the Theban governor Rekhmira (tomb 10). This is one of the largest — the first room more than 65 ft. wide, the second more than 82 — and its themes are extremely varied: investiture of the vizier, royal audience, procession of tribute bearers, work in the fields, temple storerooms, funerals, feast of the dead (PL. 371). The refined style of the second half of the 18th dynasty is particularly well represented by the paintings in tomb 56 (the hunt, barbers at work), tomb 38 (banquet scenes with graceful, delicate female figures), tomb 52, one of the best-preserved (banquet scene with the famous figure of the blind harpist), tomb 69 (agricultural scenes and scenes of the hunt executed with unusual naturalism), tomb 74 (animated scenes of military life), tomb 78 (the well-known scene of the dancer). The artistic expression of the period immediately preceding the Amarna era is splendidly exemplified in the unfinished reliefs of tomb 55, built for the vizier Ramose (FIG. 677), which, in addition, is unique from the structural viewpoint, with its spacious colonnaded vestibule containing two groups of 16 columns each, in rows of 4; this tomb also contains a painted funeral scene in which the groups of women mourners are particularly fine.

Deir el Medineh. This, the workers' village of the Theban necropolis, was developed especially during the 19th and 20th dynasties. Situated in a level valley and surrounded by a wall, the village is traversed by a north-south thoroughfare and by lesser streets running at right angles to this. A systematic exploration of the site was conducted by Bruyère. The dwellings appear to have, as a rule, three divisions: entry, living room, kitchen. The necropolis, on the west side, comprises a series of about forty tombs of artists and chief artisans; these are characterized by vestibules surmounted by small brick pyramids and underground chambers decorated with paintings. The best-preserved is tomb 1, whose underground chamber contains a cycle of scenes relating to the otherworldly life of the dead man; the style is conventional. On the north side of the valley is a small Ptolemaic temple (roughly $29 \times 50$ ft.), in a good state of preservation. Preceded by a portal, it has a hypostyle hall with two columns, a vestibule, and three chapels with religious reliefs.

BIBLIOG. B. Bruyère, Rapport sur les fouilles de Deir el Médineh, 14 vols., Cairo, 1924-53.

Qurnet Mura'i. The necropolis here, comprising about fifteen tombs, has been subject to much devastation and there are only

the remains of decorations. Tomb 40, datable to the reign of Tutankhamen, contains an interesting scene depicting a procession of Nubian tribute bearers.

Biban el Harim or Biban el Sultanat. The necropolis reserved for royal queens and princes of the 19th and 20th dynasties, the "Valley of the Queens," contains about seventy tombs, many of them entirely ruined. The painted decorations that survive are funerary in character; the details are carefully worked and the compositions balanced, yet there is the stamp of a chilly academicism upon them. This stylistic tendency appears most clearly in tomb 60, the great burial (discovered by Schiaparelli) built for the wife of Ramses II, Queen Nofretari (PL. 382).

BIBLIOG. PM, I, pp. 39-49.

e. Upper Valley. Erment (l) ('Iwni, then 'Iwn-Mnt; Ἑρμῶνθις, Ermonthis). In this locality, whose present name preserves an allusion to the ancient local god Monthu, may be noted two propylaea of Roman times and a temple pylon of Thutmosis III. Numerous architectural fragments have been recovered, some going back to the 11th dynasty. The necropolis contains tombs of various periods, among them a predynastic group, and the cemetery of the sacred Buchis bulls, which ranges from the 30th dynasty to Diocletian.

BIBLIOG. PM, V, pp. 151-61; R. Mond and O. H. Myers, The Temples of Armant, London, 1940.

Tod (r) (D̲rty; Τούφιον, Touphion). The remains of the temple dedicated to Monthu reveal a complicated and interesting stratigraphy: the earliest sanctuary (decorated with reliefs), whose construction goes back to the 11th dynasty, was destroyed under Sesostris I and the material in part reused in the foundations of the new temple; to this a porch was added under the Ptolemies. Of the comparatively modest temple of Sesostris I only a wall remains; nonetheless its general ground plan can be made out. In the foundations of a side chapel was discovered an important deposit in the name of Amenemhet II, bearing witness to relations with western Asia (cylinders with cuneiform inscriptions).

BIBLIOG. PM, V, pp. 167-69; F. Bisson de la Roque, Le trésor de Tôd, Cairo, 1950.

Gebelein (l) (Pr-Ḥtḥr, Pi-Ḥatḥōr; Παθῦρις, Pathyris). This was one of the centers of the cult of the goddess Hathor; unrelated elements of her temple have been found belonging to the 11th, 20th, and Ptolemaic dynasties. The necropolis comprises a group of predynastic burials and some tombs of the First Intermediate Period.

BIBL.: PM, V, pp. 162-64.

Mialla (r). In this necropolis of the First Intermediate Period is preserved the largest rock-cut tomb of the epoch; it was constructed for the nomarch Ankhtifi. The central room originally had 30 columns decorated with reliefs and paintings.

BIBLIOG. J. Vandier, Mo'alla: La tombe d'Ankhtifi et la tombe de Sébekhotep, Cairo, 1950.

Esna (l) ('Iwnyt, Iunyet; Λατόπολις, Letopolis). Of the remains of a Ptolemaic and Roman temple dedicated to Khnum, the hypostyle hall ($107 \times 53$ ft.) is perfectly preserved; it contains 24 columns over 43 ft. high (the columns are in two groups of 12, three rows of 4 in each group; the first 3 columns of each group are joined by intercolumniations). The columns and the walls are decorated with reliefs. A second Ptolemaic temple, no longer extant, is documented by drawings and reliefs of the beginning of the last century, as is a vanished Ptolemaic and Roman temple dedicated to Isis which stood on the bank opposite, at El Hilla (Contralatopolis). A minaret of the Islamic period (1082) is another feature of the locality.

BIBLIOG. PM, V, pp. 165-67; 170-71, V, pp. 110-18.

El Kab (r) (Nḫb, Neḫeb; Εἰλειδυίας πόλις). Chief town of the 3d nome of Upper Egypt, this was the center of the cult of the vulture-goddess Nekhbet. The many sacred buildings have been explored, but not exhaustively, by Clarke and Capart. Within the remains of the city wall is a sacred precinct enclosing the ruins of three temples. The largest was built in the Late Period utilizing 18th-dynasty materials; it has three pylons, a hypostyle hall, and a sanctuary. Beside it are the remains of a temple of Amenhotep II, much altered under Ramses II (pylon; court with a colonnade along the outer sides; hypostyle hall with 6 columns, in two axial rows, and 2 pillars; vestibule; three shrines). The third temple, probably a Birth House, is of the Late Period. Outside the city wall are the remains of two chapels with ambulatories, one going back to Thutmosis III, the other a 30th-dynasty work. The necropolis comprises, in the part

on the level plain, a cemetery area with tombs and mastabas of the Old and Middle Kingdoms; in the hilly zone to the north there are about ten rock-cut tombs prepared for the local princes of the end of the First Intermediate Period and the beginning of the New Kingdom. Of greatest importance among the rock-cut burials are tomb 5, for its biographical texts relating to the expulsion of the Hyksos, and tomb 3, for its decorative themes (farming, banquet, funeral scenes). In the desert zone to the east may be seen a partially rock-cut tomb of Ptolemaic times, reached by a stair excavated in the rock, a chapel of the 19th dynasty dedicated to Thoth, and a small temple having a single hypostyle room with four Hathor columns. The last, built by Amenhotep III, was several times restored and enlarged.

BIBLIOG. PM V, pp. 171-91; J. Capart, Les fouilles d'el Kab, Chronique d'Egypte, XII, 1937, pp. 132-46, XIII, 1938, pp. 191-209.

Kom el Ahmar (l) (Nḫn, Neḫen; Ἱεράκων πόλις, Hierakonpolis). This very early center of the Horus-falcon cult, was explored by Quibell. In addition to the city wall, there have been distinguished a great predynastic burial ground, a predynastic fortified palace, and the precinct wall of a temple. Deposits discovered within the city wall and the precinct wall have yielded very important monuments of the predynastic era and of the 1st dynasty, suggesting the greatness of the city in those times. These finds include the macehead of the Scorpion King (PL. 325), the famous palette of King Narmer (PL. 324), and numerous monuments of King Khasekhem (2d dynasty), the most ancient ruler of whom statues have been preserved. The 6th dynasty is represented by a unique piece: the life-sized copper group representing Pepi I with his son (Cairo, Egyptian Mus.). From the same period comes a superb falcon head in gold, with its eyes inlaid in semiprecious stones (Cairo, Egyptian Mus.). In the hills to the west are found two groups of rock tombs: one group from the end of the Old Kingdom, with decorations reflecting a typically provincial style; the other group from the New Kingdom.

BIBLIOG. PM, V, pp. 191-200.

Edfu (l) (Ḏbʾ Edbō and Bḥdt; Ἀπόλλωνος πόλις). The chief town of the 2d nome of Upper Egypt, whose god was the Horus falcon — called Behdety, meaning "He of Behdet," probably because originally from the city of that name in the central Delta — has an almost perfectly preserved temple of Horus from the Ptolemaic era (PLS. 379, 380; FIG. 698). Built and decorated in stages between 237 and 57 B.C., the temple of Edfu is singularly harmonious in line. It is about 450 ft. in depth and consists of the following sequence of elements: pylon (front width ca. 260 ft., height 115 ft.); court (surrounded on three sides by colonnades with elaborate floral capitals); first hypostyle hall (containing 18 columns in two groups of 9, three rows of 3 in each group; the first 3 columns of each group joined by intercolumniations); second hypostyle hall (containing 12 columns in two groups of 6, three rows of 2 in each group); first vestibule; second vestibule; sanctuary (containing a monolithic granite naos, work of the 30th dynasty), about which are clustered minor chapels. The complex is surrounded by a wall that joins the pylon, and is everywhere decorated with reliefs treating religious themes. Near the temple's entrance is the Birth House, which has two rooms surrounded by a deambulatory portico with full intercolumniations. In the vicinity of the southeast corner of the temple are the remains of a pylon that formed part of a preexisting temple of Ramses III. West of the temple have been discovered a mastaba field from the end of the Old Kingdom and a Roman necropolis.

BIBLIOG. PM, V, pp. 200-05; VI, pp. 119-177; K. Michalowski and others, Tell Edfu, Fouilles franco-polonaises 1937-1939, 3 vols., Cairo, 1937-50.

Gebel Silsileh (l and r) (Ḫny; Silsilis). This hill, cut through by the Nile, is the sandstone quarry from which were taken most of the building materials for the temples in Middle and Upper Egypt. On both banks, but more numerous on the left one, are rock-cut chapels and steles of the New Kingdom. The most notable speos was excavated and decorated under Horemheb. Five openings created by four pillars give access to a rectangular vestibule aligned on the main axis, which leads into an almost square sanctuary. Noteworthy among the decorations is the scene of the triumph of Horemheb.

BIBLIOG. PM, V, pp. 208-21.

Kom Ombo (r) (Nbyt, Enbōyet; Ὄμβοι, Omboi). Here are found the ruins of a Ptolemaic temple dedicated to Haroeris and Sobek; the existence of earlier sacred buildings is documented by the recovery of architectural elements belonging to the 18th dynasty. The temple, standing inside a brick precinct wall having a monumental gate near the Nile, is unusual in that it is bipartite along its axis. The pylon appears to be incorporated into the surrounding wall; it precedes a court colonnaded on three sides. The rooms that follow are surrounded by an internal wall; this encloses the first hypostyle hall (containing 15 columns with floral capitals, arranged in three transverse rows of 5, the first row having intercolumniations to their full height), the second hypostyle hall (three transverse rows of 5 columns), three vestibules, and two sanctuaries surrounded by minor apartments. As is usual, walls and columns are ornamented with relief scenes pertaining to the cult. The Birth House northwest of the pylon is badly damaged.

BIBLIOG. PM, VI, pp. 179-201.

*f. First Cataract area.* Aswan (r) (Swnw, Swēn; Συήνη, Coptic Suan). In ancient times, this locality was a source of red (syenite) granite, and the quarries to the south still contain unfinished monuments — an obelisk, a colossal statue, a sarcophagus — in which the stoneworking technique can be studied. The town's antiquity is documented by rock inscriptions from the Middle and New Kingdoms and by a Ptolemaic temple dedicated to Isis. From the 4th century of our era this center was an episcopal seat. Something over half a mile away in the desert was the famous monastery of St. Simeon (Deir Amba Samaʿan), founded in the 8th century and dedicated to the hermit Simeon. Abandoned in the 13th century, it was explored by Monneret de Villard in 1924-25. Its surrounding wall enclosed a large three-aisled church, a baptistery, and a rock-cut chapel. Part of the city wall of Aswan is Islamic, perhaps from the time of the Arab conquest. The Arab cemetery is rich in tomb steles and contains many small mausoleums of the 11th century. Except for the great dam and a museum of some importance, the modern city has little of interest to offer.

BIBLIOG. PM, V, pp. 221-44; S. Clarke, Christian Antiquities in the Nile Valley, Oxford, 1912, p. 89; U. Monneret de Villard, Il convento di San Simeone presso Aswan, Milan, 1927.

Geziret Aswan (ʾbw, Yēbu; Ἐλεφαντίνη, Elephantine). The chief town of the 1st nome of Upper Egypt, as well as of the area around the First Cataract, and the center of the cult of the ram-god Khnum is this island in the Nile off Aswan. In its limited area (less than a mile long and about a third of a mile wide) there is much of interest: rock inscriptions ranging from the Saite period back to the Old Kingdom; a mole constructed with materials from New Kingdom buildings; a Nilometer; a cemetery for sacred rams, with a few remains of buildings serving religious functions; a chapel built under Trajan, in part with New Kingdom elements; traces of a temple dedicated to Khnum, preceded by a granite portal of Alexander II and a group of Old Kingdom private chapels each in the form of a naos. Up to the beginning of the last century there existed on the island two important peripteral buildings: one of Amenhotep III, the other of Thutmosis III; unfortunately, nothing remains of these but drawings and incomplete reliefs. The rock necropolis of the princes of Elephantine is on the western shore near the village of Qubbet el Hawa; halfway up the hill, it is reached by two ancient staircases cut in the rock. The tombs, numbering about thirty, range in date from the 6th dynasty to the 12th; certain ones are interesting for their ground plans and for their decorations, the content of which is in many cases biographical. Most of the tombs comprise a rectangular apartment with columns, a chapel, and a sarcophagus chamber. Of particular interest are tombs 25 and 26 (belonging to a 6th-dynasty father and son), which have two separate entrances but communicate on the interior. The room of the father has 18 columns, in three rows, that of the son 14 columns arranged in two rows. Some of the 12th-dynasty tombs show a distinct rhythm of axial perspective elements; this is especially true of tomb 31, which has a small court, a rectangular room arranged axially with two rows of 3 columns, a corridor flanked by niches with statues of the dead, and a square cult shrine with 4 columns and a niche.

BIBLIOG. PM, V, pp. 224-29.

Siheyl (Stt; -σῆτις). Numerous rock-cut texts and inscriptions are preserved on this island.

BIBLIOG. PM, V, pp. 249-53.

Philae (P-ἰʾ-rk, Pilak; Φιλαῖ, Φιλή). The many sacred buildings on the island, which is about 1,300 ft. long and 440 ft. wide, bear witness to the great importance achieved here in Greco-Roman times by the cult of Isis. The monuments are now largely submerged for most of the year as a result of the construction of the great dam. At the south end there are, to the west, a peristyle cloister of the 30th dynasty and a long colonnade (32 columns) of the Roman epoch, and to the east, a lesser colonnade preceded by the ruins of a small temple dedi-

cated to Arsenuphis. These elements form an approach to the Temple of Isis, whose first pylon (ca. 150 ft. wide, 60 ft. high), shows the traditional representations of the ruler sacrificing prisoners to the god. In the court that follows has been incorporated, to the west, the peripteral Birth House, reached by a secondary entrance in the first pylon. The east side of the court has a door communicating with the service quarters. The second pylon (ca. 105 ft. wide, 72 ft. high), similar in its decoration to the first, but not on the same axis, communicates with the hypostyle hall (two groups of 5 columns with floral capitals which preserve their lively polychrome ornament), the vestibule, and the sanctuary; on the roof there is a chapel dedicated to Osiris. All parts of the temple, the outside as well as the inside, are decorated. Begun in the Ptolemaic age, the temple was completed under the Empire: the cartouches of Tiberius, Domitian, Trajan, and Hadrian recur. There are also minor sacred buildings: to the east, a peristyle pavilion (14 elements) of Trajan, and the remains of a small Ptolemaic temple with an *in antis* porch, dedicated to Hathor; to the west, a chapel, decorated under the Antonines, dedicated to Osiris. The north side of the island is occupied by constructions of the Roman era, among them a monumental gateway.

Bibliog. PM, VI, pp. 206-55.

Bigeh (Snmt, Senmet; -σῆνις). Facing Philae is the island of Bigeh, considered a natural frontier of Egypt proper. Numerous rock inscriptions of the Ptolemaic and Roman periods occur here.

Bibliog. PM, V, pp. 236, 255-58.

*Peripheral regions.* The following account deals with Lower Nubia from the First to the Second Cataract, with the various oases, and with the Sinai Peninsula. The colonization of Lower Nubia goes back to the Old Kingdom (for Upper Nubia see SUDAN) Lower Nubia is particularly interesting because of the survival of numerous cult buildings, although many of these are now submerged for the greater part of the year as a result of the building of the dam.

*a. Nubia.* Dabod (l). The small Temple of Isis here has as its original nucleus a Meroitic chapel; around this were constructed, in the Ptolemaic era, six apartments and a colonnaded forecourt, now destroyed.

Bibliog. PM, VII, pp. 1-5.

Kalabsha (l) (Talmis). A great temple here, built in the Augustan age, is dedicated to the local god Mandulis. The pylon, which is not parallel to the other transverse elements, is partly ruined; there follow a court, originally colonnaded on three sides; a hypostyle hall (12 columns in two groups, each of three rows, of which the first row of columns has full-height intercolumniar walls); two hypostyle vestibules (2 columns); and a sanctuary. The temple has two precinct walls joining the pylon. At a short distance from Kalabsha, in the Beit el Wali area, is a rock-cut temple going back to the reign of Ramses II. Preceded by a flight of stairs, it has a court leading, through three openings, into a hall developed at right angles to the main axis (2 columns), followed by a sanctuary. The decorations of the court commemorate military campaigns.

Bibliog. PM, VII, pp. 10-27.

Dendur (l) (Tutzis). The Temple of Denduris of the Augustan era is preceded by a monumental gate and is composed of three sections: pronaos, vestibule, and sanctuary.

Bibliog. PM, VII, pp. 27-33.

Garf Husein (l). The temple for which this locality is known was dedicated by Ramses II to Ptah; it is partly built on, and partly excavated into, the rock. The pylon leads into a court with a portico on three sides (4 columns on the front and 4 Osiris pillars on the north and south sides); this court is cut into the rock. There follows the underground part: a great hall with 6 pillars (two rows of 3); a vestibule with two pillars, giving access to five cruciform sanctuaries, the largest of them being the one on the central axis.

Bibliog. PM, VII, pp. 33—37.

Dakka (l) (Pselkis). The construction of the temple dedicated to Thoth goes back to Ptolemaic and Roman times; an unusual feature is its orientation toward the north. The pylon, in a good state of preservation, is followed by two courts and a chapel (the original nucleus) constructed by the Nubian king Ergamenes; at the back is the sanctuary, decorated under Augustus.

Quban (r) (Contra-Pselkis). The remains of a 12th-dynasty fortress, rectangular in plan, enclosed in a triple circle of walls with round bastions, are found here. There have also been discovered on this site architectural fragments of sacred buildings with cartouches of Amenemhet III, Thutmosis III, and Ramses II.

Bibliog. PM, VII, pp. 40-50.

El Sebu'a (l). The great temple dedicated by Ramses II to Amen and Ra-Horakhte shows similiarities to that of Garf Husein. A monumental gate, preceded by a sphinx and a colossal statue of the Pharaoh, one on each side, leads into the first court (6 human-headed sphinxes in two axial rows of 3); there follow the first pylon, of brick; the second court (4 hawk-headed sphinxes in two rows); the second pylon, and the third court, with lateral porticoes (5 Osiris pillars). At this point begins the underground part, comprising a square room (four axial rows of 3 pilasters, the 2 central ones of the Osiris type), a vestibule, and five cruciform chapels.

Bibliog. PM, VII, pp. 53-64.

'Amada (l). The relatively small (ca. 75 × 33 ft.), well-preserved Temple of 'Amada has an original nucleus going back to Thutmosis III; this comprises a court with a front portico (channeled columns) and a vestibule and three sanctuaries, the central one subdividing at the back into two lateral chapels. The decoration is the work of Amenhotep II; the court was transformed by Thutmosis IV into a pillared hall (four axial rows of 3 pillars, the outer ones joined by intercolumnar walls). The temple was restored by Seti I, who also built a kiosk.

Bibliog. PM, VII, pp. 65-75.

Derr (r). The rock-cut temple here was dedicated by Ramses II to Ra-Horakhte. It comprises a first hypostyle hall (originally 12 pillars in three transverse rows, the last 3 pillars of the Osiris type), a second hypostyle hall, irregular in plan (two axial rows of 3 pillars), with three sanctuaries at the back. The over-all depth of the temple is 107 ft. The decorations treat religious and military subjects.

Bibliog. PM, VII, pp. 84-90.

'Aniba (l). Of this once important town there remain part of the walls, a Middle Kingdom fortress with a triple circle of bastioned walls, the ruins of a temple, and a magazine of the 18th dynasty. The site also has a necropolis comprising a group of rock tombs (the most interesting one, from the point of view of decoration, was prepared for a 20th-dynasty official); a burial area of tombs with pyramidal superstructures (18th-20th dynasties); and, in the Karanog neighborhood, a cemetery of the Meroitic era. On the opposite bank, at Qasr Ibrim, are rock chapels constructed by governors of the 18th and 19th dynasties.

Bibliog. PM, VII, pp. 75-81.

Abu Simbel or Ipsambul (l). The locality is famous for the imposing rock temple consecrated by Ramses II to Ra-Horakhte, Amen, Ptah, and himself. A striking feature of the complex is the gradual decrease in the size of the rooms as the sanctuary is approached. Preceded by a court and a terrace, the temple has a façade schematically recalling a pylon; against this are carved four colossal statues, over 65 ft. high, of the Pharaoh enthroned, carved directly in the hillside. On the front and sides of the thrones minor figures are sculptured. The façade is surmounted by a row of 22 cynocephali in high relief; above the entrance is a niche with a statue of Ra-Horakhte. The interior consists of a great rectangular hall (58½ ft. long, 54 ft. wide) with Osiris pillars (two axial rows of 4; height, ca. 32½ ft.) on whose surfaces are scenes of war, among them a depiction of the battle of Kadesh. Behind this is a second room (24 ft. long, 36 ft. wide) with four pillars decorated with religious scenes; three doors lead from this second room into the vestibule, which communicates with three shrines, of which the central one, with one pillar, has, sculptured into the rock at the back, a statue of the titular divinity. The first room also connects with eight minor apartments. The total depth is 117 ft. To the north is a second rock-cut temple, dedicated by Ramses II to the goddess Hathor. On its façade, three on either side of the entrance door, were six great niches, each containing a colossal standing statue (height, ca. 32½ ft.). In both groups the central figure is Queen Nofretari; on either side of her is the king. The underground part of the temple comprises an almost square hall (36 ft. on a side) with Hathor pillars (two axial rows of 3; height 10 ft.), giving access through three doors to the vestibule and to three cruciform shrines.

Bibliog. PM, VII, pp. 95-119.

Gebel Adda (r). The rock temple on this hill, near Abahuda, was dedicated by Horemheb to Amen-Ra and Thoth. Preceded by a flight of steps, it has a columned hall; adjoining this, on a higher level, are three cruciform shrines.

BIBLIOG. PM, VII, pp. 119–23.

Faras (l). In the remains of a temple of Tutankhamen (81 × 182 ft.) can be distinguished the court, with a portico on the sides (originally two rows of 7 columns), and the hypostyle hall, with 12 columns (three rows of 4). There have been discovered as well the remains of two other 18th-dynasty temples and a rock chapel from the 19th.

BIBLIOG. PM, VII, pp. 124–27.

Buhen (l). This important site faces the present Wadi Halfa, near the Second Cataract. Among the remains of a great Middle Kingdom fortress (enlarged in New Kingdom times), which has an outer wall with rectangular bastions, are the ruins of two temples. The temple to the north, of brick except for the pillars, probably goes back to the Middle Kingdom and was restored under Amenhotep II; it has two courts, a vestibule, and three shrines. The temple to the south, constructed by Queen Hatshepsut, originally had a sanctuary with five rooms surrounded by a peripteral colonnade (26 columns). Thutmosis III eliminated the row of columns at the back, enclosed the complex with a wall, and created a preceding portico with pillars and columns. In the area have been discovered burial grounds of the Middle and the New Kingdoms.

BIBLIOG. PM, VII, pp. 129–39.

*b. The Oases.* Siwa Oasis. There are extant here the ruins of two temples dedicated to Amen; the one near the village of Aghurmi going back to the 26th dynasty is probably the temple visited by Alexander the Great. In the Qaret el Musabberin area are underground tombs prepared for officials of the 26th–30th dynasties; they are decorated with funeral scenes.

BIBLIOG. PM, VII, pp. 311–16.

Bahrieh Oasis. The remains of a temple of the epoch of Amasis are to be seen here; there are also the remains of a necropolis having some underground tombs of considerable size, with pillared or columned halls. The decorations are for the most part in a good state of preservation.

BIBLIOG. PM, VII, pp. 299–311.

Dakhla Oasis. The ruins of two temples, one of the New Kingdom, the other of the Roman period, are to be seen here.

BIBLIOG. PM, VII, pp. 295–98.

Kharga Oasis. The remains of a large temple (136 × 66 ft.), begun under the Persian domination (Darius I) and finished in Roman times, are a historic feature of this oasis. Preceded by a monumental gate, the temple consists of a colonnaded court and three hypostyle halls, the last of these surrounded by chapels. In the neighborhood of Qasr Zaiyan is a small Ptolemaic temple restored under Antoninus Pius.

BIBLIOG. PM, VII, pp. 277–95.

El Bagawat. In the desert surrounding the great oasis situated near the city of El Kharga are the ruins of about two hundred domed funerary chapels of the Early Christian period, which can be divided into two groups. Particularly important are the frescoes ornamenting the domes in two chapels of a large building; they represent scenes from the Old and New Testaments and subjects of a symbolic nature (paradise, orants). They are close in style to the frescoes in the catacombs of Alexandria.

BIBLIOG. W. de Bock, Matériaux pour servir à l'archéologie de l'Egypte chrétienne, St. Petersburg, 1901, p. 7; C. M. Kaufmann, Ein altchristliches Pompeii in der libyschen Wüste, Mainz, 1902; Cabrol-Leclerq, II, col. 31; P. Karge, in F. Fessler, Ehrengabe deutscher Wissenschaft ... dem Prinzen Johann Georg Herzog zu Sachsen zum 50. Geburtstag gewidmet, Freiburg im Breisgau, 1920, p. 283 ff.; A. Fakhry, The Necropolis of el-Bagawāt in the Kharga Oasis, Cairo, 1951; G. Millet, Cahiers archéologiques, VIII, 1956, p. 1.

Wadi Natrun. A group of monasteries, almost all destroyed during the Arab invasions, stood here in the desert in the Early Christian period. Some — among them Deir el Suryani, Deir Amba Bishoi, Deir el Baramus, and Deir Abu Maqar — were rebuilt during the 9th century. The most characteristic, and the most interesting from the artistic point of view, is Deir el Suryani, rebuilt during the patriarchate of Jacob (819–830), according to tradition by two monks from Mesopotamia, Mattai and Abraham. Inside a wall stand two churches, the smaller of them having a rectangular narthex and choir, as at Tur 'Abdin. The three-chambered sanctuary (the middle room is covered by a cupola) is repeated in the same form in the larger church. Highly important are the stucco decorations (ca. 907–44) and the wooden door, which show strong Arab influence. The frescoes of the *Annunciation* and the *Nativity* are accompanied by Syriac inscriptions, and it is likely that the artists came from Syria.

BIBLIOG. U. Monneret de Villard, Les églises du Monastère des Syriens au Wadi el-Natrūm, Milan, 1928.

*c. Sinai.* The exploitation of the mines here for their copper and derived minerals, beginning with the first dynasties and going up to the end of the New Kingdom, is amply documented by inscriptions, reliefs, and steles found at Wadi Magara and at Serabit el Khadim. In the latter locality subsists the ruin of a temple dedicated to the goddess Hathor, built and enlarged over a period covering various epochs (12th–20th dynasties). The pylon, going back to Thutmosis III, was preceded by a long row of apartments with commemorative steles; there follow similar rooms, adjoining the older part of the temple. Owing to the nature of the terrain, the two parts of the temple are on slightly different axes.

BIBLIOG. PM, VII, pp. 339–66.

Sergio BOSTICCO

Material on Islamic sites was contributed by Francesco Gabrieli.

Illustrations: 10 figs. in text.

**EGYPTIAN ART.** The art of ancient Egypt constitutes one of the earliest and most significant achievements of mankind. Its importance may be gauged not only by the fame that its surviving monuments have enjoyed throughout history — especially that of the pyramids — but also by the intrinsic quality of its creations and their profound impress on the imagination and artistic language of classical antiquity and of Western civilization as a whole.

The determinants of Egyptian artistic development are to be found essentially in the natural conditions of the country: the narrow river valley, protected on both sides by desert, formed a self-contained geographical and cultural entity. Among ancient agricultural civilizations Egypt had a singularly autonomous culture characterized by a long, relatively uninterrupted development; nevertheless, this is not to say that the country was hermetically sealed off from contact with other cultures (see AFRICAN CULTURES; ASIA, WEST: ANCIENT ART). From the predynastic period to the conquest by Alexander the Great, however, Egyptian art follows, through phases of flowering and decline, innovation and reaction, a development that is always self-consistent. The persistence of such a unified attitude through three millenniums presupposed a tenacious adherence to tradition and is manifested in largely anonymous art production. Individual styles and schools can, of course, be distinguished, but they are firmly grounded in the impersonal over-all development of Egyptian art. The motivation of this art arose particularly from religious and funerary needs centering around glorification of the divine Pharaoh and the gods and the preparation for the afterlife. Egyptian art lost its distinctive traditional identity when alien elements were introduced, engendering new expressive solutions animated by new ideals (see COPTIC ART; HELLENISTIC ART; NUBIAN ART; ROMAN ART OF THE EASTERN EMPIRE).

The dates given in this article follow the so-called "short chronology," which places the beginning of the dynastic period at about 3000 B.C. The difference between this system and that used in the geographical article on Egypt (q.v.) involves chiefly the chronology of the earliest dynasties and has little bearing on the history of the art of the country.

SUMMARY. The prehistoric foundations of Egyptian art (col. 619): *Rock art of Upper Egypt; The sedentary phase: the beginnings of art in the Nile Valley; The sudden advance of art.* The origins of the systems of representation and writing in the period of unification (col. 622). The Thinite period (col. 626): *Architecture; Relief and painting; Sculpture in the round; Minor arts.* Art of the Old Kingdom (col. 632): *Architecture: a. The royal tombs; b. Palaces and temples; c. The tombs of court officials; d. Provincial tombs; Relief and painting; Sculpture in the round; Minor arts.* The First Intermediate

Period and the 11th dynasty: The loss and recovery of artistic traditions (col. 653). Art of the Middle Kingdom (col. 657): *Architecture: a. The royal tombs; b. The provincial burials of the nomarchs; c. Temples; Relief and painting; Sculpture in the round; Minor arts.* Art of the New Kingdom (col. 668): *Architecture: a. Temples and secular structures; b. The royal tombs; c. Private tombs; Relief and painting; Sculpture in the round; Minor arts.* The transition from the New Kingdom to the Late Period (col. 696). The Late Period (col. 697): *Architecture: a. Temples; b. Private tombs; Relief and painting; Sculpture in the round; Minor arts.*

THE PREHISTORIC FOUNDATIONS OF EGYPTIAN ART. The earliest Egyptian historical and religious representations (ca. 3000 B.C.) derive from the same system of conceptual logic, order, and pictorialization that gave birth to the art of writing in hieroglyphs. This system emerged during the relatively short period of struggle for unification between Upper and Lower Egypt and was augmented and firmly established during the first two dynasties. It remained fundamental to all artistic production in Egypt until the end of Pharaonic culture. The victors of this struggle adopted the point of view and the manner of representing the tangible world that had been prevalent in the Nile Valley since prehistoric times (see MEDITERRANEAN PROTOHISTORY); this age-old Nilotic tradition was the foundation of Egyptian art of historical times. Characteristic Egyptian elements and dominant stylistic tendencies emerged from the multiplicity of prehistoric forms, and these distinctive qualities were to determine the character of painting, relief, and sculptural work throughout historic times.

*Rock art of Upper Egypt.* The earliest surviving pictorial representations in Egypt are drawings on cliffs, which belong to the rock art practiced extensively in North Africa since the end of the ice age. This art was introduced into Egypt from the west and spread to the edges of the oases of El Dakhla and El Kharga and as far as the Upper Egyptian and Nubian Nile valleys. The earliest representations of elephants and giraffes — small, silhouettelike figures generally chiseled or, more rarely, scratched into the living rock — appeared toward the end of this prehistoric development. These earliest representations of African wild game were followed during the next phase by representations inspired by Nilotic animals resembling hippopotamuses. Representations of ships appeared somewhat later, and their earliest occurrences can be dated approximately by the existence of similar ships on the painted pottery of the Amratian and Naqada (Gerzean) culture. In geographical distribution, the area of these cliff drawings is bounded to the west and east by the southern part of the Upper Egyptian Nile Valley and to the north by the great bend of the Nile near Qena (Wadi Hammamat and several lateral valleys); that is to say, the rock art coincides with the area in which the main centers of prehistoric art are found.

The appearance of cliff drawings in Egypt may probably be related to the same phenomenon that led to the settlement of the Nile Valley — the gradual encroachment of desert sands on former hunting grounds. Hunters resorted to the magic of cliff drawing in a futile attempt to conjure up the rapidly disappearing game; and at the same time, the first tribes of hunters began to retreat to the security of the Nile Valley.

*The sedentary phase: the beginnings of art in the Nile Valley.* The occupation of the Nile Valley by the first permanent settlers took place simultaneously in Upper Egypt, at the edges of the Fayum oases, and in Lower Egypt. The sites of habitation lie at the outer limits of the valley in the dry elevations at the edge of the desert, beyond the belt of fertility and beyond reach of the annual inundation. The living customs of these new arrivals did not differ substantially from those of the earlier nomadic inhabitants. With the increased security and stability brought about by the changeover to an agricultural economy, there arose increased demands for housing, implements, dress, and personal adornment. Techniques of production were steadily improved in the trained hands of specialized artisans.

Two isolated and clearly differentiated areas may be distinguished from the very outset: Upper and Lower Egypt. Upper Egypt, a narrow valley confined by cliffs, is bordered on the south by the cataract of the Nile at Aswan and on the north by a clearly defined geographic frontier at Asyut and is topographically homogenous. The inhabitants of the area are the descendants of the Hamitic game hunters responsible for the cliff drawings, and this same pictorial tradition still survives in the native handicrafts of the region. Finds made in the habitations and cemeteries of the area (vessels, utensils, jewelry, and figurines) testify to a continuous development of the pictorial representation of man's surroundings from the predynastic Badarian culture via the Amratian and Naqada culture to the unification of Upper and Lower Egypt in historical times. Lower Egypt, consisting of the widening, wedge-shaped valley immediately to the south of the division of the Nile and the Nile Delta itself, is less homogenous and less isolated than Upper Egypt. At the eastern edge of the Delta is a land connection to western Asia, which opened the way to influences from the youthful civilizations developing there. The interior of the Delta and its centers of Buto and Sais, represented on monuments of the earliest dynasties, have yielded little archaeological material because of the extent of the inundations in this region. The special character of Lower Egypt may, however, be best observed in the early settlements at Helwan and Ma'adi on the eastern shores of the lower Nile, later the area of Memphis. The settlements here are large and indicate denser habitation and a more developed agrarian economy than that found in contemporaneous communities to the south. The paucity of arts and artifacts in these settlements is therefore surprising: personal adornments are rare, and the ceramic products hardly compare with the technically superior, richly decorated wares of Upper Egypt. The lack of a pictorial tradition in the north seems to be responsible for this contrast. The differing burial habits in the north and in the south are also significant for the future development of art in the two areas. At the western edge of the Delta, at Merimdeh and Helwan, the dead were buried within the village, sometimes in the huts that they had inhabited; that is, the dead remained in the community of the living. In Upper Egypt, the dead were interred exclusively in cemeteries at the edge of the desert, away from the settlement. Consequently, the dead had to be fitted out with food and drink, arms and implements, and personal adornment. The prehistoric artisan of Upper Egypt, steeped in the very old pictorial tradition of the rock art, developed his skills in the service of the cult of the dead. The development of Egyptian art until the 1st dynasty is known entirely from Upper Egyptian material.

Representational art has been found in the earliest archaeological strata. A generously proportioned female figure of ivory found in a grave near Badari (Br. Mus.) incorporates all the details essential both for its "actual" appearance and for the performance of its magical service to the deceased. The male and female figures of ivory found in the graves of the later Amratian and Naqada cultures are somewhat more slender; others, of fired clay and decorated with color, are also of simpler, less full-bodied form. A spare figure of a woman brewing beer was intended to transpose magically the brewing process to the world of the deceased. In these figures there is hardly a hint of characteristically Egyptian form; but in their various types, they are the ancestors of the typical servant figurines to be found later in the development of Egyptian art.

The earliest ceramic wares of Upper Egypt are distinguished from those of Lower Egypt by their finely finished surfaces and the excellent technical quality of their firing. With the exception of some incised wickerlike patterns filled with white pigment, this early ware is undecorated. The vessels are covered with a solution of iron oxide that fires to a dark red, and the earliest painted decoration appears in white motifs applied against this dark ground. Outline drawings of animals, occasionally also of human beings, are placed between geometric and plant forms on the exteriors of round-bodied vases or on the interiors of flat bowls (PL. 319). It is significant that in the earliest examples of this ware representations of the hunt should survive. Soon, however, the Nilotic landscape and its characteristic phenomena (hippopotamuses, crocodiles, fish, primitive ships) prevailed. The surrounding world was experienced in terms

of isolated abstractions, not in significant juxtapositions or natural sequence as in the cliff drawings. In the white-figured painting of the Amratian culture, the figures appear frozen into immobile symbols and might easily be detached from the surrounding picture plane. Palettes of dark schist that were used for the mixing of eye paint were made in the shapes of animals — elephants and hippopotamuses (PL. 319), lions, turtles, fish, birds — as well as purely abstract rectangles and rhomboids. The outlines of the animal palettes, with the appendages reduced to merely vestigial indications, correspond to similar representations on the ceramic wares. The same tendency toward abstraction may also be observed in the development of cliff drawing and derives from the general stylistic direction of art of the Early Stone Age; moreover, this tendency is responsible for the "hieroglyphic" character of Egyptian art.

After the middle of the 4th millennium B.C., new ceramic wares that are without direct antecedents appeared in the graves of Upper Egypt. These are large squat vessels on which silhouettelike figures are painted in dark red against a pink ground. These "red-figured" vases represented the principal wares of the Naqada culture (PL. 319). The motifs of the hunt that were prevalent earlier disappeared and were replaced by pictures of many-oared ships complete with deck cabins, oars, pennants, and standards. The latter may be considered the forerunners of the nome standards. In addition to these motifs, there are representations of human figures, most frequently of women lifting their arms in dance movements. Scenes also occur in which one or more ships comprise the main subject and figures of women occupy the field above. Although these representations are probably not interrelated parts of an over-all conception, there is marked unity evident in their arrangement. Pictures of ships with similar female marginal figures also appeared on a larger scale as the subjects of the first independent pictorial representations. At the same time polychrome painting, no longer confined strictly to the decoration of everyday utensils, began to develop as an independent technique. The earliest example of this new style of painting is a large linen cloth from a tomb near Gebelein (PL. 327); its fragments contain scenes rendered in red, black, and white — and possibly green, although this is now faded beyond recognition.

*The sudden advance of art.* The presence of nautical themes such as dominate the art of the Naqada culture would seem to indicate a significant increase in navigation and commerce on the Nile. The two areas — Upper and Lower Egypt — began to draw closer together. The manufacture of multicolored vessels of hard stone originated at the edge of the Upper Egyptian Nile Valley and in the mountains of the Eastern Desert. The development of these receptacles was gradual and culminated in the stone vessels of the first two dynasties. In working with vessels of stone, the Egyptian craftsman acquired the experience that soon afterward permitted him to create the first stone reliefs and statues. Faïence was invented during this period as an inexpensive substitute for fine, colored stone.

The art of carving in relief developed from the practice of furnishing utensils with incised decoration. A three-dimensional effect was sought from the very beginning; not only are the contours of the figures rounded off at the edges, but details of anatomy are also indicated in the round rather than by means of incised lines. It is noteworthy that the conspicuous improvement in the artistic quality of luxury items was accompanied by a renewal of interest in the representation of desert animals. For the first time they were carved in ivory in the new three-dimensional relief style, and formed the handles of knives and combs. These subjects of desert fauna are absent from the repertory of contemporary vase painting. This new applied art was encouraged by the patronage of the new masters of Upper Egypt, who by giving employment to the local artisans made their contribution to the rapid flowering of indigenous art in this region. These new overlords seem to have come to the Nile Valley with the last wave of nomadic hunters and warriors from the Eastern Desert. Their rise to political supremacy over the native inhabitants appears to have been gradual; and

with their advent, the prehistory of Egypt entered its final and decisive phase.

The subterranean sepulchral chamber of Hierakonpolis (Kom el Ahmar), which yielded the earliest preserved remains of Egyptian wall painting (PL. 320), may be the tomb of a member of this ruling class. The burial chamber is faced with rectangular bricks, and one wall is carefully primed and bears representations set against an ocher background. A dado below is painted black and bordered with a red strip. The central composition consisting of six large ships was first laid out with red lines. Single figures, as well as groups of human beings and animals, are dispersed among the ships and around the edges of the composition. The figures are more emphatically articulated than those on the linen cloth mentioned earlier (PL. 327), and their heads are clearly rendered in profile. The postures of the figures and the position and movement of their joints are differentiated according to the action in which they are engaged. Ground lines appear for the first time. In the group of two warriors in the lower right-hand corner (PL. 320), the vanquished is shown head down — that is, not as observed in nature but as suggested to the artist's imagination by his role. At the lower left, the closed group of a warrior smiting three cowering prisoners with his mace comprises the first known representation of a military triumph — a pictorial type that continued virtually unchanged in Egyptian art for three thousand years. In the heraldic group of a man wearing a typical Egyptian kiltlike girdle and flanked by two lions, the influence of Mesopotamian glyptic art of the Jemdet Nasr period is noticeable. The world of the living is represented on the walls of a tomb for the first time in these pictures, with the purpose of magically sustaining the deceased in the afterworld.

A knife handle carved of ivory from Gebel el Arak (PL. 321) shows themes similar to those painted on the walls of the tomb at Hierakonpolis. In the sculptural technique of this object both the individual figures and the composition are more clearly articulated and finished. The figures have a greatly increased sense of volume about them, and the modeling is confined to a few essential details. On one side of the handle is a representation of a hunt. A heraldic group composed of a bearded lion-tamer wearing a kind of turban and a long robe and flanked by two upright lions terminates the composition at the top. The subject is not typically Egyptian and seems to have been inspired by similar representations on Mesopotamian cylinder seals. The other side of the handle depicts a battle scene, divided into two registers. The two groups of participants fight with the same types of weapons and are distinguished only by their hair styles and the types of their ships. The ships represented in the lower register resemble those on the red-figured Egyptian pottery. Those of the register above, with upcurved prows and bows, recall ships represented on Mesopotamian cylinder seals. It would appear that the Upper Egyptian artisan meant to characterize an unknown northern enemy by the alien type of ship — one transmitted to him through imported glyptic art.

The struggles that preceded the political integration of the Nile Valley had now begun. Upper Egypt pushed north as far as the Fayum area and planted a colony at Abusir. The finds from this site are predominantly Upper Egyptian in character and bear witness to the earliest influence of Lower Egyptian stylistic tendencies on Upper Egyptian art.

THE ORIGINS OF THE SYSTEMS OF REPRESENTATION AND WRITING IN THE PERIOD OF UNIFICATION. The visual arts are the only remaining evidence of the struggles that resulted in the political unification of Upper and Lower Egypt under the leadership of the former. With new and more ambitious official tasks set before it by the victors, Egyptian art now entered the decisive phase of its development. A closely related group of large cosmetic palettes, or tablets, and maceheads (PLS. 322-25) decorated with relief allows this development to be traced from one phase to the next. The shieldlike shape of these palettes continued one of the most popular forms of the late Naqada culture. The representation was still an integral part of the object; but object and decoration were imbued with added purpose and importance. As their subject, the representations

portray the historic upheaval itself — as seen through the eyes of the victor. Because of the large size of these palettes, it is unlikely that they were intended for use in daily life. The circumstances of their discovery in the oldest strata of the religious sanctuaries of Abydos and Hierakonpolis suggest another purpose: that they were votive dedications of a religious character. Chronological development is clearly evident among the objects: in the choice of subject matter, selected for its value as interpretive of actual events; in the gradual formulation of fixed visual concepts; in the progressive clarification and logical construction of the composition; and in the evolution of the representation of human figures according to the laws of two- and three-dimensional representation.

The decoration of the "animal palette" (PL. 322), the earliest in the group, is taken from elements of the hunt. On one side,

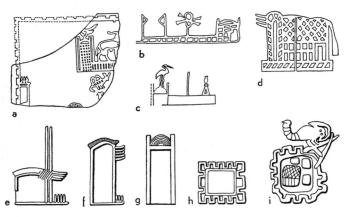

Primitive architectural forms as seen in reliefs and hieroglyphics: (*a*) Ram sanctuary within niched enclosure wall from Abydos, ca. 2850 B.C.; (*b*) sanctuary with sacred standards and naos from Abydos, ca. 2850 B.C.; (*c*) sanctuary of the heron of Buto from Hierakonpolis, ca. 2900 B.C.; (*d*) naos in the form of an animal from Saqqara, ca. 2850 B.C.; (*e, f*) sanctuaries from Upper Egypt, 3d dynasty, ca. 2650 B.C.; (*g*) sanctuary from Lower Egypt, 3d dynasty, ca. 2650 B.C.; (*h*) plan of village with niched enclosure wall from Hierakonpolis, ca. 2850 B.C.; (*i*) scorpion demolishing the wall of a city from Lower Egypt, ca. 2850 B.C.

a hunting scene is represented; on the other side, there are stalking lions and imaginary monsters loosely grouped and lacking ground lines. These predatory creatures, which here prevail over their victims according to the laws of nature, were destined soon to become — in the form of canine animals and lions, and later as winged griffins — the incarnation of the victorious power of Upper Egyptian kingship.

The representations on the "battlefield palette" (PL. 322) are arranged in a special order determined by the nature of the new subject represented. Human figures, characterized as being of foreign race by their curly hair, un-Egyptian beards, and primitive nakedness, lie dead or as prisoners on the battlefield; carrion birds descend upon their prize. The center of the picture is occupied by the victor: a powerful lion who is devouring a fallen enemy. The directions of movement, gesture, and glance tie the picture into a unified composition — from the margin to the main group and back again to the margin. The large scale of the figures and the very high relief of the "battlefield palette" demanded more convincing analysis and resolution of forms, especially human figures, than had previously been required. Whereas animals had since the earliest cliff drawings been represented by their characteristic silhouettes, two-dimensional representation of human motions had to be worked out gradually and then codified. The "battlefield palette" stands at the beginning of this development. Convincing representation in two dimensions was already the prime goal. The attitude of the body is fixed by the motion and direction of the limbs. Quite unrelated to the disposition of the body, the head appears in profile with the eye represented frontally.

On the fragmentary "bull palette" (PL. 323), the same theme of triumph is varied through the symbolization of the victor

by a wild bull. According to this vivid representation, the enemy is trampled under the hoofs and gored by the horns of a raging bull. In place of a detailed representation of the actual gruesome battle scene only the results are shown: conquered villages are represented by inscribed picture names as if in an inventory.

The macehead may also have had a votive intent. The relief representations of the macehead of the Scorpion King (PL. 325) run around the head in three clearly separated registers. The votary himself appears in human form for the first time on this monument — a king wearing the traditional crown of Upper Egypt. Only the animal tail attached to his belt remains to remind us of his origin among primeval animal forces; this animal tail was to remain part of the Pharaonic costume henceforth. The king is accompanied by his retinue, and the victory is transformed into a state function. The hoe in the king's hand alludes to an agricultural festival. The location of the action is fixed in the lower register by the presence of landscape elements — water and islands; men are engaged in irrigation work on the shores. The upper boundary of this acquatic area, which is represented with zigzag lines, forms a ground line for the king and his retinue. Papyrus plants with individual ground lines identify the location of the festival as marshy Lower Egypt. Confronting the king is his royal name represented in the form of a scorpion.

The votive palette of King Narmer exemplifies the work of the final phase of this development (PL. 324); of the entire series, it is the most advanced in style and the most significant in subject. The main scenes all have individual ground lines and are constructed as single, clearly separated compositions. Mesopotamian monsters appear once again and here playfully encompass the cosmetic depression of the palette with their long entwined necks. These fanciful beasts are held on leashes by human beings. The monsters have been tamed and may be interpreted as symbolizing the reconciliation of opposing forces. An upper register represents an important episode in the triumphal celebration — the inspection of the place of execution by the king himself. The points of arrival and departure of the royal procession are for the first time abstractly represented by means of hieroglyphs.

In the triumphal scene on the other side, King Narmer is portrayed on a colossal scale. He has seized his kneeling opponent by the hair and is about to dispatch him with a blow of his mace. The essential details of the action are effectively and economically rendered. In this main group — anticipated in the wall painting at Hierakonpolis (PL. 320) — the inevitable result of all battles is reduced to the simplest and most readily comprehensible formula. A second group repeats the main theme in a series of smaller realistic pictures. These areas may be thought of as protohieroglyphs; but they do not yet follow the abstract sequence of hieroglyphs, for they are arranged in a logical order based on mutual relationships. The composition may be divided into component parts, much like a jigsaw puzzle. For instance, one portion portrays the hawk-god delivering a personification of Lower Egypt, at the end of a tether, to the sovereign presence. Both sides of the palette represent the king striding across the top of broad, bandlike ground lines that signify the earth. The uppermost registers on both sides of the palette are occupied by twin back-to-back representations of the sky goddess, with bovine ears and horns to symbolize the heavens.

In the triumphal picture of King Narmer all the essentials of the new Egyptian world order and artistic system are set forth. With the formulation of its own visual conventions and with the representation of the human figure in space according to particular laws, Egyptian art attained the unique code of forms that was to distinguish it from the art of all other cultures. This new world order is represented in art as the one and only Truth (*maat*, or "right order"). The terrestrial existence of the king is affirmed by insignia of rank, by his courtly retinue, and by royal pomp and ceremony. Allusion to his divine nature is made by his "palace name," which identifies the ruler as the sky god Horus incarnate, as well as by the presence of appropriate deities and sacral apparatus. This art is the expression of a very selective view of the world,

and the representation of Truth was the aim of each picture, both in its rational composition and in its logical sequence. Effective transmission of this truth required immediate comprehensibility of a complex system of allusions, despite the limitations imposed by a two-dimensional representation. Impressing the beholder with the subject's latent ability to act was the very essence of royal representation. For this reason the upper half of the body was depicted frontally on the picture plane; whereas the lower part of the body, from the waist down, and the head were represented in profile to indicate the direction of movement. The position of the feet is suggestive of latent action and signifies standing as well as striding. Consequently, representation of the human figure was conceived of as proceeding from right to left, the right side of the body being that from which all action emanated. For this reason also, Egyptian two-dimensional

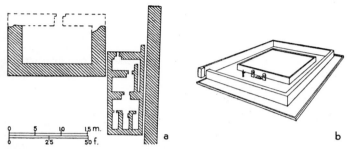

Abydos: (*a*) Plan of the temple of Khentiamentiu ("Foremost of the Westerners"), 1st dynasty; (*b*) royal tomb with steles, 1st dynasty, reconstruction after H. Ricke (*from W. Stevenson Smith*).

figures as a rule face toward the right — in drawing, in relief, and even in hieroglyphs, although these are read from the left. In standing human figures facing right, it is always the left leg that is placed forward. In the palette of Narmer, the outer and inner surfaces of the legs are carefully differentiated, but only the big toe of both feet is represented. The advanced left leg corresponds to the representation of the upper part of the body, with one shoulder projected in the direction of the gaze, thus permitting the artist to represent the front of the kilt and its decoration of beads or ornamental seam — or, in the case of naked figures, the genitals. Finally, a system of canons was evolved to govern the representation of each object — a system based on perceptions gained through application of a scientific, empirical point of view. The true nature of existence was to be determined henceforth by numbers and measures, and Man became the basic measure of all things. Ancient Egyptian measures were based on the human body: the length of an arm, the width of a hand, the width of a finger. The canon of proportions in Egyptian art was based on a definite interrelationship of these measures. The canon set forth construction of the human figure within a geometric axial system that proceeds from vertical division of the body into a right and a left half. This mathematical system of construction may be clearly observed in the guidelines and measuring points visible in certain unfinished wall paintings of the Old Kingdom. The development from the figure of the Scorpion King (PL. 325), which still betrays a lack of assurance in its lineaments, to the clear and confident representation of the human figure on the palette of Narmer (PL. 324) attests to the existence of an underlying canon by the time of the latter.

The development of hieroglyphs at the time of the first unification of Upper and Lower Egypt came as a direct consequence of this process of systematization in the visual arts. Hieroglyphs were from the beginning a supplement to the pictorial representation; the "readable picture" and the pictorial nature of writing remained two characteristic properties of Egyptian art throughout its development. Monumental hieroglyphs developed an abstract symbolism permitting them to give full expression to otherwise inaccessible realities, as well as to conventionalize and enhance familiar objects of the natural world.

In this short but decisive creative phase, influences from the distant culture of Mesopotamia were present in Egypt; they were repeatedly in evidence in isolated heraldic groups, from the paintings in the Hierakonpolis tomb to the palette of Narmer. The reverse of such influence, that is, of Egypt on the early culture of Mesopotamia, is nowhere in evidence. The severely antithetical construction of these heraldic groups appears as an alien element in early Egyptian art. The style was created in Mesopotamia especially for use on cylinder seals, and it can only have entered the Nile Valley via imported objects of Mesopotamian glyptic art. The path by which this foreign merchandise traveled to Upper Egypt must have led through Lower Egypt; however, it left no trace there, for Lower Egypt, lacking a pictorial tradition of its own, was unable to assimilate and reinterpret these foreign representations. Upper Egypt, already well versed in pictorial tradition, adapted these imported objects and perhaps imbued them with new meanings. Occasionally the alien antithetical groupings were imitated, but always in accordance with concepts relating to the world of the Nile Valley. Such foreign pictorial conceptions had no pronounced permanent effect on the development of Egyptian art or written language. The invention of writing was made possible through the invention of the pictograph and its applicability to what had until then been nonrepresentational subjects.

The decisive impulse to the creative development of Egyptian art should be sought in the specific circumstances and the demands that they imposed. The singular consistency to be observed throughout the development of Egyptian art must be understood in terms of a common theme and a common task, of common sponsors and a common Upper Egyptian workshop tradition. Historic events — victories won in Lower Egypt and the unification of both sections of the country — were represented with forceful realism for purposes of dedication to a god, such as those scenes dedicated to the deity at Abydos and the hawk-god of Hierakonpolis. Instead of receiving a share of the actual spoils of battle, the gods were awarded representations, and these were "incorporated" in the "divine eye" by means of a magic ritual in which the cult image was adorned with cosmetics. As a kind of "calling to account," these representations were required to display the name of the votary and specific designation of the event inspiring the dedication. They called for the Truth and for objectivity in the eyes of the deity. Here, Truth did not signify imitation of nature, but rather selection and transformation — observed reality subordinated to a valid system. The requirements of this art set the representation of characteristic and essential elements above that of a multiplicity of detail. A new and "right-ordered" world, founded on a base of rules and laws, was thereby created.

THE THINITE PERIOD (1st and 2d dynasties, 3000–2780 B.C.). *Architecture.* Architecture can only develop in a society that places demands on construction which go beyond mere fulfillment of a functional task, one that seeks in its constructions an expression of ideal values. These conditions came into existence in the Nile Valley only with the emergence of a ruling class at the end of the predynastic period, that is, only after the unification of Upper and Lower Egypt under a common rule.

Such prehistoric dwellings as have become known through excavation or as may be reconstructed from later representations were purely functional in character. In keeping with the mild climate and the way of life of their inhabitants, they were built of elemental natural materials. Reeds and papyrus stalks served as building material for the construction of the light huts inhabited well into historical times by shepherds, fishermen, and birdcatchers. The few types of wood native to the Nile Valley were not well adapted for larger structures. When the use of wood was unavoidable in Egyptian architecture, even in historical times, cedar from the Syrian mountain forests was imported by ship.

Development of an agrarian economy and a more settled way of life soon led to the construction of more permanent dwellings in Egypt. A clay model of a house that was found in a tomb attests to the existence of one-room houses, constructed of gobs of mud over a rectangular foundation, as the characteristic native dwelling even in prehistoric times. The sloping outer walls of the clay model may be explained as a result of

the pisé building technique; however, this detail is preserved in later buildings of rectangular bricks and is even carried over into masonry construction. The roof of the clay house model is not preserved, but it must have been flat; such roofs probably consisted of palm trunks, reeds, and Nile mud. The rectangular brick was invented toward the end of the prehistoric period for the house of rectangular ground plan.

The appearance of the earliest Egyptian sanctuaries has been

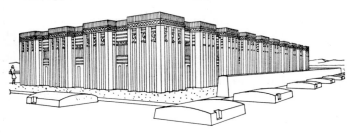

Saqqara, tomb attributed to Queen Merneith, 1st dynasty, reconstruction after J. P. Lauer (*from W. Stevenson Smith*).

transmitted to us through the representations and pictographs of historical times (FIG. 623). Various types of buildings appear, and the unfamiliar construction techniques are not always identifiable. In Upper as in Lower Egypt, the earliest sanctuaries appear to have consisted of reed huts with rounded roofs and were enclosed by a crenelated mud-brick wall.

Different types of buildings are recognizable in the triumphal scenes of the unifiers of the country, in which the vanquished towns of Lower Egypt are represented as enclosure walls strengthened by bastionlike projections. The dwellings or sanctuaries placed in these enclosures seem, according to these representations, to be simple reed huts (FIG. 623). According to the literary sources, the first king to unite Upper and Lower Egypt also founded Memphis and built a royal fortress on the site, the so-called "White Walls." This structure must have been of Lower Egyptian mud-brick construction, with the façade and rear wall emphasized by projections and recessions.

A form of monumental construction characteristic of Upper Egypt may be reconstructed from the hieroglyph for "Upper Egyptian royal sanctuary" (FIG. 623). Early forms of this hieroglyph show a free-standing skeletal construction covered with reed mats and furnished with horns to ward off the evil eye, as well an animal's tail hanging down the back. This tentlike form of construction is expressive of the nomadic origins as well as of the privileged position of the Upper Egyptian overlords, as contrasted with the subject population. This type of tent dwelling connected with the king therefore may also be assumed in the reconstruction of contemporary civic architecture. In contrast, the hieroglyph for "Lower Egyptian royal sanctuary" represents, as may be judged by the shape and the green coloring, a sanctuary constructed of reeds (FIG. 623).

After the unification of Upper and Lower Egypt, the construction of royal tombs became the most important task for Egyptian monumental architecture. This preoccupation derived from the dual nature of the king as "ruler of the Two Lands": a burial of the king in both Upper and Lower Egypt was required. The two forms of burial practiced since prehistoric times — cemetery burial in a tumulus for Upper Egypt and house burial for Lower Egypt — are both reflected in the monumental architecture of the royal tombs.

As kings of Upper Egypt, the rulers of the Two Lands of the 1st and 2d dynasties lie buried in their native nome near Abydos. The subterranean tomb chambers are lined with molded bricks; the floors and walls of these tombs are faced with imported timbers, and the ceiling is supported by wooden beams. The wooden walls were originally painted. One of these tombs, dating from the 1st dynasty, is equipped with a floor of granite that heralds the beginning of stone architecture. The tumulus rises over the timbered ceiling of the tomb chamber and the lateral rooms. It consists of heaped sand contained by a wall of brick, once probably covered with a flat brick vault. The place of offerings at the east side of the hill is indicated by two free-

standing name steles (PL. 325). The entire precinct was surrounded by a wall, outside of which lay the smaller graves of the members of the court.

The royal cemetery of Abydos lies beyond the edge of the inhabited valley in a flat desert landscape. This burial ground stood under the protection of Khentiamentiu ("Foremost of the Westerners"), a god of the cemetery who was venerated in a temple at the edge of the valley. The foundations of this brick temple have been preserved (FIG. 625) and constitute the only remains from a temple of this early period. Offset entrances lead through two outer chambers into a court, which at the back opens into the shrine containing the cult image and a chamber at each side. The precinct of the god was originally a free-standing construction of reeds. When translated into brick, it was moved back against the rear wall, enclosed, and enlarged by the addition of anterooms.

As kings of Lower Egypt, the early rulers of united Egypt are buried on the western desert plateau across from their capital at Memphis in tombs of a type adapted from the burial practices of Buto. From the size of these funerary complexes, which exceed those of Abydos by far, it seems certain that the Memphite sites must be the actual burial places, while those at Abydos are perhaps "dummy tombs" of the same rulers. The Memphite tombs have imposing superstructures of brick, with exteriors punctuated on all sides by multistepped projections and depressions. "House tombs" in type, they incorporate the characteristic articulation of the enclosure walls of Lower Egyptian royal palaces. On the east side, facing the valley, a niche is singled out as a "false entrance" and cult sanctuary. The tomb chamber itself lies under the desert floor; the secondary chambers, including the grain storehouses, are partly in the superstructure. The articulation of the outer wall with niches achieves the level of an esthetic system: colorful carpet patterns that have been painted on the niches combine the idea of the tomb as a Lower Egyptian residence with that of the tent palace of an Upper Egyptian king. The Memphite concept of a unified kingdom is thereby visually expressed.

Since the excavation of the Memphite cemetery at Saqqara is incomplete, the history of the tombs at this site is not yet clear in every detail. Tomb 3038 had a superstructure in the form of a terrace with steps on three sides, and this was later covered with the niched structure. There appears to have been an attempt to combine the tumulus with the "house tomb." A brick construction abuts the shorter, northern side of tomb 3505 (FIG. 628), the structure decorated with niches. With its passagelike chambers and its single large room, this building must have served the cult of the dead. In the architecture of this building, elements appear for the first time that anticipate the later development of Old Kingdom tomb complexes.

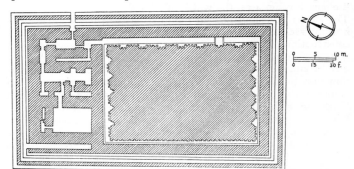

Memphis, plan of royal burial (tomb 3505), 1st dynasty (*from H. Müller*).

The architectural type of Lower Egyptian (Memphite) royal tombs may also be found in isolated instances in Upper Egypt, where it occurs for the first time in the large brick structure near Naqada that has been claimed as the tomb of Narmer. The so-called "royal residences" erected in the necropolis of Abydos during the 2d dynasty also should probably be considered tombs of the Memphite type, relocated to Abydos at the time of the dynastic struggles in order to assert Pan-Egyptian sover-

eignty in tomb construction and cult worship. The opposing dynasty in Lower Egypt also built tumuli of Upper Egyptian type in the vicinity of its royal seat: this is known through the recent discovery (of which no study has so for been published) of a royal name stele near Memphis.

*Relief and painting.* The laws governing the construction of the human figure in two dimensions and the canon of proportions developed at the time of the first unification of Upper and Lower Egypt, traceable in the evolution of votive palettes, became standards to be applied in other contexts as well. The incorporation of the visual arts within the framework of monumental architecture was thereby facilitated.

The earliest preserved monumental representation from the 1st dynasty, a cliff carving in the region of the Second Cataract, shows the victory of King Djet over the Nubians. The representation is rough and was not executed by a hand trained in art: its significance lies in the fact that the relief had been freed from its cult context and now existed independently as a monument. The purpose of this work was to proclaim the power of the king of Egypt at the southernmost frontier of the empire and to discourage potential enemies from violating the border. New tasks were set for the representational arts in the decoration of the tomb. The name steles of the royal tombs of Abydos illustrate the advanced development both of the means of pictorial construction and of the relief style, which is characterized by clarity, balance, and maturity in the stele of King Djet, the Serpent King (PL. 325). The falcon of Horus has developed from its earliest form, in which the bird was shown bent over its prey, into the erect embodiment of divinity, determined according to fixed geometric proportions. The contour of the bird, as well as the individual details, has now reached its final form. The composition incorporating the Horus falcon over the palace façade in the narrow recessed area of the stele is subtly asymmetrical; it is clearly the result of exact planning and careful preliminary drawing. In the place for offerings in the Memphite "house tomb" of the 2d dynasty, there appears a limestone panel bearing a relief representation of the owner of the tomb seated before a banquet table and a list of foods to be consumed. The relief was intended as a kind of bond between the deceased and the actual offering placed in front of the tomb niche.

The art of painting acquired a position of importance in the interior decoration of the tomb chambers of Abydos. The sparsely preserved fragments of the painted wooden wall revetments, however, do not permit a reconstruction of the subjects represented. These paintings may have continued the tradition of late-prehistoric wall painting exemplified by the tomb of Hierakonpolis (PL. 320) and applied similar representations to the future life of the king. Such subject matter is found on several small tablets of wood and ivory from royal cemeteries of the Thinite period. The first monumental relief definitely associated with stone architecture dates from the end of the 2d dynasty. It appears on the exterior of a large granite shrine that King Khasekhemui had erected within the precinct of the temple at Hierakonpolis. The front of this edifice bears the "palace name" of the royal patron between hieroglyphs for "happiness" in forceful relief on the door jambs. The only wall preserved bears a large representation of the celebration marking the founding of the sanctuary. The reliefs were effaced at a later date and are recognizable only in their outlines.

Whereas official art was closely bound in choice of subject matter to the representation of the god-king and of political and religious scenes, new subjects for pictorial representation developed in the realm of the minor arts. On steatite disks from the tomb of Hemaka (most recently, however, assigned to King Udimu) near Memphis, shaped like flattened tops, and presumably comprising parts of a game, there are representations of gazelles pursued by dogs and birds ensnared in a net. The figures are modeled in stone of a lighter color and set into the dark material of the disks. In this circular hunt representation, the figures are related to one another in pose and direction of movement and form a cohesive group (PL. 335). These subjects and compositions, developed in the applied arts, were taken over and further developed in the early reliefs of the Old Kingdom.

*Sculpture in the round.* The wealth of small figures of clay, ivory, faïence, and stone, representing both animals and human beings, attests to the fact that this small-scale art was not produced exclusively in the service of kingship but also represents the commissions of a larger social class. In the ivory and stone figures of frogs, lions, falcons, and peacocks — as well as those of men, women, and children — there is evidence of an increasing selectivity and concretization of types. Despite their small size, some of these figures are set on bases that elevate them from their surroundings. Other larger figures of men and women, also of ivory or stone and of origin similar to the small figures, in their painstaking execution of dress and hair style show the desire of an upper class "to be seen." There follows a series of realistic representations of male and female dwarfs. From the steles of the minor tombs of Abydos, it is known that such dwarfs belonged to the royal retinue.

Official functions, celebrations of victories, and state festivals, dedicated to the gods in the relief decoration of various objects, also seem to have been dedicated in the sanctuaries in the form of models. The ivory figure of a king, dressed in his coronation robe and stepping boldly forward in a ritual stride, may have belonged to a representation of the royal jubilee (Heb-Sed) that had included several figures. A seal impression of King Udimu provides evidence of the fact that, in addition to single figures, group representations showing the king hunting hippopotamuses were also produced.

Monumental stone sculpture made its appearance at the time of the unification in the pillarlike limestone image of the god Min from Koptos, a work originally over 10 ft. high. Related to this colossus is an unidentified schist statuette of a man or god. He wears a long beard and has a shaved head; a phallus sheath hangs from his belt (PL. 326). This figure proves that stone sculpture, derived from the example of vase carving in hard stone, had finally reached maturity. The eyes are represented in outline form as in hieroglyphs and dominate the entire head, which rises immediately from the shoulders without transition. The elongated forms of this and other standing figures of stone betray the influence of contemporary sculpture in ivory. Marked bodily volume, blocklike mass, and self-contained form are also qualities of another, roughly contemporary, over-life-size seated statue from Abydos (PL. 326). The body, including the limbs, is tightly wrapped in a robe. Great care is evident in the rendering of the headdress here, as in the sculpture of ivory.

The construction of the human figure as a well-proportioned form seems to have been achieved first in wood sculpture. The tombs of the royal necropolis of Abydos and, more recently, of the Memphite necropolis have yielded polychrome statues of wood that are nearly life size. In stone sculpture, construction of the figure according to definite canons of proportion and the sharp and formal elaboration of details are attained toward the end of the 2d dynasty in two seated statues of King Khasekhem. Both are under life size — one of schist (Cairo, Egyptian Mus.), the other of limestone (Oxford, Ashmolean Mus.) — and both are meant to be seen primarily from a side view. Seen from the front, the attitude of the king, seated on the inclined surface of his narrow throne, appears somewhat constricted to the present-day viewer. Body and limbs are tightly enclosed by the royal gown, which imparts grandeur as well as a closed form to the figure. The head, with the high crown of Upper Egypt, is inclined slightly forward, as in a similar ivory figure (PL. 326); and the king seems to be portrayed at an advanced age. Memphite royal sculpture early in the Old Kingdom continued this Upper Egyptian (Thinite) sculptural tradition.

Compared with the development of the human figure as represented in the round, the representation of animals in stone sculpture seems more finished and assured from the very beginning. A small granite figure of a lion that is still without a base plate (Berlin, Staat. Mus.), with gaping mouth and crouching as if about to spring, recalls the wild animals represented on the palettes at the time of the struggle for unification. Other small figures of ivory prepare the way for convincing, fully developed expression of the beast of prey in the lion couchant

with raised head and closed mouth, which became the only valid form of the type from the Old Kingdom onward. A figure of a squatting baboon (Berlin, Staat. Mus.) is the first representation of a deity made to conform to the same laws that govern other monumental sculpture. In an inscription, King Narmer is named as the dedicator of this work. The pose and formal construction derive from a tradition of similar small figures in faïence (PL. 326). However, because of its much larger scale and different material (calcite), this statue of a baboon moves the earlier tradition forward into the new system of axial composition, balanced proportions, and sculptural completeness on all four sides. The plinth now appears as the equivalent of the ground line of relief representations. In the production of monumental sculpture, the plinth serves not only as visible support for the figure but also as ground plane for the plumb line and for the transfer of proportions from the sculptor's trial piece. Lifelike representation had now become the aim of sculpture. The eyes of the baboon were at one time inlaid with colored material and the figure — or at any rate the plinth — was also painted.

Sculpture in the round developed according to the same progression discussed in connection with sculpture in relief. At its inception, in small-scale figures, Egyptian sculpture in the round did not presuppose "space consciousness" determined by architecture. It is significant that the rectangular plinth appeared first under small figures of faïence and ivory as a supporting surface and means of isolation from the surrounding world. The life-size funerary statue of wood represents the deceased in the closed world of a subterranean tomb chamber fitted out with furniture and other effects. The chapels in the sanctuaries of Abydos and Hierakonpolis are actually sealable narrow shrines for the sacred image. Such a chamber as the center of cult rites performed before the sacred statues evolved during the course of the Old Kingdom; only then did it begin to influence sculptural forms.

*Minor arts.* The few preserved examples of furniture and personal adornments of the Thinite period provide evidence of the high level of workmanship and technical progress achieved in the service of the court. Although these objects come almost exclusively from the royal cemeteries of Abydos and Memphis, they seem actually to have been utilized in the palace before they were placed in the tombs. The creative efforts involved range from simple utilitarianism to an elaboration of forms intended to approximate nature or to convey the abstract sense of symbol and pictograph.

Wooden bed frames with woven weblike "springs" were supported by bull hoofs artistically carved of ivory, and the symbolic meaning of these is connected with the old concept of the enormous bull-like power of the uniter of the Two Lands, of the "heavenly bull." The inside of the lid of a wooden chest is adorned with thin triangular panels of colorful faïence that form a geometric pattern. The edges are carved to imitate basketwork and recall the prehistoric tradition of wicker furnishings that preceded the use of wood for furniture. The royal name, set within the hieroglyph for "happiness," appears in an otherwise empty panel near the edge. This inscription denotes possession and at the same time serves a decorative purpose. The carved edges seem to have been covered originally with a thin layer of gold foil, both inside and out. The gilding of basket patterns carved in wood is also found in the decoration of walls and pillars in the royal tombs of the Memphite necropolis. The vocabulary of forms and the technique of this Thinite furniture craft must be reconstructed from sparse remains; however, its influence makes itself felt well into the early part of the Old Kingdom.

Bracelets from the tomb precinct of King Djet at Abydos supply an idea of the colorful nature of Thinite jewelry. Various components, fashioned of amethyst, lapis lazuli, turquoise, gold wire, and gold foil, are skillfully juxtaposed. The center of one such bracelet is occupied by a gold rosette; another consists of alternating gold and turquoise segments in the shape of the royal name of Horus. The turquoise parts show Horus in the old manner, with head bowed; the gold segments show him in the new upright pose. From a tomb of the early Thinite period near Naga ed Deir come amuletlike half figures of a bull and a gazelle, which are made of thin gold foil over a stucco core. The back consists of a thin sheet of gold with loops for attachment soldered to it. An amulet in the form of a beetle, made in the same technique and also from Naga ed Deir, bears a cult sign on the outer cover of the wings that is cut into the gold foil and filled with blue paste.

The production of stone vessels during the Thinite period became an art through the use of fine colored stone. The materials employed were alabaster (calcite), hard stones from the Eastern Desert and from the region of the cataracts at Aswan, diorite, amethyst quartz, rock crystal, and imported obsidian. In addition to purely functional shapes of squat profile and with pierced lugs for the fastening of the cover, there were also stone imitations of clay vessels in carrying nets, of thin-walled vessels of wrought copper, of shallow cups formed of leaves arranged edge to edge, and of woven baskets. Small ointment jars in the shape of lotus blossoms alluded to the fragrant nature of their contents. Even hieroglyphs were fashioned into vessels in order to "transform" the contents for ritual purposes according to the meaning of the particular sign.

Thinite relief, painting, and sculpture in the round — as well as the minor, or applied, arts — all unequivocally proclaim the glory of the uniter of the Two Lands in the Upper Egyptian tradition. The motifs, materials, and technique are Upper Egyptian, especially the affinity for hard stone; the use of the latter for vessels and figures relates to the long tradition of Upper Egyptian workshops. On the basis of the Memphite finds, it would appear that Upper Egyptian craftsmen were also active in Memphis itself. Here they came into contact with Lower Egyptian tastes and points of view, which began to influence their own creative work.

ART OF THE OLD KINGDOM (3d and 4th dynasties, ca. 2780–2260 B.C.). The development of Old Kingdom art proceeds from foundations laid during the Thinite period. King Zoser, the founder of the 3d dynasty, reunited Egypt and reestablished the dynastic order that had been disrupted toward the end of the 2d dynasty by the rebellion of Lower Egypt. Memphis, the northern city founded by the uniters of Egypt, henceforth became the royal residence, chief city, and seat of a central administration. As such, it attracted all the forces — commercial artistic, etc. — active in the land; consequently, Upper Egypt deteriorated to provincial status.

Stone architecture now reached its highest level in the tombs of the god-kings, who held absolute power over all the resources of the land. This era is called the "age of the pyramids," after the characteristic form of royal tomb that developed at this time. The tombs of the other members of the royal family, of the courtiers, and of the ever-increasing number of public officials are clustered around the major pyramids. In the tomb itself, statuary and wall decoration fulfill the requirements of cult ritual and at the same time serve to project and immortalize a view of the world considered to be the valid and final one. The royal cemeteries extend from Abu Roash in the north through Giza, Abusir, Saqqara, and Dahshur to Medum at the southern border of the Memphite nome.

The development of Old Kingdom art was Memphite in character; the creations of this Memphite art served later generations as a model and as the criterion for their own accomplishments. During the second half of the Old Kingdom, Memphite court art, owing to the decentralization of government and the development of a hereditary aristocracy in Upper Egypt, began to spread to the provinces.

*Architecture. a. The royal tombs.* The dualistic character of Egyptian kingship is clearly reflected during the Thinite period in two tombs that exemplify the two different burial rites: the monumental tumulus near Abydos and the monumental "house tomb" near Memphis. In accordance with the new image of a unified Egypt, King Zoser had two cemeteries — each with its own characteristic funerary institutions — combined in a single precinct near the royal seat at Memphis (Saqqara).

This sanctuary (FIG. 633) measures 1,000 × 500 Egyptian royal yards (about 600 × 300 yd.); it is enclosed by walls of white limestone that are slightly over 30 ft. high and articulated with niches representing the "white walls" of the royal residence. The focal point of the entire precinct is the tomb itself (the so-called "Step Pyramid"), a stepped structure almost 200 ft. tall (PL. 329). As an architectural type, this structure is an amplification of the monumental stone tumulus (mastaba) of Upper

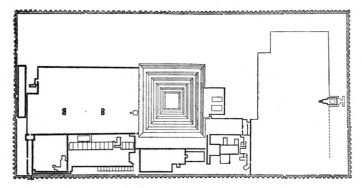

Saqqara, mortuary precinct of King Zoser.

Egypt. A burial shrine of Lower Egyptian type, which is attached to the south wall of the sanctuary, is a massive stone structure with a flat-vaulted roof and a façade articulated by niches. In deliberate continuation of Lower Egyptian (i.e., Memphite) principles, other buildings are patterned after the royal Memphite compound in their details, including the entrance hallway, the festival court with sacred chapels, the "sacristy" for the celebration of the Heb-Sed, administrative buildings for the government of the Two Lands, and the "palace"(?) of the king. The renewal of the royal existence in the hereafter is the purpose of the jubilee feast: the gods affirm and renew the sovereignty of the living king. This festival was to be re-enacted in perpetuity by the priesthood in the funerary precinct.

Various types of buildings, as well as structural peculiarities of other materials, are represented in stone in characteristic three-dimensional aspects as a requisite of the cult ritual. Various architectural elements are represented in color on the stone; airy wooden structures covered with reed mats in the nomadic manner of Upper Egypt are reproduced complete even to their framework of fluted wooden masts, low outer walls, mats stretched across crosspoles, and rolled-up reed mats above the doorways. The sacred chapels of Lower Egypt duplicate an ancient type of hut made of braided reeds. Fluting and beading as independent decorative elements have their origin in the translation of primeval reed forms into stone. Brick buildings are indicated by their outer walls, flat roofs, and representation of the interior ceiling construction consisting of round wooden crossbeams and fluted wooden supports. Wooden doors are shown in stone as standing partially open. The fluting of the supporting members probably originates in the preparation of tree trunks with the convex blade of the Egyptian ax. For reasons of structural stability, when translated into stone architecture, the slender wooden supports had to be incorporated into the façade on the exterior and attached to short projecting walls in the interior of the building.

As noted above, only the entrance hallway, the "sacristy," and the living quarters duplicate features of the actual royal residence at Memphis. The remaining buildings are in effect massive dummies that provide niches for the erection of cult images or short, narrow passageways for ritual processions. The disposition of the various buildings in the precinct and their interconnection by means of real and dummy passages do not correspond to the actual Memphite prototypes in every detail. These relationships were determined chiefly by the requirements of the burial rite and the cult of the dead: for example, the triple-aisled hallway through which the funeral procession entered the sacred precinct assumed the role of "sacred grove

of Buto." For this reason, the structural supports are decorated with a fringe of palm fronds.

Individual statues and statuary groups are found in the above-ground part of the sanctuary in all those places where the rites were performed for the king. A limestone statue of Zoser seated on his throne (PL. 331) was found in a special chamber (serdab) next to the "living quarters," where it was originally set up. In the passageways under the stepped pyramid and underneath the actual tomb, which were reserved for the use of the dead ruler, the king is represented in relief on recessed false doors to reed huts with wickerwork simulated by blue tiles. The perfected architectural design and construction techniques of this stone mortuary precinct may be considered the work of the royal architect Imhotep (q.v.), the high priest of Heliopolis himself.

The transition from the 3d to the 4th dynasty was marked by a great change in the construction of royal tombs. The Lower Egyptian, or Memphite, attitude toward the tomb as a residence for afterlife and toward the mortuary precinct as a realistic stage setting for ritual was abandoned. A reaction that took the form of a return to Upper Egyptian traditions set in. Such tendencies are apparent in the development of the royal tomb from (1) the rectangular stepped structure in the precinct of King Zoser to (2) the stepped pyramid of square ground plan at Medum and — in abstract forms of ever-increasing severity — to (3) the intermediary stage of the so-called "Bent Pyramid" of Sneferu at Dahshur and finally to (4) the geometric "crystalline" form of the true pyramid in a second tomb of the same king at the same site. True to its origin in the Upper Egyptian tumulus, the new type of tomb structure incorporates the place of offerings with its two upright steles that was already noted at Abydos. This presentation site is affixed to the east side of the pyramid. From the edge of the valley a walled causeway leads to the pyramid sanctuary. At the Bent Pyramid of Dahshur, this causeway emanates from the outer court of a masonry temple that is fitted with statuary and reliefs. With this division of the royal mortuary precinct into valley temples, causeway, and pyramid temple, the characteristic plan of the Memphite pyramid precinct was established for the first time. The ritual was now enacted on a "processional stage." The archaeological picture of this transitional era remains incomplete, however, since the second sanctuary of Sneferu, the north or "red" pyramid of Dahshur, has not been excavated and studied.

Among the successors of Sneferu, the idea of divine kingship was most fully realized and most tangibly expressed in the gigantic pyramid complexes that were constructed at Giza during the 4th dynasty. Here the valley temple is greatly expanded, the causeway vaulted over, and a gigantic so-called "temple of adoration" abuts to the mortuary area at the base of the pyramid.

At the mortuary precinct of Cheops (Khufu), the route of the causeway and the ground plan of the pyramid temple may be reconstructed from the sparse remains that exist today; but the valley temple lies buried under an Arab village. The temple of adoration consists of a court paved with slabs of black basalt, and halls supported by granite pillars are surrounded

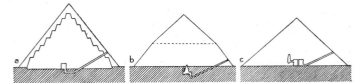

Cross sections of pyramids from the 4th dynasty that trace the evolution of the form: (a) Medum; (b) Dahshur, the so-called "Bent Pyramid" of King Sneferu; (c) Dahshur, north pyramid of Sneferu (from H. Müller).

by limestone walls. The interior faces of the enclosure walls were protected by the pillared halls and bear remains of fine relief decoration. The westernmost pillared hall provides access to the shrine that contained cult statuary.

The buildings surrounding the pyramid of Chephren (Khafre) are better preserved (FIG. 637). The valley temple is a build-

ing of rectangular ground plan that has smooth walls with an external batter. The inner chambers are arranged axially. The walls consist of a limestone core faced on both sides with large blocks of granite. At the east, two monumental portals framed by bands of inscriptions lead into a small transept, whence a similar portal on the main central axis opens into a great hall supported by square pillars (PL. 332). The floors are paved with "white alabaster" (calcite). Twenty-three statues of Chephren enthroned were placed before the front wall and around the walls of the Hall of Pillars. Narrow slits in the ceiling allowed dim light to enter this space and to be reflected by the bright floor. These early interiors of Egyptian monumental architecture are artistically successful both by virtue of their harmonious spatial relationships and through the beauty of the durable granite from which they are constructed.

From the Hall of Pillars a passageway, covered in order to shield the funeral procession from profane eyes, ascends to the pyramid temple. Although this building has been reconstructed from sparse remains, it is evident that its ground plan comprises an outer temple and the temple of adoration. In its plan, the outer temple repeats the arrangement of the Hall of Pillars of the valley temple. The temple of adoration consists of a central court surrounded by granite pillars, and its limestone walls are decorated with reliefs. The nichelike indentations of the great pillars contained colossal seated images of the king; the interstices of the western row of pillars permitted a view of the five narrow and deeply recessed statuary shrines which comprise the sanctuary proper. The funeral procession followed a narrow passageway leading from the northwest corner of the pillared hall into the walled pyramid precinct, thence to a place for offerings to the dead on the east side of the pyramid, and finally to the burial chamber within the pyramid itself, accessible only from the north side.

The development of this "processional stage," initiated at Medum, culminated in the mortuary precinct of Chephren. This huge architectural complex was designed specifically for burial rites conducted in a measured progression from the valley temple to the sanctuary proper. The construction of spatial and architectural forms according to abstract ritualistic principles follows Upper Egyptian intellectual tendencies and is in sharp contrast to Lower Egyptian architectural ideas, which favored more straightforward and concrete forms. It should be remembered that at the time when stone architecture was first developed in Egypt, Lower Egyptian architecture expressed a conception of the tomb as a replica of the royal palace, as in the mortuary complex of Zoser at Saqqara (FIG. 633).

After the reign of Chephren, the sun cult of Heliopolis began to exert its influence over the dogmas of divine kingship, the nature of the universe, and life in the hereafter; and the architectural conception of the tomb was consequently affected. Once again, the heritage of Lower Egyptian thought was in evidence. A latent spiritual crisis became apparent during the reign of Chephren's successor Radedef, who began to build his tomb at Abu Roash to the north of Giza. In the uncompleted mortuary temple of Radedef, the severe pillared construction of the earlier period was replaced by a system of granite columns. Full recognition of the new solar religion was realized during the transition from the 4th to the 5th dynasty, and the change was accompanied by a revival of Lower Egyptian traditions. King Shepseskaf, a son of Mycerinus (Menkure), completed his father's pyramid complex at Giza and incorporated a Lower Egyptian system of niche decoration into the original plan. In his own tomb, south of Saqqara, Shepseskaf preferred the "house tomb" (FIG. 641) type of burial to the pyramidal form. The inner sanctuary of his mortuary temple contains only a single shrine that seems to have been consecrated exclusively to the sun god Ra (Re). The wife and sister of King Shepseskaf, Queen Khentkaus, chose the same type of tomb as her husband's for her own burial in the cemetery of Giza.

With the advent of the 5th dynasty, which according to popular tradition originated among the priesthood of Heliopolis, sun worship was elevated to the rank of a state religion. King Weserkaf and his successor constructed sun sanctuaries at the western edge of the desert near Memphis at a site known as Abu Gurob. In the choice of their tombs, these kings returned to the pyramidal structure and also modified the Memphite mortuary temple to conform to the demands imposed by the new religion. Weserkaf moved the temple from the east side to the south side of his pyramid at Saqqara in order to take advantage of the setting sun in the performance of ritual. The tombs of his successors at Abusir, between Giza and Saqqara, return to the earlier axial arrangement with the temple at the east side of the pyramid. In the mortuary precinct of Sahura (FIG. 638), the severity of the closed exterior is moderated. The valley temple and a lateral entrance of the temple of adoration are opened to the outside with a colonnade, and granite columns take the place of rectangular pillars. Two new types of columns — one in the form of bundles of papyrus stalks with buds and blossoms, the other in the form of lotus stalks (FIG. 682) — first appeared at this time. Both of these forms are derived from the use of bundled plants as structural supports in the early reed architecture. Transformed into stone, these plants were divested of their original architectural function and were employed only for their symbolical content. An extra structure was inserted into the plan, along the axis of the sanctuary of Sahura at the base of his pyramid. The "false door" of this building, a ritual site of Lower Egyptian character, replaced the Upper Egyptian shrine for offerings to the dead that originated at Abydos. Spacious two-storied storage buildings lie to the south and to the north of the sanctuary.

The decoration of the interior is symbolical in content: the ceilings are painted blue to represent the night sky and are furnished with golden stars; the floors of black basalt represent the black earth (out of this "earth" the plant columns rise). The wall paintings are bordered at the bottom by multicolored terminal stripes over a black dado. From the reign of Weserkaf onward, wall painting represented nature as the realm of the sun god, as well as themes pertaining to the temporal and celestial power of the king. The pictorial representations are keyed to the processional ritual that was enacted along the way from the valley temple to the place of burial in the pyramid chamber — from the world of the living to the world of the dead. With the 5th dynasty, the creative development of monumental royal tomb architecture came to an end. The mortuary temples of the kings of the 6th dynasty adhere to the archetypes developed by their predecessors and mark a return to the closed exterior and the pillar construction characteristic of the early 4th dynasty.

The evolution of Egyptian architecture from the time of Zoser to that of Chephren, and from Chephren into the 6th dynasty, which could be only briefly sketched above, has recently become more intelligible. B. Grdseloff and E. Drioton determined the sites of ritual purification and anointment in the valley temple of Chephren through comparison with representations in the private tombs of the late Old Kingdom. Light reed huts, such as were erected for temporary use in front of tombs, were translated in all their essential details into stone. This feature is present in the valley temple of Chephren, where the hut played a symbolic role in the burial rite of the god-king. H. Ricke (1950) emphasized the dualistic origin of Egyptian burial rites and architectural forms and consequently interpreted the transformation in architecture from the reign of Zoser to that of Chephren — inexplicable as a purely stylistic phenomenon — in terms of the recurrent dichotomy between Upper and Lower Egyptian tendencies, with regard to both the concepts of the afterlife and the religious ritual. Together with S. Schott, Ricke sought to explain the arrangement of chambers within the pyramid as based upon their particular function in the pyramid cult. Knowledge of this pyramid cult has been transmitted to us in the form of writings on the walls of the subterranean chambers of the Pyramid of Unas at Saqqara, from the end of the 5th dynasty: the so-called "Pyramid Texts." Ricke and Schott proceeded from the hypothesis that the functions of the aboveground parts of the precinct were transferred in ever-increasing measure to the chamber reserved for the dead king in the heart of the pyramid; and they concluded that the Pyramid Texts, arranged in a sequence paralleling the ritual movement from the entrance toward the sarcophagus chamber, corresponded to specific rooms, courts, niches, and pillars of the temple precinct

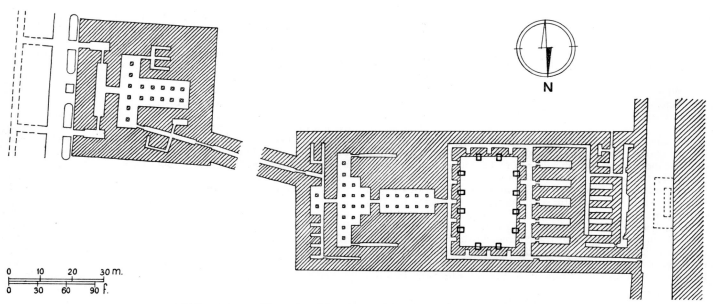

Valley and pyramid temples of Chephren at Giza (*from W. Stevenson Smith*).

and thereby made possible the interpretation of the sequence of chambers. When comprehended in this way, the pyramids and their precincts become imposing manifestations of the royal burial rites and the cult of the dead within the framework of Old Kingdom theology. Viewed against this background, every tomb becomes a telling and highly individual creation, which emanates from the spiritual conflict of opposing religious forces.

b. *Palaces and temples.* The stone reproductions of tent, reed, and brick constructions in the mortuary precinct of King Zoser at Saqqara serve to convey an idea of the appearance of the residential and administrative buildings of a royal capital during the Thinite period and the Old Kingdom. Upper and Lower Egyptian traditions formulated at the time of the unification have been fused in the multiplicity of architectural forms employed in the sanctuary of Zoser. The earlier royal palaces, which were constructed of sun-baked brick and of wood, have not been preserved; however, the plan of their interiors may have been influenced by the pillar and column architecture found in mortuary temples since the 4th dynasty.

The sanctuaries of the local Memphite gods and of the nome gods were clustered around the residence of the god-king. In Memphis, as in the nomes of both Upper and Lower Egypt, these sanctuaries continued to be built of sun-baked brick until well after the end of the Old Kingdom. These brick structures were replaced by stone temples at a later date, and none of the earlier structures have been preserved. Those Thinite sanctuaries furnished with a stone shrine for the sacred image are exceptional (e. g., the granite shrine of Khasekhemui at Hierakonpolis mentioned above). Only fragments remain from the relief decoration of a small limestone shrine dedicated by King Zoser to the nine gods of Heliopolis on the occasion of his royal jubilee at the beginning of the 3d dynasty. The stone shrine to hold the sacred image replaced the original hut of reeds such as that represented in the form of imitation reed matting on fragments of a schist shrine found in the sun sanctuary of Weserkaf (early 5th dynasty). The same origin is attested in the beaded and fluted decoration of later stone shrines.

Remains of a monumental temple have been preserved in the royal necropolis at Giza, in front of the forepaws of the Great Sphinx (PL. 333). The building faces along the axis of the valley temple of Chephren; and its walls and pillars, like those of the temple of Chephren, are constructed of local limestone and faced with ashlar blocks of granite. This temple consists of an open court surrounded on four sides by roofed, pillared halls. The inner wall of the west hall recedes *en échelon* and ter-

minates in a niche that lies approximately on the axis of the Sphinx behind. A similar recession of the inner wall is also present in the east pillared hall. If the sphinx image was already intended to represent the king as "Horus at the (western) horizon" as early as the Old Kingdom — Harmakhis, as he is known in inscriptions of the New Kingdom — the niche oriented toward the east would probably pertain to the sun rising in the person of the god Horus. The temple of the Great Sphinx accordingly would represent an antecedent of the sun temples constructed by the early kings of the 5th dynasty.

These sanctuaries of the sun at Abu Gurob at the edge of the Western Desert were "monuments of the living king to his father Ra." After the death of a king, these sanctuaries seem to have been intended to accommodate the ritual of his perpetual jubilee. As an architectural type, they constitute a special form of temple building having a plan that would seem to go back, in principle, to the sanctuary of the sun god at Heliopolis, a monumental pillar set in an open court. The first of the sanctuaries of the sun, built by King Weserkaf, was constructed of brick. One of his successors, King Neuserra, subsequently reconstructed his own brick sanctuary in ashlar masonry. This building was simply a large enclosed court, which at its western end contained an obelisk of white limestone blocks that was approximately 120 ft. tall. The obelisk proper rested on a base that was about 65 ft. high and was faced with granite. The only entrance to this court, at the eastern end, provided access to a covered ambulatory running north and south. The southern part of the ambulatory terminated at the base of the obelisk. Ramplike walks in the interior of this base led to an upper platform. At the east side of the base, sacrifices

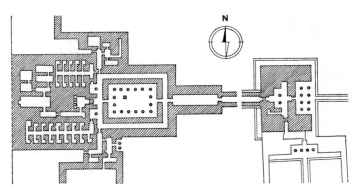

Abusir, temple complex of Sahura (*from W. Stevenson Smith*).

were conducted under the open sky on a great alabaster altar. The places for slaughtering the sacrificial animals and the storerooms were to the north of the altar. Outside the sanctuary enclosure and to the south lay a solar barque constructed of brick. The situation of the solar sanctuaries on the desert plateau necessitated the construction of a gateway in the valley and a covered causeway, recalling the valley temple of the pyramid precincts. Other than these solar sanctuaries, only fragments of stone constructions from the Old Kingdom are preserved.

*c. The tombs of court officials.* In the royal cemeteries of the 1st and 2d dynasties at Abydos and Memphis, the burials of the more important officials are to be found in immediate proximity to the royal tombs of the masters whom they served. In the Old Kingdom as well — certainly to the end of the 4th dynasty — this patriarchistic sentiment determined the location of the tombs of the court officials at Saqqara, Medum, and Dahshur, and at Giza in particular. With the gradual weakening of the absolute character of the concept of divine kingship and the centralized authority, the strict order of preference of the royal cemeteries was relaxed. Saqqara became the favorite burial site, because most officials — disregarding the location of the pyramids of their masters — sought burial places in proximity to the sanctuary of Zoser, the founder of the Old Kingdom. Saqqara and Giza are the most important cemeteries of the Old Kingdom; but Giza alone may be considered systematically excavated (H. Junker, 1929–55; G. A. Reisner, 1942). The huge cemetery of Saqqara with its tombs of early Old Kingdom officials and isolated great tomb precincts of the 5th and 6th dynasty, from the point of view of the systematic development of tomb architecture, has only been partially examined.

The characteristic external form of the tomb of an Old Kingdom official is that of the mastaba (an Arabic term meaning "bench"), which is a rectangular tumulus with slanting walls and a flat roof. At first constructed of sun-baked bricks, the mastaba was built of massive ashlar blocks from the 4th dynasty onward. The façade of these burial places, which are Upper Egyptian in origin, faces east toward the Nile. This form of tomb appeared in the region of Memphis (at Ezbet el Walda and Saqqara) as early as the 2d dynasty, when it included two nichelike false passages in its east façade suggestive of the niche articulation of the brick walls surrounding Memphite royal tombs of this period; the southerly niche developed into the focal point of cult ritual. The concept of the tomb as eternal dwelling place of the deceased dominated early Memphite tomb architecture and led during the 2d dynasty to the furnishing of subterranean burial chambers with all necessities of daily life, including baths and privies.

During the 3d dynasty, the first phase of the subsequent development, the archaic cemetery of Saqqara witnessed the transition from decorative wall niche to place of cult worship. The tombs of the officials of this period adopted the exterior form and interior decor of the earlier Memphite royal tombs, including articulation of the exterior walls by means of niches. In the partially rebuilt brick tomb of Hesira, a contemporary of Zoser, only the eastern façade is decorated with niches and is painted with colorful carpet patterns in the old manner (see above). Ten of the niches contained wooden relief panels with standing figures of Hesira (PL. 334), and the single niche that served as the place of offering for the spirit of the deceased contained a panel showing Hesira seated at his funerary banquet. The entire length of the niched eastern façade was protected by an outer wall and a roof; it was thereby sealed off from the world outside and changed into a passagelike interior space. A separate room for a statue of the deceased, a chamber known as the serdab, was later added to the anteroom that formed the entrance to the tomb. With this arrangement all the elements essential to the further development of the tombs of Memphite officials were present.

The east façade of the tomb of Khabawsokar at Saqqara, slightly later in date, exhibits a similar system of niches that are protected by a covered passageway. In the southern part of this passageway, one of the niches is pierced through in a westerly direction. A separate chamber containing a niche as a ritual site is here found within the core of the tomb, toward the west; this niche, larger than in the previous forms, is faced with limestone blocks. The representations of the owner of the tomb and his funerary banquet are on the walls of this chamber. The serdab has been placed in a position adjacent to the cult chamber; indeed, it is connected with the latter by means of a narrow slit in the wall, which permitted the statue to "see" out, though it was not visible to the onlooker.

During the transition from the 3d to the 4th dynasty the system of niches, an expression of Memphite tradition, receded in importance. The function of the niche as a link between the world of the living and the world of the dead was assumed by the "false door." This false portal with a representation of the funerary banquet over the lintel now became an integral part of the cult chamber; it eventually became the place of offerings. Whereas the royal tomb developed in ever-increasing abstraction of form into the perfect pyramid, the mastaba with its smooth slanting walls became the most widely accepted form of tomb for court officials. With this new sepulchral type, the cult chamber within the mass of the structure, in its traditional location in the southeastern corner of the superstructure, attained greater independence as an architectural space and thereby opened up new possibilities for future development.

In the large brick mastabas of the royal princes near the pyramid of Medum, a cruciform chapel (FIG. 641) developed out of the old north–south passageway with its niche facing west. The interior walls of this chapel are faced with slabs of limestone on which a new type of representation appears. At the western end of the chamber, toward the realm of the dead, is the false door, which lies exactly opposite the actual entrance to the tomb. The cruciform chapel was the first independent cult chamber and was characteristic of a series of tombs built of dressed blocks of limestone at Saqqara and Dahshur. The chamber was still of small dimensions, probably because the roofing of large spaces still presented insurmountable technical difficulties. In structures built entirely of brick, roofing consisted of the trunks of palm trees laid next to each other. In the mastabas built of limestone blocks, palm trunks are simulated in relief on the stone ceiling and are painted brown to appear like wood.

In the cemetery at Giza, which grew up around the monumental pyramids of Cheops, the mastabas of the court officials were laid out east and west of the pyramid according to a master plan. In this unified planning, the strongly centralized organization of the state under Cheops and Chephren found its most imposing expression. East of the great pyramid lie the limestone mastabas of the royal princes. The cult chamber of these mastabas is a small lateral chamber decorated with wall paintings and furnished with a false door in the west wall; the actual entrance to the chamber has been offset slightly to the north. Behind the false door lies the inaccessible statue chamber, the serdab. Additional rooms for the cult of the dead are constructed in brick before the tomb entrance and are coated with whitewash. In one such brick annex, that of Prince Ankhhaf (FIG. 641), wooden columns on round stone bases are employed as supports for the ceiling. Contemporary stone architecture for mortuary temples utilized only the four-sided pillar.

The necropolis of the court officials lies to the west of the pyramid of Cheops. Here the tombs are obviously controlled by official regulations with regard to their decoration and their relation to the cult of the dead. Neither cult chamber nor serdab is contained within their stone superstructures. The serdab statue is replaced by a "portrait head," located between the entrance shaft and the sarcophagus chamber and not utilized in the funerary rites; the pictorial decoration of the tomb is reduced to a small relief panel with a representation of the funerary banquet, which is set up at the place of offerings at the eastern side of the superstructure. The place of offerings is shielded by small antechambers of brick. The barrel vault developed from these small brick annexes; and later, during the 6th dynasty, the dome over a square ground plan evolved. Barrel vault and dome accomplish the strictly functional task of roofing over a space without using precious wood. However, neither of these architectural forms was adopted in Egyptian monumental architecture, even during later periods.

It was not until the end of the 4th dynasty that the cult chambers were enlarged; significantly this was first done in those tombs cut into the living rock, which permitted a greater ceiling span. In the spacious mastaba of Queen Meresankh III at Giza there are many more than the usual number of wall paintings. A room containing statues carved from the living rock is separated from the cult chamber by a row of pillars; nevertheless, the statues relate to the cult chamber.

The small lateral chamber with offset entrance was continued in the mastabas of the 5th dynasty at Giza and Saqqara (cf. FIG. 641); however, a significant development now occurred. Further chambers were appended to the cult chamber, and the solid self-enclosed mass of the mastaba was thereby dissolved progressively until only a sequence of loosely related rooms remained. This multiplicity of chambers was the result of the demand for cult areas for additional members of the family as well as the increased demands of a funerary ritual that had greatly increased in complexity. This development started in the tombs of the immediate members of the royal family, whose burial rites resembled those of the king himself and therefore required

in front of the cult chamber. This hall also gives access to the tomb of the ruler's son, Ptahhotep II. In one of the most significant tombs of this period, the mastaba of the vizier Mereruka from the 6th dynasty, the interior is subdivided into so many cult rooms for the master and his family that the simple cohesive arrangements of the older tombs are sorely missed. Despite the multiplicity of spatial solutions in these complex mastabas, however, a similarity of purpose is recognizable in their ground plans. As in the royal sanctuaries, the various chambers of the tombs are thematically related through the nature of the funerary ritual.

In addition to the abstract interrelationships of spatial arrangement, the false doors, statue shrines, and paintings or painted reliefs are of help in interpreting the functions of the various rooms. The paintings and reliefs cover the walls of the tomb interior above a low dado frieze, and the themes they represent generally indicate the function of the rooms. Such representations permit identification of the purpose of the rites enacted in their respective spaces — that is, to guarantee eternal life in the hereafter.

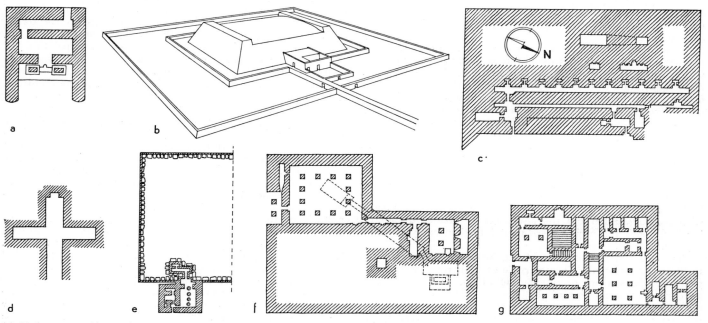

(a) Medum, pyramid temple, 4th dynasty; (b) "Mastabat Fara 'un," reconstruction of the tomb of King Shepseskaf, 4th dynasty; (c) Memphis private tomb, 3d dynasty; (d) Medum, mastaba of Atet, cruciform chapel, 4th dynasty; (e) Giza, mastaba of Ankhhaf, cult chapel with annexes, 4th dynasty; (f) Saqqara, mastaba of Ti, 5th dynasty; (g) Saqqara, mastaba of Mereruka, 6th dynasty.

rooms corresponding to those of the royal mortuary temple. The open entrance hallway of the valley temple, the pillared court of the temple of adoration, and the chambers for the cult statues were incorporated into the architecture of private tombs. The assimilation of these elements, which in the "processional stage" of the royal mortuary precincts extended from the valley temple to the sanctuary proper and the small rectangle of the mastaba, necessitated a new ground plan. A multiplicity of solutions appeared. The mastaba of Ti at Saqqara, dating from the second half of the 5th dynasty, is fronted by the large pillared court (FIG. 641). A small passageway connects the court, the sanctuary proper, and a lateral chamber in the core of the building. The cult chamber here is large, and the ceiling is supported by two pillars. Statue chambers open into the entranceway and the cult chamber by means of narrow slits. At Abusir, in the mastaba of Ptahshepses, one of the brothers-in-law of King Neuserra, a separate hall that is approached by steps and has three statue shrines is provided for the cult of statues. The space in front of this hall on the east side is fitted with lotus bundle columns similar to those of the royal mortuary temple, rather than with the pillars common to private tombs. In the lucid ground plan of the mastaba of Akhtihotep, constructed toward the end of the 5th dynasty, a pillared hall is placed

d. *Provincial tombs.* Beginning with the 5th dynasty, monumental tombs were built in the Upper Egyptian provinces as well as at the royal capital. These provincial tombs were constructed for the royal governors of the nomes, who gradually became semi-independent in their provinces and formed a hereditary nobility. In their tombs, the types of furnishings current at the royal capital were adopted. The provincial cemeteries were located in the rocky hills that rim the Upper Egyptian Nile Valley, and this physical situation necessitated modifications in the planning of the rooms. Besides outright adoption of mastabas of the Memphite type in Upper Egypt, as at Tehneh and Hamamiyeh, there developed a special type of tomb that greatly simplified the contemporary Memphite model. These tombs were carved from the living cliff rock. A path or steps, as at Aswan, led up to a courtyard high on the slope and in front of the tomb façade, which was carved out of the cliff. The ceilings either were flat or imitated vaulting, as at Qasr es Sayad, or they were supported by pillars or rows of columns placed across the principal axis of the chamber. A single-room arrangement, with the false door opposite the entrance, was the predominant form. Occasionally, as at Deshasha, the façade is emphasized by a pillared forecourt on the Memphite pattern.

The cliff tombs of Upper Egypt are not an independent, indigenous contribution to the art of the Old Kingdom. Their significance for the history of art lies in the fact that they transplanted Memphite traditions to Upper Egypt, where they survived the collapse of the Old Kingdom and contributed to the development of the provincial art of the Middle Kingdom after the reunification of the Two Lands under the leadership of Upper Egypt.

*Relief and painting.* Closely related to the development of architecture was the emergence of pictorial art in the royal mortuary temples, the tombs of court officials, and — to a lesser extent — the temples of the gods. Painted reliefs were characteristic of limestone walls, while two-dimensional paintings were commonly used on walls of brick. Polychrome relief was an innovation attributable to the Old Kingdom, for it was only after long hesitation that color was added to three-dimensional relief representation. An earlier example of this technique in a minor form was seen in the complicated inlay of painted stones on the circular disks of Hemaka (PL. 335). The introduction of limestone as a building material was by itself a substantial incentive to polychrome treatment of relief: the light natural color of the stone seemed to require the addition of such decorative effects.

The pigments employed are those which occur in Egypt in their natural state: iron oxide for red and yellow, malachite and azurite for green and blue, and white and black pigments. Their application was dictated by conventions that assigned every object a special color. The skin of men and women is differentiated through the use of red and yellow; water is painted blue, and plants are painted green. The same color conventions also apply to the painting of hieroglyphs. In addition to pure colors, modulated shades also occur: for example, elements such as the feathering of geese (PL. 328) show a mixed palette or primary colors that have been lightened by the addition of white. Both relief and painted representations depend on outline drawing determined by the laws of "complete" representation and by the accepted canon of proportion (see above). Compared with painting, relief has the advantage of greater durability; however, both techniques were used interchangeably to fulfill the same tasks.

The relief representations of the tombs are closely related to the funerary ritual. Characteristic of both royal and private tomb decorations are representations of the deceased, as well as representations of his typical sustenance. Differences in tomb pictures indicate differences in rank of the owners, for it was on rank that expectations for the afterlife were based. The king appears on the walls of his tomb in his roles as ruler of the Two Lands, as god among gods, as preserver of the world order, and as victor over the enemies of Egypt. To these attributes are added representations of successful deeds that increased his renown, such as the return of the Egyptian fleet from Syria depicted in the approach to the mortuary temple of Sahura, or the transportation by barge of huge granite columns from distant quarries at Aswan to the mortuary temple at the royal capital as portrayed in the sanctuary of Sahura. The compositions on the walls are dominated by large figures of kings and gods; narrower registers are devoted to subsidiary, often narrative, scenes. The artistic quality of the reliefs is exceptional, and they were richly painted. The eyes of royal figures in monumental representations were often inlaid with precious colored minerals in order to enhance the lifelike effect. The most gifted artists were employed in the decoration of the royal buildings, and their creations influenced the decoration of private tombs.

Only fragments of the relief cycles of royal mortuary temples are preserved; the most significant and most extensive examples are of the 5th and 6th dynasties. Reliefs in the numerous private tombs of officials are in a much better state of preservation and permit the reconstruction of the evolution of Old Kingdom wall painting from its beginnings to the multifigured scenes of the later tomb complexes. The wall paintings of private tombs represent the deceased in the more intimate domain of his family life and personal possessions. The basis

of his sustenance and existence in the afterlife is the concept of "endowment of the deceased" (provision of all the everyday necessities). Tomb decoration is centered about this concept, and all areas of life are included in the representations. Representations of the funerary banquet and a list of the offerings may be found in Memphite art as early as the 2d dynasty. In the cemetery of Ezbet el Walda, limestone relief panels with such representations are introduced into the ceilings of the subterranean sarcophagus chambers. Through the magical power of the representation, the deceased was intended to partake of the offerings represented — offerings actually placed before the niche of the tomb's superstructure. The artistic possibilities in the decoration of subterranean sarcophagus chambers were somewhat limited. The important development began when this room was accorded a new significance by the move into the tomb superstructure.

In the superstructure of the tomb of Hesira at Saqqara, wooden panels carved in relief and originally painted are set into the niches of the east wall (PL. 334). There are several standing representations of the deceased, who is also represented sitting at his own funerary banquet under an inventory of the offerings. This principal relief was destined for the ritual niche. In the niche on the opposite wall, furnishings for the tomb, such as actually accompanied the dead in earlier times, are represented in a painting. These are the oldest paintings of the Old Kingdom and represent chests, beds, and chairs, as well as everyday implements and vessels of stone. The grain of wood and the veining of stone is simulated in these objects. Between the representations of the master and those of his possessions there is an intimate connection: the deceased is characterized as "inspecting his eternal household." Because of the magical nature of the representation, he appears in a realm somewhere between life and death, not only as recipient of the offerings but also as active "custodian" of the funerary endowment. In the wooden reliefs of Hesira, the forms of the standing and seated human figure, its contours and its proportions, are secondary to the composition of the whole. The tomb of Khabawsokar is slightly later than that of Hesira. Its sacrificial niche is revetted with slabs of limestone, and the relief representations of the deceased seated at his funerary banquet and also in an upright position are united in a single composition. Below the banqueter, the list of offerings appears in magnified proportions; these provisions to ensure the sustenance of the master in the afterlife are jealously guarded.

More varied development of wall pictures appears in the monumental brick mastabas of the royal princes of the early 4th dynasty at Medum. The walls of the cruciform chapels of these tombs provide much more picture space than the walls of tombs of the earlier period. Men and women bearing offerings, with their names inscribed, are depicted approaching the sacred place, the false door. The slaughter of the sacrificial bull is also represented. The owner of the tomb, in towering proportions, appears several times and is sometimes accompanied by his wife. His attitude is dignified and immobile. Several scenes are spread before him in superposed narrow registers. These vignettes represent labors in his domain and are arranged according to the various areas of it: the harvest of figs in his gardens, the working of the soil, catching waterbirds on his ponds, shipbuilding, fishing on the Nile, and hunting in the desert. In the agricultural scenes, the master oversees the provisions for his magical sustenance. The movement and poses of the figures are represented according to typical conventions, and in the terse, schematic style of these representations the common origin of picture and hieroglyph is plainly visible. As in hieroglyphs, three figures of a kind stand for an infinite number.

The cruciform chapels of the princely tombs at Medum were faced with limestone in order to facilitate relief decoration. In addition to the vigorous high relief of the chapels of Prince Rahotep and his wife Nofret, a different relief technique appears in the chapel of Nefermaat. The outlines of the figures are recessed into the surrounding wall surface and are filled with a colored paste. This technique occurs only in this tomb, and it is described as an invention of the prince himself in an

inscription declaring that it is intended to give the pictures greater durability (PL. 335).

The limestone revetment is absent from the chapel of Atet, the wife of Nefermaat; here the brick walls are covered with stucco and painted. Little more than the frieze of grazing geese (PL. 328) is preserved from the original decoration, a large composition representing the capture of birds with drop nets. Whereas the coloring of the reliefs and the paste inlays is restricted to the primary colors, the painting of the geese is enriched by the addition of several intermediate tones. In directness and naturalism the brushwork of this early masterpiece remains unsurpassed in the long development of Egyptian art.

The "contract" for the sustenance of the deceased is a focal point of the representations in the ritual chapels of the royal princes of the late 4th dynasty, which lie east of the Pyramid of Cheops at Giza. Only a few fragments of the relief decoration of these tombs are preserved. The decoration of the tombs of officials in the necropolis west of the great Giza pyramids was restricted to a small stele with a representation of the funerary banquet, and the fertile development begun at Medum was arrested. Nevertheless, the technical execution, composition, and colors of these small relief steles are refined to a degree hitherto unknown.

There were no further significant developments in wall painting until the end of the 4th dynasty, when new themes appeared in the spacious rock-cut tombs of that period. The actual steps taken to supply sustenance for the deceased were shown, in order to ensure availability of the provisions to an even greater extent. At the entrance to the tomb chapel of Queen Meresankh III, the overseer of the consecrated sustenance unrolls a papyrus in front of his mistress to permit her to read the list of offerings. These representations are effected in sunk relief, a technique invented during the 4th dynasty for exterior representations. The outline of the figures is cut sharply into the surface of the walls, which are left intact to their full depth between the figures. The surface of the figures themselves is modeled in the same manner as in ordinary relief. The technique of sunk relief depends upon the effects of shadow to bring out the details of the contour; at the same time the modeling and the color of the surface is much better protected from wear than in the more ordinary technique of raised relief. From the entrance to the tomb of Meresankh, there is a long row of offering bearers, in relief, extending toward the place of offering. The representation of the funerary banquet at this spot is enriched by the presence of musicians and dancers. As a kind of sidelight to the funerary banquet, there is a representation of the preparation of the royal meal in the kitchen. The sarcophagus and statues for the tomb of the queen are also shown in the process of manufacture. The remaining tomb furnishings are represented on another wall.

During the 5th dynasty, tomb art was suffused with a new content; at this time sun worship was elevated to a state religion. The eternally valid world order was recognized in the power of the sun god Ra (or Re), who replenishes nature in the ordered course of the seasons and whose being sustains all creatures. These new religious ideas were expressed in representations of the world and its creatures, as created by the sun god. The finest expression of this theology is to be found in the relief decoration of the "chamber of the seasons" of the sun temple built by King Neuserra at Abu Gurob. Here, scenes of the three seasons recognized by the Egyptians are represented on the walls of the chamber; in narrow registers and between them, there are pictures evoking the self-replenishing powers of nature. The new doctrines had an effect on concepts of the afterlife and, accordingly, on provisions for the dead; the new point of view is evident in the wall decoration of the tombs. Fragments of relief of a very high quality, which show the king boating in a thicket populated by swamp birds, are preserved from the mortuary temple of King Weserkaf, the founder of the 5th dynasty. The voyage through the papyrus thickets was also adopted as a theme in the tombs of officials. Ti glides over the ponds in a light barge, in order to observe the birds nesting amid the papyrus stalks and to see the play of fish, crocodiles, and hippopotamuses in the water. Occasionally these scenes

of pleasurable excursions are joined with hunting expeditions in quest of swamp birds, in which the throwing stick and the harpoon are employed. These themes derived from life on the estate were subsequently amplified to include representation of the labors of the passing seasons. The harvest follows the period of sowing and is represented in detailed stages: cutting the grain, threshing, winnowing, and putting the grain in storage bins. The representations of bird catching in which the master himself participates are particularly successful episodes. The birds are taken from the nets and put into cages; also shown are the pens in which the captured birds are fattened for the master's table. In the representations of the hunt, the continual replenishment of nature by the process of mating and birth is expressed, in addition to the scenes of wild animals being pursued and brought to bay by the hounds. In the marshy pastures, cattle graze and are watched over by herders; the indications of landscape become more important.

The life of man in society takes on new meaning within the framework of this divine order. The figures engaged in the various pursuits are not only linked by their common activity but also by lively interrelated gestures and hieroglyphs, which, as if emanating from the mouths of the workers, take the form of outcries or a comic-strip type of dialogue. This hieroglyphic talk enhances the pictures with an aura of humor and *joie de vivre*. Nevertheless it is the deceased who ultimately benefits from this activity and from the riches of nature created by the sun god Ra. Servants bring additional offerings, as priests celebrate the rites of the cult of the dead. The various foods placed before the deceased (vegetables, bread, fowl, etc.) suggest the appearance of a still life.

The multiplicity of subjects dealing with natural phenomena, inspired by the new sun religion, remained the decisive influence in the development of art during the 6th dynasty (PL. 337). In the many-chambered tombs of the vizier Mereruka and other high functionaries, the scenes of daily life have an even greater wealth of detail, partly to increase their magical efficacy and partly to fill the great wall surface. The scenes became increasingly removed from the predominantly religious representations of the 5th dynasty. A well-ordered terrestrial existence was shown, including even representations of medical treatment and circumcision among the elements of the world order. Scenes of death, mourning, and burial depicted the end point of earthly life and the transition to the "house of eternity."

Despite this apparent inventiveness and multiplicity of phenomena, the scenes were actually determined by type. The posture of the figures and the dispositions of the groups and registers were all evolved from stock types and were adapted for each representation within a framework of canons for nature representation in Egyptian art. The great uniformity of this art does not imply that pattern books were mechanically copied; it originated in a "system" of art and in the careful training of the artist. The life-size relief representations of the owners of the tomb, as well as the rows of identical walking figures, were frequently constructed with the aid of guidelines, and in certain unfinished representations these may still be observed. However, in the cult chamber of the mastaba of Ptahneferher at Saqqara, which dates from the first half of the 5th dynasty, freely moving figures in a great variety of poses were drawn without the aid of guidelines (PL. 335).

The 5th dynasty witnessed the culmination of representational arts in the Old Kingdom. The finest art of this period is found in the mortuary temples of Weserkaf and Sahura, as well as in the private tombs of Ptahneferher, Ti, and Ptahhotep. The compositions are clear and easily recognizable, and the relief is quite low, hardly rising from the picture plane. The decoration of the tombs of the 6th dynasty is somewhat cruder and lacks the unified composition of the work of the previous dynasty. The principal wall representations in the tombs of the viziers Mereruka and Kagemni are executed in much higher relief and are more fully modeled. In the registers with small figures, on the other hand, the execution is less painstaking, and the effects are in part achieved through the use of color. Characteristic of the work of the 6th dynasty are an increase

in the number of figures, greater movement, including hitherto untried representation of fleeting actions, and an increasing emphasis upon gesture.

The growing secularization of pictorial content was followed by a wave of skepticism. The Egyptian now began to question whether all this expense for the deceased could really ensure his eternal well-being. Doubts were voiced as to whether the materialistic terrestrial scenes in the reliefs were appropriate preparation for the afterlife. In several significant tombs of the 6th dynasty (e.g., the tomb of the vizier Mehu at Saqqara), representation of ritual prevails over the scenes of daily life. At the same time, in the more modest tombs of court officials the space allotted for the ritual chamber and its pictorial contents was greatly curtailed: representations of the offerings and the grain supply were painted on the walls of the sarcophagus chamber or directly on the coffin itself. No longer was there absolute faith in the efficacy of the two-dimensional representation, and the representations on the walls were supplemented by small wooden models of kitchens, grain bins, and stables in order to ensure the sustenance of the deceased in the afterlife.

A change in the choice of colors accompanied the change from the simple groups and scenes of the early period to the large, movement-filled groups of the 6th dynasty. Knowledge of this development is incomplete, for the original coloration of the limestone reliefs is rarely preserved and then only in a fragmentary condition. It may be assumed, however, that from the 5th dynasty onward the costly greens and blues, formerly produced from malachite and azurite, were produced from pulverized glass frit consisting largely of copper oxide. The pure colors blue, green, and red in 6th-dynasty wall painting seem to be more intense than before, and the repertory of colors is increased by a number of intermediate tones. In place of a delicate light blue, such as appeared in the background of the geese painting from the tomb of Atet early in the 4th dynasty, painters of the 6th dynasty made use of a more intense shade of this color. In the paintings from the tomb of Sneferu at Dahshur, an ochre-colored background appears as an alternate to light blue.

Unfinished relief representations that have been preserved give valuable insight into the techniques which were used. At first the surface of the wall was compartmentalized into fields and registers, according to the type of representation planned. This layout was accomplished by means of a string dipped in red paint and stretched taut, or with the help of a straightedge. The ground lines on which the figures stand were drawn in this manner. The preliminary drawings for the representation were then painted directly on the smooth limestone walls with a hard pointed brush dipped in red. Next, these lines were retouched in black paint. The sculptor, proceeding from the outlines produced in this way, recessed the background with a well-sharpened chisel. The edges of the projecting silhouettes were then rounded off, and the modeling, previously only suggested in the drawing, was rendered by sculptural means. After any details still in an unsatisfactory condition had been reworked, the entire relief was covered with a thin coat of white stucco. Now the painter was able to begin the final stages, namely, the application of large areas of color with a broad brush and of small details with a delicate brush. Finally, figures were distinguished from background by a contour line.

The creation of Egyptian relief was a process involving the collaboration of several specialized artists — the draftsman, the sculptor, and the painter; therefore it is pointless to look for "the hand of the artist" in Egyptian reliefs. Artistic creativity necessarily remained anonymous within the system of Egyptian art. The artists' names immortalized in the pictures of certain tombs are not "signatures" on works definitely created by their own hands; rather, they were intended merely to include the artist named among others of the master's household and to secure his services for eternity. In the Egyptian language, the draftsman is designated "figure writer." The art of writing, which evolved the more fluid cursive from the pictorial hieroglyphs, was the basis of the preliminary sketch. Such sketches represent an extension of writing, as it were, for they are composed of an extremely simple skeletal framework of brushstrokes.

Egyptian court art of the 5th and 6th dynasties also exerted its influence on the cliff tombs of Upper Egypt. For the execution of these tombs, draftsmen and sculptors were summoned from Memphis. An original and autonomous provincial art was not developed, and the formal dependence on the example of contemporary Memphite art is evident even in the finest of the provincial tombs. Despite such influence, the rich repertory of subject matter and the clarity of composition of Memphite art was not attained in Upper Egypt. Even the quality of graphic and sculptural execution lagged behind the achievements at the cemeteries of the royal capital.

*Sculpture in the round.* As is the case with Old Kingdom reliefs, the development of sculpture in the round from the 3d dynasty onward is closely associated with the development of tomb architecture. By far the greatest number of statues preserved from the Old Kingdom come from royal mortuary temples and private tombs. The exact location within the temple precincts is known only for a small number of these statues.

The artistic canons governing the construction of the three-dimensional figure were established toward the end of the 2d dynasty. The representation of the human figure in the round was vertical and axial, consistent with the canon governing the representation of the human figure in relief. The sculpture in the round was conceived from four principal views: head on, from the two sides, and from the back. For technical reasons the back was often engaged to a wide slab to afford greater protection for the figure, and during the 5th dynasty this feature developed into the characteristic narrow backing pillar. The statue embodied the deceased in even more direct fashion than did the relief representation. It was set up in the statue chamber, or serdab, removed from the sight of the living. Statues intended to be seen were placed in the cult chamber, and from the 5th dynasty onward there were special statue shrines in which the statue formed the focal point of a cult ceremony. The function of the statue was to act as a dignified and permanent representation of the deceased that was suited to his rank. He might be represented standing in a solemn, immobile position, or seated, or squatting. The arms and hands are placed close to the body, and their position varies somewhat for standing and seated figures and for males and females. Only male figures have one hand clenched. The left leg of standing male figures is advanced, just as on reliefs; females, however, usually stand with their feet together.

At the beginning of the Old Kingdom development the single figure standing on a narrow base was characteristic. As early as the time of Zoser, statuary groups appeared, such as those in his sanctuary at Saqqara. In these groups several standing figures shared a common base and were aligned side by side. In family groups, the relationship between man and wife was generally expressed by the wife's placing her arm around the waist of the husband (PL. 340). Royal statues were distinguished from those of private individuals by symbols of rank. The royal headcloth, the crown of Upper Egypt, or less frequently that of Lower Egypt, and a long false ceremonial beard were used to identify statues of kings. Gods, in male or female human form, may appear on a common base with rulers in Old Kingdom sculpture, and their attributes are worn on their heads. The figures of standing officials lean on a staff and as a symbol of their station hold a short staff in the hand that hangs at their side. The dress of kings, as well as of private individuals, usually consists of a short white kilt, and the upper body is naked (see COSTUME). In some cases the panther skin of the priest or the long jubilee robe of the king is represented. Women wear long white robes that hug the figure tightly, and occasionally these robes are decorated with colorful patterns. Children, when they appear in family groups, are often represented naked.

Various materials were employed for Egyptian statues and their distinctive properties influenced the character of the representation. In the case of wooden figures, the body and the appendages were modeled separately and later joined; whereas statues of stone, particularly those of hard stone, were conceived as closed blocklike masses rising from a base. Openings between

the body and its appendages were usually avoided in stone sculpture. As a rule, stone statues have back slabs or pillars, which are absent in statues of wood. In the representation of the clenched fist, there is a humplike protuberance between thumb and index finger that is generally interpreted as symbolizing the staff of office held in the closed hand (PL. 340). Most Egyptian statuary was painted. With the sole exception of the reserve heads found in the tombs of Giza, on which there are no traces of color, the painting of limestone statues may be considered the general practice. The colors used for statues in the round are the same primary hues employed in reliefs. The painting of statues of hard stone, on the other hand, can be detected with certainty in but a few cases. The polished surface of a schist statuary group found in the mortuary temple of King Mycerinus yielded traces of color applied over a thin layer of stucco. In the case of statues of red or green diorite, the natural color of the stone seems to have represented the color of human skin. The hair and moustache were painted black, the pectoral ornament green, and the kilt and fingernails white. The eyes were generally painted white, with their pupils black and brown. The eyes of wooden and limestone statues — rarely those of hard stone — were sometimes inlaid with rock crystal and other material in a copper frame in order to increase the lifelike effect.

The Egyptian statue was tantamount to the individuality of the person represented; indeed, it was believed to be identical with the person — another self, as it were. Surface damage or eradication of the name inscription extinguished this individuality. Egyptian sculptors strove for such individualization and likeness. Such effort is evident in the portrait character of a number of statues and reliefs and in the fact that inscriptions tell us that a likeness is "taken from life." Still uncertain is the purpose of a plurality of likenesses of the same person in a single tomb. Sometimes several portraits of the same person were assembled as a single group (the so-called "pseudo groups"). It may be that the essence of a person was thought to be divided into a number of different qualities, each of which demanded a separate portrait. Both an idealized and a realistic likeness of a single individual were sometimes made. Even the wooden reliefs of Hesira represent the master with certain conventional portrait differences. The high priest Ranofer is ageless and has long hair and a short kilt in one of his life-size statues; in the other, he is depicted at a dignified age and has short hair and a longer kilt (Cairo, Egyptian Mus.; PL. 341). The same differences exist between two wooden statues of Kaaper, the more "aged" portrait having been dubbed "Sheik el Beled," or village mayor, by the native excavators (PL. 341).

Sculpture in the round emerged at Memphis at the beginning of the Old Kingdom with forms that were derived from those created in Upper Egypt during the first two dynasties. Along with the hard stones favored by tradition, soft limestone, easily cut by the chisel, became a favored material of the sculptor.

The life-size statue of Zoser seated on his throne is the first great work of early Memphite sculpture in the round (PL. 331). As in the case of its antecedents, the small statues of Khasekhem from Hierakonpolis, the principal views of this work are the two side views. Seen from the front, the draped upper body of the statue appears somewhat narrow and constricted; only the powerful head, with its large sunken eyes (formerly inlaid) and voluminous wig, imparts weight to this view. The facial physiognomy, with its prominent cheekbones and determined mouth, suggest that this may be the portrait of an aged man. Contemporaneous private sculpture is exemplified by some seated figures of hard stone and freestanding figures of limestone in which the compact forms of an older Upper Egyptian heritage are unmistakably present.

The life-size limestone statues that appeared early in the 4th dynasty, such as those of Prince Rahotep and his wife Nofret from Medum (PL. 338), that of Prince Hemiunu from the western cemetery at Giza (Hildesheim, Germany, Pelizaeus Mus.), and the unique bust of Prince Ankhhaf from the brick chapel of his mastaba at Giza (PL. 339), represent members of the highest social class. The bust of Ankhhaf and the reserve heads from the officials' tombs at Giza were intended as substitutes for complete statues and attest the fact that in ancient Egypt the head was considered the center of a person's individuality.

Royal sculpture from later in the 4th dynasty begins to exhibit somewhat dissimilar qualities. The statues of Sneferu in the shrines of his valley temple are made of limestone, and his features comprise an idealized likeness of a type that remained essentially unchanged from the 4th to the 6th dynasty. After the introduction of granite architecture for valley temples, royal statues were made exclusively of hard stone. The most important work of this period is a diorite statue of the enthroned Chephren (PL. 340). His strongly individualized features are the purest and most powerful expression of the idea of divine kingship that has come down to us. On the sides of the throne, the unity of Upper and Lower Egypt in the person of the ruler of the Two Lands is expressed in relief in a manner that was henceforth to remain standard: the flora of Upper and of Lower Egypt are entwined around the hieroglyph for "unification." The sky god, in the form of a hawk, spreads his wings protectingly about the royal head. Other heads found in Chephren's valley temple are even more individualized in character. These may be considered to represent a kind of humanization of the royal portrait, as is also characteristic of the group portraits of Mycerinus from his valley temple. These groups show the king with his queen (PL. 340) or in the company of the goddess Hathor and the nome goddesses. The facial features of the king, the queen, and the goddess Hathor are practically identical; only the rendering of the wig is different in the three figures.

Two portraits of Weserkaf from the beginning of the 5th dynasty — one a granite head of a colossal statue from the pillared court of his valley temple, the other a head of schist found recently in the area of his sun temple — mark a return to softer forms (Cairo, Egyptian Mus.). The 5th dynasty witnessed the high point of private sculpture in the round. To this period belong such masterpieces as the two limestone statues of Ranofer and the smaller wooden statue called the "Sheik el Beled" (PL. 341), as well as the unusually lifelike seated scribe in the Louvre (PL. 342). Representations of family groups became more common. The restrained, harmonious forms of these statues suggest the same spirit of solar religion that brought into being the comprehensive picture of harmonious world order found in contemporary reliefs. A number of small finely carved wooden figures of a certain Methethi illustrate the elegant, formal, and courtly style of sculpture characteristic of the transition from the 5th to the 6th dynasty (Brooklyn Mus.; Boston, Mus. of Fine Arts; Kansas City, Mo., Nelson Gall. of Art).

Royal sculpture of the 6th dynasty is best exemplified by a life-size copper group of King Pepi I and his son Merenra, from the sanctuary at Hierakonpolis (Cairo, Egyptian Mus.). The separate parts of these copper works were wrought or cast and then given a parcel-gilt finish. (Understanding of the technique involved and esthetic appreciation of this group is now made difficult by the heavily corroded surface.) The eyes of these figures are inlaid. In royal sculpture of the 6th dynasty new motifs also appear in small-scale works: examples include the alabaster group of Queen Ankhnesmeryre with her son Pepi II seated on her lap and the kneeling schist figure of King Pepi offering a libation of wine (Brooklyn Mus.). The eyes here are also inlaid. The forms, especially the facial features, are rigid. In a later period the motif of the king devoutly kneeling before the divinity was repeated in works on a larger scale. The end of the Old Kingdom marks a return to the "hieroglyphic" character of art.

During the 6th dynasty a much larger social class was able to commission sculpture. Consequently, private sculpture from this dynasty is more plentiful than in any previous period and is characterized by lower artistic quality and smaller scale. The former creative vitality is absent. The system of artistic production, however, and the existence of a venerable artistic tradition continued to ensure fine quality in occasional works. An inventive solution is found in the small painted limestone group of the dwarf Seneb with his wife and two children (Cairo, Egyptian Mus.); he held a low administrative post at the court as "overseer of the weavers." Because of his stunted lower

limbs, the artist devised the following method for overcoming the difference in height between the dwarf and his wife: Seneb sits with crossed legs on a seat next to her, and the children are placed in front of him, taking up the space where his legs would normally appear. The realism of this late phase of Old Kingdom art also led to relaxation of the heretofore strict laws of sculpture. The limbs were opened out from the bodies to an ever-increasing degree and without benefit of supports. In this respect, stone sculpture now resembled sculpture in wood, such as was common during this period in the form of small, rather elongated figurines.

From late in the 4th dynasty, and particularly in the 5th and 6th dynasties, the mortuary statues in the serdab were accompanied by a retinue of small figures of painted limestone. Women grinding corn, potters, brewers, cooks, and butchers are represented at work in a variety of postures, just as in contemporary relief and wall painting. Such figures were doubtless translated from the medium of relief into the more effective medium of sculpture in the round. While the figures generally are strongly vertical, there is a great deal of freedom in the poses of workers. Thus, the brewer leans over his barrel and inclines his head slightly to the left (Cairo, Egyptian Mus.). The faces, particularly those of the men, are coarse and represent the Egyptian common people with realism and humor. As in the reliefs of the late Old Kingdom, the activities of these servant figures are not limited merely to material sustenance of the deceased: musicians, dwarfs, and children at play are included for his entertainment. The 6th dynasty marked a noticeable increase in the occurrence of these servant figures, which were then placed within the sarcophagus chamber itself. These late Old Kingdom productions, which have little claim to artistic distinction, were often assembled in large groups to form fully staffed kitchens and slaughterhouses. The high point of this rather informal art was attained in the 11th dynasty.

Few representations of animals in the round have been preserved from the Old Kingdom. From the time of the first unification, theriomorphic gods and goddesses assumed increasingly humanized forms. One animal divinity, a ram of black stone, has been preserved in a fragment bearing the name of Cheops (Berlin, Staat. Mus.). The ancient image of the king's "lion might" was expressed again during the Old Kingdom in the latent power of the couchant lion with a kingly head. The figure of the lion, perhaps as an apotropaic force, was now associated with royal thrones and offering tables. An embalming table from the sanctuary of Zoser at Saqqara rests on lion legs, and the heads of roaring lions decorate the sides of the flat rectangular basin. Subsequently, this royal animal appeared only in a peaceful attitude, with closed mouth, much the same as it had appeared for the first time in ivory gaming figures of the 1st dynasty. During the 5th dynasty, heads and forepaws of lions appeared as waterspouts on the flat roofs of temples, with the water draining off between the forepaws. Two works of high artistic merit are Old Kingdom lion heads of unknown origin, which are now in Berlin (Staat. Mus.). These represent two quite different conceptions of the animal. The one head, of alabaster (calcite), is highly abstract and gives an effect of dignified majesty when seen in profile; the other, of basalt, is meant to be viewed from the front, and the head is framed by the wavy mane. The head of a hawk of wrought gold, found in Hierakonpolis, belonged to a bronze group showing a king — probably Pepi II — standing under the protection of the hawk-god (Cairo, Egyptian Mus.). Again, the forms of the bird's head are radically stylized.

Unfinished statues allow one to observe the different phases of construction. As may be seen in preserved examples, the block was first trimmed to the approximate size and contour of the figure. The base and the back were cut to their exact final dimensions, and the suitable units of scale were then marked on the resulting surfaces. By these marks every point, in height as well as depth, could be checked against the canon of proportions by means of the measuring stick or plumb line. The outlines of the figure were then sketched on this rough block with the sculptor's chisel, and the excess stone was worked away from the front and the two sides. The preliminary sketch

disappeared as work progressed and had to be periodically redrawn according to the scale markings. The types of tools employed by the Egyptian sculptor may be reconstructed from the manner in which the stone was worked. Copper chisels with both narrow and wide cutting surfaces were employed from the Old Kingdom into the 1st millennium B.C. Hard stone was probably worked with a pick as well as with cylindrical copper drills and saws. Some waste cones cut from the stone with the hollow cylindrical drill have been found. A fragment of a copper saw was discovered embedded in a granite sarcophagus, and a large copper chisel was found in a diorite quarry of the 4th dynasty. Finer details, such as the sharp delineation of the eyes or the hollowing out of the nose, lips, and ears, were carefully executed with the pick, a pointed chisel. Emery was used for the final polishing of the surface.

*Minor arts.* The furniture, personal adornment, and ornament of the Old Kingdom have been sparsely documented through a few tomb finds, supplemented by representations in reliefs and paintings. The most significant and extensive of these finds was made in the deeply buried tomb of Queen Hetepheres I, the mother of Cheops, which lies near his great pyramid at Giza (PL. 343). To this cachelike tomb, Cheops brought the furnishings from his mother's original burial in the cemetery at Dahshur, probably after tomb robbers had attempted to violate the latter. The hidden tomb contained the portable pavilion of the queen, from which the supports and frame of wood covered with sheet gold remain. In addition to the queen's bed, two chairs with armrests and a sedan chair were found. A wooden box covered with gold and inlays of faïence contained richly decorated curtains that have almost entirely disappeared. Another box, similarly covered with gold, contained large silver torques inlaid with butterflies of turquoise, lapis lazuli, and carnelian. In ancient Egypt silver had to be imported and was therefore far more precious than gold, which was mined in the Eastern Desert. A design that simulates reed matting is impressed into the gold sheathing of the pavilion's framework. The same design also appears on the backrests of the chairs, where it alternates with rosettes. The inner sides of the forward posts that supported the pavilion bear a frieze of large hieroglyphs, finely wrought in the gold and signifying King Sneferu, whose name appears again on the larger box. The title and name of the king, in large cast and engraved hieroglyphs of gold, are set into the ebony strips on the back of the sedan chair. The heavy gold poles of this chair are made in the shape of papyrus columns. The larger surfaces of this furniture, between its gold framework, are decorated with colorful faïence inlays in the form of feather patterns, rosettes, and emblems of divinity.

The tomb furniture of Queen Hetepheres is the only appreciable find of this kind which has come down to us from the Old Kingdom. The simple elegance and highly developed technical execution of the objects serve to give us a glimpse of what the furnishings of other royal tombs of the period must have been like. A belt decorated with beads of gold and semiprecious stones and clasped with a gold buckle is the most valuable find yet made in a private tomb of the Old Kingdom. Beads of gold and red and black stones are strung on threads and attached to small eyes that project from a narrow strip of gold; the color combinations form a continuous pattern of multicolored diamonds. The gold buckle is decorated with the name of the owner, Prince Ptahshepses. Two hawks, rendered in the niello technique, soar above his name (PL. 343). Though the belt itself probably dates from the 5th or 6th dynasty, this technique must have been known as early as the time of first unification: in the reliefs on the palette of Narmer the king wears a belt which, on the basis of its beaded decoration, must have been made in a similar technique.

In the statue of Nofret (PL. 338), the princess wears a diadem decorated with colorful blossoms and circular rosettes. Similar diadems have been found in the Old Kingdon tombs of Giza and are now in museums at Leipzig and Boston (Mus. of Fine Arts). Such headwear consists of a strip of copper faced with stucco, which in turn is covered with a layer of gold leaf. Large

rosettes, composed of umbellate papyrus, crested ibis, and the hieroglyph for "life," are applied to the outer surface. These rosettes were also gilt applied on a layer of stucco.

The prehistoric and protohistoric art of manufacturing vessels of hard stone terminated early in the Old Kingdom. The numerous stone vessels discovered in the subterranean passages of the stepped pyramid of Zoser represent the last important manifestation of this type of production. (The tomb of Hetepheres contained only a few alabster examples.)

THE FIRST INTERMEDIATE PERIOD AND THE 11TH DYNASTY: THE LOSS AND RECOVERY OF ARTISTIC TRADITIONS. After the collapse of the Old Kingdom, which marked the end of sump-

during the bitter rivalry and warfare among the southern nomes. The burials of the Theban princes lie on the western bank of the Nile, opposite present-day Karnak, at the entrance to the ravine of Deir el Bahri. These tombs were burrowed into the low hills that rise before the western cliffs. Here tomb architecture exhibited an innovation: a court, sometimes more than 800 ft. long and over 200 ft. wide, was excavated along an east–west axis. Facing the west end, a hall of stout pillars was carved out of the rock. From the middle of this hall a tunneled passage led to the sarcophagus chamber. The retinue of the prince was buried in the lengthwise walls of the pillared court. A brick pyramid constructed in the court or above the sarcophagus chamber — its presence is attested by the Abbott papyrus — was

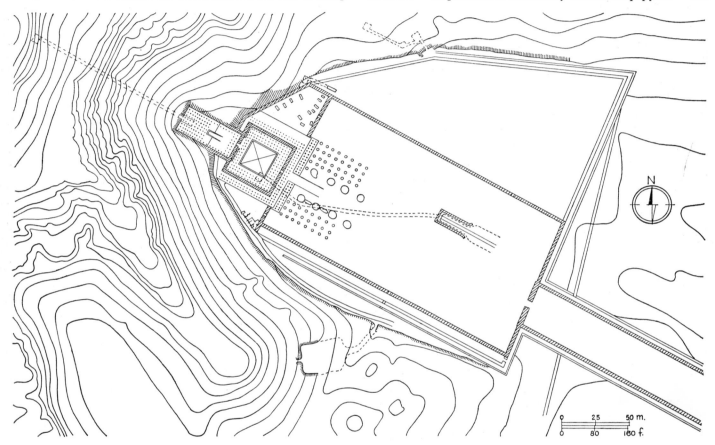

Deir el Bahri, mortuary temple of Mentuhotep II (Nebhepetra), reconstruction of ground plan, 11th dynasty (*from Lange-Hirmer*).

tuous tomb precincts (and thus, the end of serious art in the royal capital), Egyptian art continued on a more modest scale in conservative Upper Egypt under the patronage of autonomous local rulers. The custom of decorating the walls of tombs with reliefs or paintings was continued in Middle Egypt at Beni Hasan, Asyut, and Naga ed Deir. This practice persisted especially in Upper Egypt at Mialla (Mo'alla), Gebelein, and on the far southern frontier at Aswan. As the connection with the royal capital had been severed, the decoration of tombs had to be carried out by local artists. The quality of draftsmanship declined sharply, and only vague notions of the canons governing the construction of the human figure and the composition of scenes remained. Subject matter was transformed in an arbitrary and drastic manner. In a wall scene in the tomb of Prince Ankhtifi at Mialla, the princess toys with a duck tied to the end of a papyrus stalk; near at hand, her husband is harpooning fish. In the scene of a herd of donkeys from the same tomb, one animal lies stubbornly on the ground. Most of the tombs were now decorated with paintings rather than reliefs. The colors are garish; new tones such as gray, pink, and purple are employed.

The princely house of Thebes gradually gained ascendancy

intended to assert the sovereignty of the Theban princes, after the model of the royal pyramids near Memphis.

When Mentuhotep II succeeded in defeating the Heracleopolitan dynasty that had come to power in Memphis and in uniting all of Egypt under his scepter, he ordered a monumental tomb to be built below the great cliffs in the valley of Deir el Bahri (FIG. 653). In accordance with the political policy of the new dynasty, the tomb of Mentuhotep II sought to combine the tradition of the princely tomb as developed in Thebes with the Memphite type of Old Kingdom pyramid. The gigantic tomb precinct is oriented along a strict east–west axis. A broad ramp, flanked by brick walls, leads from the edge of the valley below through a monumental gateway in the thick outer wall and into a large court that at its western end adjoins the tomb proper, which is elevated on a terrace. The path traversing the court was formerly lined with sycamore and tamarisk trees. Statues of the king in his jubilee robe stood under the sycamore trees. There are indications that this court served as the site for jubilee festivals honoring the deceased king.

The tomb itself consists of two successive complexes. The anterior part is focused about a square terrace that is approached by a ramp. Pillared galleries flank the terrace on ground level,

and on the upper level an open pillared gallery also surrounds the core of the structure on three sides. The terrace is an immense platform surmounted by a pyramid. The pyramid is surrounded on all sides by rows of octagonal pillars that form a passageway, accessible only from the ramp to the east and permitting access through another portal on the west into the second part of the sanctuary. This second portion of the sanctuary is of rectangular plan and is constructed in a cut in the base of the cliff. Its architecture consists of a court surrounded by pillared porticoes, with the western one opening into a covered hall of several aisles. The shrine itself is set into the west wall of this hall.

The old concept of the king embodying the unity of the two lands is expressed in the sanctuary of Mentuhotep by providing two tombs for the king. One of these lies under the pyramid and consists of a chamber approached from the main court; it contained an empty sarcophagus as well as a statue of the king wearing the crown of Lower Egypt (PL. 348). This tomb conforms to the Memphite type. The true sarcophagus chamber, however, was approached from the pillared court of the second, or rear, sanctuary and lay nearly 500 ft. within the cliff. In this segment Mentuhotep continued the Upper Egyptian form developed by his Theban ancestors.

The significance of the temple of Mentuhotep is twofold. Here the founder of the Middle Kingdom, for the first time in the history of Egyptian architecture, placed a structure against the high Theban cliff walls. Furthermore, he fused Theban and Memphite architectural traditions into something entirely new: pillared architecture open to the exterior. This new concept would subsequently inspire one of the most grandiose of all the monuments of ancient Egypt — the New Kingdom terraced temple of Queen Hatshepsut (see below). The location of Mentuhotep's tomb, at the end of the ravine of Deir el Bahri and directly at the foot of the cliffs, was not chosen for esthetic reasons. The sarcophagus chamber of the king was most secure if placed deep within the cliff wall. The deciding factors, however, were religious and dynastic considerations: the ravine seems to have been sacred to the sky goddess Hathor, who was believed to have emerged from the cliffs in the guise of a cow — a belief current as early as the 11th dynasty.

In the foundations of the terrace, under the statue shrines, the tomb shafts of the ladies of the royal harem were located. Nearby, to the north of the temple precinct, was the tomb of Queen Nofru. The royal retinue reposed in cliff-hewn tombs at the foot of the mountains that enclose Deir el Bahri to the north and south. These cliff tombs continue the architectural type of the Theban princely burials. A large court surrounded by walls leads uphill to the tomb, and a wide colonnaded porch is placed before the façade. A passageway along the central axis leads to the interior and the cult chamber.

The founders of the Theban dynasty desired their tombs to be decorated with reliefs, in the manner of the mortuary temples of the Old Kingdom (PL. 344). The tombs of the royal retinue were also to be furnished with reliefs in their passageways and chambers. The artistic means necessary for the revival of these arts had to be created anew. The skill of the draftsmen and painters already in the service of the local aristocracy was inadequate for the demands of dynastic patronage. Furthermore, the themes and texts required for the proper decoration of a royal tomb were lacking in Upper Egyptian tradition. Prototypes were required, such as could be seen only in Memphis. Among the retinue of the king at this time was an official, an overseer of the sculptors, who reported in his autobiography that he had formerly served the Heracleopolitan house. It is plain, then, that Mentuhotep took Memphite officials into his service and that these functionaries must have imported their artistic traditions to Thebes. For the practical training of draftsmen and sculptors capable of translating imported models into monumental reliefs, the geometric layout of representations was put on a new and safer basis. In place of vertical and horizontal sectioning of the model, such as that employed to guide the artist during the Old Kingdom, a more thorough grid system was introduced during the 11th dynasty. It was founded on the canon of proportions current during the Old Kingdom but offered the advantage that the construction of figures, outlines, and many details could be more accurately fixed in relation to the small squares of the grid. This network of squares simplified the copying of Memphite models as well as the creation of original motifs (PL. 347). Through this grid system, it was possible within a few decades to establish a new artistic tradition. Because of the fragmentary state of the reliefs of Mentuhotep's mortuary temple, it is impossible to reconstruct the repertory of motifs and their disposition on the walls of the open pillared halls and the inner chambers. Nevertheless, Memphite influence is clearly in evidence, as in some battle scenes that unfortunately are preserved only in tiny fragments.

The renewed competence in drawing and sculpture gained during the 11th dynasty may be observed in the fragments of relief from the mortuary temple and cult room of Queen Nofru, as well as in several sanctuaries restored by Mentuhotep II (Nebhepetra) and his successor Mentuhotep III (Seankhkara). The height of relief is considerable, yet the modeled surface itself is relatively flat. A profusion of detail is rendered with great care. The expressive head of the king, the somewhat heavy reliefs of the statue shrine in which the king is represented drinking with his ladies, and the reliefs from the cult chamber of Queen Nefru and from a chapel in Dendera belong to this stylistic group. The sunk reliefs on the limestone sarcophagi of the ladies of the royal harem belong also in this period of the development. In one of these Queen Kawit holds her mirror with mannered elegance and gracefully raises a drinking cup to her lips while she is being combed by a female attendant (PL. 344). This motif is not Memphite but is borrowed from the primitive paintings of Upper Egyptian wooden sarcophagi of the First Intermediate Period. Here it is adapted to the context of elegant courtly life. In the representations of the hands, with fingers bent backward in an almost affected manner, there is an inclination toward formalism. The carving of the relief is executed with extraordinary precision. Although the figure proportions are still slender, the composition of the groups has become rather closed.

The last phase of the relief decoration of the tomb of Mentuhotep II shows the king in the presence of gods. In these portions, the forms are clear and well balanced. Perfection in the art of relief carving was attained during the reign of his successor Mentuhotep III, notably in the fragments from Armant and Tod. The figures are well proportioned and their modeling is more varied; details are subordinated to the appearance of the whole. These reliefs bear comparison with the finest achievements of the Old Kingdom but contrast with those in their cool, matter-of-fact approach and in the precision of their workmanship. More empty space surrounds each figure than is typical for relief representations of the Old Kingdom. The great precision that characterizes these reliefs derives from their execution on the grid system; this accuracy remained a characteristic of monumental reliefs throughout the ensuing Middle Kingdom.

The royal tombs and the tombs of the retinue also required statues. The most significant sculpture in the round created during the 11th dynasty is the statue of Mentuhotep II enthroned, wearing the crown of Lower Egypt. This statue, which is made of sandstone and painted (PL. 348), substituted for the body of the king in the dummy burial under his pyramid. This representation has no predecessor in Memphite art but must be judged a new creation. Without prototype are the tense pose with arms crossed over the chest; the cubistic treatment of the figure, which is emphasized by the blocklike throne and square base; and the harsh color contrasts of the dark brown body, the white drapery, and the red crown. The abstract geometry of this statue betrays its development from a background of "hieroglyphic" pictorial concepts. The major extant private statues of the 11th dynasty are made of limestone; none of these attains the cohesiveness of the statue of Mentuhotep II. The statues in the shrines of the harem ladies seem to have been made of wood; and sculpture in wood of the type found in the provincial tombs of the later Old Kingdom continued into the 11th dynasty. The continuity of older traditions may also be observed in a rich find of sculpture from the tomb of

EGYPTIAN ART

Meketra, a court official of Mentuhotep III. Whereas many of the private tombs of Thebes, with their limestone-revetted chambers and passages, were despoiled through use as quarries for subsequent buildings even in antiquity, the hiding place of the servant figures in the tomb of Meketra remained inviolate.

Sculpture in the interregnum adopted themes current in wall painting of the late Old Kingdom and translated these into three-dimensional forms. In some instances, the models from the tomb of Meketra depict realistic interiors: the spinning room, the mason's workshop, the slaughterhouse. Even a model of a dwelling — reduced to the representation of a colonnaded hall opening onto a garden containing trees and a pond — accompanied the deceased on his journey. A sculptor by the name of Iritsen who lived during the 11th dynasty has left us a lengthy and complex inscription on his stele. This inscription may well be the earliest statement positively attributable to an artist. At the outset, Iritsen boasts of his knowledge of the "secrets of the divine words," of the "prescriptions regarding the ritual for festivals," and of "one of every kind of magic." Then he goes on to speak about the mastery of laws governing art, such as how to represent the "walking of a man" or the carriage of a woman and how to give the impression of momentary action. Finally, he enumerates his technical abilities, including proficiency in the working of gold, silver, ivory, and ebony.

ART OF THE MIDDLE KINGDOM (12th and 13th dynasties, 1991–1650 B.C.). *Architecture: a. The royal tombs.* Amenemhet I, the founder of the 12th dynasty, moved the capital, which had remained in Thebes after the reunification of the kingdom under Mentuhotep II, back to Lower Egypt, to the area just south of Memphis. This move signified a conscious identification with Old Kingdom traditions of kingship. In Memphis the rulers of the 12th and 13th dynasties returned to the Memphite pyramid for their burials. Their pyramids, however, never attained the solidity or the size of the dressed masonry pyramids of the Old Kingdom. The dominion of kingship had changed: the rulers of the Middle Kingdom no longer had the combined resources of the two lands at their absolute disposal.

Amenemhet I constructed the core of his pyramid at Lisht of blocks transported from Old Kingdom mortuary temples at nearby Giza and Saqqara. The Pyramid of Sesostris I at Lisht exibits a new technique of construction, designed to save both building materials and man-hours. The core consists of a radiate system of walls, with interspaces that are in turn bridged by additional walls at right angles. The intervening compartments that resulted were filled with sand and rubble, and the whole construction was faced with limestone slabs. The later pyramids constructed at Dahshur and at Lahun and Hawara, farther to the south at the edge of the Fayum, were brick structures also faced with limestone slabs. This flimsy construction of pyramids, which were no longer destined to receive the body of the king, was accompanied by correspondingly more ambitious aims in the construction of the real tomb. The sarcophagus chamber lies hidden deep under the pyramid, which was intended more as an imposing symbol of royal power than as an actual burial chamber. The sarcophagus chamber of the tomb of Amenemhet III consists of one immense hollowed block of quartzite. Of a second pyramid that Amenemhet III had constructed at Dahshur, only the crowning pyramid stone of black granite has been preserved.

Of the royal mortuary temples of the Middle Kingdom, the only one that permits reconstruction of its ground plan is that of Sesostris I, which is located near his pyramid at Lisht (FIG. 658). The essential details of the plan of the temple of adoration of Pepi II, from the 6th dynasty, have been adopted and simplified. The relief decoration — to judge from the scant remains — is derived from the same sources, in both style and choice of themes. Limestone statues of Sesostris enthroned stood in front of the pillars of the great court; ten of these were found in a hiding place to which they had been removed at a later time (PL. 349). Another innovation was in evidence: statues of the king wearing the crown of Upper Egypt stood in the

relief niches of the main ramp. This ramp sculpture represents the appearance of a new type in royal sculpture; the king is represented as Osiris, the ruler of the dead. In this guise, he is enshrouded in a long garment and has his arms folded.

The most significant mortuary precinct of the Middle Kingdom was that of Amenemhet III near Hawara, at the edge of the Fayum. Herodotus and Strabo describe it as one of the wonders of ancient architecture. Only a giant field of rubble remains; it was here that a limestone statue of the king was accidentally uncovered (PL. 349). The tombs of the royal retinue and of court officials consisted of modest undecorated mastabas or simple shafts. These burials are again clustered about the pyramid of the ruler whom their occupants served.

*b. The provincial burials of the nomarchs.* While the kings of the 12th dynasty were struggling to restore order to the

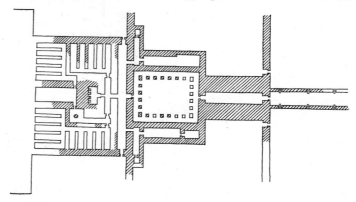

Lisht, mortuary temple of Sesostris I (*from W. Stevenson Smith*).

administration of the realm, a second power was making itself felt throughout the land — that of the nomarchs of the Middle and Upper Egyptian provinces. Their independent position and claim to authority were derived from the feudal system that had developed during the second half of the Old Kingdom, especially from the collapse of centralized government at the end of the 6th dynasty. It is generally assumed that the reunification of the realm under Mentuhotep II was achieved only through the collaboration of these petty princes. This assistance naturally would have served to increase their own power. The burial sites of these princes, near the capitals of their respective nomes, are situated in the steep embankments of the hills flanking the Nile Valley. In Middle Egypt such sites are Beni Hasan, El Bersheh, Meier, Asyut, Qaw el Kebir, and, on the far southern frontier, Aswan. A creative provincial art of significance developed during the Middle Kingdom in the service of these independent and powerful local rulers.

Even the earliest tombs of the Middle Kingdom differ from those of the Old Kingdom by virtue of their spaciousness. One of the earliest Middle Kingdom examples is the cliff tomb of Tefib at Asyut, which belongs to the Heracleopolitan era. At Beni Hasan the earlier tombs of the 11th dynasty consist of a navelike hall reaching deep into the cliff; the rear portion of this area assumes the form of a festival hall by means of colonnades laid counter to the principal axis (PL. 346). This space, with its slender polychrome lotus bundle columns, imparts an effect quite different from that of the earlier cliff tombs, where the architectural plan was based upon the fulfillment of cult requirements. These 11th-dynasty tombs probably duplicate festival halls in the palaces of the nome princes. All these tombs have one feature in common: namely, they extend deep into the cliff along a strict tunnel-like axis. At Beni Hasan a small porch supported by two fluted columns is set before the entrance to the tomb. In the interior, the architraves follow the principal axis, and the lofty hall is thereby divided into three aisles. Each aisle is covered with a flat ceiling decorated with colorful patterns, which indicate that the architect was seeking to imitate a construction of wood and other colored materials. The central aisle ends in a niche containing a statue

of the deceased. This niche is located exactly opposite the entrance to the tomb, whence it derives its light. The cliff tombs at Asyut also extend deep into the heart of the cliff along a strict axis. Not the false door but the statue shrine dictates the form of the cult focal point in Middle Kingdom tombs. In the ground plan of the tomb of Prince Hepzefa I, a contemporary

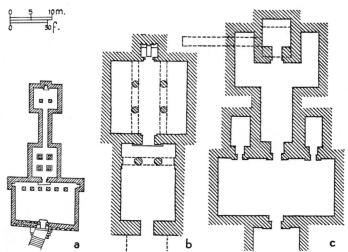

Plans of rock-cut tombs from the 12th dynasty: (a) Aswan, tomb of Sirenpowet I; (b) Beni Hasan, tomb of Khnumhotep III; (c) Asyut, tomb of Hepzefa.

of Sesostris I, two monumental shrines are arranged one inside the other (FIG. 659).

Across the Nile from Aswan, in the cliff tomb of one of the princes of Elephantine (Sirenpowet I, a contemporary of Sesostris I), the great stairway from the river to the tomb is still preserved. The exterior wall of the spacious outer hall is reinforced; a portal of fine white limestone, decorated with reliefs and inscriptions, forms the entranceway. A pillared porch has been placed in front of the wide cliff façade of the tomb and throws shadow on the sunk reliefs of the façade. This sculpture constitutes the oldest preserved monumental relief decoration of an Egyptian exterior. The two interior spaces — the large outer hall and the cult chamber with its statue niche — are united by a long, narrow passageway. In the outer hall, the architraves of the squat pillars are still arranged across the axis of the tomb. In the later tomb of Sirenpowet II, from the time of Sesostris III, on the other hand, the architraves are arranged along the main axis. The hall has become much higher, and the passageway that leads to the cult chamber is located on a higher level and is reached by means of a stairway. In the side walls of the latter tomb, there are figures of the god Osiris similar to those in royal mortuary temples.

Most highly developed architecturally are the tombs of the princes Ibu and Wahka at Qaw el Kebir near Asyut (FIG. 660). Their situation on the slope of a hill afforded occasion for a ramp, like those of royal tombs, and for a porch that served as valley temple. The level of the cult chambers is reached via a court with a pillared rear wall and a stairway. The upper pillared porch and the adjoining pillared hall are constructed of ashlar masonry. The actual cult chambers, which have flat ceilings without supports, are cut into the living rock. In addition to the uncommonly rich and complicated architectural details contained in this tomb, the ceilings are painted with colorful patterns, the walls are enlivened by reliefs of superb quality, and the anterior space is filled with a wealth of statues. The princely graves of Qaw el Kebir were begun in the middle of the 12th dynasty, and the final one was constructed during the reign of Amenemhet III. With the last-mentioned tomb, the rich artistic development of provincial art during the Middle Kingdom came to an end.

c. Temples. Only three Middle Kingdom buildings dedicated to the gods are preserved in their original state. Very few

others are known, even from their ground plans. A great number of finds of architectural members and reliefs, however, bear witness to the fact that sanctuaries to the gods were built everywhere in Egypt throughout the Middle Kingdom; but with few exceptions, these structures had to make way for buildings erected in later periods.

The founders of the Middle Kingdom and their successors restored the sanctuaries in the area of Thebes — at Gebelein, Tod, Medamud, Dendera, and, in the south, on the island of Elephantine. Blocks bearing relief decoration, which were reused during later periods of construction, provide evidence of this building activity. Of the buildings themselves, only a dilapidated little temple constructed of locally quarried rock on a hilltop about two miles north of Deir el Bahri remains. This structure consists of a forecourt and a small quadrangular building containing three shrines in its rear wall. Mentuhotep III built this temple, which comprises the simplest form of sanctuary and which developed from the primeval "hut of the god" surrounded by its fence. The front wall of the outer court is thicker than in earlier examples.

After the royal capital was moved from Thebes to Memphis, throughout the land an era of great building activity set in under the founders of the 12th dynasty. The three kings of this dynasty named Amenemhet mark a close connection with the god Amen, native to Thebes-Karnak. Of an older sanctuary, constructed during the early Middle Kingdom — the core of the later royal sanctuary of Karnak — only a few blocks of the foundation have survived. Memphite cults were transposed to the sanctuary of Karnak, as shown by the relief decoration of a limestone pillar from an otherwise unknown temple of Sesostris I (PL. 345).

The foundations of the third pylon at Karnak have yielded architectural parts from which an entire small peripteral temple of Sesostris I was reconstructed (PL. 345). This pavilion rises from a low square platform and is approached from either end by a low flight of steps. The building has the form of a pillared hall open on all four sides. The spaces between the pillars, other than the two entranceways, are bridged by low parapets. Four pillars in the interior of the building help to support the roof. All the pillars are decorated with reliefs of high quality that represent the occasion of the dedication, the jubilee festival of Sesostris I. The ground plans of two sanctuaries of the Theban god Monthu have also been reconstructed from sparse remains at Tod and Medamud near Thebes.

A temple to the sun god was built by Sesostris I at Heliopolis, once again in honor of his jubilee. Only a monolithic

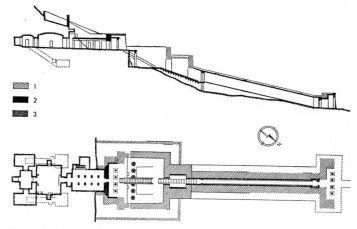

Qaw el Kebir, rock-cut tomb of Ibu, 12th dynasty. Above: Longitudinal section; below, ground plan. Key: (1) Brick walls; (2) stone walls; (3) living rock (from H. Müller).

granite obelisk about 65 ft. high remains from this structure. How the sanctuary looked is unknown; however, it is certain that the obelisks were arranged in pairs in front of the entrance, which was probably flanked by high pylons. The slender monolithic obelisk type of monument and the pylon are forms

invented during the Middle Kingdom. The pylon seems to have originated in the desire to monumentalize the entrance of the temple and strengthen the front wall. The earliest known pylon is part of the brick retaining wall of a temple of Amenemhet III at Hermopolis.

In the sanctuary of Bubastis in the Delta, granite architraves, papyrus bundle columns, and columns with capitals shaped like the head of the goddess Hathor have been found. These parts come from a great temple of Sesostris III. Away from the valley of the Nile, at the edges of the Fayum, two small temples of the Middle Kingdom have remained almost intact. The temple of Medinet Madi was protected by the Ptolemaic structures that surrounded it. Its interior holds three shrines elevated on a podium, which displayed the statues of the gods. The middle niche is wider than the two outer ones. The two side walls of the temple are extended toward the front to flank a kind of anteroom, which is supported by two papyrus bundle columns. The walls of this outer room bear reliefs and inscriptions of Amenemhet III and IV, thereby dating the structure to their reigns. The sanctuary of Qasr es Sagha adheres to this ground plan in its essential details. Seven adjoining shrines with niches, again elevated on a podium, are arranged along a narrow hall. Subsidiary chambers are reached through doorways in the two short walls. There are no inscriptions or relief representations, and in general the temple gives the impression of incompleteness.

*Relief and painting.* Only fragmentary remains serve to furnish information on wall decoration of Middle Kingdom mortuary temples and sanctuaries to the gods. The larger temples were built of brick, and only the sanctuary proper, the columns, and the portals were made of stone and decorated with inscriptions and reliefs. High relief and sunk relief exist side by side from the beginning of the 12th dynasty. The grid system was employed to bring greater "truth" to the details of the relief representations; and from this restriction to essentials and the minutely accurate representations made possible by the grid system, a new "royal style" was born.

The relief of the single Middle Kingdom pillar at Karnak (PL. 345) represents the god Ptah embracing the king. The relief is high and forceful, and details are subordinated to the total effect. The figures of god and king are differentiated only in physiognomy. The same clarity and forcefulness of design characterizes a sunk relief of Sesostris I (London, Univ. College Egyptol. Mus.) running in the presence of Min, the god of Koptos. The Heb-Sed scene on a lintel of the temple built by Sesostris III at Medamud (Cairo, Egyptian Mus.) is particularly effective in its spacious and well-balanced ornamental quality. The scenes are preserved in a severe and abstract manner. Above the double pavilion, in which the king (wearing the double crown of Upper and Lower Egypt) is represented as receiving millions of years of sovereignty from the gods of the Two Lands, soars the winged sun disk, which serves to emphasize and complete the main representation. The abstraction of forms is carried one step further in the lintel reliefs of a temple that Amenemhet III dedicated to the crocodile-god Sobek in the capital of the Fayum. Here the scene represented is translated into the complete abstraction of hieroglyphs: the royal name is placed under the protection of Sobek by positioning it between a double cult image of this god.

The decoration of the tombs of the nomarchs is in marked contrast to this new royal style. Here the artistic heritage of former times is carefully preserved and is expressive of a conservative and feudal way of life. As in the large Memphite tombs of the 6th dynasty, the tombs of the 12th-dynasty princes are predominantly decorated with representations of the funerary banquet, the inspection by the prince of his domain, and the receipt and registration of revenues from his nome. Draftsmen, painters, and sculptors who were trained in 11th-dynasty Thebes entered the service of the nomarchs after the capital was moved from Thebes to Memphis, and they were no longer able to continue in the service of the king.

Some Middle Kingdom artistic themes are new. They reflect the relatively sovereign position of the prince and his activity in the nome. Included among these subjects are representations of the prince in the company of his officials, as well as representations of memorable local events. Such choice of subject matter is derived from similar representations in the mortuary temples of the 5th and 6th dynasties. In a tomb at El Bersheh, the transport of a colossal statue from the quarry to the capital of the nome is represented. At Beni Hasan the arrival of a caravan of Semitic people is portrayed. The latter occasion was of sufficient importance for the date to be carefully recorded: an inscription on the papyrus held by the border official tells us that the event took place in the sixth year of the reign of Sesostris II. Through such details the reliefs of the Middle Kingdom become scenes definitely fixed in time, rather than timeless images.

In the festival halls the wall surfaces are elements of a spatial construction that is aimed at achieving an impressive effect, not merely at physically enclosing a cult area. The wall paintings are well adapted to the space they decorate, especially those opposite the entrance of a tomb in Meir and another at Beni Hasan. The latter is a well-balanced composition on either side of the statue niche; it depicts harpooning of fish and hunting for birds with the throwing stick.

The uniformity of artistic production and the steady development of themes which characterized the art of the Old Kingdom and which originated in the subordination to a fixed social and religious order did not recur during the Middle Kingdom. The relief decoration of Middle Kingdom tombs displays certain common elements, but there is still great variety from tomb to tomb and from place to place, in both style and selection of motifs. Even in the cemeteries in which a sequence of tombs may be observed, the draftsmen, painters, and sculptors were unable to establish a unified local style. It might be concluded from this that the artists were not regularly employed in the service of a single local prince but merely assembled for the execution of special commissions.

Wherever there was suitable stone in the cliffs from which the tombs were hewn, as at El Bersheh, Meir, and Qaw el Kebir, the decoration was executed in relief. In the necropolis of Beni Hasan, on the other hand, all the tomb decorations were painted. Painting was no longer simply a substitute for the more costly and durable technique of relief carving; it had developed characteristics and advantages of its own. In the tomb of Prince Djehuty-hetep at El Bersheh, the imposing figures of the prince and his family are done in painted relief (PL. 352). Scenes of field and garden and of household life, in which the main figures appear, are painted on the smoothed limestone walls without accompanying relief. In these tombs multiplicity of phenomena and joy in experimentation are everywhere evident. The experiments focus on representation of movement and on compact grouping of figures in action. The endless rows of wrestlers in the early tombs at Beni Hasan seem to have been projected largely for the sake of representing the human figure in a great variety of unusual poses. Such pictorial opportunities are the motive for representations such as that of the shepherds and antelopes (PL. 347). The disposition of groups in several spatial layers, which is possible only in the medium of painting, permits convincing expression of contemporaneous action. The hunt scene from the tomb of Senbi near Meir is a closely knit composition occupying a large surface. Instead of the earlier division of the picture into registers, undulating ground lines support the human figures and animals. This new arrangement, however, does not break with the old laws of representation in two dimensions in the sense of imparting an illusion of space or pictorial depth. Convincing and lifelike motion is one of the effects sought in these scenes. The hunter — the owner of the tomb — leans far forward as he draws his bow. In this unique relief should also be visualized the small plants and shrubs of the desert which were painted and which have subsequently almost disappeared. The outlines of the figures and the ground lines are indicated in relief. A representation of a hunt in the somewhat later tomb of Ukhhotep in the same necropolis represents a further development of the tendencies contained in the reliefs from the tomb of Senbu; but the once rich drawing and painting must be added

in the mind's eye: in their present condition, the sparse animal groups seem aimlessly scattered over the surface of the wall.

As it has already been suggested, the former splendor and wealth of painted details of Middle Kingdom princely tombs can hardly be appreciated in their present deteriorated state. In most cases it is possible to reconstruct the outlines of the over-all composition, as in a garden scene from the tomb of Hepzefa I at Asyut and in the unusual representation of bird catching in the latest tomb at Qaw el Kebir. The leaves of trees, shrubs, and vines are indicated only through the use of line and color. The stems of the papyrus plants appear to nod gracefully, and the severe bell-like outline of their flowers is made to approximate its real prototype through free painterly differentiation. Fine gradations of color reproduce the fur of animals and the resplendent feathers of birds in a wholly naturalistic manner. Painting may avail itself of a great variety of in-between tones that can be skillfully balanced against each other in individual works. The "geese of Medum" (PL. 328), from the beginning of the Old Kingdom, if compared to a Middle Kingdom painting, might best be placed alongside the birds in the acacia tree from the tomb of Khnumhotep (PL. 347), from the middle of the 12th dynasty. The pictorial motifs expressed in this picture are not new; they are concepts inherent in Old Kingdom painting. It is clear that the painter was familiar with earlier bird-catching scenes done in relief. However, he has invested an old theme with new qualities by emphasizing coloristic effects: dark branches, delicate green leaves, round yellow blossoms, and gaily colored feathers.

Whereas painted wall decorations have suffered great damage and deterioration of colors, one work of great significance, the wooden sarcophagus of Prince Djehuty-nekht from his shaft burial at El Bersheh, has been preserved in its original state. Among painted decorations in miniature style, the most important of the offering scenes on the interior of the sarcophagus is that of a dove (PL. 351). The long wing and tail feathers are depicted in broad brushstrokes of blue; the delicate covering of small feathers over the light ground of the body is rendered with small dots of blue framed by light red and also through fine stippling in light and dark gray. The creature appears clothed in splendid iridescent feathering. The colors are directly applied on the wood with a fine brush. The effect is one of impressionistic polychromy, for the image is also without contour lines. On the same sarcophagus, a representation of the prince is of great interest in that his arm and his upper body are not separated by a contour line but by the more painterly effect of gray shadow. In the same scene a faint cloud of smoke, emitted from the smoldering coals of an incense bowl, is depicted in delicate tones of blue. In its latest Middle Kingdom phase, painting freed itself from the conventions dictating the use of specific colors for certain objects and approached a freer, "impressionistic" concept of color.

Besides the royal reliefs and the tomb decoration of petty princes, the gravestones and steles erected by a broader social class at Abydos, the famous pilgrimage shrine of the god Osiris, form an independent branch of Middle Kingdom art. Most of these reliefs represent the deceased and other members of his family seated at a banquet table. The scene is incised on a rectangular slab that is rounded at the top. The purpose of these slabs was to symbolize participation in the blessings of the place, especially in the mysteries enacted in honor of the god. These votive tablets form an uninterrupted sequence from the 11th to the 13th dynasty. The steles from the 11th dynasty to the time of Sesostris I show clearly the gradual clarification of outline and composition in the relief technique. A sophisticated style of simple contours in sunk relief is characteristic of the middle of the dynasty. Steles from the time of Sesostris III and into the 13th dynasty are recognizable by their chessboardlike division of the surface for the accommodation of several members of the family and by the rounded part at the top incorporating the emblems of the gods.

*Sculpture in the round.* The most significant contribution of Middle Kingdom art was in royal sculpture in the round. The revival of sculpture in the round in the monumental works

of the 11th and 12th dynasties was not — as in the case of early Old Kingdom art — a steady development of the representation of the god-king in the light of changing religious concepts, but rather it was a deliberate manipulation of transmitted heritage for the strengthening of the state and the dynasty in a completely new situation.

In his Upper Egyptian capital at Thebes Mentuhotep II, the uniter of the Two Lands, was as yet hardly touched by the shifting tide in the world order. His Theban sculptors created statues that resemble hieroglyphic abstractions, to such an extent do they conform to the traditional canons. "Hieroglyphic" composition remained widespread in the early 12th dynasty under Amenemhet I and Sesostris I. But at the same time, sculpture was imbued with new functions. It was no longer confined merely to the royal mortuary temple and the sanctuaries of the capital. At the same time that new temples were built throughout the land, independent statues were also erected. These were carved of red granite or hard black stone and were usually of colossal proportions. Because of their scale, therefore, they could not have stood in the chapels of sanctuaries but must have been set up in the open air. The emergence of colossal royal statues during the Middle Kingdom affected the sculptural style itself, especially that of the heads. The eyes of a seated statue of Sesostris I (PL. 348) are set unusually deep in their sockets, and the highly polished planes of the face and body are even more strongly demarcated than usual.

Sculpture from the reign of Sesostris I exhibits a great multiplicity of forms. Next to the colossal head of a sphinx from Karnak, which is still constructed along the older abstract lines, stands a pair of granite statues of the same provenance but executed in a much softer style. The seated statues from the valley temple of Sesostris were set up in the pillared court of the temple of adoration (PL. 349). Over 6 ft. in height, they give unusual attention to corporeal articulation and sharply defined surface details for works in a soft material. Compared with the seated statue of Mentuhotep, the disposition of the parts has been substantially loosened; however, the legs are still engaged to the front of the throne and the arms to the body. The facial features are clearly delineated. The soft transitions between planes and the concentration on the eyes and the mouth aim at a forceful lifelike appearance. With the exception of black cosmetic lines, no traces of color remain on these statues.

No inscribed statue of King Amenemhet II has been preserved. Some of the tendencies and forms in vogue during his reign, however, may be deduced from a larger than life-size schist head of a sphinx with female hair style and eyes that were originally inlaid (PL. 350). This head can be dated with the help of a much smaller sphinx found in Syria, which bears the name of a daughter of Amenemhet II. In the highly articulated contours of its polished surface, the sphinx head in the Brooklyn Museum brings to maturity the tendencies suggested in the statue of Sesostris I and transforms this style into one of courtly elegance and formal beauty. This superb head constitutes the high mark of the "classical style" of the mid-12th dynasty. Although no inscribed statues of Sesostris II are known, two colossal seated images from Tanis may be considered to be representations of this king (Cairo, Egyptian Mus.). Obvious traces of later reworking, however, reduce their value in an examination of 12th-dynasty sculpture. Nevertheless, the soft transitions of the forehead (without modeled brows), the sagging upper lids, the creases at each side of the nose at the eye level, and the narrow mouth very likely all belong to the original conception. Two larger than life-size seated statues of Nofret, the wife of Sesostris II, of polished hard black stone and with eyes that were once inlaid, are heavier in their forms than the head of the sphinx discussed above. The face is framed by an ample wig that lends an air of ceremonious dignity to the figure.

The most marked change occurred in the reign of Sesostris III. The head of a life-size seated statue of the king from Medamud (PL. 350) exhibits an increasing realism in the carving of the eyes and mouth. The bone structure of the forehead and cheeks and the tense play of muscles in the cheek and mouth area are dominant features of this head. The heavy-lidded eyes impart

an expression of weariness and tension. The pull of the cheek muscles continues into the lips, and one plane merges almost invisibly into another. The result is a tense, dynamic, and yet harmonious, entity.

The impetus for the new movement toward firmly modeled, naturalistic sculpture seems to have come from Upper Egypt. Several statues of figures in a position of prayer — an innovation of this period — were dedicated by Sesostris III in the mortuary temple of Mentuhotep; colossal images were erected at Karnak and Abydos. The change is not to be understood as merely a formal (i.e., esthetic and technical) development: it represents the breakthrough of a new point of view that has more general application. The sculptors by this time had fully mastered the technique of carving in hard stone. Concepts that had long been present in literature (first in the period of the domination of Heracleopolis and then at the beginning of the 12th dynasty) now for the first time entered royal portraiture. The instructions of Amenemhet I to his son and successor show the ruler to be responsible only to himself and to govern in terms of his own moral convictions. This attitude toward the responsibilities and prerogatives of kingship understandably had consequences in royal portraiture. The features are not those of an individualized "portrait" in the present sense of the word. Rather, they portray the ideal characteristics of a Middle Kingdom sovereign: a visage conveying the experience of age, heroic conduct, and the heavy burden of responsibility. These characteristics become the appurtenances of a type and are assumed by Amenemhet III, the successor of Sesostris III. Similar qualities are applied even to representations of the gods, and, in milder form, of the queen. The statues of Amenemhet III represent further development; in the large versions of dark hard stone, facial expression gains in force.

Among the most striking creations of this period are sphinxes, a number of which have been found at Tanis and elsewhere. Old Kingdom sculptors had superposed the head of the king on the body of the lion; by uniting two concepts, they had created an entirely new type. In the royal sphinx, the face of the king is inserted like a mask into the lion's head and framed by the mane (PL. 354). The lion-mane sphinxes are set on high bases and should be visualized — again as in the New Kingdom — as flanking the approach to the entrance of a sanctuary.

An emphasis of the heroic aspect and a simultaneous hardening of the features distinguish a greater than life-size statue identified as Amenemhet III (PL. 353). The figure is furnished with a strange wig and beard, the panther skin of a priest, and the staves of divinity; it was found at Mit Faris in the Fayum, a province that was largely opened to cultivation by this king. In this same region, Amenemhet III also erected two seated statues on 40-ft. bases; according to the report of Herodotus, these remained visible above water level during times of inundation. Such colossal free-standing statues provide evidence of the extent to which sculpture became divorced from architecture and embarked on an autonomous course during the Middle Kingdom. Here, statues of the king were erected amid the landscape to be visible from afar and to honor the king as the source of fertility. A statuary group from Tanis, known as the "fish offering," also probably represents the king as the bringer of fertility. Two male figures with impressive wigs and beards, of a type not worn since predynastic times, are shown standing shoulder to shoulder (Cairo, Egyptian Mus.) and offering fish in their outstretched hands. The sculptural forms are even harder than those of the Mit Faris statue. The foreheads of both figures are damaged, but a fragmentary figure from a similar group in the Museo Nazionale Romano has the uraeus, the sign of royalty, preserved. It may be concluded that the Tanis group also represents the king in the guise of two Nile divinities.

A life-size limestone statue of the king enthroned was found in the rubble of the mortuary temple before the Pyramid of Amenemhet III at Hawara, at the edge of the Fayum (PL. 349). His face shows the same basic structure as other statues of the king, but the features are those of an idealized likeness created especially for a mortuary temple. The maturity of this work, the spiritualization of the physiognomy, and the bonding of the whole into a unity filled with inner tension can be seen by a comparison with a similar work of the early 12th dynasty shown in the same plate. The development of sculpture after the reign of Amenemhet III and in the 13th dynasty reveals a stagnation of creative force. The tradition of colossal statuary in hard stone continued well into the 13th dynasty. Technically, the forms are masterfully executed, but the expressions are either tortured or empty.

The private sculpture of the Middle Kingdom also lacks that unity which characterized the art of the Old Kingdom, where sculpture developed exclusively at the royal capital as mortuary sculpture. From the Middle Kingdom, tomb statues, in the Old Kingdom sense, are found in the cliff tombs of the nome princes, where they are often carved from the same living rock as the shrine itself but have come down to us in a sadly mutilated state. Free-standing statues from these tombs, however, bear witness to the high quality still attained and to the close connection with the development of royal sculpture. The life-size seated statue of gray granite portraying Lady Sennuwi, the wife of Prince Hepzefa of Asyut, was found at Kerma in the Sudan, the farthest outpost of Egyptian civilization; it is now in the Museum of Fine Arts, Boston. Its dignified pose and human qualities make it a typical work of the late years of the reign of Sesostris I and the equal in quality of royal statuary. The tombs of the retinue in the royal cemetery at Lisht have yielded virtually the only examples of life-size private statues from the early years of the 12th dynasty. Small sculpture predominates in this period.

At the beginning of the 12th dynasty a new type, the "block" statue, was developed for private persons, and this type persisted until the end of Egyptian sculpture. The oldest examples (PL. 354) date from the period of Amenemhet I. These are somewhat less than life-size figures in a squatting position; their knees are drawn up to their chests and their hands are crossed over their knees. The figures are contained within a block, as it were; hence, their name. The arms and legs emerge in high relief from the surface of the solid block, and the heads are engaged to a semicircular back pillar. The earliest of these works come from Saqqara and were set up in the statuary niches of a pillared hall, where they filled the entire width of their niches. The purpose of the block was to secure greater permanence and durability. Soon afterward the final formulation of the type was developed: the squatting figure with drawn-up legs became a solid block from which only the feet emerged. The head arose from this cubelike base with great effect. The sheathing of the human body and its limbs was characteristic of the statues of King Mentuhotep. This tendency was carried a step further in the Osiride figures that Sesostris I had set up along the ramp leading to his mortuary temple and in Abydos and Karnak. Squatting figures wrapped in drapery had already appeared in the small sculpture of the First Intermediate Period aboard the wooden ship models; this occurrence was in a religious context that has not as yet been satisfactorily explained.

The numerous small figures and figure groups of dark hard stone, which were set into steles or erected in small shrines, were dedicated at Abydos by a much broader social class. Statues on a larger scale, which increased in number during the late 12th dynasty, come mostly from temples. The private temple statue goes back to the end of the Old Kingdom, a time when more and more royal prerogatives passed to lesser personages. As related in the inscriptions on such statues, the erection of a statue of the person in question entitled him to participate in the banquet of the gods. By this token, the statue erected in the temple precinct, and through it the person represented, retained a close connection with the world of the living. The deceased is represented as he appeared in life, with signs of age in his features indicative of dignity and wisdom. The head becomes the essential feature; and the body is often shrouded in a robe or in a kilt reaching up to the breast. The seated quartzite statue of Khertihotep (PL. 354), attributed on stylistic grounds to the reign of Sesostris III, is a masterpiece of simplicity and introspective portraiture. The last significant work of private sculpture of the Middle Kingdom is the statue of the court official Sebekemsaf (PL. 354) from Armant. The dignity

of his portly person is well expressed in the erect carriage and the conventional forms of the portrait.

In addition to the aforementioned small sculpture of stone and wood, the artists of the Middle Kingdom also produced a host of figures and figure groups of human beings and animals in limestone, faïence, and copper. Their function cannot always be established with certainty. The copper figure of Princess Sebeknakht with an infant at her breast (Brooklyn Mus.) is cast in several parts and, like a similar piece in Berlin (Staat. Mus.) is possibly a votive offering. Objects in faïence, such as the hippopotamuses with marine plants applied in paint, were made especially for tombs and probably represent adaptations from relief representations. Other forms, such as the monkey playing the harp, may refer to animal fables. A masterpiece of ivory carving found in a tomb near Lisht is of purely secular character. This work represents a group of dancing dwarfs, which were tied to strings and could be set in motion on a board. These figures were toys (see GAMES AND TOYS).

*Minor arts.* Elaborate, large-scale jewelry is known only from the 12th dynasty onward. The jewelry of this period surpasses in quality all subsequent Egyptian gold- and silver-work, both in the nobility of its forms and in the harmonious color schemes of the inlays of polished semiprecious stones. The conquest of the Nile Valley as far as the Second Cataract was prerequisite for the development of this applied art, for with the annexation of this area access to the rich Nubian gold mines in the Eastern Desert was secured.

The richest finds of jewelry come from caches in the tombs of princesses at Dahshur and Lahun. From the same sites come little chests containing cosmetic implements: mirrors, golden razors, ointment jars of obsidian and gold, and even a dagger with a decorative grip having strips of colored inlay. Chests revetted with gold and ivory contained diadems, necklaces with pendants, rings, and the pectorals characteristic of the Middle Kingdom. Two diadems of Princess Khnumet, the daughter of Amenemhet II, are works of very distinctive character (Cairo, Egyptian Mus.). One consists of gold wire thinly drawn into delicate star-shaped flowers. The wires are held together at regular intervals by large cross-shaped members consisting of four papyrus blossoms arranged about a round disk and inlaid with carnelian and turquoise. This delicate creation contrasts with the other diadem, in which severely stylized floral forms and circular disks with stiff flowers compose a symmetrical entity. The individual members are made of gold and are decorated with cut semiprecious stones that are pasted into pockets in the metal.

The pectorals are made in this same cell-like technique. During the Middle Kingdom they were a form of female adornment worn on wide bands falling over the breasts. This fashion of adornment may be seen in the reliefs of the daughters of the nome princes at El Bersheh (PL. 352). The motifs of the pectorals from the tombs of the princesses are drawn from the repertory of royal symbolism; the earliest date from the time of Sesostris II. The composition of the ornament, the middle of which is occupied by the royal name, is strictly symmetrical. The royal name is set over the hieroglyph for "millions of jubilees of kingship" on a base plate and is flanked by two hawks. On a pectoral bearing the name of Sesostris III (PL. 361), hawk-headed griffins trample Semites. The Upper Egyptian crown-goddess soars above the scene with outspread wings. The largest of these pectorals bears the name of Amenemhet III and marks the end of the Middle Kingdom development of this form. In the crowded composition, symbolism and hieroglyphs are replaced by objective themes: the king in human form smites a Semite while holding him by his hair.

Pectorals also crossed the Egyptian frontiers and reached the court of the princes of Byblos in the form of gifts from Amenemhet III. The technique of granulation, which was imported to Egypt, appears for the first time in gold objects from the Dahshur treasure. It occurs on objects that are not indigenous Egyptian forms, such as gold rings and pendants constructed of small rings and segments of rings. The forms as well as the technique employed indicate Cretan origin. A

medallion with a colorful scene of a couchant bull that is protected by a disk of rock crystal is paralleled by a find from the Palace of Knossos. Vases of Cretan Kamares ware (see CRETAN-MYCENAEAN ART) have been found in a few Egyptian tombs of the 12th dynasty. Their spiral patterns and palmettes rendered

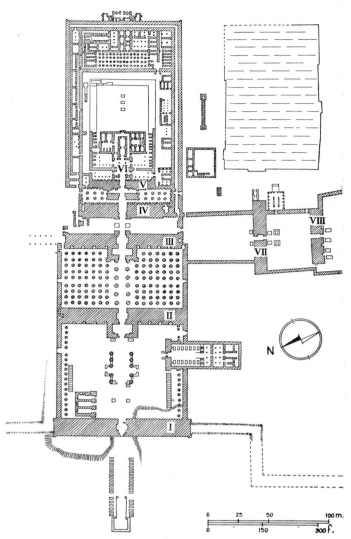

Karnak, temple of Amen, partial ground plan, 18th–20th dynasty and after, ca. 1570–1085 B.C. (*from Lange-Hirmer*).

on a dark ground influenced the polychrome ceiling decoration of the tombs of the 12th-dynasty nomarchs.

These cultural contacts continued during the weaker regime of the 13th dynasty; and they were not completely disrupted by the Hyksos invasions. This continuity is evidenced by the survival of spiraliform ornament and palmettes on the faïence bowls from Kerma in the Sudan. The only Hyksos contributions to the culture of the Nile Valley were the horse and the battle chariot. Immediately after the expulsion of the Hyksos by a Theban dynasty, relations between the Nile Valley and the Aegean area again flourished in the creation and exchange of jewelry. The most noted examples of the cultural exchange of this period are the ax and dagger blade found in the tomb of Queen Ahhotep. On the dagger blade there appears a lion in flying gallop pursuing a calf. The figures are composed in gold wire that is inlaid on a metal-sulphur alloy. The inlaid composition is well contrasted with its dark background. The technique, known as niello, and the type of representation, are of Mycenaean origin.

ART OF THE NEW KINGDOM (18th to 20th dynasty, 1570–1085 B.C.). After the dissolution of the Middle Kingdom, the

Asian Hyksos subjugated Egypt and ruled from their capital at Avaris in the Delta. Only Thebes and Lower Egypt were able to maintain their independence to a certain degree; and from this quarter came liberation under the leadership of Theban princes. The expulsion of the foreigners and the reunification of the Two Lands prepared the way for the most brilliant era in Egyptian history. Through the struggles for liberation and through conquests in both the north and the south, Egypt grew beyond its former national frontiers. Palestine, Syria and its rich coastal lands, and Nubia as far as the Fourth Cataract were annexed as provinces. With the booty of war and the tribute of subject peoples, enormous riches streamed into Egypt, especially into its capital city, which now began to develop into a metropolis. This capital city — as once before, at the beginning of the Middle Kingdom — was Thebes, whose god Amen became the national deity. Contacts and familiarity with foreign cultures, customs, and products expanded the Egyptian point of view and enabled Egypt to emerge from its previous isolation. The common border with the great Hittite empire emerging to the east drew Egypt, for the first time in her history, into the larger sphere of world politics.

The development of art during the New Kingdom — a development of almost five hundred years — falls into three periods, which correspond roughly to three stages of the political development. The first important period extends from the revival of art early in the 18th dynasty to the last years of the reign of Amenhotep III, that is, from 1550 to 1370 B.C. This period corresponds to the political ascendency of the new masters, the securing of world dominion through the long military campaigns of Thutmosis III, and the establishment of a native artistic tradition. This first period was the most flourishing for art during the entire New Kingdom — a period of constant development based on the ancient patterns of Egyptian (more specifically, Theban) tradition. The utmost sophistication of expression was attained at this time.

The second period encompasses the time of spiritual and political crisis that distinguished the later years of the reign of Amenhotep III as well as the reign of his son and successor, Amenhotep IV (Akhenaten), whose break with the national god Amen led to a temporary relocation of the royal capital to Middle Egypt (Tell el 'Amarna). In the history of Egyptian art, this period represents a time of remarkable expressiveness.

The third period comprises the 19th and 20th dynasties, the Ramesside era (1320–1085 B.C.). The political capital was moved to Tanis in the Delta; however, Thebes, remained the religious capital. At this time, the realm was threatened from the east and from the north. Architectural activity witnessed a tremendous increase, compared with that of earlier periods in Egyptian history, and temples were built on a gigantic scale. Nevertheless, the forms of artistic expression became somewhat stereotyped and monotonous.

*Architecture: a. Temples and secular structures.* The development of Middle Kingdom monumental architecture is intimately associated with the reemergence of Thebes as the political and religious capital of Egypt and the emergence of the god Amen as the national deity. The role of Thebes as capital of the 11th dynasty was a brief one; but the affinity of the 12th-dynasty kings, who once more chose Thebes as their capital, for this city is evidenced in a series of architectural constructions and sculptural dedications. The core of the sanctuary of Amen at Karnak may date from the beginning of the 12th dynasty; but the splendid rise of Thebes really took place at the beginning of the 18th dynasty. Its growth is attested by the extensive architectural development of this period, which was almost entirely in the service of the god Amen, "lord of the throne of the Two Lands." As such, he was united with the sun god as Amen-Ra. Other gods were brought into relationship with him, such as his wife Mut and their child Khonsu. Thus a new religious system founded on the god Amen emerged in Thebes, and with this development Thebes became a center of great religious importance.

The new religious system posed special problems for the architect. In the spacious city of Thebes, which occupied both shores of the Nile, various sanctuaries united in festivals of the god Amen: in a procession of barges, the god Amen left Karnak and visited his "harem," the temple of Luxor to the south of the city, and the necropolis west of Thebes. The royal mortuary temples in the necropolis were at the same time temples of Amen, and his barge reposed at these sanctuaries. The nature of this god and his cult and the ceremonial processions in his honor determined the initial form and subsequent development of the sanctuaries. Sanctuaries were constructed at Karnak and in the Theban area, at Tod and Medamud, as early as the Middle Kingdom. The structures of the New Kingdom could therefore fall back upon an old local tradition. In particular, the peripteral temple continued to flourish under the 18th dynasty as commemorative structure and votive building, in connection with the jubilee festival, and as temporary repository for the sacred barge or cult image. An example of this recurrent form is the little temple erected by Hatshepsut at Medinet Habu. The appearance and layout of the sanctuary of Amen at Karnak during the Middle Kingdom are not definitely known. The original structure seems to have survived into the New Kingdom, and it was expanded early in the 18th dynasty. The shrine of Amen seems originally to have been merely a little chapel attached to the older precinct of the sanctuary. The original ground plan is no longer discernible amidst the later additions and changes. The more modest constructions of the early 18th dynasty were frequently torn down to be used as fill for the foundations of larger constructions and have been reclaimed only in recent times. An example of such a find is the limestone shrine of Amenhotep I, erected on the occasion of his jubilee and decorated inside and out with reliefs.

A very active period of building began at Karnak during the reigns of Thutmosis I, Hatshepsut, and Thutmosis III. Thutmosis I expanded the plan of the Middle Kingdom sanctuary (FIG. 668) toward the west, in order to gain space for a new shrine and subsidiary rooms. He enclosed the expanded sanctuary on three sides with a wall, and the fourth side became the pylon, a mighty gateway consisting of two towers with niches for two flagpoles. A larger, still mightier pylon (IV) was placed in front of this inner pylon (V), and obelisks of rose-colored granite more than 65 ft. tall were placed before the outer pylon. The narrow space between the two pylons was covered with a wooden roof supported by wooden columns. Soon afterward this was torn down, when Queen Hatshepsut erected 100-ft. rose granite obelisks in that area (PL. 355). Under Amenhotep III and Ramses I the New Kingdom temple precinct grew westward, toward the Nile: further pylons (II and III) were constructed along the old axis. At the same time, a connection was created with the nearby sanctuary of Mut to the south. At the south side of the pylons for this connective structure (VII and VIII), colossal statues were erected.

The main elements of the central structure at Karnak, namely, pylons and obelisks preceding a closed court — also, according to the reconstruction of Ludwig Borchardt, colonnades fronted by Osiride statues lined the inner walls — seem to have been borrowed from the temple of the sun-god Ra at Heliopolis. This interpretation appears reasonable, for in his sanctuary at Karnak Amen is equated with Ra-Horakhte ("sun at the horizon"). The inner shrine at Karnak also took on its final form during this early part of the 18th dynasty. Its consists of an elongated granite-walled room that is accessible from the west through a portal and has a window opening toward the east. The barge of the god rested on a support in this chamber. In its present form the shrine goes back to the reign of the Macedonian Philip Arrhidaeus (323–317 B.C.); in its shape and relief decoration, however, it derives from a predecessor erected by Thutmosis III. Of the original structure of Thutmosis III, only the Hall of Annals in front of the shrine remains partly standing. The ceiling was supported by two powerful granite pillars decorated with flora of Upper and Lower Egypt in high relief. The greatest architectural contribution of Thutmosis III to the sanctuary at Karnak was the construction of his ceremonial temple (PL. 355) to the east of the Middle Kingdom precinct, as well as an enclosing wall for the entire precinct, which had been expanded toward the east. The ceremonial temple is en-

tered from the west through a portal with Osiride statues of the king. It is the earliest basilica with the nave elevated above the side aisles, and its ceiling was supported by "tent pole" columns. The fenestrated exterior walls rest on square pillars that also support the stone ceiling beams covering the two aisles.

The 18th dynasty was a period of great architects, and the names of several of these personalities have come down to us. Ineni was architect from the reign of Amenhotep I through that

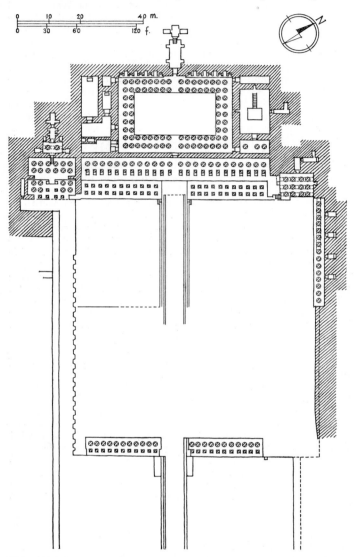

Deir el Bahri, mortuary temple of Queen Hatshepsut (*from Lange-Hirmer*).

of Thutmosis III. In his autobiography he tells how, during the reign of Thutmosis I, he supervised construction of the pylons with their flag masts, a colonnaded hall, and a gateway with a door of Asiatic metal bearing a representation of Amen in gold, in addition to the erection of a pair of obelisks. This reference can only apply to the Karnak sanctuary described above. Ineni was active on the western shore of the Nile as well. There, since the beginning of the 18th dynasty, the arrangement and forms of the royal tombs had been in a state of constant change and evolution. The pyramidal form, which had been maintained by the Theban princes of the 17th dynasty, was now abandoned permanently, and the temple of adoration was divorced from the tomb. Amenhotep I introduced these innovations. His successor Thutmosis I was the first to build his tomb in the so-called "Valley of the Kings." This valley, with its short lateral arroyos, was to become the site for the tombs of all the kings from the 18th to the 20th dynasty — with the single exception of Amenhotep IV (Akhnenaten). This move was an attempt

to protect the royal tombs from grave robbers. The best commentary on these precautions is the famous passage from the autobiography of Ineni, who supervised the construction of the tomb of Thutmosis I: "I saw how it was dug in all secrecy, none seeing, none hearing."

From an architectural viewpoint, the most revolutionary and most significant example of the mortuary temples of the 18th dynasty has been preserved. This is the structure that Queen Hatshepsut had built by her architect Senmut in the valley of Deir el Bahri, immediately to the north of the tomb of Mentuhotep II. This earlier tomb, more than five hundred years older, contributed much to the form of Hatshepsut's precinct. The temple of the queen also is constructed in terraces with superposed pillared galleries (FIG. 671). Since Hatshepsut's sanctuary abuts directly on the high cliff to the rear, the pyramid that was part of the temple precinct of Mentuhotep is no longer included. The pillared halls and open courts of both lower terraces are arranged along a transverse axis in front of the three great steps to the inner precinct, so that the sheer cliff appears to rise immediately behind the uppermost terrace as a mighty crown for the whole structure.

On both sides of the pillared halls of the middle terrace there are sacred sanctuaries: to the south, the chapel of Hathor, the protectress of the valley; to the north, the chapel of Anubis, the god of the dead. Both chapels are carved into the face of the cliff. In the anteroom of the chapel of Hathor, there are pillars and columns with capitals shaped like the head of the goddess with a sistrum above. The Anubis chapel has faceted columns of sixteen sides.

The upper terrace is the core of the sanctuary. This is perceived at once from the Osiride statues of the queen that at one time fronted the pilasters of the entire façade. From the end of the massive central ramp, a granite portal leads into a court surrounded by double colonnades. The west wall is articulated by niches that once contained statues. In the middle of the west wall another granite portal leads into the inner sanctuary, which was cut into the cliff and consecrated to the god Amen. The rooms for the cult of the queen and her father Thutmosis I are to the south of the court and are vaulted. To the north, the colonnaded court is abutted by another court containing a great stepped altar for the cult of the sun god Ra-Horakhte.

The terraced temple of Hatshepsut is placed at the western end of an elongated court, just as in the 11th-dynasty sanctuary. A monumental ramp, flanked by painted sphinxes, led from a gateway at the edge of the valley to the great portal of the court. The main passageway of the sanctuary, in the interior of the court as well as on the first terrace, was similarly flanked by sphinxes. Here, as in the mortuary temple of Mentuhotep II, trees were incorporated in the plan of the main court. The interpretation of the whole structure is furnished by the cycle of reliefs that decorated the pilastered halls. The representation of the peaceful expedition that the queen dispatched to the land of Punt (Somalia) for the purpose of bringing back myrrh trees has a direct bearing on the structure itself. These trees, sacred to Amen, were planted on the temple terrace, thereby transforming the structure into a "terrace of myrrh." The terraced arrangement of open pilastered halls is perfectly adapted to its natural setting of cliffs. The great cliff, which contains the burial shaft of the queen herself on its opposite side, is actually included in the architectural planning, as crown and culmination of the last terrace. Nevertheless, esthetic considerations alone did not determine the choice of this location; rather, it was the sanctity of this valley in relation to Hathor, the goddess of the mountain, and its proximity to the tomb of Mentuhotep II, the founder of Theban sovereignty. Interrelations with the sanctuary of Amen at Karnak also influenced the choice of this site.

The temple of Hatshepsut at Deir el Bahri remained unique. Her successor Thutmosis III constructed a much more modest temple in the flat region at the edge of the valley. This temple repeats isolated details of Hatshepsut's temple in simplified form. Only the ground plans of the mortuary temples of Thutmosis III and his successors can be reconstructed. From the immense sanctuary of Amenhotep III, only two colossi of the king (PL. 356) and some insignificant architectural remains have been

preserved. The latter details confirm the tendencies that seem to have been characteristic of this period, particularly the inclination to build on a colossal scale. The pylon (III) of Amenhotep III in the temple complex of Amen at Karnak, with its eight flag masts, is another example of this characteristic. Other than this pylon, Amenhotep III does not seem to have undertaken any construction at the temple of Karnak itself. To the south of the complex of Amen, he did build the sanctuary of Mut, which replaced an earlier and smaller temple that stood on this site. This sanctuary is connected to the sanctuary of Amen by the pylons of Hatshepsut and Thutmosis III. But the most significant contribution of Amenhotep III was the temple at Luxor, dedicated to the gods Amen, Mut, and Khonsu.

The Luxor temple, which was built as a replacement for an earlier sanctuary, manifests a more homogenous organization (FIG. 673). As in the earlier mortuary temples on the west bank (the temples of Thutmosis III and Thutmosis IV), a great court is placed before the temple proper and is enclosed on three sides by halls supported by double colonnades of the bundled papyrus type (PL. 357). Another colonnaded hall leads to the interior

This era was followed by a period of transition under Akhenaten, who sought to replace the traditional Theban worship of Amen with a cult centered about the solar disk Aten and based in part on old Heliopolitan traditions. On the occasion of his jubilee, celebrated prematurely in Thebes, Akhenaten built a sanctuary of Aten outside that of Amen at Karnak, and another at Hermonthis. Of the sanctuary of Aten at Karnak, an open court with colossal statues of the king has been preserved; at Hermonthis parts of an obelisk remain.

The religious reforms instituted by Akhenaten led to a conflict with the priesthood of Amen, and in the sixth year of his reign the royal capital was transferred from Thebes to Tell el 'Amarna in Middle Egypt. The Aten sanctuaries of this new and hastily constructed city were built of small limestone blocks and unbaked bricks and were destroyed after the death of Akhenaten. Painstaking excavation of the site of Tell el 'Amarna yielded little more than the ground plan of these structures, which often could be reconstructed only with the aid of representations on reliefs from the area. The sanctuaries lie within great courtyards surrounded by walls and are oriented

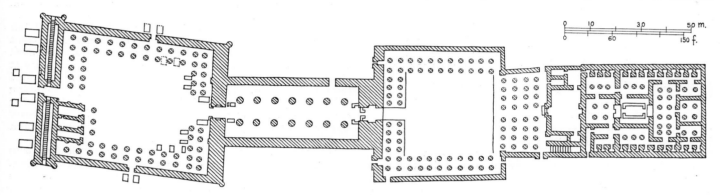

Luxor, temple, 18th–19th dynasty, ca. 1570–1200 B.C. (*from Lange-Hirmer*).

of the temple. A colonnaded transept succeeds this colonnade, and at the sides of this area are chapels to Mut and Khonsu, each containing a sacred barge. The transept is followed by a smaller and narrower room with four columns, which is in turn followed by a second chamber of similar dimensions. This was the holy of holies, sacred to the god Amen, and on a pedestal at its center stood the sacred barge of Amen. (Under Alexander the Great, the columns were removed from this chamber, and a barge chapel open on two sides was inserted within the area.) Next is another transept, accessible from the chapel only through a small side entrance by way of some subsidiary chambers. The whole is culminated by a square chapel that contained the cult image of the sacred triad.

The rooms are laid out on an incline, rising steadily from the entrance to the rear wall. At the same time, the ceilings become progressively lower, the rooms progressively smaller, and the light dimmer. In effect, this arrangement produces a processional architecture that is focused on an inner sanctum in a camera-like manner.

Access to the great courtyard in the temple of Luxor is not by way of pylons but is through an elongated hall with a roof that was formerly supported by papyrus columns slightly more than 50 ft. tall, which are still standing. This hall seems to have been adapted from those of the royal residences. The interior walls of this hall were decorated by King Tutankhamen with representations of that festival which annually united the sanctuaries of Luxor and Karnak in a splendid procession. On such occasions, Amen would be transported by barge from Karnak south to his "harem" at Luxor. In addition, there was an overland festival route, which Amenhotep III had lined with ram-headed sphinxes.

The lucid ground plan and the noble forms of the columns — despite aspirations to colossal proportion — make the temple at Luxor one of the finest examples of architecture from the most flourishing era of building during the New Kingdom.

toward the east. A colonnaded porch and a passageway open to the sky provide access to a string of courts that are separated from one another by pylons. Sacrifices to Aten were made on great open-air altars in these courtyards. The prototype of these sanctuaries is recognizable in the sun temple of Heliopolis. In details, however, the architects of Amarna adapted this model in a markedly independent manner.

The death of Akhenaten put an end to his religious reforms. Tutankhamen, who was the son-in-law of the Reformer and succeeded him on the throne of Egypt, again recognized the worship of Amen and removed the royal capital to Thebes. During the reign of Horemheb the worship of Amen was secured once and for all. Building activity on the temple of Karnak was resumed, and under Horemheb the second pylon, larger than the pylon of Amenhotep III, was built. The Aten sanctuary of Akhenaten near Karnak was torn down, and its blocks were reused as fill for the ninth and tenth pylons terminating the festival route to the nearby sanctuary of Mut.

At the beginning of the 19th dynasty, under Seti I and Ramses II, the most ambitious builders of Egyptian history, the sanctuary of Karnak (FIG. 668) underwent its last and most impressive phase of expansion. The great colonnaded court was constructed between the second and third pylons; its central passageway is formed by two rows of papyrus columns nearly 70 ft. high, with open bell-shaped blossoms as capitals. It is possible that Amehotep III had planned or even begun this passage simply as access to his third pylon. The aisles consist of bundled papyrus columns slightly more than 40 ft. tall — a veritable forest of 122 columns. The great colonnaded court of the temple of Karnak is a basilica similar to the festival hall of Thutmosis III. Lighting is provided by great windows with stone screens that are built into the clerestory walls of the nave. This gigantic hall contains no sanctuary of its own. The columns have smooth shafts and are covered with inscriptions and polychrome representations. On the northern exte-

rior wall of this hall, Seti I had his victories represented in monumental sunk reliefs and dedicated them to the god Amen.

A novel and significant construction is the temple of Seti I at Abydos, the city sacred to Osiris and to the dead. This temple was also completed by Ramses II. Whereas the most common building material since the beginning of the 18th dynasty was sandstone, this temple was constructed of lime-

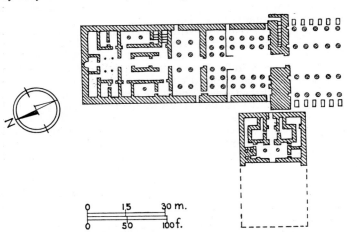

Karnak, temple of Khonsu, 20th–21st dynasty, ca. 1200–935 B.C. (*from Lange-Hirmer*).

stone. The capitals and other architectural members are therefore more finely detailed. The architects of this building were faced with finding a solution for a new problem, namely, that the temple was sacred to several gods. Chief among these was the Ramesside triad: Amen, the god-king of Thebes; Ra-Horakhte of Heliopolis; and Ptah of Memphis. In addition, the triad of Abydos (Osiris-Isis-Horus) and the god-king were accommodated. The seven chapels are arranged in a row at the rear of the temple, and the front of the temple contains seven entrances, one for each chapel. The central chapel is reserved for Amen. Behind this row of chapels there is a transept with lateral chambers, accessible from the chapel of Osiris and subsidiary to the cult of the Abydos triad. The most significant details of these chapels are their painted relief representations, which have been well preserved. The subjects of these reliefs relate to the shrine and to the rites performed there.

Toward the west, the temple is adjoined by a peculiar subterranean construction, the dummy tomb of Seti I that was modeled upon the mythical tomb of Osiris. As in the conception of the latter, this cenotaph was formerly buried under a hill planted with tamarisk. The substructure into which the dummy tomb has been cut rises like an island from a surrounding moat. The use of granite and the absence of all inscriptions or representations recall the architecture of the valley temple of King Chephren from the 4th dynasty.

The construction of sanctuaries for the local deities was not merely an act of piety on the part of the king; it also served to consolidate his city, as well as the entire land, into a political religious entity and thereby to secure his reign. The numerous temple constructions of the 12th dynasty are indicative of this purpose, which applies also to the temple-building activity during the New Kingdom. Temples to Egyptian deities had special significance in recently annexed provinces, especially Nubia. Here, near the Second Cataract, Hatshepsut and Thutmosis III built the southern temple of Buhen, which was consecrated to the "Horus of Buhen." This edifice has the form of a peripteral temple with a colonnade around three sides of the closed core of the structure. Such temples in the new provinces not only served to proclaim the power of the Egyptian god-king but were also part of the process of Egyptianization of the foreign land. Most of the sanctuaries in lower Nubia are dedicated to Egyptian deities, usually the triad of Amen, Ra-Horakhte, and Ptah. In the narrow river valley of Lower Nubia, the temple plans often take on the form of *hemispeoi*

("half caves"), with their inner chambers carved out of the western cliffs (Beit el Wali, Garf Husein, and El Sebu'a).

Ramses II emerged as the greatest temple builder in the land of Nubia as well. His most significant construction was the cliff temple of Abu Simbel (PL. 359). This temple was dedicated to the triad of Amen, Ra-Horakhte, and Ptah and also served the cult of the king. The typical Egyptian mortuary temple — with its colossal statues of the king in front of great pylons, forecourts, porch, rock-cut chambers, and sanctuaries — was here transformed into cliff architecture and modified. From the entrance, flanked by two pairs of seated colossi about 65 ft. high, the various rooms of the building extend for nearly 150 ft. into the heart of the cliff. The main court of the temple has become an elongated pillared hall, with statues of the king in front of the pillars; the storerooms are accessible from this main court. The entrance to the next court is emphasized by a thickening of the dividing walls that is suggestive of the pylon. From this point three separate entrances lead to the three shrines, of which the middle one is the sanctuary proper. The entrance of the temple is oriented toward the east quite precisely, in order that the first rays of the rising sun fall on the holy of holies.

Among the successors of Ramses II, only Ramses III left temples constructed on a colossal scale. These temples represent a continuation of essentially the same ground plan. The most significant addition of Ramses III to the national sanctuary at Karnak is the temple of Khonsu (FIG. 675), which is oriented toward the south. This temple forms a new and imposing point of departure for the festival route to Luxor. A smaller temple that was built across the principal axis of the sanctuary and next to the final, second pylon of Horemheb was also built during the reign of this king.

Ramses III built his sandstone mortuary temple (FIG. 676) at Medinet Habu, on the western shore of the Nile near Thebes. A gigantic pylon approximately 225 ft. wide, with surfaces formerly decorated with monumental painted reliefs, forms the entrance to the first court. From the south wall of this court, two entrances lead to the adjacent royal palace. A granite doorway through the second pylon leads to the second court, which is surrounded by pilastered and colonnaded halls. Only the bases have been preserved from the colossal seated statues of the king that once flanked the entrance to the temple. A porch with Osiride statues and columns precedes the actual sanctuary, a colonnaded basilica that is succeeded by two smaller halls.

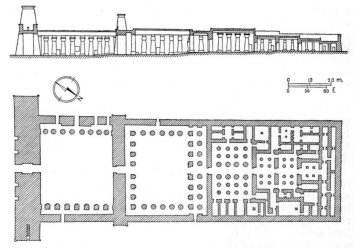

Medinet Habu, mortuary temple of Ramses III. *Above*: Longitudinal section; *below*: ground plan (*from Lange-Hirmer*).

Then comes the holy of holies, containing the granite base for the barge of Amen. Again, in this temple the successive rooms rise in level, become narrower and lower in height, and receive progressively less light. The entire temple precinct, including the palace to the south, the administrative rooms, the courts, fountains, and barrel-vaulted storerooms, is surrounded by a

single mighty wall of brick with projecting towers. During
the later years of the reign of Ramses III, an even thicker wall
was extended around this inner precinct; this also enclosed the
small peripteral temple constructed toward the east by Hatshepsut
and Thutmosis III. This fortified aspect is a unique character-
istic of the Medinet Habu temple and seems to have been the
result of special conditions that prevailed late in the New
Kingdom. Turmoil was characteristic of this period in Egyptian
history. The precinct is accessible only through the two mighty
gateways: from the east through the "high gate" (PL. 359) and
from the west through a similar gateway. The upper chambers
of the "high gate" seem, according to their relief representations,
to have served for visits of the king with ladies of his harem.

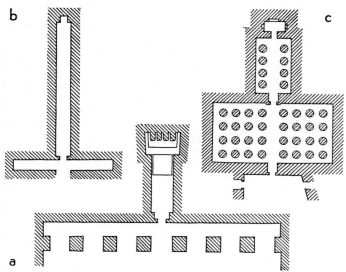

Necropolis at Thebes, plans of rock-cut tombs of the 18th dynasty: (a) tomb
of the vizier Ramose; (b) tomb of the vizier Rekhmira; (c) tomb of Ineni.

A canal joined the eastern gate with a river landing and provided
access for the barge processions of Amen.

The palace of Ramses III, annexed to the mortuary temple,
is a small building that contains only the essential official rooms
(colonnaded court and throne room), as well as the most nec-
essary private chambers (dressing room, bedroom, bath, and
privy). A "window of appearances" with a balcony, which is
reached from the interior of the palace by a stairway, opens
onto the colonnaded hall of the temple. Palaces connected with
mortuary temples also exist in the neighboring precinct of
Horemheb and in the mortuary temple of Ramses II, the
"Rameseum" (PL. 358). These palaces are similarly situated
and have similar ground plans. Apparently inhabited by the
king only on special occasions and for a short period, they
appeared at a period when Thebes was no longer the only
royal residence. The New Kingdom provides the first remains
of actual royal residences: a large palace of Amenhotep III on
the western shore of Thebes, near Medinet Habu at a site
known as Malkata, as well as several palaces of Akhenaten at
his new residence of Amarna. The ground plan of a palace
of Akhenaten at Amarna is relatively homogeneous. Above all,
importance is allotted to external effect in monumental gateways
and colonnaded porches. The ground plan of a palace of King
Merenptah near Memphis is also known, and parts of the
decoration from palaces of Seti I and Ramses II at Kantir in
the Nile Delta have been preserved. These royal palaces, like
private dwellings, were constructed of sun-dried brick, and
their ceilings were supported by wooden columns. The use
of stone as a building material was restricted to column bases,
door frames, and bathroom floors.

*b. The royal tombs.* Because of the separation of the royal
tomb and the temple of adoration, the body of the king, which
was deposited in the lonely Valley of the Kings, was abandoned
to its fate while cult services in his mortuary temple honored

his memory. The royal tombs in the Valley of the Kings had
no provision for worship: their task was simply to remain
hidden and inviolate. No longer were the passageways and
chambers carved into the cliffs merely to serve as the grave
of the king and for his provisioning in the afterlife, as was the
intent in the tomb of Tutankhamen. The architectural plan
— the sequence of passageways, antechambers, and finally the
sarcophagus chamber — closely associated with the pictorial
decoration of the walls, was intended to supply the milieu
for existence in the afterworld as well as to provision this
existence.

The passageways and chambers of the older tombs are laid
out at right angles. At first the ground plan of the sarcophagus
chamber was oval, but later it changed to a rectangular plan.
The ceilings are decorated with stars and are supported by
pillars. The transformation to the axial arrangement of pas-
sageways and chambers occurred in the tomb of Akhenaten
at Tell el 'Amarna. The same type of axial arrangement was
incorporated in the Theban tomb of Horemheb and remained
the norm for royal tomb architecture throughout the 19th and
20th dynasties. The passageways are interrupted periodically
by deep shafts, which are designed to foil tomb robbers. The
significance of the succession of chambers and passageways may
be gleaned from the decoration of their walls. The earliest
known examples of these subjects from this period are the
representation of the king in the company of the gods and the
illustrations from the "Book of That Which Is in the World
beyond the Grave," a kind of guide to the afterlife.

*c. Private tombs.* More than three hundred tombs from
the New Kingdom are known on the western shore of Thebes
alone. These have been provided with numbers for easier
identification. More than half of these burials are from the
18th dynasty. Generally the tomb façades are undecorated;
occasionally, however, as in the case of tomb 131, the façade is
articulated by niches. Representations of tombs in wall deco-
ration from the late 18th dynasty show that a pyramid of bricks
was erected over the entrance, and fragments of such brick
pyramids have been preserved in the necropolis of Deir el
Medineh.

The local rock is for the most part soft; consequently, the
chambers are narrow. Their walls were usually faced with
Nile mud and stucco as a base for the paintings; only in the
deeper tombs does the compact nature of the limestone permit
the execution of finely detailed reliefs. The rock-cut chambers
are of several forms; nevertheless, a recognizable common
denominator exists (FIG. 677). This recurrent form is a narrow
transept, from the middle of which — opposite the entrance
of the tomb — a passageway extends toward the west. In some
instances, this passageway may also be amplified into a spacious
hall. At the west end of this "deep hall," there is a place for the
celebration of the ritual. This transept form goes back presumably
to Middle Kingdom prototypes, for in the tomb of the architect
Ineni (FIG. 677) an open pillared hall before the tomb replaces
the interior transept. The generally narrow and low chambers
are decorated with colorful paintings on ceilings and walls.
The tombs appear to be festive chambers in which the living
assembled during the great feasts of the necropolis in order to
participate in the banquet of the dead. The ever-increasing
importance of the cult of the dead asserted itself after the middle
of the 18th dynasty through the enlargement of the space
designated for the use of the cult (tomb 96a). At times this
space was furnished with pilasters. In two of the most significant
examples (tombs 55 and 48), constructed during the period of
transition from Amenhotep III to Akhenaten, the colonnaded
halls of earlier royal mortuary temples were translated into
rock-cut architecture. During the 19th and 20th dynasties,
the use of the pilaster as the supporting member predominated.

*Relief and painting.* The building activity of the New
Kingdom rulers greatly stimulated the representational arts.
Stone was now used for temple construction to a greater extent
than ever before. Because of this increased use of stone, larger
surfaces were available for relief decoration than had been

the case during the Middle Kingdom. Granular sandstone from Gebel Silsileh was employed in the national shrine of Karnak, in the temple of Luxor, and in the royal mortuary temples of the 19th and 20th dynasties. The older mortuary temples and the buildings of Seti I on the western shore of Thebes and at Abydos were executed in fine limestone. Costly hard stones such as alabaster (calcite), quartzite, and red granite were used only in small chapels and sanctuaries. In all New Kingdom sanctuaries — as during earlier periods — relief was the sole form of wall decoration. The nature of the stone influenced the technique as well as the form of the reliefs: limestone permitted the most delicate execution. Representations in the temples portray the king in his relationship to the gods and in his role at the great festivals; the choice of themes is therefore limited. Great cycles of relief decoration, such as the representations of pious deeds in the terraced temple of Hatshepsut at Deir el Bahri or the great jubilee of Tutankhamen in the temple of Luxor, are exceptional occurrences. The great battle scenes did not arise until the transition from the 18th to the 19th dynasty.

Renewed construction of rock-cut tombs was accompanied by new advances in wall painting. Because of the poor quality of the stone, the decorations were painted; and painting began to pursue its own course, independent of relief. The themes were drawn increasingly from daily life, and the freedom and facility attainable in the medium of painting was better adapted to this sort of subject matter than was the more rigorous technique of relief decoration. The possibilities of representation discovered in painting did, nevertheless, exert influence on contemporary relief decoration; therefore it is difficult to consider New Kingdom relief and painting independently.

During the New Kingdom relief decoration, as well as painting, was derived from old traditions that had never been completely abandoned during the transition from the end of the Middle Kingdom to the beginning of the 18th dynasty. Fragments of the mortuary temple and of a chapel of Amenhotep I in the temple of Amen at Karnak (PL. 360) exhibit a vigorous style of relief similar to the reliefs of Sesostris I from Karnak (PL. 345). A lintel with sunk reliefs of Thutmosis I from the temple of Naqada is closely related to works of the late 12th dynasty from Medamud; yet the individualization of the facial features and the increasing humanization of images of New Kingdom kings are new tendencies. A certain simple elegance of outline is also characteristic of New Kingdom relief decoration.

The beginnings of the mature phase of New Kingdom relief are evidenced in the varied and unusual scenes on the walls of the terraced temple of Queen Hatshepsut in the ravine of Deir el Bahri. The relief decoration of the open pillared courts is as unique as the architecture of this precinct. On the walls of the northern pillared hall of the middle terrace, the divine conception and birth of the queen are represented. The underlying significance of these representations is highly political: they provide justification of Hatshepsut's dynastic rights through the intervention of Amen. Even more unusual than the theme itself is the "lyrical" manner in which the miracle of the divine conception and the humanness of this intimate act are represented, accompanied by explanatory texts. In one large picture Queen Ahmes, the expectant mother, is shown being led by various deities to her bed of labor. The expedition that the queen sent to the land of Punt (Somalia) is represented on the walls of the southern pillared hall of this middle terrace (PL. 360). The Egyptian embassy is accompanied by armed warriors, but there is no evidence of tribute being collected. Shiploads of myrrh trees, incense, and other precious items native to this distant wonderland are shown being obtained through peaceful negotiations with the royal family of Punt in exchange for presents. Lively interest in the exotic, characteristic of this period, is evident in the humorous representation of the obese queen of Punt and in the detailed representations of the local cone-shaped huts erected on stilts, as well as those of the terrestrial and aquatic animals of the region.

A few decades later, with similar, almost scientific interest, Thutmosis III was to have the animals and plants brought back by him from Syria represented in a room (the so-called "botanical garden") behind his ceremonial temple at Karnak.

A new attitude of grace and effortlessness marks the human figures represented in these reliefs. Egyptians and people of Punt confront each other in similarly dignified poses. Groups of men walk freely and erectly as they carry myrrh trees to the waiting ships; they show no signs of physical exertion. Human beings, animals, and even plants are all instilled with the same relaxed assurance in movements and gestures that are graceful and expressive. Here, too, accompanying texts provide the narrative thread for the interpretation of individual scenes. The friezelike arrangement of the figures, which are represented in very low relief, the delicate gradations of the remaining color, and the rich polychromy of the representations bordering the walls at the top unite to create a festive, decorative effect within an architectural framework of pillared halls. The manifold riches of this peaceful and beautiful world are represented here not merely for gratification of the personal pride and glory of the queen; rather, these scenes are primarily intended to serve as an expression of praise and thanks to Amen.

The representations of the divine conception and birth of the queen were later adopted by Amenhotep III in the decoration of his temple at Luxor. The other themes, such as the foreign embassies with their exotic details, however, were not continued. The reign of Queen Hatshepsut was followed by the long series of military expeditions conducted by Thutmosis III. These are immortalized in the reliefs, the so-called "war diaries," and inscriptions that cover the south side of the seventh pylon at Karnak. In two gigantic relief compositions, which take up almost the entire height of the pylon on both sides of the gateway, the victorious king is shown smiting a group of prisoners in the presence of Amen. Through various details, these prisoners symbolize the inhabitants of the lands north and south of the royal frontiers.

The oldest representations on the walls of 18th-dynasty private tombs also demonstrate the continuation of old traditions. The earliest example of this survival — in the burial of a certain Tetiki (tomb 15), from the beginning of the 18th dynasty — borrows from prototypes in Middle Kingdom wall painting. This debt is especially evident in the representation of the funerary banquet, here augmented by the presence of other members of the family. In the decoration of a chamber of the tomb as a simulated arbor, new ideas that reached maturity in the following generation become apparent.

The basis for a resurgence of the representational arts was proficiency in the delineation of the figure according to formal canons laid down for the body proportions. The grid system, the contribution of the Middle Kingdom, greatly facilitated the reestablishment of such basic principles. Characteristic of this renewal are the few remaining paintings in the burial of Minnakht (tomb 87; PL. 363). The types represented, their postures, and the gestures of the wailing women, conceived in a hieroglyphic manner, are sharply outlined according to the traditional canons of Egyptian art. The figures are assembled in well-ordered registers; they are painted in yellow, black, and white and are set against a pale blue background. Above the wailing women, other funerary activities are represented as occurring on a pond and before a building in a garden. With these indications of location, the topographic element entered representational art to a degree unknown earlier.

The themes of New Kingdom tomb paintings were largely determined by time, place, and the individual values of terrestrial (governmental and social) existence rather than by the timeless and eternally valid order that characterized the representations of earlier times. The owner of the tomb appears as in life, engaged in the official functions he carried out before his death, such as the presentation of the embassies of foreign peoples, their tribute, and exotic merchandise to his monarch. The vizier is depicted in his office or overseeing work in the storerooms of the temple of Amen; the military official oversees distribution of provisions to the troops. The representation of the enthroned king whom these officials served during their lifetimes places these scenes within a definite chronological framework. Nor have old themes been forgotten; catching

birds with the throwing stick, harpooning fish in the papyrus ponds, hunting in the desert. The last of these subjects has undergone a certain transformation. The hunter now often rides in a light chariot drawn by horses — introduced into the Nile Valley by the Hyksos — and the quarry is shown fleeing in flying gallop. Although it existed in isolated instances in Egyptian art of an earlier period, the motif of the flying gallop was probably transmitted to the art of the New Kingdom via imported examples of Mycenaean minor arts.

The representation of the funerary banquet also underwent a transformation and took on a new meaning. The nourishment of the deceased acquired the nature of a festive "symposium," celebrated each year by the living in company with the dead on the "Feast of the Desert Valley." During this feast, Amen crossed the Nile in his barge in order to visit the goddess Hathor in her grotto sanctuary at Deir el Bahri. On this occasion Amen also visited the mortuary temples of the kings. All the tombs in the necropolis partook of the splendor of his ritual appearance. The entire populace of Thebes joined in this procession and then spent the night in the tombs of their ancestors. On this occasion music, dance, and intoxicating spirits obliterated the curtain between the living and the dead; and the tomb became the "house of the joyous heart." It was this Feast of the Desert Valley which lent the gay and worldly note to the accessible chambers of the tombs and which temporarily brought the deceased back to the pleasures of the world of the living. The individual themes of the representations generally pertain to that narrow zone between life on earth and the hereafter. The representation of the deceased in his official function and that of his enthroned monarch occupy the main wall of the antechamber, opposite the entrance of the tomb. Both lengthwise walls of the deep hall, joined at the west by the cult site, bear representations of the funeral procession and burial rites, as well as others of a religious nature. During the 18th dynasty the sarcophagus chamber was as a rule devoid of pictorial decoration. The arrangement of scenes elsewhere does not conform to any rigid system, and there is much variation from tomb to tomb. Thus, for example, the funerary banquet may occupy the antechamber as well as the last room of the tomb.

From the first appearance of the New Kingdom style until the end of the reign of Amenhotep III, the development of pictorial art may be followed best in the painted tombs of Theban officials. Relief representations of this period are known from the beginning of the development, when they evidence influence of the great relief cycles of Hatshepsut, and from the end of the development in several significant private tombs dating from the reign of Amenhotep III. During the New Kingdom, figure outlines were marked by certain stylistic qualities which distinguish them from those of the early Middle Kingdom created according to the same set of canons and proportions; these qualities include the slimness, agility, and lightness of the figures, their graceful postures, and the expressive nature of their movements. These new stylistic tendencies were effectively expressed in the fluid brush technique and subtle color gradations of New Kingdom painting.

The intensive development of painting had already begun during the peaceful years that followed the conquests of Thutmosis III. Wealth, luxury, and a comfortable way of life are expressed in the paintings of this period, especially representations of festive banquets. In the tomb of the vizier Rekhmira (PL. 362), from the early years of the reign of Amenhotep II, the banquet is still arranged in long horizontal registers. The guests squat singly or in pairs on reed mats placed on the floor and wear myrrh in their hair. Young girls with braids serve beer and wine in shallow drinking bowls, anoint the guests, and place wreaths of flowers about their shoulders. The underdrawing shows that the painters were not averse to experimenting occasionally with free delineations of individual figures; for example, the device of overlapping figures among the serving girls ties these figures closer to the guests and creates an impression of spontaneity, liveliness, and depth. One of the girls turns coquettishly while filling a cup and offers the guest a three-quarter view of her lovely back.

A similar subject is represented in the somewhat later tomb

of Nakht (PL. 362), dating from the time of Thutmosis IV. The youthful profiles of maidens wearing heavy wigs are of great beauty and are set off by great golden earrings. The banquet is animated with a charming vignette: one of the young ladies turns to offer her neighbor a piece of fruit. Delicate nuances of attitude come into play; the gesture is accompanied by a modest lowering of the lashes, and the recipient of the gift seeks to conceal her own fruit. There is an abundance of such little episodes and genre scenes in the wall paintings of this period. Inventiveness and great freedom of execution give these scenes an air of immediacy and closeness to life. The allure of feminine charm and beauty is expressed with almost endless variety. Eventually the subsidiary figures of such banqueting scenes were relegated to a separate band. The group

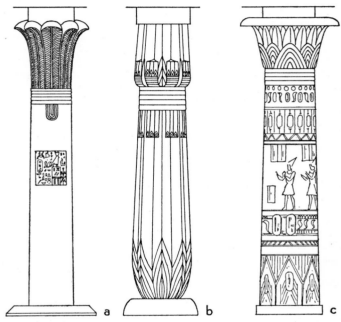

Types of columns: (a) palmiform, from Abusir, 5th dynasty; (b) bundled papyrus, from Luxor, 18th dynasty; (c) campaniform, from Karnak, 19th dynasty.

of maidens dancing and making music in a painting in the British Museum (PL. 363), from the time of Amenhotep III, is depicted in a separate strip below another scene where guests are represented festively seated in a row. A female flute player and three girls who accompany her with song and handclapping are shown squatting on a mat in a group that is closely knit through overlapping of bodies and limbs. Two of the figures are shown in the usual profile view, while the faces of the other two are represented frontally — an innovation. The overlapping of the figures and the transition from profile to en face views serve the purpose of spatial integration; the musicians are conceived of as sitting in a half circle. The device of spatial overlapping is accentuated by the curvilinear play of the draperies. Although bodily volume is suggested, the figures remain bound to the laws of two-dimensional representation. The effect of space and bodily mass is negated by the common base line of the reed mat and by the flat pattern of the inscriptions occupying the upper field of the picture.

The coloristic devices employed in these three examples are varied. In the earlier, Rekhmira picture (PL. 362), the colors are applied in clearly differentiated areas adjacent to each other. The simple garments are painted white. The yellow folds of the garments worn by the maidens in the tomb of Nakht (PL. 362) are also indicated without gradations. In the group of musicians (PL. 363), lighter and darker tones on the soles of the feet serve to create the impression of volume. Hatching and modeling with purely painterly means developed in the brush technique of New Kingdom wall painting. When this brush technique became sufficiently assured, underdrawing was dis-

pensed with. In this way a truly painterly manner of representation evolved again during the New Kingdom, such as had already existed during the late Middle Kingdom. The horses in the representation of the display of Syrian tribute in the tomb of Nebamun (PL. 372), from the early years of Amenhotep III, are rendered in this painterly manner. The unfinished state of this picture allows one to study the technique more closely. This free painterly technique, however, was generally confined to small figures in subsidiary scenes and to the representations of plants. No use of this technique was made in important representational paintings.

Even in the painting of the mature phase, during the reign of Amenhotep III, the effect of the figures still depends to a great degree on outline. The progressive increase in mastery and expressiveness is followed best in representations of mourners. In the early paintings from the tomb of Minnakht (PL. 363), the scene of mourning was composed of individual figures arranged either in a single row or in tiers. In the paintings of the tomb of Ramose, from the first year of the reign of Akhenaten, the mourning women are arranged in rhythmic groups (PL. 381). The gestures of these figures are varied, and their hands are very expressive. Restrained, inward sorrow is powerfully evoked. In the tomb of the sculptors Nebamun and Ipuki, sorrow and desolation are grippingly represented in the features of one figure shown mourning at the coffin of the deceased. The phases in the development of graphic and painterly representation have been traced here in a survey of a few examples. It should also be mentioned that certain colors and tones were preferred to others and that these varied from tomb to tomb during the same generation; therefore it is difficult to speak of color chronology with authority. Nevertheless, several generalizations are possible. During the early period, pure colors on a blue-green or white ground prevailed. During the middle of the 18th dynasty, the colors became more translucent and more rich in gradations. The employment of dull, opaque tones was characteristic of the mature phase.

As if in reaction to the late phase of the development in painting, several significant tombs during the transition from the reign of Amenhotep III to that of Akhenaten were decorated with reliefs. The former themes from the official public life of the owner of the tomb came to the fore once again, along with the portrayal of the king, either enthroned or bestowing favors upon the deceased from the window of appearances in the palace. During this same later phase, the art of painting as such was practiced within the royal palace for representational and ornamental decoration of walls and floors. In the reliefs from the tombs of Khaemhet, Kheruef, and Ramose the scenes are arranged in clearly constructed registers, and genre subjects are rarer. In contrast to the wealth of figures that characterized the paintings, relief decoration tends to be confined to representation of the essential. Rather than agitation and motion, measure and dignified restraint once again prevail.

The tomb of the vizier Ramose, discussed above for its paintings, was decorated chiefly with reliefs. In these works, two completely different styles may be observed on the opposite walls of the same tomb (PL. 364). The earlier reliefs differ from the reliefs of the later years of the reign of Amenhotep III only in their elegant contours, fine details, and delicately chiseled faces; but the later reliefs exhibit a completely different style. Their execution is sketchy; several subsidiary scenes appear to be merely preliminary sketches. The composition of the principal representation is dominated by the rich architecture of the window of appearances, in which the king and his queen stand beneath the image of the new sun god. As in another royal relief of this time (PL. 365), the sun's rays terminate in human hands. The haggard figure of the king leans over the windowsill after having awarded distinctions to his vizier. All the other representations are subordinated to this scene. Small figures appear at the sides of the window of appearances, such as the courtiers and palace servants who bow devoutly in the presence of their king (PL. 364). In a subsidiary scene, Ramose himself appears. His appearance approximates that of the king, except that his elongated bald head with its scrawny neck is bowed in homage to his sovereign.

The transformations in art and religion occurred while the tomb of Ramose was still in the process of decoration. During the first years of the reign of Akhenaten, the older formal tradition in art remained intact in royal as well as private monuments. The new style made its first appearance in the reliefs and statues of a sanctuary that Akhenaten had built to his new god near the temple of Karnak. When it appeared — as in the tomb of Ramose — it appeared suddenly and in completely developed form.

The establishment of the new capital at Akhetaten (Tell el 'Amarna) took place during the sixth year of Akhenaten's reign. The new and expressive style created in Thebes developed its full potential in the decoration of the temples and palaces of the new capital. Sunk relief prevailed in Amarna because of the expressive possibilities it offered in the sharp play of light and shadow. One of the most complete pieces is a block from a limestone balustrade, with sharply cut details that show the king's almost feminine body and his thin weakish limbs. The physiognomy, with its receding forehead, slack jaw, and soft lips seems almost a caricature of the Egyptian concept of the god-king and of the refined style of the preceding period of Egyptian art.

Large relief compositions of this period have been preserved only in the cliff tombs of the royal family and of officials, which were constructed in the vicinity of the new capital. The king, as creator of the new solar religion, and his family — at official functions such as the worship of the sun in the temple, state receptions, and the awarding of decorations — form the subjects of these compositions. The royal family is also represented in more intimate views of palace life. Only rarely are the scenes arranged according to a fixed sequence of events; usually they are related both in time and space to the main representation. The place of the action (palace or temple) is reproduced accurately, with its characteristic exterior architecture and sequence of rooms; in fact, the exactness of the representations enabled reconstruction of the sparse architectural remains that were excavated. The sun disk appearing above the representations of palace and temple suggests simultaneity of location, that is, a synchronous indoor-outdoor scene.

In the rare instances where tomb representations depict scenes from the life of the deceased, significant events relating to his official capacity are selected. Thus, the chief of police Mahu has himself represented as he submits to the vizier a report concerning the arrest of suspects. The presentation of the report is accompanied by an expressive gesture. The dignified vizier, leaning on his staff, receives the report as his retinue listens with rapt attention. Psychological tensions produce in the group a dynamic, yet cohesive, unity. The representation of fleeting action and direct, uninhibited human feeling was at the core of this new style.

New forms were called into being by the break with older traditions — by the new doctrines of solar worship, which now taught that the sun originated and sustained every form of life. The visual arts provided the most immediate expression of this new Truth; therefore they are comprehensible only in terms of the new religious dogma. Small altars that once stood within the private villas of Tell el 'Amarna present the royal family in a an intimate setting; the king fondles his youngest daughter (PL. 365), caresses his wife, or presents jewelry to his children. The unregal, almost sickly bodies, the frail limbs, and the delicate fingers enhance the intense paternal feeling of the scene, which may be sensed even in the fluttering neckbands of the high crown.

The phenomenon of the art of Amarna is highly significant in the context of world art, since it emanated from the spiritual force of a single man — and a man who was not an artist. The artists and craftsmen of the time developed the new style with amazing rapidity; their achievement amounted to nothing short of a revolution, an astounding break through the barriers of tradition. The limits of the traditional system of Egyptian art were stretched to the breaking point. The spiritual as well as artistic background of the phenomenon of Tell el 'Amarna may be found in the religious, social, and artistic development of the time of Amenhotep III. In art, the roots of the new

style may be found in the secularization of themes, the increased expressiveness, and the preoccupation with transitory actions occurring at fixed points in space and time.

After Akhenaten's death, his youthful son-in-law Tutankhamen assumed the scepter of Egypt. Persuaded to restore the old faith, he also transferred the capital back to Thebes. However, only a short reign was allotted him. The rich treasure found intact in his tomb in the Valley of the Kings contained many objects that had been made during the time of Aten worship. An example of this carry-over is his costly throne (PL. 391), which bears an image of the young king relaxing on a comfortable chair as his wife proffers a drink with a graceful and tender gesture. The rays of Aten, executed in resplendent gold, surmount the representation.

procession that brought the barge of Amen from Karnak to Luxor. The composition is a continuous one, and when the enormous scope of the representation is considered, the treatment of masses of people is varied and pleasing in rhythm. These reliefs may be thought of as marking the permanent restoration of the old order.

Since it constituted the end phase of a stylistic tendency, the art of the Amarna period was not capable of further development. A revitalization of the foundations of Egyptian art was called for — a reassertion of the concept of divine kingship, the dignity of which Akhenaten had done so much to destroy. In the early part of the 19th dynasty, Seti I tried to rejuvenate this basic idea in the spirit of earlier times. His reliefs on the north wall of the great colonnaded hall at Karnak show

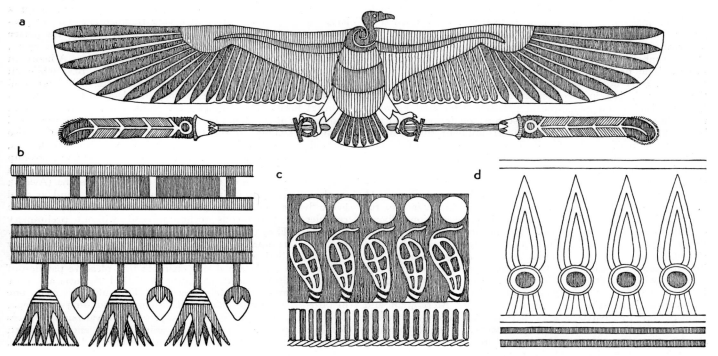

Decorative motifs from paintings in Theban tombs of the New Kingdom.

The artistic heritage of Tell el 'Amarna was perpetuated in a group of reliefs from Memphis that were apparently created by Amarna artists in the service of Akhenaten. The most significant of these come from a tomb that Horemheb had built in Memphis while he was still a general stationed there, before his ascent to the throne (PL. 367). The continuing presence of the Amarna spirit is felt in the manner in which the figures move: runners, horsemen, and a group of soldiers dragging a beam. It is also apparent in the group of Negro prisoners who, conscious of their fate, squat stoically on the ground. In another relief from Memphis (PL. 367) one of the figures is wrenched by uninhibited, inconsolable grief; in yet another, a small hut is in the process of being torn down. All these touches are characteristic of the Amarna tradition. In addition to the vitality of these narrative episodes, however, the artist has invested the important personages following the coffin in a funeral procession scene with notable pomp and dignity. The interior emotional participation is graduated by means of subtle nuances of gesture and facial expression according to the rank of the person represented.

The paintings from the Theban tombs of this period of restoration were far more subject to local traditions of the pre-Amarna period and remained relatively immune to the new influences. The most significant pictorial compositions of this period are the long relief strips with which Tutankhamen decorated the walls of the colonnaded outer hall of Amenhotep III in the temple of Luxor. These carvings represent the festival

him in an attitude of pious obeisance to the old forms and rituals. Seti is represented as worshiping the gods, who in turn offer him the symbols of a long reign (PL. 369). His reliefs in the temple of Abydos are imbued with the same spirit (PL. 368). He ordered the walls of the sanctuaries covered with representations of the divine barge in its shrine and scenes of the sacred rites being performed before it. These works, executed in masterful high relief, recall the best works from the time of Amenhotep III in technique, but they are inferior to the latter in their formal achievement.

The representations of the king engaged in pious worship in the presence of the gods were not the most significant expression of these new times, however. The greatest task before the new rulers was to secure the land from encroachment by foreign enemies. The 19th and the 20th dynasties witnessed a period of grave struggle in an effort to maintain Egyptian supremacy over the lands of the Fertile Crescent. It even became necessary to defend the very borders of Egypt against invading hordes. These struggles served to renew the heroic ideal of Egyptian kingship that had been established at the beginning of the New Kingdom in the wars of liberation from the Hyksos and in subsequent conquests abroad.

Thutmosis III had immortalized his Syrian campaign in diary fashion in a series of inscriptions honoring Amen in the porch of the sanctuary at Karnak. Following this example, Seti I dedicated a series of monumental battle reliefs on the northern outer wall of the great colonnaded hall of the same

temple in a gesture of gratitude for victory. The well-balanced composition of these reliefs shows the king in his chariot slaying his chaotically dispersed enemies. This motif was first encountered in the reliefs on a battle chariot of Thutmosis IV; but the scheme of the composition is even older and presumably relates back to the representations of the desert chase in private tombs of the New Kingdom. A granite relief of Amenhotep II at Karnak, which depicts the king as "master archer" shooting at copper disks from his racing chariot, may be cited as another antecedent of this type of representation. The first occurrence of this scheme as an independent composition is on a coffer from the tomb of Tutankhamen, where it is rendered in miniature in a decorative context (PL. 368).

Seti I elevated the battle relief to the status of a monumental representation in sunk relief on the exterior walls of the temple. At the same time, it became a continuing chronicle of his campaigns. In the temple of Karnak, the sequence of pictures begins at the north exit with a representation of the departure of the king for battle; also shown are various battles, the triumphal return, and the final dedication of the spoils to Amen. The principal scenes are invariably those of battle. However, it is not actual combat that is shown, but merely the enemy fleeing in disorder at the approach of the king. Minor episodes and geographical details are inserted between the main scenes. In the later battle scenes, the dramatic contrast between the huge silhouette of the triumphant royal chariot and the frantically fleeing foe is abandoned in favor of a more objective account of the actual event. The various phases of the battle such as crucial encounters, siege, and eventual capitulation, are all included within the framework of a large self-contained composition. A good example of this type is Ramses II at the Battle of Kadesh (PL. 369), an event which is also recounted in an epic text. The pictorial representation adheres closely to the literary account. The battle is depicted within the framework of a maplike view of the city surrounded by the river Orontes, with the Egyptian camp spread out below. The interspersed skirmishes and the personal exploits of the king, together with the enormous increase in the number of figures included within a single geographic "view," serve to create an over-all impression of confusion. Under Merenptah and Ramses III the battle scenes became increasingly abstract, and the details lost touch with actuality. The portrayal of the king standing over the defeated enemy with taut bow and arrow now assumed a symbolic purpose.

The last significant monument of New Kingdom relief is Ramses III's hunt for wild bulls depicted on a pylon of the temple at Medinet Habu. The significance of these reliefs lies less in their general composition than in the extremely lifelike rendering of the wounded and desperate bulls collapsing in a reed thicket.

The *joie de vivre* of earlier periods is missing from the pictorial decoration of 19th- and 20th-dynasty private tombs. In the tombs of priests and temple officials, scenes of earthly life are restricted to representations of the owner of the tomb participating in official functions such as festivals, processions, and temple rites. The gay public banquets of former days now become dignified repasts for the dead that are celebrated by priests. The realistic expression of grief, however, is retained in the representation of funeral processions. Whereas the earlier scenes of gaiety were intended to relieve the gloomy and uncertain prospects of the afterlife, the emphasis was now on scenes showing the deceased worshiping the spirits and demons of the underworld. As a treatment of life in the afterworld, tomb decoration withdrew to an ever-increasing extent to the innermost underground chambers of the actual tomb. The constant, mechanical repetition of imaginary actions was bound to transform tomb art into sterile formalism. The drawing becomes dry, and the colors are monotonous and dull; the prosaic figures are set against a dull yellowish background. Gay scenes of daily life become exceedingly rare. Among the few examples of these are the fishing scenes in the tomb of the sculptor Ipi at Deir el Medineh (PL. 366). These are inventive creations in their humorous characterization of genre types, in the representation of leaves and branches of trees,

and in their transfixing of the unique and the essential. The spontaneity of the drawing recalls the sketches on marble fragments which were used as artists' study pieces and which were found in large numbers in the artisans' quarter at Deir el Medineh.

Flowers and garlands were indispensable at New Kingdom festivals of the gods and the dead, and they were dedicated along with the usual offerings. At banquets, the heads and shoulders of the guests were adorned with flowers. Multicolored garlands appeared in the decoration of walls and tombs. When, at the height of the development of painting, representational scenes entered into the decoration of palaces and even of private dwellings in a purely ornamental context, it was an indication of the degree of secularization of subject matter that had been reached in painting in the service of the dead.

The first decorative representational wall paintings on a larger scale (unfortunately in a very fragmentary state of preservation), occur on the walls, floors, and ceilings of the palace of Amenhotep III at western Thebes (Malkata). In one room, the decoration depicts calves amid papyrus thickets. A bedroom was decorated with friezes of the dwarf-god Bes, while an audience hall seems to have been decorated with large wall paintings showing the king enthroned, a lady of the court, and a desert hunt. The ceilings were painted with doves in flight, and figures of the flying heron-goddess have also been preserved from the ceilings of the temple halls. The floors were also painted; preserved fragments show a lake with lotus flowers, fish and swimming ducks, and friezes of plants and swamp birds around the perimeter. Similar floors have also been preserved from one of the palaces at Tell el 'Amarna (Awata); in these calves frolic in thickets surrounding a pond as wild geese hover above (PL. 366). The colors are applied with completely spontaneous technique and without any preliminary drawings. They usually resemble glazes and are applied directly to the white stucco ground *al secco*. Stylistically, they may hardly be distinguished from the paintings of Malkata. The wall paintings of a small side chamber in a pleasure pavilion of Akhenaten in the northern sector of Tell el 'Amarna are more subtle and more delicately executed. The subject is again one of birds in a papyrus thicket. This curious building contained, in addition to rooms for brief stays of the royal family, spaces for cattle and smaller domestic animals. An enclosed court, connected to the royal habitation through a large window, served as an aviary.

Some scholars have detected Cretan influence in the decoration of palace areas with scenes from nature, and they substantiate their claims with examples where delicate vines occur side by side with the more austere forms of the papyrus plant. In argument against this supposition, it may be pointed out that the painting of Egyptian floors of this period generally represents the flora and fauna of the Nile Valley and that the impressionistic brushwork of these paintings fits readily within the stylistic development of Theban tomb painting.

As in the palace at Malkata, a large narrative wall painting is also found in a palace at Amarna. Here, as in several of the reliefs that have been preserved, the royal pair and their six daughters are shown in an intimate scene of family life. The naked bodies of the little princesses are skillfully represented, with volume achieved by purely coloristic means. The origins of such coloristic modeling may be traced to the time of Amenhotep III. This technique is also employed, as a supplementary device, to enhance the impression of volume in the finely painted tomb reliefs of Queen Nofretari (PL. 382). Wall paintings are also found in more modest structures. For example, a private house of the Ramesside period in the artisans' quarter of Deir el Medineh has a scene of a courtesan playing a flute and dancing beneath a rinceau painted over the bed of the owner.

*Sculpture in the round.* In the development of New Kingdom sculptural forms, the artistic tendencies discussed in relation to relief and painting may also be observed. In this medium as well, the beginnings may be linked with Theban monuments of the Middle Kingdom. These prototypes were accessible throughout their long evolution — from the hard "archaic" forms of the

statues of Mentuhotep II and his court to the fully developed portraits of Sesostris III, and beyond the empty formalism of late Middle Kingdom statuary.

After the Second Intermediate Period, from which no statuary has been preserved, statues on a small scale again appeared about the time of the foundation of the new dynasty and with the stabilization of the new regime. These first works generally represented members of the royal family. The favorite material was a variety of hard limestone that had only occasionally been employed during earlier periods. The structure of this stone permitted fine polishing of the surface and rendering of minute details. The regeneration of sculpture at this time was based upon the restoration of formal clarity and construction according to the traditional canons governing sculpture. In short, the old "hieroglyphic" conception of art was revived, and particular Theban prototypes were copied. The short wig of the very small statue of Ahmose in the Louvre, for example, betrays deliberate borrowing from the works of the 11th dynasty; but the new works are not mere copies. They give evidence of a change in the over-all concept of form, which is characterized by new qualities of directness and courtly elegance. These stylistic tendencies may be clearly observed in two female torsos of this period — one in Chicago, the other in New York — both of which exhibit in the highest degree the careful rendering of the hair and personal adornments characteristic of this period. A somewhat later, less than life-size statue of the beloved vizier Yuya (Met. Mus.) is in type an adaptation of the statue of Sebekemsaf of the 13th dynasty (PL. 354).

After these small-scale works of the first phase, the new style underwent its greatest development in connection with architecture. The heads of the larger than life-size, painted Osiride statues of Amenhotep I, the founder of the new dynasty, which flanked the access to his mortuary temple, aim — just as in the finely carved reliefs of this king — at the depiction of individualized features. The final formulation of the royal image was arrived at during the reigns of Thutmosis I, Hatshepsut, and Thutmosis III. In this style, the sculptors looked back to the monumental sculpture of the early 12th dynasty, especially to the creations of the time of Sesostris I. The influence of this earlier period is evident in a colossal head in Cairo (Egyptian Mus.) and in another (Mus. Egizio) in Turin. At the same time, however, these works are also imbued with the spirit of the new period. Characteristic of the new direction is the heightened expressiveness, particularly in the cheeks, eyes, and gracefully curved lips.

The terrace temple of Hatshepsut was filled with a wealth and diversity of statuary hitherto unknown. Large sphinxes of sandstone and granite flanked the monumental ramp, the central aisle of the court, and both lower terraces. Colossal Osiride statues were engaged to the pillars of the uppermost terrace, and kneeling figures of granite that depicted the queen bearing offerings were apparently set up between the pillars of the open hall. This sculpture was conceived wholly in the service of architecture, and the buildings were now directed toward the outside world. In the outer temple, the queen was represented only in the guise of a male ruler. Two large seated statues, recovered from the inner temple, show the queen in her female guise (PL. 370); both statues apparently stood in the Hathor sanctuary of the inner terrace. In these the harder forms of the monumental sculpture from the outer parts of the temple are refined and softened. The rich accumulation of statuary adorning the temple of Hatshepsut was vengefully destroyed soon after her reign by her successor Thutmosis III, and the fragments were buried. For this reason many of the fragments have retained their original colors. Whereas the sculpture of limestone and sandstone was once completely painted, the coloration of the granite figures and sphinxes was confined to the eyes, lips, and attendant attributes of the goddess. The natural reddish color of the granite was equated with the color of skin. Although the representations of Hatshepsut offer certain features that would seem to bear resemblance to her actual appearance, the statues are in reality "type portraits"; that is to say, they are "superindividual" versions of lifelike royal portraits, incorporating forms which are characteristic of an earlier phase of New Kingdom sculpture and which provide the foundation for further formal development. From the existent portraits of this period, only the general tendencies of the development from generation to generation can be established.

A green schist statue of Thutmosis III (PL. 370) from Karnak falls within this tradition but surpasses the portrait of Hatshepsut in its suppleness of posture and lifelike expression. This statue is similarly an "ideal portrait," although here the masculine profile with the characteristic "Thutmoside nose" appears more individualized than in the portraits of the queen. In other statues of the king this distinctive feature is ignored and the expression of inner spirit is enhanced by detailed representation of other organic elements, especially the mouth and its surrounding area. In the portrait heads of Amenhotep II the face becomes narrower, and the forms are more decorative and graceful, particularly the beautiful curve of the brows. These are somewhat idealized portraits of a youthful king whose athletic appearance is also attested in contemporary texts.

In the head of Amenhotep III in Hanover (Kestner-Mus.), the facial forms are more expansive, and their expression is more realistic. The curve of the brows swings high into the area of the forehead. The eyes are almond-shaped and elongated and are set diagonally in relation to the axis of the head. The head itself is fully rounded, with full cheeks and lips. A colossal head of brown quartzite (Br. Mus.), found in the area of the mortuary temple of Amenhotep III in western Thebes, belongs to a later phase. A new formal principle is evident here: each plane of this head is incorporated into an over-all rhythm of the features. The almond-shaped eyes with their extended cosmetic lines, the lips, and the chin all enhance the total expression with the daring abstraction of their forms.

Deviating from the logical development of formal tendencies inherent in Egyptian sculpture since its revival at the beginning of the New Kingdom, in the late years of the reign of Amenhotep III sculpture suddenly turned from the balanced and formal style familiar in earlier periods to a new style that might well be termed "expressionistic." The sculptor of the quartzite head of Amenhotep III sought to raise the expression of royal majesty into the sphere of the superhuman. Akhenaten, the successor of Amenhotep III, seized upon these new artistic possibilities and transformed them in keeping with the spirit of his new solar religion. In the colossal statues of painted sandstone (PL. 374) that stood before the pillars in the court of the Aten sanctuary at Karnak, the same elongated bodily forms, effeminate features, thin and weakish limbs, and portrait qualities appear that are already familiar from reliefs. The insignia of temporal rule are detailed and increased to a degree hitherto unknown. The inscriptions on these statues do not identify the king specifically but instead refer to the sun god, who was revered by his apostle the king. New ideals of spiritualization and introspection are proclaimed, for which the figure of the king himself is to serve as inspiration. The forms employed in the art of this period mark the first major break with tradition, a rebellion against the entire previous course of art, which had been devoted to the service of Amen.

The succeeding development of sculpture in the round is known to us only through the finds of the new capital at Akhetaten (Tell el 'Amarna). This knowledge is based largely upon the productions of several distinguishable ateliers that seem to have been active toward the end of the Amarna period, shortly before the death of Akhenaten and the abandonment of the city. Most of the works that have been preserved are unfinished. They are therefore particularly valuable for studying sculptural techniques. Trial pieces have also survived, as well as a large number of unusual plaster casts from the period. The portrait heads of the king, his family, and his retinue are usually less than life-size in the Amarna style. In comparison with the colossal statues of the king at Karnak, the expression is milder and a kind of spiritual beauty is immanent in the figure.

With the resolution of religious tensions, toward the end of the Amarna period, art left off its revolutionary cast. Fine-grained soft sandstone and hard brown quartzite were the

favorite materials of sculptors at this time. Separately worked heads and limbs of quartzite were made for bodies executed in another material, usually hard limestone. Unfinished parts frequently reveal traces of preliminary drawing and corrections. The portrait heads are very varied; however, because of contemporary idiosyncrasies they all share, it is often difficult to establish the identities of the subjects. Queen Nefertiti (PL. 375), princes, and princesses are among the subjects represented. The famous polychrome head of Nefertiti (Berlin, Staat. Mus.) wearing a high headdress, in which one eye is inlaid with rock crystal, is a sculptor's model or trial piece from the hand of a great master. The impact of the queen's exquisite features is heightened by the outsize headdress, which is supported by the delicate neck without any other reinforcement. This daring construction is so carefully balanced that it rests securely on a bust of rather small diameter. The lowered eyelids and delicate creases at the corners of the mouth would seem to intimate that the queen has here reached a fairly advanced age, about that indicated in a limestone statuette from the same workshop (Berlin, Staat. Mus.). Portraits of princesses exhibit in common the same elongated skull, though in limestone examples the forms are softer and rounder. Such elongated skulls also occur in relief in the representation of adults; they are to be interpreted as an artistic convention of the time. The torso of a princess (PL. 374), once part of a family group, reveals careful observation of nature, evidenced in the representation of such details as slight contractions of the skin.

It would be an error to label the art of Amarna simply as realistic in style. As is apparent in preserved examples, natural forms are observed with unusual sharpness; nevertheless, they are at the same time transmuted to conform with an ideal of beauty of the period. This relationship of nature and art is best illustrated by ancient plaster casts found in a sculptor's studio at Amarna. Included among these are masks cast from living and dead subjects or from portraits freely modeled in clay; the eyes are always fully open. In addition to members of the royal family, courtiers were portrayed (PL. 375); these masks are unique testimony of the actual appearance of the people of Amarna. However, no comparably realistic portrayals occur among major finished works, as evidenced in other plaster casts taken from completed works of art or from more ambitious works still in progress. The most significant cast in this series is a mask of Akhenaten himself. Like no other image of Akhenaten, this cast reflects the intense spirituality of this extraordinary man. The facial forms convey his uncommon nature without resort to expressionistic exaggeration.

The return to the religion of Amen and to old Nilotic traditions was inaugurated by Tutankhamen with numerous dedications of statues and statuary groups, especially in the temple of Karnak. The statue groups show Tutankhamen in the company of Amen (Turin, Mus. Egizio), under the protection of the god (Louvre), or between Amen and Mut (Cairo, Egyptian Mus.). The sculptural forms of these statues and groups, as in reliefs of the same king in the temple at Luxor, continue tendencies of the late Amarna style. This continuity is most clearly seen in the colossal quartzite statues of the king in his valley temple.

A new type of royal portrait was created in the 19th dynasty. One masterly example of this type has been preserved; most of the others that remain are weak in comparison. This masterwork is an enthroned statue of Ramses II (PL. 377). The rich forms — the heavy blue crown, under the weight of which the head of the sovereign seems slightly bowed, the tense visage, the right arm assertively holding the scepter, and especially the fine uniform folds of the long gown — are worked with metallic precision. The technique results in the same cool smoothness that was characteristic of the reliefs of Seti I at Karnak and Abydos. There is much in the portrait of Ramses which suggests that it may have been adapted from statues of Seti. It may even be possible that an unfinished statue of Seti I was completed as Ramses II. A seated statue which is very similar to the one in Turin and which is now at the monastery of Grottaferrata near Rome bears the name of Seti I. The tone of devout piety observed earlier in the reliefs is echoed

in sculpture in the round in small-scale figures of the king in which the ruler, kneeling in the attitude of *proskynesis* (semiprostrate entreaty) dedicates an offering to the god. There are also larger statues of the king in a standing, sitting, or kneeling position, with a figure of the god or a cult symbol held before him. The gesture of kneeling in devotion was adopted earlier among the representations of votive dedications in the tomb of Rekhmira. During the Ramesside period, this representation of a momentary posture was developed into a monumental subject.

A wealth of colossal statues, both standing and seated, populated the courts of Ramesside temples. Some of these statues are technically assured and unusually refined in their execution, despite their gigantic scale. Others, however, are calculated mainly for their over-all effect within an architectural framework. The most famous examples of this style are the colossi of Ramses II, hewn directly from the sandstone cliff around the entrance of his rock-cut temple at Abu Simbel (PL. 359). The same progression from art on a small scale to monumental art may be followed in the representations of the king holding one or two ritual staffs, a sculptural type popular during the period of Ramses III and later. In these the king does not appear with his usual tall ceremonial crown but instead wears a simple wig with the symbolic uraeus over the forehead (PL. 376). His features are somewhat generalized and immobile. Finally, motifs that were formerly presented exclusively in relief are reproduced in the round: for instance, a small granite statue shows Ramses VI as conqueror of the Libyans (Cairo, Egyptian Mus.). Ramses holds his weapon in his right hand, and with his left hand he seizes a bound prisoner by the hair. Much of the former symbolic strength of this scene — discussed in connection with its relief representations — is now lost.

During the five hundred years of its development, private sculpture of the New Kingdom not only continued types inherited from the Middle Kingdom (block statues and draped figures) but also brought forth a wealth of new forms. Only a few examples of grave statuary of high quality have been preserved. In the Theban cliff tombs these works were usually carved from the living rock. Although small individual statues are occasionally found, family groups are more common. Another popular type, the kneeling votary holding a stele in his outstretched hands reflects the spiritual aspirations of this period. The front of these steles bears a prayer to the rising sun.

Of greater artistic significance are the temple statues of hard stone, which also continue tendencies of the Middle Kingdom. As demonstrated by hieroglyphic texts, the temple statue in the New Kingdom was intended not only to assure the magical sustenance of the deceased at the offering table of the gods but also to guarantee him a place in the company of the living. Through inscriptions relating to the life and special qualities of the person represented, the statue took on the character of a "personal memorial." The early phase of this development is exemplified by the statues of Senmut, the architect of the terraced temple of Deir el Bahri. He was the protégé of Queen Hatshepsut and the mentor of her daughter Nefrura. His office as educator was the theme of a number of statues and statuettes that Senmut was allowed to erect in Theban temples as reward for his faithful service. Two block statues in Berlin (PL. 376) and Cairo (Egyptian Mus.) are entirely covered with inscriptions, and their blocklike forms are far more abstract than those of their Middle Kingdom prototypes. The block is no longer thought of primarily as a representation of a squatting human body with arms across the knees but merely as a field for long inscriptions. The feet have also been absorbed into the abstract form of the block. All the more effective, therefore, is the impact of the official's head rising above this abstract mass, as well as that of the little princess in front of him. Her body is similarly swallowed by the block. Other small figures of Senmut show him in group scenes, either sitting or kneeling with the princesses on his arm or on his lap.

The mature stage of the development of these commemorative statues is exemplified by the family group of Sennefer (PL. 376) from the temple of Karnak (from about the time of Amenhotep II and Thutmosis IV). Within the severe composition of the group

as a whole, the trend toward a more organic and "up-to-date" representation is apparent in such modish details as the elaborate coiffures and the pectoral of Sennefer, which suggest a large collar in outline. The facial features do not disclose realistic portrait tendencies; rather, they conform to the ideal type of the time, as reflected also in the royal portraits. A number of statues of Amenhotep, son of Hapu, one of the most important officials during the reign of Amenhotep III, have been preserved. These portray him as a scholar in the position of the seated scribe. The body, with somewhat widely placed arms and with schematically represented folds of flesh across the breast, seems to harbor intense vitality. The intellectual bent of the subject is particularly evident in the pensive attitude of the head, which inclines slightly forward. While the execution of the scribe types conforms to the sculptural style of the time of Amenhotep III, even in their portrait features, another scribe figure shows the same person with expressive signs of age (PL. 376). The external conventions of representation — the crossed legs contained within the block, the long kilt knotted below the breast, the form of the wig, and the formal expression of old age, recalling Middle Kingdom tradition — have acquired individualized, almost spiritualized, expressive qualities.

In addition to the statues of hard stone prevalent from the middle of the 18th dynasty onward, there appeared a wealth of small wooden figures of stylishly clad women with heavy wigs, graceful figures of naked young girls, male figures, and small family groups dressed in the style of the period. This miniature art flourished from the end of the 18th dynasty well into the 19th dynasty, and most of these small figures were found in tombs. A votive character might also be attributed to small groups that represent the dedicant as a scribe crouching before the god of wisdom; the deity appears in monkey guise and stands on an elevated pedestal. These stone figures are frequently let into a wooden base. Few private sculptures from the Amarna period have been preserved, and these are invariably small-scale works. The statues in the tombs of the new capital were carved from poor local limestone, akin to that of the Theban tombs. It may be that the new doctrine did not allow statues of private individuals to be placed in temples along with the royal statues.

A small group of three men and a boy (Met. Mus.), rendered in painted sandstone, shows the same "slouch" and the unconventional representation of a psychological interrelationship that also characterizes the modest group portraits of Akhenaten and Nefertiti.

The period of restoration under Tutankhamen is represented by one great masterpiece, the portrait of a scribe dedicated by the general Horemheb in the Ptah temple of Memphis (Met. Mus.). The sophistication of the forms and the sensitivity and psychological acuity apparent in the features of the subject are the heritage of the Amarna period, as attested by a comparison with portraits of Amenhotep, son of Hapu, which are less than a generation older. This heritage is also evident in a series of individual statues and statuary groups of limestone that extends into the early 19th dynasty. A beautiful example in Florence (Mus. Archeol.), with the face of a mature woman framed by a heavy wig and excessively delicate bodily forms, is still very close to the style of Amarna. In other statues and statuary groups, the sensitivity of this masterwork has been replaced by arid formalism.

In the Ramesside period the courts of temples of Amen were increasingly populated with private statues. These Ramesside works represent the dedicant in the form of a block statue in a standing, sitting, or kneeling position; usually the votary is accompanied by images of the gods, cult symbols, attributes of deity, or royal figures. The tendencies manifested in royal sculpture also affected private sculpture. The prototype of these figures in company with images of deities seems to have been developed first in the realm of private sculpture. In private sculpture the type can be traced to the time of Thutmosis III: for example, the limestone statue of the general Djehuty from Karnak (Cairo, Egyptian Mus.). The composition of these "protector" statues of the 19th and 20th dynasties is very revealing in connection with the religious developments of the late New Kingdom, for on the basis of their artistic qualities, they bear witness to a gradual decline from the spirituality of the preceding period. One of the last significant works of art of this period of decline is a scribe figure of Ramsesmakht, who lived during the reign of Ramses IV. The composition, with the baboon-god of wisdom behind the head of the subject, may have been suggested by earlier royal portraits in which the head of the king was enveloped by the outspread wings of the hawk-god. This arrangement was an innovation of the time of Chephren (PL. 340) and was revived in the New Kingdom under Thutmosis III.

*Minor arts.* The victorious military campaigns of the Thutmoside kings, the tribute of the subjugated peoples, and the acquisition of the rich Nubian gold mines soon created great prosperity in Egypt. This wealth benefited not only the temples of the gods and the kings but also the public officials, who constituted an ever-increasing class. Frank *joie de vivre* and the taste for beauty induced luxury in fashion and personal ornament. The luxuries demanded by the ladies of this class initiated a rich development in finely wrought cosmetic utensils and receptacles. The minor arts in the service of everyday needs performed greater and more varied tasks during the New Kingdom than during other eras. After the death of their owners, these precious objects were consigned to the grave along with the body. Despite subsequent plundering, an abundance of precious jewelry and other items used in everyday life has survived from the New Kingdom.

Among the tomb caches that have been discovered are the burial accouterments of Queen Ahhotep, from the beginning of the 18th dynasty. Included in this trove is a pectoral bearing the cartouche of King Ahmose, which in technique is related to jewelry of the late 12th dynasty. A ceremonial battle ax and dagger in Cairo betray Mycenaean influence in their niello technique and their subject matter (the winged griffin and animals in flying gallop). Precious jewelry of three royal consorts of Thutmosis III has also survived. Of exceptional beauty is a diadem of gold foil with rosettes applied and two gazelle heads in place of the usual uraeus over the forehead. Another headdress consists of more than nine hundred golden rosettes inlaid with colorful glass paste and semiprecious stones. This was a flexible adornment which covered the entire wig.

A shallow drinking cup of beaten gold, with a frieze of interconnected floral calyxes and fishes applied in two concentric rows about an engraved central rosette, was a gift of Thutmosis III to his general Djehuty. Similar motifs comprise the ornament on numerous cups of green faïence. A new branch of the minor arts developed during the early 18th dynasty from the older technique of glazed earthenware (faïence). This technique made use of brightly colored glass paste. A turquoise cup with blue and yellow "combed" decoration (Munich, Antikensamml.) bears the cartouche of Thutmosis III. The technique of manufacturing glass reached its high point during the Amarna period, and the production of "core wound" vessels of blue glass with colored threads applied and little white glass amphorae with polychrome decoration on the rim continued into the 19th dynasty.

The tomb of Tutankhamen presents numerous samples of the excessively rich development of the goldsmith's art, as well as the production of costly implements and furniture in a variety of techniques during this period. Of the two inner sarcophagi, which contained the actual mummy of the king, the outer coffin is of oak and has a richly gilt coating of stucco inlaid with glass paste in imitation of feather patterning. The inner coffin is wrought of gold and is inlaid with glass paste and semiprecious stones set in compartments similar to cloisonné work. The most costly articles are diadems, collars and necklaces with pectorals, rings, and earrings (which came into vogue in Egypt with the Near Eastern princesses at the court of Thutmosis IV), as well as golden sandals of the king that are richly decorated with colorful inlays. The ceremonial staffs of the king are decorated with ornamental patterns composed of bark and lustrous beetle wings. The curved lower parts of walking sticks terminate in carved figures of bound Syrian

and Negro captives. In addition, there was a rich find of furniture: beds, chairs, camp stools, and costly thrones (PL. 391); headrests of ivory or wood with figured decoration and others of turquoise glass; chests inlaid in ivory with animal and plant friezes, with genre representations in delicately colored relief, or with painted miniatures of the hunt and of battle (PL. 368).

A find of jewelry and vessels of precious metal from the temple precinct of Bubastis in the Delta (Tell Basta) — parts of which reached Cairo (Egyptian Mus.), New York (Met. Mus.), and Berlin (Staat. Mus.) — is ascribed to the end of the 19th dynasty (ca. 1200 B.C.) because of the appearance of the name of Queen Tausert, the wife of Seti II. A necklace of the queen, decorated with pearls and cornflower pendants of gold wire, is the first instance of the filigree technique, which was not widely diffused in Egypt until Ptolemaic times. One vessel from this treasure, now in Cairo, has a golden handle in the shape of a rampant goat. The shoulder and neck of this vessel bear inscriptions and engraved representations, which include motifs (fishing and bird catching in papyrus thickets, the winged griffin flanked by palmetto trees) that attest the active cultural exchange of the times. This tradition in gold- and silverwork lasted beyond the end of the New Kingdom and is again encountered in the rich find of precious metalwork in the tomb of King Psusennes in Tanis (21st dynasty, ca. 1050 B.C.; Cairo, Egyptian Mus.). A large silver cup in this cache bears a purely Egyptian motif on an inset emblem of gold: girls who swim amid fish and reach out for waterfowl, a theme known from silver cups of the late 18th dynasty (PL. 378) and also subsequently documented in a colored sketch on limestone (Turin, Mus. Egizio).

More modest in choice of materials than the vessels from royal tombs, but certainly no less accomplished in technical execution, are the delicate and varied cosmetic utensils of the New Kingdom. The tradition of hand mirrors goes back to the Old Kingdom. The round mirror disk of silverplated copper was originally set into a handle shaped like a papyrus stalk and blossom (PL. 344). This form of handle seems to have been chosen because of the association of the shape with the hieroglyph for happiness. During the Middle Kingdom the head of Hathor, the goddess of love, was inserted between the grip and the blossom, for papyrus was commonly associated with this goddess. These simple forms also prevailed during the first half of the 18th dynasty. The secularization of themes, noticeable even in tomb paintings after the middle of the 18th dynasty, also affected such domestic implements. The human figure in the round now became an integral part of such instruments, and a graceful nude maiden replaced the Hathor head. At times the female form was cast along with the papyrus blossom as a single unit, while in other instances it was carved separately of wood (e.g., the beautiful maiden now in Bologna, who holds a young bird in one hand and toys with her earring with the other). Hand mirrors were always kept in sheaths or cases to protect the polish of their reflecting surfaces. An elaborately worked mirror case belonging to a princess of the 21st dynasty is decorated with ivory inlay that includes all the popular motifs for toilet articles of the New Kingdom: the nude maiden with flowers, papyrus blossoms, wild ducks in flight, etc.

Dainty pierced reliefs of wood or ivory adorned shallow cups and other receptacles for ointment. The decorative motifs are varied and include plants, animals, figures of young girls, and male and female domestics. Spirited animal groups of Mycenaean type also occur, such as the lion chasing a calf. In the representations of maidens playing the lute or beating drums, prototypes derived from tomb painting are evident. Papyrus bundles and peaches usually symbolize festive banquets, and the swampy thicket is an allusion to nature as the setting for erotic love and intercourse. Hieroglyphs with auspicious connotations are sometimes worked into the compositions. The wild duck also belongs to this romantic setting of marshland. Carved of ivory and hollowed, the figure of the duck often serves as a receptacle for cosmetic creams; the wings serve as the lid of the vessel, as they are hinged and swing aside. Some of these duck receptacles are provided with handles in the form of swimming maidens. This motif may have been inspired by the romantic lyric poetry that flourished during the New

Kingdom. Graceful servants, Negresses, and Syrian slaves, each carrying a great container which served as an ointment jar, exemplify the sort of domestic art popular during this period. These figures appear in relief as well as in the round. Figures of both male and female slaves frequently carry a receptacle on their bent necks. These figure utensils are generally set into small rectangular base plates, as were the tomb statuettes. They do not comply with the customary Egyptian canon of axial composition but carry their loads freely and in a wholly naturalistic manner. The bodies bend forward or to the side under the strain of the heavy loads, and sometimes the weight of the burden is even expressed by a spiral twist of the body.

With the upsurge of the ancient Egyptian technique of faïence during the reign of Akhenaten, architectural members and building interiors were also revetted with colorful inlays. Tiles appear to have replaced the practice of floor painting. The tiles are decorated with motifs similar to those which earlier adorned the painted floors: aquatic plants and water birds taking flight. Wall decorations of faïence with applied relief representations have been preserved from a palace of Seti I and Ramses II at Kantir in the northeastern sector of the Delta, as well as from the palace of Ramses III near his mortuary temple at Medinet Habu.

THE TRANSITION FROM THE NEW KINGDOM TO THE LATE PERIOD (21st to 24th dynasty, 1085–712 B.C.). The end of the New Kingdom was marked by a change in dynasties and by the political division of the land into Theban and Thinite lines.

The 22d dynasty of Libyan mercenary chiefs was able to restore political unity for only a brief time. The political stronghold during this period was the Delta sector. The political influence of Thebes became progressively less significant; however, Theban artistic traditions survived for several centuries, until the Late Period was ushered in with the 25th dynasty.

As a consequence of the general poverty of this transitional period, there was no appreciable architectural activity. The rulers of the 22d dynasty occupied themselves with the completion of buildings begun by the Ramesside kings, such as the temple of Khonsu at Karnak initiated by Ramses III (FIG. 675). King Sheshonq I, the founder of the 22d dynasty, built a wide colonnaded court to enclose the façade of the little temple of Ramses III, in front of the western pylon. The huge first pylon, which now gives access to the court, seems to have been constructed in Ptolemaic times to replace the western wing of this colonnaded hall. A temple of Amen built by Sheshonq I and Osorkon I at El Hibeh in Middle Egypt is a modest structure. In this building the parapets between the columns that are characteristic of the Late Period are present for the first time. At Bubastis, the capital of the 22d dynasty, a granite gateway of Osorkon II that is decorated with representations of his jubilee has been preserved.

In the few extant reliefs and paintings of this period, the same continuance of Theban traditions may be observed. The sunk reliefs of the Hall of the Bubastides, built by Sheshonq I, and the great representation of the victory over Rehoboam of Judaea on the south face of the pylon adjacent to this hall display a clarity of contour that is reminiscent of Theban New Kingdom relief. Blocks from the temple of El Hibeh show fine modeling in high relief and a broad treatment of details. In the medium of wall painting, the Theban period came to a close with the painted tombs of the 21st dynasty burial of Nepaneferher (tomb 68); but traditional themes persisted in the representations of mourners and of a necropolis on a painted sarcophagus of the 22d dynasty from Deir el Medineh (Berlin, Staat. Mus.).

Little royal sculpture in the round has been preserved from this intermediary period. A quartzite torso of Osorkon II found at Byblos is closely related to the Ramesside period in its style. A life-size head now in Philadelphia (Univ. Mus.), which once belonged to a kneeling figure of Osorkon II from Tanis (Cairo, Egyptian Mus.), is consciously drawn from sculptural forms of the Thutmoside period. The same tendencies may be observed in statues of the royal princes who served as high priests of Amen at Thebes. Most of these are of the block-

statue type, and their cubistic bodies are entirely covered with figures of gods, divine symbols, and inscriptions.

Bronze sculpture appeared in quantity for the first time during the 22d dynasty, but the technique was not new to Egypt. The sphinx figure of Thutmosis III in the Louvre, richly embellished with the royal name in hammered gold, is an isolated antecedent of this new branch of metalcraft. The technique seems to have developed in Lower Egypt, where metals — especially silver — for the inlays were readily available from trade with the Near East. A bronze statuette of Osorkon I (Brooklyn Mus.) was found at Tell el Yahudiyeh in the Delta. The largest of these bronze figures, a statuette of Takushit (Athens, Nat. Mus.; ca. 27 in. high), is believed to have been found at Bubastis. The most significant example of the type is a statuette of Queen Karomama, the wife of Takelot II (PL. 378). The inscriptions on the base plate of the statuette and the apparel of the queen, with its wide collar and rich feather design, are decorated with applied silver, gold, and electrum. The portrait features recall Ramesside prototypes, whereas the body forms show a new slenderness and fluidity of contour. The damascene technique of inlaying bronze with strips of precious metal was accompanied by the practice of partially covering bronze statuettes of the gods with gold foil. Rich inlays of glass paste in grooves and cells that were cast with the figure now also became common. As examples of the applied arts of this transitional period, the burials in the royal necropolis of Tanis have yielded rich finds of masks of wrought gold, pectorals, precious vessels, and a sarcophagus of wrought silver decorated with the head of a hawk. As they had during the Ramesside period, Egyptian minor arts of the 10th and 9th centuries B.C. again exercised strong influence over the applied arts of Syria and Palestine.

THE LATE PERIOD (25th dynasty through early Roman rule, 712 B.C. to 2d century of the Christian era). The term "Late Period" encompasses the last native Egyptian dynasties (26th and 30th), as well as the centuries of foreign domination by Nubians, Persians, Macedonian Ptolemies, and the Roman emperors. The time of indigenous Egyptian cultural development was past. Time and again the Egyptians were drawn into the wars and internal political disputes of foreign powers; repeatedly, foreign armies invaded the Nile Valley and plundered its sanctuaries. Egyptian kingship was divested of its divine attributes and secularized. Even in brief intermittent periods of national autonomy during this era, the spiritual ties to ancient religious foundations were absent. As a consequence of the gradual dissolution of political power, traditional religious beliefs, and the doctrine of divine kingship, the significant purpose and relevance of older Egyptian art was irretrievably lost. The political unity of the land, symbolized in the conception of Egyptian kingship as ruler of the Two Lands, was also relegated to the past. The lack of a supreme national deity strengthened the cults of the many local gods and resulted in the development of separatist theological systems. Because of the generally unsettled conditions of the times and the rapid succession of dynastic changes, monumental creations in the arts were very rare. The conventions and canons of Egyptian art and writing again became a persistent force in the preservation of ancient traditions in the popular consciousness and served as an active link between the old and the new. There were sporadic attempts at revival or innovation in the arts, but these inevitably gave way to empty formalism. The technique of working hard stone was practiced with uncommon virtuosity during the Late Period, but the works created seldom reflected the spiritual diversity of the times. Artistic expression was somewhat conventional and impersonal, so that the creations of this period are characterized by their "timeless" (i.e., indefinite) quality.

The concept of a kingship founded on an intimate relationship between the king and the gods was so deeply rooted in Egyptian popular consciousness that enlightened and cosmopolitan native rulers as well as foreign masters — Persians, Ptolemies, and Romans — had recourse to ancient artistic traditions in order to document and secure their royal claim. During the reigns of these diverse rulers, temples were built and equipped with statues, reliefs, and hieroglyphic inscriptions until well into Roman times; and in these temples foreign rulers, as legitimate heirs to the Pharaohs, venerated and sacrificed to the Egyptian gods. In addition to official art, there existed private sculpture in the form of temple statues of high functionaries, for the most part members of the priestly class. The portraits of these eminent Egyptians are the most significant contribution of Egyptian art of the Late Period.

With the conquest of Egypt by Alexander the Great and with the establishment of Alexandria as the center of Hellenistic culture and art in its function as the capital of the Ptolemaic kings, there began a struggle between Egyptian and Western thought which in art ultimately led to the assimilation of foreign influences.

*Architecture: a. Temples.* The Late Period began with the 25th dynasty (712–663 B.C.), which was Nubian in origin. During the New Kingdom the region south of Egypt had for centuries remained under the influence of Egyptian culture. After the end of the New Kingdom it had declared itself autonomous under local rulers; nevertheless, the area preserved the orthodox belief in Amen. This orthodoxy was the origin of Nubian claims to Thebes as the abode of their god, and it was in the name of Amen that Egypt was occupied by Nubian invaders. The center of Nubian might remained, however, the capital of Napata, far to the south in the Gebel Barkal (see NUBIAN ART). Here, as well as at Kawa and Sanam, the Nubian kings erected temples purely Egyptian in form. Adopting these temples as a model, the Nubian king Taharqa (688–663 B.C.) added a high colonnade of kiosklike forms to the west and east sides of the temple of Amen at Karnak. Of the western colonnade, erected in front of the pylon of Horemheb, one of the twenty 70-ft. papyrus columns with open-blossom capitals has been set up again. Similar colonnaded porches were also added to the temple of Monthu in the northern sector of Karnak and to the temple at Luxor.

The architectural activity of the 26th, or Saite, dynasty (663–525 B.C.) — a local dynasty originating at Sais in the Nile Delta — was confined to Lower Egypt, including Memphis. At Memphis and in the Delta, only isolated parts of the temples of this period have been preserved, such as the colossal monolithic naos of Amasis (569–525 B.C.), the former inner sanctum of the temple of Mendes (Tell el Rub'). Herodotus reports that the royal tombs of the Saites lay within the precinct of the great temple of Neith at Sais, close to the sanctuary proper (*Histories*, II, 159).

After the conquest of Egypt by the Persian king Cambyses (525 B.C.), Darius I (521–486 B.C.) built a temple of Amen in the Kharga Oasis in purely Egyptian style (PL. 379), and to this Nectanebo II (358–341 B.C.) of the native 30th dynasty added a beautiful entrance hall with palmiform and papyrus columns with blossom and composite capitals. As evidence of the building activity of the 30th dynasty (378–341 B.C.), there exist minor additions to older temples in Upper Egypt. Even more important remains are the ruins of a gigantic temple near the present-day village of Behbit el Hagar in the Delta. This temple, constructed of granite from Aswan, was demolished by an earthquake. The oldest temple on the island of Philae, near the First Cataract, also goes back to the 30th dynasty.

With the advent of the Ptolemaic dynasty (332–330 B.C.), the cultural center of Egypt moved north permanently to the Greek capital of Alexandria. Upper Egypt turned from the foreign usurpers and withdrew into its ancient religious heritage. Ironically, however, it was during these last three centuries of the 1st millenium B.C. that architecture in Upper Egypt experienced a final notable revival. The cause is readily discernible: architecture was now in the service of a Greek dynasty that actively sought to reconcile opposites and to cater to the religious sensibilities of its subjects. The temples were built in a purely Egyptian style and were dedicated to the old local gods. In the decoration of these edifices, the Ptolemies appeared in reliefs and statues as the legitimate successors of the Pharaohs.

Under the direction of Philip Arrhidaeus the sanctuary of Karnak was restored. The fine reliefs on the granite walls adhere closely to the style of the Thutmoside period. It was probably at this time that the middle sanctuary of the temple precinct at Karnak was enclosed by a high brick wall with three monumental gateways; the southwest portal was constructed by Ptolemy III (Euergetes). The greatest architectural achievements of the Ptolemies are a number of temples, some of which are still intact. Under Ptolemy III the gigantic temple of Horus at Edfu was begun in 237 B.C.; it remained unfinished until the time of Ptolemy XIII, who completed the structure in

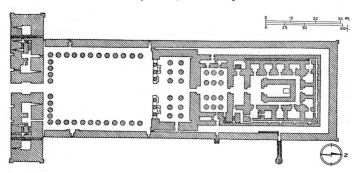

Edfu, temple of Horus, Ptolemaic period (*from Lange-Hirmer*).

57 B.C. (PLS. 379, 380). The ground plan adheres closely to the scheme developed toward the end of the New Kingdom (FIG. 699), but here it is made more complex by the addition of several forehalls. The temple proper, with its wide colonnaded porch, is surrounded by a high enclosing wall of stone, through which gigantic pylons provide access to a spacious colonnaded court. An innovation of Ptolemaic temples is the so-called "Birth House," situated near the main entrance and as a rule oriented at a right angle to the main temple axis. This Birth House usually had the plan of a peripteral temple and was regarded — judging from representations and inscriptions — as the place where the deity was born.

Two of the most significant of Ptolemaic temples are the temple of Hathor at Dendera and the temple of Sobeck and Haroeris at Kom Ombo (FIG. 700). The two sanctuaries of this latter temple are combined in one building and have a common entrance. Also of the Ptolemaic era is the temple of Isis and the surrounding sanctuary on the island of Philae. The buildings of this sanctuary are disposed according to the geographical character of the island, so that an inscription of the time was able to compare the whole complex to a mighty "ship." The relief decoration of many temples was not completed until Roman times. Besides the customary and oft-repeated pictures of the king in an attitude of adoration before a divinity, the subjects include a representation of a procession, which at Edfu and Dendera wound its way up one staircase to the sanctuary of Osiris on the roof of the temple, then down the other and back into the temple. The temple inscriptions also relate in detail the dates of construction and list the names of individual rooms.

Characteristic of Late Period temples, Birth Houses, and kiosks are the parapets that are inserted into the colonnade to about half the height of the columns. Their purpose was to prevent outsiders from peering into the temple (cf. PL. 379). Another favorite element of temple architecture during this period was the diversity of the column capitals. Of the older column types, only the palmiform was preserved intact. The bell form of the papyrus capital was combined with various ornamental floral elements. In the composite capital, sculptured blossoms were set one within the other; the capital thereby took on the appearance of an upright floral garland. These forms had already appeared in the representations of small wooden throne pavilions during the New Kingdom. These two-dimensional forms seem to have been translated into full-scale architecture during the Amarna period. In temple architecture, the composite capital emerged during the 30th dynasty,

in the hall of Nectanebo I at Philae and in the porch of Nectanebo II at Hibis (PL. 379). The columns are of the round type current since Ramesside times; the capitals, however, vary from column to column.

*b. Private tombs.* During the short period of importance that the presence of the Nubian dynasty conferred upon Thebes, a few significant private tombs were built in the western necropolis. While the kings resided at Napata, the sovereignty of Thebes lay in the hands of the so-called "Divine Consort of Amen," a Nubian princess. The tombs of these Divine Consorts are small, templelike chapels decorated with reliefs and are located within the precinct of the temple of Medinet Habu. Their architectural significance lies in the fact that they mark the first known occurrence in Egypt of the true vault, that is, one that is composed of wedge-shaped blocks.

The most significant tomb structures of this period are found at El Asasif, at the end of the valley of Deir el Bahri. The most spacious burial is that of Petamenopet (tomb 33). The structure above ground is of brick and consists of a pylon-like gateway and an enclosing wall articulated on the exterior with niches. The burial chambers and the cult areas are cut into the cliff at several levels. Stairs lead to spacious subterranean halls with ceilings supported by pillars. In the axial arrangement of the stairs, passageways, and chambers, the survival of the type of ground plan employed for royal tombs of the New Kingdom may, perhaps, be noted. Tombs of officials were built at Thebes until the 26th dynasty. These are worthy of mention, if only for their relief decoration. A small tomb in the southern part of the necropolis of Giza, which is decorated largely with religious representations in its superstructure, appears to date from the 25th dynasty as well. The tombs of the Persian period discovered at Saqqara have no superstructures and are designed especially for the protection of the deceased: a sarcophagus of polished black granite, weighing several tons, was placed in a shaft that was over 80 ft.

A tomb of unusual form was constructed at the beginning of the Ptolemaic period by Petosiris, the high priest of Hermopolis. The superstructure of this tomb resembles a small Late Period temple with composite capitals and a parapet between the columns. In the history of Egyptian art, this tomb is particularly interesting because of its relief decoration (see below). The tombs with walls painted in the hybrid Greco-Egyptian style, at Tuneh el Gebel in the vicinity of the tomb of Petosiris, as well as the catacomblike tombs with Egyptian-

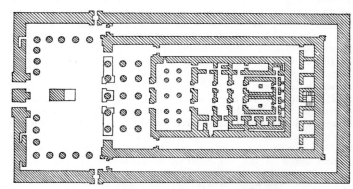

Kom Ombo, temple, Ptolemaic period (*from Lange-Hirmer*).

izing relief decoration near Alexandria, belong in architectural type to the Hellenistic style (see HELLENISTIC ART).

*Relief and painting.* A clear, consistent development cannot be traced in the relief decoration of the Late Period. The study of the art of this period is dependent on several groups of monuments; each group corresponds to a distinctive local tradition. Royal reliefs from the Nubian period have been preserved in the temple at Gebel Barkal (see NUBIAN ART). The reliefs of Theban private tombs of the 25th and the early

part of the 26th dynasty do not display any uniform tendencies even during this short period. Their decoration reverts to old forms and themes, readily accessible in diverse Theban tombs and temples of preceding periods. Early in the 26th dynasty, an official named Ibi in the service of the Divine Consort copied for his burial chamber the decoration of the tomb of a 6th-dynasty official who bore the same name. The 6th-dynasty prototype is at Deir el Gebrawi near Asyut. The representations in the later tomb are changed in certain details and are combined with new themes. A grid based upon the Late Period canon has been preserved in these reliefs. The human body was at this time divided into 21 units from the soles of the feet to the upper eyelid, not 18 as during the New Kingdom. In the roughly contemporaneous burial of Pabes (tomb 279), the raised and sunk reliefs recall the mature style of the 18th dynasty; however, they differ from 18th-dynasty reliefs in the sharpness of their contours, as well as in the pedantic execution of details and modish touches such as the tasseled edges of the pleated garment. Even in cases where a definite prototype can be established, the term "transformations," rather than "copies," should be applied. An example of such adaptations is the fragment of a beautiful relief in the Brooklyn Museum (PL. 383) that bears a representation of the extraction of a thorn and another of a woman holding an infant amid trees. This representation was probably derived from a relief at Thebes in the tomb of Menna from the mid-18th dynasty (tomb 69). Other reliefs manifest the realistic depiction of old age that was current in sculpture in the round. An example of this tendency is a fragment in Kansas City (Nelson Gall. of Art), probably from the tomb of Mentuemhat at Thebes (tomb 34; see below). This realistic strain in portrait sculpture may also be noted in a relief of King Psamtik I (Br. Mus.) that — like similar reliefs of Psamtik II (Vienna, Kunsthist. Mus.) and Nectanebo I (Br. Mus.) — probably comes from a Delta sanctuary. The Delta sovereigns seem to have employed Theban artists at the beginning of the 26th dynasty.

A series of fine limestone reliefs from the area of Memphis, which consist of a single register bordered at the top by an astragal, forms a closely knit stylistic group. The problem of their original function has not yet been satisfactorily answered. They may have decorated a large pedestal, or they may have served as a narrow frieze adorning a small chamber. The representations show the owner of the tomb seated and receiving people who approach with offerings; also present are musicians and a dancing girl. The oldest piece of this group, the Henat relief (PL. 384), has been attributed to the last decade of the 26th dynasty (ca. 530 B.C.), on the basis of genealogical evidence. The later reliefs of the series approach Ptolemaic art in style. The sites of these finds, for which single examples of this group have been named, as well as the style of high relief and the character of the inscriptions, would seem to indicate Memphite origin and the influence of Old Kingdom prototypes. A relief of this period now in Baltimore (Walters Art Gall., no. 274) is an example of faithful copying of such an Old Kingdom model. The Late Period characteristics of these reliefs include the expansive deployment of the figures, the wide skulls, and the careful attention paid to minor details. Subsequently, ornamental floral motifs and modish, richly pleated garments were commonly introduced. The figures achieve a greater sense of volume in their isolation, and the approximation of bodies in motion becomes more marked. The most significant example from this group is the relief of Tanefer (PL. 384), which dates from the 30th dynasty (mid-4th cent. B.C.). A maiden playing on a lyre on a slightly later relief fragment (Cleveland, Mus. of Art) was adapted from a Memphite relief of the late 18th dynasty.

These so-called "Neo-Memphite reliefs" incorporate motifs of the Old and New Kingdoms, but they are adapted to suit contemporary formal tastes. As a result, new artistic tendencies were inspired by the old. Royal relief sculpture of this period continually reflected Old Kingdom prototypes. The Nubian King Taharqa had two characteristic Old Kingdom scenes copied for his temple at Kawa: the triumphant king in the guise of a sphinx trampling his enemies, and the van-

quished Libyan prince and his family. A group of jubilee scenes found in the palace of Apries at Memphis also reveals the frank employment of copyists. In the chambers under the 3d-dynasty stepped pyramid of Zoser at Saqqara, the traces of a grid on reliefs of the king attest the presence of copyists once again. Nevertheless, this reliance upon earlier prototypes should not be overemphasized; nor should it even be considered the decisive ingredient of the Late Period style. It must be remembered that the art of the early Middle Kingdom and the Old Kingdom also developed in close association with the art of the preceding periods. During the relatively short period in which Late Period art evolved, older monuments were more widely available for study than ever before; yet, on balance, what the draftsmen and sculptors were able to borrow during this brief period of activity was more in the nature of outward form rather than deeper philosophical or spiritual content.

A new type of representation appeared in the decoration of shrines of the late 26th dynasty, which were usually made of dark hard stone. The surface of the stone was highly polished, and the figures were executed in sunk relief in such a way that their rough surfaces were strongly contrasted with the dark and highly polished backgrounds. In the black granite sarcophagi introduced during the Persian period, and especially in the granite royal reliefs of the 30th dynasty, this technique was practiced with great virtuosity. In these last-named reliefs, although the contours are extremely elegant and precise, the figures retain much of their organic volume. In the temple reliefs of the Ptolemaic period, the contours are cut deeper into the stone and display greater freedom and boldness in their execution. The modeling is also firmer and more lifelike. The arrangement of kings and gods confronting each other lends a decorative effect to these representations.

During the Roman occupation the friezes became narrower, the compositions more monotonous and the details more insistent. Hellenistic stylistic tendencies had little noticeable effect, whereas the old Egyptian canons governing the construction of the human figure were still strictly adhered to. Still, the influence of Hellenistic art did manifest itself in isolated details. In the mortuary temple of the high priest Petosiris near Hermopolis, the walls of the outer chamber bear low-relief scenes of everyday life. The participants and the low-relief style are Egyptian; however, they have been transformed by the introduction of Greek drapery with rich folds and wholly mundane representations of contemporary life. The threshing of grain was now accomplished with flails (PL. 384), not by driving cattle over the threshing circle as was formerly done. A lathe appears for the first time in representations of artisans at work; and in the metalsmith workshops rhyta of foreign origin are being manufactured.

Hieroglyphic inscriptions appear within the picture plane as before. In other scenes, purely Greek motifs are translated into the Egyptian low-relief technique. In the representations of offering bearers in Greek dress, the plants and animals borne on their heads and in their hands are rendered in the style of Hellenistic stucco ornament; that is, they fill the entire background. A change has also taken place in the color choice. The background is now painted a dull green; and on this ground, a bluish red appears against tones of brown. The Egyptian draftsmen and sculptors who created the decoration of the tomb of Petosiris were familiar with Hellenistic art and were able to translate these imported motifs into Egyptian low relief. The scenes influenced by Hellenistic art are confined to the outer hall of the tomb. The rear chambers, which accommodated cult rituals, are decorated with mortuary texts in hieroglyphs and religious representations in Egyptian style.

*Sculpture in the round.* That the 25th dynasty marked the beginning of a new era in Egyptian history is most apparent in the sculpture in the round of the period. The highly polished, larger than life-size head of King Taharqa from Thebes (PL. 386), with its rounded skull and caplike support for a high feather crown, presents an image of the sovereign unknown to the art of earlier periods. In the broad, squat forms of the

physiognomy and in the black stone polished to a metallic luster the Nubian origin of the ruler is immediately apparent. The traditional Egyptian image of the ruler is restated in terms of Negro Africa. Negroid features are even more pronounced in a statuette of the Nubian official Irigadiganen (Cairo, Egyptian Mus.). Such characteristics are also present in the statues of Theban officials. A bust and a statue of Mentuemhat, the governor of Thebes from the reign of Taharqa to that of Psamtik I, are the two most significant works of this period (Cairo, Egyptian Mus.). Both figures are imbued with extraordinary power and purposefulness; but in their forms they are quite different. The head of the bust of Mentuemhat incorporates highly realistic indications of old age (PL. 386): except for a stiff fringe of hair that resembles the edge of a helmet, the man is bald-headed; his brows are knit, and under his eyes there are sagging folds of skin. A certain mature introspective quality also pervades the statue of the governor in which he wears a long wig in the fashion of the New Kingdom. The expansive chest and wide shoulders are reminiscent of Old Kingdom statues. Following these two masterpieces in importance is another series of statues of the same subject. Like contemporary reliefs, these sculptural portraits emulate a variety of prototypes. A draped statue in the style of the 18th dynasty is but one of several examples of such borrowing that could be named (Berlin, Staat. Mus.). Similar tendencies are apparent in the statues of Petamenopet; one of these, in quartzite, represents this official as a scribe in the style of the Old Kingdom (PL. 388).

The statues of the Divine Consorts of Amen exhibit little evidence of the Nubian origins of their subjects. In their bodily forms, as well as in the choice of attributes, they recall royal statues of the late New Kingdom (PL. 386). More ample female forms do not appear until the 26th dynasty.

The origins of Saite royal sculpture remain obscure. They may — as seems to be indicated by a relief of Psamtik I — lie in the art of the Nubian dynasty. Inscribed statues of Psamtik II, Apries, and Amasis have been preserved. The most significant of these is the life-size head of Apries in "battle helmet" (PL. 387). The impression is one of masklike immobility, and this air of imperturbability gives the subject a remote and awesome aspect. The new direction in portraiture is marked by generalized features, a quality of timelessness, and idealization. The deliberate adoption of the severe and timeless style of an earlier period carried with it the danger of mechanical repetition according to a fixed scheme or formula. This uninspired reliance upon formula is illustrated in a royal head in Berlin and in a sphinx head of Amasis in the Capitoline Museum. Statues of officials increased in numbers during the Saite period. Most of these are temple statues, kneeling figures that bear a miniature naos. The last Egyptian scribe portrait is the figure of Nespekashuti from Karnak (PL. 388), which dates from the time of Psamtik II. The features of the sitter are vague and idealized, as in contemporary royal sculpture.

During the 26th dynasty small sculpture in bronze also experienced a marked upswing. Countless images of gods and sacred animals have survived from this period. Most of these are objects of the common, mass-produced variety. The seated cats, however, must be considered among the great creations of animal sculpture in any period. These hollow cast figures of cats and ibis served as votive offerings and as coffins for the mummified remains of the sacred animal. Small-scale bronze sculpture was manufactured for a large segment of the population, and its creation continued without interruption throughout Ptolemaic and into Roman times.

No statue of a Persian king has thus far been found in Egypt, and inscribed statues of officials of the Persian period (27th dynasty) are very rare. Those which have been found lack heads. On the one hand, Saite forms continued during this period; on the other hand, the beginning of a new kind of portraiture seems to date from this time. This conception of the portrait ultimately produced the famous so-called "green heads" of priests (see below). The influence of Achaemenian art is apparent in the jewelry of this period and in small figures of roaring lions.

Knowledge of 30th-dynasty monumental sculpture is derived from two headless statues of Nectanebo I (Vat. Mus.; Paris, Bib. Nat.), both of which are unusually expressive in body structure, and from several idealized portraits that anticipate the forms of the colossal statue of Ptolemy II also in the Vatican. The most significant piece of 30th-dynasty sculpture that has been preserved is the lion of Nectanebo II (Vat. Mus.). With its head turned sideways and front paws crossed, the animal is set on a base plate in the natural oblique position of a lion at rest.

The 4th century B.C. was a very important period for the development of private sculpture in Egypt. Two groups of heads of polished hard stone, predominantly green schist, provide characteristic illustrations of this final phase of native Egyptian sculpture. There are two recognizable types among these: the idealized portraits with elongated bald heads and the heads with realistic portrait features. Both groups are closely associated and represent the two major possibilities in portraiture. Whether both types of image were made for statues of the same person to be erected side by side cannot be definitely established because of the fragmentary state of preservation of these works.

Of the numerous ideal portraits (the so-called "bubble heads") that have been preserved, some are strongly reminiscent of 26th-dynasty forms, and also of the "neo-Memphite" reliefs of the late 26th dynasty. Other "bubble heads" (PL. 389) can be assigned to the first half of the 3d century B.C. on the basis of the similarity of their mouths and eyes to those of the statue of Ptolemy II in the Vatican (PL. 390). This type remained popular during the Ptolemaic period, but became progressively more rigid in its forms. The portrait type of the priest with shaven skull was employed in Egypt as far back as the late Middle Kingdom. Elongated skulls were a preference during the Amarna period, as may be seen in the quartzite heads of Amarna princesses. This shape of skull also occurred in portraits of officials during the Ramesside and Libyan periods. However, all these earlier examples of the type lack the high surface polish that is so characteristic of the "bubble heads" of the Late Period.

The realistic heads of this group are all less than life size and continue the "old age" portrait tradition of the 25th dynasty, which had been interrupted during the Saite period. The greatest creation of this period is without doubt a green head in Berlin (Staat. Mus.). These heads also are generally bald, but the bone structure of the skull is more pronounced in them. The dating of these individualized portraits, in the absence of the genealogical and epigraphic evidence that would perhaps be supplied by the missing bodies, remains an unsettled question. The dating of the Berlin green head serves as point of departure for the dating of the whole group. Some scholars have sought to assign this head to the Ptolemaic period, and they assert that the "densification and transparency of the features" is the result of Hellenistic influence. Nevertheless, the head fits readily within the bounds of native Egyptian tradition. Its construction conforms to the ancient conception of a statue as a four-sided relief. The organic sense of mass achieved in the green head does not surpass that attained, for example, in the heads of the Amarna princesses. The conspicuous element of innovation in the green head was its expression of extreme concentration; still, the means by which this effect was achieved were entirely and peculiarly Egyptian. The eyes are incised in a linear, almost "hieroglyphic," manner. The folds of skin that radiate from the base of the nose to the corners of the mouth, the crow's-feet about the eyes and ears, and the wrinkles of the brow — all these elements are indicated by purely linear means. When compared with later examples of this type from the Ptolemaic period, the purely Egyptian style of this masterpiece should be self-evident.

The beginnings of this type of portraiture are found in the Nubian period and also in the late Middle Kingdom. Closely related to the Berlin green head are a kneeling figure of Psamtik-Sa-Neith (Cairo, Egyptian Mus.), a work of the Persian period, and a small head in the Brooklyn Museum (PL. 389), which is very similar to the Berlin head in its unusually self-

contained and assured expression. The features of the Cairo figure, however, are not so realistically portrayed. The heads in Brooklyn and Berlin may be considered purely Egyptian in character and probably date from the pre-Ptolemaic era (ca. 4th cent. B.C.). These works are followed by the so-called "small green heads," which continue into the Ptolemaic period. At this time the influence of Hellenistic and republican Roman portraiture became gradually more pronounced, even in the traditionally Egyptian portrait statues with back pillars.

At a time when the dissemination of Hellenistic art under the Ptolemaic rulers had begun throughout the Nile Valley, Egyptian art was suddenly confronted with the danger of losing its age-old task and chief incentive — the execution of commissions for the royal house. In order to conserve the traditional artistic heritage, small-scale limestone models or patterns were made, the face of which represented the subject to be copied and the back the system of measures according to which this work was to be executed. Generally these objects served as models for official art: heads of kings and gods with their attributes, parts of the human body, details of architecture, and so forth. They were meant to be translated into relief as well as copied in sculpture in the round. These portable workshop models, which convey the appearance of the subject in the most precise detail, were generally kept in temples in order to facilitate work on new commissions. After the reign of Ptolemy II, Hellenistic traits entered to an ever-increasing extent into the royal portraits executed in Egyptian style. The same development has already been observed in the statues of priests and secular officials. It was not until Roman times that these Hellenistic influences were expurgated. Subsequently, Roman emperors were represented in Pharaonic guise and according to the traditional Egyptian canons. The portrait heads of these emperors are simple and of the idealized type. A royal head found in the Tiber (Rome, Mus. Barracco) exemplifies this last phase of Egyptian official art.

A group of dated royal statues from late in the 1st century of the Christian era were found at Benevento in Italy. Here, in A.D. 88 the emperor Domitian, who first accorded official recognition to the Egyptian cults that had been flourishing for years on Italian soil and throughout the empire, founded a temple of Isis. Portraits of the emperor in Egyptian style were commissioned to be executed in Egypt for the adornment of this sanctuary. A few individualized "portrait features" are superficially applied to these otherwise idealized statues of purely Egyptian type; yet these statues also reveal the final breakdown of the system of canonic forms and the structure of Egyptian sculpture. The bodies appear to be pressed into their back pillars. Western conceptions had begun to permeate the construction of the figure, especially in the representation of muscles. There occurred a brief revival of the Egyptian style during the reign of Hadrian, who visited Egypt in A.D. 130. Thereafter, imperial statues in Pharaonic garb exist only for the emperor Caracalla (A.D. 211–17); but in these the head of the emperor is done as a standard Roman portrait.

*Minor arts.* Among the finds of the Late Period, the applied arts cannot be given the importance that such works had in the examination of earlier periods, simply because their quantity is insufficient for a comprehensive study of the productions of the period. The reason for this lies in the fact that during the Late Period the cultural center of Egypt was the Delta area; and the ground of this region has been much less kind to the preservation of antiquities than have the tombs at the edge of the desert in Upper Egypt. Some small precious objects have come to light, especially in the burials of the Nubian kings (see NUBIAN ART). The techniques of metalworking and metal polychromy continued during the 25th dynasty and into the Roman period (e.g., the *Mensa Isiaca*, Turin, Mus. Egizio). Since the Saite period Egypt has been engaged in friendly intercourse with other Mediterranean lands, and this exchange, funneled in part through the Greek trade emporium of Naukratis in the Delta, brought foreign types of jewelry and vessels to the Nile Valley. As evidence of the Persian period only isolated finds of Achaemenian objects have been made on Egyptian soil. The 30th dynasty witnessed a great expansion of the production of faïence ware. The faïence inlays and figurines of this period are of unusually fine quality. During the Roman period the art of multicolored hieroglyphs (PL. 392) and figure inlays in millefiori glass was developed. The craft of the Ptolemaic goldsmith was dominated by Hellenistic forms.

BIBLIOG. *General*: J. Capart, L'art égyptien, 6 vols., Brussels, 1909–48; W. Wreszinski, Atlas zur altägyptischen Kulturgeschichte, 3 vols., Leipzig, 1923–36; J. Capart, Documents pour servir à l'étude de l'art égyptien, 2 vols., Paris, 1927–31; B. Porter and R. L. B. Moss, Topographical Bibliography of Ancient Egyptian Hieroglyphic Texts, Reliefs and Paintings, 7 vols., 1st ed., Oxford, 1927–51, 2d ed., 1960 ff.; G. Steindorff, Die Kunst der Ägypter, Leipzig, 1928; G. Farina, La pittura egiziana, Milan, 1929; S. Clarke and R. Engelbach, Ancient Egyptian Masonry, London, 1930; H. Schäfer, Von ägyptischer Kunst. 3d ed., Leipzig, 1930; H. Ranke, The Art of Egypt, Vienna, 1936; R. Hamann, Ägyptische Kunst, Berlin, 1944; W. S. Smith, A History of Egyptian Sculpture and Painting in the Old Kingdom, 1st ed., Boston, 1946, 2d ed., 1949; I. E. S. Edwards, The Pyramids of Egypt, Harmondsworth, 1947; H. Frankfort, Kingship and the Gods, Chicago, 1948; A. Lucas, Ancient Egyptian Materials and Industries, 3d ed., London, 1948; Enciclopédie photographique de l'art, V, Le Musée du Caire, Paris, 1949; H. Frankfort, H. A. Frankfort, J. A. Wilson, and T. Jacobsen, Before Philosophy, Harmondsworth, 1949 (orig. ed. The Intellectual Adventure of Ancient Man, Chicago, 1946); H. Frankfort, The Birth of Civilization in the Near East, Bloomington, Ind., 1950; H. A. Frankfort, Arrest and Movement: An Essay on Space and Time in the Representational Art of the Near East, London, 1951; C. Aldred, The Development of Ancient Egyptian Art, London, 1952 (orig. ed. in 3 vols.: Old Kingdom Art in Ancient Egypt, London, 1949; Middle Kingdom Art in Ancient Egypt, London, 1950; New Kingdom Art in Ancient Egypt during the Eighteenth Dynasty, London, 1951); E. Drioton and J. Vandier, Les peuples de l'orient méditerranéen, II, L'Egypte, 3d ed., Paris, 1952; J. Vandier, Manuel d'archéologie égyptienne, 3 vols., Paris, 1952–57; W. C. Hayes, The Scepter of Egypt, 2 vols., New York, 1953–59; A. Badawy, A History of Egyptian Architecture, I, Cairo, 1954; A. Lhote, Les chefs-d'œuvre de la peinture égyptienne, Paris, 1954; A. Mekhitarian, Egyptian Painting, Geneva, 1954; E. Iversen, Canon and Proportions in Egyptian Art, London, 1955; W. Wolf, Die Welt der Ägypter, Stuttgart, 1955; K. Lange and M. Hirmer, Egypt: Architecture, Sculpture and Painting in Three Thousand Years, London, 1956; J. A. Wilson, The Culture of Ancient Egypt, Chicago, 1956 (orig. ed. The Burden of Egypt, Chicago, 1951); W. Wolf, Die Kunst Ägyptens, Stuttgart, 1957; W. S. Smith, The Art and Architecture of Ancient Egypt, Harmondsworth, 1958; H. W. Müller, Ägyptische Malerei, Berlin, 1959; W. S. Smith, Ancient Egypt as Represented in the Museum of Fine Arts, 4th ed., Boston, 1960.

*Prehistory and protohistory. a. Rock art of Upper Egypt*: H. A. Winkler, Rock Drawings of Southern Upper Egypt, 2 vols., London, 1938–39. *b. The sedentary phase: the beginnings of art in the Nile Valley*: G. Galassi, L'arte del più antico Egitto nel Museo di Torino, RIASA, N.S., IV, 1955, pp. 5–94. *c. The sudden advance of art*: A. Scharff, Die Frühkulturen Ägyptens und Mesopotamiens, Der alte Orient, XLI 1941; H. J. Kantor, The Final Phase of Predynastic Culture: Gerzean or Semainean (?), JNES, III, 1944, pp. 110–36; H. J. Kantor, Further Evidence for Early Mesopotamian Relations with Egypt, JNES, XI, 1952, pp. 239–50; E. Baumgärtel, The Cultures of Prehistoric Egypt, I, 2d ed., London, 1955, II, 1958; W. Kaiser, Stand und Probleme der ägyptischen Vorgeschichtsforschung, Z. für ägyptische Sprache, LXXXI, 1956, pp. 87–109; W. Kaiser, Zur inneren Chronologie der Naqadakultur, Archaeol. Geog., VI, 1957, pp. 69–77. *The origin of the systems of representation and writing in the period of unification*: S. Schott, Hieroglyphen: Untersuchungen zum Ursprung der Schrift, Abh. der Ak. der Wissenschaften und der Literatur in Mainz, Geistes- und sozialwissenschaftlichen Klasse, XXIV, 1950; S. Schott, Kulturprobleme der Frühzeit Ägyptens, Mitt. der d. Orient-Gesellschaft zu Berlin, LXXXIV, 1952.

*Thinite period. a. Architecture*: H. Ricke, Bemerkungen zur ägyptischen Baukunst des alten Reiches, I, Beiträge zur ägyptischen Bauforschung und Altertumskunde, I, 1944; W. B. Emery, Great Tombs of the First Dynasty, I, Cairo, 1949, II, London, 1954; J. P. Lauer, Sur le dualisme de la monarchie égyptienne et son expression architecturale sous les premières dynasties, BIFAO, LV, 1956, pp. 153–71; J. P. Lauer, Evolution de la tombe royale égyptienne jusqu'à la pyramide à degrés, MdIK, XV, 1957, pp. 148–65. *b. Relief, painting, and sculpture*: H. G. Fischer, A Fragment of Late Predynastic Egyptian Relief from the Eastern Delta, Artibus Asiae, XXI, 1958, pp. 64–88; H. W. Müller, Ein neues Fragment einer reliefgeschmückten Schminkpalette aus Abydos, Z. für ägyptische Sprache, LXXXIV, 1959, pp. 68–70.

*Old Kingdom. a. Architecture.* (1) *Royal tombs*: J. P. Lauer, Etudes complémentaires sur les monuments du roi Zoser à Saqqarah: Réponse à H. Ricke, AnnSAntEg, Sup. 9, 1948; H. Ricke, Bemerkungen zur ägyptischen Baukunst des alten Reiches, II, Beiträge zur ägyptischen Bauforschung und Altertumskunde, V, 1950; S. Schott, Bemerkungen zum ägyptischen Pyramidenkult, Beiträge zur ägyptischen Bauforschung und Altertumskunde, V, 1950; A. Fakhry, H. Mostafa, and H. Ricke, The Bent Pyramid of Dahshur, AnnSAntEg, LI, 1951, pp. 509–623; H. Bonnet, Ägyptische Baukunst und Pyramidenkult, JNES, XII, 1953, pp. 257–73. (2) *Palaces and temples*: F. W. von Bissing, Das Re-Heiligtum des Königs Ne-woser-re (Rathures), I, Der Bau, Berlin, 1905; S. Hassan, The Sphinx, Its History in the Light of Recent Excavations, Cairo, 1949; W. Kaiser,

Zu den Sonnenheiligtümer der 5 Dynastie, MdIK, XIV, 1956, pp. 104–16; E. Winter, Zur Deutung der Sonnenheiligtümer der 5 Dynastie, Wien. Z. für die Kunde des Morgenlandes, LIV, 1957, pp. 222–33. (3) *Tombs of court officials*: H. Junker, Gîza, 12 vols. (Ak. der Wissenschaften in Wien, Philosophisch-historische Klasse, Denkschriften, 69 ff.), Vienna, Leipzig, 1929–55; G. A. Reisner, The Development of the Egyptian Tomb down to the Accession of Kheops, Cambridge, Mass., 1936; G. A. Reisner, A History of the Giza Necropolis, I, Cambridge, Mass., 1942. (4) *Provincial tombs*: H. Kees, Studien zur ägyptischen Provinzialkunst, Leipzig, 1921; H. Brunner, Die Anlagen der ägyptischen Felsgräber bis zum mittleren Reich, Ägyptologische Forsch., III, 1936. b. *Relief and painting*: L. Klebs, Die Reliefs des alten Reiches, Abh. der Heidelberger Ak. der Wissenschaften, Philosophisch-historische Klasse, III, 1915; A. Erman, Reden, Rufe und Lieder auf Grabbildern des alten Reiches, AbhPreussAk, Philosophisch-historische Klasse, XV, 1918; P. Montet, Les scènes de la vie privée dans les tombeaux égyptiens de l'ancien empire, Strasbourg, London, New York, 1925; C. R. Williams, The Decoration of the Tomb of Per-nēb, New York, 1932; A. Hermann, Zur anonymität der ägyptischen Kunst, MdIK, VI, 1936, pp. 150–57; J. A. Wilson, The Artist of the Egyptian Old Kingdom, JNES, III, VI, 1947, pp. 231–49; W. Wolf, Die Stellung der ägyptischen Kunst zur Antiken und Abendländischen und das Problem des Künstlers in der ägyptischen Kunst: Zwei Aufsätze, Hildesheim, 1951. c. *Sculpture*: G. A. Reisner, Mycerinus, Cambridge, Mass., 1931; H. Schäfer, Das altägyptische Bildnis, Leipziger ägyptologische S., V, 1936; A. Scharff, Egyptian Portrait-sculpture, Antiquity, XI, 1937, pp. 174–82; A. Scharff, On the Statuary of the Old Kingdom, JEA, XXVI, 1940, pp. 41–50; R. Anthes, Werkverfahren ägyptischer Bildhauer, MdIK, X, 1941, pp. 79–121; J. D. Cooney, A Tentative Identification of Three Old Kingdom Statues, JEA, XXXI, 1945, pp. 54–56; B. von Bothmer, A Wooden Statue of Dynasty VI, BMFA, XLVI, 1948, pp. 30–36; J. H. Breasted Jr., Egyptian Servant Statues (Bollingen ser. XIII), Washington, D. C., 1948; J. D. Cooney, A Colossal Head of the Early Old Kingdom, Brooklyn Mus. B., IX, 3, 1948, pp. 1–12; B. von Bothmer, Notes on the Mycerinus Triad, BMFA, XLVIII, 1950, pp. 10–17; H. Junker, Das lebenswahre Bildnis in der Rundplastik des alten Reiches, AnzÖAk, Philosophisch-historische Klasse, LXXXVII, 1950, pp. 401–06; A. Shoukri, Die Privatstatue im alten Reich, AnnSAntEg, Sup. 15, 1951; G. Steindorff, A Royal Head from Ancient Egypt (Freer Gall. of Art, Occasional Pap., I, 5), Washington, D.C., 1951; J. D. Cooney, Three Egyptian Families of the Old Kingdom, Brooklyn Mus. B., XIII, 3, 1952, pp. 1–18; N. Scott, Two Statue-groups of the V Dynasty, BMMA, XI, 1952, pp. 116–22; J. D. Cooney, The Wooden Statues Made for an Official of King Unas, Brooklyn Mus. B., XV, 1, 1953, pp. 1–25; F. Daumas, Le trône d'une statuette de Pepi I trouvé à Dendera, BIFAO, LII, 1953, pp. 163–72; P. Reuterswärd, Studien zur Polychromie der Plastik, I: Ägypten (Acta Univ. Stockholmiensis, III, 1), Uppsala, 1958. d. *Minor arts*: S. Hassan, Excavations at Giza, 1929–30, Oxford, 1932, pls. 51–52; E. Drioton, La ceinture en or récemment découverte à Sakkarah, BIE, XXVI, 1944, pp. 77–99; G. A. Reisner and W. S. Smith, A History of the Giza Necropolis, II, Cambridge, Mass., 1955; A. Moustafa, Reparation and Restoration of Antiques: The Golden Belt of Prince Ptah-shepses, AnnSAntEg, LIV, 1957, pp. 149–51.

*First Intermediate Period and 11th dynasty*: E. Naville, The XIth Dynasty Temple at Deir el-Bahari, 3 vols., London, 1907–13; H. E. Winlock, The Theban Necropolis in the Middle Kingdom, Am. J. of Semitic Languages and Literatures, XXXII, 1915, pp. 1–37; H. Bonnet, Zur Baugeschichte des Mentuhoteptempels, Z. für ägyptische Sprache, LX, 1925, pp. 40–45; F. Bisson de la Roque, Tôd 1934–36 (Fouilles de l'Inst. fr. d'archéologie o., XVII), Cairo, 1937; D. Dunham, Naga-ed-Dêr Stelae of the First Intermediate Period, Boston, 1937; M. Werbrouck, La décoration murale du temple de Mentouhotep, B. des Mus. royaux d'art et d'histoire, Ser. 3, IX, 1937, pp. 36–44; M. Baud, Le métier d'Irtisen, Chr. d'Egypte, XIII, 1938, pp. 21–34; R. Mond and O. Myers, Temples of Armant, 2 vols., London, 1940; H. Steckeweh, Oberägyptische Architektur zu Beginn des mittleren und des neuen Reiches (Bericht über den 6 Int. Kongress für Archäologie, 1939), Berlin, 1940, pp. 261–63; H. E. Winlock, Excavations at Deir el Bahri 1911–31, New York, 1942; H. E. Winlock, The Rise and Fall of the Middle Kingdom in Thebes, New York, 1947; J. Vandier, Mo'alla (Inst. fr. d'archéologie o., Bib. d'Et., XVIII), Cairo, 1950; E. Winlock, Models of Daily Life in Ancient Egypt (Met. Mus. of Art, Egyptian Expedition, Pub., XVIII), Cambridge, Mass., 1954; E. Riefstahl, Two Hairdressers of the XIth Dynasty, JNES, XV, 1956, pp. 10–17.

*Middle Kingdom. a. Architecture.* (1) *Royal tombs*: O. Firchow, Studien zu den Pyramidenanlagen der 12 Dynastie, Göttingen, 1942; L. Grinsell, Egyptian Pyramids, Gloucester, 1947, pp. 157–69, 178–82. (2) *Provincial burials of the monarchs*: H. Steckeweh, Die Fürstengräber von Qâw (Veröffentlichungen der E. von Sieglin-Expedition in Ägypten, VI), Leipzig, 1936, pp. 42–44; H. W. Müller, Die Felsengräber der Fürsten von Elephantine, Ägyptologische Forsch., IX, 1940, pp. 96–103. (3) *Temples*: L. Borchardt, Ägyptische Tempel mit Umgang, Beiträge zur ägyptischen Bauforschung und Altertumskunde, II, 1938, pp. 56–57; P. Lacau and H. Chévrier, Une chapelle de Sésostris Iᵉʳ à Karnak, Cairo, 1956; G. Roeder, Hermopolis 1929–39, Hildesheim, 1959, pp. 40–50. b. *Relief and painting*: L. Klebs, Die Reliefs und Malereien des mittleren Reiches, Heidelberg, 1922; H. W. Müller, Die Totendenksteine des mittleren Reiches, MdIK, IV, 1933, pp. 165–206; D. Dunham and W. S. Smith, A Middle Kingdom Painted Coffin from Deir el-Bersheh, in Scritti in onore di I. Rossellini, I, Pisa, 1949, pp. 263–68; W. S. Smith, Paintings of the Egyptian Middle Kingdom at Bersheh, AJA, LV, 1951, pp. 321–32; W. S. Smith, A Painting in the Assiut Tomb of Hepzefa, MdIK, XV, 1957, pp. 221–24; H. G. Fischer, An Example of Memphite Influence in a Theban Stela of the Eleventh Dynasty, Artibus Asiae, XXII, 1959, pp. 240–52. c. *Sculpture*: F. W. von Bissing, Ägyptische Bronze- und Kupferfiguren des mittleren Reiches, AM, XXXVIII, 1913, pp. 239–69; C. Ricketts, Head of Amenemes III in Obsid-

ian, JEA, IV, 1917, pp. 71–73; H. G. Evers, Staat aus dem Stein, 2 vols., Munich, 1929; H. R. Hall, Two Middle Kingdom Statues in the British Museum, JEA, XVI, 1930, pp. 167–68; H. Gauthier, Une nouvelle statue d'Amenemhet Iᵉʳ, in Mél. Maspéro, I, Cairo, 1935, pp. 43–53; H. Kayser, Die Tempelstatuen ägyptischer Privatleute im mittleren und im neuen Reich, Heidelberg, 1936; L. Habachi, The Monuments of Biyahmu, AnnSAntEg, XL, 1940, pp. 721–32; H. Senk, Der ägyptische Würfelhocker, Forsch. und Fortschritte, XXVI, 1950, pp. 5–9; Brooklyn Inst. of Arts and Sciences, Mus., Egyptian Art in the Brooklyn Museum Collection, New York, 1952, pls. 24–29; E. Brunner-Traut, Frühe Kupferstatuette eines unbekleideten Mannes, in Ägyptologische Studien H. Grapow gewidmet, Berlin, 1955, pp. 12–16; Brooklyn Inst. of Arts and Sciences, Mus., Five Years of Collecting Egyptian Art, 1951–56: Catalogue of an Exhibition, New York, 1956, pls. 7–13; H. Senk, Eine "sondergeometrische" Stilphase in der ägyptischen ersten Zwischenzeit, Forsch. und Fortschritte, XXXIII, 1959, pp. 272–77. d. *Minor arts*: J. de Morgan, Fouilles à Dahchour, 2 vols., Vienna, 1895–1903; A. Mace and H. E. Winlock, The Tomb of Senebtisi at Lisht, New York, 1916; G. Brunton, Lahun I: The Treasure, London, 1920; G. Möller, Die Metallkunst der alten Ägypter, Berlin, 1924; P. Montet, Byblos et l'Egypte, Paris, 1928; H. E. Winlock, The Treasure of El Lâhûn, New York, 1934; H. J. Kantor, The Aegean and the Orient in the Second Millennium B.C., Bloomington, Ind., 1947; J. Vercoutter, Essai sur les relations entre Egyptiens et Préhellènes, Paris, 1954; H. Kees, Das alte Ägypten, eine kleine Landeskunde, Berlin, 1955.

*New Kingdom. a. Architecture.* (1) *Temples*: E. Naville, The Temple of Deir el-Bahari, 6 vols., London, 1894–1908; L. Borchardt, Zur Geschichte des Luqsortempels, Z. für ägyptische Sprache, XXXIV, 1896, pp. 122–38; G. Jéquier, Les temples memphites et thébains dès origines à la XVIIIᵉ dynastie, Paris, 1920; G. Jéquier, Les temples ramessides et saïtes de la XIXᵉ à la XXXᵉ dynastie, Paris, 1922; H. Schäfer, Die angebliche Basilikenhalle des Tempels von Luksor, Z. für ägyptische Sprache, LXI, 1926, pp. 52–57; U. Hölscher, The Excavations of Medinet Habu, I–IV (Chicago Univ., O. Inst., Pub., XXI, XLI, LIV, LV), Chicago, 1934–51; C. Robichon and A. Varille, Le temple du scribe royal Amenhotep fils de Hapou (Fouilles de l'Inst. fr. d'archéologie o., XI), Cairo, 1936; L. Borchardt, Ägyptische Tempel mit Umgang, Beiträge zur ägyptischen Bauforschung und Altertumskunde, II, 1938; A. Varille, Karnak (Fouilles de l'Inst. fr. d'archéologie o., XIX), Cairo, 1943; L. Christophe, Karnak-Nord, 1945–1949 (Fouilles de l'Inst. fr. d'archéologie o., XXIII), Cairo, 1951; P. Barguet, La structure du temple Ipet-Isout d'Amon à Karnak du moyen empire à Aménophis II, BIFAO, LI, 1952, pp. 145–55; H. Ricke, Das Kamutef-Heiligtum in Karnak, Beiträge zur ägyptischen Bauforschung und Altertumskunde, III, 2, 1954; C. Robichon, P. Barguet, and J. Leclant, Karnak-Nord, 1949–1951 (Fouilles de l'Inst. fr. d'archéologie o., XXV), Cairo, 1954; H. Ricke, Der Totentempel Thutmosis III, Glückstadt, n.d. (2) *Secular structures*: H. Ricke, Der Grundriss des Amarna-Wohnhauses (Ausgrabungen der d. Orient-Gesellschaft in Tell El-Amarna, 4), Leipzig, 1932. (3) *Royal tombs*: H. Grapow, Studien zu den thebanischen Königsgräbern, Z. für ägyptische Sprache, LXXII, 1936, pp. 12–39; G. Steindorff and W. Wolf, Die thebanische Gräberwelt, Leipziger ägyptologische S., IV, 1936, pp. 73–94; A. Piankoff, The Tomb of Ramesses VI, 2 vols. (Bollingen Ser. XL), New York, 1954. (4) *Private tombs*: L. Borchardt, O. Königsberger, and H. Ricke, Friesziegel in Grabbauten, Z. für ägyptische Sprache, LXX, 1934, pp. 25–35; G. Steindorff and W. Wolf, Die thebanische Gräberwelt, Leipziger ägyptologische S., IV, 1936, pp. 32–65. b. *Relief and painting*: F. W. von Bissing and M. Reach, Bericht über die malerische Technik der Hawata-Fresken im Museum zu Kairo, AnnSAntEg, VII, 1906, pp. 64–70; N. de G. Davies, The Tomb of Nakht at Thebes, New York, 1917; E. Mackay, Proportion Squares on Tomb Walls in the Theban Necropolis, JEA, IV, 1917, pp. 74–85; E. Mackay, The Cutting and Preparations of Tomb Chapels in the Theban Necropolis, JEA, VII, 1921, pp. 154–68; N. de G. Davies, The Tomb of Puyemrē at Thebes, 2 vols., New York, 1922–23; N. de G. Davies, The Tomb of Two Sculptors, New York, 1925; N. de G. Davies, Two Ramesside Tombs at Thebes, New York, 1927; H. Frankfort, The Mural Painting of El-'Amarneh, London, 1929; N. de G. Davies, The Tomb of Ken-Amun at Thebes, 2 vols., New York, 1930; N. de G. Davies, The Tomb of Nefer-hotep at Thebes, 2 vols., New York, 1933; M. Wegner, Stilentwicklung der thebanischen Beamtengräber, MdIK, IV, 1933, pp. 38–164; A. H. Gardiner, ed., The Temple of King Sethos I at Abydos, 4 vols., London, Chicago, 1933–58; L. Klebs, Die Reliefs und Malereien des neuen Reiches, I, Abh. der Heidelberger Ak. der Wissenschaften, Philosophisch-historische Klasse, IX, 1934; N. de G. Davies, Paintings from the Tomb of Rekh-mi-Rē at Thebes, New York, 1935; N. M. Davies and A. H. Gardiner, Ancient Egyptian Paintings, 3 vols., Chicago, 1936; J. Vandier, Une fresque civile de Deit el-Medineh, Rev. d'Egyptologie, III, 1938, pp. 27–35; M. Werbrouck, Les pleureuses dans l'Egypte ancienne, Brussels, 1938; F. W. von Bissing, Der Fussboden aus dem Palaste Amenophis IV zu el-Hawata im Museum zu Kairo, Munich, 1941; N. de G. Davies, The Tomb of the Vizier Ramose, London, 1941; N. de G. Davies, The Tomb of Rekh-mi-Rē at Thebes, New York, 1943; N. de G. Davies, Seven Private Tombs of Kurnah, London, 1948; A. Mekhitarian, Personnalité de peintres thébains, Chr. d'Egypte, XXXI, 1956, pp. 238–48; A. Mekhitarian, Un peintre thébain de la XVIIIᵉ dynastie, MdIK, XV, 1957, pp. 186–92. c. *Sculpture*: H. Schäfer, Kunstwerke aus der Zeit Amenophis IV, Z. für ägyptische Sprache, LII, 1914, pp. 73–87; H. Schäfer, Amarna in Religion und Kunst, D. Orient Gesellschaft (Sendschrift, VII), Berlin, 1931; H. Schäfer, Das simonsche Holzköpfchen der Königin Teje, Z. für ägyptische Sprache, LXVII, 1932, pp. 81–86; H. Schäfer, Die simonsche Holzfigur eines Königs der Amarnazeit, Z. für ägyptische Sprache, LXX, 1934, pp. 1–25; H. Kayser, Die Tempelstatuen ägyptischer Privatleute im mittleren und neuen Reich, Heidelberg, 1936; E. Otto, Zur Bedeutung der ägyptischen Tempelstatue seit dem neuen Reich, Orientalia, XVII, 1948, pp. 448–66; B. von Bothmer, Two Heads of the New Kingdom, BMFA, XLVII,

1949, pp. 42–49; C. De Witt, La statuaire de Tell el Amarna, Antwerp, 1950; H. W. Müller, Ein ägyptischer Königskopf des 15 Jahrhunderts v. Chr.: Ein Beitrag zur Stilentwicklung der Plastik der 18 Dynastie, Münchner Jhb. der bildenden K., Ser. 3, III–IV, 1952, pp. 67–84; R. Anthes, Der Kopf der Königin Nofretete, Berlin, 1954; B. von Bothmer, Membra Dispersa: King Amenhotep Making an Offering, BMFA, LII, 1954, pp. 11–20; C. Aldred, A Statue of King Neferkare Ramesses IX, JEA, XLI, 1955, pp. 3–8; W. D. van Wijngaarden, Ein Torso von Ramses VI, in S. in Memoria di I. Rosellini, II, Pisa, 1955, pp. 293–99; C. Aldred, Amenophis Redivivus, BMMA, XIV, 1956, pp. 114–21; S. Bosticco, Frammento di statua di Sethos I a Grottaferrata, Aegyptus, XXXVI, 1956, pp. 18–26; C. Aldred, The End of the El-Amarna Period, JEA, XLIII, 1957, pp. 30–41; M. L. Friedman, A New Thutmoside Head at the Brooklyn Museum, Brooklyn Mus. B., XIX, 2, 1958, pp. 1–5; G. Roeder, Thronfolger und König Smench-ka-Rē (Dynastie XVIII), Z. für ägyptische Sprache, LXXXIII, 1958, pp. 43–74; C. Desroches-Noblecourt, Ancient Egypt: The New Kingdom and the Amarna Period, London, 1960. *d. Minor arts*: F. W. von Bissing, Ein thebanischer Grabfund aus dem Anfang des neuen Reiches, Berlin, 1900; F. W. von Bissing, Metallgefässe (Cat. général des antiquités égyptiennes du Musée du Caire), Vienna, 1901; G. Bénédite, Miroirs (Cat. général des antiquités égyptiennes du Musée du Caire), Cairo, 1907; C. C. Edgar and J. Maspéro, Le Musée égyptien, II, Cairo, 1904, pp. 93–108, pls. 43–55; E. Vernier, La bijouterie et la joaillerie égyptiennes, Mém. de l'Inst. fr. d'archéologie o., II, 1907; E. Vernier, Bijoux et orfèvreries, 4 vols. (Cat. général des antiquités égyptiennes du Musée du Caire), Cairo, 1907–27; H. Schäfer, ed., Ägyptische Goldschmiedearbeiten (Königliche Mus. zu Berlin, Mitt. aus der ägyptischen Samml., I), Berlin, 1910; G. Jéquier, La décoration égyptienne: Plafonds et frises végétales du nouvel empire thébain, Paris, 1911; H. Carter, The Tomb of Tut-Ankh-Amen, 3 vols., London, New York, 1923–33; G. Möller, Die Metallkunst der alten Ägypter, Berlin, 1924; C. R. Williams, Gold and Silver Jewelry and Related Objects: Catalogue of Egyptian Antiquities, New York, 1924; A. Scharff, Altes und Neues von Goldschmiedearbeiten der ägyptischen Abteilung, Berliner Mus.: Berichte aus den preussischen Kunstsammlungen, LI, 1930, pp. 114–21; W. Wolf, Das ägyptische Kunstgewerbe, in Geschichte des Kunstgewerbes, IV, Berlin, 1931, pp. 48–142; W. Kronig, Ägyptische Fayence-Schalen des neuen Reiches, MdIK, V, 1934, pp. 144–66; W. C. Hayes, Glazed Tiles from a Palace of Ramesses II at Kantīr, Met. Mus. Pap., III, 1937; D. W. Phillips, Cosmetic Spoons in the Form of Swimming Girls, BMMA, XXXVI, 1941, pp. 173–75; E. Riefstahl, Toilet Articles from Ancient Egypt, New York, 1943; H. J. Kantor, The Aegean and the Orient in the Second Millennium B.C., Bloomington, Ind., 1947; J. D. Cooney, Three Ivories of the Late XVIII Dynasty, Brooklyn Mus. B., X, 1, 1948, pp. 1–16; E. Riefstahl, Glass and Glazes from Ancient Egypt, New York, 1948; H. E. Winlock, The Treasure of Three Egyptian Princesses (Met. Mus. of Art, Dept. of Eg. Art, Pub., 10), New York, 1948; W. K. Simpson, The Tell Basta Treasure, BMMA, VIII, 1949, pp. 61–65; P. Montet, La nécropole royale de Tanis, II, Les constructions et le tombeau del Psousennès à Tanis, Paris, 1951; W. S. Smith, An Eighteenth Dynasty Egyptian Toilet Box, BMFA, L, 1952, pp. 74–79; W. K. Simpson, The Vessels with Engraved Designs and the Répoussé Bowl from the Tell Basta Treasure, AJA, LXIII, 1959, pp. 29–45.

*Transition from the New Kingdom to the late period*: E. Chassinat, Une statuette de bronze de la reine Karomama (XXIIᵉ Dynastie), MPiot, IV, 1897, pp. 15–25; H. Ranke, Koptische Friedhöfe bei Karāra und der Amontempel Scheschonks I bei el-Hibe, Berlin, 1926; F. W. von Bissing, Eine Priesterfigur aus der Bubastidenzeit, Pantheon, II, 1928, pp. 590–94; R. Anthes, Technik und Datierung einiger Bronzen mit farbigen Glaseinlagen, Berl. Mus.: Berichte aus den preussischen Kunstsammlungen, LIX, 1938, pp. 69–76; F. W. von Bissing, Unterteil eines Menits des Stadtvorstehers und Vesiers Harsiesis: Ein Beitrag zur Geschichte der Metallpolychromie, Nachr. der Gesellschaft der Wissenschaften zu Göttingen, Philosophisch-historische Klasse, N.S., 3, IV, 1939; G. R. Hughes, The Bubastite Portal (Chicago Univ., O. Inst., Epigraphic Survey, Reliefs and Inscriptions at Karnak, 3), Chicago, 1954.

*Late period*: *a. Architecture*: G. Jéquier, Les temples Ramessides et Saïtes de la XIXᵉ à la XXXᵉ dynastie, Paris, 1922; G. Lefebvre, Le tombeau de Petosiris, 3 vols., Cairo, 1923–24; G. Jéquier, Les temples ptolemaïques et romains, Paris, 1924; H. E. Winlock, H. White and N. de G. Davies, The Temple of Hibis in El-Khargeh Oasis, 3 vols., New York, 1938–53. *b. Relief and painting*: G. Maspéro, Le Musée égyptien, II, Cairo, 1904, pls. 38–41; A. Scharff, Ein Spätzeitrelief des Berliner Museums, Z. für ägyptische Sprache, LXXXIV, 1938, pp. 41–49; R. Anthes, Das Berliner Henat-Relief, Z. für ägyptische Sprache, LXXV, 1939, pp. 21–31; G. Steindorff, Catalogue of the Egyptian Sculpture in the Walters Art Gallery, Baltimore, 1946; Encyclopédie photographique de l'art, V, Le Musée du Caire, Paris, 1949, pls. 185–91; W. S. Smith, Three Late Egyptian Reliefs, BMFA, XLVII, 1949, pp. 21–29; B. von Bothmer and J. D. Cooney, Three Early Saite Tomb Reliefs, JNES, IX, 1950, pp. 193–203; S. Wunderlich, A Group of Egyptian Reliefs of the Saite Period, B. of the Cleveland Mus. of Art, XXXIX, 1952, pp. 44–47; B. von Bothmer, Ptolemaic Reliefs, BMFA, L, 1952, pp. 19–27, 49–56, LI, 1953, pp. 2–7; B. von Bothmer, Ptolemaic Reliefs, BMFA, L, 1952, pp. 19–27, 49–56, LI, 1953, pp. 2–7; C. Desroches-Noblecourt, La cueillette du raisin dans la tombe d'une musicienne de Neïth à Saïs, Arts asiatiques, I, 1954, pp. 40–60; C. Robichon, P. Barguet, and J. Leclant, Karnak-Nord, IV, Fouilles de l'Inst. fr. du Caire, XXV, 1954, p. 131, pl. cxiv; E. Iversen, Canon and Proportions in Egyptian Art, London, 1955. *c. Sculpture*: W. Wreszinski, Eine Statue des Montemhet, O. Literatur Z., XIX, 1916, pp. 10–18; K. Bosse, Die menschliche Figur in der Rundplastik der ägyptischen Spätzeit, Ägyptologische Forsch., I, 1936; R. Anthes, Der berliner Hocker des Petamenophis, Z. für ägyptische Sprache, LXXIII, 1937, pp. 25–35; R. Anthes, Ägyptische Bildwerke rings um den grünen Kopf, Jhb, des d. archäol. Inst., Archäol. Anz., LIV, 1939, pp. 377–402; G. Snijder, Mitteilungen aus dem Allard Pierson Museum: Hellenistisch-römische Porträts aus Ägypten, Mnemosyne, Ser. 3, VII, 1939, pp. 241–80; A. Scharff, Bemerkungen zur Kunst der 30 Dynastie, in Museo egizio gregoriana, Misc. gregoriana, Vatican City, 1941, pp. 195–203; H. Drerup, Ägyptische Bildnisköpfe griechischer und römischer Zeit Orbis Antiquus, 3), Münster in Westfalen, 1950; B. von Bothmer, The Signs of Age, BMFA, XLIV, 1951, pp. 69–74; J. D. Cooney, The Portrait of an Egyptian Collaborator, Brooklyn Mus. B., XV, 2, 1953, pp. 1–16; J. Leclant, Enquêtes sur les sacerdotes et les sanctuaires égyptiens (Inst. fr. d'archéologie o., Bib. d'Et., XVII), Cairo, 1954; H. W. Müller, Ein Königsbildnis der 26 Dynastie mit der blauen Krone im Museo Civico zu Bologna, Z. für ägyptische Sprache, LXXX, 1955, pp. 46–68; H. W. Müller, Der Torso einer Königsstatue im Museo Archeologico zu Florenz: Ein Beitrag zur ägyptischen Plastik der Spätzeit, in S. in memoria di I. Rosellini, II, Pisa, 1955, pp. 181–221; Brooklyn Inst. of Arts and Sciences, Mus., Five Years of Collecting Egyptian Art, 1951–56: Catalogue of an Exhibition, New York, 1956, pls. 13–22; H. W. Müller, Ein weiterer Arbeitsbericht des Corpus of Late Egyptian Sculpture (CLES), in Akten des 24 Int. Orientalistenkongresses München, Wiesbaden, 1959, pp. 64–67; Brooklyn Inst. of Arts and Sciences, Mus., Egyptian Sculpture of the Late Period, New York, 1960. *d. Minor arts*: G. Möller, Die Metallkunst der alten Ägypter, Berlin, 1924; Corning Museum of Glass, Glass from the Ancient World: The Ray Winfield Smith Collection, Corning, N.Y., 1957.

Hans Wolfgang Müller

Illustrations: PLS. 319–392; 23 figs. in text.

## EMBLEMS AND INSIGNIA.

Signs that represent social, political, and economic entities are called "emblems" or "insignia." These signs evoke directly the thing, body, or category for which they stand. All cultures have developed such conventional visual devices to represent persons, their function or rank, concepts, etc. These signs range from the emblems of civil and ecclesiastical rank (e.g., crowns, scepters, necklaces) or social status (e.g., types of headdress, costume) to the more abstract, imaginative, and always decorative insignia (e.g., monograms, coats of arms) that appear on costumes, arms, flags, seals, coins, furnishings, and buildings (in the last instance sometimes becoming major architectural elements). Basically, this material is directly functional; that is, it serves the practical ends of society. Other emblematic forms, however, such as the "emblem books" of 17th-century Europe, incorporate an extensive symbolic content that is often ethical or moralistic in tone.

SUMMARY. General considerations: Emblems and art (col. 710). Primitive cultures (col. 712). The ancient world (col. 715): *Near East; Iran; Greco-Roman civilization.* Middle and Far East (col. 719): *India and southeast Asia; Nomads of the steppes and Far Eastern civilization; Islam.* Medieval through modern West (col. 724): *Middle Ages and heraldry; Concept of the emblem: Renaissance and baroque; Emblems in the modern world.*

GENERAL CONSIDERATIONS: EMBLEMS AND ART. To the extent that both emblems and insignia represent something else, they can be called "symbols" or "signs"; but from a strictly art-historical viewpoint, the term "symbolism" (see SYMBOLISM AND ALLEGORY) has a broader and more poetic sense. The artistic symbol generally preserves a distinction between the image that has been evolved and the thing or idea that is being symbolized, while the emblem is a conventional sign that evokes fairly directly and simply the thing or idea to which it refers. Thus the sculptures by Michelangelo (q.v.) in the Medici Chapel (Florence, S. Lorenzo) are commonly interpreted as symbolizing the dual conceptions of the active and the contemplative life. The thoughtfully posed Lorenzo evokes the latter conception, while the more vigorously and tensely arranged Giuliano symbolizes the former. In contrast to these oblique references to certain philosophical truths (expressed through the poses and expressions of Michelangelo's figures), we may also note that Giuliano's military status is emblematized by the marshal's baton that he carries. Thus the symbol may give a general or even shadowy indication of immensely complex and significant religious or philosophical ideas, sometimes in an intentionally obscure manner, whereas the emblem is intended to be recognized clearly and its significance understood immediately.

While the symbol generally is the result of invention or inspiration (its use therefore requiring a certain degree of sophistication), the emblem generally arises from customary ideological attitudes or obvious social conventions, or from the wish to concretize a particular conception for practical ends. The emblem often has its origin in the symbol and is, in a way, a vulgarization of it. A single color may be symbolic (e.g., purple may be symbolic of royal power, but the colors of a flag or the insignia of a city, a quarter, or an association are merely emblematic).

From a formal point of view, the emblem generally implies a schematization or stylization of the image in the manner of an abbreviation or a cipher. The various processes of stylization are often associated or combined. One such process is the progressive reduction of the original symbolic image. The cross, for example, which was originally a historical-religious image connected to a particular event, gradually acquired a conventional or emblematic character (e.g., the insignia of chivalry). An image may progressively be reduced to a single graphic device, finally becoming a mere ideogram. Although the emblem is thus a sort of pictorial shorthand accessible to society in general, the process occurs in reverse when an artist incorporates elements of emblematical schematization in his work. For this reason the terms "emblematic" and "heraldic" are used in art criticism to indicate the decorative stylization of an image or the rhythmic development of forms on a plain field of color.

An emblem must be immediately recognizable, regardless of the materials or the techniques employed in its execution or the object on which it may be used. The same emblematic image may appear in the monumental dimensions of architecture and decorative sculpture or on a correspondingly smaller scale on arms and armor, tapestries, textiles, embroideries, jewels, seals, etc. In designing an emblem, therefore, such considerations as the limitations of various materials, technical processes, and varying degrees of skill in execution must be taken into account.

The emblem is usually conceived in two dimensions, and suggestion of plastic relief and perspective are generally eliminated so that it may be reproduced easily in all materials and techniques. The colors are usually flat, ensuring a strong contrast between the image and the ground. Moreover, since each color variation has a precise significance, subtleties of light and shade are excluded. Alois Riegl, in his *Stilfragen* (Berlin, 1893), has shown how closely emblems are associated with (and often eventually transformed into) ornamental motifs (see ORNAMENTATION).

Emblems, in fact, represent a continuing process of collective expression, although they, no doubt, appear more developed in those periods when the interest in the allegorical or symbolic expression of ideological material is greatest.

There are innumerable types of emblems. An emblem may refer to the past, evoking a memorable ancestry, possession, person, or occurrence; or it may refer to the future, designating a program or a principle of conduct. It can have a religious, civil, familial, or personal character. The image may be determined by memory or tradition; sometimes it illustrates a written motto. Civil and military decorations and distinctions of grade and function also belong under the heading of emblems. Again, an objective image, e.g., a portrait, may have an emblematic character. For example, the portrait of a sovereign on coins represents the state and suggests the whole historic period connected with his reign. Emblematic images commonly occur in objects having a public function: emblems of the state and of the reigning house are generally found on public buildings, on coins, on the arms and uniforms of the army, on seals, on paper money, on postage stamps, etc. (see ARMS AND ARMOR; COINS AND MEDALS; COSTUME; DRAWING). A monument or a public building may have an emblematic function. Typical examples are commemorative structures and triumphal arches (see STRUCTURAL TYPES AND METHODS).

Emblems are also associated with economic, industrial, and commercial activities. The arms of medieval guilds (generally representing a profession or craft) are undoubtedly emblematic, but trademarks which authenticate a product as coming from a particular factory, workshop, or manufacturer (thus guaranteeing its quality) are also of this nature, as are distinctive types of packaging (see PSYCHOLOGY OF ART).

Although there has been a continuing decline in the use of symbols and allegories of religious or political significance, the use of the emblem for practical ends has greatly increased. One of the characteristic signs of our times and a subject of study for psychologists and linguistic scientists is the progressive merging of the image and the motto (at one time called the "body" and the "soul" of the emblem). Thus the graphic form of a sign or a group of words may take on a significance once typical of the figure (e.g., Coca-Cola signs), or, conversely, the figure may assume the function of a sign. This identification, particularly notable in the insignia of advertising and in luminous signs, may perhaps be explained by the fact that modern means of communication facilitate the convergence of the graphic and colored emblem and the verbal (or musical) slogan.

Giulio Carlo ARGAN

PRIMITIVE CULTURES. Because we do not know the precise significance of the images and implements of the Paleolithic age, we cannot tell exactly when and where conventional images or objects were first used to convey an emblematic meaning. Such meanings are conveyed not only by clearly identifiable forms (such as scepters or coats of arms) but also, and primarily, by feelings intimately and traditionally associated with particular costumes, weapons, designs, or colors.

We have no way of knowing when, if at all, conventional themes that might have been to some degree emblematic appeared in the paintings or carved objects of the prehistoric caves, nor whether the signs or ciphers that appeared on shields, roofs, pennants, and trees always signified the same thing. There is, for example, no proof that the bored sticks (arbitrarily called "batons of command") of the Magdalenian epoch actually were used by dignitaries or persons in authority; or that the pole (probably a kind of harpoon) that is surmounted by the figure of a bird and appears next to a fallen human figure in the Cave of Lascaux (P. Graziosi, *Palaeolithic Art*, New York, 1960, pl. 283b) may legitimately be called an emblem, although it is similar to some late-prehistoric bronze batons that have been found throughout Europe and have sometimes been identified as emblems.

For the earliest information that can lead to at least hypothetical conclusions, therefore, we must turn to the primitive cultures. We also have evidence from the beginnings of various early civilizations (in Egypt, in Persia, the Eurasian nomadic cultures, etc.) suggesting an early connection between the figure emblem and religion, magic (q.v.), and totemism (q.v.). This evidence consists specifically of objects with single animal or plant images raised on staffs to display them more conspicuously. Such emblems occur in the initial development of all secular, social, or military insignia. In the field of prehistoric art, distinctions must be made between personal ornaments, amulets, and emblems. The attributes that such emblems may express include sacredness, power, status, and various functions or callings. All cultures develop a fundamentally similar system of meaningful usages shown, for example, in types of head coverings, costumes, or tools and weapons. The ornamentation of such objects is generally determined by the status of the person for whose use they are intended.

* *

Primitive societies generally develop signs in the form of symbols or emblems for all the strata, divisions, or classes of which they consist, and for all individuals in so far as they belong to such groups. That these emblems have great ritual significance is indicated by the fact that they are conferred on more or less solemn occasions (e.g., ceremonies of initiation, investitures, consecrations, etc.). Severe proscriptions regulate their use, and dire penalties are invoked against misuse. The social divisions represented by the emblems also have a religious and ritual significance in primitive societies.

Emblematic signs may take the form of independent objects (e.g., personal ornaments, costumes, headdresses, figured panels on the façades of buildings, thrones, canopies), or they may be developments, modifications, or amplifications of utilitarian objects (e.g., houses of greater dimensions for chiefs, special decorations on the canoes or houses of eminent persons; PL. 393). Thus, whereas the houses of the Maori chiefs (New Zealand) are lavishly decorated, inside and out, with engraved panels and ornamental statues, common houses have no ornament whatever. The house of a Baganda chief (Uganda) is recognizable by the height of its roof and the grandeur of its rachitecture.

Upper classes may be distinguished by their clothing and personal ornaments (PLS. 393, 394) as well as by their dwellings. Among some tropical peoples, only the members of the dominant class may put on clothing. In Samoa, only nubile women of high rank may wear the *siago*, a local tapa fabric; others who venture to wear it are penalized. In Assam, no one of low rank may wear the chuddar (a mantle thrown over the shoulders but covering the whole person) unless he folds it on the left side as well as on the right, since only persons of rank may wear this garment folded on the right side only. The nobles of Uganda wear leopard skins and carry daggers. The nobles of the old Quiché empire (Guatemala) wore a white or multicolored cotton costume.

Clothing and ornaments also distinguish various age groups. Boys and girls receive the clothing or ornaments of adults at initiation ceremonies in the Solomon Islands and New Hebrides; a belt is given to both sexes. The Nāga girls (Assam), however, go naked until marriage and only then put on a skirt. Headdresses are precise indications of rank among many peoples, for instance, the Azande of central Africa. Samoan chiefs spent fortunes for crimson or scarlet ornamental feathers — brought from the Fiji Islands or Tonga — for their headdresses. Among the Indians of Virginia, important chiefs were distinguished by a long tuft of hair on their necks. When an individual was elected war chief among the Abipones of the Chaco (South America), his hair was parted by a shaven line.

There are numerous examples of distinctive color usages among primitive peoples. In central Celebes, yellow was a distinctive sign of nobility, and only women of rank wore diadems of this color; among the Malays, a yellow mantle (*baju*) was a unique privilege of the raja; the district chiefs of the Wanjambo (central Africa) were distinguished by their cotton mantles or scarlet sheets; and women of high rank in Tahiti painted their cheeks red and the lower parts of their bodies dark blue.

The poncho is the typical dress of the Araucanians (South America). Ordinary individuals wear greenish-blue ponchos, but those of distinguished persons are of a vivid red with blue and white stripes, multicolored designs of flowers and animals, and rich fringe at the border. Among the Galla of Ethiopia, persons of noble rank wore a white mantle adorned with green pearls, and also an ivory bracelet on the forearm.

Tattoos have great emblematic value. Among the Koita (New Guinea), tattooing is performed from neck to navel on engaged girls. Shortly before marriage, another tattoo is added between the breasts in the form of a V. The case of the Songhoy (Sudan, bend of the Niger) is typical: divided into very numerous groups over a wide area, these people are distinguished by a diagonal scar under the right eye; this scar is also common to all members of the subtribes. Although Maori slaves are not tattooed, members of other classes are tattooed on the face. The amount and type of this tattooing depends upon the individual's wealth.

Personal ornaments assume social importance not merely because of their cost but also because of their traditional significance. Among the natives of New Georgia (Solomon Islands), the sole ornament of the chiefs or the most renowned warriors is a bracelet made of a single shell. Among the Aztecs, only chiefs had the right to have gold ornaments and precious stones sewn on their clothes. The Koita and the Roros (British New Guinea) wear ample ornamental pectorals composed of a vertical strip (of bark or fiber) with two rows of artificially

pointed wild boar's teeth inserted at the sides and tufts of feathers and string laces hanging from the base.

Arms frequently have an emblematic significance. The characteristic oval shields of the Masai (Kenya) are made of animal hides and decorated on the outer sides with red, black, and white and sometimes also blue and yellow geometric designs. These designs vary according to the tribe and the deeds of the warrior (PL. 398).

The distinctive signs of rank vary widely in different cultures. Among the Ashanti (Ghana), the sons of the king, to symbolize their membership in the royal family, wear elephant tails, while the chieftain's authority is symbolized by a hereditary royal chair. Among the Musgu (Sudan), every chief wears the horn of some animal as a distinctive ornament. The Maori chieftains have batons of command that generally consist of a whale's rib decorated with numerous engravings. A battle-ax of porphyry or some other precious stone was the typical emblem of the highest Araucanian nobles. Lesser personages had silver-headed sticks with or without (depending on their rank) a silver ring circling the middle.

The sunshade — in the form of either an umbrella or a canopy — is an emblem of state very frequently found in Africa and continental and insular Asia. Among the Ashanti, the three principal chiefs of the kingdom are entitled to silk umbrellas surmounted by gold emblems. Chiefs of a lower order have silken umbrellas surmounted by wooden emblems, and those in the next lower rank have cotton umbrellas. The supreme monarch of the early Quiché kingdom had as his personal emblem a triple canopy adorned with precious feathers. The chief of the next lower rank had a double canopy, and the next a single canopy.

Conspicuous examples of tribal emblems are found among the Koita, Mekeo, and Roro tribes of New Guinea. On ceremonial occasions and in the meetinghouse, the members of each tribe carry what are called *öaöa*. The most important *öaöa* are bunches of multicolored feathers and other objects for dances and ceremonies, and stakes, with incised designs on their points, which are placed in the meetinghouse and which represent the head and sawlike teeth of a pike, or the tail of some other fish, or the shell of a crayfish. The feather emblems are mounted on a supporting frame of copper or bent reeds, and the feathers are arranged in parallel symmetrical patterns. Sometimes series of shells are similarly mounted.

Emblematic figures identical to those carved on stakes are found as tribal signs on betel spatulas, wooden coconut scrapers, etc. Legends account for the choice of a particular emblem by a given group. The stylized head of a bird with an elongated beak and a curved neck is typical. Extremely geometric designs representing fish, crocodiles, snakes, lizards, parrots, and human figures are also, but less frequently, found. These may refer to the owner of the meetinghouse, to groups of strangers who are housed there, to the chief of the tribe, etc. The supreme chiefs and the various subchiefs have distinctive emblems that are incised and painted on ornamental panels in the meetinghouse and that consist of geometric figures, series of lozenges between large dentellated borders, coupled triangles or bands in zigzag arrangements, or combinations of these.

The emblems of secret societies generally consist of ornamental objects for ceremonial use. The members of each of the subdivisions of the Tamate society in the Banks Islands are recognizable by the varieties and arrangement of the leaves and flowers which they wear in their caps on ceremonial occasions. If a stranger wears one of these arrangements, he must pay for the offense by making a gift of a hog, and he is also publicly (but symbolically) beaten by an initiate. Thereafter he may become a member of the society by paying the traditionally established dues. In Africa too, secret societies confer distinctive signs on their members. The leopard men (Congo), for example, are distinguished by a leopard skin falling to the knees and another covering the head. The order of the Arioi in the Society Islands (Polynesia) — dedicated to dances and sacred performances — was divided into eight grades, each having different types of tattooing and decoration. The Sauks and the Fox (Algonquians of Wisconsin) and the hunters of the

prairies (Arapaho, Cheyenne, etc.) had many military associations, each distinguished by its own costumes, ceremonies, dances, chants, and war emblems. Special signs (e.g., the so-called "message sticks") marked individuals on diplomatic missions.

<div align="right">Vittorio LANTERNARI</div>

Symbolic customs and usages were developed beyond those of primitive cultures in pre-Columbian American civilizations (e.g., by the populations of Mexico and of the Andean countries). The elaborate sacred and social symbolism developed by these peoples was on the level of those of the great prehistoric civilizations of Eurasia, and is conspicuously reflected in representational art and decoration.

In the Aztec society, an outstanding farmer, hunter, warrior, artisan, magician, or priest could attain a high social rank, of which his costume would become emblematic. For example, a warrior could wear a particular costume (elaborate to a degree according to the number of enemies he had captured) and finally enter a military order as a knight of the eagle or of the ocelot. Special rites and dances were restricted to these orders. A political chief was distinguished by a band of animal skins — from which hung two appendages of a particular shape — that was worn on the forehead. Administrative chiefs wore diadems of gold, jade, or turquoise, according to their office. The ceremonial costume of the Aztec priests varied according to the divinity being celebrated, and special emblems, corresponding to their names and activities, were assigned to the divinities themselves. The *Codex Florentinus* (Madrid), one of the few original Aztec manuscripts that have come down to us, is exceptionally rich in illustrations of this sort.

Among the ancient Maya, especially in their "classic" period (from the early 4th to the late 6th century of our era), the headdress was one of the principal emblems of rank. Sandals, feathered mantles, and jaguar skins also had emblematic significance. The *Halach uinic* (the just man), who represented at once the political, military, and sacerdotal power, was distinguished by various emblematic attributes according to his several functions. As administrative head of the state, he held in his right hand a "scepter manikin" (an anthropomorphic figurine with a long curved nose and one of its legs ending in the head of a serpent) and in the left a round shield. As head of the religious hierarchy, he wore a double-faced bar on his chest. This was generally worn horizontally, but sometimes one end rested on one shoulder. This emblem ended in a snake's head and sometimes in a human head. His emblem as supreme leader was a lance or throwing stick. The richness of the costumes, crests, and official insignia of Mayan dignitaries, warriors, and priests is shown particularly clearly in the wall frescoes of Bonampak (PL. 396).

From the beginnings of the most archaic Andean civilizations comes evidence (mostly in the form of paintings on vases) indicating that distinctions between social classes were made. Representations of persons being carried on litters (a privilege reserved for the nobility) and distinctive types of dress (I, PL. 173) constitute such evidence. In Mochica pottery (I, PLS. 176, 179, 186, 191) may be recognized costumes of particular social groups (priests, warriors, runners, dancers, etc.). Leaders among the Incas were distinguished from their subjects by large earrings and multicolored turbans that were wound four or five times around the head. Elaborate forehead ornaments were connected to these turbans by a long fringe. The members of the nobility wore similar turbans but of different colors. The symbol of the Inca (the ruling chief or emperor) was a staff ending in a golden star, while the royal standard consisted of the personal seal of the sovereign painted on a small cotton or linen flag that was hung on a staff.

THE ANCIENT WORLD. *Near East.* Emblematic forms are found in Egyptian art dating back as far as prehistoric times. On pottery of this period and on predynastic votive objects have been found whole series of processional standards surmounted by emblems often in plant and animal forms (see DIVINITIES). Some of the emblematic standards of the proto-

dynastic period had an apotropaic character and were carried before the Pharaoh in processions (e.g., macehead of the Scorpion King, PL. 325; palette of King Narmer, PL. 396). A few of the highest priests wore pectorals adorned with complicated emblems, as seen in tomb reliefs dating as far back as the 3d dynasty. High standards surmounted by the head of a divinity or a sacred animal are shown at the left side of statues of standing persons, royal or priestly, of the New Kingdom (e.g., two statues of Ramses III with standards showing the ram of Amen; Cairo, Eg. Mus.). Sometimes there are two emblems, as in the statue of Prince Kha-em-Wast (London, Br. Mus.).

The emblem is found notably developed in Egyptian decorative work. National unity was expressed emblematically by the crossing of the papyrus and lotus plants (representing Upper and Lower Egypt respectively) around the hieroglyphic sign *sm* (meaning "to unite"). Such an emblem usually occurs on the lateral faces of the cubic throne on which the Pharaohs sat; the diorite statue of Chephren (Cairo, Eg. Mus.) gives us a classic example of this usage.

The emblems of royal power were especially important in their symbolic function. They showed continuity across the centuries and of course became an element of official art as well as common decorative forms. They were generally made of precious materials. Among the various royal emblems were the "white crown" of Upper Egypt, tall and conical in form (PL. 324, front); the "red crown" of Lower Egypt, in the form of a fez with a long, thin peak at the back and a curl at the front (PL. 324, back, top scene); the "blue crown" adorned with a feather; another with double feathers; and the headdress of the queen (PL. 382) in the form of a vulture. Some of these emblems include divine attributes (symbols of Osiris, Min, Amen, Mut) that clearly reveal their sacramental origin. The best example of such an emblem is the erect serpent, symbol of the goddess Wadjet, that appears on the foreheads of the Pharaohs as part of the crown. Scepters in the forms of crooks or flails are attributes of the god-king Osiris, while the scepters with the head of Set are closely connected with divine emblems. Other types of scepters and batons of command — generic signs of authority though not necessarily regal — may be seen in the paintings, reliefs, hieroglyphics, and in royal furnishings, which include some magnificent pieces of jewelry (PL. 361).

In the Asiatic Near East, only kings and gods are distinguished by emblems. The staff and the magic circle are exclusively divine attributes, while both gods and kings may be shown with the mace or with a weapon resembling a billhook, perhaps originally a boomerang. Two typical motifs on seals are emblematic in character. One is Anatolian, the other Palestinian, and both are reworkings of the Egyptian scarab motif, which eventually became the royal emblem. In Anatolia, the so-called "Cappadocian symbol" or "royal sign" has frequently been found; it is a four-pointed star, enlarged at the center but with acute angles at the points. Volutes and spirals — sometimes accompanied by dots — fill the spaces between the points. This emblem may have originated in a corruption of the Egyptian scarab motif during the Hyksos period. In Palestine, a stylized scarab with four wings has been found on seals of the first millennium B.C. According to a recent theory, this motif was later modified (following the reforms of Josiah; 639–608 B.C.) by the suppression of one pair of wings in such a way as to make the original Egyptian motif unrecognizable. The use of battle standards is illustrated by the Assyrian relief of Nimrud from the time of Ashurnasirpal II (London, Br. Mus.) in which a military parade is depicted. On the battle wagons are hoisted standards that terminate in figures.

<div align="center">* *</div>

*Iran.* In the pre-Achaemenian period (ca. 3000–550 B.C.), only divinities were represented by emblems. Kings as well as individuals belonging to various social and ethnic groups were distinguished by their manner of wearing hair and beard, their costumes, and their weapons. The divine emblems, however, cannot be assigned to specific deities, partly because of the paucity of epigraphic material (and insufficient understanding of the material available) and partly because these emblems

were not usually inscribed and only rarely described in texts. Some divine emblems — celestial bodies such as crescent moons, sun disks, and stars — go back to Mesopotamian prototypes. The cross found on clay seal impressions of proto-Elamite tablets (ca. 3000 B.C.) from Susa may, however, be a specifically Iranian emblem. This emblem recurs on later seals of the Kassite type and on a few objects from Luristan (900–800 B.C.). (Throughout this discussion, it must be remembered that all interpretations of ancient emblems are at best intelligent hypotheses.) The Mesopotamian influence — which dominated the imagery of western Iran during the 2d and 3d millenniums — is exemplified in a rock relief of Annubani at Sar-i Paul. This relief shows the goddess Inanna (Ishtar) giving to the king a ring that symbolizes divine authority in Mesopotamia. Two standard finials found in Iran are probably divine emblems of a type also found in Assyrian battle scenes.

In the Achaemenian period (ca. 550–331 B.C.), the principal divine emblem was the winged sun disk, identified with Ahura Mazda, who frequently rises from the disk (e.g., the rock relief of Darius, at Bīsutūn). However, this god also occurs in conjunction with the moon-crescent emblem. Both symbols — which also appear without the figure of the god — were derived from Assyrian and neo-Babylonian sources. Some religious meaning may have been attached to the various animals, birds, and winged monsters which occur singly and in combination with other animals, human heroes, gods, or worshipers on Achaemenian stamp and cylinder seals. Sphinxes, for example, have been associated with a solar symbol.

Of the emblems which originated in this period, the most important was the crenelated royal crown first worn by Darius at Bīsutūn. It was probably derived from the mural crown of the Assyrian queen. A similar crown was worn by the Hittite goddesses of Yazilikaya. This crown may originally have been derived from architectural crowns worn by Old Babylonian goddesses. After Bīsutūn, the headgear of king and god — whose crowns are shown in seals and metalwork both with and without crenelations — seems to have become similar. On the basis of this development we may hypothesize the occurrence, during the reign of Darius, of a change in the position of the king in relation to the deity. The staff or scepter topped by a globe and probably originally covered with gold foil was a royal emblem of authority. It seems to have been almost twice as long as the staves that were carried by the ushers in the procession of delegations on the reliefs at Persepolis. The blossom held by the king and crown prince differs from those of the courtiers. It has two flanking buds, and the resulting trefoil outline may distinguish it as a plant held only by god and king. The lions that decorate the hem of Darius's robe and the sleeve of that worn by Xerxes in Persepolis may also be royal emblems. Emblems of rank or function are carried by the king's retinue. The towel carried by one figure, for example, is an attribute of his status as official towel bearer. The principal emblem of the priestly office was a bundle of rods (twigs of the haoma plant), though a staff was also carried. That standards were used in battle is shown by traces in the mosaic of the battle of Alexander and Darius (VII, PL. 154).

The most important divine emblems featured on the monuments of Iran during the Arsacid period (ca. 250 B.C.–A.D. 224) were the fire altar and, on an altar at Tang-i Sarwak, the baetyl (probably of Syrian influence). The fire altar occasionally occurs on Parthian seals. Royal emblems which distinguish the king are a diademed miter or the diadem alone. The king's bushy hair, which is more voluminous than that of the members of his retinue, also has emblematic value. The miter is tall, gem- or pearl-studded and, on coins, adorned by a star, blossom, bull's horn or, as in one instance, by a row of stags. In two instances the king holds a ring as the emblem of rulership. Probably the anchor on the coins of Elymaïs should also be regarded as a dynastic emblem developed under Seleucid influence. Divine and royal emblems are combined in the crowns of the Sassanian kings (A.D. 224–642). Every king wore a crown of distinctive form. If a ruler temporarily lost his throne, his reinstatement seems to have required the adoption of a new crown. The crown originally consisted of the diadem to which the emblems were attached, while the spherical covering of the crown seems to have been a separate element (III, PL. 399, 11). In addition to the various arrangements of pearls and gems on the diadem, the following emblems appear: crenelations, rays, flutes, double wings (with or without a bird's head), palmette, moon crescent, and six-pointed star. The crenelations are probably derived from the crown of Ahura Mazda or Anahita; they may however, go back to Achaemenian crowns. The rays refer to Mithras, the flutes of the crown to Anahita. The double wings originally established a connection with Vārangna, as in the crown of Bahram II (A.D. 276–93); the frequent use of wings in the Sassanian crown, however, indicates a more general meaning (at least in later times). Moon crescent and star were thought by E. Herzfeld (1938) to refer to Māh and Tīr (Tishtrya). The colors of the crown also seem to have been important. Features of various animals appear in the crowns of princes and nobles, on bowls, and in other works of Sassanian art. Standards were carried into battle (e.g., the reliefs of Bahram II and Ormizd II at Naqsh-i-Rustam), continuing in this instance, as in many others, a long emblematic tradition. In the reliefs of Taq-i-Bustan, the umbrella appears as a royal emblem. This emblem — derived from Mesopotamia — eventually became one of the most characteristic emblems of sovereignty in India.

Edith PORADA

*Greco-Roman civilization.* The Greek term *emblema* signifies a figuration made independently of the object to which it is to be added. It stands for a more precious element that may be applied, for example, to a metal or terra-cotta vase, and it may sometimes be transferred from one object to another. The use of this word in connection with painting, sculpture, architecture, ceramics, etc., is well documented throughout classical history.

In the field of mosaic art, an *emblema* was a small, portable mosaic, executed with special care in the workshop of the artist, and designed to take the central place in an already-prepared large mosaic. The tesserae of this central portion were smaller than those of the large mosaic, and the *emblema* was fixed in place with special plaster.

Included in the category of *emblema* are the *clupei*, or busts in tondi, which were placed in the middle of elaborate Roman sarcophagi. These represented the personage interred within, and they are closer approximations of the emblem in the modern sense than are the other *emblema* mentioned above.

The use of decorative metal or terra-cotta shields on the outsides and insides of buildings was already common in classical Greece, at Olympia, for example (Pausanias, *Description of Greece*, v, 23, 7). This usage was derived from the old custom whereby each warrior of rank decorated, in painting or relief, the outside of his shield with an *episemon* or emblem (i.e., a Gorgon, Typhon, the Hydra, Argo Panoptes, lions, panf thers, wild boars, horses, dolphins, and even inscriptions o a magical nature).

Pliny mentions the fact that the first five legions of the Rome of Romulus had various animals as emblems (i.e., eagle, wolf, bull, horse, and boar; Pliny X, 16). Similarly, each region, tribe, and city had, from remotest antiquity, an animal or plant emblem. Though these emblems originally had magical or religious connotations, they eventually lost these and became merely kinds of insignia. They also might come to serve as a sort of trademark. For example, the arms of the city of Lagash (3d millennium B.C.) — consisting of an eagle with a lion's head — appear on the silver vase of Entemena (I, PL. 504). Similar arms of later regions and cities were the triskelion of Sicily, the silphium of Cyrene, the bear of Berne, the bull of Turin, etc. These arms were also used on coins, serving to authenticate them and to indicate their place of origin. When alliances between two or more cities were made, their several emblems generally appeared together on the relevant documents or treaties. Such signs provide valuable data to the historian.

Silvio FERRI

True emblems or objects indicative of power (military or political) were so numerous and varied in the Greco-Roman world that it would be difficult even to enumerate them. In this large category must be included crowns and diadems (the original royal connotations of which continually became vaguer in the classical period, not to be reestablished until the late Roman Empire); the emblems of sovereigns, magistrates (scepters, lictors' rods; PL. 393), and priests; the emblems of the agonothetes (*litui*, or staffs of a special form which developed into pastoral staffs in Christian times; see LITURGICAL OBJECTS); and military emblems (properly *signa*), one type among which was originally connected with religious insignia (i.e., the staff surmounted by animal figures or another symbol, similar to those of the primitive world and of the ancient East). This type of military emblem appeared in Etruria (painted slab from Caere; Br. Mus.) and spread to the Roman world in particular. The colored cloth (*vexillum*) attached to the staff was an early type of flag.

The emblems of class (the rings of the knights), the honorific emblems (*phalerae*), and those denoting rank (*fibulae*) are frequently classified as personal ornament and jewelry.

MIDDLE AND FAR EAST: *India and southeast Asia.* Though emblemlike forms were greatly elaborated in the Hindu, Buddhist, and Jain religious iconography, they were developed only for secular purposes. The emblems of rank were the crown, the umbrella, the yak-tail fan and the peacock fan. Miters (*kirīṭa-mukuṭa*) were used as crowns. They were flattened (until ca. A.D. 600), high and cylindrical (600–900), conical (900–1200), or conical with a broadened top (after 1200). The diadem (*chanavira*) was also used as a crown. Until about A.D. 500, it took the form of a circlet decorated with flower forms. Thereafter it became pinnacled and was often combined with the *kirīṭa-mukuṭa*, or with flying bands (*vīrapatta*), or with piled-up, matted hair (*jaṭā-mukuṭa*) and a pot-shaped crown (*karanda-mukuṭa*). The central Asian crown (e.g., of the Timurid princesses) probably developed from the pinnacled diadem still surviving in Buddhist art and in the Javanese *Wayang* costume. The Khmer kings of Cambodia favored the multiple *chanavira* (in India worn mainly by queens and goddesses). The earlier Indo-Moslem sultans wore crown caps, but the later emperors and sultans wore turbans adorned with a diamond and pearl crest. Akbar's consort, the empress Maryam-az-Zamānī (A.D. 1562–1623), had a balloon-shaped crown. Crowns (of European type) are, as mere emblems, depicted on Moghul miniatures (ca. 1620–60). The last Moghul emperors (1806–57), the kings of Oudh (early 19th cent.), and the begums of Bhopal wore a *Tāj-kulāh* (a short conic or balloon-shaped cap studded with jewels) of Iranian-Afghan origin.

One or several umbrellas (*chattra*, used also for Buddhist reliquary shrines and Hindu images) were held above and around rulers (those with greater power had more than one *chattra*); and small symbolic gold umbrellas were fixed on the palanquins of reigning queens. The *camari* or *caurī*, a fly whisk made from the tail of the Tibetan yak, was the privilege of deities and sovereign princes. The *mōrchāl*, a fan consisting of a bundle of peacock feathers, was the privilege of hierarchs, high feudatory princes, queens, and Moslem begums.

Standards similar to those of ancient Egypt (with a theriomorphic or anthropomorphic divine figure on a horizontal support at the top of the pole) are described in the classic epics and are also among the symbols on punch-marked coins (since ca. 6th cent. B.C.). They were also used in the pre-Hindu civilization of Indonesia (e.g., in Nias). Horsemen and elephant riders with flags, somewhat like the ancient Roman labarum, are carved on the railing gates of the Sanchi stupa. The cloth (decorated with diagonal and cross lines) hangs from a horizontal bar beneath a *triratna* (trident and the Wheel of the Law) crest. In Indonesia, the radiating sun disk (and other symbols, not always identifiable) is mounted instead. The Moslems added, as emblems of sovereignty (which included the sun, the lion, a fan, and the kettledrums) the *Mahī-Marātib*, a set of standards ending in golden disks and globes, heads of dragons, crocodiles, and tigers, a hand (*pañja*, perhaps representing that of Fatima),

or a trident. Probably these were of central Asian origin, though some (the tiger, crocodile, and trident) may have been taken over from the Hindus.

A flag (consisting of a long streamer) fastened to a trident pole appears on the Indra relief at Bahja. In the armies of ancient Cambodia (Bayon and Angkor Wat) and Java (Panataran), however, a cloth flag is fastened vertically along the flagpole. In most cases it is without any design but with horizontal (Cambodia) or vertical (Java) fringes, apparently following a Chinese practice.

In the Indo-Moslem armies, flags were common; their poles ended in a spearhead, globe, trident, or *pañja*, from which hung tufts of yak tail. The cloth, which was either pink or green, had no special design. Special colors for flags appeared for the first time in the 18th century, but these flags have not been studied extensively.

The early Indian coins (ca. 6th cent. B.C.) were square gold or silver pieces punched with symbols (of which there were 283 variants), generally several on each piece. Among these symbols were the sun disk (with or without rays); mountains and chaityas (reliquary shrines) sometimes surmounted by half-moons, stags, bulls, trees, etc.; various flowers, trees (enclosed by a railing), cows, calves, dogs, horses, snakes, fish, scorpions, tortoises, frogs; standards (within a railing) crowned by some animal or animal head (often buffalo heads); dancing girls (goddesses?) by the side of one or several buffalo heads; other human figures; tridents, shields, game boards, etc.

The Greco-Bactrian and Indo-Greek kings issued coins of Greek design and workmanship, showing the royal portrait or the image of a Greek deity (which, however, often stood for an Indian or Iranian equivalent), inscriptions (first in Greek, later in Greek and Karoshthi), and a monogram (perhaps that of the mint or mintmaster). The elephant (of Indra) and the bull (of Śiva) are also found (see COINS AND MEDALS). The Indo-Scythian and Kushan emperors (1st, 3d, and 5th cent. of our era), though copying the Roman coinage, placed their portraits on one side of their coins, and on the other the images of all the deities (Greek, Zoroastrian, Indian) venerated in their empires, as well as unintelligible symbols apparently evolved from those on the punch-marked coins. Similar mysterious devices occur also on the coins of the Gupta emperors (4th–6th cent. of our era). On the later Kushan coins the figure of Śiva — trident in hand, leaning against his bull, Nandi — predominates. On the coins of the Indian kingdoms (first Kushan vassals, later independent) we find versions of the older punched coins combined with relief designs of palm trees, elephants, bulls, rhinoceroses, lions, horses, the goddess Lakṣmi (also with elephants in the form of Gajalakṣmi), or the god Kārttikeya. The Sātavāhana emperors of the Deccan preferred the elephant (and sometimes the bull). The Gupta emperors, whose coinage probably is the most beautiful in India, had their portraits (sometimes also those of their empresses) depicted on one side of their coins, and on the other the images of a number of Hindu deities. Images of goddesses are common on these coins (e.g., Ambikā, sitting on a lion, or Gajalakṣmi on a lotus, sometimes standing or enthroned; a type derived from the Iranian Ardokhsho-Tyche), as is that of Garuḍa, the eagle of Viṣṇu (seen *en face*). Later debased Hindu coinage was either an offshoot of the Sassanian coins (Gadhaiya), or bore the figure of a horseman, or the (by then fully developed) escutcheon of the ruling dynasty.

Early Indo-Moslem coins merely show inscriptions, except those of the Ghaznevids who had taken over the Hindu Sāhī horseman type. The Moghul coins also bore only inscriptions, except certain gold issues intended merely as presents at court ceremonies; those of Akbar (1556–1605) have a falcon, a duck, a Hindu archer and girl (Rāma and Sītā), or an adaptation thereof. The gold issues of Jahangir (1612–14 and 1618–25) show his head or full portrait sitting with a liquor cup (coinage of the atabegs of Mosul and of the Seljuks), a lion and the sun, the sun alone, or the signs of the zodiac. On many late Moghul coins additional symbols (roses, shamrocks, thistles, umbrellas, fish, trees, the sun, sabers, daggers, swastikas, fans, etc., and even punch-mark designs) and also Devanagari inscriptions are found.

These were issued by Moghul vassal princes to whom Shah Alam II (A.D. 1759–1806) had granted the mint rights; the emblems represent either the mint or the ruler issuing the coins, the practice varying considerably. The sultans of Mysore, not connected with the Moghuls, used either a tiger and a battle ax (Haidar 'Alī), or an elephant, with or without flag (Tipū Sultān).

Seal (mudra) emblems, for ministers, courts, police stations, monasteries, and villages first appeared in great number in the Gupta period. The emblems generally occupy the upper third of the oval seal, the rest being allotted to the inscription. They are either representations of various gods (Sūrya, Candra, Lakṣmi, Durgā) or symbols (conch, trident, flagstaff, lion, etc.), the most impressive being the Buddhist Wheel of the Law between two deer (Sarnath and Nalanda monasteries). On later seals, only the royal escutcheon was used. On the seals of the rings and on those of the copperplates (inscribed with grants of fiefs, tax-free lands for Brahmans, and other privileges), the upper third bears the emblem of a deity, in the middle tier is an emblematic device or the name of the ruler, and on the lower third there is generally a lotus seen from above or from the side. Many symbols are repetitive but may be distinguished by the position of the animal (couchant, rampant, *en face*, facing left or right, etc.) or by the addition of other symbols. The most beautiful seals we know are those of the Pala emperors of Bengal and of the eastern Chalukyas of Andhra.

The known emblems of the Indo-Moslem rulers are few: the lion (found on various city gates at Bidar, Chanderi, Bijapur, Jaunpur, etc.); the lion and the sun (throne hall at Bidar, coins of Jahangir); a Sagittarius in the form of a man-leopard shooting an arrow (Srinagar, Madin Shah); the elephant (palace gates at Delhi, brackets in Agra and Lahore palaces); a lion or a mythical monster (lion, elephant, crocodile, and griffin combined) holding small elephants in his claws ('Ādilshāhs of Bijapur, Marāthas); and a pair of fish (Bijapur, nawabs of Oudh). Among the Rajput princes (16th–20th cent.) the most common emblems were the sun (Udaipur and other Sūryavaṁśī dynasties), lion (Revah), the goddess Durgā (Jodhpur, Bikaner), etc. In Farther India only a few of these emblems are found. (See also SYMBOLISM AND ALLEGORY.)

Hermann GOETZ

*Nomads of the steppes and Far Eastern civilization.* The Agathyrsi lived in the westernmost area of the Scythian territory (present Hungary) and in Transylvania. They made swords of iron and pole tops of bronze with a roe or bird emblem that may have been standard finials for both tent and wagon poles. Such objects occur everywhere within the domain of Eurasian nomads, but the pole finial with the roe had appeared earlier on Assyrian stone reliefs. Nomadic art products are characteristically magical and totemistic (see MAGIC; TOTEMISM), the magic being chiefly connected with hunting activities. What Scythia and Siberia produced is rightly called "animal style." Indisputable proofs of the emblematic nature of Scythian art are the small heads of elks, vultures, bears, wolves, etc., in wood and bone carvings or bronze and gold castings. In these, two heads are very often united, generally those of an elk and a vulture. The heads of the vultures and elks are frequently coupled with Assyro-Iranian palmettes.

Herodotus wrote about the well-known Scythian bronze or copper caldrons, which were sacrificial vessels as well as national insignia. From personal experience, Herodotus describes an exceptionally large specimen standing at Exampios between the rivers Borysthenes (Dnieper) and Hypanis (Kuban). Erected by King Ariantes as a memorial of a census, it was cast of bronze arrowheads delivered by the king's subjects. An archaeological parallel is the type of great bronze caldron with large winged figures and masks of lions or griffins produced by the Urartu (q.v.) and found throughout the Mediterranean world. Siberian peoples also cast vases of bronze or copper, but these were usually bigger and cylindrical, on a rather short and sturdy (often conical) stem. The bodies of these caldrons are quartered by perpendicular ribs. The influence of square Chinese sacrificial vessels on Hunnic and Sino-Hunnic ones is indisputable.

The tapestries found by the Kozlov expedition in northern Mongolia, in a great kurgan of Noin-ula, are undoubtedly the native work of Huns, but Hellenistic and Iranian elements may be observed on them. Quilted stuffs were typically Hunnic, as was the love of fantasy and fairy tales that showed itself in Hunnic products. These characteristics spread to countries far in the northwest, to Ananino and Perm. These northwestern wooded countries also produced animal compositions with forms which became very popular in the China of the Han period (see ASIATIC PROTOHISTORY; CHINESE ART). These scenes probably illustrate deeds and legends of which no other record remains and which we therefore cannot interpret.

The last great phase of Eurasian nomad art is that of the Huns and Avars in Hungary. The Huns ruled this region from A.D. 375 to 453, and the Avars ruled it from 568 to 890. In many places in Hungary tombs have been found containing objects characteristic of the nomads. These objects show, for the most part, an affinity with the forms of Scythian-Siberian emblematic art. Some of the objects found at Szentes, in southern Hungary, have decorations that resemble Chinese cosmic symbols. These, perhaps used as emblems, prove the long contact of preceding generations with the Chinese world.

The art of the nomads was based on popular beliefs, which included superstitions dating back to prehistoric times. The heads of wild boars — commonly found in the works of the Scythians and the Huns — cannot be other than magical emblems. Heads of vultures united with palmettes (indicating the palm tree or tree of life) have emblematic significance and are good-luck charms.

The heads of animals on the tops of sticks (wild goats, argalis, roes, stags, etc.) are not merely decorative and probably have emblematic significance. Of great interest are the stones on the tomb of the Chinese general Ho Ch'ü-ping in Shensi. These are covered with incised carvings of creatures that look like ogres devouring their victims. They are closely related to the gold plaques from Siberia upon which animal combats are depicted. Whether these carvings are Chinese works or Hunnish emblems looted by General Ho Ch'ü-ping is uncertain. Boars also occur among the carvings on these stones.

Among the Voguls the cult of the bear and the dog was widespread, and the dog was a common totem. A carved sandstone object from Ordos, now in Stockholm (Mus. of Far Eastern Ant.), with the heads of a dog and an eagle, can certainly be interpreted as a phallus and therefore as a totemistic emblem.

Of all the animals of the Chinese zodiac, only those of lucky constellations — dog, hare, porcupine, leopard, griffin, stag, sheep, tapir, tiger, pig — are found in the scenes of animal combat on Siberian and Sino-Siberian plaques.

In summary, there are such totems as the dog, bear, wolf, and eagle among the motifs of nomadic art. Various wild animals (boars, stags, elks, roes, ibexes, and argalis) are the motifs of magical hunting charms, and realistic hunting scenes have the same magical purpose. Other emblems were symbols of power; the griffin and tiger, for example, were totems of physical strength among the Chinese as well as the nomads. Horns and antlers were frequently used emblematically. Sometimes the heads of eagles appear on the branches of antlers and even on the hands and feet of other emblematic figures. Although animal forms predominate, the Assyro-Iranian palmette (symbolizing the tree of life) also appears as an emblem and augury.

Zoltán TAKÁTS

With the exception of the dragon (symbol of heaven) that appears on the imperial standards and on patents of nobility, Chinese civilization has produced no coats of arms (i.e., insignia) or emblematic images. This fact may be explained by the ideographic character of Chinese writing, whereby a single character could represent an idea. The standards of the various armies bore the character designating the given name and surname of the commander, or the character representing his title of nobility. Since a commander could express his qualities by variations in the form of his surname on the banners, it was not necessary to have a special nonideographic design.

Piero CORRADINI

The language of insignia in the feudal civilization of Japan is close to that of Europe in many respects. The Annals of the Court of Nara (A.D. 711–93) mention family crests that were given by the emperor to his courtiers as a sign of his favor. During the Heian period (A.D. 792–1185), the nobility decorated their carriages and litters with their crests, and the military used their crests on standards and tents. It seems that prior to the adoption of the crests, Japanese clans were distinguished by the colors white, red, and black combined in various ways. From the 14th century on, the crests began to appear on kimonos in five places: at the back of the neck, on the two lapels, and on the sleeves (PL. 9). During and after the 17th century, these crests were in general use. It is estimated that 4,560 crests exist, 120 of which are famous in history. Many commercial firms use the crests as trademarks.

The elements composing the crests are taken from fauna, flora, the signs of the zodiac, and artisans' tools, or they may consist of variously stylized ideograms enclosed in triangles, lozenges, hexagons, and circles. They are distinguished as follows according to their use: (1) *jōmon*, the distinctive family arms, officially fixed, (2) *honmon*, the traditional family arms, (3) *hi-mon*, the secret arms, (4) *kae-mon*, or *uramon*, the individual arms used by a single member of the family, together with those of the family itself. Important crests are the chrysanthemum ( (*kiku no mon*) and the Paulownia (*kiri no mon*). The chrysanthemum with sixteen petals became the exclusive crest of the emperor at the end of the 19th century. The chrysanthemum crest with fourteen petals (*ura kiku*) and several variants of it were used by imperial princes or princes of the blood and by some patrician families. The *kiri no mon* is composed of three Paulownia leaves surmounted by three blooms. The *goshichi* and the *gosan* are variant forms of Paulownia crests. The *goschichi*, with five outer and seven inner blossoms, has been adopted as its emblem by the Ministry of Foreign Affairs.

Great Japanese cities also have arms — generally of recent origin — which are either ideograms, kana characters that spell the name of the city, or symbols that recall the history of its founding.

When insignia, standards, and banners began to be used in Japan is uncertain. Documents of the 13th century tell of the insignia (*uma jirushi*) that horsemen attached to their saddles. These rectangular pieces of cloth were decorated with either familial or personal arms or other symbols. They were held erect by two poles slightly higher than the helmeted head of the horseman. A variant of the *uma jirushi*, called *matoi*, consisted of a domed cusp surmounted by distinctive symbols of wood or metal from which hung long ribbons of paper or fur. The *matoi* were held high, like the *uma jirushi*.

Salvatore MERGÉ

*Islam.* Literary sources and archaeological material often do not provide an adequate record of the use of emblems in the various periods and regions of Islamic civilization. Among the pre-Islamic Arabs, rudimentary emblems may be assumed to have existed on the basis of the fact that standards were used by various tribes during warfare. It is possible that some insignia or emblems appeared on these standards. We know that the champions who offered themselves for single combat wore distinctive signs on their armor, but nothing more specific is known of these signs. From the earliest beginnings of Islam, we find generic color emblems, the signs of certain factions. Green was probably the color of the Prophet himself and of his descendants through his daughter Fatima. This color is mentioned in the Koran and was considered the restorative and healthful color of paradise itself. White and black appear to have been the respective colors of the two families of Mecca who succeeded each other in the caliphate, the Ommiads and the Abbassides. Black flags were the emblems of the Abbasside revolt, and when this dynasty had won, black became the state color and was used in ceremonial clothes, on standards, and on devices of all kinds. Under the Ommiads and Abbassides, red was the color of the Kharijite rebels, and the expression "to raise the red" was used in historical records to indicate a Kharijite revolt. Aside from these color usages, however, we know nothing more specific about the insignia and emblems (*'alam, shi'ar*) of this period. Sporadic references in texts allow us to infer rather than to confirm their existence.

True emblems are documented in the Moslem world only after the year A.D. 1000. Emblems flourished in the eastern regions of the caliphate where non-Arab dynasties reigned (Turks, Persians, Moghuls). While these eastern countries assimilated Arabic-Islamic culture, it was mingled with their own conceptions, usages, and customs (especially those relating to court and military life). Islamic heraldry became particularly common in Turkish regions or those under Turkish dynasties (Seljuks, Ortuqids, etc.). With the establishment of a warlike aristocracy, coats of arms appeared on costumes, armor, objects of daily use, and dedicatory and mortuary inscriptions. This heraldry — which appears also in purely Arabic areas (e.g., dynasties of the Rasulids of Yemen and of the Nasrids of Andalusia) — has not been studied exhaustively for any periods but those of the Ayubites and Mamelukes of Egypt and Syria (13th–16th cent. of our era). L. A. Mayer has given us a systematic corpus of such Saracen heraldry, including the arms — represented on cups, bowls, lamps, plates, and candelabra of the Ayubite-Mameluke period as well as on fortresses, bridges, and tombs — of the individual emirs (practically all of whom were Turks or Kurds). These arms are sometimes true *armes parlantes*; that is, they allude to the name of the holder. A cat, for example, appears on the arms of Sultan Baybars, *baybars* being the Turkish name of this animal. Sometimes the emblems refer to the office and title of the holder (the inkpot for the *dewādār*, the spade or the bow for the *silāhdār*, the polo mallet, *chōgān*, for the *chōgāndār*, the handkerchief for the *ğāmdār*, etc., following the elaborate hierarchy and nomenclature of Mameluke society). Other emblems — such as eagles, bowls, rosettes, and fleurs-de-lis — had no reference to titles ,and they, in addition to the objects previously mentioned, constituted the most frequent heraldic themes of this period. These insignia appear either alone or in various combinations, sometimes without lettering, sometimes accompanied by formulas of wishes and homage. The most common of these formulas is *izz li-mawlānā* ("glory to our Lord"), accompanied by the name of the owner. The formulas may also allude to the accomplishments of the owners or take the form of dedications (e.g., those of Sultan Baybars to Ḥiṣn-al-Akrād in Syria). Their interpretations, though not always clear, throw some light on the political institutions as well as the artistic history of the Mameluke period. Still less studied, but worthy of investigation, are the insignia of the other Turkish dynasties, especially those of the Ottomans. The latter culminated in the dynastic insigne of the crescent and the star and were reflected in the hierarchical system (as in the standards with varying numbers of horse tails). Another type of Ottoman emblem was the *ṭuğrā* (an ornamental specimen of calligraphy), or seal of the sultan, which was different for each sovereign and equivalent to an authenticating seal on documents.

Although it is unlikely that the origin of the emblems of Islamic chivalry was purely Western, the opposite assumption — that they originated in Turkey or central Asia — is equally untenable. A series of cross influences, beginning with the Crusades and continuing to later times, may be posited, but the present state of our knowledge does not permit us to go beyond this general hypothesis.

Francesco GABRIELI

MEDIEVAL THROUGH MODERN WEST. *Middle Ages and heraldry.* Although the subject has been insufficiently studied and our knowledge is therefore limited, we may assume that the need for emblems increased with the birth of medieval society. In a time when few people could read, the representational image often served an explanatory or mnemonic purpose. Many popular usages of the time (e.g., a tavern identified by the sign of a flask, or an artisan's workshop by a display of his tools) originated in antiquity and continued through the Middle Ages without interruption.

The various costumes and appurtenances of the Holy Roman Empire were richly decorated. Each element of their design (e.g., the several parts and even the various stones of the imperial crown; PL. 395) had an allegorical function, indicating such things as universality and absolute power. The emblems of papal power had a similar character. The pontifical tiara (the triregnum), especially under Boniface VIII, came to represent the spiritual and temporal papal powers. The cross, the scepter, and the pallium (symbol of the universe) are other objects which, in addition to their ecclesiastical significance, could take on an identifying function in a military context, as in the Crusades. Saints are recognized by emblems of martyrdom (as pagan divinities had previously been distinguished by their attributes). The emblems on coins and seals show that many antique elements and classical references were carried over into medieval coats of arms (e.g., the wolf of Rome, the griffin of Perugia, etc.; PL. 401). The several towers in city walls, the gates, and the principal buildings (including religious edifices) also were pictured emblematically. Because of their symbolic importance, such buildings were often richly decorated and preserved with special care.

Distinctions of grade and class that were not indicated by representational emblems were shown, for example, by dress, as in the clothes of the functionaries in the Byzantine mosaics in the Church of S. Vitale, Ravenna. Ciphers, letters of the alphabet (e.g., since earliest Christian times, the monogram of Christ), series of bands, or stripes, and even pieces of textile also served to indicate such distinctions.

Colors, too, served emblematic purposes in the Holy Roman Empire. Purple was the imperial color, and the prerogative of wearing a purple robe was reserved for the emperor alone. Even the buildings which he frequented were set apart by their color rather than by their form. The color rather than the style of their habits distinguished one monastic order from another, and color was also significant in liturgical objects (q.v.).

Before true systems of heraldic insignia were developed in the medieval West, personal emblems of various sorts were doubtless in common use, particularly on the field of battle (e.g., zoomorphic devices on crests, shields, sword hilts, etc.). Little is known about the early standards and labarums that held pieces of cloth upon which the various picturesque emblems of citizens or combatants were displayed. These preheraldic emblems are known to us partly through the elaborate trappings and harnesses of horses in 13th- and 14th-century miniatures and paintings.

Zoomorphic and anthropomorphic devices also occur, often in imitation of antique styles, in the numerous seals and crests of this period. Celebrated warriors were often compared to animals, which would, of course, be incorporated in their seals (a typical example is that of Henry the Lion, duke of Saxony); or the emblematic animal might be derived in some other (often punning or allegorical) way from the name of the owner of the crest or seal (PLS. 399, 402). These figurations also sometimes translated into pictorial terms a motto or *cri de guerre*, and thus an explicitly apotropaic quality.

From a mixture of all these elements there appeared — as early as the first half of the 12th century — the system called "heraldry." This system followed rigorous principles of arrangement and combination of geometric figures, delineated fields of color, symbolic figures in themselves emblematic (e.g., the eagle as king of the birds, the lion as king of the four-footed beasts, the lily as the most beautiful flower), animals, and natural objects. The continual creation of new arms complicated heraldry to such a degree that it is difficult to find a unique set of family arms or to relate one of many similar coats of arms to a particular family. As a rule, the artistic aspect of heraldry — which is a form of schematization — was secondary. The coat of arms could be and often was freely adapted, according to the style of a particular period, for monumental or decorative purposes.

Heraldic insignia were commonly applied to monuments. Family and communal insignia appear on palaces, altars, and sarcophagi (PL. 400) as well as on vaults, along the walls of rooms, on the façades of civil buildings, in the halls and cloisters of universities, on portals, and on city gates, aqueducts,

triumphal arches, and streets. Sometimes their allusion is not immediately obvious (as in Bernini's Fontana delle Api in Rome, in which the bees, which constitute the Barberini arms, are incorporated naturalistically into the design) or may even be farfetched (as in the rococo churches and chapels of Austria and Bavaria, where a repetition in triplicate of the same elements alludes to the Trinity). In recent times, whole buildings have had ground plans in the form of the swastika.

A development analogous to the schematization of heraldry affected the appearance of naval and military flags (PL. 397), standards, and costumes. The free expression of fantasy (grounded in such literary sources as encyclopedic and astrological texts) that had been characteristic of early medieval emblems seems to have become extremely limited. Perhaps for this reason, a new form of emblem came into being during the Renaissance (see below). These emblems employed elements of popular medieval culture as well as others stemming from antiquity. They were more controlled in style and limited in type than the preheraldic emblems.

The signs of the various guilds and workshops (to which Florentine convivial songs often allude) generally displayed the tools of the craft in question in a decorative manner. Later on, words (the name of the craft or service) were also included (see PUBLICITY AND ADVERTISING). Especially picturesque were tavern signs and the shop signs that consisted simply of replicas, in wood or iron, of the products sold. The former bore stylized images of flowers, animals, and the like, and the taverns themselves had long, colorful names. These signs were particularly numerous in regions where (as in Bavaria) ironwork of a high degree of artistic development — often enhanced by polychrome decoration — was being produced. Unfortunately, many of these picturesque signs have disappeared because of the communal taxes that were placed on them during the 19th century.

Another variety of insignia is that which is connected with popular devotion and deals with sacred or hagiographic images. These became symbols of groups of the faithful or of particular places and took the form of processional standards. Standards of this type are used by all Catholic and Orthodox nations of Europe and Latin America. This usage probably became general during the Middle Ages, and may be connected with the rise of religious confraternities. The spirit and artistic feeling of the Middle Ages is undoubtedly characteristic of such insignia.

* *

*Concept of the emblem: Renaissance and baroque.* In the Renaissance, the emblem was defined as the visual representation of an idea or conception. The true emblem does not differ much from a vignette, except in so far as it is combined with an epigram or inscription giving it moral significance. It is very similar to the device (impresa), which represents symbolically a proposition, wish, or line of conduct, employing a motto and a figure that reciprocally interpret one another. Emblem and device are akin but distinct (see below). Both can be called symbols, but as such they have a much more definite and precise meaning than does a poetic symbol.

This element of the recondite that is characteristic of the emblem goes back to its Humanistic origin, when the cult of the metaphor was connected with and suffered from a refined but erroneous interpretation of Egyptian hieroglyphics. Baldassare Castiglione wrote in his *Il Cortegiano* (XXX): "If the words which the writer uses seem somewhat difficult — that is, of a recondite precision... they give a greater authority to the writing as a whole and keep the reader more attentive and alert, so that he tends to consider everything more carefully, and to take greater delight in the ingenuity and the propositions of the writer." Knowledge of hieroglyphics was spread by the Aldine Press edition of the *Hieroglyphica* of Horapollon (1505). This book, presumably translated from Egyptian into Greek by an unidentified Egyptian author of antiquity, was discovered by the Florentine priest Cristoforo de' Buondelmonti on the island of Andros in 1419. It excited the interest of the Florentine Humanists and especially of Marsilio Ficino. The book was entirely devoted to descriptions of the enigmatic hiero-

glyphics. The Humanists invested these symbols with false meaning and held that they represented the secret wisdom which the priests guarded and which only the initiate could decipher. Thus arose a false tradition that — although it retarded the proper interpretation of the hieroglyphics for two centuries — enriched the development of literature and provided new decorative motifs for the arts.

These hieroglyphics were not altogether new to the painters of the Quattrocento, who embraced them as a new source of inspiration. Similar devices had existed since antiquity. The device was used by the Greeks (as may be inferred from the *Seven against Thebes* by Aeschylus) and the Romans (e.g., the dolphin entwined in the anchor which — well known in the Renaissance and used as his trademark by Aldus Manutius — goes back to a famous coin of Titus). Devices were initially used to distinguish individuals (exactly as in the *Seven against Thebes*), especially in war and in tournaments, and they were therefore spoken of as a person's "arms" or "shield" (PL. 398). Later they developed into a true emblematic language referring to ancestry, rank or prestige, and office. The term "heraldic" later came to be applied to such compositions, since heralds were in charge of what had become the science or the art of devising them. (The term "herald" is of military origin and comes from the German *Hariwald* or *Heriwald*.) The device was especially esteemed in the courtly society of medieval France (cf. some references in the poetry of Machaut and Froissart). When Louis XII made his expedition into Italy, the French habit of decorating hats, clothing, and flags with what they called *devises* caught the fancy of some of the Italian literati. This historical incident, however, only added a new element to the already well-known usages of heraldry. Coats of arms became legal property in connection with a hereditary title, and were subject to change (additional quarterings, etc.) upon the contracting of marriages, alliances, etc. An early heraldic form was that of the *armes parlantes*, or arms that contained a punning allusion to the name of the family (i.e., an object or subject the name of which sounded like the family name). Many of these allusions have become obscured with the passage of time and with changes in the language. Few Englishmen today, for example, know that the name "Montagu" can be derived from the three lozenges of the ancient Montacute arms. These lozenges are heraldic representation of a mountain with three peaks.

At the beginning of the Cinquecento, various factors — among them taste (as in the cult of the metaphor), scholarly speculation (as in the pseudoarchaeology of hieroglyphics), and fashion introduced by historical events (the French invasions) — combined to introduce an emblematic trend that became one of the most conspicuous elements of 17th-century literature and art. The texts that initiated a very long series of publications of this literary-emblematic kind were those of Alciati and Giovio. The first edition of the *Emblematum liber* by the lawyer Andrea Alciati came out in Augsburg in 1531. The word "emblem," signifying in Greek and in Latin (Cicero) "accessory ornament" (cf. the French *appliqué*) and in Latin *opera musiva* (a type of mosaic) and "ornament of discourse" (Quintilian), was taken by Alciati from the *Adnotationes in Pandectarum libros* (Paris, 1508) by Guillaume Budé, where it was the equivalent of *opera musiva*. In this sense it is found in the *Hypnerotomachia Poliphili* by F. Colonna — published in Venice in 1499 — in which several modern hieroglyphic inventions and emblematic figures are found. Among these is the famous emblematic device from the coin of Titus, the dolphin and anchor with the motto SEMPER FESTINA LENTE. The *Hypnerotomachia* was influenced by Leon Battista Alberti, who, in his *On Architecture* (VIII, 4), speaks of hieroglyphics and whose work contributed in great measure to the development of emblems. In *De verborum significatione* (Lyons, 1530), Alciati declared: "Words symbolize, and things are symbolized by them. But things can also be symbolized by other things, as exemplified by the hieroglyphics of Horus and Chaeremon [the *Hieroglyphica* of Horapollon]. To demonstrate this, we have compiled a book entitled *Emblemata*."

In 1517, Filippo Fasanini translated the *Hieroglyphica* of Horapollon into Latin, and spoke of the practical and decorative applications of hieroglyphics. Alciati later made similar observations in the 1551 edition of his *Emblemata*, showing how emblems could be used in the ornamentation of furnishings, walls, clothes, etc. Fra Urbano Valeriano Bolzanio (ca. 1443–1524) — who was in touch with F. Colonna, Giovanni de' Medici (later Leo X), and other Humanists — was active in spreading the knowledge of hieroglyphics. His nephew Piero Valeriano published (Basel, 1556) an extensive treatise called *Hieroglyphica sive sacris de Aegypti aliarumque gentium literis*. In Valeriano's work, hieroglyphics are fused with the symbolism of the medieval lapidaries and bestiaries, as well as that of the *Physiologus*. The latter is a collection of symbols (of Alexandrian origin) presumably derived from animal life (i.e., the stork who holds a stone in his claw, symbol of the vigilant man who guards himself against his enemies; the phoenix rising from the ashes, symbol of the Resurrection; the pelican piercing his breast to feed his young, symbol of the Eucharist). Among the painters inspired by hieroglyphics were Pinturicchio (Borgia apartments in the Vatican), Leonardo (various sketches), Mantegna (*Triumph of Caesar*, England, Hampton Court), Giovanni Bellini (*Allegories*), and especially Dürer (a woodcut showing Emperor Maximilian surrounded by emblematic animals). In his woodcut, Dürer carefully followed the text of his friend Willibald Pirckheimer, *Interpretatio quarundam literarum Aegyptacorum ex Oro Niliaco*. Another Humanist at the court of Maximilian, Konrad Peutinger (to whom Alciati had dedicated his work), had, at the request of the Emperor, attempted to trace the latter's genealogy to Osiris. The Humanists surrounding Maximilian were fascinated by the science of hieroglyphics. Dürer's woodcut was the result of their speculations, and was intended as the central part of the Maximilian's triumphal arch.

Alciati, in addition to hieroglyphics, utilized the epigrams of the *Greek Anthology*. In many cases he translated single Greek epigrams into Latin and added the figure which was called for by the text. Traces of three epigrams laten included in the *Anthology* were found on the walls of a cubiculum in a house in Pompeii: each was illustrated by a picture. There is thus only a nominal difference between an emblem of Alciati and an epigram of the *Anthology*. Another emblem is taken from an idyl of Theocritus: Cupid is stung by a bee and complains to his mother, Venus, of the distressing pain that is caused by this small insect. Venus, smiling, replies: "You too, son, are like this creature, because you are small and cause serious wounds." The motto of this emblem reads: DULCIA QUANDOQUE AMARA FIERI ("Sweet things sometimes become bitter"). Here then is an idyl of Theocritus turned into an emblem, a figure accompanied by a motto which interprets its moral sense and — accompanied by a fragment of verse or prose — "explains" the story represented by the figure and thus transports the latter into the moral realm.

The moral of the idyl concerning Cupid stung by a bee was not so obvious to the Cinquecento and Seicento as it seems to us. The Spaniard Gracián, author of a curious treatise on wit and conceits entitled *Aguzeda y arte de ingenio* (1649), was enchanted with the emblems of Alciati and speaks of "ponderación misteriosa." The 17th-century man delighted in this juxtaposition of the small bee and the small god as inflictors of wounds, for in juxtapositions of this sort lay the essence of conceit or subtle wit. Emblems at first seemed designed chiefly to satisfy those didactic ends that the esthetics of the Renaissance assigned to poetry in general (thereby continuing medieval currents of thought, e.g., the symbolic treatment of the metamorphoses as rendered in the *Ovide moralisé*). They also provided a convenient means of combining the various art forms. Lastly, in the Seicento, emblems proved to be a form of expression (in the guise of wit) peculiarly suitable to the spirit of the time. In all the phenomena of nature, in everything that was knowable, men found fuel to feed their intellectual passion. They derived mysterious conceits, symbols, and devices from the various aspects of earth and sky as well as from plants and animals. Even the language of God fed their fancy. The 17th-century man thought of God as a being similar to himself. Emanuele Tesauro (a theoretician of the conceit) wrote of God as "a witty inventor of fables mocking his own high concep-

tions before men and angels by means of various heroic devices and figured symbols" (*Cannocchiale Aristotelico*, Venice, 1655). To the 17th-century man, the sky was nothing but "a vast blue shield where ingenious nature designs what she meditates, forming heroic devices and mysterious and witty symbols of her secrets." Thunder and lightning were "formidable conceits of nature, at once silent and vocal, having the arrow for a body and thunder for a motto." Dreams, ambiguities, oracles, and monsters were also witty conceits; indeed, everything for the 17th-century man was oracle, monster, ambiguity. Because every poetic image contained a potential conceit, the Seicento was the "emblematic century," during which the imagination was extended to its fullest power. The 17th-century man did not stop at fantastic conceptualization of the image; he needed to transform it into something that his senses could apprehend. He wished to make the image extrinsic, to project it into a hieroglyph or an emblem. The device, the emblem, and the hieroglyph were called by Gracián the precious stones in the gold of elegant discourse.

The emblematists of the 16th–17th centuries did not limit their sources of inspiration to allegory. Although they did no more than dip into the medieval thesaurus, they lent a new aspect to very old things by taking advantage of the vogue for hieroglyphics. Instead of putting new wine into old bottles, they put old wine, somewhat diluted, into new. With all their pretence of mystery — a pretence more evident in the Italian devices than in the emblems — the emblematists were nevertheless the passers of depreciated coinage. This accounts for the derivative, repetitive, and gradually declining quality of emblematic literature.

In his *Dialogo delle imprese militari e amorose* (Rome, 1555) Paolo Giovio recalls a conversation with Ludovico Domenichi on the origin of devices. In the course of this discourse he named five essential qualities of the device, as follows: (1) There should be a proper proportion between body (figure) and soul (motto). (2) The device should not be so obscure as to require a sibyl to interpret it, nor so obvious that any common person (*plebeius*) could understand it. (3) Above all, the device should look well, that is, it should represent something pleasing to the eye such as stars, fire, water, trees, instruments, animals, or strange birds. (4) The human figure should not appear in it. (5) The motto — which is the soul of the device — should be in a different language from that of the designer of the device, so that the sentiment or meaning would be somewhat hidden; the motto should be brief, though not so brief as to be obscure or dubious.

The rules concerning the device were discussed and fixed with academic rigor in Italy, while on the other side of the Alps the emblem developed rather freely and its designers were unhampered by precepts. It may be said that the device is to the emblem as classic is to romantic. In the Italian academies of the 16th and 17th centuries, devices were not only designed, but they were also the subject of sterile exhibitions of rhetoric. The devices became so characteristically Italian that Menestrier, in his *Philosophie des images* (1682), could say that Cardinal Mazarin "had brought this taste and this inclination from his country into France." The books of Alciati and Giovio had a great influence.

In Holland the emblem became a salient feature of the national literature. Vondel, Roemer Visscher (*Sinnepoppen*, Amsterdam, 1614), and especially Cats — whose volumes formed for a lengthy period one of the ornaments of Dutch literature (*Silenus Alcibiades sive Proteus*, Middelburgh, 1618; *Maechdenplicht*, Middelburgh, 1618; *Spiegel van den ouden ende nieuwen Tijd*, the Hague, 1632) — wrote about emblems. Jakob Cats was inspired particularly by proverbs and everyday life. Daniel Heinsius was the first to print an original work on emblems in Dutch (emblems of love, first edition published under the pseudonym "Theocritus" at Ghent at the beginning of the 17th cent.). His work gave a graphic form to many of the conceits of the classicists and the Petrarchians. This book was followed by many others. [P. Corneliszoon Hooft, *Emblemata amatoria*, Amsterdam, 1611; Otto van Veen (Vaenius), *Amorum emblemata* Antwerp, 1608; PL. 404]. Vaenius, a pupil of Federigo Zuccaro, was the master of Rubens between 1596 and 1600.

Thus emblems came to be used in Germany through the so-called *Stammbücher* and the *Alba amicorum* (e.g., the emblems of Théodore de Bry and of his son Johann-Théodore, *Emblemata nobilitati et vulgo scitu digna*, Frankfurt, 1593; and *Emblemata secularia*, Oppenheim, 1611). In Holland, books of love emblems were customarily given by suitors to their ladies, and the names and arms of the lovers were placed on the frontispieces. The development of realism in Dutch emblems paralleled the rise of genre painting, and the emblems of this period provide interesting documents for the history of costume (e.g., J. de Brune, *Emblemata of Zinnewerck*, Amsterdam, 1624).

The Jesuits adopted emblems and devices — as well as other elements of Humanist culture — as instruments for the diffusion of edifying doctrines, especially in the education of boys of noble or royal families. The charm of these vignettes appealed particularly to relatively uncultivated persons. The emblems also provided suggestions for the religious and civil celebrations that constituted such an important part of the activities of the Society of Jesus, and they supplied ideas for sermons. A Jesuit of the Low Countries, Hermann Hugo, wrote the most popular volume of Jesuit emblems (*Pia desideria*, Antwerp, 1624), which contained illustrations by Boetius van Bolswert. Many editions of this book were printed, and it was sometimes imitated. The idea of turning love emblems into religious emblems was first adopted by Vaenius in *Amoris divini emblemata* (Antwerp, 1615). Among the Jesuit emblems are several curious ones of baroque character, for example, those of the Sacred Heart, all in the form of a heart, designed by Anton Wierix (*Cor Iesu amanti sacrum*), and the *Ova Paschalia* of Georg Stengel (Ingolstadt, 1672) all in the form of an egg, etc.

The literature of devices is fairly extensive in Italy. Among the earliest writers of treatises on this subject were Ludovico Domenichi and the Florentine polygraphist Gabriello Simeoni. The latter's treatise — *Le imprese eroiche e morali* (Lyons, 1559) — was reprinted in French in 1561 together with the first book to discuss the devices of historic personages, the *Devises héroiques* of Claude Paradin (Lyons, 1551), with engravings attributed to Petit Bernard. This work appeared in Latin in 1562 when the Antwerp publisher Plantin brought out *C. Paradini et Gabrielis Symeoni heroica symbola*. This publisher distinguished himself by printing a number of books on emblems, among them the monumental *Imago primi saeculi Societatis Jesu* (1640) with emblems celebrating the triumphs of the Society engraved by Cornelis Galle. The most notable treatise concerning the use of emblems in the education of princes was written by a Spaniard, Diego Saavedra y Fajardo, *Idea de un príncipe político cristiano*, Munich, 1640, which later appeared in Latin (PL. 404).

Among the artists who illustrated books on emblems and devices were Jost Amman, Stefano Della Bella, Abraham Bloemaert, the aforementioned De Brys (who were sometimes influenced by Breugel), Jacques Callot, Agostino Carracci (who retouched the engravings of Bonasone in Achille Bocchi's *Symbolicarum quaestionum*, 1574), the Cochins, Cruikshank, the Galles, Gravelot, Hans Holbein, Jan Luyken (the last artist of merit to have produced etchings of emblems in quantity), Matthäus Merian, Crispin de Passe, and R. and E. Sadeler. Emblems and devices used for decorative purposes were innumerable. Great Italian painters, for example, often painted devices on the covers of portraits. Titian painted a device of love for the portrait of Sperone Speroni. Another was painted by Lorenzo Lotto on the cover of his magnificent portrait of Bernardino de' Rossi (PL. 403). Lotto lost no opportunity to utilize and design emblems (e.g., intarsias of the choir stalls of S. Maria Maggiore, Bergamo). An emblem in enamel enriches a miniature of Queen Elizabeth (formerly in the Pierpont Morgan Coll.; sold in June, 1935, no. 99, at auction at Christie's), probably an English work of the second half of the 16th century. Devices and mottoes are frequently found in Elizabethan miniatures. In the St. Sebastian by Mantegna (PL. 403), there is a lighted, smoking candle and a banderole with the inscription; NIL NISI DIVINUM STABILE EST, CAETERA FUMUS ("Only the divine is lasting; the rest is smoke"). Giovanni-Battista Caccini, Gregorio Pagani, and others decorated the doors of

the Cathedral of Pisa with devices and mottoes. A door of St-Maclou in Rouen was decorated (perhaps by Jean Goujon) with an emblem from Alciati. Danese Cattaneo decorated the armor of the Minerva on the Fregoso tomb (Verona, S. Anastasia) with an ermine and the motto POTIUS MORI [QUAM FOEDARI] ("Rather death [than dishonor]"). Bartolommeo Ammanati carved devices as part of the ornamentation of the overdoor of the Palazzo Budini-Gattai near the Via de' Servi in Florence. The architect and sculptor Jean-Jacques Chenevrière provided emblems to decorate S. Luigi de' Francesi in Rome. Italian and German state apartments were often decorated with devices and emblems. Hieroglyphics and emblems were used by Vasari in the Sala degli Elementi and other rooms in the Palazzo Vecchio, Florence. Devices adorn the gallery of Palazzo Farnese in Rome and the ceiling of the atrium of the Villa Farnese at Caprarola, near Rome, where the decoration follows the ideas of Annibale Caro. Devices are found in the rooms of the Villa del Cataio and adorn the room painted by Luca Giordano in the Palazzo Riccardi in Florence. Political emblems are found in the Rathaus of Nuremberg and emblems of love in a gallery of the Castle of Ludwigsburg near Stuttgart. An ornamental medal with a device was worn by Cinquecento courtiers on their hats. Bartolommeo Veneto illustrated this fashion in his portraits. Moretto's portrait of a gentleman (1526; London, Nat. Gall.) and the self-portrait of G. P. Lomazzo in the Brera include this ornament, as does a portrait by Mostaert in the Staatliche Museen in Berlin. Devices were also seen on ladies' clothes; G. B. Strozzi, for example, wrote verses for the devices which adorned the dress given by Bianca Capello to Caterina Strozzi Frescobaldi. Mary Stuart embroidered a famous series of devices on the curtains of a state bed. The device of Clement VII, CANDOR ILLAESUS ("Unblemished purity"), appears on the border of the tapestry by Raphael representing the *Blinding of Elymas* (the cartoon for which is now in the Vict. and Alb., London), and devices invented by Perrault adorn the arras of the Four Elements and the Four Seasons executed for Louis XIV. Emblems decorated the carriage, made in Germany in 1644, of Monsignor Fabio Chigi; and Alexander VII gave to Queen Christina of Sweden a carriage "with mysterious silver figurines" designed by Bernini. Sometimes emblems are discovered on the most diverse objects, for example: a small ivory chest with precious intarsia work bears two emblems by Otto Vaenius (Kassel, Landgraven Mus.); medallions with emblems by Hugo adorn the confessionals of the church at Banz (near Lichtenfels in Franconia); and emblems are also found on innumerable small religious images and Sèvres porcelain of the early 19th century. The widely diffused emblems of Otto Vaenius (frequently found on the porcelain mentioned above) are seen, for example, in Vermeer's *Lady Standing at the Virginals* (London, Nat. Gall.). In the background of this painting there is a picture of Amor holding a piece of paper on which the letter "A" is written. Similar emblems of love occur on a small silver box with filigreed enamel work (Mostra degli argenti, Genoa, 1950).

Sometimes devices were incorporated in volumes of verse. Examples are Maurice Scève's *Delie, objet de la plus haute vertu* (Lyons, 1544), B. Percivallo's *Rime e imprese* (Ferrara, 1588), and Ercole Tasso's curious little book, *La Virginie, ovvero Dea de' nostri tempi*, a treatise in which are found rhymes, devices, and cabalistic demonstrations. Although the inventors of devices were often "adventurers of the pen" who wrote only for money, some, such as Gabriello Simeoni, were ecclesiastics, and the subject was not disdained by some famous writers. Among these were: Scève, Marot, Jodelle, and Ronsard in France; Tasso and Marino in Italy; and in England, Samuel Daniel (who translated Giovio's book in 1588), Greene, Nash, Sidney, Spenser, Drummond of Hawthornden, and Shakespeare himself. The latter, with the actor Burbage, made up the device of the Earl of Rutland. In *Pericles*, Shakespeare describes some devices taken in part from Paradin.

In the 17th century, and especially in the 18th, the quality of emblematic literature declined. This deterioration was particularly marked in the designs of the devices, and these works were less and less addressed to an intellectual elite. Greater care, however, was taken in the illustrations that appeared in certain volumes concerning allegory called "iconologies." The series of these was begun by the Perugian Cesare Ripa (*Iconologia*, Rome, 1593 and 1603). His book went through a number of editions, and the final, monumental work in five volumes was published in Perugia in 1764–67. Iconology was as important to the Enlightenment in philosophy and classicism in literature as emblematology had been during the Jesuit-baroque period. Condemned and ridiculed by Winckelmann among others (*Versuch einer Allegorie*, Dresden, 1766), the vogue for emblems was not cultivated by the intellectual elite of the 18th century. It continued to be popular in less advanced circles (almost exclusively English), however, and emblems were still used for educational purposes. Books on emblems — especially those of the 16th century — were sought by bibliophiles for the beauty of their illustrations. In the period during which emblems were most popular, the term "emblem" was extended to vignettes that had nothing to do with symbolism. It also included, in this period, pictures from the Bible, from the lives of the saints, and from books of devotion. In England, the term "emblem" was applied also to political caricatures. As distinguished from emblems, devices continued to be employed for practical reasons (e.g., in the impresses of publishers, in commemorative medallions and in ex-libris).

Vestiges of Dutch emblematics were transmitted through Jan Steen to Hogarth (q.v.). In the famous scene of the breakfast in *Marriage à la Mode*, for example, the moral of the picture is underlined by symbolic objects and animals taken from the *Depraved Family* of Steen (Paris, Coll. Schloss), from which Hogarth also evidently borrowed the composition. The fantastic clock in Hogarth's picture is a hybrid collection: a porcelain cat on a bronze clock is surrounded by fronds among which fish are seen to swim. Below the clock is a figure of Buddha from whose navel issue serpentine arms carrying candles. All this is like a symbol of the ill-matched marriage pair. In the aforementioned *Depraved Family* of Steen, the peacock's tail on the table and the monkey who pitches the cards on the floor are emblems taken from popular ideas of vice. In other scenes from the *Marriage à la Mode* series by Hogarth, the pictures on the walls contain symbolic allusions to the scene represented. Through Steen and Hogarth, the taste for the emblem was transmitted to Victorian painting, to the "pictur'd morals" of Augustus Leopold Egg or William Powell Frith, or of Pre-Raphaelites like Holman Hunt (*The Awakening Conscience*). In the *Worship of Bacchus* (London, Tate Gall.) by Cruikshank (q.v.) the aim is to illustrate synoptically all the episodes to which drinking can give rise. In this work a fullness of incident equal to that of the *Proverbs* (attrib. to Pieter Bruegel the Elder) is attained. These works of Hogarth and Cruikshank — the first with its witty proverbial chatter, the second with its nightmarish atmosphere provoked by the curse of alcohol — are typical incarnations of the bourgeois taste of the time. These were, for the positivistic 19th century, what the *Last Judgments* by Michelangelo was to the 16th century. Between the *Proverbs* and the *Worship of Bacchus* by Cruikshank is comprised the whole range of emblematic literature.

Mario PRAZ

*Emblems in the modern world.* It would be a mistake to suppose that — because the modern West is less interested in the visual representation of ideas — there has been any diminution in the use of emblematic configurations. On the contrary, from the end of the 16th century the establishment of certain norms (typical in baroque times are the inventions of religious emblems e.g., the Sacred Heart; III, PL. 307) caused a rapid spread and secularization of emblems.

The development of the centralized, bureaucratic state has given rise to a whole new series of emblems and insignia. All governments use official insignia or seals to guarantee the authenticity of their documents. Public bodies and even private organizations have emblems (in Continental countries, duly taxed) that are constantly reproduced, even on ordinary letter paper. A fairly recent phenomenon is the use of emblems by political parties. These emblems tend to become identified with the state in cases where the party acquires absolute power.

Each political party tries to represent its program by an image. Communist parties all over the world use the hammer and sickle as their emblem, as an allusion either to the laboring classes or to the union of peasants and factory workers in their championship of certain social rights. The Italian Fascist party chose the lictors' rods in allusion to the union of the conservative forces representing national discipline as well as to the governmental ideals of ancient Rome. The German National Socialist party adopted the swastika as an esoteric symbol of continuity and force. Not infrequently, modern political emblematology is based on historical references. The Napoleonic armies, for example, used the Roman eagles on their insignia, and the emblems of the German armies often originated in old Germanic myths.

From the beginning of the last century, letters of the alphabet have taken on emblematic significance. Examples are the letters "R F" (République Française) on the French revolutionary flags, and "N" (Napoleon) on the flags of the Empire. State emblems — unlike municipal emblems, which are tied to ancient civic traditions — utilize a rather restricted range of imagery.

The wider employment of emblematic images by private associations and organizations of all kinds has not given rise to any new heraldic system worthy of note. The development of modern devices has been more interesting. Those which represent small, familiar enterprises (e.g., the flask to indicate the tavern; the hat, the clock, or the boot to indicate the hatter, the watchmaker, or the shoemaker) are generally naturalistic and descriptive, and are sometimes so far developed as to constitute genre scenes. Emblems relating to larger enterprises, however, tend to become schematized or reduced to insignia. These signs are constantly repeated, and their typography often tends to assume a recognizable quality as well. The increased volume of advertising associated with modern commerce has vastly increased the significance of the trademark. Because they have become so essential to effective merchandising, modern trademarks are carefully designed for optimum visual impact.

* *

BIBLIOG. *a. Origins of emblems and insignia*: Reallexikon der Vorgeschichte, XII, p. 377; EI, s.v. Emblema. *b. Primitive cultures*: E. Merker, Die Masai, Berlin, 1910; C. G. Seligman, The Melanesians of British New Guinea, Cambridge, Eng., 1910; J. Roscoe, The Baganda, London, 1911; E. Crawley, Dress, Drinks and Drums, London, 1931; G. Landtman, The Origin of the Inequality of the Social Classes, London, 1938; C. von Fürer-Haimendorf, Die nackten Nagas, Leipzig, 1939; J. Belaieff, The Present-day Indians of the Gran Chaco, HSAI, I, 1946; M. Trowell and K. P. Wachsman, Tribal Crafts of Uganda, London, New York, Toronto, 1953; B. Lindskog, African Leopard-Men, Uppsala, 1954; J. Rouch, Les Songhay, Paris, 1954; J. Soustelle, La vie quotidienne des Aztèques à la veille de la conquête espagnole, Paris, 1955; R. H. Codrington, The Melanesians, Studies in their Anthropology and Folklore, New Haven, 1957. *c. Egypt*: G. Jéquier, Les frises d'objets des sarcophages du moyen empire, Mémoires de l'Institut français d'archéologie orientale du Caire, XLVII, 1921, pp. 11-15, 162-91; W. C. Hayes, The Scepter of Egypt, I, New York, 1953, pp. 284-87; W. S. Smith, The Art and Architecture of Ancient Egypt, Harmondsworth, 1958, pp 15-18, figs. 3-4, pl. 6. *d. Asiatic Near East*: E. Unger, Assyrische und babylonische Kunst, Breslau, 1927, pl. 104; K. Galling, Beschriftete Bildsiegel des ersten Jahrtausends v. Chr. vornehmlich aus Syrien und Palästina, Zeitschrift des deutschen Palästina-Vereins, LXIV, 1941, pp. 121-202; D. Diringer, The Royal Jar-Handles Stamps of Ancient Judah, Biblical Archaeologist, XII 1949, pp. 70-86; G. A. Wainwright, The Cappadocian Symbol, Anatolian Studies, VI, 1956, pp. 137-43. *e. Iran*: E. Herzfeld, Am Tor von Asien, Berlin, 1920; L. Légrain, Empreintes de cachets élamites, Mission archéologique de Perse, Mémoires, XVI, 1921; E. Herzfeld, Khusrau Parwēz und der Ţaq i Vastān, Archaeologische Mitteilung aus Iran, IX, 2, 1938, p. 91 ff.; K. Bittel, Yazilikaya, Deutsche Orient-Gesellschaft, wissenschaftliche Veröffentlichung, 61, 1941; E. D. Van Buren, Symbols of the Gods, Analecta Orientalia, XXIII, 1945, pp. 110-13; E. D. Van Buren, The Rod and Ring, Archiv Orientální, XVII, 1949, pp. 434-50; K. Erdmann, Die Entwicklung der sasanidischen Krone, Ars Islamica, XV-XVI, 1951, p. 120, col. 1; E. Borowski, A Bronze Standard from Persia, Archaeology, V, 1952, pp. 22-24; W. B. Henning, The Monuments and Inscriptions of Tang-i Sarvak, Asia Major, II, 1952, pp. 151-78; H. Porratz, Das Kampfmotiv in der Luristankunst, Orientalia, XXI, 1952; E. Schmidt, Persepolis, I (Chicago Univ. Oriental Inst. Publications, 68), Chicago, 1953; F. Altheim and R. Stiehl, Ein asiatischer Staat, Wiesbaden, 1954, p. 71; H. Frankfort, The Art and Architecture of the Ancient Orient, Harmondsworth, 1954, p. 178 (A); R. Gobl, Aufbau der Münzprägung, in F. Altheim and R. Stiehl, Ein asiatischer Staat, Wiesbaden, 1954, pp. 100-24; E. D. Van Buren, The Esoteric Significance of Kassite Glyptic Art, Orientalia, XXIII, 1954, pp. 1-39; B. Segal, Notes on the Iconography of Cosmic Kingship, Art Bulletin, XXXVIII, 1956, pp. 75-80; S. Cammann, Ancient Symbols in Modern Afghanistan, Ars Orientalis, II, 1957, pp. 5-34, 79 ff.; R. Ettinghausen, The Wade Cup in the Cleveland Museum of Art, Ars Orientalis, II, 1957, pp. 327-66; H. J. Kantor, Achaemenid Jewelry in the Oriental Institute, JNES, XVI, 1957, pp. 1-23; T. Beran, Die babylonische Glyptik der Kassitenzeit, Archiv für Orientforschung, XVIII, pp. 255-78; H. Schmokel, Ziegen am Lebensbaum, Archiv für Orientforschung, XVIII, 2, 1958, pp. 373-78; L. van den Berghe, Archéologie de l'Iran ancien, Leiden, 1959. *f. Greco-Roman civilization*: DA, s.v. Aquila, Corona, Sceptrum, Signa militaria; A. Alföldi, Insignien und Tracht der römischen Kaiser, RM, L, 1935, pp. 1-158; W. Deonna, Deux études de symbolisme religieux, Brussels, 1955, p. 97 ff. *g. India*: H. Heras, Las orígines de la heráldica índica, Madrid, 1934. *h. Nomads of the steppes*: D. Klementz, Antiquities of the Minussinsk Museum, Objects of Metal Ages, Tomsk, 1886 (in Russ.); R. F. Martin, L'âge du bronze au Musée de Minoussinsk, Stockholm, 1892; S. Reinach, N. Kondakov, J. Tolstoy, Antiquités de la Russie méridionale, Paris, 1892; A. Heikel, Antiquités de la Sibérie occidentale, Helsinki, 1894; D. Riegl, Die spätrömische Kunstindustrie nach den Funden in Oesterreich-Ungarn, I, Vienna, 1901; O. M. Dalton, The Treasure of the Oxus, London, 1905; A. M. Tallgren, Collection Tovostine: Trouvailles isolées préhistoriques au Musée national de Finlande, [Helsinki], 1919; J. J. M. de Groot, Die Hunnen der vorchristlichen Zeit, Berlin, 1921; G. Borovka, Scythian Art, London, 1928; A. von LeCoq, Buried Treasures in Chinese Turkestan, London, 1928; N. Fettich, La trouvaille scythe de Zöldhalompuszta, Budapest, 1929; M. Rostovtzeff, The Animal Style in South Russia and China, Princeton, 1929; M. P. Griasnov, Le Kourgan de Pazyryk, Moscow, Leningrad, 1931; A. Salmony, Sino-Scythian Art in the Collection of C. T. Loo, Paris, 1933; E. H. Minns, The Art of the Northern Nomads, London, 1942; S. I. Rudenko, Der zweite Kurgan von Pazyryk, Berlin, 1952; Z. Takáts, Catalaunischer Hunnenfund und seine ostasiatischen Verbindungen, Acta Orientalia Academiae scientiarum Hungaricae, VI-VII, 1956-58. *i. Islam*: L. A. Mayer, Saracenic Heraldry, Oxford, 1933 (with earlier bibliography). *j. European Middle Ages*: J. David, Veridicus Christianus, Antwerp, 1601; A. Alciati, Emblemi di A. Alciati, Padua, 1626; H. Hawkins, Parthenia sacra, Rouen, 1632; J. Grand-Carteret, L'enseigne, Grenoble, 1902; G. Dian, Cenni storici sulla farmacia veneta . . . part 5ᵃ, Venice, 1905; W. Bombe, Gonfaloni umbri, Augusta Perusia, II, 1907, p. 1; A. Marquand, Robbia Heraldry, Princeton, 1919; M. Maclagan, Le blason en Byzance, Actes du X Congrès international d'études byzantines, Istanbul, 1957, pp. 230-31; P. Mesnard, Symbolisme et humanisme, Atti del IV convegno internazionale di studi umanistici, Padua, 1958. *k. Renaissance to modern*: K. Giehlow, Die Hieroglyphenkunde des Humanismus in der Allegorie der Renaissance, JhbKhSammlWien, XXXII, 1915, pp. 1-232; L. Volkmann, Bilderschriften der Renaissanec, Leipzig, 1923; M. Praz, Studi sul concettismo, Florence, 1946 (Eng. version, Studies in Seventeenth-Century Imagery, London, 1939, followed by a second vol., only in English, A Bibliography of Emblem Books, London, 1947); A. G. G. de Vries, De Nederlandsche Emblemata, Amsterdam, 1899; R. Freeman, English Emblem Books, London, 1948; Abd-El-Kader Salza, La letteratura delle "Imprese" e la fortuna di esse nel '500, Appendix to his vol., Luca Contile, Florence, 1903, p. 205 ff.; J. Gelli, Divise, motti, imprese di famiglie e personaggi italiani, Milan, 1906; L. Volkmann, Hieroglyphik und Emblematik bei Giorgio Vasari, in Werken und Wirken, ein Festgruss Karl W. Hiersemann zugesandt, Leipzig, 1924; P. Fuchs, La coperta con l' "Impresa d'amore" dipinta da Tiziano per il ritratto di Sperone Speroni, Dedalo, IX, 1928-29, p. 621 ff.; E. Panofsky, Titian's Allegory of Prudence, in Meaning in the Visual Arts, New York, 1955, pp. 146-68; G. F. Hartlaub, Die Spiegel Bilder des Giovanni Bellini, Pantheon, XXX, 1942, p. 235 ff.; J. Pope-Hennessy, A Lecture on Nicholas Hilliard, London, 1949, pp. 23-24; A. Spamer, Das Kleine Andachtsbild vom XIV. bis zum XX. Jahrhundert, Munich, 1930; E. Mandowsky, Ricerche intorno all'iconologia di Cesare Ripa, Florence, 1939 (extract from vol. XLI of Bibliofilia); E. Mâle, L'art religieux après le Concile de Trente, Paris, 1932; E. Zaniboni, Alberghi italiani e viaggiatori stranieri . . ., Naples, 1921; W. J. Gocolon, Flags of the World, 1929; Insegne d'osteria bergamasche, Rivista di Bergamo, X, 1931, pp. 291-339.

Illustrations: PLS. 393-404.

**EMBROIDERY.** See TEXTILES, EMBROIDERY, AND LACE.

**ENAMELS.** The technique of decorating with enamel — that is, with a fused glass paste — has had a long history, for it was practiced in widely separated parts of Europe and Asia as early as several centuries before Christ and has never been completely abandoned. The production throughout this time has not been homogeneous; great variations in technique, style, and function have occurred. Individual workshops, active over centuries in some cases, however, have produced autonomous stylistic traditions that have affinities with jewelry in general, with niello and inlay, and in technical and chromatic respects with some of the decoration of glass (q.v.) and ceramics (q.v.). Enamels may be used to cover large surfaces in their entirety or as a minor decorative element in jewelry. The major achievements in enamelwork, such as those of the Byzantine, Roman-

esque, Late Gothic, and Renaissance periods, have a value that reaches far beyond a merely decorative one. They are discussed from the stylistic point of view in the entries dealing with these styles (see BYZANTINE ART; GOTHIC ART; RENAISSANCE; ROMANESQUE ART); and are therefore treated only briefly here.

SUMMARY. Technique (col. 735). The ancient Near East and Caucasia (col. 735). Greek enamels and their imitations (col. 736). Celtic and Roman provincial enamels (col. 736). Pre-Islamic Iran (col. 738). Byzantine enamels (col. 739). Medieval Europe (col. 740). Late Gothic, Renaissance, and modern enamels (col. 742). Islamic enamels (col. 744). India (col. 744). The Far East (col. 745).

TECHNIQUE. The enamel process consists of the application of powdered glass to a metal base and the fusion of the two by a heating process. Pieces of glass, colored with oxides of metal, are ground until they are extremely fine; water is then added to make a paste that is applied to the metal base, usually with a brush. The melting point of the glass depends on the metal used to color it. If more than one glass is used, the one with the highest melting point must be applied first. Various types of metal are employed for the base, such as bronze, copper, gold, and, less frequently, silver and iron. Platinum, however, may not be used, since the glass will not adhere to it.

In antiquity and the Middle Ages the two principal methods employed were champlevé and cloisonné, described in Theophilus' *Schedula diversarum artium* in the 11th century. In champlevé enamel shallow hollows that are dug out in the metal plaque are outlined by raised portions of the plaque; the word "champlevé" (raised field) refers to these raised parts, which are not covered by the enamel. Thin layers of glass paste are applied to the hollows, and the plaque is then placed in an oven. It is usually protected from the direct flame by a kind of perforated metallic box with a long handle. In most instances there are several firings, and layers of glass paste are added after each until the enamel is as high as the raised outlines. Finally the whole surface is ground until it is level and polished.

In cloisonné enamel a single large concavity is first prepared, usually by surrounding the base plaque with a strip of metal; within this space the design is laid out in small strips of metal, usually gold, which are soldered edgewise to the base. (*Cloison* means partition or compartment.) From this point the process is the same as for champlevé. An infrequently used method similar to cloisonné employs metal wire in place of strips. In another process small pieces of cut colored glass are placed into the metal base, as a rule champlevé, either alone or in conjunction with glass paste, and heated till they adhere to it. The result is a glass "mosaic" with a striking color effect. This is even more pronounced when pieces of millefiori glass are employed (see GLASS). Millefiori is a kind of ornamental glass made by fusing together slender rods or tubes of colored glass and cutting the product transversely. Other less widely used methods are mentioned in this article in connection with the works in which they are used.

THE ANCIENT NEAR EAST AND CAUCASIA. Although the Egyptians very early made glass and decorated pottery with vitreous glazes, they do not seem to have learned the enameling process until Roman times. They had previously used pieces of glass with lapis lazuli and other colored stones in jewelry, inset and often also glued, but not fused through the use of heat. There is a slight possibility, however, that some New Kingdom jewelry was decorated with true enamel. Enamels of a cloisonné variety from a much later date have been found with Roman objects in a pyramid at Meroë in the Sudan. In Alexandria during Roman times millefiori glass was used, and complex designs composed of small pieces of figured glass were turned into decorative plaques by a process of fusion.

Enamel does not seem to have been known in Mesopotamia or other regions of the Near East at such an early date, although we have references to its existence in Persia.

In Caucasia enamelwork has been found in tombs of the early part of the Iron Age (early 1st millennium B.C.). Some bronze belt buckles from the necropolis at Koban are inlaid with iron and others with enamel of true champlevé process, fused by firing.

Some connection exists among Egyptian, Caucasian, Greek, Etruscan, and Celtic enamels, though its precise nature is difficult to determine. Present knowledge suggests a close relation between Egyptian and Greek enamels, and another between Caucasian and Celtic ones.

GREEK ENAMELS AND THEIR IMITATIONS. Greek enamels are of two types. The technique of one features a thin layer of enamel that covers a space outlined on a gold ground by a fine gold wire. Since the enamel is not as high as the wire, it cannot be polished, thus having a mat or, at times, granular finish. The enamel is usually blue or green, probably in imitation of lapis lazuli and malachite. The other type was used to encrust tiny figurines and is of a relatively late date. The figurines, most of which are colored white, were used as pendants attached to jewelry. Both types of enamel were used on necklaces, diadems, earrings, and other jewelry to alleviate the monotony of the gold. Often these touches of color were filigree rosettes or petals scattered over a plain filigree design. At other times minute enamel rosettes or leaves were hung on chains from the main part of a piece of jewelry.

These pieces were exported to much of the known world, and, as often happens with Greek objects, are less common in their country of origin than elsewhere. Numerous examples have been found in Asia Minor: Ionia seems to have been one of the main centers of production. The majority of the exports seem to have gone to Etruria and to what today is southern Russia. Etruscan finds also include pieces that are cruder than those imported from Greece and seem to be local imitations. The finest pieces from southern Russia are doubtlessly imports, but the presence of Greek artisans working there is indicated by the objects (Leningrad, The Hermitage) found in the tumulus of the second half of the 5th or early 4th century B.C. at Kul Oba near Kerch. A diadem with enamel rosettes is probably an import; a gold necklace with terminals in the form of horsemen wearing Scythian costumes and enameled filigree bands is evidently the work of a Greek craftsman. Another necklace, with lion heads as terminals, seems to imitate Persian models, although enamel is used in place of insets of colored stone. Similar examples are known from many other tombs in southern Russia (see GRECO-BOSPORAN AND SCYTHIAN ART).

The oldest extant Greek enamels probably date from the 6th century B.C. They were in fashion for jewelry from the end of the 5th through the 4th century B.C., but after the conquests of Alexander were eclipsed by a new fashion for precious stones, which were imported in huge quantities. Isolated examples in Roman jewelry date from well into the empire, which began in 27 B.C. The unique gold bracelets found at Rhayader in Wales are probably of the 2d century of our era. Their design, showing Celtic influences, is done in filigree with blue and green enamel.

CELTIC AND ROMAN PROVINCIAL ENAMELS. Enamelwork in Celtic art dates from the beginning of the La Tène period (5th cent. B.C.), which takes its name from the site in Switzerland. The earliest pieces are from tombs in the Rhine Valley and southern Germany; others, of the beginning of the 4th century, are from Bohemia and the Marne Valley. Enamelwork was brought to England (Yorkshire) and Ireland with the first Celtic invasions, during the 3d and 2d centuries B.C.

In Celtic work coral was frequently used with enamel until the coral disappeared in the 3d century of our era. Until the 1st century all Celtic enamel was red, the glass being dyed with a copper oxide that made it a brilliant sealing-wax color. Later oxidation of the copper sometimes produced either spots or a greenish patina, and sometimes the enamel itself decomposed and became whitish. Champlevé on bronze was the most common technique, but others were also used. A number of pieces have openwork bosses in which the perforations are filled with enamel. The enamel paste seems to have been applied while the boss was resting in its clay mold. After firing and the removal of the clay mold, the thin layer of enamel thus formed

was reinforced by a center of clay. Traces of this clay are still found in some pieces. This type of decoration was used on mounts from Cuperly, Marne, France (now at Saint-Germain-en-Laye, Mus. des Antiquités Nationales), and on fittings of vessels found at Basse-Yutz, Lorraine, France (London, Br. Mus.; III, PL. 115). The vessels, probably dating from the late 4th century B.C., are also decorated with plaques of coral and champlevé enamel. A helmet found in a dried-up channel of the Seine at Amfreville (Louvre; III, PL. 119), probably of the La Tène II period (3d–2d cent. B.C.), gives evidence of the use of an enamel technique approaching cloisonné. An openwork iron hoop with holes in it was attached around the outside of the bronze core of the helmet, and the enamel was placed in the hollows in the hoop. During the 3d–2d century B.C. there also appeared half-spherical buttons of iron or bronze that, after being enameled, were set on tangs with eyelets or into bronze objects. Such buttons were found at the La Tène site itself (Neuchâtel, Switzerland, Mus. d'Art et d'Histoire) as well as in La Tène III (1st cent.) centers at places such as Stradonitz, Czechoslovakia, and Mont Beuvray in Burgundy, France. In the last-mentioned find, the glass paste was first liquefied and then poured on the bosses, which had been heated red-hot and placed beside the oven. True champlevé continued to be produced in Celtic workshops on the Continent until the Roman conquest.

In England enamelwork was considerably developed during the 1st century B.C., that is, both before and after the Roman conquest. Blue and sometimes other colors were used in addition to red for plaques made to decorate trappings of horses. Elegant curvilinear motifs were executed in champlevé.

With the Roman conquest the manufacture of glass was introduced into Gaul and the Rhineland by Syrian masters (see GLASS). They brought with them millefiori pieces, which they used as an element within blown or molded vessels, but local enamelers adapted millefiori and used it on objects made for Roman legionnaires. Brooches, belt buckles, and trappings for horses, decorated with minute flowers and checkered patterns, have been found all over the Roman empire, the greatest quantity at camps of the border areas and near Hadrian's Wall in Britain. Small pyxides, possibly unguent jars, most embellished with blue and white enamel that apparently came from one workshop, were dispersed as widely. One of these was found in northern France and another in the Crimea in a tomb near Kerch (both now at Saint-Germain-en-Laye, Mus. des Antiquités Nationales), while another, now in Cologne in the Römisch-Germanisches Museum, was discovered on the Rhine. A bucket with a similar decoration was found in an Italian tomb (Brescia, Mus. Romano), and a large mount was found at Geinscheim, now in Speyer.

Remains of an enamel workshop have been discovered in a Roman villa, now called Anthée, near Dinant, Belgium. A portion of the objects with millefiori enamel found in areas as far apart as northern England, southern Russia, Syria, and North Africa were probably made there. There must have been other workshops specializing in this kind of decoration, but the principal center was near Dinant and Namur. Comparatively poor tombs in the area have yielded exceptional quantities of millefiori brooches. This type of decoration may have existed as early as the 1st century but is probably no older than the 2d or the beginning of the 3d century. The villa was destroyed during a Frankish raid about the middle of the 3d century, and production ceased. The Anthée factory also produced brooches of champlevé enamel that competed with the products of centers established in various parts of the empire — in Britain, in the Rhine Valley, and perhaps also in the Near East. Besides large quantities of small objects, such as brooches and mounts, these centers also produced a number of larger pieces, of which the entire surfaces are enameled. Some of these — a vase found at Benevento, Italy (London, Br. Mus.); an incomplete vessel, acquired by the Metropolitan Museum, New York, in 1947; an altar plaque found in the Thames, a bucket from Bartlow Hills, Essex, England, and a cup from Braughing, Herts, England (all three now Br. Mus.); and the Linlithgow patera (Edinburgh, Nat. Mus. of Antiq-

uities of Scotland) — were made either in Gaul or in England. Their bright multicolored decoration includes bands of vine patterns that are extremely close to those on red sigillate ware of the same time. Two 2d-century cups inscribed with the names of forts along Hadrian's Wall, which was built in the 2d century, probably were made in Britain. One was found in southern England at Rudge, the other in France at Amiens. Other vessels were made on the Continent, possibly in the Dinant region of southern Belgium. Among them are cups found at La Plante (Namur, Belgium, Mus. de la Société Archéologique), Canterbury (Canterbury, Royal Mus.), Bad Pyrmont (Westphalia, property of Stadtverwaltung), and Rochefort, in Jura, France (New York, Met. Mus.). These are decorated with pentagonal panels typical of the compartmentalized style of the 2d century. Orientalizing vases, composed of bronze sections and decorated with monotonous trumpet patterns or with small spirals, are also known. One of these, from La Guierche, near Limoges, France (New York, Met. Mus.) contained 3d-century coins when found. A flask from Pinguente, Istria, Yugoslavia (Vienna, State Coll.), was found with Roman objects, the latest of which seem to be from about the middle of the 3d century. The Ambleteuse Vessel (London, Br. Mus.) from the department of Pas-de-Calais in France was found with coins of the second half of the 2d century. Two small disks in the Vatican Museum with millefiori decoration are somewhat different from the types discussed and stylistically analogous to works of the 4th century. They may be evidence that these objects were produced until the barbarian invasions.

<div align="right">Françoise HENRY</div>

PRE-ISLAMIC IRAN. Traditions of jewelry and metalwork in Iran reach back to earliest times, but examples of enamels that can with certainty be dated are not found until the Sassanian period (A.D. 224–642). Nevertheless, some scholars hold that cloisonné may be of Persian rather than Byzantine origin.

In addition to the true cloisonné technique, there also existed in Iran the less common filigree process, in which wire replaced the flat metal strips. In another method the hot vitreous enamel was poured onto a gluelike layer attached to the surface to be decorated, and the object was not fired.

Achaemenian metalwork of considerable value is known from finds in a tomb at Susa, Iran; from the Oxus Treasure (Dalton, 1926), now in the British Museum; and from the Hamadan work. (The Achaemenian kings were supreme in Asia until the overthrow of Darius III in 330 B.C. by Alexander the Great.) The armlets from the Oxus Treasure are particularly fine. Terminal figures of these pieces, griffins or lions, have indentations into which stones were probably set, though enamel may have been used. Once the fill is lost, it is difficult to tell which material was employed. Two gold bracelets from Kul Oba, Crimea, now in The Hermitage, Leningrad, are decorated with blue enamel applied in the filigree technique. They are so similar to Persian jewelry that an Iranian origin seems likely.

Sassanian enamels are more numerous than Iranian ones, and more is known about them (see SASSANIAN ART). The full development of the cloisonné technique in this period, even in the peripheral regions, is attested by objects of identical workmanship but different provenances. The first of this group is a clasp found at Risano (Risinium) in Dalmatia, now in the Ashmolean Museum, Oxford, England. On one side is a rosette composed of four hearts alternating with four pointed leaves and on the other a lion or dog. Both are executed in a superior cloisonné enamel. The rosette is a variant of a motif found in the late Sassanian ruins at Taq-i-Bustan, and motifs essentially the same appear on the so-called "Cup of Khosrau" (Paris, Cabinet des Médailles; III, PL. 490). Other variations of the motif appear on an enameled clasp in Berlin (Staat. Mus.), similar to the one from Risano, though the rosette has been transformed into a four-lobed roundel. Also similar are two medallions in the British Museum, the lobes of which are modified into pointed sections. They nevertheless retain the fundamental characteristics of Sassanian ornament.

Enamel medallions decorating the ewer of Saint-Maurice

d'Agaune, Switzerland, have motifs related to reliefs on various Iranian monuments, though some few scholars still consider them Byzantine.

Other Sassanian cloisonné objects include a clasp with a griffin motif, formerly in the Campana Collection, now in the Louvre, and a pendant in the De Boisgelin Collection with a bird holding a branch in its beak. These motifs are known from Sassanian silks. These pieces can all be dated before the 7th century because of their close affinities with decorative motifs on dated monuments. Moreover, a close inspection of the figures in the reliefs at Taq-i-Bustan shows that they wear similar jewelry. An attendant in one of the king's boats has a collar made up of squares decorated with the same type of quatrefoil as that on the enameled clasp, and one of the harp players has a neck chain made up of links with rosettes like the one on the medallion in The Hermitage, Leningrad. In both of these stone reliefs the ornaments are hollowed out in a way which suggests the cloisonné technique.

Two other pieces of jewelry that depend on the same models, clearly Persian in design though found in southern Russia, may date from this period. One was found at Azzuklava (Taman Peninsula in Russia) and is now in The Hermitage. The other was discovered at Samsun, Turkey, and is now in the Louvre. Both have a rosette made up of four hearts alternating with leaves and are identical with one of the rosettes at Taq-i-Bustan. Related to all these pieces is a box-shaped clasp in Wiesbaden, Germany. It has an inscription in the Pahlavi language, giving the name "Ardashir" in epigraphic characters. These are applied in "cold" enamel inlay. The fine workmanship is reminiscent of the "Cup of Khosrau."

Bianca Maria ALFIERI

BYZANTINE ENAMELS. In Byzantium polished cloisonné enamel achieved a leading role in art for the first time. As mentioned above, the technique may have been introduced from Iran. The metal base was usually gold but sometimes silver and copper. Comparatively small enameled plaques were applied to liturgical utensils — crosses, reliquaries, chalices — and to imperial emblems used in court ceremonies. This is mentioned in the writings of Constantine Porphyrogenitus (913–59). Enamel was also used on objects of personal adornment. On large objects, such as the Pala d'Oro in St. Mark's in Venice, many enamels were sometimes used to illustrate a single, over-all iconographic scheme (PL. 405).

Byzantine enamels are first recorded in the 6th century. There are contemporaneous accounts of Justinian's golden altar in Hagia Sophia in Constantinople, on which some enamels appeared. One of the oldest pieces is the central part of a reliquary in the form of a triptych in the convent of the Sainte-Croix at Poitiers. Believed to have been a present sent by Justin II to St. Radegund, it is dated on external evidence between 565 and 575. The most important Byzantine enamel production occurred from the 10th through the beginning of the 13th century. The enamels of this period most frequently depict a single figure, often a saint, though enamels showing groups also are known. They were exported in great numbers, and can be found in collections all over the world. Important examples of this style are the enamels on the reliquary for the wood of the True Cross in the Cathedral of Limburg an der Lahn and those on a crown in the National Museum at Budapest. The enamels on the crown depict the figures of the emperor Constantine Monomachus, who reigned 1042–54, other royal personages, dancers, and personifications of virtues. A more complete discussion of individual works and their relation to Byzantine art in general is found elsewhere (see BYZANTINE ART; II, PLS. 482, 485, 486; and O. M. Dalton, *Byzantine Art and Archaeology*, Oxford, 1911, pp. 494–533).

Byzantine enamels had a considerable influence beyond the confines of the Byzantine empire, not only on the enamels of other regions but also on the other minor arts. They were consistently used as models in southern Russia and southern Italy, particularly Palermo, and sporadically employed for this purpose in Rhenish, English, and Spanish centers, and perhaps in France as well. In the Greek Orthodox countries of eastern Europe the Byzantine tradition of cloisonné enameling did not die out after the fall of Constantinople in 1453, though it declined to mass production of inexpensive devotional objects.

MEDIEVAL EUROPE. The art of enameling was continued in Gaul during the Merovingian period. Brooches and belt buckles were decorated in champlevé enamel, which was usually red in color. The best examples are a group of 7th-century belt buckles, most of which were made in the region of Toulouse, and brooches from the Rhineland.

In the Carolingian and Ottonian empires enamel was not so important as ivory carving and work in precious metals. Small champlevé plaques with decorative patterns, however, were used as subsidiary elements in sumptuous works of precious metals (PL. 395). These works were also enriched by ivories and semiprecious stones in ornate raised settings. The lower cover of the Lindau Gospels (New York, Pierpont Morgan Lib., M. 1; I, PL. 287), for example, has framing plaques with floral designs and medallions with interlaces between the arms of the cross. Similarly, on the portable altar of Adelhausen (Freiburg, Germany, Augustinerkloster) enamel crosses made up of interlace patterns are set into silver fields. Stylistically the enamels used in this way reflect the ornamental elements in manuscripts of the time (see CAROLINGIAN PERIOD; OTTONIAN PERIOD). That enamel was also used for jewelry is evidenced in pieces such as brooches of the Kettlach group, which takes its name from the town in Austria in which they were found.

*       *

Belt buckles from this period with enamel insets have been found throughout Gaul. These have thin silver strips forming C's and S's and zigzags as part of the design. A theory that they are of Visigothic origin is no longer tenable.

There are few enameled objects from England after the Anglo-Saxon invasions, and for the most part these have only a thin layer of enamel (I, PL. 288). In Scotland, however, the art continued to flourish. It was even more vital in Ireland, where, toward the end of the Roman empire, in addition to the red champlevé enamel made since the La Tène period, the millefiori technique was introduced. Remnants of millefiori sticks have been found in two workshops, one at Garranes, dating from the 5th or 6th century, the other at Lagore, from the 7th or 8th. Numerous objects of the 6th or 7th century — pins, brooches, and cups — are decorated with curvilinear champlevé motifs. At times millefiori appears on pieces that also have red enamel decoration. During the 8th century the designs became more angular and the raised metal portions thinner, imitating the glass or garnet insets in Saxon jewelry. At times panels with red and yellow interlaces appear on the same piece with millefiori panels, most of which are blue and white. Many objects with this type of decoration have been found in Norway, brought there as booty by the Vikings, and in Sweden, where they may have come through trade. Outstanding among these are the belt buckle found at Moylough in western Ireland (PL. 407) and a terminal of a staff or crosier from Ekerö, near Stockholm. The Ardagh Chalice (I, PL. 285) and the Tara brooch (both now in Dublin, Nat. Mus.) are decorated with blue and red enamel. The old Celtic practice of enameling the perforations in openwork bosses continued, but instead of clay, the reinforcement consisted of a nugget of glass fused to the enamel.

Some Swedish bronze objects of this period have enamel ornament. They are particularly well exemplified by the mounts or horse trappings with red and yellow enamel, from Vendel.

Françoise HENRY

Enamel workshops existed in Milan during the Carolingian period and continued into the Ottonian. Instead of the champlevé enamels common in Europe during these centuries, they produced cloisonné enamels on gold, probably as a result of

Byzantine influence. This style also spread north of the Alps, and workshops producing such pieces were located in the Rhineland and Lorraine. Under Archbishop Egbert (977–93), Trier (Treves), Germany, rose to a leading position. One of the most important collections of these pieces, containing a cross of the abbess Matilda, made between 998 and 1002, is in the treasury of the Cathedral of Essen.

Medieval enamels saw their greatest efflorescence in the 12th and 13th centuries. The Mosan school, which flourished in the diocese of Liège, and the Rhenish workshops, centering around Cologne, produced a large number of outstanding masterpieces, especially during the second half of the 12th century. That enamels from these two areas have much in common is not surprising; craftsmen of the period traveled extensively from place to place, fulfilling commissions for various patrons. Portable altars, large casket reliquaries, and other religious objects were sometimes completely encased in enamel plaques. Enamels were also used lavishly in combination with metal, as on comparatively large repoussé figures in gold or silver or in delicate ornamental work (PL. 211). These pieces were of considerable importance to subsequent stylistic developments, the Mosan enamels serving as prototypes for workshops located in England and northern France. The Rhenish examples exercised their greatest influence in Westphalia and Lower Saxony.

Some of the finest pieces were made for the monastery of Stavelot, not far from Liège. Among them are the portable altar now in Brussels (Mus. Royaux; PL. 409) and the reliquary triptych in the Pierpont Morgan Library in New York. The latter features scenes from the conversion of Constantine, generally attributed to Godefroid de Claire. In a period in which artistic production almost invariably remained anonymous it is exceptional that the names of two of the school's greatest artists have been transmitted to us. The other is Nicholas of Verdun (q.v.), who is best known for his altar at Klosterneuburg, near Vienna. In two leading works in Cologne, the shrine of the Magi in the Cathedral treasury and the shrine of St. Heribert in the Church of St. Heribert, enamel and repoussé complement each other to produce a rich and colorful effect that is still severely religious. The style of the individual plaque is based on the contrast between the predominantly blue and green enamel and the gold or gilt metal into which part of the design was engraved. Out of this manner developed, during the first half of the 14th century, the Gothic copper-gilt champlevé, most frequently employed in small plaques attached to caskets, crosses, and similar objects. The plaques depict figures engraved on the metal and set against a blue enamel background.

Another school, the center of which was at Limoges in southwest France, developed during the first half of the 12th century a related style, which continued into the 14th century. The workshops of this school, initially monastic, were replaced by lay enterprises of an industrial character. These depended on a comparatively large-scale production of liturgical utensils, which were exported to all parts of Europe. The quality of production was very uneven. In addition to candelabra, reliquaries, crosses, and other church furnishings, a unique product of Limoges was large tomb slabs made of copper and enameled almost in their entirety. Most have been destroyed, but the tomb of Geoffrey Plantagenet from Saint-Julien du Mans (Le Mans, Mus. B.A.), which may be dated about 1151–60, remains (PL. 398).

* *

During the Gothic period greater concern with technical skills and decorative values led craftsmen to devise several new methods of enameling. A new development in cloisonné, translucent enamel (sometimes called *émail de plique*), became popular in Parisian court workshops about 1300. The pieces, used for secular as well as for cult objects, tended to be small and were easily carried all over Europe. One of the most outstanding examples, the medallion representing the Crucifixion in the Cabinet des Médailles, Paris, shows a stylistic dependence on contemporary manuscripts.

The *basse-taille* technique, in which the design appears in low relief on a metal plaque completely covered by translucent enamel, became important during the 14th century. Silver was used frequently because it gave a brighter reflection than other metals, so that the raised parts showed strong highlights and the deeper areas, where the enamel was thicker, were darker in color. The production of reliquaries, chalices, and other religious utensils continued, but the importance of secular works grew steadily. One of the earliest and most outstanding examples of *basse-taille* enamel is the chalice of Sigmaringen (ca. 1320) in the Walters Art Gallery, Baltimore (PL. 411).

The *plique-à-jour* technique was practiced from the 14th through the 16th century. The cloisons, or partitions forming the design were soldered to one another but attached to the metal base with wax or some other material that could be removed after the firing. This substance also covered the whole metal plaque. The enamel did not adhere to it, and it served only as a temporary base. Benvenuto Cellini described a similar practice (*Trattati dell'oreficeria e della scultura*, Florence, 1568) in which the decorative design was cut out of a sheet of metal and the openings filled with translucent enamel, so that the work resembles a miniature stained-glass window. Pieces of this type are very delicate, and few have survived.

Erich STEINGRÄBER

LATE GOTHIC, RENAISSANCE, AND MODERN ENAMELS. Among Italian translucent enamels are the early-15th-century chalice and paten now in the treasury of the Cathedral of Sulmona, central Italy, by Ciccarello di Francesco; the reliquary of the True Cross in the Church of S. Maria Assunta in Cividale, near Trieste, by a Friulian goldsmith; the chalice of the second quarter of the 15th century in the Museo Nazionale in Florence by Goro di ser Neroccio, a Sienese; the miter in the Cathedral of Fiesole, which is a Florentine work of about 1460; the cross in the Cathedral of Aquila, central Italy, dated 1434, by Nicolò di Guardiagrele; and the reliquary of the True Cross in the Old Cathedral in Brescia, north Italy, begun by Bernardino Bresciano, who worked on it in 1474–87, and completed in 1533 by Giovanni Mandelli.

Enamel used as partial decoration of pieces in the full round — as distinct from complete encrustation — resembles the *basse-taille* technique. It was favored by goldsmiths of the 16th and 17th centuries as well as later.

In the 15th century Burgundy produced exquisite metal objects with translucent enamel decoration, such as the beaker of the Holy Roman Emperor Frederick III. Another good example of this type of work is the beaker of Matthias Corvinus, made in Hungary in 1462. The manner culminated in the saltcellar (Vienna, Kunsthist. Mus.) begun by Cellini in 1534 for Ippolito d'Este and finished about 1543 in Paris for Francis I (PL. 414).

The Saracchi, who worked in Milan for the Austrian court, were important during the second half of the 16th century. In the 17th century the greatest activity was in Germany, led by Christoph Jamnitzer, Friedrich Hildebrandt, and Christoph Lencker, who were surrounded by a host of south German and Bohemian artisans. They used translucent enamel on highly reflective metals. Their works are ostentatious in their color effects, which were achieved either by playing on contrasts or through use of an amazing range of a single hue. During the 17th century three generations of an Italian family, the Miseroni, worked in Prague; their *œuvre* culminated in a vessel decorated with garlands of green enamel that Dionisio Miseroni made in 1642 out of a 2,680-carat emerald. The influence of the Miseroni style spread from Prague to Nürnberg, where Bartholomeus Pfister (1650–95) worked, and to the royal Bohemian workshops. As the works became increasingly extravagant, all sense of unity was lost.

A revolutionary change occurred in the art with the development of "painted" enamel. In this technique a piece of copper is given a layer of enamel on both front and back, so that in firing both sides expand and contract to the same degree. On the surface it is possible to paint a picture in enamel without

the aid of wires or cavities to hold the fluid substance. The method seems to have originated in Flanders about the middle of the 15th century. Its spread was rapid. One of the first to be impressed by it was perhaps the French painter Jean Fouquet, believed to be the author of two small medallions, one in the Louvre, the other in Berlin.

The painted enamels produced in Lombardy and the Veneto, and to a lesser extent in Tuscany, from the middle of the century onward are characterized by strong colors, which sparkle like translucent enamel. Fine examples of beakers, plates, and bowls are in Florence, Museo Nazionale; Venice, Museo Correr; and Turin, Museo Civico. Later, north Italian enamels had a tendency to imitate French works.

Limoges in France, however, became the true home of painted enamels after the third quarter of the 15th century. At first religious themes, painted in strong colors, predominated, but gradually these were replaced by secular subjects in grisaille. In its imitation of the style and technique of actual painting, enamel carried the seeds of its own destruction. Beginning in the 16th century copies were made of famous altarpieces, portraits, and prints, while designs made expressly for the medium were rare. The whole production of Limoges should not be condemned for this reason, however. The second half of the 15th century was still rich in original works, among them the "Monvaerni" group and the works attributed to the Master of the Orléans Triptych, as well as various anonymous pieces in a more popular manner. ("Monvaerni" is believed to have been an individual who most probably headed a workshop. The group is characterized by pieces with white backgrounds.) One of the leading artists at Limoges was Nardon Pénicaud, who was active in the first quarter of the 16th century. He was succeeded by his descendants and followers, especially Jean I Pénicaud (active 1510–40), and by other families, particularly the Limosins (PLS. 414, 415, 416). Léonard I Limosin (ca. 1505–77), who was influenced by Italian mannerism, was the most outstanding of this family. Grisaille came into fashion, and Limosin's followers worked in an increasingly loose and fluent manner — most apparent in the landscape elements — that helped to weaken the tradition of enamel decoration. Jean III Pénicaud was an expert in this manner, but it became lifeless in the hands of most other artists. Even the talented Pierre Reymond produced elegant works devoid of deeper values (PL. 417). Finally, Limoges was reduced to turning out pretty little boxes for snuff and pills, umbrella handles, and other delightful and useless paraphernalia of the 18th century. In this work enamels can be distinguished from painting on porcelain or ivory only by the differences in the base material used.

The 17th century also saw an efflorescence of enamel in Switzerland, with its main center at Geneva. Many French artisans had found political and religious refuge there by the beginning of the century. One of them, Jean I Toutin (1578–1644), is known for his process of grinding the enamel so fine that it could be dissolved in oil and then applied with the brush with the ease and subtlety of oil paint. None of Toutin's own works are known, only those of his followers. If they seem more capable of innovation and more sensitive to the baroque and rococo styles than those of the Limoges artists, they are also further removed from the essence of the medium. The portraits of Jean Petitot the Younger, who lived in the second half of the 17th century, are mere reproductions. There are 250 of these at Windsor Castle alone. Nevertheless, the manner spread throughout Europe, especially for ornamentation.

In the 19th and early 20th centuries enamelwork was limited to jewelry and decorative objects of little importance. In recent decades, however, there has been a revival. Enamel is employed for religious art and has turned to contemporary styles instead of imitating the past. The monks of St. Martin de Liguge, who are leaders in the new production of enamels, have turned to the most vital painting of our day and have used designs by Marcel Feuillat and Georges Rouault (PL. 420). Other artists are becoming increasingly interested, and the revival is spreading.

Luigi MALLÉ

ISLAMIC ENAMELS. Despite the example of the Byzantine, Sassanian, and ancient Greek traditions, enamels never became an integral part of the Islamic artistic heritage. Silver, copper, and gold inlay on bronze did, however, become important. There are a few pieces, some small gold objects of the Fatimid dynasty (10th to 12th cent.) and the famous and unique copper bowl in Innsbruck (Tiroler Landesmus.; PL. 408). The latter is decorated with cloisonné both inside and out, partly in the form of medallions. Figures of Alexander the Great, dancers, musicians, and others, as well as birds, animals, palmettes, and various decorative motifs, appear. An inscription states that the bowl was made for Daud ibn-Suqmān, a Seljuk ruler in Mesopotamia from 1108 to 1144. Many of the motifs are based on Byzantine prototypes, and possibly the bowl comes from a workshop that was only temporarily active in Mesopotamia. Moresque swords of the 14th and 15th century made use of cloisonné, for example, on the handles and mounts of some examples in Kassel, Germany, and in Paris. This type of work seems to have achieved some importance in Granada, Spain. Still later, from the 16th century, it enjoyed widespread use on the handles and sheaths of Persian and Turkish daggers. From some of these it can be concluded that translucent enamel was also known in the Near East.

Ernst KÜHNEL

INDIA. Enamel is found only in the northwest part of India. As enamelwork and related inlay techniques had been known both in the ancient Near East and in Central Asia, acquaintance with enamel might be expected in the area of Gandhara (q.v.) art under Achaemenian, Greco-Bactrian, Parthian, and Kushan rule. So far only one isolated example has been discovered, however: a pendant (2 $\frac{7}{8}$ in. diam.) of the early 5th century of our era, found at Sirkap (Taxila), now in the Cleveland Museum of Art. The obverse shows a Tyche (goddess of fortune) in late Roman costume holding a lotus and a bunch of lotuses of the classic Gupta type, rather than a cornucopia, in her hands. Its design features an embossed gold sheet, enclosed by two ornamented circles, with a top piece of flowers of red cloisonné enamel (resembling jewelry of the Migration period). On the reverse a 12-petaled lotus has been engraved. Otherwise enamel was used mainly for the eyes of bronze Buddha images (Gandhara style). On the other hand, bangles and beads of colored glass or silicate fragments and pastes became common all over India.

The present varieties of Indian enamel go back to two centers, Jaipur and Persia. Jaipur enamel (minākarī, in the champlevé technique) is claimed to have been imported from Lahore by Sikh craftsmen summoned by Maharaja Man Singh of Amber (late 16th cent.). The Jaipur palace collection has a staff belonging to Man Singh that is 52 in. long and covered with 33 gold cylinders decorated with animals, landscapes, and flowers. The staff ends in a jade crosspiece with jewels. But the Sikh sect had not yet fully emerged in the 16th century, and the technique and designs of the staff are later. It seems more probable that Jaipur enamel was first introduced at the Moghul court (see MOGHUL SCHOOL) under Shah Jahan (1628–58) by Italian goldsmiths. The technique of Jaipur enamel is reminiscent of old Florentine work, and almost all the designs are characteristic of classic Moghul art under Shah Jahan. The Salar-Jang Museum at Hyderabad in the Deccan possesses a beautiful dagger of Shah Jahan; and the rajas of Chamba had a collection of enameled festival daggers presented by him. The collection was destroyed by fire in 1937. Toward the end of the 17th or in the early 18th century, when the Moghul court went bankrupt and the Sikhs were persecuted by the emperor Aurangzeb, enamelwork may have been brought to Jaipur by the five Sikh families who are still its hereditary representatives. Thereafter a certain number of Rajput motifs penetrated into the otherwise carefully preserved Moghul tradition (see RAJPUT SCHOOL).

In the late 18th and early 19th centuries the Jaipur technique spread to other princely courts and then to various commercial centers: Alwar, Jodhpur, Udaipur, Partabgarh, Jhalawar, Delhi,

Lucknow, Rampur, Benares, Bahawalpur, Multan, Hyderabad in Sind, Karachi, and the former Rajput states of the western Himalaya. With this expansion, techniques and designs became differentiated, and a certain specialization of production developed. Among the best pieces dating from the 18th century are a sword presented by Nawab Shujā'-ud-daula of Oudh to Maharaja Balwant Singh, and the sword of Haidar Ali, sultan of Mysore.

Enamel originally was a luxury industry, though later cheaper decorative objects were produced also. Enameled items included sword and dagger hilts and sheaths; ceremonial staffs and fans (*mōrchāls* and chowries); jewelry (armlets, anklets, bangles, necklaces, scent lockets, charms, and backs of gems); cups, plates, hookah bowls, and large vases; and horse, elephant, and camel trappings. The ground was chased or engraved into the gold or silver base. Later brass and copper were used. At Multan it was blocked out by means of dies, and in Kashmir by repoussé. The best Moghul and Jaipur enamel compares favorably with the best Chinese cloisonné, but later work was often crude. Bahawalpur work, characterized by large patterns and surfaces, made much use of deep blue and green; Lucknow, Rampur, and Multan work was finely etched but employed petty designs; Himalayan work utilized crude blue and yellow designs; and Benares and Partabgarh work specialized in jewel imitations. At present there is a complete degeneration in forms, designs, and colors of enamel, which is mainly applied to cigarette boxes, ashtrays, and similar objects. The technique has been kept alive by the schools of art, but export to foreign countries has not proved a sufficient substitute for the loss of the former princely customers.

The second type of Indian enamel, true painting with silicated paints, was introduced from the Persia of Fath Ali in the early 19th century via Afghanistan to Kashmir (then an Afghan province) and via Sind (then also an Afghan dependency) to Cutch, the Hindu state between Sind and Kathiawar in Gujarat. The pictures and floral designs there are the same as in Persia, though often degenerated or slightly Indianized. The prevailing color scheme, with light pink predominating, indicates that China may have been the country of origin of this technique.

Hermann GOETZ

THE FAR EAST. The Chinese name for cloisonné enamel is *ta-shih-yao* ("Arabian ware") or *fa-lan*, according to some derived from the term for Byzantium. Both point to a foreign origin of the technique. Cloisonné may have been introduced as early as the T'ang period (618–906), since many Western shapes, patterns, and techniques were carried into Chinese art at that time. Although stone and glass insets in bronze, gold, and silver were common before the Christian era, we do not known of any cloisonné pieces dated before the 14th century. The technique, therefore, may have been introduced into China during the Yüan dynasty (1260–1368), when contact with the West was once again very close. Stephen Bushell (1919) refers to a piece with the mark of Chih-chêng (1341–67) of this dynasty, but no such piece is known today. The first dated cloisonnés have the mark of Hsüan-tê (1426–35). It is found on small dishes and cup stands that have the same shape and decoration as the porcelain of his time. The enamels have a few simple colors: dark turquoise, used as the ground; dark green, sometimes almost black; cobalt blue; red; yellow; and white. The decoration consists of floral patterns of lotus, pomegranates, peonies, and scrolls typical of the period. The technical quality is not high; there are holes and bubbles in the enamel. The cloisons are of gilt copper.

The most common reign mark on Ming cloisonné is that of Ching-t'ai (1450–57), whose rule was so well known for this product that the mark was often imitated on vessels of later periods. In fact, during the 18th century, cloisonné enamels were also called "Ching-t'ai-lan." Several types of vessels are known from this short period and from the whole second half of the 15th century: tripod-shaped bronze incense burners, basins, circular boxes, bottle-shaped vases, and jars. The colors were the same as during the reign of Hsüan-tê, and the patterns

mostly floral, with the lotus dominating. There is, moreover, an obvious connection between the cloisonné and the enamel decoration on ceramics of the time.

Another cloisonné group dates from the end of the 15th to the late 16th century. In these pieces the colors are more varied and sometimes also mixed; red with white and green with yellow are common mixtures. Some of these enamels are marked Ching-t'ai, others have a Chia-ch'ing mark, but as often as not the marks are no indication of the actual date. The shapes and patterns resemble those used for porcelain, lacquer, and other applied arts. Large dishes, incense burners, ewers, and boxes are decorated with dragons, phoenixes, mandarin ducks, *ch'i-lin* (fabulous beasts), and flowers.

At the end of the Ming dynasty and the beginning of the Ch'ing (1644–1912) the colors were of the same type as before, but the mixed colors were more finely divided and the quality higher. Cloisonné was used on all kinds of objects, practical as well as decorative. Figure patterns became more common.

The cloisonné work of the reign of K'ang-hsi (1662–1722) continued the Ming tradition, but the technical quality was much higher than in the earlier periods. To the Ming colors were added light hues of grayish white, yellow, and yellowish green, and the designs became more crowded. The emperor himself established factories for many kinds of art objects, the sixth on the official list being enamels. Well-known pieces from this period are sets of incense vessels for the Buddhist temples around Peking, the shapes of which were borrowed from old sacrificial bronzes. More intricate patterns and lighter colors characterizd the Yung-chêng and Ch'ien-lung periods (1723–95). A perfection of technique had been acquired that resulted in a smooth and evenly polished surface. The bronze accessories were very often heavy gilt.

The cloisonné enamels from the 18th and 19th centuries are mostly imitations of the older types, but a very active industry exists at Peking and Tientsin to this day. In the beginning of the 20th century a black ground was introduced as contrast to gilt cloisons and bright colors. Many old patterns have been taken from other art fields, and colors are varied.

Champlevé enamels were also produced during the late Ming and Ch'ing periods, especially for Buddhist bronze sculptures and incense vessels in the shape of mythical animals. Champlevé by itself, however, does not seem to have played an important role, but was used more often with other techniques.

Painted enamel on copper, also produced in China, was called *yang-tz'u*, literally "foreign porcelain." Thus, its name indicates its foreign sources. Limoges enamels were brought to China by French missionaries during the reign of K'ang-hsi and were copied at Peking and Canton for the European market. The first dated works with purely Chinese designs are from Yung-chêng's reign (1723–35) and contemporary with *famille rose* porcelain. The same artists painted on both copper and porcelain, and a few works are signed. Among pieces of the finest quality are dishes, teapots, and similar vessels with landscapes in blue enamel on a white ground. Canton seems to have been the center for this industry, but in later periods painted enamels were also produced at other places. The Chinese themselves, however, accepted this kind of enamel only as foreign, and most of it was made for export. There are many examples of enameled plaques mounted on European furniture, a large portion of these being decorated with European subjects. Nevertheless, there are items of first quality in purely Chinese taste, probably made for the court.

In Japan the cloisonné enamel technique can be traced back much earlier than in China. The first known example, of a primitive type, is a small bronze plaque with a rosette pattern in cloisonné, excavated from a burial of the Tomb period (ca. 3d–6th cent. of our era). In this piece, as in some Korean jewelry of the Silla period, the vitreous material was dropped into the cloisons. A silver mirror in cloisonné, belonging to the imperial treasure house (Shōsōin) at Nara, dates from the Nara period (8th cent.). It was long attributed to the T'ang period and called a Chinese work but is now more convincingly described as Japanese. The technique is a more primitive one than that of the later Chinese examples. The

translucent glass forms a thin layer on a chased gold base in the form of a rosette. The pattern is formed by individual gold sheets fixed to the silver base by means of lacquer. The cloisons are made in the usual way, by turning the edges of the sheets up and by soldering gold strips to them.

There is no true link between these early pieces and the true cloisonné, or *shippo*, as it is called in Japan, which was introduced from China by Hirata Donin (d. 1646). Having learned the Chinese technique in Korea, he worked for the Tokugawa shogun Iyeyasu in Kyoto. His products were for the most part small ornaments on iron, copper, or silver with gold cloisons, used mainly on sword furniture. Both translucent and opaque enamel was used, and the surface was either polished or unpolished. The colors were few at first, mainly green and white, but were gradually increased by the addition of brown, red, yellow, blue, purple, and lilac; colorless enamel was also used. The finest works of the Hirata school, which continued for centuries, utilize translucent enamels.

Only in the 19th century did a further development occur in cloisonné enamel which came into use for various kinds of vessels. Kaji Tsunikichi started an important workshop at Nagoya in 1838, the products of which were very successful among foreigners until 1853. He passed his trade secrets on to Yoshimura Taiji. At the end of the century Nomikawa Yasuyuki of Kyoto was a great artist in the field. J. Ando of Nagoya worked with translucent enamels on silver. All these artists introduced a new style that permitted naturalistically represented subjects to be used on vases, bowls, dishes, and other vessels. Most common were flowers and birds reproduced in realistic colors with a skill more reminiscent of painting in water colors than of metalwork. This type of Japanese enamelwork was intended chiefly for export.

Bo GYLLENSVÄRD

BIBLIOG. *General*: J. Labarte, Recherches sur la peinture en émail dans l'antiquité et au moyen-âge, Paris, 1864; E. Garnier, Histoire de la verrerie et de l'émaillerie, Tours, 1886; E. Molinier, L'émaillerie, Paris, 1891; M. Rosenberg, Geschichte der Goldschmiedekunst auf technischer Grundlage, 6 vols., Frankfort, 1909–22; L. F. Day, Enameling, London, 1927; H. Bossert, ed., Geschichte des Kunstgewerbes aller Zeiten und Völker, 6 vols., Berlin, 1928–35; E. McClelland, Enamel Bibliography and Abstracts, 1928–1939, Columbus, Ohio, 1944; C. Hasenohr, Email, Dresden, 1955. H. Maryon, Metalwork and Enameling, A Practical Treatise on Gold- and Silversmith's Work and Their Allied Crafts, 3d ed., New York, 1955. *The ancient world*: R. Virchow, Das Gräberfeld von Koban, Berlin, 1883; J. de Morgan, Mission scientifique au Caucase, Paris, 1889; S. Reinach, N. Kondakov, and I. Tolstoy, Antiquités de la Russie méridionale, Paris, 1891; J. Pilloy, L'émailleries aux II° et III° siècles, B. Archéologique, 1895, pp. 231–34; F. H. Marshall, Catalogue of the Jewellery, Greek, Etruscan and Roman, in the Department of Antiquities, British Museum, London, 1911; E. H. Minns, Scythians and Greeks, Cambridge, England, 1913; N. Rostovtzeff, Iranians and Greeks in South Russia, Oxford, 1922; F. Henry, Emailleurs d'Occident, Préhistoire, II, fasc. I, 1933, pp. 65–146; K. Exner, Zwei Römische Emailgefässe aus dem freien Germanien, Marburger Studien, Darmstadt, 1938; K. Exner, Die provinzialrömischen Emailfibeln der Rheinlande, Bericht der römischgermanischen Kommission, 1939, Berlin, 1941, pp. 31–121; P. Jacobsthal, Early Celtic Art, Oxford, 1944; W. H. Forsyth, Provincial Roman Enamels Recently Acquired by the Metropolitan Museum of Art, AB, XXXII, 1950, pp. 296–307; B. Hronda, Die bemalte Keramik des zweiten Jahrtausends in Nordmesopotamien und Nordsyrien, Berlin, 1957. *Iran*: I. Smirnov, Vostochnoye serebro (Oriental Silver), St. Petersburg, 1909; O. M. Dalton, The Treasure of the Oxus, 2d ed., London, 1926; E. Margulies, Cloisonné Enamel, SPA, I, pp. 779–83; T. Rice, Achaemenid Jewelry, SPA, I, pp. 377–82; P. Ackerman, Sassanian Jewelry, SPA, I, pp. 771–78; A. Parrot, Acquisitions et inédits du Musée du Louvre, 9: Orfèvrerie et bijouterie iranienne, Syria, XXXV, 1958, p. 175 ff. *Medieval and postmedieval*: E. Viollet-le-Duc, Dictionnaire raisonné du mobilier français de l'époque carlovingienne à la renaissance, II, Paris, 1871; J. Labarte, Histoire des arts industriels au moyen-âge et à l'époque de la renaissance, Paris, 1875; E. Molinier, Dictionnaire des émailleurs depuis le moyenâge jusqu'à la fin du XVIII° siècle, Paris, 1885; E. Rupin, L'oeuvre de Limoges, Paris, 1890; O. von Falke and H. Frauberger, Deutsche Schmelzarbeiten des Mittelalters, Frankfurt, 1904; H. Cunynghame, European Enamels, London, 1906; J. Marquet de Vasselot, Les émaux limousins de la fin du XV° siècle et de la première partie du XVI° siècle, Paris, 1921; H. Clouzot, Dictionnaire des miniaturistes sur émail, Paris, 1925; J. Marquet de Vasselot, Bibliographie de l'orfèvrerie et émaillerie française, Paris, 1925; M. Chamot, English Mediaeval Enamels, London, 1930; V. Juaristi Sagarzazu, Esmaltes, Barcelona, 1933; A. Mihalik, L'origine dello smalto filogranato, Rome, Budapest, 1933 (also published in Corvina, XXI–XXIV, 1931–32); W. L. Hildburgh, Medieval Spanish Enamels, Oxford, 1936; F. Rossi, EI, XXXI, 1936, s.v. Smalto; M. C. Ross, Austrian Gothic Enamels and Metalwork, J. of the Walters Art Gall., I, 1938, pp. 71–83; F. Torralba Soriano, Esmaltes aragonesas, Zaragoza, 1938; F. de P. Léon, Los esmaltes de Uruapán, Mexico City, 1939; M. C. Ross, An Enameled Reliquary from Champagnat, in Medieval Studies in Memory of A. K. Porter, Cambridge, Mass., 1939, II, pp. 467–77; M. C. Ross, The Master of the Orléans Triptych, J. of the Walters Art Gall., IV, 1941, pp. 9–25; G. Arwidsson, Vendelstile, Email und Glas im 7–8 Jahrhundert, Uppsala, Stockholm, 1942; M. Gauthier, Emaux limousins champlevés des XII°, XIII° et XIV° siècles, Paris, 1950; S. Collon-Gevaert, Histoire des arts du métal en Belgique, Brussels, 1951; P. Thoby, Les croix limousines de la fin du XII° siècle au debut du XIV° siècle, Paris, 1953; K. Guth-Dreyfus, Translucides Email in der ersten Hälfte des 14 Jahrhunderts am Ober-, Mittel- und Niederrhein, Basel, 1954; F. Henry, Irish Enamels of the Dark Ages and Their Relation to the Cloisonné Techniques in Dark Age Britain, London, 1956; M. Postnikova-Loseva and N. G. Platonova, Russkoye khudozhestvennoye serebro XV–XIX vv. (Russian Art in Silver, 15th to 19th Centuries), Moscow, 1959; U. Middeldorf, On the Origins of "Email sur Ronde-Bosse," GBA, LV, 6, 1960, pp. 233–40. *India*: B. Baden-Powell, Handbook of the Manufactures and Arts in the Punjab, Lahore, 1872; S. Jacob and T. Hendley, Jeypore Enamels, London, 1886; T. Hendley, Ulwar and Its Art Treasures, London, 1888; T. Hendley, Memorials of the Jeypore Exhibition, 1883, London, 1893; G. Watt and P. Brown, Indian Art at Delhi, 1903, London, 1904; A. K. Coomaraswamy, Arts and Crafts of India and Ceylon, London, Edinburgh, 1913. *The Far East*: R. L. Hobson, On Chinese Cloisonné Enamel, BM, XXI, 1912, pp. 137 ff., 202 ff., 319 ff.; R. L. Hobson, A Note on Canton Enamels, BM, XXII, 1913, p. 165 ff.; S. Bushell, Chinese Art, II, London, 1919; P. Simmons, A Gift of Chinese Cloisonné Enamel, BMMA, XXIV, 1929, p. 222 ff.; W. L. Hildburgh, Chinese Painted Enamels with European Subjects, BM, LXXIX, 1941, p. 78 ff.; S. Jenyns, The Problem of Chinese Cloisonné Enamels, Transactions of the O. Ceramic Soc., 25, 1949–50, pp. 49–64; R. M. Chait, Some Comments on the Dating of Early Chinese Cloisonné, O. Art, III, 1950, p. 67 ff.; H. Garner, The Arts of the Ming Dynasty: Metalwork, Including Enamels, Transactions of the O. Ceramic Soc., 30, 1955–57, pp. 45–51; D. Blair, The Cloisonné-backed Mirror in the Shosoin, J. of Glass Studies, II, 1960, p. 83 ff.

Illustrations: 405–420.

**ENGLAND.** See GREAT BRITAIN.

**ENGLISH ART.** See GREAT BRITAIN, ART OF.

**ENGRAVINGS AND OTHER PRINT MEDIA.** Engraving is the process of incising a design into a hard surface. The resulting engraved surface may be a work of art in itself, such as the cameo, the carved gem (see GEMS AND GLYPTICS), or niello; or it may be combined with another technique for decorative purposes, as in damascene, intarsia (see INLAY), or enamel (see ENAMELS). The surface may also be used to reproduce the incised design in a different material, as the die for striking coins (see COINS AND MEDALS), the seal (see SEALS), and the plate for printing. From the last, the only form of engraving to be treated in this article, is derived the type of art work known as the print. The development of this form of engraving and other techniques of print making was intimately related to that of the printed book (see GRAPHIC ARTS).

The engraver's plate (matrix) may be of wood, metal, or any other material capable of taking ink and transferring it to paper under proper pressure. The image drawn on the plate may be reproduced many times. Incising the plate may be done either directly, that is by sheer manual strength, as in woodcut, line engraving, dry point, or mezzotint, or indirectly through the action of chemicals, as in etching and related techniques. Lithography and the silk-screen process are also usually associated with these because of the similarity of results obtained, but they are actually graphic methods entirely unrelated to engraving.

SUMMARY. Significance of the art of engraving (col. 748). Wood engraving (col. 749); *Printing*. Metal engraving (col. 751): *Dry point; Burin or line engraving; Mezzotint; Etching; Relief prints; Aquatint; Soft-ground etching; Stipple engraving*. Printing copperplates (col. 757). Color prints (col. 758). Combined processes (col. 758). Historical account (col. 759): *The Western world; The Islamic world; India; China; Japan*.

SIGNIFICANCE OF THE ART OF ENGRAVING. The two essential elements of the engraved print, aside from the matrix and the engraving agent, are ink and paper, or in other words, black and white. They are equally important; they complement each

other, the black giving body to the image, the white giving it life.

An engraving is not simply a drawing carried out on wood, metal, or stone. It is a work conceived in terms of the material on which it is to be realized, whose properties automatically define the resources and possibilities of the medium. This premise is indispensable to a proper appreciation of graphic styles. It is on a plate or wood block and not on paper that the creative act of the artist is accomplished, and this is done before the final and revealing act of printing occurs. The engraver does not have his work constantly in sight and under his control, as does the painter or sculptor. Furthermore, he must execute his design in reverse and at a very close view, under deceptive and difficult conditions of visibility. The whole procedure is fraught with risk and uncertainty; therefore, extensive technical testing must be done at each stage of the work.

Engraving as an independent art form is capable of expressive power equal to that of painting, and genuine masterpieces have been produced in the field of original engraving. Engravings are called "originals" when the creator of the design and the executor of the plate are the same person. There is in addition another kind, called "translation," or facsimile engraving. This form of engraving is devoted to the reproduction and popularization of paintings and drawings. It attains at times an astonishing technical perfection, in which there does exist a modicum of originality, for the facsimile engraver must seek the means most adapted to translating one graphic language into another with the greatest fidelity of interpretation. This choice of means always bears the stamp of personal taste and talent.

In engraving, form and value must be reduced to a system of linear elements, for line in its infinite variations of direction, length, thickness, density of placement, and angle of coincidence is the formal and expressive means peculiar to the medium. Although every artist has his own individual manner of attacking metal or wood, the engraved line is inherently strong and beautiful, and printing enhances its qualities. The line may be reserved (that is, the part of the block to be printed is left intact while the rest is cut away), as in woodcuts, or cut in depth, as in the metal techniques. In the first case, the density of ink is uniform all over the plate, because the portions of the block which do the printing are all of the same height. In the second instance, the density can be regulated, since it depends on the depth of the cutting, and thus on the receptive capacity of the furrows. From this fact results the wider expressive range of metal engraving, which responds to any requirement in the rendering of value, even achieving an effect suggesting color.

WOOD ENGRAVING. Fruitwood (pear, apple, cherry) and some other woods of great hardness (such as box, sycamore, dogwood) are preferred for woodcuts. The trunks of the trees may be cut either longitudinally, with the grain (side wood), or transversely, against the grain (end wood), in making the block. From this fact derive the two methods of engraving in wood, rather different in character and technique (PL. 421). The earlier method, which results in the woodcut, employs a block cut with the grain. The print is characterized by a simple and summary pattern of linear contours, emphasized and integrated by lively and often powerful contrasts of black areas and large white spaces. The second method, developed much later, makes use of a block cut cross grain and results in a print properly called a wood engraving. Even though it preserves the lines of the woodcut, it uses them to render a variety of gray tonal areas; it approximates the effects of engraving on metal, with which it is sometimes confused. After it had achieved an extraordinary level of technical refinement, wood engraving was used as a means of facsimile reproduction. Both the woodcut and the wood engraving are produced by relief techniques; that is, on the block the lines to be printed are preserved intact, or reserved, while the white areas are cut away.

The basic tool for woodcuts is the gouge, a small blade fitted into a handle, which is used to isolate the reserved line by cutting a trench on either side of it. This allows the line to stand free and indicates the areas to be cut away (in contrast to work in metal). The gouge must be kept sharp by grinding. An ordinary carpenter's gouge (occasionally driven by a mallet) is used to empty the broad white areas. If subtle shading is required, the tint tools are brought into use. These small V-shaped instruments, which can empty the trench with a single thrust of the hand, can, with infinite patience and ability, also be used to produce crosshatching in facsimile wood engravings.

The design is laid in in pencil on the carefully smoothed block, gone over in ink, and usually carried to a high degree of finish. If the block, which is the height of printers' type, is then covered with quick-drying printing ink, the design remains sufficiently visible on the dark surface, and the areas that are cut can be seen to better advantage. The trench must never undercut the adjacent reserved line because of the danger of weakening it and causing it to break in printing. Normally, when the distance between reserved lines permits, the angle of cutting should be 45 degrees. When the lines are closer together, the cutting should approach verticality. In order to make the work more visible as it progresses, the incised strokes are usually dusted with ground chalk. Proofs can be made easily and quickly on tissue paper. If a mistake is made, the only remedy is to patch the damaged area and rework the design.

Linoleum is often used today in this type of engraving because of its considerably lower cost and the greater ease of cutting involved, but it lacks both the durability of wood and its crispness of edge. Linoleum is particularly useful in making white-line prints with a black or colored ground. The cutting of these is done with a burin.

The tool used in cross-grain wood engraving is the same burin that is used in metal engraving, and the wood most suited is Turkish boxwood. Because of its small dimensions the boxwood trunk is cut in successive pieces that are fitted together to form a single block, on which the reserved image is carefully drawn with pen or brush. The preferred burin of the wood engraver is of elongated lozenge shape, with which the thickness of line can be easily varied. This burin is used to cut out the whites. The grays are next rapidly obtained with a special toothed tool; however, only very expert technicians can disguise the uniform mechanical appearance resulting from its use. It is extremely important that the tools be kept sharp. Both hands must be used in the cutting, the right holding the burin, the left steadying the block and turning it while the burin traces curves.

The thrust of the blade should come from the shoulder rather than from the palm of the hand, against which the handle is supported. Circular dots and curves are obtained by turning the block under the burin, held perpendicular to it. A false move endangers the whole work. Rich effects may be produced with special tools or by varying the depth of cutting, which causes the ink to take more or less heavily in printing. Deeper values are obtained by striking certain areas on the paper in the course of printing. Sandpaper and other abrasives can also be used to obtain special effects.

*Printing.* Wood-block printing is a simple operation that can be done by hand and generally does not require the use of machinery. Printing inks give the best results. A gelatin or hide roller or dabber is used to pick up ink from a glass or zinc plate and transfer it to the block. Great care must be taken not to get ink into the whites. The inked block is then put face down on a sheet of paper, and pressure is applied. If there is sufficient ink on the block, the paper should stick to it firmly enough for the block to be turned over without disturbing the paper. Then comes the most delicate phase of the operation, which consists of stroking the back side of the paper uniformly all over with a burnisher, paper knife, spoon, or dabber. If the paper is very fine and soft, it is a good idea to cover it with a stiffer sheet that can more safely withstand pressure. If stronger paper is used, it is possible to use a letterpress printing press, or even better, a press especially designed for woodcuts. However, the old hand press still remains the best, because it can be easily regulated. Strong papers may be dampened. (The English engravers say that for printing paper ought to be dry to the touch and cool on the cheek.)

For color printing from several blocks, precision of placement is extremely important. The life of a wood block is very long, exceeding that of a metal plate that has not been steel- or chromium-plated. Wood blocks should be kept in a dry place and the backs impregnated with oil.

METAL ENGRAVING. Metal engraving differs from wood engraving (in which the lines are reserved) in that the lines to be printed are incised into the surface of the plate. These incised lines retain the ink, which is then, under the pressure of the press, soaked up by the paper. The metals most used for engraving are zinc, steel, and copper. The last is preferred because of its ductility, compactness, durability, and sensitivity, and also because in etching it permits regularity of biting, thus producing a more extensive and precise gradation of values. Steel, which stands up better than copper in successive printings and lends itself to lines of exceptional delicacy, is seldom used today because it is susceptible to rust and cannot easily be made into workably thin plates. Zinc is unreliable, being soft and perishable.

In the past copperplates were prepared with the coppersmith's hammer, resulting in unequal compactness and homogeneity of surface. The plate was perfectly finished with the flat-faced hammer and was then polished with pumice, engraver's charcoal, and metal polish. In 1849 the pneumatic hammer and the rolling mill began to be used instead; these were replaced in more recent times by the electrolytic process. The thickness of a copper plate (starting at a minimum of about a millimeter) increases in relation to its surface area, because it must not curl or bend in use. It is customary to bevel the edges of the plate in order to prevent them from cutting into the paper during the printing. The bevel, entirely free of marks and thoroughly cleaned, acts as a brake to the crushing action of the copper on the paper and appears in the finished print as an elegant little frame.

Metal can be engraved in two ways: directly, by force of hand, as in dry point, line engraving, and mezzotint; or indirectly, through the chemical action of an acid, as in etching and its derivatives, aquatint and soft-ground etching. Good working equipment for the engraver includes a table to which a transparent plane is attached, inclined at a 45-degree angle; it distributes the light over the working area and shields the eyes from the damaging glare of the bare copper.

*Dry point.* Dry point is the simplest method of metal engraving. The design is obtained by scratching directly on the bare copper with a steel point or a gem chip. The dry point, unlike the burin, does not remove the metal from the furrow as it cuts, but lifts the edges, producing little raised mounds on each side of the line. These, called the burr, give to dry point its characteristic appearance (PL. 421). When printed, the burr as well as the incised furrow retains the ink, imparting to the printed line a velvety appearance. The chromatic intensity of the line is thus directly dependent on manual strength. The burr can be either wholly or partially preserved or removed entirely by using the scraper (a pointed triangular blade that cuts at all three angles and is used horizontally in a direction slightly diagonal to that of the engraved line).

The effectiveness of the line can be tested during the course of the work by smearing the plate with an oil black and drying it with the palm of the hand. This must be done carefully, as the burr is very fragile, a fact that also makes it impossible to use the press for proofs. For the same reason, each plate can be used to make 10 prints at most, although the life of the burr may be somewhat prolonged by chromium plating.

Dry point is many times undertaken by beginners, who mistake its simplicity for ease. Actually, it is a delicate and difficult technique, requiring singular manual dexterity, quickness of eye, decisiveness, and sensitivity. It is very valuable as a harmonizing agent in etching, which in turn can enrich dry point, conferring on it a certain sense of color. Diamond points are the most easily handled and versatile and make a deeper and wider line than does steel, which is less reliable. The first exponents of the dry point were Dürer and the Housebook Master. The first to exploit all its possibilities was Rembrandt.

*Burin or line engraving.* The burin is the basic instrument of engraving. It is a four-sided steel rod, cut diagonally at one end to form a sharp point for cutting. The shaft of the burin is lozenge-shaped in cross section, and variation in the corner angles of the lozenge determines the kind of line produced by the point. That is, a burin having a shaft that is nearly square in cross section will produce a broader, shallower line (and be better adapted to turning curves) than one that is more elongated or diamond-shaped. The latter burin makes deeper and more delicate lines, but the point is easily broken, because it tends to stick in the metal. The shaft is fixed in a mushroom-shaped wooden handle, shaved off so as to permit use of the instrument almost flat on the copper plate. The temper of the burin must be correct so that the point will not break; it is sharpened on three sides, the two side-planes and the diagonal plane of the point being passed in succession over an oilstone.

The tool is held with the end firmly placed between the thumb and index finger, which guide it under pressure from the heel of the hand. It should not be tightly grasped and forced along, for a scarcely perceptible undulating movement facilitates the cutting. It is a mistake to use a burin that is too long, as the tool tends to get out of control and to slip onto the finished parts of the plate. The fingers ought to be kept near the point, and the cutting force should come from the arm more than from the hand. The position of the body should be comfortable and steady, whether the engraver works sitting down or standing with the plate vertical on a easel, as the old masters of line engraving did. For engravings of small format it is more feasible to sit, resting the plate on a small leather cushion filled with sand, which allows it to be easily turned against the burin when cutting curves. The rectilinear shape of the blade, while perfectly suited to tracing straight lines, does not lend itself well to making curves, and the point easily slips or breaks while executing them. The burin enters the metal with the point and cuts it with its two diverging lateral edges, tracing a furrow that is triangular in section and removing from the plate a curly strip of metal that rolls up and springs away. It is necessary to be in constant control of the tool while pushing it along, so as to be able to disengage it easily from the metal and bring it back to the surface without breaking the point. The stroke is made in the opposite direction from that of a pencil or pen, that is, from right to left.

In transferring the design from paper to metal, it is customary to prepare the plate with smoked etcher's wax, on which the design is drawn in reverse with the aid of red tracing paper. The tracing is then gone over lightly with the dry point, after which the wax is removed, and the burin begins its work, lightly at first, since it is much easier to enlarge a line than to reduce it.

According to orthodox technical usage, cutting begins with a series of parallel lines called hatching, and the engraver aims at achieving the maximum effect by varying the thickness and density of this first set of lines. The density of hatching (that is, the distance between individual strokes of the burin) is carefully calculated in advance, while the thickness of each line is varied simply by the manipulation of the tools. The next step in working the plate is the addition of crosshatching, that is, a set of parallel lines crossing the original hatching either at acute angles to model form or at right angles to suggest space. Traditional engraving technique also includes a complicated set of rules for the rendering of flesh, hair, water, fabrics, and other objects and textures. Infrequently, another set of crosshatchings, called double crosshatchings, is added, diagonal to the preexisting right-angle hatching or at right angles to diagonal hatching. Further, as a means of clarifying and harmonizing values, light linear interjections are traced midway between and parallel to two hatch marks. Finally dots are placed at the center of the little white lozenges, called almonds, created by the crosshatching. The direction of the hatching preferably conforms to the direction of the transversal section of the form represented (PL. 421).

Once the cutting is finished, the burr raised by the burin at the sides of the trenches is removed with a scraper, and the plate is rubbed with engraver's charcoal and metal polish.

Tests must be conducted on the press often during the execution of a line engraving, and the trial prints that result are called states — first, second, third, and so on, according to their order of execution. Such proofs, common to all forms of metal engraving, are often considered more valuable than the finished work.

The final proof of state, taken from the finished plate that still lacks the name of the author of the composition, of the engraver, and of the publisher, as well as a title and the occasionally found dedication, is called unlettered. Such a proof is particularly precious, because, as the first print to be made from the finished plate, it represents the freshest product of engraving. Some unlettered prints, with a little symbolic mark or design on the lower margin, are called "courtesy" proofs. The engraver printed a certain number of them in order to raise the price, then canceled out the mark (which had been executed in the lightest possible dry point), and proceeded to cut in the lettering for the general issue.

The use of the burin requires physical strength, slowness, and calculation that undoubtedly hamper spontaneity. Severity rather than sensuousness is the most striking characteristic of the medium, and this, along with the precision and elegance of finely drawn lines, constitutes its special beauty. Line engraving developed from the sparse linear notations of the earliest Gothic prints toward a concern with the representation of tonal values and texture, and utimately toward the attempt, dictated by the requirements of facsimile engraving, at suggesting the richness of color. In the course of its long development, it has often produced works of astonishing refinement of technique and expression but has sometimes degenerated into affectation.

*Mezzotint.* Mezzotint was invented by Ludwig von Siegen (1609–80?), who presented the secret to Prince Rupert of Bavaria. It consists of an allover abrasion of a copperplate, which gives a rough surface that will produce a completely black impression when printed. At first the preparation of the plate was undertaken with all sorts of instruments, such as files, roulettes, and etcher's needles of various kinds. In 1672 the Dutchman Abraham Bloteling (1640–90) invented a tool especially for the purpose, called a rocker, a sort of comb with slightly curved steel teeth, which is drawn over the plate with an undulating movement, first from top to bottom, then from right to left, then on two diagonals. This series of four movements constitutes a single stroke, and about twenty strokes produce a perfectly homogeneous rough grain or ground over the whole surface. The English use a machine of their own invention for grounding the plate.

The design is formed by the patient extraction of the whites (a procedure opposite to that of the other forms of metal engraving, in which the blacks are cut out). This is done by scraping and flattening the grain with small burnishers and scrapers. Next, the roulettes are used to finish the design and especially to correct mistakes (by replacing the ground), while the burin and dry point may be used to deepen the blacks. There are also other ways (generally less reliable and less satisfactory) to ground the plate, which are useful when mezzotint is combined with other techniques, as it often is today. Carborundum, sand, pumice, or even nitric acid may be used.

The printing of mezzotint engraving is extremely difficult because of the number of relief planes of the plate surface and particularly because of the necessity to keep the white areas free of ink. The fragility of the ground, too, contributes to the difficulty of the technique, which requires extremely long practice to perfect.

Mezzotint engraving, which concentrates on the representation of values, is almost entirely divorced from line. This imparts a softness that is little suited to original works but extremely useful for the reproduction of painting. Composition in terms of tonal areas rather than line is also admirably suited to color printing. The mezzotint process can also be of great assistance to other techniques, because it can produce blacks of a wonderful velvety appearance not obtainable by other means.

*Etching.* At the present time etching, of all the graphic techniques, is the one most used by painters because of the relative ease and rapidity of execution peculiar to it and the very extensive range of values of which it is capable. These values may, furthermore, be manipulated to approximate the effects of color. Etching for this reason was long opposed by the purists who disapproved of its proximity to painting. Its main characteristic is fluency and freedom of line (PL. 422), and it permits a multiplicity of effects, especially when used in combination with other techniques.

The process consists of covering the metal plate with an acid-resistant varnish, or ground, then drawing upon the ground with an etcher's needle. This bares the metal to the corrosive action of an acid into which the plate is placed. The acid bites out the furrows that will later receive the ink for printing. The acid-resistant ground may be either liquid or solid. The solids are made from a base of beeswax, bitumen, and rosin in variable proportions, the wax generally in a quantity double that of the other materials. The mixture is made in a water bath, and it is then put inside fine silk, which serves as a filter in the course of application to the plate. The liquids are usually solutions of bitumen in turpentine and can be spread cold, but they suffer from the disadvantage of rapidly losing elasticity and splitting under the needle.

The first step in etching is the cleaning of the plate, of primary importance because only an absolutely grease-free surface guarantees the adherence of the ground. Every trace of grease is eliminated by wiping the plate with surgical gauze dipped in aqua regia, gasoline, chloroform, caustic soda, or denatured alcohol. The plate is then heated to the temperature necessary to liquefy the ground, which is laid down in a light layer and distributed by a dabber of wadding covered with the softest silk. Once a uniform ground is obtained, the surface is smoked in order to fortify the varnish and turn it black, thus increasing the visibility of the design when it is drawn. The smoking of the ground is done by slowly passing the plate back and forth face down over a kerosene flame until a fine clear black is obtained. The plate is then left to cool.

The next step is to transfer the design from paper to the smoked ground or to execute it freehand directly on the ground. The design can be transferred in reverse with a hard pencil and tracing paper (preferably red, prepared with sanguine). The reversal can also be obtained either by oiling the paper with kerosene to make it transparent, or better, by cutting it on a sheet of thin plastic, then filling the scratches with sanguine, reversing the plastic sheet on the plate, and pressing it into the ground with the fingernail or a paper knife. An extremely precise image can thus be obtained. When drawing from life on the plate, one must turn his back on the subject and look at it in the mirror. Once the design has been transferred, it is ready to be incised in the ground.

The proper tool is the etcher's needle, which is usually steel and which may be of almost any thickness from a very fine needle to a heavy nail. Since the actual engraving agent in etching is the acid, it is necessary to prepare the plate for the action of the acid in such a way that the biting can be controlled throughout. Therefore, the depth to which the plate will be bitten is the first thing to be established. It is also important to determine at this point the distance between etched lines, for the registering of values depends on this as well as on their depth and on the density of the crosshatching. The following possibilities of execution present themselves to the etcher: a single plane in depth obtained with a single biting (line biting); a single plane in depth achieved with a series of bitings (line and tone biting); many planes in depth made with a single biting; or many planes in depth obtained with several bitings. These several procedures produce different results. Simplicity of execution is always advisable.

The gleam of the bare copper as it is uncovered by the needle makes the outlines look deceptively thick. The actual thickness of the needle is regulated by use of an Arkansas stone; while the point is pulled over glass or cardboard to dull it. This latter step is necessary, for the needle in tracing the design in the ground should just touch the copper beneath without digging into it. This ensures an even biting. The needle is held as nearly perpendicular to the plate as possible, and the

pressure of the hand on it should be light and steady. In cold weather the plate is kept warm over a heater so that the ground will yield readily under the needle. Precautions must be taken against the destruction of the ground between etched lines, which would cause them to run together.

Once the tracing of the design in the ground is finished, a liquid ground of bitumen is applied to the back of the plate to protect it from the acid. When this has dried, the plate is ready for the acid bath, in basins of porcelain, glass, or acid-resistant plastic. The most frequently used media are nitric acid, Dutch mordant, and iron perchloride. Nitric acid acts violently, giving a rich ragged pictorial line, but it tends to raise the ground, while Dutch mordant bites slowly and cleanly, offering security. Iron perchloride is quite rapid and clean and does not give off toxic fumes, as the nitric acid bath does.

The biting may be carried out in a single immersion, or in several, until the desired darks are obtained. It is a good rule to obtain a first state rapidly, bite it, print it on the press, and then resume work on a regrounded plate. If more than one immersion is used, the linear composition must be prearranged in such a way as to make possible gradual isolation of the parts that have been sufficiently bitten. It is necessary to keep in mind the fact that the acid bites not only in depth but laterally as well, thus tending to widen the furrows. The action of the acid is related to its strength (which is checked by a hydrometer), to the length of the immersion (which must be timed by clock), and to the temperature of the bath. Heat accelerates the process. The action of the acid produces little bubbles along the lines, which must be removed with the barbs of a feather, as they can interfere with the biting.

If the plate has been bitten too much, repairs may be made by scraping down with burnishing tools or abrasives such as Carborundum, emery paper, engraver's charcoal, or metal polish. If the outline is to be modified, the plate must be reground for another biting, unless the changes can be made with dry point or burin.

*Relief prints.* Any etched plate can also be printed like a wood engraving, so that the incised lines come out white instead of black. This kind of print is produced by the careful inking of the surface with lithographic or printing ink; the ink must not be allowed to enter the furrows. The practice derives from the *manière criblée* or *opus interrasile*, a medieval form of engraving on metal in relief. A variant frequently used today consists of inking the plate in the usual way, drying it by hand, and then coating the whole surface with colored ink.

It is also possible to engrave metal in relief by drawing on a clean plate with any acid-resistant substance, such as bitumen on a brush, soft ground, lithographic pencil, or ink, and then biting with a very slow acid that will respect the delicacy of the line. The auxiliary use of aquatint offers unlimited possibilities of rich effects and is particularly valuable in preventing the relief etching from looking like a woodcut.

*Aquatint.* Aquatint is a process devoted to the exploitation of chiaroscuro effects, not of line. Rarely used alone, precisely because it lacks a firm linear foundation, it is generally employed to provide a tonal addition to linear techniques (PL. 422). It lends itself admirably to color prints because of the density of color areas obtainable.

In order to produce a broad range of values with precision, a granular preparation of the plate is employed, the interstices between the grains being left to the action of the acid. The two types of granular ground used might be termed positive and negative. In the first case, a resinous substance in granular form is deposited on the metal surface. The plate is then heated so that the grains melt enough to adhere to the plate. Acid will then bite in the interstices between the grains. There are also resins suspended in alcohol that may be spread on the plate by brush. When the plate is subjected to heat, the alcohol evaporates, and the resin clots together in grains.

For a negative grain the plate is prepared with a ground of white wax onto which the dust of a water-soluble salt (usually common table salt) is sieved. When the plate is intensely heated,

the grains of salt penetrate the wax ground. The plate is then cooled and immersed in cold water, which dissolves the salt, laying bare the copper. This leaves the flowerlike marks the salt has created open to the action of the acid. Salt graining permits prolonged biting, while that with resinous substances does not, because of the tendency of the acid to undermine the grains.

If the print is to be a pure aquatint, the design can be summarily indicated on the granulated ground with a soft pencil. The biting is then executed in order of value intensity, beginning with the lights. Each tonal area is covered when it is sufficiently bitten, and the process progresses to the deepest darks, as if it were a water color in reverse. Timing is indispensable for this process. A sample plate cut in strips from white to black acts as a control keyboard of values.

Another variety of aquatint is done with a brush, with which the acid is applied directly to the bare copper, producing beautiful though rather light and delicate grays. Still another process involves the spreading of a mixture of sulfur and olive oil on the plate with a brush, this too producing only light values. There is also the sugar process, in which one draws directly on the bare copper with pen or brush loaded with India ink diluted in a saturated solution of sugar or gum arabic. As soon as the design dries, the plate is grounded over heat with etcher's wax, then immersed in water. The drawn lines heave up, detaching the ground above them. The ink is then washed away, and the design remains on the copper itself. If the lines are thin, the plate can be bitten, but if they are broad, particularly if they were drawn with the brush, it is necessary to ground the plate with bitumen, producing a drawn aquatint. This process has been much used by Rouault and Picasso. There are numerous other ways of preparing the plate for value biting, for example, running a grounded plate sprinkled with sand or covered with sandpaper through a press or pressing a piece of fabric into a still-warm wax ground.

*Soft-ground etching.* Soft-ground etching, invented toward the middle of the 18th century, makes use of a very soft, greasy ground. This is obtained by mixing into ordinary ground an equal quantity of tallow (in summer, two-thirds tallow) in a water bath. The soft ground is spread on the warm plate in the usual ways over a very light layer of pure tallow. The design is not executed with the etcher's needle, but with regular pencils on one or more sheets of paper laid over the ground. For greater safety and convenience, the sheet can be wet, its edges folded over onto the back of the plate and pasted there. On drying, the paper will remain perfectly taut. The ground attaches itself, under the pressure of the pencil, to the back of the paper and is removed with it when the design is finished. Because of the texture of the paper, the pencil mark transmits to the metal its own characteristic aspects, so that the finished etching has the appearance of a pencil drawing (PL. 422).

The biting is rather long, being done with light acids, such as Dutch mordant, and is carried out in a series of successive immersions. Different types of papers and pencils give a great variety of effects. Used by itself, this technique does not really give very attractive results, but it combines well with aquatint, for which it acts as a splendid linear preparation. It can also be used as a preparation for aquatint by printing on the soft ground the weave of any fabric. This is done by running the plate through the press. The soft-ground technique can also be combined with other processes.

*Stipple engraving.* Stipple engraving, "hammerwork" (or the punch-and-hammer method), and the crayon manner form a group of related techniques that make use of the dot or stipple, which is obtained either by direct manual action or by some chemical process. Stippling has been used as a subsidiary of line from the beginnings of engraving, but it was first exploited as an independent technique by Giulio Campagnola in the 16th century. The technique was later systematically developed by William Ryland, who transmitted it to Francesco Bartolozzi, its most authoritative exponent. It had a brief period of popularity, especially in England, because it lent itself well

to color prints, but today it is almost completely abandoned. The stippling is obtained with burin, dry point, acid, or by hammering on a special punch stamp, the last-mentioned method being the *opus mallei* of the northern engravers.

Also unused today is the crayon manner, which was much in vogue in the 18th century for the reproduction of drawings (PL. 422). In this technique roulettes of various shapes and thickness were used, either alone or as a preparation for biting, aided by the fine lines of burin and dry point, to duplicate the appearance of pencil strokes. The resulting line is close in appearance to the characteristic line of lithography.

PRINTING COPPERPLATES. Pulling prints is a delicate operation, actually an art in itself, requiring long experience, taste, and precision of execution. Inferior printing can spoil a good plate, as careful printing can salvage a mediocre one. It is almost impossible to produce the ideal plate, that is, one that can be perfectly printed by any trained person using conventional means.

The engraver's press consists of two steel cylinders, which turn on their axes and subject a plane passed between them to great pressure. The action of the cylinders is controlled by a wheel attached to the upper cylinder. Between the upper cylinder and the plane is placed a flannel pad that softens the pressure on the engraved plate and distributes it regularly over the surface. The essentials for printing are paper, ink, and gauze "veils."

The paper must be pure linen containing very little size, and the surface must be both strong enough to withstand the crushing of the press and sensitive enough to pick up the most delicate lines of the engraving. These qualities are offered particularly by Chinese and Indian papers, which because of their softness must be pasted on a backing paper. The two are then recut to the exact dimensions of the engraved plate. Japanese papers made of soft vegetable fibers are also highly regarded. These must be dampened with water and put under a weight some hours before printing, thus ensuring that they will take the engraved image completely, while Chinese and Indian papers are not wet until immediately before the operation.

The ink is made of black powder, mostly mineral in origin, ground with cooked nut oil. Its density and color are adjusted to the inclination of the engraver, and its fluidity is maintained with heat during the whole printing process. For this reason the plate is placed on a heated surface, and the ink is distributed on it in little blobs, which are spread on the surface and made to penetrate thoroughly into the incised lines by means of a leather or flannel dabber. The plate is then dried by blotting the ink from the surface little by little with cotton gauze tightly wrapped into a ball. At this point the plate may be printed. The soft and mysterious reproduction obtained (an impression called "veiled") is preferred by many engravers. The same effect can also be achieved by drying the plate with the palm of the hand.

The normal printing (called dry printing), however, involves the further cleaning of the plate with the palm of the hand after the gauze swab has been used. The hand must be wiped over the plate with force, cleaned often, and the grease removed with chalk dust or powdered magnesia. After the engraved surface has been thus treated, the edges of the plate are cleaned with chalk.

If it is necessary to reinforce, attenuate, or soften some or all of the engraved lines, the "veils" (a mid-19th-cent. innovation) may be used in the printing. The veils, which must be of a very soft material completely without size, act osmotically, drawing the ink from the incised line, while shielding the intermediary whites from it. They may be used either to blend or to heighten values. The blending veil, which is intended to minimize contrasts, is passed with a rapid and forceful circular motion over the whole plate, after it has been dried by hand. Its action is uniform over the entire surface. The heightening veil, on the contrary, operates on different parts of the design and is employed to accentuate contrasts and heighten values. It is simply a pointed tuft of gauze that

is passed lightly over the surface, picking ink out of certain areas.

Once the preparation is finished, the still-warm inked plate is attached face up to the plane of the press over an underliner of paper or zinc of the same size as the paper that will be printed. The sheet of paper that is to receive the impression is then placed on the plate, the whole covered with the flannel padding, and the press turned. As soon as the print emerges from the press, it is hung on a line to dry slowly, so that the ink will have time to coagulate without losing its bloom. It is subsequently redampened and ironed flat again between two cardboards. As they come from the press, the prints are numbered in sequence with a fraction. The denominator represents the total number of prints made from a plate, and the numerator that of the order of printing. The most prized prints of all may be "courtesy" proofs, pulled from the finished plate before the numbered series was begun. The number of good prints that can be produced from a single plate is limited because of the wearing down of the copper, but the life of the plate (and consequently the number of prints) can be extended by steel plating, first practiced by the Italian Calamatta. Nowadays chromium plating is generally used.

COLOR PRINTS. From the beginning woodcuts or engravings were frequently made expressly for subsequent coloring by hand, but these were not true color prints, the color of which is composed on the plate or plates and occurs as a direct result of printing. The origins of the color print can be traced back to the chiaroscuro woodblocks of Ugo da Carpi (1480?–1520?). The first color prints in metal engraving were done with single plates that printed each color in succession. The difficulty of obtaining a satisfactory alignment of neighboring color areas with this method is very great, however. Further problems are created by the behavior of colored pigments (as opposed to ink), some of which, such as the earth pigments, print very intensely, while others, such as the lacs and the gelatinous pigments, produce tones of a much lower key. The intended color harmonies are thus distorted. It was, therefore, necessary to compensate for this in the biting of the plate, deepening the lines in areas to be printed in weak pigments. Line engraving is not really suited to color, because the nervous interaction of the lines and the white of the paper disrupts the effect. Aquatint and mezzotint, both of which can be used to obtain solid tonal areas, are well adapted to color, however.

As a consequence of Newton's discoveries of the nature of light, it has become the practice to use three separate plates in making one color print, each plate printed in one of the three primary colors: red, yellow, and blue. Occasionally, a fourth plate is added for black. Metal engraving as a medium for color printing has been entirely replaced today by lithography and woodcutting (using multiple blocks, one for each color in a single print). The recently invented silk-screen process (actually, completely outside the sphere of engraving), in which cutout masks are superimposed, offers great advantages for color printing and may eventually be the only medium employed.

COMBINED PROCESSES. The capricious combination of disparate techniques characteristic of the graphic arts at the present time is both a consequence and a symptom of the contemporary search for unusual effects. The idea of combining techniques is not new, for the superimposition of a copperplate on a wood block has been practiced from the end of the 11th century (and it remains the simplest of the possible combinations). Today, however, these mixtures of technique are not confined to compatible media, but frequently involve graphic processes of essentially antithetical natures.

Lithography is extremely valuable as a preparatory technique (and occasionally, under special conditions, as a final touch), especially for color. Etching, line engraving, and dry point have always been allied to mutual advantage: etching as a preparation for the burin; line engraving as a reinforcement for the etching; dry point as a harmonizing agent. Aquatint is often added to linear outline, though the soft and granular character of soft-ground etching may sometimes be preferred.

Lithography can provide a fine background for wood or metal line engraving, while the lithographic crayon can intervene to support the engraved outline. Combinations of aquatint, mezzotint, and lithography offer a wide range of highly original effects in the field of color.

Preoccupation with technique and the deliberate complication of means occupy a large part of the graphic artist's thinking today, possibly at the expense of spontaneity.

Technical elaborations that go beyond the realm of the graphic media, such as the addition of extraneous materials to the simple sheet of paper (as in collage) or retouchings in tempera or water color will not be considered here. The preservation of orthodox purity of technique remains the best guarantee of the completeness, effectiveness, and sincerity of graphic realization.

HISTORICAL ACCOUNT. The process of obtaining a series of copies by means of a stamp or counterfoil is very ancient. It can be traced back to the stamping of vases and to the method of printing geometric designs on skins with a little wooden or terra-cotta block practiced by the Neolithic peoples of Europe (and still today by the Amazon and Chaco tribes of Brazil). Another of the earliest forms of graphic reproduction was used by the Egyptians in the decoration of sarcophagi, a technique that at first employed leather stencils, later replaced by the wooden blocks used by all Oriental peoples for the printing of fabrics. Shortly before the beginning of the Christian era, the practice of taking impressions from relief sculpture became widespread in China. These impressions were made by covering the relief sculpture of funerary slabs with wet parchment, which was pushed down into the carved hollows with care, and then coloring the parts in relief with a swab. A design in the same direction as the original was thus obtained.

It is likely that true woodcuts were executed even before the printing of the *Diamond Sutra* (Br. Mus.), dated 868, whose illustrations are considered to be the earliest existing specimens of that art form. At about the same time the printing of didactic books was begun in China. Each page of these books, which were completely devoid of illustrations, was printed from a single wood block. Thus, the earliest form of engraving as we know it was the woodcut, which did not become common in the West until much later because of the rarity of paper.

Paper, one of the essential elements of print making, was invented in A.D. 105 in China; from there its use spread to Persia in the 7th century and then to Europe, by way of Spain, through the conquests of the Arabs. Early paper was made of cotton and hence was not well suited to receiving impressions. Once linen came into use in Europe for household purposes, however, linen rags became the basis for paper manufacture. Such paper was produced cheaply and in quantity from the middle of the 14th century in Italy at Fabriano, Padua, and Treviso. This production coincides with a period of rapid technical development in the graphic arts, so that by the end of the 14th century, when the first printed impressions on paper appeared in Europe, Cennino Cennini was teaching a perfected woodcut technique for printing on cloth (by hand and using water inks). Another factor of great importance for the emergence of engraving as a major art form was the ever-growing demand for cheap religious images and for playing cards, which were known in Viterbo in 1379, though they had been circulating in Venice for some time before that.

*The Western world.* The earliest dated print seems to be *The Virgin*, of 1418, preserved in Brussels (Cabinet des Estampes, Bibliothèque Royale). This print was undoubtedly made from a metal plate, which was, however, engraved in relief like a woodcut. There exists a wood block of an even earlier date, the famous *Bois Propat* of 1370 (thus named after its discoverer). Of walnut cut with the grain, this block could hardly have been intended for printing, since its dimensions exceed those of the paper and parchment available at the time. Another early work, the *St. Christopher* of 1423 (PL. 423), seems certainly to have been printed from a wood block.

Early relief engravings were made also on metal; these harmonized and enriched lines and planes with floral and geometric ornament incised with burins and with small steel punch stamps struck by a hammer. This technique is called *opus interrasile*, or damask work, and because of its double nature, it can be printed either positively or negatively (that is, as if it were a woodcut, or as if it were a copperplate). This fact, as well as the one that any writing on such plaques would print in reverse and the consideration that relief engraving on metal is a long and difficult process, gave rise to the supposition that such metal plates, evidently produced by goldsmiths, were intended for practical use as book covers, tabernacle shutters, reliquary covers, and the like, as well as for printing. This hybrid genre might be considered a transition from wood to metal engraving.

The social climate of the 15th century favored the production of the so-called "block books," which were derived from wood blocks, each block bearing the entire text and related illustration for one page. Such books met with great popular favor, especially in Germany, where among the many titles represented were *Ars moriendi, Apocalypse, Biblia pauperum, Speculum humanae salvationis,* and *Song of Songs.* The multitude of block-book illustrations comprise an anonymous production, tied to the narrative necessities of the text, endlessly repetitive in style and composition, and seldom rising above mediocrity. It is possible that many of these books were made in monasteries, gradually replacing the illuminated manuscript.

The woodcut was brought to a higher level of development in northern Europe than in Italy. The actual cutting of the block, after its careful preparation by the artist, was entrusted to extremely skilled craftsmen specially trained in this technique. After Gutenberg's invention of movable type and the printing of the Bible in Mainz in 1455, the popularity of "block books" declined, and they were gradually replaced by books of new kind, in which movable type and woodcuts were used together (see GRAPHIC ARTS).

In Italy the production of these new books began with the *Lattanzio* in 1465, printed at Subiaco, and the *Meditationes* of Cardinal Turrecremata in 1467. These were followed by a whole series of titles: *De re militari* of Valturius, published in Verona in 1472, with fine illustrations, probably by Matteo de' Pasti; the *Aesop* of 1479; the Naples *Aesop* of 1485; *De claris mulieribus,* published in Ferrara, 1497.

In Florence the production of the illustrated book did not commence until rather later. When it did appear, however, it was firmly grounded in the local stylistic tradition of Botticelli and the Lippis. The true flowering of the Italian illustrated book, of brief duration and already entering a phase of exhaustion by the beginning of the 16th century, took place in Venice largely through the efforts of the great publisher Aldus Manutius. The Aldine editions include the *Supplementum chronicarum,* 1486; the *Triumphs* of Petrarch, 1488; the Bible of Malermi, 1490; the *Divine Comedy,* 1491; the *Aesop* and the *Decameron,* 1492; the *Histories* of Herodotus, 1494; and the most beautiful book of the Renaissance, Francesco Colonna's *Hypnerotomachia Poliphili,* published in 1499. This wonderful volume is distinguished for the elegant design of its pages, for its perfect equilibrium between text and illustration, and for the orthodox linear purity of its woodcuts (I, PL. 308; VI, PL. 404).

German book production of the time, extensive but strictly utilitarian in purpose, is best exemplified by the *Nürnberg Chronicle* of 1493, which contains 1,809 woodcuts. Single sheet engravings by clearly identifiable masters did not appear north of the Alps until the beginning of the 16th century.

Metal engraving had by this time achieved a measure of distinction as an art form, its development having begun at the middle of the 15th century, somewhat later than that of wood. It appeared in Italy considerably later than in Germany, but seemingly entirely independently. Since metal was in earlier times engraved for ornamental purposes, the 15th-century invention of metal engraving really consisted of the idea of printing the engraved plates with the press. In Italy up to the time of Mantegna, copper engravings were printed with a vertical pressure by a letter press and in unsuitable light inks, while the

cylinder press and solid inks seem to have been known in Germany as early as 1430. From the technical point of view the superiority of early German prints is undeniable.

All that can be said about the origin of Italian engraving is that it derived from niello and seems to have begun among the goldsmiths of Florence. Vasari attributed the invention to Maso Finiguerra (1426–64), who made impressions of his nielli filled with lampblack on paper in order to test their effect. The idea was supposedly suggested to him by the carelessness of a laundress, who put wet washing down on such a niello. Whether this is true or not, a flourishing production of anonymous copper engravings did occur in Florence, some of which are attributable on the basis of style to known personalities, such as Botticelli, Verrocchio, Baldovinetti, Filippino Lippi, and the wraith-like Baccio Baldini. All of these, with the exception of Baldini, would have served as inspirers of the engravers, rather than as actual executants.

This production is generally divided, because of the necessity for classification, into two groups based on graphic characteristics, the fine manner and the broad manner. In the former, earlier style, shadows were obtained with little delicate strokes going in all directions, timid, uncertain, and confused, and the characteristic outline is plainly derived from niello. Such prints are believed to have come from the workshop of Finiguerra. The second style was more simple, clear, and summary, the hatching of the shadows being longer, parallel, and regularly spaced. In general this style tended to dissociate itself from the technique of the goldsmiths and to seek a new and more independent means of expression.

A chronology of the fine manner includes: about 1460, the series *The Planets* (PL. 423), followed by numerous copies; 1465–70, the 24 prints of the Otto Collection, of ornamental character, intended for the decoration of boxes and little chests; 1477, the *Monte Santo di Dio* of Bettini, possibly the first book illustrated with copper engravings; 1481, 19 subjects from the *Divine Comedy*, many of which derive from the drawings of Botticelli. Most important is the series of 50 so-called "Tarocchi Cards of Mantegna," erroneously attributed and not playing cards, but a series of instructive allegories that was copied over and over (III, PL. 201).

The chief representative of the broad manner was the Florentine Antonio Pollaiuolo (d. 1498), whose *Battle of the Nudes* (PL. 424) was its first masterpiece. This famous engraving is filled with the dynamism of energetic contour line, which finds its completion and reinforcement in its contrast with the quiet arrangement of parallel strokes that easily and knowledgeably model the forms. Andrea Mantegna (q.v.) demonstrated the expressive force of engraving, maintaining a constant level of tension through firm hatching of exceptional power. Of all the prints attributed to him, modern criticism accepts only seven as actually from his hand, the others being *The Madonna and Child*, the two *Bacchanals* (PL. 424), *Battle of Sea Gods*, *The Entombment*, and *The Risen Christ btween SS. Andrew and Longinus*.

Numerous secondary figures, surrounding these two great stars of Quattrocento engraving, were attracted now by one, now by the other, and all were more or less influenced by the many German prints then current in Italy. Every one of these was of Venetian, Paduan, Ferrarese, or Florentine origin, as for instance, Zoan Andrea, Mantegna's follower and collaborator, of whose output 17 good prints survive, most of them ornamental in character. Others were the two Carmelite brothers Giovan Maria and Giovanni Antonio da Brescia, whose style was conventional and decorative; the pleasing Nicola Rosex ("Nicoletto da Modena"), who left 97 prints (PL. 427); the attractive engraver whose signature was the monogram I.B. with a bird, who has recently been identified as Giambattista Palumba (10 prints; PL. 425); the Venetian Girolamo Mocetto (18 modest prints); Benedetto Montagna of Vicenza, a good draftsman of notable technical refinement (41 prints); and the Florentine Cristoforo Robetta, who introduced the background landscape derived from Dürer (PL. 425). Rather more important was the personality of Jacopo de' Barbari, the Maestro del Caduceo, a cultured Humanist and friend of Dürer, whose charac-

teristic ductile and attenuated graphic style was so singular as to compensate for the weakness of construction evident in almost all of his 30 prints. Of a very different bent was the versatile Giulio Campagnola (Padua; 1482?–1514?), who sought to interpret Giorgione (as in the *Reclining Nude*) and used a stipple technique that was the first of its kind. Among his few prints, all of them noteworthy, the *Stag*, the *Astrologer*, and especially *Christ and the Woman of Samaria* (PL. 426) must be cited. Domenico and Marcello Fogolino were his followers.

The activity of these engravers fell in the first quarter of the 16th century, when German engraving had already achieved its greatest splendor in Dürer. Gothic in its origins and concerned above all with the expressions of content through the medium of line, northern engraving, which had begun some ten years before the Italian, remained for a long time an anonymous production devoted to monotonous repetition of style and subject. The Cologne and Lübeck Bibles appeared about 1480 and 1494 respectively, and in 1493 came the important *Nürnberg Chronicle*. Northern engraving up to this time had been chiefly a publishing enterprise entrusted to special workmen; however, a few rare detached sheets by artists identifiable by their initials or by the titles of their best-known work do exist. For instance, it has been possible to isolate the Master of the Playing Cards (active in Basel from 1430 to 1445), named for his major activity, who was one of the first to abandon wood for metal engraving. The work of Master E.S. (active around Lake Constance, 1440–67), whose 317 prints are outstanding for their decorative character and for their evident derivation from goldsmith's work, includes the celebrated *Einsiedeln Madonna* (1466), the *Hortus conclusus*, and a *Nativity* with stylish grotesqueries as ornament. Israhel van Meckenem (b. before 1450, d. 1503), his pupil, made a business of producing prints, of which 570 survive. Most of these are rather banal, but some are genuine masterpieces, such as the *Dance of Salome* and the *Death of Lucretia*. The first engraver to sign his works with a monogram and a mark was the painter Martin Schongauer (q.v.), a strong and dramatic personality and one of the truly great German artists, who executed 115 prints. His masterpiece is a *Nativity*, but his *Temptation of St. Anthony* (PL. 427), much prized by Michelangelo, a *Magdalen*, and a *St. Michael* should be cited as well. Also important were Hans Baldung-Grien (q.v.), who was devoted to the woodcut and whose work has an uncommon expressive force, and Lucas Cranach (q.v.), the able, powerful, and prolific designer of the wood blocks for Luther's Bible and the astute portraitist of the great reformer himself. Rich in talent as well were the soldier Urs Graf, who occupied himself with subjects from his trade, and Hans Burgkmair (q.v.), who celebrated the name of Maximilian in many wood blocks. The Gothic period drew to a close with Veit Stoss (1439?–1533) and the Housebook Master (active 1475–90), whose works, especially such a print as the latter's *Two Lovers*, reveal the spirit of the Renaissance.

The Gothic tradition of minute description was reaffirmed in the context of Renaissance pictorialism by Dürer (q.v.), whose attention to light, shade, and tone was a significant innovation. Dürer's greatness resides in the fact of his having known how to temper the innate and irrepressible Gothic spirit of German engraving with the Italian Renaissance love of nature. This Gothic survival in Dürer's work is clearly apparent in the evident ascendancy of content over firmly and perfectly defined classical form. The measure of his genius in the woodcut was apparent as early as 1498 in the series of the *Apocalypse* (PL. 467); it was also evident in the *Large* and *Small Passions* and in the *Life of the Virgin*; and it was reasserted in the monumental *Triumph of Maximilian* of 1526. It does not seem that Dürer ever personally cut blocks, but he assiduously guided the executants throughout the work. His efforts in metal culminated in the masterpieces of the *Melencolia* (III, PL. 203); *St. Jerome in His Study*; *St. Eustace*; *Knight, Death, and the Devil* (PL. 297); *Nemesis* (*Large Fortune*); and in his depictions of tender madonnas, as well as in his masterly dry point (the first of its kind) *St. Jerome by a Pollard Willow* (1512). Dürer was among the first to experiment with etching, and he introduced the portrait and landscape into engraving.

Under Dürer's aegis, but all more or less influenced by Marcantonio Raimondi, was a group of Nürnberg engravers called the Small Masters because of the diminutive size of their prints. Among them were the admirable technicians and able decorators Jörg Pencz, and Barthel and Hans Sebald Beham, as well as Heinrich Aldegrever, the author of refined and delicate works. The very gifted, versatile, and imaginative Albrecht Altdorfer (q.v.) was the last of the great German engravers (PL. 427). After him German engraving began to decline, partially because of social and political factors, but possibly also because of the disorientation brought about by the introduction of Italian Renaissance style and artistic criteria.

The Dutchman Lucas van Leyden (q.v.) is important primarily because he was the first to pose the atmospheric problem, which he resolved by lightening the background stroke into evanescence, at the same time preserving intact the descriptive precision of line. He thus conveyed the sense of air-filled distances and conferred on the print a new clarity and transparency (PL. 427). Artistically precocious, possessing a detailed, sober, and considered manner, Lucas van Leyden, a facile composer of multifigure scenes, lacked the emotional magnitude necessary to true greatness. He was among the first to use the copperplate and in the very early days of etching combined its techniques (used for preparation) with line engraving (reinforcement by the burin).

The first to use etching seems to have been Daniel Hopfer, who employed it some time before the first dated etching, *Woman Washing Her Feet* (1513) by Urs Graf. This was followed by six etchings by Dürer, the most noted of which is the *Cannon* (1518), a line-bitten print with hatching of uniform thickness, much resembling a woodcut. However, the true importance of etching, which resides in its peculiar suitability to the creation of original designs, was grasped by Parmigianino (q.v.), who may rightly be considered, if not the inventor, the true discoverer of the innate possibilities of the etched line. He left very few prints, among them an *Entombment*, an *Adoration of the Shepherds*, and the *St. Thais* (PL. 428). His pupil, Andrea Meldolla, called "Lo Schiavone" (1522–82), engraved his own designs and those of his master in a softer, more atmospheric manner. Paolo Farinato, Bartolomeo Passarotti, and Camillo Procaccini were his followers. Line and tone biting and the use of a variety of etcher's needles (which had already been adopted by Augustin Hirschvogel) were studied by Federigo Barocci (1526 or 1528–1612), pupil of Giovanni Battista Franco. In his important experimental piece, *The Annunciation* (PL. 429), Barocci also explored the possibilities of crosshatching and the use of auxiliary stipples. His close followers were Francesco Vanni, Ventura Salimbeni, and Vespasiano Strada. Etching, by this time mature and on its way to becoming the favored medium of the original print, was to flourish in the following century, reaching its apex in Holland with Rembrandt.

Pure line engraving, on the other hand, was in the process of becoming a medium for the translation or reproduction of paintings and drawings rather than a means of original creation. Marcantonio Raimondi (q.v.), the most important engraver of the 16th century, is generally thought to be responsible. Encouraged by Raphael, who sensed the possibilities of the engraved translation of his works (such as, for example, the much-admired *Lucretia* of 1510; PL. 425), and attracted by the pictorialism of Dürer and Lucas van Leyden, Marcantonio assimilated some aspects of German line engraving to create a technique more adapted to the translation of painting. He was an interpreter more than a copyist, because of his personal contributions to the composition of the frequently summary or incomplete designs of his great inspirer. The strength and sureness of constructive outline, the amplitude of vision, and the solidity of classically felt form characteristic of Marcantonio justify his title of "father of Italian line engraving." The *Massacre of the Innocents*, the *Judgment of Paris*, the dramatic *Phrygian Plague*, the *Dream of Raphael*, and the monumental *Quos Ego* were all landmarks in his long career. His close followers were Agostino Veneziano (ca. 1490–1540), engraver of the *Three Marys*

and the *Sorcerer*, Marco Dente da Ravenna, and the Maestro del Dado (*The Tale of Psyche*). His influence was felt as well by Jacopo Caraglio (1500?–70), whose work is characterized by a delicate pictorialism (*Adoration of the Magi, Loves of the Gods, Rape of the Sabines*), Beatricetto (the *Samaritan Woman* and depictions of various Roman antiquities), Giulio Bonasone (*Adoration of the Shepherds* and 353 other rather undistinguished prints), and the highly active archaeologist and scholar Enea Vico (the *Accademia of Bandinelli* and 500 other copper engravings). A group of Mantuans came to Rome with Giulio Romano, among them Giovanni Battista Scultori (1503–75), a brilliant and vigorous technician (*Naval Battle* and *Allegory of the River Po*, PL. 426), and his children Adamo and Diana, and Giorgio Ghisi (1520–82), the most active imitator of Raimondi (*Wounded Procris*). G. B. Franco, G. B. del Moro, and Giambattista Fontana were active in the Veneto.

At this time a real engraving business sprang up in Rome (a center for foreign engravers and merchants), where it flourished for about two centuries. Lafréry, Salamanca, Van Aelst, Orlandi, Barlacchi, Cock, Thomassin, and many others established an active publishing business, creating the fad for Roman views, ruins, and archaeology. The pictorial current became ever more important with Cornelius Cort (1530–78), who exerted a great influence on technique, both in Rome and outside it.

In the second half of the century the center of graphic production shifted from Rome to Bologna. The Carraccis (see CARRACCI), who virtually re-created line engraving, were at the helm. Agostino, the major engraver of the century after Marcantonio, created a freer and looser, easier and bolder system of hatching, at the same time enlarging the format of his engravings, until he began to fill great contiguous plates to make one engraving, such as the seven of the *Adoration of the Magi*. His dexterity is documented in the celebrated portrait of Titian and in the unfinished *St. Jerome*. Less active than he, but a more finished artist, Annibale engraved the *Christ* of Caprarola, his masterpiece, and *Pietà* (PL. 430); Ludovico's graphic works are few but estimable. The academy of the Carraccis nourished tradition for a long time, and the burin of Agostino passed into the able hands of Cherubino Alberti (1553–1615), who employed it especially for reproducing in a dashing and elegant style the works of Polidoro da Caravaggio. Francesco Villamena's (active 1586–1622) work is even more simple and cursive, as in the seven prints of the *Vari costumi* and *The Blind Man* (PL. 429); he was also responsible for the engraving of Etienne Dupérac's great map of Rome.

The woodcut in the early 16th century anticipated the orientation of painting by posing the problem of light. Two successive and intimately connected inventions reveal that interest: the *camaïeu* manner, so called because of a certain similarity to the cameo, and the chiaroscuro technique, both of which were based on the superimposition of several wood blocks. The former, of German origin, was done with two blocks, one of which, carrying the linear design, was generally printed in black over the second, which carried a general background tone. (The highlights, which remained white, were reserved.) This process, which quickly became widespread among German wood cutters, produces a print that looks like a pen-and-ink drawing on colored paper, heightened with white. A good example, the *St. Christopher* of Lucas Cranach (ca. 1506), has an orange ground.

The *camaïeu* suggested to Ugo da Carpi his chiaroscuro technique, which differed from the *camaïeu* in omitting the first block bearing the linear design, and using instead three, four, or more blocks. The print had the appearance of a water color in flat washes. In 1516 Ugo asked the Venetian Senate for protection of his discovery "of producing with wood blocks prints that look as if they had been done with the brush." He reproduced works of Parmigianino and Raphael, from whom he took (among other things) the *Diogenes* (four blocks), his finest work (PL. 428). Ugo's most famous prints are the *Miraculous Draught of Fishes* and *Raphael and His Mistress*. The followers of Ugo da Carpi were Antonio da Trento, who generally limited the number of blocks to two and who gave hatching

precedence over tonal area; Nicolà Vicentino, who was rather more important, the spiritual rather than the technical imitator of Ugo, maintaining the style of Ugo at its original high level (*Martyrdom of SS. John and Paul* and *Christ Healing the Lepers*); and Andrea Andreani, whose calculated and conventional style was far removed from that of the master. Thus, the chiaroscuro technique was exhausted rather quickly and did not revive, despite the later efforts of Count Zanetti. The facsimile woodcut in this period was focused on the work of Titian, whose most creditable interpreter was Niccolò Boldrini. At a later period various attempts were made to combine wood and copper, but they were soon abandoned.

The first illustrated book to appear in France was the *Verdun Missal* of 1481, which was followed by a healthy number from various publishers, especially Antoine Verard, who is considered to be the creator of the rather widespread type of Gothic Books of Hours that was perfected by Geoffroy Tory (1480–1533). Despite this fact, French engraving was rather late in developing, and only about 1540 was a school formed around the Italian etchers at Fontainebleau, particularly Antonio Fantuzzi. Anonymity ceased with Jacques Prévost, engraver of a portrait of Francis I. Jean Duvet, Etienne Delaune, and Jacques Androuet Ducerceau (PL. 163) should be cited as well. Woodcutting was hardly practiced at all in the second half of the 16th century.

The 17th century produced some of the greatest French engravers, among them Jacques Callot (q.v.). Callot, whose training was largely Italian, brought to his art a bold, passionate, and ironic temperament and an extraordinary quickness and sureness of hand. After his training with Giulio Parigi and Remigio Cantagallina in Florence, Callot took up etching and subsequently introduced the technical innovation of using a very hard ground on the plate, thus making it possible to vary the thickness of the line, modeling it along its whole course. The *Capricci di varie figure* (V, PL. 241) and the *Temptation of St. Anthony* appeared in 1617, the first of Callot's some fourteen hundred prints. Then followed the celebrated *Fair at Impruneta*, the *Balli di Sfessania* (24 plates of subjects from the *commedia dell'arte*), the *Gobbi*, the *Nobility of Lorraine*, the *Gypsies* (PL. 432), the *Miseries of War*, and the *Siege of La Rochelle* for Louis XIII. Callot's influence was considerable both within France and beyond throughout the century (III, PL. 302). Abraham Bosse (1602–76) followed his lead with about two thousand prints illustrative of the customs and social milieu of the period, seen and reported with the satirical but measured glance of a teacher and moralist (PL. 433). Close to Callot and Bosse, in life more than in art, were Israël Silvestre (VIII, PL. 438), Nicolas Cochin the Elder, Sébastien Leclerc (with 3,412 prints), the witty and graceful eclectic Pierre Brebiette, and the three very prolific Perelles. The solitary dreamer Claude Lorrain (q.v.) engraved about twenty copper plates for his own amusement, finding his inspiration in the Roman Campagna and seeing in it, even in its pastoral feeling, the noble and grandiose aspects, all rendered in engraving with an appealing awkwardness.

The engraved portrait, more than anything else, brought fame to French graphic art. Michel Lasne (1590–1667) surrounded his sitters with baroque trappings; Jean Morin rendered them in the most minute detail. Claude Mellan (1598–1688), following in footsteps of Hendrick Goltzius and Callot, exploited the varied line without use of crosshatching, leaving white predominant. Robert Nanteuil, the greatest of the line engravers, fixed in copper the personalities of his age, using a technique at once robust and delicate (*Colbert*, PL. 433). He was the head of a school, the first of its kind in Europe, which boasted among its members Jean Morin, Antoine Masson, and François de Poilly. Philippe de Champaigne, following the example of Rubens, surrounded himself with copyists, and the illustrator François Chauveau (1613–76) did the same in the interests of his vast professional activity. Gérard Audran (1640–1703) lent the prestige of his burin to the interpretative reproduction of the works of Lebrun, and his teaching survived in a group of brilliant technicians. The Fleming Gérard Edelinck (1640–1707), imitator of Nanteuil, despite his virtuosity remained only

a copyist. The impulse given to artistic activity by the Sun King, through the informed and dedicated efforts of his minister Jean Baptiste Colbert, depended on the strict organization of disciplined and carefully nurtured graphic production. The great print dealers were coming to the fore, and the first important collections were being formed. In 1667 the vast collection of the Abbé Michel Marolles became the nucleus of the Cabinet des Estampes of Paris, then being established, and at about the same time was founded the Cabinet du Roi, which later became the Chalcographie of the Louvre. The Academy, founded in 1648, opened its doors to engravers in 1655.

During the 16th century the bustling city of Antwerp had an active and brilliant school of engraving. About the middle of the century the engraver and publisher Hieronymus Cock, securing the collaboration of Giorgio Ghisi, reproduced Bruegel (q.v.) and launched Cornelis Cort, whom Vasari regarded highly. The admirable virtuoso Hendrik Goltzius (q.v.) displayed his elegant and conventional style, and whole dynasties of engravers flourished: the Collaert, the de Jode, the Wierix, and the Sadeler families (the last-named active mostly in Italy). In 1608 Rubens, back from his Italian sojourn, intending to popularize his works, as had Raphael, gave impetus to a whole school of engraving devoted to the rendering of equivalents of color. Both Cornelis Galle and Pieter Soutman worked for him, but Rubens preferred Lucas Vorstermans, a pupil of Goltzius and an engraver of the first rank. Because of temperamental incompatibility, Vorstermans left the field to his pupil Paulus Pontius, the two brothers Boetius and Schelte Bolswert, and other minor figures. However, Vorstermans remains the true interpreter of Rubens, his engravings marvelously rendering the coloristic richness and bombast of Rubens' style with a contour line even more agile, varied, and refined than that of his master Goltzius. Cornelis Bloemaert II (1618–80), another good pupil of the same master, Cornelis Visscher (1620–58), and Jonas Suyderhoff were all active at the same time.

For the same purpose and with equal success, Anton van Dyck turned to etching. The *Christ Mocked* is a piece of great bravura, but his portraits are particularly admirable for their immediacy and liveliness of composition (PL. 433). He also called on engravers for help in the production of a series of portraits of illustrious contemporaries, known as the *Iconography*, which was left incomplete. The painterly direction given to engraving by these two great figures fostered the acceptance of mezzotint, which was invented by Ludwig von Siegen in 1642. Later another Fleming, Gilles Demarteau, was to invent the crayon manner for the reproduction of drawings.

Etching, amenable to creative purposes, replaced line engraving as the medium of original prints, rising to great heights in Italy and greater still in Holland. From the beginning of the 17th century date the two etchings attributed to Caravaggio, the *St. Peter Denying Christ* (1603) and the *Fortuneteller* (PL. 429; undated, but generally considered to be slightly earlier than 1603). Using Parmigianino and the Carraccis as sources and employing a summarizing and facile needle, Guido Reni arrived at a style perfectly suited to rendering the typical expression of his painting (PL. 430). His pupil Simone Cantarini da Pesaro (1612–48) engraved rather agreeable prints (a little *St. Anthony* and a number of the *Flight into Egypt*), whose fluency of style perfectly masked the most painstaking effort. Guercino engraved two copperplates, the shadows formed by thickened parallel strokes that diminish in the lights (PL. 430). More important was the Genoese Giovanni Benedetto Castiglione, called "Il Grechetto" (1610–65), the true precursor of Tiepolo and the plein-air artists, an excellent renderer of animals, whose light and delicate lines are disposed in carefully calculated yet vibrant layers (*Feast of Pan*, PL. 436; *Melancholy*; *Genius of Painting*; *Diogenes*). He was the inventor of the monotype. The Venetian Giulio Carpioni (1611–74) was responsible for a number of forceful and concisely stated prints; the names of Odoardo Fialetti, Giovanni Andrea Sirani, the Genoese Bartolommeo Biscaino, and Andrea Podestà, all more or less derived from Grechetto, should be recalled as well. Bartolommeo Biscaino (1632–57) is especially to be remembered for his *Satyr Family* and *Salome*. Giovanni Francesco Grimaldi (1608–80),

Lodovico Mattioli, and Giuseppe Maria Crespi all worked in Bologna. In Rome the illustration of the antique served as the basis for a flourishing trade, monopolized by the indefatigable Pietro Santi Bartoli, called "Il Perugino" (1635–1700), who reproduced the masterpieces of Roman civilization. Other well-known depicters of the Roman view were G. B. Falda (1648–78), author of *Le fabbricche*, *Le fontane*, *I palazzi*, and *I giardini di Roma*; G. F. Venturini; and the architect Alessandro Specchi (1668–1729). Many copperplates were engraved by the two Aquilas, Pietro and Francesco Faraone. Carlo Maratti (1625–1713) adapted the manner of Giudo Reni to engraving. The portraitist Ottavio Leoni (1578–1630) was a technical innovator, employing a pliable and highly adaptable manner of blending dot into line, which was extremely useful in portraiture (PL. 429). The imaginative, exuberant, and uneven Pietro Testa (d. 1650), called "Il Lucchesino," did not completely work out his whimsical and often superabundant compositions (PL. 431), but left them unelaborated, full of a sketchlike impulsiveness that sometimes anticipated by three centuries present-day tendencies. The Florentine Antonio Tempesta (1555–1630) engraved hunting and military scenes, animals, Biblical episodes, and lives of saints, all in a robust but conventional and decorative style (PL. 428). His pupil Remigio Cantagallina (1582–1630), with the architect Giulio Parigi, was responsible for the Florentine training of two great graphic masters, Jacques Callot and Stefano Della Bella (1610–64), called "Stefanino." The latter, who began as a goldsmith, at first was much influenced by Callot, but soon developed his own style, more soft and clinging than Callot's vigorous manner. Stefanino went to Rome in 1632 and in 1640 to Paris, where he earned the support of the collector Mariette and worked with Israël Silvestre. He subsequently met Rembrandt in Amsterdam and succumbed to his influence, dedicating himself to prints of small format etched with a delicate, vivacious, and playful needle. He made innumerable marine and battle scenes, landscapes, caprices, vignettes, portraits, and decorative prints, all heightened tastefully with light brushwork in acid (PL. 431).

In Naples Jusepe de Ribera (q.v.), a follower of Caravaggio, executed late in his career 17 copperplates characterized by strong contrasts, such as the *Martyrdom of St. Bartholomew*, *Drunken Silenus*, and various figures of saints. The romantic imagination of Salvator Rosa (q.v.) is reflected in his 90 prints, all in a light vein, yet full of fire. They include the *Jason and the Dragon* (PL. 436), the *Capricci*, the *Combats of Tritons*, and other mythological scenes. Also to be mentioned are Solimena, Raffaello Schiaminossi, and Giovanni Battista Mercati, who was active in Rome during the first half of the century.

In Holland the 17th century was the time of the original etching, while line engraving, even as a reproductive medium, was falling into disuse at the hands of the heirs of Goltzius (except for the able Bloemaert). Pieter Claesz. Soutman, released from his dependence on Rubens, discovered and promoted Jonas Suyderhoff (ca. 1613–86) and Cornelis Visscher (d. 1662), while at the same time many painters turned to etching as a vehicle for original expression. Inspired by the love of nature and greatly influenced by Adam Elsheimer (1578–1620), whose unusual compositions, spirit of experimentation, evocative tonal biting, and predilection for nocturnes they found sympathetic, the painter-etchers turned out highly individual works, executed with impeccable technique and completely alien in spirit to the contemporary rhetorical baroque style. All the Dutch masters of this period were somewhat indebted to the Italian etchers in matters of technique and execution, and the Alpine landscape of Italy was a favorite subject of representation. Among the landscapists were Allart van Everdingen (1621–75), author of about a hundred views with small figures and cattle, and his pupil Jacob Ruisdael (1628–82), who left 10 prints of beautiful breadth and spirited execution, the amplitude of which rises above grandiosity. The style of Anthonie Waterloo (ca. 1610–90) on the other hand was very delicate; Jan Both (d. 1652) and Nicolaes van Berchem also worked in a graceful, luminous, and pictorial manner in their rural Italianate compositions. The latter, an especially gifted portrayer of animals, produced a pupil of even greater sensitivity,

Karel Dujardin (1635–78). Paulus Potter (1625–54) was endowed with great acuteness of observation (PL. 434), as was Adriaen van de Velde (1635?–72). Reynier Nooms (1623–65?), called Zeeman (Sailor), was renowned for his marine scenes.

The work of the gentle Adriaen van Ostade (1610–85) was devoted to the humble life of the peasants represented in the picturesque disorder of their everyday surroundings, and his style was based on robust, simple, and summarizing contour drawing, heightened with a minimum of conventional tonal areas. The latter were indispensable to the detailed description in which he delighted (PL. 434). He was distantly followed by Cornelis Bega and Cornelis Dusart. The stature of Hercules Seghers (q.v.), the "demonic experimenter" whom Rembrandt admired and studied, is only augmented by comparing his work with that of these others. This tormented and mysterious figure, a draftsman of unexcelled power, attempted the most curious and unorthodox combinations of technique. Starting with a firm precise linear foundation, he disguised it, violated and destroyed it, then recomposed it, arriving at original graphic effects with a dramatic hallucinatory sense of nature (PL. 435).

Rembrandt van Rijn (q.v.) was the greatest graphic artist of all time. The artist's mental image was virtually reembodied in the copper as Rembrandt worked on the plate, opening, closing, and modeling the metal with absolute ease and mastery, using his inimitable stroke, unconventional and antirhetorical, spontaneous and sensitive. His *Prodigal Son* (PL. 434) reveals him in a mood of tender pathos; the fourth state of the *Three Crosses* (PL. 435, first state) is a tragic vision of uncontainable anguish; the *Doctor Faust* displays the fervor of his imagination; and the *Reclining Negress* makes apparent his refined sensitivity of psychological and physical observation. Rembrandt's world was perceived in terms of light, rendered by graduated values of unequalled precision. The palpitating shadow that fills the mysterious portrait of Jan Six is an example. The influences Rembrandt experienced were completely assimilated into his own style, and his exceptional stature can best be seen by comparing his work with that of those around him, such as Ferdinand Bol, Jan van Vliet, and Jan Lievens, all skilled craftsmen.

France, even though barren of artists of great stature, was still the most important center of graphic activity in the 18th century. The interest in prints was sustained by the great merchants, most important of whom was Pierre Jean Mariette (1694–1774), an illustrious amateur and scholar of the graphic arts (VIII, PL. 438); by Pierre François Basan (1723–97), an ambitious engraver and publisher, to whom is due the unlettered print; by Gabriel Huquier (1695–1772), specialist in decorative prints; and by G. F. Joullain, perceptive writer. Public sales were frequent, and new techniques appeared. In 1768 Jean Baptiste Leprince claimed credit for the invention (in fact, not entirely his) of the rosin etching process, thus depriving Jean Charles François and François Philippe Charpentier of their due. The new method, which permitted tonal effects, greatly facilitated the making of color prints, until that time produced according to the technique started by J. C. Le Blon (1667–1741), that is, by using multiple mezzotint plates. This latter process was further explored by the Dagotys and brought to perfection by Philibert Louis Debucourt (1755–1832) in his *Promenade publique*. The crayon manner, intended for the reproduction of drawings, was invented and perfected by Gilles Demarteau. The pastel technique appeared, and the salt process aquatint was initiated by Stapart. An invention that permitted an artist to execute a profile on copper with only a brief sitting popularized the portrait.

Facsimile engraving, very widespread in the 18th century, reproduced paintings of Watteau, Boucher, Fragonard, Chardin, Lancret, and Greuze. About the middle of the century Jacques Philippe Lebas (1707–83) and the German Jan Georg Wille (1715–1808) set up their studios in Paris. These two — particularly Lebas, member of the Academy, engraver to the king, and pupil of Nicolas Henri Tardieu, (1674–1749) — were responsible for the rise of a whole group of excellent technicians, first among whom were Moreau le Jeune and Charles Nicolas Cochin. The restrained style of Wille had much vogue among the followers of Jacques Louis David. Wille was the chief expo-

nent of the *gravure rangée* (the military cut, as it was called by Luigi Calamatta), which was supported and popularized by Bervic and favored even by Drevet over the *gravure libre* of Lebas. Appropriate to the gallant and frivolous spirit of the period was the print of the small format — the vignette — which became increasingly popular. Among its gifted creators were Chauffard (1730–1809), author of more than 900 elegant decorative prints, and Moreau le Jeune (1741–1814), who left over 2,000 agreeable prints of conventional composition, illustrative of the society of the epoch. Among the very few original engravers, a special place belongs to Gabriel de Saint-Aubin (1724–80), who, to a greater degree than his brother Augustin, revealed in a few lively, spontaneous, and vibrant etchings an exceptional sensitivity and geniality that anticipated the future. Boucher and Fragonard also engraved some charming original copperplates, and the former also reproduced a considerable number of paintings by Watteau. Of the two Cochins, both named Charles Nicolas, the father, an excellent facsimile engraver, left 500 prints. The son (1715–90), rather more famous than his father, not only as a virtuoso but also as a writer on esthetics and technique, reprinted with valuable comments the *Traité des manières de graver en taille-douce* ... of Abraham Bosse.

The woodcut was in a thoroughly decadent state and almost completely abandoned, despite Jean Michel Papillon's efforts to resuscitate it through the publication of his *Traité historique et pratique de la gravure sur bois* in 1766. Toward the end of the century the Englishman Thomas Bewick (1753–1828) replaced the block cut with the grain with a block cut cross grain, and the gouge with the burin. He evolved the new technique properly termed wood engraving. As already explained, the traditional linear technique of the woodcut is reversed, and pictorial effects rather similar to those of metal in the fineness of grays and the exact registering of values are obtained. Because it could be inserted into the typographical text, the wood block came to replace the copperplate in book illustration, thus making possible the simultaneous printing of picture and text at a considerable saving of time and money. The French book profited greatly from this. Wood engraving was also later used as a reproductive medium. At the end of the century all forms of engraving became lighter, fresher, and more imaginative, because of the influence of Tiepolo.

During the 18th century engraving became important in England, the richest nation of Europe, where collectors abounded and where the portrait was in great vogue. Line engraving was anathema to the great portraitists, Reynolds, John Hoppner, Raeburn, Gainsborough, Lawrence, and Romney. Mezzotint (which was, in fact, called the English manner) was far more suitable to the faithful reproduction of their painting style, as it eliminated line, concentrating on the soft and indistinct and achieving an undeniable attractiveness. Sir Joshua Reynolds, president of the Royal Academy, following the example of Rubens, surrounded himself with virtuoso engravers, beginning with John Smith (1652–1742) and continuing with the Irishmen James McArdell, Richard Houston, and James Watson (1740–90), who were the strongest and most prolific of the group. Also included were the Englishmen Thomas Watson, William Dickinson, John Jones, Robert Dunkarton, Richard Earlom, Valentine Green, and the great John Raphael Smith (1752–1812). Smith's pupils continued his tradition into the following century. In 1797 Gainsborough published some soft-ground etchings of landscapes, which he had engraved for his own amusement. The field of original etching also included William Hogarth, the great antagonist of Reynolds; however, Hogarth's fame is due only in part to his graphic work, in which he was in any case far from a virtuoso (PL. 440).

Political caricature attained maximum potency in the work of Thomas Rowlandson (q.v.), and was practiced as well by James Gillray, Henry William Bunbury, Robert Dighton, and George Cruikshank. William Blake (q.v.) was a mystic of genius who reached expressive heights in the hallucinatory reevocation of his own poems, in depictions of Biblical episodes, and in the gloomy visions of his inexhaustible imagination, realized by transferring the woodcut technique onto metal through the use

of acid. Among his most telling works are the Book of Job and the illustrations of Virgil.

German engraving lost its most outstanding original personalities to other countries: Adam Elsheimer, previously mentioned, to the Low Countries; Wenzel Hollar (1607–77) to England, where he produced many prints of uneven quality; and the Greuter family to Rome, where its members worked as able copyists. In the 18th century the very active Sadeler family, facile and elegant engravers of Belgian origin, worked in Bavaria, as did the Kilians and the Sandrarts. Jan Georg Wille found fame in France working with Georg Friedrich Schmidt (1712–75). The Pole Daniel Chodowiecki (1726–1801), a pleasant and graceful vignettist, established himself in Germany and enjoyed great popularity. In the following century, however, German engraving recovered its strength.

The great names of Tiepolo, Canaletto, and Piranesi ornament Italian engraving of the 18th century. Facsimile engravers multiplied, refined but cold in technique. Pure line engraving remained bound to etching, which increasingly dominated the field, whether in the hands of the archaeologists who followed Pietro Santi Bartoli, those of the "ruins engravers" around Pannini, or those the of "view engravers," followers of Giovanni Battista Falda and Alessandro Specchi, with Giuseppe Vasi (1710–82) at the head. Vasi characteristically saw in terms of large masses and planes and avoided the use of coulisses, preferring his front planes in shadow (PL. 438). His major work, *Delle magnificenze di Roma antica e moderna*, dates from 1747. Luca Carlevaris (1663–1730) initiated engraved views of Venice in 1703 with his 104 scenes of the city. This trend was continued by Michele Marieschi, Giovanni Francesco Costa, and Antonio Zucchi. The Calcografia Camerale Romana (today the Calcografia Nazionale) was established in 1738 through the efforts of Pope Clement XII Corsini, who acquired the plates of the print shop of Gian Domenico de Rossi, which had come from a number of publishing houses active in Rome since the middle of the 16th century. In Bassano the Calcografia Remondini was a training ground for superior technicians, while in Venice flourished the shop of Joseph Wagner (1706–86), from which emerged Fabio Berardi, Giovanni Volpato, and Francesco Bartolozzi (1728–1815). The last-named became famous in England for his extremely refined and rather fussy stipple technique. He engraved about fifteen hundred plates, a few of them original, and timidly attempted the three-color print on a single plate. Marco Pitteri (1703–86) reproduced the paintings of Giambattista Piazzetta and Pietro Longhi, taking from French engraving the use of the sheaf of parallel lines and the variation of thickness within the single stroke, the whole integrated by suitable stippling. Volpato opened a school in Rome, in which the line engraver Rafaello Morghen (1758–1833) was trained. The best-known line engraver, other than Morghen, was Giuseppe Longhi (1766–1831), teacher of engraving at the Accademia di Brera and author of a fine treatise on esthetics, *La calcografia*. More or less in the sphere of Morghen and Longhi, and under the wing of the Calcografia Camerale, were Giovanni Volpato and various others, among them Luigi Calamatta (1801–69). In Paris Calamatta earned the support of Ingres, who entrusted to him the reproduction of his *Vow of Louis XII*. The resulting print is a masterpiece of engraving. Calamatta later taught for many years at the Brussels Academy, where his training produced excellent engravers.

Original engraving was centered in Venice. Marco Ricci (1679–1729), pupil of his uncle Sebastiano, engraved 22 copperplates of broad, airy, and well-realized landscapes. Far superior to all the others, however, were the celebrated views of Canaletto (q.v.), which are pervaded by a mood of pathos-tinged contemplation. He executed these in an extremely simple drawing style composed of parallel strokes without crosshatchings, to which the white of the paper, employed with unsurpassable skill, seems to give the breath of life. Bernardo Bellotto (1724–80), his nephew and pupil, followed his style, greatly increasing the dimensions of the plate. His production is represented by large views of Dresden, Pirna, and Warsaw. Giovan Battista Tiepolo (q.v.) made use of his free-flowing and brilliant needle in 35 original plates (the *Capricci*, V, PL. 241; the *Divertimenti*;

the *Scherzi di fantasia*) and reached his peak as a graphic artist in his masterly *Adoration of the Magi* (PL. 437). Steeped in light, whimsical and rapid, his graphic technique reflected the characteristics of his painting. Of Tiepolo's two sons, Lorenzo and Giovanni Domenico, the latter (1727–1804), more gifted, perfected his father's technique without sacrificing its luminosity and sprightly freedom. He interpreted and reproduced his father's paintings. Of his 173 prints, the 24 variations on the theme of the *Flight into Egypt*, a diverting virtuoso display of technical skill and invention, and a number of little portraits are particularly memorable. Lorenzo differed from his brother in his preference for lower values.

The most eminent figure of the 18th century was Giovanni Battista Piranesi (q.v.), architect, archaeologist, and engraver. Of all his related activities, engraving was that which permitted him to realize most fully the ruling passions of his life, the celebration of the grandeur of Rome and its monuments (PL. 438). The *Archi trionfali*, the *Antichità romane*, the *Magnificenza e architettura dei Romani*, and the *Vedute di Roma* (I, PLS. 309, 410) are his major works, scholarly as well as artistic. His masterpiece was the prison series, *Carceri d'invenzione*, which reveals his dominant interest in pictorial space and his characteristic vigor of execution (PL. 439). (This type of engraving has come to be called intense etching.) His son Francesco (1756–1810) supported his efforts, continuing with understanding and appreciation the grandiose work, which was later reechoed in pedestrian fashion by a talented imitator, the architect Luigi Rossini (1790–1857). Notable also in this period, especially toward the end of the century, was the activity of the cartographers, as for example the great map of Rome by Giovanni Battista Nolli, on which the younger Piranesi collaborated.

One of the most powerful geniuses of the graphic arts, the Spaniard Francisco Goya (q.v.) belonged to both the 18th and 19th centuries. In 1799 his 80 *Caprichos* (PL. 440; V, PL. 241) appeared, anticipating surrealism, proclaiming the freedom of line, and inaugurating a technique related to painting (VI, PL. 402). The linear design, executed in the frenzy of the first idea, was given weight and support by solid fields of aquatint, a true substitute for color. The 82 *Disasters of War* followed; in 1816 appeared the *Tauromachias*, and in 1819 the 22 *Disparates* (wrongly called *Proverbs*). All of these achieved recognition during the Second Empire, when they exercised a profound influence on French art.

During the 19th century the graphic media were taken up even more by painters, and after 1850 almost every painter attempted at least some graphic work. This production, in which techniques were mixed and assimilated, reflected the new directions of painting, in which regional differences tended to be eliminated. Etching became richer in contrasts, and the veils came into use in printing, often injuring the freshness of the engraving.

France, with a large group of artists of the first rank, particularly the two great graphic masters Honoré Daumier (q.v.) and Charles Meryon, produced the most important work. Pure line engraving in harmony with the classicism of David was restored to importance by Charles Clément Bervic (1756–1822), pupil of Wille. Facsimile engraving had by this time expired, however. Orthodox burin engraving, after the true virtuoso creativity of Henriquel Dupont (1797–1892), was supplanted by the free cutting of Flameng and Gaillard and fell into disuse by the end of the century. A masterpiece of the early 19th century was the portrait of Monseigneur de Pressigny by Ingres (PL. 440). In 1816 occurred the brief popularity of the steel plate, though etching and lithography were to become the dominant graphic techniques. The latter, invented in 1796 by Alois Senefelder and rapidly diffused for commercial purposes in Germany, became popular because of its simplicity and speed of both execution and printing, its low cost, and its particular adaptability to printing in color. The lithographic process involves working on stone (today sometimes metal plates) with an ink-resistant greasy material. It became the preferred medium for color printing used by every illustrated newspaper. France saw the circulation of thousands of prints by Emile and Antoine Vernet, Eugène Devéria, Tony and Alfred Johannot, Célestin

Nanteuil, Eugène Isabey, Eugène Lami, as well as by the very popular Nicolas Toussaint Charlet, his pupil Auguste Raffet, and that formidable draftsman, Théodore Géricault. The example of Goya led Eugène Delacroix to commit the dramatic scenes of Faust to stone in 1828.

Two newspapers, *Caricature* and *Charivari*, owed their fame to the contributions of Honoré Daumier and Paul Gavarni. Daumier (q.v.), an artistic personality endowed with exceptional expressive power, prodigious visual memory, and great facility of invention and improvisation, used these qualities as weapons of social satire that has made his work immortal (III, PL. 430). Four thousand of his prints, which appeared in the two newspapers, depicted the foibles of the *bourgeoisie* and the cynicism of the legal profession (PL. 120). The latter was his favorite target. In these prints Daumier sometimes achieved those grandiose dramatic forms that Balzac was to call Michelangelesque. The lively draftsman Guillaume Sulpice Chevalier, called Paul Gavarni (1804–66), perfected his technique by working on newspapers and magazines and devoted his refined crayon to the representation of human types found amusing by the public (*Thomas Vireloque*; PL. 442), to Parisian life (III, PL. 430), and to feminine elegance (*Les Lorettes, Les Etudiants, Les Parisiens, Les Enfants terribles*).

In the hands of these two great figures, lithography almost smothered engraving, especially since at this time it was also used for making reproductions. Although lithography began to decline after 1850, it was still practiced by Henri Fantin-Latour, with his floral, and musical subjects; by Alexandre Lunois, Rodolphe Bresdin (called Chien Caillou), Eugène Carrière, and Odilon Redon (q.v.), with his metaphysical visions in superb blacks. Foremost, however, was Henri de Toulouse-Lautrec (q.v.). His 350 graphic works mirror the surroundings of his unhappy existence; his sad sensitivity was conveyed by a rapid and intense touch.

In the second half of the century etching regained its preeminence. Baudelaire wrote in 1862, "Etching is all the fashion." All the important French painters were more or less involved with it. Corot (q.v.) achieved a lyrical quality with his spidery, tangled, fulminating line, vibrant with emotion (PL. 442). Of the school of Barbizon were Charles Jacque (1813–94), author of more than a thousand little scenes, executed with nervous vivacity; Charles Daubigny (q.v.), creator of about one hundred fifty landscapes as well as numerous vignettes in wood; and Théodore Rousseau (1812–67), producer of four prints of the highest quality. The great Jean François Millet (q.v.) recounted the life of the humble rural folk on 20 plates, executed with simplicity of means and monumental breadth of vision. The tragic visionary Charles Meryon (1821–68) fixed in copper his immortal views of Paris: *L'Abside de Notre-Dame, La Morgue, La Pompe de Notre-Dame, Le Petit Pont*. They are rendered in a precise pictorial handwriting, pervaded with a sense of controlled ardor in the slow and ordered composition. The artist saw them within their surrounding atmosphere, in the multiple qualities of external appearance, with a feeling for material bordering on the prodigious. Félix Bracquemond (1833–1914) figured in the resurgence of etching as the author of 773 technically admirable prints and also as the animator, advisor, and collaborator of a number of other artists. Among them were Edouard Manet (q.v.), who produced 76 etchings after his paintings, all rather slovenly but powerful; and Edgar Degas (q.v.), who authored 45 copperplates as well as 21 lithographs. Alphonse Legros (1837–1911) made more than eight hundred prints of varying character, some austere, profoundly felt, robustly constructed, and full of strong contrasts and a sense of the dramatic (PL. 443). Others were less forceful, delicate as spider webs, but always evocative and masterfully executed, whether landscapes, action scenes, or portraits. Together with Bracquemond and the publisher Alfred Cadart, Legros founded the Société des Aquafortistes, in which both French and foreign painters were active. The landscapist Maxime Lalanne published an excellent technicel treatise. The sculptor Auguste Rodin engraved dry-point portraits of famous personalities, and both the mundane Paul Helleu (approximately fifteen hundred prints) and the Armenian artist Edgar

Chahine dedicated themselves to dry point as well. Jean Louis Forain (1852–1931) brought to the realm of satire a brilliant but inconsistent style, as did Théophile Steinlen (1859–1923). Albert Besnard (1849–1935), pupil of Legros, engraved cursive and somewhat academic prints, some of which are effective. Rodolphe Jacquemart; the romantics Guillaume Descamps, Célestin Nanteuil, Rodolphe Bresdin, Théodore Chassériau, and Louis Adolphe Hervier; the Rembrandtesque Auguste Brouet; Félix Buhot; and the realist Paul Huet — all were notable engravers. Louis Legrand (1863–1951), master of etching, took up with gusto the erotic themes of his master Félicien Rops. Some two hundred prints by Camille Pissarro (q.v.) reveal the artist as an impassioned observer of nature. Renoir made very few prints.

Wood engraving had been revolutionized by Thomas Bewick (1753–1828). Gustave Doré (1832–83) was quick to sense the importance of the new technique for book illustration, creating the *bois de teinte*, which could be printed at the same time as the text. This facile, rather superficial, and melodramatic draftsman, possessed of an inexhaustible imagination, illustrated 120 books, the most successful of which were the first, the *Contes drolatiques* of Balzac and *Baron Munchhausen*. Doré himself only laid in the design on the block, indicating outlines and tonal areas, while the actual cutting was performed by numerous expert collaborators trained by him, working under the direction of Héliodore Pisan and Stéphane Pannemaker.

Auguste Lepère (d. 1918) inspired a whole group of woodcutters, such as Henri Rivière, Tony Beltrand and his four sons, Amédée Joyau, Pierre Bonnard, and Edouard Vuillard. Some of these were dedicated to the color print, which met with extraordinary success, partly owing to the interest in Japanese prints in Paris about 1870. Paul Gauguin reaffirmed his primitivism by repudiating hatching and returning to pure outline, as did Félix Vallotton, Maurice Denis, Aristide Maillol, and Émile Bernard.

English etching began its renascence with the *Liber studiorum* of Turner (q.v.), in which he combined it with mezzotint. John Crome (q.v.) made a distinguished contribution to its use in landscape, as did John Sell Cotman (1782–1842) with a fine group of soft-ground etchings. Other contributors were John Constable, Thomas Girtin, Andrew Geddes, and Sir David Wilkie. Somewhat later appeared the surgeon Francis Seymour Haden (1818–1910), admirer and student of Rembrandt, who produced about two hundred admirable etchings and dry points. His young American brother-in-law, the refined esthete James MacNeill Whistler (q.v.), published his freshly rendered *Views of the Thames*. Whistler also produced a collection of Venetian subjects, executed with a rather mannered elegance and a light touch and printed with loving care.

The Belgian Félicien Rops (1833–98) produced 300 prints of literary inspiration, infused at times with an open eroticism. He used all the graphic techniques (particularly lithography and soft-ground etching) with a skill so exceptional that it masked the structural deficiences of his compositions. James Ensor (q.v.), one of the great and complex personalities to emerge from impressionism, attempted new processes requiring the most delicate manipulations. He employed a line clearly derived from Rembrandt, used sometimes for the representation of reality and sometimes to express the subconscious, with highly evocative and occasionally disturbing results. Other Belgian graphic artists of this generation are Albert Baertson (1866–1922), master of aquatint; the idealist Fernand Knopff; Armand Rassenfosse; Jules de Bruycker (1870–1945); and the impressionist Theo van Rysselberghe (1862–1926).

In Holland Pieter Dupont (1870–1911) went back to the traditional techniques of line engraving, while Jozef Israels (1824–1911), Philippe Zilcken (1857–1930), Storm van 's Gravesande, and Jan Toorop (1858–1928) worked in etching. The greatest was Johan Barthold Jongkind (1819–91), whose 22 plates were light, spontaneous, and concise (PL. 441).

The Swede Anders Zorn (1860–1920) was a virtuoso of outstanding ability, whose explosive stroke rendered nudes and portraits of great vitality. His portrait of Renan, for example, is a masterpiece. The Norwegian Edvard Münch (q.v.) made woodcuts and lithographs.

In the early years of the century facsimile engraving continued in favor in Germany, where the tradition was maintained by Johann Friedrich von Müller (1782–1816), Joseph von Keller (1811–73), and Eduard Mandel (1810–82). Original etching was particularly popular with the romantics, such as Moritz von Schwind (1804–71); the genial illustrators Ludwig Richter (1803–84) and Alfred Rethel (1816–59), both also woodcutters; Adolf von Menzel (1815–1905); and Wilhelm Leibl (1844–1900). Most representative of the period was Max Klinger (1857–1920), author of a series of many etchings, executed with that technical perfection and exhaustive accuracy of outline that are at once the virtue and defect of German art. Three famous periodicals should be mentioned because of their graphic contribution in the field of humor and satire: *Fliegende Blätter*, *Simplizissimus*, and *Jugend*.

The first notable figure in 19th-century Italy was that of Bartolomeo Pinelli (1781–1835), the popular and highly prolific Roman illustrator, whose extraordinary inventive powers and facility of hand only confined his art within a conventional cipher (PL. 441). Limited, but rather more valuable, was the production of Luigi Sabatelli (1772–1850), whose best print was the *Plague of Florence*. In Naples the Gigante brothers, Giacinto (1806–76) and Achille (1830–85), represented in engraving the school of Posillipo. Filippo Palizzi (1818–99) brought to Neapolitan graphic art his attentive curiosity and love for animals, engraved in a pictorial manner with great skill. Later Giuseppe de Nittis (1846–84), who worked in the Parisian mode, Francesco Michetti, (1851–1929), and Domenico Morelli engraved occasionally. In Rome the Spaniard Mariano Fortuny, a subtle researcher, achieved exceptional refinement of execution, which did not, however, save him from a frivolous superficial elegance that has taken the name *fortunismo*. The two figures who brought Italian graphic art into international prominence in the 19th century were Giovanni Fattori and Antonio Fontanesi. Fattori (1825–1908) produced immediate, architectonic and evocative compositions, the expressive power of which is enhanced by the apparent inexperience of the engraver. The caustic and subtle Telemaco Signorini (1835–1901) engraved with vivacity and with the descriptive precision of an illustrator, translating his own painting with refined sensibility. His style was that of a convinced realist (as, for example, the illustrations for the stories of Diego Martelli). Fontanesi (1818–82) based his landscapes on atmospheric appearance. His attention to values, already rigorous in lithographs, became more intense in the etchings. He fostered the development of a group of admirable virtuoso etchers in Turin, all more or less dependent on him stylistically. They were united under the name of L'acquaforte. Line engraving, still in use at the beginning of the 20th century as a means of reproduction, was later supplanted by the photographic processes.

The 20th century marked the definitive triumph of the original print. During the first decades lingering 19th-century currents persisted, and only after World War I did the new tendencies (which had, however, already been partially defined in the reaction against impressionism) emerge with clarity. Fantasy prevailed over reality, conquering it almost entirely. The graphic media were, however, rather slow to follow the advances of painting.

In Paris the old Société des peintres-graveurs français (founded 1889) was joined by the Peintres-graveurs indépendants (1923) and the Jeune graveur contemporaine (1929). French graphic art in this century can boast the great names of Henri Matisse (q.v.), pupil of Gustave Moreau and author of approximately three hundred prints, and Pablo Picasso (q.v.), artist of some four hundred prints ranging from the *Repas frugal* to the *Natural History* and *Minotauromachia* (PL. 443). Georges Rouault (q.v.) amalgamated the most varied techniques into powerful mystical images reflecting the solitude of man; Jacques Villon (see DUCHAMPS) emerged from cubism with an exemplary purity of style; and the Russian Marc Chagall (q.v.) created 500 exuberant and imaginative illustrations. A resurgence of line engraving was brought about by the Pole Joseph Hecht (1891–1952) and the Englishman Stanley Hayter (b. 1901), who in the United States, surrounded by fervent and

skillful followers, pioneered the return to pure elegant line, liberated from reality.

Also devoted to burin engraving were J. E. Laboureur (1877–1943); Etienne Cournault (1891–1948); L. J. Soulas (1905–1954), who cut both copper and wood with great sureness of hand; R. Vieillard (b. 1907); A. Decaris (b. 1901); and C. Berg (b. 1904). From the technical eclectics emerged M. de Vlaminck (1876–1958); the prolific Jean Frelaut (1879–1954), with more than one thousand prints; Raoul Dufy (1877–1953); Robert Lotiron (b. 1886); G. Cochet (b. 1888); P. Dubreuil (b. 1891), with some five hundred prints; E. Goerg (b. 1893); and R. Cami (b. 1900). In lithography worked Marc Chagall (II, PL. 296), A. de la Patellière (1890–1932), A. Derain (q.v.), Luc Albert Moreau (1882–1948), Georges Braque (q.v.), J. Bersier (b. 1895), L. Lang (b. 1899), M. Brianchon (b. 1899), Fernand Léger (q.v.), A. Manessier (b. 1911), and A. Fougeron (b. 1912). Etching and dry point were practiced by André Jacquemin (b. 1904), who combined them agreeably; A. Dunoyer de Segonzac (b. 1884), who worked with a subtle and nervous line; R. Lotiron (b. 1886); G. Cochet (b. 1888); Yves Alix (b. 1890); P. Guastalla (b. 1891); Marcel Gromaire (b. 1892), robust synthetic constructor; J. Deville (b. 1901); and the two Swiss, R. Wehrlin (b. 1903) and Aimé Montandon (b. 1913).

In Germany artists who were active in both the 19th and 20th centuries include Hans Thoma (1839–1924); Leopold von Dalckreuth (1851–1928); the isolated figure of Kathe Kollwitz (q.v.), who portrayed in lithographs touching images of a doleful humanity; E. Orlik (1870–1932); Alfred Kubin (1877–1959); W. Geiger (b. 1878); R. Grossman (b. 1882); and G. Meid (b. 1883). The art of Max Liebermann was joined by that of Lovis Corinth (1858–1925) and the more prolific Max Slevogt (1868–1932). Expressionism made its appearance about 1905 with the Brücke group (V, PL. 211) including Ernst Ludwig Kirchner (1880–1938), Max Pechstein (1881–1955; PL. 443), Karl Schmidt-Rottluff (b. 1884; PL. 444), and Emil Nolde (q.v.), who alternated visions of fantasy with those of reality (V, PL. 212); he also produced a number of views of the port of Hamburg.

Lithography was the preferred graphic medium of Oscar Kokoschka (q.v.). In Dresden worked the landscapists B. Kretzchmar (b. 1889) and O. Lange (1879–1944); the line engraver P. A. Bockstiegel (b. 1889); Otto Müller (1874–1930); Franz Jansen (b. 1885); and Otto Pankok (b. 1893). Karl Hofer (1878–1955) and Max Beckmann (q.v.) vigorously summarized form, while George Grosz (1893–1959) brought to satire acuteness of vision and ingenuity of composition. In a different direction Paul Klee (q.v.), cofounder with Wassily Kandinsky in 1911 of the Blaue Reiter group, made valid statements of his convictions. This may also be said of Alfred Kubin.

In England, on the death of Whistler, the pre-Raphaelites were active. Dante Gabriel Rossetti (1828–82), Walter Crane (1845–1915), William Holman Hunt (1827–1910), William Morris (1834–96), and E. C. Burne-Jones (1833–98) belonged to this group. Audrey Beardsley (q.v.), Arthur Rackham (1867–1939), and Charles Ricketts devoted themselves to book design and illustration. Etching, for the most part used in scenic views, was further developed by Muirhead Bone (1876–1953), who was expert in all techniques. Oliver Hall, Robert Goff (1837–1922), W. Strang (1859–1921), and Frank Brangwyn (1867–1956), who excelled in printing with veils, also worked with this technique. Charles Shannon and Charles Conder turned enthusiastically to lithography.

Spain is stylistically connected to Paris, where most of the modern Spanish artists have lived. These include Picasso, Joan Mirò, Salvador Dali, Juan Gris, Manolo, and Luis Quintanilla. In the first rank of Belgian graphic artists are the wood cutters Frans Masereel, Nicolas Eeckman, and Edgard Tytgat.

Active in Italy after World War I were Anselmo Bucci (1887–1955), author of approximately three hundred plates, among which is the very lively series *Paris qui bouge*; Umberto Prencipe (b. 1879), romantic landscapist, with his views of Orvieto; Antonio Carbonati (1893–1956), able technician, whose very abundant output, starting in 1910 with splendid little views of Paris, gradually degenerated into narrative prettiness; Ben-

venuto Disertori (b. 1887), who returned to simplicity of line with a broad and calculated stroke, uncluttered by crosshatchings; Carlo Alberto Petrucci (b. 1881), who has expressed in some two hundred prints the poetic aspects of Rome and the Campagna; Marcello Boglione (1891–1957) of Turin, the last follower of the group of skilled etchers around Antonio Fontanesi; Cino Bozzetti; Alberto Martini (1876–1954), who echoed Rops; and Raoul Ferenzona (1879–1946). Futurism had little effect on the graphic arts, the few prints by Umberto Boccioni preceding his participation in the movement. Carlo Carrà, however, has projected his primordial world on metal and stone. Giorgio Morandi (b. 1890) with ecstatic concentration transfigures everyday objects or bits of landscape with his calm and ordered stroke and with his extreme sensitivity to the play of values, making of them testimonials of his own joy in creation (PL. 444). Luigi Bartolini (b. 1892) is gifted with great power and facility of linear expression. Massimo Campigli (b. 1889) expresses on stone his nostalgia for the past; Mino Maccari (b. 1898), expert in all techniques, continues in Italy the tradition of social satire; Giuseppe Viviani (b. 1898) wraps in delicate linear embroidery graphic images of touching poetry; Giacomo Manzù (b. 1908) has dedicated the best of his plastic sensibility to illustrations for the *Georgics*. Leonardo Castellani (b. 1896), Lino Bianchi Barriviera (b. 1906), and Celestino Celestini (b. 1882), all robust graphic artists, choose landscape as their preferred subject, while Giovanni Romagnoli (b. 1893) and Pio Semeghini (b. 1878) are primarily concerned with the figure. Mario Vellani Marchi (b. 1895) devotes himself to lithography.

Wood engraving, after the attempt of Adolfo de Carolis and Duilio Cambellotti to revive it (an attempt largely dependent on the work of D'Annunzio for content, as for example, illustrations for *La figlia di Jorio* and *Il notturno*), achieved high drama and powerful vitality at the hands of Lorenzo Viani (1882–1936).

Since World War II the color print has been of primary importance. The development of the silk-screen process having eliminated restrictions on format, color prints have grown increasingly larger, often to poster size. Thus, a new art form, neither engraving nor painting (though it derives from both), is emerging with its own valid stylistic characteristics. It should be kept separate from the two parent arts. At mid-century graphic production has reached such proportions and such a diversity of stylistic trends that a critical definition is nearly impossible to make at this time.

Mexico has a school founded by Jose Guadalupe Posada (1851–1913) and continued by Diego Rivera (q.v.), José Clemente Orozco (q.v.), D. A. Siqueiros (q.v.), and Jean Charlot (b. 1898). The highly developed characteristics of these artists are very original. Canada and the countries of Central and South America have not as yet developed a notable graphic production.

About 1910 art in the United States, after a period of dependence on Europe, began to draw on its native resources (see AMERICAS: ART SINCE COLUMBUS). Joseph Pennell (1860–1926); John Sloan (q.v.); Edward Hopper (q.v.); George Bellows (1882–1925), one of the pioneers, with Pennell, of American lithography; John Taylor Arms (b. 1887), H. Webster, D. S. MacLaughlan, and Louis Rosenberg — all have dedicated themselves mainly to the representation of scenes of city life. More recently T. H. Benton (b. 1889), H. Wickey (b. 1892), Peggy Bacon (b. 1895), R. Soyer (b. 1889), and many others have been concerned with regional themes of the Middle West. Somewhat later Americans took up the problem of the color print, in which they were greatly aided by the silk-screen process. All of these artists have been preoccupied with technique, and their works are of indisputable technical perfection.

Carlo Alberto PETRUCCI

*The Islamic world.* Engraving, in the sense of graphic art, was not practiced in the Islamic world. European copper engravings (especially Dutch and Portuguese), however, were often found in the albums that were fashionable from the 16th to the 18th century among art lovers in Persia, Turkey, and

India. In these were gathered miniatures, brush drawings, quick sketches, and pages of calligraphy. The Oriental collectors did not fully appreciate the peculiar technical limitations and resources of the graphic arts, and prints were admired only for their detailed execution.

Occasionally copies of these prints were made by hand, a long and difficult labor of imitation. In fact, until the late 19th century, it was customary to copy by hand even the most popular and widely diffused texts, for example, the Koran, which frequently had calligraphic decoration. Only much later did the change to lithography and other European printing techniques occur.

In the field of textiles, designs were printed on linen, cotton, and eventually on silk, by means of little wooden or metal stamps on which the motifs to be reproduced had been incised. There exist Egyptian and Iraqi examples of printed textiles from as early as the 10th century. From the medieval period India was preeminent in this field, particularly because of its productions of polychrome textiles.

In the case of leather bookbinding, the cover decoration was obtained by stamping (either dry or with gold) from the earliest times of Islam. This was partially a continuation of Coptic tradition. Blocks and engraved punch stamps of leather or metal were used. From about the 14th century, particularly in Egypt and Persia, the inside of the binding was preferably decorated with filigree arabesques cut out of the leather (later, out of the paper).

Another form of engraving that existed in the Moslem world was the decoration of metal utensils, which were engraved with ornamental and figural motifs, and later encrusted with copper, silver, or gold. This art has been practiced from the beginning of the Islamic period in all Moslem countries. As in the West, metal presses were used for the minting of coins.

Ernst KÜHNEL

India. The development of graphic art in India is very recent. Even though the principles of graphic reproduction have been known for many years, social conditions did not favor its growth until a short time ago. The steatite seals of the Harappa and Indus civilizations (see INDUS VALLEY ART) reproduced designs in clay. Clay seals and pilgrimage souvenirs modeled in brass or terra cotta, as well as the stone matrices themselves, have been common up to the present day.

The printing of textiles with engraved wooden blocks was very common, the cloth being imported into Egypt during the Middle Ages and into Europe in the 17th and 18th centuries. Occasionally scenes with figures can be found on cotton fabrics of the 12th and 13th centuries. There are notable examples of ancient Indian engraving on stone or copper from Rajgir (a lota in the Vict. and Alb., London; 2d cent. B.C.) and from Nagarjunakonda (3d cent. B.C.).

Since paper was not introduced into India before the 14th century, all pictures except murals were made on palm leaves or cotton cloth. It seems that during the late Gupta period (6th–8th cent.) stencils were used in the execution of paintings, and that they were also used in different combinations for at least a part of the murals of the late Ajanta (q.v.) period. Tibetan paintings in the Indian tradition are often elaborations of woodcuts. Although it is impossible to establish exactly when this practice originated, there is reason to believe that it was introduced between the 7th and 11th centuries. The use of the stencil technique was also very common in late Moghul and Rajput miniature painting. In this case the design was first executed on parchment, the outlines pricked, and the design transferred to paper by pouncing. At the beginning of the 19th century, especially at Jaipur, the Ragmala paintings (a type of lyrical love scene, including references to music and nature) were mass-produced in this way, each one being finished individually by a painter. Such pictures were then sold all over India to the lower aristocracy and the rich merchant class, who used them for the decoration of the women's quarters. However, for economic reasons, this art form was never popularized by graphic reproduction, even though the traditional Indian style

of painting using emphasized outlines and flat tonal areas would have been eminently suited to it, especially to the woodcut.

The style of many 20th-century Indian painters would also lend itself well to engraving, but only a few have tried it. These include N. S. Bendre (Baroda; dry point), M. Dutta Gupta (Calcutta; linocut), Satyen Ghosal (Calcutta; woodcut), Sudhir R. Khastgir (Dehra Dun; woodcut), K. S. Kulkarni (Delhi; woodcut), Kamala and Jagdish Mittal (Bulandshahr and Hyderabad; woodcut), Laxman Pai (Goa and Paris; woodcut, etching), Roopkrishna (Lahore and London; etching), Madhav Satawalekar (Bombay; woodcut), the famous Bengalese poet, Rabindranath Tagore (Shantiniketan), Kiron and Gertrude Sinha (Shantiniketan; woodcut and block-printed fabric). The abrupt introduction of modern printing processes has prevented the development of illustrational graphic art.

Hermann GOETZ

China. The origins of the Chinese woodcut seem to spring from the use of the seal (see SEALS), an object of great antiquity. In the centuries following the introduction of Buddhism into China, the seal was adapted first to the manufacture of printed amulets, then to that of images of the Buddha, with or without text. These were reproduced simply by pressing an engraved block of wood on paper or cloth. Our documentation of this early development is confusing and incomplete, as Chinese print making has not as yet been the subject of a systematic investigation, except for the studies carried out in China by Chêng Chên-to and indirect research by Paul Pelliot (1953) and T. F. Carter (1955).

The engraving of images on wood appeared early in China, but certainly not before about A.D. 500, the period in which the relief engraving of seals began. (With such seals, a colored image could be obtained on a white background.) The oldest evidence of the existence of images reproduced by a process of this kind is the comment of the pilgrim I-ching (692), who after returning from his Indian sojourn (673–85) wrote: "They [the Chinese] make chaityas [small stupas or shrines] of clay, and they stamp images in clay under pressure or print them on silk organza or paper to be given as offering, wherever one may be." As Pelliot noted, this text is the first to state expressly that such images were printed on silk or paper, and it seems, from the way in which it is expressed by I-ching, that the process was common in China. Pelliot also noted that an official chronicle of the Sui dynasty (581–618) refers to the fact that Taoist priests made amulets on which they engraved the constellations, the sun, and the moon. He maintained that these amulets were in fact printed by means of little blocks that were similar to the seals of the period.

The discoveries made at Tun-huang and Turfan (qq.v.) have brought to light numerous fragments of paper of varying lengths on which were reproduced repeated images of the Buddha. These fragments date certainly later than the 9th or 10th century. The reproductions were made by little blocks or cubes of wood, of which two examples have been found (one an intaglio block, the other in relief). A minute intaglio plate of metal, which can print the image of the Buddha both positively and negatively, has also been discovered.

The discovery of these demonstrates that the engraving process had been known in China for some time before the 9th or 10th century, since it had penetrated into Central Asia (q.v.) by that time. If the metal plate found at Turfan (by the German archaeologists) cannot be exactly dated, the engraved wood block found by Pelliot at Duldur-akhur in 1907 is datable with some precision, because of documents uncovered in the same area, which are of about 750–800. The intaglio plate of Tun-huang, depicting a seated Budda, is provided with a handle that makes it possible to reproduce the image with ease. This is done by coating the reserve areas of the plate with ink, so that in printing the white of the paper indicates the forms. If the ink is allowed to penetrate into the incised design and the reserve areas of the plate carefully cleaned, a black-on-white impression results. This plate could not be later than the date of the closing of the treasure chamber in which it was found (1004).

It is certain that the print industry was perfected and developed under the T'ang dynasty (see PL. 445), when engraving was more often carried out on wood than on any other material. Contrary to the earlier practice in seals and stamps, the process was a negative one in which the forms represented in the composition were indicated by printing the reserve areas in black. The discoveries made at Tun-huang have brought to light a number of prints and printed cylinders that may be considered the oldest known. Numerous prints on paper are amulets or votive offerings, depicting the Buddha or a bodhisattva with an appropriate Chinese text. All the prints of this type belong to a popular provincial art, peculiar to the region of Tun-huang. Some are dated in the years from 947 to 983. Among them also are prints of superior quality obviously executed by skilled artists; these perhaps come from a more progressive province. An example is *Avalokiteśvara (Kuan-yin) Surrounded by Divinities*, in a square frame ornamented with vajra forms.

The same thing is encountered in the printed work that can be considered the oldest known book, the "Diamond Sutra" (*Chin-kang-ching*; Br. Mus.) discovered by Sir Aurel Stein in 1907. The text is preceded by a print depicting the Buddha teaching and terminates with a colophon printed on May 11, 868. According to Stein and Pelliot, this is not a local work but probably comes from Szechwan. The refinement of this print proclaims an art that had already realized the fullness of its expressive means. It is curiously similar to many prints of later date illustrating Buddhist writings, which gives the impression that this type was established and became canonical at an early date and that it was subsequently employed by a number of schools.

Other prints, which were discovered in Chekiang, reveal a drawing style of thicker outline. Some of these adorn the beginning of a dharani (formula or charm), "Sutra of the Addresses to Divinities and of the Amulets of the Chest of Treasures." A number of examples of this print style are known, the oldest of which is dated 956. This type was also later extensively used in Buddhist books. There are still others of different character, such as the illustrations of the "Rules of Confession in the Ts'en-pei Bodhi Enclosure," limited to two little Buddhas placed at the top of each page. Two little figure engravings are found in the "Illustrated Commentary on the Book of Rites," each of which has a text at the bottom of the page, a horizontal title at the top, and a vertical legend accompanying the figure. This text dates from the beginning of the Sung dynasty (960–1279) and is not a Buddhist book; the illustrated volumes of the Sung period had begun to appear.

The art of print making was by this time widespread in China, and it was particularly lively in Szechwan and in the region of the lower Yangtze River, even though prints were used almost exclusively for popular needs and for Buddhist and Taoist texts. However, during the first half of the 10th century the official use of graphic art in the publication of the classics began. The advent of the Sung dynasty and the resulting almost complete unification of China facilitated the expansion of the new technique. In addition to illustrated editions of the classics and commentaries on the classics, other texts were published with pictures. The "Book of Music" of Chen Yang included prints showing musical instruments or people playing them. The "Commentary on the K'ao-kung Chapter of the Chou-li by the Man from Chüan-chai" of Lin Hsi-yi contains prints representing various objects. Books of all kinds were illustrated, one of the most famous being the "Album of Various Drawings of Plum Blossoms" of Sung Po-jên, in which are represented flowers and flowering branches. The prints in this book are the oldest examples of an art genre that has continued down to the present. All these prints reveal a developed art form. Two distinct types, depending on whether they were intended to illustrate religious or secular works, can be ascertained. The former reveals the characteristics already present in the print of 868 in the "Diamond Sutra," while the latter offers more individualized drawing styles. The illustrations for the religious works in some examples create the impression of a folk art, as in the "Lotus Sutra," which shows many scenes of miracles.

The illustrated volumes of the Yüan period (1260–1368) are somewhat different in character and of limited number. The first page decoration of the "Commentary on the Diamond Sutra," dated 1340, is firmer in draftsmanship than works of the Sung period. The sutras, of which there remain a good number, contain prints of the same type as those of the Sung dynasty (sometimes combined with a rather strong Tibetan influence, due to the Lamaism that prevailed at the court of the Mongols in Peking).

Works such as the "Treatise on Eating and Drinking" of Hu-ssŭ-huei and the "Medical Herbary of the Ta-kuan Period" are illustrated with prints representing animals, fish, trees, and plants. These present curious analogies to those of the *Pen-ts'ao* of T'ang Shen-wei, published during the Sung dynasty in the early 12th century. Other works that are included in the category of the classics or connected with them contain illustrations that in some cases recall those of Sung editions, such as the "Simple Commentary on the Book of Filial Piety" of Kuan Yün-chih and the encyclopedia *Shih-lin-kuang-chi*, in which some illustrations (those representing the wise men of antiquity) are characterized by a heavier and more massive drawing style. The period from the end of the T'ang dynasty to the end of the Yüan constitutes the first phase of this art. The Ming epoch was its golden age, especially in the Wan-li period (1573–1620), when its masterpieces were produced.

Throughout the Ming dynasty (1368–1644) the number of illustrated books multiplied; it was no longer a matter of a few volumes but of thousands. From these, published over three centuries, it is rather difficult to select examples to describe the notable artistic flowering of the print. From the beginning of the dynasty to the middle of the 16th century the greatest number of illustrated books consisted of the Buddhist sutras and Taoist works. Only in the second half of the 16th century did the number of books with pictures belonging to other areas of Chinese literature increase, finally outnumbering the illustrated religious works. Some of these editions consisted only of plates with a brief text and were in fact albums of prints. It is possible to distinguish the various regions in which real publishing houses arose.

The illustrated books can be divided into five categories according to the position of the pictures in relation to the text. These are: (1) those having a frontispiece illustration; (2) those with illustrations grouped at the beginning of the work, regardless of the number of chapters; (3) those having illustrations at the head of each chapter; (4) those in which the illustrations are scattered throughout the body of the text; and (5) those in which the illustrations are grouped together at the end of the book. The illustrations are in different shapes, medallions or rectangles; they may occupy one or more successive pages; and they are found either at the upper part of the page or interpolated into the text.

Also in the Ming era appeared illustrations in several colors and others printed from relief blocks by a process that was later improved. The illustrations that adorn the volumes of this period are of considerable variety. Not only do they represent objects, plants, animals, and human figures, but also scenes of daily life and conventional motifs. In the "Works of the Villa of Clouds" are represented the most celebrated landscapes. One edition of this work dates from the beginning of the Ming era. Other landscapes from the Chia-ching (1522–67) period of the Ming dynasty are worthy of note, such as that which appeared under the title *Boat and Snow*. Out of a black background are hacked mountains and the shores of a lake on which sails a ship battered by a snow storm.

During the reign of Lung-ch'ing (1567–73) and especially during that of Wan-li (1573–1620) the number of illustrated editions became considerable, any subject providing a pretext for illustration. These prints constitute a remarkable document of the development of Chinese life at this time — court and middle-class life and that of the lower classes, the peasants, and the artisans. At the same time the technique of print making attained the highest level of perfection, as is attested to by the many small masterpieces in every book and by the magnificent albums of prints. Among these, special mention should be given to the "Works Illustrated and Printed by

Various Members of the Huang Family," which was issued between 1582 and 1627 and which in its ensemble constitutes a series of albums of prints notable for their refinement and beauty of design. They illustrate either Buddhist works, classics, or famous novels, such as the "Tales of the Western Chamber." The Huang family reached its greatest fame between 1610 and 1643, during which years the greater part of this publication appeared. At about the same time was published the "Album of the Ten Bamboo Studio," the oldest and most perfect collection of polychrome prints, in which five colors were used in compositions of rectangular or medallion shape. This work, composed by Hu Chêng-yen at the end of the Ming period and executed by a number of famous engravers, was one of the works that signaled the culmination of Chinese graphic art.

At this same time Christianity was brought to China by the Jesuits, who printed a number of illustrated books, the influence of which was felt immediately. The most famous was the "Illustrated Life of Our Lord," which contained about fifty pictures representing the life of Christ. These were patterned after the group of illustrations published by Father Nadal at the Plantin publishing house in Antwerp, at the end of the 16th century.

The Ming, however, were destined to succumb to the Manchu, who established the Ch'ing dynasty (1644–1912). Under the early Ch'ing rulers book illustration and the publication of albums of prints were continued. High quality was maintained in the "Album of the Bank" and the "Album of Antiquities," both designed by the poet-painter Chen Lao-lien, the first about 1640, the second in 1651. Also of notable achievement, was the "Illustrated Album of Landscapes (of the Park) of Supreme Peace," for which 44 prints, designed by the painter Hsiao Yün-ts'ung, were engraved and published in 1648. These works, as well as many others less well known, are authentic masterpieces, in which the drawing style of fine and soft line offers refinement of expression in both figures and landscapes.

From the reign of K'ang-hsi (1662–1722) graphic art began to fall into decadence. Beautiful illustrated books still appeared, but they did not equal the perfection of their predecessors. These include: "Western Chamber Collection" of You T'ung, published in 1694; a new illustrated edition of the "Short Account of Famous Persons" of Wang Yün of the Yüan dynasty, executed during the reign of Ch'ien-lung (1736–95); "Local History of the Kuei-chou"; "Drawings to Illustrate the Chou-ko Chapter of the Li-sao," executed under the emperor K'ang-hsi; "Famous Places of the Chiang-nan," from the time of Ch'ien-lung; and "Drawings of the Hundred Butterflies" of the Tao-kuang period. In all these works, however, the slow process of deterioration can be noted. The Chinese print fell into decadence and lost its significance as art long before the fall of the Ch'ing dynasty. (See PL. 445.)

<div align="right">Louis HAMBIS</div>

*Japan.* The Japanese took from China the woodcut technique, which required a designer, a cutter, and a printer. The history of the Japanese woodcut commenced about the middle of the 17th century and lasted until almost the end of the 19th. The wood generally used was cherry, cut with the grain. Water inks were employed in the printing. The earliest prints, called *sumi-e*, were in black and white and represented Buddhist subjects (generally in a traditional style and endlessly repeated). However, the artists soon turned their attention to daily life, following the example of the painter Moronobu (ca. 1625–ca. 1695), who recognized in the print a means of popularizing his powerfully realistic, vigorous, and passionate works. He was the founder of the Ukiyo-e (q.v.). His follower Kiyonobu I (1664–1729), creator together with Kiyomasu of the Torii school, was the first to make individual prints, most of which were dedicated to the theater, its programs, the plays, and portraits of actors. He was followed in this by a whole troop of print makers, who began to color their black-and-white works by hand, gradually bringing into being the color print. At first only green and pink were used, but later a number of colors were employed. This early period of Japanese graphic art remains very obscure, partly because of the ease with which

artists changed their names and of the custom of using one name in common for a whole group of masters.

The most active research in the field of color was carried out by Okumura Masanobu (1686–1764), facile composer and refined colorist, who delighted in representing the courtesans of his day. He exerted great influence on Shigenaga (1697–1756), his fellow pupil under Kiyonobu. Toyonobu (1711–85) followed them, and with Harunobu the Japanese print became free, lively, and dynamic, executed with as many as seven or eight blocks (and about 1765 even 11 or more). Great precision was attained in the superimposition of these many blocks, and the color became ever more refined and delicate. Harunobu (1725–70), with his numerous pupils, produced many prints, rich in technical refinements. He loved serene idyllic scenes and the enchantments of youth (PL. 446). His imitator Koryūsai, as prolific as he, is remembered for his prints of courtesans. Little is known of the lives of these last two artists. Shigemasa (1739–1820) and Katsukawa Shunshō (1726–92), both able illustrators, devoted themselves to a realistic recounting of subjects primarily drawn from the theater and actors; they shared a particular inclination toward dramatic effects (PL. 447).

The Japanese print reached its apex with Torii Kiyonaga (1752–1815), who left more than eight hundred prints, among which are the most prized of the Ukiyo-e ("fleeting world") school. His elongated female figures characterized by an impassive dignity are colored with a sober harmony of tone. He was among the first to introduce the diptych and the triptych and to treat landscape realistically.

In the last years of the 18th century appeared the prints of the singular Sharaku, dedicated to caricature and social satire. His concise, often brutal prints, have an uncommon expressive power. At the same time the great Utamaro (q.v.; 1753–1806) reached his artistic maturity and great popular fame, achieved by his new interpretation of the feminine world, which occupied a large part of his work (PL. 446). An elegant and precise draftsman, he sought unusual effects. Utamaro has remained the favorite Japanese artist of the Western world, largely because of the work of Edmond de Goncourt. Still in demand are his three books of natural history, devoted to insects, birds, and shells.

The greatest Japanese artist is Hokusai (q.v.), who called himself "the old man mad for painting." His immense *œuvre* (PL. 447; VII, PLS. 296–300), which embraces the whole visible world, began with the 13 volumes of the *Mangwa*, a sort of picture encyclopedia (actually, his sketchbooks) composed of rapid sketches in a sensitive and precise drawing style. Of revealing acuteness of observation and rapidity of realization, these sketches invested the most diverse subjects with artistic interest. He was the founder of the realistic school, drawing his inspiration and his models from the people. Hokusai was less gifted than others in using color, even though he wrote a treatise on the subject (which was, however, of a more technical than esthetic character).

About fifty pupils continued his style after his death, which marked the beginning of the decline of the Japanese print. Among the best of the artists living at this time were Toyokuni I, Kunisada, Utagawa Kuniyoshi, and Hiroshige (q.v.). The last is especially well known (PL. 447; VII, PLS. 237–242). Important in Europe in the late 19th century, the Japanese woodcut aroused great enthusiasm, especially in Paris, contributing to a new interest in the color print.

<div align="right">Carlo Alberto PETRUCCI</div>

BIBLIOG. *The Western world: a. Technique*: J. C. Le Blon, L'art d'imprimer les tableaux, Paris, 1768; J. J. Bylaert, Nieuwe Manier om Plaet-Tekeningen in 't Koper te brengen... (Nouvelle manière de graver en cuivre), Leiden, 1772; J. Stapart, L'art de graver au pinceau, Paris, 1773; A. Bonnardot, Essai sur l'art de restaurer les estampes et les livres, 2d ed., Paris, 1858; M. Schasler, Die Schule der Holzschneidekunst, Leipzig, 1866; A. de Lostalot, Les procédés de la gravure, Paris, 1882; S. R. Koehler, Etching, Its Technical Processes, New York, London, 1885 (see also ZfBk, IX, 1897–98, pp. 30–35); R. Portalis, La gravure en couleurs, GBA, LXIII, 1888, pp. 441–57, LXIV, 1889, pp. 29–41, 196–212, 322–38; H. von Herkomer, Etching and Mezzotint Engraving, London, 1892; S. R. Koehler, Old and Modern Methods of Engraving, Philadelphia, 1892; H. W. Singer and W. Strang, Etching, Engraving, and the Other Methods of Printing

Pictures, London, 1897; W. Ziegler, Die Techniken des Tiefdruckes, Halle, 1901; D. Cumming, Handbook of Lithography, London, 1904; C. J. H. Davenport, Mezzotints . . ., London, 1904; S. T. Prideaux, Aquatint Engraving, London, 1909; H. Struck, Die Kunst der Radierens, Berlin, 1909; R. M. Burch, Colour Printing and Colour Printers, London, 1910; A. Geissberg, Teigdruck und Metallschnitt, Monatsschrift für Kw., V, 1912, p. 311 ff.; A. M. Villon, Nouveau manuel complet du graveur, 2d ed., 2 vols., Paris, 1914; E. S. Lumsden, The Art of Etching, London, Philadelphia, 1925; J. Poortenaar, The Technique of Prints and Art Reproduction Processes, London, 1933; H. J. Plenderleith, The Conservation of Prints, Drawings, and Manuscripts . . ., Oxford, 1937; H. Sternberg, Silk Screen Color Printing . . ., New York, 1942; S. W. Hayter, New Ways of Gravure, New York, 1949. b. Collectors' manuals: K. H. von Heineken, Idée générale d'une collection complète d'estampes, Leipzig, Vienna, 1771; J. A. von Bartsch, Anleitung zur Kupferstichkunde, 2 vols., Vienna, 1821; A. Andresen, Handbuch für Kupferstichsammler, Leipzig, 1870–73; W. H. Willshire, An Introduction to the Study and Collection of Ancient Prints, 2d ed., London, 1877; L. A. Fagan, Collectors' Marks, London, 1883, arranged and ed. M. I. D. Einstein and M. A. Goldstein (with additions), St. Louis, 1918; W. L. Schreiber, Manuel de l'amateur de la gravure sur bois et sur métal au XVe siècle, 8 vols., Berlin, Leipzig, 1891–1911 (2d rev. ed., Handbuch der Holz- und Metallschnitte des 15. Jahrhunderts, 8 vols., Leipzig, 1926–30); G. Bourcard, A travers cinq siècles de gravures, Paris, 1903; F. Lugt, Les marques de collections de dessins et d'estampes, Amsterdam, 1921; A. Whitman, Print-Collector's Handbook, rev. and enlarged by M. C. Salaman, London, 1921; C. M. Briquet, Les filigranes: Dictionnaire historique des marques du papier dès leur apparition vers 1282 jusqu'en 1600, 2d ed., 4 vols., Leipzig, 1923; H. Leporini, Der Kupferstichsammler: Ein Hand- und Nachschlagebuch samt Künstlerverzeichnis für den Sammler druckgraphischer Kunst . . ., Berlin, 1924. c. Dictionaries and catalogues: J. Strutt, A Biographical dictionary . . ., 2 vols., London, 1785–86; J. A. von Bartsch, Le peintre graveur, 21 vols., Vienna, 1803–21 (supplements by R. Weigel, Leipzig, 1843, and by J. Heller, Nürnberg, 1854); P. Zani, Enciclopedia metodica critico-ragionata delle belle arti, part 1, 19 vols., part 2, 9 vols., Parma, 1817–24; A. P. F. Robert-Dumesnil, Le peintregraveur français . . ., 11 vols., Paris, 1835–71; P. J. Mariette, Abecedario, 6 vols., Paris, 1851/53–1859/60; C. Le Blanc, Manuel de l'amateur d'estampes, 4 vols., Paris, 1854–90; G. K. Nagler, Die Monogrammisten und diejenigen bekannten und unbekannten Künstler aller Schulen . . ., 5 vols., Munich, 1858–79; J. D. Passavant, Le peintre-graveur, 3 vols., Leipzig, 1860–64; A. Andresen, Der deutsche peintre-graveur . . ., 5 vols., Leipzig, 1864–78; J. P. van der Kellen, Le peintre-graveur hollandais et flamand, Utrecht, 1866; E. Dutuit, Manuel de l'amateur d'estampes, 6 vols., Paris, 1881–88; C. Brun, Schweizerisches Künstler Lexikon, 4 vols., Frauenfeld, 1905–17; A. Baudi di Vesme, Le peintre-graveur italien, Milan, 1906; L. Delteil, Le peintre-graveur illustré (XIXe et XXe siècles), 31 vols., Paris, 1906–30; M. Bryan, Bryan's Dictionary of Painters and Engravers, rev. and ed. G. C. Williamson, 5 vols., London, 1926–34; P. A. Lemoisne, Les xylographies du XIVe et du XVe siècle au Cabinet des estampes de la Bibliothèque nationale, 2 vols., Paris, 1927–30; J. E. Darmon, Dictionnaire des gravures en couleurs, en bistre et en sanguine du XVIIIe siècle, des écoles française et anglaise . . ., rev. ed., Montpellier, 1929; F. G. Waller, Biographisch Woordenboek van noord Nederlandsche Graveurs, The Hague, 1938; A. Pelliccioni, Dizionario degli artisti incisori italiani, Carpi, 1949; L. Servolini, Dizionario illustrato degli incisori italiani moderni e contemporanei, Milan, 1956. d. General histories: F. Baldinucci, Cominciamento e progresso dell'arte dell'intagliare in rame . . ., 2d ed., Florence, 1767; G. Longhi, La calcografia, Milan, 1830; L. de Laborde, Histoire de la gravure en manière noire, Paris, 1839; J. Maberly, The Print Collector . . ., London, 1844, New York, 1880; J. Heller, Handbuch für Kupferstichsammler . . ., 2 vols., Leipzig, 1870–73; J. C. Smith, British Mezzotint Portraits, 4 vols., London, 1883; A. Whitman, The Masters of Mezzotint, London, 1898; G. Pauli, Inkunabeln der deutschen und niederländischen Radierung, Berlin, 1908; G. Bourcard, Graveurs et gravures, France et etranger: Essai de bibliographie 1450–1910, Paris, 1910; H. C. Levis, A Descriptive Bibliography of the Most Important Books in the English Language Relating to the Art and History of Engraving and the Collecting of Prints, London, 1912; P. Gusman, Le gravure sur bois et d'épargne sur métal, du XIVe siècle au XXe siècle, Paris, 1916; P. Colin, La gravure et les graveurs, 2 vols., Brussels, 1916–18; P. Kristeller, Kupferstich und Holzschnitt in vier Jahrhunderten, 4th ed., Berlin, 1922; H. E. A. Furst, The Modern Woodcut . . ., London, 1924; W. M. Ivins, Jr., Prints and Books, Cambridge, Mass., 1926; A. Reichel, Die Clair-obscur-schnitte des XVI., XVII., und XVIII. Jahrhunderts, Zurich, 1926; A. H. Hind, A History of Engraving & Etching from the 15th Century to the Year 1914, Boston, 1927; D. P. Bliss, A History of Wood Engraving, London, New York, 1928; J. H. Slater, Engravings and Their Value, rev. by F. W. Maxwell-Barbour, 6th ed., New York, 1929; E. Bock, Geschichte der graphischen Kunst, Berlin, 1930; L. Servolini, La xilografia a chiaroscuro italiana, Lecco, 1930; A. M. Hind, An Introduction to a History of Woodcut, with a Detailed Survey of Work Done in the Fifteenth Century . . ., 2 vols., Boston, London, 1935; J. Laran, L'estampe, 2 vols., Paris, 1959. e. Special studies: P. Zani, Materiali per servire alla storia . . . dell'incisione, Parma, 1802; W. Y. Ottley, An Inquiry into the Origin and Early History of Engraving, 2 vols., London, 1816; L. Cicognara, Memorie spettanti alla storia della calcografia, Prato, 1831; L. J. Alvin, Les commencements de la gravure aux Pays-Bas, Brussels, 1857; J. Renouvier, Histoire de la gravure dans les Pays-Bas et en Allemagne, Brussels, 1860; G. Duplessis, Histoire de la gravure en France, Paris, 1861; T. O. Weigel and A. C. A. Zestermann, die Anfänge der Drukkerkunst in Bild und Schrift, Leipzig, 1866; J. W. Holtrop, Monuments typographiques des Pays-Bas au quinzième siècle, The Hague, 1868; I. Rosell y Torres, Estampa española del siglo XV, Museo español de antigüedades, XI, 1873, p. 445 ff.; A. Essenwein, Die Holzschnitte des XIV. und XV. Jahrhunderts im Germanischen Museum in Nürnberg, Nürnberg, 1875; R. Portalis and H. Beraldi, Les graveurs du dix-huitième siècle, 3 vols.,

Paris, 1880–82; H. Delaborde, La gravure en Italie avant Marc-Antoine, Paris, 1883; W. M. C. Conway, The Woodcutters of the Netherlands in the Fifteenth Century, Cambridge, Eng., 1884; G. Duplessis, Les libres à gravures du XVIe siècle, Paris, 1884; R. Muther, Die deutsche Bücherillustrationen der Gothik und Frührenaissance, Munich, 1884; H. Beraldi, Les graveurs du XIXe siècle, 12 vols., Paris, 1885–92; F. Lippmann, The Art of Wood-Engraving in Italy in the Fifteenth Century, 2d ed., London, 1888; G. Gruyer, Les livres à gravure sur bois à Ferrare, GBA, LXIII, 1888, pp. 89–102, 339–48, 416–32, LXIV, 1889, I, pp. 137–58, 241–46, 339–46; F. Lippmann, Engravings and Woodcuts by Old Masters (sec. XV–XIX), 5 vols., London, 1889–1900; C. von Lützow, Geschichte des deutschen Kupferstiches und Holzschnittes, Berlin, 1891; P. Kristeller, Zur Geschichte der ältesten italienischen Holzschnitte, JhbPreussKSamml, XIII, 1892, pp. 172–78; C. Schreiber, Playing Cards, 3 vols., London, 1892–95; L. A. Fagan, History of Engraving in England, London, 1893; V. M. d'Essling, Les Missels Imprimés à Venise de 1481 à 1600, Paris, 1894; P. Kristeller, Die italienische Niellodrucke, JhbPreussKSamml, XV, 1894, pp. 94–119; P. Kristeller, Books with Woodcuts Printed at Pavia, Bibliographica, I, 1895, p. 347 ff.; N. Rondot, Les graveurs d'estampes sur cuivre à Lyon au XVIIe siècle, Lyon, 1896; N. Rondot, Les graveurs sur bois à Lyon au XVIe siècle, Lyon, 1896; W. Weisbach, Die Baseler Buchillustration des XV. Jahrhunderts, Strasbourg, 1896; F. Herbert, Les graveurs de l'école de Fontainebleau, Annales de la Soc. historique et archéologique du Gâtinais, XIV, 1896, pp. 56–102, 257–91, XVII, 1899, pp. 1–53; P. Kristeller, Early Florentine Woodcuts, 2 vols., London, 1897; N. Rondot, Graveurs sur bois à Lyon au XVIe siècle, Paris, 1898; J. Lewine, Bibliography of 18th Century Art and Illustrated Books in English and French, London, 1898; C. Dodgson, The Grotesque Alphabet of 1464, London, 1899; A. Claudin, Histoire de l'imprimerie en France au XVe et XVIe siècles, 3 vols., Paris, 1900–04; P. Kristeller, Ein venetianisches Blockbuch, JhbPreussKSamml, XXI, 1901, pp. 132–54; C. Häbler, Tipografia ibérica del siglo XV, The Hague, 1902; L. Baer, Die illustrierten Historienbücher des XV. Jahrhunderts, Strasbourg, 1903; H. Bouchot, Les deux cents incunables xylographiques du Département des estampes, Paris, 1903; C. Dodgson, Catalogue of Early German and Flemish Woodcuts in the British Museum, London, 1903; J. Poppelreuter, Der anonyme Meister des Poliphilo, Strasbourg, 1904; S. Colvin, Early Engraving and Engravers in England (1545–1695), London, 1905; P. Kristeller, Der venezianische Kupferstich im XV. Jahrhunderts, Die graphischen Künste, XXX, 1907, Mitt. der Gesellschaft für vervielfältigende K., I, p. 1 ff.; D. M. Stauffer, American Engravers upon Copper and Steel, 2 vols., New York, 1907; V. M. d'Essling, Les livres à figures vénitiens de la fin du XVe siècle et du XVIe siècle, 4 vols., Paris, Florence, 1907–14; M. Lehrs, Geschichte und kritischer Katalog des deutschen, niederländischen und französischen Kupferstichs im XV. Jahrhundert, 9 vols., Vienna, 1908–34; M. Geisberg, Die Anfänge des deutschen Kupferstiches und der Meister E. S., Leipzig, 1909; L. Rosenthal and J. Adhemar, La gravure . . ., Paris, 1909, 2d ed., rev., 1939; A. M. Hind, Catalogue of Early Italian Engravings . . . in the British Museum, ed. S. Colvin, 2 vols., London, 1909–10; L. Delteil, Manuel de l'amateur d'estampes du XVIIIe siècle, Paris, 1910; F. Weitenkampf, American Graphic Art . . ., New York, 1912, rev. ed., 1924; H. W. Davies, Catalogue of a Collection of Early Printed Books in the Library of C. Fairfax Murray, 2 vols., London, 1913; P. Kristeller, Die lombardische Graphik der Renaissance, Berlin, 1913; J. Duportal, Etudes sur les livres à figures édités en France de 1601 à 1660, Paris, 1914; C. Dodgson, Woodcuts of the 15th Century in the John Rylands Library, Manchester, 1915; L. Burchard, Die holländischen Radierer vor Rembrandt, Berlin, 1917; W. M. Ivins, Jr., A Catalogue of Italian Renaissance Woodcuts, New York, 1917; P. Jessen, Der Ornamentstich, Berlin, 1920; T. Borenius, Four Early Italian Engravers, London, 1923; F. Courboin, Histoire illustrée de la gravure en France, 6 vols., Paris, 1923–26; M. Geisberg, Der deutsche Einblatt-Holzschnitt in der ersten Hälfte des XVI. Jahrhunderts . . ., 43 vols., Munich, [1923–29]; L. Carteret, Le trésor du bibliophile romantique et moderne (1801–1875), 4 vols., Paris, 1924–26; A. J. J. Delen, Histoire de la gravure dans les anciens Pays-Bas et dans les provinces belges, dès origines jusqu'à la fin du XVIIIe siècle . . ., I, Brussels, II, Paris, 1924, 1935; E. Dacier, La gravure de genre et de mœurs, Paris, 1925; A. Rümann, Die illustrierten deutschen Bücher des XIX. Jahrhunderts, Stuttgart, 1926; N. Clément-Janin, Graveurs et illustrateurs, Paris, 1927; E. Lieure, La gravure au XVIe siècle en France, Paris, 1927; L. Réau, La gravure d'illustration en France au XVIIIe siècle, Paris, 1928; J. Laver, A History of British and American Etching . . ., London, 1929; A. Blum, The Origin and Early History of Engraving in France, new ed., New York, 1930; R. Brun, Le libre illustré en France au XVIe siècle, Paris, 1930; C. W. Drepperd, Early American Prints, New York, London, 1930; M. Geisberg, Bilder-Katalog zu Max Geisberg: Der deutsche Einblatt-Holzschnitt in der ersten Hälfte des XVI. Jahrhunderts . . ., Munich, [1930]; H. Girard and H. Moncel, Les beaux livres d'autrefois: Le XIXe siècle, Paris, 1930; M. Pittaluga, L'incisione italiana nel cinquecento, Milan, 1930; A. Blum, La gravure en Angleterre au XVIIIe siècle, Paris, 1931; A. Calabi, La gravure italienne au XVIIIe siècle, Paris, 1931; A. Martin, Le livre illustré en France au XVIIe siècle, Paris, 1931; E. von Rath, Buchdruck und Buchillustration bis zum Jahre 1600, Handbuch der Bibliothekswissenschaft, I, 1931, pp. 332–460; J. Rodenberg, Der Buchdruck von 1600 bis zur Gegenwart, Handbuch der Bibliothekswissenschaft, I, 1931, pp. 461–568; H. van Hall, Repertorium voor de Geschiedenis der Nederlandsche Schilder- en Graveerkunst, sedert het Begin der 12de Eeuw . . ., 2 vols., The Hague, 1936–49; E. F. Gollerbakh, Sovetskaya grafika, Moscow, 1938; Warsaw, Museum Narodowe, Grafika polska, Warsaw, 1938; A. M. Hind, Early Italian Engraving . . ., 7 vols., New York, London, 1938–48; O. H. Giglioli, Incisori toscani del seicento, Florence, 1942; C. Zigrosser, The Artist in America, New York, 1942; W. M. Ivins, Jr., How Prints Look, New York, 1943; L. Donati, Incisioni fiorentine del quattrocento, Bergamo, 1944; E. Hultmark, Svenska kopparstickare och etsare, 1500–1944, Uppsala, 1944; L. B. Fingert, ed., Grafika, Leningrad, 1947; C. Zigrosser, The Book of Fine Prints, rev. ed., New York, 1948;

F. W. H. Hollstein, Dutch and Flemish Etchings, Engravings and Woodcuts, ca. 1450–1700, 14 vols., Amsterdam, 1949–56; P. E. Kornilova, Russkaya gravyura XVI–XIX vv., Leningrad, 1950; O. Fischer, Geschichte der deutschen Zeichnung und Graphik, Munich, 1951; J. Romero Brest, Pintores y grabadores rioplatenses, Buenos Aires, 1951; Toulouse, Musée Paul Dupuy, Les graveurs en taille-douce de 1600 à 1800, Toulouse, 1951; A. Petrucci, L'incisione italiana: Il quattrocento, Rome, 1952; M. Pittaluga, Acquafortisti veneziani del settecento, Florence, 1952; A. M. Hind, Engraving in England in the Sixteenth and Seventeenth Centuries, 2 vols., Cambridge, Eng. 1952–55; C. Angelieri, Bibliografia delle stampe popolari a carattere profano, Florence, 1953; W. M. Ivins, Jr., Prints and Visual Communication, Cambridge, Mass., London, 1953; L. Servolini, L'incisione originale in Ungheria, Bologna, 1953; P. J. Sachs, Modern Prints and Drawings, New York, 1954; F. W. H. Hollstein, German Engravings, Etchings and Woodcuts, ca. 1400–1700, 5 vols., Amsterdam, 1954–57. *The Eastern World*: *a. Islam*: M. S. Dimand, A Handbook of Muhammadan Art, 3d ed., New York, 1958. *b. China*: B. Laufer, Paper and Printing in Ancient China, Chicago, 1933; P. Pelliot, Les débuts de l'imprimerie en Chine, Paris, 1953; T. F. Carter, The Invention of Printing in China and Its Spread Westward, rev. ed. L. C. Goodrich, New York, 1955. *c. Japan*: S. Tajima, Masterpieces Selected from the Ukiyo-e School, 5 vols., Tokyo, 1906–09; W. von Seidlitz, A History of Japanese Colour-Prints, Philadelphia, 1910; B. Stewart, Subjects Portrayed in Japanese Colour-Prints . . ., London, 1922; L. Binyon and J. J. Sexton, Japanese Colour Prints, New York, London, 1923; Yoshida, Japanese Wood-block Printing, Tokyo, Osaka, 1939; L. V. Ledoux, Japanese Prints in the Collection of Louis V., 5 vols., Princeton, 1942–51; C. W. Schraubstadter, Care and Repair of Japanese Prints, New York, 1948; J. Hillier, Japanese Masters of the Colour Print, London, 1954; H. Gonsaulus, The Clarence Buckingham Collection of Japanese Prints: I, The Primitives, Chicago, 1955; O. Statler, Modern Japanese Prints, an Art Reborn, Rutland, Vt., 1956.

Illustrations: PLS. 421–448.

**ENSOR**, JAMES. Belgian painter, important forebear of modern expressionism (q.v.). Ensor was born on Apr. 13, 1860, of a British father and Belgian mother, in Ostend, where he spent his entire life. He died there on Nov. 19, 1949. The family income was derived from a souvenir shop; its stock of carnival masks and puppets inspired the bizarre personages of Ensor's paintings. He studied at the Brussels Academy from 1877 to 1880 and then began exhibiting paintings that were naturalistic in style (in the Netherlandish tradition) and slightly influenced by impressionism. These were rejected by the critics because of their realistic subjects. In 1884 he and a number of progressive Belgian artists founded The Twenty, a group whose exhibitions introduced radical art to Belgium. By 1886 Ensor had won some notoriety for paintings with strange themes reminiscent of Poe (whom he admired) and late-medieval apocalyptic art; but in 1889, even The Twenty found his treatment of Christian themes rather blasphemous and refused to exhibit *The Entry of Christ into Brussels*. This narrow view was quickly modified, and by 1892 he was recognized by advanced artists throughout western Europe as a great master of expressionistic art. In 1896 he gave his first one-man show, in Brussels, and in 1899 a large retrospective exhibition of his works was held in Paris. Ensor was named a Chevalier of the Order of Leopold in 1903 and a baron in 1929, but official recognition was long based only on his early naturalistic painting. After the beginning of this century, a number of public exhibitions were devoted to his work, principally in Antwerp (1921), Brussels (1929), Paris (1932, 1939), and New York (1951). In 1942 false reports of his death produced premature obituaries, and not long thereafter several of his paintings and innumerable etchings were lost in the burning of the Ostend museum. The best of his many etchings is perhaps *The Cathedral* (1886).

Ensor's fame rests upon his work in the so-called post-impressionist era, 1885–1900. During this period he explored the symbolic and exotic themes that so attracted *fin de siècle* Europe, expressing these in an art of free, wiry line and bold color. His influence coincided with that of Edvard Munch (q.v.) and, like the Norwegian master, Ensor was a major figure among the German expressionists (see EXPRESSIONISM).

By the beginning of this century, Ensor had stated his major themes and had already produced his best work; the rest of his career was devoted largely to variations upon established motifs. His work is related to much modern art with psychological overtones, particularly to that of Paul Klee (q.v.).

Among his major works are *The Lamp Boy* (1880; Brussels, Mus. Royaux B.A.), *Woman Eating Oysters* (1882; Antwerp, Mus. Royal B.A.), *The Entry of Christ into Brussels* (1888; V, PL. 122), *Maskers Quarreling over a Hanged Man* (1891; V, PL. 203), and décor for the ballet *La Gamme d'Amour* (1912).

BIBLIOG. M. Maeterlinck et al., James Ensor, Paris, 1899; A. Croquez, L'œuvre gravé de James Ensor, Paris, 1935; P. Fierens, James Ensor, Paris, 1943; J. Ensor, Les Ecrits de James Ensor, Brussels, 1944; F. Fels, James Ensor, Geneva, 1947; L. Tannenbaum, James Ensor, New York, 1951; P. Haesaerts, James Ensor, New York, 1959.

Robert L. HERBERT

**EPIGRAPHY.** See CALLIGRAPHY AND EPIGRAPHY.

**EPSTEIN**, JACOB. Although Epstein is generally considered an English sculptor, he spent the first 22 years of his life in New York City, where he was born in 1880 of Polish-Jewish parents. He died in London in 1959. Epstein drew and modeled as a boy and later joined a class at the Art Students League under George Grey Barnard. In 1902 he went to Paris, where he studied for a short time at the Ecole Nationale des Beaux-Arts and later at the Académie Julian. He settled in London about 1907, where he received his first large commission — a series of stone carvings for the British Medical Association building. In 1911 Epstein carved a large figure in the manner of an Egyptian winged sphinx for the tomb of Oscar Wilde in Paris (Père-Lachaise Cemetery). His other work of this period shows a strong influence of cubism and of African Negro sculpture (of which he assembled a fine collection). Examples of his work in this cubist-African style are the *Animal Head* carved in flenite (1912), *The Rock Drill* (bronze, 1913), and the *Mother and Child*, of white marble (1913; New York, Mus. of Mod. Art). His *Venus* (1917; New Haven, Conn., Yale Art Gall.) — a large, angular, and totemic statue carved in marble — was still cubist in style. At this time Epstein began to make portraits; among the earliest of these are the sensitive mask *Mrs. Epstein* (1916; England, private coll.) and the gaunt *American Soldier* (1917; New York, Met. Mus.). The latter, with its light-reflecting surfaces, is reminiscent of Rodin. The full-length bronze figure *Christ Showing the Stigmata* (1919; Wheathamstead, Eng., A. Cheny-Garrard Coll.) is expressive and moving but entirely different from the *Venus* in style. During the next 25 years a long series of portraits assured Epstein's fame in England and the United States. Particularly fine are the *Joseph Conrad* (1924; England, Muirhead Bone Coll.) and the *Oriel Ross* (1931; New York, Mus. of Mod. Art). His life-size *Madonna and Child* (1927; I, PL. 131) is also a "portrait," the models having been an Indian woman and her son. The appeal of this group derives from its heightened naturalism, particularly in the poignant facial expressions. In 1929 Epstein executed the most remarkable of his public monuments, the *Night* and *Day* on the façade of the London Transport building near St. James's Park. These colossal, primitive figures carved in stone — akin to the mural figures of Rivera, Orozco, and their pre-Columbian ancestors — have little in common with Epstein's expressive portraits. Other monumental carvings are the *Sun God* (1931) and *Adam* (1939; Blackpool, Eng., Louis Tussaud's Waxworks), a huge figure carved in alabaster.

The two categories into which Epstein's work may be divided — portraits in bronze and monumental works in carved stone — are broadly unified by the imprint of the artist's personality, yet each is so distinctive as to seem at first glance hardly related to the other. His stonework is usually massive in scale, bold and primitivistic in style, sometimes harsh and ungainly. His portraits, on the other hand, are direct impressions of the sitter executed with all the spontaneity possible in the clay medium. The sitter's individual characteristics — his eyes, hair, hands, and the texture of his skin — are emphasized to the point of exaggeration. Whether Epstein achieved a likeness or not — and he often did — each of his portraits is a remarkably vivid expression of the human being, colored

by the style and emotional bias of the artist. Although his large sculptures in stone were often considered sensational in their day, Epstein may well be best remembered for his emotionally charged portraits.

BIBLIOG. J. Epstein. Let There Be Sculpture, New York, 1940; R. Black The Art of Jacob Epstein, Cleveland, New York, 1942; J. Epstein, Epstein, an Autobiography, London, 1955.

Henry R. HOPE

**ERNST**, MAX. German-born Dada and surrealist painter and sculptor. He was born in Brühl, Apr. 2, 1891. His father, an amateur painter, introduced him to art, and shortly after beginning studies in philosophy at the University of Bonn in 1909, Ernst turned to painting as his life's work. In 1911 he joined the Young Rhineland group, formed by August Macke, and its activities put him in touch with progressive artists throughout Germany and France, especially Der Sturm, with which he exhibited in 1916. Ernst spent 1914–18 in the army, and in 1919, having seen the Zurich Dada group's reviews, he and his friend Baargeld (Alfred Grünewald) established a Cologne branch of Dada — a nonsense art with serious satirical intent. They edited the journals *Bulletin D*, *Der Ventilator*, and *Die Schammade*. In 1920 Ernst's old friend Hans (Jean) Arp joined the Cologne group, and they celebrated international Dada in one of the most famous Dada exhibitions, held in a public urinal. An exhibition of Ernst's collages was held in Paris in May of the same year at the instigation of André Breton, and the opening was accompanied by another Dada manifestation. Two years later he moved to Paris, and after a short trip to the Orient with Paul and Gala Eluard, in 1924 he joined the new surrealist movement, to which he long remained faithful. In 1934 he began to work in sculpture while staying with Giacometti in switzerland. Interned in 1939 in France, he got over the border to Spain and flew to New York in July, 1941, where he was met by his son Jimmy (b. 1920), a well-known American painter in his own right. He lived in Sedona, Arizona, with his fourth wife, the painter Dorothea Tanning, from 1946 until 1952, when they moved to Paris, and then in 1954 bought a farm in Huismes, Touraine. The same year Ernst won the Grand Prize at the Venice Biennale.

Among Ernst's major paintings are *The Elephant of the Célèbes* (1921); *Revolution by Night* (1923; both, London, Roland Penrose Coll.); *Woman, Old Man and Flower* (1923–24; New York, Mus. of Mod. Art); *The Entire City* (1936; Carcassonne, Aude, James Ducellier Coll.); *The Joy of Life* (1936; Roland Penrose Coll.); *Europe after the Rain* (1941; Hartford, Wadsworth Atheneum); *Euclid* (1945; Houston, J. de Menil Coll.); and *The Horde* (V, PL. 134). His more recent work bears only a vague resemblance to that of the surrealist period. Ernst is of major significance in the graphic arts, especially in book illustration and folios of original compositions, such as the *Histoire naturelle* (1926), and his own collage novels *Femme 100 têtes*, etc. (see *Writings*). Paul Eluard wrote poems for Ernst's collages which were published in two books in 1922: *The Misfortunes of Immortals* and *Repetitions*. Ernst was one of the most important painters of the Dada and surrealist movements, although he broke with the surrealists in 1938, and they in turn with him in 1954. He was not satisfied with the visualization of shocking images by means of an old-fashioned technique but was a true innovator in every sense, particularly in the use of collage and in his own invention of "frottage," or texture rubbings. If the impact of his art was felt most in the 1920s, he remains a vital force in modern Western art.

WRITINGS. Femme 100 têtes, Paris, 1929; Rêve d'une petite fille qui voulut entrer au Carmel, Paris, 1930; Semaine de Bonté, Paris, 1934; Beyond Painting and Other Writings by the Artist and His Friends, New York, 1948.

BIBLIOG. M. Ernst, Oeuvres de 1919 à 1936, Paris, CahA, 1937; At Eye Level: Paramyths, Copley Galleries, Beverly Hills, 1949; J. Bousquet and M. Tapié, Max Ernst, Paris, 1950; Brühl, Schloss Augustusburg, Max Ernst: Gemälde und Graphik, 1920–50, Brühl, 1951; P. Waldberg, Max Ernst, Paris, 1958; Musée National d'Art Moderne, Max Ernst, Paris, 1959; Museum of Modern Art, Max Ernst, New York, 1961.

Robert L. HERBERT

**ESCHATOLOGY.** Preoccupation with death and ideas concerning the afterlife have been sources of inspiration for art throughout history. Deeply felt beliefs about these have inspired the shapes and the decoration of tombs (graves, sarcophagi, etc.), extensive repertories of symbols, and varied representations of man's fate in a future life. Certain art traditions are represented almost exclusively in funerary art. The idea of death affects all art cultures, despite differences in religious thought, and it evokes similar themes in primitive civilizations, in polytheistic societies, and in the Christian world, in each case enriched according to the ideology, environment, and social needs of the society. The funerary and eschatological themes are not only closely bound to religious iconographies (see BIBLICAL SUBJECTS; DEMONOLOGY; DEVOTIONAL OBJECTS AND IMAGES, POPULAR; DIVINITIES; MYTH AND FABLE; SYMBOLISM AND ALLEGORY) but also touch upon other aspects of representational art (see GENRE AND SECULAR SUBJECTS; PORTRAITURE). At times funerary themes may be the first incentive to representational art.

SUMMARY. Ideas on survival and funerary customs as a source of art inspiration (col. 788). Prehistory and protohistory (col. 791). The primitive world (col. 792). The ancient world (col. 802): *Near East; Greece and Rome; Iran.* The East (col. 811): *India and southeastern Asia; China and Japan.* The Islamic world (col. 819). The Christian world (col. 820): *Death; The Apocalypse; The Last Judgment; Hell and paradise; Funerary architecture and sculpture.* Popular and folk imagery (col. 828).

IDEAS ON SURVIVAL AND FUNERARY CUSTOMS AS A SOURCE OF ART INSPIRATION. The term "eschatology" embraces religious doctrines, beliefs, and traditions regarding the ultimate fate of man and of the world. The importance of eschatology in the Christian religion has caused the terms and the concept to be applied to all other religions, even when the corresponding notions are not strictly analogous. Actually, among the various doctrines, present and past, a clear eschatological concept seems to be the exception rather than the rule. An eschatological orientation is brought about by a variety of factors that are not necessarily basic to the definition of a religion. One of these is the linear representation of time (in other words, its development from a beginning toward an end), which directs religious interest toward the future, while breaking away from a past that is unrepeatable and, therefore, left behind for all time. When, instead, time is represented in a cyclical form (that is, in periods the beginnings and ends of which meet), interest is turned toward first, and not last, things. In such cases a mythology, rather than an eschatology, is developed, in so far as myths pertain to origins or to the time of origin. A return to ancestors, to the creator, or to the primordial condition and place (the "cosmic center") characterizes the afterlife in several religions, which are thus obliged to define those original conditions even in relation to death. This is a consequence of the feeling Mircea Eliade has called "nostalgia for heaven" or "the desire to overcome the human condition in a natural way and to reattain the divine condition." These concepts and the religious art inspired by them cannot be appropriately defined as eschatological, since they pertain to the whole of the religion and not only to the representation of a beyond. For example, the association and sometimes the identification of the deceased with animals in the art of certain primitive peoples must be seen in relation to the concept of a primordial or paradisiacal animal state; it cannot be viewed simply as a ceremonial for the dead. It can be explained only in a mythical and cosmological sense.

Eschatological considerations enter when the condition of the afterlife, hitherto undifferentiated, begins to polarize its positive aspects into a paradise and its negative ones into a hell. The aspiration to surmount the human condition can no longer be realized naturally. Acquired merits — not always of an ethical order — lead to a state in which the human condition is raised to a heavenly level; faults, or lack of merits, lead to an infernal level. In other words, the afterlife, being conditioned by earthly experience, is considered as subsequent to the life on earth (though not necessarily an absolute ultimate

phase, as it is in the Christian concept). Before the development of this concept, it was the earthly experience that was conditioned by the beyond, in the sense of the original state and the beginning of existence, so that the beyond was thought of as earlier than the earthly life. After the development of eschatological concepts, representations of the afterlife include, side by side with superhuman or prehuman beings (gods, demons, monsters, etc.), men who have passed through human experience. The sharper the separation in these representations between the dead human beings and the nonhuman creatures who populate the beyond, the more precise is the eschatological orientation, which is realized at the expense of the mythical and cosmological orientation.

The success with which representational art renders all this is apparent, for example, in the images of the beyond found in Egypt and India. The Egyptian artist drew a clear distinction within the population of the beyond between the dead and the nonhuman beings. The former were portrayed realistically, as realism was understood in the traditional style, while the latter were conceived as monstrous figures. They were monsters not so much in a literal sense as in the symbolism of the horrific, corresponding to a well-defined ideology. The only anthropomorphic divine being was Osiris, who also represented the only allusion to the cosmological aspect of Egyptian belief. In other words he was connected with mythology rather than eschatology. (He founded a kingdom after his death in the mythical time of the origins.) His image was highly idealized and adorned with the regal insignia. He was not an ordinary man and he did not become one of the ordinary dead, any more than did the Pharaohs, who were identified with Osiris at their death. The belief in and the representation of the judgment of the dead by Osiris was a completely eschatological concept that had important subsequent developments.

The Indian, or originally Indian, ideology did not shake itself free from the cyclic concept of time; it did not realize an ultimate existence in an absolute sense. It reached, so to say, a compromise through the doctrine of reincarnation; the beyond was conceived as the origin and, at the same time, the consequence of the terrestrial existence. It is from this concept that the beyond, in its unity of space and time, derived its character of an undivided cosmic center. (Pleasure and suffering were not final, but *sub specie aeternitatis* inseparable from each other.) As a consequence of the illusory spatial view of reality, however, the beyond appeared divided into heavens and hells. These two aspects of the beyond had almost the function of marking the different stages or the points of reference of a continuous itinerary that had no specific destination. Consequently, it was not the deceased in his human aspect but a reincarnation that was to find a place among the population of the other world. This happened only in the heavens, however, in which the dead became gods, while in the hells it was real human beings who were tormented by monsters and demons. One might be led to interpret survival in human form as a painful, infernal experience, and in reality this agreed with the pessimistic concept of individual life, from whose countless forms the soteriologic doctrines current in India today tend to free man.

From these main sources the concept and the representations of the beyond prevalent in the Western pre-Christian world, as well as in the Asiatic world, were derived. In the pre-Christian West the concept did not emerge clearly, and the representations were infrequent and often mingled with mythological elements, as, for instance, the Greek Nekyia and the Etruscan Hades. Christian eschatological iconography, however, attained a considerable development, not only through the transfiguration of elements derived from Egypt and Greece (judgment with *psychostasia* or weighing of souls, torment of the damned, etc.), but also through the use of the new and original themes of the Apocalypse and of the hagiographical texts.

Strictly speaking, ideas and images of a truly eschatological nature should not be confused with those concerning relations between the living and the dead, funeral rites and customs, and treatment of the dead, which underlie a vast series of art manifestations — for example, shapes of coffins, production of funerary gifts, symbols of death, and creation of funerary architecture. However, the human experience of death may give rise to actions inconsistent with idealogy; for example, it sometimes happens that the actual treatment of the dead in a particular civilization or religion involves practices contrary to an eschatological doctrine of the same society, as in the custom of material offerings (even if limited to flowers) that has survived in Christian funerals. When the cosmological prevails over the eschatological interest, the event of death, the presence of the corpse, and the feelings of the survivors come to the fore, and the living make provision for the dead without regard to any doctrine of an afterlife. This behavior cannot be interpreted as truly eschatological. In ancient Mesopotamia, for instance, there was a highly elaborate cosmology but a markedly primitive eschatology. The realm of the dead was clearly defined and established in the Mesopotamian conception of the universe; but the apparent condition of the dead man was that of a buried corpse surrounded by dust and mud, and these would be his only food unless providential gifts were offered by the living. Thus the relation between the living and the dead can lead, apart from any eschatological orientation, to the identification of the condition of the dead man with the corrupt state of the corpse; hence comes the behavior toward the "destitute dead," which we find in some form in all religions.

The needs of the destitute dead were the same as those of the corpse. Besides food, the dead body required all the means of life, from a home with household goods to the equipment necessary to work and fight. The adaptation of these means of subsistence to the nonmaterial needs of the dead allowed the transformation of utilitarian production, in certain fortunate instances, into artistic production. In some ancient cultures the dwelling of the dead lost its pure functionality and acquired a richer form, using elements to mark the tomb that had no definite function in themselves: symbols or allusions to eschatologies, cosmologies, or mythologies capable of interpreting in terms of the culture the natural experience of death; representations recalling the physical aspect and the activities of the dead; or other representations of the presence of the dead, the event of death, and the sorrow of the living (as, for instance, in the theme of the prothesis — lying in state of the dead — widespread in classical antiquity). The funerary receptacles, too, (cinerary vases, urns, sarcophagi) came to be characterized by great freedom of form — the ideal condition for artistic production — as long as they fulfilled their function of preserving the remains of the dead. The whole funerary apparatus began to lose its original concept; perspectives and materials also began to change. A luxury production was reached, esthetically and technically refined, without any parallel in contemporary secular work. Wealth, that is to say, the means of exchange, was substituted for food offerings; the receptacles for food and drink were objects of beauty. Everything was meant for preservation, not for consumption. The initial purpose of satisfying the needs of the dead was abandoned, thus opening new perspectives. This explains the enormous quantity of valuable products (ceramics, textiles, jewels, etc.) that has come down to us by way of tombs from these dead civilizations, while nothing, or almost nothing, has remained from their production for the living. Also part of their relics are "substitution figures" of the women and servants of the dead, as well as scenes of real life — banqueting and the like, also substitutes for reality — which were the subjects of Egyptian, Etruscan, and other funerary reliefs and paintings. An ultimate and most important need was the protection of the corpse from decay; this was linked to mythical-cosmological concepts (doctrine of the doubleganger) or eschatological concepts (resurrection) and manifested itself primarily in ritual tradition. The need was met by various widespread expedients ranging from embalment to the funerary mask and from the latter, with a total break from the original purpose, to the death portrait (see PORTRAITURE). This break also opened the way to a free artistic expression.

The cult of the "powerful dead person" cannot be sufficiently explained either by an eschatological orientation or by

the treatment of the destitute dead. The idea of the powerful dead, like that of the destitute dead, can be found at all levels and in all religions, including the Christian. The documentation is offered chiefly by architecture: megalithic monuments, Egyptian pyramids with their funerary temples, Greek *heroa* (sanctuaries dedicated to deified heroes), funerary temples of the Hindus, and others. The grandiosity of such funerary buildings appears at times disproportionate to their function, or at least to all other buildings, religious or secular. Their function transcended the simple concept of the grave and they assumed the aspect of a place of worship, differing from the function of true temples only in that the homage was addressed not to the gods but to the powerful dead.

These buildings, their development, and their architectural specialization found a counterpart in the more discreet monuments of the Christian world. However, among the private tombs of the Early Christian era there were some grandiose ones, such as the so-called "Mausoleum of Galla Placidia" (PL. 458; II, PL. 425) and that of Theodoric (PL. 457) at Ravenna. It may also be noted that the Early Christian basilicas were built over the tombs of martyrs and often had a specifically cemeterial character.

In the veneration of the saints, too, whose relics were preserved and to whom the churches were dedicated, is implicit the cult of the powerful dead, with all its effects on architecture and the other arts. Burials of the ordinary dead tended to be related to those of the saints; in the early cemeteries the ordinary dead were buried near the tombs of saints. (In very early times and in a totally different religious sphere the same phenomenon occurred at Abydos. The dead were interred near the burial place of Osiris or near the pyramids of kings, which were surrounded by mastabas, the tombs of nonregal persons.) Later the same tendency appeared in the churches. The social rank of private citizens brought about the pomp of monumental tombs and chapel tombs, the apparatus of funerals, and the solemn and gruesome worldliness of funerary symbols, particularly during the Counter Reformation and the baroque era. These were climaxed by the eclectic ostentation of the architecture and sculpture in modern cemeteries.

Dario SABBATUCCI

PREHISTORY AND PROTOHISTORY. The concept of protecting and equipping the dead, independent of any particular ideology regarding the beyond, dominated the world of prehistory from paleolithic times. In the careful burials of the Upper Paleolithic period — as at the Balzi Rossi near Ventimiglia, Italy — one finds that the corpses were painted with red ocher. This suggests the transformation of a magico-religious concept — that of blood understood as the principle and symbol of life — into a deliberate and specific act of decoration. In the cultures of the later Stone Age and of the early Bronze Age the burial usually included rich ornaments, clothes, food, instruments, and household goods. In areas where the megalithic cultures spread, tombs have a monumental form (dolmens, corridors, cists, etc.; PL. 456) or consist of artificial caves imitating houses excavated in the rock. Stone or molded figurines, usually feminine and nude, accompanied the dead. Presumably they were substitutes for the human sacrifice of servants or concubines or were symbolic of the Great Mother Goddess. Various other concepts inspired the making of aniconic or partially iconic steles, placed near the tombs, and reliefs with images or complex symbolic representations of boats, animals, and other subjects. Two examples are the rock tombs of Petit-Morin in France and of Anghelu Ruju in Sardinia.

A profound change took place, however, during the Bronze Age. This was connected with new cults, which added new gods of a solar or celestial type to the traditional ones of an earthly nature. The concept of the tomb as the residence of the dead person and of the objects placed in it as goods of immediate practical use was replaced by the sacrificial rite of cremation, often involving the destruction of a part of the funerary offerings. New symbolic types and subjects appeared, such as the chariot and pictures of birds, the latter being con-

sidered the means of revealing the gods' will. The cinerary urn containing the burned bones (PL. 451) became an object of decoration. In the developed Iron Age the rite of inhumation was again preferred in several regions; however, there survive numerous traces of the previous religious concepts in funerary customs and in the objects placed in tombs. There are also fusions of the two concepts; e.g., ossuaries shaped like houses or containing anthropomorphic elements.

\* \*

THE PRIMITIVE WORLD. In the art of primitive peoples special importance is attached to the idea that after death the soul takes a form somehow connected with animals. There are various types of belief, not always clearly distinguishable: the soul may live on in animal form, or an animal may act as a guide to the world beyond, or there may be animal guardians, such as Cerberus, at the gates of the other world. Frequently the birds, snakes, and other creatures associated with death are regarded as ominous and their appearance or call is thought to presage someone's death. They are also assigned a cosmic significance; for instance, certain birds have solar characteristics. Lunar associations are made with snakes, especially if they are conceived as possessing horns or as having a head at each end of the body. Since life in the other world implies living with ancestors, and since the mythical ancestors are often theriomorphic, it is understandable that animals associated with death often have totemic implications also. Similarly, no sharp distinction can be drawn between the idea of the soul's survival in animal form and the idea of so-called "bush souls," which seems to be especially characteristic of hunting cultures.

Considerable artistic development is associated with theriomorphic coffins and other funerary furniture. In Nias the body is carried on a litter of animal form, then laid in a coffin also of animal form, and finally hung in the forest or installed in a house. The skull of a chief is usually removed from the coffin after a time and preserved in front of the house in a stone urn in the form of a mammal or bird, most frequently the hornbill. In Bali the dead are burned in a coffin of animal form, which may be in the shape of a cow, a lion, a deer, or a fantastic half-elephant half-fish, according to caste. On the islands of San Cristobal and Santa Ana in the Solomons there is a particularly clear connection between the idea of survival in animal form and theriomorphic funeral furniture. After a certain time the remains of the body are exhumed, stuck together with resin, made into the shape of a shark, and set adrift on the sea; the first sea creature to approach the body will be its future reincarnation. The skull, or at least the lower jaw, is sometimes preserved in a large wooden reliquary shaped like a shark or a bonito (PL. 449). The inhabitants of the Palau Islands in Micronesia believe that the souls of the dead dwell in certain sacred fishes, and for this reason the cult instruments used to preserve the connection with the ancestors are made in the shape of a fish.

The soul is frequently believed to survive in the form of animals associated with the grave or with the earth, particularly the snake. Snake motifs are used on coffins, tombs, urns, and skulls. The naga (serpent), common in the cult and mythology of the ancestors in the Pacific, is a characteristic element of the megalithic culture complex linking Oceania to Southeast Asia; other features of this complex include the modeling of skulls, theriomorphic coffins, and the hornbill as bird of death and of the ancestors.

Birds also are frequently associated with the departed soul, presumably because of the belief that the soul, once freed from the body, can fly or move very rapidly. Sometimes the soul is believed to occupy a bird's body; sometimes it is borne to heaven by a bird. Both types of belief have extraordinarily wide distribution, and in art the bird as vehicle of the soul appears especially significant. Nowhere is its outstanding importance more evident than in the art of the island of Santa Cruz, where almost all objects are decorated with it, the figure of the "soul bird" being represented in every style from the naturalistic to the completely abstract. Similar notions of the

"soul bird" form the spiritual background of certain cult objects and ornaments either made of feathers or decorated with them. For instance, at certain festivals of the dead the Toraja of the central part of the island of Celebes decorate the charnel house with hens' feathers; these feathers are supposed to be the wings on which the scent or "shadow" of the decorated soul houses is carried to the land of souls.

Birds also play a decisive part in the journey to the other world among the shamans of Siberia. Among the Yakuts, Tungus, and Dolgans the coffin of a shaman lies in state supported on posts; at the head or feet, or both, is placed a figure of a hawk, cuckoo, robin, or some other bird. These birds are the forms assumed by the spirits that helped the shaman on his journeys to heaven in his lifetime. It is one of a shaman's duties to lead the dead into the next world, and on the way he calls for help to the koori bird, without whose aid he would never be able to make his way back from the land of the dead; in fact, he accomplishes the most difficult part of the journey riding on its back. Among the Dolgans nine poles are set up in a row, each with the wooden figure of a bird on top, all facing in the same direction. Each pole, hence each bird, stands higher than the preceding one, to represent the successive stages of the shaman's journey to heaven. The ceremonial costume worn by a shaman while practicing his art is usually a symbolic representation of a bird.

Mammals also may appear as traveling companions of the dead or as their reincarnation. In the megalithic culture of southeast Asia coffins and ritual houses are often decorated with pictures of buffaloes, bulls, horns, and similar subjects. There is an obvious similarity of idea between the bull-shaped coffins native to Borneo and other places and the well-known Toraja rite of burying a person of eminence in the body of a buffalo sacrificed for that purpose. There is an analogous practice in Africa.

The journey to the other world is rarely represented in the art of primitive peoples, for the simple reason that with them the plastic arts, much less suited to epic subjects such as the journey of the soul, are more important than drawing and painting. In rock paintings the subject is for the most part extremely problematic, though some of the Australian and South African examples could easily have reference to the soul's journey. Examples of such representations can be found among the Dyaks of the Barito River region (Borneo), where both tools and the walls of houses are often adorned with pictures illustrating the way to the next world, as well as landscapes and settlements in it. Other examples may be cited from ancient Mexico (PLS. 461, 465).

The mode of transport by which the dead are to accomplish their journey corresponds to that actually used by the living, either now or in the past (see VEHICLES). For instance, sledges as funeral equipment are found among Arctic and sub-Arctic peoples; burial in or with a boat is characteristic of coast dwellers and fisherfolk. The idea of the bark of the dead, together with various other concepts such as the ladder of the ancestors and the eye ornament, not all of which have funerary connections, seems to be characteristic of megalithic cultures. All these phenomena can be traced from the Sunda Islands as far as northwestern America, the classic examples being in Nias and among the Batak peoples of Sumatra. The occurence of a boat in the ritual of the dead, however, does not always mean that the soul was believed to travel by boat to the land of the dead; often the boat was simply one of the possessions of the deceased and was put with him in the same manner as his clothes and weapons, and in other cases it is doubtful whether coffins hollowed out of tree trunks are to be regarded as boats at all.

The connection between the bark of the dead and the journey to the next world is quite patent among the Malays and in those parts of Oceania that have been influenced by them. The ship of the soul is of outstanding importance both in their art and in their lore of the beyond. The Toraja of the western part of Celebes lay on the grave a pair of oars (sometimes only in miniature) with which the deceased is to row himself in his coffin-ship across Lake Nompi-nompi to the land of the ancestors. In Borneo and Sumatra little "soul boats" are often made in the shape of a hornbill; the mast is regarded as a symbol of the tree of life, and each of the carved figures standing in the boat has its particular significance. The ferryman is in the bow, the steersman at the stern, and between the two are the dead passengers. The connection with the other world is also apparent in the custom of using ritual boats (usually suspended) as places for sacrifice to the ancestors, or of regarding them as residences for the spirits of the dead. In the Truk Islands of Micronesia a little suspended boat is one of the cult implements of the "evokers of spirits," whose special faculty is to call up the spirit of a dead person and ask it questions about the treatment of a disease or the most effective magical means for increasing the yield of the harvest or of the fisheries. These "soul boats" are often provided with carved figures of birds, again emphasizing the connection with the other world. The bird depicted is the frigate bird, which is regarded as the bird of souls in large areas of Oceania. It carries the departed soul of the dead to the land of souls and is held to be the bird of the gods.

The ceremonial adornment of the corpse is part of the funeral ceremony and cannot as a rule be regarded separately, although there are instances of the ornaments being removed before burial. On the Gazelle Peninsula of New Britain, for example, the deceased, if of high rank, is placed on a chair-shaped bier wearing all his ornaments, and his relatives and friends come to admire his rings of shell money; but these valuable adornments are removed before burial. This custom is explained by the belief that the spirit of the dead takes only the "shadow" of these things with him into the other world; this suffices to ensure for him a favorable reception. There can hardly be any doubt that the ornaments provided for the exposition are to be regarded basically as part of the funerary equipment.

Different forms of burial are frequently combined. Certain types are characteristic of different peoples and cultures, but different customs are also found even within a single cultural group. Sometimes this is due to the existence of different racial levels that have preserved various ancient customs in spite of fusion with different tribes; in other instances difference in burial customs corresponds to difference in social status, chiefs, nobles, and slaves being buried in different styles. The manner of death is also frequently important; those fallen in battle, for instance, are not always buried in the same way as those who die naturally.

The most common ways of disposing of the corpse among primitive peoples, excluding those in which no trace of art is found, are burial, cremation, and mummification. In the first of these, the corpse generally is simply laid in the earth, but it may be wrapped in matting, hides, or cloth to protect it from direct contact with the soil. Urn burial, in which the entire corpse is placed in a pottery vessel, occurred in America among the Tupi of the Amazon Valley and in the regions influenced by them (PL. 452) and in the pre-Columbian culture of Moundville, Ala. The latter example and others in northwestern Africa and southern and eastern Asia were clearly due to the influence of higher cultures. Urn burial was also the usual practice among the pre-Columbian peoples of Mexico. A Totonac relief shows a death demon in the form of a skeleton climbing out of a funerary vessel. From the point of view of art the different forms of coffin are of particular importance (PL. 449).

The distribution of the practice of cremation among primitive cultures reflects for the most part the influence of higher ones. It was extremely rare in West Africa, which came under the influence of the ancient Mediterranean civilizations, and in the part of East Africa influenced by the ancient Orient. Certain South American examples of cremation were originally derived from the higher civilization of Colombia, and cremation among the Indians of California was perhaps of Mexican derivation. It is difficult to explain, except by the influence of a superior civilization, the sporadic occurrence of cremation in central and southeastern Asia and Indonesia. Considering the general trend of diffusion, it is puzzling to

find that cremation was practiced by the very primitive aborigines of Tasmania, who died out at the end of the 19th century, and also by a few extremely backward groups in Melanesia.

In some places cremation is only one stage of the burial process. When the ashes or the remains of calcined bones are preserved, the ways in which they are kept offer many opportunities to the artist. For instance, among the Giliaks of northeastern Asia the remains of the corpse after cremation are preserved in a richly decorated ritual hut, the architecture of which shows a connection with ancient Chinese artistic traditions. The pre-Columbian Tarascans of Mexico, like the Aztecs and Mixtecs, cremated their chieftains and then made up the remains into a mummylike bundle, which was put into a large urn and buried under one corner of a pyramid.

The style of mummification depends partly on technical skill and partly on the facilities available in a district. In some arid regions the salt content of the ground is so high that corpses are preserved for a long time without special treatment. In other places the corpse is dried by being exposed to the action of smoke (Madagascar, northern Congo, Australia, New Guinea, Marquesas Islands, southeastern Asia), while in still others it is filled with honey (western Sudan, China). The embalming of corpses, often combined with fumigation, is characteristic of the higher cultures and their immediate sphere of influence.

Mummification was widely practiced by the peoples of the Andes, the royal mummies of the Incas being especially impressive; wearing golden masks, they used to sit on golden thrones in the temple of Cuzco. The masks were necessary because the custom was to block the orifices of the body with cotton, wrap the corpse in cloth, and place it in a sack filled with certain plants, so that the human form was no longer recognizable. The masks for royal mummies were of gold, those of others, of wood. Even before the time of the Incas the coast dwellers of Peru made similar bundles and gave them a human appearance by attaching an artificial head made of a cloth cushion with a wooden nose and eyes of mussel shells, or else a facial mask entirely of wood, earthenware, silver, or gold. The mummification of deceased rulers was also customary in the high culture of Colombia. Its occurrence in the Aleutian Islands suggests a connection between the practices of America and Asia. Highly evolved methods of mummification are found also in the Canary Islands, among other places, and in certain parts of Australia.

Mummification is often combined with other forms of disposal of the corpse: the mummy may be buried or exposed on a platform, or mummification may constitute only one stage of the process. In certain cases the whole body is not preserved but only certain parts, such as the bones, skull, or hair.

To preserve the skull and ensure that the features of the living man will continue to "live," complicated operations are often necessary. In the central part of Celebes this is achieved by attaching a wooden mask to the skull. New Guinea and New Ireland are the classic examples of regions where modeling on skulls is practiced, often in a highly artistic manner characteristic of the megalithic culture of Oceania. (An isolated instance of this was found among the Toltecs in Mexico.) The soft parts, once gone, are replaced by earthenware; the eye cavities are then painted in a dark color and filled with wax, into which two cowries are inset in an oblique position, so that the opening of the shell and its indentations form eyelids and eyelashes. There is often embedded in the eye cavity a piece of *Cypraea tigris* shell with a round buttonlike object in the middle; the concave bluish-white surface represents the sclerotic, and the darker color of the button, the iris. To complete the realistic effect the hair of the deceased person is glued onto the skull. At the hairline parallel rows of cowries, kernels of the coix plant, or boars' teeth are occasionally inserted. Around the eyes, nose, and mouth the modeled head is painted with decorative curves to resemble the tattooing on the living face, a particularly rich development in Maori art.

Skulls that are considered full of power are often stored in special receptacles; in Africa, wooden ancestor figures may be carved on the lids of such receptacles. In eastern Melanesia

modeled heads are kept in special shrines made of rushes and richly decorated with rings. In New Guinea they are placed on a portable frame artistically carved and polychromed (PL. 449). In New Ireland, the New Hebrides, and elsewhere they are put on posts set between the shoulders of ancestor figures. In some parts of Melanesia the skulls of chiefs and of slain enemies are made into masks for warriors in the belief that the power of the deceased will thus pass to the wearer. The head is cut in two behind the ears without damaging the face, and the facial half prepared in the same manner as a skull.

The ritual use of human bones is not limited to primitive peoples. In various higher cultures — for example, that of Tibet — drinking cups and drums made of skulls and flutes and other musical instruments made of human bones play an important part. In pre-Columbian Mexico there was a ritual musical instrument made of a thighbone with transverse cuts along it, played by scraping with a shell or with the shoulder blade of a deer. In West Africa small pieces of skin or other fragments of a corpse are often inserted into portraits of ancestors — a custom possibly derived from the Christian cult of relics.

Among sepulchral buldings must be included the huts that, although frequently built over a grave, are not intended as dwelling places for the dead but rather as shrines to which gifts may be brought on certain occasions and in which the ancestors may take up residence for a short time. The Batak of Sumatra build in the marketplace temple huts dedicated to distinguished ancestors; in these the shamans evoke the ancestral spirits. In Nias every village of any size possesses a hut (*bale*), consisting as a rule of only a roof rising from the ground or supported on posts. This hut is supposed to be the lodging of the ancestors, and it is used when closer contact with them is desired.

There is sometimes a tendency to "sanctify" objects and practices that are ancient or even merely old. In Nias the *bale* hut supported on posts has typical features in common with the open dwelling huts that have long ceased to be built. In Africa the spirit houses and little huts commonly built over graves are mostly conical, although concial dwelling huts are extremely rare. Where huts are not built for ancestors, it is sometimes the custom to consecrate to them certain holy places out of doors or in the house, for example, the hearth or the threshold. The simplest type of ancestral altar is an offering bowl laid on the ground, on an altar of earth, stone, or clay, or on a board. There is an indescribable variety of these objects, some of them artistically interesting. A typical accessory to the ancestral altar in the megalithic culture of southeast Asia and Oceania is a little ladder, often inverted, because the spirits of the dead do everything in an opposite way from the living. Among the Batak these "soul ladders," supposed to facilitate the descent of the spirits, always have an uneven number of rungs, because ladders used by the living always have an even number. Of the offering boards the most artistically important are those widely distributed in Melanesia, painted or carved in openwork with ancestor figures, usually highly stylized, in which the ancestors are believed to dwell.

Mana (extraphysical power) is attributed to certain insignia of rank, whose bearer, the chief, is thus marked out as a living ancestor, the representative of the power inherited from his forbears and supported by them. Thus forms of scepter in Africa are derived from the staves of office of mighty ancestors or from carved figures of them. A throne in the form of a chair is explained as the dwelling place of the ancestral soul, which means, of course, that throne and ancestral altar became indistinguishable both in form and function. Carved thrones with representations of ancestors are extremely common, and among the Yoruba and the Bozo of the upper Niger, the sacred stool is often a cult object. These emblems of rank are kept in certain sacred huts which recall the huts of the ancestors. In the same category also belong the mysterious ceremonial stools from the Sepik River area in New Guinea, which always bear the depiction of an ancestor or a spirit, though their exact purpose is not known. The spirit thrones so far mentioned, though simpler in form, show analogies, again, with the megalithic culture complex.

The influence of megalithic culture is particularly evident in southeastern Asia. In Nias, for example, at the death of an adult (or in some places, of the head of the family only) an artistic wooden figure is made and placed among the other ancestor figures. When the soul of the deceased is to be installed in this figure, the relatives go to the grave to look for it. The soul is found in the form of a spider, which is brought to the ancestral statues in a bamboo tube, then released so that the soul may enter the figure. Meanwhile there is dancing, and the genealogy of the deceased is recited. Contact with the ancestors is ensured not only by means of these ancestral statues but also by the preservation of skulls, though only in the families of chiefs. The skulls are kept in monuments or containers specially made for the purpose, often consisting of upright stones with a horizontal stone laid across the top. Other monuments take the form of a truncated pyramid with the skull in the upper part, while still others are bird-shaped. An upright stone is erected for a chief and a horizontal one for his wife. These stone skull containers are usually constructed in front of the house, and the ceremony that follows their erection connects them with the ancestor figures within. The figures themselves are placed either on a board or on a kind of throne with an open umbrella over it. In the south of Nias stone monuments (darodaro) are erected about a year after the death of a chief or his wife; they consist of a long, broad stone laid over two or more uprights, probably derived from the similar monuments just described. They are often combined with the representation of a wooden bench and the imprints of feet. Behind the darodaro stands a column (tedro hulu); it is often decorated and serves as back support for the corpse. In central Nias stone pillars in human form (behu) are erected, often with the skull preserved in the top; they are supposed to ensure that the deceased will be treated as a chief in the other world. Among the Naga tribes of Assam (India) buffalo heads carved in wood, or sometimes the skulls of actual buffaloes, are placed on memorial stones as an indication that sacrifice has been offered. Such customs, with various individual features, are widely distributed over the earth's surface, always in a significant connection with other factors of the megalithic culture complex.

Comparative study has established that ritual columns can be regarded as substitutes for or precursors of a typical megalithic monument, the menhir. Megalithic culture has affected enormous areas of Oceania (especially important centers being Umboi in the Bismarck Archipelago, the eastern Solomons, the Banks Islands, and the east-central part of the New Hebrides.) Hence it is plausible to attribute to megalithic cultural influence such phenomena as the carved grave columns that occur in Arnhemland and on the islands of Melville and Bathurst, which belong ethnologically to Australia, for these columns have no parallel in the art of the Australian aborigines.

In the remote parts of northeastern Asia carved sepulchral pillars are found with androgynous figures that are typically megalithic. The Ainu, who are considered to be the aborigines of Japan, set up on their graves posts that have a spear-shaped top for a man and a round top for a woman. The Eskimos of southern Alaska sometimes erect grave pillars adorned with human and animal figures, comparable to those of the Athabaskan tribes in Alaska and British Columbia. These grave pillars and memorial columns represent the genealogical connections or the most important experiences of the deceased person and may be considered modest prototypes of the famous memorial pillars of the Tsimshian, the Haida, and other tribes of northwestern America. These carved pillars of the northwestern Amerinds, usually designated in literature as totem poles, are sometimes grave pillars or memorial columns and sometimes internal or external supports of a house.

In Africa megalithic elements are found scattered over a wide area, with three main regions of concentration. In southern Nigeria, northwestern Cameroons, and the Niger-Senegal district there are megalithic constructions, elliptical stone circles, phallic stones, and numerous other signs of megalithic culture and mythology. In southern Ethiopia, and less characteristically in eastern Sudan and Kenya, megalithic culture is represented by grave pillars, ancestor figures, architectural constructions, and the erection of trophies (PL. 451). Finally, on and near the eastern coast, in the region of the ancient Rhodesian culture, and farther west as far as central Angola, are found constructions of a monumental type, the fanany beliefs of Madagascar, and evidences of human sacrifice. Naturally, not all the elements of the culture complex are to be found in the zones of secondary influence of these three centers.

The more extravagant the grave gifts became and the more costly in material goods and human lives, the greater the inducement to be satisfied with substitutes, especially after European colonization and in view of the belief that the dead require only the essence or "shadow" of the gifts. In some cases human sacrifice is imitated rather than actual; for instance, among the Carrier Indians of British Columbia the ritual burning of widows has long ceased to be practiced, but during her husband's cremation a widow is required to lie beside the pyre until she is nearly dead of heat. In other cases a milder form of sacrifice was substituted: in many parts of Indonesia the human offering has now been replaced by a buffalo. The offering of the hair, which is very widespread, can be considered, at least in many cases, a substitute for an earlier human sacrifice. More common and more important for its influence on the art of primitive peoples is the custom of substituting models for real people or valuable objects. Tribes in the far north put the whole of a man's property into the grave with him; among the Eskimos, however, weapons, kayaks, and similar possessions are so hard to come by that the dead man is provided only with wooden models. There are analogies in other parts of the world.

The cult of the dead and of the ancestors has a very important influence on the art of primitive peoples, especially in connection with sculpture in the round and masks. Statues of the dead serve the same purpose as mummification, ensuring the survival of the soul (PLS. 450, 451); the psychic essence of the deceased person is believed to be magically transferred to his image. Very frequently a lock of his hair is glued to it, or some of his clothes or ornaments. The inhabitants of the island of Kisar, near Timor, place a stone beside a dying person so that the soul at its departure many enter into it; immediately after the death they place on the stone a little human figure made of horn, tin, ivory, or wood, usually in a crouching attitude, and the stone receives a personal name. Frequently the figure is regarded as only a temporary dwelling place for the soul. When the inhabitants of the New Hebrides want to communicate with the spirit of a dead man, they entice it into the ancestor figure by spells, music, and food offerings and then pray to it after they have heard some noise that makes them think the soul has entered the image.

To those who believe that souls can be thus transferred, the images of the dead and of ancestors are not just memorials but are magically identified with the dead. Many customs exemplify this; for example, a Chippewa widow would carry about with her a manikin, made of her dead husband's clothes and ornaments, to represent him. Most figures of the dead and of ancestors are treated as portrait statues by those who pay devotion to them, regardless of any objective resemblance to the deceased. The image is accepted as a perfectly adequate vehicle for the personality of the dead person, although the personality is, of course, gradually forgotten. Only very eminent kings and other famous characters lived on in memory, and their statues also had their names attached to them.

Thus the Bakuba kings of Bushongo in the southern Congo had portrait statues made of themselves; nearly all of the 17 known at present are identified (II, PL. 113). King Shamba Bolongongo (1600-20?), ninety-third in the list of 120 Bakuba kings, was the first who had his statue made "in order that men might remember him afterward." He is represented playing the game of lela, which is known all over Africa. King Mikope Mbula (ca. 1810-40), who introduced the previously prohibited custom of marriage with slaves, is accompanied by a small female figure of a slave. Each of these statues, examined by itself, creates the impression of a portrait; but seen

all together, though they are hundreds of years apart in time, they seem like the work of a single artist, almost the only differences being in the attributes. This shows how much the style of portraiture was influenced by an ideal notion of what a king should be. The same is true of the great bronze heads with wings from Benin. The absence of individual character is due not to lack of artistic ability but to a concept of the nature of personality totally distinct from that of Europe. This is quite clear in the design of three royal statues from the old kingdom of Dahomey. They represent three kings: Ghezo (1819–58), whose nickname was Kokoula ("Cock"); Glele (1858–89), called Kinikini ("Lion"); and Gbehanzin (1889–94), called Gbowele ("Shark"). The artist completely avoided rendering their individual facial characteristics, thereby laying all the more emphasis on the animal sobriquets, which probably have a totemistic significance. Ghezo is shown as a man dressed in feathers, Glele as a lion with human legs, and Gbehanzin as a creature with human arms and legs but a fish's head and scaly breast. Lifelike resemblance in a series of ancestral portraits such as these is also reduced by the fact that the artist strives to emphasize the suprahuman traits of the spirits according to tribal tradition.

In view of the very wide distribution of burial in the fetal position and the frequent occurrence of human figures carved in this attitude, it seems obvious to suggest a connection between the two. Elsewhere the artist may have drawn his first inspiration from the sight of a dead body. It may be supposed that the famous Easter Island statues in "skeletal" style (PL. 451) were inspired by the sight of half-decayed corpses or of persons who had died of hunger. The tradition according to which an early artist met some spirits whose projecting ribs were very conspicuous and that he introduced the "skeletal" style for that reason may be an explanation developed later to account for an artistic tradition that was no longer understood. The pre-Columbian Chimu of the Peruvian coast believed that the dead live on in the form of skeletons. On their painted pottery one often sees skeletons dressed as living people and taking part in earthly amusements, mostly as musicians and dancers. The dance of death was as common in ancient Peru as in medieval Christendom.

The more faded and mythical the real personalities of the ancestors became, the more they were represented in art under fantastic and demonic guise. The representations of mythical ancestors of a tribe were not bound by the limitations of human anatomy. In Nias, for example, some of the ancestor figures have male genitals and female breasts; others, female genitals and a beard. Such representations are expressions of the Nias creation story, according to which the original being was spherical and bisexual and the first human couple resulted when it was cut in two. Similar androgynous ancestor figures as well as masks are found among the Bajokwe in eastern Angola. The famous *uli* statues of central New Ireland are often lifesize or over and represent famous chieftains of ancient times, without any trace of individual portraiture. A feature of the conventional style is a peculiar head ornament resembling a helmet, probably a reminiscence of a hairstyle no longer in use. One feature of these figures that ethnologists have not yet completely explained is their apparent bisexuality; they have a large phallus and also firm and swelling breasts. The present aborigines maintain that this has nothing to do with bisexuality and that the large breasts only indicate the strength of a well-nourished chief. Because of the fact that in the northern part of the island certain ritual dances are performed by men wearing artificial breasts, it seems not impossible that the *uli* figures may actually represent men disguised to play women's roles in ceremonies from which women were excluded, a phenomenon with parallels in other parts of the world.

Ancestor masks are as a rule even less naturalistic than figures in the round and emphasize even more strongly the fantastic and demonic. Besides actual death masks, not worn by the living but bound onto the heads of the deceased (in Peru, Mexico, the Aleutian Islands, Central Asia, Celebes, and elsewhere), there are also facial masks, tilted masks (worn not over the face but tilted up over the head), and masks worn on top of the head. The mask is never more than a part, though the most important and expressive one, of a disguise concealing the entire body of the wearer. The disguised person becomes another being, the dead man or the ancestor whose spirit is embodied in the mask. Masks are thus an essential element in the dramatic art of primitive peoples, and the wearer is playing a role. At the same time the mask is a cult object, and the masked dance represents a profound mystery of transformation. As an element in a religious-dramatic ritual the mask reaches its fullest expressiveness only when it is in action. Thus, in contrast to the impressive stillness of the ancestor figures, masks have a passionate and very dynamic aspect. The statues rarely express action.

At certain festivals among the Pangwe of West Africa the ancestor figures are used as actors in a puppet play, a custom that has remote connections with the ancient Mediterranean. A similar practice seems to have existed on Easter Island: at the festival of the ripening of the bananas the ancestor figures were hung by cords around the necks of the participants and rocked in their arms in time to the singing. Typical of the cult of the dead is the tilted topeng mask of the Toba-Batak in northern Sumatra: at the feast in honor of a dead chief it is worn by a slave, who waves a pair of wooden hands and dances to represent the dead man. In earlier times the slave was slaughtered at the end of the ceremony.

In regions where secret societies are important the masked dancers at funerals are usually drawn exclusively from their members. The masks of the secret societies may represent, besides ancestors or the head of the clan, various nature demons, especially bush spirits. In the secret societies, too, the masks are sometimes used for activities other than funerals. In the eastern part of New Britain, for instance, the masks of the Mengen people have a complex of functions. Here the original form of the mask was simply a cowl of netting worn by a mourner to make himself more like the dead person and to appear as a scarcely recognizable smokelike ghost. (This is a very widespread idea that occurs among Indo-European, Semitic, Altaic, and other peoples; the dead person or the demon of death is regarded as "the hidden one" and frequently so called.) Among the Mengen the masked dances are held not only on the occasion of a death but also for circumcisions and at the harvest. Their neighbors, the Baining, also hold masked dances at harvesttime, using masks of bark that may be more than 15 ft. high; one may assume that the ancestors represented by the masks are supposed to increase the fertility of the fields.

Figures of the dead are sometimes placed in direct contact with bodily remains of the person represented, emphasizing the close connection between the two. According to one ethnological theory, ancestor figures originated when the wooden pole set up on a grave (or alternatively the tree sacred to the ancestors) was combined with the preserved skull to form a figure representing the ancestor. There are, indeed, tribes among whom the skull and figure (or pole) are found combined, for instance, in the New Hebrides, where actual skulls are set up on lay figures made of bamboo and straw and carefully painted to give an extremely realistic appearance. In other instances a skull mask may be set on a pole which has only a vague suggestion of human form. Even in figures that contain nothing of the dead body, however, it is often believed that the soul of the deceased person has taken up residence. Again, the remains may be artificially restored. The eastern Toraja of Celebes, at one stage in their funeral ceremonies, dig up the bones, tie them together, and attach a wooden mask and artificial arms with armlets. A similar procedure existed among the pre-Columbian coast dwellers of Peru.

The connection between ancestor figures and such relics as skulls is most obvious in the art works in what is called the Korwar style of southeastern Asia and Oceania. The best-known examples are the crouching figures from the northwest coast of New Guinea: the heads of the figures are larger than life size, cubical in shape, and contain skulls. These images often wear the typical Malayan pointed hat, which has not been worn in Melanesia within human memory. Further,

the figures have straight hair, unlike the curly-haired Melanesians. These features and the fact that the Korwar style is found in the extreme northwest of New Guinea indicate that it originated farther west, where it is found in Timor and Flores, and especially among the Batak of Sumatra, and in Nias. Farther east it occurs in the Trobriand Islands, the Solomons, and, surprisingly enough, in eastern Polynesia on Easter Island and the Marquesas. Stylistic comparison indicates the probable origin of this style: all the characteristics of the Korwar style can be found in a more refined form in the Khmer culture of Indochina. The range of distribution, the shape of hat, and other elements suggest that the Khmer style was carried to Oceania by waves of Malay migrants and there somewhat debased or modified by the local population, presumably about the 8th century of our era. This theory, being based solely on stylistic considerations, does not, however, answer the question of how works of art of this type came to be combined in New Guinea with the idea of preserving ancestral skulls.

Such problems as the origin of the Korwar style illustrate the connection between the study of funerary art among primitive peoples, which often has a magical or mana character, and historical ethnology in general. By ethnological research, connections can be traced over great distances and long periods of time. It may, then, be suggested again that megalithic migrations played a basic part in the history of ancestor figures. The highly characteristic megalithic pillar cult, the cult of graves, the system of commemorative festivals, the monumental construction, and the great interest the megalithic peoples took in death, the beyond, and the perpetuation of their achievements — all these offer points of comparison with the beliefs and stylistic notions expressed in the ancestor figures of primitive peoples. For instance, the megalithic monuments of the Khasi in Assam are not merely memorials of the ancestors; they are called by the names of the ancestors and are believed to incorporate their souls. The same connection of memorial stones with actual ancestors is found also in wide areas of Oceania, southern Asia, Africa, and elsewhere. Without doubt a large proportion of ancestor figures have a connection with the grave, or the bodily remains. In northeastern Africa, especially in southern Ethiopia, in a culture which has definite megalithic connections, gravestones and anthropomorphic grave pillars are found together (PLS. 88, 89).

Ethnology shows that although in recent times wood sculpture has predominated, at one time it was secondary to sculpture in stone, for which it later became a substitute. This is especially true in Africa. The mortuary figures of soft steatite discovered in the Noqui Mountains of northern Angola have a tradition that demonstrably goes back at least to the 16th century. They stood encircled by wooden figures in the same style, and the whole group represented a clan or an extended family. The wooden figures fell victim to termites within a few years, and only the stone figures remain as evidence of the surprisingly high standard of funerary art in the old kingdom of the Congo. The present population makes only wooden ancestor figures, at best in a style related to that of the old stone statues, although simplified. Some of the stone examples show an unmistakable kinship with the sacred sculpture of the higher civilizations of southeastern Asia. Ethnological study of the culture of the southern Congo and northern Angola has brought to light a coherent complex of megalithic elements (mummification, stone tombs, *fanany* beliefs, and human sacrifice) that have a clear connection with the higher culture of Zimbabwe in Southern Rhodesia. Asiatic influences certainly reached Zimbabwe, probably indirectly, so it seems not impossible that the funerary art of Angola may have received its decisive inspiration from the East. The occurrence of steatite statues in the cultural region of Zimbabwe is evidence for this, but on the other hand there are no grave statues which could have been the prototypes of those in Angola. There is, however, another connection between the ancient kingdom of the Congo and megalithic culture, and many tribal traditions support it: the historical roots of the ancient kingdom point toward the north, for example, to the Kissi in upper Guinea, the Mende in Sierra Leone, and the Esie of southern Nigeria, where stone grave sculpture and other megalithic elements are found.

<div style="text-align:right">Laszlò Vajda</div>

THE ANCIENT WORLD. *Near East.* The funerary traditions of the great civilizations of the ancient Near East represent a special development of those prevalent in the Neolithic period. Egypt yields ample documentary evidence of a highly developed eschatology in written texts, funerary customs, and art. Chief attention was given to the corpse. It was protected through inhumation, the limbs being held in place by bandages; later, mummification was adopted. This method was successfully practiced on a wide scale only from the time of the New Kingdom. The Egyptians ensured survival through preservation of the appearance of the dead person in masks on the anthropomorphic sarcophagi and also, though in another sense, in the individual portrait, which appeared even in the Old Kingdom as a well-developed artistic theme (see PORTRAITURE).

Egyptian burial equipment, bound to the ancient prehistoric concept of the needs of the dead, became progressively more complex and rich, reaching a peak in the gorgeous furnishings found in the tombs of the Pharoahs of the New Kingdom, especially that of Tutankhamen (PL. 449). In addition to clothing, jewels, amulets, and flowers, tombs contained furniture, weapons, carts, pottery, stone receptacles, baskets, games, musical and writing instruments, toilet implements, necklaces, and bracelets. The most important item of the funerary equipment was the sarcophagus, made of stone or wood in the form of either an oblong box (originally shaped like a house) or an anthropomorphous mummylike container. The latter was decorated with vivid colors and gold, particularly the mask, or with carved figures and hieroglyphic inscriptions (PL. 449). Canopic jars, of which the earliest go back to the 4th dynasty, were intended to contain the entrails. There were four for each body, each presided over by one of the four sons of Horus. The tomb, originally built as shelter for the dead, became in Egypt one of the highest architectural and monumental manifestations of the preclassic ancient world, as evidenced by the pyramids (PL. 456), the funerary temples, the sacred boats, and the vast and complex rock tombs cut in the terraces of the Nile and richly decorated.

The preservation after death of the personality, physical characteristics, and habits of the deceased was ensured not only by the funerary portraits (the so-called "reserve heads") but also by the reliefs and paintings frequently executed on the walls of the tombs from the time of the Old Kingdom, depicting scenes of family life, banquets, agriculture, hunting, and the like. From the end of the Old and through the entire Middle Kingdom such subjects were often represented in small wooden models featuring servants, dancers, craftsmen, cooks, peasants, herdsmen, boatmen, and frequently the milieu in which they operated (PL. 460). In some paintings in New Kingdom tombs at Thebes the scenes of domestic life are accompanied by pictures of funerals, showing the funeral procession crossing the Nile to the tomb, the ritual lamentation, the ceremony of the "opening of the mouth and of the eyes" carried out on the mummy by the officiating priest, and the burial itself.

In the New Kingdom numerous pictures of the other world appear among the illustrations of the funerary papyri. Very widespread was the idea of a kingdom of the dead, ruled by Osiris, into which the dead entered after proving their virtue during life. A typical illustration of this is the scene of the judgment of the soul, which takes place in a vast hall; on one side, sitting under a canopy, is the god Osiris; ranged about him are 42 judges, each of whom tries one particular sin. At the center of the composition a balance bears on one plate the heart of the dead person and on the other the symbol of truth; Horus and Anubis verify the correctness of the weight, while Thoth writes the verdict in his book. The deceased is led into the hall by Anubis to be judged before the goddess Maat. A hybrid monster with a crocodile head, the forepaws and shoulders of

a lion, and the hindquarters of a female hippopotamus, the "devourer of the dead," stands waiting with open mouth, ready to consume the dead who are found wanting (PL. 464). The residence of the "justified" (Field of Offerings of Food or Field of Reeds) is represented as a cluster of little islands surrounded by canals. On these islands the dead pursue agricultural activities and make offerings to the gods. The underworld depicted in the regal tombs is populated by monsters.

In the civilization of the ancient Near East, which was contemporaneous with the Egyptian, literary texts amply describe the conception of the hereafter and the fate awaiting the soul. The Sumero-Akkadian texts relate how, after death, the soul descends into Aralu, the kingdom of the underworld, while the body remains in the tomb surrounded by food and objects of everyday use. The city of the dead, situated under the ground, is governed by Eresh-Kigal, the goddess of the underworld. Seven walls, watched by guardians, surround the huge city, which is full of dust and ruins and enveloped in darkness. There the dead, after being judged by Eresh-Kigal, feed on dust and mud; only the offerings of relatives can somewhat lighten their fate. A few texts mention an island of the blessed, but this was reserved for a few chosen souls to whom the gods had granted immortality. The pessimism that inspired Mesopotamian eschatology explains the absence of artistic representations except for a few scenes representing funerary sacrifices.

Burial customs were primitive: the corpse was wrapped in matting or bandages and placed in a grave dug in the soil, or it was put into a terra-cotta sarcophagus or inside two conical jars that fitted together. The tombs did not always constitute a necropolis outside the town; a dead person might be buried under the floor of his own dwelling, as sometimes happened in neolithic cultures. In this religious concept it was considered important that the dead receive libations of pure water, and the eldest son was usually the "maker of the water libation," which was probably the reason for domestic burials.

The Sumerian regal tombs of Ur (first half of the 3d millennium B.C.) constitute a unique phenomenon. In ample graves dug in the soil and covered by domes were found a great number of corpses, spaced with regularity and surrounded by exceptionally rich burial equipment comparable to that of the Egyptian tombs: objects to be used in games, musical instruments, boats (probably for crossing the river of the dead), and other objects. The bodies are probably those of the king's retinue, sacrificed to be near the dead sovereign in accordance with a custom known in prehistory and appearing again at a later date.

Among the Palestinian peoples is found the idea of a realm of the dead (Sheol) where the shades (*rephaim*) were to be found. After death the soul went down to this region, not unlike the Mesopotamian Aralu, and led a life of sadness. According to the Canaanites, however, the soul maintained a closer relation with the body left in the tomb, feeding on the food left near the body and refreshing itself with water brought by suitable ducts to the place of burial, as seen in the tombs of Ugarit. From this belief arose the fear that the tombs might be violated, hence the dead were buried in the most secret places.

In Syria and Palestine both cremation and inhumation were practiced. Cremation occurred more frequently than in Mesopotamia, and its existence is testified to both in the prehistoric era (the Khudheirah urns) and in the historical era (hut ossuaries of Ugarit). The tombs of the historical period were generally of an underground or a well type, the first more frequent in very ancient times (Byblos), the second in the first millennium B.C. The dead body might be placed directly into such tombs (as at Tell el-Jarra, where a stone serves as pillow) or inside jars or sarcophagi. The latter, obviously inspired by Egypt, were very frequent in the royal tombs of Byblos and Sidon and have also been found in Palestine (Beth Shan, Tell el-Far'ah). The case-shaped sarcophagus is older than the anthropomorphous one. The dromos tombs of Ugarit (Mīnet el-Beidā) are of a special type (of Mycenaean origin), as are the tombs of

the Hyksos, in which the body of a horse or a donkey has been found with the dead man. Children were always buried in jars. The funerary equipment was never very elaborate, and only at a later period did ceramics begin to be abundant, except for the Hyksos tombs. The reason for this poverty was perhaps the fear expressed in inscriptions that the avidity of robbers might violate the repose of the dead.

Among the representations of funerary subjects are the reliefs on the sarcophagus of Ahiram, king of Byblos, who lived the 10th century B.C. (PL. 453). On the principal side is the king himself, portrayed as a dead man, before a table loaded with food for the funeral meal, while people render homage and make offerings and female mourners with bare breasts lament. This iconography is an isolated case in the Middle East and was presumably inspired by Egypt.

In Anatolia, also, cremation and inhumation existed side by side from the most ancient times. In the royal tombs of Alaca Hüyük (late 3d millennium B.C.) the bodies were buried with many vases, statuettes, weapons, and jewels; the so-called "banners" — openwork bronze pieces whose use is not known — are typical. The Hittite kings were cremated, as we learn from a literary text found at Bogazköy containing a funeral ritual. A frequent custom in Anatolia was inhumation under the floor of a private dwelling, with corpses placed in pithoi or in earthenware urns (Kültepe). There are many cemeteries, however, particularly in the western part of the country, situated outside towns (Yortan, Babaköy). Most of the burial equipment was of earthenware. Although we have no direct evidence of belief in an afterlife by the peoples of Anatolia, the funerary equipment and the cultural milieu with which they had contact support the hypothesis that their ideas did not substantially differ from those of the other populations of the Middle East. The king alone was deified after death, as is revealed by the formula, "My sun has become a god," used to announce the sovereign's death. This belief spread from Anatolia to the Aramaic area under Hittite influence.

In this location appeared another kind of funerary product, otherwise unknown in ancient Asia Minor, which was to reach notable development in the West. This was the stone stele with a relief showing the dead person sitting at a banquet, at times in the presence of servants and relatives; women sometimes have their children in their laps or hold lutes or pomegranates. The latter symbol is evidently connected with the belief in resurrection or in rejuvenation, as are the ears of corn sometimes held by men.

Sergio BOSTICCO and Giovanni GARBINI

*Greece and Rome.* The funeral customs of the Aegean peoples during the Bronze Age did not differ substantially from those of the neolithic tradition, which reached various stages of development in the civilizations of the Near East regarding the protection of the corpse and the burial equipment. The Homeric epics give an idea of the conceptions of the afterlife in the Mycenaean world. The dead were "beings without substance"; their souls descended into the darkness of Erebos but continued to exist in vague, uncertain form, mourning for life on earth (cf. the Nekyia, *Odyssey*, xi). A civilization in which such beliefs prevailed could not have a highly developed funerary art. Indeed, the *Iliad* (xxiii) indicates that human corpses were burned with those of dogs and that the bones were collected in a basin and covered by a sepulchral mound. At times a funerary monument is mentioned. From Mycenae there are steles with reliefs; masks of gold (PLS. 73, 449), the metal which was the symbol of life; and large domed chambers (PL. 68) of Cretan architectural type.

In the Geometric period, probably dating from the 10th century to about 700 B.C., the remains were cremated and placed in tombs with perforated vases through which offerings could reach the dead. Some of these, particularly those from the necropolis near the Dipylon in Athens, are among the most typical and magnificent examples of Geometric pottery. They are sometimes decorated with funeral scenes (PL. 461; III, PL. 132).

Ideas that were to take a more decided form in the course of the 7th century B.C., when the whole Eurasian continent was in the throes of a vast spiritual crisis, probably had their origin at this time. The dead were no longer thought of as dim and vanishing but as active and terrible, the ancient kings attained the status of heroes or were even worshiped as gods. More emphasis was laid on burial rituals and the care of tombs; and ancient popular beliefs emerged again, favored by the decadence of aristocratic rule and by the birth of the tyrannies. Stones were more often placed above tombs; these stones, with their erect position and their lasting material, were an allusion to survival. Inside the tombs were placed slightly anthropomorphous stones. On Italian soil the warrior of Capestrano provides a curious and significant example of a figure of a dead warrior, raised from his horizontal position, fully armed, and with his face covered by a mask (V, PL. 35).

The funerary statue and the carved stele, particularly the latter, went through a special development in the course of the archaic age. The stele represented the "living dead" as warrior, athlete, maiden, or the like. The steles of Attica and of the islands give a vague idea of the state of the dead, who may hold a pomegranate, as in the Oriental steles; in Laconia (Sparta, Chrysapha) the steles clearly indicate the heroized state of the dead.

This same period saw the growth of cults, such as the Eleusinian and Orphic mysteries, which up to then had been at least ignored, if not prohibited. These taught no specific doctrines on the nature of the afterlife but only the way to happiness in the next world. At Eleusis this was through initiation; among the followers of Orpheus, through purity. The Orphic instructions for behavior during the journey to the tribunal of Persephone and before it are expounded in a didactic poem, "Orpheus' Descent to Hades," fragments of which have been discovered in tombs. If the deceased had carried out these instructions faithfully, the verdict would be that he "take his place among the other heroes."

In Italy, as generally in central and southern Europe, cremation was apparently widespread from the beginning of the Bronze Age and throughout the Iron Age. At first there were increased numbers of ossuaries containing little equipment, then growing differentiation of individual tombs and richness of equipment, particularly in the Villanova culture. Ossuaries shaped like houses (III, PL. 124) were one development. Cremation and inhumation coexisted, as in Rome in the archaic cemetery of the Forum. Corpses were placed in hollowed tree trunks or in stone cases, which were rudimentary forms of the sarcophagus. The use of the sarcophagus, widespread in the East, remained a substantially alien custom in Greece proper and in classical civilization, although it appeared in the outlying zones in contact with Asia Minor (sarcophagi of painted terra cotta at Klazomenai) and with the Punic and Italic world (Sicily).

The theme of the dead person who went on living in his own environment — only hinted at with great discretion in Greece — expressed itself openly in Italy from the 7th century B.C. through the development of funerary architecture (mounds and domed tombs; PL. 456); the imitation house within rock tombs (PL. 458); the increase in jewels, weapons, instruments, and furnishings of tombs; and the appearance of exceptionally rich Orientalizing tombs such as the Regolini-Galassi tomb at Caere (Cerveteri; V, PL. 25) and the Barberini and Bernardini tombs at Praeneste (Palestrina). From the early vase covered with a helmet the ossuary developed into an anthropomorphous shape, particularly around Clusium (Chiusi). This development began with the application of metal masks to the lids and continued with the creation of forms imitating human busts with heads in which there was a tendency to portraiture (incorrectly called "canopic jars" — a term properly used for certain Egyptian funerary vases; PL. 449). The "vase-person" concept is indicated by the frequent placing of the jar on a little throne inside the sepulchral chamber (III, PL. 136). In the later archaic age the dead were represented banqueting or surrounded by relatives and servants, together with scenes of games and funerals, as in the great wall paintings of the tombs of Chiusi and Tar-

quinia (I, PLS, 363, 364, 368, 374; V, PLS. 41, 42, 46) and the reliefs on urns and tombstones.

In Greece similar representations were rather rare, though they are found on pinaces and funerary vases. There was, instead, a continuation of the archaic tradition of the stele (PL. 450; III, PL. 357), which in the second half of the 5th century began to include scenes of the dead taking leave of the living (III, PL. 369) or of mythical figures such as Charon (PL. 462). This iconographic tendency to represent the afterlife with its demons and divinities flourished particularly in southern Italy (as in the vases of the 4th cent. B.C. from Taranto) and in Etruria (the great painting of the Nekyia in the Tomb of the Ogre at Tarquinia).

The general development of Italic art during the 5th and 4th centuries B.C. replaced the archaic disorder with the beginnings of a system, apparent in the arrangement of cemeteries. Sepulchral roads were built at Cerveteri and at Orvieto (necropolises of Cannicella and of Crocefisso del Tufo), and the arrangement of the rows of sepulchral chambers recalls a military camp. This concept continued during the Roman empire, as seen in the Villa Wolkonsky complex along Via Statilia in Rome and in the tombs near S. Paolo fuori le Mura and on the Isola Sacra, between Ostia and Porto.

The Etruscan sarcophagus bearing the portrait of the deceased lying at ease on the lid (PL. 454), often combined with the architectural form having a roof-shaped cover, was continued in the funeral art of the Roman epoch. Where cremation prevailed there appeared in time cells and loculi, anticipating the Roman columbaria. Etruscan sarcophagi and paintings represented with increasing frequency the theme of the journey of the dead to the other world, escorted by Charun and Vanth. The dead take leave of their relatives, while other relatives wait for them at the entrance of Hades, pointing to the continuity of life (PL. 462) — a motif that continued to appear during the Roman empire (Seneca, *Apocolocyntosis*, 13). The journey was made on foot, on horseback, or in a chariot. Other urns and sarcophagi show the portal of Dis (*ianua Ditis*) or creatures symbolizing the power of death (centaurs, Scyllas, Tritons, etc.), some of which also belong to the Roman funerary repertory (Vergil, *Aeneid*, VI). The sarcophagus shaped like an altar took its place beside the other forms, expressing in another way the superhuman character of the dead (Partunus tomb, Tarquinia; tomb of the Scipios, Rome). The eschatological representations do not directly reflect any doctrine on salvation but often bear Dionysiac symbols or allusions of an allegorical nature, as in the mythological scenes so frequent on the cinerary urns of Volterra, Chiusi, and Perugia.

Toward the end of the republican period funerary art in Rome seems to have been reduced to the building of columbaria, often without paintings. There were, however, some imposing tombs and mausoleums built in the Italic tradition (mausoleums of Augustus in Rome and of Munatius Plancus in Gaeta inspired by Etruscan mounds) or in exotic traditions (pyramid of Cestius).

The custom of placing statues over tombs, frequent after Alexander the Great, gained increasing popularity, especially, in the Roman world, the reproduction of the features of the dead in portrait busts. This custom, with its roots in the habit of preserving and carrying in the funeral procession the images of ancestors (*imagines maiorum*; PL. 451), recalls the archaic anthropomorphous ossuaries of Etruria. Portrait art flourished during the republic and the empire (see PORTRAITURE); clay and marble busts, sometimes copied from a death mask, gained in popularity, and often busts and heads of several members of a family adorned the niches of a sepulcher or constituted the central motif of the funerary steles common in the provinces. The theme of the *tête coupée*, which had already appeared in Etruria, recurred frequently in the south of France (III, PL. 111) and became, like the themes of the wild animal (III, PL. 112), the rapacious monster, and the horse, a characteristic feature of Celtic funerary symbolism.

Toward the end of the Roman republic and at the beginning of the empire the custom of cremation prevailed and caused a marked development in the shapes of sculptured urns

(PL. 452) and funerary altars. Later, during the 2d and 3d century of our era, inhumation reappeared and sarcophagi were more widely used. This development was accompanied by the abandonment of the columbarium and the reappearance of funerary houses and shrines, as seen at the crossing of Via Latina and Via Asinaris near Porta San Giovanni in Rome and in the cemetery of the Isola Sacra near Ostia. In such shrines the place of the loculus was taken with increasing frequency by the *arcosolium* (an arched cell designed to receive a sarcophagus) and the *forma* (a grave cut into the floor). A curious fact is that during the same epoch in metropolitan Greece, where it had never been previously accepted, the sarcophagus was widely used, both in sepulchral chambers (Tatoi, near Athens, and Delphi) and in the open (the necropolis near the Dipylon in Athens). The Greek type of sarcophagus, generally decorated on all sides, is unlike the Roman, which is carved on one of the long sides only. The bath-shaped sarcophagus, which appeared only in archaic Klazomenai, became a cask-shaped one, usually adorned with Bacchic motifs. The sides of the sarcophagi afforded an ideal space for the illustration of eschatological ideas, and there appeared scenes similar to those on the Etruscan urns (V, PL. 28).

It is impossible to list all the iconographic themes (see E. Robert, *Die Antiken Sarkophag-Reliefs*, Berlin, 1890–1919, and F. Cumont, 1942, whose findings may also be applied to mural paintings and stucco reliefs). Some of the principal motifs are the following: (1) The Soter, or savior (Hercules, Orpheus, etc.). The dead one entrusts himself to one who triumphed over evil (spiritual death) and identifies himself with him (Hercules on the Ludovisi sarcophagus, Mus. Naz. Romano). (2) Virtus ("recludens immeritis mori caelum," Horace, *Carmina*, III, II). Scenes of lion and boar hunting and of battles with the Amazons, Gauls, or Germans portray the deceased as the chief character. The battle of Issus had already appeared on Etruscan urns, as well as battles with Gauls (H. Brunn and G. Körte, *I rilievi delle urne etrusche*, III, Rome, Berlin, 1870–1916, cxi–cxii). (3) Wisdom (Odysseus; philosophers; Muses; figures with rolled manuscripts, symbol of wisdom; people with musical instruments, symbol of the planetary harmony of the spheres, perceptible only to the incorporeal). (4) Eternal life (open door; Seasons; Romulus and Remus; Eros and Psyche, symbol of perpetual life; the Dioscuri, symbol of the eternal movement of the heavens; journey to the island of the blessed on the back of marine monsters). (5) Heroized mortals (rape of the daughters of Leucippus; rape of Ganymede; Selene and Endymion; Dionysos and Ariadne; all myths expressing union with a god). (6) Scenes of the life of the deceased (rarer than the others). Sarcophagi bearing battle scenes should be included in this group only when the personal elements are unmistakably identifiable.

Motifs that echoed older traditions continued in occasional use. Among those of the 3d century were (1) journey on horseback (Rome, Mus. Naz. Romano, Ludovisi Coll.) and (2) the rape of Proserpine (London, Br. Mus., from the tomb of the Nasonii; the tomb of Vincentius and Vibia, Rome, which also shows the judgment in Hades and the eternal banquet).

Some themes may be ascribed to religious tendencies of the time, although the problem has never been treated systematically. Metilia Acte, a priestess of Cybele, as we are informed by the inscription on her sarcophagus (W. Amelung, *Die Skulpturen des Vatikanischen Museums*, I, Berlin, 1903), had represented on it the story of Alkestis (return from death), a theme with too general a content to permit a conclusion. M. Ulpius Faedimus was a priest of Isis; the lid of his sarcophagus, found at Ostia (Rome, Lateran Mus.; O. Benndorf and R. Schöne, *Die Antiken Bildwerke des Lateranenischen Museums*, Leipzig, 1867, nos. 507–8) shows the Seasons, a motif that corresponds to the character of Isis but is not characteristic of her alone. Aelius Magnus was a follower of Mithras at Oea in Tripolitania; the paintings in his tomb represent him among trees and flowers, weeping genii, a figure with a candlestick, two peacocks, and a springing lion. The trees, flowers, and candlestick are characteristic of the Mithraic cult; the other elements are not. In the adjacent room, where his wife was entombed,

the paintings show a portrait of the dead woman holding a scroll, enclosed within a medallion held up by two women; two naked people lie weeping on a red cloth, while others walk about with candlesticks. A crown is carried by two genii; a lioness is also shown; on the tomb itself are represented circus races (M. J. Vermaseren, *Corpus inscriptionum et monumentorum religionis Mithraicae*, The Hague, 1956, no. 113, with bibliog.). In this instance also, characteristic elements were intermingled with general ones (medallion, crown, races in the circus).

The funeral urn in the Lateran Museum in Rome representing vintage scenes, which can be dated A.D. 250–75 (O. Benndorf and R. Schöne, *op. cit.*, no. 310, pl. xix; C. C. van Essen, *De Kunst van het Oude Rome*, The Hague, 1954), may have belonged to a follower of Dionysos. He could not have been a Christian, since his body was cremated, but the same vintage scenes appear in Christian monuments. Other monuments with Bacchic scenes leave no doubt that they belonged to followers of Dionysos. Initiates of the Eleusinian mysteries had monuments of the type of the sarcophagus of Torre Nova (Rome, Gall. Borghese), with scenes of that cult. Since the worshipers of Mithras placed a special value on the myth of Phaëthon (F. Cumont, 1942, p. 17; G. H. S. Snijder, "De symbolica Phaetontis Fabulae interpretatione apud Romanos," *Mnemosyne*, LV, 1927, p. 401 ff.), sarcophagi showing Phaëthon may perhaps be attributed to them. Vollgraff hypothesizes (*Mededeelingen van de Koninklijke Akademie van Watenschappen*, N.S., XVIII, 8, 1955, p. 205 ff.) that heads with a cross-shaped scar belong to the Mithraic initiates; among these is that of a general on a great sarcophagus with a scene of a battle, perhaps against the Dacians (Rome, Mus. Naz. Romano, Coll. Ludovisi). The theme was very suitable to the cult, but not all the numerous sarcophagi showing battle scenes can be ascribed to them. Our knowledge of the Pythagoreans is represented by a text of the musicologist Aristeides Quintilianus testifying to the importance they gave to the myth of Marsyas' punishment by Apollo. Moreover, the inscription on the sarcophagus of Octavius Valerianus (Rome, Lateran Mus.; O. Benndorf and R. Schöne, *op. cit.*, no. 488; C. C. van Essen, *op. cit.*, pl. lxvi) suggests a reference to the Orphic verse later accepted by the Pythagoreans that the dead "were fleeing a harsh and profoundly painful cycle."

To the Gnostics may be attributed, although with considerable caution, sarcophagi with scenes of the Red Sea, of Circe, of Adonis, and of Prometheus in the act of creating man. This last motif brings to mind the Pythagoreans and the followers of the mysteries of the Great Gods of Samothrace; but the connections have still to be clarified.

Carolus C. VAN ESSEN

*Iran.* According to Zoroastrian belief, the soul of the deceased ascended to heaven, where it was greeted by Vohu Manah, one of the archangels, introduced to Ahura Mazda (Oromasdes), then escorted to a golden throne (*Vendidad*, XIX, 31, 32). We discover this same concept in the inscriptions of Antiochus I of Commagene (69–34 B.C.), who writes that his soul after death will ascend "to the heavenly thrones of Zeus Oromasdes" (W. Dittenberger, *Orientis graeci inscriptiones selectae*, Leipzig, 1903, no. 383). On a monument erected by Antiochus at Nimrud Dagh there is a sculpture showing the enthroned Ahura Mazda greeting Antiochus; another scene depicts the meeting of Antiochus with the special god of his dynasty, Mithras, here identified with Helios. In the Zoroastrian theology of the Gathas (part of the sacred writings), Mithras was replaced by Vohu Manah.

In Scythian art there is a corresponding scene representing the king before the seated Great Goddess in an act of communion, obviously after his death. Zoroastrian texts inform us that the soul after its ascension was given a beverage of immortality to drink and "spring butter" to eat and then placed on its throne. The various scenes of communion in Scythian art are accordingly best interpreted as representing this heavenly communion of which the soul partakes after death. Because

Iranian art was primarily a royal art, the communicant is probably a king or a member of his family.

This heavenly communion recalls the funerary banquet celebrated on earth in anticipation of the heavenly meal. Such a banquet was either a meal served to the dead as a kind of sacrifice or a meal served in honor of the dead. The first type of funerary banquet was used in the cult of the fravashi (protecting angels), but there seem to be no pictorial representations of it. The second type, however, in which the dead person as guest of honor partakes with the living, is well represented.

The famous "sarcophagus of the satrap" from Sidon (Istanbul, Archaeol. Mus.) contains a blend of Iranian and Greek artistic elements, with a slight admixture of Semitic detail in the dress of the servants, but its leading motifs are exclusively Iranian. The deceased ruler reclines on his *taxt* (a kind of divan-throne) and drinks the wine served him in a rhyton; his wife is seated in silent sorrow in a chair on his left. The same iconographic motif of the funeral repast is found in the Greco-Persian tomb relief from Çavuşköyu and in northern Iranian paintings from southern Russia, such as the well-known scenes from the graves of Kerch (Pantikapaion). Other banquet scenes are depicted on wall paintings from Dura-Europos and on funerary monuments from Palmyra; these exhibit characteristics of Parthian art.

On the sarcophagus of Sidon there is a representation of the quadriga, or chariot drawn by four horses abreast. The groom seizes the bridles of the horses, and the charioteer looks back on the seated ruler. Compositional devices have slightly altered here the motif of the warrior's farewell found in archaic Greek art. Is the driver bidding farewell to the dead ruler, or is he inviting him to take his place on the quadriga? The answer may be supplied by reference to corresponding scenes in Mithraic art and to eschatological Pahlavi texts. On reliefs representing the Mithraic mysteries there is an ascent to heaven of Mithras, with the Sun God acting as his charioteer; Mithras is entering the quadriga to take his place beside the Sun God. This scene has always been interpreted as the ascension of Mithras; it also seems highly significant that this motif is associated with the sacred meal celebrated by Mithras and Helios. Furthermore, the Pahlavi text *Dātastān-i Dēnīk* (30:2) says that "the soul of the just" ascends to paradise in a coach drawn by four horses.

Also represented on the sarcophagus is a horse led by a groom. The horse occupies a prominent position on Palmyrene sepulchral monuments, where it is accompanied by three youths of the dead man's retinue. The horse played a central role in the funerary ceremonies of all Iranian tribes, especially among those which retained more of their nomadic customs. The saddle horse was often sacrificed at the grave with a great slaughter of other horses. This custom was prevalent among the Ossets of the central Caucasus up to modern times. There are no extant Iranian representations of the horseman carried into heaven, however, as in the scene depicted on a stele in Albano Laziale, Italy. Classical art also used Pegasus, the winged horse, as a symbol of immortality, and the figure of Pegasus engraved on gems and carved stones in Iran may be given this interpretation.

The sepulchral monument of Antiochus I offers also the motif of the ancestors. In view of the strong sense of family solidarity that characterized Iranian peoples, it is only natural that the statue of the king in the midst of his deities should be flanked by two rows of representations of his forebears, welcoming into heaven the newly arrived member of the royal clan. They form a sort of heavenly assembly acclaiming the ruler. According to Iranian belief (*Aogemadaēča*, 15) it was the fravashi who went to meet souls.

Winged Nike figures of Hellenistic origin are found on the rock monuments at Taq-i-Bustan, where they should be identified with Vanaiñiti as depicted on Kushan coins (see KUSHAN ART). The cup with pearls (fruit?) and the diadem with pearls here may symbolize immortality and, of course, victory. The receiving of the diadem is a classic Iranian eschatologic motif.

Zoroastrian religion strictly prohibited mourning and lamentation; in non-Zoroastrian circles, however, especially in eastern Iran, in Armenia, and among the northern Iranian tribes, mourning rites were frequent, and they occurred throughout Iran at royal funerals. A fine wall painting discovered in eastern Turkistan shows the extreme expressions of mourning for which the Iranians were known (Herodotus, *Histories*, IX, 24). Sculpture also took up this motif. In one figure blood streams from a self-inflicted head wound; another shows a woman tearing out one of her rich tresses. To the rites of mourning also belonged the dancing and singing of dirges mentioned by Ammianus Marcellinus (*Rerum gestarum*, XIX, 1, 10) and the lascivious dances referred to in Armenian chronicles, but no representations of these ceremonies are extant.

To the eschatological motifs belongs the fight of the hero or god against the terrible dragon Azhi Dahaka, the great opponent of Ahura Mazda and of all good powers. A magnificent mural painting showing the hero and his retinue fighting the dragon has been discovered in eastern Iran, where Azhi Dahaka enjoyed great fame and was a prominent symbol in warrior societies. The survival in art of this motif, intimately connected with the "last battle" at the decisive turn of world history, testifies to its great role in Iranian religious art.

Many tombs of the Parthian period are characterized by the use of death masks and steles. The significance of these masks is rather uncertain. Gold masks in the Bosporan kingdom may be attributed to Hellenistic influence, but there is an earlier horse's death mask in Pazyryk that testifies to ancient Scythian origins. Masks or thin leaves of gold were used to cover the face of the deceased in Mesopotamian graves of the Parthian period. Of a different character are clay masks, also from the Parthian epoch, which are realistic heads of various ethnographic types, mostly bearded (Rostovtzeff, 1922). These masks possibly were pasted onto wooden coffins; they obviously represent the dead.

Representative of steles found in Parthian Mesopotamia are two from Ashur showing realistic male figures in Parthian dress, one, a civilian, with a palm branch; the other, a warrior.

Methods of burial differed greatly among various Iranian peoples and at different periods. The Avestan word *daxma* ("place of burial") originally meant "place of cremation" or "pyre," and the numerous cinerary urns found in eastern and western Iran prove that the dead body was often cremated. Ammianus Marcellinus (*Rerum gestarum*, XIX, 2, 1) relates that the body of a young Chionite prince was burned and the ashes collected in a silver urn. But the many ossuaries excavated in eastern Iran testify that other methods of burial were also used. In such an ossuary (Pahlavi, *astōdān*) were preserved bones stripped of flesh by exposure of the body to wild beasts. This exposure was ultimately accepted as the regular Zoroastrian funerary ceremony. These ossuaries were decorated with representations of the virgins of paradise from Iranian eschatology or with other scenes of the afterlife.

Sarcophagi are known chiefly from Parthian times; they were probably used also in the Achaemenian rock tombs, but no specimens have been found. Some Parthian sarcophagi, the so-called "slipper coffins," had a richly decorated surface with a syncretistic mixture of deities, a flute player, and a warrior probably representing the dead person. Others were of bronze and contained alabaster vases and gold ornaments.

The use of coffins and sarcophagi suggests embalming (Herodotus, *Histories*, I, 140), although this practice would have been altogether contrary to the Zoroastrian usage described above. Highly interesting is the use in eastern Iran of sarcophagi decorated with a dragon's head and tail.

The Achaemenian rock tombs consist of a single passage cut into the rock with a number of deep niches in which as many as three coffins were deposited (PL. 457). The corpses were perhaps embalmed in wax. Of possible sepulchral gifts nothing has been left to posterity. Such tomb chambers are found also in southern Russia and Asia Minor, where the walls often were coated with stucco and painted. Another and older type of rock tomb is the Median tomb; an example from about 550 B.C. is at Qyzqapan. These tombs provide interesting architectural details related to more archaic stages when the ceiling was of wood. The chamber is wide enough to

contain a rich inventory of tomb furniture and other small objects.

Mausoleums are represented especially by the tomb of Cyrus at Pasargadae (see IRANIAN PRE-SASSANIAN ART CULTURES). It had the shape of a house with gables, presumably an archaic pattern, and contained "a table covered with goblets, a golden coffin, numerous garments, and ornaments set with precious stones" (Strabo, *Rerum geographicarum*, XV, 3, 7). The house was placed on a substructure of six stages, the house itself being the seventh, so that the mausoleum took the form of a Mesopotamian ziggurat (see COSMOLOGY AND CARTOGRAPHY), thus blending Iranian and Mesopotamian components.

The nomad Iranians practiced burials in great tumuli, well known from the kurgans of southern Russia. They contained many objects, often of great value, revealing to us the rich civilization of the European Iranians as well as the wholesale slaughter of their horses in honor of their dead (Herodotus, *Histories*, IV, 72). The tumulus erected by Antiochus I at Nimrud Dagh incorporated Hellenistic elements to form a gigantic mausoleum.

The "tower of silence" (*daxma*, or place of burial) was developed for the specifically Zoroastrian usage of exposure of the corpse. No greater contrast can be imagined than that between the sad and desolate melancholy of these forlorn places, with birds of prey feasting on the corpses, and the rich non-Zoroastrian graves of Iran, including the rock tombs in which the walls depict the life of the deceased in this world and the world to come.

Geo WIDENGREN

THE EAST. *India and southeastern Asia*. The religions of India or of Indian origin conceive of an infinity of space and time, a periodic creation and destruction of innumerable worlds, and a transmigration, in one form or another, of souls (see BUDDHISM; HINDUISM). What happens to man after death is interpreted not as an ultimate fate but as a repetition of life on a higher or lower level, the circle of samsara (transmigration). Only a great saint obtains delivery by merging into the one ineffable godhead or the no less transcendental nirvana or by retreating into his own pure self. Other mortals hope to reach this goal by intermediate stages, especially after rebirth as gods. Within this general framework of ideas, however, is a great variety of beliefs, from simple animism to the idea of a central world mountain (Mt. Kailasa, or the mythical Mt. Meru, or Mandara), around which the various continents or worlds are grouped. Either beneath it or in the iron mountains enclosing the habitable world are the hells; on its slopes dwell the minor gods; its top is either the seat of the highest godhead or, as later conceived, of Indra (the lord of this world). The heavens of the higher deities are lost in transcendental spheres beyond. According to his karma (fate determined by his good and evil conduct), a man is reborn in one of the fiery or ice-cold hells as a *preta* (hungry spirit), a *bhūta* (demon), an animal, a man on a lower or higher social level, or a minor or major deity. Even the gods may fall, though their divine life seems immensely long. In most cases it is assumed that for ultimate salvation a rebirth in human form on this earth, and especially in India, is necessary.

Although Hinduism has elaborated a system of hells (less complex than that of Buddhism), their representation has played a subordinate role in art. In the hot hells sinners are burned, boiled, and filled with liquid metal, sensual persons must embrace red-hot figures of the opposite sex, and the like; in the cold hells others are punished by such torments as being driven naked over freezing lakes. In other hells they are torn by wild animals or forced to climb trees whose branches are knives and to walk through forests whose falling leaves turn into swords. Some are crushed between rocks or flung from mountains into gigantic thorn trees, thrown into mortars, impaled, flayed, crucified, beheaded, trampled under the feet of elephants, sawed into pieces, or dismembered in other ways.

Even in the medieval Hindu temples which are conceived as models of the cosmic Mt. Meru (see COSMOLOGY AND CARTOGRAPHY) and which have friezes representing all stages of life, there are no representations of hell. These temples

are frequently called Meru or Kailāsa, as the Kumbha Meru at Chitorgarh or the Kailāsa at Conjeeveram (anc. Kanchipuram) and at Ellora (see DECCAN ART; DRAVIDIAN ART). Later, the visit to hell of the righteous king Yudhiṣṭhira, described in the great national epic, the *Mahābhārata*, was the most popular representation, but even this was very rare, although a number of episodes from the *Mahābhārata* are depicted on temple walls and in illuminated manuscripts of the 16th century and later. One version is preserved in the *Rasm-nāma*, the Persian translation of the epic prepared and illustrated for the Moghul emperor Akbar in 1584 and now in Jaipur (PL. 466).

Outside India proper, Hindu representations of hell occur only occasionally, as in the reliefs of the temples of Prambanam (Java). But a kind of *yamāpaṭa* (picture scroll used in the *Wayang kulit*, or shadow play) on this theme is rather common in Balinese art. Yama, green-skinned and dressed in red, bears in his hands a club and a lasso. In these representations many tortures are carried out by demonic dogs, birds, pigs, and gigantic ants. Some of these representations are illustrations of the poem *Lingga Peta*.

Rebirth on earth or in one of the paradises as a god seems to have had much more appeal as a theme for the Hindu imagination. This impression may be distorted, however, since all funeral monuments or temples were commissioned by members of the temporal or priestly aristocracy, who believed that they had assured their access to heaven by religious donations, support of priests, and the performance of certain rituals.

Memorial stones and shrines for the deceased are very common. In northern India they are of two types: the *deval*, a stone pillar covered by a diminutive chapel, the four sides of which have reliefs of the principal Hindu deities; and the *pāliyā*, a stone slab on which the deceased is depicted, on foot or on horseback, by the side of the wives and concubines who became suttees (Skr., *satī*) at his death. This voluntary death of a widow by fire at the side of her dead husband was thought to be of great importance for her husband's eternal bliss as well as her own. The custom seems to have been very old in southern India; in the north it cannot be traced beyond the early 6th century. The earliest relief of a suttee is on a memorial stele at Sangsi, near Kolhapur (ca. A.D. 500). Memorial stones for widows often show merely a hand or a raised arm; L. Frobenius sees in this a connection with early Near Eastern cults ("hand of Fatima"; symbol of the goddess Tanith). Funeral steles in the Deccan have three rows of relief. At the bottom the circumstances of death are depicted — e.g., a duel, a land or naval battle, a siege; in the next frieze the deceased is caught up by two nymphs and carried to heaven; at the top he is shown kneeling before the linga of Śiva.

Actual representations of heaven, too, are rare and late. Perhaps the hope for the absorption of the devotee after death into the highest deity or his rebirth as a god rendered the subject uninteresting. Only in late Vishnuism, with its express distinction between God and creation, did the idea of a heaven in which the blessed enjoy the loving presence of God win importance. This heaven, Vaikuṇtha, is depicted as a royal court. Finally, with the rise of Kṛṣṇa mysticism, heaven was imagined as an idealized Vṛndāvana (mod. Brindaban, where Kṛṣṇa, according to legend, spent an idyllic childhood) where the ordinary pious were reborn as cows or cowherds (Skr., *gopa*) in order to witness the eternal love game (Skr., *līlā*) of Kṛṣṇa, while the truly devout were reborn as milkmaids (Skr., *gopī*) in order to enjoy the love of the heavenly bridegroom, especially in the *Rasalīlā* dance. Paintings, embroideries, and figured brocades on this subject are favored by the Vallabhacharya sect, though known also to others.

The extent to which deceased kings and queens were regarded in India as having become united with and thus identical with the supreme godhead has not yet been studied. This concept existed in Sumatra, Java, Cambodia, and Champa (Annam), and there are traces of it in India also. Many temples were named after their builder, as was the Rājarājeśvara at Tanjore (the Bṛhadīśvara erected by King Rājarāja Cola); but there is so far no evidence that Śiva temples combining the name of their founder with *īśvara* or *nātha* ("lord") or Viṣṇu temples

with names ending in *svāmin* ("lord") were necessarily intended to be funeral shrines as well, as they were in Cambodia and Champa. The custom of funeral temples still exists in Rajasthan and the former Maratha States. At Mandor, near Jodhpur, Śiva temples were erected in memory of prominent maharajas. In the burning grounds near the various Marāṭha capitals Śiva temples for each ruler were built, with a second Śiva statue (possibly representing the deceased) behind the linga or even a portrait doll dressed in the clothing of the deceased. For queens a yoni (Great Mother symbol) was placed in the temple.

In Indian Asia living rulers often attempted an apotheosis by means of Tantric rites, including human sacrifices and the use of alcohol. After death these rulers were definitely treated as gods. The designation for Javanese temples, *caṇḍī*, is derived from *Caṇḍīgṛha* (house of the goddess of death). In pits underneath the cult images urns have been discovered containing human ashes and bones, gold leaves with magic inscriptions, and various stones and pieces of metal arranged in harmony with their magic qualities. When the ashes were buried at a sacred fountain, the urn was placed in a watertight chamber at the bottom of the basin, the images serving as waterspouts. Similar spouts found in the Kulu Valley of the Himalaya and in Nepal probably served the same purpose. In temples in which the ashes of deceased deified rulers were placed, the cult statues have symbols slightly dissimilar to the customary attributes of the gods. The Buddha, for example, has no *uṣṇīṣa* (topknot); Śiva or Viṣṇu carried a conch (symbol of the *mukta*, or liberation of the soul) or a lotus (symbol of the *bhākta*, or devotee); the goddesses carry a book (for *prajñā*, wisdom) or a lotus (for *śakti*, divine power) in their folded hands. Most famous among such statues are the so-called "Viṣṇu of Belahan" (King Erlaṅga), the Harihara of Sunberjati-Simting (King Kṛtarājasa), and the Prajñāpāramitā (Dedes, queen of Rājasa of Singasari) at Leiden (Rijksmus. voor Volkenkunde).

The fact that this funeral cult developed more in southeastern Asia than in India itself has been attributed to a resurgence of indigenous ancestor worship, identifying the dead with the sun and the earth and these in turn with Śiva and Śrī. The other Hindu deities were fused in a syncretism not intelligible in the light of the imported Indian tradition alone. Meru became the world mountain of the spirits; therefore many temples were built on the slopes of mountains or, later, became systems of successive terraces. The linga became the menhir; the statues of the gods, those of spirits. Such ideas underlie the funeral ritual in Bali, with its flower dolls (*sekar* or *puspa*), its sarcophagi in the shape of cows, lions, deer, crocodiles, or dragons, and its tall cremation towers (*wadah* or *badé*). They underlie also the shadow play (*Wayang kulit*) with its offerings, its "world mountain scene" (*gunnungan*), and its "world tree" (*kekayon*).

In Champa (Annam), originally a Hindu colony (see CHAM, SCHOOL OF; VIETNAM), and Cambodia (see KHMER) the royal funeral cult was based on the apotheosis of the deceased kings and queens. The rulers were identified with Śiva or Devi and occasionally with Viṣṇu, Buddha, or the Bodhisattva Avalokiteśvara. In Champa Śiva was venerated in the form of Bhadreśvara (Lord of Glory), symbolized by a fiery linga. The later orthodox shape of the linga (no longer a male member, but a pillar, first square, then octagonal, finally round in cross section) lent itself to the Far Eastern symbolism in which the square represented the earth and the circle represented heaven. The yoni, female counterpart of the linga, in Champa symbolized Bhāgavatī Kauthāreśvarī, also called (Yan) Po Nagar, the mistress of the kingdom (originally the goddess Nha-trang). Over the ashes of nonruling princes and princesses steles (*kut*) were erected, often in the form of busts. Sometimes the deceased prince was depicted embracing a living one. Golden crowns were made for these busts.

In Cambodia, also, the state cult, from the 9th century on, centered around a fiery linga, the Devarāja. It was venerated on an artificial mountain (Meru) of superimposed terraces which each ruler erected anew, the former one becoming the funeral shrine of his predecessor. Thus Mahendraparvata (Phnom Kulên) was erected by Jayavarman II, Bakong by Indravarman I, Phnom Bakheng by Yaśovarman I. The central temple on top of the terraced pyramid was dedicated to the dead ruler, the shrines surrounding it to various members of his family. Under Rājendravarman II (944–68) the ritual was changed. The Bayon, in the center of the capital, Angkor Thom, became the permanent Devarāja temple. Independent funerary temples were constructed for kings, queens, and even princes and princesses; other persons of rank were apotheosized in portrait statues representing various gods and goddesses. The funerary character of these temples is emphasized by the presence of statues of the god of death, Yama Dharmarāja (misnamed "the Leper King"), and by the arrangement of the reliefs in their galleries counterclockwise (*prasavya*), the sequence of death, rather than clockwise (*pradakṣiṇā*), the sequence of life. The burial casket, placed in a pit beneath the linga or divine image, was often divided into 8, 12, 26, or 44 compartments. The central space contained a silver box with the ashes and some of the bones; the others, as in Java, were filled with gold leaves bearing magic formulas and with stones and metals selected for their magical properties.

Buddhist speculations about the structure of the universe — including the character of its heavens and hells — are more highly developed than those of Hinduism, but Buddhist art in India has left very few representations of heaven and none of hell. The Sanchi, Bodhgaya, and Amaravati reliefs depict the Trayastriṁśa heaven of Indra and the Tushita heaven before or on the occasion of the Bodhisattva's descent to earth to be born as Māyā's son, Siddhārtha Gautama.

Māra, the lord of all sensual pleasures and of death, plays the devil's role of tempter; and his legions, represented in many Gandhara reliefs and in one fresco at Ajanta, closely resemble medieval devils, with faces on their bellies or backsides, with terrible masks, even with animal heads. These represent the evil forces of this world, however; they have nothing to do with hell.

Hell is merely the worst inferno in the eternal circle of life (samsara). The Wheel of Life is one of the great symbols of Buddhist art. It comprises six stages of transmigration: gods, semidivine beings (titans, asuras, yakshas), men, beasts, ghosts (*preta*), and demons in hell (*bhūta*). The six ways of life (*gati*) are represented by illustrations of the pleasures of the gods, the pride and sorrow of the semidivinities, the miseries of human life, the cruel fate of animals, the insatiable hunger and thirst of the ghosts, and the tortures of hell. The nidanas (forces that determine the rigid cycle of transmigration) are symbolized by animals: the cock, for example, denotes voluptuousness, the pig, dull ignorance. The earliest representation of this type is in Cave XVII at Ajanta (ca. A.D. 500), but only a fragment is preserved; most known examples are from Tibetan monasteries.

In China and Japan this wheel was replaced by a series of paintings describing the ten worlds, four of enlightenment and bliss (the saints, the blessed in paradise, the bodhisattvas, the buddhas), two of choice between good and evil (men and gods), and four of ignorance and pain (hell, ravenous demons, ghosts, and animals). In these paintings the gods float in costly palaces, surrounded by musicians and dancing girls; the titans are at war with Indra for the possession of the latter's mistress; man's life is described from birth to death; the ghosts, with bloated bellies but hardly a vestige of a mouth, beg for food and water. The most famous set of these works is in the Taimadera temple near Nara, Japan.

Hell scenes found outside of India generally illustrate Jātakas (stories of the former lives of the Buddha) or Avadānas (legendary episodes of the Buddha's life on earth). The oldest surviving hell scene is in the Cave of the Navigator at Kizil in Chinese Turkistan (ca. 7th cent.; see ASIA, CENTRAL). It depicts the adventures of the merchant Śroṇakoṭikarṇa, whom a storm drives to the ends of the earth. He visits the city of the hungry ghosts; he sees people enjoying the beauty of heavenly women and others being eaten alive by dogs or having their skulls opened by a fiery circular saw. In temple ruins at Bezek-

lik and Murtuk, sinners condemned by Yama are boiled in caldrons or stretched on gibbets by demons with the heads of horses or bulls.

The relief frieze (later covered over) ornamenting the lowest story of the Borobudur temple in Java (9th cent.) showed the horrors of the various hells side by side with the sins they punish. The text illustrated here is uncertain but may be the Kuñjarakarṇa legend, a popular story in ancient Java ending in a hymn to the Dhyani Buddha Vairocana, to whom the Borobudur temple was dedicated. All other hell pictures belong to the period when Hinduism and Mahayana Buddhism, favored by the Indian or semi-Indian colonial aristocracy, were swept away by Hinayana Buddhism, which had the support of the indigenous masses. In Cambodia the iconography was based on such literary sources as the *Trai Phum*, the *Mahānarada Jātaka*, the *Kassapa Jātaka*, and the *Saḍgatikārikā* by Dharmika Subhuti. In Burma the artists utilized principally certain Jātaka texts. One example is an illustrated roll of the *Nimi Jātaka*, dated 1869, preserved in the Musée Guimet, Paris. The tile reliefs of the great pagodas at Pagan, however, are restricted to vague literary allusions.

In Thailand the story of Pra Mālai (*Māleyya Thera Sutta*) has been very popular since the early 16th century. His visits to hell and heaven are depicted in many manuscripts (dating, for the most part, from the 18th and 19th centuries) and also in bronze. Pra Mālai sits on a lotus behind a socle on which various devils and the damned surround a caldron in which others of the damned are being boiled.

In China and Japan the introduction of rites for the souls of the deceased by Amoghavajra, who was associated with the founding of the Shingon sect, was closely connected with the fear of hell and the interest in hell scenes. The Japanese Jigoku Zōshi and other series of illustrations (PL. 466), however, vary the wearying sadism of these scenes by a horrible grandiosity or a sardonic burlesque; the ghost pictures (Gaki Zōshi) of the old masters as well as those of the Ukiyo-e school (q.v.) are marvels of macabre imagination. On the other hand the cult of Kuan-yin (Kwannon), with its belief in the effectiveness of devoted prayer, countered those fears, so that the majority of hell scenes became mere accessories to representations of the great savior deity. Under the influence of the Ming government, however, Chinese Buddhist representations of hell were adjusted to the Taoist concept of the 10 divine courts of justice and the 10 prisons of the earth (*ti-yu*). Kuan-yin, hitherto a male deity, was fused with Yin-yang-sze and Miaoshan into the Goddess of Mercy.

In addition to the Wheel of Life, hell representations in Tibet fall into two groups: pictures of the god of death and illustrations of the *Bar do t'os sgrol* (Tibetan Book of the Dead). In both, descriptions of the tortures of hell are practically absent, though the deities, surrounded by flames, look terrible enough. Yama (Tibetan, gSin rje; Mongolian, Erlik), god of death and hell (or as judge of the dead, Dharmarāja, King of the Law), a horrible, blue, fat-bellied monster, sometimes depicted with a bull's head, mace and lasso in his hands, rides on a bull saddled with the skin of a flayed man or demon. Sometimes he is accompanied by his sister Yamī and by dancing skeletons (*citipati*, *smaśanapati*), witches (*ḍākinī*), and ghouls (*vetāla*). Yama's consort, with whom he is sometimes shown coupled (Yab-Yum), is lHa mo (Kali), no less horrible: blue, drinking human blood from a skull, riding on a mule saddled with a tiger skin. Both are opposed by the tutelary god (*yi dam*) Yamāntaka (Tibetan, gSin rje gśed; Mongolian, Erlik tonilgham), conqueror of death, a manifestation of the benign Bodhisattva Mañjuśrī but also of horrible appearance. To the condemned even the benign gods look horrible: the savior Avalokiteśvara, or Kuan-yin, visits hell in the disguise of the terrible god Mahākāla.

This is also a key idea underlying the *Bar do t'os sgrol*. A lama explains to the deceased the visions of the next world: first the primordial light, then the benign deities (Dhyani Buddhas), the angry deities (terrible aspects of the benign deities), the *ḍākinī* and guardian deities of the world of the senses, the court of Dharmarāja, and the path among the abysses

of anger, voluptuousness, and ignorance, until at last the six worlds of reincarnation are traversed. At each stage the soul of the deceased could supposedly find salvation through positive acceptance of the divine forces and realization of the emptiness (*śunyatā*) of all these terrible visions, but most are incapable of doing so. The illustrations depict the deceased in yoga posture on a lotus, surrounded by symbols of the senses or elements, by the benign and terrible deities, or by the *ḍākinī* and tutelary goddesses.

The high clergy sought salvation in the realization that all these deities were in the last analysis products of imagination clouding the ultimate essence of buddhahood. For those less spiritually advanced more intelligible hopes and helpers were necessary. These were found in the cults of the saviors Maitreya, Mañjuśrī, Tārā, and especially Avalokiteśvara, and in the paradises of the Dhyani Buddhas, particularly the Amitābha heaven.

Though these ideas developed in India, they gained importance chiefly in Central Asia and the Far East, especially through the Pure Land sect, or Lotus sect (Ch'ing-t'u-tsung), with its Chinese successor, the T'ien-t'ai (in Japan, Tendai) sect, and its Japanese offspring, the Jōdō, Shin, and Ji sects. They had been imported from the Kushan empire in the late 2d century, established a strong foothold by about 400, and since the 6th century have been the most important form of Far Eastern Buddhism. Their basic texts are the *Sukhāvatīvyūha*, the *Amitāyurdhyānasūtra*, and especially the *Saddharmapuṇḍarīkasūtra*. They teach the hope of a life after death in Sukhāvatīlokadhātu, the sphere (*lokadhātu*) of beatitude (*sukhā*), also called the "Western Paradise" because of its imagined location. Over this paradise reigns Amitābha (Infinite Light), also called Amitāyus (Infinite Life). The blessed live on lotus flowers in beautiful lakes surrounded by wondrous trees, amid gods and beautiful fairies in jeweled palaces, listening to the sounds of divine music and breathing in the most exquisite fragrances. This paradise is accessible to all who pray to Amitābha (O-mi-t'o, Amida) or to his emanation, the Bodhisattva Avalokiteśvara (Kuan-yin, Kwannon), the all-merciful savior. "Oṃ maṇi padme hūṃ," the formula for his invocation, thus became the magic key to heaven.

Under the influence of the earlier Vajrayana or Mantrayana sect (Chin., Mi-tung; Jap., Shingon-shu), other Dhyani Buddhas, particularly Bhaiṣajyaguru and Samantabhadra, were occasionally represented with similar paradises. All of them are often depicted in the cave temples of Tun-huang (q.v.) on the frontier between China and eastern Turkistan. They are not so common in the cave temples of Lung-mên and Yün-kang, the sculptures of which are devoted for the most part to the savior bodhisattvas Avalokiteśvara and Maitreya or to the Buddha expounding the *Saddharmapuṇḍarīkasūtra*. In Japan the Amida cult and the art devoted to it flourished especially in the Fujiwara period (9th–12th cent.), although the cult has remained popular up to the present day. Painted in gold, Amida is represented in his paradise, surrounded by bodhisattvas and hosts of angels playing musical instruments or rising, like the sun, from behind a mountain (vision of Hōnen Shōnin, founder of the Jōdō sect).

A deification in the Hindu sense was unknown to Buddhism, which stressed the negation of the soul and the practice of ethics rather than magico-mystical identification with the godhead. Nevertheless, the same practices were observed in the construction of stupas (also called *dhātugarbha*, hence dagoba and finally pagoda), which were shrines for the relics (*dhātu*) of the Buddha and his disciples or for holy scriptures or sacred images. The stupas were at the same time ideal representations of the world, transmitting the beneficent influence of these relics to the whole universe. Though often the relics were merely kept in a set of boxes in the interior of the stupa, in other instances they were arranged in a set of nine chambers.

In southeastern Asia kings were deified as Buddha, Avalokiteśvara-Amoghapaśa, or Avalokiteśvara-Lokeśvara, and queens as Tārā or Prajñāpāramitā; but this represents no more than a transfer of Saivistic-Tantric practices. This is also true of the 14th-century statue at Sungei Langsat of the Menangkabau

(Sumatra) ruler Ādityavarman represented as Bhairava-Kṣe-trajña in the midst of flames on a heap of human skulls.

Hermann GOETZ

*China and Japan.* In the traditional Chinese concept the individual was formed by the interaction of the two basic principles of *yin* and *yang* and at death was dissolved into these two constituents. The *yin* soul (*p'o*) lived on in the grave and still needed everything that belonged to the living. This idea stimulated a realistic trend in art; represented in the tomb, along with mythological and cosmological subjects, were the equipment and servants that go with high estate on earth. The Chinese ritual for the dead required that the tomb be furnished with figures of men, animals, and implements (*ming-ch'i*) representing the belongings given to the deceased to take with him. They were to function as magical substitutes and for that reason were made in early times of perishable materials (straw etc.) and later, after the introduction of cremation, of paper. It is probable that at one time real people and the actual belongings of the deceased were used.

These funerary figures occurred in northern China from the 5th or 4th century B.C. and were produced in great numbers from the Han period (206 B.C.–A.D. 221) until the end of the T'ang (618–906). They were made of wood, precious metals, or terra cotta (PL. 460), the last being especially popular. The terra-cotta pieces were manufactured in molds in two halves, pressed together, worked over, and then glazed and baked; later they were painted. The subjects were varied: vases, model houses, carts, domestic animals (pig, dog, fowl, cow, horse, and camel), female dancers and musicians, pretty ladies, servants, warriors, tomb guardians, and fabulous beasts (the so-called "earth spirits"). How they were arranged in the tomb is not known, though guardians and fabulous beasts always appeared in pairs. The other objects presumably corresponded in number to the earthly rank of the deceased.

The figures of the Han period have been described as "naturalistic symbols" (Sirén, 1931), and their magical function was thought to account for their realistic form. This idea has become somewhat questionable since the discovery of funerary figures of the 5th and 4th centuries B.C., called, from the places of their discovery, Ch'ang-sha, Hui-hsien, and Sha-ti figures. They are clothed, made of wood or pottery, and have stylized geometric faces and ecstatic gestures that have been simplified to abstract linear outlines. From Han times onward, though the bodily forms were stiff, the figures reproduced more or less realistically details of clothing and hair style. From the 6th to 9th century funerary figures of a highly evolved style representing the subject's type and social status were mass-produced. They convey, in a unique artistic expression, the sense of arrested motion. After the T'ang period pottery objects in general were replaced by paper figures which were burned.

A parallel to the Chinese mortuary cult is found in Japan between the 3d and 6th century. The Japanese *haniwa* figures are thought to have been substitutes for sacrifices of living beings. The earliest are of the 3d century of our era and consist of terra-cotta cylinders, sometimes with lids, which were erected in concentric lines outside the tumulus, perhaps representing a magic wall of protection. The figured *haniwa* of the 4th to 6th century were also erected outside the tumulus, either on its summit or at the entrance. They represented servants, entertainers, warriors, women, domestic animals, apes, deer, and model houses. They were made with a cylindrical base or mounted on a cylinder so as to be thrust into the ground. After the 6th century the Buddhist custom of cremation put an end to the older funeral practices.

In the offering shrines of Chinese tombs were placed pictures that may be regarded as illustrations of the world beyond. In so far as one can speak of a different iconography for the *yang* and *yin* souls, it is important to determine what became of the *yang* soul (*hun*), because the literary sources give us no information. Within the iconographic limits of the offering shrines (*ssŭ*) the only possible allusions to the person of the deceased are the procession of horsemen and chariots and the scene that terminates the procession. In the Wu Liang-tz'ŭ (Shantung) this occupies the center of the rear panel. Its elements include a two-story building, open in front and flanked by two gate towers; a fantastic tree with interlaced branches on which are birds at which an archer is aiming; and an empty wagon whose horse is tied to the tree. In the upper story of the palace honors are being paid to a woman, and in the lower, to a man in official costume. On the roof are fabulous creatures and phoenixes. These scenes have been interpreted as representing the visit of King Mu to Hsi-wang-mu, or the deceased being welcomed in the celestial palace, or the banquet of the ancestors. But the first of these interpretations can no longer be accepted, and in the case of the banquet it is uncertain whether the person being honored is the deceased. The welcome (suggested by Fischer, 1931) is questionable also, for on related monuments all the divine or mythological figures are identified either by inscriptions or by such attributes as wings and crowns. In all comparable representations the typical arrangement is one or more persons on thrones in the palace, two symmetrical towers to the right and left, the horse outside the towers, and two phoenixes on the roof. The identification of the central figure as the deceased is supported by a similar scene in the central chamber of the tomb at Liao-yang (Han dynasty); by the banquet of the dead, with servants and dancers, in the tombs of Korea (5th–6th cent.); and by the sculptured tomb of Wang Chien in Szechwan (9th cent.). This suggests that the subject, which is not uncommon in tombs and on offering shrines, should be interpreted as the heroized dead.

Reacting against the state religion of feudal times, Taoism (q.v.) developed in the Han period into a religion of salvation for the individual. The immortality in which this promise of salvation culminated was a material survival of the individual, that is to say of the *yin* and *yang* souls in their entirety, although in altered form. An immortal can fly and therefore reaches places inaccessible to a mortal, where he can find the elixir of immortality that ensures the prolongation of his existence. Out of ancient myths about remote countries the speculations of popular Taoism developed divine personages and Elysian fields that sometimes became the subject of mystery cults; in addition there were the sacred mountains where the immortals dwelt. The pictures inspired by these ideas represent the Isles of the Blessed in the east, a mountain landscape peopled by immortals, or the paradise of Hsi-wang-mu (the Western Mother Queen) and Tung-wang-kung (the Eastern Father King), sometimes identified with the Kunlun Mountains, where earlier sources placed the palace of the emperor of heaven.

Hsi-wang-mu was sometimes represented full face, with wings and with jade ornaments on her head, sitting on a dais surrounded by the hares of the moon eating the herb of immortality, by winged creatures on clouds, creatures with human heads and animal bodies, and a genius with a pearl scepter; or by praying figures, a fox with nine tails, and a solar bird with three legs. Elsewhere she was shown full face on a throne with tigers and dragons, accompanied by the nine-tailed fox, the solar bird, lunar hare and toad, and genii bearing branches, sometimes with horsemen and a carriage approaching her. On bronze mirrors of the 1st to 5th century of our era, Hsi-wang-mu and Tung-wang-kung were shown with wings on the dragon-and-tiger throne. On Han mirrors they are identified by inscriptions, and on those of the Six Dynasties by round or pointed crowns. These mirrors represent the afterlife of the blessed.

The Isles of the Blessed are represented as borne on the backs of tortoises in the eastern ocean of P'o-hai. The best known of them is P'êng-lai-shan (Jap., Hōraizan). The palaces there are of gold and silver, all beings and animals are white, the immortals fly on storks over the sea to the fountain of jade and the herbs of immortality. No representations earlier than the T'ang period have survived. On mirrors of this era the islands appear as four rocks in the ocean, inhabited by birds, animals, and genii riding on phoenixes and storks. In some Japanese lacquer examples Hōraizan is a rocky island in the sea supported by tortoises, with hermitages visible on the cliffs. The resemblance of this type of representation to those of Mt. Meru (see above, *India and southeastern Asia*) suggests

a common prototype. Mountains as the abode of the immortals (*hsien*) represent the Taoist ideal of unity with nature. The Han mirrors show stylized mountains, immortals riding on tigers, or Taoist lute players (*po-ya*) with a teacher and a listener. There are similar scenes on T'ang mirrors and Japanese lacquer work. The fact that only a few late representations of the Taoist paradise are known does not invalidate the assumption that it was a subject of early Chinese painting and that it was important in the development of Chinese landscape painting (see LANDSCAPE IN ART).

<div style="text-align: right">Doris CROISSANT</div>

THE ISLAMIC WORLD. Islamic eschatology is based mainly on the Koran, which was influenced by Christian popular beliefs in the afterlife. It shows traces of Judaic and Zoroastrian influences, although they are of only secondary importance. The two future worlds, where reward and punishment are meted out, are vividly described in the sacred book of Islam: for the reprobates, handed over to the angels of justice, there is a hell of fire, ice, and other tortures, where they are fed on boiling pitch and putrescence and flogged with chains; green heavenly gardens with streams of honey and milk await the chosen, who lie on soft cushions and carpets and are served with delicious food and drink in the company of angelic female creatures, the well-known houris. These materialistic concepts correspond to the time and setting of Mohammed's mission. The Islamic hell does not greatly differ from the parallel Christian concept. But the lofty spirituality of the Christian paradise, culminating in the beatific vision, is almost entirely absent. In Islamic faith all living people will necessarily come to one or the other of these two places as a just retribution for their actions in life; apart from the prophets and martyrs for the faith, however, who will have immediate access to heaven, both the just and the reprobate will reach their final destination only after the end of the world, when they must cross the slender Al Sirat bridge. The just will cross easily to paradise, while the evil will fall into hell, which lies below. The glory of the chosen will be eternal. As for the damned, Islamic orthodoxy admits a final act of forgiveness by God, who will leave only the infidels to eternal punishment. Islam has no concept of a purgatory; however, the Koran contains a vague allusion to a kind of limbo for those whose good and bad deeds seem to balance.

To the concepts of the Koran, copious but monotonous, theological speculation and popular fancy added at a later date a great variety of details, with regard both to the premonitory signs of the hour of the end of the world (apparition of the Antichrist, irruption of barbaric populations, and descent to earth of Jesus and of the messianic Mahdi) and to the configuration, structure, and subdivision of the two future realms. The description of these has often been connected with the Prophet's miraculous ascent to heaven, a belief based on the interpretation of an obscure verse of the Koran (XVII, 1) in which is mentioned a night journey (*isrā'*) by Mohammed from Mecca to the "temple that is more remote." This at first was taken to be Jerusalem and at a later date, heaven. While the Koran does not offer any further explanation of this point, popular piety developed these few words into a full story, according to which the Prophet, riding the winged steed Burāq and guided by the angel Gabriel, visits heaven and hell. Both are minutely described in all their subdivisions. These accounts of Mohammed's ascent (*Mi'rāj*) have contributed greatly to Moslem eschatology and to the corresponding iconography.

The positive data of the Koran, enlarged by exegesis, the canonical traditions (Hadith), and pious literature, have given rise to works in both literature and the representational arts. The narration of the Syrian poet and thinker abu-al-'Ala' al-Ma'arri (11th cent.) stands out among the literary descriptions of Moslem afterlife. He tells in his *Epistle of Forgiveness* (*Risālat al-gufrān*) of the journey in the other world of a friend and correspondent. It is a work, however, in which the jocular and satirical elements — which appear blasphemous to some — prevail over the pious.

Of a completely different character are the descriptions of the two realms (accompanied, as in Dante's exegesis, by graphic plans) by the Arabic-Spanish mystic ibn-'Arabi (13th cent.), who united speculative subtlety with the enthusiasm of mystical initiation. Both abu-al-'Ala' and ibn-'Arabi were considered by Asín Palacios in his theory of the influence of Moslem eschatology on Dante's *Divine Comedy*. More recent studies and discoveries point away from this learned Arabic literature (which was never translated into contemporary European languages and was, therefore, inaccessible to Dante) and suggest that the popular and pious Moslem literature, in conjunction with the obvious classical and Biblical sources, influenced the formation and structure of the *Divine Comedy*. This includes the devotional *Mi'rāj* literature, with its entirely noncanonical descriptions of Mohammed's journey to the next world. At least one version has reached us through the Castilian, Latin, and French translations made at the court of Alfonso the Learned during the 13th century. This is the celebrated *Book of the Ladder*, edited by Cerulli from the translations and quoted under this title by Dante's contemporaries (Fazio degli Uberti, *Dittamondo*). Since these discoveries the whole question of the relationship between Moslem eschatology and Dante's poem has entered into a new, concrete phase.

These same *Mi'rāj*, or descriptions of Mohammed's journey, rather than the works of abu-al-'Ala' and ibn-'Arabi, are responsible for the artistic representations of the Moslem afterlife, including the countless illustrative miniatures that such writings, in both prose and verse, have inspired in the Moslem world. The best-known example of this is the *Mi'rāj-nāma* of the Bibliothèque Nationale in Paris, written in eastern Turkish and illustrated by a series of magnificent miniatures of the Herat school (15th cent.). R. Ettinghausen has published another group of fine Persian miniatures from the Seraglio Museum of Istanbul. These originally illustrated a similar text and are now cut and gathered in an album; they appear to belong to the 14th century and are attributed to the great Persian master Ahmed ibn-Mūsā. According to Ettinghausen, they had decisive importance in determining the Persian illustrative style of the Mongol period. The favorite subjects of both these cycles, as well as of similar isolated representations, are the journey of the Prophet led by Gabriel and riding Burāq, the heavenly cock, the pause at the gates of heaven, Mohammed meeting the prophets, the angels and houris, and other scenes of heaven; the graphic illustration of hell is comparatively rare. Though very stylized, these illustrations of Moslem eschatological literature constitute one of the highest peaks reached by the Persian art of miniature in the 14th century or later. No older examples of Arabic miniatures on these subjects are known.

<div style="text-align: right">Francesco GABRIELI</div>

THE CHRISTIAN WORLD. In Christian theology the term "eschatology" refers to the Four Last Things, or final ends of man: death, the Last Judgment (doomsday), paradise, and hell. Between death and the Last Judgment come the signs presaging the end of the world, according to the revelations in the Apocalypse of St. John.

*Death.* In contrast with the view of pagan antiquity, that the brevity and uncertainty of life were an invitation to enjoy its worldly pleasures, Christians regard the certainty of death as an incentive to live virtuously in order to be always ready to appear before the Divine Judge.

In the Middle Ages three major themes dealt with the subject of death: the three living and the three dead, the dance of death, and the triumph of death. Of relatively late origin, these were treated by artists with the manifest intention of rousing in the faithful the fear of their last hour.

The first of these themes depicts three young noblemen, returning from the hunt with falcons, who are suddenly stopped short by three corpses in varying degrees of decay. The corpses rise from their coffins and fling at them the fearful admonition: "What you are we were; what we are you will be." This subject, derived from an Eastern legend that gained circulation

ESCHATOLOGY

in the West in the 13th century through the poems of Baudouin de Condé and Nicolas de Margival, became one of the favorite themes of Franciscan and Dominican sermons. With the development of printing in the second half of the 15th century it enjoyed its greatest popularity.

In the earliest examples the number of persons represented varied; occasionally, as in the frescoes in the Cathedral of Atri, there are only two. It is possible that the theme of the journey of the Magi helped establish their number at three, in view of the fact that in the late 15th century the three living are, like the Magi, always shown on horseback and wearing crowns, and the dead, counterparts of the living, are also wearing crowns. The encounter takes place before a cross at a crossroads (fresco at Saint-Riquier in northern France). Sometimes the dead remain lying in their coffins; again, they may rise up in their shrouds and assume threatening attitudes, as in the fresco of La Ferté-Loupière, where one of them is preparing to hurl a spear at the living, and in the engraving by the Housebook Master (Master of the Amsterdam Cabinet), in which one clutches with a skeletal hand the cloak of a nobleman. The horror and terror of the three living are conveyed in various ways. At Hal (Belgium) they are depicted convulsively clinging to the necks of their horses. In a miniature by Jean Colombe in the *Très Riches Heures* of the Duc de Berry (Chantilly, Mus. Condé) the horsemen are fleeing from the skeletons, and even the animals are seized with panic. Italian painters added to the group the Egyptian anchorite St. Macarius, who shows the hunters the three corpses lying side by side (Pisa, Camposanto; PL. 468).

An increasing obsession with death in the later Middle Ages, inspired by the epidemics of the Black Death and the charnel houses of the Hundred Years' War, expanded the theme into the dance of death, or *danse macabre* (for the derivation of the word "macabre," see Rosenfeld, 1954, p. 118), addressed to all classes of society. A vast flowering of literature on the subject preceded and coexisted with this type of representation, which has as its major motif not the fear of death but the complete leveling of classes by death, without regard for age, sex, fortune, or rank. Rich and poor, clergy and laity, popes and emperors — all must pass through the same portal. To the disinherited the dance of death may thus have provided a certain satisfaction and consolation, but this implication should not be exaggerated, as the poor were no more spared than the rich.

The dead, as the counterparts of the living, were originally depicted as desiccated corpses still covered with flesh hanging like beggars' rags. The completely fleshless skeleton did not appear until the 16th century (in the wake of anatomical knowledge). Toward the end of the 15th century the dance of death, until then always enacted by men, began to be shown with female participants. Since women at that time were generally without a profession, emphasis was placed on condition rather than on rank: the virgin, the newly married, the pregnant, the spinster. This innovation first appeared in 1485 in a series of woodcut illustrations published in Paris by Guy Marchand. In France and the Germanic countries the dance of death was a favorite theme in painting, but it was relatively rare in sculpture, one of the few examples being the carved wood friezes of the porch of St-Maclou, Rouen.

This eschatological theme was used primarily to decorate the cloisters of monasteries, the open courtyards of which normally served as cemeteries. Such macabre friezes and borders occur also along the naves and chapels of medieval churches, also used for burials. The earliest dance of death was in all probability the one painted in Paris in 1425 under the wooden galleries of the Cemetery of the Innocents, which was destroyed in the 16th century. This probably served as the prototype for the later paintings at Basel (1440) and Lübeck (1463), the latter now destroyed. The outstanding depictions of the dance of death surviving in France are those at Kermario in Brittany (ca. 1440); in St-Robert at La Chaise-Dieu near Lyon (1460; PL. 468); at Meslay-le-Grenet near Chartres (1490); and at La Ferté-Loupière in Burgundy (1520). A complete inventory is given by Rosenfeld (1954, pp. 355-56). The composition always followed a fixed scheme, variations being made for local characteristics. The dead of highest social standing lead the procession, laity alternating with clergy; the emperor thus comes after the pope, the high constable after the patriarch, the knight after the archbishop, in keeping with the immutable order of rank.

Toward the end of the 15th century the repertory of the dance of death was enriched by a variant called *ars moriendi*, or the art of dying. This appellation originated with the writings of the French theologian Jean de Gerson; the theme was popularized by an edition of his work with wood engravings published by the Parisian bookseller Vérard. The *ars moriendi* belongs to a special type of medieval literature that had a great vogue: the *altercatio* or *disputatio*, which consisted of a duel between God and Satan in which the stake was a human soul in danger of death. The soul was saved at the last moment by its guardian angel.

Germany and German Switzerland in various ways made their own contribution to the theme of the dance of death. In northern Germany the dances of death of the Marienkirchen of Berlin (1484) and Lübeck (1463) were completely ruined in World War II. But closely similar ones survive in German Switzerland (Basel, Dominikanerkloster, 1440; Bern, Dominikanerkloster, 1516; and Lucerne, Mühlenbrücke, 1526). A series by Hans Holbein the Younger (*Imagines mortis*, 1523-26) inaugurated a new phase in the evolution of the theme. This consists of small genre scenes in which a sardonic Death comes on his victims unawares in their daily occupations: the pope in conclave, the emperor surrounded by his courtiers, the mason on the scaffold, the peasant behind his plow.

French woodcuts of this type (*Simulacres de la mort*, Lyon, 1538) and their German counterparts appear to derive from the *Heures de Simon Vostre* (Paris, 1512), in which a mocking skeleton in disguise tricks his victim in order to cut short his life. Two followers of Albrecht Dürer, Hans Burgkmair of Augsburg and Hans Baldung-Grien (qq.v.), turned this theme to good account in their paintings and engravings (e.g., Burgkmair's *Lovers Surprised by Death*, 1510). Baldung exploited a vein of macabre eroticism by coupling love with Death, as in two little panels in Basel (both dated 1517), with Death in one kissing a nude young girl (PL. 468), in the other seizing a girl by the hair and pointing to an open grave.

In German Switzerland Urs Graf and Niklaus Manuel introduced coarser variations on the theme of love and death. The subject was revived in the 19th century in the woodcuts of Alfred Rethel, inspired by the revolution of 1848.

The taste for the macabre found fertile soil in portraits and still lifes, chiefly in the Low Countries and Germany. A famous example, and the earliest known of this type, is the picture of a skull placed beside a brick, painted on the verso of the triptych of Jean de Braque by Rogier van der Weyden (ca. 1450; Louvre). In the 17th century the taste for the macabre in still life appeared in the type generically known as the *vanitas*: objects arranged in confusion around a skull as symbols of a precarious and ephemeral existence — a broken wine glass, a burning candle, bursting soap bubbles.

The macabre appeared again in 19th-century portraiture; the Swiss Arnold Böcklin, for instance, painted a self-portrait in which he appears holding brush and palette, while Death watches him from behind, plucking the strings of a violin (Berlin, Staat. Mus.).

In Italy the essentially Franco-German theme of the dance of death found expression only in a few places in the north, such as Clusone, near Bergamo (1485) and Pinzolo, in the province of Trento (1539). It was transformed instead into the triumph of death, which derived in all probability from Petrarch's *Trionfi*. The fresco in the Camposanto, Pisa, dating from about the time of the great plague of 1348 and unfortunately ruined in World War II, was the prototype. In the 15th century the depiction of this theme reached its peak in the anonymous fresco from the Palazzo Sclafani in Palermo (ca. 1417; PL. 468) and in Lorenzo Costa's fresco in S. Giacomo Maggiore, Bologna (ca. 1490). Woodcuts popularized the subject, which spread to regions outside Italy (e.g., the stained-glass windows of Rouen Cathedral). Less prevalent in Italy were the singular

images of the encounter of Death and Life, the most important of which are those of Paolo Bonomini in S. Grata, Bergamo, which depict skeletons dressed in 18th-century costume.

*The Apocalypse.* The New Testament text of the Apocalypse contains the revelations of the end of the world in words addressed to the seven churches of Asia Minor. In its three theophanies, or divine apparitions, it offered artists a number of eschatological themes that have their roots in Egyptian mythology, Babylonian astrology, and particularly the Old Testament. With the exception of the Psalms and the Gospels, no book of the Bible has been so frequently illustrated throughout the centuries, in spite of the difficulties it offers to transcription into visual terms. Manuscript illumination was the source of a few isolated themes of monumental decoration, the most remarkable being the mosaics of Galla Placidia in S. Paolo fuori le Mura, the Apocalyptic Christ of S. Pudenziana, and the Christ in Majesty with the 24 elders in SS. Cosma e Damiano in Rome (now destroyed).

Byzantine art for obvious reasons (see IMAGES AND ICON-OCLASM) made only an indifferent and late contribution to the theme of the Apocalypse, restricted for the most part to the fresco cycles at Dečani, in Yugoslavia, and the monastery of Dionysiou, at Mount Athos. In the West the harvest was rich, especially in manuscript illumination. Some of the earliest and most remarkable examples are those illustrating the commentaries on the Apocalypse compiled near the end of the 7th century by Beatus, Abbot of Liebana, in Asturias, referred to as the Beatus manuscripts. Among the most celebrated are those of Gerona Cathedral, in Spain (975), and Saint-Sever, in Gascony (mid-11th cent.; Bib. Nat., Paris), which to a certain extent were the inspiration for the sculptured tympanums of the churches of Moissac, in Languedoc, and of La Lande de Cubzac, in the Bordeaux region (both 12th cent.). In these can be seen the theophany of Christ in Majesty, with the double-edged sword proceeding from his mouth, or adored by the 24 elders.

In the sphere of monumental wall painting, mention should be made of the Apocalypse of the Romanesque church of the village of Saint-Savin, in the Poitou region, whose iconography inclines toward the northern Gothic. In a class by itself is the huge Apocalypse tapestry series at Angers (see TAPESTRY AND CARPETS), executed from cartoons by the Flemish Jean de Bandol, called Hennequin de Bruges, and woven (1375–81) in Paris by Nicolas Bataille (VI, PL. 387). These tapestries, whose iconography is connected with codex miniatures, were commissioned for the private chapel of Louis I of Anjou, brother of King Charles V. Despite their imperfect condition, they constitute the most complete depiction of the Apocalypse surviving from the Middle Ages.

In Italy the frescoes of S. Pietro al Monte at Civate, near Como, of the Cathedral at Anagni, near Rome, and of the Upper Church at Assisi by Cimabue foreshadowed Luca Signorelli's masterpiece in the Cathedral of Orvieto, the great frescoes inspired by Dante's *Divine Comedy* in the New Chapel (Capella della Madonna di S. Brizio), depicting the end of the world and the preaching of the Antichrist (1500–04; PL. 179).

From the Germanic countries unquestionably the most interesting example is the Bamberg Apocalypse, a masterpiece of Ottonian illumination, executed about the year 1020 in the scriptorium of the Benedictine abbey of Reichenau, on Lake Constance (PL. 467). Illustrations of the Apocalypse gained wide diffusion through the medium of printing. The Cologne Bible (1479) and the Nürnberg Bible (published in 1483 by A. Koberger), from which Albrecht Dürer derived a number of motifs for the 14 plates he engraved on wood in 1497–98 (PL. 467), figured prominently in this. Crowded with details, these woodcuts by Dürer emphasize the limitations of his early work, their dry linear quality not lending itself to such elusive subject matter so readily as etching, with its effects of chiaroscuro. Despite this, their fame was so great that they served as models for numerous artists, not only in Germany but also in France and Russia (frescoes of the Church of the Prophet Elias at Yaroslavl on the Volga, based largely on the

engravings by Claes Jan Visscher, called Piscator, in *Theatrum Biblicum*, published in Amsterdam in 1650). In Protestant Germany the influential Wittenberg Bible was illustrated with plates derived with only slight modification from the atelier of Cranach.

In France illustrations of the Apocalypse enjoyed a special vogue during the 16th century. It was the subject of a series engraved on copper by the goldsmith Jean Duvet of Langres (*L'Apocalypse figurée*, 25 plates, 1546–55), and there is a masterful sculpture of the Four Horsemen on the tomb of Bishop Jean de Langeac in the Cathedral of Limoges. Dürer's influence reached as far as Burgundy, where it appeared in the stained-glass windows of the chapel of St. John in Saint-Florentin (1529). The windows of the Sainte-Chapelle at Vincennes, commissioned by Henry II and designed by Philibert Delorme (not by Jean Cousin, as generally believed), were more influenced by the Italian Renaissance.

The Renaissance preference for Apocalypse cycles later yielded to single visions (El Greco's *Opening of the Fifth Seal*, New York, Met. Mus.; Rubens' *Apocalyptic Woman*, Munich, Alte Pin.). One of the most widespread motifs in the baroque era shows the Virgin surrounded by the rays of the sun, with a halo of stars around her head, standing on a half-moon with the serpent under her feet.

*The Last Judgment.* Iconographic sources for the theme of the Last Judgment are numerous: from the Byzantine world came the visions of St. Ephraem Syrus (4th cent.) and the legends of the descent of the Virgin and St. Paul into the lower regions; from the Bible came the visions of Daniel and the Book of Job from the Old Testament and the Gospel of Matthew and the Apocalypse of St. John from the New Testament; to these were later added the *Golden Legend* of Jacopo da Voragine, Archbishop of Genoa, and the hell scenes of the mystery plays. The Last Judgment was not always depicted in full; frequently representations were limited to single episodes.

In the earliest representations of the Last Judgment the theme was restricted to the figure of Christ receiving the elect or the isolated figure of Christ with either the letters alpha and omega or the symbols of the four Evengelists (Maiestas Domini). Later the theme was amplified and various scenes were arranged in parallel bands, as in the 9th–10th-century Vatican manuscript of Cosmas Indicopleustes. This iconography, probably of Byzantine and not Western origin as suggested by Kunstle, spread widely in the West through the school of Reichenau (Church of St. George on the island of Reichenau, 11th cent.). From the 11th century on, the bands were integrated into a single composition divided horizontally in superimposed sections. There were usually three main themes: at the top, the Parousia (Second Coming of Christ, or coming of Christ in judgment); in the center, the separation of the righteous from the wicked; and below, the resurrection of the dead.

In Byzantine art and within its sphere of influence Christ preceded by angels blowing trumpets was combined with the Deësis (the Virgin and St. John the Baptist interceding for sinners) and sometimes also with the apostles. In addition there was the Hetimasia, or preparation of the throne (Psalms, 9:7), showing an empty throne on which were placed the divine symbols. In Byzantine art the scene of the Parousia was always preceded by either the Resurrection of Christ or His descent into limbo (Anastasis). All these scenes are included in the mosaic at the Cathedral of Torcello (12th cent.), which is composed of five horizontal bands one above the other. At the top is the Anastasis, below it the Parousia, then the Deësis, next the Hetimasia, and at the bottom the resurrection of the dead. The Resurrection of Christ as an independent theme occurs constantly in the churches of the Balkan peninsula (13th–14th cent.).

The theme of the separation of the righteous from the wicked was symbolized in Early Christian art by sheep and goats (S. Paolino da Nola at Fondi, ca. 400, now destroyed; Early Christian sarcophagus covers); frequently lambs were substituted for sheep, and female goats for male ones. This symbolism was derived primarily from St. Matthew (25:31–46)

and also from the Doctors of the Church (e.g., St. Augustine, *De civitate Dei*; St. Jerome, *Epistles*).

Guided by angels, the elect advance toward the Heavenly Jerusalem, while demons hurl the damned into the jaws of the leviathan. The elect are clothed, but the damned remain naked, in accordance with the medieval view that nakedness was a humiliation. Both, however, bear the signs of their earthly callings (miter, crown, tonsure, etc.); the Last Judgment is governed by the same sense of justice and equality as the dance of death. Often shown leading the procession, especially in the 13th century, was a Franciscan. St. Peter receives the elect on the threshold of the Heavenly Jerusalem; their bliss is symbolized by the bosom of Abraham, to which flow their souls. The damned, with expressions of despair on their faces, are chained together in pairs like convicts.

During the 13th century marginal motifs were often added to the theme of the separation of the righteous from the wicked: the Church, the beggar Lazarus, or the wise virgins representing the elect; the Synagogue, Dives, the foolish virgins representing the damned.

The theme of the Church prevailing over the Synagogue originated in a sermon by St. Augustine. The Church was usually personified by a crowned queen at the cross holding a chalice filled with the blood of the Saviour. Sometimes she was surrounded by a nimbus (stained-glass windows at Châlons-sur-Marne) or seated on a four-headed beast, which symbolized the four Evangelists (miniature of the *Hortus deliciarum* by Herrad von Landsberg). She triumphantly faced the Synagogue figure, who, according to the Lamentations of Jeremiah, was deprived of a crown ("the crown is fallen from our head") and has a bandage over her eyes (stained-glass window in Elisabethkirche, Marburg an der Lahn). A broken spear is the sign of her defeat (Cathedral portal, Freiburg im Breisgau). This iconography was established in the 13th century by Albertus Magnus (*De sanguine Christi*) and St. Thomas Aquinas and was faithfully followed in the cathedrals of Rheims and Strasbourg. But in late medieval painting, under the influence of the mystery plays, the Synagogue was represented with additional elements: her skin was dark in the likeness of Mohammedan Moors; she wore the pointed Hebraic cap; and as a sign of derision she rode a donkey and carried for an emblem the treacherous and poisonous scorpion.

The depictions of Lazarus and Dives and of the wise and foolish virgins were inspired by the two most popular eschatological parables (Luke 16:19–31; Matthew 25:1–12), which in the Middle Ages were frequently the texts of preachers. Lazarus was customarily depicted at the door of the rich man, who denied him even the crumbs from his table; but in the next scene Lazarus' soul was transported by an angel to the bosom of Abraham, while Dives was thrown into hell, where he begged in vain for a drop of water.

The theme of the wise and foolish virgins, of frequent recurrence in sculpture, owed its wide dissemination as a personification of the elect and the damned to the work of Abbot Suger. In France it occurred only as a subordinate motif, limited to the decoration of the lintels and archivolts of churches, but in Germany it assumed a monumental character (Freiburg, Nürnberg, Strasbourg), with life-size figures in full relief rising in the splays of portals. The wise virgins are received by Christ, the Bridegroom; the foolish virgins allow themselves to be seduced by Satan, Prince of the World. The latter is dressed as a fashionable youth wearing a tunic split at the seam, through which can be glimpsed a swarm of worms and toads, symbols of corruption.

In depicting the resurrection of the dead, artists reflected the great confusion of theological speculation regarding the exact mode of its occurrence. The prevalent belief in the Middle Ages, following St. Paul (I Cor. 15:52), was that the resurrection would occur *in ictu oculi* ("in the twinkling of an eye") and that the bones of the dead would instantly be covered with flesh. In Signorelli's frescoes at Orvieto a few of the resurrected are skeletons, others are covered with strips of flesh. In some works the dead find themselves still entangled in their shrouds; in others they are naked or completely clothed.

Their reactions on seeing again the light of day are varied: they stretch their limbs still numb from the long sleep of death, they screen their eyes with their hands, or they clasp their hands in attitudes of prayer. Touching scenes of reunion occur: husband and wife embrace tenderly before turning toward the gate of paradise.

In Byzantine art not only the earth — symbolized by wild beasts bringing back the human remains they have devoured — but also the sea yield up the bodies buried in their depths; the sea is personified by a seated woman surrounded by marine monsters belching forth the drowned (mosaic of the Cathedral of Torcello), as in representations of the story of Jonah. In the center of the scene of the resurrection, both in the Byzantine world and in the West, there frequently appeared a very ancient motif of Egyptian origin, transmitted to Christian art through Coptic frescoes: the weighing of souls. The archangel Michael, replacing the god Horus or Anubis, supervises the scales (PL. 464), a function performed among the Greeks by Hermes Psychopompos. In the West the hell scenes of mystery plays were reflected in these depictions, Satan the deceiver sometimes being shown with a hook trying to tip the scales in his favor.

The most remarkable representations of the Last Judgment occurred in Italy in the regions influenced by Byzantine art, at Palermo (Cappella Palatina) and Torcello (PL. 463). But the earliest fresco of the subject is at S. Angelo in Formis (near Capua); it influenced that of Pietro Cavallini in S. Cecilia in Trastevere, Rome, and Giotto's in the Scrovegni Chapel, Padua. The rear interior wall of the church was the place regularly assigned to this subject.

A particular fondness for the Last Judgment is evidenced in French sculpture of the 12th and 13th centuries, in which the evolution of the theme can be followed in the tympanums of Autun, Moissac, and Bourges. In the French cathedrals the Last Judgment was placed in the tympanum over the central portal; if the space was insufficient, the composition spilled over into the archivolt.

In rare cases the Last Judgment occurred in condensed form on pulpits (those of Nicola Pisano in the Baptistery of Pisa and the Cathedral of Siena), on tombs (sepulcher of Inez de Castro in the Portuguese Cistercian church of Alcobaça), and even on a pier ("Pilier des anges" in the Cathedral of Strasbourg; VI, PL. 359).

Panel paintings depicting the Last Judgment became common in the late Middle Ages, the prevalent form being the triptych with the scene of the judgment in the central panel and heaven and hell on the wings. The Last Judgment also adorned the halls of public buildings to exemplify Justice. Usually the composition was divided into three horizontal bands: below, the resurrection of the dead, having as a central motif the weighing of souls; in the middle, the separation of the elect from the damned; at the top, Christ in judgment, at first represented in the semblance of the Apocalyptic Christ but later replaced by the Evangelical Christ, showing in his side and hands the wounds of the crucifixion (Troescher, 1934). From this type derived the representation in which the Saviour was depicted surrounded by angels displaying the instruments of the Passion. This theme of heraldic derivation (the instruments of the Passion are the "arms of Christ"), which developed in France and was masterfully handled in the tympanum of Bourges Cathedral, spread throughout Christendom during the Middle Ages.

A radically new concept of the Last Judgment was introduced by Michelangelo (q.v.) in 1540, in his celebrated fresco on the rear wall of the Sistine Chapel (PL. 179). Instead of the balanced composition favored by the French Gothic sculptors, Michelangelo created an essentially dynamic design. For the horizontal divisions he substituted a rhythmic flow of ascent and descent. The elect seem drawn up to heaven, the damned down into the abyss. The figure of Christ dominates the composition, no longer enthroned over a double rainbow but standing in the act of hurling retribution on the crowd of the damned.

This revolutionary titanic fresco, like Dürer's Apocalypse

illustrations, inspired innumerable imitators in many countries. In Venice, in the Great Council Chamber of the Doges' Palace, Tintoretto (q.v.) substituted for Michelangelo's ascending and descending motion a gyration of figures disposed in concentric arcs, as if swept by a cosmic cyclone around the judging Christ, sole fixed point in the composition. At Antwerp Rubens (q.v.) executed dazzling variations on the Last Judgment theme (Munich, Alte Pinakothek). But this new conception, of a world ruled by the laws of attraction and gravitation, was not that of the Bible; it was no longer Christian.

*Hell and paradise.* The word "paradise" originally designated the royal park of a Persian monarch (*pairidaēza*). *Parvis*, a colloquial variation of the French for "paradise" (also a rare English usage) signifies the open space in front of a church portal; and the church square (*sacrato*) at the entrance of Old St. Peter's in Rome was called the Paradisus.

Christian tradition distinguishes the terrestrial paradise, from which Adam and Eve were expelled, and the celestial one, for the elect. In Early Christian art an Eastern derivation is clear; paradise was conceived as a place of refreshment, an oasis of palm trees watered by the springs of the Four Rivers and possessing the Fountain of Life. The worship of water is characteristic of desert nomads, and the concept of Mohammed's paradise is not far from the Christian one.

In the West the iconography of paradise was enriched by two motifs: the Heavenly Jerusalem and the bosom of Abraham. (In Byzantine art two more patriarchs were added, Isaac and Jacob.) The motif of Abraham's bosom was derived from the parable of Lazarus and Dives, but instead of a single soul the patriarch received three or more in the form of naked children, brought to him in a cloth by an angel. The Heavenly Jerusalem appeared as a fortified city guarded by angels; four towers symbolized the Evangelists and twelve gates the apostles. Later representations were limited to the figure of Christ or the Virgin surrounded by a choir of angels and saints, as in the *Paradise* of Nardo di Cione in S. Maria Novella, Florence (PL. 465). Dürer pictured the Heavenly Jerusalem in the semblance of his native city, Nürnberg.

Hell, as the antithesis of paradise, was conceived as a furnace or dark cave inhabited by demons, sometimes commanded by the figure of Lucifer (PL. 466). As the counterpart of Abraham's bosom, especially in northern Europe, there were the jaws of the leviathan (Job 41) and the bodies of the damned perpetually alive and perpetually in torment. Sculptors and painters of the 12th and 13th centuries generally limited themselves to representing two of the capital sins: avarice and lust. Avarice, as seen in the Romanesque capitals of Auvergne, is personified as a man burdened with a purse hanging from his neck; Lust, as a woman with serpents sucking her breasts and toads gnawing her sex organs. Toward the end of the Middle Ages the punishments of hell began to be differentiated according to the theological scheme of the seven capital sins: thus the envious were plunged to the waist in an icy stream, the gluttonous were forced to swallow putrid water, and the lustful to breathe poisonous fumes.

Alongside the representations of paradise and hell, although comparatively rarely and more particularly in the sphere of folk art, are found depictions of purgatory (II Maccabees, 12: 43–45, which Protestants do not include in the canon of the Bible). These are barely distinguishable from depictions of hell except for the presence of the Virgin giving comfort to souls deprived of the beatific vision.

Louis RÉAU

*Funerary architecture and sculpture.* Naturally, the eschatological theme found its logical expression in funerary architecture and sculpture. Mausoleums (PLS. 457, 458), funerary chapels, tombs, and sarcophagi (see STRUCTURAL TYPES AND METHODS) always reflect the taste, the iconographic traditions, and the religious beliefs of an epoch.

During the Early Christian period the motif that appeared most commonly on the front of sarcophagi was the praying figure, accompanied at times by Biblical scenes referring to salvation after death and to beatitude (see BIBLICAL SUBJECTS). In the Byzantine world symbolic elements prevailed, representing the joys of heaven (palms with dates, peacocks, doves, etc.).

During the late Middle Ages a new style gained popularity: the deceased person was represented on the front of the sarcophagus, alone or accompanied by his patron saint, kneeling in prayer before the Virgin (tomb of Guglielmo di Castelbarco, Verona, 1319), and his effigy lay on the lid, generally clothed in noble garments (PL. 455). The structure of the tomb became increasingly more complicated (PL. 455). In the tomb of Robert of Anjou by Giovanni and Pace da Firenze in the Church of S. Chiara in Naples the effigy reclines at the base; in the upper sections are shown the subsequent stages of the life of the soul after death, culminating in the ultimate vision of Christ in Majesty. Scenes recalling the most important episodes in the life of the dead person often preceded the eschatological images (tomb of Cangrande della Scala, Verona, 1330; VI, PL. 367). In order to portray the features of the dead person the death mask (see MASKS) came into use (tomb of Azzone di Castelbarco at Loppio, Italy).

At the end of the Middle Ages in the countries north of the Alps a taste for the macabre began to appear; the tomb effigy might represent a naked corpse eaten by worms, as in the fragmentary tomb of Cardinal Lagrange (1402) in the Musée Lapidaire at Avignon and in the regal tombs of Louis XII, Francis I, and Henry II in the Cathedral of St-Denis (16th cent.). In the monument of René de Châlons in Barle-Duc, the Lorraine sculptor Ligier Richier has portrayed the dead man standing, a true living skeleton with tatters of wrinkled flesh hanging from his bones, in the act of offering to God the heart torn from his breast.

In the northern countries this tendency to represent corpses in the various stages of decay prevailed until the 19th century. In Renaissance Italy the figures were more composed and serene; the tombs presented rather a glorification of the life and virtues of the deceased. The theme of death again came to the fore in the baroque period; the skeleton, holding sickle and hourglass, was often the dominant motif of funerary monuments, as in the tombs by Bernini of Urban VIII (II, PL. 275) and Alexander VII in St. Peter's in Rome. This was succeeded, in the neoclassicism of the late 18th and the 19th century, by Canova's winged genius with extinguished torch. In contemporary times these macabre, symbolical, and allegorical themes have been dropped, and there is a return to simpler forms, both in architecture and in ornament (PL. 459). Often a tomb is marked only by a cross.

\* \*

POPULAR AND FOLK IMAGERY. The eschatological themes have been amply treated in popular art. Representations of death (*imagines mortis*) on European playing cards and game tables have been especially popular, and an image of death appeared even on some English satirical banknotes of 1818–19. It was transformed into the figure of Charon in some Belgian prints of the beginning of the 19th century; in these the admonition proper to the theme was completely reversed: the man portrayed at table cheerfully drinking reappears, glass in hand, in Charon's boat.

Death is still represented as a skeleton today, not only on playing cards and game tables, which mostly repeat the old patterns, but also in carnival masks, marionettes, and toys and in the witches' houses and horror chambers of fun fairs.

There are numerous 17th–19th-century representations of a fantastic animal whose features are represented with comparative uniformity. This image had its source in the prevalent stories of apocalyptic beasts that made sudden appearances in the sea or in the countryside and destroyed villages and crops. Popular fancy identified these monsters with the beast of St. John's Apocalypse, and the anonymous artists who portrayed it gave it such typical traits as a long tail. One such print, produced in France early in the 17th century, shows the monster with tail and horns devouring a man over whom stands a cross; the beast of Gevaudan (Rouen, 18th cent.) is also a monster with a long tail, devouring a newborn infant; the "savage beast"

of Orléans (early 19th cent.) is a large animal with a spotted coat killing a peasant.

Popular graphic descriptions of the Last Judgment are found in prints illustrating the course of human life. In one of these (Rouen, early 19th cent.) a scene of judgment is shown below a ladder, with God bearing the symbol of the Trinity above a multitude of souls writhing in flames; this image appears also in a French print of the early 18th century. To the same period belongs a similar Belgian print, in which, however, the Trinity is represented as three persons. The theme of the Last Judgment, portrayed in popular form, was used to illustrate the conclusion of time in a print of the creation of the world (Nantes, 1830). These random examples show the vitality and not merely the survival of an artistic inspiration which had and still has expressive significance of a high order irrespective of any religious cult.

Annabella ROSSI

BIBLIOG. *General*: J. A. MacCulloch, Hastings' Encyclopedia of Religion and Ethics, Edinburgh, 1912, s.v. Eschatology, p. 373 ff.; J. A. MacCulloch, A Critical History of the Doctrine of a Future Life, 2d ed., Edinburgh, 1913; J. G. Frazer, The Belief in Immortality and the Worship of the Dead, 3 vols., London, 1913–24; A. J. Wensinck, The Semitic New Year and the Origin of Eschatology, ActaO, I, 1922, p. 158 ff.; A. Parrot, Le "refrigerium" dans l'au-delà, Paris, 1937; F. Cumont, Lux Perpetua, Paris, 1949; G. van der Leeuw, Urzeit und Undzeit, Eranos-Jahrbuch, XVII, 1949, p. 11 ff.; E. de Martino, Morte e pianto rituale nel mondo antico, Turin, 1958. *Prehistory and protohistory*: J. Grimm, Über das Verbrennen der Leichen, in Kleinere Schriften, II, Berlin, 1865; O. Olshausen, Leichenverbrennung, ZfE, XXIV, 1892, Verhandlungen, p. 129 ff.; S. Müller, Nordische Altertumskunde, I, Strasbourg, 1897, p. 360 ff.; J. Déchelette, Manuel d'archéologie préhistorique, celtique et gallo-romaine, I, Paris, 1908, p. 465 ff.; E. Rohde, Psyche, Tübingen, 1925, p. 27 ff.; G. Wilke and F. von Duhn, RLV, VII, 1926, s.v. Leichenverbrennung, p. 276 ff.; G. Wilke, RLV, XIII, 1929, s.v. Totenkultus, p. 409 ff.; G. Kossack, Studien zum Symbolgut der Urnenfelder- und Hallstattzeit Mitteleuropas (Römisch-germanische Forsch., XX), Berlin, 1954; H. Müller-Karpe, Das urnenfelderzeitliche Wagengrab von Hart, Oberbayern, Bayerische Vorgeschichtsblätter, XXI, 1955, p. 46 ff. *The primitive world*: K. T. Preuss, Die Begräbnisarten der Amerikaner und Nordostasiaten, Königsberg, 1894; L. Rütimeyer, Über Totenmasken aus Celebes und die Gebräuche bei zweistufiger Bestattung, Verh. der naturforschenden Gesellschaft in Basel, XXI, 1907, p. 290 ff.; N. W. Thomas, The Disposal of the Dead in Australia, Folk-lore, XIX, 1908, p. 388 ff.; C. Nimuendajú-Onkel, Die Sagen von der Erschaffung und der Vernichtung der Welt als Grundlagen der Religion der Apapocúva-Guarani, ZfE, XLVI, 1914, p. 284 ff.; W. J. Perry, Myths of Origin and Homes of the Dead in Indonesia, Folk-lore, XXVI, 1915, p. 138 ff.; E. Smith, On the Significance of the Geographical Distribution of the Practice of Mummification, Manchester, 1915; J. Warneck, Das Opfer bei den Toba-Batak in Sumatra, Archiv für Religionswissenschaft, XVIII, 1915, p. 333 ff.; R. Heine-Geldern, Kopfjagd und Menschenopfer in Assam und Birma und ihre Ausstrahlungen nach Vorderindien, MAG-Wien, XLVII, 1917, p. 1 ff.; P. Sartori, Der Seelenwagen, in Festschrift für E. Hahn, Stuttgart, 1917, p. 241 ff.; B. Ankermann, Totenkult und Seelenglaube bei afrikanischen Völkern, ZfE, L, 1918, p. 89 ff.; P. M. Küsters, Das Grab der Afrikaner, Anthropos, XIV, 1919, p. 639 ff., XVI, 1921, p. 183 ff., XVII, 1922, p. 913 ff.; A. Krämer, Die Malanggane von Tombàra, Munich, 1925; R. Moss, The Life after Death in Oceania and the Malay Archipelago, Oxford, 1925; G. Róheim, The Pointing Bone, JRAI, LV, 1925, p. 90 ff.; G. Peekel, Die Ahnenbilder von Nord-Neu-Mecklenburg, Anthropos, XXI, 1926, p. 806 ff.; E. O. James, The Concept of the Soul in North America, Folk-lore, XXXVIII, 1927, p. 338 ff.; E. Camerling, Über Ahnenkult in Hinterindien und auf den Grossen Sunda-Inseln, Rotterdam, 1928; P. M. Schulien, Opfer und Gebet bei den Atchwabo in Portugiesisch-Ostafrika, in Festschrift für W. Schmidt, Mödlin, 1928, p. 677 ff.; K. Stülpner, Der Tote in Brauch und Glauben der Madegassen, Leipzig, 1929; W. D. Hambly, Serpent Worship in Africa, Chicago, 1931; R. P. Arndt, Die Megalithenkultur der Nad'a (Flores), Anthropos, XXVII, 1932, p. 11 ff.; C. J. Bonington, Ossuary Practices in the Nicobars, Man, XXXII, 1932, p. 105 ff.; W. Klingbeil, Kopf- und Maskenzauber in der Vorgeschichte und bei den Primitiven, Berlin, 1932; J. W. Layard, The Journey of the Dead from the Small Islands of Northeastern Malekula, in Essays Presented to C. G. Seligman, London, 1934, p. 113 ff.; E. Doerr, Bestattungsformen in Ozeanien, Anthropos, XXX, 1935, pp. 369 ff., 727 ff.; S. Lagercrantz, Fingerverstümmelungen und ihre Ausbreitung in Afrika, ZfE, LXVII, 1935, p. 129 ff.; B. A. G. Vroklage, Die Megalithkultur in Neuguinea, ZfE, LXVII, 1935, p. 104 ff.; T. Körner, Totenkult und Lebensglaube bei den Völkern Ostindonesiens, Leipzig, 1936; H. H. Böhme, Der Ahnenkult in Mikronesien, Leipzig, 1937; J. Kenyatta, Kikuyu Religion, Ancestor Worship and Sacrificial Practices, Africa, X, 1937, p. 241 ff.; J. W. Layard, Der Mythus der Totenfahrt auf Malekula, Eranos-Jahrbuch, 1937, p. 241 ff.; W. C. MacLeod, Self-sacrifice in Mortuary and Non-mortuary Ritual in North America, Anthropos, XXXIII, 1938, p. 349 ff.; J. Söderström, Die rituellen Fingerverstümmelungen in der Südsee und in Australien, ZfE, LXX, 1938, p. 24 ff.; F. R. Lehmann, Weltuntergang und Welterneuerung im Glauben schriftloser Völker, ZfE, LXXI, 1939, p. 103 ff.; C. Schuster, Bird-designs in the Western Pacific, Cultureel Indie, I, 1939, p. 232 ff.; E. Volhard, Kannibalismus, Stuttgart, 1939; A. Steinmann, Das kultische Schiff in Indonesien, IPEK, XIII–XIV,

1939–40, p. 149 ff.; A. J. Hallowell, The Spirits of the Dead in Saulteaux Life and Thought, JRAI, LXX, 1940, p. 29 ff.; H. Schärer, Die Bedeutung des Menschenopfers im dajakischen Totenkult, Mitteilungsblatt der deutschen Gesellschaft für Völkerkunde, X, 1940; K. Weinberger-Göbel, Zur Brandvestattung in Melanesien, ZfE, LXXII, 1940, p. 114 ff.; C. van Wylick, Bestattungsbrauch und Jenseitsglaube auf Celebes, The Hague, 1941; J. W. Layard, Stone Men of Malekula, London, 1942; F. M. Schnitger, Tierförmige Särge in Asien und Europa, Paideuma, II, 1942, p. 147 ff.; A. Friedrich, Knochen und Skelett in der Vorstellungswelt Nordasiens, Wien. Beiträge zur Kulturgeschichte und Linguistik, V, 1943, p. 189 ff.;A. Steinmann, The Ship of the Dead in the Textile Art of Indonesia, Ciba Rev., LII, 1946, p. 1885 ff.; R. M. and C. H. Berndt, Sacred Figures of Ancestral Beings of Arnhem Land, Oceania, XVIII, 1948, p. 309 ff.; S. Brown, The Nomoli of Mende Country, Africa, XVIII, 1948, p. 18 ff.; J. Guiart, Les effigies religieuses des Nouvelles Hebrides, JSO, V, 1949, p. 51 ff.; M. D. W. Jeffreys, Funerary Inversions in Africa, Archiv für Völkerkunde, IV, 1949, p. 24 ff.; P. Wirz, Über einige figürliche Schiffs- und Vogeldarstellungen in Indonesien, Indien und Persien, Archiv für Völkerkunde, IV, 1949, p. 186 ff.; A. E. Jensen, Über das Töten als kulturgeschichtliche Erscheinung, Paideuma, IV, 1950, p. 29 ff.; A. Lommel, Bhrigu in Jenseits, Paideuma, IV, 1950, p. 93 ff.; A. Riesenfeld, The Megalithic Culture of Melanesia, Leiden, 1950; H. Damm, Sakrale Holzfiguren von den nordwestpolynesischen Randinseln, Jhb. des Mus. für Völkerkunde zu Leipzig, X, 1950–51, p. 74 ff.; B. Holas, Sur l'utilisation rituelle des statuettes funéraires au royaume de Krinjabo, Côte d'Ivoire, Acta Tropica, VIII, 1951, p. 1 ff.; H. Huber, Das Fortleben nach dem Tode im Glaube westsudanischer Völker, Mödling, 1951; H. Lavachéry, Stèles et pierres-levées à l'Île de Pâques, in Südseestudien: Gedenkschrift an F. Speiser, Basel, 1951, p. 413 ff.; P. Wirz, Eine "Totenfigur" aus dem Gebiete der Jatmül, Jhb. des Mus. für Völkerkunde zu Leipzig, XI, 1952, p. 91 ff.; H. Nachtigall, Die erhöhte Bestattung in Nord- und Hochasien, Anthropos, XLVIII, 1953, p. 44 ff.; H. Damm, Mikronesische Kultboote, Schwebealtäre und Weihegabenhänger, Jhb. des Mus. für Völkerkunde zu Leipzig, XIII, 1954, p. 45 ff.; K. Laumann, Geisterfiguren am mittleren Yuat River in Neuguinea, Anthropos, XLIX, 1954, p. 27 ff.; T. Monod, A propos des jarres-cercueils de l'Afrique occidentale, in Afrikanistische Studien, Festschrift für D. Westermann, Berlin, 1955, p. 30 ff.; R. Verly, La statuaire de pierre du Bas-Congo, Zaïre, IX, 1955, p. 451 ff.; H. Baumann, Die Frage der Steinbauten und Steingräber in Angola, Paideuma, VI, 1956, p. 118 ff.; S. Lagercrantz, Skull Cups, Transactions of the Westermarck Soc., III, 1956, p. 135 ff.; D. Zélénine, Le culte des idoles en Sibérie, Paris, 1957. *The ancient world. a. Near East*: F. Schwally, Das Leben nach dem Tode nach den Vorstellungen des alten Israel und des Judentums, Giessen, 1892; E. A. T. W. Budge, The Mummy: A Handbook of Egyptian Funerary Archaeology, Cambridge, England, 1925; H. Kees, Totenglauben und Jenseitsvorstellungen der alten Ägypter, Leipzig, 1926; G. Furlani, La religione babilonese e assira, II, Bologna, 1929, pp. 327–45; A. H. Gardiner, The Attitude of the Ancient Egyptian to Death and the Dead, Cambridge, 1935; G. Contenau, La civilisation phénicienne, 2d ed., Paris, 1949, pp. 186–222; A. G. Barrois, Manuel d'archéologie biblique, II, Paris, 1953, pp. 274–323; O. R. Gurney, The Hittites, 2d ed., Harmondsworth, 1954, pp. 164–69; M. Haran, The Bas-Relief on the Sarcophagus of Ahiram King of Byblos in the Light of Archaeological and Literary Parallels from the Ancient Near East, Israel Exploration J., I, 1958, pp. 15–25. *b. Greece and Rome*: L. Rademacher, Das Jenseit im Mythos der Hellenen, Bonn, 1903; C. Pascal, Le credenze d'oltretomba, 2 vols., Catania, 1912; G. Wissowa, Religion und Kultus der Romer, 2d ed., Munich, 1912; A. Dieterich, Nekyia, 2d ed., Leipzig, 1913; D. Randall-McIver, Villanovans and Early Etruscans, Oxford, 1924; F. von Duhn and F. Messerschmidt, Italische Gräberkunde, 2 vols., Heidelberg, 1925, 1939; D. Randall-McIver, The Iron Age in Italy, Oxford, 1927; C. C. van Essen, Did Orphic Influence on Etruscan Tomb Paintings Exist? Amsterdam, 1927; F. Cumont, Recherches sur le symbolisme funéraire des Romains, Paris, 1942 (with bibliog.); N. Turchi, Le religioni misteriosofiche del mondo antico, Milan, 1948; W. B. Kristensen, Het Leven uit de Dood, 2d ed., Haarlem, 1949; M. P. Nilsson, A History of Greek Religion, 2d ed., Oxford, 1949; W. B. Kristensen, Inleiding tot de Godsdienstgeschiedenis, Arnhem, 1955; W. B. Kristensen, Symbool en Werkelykheid, Arnhem, 1956. *c. Iran*: F. Cumont, Textes et monuments figurés relatifs aux mystères de Mithra, 2 vols., Brussels, 1896–99; M. I. Rostovtzeff, Iranians and Greeks in South Russia, Oxford, 1922; F. Sarre, Die Kunst des alten Persien, Berlin, 1923; H. S. Nyberg, Die Religionen des alten Iran, Leipzig, 1938; G. Widengren, Hochgottglaube in alten Iran, Uppsala, 1938; E. Herzfeld, Iran in the Ancient East, London, 1941; H. H. von der Osten, Die Welt der Perser, Stuttgart, 1956; I. Kleemann, Der Satrapen-Sarkophag aus Sidon, Berlin, 1958. *The East. a. India and southeastern Asia*: J. Edkins, Chinese Buddhism, London, 1880; L. Feer, L'enfer indien, JA, CXLI, 1892, p. 185 ff., CXLII, 1893, p. 112 ff.; A. Grünwedel, Mythologie des Buddhismus in Tibet und der Mongolei, Leipzig, 1900; H. Haas, Amida-Buddha unsere Zuflucht, Leipzig, 1910; G. Cœdès, Note sur l'apothéose au Cambodge, B. Commission archéol. d'Indochine, 1911, p. 38 ff.; A. Grünwedel, Altbuddhistische Kultstätten in chinesischen Turkistan, Berlin, 1912; C. Duroiselle, Pictorial Representations of Jātakas in Burma, Ann. Rep. Archaeol. Survey India, 1912–13, p. 87 ff.; H. H. Juynboll, Die Hölle und Höllenstrafen nach dem Volksglauben auf Bali, BA, IV, 1914, pp. 87 ff., 293 ff.; M. Roeské, L'enfer cambodgien d'après le Trai Phum (Trī Bhūmī), "Les trois mondes," JA, 1914, p. 587 ff.; A. K. Coomaraswamy, Rajput Painting, Oxford, 1916; H. Kern, Iets over de Hellen der Buddhisten, Verspreide Geschriften, IV, 1916, p. 233 ff.; A. Grünwedel, Buddhistische Kunst in Indien, 2d ed., Berlin, 1919; J. L. Moens, Hindu-Javaansche Portretbeelden: Çaiwapratiṣṭa en Boddhapratiṣṭa, Tijdschrift Indischen taal-, land- en volkenkunde, LVIII, 1919, p. 493 ff.; P. Pelliot, Les grottes de Touen-Houang (6 fascicles of plates), Paris, 1920–24; H. Kern, De Legende van Kunjarakarna, Verspreide Geschriften, X, 1922, p. 1 ff.; N. J. Krom, Inleiding tot de Hindoe-Javaansche Kunst, The Hague, 1923; P. Wirz, Der Totenkult auf

Bali, Stuttgart, 1928; A. K. Coomaraswamy, Picture Showmen, Indian Historical Q., V, 1929, p. 182 ff.; A. K. Coomaraswamy, A Pastoral Paradise, Rūpam, XLII–XLIV, 1930, p. 14 ff. (see BMFA, XXVIII, 1930, p. 63 ff.); W. Stutterheim, The Meaning of the Hindu-Javanese Caṇḍī, JAOS, LI, 1931, p. 1 ff.; G. Tucci, Indo-Tibetica, 4 vols. (Vol. III in 2 parts, Vol. IV in 3), Rome, 1932–41; G. Cœdès, Aṅkor Vat, temple ou tombeau? BEFEO, XXXIII, 1933, p. 303 ff.; P. Mus, Cultes indiens et indigènes au Champa, BEFEO, XXXIII, 1933, p. 367 ff.; J. Przyluski, Pradakṣina and Prasavya in Indochina, in Festschrift Moriz Winternitz, Leipzig, 1933, p. 326 ff.; L. A. Waddell, The Buddhism of Tibet or Lamaism, Cambridge, 1934; P. Mus, Barabudur, Hanoi, 1935; H. von Glasenapp, Buddhismus in Indien und im Fernen Osten, Berlin, 1936; J. Przyluski, Is Angkor Vat a Temple or a Tomb? JISOA, V, 1937, p. 131 ff.; F. M. Schnitger, Forgotten Kingdoms in Sumatra, London, 1939; P. H. Pott, A Remarkable Piece of Tibetan Ritual Painting, IAE, XLIII, 1943, p. 215 ff.; S. Cammann, A Tibetan Painting in the Freer Gallery of Art, GBA, XXV, 1944, p. 283 ff.; P. H. Pott, Die "ars moriendi" von Tibet, Phoenix, I, 9, 1946, p. 1 ff.; J. L. Davidson, Buddhist Paradise Cults in 6th Century China, JISOA, XVII, 1949, p. 112 ff.; G. Tucci, Il Libro tibetano dei morti, Milan, 1949; G. Tucci, Tibetan Painted Scrolls, Rome, 1949; S. Hummel, Kuan Yin in der Unterwelt, Sinologica, II, 1950, p. 291 ff.; L. P. Briggs, The Ancient Khmer Empire, Philadelphia, 1951; H. G. Quaritch Wales, The Making of Greater India, London, 1951; M. M. Deneck, Un manuscrit birman au Musée Guimet, BSEI, 1952, p. 63 ff.; E. Waldschmidt, Zur Śroṇakoṭikarṇa-Legende, Göttingen, 1952; J. L. Davidson, The Lotus Sutra in Chinese Art, New Haven, 1954; A. B. Griswold, A Warning to Evildoers, Artibus Asiae, XX, 1957, p. 18 ff.; W. Y. Evans-Wentz, The Tibetan Book of the Dead, According to Lama Kazi Dawa-Samdup's English Rendering, 3d ed., London, New York, 1957; D. Seckel, Buddhistische Kunst Ostasiens, Stuttgart, 1957. *b. China and Japan*: E. Chavannes, La Sculpture sur pierre en Chine au temps des deux dynasties Han, Paris, 1893; E. Chavannes, trans., Les mémoires historiques de Se ma T'Sien, 5 vols., Paris, 1895–1905, II, p. 151 ff., III, pp. 436 ff., 513 ff.; S. W. Bushell, Chinese Art, 2 vols., London, 1909; B. Laufer, Chinese Pottery of the Han Dynasty, Leiden, 1909, p. 174 ff.; E. Chavannes, Mission archéologique dans la Chine septentrionale, 4 vols., Paris, 1909–19; E. Chavannes, Le T'ai chan, Paris, 1910; L. Wieger, Taoïsme, II, Hsienhsien, 1913 (repr., Paris, 1953), p. 131 ff.; E. Erkes, Das Zurückrufen der Seele (chao-hun) des Sung Yüh, Leipzig, 1914; B. Laufer, Chinese Clay Figures, Chicago, 1914; Chōsen Koseki Zufu (Korean Antiquities Illustrated), 15 vols., Seoul, 1915–35; Chōsen Kofun Hekigawashu (Wall Paintings of Ancient Korean Tombs), Tokyo, 1916; T. Sekino, Shina Santōsho ni okeru kandai fumbo no hyōshoku (Remains of Funerary Monuments of the Han Dynasty in Shantung Province, China), Tokyo, 1916; E. Erkes, Das Weltbild des Huai-Nan-Tzu, ÖAZ, 1918, p. 42 ff.; W. P. Yetts, The Chinese Isles of the Blest, Folk-lore, XXX, 1919, p. 35 ff.; K. Tomioka, Kokyō no kenkyū (Art of Ancient Mirrors), Kyoto, 1920; A. Hetherington, The Early Ceramic Wares of China, London, 1922; O. Rücker-Emden, Chinesische Frühkeramik, Leipzig, 1922; E. Erkes, The Ta-chao: Text, Translation and Notes, in Hirth Anniversary Volume, London, 1923, p. 67 ff.; A. Hetherington and R. C. Hobson, The Art of the Chinese Potter, London, 1923; E. Fuchs, T'ang Plastik, Munich, 1925; C. Hentze, Figurines de la céramique funéraire, Hellerau, 1927; C. Hentze, Chinese Tomb Figures, London, 1928; Shōsōin Gyomotsu Zuroku (Catalogue of the Imperial Treasure of Shōsōin), 14 vols., Tokyo, 1928–35, II, pl. 4; O. Fischer, Die Chinesische Malerei der Han Dynasty, Berlin, 1931, p. 98 ff.; O. Sirén, Über die Stilentwicklung der chinesischen Grabfiguren, Wien. Beiträge zur Kunst und Kultur Ostasiens, VI, 1931, p. 3 ff.; Chêng Tê-k'un, The Travels of the Emperor Mu, J. North China Branch Royal Asiatic Soc., LXIV, 1933, p. 124 ff.; Chêng Tê-k'un and Shen Wei-chün, Chung-kuo ming-ch'i (Chinese Tomb Figurines), Peiping, 1933; B. Karlgren, Early Chinese Mirror Inscriptions, BMFEA, VI, 1934, p. 9 ff.; S. Gotō, ed., Kokyō Shuei (Select Collection of Ancient Mirrors), 2 vols., Tokyo, 1935, figs. 7, 8, 50, E. Erkes, Die Totenbeigaben in alten China, Artibus Asiae, VI, 1936; p. 26 ff.; P. Pelliot, Die Jenseitsvorstellung der Chinesen, Eranos-Jahrbuch, 1939, p. 61 ff.; H. Dubs, An Ancient Chinese Mystery Cult, Harvard Theological Rev., 1942, p. 221 ff.; W. Fairbank, A Structural Key to Han Mural Art, HJAS, VII, 1942, p. 52 ff.; Chêng Tê-k'un, The Royal Tomb of Wang Chien, HJAS, VIII, 1944–45, p. 235 ff.; Freer Gallery of Art, A Descriptive and Illustrative Catalog of Chinese Bronzes . . ., Washington, 1946; M. Loehr, Clay Figurines and Facsimiles of the Warring States Period, Monumenta Serica, X, 1946, p. 326 ff.; A. de C. Sowerby, Clay Figurines of the Pre-Han Period in China, J. O. Studies, Hong Kong, I, 2, 1946; A. de C. Sowerby, An Unknown Culture from the Ordos Area, Notes d'archéologie et d'ethnologie chinoise, Mus. Heude, I, 1946; J. A. Pope, Sinology or Art History, HJAS, X, 1947, p. 388 ff.; A. G. Wenley, The Question of the Po-shan hsiang-lu, Arch. Chin. Art Soc. Am., IV, 1948–49, p. 5 ff.; J. Buhot, Histoire des arts du Japon, I, Paris, 1949, p. 146 ff.; Chêng Tê-k'un, The Royal Tomb of Wang Chien, Sinologica, II, 1950, p. 50 ff.; H. Maspero, Le Taoïsme, Paris, 1950; R. C. Rudolph, Han Tomb Art of West China, Berkeley, Los Angeles, 1951, figs. 96, 97, 100; G. Ecke, Once Again Hui-hsien: Fraud and Authenticity of the Figurines, Artibus Asiae, XV, 1952, p. 305 ff.; Nihon no Chōkoku (Japanese Sculpture), I, Jōdo jidai (The Ancient Period), Tokyo, 1952; M. Kaltenmark, Le Sio Sien Tchouan: Biographies légendaires des immortels taoïstes de l'antiquité, Peking, 1953, p. 9 ff.; G. Ecke, Hui Hsien Ware in the Collection of the Honolulu Academy of Arts, Honolulu, 1954; W. Fairbank and K. Masao Kitano, Han Mural Paintings in the Pei-yuan Tomb at Liao-yang, South Manchuria, Artibus Asiae, XVII, 1954, p. 238 ff.; S. Noma, The Art of Clay, Primitive Japanese Clay Figurines, Earthenware and Haniwa, Tokyo, 1954 (text in Jap. and Eng.); S. Cammann, Significant Patterns on Chinese Bronze Mirrors, Arch. Chin. Art Soc. Am., IX, 1955, p. 43 ff.; Chang Ch'eng-tsou, Ch'ang-sha ch'ou-t'u Ch'ou-ch'i k'i tu-lu (Catalog of Ch'u and Ch'i Objects Excavated at Cha'ng-sha), Shanghai, 1955; E. von Erdberg-Consten, Die Hui-hsien Figuren und die Kunst der späten Chou Zeit, Oriens Extremus, II, 1955, p. 1 ff.; P. W. Meister, Zu einer Gruppe von Grabfiguren aus "Sha-ti," Oriens Extremus, II, 1955, p. 12 ff.; Wang-Han-mu pi-hua (Wall Paintings of a Han Tomb at Wang-tu), Peking, 1955; Sekai Tōji Zenshū (Ceramic Art of the World), VIII (From Ancient China to the Six Dynasties), Tokyo, 1955, IX (Sui and T'ang Dynasties), Tokyo, 1956, I (Japan: Prehistoric, Protohistoric and Early Historic Periods), Tokyo, 1958; A. Bulling, Die Kunst der Totenspiele in der östlichen Han Zeit, Oriens Extremus, III, 1956, p. 28 ff.; Tseng Chao-chü et al., I-nan ku hua-hsiang shi-mu fa-chüeh pao-kao (An Ancient Picture Brought to Light in the Excavation of a Tomb near I-nan), Nanking, 1956; H. Köster, Symbolik des chinesischen Universismus, Stuttgart, 1958, p. 89 ff.; J. E. Kidder, Japan before Buddhism, London, 1959. *The Islamic world*. E. Cerulli, Il "Libro della Scala" e la questione delle fonti arabo-spagnole della Divina Commedia, Vatican City, 1949; R. Ettinghausen, Persian Ascension Miniatures of the Fourteenth Century, Rome, 1957. *The Christian world. a. General*: R. Garrucci, Storia dell'arte cristiana, 6 vols., Prato, 1872–81; W. Oesterley, Doctrine of the Last Things, London, 1908; G. Hölscher, Ursprünge der jüdischen Eschatologie, Giessen, 1925; Mâle, II; K. Künstle, Ikonographie der christlichen Kunst, 2 vols., Freiburg im Breisgau, 1928; L. Réau, Iconographie de l'art chrétien, II, L'iconographie de la Bible, Ancien et Nouveau Testament, Paris, 1957. *b. Death*: G. Vallardi, Trionfo e danza della morte a Clusone, Milan, 1859; P. Vigo, Le danze macabre in Italia, Livorno, 1878, 2d ed., Bergamo, 1901; D. Largajolli, Una danza dei morti del secolo XVI nell'Alto Trentino, Arch. fiorentino, V, 2, 1886; L. Dimier, Les danses macabres et l'idée de la mort dans l'art chrétien, Paris, 1908; K. Künstle, Die Legende der drei Lebenden und der drei Toten und der Totentanz, Freiburg im Breisgau, 1908; W. F. Storck, Die Legende von den drei Lebenden und den drei Toten, Tübingen, 1910; A. Reuter, Beiträge zu einer Ikonographie des Todes, Leipzig, 1913; W. Weisbach, Trionfi, Berlin, 1919; W. Stammler, Die Totentänze des Mittelalters, Munich, 1922; F. Weber, Das Todes Bild, Berlin, 1923; G. Buchheit, Der Totentanz: Seine Entstehung und Entwicklung, Leipzig, 1926; E. Döhring-Hirsch, Tod und Jenseits im Spätmittelalter, Berlin, 1927; W. Mulertt, Die französischen Totentänze, in Festschrift für E. Wechssler, Jena, 1929, p. 132 ff.; E. Cohyte, The Dance of Death in Spain and Catalonia, Baltimore, 1931; F. Warren, The Dance of Death, London, 1931; A. L. Mayer, Der Triumph des Todes im Palazzo Sclafani in Palermo, Pantheon, IX, 1932, p. 33 ff.; W. Rotzler, RDK, s.v. Drei Lebende und drei Tote, cols. 512–23 (with biblicg.); W. R. Valentiner, Le maître du triomphe de la mort à Palerme, GBA, XVIII, 1937, p. 23 ff.; J. M. Clark, The Dance of Death in the Middle Ages and the Renaissance, Glasgow, 1950; L. Guerry, Le thème du triomphe de la mort dans la peinture italienne, Paris, 1950; S. Camargo, La muerte y la pintura española, Madrid, 1954; H. Rosenfeld, Der mittelalterliche Totentanz, Cologne, 1954, pp. 349–63 (with biblicg. and examples of the major representations of the dance of death in individual localities). *c. The Apocalypse*: H. Wölfflin, Die Kunst Albrecht Dürers, Munich, 1908; H. Wölfflin, Die Bamberger Apokalypse, Munich, 1921; C. Schellenberg, Dürers Apokalypse, Munich, 1923; K. Lohmeyer, Die Offenbarung Johannes, Tübingen, 1926; W. Neuss, Die Apokalypse des Hl. Johannes in der altspanischen und altchristlichen Bibelillustration, Münster in Westfalen, 1931; W. Neuss, RDK, s.v. Apokalypse, cols. 751–81 (with biblicg.), s.v. Ekklesia und Synagoge, cols. 1189–1215 (with biblicg.); F. van der Meer, Maiestas Domini, Théophanies de l'Apocalypse dans l'art chrétien, Vatican City, 1938; J. Renaus, Le cycle de l'Apocalypse de Dionysiou, Paris, 1942; H. Féret, L'Apocalypse de Saint Jean, Paris, 1943; Reallexikon für Antike und Christentum, I, Stuttgart, 1950, s.v. Apokalyptik, col. 504 ff.; C. Brütsch, Clarté de l'Apocalypse, Geneva, 1955; S. Giet, L'Apocalypse et l'histoire, Paris, 1957. *d. The Last Judgment*: P. Jessen, Die Darstellung des Weltgerichts bis auf Michelangelo, Berlin, 1883; G. Voss, Das jüngste Gericht in der Kunst des frühen Mittelalters, Leipzig, 1884; A. Bouillet, Le jugement dernier dans l'art aux douze premiers siècles, Paris, 1894; V. Massèna and E. Müntz, Pétrarque: Ses études d'art, son influence sur les artistes, Paris, 1902; M. Landau, Hölle und Fegfeuer, Heidelberg, 1909; W. H. von der Mülbe, Die Darstellung des jüngsten Gerichts an den romanischen und gotischen Kirchenportalen Frankreichs, Leipzig, 1911; G. Troescher, Weltgerichtbilder in Rathäusern und Gerichtsstätten, Wallraf-Richartz Jhb., N.S., II/III, 1933/34, p. 139 ff.; W. Drost, Das jüngste Gericht des Hans Memling, Vienna, 1941; P. Vulliaud, La fin du monde, Paris, 1952; A. M. Cocagnac, Le jugement dernier dans l'art, Paris, 1955; J. Rupert, The Illustrations of the Heavenly Ladder of Climacus, Princeton, 1956; C. de Tolnay, Michelangelo, V, The Final Period, Princeton, 1960. *Popular and folk imagery*: C. Nisard, Histoire des livres populaires, 2 vols., Paris, 1854; P. L. Duchartre and R. Saulnier, L'imagerie populaire, Paris, 1925; A. Martin, L'imagerie orléanaise, Paris, 1928; A. Bertarelli, L'imagerie populaire italienne, Paris, 1929; E. H. van Heurck and G. J. Boekenoogen, L'imagerie populaire des Pays-Bas, Belgique-Hollande, Paris, 1930; A. M. Hind, An Introduction to a History of Woodcut, 2 vols., London, 1935; E. Bona, Arte religiosa popolare in Italia, Rome, 1942; L. Réau, Iconographie de l'art chrétien, 3 vols., Paris, 1955–59; R. Villeneuve, Le diable dans l'art, Paris, 1957; L. Kriss and R. Rettenbeck, Das Votivbild, Munich, 1958.

Illustrations: PLS. 449–468.

# PLATES

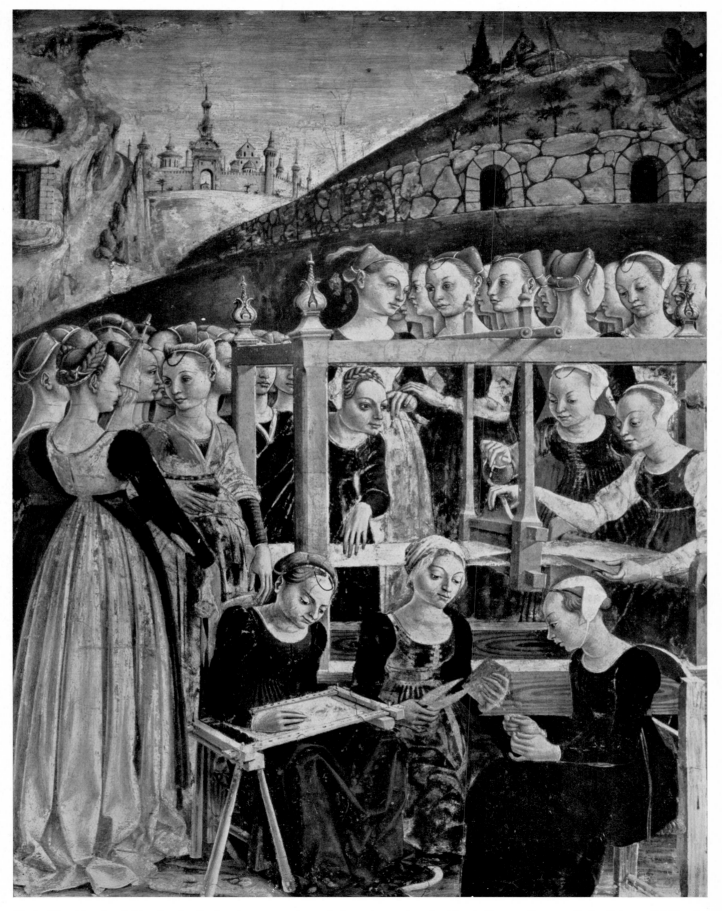

**Pl. 1.** The Month of March, detail showing woman's work (weaving and embroidery). Fresco. Ferrara, Italy, Palazzo Schifanoia.

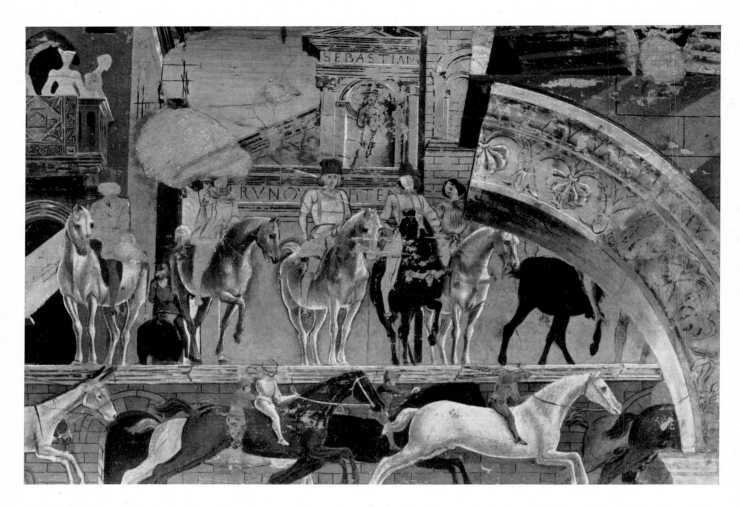

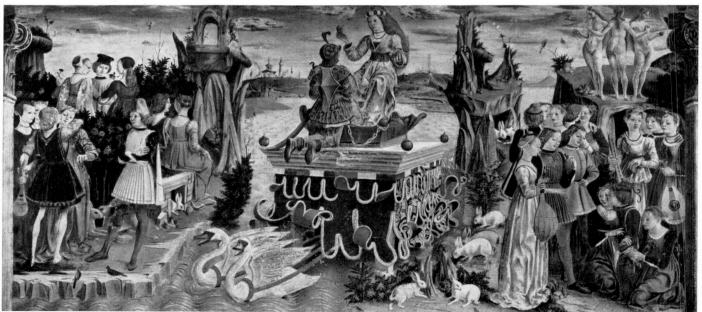

Pl. 2. The Month of April, two details. Fresco. Ferrara, Italy, Palazzo Schifanoia. *Above*: The race of horses and asses. *Below*: Triumph of Venus.

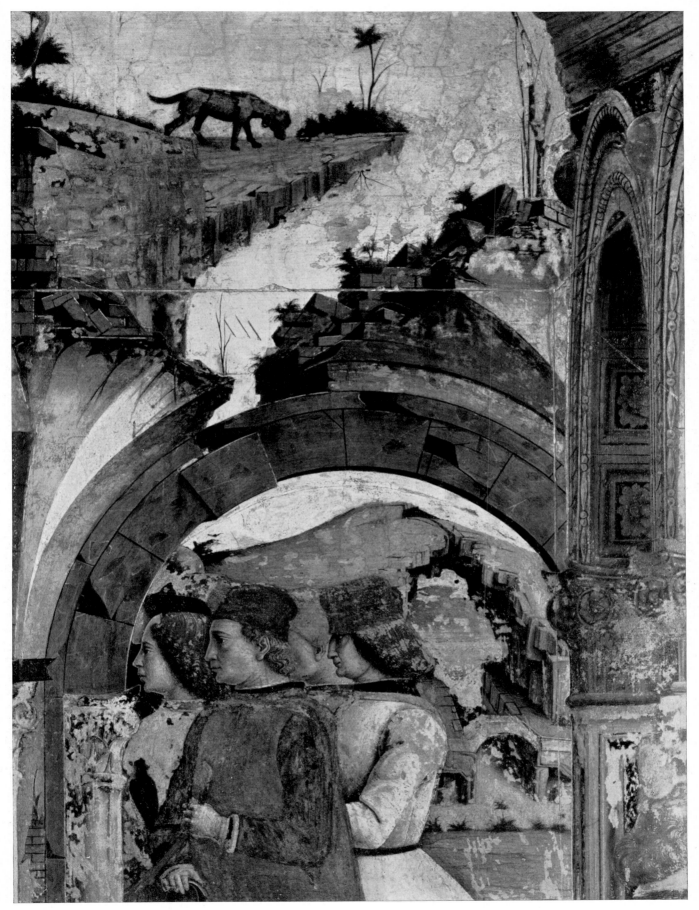

Pl. 3. The Month of March, detail showing the departure for the hunt. Fresco. Ferrara, Italy, Palazzo Schifanoia.

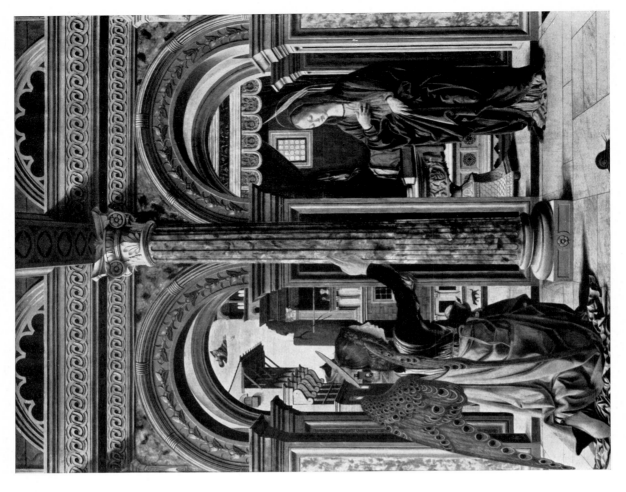

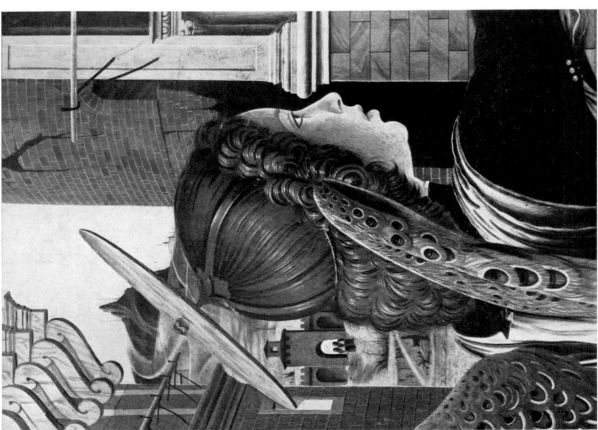

Pl. 4. The Annunciation, detail and whole. Panel, 4 ft, 6 in. × 3 ft, 8½ in. Dresden, Gemäldegalerie.

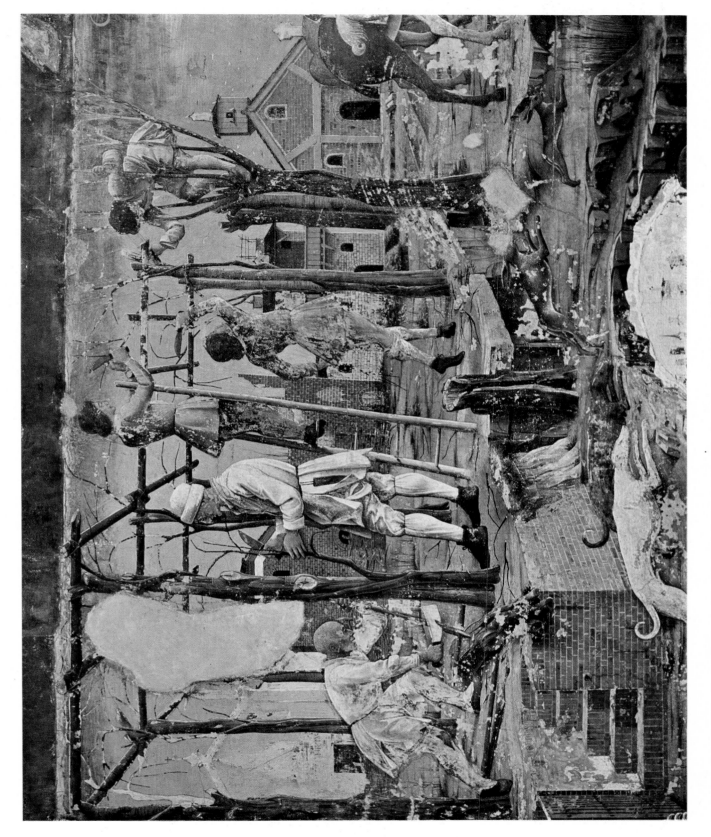

Pl. 5. The Month of March, detail showing the pruning of the vines. Fresco. Ferrara, Italy, Palazzo Schifanoia.

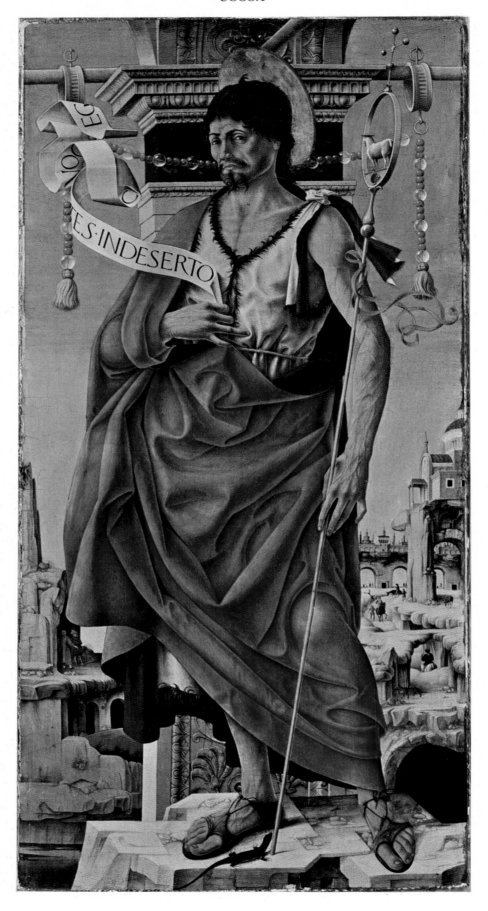

Pl. 6. St. John the Baptist. Panel, 44 1/8 × 21 5/8 in. Milan, Brera.

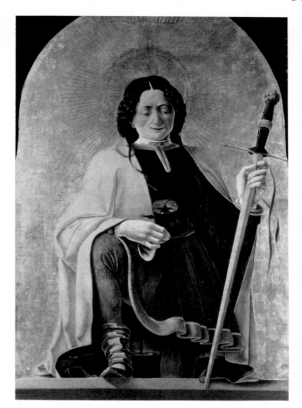

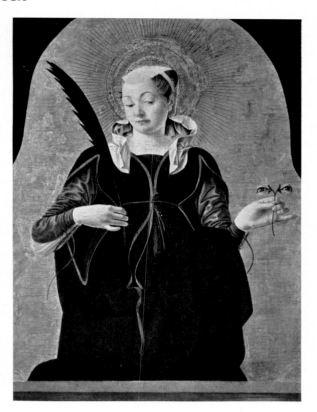

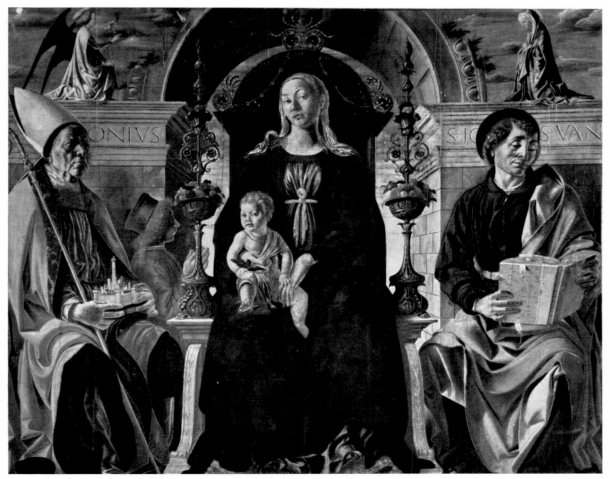

Pl. 7. *Above, left*: St. Florian. Panel, 31¼×21⅝ in. *Right*: St. Lucy. Panel, 31¼×22 in. Both, Washington, D.C., National Gallery. *Below*: Virgin and Child with SS. Petronius and John the Evangelist and Donor, shown with the Annunciation. Canvas, 7 ft., 5⅜ in. × 8 ft., 8¾ in. Bologna, Pinacoteca Nazionale.

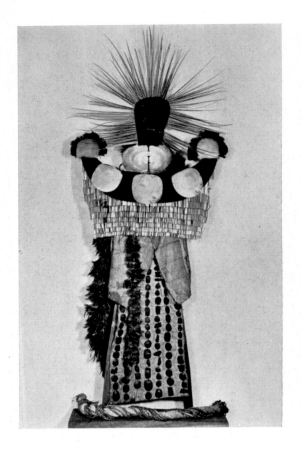

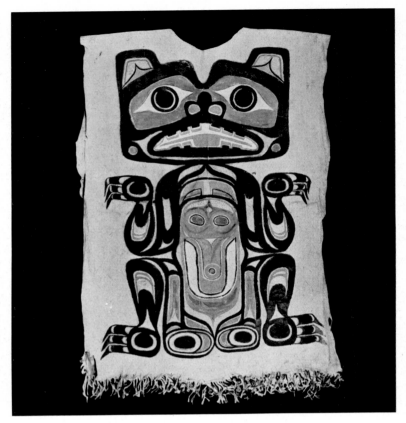

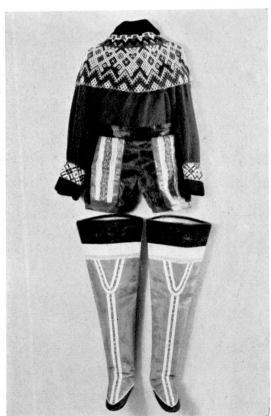

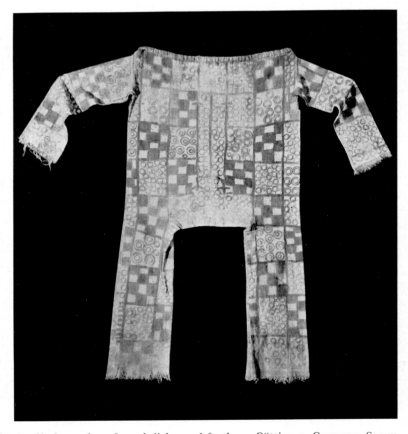

Pl. 8. *Above, left*: Mourning dress, Tahiti, Society Islands. Cloth, mother-of-pearl disks, and feathers. Göttingen, Germany, Sammlung der Universität, Institut für Völkerkunde. *Right*: Tlingit dance costume with painted representation of a bear, Alaska. Skin. Seattle, Washington State Museum. *Below, left*: Angmagssalik Eskimo dress, Greenland. Cloth, colored beadwork, sealskin, and fur. Paris, Musée de l'Homme. *Right*: Senufo dance costume, Volta region, Africa. Cotton. Basel, Switzerland, Museum für Völkerkunde.

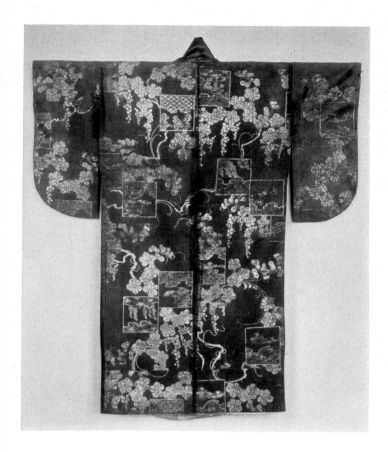
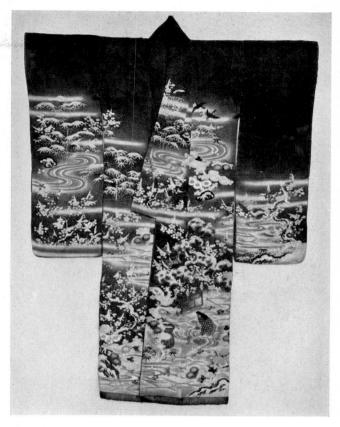
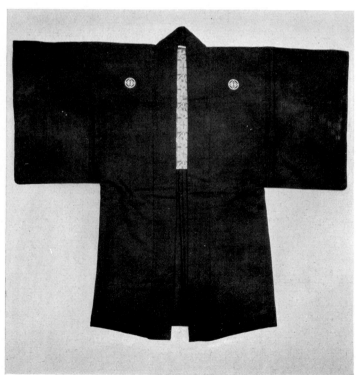
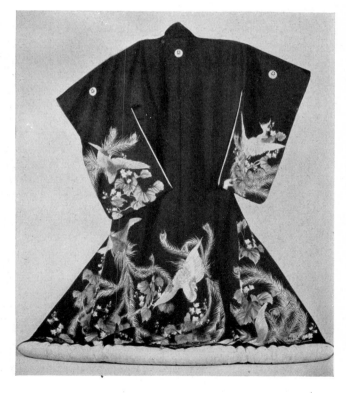

Pl. 9. Japanese costumes. *Above, left*: Robe for No drama, 16th–17th cent. Silk printed in gold. Tokyo, National Museum. *Right*: Kimono, 19th cent. Silk. *Below, left*: Haori with family crest, 19th cent. *Right*: Woman's wedding cloak, 19th cent. Embroidered silk. Last three, New York, Metropolitan Museum.

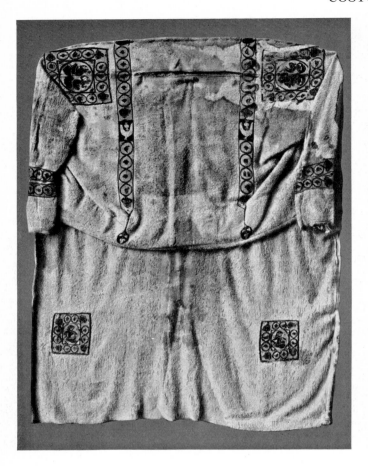

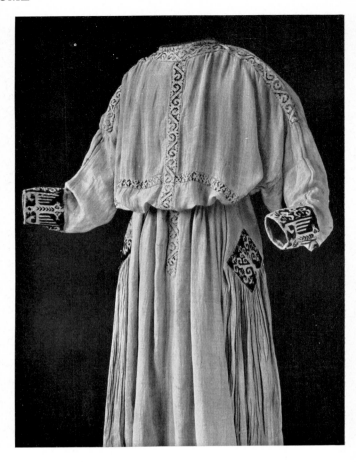

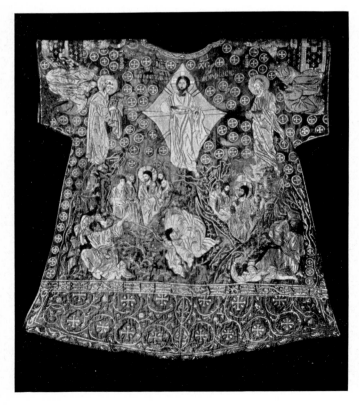

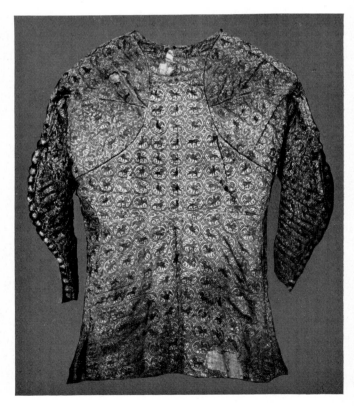

Pl. 10. *Above, left*: Tunic, Coptic, 4th–5th cent. Linen with tapestry-woven decoration. Berlin, Staatliche Museen. *Right*: Alb, German, 13th cent. Linen. Munich, Bayerisches Nationalmuseum. *Below, left*: So-called "dalmatic of Charlemagne," Byzantine, ca. 1400. Silk embroidered in silver and gold. Rome, St. Peter's, Treasury. *Right*: Jerkin of Charles of Blois, French, 16th cent. Embroidered silk. Lyons, Musée Historique des Tissus.

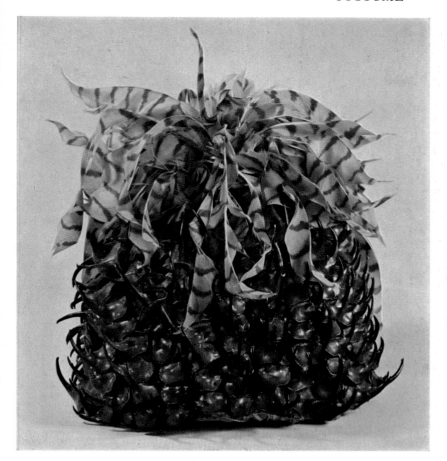
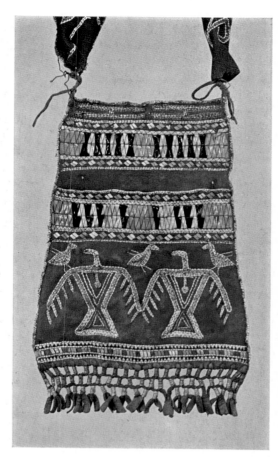
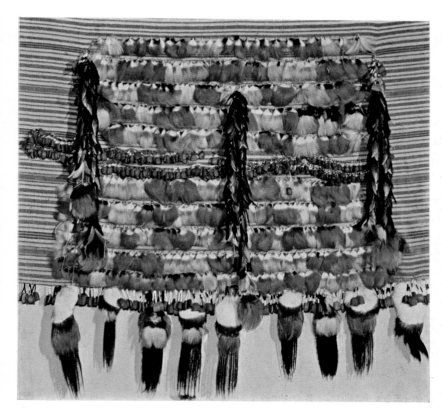
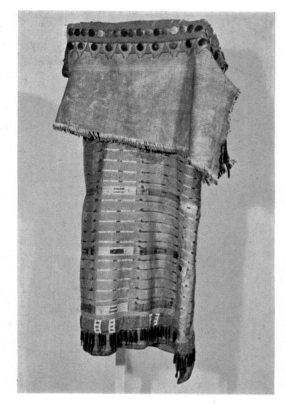

Pl. 11. *Above, left*: Boa braided cap, Congo. Beetle wings and feathers. Tervueren, Belgium, Musée Royal de l'Afrique Centrale. *Right*: Iroquois pouch with quill embroideries representing the thunderbird, New York. Skin. Cambridge, Mass., Peabody Museum of Archaeology and Ethnology. *Below, left*: Jívaro dance apron, Ecuador. Feathers. Hamburg, Museum für Völkerkunde. *Right*: Cree woman's embroidered dress, Canada. Cambridge, Mass., Peabody Museum of Archaeology and Ethnology.

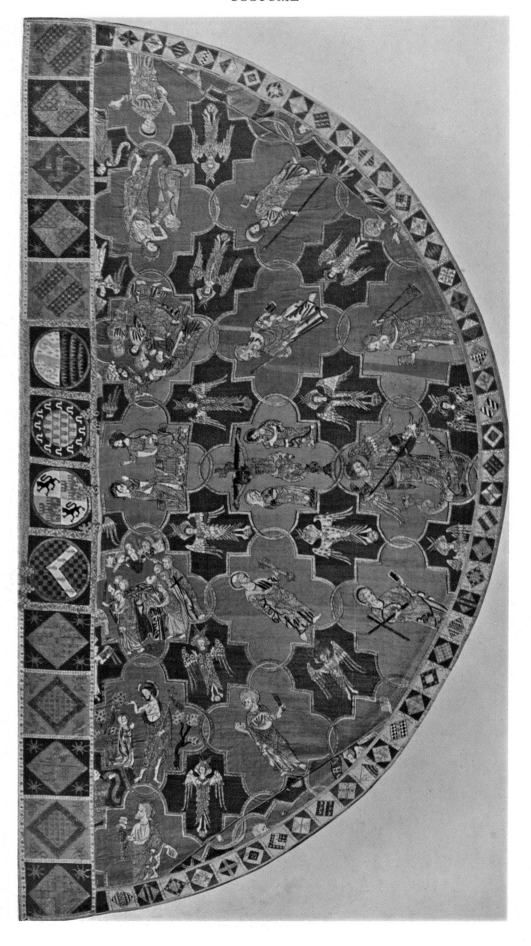

Pl. 12. Cope in opus Anglicum, English, 14th cent. London, Victoria and Albert Museum.

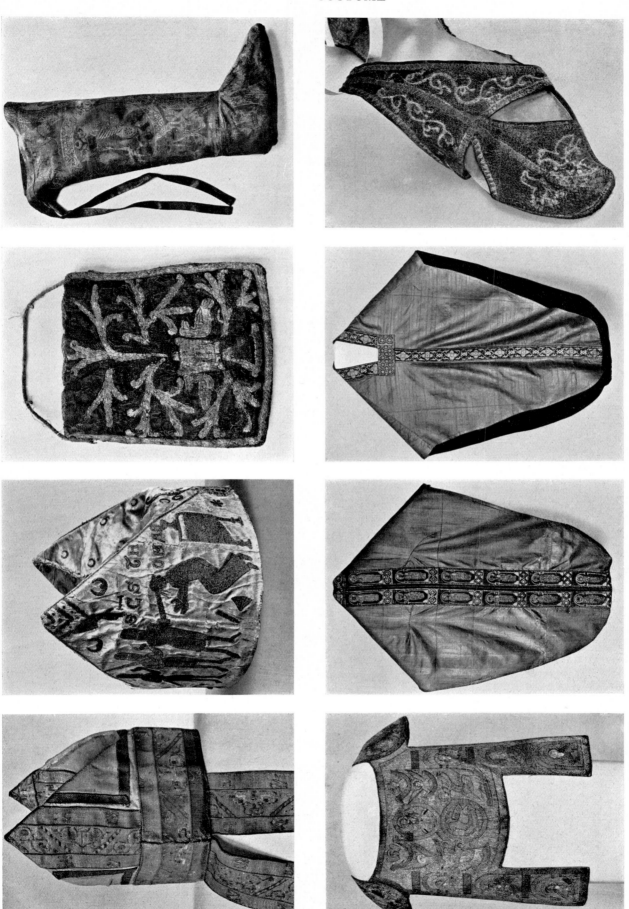

Pl. 13. *Above, left:* Miter of Bishop Hartmann, 12th cent. Silk. Bressanone, Italy, Museo Diocesano. *Center, left:* Miter from the abbey of Seligental, near Landshut, Germany, English, early 13th cent. Linen and silk. Munich, Bayerisches Nationalmuseum. *Center, right:* Reliquary bag, from the Cathedral of Augsburg, late 12th cent. Silk and gold embroidery. Augsburg, Germany, Diocesan Museum. *Right:* Hose of Pope Clement II (1046–47). Silk damask. Bamberg, Germany, Cathedral. *Below, left:* Rational, mid-13th cent. Silk and gold embroidery. Regensburg, Germany, Cathedral Treasury. *Center:* So-called "chasuble of St. Willibald," back and front views, 12th cent. Silk and gold embroidery. Eichstätt, Germany, Cathedral. *Right:* Pontifical sandal of St. Gotthard, 11th cent. Niederaltaich, Germany, sacristy of the Benedictine church.

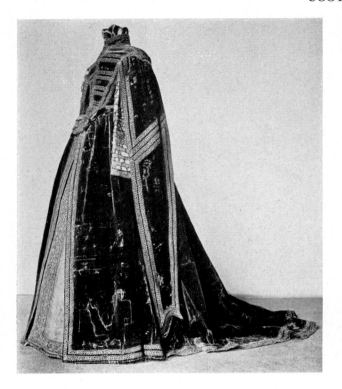

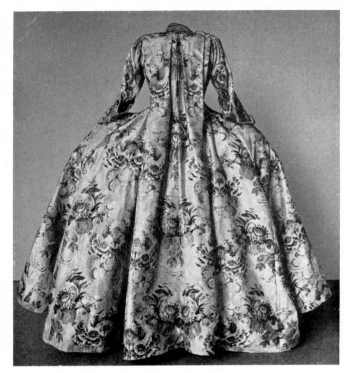

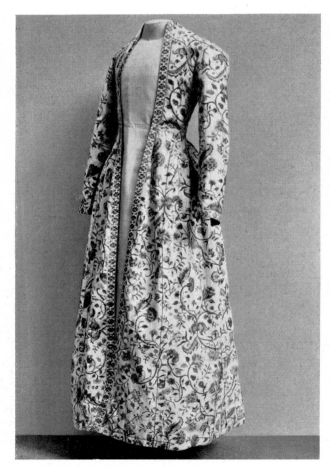

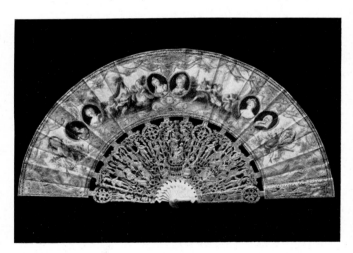

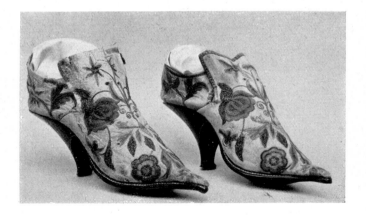

Pl. 14. *Left, above*: Dress of the princess Dorothea Sabina von Pfalz-Neuburg, second half of 16th cent. Velvet and lace. Munich, Bayerisches Nationalmuseum. *Below*: Woman's dressing gown, French, 17th–18th cent. Painted Indian cotton. New York, Metropolitan Museum. *Right, above*: Woman's robe, 18th cent. Brocade. Munich, Bayerisches Nationalmuseum. *Center*: Fan, 18th cent. Carved ivory, embroidered and painted cloth. Florence, Coll. Serristori. *Below*: Woman's shoes, French, 17th cent. White kid embroidered in silk. New York, Metropolitan Museum.

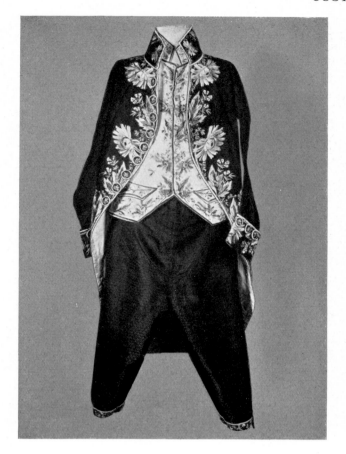

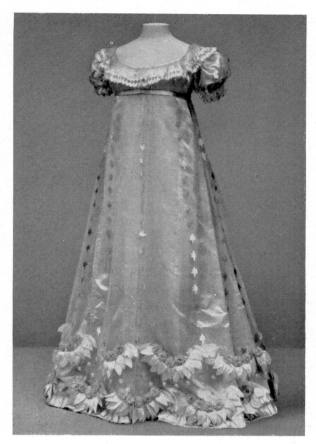

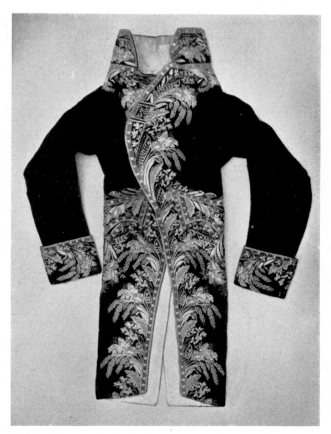

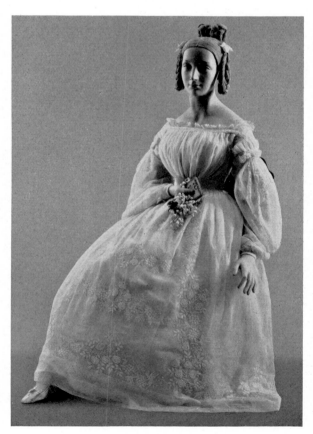

Pl. 15. *Above, left*: Italian costume, late 18th cent. Lucca, Italy, Coll. Garzoni. *Right*: Evening dress, French, early 19th cent. Satin, embroidered tulle, and lace. *Below, left*: Coat of a man's court costume, French, 1804–14. Embroidered brocaded velvet. *Right*: Wedding dress, French, ca. 1837. Embroidered muslin. Last three, New York, Metropolitan Museum.

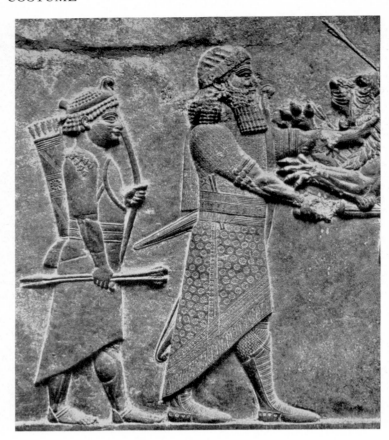

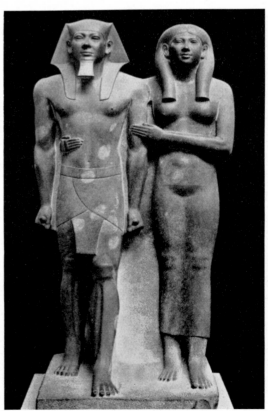

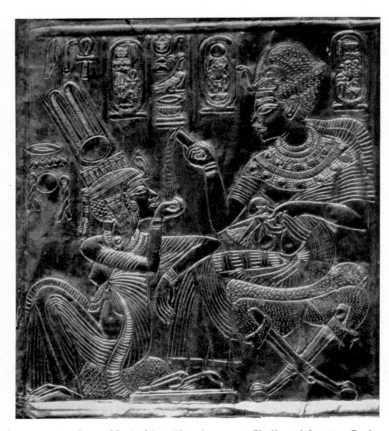

Pl. 16. *Above, left*: Mesopotamian dress. Statuette of a woman, from Mari, 3d millennium B.C. Chalky alabaster. Paris, Louvre. *Right*: Assyrian costume. Ashurbanipal and an archer hunting, relief from Nineveh, detail, ca. 668–626 B.C. Alabaster. London, British Museum. *Below*: Egyptian costume. *Left*: Mycerinus and his queen, 4th dynasty, middle of 3d millennium B.C. Slate. Boston, Museum of Fine Arts. *Right*: Tutankhamen and his queen, detail of a shrine from his tomb, 18th dynasty, middle of 2d millennium B.C. Carved wood overlaid with gold. Cairo, Egyptian Museum.

Pl. 17. *Above, left*: Cretan costume. Figurine from the palace of Phaestos, 1700–1600 B.C. Glazed terra cotta. Heraklion, Crete, Archaeological Museum. *Right*: Archaic Ionic costume. Figurine from Monteguragazza near Bologna, early 5th cent. B.C. Bronze. Bologna, Museo Civico. *Below, left*: Classic Greek costume. Mirror handle, mid-5th cent. B.C. Bronze. Athens, National Museum. *Right*: Hellenistic Greek costume. Figurine of Tanagra type, 3d–2d cent. B.C. Terra cotta. Munich, Antikensammlungen.

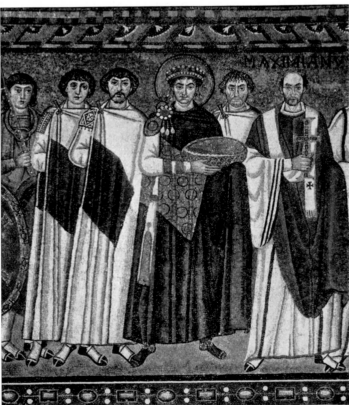
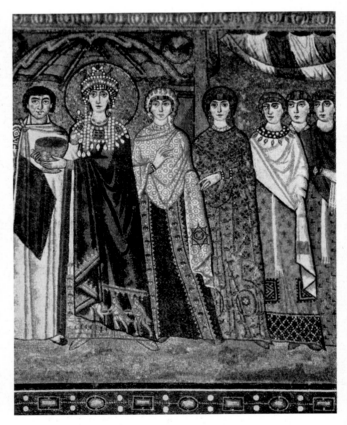

Pl. 18. *Above, left*: Roman man's dress, late 1st cent. B.C. Marble. *Center*: Roman woman's dress, early 2d cent. Marble. Both, Naples, Museo Nazionale. *Right*: Barbarian costume. Dacian prisoner, 2d cent. Porphyry and marble. Florence, Boboli Gardens. *Below*: Byzantine court costume. The emperor Justinian and the empress Theodora and their suites, details, mid-6th cent. Mosaic. Ravenna, Italy, S. Vitale.

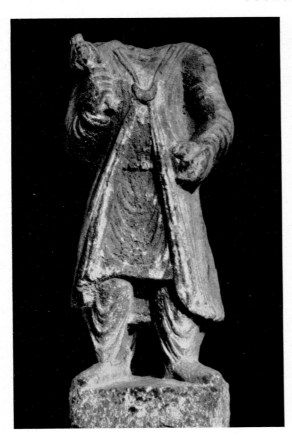
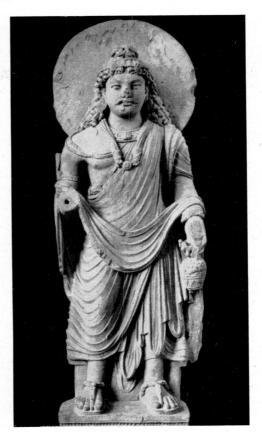
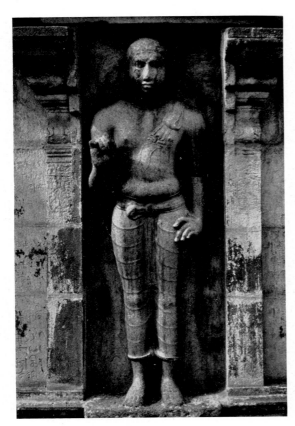
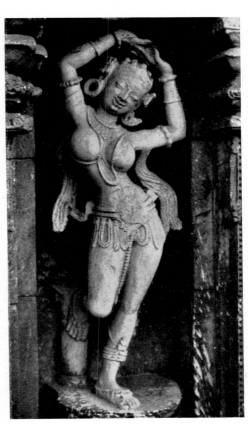

Pl. 19. *Above, left*: Indo-Iranian dress. Figure of an offering bearer, Afghanistan, Kushan period, 1st–3d cent. Stone. Paris, Musée Guimet. *Right*: Dress of Buddhist monk. The bodhisattva Maitreya, from Gandhara, 2d–3d cent. Stone. Formerly, Mardan, Pakistan, Guides' Mess. *Below*: Indian dress. *Left*: Figure of a divinity, ca. 8th cent. Stone. Bhuvaneshwar, Orissa, India, Paraśurāmeśvara temple. *Right*: Figure of a dancer, ca. 8th cent. Stone. Bhuvaneshwar, Liṅgarāja temple.

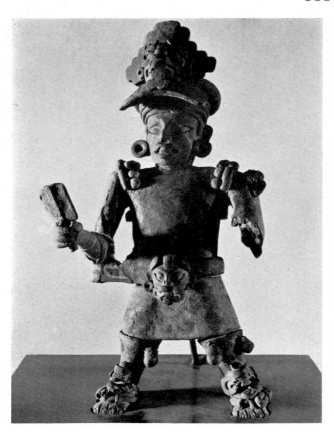

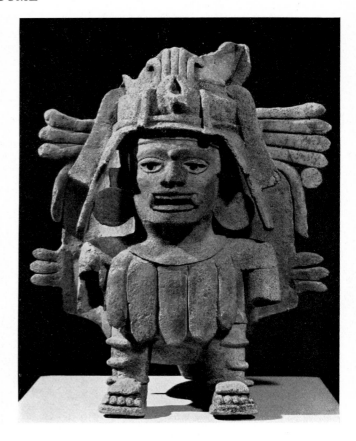

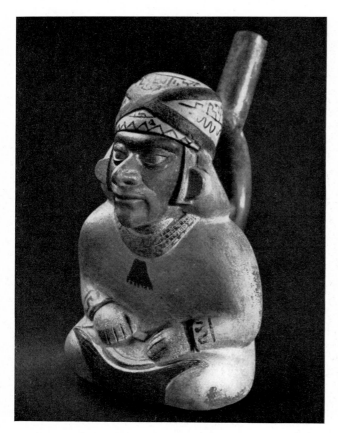

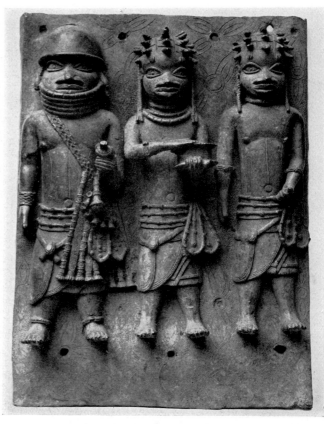

Pl. 20. *Above, left*: Pre-Columbian costume. Zapotec figurine in ceremonial dress, Oaxaca, Mexico. Terra cotta. Mexico City, Museo Nacional de Antropología. *Right*: Mayan costume with feather ornaments. Figurine from northeast Yucatán, Mexico. Terra cotta. Hollywood, Stendahl Art Galleries. *Below, left*: Man's dress of the ruling class. Figurine from the Moche Valley, Peru. Clay. Lima, Museo Nacional de Antropología y Arqueología. *Right*: Ceremonial dress from Benin, Nigeria, ca. 1500 (?). Bronze. London, British Museum.

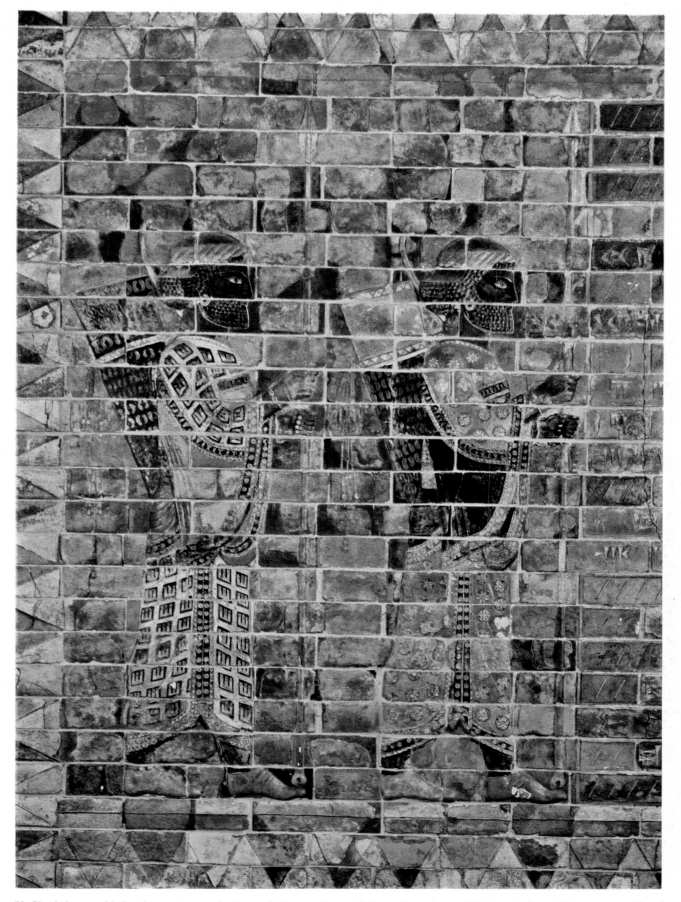

Pl. 21. Achaemenid Persian costume. Archers of the royal guard from the palace of Darius in Susa, 5th cent. B.C. Glazed brick. Paris, Louvre.

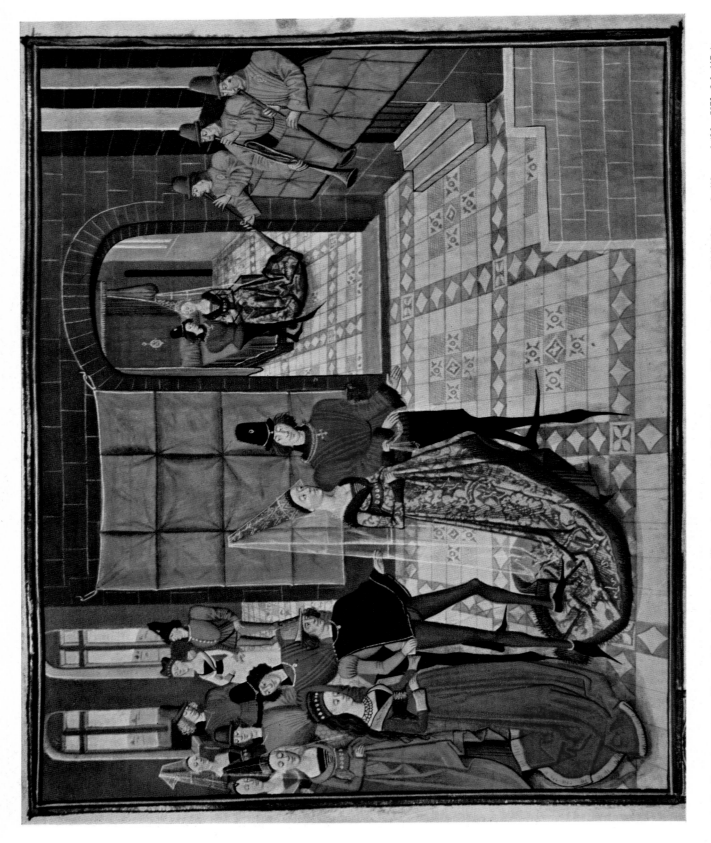

Pl. 22. French costume. The wedding of Renaud de Montauban, second half of 15th cent. Illumination. Paris, Bibliothèque de l'Arsenal (Ms. 5073, fol. 117v).

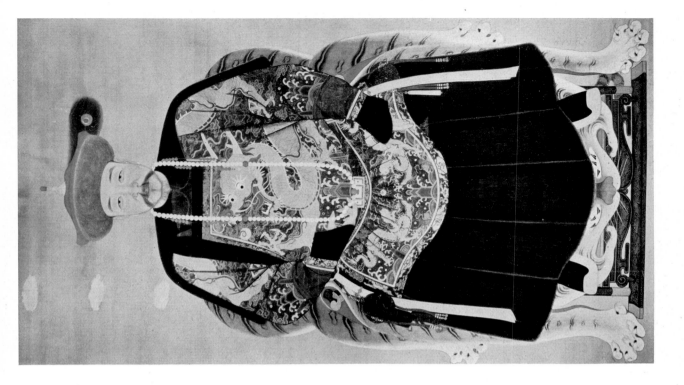

Pl. 23. Chinese court costume. *Left*: Figure of an offering bearer, from Tun-huang, T'ang dynasty (618–906). Color on silk. Paris, Musée Guimet. *Right*: Manchu nobleman of the 17th cent. in winter court dress, Ch'ing dynasty (1644–1912). Woodcut. New York, Metropolitan Museum.

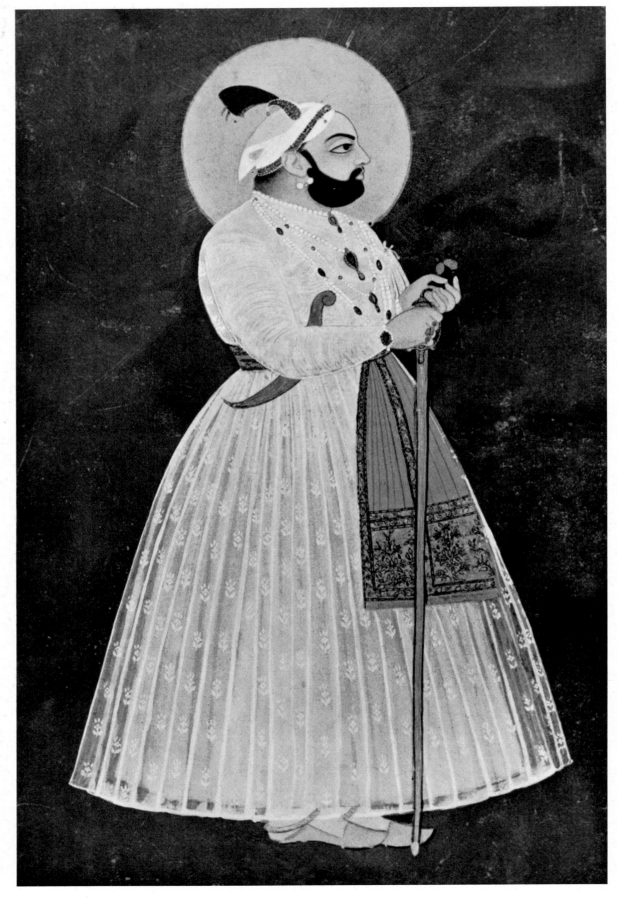

Pl. 24. Royal Indian costume, 18th cent. The Maharana Pratap Singh XI of Udaipur. Rajput school. Udaipur, Indian Union, Coll. of the Maharana.

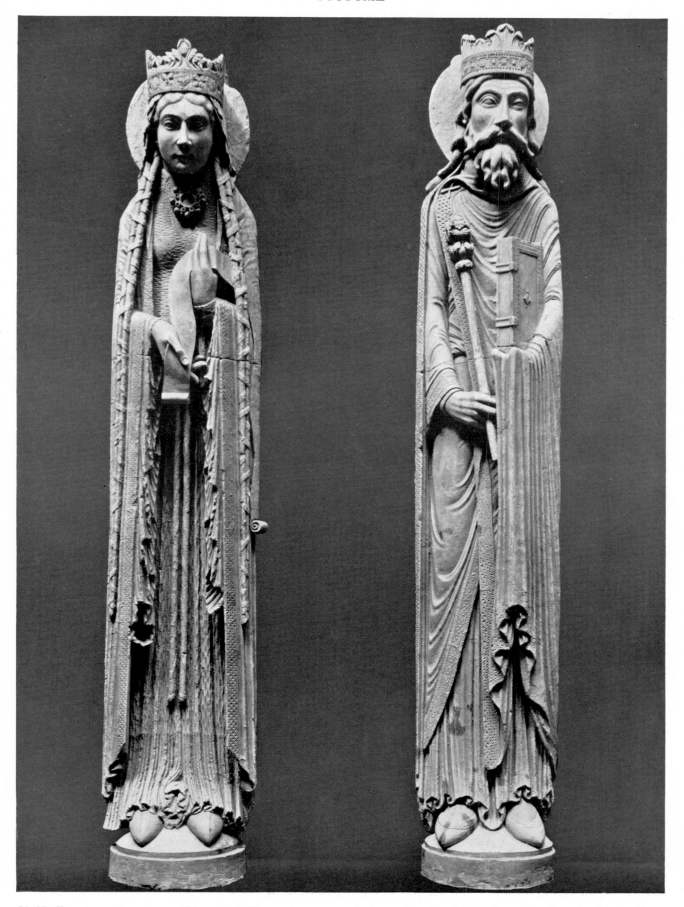

Pl. 25. French court costume, 12th cent. A king and a queen, plaster casts of sculptures from the Church of Notre-Dame (destroyed) at Corbeil, Seine-et-Oise, France. Paris, Louvre.

# COSTUME

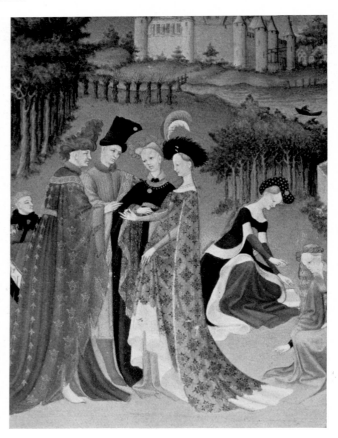

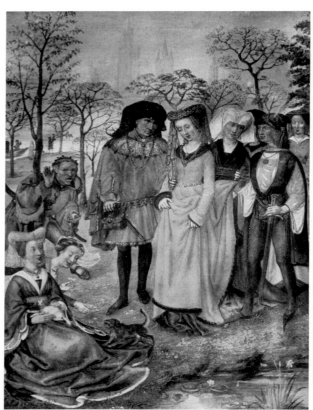

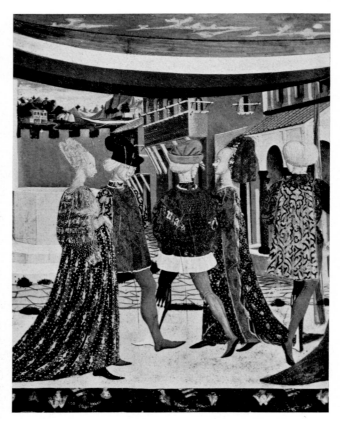

Pl. 26. *Above, left*: German costume, 14th cent. Manessa Codex. Illumination. Heidelberg, Universitätsbibliothek (Ms. 848, fol. 110v). *Right*: French costume, early 15th cent. Limbourg brothers, illumination from the *Très Riches Heures du Duc de Berry*. Chantilly, France, Musée Condé. *Below, left*: Flemish dress, second half of 15th cent. Illumination from the Grimani Breviary. Venice, Biblioteca Marciana. *Right*: Florentine costume, mid-15th cent. Wedding *cassone* of Boccaccio Adimari and Lisa Ricasoli, detail. Florence, Galleria dell'Accademia.

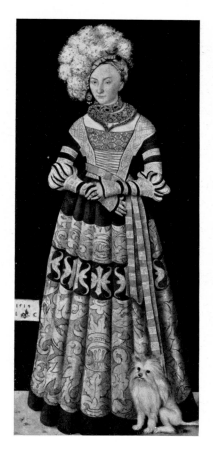

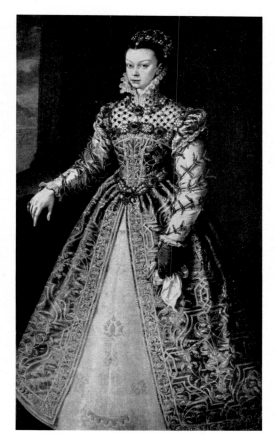

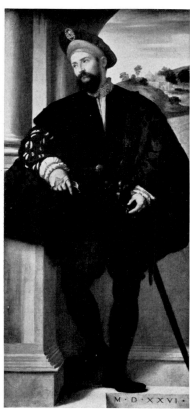

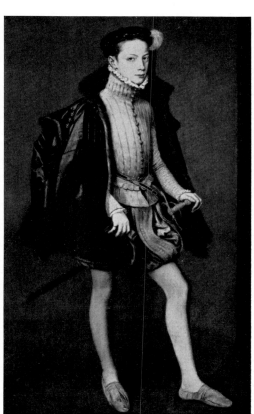

Pl. 27. Costumes of the 16th cent. *Above, left*: L. Cranach the Elder, Katharina von Mecklen-
burg, 1514. Panel. Dresden, Gemäldegalerie. *Right*: A. Sánchez Coello, Elizabeth of
Valois, Queen of Spain, ca. 1560. Canvas. Vienna, Kunsthistorisches Museum. *Below,
left*: Moretto da Brescia, Italian nobleman, 1526. Canvas. London, National Gallery.
*Right*: A. Mor, Alessandro Farnese, 1557. Canvas. Parma, Galleria Nazionale.

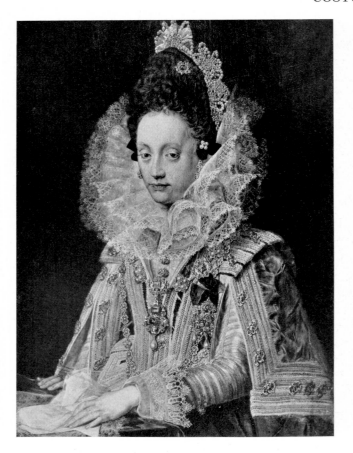

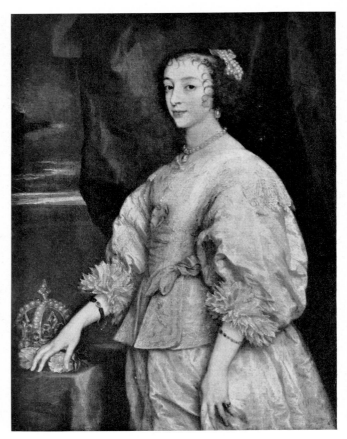

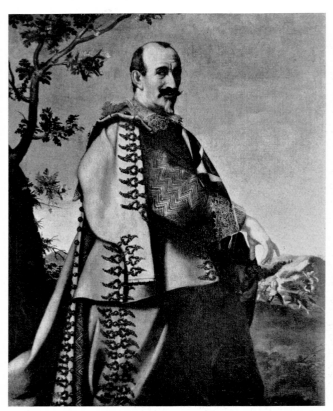

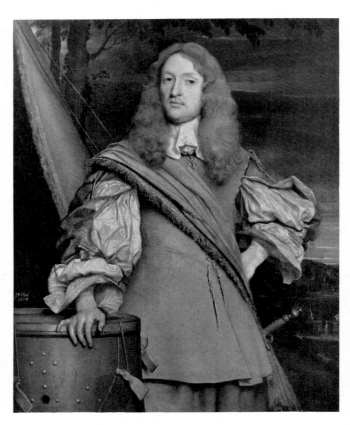

Pl. 28. Costumes of the 17th cent. *Above, left*: P. Candid, the duchess Magdalena von Neuburg, 1613. Canvas. Munich, Bayerische Staatsgemäldesammlungen. *Right*: A. van Dyck, Henrietta Maria of England, ca. 1635. Canvas. Windsor, England, Royal Collections. *Below, left*: C. Dolci, Ainolfo de' Bardi, Knight of Malta, ca. 1632. Canvas. Florence, Pitti. *Right*: J. Wright, Colonel John Russell, 1659. Canvas. London, Victoria and Albert Museum.

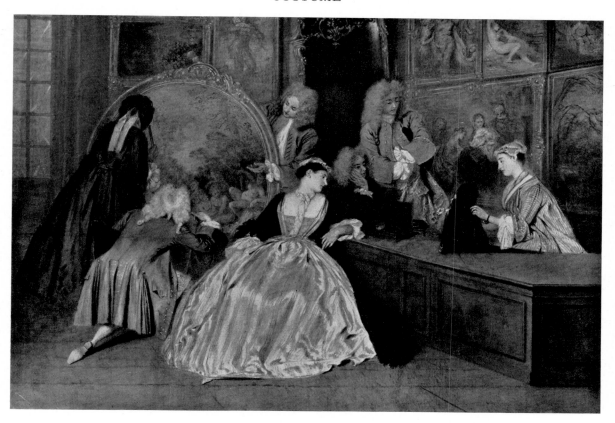

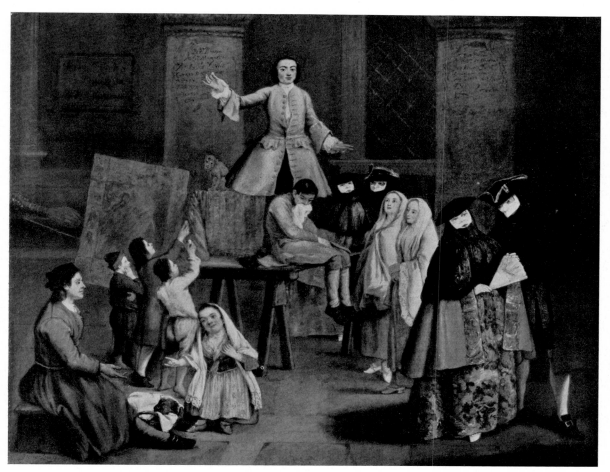

Pl. 29. *Above*: French costume, first half of 18th cent. J. A. Watteau, Gersaint's Signboard, detail, 1720. Panel. Berlin, Staatliche Museen. *Below*: Venetian costume, mid-18th cent. P. Longhi, The Tooth Puller. Canvas. Milan, Brera.

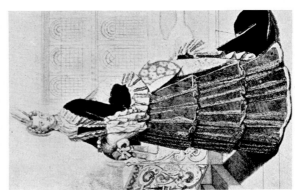

Pl. 30. Fashion plates. *Above:* Court costumes, first half of 15th century. *Left:* Pisanello (A. Pisano), sheet of costume studies. Pen and water color. Bayonne, France, Musée Bonnat. *Center:* Woodcuts from C. Vecellio, *Habiti Antichi et Moderni di tutto il mondo*, Venice, 1598. Venetian dress (*left*), early 16th cent.; costume of a Spanish nobleman (*right*), 16th cent. *Right:* French costume, early 17th cent. Etching by A. Bosse, from *Jardin de la noblesse française*, 1629. *Below, left:* French costume, early 18th cent. Engraving. *Pair at right:* Costumes of late 18th cent. Engraving. *Second left:* French dress, late 17th cent. Engraving. *Center:* Women's headdresses, second half of 18th cent. Engraving. *Pair at right:* Costumes of late 18th cent. Engravings from the *Journal des Luxen und der Moden*, Weimar, 1788.

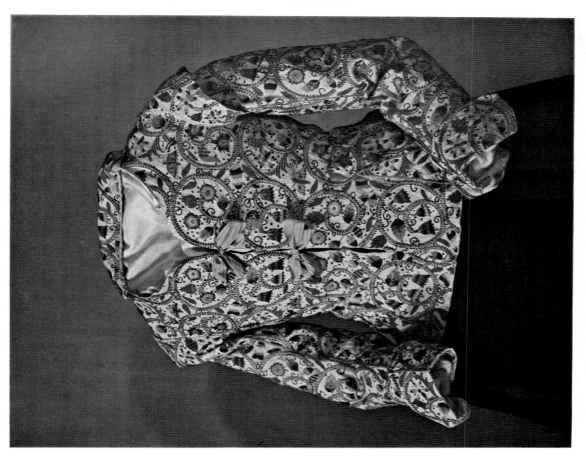

Pl. 31. *Left*: Man's costume, period of James I (1603–25). Embroidered silk. London, Victoria and Albert Museum. *Right*: Woman's jacket, England, early 17th cent. Embroidered silk. Chipping Sodbury, Gloucestershire, England, Eric B. Porter Coll.

Pl. 32. Italian gala folk costume. *Left*: Dress of Monte Sant'Angelo, Apulia. *Center*: Costume of Piana dei Greci, Sicily. *Right*: Fisherman's costume from Cagliari, Sardinia. All, Rome, Museo Nazionale delle Arti e delle Tradizioni Popolari.

Pl. 33. Fashion plates. *Above, left:* Gala dress, France, ca. 1805. *Center, left:* Walking dress from *Costumes Parisiens*, Paris, 1826. *Center, right:* Walking dress from *La Mode*, Paris, 1834. *Right:* Walking dress from *Le Moniteur de la Mode*, Paris, 1852. *Below, left:* Walking dress from *Haute Nouveauté de Paris*, Paris, 1873. *Second left:* Walking dress, ca. 1890. Lithograph. *Center:* M. de Solar, dinner dress, 1900. Lithograph. *Second from right:* Kaby, evening dress, 1924. Dry point. *Right:* C. Dior, afternoon dress. 1950. Drawing.

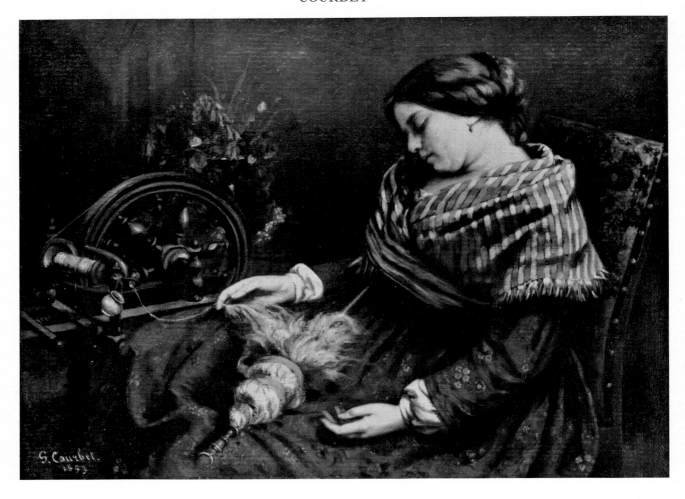

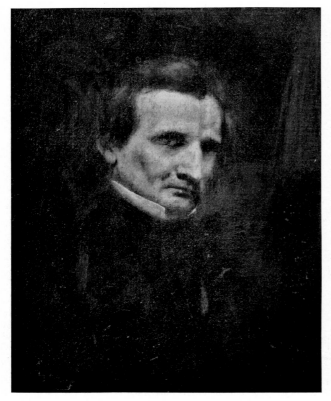

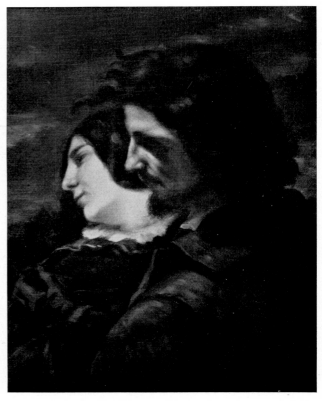

Pl. 34. *Above*: The Sleeping Spinner. Canvas, 35⁷/₈×45¹/₄ in. Montpellier, France, Musée Fabre. *Below, left*: Hector Berlioz. Canvas, 24×18⁷/₈ in. Paris, Louvre. *Right*: Lovers in the Country. Canvas, 24×19³/₄ in. Paris, Musée du Petit-Palais.

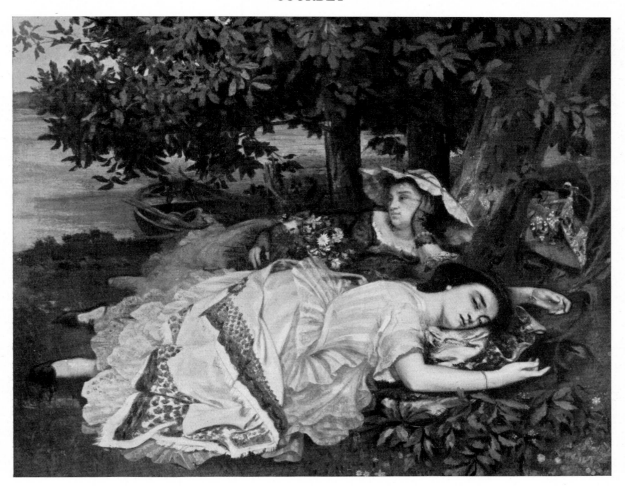

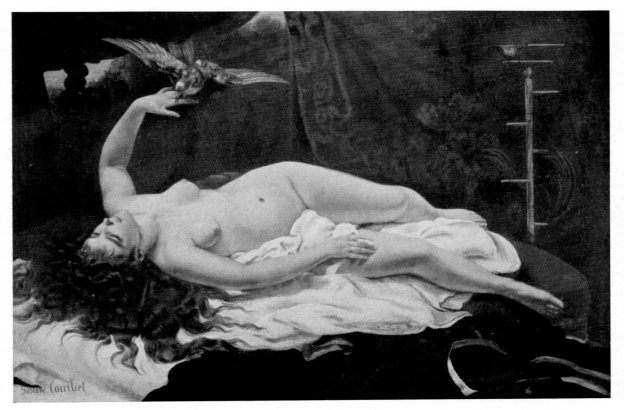

Pl. 35. *Above*: Young Ladies by the Seine. Canvas, 5 ft., 8 1/2 in. × 6 ft., 9 1/8 in. Paris, Musée du Petit-Palais.
*Below*: Woman with a Parrot. Canvas, 4 ft., 3 in. × 6 ft., 5 in. New York, Metropolitan Museum.

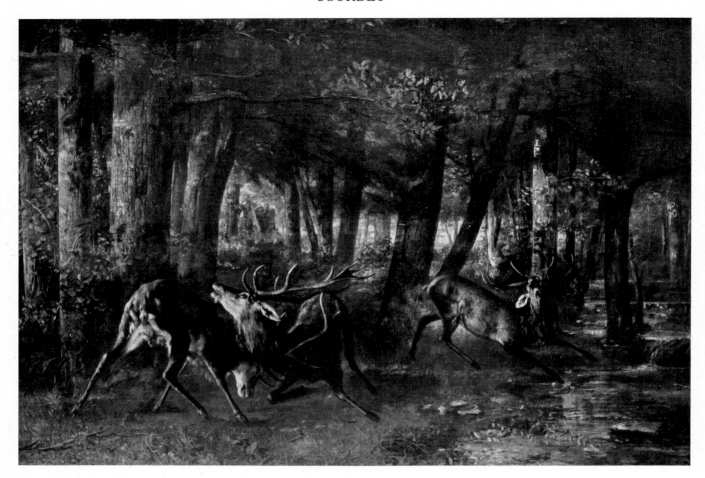

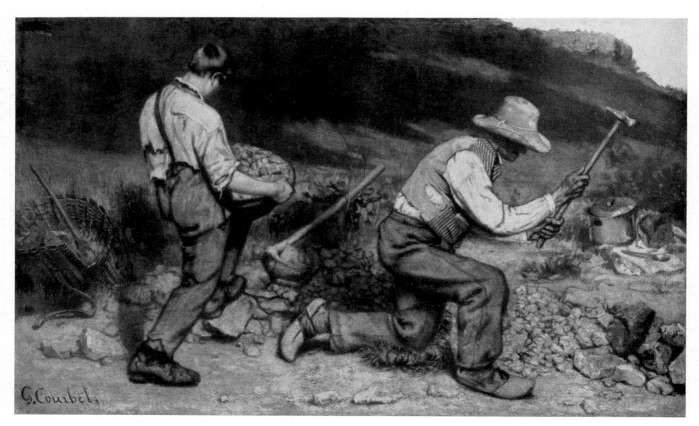

Pl. 36. *Above*: Fighting Stags. Canvas, 11 ft., 9 in. × 16 ft., 5³/₈ in. Paris, Louvre. *Below*: The Stone Breakers. Canvas, 5 ft., 2⁵/₈ in. × 8 ft., 6 in. Formerly, Dresden, Gemäldegalerie. (Destroyed in 1945.)

Pl. 37. The Man with the Leather Belt (self-portrait). Canvas, 39 3/8 × 32 1/4 in. Paris, Louvre.

Pl. 38. The Artist's Studio. Canvas, 11 ft., $9^{3}/_{8}$ in. × 19 ft., $6^{5}/_{8}$ in. Paris, Louvre.

Pl. 39. The so-called "Fürstenaltar," showing the Virgin and Child with saints and donors. Panel; central section, 41³/₄×36¹/₄ in.; wings, 41³/₄×18¹/₈ in. Dessau, Germany, Staatliche Galerie.

Pl. 40. *Above, left*: Bathsheba at the Bath. Panel, 14¹/₈×9¹/₂ in. *Right*: Apollo and Diana. Panel, 18¹/₂×13³/₄ in. Both, Berlin, Staatliche Museen. *Below*: Reclining Nymph. Panel, 23¹/₄×36¹/₄ in. Leipzig, Museum der bildenden Künste.

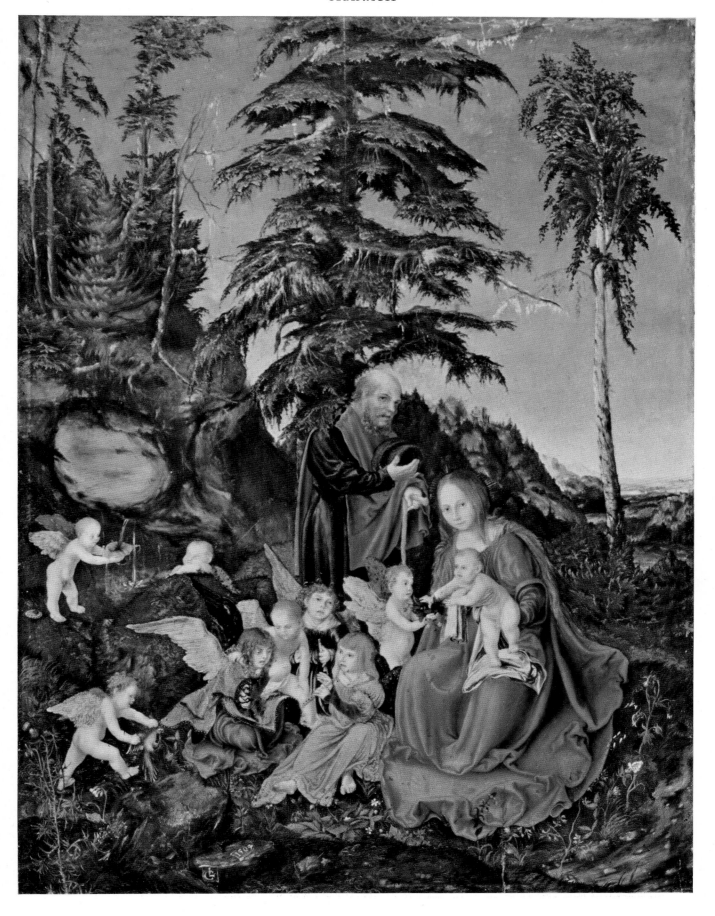

Pl. 41. Rest on the Flight into Egypt. Panel, 27 1/8 × 20 1/8 in. Berlin, Staatliche Museen.

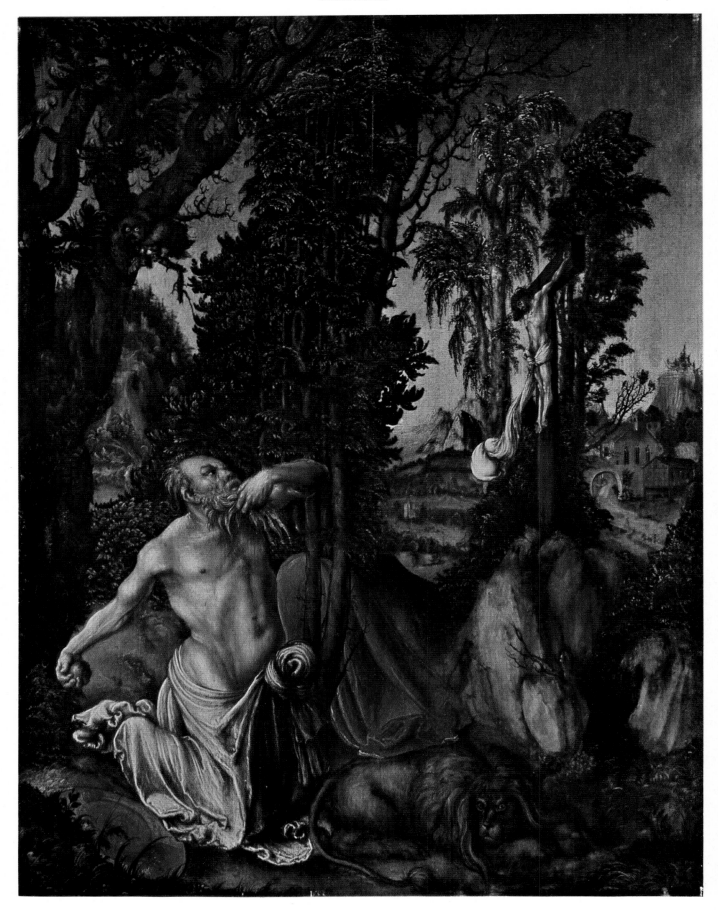

Pl. 42. St. Jerome Penitent. Panel, 21⁵/₈×16¹/₈ in. Vienna, Kunsthistorisches Museum.

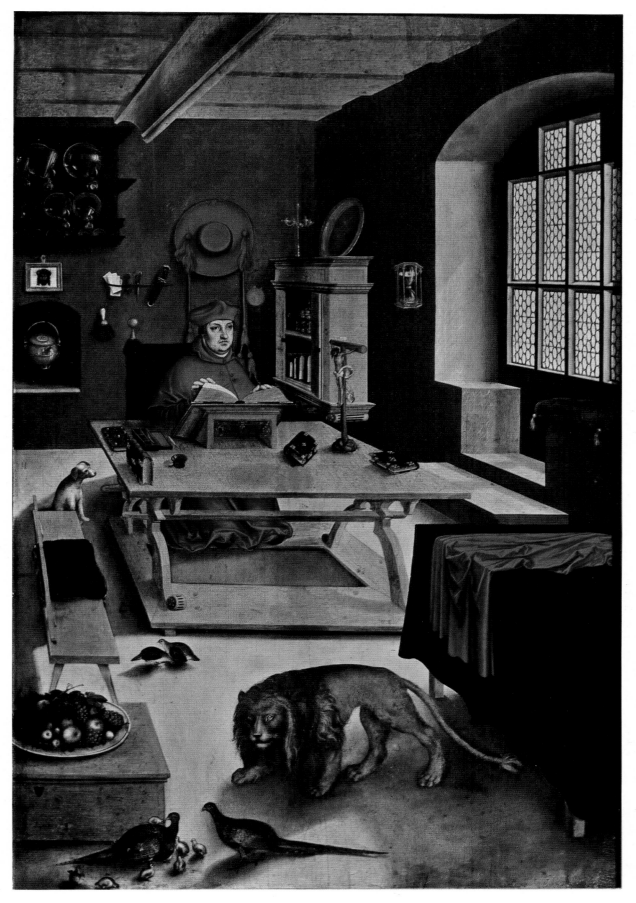

Pl. 43. Cardinal Albert of Brandenburg as St. Jerome in His Study. Panel, 45$\frac{1}{4}$×30$\frac{1}{4}$ in. Darmstadt, Germany, Landesmuseum.

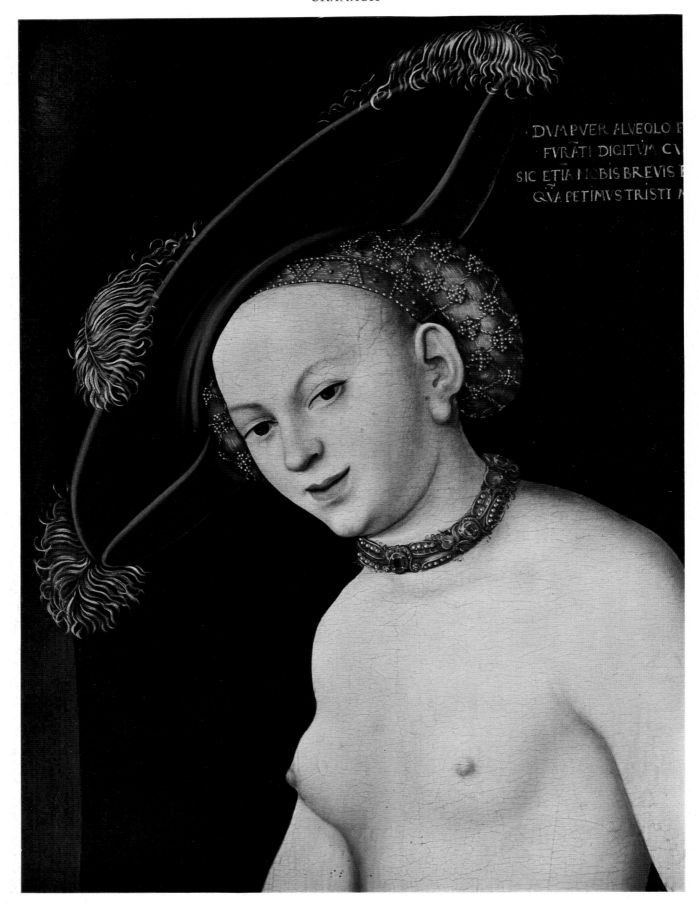

Pl. 44.  Venus with Cupid as a Honey Thief, detail. Panel; full size, 5 ft., 6½ in.  ×  2 ft., 2⅜ in. Rome, Galleria Borghese.

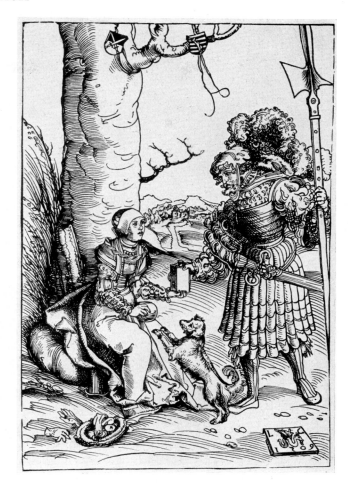

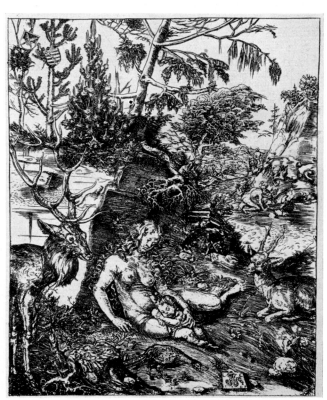

Pl. 45. *Above, left*: Duke Ernest of Brunswick-Grubenhagen. Oil and gouache on paper, 13³/₈×9 in. Reims, France, Musée des Beaux-Arts. *Right*: David and Abigail. Woodcut. *Below, left*: Landesknecht, and lady with a plumed hat. Woodcut. *Right*: Penance of St. John Chrysostom. Engraving.

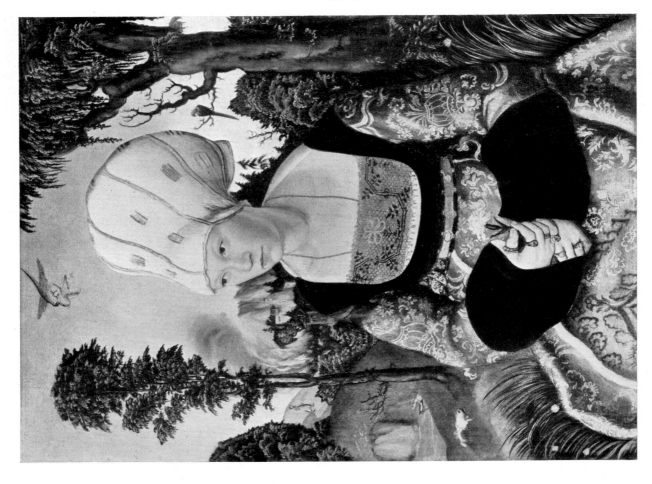

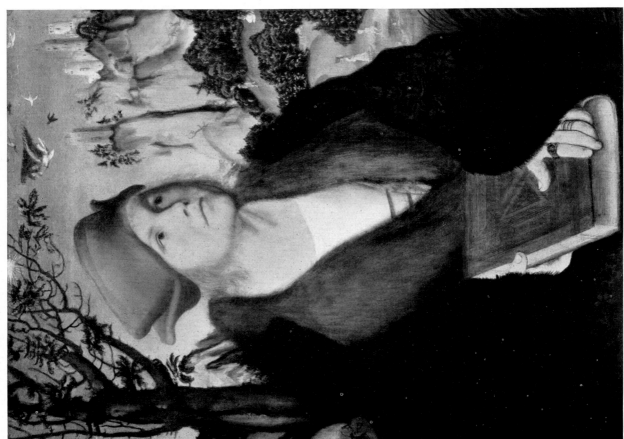

Pl. 46. *Left*: Portrait of Johannes Cuspinian. Panel, 23¼×17¾ in. *Right*: Portrait of Anna Putsch, wife of Johannes Cuspinian. Panel, 23¼×17¾ in. Both, Winterthur, Switzerland, Oskar Reinhart Coll.

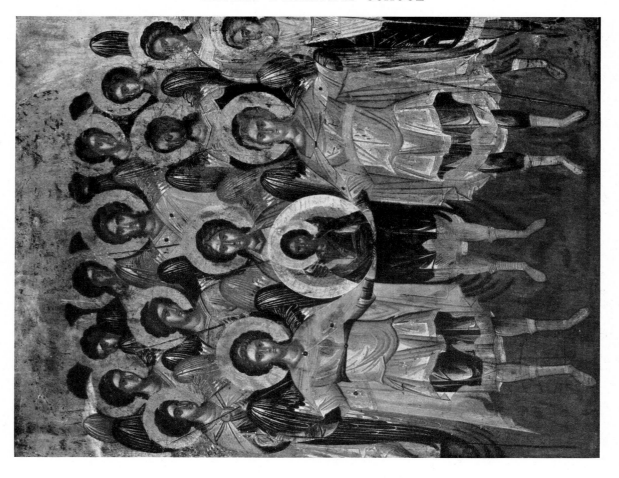

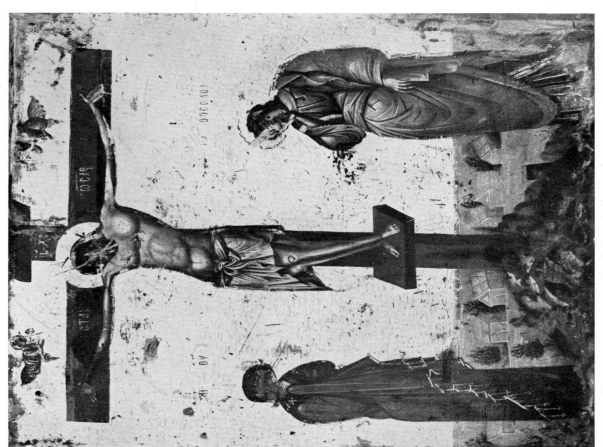

Pl. 47. *Left*: The Crucifixion, from Salonika, 14th cent. Panel, 47¹/₂×39³/₈ in. Athens, Byzantine Museum. *Right*: Assembly of Angels, 16th cent. Panel, 23⁵/₈×18⁷/₈ in. Athens, Coll. S. Haracopos.

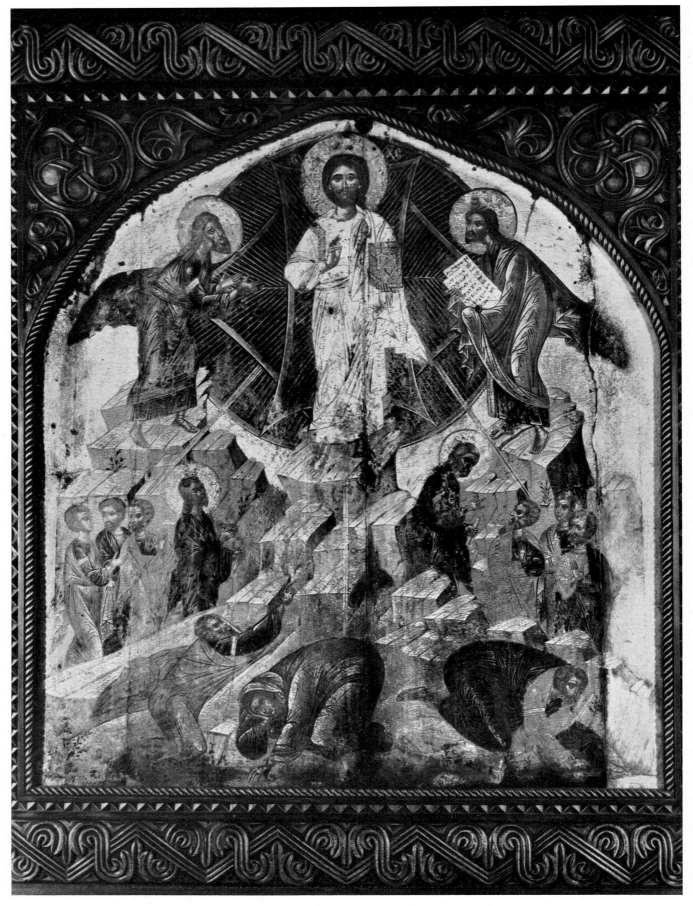

Pl. 48. The Transfiguration, 16th cent. Panel, 4 ft., 9 1/8 in. × 4 ft., 3 1/8 in. Athens, Benaki Museum.

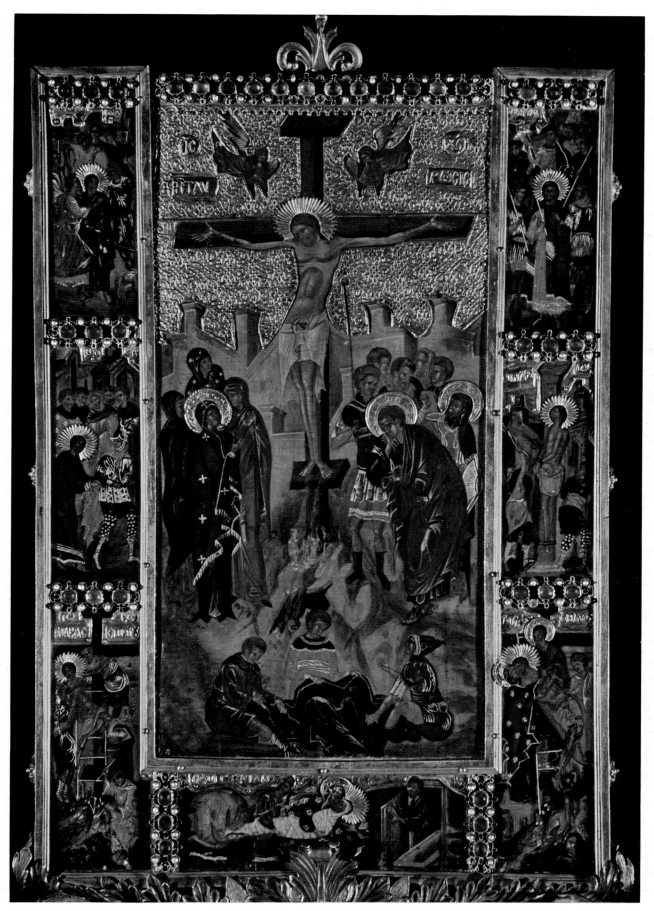

Pl. 49. The Crucifixion and scenes of the life of Christ, from the Reliquary of Cardinal Bessarion, 15th cent. Panel, with silver and precious stones, $18^{1}/_{2} \times 12^{5}/_{8}$ in. Venice, Accademia.

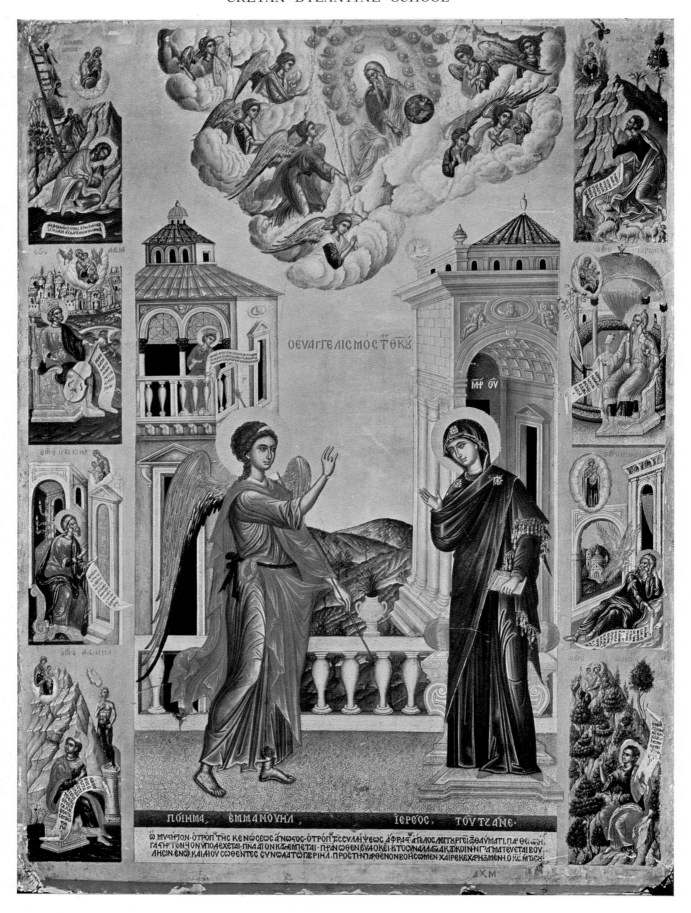

Pl. 50. Emmanuel Tsane, The Annunciation, with prophets, 1640. Panel, 37³/₄×28³/₈ in. Berlin, Staatliche Museen.

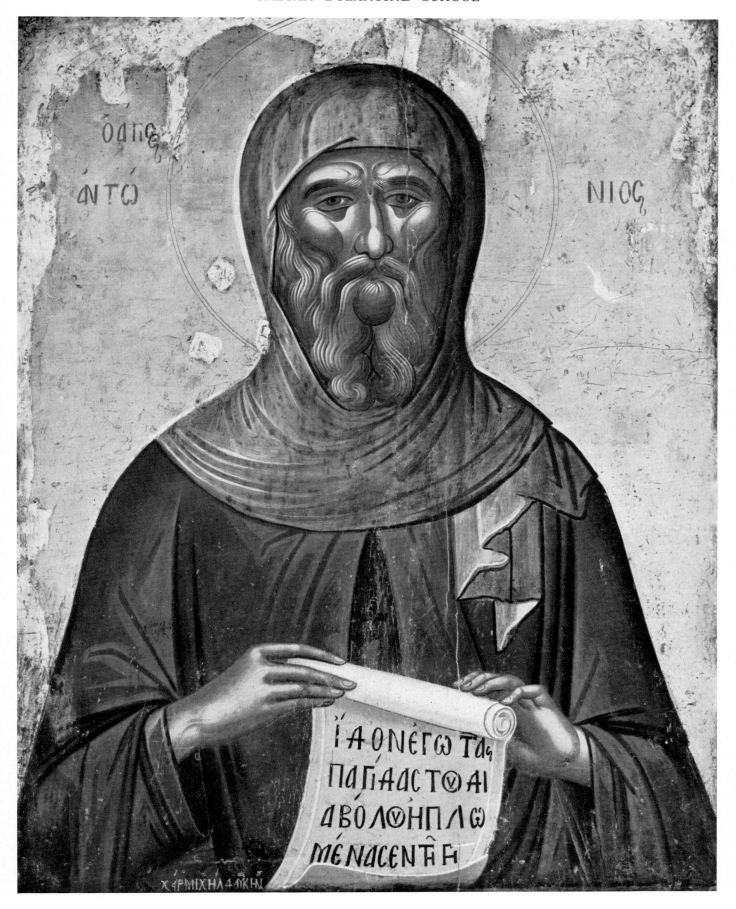

Pl. 51. Michael Damaskenos, St. Anthony, 16th cent. Panel, 33 ⁷/₈ × 26 ³/₈ in. Athens, Byzantine Museum.

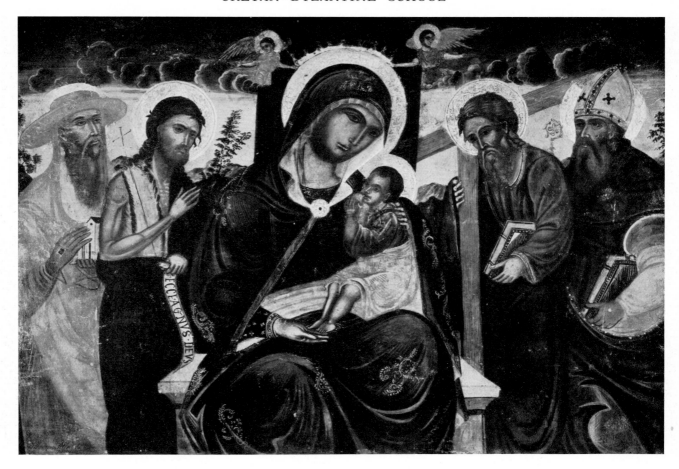

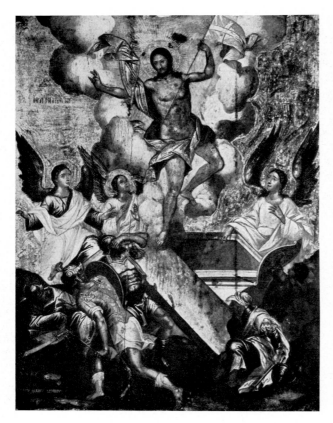

Pl. 52. *Above*: Giuseppe Allori, Virgin and Child with SS. Jerome, John the Baptist, Andrew, and Augustine, 15th cent. Panel. Private coll. *Below, left*: Elias Moschos, The Resurrection, 1687. Panel, 37³/₄×20¹/₂ in. Athens, Byzantine Museum. *Right*: Virgin and Child, 1740. Panel, 12⁵/₈×9¹/₂ in. Formerly, Athens, Theodore Macridy Coll.

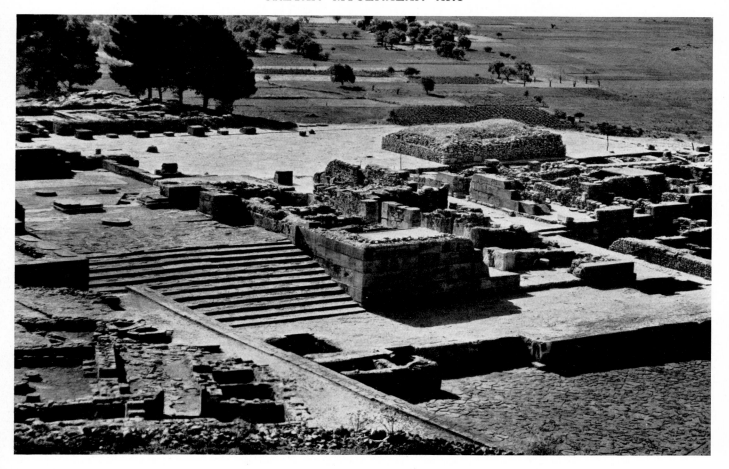

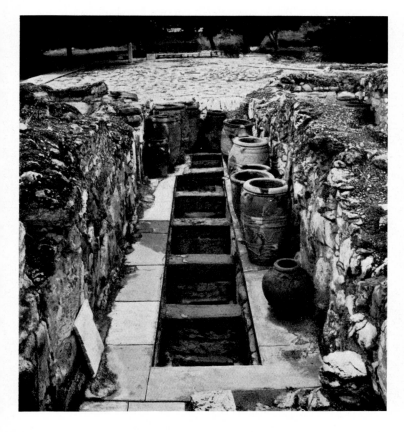

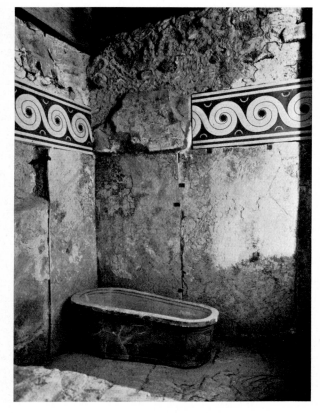

Pl. 53. *Above*: Phaestos, porticoes and large court of the second palace. *Below*: Knossos, second palace. *Left*: West magazines. *Right*: Bathroom of the so-called "Queen's Megaron."

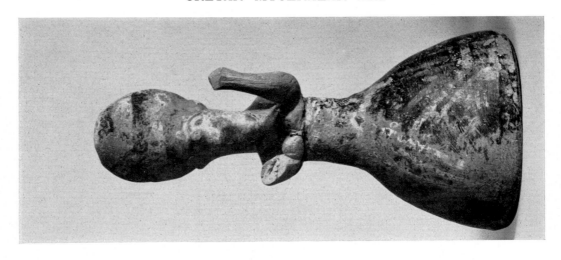

Pl. 54. Terra cottas of the prepalatial period, 2500–2000 B.C. Heraklion, Archaeological Museum. *Left and right*: Votive statuettes, from the sanctuary of Mt. Petsopha. Ht., 6⁷/₈ in. and 5³/₄ in. *Center*: Vase in the shape of a bird, from Koumasa. Ht., 6³/₄ in.

Pl. 55. Snake goddesses, from the sacred treasure of the palace of Knossos, 1700–1600 B.C. Faïence, ht., 13⅝ in. and 11⅝ in. Heraklion, Archaeological Museum.

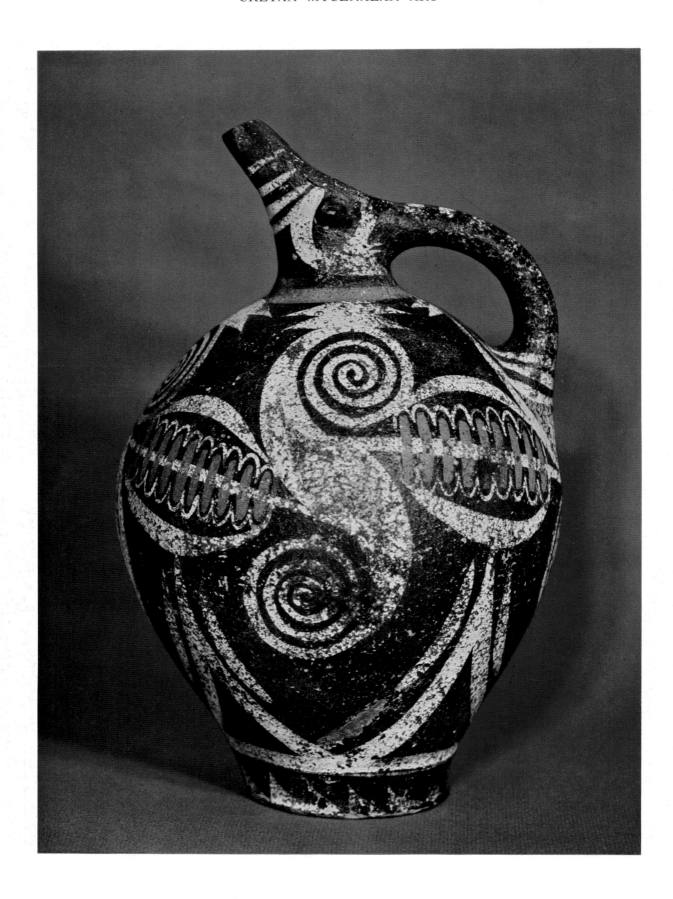

Pl. 56. Pitcher in the Kamares style, from the palace of Phaestos, 1800–1700 B.C. Ht., 10¼ in. Heraklion, Archaeological Museum.

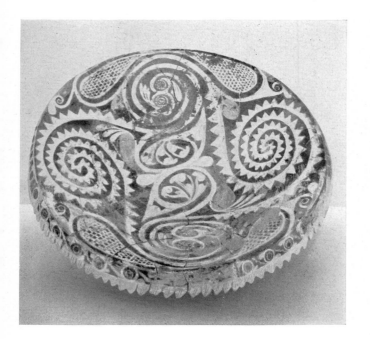

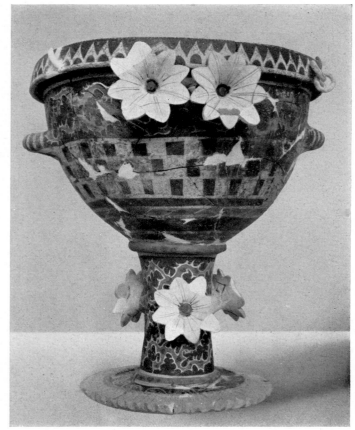

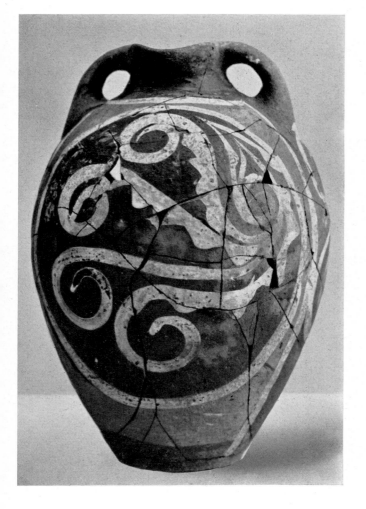

Pl. 57. Pottery in the Kamares style, from the palace of Phaestos, 1800–1700 B.C. Heraklion, Archaeological Museum. *Above, left*: Fruit stand. Ht., 9¹/₂ in., diam., 20⁷/₈ in. *Right*: Crater. Ht., 17³/₄ in., diam., 15 in. *Below, left*: Amphora. Ht., 13³/₄ in. *Right*: Pithos. Ht., 15³/₄ in.

Pl. 58. Dancing girl, detail of a wall painting from the second palace of Knossos, 1700–1400 B.C. Width, 14⅝ in. Heraklion, Archaeological Museum.

Pl. 59. Sculpture from Knossos, 1700–1400 B.C. Heraklion, Archaeological Museum. *Left, above:* Rhyton in the shape of a lioness's head, from the Treasury of the Central Palace Sanctuary. Marblelike stone, l., 11³/₈ in. *Center:* Fragment of a frieze in relief, with half rosettes. Schist, ht., 7¹/₄ in. *Below:* Ceremonial ax in the shape of a leopard. Slate, l., 5⁷/₈ in. *Right:* Rhyton with boxing and bull-racing scenes. Steatite, ht., ca. 18¹/₂ in. (Partially restored.)

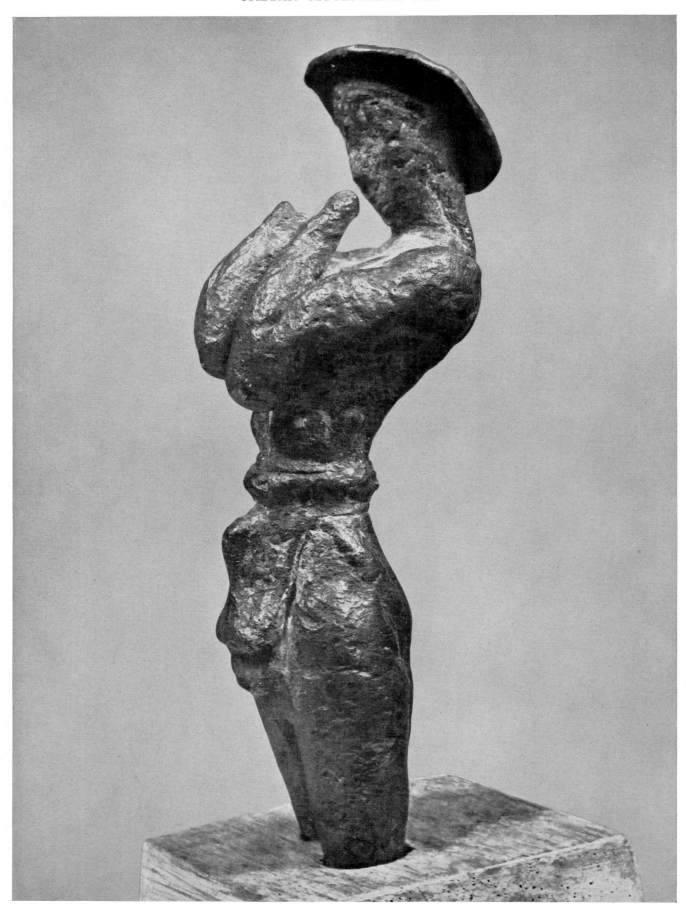

Pl. 60. The so-called "Flute Player," votive figurine of a worshiper, from Tylissos, 1700–1400 B.C. Bronze, ht., 5 5/8 in. Leiden, Netherlands, Rijksmuseum.

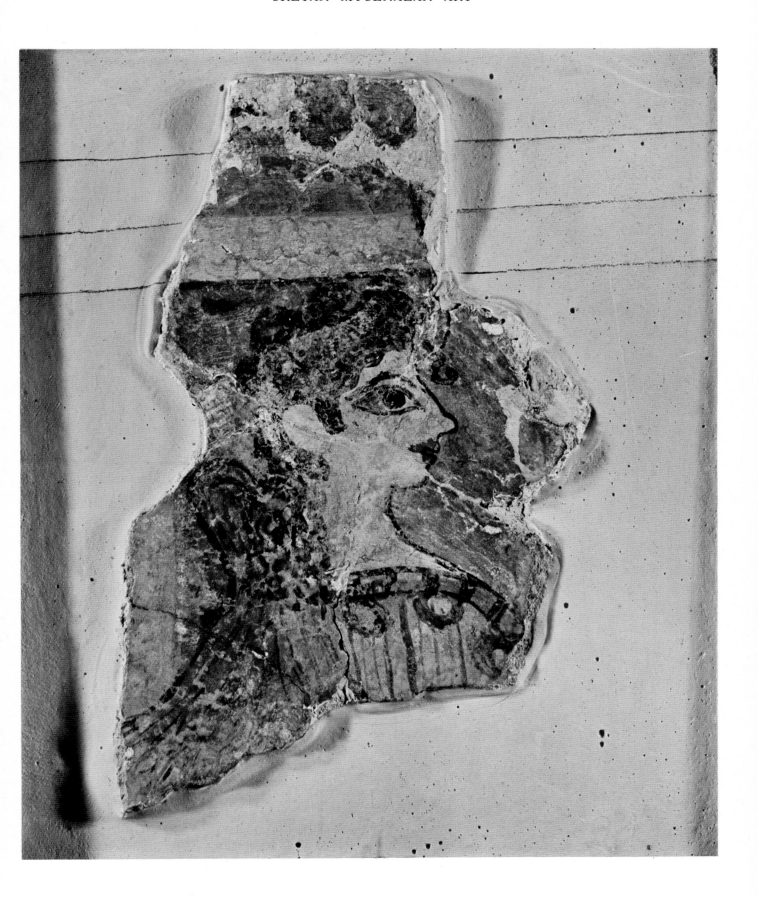

Pl. 61. "La Parisienne," fragment of a fresco from Knossos, 1600–1500 B.C. Ht., 9⁷/₈ in. Heraklion, Archaeological Museum.

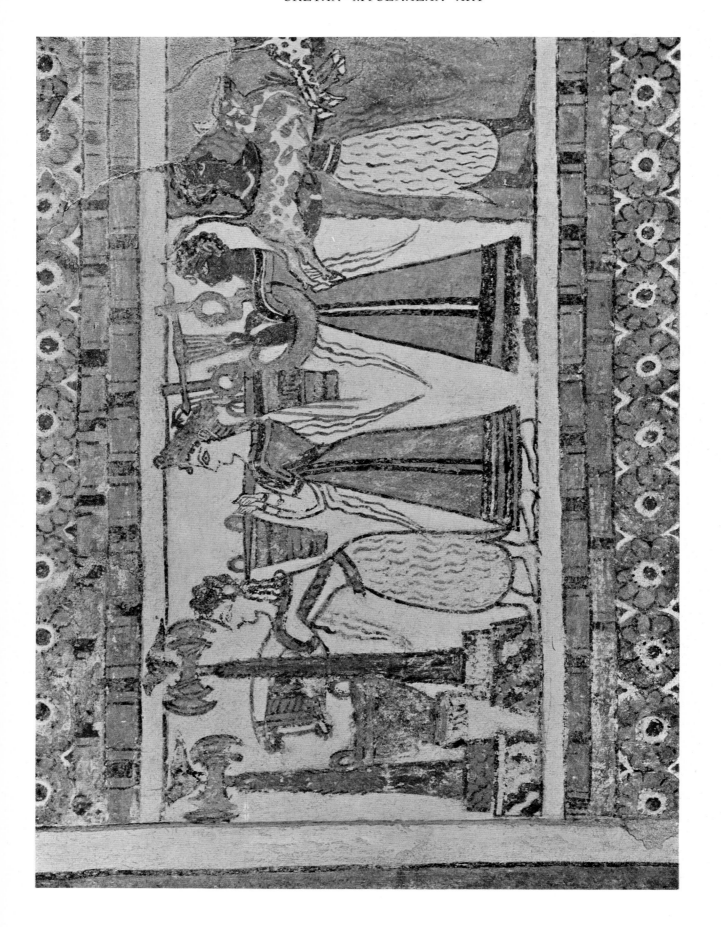

Pl. 62. Libation procession, detail of the painted sarcophagus from Hagia Triada, 1500–1400 B.C. Limestone. Heraklion, Archaeological Museum.

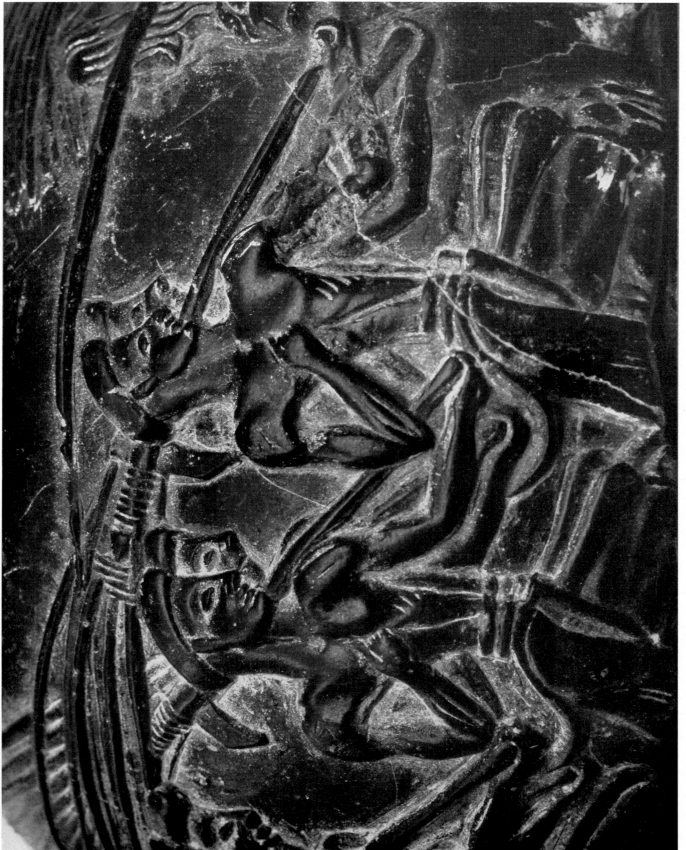

Pl. 63.  Procession of harvesters, detail of the bas-relief decoration of the rhyton known as the "Harvester Vase," from Hagia Triada, 1600–1500 B.C.  Steatite, ht. of detail, 2³/₄ in. Heraklion, Archaeological Museum.

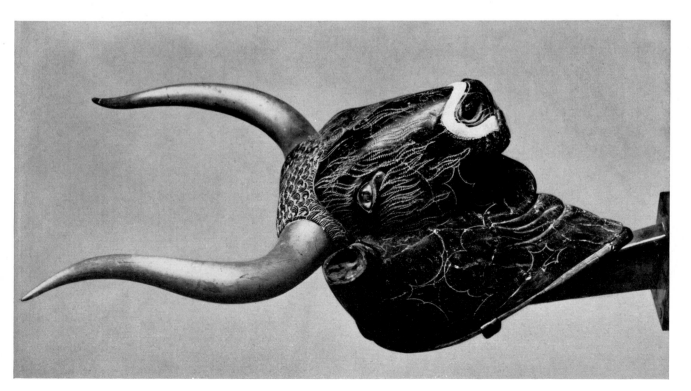

Pl. 64. Sculpture from Knossos, 1600–1500 B.C. Heraklion, Archaeological Museum. *Left*: Bull's-head rhyton. Steatite; ht. of head, 12 in. *Right*: Acrobat. Ivory, l., 11⁵⁄₈ in.

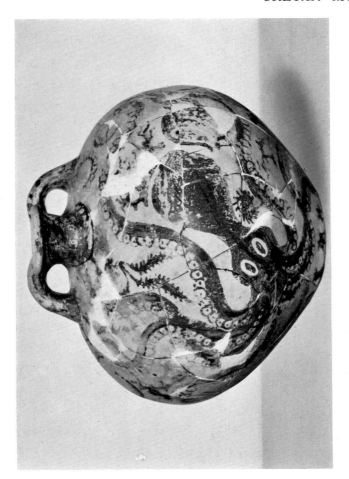

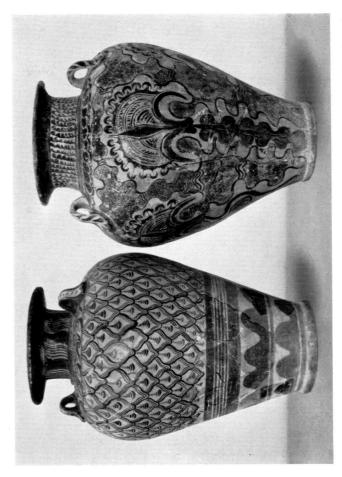

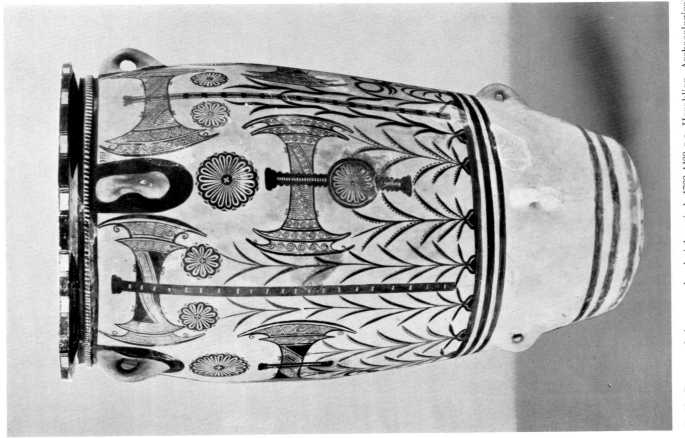

Pl. 65. Pottery of the second palatial period, 1700–1400 B.C. Heraklion, Archaeological Museum. *Left*: Pithos in palace style, from Knossos. Ht., 52³/₄ in. *Right, above*: Amphora in naturalistic style, from Gournia. Ht., 7⁵/₈ in. *Below*: Amphoras in palace style, from Knossos. Ht., 27¹/₂ in.

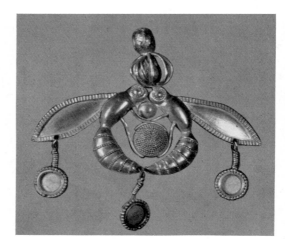

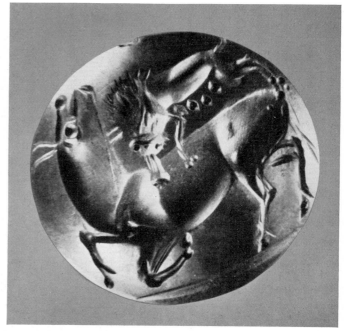

Pl. 66. Goldsmith's work and engraved gems of the second palatial period, 1700–1400 B.C. Heraklion, Archaeological Museum. *Above, left*: Pendant in the shape of a duck, from Knossos. Gold, ht., ca. ³/₄ in. *Center*: Pendant with representations of wasps, from the necropolis of Mallia. Gold, ht., ca. 1³/₄ in. *Right*: Pendant, from Hagia Triada. Gold, ht., ca. ⁷/₈ in. *Center, left*: Ring with ritual representation, from the necropolis of Isopata near Knossos. Gold, l., ca. 1¹/₈ in. *Right*: Earrings in the shape of bull skulls, from Knossos. Gold, ht., ca. 1³/₈ in. *Below*: Seals from the Knossos necropolis area. Sardonyx (*left*) and hematite (*right*).

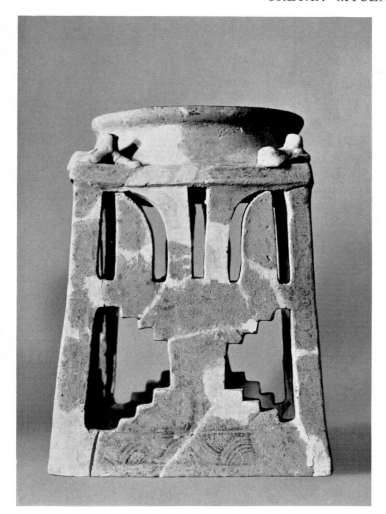

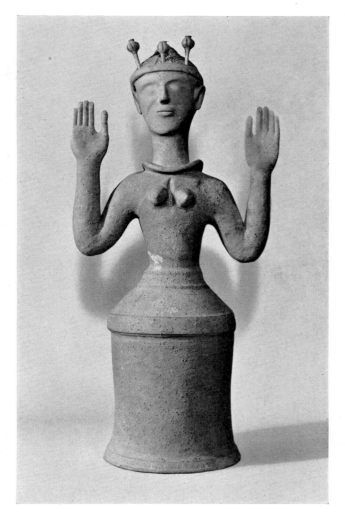

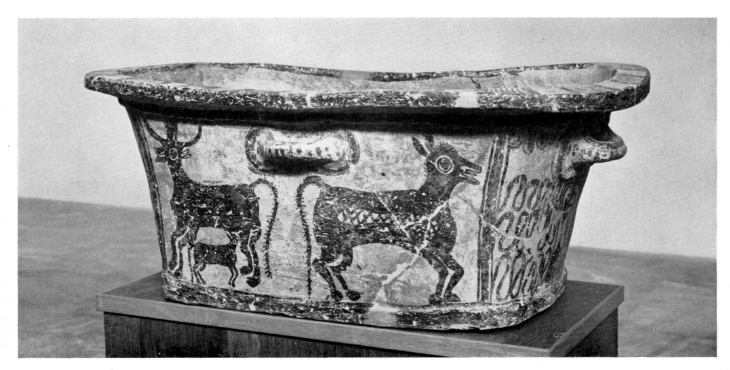

Pl. 67. Pottery of the postpalatial period, 1400–1100 B.C. Heraklion, Archaeological Museum. *Above, left*: Vase support in the shape of an altar, from Karphi, near Lasithion. Ht., 12⅝ in. *Right*: Statuette of a divinity (?), from Gazi. Ht., 31⅛ in. *Below*: Oval sarcophagus (?), from a tomb at Gournia. Ht., 18¼ in.

Pl. 68.  Mycenae, the so-called "Treasury of Atreus," interior view and dromos. Ht. of interior, ca. 44$^{1}/_{2}$ ft.

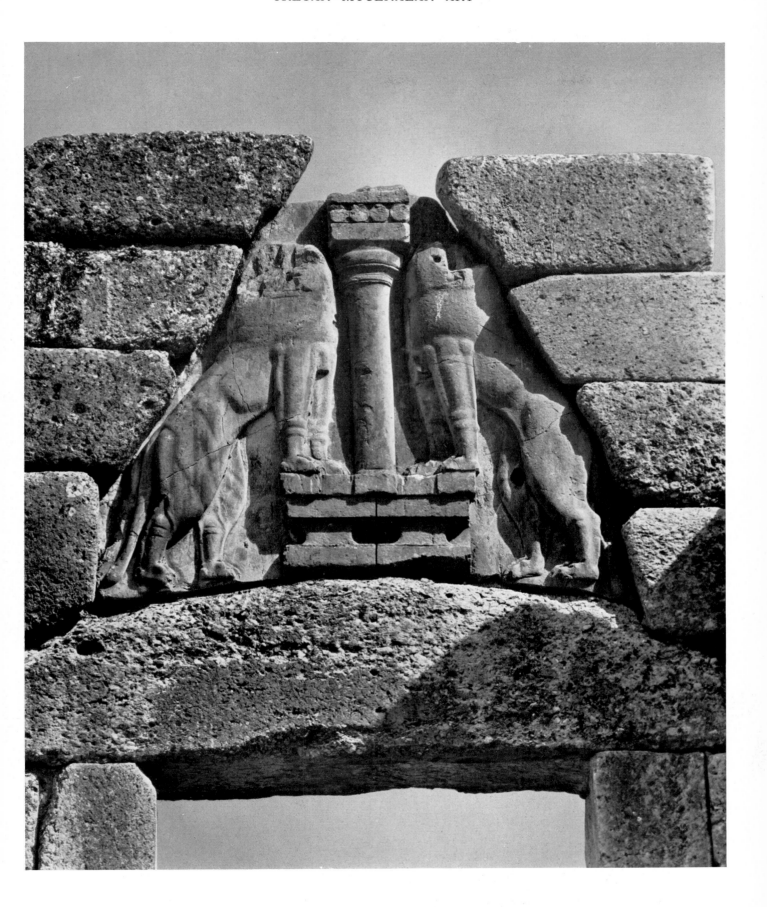

Pl. 69. Mycenae, the Lion Gate, detail. Limestone; ht. of sculpture, 9 ft., 6 1/8 in.

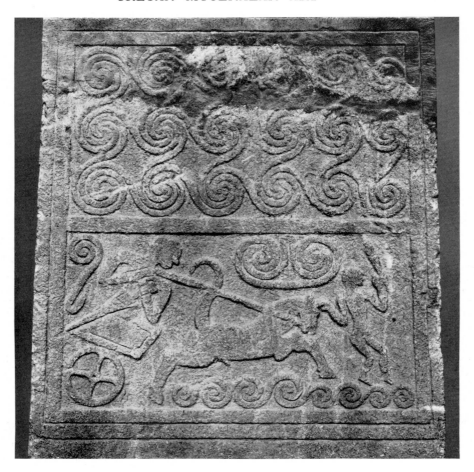

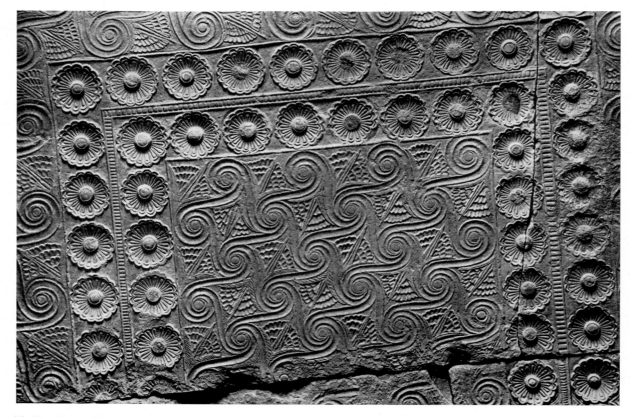

Pl. 70. *Above*: Tombstone, detail, from the royal tombs at Mycenae, 1600–1500 B.C. Limestone; full ht., 4 ft., 4³/₈ in. *Below*: Fragment of a ceiling, from a beehive tomb near Orchomenos, 1500–1400 B.C. Schist. Both, Athens, National Museum.

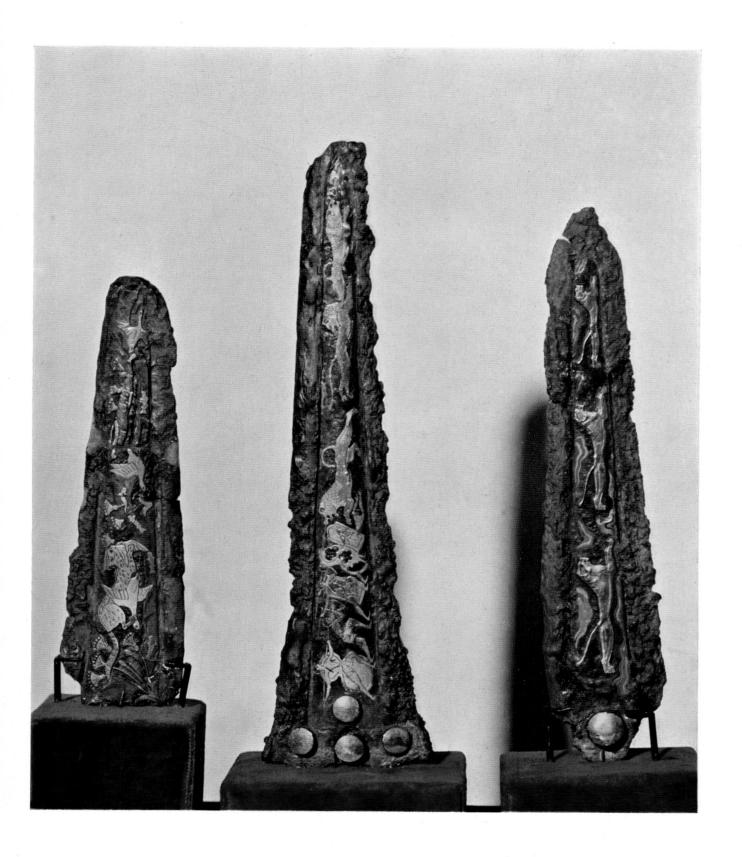

Pl. 71. Inlaid dagger blades, from the royal tombs of Mycenae, 1600–1500 B.C. Bronze and electrum; length of longest, 9 in. Athens, National Museum.

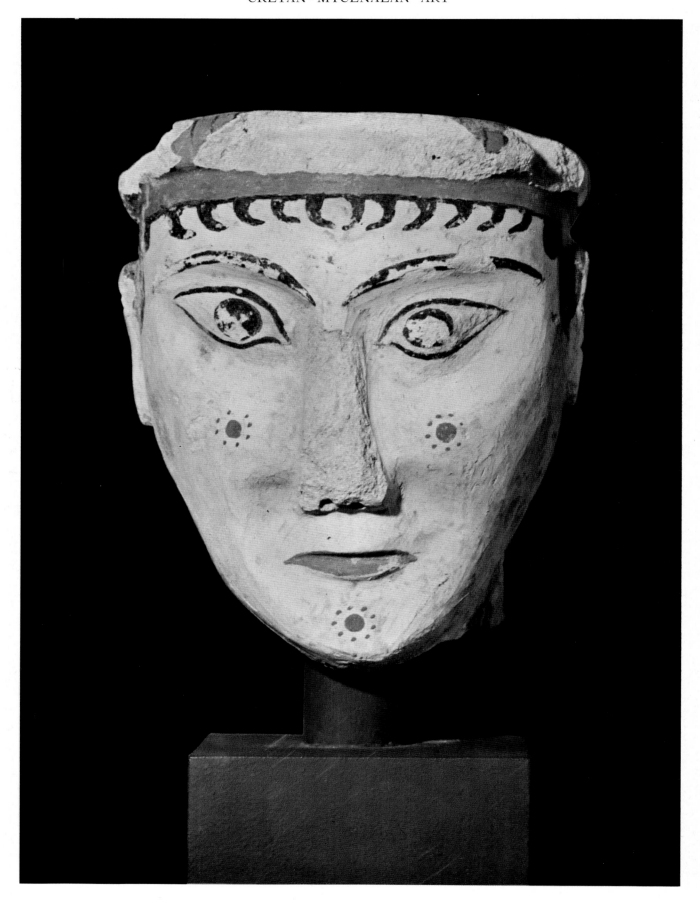

Pl. 72. Head, probably from a sphinx, from Mycenae, 1400–1100 B.C. Painted stucco, ht., 6⁵/₈ in. Athens, National Museum.

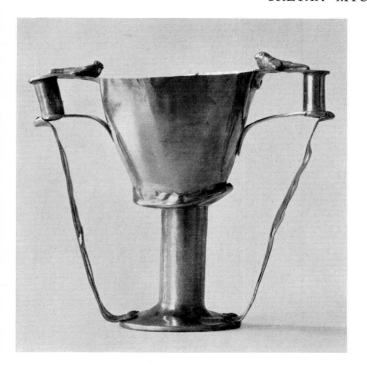

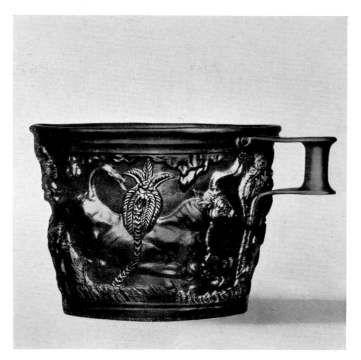

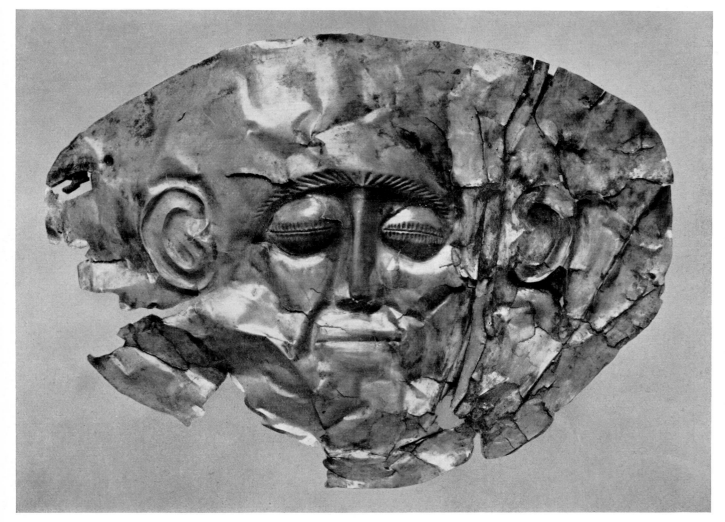

Pl. 73. *Above, left*: The so-called "Cup of Nestor," from the royal tombs of Mycenae, 1600–1500 B.C. Gold, ht., 5³/₄ in. *Right*: Cup with repoussé decoration, from Vaphio, 1600–1500 B.C. Gold, ht., 3¹/₈ in., diam., 4¹/₈ in. *Below*: Funeral mask, from the royal tombs of Mycenae, 1600–1500 B.C. Gold, ht., 11³/₄ in. All, Athens, National Museum.

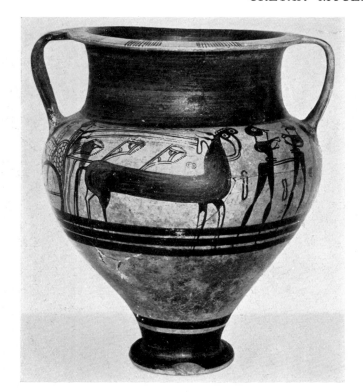

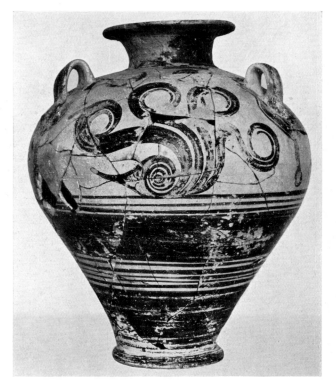

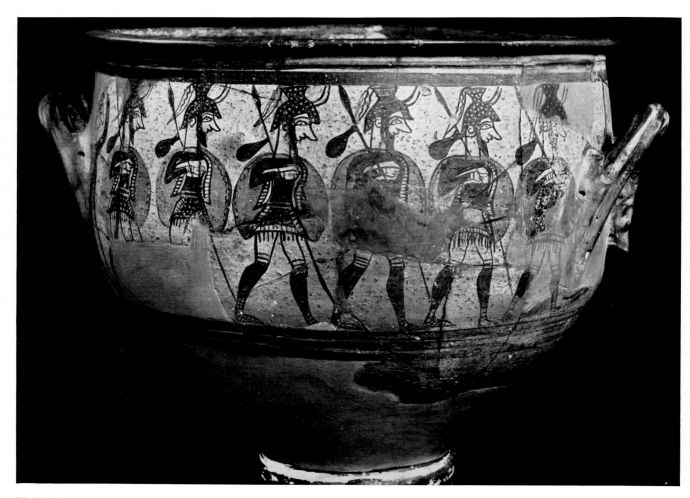

Pl. 74. Late Mycenaean pottery, 1400–1100 B.C. *Above, left*: Crater with representations of chariots, from Salamis (Enkomi), Cyprus. Ht., 17¹/₈ in. Boston, Museum of Fine Arts. *Right*: Vase with stylized decoration. Athens, Museum of the Agora. *Below*: The so-called "Warrior Vase," from Mycenae. Ht., 14¹/₈ in. Athens, National Museum.

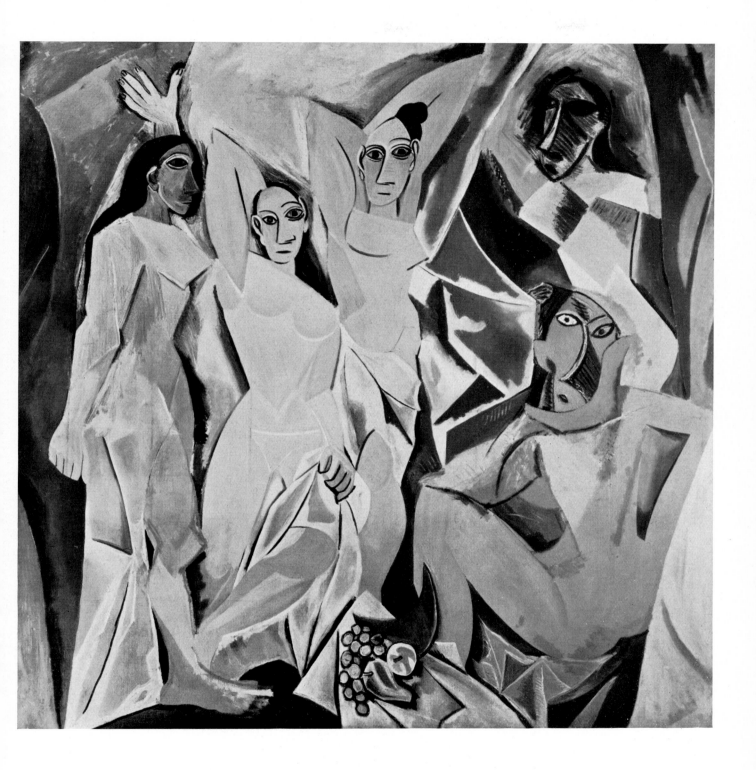

Pl. 75. P. Picasso, Les Demoiselles d'Avignon, 1907. Canvas, 8 ft. × 7 ft., 8 in. New York, Museum of Modern Art.

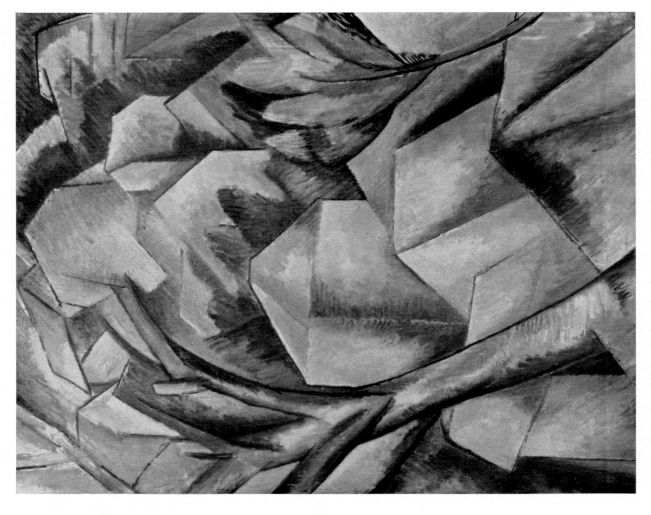

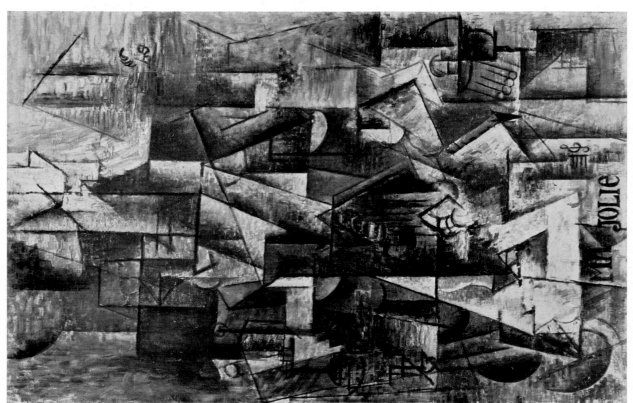

Pl. 76. *Left*: P. Picasso, Ma Jolie (Woman with a Zither or Guitar), 1911-12. Canvas, 28³/₄×23¹/₄ in. New York, Museum of Modern Art. *Right*: G. Braque, L'Estaque, 1908. Canvas, 39³/₈×25³/₄ in. Bern, Kunstmuseum.

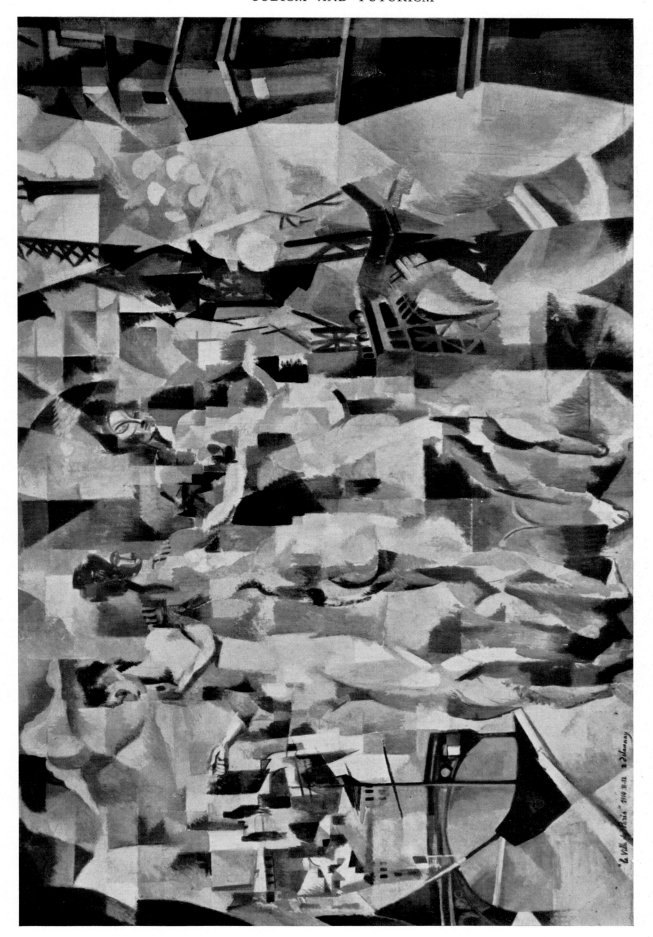

Pl. 77. R. Delaunay, The City of Paris, ca. 1910–12. Canvas, 8 ft, 9 in. × 13 ft, 3⁷/₈ in. Paris, Musée d'Art Moderne.

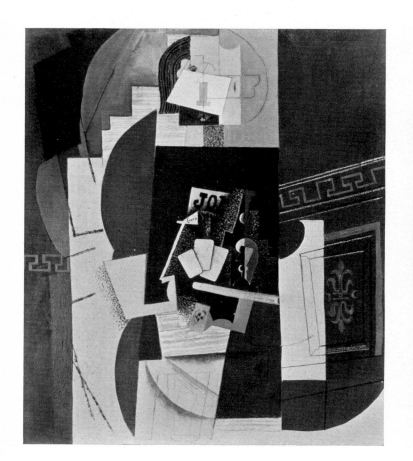

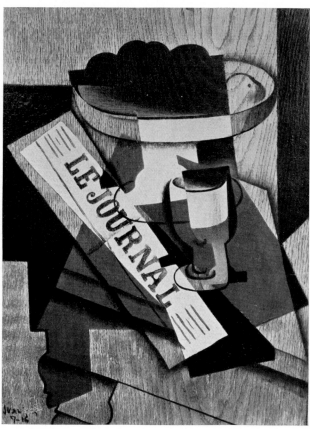

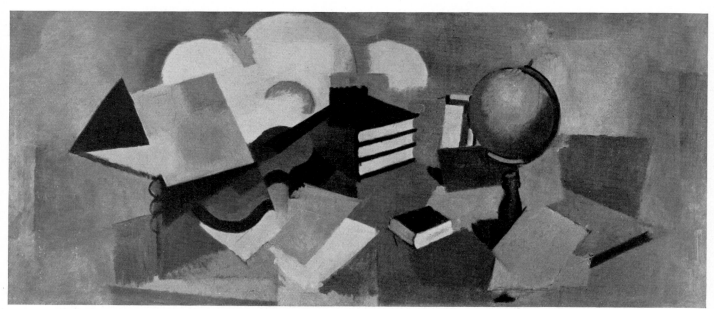

Pl. 78. *Above, left*: P. Picasso, Card Player, 1913–14. Canvas, 42¹/₂×35¹/₄ in. *Right*: J. Gris, Fruit Dish, Glass and Newspaper, 1916. Panel, 21⁵/₈×15 in. Both, New York, Museum of Modern Art. *Below*: R. de la Fresnaye, Emblems (La Mappemonde), ca. 1912. Canvas, 2 ft., 11 in. × 6 ft., 6³/₄ in. Washington, D.C., Phillips Coll.

Pl. 79. *Above*: F. Picabia, Physical Culture, 1913. Canvas, 35¹/₄×46 in. Philadelphia, Museum of Art. *Below, left*: A. Glei-
zes, Vierge de Majesté, 1924. Canvas, 7⁷/₈×7¹/₂ in. Paris, Musée d'Art Moderne. *Right*: M. Duchamp, Nude Descend-
ing a Staircase, No. 3, 1916. Water color, ink, crayon, and pastel on photographic base, 58×35¹/₂ in. Philadelphia,
Museum of Art.

Pl. 80. J. Gris, Still Life, 1914. Collage of colored paper, printed matter, and charcoal, 23 1/2 × 17 1/2 in. Philadelphia, Museum of Art.

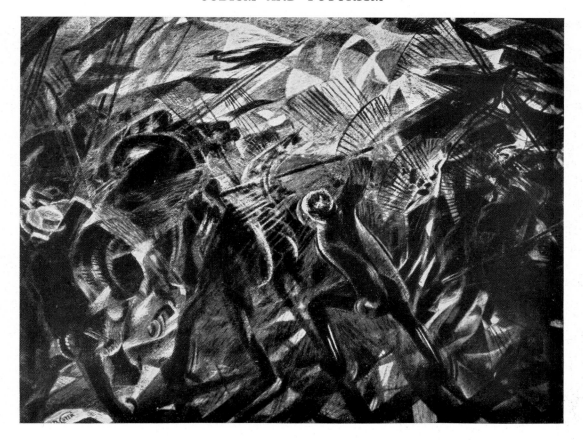

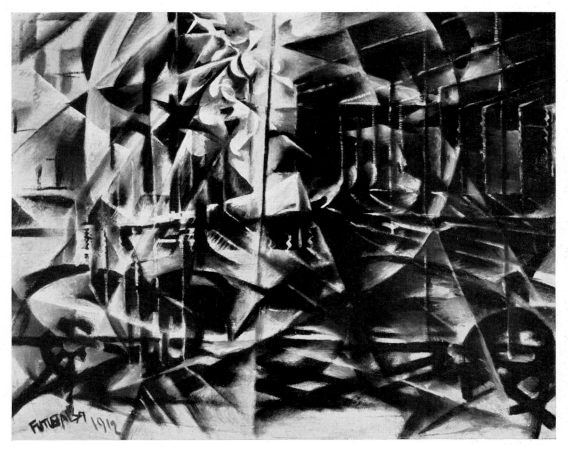

Pl. 81. *Above*: C. Carrà, Funeral of the Anarchist Galli, 1911. Canvas, 6 ft., 6¼ in. × 8 ft., 6 in. *Below*: G. Balla, Speeding Automobile, 1912. Panel, 21⅞×27⅛ in. Both, New York, Museum of Modern Art.

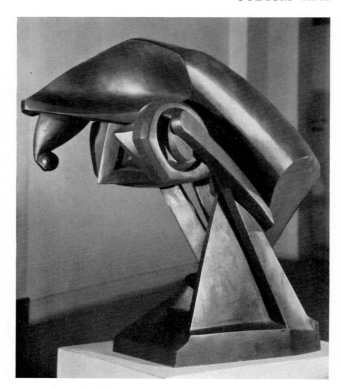

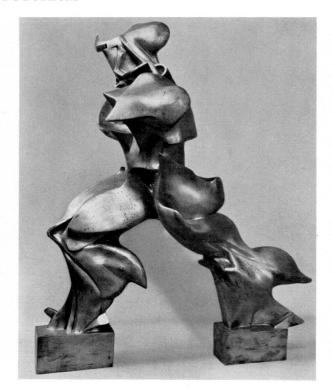

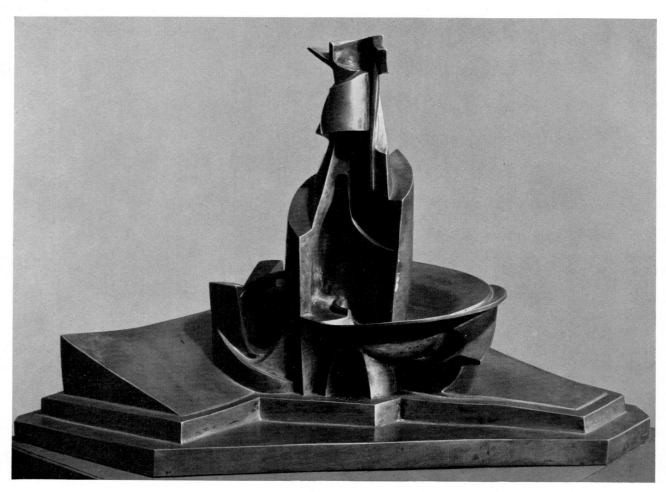

Pl. 82. *Above, left*: R. Duchamp-Villon, Horse, 1914. Bronze, ht., 39³/₈ in. Paris, Musée d'Art Moderne. *Right*: U. Boccioni, Unique Forms of Continuity in Space, 1913. Bronze, ht., 43¹/₂ in. *Below*: U. Boccioni, Development of a Bottle in Space, 1912. Bronze, ht., 15 in. Last two, New York, Museum of Modern Art.

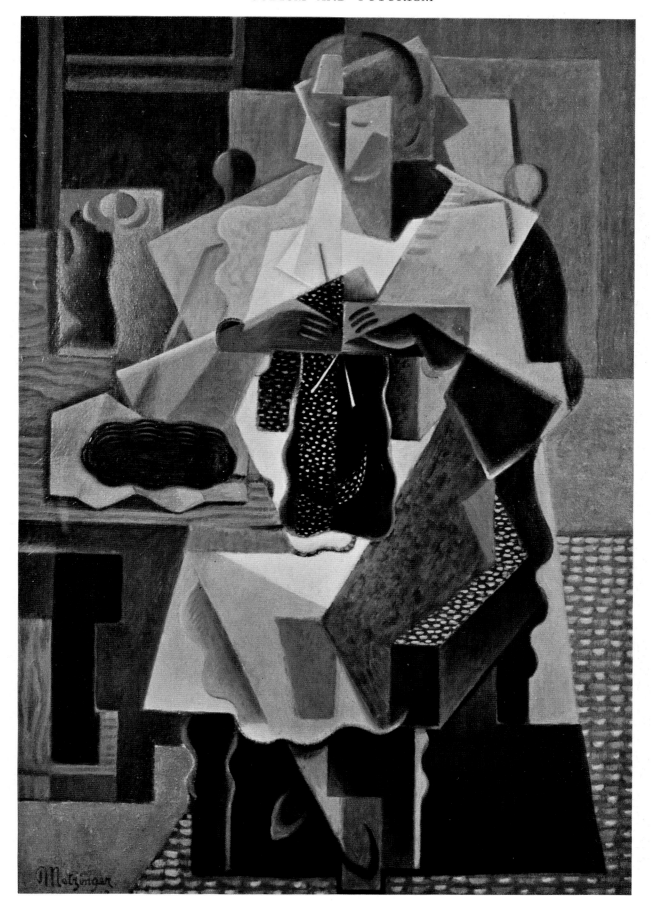

Pl. 83.  J. Metzinger, Woman Knitting, 1919. Canvas, 45⅝×31⅞ in. Paris, Musée d'Art Moderne.

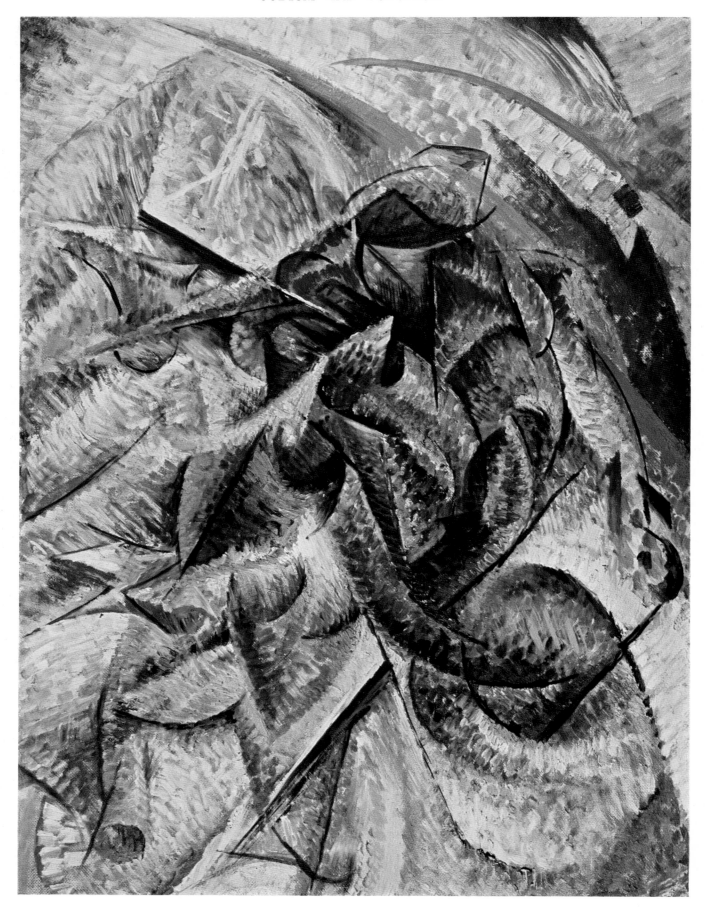

Pl. 84.  U. Boccioni, Dynamism of a Cyclist, ca. 1913. Canvas, $37^3/_8 \times 27^1/_2$ in. Milan, Coll. G. Mattioli.

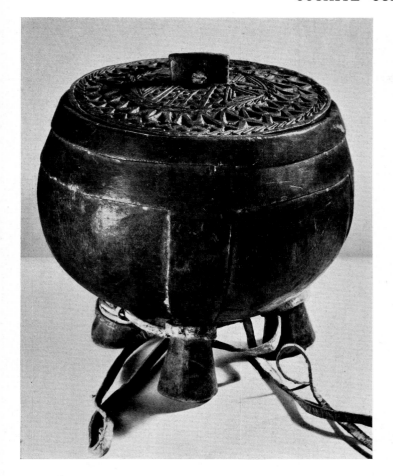

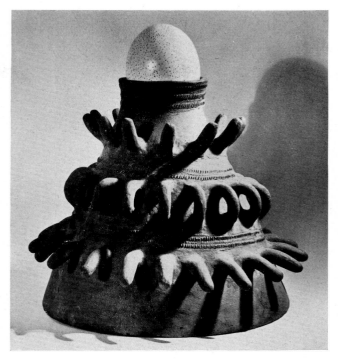

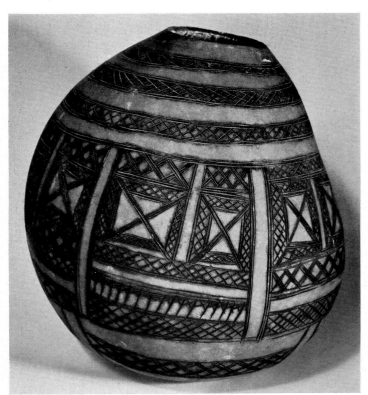

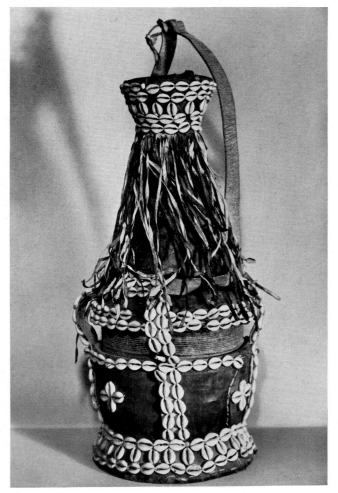

Pl. 85. *Above, left*: Somali butter container with carved cover. Wood. Rome, Museo Pigorini. *Right*: Konso-Gauwada roof ornament with phallic symbols, from southern Ethiopia. Clay. Frankfort on the Main, Städtisches Völkermuseum. *Below*: Somali containers. *Left*: Incised gourd. *Right*: Wooden bottle with a covering of leather and cowrie shells. Last two, Rome, Museo Africano.

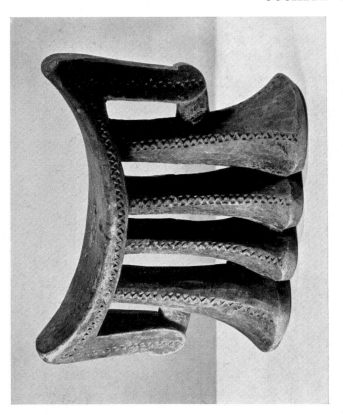

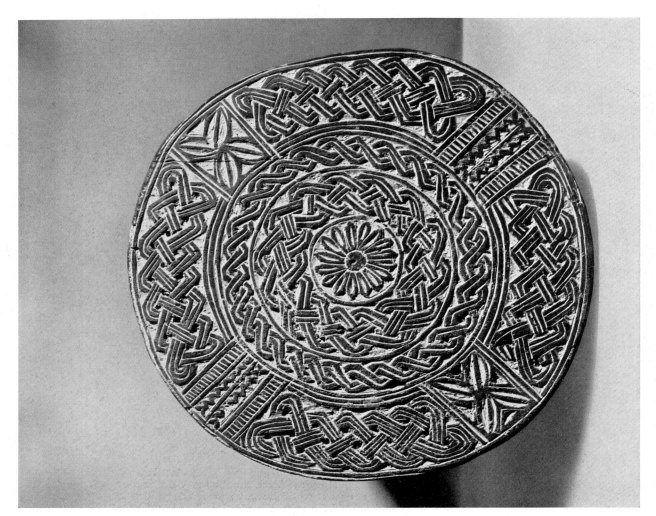

Pl. 86. *Left*: Carved disk for the apex of a roof, from Merca, southern Somalia. Wood. Rome, Museo Africano. *Right*: Women's neck rests, from Bardera, southern Somalia. Wood. Rome, Museo Pigorini.

Pl. 87. Gravestones, from the Gurage region (?), southern Ethiopia. Stone. Rome, Museo Africano.

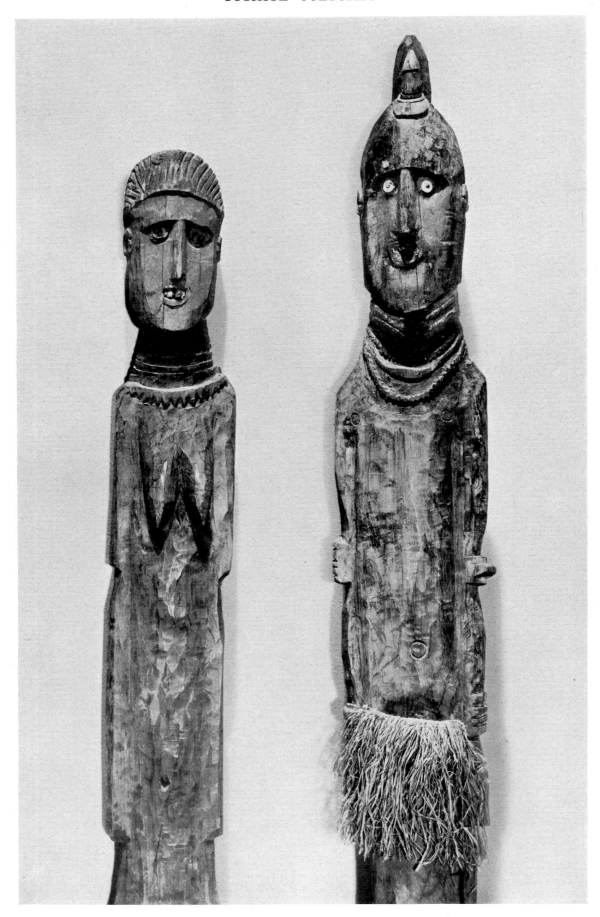

Pl. 88. Konso funerary figures, from southern Ethiopia. Wood. Rome, Museo Africano.

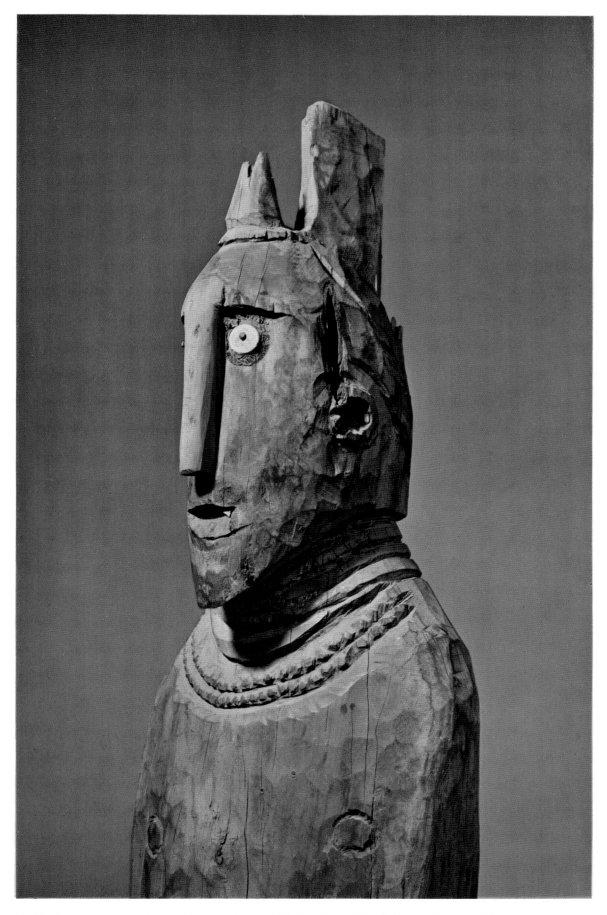

Pl. 89. Konso funerary figure, from southern Ethiopia, detail. Wood. Rome, Museo Africano.

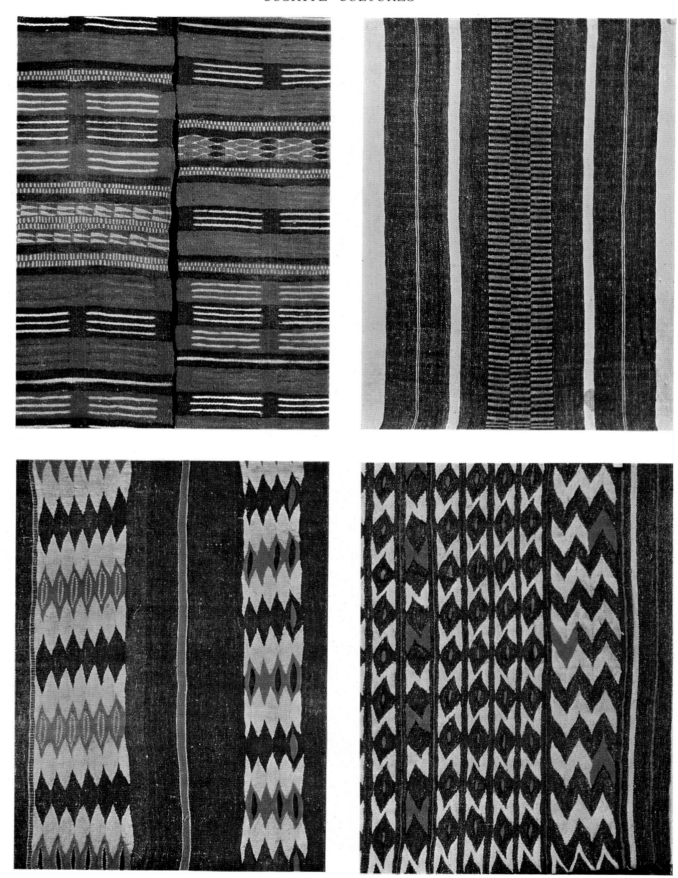

Pl. 90. *Above, left*: Polychrome striped cloth, from Bonga, Kafa region, Ethiopia. *Right*: Detail of a Galla-Gudru woman's cloak, from Ethiopia. *Below*: Details of Galla men's cloaks, from the Jimma region, Ethiopia. All, Rome, Museo Pigorini.

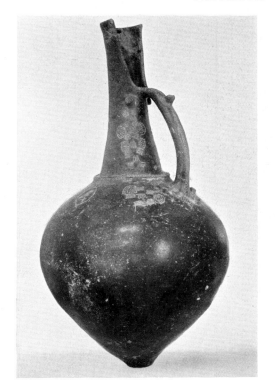

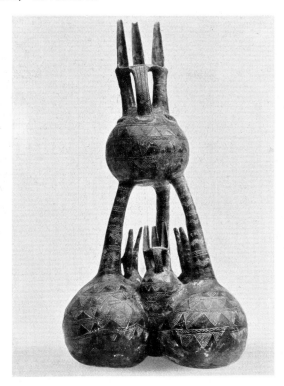

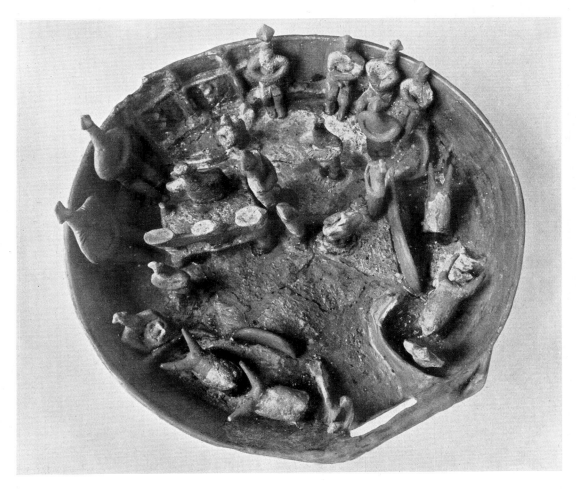

Pl. 91. *Above*: Examples of "red polished" pottery with engraved decoration, from Vunus, Bronze Age. *Left*: Jug, ca. 2400 B.C. Ht., 30¹/₄ in. *Right*: Composite vessel, 2400–2100 B.C. Ht., 32⁵/₈ in. *Below*: Terra-cotta group, perhaps representing a ceremony in a sacred enclosure, Bronze Age. All, Nicosia, Cyprus Museum.

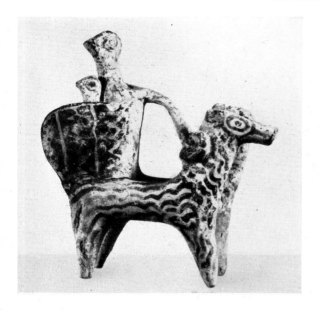

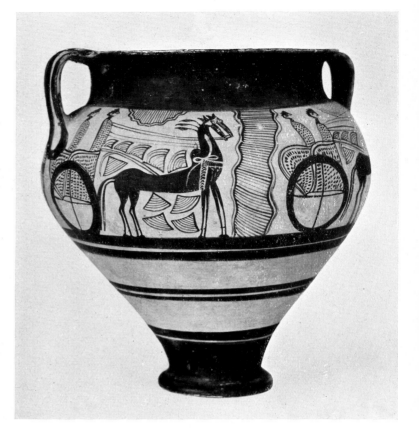

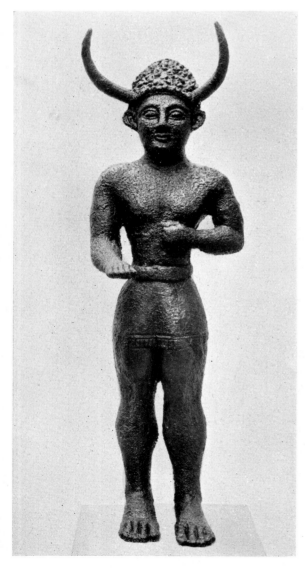

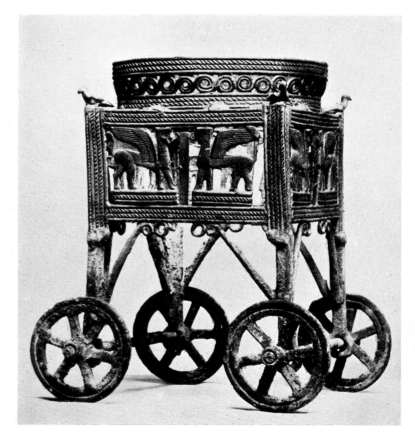

Pl. 92. *Above, left*: Chariot group (?), 13th cent. B.C. Terra cotta, ht., 4³/₄ in. Rome, Museo Pigorini. *Right*: Crater in the Mycenaean-Orientalizing style, ca. 13th cent. B.C. New York, Metropolitan Museum. *Below, left*: Horned god, the so-called "Apollo Alasiotas," from Salamis (Enkomi), 13th cent. B.C. Bronze. Nicosia, Cyprus Museum. *Right*: Cart decorated with sphinxes, for offerings or perfume, from Salamis (Enkomi), 11th cent. B.C. Bronze, ht., 13³/₈ in. Berlin, Staatliche Museen.

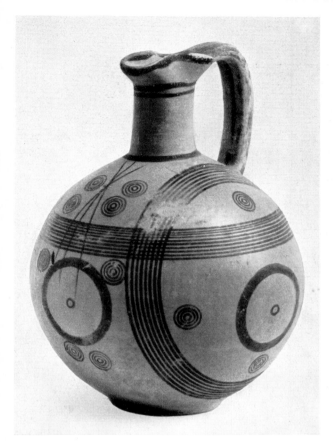

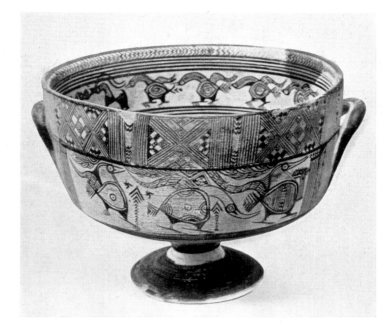

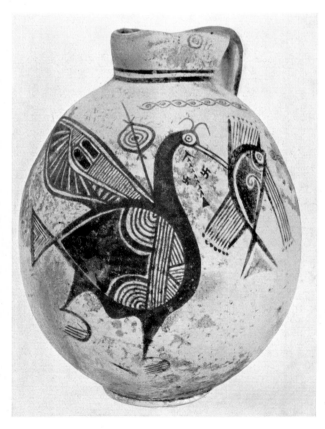

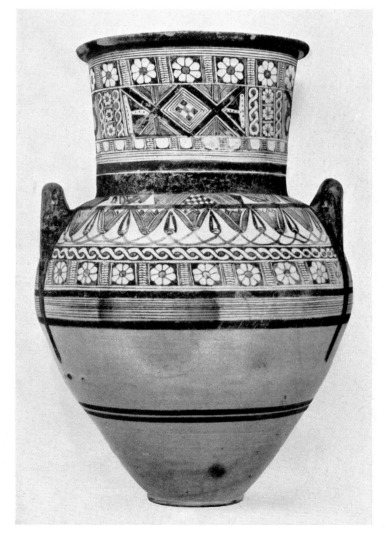

Pl. 93. Examples of Cypro-Geometric and Cypro-archaic painted pottery. *Left, above*: Spherical jug, from Stylli, 8th cent. B.C. Stockholm, Medelhavsmuseet. *Below*: Jug with a bird catching a fish, 8th–7th cent. B.C. Ht., 13 3/4 in. *Right, above*: Cup with decorative bands of geometric motifs and birds, 7th–6th cent. B.C. Diam., 9 7/8 in. *Below*: Amphora with rosettes and lotus flowers, from Peristerona, 7th cent. B.C. Ht., 35 7/8 in. Last three, Nicosia, Cyprus Museum.

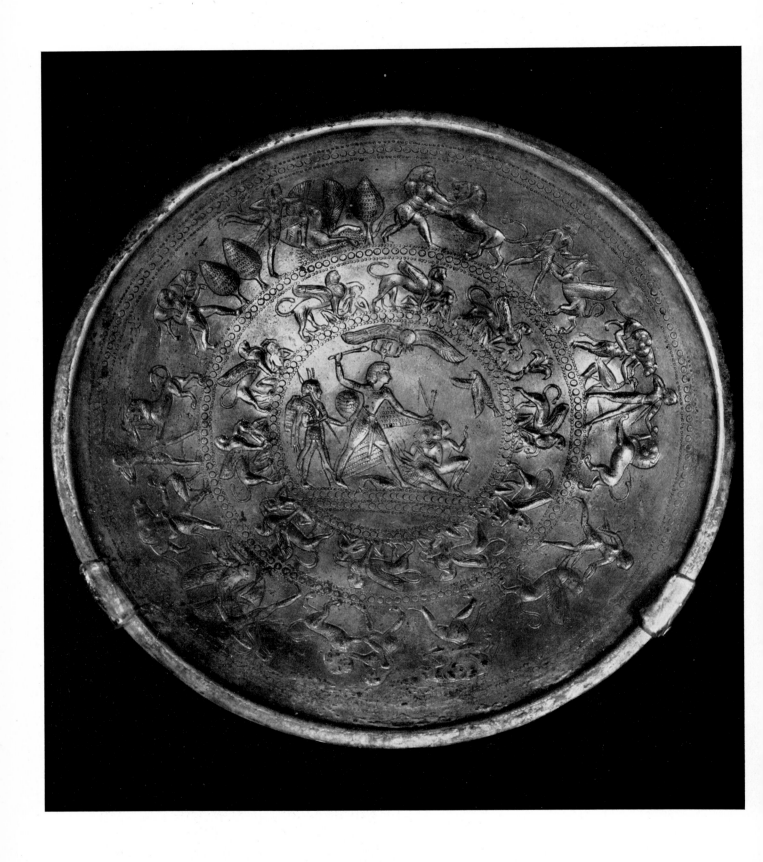

Pl. 94. Embossed silver plate, from Idalion, 8th–7th cent. B.C. Diam., 7¼ in. Paris, Louvre.

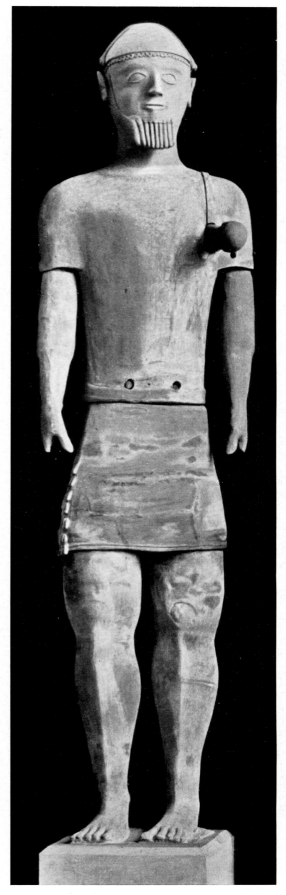
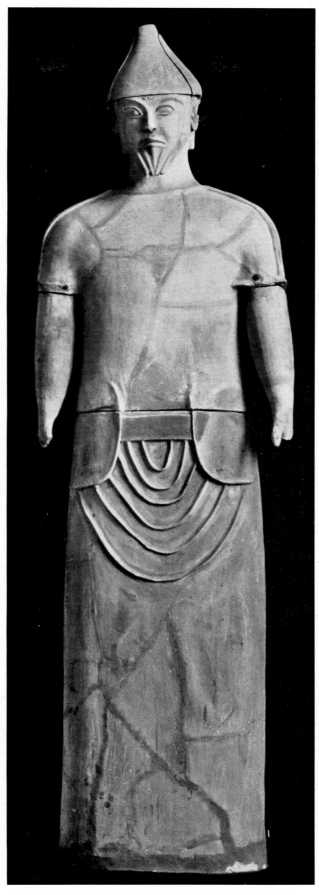

Pl. 95.  Votive statues, from Agia Irini, 7th–6th cent. B.C. Terra cotta, ht., 5 ft., 10 1/8 in. and 6 ft., 1 5/8 in. Nicosia,
Cyprus Museum.

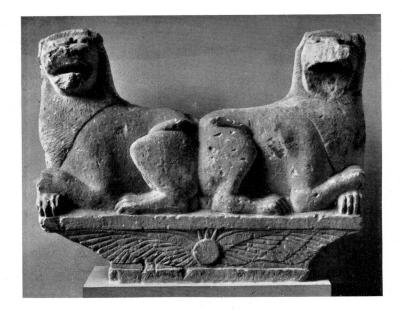

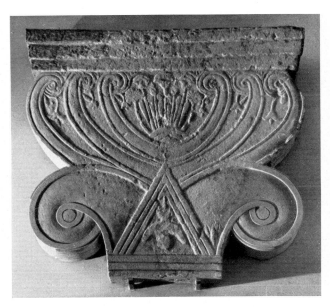

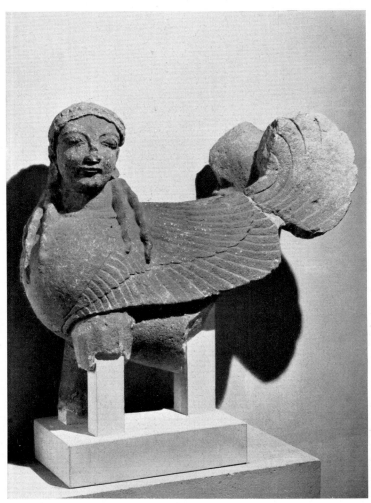

Pl. 96. *Above, left*: Crouching lions, 6th cent. B.C. Limestone. *Right*: Capital, from Athienu, second half of 6th cent. B.C. Stone. *Below, left*: Sphinx with female head, from Marion, late 6th cent. B.C. Limestone. *Right*: Capital in the form of a Hathor head surmounted by a naos, from Kition, ca. 500 B.C. Limestone, ht., 4 ft., 4³/₈ in. All, Paris, Louvre.

Pl. 97. Female head, from Arsos, first half of 6th cent. B.C. Limestone, ht., 19¼ in. Nicosia, Cyprus Museum.

Pl. 98. Worshiper carrying a flower, from Trikomo, ca. mid-6th cent. B.C. Limestone. Paris, Louvre.

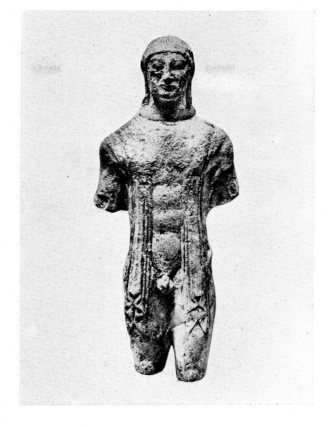

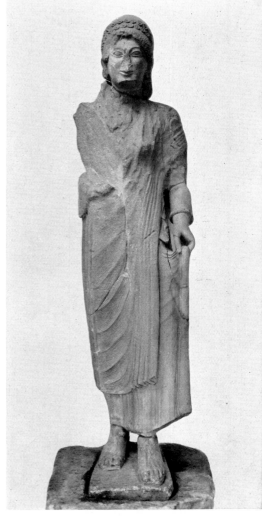

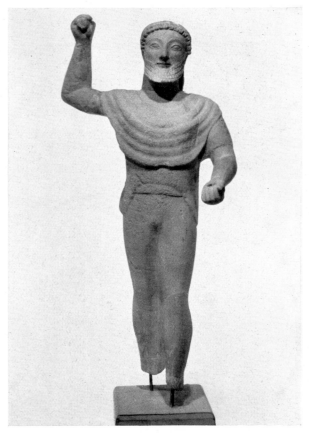

Pl. 99. *Above, left*: Worshiper, upper portion, from Arsos, 6th cent. B.C. Limestone. *Right*: Kouros (a so-called "Apollo"), from Mersinaki, late 6th cent. B.C. Limestone, ht., 9¹/₂ in. Both, Nicosia, Cyprus Museum. *Below, left*: Kore, from Vuni, first half of 5th cent. B.C. Limestone; ht., including base, 4 ft., 11⁷/₈ in. Stockholm, Medelhavsmuseet. *Right*: Votive statuette, the so-called "Zeus Keraunios," from Kition, early 5th cent. B.C. Limestone, ht., 22 in. Nicosia, Cyprus Museum.

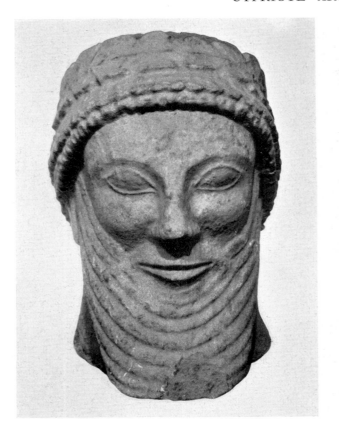

Pl. 100. *Above, left*: Bearded head, ca. 500 B.C. Limestone, ht., 13³/₄ in. Nicosia, Cyprus Museum. *Right*: Bearded head, ca. 500 B.C. Sandstone, ht., 12¹/₄ in. Paris, Louvre. *Below, left*: Female head with diadem, from Vuni, mid-5th cent. B.C. Limestone, ht., 13 in. Nicosia, Cyprus Museum. *Right*: Male head, 5th cent. B.C. Limestone. Paris, Louvre.

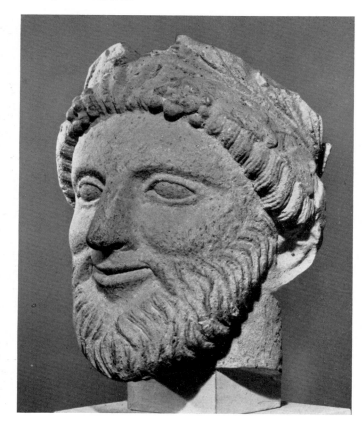
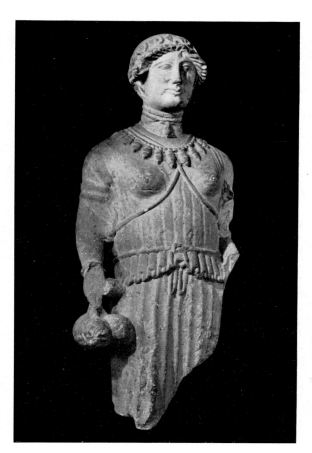
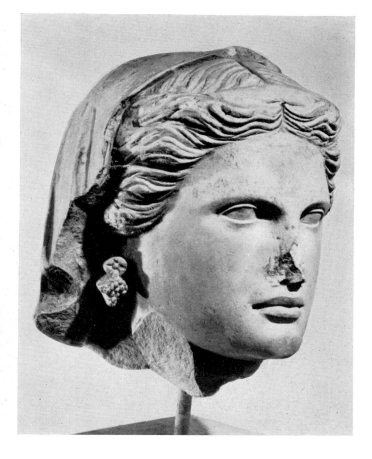

Pl. 101. *Above, left*: Head of Athena, from Vuni, mid-5th cent. B.C. Limestone, ht., 4¹/₈ in. Stockholm, Medelhavsmuseet. *Right*: Bearded head, 5th cent. B.C. Limestone. Paris, Louvre. *Below, left*: Female statue, from Pila, late 5th cent. B.C. Limestone. Paris, Louvre. *Right*: Female head, from Arsos, 4th cent. B.C. Limestone. Nicosia, Cyprus Museum.

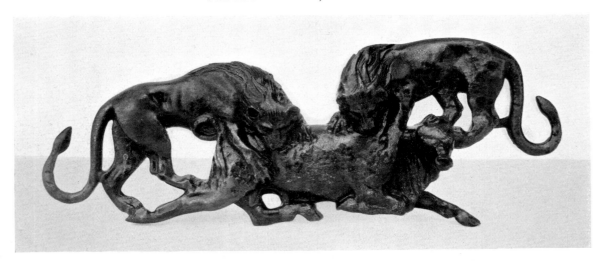

Pl. 102. *Above*: Lions attacking a bull, from Vuni, mid-5th cent. B.C. Bronze, ht., 3¹/₂ in. *Center*: Heifer, from Vuni, mid-5th cent. B.C. Bronze, ht., 7⁷/₈ in. Both, Nicosia, Cyprus Museum. *Below, left*: Stater from Marion, second half of 5th cent. B.C. *Right*: Stater from Lapithos, after 390 B.C. Last two, Stockholm, Medelhavsmuseet.

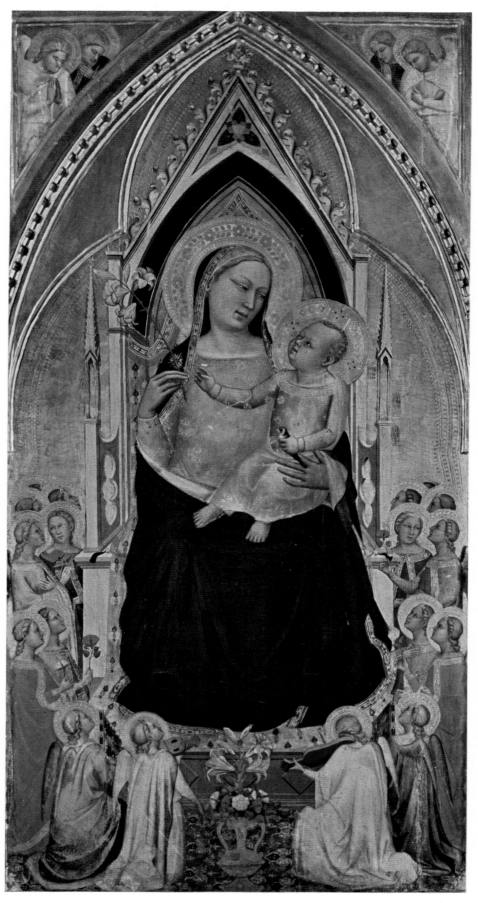

Pl. 103. The Virgin Enthroned, with angels and saints, central section of the Polyptych of S. Pancrazio. Panel, 5 ft., 6 1/8 in. × 1 ft., 9 5/8 in. Florence, Uffizi.

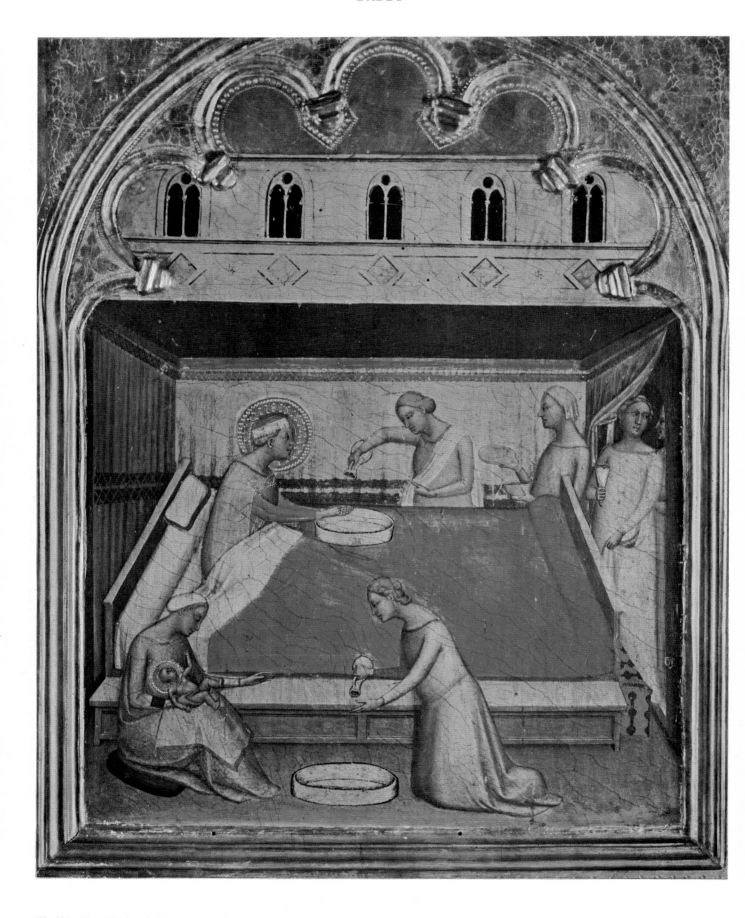

Pl. 104. The Birth of the Virgin, scene from the predella of the Polyptych of S. Pancrazio. Panel, 19³/₄×15 in. Florence, Uffizi.

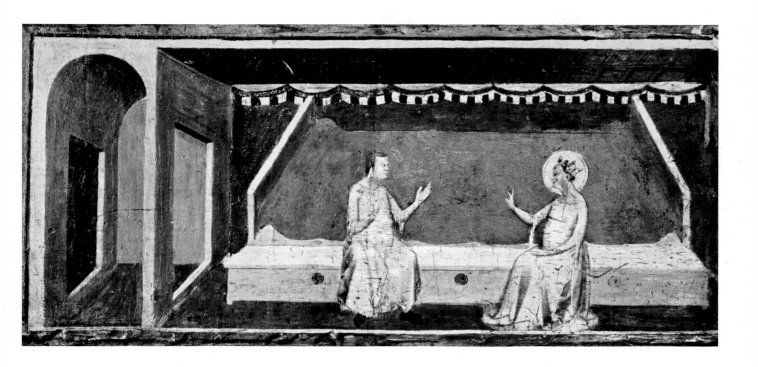

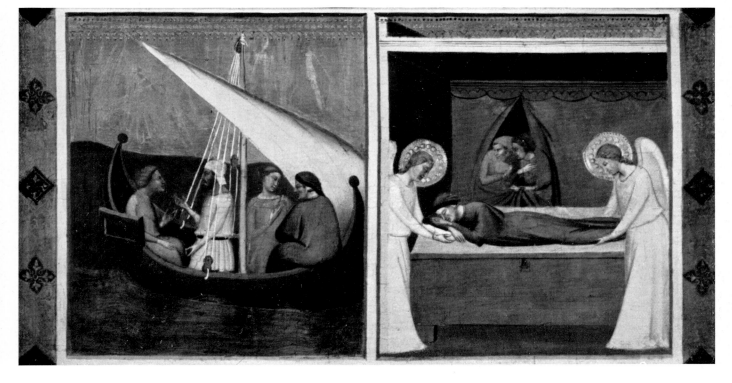

Pl. 105. *Above*: SS. Cecilia and Valerian, showing the saint urging her husband to conversion, from a predella with scenes of the
life of St. Cecilia. Panel, 7¹/₂ × 15³/₄ in. Pisa, Italy, Museo Civico. *Below*: Two scenes from a predella depicting the legend of
the Virgin's Girdle. Panel; full size, 10¹/₄ in. × 6 ft., 10¹/₄ in. Prato, Italy, Museo Comunale.

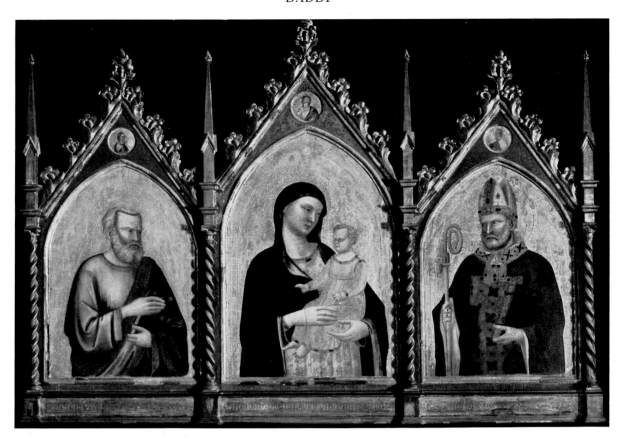

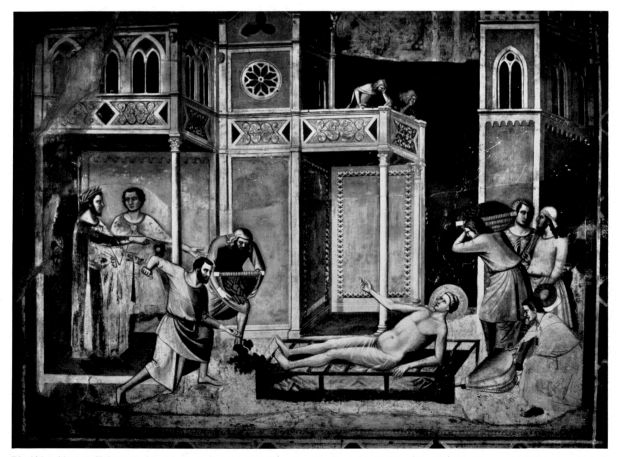

Pl. 106. *Above*: Triptych of the Ognissanti, showing the Virgin and Child with SS. Matthew and Nicholas. Panel, 4 ft., 8³/₄ in. × 6 ft., 4³/₈ in. Florence, Uffizi. *Below*: Martyrdom of St. Lawrence. Fresco. Florence, Sta Croce, Pulci-Berardi Chapel.

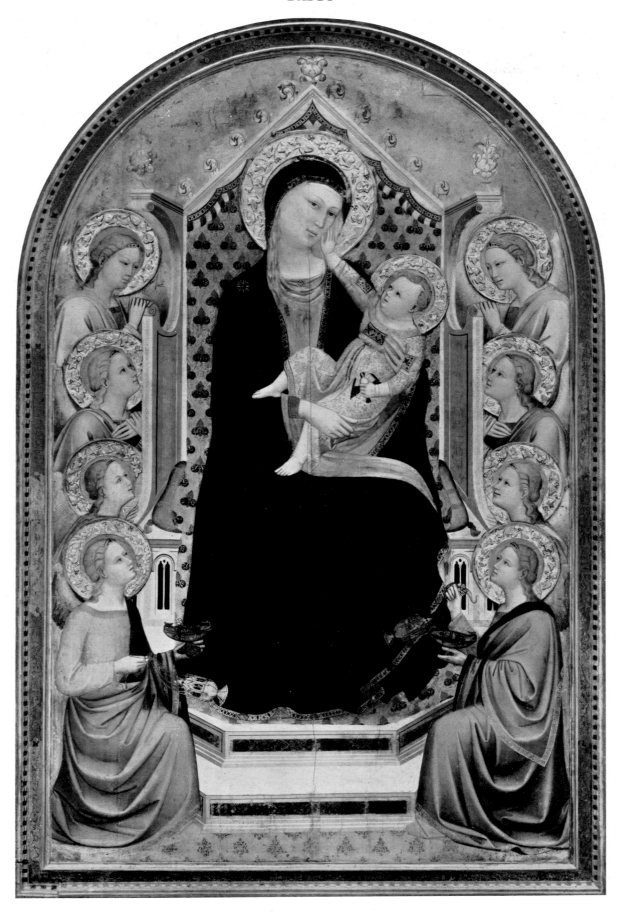

Pl. 107. Virgin and Child, with angels. Panel, 8 ft., 2³/₈ in. × 5 ft., 10⁷/₈ in. Florence, Orsanmichele.

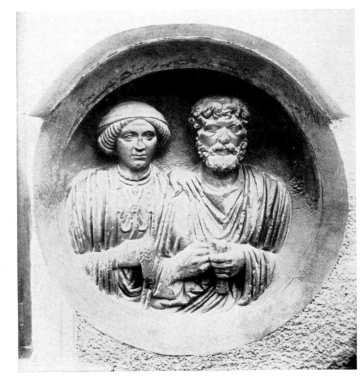

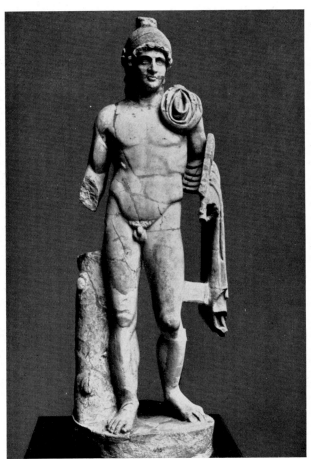

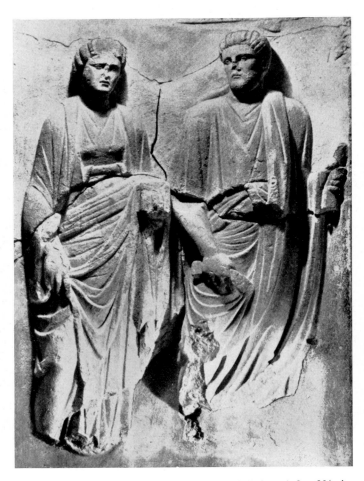

Pl. 108. *Above, left*: Gravestone, upper portion, from Leitha-Prodersdorf, Austria, 1st cent. Sandstone; full ht., 6 ft., 2⁵/₈ in. Eisenstadt, Austria, Burgenländisches Landesmuseum. *Right*: Funerary clipeus, Wels (anc. Ovilava), Austria, 2d cent. Wels, Hauptplatz. *Below, left*: Mars, from Zollfeld (anc. Virunum), Austria, first half of 2d cent. Marble, ht., 48⁷/₈ in. Klagenfurt, Austria, Landesmuseum. *Right*: Funerary relief from the Göggingen bridge, Augsburg, Germany, second half of 2d cent. Limestone, ht., 5 ft., 11¹/₄ in. Augsburg, Städtisches Maximilianmuseum.

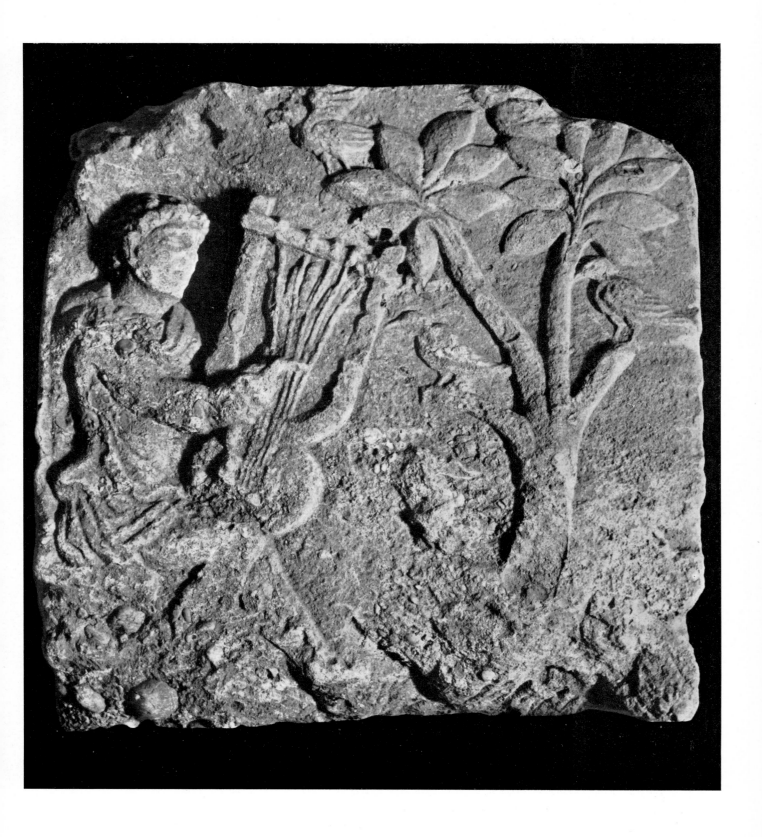

Pl. 109.  Relief showing Orpheus, Enns (anc. Lauriacum), Austria, 3d cent. Breccia, ht., 33 ¹/₂ in. Enns, Museum.

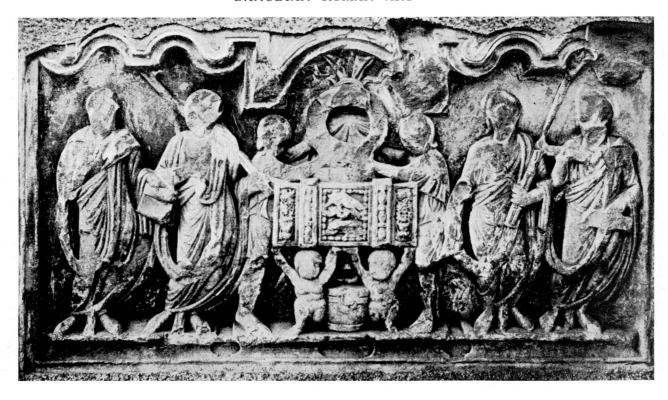

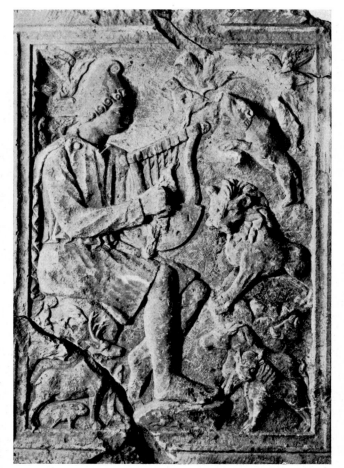

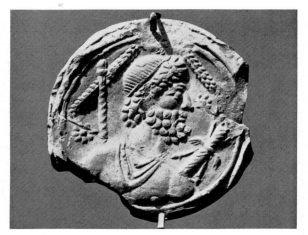

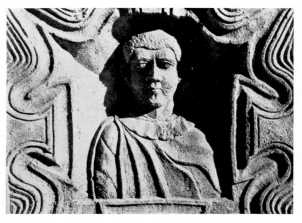

Pl. 110. *Above*: Relief with *sella curulis*, second half of 2d cent. Marble, ht., 45⁵/₈ in. Waltersdorf, Austria. *Below, left*: Orpheus, bas-relief from Dunapentele (anc. Intercisa), Hungary, 3d cent. Ht., 46¹/₂ in. Budapest, National Museum. *Right, center*: Impressed head of Jupiter, from Petronell (anc. Carnuntum), Austria, 3d cent. Terra cotta, ht., 3¹/₈ in. Deutsch Altenburg, Austria, Museum Carnuntinum. *Right, below*: Detail of a sarcophagus, from Sremska Mitrovica, Yugoslavia, 3d cent. Limestone. Belgrade, Museum of Art and Archaeology.

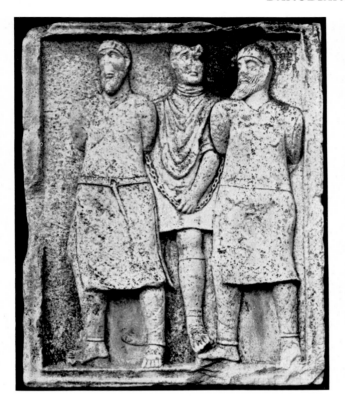

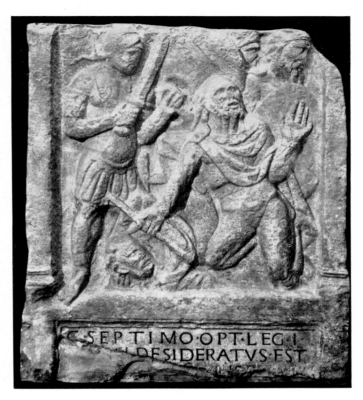

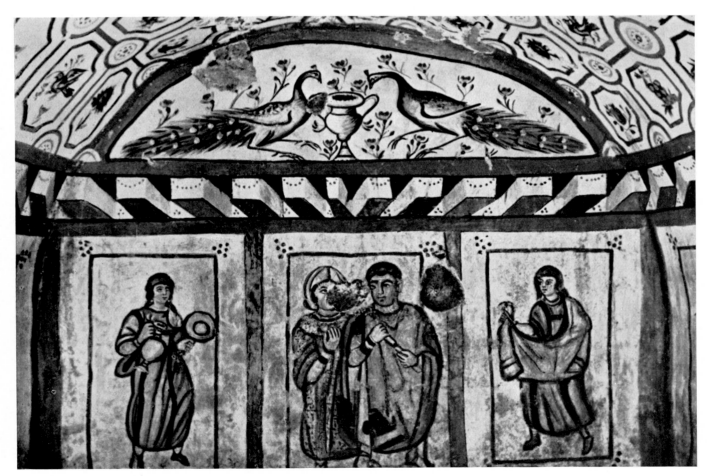

Pl. 111. *Above, left*: Metope showing prisoners, from the monument at Adamklissi, Dobruja, Romania, first half of 2d cent. Limestone, ht., 4 ft., 9⁷/₈ in. Bucharest, National Museum. *Right*: Gravestone, from Alt-Szöny, Hungary, late 2d – early 3d cent. Limestone. Budapest, National Museum. Photographed from a cast in the Museo della Civiltà Romana, Rome. *Below*: Wall painting in a tomb, detail, 4th cent. Silistra (anc. Durostorum), Bulgaria.

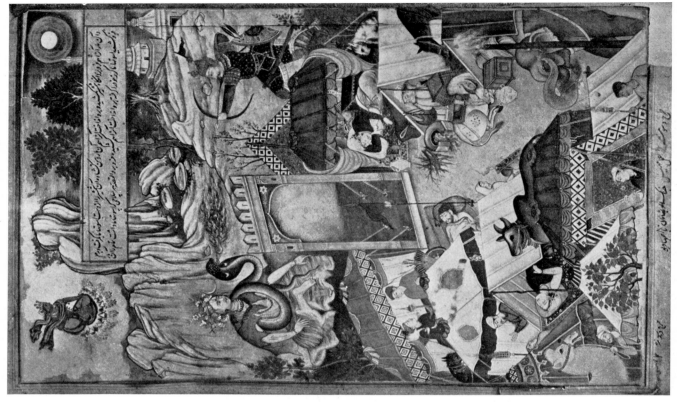

Pl. 112. Miniatures from the *Razm-nāma*. *Left*: Bhīma, dressed as a woman, kills Kīcaka, who had attempted to seduce Draupadī. *Right*: Aśvatthāmān attacks the Pāṇḍava camp at night and enters after propitiating the god Śiva. Jaipur, India, Royal Library.

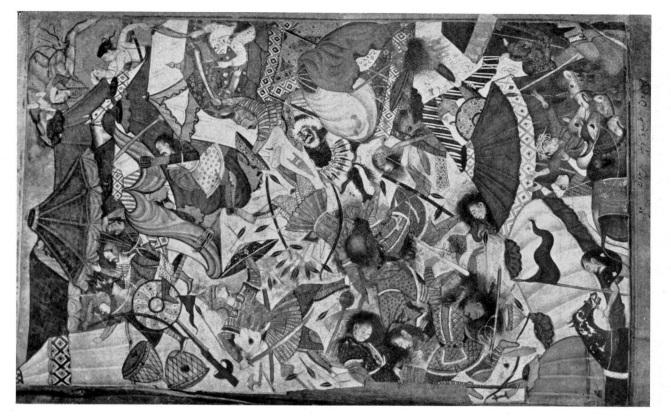

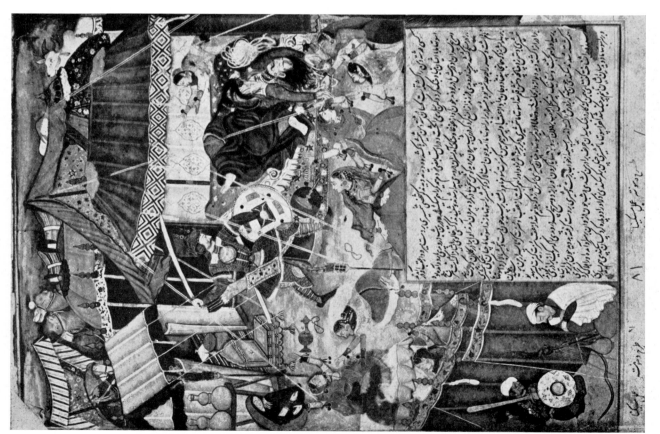

Pl. 113. Miniatures from the *Rasm-nāma*. The attack on the Pāṇḍava camp. *Left*: Aśvatthāmān kills Dṛṣṭadyumna, leaving the gate guarded. *Right*: The sons of Draupadī are slain. Jaipur, India, Royal Library.

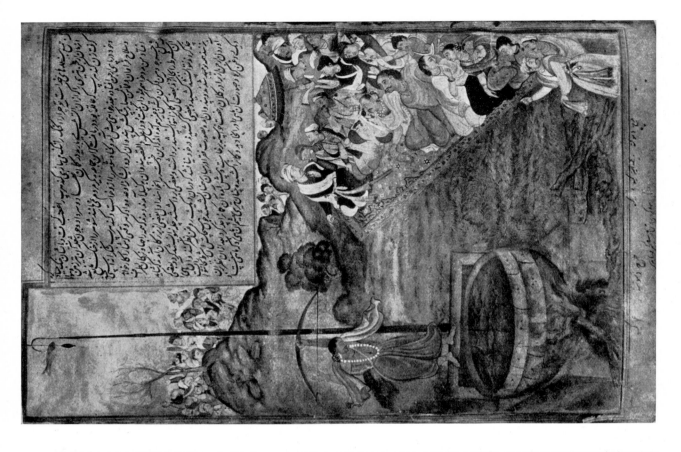

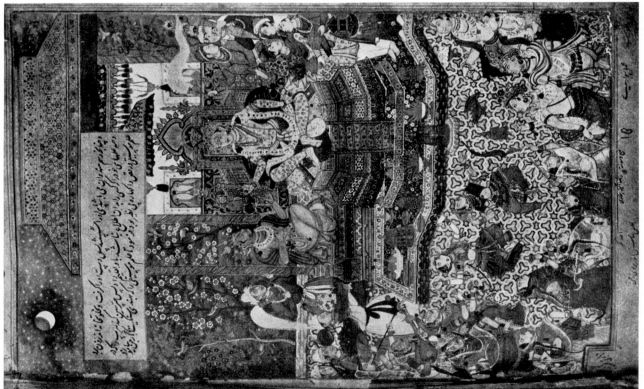

Pl. 114. Miniatures from the *Rasm-nāma. Left*: Arjuna, seated beside Indra, witnesses the joys of heaven. *Right*: Contending suitors demonstrate their prowess to Draupadi. Jaipur, India, Royal Library.

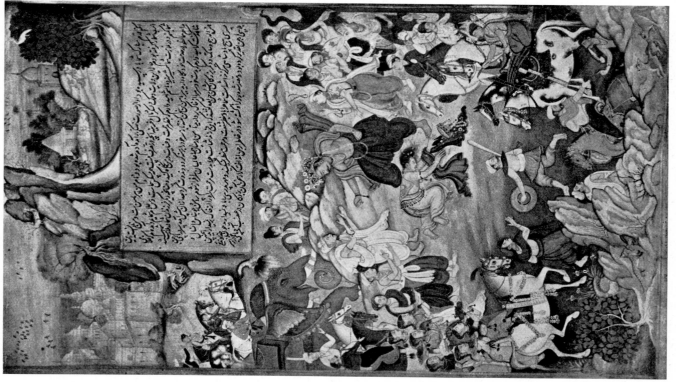

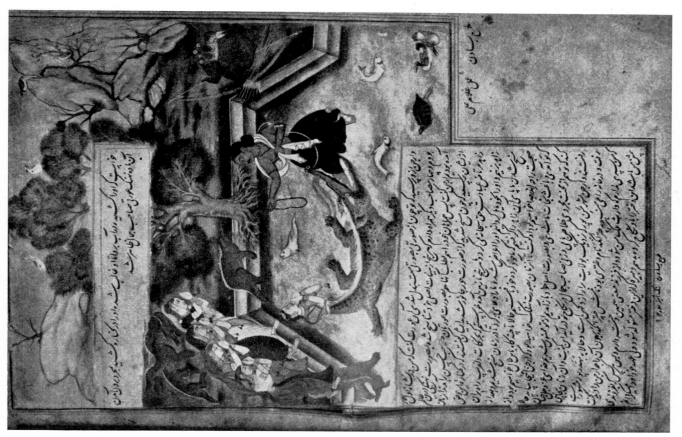

Pl. 115. Miniatures from the *Rasm-nāma. Left:* Arjuna releases an apsaras imprisoned in a crocodile. *Right:* Arjuna spurns his son's offer of all his resources. Jaipur, India, Royal Library.

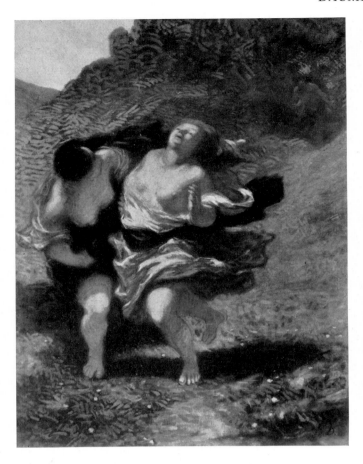

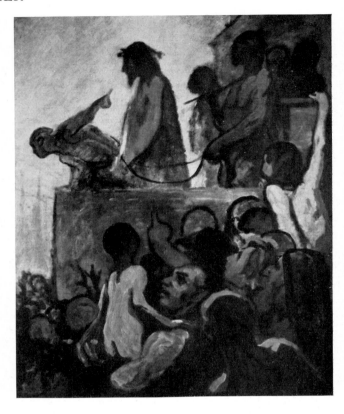

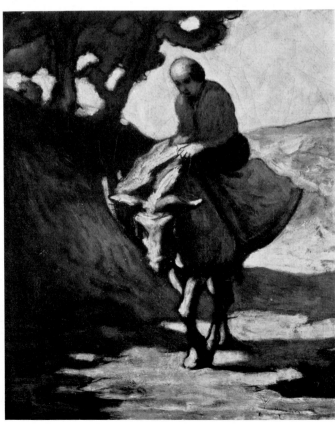

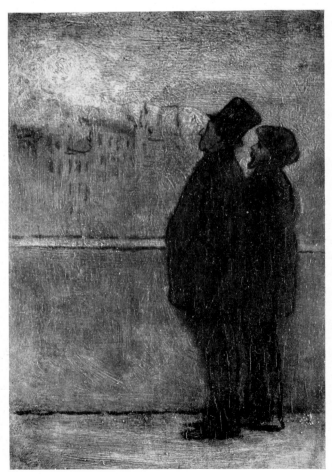

Pl. 116. *Above, left*: Nymphs Pursued by Satyrs. Canvas, 4 ft., 3³/₄ in. × 3 ft., 2¹/₄ in. Montreal, Museum of Fine Arts. *Right*: "We Want Barabbas." Canvas, 5 ft., 3 in. × 4 ft., 2 in. Essen, Folkwang Museum. *Below, left*: Return from Market. Canvas, 13³/₄×11 in. Winterthur, O. Reinhart Coll. *Right*: Les Noctambules. Panel, 11×7¹/₂ in. Cardiff, National Museum of Wales.

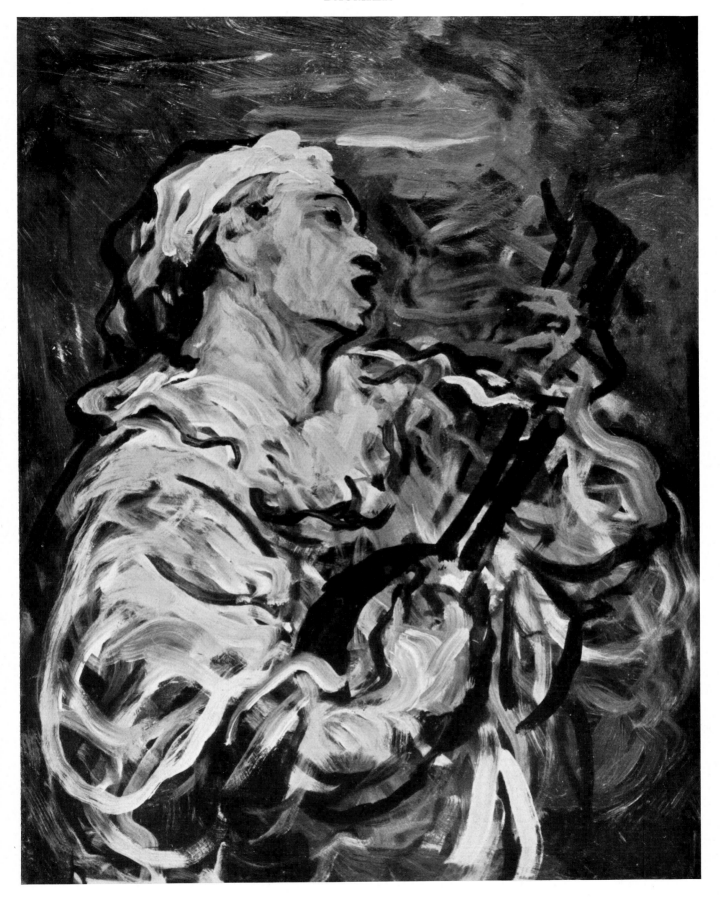

Pl. 117. Pierrot Strumming the Guitar. Panel, 13³/₄×10¹/₄ in. Winterthur, Switzerland, Oskar Reinhart Coll.

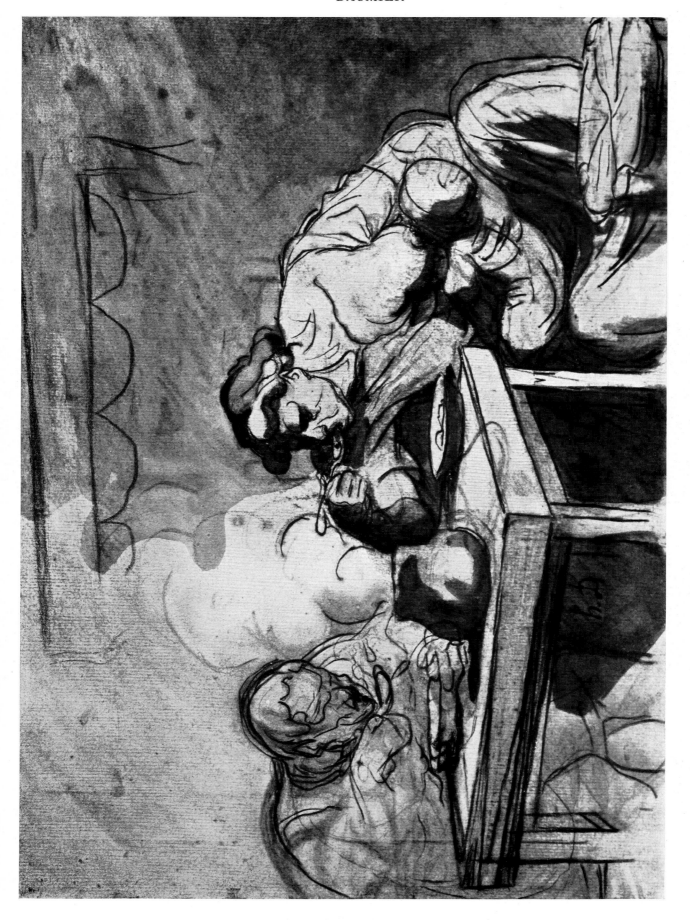

Pl. 118. La Soupe. Pen drawing and water color, 11×15³/₄ in. Paris, Louvre, Cabinet des Dessins.

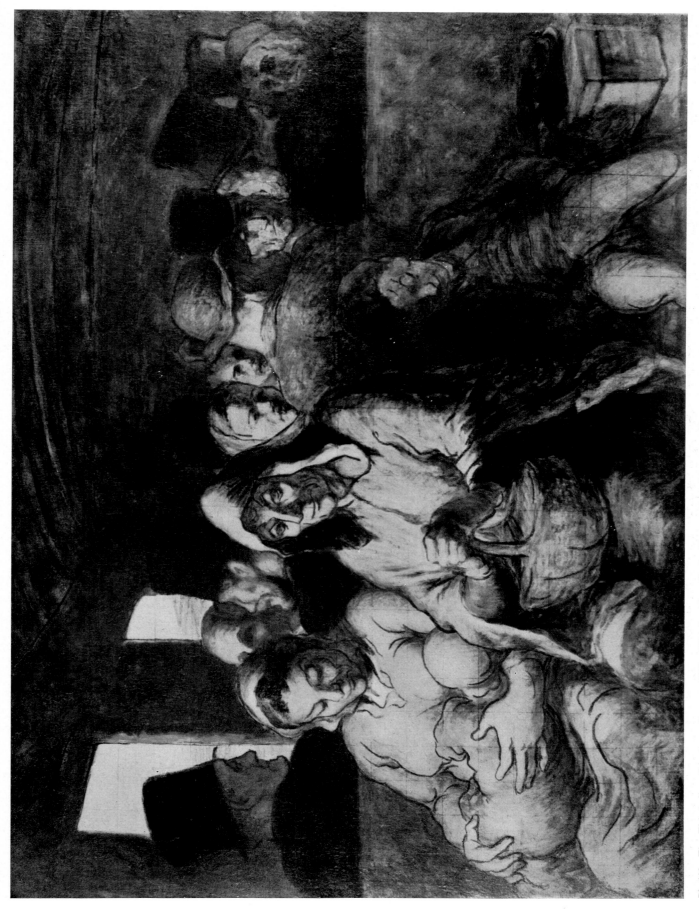

Pl. 119.  The Third-class Carriage. Canvas, 25³/₄×35¹/₂ in. New York, Metropolitan Museum.

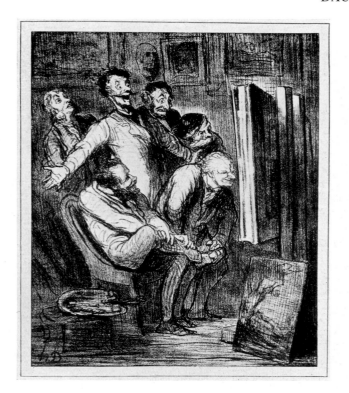

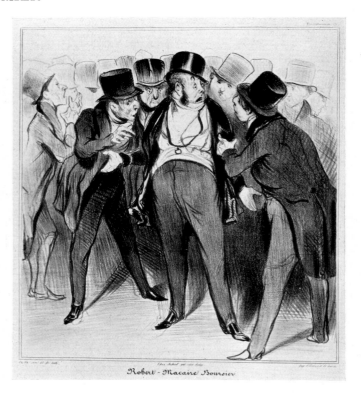

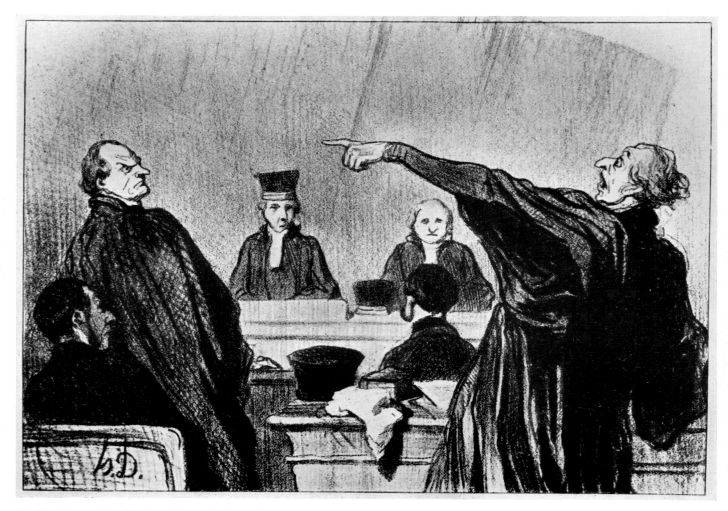

Pl. 120. *Above, left*: The Art Critics. Lithograph. *Right*: Robert Macaire, Stockbroker. Lithograph. *Below*: Lithograph from the series *Les Gens de Justice*.

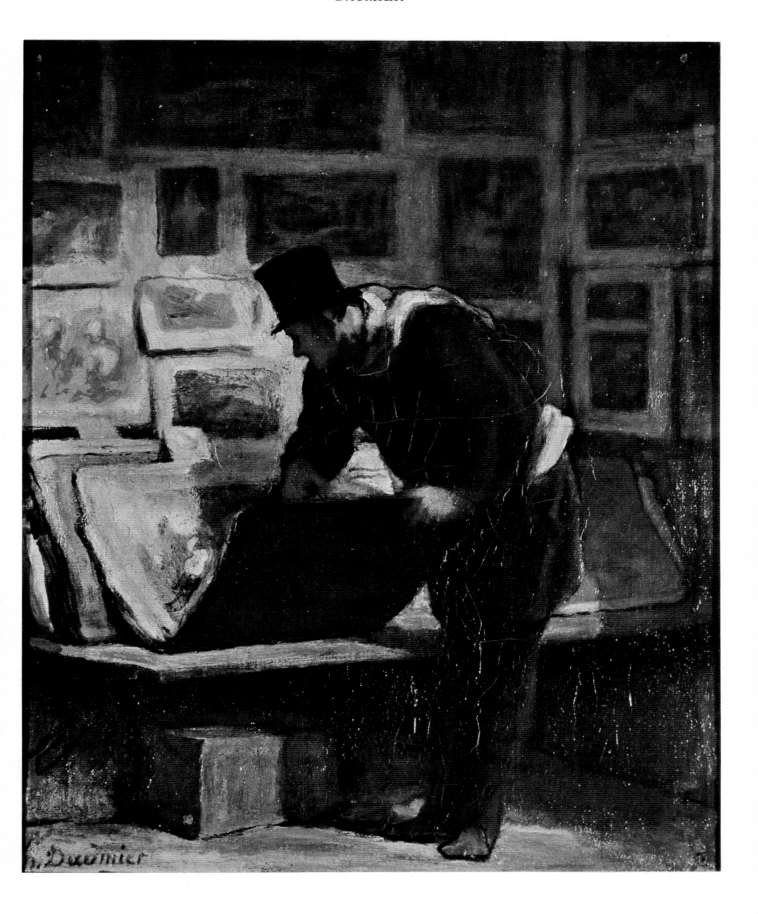

Pl. 121. The Print Collector. Canvas, $15^{3}/_{4} \times 12^{5}/_{8}$ in. Paris, Musée du Petit-Palais.

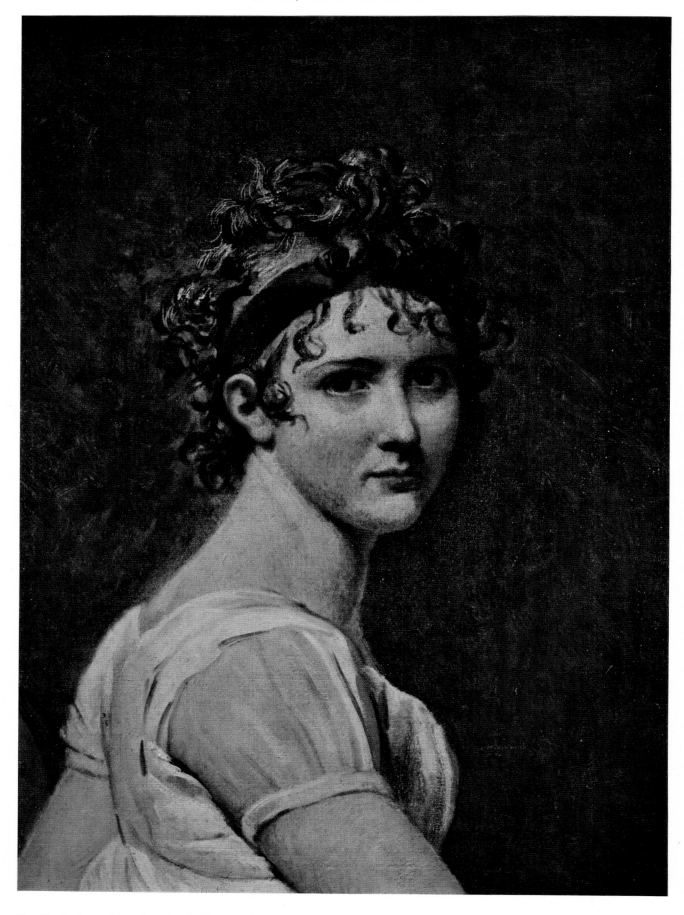

Pl. 122. Madame Récamier, detail. Canvas; full size, 5 ft., 6⁷/₈ in. × 7 ft., 10¹/₂ in. Paris, Louvre.

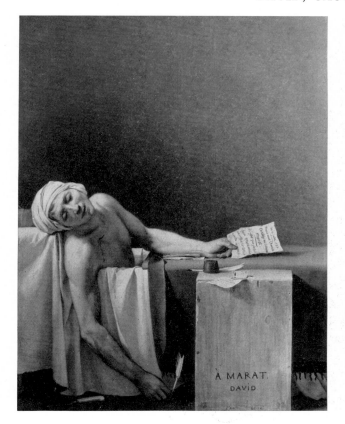

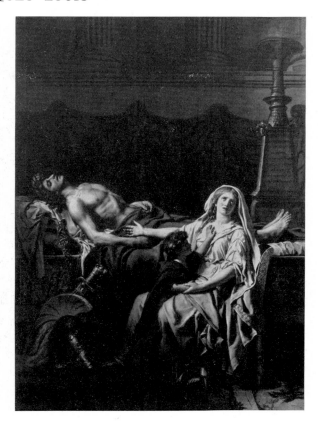

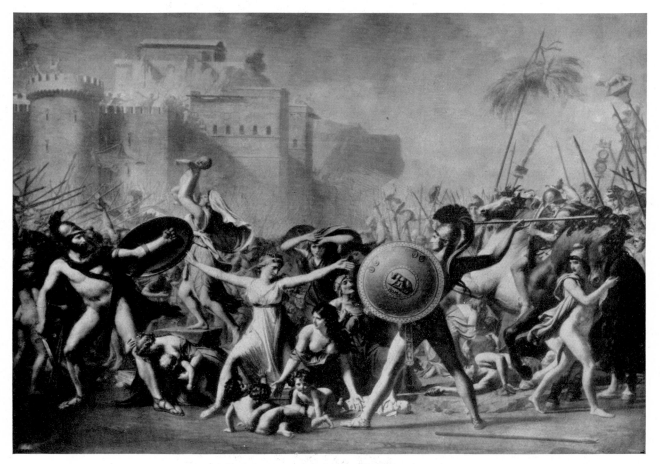

Pl. 123. *Above, left*: Death of Marat. Canvas, 5 ft., 3³/₄ in. × 4 ft., 1 in. Brussels, Musées Royaux des Beaux-Arts. *Right*: Andromache by the Body of Hector. Panel, 9 ft. × 6 ft., 7⁷/₈ in. Paris, Ecole des Beaux-Arts. *Below*: The Sabine Women Ending the Battle between the Romans and the Sabines. Canvas, 12 ft., 8 in. × 18 ft. Paris, Louvre.

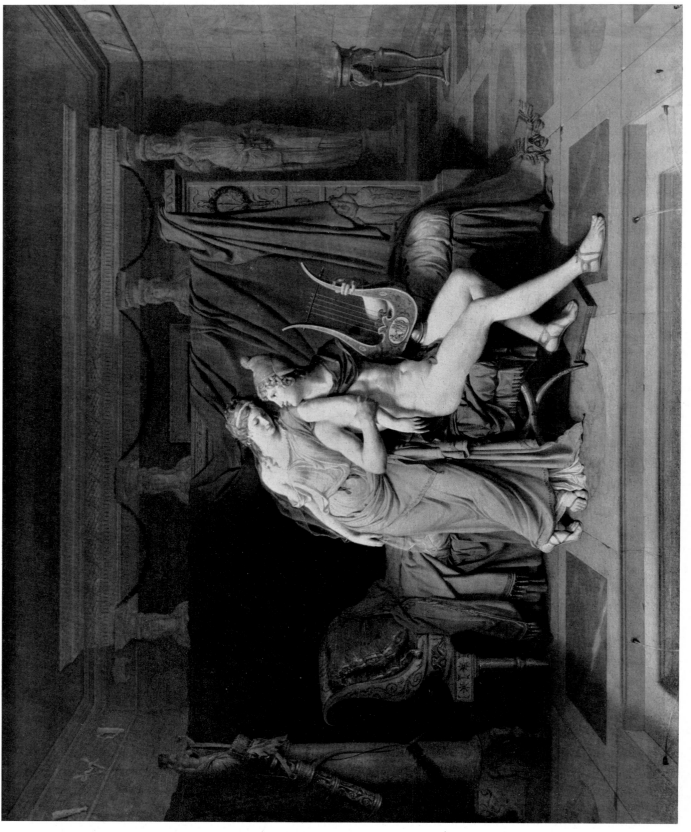

Pl. 124. Paris and Helen. Canvas, 4 ft., 9⁷/₈ in. × 5 ft, 10⁷/₈ in. Paris, Louvre.

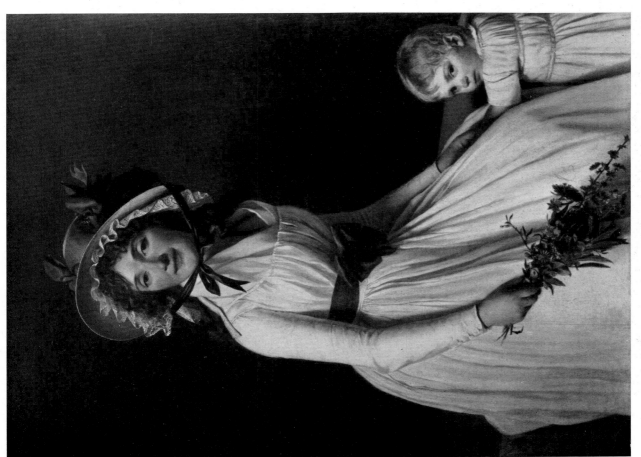

Pl. 125. *Left*: Madame Sériziat and Her Daughter. Canvas, 4 ft, 4 in. × 3 ft, 2¼ in. *Right*: Monsieur Sériziat. Canvas, 4 ft, 4 in. × 3 ft, 2¼ in. Both, Paris, Louvre.

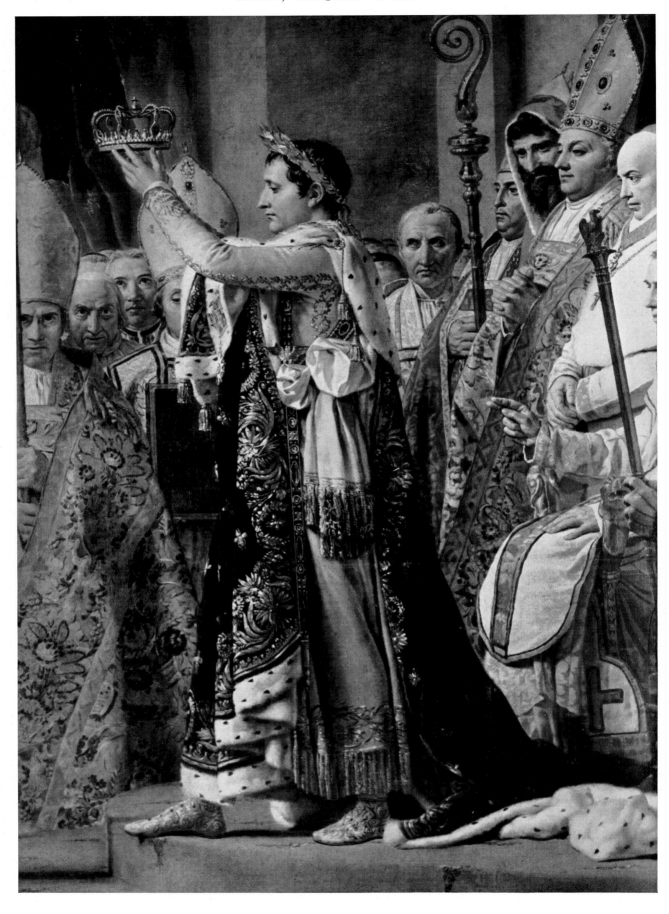

Pl. 126.  The Coronation of Napoleon and Josephine, detail. Canvas; full size, 20 ft. × 30 ft., 6¹/₂ in. Paris, Louvre.

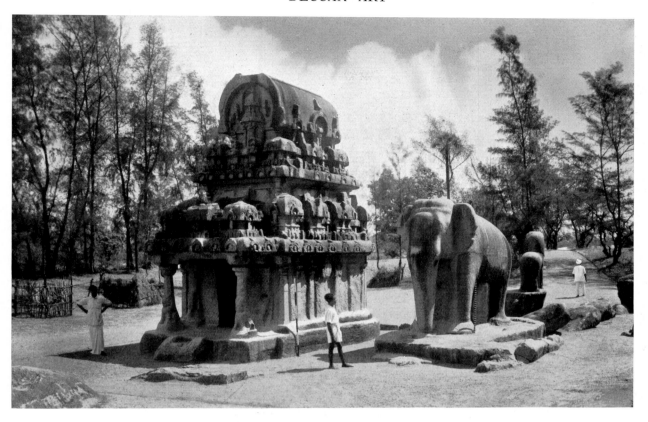

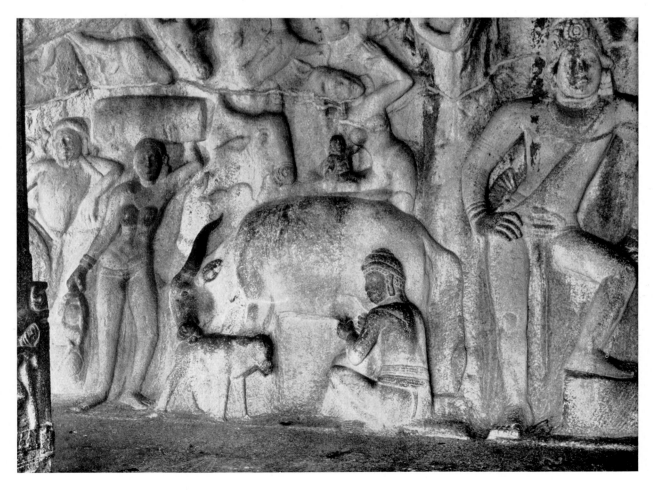

Pl. 127. Mamallapuram, Madras, 7th cent. Rock sculpture. *Above*: Ratha and elephant. *Below*: Milking scene.

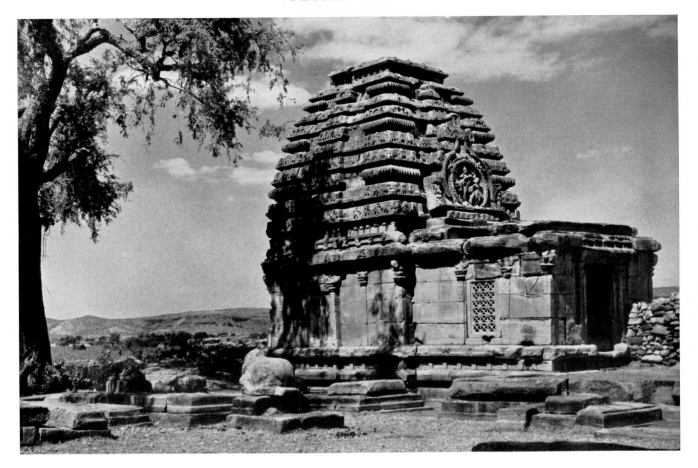

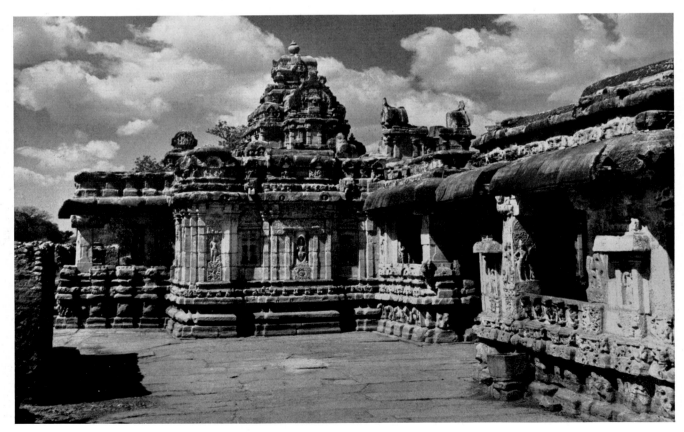

Pl. 128. Pattadakal, Mysore, 8th cent. *Above*: The Jambhuliṅga temple from the southeast. *Below*: The Virūpākṣa temple.

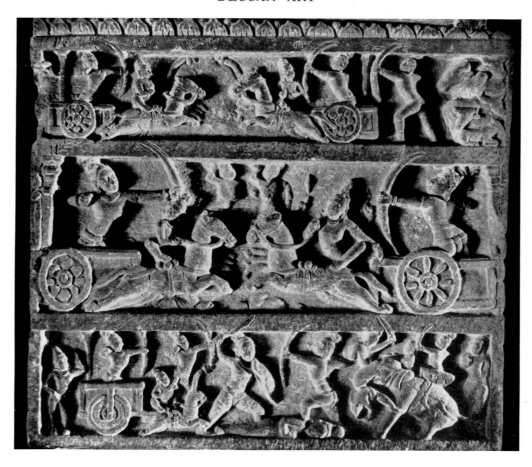

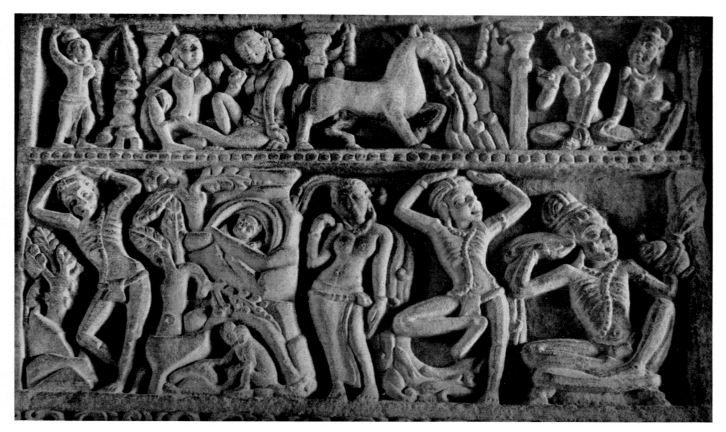

Pl. 129. Pattadakal, Mysore, 8th cent. *Above*: The Mallikārjuna temple, pillar relief in the interior. *Below*: The Virūpākṣa temple, pillar relief in the interior.

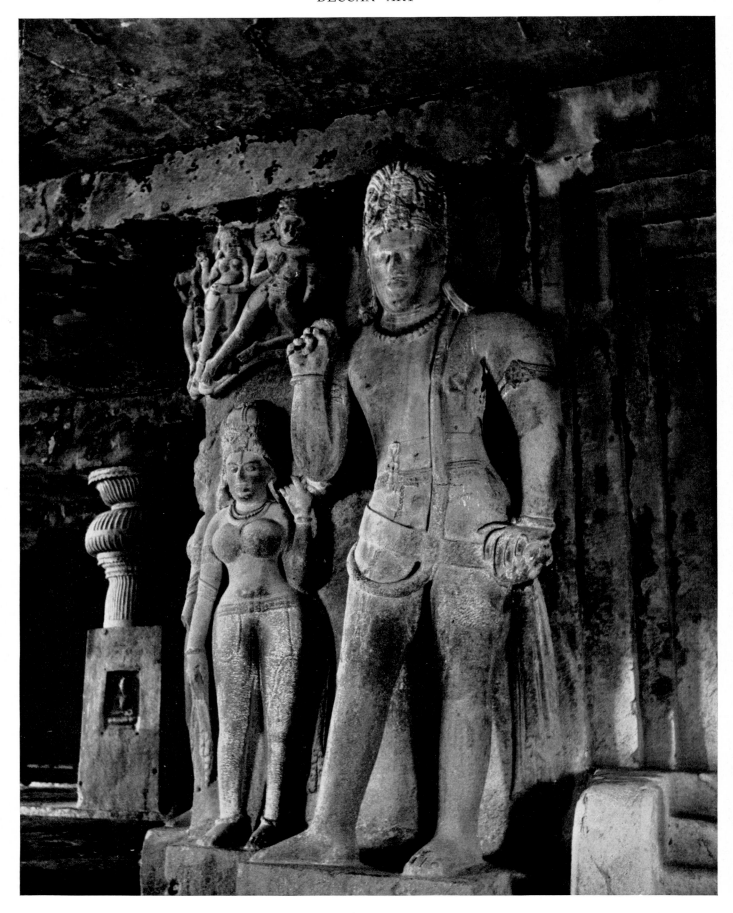

Pl. 130.  Ellora, Maharashtra, temple interior with rock sculptures, Cave XXIX, 7th–8th cent.

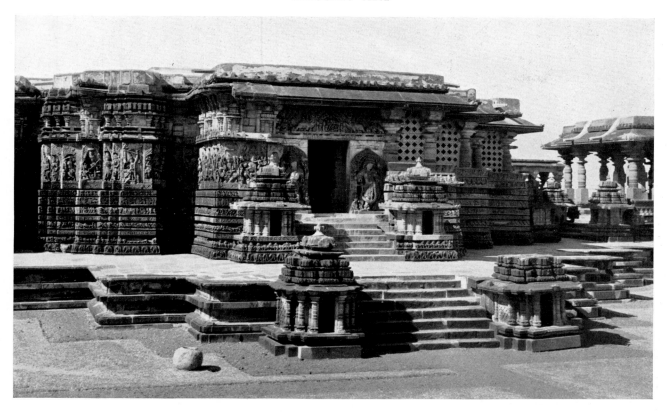

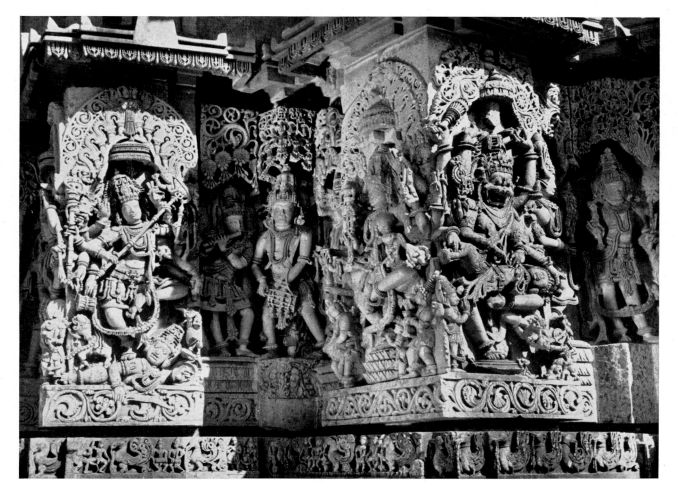

Pl. 131. Halebid, Mysore, the Hoyśaleśvara temple, rear view and detail of the exterior decoration, 12th cent.

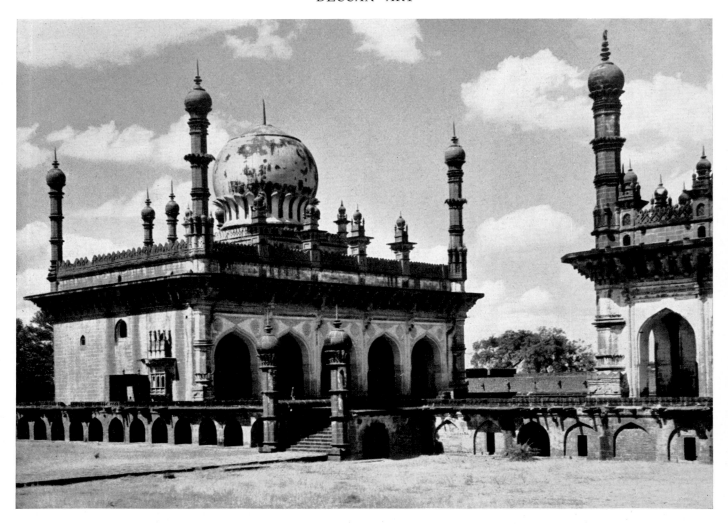

Pl. 132. Bijapur, Mysore. *Above*: The Ibrāhīm Rauza mosque, first half of 17th cent. *Below*: The Shērzah Burj, lion reliefs, 1671.

Pl. 133. Madura, Madras, palace of Tirumala Nāyak, detail of the interior, 17th cent.

Pl. 134. *Above*: The Bellelli Family. Canvas, 6 ft., 6³/₄ in. × 8 ft., 3⁵/₈ in. Paris, Louvre. *Below*: The Cotton Exchange at New Orleans. Canvas, 28³/₈×35³/₈ in. Pau, France, Musée des Beaux-Arts.

Pl. 135. Absinthe. Canvas, 36¼×27 in. Paris, Louvre.

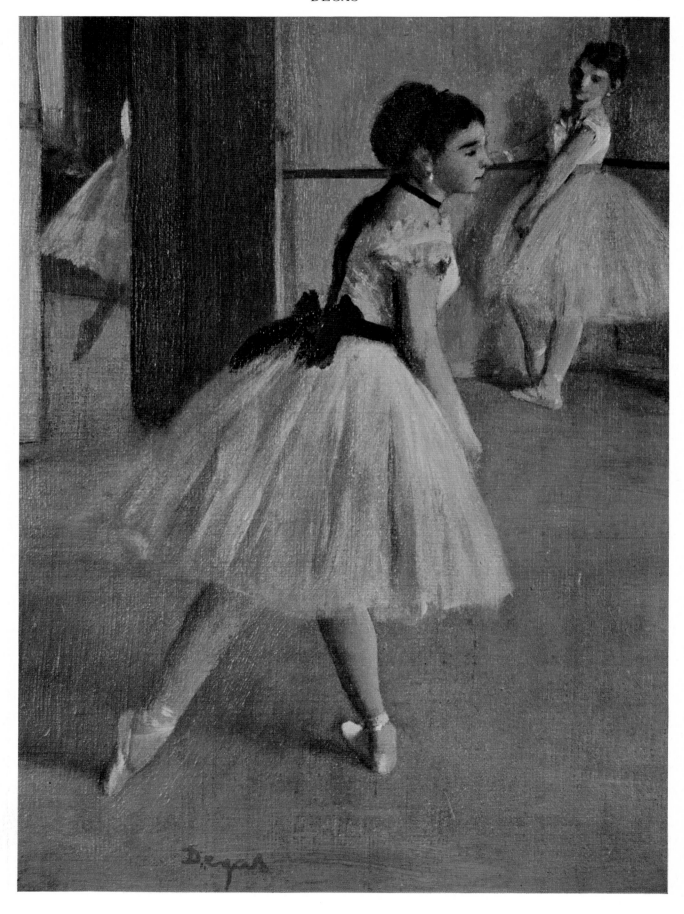

Pl. 136. The Dance Foyer at the Opera, detail. Canvas; full size, 12³/₄×18¹/₄ in. Paris, Louvre.

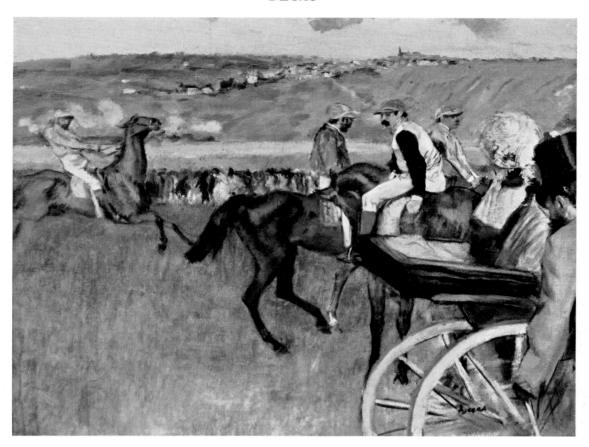

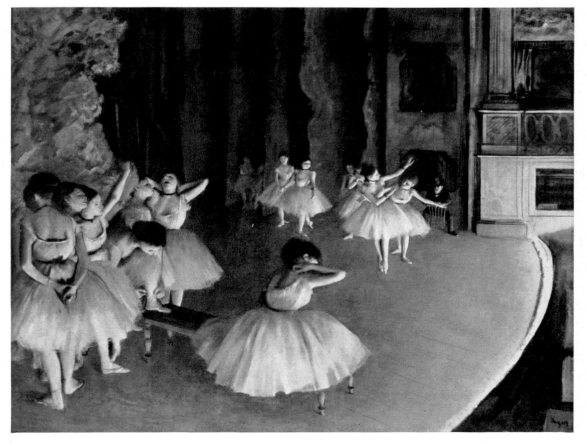

Pl. 137. *Above*: Amateur Jockeys near a Carriage. Canvas, 26¹/₈×32¹/₄ in. *Below*: The Rehearsal. Canvas, 26×32¹/₄ in. Both, Paris, Louvre.

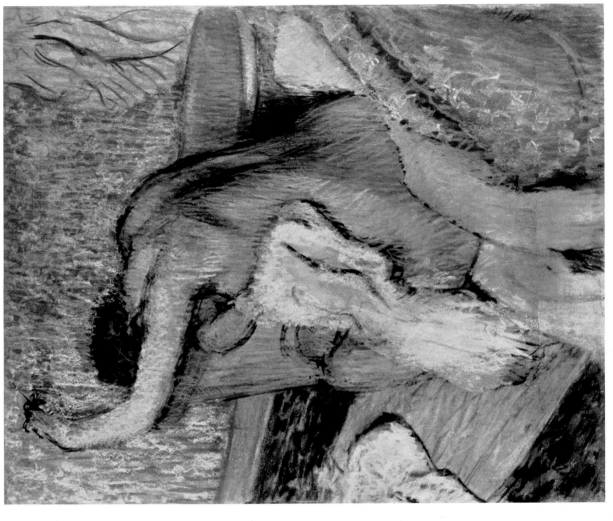

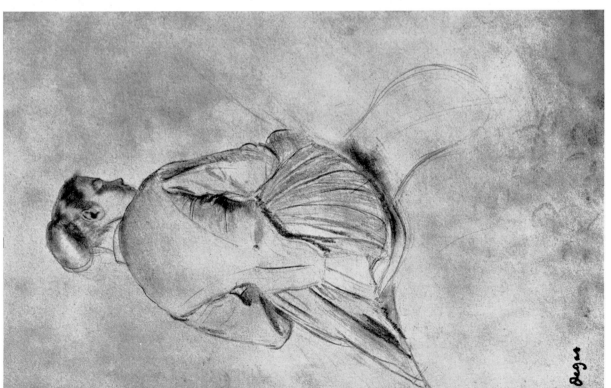

Pl. 138. *Left*: Woman on Horseback. Pencil drawing. Paris, Louvre. *Right*: After the Bath. Pastel and water color, $29^{1}/_{8} \times 22^{7}/_{8}$ in. London, Courtauld Institute.

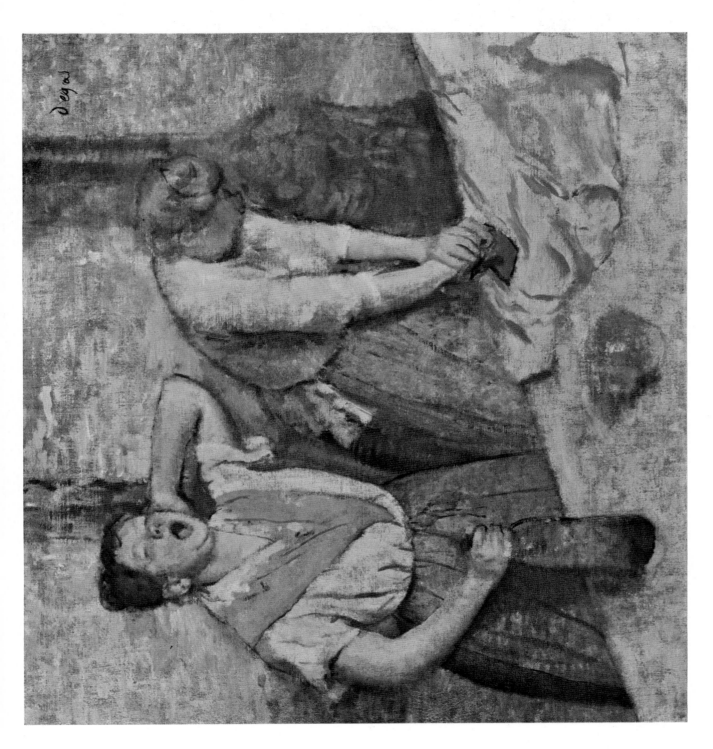

Pl. 139. Two Laundresses. Canvas, 29⁷/₈ × 32¹/₄ in. Paris, Louvre.

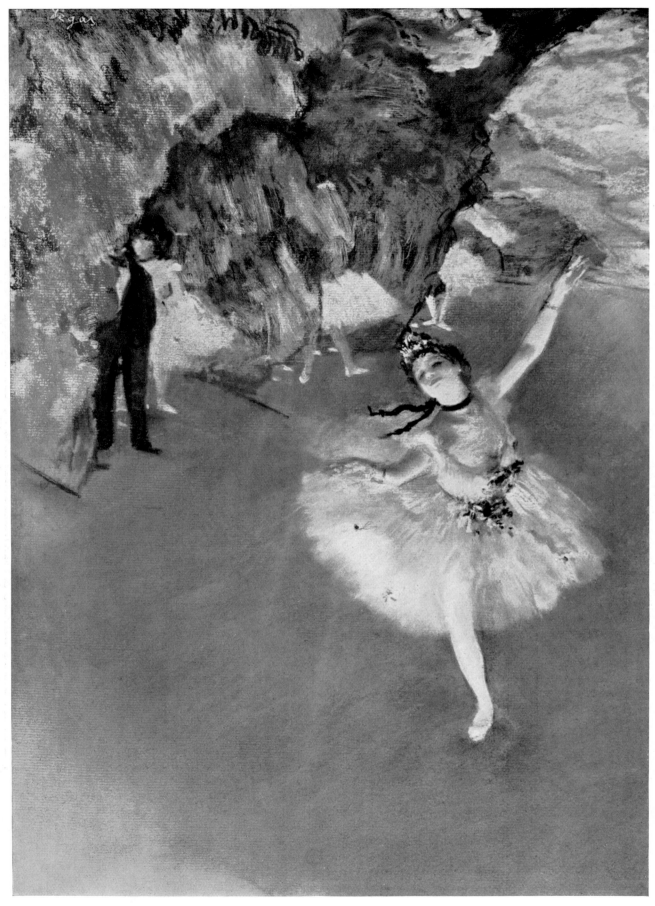

Pl. 140.  The Star Bowing.  Pastel, $22^{7}/_{8} \times 16^{1}/_{2}$ in.  Paris, Louvre.

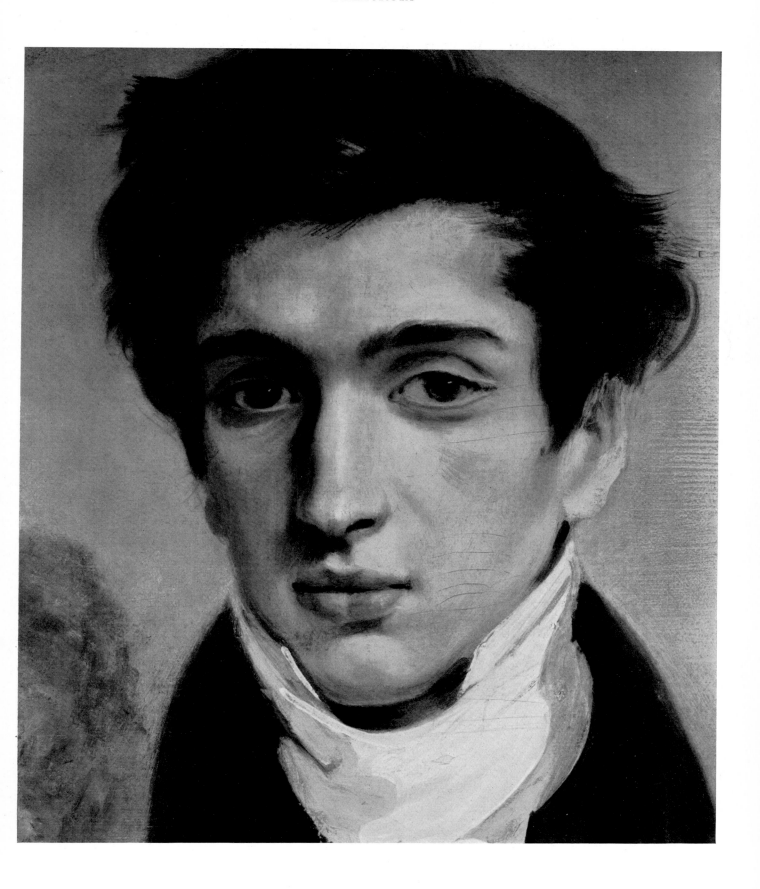

Pl. 141. Portrait of Baron Schwiter, detail. Canvas; full size, 7 ft., 1⅞ in. × 4 ft., 8¼ in. London, National Gallery.

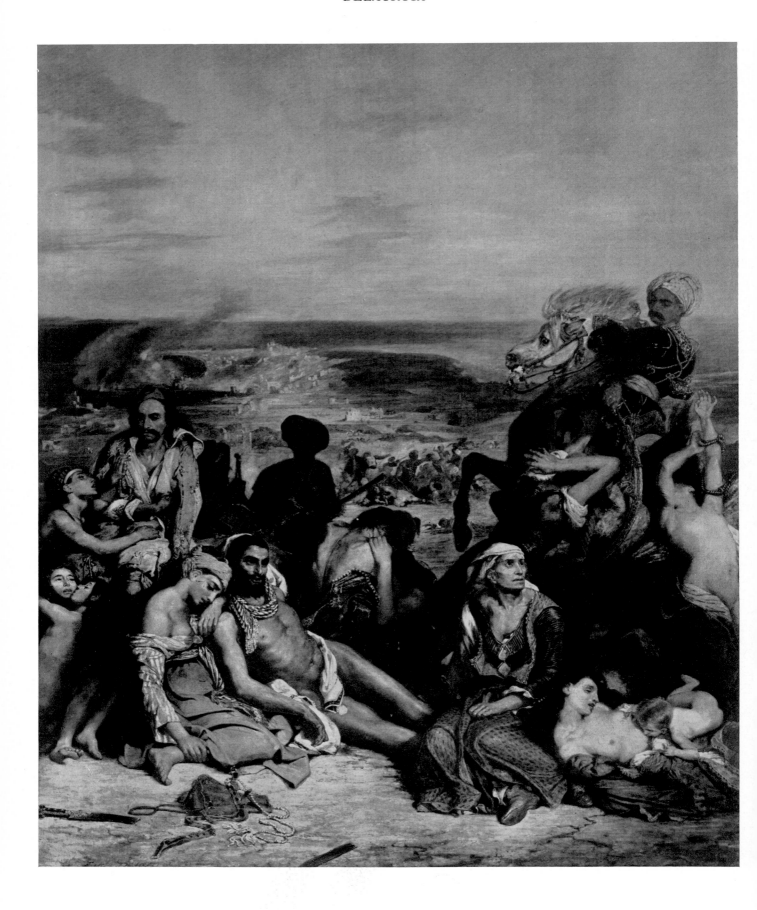

Pl. 142.  The Massacre at Chios. Canvas, 13 ft., 10$^{1}$/$_{8}$ in.  ×  11 ft., 6$^{5}$/$_{8}$ in. Paris, Louvre.

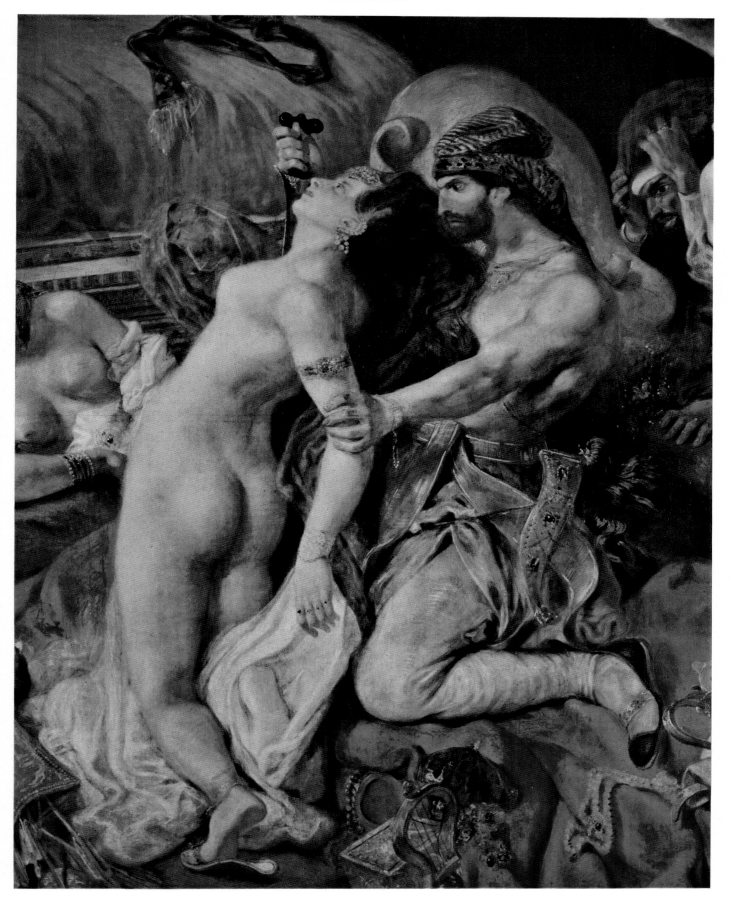

Pl. 143.  The Death of Sardanapalus, detail. Canvas; full size, 12 ft., 11$^1$/$_2$ in.  ×  16 ft., 2$^7$/$_8$ in. Paris, Louvre.

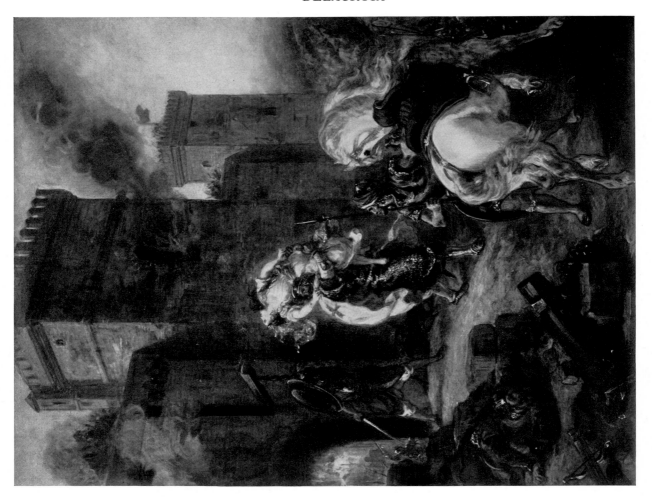

Pl. 144. *Left, above:* Study for The Death of Sardanapalus. Slate pencil, pen and ink, and sepia wash, 11×15³/₄ in. Bayonne, France, Musée Bonnat. *Below:* Dante and Vergil in Hell. Canvas, 5 ft, 10⁷/₈ in. × 7 ft, 10¹/₂ in. *Right:* The Abduction of Rebecca. Canvas, 39³/₈×31⁷/₈ in. Last two, Paris, Louvre.

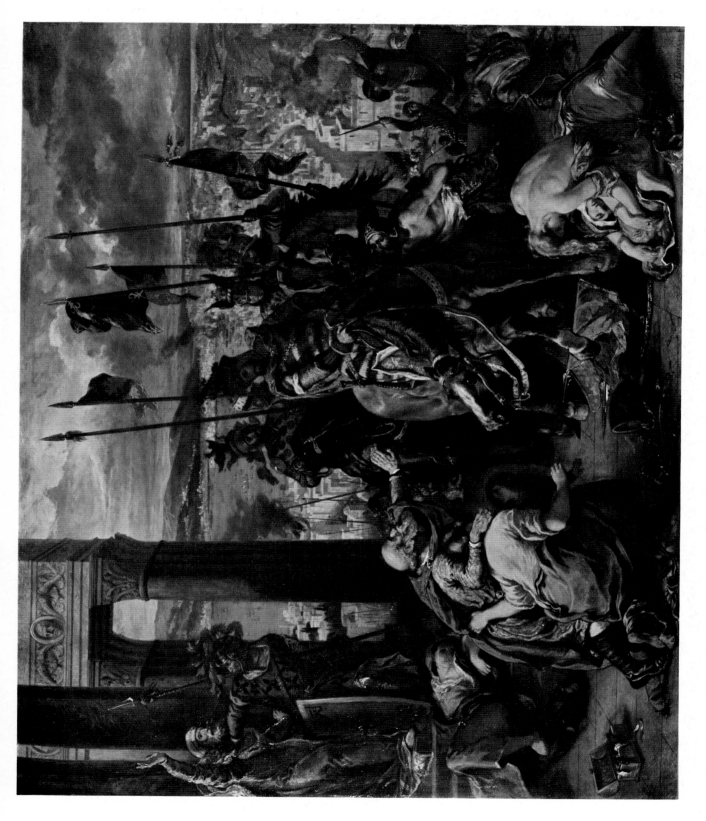

Pl. 145. Entrance of the Crusaders into Constantinople. Canvas, 13 ft., 3⁷/₈ in. × 16 ft., 1³/₄ in. Paris, Louvre.

Pl. 146. Self-portrait. Canvas, 25 1/4 × 20 1/8 in. Paris, Louvre.

Pl. 147.  Virgin and Child. Marble. Ferrara, Italy, Museo dell'Opera del Duomo.

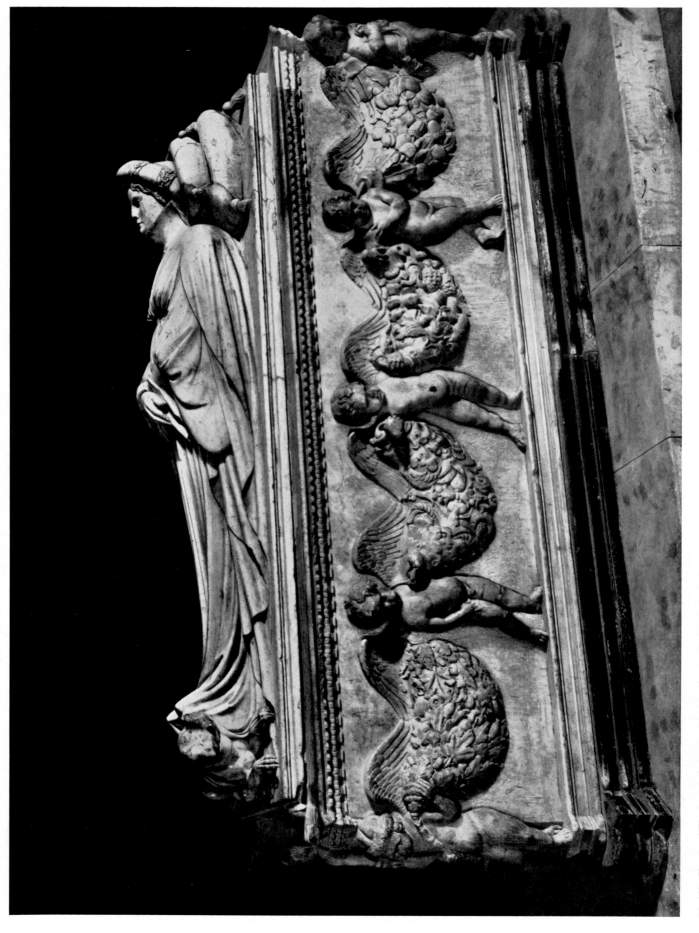

Pl. 148. Tomb of Ilaria del Carretto. Marble. Lucca, Italy, Cathedral.

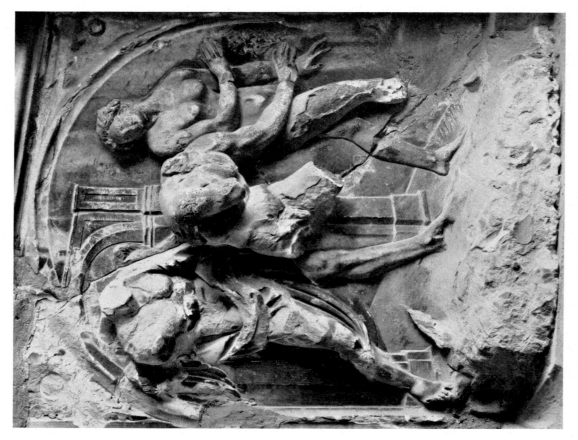

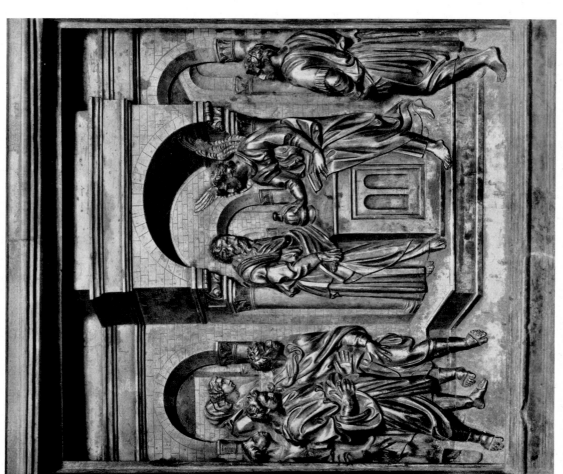

Pl. 149. *Left*: The Appearance of the Angel to Zacharias, relief on the baptismal font in the Baptistery, Siena, Italy. Gilt bronze, 24³/₈×24³/₄ in. *Right*: The Expulsion from Paradise, relief from the dismantled Fonte Gaia, formerly in the Piazza del Campo, Siena. Marble. Siena, Palazzo Pubblico, Loggia.

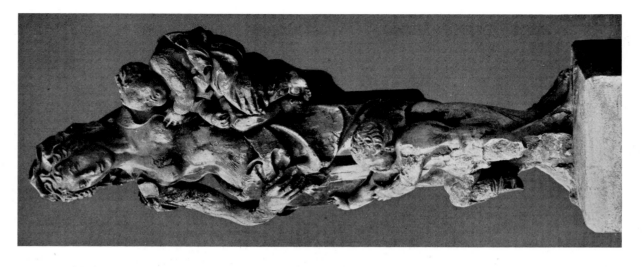

Pl. 150. *Left*: St. Leonard. Painted wood. Massa, Italy, Madonna degli Ulivi. *Center and right*: Sculptures from the dismantled Fonte Gaia, formerly in the Piazza del Campo, Siena. Virgin and Child (*center*) and Charity (*right*). Marble. Siena, Palazzo Pubblico, Loggia.

Pl. 151. Altar, showing the Virgin and Child with saints. Marble. Lucca, Italy, S. Frediano, Trenta Chapel.

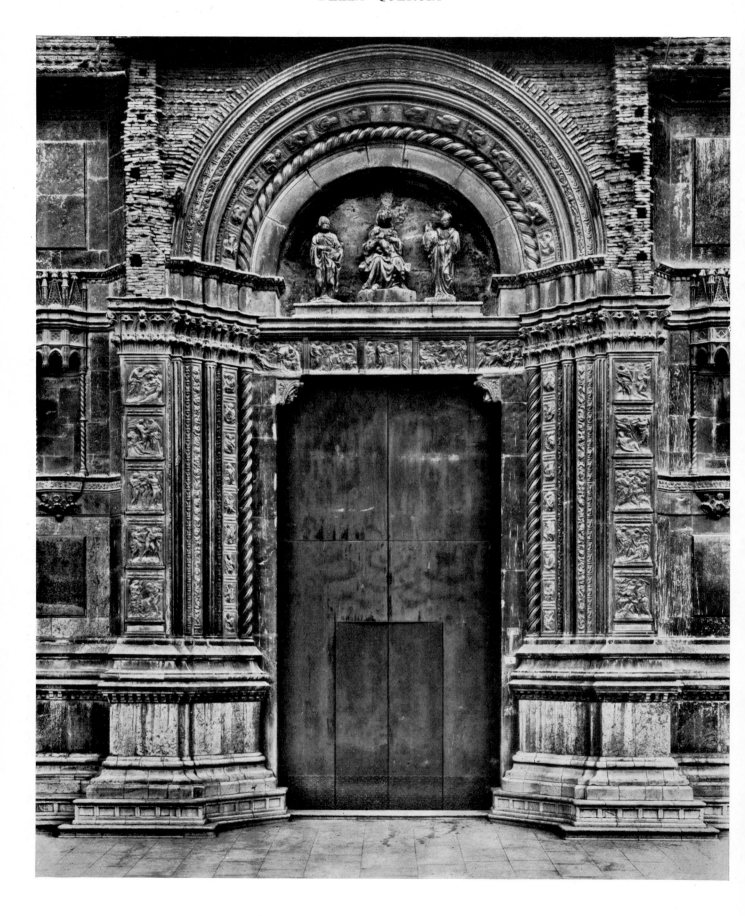

Pl. 152. Bologna, Italy, S. Petronio, central portal of the façade, with scenes from the Old and New Testaments.

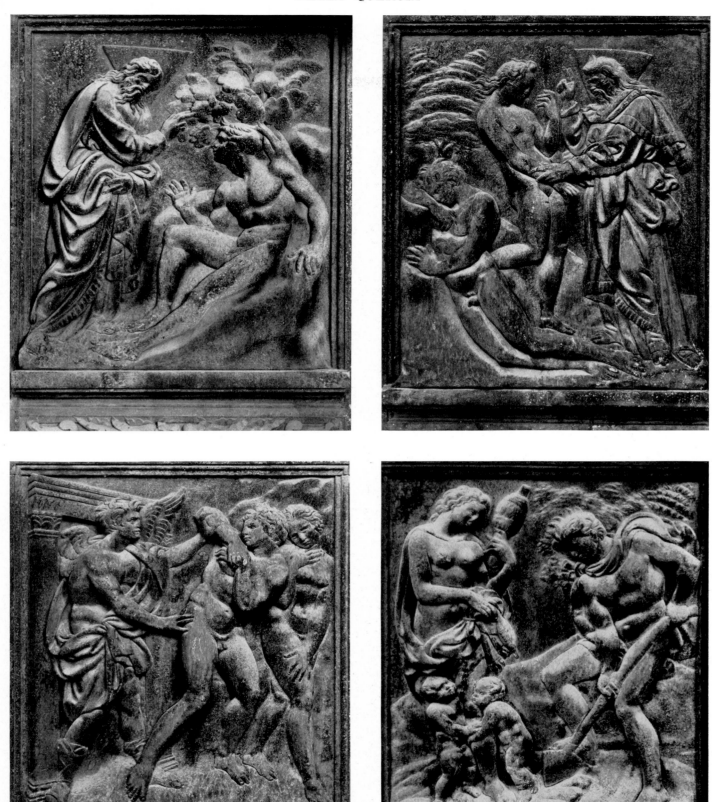

Pl. 153. Bologna, Italy, S. Petronio, reliefs on the central portal of the façade. Marble. *Above, left*: The Creation of Adam. *Right*: The Creation of Eve. *Below, left*: The Expulsion from Paradise. *Right*: The Labors of Adam and Eve.

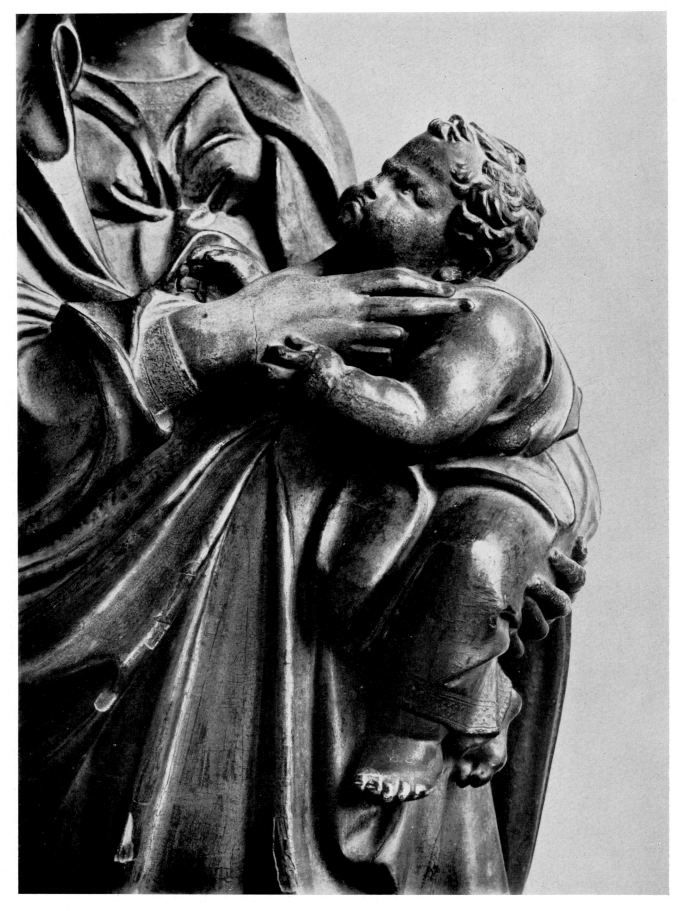

Pl. 154. Virgin and Child, detail. Painted wood. Siena, S. Martino.

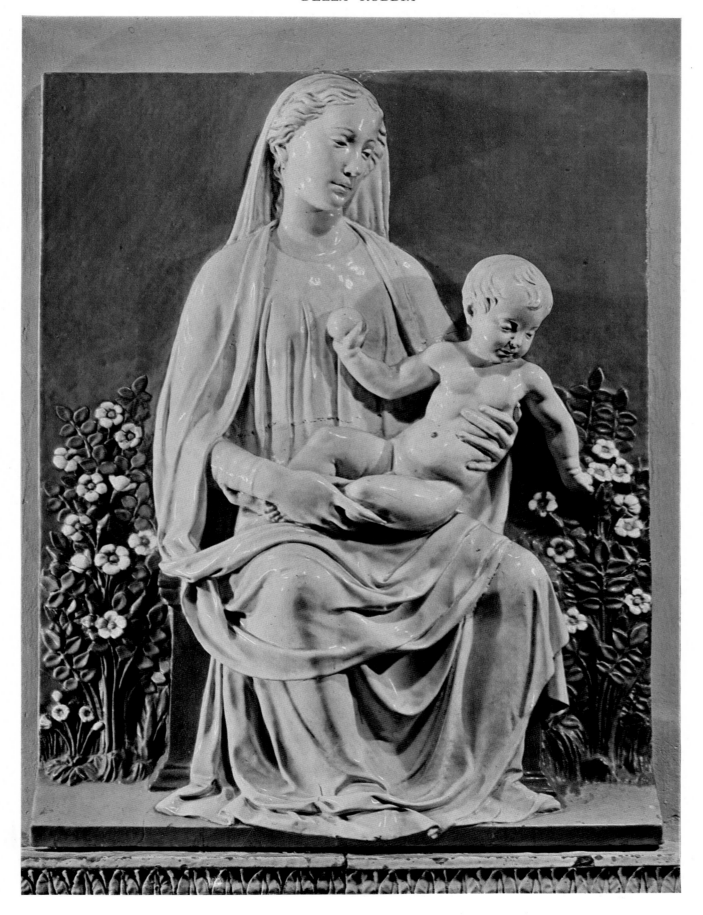

Pl. 155.  L. Della Robbia, Madonna in the Rose Garden. Enameled terra cotta. Florence, Museo Nazionale.

Pl. 156. L. Della Robbia, tomb of Bishop Benozzo Federighi, detail of the frame. Enameled terra cotta. Florence, Sta Trinita.

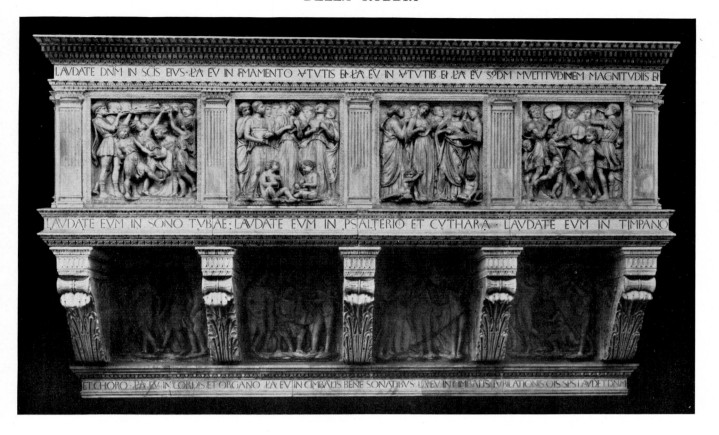

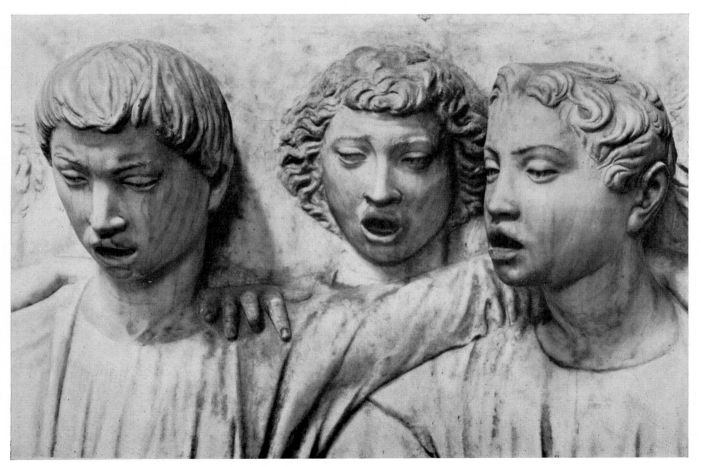

Pl. 157. L. Della Robbia, singing gallery, main section (*above*) and detail of one of the panels (*below*). Marble. Florence, Museo dell'Opera del Duomo.

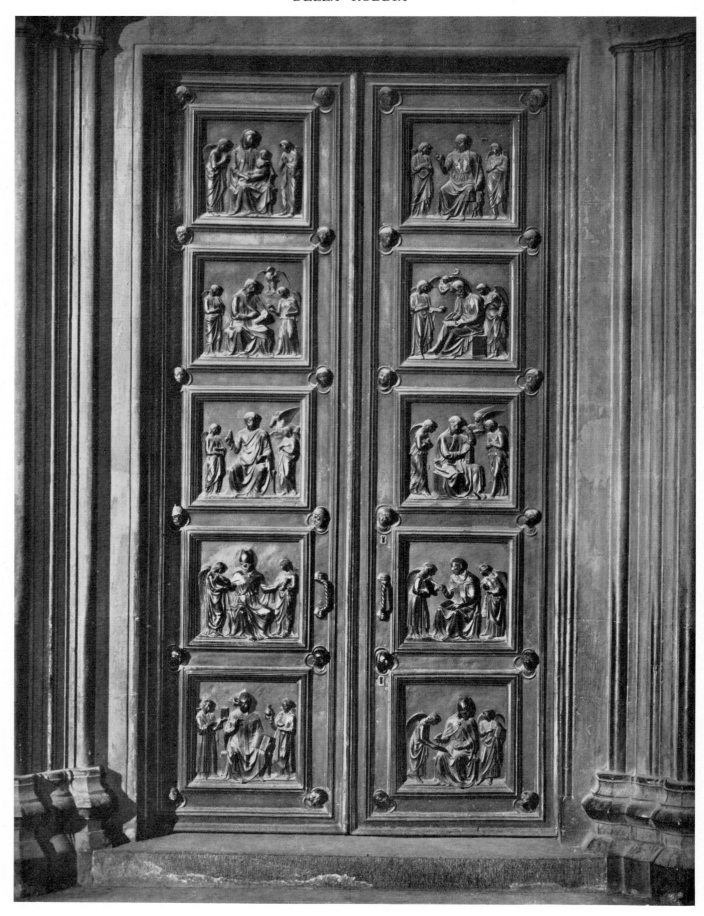

Pl. 158. L. Della Robbia, bronze doors of the New Sacristy, Florence, Cathedral.

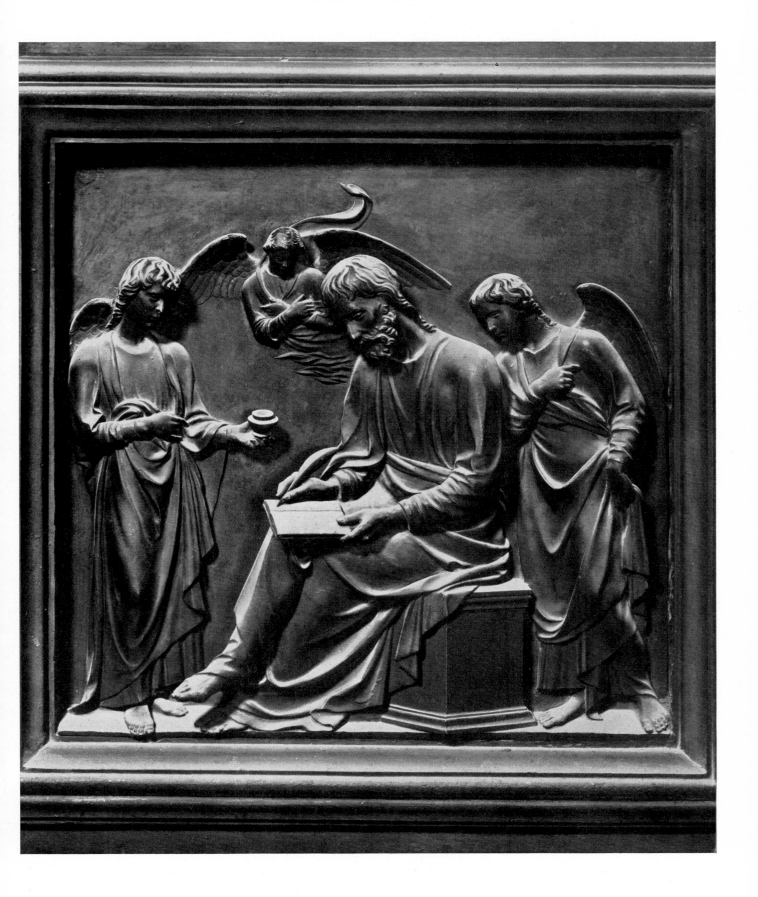

Pl. 159. L. Della Robbia, St. Matthew the Evangelist, detail of PL. 158.

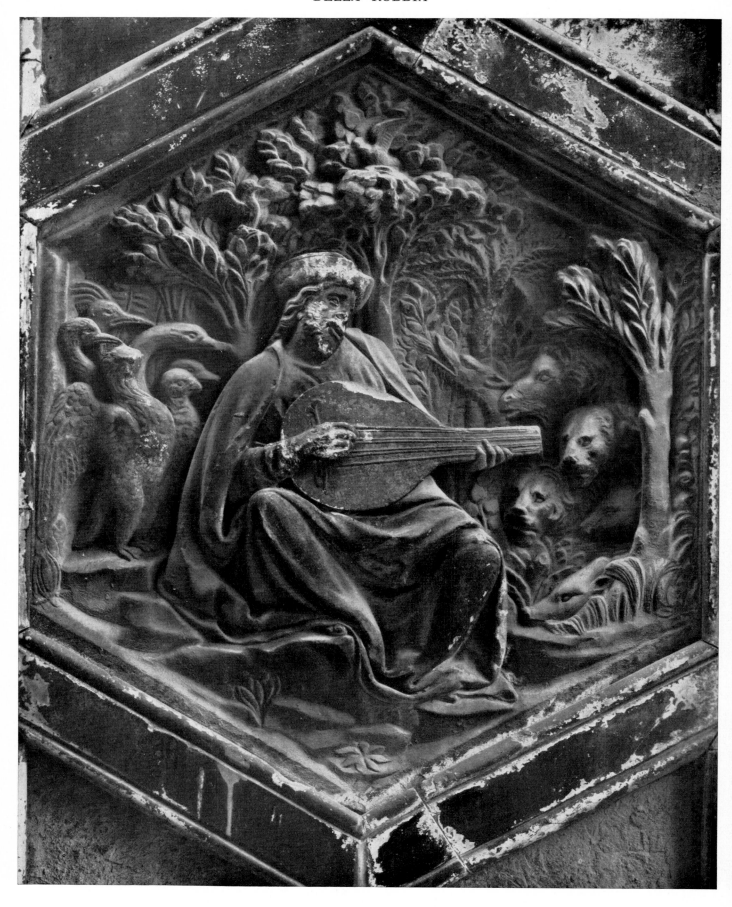

Pl. 160. L. Della Robbia, Orpheus, or Music. Marble. Florence, Campanile of the Cathedral.

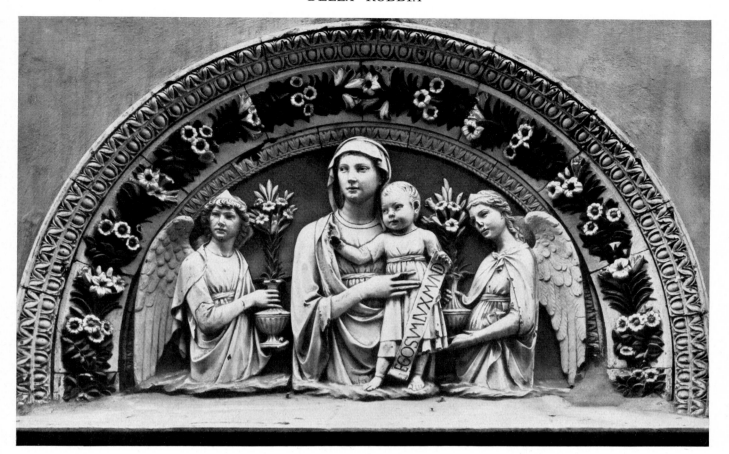

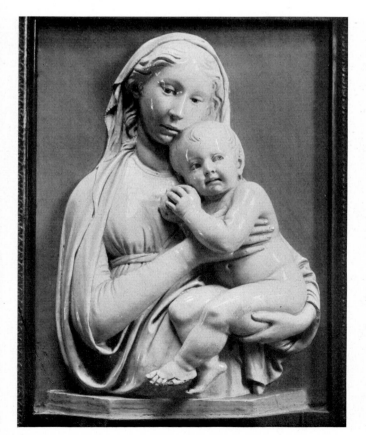

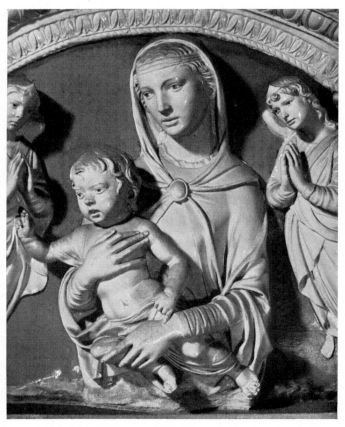

Pl. 161. L. Della Robbia, enameled terra cottas. *Above*: Lunette from the Via dell'Agnolo, Florence, showing the Virgin and Child with angels. *Below, left*: Madonna of the Apple. Both, Florence, Museo Nazionale. *Right*: Virgin and Child with angels, detail of a lunette. Florence, Palazzo di Parte Guelfa.

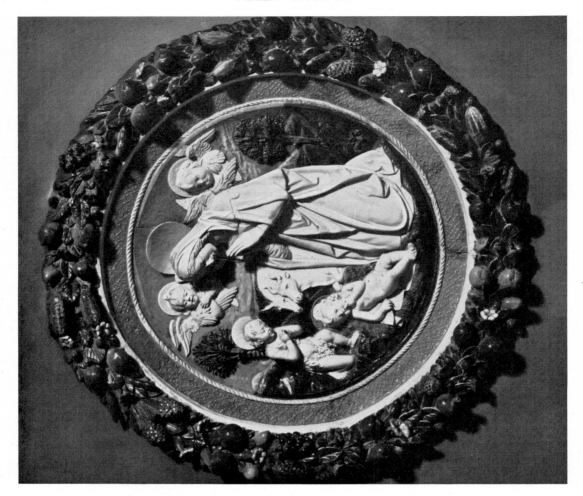

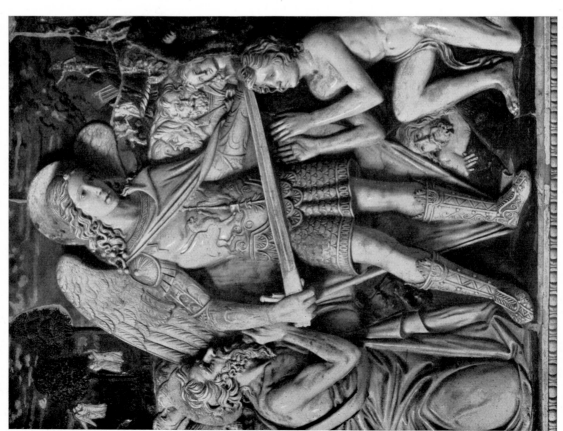

Pl. 162. *Left*: G. Della Robbia, The Last Judgment, detail. Enameled terra cotta. Florence, Museo Nazionale. *Right*: A. Della Robbia, Virgin Adoring the Child. Enameled terra cotta. Volterra, Italy, S. Girolamo.

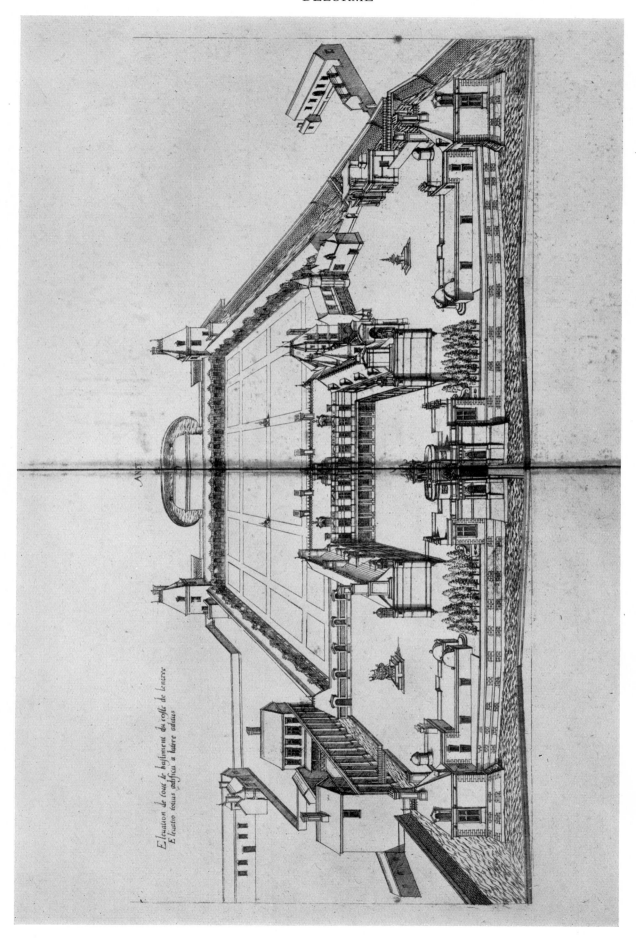

Pl. 163. Anet, Eure-et-Loir, France, the Château. Engraving by J. A. Ducerceau from *Les plus excellents Bastiments de France*, II, Paris, 1579.

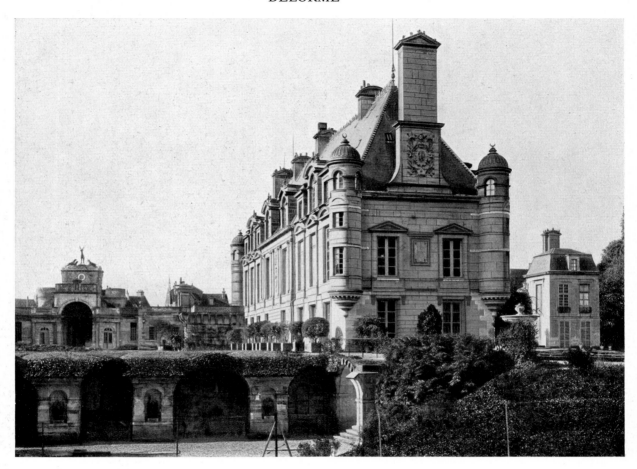

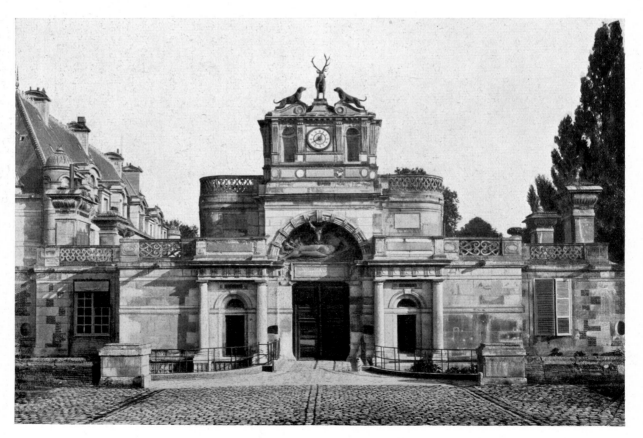

Pl. 164. Anet, Eure-et-Loir, France, the Château. *Above*: View from the garden. *Below*: Main entrance.

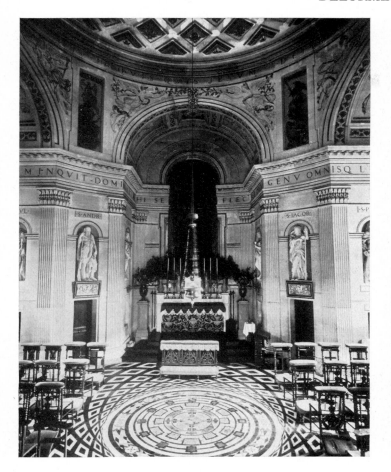

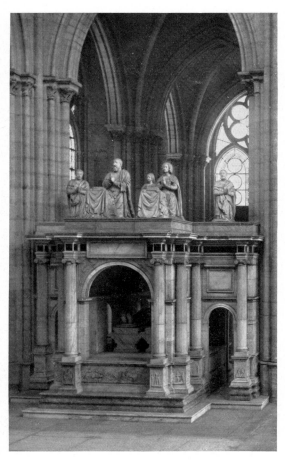

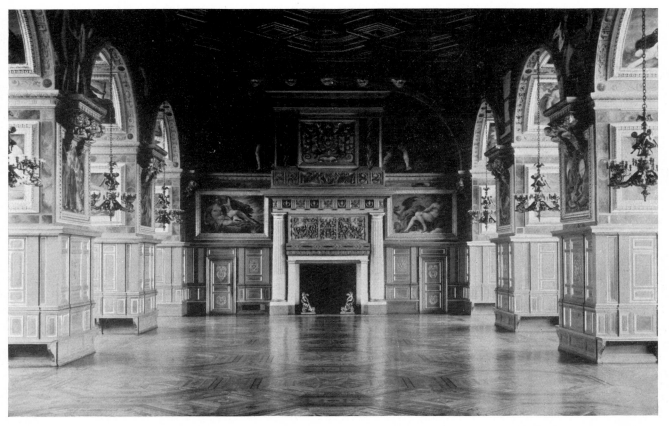

Pl. 165. *Above, left*: Anet, Eure-et-Loir, France, chapel of the Château, interior. *Right*: Tomb of Francis I, Abbey church of St. Denis, Saint-Denis, Seine, France. *Below*: Fontainebleau, Seine-et-Marne, France, Château, Gallery of Henry II.

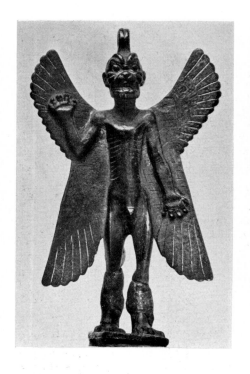
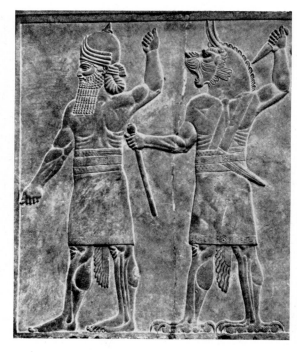
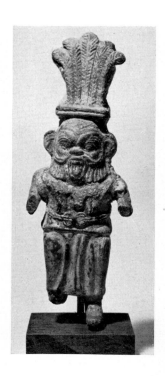
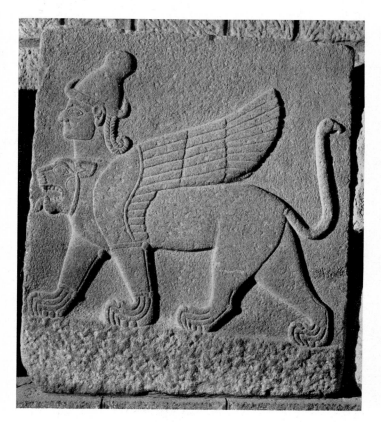

Pl. 166. *Above, left*: The Assyrian demon Pazuzu, first half of 1st millennium B.C. Bronze, ht., 5⁷/₈ in. Paris, Louvre. *Center*: Assyrian demon, detail of a relief from the Palace of Sennacherib in Nineveh, 7th cent. B.C. Stone. London, British Museum. *Right*: Bes, from Memphis, Egypt, 3d cent. B.C. Terra cotta, ht., 9¹/₄ in. Amsterdam, Allard Pierson Museum. *Below, left*: Syrian-Hittite sphinx, from Carchemish, 9th cent. B.C. Basalt, ht., 4 ft., 3¹/₈ in. Ankara, Archaeological Museum. *Right*: Lion demons in crocodile skins, detail of a seal ring from Tiryns, Greece, 15th–14th cent. B.C. Gold. Athens, National Museum.

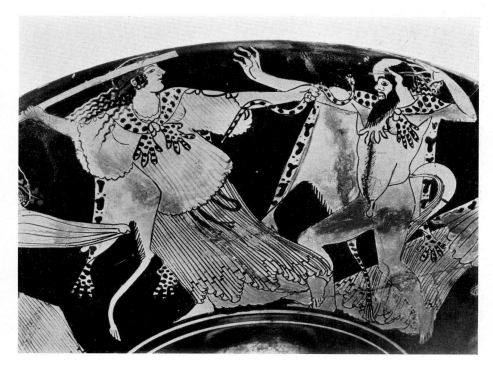

Pl. 167. *Above, left*: Gorgons, detail of a proto-Attic amphora, mid-7th cent. B.C. Eleusis, Greece, Museum. *Right*: Sphinx, from Spata, Greece, late 6th cent. B.C. Marble. Athens, National Museum. *Below, left*: "Harpy," detail of the "Harpy Tomb," from Xanthos, Asia Minor, ca. 500 B.C. Marble. London, British Museum. *Right*: Maenad and Silenus, detail of an Attic kylix attributed to the Brygos Painter, 490–480 B.C. Munich, Antikensammlungen.

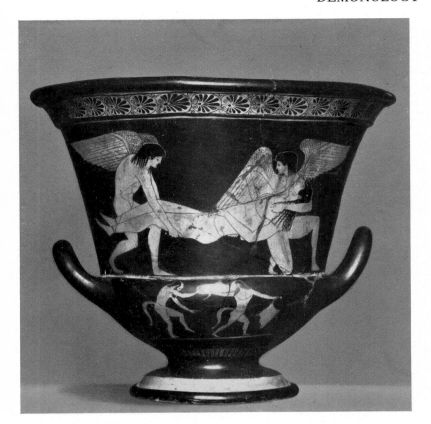

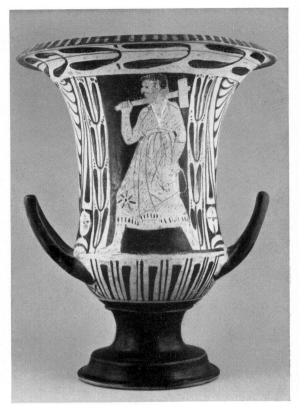

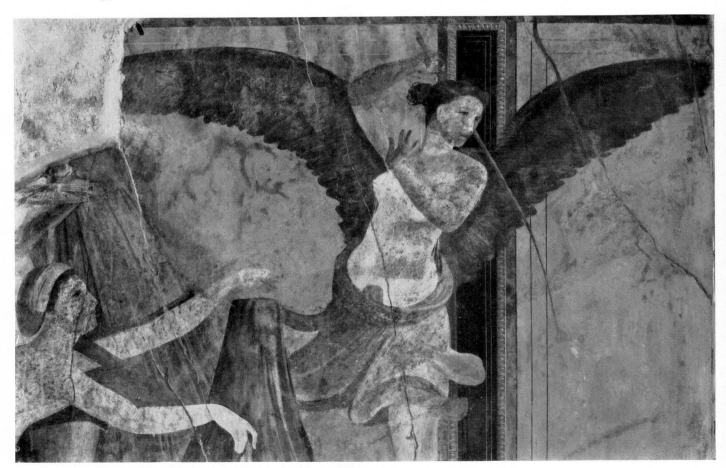

Pl. 168. *Above, left*: Hypnos and Thanatos carrying the corpse of Sarpedon, scene on an Attic crater by Myson, 500–490 B.C. Paris, Louvre. *Right*: Charun, represented on an Etruscan crater from Vulci, second half of 4th cent. B.C. Ht., 16¹/₈ in. Berlin, Staatliche Museen. *Below*: Female demon, detail of a wall painting in the "Villa of the Mysteries," Pompeii, ca. 40 B.C.

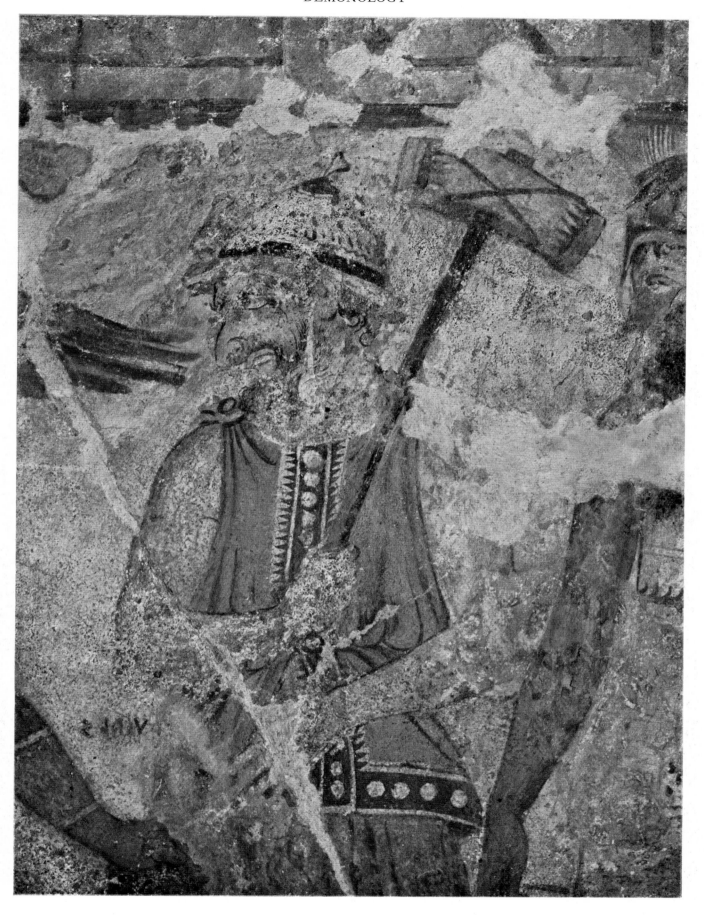

Pl. 169. Charun, detail of Etruscan wall painting from the François Tomb, Vulci, 3d–1st cent. B.C. Rome, Museo di Villa Albani.

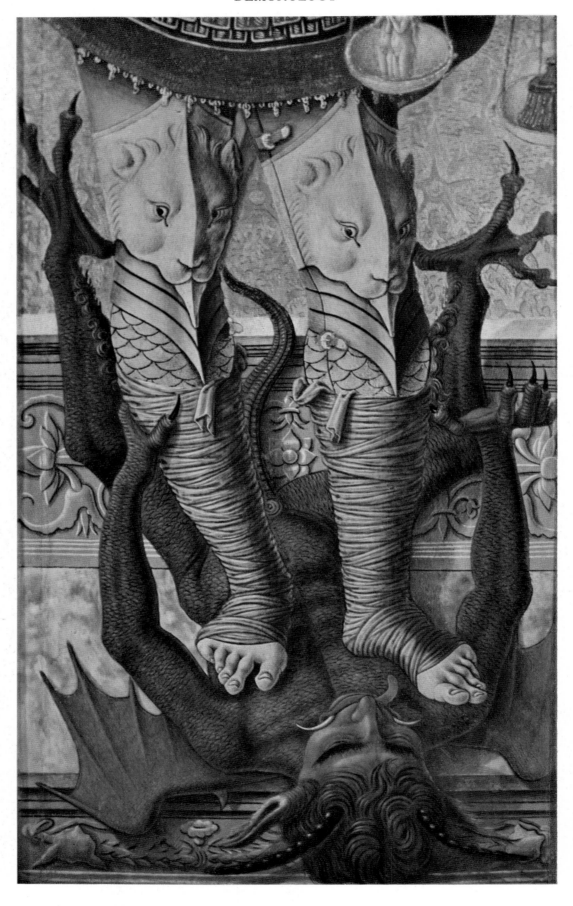

Pl. 170. C. Crivelli, The devil trodden by the Archangel Michael, detail of a predella panel of the Demidoff Altarpiece, 1476. London, National Gallery.

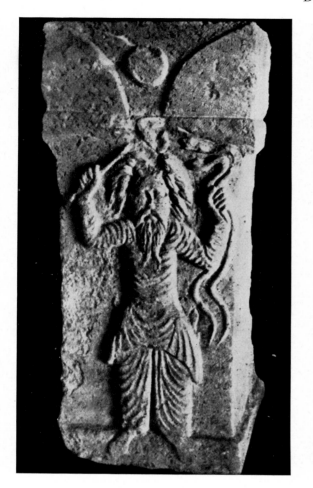

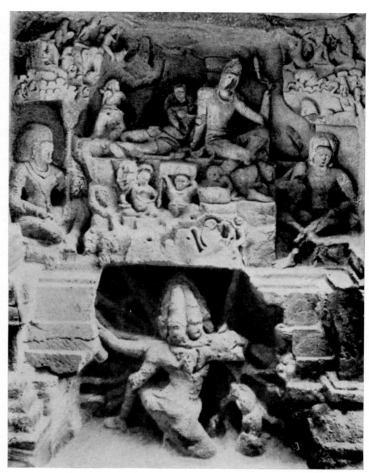

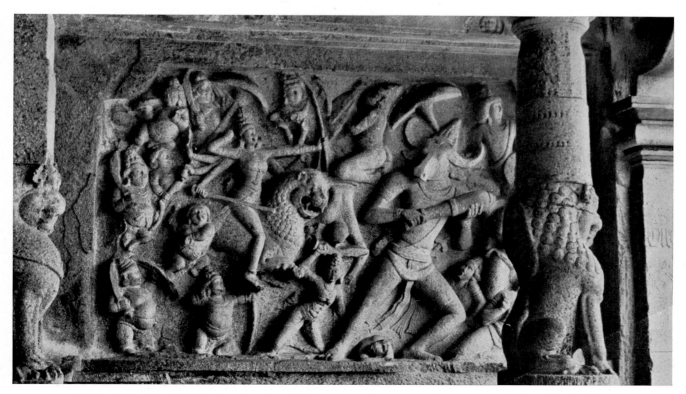

Pl. 171. *Above, left*: Relief probably representing Ahriman, 2d–3d cent., from the excavations of Hatra, Iraq. Stone. *Right*: Śiva and Pārvatī on Mt. Kailāsa with the demon king Rāvaṇa imprisoned underneath, 10th cent. Rock sculpture. Ellora, Maharashtra, India. *Below*: The goddess Durgā kills the demon Mahīṣa, 7th cent. Rock sculpture. Mamallapuram, Chingleput District, Madras, India.

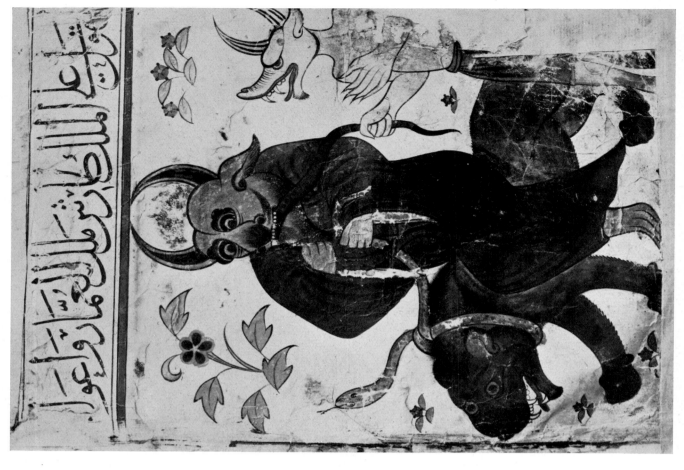

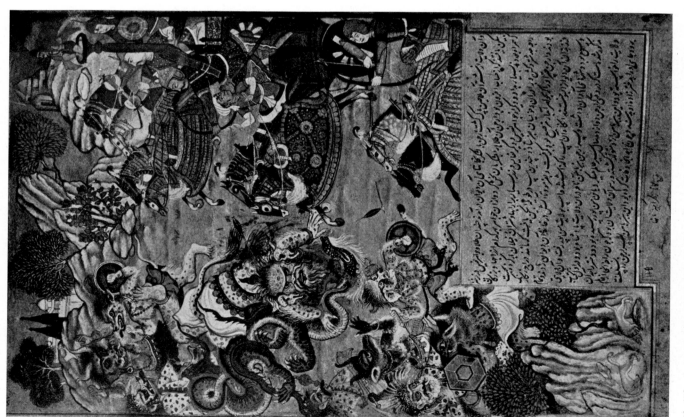

Pl. 172. *Left:* Daswanth (attrib.), The defeat of the demon king Vibhiṣāna by Arjuna, miniature of the *Rasm-nāma*, Moghul school, 16th cent. Jaipur, India, Royal Library.
*Right:* The king of the demons, Islamic miniature, 14th cent. Paris, Bibliothèque Nationale.

Pl. 173. *Left:* Bear in the grip of a demon, 117 B.C. Rubbing of a relief on the tomb of Ho Chü-ping, Shensi, China. *Right, above:* Li Lung-mien (attrib.), demons personifying thunder, China, 10th–11th cent. Ink on silk. Location unknown. *Below:* Scroll of the Hungry Demons, detail, Japan, 12th–13th cent. Color on paper; ht., 11 in. Tokyo, National Commission for the Protection of Cultural Properties.

Pl. 174. Head of a demon, detail of a group representing the hosts of Māra, 2d–3d cent. Schist; full size, 22¼ × 12¼ in. Lahore, Pakistan, Central Museum.

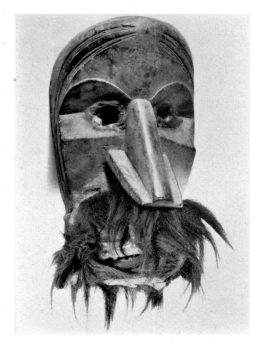

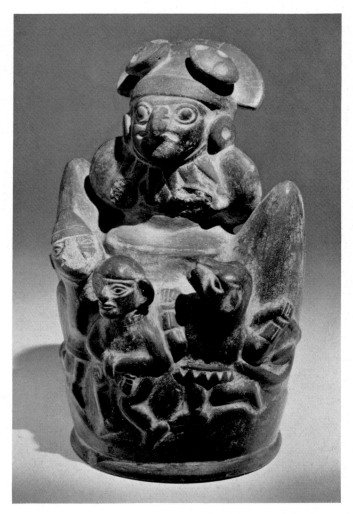

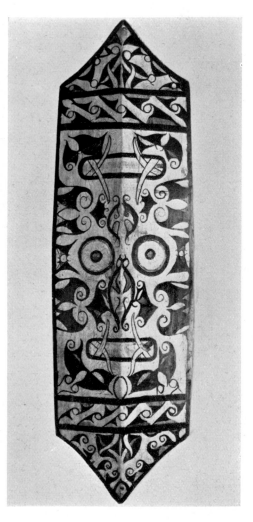

Pl. 175. *Left, above*: Head of the demon Ai-pec, Mochica pottery, Peru. *Below*: Demons and spirits on a mountain, Chimu pottery, Peru. Both, Hamburg, Museum für Völkerkunde. *Right, above*: Demonic council mask of the Kran, Liberia. Wood. Vienna, Museum für Völkerkunde, E. Becker-Donner Coll. *Below*: Painted shield with schematic representations of demons, North Borneo, Indonesia. Wood. Rome, Museo Pigorini.

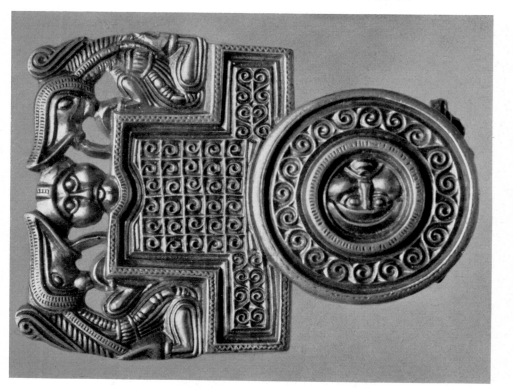

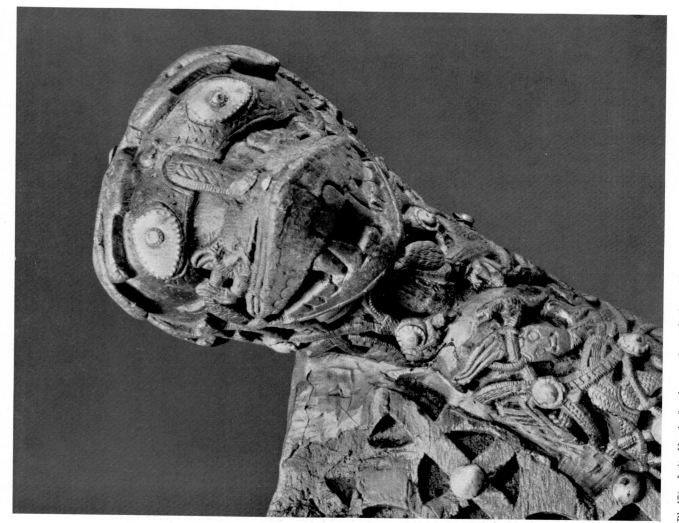

Pl. 176. *Left*: Head of a demon, from Oseberg, Norway, ca. 850. Wood. Oslo, Universitetets Oldsaksamling. *Right, above*: Fibula showing a head with menacing demons, from Galsted, Schleswig, 6th cent. Silver. Copenhagen, Nationalmuseet. *Below*: Demons attacking a church, textile from the church of Skog, Sweden, ca. 1100. Wool and silk. Stockholm, Historiska Museet.

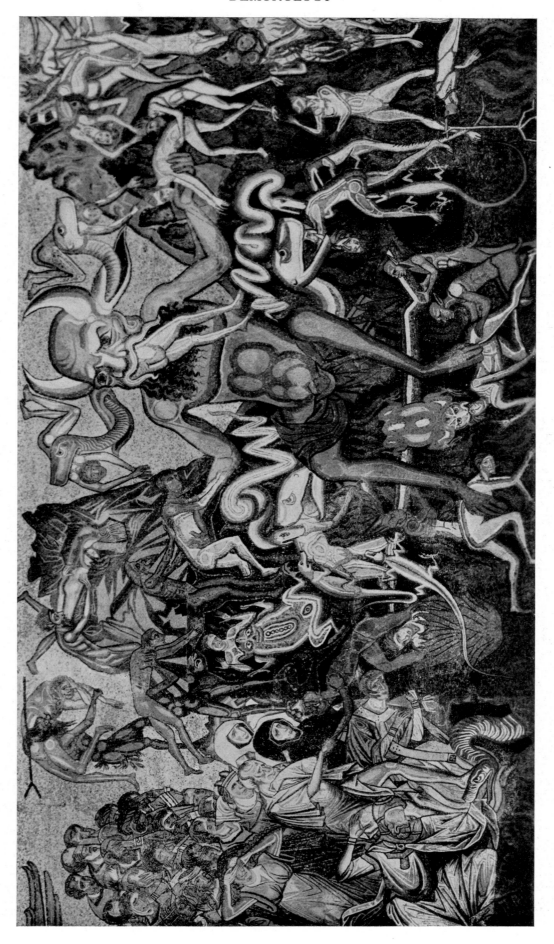

Pl. 177. Hell, 13th cent. Florence, Baptistery, detail of the mosaic in the vault.

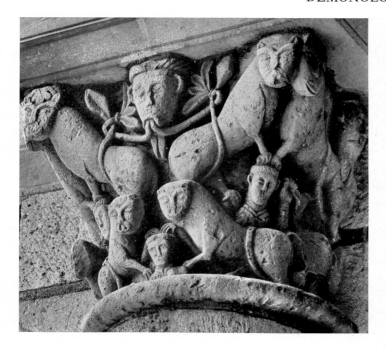

Pl. 178. Demons in sculptural decoration of medieval churches. *Left, above*: Capital, 12th cent. Stone. Saint-Benoît-sur-Loire, Loiret, France, Abbey Church. *Center*: Capital, ca. 1200. Stone. Strasbourg, Cathedral, west transept. *Below*: Detail of a choir stall, 14th cent. Wood. Cologne, Cathedral. *Right, above*: Pilaster, early 12th cent. Stone. Souillac, Lot, France, west portal of Church of Ste-Marie. *Below*: Bracket, 12th–13th cent. Stone. León, Spain, Cathedral.

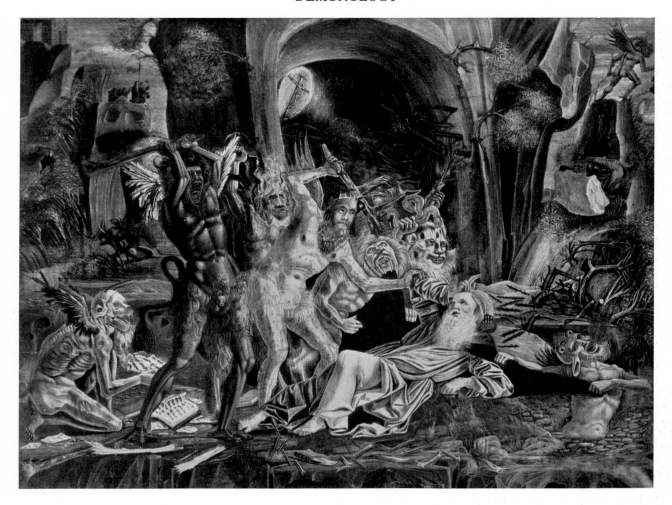

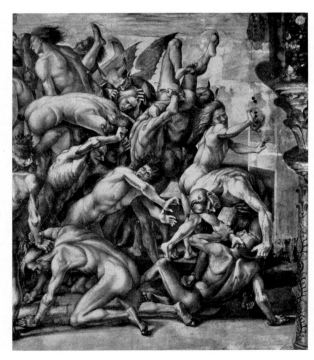

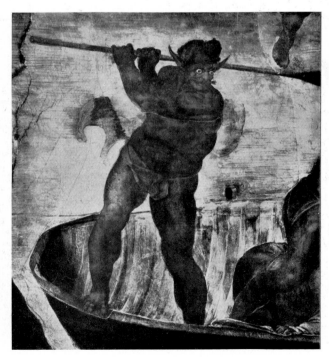

Pl. 179. *Above*: B. Parentino (1434–1531), The Temptation of St. Anthony. Panel. Rome, Galleria Doria Pamphili. *Below, left*: L. Signorelli, Devils and the Damned, detail, 1500–04. Fresco. Orvieto, Cathedral. *Right*: Michelangelo, Charon, detail of The Last Judgment, 1535–41. Fresco. Rome, Sistine Chapel.

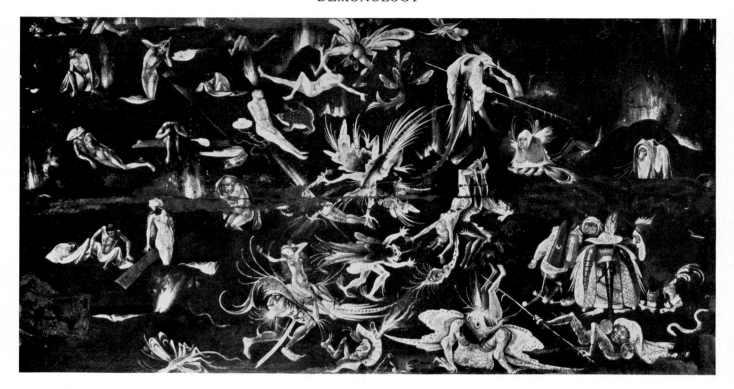

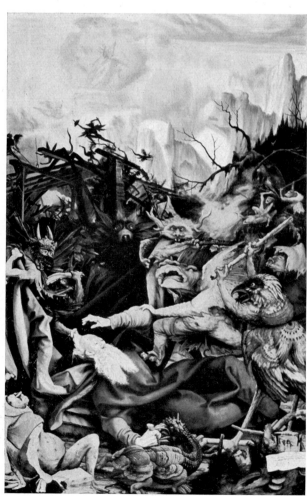

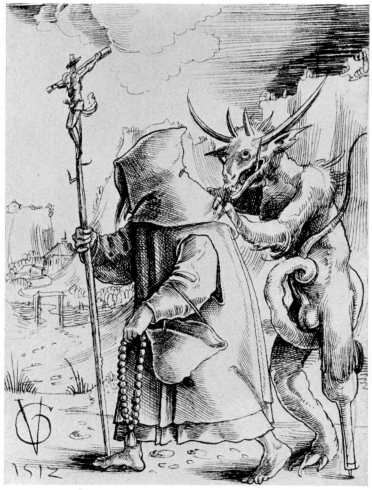

Pl. 180. *Above*: H. Bosch, The Last Judgment, fragment, early 16th cent. Panel. Munich, Alte Pinakothek. *Below, left*: M. Grünewald, The Temptation of St. Anthony, detail of the Isenheim altar, early 16th cent. Panel. Colmar, France, Musée d'Unterlinden. *Right*: U. Graf, Hermit and Devil, 1512. Pen drawing. Basel, Switzerland, Kunstmuseum, Kupferstichkabinett.

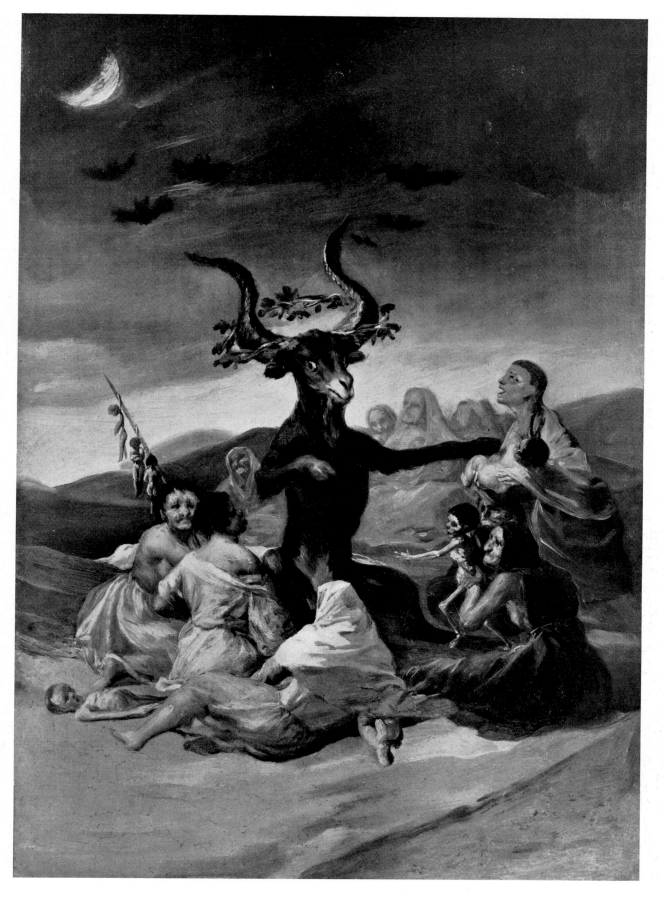

Pl. 181. F. Goya, Witches' Sabbat, first quarter of 19th cent. Canvas. Madrid, Museo Lázaro Galdiano.

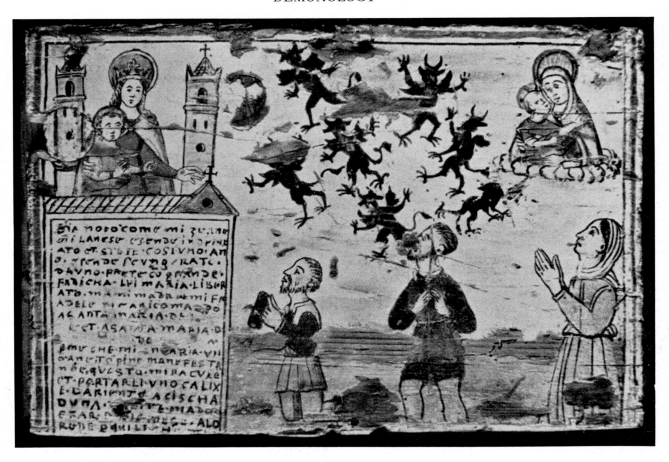

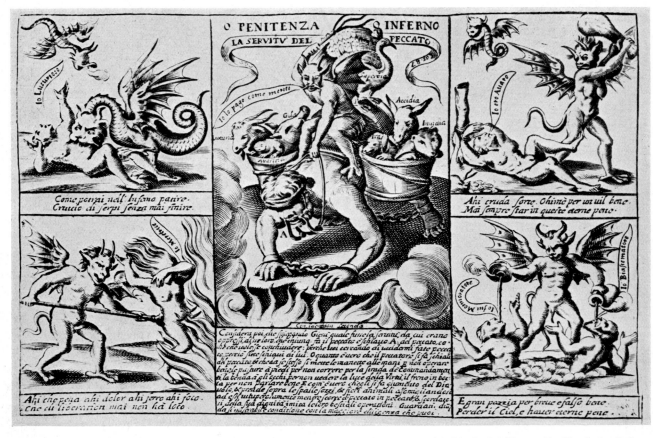

Pl. 182. *Above*: The Virgin exorcises demons, mid-16th cent. Panel. Sanctuary of S. Maria del Monte, Emilia, Italy. *Below*: "O Penitenza o Inferno," Italian popular print, 18th cent. Bassano del Grappa, Italy, Museo Civico.

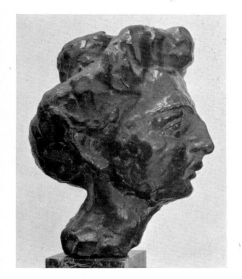
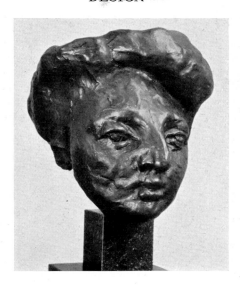
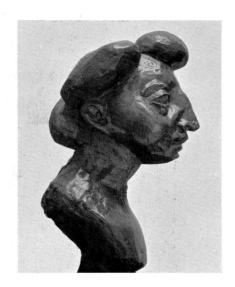
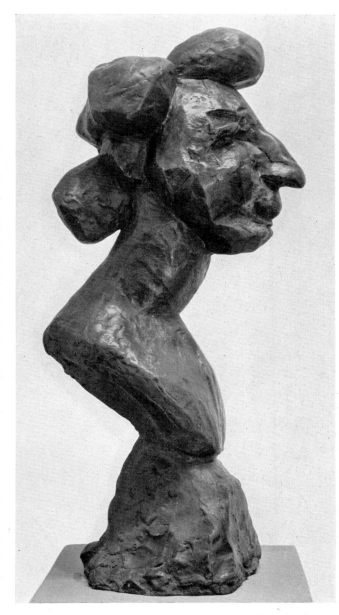
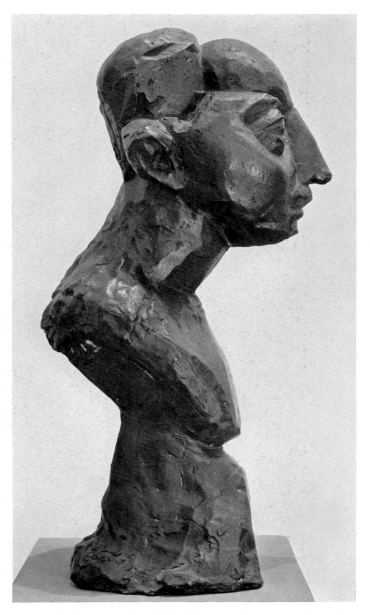

Pl. 183. H. Matisse, five bronze sculptures of Jeannette. *Above, left to right*: Jeannette, I and II, 1910, and III, 1910–11. Ht., 13 in., 10³/₈ in., and 23³/₄ in. *Below*: Jeannette, IV and V, 1910–11?. Ht., 24¹/₈ in., 22⁷/₈ in. New York, Museum of Modern Art.

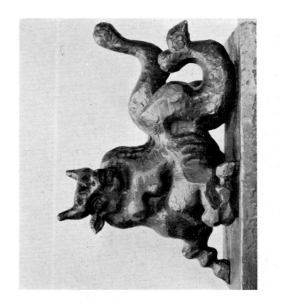

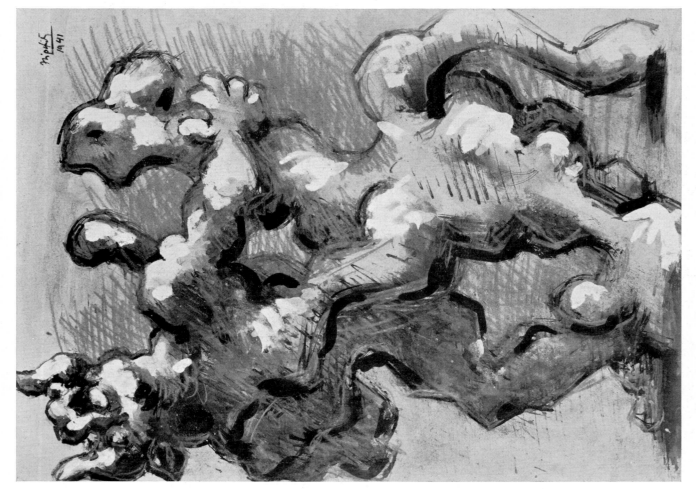

Pl. 184. J. Lipchitz, The Rape of Europa. *Right, above:* The Rape of Europa, II, 1938. Bronze, l., 23¹/₈ in. *Left, and below, right:* Two studies in gouache, The Rape of Europa, IV, 1941. Both, 18³/₄×13⁵/₈ in. New York, Museum of Modern Art.

Pl. 185. P. Tchelitchew, Hide and Seek, with three of the studies. *Left, above*: The finished work, 1940-42. Oil on canvas, 6 ft., 6½ in. × 7 ft., ¾ in. *Below*: Study called Tree into Hand and Foot with Children, ca. 1939. Ink with pen and brush, 13⅞×16¾ in. *Right*: Two studies called Head of Autumn, 1941. Ink with pen and brush, 12½×14⅝ in. (*above*); gouache and water color, 13×14⅞ in. (*below*). New York, Museum of Modern Art.

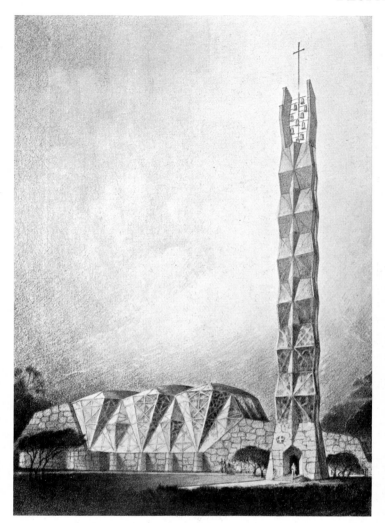

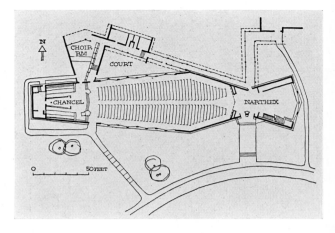

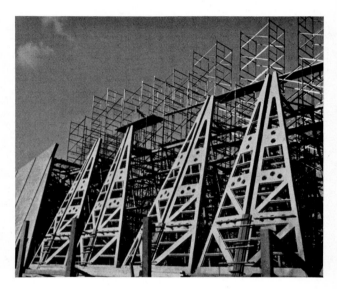

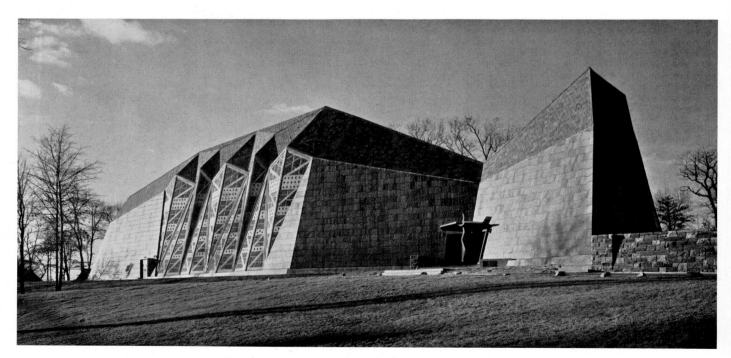

Pl. 186. Harrison and Abramovitz, First Presbyterian Church, Stamford, Conn., completed 1958. *Left, above*: Drawing of the project, by Hugh Ferriss. *Right, above and center*: Plan, and detail of windows under construction, 1956. *Below*: The completed church, south entrance.

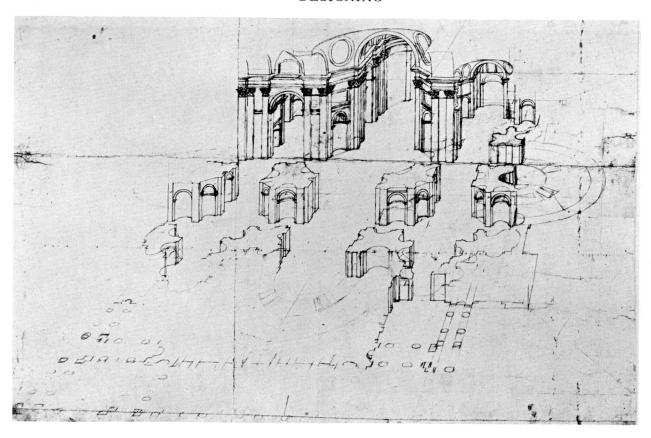

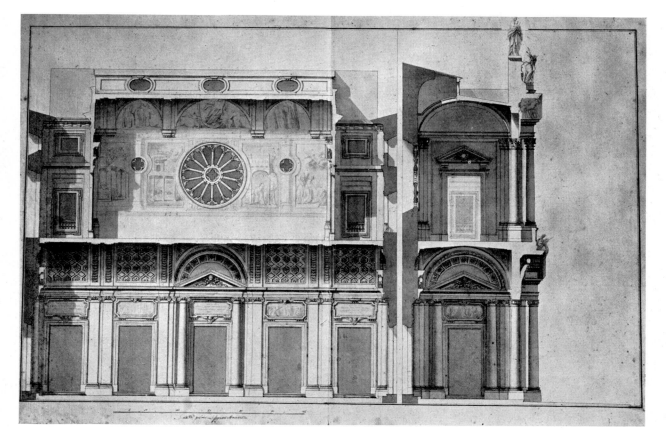

Pl. 189. Axonometric projection and section. *Above*: B. Peruzzi, axonometric drawing of his project for St. Peter's in Rome, ca. 1520. Florence, Uffizi, Gabinetto dei Disegni e Stampe. *Below*: F. Fuga, two sections of the atrium of S. Maria Maggiore in Rome, ca. 1743–50. Rome, Gabinetto Nazionale delle Stampe.

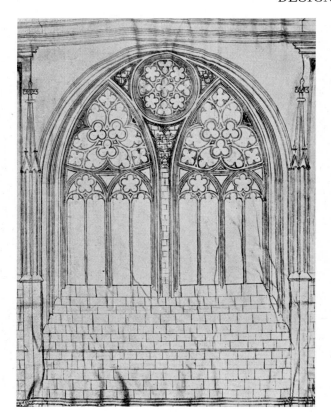

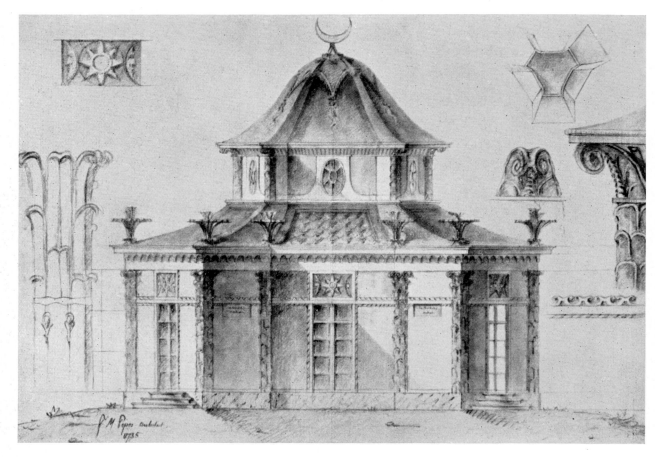

Pl. 190. Studies of details. *Above, left*: P. Parler, detail of the tower for the Cathedral of Prague, mid-14th cent. Vienna, Akademie der Bildenden Künste. *Right*: Michelangelo (?), studies of capital and base. Florence, Galleria Buonarroti. *Below*: F. M. Piper, 1746–1824, drawing with details for a Turkish pavilion in Haga Park, near Stockholm. Stockholm, Academy of Art.

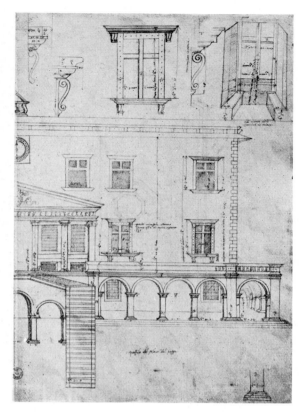

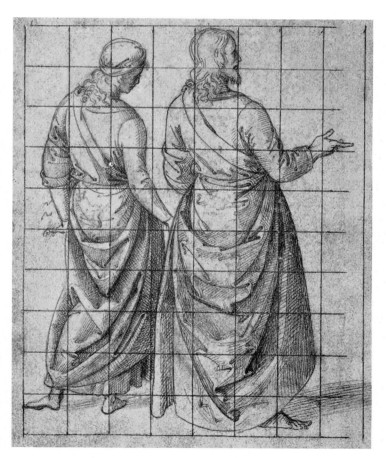

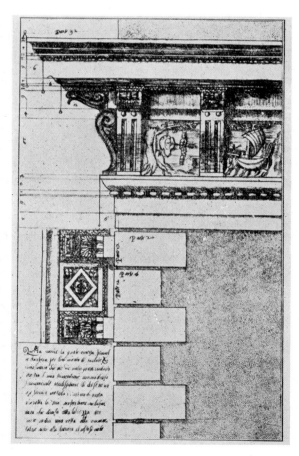

Pl. 191. Scale and dimensions. *Left, above*: Trial sketch on stone of Egyptian hieroglyphs with proportion squares, from Deir el Bahri, 18th dynasty. New York, Metropolitan Museum. *Below*: Raphael, preparatory drawing with transfer lines. Venice, Accademia. *Right, above*: B. da Sangallo, 1496–1552, study for elements of façade and staircase, Villa di Poggio a Caiano, near Florence (I, PL. 305). *Below*: Vignola, 1507–73, drawing for architectural treatise, showing cornice of Villa Farnese, Caprarola, Italy. Both, Florence, Uffizi, Gabinetto dei Disegni e Stampe.

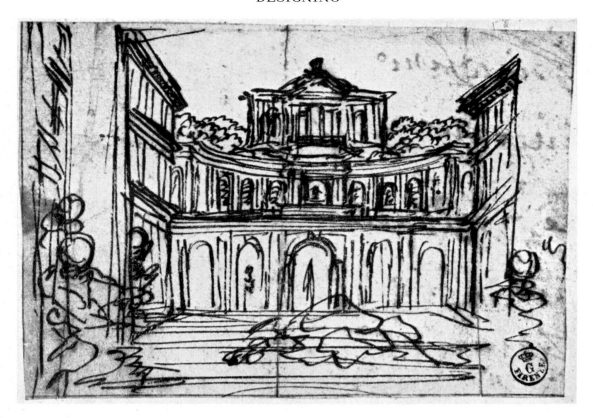

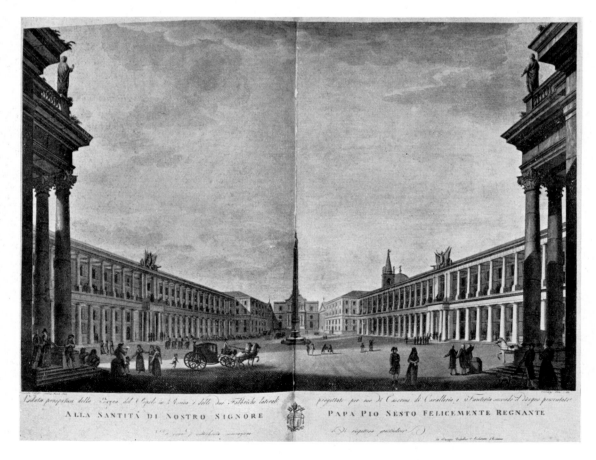

Pl. 192. Perspective drawing. *Above*: Pietro da Cortona (P. Berrettini), sketch for the courtyard of the Palazzo Pitti in Florence, 1640–47. Florence, Uffizi, Gabinetto dei Disegni e Stampe. *Below*: G. Valadier, design for Piazza del Popolo in Rome, ca. 1793. Etching by V. Feoli after Valadier's water color. Rome, Biblioteca dell'Istituto di Archeologia e Storia dell'Arte.

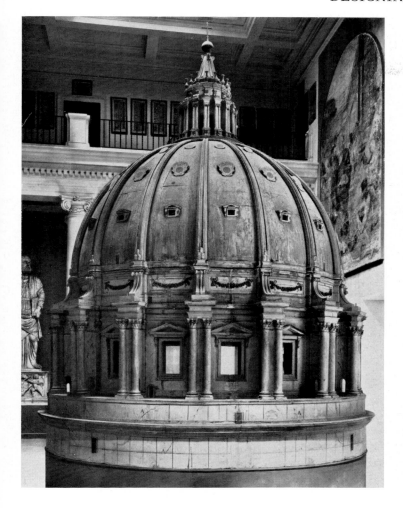

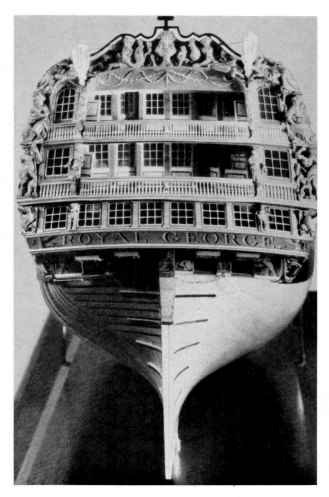

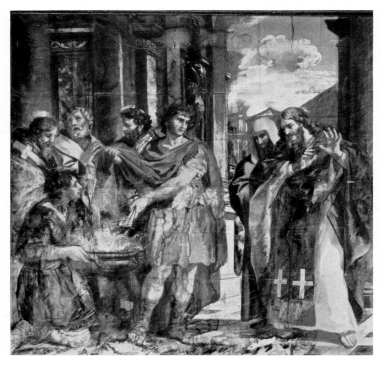

Pl. 193. Models. *Above, left*: Wooden model of Michelangelo's design for the dome of St. Peter's in Rome (I, PL. 403). Rome, Museo Petriano. *Right*: Model showing the stern of the "Royal George," 1756. Greenwich, England, National Maritime Museum. *Below, left*: Pietro da Cortona (P. Berrettini), 1596–1669, color guide for a tapestry, used by mirror reflection in weaving. Tempera. Florence, Coll. Corsini. *Right*: B. Spence, b. 1907, model of dormitories at Queen's College, Cambridge, England.

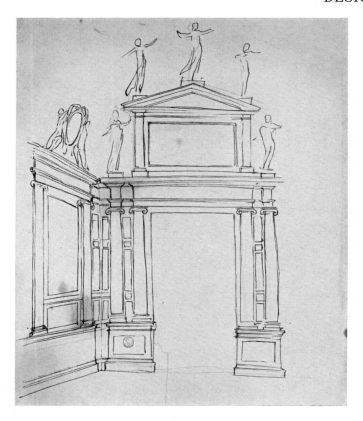

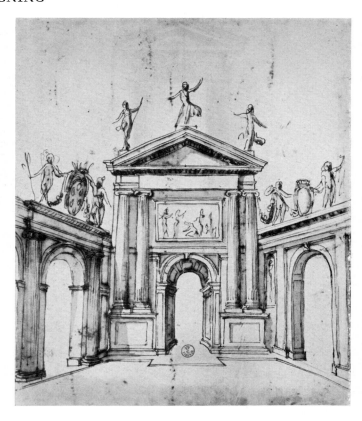

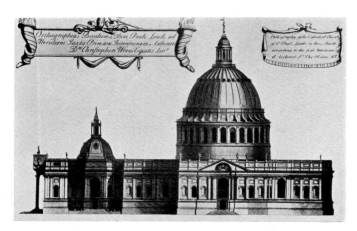

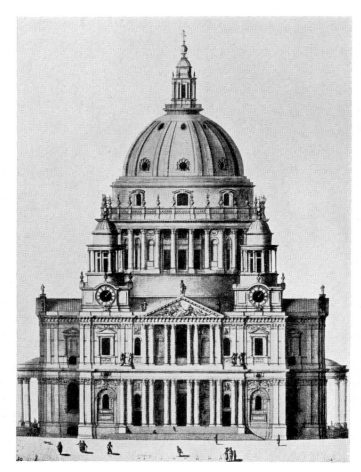

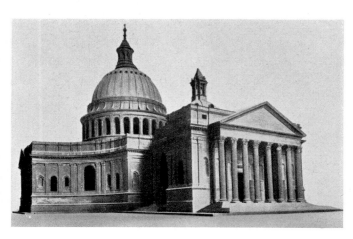

Pl. 194. Successive variations of a project. *Above*: G. A. Dosio, 1533–1609, two drawings for a triumphal arch. Florence, Uffizi, Gabinetto dei Disegni e Stampe. *Below*: C. Wren, three designs for St. Paul's Cathedral in London, ca. 1666–75, including the first (*left, center*) and (*right*) a variant of the final (II, PL. 147). Oxford, All Souls College.

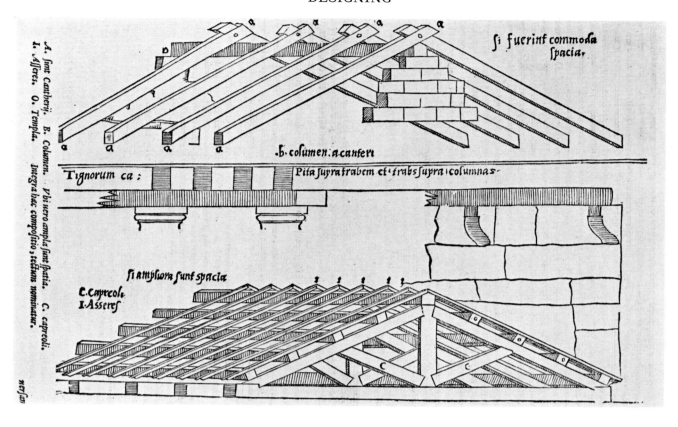

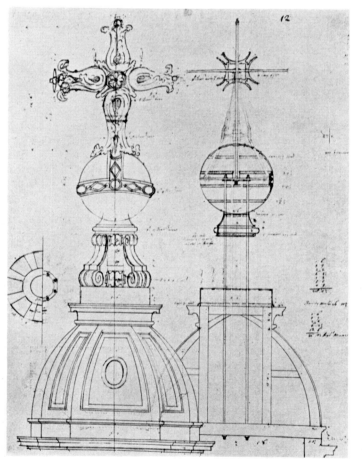

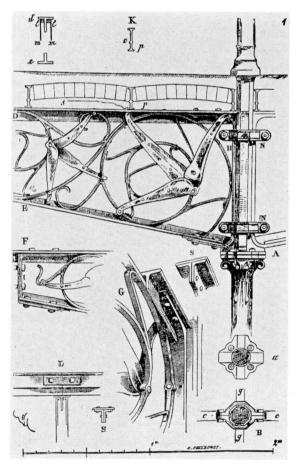

Pl. 195. Structural and technical drawing. *Above*: Roof structure, from Vitruvius, 1st cent. B.C., *De Architectura* (ed. 1567). *Below, left*: C. Wren, detail drawing of cross for the dome of St. Paul's Cathedral in London, ca. 1666–68. Oxford, All Souls College. *Right*: Construction in iron, from E. E. Viollet-le-Duc, *Entretiens sur l'architecture*, 1864.

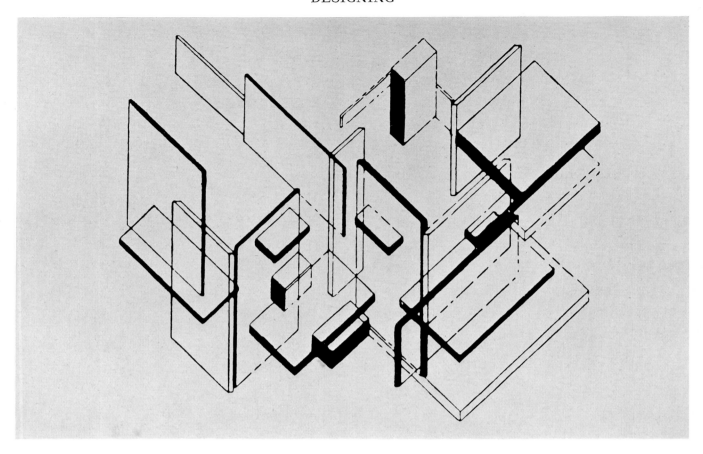

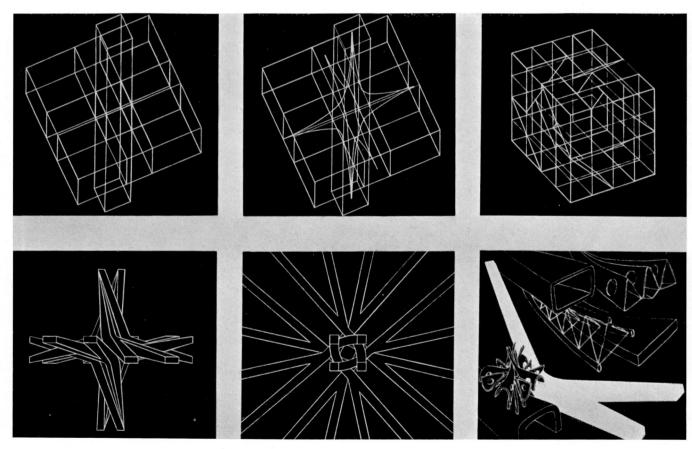

Pl. 196. Examples of contemporary structural drawing. *Above*: T. van Doesburg, axonometric drawing of a house, 1920. *Below*: K. Wachsmann, analysis of a design for a structural element, based on three intersecting bars contained in a cubical space (*upper row, left*) and the penetrating lines of force (*upper row, center*).

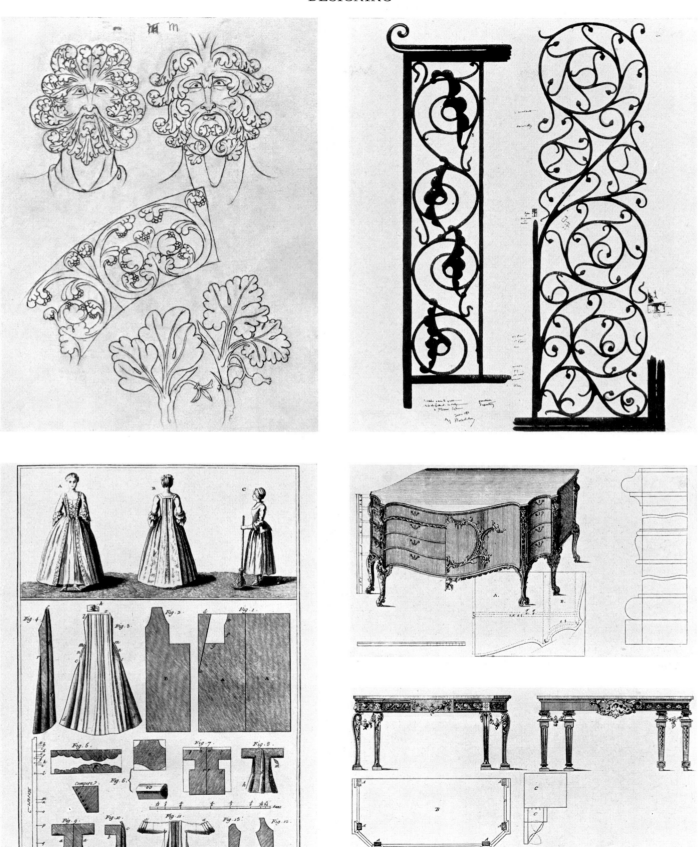

Pl. 197. Examples from manuals of design. *Above, left*: Architectural decorative motifs, from the textbook of Villard de Honne-court, active 1230–35. Paris, Bibliothèque Nationale (Ms. 19093). *Right*: Designs for ironwork, from E. E. Viollet-le-Duc, 1814–79, *Compositions et dessins. Below, left*: Dress models with patterns, from *Encyclopédie des Arts et des Métiers*, 1751–80. *Right*: Furniture designs, published 1753 and 1760, from T. Chippendale, *The Gentleman and Cabinet Maker's Director.*

# DESIGNING

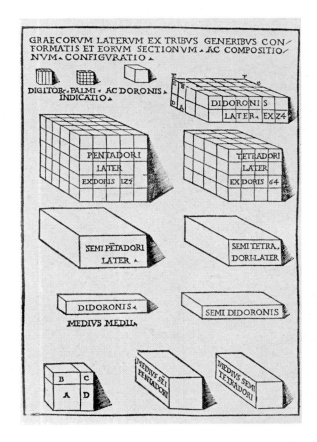

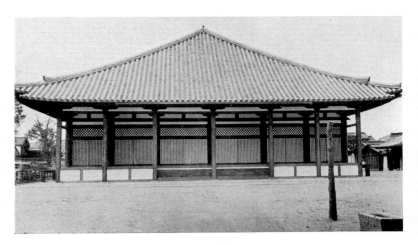

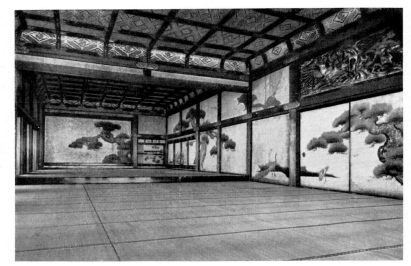

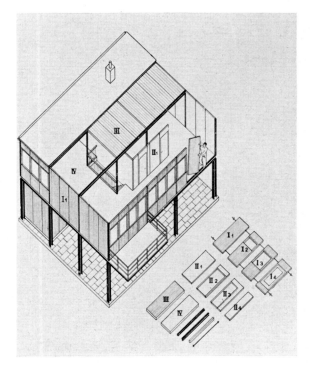

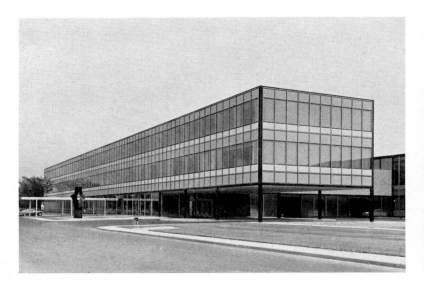

Pl. 198. Design with uniform elements. *Left, above*: Various shapes of brick used in Greek temples, from Vitruvius, *De Architectura* (ed. 1521). *Below*: E. Friberger, b. 1889, axonometric view and standard units of a prefabricated house, Sweden. *Right, above*: Hall of the Gokurakuin in Nara, Japan, Kamakura period, 12th–14th cent. *Center*: An interior of the Nijō castle in Kyoto, Japan, 17th cent. *Below*: Eero Saarinen, General Motors Technical Institute, Warren, Mich., 1951–55.

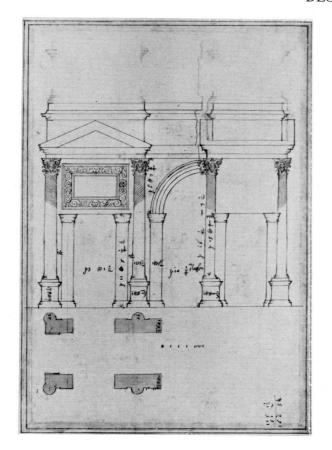

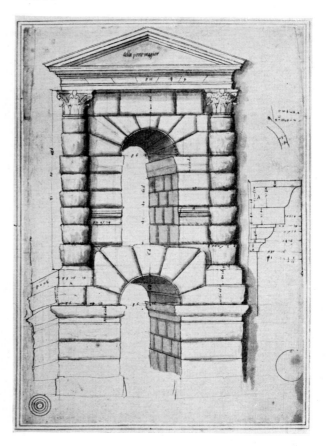

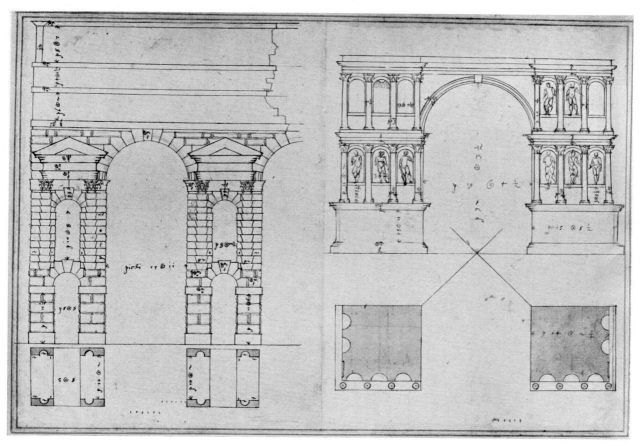

Pl. 199. Drawings and ideal restorations of ancient monuments. A. Palladio, 1518–80. *Above, left*: The Arch of Jupiter Ammon (now destroyed), in Verona. *Right*: The Porta Maggiore in Rome. *Below*: The Porta Maggiore and the Arch of Janus in Rome. All, London, Royal Institute of British Architects.

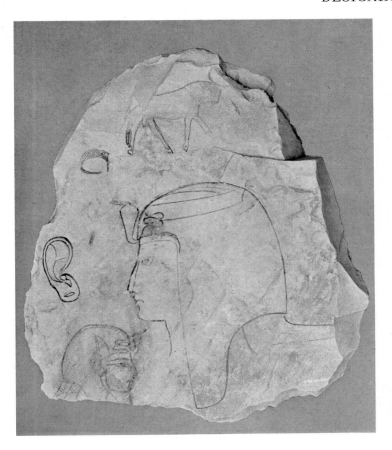

Pl. 200. Sketches and studies for painting and sculpture. *Above, left*: Egyptian ostracon with artist's sketches, from the Valley of the Kings, 19th–20th dynasty. Limestone. New York, Metropolitan Museum. *Right*: Raphael, sketch for Transfiguration. London, British Museum. *Below, left*: Drawing from the notebook of J. B. Neumann, 1687–1753, with four varying designs for a ceiling in the Residenz in Würzburg. Würzburg, Germany, Universitätsbibliothek. *Right*: J. Sansovino (attrib.), drawing for a tomb, ca. 1495. Florence, Uffizi, Gabinetto dei Disegni e Stampe.

# DESIGNING

Pl. 201. Fresco with preparatory drawings. Pontormo (J. Carucci), 1494–1557, lunette with Vertumnus and Pomona in the Villa di Poggio a Caiano, near Florence. *Left, above*: Initial drawing for the whole. *Center*: Study for one of the figures. *Right, above*: Sketch for one of the putti. All three, Florence, Uffizi, Gabinetto dei Disegni e Stampe. *Below*: The completed lunette. Fresco.

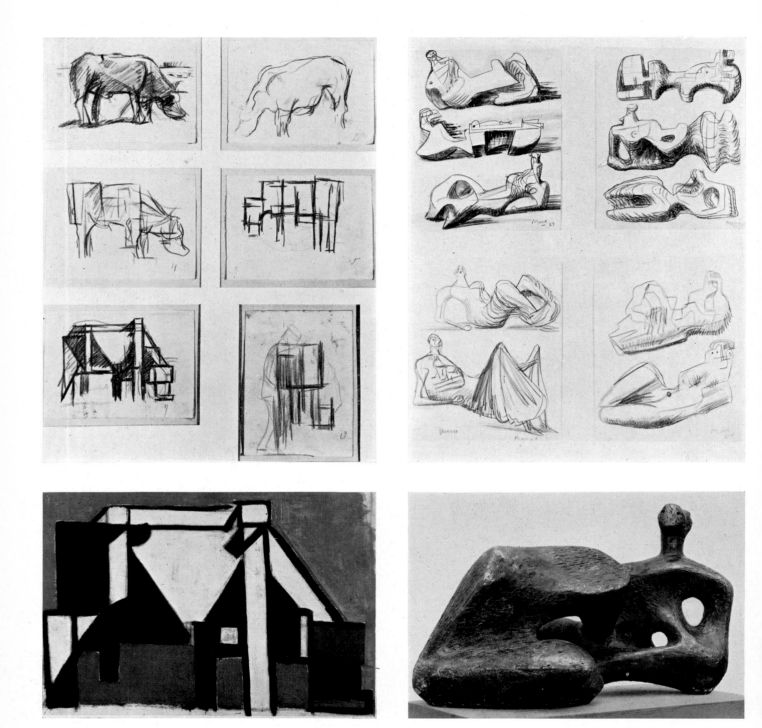

Pl. 202. Studies for abstract works. *Left*: T. van Doesburg, The Cow, ca. 1916, series of pencil drawings, each $4^5/_8 \times 6^1/_4$ in., and (*below*) version in gouache on paper, $15^5/_8 \times 22^3/_4$ in., preliminary to final in oil. New York, Museum of Modern Art. *Right*: H. Moore, b. 1898, studies in chalk, gouache, and pencil, and (*below*) bronze model of a travertine sculpture for the UNESCO building, Paris. Much Hadham, England, I. Moore Coll.

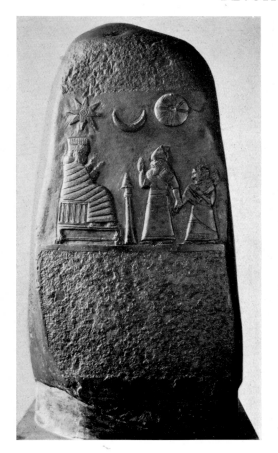
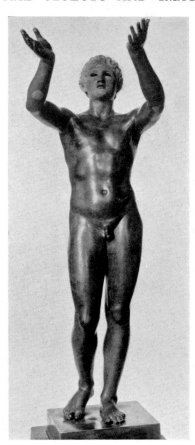
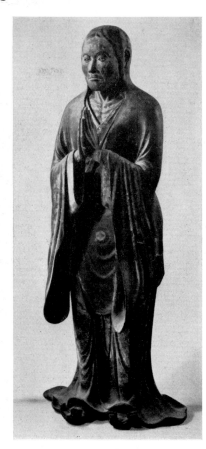

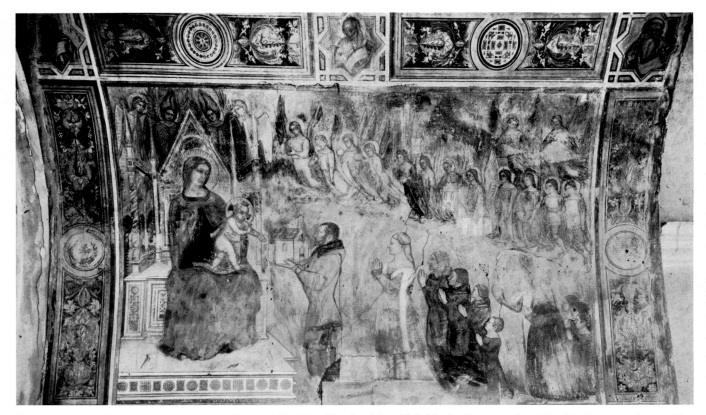

Pl. 203. Presentation and prayer scenes. *Above, left*: The Kassite king Melishipak II presenting his daughter to the goddess Inanna, relief from Susa, end of 13th cent. B.C. Diorite, ht., 35 1/2 in. Paris, Louvre. *Center*: Praying boy, Greek, late 4th cent. B.C., attributed to Boidas. Bronze, ht., 4 ft., 2 3/8 in. Berlin, Staatliche Museen. *Right*: Japanese orant, 13th cent. Wood, ht., 5 ft., 6 1/2 in. Kyoto, Myōhōin. *Below*: The Porro family praying before the Virgin, second half of 14th cent. Fresco from the Oratory of Mocchirolo, Brianza, Italy. Milan, Brera.

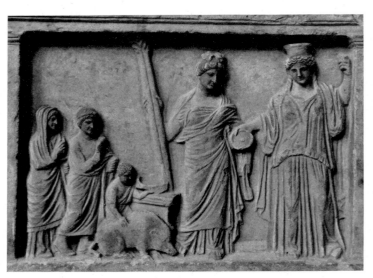

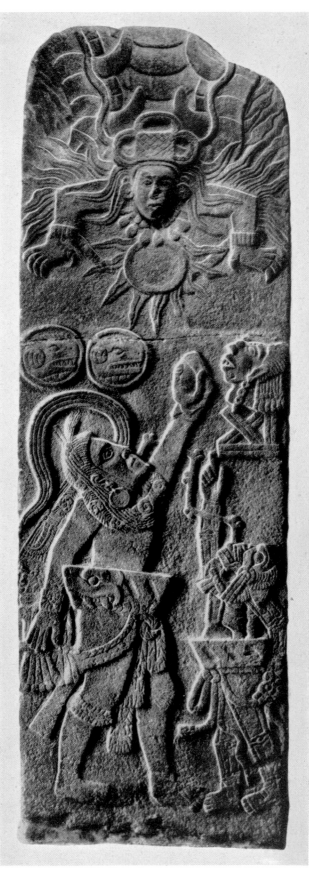

Pl. 204. Offering scenes. *Left, above*: Priest presenting offering, relief from Ur, ca. mid-3d millennium B.C. Limestone, ht., 8⅝ in. London, British Museum. *Center*: Demeter and Kore receiving offerings, Greek relief from Eleusis, second half of 4th cent. B.C. Marble, ht., 18⅞ in. Paris, Louvre. *Below*: Offering bearer with sword and statuette, India, 1st cent. Stone. Mathura, Museum of Archaeology. *Right*: Presentation of an offering to the sun god, stele from Santa Lucia Cozumalhualpa, Guatemala, Maya period. Stone. Berlin, Museum für Völkerkunde.

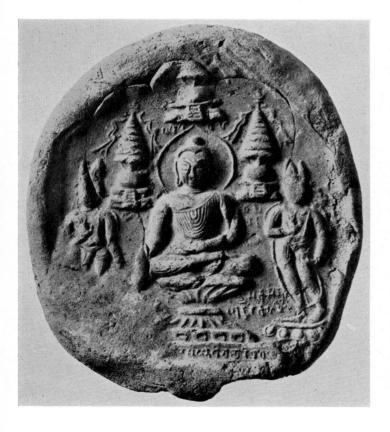

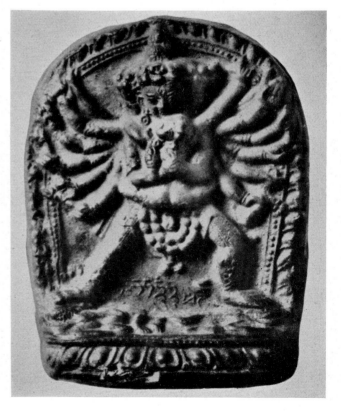

Pl. 205. *Above*: The *caṅkrama* (promenade) of the Buddha, showing symbols of his veneration, mid-2d cent. B.C. Stone. Bharhut, India. *Below*: Two *ts'a ts'a* (Indo-Tibetan Buddhist clay votive molds). Rome, private coll.

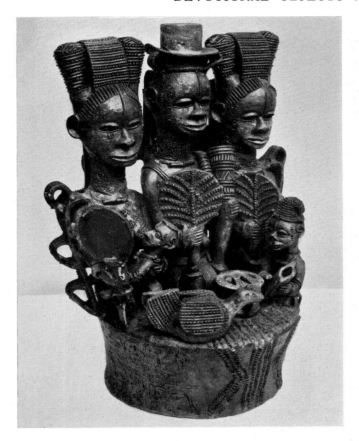 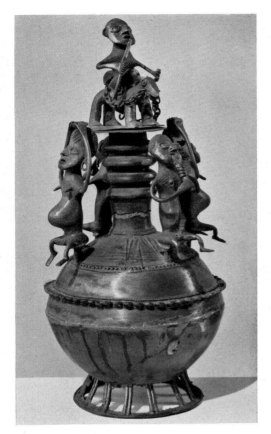

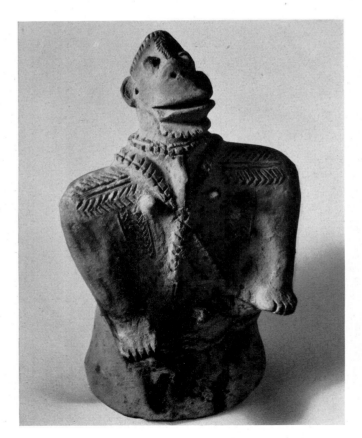 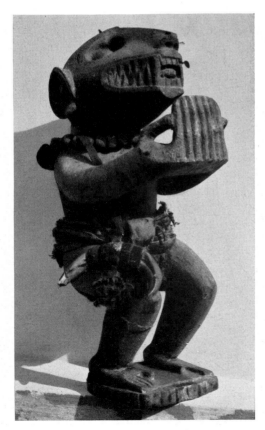

Pl. 206. *Above, left*: Ibo offering bearers with children and a hen, Nigeria. Terra cotta. London, British Museum. *Right*: Igbira vase for offerings, Nigeria. Brass. Hamburg, Museum für Völkerkunde. *Below, left*: Sao votive statuette, Tchad. Terra cotta. Paris, Musée de l'Homme. *Right*: Baule votive statuette, Ivory Coast. Wood. Abidjan, Ivory Coast, Museum.

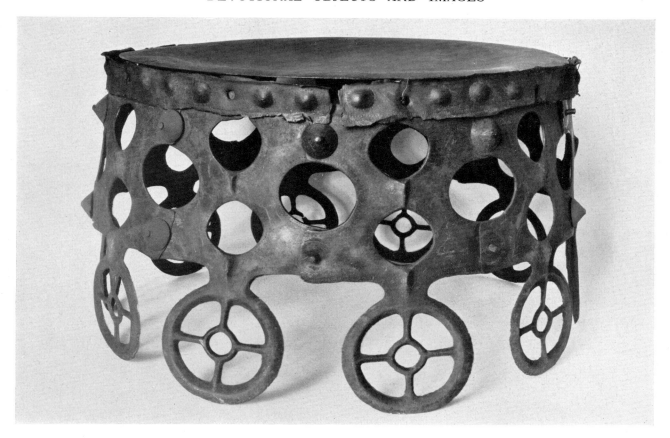

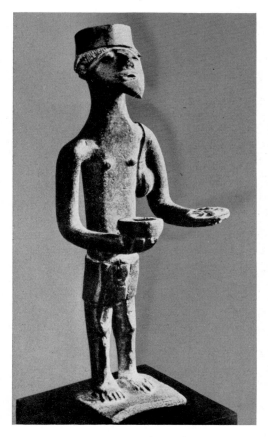

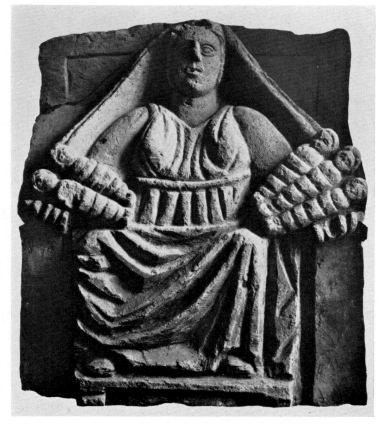

Pl. 207. *Above*: "Sun chariot," from Balkakra, Scania, Sweden, 14th–13th cent. B.C. Laminated bronze, diam., 15³/₄ in. Stockholm, Historiska Museet. *Below, left*: Sardinian figurine of offering bearer, nuraghi period, 8th cent. B.C. (?). Bronze, ht., 4⁷/₈ in. Cagliari, Sardinia, Museo Archeologico. *Right*: Votive statue of mother with children, from an Italic sanctuary near Capua, 4th–3d cent. B.C. (?). Stone, ht., 41³/₈ in. Capua, Museo Provinciale Campano.

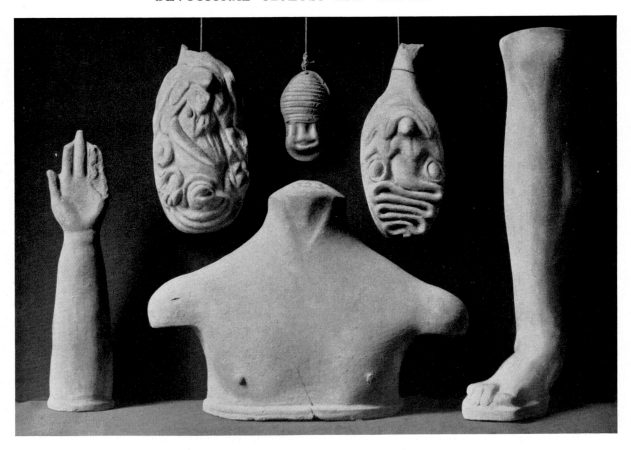

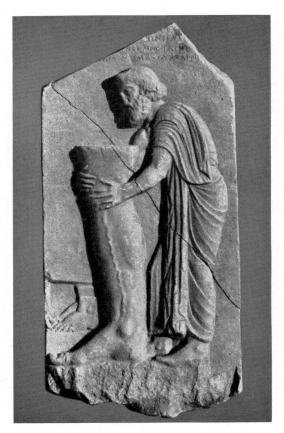

Pl. 208. Anatomical ex-votos. *Above*: Life-size ex-votos of parts of the human body, from Cerveteri, Italy, 3d–1st cent. B.C. Terra cotta. Rome, Vatican Museums. *Below, left*: Greek relief, 4th cent. B.C. Marble. Athens, National Museum. *Right*: Ex-voto, first half of 19th cent. Panel. Emmerthal, Bavaria.

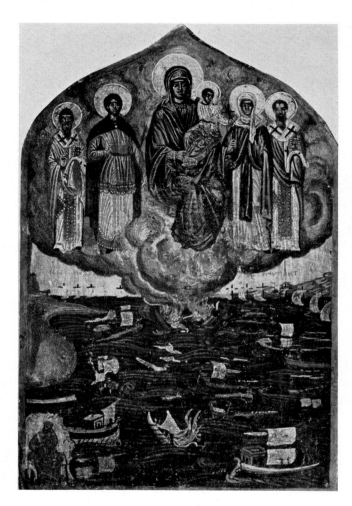

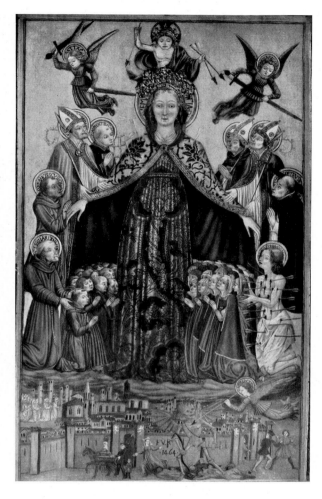

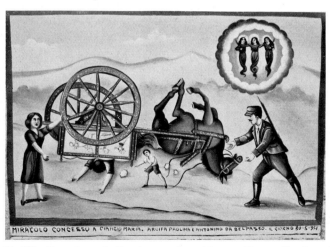

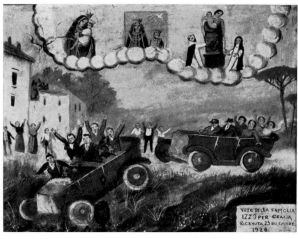

Pl. 209. Ex-votos of disasters and accidents. *Above*: Earthquake scene, votive relief, House of Caecilius Iocundus, Pompeii, A.D. 63–79. Marble, ht., 5⅛ in. *Center, left*: Ex-voto of the Battle of Lepanto (Naupaktos), Athens, 1571. Panel. Munich, Bayerisches Nationalmuseum. *Right*: B. Bonfigli and workshop, Mother of Mercy, 1464. Gonfalon. Perugia, Italy, S. Francesco al Prato, Cappella del Gonfalone. *Below, left*: Ex-voto, 1952. Panel. Trecastagni, Sicily. *Right*: Ex-voto, 1928. Panel. Naples, Church of the Madonna del Carmine.

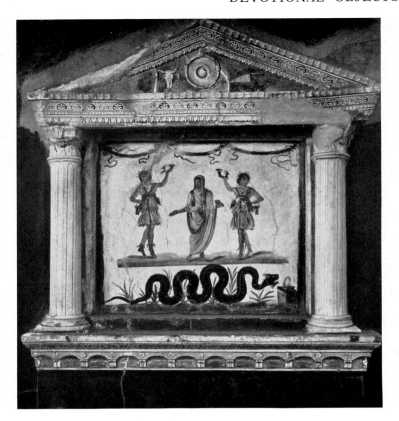

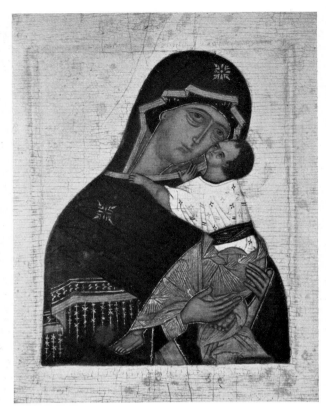

Pl. 210. Devotional images. *Above, left*: Altar of the *lares domestici*, House of the Vettii, Pompeii, A.D. 63–79. Wall painting and stucco. *Right*: The Virgin Glykophilousa, Moscow, 16th cent. Panel, $10^{1/4} \times 7^{5/8}$ in. Paris, Louvre. *Below, left*: Crucifix known as the "Holy Face," 11th–12th cent. Wood. Lucca, Italy, S. Martino. *Right*: J. de Juni, Our Lady of Sorrows, 16th cent. Polychromed wood. Valladolid, Spain, Church of Nuestra Señora de las Angustias.

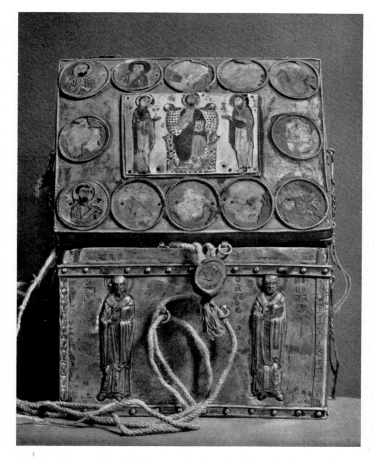

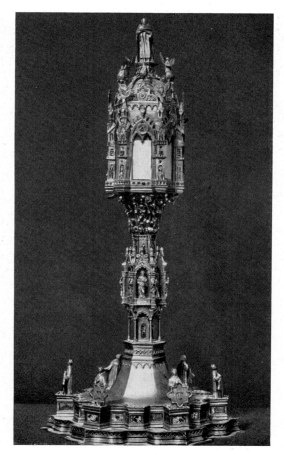

Pl. 211. *Above, left*: Reliquary of the Buddha (?), from Piprawa, Nepal, 4th cent. B.C. Terra cotta. Patna, Museum. *Right*: Pagoda-shaped Buddhist reliquary, 13th cent. Gilded bronze. Nara, Japan, Saidaiji. *Below, left*: Reliquary of St. Praxedis, 11th cent. Silver and enamel. Rome, Vatican Museums. *Right*: Reliquary of St. Thomas Aquinas, first half of 15th cent. Gilded silver and enamel. Bologna, S. Domenico.

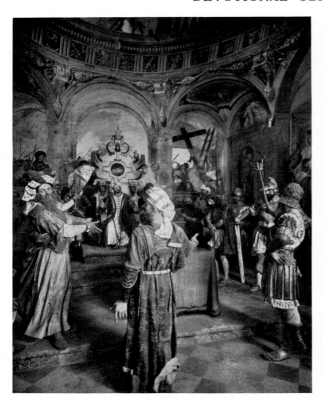
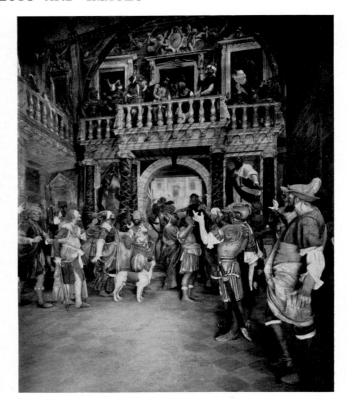

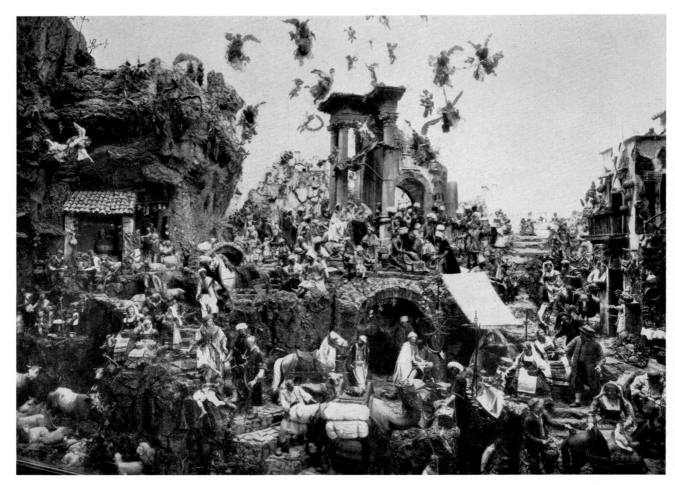

Pl. 212. *Above*: G. Ferrari and assistants, scenes from the Passion, 16th cent. Painted wood and terra cotta. Varallo, Italy, Sacro Monte. *Left*: Christ Condemned to Death. *Right*: Ecce Homo. *Below*: G. B. Polidoro, G. Sanmartino, and others, Nativity scene, 18th cent. Naples, Museo Nazionale di San Martino.

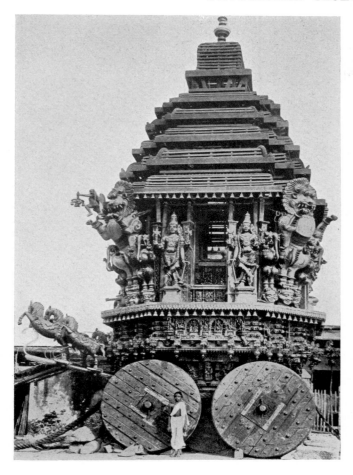

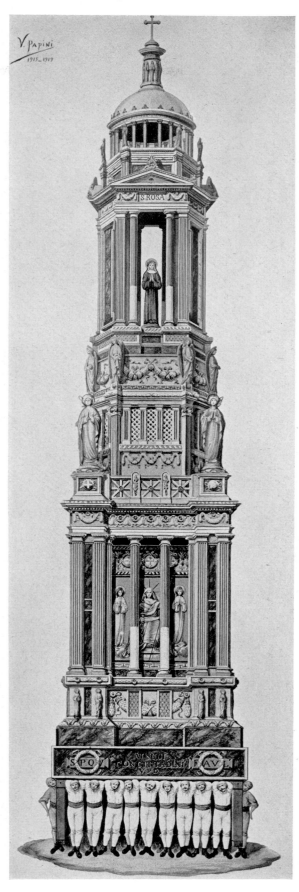

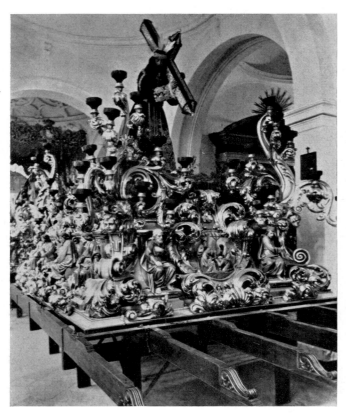

Pl. 213. Processional apparatus. *Left, above*: Processional car, Tanjore, India. Painted wood. *Below*: Christ carrying the Cross, 18th cent. Gilded and painted wood. Málaga, Spain, S. Domingo (destroyed?, 1931). *Right*: Tower of St. Rose (water-color rendering by V. Papini). Viterbo, Italy, S. Rosa.

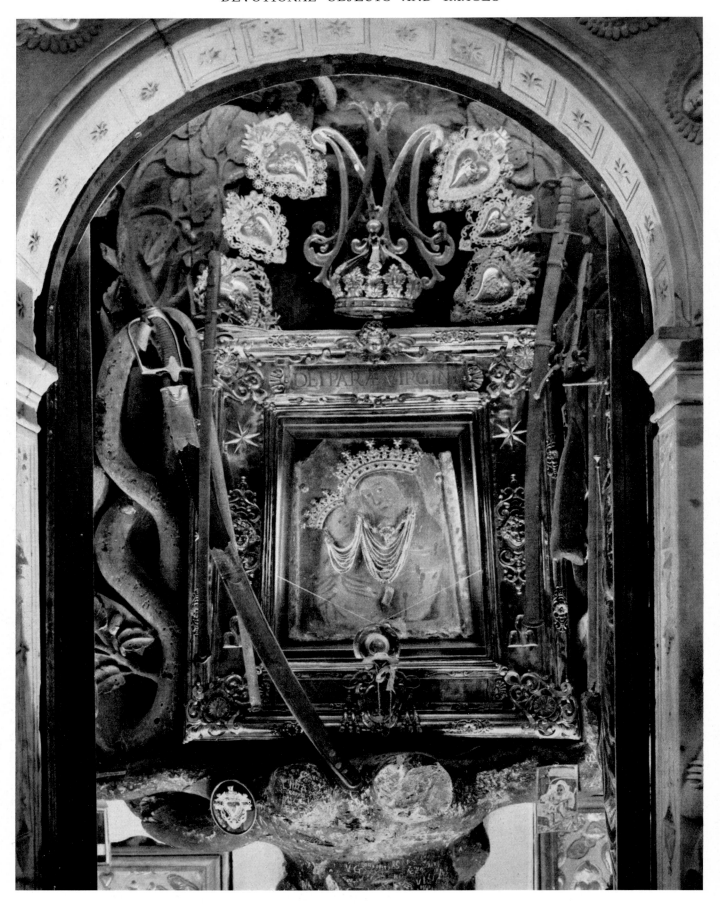

Pl. 214. Sanctuary of the Madonna della Quercia, near Viterbo, Italy, detail of main altar with miraculous image of Virgin and Child decorated with crowns and necklaces and surrounded by ex-votos.

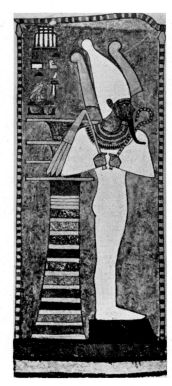

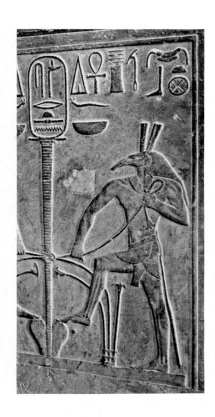

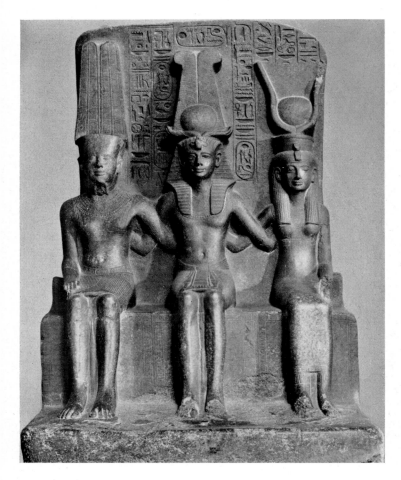

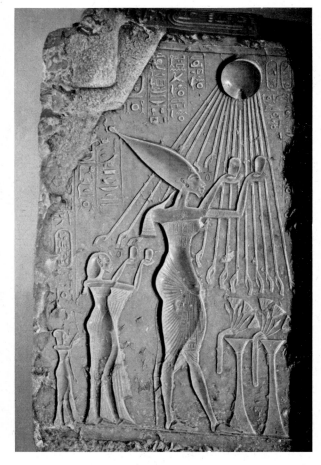

Pl. 215. *Above, left*: The goddess Hathor, palette from Gerze, Egypt, 4th millennium B.C. Schist. *Center*: Osiris, wall painting in tomb of Horemheb, Thebes, late 18th dynasty. *Right*: Set, detail of the throne of a statue of Sesostris I, 12th dynasty. Limestone. Cairo, Egyptian Museum. *Below, left*: Amen and Mut with Ramses II, 19th dynasty. Granite, ht., 5 ft., 8 1/2 in. Turin, Museo Egizio. *Right*: Aten, worshipped by Akhenaten, relief from Tell el 'Amarna, ca. 1360 B.C. Limestone. Cairo, Egyptian Museum.

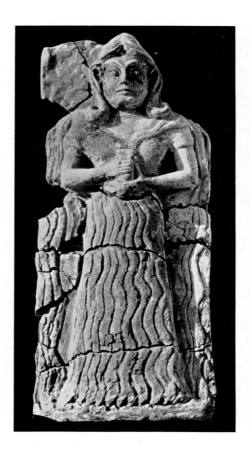
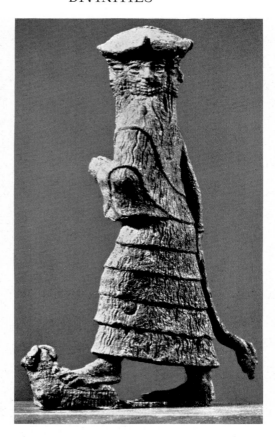
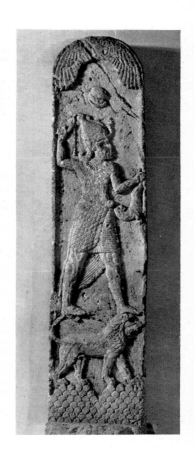

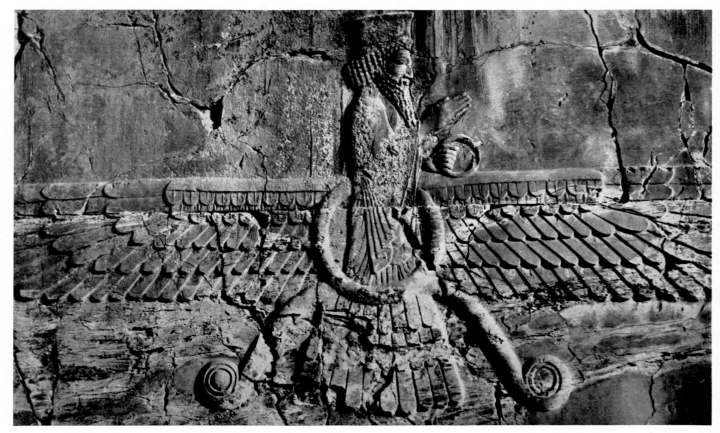

Pl. 216. *Above, left*: "Goddess of the gushing vase," from Ur, Mesopotamia, 21st–20th cent. B.C. Terra cotta, ht., 29 1/2 in. Baghdad, Iraq Museum. *Center*: Four-faced god from Ishchali, Mesopotamia, 18th cent. B.C. Bronze, ht., 6 3/8 in. Chicago, University, Oriental Institute. *Right*: The god El on a lion, stele from 'Amrit, Syria, 6th–5th cent. B.C. Limestone, ht., 5 ft., 10 7/8 in. Paris, Louvre. *Below*: Ahura Mazda, 6th cent. B.C. Stone. Persepolis, Tripylon Gate.

# DIVINITIES

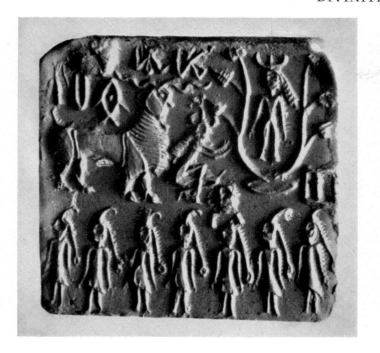

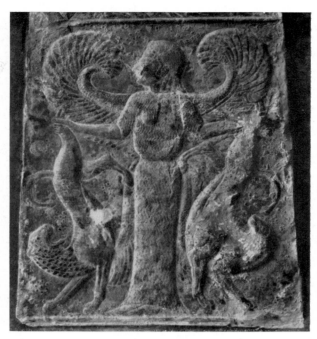

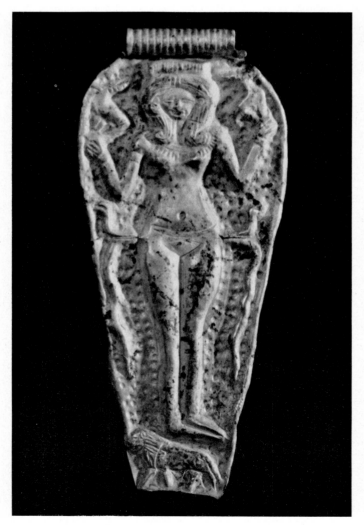

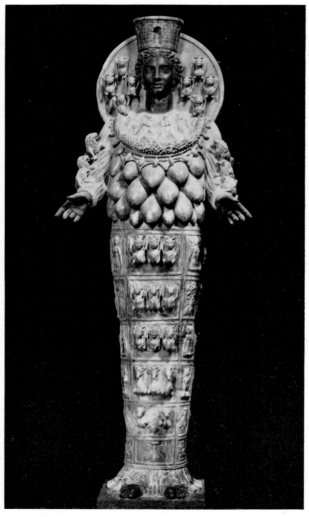

Pl. 217. *Above, left*: Seal showing female divinity, from Mohenjo-daro, Pakistan, 3d–2d millennium B.C. Steatite. New Delhi, Museum of Central Asian Antiquities. *Right*: "The Lady of the Beasts," detail of a bronze plaque from Olympia, 7th cent. B.C. Athens, National Museum. *Below, left*: Mother goddess on a gold pendant, from Ras Shamra, Syria, 15th cent. B.C. Paris, Louvre. *Right*: Artemis of Ephesos, Roman copy of a Hellenistic original. Bronze and alabaster. Naples, Museo Nazionale.

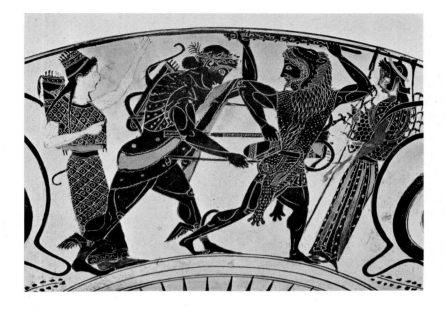

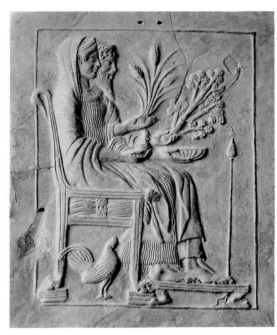

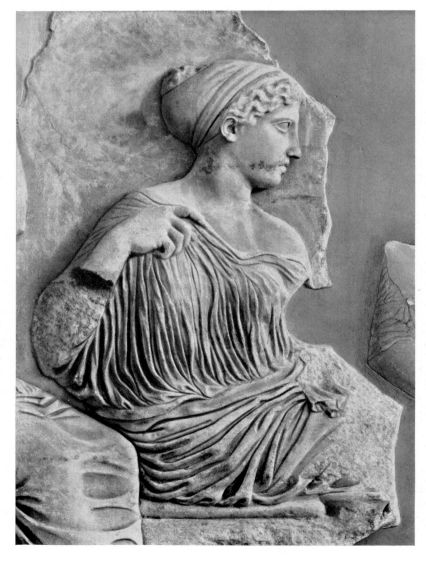

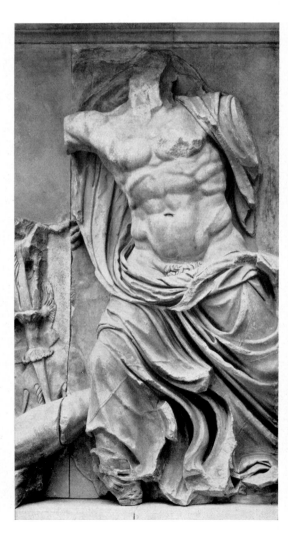

Pl. 218. *Above, left*: Artemis, Apollo, Herakles, and Athena, detail of a black-figured Attic kylix, 520–510 B.C. Munich, Staatliche Antiken-sammlungen. *Right*: The gods of the lower world, Hades and Persephone, pinax from Locri, 5th cent. B.C. Reggio Calabria, Italy, Museo Nazionale. *Below, left*: Artemis, from the eastern frieze of the Parthenon, 442–438 B.C. Athens, Acropolis, Museum. *Right*: Zeus, from the eastern frieze of the Great Altar of Zeus at Pergamon, ca. 180–160 B.C. Berlin, Staatliche Museen.

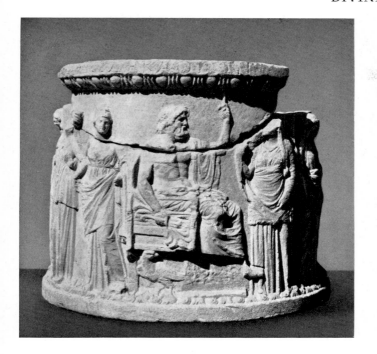
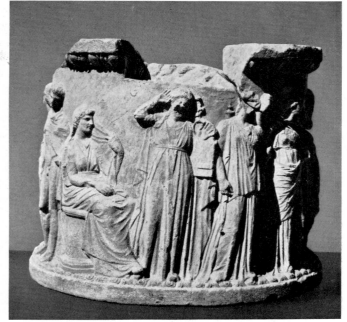
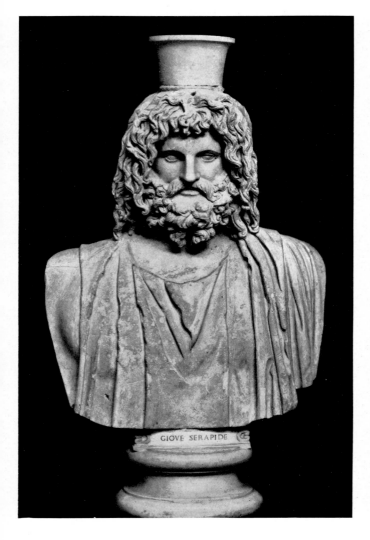
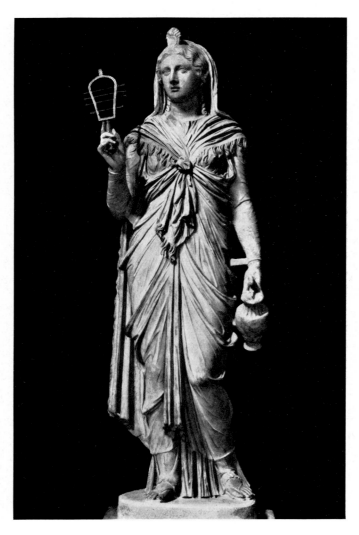

Pl. 219. *Above*: The gods of Olympus, two details of a neo-Attic round altar, second half of 1st cent. B.C. Marble. Ostia Antica, Italy, Museo Ostiense. *Below, left*: Zeus-Serapis, Roman copy of a Greek original of the 4th cent. B.C. Marble. Rome, Vatican Museums. *Right*: Isis, Roman sculpture from a Hellenistic original. Marble. Rome, Capitoline Museum.

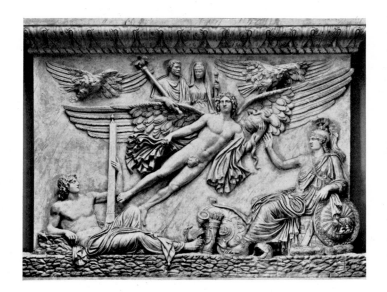

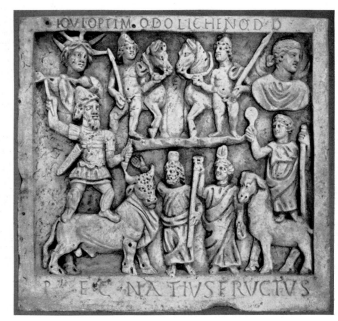

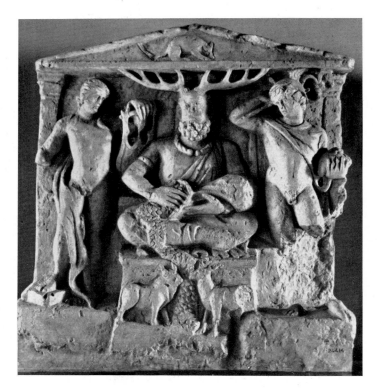

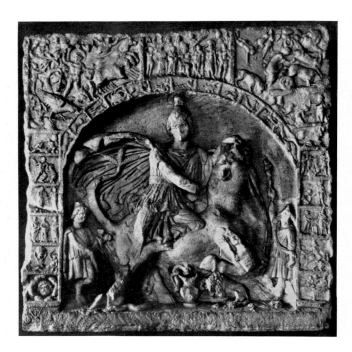

Pl. 220. *Above, left*: Apotheosis of the emperor Antoninus Pius (A.D. 161–69) and the empress Faustina in the presence of the goddess Roma, relief from the base of the Column of Antoninus Pius. Marble. Rome, Vatican Museums. *Right*: Jupiter Dolichenus and Juno Regina on sacred animals with Serapis and Isis between them and the Sun, the Moon, and the Dioscuri above, Roman relief, 3d cent. Marble. Rome, Capitoline Museum. *Below, left*: Cernunnos between Apollo and Mercury, relief on a Gallo-Roman altar from Reims, 2d cent. (cast of original in Reims, Musée Historique et Lapidaire). *Right*: Mithras Tauroktonos, Roman relief from Osterburken, Germany, 2d–3d cent. Marble. Karlsruhe, Germany, Landesmuseum.

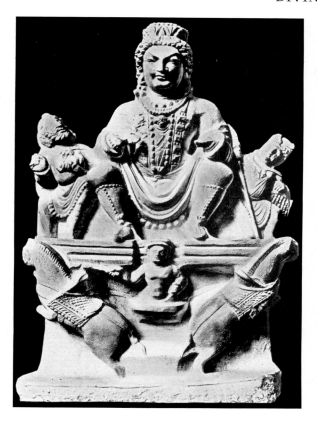

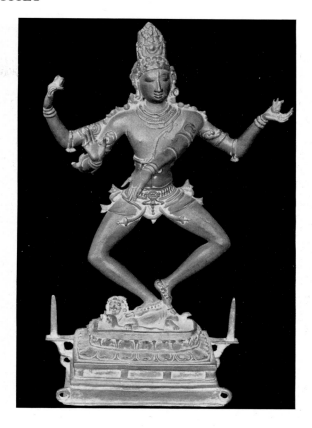

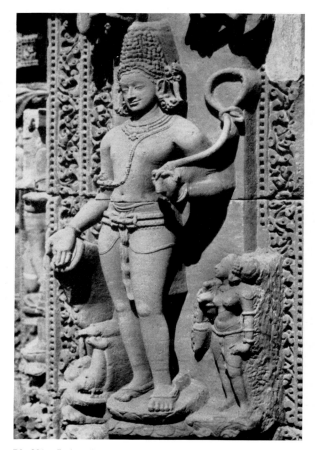

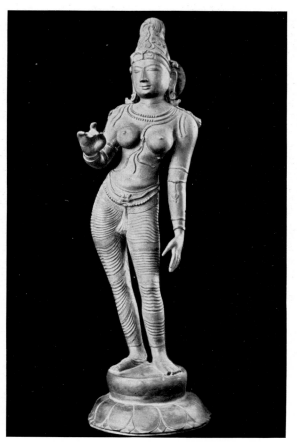

Pl. 221. *Left, above*: The sun god, Sūrya, in Kushan dress, from Khair Khaneh, Afghanistan, ca. 5th cent. Marble. Kabul, Afghanistan, Museum. *Below*: The god Varuṇa, 12th–13th cent. Stone. Bhuvaneshwar, India, Rājrānī temple. *Right, above*: Dancing Śiva (Naṭarāja) from Tiruvarangulam, Andhra Pradesh, India, early Chola period, 11th cent. Bronze. *Below*: The goddess Pārvatī, 19th cent. Bronze. Last two, New Delhi, National Museum of India.

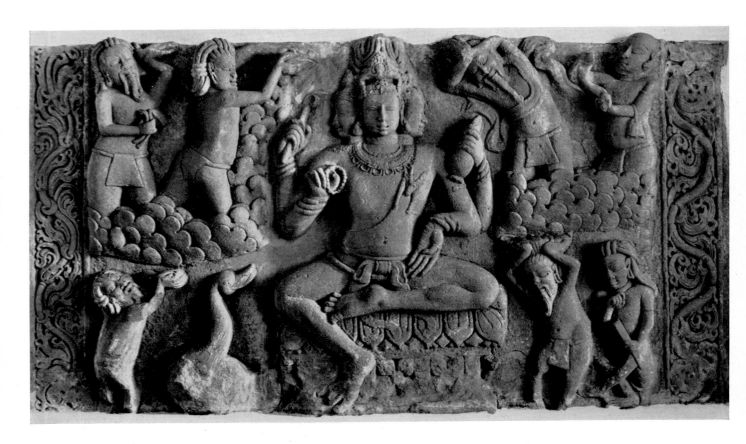

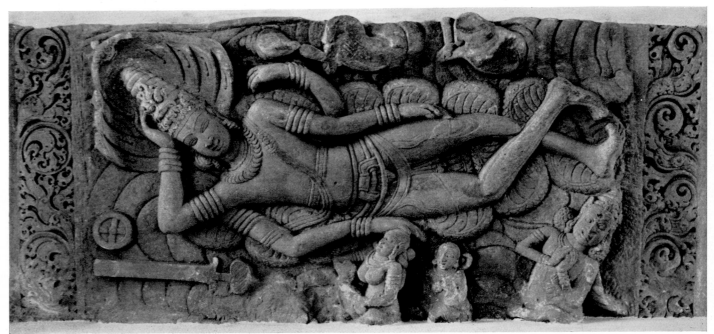

Pl. 222. *Above*: The god Brahma, from Aihole, Bombay province, India, 5th–7th cent. Stone. *Below*: The god Viṣṇu sleeping on the serpent Ananta (Śeṣa), from Aihole, 5th–7th cent. Stone. Both, Bombay, Prince of Wales Museum.

Pl. 223. *Above, left*: The god Gaṇeśa, from southern India, ca. 11th cent. Bronze. New Delhi, Museum of Central Asian Antiquities. *Right*: Tantric Buddhist divinity with his counterpart, Nepal, 11th–12th cent. Bronze. Rome, Museo d'Arte Orientale. *Below, left*: The god Hevajra, from Cambodia, 12th cent. Bronze. Bangkok, National Museum. *Right*: Statue of a queen deified in the likeness of Prajñāpāramitā, from Cambodia, 12th–13th cent. Stone. Paris, Musée Guimet.

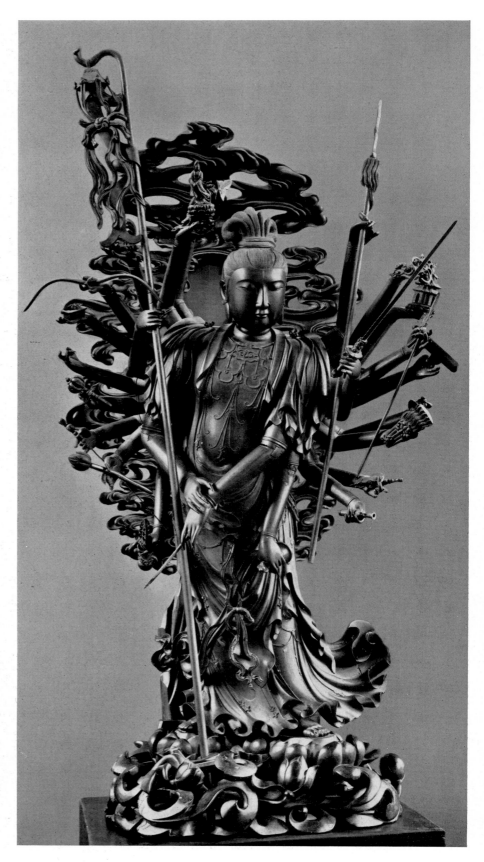

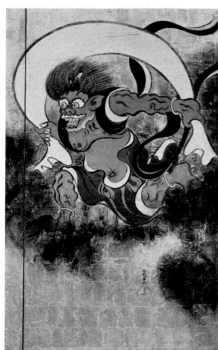

Pl. 224. *Left, above*: Divinity K'uei Hsing associated with the Chinese god of literature, Ming period. Rubbing from a relief. *Below*: Ogata Kōrin, the Japanese wind god, detail of a screen, 18th cent. Color on paper. Tokyo, National Commission for Protection of Cultural Properties. *Right*: Kuan-yin of the thousand arms, from China, 18th cent. Wood. Paris, Musée Guimet.

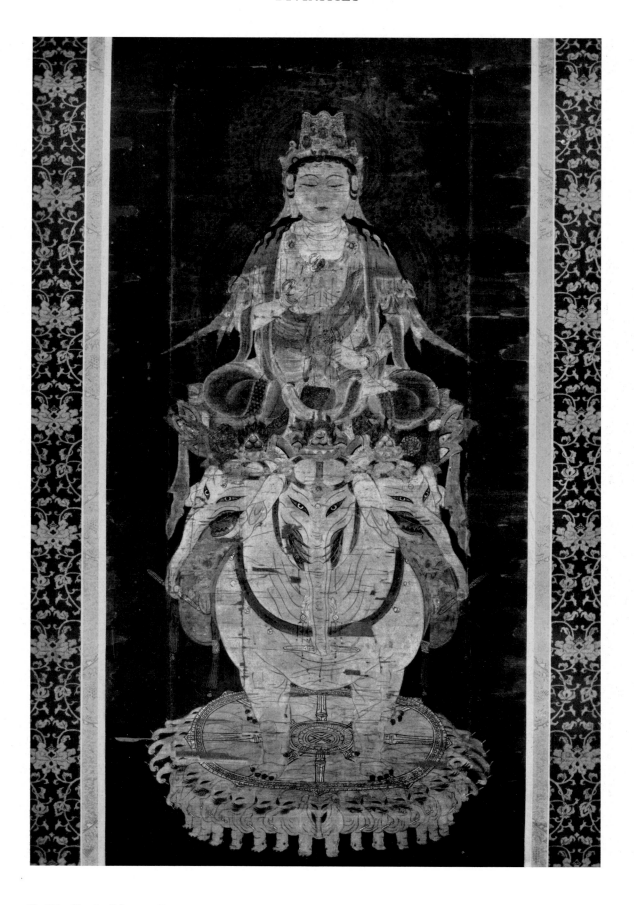

Pl. 225. The bodhisattva Fūgen Emmyō (Vajrāmoghasmayasattva), Japanese, first half of 12th cent. Color on silk, 51 1/8 × 26 3/8 in. Kyoto, Matsunoo-dera.

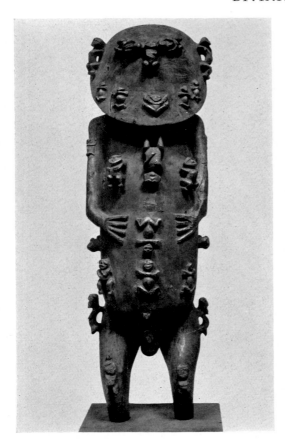

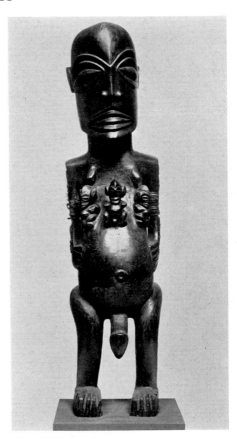

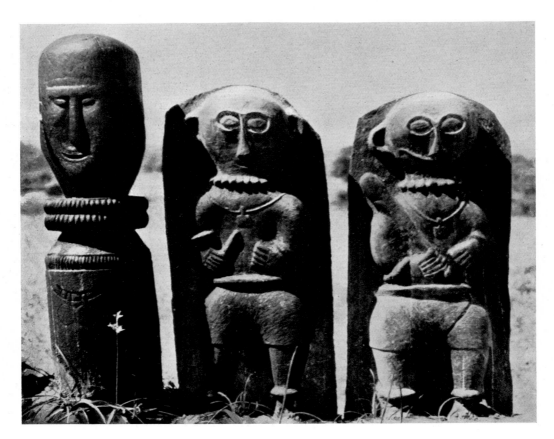

Pl. 226. *Above, left*: Tangaroa, god of the sea, in the act of creating gods and men, Rurutu, Tu-
buaï (Austral) Islands. Wood. *Right*: The god Rongo with his three sons, Rarotonga,
Cook Islands. Wood. Both, London, British Museum. *Below*: Effigies of the cattle god Bir
Kuar, of the Ahir tribe of Rothas, Bihar, India. Stone.

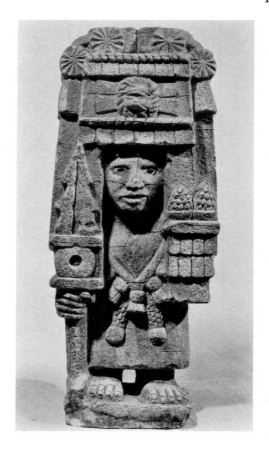

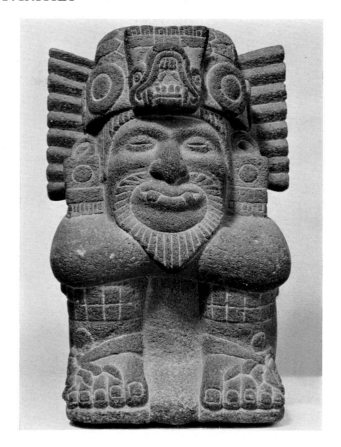

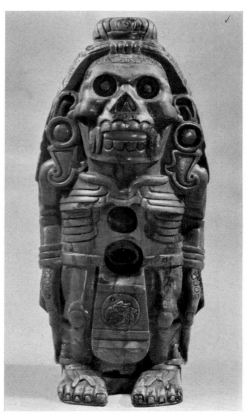

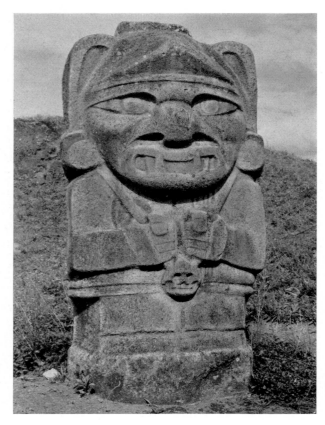

Pl. 227. *Above, left*: Aztec corn goddess, from Mexico. Stone. Rome, Lateran Museum. *Right*: Bearded god Tonacatecuhtli, from the Mexican plateau (?), Aztec period. Basalt. Basel, Museum für Völkerkunde. *Below, left*: Xolotl, monster god, from the Mexican plateau, Aztec period. Nephrite. Stuttgart, Linden Museum. *Right*: A god wearing a human skull. Stone. San Agustín, Huila, Colombia.

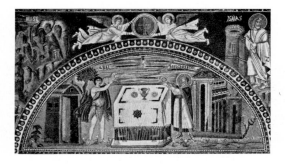

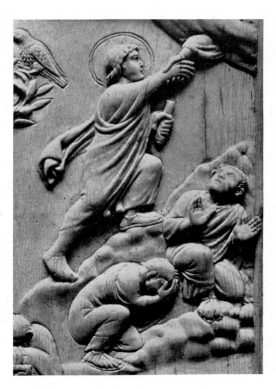

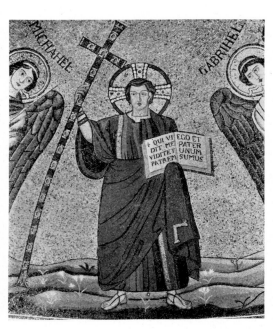

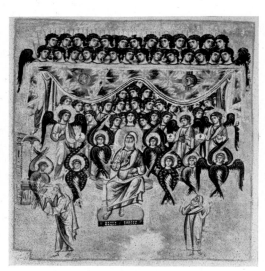

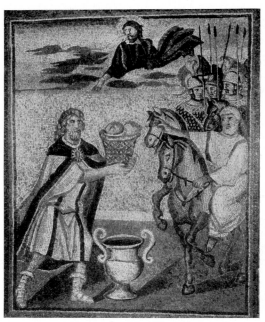

Pl. 228. The Father. *Above*: The Hand of God. *Left*: The Vision of Ezekiel, from the Synagogue of Dura-Europos, ca. 250. Fresco. Damascus, National Museum. *Right*: The sacrifices of Abel and Melchizedek, first half of 6th cent. Mosaic. Ravenna, S. Vitale. *Center, left*: The Hand of God, in the Ascension, detail of an ivory, ca. 400. Munich, Bayerisches Nationalmuseum. *Right*: Christ manifesting the Father, detail of a mosaic from S. Michele in Affricisco, Ravenna, 6th cent. Berlin, Staatliche Museen. *Below, left*: The Ancient of Days in the Vision of Ezekiel, 11th cent. Illumination. Rome, Vatican Library (Vat. gr. 1162, fol. 119v). *Right*: The Word, in the meeting of Abraham and Melchizedek, ca. 440. Mosaic. Rome, S. Maria Maggiore.

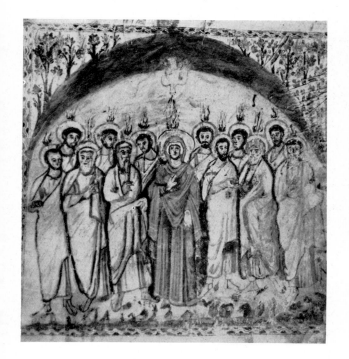

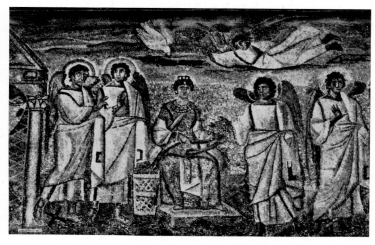

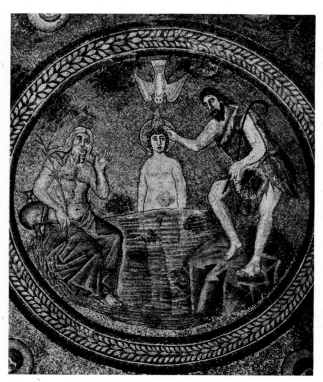

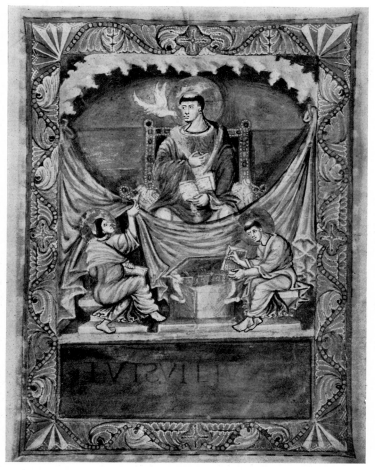

Pl. 229. The Holy Spirit. *Above, left*: Pentecost, in the Rabula Gospels, 6th cent. Illumination. Florence, Biblioteca Laurenziana (Plut. I 56, fol. 14v). *Right*: The Annunciation, detail of triumphal arch, ca. 440. Mosaic. Rome, S. Maria Maggiore. *Below, left*: The Baptism of Christ, late 5th cent. Mosaic. Ravenna, Baptistery of the Arians (now Oratory of S. Maria in Cosmedin). *Right*: St. Gregory the Great inspired by the Holy Spirit, second half of 9th cent. Illumination. Paris, Bibliothèque Nationale (Lat. 1141, fol. 3).

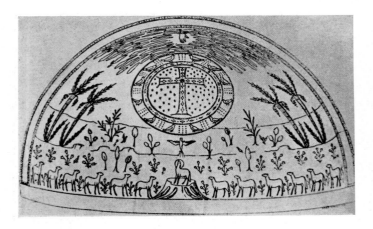

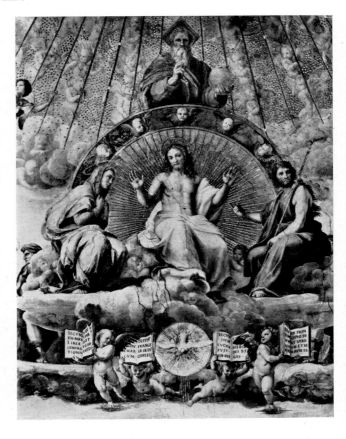

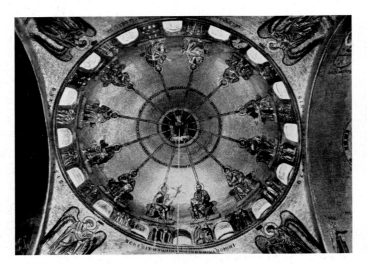

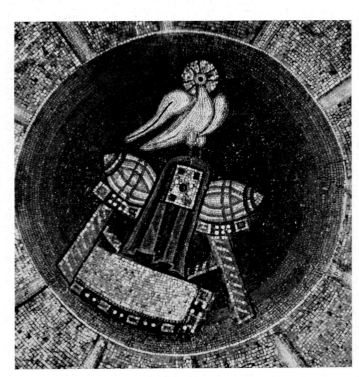

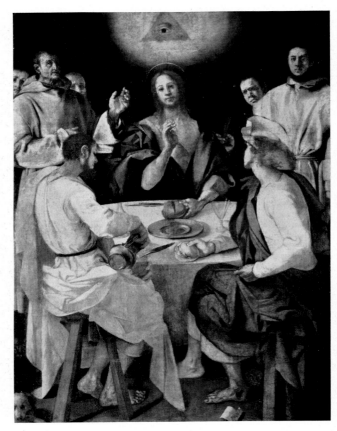

Pl. 230. The Trinity. *Left, above*: St. Paulinus of Nola's plan of the Trinity for a mosaic, 5th cent. (graphic reconstruction by F. Wickhoff, 1889). *Center*: Pentecost, 12th cent. Mosaic. Venice, St. Mark's. *Below*: The Hetimasia Trinitaria, 11th cent. Mosaic. Hosios Lukas, Phocis, Greece. *Right, above*: Raphael, The Trinity, detail of the *Disputa*, 1508–11. Fresco. Rome, Vatican, Stanza della Segnatura. *Below*: Pontormo, Supper at Emmaus. Panel. Florence, Uffizi.

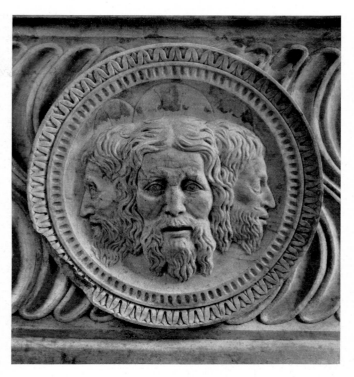

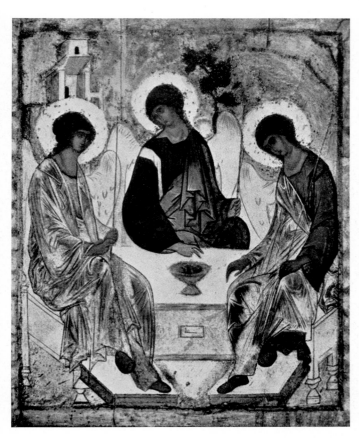

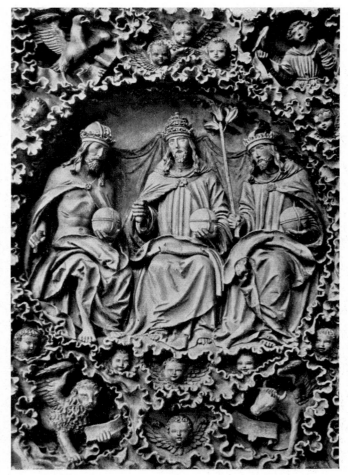

Pl. 231. The Trinity. *Left, above*: The Father and the Son, 9th cent. Illumination, detail. Utrecht, Netherlands, University Library (Scrip. Eccl. 484, fol. 64v). *Center*: Abraham and the Three Angels, first half of 6th cent. Mosaic. Ravenna, S. Vitale. *Below*: A. Rublëv, icon of the Angelic Trinity, 1410. Panel. Moscow, Tretyakov Gallery. *Right, above*: Michelozzo and Pagno di Lapo Portigiani, The Holy Trinity, 15th cent. Marble. Florence, Museo Bardini. *Below*: The Holy Trinity, detail of the Vasai Altar, ca. 1515. Marble. Baden, Austria, St. Helena.

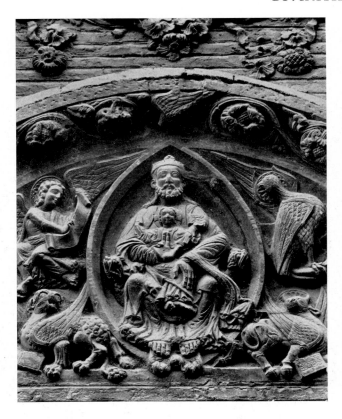

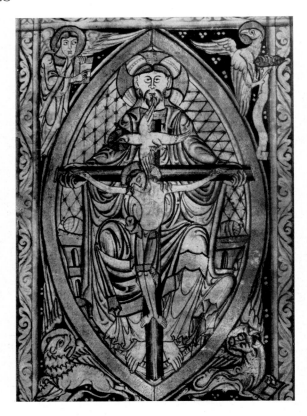

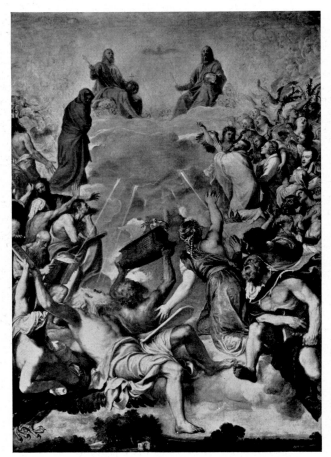

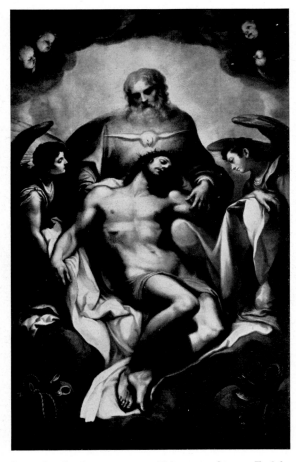

Pl. 232. The Trinity. *Above, left*: God the Father holding the Son, detail of tympanum, 12th cent. Stone. Tudela, Navarre, Spain, S. Nicolás. *Right*: The Throne of Mercy, first half of 12th cent. Illumination. Cambrai, Bibliothèque Municipale (Ms. 234, fol. 2). *Below, left*: Titian, The Triumph of the Trinity, 1551–54. Canvas. Madrid, Prado. *Right*: L. Cardi (Il Cigoli), The Trinity, 1592. Canvas. Florence, Sta Croce.

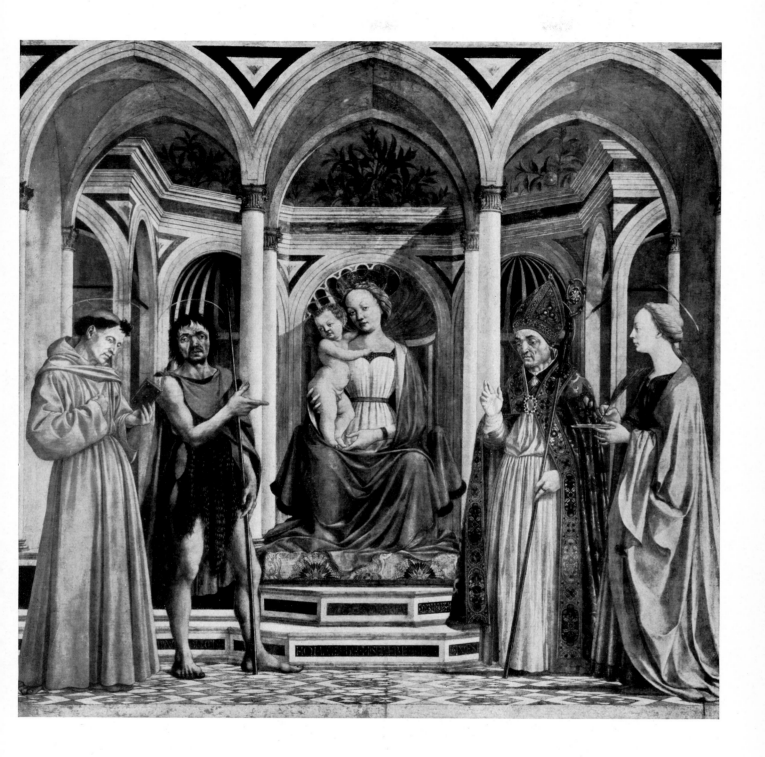

Pl. 233. The Virgin and Child with SS. Francis, John the Baptist, Zenobius, and Lucy, altarpiece from the Church of S. Lucia dei Magnoli, Florence. Panel, 6 ft., 10¹/₄ in. × 7 ft. Florence, Uffizi.

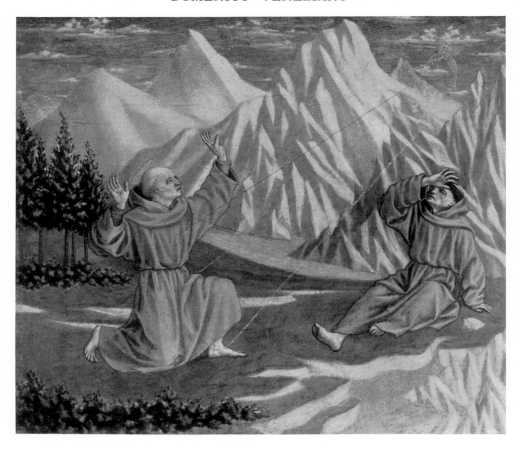

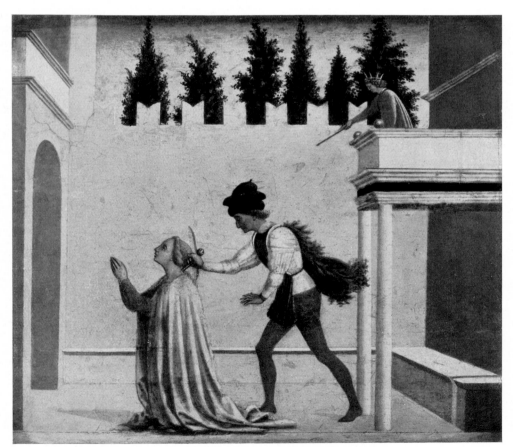

Pl. 234. Scenes from the predella of the S. Lucia dei Magnoli altarpiece. *Above*: St. Francis Receiving the Stigmata. Panel, 10¼×11⅞ in. Washington, D.C., National Gallery. *Below*: The Martyrdom of St. Lucy. Panel, 9⅞×11¼ in. Berlin, Staatliche Museen.

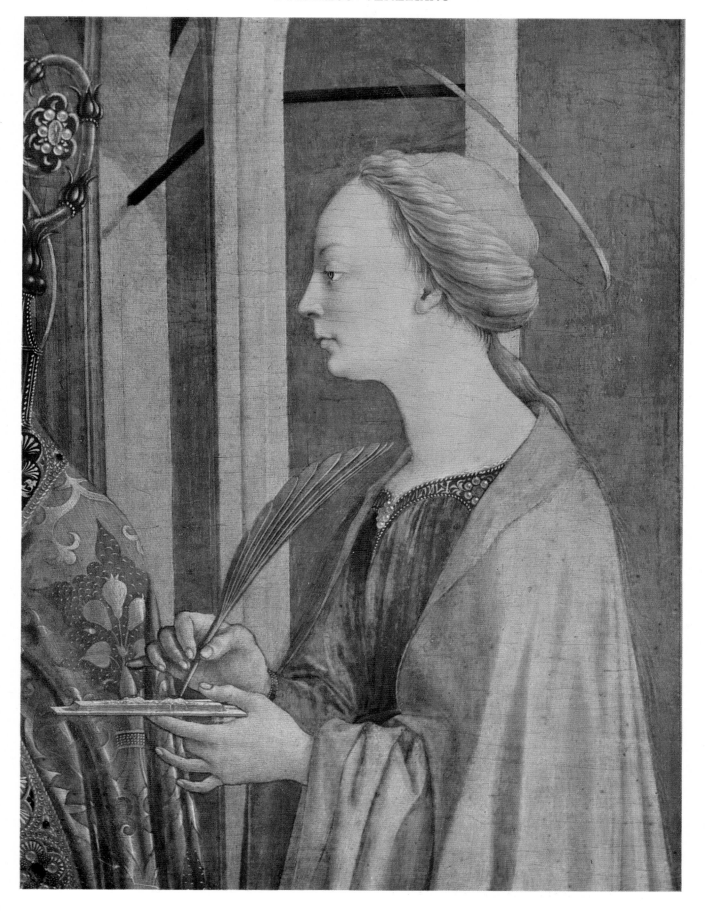

Pl. 235. St. Lucy, detail of PL. 233.

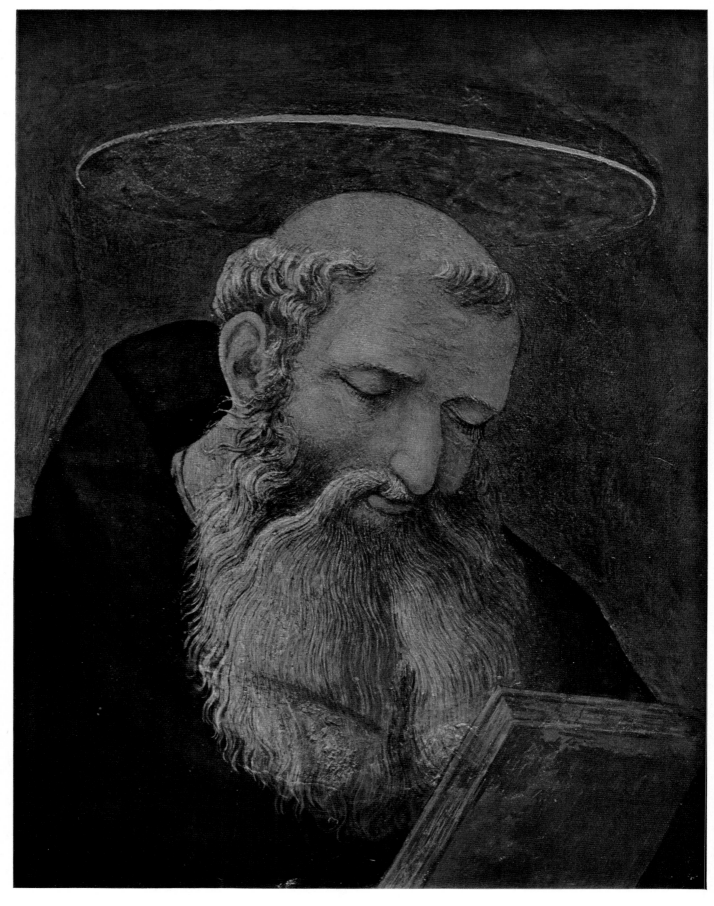

Pl. 236. Detached fresco fragment, perhaps representing St. Anthony, 15³/₄×13 in. London, National Gallery.

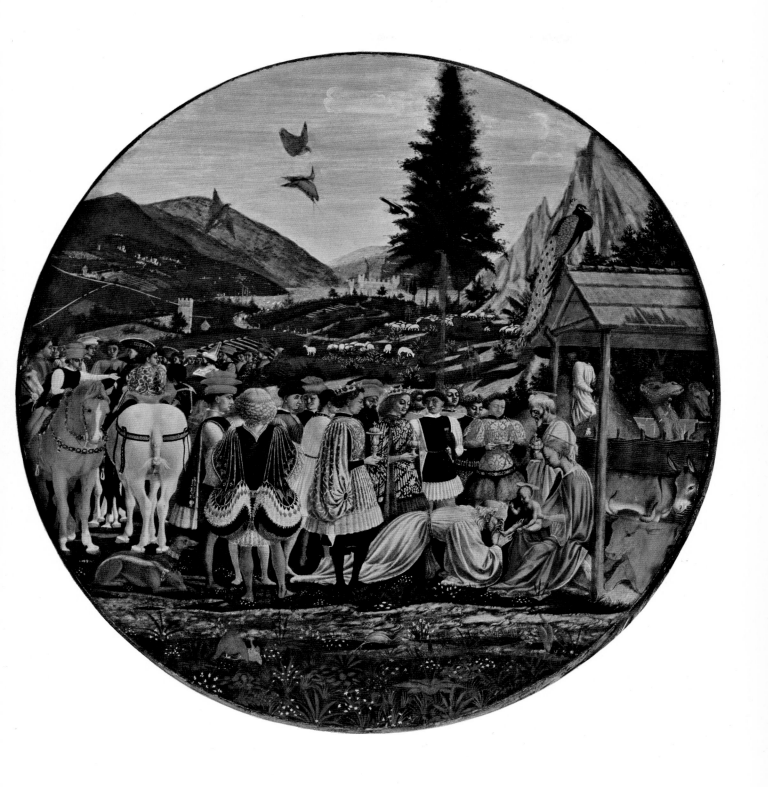

Pl. 237. Adoration of the Magi. Panel, diam., 33 1/8 in. Berlin, Staatliche Museen.

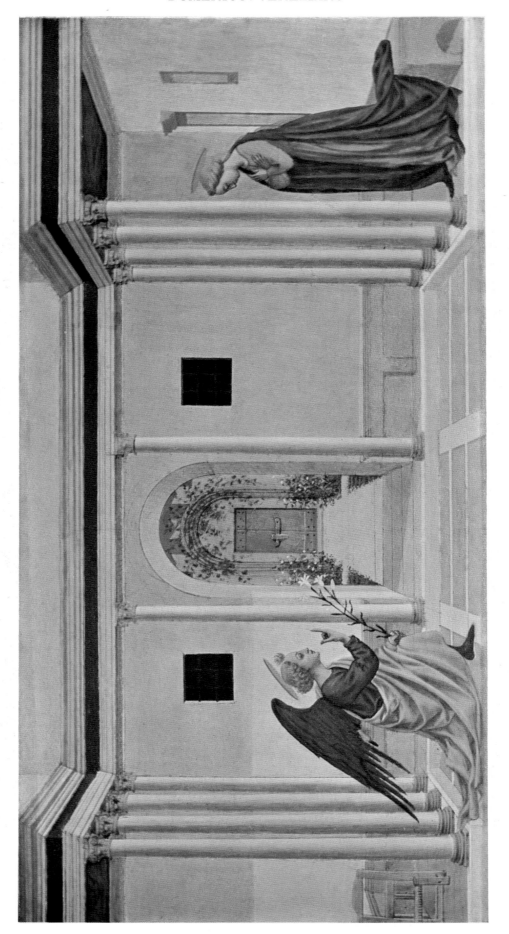

PL. 238. The Annunciation, from the predella of the S. Lucia dei Magnoli altarpiece. Panel, $10^5/8 \times 21^1/4$ in. Cambridge, England, Fitzwilliam Museum.

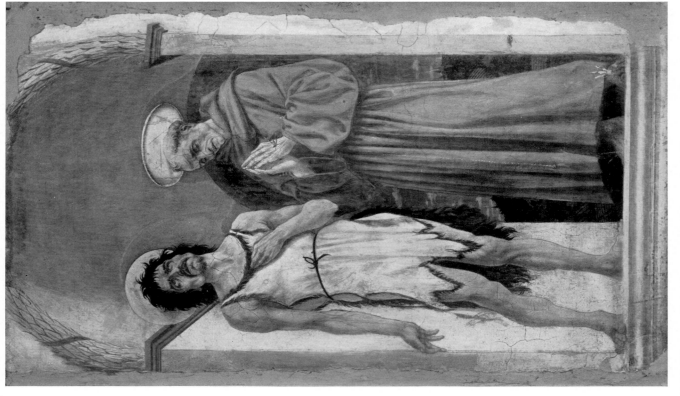

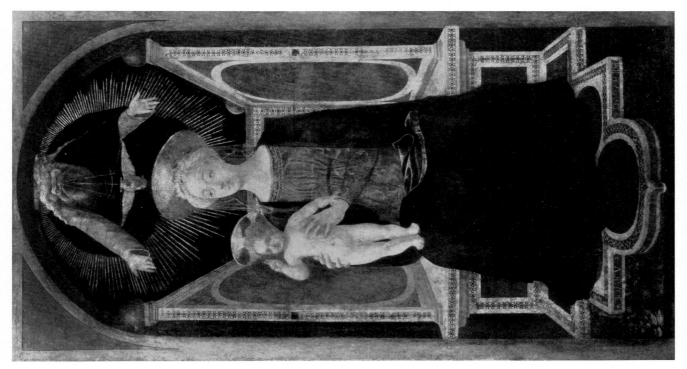

Pl. 239. *Left*: The Virgin Enthroned, with God the Father and the Holy Spirit (the so-called "Carnesecchi Tabernacle"). Fresco transferred to canvas; 7 ft., 10⅞ in. × 3 ft., 11¼ in. London, National Gallery. *Right*: John the Baptist and St. Francis. Fresco. Florence, Sta Croce.

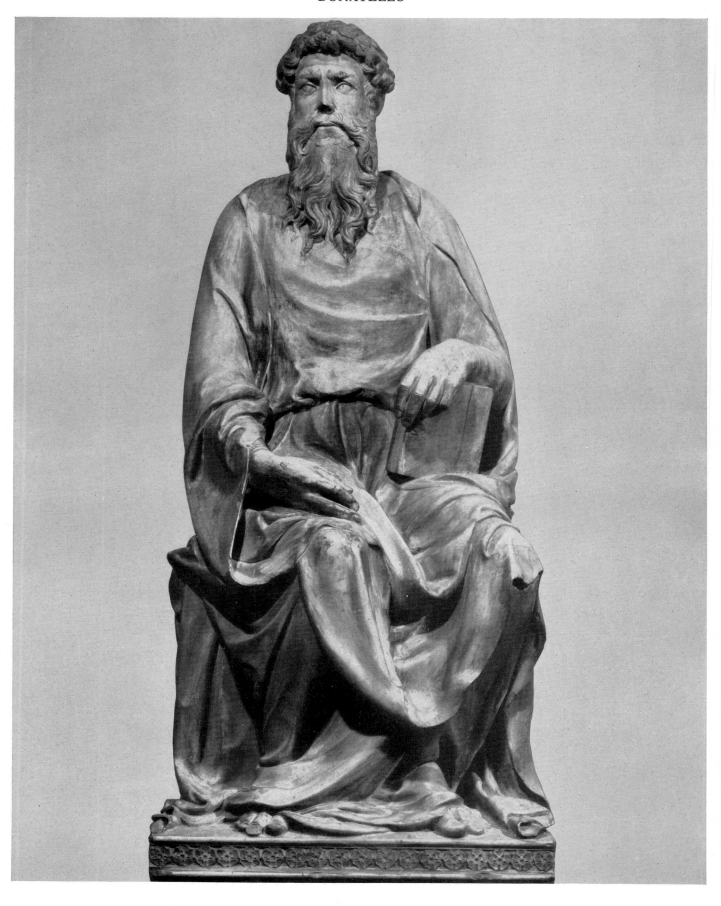

Pl. 240. St. John the Evangelist. Marble, ht., 6 ft., 10⅝ in. Florence, Museo dell'Opera del Duomo.

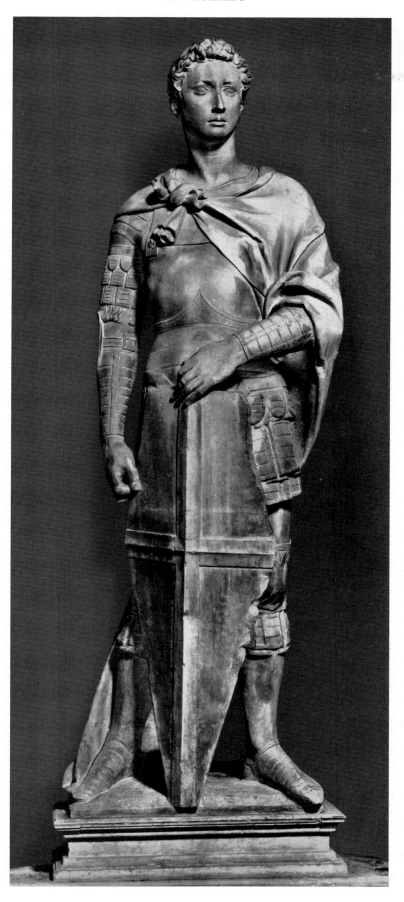

Pl. 241. St. George. Marble, ht., 6 ft., 10¹/₄ in. Florence, Museo Nazionale.

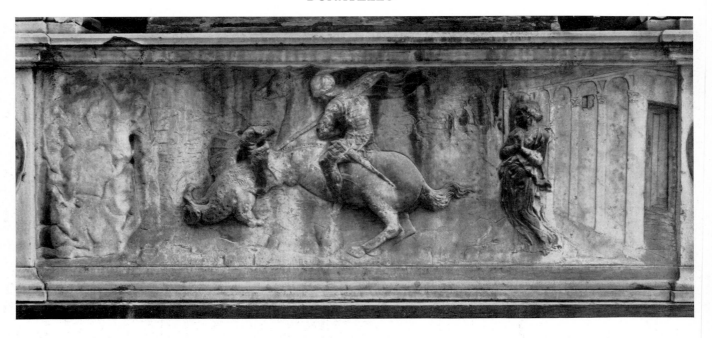

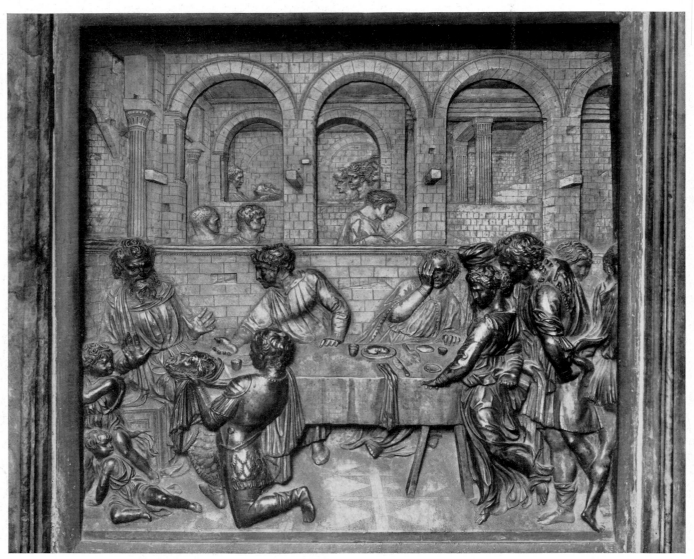

Pl. 242. *Above*: St. George Slaying the Dragon, originally the base of St. George, PL. 241. Marble, 15³/₈ × 47¹/₄ in. Florence, Orsanmichele. *Below*: The Feast of Herod, relief on baptismal font. Gilt bronze, 23⁵/₈ × 23⁵/₈ in. Siena, Italy, Baptistery.

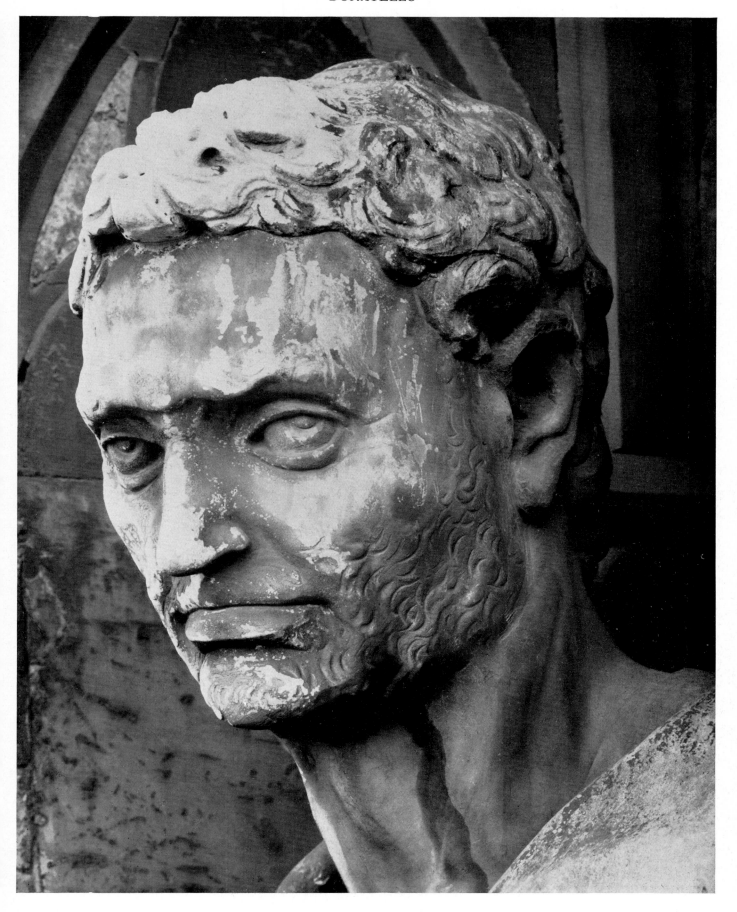

Pl. 243. Jeremiah, detail, from the Campanile of the Cathedral. Marble; full ht., 6 ft., 3¹/₄ in. Florence, Museo dell'Opera del Duomo.

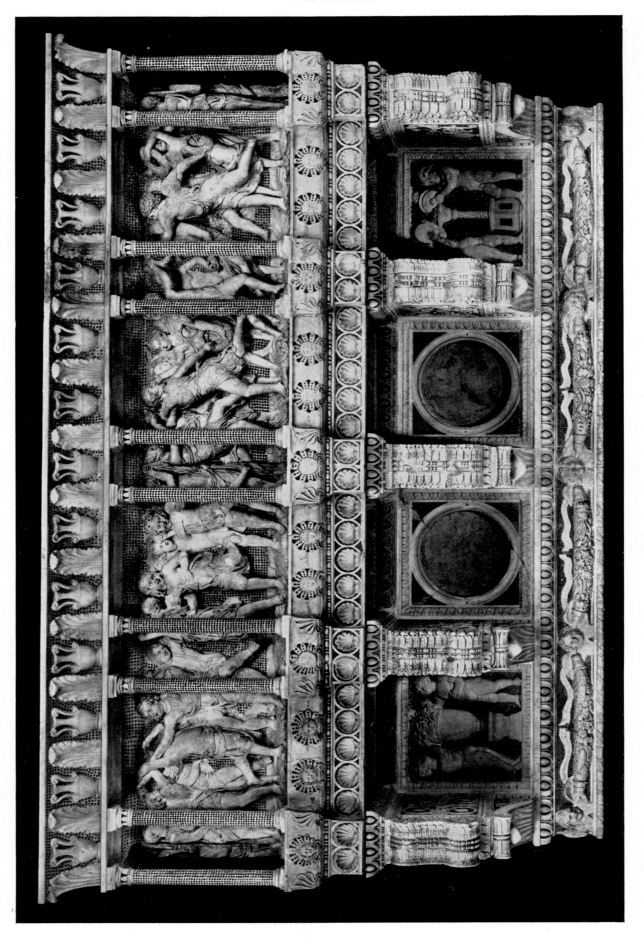

Pl. 244. Singing gallery from the Cathedral of Florence. Marble. Florence, Museo dell'Opera del Duomo.

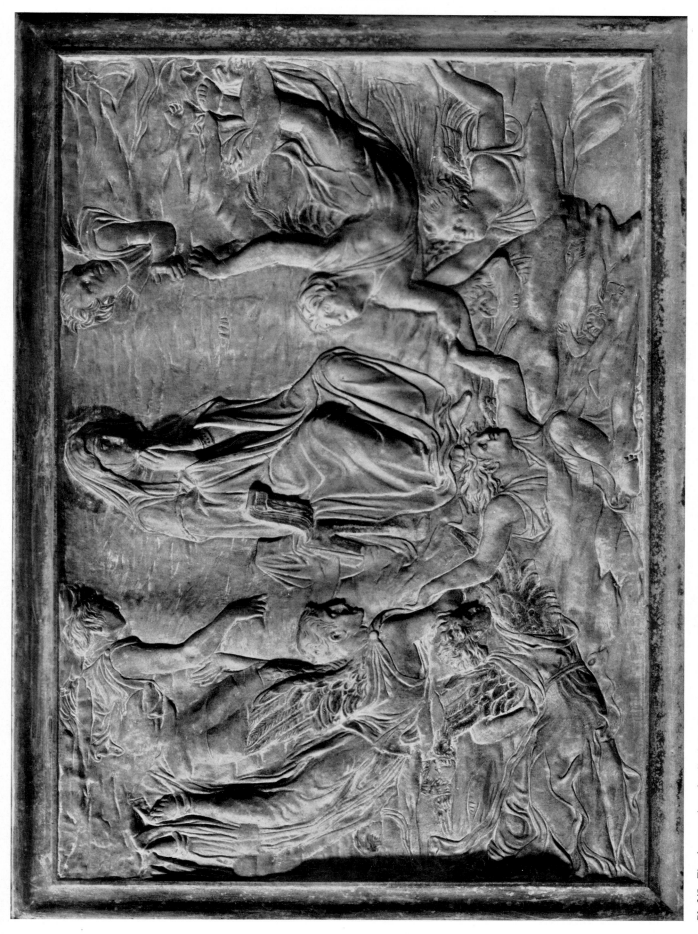

Pl. 245. The Assumption, detail of the Brancacci Tomb. Marble, 21¹/₈ × 30³/₄ in. Naples, S. Angelo a Nilo.

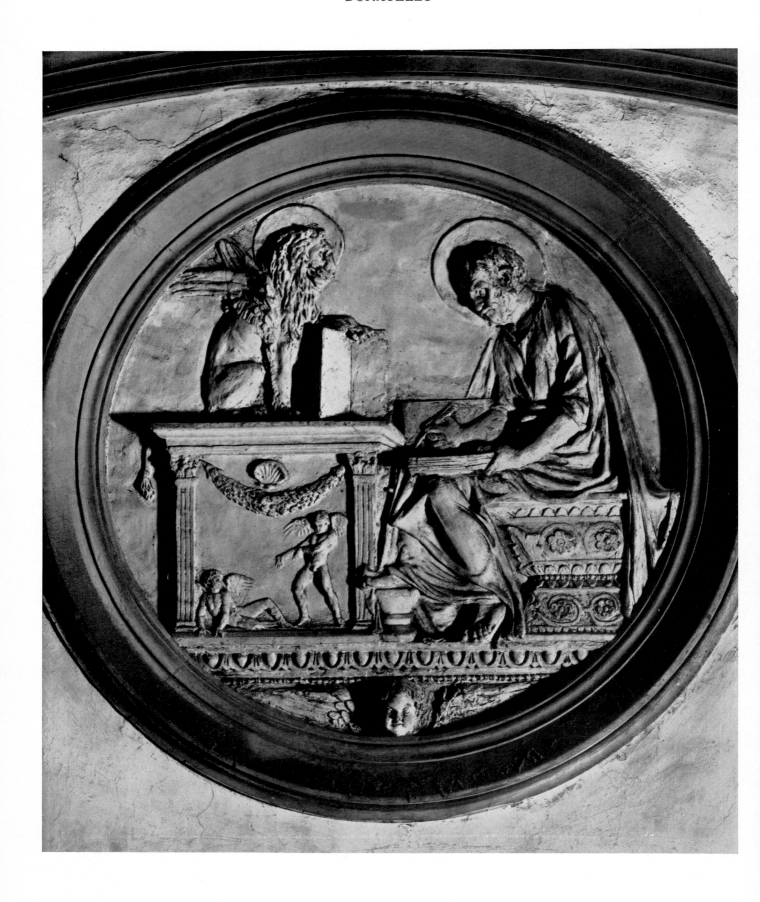

Pl. 246. St. Mark the Evangelist. Stucco. Florence, S. Lorenzo, Old Sacristy.

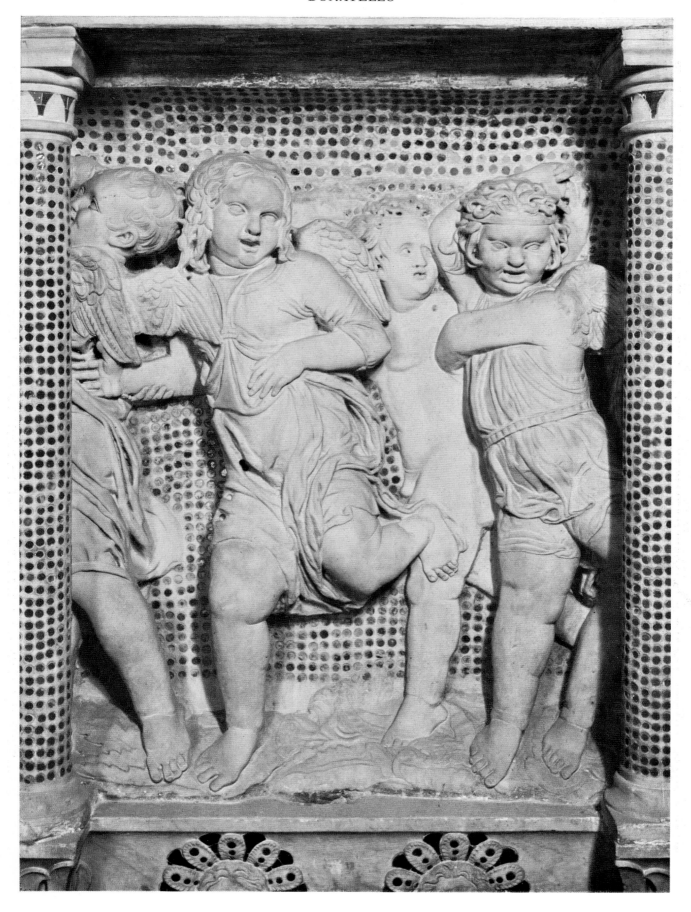

Pl. 247. Dancing putti, detail of PL. 244.

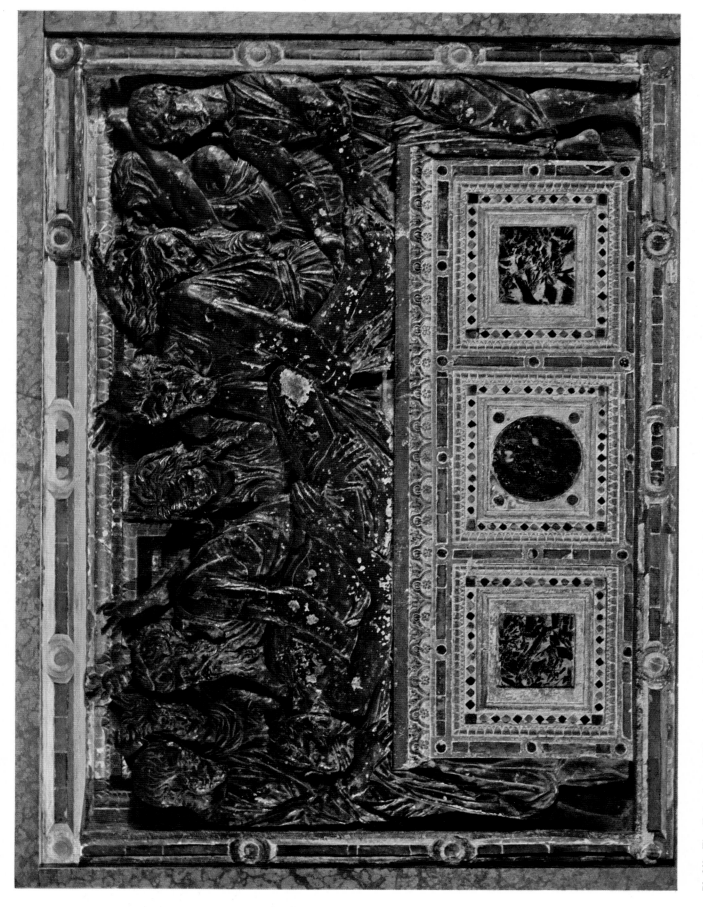

Pl. 248.  The Entombment.  Limestone, 4 ft., 6¾ in. × 6 ft., 2 in. S. Antonio, Padua, Italy, high altar.

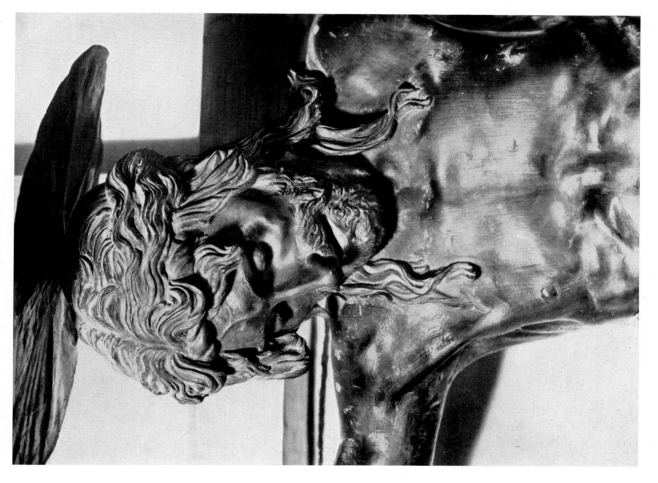

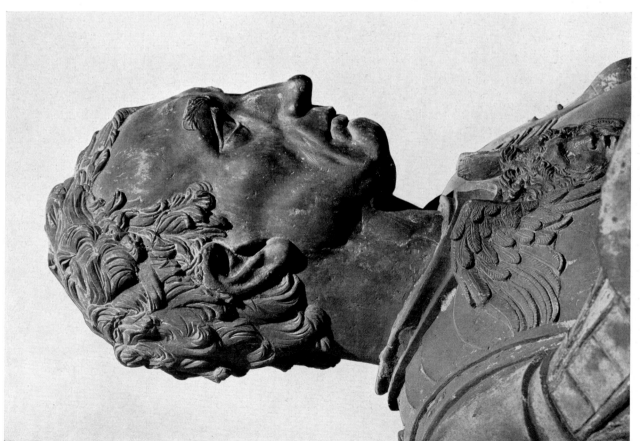

Pl. 249. *Left:* Monument to Erasmo da Narni, called "the Gattamelata," detail. Bronze. Padua, Italy, Piazza del Santo. *Right:* Crucifix, detail. Bronze; full ht., ca. 5 ft., 11 in. Padua, Italy, S. Antonio, high altar.

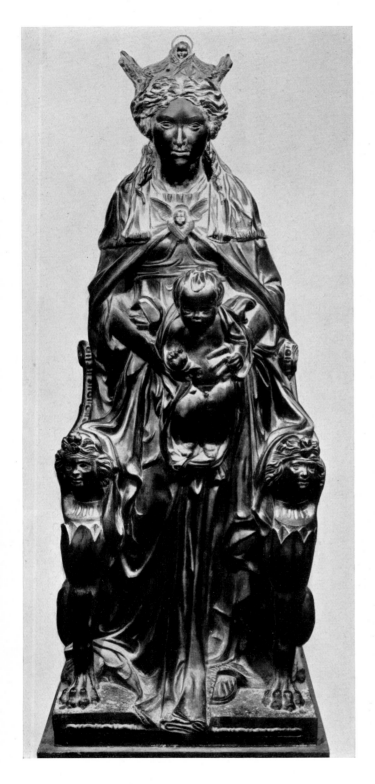 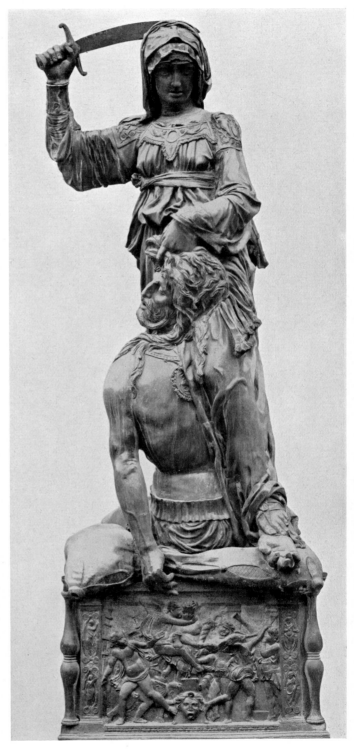

Pl. 250. *Left*: Madonna and Child. Bronze, ht., 5 ft., 3 in. Padua, Italy, S. Antonio, high altar. *Right*: Judith and Holofernes. Bronze, ht., 7 ft., 8⁷/₈ in. Florence, Piazza della Signoria.

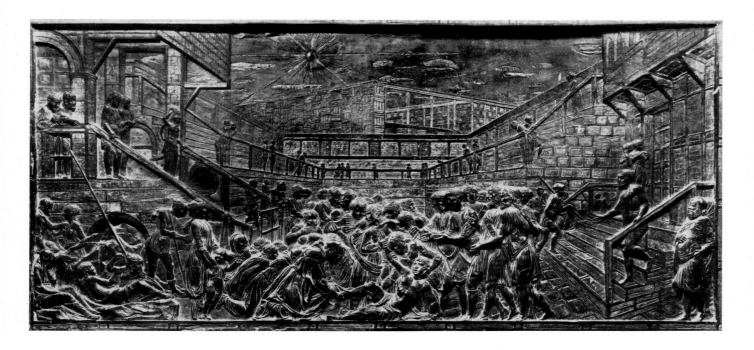

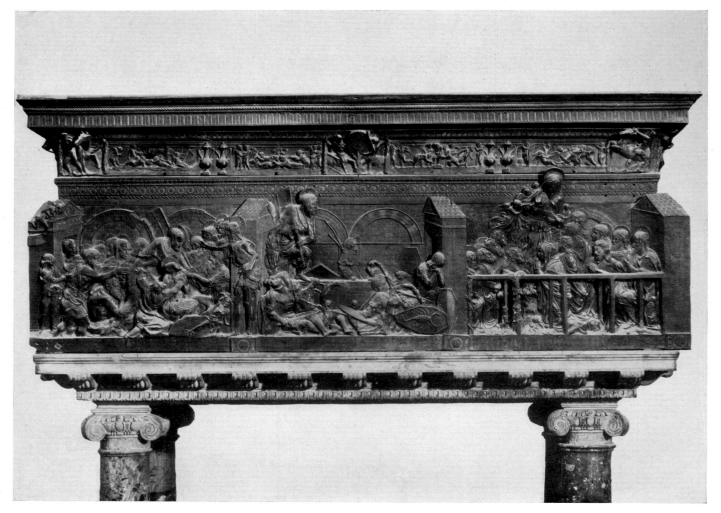

Pl. 251. *Above*: St. Anthony healing the young man's foot. Bronze, 22½×48½ in. Padua, Italy, S. Antonio, high altar. *Below*: South pulpit, S. Lorenzo, Florence. Bronze.

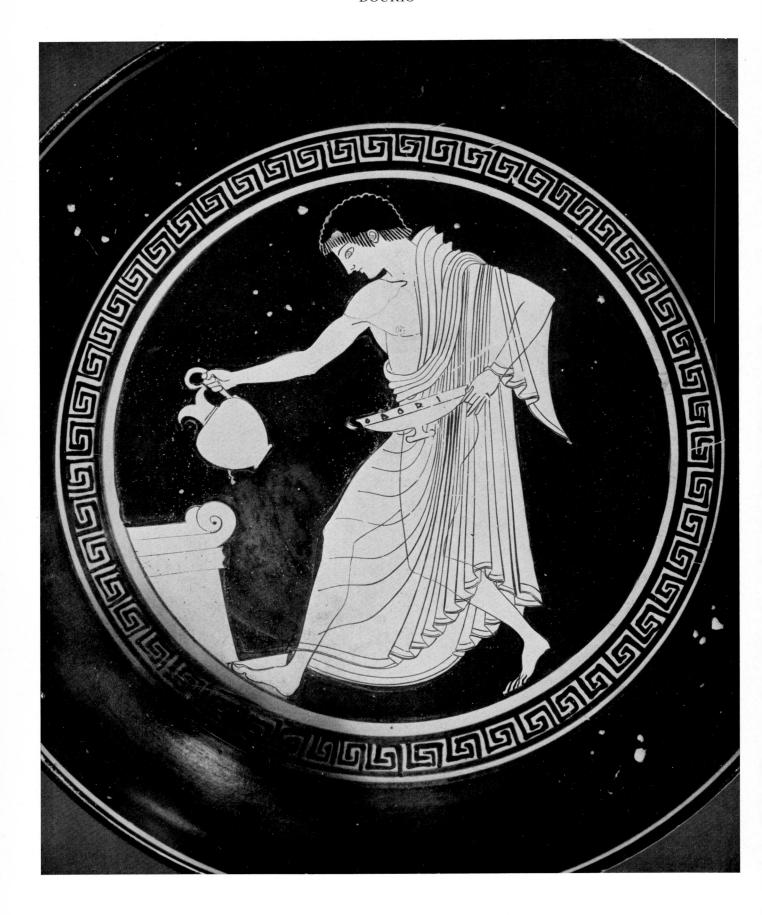

Pl. 252.  Detail of the interior of a kylix, ca. 500 B.C. Diam. of kylix, 9¹/₈ in. Athens, National Museum.

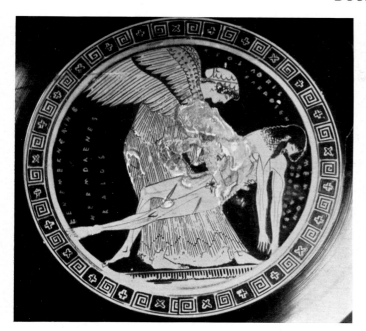

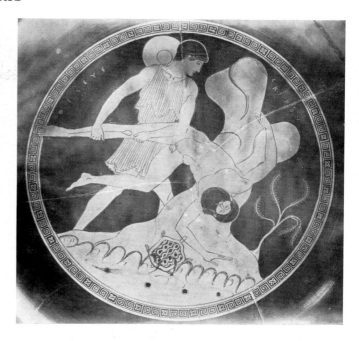

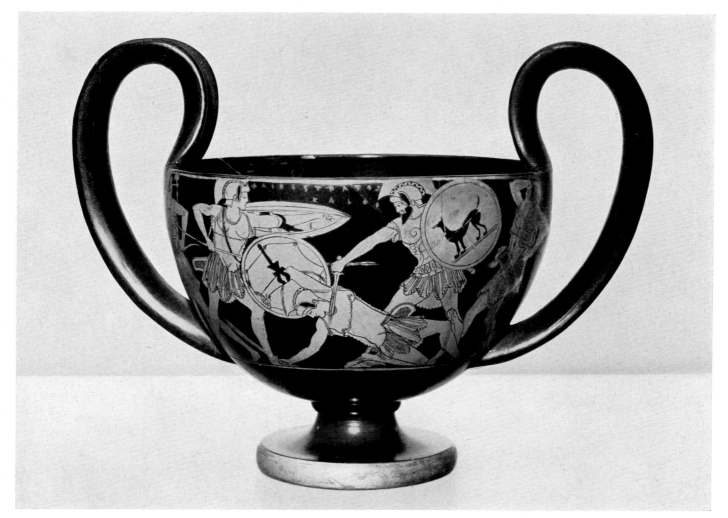

Pl. 253. *Above, left*: Eos holding the body of her son Memnon, detail of the interior of a kylix, ca. 490 B.C. Diam. of kylix, 10¹/₂ in. Paris, Louvre. *Right*: Theseus in combat with Skiron, detail of the interior of a kylix, ca. 490 B.C. Diam. of kylix, 13 in. Berlin, Staatliche Museen. *Below*: Kantharos with Amazonomachy scenes, ca. 480 B.C. Ht., 7¹/₈ in. Brussels, Musées Royaux d'Art et d'Histoire.

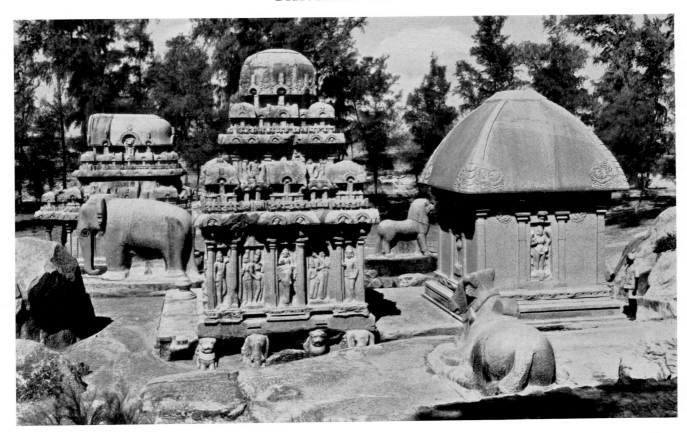

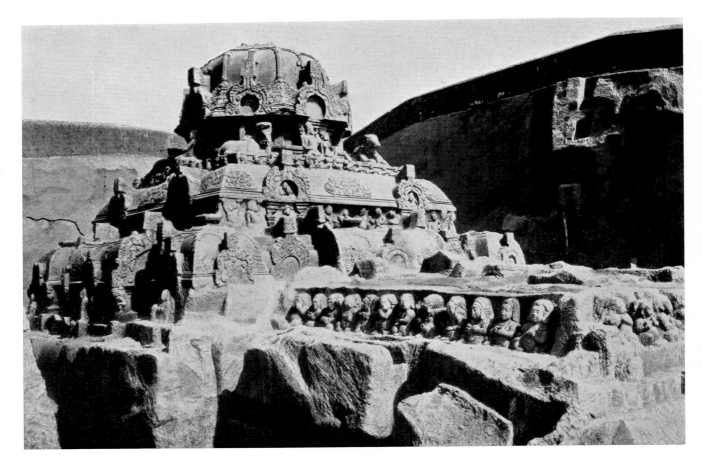

Pl. 254. *Above*: Mamallapuram, Chingleput District, Madras, rock-cut rathas, Pallava period, 7th cent. *Below*: Kalugumalai, Tirunelveli District, Madras, the unfinished rock-cut temple of Veṭṭuvan Koil, Pāṇḍya period, 7th–8th cent.

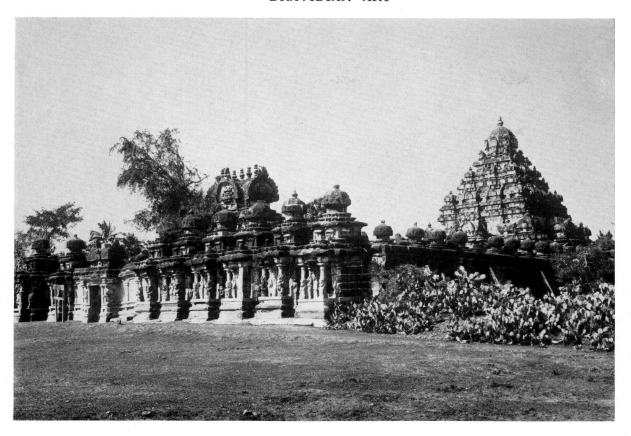

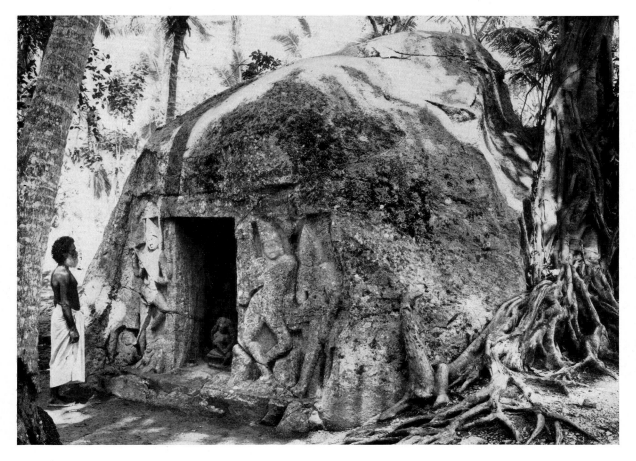

Pl. 255. *Above*: Conjeeveram (anc. Kanchipuram), Chingleput District, Madras, Kailāsanātha temple, Pallava period, 7th–8th cent. *Below*: Vilinjam, near Trivandrum, Kerala, unfinished cave temple, 8th cent.

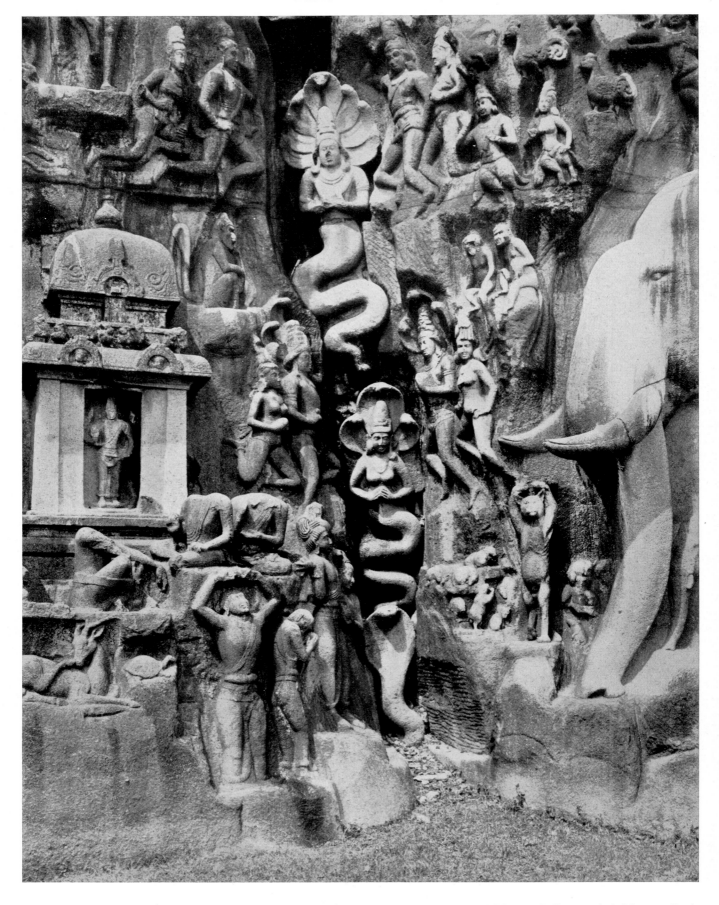

Pl. 256. Relief known as "Arjuna's Penance," detail, Mamallapuram, Chingleput District, Madras, Pallava period, 7th cent. Rock sculpture.

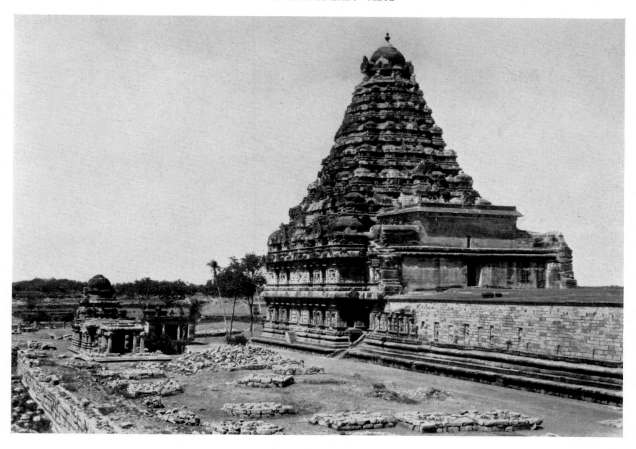

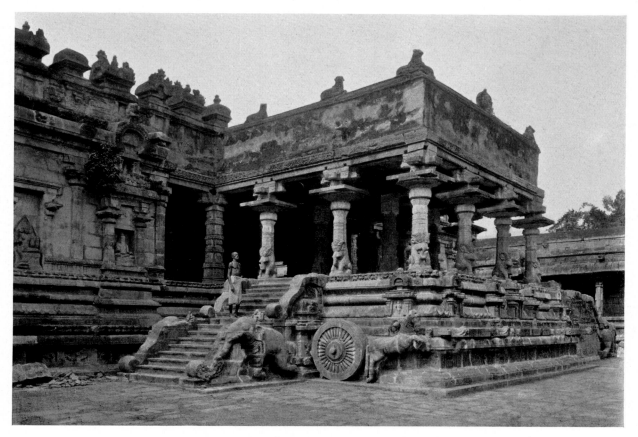

Pl. 257. *Above*: Gangaikondacholapuram, Trichinopoly District, Madras, Bṛhadīśvara temple, early Chola period, 11th
cent. *Below*: Darasuram, Tanjore District, Madras, the hypostyle hall (Alaṅkāra Maṇḍapa) of the Airāvate-
śvara temple, Chola period, 12th cent.

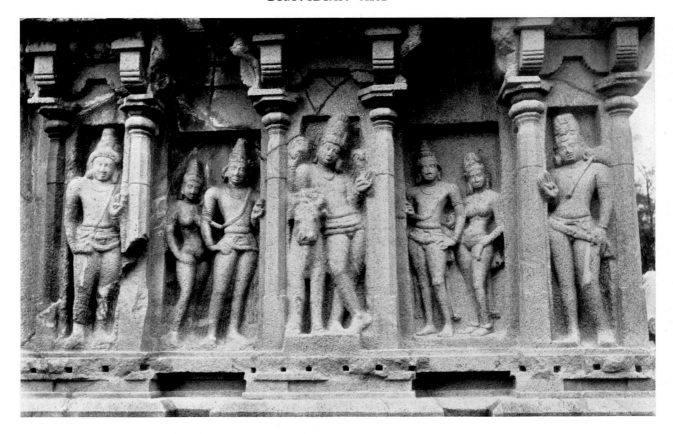

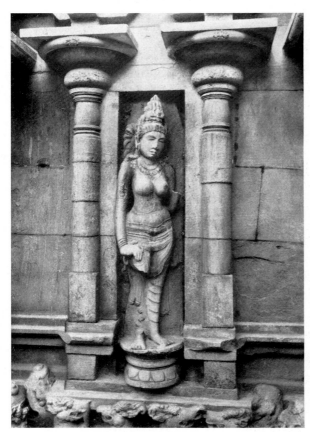

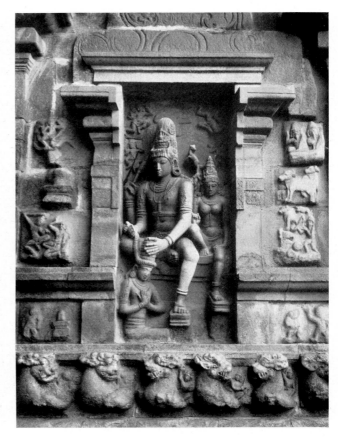

Pl. 258. *Above*: Śiva Vṛṣavāhana with royal attendants, detail of the Arjuna Ratha, Mamallapuram, Chingleput District, Madras, Pallava period, 7th cent. Stone. *Below*: Stone sculpture of the early Chola period, 11th cent. *Left*: Female figure (goddess?) on the Kuraṅganātheśvara temple, Srinivasanallur, Trichinopoly District, Madras. *Right*: Śiva Caṇḍeśānugrahamūrti on the Bṛhadīśvara temple, Gangaikondacholapuram, Trichinopoly District.

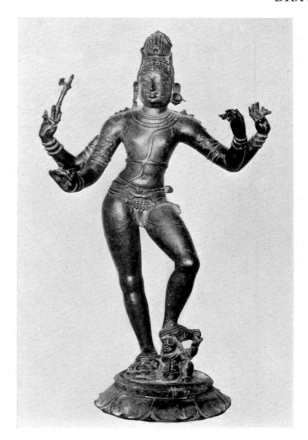 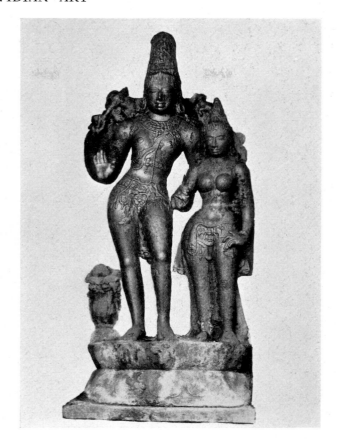

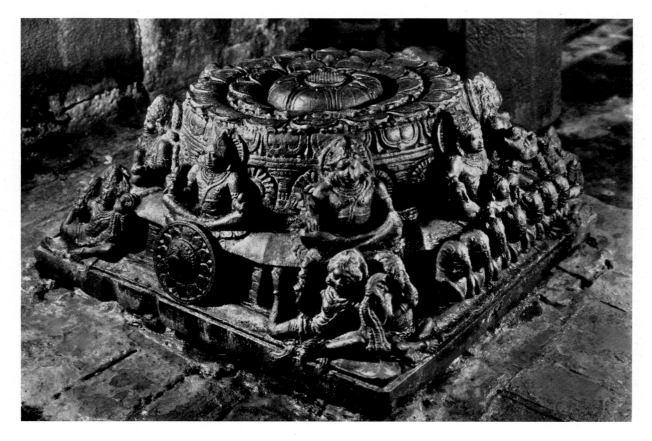

Pl. 259. Sculpture of the early Chola period, 11th cent. *Above, left*: Śiva Tripurāntaka. Bronze, ht., 2 ft., 10 in. Tanjore, Madras, Art Gallery. *Right*: Śiva and Parvatī. Stone, ht., ca. 40 in. Mayūranāthasvāmi temple, Mayuram, Tanjore District. *Below*: The sun as a lotus surrounded by the eight planets (*grahas*) above a seven-horse chariot. Stone. Bṛhadīśvara temple, Gangaikondacholapuram, Trichinopoly District, Madras.

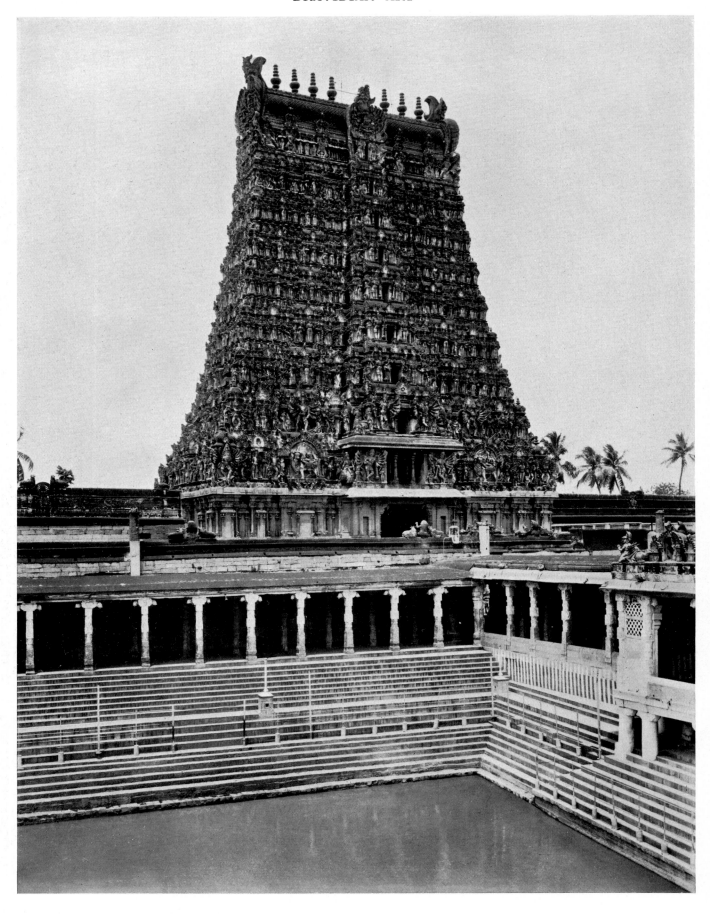

Pl. 260. Madura, Madras, Mīnāksī temple, the south gopura and lily tank, Vijayanagar period, 17th cent.

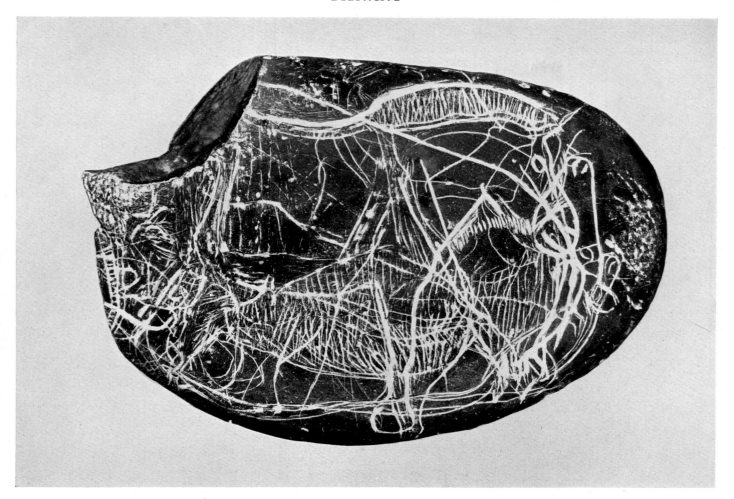

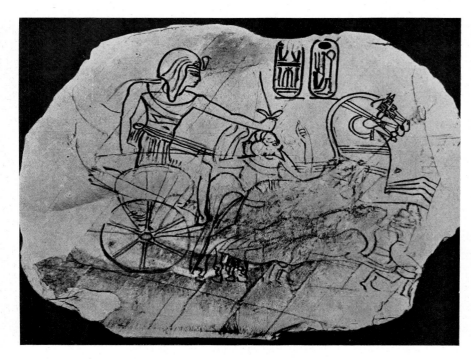

Pl. 261. *Above and below, left*: Upper Paleolithic linear and naturalistic drawings. *Above*: Animal figures scratched on a stone, from the cave of La Colombière, Ain, France. L., 4³/₄ in. Cambridge, Mass., Peabody Museum of Archaeology and Ethnology. *Below, left*: Reindeer head incised on rock, cave of Tuc d'Audoubert, Ariège, France. *Below, right*: Pharaoh in war chariot, Egyptian drawing on terra cotta (ostracon), 12th cent. B.C. Cairo, Egyptian Museum.

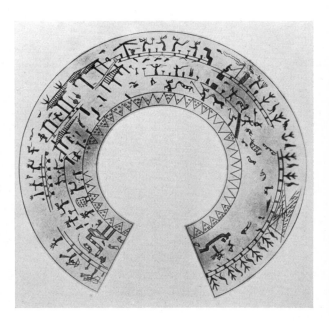

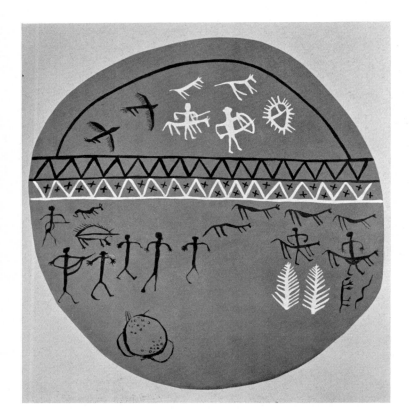

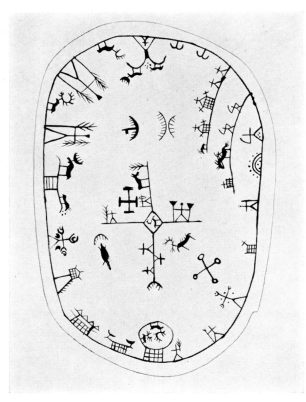

Pl. 262. Schematic linear representations. *Left, above*: Detail of Greek vase, Geometric style, 8th cent. B.C. Athens, National Museum. *Below*: Shamanic drum of the Abakan Tartars, from Minusinsk, southern Siberia. Skin. Stockholm, Statens Etnografiska Museum. *Right, above*: Development of decoration of Iberian vase, from San Miguel de Liria, Spain, detail, 3d–2d cent. B.C. Valencia, Museo Prehistórico. *Center*: Mirror rubbing, from Chao Ku, Honan, 5th–3d cent. B.C. Bronze, diam., 17³/₄ in. Property of Chinese government. *Below*: Lappic drum, from Lycksele, Lapland. Skin. Stockholm, Statens Etnografiska Museum.

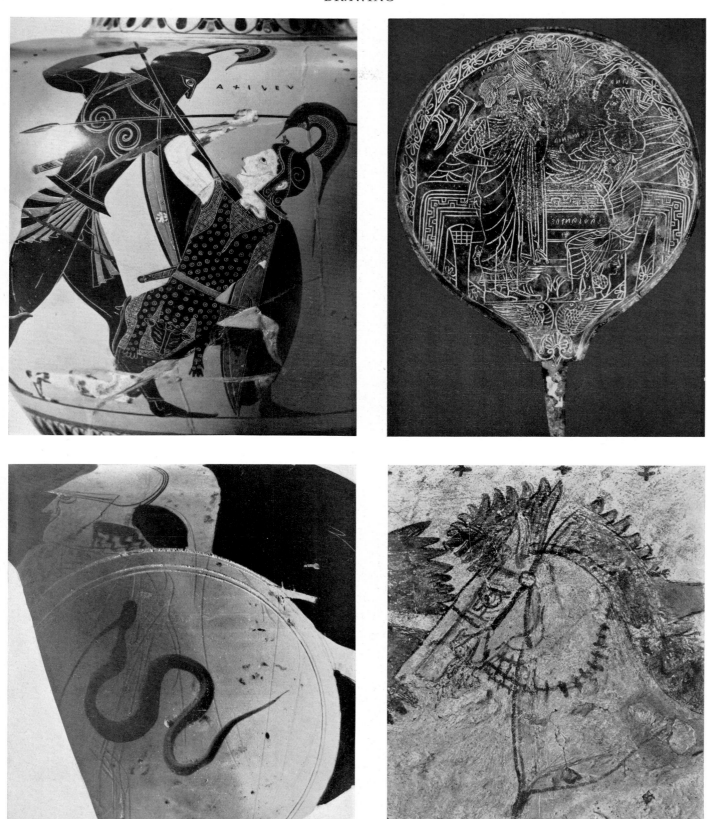

Pl. 263. *Above, left*: Exekias, Achilles killing Penthesileia, detail of Attic black-figured amphora, ca. 540 B.C. London, British Museum. *Right*: Story of Helen, scene on incised mirror, from Palestrina, Italy, ca. mid-5th cent. B.C. Bronze, diam., 6¼ in. Rome, Museo di Villa Giulia. *Below, left*: Fragment of Attic red-figured vase, with traces of abandoned preparatory drawing, ca. mid-5th cent. B.C. Orvieto, Italy, Museo Faina. *Right*: Horse's head, showing corrections in drawing, detail of Etruscan wall painting, ca. mid-6th cent. B.C. Tarquinia, Italy, Tomb of the Bulls.

# DRAWING

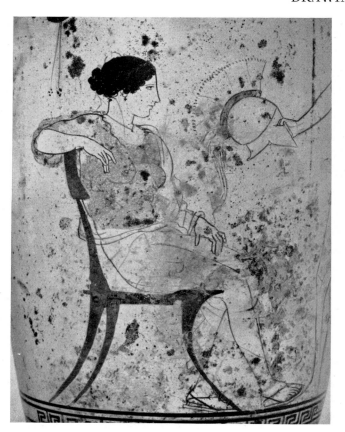

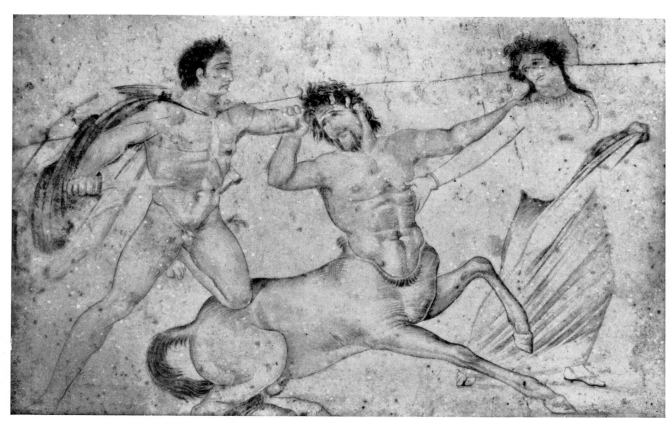

Pl. 264. *Above, left*: Achilles Painter, detail of Attic lekythos, from Eretria, Greece, ca. 450 B.C. Full ht., 16 1/2 in. Athens, National Museum. *Right*: Aphrodite and Eros, engraving on ivory, from Pontus, 5th–4th cent. B.C. Leningrad, The Hermitage. *Below*: Peirithoos, Hippodameia, and the centaur Eurytion, from Herculaneum, copy of a painting attributed to Zeuxis, first half of 4th cent. B.C. Monochrome on marble, w., 17 3/4 in. Naples, Museo Nazionale.

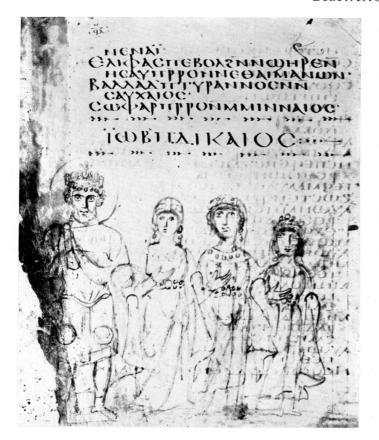

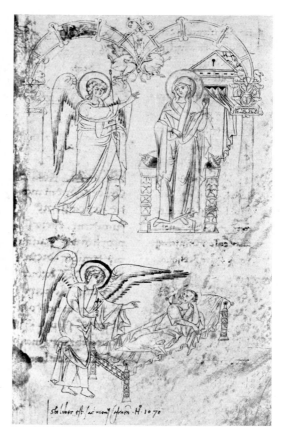

Pl. 265. *Above, left*: Job and his three daughters, 5th cent. Miniature, 11¹/₂×10¹/₄ in. Naples, Biblioteca Nazionale (Ms. I. B. 18, fol. 4v). *Right*: The Annunciation and the apparition of the angel to Joseph, 11th cent. Miniature, 13³/₄×9⁷/₈ in. Montecassino, Archivio dell'Abbazia (Ms. 99, fol. 2r). *Below, left*: God the Father, 992–95. Miniature, 12⁵/₈×7⁷/₈ in. Paris, Bibliothèque Nationale (Ms. lat. 943, fol. 5v). *Right*: A Dwarf of the Court of Murad III as the Planet Mars, Persian, late 16th cent. Ink on paper with touches of gold, 5³/₈×4¹/₈ in. Cambridge, Mass., Fogg Art Museum.

Pl. 266. *Above, left*: The goddess Durgā, Indian, school of Kangra, 19th cent. Stencil on parchment. Baroda, Museum. *Right*: The anchorites, first half of 14th cent. Sinopia. Pisa, Camposanto. *Below, left*: Leonardo da Vinci, Adoration of the Magi, detail. Panel underpainted in brown; full size, ca. 8×8 ft. Florence, Uffizi. *Right*: Raphael, cartoon for the School of Athens, detail. Charcoal, black chalk, and white. Milan, Pinacoteca Ambrosiana.

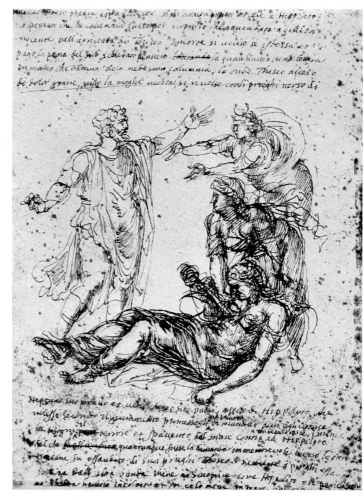

Pl. 267. *Above, left*: Villard de Honnecourt, plan of an apse and figure of Christ. Pen on parchment, 9¹/₈×6 in. Paris, Bibliothèque Nationale (Ms. 19093). *Center*: Paolo Uccello, perspective study of a chalice. Pen, 11³/₈×9⁵/₈ in. (No. 1758 A.) *Right*: J. Barozzi (Vignola; attrib.). Rule for column entasis. Pen. (No. 7915 A.) Both, Florence, Uffizi, Gabinetto dei Disegni e Stampe. *Center, left*: Ciriaco d'Ancona, Hadrian's temple in Cyzicus. Pen on vellum; each page, 10×6¹/₈ in. Oxford, B. Ashmole Coll. (Ashmole ms. fols. 133v, 134r). *Below, left*: B. Peruzzi, sheet of studies. Pen, 8¹/₈×11¹/₄ in. Florence, Uffizi, Gabinetto dei Disegni e Stampe (no. 700 A). *Right*: Pirro Ligorio, Death of Phaedra. Pen, 12⁷/₈×8⁵/₈ in. Munich, Staatliche Graphische Sammlung (no. 1013).

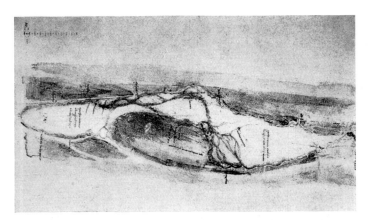

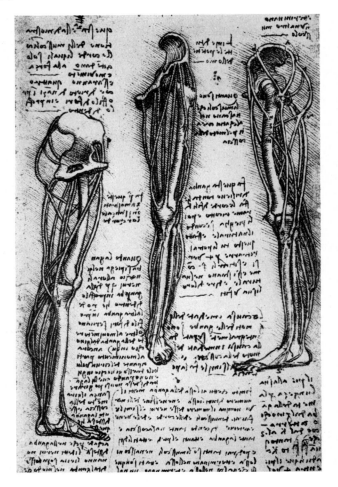

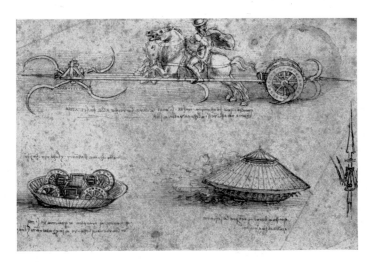

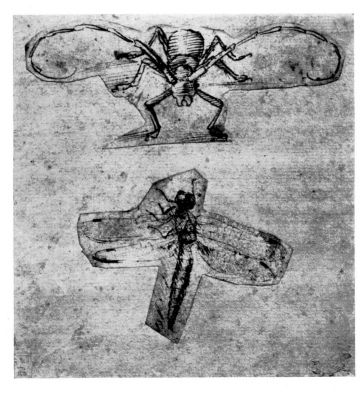

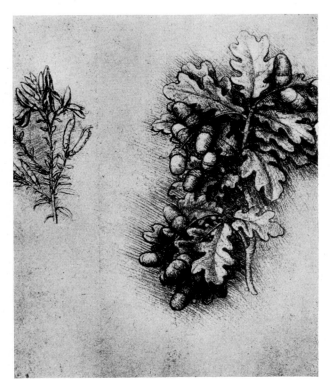

Pl. 268. Leonardo da Vinci. *Left, above*: Map of the bed of the Arno near Florence. Pen and wash, 8³/₄×15¹/₂ in. Windsor, England, Royal Library (no. 12679). *Center*: Armed chariot, tank, and partisan. Pen and wash, 6³/₄×9³/₄ in. London, British Museum (vol. 73, no. 1860-6-16-99). *Below*: Flying beetle and dragonfly. Pen on reddish paper, 4³/₄×4³/₈ in. Turin, Biblioteca Reale. *Right, above*: Anatomical studies. Pen, 8¹/₂×4³/₈ in. (No. 12619.) *Below*: Botanical studies. Pen, 6¹/₈×4³/₄ in. (No. 12422.) Both, Windsor, England, Royal Library.

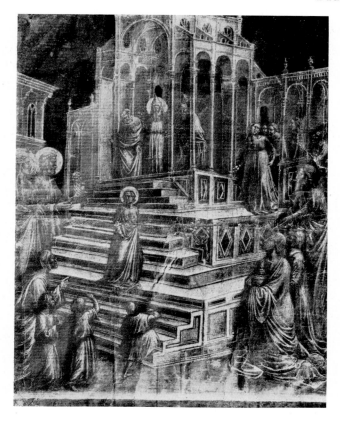

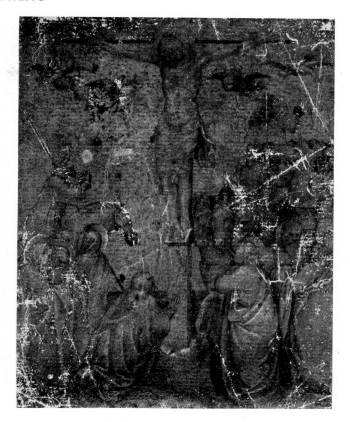

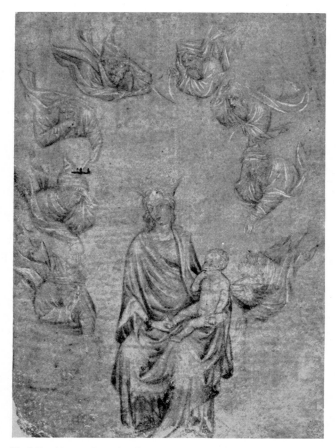

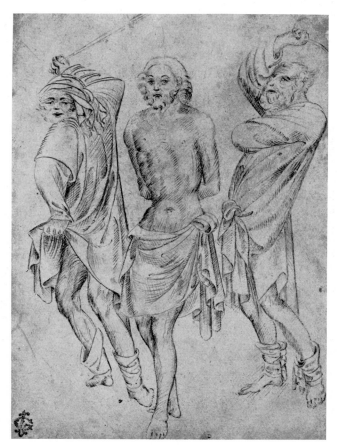

Pl. 269. *Above, left*: T. Gaddi, Presentation of the Virgin in the Temple. Pen and water color heightened with white, 14³/₈ × 11¹/₈ in. Paris, Louvre, Cabinet des Dessins. *Right*: Giovanni da Milano, Crucifixion. Bistre heightened with white, 11 × 8⁵/₈ in. Berlin, Staatliche Graphische Sammlung. *Below, left*: Michelino da Besozzo (?), Madonna and Child with prophets. Brush drawing heightened with white, 3³/₄ × 5¹/₂ in. Rome, Gabinetto Nazionale delle Stampe. *Right*: Stefano da Verona, Flagellation of Christ. Pen, 11¹/₈ × 8 in. Vienna, Albertina (no. 24013).

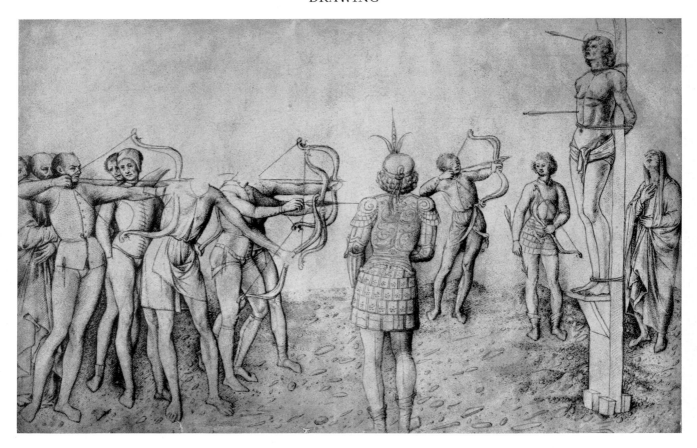

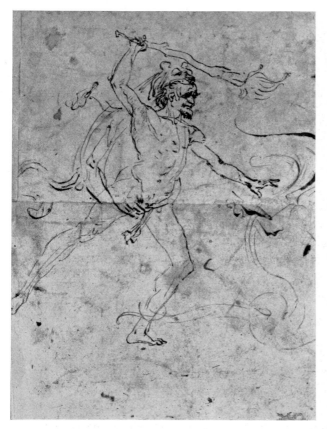

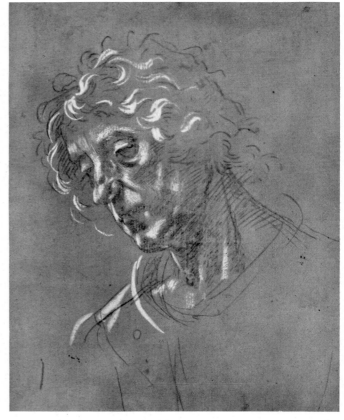

Pl. 270. *Above*: J. Bellini, The Martyrdom of St. Sebastian, sketchbook page. Pen on vellum, $11^3/_8 \times 16^1/_2$ in. Paris, Louvre, Cabinet des Dessins. *Below, left*: A. Pollaiuolo, study for Hercules and the Hydra. Pen, $9^1/_4 \times 6^1/_2$ in. London, British Museum (no. 1510–8). *Right*: Filippino Lippi, head of a man. Metal-point on a blue-grey prepared surface, heightened with blue, $9^1/_2 \times 7^1/_4$ in. Windsor, England, Royal Library (no. 12822).

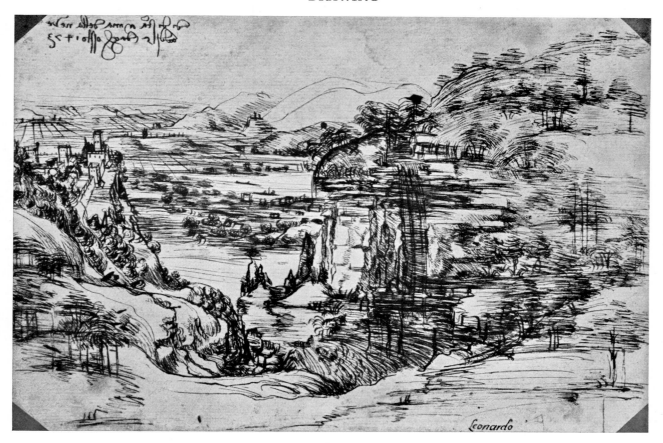

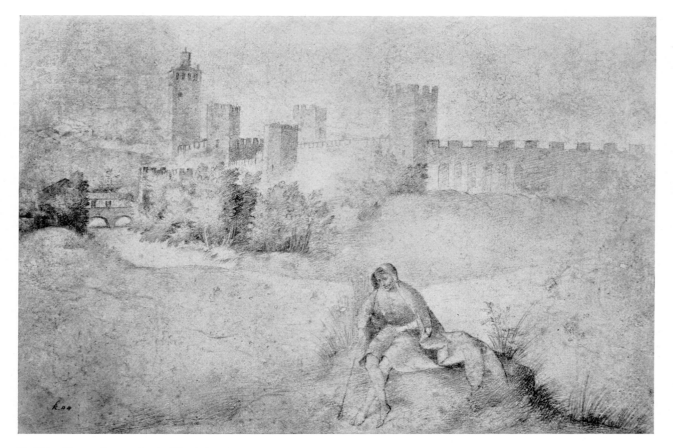

Pl. 271. *Above*: Leonardo da Vinci, landscape. Pen, 7⁵/₈×11¹/₄ in. Florence, Uffizi, Gabinetto dei Disegni e Stampe. *Below*: Giorgione, view of Castelfranco with a shepherd. Red chalk, 7⁷/₈×9⁷/₈ in. Rotterdam, Museum Boymans-Van Beuningen.

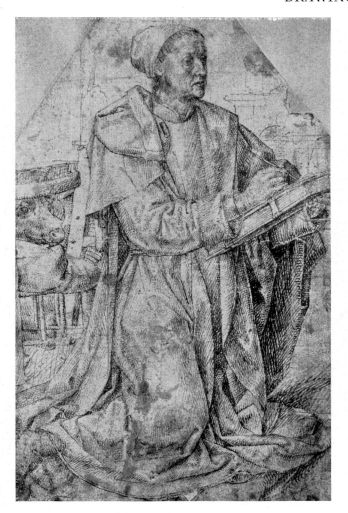

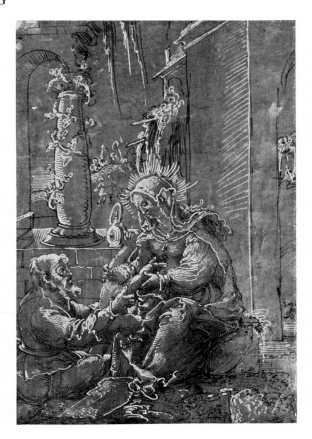

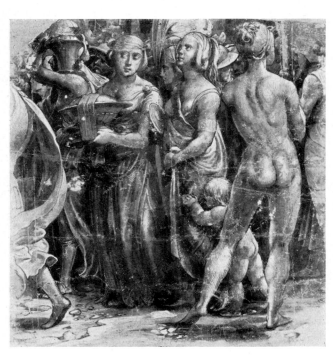

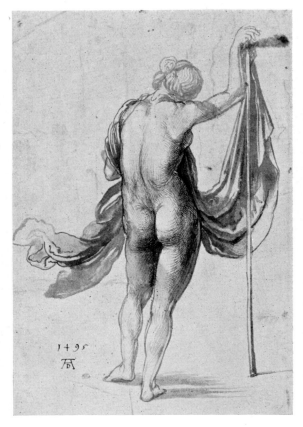

Pl. 272. *Above, left*: H. van der Goes, St. Luke painting the Virgin. Pen, 7¹/₂×4³/₄ in. Rotterdam, Museum Boymans-Van Beuningen (no. 94). *Right*: Master of St. Simon, Holy Family. Pen on red-brown paper, heightened with white, 13×6¹/₂ in. (No. 1909:76.) *Below, left*: H. Holbein the Younger, triumphal procession, fragment. Pencil and wash on dark-green paper, heightened with white, 8¹/₈×7³/₈ in. (No. 1036.) Both, Munich, Staatliche Graphische Sammlung. *Right*: A. Dürer, female nude. Pen, 12⁵/₈×8¹/₄ in. Paris, Louvre, Cabinet des Dessins.

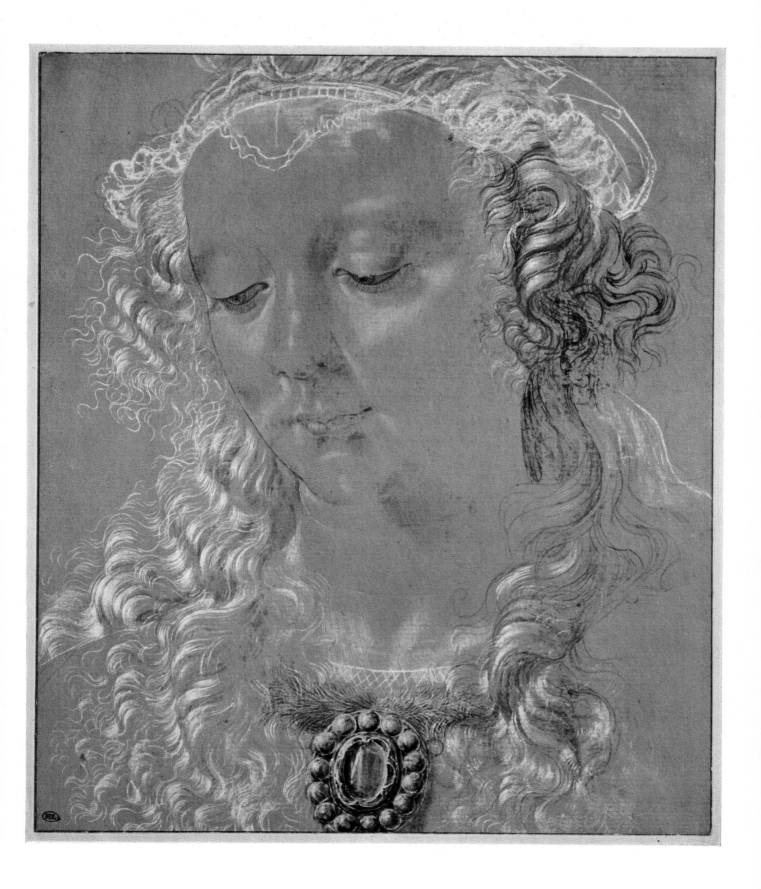

Pl. 273. Leonardo da Vinci (?), head of a woman. Pen and ink and wash on light-red paper, with white pencil, 10¹/₂×8⁷/₈ in. Paris, Louvre, Cabinet des Dessins (no. 18965).

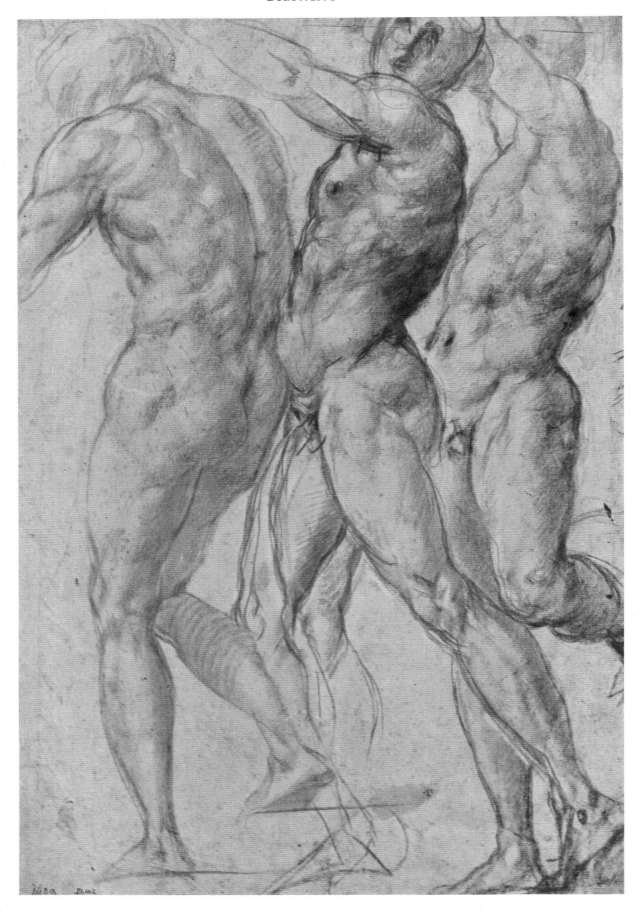

Pl. 274. Pontormo, studies of three walking men. Red chalk. Lille, France, Musée des Beaux-Arts.

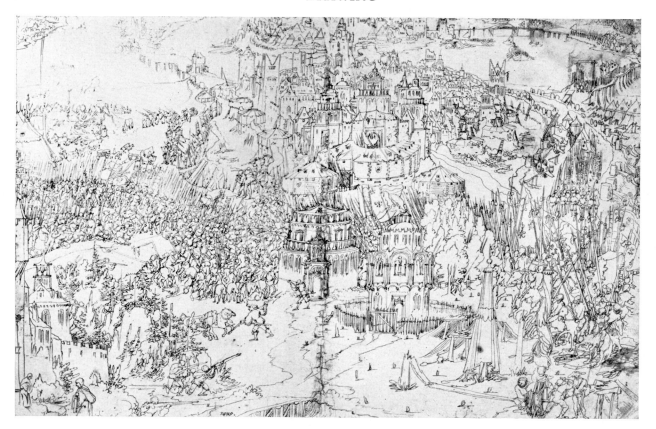

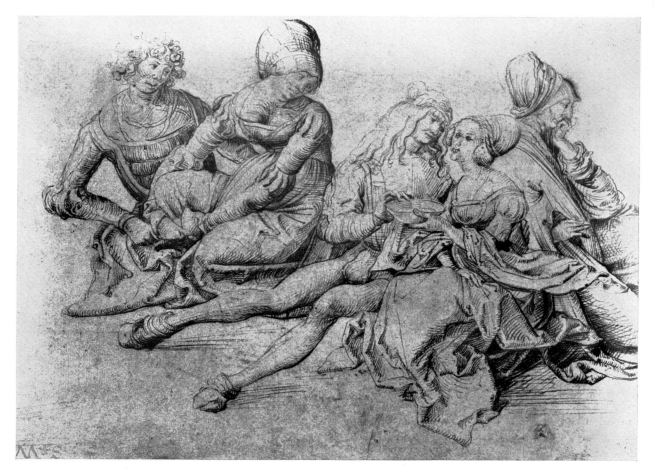

Pl. 275. *Above*: W. Huber, The Battle of Pavia. Pen, $11^{1}/_{8} \times 16^{7}/_{8}$ in. (No. 34793.) *Below*: H. von Kulmbach, pair of lovers. Pencil and pen, $7^{1}/_{4} \times 10$ in. (No. 1928:101.) Both, Munich, Staatliche Graphische Sammlung.

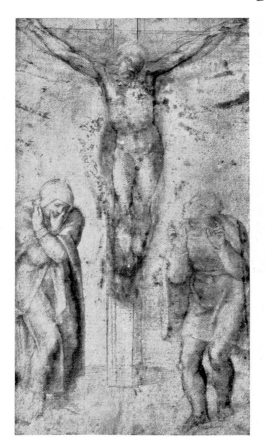

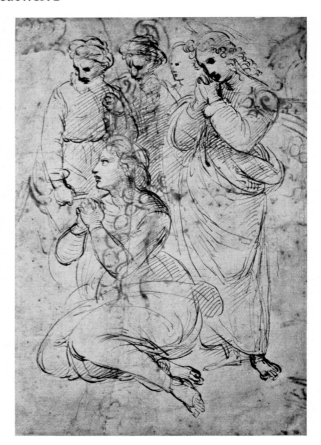

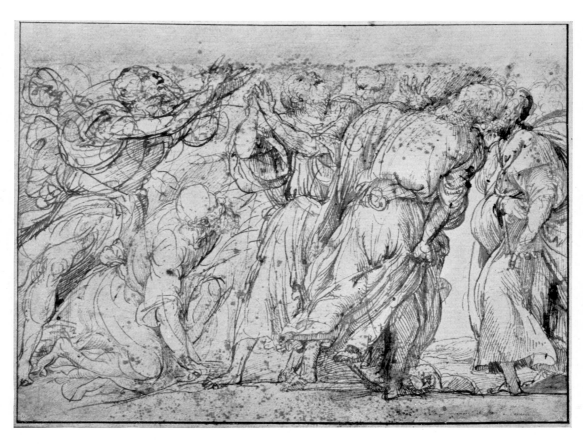

Pl. 276. *Above, left*: Michelangelo, Crucifixion with the Virgin and St. John. Charcoal, 15×8¼ in. Windsor, England, Royal Library (no. 12775). *Right*: Raphael, study for the Deposition in the Borghese Gallery, Rome. Pen, 9¾×6¾ in. London, British Museum. *Below*: Titian, study of apostles for the Assumption in the Church of the Frari, Venice. Pen, 9⅛×12 in. Paris, Louvre, Cabinet des Dessins.

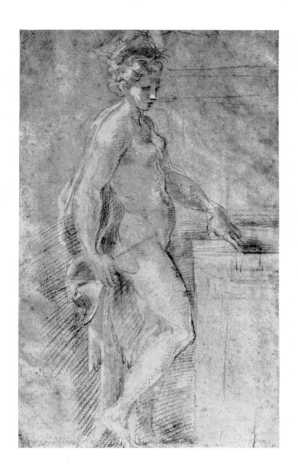

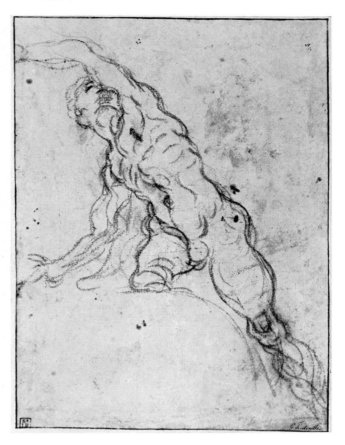

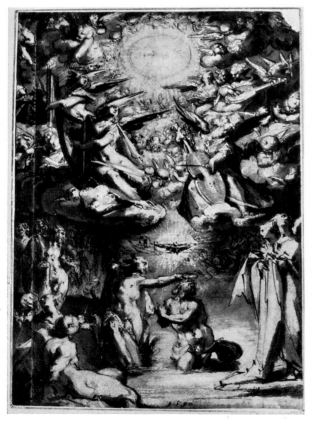

Pl. 277. *Above, left*: Il Parmigianino (F. Mazzuoli), study of a nude ("Diana"). Charcoal heightened with white, 16³/₈×9⁷/₈ in. Rome, Gabinetto Nazionale delle Stampe. *Right*: Tintoretto, male nude. Pencil, 13³/₄×9⁷/₈ in. Oxford, Ashmolean Museum. *Below, left*: J. Muller, Baptism of Christ. Pen and wash with white, 11⁵/₈×8¹/₄ in. Munich, Staatliche Graphische Sammlung (no. 1013). *Right*: L. Cambiaso, The Preaching of John the Baptist. Pen and wash, 13⁵/₈×7⁵/₈ in. Florence, Uffizi, Gabinetto dei Disegni e Stampe (no. 13756).

Pl. 278. *Above, left*: Rembrandt, Susanna led to judgment. Pen, 9³/₈ × 7³/₄ in. Oxford, Ashmolean Museum. *Right*: Claude Lorrain, study of trees. Pen, brown ink, and wash over traces of black chalk, 12¹/₈ × 8³/₈ in. London, British Museum (no. O.0.7-225). *Below*: N. Poussin, Bacchus and Ariadne. Pen and bistre, 6¹/₈ × 9⁷/₈ in. Windsor, England, Royal Library (no. 11911).

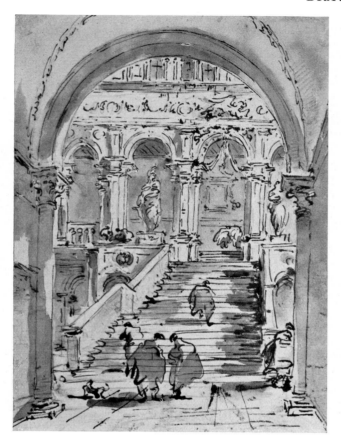
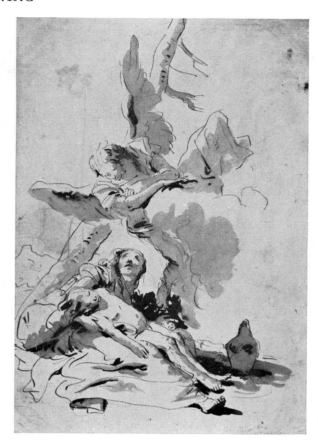
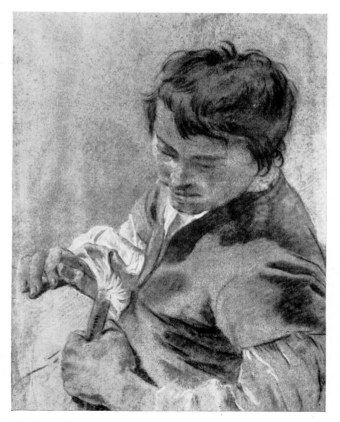
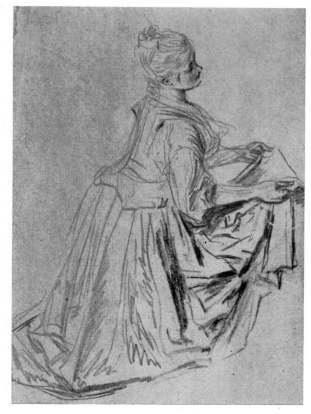

Pl. 279. *Above, left*: F. Guardi, The Stairway of the Giants in the Doges' Palace, Venice. Pen and wash over red chalk, 10¼×7⅜ in. New York, Metropolitan Museum (no. 37-165-85). *Right*: G. B. Tiepolo, Hagar and Ishmael. Pen and wash, 16⅛×11 in. Stuttgart, Graphische Sammlung der Staatsgalerie. *Below, left*: G. B. Piazzetta, The Little Drummer. Pencil and charcoal with white, 20½×15⅜ in. Venice, Museo Correr (no. 7057). *Right*: A. Watteau, kneeling woman. Black and red chalk, 6¾×4⅞ in. Valenciennes, Musée des Beaux-Arts (no. 587).

# DRAWING

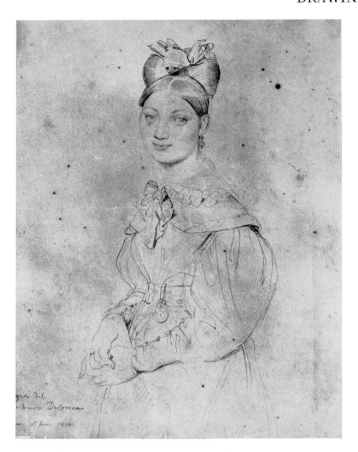

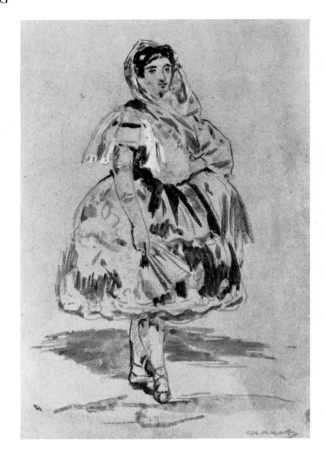

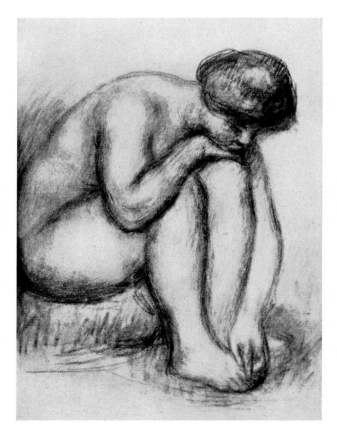

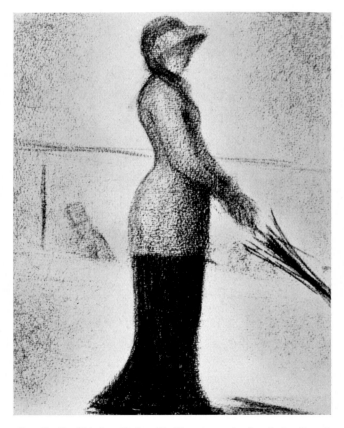

Pl. 280. *Above, left*: J. A. D. Ingres, portrait of Mme. Delorme. Pencil, 12×8³/₄ in. *Right*: E. Manet, study for Lola. Pencil, Chinese ink, and water color, 10×6³/₄ in. (RF 1102.) *Below, left*: A. Renoir, study of a nude. Red chalk. All three, Paris, Louvre, Cabinet des Dessins. *Right*: G. Seurat, study for La Grande Jatte. Pencil, 11³/₄×8⁷/₈ in. Paris, C. M. de Hauke Coll.

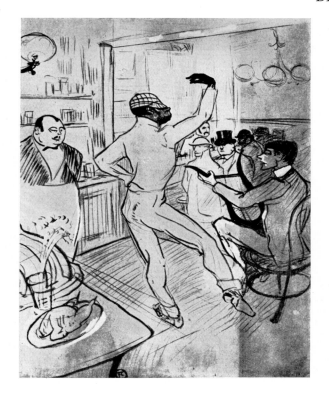

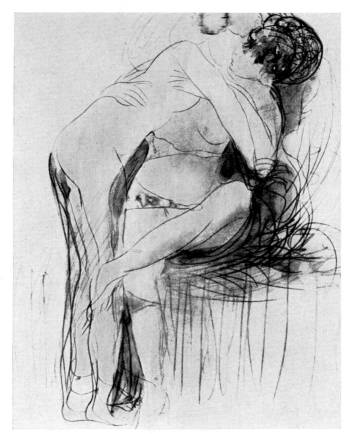

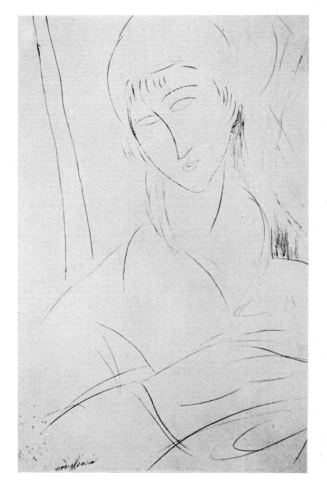

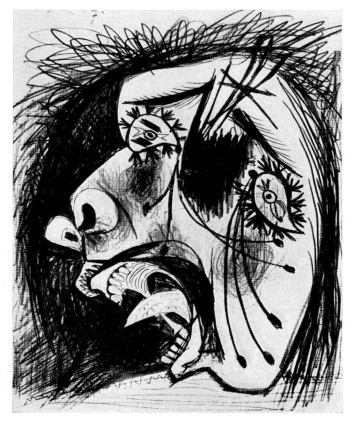

Pl. 281. *Above, left*: H. Toulouse-Lautrec, "Chocolat Dancing." Chinese ink and blue pencil heightened with white, 30$^1$/$_4$×24$^1$/$_8$ in. Chicago, Art Institute. *Right*: A. Rodin, Lovers. Pen. Paris, Musée Rodin. *Below, left*: A. Modigliani, portrait of a woman. Pencil, 18$^1$/$_2$×11 in. Chicago, Art Institute. *Right*: P. Picasso, study of a head for Guernica, 1937.

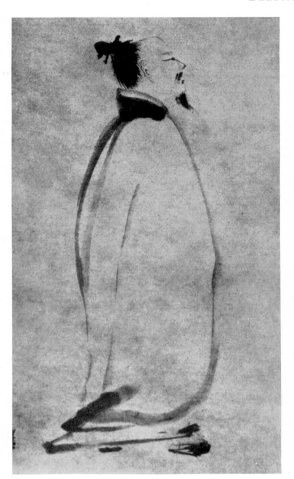

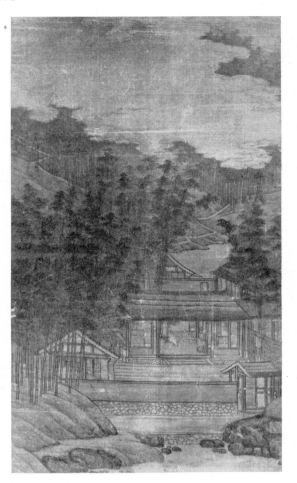

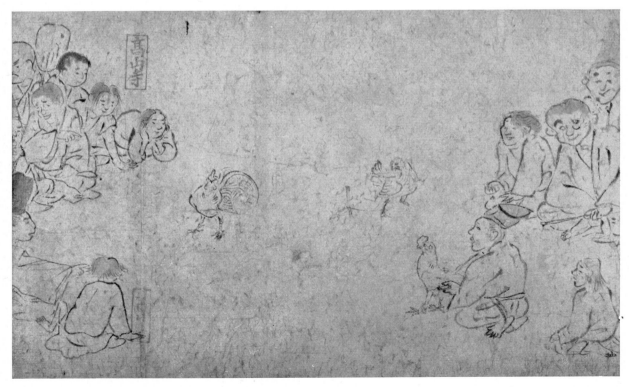

Pl. 282. *Above*: Chinese, Sung period. *Left*: Liang K'ai, The Poet Li Po (cropped). Ink on paper; full size, 32¼×12 in. Tokyo, National Commission for the Protection of Cultural Properties. *Right*: Li Wei, Retreat in a Bamboo Grove. Ink on silk, 29⅝×16½ in. Boston, Museum of Fine Arts. *Below*: Kakuyu (Toba Sōjō; attrib.), Animal Caricatures Scroll, Japanese, 12th cent. Ink on paper, ht., 12 in. Kyoto, Kōzanji.

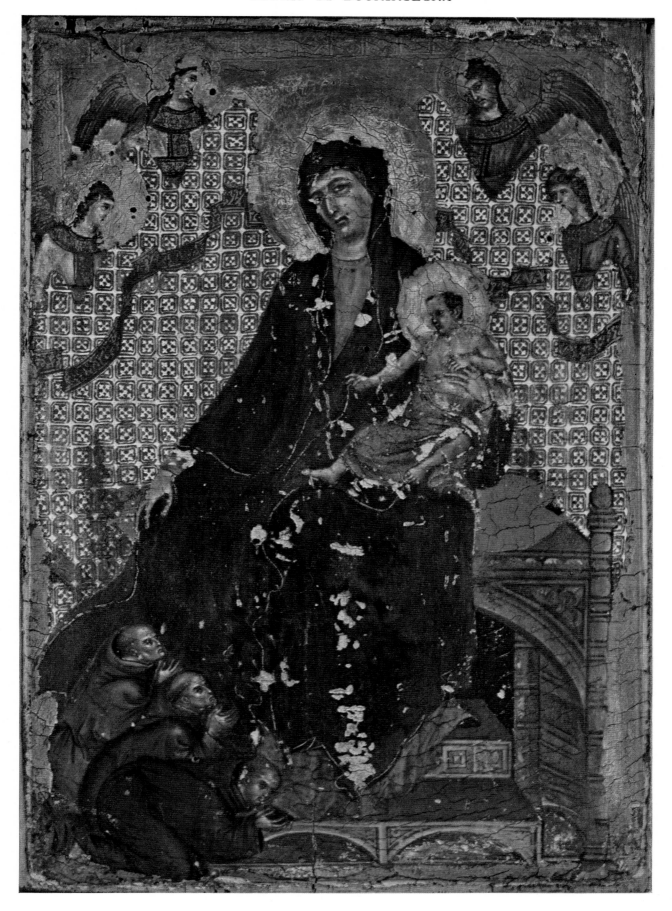

Pl. 283. The Madonna of the Franciscans. Panel, 9¹/₄×6¹/₄ in. Siena, Italy, Pinacoteca.

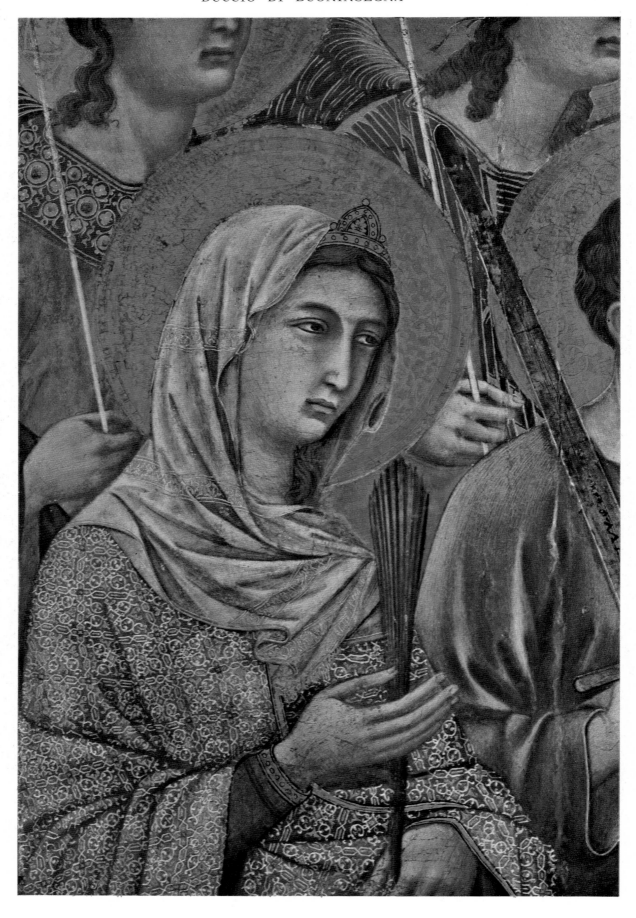

Pl. 284. St. Catherine, detail of the front of the Maestà, PL. 285, *above.*

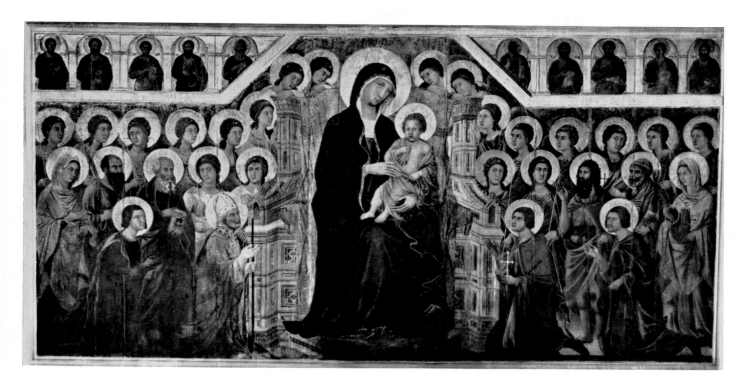

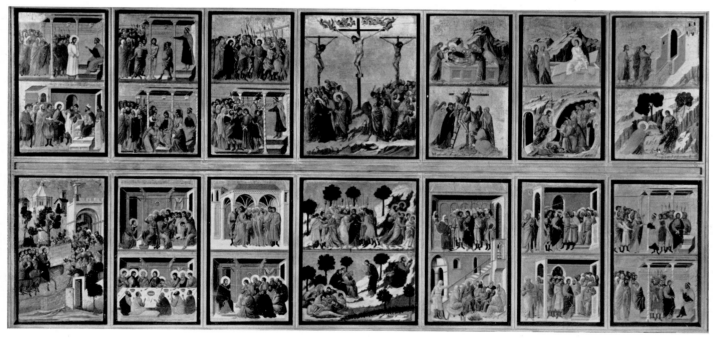

Pl. 285. The Maestà. *Above*: The front, main area, the Virgin and Child with angels and saints. Panel, 6 ft., 11¹⁄₈ in. × 13 ft., 11³⁄₄ in. (Photographed before restoration.) *Below*: The back, main area, scenes from the Passion. Panel, 6 ft., 11¹⁄₂ in. × 13 ft., 11³⁄₈ in. Siena, Italy, Museo dell'Opera del Duomo.

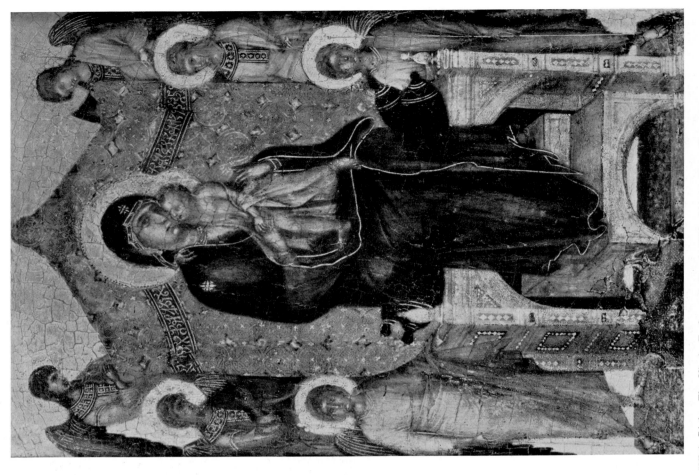

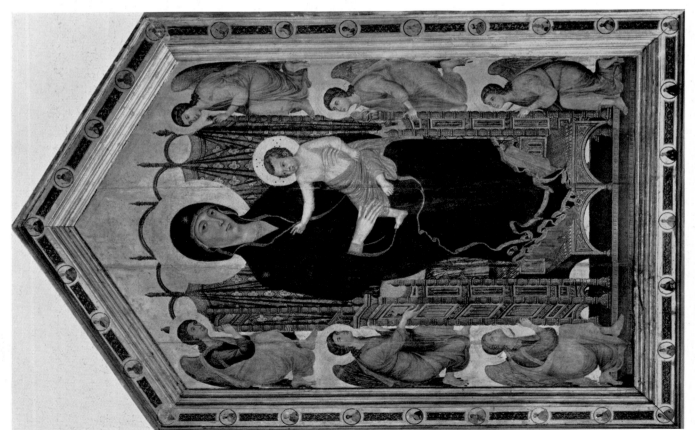

Pl. 286. *Left:* The Rucellai Madonna. Panel, 14 ft., 9¹/₈ in. × 9 ft., 6¹/₈ in. Florence, Uffizi. *Right:* The Virgin Enthroned. Panel, 12³/₈×9¹/₈ in. Bern, Kunstmuseum.

Pl. 287. The Virgin and Child with saints. Panel, 5 ft, 6⁷/₈ in. × 7 ft, 9¹/₄ in. Siena, Italy, Pinacoteca.

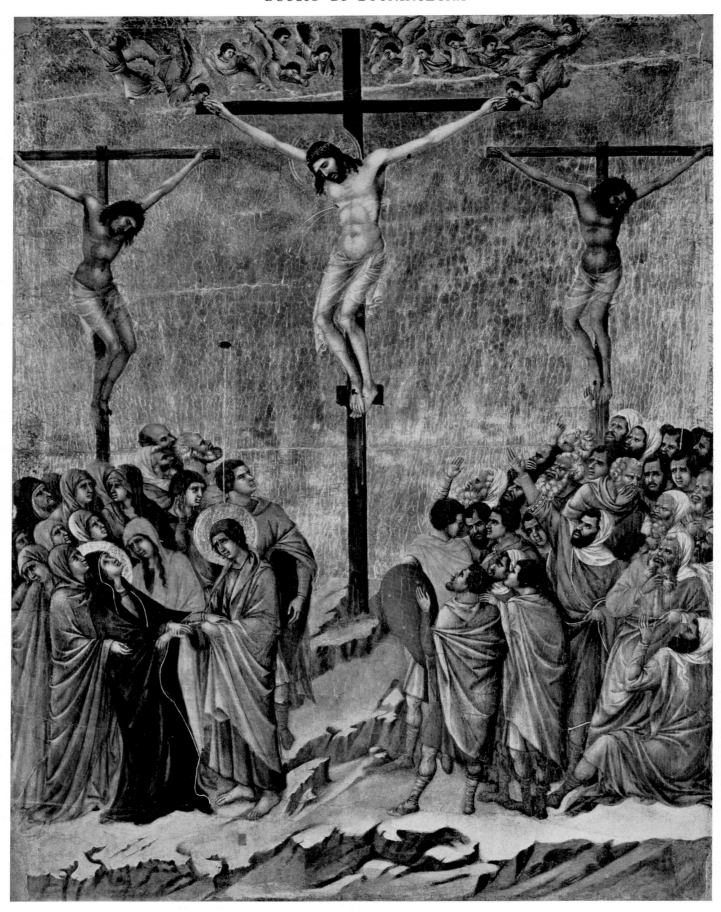

Pl. 288. The Crucifixion, scene from the Maestà, PL. 285, *below*. This panel, 40¹/₈×29⁷/₈ in.

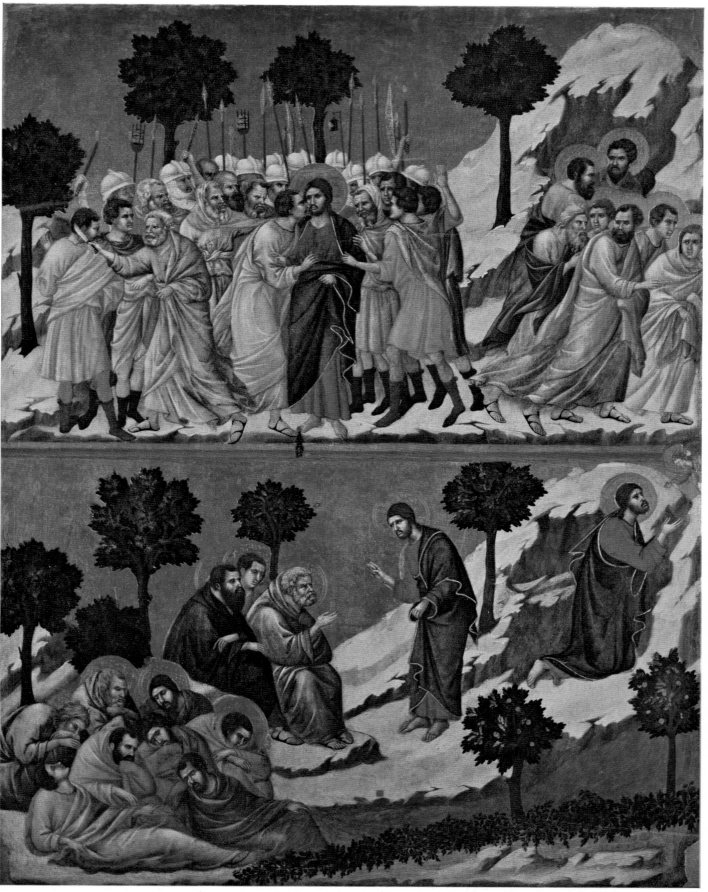

Pl. 289. The Taking of Christ (upper portion of panel) and the Agony in the Garden, scenes from the Maestà, PL. 285, *below.* This panel, 40 1/8 × 29 7/8 in.

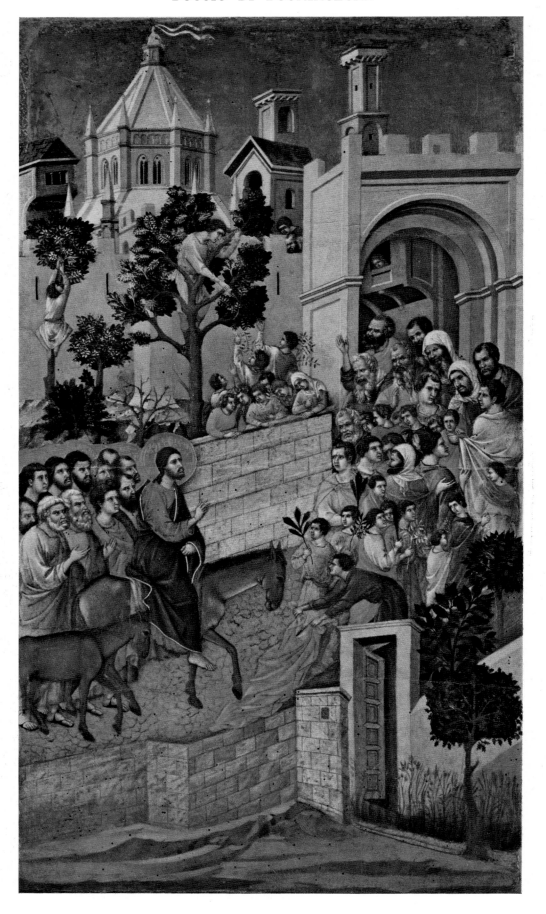

Pl. 290. The Entry into Jerusalem, scene from the Maestà, PL. 285, *below*. This panel, 40¹⁄₈×21¹⁄₈ in.

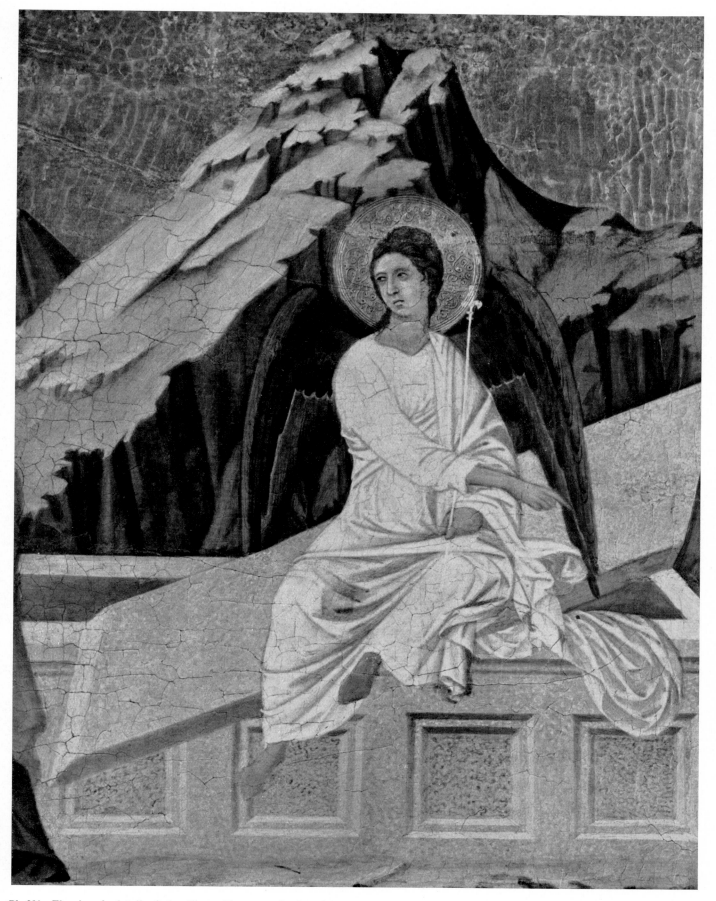

Pl. 291. The Angel, detail of the Three Marys at the Sepulcher, one of the panels of the Maestà, PL. 285, *below*. Complete panel, 40 1/8 × 21 1/8 in.

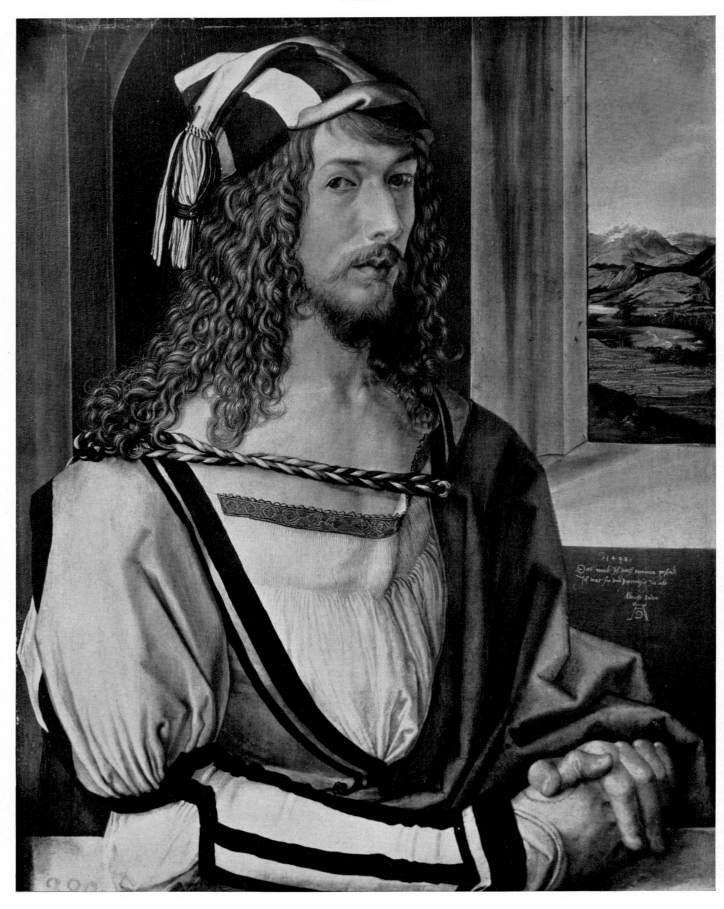

Pl. 292. Self-portrait. Panel, 20¹/₂ × 16¹/₈ in. Madrid, Prado.

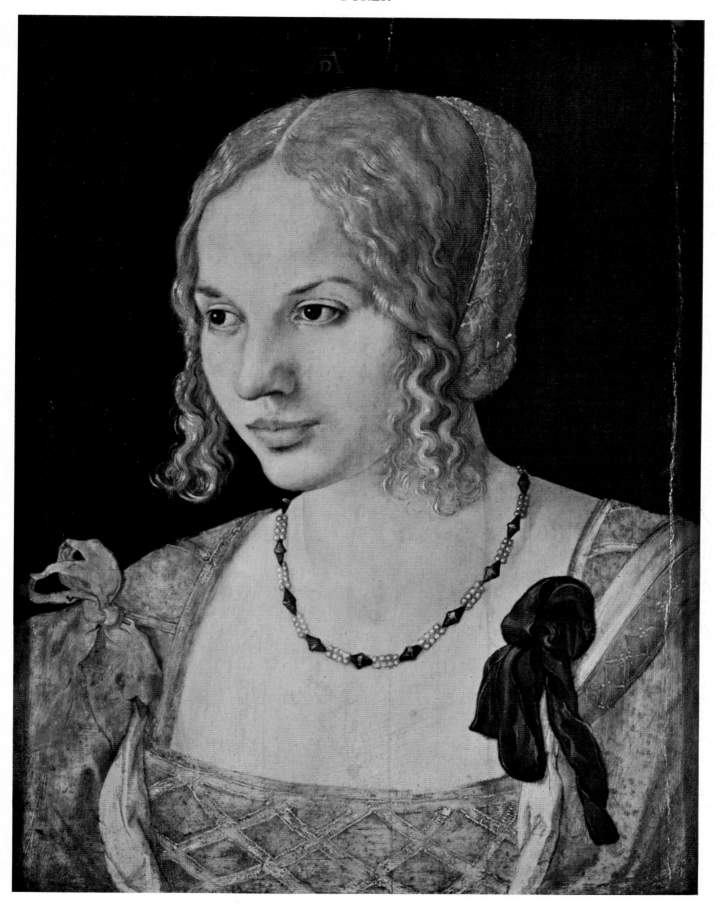

Pl. 293.  Portrait of a girl in Lombard dress.  Panel, 13³/₄×10¹/₄ in.  Vienna, Kunsthistorisches Museum.

Pl. 294. Pond in the Woods. Water color and gouache, $10^{1}/_{4} \times 14^{5}/_{8}$ in. London, British Museum.

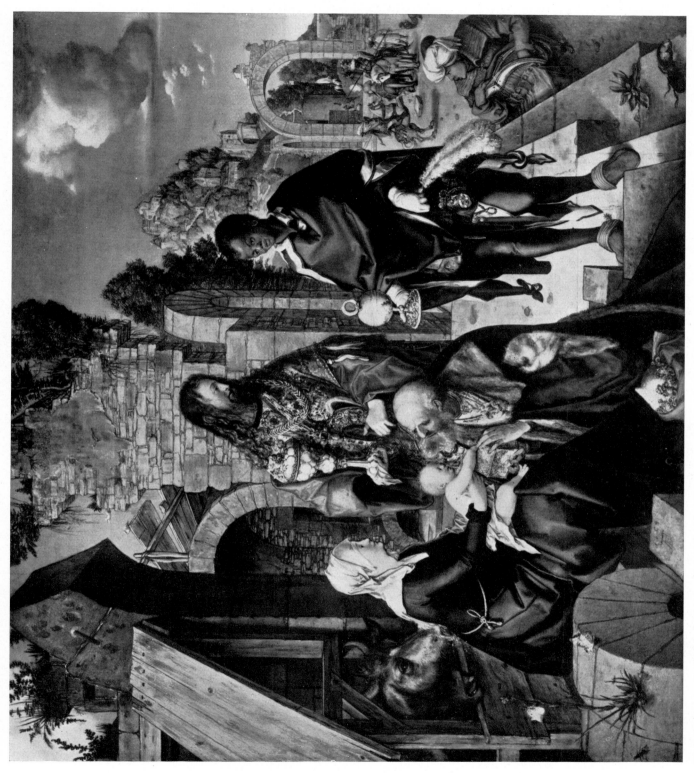

Pl. 295. Adoration of the Magi. Panel, 37³/₈ × 44⁷/₈ in. Florence, Uffizi.

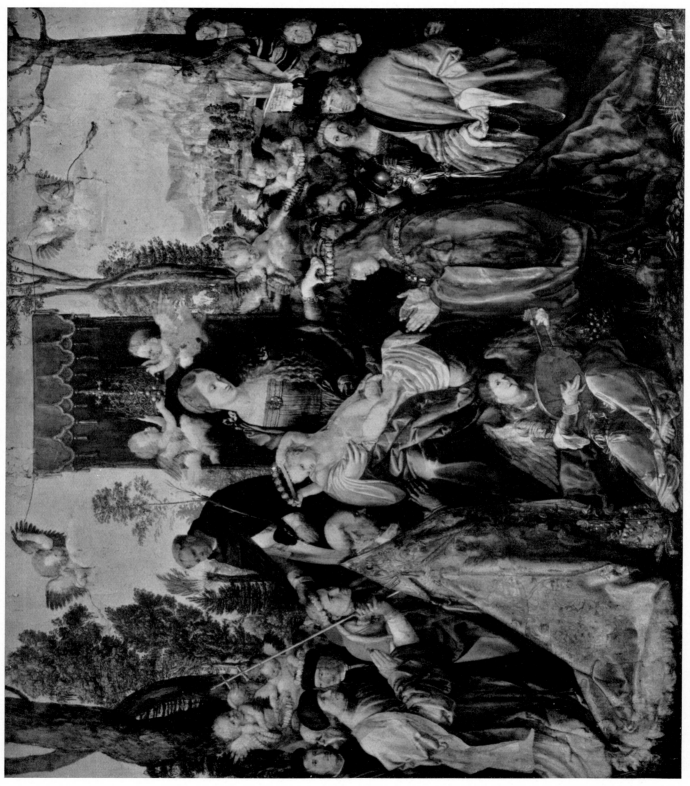

Pl. 296. The Feast of the Rose Garlands. Panel, 5 ft., 3³/₈ in. × 6 ft., 3⁵/₈ in. Prague, National Gallery.

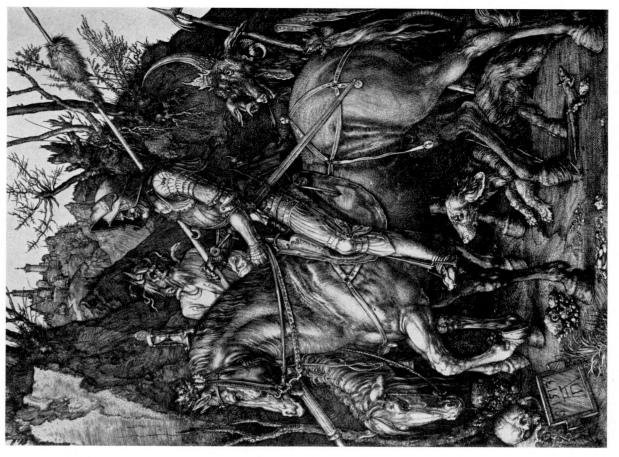

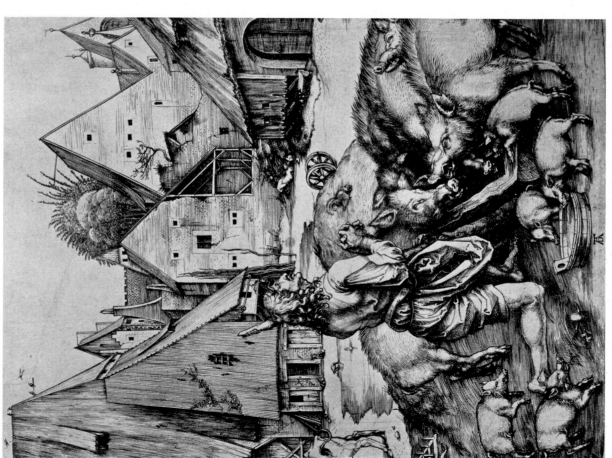

Pl. 297. *Left:* The Prodigal Son. Engraving, 9³/₄×7¹/₂ in. *Right:* Knight, Death, and the Devil. Engraving, 9⁵/₈×7¹/₂ in.

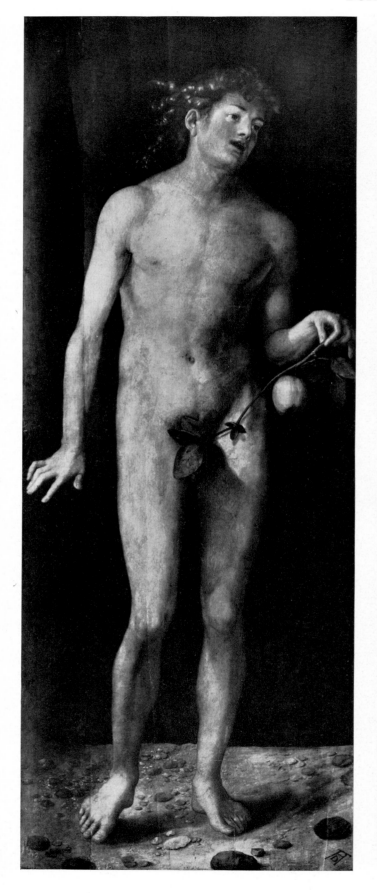
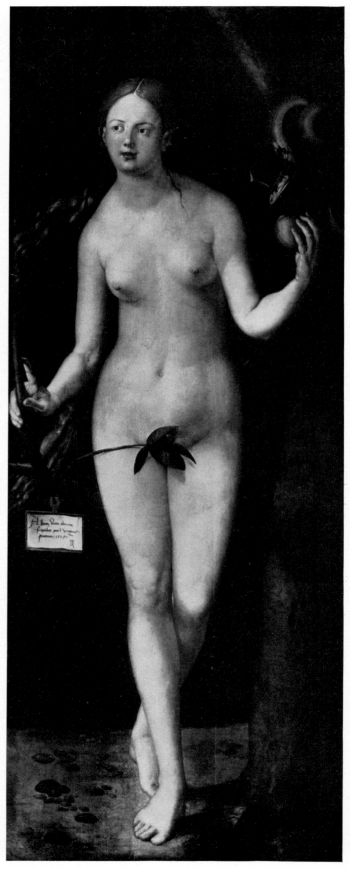

Pl. 298. *Left*: Adam. Panel, 6 ft., 10¹/₄ in. × 2 ft., 7⁷/₈ in. *Right*: Eve. Panel, 6 ft., 10¹/₄ in. × 2 ft., 7¹/₂ in. Both, Madrid, Prado.

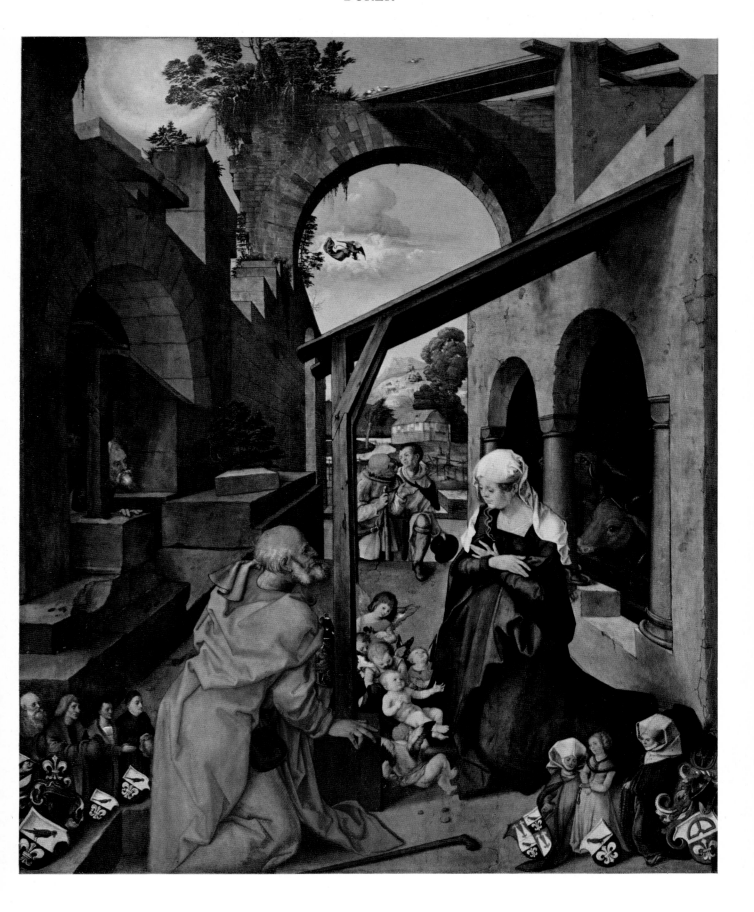

Pl. 299. The Nativity, central section of the Paumgärtner Altarpiece. Panel, 5 ft., 1 in. × 4 ft., 1⁵/₈ in. Munich, Alte Pinakothek.

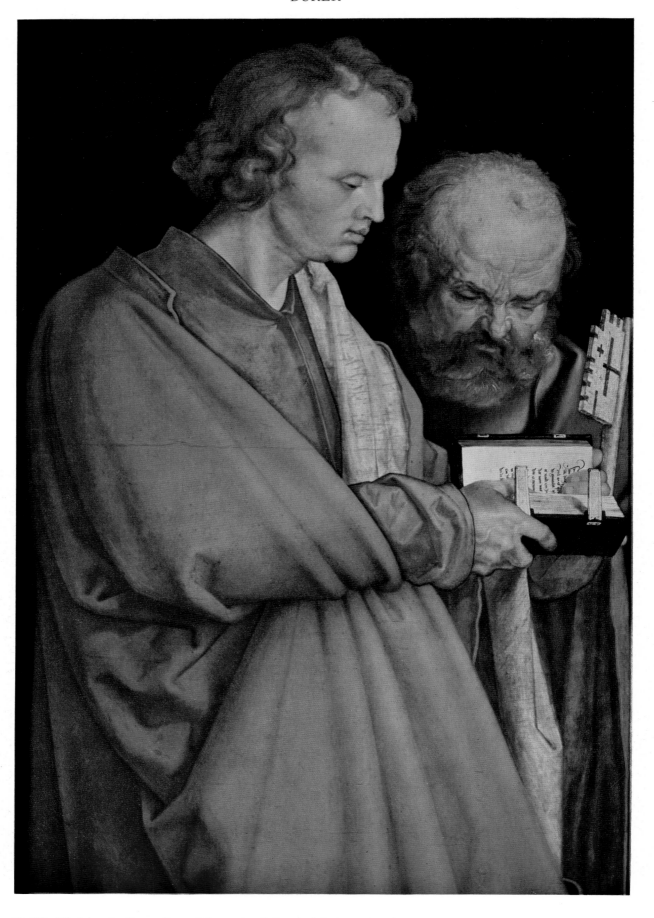

Pl. 300. SS. John the Evangelist and Peter, detail. Panel; full size, 7 ft., ⁵/₈ in. × 2 ft., 5⁷/₈ in. Munich, Alte Pinakothek.

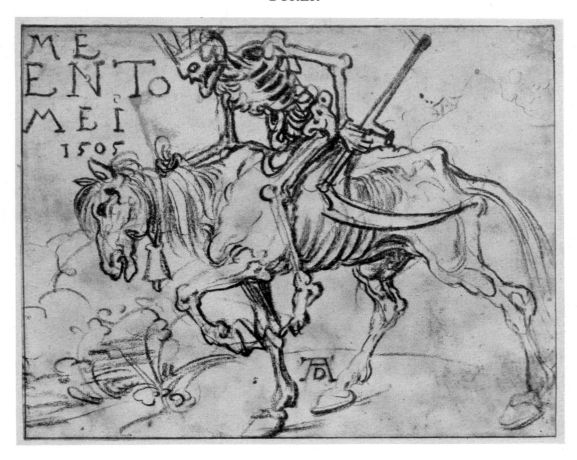

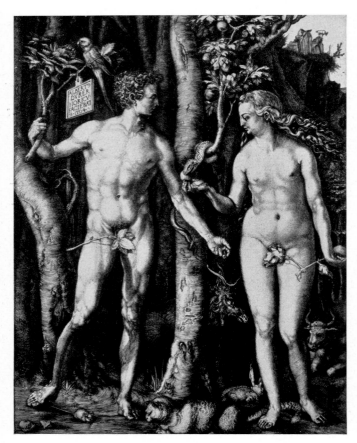

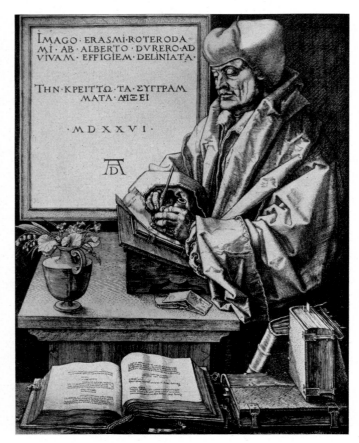

Pl. 301. *Above*: Crowned Death on a Thin Horse (Memento mei). Drawing, 8¼×10½ in. London, British Museum. *Below, left*: Adam and Eve. Engraving, 9⅞×7⅝ in. *Right*: Erasmus. Engraving, 9⅞×7⅝ in.

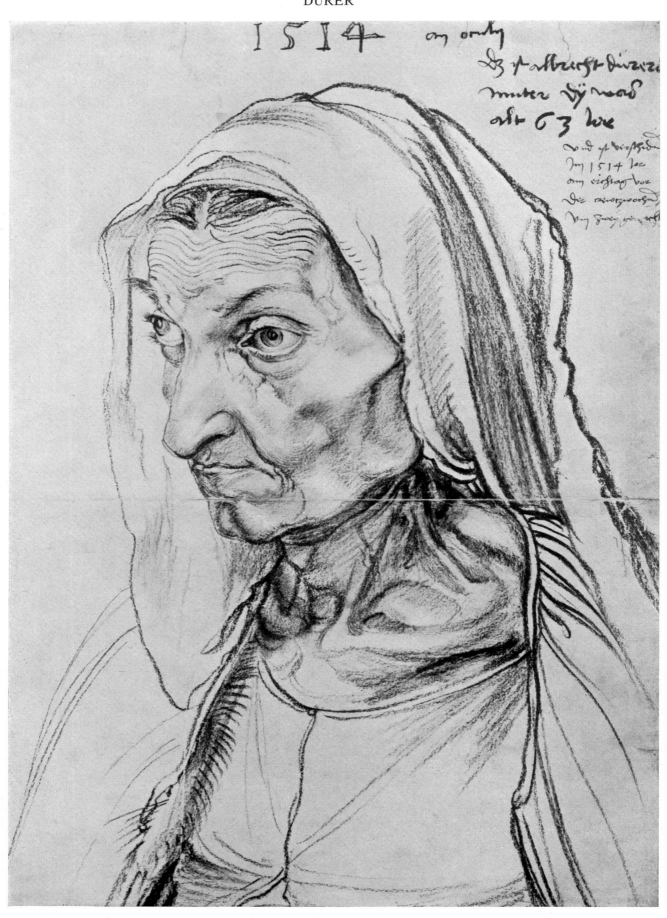

Pl. 302.  Dürer's mother.  Drawing, 16¹/₂ × 11⁷/₈ in.  Berlin, Kupferstichkabinett.

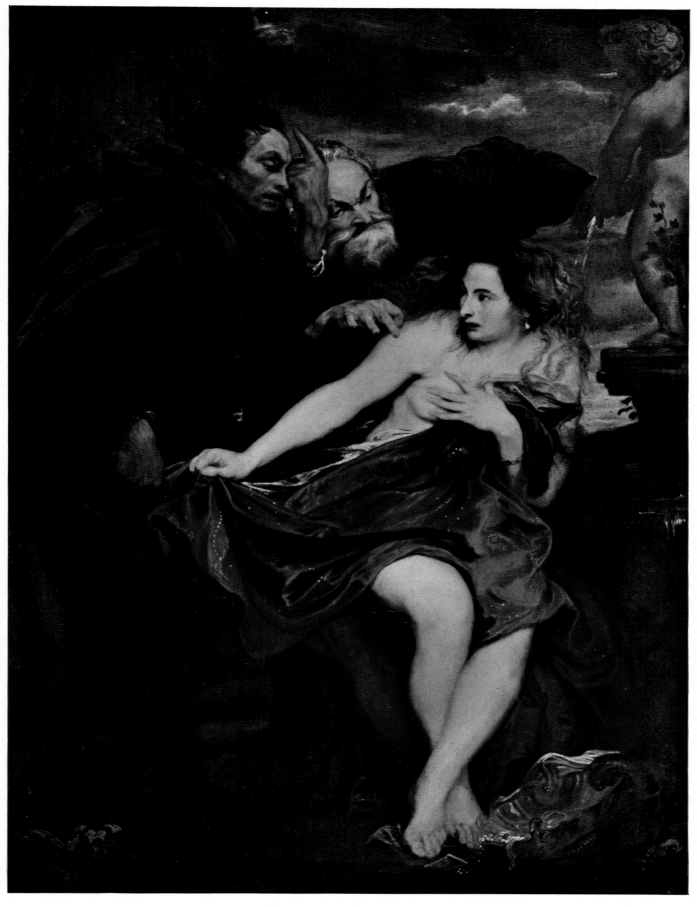

Pl. 303. Susanna and the Elders. Canvas, 6 ft., 4³/₈ in. × 4 ft., 8³/₈ in. Munich, Alte Pinakothek.

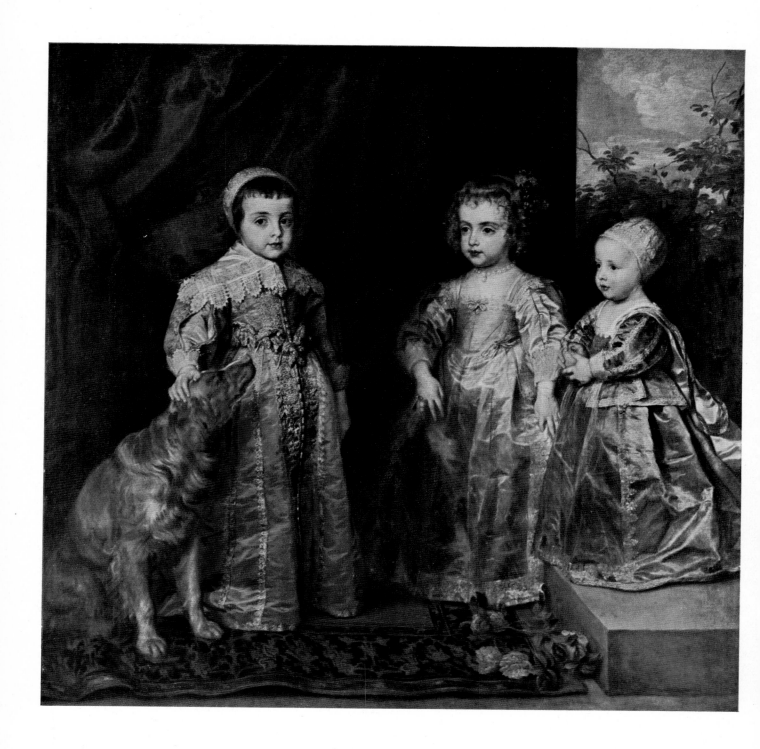

Pl. 304. Children of Charles I of England. Canvas, 4 ft., 11 1/8 in. × 5 ft., 5/8 in. Turin, Galleria Sabauda.

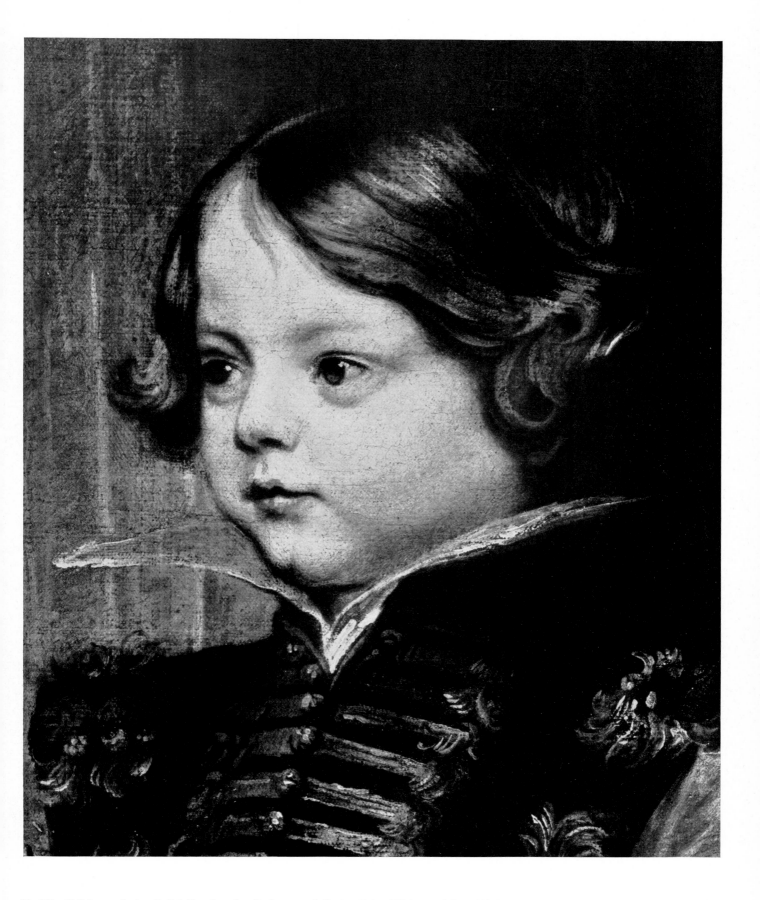

Pl. 305. Children of the Balbi Family, detail. Canvas; full size, 7 ft., 2⁵/₈ in. × 4 ft., 11¹/₈ in. London, National Gallery (on loan from Coll. Lady Lucas, Selborne, England).

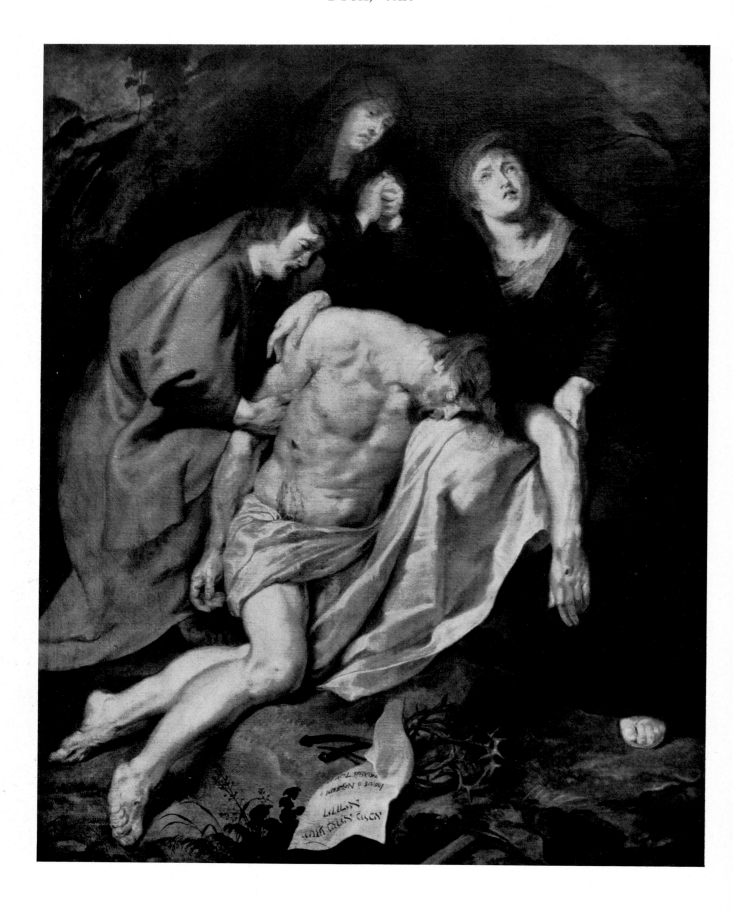

Pl. 306. The Lamentation. Canvas, 6 ft., 7⁷/₈ in. × 5 ft., 1³/₈ in. Munich, Alte Pinakothek.

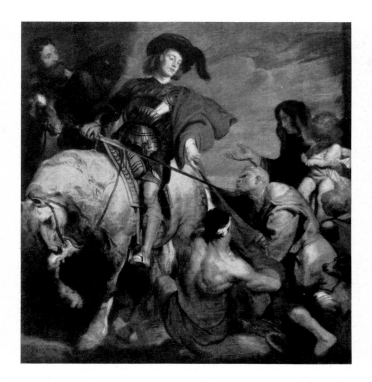
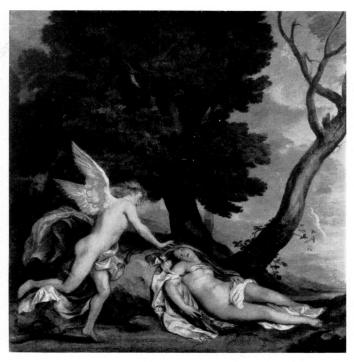
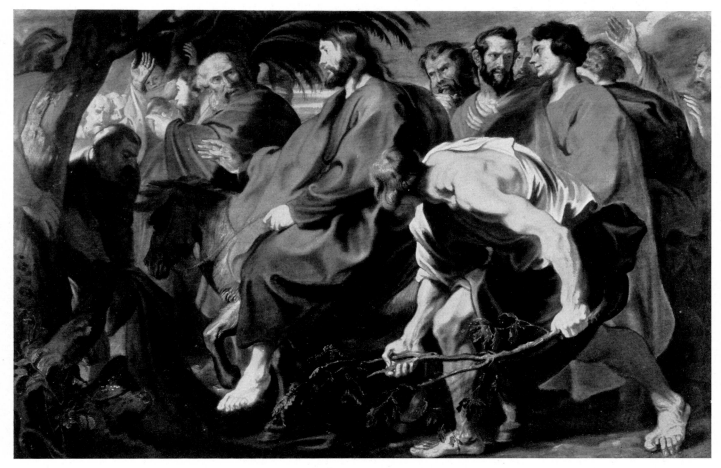

Pl. 307. *Above, left*: St. Martin Dividing His Cloak. Canvas, 9 ft., 4¹/₄ in. × 7 ft., 9³/₄ in. Windsor, England, Royal Colls. *Right*: Cupid and Psyche. Canvas, 6 ft., 6³/₈ in. × 6 ft., 3⁵/₈ in. London, Buckingham Palace, Royal Colls. *Below*: Entry into Jerusalem. Canvas, 4 ft., 9¹/₂ in. × 7 ft., 5 in. Indianapolis, Ind., John Herron Art Museum.

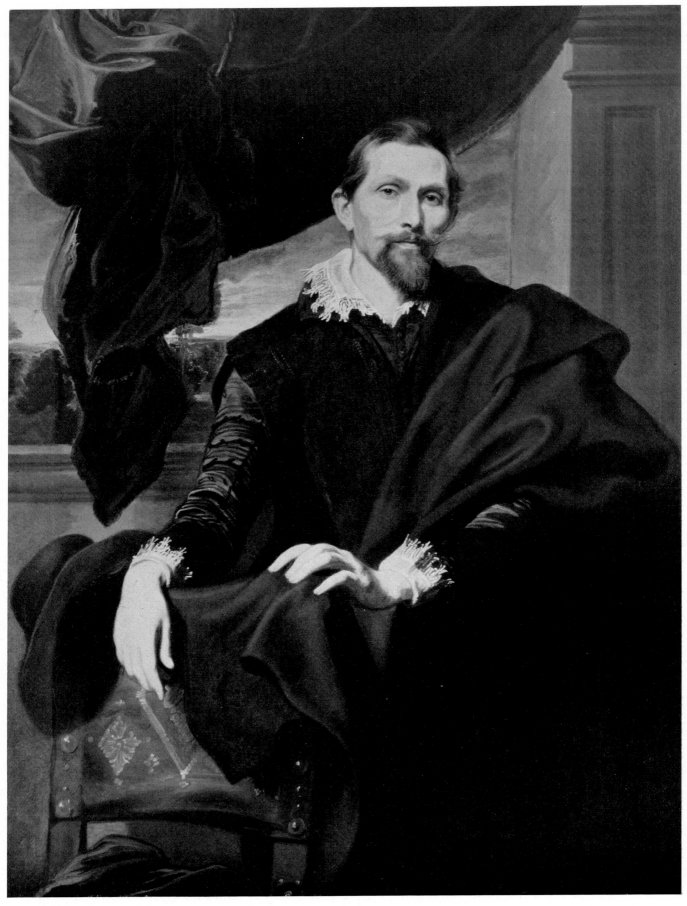

Pl. 308.  The painter Frans Snyders. Canvas, 4 ft., 7¹/₈ in.  ×  3 ft., 4¹/₈ in. New York, Frick Coll.

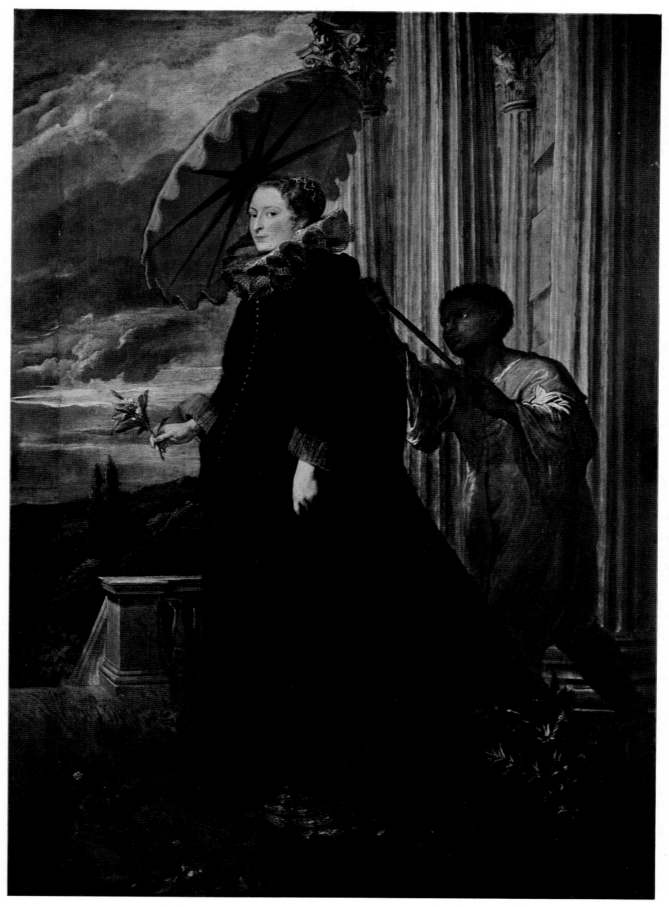

Pl. 309.  Marchesa  Elena  Grimaldi, Wife of Marchese Nicola Cattaneo. Canvas, 8 ft., 1 in.  ×  5 ft., 8 in. Washington, D.C.,
    National Gallery.

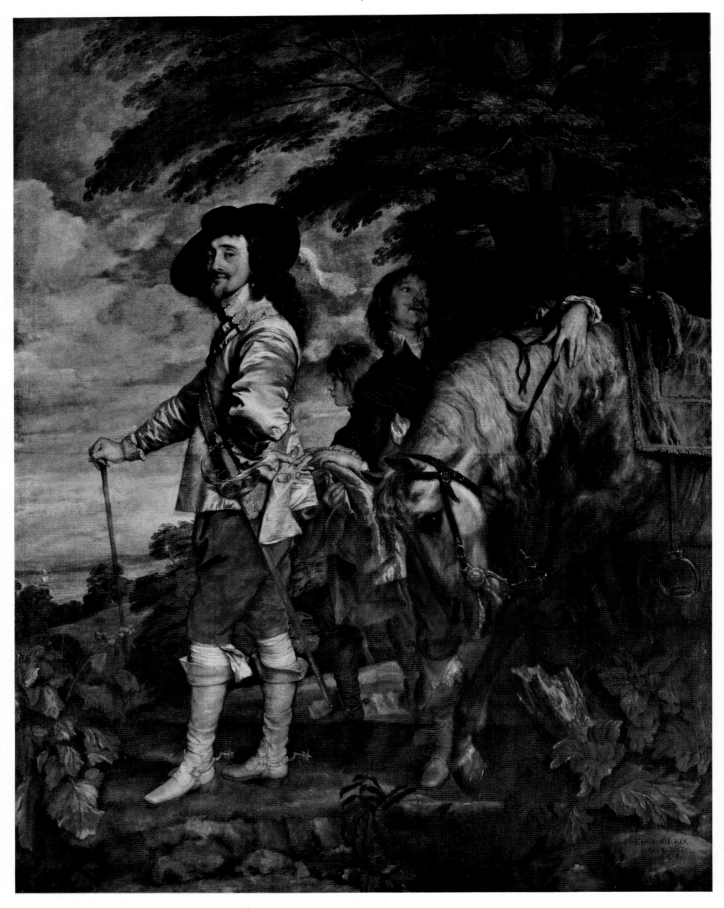

Pl. 310. Charles I of England in hunting dress. Canvas, 8 ft., 10¼ in. × 6 ft., 10⅝ in. Paris, Louvre.

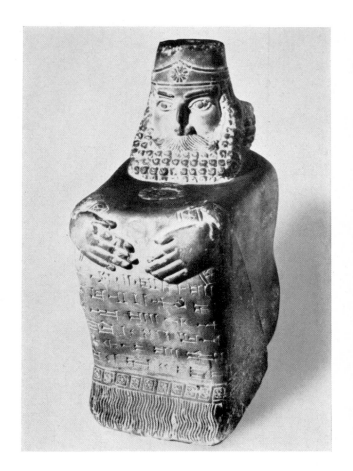

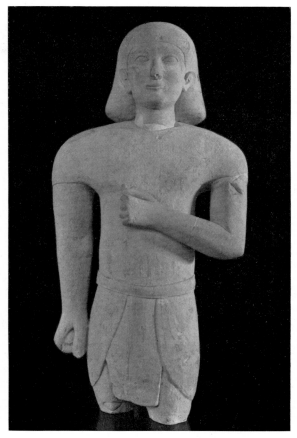

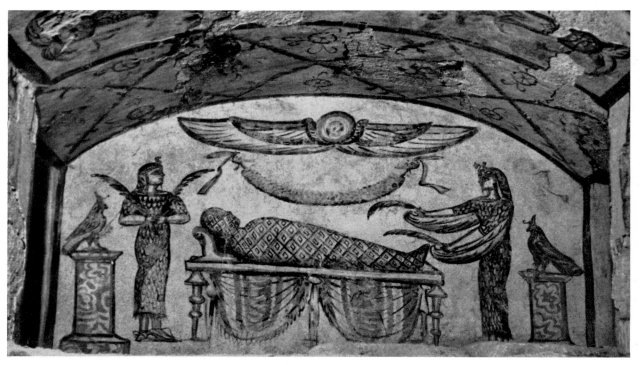

Pl. 311. *Above, left*: Ashurbanipal depicted in Egyptian block style, second half of 7th cent. B.C. Limestone, ht., 15³/₈ in. Prague, private coll. *Right*: Cypriote statue in Egyptian style, 600–550 B.C. Limestone, ht., 4 ft., 3⁵/₈ in. New York, Metropolitan Museum. *Below*: The deathwatch of Osiris, Greco-Egyptian wall painting, 1st cent. Alexandria, eastern necropolis.

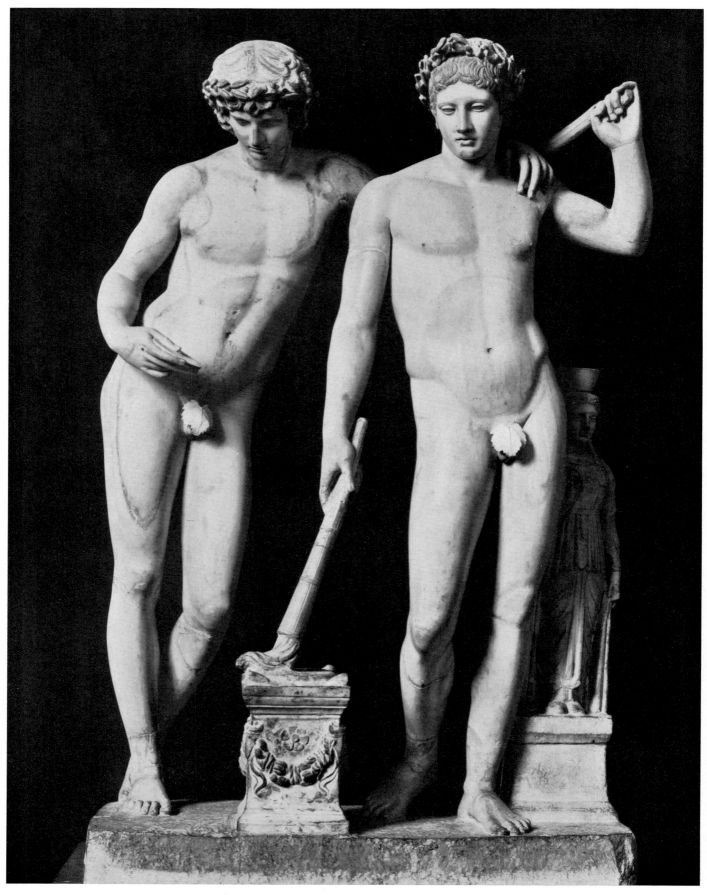

Pl. 312. So-called "Group of S. Ildefonso" (Castor and Pollux?), with one figure in the style of Praxiteles, the other in that of Polykleitos, second half of 1st cent. B.C. – first half of 1st cent. Marble, ht., 5 ft., 3 in. Madrid, Prado.

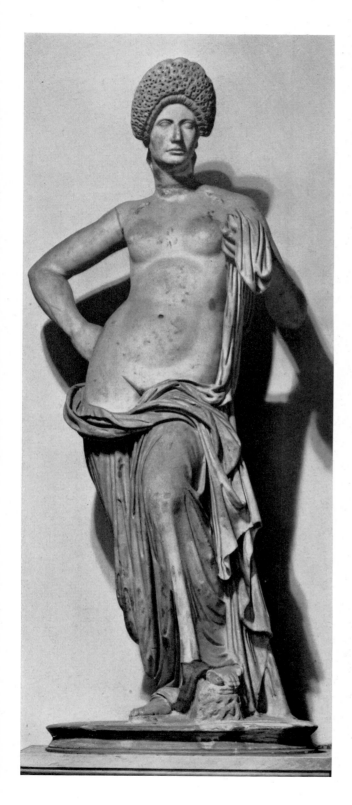 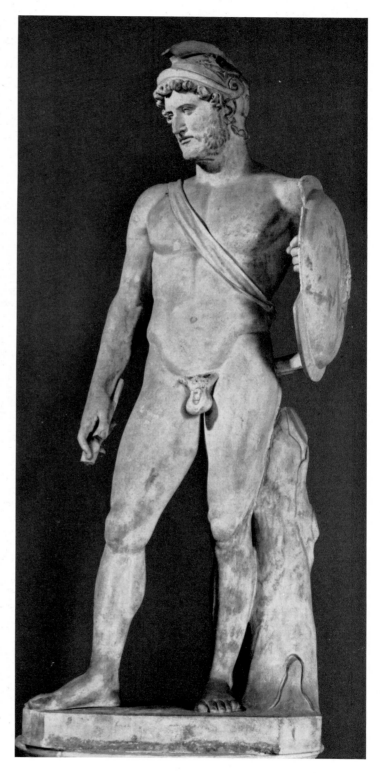

Pl. 313. *Left*: Roman matron depicted as Venus (in the style of the Aphrodite of Arles), last quarter of 1st cent. Marble, ht., 6 ft., 2³/₄ in. *Right*: Hadrian depicted as Mars (in the style of the Borghese Ares), A.D. 117–38. Marble, ht., 6 ft., 8¹/₄ in. Both, Rome, Capitoline Museum.

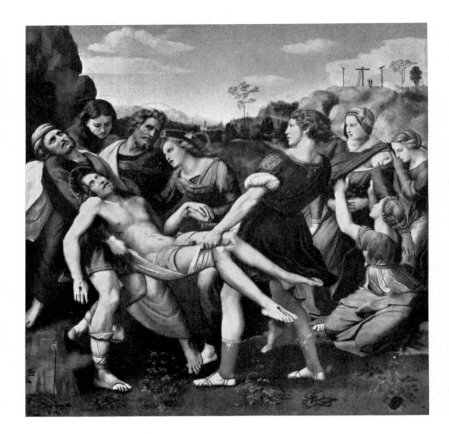

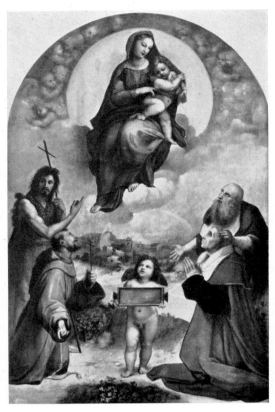

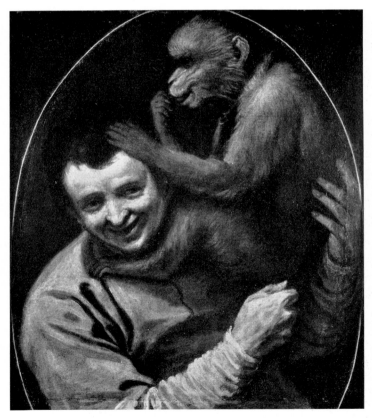

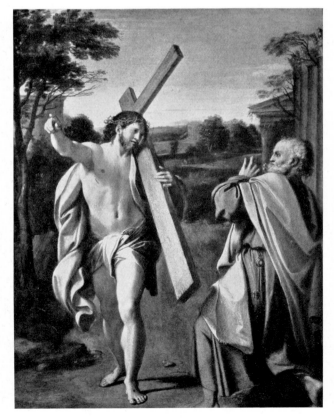

Pl. 314. *Above*: Varying styles of Raphael. *Left*: The Deposition, 1507. Rome, Galleria Borghese. *Right*: The Madonna of Foligno, 1511–12. Rome, Vatican Museums. *Below*: Varying styles of Annibale Carracci. *Left*: Man and Ape, before 1595. Florence, Uffizi. *Right*: "Domine quo vadis?," after 1600. London, National Gallery.

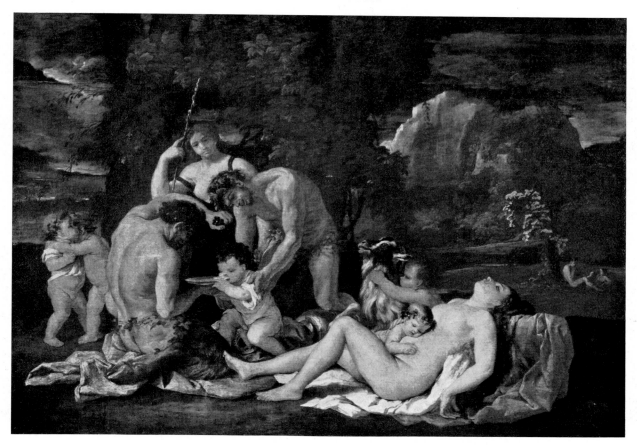

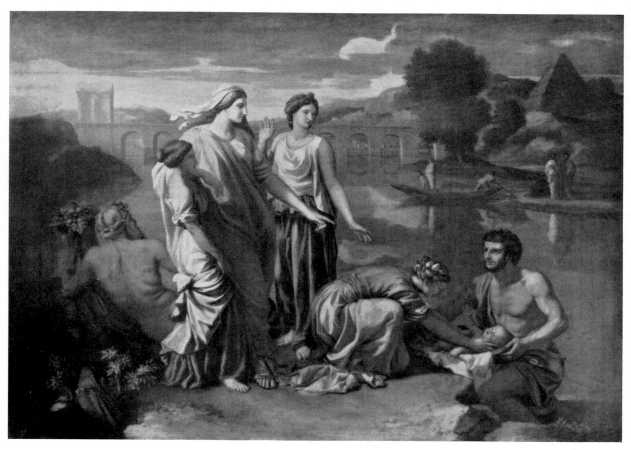

Pl. 315. Venetian and classical styles of Nicolas Poussin (ca. 1594–1665). *Above*: Bacchanal. *Below*: The Finding of Moses. Both, Paris, Louvre.

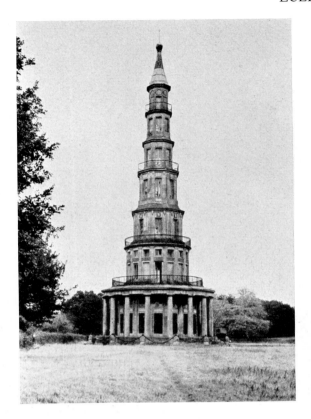

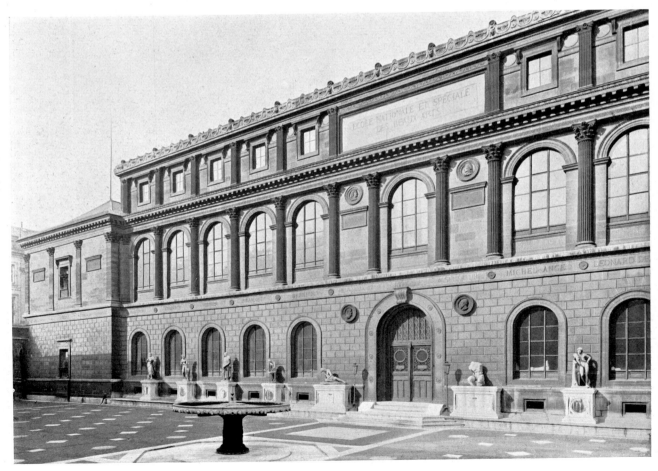

Pl. 316. *Above, left*: Le Camus de Mézière, pagoda in the garden at Chanteloup, near Amboise, France, 18th cent. *Right*: Dropmore, Buckinghamshire, England, two views, latticed garden wall with classical portico (*above*) and Chinese aviary (*center*), early 19th cent. *Below*: F. Debret and J. F. Duban, Ecole des Beaux-Arts, Paris, 19th cent.

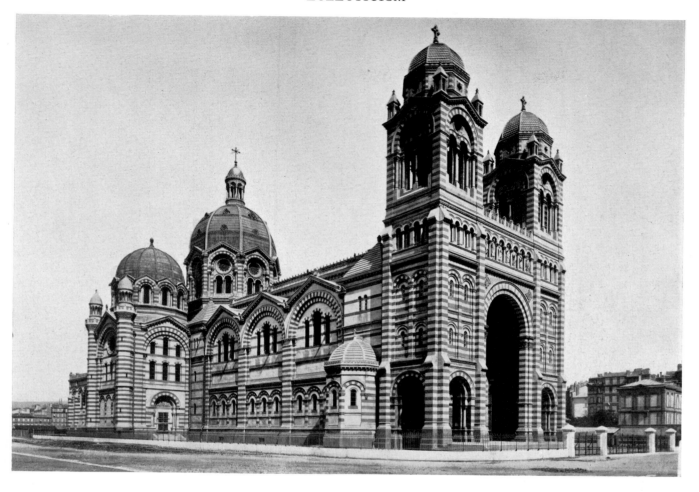

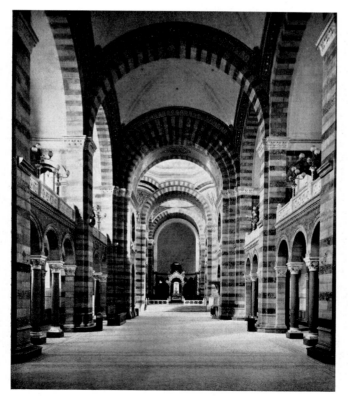 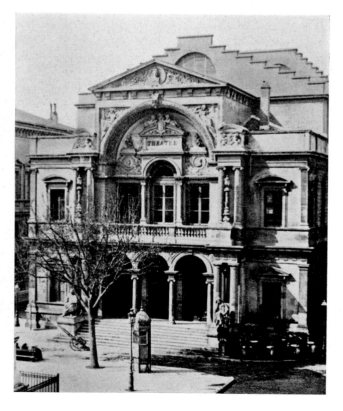

Pl. 317.  French 19th-cent. architecture. *Above, and below, left*: L. Vaudoyer, Cathedral of Marseille, exterior and interior. *Below, right*: L. Feuchère, Le Théatre, Avignon.

Pl. 318. Italian 20th-cent. architecture. *Left*: L. Carimini, S. Giuseppe di Cluny, Rome. *Right*: C. Busiri-Vici, Hotel Principe, Via Veneto, Rome.

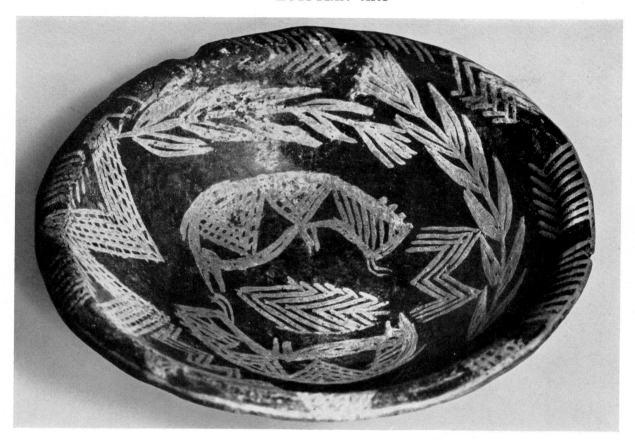

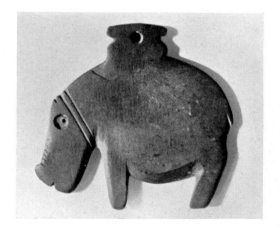

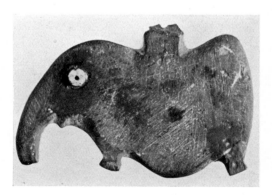

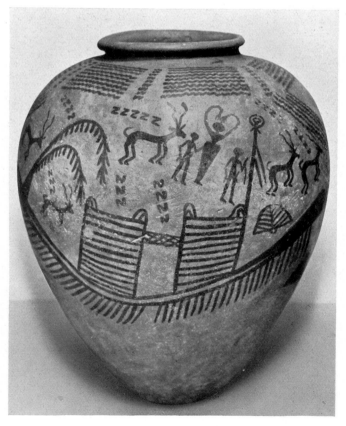

Pl. 319. Predynastic period. *Above*: Painted bowl of the Amratian culture, from Upper Egypt. Cairo, Egyptian Museum. *Below, left*: Two cosmetic palettes of the Naqada culture. Slate. Boston, Museum of Fine Arts, and private collection. *Right*: Pink ceramic vase of Naqada culture, with figures painted in red, from Abydos. Ht., 12¹/₄ in. Cairo, Egyptian Museum.

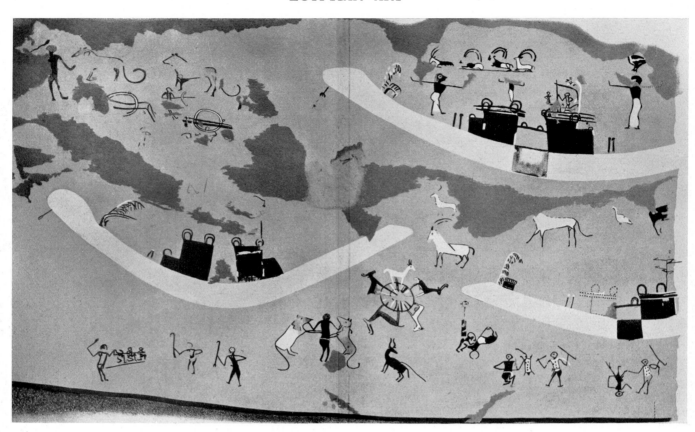

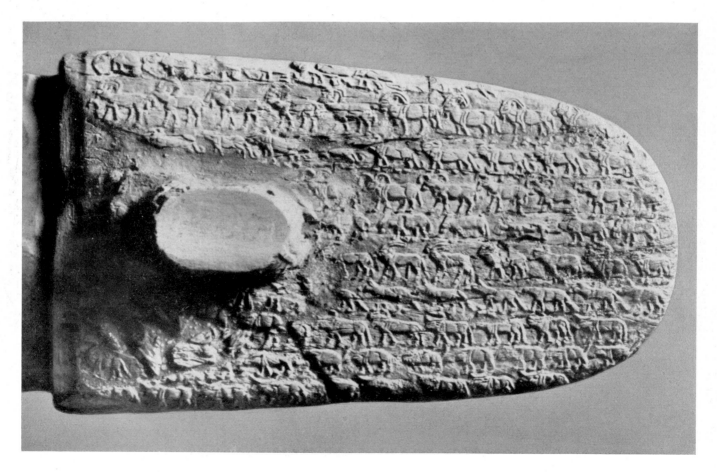

Pl. 320. Predynastic period. *Above*: Wall painting of a sepulchral chamber, from Hierakonpolis. Cairo, Egyptian Museum. *Below*: Knife handle with decoration in relief, from Abu Zaidan. Ivory; full l., 9¼ in. New York, Brooklyn Museum.

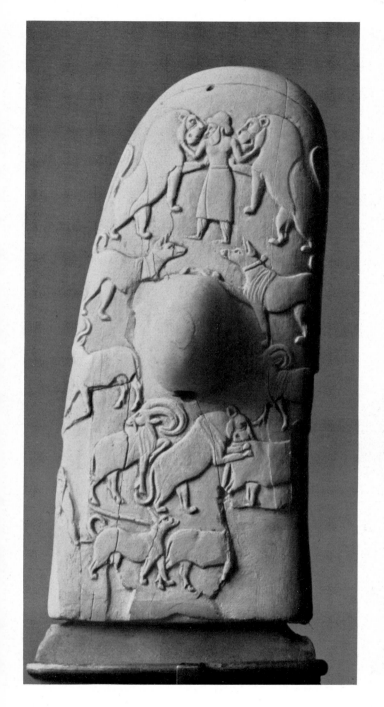
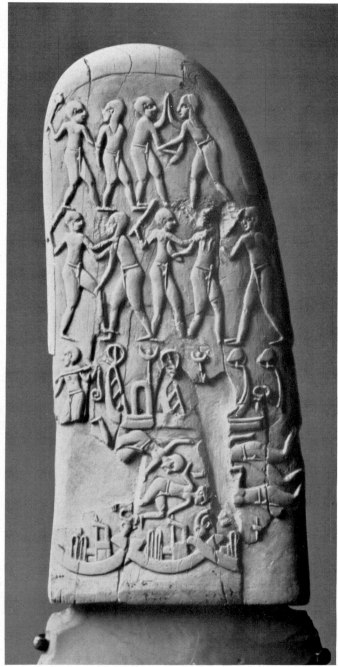

Pl. 321. Knife handle with decoration in relief, from Gebel el Arak, views of both sides, predynastic period. Ivory. Paris, Louvre.

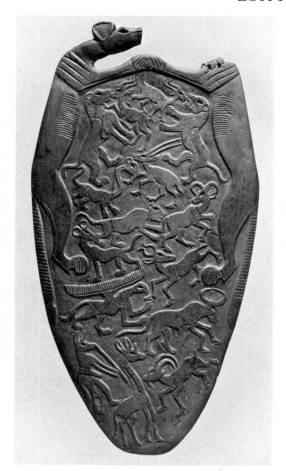
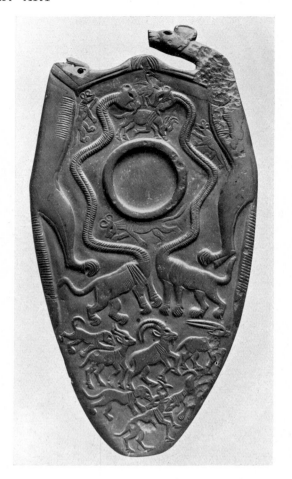

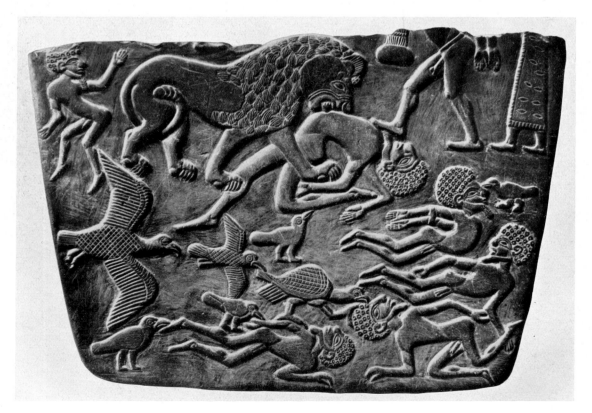

Pl. 322. Predynastic period. *Above*: Tablet, from Hierakonpolis, front and back. Schist, ht., 17 in. Oxford, Ashmolean Museum. *Below*: Fragment of a tablet, probably from Abydos. Schist, w., 11¾ in. London, British Museum.

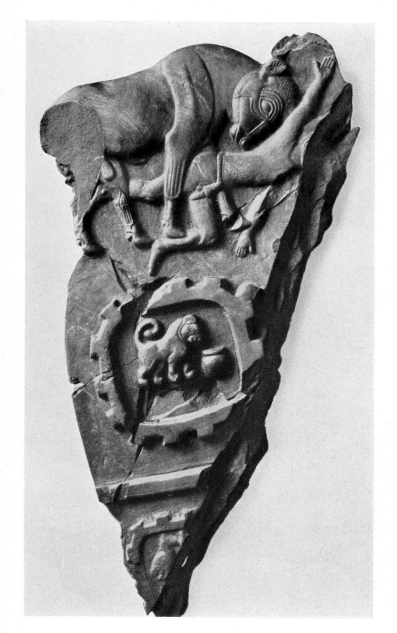

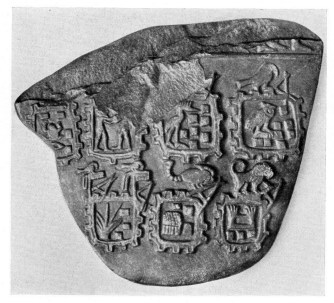

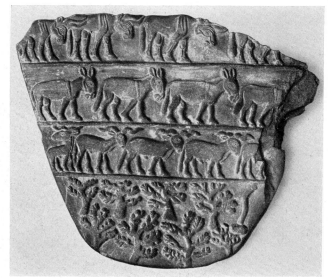

Pl. 323. *Left*: Fragment of a tablet, probably from Abydos, predynastic period. Schist, ht., 10¹/₄ in. Paris, Louvre. *Right*: Fragment of a tablet commemorating a victory, front and back, late predynastic period. Schist, ht., 11 in. Cairo, Egyptian Museum.

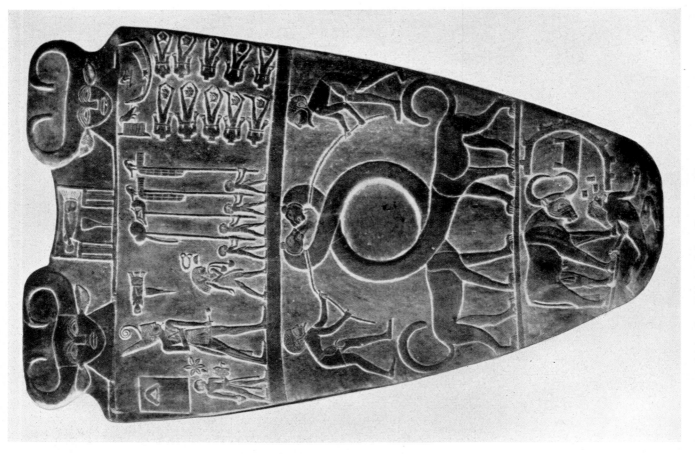

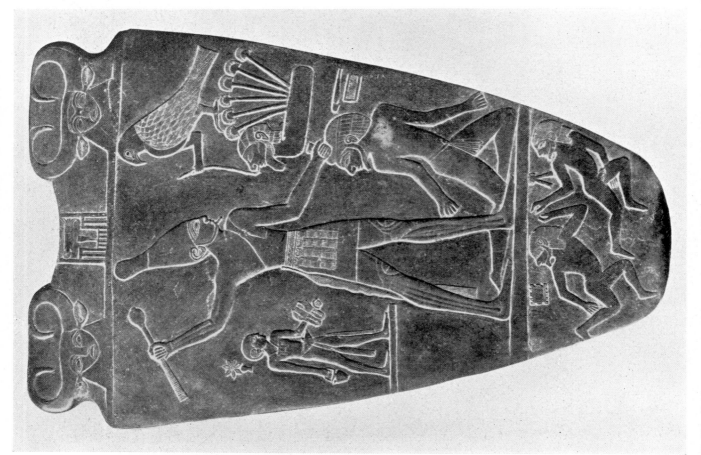

Pl. 324. Tablet commemorating a victory of King Narmer, from Hierakonpolis, front and back, 1st dynasty. Schist, ht., 25¼ in. Cairo, Egyptian Museum.

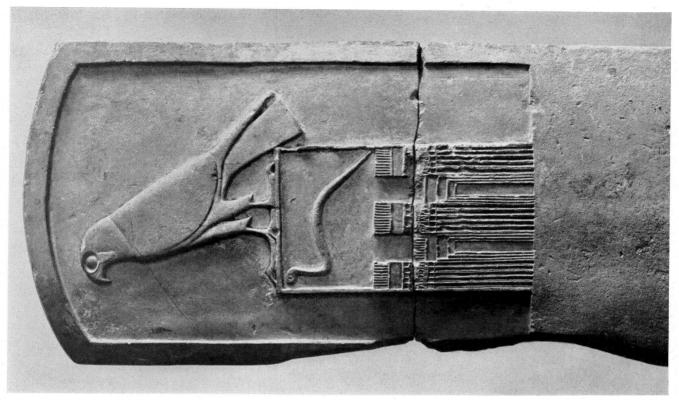

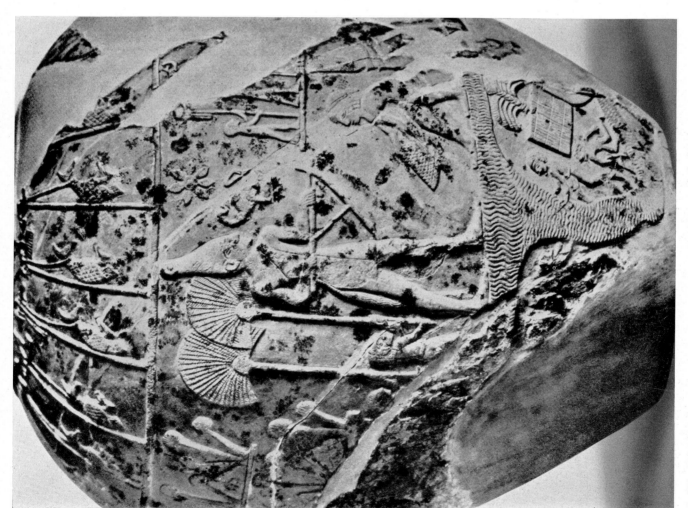

Pl. 325. *Left:* Macehead of the Scorpion King, from Hierakonpolis, late predynastic period. Limestone, ht., 9¹/₈ in. Oxford, Ashmolean Museum. *Right:* Funerary stele of the Serpent King, from Abydos, 1st dynasty. Limestone, w., 21⁵/₈ in. Paris, Louvre.

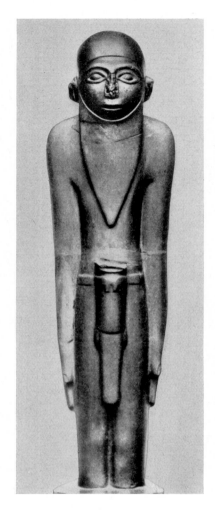

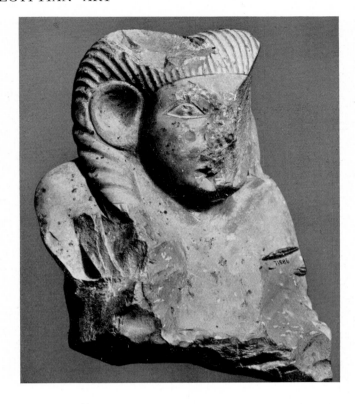

Pl. 326. *Above, left*: Figure of a man or a god, predynastic period. Schist, ht., 15³/₄ in. Oxford, Ashmolean Museum. *Right*: Upper part of a seated figure, from Abydos, 1st–2d dynasty. Limestone, ht., 13³/₄ in. Cairo, Egyptian Museum. *Below, left*: Figurine of a king wearing the crown of Upper Egypt, from Abydos, late predynastic period or 1st dynasty. Ivory, ht., 3³/₈ in. London, British Museum. *Right*: Baboon, from Abydos, 1st–2d dynasty. Faïence, ht., 2 in. Munich, Staatliche Antikensammlungen.

Pl. 327. Fragments of painting on linen from Gebelein, predynastic period. Turin, Museo Egizio. *Above*: Hippopotamus hunt. *Below*: Boats.

Pl. 328. *Above*: "The geese of Medum," detail of a wall painting from Medum, early 4th dynasty. *Below*: Cattle at the ford, detail of a wall painting from Dahshur, 4th dynasty. Both, Cairo, Egyptian Museum.

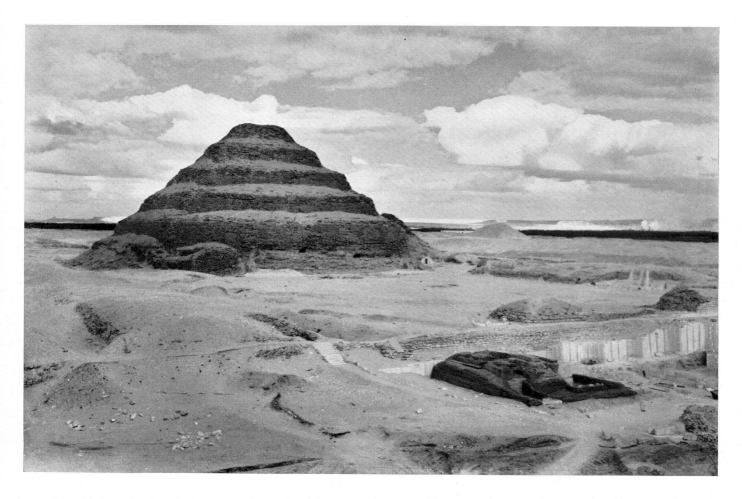

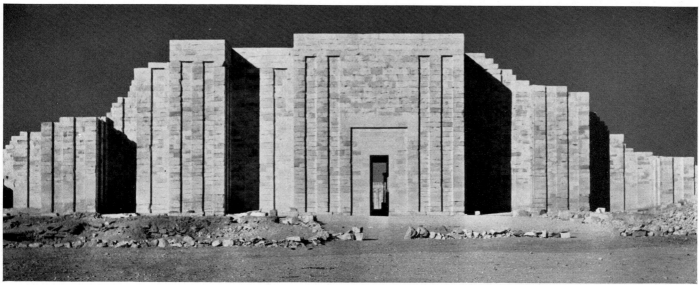

Pl. 329. Funerary precinct of King Zoser, near Saqqara, 3d dynasty. *Above*: View showing the Step Pyramid. *Below*: Enclosure wall and entrance to the columned processional hall.

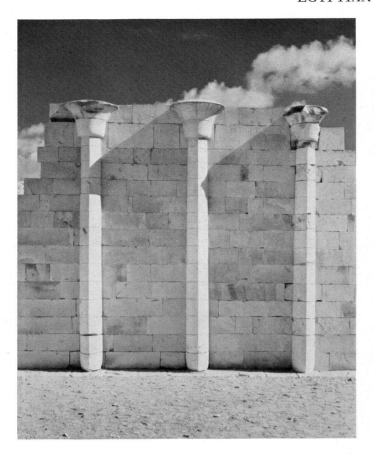

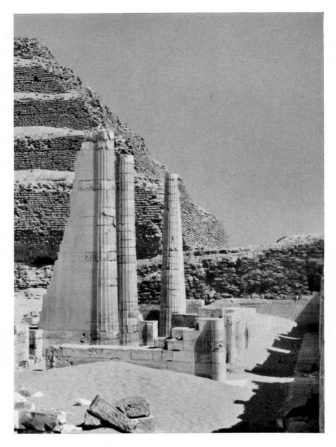

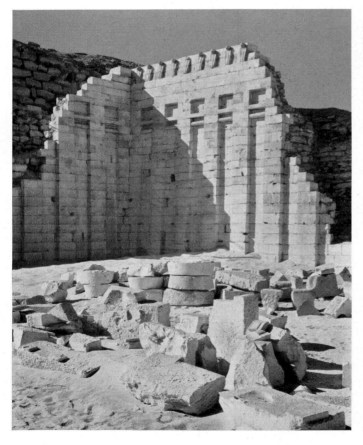

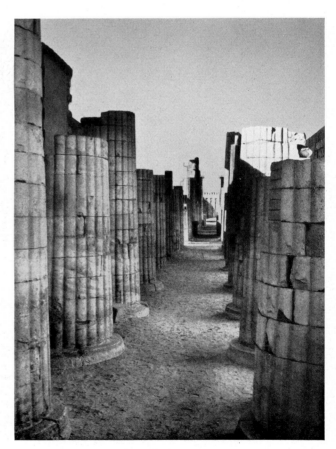

Pl. 330. Funerary precinct of King Zoser, near Saqqara, 3d dynasty. *Above, left*: Papyrus half columns. *Right*: The temple. *Below, left*: The South Building. *Right*: The columned processional hall.

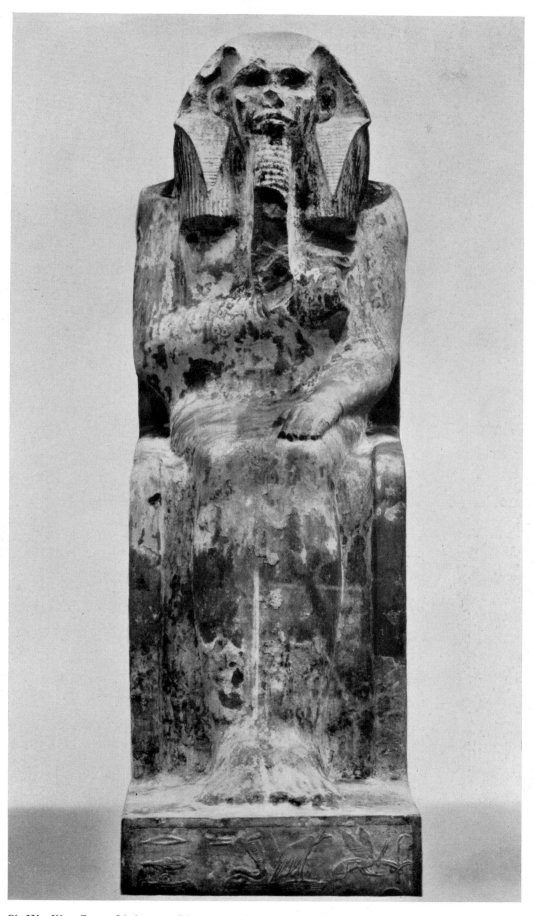

Pl. 331. King Zoser, 3d dynasty. Limestone with traces of color, life size. Cairo, Egyptian Museum.

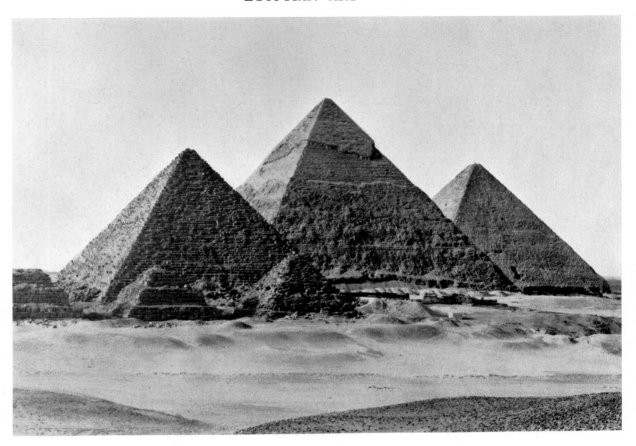

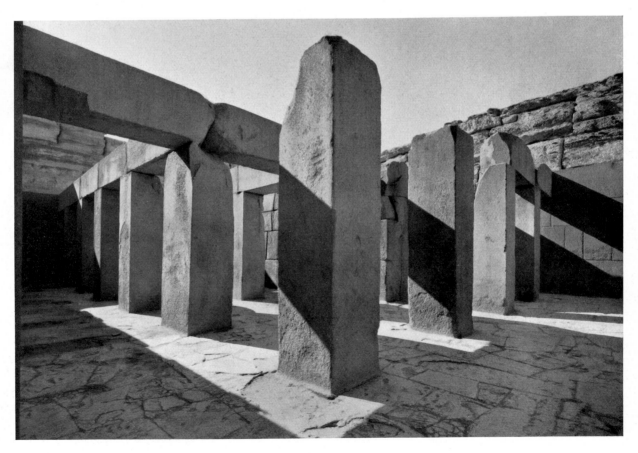

Pl. 332. Giza, 4th dynasty. *Above*: The pyramids of Kings Cheops (Khufu), Chephren (Khafre), and Mycerinus (Menkure). *Below*: The Hall of Pillars in the Valley Temple of King Chephren.

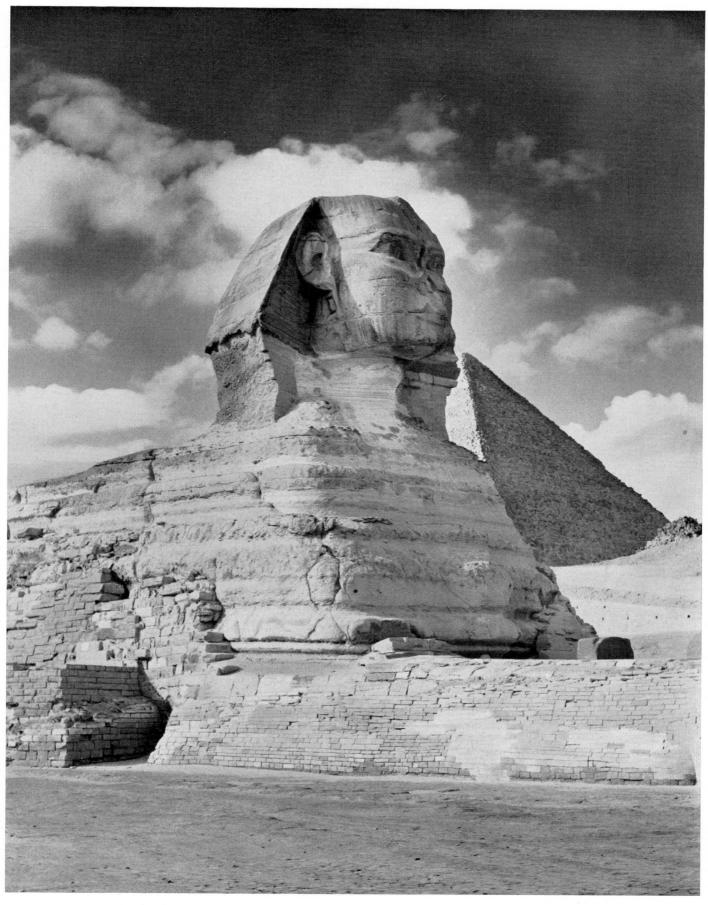

Pl. 333. Giza, The Great Sphinx, 4th dynasty. Stone; ht., ca. 66 ft., l., ca. 240 ft.

Pl. 334. *Left:* King Zoser in the sacred race, relief in the South Building of the funerary precinct near Saqqara, 3d dynasty. Limestone. *Center:* Panel relief with representation of the deceased, from the tomb of Hesira in Saqqara, 3d dynasty. Wood, ht., 4 ft., 7½ in. Cairo, Egyptian Museum. *Right:* The deceased at table, relief in the tomb of the priest Ptahhotep, near Saqqara, 5th dynasty. Painted limestone, life size.

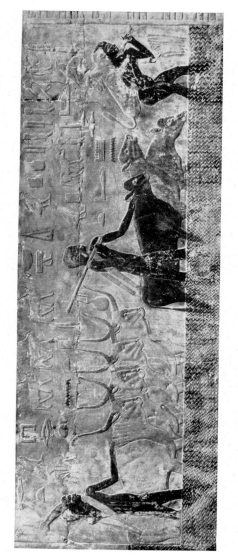

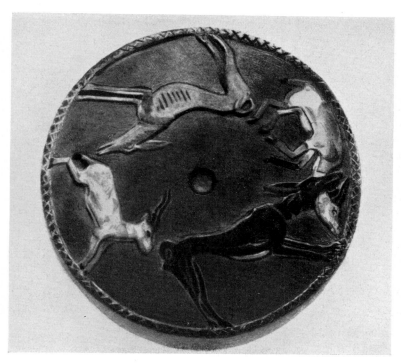

PL. 335. *Left, above:* Disk showing hunting scene in relief, from the tomb of Hemaka, near Saqqara, 1st dynasty. Steatite inlaid with painted alabaster, diam., 3³/₈ in. *Below:* Hunting scene, from the tomb of Nefermaat, near Medum, early 4th dynasty. Inlay of colored paste in stone, ht., 12⁵/₈ in. Both, Cairo, Egyptian Museum. *Right, above:* Preparatory drawing for a wall painting in the tomb of Ptahneferher, near Saqqara, 5th dynasty. *Below:* Return of the herd, detail of a relief in the tomb of Ti, near Saqqara, 5th dynasty. Painted limestone.

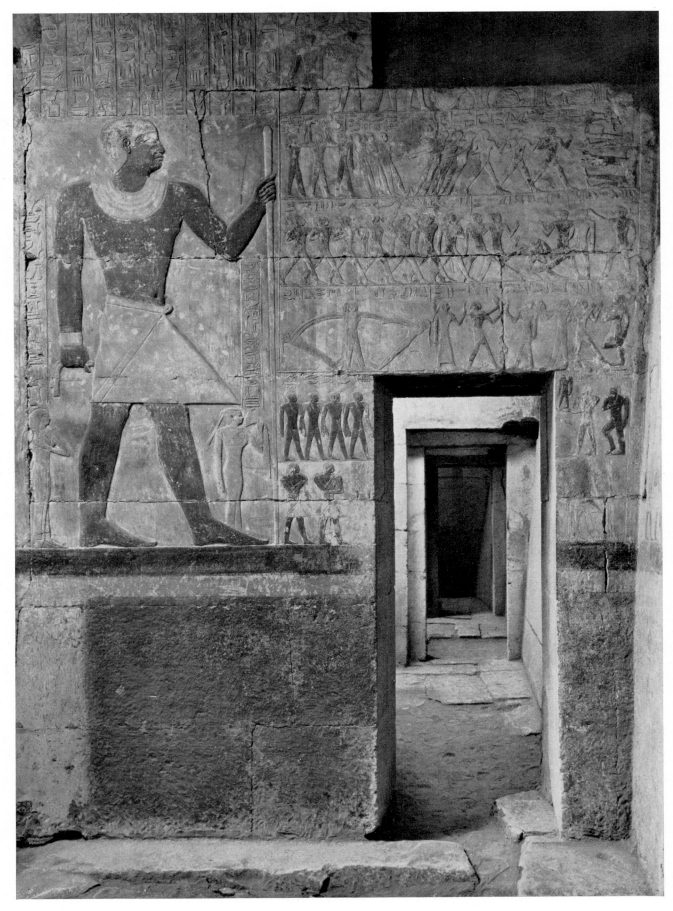

Pl. 336.  Entrance to the tomb of Mereruka, near Saqqara, 6th dynasty.

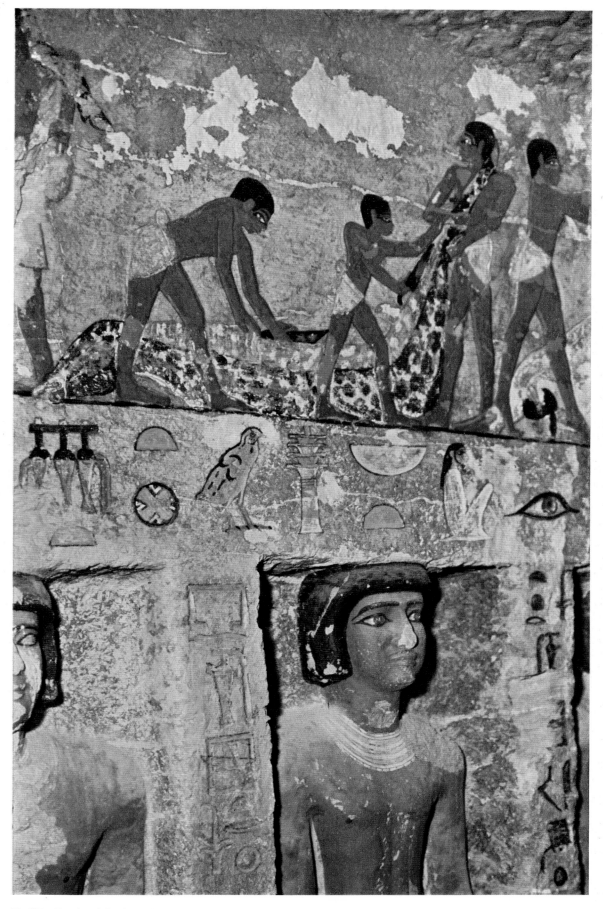

Pl. 337. Tomb of Irukaptah, near Saqqara, detail of the interior, 6th dynasty.

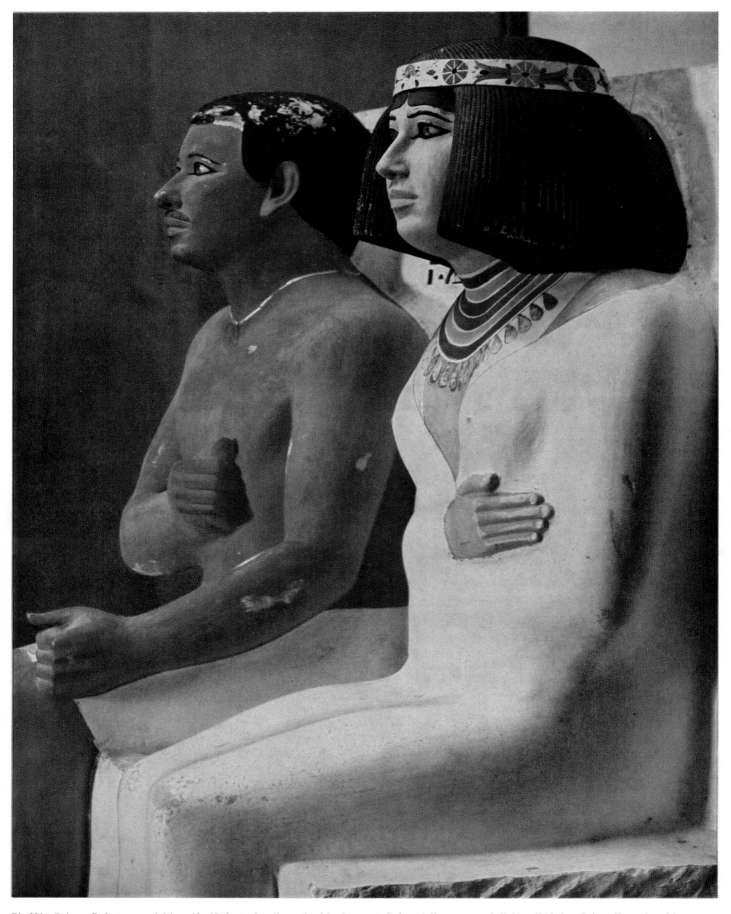

Pl. 338. Prince Rahotep and his wife Nofret, detail, early 4th dynasty. Painted limestone; full ht., 47 1/4 in. Cairo, Egyptian Museum.

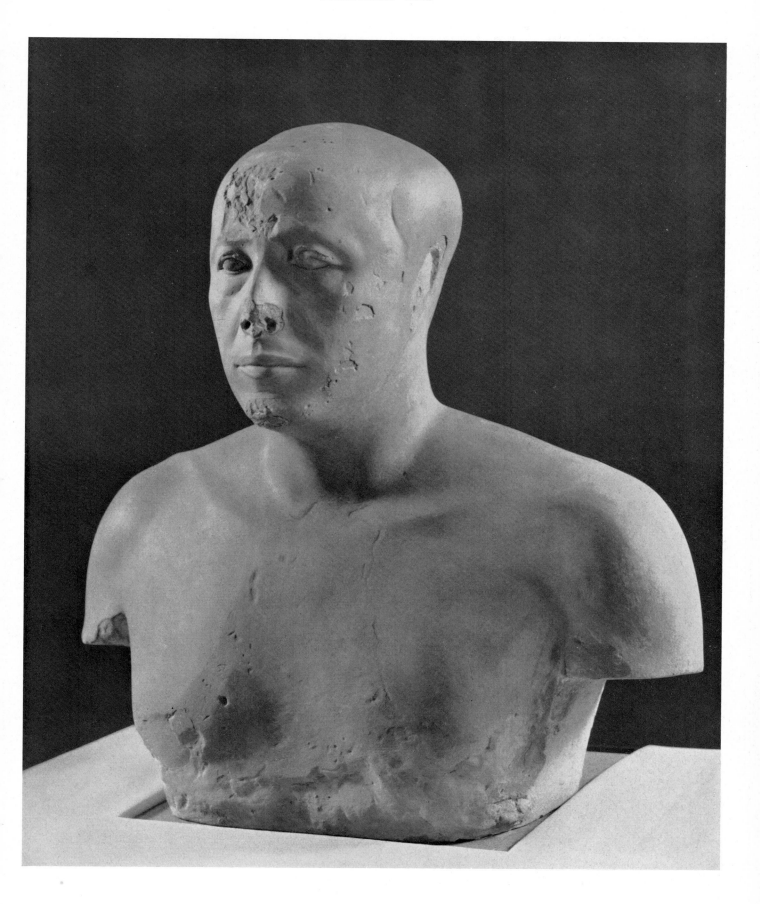

Pl. 339. Bust of Prince Ankhhaf, 4th dynasty. Limestone coated with carved and painted plaster, ht., 22⁷⁄₈ in. Boston, Museum of Fine Arts.

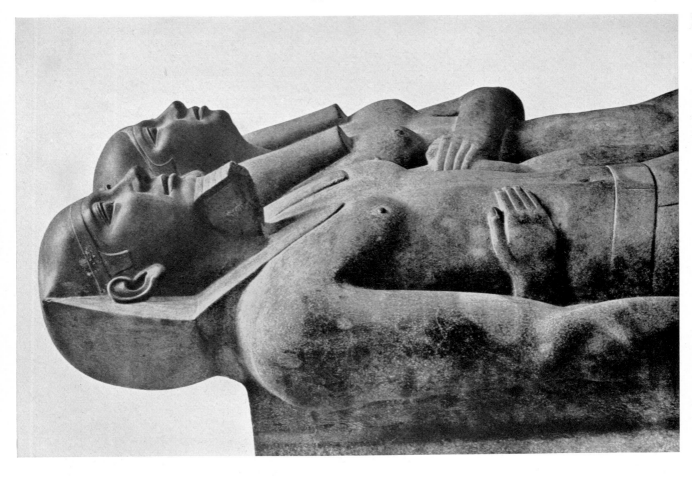

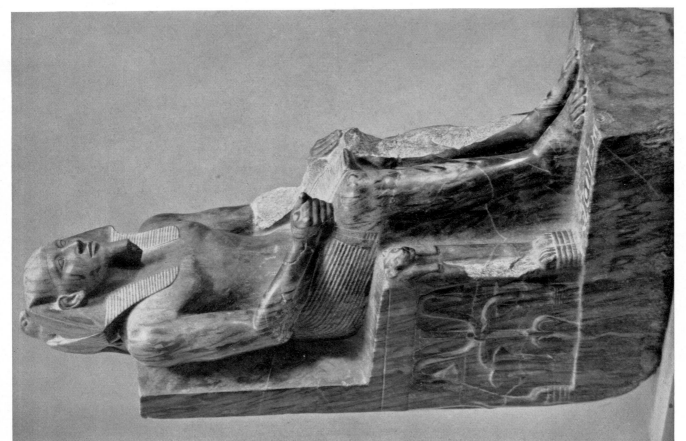

Pl. 340. 4th dynasty. *Left:* King Chephren (Khafre). Diorite, ht., 5 ft., 6 1/8 in. Cairo, Egyptian Museum. *Right:* King Mycerinus (Menkure) and his queen, detail. Painted slate; full ht., 4 ft., 7 7/8 in. Boston, Museum of Fine Arts.

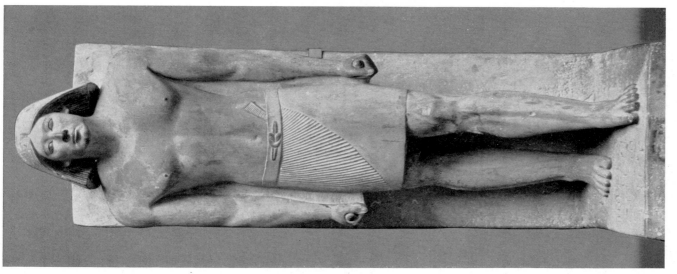

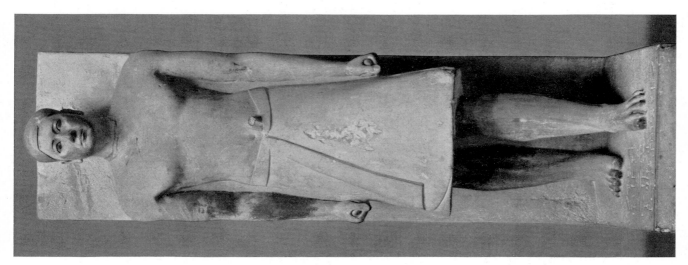

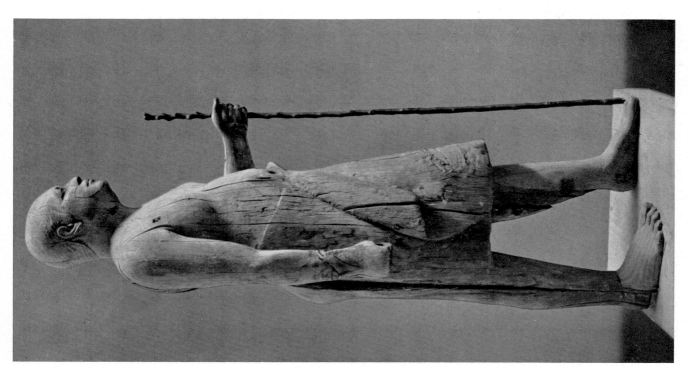

Pl. 341. 5th dynasty. *Left:* Portrait of Kaaper, called the "Sheik el Beled," found near Saqqara. Painted limestone, ht., 6 ft., ⁷/₈ in. *Center and right:* Two statues of the high priest Ranofer, found near Saqqara. Wood, ht., 43¼ in. and 5 ft., 10⁷/₈ in. All, Cairo, Egyptian Museum.

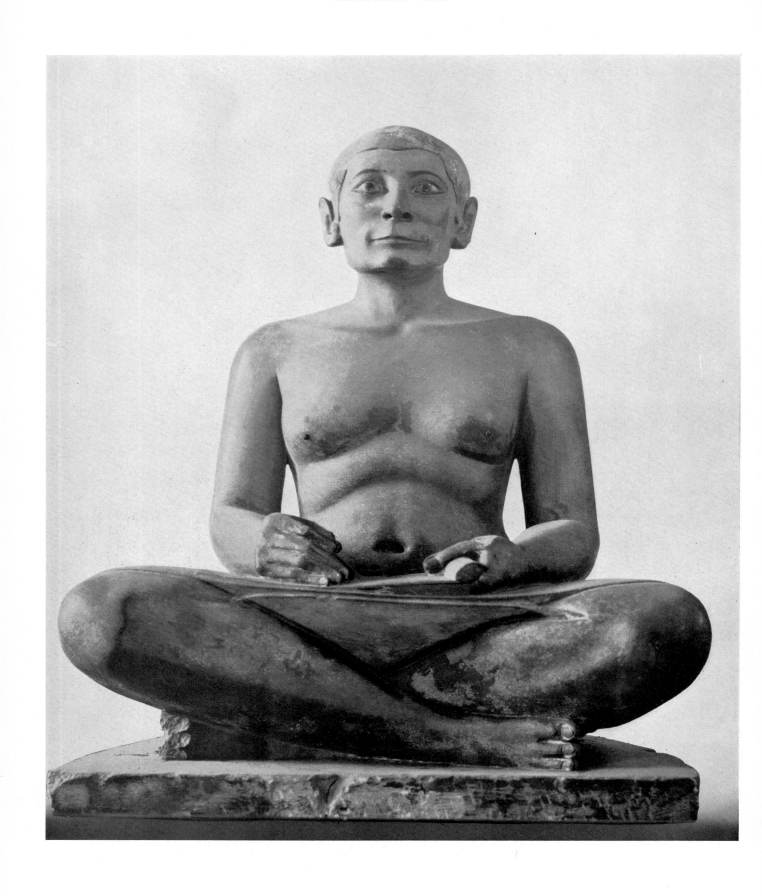

Pl. 342.  Seated scribe, from Saqqara, 5th dynasty. Painted limestone, ht., 20⅞ in. Paris, Louvre.

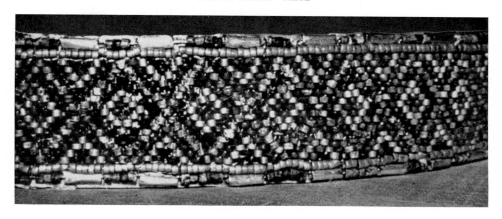

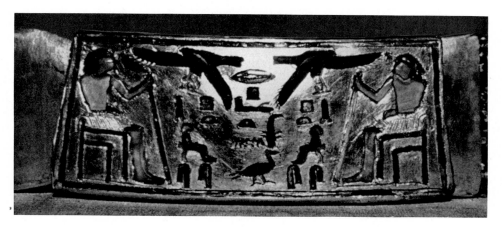

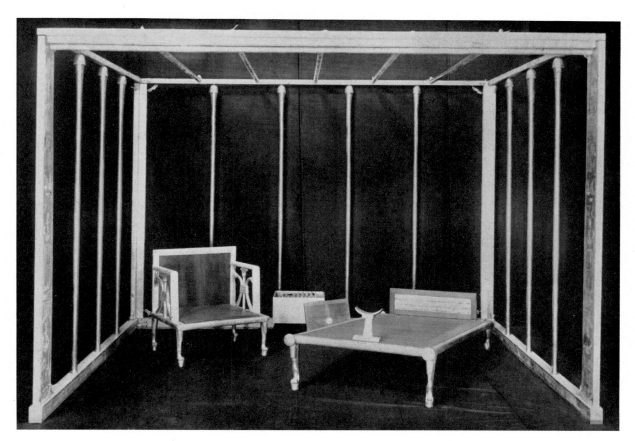

Pl. 343. *Above and center*: Two details of the girdle of Prince Ptahshepses, from Saqqara, 5th or 6th dynasty. Gold leaf with beads of colored stone; gold buckle with colored paste inlay. *Below*: Furniture from the tomb of Queen Hetepheres I, Giza, 4th dynasty. Wood with gold leaf. Both, Cairo, Egyptian Museum.

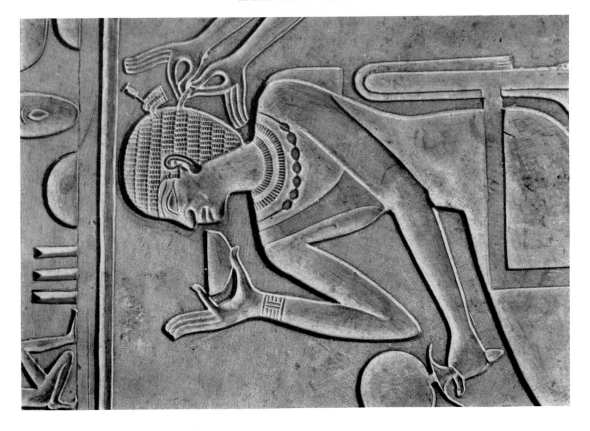

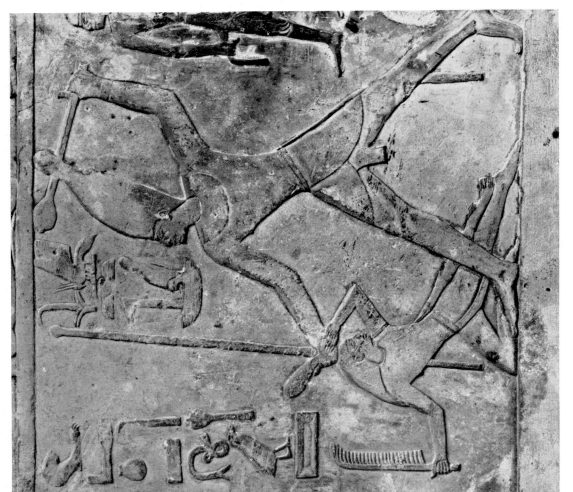

Pl. 344. *Left:* King Mentuhotep overpowering an enemy, detail of a relief from the funerary temple of Mentuhotep at Deir el-Bahri, near Thebes, ca. 2050 B.C. Painted limestone, ht., 10⅝ in. *Right:* Queen Kawit, detail of her sarcophagus from Deir el-Bahri, ca. 2050 B.C. Painted limestone. Both, Cairo, Egyptian Museum.

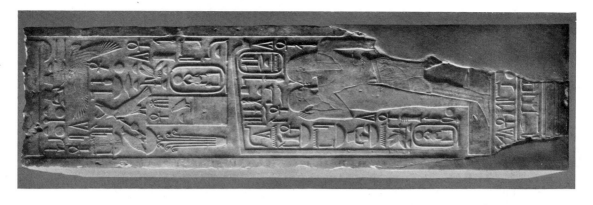

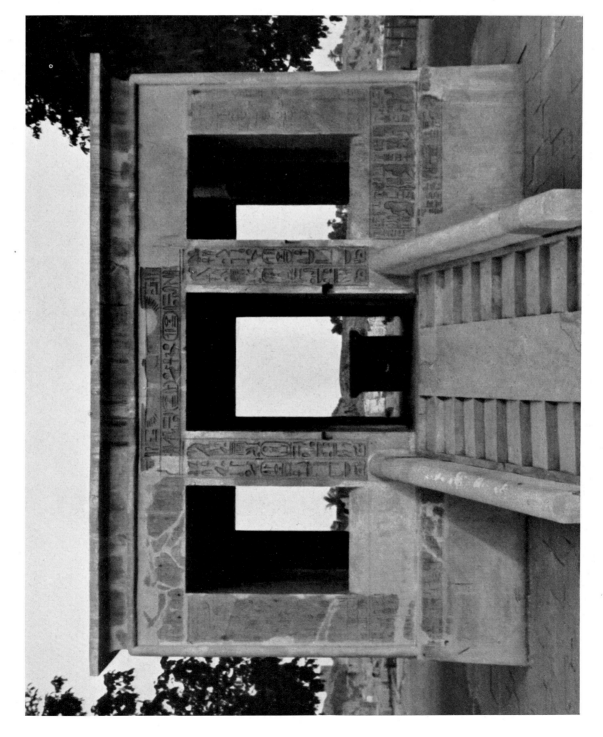

Pl. 345. *Left*: Karnak, Heb-Sed pavilion of Sesostris I, ca. 1940 B.C. (Reconstruction.) *Right*: Detail of a pillar from a building of Sesostris I at Karnak, ca. 1940 B.C. Full ht. of pillar, 10 ft., 11⁷/₈ in. Cairo, Egyptian Museum.

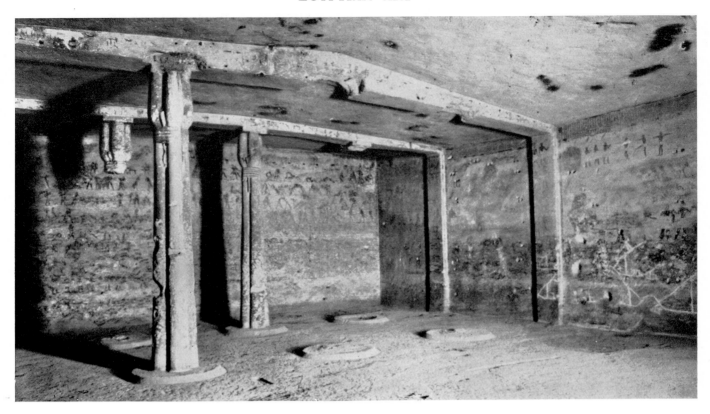

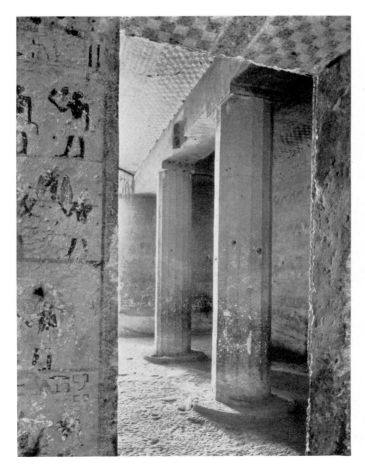

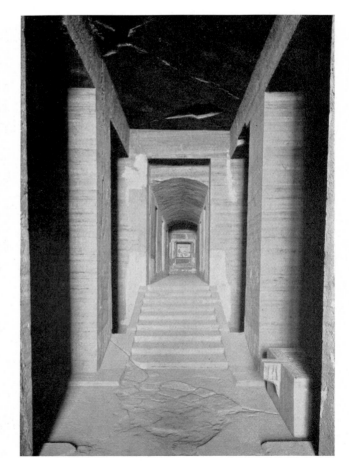

Pl. 346. *Above*: Interior of the tomb of Prince Khety, near Beni Hasan, ca. 2000 B.C. *Below, left*: Interior of the tomb of Prince Amenemhet, near Beni Hasan, ca. 1950 B.C. *Right*: Interior of the tomb of Prince Sirenpowet II, near Aswan, ca. 1870 B.C.

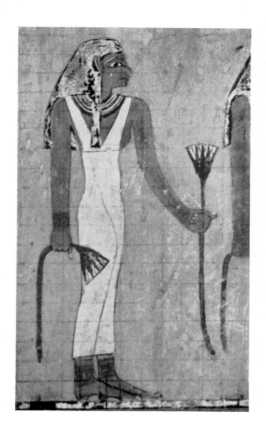

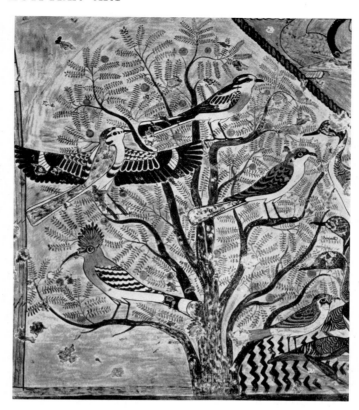

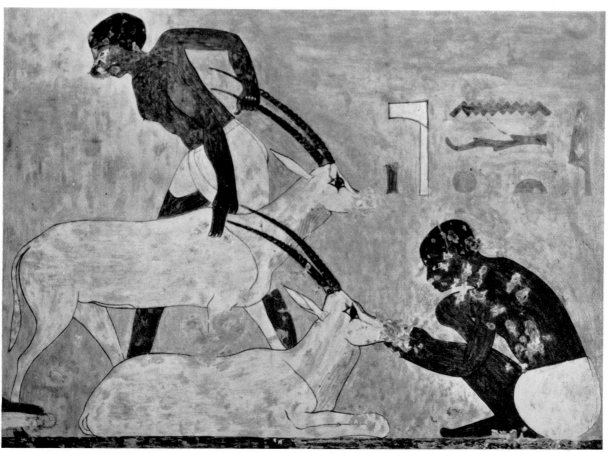

Pl. 347. *Above, left*: Figure of a woman painted over proportion squares, wall painting in the tomb of Prince Sirenpowet, near Aswan, ca. 1870 B.C. *Right and below*: Wall paintings in the tomb of Prince Khnumhotep III, near Beni Hasan, ca. 1880 B.C. *Right*: Birds in an acacia tree. *Below*: Shepherds and sable antelopes.

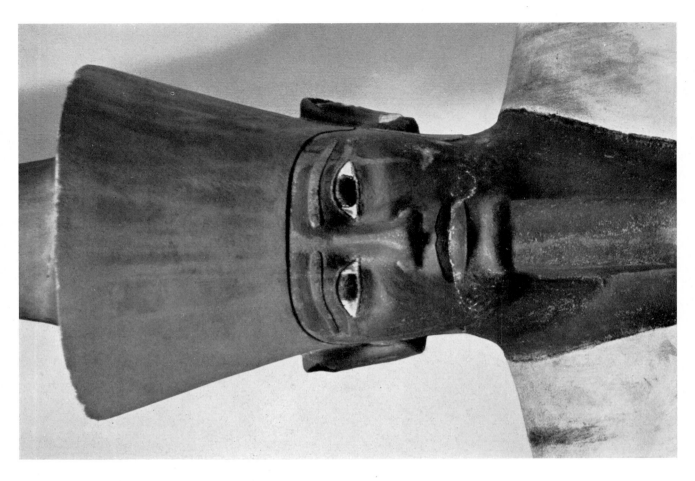

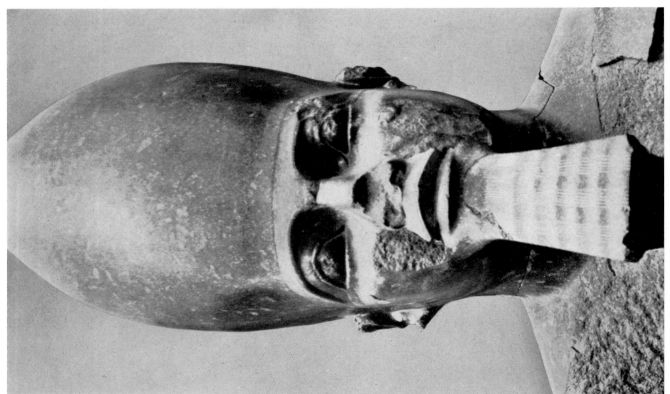

Pl. 348. *Left*: King Sesostris I, detail of a colossal statue, from Tanis, ca. 1940 B.C. Diorite. *Right*: King Mentuhotep, detail, from Thebes, ca. 2050 B.C. Painted sandstone; full ht., 6 ft. Both, Cairo, Egyptian Museum.

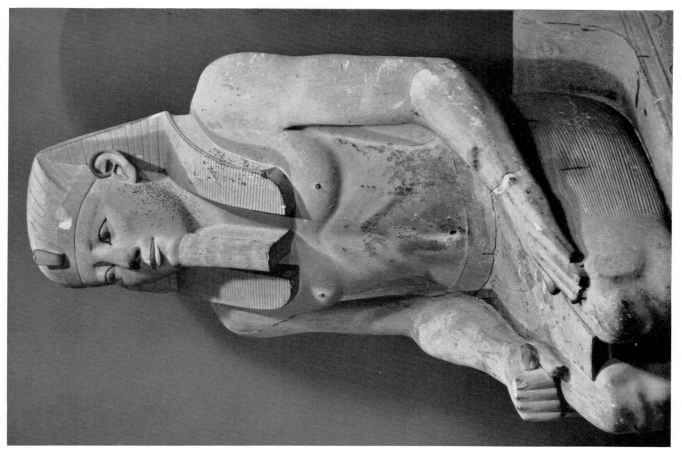

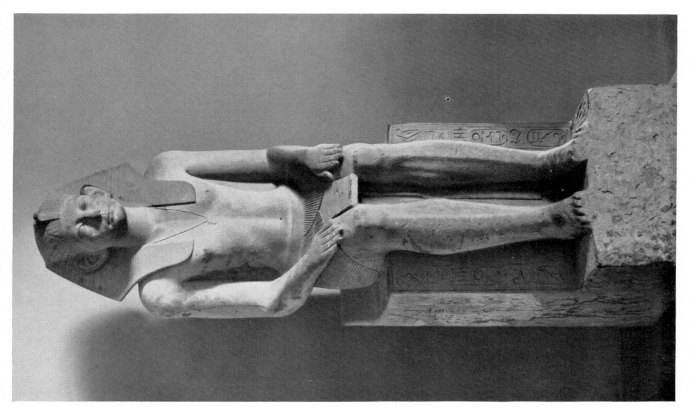

Pl. 349. *Left*: King Amenemhet III, from Hawara, Fayum, ca. 1800 B.C. Limestone. *Right*: King Sesostris I, detail, from Lisht, ca. 1930 B.C. Limestone, ht., 5 ft., 3 in. Both, Cairo, Egyptian Museum.

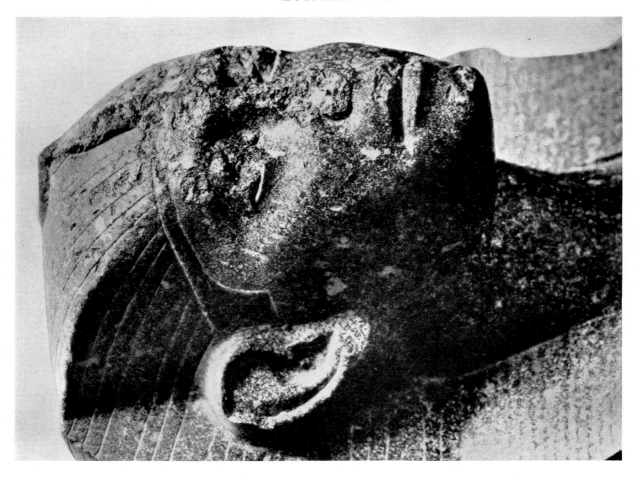

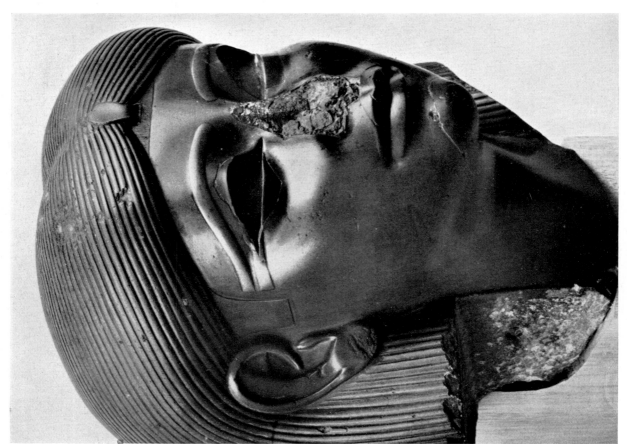

Pl. 350. *Left:* Head of a sphinx, ca. 1900 B.C. Schist, ht., 15³/₈ in. New York, Brooklyn Museum. *Right:* Head of Sesostris III, detail of a statue from Medamud, ca. 1860 B.C. Diorite. Paris, Louvre.

Pl. 351. Detail of painted wooden sarcophagus of Prince Djehuty-nekht, from El Bersheh, ca. 1850 B.C. Boston, Museum of Fine Arts.

Pl. 352. Painted bas-relief from the tomb of Prince Djehuty-hetep at El Bersheh, detail showing a daughter of the prince, ca. 1850 B.C. Cairo, Egyptian Museum.

Pl. 353. Amenemhet III, detail, from Mit Faris, Fayum, ca. 1820 B.C. Diorite; ht. of face, 10¹/₄ in. Cairo, Egyptian Museum.

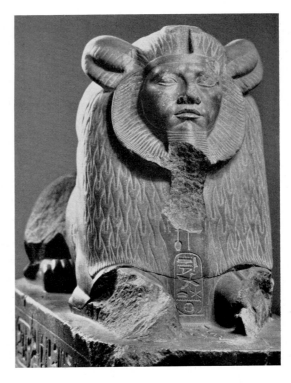

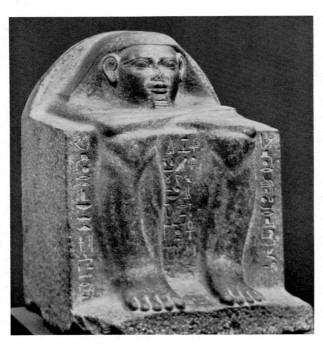

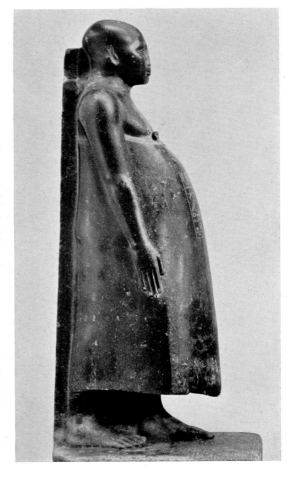

Pl. 354. *Above, left*: Khertihotep, ca. 1850 B.C. Quartzite, ht., 29¹/₂ in. Berlin, Staatliche Museen. *Right*: Sphinx of Amenemhet III, from Tanis, ca. 1820 B.C. Diorite, ht., 39³/₈ in. *Below, left*: Cube statue of Hetep from Saqqara, ca. 1980 B.C. Grey granite, ht., 29¹/₈ in. Both, Cairo, Egyptian Museum. *Right*: Sebekemsaf, from Armant, ca. 1750 B.C. Black granite, ht., 4 ft., 11¹/₈ in. Vienna, Kunsthistorisches Museum.

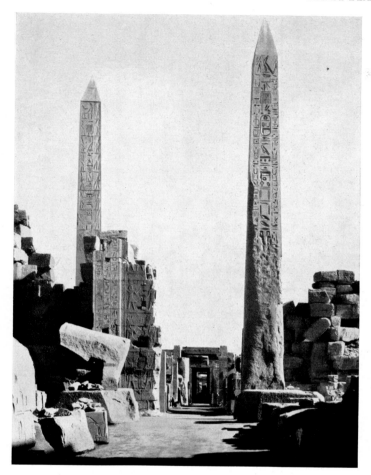
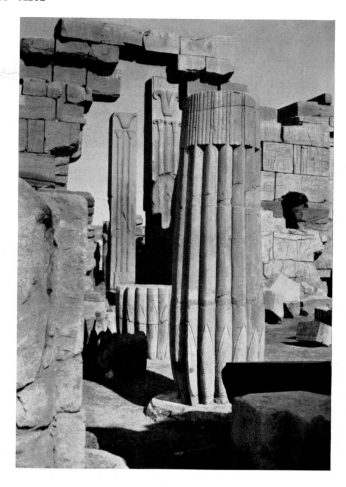

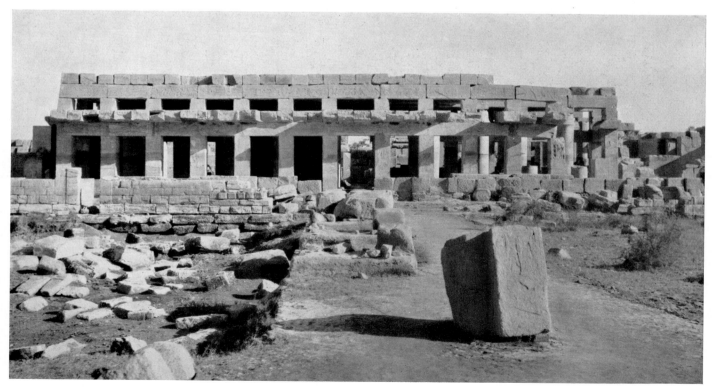

Pl. 355. Karnak, temple of Amen, 18th dynasty. *Above, left*: Pylon and obelisk of King Thutmosis I and obelisk of Queen Hatshepsut, ca. 1500 B.C. *Right*: South courtyard and Hall of the Annals of Thutmosis III, ca. 1450 B.C. *Below*: Ceremonial temple of Thutmosis III, western façade, ca. 1450 B.C.

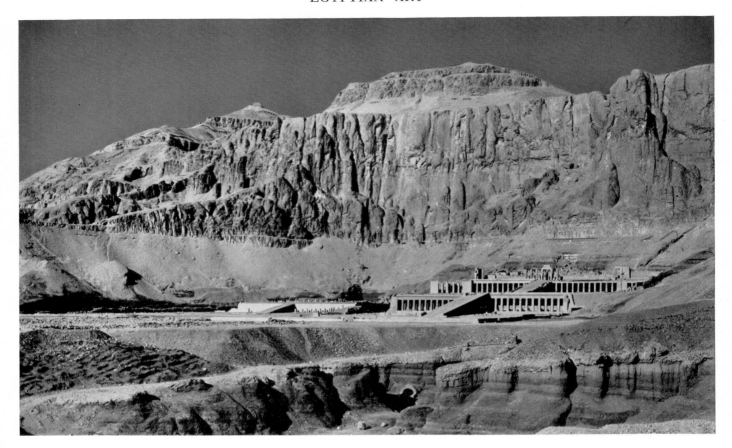

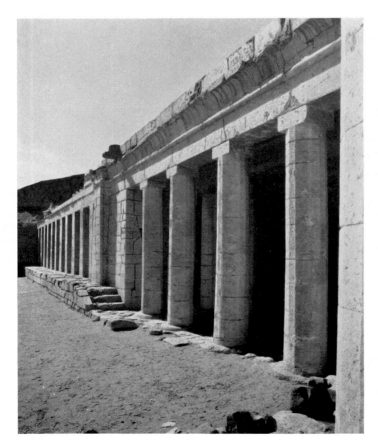

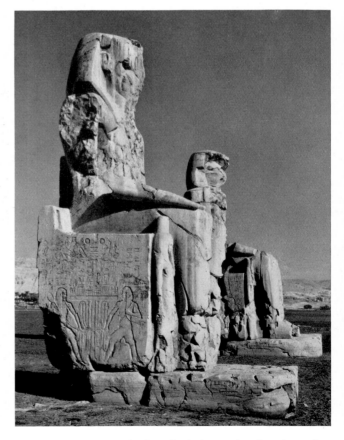

Pl. 356. *Above*: Deir el-Bahri, near Thebes, temple of Queen Hatshepsut, ca. 1480 B.C. *Below, left*: Detail of above, showing the atrium of the Anubis sanctuary and the Hall of Birth. *Right*: Seated statues of Amenhotep III, known as the "Colossi of Memnon," near Thebes, ca. 1380 B.C. Quartzite; original ht., ca. 64 ft.

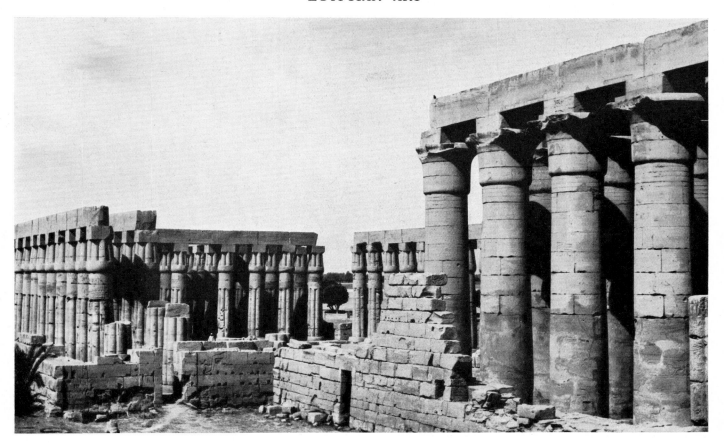

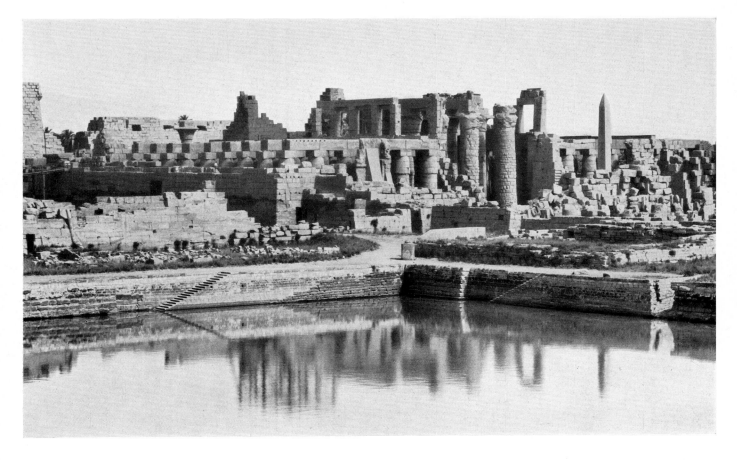

Pl. 357. *Above*: Luxor, temple of Amen-Mut-Khonsu, the great courtyard and the colonnade of King Amenhotep III, ca. 1400 B.C. *Below*: Karnak, the sacred lake and temple of Amen, 1312–1235 B.C.

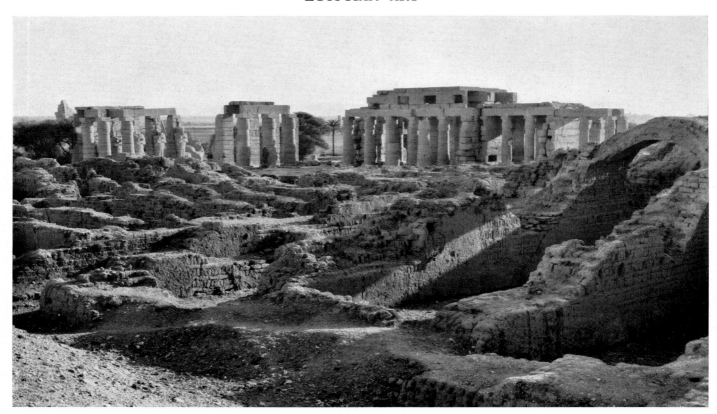

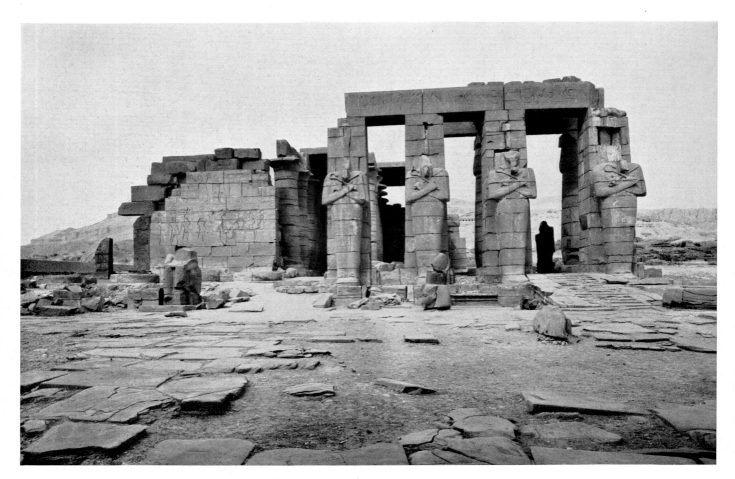

Pl. 358. Thebes, funerary temple of King Ramses II, known as the "Rameseum," ca. 1250 B.C. *Above*: View of the storerooms and the temple. *Below*: View of the Hypostyle Hall with Osiride statues facing the second courtyard.

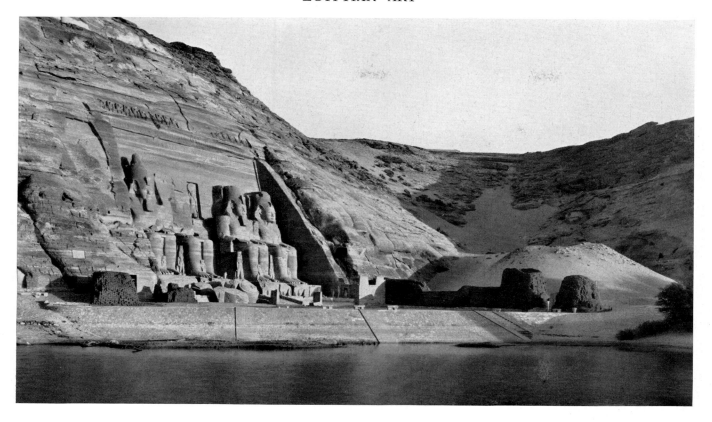

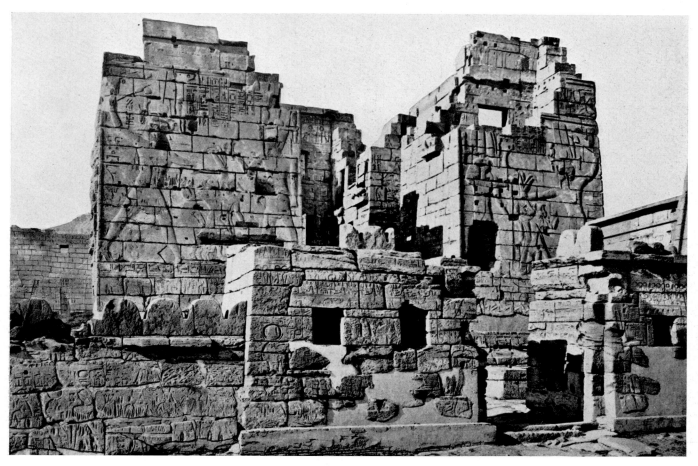

Pl. 359. *Above*: Abu Simbel, the rock-cut temple of Ramses II, with colossal seated statues of the king, ca. 1250 B.C. *Below*: Medinet Habu, Thebes, the fortified gate in the outer enclosure of the temple of Ramses III, ca. 1180 B.C.

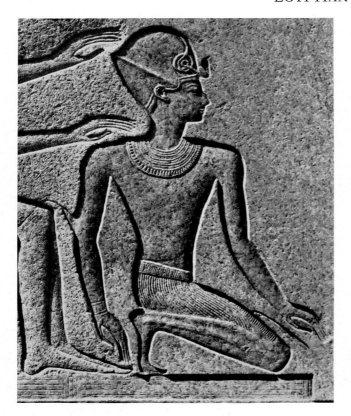

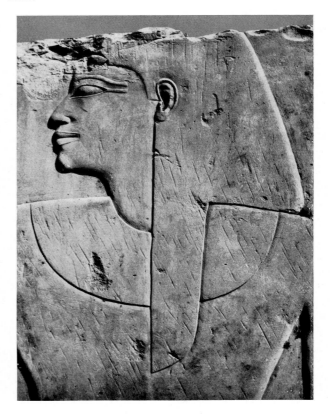

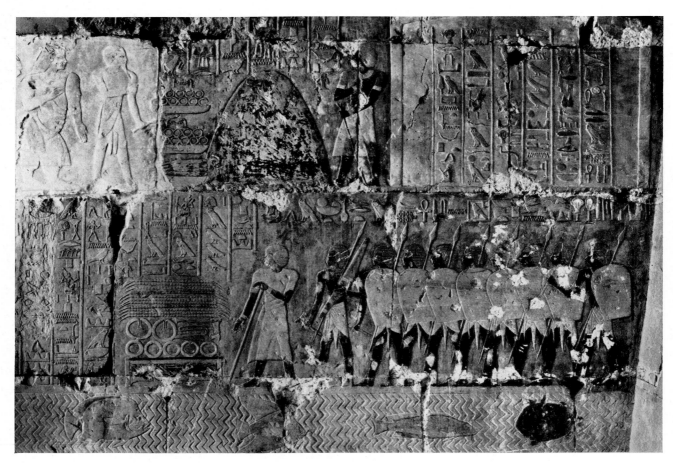

Pl. 360. *Above, left*: Queen Hatshepsut, detail of relief on the cusp of the fallen obelisk of the queen at Karnak, ca. 1480 B.C. *Right*: King Amenhotep I, fragment of a relief from his temple near Karnak, ca. 1550 B.C. *Below*: The arrival of the Egyptian embassy in Punt, relief in the temple of Queen Hatshepsut at Deir el-Bahri, near Thebes, ca. 1480 B.C.

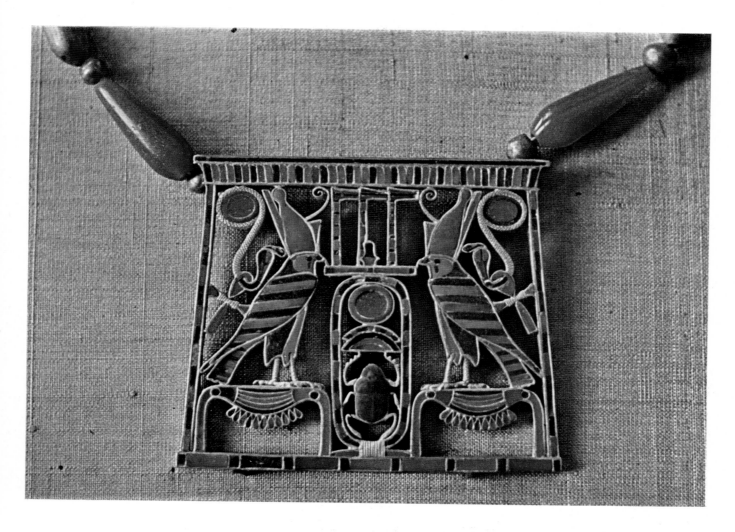

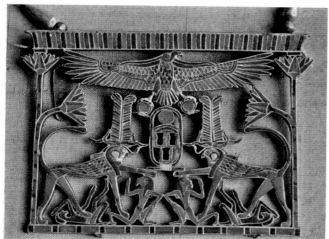

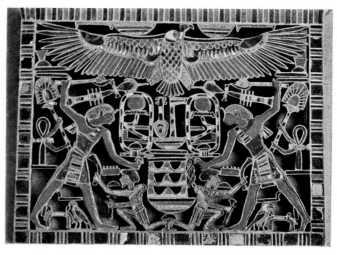

Pl. 361. Pectorals with names of Kings Sesostris II, Sesostris III, and Amenemhet III, from Dahshur, ca. 1890–1800 B.C. Gold and semiprecious stones. Cairo, Egyptian Museum.

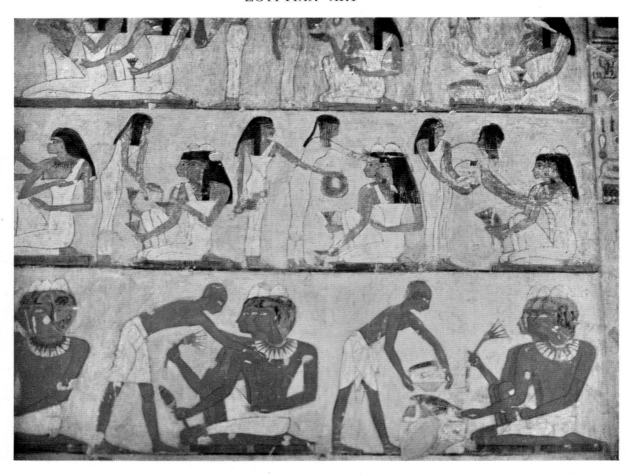

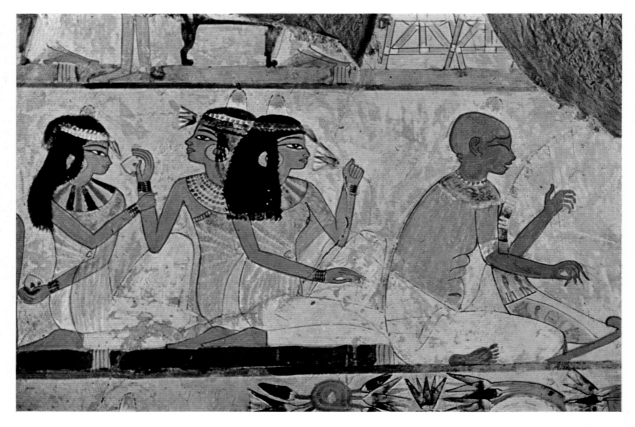

Pl. 362.  *Above*: Festival scenes, wall painting in the tomb of Rekhmira in the necropolis at Thebes, ca. 1435 B.C.
*Below*: Festival scene, detail of wall painting in the tomb of Nakht in the necropolis at Thebes, ca. 1420 B.C.

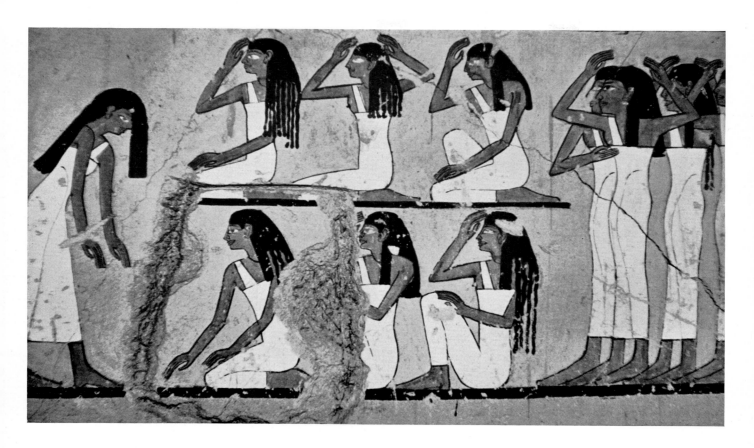

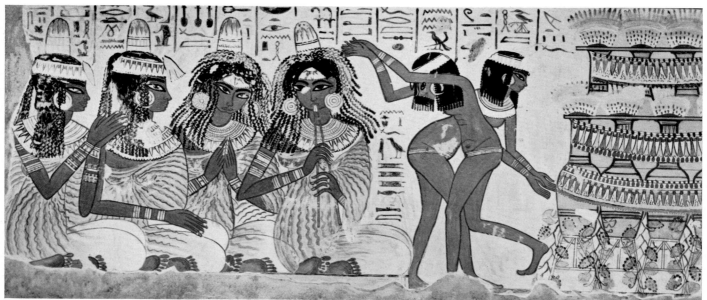

Pl. 363. *Above*: Weeping women, wall painting in the tomb of Minnakht in the necropolis at Thebes, ca. 1480 B.C. *Below*: Musicians and dancers, wall painting from a tomb in the necropolis at Thebes, ca. 1400 B.C. London, British Museum.

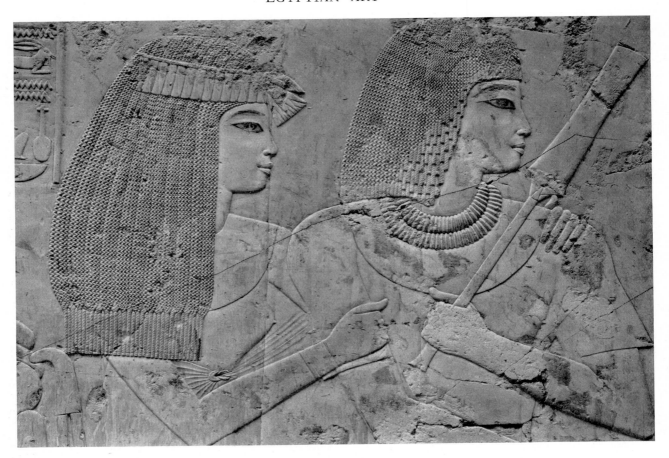

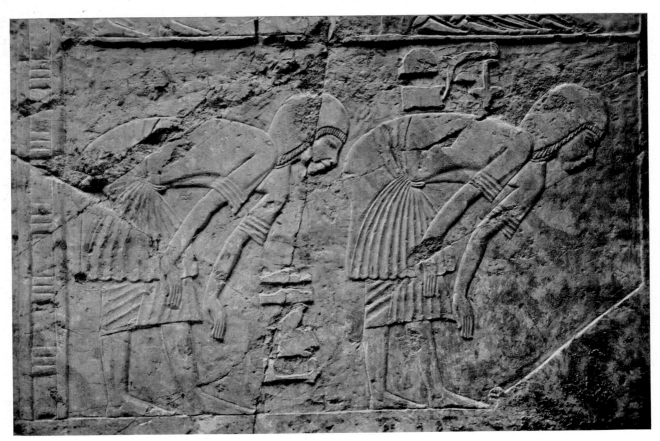

Pl. 364. Details of wall reliefs in the Hall of Pillars in the tomb of the vizier Ramose in the necropolis at Thebes, ca. 1370 B.C. *Above*: The brother of Ramose and his wife. *Below*: Servants bowing at an audience.

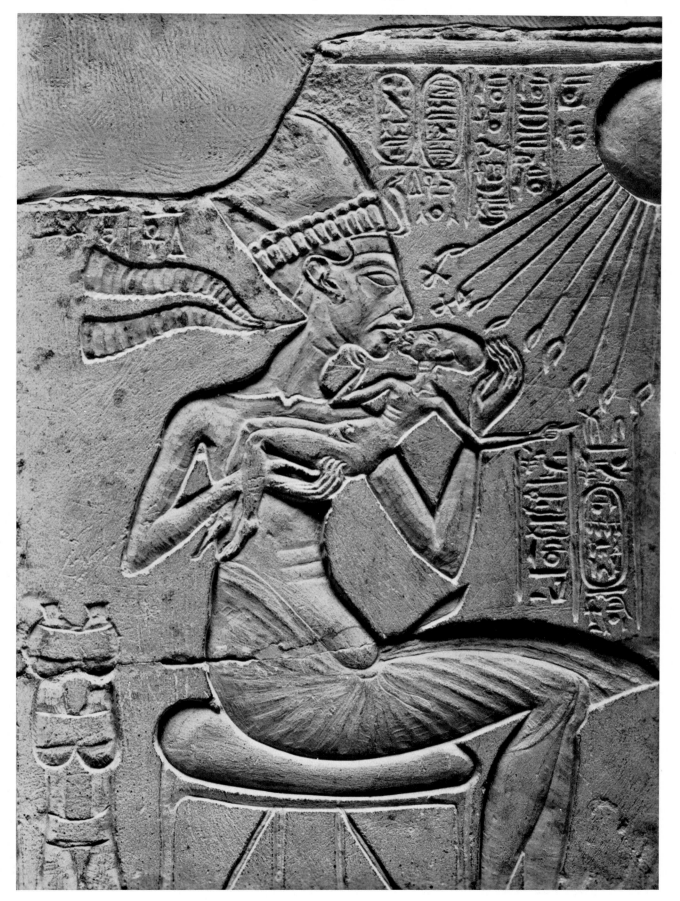

Pl. 365. King Akhenaten with his daughter under the rays of Aten, detail of a relief on an altar from Tell el 'Amarna, ca. 1360 B.C. Limestone. Berlin, Staatliche Museen.

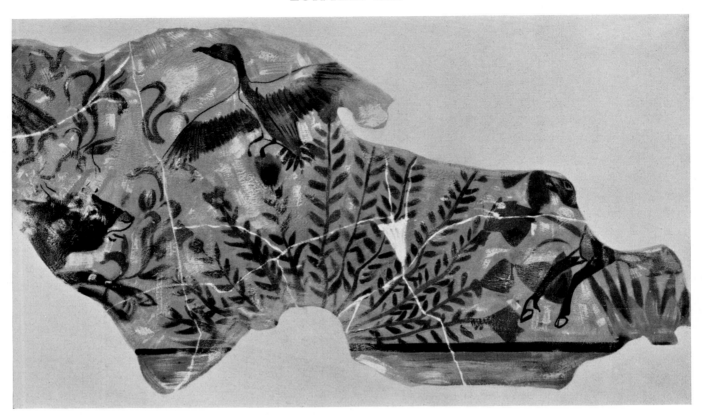

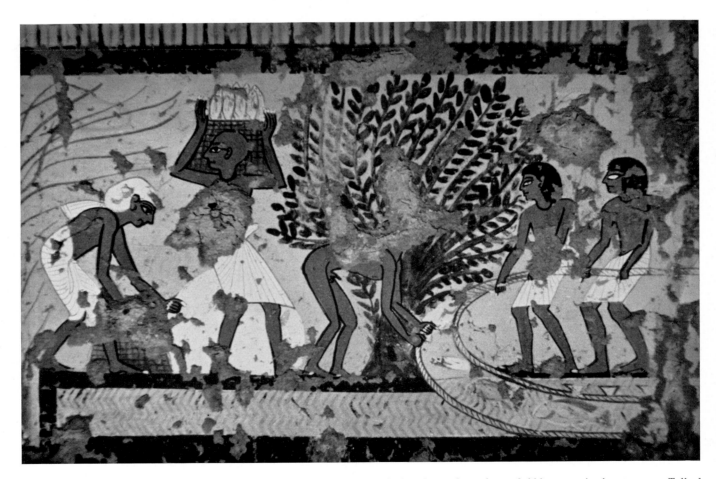

Pl. 366. *Above*: Ducks and calves among bushes, fragment of floor painting from the palace of Akhenaten in Awata, near Tell el 'Amarna, ca. 1365 B.C. Cairo, Egyptian Museum. (From a copy by Reach.) *Below*: Fishing scene, detail of a painting on stucco in the tomb of the sculptor Ipi at Deir el-Medineh, ca. 1250 B.C.

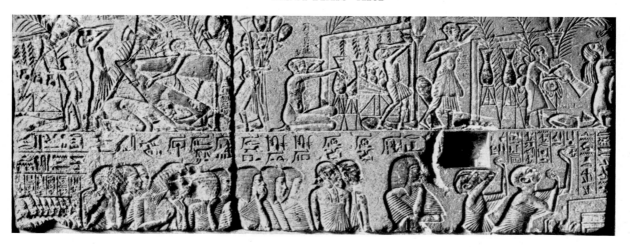

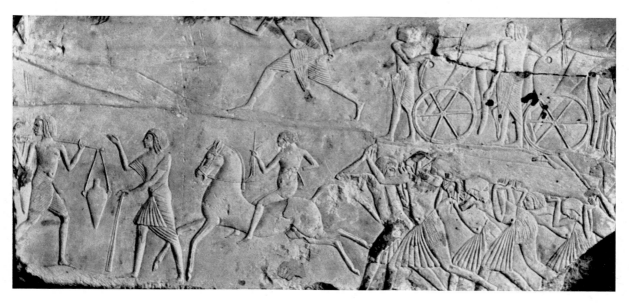

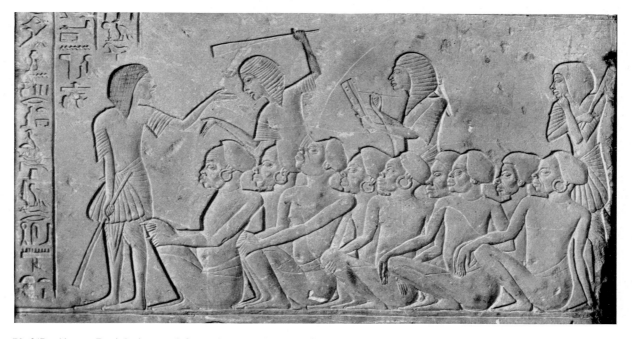

Pl. 367. *Above*: Burial rites and funeral procession, relief from a tomb in Memphis, ca. 1335 B.C. Limestone, l., 4 ft., 3 1/8 in. Berlin, Staatliche Museen. *Center and below*: Camp scene and Negro prisoners with Egyptian guards, reliefs from the tomb of Horemheb in Memphis, ca. 1355 B.C. Limestone. Bologna, Museo Civico.

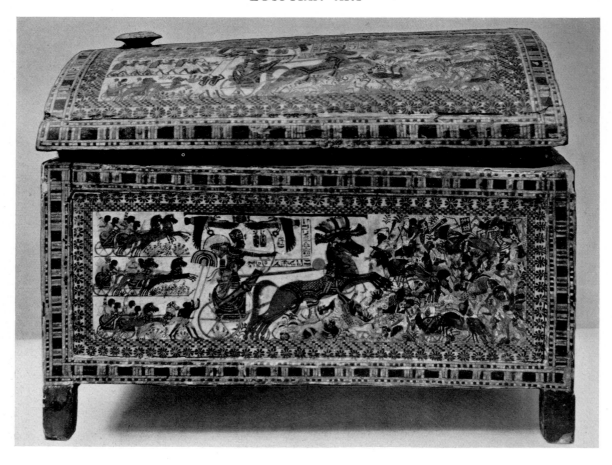

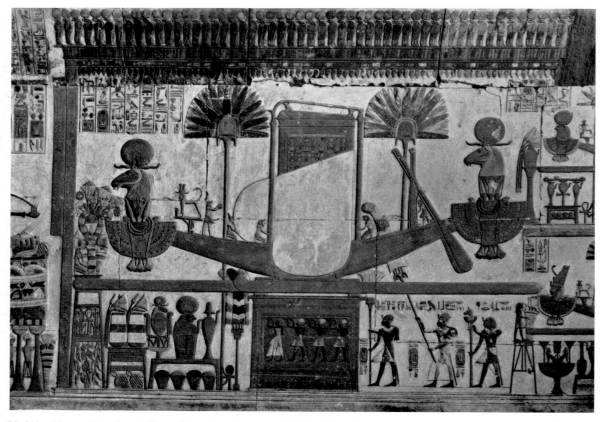

Pl. 368. *Above*: Wooden coffer with painted scene showing King Tutankhamen triumphing over Asian enemies, from the tomb of Tutankhamen, Valley of the Kings, Thebes, ca. 1350 B.C. L., ca. 19³/₄ in. Cairo, Egyptian Museum. *Below*: Amen's boat, painted relief in the chapel of Amen, temple of Seti I, Abydos, ca. 1300 B.C.

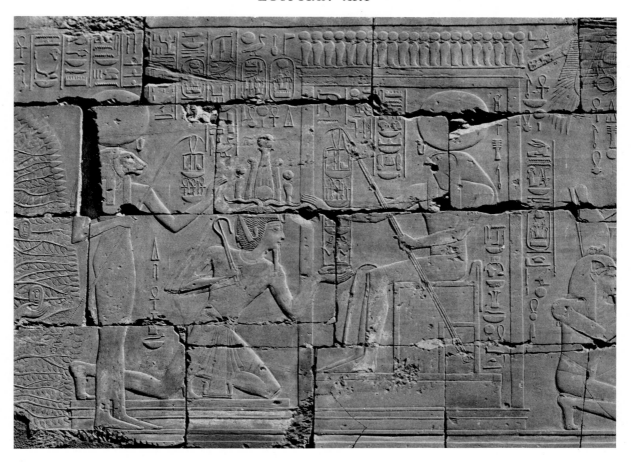

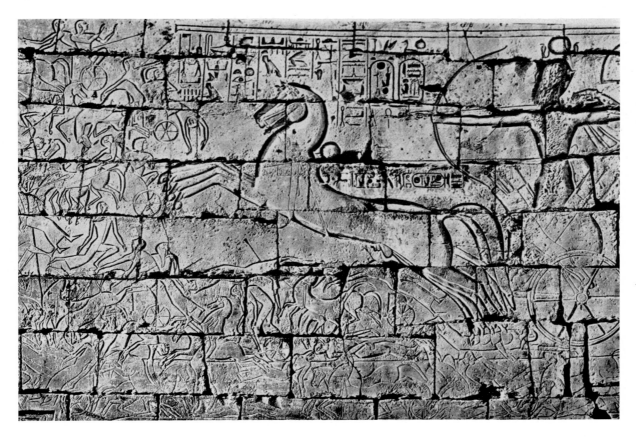

Pl. 369. *Above*: King Seti I before Ra-Horakhte, wall relief from the Hypostyle Hall at Karnak, ca. 1300 B.C. *Below*: Ramses II at the Battle of Kadesh, detail of a relief on the pylon of the "Rameseum" at Thebes, ca. 1285 B.C.

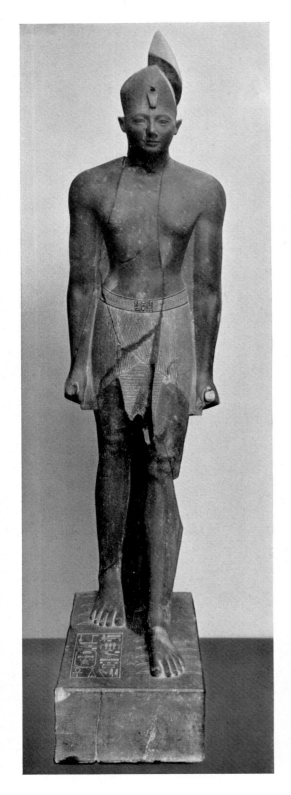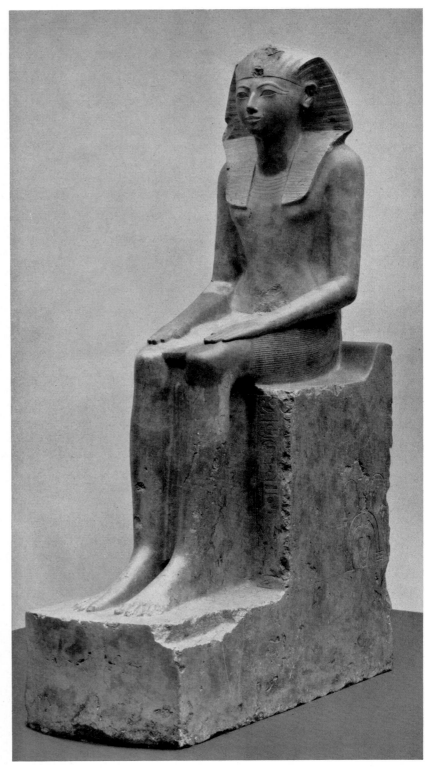

Pl. 370. *Left*: King Thutmosis III, from Karnak, ca. 1450 B.C. Schist, ht., 6 ft., 6³/₄ in. Cairo, Egyptian Museum. *Right*: Queen Hatshepsut, from her temple at Deir el-Bahri, near Thebes, ca. 1480 B.C. Limestone, life size. New York, Metropolitan Museum.

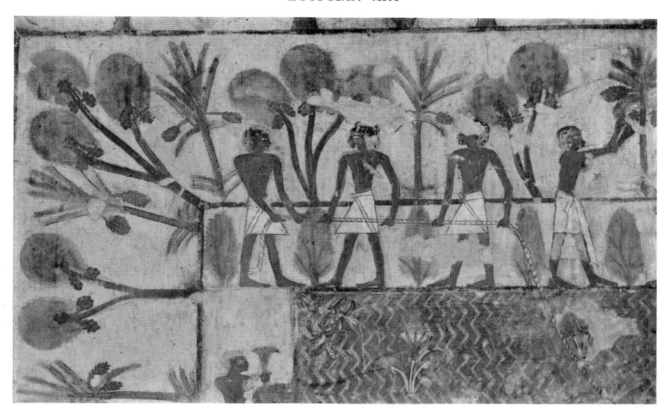

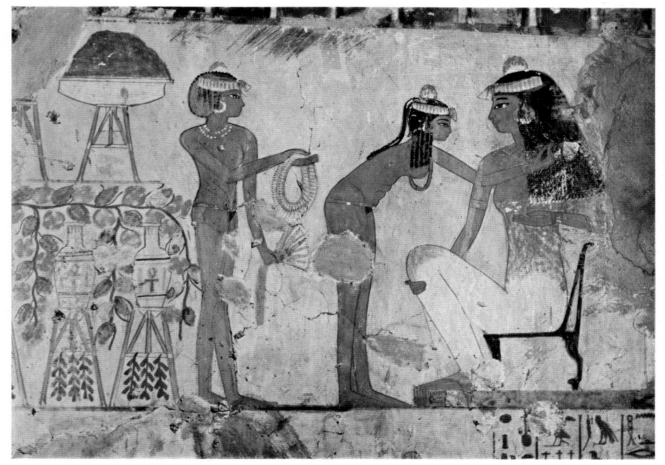

Pl. 371. *Above*: Garden, detail of the feast of the dead, painting on stucco in the tomb of Rekhmira in the necropolis at Thebes, ca. 1435 B.C. *Below*: Preparation of a feast, detail of a wall painting in the tomb of Djeserkura in the necropolis at Thebes.

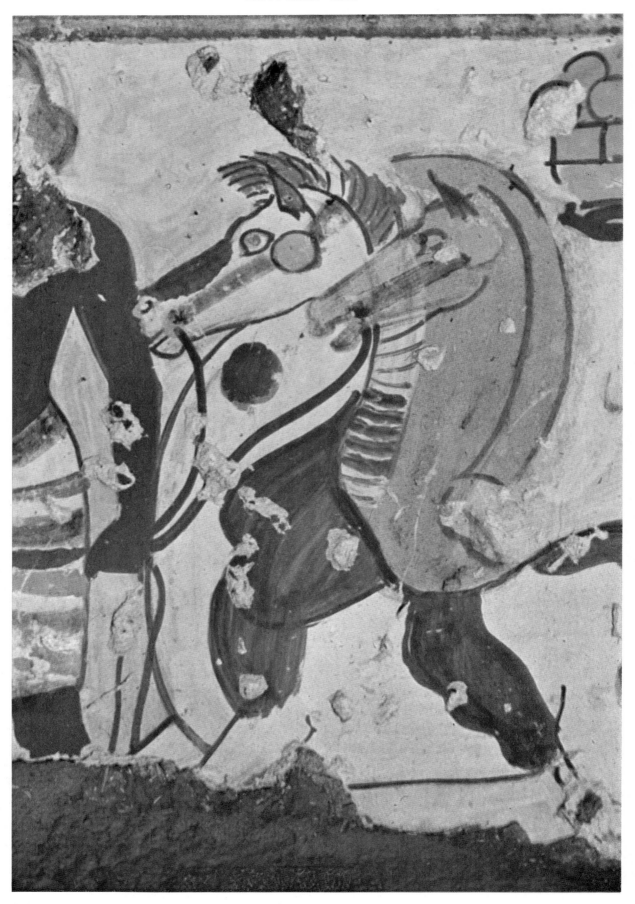

Pl. 372. Tribute of Syrian horses to the Egyptian king, detail, painting on stucco in the tomb of Nebamun in the necropolis at Thebes, ca. 1400 B.C.

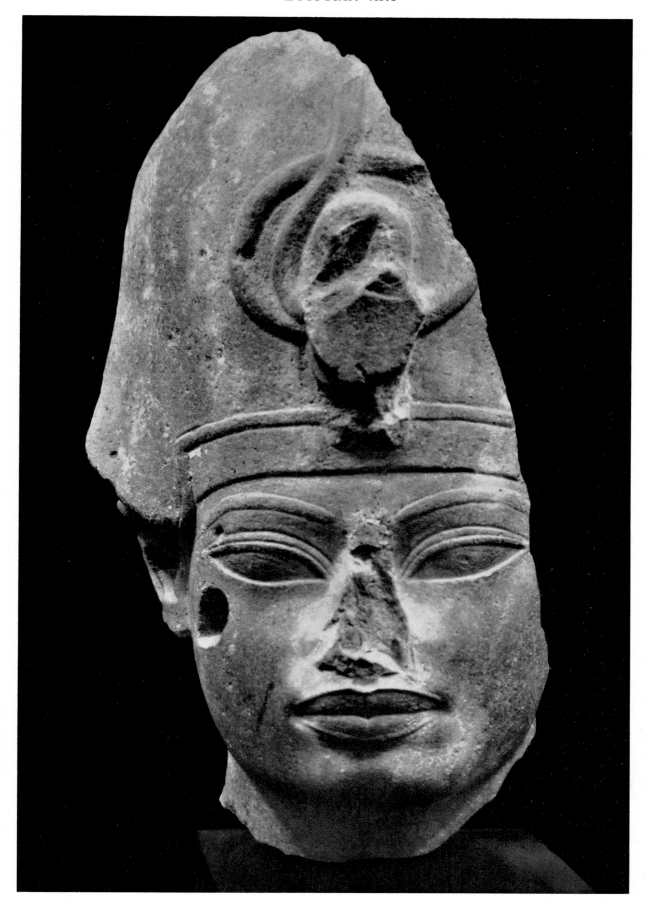

Pl. 373.  Head of Amenhotep III, from Memphis, ca. 1380. B.C. Quartzite, ht., 13⅝ in. New York, Metropolitan Museum.

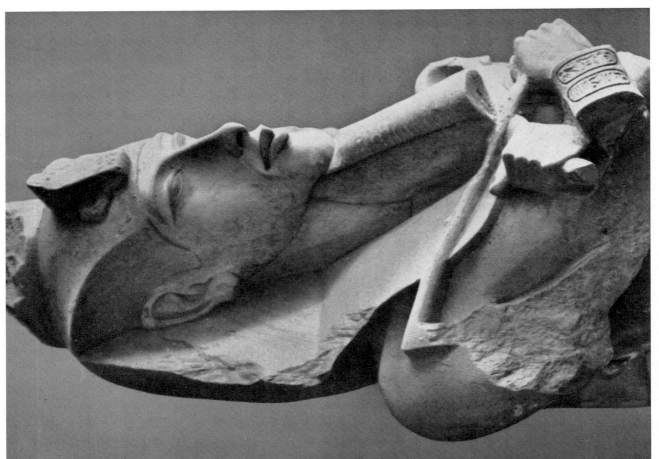

Pl. 374. *Left:* King Akhenaten, upper part of a colossal statue from the temple of Aten at Karnak, ca. 1365 B.C. Sandstone. Cairo, Egyptian Museum. *Right:* Torso of a princess, fragment of a small group from a sculptor's atelier in Tell el 'Amarna, ca. 1360 B.C. Quartzite, ht., 5⅞ in. London, University, Museum of Egyptology.

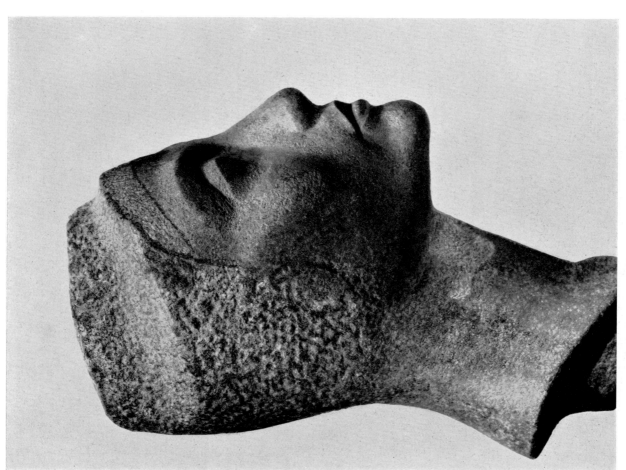

PL. 375. *Left:* Queen Nefertiti, unfinished head from a sculptor's atelier in Tell el 'Amarna, ca. 1350 B.C. Quartzite, ht., 13 in. Cairo, Egyptian Museum. *Right:* Mask, from a sculptor's atelier in Tell el 'Amarna, ca. 1350 B.C. Plaster, ht., 9½ in. Berlin, Staatliche Museen.

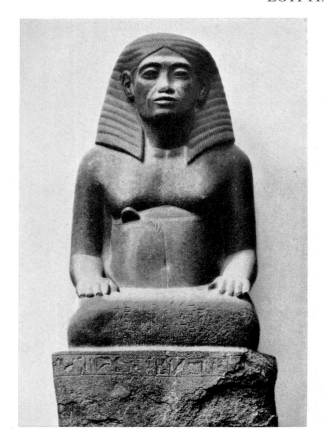 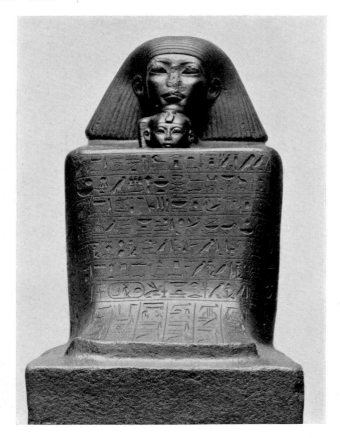

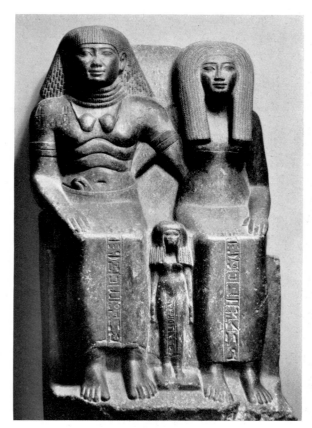 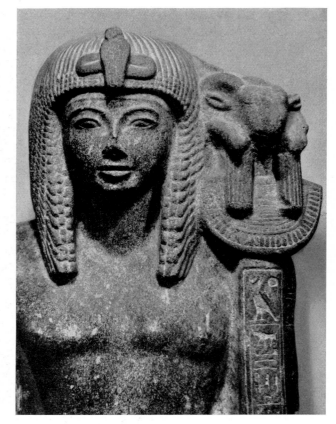

Pl. 376. *Above, left*: Amenhotep, son of Hapu, represented as a scribe, ca. 1400 B.C. Black stone, ht., 4 ft., 3¹/₈ in. Cairo, Egyptian Museum. *Right*: Cube statue of Senmut with Princess Nefrura, from Thebes, ca. 1480 B.C. Black stone, ht., 39³/₈ in. Berlin, Staatliche Museen. *Below, left*: Sennefer with his consort and his daughter, from Karnak, ca. 1410 B.C. Black granite, ht., 47¹/₄ in. *Right*: King Ramses III, detail of a statue from Mit Rahina, ca. 1180 B.C. Granite. Last two, Cairo, Egyptian Museum.

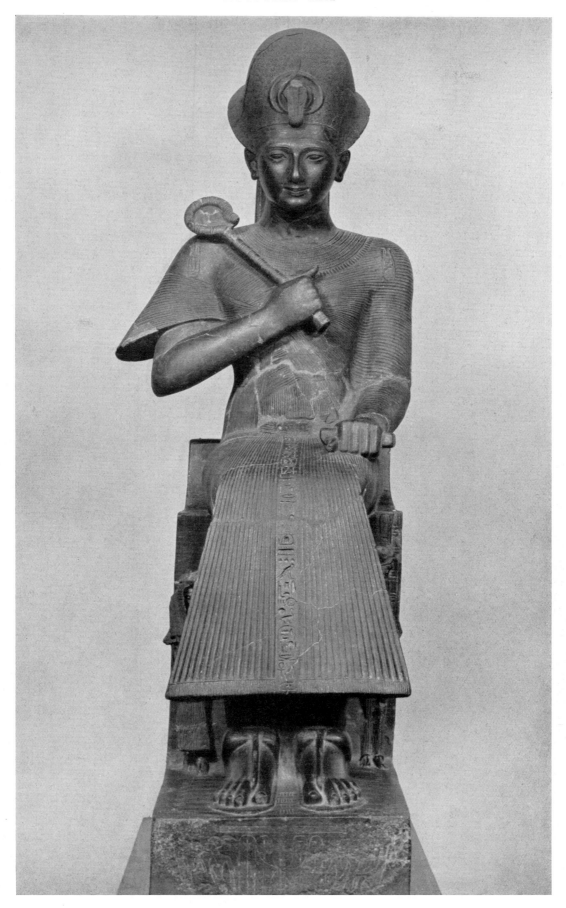

Pl. 377. Ramses II, from Karnak, ca. 1290 B.C. Black basalt, ht., 6 ft., 4³/₈ in. Turin, Museo Egizio.

Pl. 378. *Above, left*: Unguent dish in the form of a Syrian prisoner carrying a burden, New Kingdom. Wood. Paris, Louvre. *Center*: Mirror handle, ca. 1350 B.C. Wood, ht., 6¼ in. Bologna, Museo Civico. *Below*: Girls swimming among fish and water birds, detail of vase, from Tanis, ca. 1050 B.C. Silver repoussé with center decoration in gold. Cairo, Egyptian Museum. *Right*: Queen Karomama, from Thebes, 9th cent. B.C. Bronze damascened with gold and silver, ht., 23¼ in. Paris, Louvre.

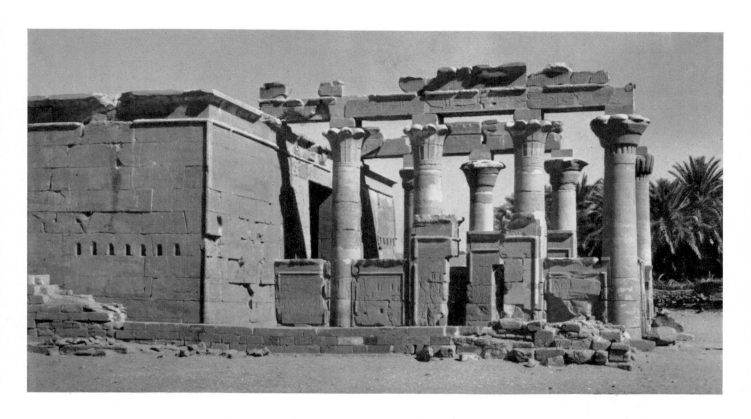

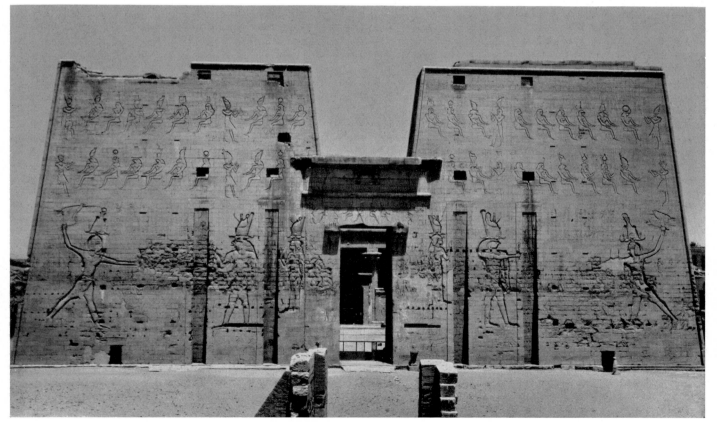

Pl. 379. *Above*: Temple of Hibis in the Khārga oasis, 5th–4th cent. B.C. *Below*: Pylon of temple of Horus at Edfu, 3d–1st cent. B.C.

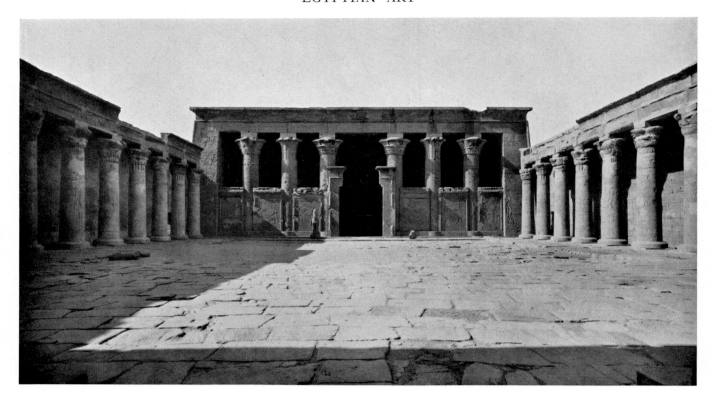

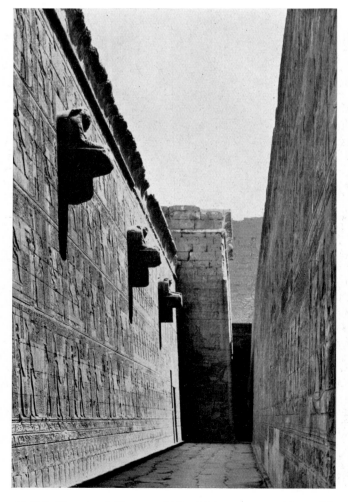

Pl. 380. Temple of Horus at Edfu, 3d–1st cent. B.C. *Above*: The great court and atrium. *Below, left*: Western interior ambulatory. *Right*: Sanctuary containing the naos.

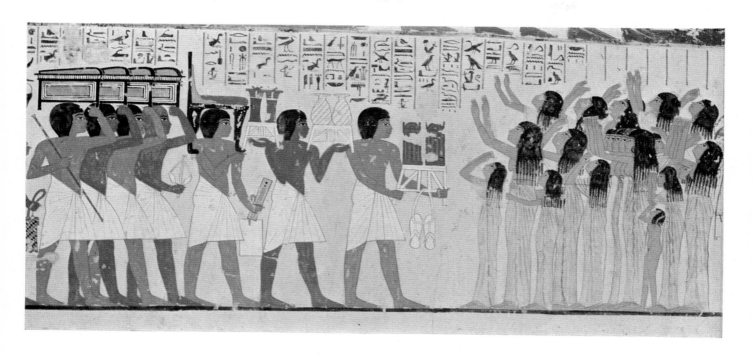

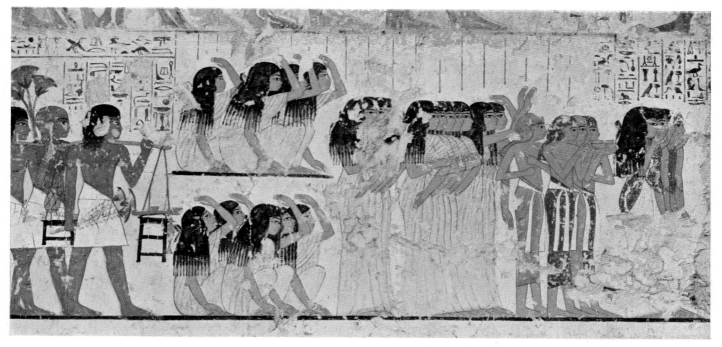

Pl. 381. Funeral scenes, details of a painted wall frieze in the tomb of Ramose in the necropolis at Thebes, ca. 1370 B.C.

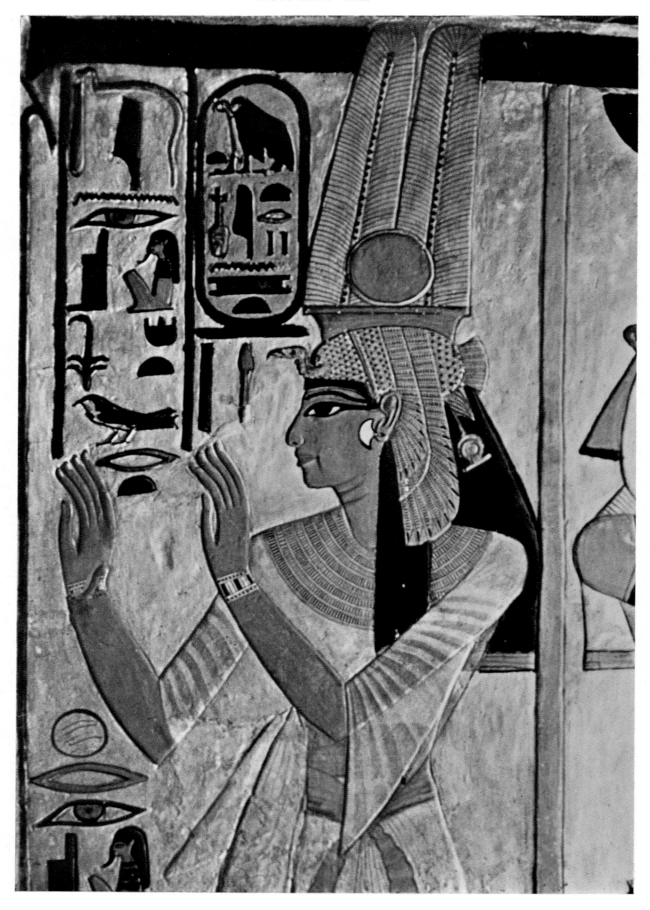

Pl. 382. Queen Nofretari, detail of a painted bas-relief in her tomb in the Valley of the Queens at Thebes, ca. 1250 B.C.

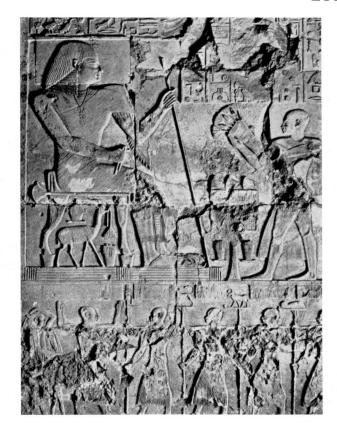

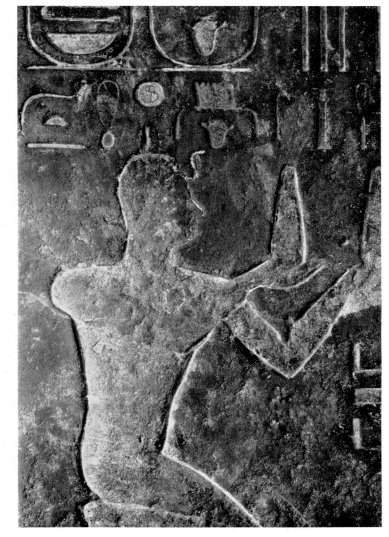

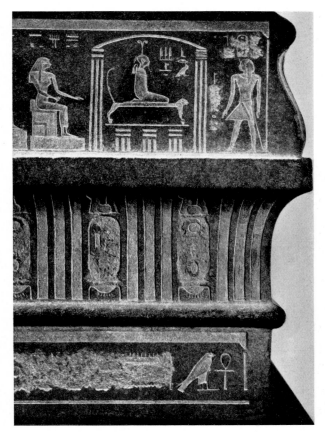

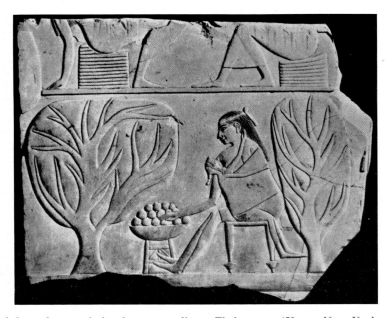

Pl. 383. *Above, left*: Sacrifice before Pabasa, detail of a relief from her tomb in the necropolis at Thebes, ca. 650 B.C. New York, Metropolitan Museum. *Right*: Psamtik I offering a sacrifice, detail of a relief from Rosetta (Rashid), ca. 630 B.C. Basalt. London, British Museum. *Below, left*: Mythological representations, detail of a chest of Amasis, from Benha, ca. 540 B.C. Cairo, Egyptian Museum. *Right*: Woman nursing her child under a fruit tree, fragment of a relief from the tomb of Mentuemhat in the necropolis of Thebes, ca. 650 B.C. New York, Brooklyn Museum.

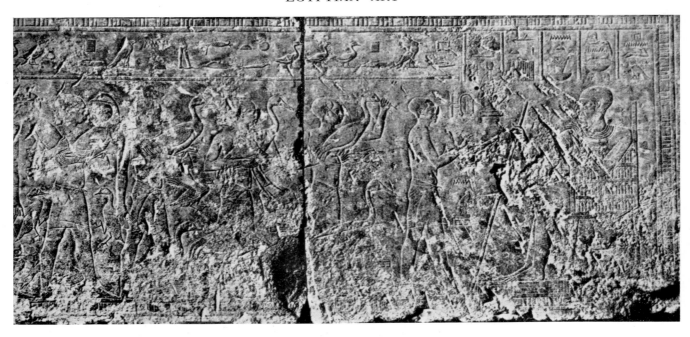

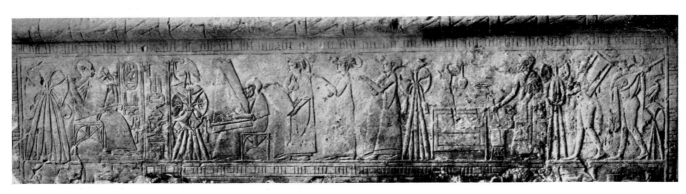

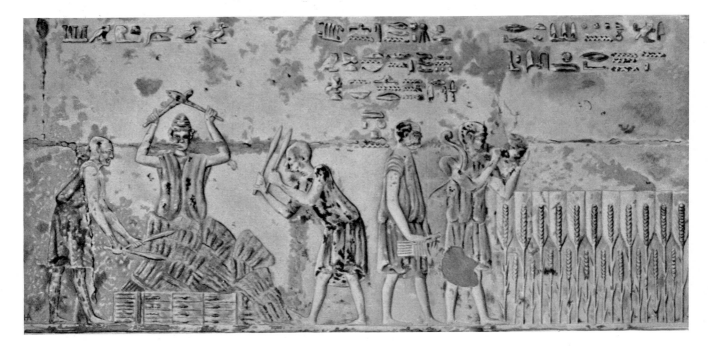

Pl. 384. *Above*: Relief of Henat, from Memphis, ca. 530 B.C. Limestone, l., 6 ft., 6 in. Berlin, Staatliche Museen. *Center*: Relief of Tanefer, from Memphis, 4th cent. B.C. Limestone, l., 45¹/₄ in. Alexandria, Greco-Roman Museum. *Below*: Harvest scene, painted relief in the tomb of Petosiris, near Hermopolis, ca. 300 B.C. (Photographed from a reproduction.)

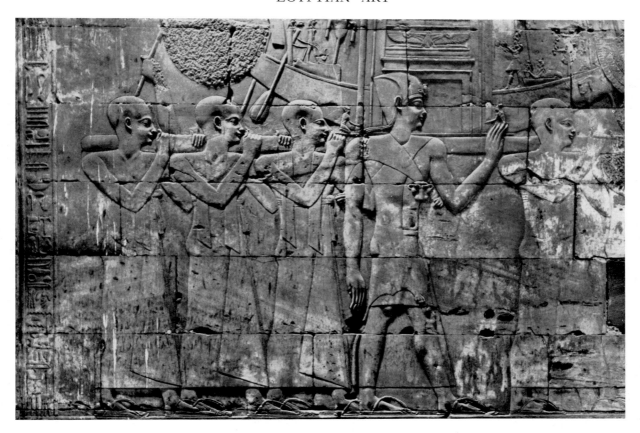

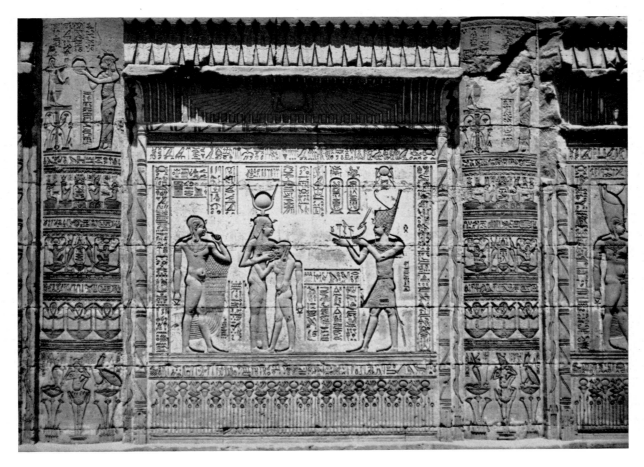

Pl. 385. *Above*: Boats carried in procession, detail of a relief in the temple of Horus at Edfu, 2d cent. B.C. *Below*: The emperor Trajan offering a sacrifice to gods, relief in the "Birth House" in Dendera, 2d cent.

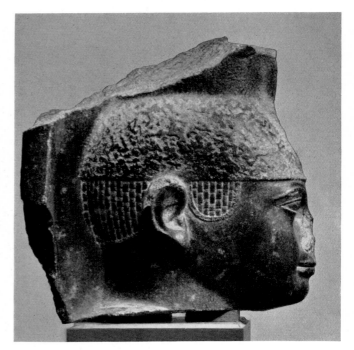

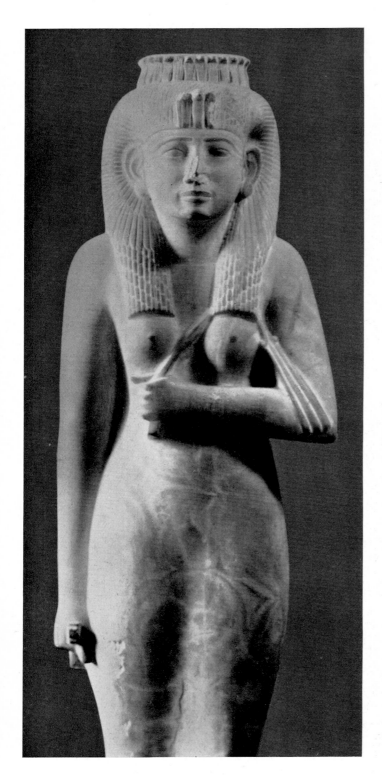

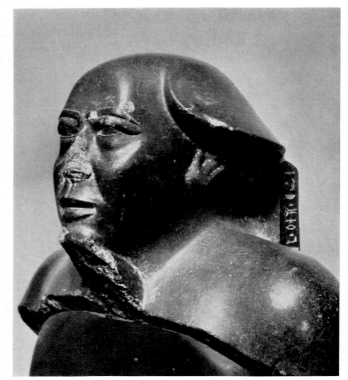

Pl. 386. *Left*: The "wife of the god" Amenirdis, from Karnak, ca. 700 B.C. Alabaster, life size. *Right, above*: Head of King Taharqa, from Thebes, ca. 670 B.C. Black diorite, ht., 13³/₄ in. *Below*: Head of Mentuemhat, from Karnak, 7th cent. B.C. Black diorite, ht., 18¹/₈ in. All, Cairo, Egyptian Museum.

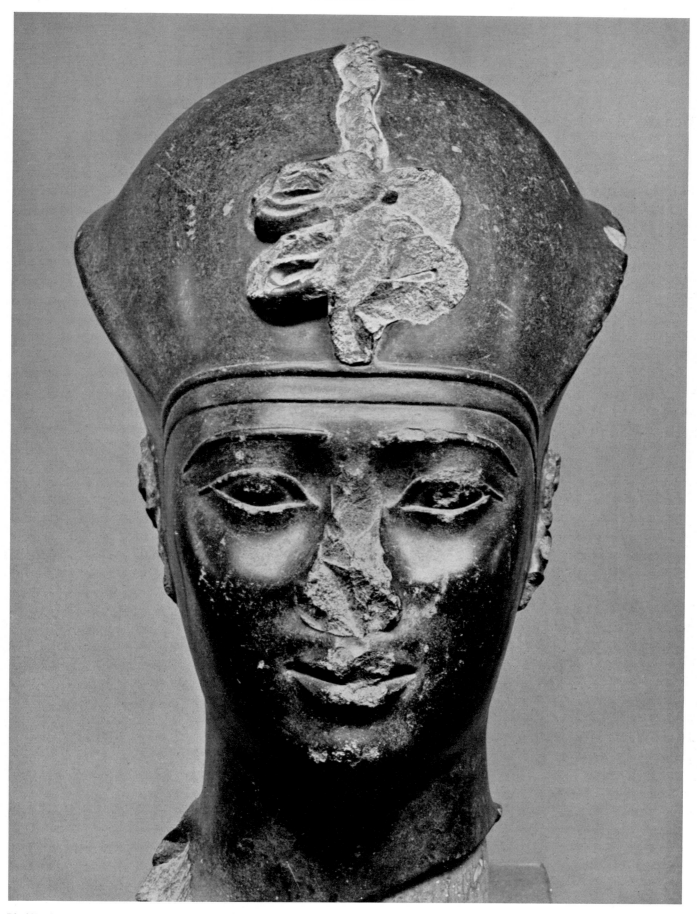

Pl. 387.  Head of King Apries, ca. 575 B.C. Black diorite, ht., 15 3/4 in. Bologna, Museo Civico.

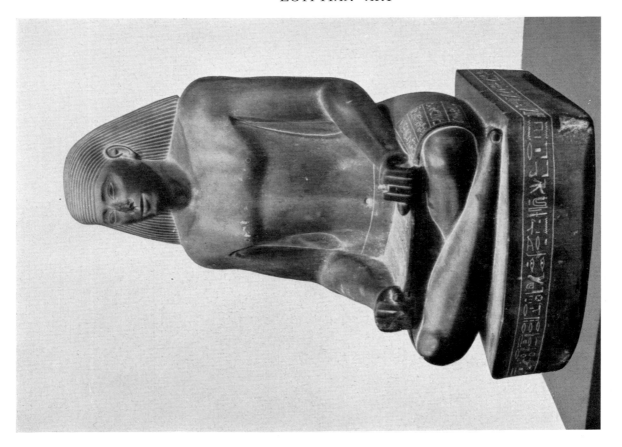

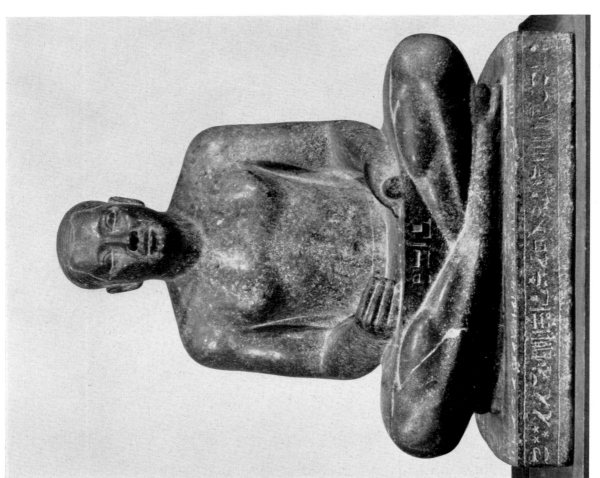

Pl. 388. *Left*: Petamenopet as a scribe, from Karnak, ca. 650 B.C. Quartzite, ht., 29½ in. *Right*: Nespekashuti as a scribe, from Karnak, ca. 590 B.C. Green schist. Both, Cairo, Egyptian Museum.

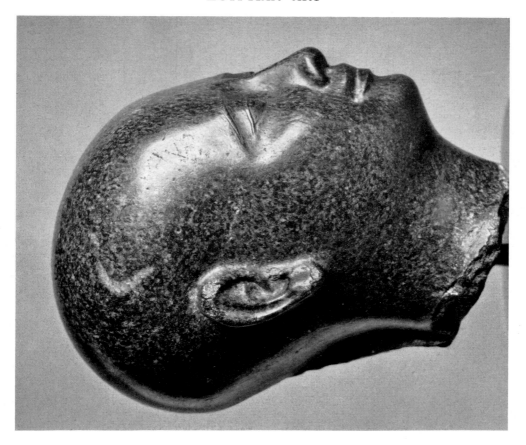

Pl. 389. *Left:* Head of a priest, 4th cent. B.C. Green schist, ht., 5⁷/₈ in. New York, Brooklyn Museum. *Right:* Head of a priest, ca. 260 B.C. Diorite, ht., 8⁵/₈ in. Berlin, Staatliche Museen.

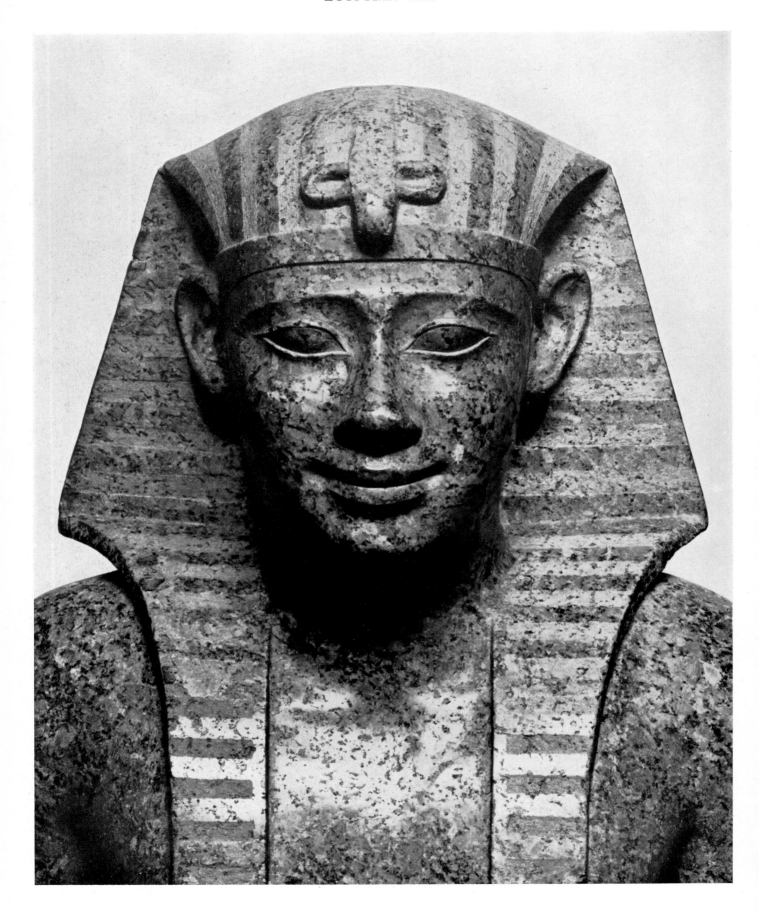

Pl. 390. Ptolemy II Philadelphus, detail of a colossal statue from Heliopolis, ca. 260 B.C. Red granite. Rome, Vatican Museums.

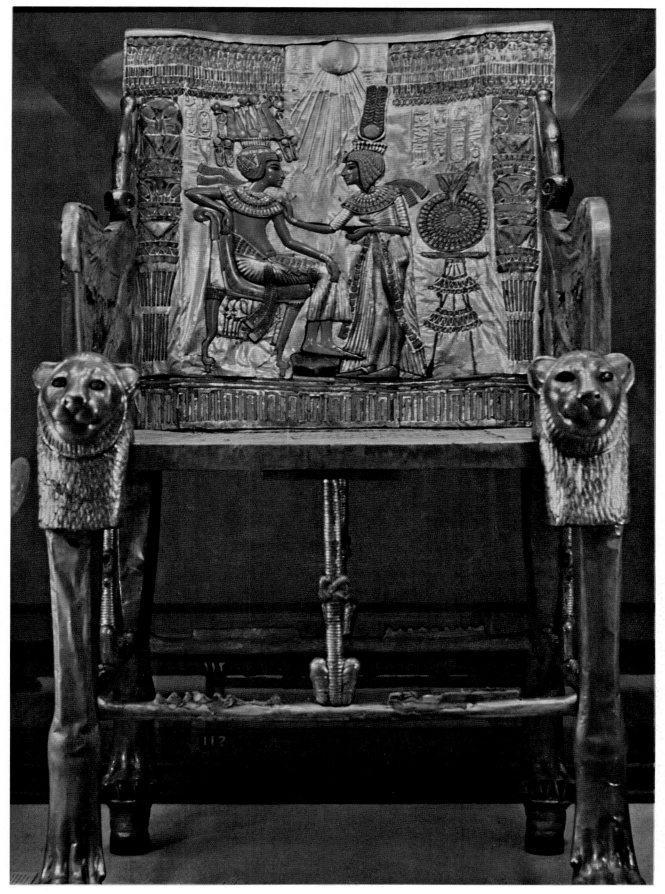

Pl. 391. Throne of Tutankhamen, from his tomb in the Valley of the Kings at Thebes, 1352–1346 B.C. Wood covered with gold leaf and inlaid with colored ceramic. Cairo, Egyptian Museum.

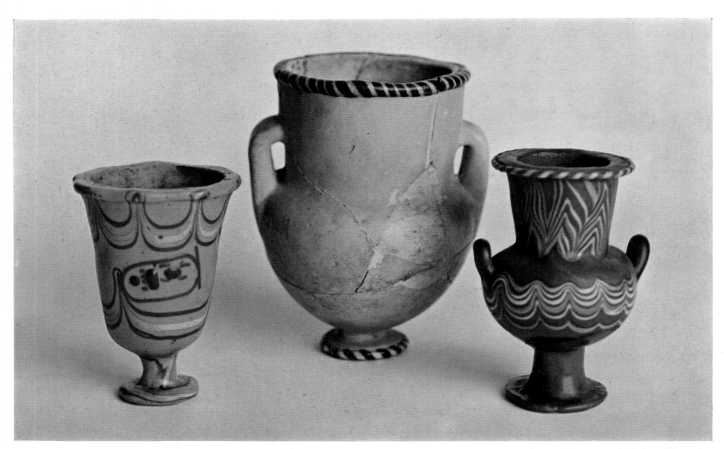

Pl. 392. *Above*: Sarcophagus of Petosiris, detail, ca. 300 B.C. Hieroglyphics of polychrome enamels set into wood. Cairo, Egyptian Museum. *Below*: Vases of colored glass, 18th–19th dynasty. Munich, Ägyptische Staatssammlung.

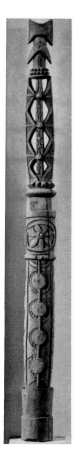
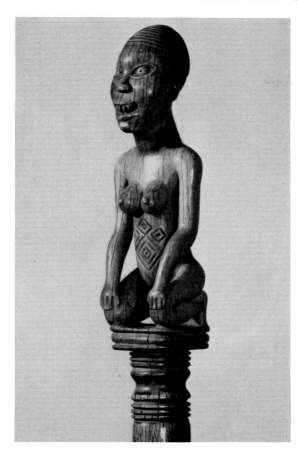
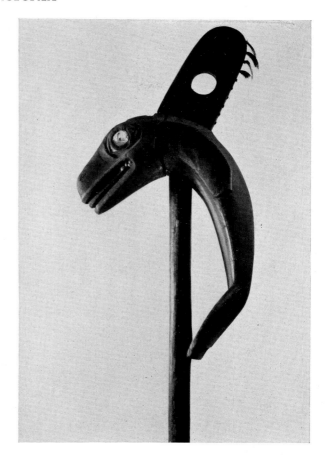

Pl. 393. *Above, left*: Ornamental post of a chief's house, from St. Matthias islands, Melanesia. Wood. Hamburg, Museum für Völkerkunde. *Center*: Mayombe ceremonial staff, Congo. Ivory. Tervueren, Belgium, Musée Royal de l'Afrique Centrale. *Right*: Tlingit ceremonial staff with killer whale, Alaska. Wood. Seattle, Washington State Museum. *Below, left*: Egyptian flail, symbol of kingship, Middle Kingdom. Wood and ceramic. New York, Metropolitan Museum. *Center*: Xerxes with a scepter, followed by servants carrying the flabellum, early 5th cent. B.C. Stone. Persepolis, the "Harem." *Right*: Roman lictors' fasces, first half of 1st cent. B.C. Marble, ht., 5 ft., 5 in. Rome, Palazzo Rospigliosi. (Photographed from a cast.)

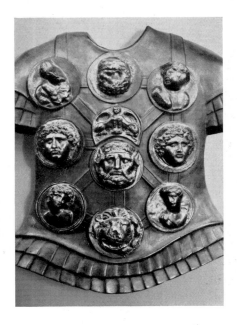

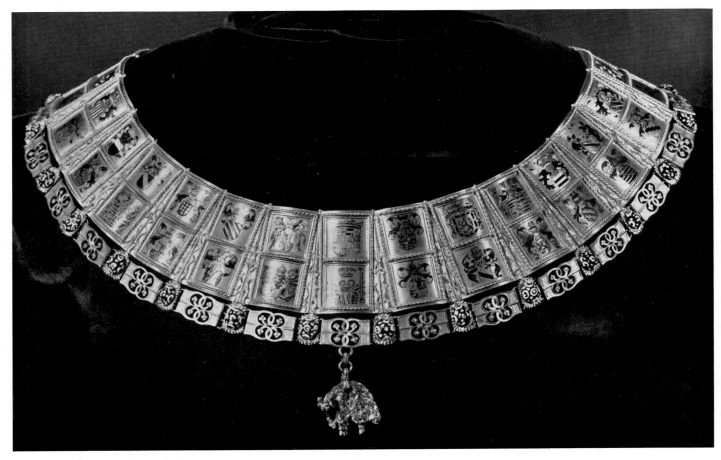

Pl. 394. *Above, left*: Roman silver phalerae on model cuirass, 1st cent. Berlin, Staatliche Museen. (Photographed from a cast.) *Center*: Insignia of the Ashanti psychopomps, west Africa. Gold. London, British Museum. *Right*: Pectoral of a Korean official, 19th cent. Embroidered silk. *Below*: Collar of the order of the Golden Fleece, 17th cent. Gold and enamel. Vienna, Schatzkammer der Wiener Hofburg.

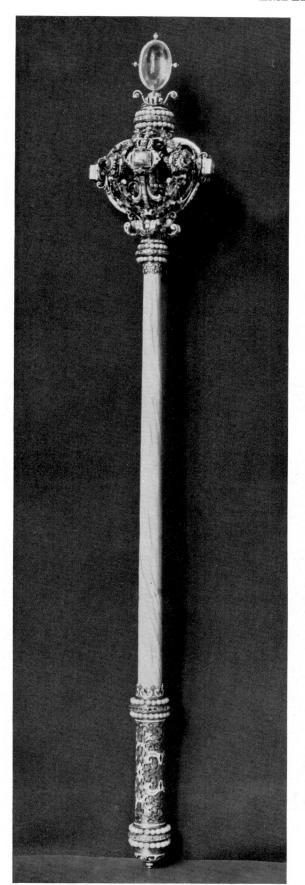

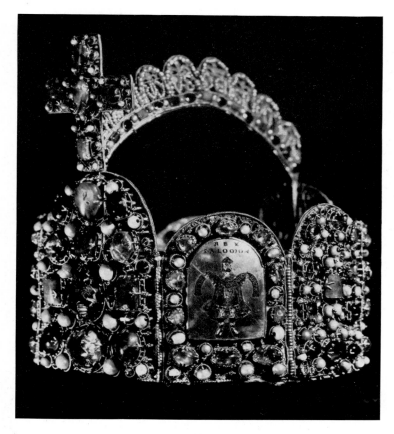

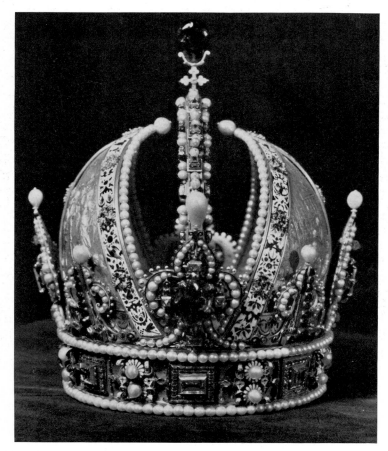

Pl. 395. *Left*: A. Osenbruck, scepter of the emperor Matthias of Hapsburg, 1612–15. Ivory, precious metals, and gems. *Right, above*: Ottonian crown of the Holy Roman Empire, 10th cent. Precious metals, enamels, and gems. *Below*: Crown of Rudolph II of Hapsburg, 1602. Precious metals, enamels, and gems. All, Vienna, Schatzkammer der Wiener Hofburg.

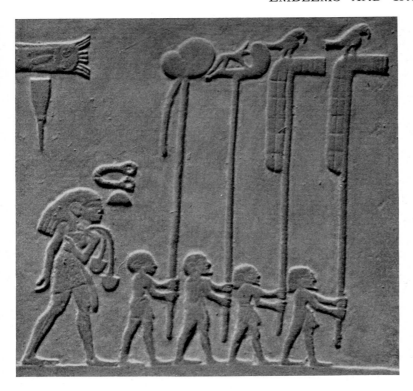

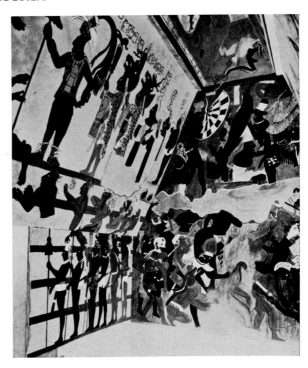

Pl. 396. *Left, above*: Egyptian protodynastic standards, detail of the palette of King Narmer, early 3d millennium B.C. Slate; full ht., 25¹/₄ in. Cairo, Egyptian Museum. *Below*: Standard of a Roman legion, 2d–3d cent. (?). Bronze. Wiesbaden, Sammlung Nassauischer Altertümer. *Right, above*: Mayan priests, dignitaries, and warriors in ceremonial costume carrying standards. Wall painting (reproduced from a facsimile). Bonampak, Chiapas, Mexico. *Center*: Silver denarius of Marcus Antonius, showing Roman legionary standards, 31 B.C. Rome, Museo Nazionale Romano. *Below*: Banderole from Källunge, Gotland, Sweden, 10th cent. Bronze. Stockholm, Historiska Museet.

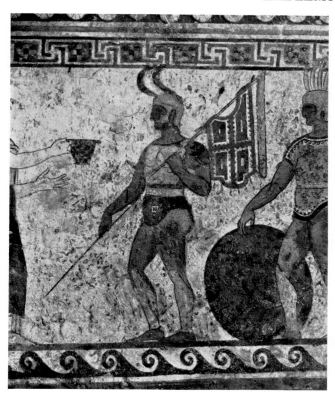
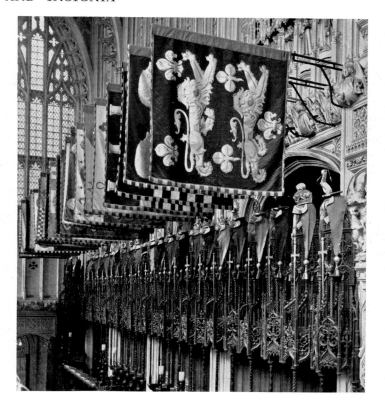
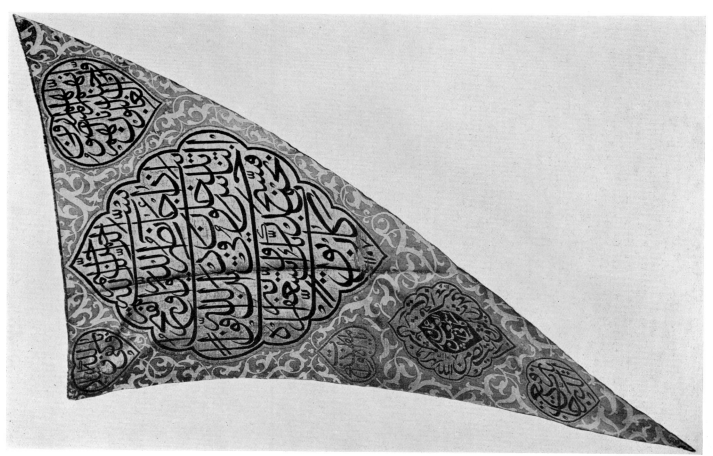

Pl. 397. *Above, left*: Italic warrior with standard, detail of wall painting from a tomb at Paestum, ca. 350–300 B.C. Naples, Museo Nazionale. *Right*: Banners with heraldic emblems. London, Westminster Abbey, Chapel of Henry VII. *Below*: Banner, from Kashan, Iran, 1692. Silk brocade, l., 7 ft., 2⅝ in. Teheran, Beghian Coll.

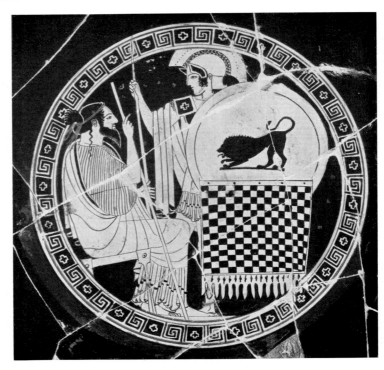

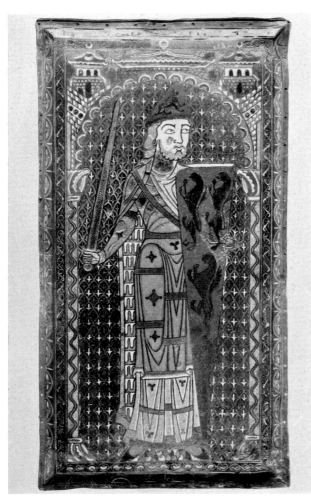

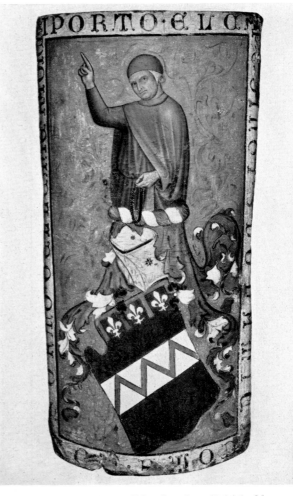

Pl. 398. *Above, left*: Shield of the Masai warriors in Kenya, with emblematic paintings. Skin. London, British Museum. *Right*: Triptolemos Painter, emblem on shield of Greek warrior, detail of Attic kylix, ca. 480 B.C. Rome, Vatican Museums. *Below, left*: Plantagenet king with heraldic shield, Limoges enamel plaque, 1129–89. Le Mans, Musée des Beaux-Arts. *Right*: Taddeo di Bartolo, heraldic shield, late 13th–early 14th cent. Panel. Florence, Museo Bardini.

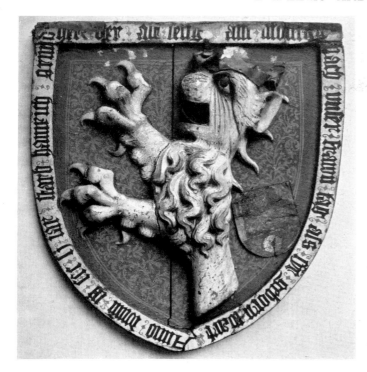
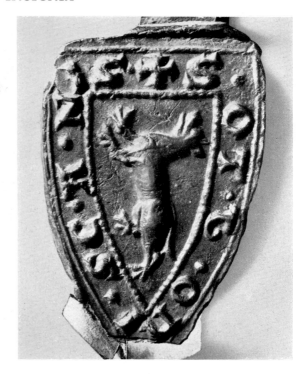

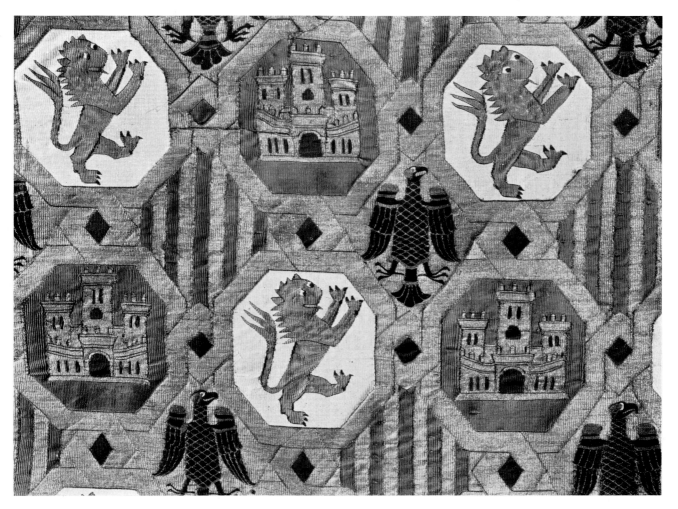

Pl. 399. *Above, left*: Arms from the tomb of Heinrich Grundherr, 1351. L., ca. 13 in. *Right*: Seal showing the arms of Otto Canis (dog), 13th cent. L., 2¹/₈ in. Both, Nürnberg, Germanisches National-Museum. *Below*: Robe of the archbishop Sancho of Aragon, detail, 13th cent. Brocade. Toledo, Spain, Cathedral.

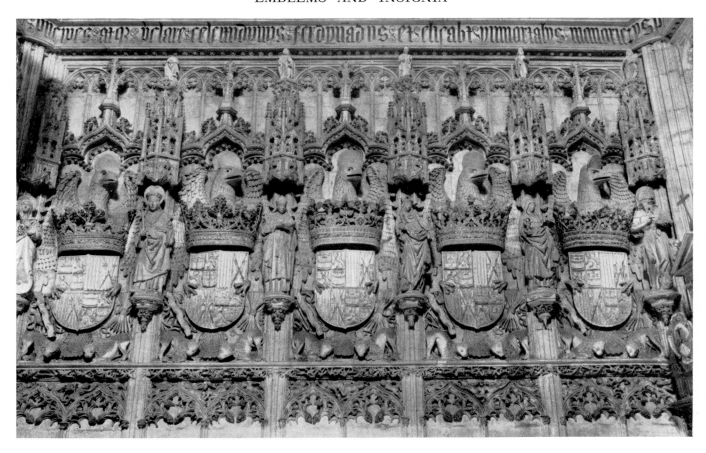

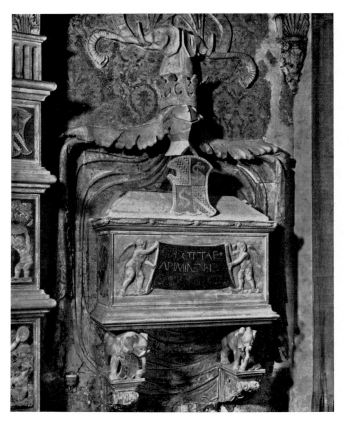

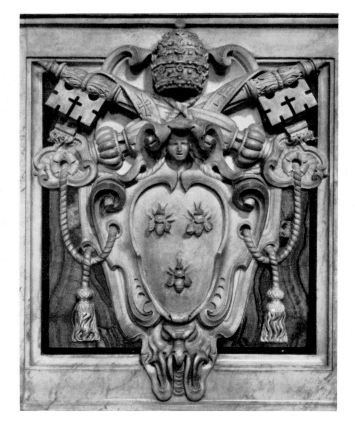

Pl. 400. *Above*: Arms of Castile and Aragon, 16th cent. Stone. Toledo, Spain, S. Juan de los Reyes. *Below, left*: Agostino di Duccio and assistants, tomb of Isotta degli Atti with heraldic emblems, 15th cent. Marble. Rimini, Italy, Tempio Malatestiano. *Right*: G. L. Bernini, papal and family emblems of Urban VIII Barberini, 1624–33. Marble. Rome, St. Peter's, detail of the baldacchino. (Cf. II, PL. 267.)

Pl. 401. *Left, above*: Romulus and Remus and the she-wolf, emblem of Rome, on a Roman-Campanian didrachma, late 4th cent. B.C. Silver. Rome, Museo Nazionale Romano. *Center*: The Roman eagle, relief from Trajan's Forum, early 2d cent. Marble, l., 9 ft., 2¼ in. Rome, SS. Apostoli. *Below*: Matteo di Ser Cambio, exchange association emblem on enrollment certificate, 1377. Illumination. Perugia, Collegio del Cambio. *Right, above*: Donatello, lion supporting emblem of Florence, 1420. Marble. *Below*: Lorenzo di Pietro, S. Bernardino with Confraternity emblem, 15th cent. Polychromed wood. Last two, Florence, Museo Nazionale.

Pl. 402. *Above*: Agostino di Duccio and assistants, monogram of Isotta and Sigismondo Malatesta, detail of a chapel rail, 15th cent. Marble. Rimini, Italy, Tempio Malatestiano. *Center, right*: Primaticcio and assistants, initial of Henry II of France, detail of a fireplace, 16th cent. Stone. Fontainebleau, Château, Gallery of Henry II. *Below, left and right*: Crests of Anne of Brittany (ermine), 1476–1514, and Louis XII of France (porcupine), 1462–1515. Stone. Blois, Château.

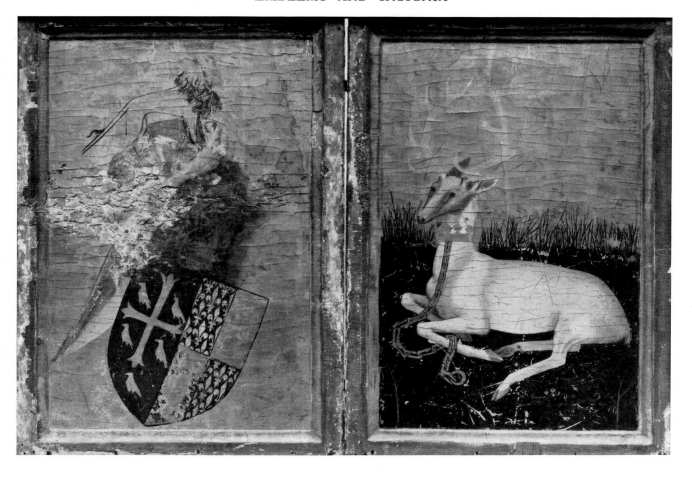

Pl. 403. *Above*: Escutcheon quartered with the arms of England and of Edward the Confessor; and the white hind of Richard II; back of the Wilton Diptych, 15th cent. Panel, 11³/₈×18¹/₈ in. London, National Gallery. *Below, left*: L. Lotto, Allegory, cover of the portrait of Bernardino de' Rossi, 16th cent. Panel, 22¹/₄×17¹/₈ in. Washington, D.C., National Gallery. *Right*: A. Mantegna, motto and candle, detail of St. Sebastian, 15th cent. Panel. Venice, Ca' d'Oro.

## LIBRO PRIMO. 52

a cui giunſe i motti, *FALLIMVRIMAGINE*; o l'altro,

*TE PIETAS ME FALLIT AMOR*; vna dell'ingegno-
ſe, e conſiderate c'hò trà le molte veduto. Si eſprimono tal'ho-
ra figure contrarie al nome, poi che gli antichi pinſero la Sta-
tua dell'Honore in habito di donna, come che alle donne prin-
cipalmente conuenga eſſer di quello bramoſe; e la Statua del-
la Virtù, in habito d'huomo, facendo ella virile chiunque la
poſsiede. Et al'hora Figure, che all'effetto della coſa conuen-
gano, e che ſi eſprima etiandio nel motto, come l'Impreſa di
quella Signora Spagnola, di cui innamorato Re Alfonſo, e la-
ſciandoſa per ſpacio di tempo d'vn'altra fece dipingere i Paſ-
ſatoi, col motto ſignificante l'effetto, *PASSERAN LOS*

Quando ſi
eſprimono
le figure cō
trarie al no-
me.
Statue del-
l'Honore,
Impreſa di
vna Signo-
ra Spagno-
la,

*PASSADORES*, per inferir che quel nuouo amore era di
paſſata, e che ritornato ſarebbe ad amar lei. Eſprime tal'hor
la Fi-

## Symbola Politica. 27
### SYMBOLUM IV.

## DIVINI AMORIS. 39

Pl. 404. *Above, left*: "Fallimur imagine"; "Passeran los passadores," emblems from G. C. Capaccio, *Delle Imprese*, Naples, 1592, book I, p. 52. *Right*: "Insuetum per iter," emblem from *Rime degli Accademici occulti*, Brescia, 1568, p. 85. *Below, left*: "Non solum armis," political symbol from Saavedra Fajardo, *Idea Principis . . .*, Brussels, 1649, p. 27. *Right*: Divine Love, emblem from O. Vaenius, *Amorum Emblemata*, Antwerp, 1608, p. 39.

Pl. 405. Daniel, Byzantine medallion, detail of the Pala d'Oro, 11th cent. Gold, cloisonné enamel, and precious stones. Venice, S. Marco.

Pl. 406. Manuscript cover with Christ in Majesty, from Limoges, late 12th cent. Gilded copper and champlevé enamel. Paris, Musée de Cluny.

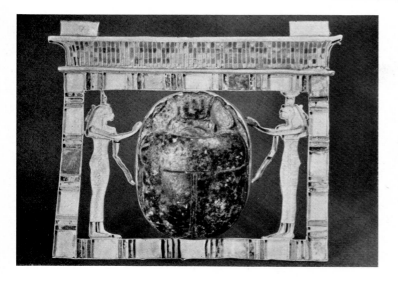

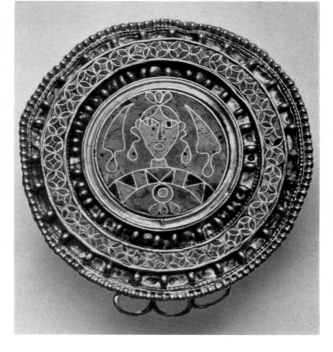

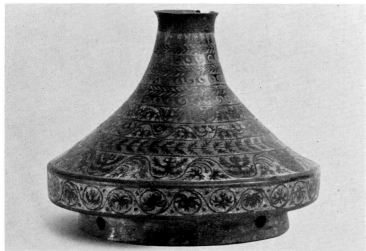

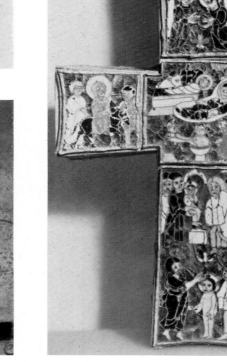

Pl. 407. *Left, above*: Egyptian pectoral of the Vizier Paser, 19th dynasty, from the Serapeum, Alexandria. Gold, semiprecious stones, and glass paste, 3¹/₂×3⁷/₈ in. Paris, Louvre. *Center*: Roman provincial finial mount, late 1st–early 2d cent. Champlevé enamel on bronze, ht., 4¹/₈ in. New York, Metropolitan Museum. *Below*: Belt-shrine, detail of ornamental plaque, from Moylough, Ireland, 6th–7th cent. (?). Enameled bronze, diam., 1⁵/₈ in. Dublin, National Museum of Ireland. *Right, above*: The "Castellani Fibula," from northern Italy, 8th cent. (?). Gold and cloisonné enamel, diam., ca. 2³/₈ in. London, British Museum. *Below*: Byzantine cross with scenes from the life of Christ, 6th–7th cent. Gold and cloisonné enamel. Rome, Vatican Museums.

Pl. 408. *Left, above:* Reliquary chest, from Limoges, second half of 12th cent. Champlevé enamel. Washington, D. C., National Gallery. *Below:* Reliquary chest with scene of a bishop's martyrdom, from Limoges, 13th cent. Copper and champlevé enamel. Sens, France, Cathedral Treasury. *Right:* Islamic bowl with the legend of Alexander, 12th cent. Cloisonné enamel on copper. Innsbruck, Austria, Tiroler Landesmuseum Ferdinandeum.

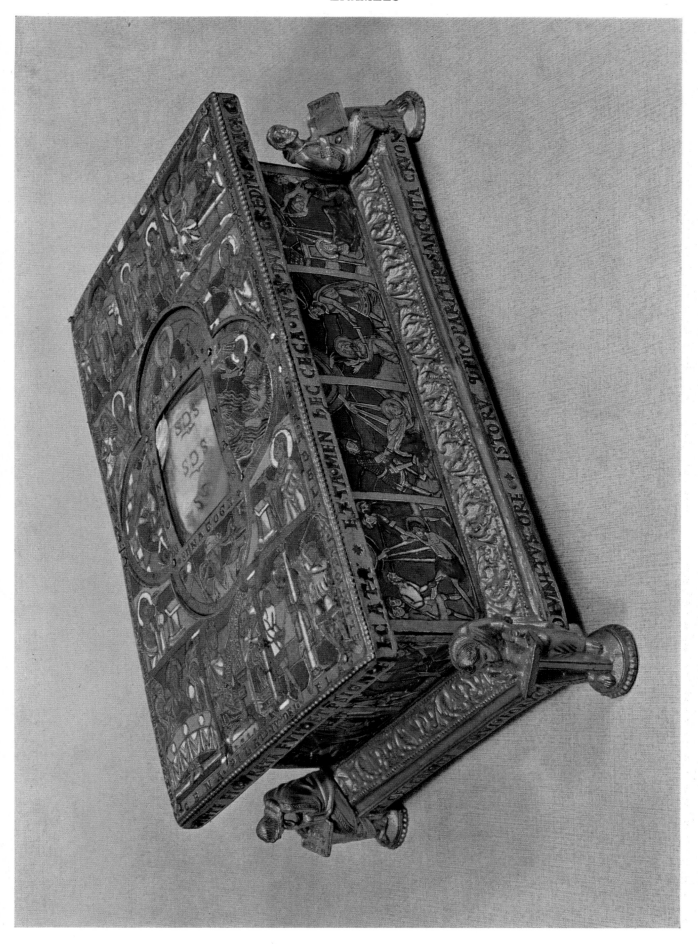

Pl. 409. Portable altar, from Stavelot, Meuse region, ca. 1165. Gilded copper and champlevé enamel. Brussels, Musées Royaux d'Art et d'Histoire.

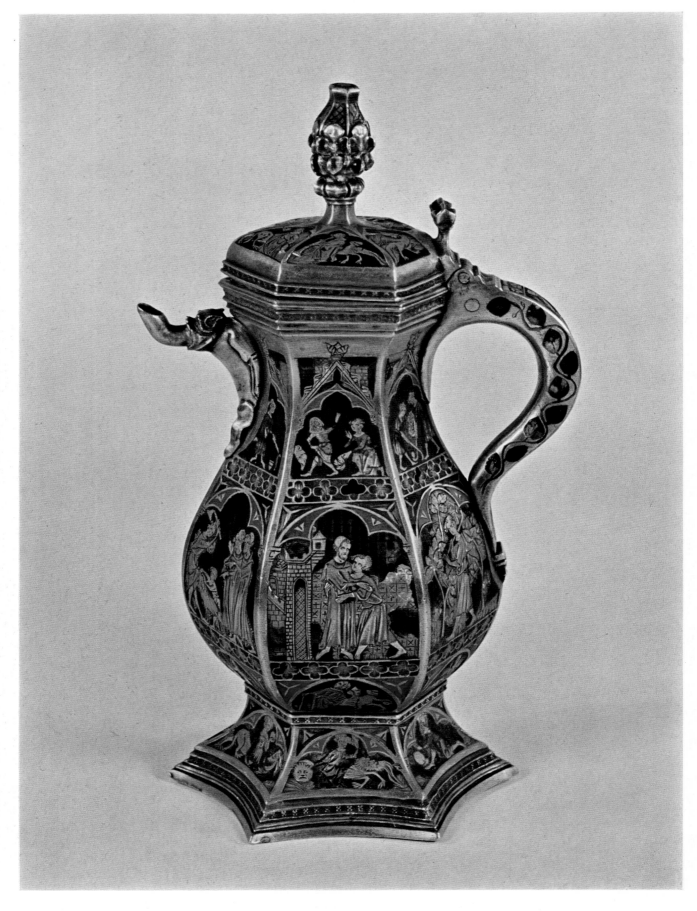

Pl. 410. Pitcher, Paris, ca. 1330–40. Silver and transparent enamel. Copenhagen, Nationalmuseet.

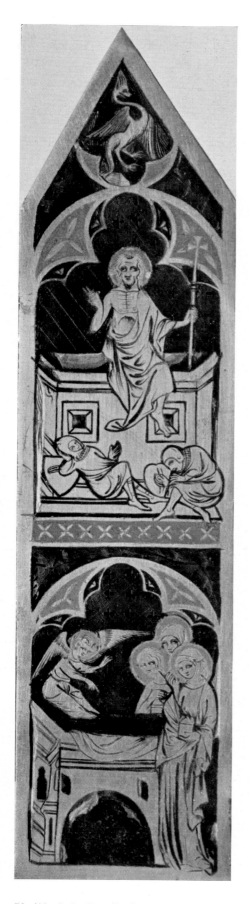

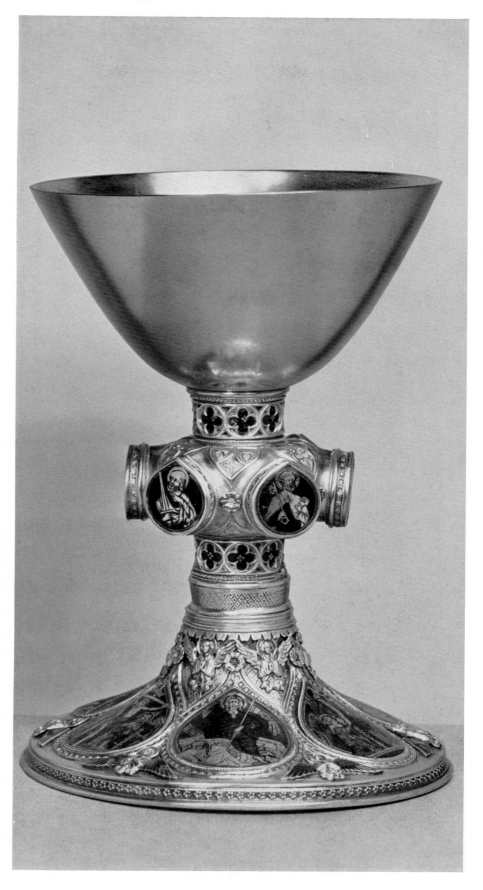

Pl. 411. *Left*: Detail of small altar tryptych, with scenes of the Passion, from northern France, early 14th cent. Translucent enamel. Milan, Museo Poldi Pezzoli. *Right*: Rhenish chalice, from St. Johann zu Konstanz, ca. 1320. Gilt silver with enamel medallions, ht., 8⅛ in. Baltimore, Walters Art Gallery.

Pl. 412. *Left*: Pax with the Pietà, from Florence, 15th cent. Silver, niello, and enamel. Florence, Museo Nazionale. *Right*: Madonna in the Rose Bower, from France, 15th cent. Precious metals and stones, with enamel. Altötting, Germany, parish church.

Pl. 413. Jean II Pénicaud (attrib.), plaques with the life of Christ and Biblical subjects, from Limoges, second half of 16th cent. Painted enamel heightened with gold. London, Wallace Coll.

Pl. 414. *Left, above:* Jean III Pénicaud, plaque showing an adventure of Hercules, second half of 16th cent. Enamel on copper. Lyons, Musée des Beaux-Arts. *Below:* B. Cellini, detail of the saltcellar of Francis I, second quarter of 16th cent. Gold and enamel. Vienna, Kunsthistorisches Museum. *Right:* Léonard I Limosin, portrait of Anne, Duc de Montmorency, Constable of France, 1556. Enamel on copper. Paris, Louvre.

Pl. 415. *Left:* Triptych of Louis XII, center panel, from Limoges, ca. 1500. Enamel on copper. London, Victoria and Albert Museum. *Right:* Léonard I Limosin, after design by Niccolò dell'Abate, altarpiece for Sainte-Chapelle, Paris, with life of Christ and portraits of Henry II of France and Catherine de' Medici, 1552–53. Painted enamel, ht., ca. 40 in. Paris, Louvre.

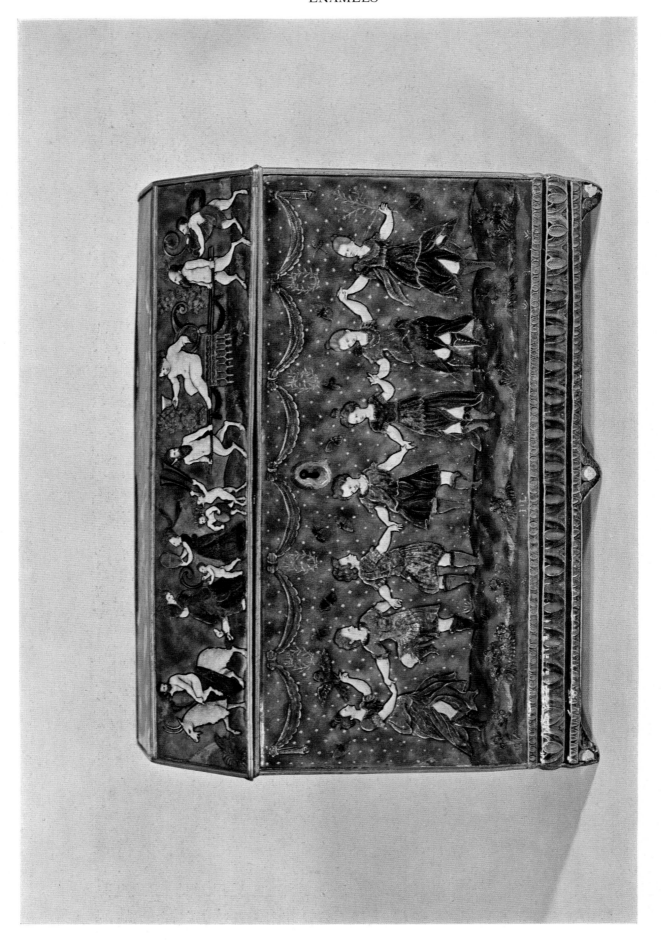

Pl. 416. Jehan II Limosin, coffer with dances and bacchic scenes, first half of 17th cent. London, Victoria and Albert Museum.

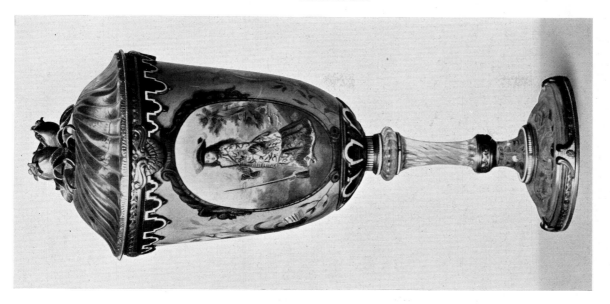

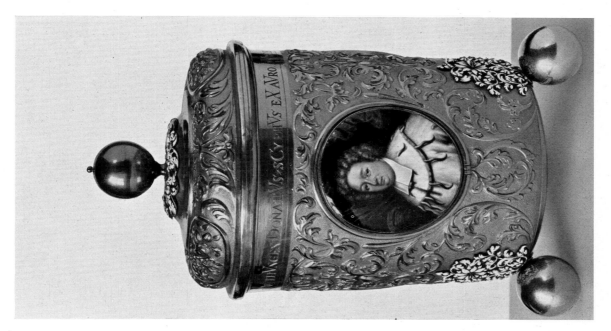

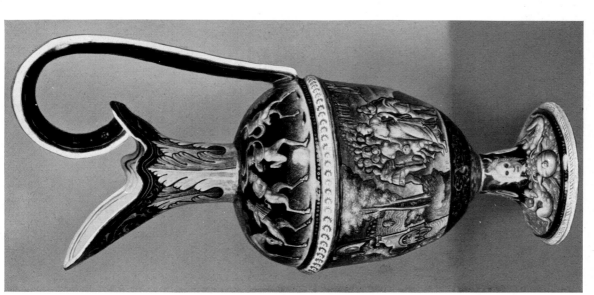

Pl. 417. *Left*: P. Reymond, ewer with bacchic scene and the Crossing of the Red Sea, ca. 1560. Enamel. Paris, Louvre. *Center*: P. Boy The Elder, box decorated with medallions, 1698. Silver and enamel, ht., 8¼ in. Pommersfelden, near Bamberg, Germany, Castle. *Right*: J. F. Ardin, covered cup with portrait medallion, early 18th cent. Crystal, silver, and enamel, ht, 7⅞ in. Baltimore, Walters Art Gallery.

Pl. 418. *Above, left*: Dish decorated with Taoist sages, China, Ch'ien-lung period (1736–95). Canton enamel. *Right*: Snuff bottle, China, Ch'ien-lung period. Cloisonné with coral stopper, ht., 2³/₈ in. *Below, left*: Incense burner, China, Ch'ien-lung period. Cloisonné enamel, ht., 24³/₈ in. *Right*: Incense burner, China, 19th cent. Cloisonné enamel on copper, ht., 16¹/₈ in. All, New York, Metropolitan Museum.

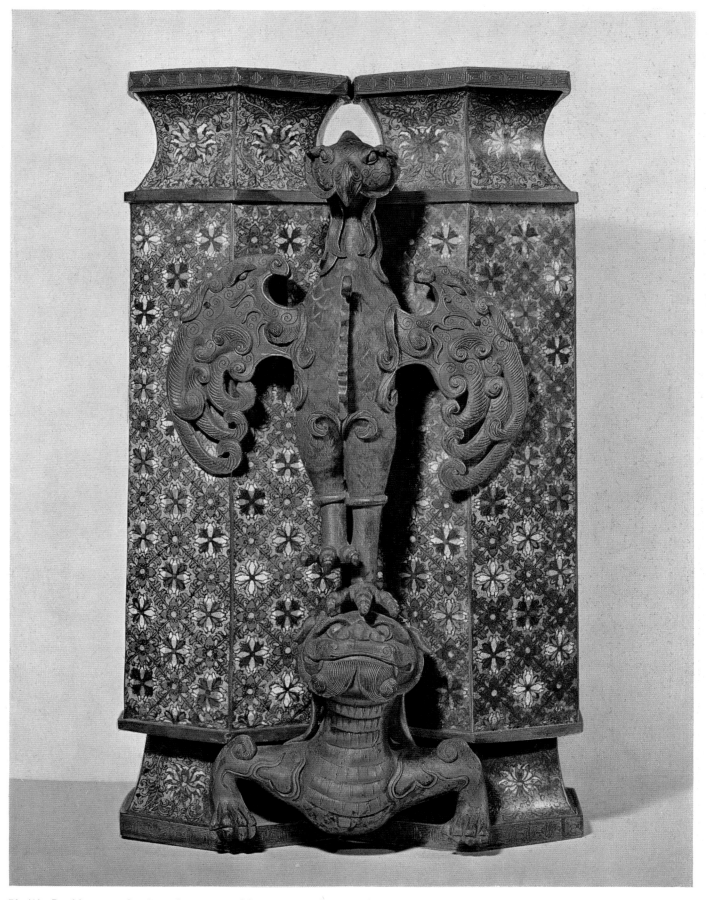

Pl. 419. Double vase of "champion" type with monsters of bronze figuring as supports, China, Yung-chêng period (1723–35). Cloisonné and bronze, ht., 25⅝ in. New York, Brooklyn Museum.

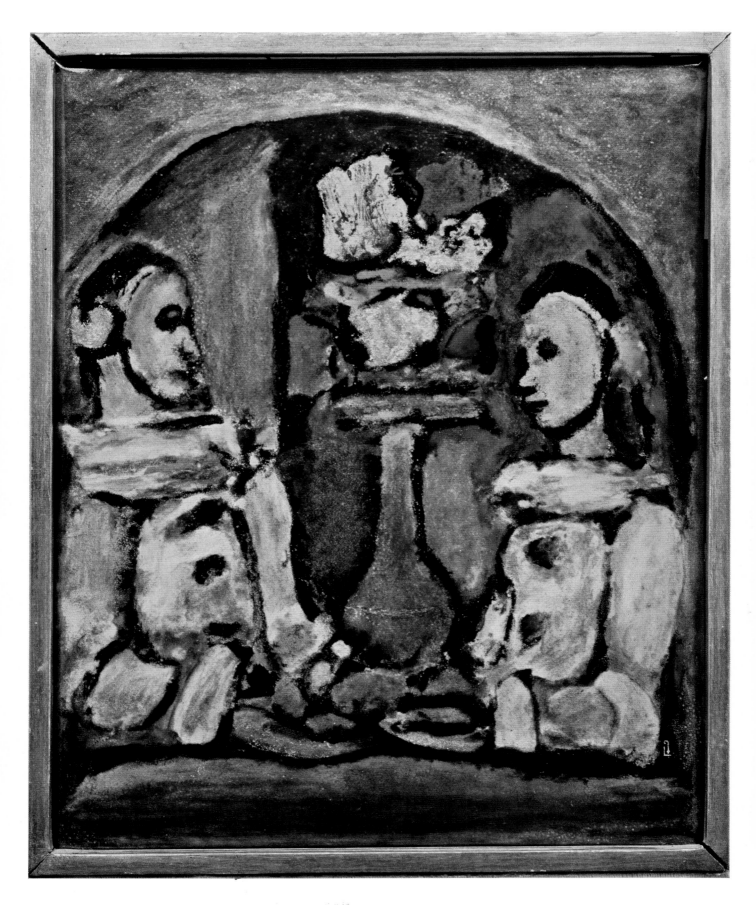

Pl. 420. G. Rouault, Cirque de l'Arc-en-Ciel. Enamel on copper. Paris, Musée d'Art Moderne.

Pl. 421. Technical aspects. *Above, left*: Plank block (side grain). *Right*: End grain. *Below, left*: Dry point. *Right*: Engraving in various stages.

Pl. 422. Technical aspects. *Above, left*: Etching. *Right*: Aquatint. *Below, left*: Soft-ground etching. *Right*: Crayon, or chalk, manner.

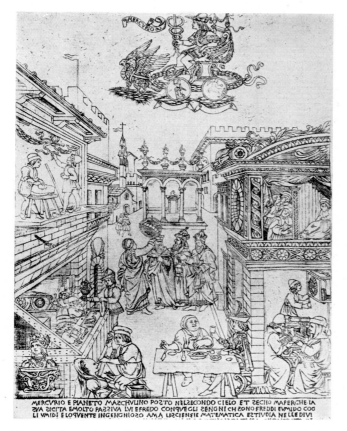

Pl. 423. *Above, left*: The Buxheim St. Christopher, 1423. Woodcut. Manchester, England, J. Rylands Library. *Right*: Portrait of a woman, Florentine, 15th cent. Engraving. Berlin, Kupferstichkabinett. *Below, left*: Maso Finiguerra (?), Mercury, from *The Planets* series, ca. 1460. Engraving. *Right*: Master D, The Mystery of the Incarnation. Woodcut.

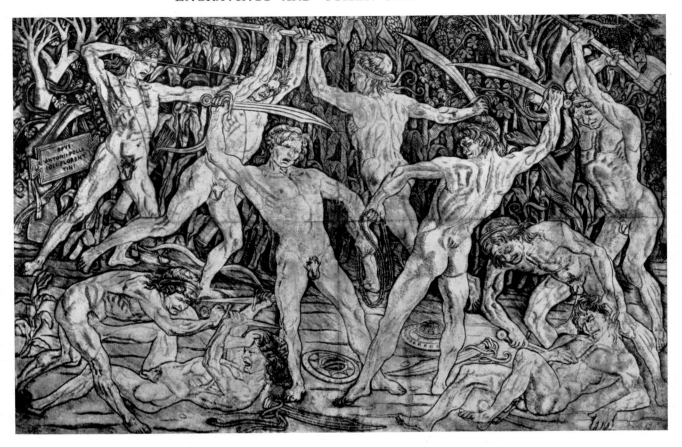

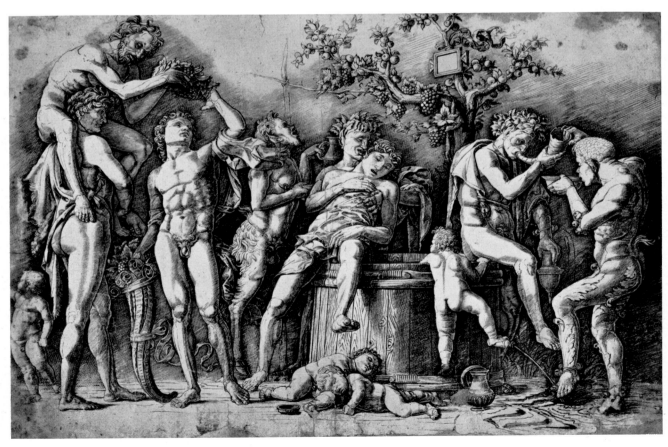

Pl. 424. *Above*: A. Pollaiuolo, Battle of the Nudes, ca. 1465. Engraving. *Below*: A. Mantegna, Bacchanal with the Wine Cask, second half of 15th cent. Engraving. Both, Florence, Uffizi, Gabinetto Nazionale dei Disegni e Stampe.

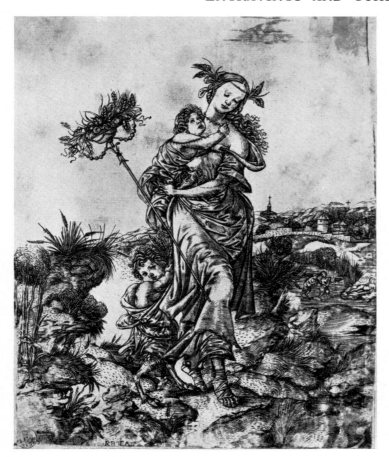

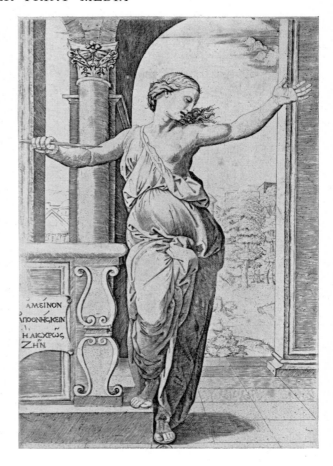

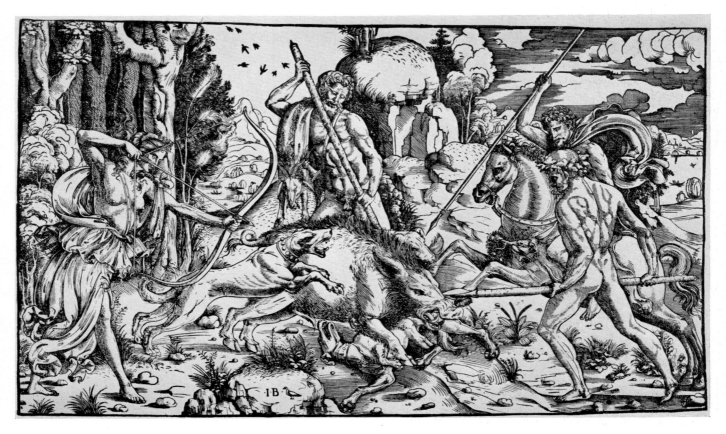

Pl. 425. *Above, left*: C. Robetta, Allegory of Abundance, before 1512. Engraving. *Right*: M. Raimondi, Lucretia, 1510. Engraving. *Below*: Monogrammist I. B. with the Bird, hunting scene, ca. 1503. Engraving.

Pl. 426. *Above*: G. Campagnola, Christ and the Woman of Samaria, before 1515. Engraving. *Below*: G. B. Scultori ("Mantovano"), Allegory of the River Po, 1538. Engraving.

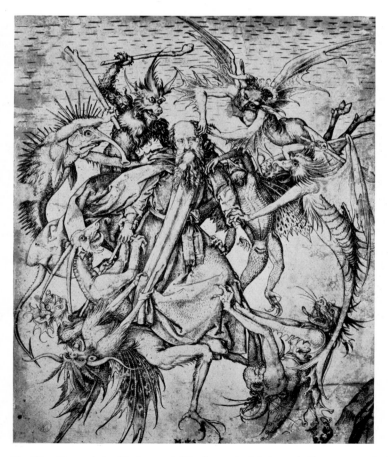

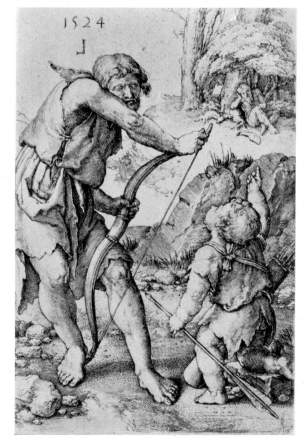

Pl. 427. *Above, left*: N. Rosex ("Nicoletto da Modena"), Fortune, early 16th cent. Engraving. *Right*: A. Altdorfer, St. George and the Dragon, 1511. Woodcut. *Below, left*: M. Schongauer, Temptation of St. Anthony, ca. 1471–73. Engraving. *Right*: Lucas van Leyden, Lamech and Cain, 1524. Engraving.

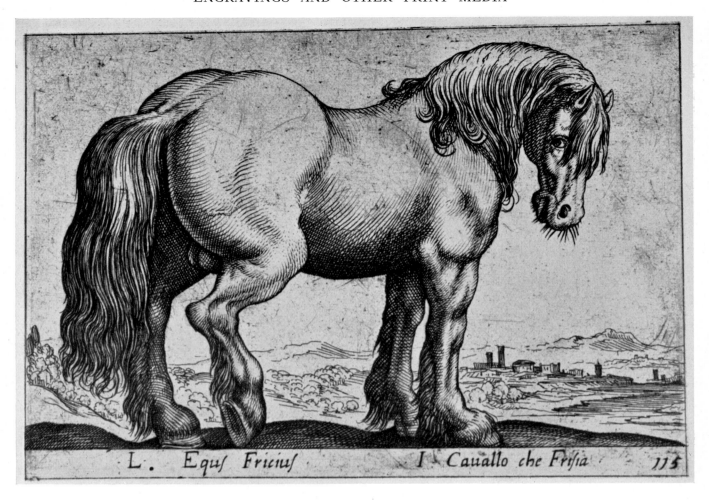

L. Equſ Friciuſ          I. Cauallo che Friſia          115

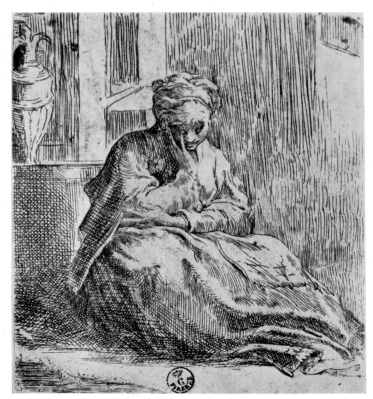

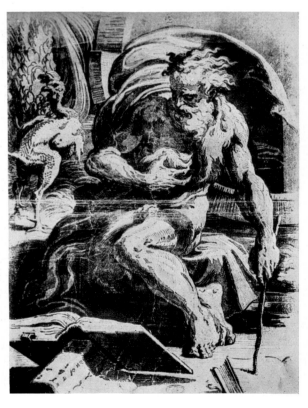

Pl. 428. *Above*: A. Tempesta, The Frisian Horse. Etching. *Below, left*: Parmigianino (F. Mazzuoli), St. Thais. Engraving. *Right*: Ugo da Carpi, Diogenes. Wood engraving.

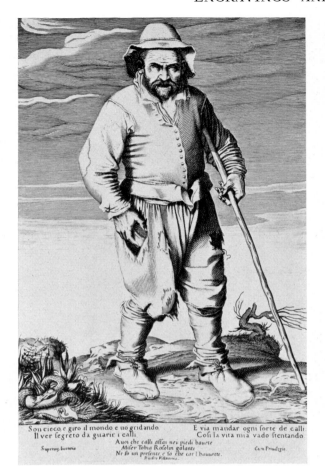

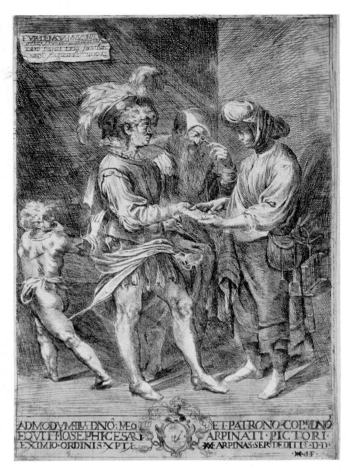

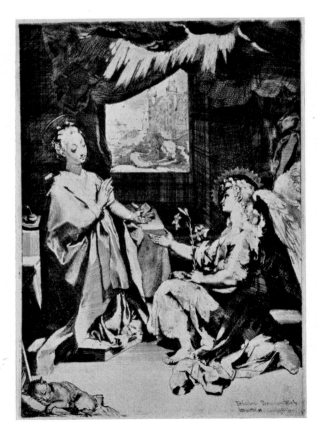

Pl. 429. *Above, left*: F. Villamena, The Blind Man. Engraving. *Right*: Caravaggio (?), The Fortuneteller. Etching. *Below, left*:
F. Barocci, The Annunciation. Etching. *Right*: O. Leoni, portrait of G. B. Marino, 1624. Engraving.

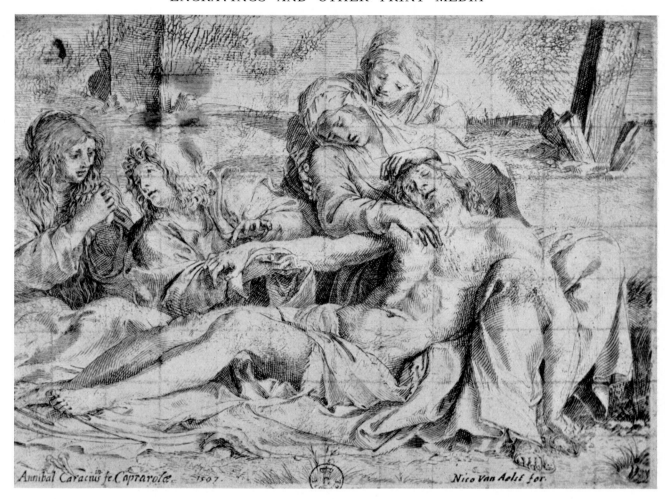

Pl. 430. *Above*: Annibale Carracci, Pietà, 1597. Engraving. *Below, left*: G. Reni, Holy Family. Etching. *Right*: G. F. Barbieri ("Guercino"), St. Anthony of Padua. Etching.

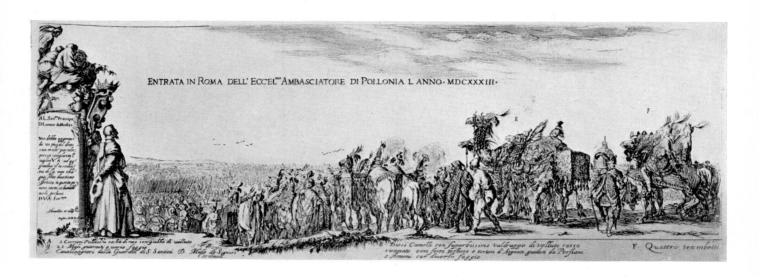

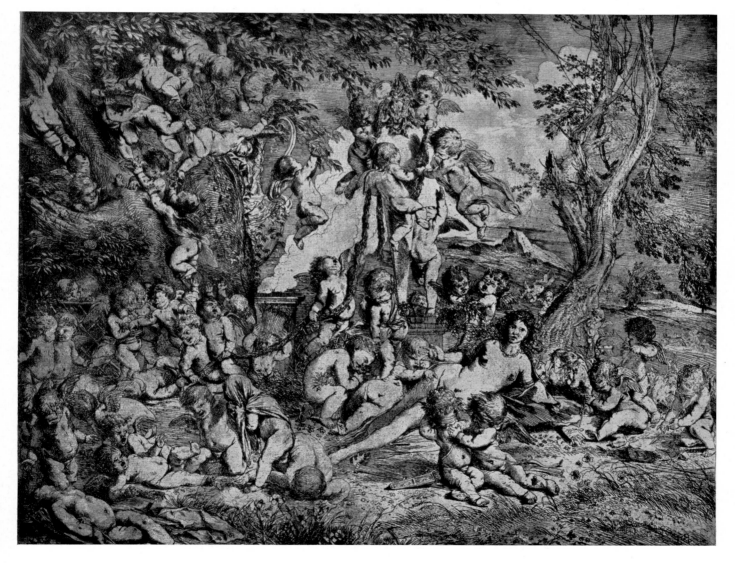

Pl. 431. *Above*: S. Della Bella, Entry into Rome of His Excellency the Ambassador of Poland in the year 1633. Etching. *Below*: P. Testa, Venus and Cupids. Etching.

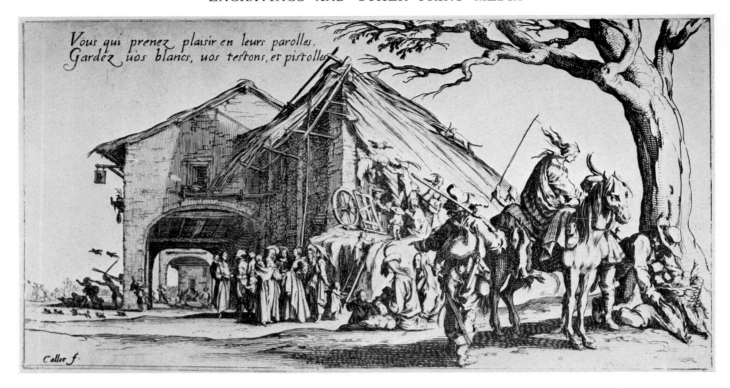

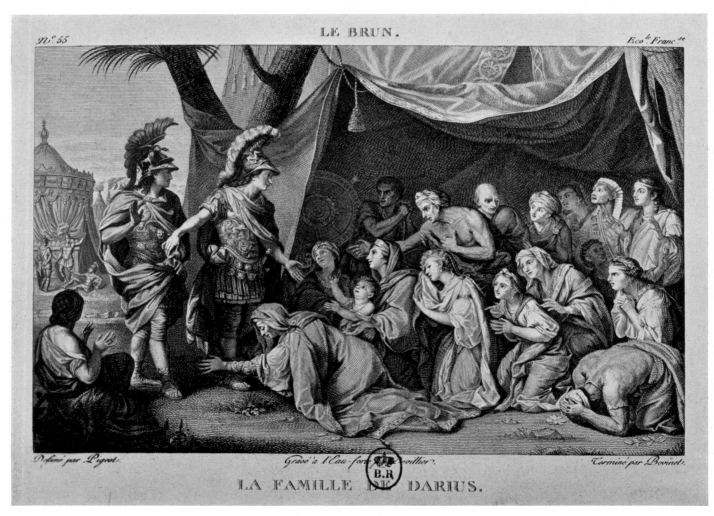

Pl. 432. *Above*: J. Callot, Gypsies. Etching. *Below*: Etching after a painting by C. Lebrun, The Family of Darius, 1662–68.

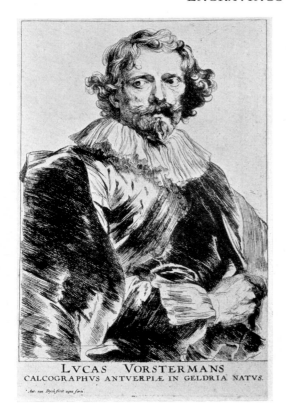

LVCAS VORSTERMANS
CALCOGRAPHVS ANTVERPIÆ IN GELDRIA NATVS.

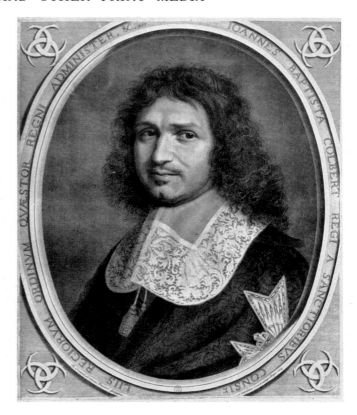

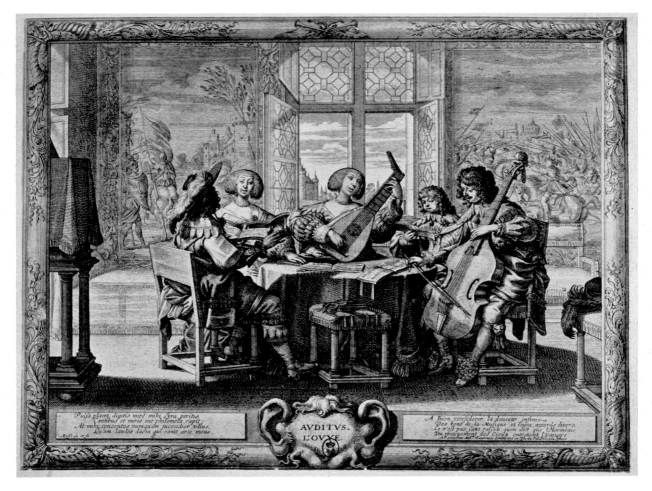

Pl. 433. *Above, left*: A. van Dyck, portrait of Lucas Vorstermans, ca. 1626–32. Etching. *Right*: R. Nanteuil, portrait of Colbert, 1668. Engraving. *Below*: A. Bosse, Allegory of Hearing. Etching.

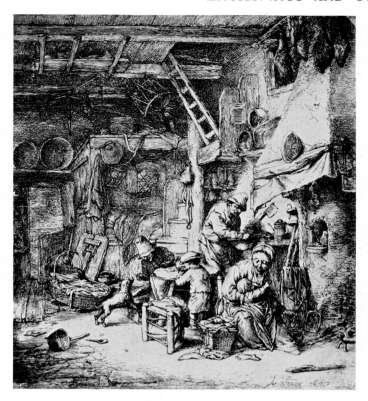

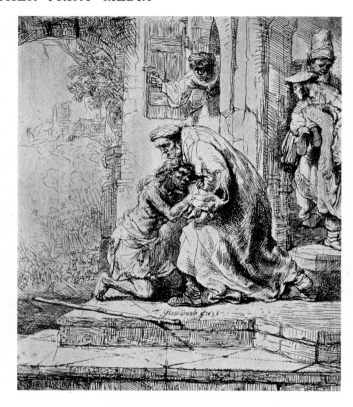

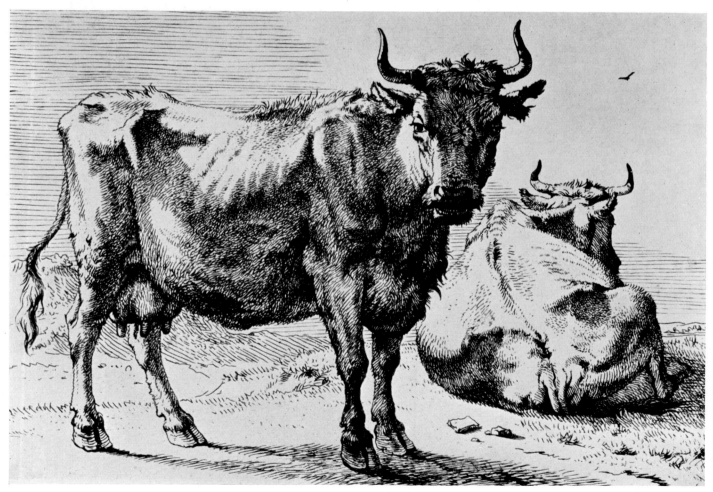

Pl. 434. *Above, left*: A. van Ostade, Peasant Family. Etching. *Right*: Rembrandt van Rijn, The Return of the Prodigal Son, 1636. Etching. *Below*: Paulus Potter, Cows. Etching.

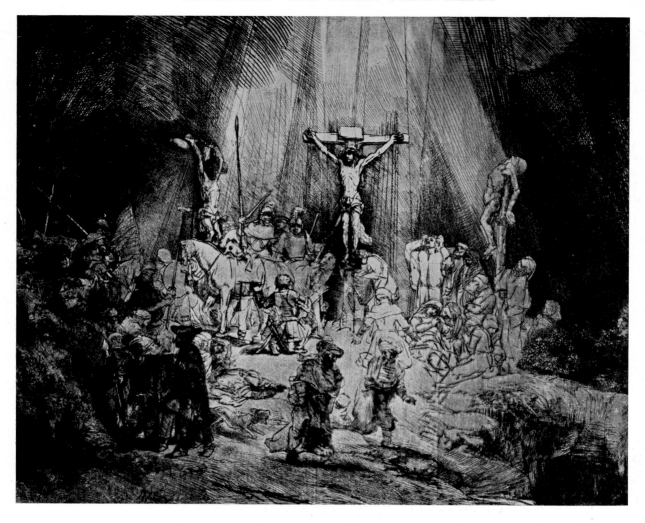

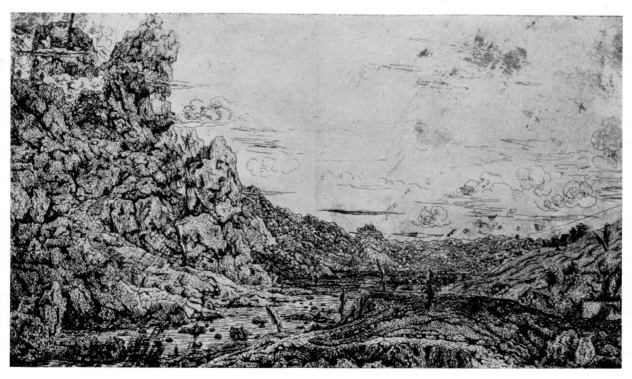

Pl. 435. *Above*: Rembrandt van Rijn, The Three Crosses, 1653, first state. Etching. *Below*: H. Seghers, Landscape. Etching.

Pl. 436. *Above, left*: G. B. Castiglione ("Grechetto"), The Feast of Pan, 1648. Etching. *Right*: S. Rosa, Jason and the Dragon. Etching. *Below*: Canaletto, The Hermit. Etching.

Pl. 437. G. B. Tiepolo, Adoration of the Magi. Etching.

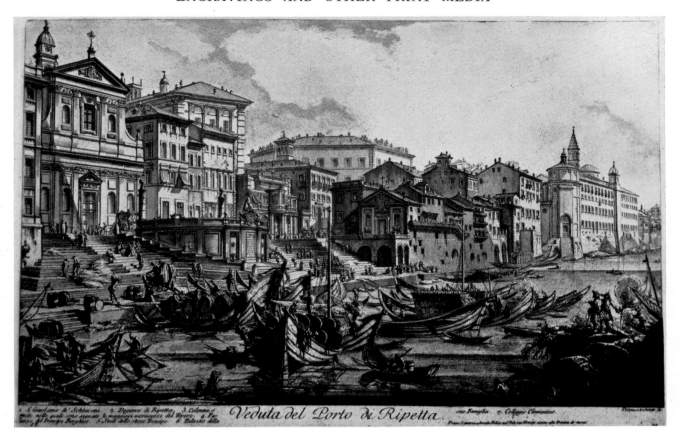

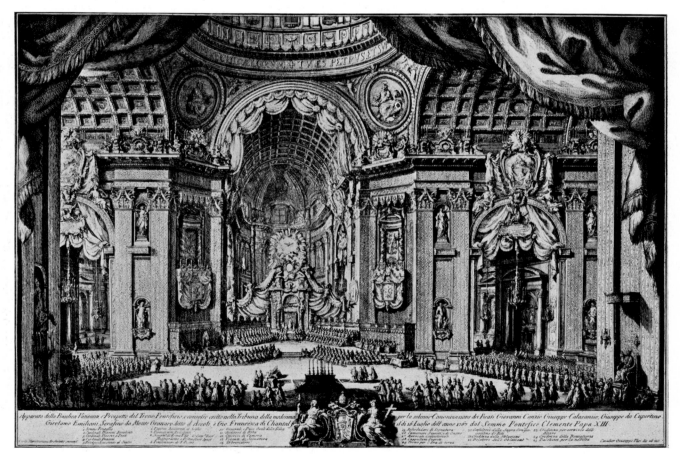

Pl. 438. *Above*: G. B. Piranesi, view of the Porto di Ripetta in Rome. Etching. *Below*: G. Vasi, scene in the Vatican Basilica showing decoration for a canonization (of 1767). Etching.

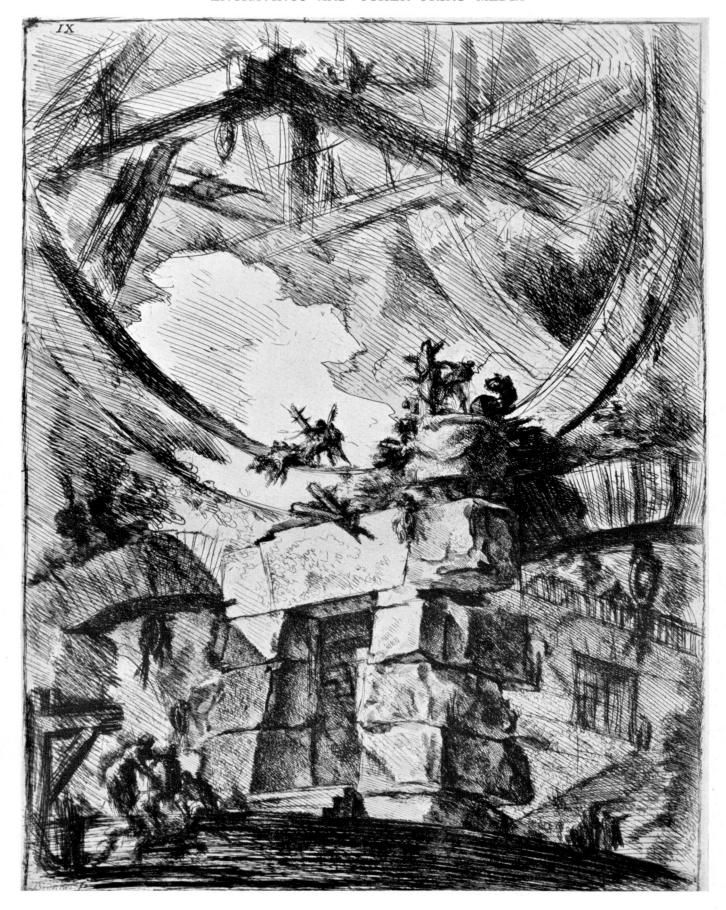

Pl. 439. G. B. Piranesi, etching from the prison series, pub. 1750.

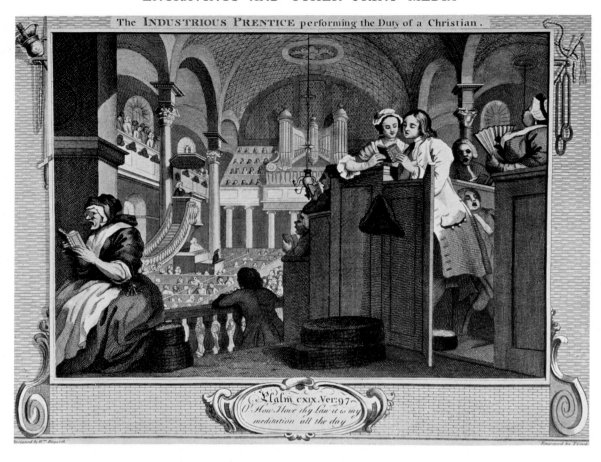

Pl. 440. *Above*: W. Hogarth, The Industrious Prentice, from *Industry and Idleness*, pub. 1751. Engraving. *Below, left*: J. A. D. Ingres, Gabriel Cortois de Pressigny, 1816. Etching. *Right*: F. Goya, "Por que fue sensible," no. 32 of *Los Caprichos*, 1796–99. Aquatint.

Pl. 441. *Above*: B. Pinelli, Roman Carnival, 1830. Etching. *Below*: J. B. Jongkind, Sunset over the Port of Antwerp, 1868. Etching.

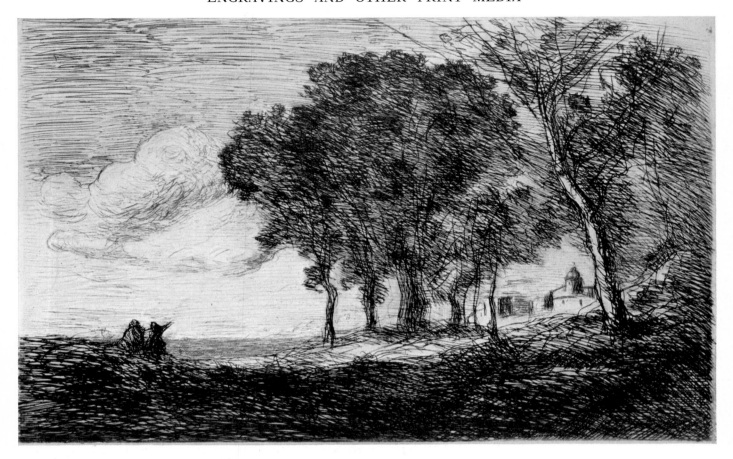

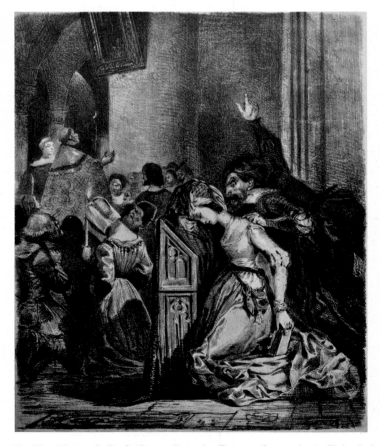

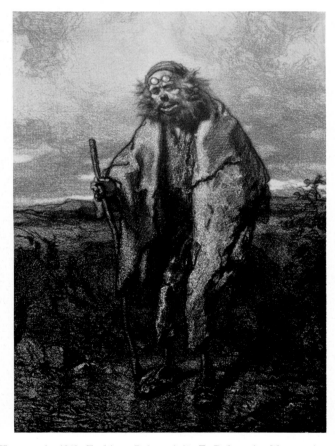

Pl. 442. *Above*: J. B. C. Corot, Dans les Dunes: Souvenir du Bois de la Haye, pub. 1869. Etching. *Below, left*: E. Delacroix, Marguerite in Church, 1826–27. Lithograph. *Right*: P. Gavarni, Thomas Vireloque. Lithograph.

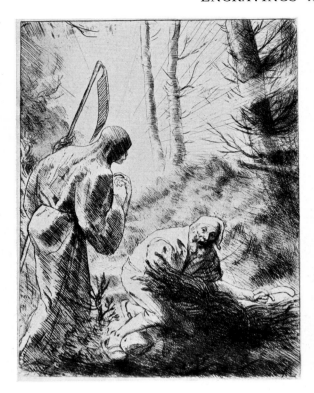

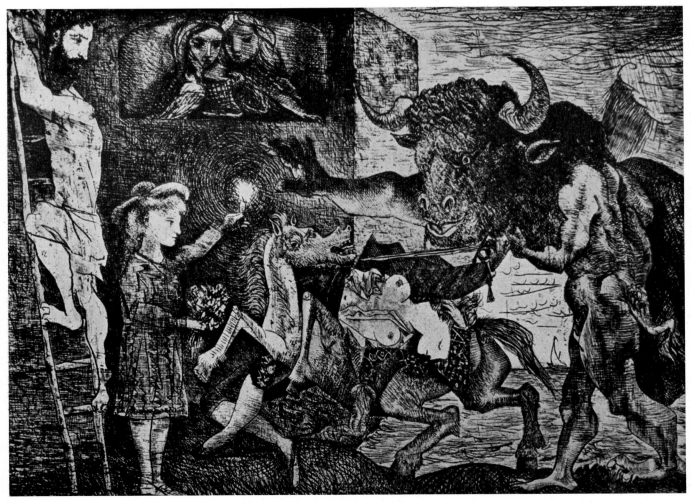

Pl. 443. *Above, left*: A. Legros, Death and the Woodcutter. Etching. *Right*: M. Pechstein, After the Bath. Lithograph. *Below*: P. Picasso, Minotauromachia, 1935. Etching.

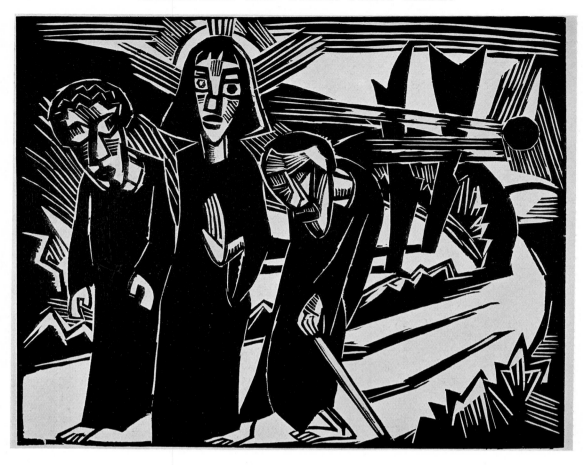

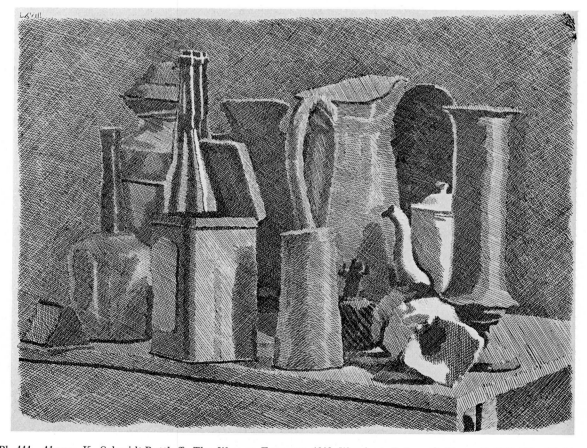

Pl. 444. *Above*: K. Schmidt-Rottluff, The Way to Emmaus, 1918. Woodcut. *Below*: G. Morandi, Still Life. Etching.

Pl. 445. Chinese prints. *Left*: Two prints after paintings by Wu Tao-tzǔ, T'ang dynasty (618–906).
*Right*: Two genii of the door, mid-19th cent. Woodcuts.

Pl. 446. Japanese prints. *Left*: Suzuki Harunobu, Tea house, mid-18th cent. Woodcut. *Right*: Kitagawa Utamaro, Woman with a Glass Toy, second half of 18th cent. Woodcut.

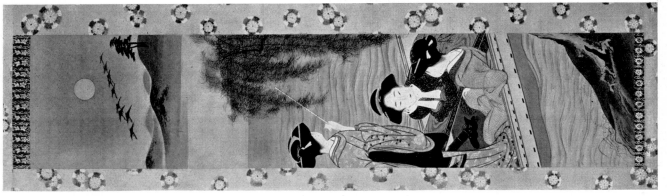

Pl. 447. Japanese prints. *Left:* Katsukawa Shunshō, scene from *Genre Scenes of the Twelve Months*, mid-18th cent. Woodcut. *Right, above:* Katsushika Hokusai, Fine and Breezy, from *Thirty-six Views of Mt. Fuji*, early 19th cent. Woodcut. *Below:* Andō Hiroshige, Kambara, from *Fifty-three Stages on the Tōkaidō Highway*, first half of 19th cent. Woodcut.

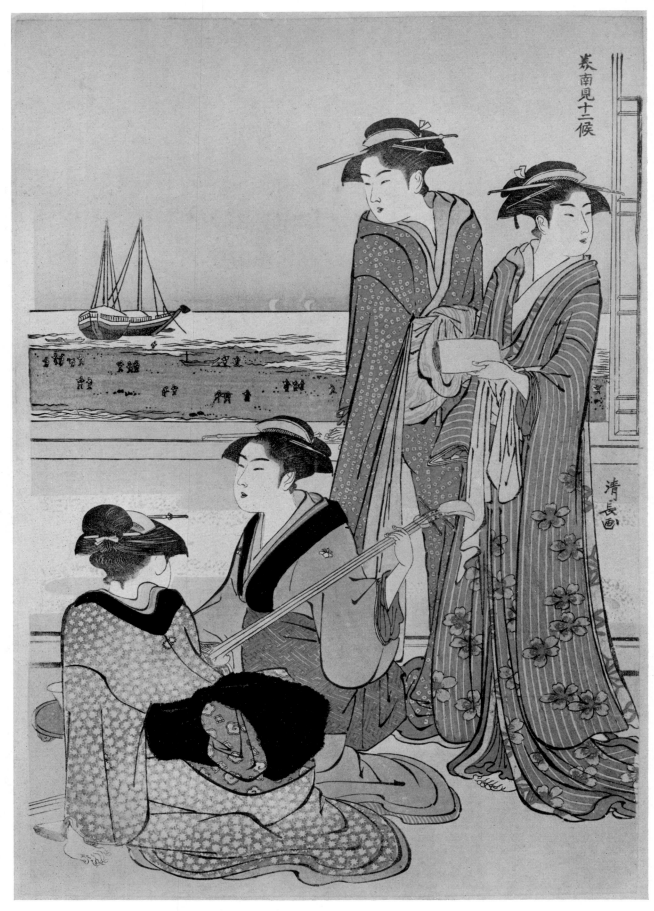

Pl. 448. Torii Kiyonaga, Gay Quarters at Shinagawa, Japan, second half of 18th cent. Woodcut.

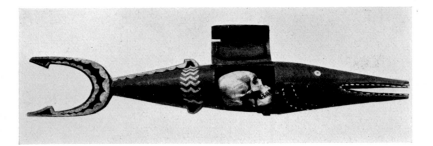
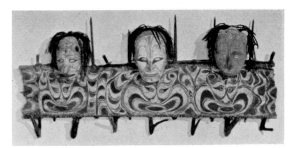

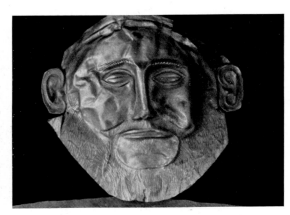
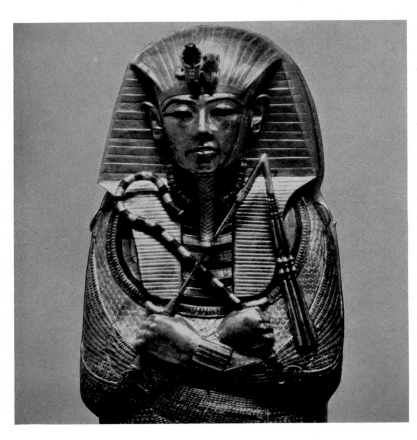
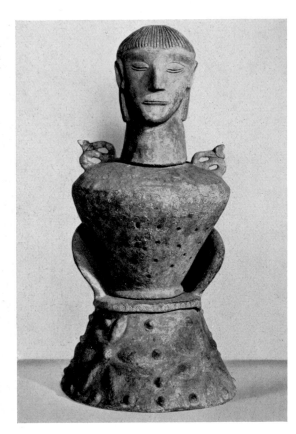

Pl. 449. Preservation of the dead and use of anthropomorphic shapes in burial objects. *Above, left*: Skull receptacle in the shape of a bonito, from Santa Ana, Solomon Islands. Painted wood. London, British Museum. *Right*: Painted board with ancestor heads, from Sepik region, New Guinea. Hamburg, Museum für Völkerkunde. *Center, left*: Wangata gynecomorphous bier, detail, Congo. Wood. Tervueren, Belgium, Musée Royal de l'Afrique Centrale. *Right*: Funerary mask, from the royal tombs, Mycenae, Greece, 1600–1500 B.C. Gold, ht., 12 3/8 in. Athens, National Museum. *Below, left*: Mummy case of Tutankhamen, detail, 1358–1349 B.C. Gold and precious stones; full ht., 6 ft., 7/8 in. Cairo, Egyptian Museum. *Right*: Etruscan canopic vase, from Sarteano, near Chiusi, Italy, second half of 7th cent. B.C. Terra cotta, ht., 29 1/8 in. Florence, Museo Archeologico.

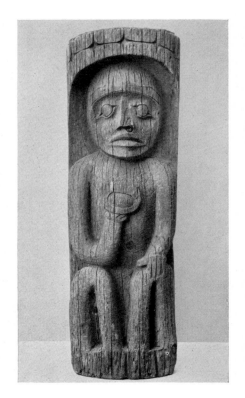

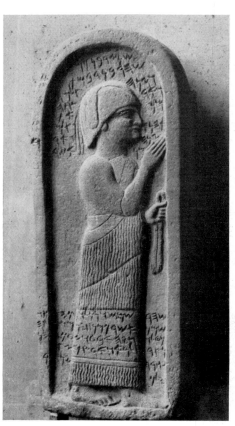
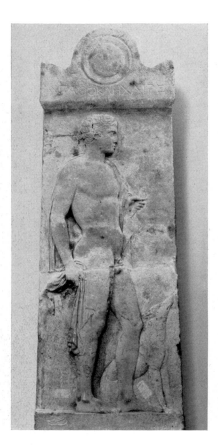
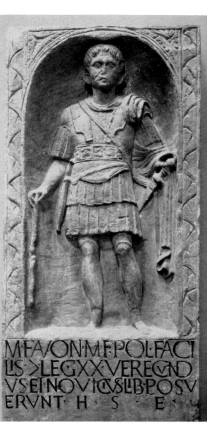

Pl. 450. Funerary steles. *Above, left*: Stone with two breastlike protuberances, near nuraghe at Tamuli, Sardinia, 2d–1st millennium B.C. *Center*: Menhir stele, from Fivizzano, Italy, 2d–1st millennium B.C. Stone, ht., 39 3/8 in. La Spezia, Italy, Museo Archeologico Lunense. *Right*: Tomb figure, from Vancouver Island, British Columbia. Wood. Copenhagen, Nationalmuseet. *Below, left*: Aramaic funerary stele, from Neyrab, Syria, first half of 6th cent. B.C. Basalt, ht., 36 5/8 in. Paris, Louvre. *Center*: Greek funerary stele, from Thespiai, Greece, ca. 440 B.C. Marble, ht., 8 ft., 6 3/8 in. Athens, National Museum. *Right*: Roman funerary stele, from Camulodunum (mod. Colchester), England, late 1st cent. Stone, ht., 5 ft., 10 7/8 in. Colchester, Museum. (Photographed from cast in Rome, Museo della Civiltà Romana.)

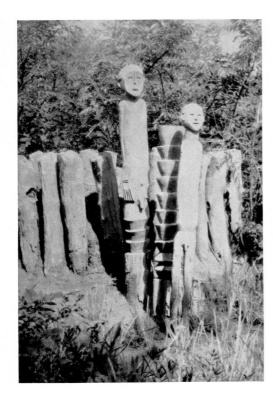
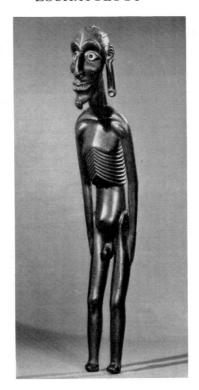
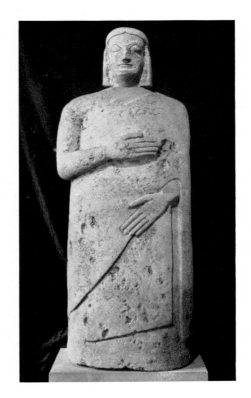
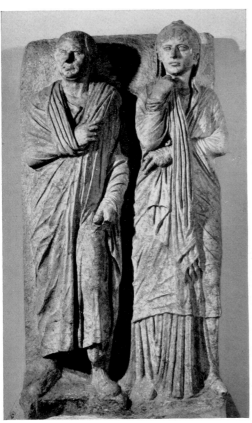
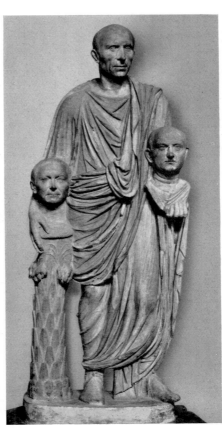
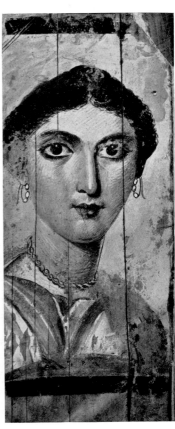

Pl. 451. Images of the dead. *Above, left*: Bongo tomb figures of Chief Ngul and his son, Tonj region, Sudan. Wood. *Center*: Ancestor figure in "skeletal" style, from Easter Island. Wood. Auckland, New Zealand, Auckland Museum. *Right*: Etruscan cinerary statue, from Chianciano, Italy, late 6th cent. B.C. Limestone, ht., 4 ft., 5½ in. London, British Museum. *Below, left*: Portrait statues on a Roman funerary stele, ca. mid-1st cent. B.C. Marble, ht., 6 ft., ⅞ in. Rome, Palazzo dei Conservatori, Museo Nuovo. *Center*: Portrait statue of Roman holding busts of his ancestors, 1st cent. Marble, ht., 5 ft., 10⅞ in. Rome, Museo del Palazzo dei Conservatori. *Right*: Portrait of the deceased attached to mummy wrappings, from Fayum, Egypt, ca. mid-2d cent. Panel, ht., 13¾ in. Paris, Louvre.

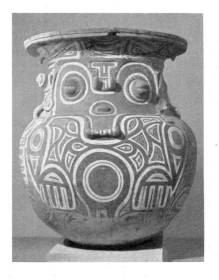
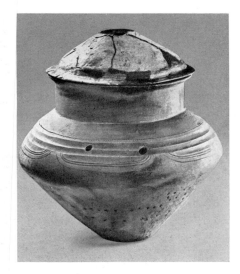
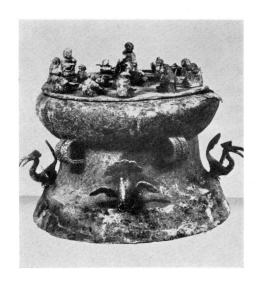
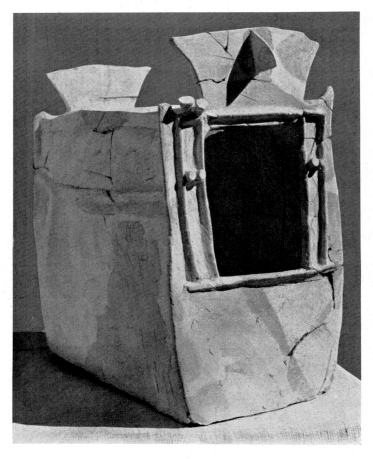

Pl. 452. Urns. *Above, left*: Funerary urn, from Marajó, Brazil. Terra cotta. Belém, Brazil, Museu Paraense Emilio Goeldi. *Center*: Ossuary of the early "urn-field" culture, with soul apertures, 1200–1000 B.C. Terra cotta, ht., 15³/₈ in. Singen, Germany, Hegau-Museum. *Right*: Bronze found in tomb on Mt. Shih-chai, Yunnan, China, Han dynasty (206 B.C. – A.D. 221). Property of the Chinese government. *Below, left*: Neolithic Palestinian cinerary urn. Terra cotta. Jerusalem, Jordan, Archaeological Museum. *Right*: Cinerary urn, from tomb of the Platorini, Rome, 1st cent. Marble, ht., 24 in. Rome, Museo Nazionale Romano.

Pl. 453. Sarcophagi. *Above*: Phoenician sarcophagus of Ahiram, from Byblos, 11th–10th cent. B.C. Limestone, l., 9 ft., 9³/₈ in. Beirut, Lebanon, National Museum. *Below*: Sarcophagus with garlands and the deceased at a feast, from Tripoli, Lebanon, 2d cent. Marble. Istanbul, Archaeological Museum.

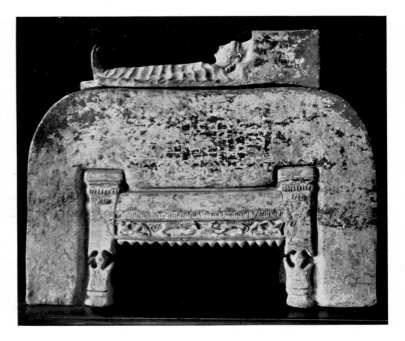

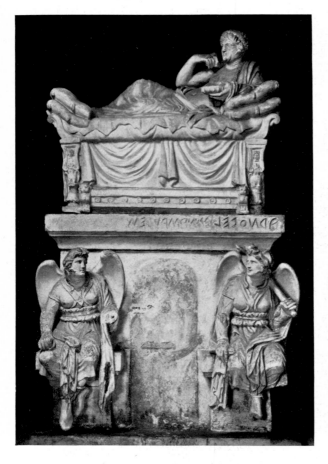

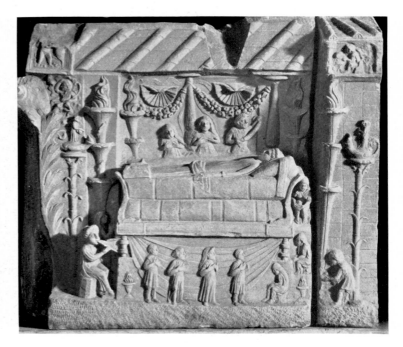

Pl. 454. From funerary couch to burial monument. *Above, left*: Model of an Egyptian New Kingdom funerary couch, 12th–11th cent. B.C. Limestone, l., 9¹/₂ in. Turin, Museo Egizio. *Right*: Etruscan burial urn in the shape of a funerary couch with the deceased reclining, 6th cent. B.C. Terra cotta. Paris, Louvre. *Below, left*: Etruscan burial monument, 2d cent. B.C. Travertine coated with polychromed stucco. Perugia, tomb of the Volumnii. *Right*: Roman relief showing the deceased on funerary couch, from monument of the Haterii, early 2d cent. Marble. Rome, Lateran Museums.

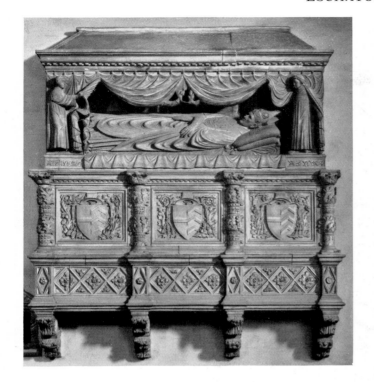

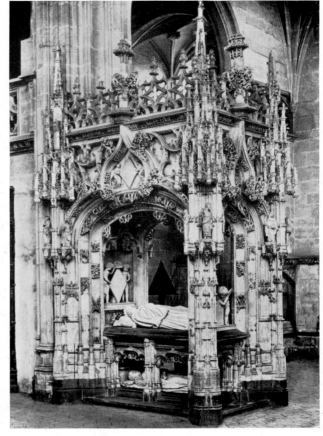

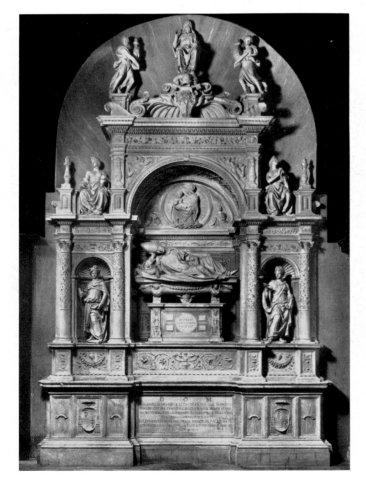

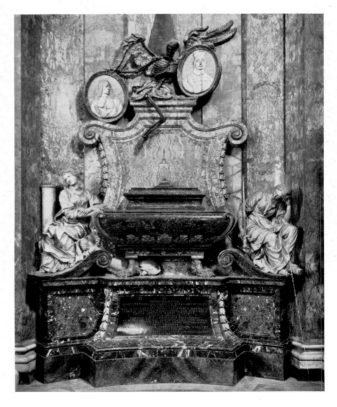

Pl. 455. From funerary couch to burial monument. *Above, left*: Tomb of Cardinal Marco da Viterbo, Tuscan school, 14th cent. Marble. Viterbo, S. Francesco. *Right*: Tomb of Margaret of Austria, 16th cent. Marble. Brou, France, Cathedral. *Below, left*: A. Sansovino, tomb of Cardinal Ascanio Sforza, 1507. Marble. Rome, S. Maria del Popolo. *Right*: G. Mazzuoli, tomb of Stefano Pallavicini. Polychromed marble and bronze. Rome, S. Francesco a Ripa.

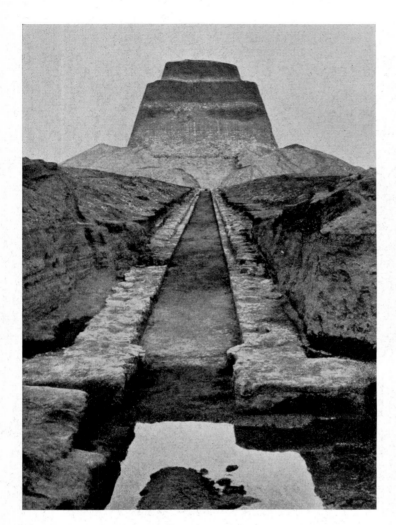

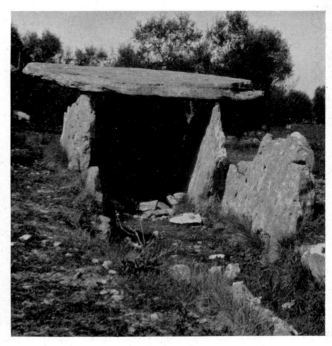

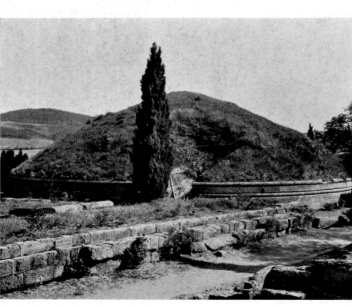

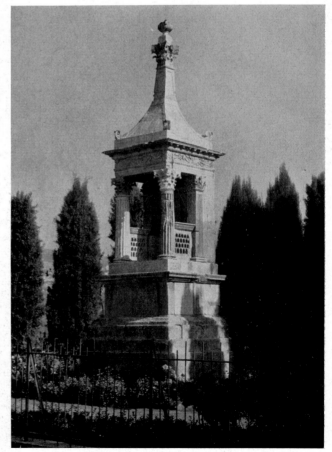

Pl. 456. Tombs and mausoleums. *Above, left*: Medum, Egypt, the pyramid, 3d–4th dynasty. *Right*: Bisceglie, near Bari, Italy, Bronze Age dolmen. *Below, left*: Cerveteri, Italy, Etruscan tumulus, 7th cent. B.C. *Right*: Sarsina, near Forlì, Italy, Roman mausoleum, late 1st cent. B.C. Marble.

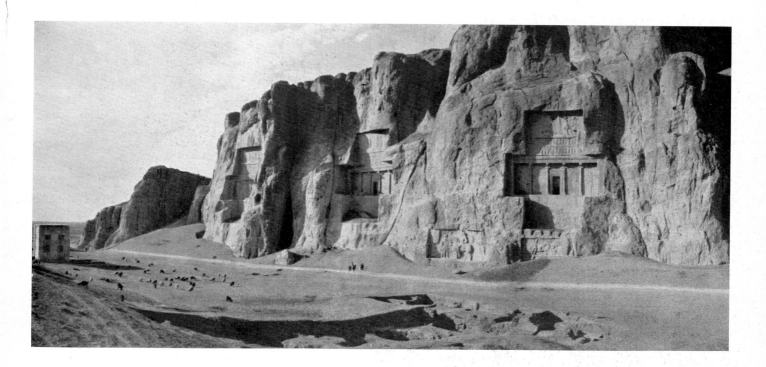

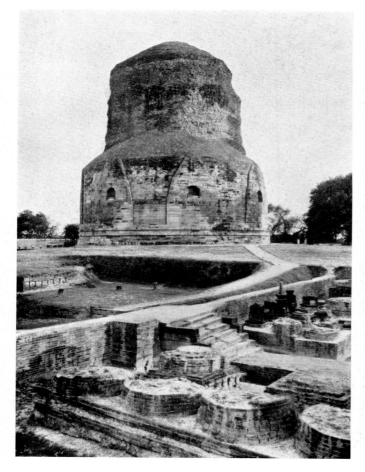

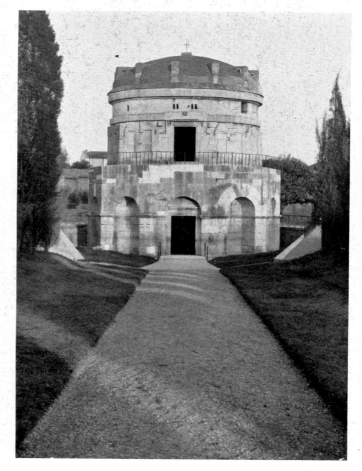

Pl. 457. *Above*: Naqsh-i-Rustam, Iran, tombs of the Achaemenids, 6th–5th cent. B.C. *Below, left*: Sarnath, near Benares, India, Dhā-mekh stupa, ca. 6th cent. *Right*: Ravenna, Mausoleum of Theodoric, 4th cent.

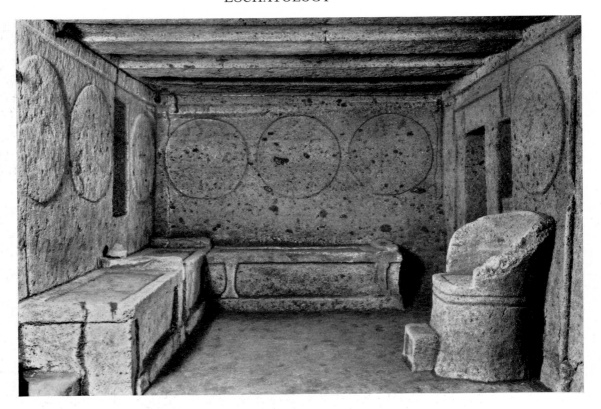

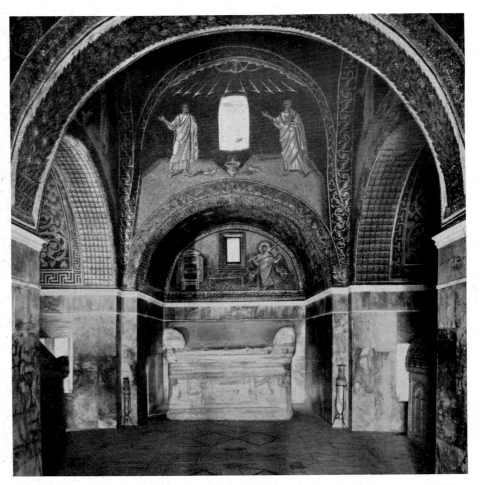

Pl. 458. *Above*: Cerveteri, Italy, Etruscan necropolis, Tomb of the Chairs and Shields, detail, late 7th–early 6th cent. B.C. *Below*: Ravenna, so-called "Mausoleum of Galla Placidia," 5th cent.

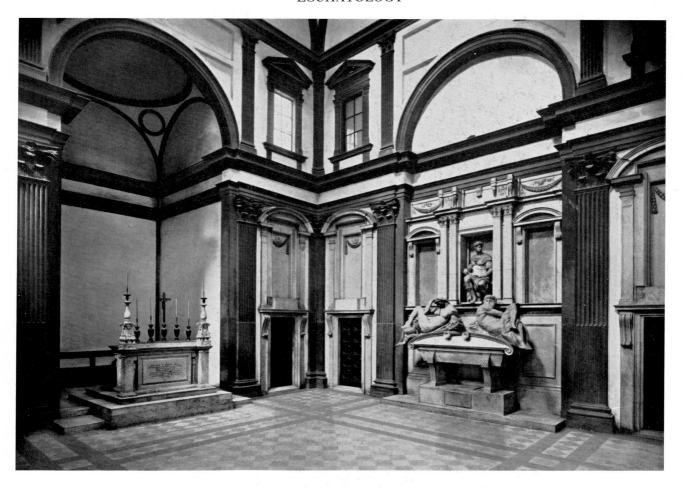

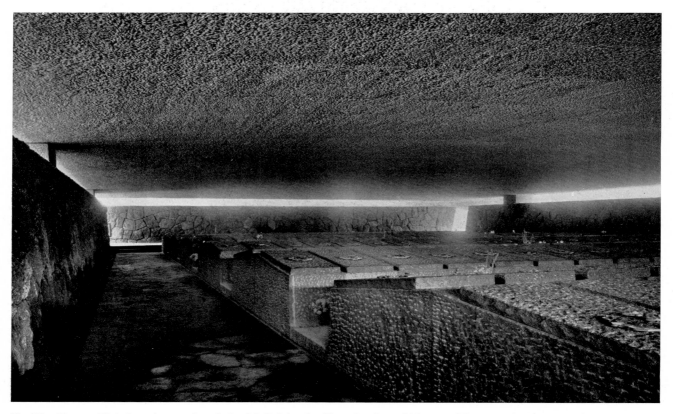

Pl. 459. *Above*: Michelangelo, tombs of the Medici in the New Sacristy, 16th cent. Florence, S. Lorenzo. (Cf. IX, PLS. 530, 531.) *Below*: Tombs in the World War II memorial park of the Fosse Ardeatine, Rome.

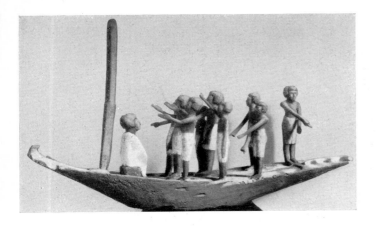

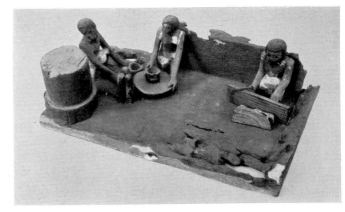

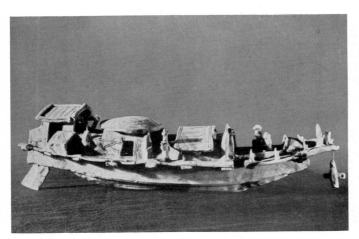

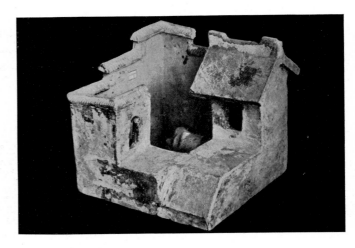

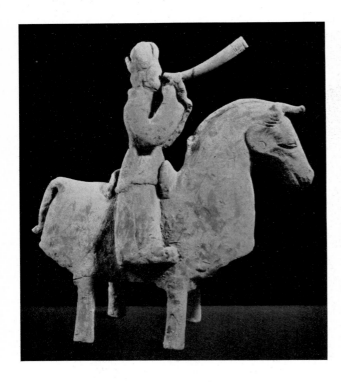

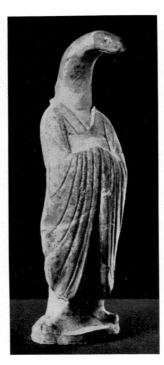

Pl. 460. Tomb furnishings. *Above*: Egyptian wooden models. *Left*: Ship forming part of funeral cortege, early 2d millennium B.C. Turin, Museo Egizio. *Right*: Potter's shop from tomb at Saqqara, late 3d millennium B.C., 15×10¼ in. New York, Metropolitan Museum. *Center and below*: Chinese terra-cotta models and figurines. Property of the Chinese government. *Center*: Ship and pigsty, Han dynasty (206 B.C. – A.D. 221). L. of ship, 21¼ in. *Below, left*: Knight, Northern Wei dynasty (386–535). Ht., 15⅜ in. *Middle*: Serpent-headed figure. Ht., 15¾ in. *Right*: Female figure. Ht., 18½ in. Last two, T'ang dynasty (618–906).

Pl. 461. Depiction of funerals. *Above, left*: Funeral cortege, Nayarit style, from northwest Mexico. Terra cotta. Hollywood, Stendahl Art Galleries. *Right*: Exhibition of the deceased and funeral lamentation, detail of Geometric-style amphora from the Kerameikos cemetery, Athens, 8th cent. B.C. Full ht., 5 ft., ³/₄ in. Athens, National Museum. *Below*: Antoine le Moiturier, tomb of Philippe Pot, 15th cent. Polychromed stone. Paris, Louvre.

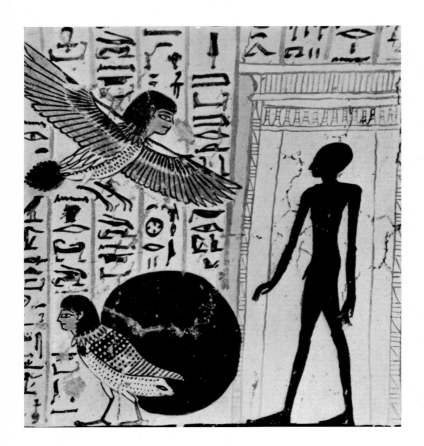

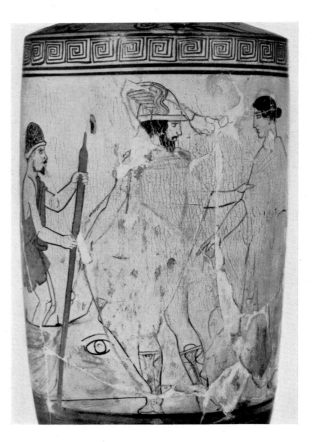

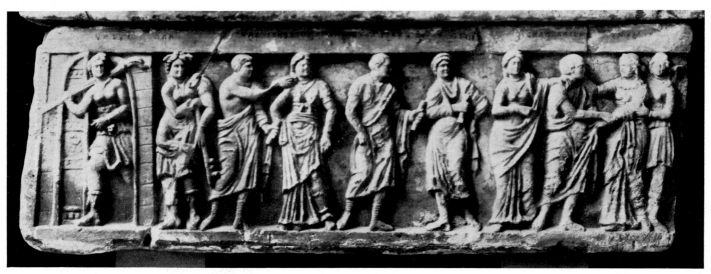

Pl. 462. The dead and entry into the other world. *Above, left*: "Soul birds" and "shadow" of the deceased, wall painting in tomb of Iri-Nufer at Deir el-Medineh, 13th cent. B.C. *Right*: Hermes Psychopompos and Charon, detail of Attic lekythos, ca. mid-5th cent. B.C. Ht. of figured band, 7 1/2 in. Munich, Staatliche Antikensammlungen. *Below*: Husband receiving his wife and cortege of relatives on threshold of Hades in the presence of demons from the other world, relief on Etruscan sarcophagus, from Chiusi, Italy, second half of 2d cent. B.C. Alabaster, l., 6 ft., 2 3/8 in. Palermo, Sicily, Museo Nazionale.

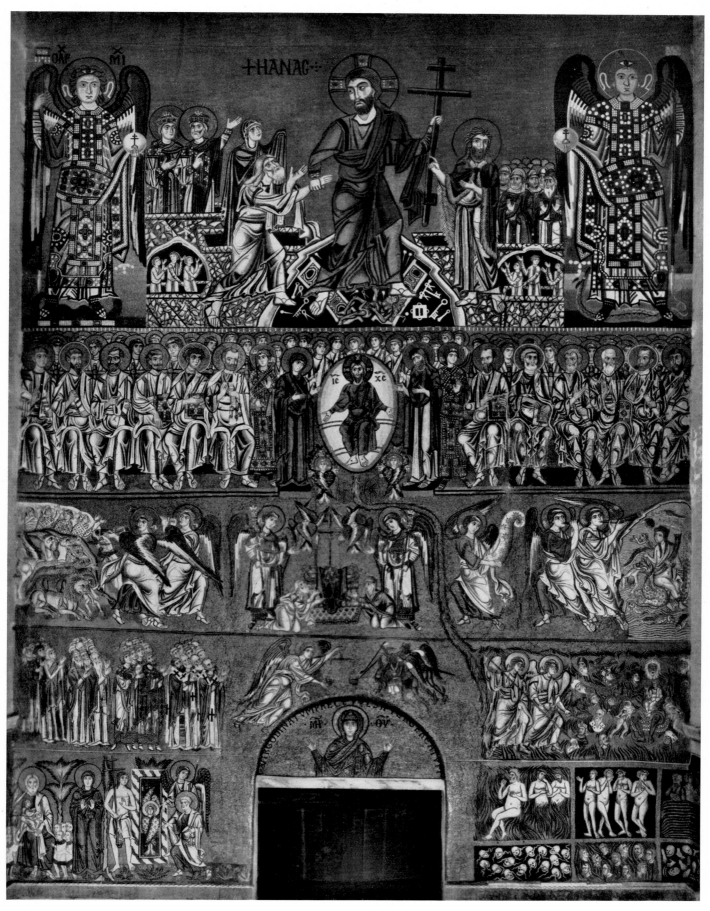

Pl. 463. Last Judgment, 13th cent. Mosaic. Cathedral of Torcello, near Venice.

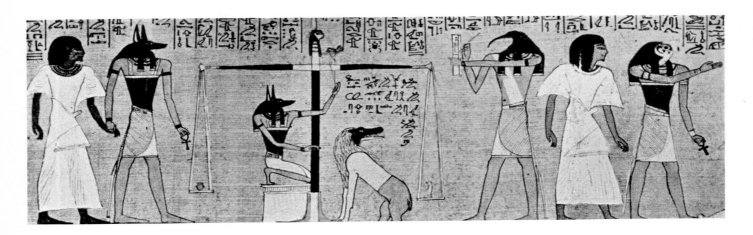

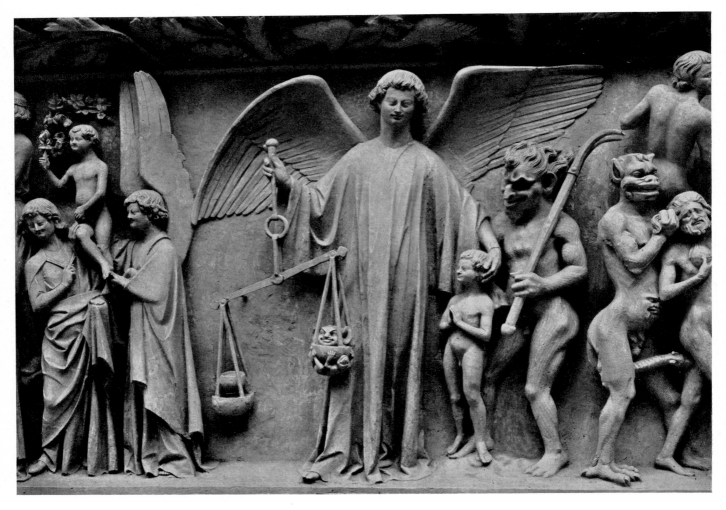

Pl. 464. Judgment and weighing of souls (*psychostasia*). *Above*: The Egyptian god Anubis leading the deceased to the scale where his heart will be weighed before the goddess Maat, Hu-Nefer papyrus, 1550–1030 B.C. London, British Museum. *Below*: The weighing of souls, detail of Last Judgment, mid-13th cent. Marble. Bourges, France, Cathedral.

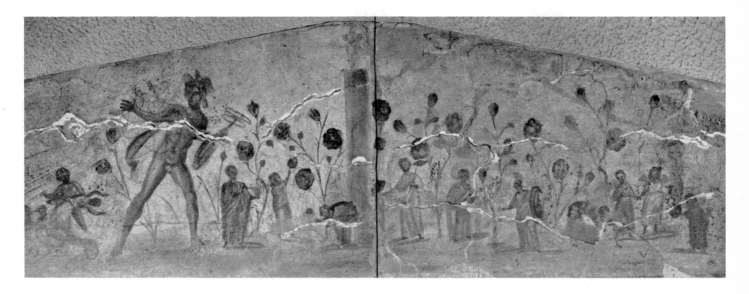

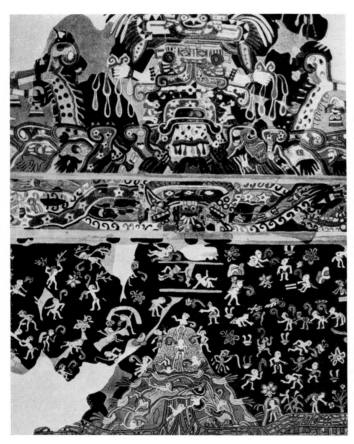

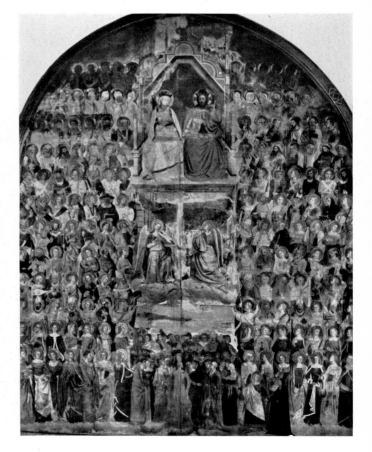

Pl. 465. The other world and Paradise. *Above*: Hermes Psychopompos and souls of the dead in the Elysian Fields, from tomb of the Gens Octavia, Rome, early 3d cent. Wall painting, l., 7 ft., 7 in. Rome, Museo Nazionale Romano. *Below, left*: Paradise of the drowned, protected by the god Tlaloc. Wall painting. Teotihuacán, Mexico, Palace of the Priests. *Right*: Nardo di Cione, Paradise, 14th cent. Fresco. Florence, S. Maria Novella.

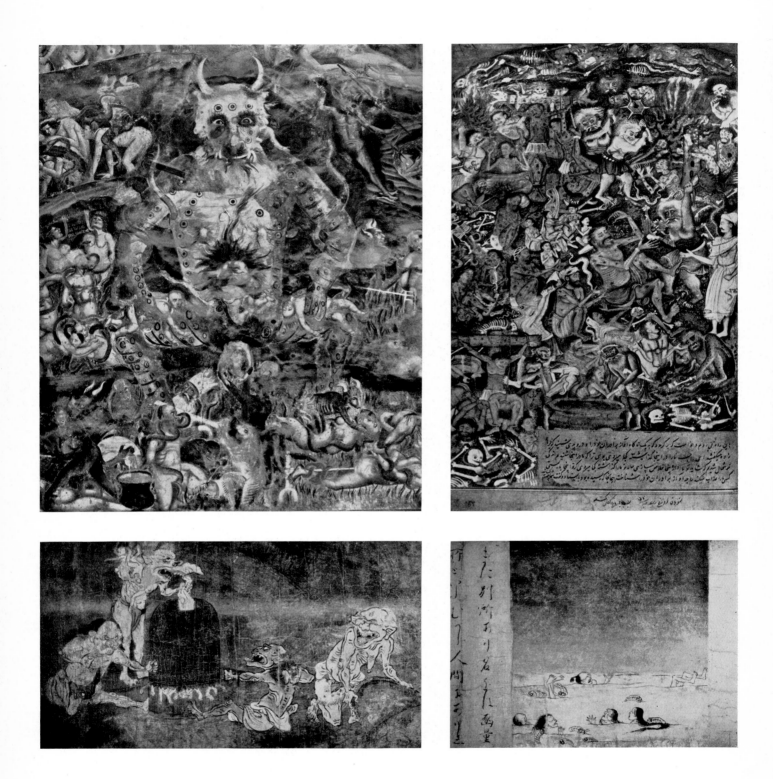

Pl. 466. Hells. *Above, left*: Hell, Pisan school, 14th cent. Fresco. Pisa, Camposanto. *Right*: Descent of Yudhiṣṭhīra to Hell, India, 16th cent. Miniature from the *Rasm-nāma*. Jaipur, India, Royal Library. *Below, left and right*: Two Japanese depictions of hell, Kamakura period, 12th–13th cent. Color on paper. Tokyo, Commission for the Protection of Cultural Properties.

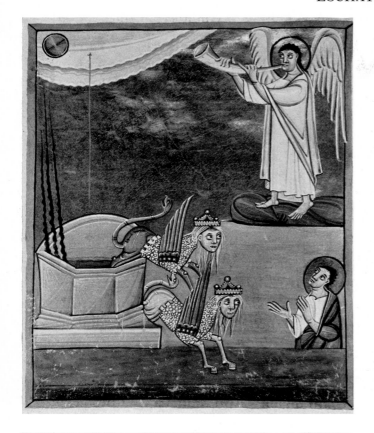

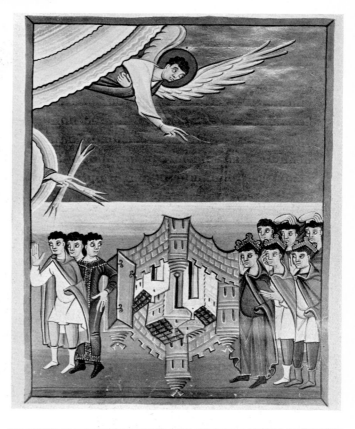

Pl. 467. Apocalyptic scenes. *Above*: Miniatures from Apocalypse of St. John, Reichenau, ca. 1020. Bamberg, Germany, Staatliche Bibliothek. *Left*: The Fifth Trumpet (fol. 23r). *Right*: The Fall of Babylon (fol. 45r). *Below*: A. Dürer, Apocalypse woodcuts. *Left*: Seven-headed Dragon and Beast with two horns like a lamb. *Right*: The blessed rewarded and sinners punished.

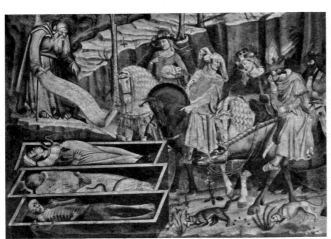

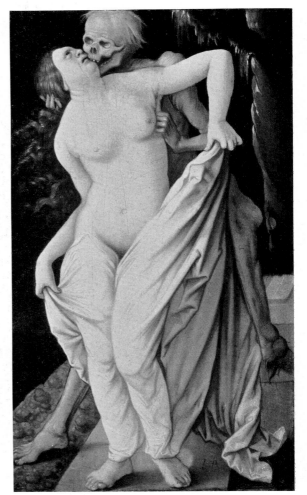

Pl. 468. Allegories of Death. *Left, above*: L. Costa, Triumph of Death, ca. 1490. Fresco. Bologna, S. Giacomo Maggiore, Bentivoglio Chapel. *Center*: The three living and the three dead, detail of Triumph of Death, Pisan school, 14th cent. Fresco. Pisa, Camposanto. *Below*: Dance of Death, detail, 15th cent. Fresco. La Chaise-Dieu, France, St-Robert. *Right, above*: Triumph of Death, detail of fresco from Palazzo Sclafani, 15th cent. Palermo, Sicily, Galleria Nazionale della Sicilia. *Below*: H. Baldung-Grien, Death Kisses a Maiden. Panel, 11 5/8 × 6 7/8 in. Basel, Öffentliche Kunstsammlung.